𝕿𝖍𝖊 𝕹𝖊𝖜 𝖄𝖔𝖗𝖐 𝕿𝖎𝖒𝖊𝖘
Guide to the Arts
of the 20th Century

Volume 1 1900 –1929

The New York Times Guide to the Arts

Guide to the

Arts

of the **20th Century**

Volume 1 1900–1929

FITZROY DEARBORN PUBLISHERS
CHICAGO · LONDON

Copyright © 2002 The New York Times

For information write to:

FITZROY DEARBORN PUBLISHERS
919 North Michigan Avenue, Suite 760
Chicago IL 60611
USA

or

FITZROY DEARBORN PUBLISHERS
310 Regent Street
London W1B 3AX
England

$10/02$

British Library and Library of Congress Cataloging in Publication Data are available.

ISBN 1-57958-290-7

First published in the USA and UK 2002

Typeset by Print Means, Inc., New York, New York

Printed by Edwards Brothers, Ann Arbor, Michigan

Cover Design by Peter Aristedes, Chicago Advertising and Design, Chicago, Illinois

Cover Photos
Top, left to right: Theatrical producer Harley Granville-Barker; detail from the jacket design for *All Quiet on the Western Front* by Erich Maria Remarque; photo from *The South Pole: An Account of the Norwegian Antarctic Expedition in the Fram, 1910–1912* by Roald Amundsen; silent film actress Gloria Swanson. Middle, left to right: Dancer Tamara Geva; *The Oyster Gatherers* by John Singer Sargent; author Ernest Hemingway. Bottom: Detail from *Social Chaos* by Diego Rivera.

Contents

VOLUME 1

VOLUME 2

VOLUME 3

VOLUME 4

Contributors

New York Times Contributors

D. J. R. Bruckner (Introduction, 1910s, 1920s; literature article selections) has been editor of *The New York Times* Book Review and theater critic for *The Times* for 20 years. He was previously the labor editor of *The Chicago Sun Times,* the national affairs columnist of *The Los Angeles Times* and the Vice President for Public Affairs of the University of Chicago. He has written several books about art and photography and a critical account of the life and work of the American type designer Frederic W. Goudy.

Patricia Cohen (Introduction, 1960s) is Ideas Editor at *The New York Times* and the founding editor of the paper's Arts & Ideas section. She has worked at *The Washington Post, Rolling Stone* magazine and *New York Newsday* and *Newsday.*

Holland Cotter (art and architecture article selections) is an art critic for *The New York Times.* He studied poetry with Robert Lowell at Harvard University and has graduate degrees in art history from the City University of New York and Columbia University, where he has taught South Asian and Islamic art. He was editor of *New York Arts Journal,* contributing editor at *Art in America* and an editorial associate of *Art News.* He has published work in magazines and journals in the U.S., Europe and Asia, and is at work on two books, one on early Indian Buddhist sculpture, the other on art in New York between 1954 and 1964.

Ken Emerson (Introduction, 1900s), the former Articles Editor of *The New York Times Magazine* and Op-Ed Editor of *New York Newsday,* is the author of *Doo-dah!: Stephen Foster and the Rise of American Popular Culture.* He is currently working on a book about popular songwriters associated with the Brill building in New York City during the 1950s and 1960s.

Mel Gussow (Introduction, 1980s; theater article selections), cultural writer for *The New York Times,* is the author of the biography, *Edward Albee: A Singular Journey.* He has also written books about Harold Pinter, Tom Stoppard and Samuel Beckett, and was the co-editor of the *Library of America* two-volume edition of the plays of Tennessee Williams. Mr. Gussow was a recipient of a Guggenheim Fellowship and of the George Jean Nathan Award for Dramatic Criticism (for reviews and essays that appeared in *The Times*).

Bernard P. Holland (music article selections) has been the national music critic of *The New York Times* since October 2000. Previously, he had been chief music critic for more than five years. Prior to joining *The Times* in 1981, he was music critic for *The Pittsburgh Post Gazette;* a self-employed music teacher from 1968 to 1980, and a student of piano and composition at the Vienna Academy of Music, at the Paris Conservatory and in London, from 1958 to 1966.

Anna Kisselgoff (dance article selections) was named Chief Dance Critic of *The New York Times* in 1977. She had been a dance critic and cultural news reporter since joining the newspaper's cultural news department in 1968. She has reviewed performances by all major dance companies and has written extensively on the dance, not only for *The Times* but for *Dance News, On Pointe, Playbill* and other publications. She began studying ballet in New York at the age of four with Valentina Belova and trained for eight years with Jean Yazvinsky, a former dancer in Diaghilev's Ballets Russes.

John Leonard (Introduction, 1950s, 1970s) is a book critic for *The Nation,* media critic for *CBS News Sunday Morning* and television critic for *New York* magazine. His books include *The Last Innocent White Man in America, When the Kissing Had to Stop* and *Lonesome Rangers.* He has been a columnist for *The New York Times, Newsday, Life* and *Esquire,* and was the editor of *The New York Times* Book Review in the 1970s and the Literary Editor of *The Nation* in the 1990s.

Edward Rothstein (Introduction, 1930s, 1990s) is Cultural Critic at Large for *The New York Times,* writing criticism on literature, music, intellectual life, the arts and technology. He was chief music critic of *The New York Times* (1991–1995), a technology columnist for *The New York Times,* and the music critic for *The New Republic* (1984–1991). He is the author of *Emblems of Mind: The Inner Life of Music and Mathematics,* which was named one of the 25 best books of 1995 by both *Publisher's Weekly* and the New York Public Library. He has won two ASCAP-Deems Taylor Awards for his music criticism and an Ingram Merrill Foundation Award, and was a Guggenheim Fellow in 1991.

Julie Salamon (television article selections) became a television critic for *The New York Times* in May, 2000. Prior to joining *The Times,* she was a reporter for the *Wall Street Journal,* covering banking and commodities from 1978 to 1983, and was the paper's film critic from 1983 to 1995. Her work has also appeared in *The New Yorker, The New Republic, Vogue* and *Vanity Fair.* Ms. Salamon is the author of five books: *White Lies* (a novel), *The Devil's Candy* (a work of nonfiction), *The Net of Dreams* (a family memoir), *The Christmas Tree* (a novella which was a *New York Times* best-seller) and *Facing the Wind* (a nonfiction narrative).

A. O. Scott (Introduction, 1940s; film article selections) is a film critic at *The New York Times* and a frequent contributor to

The New York Times Book Review and the Sunday *Magazine.* Previously, he was the Sunday book critic for *Newsday* and a member of the editorial staff of *The New York Review of Books* and *Lingua Franca.* He has contributed to *The Salon Readers Guide to Contemporary Authors,* and his essays on literature and popular culture have appeared in *The New York Review of Books, The New Yorker, Slate* and other publications.

Special Contributor

Susan Doll is an instructor of film studies at Oakton Community College and holds a Ph.D. in film studies from Northwestern University. She has written books on Elvis Presley and Marilyn Monroe and has published various film-related articles.

Research Coordinator

Ingrid Nyeboe, President of Print Means Inc., holds a Magister degree in Theater from the University of Copenhagen. From 1969 to 1993, she worked as a director, managing director and fundraiser in Off Off Broadway theaters.

Researchers

Carole Ashley is an artist, writer and translator and is an editor at Lusitania Press. She was a contributing editor to *Vice Versa* and has written for *The Tribeca Trib.*

Frank Caso is a freelance writer and editor who has, among other things, published more than 200 book reviews.

Mary Morley Cohen is a Ph.D. candidate in cinema and media studies at the University of Chicago and teaches classes in the history of cinema.

Danielle Goldman is currently working toward a Ph.D. in performance studies at New York University. She dances with Troika Ranch Dance Theater and with various independent choreographers in New York City.

David Laborier graduated from Berklee College of Music with a degree in jazz performance and is currently a guitar instructor at the Westerhoff School of Music and Art.

Anja Musiat holds a master's degree in performance studies from New York University and is completing a second master's program from the University of Copenhagen.

Matthew Guy Nichols, consultant to Phillips Auctioneers and contributor to *Art in America,* holds a Ph.D. in the history of art from Rutgers University. His dissertation was on Andy Warhol's art of the 1950s.

Cary Paquette holds a degree in Fine Arts from New York University. She currently resides in Washington, DC, where she works for The Washington Post.

Peter Schimpf is music critic for the *Bloomington Independent* and the *Columbus Republic* and is pursuing a Ph.D. in musicology at Indiana University.

Christopher Stahl is a Ph.D. candidate in the department of performance studies at New York University. He has delivered papers in theater and contemporary performance at the conferences of the Association for Theater in Higher Education and Performance Studies International, and contributed to publications such as *LGNY, Culture Shock* and *Theatrical Index.*

Elke Worndle, a mezzo soprano, has studied at the Musical School of Villa Liebenstein, the Mannheim Conservatory and Berklee College.

Publisher's Note

The 20th century was a time of unprecedented change in human history, in almost every way imaginable—politically, technologically, socially, culturally, esthetically. Not surprisingly, these changes significantly affected the course of artistic practice and production during this period. While *The New York Times Guide to the Arts of the 20th Century* accomplishes many things, above all else it chronicles this evolution and the resultant public response.

For each of the seven arts addressed here, academically trained researchers pored over the indexes and microfilm archives of *The New York Times* for the years 1900 to 1999 and gathered hundreds of articles concerning the key events and achievements in that medium. This material then went through a collaborative, multistage review by some of *The Times's* top cultural contributors, who winnowed and supplemented the selections to produce this compilation of 2,500 critical reviews, news stories, essays, interviews and editorial commentaries.

As might be expected, the coverage offered in these volumes is a legitimate subject of contention. Any attempt at detailing such a broad and rich field of creative endeavor would involve practical limitations and subjective judgments. The added restriction of drawing the content from a single journalistic source—even one as respected and influential as *The Times*—excludes any attempt at producing a definitive survey of the subject matter. Certain aspects of the selection were driven as much by the newspaper's coverage throughout the century as by the accepted academic views of today. Thus, the literature selections address a high proportion of nonfiction works, reflecting a similar editorial focus by the paper, and certain aspects of popular music are represented incompletely, as they were by *The Times* for much of the century.

Furthermore, journalism and journalistic criticism are imperfect ventures. The interpretations and even the facts presented herein sometimes prove inaccurate, though in that inaccuracy the astute reader may yet find pertinence. For example, one article from 1909 credits bandmaster John Philip Sousa with originating ragtime music (untrue) and declares the popular genre dead (also untrue). Though specious in content, this item precisely reflects prevailing critical prejudices and thus documents a significant musicological issue of the period.

Such limitations and subtleties are the exception here, rather than the rule. More representative of the collection overall are the make-or-break theater reviews of Alexander Woollcott, enlivened by his piercing Algonquin wit; the wide-ranging coverage of the burgeoning film industry early in the century; the criticism of John Martin that helped shape the development of modern dance over five decades; the calculated yet impassioned defenses of abstract art by various *Times* writers in the 1940s; or the pioneering architectural criticism of Ada Louise Huxtable.

These articles, written during and for precise moments in time, offer a unique and valuable view of 20th century artists, their work and their public. Some offer the words and thoughts of the artists themselves. Others include revealing details that have been lost to the standard retrospective histories. As primary source documents, all convey the artistic, critical and popular perceptions and prejudices of their time in a way that no other material can.

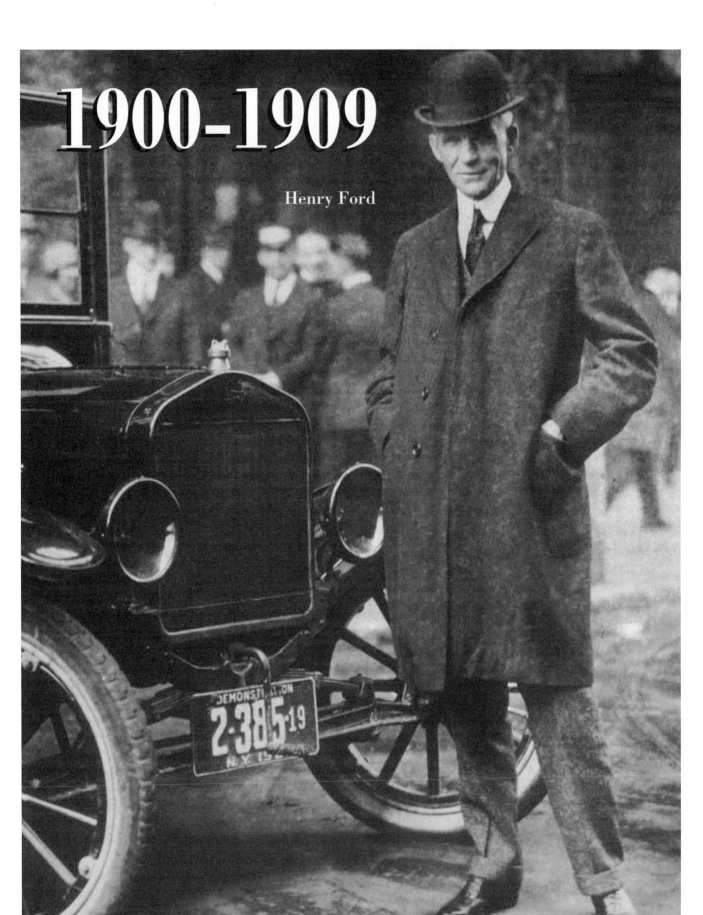

1900-1909

Henry Ford

MAJOR EVENTS OF THE DECADE

Boxer Rebellion in China. The Boxers, an anti-foreign society, lay a two-month siege to the foreign embassy quarters in Peking. The revolt is a reaction to long-standing foreign domination of China.

Up from Slavery, Booker T. Washington's autobiography about his move from Southern slave to cofounder of the Tuskegee Institute, is published.

The Russo-Japanese War begins, sparked by Russian designs on Korea. The following year, Japan delivers Russia a humiliating defeat, signaling Japan's rise as a major world power.

The Royal Academy of Dramatic Art is founded in London, and the Abbey Theatre is founded in Dublin. Both produce some of the 20th century's greatest stage and screen actors.

Ida Tarbell publishes an expose of Standard Oil titled *History of Standard Oil*, and Lincoln Steffens publishes *The Shame of the Cities*, both exposing corrupt business and political practices. In 1906, Upton Sinclair writes *The Jungle*. U.S. President Theodore Roosevelt disparagingly refers to these writers as "muckrakers," but the group adopts the title in the name of reform.

Henry Ford introduces the Model T, an inexpensive motor car that becomes affordable to the masses. Assembly-line production begins in 1909.

Jack Johnson becomes the first African American heavyweight boxing champion.

Frank Lloyd Wright designs the Robie House, an example of the prairie style that is the hallmark of his career.

The Boer War ends with Peace of Vereeniging. The bitter conflict, which began in 1899, concludes with the British forcing the Boers (Dutch colonists) to accept British rule.

French composer Claude Debussy, an Impressionist who helped introduce a more intangible, vague style to classical music, produces his only completed opera, *Pelleas et Melisande*, in Paris.

French filmmaker Georges Melies, pioneer of fantasy films and special effects, releases *A Trip to the Moon*. Melies and *Trip* influence filmmakers worldwide to create longer films with fuller, more complex story lines.

Composer George M. Cohan debuts his musical *Little Johnny Jones* on Broadway, which generates several song standards ("Give My Regards to Broadway") and crystallizes a style of American popular theater.

The San Francisco earthquake and its ensuing fires leave 3,000 dead.

The first console gramophone with an internal horn appears, which is manufactured by Victor Victrola. The gramophone plays recorded discs, invented in 1903, not cylinders.

1900　1901　1902　1903　1904　1905　1906　1907　1908　1909

Orville and Wilbur Wright achieve flight with a heavier-than-air craft at Kitty Hawk, North Carolina, initiating a revolution in transportation.

Panama declares independence from Columbia. Shortly thereafter, the Hay-Bunau-Varilla Treaty grants the U.S. rights to the Panama Canal Zone. The following year, the U.S. begins building the Panama Canal.

Opera star Enrico Caruso records *Vesti la Giubba*, the first record to sell one million copies.

American modern-dance pioneer Isadora Duncan begins performing her dances influenced by Greek art, marked by bare feet and flowing scarves.

Oklahoma becomes a state.

In Paris, the first exhibit of Cubist works is held, featuring the work of Pablo Picasso and Georges Braque. Cubism, which breaks down images into geometric shapes until they are virtually unrecognizable, marks an important step toward pure abstraction.

Turn-of-the-century immigration to the United States peaks with the arrival of 1.285 million new citizens.

Robert E. Peary, Matthew Henson and 50 Eskimos become the first men to reach the North Pole. Peary's claims are disputed by Dr. Frederick Cook, who announces that he had reached the Pole in 1908, but Peary's claim is generally supported.

The National Association for the Advancement of Colored People is founded by W.E.B. DuBois.

Russian Sergei Diaghilev premieres his Ballet Russe in Paris, introducing the Russian tradition to the West.

Bakelite is introduced. The first commercially successful plastic, it heralds a revolution in materials engineering that will profoundly affect everyday life.

An abortive revolution occurs in Russia. Demonstrators are shot in St. Petersburg, beginning a period of strikes and political unrest. Though Czar Nicholas II grants limited reforms at this time, this is a precursor to the Russian Revolution.

Albert Einstein formulates the theory of relativity.

German composer Richard Strauss composes his first opera, *Salome*, notable for extending the horizons of the orchestra's role in opera.

In Paris, the Salon d'Automne exhibits the work of Henri Matisse and other painters known as the fauves, who use bright, pure colors disconnected from academy styles of painting.

The first nickelodeon—a facility devoted solely to the exhibition of films—opens in Philadelphia.

American financier J.P. Morgan forms the world's first billion-dollar corporation, U.S. Steel.

Queen Victoria dies, signaling the end of a 63-year reign and the end of an era.

U.S. President William McKinley is assassinated by anarchist Leon Czolgosz. Theodore Roosevelt is sworn in as the new President.

Italian engineer Guglielmo Marconi broadcasts radio waves from England to Newfoundland, marking the invention of the radio.

INTRODUCTION

AMERICA AT A CULTURAL CROSSROADS
By Ken Emerson

George Hurstwood is a man in a hurry. The saloonkeeper has just embezzled $10,000 and can't wait to ditch his wife and run off with Caroline Meeber. He dashes into a drugstore in downtown Chicago, rushes into a telephone booth, and makes a long-distance call. Back in the street, he jumps into the nearest cab—whose driver "beat[s] his horse into an imitation gallop."

With that cantering nag, *Sister Carrie,* first published in 1900, jolts out of our own era and into the distant past. Theodore Dreiser's first novel is as betwixt and between as the decade it inaugurated. On the one hand, the opening years of the twentieth century are recognizably modern, comfortably close to our own experience; on the other, they seem disconcertingly antique.

By 1900, America had become the economic colossus it remains today, enjoying the highest standard of living the world had ever known and supplanting London as the capital of international finance. The novelist Frank Norris hailed the "American commercial invasion of England," predicting that the economic onslaught would not cease until it had cornered the world's markets. In 1901, J.P. Morgan bought out Andrew Carnegie to form U.S. Steel, the first billion-dollar corporation. A couple of years later, the assembly line of the Ford Motor Company started rolling. By 1907, in the words of one economic historian, "the American industrial map [had taken] its modern form."

In addition to a world-class industrial economy, the United States had acquired, almost overnight, a globe-girdling empire. The war against Spain in 1898 had lasted less than three months but left America in possession of Cuba, Puerto Rico, the Philippines, and Guam, to which Hawaii was added by annexation. Rudyard Kipling was the laureate of the British Empire, but it was America's occupation of the Philippines that inspired him to write "The White Man's Burden," his infamous ode to colonial authority and the racial superiority that justified it. In 1900, America even gained a toehold in China by sending troops to help crush the Boxer Rebellion.

This expansion did not go unopposed. Andrew Carnegie helped found the Anti-Imperialist League and offered to buy the Philippines for $20 million in order to set them free. But when William Jennings Bryan ran for president in 1900 as a Democrat averse to empire, he lost in a landslide and failed to carry even his home state of Nebraska. The ease and rapidity of America's economic and imperial conquests moved New York State Senator Chauncey Depew to boast, "There is not a man here who does not feel 400 per cent bigger in 1900 than he did in 1896, bigger intellectually, bigger hopefully, bigger peacefully."

In 1901, both Queen Victoria and William McKinley died. Upon the assassination of the latter, Theodore Roosevelt became President of the United States. As surely as Britannia's Queen had presided over the previous era, T.R. dominated the world stage during the ensuing decade. The first American president ever to travel abroad, the Rough Rider wrested from Colombia a swath of Central American isthmus for the Panama Canal, brokered a settlement of the Russo-Japanese War (for which he won the Nobel Peace Prize), and sent a Great White Fleet of sixteen warships around the world to demonstrate American might. No longer confined to banana republics, gunboat diplomacy ruled the waves.

America in the first decade of the twentieth century was a world power in every realm except for the cultural, where it limped along like Dreiser's horse-drawn hansom. No native paintbrush or pen matched the might of Roosevelt's big stick. One-third of the U.S. population was foreign-born in 1900, yet American artists seemed determined to reverse the flow of immigration. One of America's two greatest living novelists, Henry James, lived in England and wrote that "you had to be, blessedly,

3

an American for all sorts of things: so long as you hadn't, blessedly or not, to remain in America." The other returned to the United States in 1900 after almost a decade's absence abroad, but Mark Twain was past his literary prime. William Dean Howells was referring not only to Twain's ice-cream suits when he called his friend a "whited sepulchre." Like Henry James, two of America's most dashing painters, James Whistler and John Singer Sargent, lived in England, while Mary Cassatt, an acolyte of Degas, preferred to paint domestic scenes and portraits in France. The American women who invented modern dance, Isadora Duncan and Ruth St. Denis, like Loie Fuller just before them, also spent much of the decade abroad. "By the methods of the civil war and the commercial conceptions that followed it, America created the twentieth century," Gertrude Stein wrote, but that did not prevent the maven of modernism from moving to Paris in 1903. When it came to the arts, America was no better than Oakland, California: "There is no there there."

The American artists who stayed at home prompted the philosopher George Santayana, who would leave the States for good in 1912, to delineate in a famous essay the discrepancy between America's cultural and more worldly accomplishments:

> The truth is that one-half of the American mind, that not occupied intensely in practical affairs, has remained, I will not say high-and-dry, but slightly becalmed; it has floated gently in the backwater, while, alongside, in invention and industry and social organization, the other half of the mind was leaping down a sort of Niagara Rapids. This division may be found symbolized in American architecture: a neat reproduction of the colonial mansion—with some modern comforts introduced surreptitiously—stands beside the sky-scraper. The American Will inhabits the sky-scraper; the American Intellect inhabits the colonial mansion. The one is the sphere of the American man; the other, at least predominantly, of the American woman. The one is aggressive enterprise; the other is all genteel tradition.

During the first decade of the twentieth century, what are conventionally designated the high arts lagged behind not only America's economy and empire, but also the arts in Europe. Architecture is one of the few exceptions because it is, after all, a practical art and was commissioned in the absence of an American aristocracy by the captains of the nation's industries. Louis Sullivan's soaring sky-scrapers and Frank Lloyd Wright's ground-hugging prairie houses made architecture one of the few arts (modern dance was another) in which America was internationally advanced.

Modern painting, according to one critic, began officially in Paris in 1905, when the Salon d'Automne exhibited the Fauves: Matisse, Derain, Vlaminck, and Rouault. Two years later, Apollinaire accompanied Braque to Picasso's studio in the Rue Ravignan and Cubism was born, the offspring of Picasso's *Les Demoiselles d'Avignon*. Meanwhile, Richard Strauss was raising a ruckus at the Dresden Opera with dissonances that slithered as provocatively as his Salome danced, and Arnold Schoenberg was causing scuffles in Vienna by discarding the tones of the conventional scale as if they were so many superfluous veils. Elsewhere, after his rejection by Maude Gonne and the rejection by obstreperous audiences at the Abbey Theatre of his friend John Millington Synge's *The Playboy of the Western World* for its unflattering portrayal of the Irish, William Butler Yeats was emerging from the Celtic Twilight and the late romanticism of his early verse into the bracing daylight of modern poetry.

The notion of progress in the arts has been discredited in our post-modern era, and rightfully so. By what measure is Don DeLillo superior to Dickens, or Jackson Pollock more advanced then Giovanni Bellini? Yet few artists active in the United States between 1900 and 1909 bear comparison to their greatest contemporaries in Europe. For the most part, as Santayana wrote, they "floated gently in the backwater."

American audiences, at least those who read *The New York Times*, concurred. It's remarkable how many of the reviews that appear in the following pages are of European writers and painters, European actors in European plays, European singers in European operas, and European conductors leading European symphonies. (Americans composed less than five percent of the repertory performed by U.S. symphony orchestras between 1900 and 1910.) Who can blame American audiences,

or *The New York Times*? There was, during the first decade of the twentieth century, no American Tolstoy, Ibsen, Shaw, Yeats, Rodin, Cézanne, Mahler, or Puccini. Painting some of the most powerful canvases of his long career in the anchorite seclusion of Prout's Neck, Maine, Winslow Homer was widely honored but seldom glimpsed. Charles Ives lived closer to hand on Central Park West but was better known as a crackerjack insurance salesman than as a composer. His Second Symphony, written between 1898 and 1902, would not be performed until Leonard Bernstein conducted a radio broadcast half a century later. Faulkner, Fitzgerald, Hemingway, Robert Frost, T.S. Eliot, Eugene O'Neill, George Gershwin, Aaron Copland, Louis Armstrong—most of the artists whom we think of as our cultural patrimony and who would win world prominence—were a decade or more in the future. It was the burgeoning popular arts during this period rather than the high arts that would establish America's international cultural identity.

The genteel tradition that Santayana indicted was, in his formulation, a complex mix of Calvinism and debased Transcendentalism. But it was also mere prudery, which despite Queen Victoria's death was still alive and kicking in early twentieth-century America. ". . . [A]ny one brought up among Puritans knew that sex was sin," Henry Adams wrote in his famous autobiography, privately published in 1906 and not publicly available for another twelve years. "American art, like the American language and American education, was as far as possible sexless." "In the year 1900," *The New York Times* observed, "morals are opposed to the nude." Thomas Eakins knew this all too well, having resigned as a teacher at the Pennsylvania Academy of the Fine Arts in 1886 over his insistence that female students be permitted to sketch nude male models from life. In 1908, two years before his death, he reiterated his protest against American prudery by painting two versions of *William Rush and His Model,* in which the Philadelphia sculptor of a bygone era (1756–1833), a founder of the Pennsylvania Academy, helps down from a modeling platform a woman presented in scrupulously realistic and defiantly full frontal nudity. (Rush had scandalized Philadelphia when it was discovered that the daughter of a socially prominent family had posed for him in the altogether.) American censoriousness extended from the traditional arts to a fledgling form of twentieth-century entertainment, the cinema. On Christmas Eve of 1908, Mayor George B. McClellan shut down all the nickelodeons in New York City, citing safety conditions as a cover for his moral objections to the one-reelers and their audiences huddled in the dark. Exhibitors won an injunction and reopened, however, and the judge granting the injunction ran for mayor and won.

Genteel America clung to its innocence, embracing *Peter Pan* and the Boy Scouts, both imported from England. Ernest Thompson Seton founded the Woodcraft movement, a precursor to the Boy Scouts of America, in 1902 in order to save the nation's youth from becoming "flat-chested cigarette-smokers, with shaky nerves and doubtful vitality." There's something endearingly boyish about the decade, starting with the President and his boundless enthusiasms. "You must always remember," a British diplomat said, "that the President is about six." One of the most popular books of the decade, Jack London's *The Call of the Wild* (1903), bristled with adult themes, but it was above all a boys' adventure book. Among the most appealing paintings of the period is George Bellows's *Forty-Two Kids* (1907), in which a swarm of boys merrily skinny-dips in New York City's East River. Their nakedness is not an invitation to voyeuristic pederasty, but a celebration of boisterous innocence. Since Freudianism did not become established in the United States until the father of psychoanalysis visited Clark University in Worcester, Massachusetts, in 1909, ignorance of sexuality before puberty was bliss. America did such a good job defending its virginity during the first decade of the twentieth century that a major cultural history, Henry F. May's *The End of Innocence: A Study of the First Years of Our Time,* doesn't begin until 1912. (America was not the only laggard. In England, Virginia Woolf famously observed, "On or about December 1910, human character changed.")

The pressure to preserve innocence is one of the themes of Henry James's *The Golden Bowl* (1904), in which no one dares to acknowledge that Maggie Verver's husband has had an affair with her father's new wife. A family friend, Fanny Assingham, is not alone in feeling "embarrassed by the difference between what she took in and what she could say, what she felt and what she could show."

The impossibility of ever coming right out and saying something is excruciating for nearly everyone, including many readers. For those who persist, however, *The Golden Bowl*'s "rapid play of suppressed appeal and disguised response" yields high comedy and high tragedy.

James was so decorous a novelist that he scarcely even adumbrated (a favorite word of his) what the Ververs' spouses were up to. Indeed, *The New York Times Book Review* accused him of "a kind of restless finicking inquisitiveness, a flutter of aimless conjecture, such as might fall to a village spinster." James partook of the genteel tradition that he scrutinized and skewered, and no one indicted *The Golden Bowl* for indecency. *Sister Carrie,* on the other hand, so offended its publisher's wife that the book was withdrawn and sold only 465 copies. Not until 1907 would Dreiser's story of a woman who is kept by one man and cohabits with another be reissued. Even then *The New York Times Book Review* warned that it did not "recommend the book to the fastidious reader, or the one who clings to 'old-fashioned ideas.' It is a book one can very well get along without reading." A devastated Dreiser did not publish a second novel until 1911.

James, born to economic and Protestant privilege, was the last great American novelist of the nineteenth century; Dreiser, son of an impoverished German Catholic immigrant, was the first important American novelist of the twentieth. The suppression of *Sister Carrie* helps explain why the American novel did not prosper during the first decade of the new century. So do bad luck and timing. William Dean Howells, "the dean of American letters," was very much alive, but his best novels were behind him. Many of the novelists who had been inspired by his social realism and pursued it further died young. Several superb novels and novelists appeared in the late 1890s: Stephen Crane's *The Red Badge of Courage* (1895), Harold Frederic's *The Damnation of Theron Ware* (1896), Kate Chopin's *The Awakening* (1899), Frank Norris's *McTeague* (1899). By 1904, all these authors were dead, and though Henry James's friend, Edith Wharton, first won acclaim with *The House of Mirth* in 1905, the bulk of her work appeared in the following decades.

It was Norris, a reader at Doubleday, Page & Company, who recommended that the house publish *Sister Carrie.* Norris had absorbed the naturalism of Émile Zola and believed that people are driven by hereditary, environmental, social, and economic forces beyond their control. In *The Octopus* (1901), the first novel in Norris's projected trilogy about the production, distribution, and consumption of wheat (the second, *The Pit,* was published posthumously in 1903), farmers in California's San Joaquin Valley are powerless to escape the tentacles of the Southern Pacific Railroad. Norris recognized a kindred spirit in many passages from *Sister Carrie*:

> Among the forces which sweep and play throughout the universe, untutored man is but a wisp in the wind. Our civilization is still in a middle stage, scarcely beast, in that it is no longer wholly guided by instinct; scarcely human, in that it is not yet wholly guided by reason.

Such sentiments also suffuse *The Call of the Wild.* When Buck, half St. Bernard and half shepherd, sheds all traces of domestication and reverts to "the dominant primordial beast" in order to survive in the wilds of the Yukon, the allegorical application to human beings is unmistakable. London's naturalism mixed Nietzsche, Darwin, and Marx. His fellow Socialist, Upton Sinclair, added the influence of contemporary muckraking journalists like Lincoln Steffens and Ida Tarbell (illustrating yet again his primacy, it was Teddy Roosevelt who dubbed them muckrakers). Sinclair may not have converted many Americans to Socialism when he exposed the evils of the meatpacking industry and capitalism in *The Jungle* (1906), but within six months Congress passed the Pure Food and Drug Act and the Beef Inspection Act.

These reform measures imposing public oversight on private enterprise epitomized America's Progressive Era, as the period from 1890 to 1920 is often called. Railing from his bully pulpit against "the malefactors of great wealth," trust-busting T.R. was a card-carrying leader of the Progressive movement, which preferred regulation to revolution, thereby frustrating radicals, and espoused an optimistic faith in the rationality and perfectibility of humankind, thus rejecting the grim determinism of naturalism.

Henry James was too conservative personally and politically to tolerate Socialism, and too profoundly aware of what a character in *The Golden Bowl* calls "Evil—with a very big E" ever to put much stock in Progressivism, but he knew as well as anyone where power lay. When the iron shutter of a London shop clatters down, Maggie Verver's Italian fiancé recognizes, "There was machinery again, just as the plate glass, all about him, was money, was power, the power of the rich peoples." But Maggie is an heiress to millions. Like most of James's characters, no matter how circumscribed by the necessity to keep up social appearances, she enjoys freedom of choice and of conscience. That's why we still read James: to learn what, how, and why his characters choose, even (and especially) when they choose poorly. Carrie, on the other hand, like many of the protagonists in naturalist novels and Lily Bart in *The House of Mirth*, is penniless. (Despite the nation's newfound affluence, a 1904 study found ten million Americans living in poverty.) She has "only an average little conscience, a thing which represented the world, her past environment, habit, convention, in a confused way." We don't identify with Carrie's ineffectual conscience, but with her enormous craving. Dreiser's characters are drawn as helplessly as moths to the bright lights of department stores and swank saloons, to consumer goods and consumer pleasures.

Henry Adams, whose lineage was even more distinguished than Henry James's, shared the naturalists' fascination with magnetism and force. The grandson and great-grandson of presidents marveled at the forcefulness of America's new one, who "showed the singular primitive quality that belongs to ultimate matter—the quality that mediaevil theology assigned to God—he was pure act." Roosevelt, continued Adams, wielded "unmeasured power with immeasurable energy."

Adams was even more mesmerized by the turbines at the Universal Exposition held in Paris in 1900:

> As he grew accustomed to the great gallery of machines, he began to feel the forty-foot dynamos as a moral force, much as the early Christians felt the Cross. . . . Among the thousand symbols of ultimate energy, the dynamo was not so human as some, but it was the most expressive.

An Italian visitor was so enthralled by the exposition's Palace of Electricity, twinkling with 5,700 incandescent bulbs, that he named his daughters Luce (light), Elettricità (electricity), and Elica (propeller)—the third after Orville and Wilbur Wright's first flight at Kitty Hawk in 1903.

The advances and projections of imperial, industrial, and technological power at the beginning of the twentieth century excited and influenced many people, including philosophers. Henri Bergson celebrated the creative energy of the *élan vital*. The pragmatism of William James, Henry's older brother and probably America's most influential public intellectual, came close to identifying truth with whatever works—i.e., acts forcefully on the world. In much American literature of the decade, this translated into a single-minded realism impatient with introspection, abstraction, idealism, and romance. While Freud burrowed into the unconscious and the Wright Brothers took to the skies, most American fiction stuck to the surface of things.

Realism also became the rallying cry of the most interesting new American painting of the period. At the turn of the century, while American plutocrats like J.P. Morgan and Henry Clay Frick plundered Europe and festooned their mansions with the glories of its past, most contemporary American painters were under the sway of Impressionism, which was already *passé* in Europe. "Art in America, of that era," said the painter Everett Shinn, "was merely an adjunct of plush and cut glass. . . . Art galleries of that time were more like funeral parlors wherein the cadavers were displayed in their sumptuous coffins." *The New York Times* begrudgingly admired Mary Cassatt but considered "the apostle of the ugly woman in art" more a French than an American painter. The greatest painters living in the United States were Winslow Homer, "the Hermit of Scarborough" as *The Times* dubbed him (Scarborough is just up the road from Prout's Neck); Albert Pinkham Ryder, who had all but ceased painting his dark canvasses with their mystical

inner glow and lived alone in a debris-strewn apartment on West Fifteenth Street; and Thomas Eakins. Of the three it was easily Eakins who had the greatest influence on the next generation of American painters.

The most important exhibition of contemporary American art in the first decade of the twentieth century occurred in 1908, the same year Eakins painted two versions of *William Rush and His Model.* The Macbeth Gallery, New York's first gallery specializing in American art, exhibited "The Eight," a group that had formed in protest after the National Academy of Design declined to display works by three of the painters. Their ringleader was Robert Henri, the son of a riverboat gambler and alleged murderer who had changed Robert's name from Cozad to Henri to elude the police (the charge was eventually dropped). Henri's sidekicks were John Sloan, William Glackens, George Luks, Everett Shinn, Maurice Prendergast, Ernest Lawson, and Arthur Davies. Prendergast, Lawson, and Davies were friends more than artistic allies, but the others advocated an all-American realism that eventually caused them and George Bellows to be called "the Ashcan School."

Henri, Sloan, Glackens, Luks, and Shinn had become friends in Philadelphia, where all of them absorbed the influence of Eakins's realism and everyone but Henri, an inspiring teacher, supported his art and honed his skills by drawing illustrations for newspapers. Eventually they moved to New York and found in the city their great subject. Luks might as well have been speaking for all of them (and Bellows) in a blustering interview he gave *The Times.* Channeling the spirit of Walt Whitman (dead only thirteen years), Luks described his "habit of making quick sketches in and out of season, on the street, in the café, the barroom, Central Park, on the steamers to Coney Island, wherever men, women, and children are natural and show themselves as they are."

The Ashcan School painted New Yorkers trudging through the snow and thronging the beach, a dust storm on Fifth Avenue and a hairdresser's window on Sixth, McSorley's Bar (their favorite saloon), Chez Mouquin (their favorite restaurant), actors and urchins, boxing rings and construction sites. A subhead in *The New York World* heralded the Eight as "Rebels" who "Dared to Paint Pictures of New York Life (Instead of Europe)." They pictured the city where Carrie Meeber became a star and George Hurstwood became a bum. Their mundane subjects and frequently muddy-brown palettes prompted William Merritt Chase, a reigning American Impressionist and friend of Whistler and Sargent, to dismiss the Ashcan School as "depressionists." John Sloan made it clear that the last thing he and his colleagues were interested in was painting a pretty picture:

> [W]e were opposed to impressionism, with its blue shadows and blue lights, because it seemed 'unreal.' We chose our colors from observation of facts and qualities of the things we painted, with little reference to phenomena of light effects. . . . We realists. . . were revolting against the corruption of eyesight painting.

Although few of their paintings were risqué, the Eight still risked censure. Henri's 1909 *Salomé* was rejected by the National Academy of Design because it portrayed a hoochie-koochie dancer who, though fully clothed, exuded an exuberant sexuality. Within four years, Strauss's operatic vamp had become a staple of the vaudeville circuit. The undisputed queen of vaudeville, Eva Tanguay, wriggled lubriciously in the role in addition to singing salacious songs such as "Go As Far As You Like" and "It's All Been Done Before But Not the Way I Do It." Arrested once for performing in tights on a Sunday, Miss Tanguay and Henri invited opprobrium in a period when five wealthy Clevelanders commissioned ten American artists to portray Christ and let the public decide what Jesus really looked like.

Vaudeville and other forms of popular culture provided the Ashcan School with subject matter and energy. Luks performed with his brother in a vaudeville act. Like Stephen Crane and Theodore Dreiser, many of these painters were newspapermen eager to capture and communicate quickly whatever they witnessed. This was also the era that saw the invention of the American comic strip, beginning in 1896 with Richard Outcault's *Hogan's Alley,* one of whose characters, a snaggle-toothed urchin in a nightshirt named the Yellow Kid, inspired the term "yellow journalism." All was

fair in the circulation war between Joseph Pulitzer's *New York World* and William Randolph Hearst's *New York Journal.* (Carrie Meeber and Hurstwood, incidentally, read the *World.*) Although journalistic ethics suffered (scare headlines and dubious "scoops" may have played as great a role as the sinking of the *Maine* in plunging the U.S. into war against Spain), journalistic esthetics flourished. When Hearst hired Outcault away from Pulitzer, Luks took over *Hogan's Alley* and continued the strip for fourteen months. A naturalist through and through, Outcault evoked the plug-ugly squalor and street-savvy humor of New York City's slums in *Hogan's Alley* and its successor, *The Yellow Kid.* In 1902, he reversed field and introduced *Buster Brown,* a coddled rich kid, in James Gordon Bennett's *New York Herald.*

Outcault's great rival and opposite was Winsor McCay, whose *Little Nemo in Slumberland,* launched in the *Herald* in 1905, was a graphic fantasy that has yet to be surpassed. In every strip, Little Nemo dreamed a dream that allowed McCay to draw upon the sinuous lines of Art Nouveau, the international turn-of-the-century decorative style, and to anticipate Surrealism and psychedelia. McCay went on to create and exhibit on the vaudeville circuit the first successful animated cartoon, *Gertie, the Trained Dinosaur.*

Outcault, McCay, and George Herriman, who introduced *Krazy Kat,* the most literate of comic strips, in 1910, paved the way well before Walt Disney for the international popularity of American comic strips and cartoons. Their enduring influence contrasts to that of the Ashcan School, which was eclipsed in 1913 when the Armory Show, organized in large measure by Arthur B. Davies, one of the Eight, displayed France's Fauves and Cubists. This milestone show, the most important American exhibition in the second decade of the twentieth century, made the Ashcan School's attachment to realism seem simplistic and naïve. While American painters were arguing over realism in terms that Gustave Courbet might have used fifty years earlier, Europeans were exploring the frontiers of Cubism and Expressionism.

Americans owed their initial exposure to advanced European painting to a photographer. Alfred Stieglitz was initially of the Pictorialist persuasion. Like his friend Edward Steichen, he believed that photography should aspire to the condition of painterly art. Pictorialists favored soft focus, photographic manipulation, and every trick of the trade that made their prints look like paintings. They differed diametrically from the other major trend among early twentieth-century American photographers: documentarians like Jacob Riis and Lewis Hine who, in the spirit of and sometimes in tandem with muckraking journalists, depicted the hardships and humanity of the poor and the working class.

In 1905, Stieglitz and Steichen opened the Little Galleries of the Photo-Secession at 291 Fifth Avenue and exhibited Steichen's photographs. Because he was attracted to painting almost as passionately as to photography, within a couple of years Stieglitz was showing Matisse and Cézanne and, in 1909, two very young American painters, Marsden Hartley and John Marin, who were more interested in Ryder than in Eakins, in Cubism and Expressionism than in the Eight. The exhibitions at 291 Fifth attracted relatively little public notice, but they blazed the trail for the Armory Show, which would leave the realism of the Ashcan School in the dust. ". . . I could not see anything truly original or searching in their paintings," observed Stieglitz with avant-garde uncharitableness.

In 1906, Teddy Roosevelt joined Booker T. Washington in congratulating students at an African-American trade school. According to *The Times,* the President cited the opinion of an unnamed "French literary man" that "there were but two chances for the development of schools of American music, of American singing, and those would come, one from the colored people and one from the vanishing Indian folk." Antonin Dvořák had made the same point more eloquently in 1893 when he dedicated two movements of his "New World" Symphony to an African-American and a Native American theme. The Indian influence on American music has been slight, but by the first decade of the twentieth century, African Americans were well on their way to making an indelible mark.

It was not a propitious time. James Weldon Johnson, who composed "Lift Every Voice and Sing," the "Negro National Anthem," in 1901 with his brother, John Rosamond Johnson, wrote that the black

man's "civil state was, in some respects, worse than at the close of the Civil War. . . . [H]e was disenfranchised, 'Jim Crowed,' outraged, and denied equal protection of the laws." Lynchings were commonplace (115 recorded in 1900 alone), and so were "coon songs" that derided African Americans as fools whose razor-toting, chicken-stealing, watermelon-eating ways were at once laughable and dangerous. Some of these songs were written and performed by blacks who had few ways to make a living other than by catering to white stereotypes. To his lifelong regret, the talented black composer and performer Ernest Hogan wrote "All Coons Look Alike to Me." (Legend has it that Hogan had originally been inspired by the line, "All whores. . . ," but realized *that* would never sell.)

Preaching patience and bootstrap self-reliance, Booker T. Washington won national recognition as black America's spokesman. After the publication in 1901 of his autobiography, *Up from Slavery*, he dined with T.R. at the White House. But William E. B. Du Bois challenged Washington and white as well as black America in 1903. "Mr. Washington represents in Negro thought the old attitude of adjustment and submission," Du Bois wrote in *The Souls of Black Folk*, which observed prophetically, "The problem of the twentieth century is the problem of the color-line." To address and redress that problem, Du Bois helped found the Niagara Movement in 1905 and the National Association for the Advancement of Colored People in 1910.

Steeped in spirituals, which Du Bois called the Sorrow Songs, *The Souls of Black Folk* insisted "there is no true American music but the wild sweet melodies of the Negro slave." With the exception of John Philip Sousa's marches, there was no truer American music at the turn of the century than ragtime—and even America's favorite bandleader incorporated its African-American syncopations in his concerts. Today ragtime is remembered primarily for Scott Joplin's elegant, formal compositions for piano, starting with "Maple Leaf Rag" in 1899. Joplin was a genius who invested with concert-hall dignity the music he had learned in a St. Louis saloon. But ragtime, albeit bastardized, was also the rhythm of Tin Pan Alley standards such as Ernest Metz's "Bill Bailey, Won't You Please Come Home?" (1902) and coon songs that did as much to degrade blacks as Joplin did to dignify them. (Indeed, one of the first appearances of the word "rag" is in the sheet music for "All Coons Look Alike to Me.") No wonder many whites were confused, as they would be by rock 'n' roll a half-century later. *The New York Times* even credited Sousa with having invented ragtime and, citing the bandleader, declared its demise in 1909, two years before Irving Berlin's "Alexander's Ragtime Band" made it more popular than ever.

Ragtime also inspired classical composers in America and abroad, from Claude Debussy, who wrote *Golliwoggs' Cake-walk* in 1908, to Charles Ives, who composed four ragtime dances for small orchestra in 1902–04. Ives was attuned to the American vernacular as few of his compatriots were. As the articles that follow attest, during the first decade of the twentieth century even more than today, to American audiences classical music meant European music. The ultimate authority was Richard Wagner, and only reluctantly did Americans adjust to the "strange, new wonderland" of Debussy, the "cacophony" of Strauss ("the Wild Man of Munich"), and the "vague and indeterminate bigness of conception" of Gustav Mahler, who conducted the New York Philharmonic in 1909–10, attracting the smallest audiences in its history.

Americans thrilled to visiting virtuosi like Fritz Kreisler and Artur Rubinstein and adopted as their own the Neapolitan tenor, Enrico Caruso. Dubbed by one historian "the Babe Ruth of opera," Caruso was so popular he even appeared in a silent film. Among the very few Americans to crash this gilded circle were the divas Olive Fremstad, who starred in the scandalous American premiere of Strauss's *Salome*, and Mary Garden, who appeared in the second New York production. Fremstad, the first great American Wagnerian soprano (and the thinly disguised heroine of Willa Cather's 1915 novel, *The Song of the Lark*), and Garden, who starred at Debussy's insistence in the world premiere of *Pelléas et Mélisande,* were pioneer American voices in international opera.

American classical composers also played second fiddle. As *Times* critic Richard Aldrich dryly observed, "the danger of producing 'the great music of the world' does not seem imminent in America just now." George Chadwick, Horatio Parker, Arthur Foote, Edward MacDowell, and Amy Beach hailed from New England and congregated for the most part in Boston, "musically a German

province," in the words of one music historian. Try as they occasionally did to go native, none of them could escape the late Romantic idiom of their European elders. Beach, the first American woman to compose a symphony, had the additional burden of a Brahmin husband. During their fifteen-year marriage she all but ceased performing, and only after she was widowed in 1910 did she resume a public career.

Charles Ives, whom Horatio Parker taught at Yale, scarcely even tried to have a public career. Ironically, the music of America's first great classical composer, alluding to Hawthorne, Emerson, and Thoreau, drawing on spirituals, camp meeting hymns, and Stephen Foster tunes, was too American for American audiences of the time to apprehend. Too American and, in its cavalier key signatures and robust dissonances, too advanced. *The New York Times'* criticism of Strauss's "orchestral chaos" might just as easily have been leveled against Ives if his Second Symphony had been performed when it was composed: "There is an incoherent tossing about of all the themes, apparently in every key, in every interlocking rhythm, and with an effect that can only be described as a bedlam of sound." Horatio Parker, Ives wrote, "was governed too much by the German rule." His pupil broke all the rules.

The most vital American theater during the first decade of the twentieth century also broke all the rules. *The Times* reserved many of its lead reviews for European actresses like Sarah Bernhardt, Ellen Terry, and Mrs. Patrick Campbell in European plays, from Shakespeare's to Sardou's to Shaw's. Discerning the emerging American cult of celebrity, Henry James, himself an unsuccessful playwright, wrote that

> Mlle. Sarah Bernhardt is not, to my sense, a celebrity because she is an artist. She is a celebrity because, apparently, she desires with an intensity that has rarely been equalled to be one. . . . She is too American not to succeed in America.

Although Ibsen initially provoked "one of those cries of outraged purity which have so often and so pathetically resounded through the Anglo-Saxon world" (the words, again, are Henry James's), Americans tried to convert the Norwegian playwright, like Wagner before him, into an unlikely apostle of uplift. But the theatrical action was definitely elsewhere in America, in vaudeville, revues, and, eventually, musical comedy.

In 1900, *The Times* proclaimed Marie Dressler "a star" for her turn in a "musical farce" that consisted of "some smart sayings from Miss Dressler, a lot of pretty girls, good songs, lively music, and . . . an amusing lot of nonsense, even if the dramatic niceties have been cut to shreds." Dressler sang a coon song and other tunes that *The Times* predicted "will soon be whistled all over town."

The roots of such unruly entertainment lay in vaudeville, the national circuit of touring performers that included Dressler, scandalous Eva Tanguay, sarcastic W.C. Fields, Julius (not yet "Groucho") Marx and his brothers, and Bert Williams and George Walker. Billed "Two Real Coons," Williams and Walker were real, all right, but that did not spare them the indignity of performing in blackface.

Vaudeville was also one of the few venues in America for modern dance and played a greater role than traditional ballet in its development. Loie Fuller and a New Jersey farm girl christened Ruth Dennis started out on the circuit. Fuller graduated to the Folies Bergères, where she twirled brilliantly colored and spectacularly lit swirls of silk, enthralling Rodin and Mallarmé. Under Fuller's influence, St. Denis performed a skirt dance and then elaborated an Orientalism all her own that was a counterpart to Isadora Duncan's equally ersatz incarnation of classical Greece. St. Denis's Orientalism extended to Salome. When she returned to America (and vaudeville) in 1909 after three years in Europe, a reviewer extolled her for "out-Saloméing all the Salomés." American in origin if not inspiration, modern dance established itself in the United States before ballet, which did not really take root until Anna Pavlova appeared on point in *Coppelia* at the Metropolitan Opera in 1910.

American movies as well as modern dance owe much to vaudeville. One-reelers were projected in vaudeville houses, and vaudeville acts warmed up the audiences that flocked to the nickelodeons, as movie houses were nicknamed in 1905 after a successful Pittsburgh theater. By the beginning of

1907, *Variety* estimated there were 2,500 nickelodeons in the United States. (Despite their name, most theaters charged a dime, which still made movies the cheapest form of popular entertainment.) Vaudeville also provided film with many of its early stars, from cross-eyed Ben Turpin, who started making comedies in 1907, to Buster Keaton and Charlie Chaplin, who made their screen debuts in the following decade.

American film was rudimentary in the 1900s and not as highly developed as the industry and artistry in France. But in 1903 Edwin S. Porter's *The Great Train Robbery* lay the groundwork for the feature film by packing fourteen action-charged scenes into twelve minutes. One of the actors in that film, G.M. Anderson, became the movies' first cowboy star in 1908's *Broncho Billy and the Baby.* A year after John Wayne was born, Broncho Billy established the archetype that Wayne and countless others would embody. Also in 1908, D.W. Griffith directed his first film, *The Adventure of Dollie,* the tale of a girl who is kidnapped by gypsies, stuffed in a barrel, and happily survives a tumble over a waterfall. With cameraman G.W. Bitzer, Griffith began to articulate the syntax of film, the close-ups, crosscuts, and pacing we take for granted today. In 1909, he adapted Frank Norris's *The Pit,* cutting between shots of the famished poor and grain speculators profiting from their starvation. Eager to enhance the medium's reputation and to disarm would-be censors, Griffith also filmed Robert Browning's poem, "Pippa Passes," and distilled Tolstoy's *Resurrrection* in one reel. Two-reel films began to appear in 1909 (although each reel was often exhibited separately for a week) and paved the way for milestones like Griffith's *Birth of a Nation,* which premiered in 1915.

Reviewing "a screaming farce" in 1907, *The Times* noted that "the whole idea is to string vaudeville beads on a farce thread." One of the most popular necklaces fashioned from vaudeville was the revue, epitomized by Florenz Ziegfeld's annual *Follies,* which also debuted in 1907 and thrived far into the 1920s. *The Follies* (in 1911 they became *Ziegfeld's Follies*) showcased beautiful broads (beginning with Ziegfeld's common-law first wife, the French actress Anna Held), broad comedians, singers, lavish costumes, and opulent sets. Instead of dashing on and off the stage in vaudeville's brief, disjointed turns, the performers in a revue appeared and reappeared in different combinations, joining in songs and comic routines. The first *Follies* lampooned Teddy Roosevelt and Andrew Carnegie in topical skits. W.C. Fields, Fanny Brice, Will Rogers, Bert Williams, and Eddie Cantor starred in subsequent editions, which also introduced still-familiar popular songs such as "Shine On, Harvest Moon" (1908) and "By the Light of the Silvery Moon" (1909).

Another extension of vaudeville was the musical theater of George M. Cohan, who had toured with his parents and sisters as the Four Cohans. Tiring of the road, he expanded his song-and-dance act into full-length entertainments, writing and starring in *Little Johnny Jones,* which opened in 1904 and boasted among its musical numbers "Yankee Doodle Boy" and "Give My Regards to Broadway." *George Washington, Jr.* (1906), another paean to patriotism, featured "You're a Grand Old Flag."

Forsaking the foreign tongues of opera and the pear-shaped tones of imported "legitimate" theater, these vaudeville-derived forms of popular entertainment reveled in the snappy American vernacular that their audiences spoke, and audiences applauded in recognition. Yet it was not until the revue and the musical play absorbed another alien influence that the musical comedy commanded center stage.

Shortly after Ziegfeld's first *Follies* opened in the rooftop garden of the New York Theater, Franz Lehár's *The Merry Widow* waltzed into the New Amsterdam and sparked a craze for Viennese operetta. The operetta form was already well established in America. Gilbert and Sullivan had come from England in 1879 to direct a production of *H.M.S. Pinafore.* Sousa had written operettas, most notably *El Capitan,* in the 1890s, and Victor Herbert, the Irish-born conductor of the Pittsburgh Symphony Orchestra, was writing them now. His *Babes in Toyland,* inspired by L. Frank Baum's 1900 children's book, *The Wizard of Oz,* was a rousing success in 1903. Just to make sure, however, that the English version of *Die lustige Witwe* did not sound foreign to American ears, *The Merry Widow*'s producers cast in the leading male role a veteran of Cohan's musical plays. When operetta's alternation of spoken dialogue and sweet, tuneful songs, its integration of music and plot, and its light-

headed mixture of romance, comedy, and fantasy merged with indigenous American musical entertainments, the musical comedy coalesced, contemporaneously with jazz, in the 1910s and 1920s. Both jazz and musical comedy trace their origins to the first decade of the twentieth century and surpass in their enduring and universal influence most other American achievements in the arts during this period.

Teddy Roosevelt left office on March 4, 1909, entrusting the White House to his handpicked successor, William Howard Taft, and went on an African safari. The decade that lay ahead brought domestic discord and international conflagration but also a quickening of American culture, from the Armory Show and Georgia O'Keefe and the arrival of Serge Diaghilev's Ballets Russes to *Birth of a Nation,* Jerome Kern's early musicals, Robert Frost's first volume of poetry, Willa Cather's first novels, and W.C. Handy's "The Memphis Blues" and "St. Louis Blues." After the United States entered the geopolitical conflicts of Europe, it no longer trailed behind the culture of Europe, and in many respects it shot ahead. American democracy proved fertile soil for the cultivation of the popular arts in particular. Still, it is impossible not to sympathize with the dismay of Henry James two years before his death in 1916. As World War I, the Great War, dawned and drove the last nail into the coffin of the genteel tradition, he wrote to a friend

The plunge of civilization into this abyss of blood and darkness. . . is a thing that so gives away the whole long age during which we have supposed the world to be, with whatever abatement, gradually bettering, that to have to take it all now for what the treacherous years were all the while really making for and meaning is too tragic for any words.

ART AND ARCHITECTURE

THE WEEK IN ART

The collection of some 620 Japanese paintings and color prints, selected in Japan by Mr. J. D. Millet and Prof. Ernest Fenerosa of Boston, represents the combined attempts of these two men to revive the old Japanese arts of color printing and water-color painting. The attention of art lovers is strongly directed to the display, which will delight the soul of any one with a decorative sense. Some of the paintings are on silk, but the majority are on paper, and all have mats of appropriate tone and color selected by the artists themselves. It must be confessed that these prints and paintings grow tremendously upon one. When first seen, and especially those which show more or less successful attempts at the rendering of perspective and atmosphere, in which Japanese painting and decoration have always been lacking, there is a sense of disappointment; a feeling also arises that Prof. Fenerosa and Mr. Millet had far better have left the old boatman on the Sumida River, who they found had been an artist, to his more prosaic occupation, than to have recalled him to a work which is influenced by modern methods and ideas, and which, consequently, must lose some of its quaint and distinctive charm. As one looks closer into these productions of the old boatman and his companion artists one sees, however, that the characteristic Oriental subtlety of taste, grace of line, and sureness and delicacy of touch and charming and indefinable delicious decorative color sense are all here, and cannot be taken away. Then one turns to the catalogue to read how Mr. Millet, who knew that the old school of color painting had passed away in the revolution of 1865, returned to Japan in 1896, found that three artists who had learned the process were still living, gave an order for several hundred prints, and returned to Japan in 1899 to find awaiting him those shown in the present collection.

* * *

PICTURES AT SOCIETY DISPLAY

The twenty-second annual exhibition of the Society of American Artists, better known in the art world by the shorter and more affectionate title of "The Society," will open to the public in the Fine Arts Galleries in West Fifty-seventh Street this morning, and will remain open week days and evenings and Sunday afternoons inclusive until the evening of Saturday, April 28.

This exhibition, as usual, is the last of the important public art exhibitions of the year in New York, and there remains only that of the Society of American Landscape Painters, to be held next month before the closing of the exhibition season. More interest than ever is felt and expressed in this year's display of the society for the reason that the old Academy of Design, having no present home, combined its Fall and Spring exhibitions into one, and held the same in the fine arts galleries in midwinter. With no Spring academy there remained only the society display for the exhibition of the work of the Winter, and the artists accordingly sent in so large a number of canvases that, despite the efforts of the jury, the exhibition is larger by some seventy-five numbers than ever before, comprising 375 works, including a few miniatures, and it must be regretfully said, contains so many inferior works as to be poorer in quality than for some years past.

The society display has not since its earlier years ever been a distinctively bad one, and one can always be sure of finding in it not only characteristic examples of many of the stronger, and especially the younger painters, but also, as a rule, clever work by new painters. This year there is some strong work and also two or three canvases by comparatively unknown brushes, which call for recognition. There are, however, too many purely decorative works, too many painty and inferior portraits, and some canvases inferior in merit, and whose acceptance would appear to indicate a regrettable tendency to adopt the old Academy traditions of admitting works on names which formerly had prestige.

One must this year look for the distinctively clever work which was formerly characteristic of the society displays to the smaller exhibition of the society's seceding members, that of the "Ten American Painters," now in progress at the Durand-Ruel Galleries. It cannot be gainsaid that were such painters as Weir, Childe Hassam, Simmons, Metcalf, Benson, Twachtman, Tarbell, Reid, and de Camp represented in the present society display by any or all of the canvases they show in the Durand-Duel Galleries the exhibition would produce a very different impression upon the visitor. For the first time since the secession of these men, the society gives evidence that their argument for their leaving had some foundation. If the organization is not becoming commercialized, as they claimed when they seceded, it is certainly weakening in the quality of its annual displays.

It is always somewhat unfair to discuss the awarding of the annual Webb and Shaw Prizes without recognizing the limitations of these prizes. When it is remembered that the Webb Prize ($300) for the best landscape in the exhibition, must be painted by an American artist under forty years of age, and that this consequently rules out such landscapists as Ben Foster, William M. Chase, and others of their standing, and that it cannot be competed for by artists who have already received the prize, among whom are J. F. Murphy, D. W. Tryon, W. A. Coffin, Bruce Crane, George H. Bogert, and W. L. Lathrop, the selection by this year's jury of the uninteresting, dry, and flat "Autumn in Brittany," by W. Elmer Schofield for this prize in preference to others by men like those mentioned, and others ineligible for one reason or another, cannot be justly condemned. The jury probably had little or no choice.

The limitations of the Shaw Prize of $1,500 for the best composition containing one or more figures, namely, that a good figure work might bring a higher ilgune at private sale, and which deters many good figure men from competing, does not explain, except on this last supposition, why the jury should have given this prize to Irving R. Wiles's single female figure fancy portrait, "The Yellow Rose," despite its charming color and good drawing, in preference to Seargent Kendall's "End of the Day," a study of a mother and child, which is certainly the best figure work, and, with the exception of Cecilia Beaux's portraits, the best portrait work in the display. It is said the jury's vote on these canvases was for some hours a tie. This canvas marks a notable advance for the artist. The drawing and pose of the figures are natural and true. The young mother in her evening dress of mourning bends down over the little child on her knee, in its simple short frock, which, with a half weary expression is studying an open book. The flesh tones are warm and rich, the textures beautifully painted, and the picture is painted with thorough understanding and intelligence. Especially notable is the modeling of the child's chubby little legs.

The more interesting pictures, as usual, are to be found in the large Vanderbilt Gallery. Among the portraits in this gallery are William H. Hyde's of the twin daughters of Bishop Potter, one now Mrs. Hyde, and of his brother. Mr. J. E. Hindon Hyde. The former has good character and expression, and the figures are well drawn, but the color is hard and unpleasing. The latter is perhaps better as a portrait, but is somewhat stiffly posed, and is also hard in color. Neither work is entirely worthy of Mr. Hyde's brush. William M. J. Rice's "Portrait of a Woman" has good pose and a well carried out color scheme of mauve. Cecelia Beaux's portrait of the Rev. Dr. Huntington of Grace Church, which depicts him seated in his study, has her characteristic breadth and strength of handling and Sargent-like dash, but is hardly equal to her Philadelphia successes.

The flesh tones are especially good, and the modeling of the hands should be studied by all young portrait painters. R. V. Brandegee's portrait of the late Miss Sarah Porter is a good study of character and is fresh in color, and Paul Moschcowitz's "Portrait of a Man" has a soft and decorative color scheme, but is marred by careless drawing and poor foreshortening of an arm. Frank Fowler's "Portrait of a Boy" is good in expression, but is somewhat painty and the legs have no modeling at all. William Thorn's "Portrait of Miss C.," while it has a certain decorative quality, is repellent and unrefined in color. Of the landscapes in the Vanderbilt gallery, one of the best is H. Bolton-Jones's "Back of the Sand Dunes," clear aired, strong and rich in color, one of the best canvases he has yet produced, and which is in such marked contrast to his nearby landscape, the chromo-lithograph "Brook," as to show how uneven a painter he is.

William M. Chase's "Spring" is a delightful plein-air view of his beloved Shinnecock Hills, clear-aired and fresh in color; Ben Foster's "Summer Night" is a fine landscape, beautifully composed, full of mystery and sentiment, the wind sweeping through it, and which, were the artist a younger man, would have won him the Webb prize. William M. Chase's "Rest by the Wayside" has splendid distance and outdoor feeling, and W. H. Howe's "Summer Outing" is rich in color and full of sunlight. Other landscapes in this gallery that must be noted are O. H. Bacher's "Winter," with its pink snow; Henry C. Loe's "Black Ash Swamp," with delicate and delicious color scheme; Louis Loeb's fine large decorative panel, "Temple of the Winds—Sunset," extremely delicate in color and with strongly drawn figures; W. S. Robinson's "Summer in Picardy;" A. W. Dow's "Marsh Islands," which, although a little hard, has remarkably fine distance and charming color and sentiment; Walter Clark's "In Early Leaf" and "September," both with delicate and well carried out color schemes; Bruce Crane's "Fisher's Hut," strong in composition and cool and fresh in color; C. W. Eaton's "Spring Sunset," a glow of color; W. A. Coffin's "Rainy Weather," with its delicate and diaphanous mist; H. D. Murphy's "The Marshes," with splendid sweep of air and sky; Carleton Wiggins's, "Late Afternoon, L. I.," full of sunlight and air; John F. Weir's "Sunny Morning;" and Samuel Isham's decorative panel, "Spring."

Of the marines and coast scenes there is a characteristic example of Winslow Homer, "High Seas," which, although of course strong, makes one fear that the artist is overworking the Maine Coast; a large marine by Howard R. Butler, "The Sea at Evening," soft and sweet in color, delicious in feeling and sentiment, with fine shadows, the cumuli in the upper sky a little hard; "The Storm," by George H. Bogert, well composed and rich and deep in color, but perhaps a little too sombre, and Charles H. Woodbury's "Heavy Seas," with fine movement, but opaque in color. Mention must also be made before leaving this gallery of O. R. Bearse, Jr.'s "Study of a Female Head," "Mona Rosa," and his decorative figure group, "Toilet of a Zephyr"; of George W. Maynard's "The Capture," a marine, with figures of a sea horse and merman, a good motif, but becoming wearisome; of C. C. Curran's "Early Morning in Madison Square," another study of the Dewey Arch, which is being painted ad nauseam; of J. W. Morrice's "La Communiante," a combination of Raffaelli and Manet; of John La Farge's large study of the Japanese divinity of Contemplation, with its refined and delicate color scheme, before described when shown at the Lotos Club; of Louise Cox's "Madonna," stiffly drawn but good in color; of Henry Prellwitz's "Idyl," decorative and finely drawn, but not pleasing in color; and of Kenyon Cox's figure composition, "Hope and Memory," characteristically strong and good in drawing and pose, but unpleasing in color.

* * *

May 26, 1900

THE WEEK IN ART

In addition to his artistic ability, Frederic E. Church had the faculty of making friends. His success from the start,

was largely due to this capacity, which he possessed in a rare degree. He painted, or, rather, he began to paint in the days when there were few collectors, and art was a very new thing in America. Hence there were then art patrons in the true sense of the word, and to the patronage of such men as the late John Taylor Johnston, William Tilden Blodgett, William E. Dodge, Cyrus Field, and William H. Osborn, Church's early fame, which enabled him to reach financial success in a comparatively short time, was chiefly due. These art patrons did more than buy the pictures of Church, Kensett, Bierstadt, and a few others whom they favored. They made the artists their intimate friends, invited their wealthy fellows to inspect the paintings they had already purchased from them, and sang their praises in and out of season. The present writer can remember how as a boy of thirteen or fourteen he was taken by his father to the residence of William Tilden Blodgett in East Twelfth Street, New York, where Mr. Blodgett's widow still resides, to see Church's "Heart of the Andes," and how with reverential awe he looked at the canvas. He can also recall Mr. Blodgett's warm and enthusiastic extolling of Mr. Church's work, and how he came away impressed with the idea that there was only one landscape artist in the world, and that his name was Church.

This period of American art was, of course, only a formative one. It could not long exist, and the artist of to-day has to make his own way without any special patron, notwithstanding the foolish extolling of certain business collectors as art patrons this past season. Conditions were different during the period when Church painted his more notable canvases, and it was fortunate for him that they were. All this reminiscence is not intended as any reflection upon the memory of the landscapist or in any way to wound the feelings of his devoted friends, of whom few men of his time had more. Church undoubtedly played an important part in the development of American art, for with Sanford, Gifford, Kensett, and a little later on with Cropsey and Bierstadt he carried on the art of landscape painting begun here by Thomas Cole and Asher B. Durand, and advanced it. He was also the first landscapist to bring to the attention of the American public the exceeding richness and beauty of the tropical landscapes of South America, and the grandeur of some of the wild scenery of the South and West. Crude as some of his work now seems, and thin or lurid as his color, he was unquestionably a painter of ability and of imagination.

The exhibition of Church's works now at the Metropolitan Museum is a loan one, and contains fourteen examples, all representative, and which give an adequate idea of his scope and his quality. All art lovers will be most interested in the still famous "Niagara Falls," loaned by the Corcoran Art Gallery of Washington, and "The Heart of the Andes." The former canvas, seen in New York after the lapse of many years, while a little too panoramic in effect, is a faithful and characteristic rendering of the great cataract, and may be said to be the most satisfactory painting of the impossi-

ble-to-be-painted falls ever done. "The Heart of the Andes," which has been in retirement for some years, is a remarkable piece of composition, and although, like the Niagara, suggestively like a panorama, has, like the Niagara, a certain sense of power and truthfulness. There is too much detail work in the tropical foliage of the foreground, but the gradual rising of the land to the far-off, snow-covered peak in the background is well given, and there is good light effect, if somewhat hard atmosphere. Older art lovers will, perhaps, be more glad to see of Church's South American series the "Morning in the Tropics," loaned by Mr. William E. Dodge and "The Mountains of Ecuador," loaned by Mrs. William H. Osborn. In both of these canvases the artist caught with some success the damp, yellow, misty, and heavy morning air of the tropical wilderness. There were many jokes made on these canvases when they were first shown. They were called "examples of Church's malarial art," a convincing evidence of their realism.

* * *

September 1, 1900

THE WEEK IN ART

We take up the cudgel for our own American furniture. It is generally quite as good, if not better in form, and even ornamentation, than is the common run of English. Suppose we do make our tables, chairs, and other things in the "Far West." We do so because the rough material and the furniture factory are contiguous. Despite Morris, public taste in England, as far as relates to furnishing, is not a whit better than in the United States. We do not think that our designers are pervaded with German art, as has been asserted, and so copy the fads of Berlin.

Every day shows that our large manufacturers of furniture do not rely on their own individual tastes, but employ the best talent for the designing of the objects they put on the market. That abomination, the gold chair, is more common in England than the United States. One common fault in both countries is to erect furniture barricades in drawing rooms, so as to prevent free entrance into a room. All of us on this side of the water appreciate Chippendale and Sheraton, and we can make the most servile copies of these masters. Michigan will turn you out Chippendales by the car load if you want them. Sheraton is common in Omaha. We have the imitative faculty strongly developed, and in addition the mechanical skill. Does not some one in England want a shipment of American furniture? There is no question that for form and durability it would find a ready sale in England. There is no use in decrying the art movement in the United States. That is evident when the commoner household objects are examined. The progress of the finest art the world has known commenced in Greece with the designing of a simple lamp. The Temple followed in due time.

* * *

September 29, 1900

THE WEEK IN ART

We prate a great deal about Johann Joachim Winckelmann and rarely read him. What could a man who died before the close of the eighteenth century, and who wrote on art at that early time, know about his subject? True, Winckelmann theorized a great deal, and many of the antique statues he lifted up in his admiration we have toppled over long ago. But for all that Winckelmann had many excellent ideas, and speculative as he was, he was often perfectly sound. There is that chapter of his entitled "Influences of Climate on Conformation." We have ventilated that topic very much of late. It is the constant theme of the anthropologist. This "conformation" is of constant introduction in modern art criticism. Winckelmann is directing the attention of his reader to the beauty of the old Greek, and he writes: "We must therefore, in judging of the natural capacity of nations, and of the Greeks especially, in this respect, take into consideration not merely the influence of climate alone, but also that of education and government. For external circumstances effect not less change in us than does the air by which we are surrounded, and custom has so much power over us that it modifies in a peculiar manner even the body and the very senses with which we are endowed by nature; thus, for instance, an ear accustomed to French music is not affected by the most touching Italian symphony."

Some of Winckelmann's conclusions as to present races or those of his time might be disputed to-day, but generally he is right as to the past. The sculptor or the painter does not invent. He carves in marble or puts on canvas what he sees. That is instinct. So our old authority writes: "Rubens, notwithstanding he resided for many years in Italy, designed his figures, invariably, in the same manner as if he had never left his native land; and many other examples might be adduced in support of my opinion." We smile to-day at those "montaignes de chair" which the great Flemish master presented. In The London Truth a critic makes an attack on the nude as presented in French art. His remarks are principally directed toward the French sculptors. He compares the art of the Frenchman to that of the Greek. The trouble, he insists upon, lies in the impossibility of procuring the proper model. It is non-existing. Some of the reasons presented are fairly amusing, and not without a little truth. The northern race is now the dominant one. The representative of this race is a heavy eater, and we may add that sometimes he is a hearty drinker. The Maecenasian art, or the man who buys statue or picture, is "not himself clean built." If it is cold, he flies from London or New York and finds a climate to suit him elsewhere. "His body is a quick-combustion stove, wrapped up in warm garments that prevent light, easy motion. Men of the money-making class have considerable girth of waistcoat. Their daughters, when married, soon take on an over-ripe appearance. They could figure well in paintings such as Roybet paints as 'femmes plantureuses.' But they are not sculptural." Perhaps the London critic has

seen too many nudes in marble at the Paris Exposition. It is a vexatious question, after all. In the year 1900 morals are opposed to the nude. You may not be a Philistine, and yet be forced to acknowledge that in modern art there is not one nude figure in the million which is an unqualified success. Maybe the old Greek was made to be copied in marble and for little else. But then he was highly appreciative of poetry and music, and a hero besides. We cannot believe that the human form has deteriorated. It may have changed, and that is all. No matter what are our ideas of to-day, old Winckelmann may still be read with satisfaction.

* * *

March 19, 1901

THE TEN BOLTERS

Exhibition of Artists Who Seceded from the Secession

How far ahead we are over here on the strenuous side of art, when we compare Europe with America, will be evident if one considers that in Paris and Munich the painters have gone the length of one secession only, while in New York they have seceded from the secessionists. The Society of American Artists gave the cue to the French artists of the Salon called after the Champ de Mars, and then the "Secession" at Munich was organized. But neither city could catch up with New York. The poor fellows were congratulating themselves that they were regular Yankees of the strenuous life, who could give their elders and inferiors a chance to see how pictures ought to be painted, when New York took the lead again with the Ten, a section of the Society of American Artists who could no longer stand their slow-going comrades, and so bounced off on their own hook, leaving the air of the studios full of atmosphere of a rather warm sort, vibrating, in fact, with expressions far less suited to "interiors" than the "open air."

There are signs in Paris, however, that a similar process of scission, as the bacteriologists term it, is impending in the Champ de Mars Salon. A wave of Chauvinism has passed again over France, and this time found the art world susceptible. Foreign artists who win a medal that carries with it a money prize will hereafter get the medal, but not the money. Although Americans were among the earliest members of the Champ de Mars Salon, their privileges are to be curtailed in certain matters. In other words, though the Champ de Mars has hitherto refused to dance to the piping of their former comrades of the Old Salon and have declined all advances looking to a consolidation, yet the signs of change are evident. A party in the newer body is growing more and more conservative, more and more ready to apply the ordinary pressure on the enterprising artist in love with novelties, and make it so uncomfortable for him that presently he will have to break away and form a little clan of his own with such of his fellows and such of the

rejected as he thinks deserving of the same attention that he demands for himself. And in Munich, too, we may look for some movement of the same kind among the "Secession."

But even then, will they overtake the New York standard? Will they not discover that the fleet-footed American has taken a fresh start, and find that some mysterious force akin to that which splits the protoplasmal cell has already cracked the Sacred Ten? Like the organisms that float in long colonies on the ocean and break apart, only to form new creatures, shall we not see a fresh birth presently, called, let us say, a Vibrating Seven? By all means let us hope so; for as nature has been supposed to abhor a vacuum, so the arts must abominate stagnation.

The signs of impending scission and rebirth are not wanting to the little exhibit made by the Ten in the big gallery at Durand Ruel's. The Ten are only Nine (or is it only Eight) owing to the absence of Mr. Edward Simmons. Does this mean that he wants the whole gallery to himself? But, in truth, his methods are not those of the majority of the Ten. He does not vibrate up to the proper standard of vibration, and a mean-souled world is ready to imagine that he feels himself a little more unvibratory, a little too slow in his painting than comports with the professional ideals of the majority. Mr. Thomas Dewing exhibits two seated ladies who do not vibrate at all, they are so finished and sedate, so booky and unblowsed by sun and wind. What a delicious elegance in the arm and slender fingers of that one who sits pensive in her chair as if she had never heard the word golf or dreamed that such a thing as a bicycle existed! How carefully wrought is every feature! What a vista of pencil drawing and hours of absorbing labor does one not perceive behind the delicate modeling and air of perfect rest in this graceful yet not too beautiful maiden! Somehow Mr. Dewing's pictures belong in a different gallery from the others here.

Beside them hangs a batch of work by an archvibrator, Mr. Childe Hassam, which cries aloud for a separate gallery and a big one, too. This mosaic of rough paint which is most cleverly placed on canvas to form a mass of houses, a street, a square, a section of a town, with sunlight beating on some walls and with vivid colors springing out from the shadow, the merely relative shadow, of yet other walls, is so different from the methods employed by Messrs. Dewing and Simmons that one wonders how such opposites as he and they are in their views of art can hold together. Mr. J. Alden Weir may supply the bridge between them, for he has pictures in both styles. In the portraits of two little girls riding on donkeys he employs the mosaic style. The animals are not very living, nor has he caught the look of their rough hides nor the expression of their stubborn eyes; but there is a naive charm about the childish faces. The "Young Lady with Flower" is of another sort, and a very charming sort it is. She is seated, clad in a white, flowered gown with narrow bands of black lace running across. The face, crowned by a towering mass of hair, is very delightfully modeled. Stiff and strange of lengths

is the other portrait of a young lady who looks out from the canvas; her attitude, the high-necked, old-fashioned dress, and the breastpin give the impression of a wish to recall the painters of a hundred years ago.

John H. Twachtman also belongs in this company. His two cascades are really foaming with masses of churned-up water, and his view of Gloucester is smashed in with great sweeps of white paint. Willard L. Metcalf may hold on; but his "Ebbing Tide" is perhaps scarcely vibratory enough for its surroundings. Very delightful it is, all the same, with its green water near and blue water afar, and its gay strip of land and its high horizon against a dull gray sky. His "Fish Wharves" is another excellent seaside view, the sunlight shining bravely on smacks and catboats and dories. His portrait of mother and child is less happy. Robert Reid has a nude bather perched in a tree in the Anders-Zorn way, to the great discomfort, one might imagine, of her tender skin; she has a weirdly foreshortened left arm. The best is a little girl standing on a woman's knee, the face timid, yet inquiring. Joseph R. De Camp still paints enough like the others to hold his place. His "Green Shawl" (on the shoulders of a young woman who stands to gaze upon herself in a cheval glass) is a famous piece of color in itself, while the pink rose she holds to one ear and the figure and face are not particularly interesting.

Messrs. Tarbell and Benson are of the same sort—not vibrators of the first rank always, but meaning to be to the top of their bent. Mr. Benson's Paris picture which took a silver medal was rightly honored. The baby standing in the sunlight on autumnal grass against a background of sea, with a little girl seated near, is a thoroughly successful and beautiful attempt to paint in the open. The flesh painting is luminous, the sunlight strong and true, the attitudes of the two children natural, and the coloring delightful.

If the Vibratory Seven do split off from the Sacred Ten, they must consist of Messrs. Hassam, Reid, Benson, Weir, Twachtman, Tarbell, and De Camp. All that Messrs. Simmons, Dewing, and Metcalf have to do is to choose other seven from the Society of American Artists who have ripened since the Sacred Ten withdrew, and fill up their mystic number once more. That the Vibratory Seven will hold together indefinitely cannot be imagined. In time they may divide into a Four and a Three. Meantime those who censure this progressive subdivision on the ground that it introduces hard feelings and increases the number of exhibitions to an intolerable degree merely show their selfishness and unwisdom. Painters of easel pictures ought to give the widest scope to their individuality. When they find the furies of the large organizations like the Academy and the Society hostile to their work, it is right to set up for themselves rather than allow themselves to fall into the habit of painting for the probable taste of the jury. Hail to the Sacred Ten! Would there were more of them.

* * *

April 25, 1901

WOMAN'S ART CLUB

Twelfth Annual Exhibition by the Society of Woman Painters

The regular Spring exhibition by woman painters is held this year at Clausen's Gallery. While not so large as that shown last year in the galleries of the Arts Club, and lacking as it does pictures as fine as three or four in the eleventh exhibition, the quality of the exhibits is evener and the general impression is a good one. Landscapes by Mrs. Charlotte B. Coman, Miss Alethea Platt, and Clara Weaver Parrish; figures by Miss Helen Watson Phelps, Miss H. Campbell Foss, and Miss Ruth Pine Burgess; portraits by Miss Constance Curtis and Miss Lee Lufkin; flower pieces by Mrs. E. D. Scott, Miss Gabrielle Clements, and Miss Amy Cross, and designs for decorations by Mrs. Ella Condie Lamb keep the average high. The last named has produced for the Sage Memorial at Cornell University a number of fine symbolical figures, sketches for which in colors are here, as well as one design in mosaics, the head of an angel with aureola. The figure of Music is particularly good, the artist understanding the difficult art of making a charming face and graceful figure without falling into the common mistake of banality.

"Revery," by Miss Frances S. Carlin, is a little nude female figure standing against a tapestry background with head pensively inclined and a flower in one hand, a figure very carefully drawn, almost miniature in workmanship. Miss Rose Clark of Buffalo sends a standing figure of a little girl in long old-fashioned dress, striped dull red and green; a very pleasing portrait called "Hester," with chubby, dark-eyed face and chubby folded hands. Two portraits by Miss Constance Curtis consist of a front-face half-length "Félicie," rich in color, and a profile head of a young lady, very direct in workmanship and instinct with life. Miss Lee Lufkin shows portraits of Miss Newman and Miss Waring, together with a picturesque bit from an old French town like Chartres, with washer-women in a shed by the side of the old moat. The portrait of Eugene Field by Miss Phelps is the likeness of a sensitive, energetic man, that tallies well with Field's character and career; it is the best portrait in the exhibition. That of Miss Bertha Runkle, author of "The Helmet of Navarre," painted by Miss Burgess, wears a half smile and is a careful and interesting likeness.

In still-life the "Lemons" of Mrs. Scott bear away the palm; they are in a tilted brass dish, with the white paper still round some of them. Her "Yellow Roses," in a pale blue tureen, are excellent also. Two little bits of still-life by Miss M. C. W. Reid; "Roses," by Miss Carlin; "White Lilies," by Miss Clements; "Japanese Poppies," by Miss L. C. Hunter; and "Yellow Lilies" (with green Chinese jar), by Miss Platt, are painted in oils or water colors with all the sensitive love of flowers we expect in women. Among the sketches for landscapes, rather than finished pictures, one may note Miss S. M. Ketchman's "Breezy Day—Coast of Maine," Miss

Alice Cushman's water color "Edge of the Marsh," Miss Ida Haskell's sketch in oils, Miss Platt's nicely toned pastel of a rural scene at twilight, Miss Swinburne's pastel "Nightfall," with tones of lilac and mauve, and Mrs. Wigand's "Across the Lots," with an excellent painting of soft, bloomed grasses in the pasture. Miss Blanche Dillaye's "Evening" is a little landscape in which the trees are massed finely and the purple distance well contrasted with the sky, partly occupied with a long yellow flush. Nor should Miss Burgess's harvest field in pale morning sunlight be forgotten, nor Mrs. Wyant's "Windy Day," owing to the lively impression made by the sketch. "Venetian Garden" and a townscape, "Misty Morning," by Miss F. W. Tewksbury, are happy and unconventional subjects well carried out.

In the lower gallery at Clausen's Mrs. Rhoda Holmes Nicholls shows a score and more oil paintings and water colors, flower pieces, marines, landscapes, bits of Venice, and figures. A stately procession of blacks is her "Crossing the Great Karroo, Cape Colony," a large oil painting from her visit to South Africa. Perhaps she paints Venice best of all; there is a delicately wrought view of Venice from a distance, seen from the way to the Lido, which expresses very well the charm of the city of the lagoons. "Search the Scriptures" is a woman with Bible and "Indian After the Chase" a good figure in water colors. These pictures will remain till May 8.

* * *

April 2, 1902

AN IMPENDING SCANDAL

If anything were still required to prove the unfitness of the present Director of the Metropolitan Museum for the place he incumbers it would be the wish, expressed now many times by him and printed in divers newspapers without denial, that the big bronze called "Saturnalia," designed by Biondi, should be bought and made part of the permanent sculpture in the museum.

No one expects Director Di Cesnola to know anything about the fine arts, for his life and writings on the Cypriote antiques, whose value he promptly destroyed by foolish cleansings and restorations, are there to stop the mouths of those who are personally his well wishers. But so long as the managers of the Metropolitan continue to keep him as Director he would do well to avoid anything that exposes his ignorance to the public. Americans are so good natured and easy going, many of them are so blind to the requisites to be expected from a man at the head of a great museum, that the Director's gallant services in the civil war seem to them to warrant his retention, although he is the laughing stock of those who know what the Boston and Chicago museums get from men in such positions, not to speak of the great European art museums. Apparently this indifference or ignorance is permitting the grave incompetency of the Director to pass unrebuked.

Since the death of Dupre of Florence there has been no sculptor in Italy to whom the world turns for work that con-

noisseurs heartily commend. But this group by Biondi, if it can be called a group, is so uncommonly offensive in technical qualities and so disgusting in subject that one stands appalled at the abyss to which modern Italian sculpture has sunk, when it is sent to France and the United States as representative of the plastic work of a great nation which at one time led the world in art and still from time to time produces a master. The thing is so bad that to suppose a community in this country would ever accept it as a gift implies an insult to the National intelligence. One might have supposed that a man who has passed forty years of his life here would have learned more respect for Americans than to dream they would desire such a crude and barbarous work as the "Saturnalia," disguised though its essential vulgarity may be by a pretense of historical verity. It is a confused line of staggering drunken people, ladies and harlots, Pretorians and Roman Senators, pitilessly modeled out in the round and larger than life, cast in bronze—and placed, strange as the tale may read, as the centrepiece in the new Fifth Avenue wing of the Metropolitan Museum! This is a scandal and an outrage. Consules viderent!

* * *

April 7, 1903

REMINGTON'S WEST

How One Man Sees the Indians, Cowboys, and Bandits of the Southwest—The Fight for the Waterhole—Busting the Bronco

Less than a dozen paintings in one of the Noé galleries, 368 Fifth Avenue, set forth the views that Mr. Frederick Remington, painter and sculptor, takes of the life and looks of those vanished or almost vanished dwellers on the plains who had their short existence cut off by the advance of railways and of farms—their existence, at any rate, in the picturesque ancestral garb of the Indian and that of the vaquero. The wide gray plains and amethystine hills painted by Mr. Remington are no longer insecure by reason of the Apaches and other "bad Injuns," or the white man who held up the "overland stage." The Indians are rusting away on their reservations, the bad white men are "going through" trains or have turned up their toes in accordance with the rude law of compensation in that land; some of them are Colonels and Judges in well-settled communities East or West; and the overland coach survives in the mimic raids on sawdust under Buffalo Bill.

The most striking scene among the ten pictures, if not the best painting as to composition and brushwork, is called "A Water Hole in the Arizona Desert." A bunch of white men, cowboys, or prospectors, ahead of a band of Indians, have reached a depression in the pale yellow plain at some distance from a range of violet hills, where a patch of blue water shows the coveted drinking place. Their horses are hidden from the pursuers by the steep banks of clay, which echo the violet hills in their hue, and they themselves are at the top of this big natural rifle pit taking cool aim at the Indians, who, far out on the plain, are riding in a circle round the spot, firing as they go. Here and there a horse has been hit and rolls on the ground. So long as the Indians expose themselves they are sure to lose, for the whites have an inmense advantage as to cover, and until ammunition and food are exhausted it will be impossible to rush so impregnable a position as they occupy. The picture therefore appeals to the racial instinct which insists that only a dead is a good Injun and flatters the feeling of the invincibility of the white. It is Leatherstocking over again under different skies and different conditions, with the redskin as usual in the position of the lion in the fable as he was carved by the man.

The reverse of that medal is shown in "Missing," a solitary cavalry man of the United States Army, marching along with a lariat loosely looped about his neck and his hands bound behind his back. Two long open files of mounted Indians accompanying him across the dusty plain, their grim faces haughty under their war bonnets, an escort of death for the doomed soldier. But observe that Mr. Remington shows the tremendous odds in favor of the redskins, suggesting that a whole troop of Indians are needed to down one white man. He has made his captive proud and unflinching, his Indian braves concentrated and sinister, their satisfaction only shown in the lifted chins and quiet air of ownership of the desert as they sweep the horizon with their steady eyes for signs of further prey. They sit their horses as if part of them, and they have the raptorial look of the bird whose feathers they proudly wear in proof of chieftainship. Here is another tragedy of the plains very ably told by the painter's craft.

"The Parley" is the meeting of a band of Indians with a trapper of long ago. The chief has his back turned and speaks in sign language; the trapper has a great beard, a long Canadian cap, and a powder horn slung about him. All the aspects are peaceful. "A Change of Ownership" sees a number of Indians rounding up a bunch of horses by riding round them, waving blankets preparatory to sending them helter-skelter on a bee-line for the distant hills, away from their white or Indian owners. "A Reconnaissance in the Moonlight" is one of the best here in the way of composition. On a ridge crowned by dark woods three men have halted their horses in the snow; one holds the horses of the other two and the latter are cautiously walking toward the wooded crest in the moonlight. The scene suggests peril of some kind. A green sky pointed with stars is above, a pale greenish mantle of snow below. One feels that the danger, if danger there be, lurks within or beyond the trees toward which the tracks of the two men in the smooth snow are pointing.

"Jumping the Overland" is a fight for life between men on a stage and bandits among the rocks. The six horses are tearing down a steep road, and the driver with foot on the brake is attending to his business, while the puffs of smoke on the hillside near spots of color give a clue to the number of the bandits. There is much variety of action in the team as it plunges forward toward the spectator; they are not carefully

trained carriage horses, but any old material more or less redeemed from the bronco or wild condition of the herd.

In "His First Lesson" we see the caballo bronco in the hands of his tormentors, one hind leg pulled up to prevent him from kicking, a saddle being cinched by one man, who keeps at a respectful distance, his head held firmly by another, his mouth wide open, ears flat, eye viciously rolling—they "have him foul" and he will have to give in. A very different study of horses is "A Squaw Pony," a black and white beast, whose spirit has long been broken. "A Courier's Halt to Feed" is a group of two men without their horses, who have kindled a fire the smoke from which rises straight in the air and shows that no wind is blowing.

These pictures are more notable for drawing than for color. Mr. Remington is not always sure of his color values and will often exaggerate a tone unduly, all allowance made for the peculiar effects of the desert light and landscape. In the hides of his horses and the flesh-tints of his white men he has not reached the best that is possible; there is still a little too much garishness in his color-schemes, a little hardness in his brushwork. Mr. Schreyvogel has painted a big picture of Gen. Custer and staff meeting a tribe of Indians; the canvas is on exhibition at the Knoedler Gallery. He has the same fault, only in a much greater degree, and he is a beginner. As Mr. Remington paints with greater ease and devotes himself more to the color-scheme, he will tend to greater strength in this very important element of a perfect picture. Undoubtedly his bronzes have been of use to him in the study of the action as well as the anatomy of the horse, but modeling does not bring practice in pure painting; quite the contrary. Meantime one can but recognize how able he is to seize and emphasize an idea, so that his pictures explain themselves at a glance and need no titles.

* * *

May 9, 1903

THE ART OF RODIN

Sculptures by the Famous French Impressionist at the Arts Club

True to its purpose of showing from time to time some of the more interesting foreign work, the National Arts Club has taken advantage of the visit of Miss Loie Fuller to New York in order to exhibit her collection of sculpture by Rodin and others.

These plaster casts, bronzes, marbles, drawings, and paintings by the master impressionist and a few kindred artists will be visible by card of member until the 16th.

The dances executed by Miss Fuller at the Universal, and later at her own little theatre in Paris, created a veritable furor among the Paris artists. Many sculptors, including Rodin, Gérôme, and Rivière, have attempted to model the impression made by her floating draperies; painters have tried to reproduce the color effects; and whether entirely successful

or not, one has to give them the credit of the struggle with most difficult problems.

A number of these gallant struggles with the well-nigh impossible are to be seen in the little galleries of the club. It is the exhibition of Rodin sculptures, however, that makes Miss Fuller's collection particularly interesting, for on the one hand never before have so many been shown here at the same time, and on the other Rodin himself is the sculptor most discussed, most condemned, most admired and copied at the present day.

Just now Boston is rejoicing because Major Higginson has added three small bronzes by Rodin to the two he had already lent to the Museum of Fine Arts. They are "Vulcan Creating Pandora," "The Death of Alcestis," and "Brother and Sister." Those which have been for some time on exhibition in this museum are "The Flight of Love" and "Ceres"; both are marbles.

All five belong to the small groups which Rodin models with an idea of fitting them into some grand scheme like the gateway of the Palais des Arts Décoratifs, which came to naught because the official who encouraged the plan lost his place, or the more widely famous composition to represent Dante's Inferno. After a time they may seem to the sculptor unworthy or unsuitable to the grand scheme, and then he carves them in marble or models them for bronze as independent symbolisms.

The present collection allows a much wider view of his work. Here in plaster are the large Adam and Eve, with their tremendous muscular development and their suggestions of Michael Angelo. "The Thinker" is here in bronze, a beautiful nude man of mature age, very Dantesque in spirit, the bronze very lovely in patina. The monument to Victor Hugo is represented by the powerful pensive head and by one of the two side figures, female and symbolical, which whisper in the poet's ears. The Hugo, seated on the rocks of Jersey like a Nocturne with scarce a bit of drapery on him, was the focus of a whirlwind of criticism and enthusiastic admiration when at last the sculptor showed it.

Another monument over which people came to blows was that for Honoré de Balzac. The sculptor withdrew it owing to the violence of the attacks made upon it. A small bronze head recalls this cause célèbre in the sculptural world of Paris. It shows one of Rodin's attempts to portray the genius who was at the same time a prodigy of industry and a monster in the life he led. And it is the head of a monster we see here. The head of the statue actually shown and immediately disapproved is much more human than this, with its haughty beak of a nose rising out of the old dressing gown like the proboscis of an Indian warrior wrapped in his blanket.

Typical of Rodin's methods is "The Divine Hand," an immense hand holding up a mass of clay in which little figures of a man and a woman are described like worms in a fresh cut sod, but each human worm is very beautiful in modeling. This, too, was part of a grand group; the Biblical fashioning of man from clay by the Almighty has been treated here in a fresh and startling fashion, a fashion be it remarked,

that sets the teeth of the Philistine on edge. A recumbent nude woman belongs to a group for a "Temptation of St. Anthony," though in truth the name is ill-chosen, or the sculptor made a mistake to attempt such a subject.

The little figure is far too tragic. It is more like the Virgin of the Ether in the epic of the Finlanders, who was the sport of billows for centuries in the days of chaos. Her attitude is that of an utterly lonely maiden rolled up on the crest of a wave, not that of a temptress. Rodin is out of his element when the subject is sportive or sweetly seductive.

Like every strong artist, various currents have tossed Rodin about. There was his apprenticeship to the Sevres factory; much more important was his drudgery in Brussels as a stone cutter. There is his profound study of the old French carvers of wood and stone, who have left their works but not their names in the cathedrals at Beauvais, Rheims, Chartres, and Rouen.

There are certain examples of work by Rude and Carpeaux, even sometimes of Dalou—by the way, there is an admirable bust of Dalou by Rodin in this collection—and, of course, there is the overwhelming influence of Michael Angelo. To which of these influences, however, can one assign the "St. John the Baptist" and the little bronze in this collection of the head of John the Baptist on the charger not to speak of the "Divine Hand"? Unclear of purpose, perhaps, unfortunate in having missed at first the full measure of inspiration, the curious relief called "The Moon and the Earth" is certainly unlike the work of any other master.

Rodin is not an impressionist without being subject to the dangers of impressionism. He who little dares achieves little. Rather is he a man of many, almost one might say continual, mistakes, a groper and stumbler in the dark. But also he is not the humbug that the outraged sculptors of another brand call him. When he fails, he has at least tried grandly, and in that he forms a brilliant contrast to the men who hug mediocrity to them like an amulet.

Rodin's work has a good deal of the quality of Wagner's music; it seizes one and carries one along despite all protests; it excites and disquiets one. But it makes one think and in the end compels one, however reluctantly, to acknowledge its power. The subject may have a classical name, but the art is not classic; rather is it barbaric of the Middle Ages in whose literature Wagner instinctively sought his subjects. May he live long and find the time to carry out some of the tremendous undertakings that wait for completion!

It would be unfair to forget the very admirable head of Rodin modeled by Mlle. Claudel, a splendid bronze, full of character and force. Comparisons can be made with a very early etched likeness of the sculptor by Bastiene-Lepage, an early oil portrait by Benjamin Constant, and a later but apparently not recent head of him on canvas by John S. Sargent. Then there is a fine late photograph by Steichen, the American painter and art photographer, who is further seen in a painting of Beethoven, a very remarkable work indeed.

Nor can one easily overlook, despite its small size, a statuette by Rivière carved in tinted marble, the head, hair, and feet exquisitely wrought of ivory, which shows Loie Fuller at mid-career in one of her dances, the face almost laughing, the feet twinkling, the marvelous draperies swinging like the wings of a big Luna moth. Better than Gérôme in his sketch-model of the danseuse has the patient skill of Rivière expressed the jollity of the dance. There are but two of these captivating little creations in existence. The other belongs to the royal collections of Saxony.

* * *

June 28, 1903

CALL ON MODERN ARCHITECTS

Present Practice of the Profession Demands Much More Than Designing and Drawing Plans—Engineering Problems Which Have to be Solved

Some months ago two young New Yorkers who make up an architects' firm that has a record of winning entered a competition to design a "model village" for the housing of boys and girls, waifs of the street. Nearly a hundred separate structures would be necessary, and these were to be spread over a tract of rolling country 277 acres in extent. Five architectural firms were invited to submit designs. In commissions—it having been decided to spend something like a million and a half of dollars—between $70,000 and $80,000 would go to the winner, a notable prize. Besides this, the honor and repute of success would be great.

The manner in which the successful competitors secured the award and the amount of preliminary work done in order to secure this result furnish a typical example of what architectural practice has developed into to-day, and show what great business concerns modern architects' offices have become. It has often been said with much shallowness that all the equipment and capital the novelist requires is a table, a pen, some ink, and paper, and also it is generally considered that an architect's needs are merely an office, a few pictures and books, drawing paper and colors, and with these any building can be designed. The actual conditions are, however, very different.

By the terms of the competition $500 was to go to each of the five contesting firms toward the cost of preparing their drawings. The winning architects, however, before they made their design invested literally thousands of dollars in preliminary work. For months before pen or pencil was put to paper they were collecting material on every hand. Only the barest idea of what they would eventually design was then in their minds. First, they realized, information must be gathered as to a hundred different conditions.

Not content with the topographical and other details furnished them, they studied these 277 acres on the ground itself, traversing them personally and sending their men over them. Nor were their own studies and those of their office force sufficient. Every point of view must be considered thor-

oughly, and thus they sent up a landscape gardener, a surveyor, and an electrical expert. These men thrashed out with thoroughness the problems submitted to them and they made elaborate reports and recommendations, which were all gathered together and gone over by their principals. Slowly the plan began to evolve itself in these architects' minds.

After some weeks the investigations gradually narrowed themselves down. The questions of plumbing, lighting, ventilation, power, grading, and beautifying had been considered. The preliminary work was well nigh over, and, the practical necessities having been considered, it was possible to take up the detail of architectural design and actual building construction, which heretofore could only be considered generally and roughly. The "model village" had now to be given substance. But the extended studies had themselves worked out the full problem thoroughly.

On a floor of one of the rooms of these offices given over especially to this purpose a topographical map of this site among the hills was laid out. With all the accumulated matter from the experts and their own memoranda, aided by their most expert designers, these architects worked for some days over this. They had now determined very nearly what buildings would be required to fulfill the competition's conditions, and had settled upon their size, general design, and character.

Cardboard Models Used

Precisely on scale and of the proper shape each building was cut out of pasteboard. With these buildings in miniature, over the map on the floor a game of design of much practical value was played. Day after day these men, as their other duties allowed them, would retire into this room and move these flat strips of pasteboard up and down over the topographical floor map, arranging them in every conceivable position and combination, until at last the final plan suggested itself.

It is seldom, of course, that such a great and complicated piece of design comes before an architect. Most frequently it is but a single building with which he has to deal, and not a proposition involving acres of ground. Yet the principle and the problem are the same. The art end has come to be but a fragment of the work involved, though an important fragment, the shell that must harmoniously combine with all else, yet is but one of a dozen considerations.

In fact, the days when the architect was before all a man whose chief merit was that he could make a charming design, afterward fitting the interior and the planning generally to this exterior, have long since passed and gone. One of the most distinguished architectural firms of the country, a concern that is famous for its artistic designs and does its greatest work on fine residences, libraries, splendid public buildings, and structures generally of the monumental order, has but one of its three partners who pays any attention to design. This man, too, spends vastly more time in the securing of important contracts than he does in actually drawing or planning. A second of the partners concerns himself entirely with the problems of construction, supervising his engineers and

experts. The third partner handles the firm's finances, which are as great and as complicated as those of a large mercantile house, an expenditure of thousands of dollars a week being necessary to keep things running and pay the dozens of men employed.

So remarkably, indeed, has architecture developed that recent years have seen an extraordinary phase of it. Latterly there has come into the building field one enormously big construction company and several others very nearly as large. These enterprises concern themselves solely with the putting up of commercial edifices. They are highly capitalized and have large funds to draw upon. Expert financiers and engineers make up their chiefs of staff, and each company is compactly divided into departments, precisely as is a manufactory. With the exception that the product is in each case a big building built on its own site, instead of one of a thousand articles made under one roof, these companies are purely and simply combinations of manufacturers.

Architecture a Minor Detail

Relatively the architecture here is a minor detail. It is the engineering problems, the work of actual stone, brick, and steel construction, that stand out most prominently. Much of the architecture is purchased on order for the individual structure, as any expert services would be. In some cases, indeed, for buildings of this nature an architect is not needed. So simple are the problems in that direction that some member of the construction company's staff can easily take them in hand. When they are rather beyond this the company merely engages an architect to design the exterior. The architect has simply to make the front. In all its details otherwise the building has been laid out. He gets his fee and the building goes up successfully. It has been a case of the experts engaging the architect instead of the architect the experts.

Commercial building construction has not cut seriously into the profession of architecture, however, though it has had an influence in making the modern architect's office more than ever a business place. Despite the multiplication of construction demands, the gaining of every inch of rentable floor space possible, the placing of highly developed systems of ventilation, plumbing, heating, chutes, electric wires (which now according to the very best methods must be carried in special piping), the designer is yet all powerful, and the firm that lacks one of the first rank is hopelessly behind in the race. But nowadays the designer must be an engineer, too, almost an expert on electricity materials, steel frames, heating and pipes of all sorts, and interior decorations. He can hire experts, but he has got to know enough about all these subjects to get the meat out of their reports. He must be a sufficiently good business manager to finance his firm when it is carrying along half a dozen big jobs. One little item alone in his expense is that first quality draughtsmen will cost him $40 a week. It would be difficult to carry an architect's office through in the time of rush of big work without a number of these.

One of the biggest prizes of the past year among the architects was a huge Government building. Design in this was all

important. It was not a towering skyscraper, where each cubic foot of space was the first consideration, and the practical details, after being settled, had then to be given a touch of art, but a structure in which beauty must be the starting point. Two men, each less than forty years of age, made up a firm that set out to win it, and did eventually win. The decision being reached that they should compete, one of these partners took his grip one afternoon and went out into the country. No word from the office, it was agreed, was to reach him; he was to be lost to the world. In four days he was back with a number of sketches. The building that was afterward approved lay before them in the rough.

And then the work was just begun. The little sketches were like an author's notes for a novel, they but suggested the way. Hundreds of detail plans had to be drawn, sets of calculations in line and dot, masses of black and red ink, all working up to the final series of plans that were submitted. Ornamental studies, taking weeks of care, had to be prepared; there were drawings of floors in detail, of great halls, of steel and stone construction, laid out to the veriest point.

Cost of Preliminary Work

What investment in actual money, to say nothing of the time, preliminary work of this sort costs the modern architect it would be difficult to say. But a thousand dollars here and a thousand there would be but a fraction. One architect of large practice calculated the other day that fully 50 per cent of his fees would have to go in actual working expenses. That is, if his office took in during the year $50,000 in commissions there would be but $25,000 of it clear profit, and then only if the office had been administered on a most careful basis.

"And let me tell you," said this architect, "$50,000 in commissions means $1,000,000 worth of building done during the year. It has to be a pretty good firm to get that quantity, a firm that is fortunate and has some sort of a reputation for being successful in big things."

Of course no living man with anything of an architectural practice could spare the time required to-day to design and to plan out the elaborate interiors made necessary by modern tendencies. What the big architect does is simply to direct. He trains men into his way of thinking, his way of looking at a problem of decoration. As he gets the opportunity he talks this and that over. The understudy works it out, precisely as the man himself would have done. "Organization is the one thing important to-day," a certain architect of New York said recently in conversation. "To succeed you must build up an organization. The real science of architecture in these days is just that. You know just what is to be done; you can yourself do it all. Now, when you have ten or twenty men who can carry out the work precisely in that manner there is your organization. All it needs is to be started; directed here and there. Architecture has come to be too big to be carried on otherwise."

And now the architect is coming into a field, that of interior decoration. In its entirety this includes not only the treatment of the walls, but hangings as well, and often floor coverings and furniture. Not only are many more beautiful country houses being built than formerly, but these are increasing in comparative beauty, and the city house is steadily growing more magnificent. Besides this, business buildings now demand more and more in the way of decorative adornment within, and banking institutions especially are making a point of ornate finishings and furnishings.

For the architect to get the best effect for his building he must take into consideration all of these. Much of it must be his own design, all of it he must at least supervise and follow through from the beginning to the end. What he generally actually does in practice to-day is to plan out color schemes and effects for each of the rooms, especially if this be a large commercial establishment. Directly under his supervision the walls are handled, and frequently the hangings. In addition he frequently consults regarding the furniture, and thus interior as well as exterior comes to be his own.

Think Fees Too High

There are some people, however, who think the honors and emoluments of the modern architect are too great, even considering his duties and the many expenses of carrying on his business. An interesting contention is brewing between Government officials and the American Institute of Architects. The Government, it is understood, is to claim that for the new big Government buildings to be erected very speedily in Washington the architects' fee is excessive. It has been suggested that officers of the Engineer Corps of the army superintend the erection of these buildings, and that the architects' work be concluded with the making of their plans. In other words, this means that architects should be engaged merely for architectural matters, and that the construction should be put in the hands of Government employes.

To this the architects are replying that they, better than any engineers, can construct their own buildings; that one half of even the largest fees is eaten up by the expense of getting out the plans and specifications, and that when all is said and done there is not the money in conducting an architectural practice that the public seems to imagine. It may be a very pretty contest before it is decided.

* * *

November 6, 1903

THE CASSATT OILS AND PASTELS

Ugly Women in Curious Gowns and Babies in No Gowns at All

The Durand-Ruel Galleries are enlivened by the strong, positive colors used by Miss Mary Cassatt in the confection of her figure pieces, which for the most part are portraits of nurses, mothers, and babies. Miss Cassatt is an American who makes Paris her home and has won distinction among the devotees of decoration and open-air painting. She belongs to the camp of Monet and Renoir, d'Espagnat, and other

young impressionists of the newest variety. Yesterday a collection of twenty-five oils and pastels, only a few of which have been shown before, was opened to the public. It will close on the 21st.

Miss Cassatt did not always paint in the style of Renoir, as one perceives from a profile seated lady called "Dans la Loge," which shows the interior of a theatre where a staid middle-aged woman, seated in profile, is using her opera glass intently. The brown tones of the auditorium, the blacks and browns of hat, hair, and dress, form a strong contrast to the schemes of color she now prefers; but it is clear from this early work that she had from the first a strong individual touch. With the growing influence of the advanced modern French masters she has taken to positive color-masses which make her pictures, if not gay, the powerful carriers of color. At the same time she has sacrificed all attempt to select figures fine in line and beautiful in color. Take her "Young Woman Plucking a Fruit" as an example of a choice of the plainest of her sex as models, girls not merely plain of feature but queer in drawing and awkward in action, peasant figures having nothing of the poetry of rustic life such as Millet understood the art of producing. Miss Cassatt represents a very violent reaction against the prettiness of Bouguereau's and Cabanel's women, or the style of the Parisian women of Madeleine Lemaire. She is the apostle of the ugly woman in art, like certain novelists of her sex who at one time, following in the track of Charlotte Bronté, made the woman to whom Fate has been unfair in the matter of looks the heroine of their romances.

In her later style Miss Cassatt is seen at her best in "The Toilet," which depicts in oils a scene of the nursery. A stalwart, black-haired nurse in a startling gown of green, lilac, and white stripes, is washing a small, nude child. The sunburned arms and legs of the victim of the moment are well defined against the white torso. The feet are in a basin of water on the floor, and the child has resigned itself to those ablutions which the odious tyranny of grown people force upon it. The group is original in composition and finely brushed in, with long, intelligent sweeps of paint. The coloring is strong and not untrue. Another nursery scene has a touch of sweetness. A small girl nude to the waist stands on the bed, looking down with a serious expression, while her mother, to whom Providence has allotted a very ugly nose and a full, coarse mouth, sits holding her—"After the Bath." The color scheme is interesting. Against the dark-blue wall one sees the yellow-flowered furniture and the bright dress. The brushwork is broad and easy; the color values fine. Yellows are prodigally used for "The Baby's Awakening"—in the mother's gown, the table on the left, the baby's hair—and these notes harmonize well with the green trim of the woodwork. "Infantile Caresses" is a charming scene of young woman and baby in pale sunlight against a flowery hedge, the faces in shadow. "Little Girl in a Big Hat" is still more sketchy in treatment than those just mentioned. The little girl has a gay hat, a squirrel face, and looks out of the scene like some small furry animal; the mother has a pensive look;

despite the glow of nasturtiums in her own hat. A "Seated Woman" in a lilac dress holding a red flower in her hand just misses being a very remarkable picture. "The Woman With a Dog" is a French bonne of more than common plainness who sits in the sunlight with a bit of a French town scene in the background and a black dog on her lap. Her lilac and white Summer hat is a fine bit of painting, contrasting with the solid, ruddy cheeks it shadows.

The pastels are particularly interesting; one feels Miss Cassatt handles this material with more pleasure and perhaps more skill than oils; at any rate, the pastel suits better her color schemes. "The Cup of Tea" is a bust portrait of a young woman who sits a trifle self-conscious, with eyes turned to her left, a green saucer and cup in her hand, wearing a yellowish thin-stuffed jacket over a white waist. She has brownish hair, thick, ugly nose and lips, and a neck with strong green reflections, as if from the cup in front of her. Perhaps the ugliest in all this gallery of ugly faces is the seated child, with pale hair, in dress of turquoise blue, her eye sockets exaggerated in drawing. A profound pity for this sport of nature seizes one. A pleasing group of mother and small girl baby shows them playing with each other's fingers. The amused look of the child is delightfully told. The mother wears a green-flowered dress. In the rendering of stuffs one often finds passages of extreme clearness, done with a certainty of touch and a correctness in seizing the color that excites one's admiration. There are two pastels, heads of the same little girl in blue dress and pink hair ribbons, which are especially well drawn, the same merry little face being taken from different angles.

What is particularly agreeable in most of these pastels is the refusal to carry out details which are unnecessary to the picture, the kind of refusal one often sees in portraits by Franz von Lenbach. Miss Cassatt would excel in posters owing to her cleverness in presenting figures in broad, flat colors, and perhaps she might make a mark in stained glass. She showed an uncommon strength and individuality long ago in colored drawings, not entirely unreminiscent of Japanese color prints. This is the largest and most important exhibition she has made so far in New York. It is well worth examination and discussion, if for no other quality, then the tone effects of bold yet not harsh colors.

* * *

November 29, 1903

A NOTED IMPRESSIONIST

*Atmospheric Notes from Town and Country
by the Late Camille Pissaro*

The Pissaros at Durand-Ruel's are just enough in number to form a single round of the large gallery, with distance enough between to isolate each canvas. Instead of the high key one finds in Claude Monet, in Renoir, in Montenard, the tones

are rather subdued. Landscape, townscape, crowded market place, views of such familiar places as the Carrousel Court of the Louvre with its little triumphal arch, snowscapes in the Tuflerie gardens, bits from Bazincourt and Pontoise, foggy mornings at Rouen, figure pieces from the bare, arable lands of Normandy—all are cast in the same quiet color scheme, all are notes more or less elaborate from the portfolio of a most industrious painter, who became known to the world of collectors after he had passed middle age. The difference between his work and that of his later master, Monet, is seen when one leaves the gallery and catches sight of one of Monet's brilliant canvases in the outer rooms. Then one realizes how difficult it is for the disciple to emulate the master, whose creative force is seen in all that he touches, even in those pictures which add nothing to the master's fame, but may be counted among the master's mistakes.

Camille Pissaro owes much to Millet and Corot, and, now that he is dead, the attempt is being made by his admirers in Paris to hail him as a master of originality. He lived a country life at Eragny, whose flat horizons appear in two paintings in the present collection, one an Autumnal scene at sunset; but from time to time he went to Rouen or Paris or Dieppe in order to add the picturesque architecture of the one, the alert human life of the other, the seaside views of the third, to his series of thoughtful pictures. There is no forcing of the note in either case, but a patient, delicate power of observation is showed in the use of values producing atmospheric and tonal qualities which are peculiarly agreeable to contemplative minds in harmony with his own views of art. Although his reputation outside of France was not widespread, he had a host of admirers at home who appreciated very keenly the gentle beauty of the atmospheric effect, in his townscapes and views of Normandy towns and fields. The Luxembourg contains no less than eight of his pictures, including views of the Avenue de l'Opera and the Boulevard Montmartre, but it must be noted that it was not the Government buyer but a private collector who placed them there. It was M. Caillebot, another Impressionist, who left them to the national gallery of modern paintings. Among them is a townscape, "Red Roofs," which is considered one of his triumphs.

The term Impressionist is comparatively recent; it started in the year 1874 from the title Claude Monet gave to one of his pictures of a sunset at a special exhibition of "come-outers," which was seized upon as a joke by one of the comic papers, Pissaro, as well as the late Sisley and Renoir, exhibited at the same time, so that there was plenty of ammunition provided for those who heaped scorn on the adventurers and perhaps hoped to crush them by sarcasm and abuse. Pissaro was then scarcely known. During the Franco-German war his little dwelling in Argenteuil was destroyed by the enemy at the investment of Paris, and with it went all his sketches and pictures. It is only since 1874, when Monet's "Impression" made such a furore among admirers and scoffers, that Pissaro has been winning a way to the front; and he was over fifty before he became a favorite. One can scarcely fail to draw the conclusion, after examining the two-score pictures here that

the example of Monet had everything to do with the handling of his brush after 1870.

Pissaro was a hale old man at seventy-three, wearing a majestic white beard. He was a spirited talker. As a workman he put the most unbending industry as well as taste and talent into whatever he undertook, whether it was his first Salon picture (1859), a rustic scene of gateway and donkey, or an etching, or a lithograph. His death was sudden and unexpected, being the result of an operation from which he did not rally. Some of the personal liking many artists felt for Corot seems to have descended to his pupil, and, like Corot, his fame had to wait until very late in life. His quiet skill in catching types of rustics is seen in No. 12 of this collection, "Marché à la Volaille"; in No. 17, "Paysannes Ramassant l'Herbe," and No. 18, "Marchande de Marrons." The exhibition will remain till the 12th of December.

* * *

January 23, 1904

PICTURES BY GEO. INNESS, JR.

Views of Rustic Life by a Noted Cattle and Landscape Painter

A collection of twenty-six paintings by Mr. George Inness, Jr., hangs in the upper gallery at Clausen's, 381 Fifth Avenue. They offer a very even and united show of canvases, having a strong tonal quality in which red and gold predominate. Saturday next will be the last day to see them.

"End of the Day," a circular canvas which took a silver medal at the Pan-American, occupies the west wall of the little gallery. A peasant woman sits in the evening glow while the ewes and lambs pass her as they plod homeward. This picture, however, is not on the catalogue, which contains only paintings of much later date. Nor is it by any means the best here; a number of recent paintings are more original and stronger in color.

And first as to pictures in which a story is told: "Tragedy at Sam's Point" foreshadows the fate of the black and white bull which has been forced by the red bull to the edge of the cliff on which his hind legs are already seeking a purchase down the treacherous slope. A moment more and he will roll backward from the hilltop and break his back on the rocks below. A cow looks on, and to the left one sees a valley with arable fields and pastures. "The Wood Sawyers" is another story of country life, but not a tragedy. A rough platform of logs has been thrown together in a clearing of the forest, and two men are at work sawing through a log which they have hoisted to the top of the platform. The man on the right has placed one foot against the log as he hauls the saw toward him, the other moves slightly forward as he pushes the saw in the same direction. The air is full of a pale golden light. "The New-Born Lamb" is shown in a big, broad basket which a young woman in an ivory-white woolen shirtwaist and dark skirt half supports in her arms, half props on the back of an

ewe; evidently this latter is the mother, for she curves her neck round so as to look into the basket at her hopeful offspring. The shepherdess, whose face as she looks down is in shadow, is followed by another sheep, and there are cattle in the background. "The Mower" is a middle-aged man at work in a rough pasture, his own head coming dark against a creamy "thunderhead" on the horizon, where a hill slopes across the background.

"In the Fall" is a farm scene with a flock of sheep crowding round a man with a pail held high above their eager noses. He is in shirt sleeves, blue overalls, and a felt hat that shadows his face. A soft, pale-golden light floods the scene, the fleeces of the sheep being remarkably well rendered. In the "Brush Burners" there is a murky sky, against which three men appear, with the last rays of sunset or the light of a fire on their upper figures. One stands upright, the others are bent over as they gather brush for the fire. One of the finest canvases is called "Glowing Wood." The sunlight falls level through the gorgeous Autumn foliage and makes the depths of the rough woods glow like the centre of a fire.

A good figure is "The Milk Maid," seen as she balances with one arm the weight of the pail and steps away from the cows. These are lit by the sunset on their sides and horns as they gaze after her. The same time of day is seen, and much the same season, in "The Setting Sun" and "Edge of the Wood." In the latter one sees gleams in the depths of the wood where some particularly vivid mass of Autumn leaves has caught the rays of the setting sun, while the clouds through the tree tops reflect the glow. No. 13 shows a woman in a white cap driving home four cows. Particularly lovely in coloring and sentiment is No. 15, "Gathering the Flock," in which a burst of sunlight from a golden cloud strikes the cheek and unlifted arm of the shepherdess, and the backs of the dog and flock of the sheep behind her.

Another time of day is found in "Dawn in the Meadow," where the shepherdess leans against the trunk of a silver birch. "On the Hills" is almost night, but a glint of light falls on a meadow in the valley, and there is a fine effect of movement in the clouds. In the darker shadow to the left stands a man in shirt sleeves, while the flock of sheep extends across the foreground from the middle to the extreme right. A very natural scene is "Through the Pasture," with its rolling clouds, rough, half-cultivated fields, and the common or "State" cows meandering forward in a bunch.

Some foreign landscapes are here like the "Canal at Moret," with its boat coming bow on down the straight water, the horses on the towpath to the right, the blue sky repeating itself in the stagnant water. "By the River" is another French landscape, with a golden tinge on the clouds, a rude skiff, and an affectionate couple. Among the many canvases treated with a golden glow, not the least enjoyable is "On the Loing, France," with its misty distances, its little white figures on the path by the river to the right, and its tree masses to right and left, very vaporous and yet not weak.

A good many of these pictures are marked "sold," which is none the less remarkable because Mr. Inness has to stand constant comparison with his father, and sometimes recalls the elder Inness, more by the subjects and seasons he chooses than his manner of handling paint. As an offset to this embarrassment, he is one of our landscape and cattle painters whose pictures are sought. Last year a gentleman from a Western city bought six landscapes by George Inness, Jr., at one visit to New York, three of them for presentation to the museum which he has given to Minneapolis and three for his own private gallery. No one who cares for work by colorists should fail to visit this collection of warm and mellow canvases, as sunny in their expression as they are in fact.

* * *

February 7, 1904

ARTISTS AND THE SOCIETIES THEY CONTROL

Said the other day one of those extremely disagreeable artists who must blurt out the truth, the unpardonable truth, or die in his tracks:

"New York is the biggest city and also the greatest market for art work on the continent: she has the most artists and exhibitions; yet American painters and sculptors in other cities of the land and in Europe do not look to New York, but to Philadelphia and Pittsburgh and Boston, even to far-away Chicago—anywhere rather than New York. Why is it so?"

"Because," he was answered, "New York makes no effort to interest the outsider and his chums. New York exhibitions are neither international nor Pan-American, not even inter-State. They are sufficient unto themselves and accept the work of outsiders only on sufferance."

"Umph!" Said the Artist.

That our exhibitions are not as attractive as they might be is generally accepted, but the reason is not clear to those who are responsible for the conditions that prevail. The reason is that the artists themselves exercise control and have not known how to make use of the opportunities presented them. Their very numbers give them inevitably the command, and since they are human, the majority rules and the majority does not understand what is best for the guild. Thus they are in danger of forfeiting the confidence of the public and preventing that assistance from laymen which they crave and which they might deserve, that assistance without which they can never hope to occupy the position they ought to hold.

We have in this country among our politicians artistic politics and to spare—look at Mr. Murphy of Tammany Hall in the last municipal campaign, to go no further afield for an example. But the politics of artists are very inartistic indeed! And why should they not be inartistic? It is no sphere for them in which to exercise their faculties. Their sphere is one in which the wider duty to the country, not their own self-interest, should be the animating force. And while one cannot blame them for gravitating naturally and unconsciously toward lower levels, one can point out their mistake

and exhort them to view the situation from a higher viewpoint, not merely for the sake of the public, and the sake of the arts as an index of American cultivation, but for their own sake as well, since many of their methods are sure to injure them in the long run.

As to Lay Members

There are members of the Sculpture Society who maintain that the sculptors do not hold the place in public estimation to which their numbers and talents entitle them, and so, with the energy of freemen, propose to find out why this is and what remedy can be found. And yet in its short career the Sculpture Society, a combination of sculptors and laymen, has outshone the architects and painters in the novelty and scope of two out of the five exhibitions it has held. Moreover the Columbian World's Fair, the Pan-American and the St. Louis Fair have stimulated sculpture on a grand scale and given chances never known before of studying objectively the relations of sculpture to architecture, the city square, and the formal garden. Members of the Society of Mural Painters have had opportunities not only at the international exhibitions, but in many public and private buildings. Still, they, too, are far from content with their situation. The Society of American Artists is accused of narrow views and an exclusiveness on the part of its committees for acceptance of works which injures its exhibitions. As for the Academy of Design, that is assailed to-day with the same ferocity it has borne with apparent equanimity during the past half century. On the other hand, the Architectural League, an exhibiting society of a composite membership, that confines its energy to one annual show, has been successful on the narrow lines laid down.

When we examine the management and organization of these prominent societies of New York we find that those having the greatest successes to their credit are composite as to membership, having lay as well as artist members. This is a difference worth pondering. But perhaps it would be better to take examples from other cities, thus avoiding personalities too near home, and showing by analogy what may be expected in our own local organizations if they do not devise means to avoid similar results. The topic is worth discussion, and it may be that some of the artists will feel moved to express themselves on a matter so vital to the interests of the public as well as of themselves.

No Laymen in These

Through the ready wit of a business-like Quaker from Pennsylvania a charter for a Royal Academy was obtained by him from one of the Georges and London's long-lived disseminator of the arts entered on its career. Observe that London had many artists at the time, so many that the Royal Academy seemed to require no assistance from laymen. Outside the charmed circle a host of other artists existed even then.

As was natural, the Academicians felt themselves sufficient for the task, and as time went on they perfected that system which has been so violently attacked by the British press in recent times. They monopolized all the good space in their shows, each Academician having the right to place eight pictures on the line. When Chantrey left his bequest they saw to it that the sculptures and paintings bought with its income were those of Academicians and Associates, and very bad they are! Their Presidents were always knighted, the one exception being the second President, Benjamin West, who was a Quaker. They enlisted fashionable society in natural consequence of their prerogatives as a Royal Institute. Their schools, as George F. Watts and other leading painters have stated, were practically worthless, the students going elsewhere for instruction while keeping up their membership in the Academy school for obvious reasons of future advancement. Those Academicians who agreed to "teach" in the schools were paid and were changed frequently, so that no permanent influence of a master was possible. The Royal Academy, with its splendid palace, its endowment and social impetus, its negation of a true leadership in the arts, remains as a sad warning of what happens when artists have complete control.

The exhibitions of the Paris Salon have been scarcely more satisfactory than those of the London Academy, although they have been more hospitable to outsiders and even to foreigners. When we hear demands for an annual Salon in New York it is not that the artists here desire to see exhibitions so crammed with mediocre, flat, and sensational work as most of the Paris salons are, but that they recognize the value of concentrating public attention on one annual show. And in Berlin it is only when they have an international that the annual exhibitions please lovers of the arts. There, also, the rule of the artists is not productive of happy results; but the aid of Government through prizes and honors, the assistance given them by placing a great art palace at their disposal, bring the public attention so to bear that financially at least these exhibitions are a success.

Where Lay Members Control

To revert to the United States once more: The Pittsburgh exhibitions are not under the direct management of artists. While native art is not neglected, the system is to bring foreign work and the work of Americans who live abroad into the same exhibition, so that Pittsburgh often has picture shows better than New York.

The recent history of the Pennsylvania Academy is another well-known example of the value of lay management. Instead of sitting down to wait for artists to send in works, the managers of the old Pennsylvania Academy, which ten or fifteen years ago was moss-grown and scarcely heard of outside of Philadelphia, moved heaven and earth to get together once a year a capital representative American exhibition. True it is, that such exhibitions do not in the main consist of what is produced by painters and sculptors in Pennsylvania during the year, and in that respect the comparisons often made between the exhibitions of the New York and Philadelphia Academies are at fault, and may even be called unfair. That, however, is a matter affecting the artists, not the public. And an exhibition is

an appeal to the public, not a means for satisfying the personal demands of the exhibitors.

The fact, if fact it be, and the above considerations seem to bear it out, that artists when left to themselves do not manage their organizations in the wisest way, does not cast any discredit on them. The demands of such societies are greater than artists should be asked to meet. Theirs is a training, theirs is a life exquisitely unsuited to such requirements. One constantly finds that the artists who represent most in art and form the brightest relief in their works to the general run of the exhibits are the most restive under such claims on their time and energies as organizations make. They fail to exhibit; often they withdraw from the societies entirely. Often the work falls on the least representative, the narrowest minds.

Why should we expect that a man who has chosen one line of work, one method of painting, let us say, who has practiced it as a student, talked it and perhaps taught it later, could falsify his creed by accepting work produced by a system or method he has always detested? That is demanding too much of human nature. Those, therefore, who pillory your Royal Academician or your National Academician because he finds himself unable to admit to his own exhibition some work which, he is convinced, is tricky or foolish or merely the truckling to a passing fad of the aesthetic public, make a great mistake. They are listening to the talk of the younger men of the ateliers who answer contempt with scorn and in their own way are as unreasonable and narrow as the generation ahead of them. It is only the exceptional artist who can see that art is so wide that it may include an almost infinite variety of methods.

Artists and the Public

Artists need the assistance and advice of laymen more than members of almost any other profession, and just in so far as they can be convinced of this will they get it. The public needs the artists in a thousand ways, but the public has little confidence in those organizations which are composed of artists alone. The elements for a large, useful, healthy federation are present, but there is no real union, no confidence, no leader. It is fair to say that on the whole those societies leavened by lay membership thrive best. It is fair to infer that we shall never have the great building with ample galleries sufficient for a grand annual exhibition of architecture, sculpture, painting, and the arts and crafts, which is so ardently desired by many, perhaps by all the artists, until there is a closer alliance between the laity and the artistry. The various organizations will have to make concessions, cease acting as if each were a little republic independent of all the rest of the world, and cast to the winds the foolish fear that a close combination of artist societies and a big lay membership may in some way destroy their separate identities.

An endowment dropped from the clear sky upon one or other of these societies would not help it permanently, since the inevitable result would be for that society to close its ranks and begin the career of narrow conservatism and self-seeking which has made the Royal Academy a reproach.

In a commercial atmosphere like ours there is indeed abundant need of some centre where artists may pursue their ideals without the ugly obtrusion of monopoly and money-getting, some place where men of the other professions and business men may cast off the coils of worry as to financial things. Were the artists to abjure self-seeking and appeal to the public on high level they might obtain all they require in the way of facilities and endowment for the proper exhibition of their work. The ideal organization toward which they ought to labor in unison is a federation in which the public has a part, so that the lay membership shall always act as a drag on the tendency to set up narrow standards, a tendency inherent in human nature and therefore to be expected and foiled.

CHARLES DE KAY

* * *

April 13, 1905

WATER COLORS BY HOMER

Fisherman's Life Out of Doors in Canada and Florida

The lower gallery of the Knoedler establishment has two wallfuls of water colors by the Hermit of Scarborough to the number of twenty or thereabouts, water colors that range in date of making from 1880 to 1904. They are racy products of the somewhat grim but robust Homeric mind and cannot fail to give a fillip to the aesthetic sense of people lulled to a coma by the hollow inanities of Italian water colors, the simpering of the ordinary French producer of aquarelles and the fearsome dullness of the British output.

The Saguenay has afforded Mr. Homer capital chances for strong color effects, which may seem overdone to those who have never boated on that river. "Fishing the Rapids, Saguenay River," and "Under the Falls, Grand Discharge"— great sheets of blue separated by red-shot spuma—have brown foam instead of white, for the simple reason that the waters of the river are impregnated with iron and this shows when the surface is stirred into foam. In these two views which belong to 1885 Mr. Homer produced a couple of pictures on the biggest scale, full of his extraordinary power and with all his avoidance of the unessential. Another very impressive piece, but without colors, being almost entirely in sepia, is "Sky Line in Canada," a slight reinforcement of a green tint being employed to vary the black and white. The sky line means the array of pines and other trees in silhouette beyond the smooth water. From 1891 is "Building the Smudge," an old and a young man landed on a broad rock by the water side to catch the smoke of a fire. A striking open sea marine from the Bermudas is called "Sharks" (1885). Four of the monsters are playing near a derelict, the hull of an abandoned fishing sloop. In "Deep-Sea Fishing"—two men in two skiffs hauling at the ends of a seine—(1894), the big billows are given as perhaps only Homer can paint them, but

the relative values of the water on this side and beyond the boats are not quite true, so that at first glance the forewater looks like foreground. From 1892 is "Man Fishing; Adirondacks," late afternoon on a lake with a man in a canoe and just two water lilies off to the right.

"Landing the Pike" is the somewhat puzzling title of a shore view with two natives of the Adirondacks carrying a canoe on their shoulders. "Mink Lake" is remarkable for its cloud masses and sheets of white light.

Last year's work includes "Black Bass in Florida," a picture of the fish rising clear of the surface, and "Channel Bass, Florida," "Pike" and "Black Bass" are similar studies of game fish struggling to rid their jaws of the fly. The colors are strong in "Trout and Float"; one can count the red and yellow speckles and note their reflections in the water. Other water colors are a jam of logs called "Hudson River at Blue Ledge," "Fishing on the Ouananiche, Lake St. John," "Herring Fishing," and "In the Rapids."

* * *

May 7, 1905

AMERICANS FEAR COLOR IN SCULPTURE

Brilliant Colors Were Used in Sculpture and Architecture by Greeks of the Great Epoch—We Should Go Back to First Principles, Says This Critic

Sculpture is taking such a place in the art of to-day that it bids fair to wrest the first rank from painting, and, while architecture is bound hand and foot to the chariot of commerce, emancipate itself to some degree from the trammels of convention and develop into an independent art. Not that the great majority of statues modeled to-day and turned into marble by the artisan or into bronze by the founder are properly to be included among works worthy of preservation; but that in the mass of poor statuary clawed together out of the patient clay one sees now and then a hint that the art of the sculptor may have a rebirth, provided the coming generation has the wit to sift the wheat from the chaff and insist that the price of masterpieces shall not be paid to masters of the commonplace.

Nothing in art is quite so easy to do as modeling in clay; no branch of art is more weighed down by mediocrities than sculpture. As it is accepted today, sculpture does not demand of its professors anything more than architecture, viz., the intelligence to crib ideas wherever found and after mulling them over enough—to ruin what little good was once in them—produce them as original work. Any ordinarily bright artisan can set up as a sculptor when he has a few courses in an art school back of him, provided he can pay for a studio. And if he has a few friends he may secure a commission without much fear that the committee who will examine his model can tell good from bad. And so it comes about that our battlefields of Gettysburg and Chattanooga are covered with bronze and stone monuments which testify to the patriotism

"Europe," by Daniel C. French. For the Front of the Custom House, Bowling Green.

and wealth of cities and towns of the United States, but also, alas, to the deep ignorance, nay, one may say the amazing impudence, of hundreds of sculptors who could not carve a newel post in a craftsmanlike way.

As in architecture, so in this wholesale sculpture, there is a commercial instead of an artistic origin to it; there are behind it "jobs" (sweet word!) and a very extraordinary pouring out of money, considering the wretched objects acquired. Apparently our vaunted acuteness deserts the Monument Committees taken here and there "from our midst," for, while always striving to drive a bargain, they are most unmercifully plucked, as all men must be who venture on a field they know nothing of without taking advice of experts. Innocent of a distinction between bronze and spelter, between one marble or another, unable to distinguish sound, well-cast and well-finished metal work from the tricky products of factories, they pay the price of the best for the worst sort of output and so, between bad sculptor and bad material, they cumber the earth with statuary of the most disheartening kind.

These are probably hopeless and must be left to their fate, since they are too wedded to their idols, their belief that any man can do pretty much anything without long training, to expect them to change. But with regard to statuary of a higher class, produced by men and women of talent and training, there is a danger which may be avoided in some degree.

The danger is the monotony that has befallen sculpture owing to mistaken ideas as to the purpose of the art and what the art was in the great epochs of its flowering. When you walk about the Rotunda of the Capitol at Washington or down the Sieges-Allee in Berlin you begin to realize what it is for nations to borrow ideas in art from other ages and other climes without regard to their own people and climate. They always borrow the wrong thing. If it is in any way possible, they begin at the wrong end and copy the least appropriate thing first, or, as the homely farm phrase has it, put the cart before the horse. All that white marble in the rotunda,

all those groups and busts and benches of white marble in the Sieges-Allee are there because a hundred years or so ago it was assumed that the Greeks left their marble statues white. The assumption rested on marbles made by Romans, some of which, though by no means all, were left untinted, just as they came from the polisher's hand. Wherefore we had the cold, glittering statues of Canova and Thorvaldsen and the dismal statues and groups of the American, British, French, and German sculptors who made Rome their Mecca. As usual, they began at the wrong end, and even so, did not know how to go about it. Instead of lingering in Italy, they should have pressed on to Greece, and there, inducing Governments to explore and dig up what statuary remained in the earth, satisfy themselves what that sculpture really was which made Greece the most famous land on the globe. What thousands of hopeless inanities in nice, clean, respectable Carrara, sweetly suited for Brussels carpets and hideous window curtains might not have been spared the Victorian age in England and those arid years befo' the wah here in youthful America!

The marble from the Pentelican Hill near Athens has a good deal of iron in it which sometimes shows in minute grains when polished, and is said to be the cause of the yellow tinge on the weathered sides of Parthenon and Propylaia. The east end of the Parthenon seems to have oxidized more than any other part, some stones having turned pale orange, others a rust color. But in their architecture and in their statues as well the Greeks did not wait until weathering removed the dazzling whiteness of the freshly polished Pentelic marble; they painted or tinted column and architrave, placed salient colors on the background of the metopes and on the triglyphs; brilliant also were the decorative mask and leaf forms on the corners of the roof; less bright, perhaps, the reliefs carved on the wall under the porches that ran round the Parthenon and similar temples. So at Olympia the architecture has been proved to have had brilliant colors by finding the stones themselves. And as to statuary—well, if the popular statuary, the terra cottas of the graves and temple catchalls did not prove it, the brightly colored statues of Parian marble found on the Acropolis in 1885 would remove all doubt. Fourteen draped female figures were discovered, their hair tinged reddish, lips and eyeballs colored, their robes enameled with brilliant colors to simulate embroidery; they wear bracelets and diadems and big gold earrings in place, says Ernest Gardner:

"The effect of this coloring, whether on face or garments, is to set off and enhance by contrast the beautiful tint and texture of the marble. Those who have only seen white marble statues without any touches of color to give definition to the modeling and variety to the tone can have no notion of the beauty, life, and vigor of which the material is capable."

For our marble statues we use Carrara, which has the advantage, if in truth it be so great an advantage after all, of supplying large blocks of a very even, cheesy, fine-grained, and dead-white stone, but the distinct disadvantage that it does not grow old beautifully like Pentelic and Parian. But the worst of it is that, caught as ever in the copyist's error, we

"Sacajawea, the Indian Guide of Lewis and Clark." Alice Cooper, Sculptor. Cast by the Henry-Bonnard Bronze Company.

follow Roman instead of Greek precedent, and try to make ourselves believe that this dead-white Carrara is beautiful. The natural instinct rebels. No child cares for a white Carrara statue; if the subject interests it for a moment, the material tires. There are, however, still many people who think there is something holy in the absence of color; through some fantastic involution of asceticism with aestheticism they fancy there is merit in cold white marble and naughtiness in rose color. Which reminds one that there are people who are shocked if you say God, with a short o, and beg you to say Gawd, as more reverent to your Creator!

Our danger is in this painful narrowness which seems peculiar to Northern Europe and North America, showing itself in a constricted art expression, a timid use of the natural advantages of a splendid climate, not unlike that of Greece for many months in the year, a squalid dependence on a parcel of European masters who themselves are rather scant of brains, heart, and knowledge. Ours is a land that calls for splendid color effects. What are these dull bronzes doing in our parks when they might so easily shine with the beauty of

strong colors? Why these rows of desperately ugly and uncouth worthies all in white Carrara, when in Tennessee and Vermont we have marbles and granites of almost any tone required? In fact, our sculpture ought to go back to first principles and start with carved wooden figures painted, gilded, and tinted, in order to learn that lack of color is not necessarily good taste, and that the grain of wood is as important as the grain of marble. We have taken sculpture from the wrong end, and the error is still dogging us like any other crime against the right. We must have polychrome sculpture, and that quickly, or the people will revolt against the stupid things that pass for sculpture and the art will perish.

Some attempts have been recently made in New York to escape the disagreeable effect of newly cast and burnished bronze. There have been artificial patinas, of course, but the cases to which allusion is made are gilt statues. The "Sherman" of Saint Gaudens and the "Alma Mater" of French have been gilt, though it may be that the natural ingredients of the city air would by this time have given both these statues a natural patina finer than their present gold-beater's skin.

The illustration shows Miss Alice Cooper's bronze figure of Sacajawea, the Indian squaw who served Lewis and Clark as a guide in their voyage of discovery across the plains of the Northwest. It is for the exposition at Portland, Oregon, and was cast this week at the Henry-Bonnard Bronze Foundry. The bronze has received a patina, but not a green or a very brown one. The other illustration is one of the four groups representing continents, by Daniel C. French, which will stand on advanced pedestals on the Bowling Green front of the new Custom House. They are to be carved in a Tennessee marble of a reddish gray tone. May we not hope that the statuary on the façade itself will have some strong if not brilliant color, so that New York shall begin the transformation of sculpture from a cold and repellant formalism into something youthful and passionate?

CHARLES DE KAY

*　　*　　*

June 4, 1905

A PAINTER OF TYPES FROM THE PEOPLE OF NEW YORK AND PARIS

Unconventional in Method and Treatment, He Follows His Own Lines Rather Than the Teachings of the Art Schools—Believes in Eliminating Details

Until recently the name of George Benjamin Luks was scarcely known in New York, except that occasionally an illustration or a caricature signed by him caught one's eye through the singularly individual stamp of the work. Last year a little exhibition at the National Arts Club revealed his strong personality. The bust of the prizefighter "Yank Sullivan," bruised and battered in an encounter—low brow, defiant leer, degenerate type—and the portrait of a barroom

"Boy With a Shovel"

habitué bearing the marks of a life devoted to drink, excited a good deal of comment, for the most part far from complimentary. His "Boy with a Shovel" and "Dumping Snow from the Docks," however, did not rouse the criticism of those who were shocked by types from low quarters. No one could deny the power of these scenes from New York life. And so it came about, although his "Parisian Coachman" was refused at one of the exhibitions because it was recognized at once as a disturbing element to placid genre, that the charming little group of street children dancing to the strains of a barrel organ found favor with the Society of American Artists. The hanging committee, however, managed to place it where it could scarcely be seen, so that it remains practically unknown.

To-day we reproduce . . . the "Little Spielers," as children on the east side who dance to the barrel organ are termed in the polyglot tongue of that district; the "Old Beggar Woman of Fourth Street," and the "Boy with a Shovel," in order to give an idea of the talent which has been developing itself apart from the regular walks of life—the students and painters in this city.

George B. Luks is a Pennsylvanian of Dutch descent who has made his own way with very scant regard for the lectures and warnings of his teachers. For a time he worked in Philadelphia at the School of the Pennsylvania Academy and then came to New York, where he found matters in art study not quite so narrow, but to him at least almost equally impossible. Art life in the Quartier Latin of Paris was more to his liking; but even there the tyranny of the accepted masters went against the grain; he could not subscribe to the admiration

"Little Spielers"

felt for them by pupils who hope that through the power of that admiration they are on the road to the honors of the Salons. It was the master not in favor whom he admired, the arch-impressionist Degas, the eccentric Gaguin, the uneven but powerful pleinairist Renoir. He esteems very much Sisley, Steinlen and Simon. The academical painter, on the other hand, has no valid reason for existence. To be sure, he can admire a draughtsman with the absolute devotion to small things we find in certain Germans, but only for his unflinching industry; and he never wishes to follow his lead, for he considers work of that sort of little value to the world, since it lacks imagination.

"Why, I could teach any young fellow of ordinary ability how to draw and paint in that way," exclaimed Mr. Luks, hitching his trousers as if he were a sailor and waving his arms as the subject excited him. "Nothing is easier than to study art by first drawing eyes, then noses, then mouths—and so on until the figure's complete. Pshaw! That is the kind of teaching we get in the art schools. After piecing things together, they think they've learned to paint. And so they have—to paint manikins, with no more expression than dolls. They make me tired.

"If I'd been a good scholar and believed all they told me, I'd be milling out figures to-day that wouldn't give the juries of acceptance the slightest trouble, and being welcome besides at the exhibitions because they'd be nice, harmless thirty-by-twenty canvases, warranted not to shock the most fastidious old maid—thirteen to the dozen at wholesale prices—they'd sell like hot cakes—sure! D'ye see?"

"But, Mr. Luks, you have to live while fame is coming, and juries of acceptance are cold."

"Oh, I'm all right, never fear. I make illustrations; I design posters, and so the pot boils. But I never let up on my other work, not one moment. And the habit of making quick sketches in and out of season, on the street, in the café, the bar-room, Central Park, on the steamers to Coney Island, wherever men, women, and children are natural and show themselves as they are—that habit keeps me ready for the illustration and poster work which keeps the wolf from the door, and at the same time prevents me from falling into the academical rut."

"You are an all-round impressionist, eh?"

"That's what I believe in; don't you walk off with any other old idea! Impressionist? Well, I hope so. And I rather guess I'm in good company. Did you ever hear of a great painter who wasn't one?"

"Oh, I know what you're going to say. Names there are that still draw. There's Meissonier, there's Gérôme, there's Bouguereau. But they've had their fame already, and every year fades 'em more. Industrious, painstaking, laboring at little unimportant details, until all the chumps exclaim: 'My Gawd, how that artist makes art!' But what do they tell us about the people among whom they lived? Do they ever give us even the sunlight and air, a matter of no great importance, in my opinion, let alone the human thing? Not they."

"You don't believe in drawing in the details?" the strenuous one was asked.

"Old Beggar Woman of Fourth Street"

"The more I work the more I study what can be omitted to the advantage of the picture. If I spend a month in simplifying a canvas, that month is well spent. To the devil with a lot of truck that is useless in telling what I want to say! Why should I weary people with what they know already? Haven't they imagination enough to supply the commonest things—things that merely carry their minds from the point I wish to make? If they haven't, then they're not the people for whom I paint. So suppose we let 'em rip!"

"You don't propose to conduct a kindergarten in art, then?"

"There's a plenty of painters to supply all the silly pictures needed. I don't envy 'em their job, though it may pay well enough. I like to paint just such a cheeky, sassy little boy like that one with the shovel, who has begged a cigarette and twinkles his eyes at you with the air of a lad three times his age. There's a fact from our streets any Winter. The boy's not vicious; he's merely imitative. He sees men and youths 'doing the tough,' and he admires and copies them. I'm not a reformer. I'm just a man who studies nature as I find it. Look at that old beggar woman who waits till the coast is clear of cops before she waylays you with a story. The story's no good, and perfectly unnecessary besides; for if you don't feel sorry for her just to look at her, you won't be softened by her patter. Now, somebody will say that begging's against the law, and I ought to have her arrested. Well, I have arrested her in my own way; but it's

not a way she dislikes. I paint her portrait and pay her for the sittings."

"You work fast when you get at it, I suppose."

"Usually. I don't like to let the iron cool. But I'm only able to work fast because I've drudged through years of harder drill than the schools teach, gradually learning to simplify, simplify. Oh, you can't be an impressionist all at once. If you try that trick too early, you're a dead duck. Many's the smart Aleck I've known in the schools who thought he'd begin operations where it seemed the easiest. But I never hear of 'em now. Where are they? Well, I guess they're holding down chairs in offices somewhere or designing costumes for a milliner. Or perhaps they're Academicians," added Mr. Luks, pensively, as he flicked a bit of white on an eyeball to give it life.

After some experience on a New York daily in which his quick-dispatch methods stood him in good stead, Mr. Luks determined to devote himself to scenes of life that express the many phases of existence in a great city. His notebooks from Paris teem with sketches of soldiers and priests, children and toughs of the Parisian breed, obese bourgeois and stouter bourgeoise, poets and painters of extreme Quartier Latin types, workmen at rest under the trees of the Tuileries and ferocious Anarchists enjoying themselves at a suburban vaudeville. Some of these sketches appear caricatures, though true to the fact. Here is an aesthete with a wonderful bush of hair, on which perches an amazing hat; he carries the treasures of his intellect under his arm in an immense portfolio. Yonder are grisettes that Daumier would not have refused. Waiters, coachmen, tourists, gendarmes, absinthe drinkers are caught by the flying pencil and noted down without waste of time on details. And as one watches Mr. Luks at work one perceives that, like Alexander and other painters of note, he is left-handed; he is a "gaucher," and we know the gaucher is redoubtable in art just as he in fencing with the foil and foyning with the sword.

"Perhaps I am an irreverent by nature," continues Mr. Luks as he deftly introduces an effect of robust health on the grinning mug of a street boy with one or two slaps of carmine, "but our exhibitions always set me calculating how many out of each hundred painters ought to have chosen some other profession than art. I don't see how fifty bad painters by getting together and calling themselves an Academy or a Society are any better than fifty separate painters. Flocking together don't improve the breed of feathers or of hide, no, nor the results. And the effect on the public is distinctly bad because there are fifty whooping at once and the public thinks because they are many they must be worth something."

"Perhaps your resemblance to the late Robert Ingersoll has to do with it."

"Say, are you on to that? I won't mind a bit, as long as you'll size up Ingersoll just as I do. No, Sir, I never did care much for the opinion of these old fellows who assemble themselves solemnly together and vote that their own art is A No. 1 and mine is just about izzard, and-per-se-and! Funny, isn't it?

Must have been born with a hollow on the top of my head. But, serious, now; what gain is there for me, what advantage to art in these exhibitions painters hold in all the big cities? I take a lot of trouble and paint what I feel is a smashing good picture, and when I send it to an exhibition—against my own judgment and just to please my friends—I'll be hanged if they don't refuse to hang it because it might put some of the nice old ladies' nice old work out. 'It's too noisy, Luks! Can't you give 'em sompin' tender and sweet and ladylike?' Yah! I can if I choose, but that sort don't interest me; and what is life unless you do what interests you? Why waste your time trying to please that pipe dream, the American amateur? Why, when you find him, as likely as not he thinks a chromo is the highest squeak in art.

"It's just this way; there's painters for everybody, and I happen to be a painter for the kind of man who isn't shocked by the kind of painting I like to paint. So long."

* * *

October 22, 1905

ART FOR THE PEOPLE VERSUS POPULAR ART

The art world of New York is in the condition of an army without commander in chief and general staff, in which organization exists only at certain points having little connection one with another. Here and there a number of artists find each other through the natural affinity that comes from similar experiences at art schools in America or abroad, or through a deeper connection owing to similar views as to the right way of going about to produce their work. But these groups do not extend their influence far, and, moreover, they seem quickly to reach the limits of their action. It often occurs that they lose some of their strongest men, who break away from the society in disgust and flock by themselves in a still smaller nucleus which possesses neither the numbers that carry weight nor the executive minds that know how to accomplish things. Thus the tendency is to split into smaller and smaller bodies, the older societies losing the natural energy supplied by new blood.

In fact it is like the army of the Middle Ages in Europe which had splendid material but no coherence because it had not learned to obey its leaders. Recruited at haphazard, it was not animated by the same spirit, did not pursue the same ideal, and had no thoroughgoing plan of organization which made of it a solid fabric with brain and members ready to work at the brain's command.

There was a critical moment when it seemed likely that the graphic and plastic art of New York would crystallize after a fashion round the National Academy of Design. That was when the Academy was offered a building, adjoining the Society of American Artists in West Fifty-seventh Street. It seemed at that time as if the opportunity had been offered the Academy to take the lead at any rate in painting and sculpture and so establish itself as to impose on the imagination of the

public and really make the fine arts what they naturally should be, a part of the ordinary life and thought of a great community. The opportunity was given and put aside. Since then the situation has not at all improved; quite the contrary.

There is something confusing to the public in the multiplicity of exhibitions, and there is also futility, on purely physical grounds, in offering to busy men and women so many feasts. Discovering that they have no time to visit one-quarter of the shows, a good many people make up their minds to omit them entirely, and so arrange their lives without them, just as they may cut out baseball and other athletic games, or determine to put music out of their lives. If, however, there were one part of the Winter season devoted to the fine arts and one place established therefor, the citizen would soon accept that time and place as proper to the fine arts and form the habit of attendance. Were the artists organized to deliver one grand exhibition once a year in a place large enough to acommodate a multitude, it would alter matters very materially in the attitude of the public toward art. Not so instructive to the serious student as a number of small exhibitions scattered through the Winter might prove, it would be more practical and educative to the general public, because only by this means can wider circles be reached.

What's the use of a hundred art shows, scarcely visited at all save by the exhibitors, their friends, and a few outsiders, when comparison is made with the crowds that visit such a comprehensive gathering of work as the Paris Salon? True it is, that these big collections necessarily contain much indifferent work. The majority of objects shown are really painful to connoisseurs; but the latter can select the gems and the crowd can enjoy what the crowd understands. At any rate, art which is good up to a certain standard is presented in a quantity which impresses the public and forces it to recognize at least the existence of art. In New York energy is frittered away by the various societies with their several appeals to the public—and the public ends by ignoring the very existence of art.

Such conditions might have passed with little comment while New York was still a provincial place, despite its commanding position with regard to the rest of the Union. But since it has become in population the equal of some of our great States and some of the little kingdoms in Europe—Holland, for example—it is a reflection on the citizens of New York that no concerted move is made to correct the anomaly. Private beneficence has widened the sphere of music so that the people can hear the best at the people's prices, and now a college for musicians has been started with the necessary endowment, so that tuition will not press too heavily on pupils. It is right enough that music should lead the way because it appeals relatively to more citizens, and for its enjoyment requires less preparation than the fine and kindred arts. The city does something for the dead arts and crafts in helping to sustain the Metropolitan Museum and for natural sciences in subventions for the Museum of Natural History and other foundations. Why should not the city regard the art of to-day as a proper object of encouragement directly in the line of education for the city?

Regarding this question from the comparative side, one may wonder how it comes about that other good causes should have been preferred and nothing done by the city to foster art, beyond the very superficial and inadequate attention given to manual training and drawing in the public schools. Usually one sees a community in which artists of all sorts and degrees of talent swarm aware of their presence, at least apparently, and showing certain signs of contentment over their existence, if not of local pride and parochial vanity on their account. If in addition it be shown that New York gains great sums annually through the brains and industry of her artists and artisans, the mystery deepens. How comes it that our wise men do not perceive the opportunity New York has to grasp and by the expenditure judiciously of ample funds place this city for all reasonable time to come at the head of the fine and industrial arts on this side of the Atlantic?

The answer may be sought in the obsession of politics, which exhausts the energies and sterilizes the brains of the most active citizens, so that our temporary rulers have no time, even when they have inclination and training, to look after the best interests of the city in a farsighted way. The Metropolitan and the Natural History Museum had to start as private foundations and build themselves up to the point when legislators were forced to take them seriously and listen to their claims on the public purse as organizations following out a special line of education for the people. So far there has been much talk of organizing the chief societies of artists into a coherent body and raising funds for a common centre of energy; but no single citizen and no one body of public-spirited citizens have taken hold of the matter with the energy and acumen needful to produce results.

An art palace at an accessible spot on Manhattan below Central Park would be a long-headed investment for New York City. There need be no fear that in such a building art for the people would degenerate into what is derisively called popular art; that is to say, poor and trashy art. Unless the men and women chosen to guide it were above such things, it is not likely that the art palace ever would exist. As a centre for exhibitions of architecture, sculpture, painting, landscape gardening, &c., as a place for occasional extensive exhibitions of industrial art, and particularly as a structure designed for an annual comprehensive show of fine art and the most artistic work by craftsmen, such a foundation would benefit New York in a hundred different ways, strengthening the hands of students and teachers, widening the sympathies of the public, educating professionals and laymen, and bringing to the city artists and art lovers from every State in the Union. As of old we used to export to Mexico and South America our clocks and pianos and furniture, our carriages, locomotives and frigates, so to-day we are beginning to furnish those countries with art works, more especially with monumental statues. From the aesthetic side there is a great field for argument in the use of public money to help living art in this community, but on the practical side arguments can be found in abundance which might convince the veriest Philistine that such expenditures will "pay."

The proposition might well be made to the municipality by the Fine Art Federation that a site and building should be provided below Central Park in which the most necessary functions of a big "nation" of artists and artisans could be carried on for the benefit of the public. The cost of a couple of armories would cover the expenditure, and the difference between sterile energies used as preparations for defense against internal and foreign aggression—and live, creative energies employed for the improvement of education and the ennoblement of the city, is sufficiently obvious. While the need of armories and arsenals is clear enough, equally clear is the greater importance of education. Toward refinement and the higher education citizens ought to steadily set their steps.

CHARLES DE KAY

* * *

December 26, 1905

AT THE ACADEMY SHOWS

Some Reasons Why They Are So Disappointing

A second stroll about the five galleries at the Fine Arts, on West Fifty-seventh Street, where the Academy of Design is holding exhibition for the four-score-and-first time since its existence, rouses, not for the first time, a mild wonder that so venerable an institution should not have more enthralling exhibits. Surely the National Academy ought to have the power to compel what is best among the output of the local studies and those of other cities. The largest city of the land—the greatest number of buyers—the liveliest world of art amateurs. Why is not the annual Academy an event in the art season of New York to which all who care for painting and sculpture look forward with eagerness?

Artists who have had pictures rejected will say that it is the exclusiveness of the Academicians that sterilizes the annual exhibitions. Yet only one-fourth of the exhibits this year are by Academicians and Associates, three-fourths coming from outsiders. Laymen who conduct successful art shows in other cities—Philadelphia, Pittsburgh, Buffalo, for example—may conclude that artists are not the persons to get the best from their comrades, partly because they will not take the needful time and trouble, partly because they are suspected by the outside artists of assuming a superiority of judgment not warranted by their own work. Artists very often feel more secure of impartial treatment by laymen than by their fellows. Another explanation begs the whole question, as when we hear it said that no large number of art works made in a given year can be expected to contain many objects of the very first excellence.

If, however, we take the entire output of the New York studies for one year, if we review all that is produced in this locality, we could certainly pick out enough paintings of a very high class and of great interest to fill the Vanderbilt and South Galleries with a collection, if not epoch-making in art, yet epoch-making in Academy exhibitions.

This is not done. It is said to be impossible.

There are the Academicians who must be provided with places no matter how dry and tiresome their work. Then we must forego the pictures of the mural painters which are too large or cannot wait for the date assigned to the exhibition. Precedent and objections sure to arise from the local artists bar out pictures by foreigners. The jury has to reckon with all sorts of partialities, friendships, prejudices, dislikes from personal and technical reasons. When these conflicting forces have had their play the results are rather mournful to the onlooker and decidedly prejudicial to the fame of the Academy; there is one more exhibition which is not national, does not represent the best of the year in art, and cannot be said even to give the fine bloom and selection of the studies in Manhattan!

It is more than commonly unfortunate this year that the Academy show is not far above the ordinary standard; for attention is being drawn to American art just now, owing to the expressed desire of the Metropolitan Museum to secure examples of our living and recent artists. The public may well have expected that the Academy would put forth unusual exertions to get together a record-breaking exhibit, sending, if necessary, committees to the studio of each painter and sculptor, to encourage the sending in of the best work. If such action runs counter to the rule of the Academy, the sooner the rule is changed the better. Only by having shows that excite the interest of artists and amateurs can the Academy hope to make strong artists feel that it is worth while submitting their work to the jury and reasonably expect that art lovers will throng the halls.

A painter who grows slowly but surely in the power to express a certain quiet poetry of nature is Mr. William H. Howe. "Hauling Sea Weed" has no brief for the novelty of the subject, but the movement of the slow oxen is caught admirably, and the tones of distant marsh, of seaweed piled high on the cart, of brown hides and sandy robe are kept together in fine harmony. More imaginative coloring is seen in "New Pastures," by George Inness, Jr. "Steam and Smoke," by Henry B. Snell, a scene of steamships and harbor craft just misses the standard this painter has often set in his pastels; it is a trifle dull, perhaps because the big steamship takes up an undue space. "Garden of Dreams," by Elliot Daingerfield, comes almost up to the ideas suggested by the title, but does not reach the realm of fantasy.

It is a soft moonlit outlook on strait and islands, and a nearer terraced garden with indistinct figures in the foreground. "Autumn Solitude," by E. Loyal Field, has a breath of distinction, and "Road to the Mill," by E. W. Redfield, a fine simple impressiveness, partly due to the scene, but more to the robust, broad handling.

The Academy certainly repays examination, but why must we always have to endure so many third and fourth rate pictures?

* * *

May 20, 1906

HOW THE PENNSYLVANIA RAILROAD STATION WILL LOOK WHEN COMPLETED

The new Pennsylvania Railroad station in New York, for which the plans are now practically perfected, will be unique among all the railway stations of the world in the number and convenience of its entrances and exits. This condition is due to the fact that each of the four sides of the structure is a front, opening respectively on two wide avenues and two important streets, which latter have been widened by the company to 80 feet each.

The geography of the station is interesting. It is bounded on the east by Seventh and the west by Eighth Avenue; on the south by Thirty-first and the north by Thirty-third Street, Thirty-second Street having been closed and included in the station site. In the centre of the hotel, theatre, and shopping district the advantage of its location is obvious. The frontage on the avenues is 430 feet and on the streets 780 feet, the sides of the structure forming a perfect parallelogram. As the tracks are 40 feet below the surface of the streets the station is divided into three levels. From the street level upward the walls of the structure rise to the height of 60 feet, except in the centre, where the roof of the general waiting room reaches a height of 150 feet, and the corner of Eighth Avenue and Thirty-third Street, where there is an elevation of four stories for office purposes. The architectural design of the entire exterior is a Doric colonnade, 35 feet high, surmounted by a low attic, raising the general elevation to 60 feet. The unusual extent of the building in area and its general type are suggestive of the great baths of ancient Rome. In fact, the baths of Caracalla, still magnificent in their ruins, were the inspiration of this architectural plan.

Although the building is low by contrast with its skyscraping neighbors, its scope makes it impressive, and the lofty roof of the waiting room, rising high above the top of the surrounding structure, with its eight large semi-circular openings, 72 feet in diameter, adds dignity to the group of buildings and at the same time makes them a conspicuous landmark, when seen in perspective from the streets. In appearance it is a wide departure from the conventional railway station. One misses the turrets and towers and more than

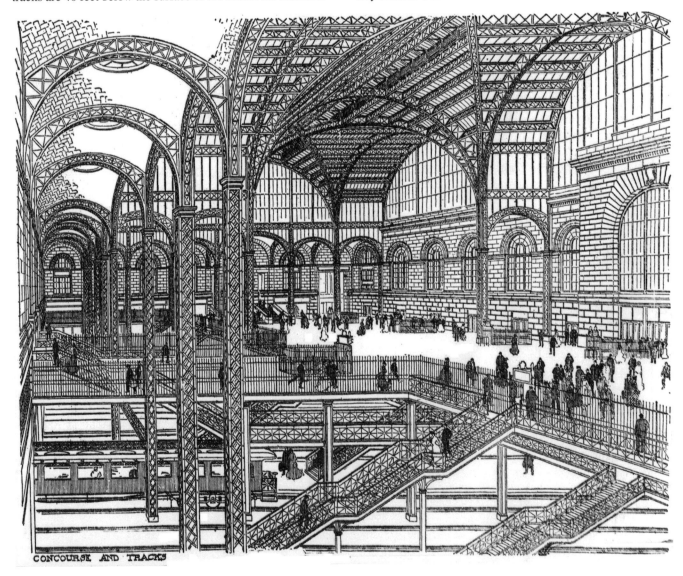

CONCOURSE AND TRACKS

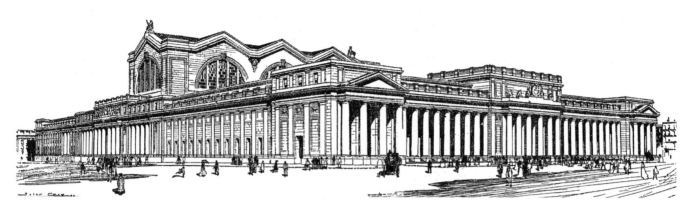

all the lofty arched train shed, but as the principal function of this station is performed underneath the streets, the upward and visible signs of the ordinary railway station are naturally absent. It will rather resemble some vast auditorium constructed on low lines for the easy ingress and egress of a multitude of people.

The exterior construction is to be of pink Milford granite, similar to the building stone of the Boston Public Library, the University Club in New York, the Court House in Pittsburg, and the Chamber of Commerce in Cincinnati. This is a particularly effective structural stone, and its soft shades of color are uncommonly pleasing to the eye.

The main entrance is fixed in the centre of the structure on Seventh Avenue, opposite the intercepted end of Thirty-second Street.

The designs for the station were made by McKim, Mead & White, architects, of New York, and will be executed under their direction.

* * *

June 28, 1906

STANFORD WHITE'S WORK

When, a generation ago, Stanford White began the study of architecture as a draughtsman in Richardson's office, he attracted the notice of his chief, and of various interested persons, by the dash and sprightliness of his drawings, attesting an unusual picturesque sensibility. His first independent works, the Music Hall of Short Hills in New Jersey, the "Bank of Banks" in Fifth Avenue, and the like, gave promise of a distinctly picturesque architect. One might say a romantic architect, except that he shared with his preceptor an animosity for the forms, even including the pointed arch, in which the greatest of the schools of romantic architecture had expressed itself. Not being, any more than Richardson himself, an analyst, he omitted or refused to observe that those forms which mediaeval architecture actually took were only one, and one may say a casual, expression of the principles which all architecture which is in the highest degree worthy of the name has in common. Historical Gothic merely illustrates those principles more brilliantly, or at least more variously, than any other historical style, principles the

application of which to new conditions and new ideas would work as brilliant a presentation of modern life as the cathedrals present of mediaeval life. To see and seize the particular point of a particular problem, and then to let your building, so to say, design itself, to stand aside and watch it grow, to be sure it is right, and let it go ahead—this is the way to create an architectural organism. It is the way to make sure that, according to your measure, you are giving a true architectural illustration of your contemporary life and advancing the art of architecture in your generation.

This is to design from within outward. Stanford White's way was as different as possible from this. It was the last exterior expression of a historical monument that appealed to him, not at all the seminal idea which germinated toward that expression. Hence his architecture was always from without inward, an architecture in which "effects" preceded causes, in which reminiscences of admired things were made as plausible as possible under the actual mechanical conditions, and to which instead of being founded on the facts of the case, the facts of the case were made to conform. In his later days, when a committeeman for a most important and extensive work suggested to him that the special conditions of the case must be made the foundation of the design, he replied that he "had no time" to acquaint himself with those conditions.

This mode of design is that which it seems our most successful and fashionable practitioners owe their success and vogue to adopting. It is not in the least "architectonic"; it is decorative to the point of being "scenic." Sometimes, when the purpose itself is scenic, as in the World's Fair at Chicago, to which Mr. White was not a contributor, it may be delightfully in place. But it has nothing to do with the progress of the art of architecture as an expression of the spirit of a nation or an age. It is fair to say that the architect who devotes himself to it is not properly so much an architect as a decorator.

Of course, all the same, this may be done well or ill. There is no question that Mr. White did it very well. His pictorial sensibility was and remained acute. His revolt against the ascetic expression of the Gothic minsters led him to look for precedents to the rococo, or at least to the full flowering of the sixteenth century Renaissance, which was the picturesque degeneration of classic severity, as the Gothic of the fifteenth, further north, was the picturesque degeneration of the monastic severity of the Middle Ages. Finally, Mr. White's pictur-

esqueness became the expression of "the lust of the flesh and the lust of the eye and the pride of life." His adaptation for New York of the Giralda of Seville, his most conspicuous work in Manhattan and that which is associated with his tragical fate, is a distinct triumph of this mundane spirit, for the classical examples of which in life we must revert to the decadence of the Romans or to the flowering of the Renaissance. That wonderful poem of Browning's, "The Bishop Orders His Tomb at St. Praxed's Church," which, according to Ruskin, comprises the whole soul of the Italian Renaissance, might well serve as a motto for the work of the riper years of Stanford White. The delight in sumptuosity of material and preciosity of effect is as far removed from classic purity as from monastic severity. This delight is conspicuously shown in one of Mr. White's latest works, the new front of St. Bartholomew's, in which he appears frankly as not so much an architect as a decorator and the chief of a decorative staff, bringing them into co-operation, and providing the associated labors of sculptors and carvers with a suitable and rich decorative setting.

One may continue to insist that this is by no means architecture in the highest sense of the term, and may still insist upon the exceptional qualities that were required to do it so well. There is, or should be, always some sense of loss and damage in seeing a born artist condemned, either by public pressure or his own volition,

To heap the shrine of luxury and pride
With incense kindled at the Muse's flame.

But it does matter whether factitiousness of effect, sumptuosity of material, "the lust of the eye and the pride of life" are "kindled at the Muse's flame" or merely produced by tradesmen to meet the popular demand. In Stanford White's case it was an artist that met the demand. And that fact does make a difference.

* * *

December 4, 1906

DISDAINS THE OLD MASTERS

But British Decline to be Shocked by Frederick Church's Views

LONDON, Dec. 3—The St. James's Gazette to-day, commenting on Frederick Church's contempt for European picture galleries, says:

"Mark Twain did not think much of the old masters, but he is a humorist and may be forgiven. Frederick Church is an American painter of reputation, and it is hard to see how he can be indifferent. He is more than indifferent, he is disgusted. After a European tour he has nothing but condemnation for the contents of the picture galleries.

"The Louvre is a terror. Any third-rate Yankee dauber could give points to Rubens. In all Europe there is no land-

scape painting either by Turner or anybody else that touches Homer Martin's 'Sand Dunes, Lake Ontario.'

"It is true Rubens, who drives Church frantic with disapproval, is not so highly considered by many people as he used to be, and as few of us have seen Homer Martin's 'Sand Dunes, Lake Ontario,' we have no right to conclude that they do not put Turner in the shade. We may be permitted, however, to compare the Italian and Dutch painters with Americans and still retain some faint appreciation for Da Vinci and Rembrandt, while Velasquez may at least be mentioned in the same breath with Sargent.

"We are afraid Church wants to shock us. As we have not seen his pictures, we decline to be shocked."

* * *

February 7, 1907

PRESIDENT AT OPENING OF WASHINGTON SALON

3,000 Persons Attend Exhibition at Corcoran Gallery

A REPRESENTATIVE DISPLAY

Five Sargents, Including the "Four Doctors"—Other American Painters Send Excellent Works

Special to The New York Times

WASHINGTON, Feb. 6—In the Corcoran Art Galleries there was opened this evening with brilliant formalities an exhibition of American pictures in the nature of a salon fulfilling the prediction of no less an artist than Alexander Harrison that sooner or later we should have a National Salon in the National capital.

Nearly 3,000 persons, including the President and Mrs. Roosevelt, Cabinet officers, diplomats, and members of both houses of Congress, attended the opening of this the first annual exhibition at the Corcoran Gallery. The attendance to-day was by card, but the doors will be thrown open to the public to-morrow and the exhibition will continue until March 7.

Three prizes have been awarded—the W. A. Clark prize of $1,000, which carries with it the Corcoran Gold Medal, to Willard L. Metcalf of New York, for his painting, "May Night"; the Charles C. Glover prize of $500, with the Corcoran Silver Medal, to Frank W. Benson of Boston, for his "Against the Sky," and the V. G. Fischer prize of $250, accompanied by the Corcoran Bronze Medal, to Edward W. Redfield of Centre Bridge, Penn., for his Winter landscape, "The Lowlands of the Delaware."

Nine paintings in this exhibition have been acquired by the Corcoran Gallery for the permanent collection. They are: J. J. Shannon's "Girl in Brown," R. M. Shurtleff's "The First Snow," Edward W. Redfield's "The Delaware River," Winslow Homer's "A Light on the Sea," Horatio Walker's "Ave Maria," Wilton Locwood's "Peonies," Mary Cassatt's

"Woman and Child," Childe Hassam's "Northeast Head-lands, New England Coast," and Albert L. Groll's "The Land of the Hopi Indians." In addition to these the gallery will obtain, if possible, Willard L. Metcalf's prize picture and Paul Dougherty's "The Land and the Sea."

On the wall of honor, which faces you as you ascend the staircase, is a splendid display of Sargent's art. In the centre hangs the portrait group recently presented to Johns Hopkins University by Miss Mary Garrett, representing Dr. William H. Welch, Dr. William Osler, Dr. William L. Halsted, and Dr. Howard A. Kelly. The "Four Doctors" are seated at, or standing by, a table in a spacious room, with a large globe at the back and dim red hangings mingling with mahogany furniture beyond it.

There are four other Sargents, two of which are new to exhibitions. The portrait of William Thorne is one of those labors of love of which the master has accomplished only a few, done with friendly touches and containing a personal note of technique which makes it precious. The stroke of the brush which unites the white collar and the chin of the sitter is an everlasting joy to the painter and a marvel to the layman. The other previously unshown portrait is of the late John Hay. Two portraits of distinguished women flank the big picture on either side. These are the "Miss Thomas, President of Bryn Mawr College," and "Miss Mary Garrett."

"Life Disarming Death," by Henry B. Fuller, occupies nearly a whole wall and is one of those impressive compositions of which we have so few in this day of experimental landscape and portraiture.

Another feature in the exhibition is a group of four portraits by Miss Cecilia Beaux—"Miss Nutting," "Mrs. Charles A. Morss," "Portrait of Mother and Child," and a portrait of a little girl. The portrait of Mrs. Morss is a two-thirds length, very rich in the painted textures of blue and brown, while perhaps the strongest woman's portrait this distinguished artist ever put on canvas is the "Miss Nutting."

The landscapes and marines are numerous and varied. Perhaps the artist as well as the layman would begin with the noble expanse of sea by Emil Carlsen, called "Surf." It is new to exhibitions, and is painted solidly and conceived with the alert and watchful spirit of a true lover of the waves. Alexander Harrison's "Curling Breakers, Brittany," hangs in the same room. In this room, too, are Schofield's striking landscapes, with their foreign air but unmistakable charm.

There are three brilliant examples of Winslow Homer, one of which has been purchased, and a still life of Autumn fruits by Chase, which glows with tempting reality. Chase is further represented by a cool gray landscape of his best type and a portrait group. Ranger has sent three of his newest works. One of the purest and most delicate of the New England landscapes is Robert Reid's "Evening," a blue, hazy moonrise.

The exhibition includes Senator Clark's collection of Dutch and English masters, which have never before been shown in Washington.

* * *

May 12, 1907

COLLECTORS AND THEIR IDEAS

Dealers Forced to Hide Important Works of Art Because Bogus Connoisseurs Object to Pictures Which Have Been Shown the Public

Judge them by their remarks when bargaining for pictures, and one might swear that a large section of American collectors of art works consider the latter as some material like butter, which must be fresh, and not shopworn, or like the morning newspaper which must be all newly ironed and unread.

More important to them than beauty or the fitness of the picture to the wall it is to adorn—of greater moment even than that name which often supplies so much value to the emptiness of ignorance, is the reply elicited by this curious question: "Has the picture ever been offered before?"

It is surprising to find that there are collectors who are swayed by the answer to that question, and yet assume to be connoisseurs and continue to believe in themselves as genuine lovers of art. For at once it is a confession that the intending buyer is guessing what the picture will bring hereafter, since he is saying to himself: Perhaps this object, having been offered for sale, did not find a buyer because it really is not worth the price asked; perhaps there is something wrong about it; perhaps, when I wish to sell again, others like myself will remember that it was long in the market, and I shall have to undergo the mental agony of getting less for it than I paid!

Such connoisseurs for investment are really interesting types of impudence and greed, for they propose to eat their cake and keep their cake, too. They are like the man who buys a yacht in the Spring, uses it all Summer, and expects to sell it at a profit in the Fall. They are supposed to be repaid for their dollars by the pleasure they get from the picture, but behold! they are out for the cash; they are just ordinary speculators who have dragged up-town their methods as sharp fellows in the street and display them without shame in the field of art. And then they expect that artists and art dealers shall subscribe to their preposterous claim to be considered connoisseurs and patrons of the arts!

Luckily there are many others who do not fall into these grimy tricks, but purchase objects of art because they feel their beauty; they acquire such things as suit them without any ulterior views, regarding the prices they pay a fair offset to the enjoyment they obtain. But the commercially minded collector is a drawback, because he infects the art dealers with his absurd ideas until they feel obliged to take into account such a ridiculous objection as the one above stated, namely, that because a picture has been offered for sale a long while, it is less valuable for that reason.

Note also that this is an argument constantly employed by crafty buyers in order to get the price down, or by indifferent ones to account for their real or assumed indifference.

Dealers have to meet all sorts of quaint follies in the course of business, but they must laugh in their sleeve when this ancient trick appears—laugh and set the art patron down for an ignoramus or a sly fellow.

The most unfortunate result of this phase of picture buying is one that meets the lover of pictures who cannot afford the luxury of high-priced things. Dealers bring in most delectable works of art, but carefully sequestrate them from view, lest their rich and foolish clients decline to purchase, because they can object that the canvases have been exhibited. After showing such objects to a few favored individuals with elongated purses and abbreviated wits, they send them to their correspondents in other cities, where the same comedy for the feeble-minded art patron is repeated. Meantime the public is deprived of the pleasure of seeing these works of art while they are passing through New York, and our resident artists fail to receive the stimulus of a sight of pictures which may or may not be masterpieces, but are often things they ought to see as part of their education.

We need not demand, indeed we do not expect, that the ordinary picture buyer shall be an altruist and think twice of the artists or the public. In Europe, it is true, owners of private galleries are glad to have other amateurs view their treasures, while in our country it is the exception rather than the rule that owners of large collections will put themselves out in the slightest degree to give others that pleasure. But we may fairly demand that they cure themselves of the silly and ignoble idea that a work of art is harmed by being exhibited. Probably they are unaware of the extent to which they are jeered by everybody, here and abroad, who knows of their bizarre conduct and how much they fall short of what men of sense expect to find in a lover of art.

C. DE K.

* * *

July 21, 1907

ART TREASURY OF WORLD TO BE HERE

Sir Purdon Clarke Says Greatest Collections Are Bought for This Country

WE LEAD INDUSTRIAL ARTS

Paris Will Soon Come to Paterson for Her Brocades, He Believes—The Injustice of the Tariff

LONDON, July 20—Sir Purdon Clarke, who was to have sailed for America to-day, has decided to remain in London a week longer in view of the negotiations under way for the purchase of several art objects for the Metropolitan Museum of Art in New York.

"Nothing has been bought during my present sojourn of a sensational nature," said Sir Purdon, but he has found important pieces filling gaps in the present collections in the Metropolitan. These include Swiss furniture of the sixteenth and seventeenth centuries, also Italian marbles, French stained glass, early wrought-iron work, Spanish ecclesiastical silver and leather work.

I asked Sir Purdon about the report current in Paris that J. Pierpont Morgan is buying important sculptures from the Château de Fontavreaux in Burgundy.

"I have heard the rumor," he replied, "and asked Mr. Morgan about it. The only answer he made was: 'I wish I could.'

"I don't believe the report, as France is becoming very careful of her public monuments and wouldn't allow any such sale. You see more and more art treasures going to America every year. These never come back, so America is destined to become the richest treasure house of art in the world. The other countries regard this drift with dismay, and meanwhile the dealers raise their prices, because they know that if Americans can't buy a thing cheaply they will buy it dearly.

"This is hard on the collector, but indicates the trend of thought in America. It is a pity that Americans who are spending vast fortunes on art do not devote a portion of it to the development of modern American talent. The 'Three Cows,' by Troyon, recently brought $65,000, and this amount at 4 per cent would keep a whole school of struggling young artists.

"The same work, when Troyon finished it, could have been bought for $1,000. America would produce many painters as great as Troyon if proper encouragement were shown them by the purchase of the work of the present generation.

"This is proved by the fact that the United States is one of the greatest centres of industrial art to-day. Better tapestries are made in New York than ever came from the looms of Beauvais, and the day is soon coming when Paterson brocades will be sought for in Paris.

"Charles M. Schwab recently showed me a complete silver dinner service manufactured in Manhattan, and I have seen nothing finer anywhere. Americans don't have to come to Europe for art, yet they do it, despite the penalty of the heavy tariff.

"I dare say that Mr. Morgan's unique collection of porcelains, &c., now in the Kensington Museum, would be taken to America immediately if the tariff were reasonable. I believe in protecting industries, but it is a pity to penalize persons who are working for their country's advancement.

"The question would be solved if everything antedating the nineteenth century were admitted free. Home industries would be protected and the museums instantly enriched beyond calculation."

I asked Sir Purdon if it was true that many artistic frauds are perpetrated on Americans. He said: "No; even if there were, it would be no hardship, as many alleged frauds are really great works of art. It is all a question of proper classification."

Sir Purdon says he is giving up his London house altogether, so with his return this time he and his family will regard the United States as their home more than ever.

* * *

August 26, 1907

MISS CASSATT'S "TRIUMPHS OF UNCOMELINESS"

PARIS, Aug. 20—Galleries of art dealers in New York and not a few of private collections of Manhattan contain paintings or pastels or color prints by Miss Mary J. Cassatt. Years ago, when these pictures came over from France, it was noted how completely this lady had assimilated some of the radical traits of the school of Impressionists begun by Edouard Manet and Degas. Like a man, like a German of the fifteenth century, she sternly repressed all longing on the part of the spectator for prettiness in women and children, such as the general public admires. Her models were triumphs of uncomeliness, even more so than those of Renoir, for example. But she demanded that the public should admire the beauty of blue eyes and a skin of blended rose and pearl and appreciate the loveliness of the combination of faces and draperies brought together in exquisite harmonies of tone. All this on a high key of color. If her women and children were obviously members of a lower caste of humanity, at any rate they had beauty of texture. What they lacked in romance they gained in wholesomeness and health. And so, thanks largely to the New York branch of Durand-Ruel, which opened exhibitions of her works from time to time, the sterling painter qualities of Miss Cassatt made their way with the American public, and her pictures have become, if not exactly popular, yet accepted as approved by connoisseurs.

Much interest was felt in New York last year when Miss Cassatt returned to her native country; for she was better known in Paris than in New York, Philadelphia, or Pittsburgh. It was as if Rosa Bonheur had made Italy her home for a quarter of a century and then returned to France, celebrated, but personally unknown. Nor were the anecdotes lacking which told how outspoken Miss Cassatt was concerning many things which offended her aesthetic sense in the hurly-burly of New York. She stayed here a very short time, and fled to her beloved France, where indeed she finds more persons who appreciate and understand her work than would be possible in America.

Praise from Clemenceau

When, in a recent speech, M. Clemenceau, Prime Minister, referred to Miss Mary Cassatt as "une de nos gloires artistiques," he voiced the sentiment prevailing in France with regard to one who is perhaps the most eminent of living American women painters. Born in Pittsburgh, the daughter and sister of well-known Pennsylvania railroad magnates, Miss Cassatt has resided for thirty years or more in France. There her art found its inspiration and developed. That Miss Cassatt should be considered one of themselves by the art-loving world of Paris, therefore, is not surprising.

Her early studies were pursued at the Academy of Design in Philadelphia, where it may be said she obtained the only conventional teaching she ever had. As soon as her art studies in Philadelphia were finished Miss Cassatt, whom the fortune of her family rendered independent of those financial considerations which so frequently hamper the art student, came abroad and traveled in Holland, Spain, and Italy. A powerful impression was made upon the young painter by the Italian primitives. Her art has always preserved this imprint. Even in her most modern productions one feels the atmosphere of the family sanctified which was the inspiration of the early Italian masters. Devoting herself almost exclusively to the depiction of women and children, she has achieved the portrayal of maternal love in a manner approached by few of her contemporaries; her mothers are Madonnas of the bourgeoisie, simple, unassuming, and unmoved.

At the conclusion of her travels Miss Cassatt came to Paris, where she fell at once under the spell of the school of impressionists then coming into prominence. M. Degas recognized the young artist's ability and encouraged her; and thus, without actually becoming his pupil, she was aided to no small degree by his interest and advice. Her early work bears the stamp of the school to which she gave her allegiance, and a reflection of the manner of Monet, for instance, is perceptible. But Miss Cassatt's art is a personal one, and as she has character, this individuality soon asserted itself.

Though preferably devoting herself to scenes of the nursery, of "soins maternels" and of domestic genre with or without tenderness, Miss Cassatt has occasionally turned her attention to portraiture. The finest thing she has ever done in that line, perhaps, is the portrait of her own sister. Among the best are also those of Mrs. Havemeyer and her daughter, which hang in Mr. Theodore Havemeyer's home in New York. It is not only with oils that Miss Cassatt has achieved distinction; she has done even more with pastels, the latter medium unquestionably being the favorite one.

Results of Her Methods

By this vehicle of expression she obtains the light tones and the flat, broad, decorative passages which a certain brand of impressionists in France have studied from the old Italian painters in fresco. Pictures of this kind are readily reproduced on the press, their colors lending themselves to the exactions of the photographic color processes now in vogue; and the attention to line, which is a very marked characteristic in Miss Cassatt's design, aiding greatly to obtain an impressive effect. A number of other Pennsylvania women have wrought in a somewhat similar vein, but directly for illustration, most of them being pupils of Mr. Howard Pyle.

In devoting herself later to oils Miss Cassatt carried her pastel and crayon methods into the richer medium. She wields the brush in a masterly fashion. Miss Cecilia Beaux, another Pennsylvanian, is her only rival in oils. As Miss Beaux has devoted herself almost exclusively to portraiture, it is natural that her fame in that line is greater, but Miss Cassatt has so strong an individuality that one may well hesitate to make comparisons where both are so able in their several ways.

Some years ago Miss Cassatt took up as a hobby the production of dry point etchings combined with color prints, attempting with a most interesting result the effects achieved

by the Japanese masters. She devoted much time and attention to the mechanical process of reproduction, as well as to the designing of the prints, spending as much as two years on a single subject. It proved an expensive but by no means useless exercise, one in which only the possessor of an independent fortune could indulge. As regards composition and tone, Miss Cassatt's prints are conceived in a Japanese spirit, but even in this phase of her art she has not departed from her favorite subjects, women and children.

Though she makes her home in France, and is highly esteemed and admired by connoisseurs of modern French art (for, say what you will, Miss Cassatt's art is French), by far the greatest number of her works are the property of Americans, whether resident in the United States or abroad. Two of her canvases hang in the Luxembourg Gallery in Paris, but, so far as the writer knows, none is to be found in the museums of the lesser cities of France, though they are in some of the best private collections of contemporary painting. Among the more recent purchasers of her works is Mr. James Stillman, who has bought a couple of pictures for the house which he has just acquired in Paris.

Absolutely devoted as she is to her lifework, and having by severe application attained a mastery of processes and a grasp of composition which many well-known artists might envy, it would surprise no one if Miss Cassatt should give to the world some works on a larger scale than heretofore, which might hand down her name to the future as one of the masters of the painter's art. In her groups of women and children, whether in oils or pastels, she has often shown uncommon ability in composition, but it remains to be seen whether she can compose and place on a wall a big composition, original in design, which meets all the complicated requirements of mural painting. She might easily make a connoisseur's as well as a popular hit by a series of illustrations dealing with the domestic life of women and children, supposing for the context one of those wide-selling books on women which the French above all other people seem to prize. French domestic life not of the lurid type, described in somewhat sober colors very different from the usual French novel for foreign consumption, would find in Miss Cassatt a well-trained, sober-minded illustrator.

She Shunned Publicity

Content with her growing fame, and eschewing notoriety, Miss Cassatt has always held aloof from publicity of every sort; the would-be interviewer finds her a difficult person to approach. The possessor of an apartment in Paris and a chateau near Chantilly, while dispensing cordial hospitality to a limited circle of chosen friends, she has never thrown open the doors of her homes to the merely curious, as is the custom with many celebrated artists in Paris. Such has been her dislike of public life that she has persistently refused to identify herself openly with any artistic enterprise. It was therefore much of a surprise to every one that she should have accepted the honorary Presidency of the Art League (of which Mrs. Mary Green Blumenschein is the Acting President) in connection with the Hostel for American Girl Students which,

with characteristic generosity, Mrs. John Hoff has recently established in Paris. As an incentive to work on the part of the girls, Miss Cassatt offers a sum of money to be divided between two of the students who should prove most deserving of encouragement. According to the conditions attending the donation, the recipients are to spend a year in the town of Saint Quentin engaged in the study of the French master-pastellists of the seventeenth and eighteenth centuries, of which the museum there contains the finest collection in the country. Among the copies made by the students a certain number of the best are to become the property of the Hostel.

In appearance Miss Cassatt is tall and slender, with features and gestures plainly betraying the strong personality which has won for her the position she now occupies. The most characteristic portrait of her which exists is a small sketch by Degas, made many years ago and now in the private collection of M. Durand-Ruel, through whose galleries the greater part of her works for the last twenty years have passed. The picture shows a glimpse through a doorway in the Louvre. Seated in the foreground is a young woman, and behind her, with her back toward the spectator, another, a slim figure in a dark gown, with hair so arranged as to look short if not actually so. Her hand rests upon an umbrella, with a suggestion of American self-sufficiency and assertiveness, the whole attitude indicative of that decision so apparent in the strength and breadth and independence of her art.

* * *

October 6, 1907

THE INCREASING MARVELS OF LOWER MANHATTAN

Group of Skyscrapers Just Completed or in Process of Construction Will Add Seventy-seven Acres of Floor Space to City's Business Section

The great financial centre of New York, probably the richest, most crowded spot on the American continent, is in the throes of a transformation. Old landmarks have disappeared. New structures are soaring up and up, as though to the highest heavens, changing the skyline, making the streets unfamiliar, lending new splendors of marble, bronze, and colored terra cotta to the narrow canons through which tides of men rush ceaselessly for the seven hours of the business day.

This business section, already containing the largest collection of great office buildings in the world, has thus become a new source of wonder to those who visit it. The majesty that excites such admiration, however, hardly hints at the added wonders of the skyscrapers, recently erected or now in the building, when the details of the structures are investigated and the results set down in simple form.

Manhattan south of the City Hall is a triangle a trifle over a mile across the base from the North River along Chambers and New Chambers Streets to James Slip on the East River,

and an equal distance in a straight line from the City Hall to the end of Battery Park. In this triangle are 320 acres of land.

The skyscrapers in this area now in the building or completed within the last year would make a single structure one story high covering 77 acres, or about one-fourth of the area. In other words, their floor space aggregates 3,386,231 square feet. The new structures would afford standing room for fully one-half of the inhabitants of Greater New York, could they be gathered together at one time.

The heart of the new Manhattan is in a little more than two blocks in area on the west side of Broadway, between Cortlandt Street and Trinity Church. Never before in the history of the world has so much steel, brick, stone, mortar, and terra cotta been piled up in such a small space.

In the midst rises the great tower of the new Singer Building, with forty-two stories in its 610 feet of brick and metal. Next to it, and reaching through to Cortlandt Street and Trinity Place, the New York City Investing Company's building is hardly less wonderful. Already the lowering walls of snowy white suggest the beauties of the towers, angles, and ornament that are to be embodied in this thirty-six-story structure, rising 400 feet in air.

Downtown Skyscrapers

Below the Singer Building, on Broadway at Cedar Street, are those, twin examples of Gothic splendor, the United States Realty Company's building and the completed Trinity Building, rich in marble, bronze, and painted glass.

In the last year the fine structure of the United States Express Company has been added to the skyscrapers that dwarf Trinity spire and hem in the churchyard as though with the walls of a china cup. The express company building looks across the graves toward Broadway from the west side of Trinity Place. Unlike the Trinity Building, which seems to take its color from its Gothic neighbor, the newest skyscraper is little more than a dull yellow background for spire, nave, and pinnacle of Old Trinity. The building is twenty-three stories high, containing 6,000 tons of steel, on a lot 143 by 120 feet in dimensions, thus having an area of 390,372 square feet. It represents an investment of about $2,500,000.

To the westward the West Street Building, a twenty-three story $2,000,000 structure, gay with green, gold, and azure terra cotta, dominates the wharves and slips of the North River.

A few blocks to the northward the Renaissance screen walls of the Church Street Terminal are rising as if by magic on their iron frames. This will be the greatest office building in the world. It can be compared with nothing but a good-sized town in itself, with its eighteen acres of floor space, 4,000 offices, 5,000 windows, thirty-nine elevators, and 30,000 electric lights. The tenants can do everything but sleep there, for there will be two clubs, restaurants, safe deposit vaults, and many shops in the structure.

From the street the Terminal will look like two buildings, each twenty-one stories high, extending two blocks on Church Street and 175 feet to the westward. One structure, the Cortlandt Building, will extend from Cortlandt to Dey Street; the other, the Fulton Building, from Dey to Fulton Street. Each floor in the Cortlandt Building will have an area of 26,000 square feet. In the Fulton Building the area on each floor will be 18,000 square feet.

Returning to Broadway, the tall skyscraper, No. 1 Wall Street, on a small, square lot, looks like a Colonial gatepost at the entrance to Wall Street.

Further down that thoroughfare the new skyscraper of the Trust Company of America has been added within the year. This $1,250,000 structure alone adds twenty-five more stories and 120,000 square feet of offices to the area of Wall Street.

More Giant Buildings Under Way

Passing northward again, toward Brooklyn Bridge, it is found that the great structures already mentioned do not exhaust by any means the list of new skyscrapers just finished or under way.

There is the Silversmiths' Building, for instance, at 15–19 Maiden Lane, and extending through to 18 and 22 John Street. It will have an area of 135,000 square feet on its floors, and will contain 2,500 tons of steel soaring upward on an E-shaped lot.

Near by, on Maiden Lane, is the new German-American Building in course of construction. It will be a twenty-story skyscraper, with 2,000 tons of steel on a triangular lot sixty feet wide at one end and twenty feet at the other, with a depth of 125 feet and a varying height of six, thirteen, and twenty stories. At Dutch and John Streets the new Franklin Building is being put up by the Thompson-Starrett Company at a cost of $500,000. On its twelve floors of somewhat irregular shape there will be 6,943 square feet of space.

The amazing growth of the skyscraper in lower Manhattan is due to causes quite apart from the vanity of the builders. A real estate man, explaining it, said: "Land has become so valuable in the financial district that a building of the ordinary dimensions no longer pays. The only way to get the money out of the land is to put up a tall office building."

This condition, in turn, reflects a real estate situation that extends to the entire city. The tendency is to concentrate business and distribute the population. Permits were taken out last year for business buildings to cost $32,000,000, a larger sum than for any previous year in the city's history. In 1905 the money so expended was $28,000,000. On the other hand, there was a decided reaction in Manhattan in the erection of apartment hotels, and the $2,000,000 spent for private residences last year was the low-water mark for such expenditures on the island in many years.

Men who read between the lines professed to see in this condition and in the great growth of the outlying boroughs the day when Manhattan would be given over almost exclusively to business and transient trade. They pointed to the wholesale houses that were being pushed further and further up lower Broadway every year; to the new retail district on Fifth Avenue between Twenty-seventh and Forty-eighth Streets, with land ranging from $12,000 to $15,000 a front foot; to one property on the avenue above Forty-second

Street the selling price of which jumped from $470,000 to nearly $700,000 in three years. Then they pointed to the growth of the outlying boroughs.

On the whole, they said, last year was the greatest for building in the history of the city, 1905 alone excepted. The new buildings in the greater city called for the expenditure of the huge sum of $225,000,000, the projected alterations for $20,000,000 more. The money loaned on mortgages was $608,544,826, only two millions less than all the gold in circulation in the United States seven years ago. Of this sum, $450,000,000 was placed on property in Manhattan and the Bronx. That is nearly as much as all the property in Louisiana is worth. The money raised on property in the Bronx—$136,000,000—was more than enough to support the combined navies of the United States and Japan for a year.

With the four new tunnels leading from lower Manhattan to Brooklyn and Jersey City, now nearly completed, the Manhattan Bridge and the Williamsburg Bridge connections under way, the section of Manhattan below Fourteenth Street has become the focus of this business concentration. The assessed valuation of the property on Manhattan south of Watts and Grand Streets was estimated last January at $731,858,110. This vast sum would pay the entire national debt of China and leave plenty to settle the $93,000,000 owed by the Kingdom of Sweden.

The enormous valuations placed on land in this district were shown by some of the transactions in 1906. The old Stewart Building, near City Hall, sold for about $4,000,000; the Lord's Court Building, 27 William Street, at nearly $3,000,000; the Coal and Iron Exchange, at the southeast corner of Liberty and Church Streets, for about $1,500,000, and the properties at 58–62 Broadway and 160–164 Broadway, for about $1,000,000 each. The site of the new Consolidated Exchange, with a frontage of 100 feet on Broad Street and a depth of 112 feet on Beaver Street, cost in the neighborhood of $830,000.

What Skyscrapers Are Worth

Such are the conditions that make towering skyscrapers costing millions of dollars a business necessity in the financial section. Some idea of the sums thus invested may be obtained from an estimate of the value on twenty-five of these great structures now standing or under way. The valuations by a real estate expert are as follows:

Building	Valuation
City Investing Company	$4,500,000
Singer Building	3,000,000
United States Express Company	2,500,000
Trinity Building	2,500,000
Trinity Addition	1,250,000
West Street Building	2,000,000
United States Realty Company	3,250,000
Broad Exchange	3,500,000
Wall Exchange	1,800,000
42 Broadway	2,000,000
Battery Place Building	1,200,000
Trust Company of America	1,250,000
Maiden Lane	800,000
Seligman	800,000
Franklin	500,000
Battery Park	500,000
Maritime	500,000
Broadway Chambers	550,000
Century Building	500,000
North American Trust	480,000
Chesebrough Building	325,000
Taber Building	300,000
Tontine Building	300,000
Cockroft Building	425,000
Orient Building	300,000
Total	**$32,250,000**

The rapidity with which such structures rise must be a source of wonder until the complete and intricate organization of the workers is understood. No army is more thoroughly marshaled or disciplined: no railroad run on a time table more accurate. Each division or subdivision of the work is in the hands of a specialist. A company that does nothing else clears the sites of the old buildings. Another concern devotes all its attention to making foundations.

Besides the architect, there are consulting engineers on weights, wind pressures, and superstructure, on brickwork, terracotta, and plumbing. There are scores of bosses for the workmen, which on the great buildings now going up downtown average from 1,200 to 1,400 on each structure.

The skyscraper becomes a visible source of wonder on the streets when it begins to soar story on story in an intricate cobweb of beams and pillars above the skyline. Probably the most wonderful thing about the skyscrapers, however, is the work on the foundations, carried on behind the preliminary board fences or among a labyrinth of timbers underground.

Lower Manhattan is peculiar. The surface is underlaid with beds of quicksand and ooze from 45 to 75 feet thick, so heavily charged with water that it quickly fills every trench, then rises and falls with the tides of the rivers, showing its connection with the currents of the harbor. This water is usually found from 10 to 20 feet below the surface. It brings up the great problem of the skyscraper.

Yet it only became a serious handicap when the sky-piercing building came into existence twenty years ago. Trinity Church spire, built in 1846, rests on masonry running ten feet below the sidewalk and about an equal distance above the waterline. The foundations of the Aldrich Court Building, in Broadway, near Bowling Green, ran down to the waterline, where they were sustained on wooden pilings. The Equitable Life Assurance Society was the first company to undertake a great office structure in 1886. Its superstructure rested on concrete foundations eight feet think, and extended nearly to the waterline.

With 1890 the steel-frame building appeared, being run up to twelve and fifteen stories. The enormous weight of these structures, which soon became popular, the treacherous character of the soil, the absolute necessity for deep and water-proof cellars to accommodate machinery and steam plants, and, above all, the shallow foundations of the adjoining buildings, brought the engineers face to face with the problem they are solving in such an amazing way.

Caisson System of Construction

This solution is the caisson, or simple air-tight bottomless box, sunk through the quicksands of bedrock, the water being kept out by compressed air as the caisson descends, and the interior being afterward filled up with cement. The caissons have become so familiar to most dwellers in Manhattan that further description is unnecessary.

They were first used in lower New York in 1892 for the Manhattan Life Building. Adopted later for the American Surety, Empire, Washington Life, and Standard Oil Buildings, and the Commercial Cable Annex, they have since become the recognized foundation of skyscrapers in the district.

The growth of the caisson idea and the relations the foundations bear to the towering skyscrapers of lower Manhattan are shown by the following figures:

1902.–42 Broadway; 21 stories, 245 feet high. Foundations, pneumatic caissons 58 feet below the curb.

1904.—Trinity Building, 111 Broadway; 21 stories, 810 feet high. Foundations, caissons 82 feet below the curb; water level, 26 feet under ground.

1906.—United States Realty Building; 21 stories, 800 feet high. Foundations 85 feet below curb; water level, 26 feet under ground.

1906.—Singer Building; 41 stories, 612 feet above curb. Foundations, caissons 92 feet below curb; water level, 21 feet below curb.

1907.—Church Street Terminal; 21 stories. Foundations, cofferdam 75 feet below curb; water level, 10 feet under ground.

The most elaborate system is probably found in the foundations of the Singer tower. There are thirty-four caissons sunk to bedrock about 90 feet below the sidewalk and systematically arranged in an area covering about 9,000 feet. Upon this base rest thirty-six steel columns holding the gridiron of beams and girders and distributing the enormous weight of 18,365 tons over the bearing surface with mathematical uniformity.

While these were elaborate, the sinking of the caissons for the United States Realty Company Building was the more spectacular. There were eighty-seven caissons sunk to bedrock 75 feet below the surface, and all were finished in sixty days, thus creating a world's record. Before that the record was held by the Trinity Building, where fifty caissons were completed in fifty-one days. Some hint of the enormous, though varying cost of these foundations for a modern skyscraper may be obtained from the bill for the United States Realty Building foundations. The eighty-seven caissons meant an investment of $500,000, or a little less than $6,000 each.

The foundations of the Singer tower may be elaborate; the sinking of the caissons for the United States Realty Building may have been spectacular, but of all the great office buildings, the foundations of the new Church Street Terminal, at Church, Cortlandt, Dey, and Fulton Streets, deserve to be called unique. If they were the only point of interest in the buildings the caissons would make the structure an engineering wonder.

The Terminal is being erected on the spot where Henry Hudson saw the waves breaking on the rock-strewn shore of old Manhattan. Far under ground and below the old water level is being constructed the five-track terminal of the Hudson and Manhattan Railroad Company for the two "McAdoo" tunnels under the North River to the Pennsylvania Railroad Station in Jersey City.

The water at this point rises within ten feet of the sidewalks and ebbs and flows with the tides in the rivers. The lower stories of the Terminal are in reality a great water-tight box of concrete, 185 feet wide, two blocks long and 8 feet thick. It extends downward to solid rock 75 feet below the sidewalks, or 65 feet beneath the water line—a depth about equal to the height of a four-story city residence. In this box or cofferdam will be four stories, including train platforms, concourse, stairways, inclined planes, waiting rooms, telegraph and telephone booths, and a restaurant.

The foundations finished, the growth of the steel structure is a matter of organization rather than a struggle with nature. The steel pillars and beams, the brick and terra cotta for the floors and walls, the maze of pipes and electric wires for ice water and hot and cold water on every floor, steam heat, fire mains, drainage, and electric lights, have been ordered months in advance and figured down to the fraction of an inch. Like a colossal Chinese puzzle, difficult to comprehend as a whole, but fitting with mathematical nicety, little remains except to put the millions of pieces together. The workmen who are to do this work have been engaged weeks in advance.

With buildings in the crowded downtown section the materials cannot be stored in any quantity on the ground, so they are brought hither in small quantities and sometimes piece by piece. A single error in delivery may delay the structure at an important point, so even this part of the work is arranged with the accuracy of a railway time table.

The structural steel that goes into the skyscrapers costs about $50 a ton at the mills, and $65 in place, the $15 difference representing the cost of transportation and labor on the ground. With varying conditions this cost runs up to $70 and $75 a ton. The average city skyscraper, fifteen stories high, 50 feet wide, and 100 feet deep, contains 1,000 tons of steel, 1,250,000 bricks, and 4,000 barrels of cement. These materials vary greatly in the larger buildings according to the nature of the foundations, the height, weight, wind pressure, and amount of ornament.

The Singer Building, for instance, contains 8,000 tons of steel, costing at least $520,000; the City Investing Company structure 17,000 tons, was placed in position at a cost of not less than $1,105,000; the Church Street Terminal, 26,000 tons, costing, at $65 a ton, at least $1,600,000.

Acres of Floor Space

As the floors are completed the most wonderful feature of the new skyscraper develops—the extent of the floor space added to the business section of the city. The area of the Singer Building will give an inkling of what this means. The Singer Building will be approximately three times as high as the spire of Trinity Church and more than twice the height of the Flatiron Building. The area of its combined floor space will be about 418,820 square feet. This means nine and a half acres, or, if on one level, as large a space as the territory from Exchange Place on the south to Dey Street on the north, Trinity Place on the west, and Pearl Street on the east—practically the heart of the Broadway financial district. If this floor space were moved uptown it would cover twenty-eight ordinary city blocks. An army of 100,000 men would be able to find standing room upon it.

Yet the towering skyscraper of the City Investing Company Building, next door, will have a floor area a third larger than that of the Singer Building; the floor space in the new Church Street Terminal, a stone's throw away, will be nearly double. The twenty-story Broad Exchange Building has an available rentable area of 350,000 square feet; the skyscraper at 42 Broadway, of 255,000 square feet; the Battery Place Building of 155,000 square feet, and the Trinity Building of 145,000 square feet. The combined floors would make a single building 290 stories, or nearly three quarters of a mile high.

The floor areas of the great skyscrapers, completed within the year or now under way, may be summarized as follows:

Building	Floors	Floor Area
Church Street Terminal,		
Cortlandt Building	21	546,000
Fulten Building	21	378,000
West Street Building	23	15,146
Singer Building	41	411,388
City Investing Company	36	686,000
United States Express Company	23	300,873
United States Realty	21	310,000
Trinity Addition	21	125,000
Trust Company of America	25	120,000
Franklin	12	60,960
German-American	20	108,000
Silversmiths'	20	135,600

Under favorable conditions the skyscraper is raised at the rate of four stories a week.

* * *

AMERICAN PICTURES IN FRANCE

It is interesting to know that hundreds of American painters are represented in the Paris Salon this Spring. It signifies many things, one being the comparative smallness of the world these days, another the restless desire of countless young Americans for means of self-expression, and still another the fact that the Salon, like the Royal Academy, is losing much of its old distinction. The number of reasonably famous and pecuniarily successful painters who do not send to the big exhibitions increases yearly. It is also true that the Salon increases in size yearly. The chances of a young painter who gets a place in one of these huge collections of paintings of all qualities gaining recognition thereby are exceedingly small.

To be sure the honor of gaining admittance to the Salon seems nearly as great as ever, because of the multitude of contestants. Rejection is the common lot in art as in all other fields of endeavor, as in life itself. Among the many young American exhibitors in this year's Salon there must be many who will never be admitted again, though they may paint better in the future, though they may prosper, as prosperity goes in the artist's career. There are a few of American birth who are as French as any of their colleagues; some who, like Boggs and Bridgeman, have lived longer in France than most of their associates of French birth. But there are others who are now enjoying their first and last Salon victory, somewhat oppressed by the reflection that it is not much of a victory after all, in spite of the thrill of joy the announcement of acceptance gave them.

The growth of the art spirit among Americans is wholesome enough and there is no place to cultivate that spirit like Paris. Art is in the air there, but even there it is elusive and the triumphs to be gained in its name are few in comparison with the disasters to which it leads. That the energy, zeal, courage, self-sacrifice of hundreds of young Americans are making themselves felt abroad, however, is a fact we may congratulate ourselves upon. It is worth while to be in the Salon even if it does not mean as much as formerly. Influence does not count for much. The fact is that thousands are now painting very well, indeed, just as thousands of others are writing fluently and agreeably. The number of men and women with an important message, however, does not increase measurably from year to year.

* * *

LEADING ARCHITECTS OF NEW YORK SEE MANY PRACTICAL AND AESTHETIC PROBLEMS CREATED BY THE PRESENT HIGH BUILDING TENDENCY

Ever and ever upward grows the beetling skyline of the city, ever increasing in height the structures of steel and stone

and concrete; structures forced upward by the forcing process of insistent demand of commercial and business interests for coigns of vantage on Manhattan's narrow, congested island.

In its early days the city had no skyline—least wise nothing that we call skyline to-day. The skyscraper has brought the one we know of now. It has brought, moreover, many problems. Will this upward trend eventually make the city a metropolis of cliff dwellers, each looking down into a sunless cañon? There is also something to be said about the architectural merits of this high-flung rampart of the gateway of the Western world. Are these rapidly uplifted promontories artistic, do these jutting headlands of steel and stone make any appeal to the sense of beauty? Would designers of a "city beautiful" have constructed them along these lines? And what is to be the future skyline? The leading architects of the city were asked these questions, and they here give answer.

LIMIT TO HEIGHT NECESSARY

Ernest Flagg Elaborates a Plan for All Future Buildings

In the Singer Tower the architect, Mr. Ernest Flagg, has illustrated his scheme for the solution of the skyscraper problem, which he wishes adopted all over the congested building area of Manhattan Island.

He states it thus:

"Our land values have been fixed on the basis of high buildings. To set a low limit of height now would be not only greatly to reduce the available area of floor space for the future and so interfere with the city's growth, but to bring about a great shrinkage in values. Such a limit would also discriminate unjustly, and I think unnecessarily, against those owners who have not already built, and in favor of those who have built and preempted their neighbors' light.

"Moreover, it is useless to discuss the fixing of such a limit at this time, for it would not be tolerated; it is, therefore, impracticable.

"Now, if we admit that present conditions cannot continue; that a limit of height to be effective must be low, and that the establishment of a low limit of height is impracticable, we arrive at the conclusion that a limitation of area must be established above a certain height, and the only thing we have to consider is the details of the plan.

"The plan I propose is simple, and I think it would be effective.

"1. I would limit three-quarters of the area of every plot to a building height not to exceed once and a half the width of the street on which it faces, with a maximum height of 100 feet.

"2. I would have no limit of height for the remaining quarter of the plot, provided that no building or part of a building should be carried above the limit mentioned within a distance of the street façade equal to the distance of the curb from the building line.

"3. I would allow of the purchase and sale between adjoining owners of the right to build high within the limit stated.

"4. I would require that all sides of any structure carried above the limit of height should be treated architecturally, and that no wood whatever should be used in the construction of the entire building or its equipment.

"This plan would protect the owner in his natural right to light and air. If only one-quarter of the adjoining land were occupied by high structures, little damage could be done him. If on certain plots a greater area were covered, the rights of adjoining owners would have to be purchased, and they would thus receive compensation for any injury they might receive. No owner could be built in on free sides and deprived of his light, as at present in any event.

"Our street façades would assume that appearance of order and sobriety which comes of a uniform height and a continuous cornice line.

"The skyline of the city, as seen from a distance, would assume a most picturesque, interesting, and beautiful appearance."

PROPORTION HEIGHT TO BASE

J. Hollis Wells Thinks Average Skyscraper Lot too Small

J. Hollis Wells of the firm of Clinton & Russell, builders of the Hudson Terminal and new Whitehall Buildings, put himself on record as an enemy of the indiscriminate building of skyscrapers in New York City.

"The average lot on which a skyscraper is built," he said, "is too small to stand a very high building. A lot of say 100 by 100 feet may stand a twenty-story building, but when the building put up on a plot of land costs far more than the land itself the equity in the property is not safe. Loan companies, as a general thing, don't like to loan money on buildings the cost of which greatly overbalances that of the land.

"Skyscrapers should be put up only when they are sound commercial propositions. For instance, in the case of the new Whitehall Building the plot of land is a very large one, well able to stand a high structure.

"Many people do not realize another thing about high buildings. The higher they are the greater the congestion will be on the lower floors. The higher they are the greater the congestion will be on the elevators and the greater the number of elevators required will be. Now, elevator shafts take up space which might otherwise be rented. So it is evident that just because the building is much higher than another it does not follow that the extra amount of floor space is advantageous. Not only are there extra cost and expenses entailed by extra elevators, but in the question of foundations the outlay is often very large.

"So what looks like a good proposition for a thirty-story building may be just as good, after all, for a twenty-story one. All depends on situation and size. I am a believer in building skyscrapers under certain conditions."

MORE TOWERS IN THE FUTURE

Pierre Le Brun Describes Skyline as It Will Probably Look

The resemblance of the design for the Metropolitan Life tower, in Madison Square, the highest skyscraper in the

world, to the famous Campanile in Venice, has already been remarked. That there was an intention to make the American structure a copy of the older tower was denied by Pierre Le Brun of N. Le Brun & Sons, the designers of the skyscraper.

"An architect cannot be said blindly to copy one building in another," said Mr. Le Brun. "He studies every type of building and learns all he can about them. The impressions he receives are bound to appear in his subsequent work, that's all. His is like the mental process of an author. The latter reads many books on a variety of topics. The results appear in his work in forms that suggest the originals, but amount to no more than so-called 'unconscious absorption.' "

"What of the skyscraper of the future?" the reporter asked. "Will concrete take the place of steel in its construction?"

"I do not think the exclusive use of concrete is practical for very high buildings," Mr. Le Brun replied. "The loss of area is too great. In other words, the piers and reinforcements in a skyscraper composed of concrete would have to be made so large and heavy to sustain the weights that too much space would be lost."

"What of external materials? Will stone, brick, or terra cotta ultimately gain precedence, one over the other?"

"I should not say it was a matter of precedence," Mr. Le Brun replied. "One or another material will be used according to the taste of the builder or the necessities of the structure, varying more or less in each case. The marble in the Metropolitan Life tower, for instance, serves as an added weight to hold down an unanchored structure. The Singer tower is light by comparison, other materials are appropriate—and so on."

"And what of New York's skyline, past, present, and future?"

"Before the days of the skyscraper," the architect replied, "New York could hardly be said to have had a skyline. The city looked rather level, with spires here and there, like that of Trinity Church. Now the tall buildings of the downtown section look like a hill with jutting pinnacles. This massing has many points of beauty.

"In the future we are likely to have more towers. I can see the city, for instance, covered with tall buildings—they should not average more than twelve stories in height—and from them many towers soaring into the air. The towers need not be set back from the façade, as has been suggested. They may be made as impressive if rising on the building line. Their position will depend, of course, upon the exigencies of the site. But with these towers New York's skyline will be as picturesque as that of some old Italian town—Bologna or Siena, for instance."

STEEL SAFER THAN CONCRETE

Cass Gilbert Emphatic In His Estimate of Building Material

"What principles does an architect keep in mind when he decides upon the height, form, and ornamentation of a modern skyscraper?"

The question was put to Cass Gilbert, architect of the new Custom House and the West Street Building, among many other structures.

"The situation in this city is a peculiar one," Mr. Gilbert replied. "It presents problems not to be found in the same form, perhaps, in any other city in the world. New York being a business centre and the gateway to the Western world nearly every important business organization finds it must have an office here. It is to their interest to be on an important business street or near the financial centre. Consider, with this fact, the location of the business section on a narrow island and the high values placed on real estate. The skyscraper, its height and floor area, become questions of business expediency, probable income, and a profitable investment—an economic question, a matter of obvious necessity.

"The skyscraper offers a structural problem, a solution for which architects are seeking on new lines. Now and then the pendulum may swing too far in one direction or another, but experience must in the end find some rational solution.

"It has been suggested that the State arbitrarily regulate the height and general appearance of our buildings. It could be done by statute, of course, but I think such a plan would be unjust and impracticable. Such regulations, as well as plans to place buildings in groups or to cause the upper stories to be set back from the building lines, have certain advantages, but would probably develop a tendency to prevent the owners of smaller sites from building and concentrate operations solely in the hands of large corporate interests combining many small properties. It may then be considered a question of public policy in so placing the advantage on the side of the larger holders of real estate.

"As for designs, it can hardly be said that architects borrow the styles of other periods or countries. Our designs may suggest or be in sympathy with other orders, but that is all. The skyscraper is a new problem, in which other styles should not be copied.

"As for skyscrapers built of concrete, if any one wants to take the responsibility for such structures he is welcome to the idea. These reinforced concrete buildings have been widely advertised. As a matter of fact concrete—the sort reinforced with wire—has been used in our buildings for at least fifteen years that I know of. No, steel construction would seem to be the only practical form for the modern skyscraper.

"In this connection it is interesting to recall the contention that the mineral resources of this country are being wasted and that the time will come when our iron mines will be exhausted. Did you ever stop to think that if that day should come—say, a thousand years hence—the iron mines would then be in the skyscrapers of to-day? That is what they did in Rome. You can still see there how the old buildings were searched for structural metal, even to the bronze anchors that bound together the blocks of stone."

GOTHIC TYPE IN SKYSCRAPERS

Francis H. Kimball Points Out Aesthetic Values in High Buildings

Mr. Francis Kimball not only has his offices in the Empire Building, one of the skyscrapers built by him, but he is practically surrounded on all sides by others, likewise his creations.

Of particular interest, in view of the limitations on architectural beauty imposed by skyscrapers, are Mr. Kimball's remarks on the Gothic style of the Trinity Building. Here is what he has to say on the subject in the last number of The New York Architect, just out:

"In the selection of Gothic for the first section built, facing on Trinity Churchyard, the juxtaposition of Trinity Church exerted a great influence, no doubt, in arriving at a decision. The fact that the same architect was responsible for the Empire Building, at the other end of Trinity Church property, did not suggest a change in style solely to be different. Here was an exceptional opportunity to treat a great façade, 300 feet high and 288 feet in depth, presumably, to the stranger, an adjunct of Trinity Church, though in reality having no financial connection, in harmony with an important church edifice; a complement rare indeed in building operations, except in one instance in this city, notably the building on the north side of Grace Church, owned by the O. B. Potter Trust, which was built in harmony with its neighbor.

"The type of Gothic selected, moreover, admitted possibly of a broader treatment than where severe ecclesiastical forms are employed. Commercial requirements must dominate in an office building, so that stone-traceried windows must give way to mere suggestions in iron, and these sparingly introduced.

"In the consideration of the treatment of the great frontage on the churchyard, it was realized that every foot would be visible, except possibly during the Summer months, when the lower section of four stories would be in part covered by the foliage of the churchyard trees. The aim was to produce a broad effect in stone, in one plane, unbroken by vertical lines of projection, depending for architectural effect on the three divisions—base, shaft, and capital; the shaft relieved by grouping of windows into features richly treated. The idea prevailed throughout both buildings except that the frontages on Thames Street were simplified on account of its lesser importance.

"Gothic in other material than stone is shorn of its proper effect. This, as well, was the opinion of the President and officers of the owner, and they rigidly adhered to this decision. Stone was used throughout every part of the exteriors of both buildings.

"The effort has been to produce a thoroughly conscientious example of Civic Gothic, and it is hoped the endeavor has not failed in its intention."

COLOR FEATURES OF FACADE

C. Grant La Farge Indicates Possible Future Innovations

C. Grant La Farge of Heins & La Farge, architects of the Cathedral of St. John the Divine, was asked regarding the future possibilities of the Gothic style, as adopted in such skyscrapers as the Trinity and United States Realty Buildings. He also spoke of the use of color in façades. This is a new development in metropolitan architecture and has been employed in the new buildings designed by Heins & La Farge in the Bronx Zoological Park.

"The Gothic offers many interesting studies for the modern architect," said Mr. La Farge. "Its lines, if you can get away from the ecclesiastical, offer possibilities for lightness of design. This is a distinct advantage in planning a modern skyscraper. Personally I am inclined to believe, however, that the style best adapted to American buildings of nearly every description is based on classical lines. They combine beauty and utility. By classical lines I mean, of course, all the adaptations of the idea, such as those of the so-called Renaissance.

"There are also great possibilities for the use of color in our façades. Terra-cotta is now generally recognized as a structural material. We will go on using it. Terra-cotta adapts itself to color. The tints should be used boldly, however, for restraint causes it to lose effectiveness. The color should be applied in masses and in decisive designs. You see the value of such use in Spain. Close at hand the colors seem to be brutal. Yet at a little distance, and softened by time and atmosphere, the effect is very rich and beautiful.

"The use of concrete in large buildings is still in the experimental stage. We are not prepared to give final conclusions regarding the effects of moisture and sudden changes from heat to cold. Its value under such conditions remains to be proved."

"What of the city of the future and its sky line?" M. La Farge was asked.

"Some way must be found to prevent the present crowded condition of our tall buildings," he replied. "I think it very likely that we shall drop into some such scheme as Mr. Flagg suggests—that of having towers, possibly set back from the building lines to gain the benefits of light and air."

* * *

June 30, 1908

909-FOOT SKYSCRAPER TO TOWER ABOVE ALL

Architects File Plans for New Equitable Life Building Here 62 Stories High

1,059 FEET TO FLAGPOLE TIP

Eiffel Tower the Only Structure Higher—Site at Broadway and Cedar, Nassau, and Pine Streets

If plans which were filed yesterday with Building Superintendent Murphy are approved and permission to build is granted, the towering Singer Building and the Metropolitan Life tower will be put in the shade by the projected new building, planned to stand on the block bounded by Broadway, Nassau, Pine, and Cedar Streets, the site of the present building of the Equitable Life Assurance Society. The cost of the new building is estimated at $10,000,000.

This new building is to be 909 feet above the curb, exclusive of the flagstaff, which will be 150 feet higher to its tip.

D. H. Burnham & Co., Chicago architects, acting for the Equitable Life, filed the plans which provide for a building sixty-two stories in height.

With its 909 feet the new building will tower nearly 300 feet over the 612 feet 1 inch of height of the Singer Building, and the Metropolitan's 637 feet 5 inches will seem also to be comparatively stunted. The Washington Monument, only 555 feet 5 1/8 inches in height, will measure scarcely more than half the height of this new skyscraper, and the famous Pyramid of Cheops, now only 451 feet high, will be actually less than half as high.

Only one structure erected by man will exceed the new building in height. That is the Eiffel tower at Paris, which towers 984 feet above the ground, and if the flagpole of the new skyscraper be included in measuring its height, even the Eiffel tower will have to take second place, for from curb to flagpole tip there will be a stretch of 1,059 feet.

The main building will be thirty-four stories, or 489 feet high, with a frontage of 167.1 feet on Broadway, 152.3 feet on Nassau Street, and 304.2 feet and 312.3 feet respectively on Pine and Cedar Streets. Above the main building will be a square tower of twenty-eight stories, capped with a cupola, the tower and cupola being 420 feet high.

The façades are to be of brick and granite, with trimmings of terra cotta. The design will be the Renaissance type, presenting bays set between pilasters of Corinthian and Doric pattern, the corners being offset with clustered columns. The bays will be elaborately decorated with carved work. The roof of the main building will be finished with cupolas several stories high set around the base of the tower. The tower structure will be in two sections, one section extending from the thirty-fourth to the forty-ninth story. The main cupola will extend above this.

The building is to be equipped with a group of thirty-eight passenger elevators built in two rows in a great elevator corridor finished in ornamental bronze. Eight of these elevators will run to the top of the tower extension. In addition to these, there will be several elevators exclusively for freight.

The details of the building, with its architectural design, were submitted to Supt. Murphy in a series of fifty-eight drawings, and a large survey map accompanied them to show the lot boundaries.

* * *

August 16, 1908

CONSTRUCTING A GREAT MODERN RAILWAY TERMINAL

One of the Most Puzzling of Modern Engineering Problems Is Involved in the Building, Without Interruption to Traffic, of New York's Grand Central Station

It is one thing to construct a modern railroad terminal, with its maze of tracks, its massive buildings and powerful electrical apparatus, on ground which is not already occu-

pied. It is quite another thing to construct the same modern terminal on ground which is being used by a train service carrying 65,000 passengers daily in and out of New York.

In one case the work of the engineers and the contractors is cut out for them, once the plans are approved. In the other the road is never clear ahead of the men who have undertaken to accomplish the task, for the construction of the new terminal on the site of the old has to be done without interruption to the train service. The thousands of passengers must not be allowed to feel that anything unusual is going on. All trains must be on time. Every business man must be set down in New York in time for him to get to his office at the customary hour. They must be no hitch, no accident, which might cost the railroad large sums in damages. And, probably more important than all the rest, there must be no unnecessary delay.

The latter proposition is what the New York Central and Hudson River Railroad is now working out at its New York terminal. It is one of the toughest jobs a railroad has ever undertaken. And incidentally the cost will be about three times as much as it would be were the railroad not obliged to maintain its passenger service in the same area in which the improvements are being made. It will cost the New York Central in the neighborhood of $70,000,000 before the new terminal, with its double track levels, its complete electric equipment, its new terminal station and its many power houses, signal towers, its other buildings and cut-offs are complete, and electrically propelled trains are running over the new tracks.

The Cost to Date

Already the road has spent about $30,000,000 and the work is not half through.

For four years the work has been going on. Another five years will probably elapse before the job is done. The greatest set-back with which the railroad men are obliged to compete is the necessity for constructing duplicate equipment in many phases of the work. When a part of the train service is shifted from one position to another in the limited space owned by the railroad, to give way for the excavation, there has to be a complete system of signals and switching and electric propelling power for the trains which move on tracks in their new and temporary location. When the excavation is complete and the tracks can be shifted back to the permanent location the entire system governing train movements on those tracks has to be again shifted.

All this is very expensive, and it also kills a lot of time which could be avoided were the operations being made on new ground, unhampered by the constantly maintained passenger service. But railroad men and engineers say that the New York Central is overcoming the difficulties in a manner which was hardly hoped for even by the men at the head of the management of the road.

A comprehensive idea of the difficulties in the path of the engineers and constructors of the new terminal system can be gained from a conversation which takes place every now and then between Adelbert R. Whaley, General Superintendent of

the New York Central electrical zone, and George A. Harwood, the constructing engineer.

Mr. Whaley is visited in his office by the constructing engineer.

"Got to have two tracks to-day," says Mr. Harwood. "Excavation is up to No. ___ track and we can't go any further."

Mr. Whaley gets out his plans of the works and studies the maze of little lines representing tracks and excavations.

"Can't you do with one track to-day?" he finally asks. "The upper level has about all it can stand now and this track on the lower level is not finished."

"I don't think so," replies the constructing engineer.

Chance for Saving

Then Mr. Whaley goes over the charts again and points out where time and money can be saved by moving one track to the lower level and allowing the adjoining track to remain until the excavation reaches it. The constructing engineer goes away, gives his orders to the foremen of the construction gangs and again the sound of blasting and the creaking of the giant steam cranes is heard in the yards and another long line of rock and earth begins to crumble away. The brunt of the responsibility falls upon the shoulders of Mr. Whaley, for he, in addition to being Superintendent of the electrical zone, is Manager of the Grand Central Terminal. The operating department of the engineer department and the construction department are so closely allied in this work of building a new system on the site of the old without interruption to the passenger service that Mr. Whaley has to have a general knowledge of all three. Without it the system would be tied up most of the time and a storm of protest would come from thousands of the road's patrons who ride in and out of the Grand Central yards each day. The manager has to go over all the plans with the engineers and has to suggest how and where the next move in the excavation work is to be made.

While the old terminal was operated all upon one level the new one will be operated on a double level. Trains will run over the heads of others. There will be practically two complete layers of terminal tracks, each emptying passengers out into the Grand Central Station.

There are in the neighborhood of 800 train movements a day over the tracks of the New York Central. Not one of these has been curtailed by the operations now under way. The maximum number of trains, including passenger trains and work trains, over the terminal system is 888 in twenty-four hours. The minimum number is 750. With a few exceptions the passenger trains have never been held up by the excavating work in the last four years. This means more than the layman realizes. And there has never been a serious accident in the works, although 1,080,000 cubic yards of material, mostly solid rock, have been removed, dozens of buildings have been torn down, the great train shed which jutted out from the Grand Central Station proper has been removed over the heads of thousands of passengers. Not a brick or a plate of glass or a bar of steel from the overhead covering has fallen upon the heads of either passenger or workman and the trains have come and gone at the rate of one in about every four minutes while this work was being accomplished.

In one month, June, there were 28,733 cubic yards of rock blasted out and removed. Three big steam shovels are now removing the earth and rock at the rate of 1,600 cubic yards a day. Last year there were 260,000 cubic yards removed and carted away to make ballast for the tracks at some remote part of the New York Central system. One construction company, the O'Rourke concern, found the task greater than it had anticipated and after a few acres of rock had been excavated on the Lexington Avenue side of the terminal the New York Central took the work off the construction company's hands and put its own staff of experts to work. Expert construction engineers were employed and now the work is forging ahead at a creditable rate of speed.

Problem of 800 Trains

But the hardest phase of construction is just ahead. The number of tracks over which the 800 trains have to be carried daily is at its minimum now. A few of the tracks on the low level, 40 feet below the surface of the street, are in operation, but the majority of tracks are still on the old, or top level. One by one these will have to be ripped up and the narrow space they occupy will be given over to the construction force and the blasters.

"Were it not for the narrow bites we have to take at the rock, the excavation could be made in one-fifth of the time" said Mr. Whaley the other day, while showing a Times reporter over the works. "But you see we can only spare one track at a time, and when it is taken up there is only a ledge of, say, 10 or 12 feet which can be blasted from the high level to the bottom of the excavation. That makes slow work. But there is no way of getting around that obstacle. The passenger service has to be maintained. It can never for a moment be interrupted. Schedules have to be run. It is a bigger proposition than the average man thinks. But we are making progress."

Night and day the work of digging the vast hole goes on. A force of 500 laborers is at work. The day shift is small, only 130 men, but a larger number would be in each other's way. With trainloads of passengers going back and forth over the tracks every few minutes during the day-light hours the percentage of time lost is very great. The men cannot work more than about one-half the time they are on duty. Gangs assigned to tearing up a track or shifting the electrical apparatus from one line of old track to a new one have to throw down their tools every few minutes to allow a train to pass.

The blasters cannot operate during the daylight hours. At night there is a force of 350 men in the works. After 9:30 o'clock at night and until 6 o'clock in the morning the train movements are at a minimum.

A force of 350 men on the night shift seems small to the layman. But the practical constructionists say that more could not be used under the existing conditions. Like the day gang, more would be in each other's way.

Working Day and Night

At no time during the day or night passengers looking out of car windows notice a cessation of activity. All along the line of work, from Forty-third Street to Fifty-sixth Street, where the tracks enter the tunnel, are little groups of men in charge of the engineers or the construction foremen. All are doing something. The telephone wires which connect every part of the works are kept constantly buzzing with queries or instructions. Danger signals are being constantly flashed by the automatic apparatus in the switch tower, and workmen are constantly springing out of the way of the moving trains.

By the double level scheme the New York Central will add 178 per cent additional space to the terminal yards. Seventeen acres were purchased not long ago and added to the 23 acres already occupied by the terminal tracks and other equipment. The total track area in the new terminal, when completed, will be more than 60 acres.

The adoption of electricity in the propulsion of trains by the New York Central brought about the necessity for the greater space. And the adoption of electricity made possible the depression of the roadbed to the level of forty feet below the surface. On either side of the old roadbed at Fifty-sixth Street, the mouth of the tunnel, the tracks will diverge and dip gradually down to the low, or suburban, level, which will reach its greatest depth at about Forty-fifth Street, and run on that level to the lower train platform at the new Grand Central Station. This low level will be used for the suburban trains. The upper level will be devoted to the express service. By this lower level the full width of Park Avenue, 140 feet, will be utilized by the road, for, after the dip beginning at Fifty-sixth Street, the suburban trains will be switched under the first level track bed, and will be run on to the many tracks which will branch out like the body of a great bottle beneath the first level.

The construction engineers have not waited for the completion of the excavation before beginning the tearing down of the old Grand Central Station to give place to the new one. Already the work of taking down the old station has begun. This station and trainshed, built in 1871, and afterward enlarged as the railroad's business grew, will be supplanted by a much larger and handsomer structure, suited to the new electric motive power and more adequate for the handling of the rapidly increasing passenger traffic. The substitution of electricity for steam has enabled the road to greatly facilitate the movement of trains in and out of the terminal.

Although the electrical system has been in operation for many months, there is still much to do before it reaches the stage intended. While the blasting is going on in the terminal yards, work is under way looking to the extension of the electrical service to Harmon, on the Hudson Division, 33 miles from New York, and to North White Plains, on the Harlem Division, 24 miles from the Grand Central Station. This territory is known as the electric zone. Within a comparatively recent time and without halting the work in the terminal territory the electric service has been extended to Yonkers, and all the Yonkers and Croton local trains now make the change from electrical power to steam at Yonkers instead of at High Bridge, as before.

New Lexington Avenue Station

A new station on the Lexington Avenue side of the terminal has already been built. In this will be the new branch Post Office. Three tracks have been laid along the low level running into this new section of the terminal. Two more tracks are now being laid on that side of the terminal, and this has enabled the engineers to begin building the northeast corner of the terminal station building. The New York, New Haven & Hartford trains are now using these new tracks, and the passengers, leaving trains at the new platform, reach the Grand Central Station by a long tunnel-like footway, which will in time be removed to give way to the permanent train passenger platform, which will run the entire length of the proposed station.

The manner in which the train shed was removed during the last few weeks is interesting. To avoid any danger of bricks, glass, or steel falling upon the heads of passengers during the tearing-down process, a movable platform was operated on wheels. And beneath this was a great hood of wood shielding the train platform from above. The train shed, constructed of steel and glass, was 530 feet long and 100 feet high. In its walls were 750,000 bricks. Two acres of glass covered the gigantic hood. All of this has been removed, up to the concourse, and the workmen are now busy rearing a temporary roof to shield passengers from the rain.

The new Grand Central Station will cover nearly four entire city blocks, extending from Vanderbilt to Lexington Avenue. The Grand Central Palace will soon come down, and on its site will be reared one wing of the station. The waiting room will be in this wing. According to the present plans the new station will be only 170 feet high, but this is subject to change at any time. In fact, the managers of the New York Central are now considering whether it would not be advisable to rear a skyscraper, the lower floors of which would be devoted to the station and the upper floors to offices, both for the railroad officials and others who desired to rent them. This may not be decided for several months, as the plans are in such a stage that the work now going on would not be interfered with were a larger station building to be decided upon.

The main entrance to the station will, like the present station, be on Forty-second Street, and near this main entrance will be the ticket lobbies, a hall 90 by 300 feet. A mezzanine floor will surround and overlook the express concourse, fifteen feet below, and approached by four great stairways. Abutting the express train platform will be twenty-four tracks. Waiting rooms, cafés, telephone booths, telegraph offices, and other conveniences for the traveling public will be on the main floor. All these will be fifteen feet below the street level.

The lowest level, where the suburban trains will enter the station, will be connected with the Subway at Forty-second Street by a broad passageway. Broad stairways will lead to the lower level. There will also be elevators for those who do

not care to waste their steps. Cab stands and the baggage rooms will be on the same floor as the express concourse, and separate departments will be built for the incoming and outgoing baggage.

The New York Central has already spent $16,000,000 on its electrical equipment alone, and the extension now being pushed out to Croton will cost $20,000,000 more. Coming and going over the constantly shifting terminal tracks there are 35 electric locomotives, which cost the New York Central $30,000 each, and 125 motor cars, costing $15,000 each. There are also about 40 electric locomotives owned by the New York, New Haven & Hartford and operated over the New York Central tracks. At the present stage of the electrical improvement an aggregate horse power, in cars and locomotives, of 127,000 is being developed. The new power house, entirely complete, at Port Morris, has a capacity of 20,000 kilowatts, which is equivalent to 27,000 horse power. From Port Morris the electric power, or the "juice," as it is called by the railroad men, travels two miles to Mott Haven Junction, where it reaches the third rails.

Electric Zone Sub-Stations

While the work of excavating the terminal has been going on the New York Central has built five sub-stations along the electric zone, each with 11,000 volt power. These sub-plants are now completed. One is at Fiftieth Street, one at Mott Haven Junction, one at the Botanical Gardens, one at Kingsbridge, and one at Yonkers. The power from the Port Morris plant is changed at these sub-stations from what is known as the three-phase alternating current, at 11,000 volts, to a direct current at 666 volts, at which voltage it reaches the third rails. Each sub-station has a storage battery.

There are another set of buildings now completed, which are known as the circuit breaker houses. They contain large circuit breakers, attached to the third rail of each track. In case of trouble on any of the tracks these circuit breakers are used to cut off the power. All this is done automatically. In the fourteen circuit-breaker houses no men are stationed. Occasionally, by request from one of the sub-stations, the circuit in a certain zone will be broken, but usually the breaking of the circuit is automatic.

A duplicate power house has also been constructed at Yonkers, with a capacity of 20,000 kilowatts. In case of accident to the Port Morris plant sufficient electricity can be generated at the Yonkers plant to operate all trains in the electric zone. So it is with nearly every phase of the electrical system. There are duplicates for everything. This must be so when all the motive power of the road emanates from one central point, instead of from the individual boilers of the locomotives as in the past.

The officials of the New York Central admit that they do not know when the new terminal will be completed.

"It may be four years. It may be six," they say when asked. "But when it is done it will be done right."

* * *

November 22, 1908

NATIONAL ART GALLERY

Artist Howard Says America Is Certain to Found One

Francis Howard, the American artist, who is promoting a plan to establish a National Art Gallery in the United States, arrived on the White Star liner Oceanic last night. The project, he said, had the indorsement of J. W. Alexander, Whistler, Sargent, Mechers, and other prominent artists, besides many wealthy and influential Americans.

"The American National Gallery is bound to come," he said. "Every other nation has a national gallery, while America has only local galleries. The first step will be the establishment of two committees—one of artists and the other of laymen. They will formulate plans, and select the location for the gallery. When this is accomplished the Government will be asked for an indorsement and endowment, as well as the granting of a site. The establishment of the gallery will be a great advance for American art. Provincial prejudice will be done away with, as the pictures will not be confined to the gallery but interchanged, as is done at the Luxembourg, Paris. It will be an inducement to Americans to bequeath pictures to the National institution instead of to local galleries, as has been the custom."

Mr. Howard said that many wealthy men had signified an intention of assisting in the establishment of the gallery. Among the cities which have been spoken of as a suitable location are New York, Chicago, and Washington. Washington had many advantages, Mr. Howland said, and there was a possibility that that city would be selected. It would be necessary to raise $2,500,000 before the building could be started.

* * *

December 6, 1908

ART AT HOME AND ABROAD

Arts and Crafts Movement So Widespread as to Come Into No Inconsiderable Competition with Machine Workers

The arts and crafts movement in this country has now reached considerable proportions, and the craftsmen have come into definite if not extensive competition with the machine workers. In a lecture given a week or so ago by Mr. Ashbee, the English leader of the arts and crafts movement, discrimination between work that could be better and more suitably done by the machine and that best suited to the labor of the hand was spoken of as the mark of an intelligent attempt to solve the problem. Ornament, no doubt would be pretty generally regarded as a proper field for hand work, and the modern craftsmen are probably wise in confining their attention chiefly to ornamental work.

In the second annual exhibition of the American craftsmen in the galleries of the National Arts Club jewelry forms the largest exhibit, and something like 600 examples are shown. It is interesting to note that within the last three or four years a marked advance has been made in the regard paid by the workers to the especial quality of the metal used. Only a short time ago it was common to find in hand-made jewelry the most extraordinary combinations of comparatively cheap metals with valuable stones, and vice versa; designs suitable to the coarsest and heaviest materials were worked out in gold and silver, there was little notice taken of the possibilities of surface, and anything intricate or delicate or severe was unknown except in the case of a few craftsmen trained in the principles of art and possessed of high ideals of beauty and appropriateness.

In the present exhibition there is a widespread attention given to this treatment of the material, one of the first considerations in any important attempt to place handicraft in direct competition with machine-made goods. There is still plenty of rather barbaric design and color, but rightly, not wrongly, applied. Mr. and Mrs. Vedder's interesting work in this direction has a note of distinction derived from the thoroughly artistic character of the design and the knowledge of artistic effect which invariably results in a true completeness at the opposite pole from false finish. Nothing could have a finer appropriateness in the relation of the design and manner of execution to the material than the three bag mounts by these competent craftsmen. One cannot but wish that they would add a metal now little favored to those in which they work with so much feeling for the right treatment—iron, that is, which reached such heights of artistic usefulness under Louis XIII, himself a metal worker of considerable skill.

Among other workers who have an innate sense of fitness are Mr. Brainerd Thresher, who manages in his combinations of rhythmical lines to keep on the safe side of the growing tendency toward "l'art nouveau"; and whose carved horn set with amethyst and gold pendants with yellowish opals are beautiful in color; Mr. Whitbeck, whose tree design in a silver pendant is admirable; Miss Grace Hazen, and Miss Sutherland. Much of the cruder work executed in the cheap metals is also effectively designed and brings out the color of copper and brass with sensitiveness to its decorative value.

In the department of textiles Mr. Albert Herter, the painter, has made a quite new departure, in a direction that will give opportunity for a wide following if Mr. Herter's tentative experiments are as successful as they bid fair to be. He has been experimenting in hand-woven textiles of both cotton and wool, in which daring contrasts of color have been produced with aniline dyes, used in accordance with the theories of Prof. Pellew. A pair of remarkably handsome curtains in the peacock blues and rich greens familiar to Mr. Herter's public have certainly none of the disagreeable metallic suggestion commonly associated with aniline colors, and the tests of exposure to weather that have been applied indicate that the color is unlikely to fade or change into sickly hues after the habit of the aniline dyes that so aroused the ire of William Morris.

Miss Amy Mall Hicks seems to uphold the banner of the vegetable dyes, on the other hand, in the hand-dyed hanging which she exhibits and her work invariably is entirely worthy of the Morris tradition.

While it is dangerous at this stage of the arts and crafts movement to insist overmuch on the charms attaching to work in which a lack of "mechanical" perfection is obvious—while insistence should for a long time to come, probably, be laid upon the desirability of as much perfection as the hand can be trained to produce—there is unquestionably a far greater beauty in hand-dyed materials than in the commercial product precisely through the inevitable irregularity of the result. The variety and unexpectedness that arise from the impossibility of thus producing absolute uniformity of tint are in themselves elements of pleasure, and the play of light and shade in the material is altogether too delightful to be willfully underestimated.

In pottery the American craftsmen show less advance, possibly because they earlier reached a high level. Mr. Charles Volkmar's pieces are so individual that each seems to excel the others in some one particular, but his present exhibit strikes no very new note. The same is true of the Van Briggle ware, which happily shows no compromise in the superb quality of its surface, the firm rich surface that has a soft lustre without a suspicion of greasiness. This surface and the refinement of the forms constitute the especial merits of this beautiful ware, which establishes a standard of character difficult to surpass. Other potteries represented are the Rookwood and the Grueby; the Markham, a once-fired pottery designed especially for flower vases, as it cools the water and keeps it cool; the Poillon garden pottery; the interesting salt glaze pottery of Mr. Russell Croaks, of which one example only is shown, and the promising work of individual potters, Miss Penman, Miss Hardenberg, and Miss Lyons. It is much to be regretted that none of the Robineau porcelains are shown, and none of Mr. Robertson's amazing and exquisite pots.

If the potteries are moving along a rather even plateau of technical competency and sober art, the ceramics are steadily mounting. Some of the work shown this year is entirely free from the touch of amateurishness that has prevailed in this art, which thus far is hardly to be called a craft. No doubt, when the decorator becomes also the maker, and the forms and the decoration are the product of one mind working upon one idea, there will be a greater individuality in the result and a finer restraint on the decorative side. At present the decoration is elaborated more or less for its own sake, and does not sufficiently spring from suggestions inspired by the form. But the thorough training in drawing and in the adaptation of designs to given spaces which is apparent in most of the ceramic work in the exhibition holds very great promise for the future of the art.

Among the finer examples are an old tureen of a shape dating back some seventy or eighty years with a sober and

rich decoration in dull blues, greens, and browns by Mrs. Anna B. Leonard, a large plate with a border of peacocks and fruits, extremely fine in execution, by Miss Middleton, and a similar plate by Miss McCrystle, with a design of parrots eating grapes, even more original and graceful, but not quite so well carried out and with one important defect, an awkward difference of scale between the bird and the other units of the design. For simple appropriateness of pattern the tea set by Miss Warren is one of the most successful efforts in this department. The bold outline of the larger units is vigorously and firmly drawn with a feeling for the beauty of the silhouette, while the spiral covering the background provides a suggestion of intricacy without confusion. Such a design ought, however, to have been executed with the utmost precision and delicacy, its special character forbids anything like cursory drawing.

The woodwork follows in the main the initiative of Mr. Karl von Rydingsvaard, who has revived the spirited and strong Scandinavian designs and executed them with the rude force characteristic of the old Scandinavian models. It is difficult to think of anything more interesting and stimulating to the mind than the weaving of historic and legendary figures into these appropriate patterns, carven sagas perpetuated in a material more durable than spoken words, and no doubt we shall in time see the fruits of this influence in new adaptations of appropriate motives closer to the modern spirit.

Reviewing the exhibition with specific mention of each triumph over materials and methods would, of course, be impossible in this limited space, but the examples cited and others indicate a distinct movement in the right direction on the part of the craftsmen in general. In design there is less eccentricity and more appreciation of the merits of proportion, balance, and dignity. Almost none of the work is spiritless, and the execution is more careful and intelligent. The tendency must, of course, be always toward the choice of objects that present the fewest difficulties and that can be sold for a low price, and this has its advantageous side as it familiarizes the general public with the pleasant quality of a simple hand-made article in comparison with the less personal appeal of the machine-made article. We note, however, that a number of the more ambitious workers in different departments have set themselves difficult tasks and grappled with them in the true spirit of the artist, whose difficulties are looked upon as merely so many incentives to achievement. As that spirit develops the future of the arts and crafts movement will become increasingly secure.

* * *

May 16, 1909

NEWS OF THE ART WORLD–AT HOME AND ABROAD

A Study of the Collection of New Paintings in the Accessions Room of the Metropolitan Museum

The Recent Accessions Room at the Metropolitan Museum this month wears a distinctive, albeit a decidedly varied, appearance. The contents range from Church's big "Heart of the Andes" to some small chalk drawings by Mr. Arthur Davies and in sculpture from a piece of sixteenth century wood carving after one of Dürer's designs to Barye's large "Tiger and Gazelle."

The picture by Church is almost too well known to require description. It will represent in the Museum the soaring ambition yoked to a very moderate technical equipment by which early landscape painters of America were inspired. Parts of the picture are not only well but beautifully painted. The clustering clouds over the mountain peak at the right are not merely colored but luminous, the relation of the more distant range at the left to the blue sky above is delicately and truly rendered. A patch cut out from the foreground at any point would show painstaking execution and faithful if not very close observation. But there is almost no suggestion of synthesis. The picture babbles garrulously of little things and big, the foreground is not the least related to the distance, the detail is in the nature of a record of strange plants and birds put there to tell homekeeping people the character of the vegetation and life in those comparatively untraveled regions. And like most travelers' tales, it depends upon the curiosity it arouses rather than upon its intrinsic merit for its effect.

The picture, however, which is a bequest from Mrs. Margaret Dows, is wholly appropriate to a museum in which American art is represented by anything like a historical arrangement. Church was the great man of his time, that time of "the old, limited, isolated art-life," of which Mr. Isham so justly and intelligently writes in his "History of American Painting." Even Ruskin almost liked him, and the critic of that belligerent little magazine, The New Path, admitted his dexterity in the laying on of color. This work of his middle period has its well-defined place in the American section of the Museum and will be even more valuable to the historian of art than "The Aegean Sea," by the same artist, which is already there, because it better represents both his faults and virtues.

A painting by Washington Allston, "The Deluge," given by W. M. Chase, goes still further back into the history of American art. Allston was born in 1779, and began to paint while he was still in college. From the story of his life one gathers that he had the precocity of a nature that never quite matures, and his romance is that of a boy who loves the gruesome and horrible and is happiest when causing flesh to creep by his performances. Only a few of us keep our child-

like sensibility to fairy tales and witch stories, and Allston lacked the delicate imagination that connects physical horror with psychological mysteries, so that his more ambitious works fail to move us. His "Spanish Girl" in the Museum is truly charming, the refined type, the bland line, and the sensitive color are elements of genuine artistic beauty, but "The Deluge" is a melodramatic subject, representing truthfully the taste of the artist, without, however, giving much idea of his most agreeable qualities. The note in the Bulletin comments justly upon the reality and sincerity of the expression of gloom and desolation in the storm-blighted landscape with its scattered corpses of men and snakes, and here again the possession of the picture by the Museum is obviously desirable since it exemplifies a phase of art and an artistic temperament highly characteristic of our young past.

The two canvases by Albert Ryder, "The Curfew Hour" and "The Smuggler's Cove," come from the Cottier sale, and were described in these columns at the time of the sale. Seeing them in juxtaposition with Allston's work, however, one is freshly aware of the change from the literary to the emotional idea. Ryder also impresses the observer with the romantic element in his subject, but to awaken the feeling of wonder and the sense of mystery which are of the essence of romance he tells no unusual or dramatic story. He places a house in a bit of pasture land, drenches it in moonlight, which also illumines the grazing cows of the foreground, throws realism to the winds, and moves the imagination by his marvelous golden tone and translucent glazes.

Nevertheless, it is not so big a stride from Allston to Ryder as from Ryder to Davies. In the seven drawings by the latter which are given to the Museum by an anonymous donor, the life of the imagination appears together with a certain definite and noble realism. The little figures—one a girl kneeling, heavy braids falling over shoulders, another a man bending a bow, another a girl with her arms over her head— are as plastic in quality as the Greek figurines and have something of their coloring to aid the illusion. One feels in them the strain of the muscles, the weight and character of the flesh, the ability, above all, to move and change. The kneeling girl, her face upturned, her heavy hair the color of burnished copper, her form slight yet built on ample lines, her strong arms showing her muscular power, is a conception of young, vigorous womanhood that would not have discredited a sculptor with the lovely, wholesome maidens of Tanagra for his models.

Another figure of a woman, peculiarly elegant and suave in line, with, however, a hint of the excessive length that enfeebles any representation of the human form, has a tender serenity of modeling that is pleasing rather than stimulating. The figures of the men are masterly in their expression of the artist's emotion, while they remain careful records of the facts of the human anatomy. They do precisely what Mr. Church could not do with his huge landscape—they tell in accurate detail what the observer cares to know concerning the construction of the forms, while they

also extract from the subject its emotional significance and subordinate everything else to that. The girls thrusting their muscular young arms forward, pushing out their deep chests, and throwing back their graciously formed heads, are living Dianas, touched with modernity in their type, but mingling suggestions of superb strength with those of winning grace and feminine sweetness, the kind of heroines we get in antique saga.

In the rhythm of these drawings, that rhythm which Mr. Laurence Binyon tells us is the secret of art, and in their delightful casualness, a quality never achieved except by the utmost expenditure either of labor or of the energy of mind that brings about labor's result, without the long-drawn process, but especially in their force and health of conception, their harking back to the ideals or a time when health of body and mind received its adequate homage, we find their great distinction. The Museum is fortunate to possess them, the public is still more fortunate to have access to them, and it is a happy incident for Mr. Davies to have them thus brought into immediate comparison with the work of the older masters, a comparison which they can meet quite fearlessly.

Three purchases of American sculpture also call for especial notice. Two are statuettes by R. Tait McKenzie, and are single figures of athletes, anatomically accurate and also showing a strong feeling for beauty on the part of the sculptor. There are no excessively developed muscles, no ugly violence of pose, no emphasis upon the projections of the figure. The lines flow graciously and the vigor of the form is veiled by the delicacy of the surface modelling. There might be a closer attention to the shape of the spaces or "holes" which play of course as important a part as the masses in the composition of a piece of sculpture, but the defect is one that intelligence easily can overcome in the sculptor's future work, while the extraordinary merits of the construction are the result of a hard-won intimacy with the facts of human anatomy and are rare enough in modern sculpture to be welcomed without reserve.

The third piece of sculpture is a bronze statuette entitled "Girl Skating," by Miss Abastenia St. Leger Eberle. The subject frequently has been shown in New York exhibitions and no one who has enjoyed the suggestions of swift motion and young impetuosity in the litle rushing figure will hesitate to acknowledge its charm or the desirability of having it included in the museum collection of American sculpture which is fast becoming an important feature of the galleries.

The magnificent group of "Tiger and Gazelle" by Barye has all of that master's intensity of force and ferocity of expression, but the stone seems a less appropriate medium for his art than the bronze, probably because the color and fineness of his "patine" were of such importance to him that we find it difficult to associate his works with a surface that does not lend itself to fastidious treatment.

* * *

August 1, 1909

TERMINAL STATION EXTERIOR COMPLETE

Last Stone in Place in the Pennsylvania's Mammoth New Structure

HALF A MILE OF WALLS

Masonry Work Required 550,000 Cubic Feet of Granite— 15,000,000 Bricks and 27,000 Tons of Steel Used

The Pennsylvania Railroad put in position yesterday the last piece of stone in the exterior of its new station here. This meant the completion of stonework inclosing some eight acres of ground.

To inclose this area has necessitated the building of exterior walls aggregating 2,458 feet—nearly half a mile—in length, and has required 490,000 cubic feet of pink granite. In addition, there have been utilized inside the concourse 60,000 cubic feet of stone. A total of 550,000 cubic feet of granite has thus been utilized in the construction and ornamentation of this building. It took 1,140 freight cars to transport these 47,000 tons of stone from Milford, Mass.

The construction of this building has called for the use of 27,000 tons of steel. There have also been set in place some 15,000,000 bricks, weighing 48,000 tons. The first stone of the masonry work was laid June 15, 1908. The entire masonry was thus completed in approximately thirteen months.

Built after the Roman Doric style of architecture, the building covers the entire area bounded by Seventh and Eighth Avenues and Thirty-first and Thirty-third Streets. The depth of the property on both streets is 799 feet 11¼ inches, and the length of the building is 788 feet 9 inches, thus allowing for extra wide sidewalks.

In designing the exterior of the building Messrs. McKim, Mead & White, the architects, were at pains to express, so far as practicable, the exterior design of a great railway station, and also to give to the building the character of a monumental gateway and entrance to a great metropolis. The structure is really a massive bridge, with entrances to the streets on its main axes and on all four sides. In this respect this building is unique among railway stations of the world, affording the maximum amount of entrance and exit facilities possible.

The Seventh Avenue façade is composed principally of a Roman Doric colonnade. Above the central colonnade is an entablature surmounted by a clock, with a dial seven feet in diameter. The centre of this clock is sixty-one feet above the sidewalk. This façade may be compared in a greatly magnified manner to the Brandenburg Gate in Berlin, through which passes so much of the traffic of that city.

The main body of the building is approximately seventy-six feet above the street level. With entrances through each of the two corners of the station on Seventh Avenue, there are carriage drives, each about sixty-three feet wide, or the width of a standard New York City street, fronted by double columns and pediments. Midway along the sides of the building, signalizing

the entrances on Thirty-first and Thirty-third Streets are series of columns of the same dimensions as those on the Seventh and Eighth Avenue façades for a distance of 117 feet. Above these colonnades there are also sculptured groups supporting large ornamental clocks.

One of the distinctive features of the building is the waiting room, which extends from Thirty-first to Thirty-third Street, its walls parallel to Seventh and Eighth Avenues for a distance of 314 feet. The height of this room is 150 feet, and its width 108 feet 8 inches. The walls of the waiting room above the main body of the building contain on each side three semi-circular windows of a radius of 33 feet 4 inches, and 66 feet 8 inches wide at the base. There is also a window of like size at each end of the waiting room.

The dignified design of the interior of the general waiting room, while fully adapted to modern ideas, was suggested by the great halls and basilicas of Rome.

* * *

September 15, 1909

CHARLES F. M'KIM, ARCHITECT, DEAD

President of American Institute of Architects—Founder of McKim, Mead & White

FAMOUS FOR HIS DESIGNS

Suffered from a Nervous Breakdown Following Stanford White's Murder—Long in a Sanitarium

Charles Follen McKim, founder of the firm of architects of McKim, Mead & White, and President of the American Institute of Architects, died yesterday afternoon at 1 o'clock at his cottage in St. James, L. I. Ever since the death of his partner, Stanford White, he had been in ill-health, and at the beginning of last year it became known that he was in a private sanitarium not far from New York, the exact location of which was known only to his family and his partners.

He was suffering from a heart affection and a nervous breakdown brought on by the shock of Stanford White's murder, and though he was for a time under the charge of Dr. Charles Hitchcock of 57 West Thirty-sixth Street, it became impossible for him to continue his work. He was ordered rest and country quiet and was obliged to go away. His death yesterday was unexpected, although he had never fully recovered. Heart trouble set in to hasten his end. His daughter was with him at the end.

Mr. McKim was born in Chester County, Penn., Aug. 24, 1847, and was the son of James Mills McKim, the well-known abolitionist. For a year Mr. McKim studied at the Harvard Scientific School, and then went to Paris, where he entered the Ecole des Beaux Arts as a pupil of Daumet. He was there for three years, from 1867 to 1870, and then returning to New York after two years spent in travel and study on the Continent of Europe, started in business as an architect. William R.

Mead joined him in 1877, and Stanford White in 1879, and the firm became nationally famous under the style McKim, Mead & White.

Its work has been as remarkable for its variety as for its excellence. It created a veritable renaissance in American architecture and brought into prominence the Italian type of design.

Among the works undertaken by the firm were cottages at Newport, Lenox, and other Summer resorts; the Boston Public Library; the New York Life Insurance Company's buildings in Omaha and and Kansas City; St. Paul's Church, Stockbridge, Mass.; St. Peter's Church, Morristown, N. J.; the Algonquin Clubhouse, Boston; and the Freundschaft Clubhouse, New York.

Mr. McKim's name was especially associated with the Boston Public Library, the Columbia University Library, the Century and other clubhouses in the city, J. Pierpont Morgan's library, and the War College at Washington. The Pennsylvania Railroad Station, in Seventh Avenue, now rapidly approaching completion, was also designed by him.

The firm was also responsible for the restoration of the White House at Washington, and has erected many well-known monuments in this and other cities. Recently it was awarded the design for the construction of the immense Municipal Office Building on Tryon Row, which will be one of the landmarks of New York.

Mr. McKim had been honored by foreigners as well as by his own countrymen. He received a gold medal at the Paris Exposition of 1900, and three years later King Edward of England awarded him another gold medal for his share in the promotion of architecture. In this he was keenly interested quite outside the interests of his own business, and he was the founder of the American Academy at Rome.

Among the societies to which Mr. McKim belonged were the American Institute of Architects, the Architectural League, the Society of Mural Painters (honorary), and the National Academy of Design. He was also a member of the Municipal Art Society, the Metropolitan Museum of Art, the American Fine Arts Society, and the Pennsylvania Society.

He was a member of the University Club and the Metropolitan Club, the homes of both of which his firm designed; the Lambs, the Brook, the Garden City Golf, and the Somerset and St. Botolph Clubs of Boston; and the Metropolitan of Washington.

Mr. McKim is survived by his daughter, Miss Margaret S. McKim.

* * *

October 24, 1909

A NOTABLE GROUP OF PICTURES REVEALING THE INTELLECTUAL VIGOR OF THE FRENCH IMPRESSIONISTIC SCHOOL

We have been made to realize afresh how great a period in Dutch painting was covered by the middle years of the seven-teenth century, but it would be decidedly amiss for the public to assume that New York picture lovers are indifferent to the great periods in the art of other countries. For modern French art they long have shown an intelligent zest, and to some of them the latter half of the nineteenth century in France seems a period as remarkable in its way as that of the Dutch little masters.

At the Durand-Ruel Galleries this month is a group of pictures which abundantly reveal the intellectual passion inspiring the masters of the so-called "impressionist" school, in the first strength of their youth. There is also a group of the later pictures of the same school, and it must be a hardened classicist who fails to recognize in the dignified little collection the note of great art as well as of great painting, or to observe how classic all these pictures seem in the presence of the still more recent schools. There are two examples of Pisarro, one belonging to the year 1870, according to the record, when the painter was taking his subjects from the region of Auvers, and painting the rich gardens of the Oise Valley with a serenity and dignity of composition and color not surpassed in his later pictures where the air circulates more mysteriously and the light is more diffused and shimmering. The second picture belongs to this later period, to the year 1901, and shows a bridge across a river, with the corner of a quay jutting out from the foreground and a line of buildings on the opposite bank—a difficult perspective boldly managed. It is a lovely painting filled with tender color and tremulous with shifting light, but it fails to hold the imagination to the same degree as the earlier work which has the quiet vigor and restraint that makes it an appropriate expression of rural France, the sweet, staid, blossoming country encircling Paris like the low-toned setting of a jewel.

The grave buildings and neat garden, the simplicity of type in the two figures, the trees that stand as in Daubigny's landscapes like men and women who have kept their meagre outlines into middle age, the comparatively low tone and rich color, all combine to make an impression of an art the unity of which includes interesting complexities and multitudinous observations.

Adjoining is a Manet of the year previous (1869), "Le Plage de Boulogne." Produced at the moment of Courbet's supreme achievement in the painting of sea and shore, it has not a little suggestion in the wan tones of the sand and the stretches of blue and green and purple in sky and water, of the master to whom "le paysage" was "une affaire de tons." But it is more than this. It is also an affair of pattern, of textures, of the differing weight and solidity of differing substances. Manet, in his youth a sailor and accustomed to all the various appearances of a great body of constantly moving water, never failed to make us aware in his sea or coast pictures of the particular character of the element, and even in this strip of liquid green deepening into purple at the horizon we feel the power and immensity of the ocean, if not so dramatically as in the best of Courbet's versions of "La Vague," certainly with no less realism and with a far finer color range.

In the foreground dotted over with gray and black figures making clean-cut shadows on the yellow sand and yellow and white parasols, we are reminded of Duret's report as to the

painter's manner of execution, how he threw his spots and patches of color upon the canvas and then brought them together and built them up to the desired brilliancy by later additions, using any method that seemed to bring about the effect without regard to tradition. One seems to see how in this picture some such attack upon the canvas was made and the ascension from a lower to a higher key accomplished, yet how limpid and fresh and unfretted the execution looks! The thick fingers of Manet were the fingers of a wizard when a brush was between them.

Of about the same period is a masterpiece by Degas which is not on exhibition, but has been brought over to the gallery in transit to its American owner, for whom it recently has been bought, coming direct from the master's studio. It is called "L'Intérieur," and stands alone among the series of race horses and ballet girls by which the public best know Degas, a composition of amazing science, intuition, and power, and a piece of workmanship so close to perfection that to call it less than perfect is an excess of caution.

The scene disclosed is a room of commonplace appearance but stamped everywhere, from the flower striped paper on the wall to the strip of carpet beside the bed, with the character of French taste. In the centre of the room is a work table with a lamp and an open workbox. The soft yet brilliant pink lining of the box strikes the high note of the color scheme, the lamp focuses the illumination of the picture almost in the centre of the composition, the light filtering in a more and more attenuated radiance through the shadows of the room. There are two figures, a young girl seated, her head on her arms in an attitude of despair, and a man standing looking at her. The story—there is often something of a story for those who care to read it in the "contes choisis" of Degas's accomplishment—is pure tragedy, as primitive as may be. It is in the execution—subtle, flexible, with unfathomable secrets of handling, with a surface so bland as almost to invite the touch—that the magic of the picture lies.

Once more we are shown with what economy of means the masterpieces of the painter's art are produced. Films of pigment are drawn across this canvas so lightly as hardly to stain its original color in places. Pigment and canvas have melted together in one substance and the observer feels instinctively that the union is indissoluble and the picture at least as imperishable as the best preserved of the old masters.

Within this casket of impeccable technique lie the treasures of color arranged in curves of hue and tint that sweep with a noble rhythm across the canvas, as where the purple black of the hat at the left rises into a royal plum color in the mass of drapery on the girl's knees, lightens still more in the reds of the floor and deepens again in the stripe of the carpet to repeat the strong dark in the man's coat. It was necessary, it appears, for a painter as sensitive as Degas to the rhythms of line to work, thus gaining his double delight by making his color march to music.

The character of the craftsmanship, honest and learned and without trick or bravura, is emphasized—if one may speak of emphasis in so quiet a work—by the modeling of the girl's

"Mother and Child," by Mary Cassat. On Exhibition at the Durand-Ruel Galleries.

bare shoulders and slight form. The young supple muscles ripple almost imperceptibly beneath the smooth skin, the girlish contours flow sensitively with an exquisite delicacy of modeling, defining the unobtrusive forms of the shoulder and arm, the weight of the head on the arm pushes the features slightly out of their normal relation, the whole figure is relaxed. The line everywhere is instinct with vitality, ready to spring responsive to the slightest movement. There is nothing in modern painting known to the present writer that is more completely an accomplished fact in art, an idea or coordinated group of ideas expressed in the painter's legitimate material.

Most of us have forgotten, by the way, if we ever knew, that Degas might by right of birth be called an American, as he was born in one of our Southern States. That the best of all his works by his own rating should come to this country is appropriate.

Close to the Pisarro of 1870 is a Monet of 1882, with cliffs, a green sea and a purple sky, beautifully balanced, not so low in tone as the early Pisarro or the early Degas, but darker than many a modern canvas, and with enough feeling for line and mass to give the composition elegance and force. Observing it, a critic of middle age, to whom the shook of battle between realist and romanticist (to give them their meaningless titles) is more than a tradition handed down in saga, asks if it is indeed possible to move ten paces out of the path trodden by one's ancestors. There have been paintings by Corot less idyllic than this clear, cool scene, severe in sentiment, as fresh as the morning, and with delicate suggestions of noble form in the pale cliffs lifting their heads to the wide dome of the sky.

To glance at the cheerful d'Espagnat in another room is to feel that restraint, measure, and poise are all with the revolutionists of the seventies who seemed then to worship new gods and yet raised these monuments to the august deities of antique art. Yet there is nothing to save us as critics from the possibility that d'Espagnat of the laughing color and racing line may turn out with the passage of time to be a sober

Greek of academic tendency. Already Gauguin, who is not represented here, recalls the Egyptians.

To cap these reminiscences of a great period, which has passd from bud to bloom among the hospitable associations of the house of Durand-Ruel, two pictures by Mary Cassatt, one an oil color, the other a pastel, hang with the Monets and Pisarros. The oil color has existed for many years. The subject is charming, a woman reading a paper in a garden, her blonde head relieved against a riot of full-hued flowers, her sprigged muslin dress and white kerchief as eloquent of the pleasant season as the blossoming garden beds, the concentration of the eyes and firm curve of the lips denoting that intelligence which in Miss Cassat's women becomes a kind of beauty. An old picture, and one whose charm has ripened with every year that has passed over its head. The pastel is in a newer tradition. It is higher in key with an interplay of yellow and blue in the color scheme that could not escape crudity under less skillful management. The subject is a mother and child, largely seen and wholesome without a suspicion of sentimentally, but full of sweetness and light in the aesthetic and ethical sense alike. Nothing could be a finer tribute to the essential sanity of modern art than Miss Cassatt's treatment of this subject, which she has made conspicuously her own. The soundness of her feeling, the breadth of her vision, the sincerity of her handling—Hellenic qualities again. It is curious to reflect that under the sober influence of this now classic art the Athenians are gathering once more to hear and tell some new thing.

LITERATURE

February 10, 1900

MR. NORRIS'S ULTRA REALISM

A MAN'S WOMAN
By Frank Norris
New York: Doubleday & McClure Company.

Conan Doyle once said: "We talk so much about art, that we tend to forget what this art was ever invented for. It was to amuse mankind—to help the sick and the dull and the weary." The majority of our novelists must emphatically dissent from this, for one and all—with a few shining exceptions—seem to have taken for their motto the blood-curdling announcement of the Fat Boy in "Pickwick," "I wants to make your flesh creep."

Mr. Norris's hero is an arctic explorer, his heroine a trained nurse, and he avails himself to the utmost of these opportunities to make our "flesh creep." The experiences in the arctic are a skillful mosaic of the worst sufferings of various expeditions. We have portrayed the extremes of cold and hunger, limbs amputated, dying and imploring companions deserted on the ice—terrible pictures of suffering and brutality. We turn for relief to the trained nurse, and we are made almost literally to assist at a fearful operation, every preparation, every detail, every movement of the surgeon and the nurse being given with a minuteness that is simply sickening. That removal of the child's hip joint is as

"Photographically lined
On the tablets of our mind"

as if we had been the nurse herself. After all this, it is, perhaps, a mere trifle to see a horse brained with a hammer, and to go through two cases of typhoid fever with almost as much attention to minutiae as was given to the operation.

We respectfully submit, Is this art?

But, steadying our nerves with restoratives, or handing the instruments to somebody else while we take a quiet little faint, let us accept Mr. Norris's canons of art and turn from the horrors to the romance.

Strong and original the book undoubtedly is, holding the reader's interest to the end. Nevertheless, it fairly bristles with faults. The hero is not only ugly—but let Mr. Norris describe him: "His lower jaw was huge almost to deformity, like that of the bulldog; the chin salient, the mouth close gripped, with great lips, indomitable, brutal. The forehead was contracted and small—the forehead of men of single ideas—and the eyes, too, were small and twinkling, one of them marred by a sharply defined cast." Beyond force and endurance, Capt. Ward Bennett possesses no qualities to atone for this villainous physiognomy. The scene in which he consigns his best friend to certain death in order to snatch the nurse from a contagion already fully risked is brutal beyond belief. That nurse, the "man's woman," is the opposite of the type commonly supposed to be a man's woman. Her characteristics, many of them fine, are distinctively masculine. The author seems to be resolved that we shall not admire what appear to be self-sacrifice and generosity in his heroine, for he takes pains to tell us that she was not inspired by philanthropy nor a great love of humanity, but she wanted "to count in the general economy of things." Ferris, whom his creator rather carelessly casts aside, is the one really noble character of the story. It is singular that at first much is made of his unselfish falsehood, and that it is afterward wholly ignored and dropped, as if Mr. Norris had changed his mind as regards the working out of his plot.

There are some fine scenes in the book, notably, the one in which Lloyd drives into the pole of the arctic chart the worn banner of the former expedition. But why persistently call the Stars and Stripes "the stars and bars," the name which was borne by the flag of the short-lived Confederacy?

As we close the story, we cannot help wondering whether it was not written to see how much ultra-realism in what is painful and repulsive a long-suffering public intends to endure. It is a pity that a strong and capable pen should do

these things. A novel is neither a chamber of horrors nor a surgical journal.

* * *

March 10, 1900

BATTLES WITH SLUMS

Jacob A. Riis's Account of a Ten Years' War and Its Results

A TEN YEARS' WAR: An Account of the Battle with
the Slum in New York
By Jacob A. Riis
Illustrated. Houghton, Mifflin & Co. $1.50.

No more righteous conflict was ever waged with this world's evil forces than the brave struggle which a lamentably few men and women have been making for the last ten years against the filth, ignorance, crime, and suffering of the worst of New York's slums.

Every New Yorker knows these facts, thanks, in an appreciable extent, indeed, to Mr. Jacob A. Riis's untiring efforts to convince them, but that their convictions have not yet been warmed to the point of enthusiastic support of the Good Government Clubs, the Tenement House Committee, and the various other effective means of combating the slums, is very evident to the reader of "A Ten Years' War." In it Mr. Riis tells the heart-breaking story of the east side, of the gallant victories won by the reform party, and, alas, of its many sad defeats, but he assures us that it is not now a losing fight. The slum can never go back to what it was before Col. Waring and Theodore Roosevelt laid their transforming touch upon its ugliness and lawlessness. The worst of the rear tenements have been pulled down, and there is a constantly increasing tendency to build houses for the poor with some slight reference to the admission of light and air.

As long as the slum was thought to be injurious to itself alone, little interest was taken in its welfare, but when the citizens of New York awoke to the fact that it was a menace to the health and well-being of the rest of the community they bestirred themselves to some effect. This new and better interest in the pitiable inhabitants of the slums does not manifest itself under the old and useless form of charity; the day of free soup and police lodging houses is gone by, and the present aim of the tenement-house workers is, first, to make their inmates desire something better, and then to help them to attain to it by their own efforts. Mr. D. O. Mills expressed this new spirit of charity when he said, at the opening of one of his hotels, "No patron of the Mills Hotel will receive more than he pays for, unless it be my hearty good-will and good wishes." The fact that the few model tenements already built pay 5 per cent. on the invested money, and that the Mills houses not only have made a clear 3 per cent. on the $1,500,000 invested, but have earned besides a fund sufficient to provide for deterioration and replacement, proves that the old form of charity is absolutely criminal. The conscienceless small capitalists of

the slums need either reform or a knock-down blow, and New York is beginning to understand this.

"It is not," says Mr. Riis, "a case of transforming human nature in the tenant, but of reforming it in the landlord-builder." The rear tenement has been disposed of by sheer brute force; the fire-proof but not light-proof tenement is to be put in its place if human power can do it. A law had been passed that gas must be kept burning in the dark halls of the "double-decker" tenements, but certain halls known to be dark were always reported as sufficiently light by the district policeman. It was soon discovered that his standard was strangely low. An order was then issued defining a light hall as one in which the sink could be seen. Halls were still reported light that were known to be inky in their blackness. The President of the Board of Health went to one tenement to settle the question for himself. The hall was very dark.

"Did you see the sink in that hall?" he asked the policeman. The policeman said he did.

"But it is pitch dark. How did you see it?" asked the President.

"I lit a match," said the policeman.

That the modern charity pays (and that is the only kind that will pay) is proved by the fact that with clean streets, pure milk, medical school inspection, anti-toxine treatment of diseases, and generally better sanitary methods the death rate in New York slums came down from 26.32 per 1,000 inhabitants in 1887 to 19.53 in 1897. New York, Mr. Riis asserts, has still the worst housing system in the world, but the keynote of all the tenement reform is to remedy this and to restore to the poor of the city the worst of their losses, and the one from which, in the author's opinion, all the rest of their misery follows—that of the home. It has been found that it is not so much wickedness as weakness, entire lack of moral sense, that ails the youth of the tenement houses, and it is an old Frenchman's saying—"No home, no family, no morality, no manhood, no patriotism"—that is the refrain of the book.

Mr. Riis, on the whole, shows that the influence of the Jewish or Italian tenants of the slums is according to how he is received and fashioned. Mr. Riis points out the importance of having laws deserving of respect, and that these laws should be enforced, lest the immigrants conclude that the whole thing is a sham. What is the sense, asks the author, of offering for sale live fowl in the markets, and then arresting the poor Jew who buys one for no other reason than to kill and eat it? Or what kind of lessons are taught to the observant stranger by "brick sandwiches" in a "Raines law hotel"?

Mr. Riis would reclaim the youth of the slum by giving him a schoolhouse in which to work, a park in which to play, and a teacher fitted to show him how to do both. That is not much, some may say, but it was not even begun until Tammany, in order to live, was absolutely forced to spend a little money on visible improvements.

* * *

March 24, 1900

TOLSTOI

His New Novel, "Resurrection," a Literary Masterpiece

RESURRECTION: A Novel
By Leo Tolstoi
Translated by Mrs. Louise Maude. With illustrations by Pasternak.
New York: Dodd, Mead & Co. $1.50.

> *And only the Master shall praise us, and only the Master*
> *shall blame,*
> *And no one shall work for money, and no one shall work*
> *for fame,*
> *But each for the joy of the working, and each in*
> *his separate star,*
> *Shall draw the Thing as he sees it, for the God of Things*
> *as they are.*

Already has the great Russian fulfilled this prophecy. As he comes to us again in his age, we perceive that "his eye is not dim, nor his natural force abated." In "Resurrection" he may have sacrificed in some degree the artist to the seer, but still, as in "Anna Karénina," he does not merely interest and charm his readers, he possesses them, he holds them in the hollow of his hand.

So living are his men and women that those we know in the flesh become as shadows. For what companion of daily life so reveals the soul within the shell as do Tolstoï's characters? He knows to the core this poor humanity of ours, and the one thing larger than his knowledge of it is his love. His novels are written of his own countrymen, of a unique race under unique conditions, and yet such is his grasp upon the very essence of our common human nature that, like Shakespeare, he belongs to all peoples. "Earth's poor distinctions fade away" upon his pages, and we realize that God "hath made of one blood all nations of men." This is genius at its high-water mark.

Pre-eminently the story of a soul born again, and by its birth into righteousness awakening and saving another; "Resurrection" does not stop here. With tremendous power it deals with "man's inhumanity to man" in its Protean forms, with his responsibility for his fellows and with the standards and aims of his life. Not a page, however, can be called a digression, for every subject is accessory to the working out of the dominant theme.

Intense, even passionate, as is Tolstoï's sympathy with the oppressed, it is always sane. His peasants are as real as Millet's. They are stolid, unresponsive, receiving an unlooked-for blessing, some with surly suspicion, others with the air of having expected more; life having dealt so hardly with them as to rob them of grateful emotion, and almost of the power of believing in any benefit as possible to them. Yet throughout this portrayal one feels the throb of the author's tenderness. Back of the dull, unlovely child of toil, he looks at the long centuries that have beaten the peasant's frame into deformity, his soul into denseness, and yearns over him but the more because he is what he is.

In the treatment of Máslova there is the same absence of sentimentality. She is no Trilby. Her degradation is wrought into the texture of her soul. She has become morally dead. Her imprisonment shames her, but toward her unspeakable profession her attitude is rather one of complacence. This point of view Tolstoï explains with his unerring insight in the chapter entitled "Máslova's View of Life." Her resurrection is an equally marvelous revelation. . . .

From the first painful and inarticulate stirrings of Máslova's benumbed conscience to her last act of renunciation, the steps are slow and difficult. At the end one feels that hers must be always a maimed life. Nekhludoff's awakening is of a different nature. Heredity, culture, fineness of fibre assert themselves in his quick, keen remorse, in his prompt readjustment of his life, in his heroic purpose of atonement. The fulfillment of that purpose Tolstoï is too true an artist to permit. We fancy it to have been almost against his will that the stern moralist averted a conclusion which could not but have marred and thwarted one life, if not both; which, however righteous as a retribution, could not but have been repulsive as a dénouement. . . .

In Tolstoï's descriptions of the Russian courts of law and of the iniquitous prison system, Mr. Kennan's account is more than confirmed. There are glints of humor in the epitome of the speeches in the poisoning case, for which one is grateful in the midst of the sombre picture. The careless and selfish men who hold life and death in their hands, "the law's delay," the blocking of justice, the loathsome prisons, with their officials callous and cruel, the innocent punished without redress, the lives "spilled like water on the ground" as the convicts march to Siberia, the sufferings of those who survive, the hopeless misery of the poor—and above all this, that other world of warmth and color and art and music, that world of soft raiment and luxurious living, with every sight and sound of woe shut out—these are the things real and palpitating upon the pages of "Resurrection."

The author warmly admires Henry George, of whose theories he is an earnest advocate. He pays a well-merited tribute to "Progress and Poverty," the striking ability of which has been more appreciated in other lands than in ours. Count Tolstoï's confession of faith, as found in "My Religion," and his theory of life, as expressed in "What to Do," will be found succinctly restated in "Resurrection." Yet the story is neither impeded nor oppressed by this weight of theories. It carries them all as easily as the ocean bears its burden of freighted ships. The reader, absorbed in the story, in the breathing men and women, in the cosmic life and incident of its pages, will scarcely be conscious that he is absorbing at the same time a religion and a philosophy. . . . He may take his readers into the filth of a prison corridor or bare before them the hideous defilement of a soul sunk in sin, but he shows what is revolting because he wishes to revolt. His realism is charged with ethical intention. His motive is the regeneration of men. . . .

"Resurrection" is no more a book for the immature than is the Bible in its entirety; but to those who have eaten of the tree of the knowledge of good and evil and to whose "animal I" the world, the flesh, and the devil are beginning to appeal, "Resurrection" comes flying a danger signal against the "mania of selfishness" that is the root of all evil, and giving a clarion call to purity.

In the closing chapter, wherein "A New Life Dawns for Nekhludoff," Tolstoï gathers up the teaching of "My Religion" and makes luminous the five "simple, clear, practical laws" of the "Sermon on the Mount," in accord with which Nekhludoff resolves to shape his future. This is not the place to examine Tolstoï's theory of religion nor to determine how far it is practicable in all its details. Certain it is that, as Tolstoï wrote in "What to Do," as Booth and Henry George and Bellamy have, each in his own way, expressed, "The greatest deed which is left us to do is the solution of those awful contradictions in which we are living." "Resurrection" impresses us anew with the conviction we have long held, that in solving these "awful contradictions" Tolstoï comes nearer than any other to the Divine idea.

As we close this book of his old age, we are tempted to declare that, take it all in all, it is the greatest work of its great author. The illustrations are unusually satisfying, having the veritism of studies from life. One fancies that the translation must retain much of the fire and force of the original. Certainly its style, with but few flaws, is admirable.

With its vital characters, its richness of dramatic incident, its marvelous insight, its brilliant style, "Resurrecton" will charm as a literary masterpiece many who will lightly toss aside its gospel as the dream of a fanatic. The reader, however, who approaches it with an open and a reverent soul can scarcely avoid the conclusion that here are the words of a prophet of righteousness to whom it has been given to know much of the mind of Christ, and who, "not disobedient unto the heavenly vision," counts it his mission to interpret that mind to the world. He will esteem this crowning work of his genius no better than a failure unless its revelation of sin, of suffering, of need, of responsibility, presses home to the conscience of every one of his readers the question he has so greatly and so simply answered in his own life: "What Must We Do Then?"

* * *

May 5, 1900

CHOPIN

Mr. Huneker's Volume on the Man and His Music

CHOPIN, THE MAN AND HIS MUSIC
By James Huneker
New York, Charles Scribner's Sons. 1900.

. . . It has not been necessary for Mr. James Huneker to wait till the present year to win reputation as a musician who is also a literary man, but his "Chopin, the Man and His Music," will add much to the notability which he has already gained. It is a work of unique merit, of distinguished style, of profound insight and sympathy, and the most brilliant literary quality.

Mr. Huneker is, or rather was, in the beginning of his career, first of all a pianist. He knows the instrument for which the music of Chopin was written, and although he says that he ruined his hands by unwise technical experiments, he nevertheless possesses a respectable facility in the manipulation of the keyboard and can study the works of the piano masters at first hand. . . . But Mr. Huneker is by nature and inclination, as well as by reading and study, chiefly a literary man. He has the literary man's love of word architecture, and he is not satisfied with a bald and uninteresting statement of any fact, no matter how important the fact may be in itself. He writes with that sheer delight in the technic of writing which is the birthmark of the born litterateur. . . .

In his "Mezzo-Tints in Modern Music," he produced the most refreshing series of essays on musical topics published in recent years, and his book on Chopin is a distinctly better work than its predecessor. . . . That Mr. Huneker is a confessed admirer of Chopin may be accepted as undeniable. It was to be supposed that a pianist would lay full stress on the importance of the Pole as an epoch maker in music. It is well that he has done so, for Chopin is in our day too likely to be regarded by the casual observer of music as the creator of a line of polite compositions for the salon, for the excitement of pockethandkerchief emotion in susceptible women.

The immense originality of this independent spirit should never be forgotten by the student of musical development. That he was not at home in the classic forms defined by Haydn and Mozart and filled out by Beethoven and Brahms was not at all to his discredit. Mr. Huneker makes no secret of the fact that Chopin was not a master of the sonata form, and rightly allots to his concertos a comparatively low place among his works. Mr. Huneker is not at all blind to their wealth of melodic beauty, but he properly admits that in the working out of themes Chopin followed the style of his other music, and not the methods of logical development used by the lofty intellects of Germany.

The author has made a seriatim study of the compositions of the wonderful master, and this the student of piano music will find invaluable. Here, perhaps, more than in any other place, Mr. Huneker shows his special fitness for the task which he set for himself. He has taken up first the preludes and the études and shown, as only a clear-headed writer fully acquainted with the works by personal study could show, that they are the most characteristic, elemental, and personal of all Chopin's compositions. He has paid a fitting tribute to the wonderful ballades, works which have no superiors in the field of imaginative music for the piano, and he has demonstrated the presence of masculine force in the genius of Chopin in his analysis of the splendid polonaises. The masterly scherzi, the most original piano compositions of Chopin's time, except, perhaps, some of those of Schumann, are treated by Mr. Huneker with fine insight and natural enthusiasm.

In studying these works the author has compared the leading editions and commentators and has made many wise and suggestive comments of his own. . . . If Mr. Huneker had done nothing more than this, he would be worthy of the highest praise, but he has written in a clear, comprehensive manner and in a glowing style, which sometimes becomes eloquent without impinging on the domain of poetry. It is in the warm imagination, the artistic sympathy, the luminous word painting of the comments that Mr. Huneker demonstrates his right to a place among the best of writers on music. . . .

His biographical sketch of the composer is excellent. It sets forth the incidents of a curious career without prejudice and without antagonism. The acquaintance of Chopin with George Sand and its baleful effects upon him are treated without any attempt to shield the composer from censure and with a clear understanding of the nature of the man and the woman. The character of Chopin will be better understood by every reader of this volume than by those who have read only Liszt or Niecks. . . .

The psychological study of the composer is interesting and admirably written. Indeed, any one who is fond of good literature will find this a delightful book, even though he may not be directly interested in the subject of music and its masters. Throughout the pages are scattered illuminative excerpts from other writers and references to literary works, which enliven the book as a whole. Mr. Huneker has been a wide and assimilative reader, and the allusiveness of his style is one of its most potent charms. . . . But perhaps it is hypercritical to censure a style which is so full of vitality and which carries the reader along with it as would a deep and rapid stream.

* * *

May 5, 1900

BRANDER MATTHEWS'S NEW DISH OF FOAM

THE ACTION AND THE WORD
By Brander Matthews
New York: Harper & Brothers. $1.50.

Prof. Brander Matthews and Mr. Frank Norris differ widely in their notions of what constitutes "A Man's Woman." As Prof. Matthews portrays her, she is as full of weakness as Mr. Norris's heroine was full of strength, and she does not make a remark in the whole course of the story that is not utterly banal. Her incoherence of character, the contradiction of her speech and action give the book its title. Her comprehensive denial of passionate utterances but twenty-four hours in the past, her complete forgetfulness of her whole attitude toward her husband, and her career, could scarcely be possible to a sane person—though granting any reasonable amount of feminine inconsistency.

"I'm not denyin' the women are foolish. God Almighty made 'em to match the men," quoth Mrs. Poyser, but the heroine of "The Action and the Word" is quite unnecessarily foolish, even for matching purposes, and her pervasive charm and universal sway over the hearts of men is the severest of satires upon the sex enslaved. Still one must confess with shame and confusion of face that Mrs. Evert Brookfield is more nearly "A Man's Woman" than Mr. Norris's strong-souled heroine. She is just the kind of woman that, in this best of all possible worlds, a clever man is likely to love, to marry, and to be consequently miserable ever after—although Prof. Matthews would dispute the last assertion.

The "novel" is scarcely a novel at all in the accepted sense. There is no lovemaking, no plot, except such as turns upon a silly woman's temptation to exchange amateur for professional acting. To point out the peril of private theatricals to women of "temperament" uncontrolled by reason appears to be the purpose of the story. This motif is emphasized by the elevation of the Metropolitan Opera House stamped upon the cover.

All the characters belong to "the smart set," and seem "about as applicable to the business of life as a pair of tweezers to the clearing of a forest." Like goldfish in a globe, they swim round and round their miniature world, wholly oblivious of "the real great world" outside, a world of thought and feeling and action, in which they would gasp and die. There is a strange fascination, however, in reading of the mystical four hundred—else why the society columns? So we gladly renew our acquaintance with De Ruyter and the Jimmy Suydams, and are interested in the astute Vicomte D'Armagnac (what would the Armagnacs of old have thought of him?) wondering the while what he really thinks of us. One notes in passing the sly fling at the "Kathryns" and "Evangelyns" and their kind with whom the society columns of the day are plentifully besprinkled. For the husband in the case, despite his "lovely eyes," one cannot but feel a gentle contempt. His father, Dr. Brookfield, with kindly ironies that are quite Howellsian, is the best character in the book. Although dear Miss Marlenspuyk is not vouchsafed us, it is a joy to have her quoted and to hope that we may one day see her again.

The tale is a very dextrously whipped and delicately flavored dish of syllabub, of which we partake with the dainty enjoyment that Prof. Matthews's "creations" never fail to call forth. Certainly, it has the rare merit of leaving no bad taste in the mouth; but having finished the feast we are conscious of sharing Uncle Remus's objection to being "fed on foam."

Read between the lines, however, it becomes a pathetic book; for there is no deeper pathos than that those to whom much has been given should miss the meanings and the opportunities of life.

* * *

September 8, 1900

A NEW BOOK FOR CHILDREN

It is impossible to conceive of a greater contrast than exists between the children's books of antiquity that were new publications during the sixteenth century and modern

children's books of which "The Wonderful Wizard of Oz" is typical. The crudeness that was characteristic of the old-time publications that were intended for the delectation and amusement of ancestral children would now be enough to cause the modern child to yell with rage and vigor and to instantly reject the offending volume, if not to throw it out of the window. The time when anything was considered good enough for children has long since passed, and the volumes devoted to our youth are based upon the fact that they are the future citizens; that they are the country's hope, and are thus worthy of the best, not the worst, that art can give. Kate Greenaway has forever driven out the lottery book and the horn book. In "The Wonderful Wizard of Oz" the fact is clearly recognized that the young as well as their elders love novelty. They are pleased with dashes of color and something new in the place of the old, familiar, and winged fairies of Grimm and Andersen.

Neither the tales of Aesop and other fableists, nor the stories such as the "Three Bears" will ever pass entirely away, but a welcome place remains and will easily be found for such stories as "Father Goose: His Book," "The Songs of Father Goose," and now "The Wonderful Wizard of Oz," that have all come from the hands of Baum and Denslow.

This last story of "The Wizard" is ingeniously woven out of commonplace material. It is of course an extravaganza, but will surely be found to appeal strongly to child readers as well as to the younger children, to whom it will be read by mothers or those having charge of the entertaining of children. There seems to be an inborn love of stories in child minds, and one of the most familiar and pleading requests of children is to be told another story.

The drawing as well as the introduced color work vies with the texts drawn, and the result has been a book that rises far above the average children's book of today, high as is the present standard. Dorothy, the little girl, and her strangely assorted companions, whose adventures are many and whose dangers are often very great, have experiences that seem in some respects like a leaf out of one of the old English fairy tales that Andrew Lang or Joseph Jacobs has rescued for us. A difference there is, however, and Baum has done with mere words what Denslow has done with his delightful draughtsmanship. The story has humor and here and there stray bits of philosophy that will be a moving power on the child mind and will furnish fields of study and investigation for the future students and professors of psychology. Several new features and ideals of fairy life have been introduced into the "Wonderful Wizard," who turns out in the end to be only a wonderful humbug after all. A scarecrow stuffed with straw, a tin woodman, and a cowardly lion do not at first blush, promise well as moving heroes in a tale when merely mentioned, but in actual practice they take on something of the living and breathing quality that is so gloriously exemplified in the "Story of the Three Bears," that has become a classic.

The book has a bright and joyous atmosphere, and does not dwell upon killing and deeds of violence. Enough stirring adventure enters into it, however, to flavor it with zest, and it will indeed be strange if there be a normal child who will not enjoy the story.

* * *

September 22, 1900

AMERICAN SUPREMACY

As It Now Is in Economic Matters—Brooks Adams's Striking Book

AMERICA'S ECONOMIC SUPREMACY
By Brooks Adams
New York: The Macmillan Company. 1900

By WORTHINGTON C. FORD
Editor of "The Writings of Washington,"
Formerly Chief of the Bureau of Statistics

A certain amount of imagination is required of the writer who would make statistics interesting, and Mr. Adams possesses this imagination in a high degree. His . . . judicious arrangement of facts shows careful work among official publications and compilations of returns, which are so repellent to the general reader. The essays bear upon one theme, the pressing necessity of determining the position of the United State as a world power. . . .

Mr. Adams is frankly an expansionist, and no one could be more extreme in his aims. Cuba and the West Indies are gravitating toward the United States, the Isthmus canal will create a necessity for taking Central America, as England has taken Egypt; the Philippines will serve as a base for operations in Asia, territorial as well as commercial. "The expansion of the United States is automatic and inevitable, and in expanding she only obeys the impulse of nature, like any other substance." China alone offers a field for future expansion, for the nation who holds the coal, iron, and cheap labor resources of that empire will, in his opinion, rule the world industrially and commercially.

Economic experience and the history of the great commercial peoples of the past control Mr. Adams's arguments. The same causes that carried the centre of social activity from Asia to Italy, from Italy to Holland, and thence to England, is forcing a progress to America, or to Germany and Russia. . . . History is dotted with the ruins of great powers, and since 1890 Mr. Adams finds evidence of decay in English economy. If the symptoms of rot have been correctly described, and point clearly to a disease, then the responsibilities now exercised by Great Britain must fall to another, and that power which is most highly organized must obtain the coveted empire. However great Russia's interests in China may be—and she has always been more Asiatic than European—her financial ability is too weak to permit her to obtain the lead, unless the mines of China fall to her share. . . .

If Russia is incapable of utilizing China to the full, and England is too much occupied in other directions to be free in

action, then the question must be between Germany and the United States. The extraordinary advances made by German industry since the foundation of the empire would point to still greater growth in the future—if markets can be found. But markets can be found only in new countries, or by pressing down wages and cost of production until German products can undersell those of all other countries. Given China and the Chinese this can be done; and with Germany an Asiatic power, the economy of the United States will be pushed to the wall. Hence, it is a life and death struggle for existence as well as for supremacy.

It is because Mr. Adams is not a blind, unreasoning admirer of the institutions of the United States that we have confidence in his diagnosis of the situation. He is as severe a critic of this country, and its shortcomings, as he is of Russia or of England. Our administrative machinery is antiquated.

"Our National corporation was created to meet the wants of a scanty agricultural population at a time when movement was slow. It has now to deal with masses surpassing, probably, in bulk, any in the world. In consequence it operates slowly and imperfectly, or fails to operate at all."

. . . We have tried to outline a part of Mr. Adams's argument in our own language, but can cover only a few points, and no quotations will suffice. The wealth of illustration and the brilliant excursions into history must be read to be appreciated. The comparison drawn between Scott and Dickens is alone a literary study of a high order, and is entirely pertinent to the text of the book. The differences in the two writers arose from their environment, and the same trend of events which destroyed the chivalry of Scott's day made the social novel of Dickens possible, gave England her manufacturing supremacy. . .

As a defense and forecast of expansion this work of Mr. Adams stands high, but the many subjects touched upon and illustrated give it a wider interest than the title would assume. It is pre-eminently a timely book, but will also have a permanent value.

* * *

May 4, 1901

DREYFUS

Extracts from the Autobiography of the Victim of the French General Staff—1894–1899

"Five Years of My Life," by Alfred Dreyfus, was published this week by McClure, Phillips & Co. The author briefly outlines his career up to the day of his arrest, Oct. 13, 1894; then he begins the story of those five years of imprisonment, carried on for a time by the diary he kept while at Devil's Island. At another time we shall discuss the book according to its merits. For the present a few extracts will suffice to indicate its character and scope. Concerning the famous plan of Commandant du Paty de Clam to have the suspected artillery officer betray himself while making from dictation a copy of the bordereau, Dreyfus writes:

As I continued writing without any sign of perturbation, Commandant du Paty tried a new interruption, and said violently: "Pay attention; it is a grave matter." Whatever may have been my surprise at a procedure as rude as it was uncommon, I said nothing, and simply applied myself to writing more carefully. Thereupon Commandant du Paty, as he explained to the court-martial of 1894, concluded that, my self-possession being unshakable, it was useless to push the experiment further. The scene of the dictation had been prepared in every detail, but it had not answered the expectations of those who had arranged it.

As soon as the dictation was over, Commandant du Paty arose and, placing his hand on my shoulder, cried out in a loud voice: "In the name of the law I arrest you; you are accused of the crime of high treason." A thunderbolt falling at my feet would not have produced in me a more violent emotion. I blurted out disconnected sentences, protesting against so infamous an accusation, which nothing in my life could have given rise to.

Next M. Cochefert and his secretary threw themselves on me and searched me. I did not offer the slightest resistance, but cried to them: "Take my keys, open everything in my house; I am innocent." Then I added: "Show me at least the proofs of the infamy you pretend I have committed." They answered that the accusations were overwhelming, but refused to state what they were or who had made them.

Here is an episode of the first court-martial:

I heard the false and hateful testimony of Commandant du Paty de Clam and the lies of Commandant Henry in regard to the conversation we had had on the way from the Ministry of War to the military prison in the Rue du Cherche-Midi on the day of my arrest. I energetically, though calmly, refuted their accusations. But when the latter returned a second time to the witness stand, when he said that he knew from a most honorable personage that an officer of the Second Bureau was a traitor, I rose up with indignation and passionately demanded that the person whose language he was quoting should be made to appear in court. Thereupon, striking his breast with a theatrical gesture, Henry added: "When an officer has such a secret in his head he does not confide it even to his cap." Then, turning to me: "As to the traitor," he said, "there he is!" In spite of my vehement protests I could not obtain any explanation of his words, and consequently I was powerless to show their utter falsity.

I heard the contradictory reports of the handwriting experts, two testifying in my favor and the other two

against me, at the same time bearing witness to the numerous points of difference between the handwriting of the bordereau and my own. I attached no importance to the testimony of Bertillon, for his so-called scientific mathematical demonstrations seemed to me the work of a crazy man.

All charges were refuted during these sessions. No motive could be found to explain so abominable a crime.

In the fourth and last session the Government Commissary abandoned all minor charges, retaining for the accusation only the bordereau; he took this document and waved it, shouting: "Nothing remains but the bordereau, but that is enough. Let the Judges take up their magnifying glasses."

And so Dreyfus was found guilty. His public degradation, which took place Jan. 5, 1895, he describes in a graphic manner. Then comes the long voyage to Devil's Island, off the coast of French Guiana. The first entry in his diary is dated April 14, 1895, and reads as follows:

Sunday, 14 April, 1895.
To-day I begin the diary of my sad and tragical life. Indeed, only from to-day have I had paper at my disposal. Each sheet is numbered and signed, so that I cannot use it without its being known. I must account for every bit of it! But what could I do with it? Of what use could it be to me? To whom would I give it? What secret have I to confide to paper? Questions and enigmas!

Until now I have worshipped reason; I have believed there was logic in things and events; I have believed in human justice. Anything that was irrational and extravagant found difficult entrance into my brain. Oh, what a breaking down of all my beliefs!

These pages fully reveal the agony that the prisoner must have suffered in waiting for news from home or from the physical and mental tortures which beset him. The last entry in the diary is dated Sept. 10, 1896. The author then continues his narrative. The extreme tortures he underwent may be judged from the following passage:

Dating from the 6th of September, I was put in the double boucle at night, and this torment, which lasted nearly two months, was of the following description: Two irons in the form of a "U" were fixed by their lower part to the sides of the bed. In these irons an iron bar was inserted, and to this were fastened two rings.

At one extremity of the bar there was a head and at the other a padlock, so that the bar was fastened into the irons and consequently to the bed. Therefore when my feet were inserted in the two rings I was fastened in an unchangeable position to my bed. The torture was hardly bearable during those tropical nights. Soon also the rings, which were very tight, lacerated my ankles.

* * *

September 28, 1901

"KIM"

Rudyard Kipling's Fascinating Story of India

KIM
By Rudyard Kipling
12mo. New York: Doubleday, Page & Co.

Rudyard Kipling is what Mr. Stockton might term a Discourager of Prophesy. Easily within the memory of the youngest of them the critics were inclined to apply to him Prof. Wilson's luckless prediction concerning Macaulay, and to declare that, while evidently "a clever lad," a clever lad Kipling "would remain, depend ye upon that, a' the days of his life." And lo, the clever lad proceeded to grow apace into an intellectual manhood as remarkable for its strength and ripeness as it had been for its precocity. . . . "Mr. Kipling's wing is arrowy in brief flights," everybody said, "but it will surely falter and fail if it tries to sustain him through a long novel."

And just as he disappointed the early prophets by work of steadily maturing quality, so he utterly demolishes the later prediction by "Kim." Clearly it is safer to reckon with what Mr. Kipling has done than to venture to assert what he may or may not do. . . .

Without doubt Mr. Kipling has his limitations. He does not love a lover; the atmosphere of romantic emotion is foreign to him. He tells us that "there are but two sorts of women in the world—those who take the strength out of a man and those who put it back," but his pen recognizes the former class only. Except "William the Conqueror," that charming girl as boyish as her name, we cannot recall that Mr. Kipling has drawn a thoroughly admirable woman. He lacks, too, the spiritual sense, the "over-soul." The influence of that "something not ourselves that makes for righteousness" has scant recognition from him. With a cold attitude toward love and religion it is obvious that there must be a certain hardness in his work, a lack of "sweetness and light."

Within these limitations, and sometimes overleaping them, "Kim" is a great book, the masterpiece of its author. As always, Mr. Kipling dares to be himself; he discards traditions, he listens only to the moving voice within. "Kim" is written with his characteristic freedom from self-consciousness, despite the fierce light that has beaten upon him during these later years. George Eliot was wont to aver that she never read a criticism of her books, but the very consciousness of the public eye upon her destroyed her spontaneity, hampered and burdened "Daniel Deronda," and extinguished her genius in "Theophrastus Such." But Mr. Kipling, while gaining immensely in grasp and in polish, has lost no whit of the

delightful abandon of his earlier tales. His story tells itself without a trace of effort or of pose.

From Odysseus on, errant feet, whether of knight, explorer, or pilgrim, have possessed magnetic charm. A goodly company has walked up and down in the earth, and gone to and fro in it, leading fascinated imaginations after them. Among the most alluring of these, Kim and the lama will henceforth have a place. The story is almost without a plot, altogether without the universal passion, and yet it holds the reader under a spell from the first page to the last. We cannot guess the secret of the author's power; it is so simple that it defies analysis. He just says, like the Christmas Spirit, "Touch my robe," and we float with him out of our own world into the mysterious, poisonous, fascinating East. We become a part of the complex and multitudinous life that quivers through the heated air of the plains of India; we climb with Kim and the lama into the hill country, and fill our lungs with the rare, snow-chilled breath of the upper altitudes. For a fleeting, elusive moment, we even wrap ourselves in the brown skins of these inscrutable Orientals; we see life through their eyes, we think their thoughts.

This is more than art; it is magic.

The illustrations heighten the illusion. Never were pictures—not du Maurier's own—in such accord with the text. They put visibly before us Kim and the lama, the jat, the woman of Shamlegh, the "big, burly Afghan," that wonderfully fearless "fearful man," Hurru Babee. They provide for the imagination molds of truth, and must possess an ethnological value not less than their artistic merit. There is a peculiar attractiveness, too, in the unusualness of their form. Like the story itself, they embody the very spirit of India.

Kim, or Kimball O'Hara, is a lad of pure white blood, the son of an Irish Color-Sergeant. His parents dying in his babyhood, he is reared, if reared it can be called, by a half caste native woman, and in all his habits and tastes is Hindu, not European. "He had known all evil since he could speak"; he had executed unlawful commissions for all sorts of people, and had gained the nickname of "Little Friend of all the World." He is a conspicuous example of the mental acumen attainable through the knowledge of men alone. When about thirteen or fourteen years of age, impelled by curiosity, restlessness, love of novelty, the spirit of adventure, perhaps, too, by a dim sense of the beauty of holiness, he attaches himself to a lama of Thibet, a "Holy One" seeking "the River of the Arrow," that "washes away all taint and speckle of sin," and gives "freedom from the Wheel of Things." Together they wander upon "the Great Search," Kim ministering to the bodily needs of his lama, and himself taking a band in "the Great Game that never ceases day and night throughout India," the Secret Service of the British Government. Never were such oddly assorted comrades as the aged lama on the one hand, simple as a child, guileless, transparent, purged of every earthly desire, filled with but one purpose; and Kim, on the other, with whom he is only an intellectual way of meeting a difficulty; to whom intrigue and suspicion are as native air.

The wanderings of this pair give Mr. Kipling the opportunity of unfolding the panorama of India, of revealing departmental methods and difficulties, of giving an insight into the mysterious contradictions and complexities of the Hindu character, at once intrepid and timid, gentle and murderous, superstitious and agnostic, false and faithful, steeped in vice and worshipping sanctity. Verily the Oriental mind slips out of our clumsy Anglo-Saxon grasp. We become aware of the futility of trying to force upon it our own point of view; we perceive that there is no elusiveness like the elusiveness of race. As we read we lose something of our glib confidence in our mission to these strange peoples; in our ability to carry them "a cartridge belt full of civilization," or a shipload of Occidental culture.

Kim himself is an example of the reflex action of the East upon the West. His Hindu proclivities and his European atavisms are depicted with great skill. His attitude toward life is that of his adoptive country, but he has the brain, the staying power, of his ancestors. His character is touched with a tender grace by his unselfish devotion to his "Holy One." To "love the highest when we see it" is a saving salt. In a sense that he knew not of, the old lama truly "won salvation for himself and his beloved," the Irish vagrant, whose "worth he did see, and to whom his heart was drawn."

As in Kim is illustrated the influence of Asia upon Europe, so in Hurree Babu is illustrated the very curious result of European culture upon the Oriental mind. We remember in the story "On the City Wall" how Wali Dad "suffered acutely from education of the English variety, and knew it." So did Hurree Babu, although, by reason of his stronger character, the results of the "hybridism of East and West" are less disastrous.

Into the mouth of Mahbub Ali, the Mohammedan horse trader, Mr. Kipling puts what we fancy is his own opinion as regards faith:

> The matter of creeds is like horseflesh. The wise man knows horses are good—that there is a profit to be made from all. . . . I could believe the same of all the faiths. How manifestly a Kattiawar mare taken from the sands of her birthplace and removed to the west of Bengal becomes lame. . . . Therefore I say in my heart the faiths are like the horses. Each has merit in its own country.

We gather from this and from "The Judgment of Dungara" that Mr. Kipling does not look upon Christian missions in India as capable of taking root in the national life. It is probable that he does less than justice to the impact already made by Christianity, but he will have done an incalculable service to its missionaries if his writings teach them the importance of studying sympathetically and intelligently the subtleties of the Hindu mind before undertaking its conversion.

It is always pleasant to catch Jove nodding, so we pounce upon "in articulo mortem," perhaps a slip of the pen, and Mr. Kipling's lapse into the common error of using "in petto" to

mean "in little," "in miniature" instead of giving it its correct significance of "in the breast—i. e., secretly."

Mr. Kipling once very unjustly characterized his own style as "jerky jargon." His worst enemies could not now catch up the phrase. While losing nothing of its force, it has gained all that can be asked of cohesiveness and smoothness. A recent article in an English magazine wisely deprecates the modern "hunt for the word." Mr. Kipling never impresses one as engaging in that chase; his concern is for the thing; hence the word is what it should be—transparent to the thought behind it. "Kim" should overturn Mr. George Moore's fantastic theory that English is a dead language.

It is, in truth, a great book in many of its aspects. When an author gives his readers his own eyes, visualization can go no further, and this Mr. Kipling does. When without any asides to his audience, his characters live, breathe, reveal themselves in word and deed, he has attained creative perfection, and this Mr. Kipling does. When without a didactic hint, he sets his readers thinking of the great problems of life, and makes them shy of the easy verdict of ignorance, he fulfills an ethical mission—and this Mr. Kipling does. And when he shows the loveliness, the aseptic quality of simple goodness, the power that comes from faithfulness to high ideals, he has done much toward teaching the lesson of Christ, that the world can be saved only through holy lives lived in it—and this Mr. Kipling does.

According to Mr. Howells "Kim" should be strictly forbidden to the public libraries. It is a book to be owned, not borrowed, to "linger over and delay, to return to again and yet again," for it is one of the few novels of these latter days that have enriched both literature and life.

* * *

August 9, 1902

A STUDY OF MAN

THE VARIETIES OF RELIGIOUS EXPERIENCE: A Study in Human Nature. Being the Gifford Lectures on Natural Religion Delivered at Edinburgh in 1901–02 By William James L.L D., &c., Corresponding Member of the Institute of France and of the Royal Prussian Academy of Sciences, Professor of Philosophy at Harvard University.
Pp. xii, 334.
New York, London and Bombay: Longmans, Green & Co. $3.20.

In its "descent and being," whatever its "ascent and cause," this book is written for the satisfaction and delight of those who like to see a lion bearded in his den. The entertainment provided for all such is the better because there are two lions of the Scottish breed that tempt Prof. James to the encounter, one the dogmatic theology of John Knox and his successors, the other the metaphysical philosophy of the Scottish schools. . . .

Such are his frankness and audacity that he is not always satisfied to call a spade a spade. Sometimes, like the Anglican curate in the story, he calls it "a d—d old shovel." Writing

more fresh and vivid cannot easily be conceived, and there are many passages in which the expression, rising to the level of the thought, is of a striking force and beauty.

In his preface Prof. James anticipates the objection that he has loaded his pages with examples taken from the extremer expressions of the religious temperament. "To some readers," he says, "I may seem to offer a caricature of the subject. Such convulsions of piety, they will say, are not sane." But he flatters himself that, reading to the end, they will have a more favorable impression, finding that he combines the religious impulses with principles of common sense which correct exaggeration and permit the individual reader to be as moderate as he likes. We are less confident than he as to the last impression. The whole tribe of mind-curers, theosophists, and the like will take great comfort in his concessions; the more steady-going will insist that his data are too pathological to furnish a sound basis for a theory of religion.

It is hardly to be imagined that these lectures will have any general operation that is favorable to religion. They will permit those who are enamored of "strange fire" to take their license in the field of subliminal fancies; they will make religion to the doubter and the agnostic more repulsive than ever, and will go far to persuade the average religious man that if these things are of the essence of religion the less of it we have the better. Nevertheless, these lectures ought to do much good. They ought to make for breadth and sympathy. Nothing is more central to them than Prof. James's sense of the plural constitution of the world. The monists do not take him in their snare. Their world for him is like the imaginary feasts of the insane person which had all the savor of her customary gruel. What delights him is the variety of experience. Because we are virtuous shall there be no more cakes and ale? Must all religion be of one kind? He thinks not. If there are those who have no incursions from the subliminal sphere, let them be happy in their condition, but let them not be contemptuous of those who have a different and perhaps richer constitution. Allowing that religions are often neurotic, Prof. James is much more inclined than are the medical materialists to limit the neurotic sphere. Many will disagree with him in kind, many more in degree, and those and these will think it as unpermissible to study religion as it would be to study physiology under exclusively pathological conditions.

Of course Prof. James denies that his conditions are all pathological. But he concedes that they shade rapidly into those that are of this description. In his first chapter he takes particular issue with the theory which ascribes to religion a sexual origin. But, whatever its origin, the sexual implication seems to be more pronounced than Prof. James would have us to believe. Many of his examples fairly reek with what he calls "theopathy," and Theodore Parker called "voluptuousness with God." Where Margaret Mary Alacoque thinks God loves her to distraction, Maudsley's idea that she was suffering from inflammation of the ovaries does not seem irrational or uncharitable.

Attempting to define religion for the purpose of these lectures, Prof. James is not at all disconcerted by the many definitions of religion that are offered. They are just the meat on which his passion for the pluralistic feeds. They imply the largeness of the fact. For his purpose this is the enthusiasm of solemn emotion. As such it is more than philosophy or morality. Concerning the latter his tone is not different from that of his father, Henry James, and in the genial latitude of his expression there are reminiscences of that great writer's "Substance and Shadow." One of his later chapters, in which he attempts to indicate the right relation of philosophy to religion, is one of the most important. The conclusion he arrives at is that the part played by philosophy or theology is quite secondary; that the material of religion is furnished by our emotional nature, and very largely by that part of our emotional nature which is subliminal. These are hard words for the rationalism which endeavors to justify religion on definitely articulate grounds. "If you have intuitions at all, they must come from a deeper level of your nature than the loquacious level which rationalism inhabits." This inferiority of the rationalistic level as a foundation for belief is just as manifest when rationalism argues for religion as when it argues against it. Witness "the argument from design."

The truth is that in the metaphysical and religious sphere articulate reasons are cogent for us only when our inarticulate feelings of reality have already been impressed in favor of the same conclusion. The unreasoned and immediate assurance is the deep thing in us; the reasoned argument is but a surface exhibition.

At the same time we are asked to observe that it is not said that "it is better that the subconscious and non-rational should thus hold primacy in the religious realm"; only that they do so hold it as a matter of fact.

Space permitting, it would be interesting and profitable to follow Prof. James along the course of his chapters "Healthy-mindedness," "Conversion," "Saintliness," "Mysticism," until we come at length to the "conclusions" of his last chapter and his postscript. In the first of these he gives not a little aid and comfort to the mind-curers and Christian Scientists. With the latter he goes a mile, and they will curse him because he does not go with them twain, and because he does not go to Mrs. Eddy for his best characteristics of the school. But such is Prof. James's stomach for the new and strange that he would prefer Mrs. Eddy to "the correct type," or "the clerico-academic-scientific type," or the deadly respectable type. Nothing is so hopeless for him as a conventionalized attitude of mind. "If mind-cure should ever become official, respectable, intrenched, the elements of suggestive efficiency which it now possesses will not be lost." Everywhere there is a frolic welcome to the eccentricities and extravagances of the religious life. Many will question whether its more sober exhibitions would not have been more fruitful of results, but the interest and fascination of the treatment are beyond dispute, and so, too, is the sympathy to which nothing human is indifferent.

* * *

October 4, 1902

SUBTLE MR. JAMES

A Study of His "Third Mannor" in "The Wings of the Dove"

THE WINGS OF THE DOVE
By Henry James
New York: Charles Scribner's Sons. 1902. Two volumes. $2.50.

By MONTGOMERY SCHUYLER

There is still a certain number of readers to whom the appearance of a new novel by Henry James is the most interesting event in current fiction. We say "still" advisedly, for it is doubtful whether there are as many of them as there were ten years ago. In time of temptation they fall away. The novelist has never spared his readers any more than himself, and of late years he has become a harder taskmaster than ever. His exactions cannot be evaded except by strictly leaving the book alone, and nothing could more unfit a reader for the intent attitude of mind proper to studying his psychology than the languid perusal which is all that most contemporary fiction requires or repays. And this professor of psychology is increasingly indifferent to the comfort of his students. It is perhaps mainly in consequence of this indifference that the first living master of psychological fiction, at least in the English language, after a career of a generation, finds himself compelled to flit from publisher to publisher. The work explains why any human publisher, as Carlyle had it, should view it with apprehension and alarm, and why a conscientious publisher's reader, even though personally an enthusiast, should freely qualify and attenuate his recommendation.

And then there is always the chance that the new novel will be a failure from its own point of view. Does anybody, do the convinced students of Mr. James, "few and faint, but fearless still," regard "The Sacred Fount" as a success? That was one of the mere fantasies, like "The Private Life," which do for an essay or a "skit," but simply refuse to be realized and become impossible exactly in the measure in which it is sought to make them possible, to "document" them and verify them and stand them on their legs. And yet "The Sacred Fount," according to the present reviewer's apprehension, is but an interlude of failure between two distinct and striking successes, between "The Awkward Age" and "The Wings of the Dove."

There have been occasions on which it seemed that Mr. James was bent on demonstrating that fiction also is one of the arts in which the subject is nothing and the workmanship everything, and that a novelist who knew his business could do without a subject, just as some composers make "interesting modulations" do duty for tunes. But that is by no means the case with "The Wings of the Dove." Distinctly the author has this time a story to tell. The theme is the frequent, one may almost say the usual, theme of Mr. James in his "third manner," the materialism and worldiness, essentially to the point of grossness, with all its superficial polish, of the world of London, and the manner in which these earthy qualities

impose themselves. This lesson begins at the beginning, in the introduction of the impossible father of Kate Croy, who thereupon goes hence and is no more seen, after inculcating upon her the moral with which he is charged that poverty is the worst of evils, a moral also inculcated by her shabby and querulous widowed sister, who stands palpably convicted of the crime of unsuccess, and acts as social Helot for her as yet virginal sister, the heroine. How can the girl, how dare she, marry the man she loves, convicted before the fact and in his own mind of unsuccess, in the face of these object lessons, not less impressive than the solemn state of Aunt Maud, surrounded with all the trophies of British triumph? A lingering and conditional engagement, till Aunt Maud relents, which she will plainly never do till she dies, in which case also we foresee that she will have taken her precautions—till, in fact, something turns up—is all that is left to these London lovers. But something does turn up, in the arrival of the delightful American heiress, Milly Theale, and her equally delightful duenna, who come, as they so often do in Mr. James's novels, bringing their ideals to confront British institutions, to aerate and spiritualize the atmosphere of the materialized society they join. Visibly and markedly Mr. James's American women in London are pilgrims "from a brighter sphere." It is let be seen that Kate likes Milly, but not less that she finds Milly's money very charming. And when it appears that Milly has a mortal malady, and that Kate's conditionally accepted lover is Milly's most acceptable nurse, the notion arises, in an indurated London imagination which shrinks from nothing, that Morton Densher shall make love to Milly's money, which shall subsequently enrich Kate. The consent of the male lover would seem to be the hardest condition in this pleasing scheme to fulfill. But it is, in a manner, obtained. He will not quite make love, but will consent to "offer the cheek" upon certain amazing conditions, one being that his betrothed temptress shall make an irrevocable commitment and take a bond of fate against the jealousy which he foresees is likely to break out in spite of her if her cold-blooded scheme goes into operation.

Of course, stated crudely, this is what Shakespeare describes as "a most filthy bargain," and all Mr. James's skill is taxed to make it clear of a man who is distinctly not a blackguard. There is the concurrent advice of Milly's best friend, the admirable Susan. There is the acquiescence of Aunt Maud in being hoodwinked. (Was Aunt Maud really hoodwinked?) There was even, in effect, the best medical advice that this was the best to do for Milly. In fact, the broad way that leadeth to destruction is made, by the astonishing subtlety of the novelist's art, the path almost of duty, certainly of humanity, though Densher cannot quite persuade himself that it is the path of honor. Milly does die, as per agreement, and does leave the money to the counselor of her declining hours, although her death is precipitated at last by the announcement of the pleasing Lord Mark, who has pursued her from London to Venice to make it, that Merton and Kate are still engaged, and that she, being duped, had better reconsider her refusal of himself. She

does, we say, leave the other girl's lover the money, with which he restores the self-respect that has necessarily been more or less frayed at the edges from all this wear and tear promptly, at last, refusing to have anything to do with it. But he finds that, between the avarice which has been imposed by London on his betrothed, and the jealousy which, after all, she had not, when it came to the point, been able to repress, she will take him with the money, or she will take the money, the captive of her own bow and spear, without him, but, in spite of the commitment, which, almost more amazingly than that it should have been made, turns out to be after all, revocable, him without the money she will not have. And, as all these characters are all the time saying: "And there you are." The rehabilitated victim and legatee depart, to make room, one imagines, for the final tableau, in which Lord Mark reaches out a shapely, aristocratic hand for Kate's, which clutches the envelope containing Milly's money, while Aunt Maud, in her character of Britannia, extends the aegis of her umbrella and her benediction over the happy and deserving pair.

This crude statement of "the argument," of course, does great injustice to the book. But so, also, one is bound to say, does the author's elaboration, for the purposes, at least, of "the general reader." It is not in laboring to be brief that Mr. James has become obscure. Often the obscurity seems willful, even perverse, certainly defiant. One is tempted to say, in his haste, that the sentences are in the minority that do not require to be read over twice. And there are very many whole pages that do require so to be studied. Mr. James seems to have become sensible to the accusation of "parenthesitis" that has been brought against his riper manner. There are not so many formal parentheses in these pages, but there are some thousands of sentences which are really parenthetical, though grammatically consecutive. And these are not by any means negligible. On the contrary, like the small claws of the lobster which the hasty eater refuses to occupy himself with, the leisurely student finds them the most toothsome morsels. But in a novel one feels that he is at least entitled to a "scenario." He feels that he has a right to repine when it is only after two pages that he finds that the function at which he is assisting is taking place at a "great historic house," and only after a page or two more that he makes out it is Lord Mark's own house, to which that astute and impecunious scion of the British aristocracy had invited the American heiress, that she might be stunned and dazzled with its evidences of antiquity and its implications of "race," while he himself was sedulously understating his advantages. Mr. James's "proposals" are not apt to be vociferous, but Lord Mark's to Milly is perhaps the acme of the unemphatic:

"Perhaps a part of what makes me remember it," he pursued, "is that I was quite aware of what might have been said about what I was doing. I wanted you to take it from me that I should perhaps be able to look after you—well, rather better. Rather better, of course, than some other persons in particular."

Mr. James's own comment, characteristically made four pages afterward, is evidently warranted:

As a suggestion to her of a healing and uplifting passion it was in truth deficient; it wouldn't do as the communication of a force that should sweep them both away.

The subtleties of analysis which the novelist goes into might do if there were a "public" of mighty poets and subtle-souled psychologists. But when the plain man finds what looks to him like an attempt to decompose immediate intuitions and trace their steps, when by hypothesis they haven't any, it is no wonder the plain man revolts. Whether it is "worth going through so much to learn so little" is a question that each reader must and will answer for himself, the common devourer of novels no doubt by abstaining. And one notes with interest that the strain has told upon the intellect of the very proofreader, who has groaningly submitted to obvious misprints of which the correction only was not obvious. Sometimes, under the strain of trying to make it out, the poor man, like Johnson's "laborious commentator," "at some unlucky moments, frolics in conjecture," as when he introduces into the astonished English language such a vocable as "namble." And small blame to the proofreader!

But, after all, none of this subtlety or of this ingenuity is wasted for the right reader. None of it is fantastic as Mr. James's failures are fantastic. These are real people—Kate Croy and Milly, the dove, and Susan Shepherd Stringham, and Aunt Maud and Densher and Lord Mark, really observed, really presented, worthy of all the elaboration that has been lavished upon them, and there is not a stroke that does not "tell." The lesson about London is as clear as in the "Awkward Age." Each is a "society drama," only the earlier is polite comedy and the later a rather sordid tragedy of low life above stairs. These latest accessions to Mr. James's portrait gallery are as credible, and as creditable, as any of their predecessors on the walls, and distinctly "The Wings of a Dove" is one of its author's high successes.

* * *

January 10, 1903

JACKSON

How He Appears in Woodrow Wilson's
"History of the American People"

By AUGUSTUS C. BUELL

One of Andrew Jackson's biographers (Amos Kendall) remarks that "Gen. Jackson founded a new political school in the United States." With all deference to Mr. Kendall's skill in political management and his aptness as a party organizer, we must question the accuracy of his estimate of the relation

that Jackson bore to the events of his time. To say that he "founded a new political school" is not accurate. The really accurate thing to say is that "the new political school" found Andrew Jackson. No one who has read or may read the last forty pages of Vol. III. and the first hundred pages of Vol. IV. of . . . Woodrow Wilson's "History of the American People," (lately published in five volumes by the Harpers and already noticed in these columns) will attempt to gainsay this proposition. Of all those who have written about Jackson and his figure in our history, not one has seemed to completely grasp the logic of his career until . . . Wilson. The five volumes of his great work all run in high planes of survey, review, and analysis of situations, events, and characters. But the masterpiece of all is his Jackson.

Quite an array of biographers . . . have told us who and what Jackson was, through all his devious fortunes from log cabin to White House. . . . But Dr. Wilson is the first to tell us why he was. In this lies the enduring historical value of Wilson's survey.

Here is the keynote, (Volume IV., Page 3:) "He is," said Jefferson, "one of the most unfit men I know of for the place!" (the Presidency). Discussing the difference—radical and constitutional—between Jefferson, the so-called Founder of Democracy, and Jackson, the man whom Democracy found, Dr. Wilson says:

Gen. Jackson professed to be of the school of Mr. Jefferson himself, and what he professed he believed. There was no touch of the charlatan or the demagogue about him. The action of his mind was as direct, as sincere, as unsophisticated as the action of the mind of an ingenuous child, though it exhibited also the sustained intensity and the range of the mature man. The difference between Mr. Jefferson and Gen. Jackson was not a difference of moral quality so much as a difference in social stock and breeding. Mr. Jefferson, an aristocrat and yet a philosophical radical, deliberately practiced the arts of the politician and exhibited oftentimes the sort of insincerity which subtle natures yield to without loss of essential integrity. Gen. Jackson was incapable of arts or deceptions of any kind. He was, in fact, what his partisans loved to call him, a man of the people, of the common people.

Jackson was the seventh President. His inaugural began the eleventh Administration. The Federal Government was forty years old when he took his oath of office. . . . Of his six predecessors, four had been Virginia aristocrats and two Massachusetts aristocrats. So strong were the traditions of the aristocratic régime that, though Jackson in 1824 had the highest Electoral vote by plurality, the House, into which the choice was thrown, elected John Quincy Adams, despite his Electoral minority of 15 votes and his popular minority of less than one-third of all the votes cast. Yet this monstrous perversion of the popular will was only the logical

end of the old aristocratic and oligarchic régime that had marked the first thirty-six years of our experiment at self-government.

During those years there had been no such thing as popular sovereignty. . . . Though the census of 1790—first in our history, and incomplete and inaccurate as it is conceded to have been—gave us 3,900,000 people all told, it is doubtful if more than 120,000 voters were represented by the electors who chose Washington President the year before. Then and for years afterward our Government, though republican in theory, was, in fact, an oligarchy. . . . In New England the aristocracy was of descent from the Puritans and roundheads, with incidental property-holding, superior education, and a powerful political clergy. In New York, New Jersey, Pennsylvania, and Maryland it was the aristocracy of wealth in manor lands, counting houses, ships, and commercial connections at home and abroad. In Virginia and the other original Southern States it was the aristocracy of birth, plantations, family traditions, and ever-increasing slaves. . . .

Take it altogether, the ethics of our governmental system up to Jackson's time (1824) did not differ seriously from the ethics of the Colonial period. The country was independent, there were no titled noblemen, and the King did not appoint Governors. For the rest we had the English system throughout. The common law of Littleton and Blackstone was our code, our suffrage was restricted on the English or Colonial basis; and no matter whether the Democratic-Republicanism of Jefferson or the Federalism of Hamilton and Adams was in the ascendency, there was no change of public servants to speak of, except in the Cabinet offices—and sometimes not even there. . . .

When the early oligarchy produced such fruit, the men whose brain and brawn were making the country naturally sought a remedy. One by one they besieged and reduced the fortresses of the aristocratic and oligarchic minority that had so long held sway. In New England they overthrew the class-suffrage—except in Rhode Island. In New York they forced the great lords of manor—the grand seignors—such as the Livingstons, Van Courtlandts, Van Wycks, Morrisses, Van Rensselaers, Hardenbergs, &c., &c., to surrender their leaseholds under a law providing for an equitable conversion of title into fee-simple. But this was not done, and the "Patroons" did not yield until a Sheriff had been shot dead and some of his posse lynched in the quiet township of Andes, Delaware County. Then, having a care for their own scalps, the manor lords of New York yielded, and the erstwhile tenants without suffrage became freeholders entitled to vote.

Similar processes, varying in character with the particular nature of the obstruction to popular sovereignty in its real sense, went on in other States. This was the great movement of the people toward real democracy. By 1824 it had reached a stage of exuberant development, at which it felt the need of a leader of its own kind and kidney.

Andrew Jackson was there, . . . a born leader of the mental, moral, and physical forces of the people . . . as they swarmed in the new West, and as they rose against the manor-lords and the "old-established families" in the East and South.

Above all, he was a fighter. That was what the common people wanted in their leader. He would never tell anything but the truth; and he was in the habit of telling that at all times and in all places, without the least regard for diplomacy—or even discretion. To all these considerations, add that he was born in a log hut, was a soldier in the Revolution before reaching the age of fourteen, and, in our second war for independence, had been Commander in Chief at New Orleans! In the Revolution he had been only a stripling. Taken prisoner, he had refused to black the boots of the British officer who captured him, and had been punished by a sword-cut, the scar of which he still wore. But his revenge had come at New Orleans, where, with about 2,300 Tennessee and Kentucky hunters—marksmen who never missed man or beast in battle or in the chase—and a few United States regulars he had destroyed in less than an hour an army nearly three times the number of his own force. . . .

Dr. Wilson says that Jackson, when first approached upon the subject of running for the Presidency, shrank from it. . . . Finally he consented to run. His defeat by John Quincy Adams, under the conditions already described, roused all the combatant energy of his nature, and thenceforward he was a most willing candidate.

When renominated in 1828 he declared to Gen. William O. Butler of Kentucky, who happened to be with him when he received the notification:

> I had doubts four years ago, William, and, of course, I was beaten. But now I have faith, and they can't beat me! "Treason, stratagem, and spoils" may prevail once, but not twice. I am in the hands of the people, and the people are strong enough now to win!

He was elected President by majorities that left no doubt as to what "popular sovereignty" must henceforth mean in this country; and that likewise sealed beyond resurrection the fate of manor-house politics and dinner-table nominations.

Of all this Jackson himself stood—the exponent, not the creator—as Dr. Wilson points out. Jackson was forced into the Presidency by the wave of popular self-assertion—by the upheaval of the common people, of whom he himself was the most perfect representative. But he did not himself start the wave rolling, nor did he agitate the upheaval. He was, as the historian points out, the effect and not the cause, the offspring and not the parent of the radical and permanent revolution in our mode of government that began in 1820 and of which the end is not yet. It was the beginning of government by organized and disciplined party, ruling by numerical majority, in lieu of government by coterie and cabals.

* * *

January 31, 1903

"THE PIT"

A Dispassionate Examination of Frank Norris's Posthumous Novel

THE PIT: A Story of Chicago
By Frank Norris
Pp. 421. New York: Doubleday, Page & Co. $1.50.

Just how much American literature lost by the death of Frank Norris is a difficult question, to which there will be many answers, none conclusive. That the work he had already done contained much of promise and something of achievement will probably be admitted by all. Opinions will differ widely as to the extent of the achievement, and achievement is, after all, the only safe basis of judgment, while recognition of a young author as "promising" is criticism not the less severe because in kindly form.

Clearly as Mr. Norris had proved himself to be a story teller with stories to tell, he had not revealed either the inerrant taste of genius or the patient industry of enlightened talent. He was in a hurry to do great things, and, conscious of strength, did not take the pains to acquire the technical skill upon which perfection of detail depends. His books, in consequence, were remarkable rather than admirable, or, at least, more remarkable than admirable, and one sometimes gets from them the impression of reading a first draft manuscript instead of the printed page. They evidence what it is customary to call fatal facility, and seem to be written at high speed and left uncorrected.

If this seeming is deceptive, and Mr. Norris did in reality give his books the careful revision without which the conscientious artist is never content, then there is a chance that his work would have been "promising" to the end of a long life, as it was to the end of one pathetically short. For there was not much difference between "McTeague" and "The Octopus," so far as literary finish went, and now comes "The Pit," with all of the small faults as well as all of the large virtues of its predecessors. Nature made Mr. Norris a marvelously accurate observer of the life around him, and to this gift added the creative imagination, but she did not endow him with an instinctive knowledge that the right word is worth a long search, and he had not discovered it for himself. He appreciated only too well the colossal effects produced by Zola, and imitated that master's devices only too successfully, for in imitating the devices he often missed the effects. Perhaps he had read both too much and too little; if he had read less his style would have been original, because he would not have thought anything about style, and if he had read more he would have been able consciously to make a style of his own—which comes to the same thing.

But Mr. Norris was what he was, and there is small profit in regretting, and less in resenting, that he was not something else. He followed a happy inspiration when he planned "the epic of the wheat," and, as "The Octopus," which dealt with the growing and the growers of what means more to humanity than any other product of the soil, was no common book, so "The Pit," which shows the fierce excitements of speculation in the staff of life, is something more than merely a piece of picturesque and vigorous writing. That it is an absolutely accurate picture of the Chicago Board of Trade and the men who contend therein is likely to be questioned by those with much personal knowledge of both, but that matters little to the rest of us, for grain brokers and their clients, or patrons, or customers, or whatever it is that grain brokers have, are at least as interesting as Mr. Norris saw them as they are in reality, and the novelist, even the realistic novelist, has the best of rights to leave history and statistics to the historians and the statisticians, and to consult only his own conscience—and needs—in regard to the amount of exaggerating and emphasizing he should do. He would not have claimed that Curtis Jadwin, his hero, is the ordinary speculator in wheat, or that every, or even any, attempt to "corner" that useful staple has passed through precisely the phases he records; but, certain as it is that there are not many Jadwins, there is no obvious reason why there should not be one of them, and, given the one, the recorded "corner" would follow naturally enough.

Business has its adventures as well as its adventurers, nowadays, and the growing tendency of novelists to substitute the comedy and tragedy of business for those of war, hunting, and other similarly antiquated forms of activity is proof of great wisdom on their part, especially as "heart interest" combines as logically and inevitably with business as with the other occupations.

It does so in "The Pit," which includes among its numerous personages several entirely comprehensible women—every one of whom, for a wonder, could safely submit her "past" to the inspection and commentary of publics even more censorious than that of Chicago is supposed to be. The reader hardly sees, perhaps, why so many men fell in love with Laura Dearborn, or why the well-matured Jadwin thought himself so lucky to win her away from his less wealthy rivals; but real life is full of mysteries of that sort, and surely the realistic novelist is under no obligation to ignore the fact that unexpected results are often reached by the solution of personal equations. Laura made quite as good a wife as the somewhat priggish grain gambler deserved. Among the minor characters—Board of Trade men of various ranks and ages, the inevitable pair of youthful lovers, a maiden aunt bewildered by millions, and the like—are several that were carefully conceived and projected, and not the less sympathetic because they are the immemorial "types" of fiction and the stage, newly costumed, each serving the familiar purpose. Indeed, if one looks below the surface of "The Pit" one soon realizes that not much more than its properties is new.

"The Octopus" seemed to be for the most part the product of actual experience, and the wheat was an essential feature of the story, but the second book of the "epic" reveals the use of second-hand information as to the methods and language of the grain speculators. The author's material was

well studied up, not unconsciously acquired and thoroughly possessed. Had the third volume of the proposed series been written, the deterioration from the first would probably have been still more marked, for Mr. Norris was able to acquire a closer knowledge of Chicago than he would have obtained in regard to a European village stricken with famine, which was to have been the scene of a book called "The Wolf," and dealing with the consumption of the wheat raised in California and made the object of a ruthless gamble beside Lake Michigan.

While on his own ground and voicing the wrongs of his own people, Mr. Norris won easier pardon for his verbal infelicities than when he wandered into new fields and imagined emotions instead of feeling them. The war between the wheat growers and the Pacific railways was something worth getting excited over; as much can hardly be said of a laborious demonstration that speculation in the necessities of life, when conducted on a large scale, is an immoral practice, and very wearing on the nerves of the speculator. The demonstration at best is not entirely convincing, and so far as it does convince it was unnecessary. Mr. Norris would have gone much further in the time allotted him if he had taken himself a little less, and his chosen profession a little more, seriously. He was a preacher turned novelist—a preacher, that is, of elementary sociology and economics, and his magnificent powers of observation and description were allowed to run wild in order that he might hasten to tell the world some true things that were not new and some new things that were not true.

* * *

April 25, 1903

THE NEGRO QUESTION

Essays and Sketches Touching Upon It by a Colored Writer

THE SOULS OF BLACK FOLK: Essays and Sketches
By W. E. Burghardt Du Bois
Chicago: A. C. McClurg & Co.

It is generally conceded that Booker T. Washington represents the best hope of the negro in America, and it is certain that of all the leaders of his people he has done the most for his fellows with the least friction with the whites who are most nearly concerned, those of the South. Here is another negro "educator," to use a current term, not brought up like Washington among the negroes of the South and to the manner of the Southern negro born, but one educated in New England—one who never saw a negro camp-meeting till he was grown to manhood and went among the people of his color as a teacher. Naturally he does not see everything as Booker Washington does; probably he does not understand his own people in their natural state as does the other; certainly he cannot understand the Southern white's point of view as the principal of Tuskegee does. Yet it is equally certain that "The Souls of Black Folk" throws much light upon

the complexities of the negro problem, for it shows that the key note of at least some negro aspiration is still the abolition of the social color-line. For it is the Jim Crow car, and the fact that he may not smoke a cigar and drink a cup of tea with the white man in the South, that most galls William E. Burghardt Du Bois of the Atlanta College for Negroes. That this social color line must in time vanish like the mists of the morning is the firm belief of the writer, as the opposite is the equally firm belief of the Southern white man; but in the meantime he admits the "hard fact" that the color line is, and for a long time must be. . . .

After an eloquent appeal for a fair hearing in what he calls his "Forethought," he goes in some detail into the vexed history of the Freedman's Bureau and the work it did for good and ill; for he admits the ill as he insists upon the good. A review of such a work from the negro point of view, even the Northern negro's point of view, must have its value to any unprejudiced student—still more, perhaps, for the prejudiced who is yet willing to be a student. It is impossible here to give even a general idea of the impression that will be gained from reading the text, but the underlying idea seems to be that it was impossible for the negro to get justice in the Southern courts just after the war, and "almost equally" impossible for the white man to get justice in the extra judicial proceeding of the Freedman's Bureau officials which largely superseded the courts for a time. Much is remembered of these proceedings by older Southerners—much picturesque and sentimental fiction, with an ample basis of truth, has been written about them by Mr. Thomas Nelson Page and others. Here we have the other side.

When all is said, the writer of "The Souls of Black Folk" is sure that the outside interference of which the Freedman's Bureau was the chief instrument was necessary for the negro's protection from supposed attempts of his former masters to legislate him back into another form of slavery, yet he admits that "it failed to begin the establishment of good-will between ex-masters and freedmen." It is proper to place beside this, of course, the consensus of fair Southern opinion that the interference in question and the instrumentalities it employed were the cause of the establishment of an ill-will previously nonexistent. Here is a point where Booker T. Washington, as a Southern negro, has the advantage of his present critic in this that he knows by inherited tradition what the actual antebellum feeling between the races was. Du Bois assumes hostility.

While the whole book is interesting, especially to a Southerner, and while the self-restraint and temperateness of the manner of stating even things which the Southerner regards as impossibilities, deserve much praise and disarm harsh criticism, the part of the book which is more immediately concerned with an arraignment of the present plans of Booker T. Washington is for the present the most important.

In this matter the writer, speaking, as he says, for many educated negroes, makes two chief objections—first, that Washington is the leader of his race not by the suffrage of that race, but rather by virtue of the support of the whites, and, second, that, by yielding to the modern commercial

spirit and confining the effort for uplifting the individual to practical education and the acquisition of property and decent ways, he is after all cutting off the negro from those higher aspirations which only, Du Bois says, make a people great. For instance, it is said that Booker Washington distinctly asks that black people give up, at least for the present, three things:

First, political power;
Second, insistance on civil rights;
Third, higher education for negro youth,

and concentrate all their energies on industrial education, the accumulation of wealth, and the conciliation of the South. The policy has been courageously and insistently advocated for over fifteen years, and has been triumphant for perhaps ten years. As a result of this tender of the palm branch what has been the return? In these years there have occurred:

1. The disfranchisement of the negro.
2. The legal creation of a distinct status of civil inferiority for the negro.
3. The steady withdrawal of aid from institutions for the higher training of the negro.

These movements are not, to be sure, direct results of Washington's teachings, but his propaganda has, without a shadow of doubt, helped their speedier accomplishment.

The writer admits the great value of Booker Washington's work. However, he does not believe so much in the gospel of the lamb, and does think that a bolder attitude, one of standing firmly upon rights guaranteed by the war amendments, and alluded to in complimentary fashion in the Declaration of Independence, is both more becoming to a race such as he conceives the negro race to be, and more likely to advance that race. "We feel in conscience bound," he says, "to ask three things: 1, The right to vote; 2, Civic equality; 3, The education of youth according to ability" and he is especially insistent on the higher education of the negro—going into some statistics to show what the negro can do in that way. The value of these arguments and the force of the statistics can best be judged after the book is read.

Many passages of the book will be very interesting to the student of the negro character who regards the race ethnologically and not politically, not as a dark cloud threatening the future of the United States, but as a peculiar people, and one, after all, but little understood by the best of its friends or the worst of its enemies outside of what the author of "The Souls of Black Folk" is fond of calling the "Awful Veil." Throughout it should be recalled that it is the thought of a negro of Northern education who has lived long among his brethren of the South yet who cannot fully feel the meaning of some things which these brethren know by instinct—and which the Southern-bred white knows by a similar instinct; certain things which are by both accepted as facts—not theories— fundamental attitudes of race to race which are the product of

conditions extending over centuries, as are the somewhat parallel attitudes of the gentry to the peasantry in other countries.

* * *

July 25, 1903

STORY OF A DOG

Jack London's Newest Book, "The Call of the Wild"

THE CALL OF THE WILD
By Jack London
Illustrated by Philip R. Goodwin and Charles Livingston Bull. Decorated by Charles Edward Hooper. 12mo. Pp. 211. New York: The Macmillian Company. $1.50.

Mr. Jack London, having made us acquainted in his previous stories with the people of the Far Northwest, proceeds in his latest and best book, "The Call of the Wild," to introduce us to a little lower stratum of the same society—a most fascinating company of dogs, good, bad, and indifferent, of which a huge fellow, St. Bernard and collie crossed, named Buck is the bright particular star.

Unlike most stories of the kind, men and women occupy a very unimportant place in this one, and not much time or trouble is taken by the author in individualizing the few humans who are necessary to carry on the action. Better still, Mr. London's dogs are not merely people masquerading in canine skins. At least this is true to a far greater extent than has usually been the case even with the best dogs of fiction; and during the delightful hour it takes to read this story one feels that he is really in a world in which dog standards, dog motives, and dog feelings are the subject of analysis, and that Mr. London himself has somehow penetrated a step or two behind the barrier which often seems so slight and transparent between man and "man's best friend."

This has perhaps resulted in the depiction by him of less lofty and edifying scenes than have been wont to occupy the pages of dog stories, but if the truth were told those dogs generally bore about the same relation to real dogs that the children in what have come to be called "Sunday school books" bear to real children. Every dog lover is thoroughly convinced that a good dog possesses more real concentrated goodness than any other animal on earth, including his masters, but that goodness never exhibits itself in any except attractive forms. A dog was never known to be "painfully good," or tiresomely good, for the beautifully simple reason that whenever the accustomed discipline is relaxed he immediately shows signs of those unregenerate impulses which are undoubtedly the spice of all character, and which no amount of civilizing influences can ever entirely eradicate from either man or beast.

Mr. London knows this, and, among all his dogs, there is not one that has any martyrlike propensities, still less one that could make any claim to perfection. Yet all, except a villain of a Spitz, win the reader's affection, for one reason or another, as no angel of a lapdog ever did. Mr. London is not

writing about highly civilized dogs, but about the half wild creatures that were used, when the gold digging began in the Klondike, to carry mails and merchandise from the seacoast into the interior. On the Pacific Slope in the Fall of 1807 dogs strong of build and thick of fur were much desired, scarce and high in price, and that was how Buck, who had been living a life of luxurious ease at Judge Miller's ranch in the Santa Clara Valley, happened suddenly to find himself on the way to Dyea, treacherously sold by his friend, Manuel, the under-gardener, to a dog agent, and later one of a train of sledge dogs, carrying mail to Dawson.

The story is really the record of the uncivilizing of Buck, the process by which the latent wild impulses of his nature, evoked by the life of hardship to which he was subjected, gradually gained the ascendancy, and finally called him back for good and all to the life of the forest and the leadership of a pack of wolves. It may be imagined that in the case of a St. Bernard weighing 140 pounds this revolution was not accomplished without signs of struggle along the course of progress, and the surmise is more than borne out by a perusal of the book. If nothing else makes Mr. London's book popular it ought to be rendered so by the complete way in which it will satisfy the love of dog fights apparently inherent in every man. Very nearly every dog's paw was against Buck, and he won his way not only to eminence, but even to just plain ordinary permission to exist, by proving himself times out of number the best all-around dog in the train. It is the rule there that no civilized dog can stand up against the "huskies," or native dogs, but Buck accomplished even that remarkable feat because he had intelligence enough to adapt himself to new conditions.

Buck's first unpleasant taste of human authority occurred at Seattle when he received his "breaking in" at the hands of a man in a red sweater, and the episode is graphically described. A long ride in a crate in an express car, lack of food and water, and what he looked upon as ill-treatment generally had all contributed to form a fund of wrath in Buck's mind that boded ill to whoever first fell foul of him— in other words, took him out of his crate. This was the man in the red sweater.

"Now, you red-eyed devil," he said, when he had made an opening sufficient for the passage of Buck's body. At the same time he dropped the hatchet and shifted the club to his right hand.

And Buck was truly a red-eyed devil, as he drew himself together for the spring, hair bristling, mouth foaming, a mad glitter in his bloodshot eyes. Straight at the man he launched his 140 pounds of fury, surcharged with the pent passion of two days and nights. In midair, just as his jaws were about to close on the man, he received a shock that checked his body and brought his teeth together with an agonizing clip. He whirled over, fetching the ground on his back and side. He had never been struck by a club in his life, and did not understand. With a snarl that was part bark and

more scream he was again on his feet and launched into the air. And again the shock came, and he was brought crushingly to the ground. This time he was aware that it was the club, but his madness knew no caution. A dozen times he charged, and as often the club broke the charge and smashed him down.

After a particularly fierce blow he crawled to his feet too dazed to rush. He staggered limply about, the blood flowing from nose and mouth and ears, his beautiful coat sprayed and flecked with bloody slaver. Then the man advanced and deliberately dealt him a frightful blow on the nose. All the pain he had endured was as nothing compared with the exquisite agony of this. With a roar that was almost lionlike in its ferocity he again hurled himself at the man. But the man, shifting the club from right to left, coolly caught him by the under jaw, at the same time wrenching downward and backward. Buck described a complete circle in the air, and half of another, then crashed to the ground on his head and chest.

For the last time he rushed. The man struck the shrewd blow he had purposely withheld for so long, and Buck crumpled up and went down, knocked utterly senseless.

Buck never forgot this lesson with the club, for it was driven home by seeing many another dog pass through the same experience, but though he learned to obey he was by no means conciliated, and the change in his character had begun.

One interesting thing described by the author is the pride which the dogs themselves take in their work when they are once harnessed to the sledge, and the way in which those already experienced in what is required instruct the new-comers. Buck was harnessed between Dave, the wheeler or sled dog, and Sol-leks, both of them dogs who took intense delight in their work and were anxious that it should go well. When it did not somebody was sure to feel their fangs. Of course the leader in the train held the place of honor, and it was Buck's jealousy of the leader, Spitz, that brought about his feud with that savage creature. It was long in reaching its inevitable culmination, though both dogs were aching to fight it out, and it was finally brought about by Spitz getting the best of Buck in a rabbit chase.

In a flash Buck knew it. The time had come. It was to the death. As they circled about, snarling, ears laid back, keenly watchful for the advantage, the scene came to Buck with a sense of familiarity. He seemed to remember it all—the white woods, and earth, and moonlight, and the thrill of battle. Over the whiteness and silence brooded a ghostly calm. There was not the faintest whisper of air—nothing moved, not a leaf quivered, the visible breaths of the dogs rising slowly and lingering in the frosty air. They had made short work of the snow shoe rabbit, these dogs that were ill-tamed wolves, and they were now drawn up in an

expectant circle. They, too, were silent, their eyes only gleaming and their breaths drifting slowly upward. To Buck it was nothing new or strange, this scene of old time. It was as though it had always been, the wonted way of things.

Spitz was a practiced fighter. From Spitzbergen through the arctic and across Canada and the Barrens he had held his own with all manner of dogs and achieved to mastery over them. Bitter rage was his, but never blind rage. In passion to rend and destroy he never forgot that his enemy was in like passion to rend and destroy. He never rushed till he was prepared to receive a rush; never attacked till he had first defended that attack.

In vain Buck strove to sink his teeth in the neck of the big white dog. Wherever his fangs struck for the softer flesh they were countered by the fangs of Spitz. Fang clashed fang, and lips were cut and bleeding but Buck could not penetrate his enemy's guard. Then he warmed up and enveloped Spitz in a whirlwind of rushes. Time and again he tried for the snow white throat, where life bubbled near to the surface, and each and every time Spitz slashed him and got away. Then Buck took to rushing, as though for the throat, when, suddenly drawing back his head and curving in from the side, he would drive his shoulder at the shoulder of Spitz, as a ram by which to overthrow him. But instead Buck's shoulder was slashed down each time as Spitz leaped lightly away.

Spitz was untouched, while Buck was streaming with blood and panting hard. The fight was growing desperate. And all the while the silent and wolfish circle waited to finish off whichever dog went down. As Buck grew winded Spitz took to rushing, and he kept him staggering for footing. Once Buck went over, and the whole circle of sixty dogs started up, but he recovered himself almost in midair, and the circle sank down again and waited.

But Buck possessed a quality that made for greatness—imagination. He thought by instinct, but he could fight by head as well. He rushed as though attempting the old shoulder trick, but at the last instant swept low to the snow and in. His teeth closed on Spitz's left fore leg. There was a crunch of breaking bone, and the white dog faced him on three legs. Thrice he tried to knock him over, then repeated the trick and broke the right fore leg. Despite the pain and helplessness Spitz struggled madly to keep up. He saw the silent circle with gleaming eyes, lolling tongues, and silvery breaths drifting upward, closing in upon him as he had seen similar circles close in upon beaten antagonists in the past. Only this time he was the one who was beaten.

There was no hope for him. Buck was inexorable. Mercy was a thing reserved for gentler climes. He manoeuvred for the final rush. The circle had tightened till he could feel the breaths of the huskies on his flanks. He could see them beyond Spitz and to either side half crouching for the spring, their eyes fixed upon him. A pause seemed to fall. Every animal was motionless, as though turned to stone. Only Spitz quivered and bristled as he staggered back and forth, snarling with horrible menace, as though to frighten off impending death. Then Buck sprang in and out, but while he was in, shoulder had at last squarely met shoulder. The dark circle became a dot on the moon-flooded snow as Spitz disappeared from view. Buck stood and looked on, the successful champion, the dominant primordial beast who had made his kill and found it good.

At the very worst point in Buck's fortune, when he refused to go on even under the lash in the hands of a brutal driver, he was rescued by John Thornton and, in Mr. London's words, "love, genuine passionate love, was his for the first time." For Thornton's sake Buck almost became the old time civilized Buck that had belonged in a gentler clime, but it could not be—the "call of the wild" had become too alluring to be resisted. More and more often he wandered away into the forest, and longer and longer did he stay and when one day he returned and found his friend murdered by the Indians the last tie was broken. Man and claims of man no longer bound him.

* * *

November 14, 1903

AN INTERNATIONAL NOVEL

It is rather cheering to find the inventor of the international novel, for such Mr. Henry James unquestionably is, returning to his first love after his recent and numerous excursions in London society. In "The Ambassadors," which has just been put between covers, after finishing a year's course in The North American, he makes this return. It should be interesting to many readers whom the usual problems of Mr. James do not interest to see themselves as others see them. And to readers who make a point of reading everything that Mr. James writes it is particularly interesting to see how much more comprehensive is his vision, as well as how much riper is his art, than in the days of "Daisy Miller" and "The American" and "The Europeans" and "The Portrait of a Lady."

Like an artist, Mr. James is much more interested in putting questions than in answering them. The question put in "The Ambassadors" amounts to a confrontation of two civilizations. The prodigal son, from a Massachusetts town, is rumored to be feeding upon husks in Paris. To his family there is urgent need that he be reclaimed. And so Ralph Waldo Emerson, so to speak, is sent out to reclaim him and bring him home. At Liverpool he meets Daniel Webster, as it were, who is in Europe about his own occasions, and who does not count for much in the story, except to apply faithfully the standards of New

England to the procedures of all other lands, and to find these wanting. But Ralph Waldo, being of an opener mind, cannot help observing and admitting that husks have agreed excellently with the prodigal. Of course he has been charged especially to "look for the woman," and he finds that it is the woman who has wrought the miracle of improvement he finds in his young friend, and this in spite of a relation, of which the irregularity, at first denied and dissembled, becomes at last incapable of disguise. He does not for that go back upon his conclusion that his ward is both reclaimed and irretrievably committed, and that for him to consent to be saved would be to consent to be damned. Meanwhile his own recreancy to his trust having been established, other missionaries come out, and chiefly the prodigal's sister. Her clear New England intelligence and her inflexible New England conscience refuse to be perverted by any sophistries. The improvement in her brother she finds mere degenerations and the relation which has wrought it simply "hideous." But she and Daniel Webster are the only two characters who retain their integrity in the presence of the allurements and the snares to which the young prodigal has gladly succumbed. And it is left in doubt whether their superior virtue is not merely superior density, density with a dash or hypocrisy.

It is really a diabolical dilemma that Mr. James has constructed, and of which he offers to his readers the choice of horns. Somewhere, in another book, he has recorded his regret at not having paid the homage he feels inclined to render to the French spirit. It seems that in "The Ambassadors" he has squared that account. For the confrontation of standards in the book is of New England and of France.

In almost the first chapter it is remarked that "Woollett,"—that is the name of the Massachusetts town—"Woollett is not sure it ought to enjoy." In one of the last, in speaking of the "text" given out by a scene of rural France, it is remarked:

The text was simply, when condensed, that in those places such things were, and that if it was in them one elected to move about, one had to make one's account with what one lighted on.

In the earlier novels, although some dull persons accused him of Anglomania about them, the novelist commonly saw to it that "Europe" did not have the better of it, and flattered the patriotic pride of the American reader. In this the American reader must entertain an uneasy suspicion that the joke is on him, or at most that honors are easy. As with most of Mr. James's recent problems, the subject does not invite discussion at tea parties. But without any doubt he has woven a delightful story about it. He is not to blame if he found the subject altogether too irresistible to be resisted, and except by Sarah Pocock he will be acquitted of an intention to corrupt anybody's morals.

* * *

April 2, 1904

MUNICIPAL MISRULE

Lincoln Steffens's McClure Magazine Papers in Book Form

THE SHAME OF THE CITIES
By Lincoln Steffens
12mo. Pp. 306. New York: McClure, Phillips & Co. $1.20.

In the eloquent and excellent "Introduction" which Mr. Steffens prefixes to these articles of his on municipal corruption (reprinted from McClure's Magazine), he dedicates the volume, "a record of shame and yet of self-respect," to "the accused—to all the citizens of all the cities in the United States." For Mr. Steffens insists and reiterates and insists again that in the misgovernment of American cities "no one class is at fault, nor any one breed, nor any particular interest or group of interests. The misgovernment of the American people is misgovernment by the American people." He cites in proof the cities turned inside out in these articles: St. Louis, a German city; Minneapolis, a Scandinavian city, with a leadership of New Englanders; Pittsburg, Scotch Presbyterian; Philadelphia, "the purest American community of all, and the most hopeless"; Chicago and New York, "both mongrel-bred, but the one a triumph of reform and the other the best example of good government that I had seen."

The foreign element excuse [adds Mr. Steffens] is one of the hypocritical lies that save us from the clear sight of ourselves. Another such conceit of our egotism is that which deplores our politics and lauds our business. This the wail of the typical American citizen. Now the typical American citizen is the business man. The typical business man is a bad citizen; he is busy: If he is a "big business man" and very busy, he does not neglect: he is busy with politics; oh, very busy and very businesslike. I found him buying boodlers in St. Louis, defending grafters in Minneapolis, originating corruption in Pittsburg, sharing with bosses in Philadelphia, deploring reform in Chicago, and beating good government with corruption funds in New York.

These two, according to Mr. Steffens, the ordinary business man who neglects politics and the "big" business man who is perniciously busy at politics—these, between them, make politics what it is. Then he attacks a fetich, what he calls the American "patent quack remedy" for political ills, the cry for the "business man in office." He points out, truly enough, that there "is hardly an office, from United States Senator down to Alderman, in any part of the country to which the business man has not been elected, yet politics remains corrupt." Then he says:

Because politics is business. That's what's the matter with it. That's what's the matter with everything—art,

literature, religion, journalism, law, medicine—they're all business, and all—as you see them. Make politics a sport, as they do in England, or a profession, as they do in Germany, and we'll have—well, something else than we have now—if we want it, which is another question. . . . The commercial spirit is the spirit of profit, not patriotism; of credit, not honor; of individual gain, not national prosperity; of trade and dickering, not principle. . . . But there is hope, not above despair, in the commercialism of our politics. If our political leaders are to be always a lot of political merchants they will supply any demand we may create. All we have to do is to establish a steady demand for good government. . . . If bad government would not "go" they would offer something else, and if the demand were steady they, being so commercial, would "deliver the goods."

Further on in this remarkable introduction Mr. Steffens having held out this hope, and having driven home his thesis of the responsibility of the whole people, having shown that the politician is not necessarily either a bad man or a bad merchant, only flattering and fooling the people because in his observation and judgment they want to be flattered and fooled, speaks out thus: "The grafters who said you may put the blame anywhere but on the people where it belongs, and that the Americans can be moved only by flattery, they—lied." Yet he says also "The spirit of graft and of lawlessness is the American spirit."

At the outset Mr. Steffens insists that what he is doing is "journalism." "This," says he, "is not a book." It is a report with a purpose; the purpose to wake up the American citizen to his responsibility, to make him utterly ashamed of himself. To that end, in the separate articles, Mr. Steffens describes in detail, though telling, as he declares, less than the truth, the conditions discovered in St. Louis when the literal-minded Mr. Folk pried the lid off that town. The first article, called "Tweed Days in St. Louis," tells that story. The third article, called "The Shamelessness of St. Louis," tells the story again, more of it, more names, after it appeared that the Exposition city declined to punish its boodlers at the first convenient election. "I made the facts just as insulting as the truth would permit," says Mr. Steffens of this third article. His object was to discover if St. Louis really was shameless. It is mighty good reading, whatever the object. The second article is concerned with the doing of "Doc" Ames and the city of Minneapolis, "a town of Scandinavians, led by New Englanders." Mr. Steffens tells the story frankly and calls it the "Shame of Minneapolis." This he takes as illustrative of "dirty police graft," as St. Louis illustrates "boodling" or traffic in city franchises and privileges. The fourth article deals with Pittsburg, called "A City Ashamed." The story of the smoky town is that of a great political-commercial machine. It is not scandalous, rather splendid, but the root of it is the exploitation of the public for the benefit of the "ring." For the mere drama, the career of Chris Magee, "boss of Pittsburg,"

is hard to beat. It is true Mr. Quay, when Magee was in declining health, began to beat the old man, to whom Pittsburg is thinking of erecting a statue. His specialty was geniality and street railways. Mr. Steffens gives the great American city of Philadelphia credit for being quite the worst of them all, in that it is apparently rather proud of its machine than otherwise, perfectly content to be exploited. Note this story concerning the sacred right of the ballot—Mr. Steffens does not hesitate to say that the Philadelphians are as much disfranchised as the Southern negroes:

A ring orator in a speech resenting sneers at his ward as "low down," reminded his hearers that that was the ward of Independence Hall, and, naming over the signers of the Declaration of Independence, he closed his highest flight of eloquence with the statement that "these men, the fathers of American liberty, voted down here once. And," he added with a catching grin, "they vote here yet."

Mention is made also of a certain bill "made in Philadelphia," a bill to enable "ring" companies to "appropriate, take, and use all water within this Common-wealth and belonging either to public or to private persons, as it may require for its private purposes." It was a scheme to sell the waterworks of Philadelphia and all other such plants in the State.

The two final articles, dealing with Chicago and New York, represent American achievement (so far) in good municipal government. The story of Chicago tells what has been done there to make the City Council a decent and intelligent body, controlled by reasons, not "considerations." Mr. Steffens thinks much has been done. In New York he praises, not the city Legislature, but the relative goodness and efficiency of the executive departments, and analyzes in a rather acute fashion what he calls the "New York," or "standard American" system of reforming corrupted cities—self-acting but spasmodic. There are words of remark also on the work and personality of Dr. Low, and the like of Mr. Jerome, all very interesting. In spite of Mr. Steffens's declaration, the book he has written is a book. It is a book exceedingly well worth reading, for, whether you agree with him or not, Mr. Steffens has ideas which command attention.

* * *

July 2, 1904

RADIO-ACTIVITY

RADIO-ACTIVE SUBSTANCES
By Mme. Sklodowska Curie
Translated. New York: D. Van Nostrand & Co. Paper. $1.

A useful compilation of papers by Mme. Sklodowska Curie, reprinted from The Chemical News, gives practically all that is known concerning the radio-active substances which of late have attracted so much attention among physicists and chemists. While containing nothing which is not known to those who have followed the progress of laboratory experiment and the development of the literature of radio-activity, it has the specific value of eliminating from the

record of actual work a great deal that is purely fanciful and imaginative, simply by not including it—the omission showing that it has no place in the literature of exact science. It is only natural, perhaps, that around such a subject as radium quacks and empirics should weave a tissue of romance, and that imagination should find for it a thousand fanciful applications to which it has no known adaptation.

In her thesis presented to the Faculté des Sciences of Paris, Mme. Curie deals with facts and exhausts them. With admirable modesty she apportions credit where it belongs, and correctly designates the investigations of Bequerel, Henry, Niewenglowski, Troost, Kelvin, Elster, Geitel, Schmidt, Rutherford, Beattie, Smoluchoeski, and others, assigning to each its relative value in the study of the subject. Her own brilliantly original work is described simply and clearly, and the chemist will be charmed with her account of the method followed in the resolution of pitchblende into its components and the separation therefrom of polonium and radium, the measuring of radio-activity, and the determination of its nature and causes of this phenomenon. It is a valuable monograph, and students of the subject will be glad to have it in so convenient a form.

* * *

October 8, 1904

THE HEART OF A BOY

FARMINGTON
By Clarence S. Darrow
12mo. Pp. 277. Chicago: A. C. McClurg & Co. $1.50.

This is a book insidiously iconoclastic. Under the innocent guise of telling as much of the truth about his boyhood's real feelings as he dares, Mr. Darrow sets about undermining a number of cherished notions and traditional beliefs. As Mr. Shaw says, he "spoils the attitude" of the orthodox writers about childhood, insisting (in all love and tenderness) on the tragedy of the attempt of parents to mold the life of their offspring, to instill virtue into them by precept, to make them pore over books when all the bounding life of youth calls for out-of-doors and play. In the manner of the telling, and in the spirit behind the telling, is a reminiscence of Heine in those autobiographical scraps of his, something of the same feeling of the tragedy of the joys of youth missed and gone, something of the same serio-comic attitude toward other people's meddlings. In fact, the book is very charming, and in much very true. Not a man who has been a real country boy, or who has been cheated by his elders (always with the best motives) of being all the boy he might have been—but, if he has grown up to be ripe enough, will seem to find himself again in many of Mr. Darrow's pages.

Behind the seeming simplicity and frankness of the story of how the boy really felt toward his parents, toward the other grown-ups, toward other boys, toward girls (in the days before the glamour of romance began to distort real values), toward his tasks, of how dimly he understood what he was taught, of

how little he has remembered of all he learned, and of how much less he has ever had any use for of what he was urged to learn, some of us will see a theory of life and education with which we will not entirely agree. But there is far more truth than untruth in the picture; so much truth at times that you are a bit afraid. The book is not exactly glad reading to people who are past the turning point between youth and age, yet to these it will appeal most. By the way, the probability is that, as you set out to read, you will think for several pages that the book is silly. That's while the author is getting you into the child's point of view. Once there it is different, as what we have said above will prove. Our impression is that Mr. Darrow has shown real art in the handling of one of the most difficult forms of literature. The reader can, however, judge for himself; he ought at least to give himself the chance to judge.

It may be well to add that the book purports to be simply a collection of what John Smith, the son of a miller, (a miller who had hoped to be something else and bookish) in a small Puritan town, can remember of his boyhood impressions and the effects upon him of advice, discipline, and education of the kind universal a generation ago, and still more or less orthodox. A visit of John (now turned of forty) to his native town starts the train. The recollections are rambling and disconnected, and most evidently autobiographical.

* * *

December 31, 1904

NOSTROMO

Joseph Conrad's New Tale of Life and Adventure in Tropical America

NOSTROMO: A Tale of the Seaboard
By Joseph Conrad
One volume: Pp. 620. New York: Harper & Brothers. $1.50.

Mr. Conrad's new story reveals its author's best qualities. It is noteworthy for good construction, good style, for the clearness and strength with which its many complex characters are developed, and particularly for the vivid reality of the scene and the comprehensive, intelligible, and masterly manner in which it reveals the true inwardness of the methods of government that prevail in that part of America that lies west and south of the Caribbean Sea.

There are plenty of stirring events sprinkled through it, for the book teems with the particularly tragical form of revolution and intrigue that is indigenous to tropical America. One cannot easily forget the sense of underlying horror and dread which the author has imparted in some subtle way to more than one of his stories, including this one, generally without allowing the vague feeling to develop into anything more tangible than one of those shadowy, inexplicable premonitions with which all people are more or less familiar. That is but one of the innumerable delicate and masterly touches to be found in Mr. Conrad's latest work.

But "Nostromo" is, upon close examination, something more than the "novel of present-day adventure" which the advertisements proclaim it—which is, perhaps, all that the careless reader could be expected to find in the book. It is not by any means the first novel in which the highly picturesque and exciting incidents connected with a South American revolution have furnished the kind of plot that is warranted to hold the reader's breathless interest from start to finish. But "Nostromo," though possessing all the minor virtues of one of these melodramatic stories, in which foreign heroes, native rascals, rich mines, courage and treachery are cleverly mingled, differs from them all in putting the old properties and persons to a serious psychological use, far removed from anything that the conventional novelist has himself ever discovered in them, much less revealed in his novel.

The Costaguana Revolution, which looms so large in Mr. Conrad's story, is not an end in itself, but simply the means which he adopts as best fitted to enable him to analyze for our enlightenment the character of those neighbors of ours to the south with whom such dramas are of painfully frequent occurrence. Never before, surely, have they been analyzed with such brilliant and comprehensive accuracy as in this book. Every character in "Nostromo" is a type, thought out from intimate knowledge and with infinite care, and described and developed with supreme skill. They are not placed on the novelist's mimic stage like puppets and then moved hither and thither to suit the usually more or less improbable exigencies of the plot; they are living, reasoning human beings, swayed by impulse, custom, and the circumstances in which they find themselves, and their characters and destinies are evolved by their author as slowly, surely, and remorselessly as Nature herself accomplishes her ends.

But apart from its truth and comprehensiveness as a picture of conditions in the South American republics, "Nostromo" was undoubtedly meant by its author to be read as a parable upon modern conditions the world over, and it is this deeper and finer significance of Mr. Conrad's story that so many seem to have missed or misunderstood. The events that in the story lead up to and follow the Costaguana Revolution are simply a parable upon the prevalent and erroneous belief that industrial prosperity and peace, and the opportunity to earn in safety individual livings are any guarantee of the ultimate contentment and progress of a people. At the beginning of this story the country of Costaguana is in a state of seemingly utter and hopeless chaos, in which the Government might be described as a body organized to exploit the people for as long a time as possible before giving place to the next stronger organized body intent upon following out the same programme. These successive bands of legalized robbers had applied this principle of extraction until the country's outlook seemed hopeless. At this point a young Englishman, native-born, but reared and educated in England, came into possession, through a concession of the Costaguana Government, of some abandoned silver mines. As it was much to his own interest to make the workings pay, and as he was an able business man, Don Carlos Gould soon had the San Tomè Silver Mine in excellent running order. Incidentally he was, to start with, a better man than the average, had high ideals, was as honest as the Costaguana business methods made possible, and looked upon himself in the light of a savior of the Costaguana people because he had established in their country a great and successful enterprise that furnished them with employment and gave to the region the aspect of being prosperous, law-abiding and secure. In the course of time he became the head and front of the country's activity, while its people were little more than helpless appendages of his mine. Finally, when at the height of his prosperity and popularity, and when his commercial scheme for reclaiming Costaguana seemed established on a sound and lasting basis, his whole carefully constructed edifice of power toppled over, for the simple reason that his ideals had been gradually lost sight of in the exigencies of business. The continuance of his successful mining operations had come to seem to him of so much more importance than any squeamish considerations of abstract principles that he had weakly submitted to the extortions of the Government as the price of being let alone.

Inevitably matters drifted to a crisis, and it was merely a question of blowing up the mines or letting the Government have possession of them altogether. The result was that Don Carlos Gould found himself the worst hated man in Costaguana, and the last condition of the Costaguaneros was worse than their first, or at least as bad.

In Mr. Conrad's story, every one who seems to be working for the benefit of poor Costaguana is really working for himself, to the ultimate ruin both of himself and of the object of his solicitude. This is true of Carlos Gould, the really upright, well-intentioned man, blinded by a wrong conception of success; it is true of all the rascally officials; and it is true of Nostromo himself, the poor unknown Italian sailor become "Capataz de Cárgadores" by virtue of his passionate ambition to be popular, noted, a man to be pointed out with pride by his townspeople. As Nostromo's ambition was the most empty and ineffective of all, yet at the same time the highest, perhaps, in an abstract sense, his name (itself one fixed on him by the foreigners) is given to the story as its symbolic title.

There is no doubt that it is a great book, greatly done, and of immense value if only to show, as it so convincingly does, that though South American revolutions are thought excellent subjects for cheap wit and sarcasm, and are commonly referred to as "comic opera revolutions," they are far from being jokes to the people who take part in them. To the participants they spell ruin, suffering, death, or tortures worse than death.

* * *

February 4, 1905

LAFCADIO HEARN

A Collected Edition of Short Stories and Papers Written in the Later Years of His Life

EXOTICS AND RETROSPECTIVES
By Lafcadio Hearn
Pp. 299. Boston: Little, Brown & Co. $1.25.

SHADOWINGS
By Lafcadio Hearn
Pp. 268. Boston: Little, Brown & Co. $1.25.

A JAPANESE MISCELLANY
By Lafcadio Hearn
Pp. 305. Boston: Little, Brown & Co. $1.25.

IN GHOSTLY JAPAN
By Lafcadio Hearn
Pp. 241. Boston: Little, Brown & Co. $1.25.

In the four volumes included under the general title of "Stories and Sketches," Mr. Lafcadio Hearn's admirers have a uniform edition of the various short papers written by him during the last half dozen years of his life and in part published separately as "In Ghostly Japan," "Exotics and Retrospectives," "Shadowings," and "A Japanese Miscellany."

The last-named title would have fitted the whole series excellently well, for it is altogether Japanese, and the range of topics discussed is varied to a perfectly amazing degree. Bits of antiquarian and ethnological investigation; little papers of research in all kinds of interesting matters relating to the people whom the author loved so well; Japanese stories retold from curious old Japanese books, with Mr. Hearn's own version of traits and occurrences that have come under his observation; a few of the exquisitely artistic and suggestive tales, impressions, descriptions which no one but a Hearn could write—these fill the four volumes with such a wealth of entertaining as well as valuable material that, in reading them, one constantly marvels how any one man found time or patience to gather and assimilate it all into such orderly shape. It is here that we gain some idea of the painstaking study, the infinite capacity for details, the special sympathy and appreciation that formed the solid basis of that wonderful power of vivid portrayal and poetic fancy that have made all of Mr. Hearn's work unique and delightful.

If he has idealized Japan and the Japanese beyond anything that they present to the ordinary superficial view, it is not from any lack of exact and intimate knowledge of them, but because his long association with the country and people and his sympathetic study of their literature have given him an insight into their characteristics that no other foreigner has ever even approximately obtained. Practically Lafcadio Hearn became a Japanese, for he lived their own life among them, adopted their religion and customs to such an extent that he was disliked by the foreign missionaries as much as he disliked them and all their efforts, and was shunned by the other European residents of the country. It is to be remembered that it is never of the new, modern, hustling Japan of the twentieth century that he writes, but of the old regime and of as much of that precious period as has survived contact with imported Western civilization. In his view all that tended to obliterate old Japan was simply unbearable desecration, and the very evident purpose of all his writings on Japanese matters has been to preserve at least the record of the vanished beauties and glories of his beloved Nippon. In these books his one pungent criticism of the work of the missionaries is the little story called "The Case of O—Dai," which would seem to put the weight of the argument on Mr. Hearn's side.

From so much that is weird, fascinating, exquisite, brilliant, it is difficult to choose for illustration so as to give any idea of the riches of entertainment that are spread out before one in the pages of these four books. The chief wonder is how their author has avoided the monotony that almost invariably attaches its unwelcome mark to any such collection of sketches and stories. A constantly varying impression is given that preserves one's unflagging interest until the last page is turned and the last glimpse into the strange soul of old Japan has been taken. Especially interesting and suggestive are a little group of essays called "Retrospectives," and another called "Fantasies." The first are psychological and aesthetic in character—a spot of relief amid the fantastic imaginings of the Oriental mind—and touch in Mr. Hearn's most characteristic manner upon several attractively subtle questions, such as the secret of our first impressions of our fellow-men, the essential qualities in what we call beauty, the psychology of color (particularly blue and red), of music, and of the human touch. The "Fantasies" discuss "A Mystery of Crowds" and some of the author's encounters with the horrors of the supernatural, and at least recognize, if they do not explain, some of the queer imaginings of childhood with which most of us have been at some time unpleasantly familiar.

No small part of these papers is devoted by the author to a very thorough description of the musical insects of which the Japanese are so fond, and he goes with almost equal thoroughness into the question of frogs and dragon-flies, the nomenclature of plants and animals, Japanese female names, and Japanese songs. This part of the book may not make as interesting reading as the tales translated from Japanese story books, unthinkably ancient, but it represents a vast amount of patient study and research on the part of Mr. Hearn, and it is by no means dryasdust information. It interprets a very distinct side of Japanese character.

Certainly no one, in view of modern happenings in the Japanese nation, can afford to miss the insight into the very spirit of Japan, which is to be gained from these books of Lafcadio Hearn's. He, more than any other English writer, was fitted to be their prophet, and he nobly began his task, even if he did not have opportunity to complete it. And yet the most devoted of Hearn's admirers must smile to note that

he calls Pierre Loti the greatest of living prose writers. The assertion is full of significance—in regard to Hearn himself.

* * *

April 22, 1905

MRS. CHESNUT'S DIARY

A Chronicle of Southern Life by the Wife of a Confederate Statesman and Soldier

A DIARY FROM DIXIE
As written by Mary Boykin Chesnut, wife of James Chesnut, Jr., United States Senator 1859–1861, and afterwards Aide to Jefferson Davis and a Brigadier General in the Confederate Army. Edited by Isabella D. Martin and Myrta Lockett Avary. Pp. xxii.–424. New York: D. Appleton & Co. 1905. Price, $2.50.

Still the civil war literature grows! Volumes of reminiscence, letters, and formal treatises have made their appearance every year since the close of the great struggle. More than 309 separate works treating of the events of 1800 to 1860 are listed as authoritative historical sources in the best bibliographies of the subject, and twice as many others have probably some claim on the student's attention. The demand for information about the war has not, however, been satisfied; each new volume meets with ready sale, and the story teller who can dress up the war heroes with a little romance and less historic incident is sure of his fortune and his fame. The truth is we are all beginning to see that great crisis in American history in proper perspective. As Gen. Gordon said in his valuable book last year, and as Gen. Lee taught all his life, there was not all of right on one side nor all of wrong on the other. And as time goes on it will probably become clear that the war was but one of the great stages in the evolution of "democratic Government on the earth."

The author of "A Diary from Dixie," the wife of James Chesnut of South Carolina, was a very intelligent woman; she was herself the daughter of a United States Senator from Alabama and her husband was a Senator in Congress for two years prior to the outbreak of the war; and during the war her time was spent in Charleston, Columbia, Richmond, and Camden, S. C. She was an intimate friend of Mrs. Jefferson Davis when both were living in Washington during the late fifties, and the trying years of the war, it seems, brought the two ladies closer together than they had ever been. A number of quotations from Mrs. Davis's letters attest this.

In tone and character this new war book is admirable, though, of course, there is no general scheme or plan or even purpose except to record the talk of the time with occasional expressions of personal views which in most instances are far from being tedious. Indeed, the circle out of which come these pleasant notes of the past is a sufficient pledge as to the nature of the work. James Chesnut, Jr., was the son of one of the wealthiest Southern planters, and his mother, still living

at the outbreak of hostilities, was the sister of the wife of the famous Philadelphia lawyer, Horace Binney. Both the Chesnuts, father and son, like so many other Southerners of rank, were educated at Princeton College. The Chesnuts, with their up-country neighbors in South Carolina, were not extremists; they had not been ardent nullifiers. The author of this diary regretted the seeming necessity of secession, and she realized, as did her husband, the great odds against which the new government would have to contend. She wrote, at Montgomery, Ala., Feb 19, 1861:

I am despondent once more. If I thought them in earnest, because at first they put their best in front, what now? We have to meet tremendous odds by pluck, activity, zeal, dash, endurance of the toughest, military instinct. We have had to choose born leaders of men who could attract love and secure trust.

But she hastens to add, not without a sigh:

Everywhere political intrigue is as rife as in Washington. . . . Everybody who comes here [Montgomery, Feb. 25] wants an office, and the many who, of course, are disappointed raise a cry of corruption against the few who are successful. I thought we had left all that in Washington. (Page 9.)

From Montgomery Mrs. Chesnut goes to Charleston to witness the attack on Fort Sumter. She had hoped against hope that bloodshed might be avoided; but her own husband, as aide to Gen. Beauregard, bore the final message to Major Anderson announcing that the guns of the Confederacy would open fire at 4:30 A. M. on that fateful 12th of April. She fell upon her knees at the firing of the first gun. Everybody, nearly, she says, had gathered in that wealthy centre of Southern life and activity to witness the opening contest—it was a pleasure to live there, but for the terrible mission on which most men had come. She speaks of Roger Pryor's speech urging action and of Louis Wigfall's abuse of Jefferson Davis for not having been a more ardent secessionist.

A few days later the Chesnuts are again in Montgomery. A portentious conversation with Alexander Stephens is recorded in the diary:

At Mr. Toombs's reception Mr. Stephens came by me. Twice before have we had it out on the subject of the Confederacy,—once on the cars, coming from Georgia here; once at supper, where he sat next me. To-day he was not cheerful in his views. I called him half-hearted, and accused him of looking back. . . . He was deeply interesting, and he gave me some new ideas as to our dangerous situation. (Page 49.)

From the very beginning despondency, intrigue, and bitter hostility dogged the footsteps of President Davis. Wigfall is an open enemy; Barnwell Rhett of South Carolina was a dis-

gruntled politician, while the friends of Howell Cobb and Robert Toombs maintain that the Southern President ought to have been taken from Georgia. And some older politicians still nursed grudges against Davis for supposed offenses dating back to Pierce's Administration. Speaking of a certain unnamed Judge, the author says:

> Mr. Chesnut persuaded the Judge to forego his private wrong for the public good. What a pity to bring the spites of the old Union into this new one. It seems to me already men are willing to risk an injury to our cause, if they in so doing hurt Jeff Davis.

All through the book we find accounts of the ever-increasing enmity of leading Southerners, both in Congress and in the field, toward the Confederate Administration. Soon after the author takes up her residence in Richmond Mrs. Joseph E. Johnston's remark that Mrs. Jefferson Davis was a "Western belle" was going the rounds of high society. A little later Mrs. Johnston modified her remark so that it stood: "Mrs. Davis is a Western woman" simply. Other influential society ladies began to criticise the President's family, contrasting them with Mrs. Robert E. Lee and her daughters, who were said to spend all their time knitting and sewing for the soldiers, declining invitations to take part in social gatherings. The author resents the insinuations and attacks on Mrs. Davis. But the opposition to the President was of a stronger texture than society gossip. The failure to follow up the victory of Manassas must be laid to the account of some one—it was decided to make Mr. Davis responsible for this. Then the President arranged the appointment of the general field officers in such a way that Joseph E. Johnston was out-ranked by men who had been his inferiors in the old army. Immediately Johnston and all his party took up the matter. Newspaper wrangles followed. Toombs, too, becomes so disgusted with the Administration that he resigned in such a way that every one understood his action as a protest against the conduct of public affairs. Wigfall goes so far as to wish he might see the President hanged, (Dec. 5, 1864): "From a small rill in the mountain has flowed the mighty stream which made at last Louis Wigfall the worst enemy the President has in Congress," and a letter from Mrs. Davis, bearing the date of Nov. 20, 1864, says: "The temper of Congress is less vicious, but more concerted in its action." Mrs. Chesnut silenced many a tirade against Mr. Davis; she greatly admired him and thought him admirably fitted for his position. That so many and such eminently respectable characters should array themselves against the Chief Executive was due, she thought, to the Southerners' views of personal and political liberty. These bold secessionists and "fire-eating" soldiers were impatient of restraint at every point. They could not permit any one, even for their own country's sake, to exercise authority over them.

Unconsciously, too, the author records a cause of this ill-feeling: The Confederate Government, in its desire to conciliate prominent families, was too lavish in bestowing important offices on members of these families. Men laughed when James M. Mason was sent to London. Mason had, to be sure, been a prominent leader prior to the war, but he was also a close kinsman of Adjt. Gen. Cooper. Robert E. Lee was thought to be another favorite—he was a close kinsman of Mason. And Custis Lee was put on Davis's staff. Northrop, a personal favorite of Davis, was kept in the commissary department throughout the war though protests were constantly pouring into the President's office. Bragg and Pemberton, as all the world knows, were rapidly elevated to high commands without having "worked their way up." If the President liked one there was no way of preventing his promoting him—even though the cause for which all were struggling suffered visibly. Still, as has been observed, Mrs. Chesnut had no intention of criticising the President.

When the end came it seems to have been expected, and the author consoles herself by the reflection that foreign enlistments, foreign loans, and overwhelming odds were the causes of the disaster. The overthrow of slavery appears almost to have come as a relief rather than as an irreparable injury. Her husband lost money on his negroes during the war, and her father-in-law lost a half million in bonds or other securities because of the necessity of supplying his thousand slaves with provisions and clothing at a very high price and at a time when their labor could not be profitably employed. That the writer lived within the belt of country laid waste by Sherman's march and suffered some rather small losses seems not to have colored unduly her entries concerning the march of the "modern Attila," as some people term him. Some sort of proof, though it is quite inconclusive to the historical student, that the responsibility for the burning of Columbia rests upon Gen. Sherman is offered.

To sum up: This diary has decided historical value, in that it shows so much of the spirit which prevailed in Charleston and Montgomery during the Winter and Spring of 1861; further, it is an intimate record of an intelligent on-looker in Richmond during a greater portion of the war; it shows more clearly than usual the working of cliques and groups of opposition leaders and the effect of this on Mr. Davis's spirit rather than his policy; it offers some unintended proof that the Confederacy fell because of the failure of the people and their leaders to cooperate vigorously in advancing the cause they had espoused.

There are some discrepancies, some events recorded earlier than the date of their occurrences, and the writer's habit of accumulating her information and "writing up" the happenings of some weeks at a sitting militate seriously against the accuracy of the work. It is, however, a lively, picturesque, and honest record of what was seen by one pair of eyes and heard by one pair of ears at a momentous epoch in American history. Both the student and the general reader will enjoy and profit by a perusal of these vital pages.

WILLIAM E. DODD
Randolph-Macon College, Virginia

* * *

May 19, 1906

RISE OF THE WEST

Fourteenth Volume of the American Nation Series Treats of the Period When the West Was Coming Into Its Own

THE AMERICAN NATION: Vol. XIV. Rise of the New West, 1819–1829
By Frederick Jackson Turner, Ph.D.
New York: Harper & Brothers. $1.50.

From the exploits of George Rogers Clark during the revolution, which made the Western country a part of the United States, to the election of Andrew Jackson, the first President chosen from a State west of the Alleghanies, the East looked upon the West as provincial. The horror with which John Quincy Adams turned the administration over to Jackson and his friends represented a real antagonism between the two sections. Prof. Turner writes the history of the United States during the period when the West was coming into its own, and the boisterous frontier was being transformed into States rivaling their sisters along the Atlantic. The rise of the West he takes as the main theme of American history during the fifteen years following the War of 1812.

Beginning with nationalism, the consolidation of all parties into one, the Republican, and an "Era of Good Feeling," the period ends in sectionalism, the resurrection of parties and factions, and nullification, the basis for future secession. The domination of the Virginia dynasty, nominated by Congressional caucus, gave way to the rule of a Western President nominated by the people. And the theory upon which the Constitution was construed grew steadily narrower. It was due mainly to Western individualism cooperating with Southern particularism that activities formerly regarded as legitimately within the scope of Federal control were handed over to the States or to the people.

Prof. Turner has, of course, to deal with affairs not exclusively Western, as his subject is the history of the Nation from 1819–1829. The most important event of the period from the Constitutional point of view is the Missouri compromise, not by any means an exclusively Western concern. The further spread of slavery and the policy which the Nation was to pursue toward the West were matters of general interest. The Missouri debate was the first discussion in Congress on a grand scale of the nature of the Federal Union, and this aspect of the dispute, it seems to us, Prof. Turner does not emphasize sufficiently. The circumstance that gave the opponents of the restriction of slavery their main strength was that they were at the same time defending the principle of the equality of the several members of the Union. The advocates of slavery restriction were forced to argue in behalf of a union between unequals, between "pigmies and giants," as Senator Pinkney of Maryland put it. The admission of Missouri on terms of inequality with the other States would have meant that Congress would pursue toward the West a provincial as opposed to a Federal policy, that the new States would come into the

Union with less powers than the older States possessed. The Southern slavery extensionists were on firm Constitutional grounds and skilfully appealed to Western pride. They won their principle, and Missouri entered on a footing of equality, but Congress prohibited slavery in almost all the rest of the Louisiana purchase.

After the "Era of Good Feeling" parties began to develop, clustering about the men who were nominated for the Presidency in 1824—Adams, Clay, Crawford, and Jackson. The conflict was largely but not wholly personal. Crawford represented the principle of nomination by Congressional caucus, and was badly beaten. The nominating caucus dropped out of American politics, and was supplanted by the party nominating convention. Clay stood for the "American System," protection. He and Adams also stood for a broad policy of internal improvements by the Federal Government. Jackson stood for the West, for the right of the people to name their own candidate, for the independence of the Executive. He was the people's choice, but Clay's influence in the House of Representatives gave the Presidency to Adams; thereby furnishing Jackson and his supporters with the rallying cry of "Corrupt Bargain." Clay received, as he had probably expected, the Secretary-ship of State. There was a "tacit understanding" the existence of which Adams seemed to admit in his diary when he wrote "I walk over fires." There was no vulgar bargaining, but there was a service rendered and a reward paid, and to Jackson it would naturally seem about the same thing. The triumphant election of "Old Hickory" is reserved for the next volume in the series.

As a Western man, in touch with the finest collection of materials on the West, the Wisconsin Historical Society, Prof. Turner has enjoyed every facility for turning out a scholarly and sympathetic history of the rise of the West. Like the other volumes in the series, this is based largely on original sources. It is accompanied with an essay on the authorities for the period, and a good index.

R. L. S.

* * *

December 22, 1906

LEW WALLACE

The Posthumous Biography of the Author of "Ben-Hur"

LEW WALLACE: An Autobiography
Portraits, maps, and illustrations. In two volumes. Volume I., pp. xiv.–502. Volume II., pp. xil.–526. Crown Svo. New York: Harper & Brothers. $5.

This work is divided into two parts, the first of which was put into shape for publication by Lew Wallace himself; the second, by Susan Elston Wallace, his widow, with the assistance of Mary H. Krout.

Part I. brings the narrative up to July 9, 1864. It includes a detailed account of the events of Lew Wallace's boyhood,

youth, and young manhood; of the circumstances which led him at fifteen to write his first romance (never published) entitled "The Man-at-Arms: A Tale of the Tenth Century"; of the conditions under which, at seventeen, he began the composition of "The Fair God," which was not destined to be finished for many years; of his hardships as a volunteer in the war with Mexico; of his experiences as a "half-baked" reporter, editor, and lawyer; of his courtship and marriage; of his connection with Indiana politics in the years immediately preceding the civil war, during which Indiana and Illinois—by reason of the Lincoln-Douglas campaigns—were storm centres, and of the part he played in the civil war up to and including the engagement of Monocacy Junction. More than 500 pages of this section of the book are devoted to the civil war period, and they contain many dramatic descriptions of battle scenes which are every way worthy of the author of the unforgettable sea fight and chariot race. On the other hand, they contain so much that is apologetic or controversial regarding points of strategy or discipline of no possible interest now, to others than historical or military specialists [Wallace, the soldier, had a fatal faculty of incurring the disfavor of his superiors], that whole chapters will probably be skipped by the general reader.

By far the most interesting part of this volume of reminiscences is the first hundred pages (to this section the title "The Call of the Wild" might well be given), in which Gen. Wallace describes the irresistible attraction exerted upon him as a boy and youth by the fields, the woods, and the streams, and tells how he finally conquered his appetite for vagabondage and made a man of himself.

Lew Wallace was born in Brookville, Ind., April 10, 1827. Five years later the Wallace family removed to Covington, on the shores of the Wabash River.

"I do not remember," says Gen. Wallace, "how I made the acquaintance of the river, but as my sixth year was the beginning of a habit of truancy, which followed me through my school terms and has even yet to be struggled against, it may be presumed that I ran away to see it and that nobody was with me."

Six-year-old Lew made friends with the Covington ferryman and spent whole days with him, going through the form of helping him propel the ferryboat and fishing and swimming with him between trips.

A little later his mother died, and after that he literally ran wild. "Two years more," he says, "went by in Covington, and, though supposedly given to school, the Summers were really spent in the woods and along the river and the Winters in sledding and trapping birds."

At 9 he ran away from Covington to Crawfordsville because he could not bear the separation from his elder brother, William, who had been put into college there.

Despite the irregular manner of his coming, he was admitted (out of respect for his father, then Governor) into the preparatory department of the college; but he heard again the call of the wild and stayed only a few weeks. "The college building," he says, "was in the woods west of Crawfordsville. North of it, under a hill, there was a stream—half river, half

creek. And they, the woods and the little river, invited me, and I took to them. Returning once, the tutor caught me, and in full session of the class stood me on a stove through the afternoon. At the letting out I escaped for good."

He was then put into a county seminary kept by an Episcopal clergyman, who tanned his hide mercilessly. "Between this teacher and myself," he says, "the casus belli were not recurrent, but continuous—with intermissions during the severest snaps of Winter. The river was a siren with a song everlasting in my ears."

In 1837 Lew was taken by his father to Indianapolis. Frequenting the studio of a portrait painter there, he conceived a passion for painting and painted a picture in the home attic with a brush made from hairs plucked from the tail of a dog, colors "swiped" from his painter-friend, and castor oil likewise "swiped" from the servant girl's sickroom. His new accomplishment got him into trouble with his next teacher, who, like all the teachers into whose keeping he was given, "kept a ferule and a bundle of selected rods." One recess, while alone in the school room, Lew pictured on the blackboard a rabbit with the head of the schoolmaster. The master quickly discovered the culprit. "Then," says Wallace, "he took the fasces from the wall. In the midst of the hush pervading he summoned me to the stand and beat me until the blood ran down my bare legs. His wrath appeased, he allowed me to take my seat, then bade me wipe the offense off the board. I declined. He started for me, fury in his face. Directly in my rear there was an open window. Before he could reach me I jumped out of the window, and taking the gait of an antelope startled by hunter and hounds, fled, never stopping until under the roof of an old farmer friend three miles in the country."

At 13, taking advantage of his father's absence from home, he "represented him" at the convention held at Tippecanoe in the interest of Gen. Harrison. "That my delegacy was by self-appointment," he says, "did not, as I saw it then, interfere with its attractiveness. In plainer terms, I ran away."

His next escapade was starting down the Wabash with another boy in a provisioned and armed skiff en route for the Texan war of independence. The expedition was held up when it had proceeded ten miles, and he was brought back to Indianapolis ingloriously by a constable.

This exploit was the last straw for the patience of Lew's father. Although the boy was not always larking—indeed, having at last found a teacher who understood him, he had developed an omnivorous taste for reading and considerable skill in writing—the much-tried parent decided to force him to earn his own living. Lew was by no means averse to doing so. He set about it with a will—and succeeded. On his first pay day he bought a rifle and went squirrel shooting, but from that time he rarely, if ever, allowed his craving for the wild to interfere seriously with an important undertaking.

Part II. tells of the role played by Gen. Wallace in the closing events of the civil war, and in the trial of the assassins of Lincoln; of the two years spent by him in Mexico following the fortunes of Juarez; of the final revision, the publication,

and the reception of the "Fair God"; of the failure of his tragedy, "Commodus"; of the composition of Ben Hur and its phenomenal success; of the troublesome problems he had to deal with as Governor of New Mexico; of his brilliant mission to Turkey, and of his careful and studious preparation of "The Prince of India."

This part of the book, although ably edited and made up largely of Gen. Wallace's letters and memoranda, lacks necessarily the literary charm of the first part. It is welcome, because it supplies the facts of that period of his life in which he achieved the most in literature, but it adds little or nothing to the reader's knowledge of his vigorous and versatile personality. It is greatly to be regretted that Gen. Wallace did not live to impart to this portion of his life-story the finish and fire he was wont to impart to every piece of writing that he gave to the world.

* * *

February 2, 1907

WILLIAM YEATS

The Poet of the Celtic Revival in a New Edition

THE POETICAL WORKS OF WILLIAM B. YEATS
In two volumes. Volume I. New York: The Macmillan Company. Per volume, $1.75.

By BLISS CARMAN

. . . Since the appearance of his first volume of verse we have all known Mr. Yeats for one of the most authentic of recent poets, the master of a very rare and fine gift. And since his lecture tour in America a few years ago we have known him for his fervid patriotism as well. Through his books alone he made the impression of a shy and elvish personality, but when he appeared in reality he was found to have plenty of fire and enough practical sense to carry home a bagful of good American money for his Irish theatre.

The first collected edition of "The Poetical Works of William B. Yeats," in two volumes, must command some attention from critics at least. It is a pity that the second volume, to contain the plays, could not have been issued along with the first, but had to be delayed until the Spring. Unlike many lyric poets, Mr. Yeats would gain distinctly in importance through a consideration of his dramatic work. He has an easy command of blank verse, and a genius for simplicity without commonness, very rare indeed. "The Land of Heart's Desire," which has been put on the boards successfully more than once, shows a masterly blending of homely phrase and scene with true poetic fancy and dignity. . . .

There are very few men who have this exceptional gift of touching upon familiar things without becoming flat and common. But Mr. Yeats is never common and never bombastic. He is sometimes obscure in his mysticism, at times almost unintelligible, but he is never turgid. His sincere taste and scrupulous workmanship save him from that. His obscu-

rity is not a matter of treatment, but of mistaken judgment. He is so steeped in the old myths of his native country that he feels them constantly in his thought, and forgets that they are entirely unfamiliar to his English readers. So that many of his references are quite blind. That Mr. Yeats is himself aware of this is attested by the fact that in one of his separate volumes, "The Wind Among the Reeds," he has added extensive explanatory notes. One of these on "Aedh, Haurahan, and Michael Robartes in these Poems," runs as follows:

"These are personages in 'The Secret Rose'; . . . I have used them in this book more as principles of the mind than as actual personages. It is probable that only students of the magical tradition will understand me when I say that 'Michael Robartes' is fire reflected in water, and that Haurahan is fire blown by the wind, and that Aedh, whose name is not merely the Irish form of Hugh, but the Irish for fire, is fire burning by itself. To put it in a different way, Haurahan is the simplicity of an imagination too changeable to gather permanent possessions, or the adoration of the shepherds; and Michael Robartes is the pride of the imagination brooding upon the greatness of its possessions, or the adoration of the magi," &c.

When a man writes poetry on the supposition that his readers will have the knowledge of such myths as these in their heads, he might as well be writing for a tribe of pigmies in the heart of Africa. Who on earth but a pedant cares what Haurahan or Michael Robartes may mean?

As a matter of fact Mr. Yeats is not pedantic at all. He is far too genuine a poet for that. And the fact that he is occasionally carried away by his love for the old fairy legends of his native land must not be held against him. It is only occasionally that he transcends common sense and loses sight of reason in a fog of mysticism. The very volume from which I have just quoted the amazing note contains a lyric as simple and captivating as "The Fiddler of Dooney."

When I play on my fiddle in Dooney,
Folk dance like a wave of the sea;
My cousin is priest in Kilvarnet,
My brother in Moharabinee.

I passed my brother and cousin;
They read in their books of prayer;
I read in my book of songs
I bought at the Sligo fair.

When we come to the end of time.
To Peter sitting in state,
He will smile at the three old spirits,
But call me first through the gate.

For the good are always the merry,
Save by an evil chance,

And the merry love the fiddle,
And the merry love to dance.

And when the folk there spy me
They will all come up to me
With "Here is the fiddler of Dooney!"
And dance like a wave of the sea.

Another very beautiful, homely poem in a like manner is "The Ballad of Father Gilligan" It recounts how the old man was called to the bedside of a dying parishioner, but instead of keeping his appointment at once fell asleep of weariness. When he awoke and hurried to the house he found the man dead, and his wife fancying that he [the priest] had been with him just before he died.

The old priest Peter Gilligan
He knelt him at that word.

He who hath made the night of stars
For souls, who tire and bleed.
Sent one of His great angels down
To help me in my need.

He who is wrapped in purple robes,
With planets in His care,
Had pity on the least of things
Asleep upon a chair.

In ballads like these Mr. Yeats is on the firm ground of poetic material, dealing with legends that are perfectly intelligible, and human emotions that are perfectly familiar. He needs no elaborate notes for these poems. That a poem should need to be explained condemns it at once. But any one can understand the story of old Peter Gilligan, and it will arouse a responsive sentiment of loving admiration, while all the mystification of the Secret Rose and Michael Robartes leaves us vacant and unmoved. And yet in the preface to the present edition, speaking of such poems, Mr. Yeats says: "I read them now with no little discontent, for I find, especially in the ballads, some triviality and sentimentality"

Mr. Yeats may be said to belong to that class of poets who err through an over-passionate devotion to their ideals. It is very easy for a poet, in his loyalty to intuitions of the imagination, to grow overmystical and to neglect the demands of intelligence and understanding in poetry. But great poetry must be rational as well as imaginative, it must spring from the actual and have a bearing upon the actual. It must deal with life as we know it; and when it ventures into the world of dreams, it must do so with caution. We must all love Mr. Yeats's exquisitely beautiful romance and glamour and lyric quality; but we can scarcely afford to have them made any more prominent and pervasive in his work than they are already, for fear we should lose his drift altogether.

* * *

May 16, 1907

IT'S A "BLURB" NOW TO PUFF NEW BOOK

Gelett Burgess Coins Odd Term for the Booksellers'
Annual Dinner

THREE M'S IN LITERATURE

Prof. Wickes Calls for Might in Words, Mirth in Treatment,
and Music in Style

Bromides, sulphites, and those who live by the "blurb" to the number of 350 sat down to dinner last night at the Aldine Club, 111 Fifth Avenue. It was the annual dinner of the American Booksellers' Association, and Gelett Burgess, author of "Are You a Bromide?" sent to every guest a copy of his work. Moreover, he had printed on the cover an example of the publisher's puff, which he dignified by the name of "blurb." This was it:

"Say! Ain't this book a 90 horse power 6-cylinder seller? If we do say it as shouldn't. We consider that this man Burgess has got Henry James locked into the coal bin telephoning for 'Information.' "

In his speech he went further and defined a "blurb" as a "sound like a publisher," and declared it was invented by the publisher who wrote across a copy of the magazine named after him, "I consider this number the best ever written."

He added that it was not the literary editors of the world's greatest newspapers who made the book, but the little girl with the pigtail braid and the box of caramels who looked over the pages to see how much conversation was in it.

"I'd rather go into the public library of an Iowa town," he said, "and find written on my book, 'This is a good book,' than have it written up in the most famous journals. It's the little girl who pays our royalties and your profits. And if she ever does grow up and finds life isn't all Richard Harding Davis, and love isn't all Robert Chambers, and death isn't all Hall Caine, we may perhaps hope for an American literature which would make even Shakespeare say, 'You've give me "Measure for Measure." ' "

The guests of the American Booksellers' Association were greeted by A. Wessels for the Booksellers' League, Simon Brentano for the booksellers of New York, and Fred A. Stokes for the publishers. A rising vote of sympathy was passed with the family of the late Dr. W. H. Drummond, the poet of the French Canadians, and then the President, W. Millard Palmer, introduced the Right Rev. Dr. Ethelbert Talbot, Bishop of Central Pennsylvania.

He announced himself as the author of one book and told of his difficulty in persuading his daughter, who acted as his stenographer, of the necessity of presenting the language of his own people of the West in all his native profanity.

"They have good hearts and their language does not show any real baseness," he said. "Why, a little Italian heard me preach one day in the West, and complimented me next morning. 'Damn pretty church, damn big crowd, damn good

talk,' was how he put it. But my daughter thought it was undignified for one occupying my high position to reproduce such language.

" 'Father, dear,' she said, 'of course I think your book's all right, but then I'm your daughter. Perhaps McClure's may take one or two of your stories. They do publish funny things sometimes, you know.'

"My heart sank, and it was a great relief for me afterward to tell her that Harper's thought if I had used the customary dashes I should have emasculated my story."

Among the other speakers was Prof. W. K. Wickes, who put in a plea for the three M's in the coming book, Might in words, Mirth in the treatment of the subject, and Music in style.

The Century Company sent to the guests copies of A. E. W. Mason's "Running Water," and brass bowls were handed around to "blur" Louis Joseph Vance's "Brass Bowl." The menus were in the shape of cigars, filled with such appropriate mottoes as "After the smoke comes the qualm." "Fumigation is the thief of time," and "Beggars shouldn't be chewers," illustrated with appropriate devices.

* * *

July 20, 1907

TWO AUTHORS WHO LOOK "BACKWARD"

Mr. Upton Sinclair Tells Us How We Shall Live in 1913 and Mr. Hutchinson in 1944

THE INDUSTRIAL REPUBLIC: A Study of America Ten Years Hence
By Upton Sinclair
Illustrated. 12mo. Cloth. Pp. 284. New York: Doubleday, Page & Co. $1.20.

THE LIMIT OF WEALTH
By Alfred L. Hutchinson
12mo. Cloth. Pp. 285. New York: The Macmillan Company. $1.25.

It is a curious paradox that among those authors who have attempted to take their readers into the future, the ones who have fascinated by their imaginations, have been more successful prophets than those who have attempted to instruct by their erudition. Jules Verne has come nearer the truth than either Edward Bellamy or H. G. Wells. There is nothing of the Frenchman's imagination in either Upton Sinclair or Alfred L. Hutchinson. That is to be regretted. Each wishes to be taken seriously. That is their privilege. The former, at the threshold of "The Industrial Republic," writes these fateful words:

"I write with all seriousness that the revolution will take place in America within one year after the Presidential election of 1912; and, in saying this, I claim to speak not as a dreamer or a child, but as a scientist and prophet."

Mr. Hutchinson also believes that the revolution will take place in 1913. But, in order that he may write with a firmer grasp of results, he places the date of his inditing at 1944, when he is supposed to be the secretary of an international committee formed to inquire into the great power and material prosperity of the United States.

Mr. Sinclair starts off with a clearly defined idea of the unjust distribution of wealth. For this he blames legislation and the selfishness of the individual. Of the other factor productive of the deplorable condition of humanity which he asserts prevails, he has nothing to say. He blames neither the Creator nor Nature for the unequal distribution of brains. Mr. Sinclair, however, does not come untutored to his task. His pages are made eloquent with original words from Jefferson and Lincoln, from Mr. Brooks Adams and Prince Kropotkin, from Messrs. Rockefeller and Schwab, and some of his illustrations are reproduced by the courtesy of Wilshire's Magazine. Personally, he writes largely and handles his autocratic, aristocratic, financial, industrial, and Socialistic terminology with an ease, grace, and familiarity that are absolutely fascinating.

For him the republic of Jefferson and Lincoln is being forged into a weapon for the enslaving of mankind, the perpetuation of the Monroe Doctrine is an instrument solely employed for the betrayal of liberty, Wilhelm II. is merely "a degenerate who sits upon a throne and proclaims himself by the grace of God the lord and master of the German people," he presents weird, vivid pictures of the slums of manufacturing centres and of great cities—and so on through every phase of international and national condition, through every phase of human life and endeavor, political, social, and industrial, and in all of it there is the unceasing cry of the French Communist, "We are going to change all that!"

Mr. Hutchinson's book is at least written by one who understands present conditions. From these conditions he draws logical conclusions. But here, again, the individual is lost sight of. Voltaire and Rousseau could predict the French Revolution; they could not foresee a Napoleon. The title of his book, "The Limit of Wealth," is the basis of his entire economic and Socialistic structure. In a certain year a law is passed which limits inheritances while the residue goes to the Government. Naturally, the effect of such a law is far-reaching, entering into every department and phase of human activity. Mr. Hutchinson's Utopia is not a condition of co-operation, but a return to competition among all classes and individuals.

The working out of the new conditions established by limiting wealth is most entertaining. Apparently the Government becomes a huge bureaucracy, at the head of which is the new Department of Public Wealth, and from this department extends a string of communication down to the smallest municipal official whose duty it may be to protect the public peace or to distribute charity to the deserving.

* * *

August 31, 1907

TRUTH AS WORKING HYPOTHESIS

Prof. James's "Pragmatism" an Exposition of Philosophy Which Denies All Philosophy—Your World Is True for You, but Need Have No Objective Validity

PRAGMATISM: A New Name for Some Old Ways of Thinking
By William James
New York. Longman, Green & Co. : Pp.

By JOSEPH JACOBS

"What is truth?" said jesting Pilate, and, according to Viscount St. Albans, would not stay for an answer. Philosophers since that time have given various replies to this puzzling question, but they have always assumed that there is such a thing as truth; that is, truth absolute, truth for all time, and truth everywhere.

Of recent years, however, there have arisen in Chicago, Oxford, and Pavia a number of philosophers who have called into question the absolute nature of truth, and have given the name Pragmatism to the theory that truth is a working hypothesis and only truth so far as it goes. Prof. James in the present volume gives, with his usual skill and persuasiveness, a popular account of this new trend of philosophic speculation, which, from the novelty of the position held and the distinction of the holder, will doubtless attract considerable attention not alone among philosophers by profession, but also among ordinary folk who do not as a rule meddle with philosophy, and especially among theologians to whom the new views especially address themselves.

At the first blush it would seem that Pragmatism is the negation of all that has hitherto passed for philosophy. Everybody has recognized that our attempts at putting into language the general relations which appear to rule phenomena are only approximate and cannot express things as in themselves they really are.

At the very earliest stages of speculation the Greeks recognized this distinction between things as they seem and things as they are. It would almost appear as if the new thought attempts to solve this difficulty by identifying the two, denying the existence of things in themselves, and reducing the universe of thought to mere phenomena. Prof. James gives some countenance to this exaggeration of his position by dedicating his book to John Stuart Mill. In the eighteenth century David Hume reduced the philosophic problem to its lowest terms by practically denying the existence of aught but a sense of phenomena at the present moment. Hume, having proved that the world does not, for purposes of thought, exist, the two Mills proceeded to investigate the laws of its non-existence from a rational point of view, and in a measure Prof. James takes up the phenomenalist line of thought, although with many modern improvements. In fact, he reduces the problem of philosophy to a problem of psychology, as is perhaps natural with a professional psychologist.

Truth is, according to him and the new school of Pragmatists, not that which answers to the reality without us, but is that which will serve as a basis for action. That heat expands metals is a truth not because it corresponds to the increased swing of the molecules accompanying the increase of temperature, but because in applying that assumption in practical activity we find that we can attain our ends by assuming the correlation of increased length with increased temperature. Truth, in other words, is working hypothesis.

Throughout this volume Prof. James keeps on assuring us that if a view of the world satisfies the aspirations, and, so far as it goes, coincides with the experience of the individual, it is, for that individual, true. . . . Prof. James's test of any proposition is, "But will it work?" This is the side of his philosophy by which he approaches the theological problems. If any of the theologisms satisfies any human soul, to that human soul it is truth. Unfortunately, quite different views of the universe have the quality of satisfying different minds. Prof. James has an interesting distinction between the tender mind of the professional philosopher and the tough mind of the modern scientist. He draws out a long list of distinctions between the two intellectual tendencies, . . . and it would almost appear that he would allow each of these views to have validity so far as they go, it depending upon a man's temperament which of the set of alternatives he will be likely to adopt. . . .

The truth seems to be that Prof. James and Pragmatists are seeking to turn the position in philosophy by refusing to obey the rules of philosophizing. The assumption that there is some abstract absolute truth independent of all human aspects of it has hitherto been the primary assumption of the philosophic world. But the Pragmatists refuse to be bound by the rules of the game or to play in philosophy's backyard. The slogan of the new school seems to be "To Hades with Hegel." Indeed, they go even further back, and refuse to consider the epoch-making question of Kant—"Are synthetic a priori propositions possible?" Prof. James seems carefully to avoid consideration of the nature of mathematic truth, even though his own touchstone of workability seems especially applicable to the relations of number and space. It is true that some modern physicists contend that the laws of motion and other quantitative truths are merely applicable to averages, but the laws of chance rule the residuum to the same iron quantitative explicitness. The whole episode, indeed, seems to be one huge mistake as to the problem at issue. Prof. James, the psychologist, treats a problem of epistemology as if it were a problem of psychology.

However, this is not the place, nor is the present writer the person, to discuss these high themes. What the readers of this Review will be chiefly interested in is the mode of presentation of these lofty topics. Here it is scarcely possible to exaggerate one's appreciation of the lucidity and skill with which so abstract a topic has been treated. The original lectures of which this book forms a reproduction were evidently adapted for the man (and woman) of the street, and they are admirably suited to their audience. Except in the title of the new view, for which Prof. James is not responsible, there is scarcely a word which

smacks of the seminar. The expository skill shown in his "Talks on Psychology" and other works is found here in even a higher degree. Prof. James knows how to use the concrete example to bring home the abstract proposition. He does not even occasionally disdain the use of the slang of the day to elucidate the problems of all time. You will find no jargon about synthetic a priori propositions in this little volume, and yet it treats of the profoundest problems of the day and has at times startling suggestions to make about them. While on the one side of his thought Prof. James shakes hands with John Stuart Mill, in other directions he approaches perilously close to the antinomianism of Nietzsche. There is even the adumbration of a new theology with a deity not absolute or perfect, whom we can help to make more perfect. Here again we meet with Mill's position as given in the posthumous essays on religion. According to Prof. James, the kingdom of truth is not without us; it is within us, and we can help to make things true if we have the will to believe.

There is something peculiarly appealing to the Anglo-Saxon mind in this latest of the philosophies. At bottom the Anglo-Saxon denies, with Prof. James, the existence of metaphysic truth. In the past he has mostly got his metaphysics from Scotland or Germany, and he will doubtless welcome a point of view which practically gets rid of ontology. As in other directions of activity, he is confident that he will muddle through somehow without rigidity of doctrine or consistency of principle. Yet the old paradox still remains true that you must philosophize even in refusing to be a philosopher, and the denial of metaphysics in the long run means that you will have to be content with the metaphysics of your grandmother.

Prof. James begins by quoting Mr. Chesterton's declaration that the most important thing about a man is his view of the universe, yet the whole lesson of his book would seem to be that a man's view of the universe is only of importance to himself. Yet this very inconsistency and others in the book give it a vitality and an individuality which make it admirable reading, and for the moment at least we may certainly agree that the most interesting thing about Prof. James is his view of the universe as presented in this book.

* * *

September 21, 1907

JOSEPH CONRAD'S LATEST AND BEST

"The Secret Agent" Fine Example of This Novelist's Ability in Analysis of Character

Mr. Joseph Conrad is a specialist in the sombre. Also he is able to write of woman without investing her with a shred of romance. Therefore, he is cut off from the wider popular favor. But there is no man alive more able than he to transmute life into words, which, being read, are transmuted into life again. His method, it seems, is almost mechanical. He takes the human creature, composite of conscious and unconscious impulses, obscurely motived in the roots of being and the tangle of desires and associations, made more complex, but not controlled by that reason which is to most men as a pilot house whose wheel is inexpertly geared to the rudder—he takes this mysterious creature, analyzes the part of each impulse in the creature's external action, and then reconstructs the whole upon white paper out of mere printed language in such fashion that the stark humanity of it throws the multitudinous detail—provided the reader has a fairly competent imagination—into the just perspective of real life. In other words, the reader, for the time being, is endowed, to his immense enlargement, with Mr. Conrad's eyes and insight; he sees and feels what Mr. Conrad would see and feel in the presence of the actuality. To compass this thing is the artist's gift, and when we insist on the "fairly competent imagination" in the reader we are not subtracting in the least from the artist's credit. So much imagination is the necessary complement of his own.

The present story, called "The Secret Agent" (Harper's), is a very complete and admirable example of Mr. Conrad's method. It is exceedingly sombre; it deals chiefly with persons in the lower and sordid walks of life, and though the scene is London and these persons include an international spy, several Anarchists, an Inspector of Police, and a reasonably handsome woman, the whole is managed without one touch of the romance in which the customary fiction of the subject stalks, glamorously and falsely enveloped. Mr. Conrad writes of Anarchists, even of foreign spies on the free soil of England, without melodrama. His secret agent, obese, indolent, shrewd in his small way, having the outward aspect of a successful plumber, of "steady fidelity to his own fireside," though his habit of wearing his hat in the house, "derived from the frequentation of foreign cafés," gives him a false air of "unceremonious impermanency," is most attached to his wife. She, in her turn, though possessed of fine eyes and showing traces of French descent in the "extremely neat and artistic arrangement of her glossy dark hair," is an entirely domestic and respectable woman, a good wife to Mr. Verloc, and devoted to a brother, rather weak in the wits, for whose sake, in fact—in order to provide him with a good home—she has married Mr. Verloc. Mrs. Winnie Verloc, like others of Mr. Conrad's women, is a creature of sluggish mentality—"incurious," says he. "Mrs. Verloc wasted no portion of this transient life in seeking for fundamental information. She felt profoundly that things do not stand much looking into. She made her force and her wisdom of that instinct."

Mrs. Verloc's mother, "a large female with a dark, musty wig" and enormous swollen legs, "heroic and unscrupulous and full of love for both her children," is another inmate of the house of Verloc. Mr. Conrad will discover why she "conceived in the astuteness of her uneasy heart and pursued with secrecy and determination" a plan to get herself admitted to a certain almshouse.

The young man of little wit is naturally the other inmate of the house of Verloc. He has his part in the tragedy also. Steevie, a creature of "immoderate compassion, apt to forget mere facts—his name and address, for instance—had a faith-

ful memory for sensations." So, gazing upon a cab horse of "aspect profoundly lamentable," and informed by the cabman that he had to make the miserable beast go because he needed the fares for his "missus and the kids at home," Steevie was near choked with grief and indignation, "at one sort of wretchedness having to feed upon the anguish of another, at the poor cabman beating the poor horse in the name, as it were, of the poor kids at home." Mr. Conrad discovers Steevie's processes even further:

"The tenderness to all pain and misery, the desire to make the horse happy and the cabman happy, had reached the point of a bizarre longing to take them to bed with him. And that he knew was impossible. For Steevie was not mad. It was, as it were, a symbolic longing. At the same time it was very distinct," because, "when, as a child, he cowered in a dark corner, scared, wretched, sore, and miserable, his sister Winnie used to come along and carry him off to bed with her as if to a heaven of consoling peace." Thus the mechanics of poor Steevie's "anguish of immoderate compassion." "Shame!" he cried, at last. "Steevie was no master of phrases, and, perhaps for that very reason, his thoughts lacked clearness and precision."

Conversely, Mr. Conrad, who is a master of phrases, and whose thoughts, even when the subject matter of them is elusive and complex beyond calculation, are both clear and precise. Therein is part of his mastery, but the secret of his real strength, one fancies, is just that sense of the potency of association in giving form to crude human impulses, which is shown in the bizarre mental symbol of Steevie's passionate tenderness. Later, Mr. Conrad shows the working of other spells of association whose key is a phrase merely. Thus is a woman driven to her death and a man to madness. Figure to yourself the murderess flying through the night and the fog, haunted by the matter-of-fact words which in England are apt to conclude the brief newspaper account of an execution— "The drop given was fourteen feet." In such fashion is the terror of the gallows made concrete—it bores at the consciousness like a fly buzzing against a window pane.

As remarked, the story is a sombre one. There is death in it, despair, revenge, a dumb, "hardly decent" passion of devotion, and a bestial and colossal selfishness; there are also all the domestic virtues. And there are Anarchists, human but freakish, each after his kind; one pathetically corpulent, gentle, harmless, and an optimist—an ex-convict; another a wizened fellow who manufactures bombs and spends his life seeking the "perfect detonator"; yet another, huge, a blonde beast, the natural Anarchist. Then there is a police officer— "principal expert in Anarchist procedure," and a Secretary of Embassy, a "Hyperborean swine," but daintily witty in society, who plans an "outrage which need not be especially sanguinary" but must be "startlingly effective." Mr. Vladimir suggests, in fact, that the blowing up of Greenwich Observatory as an act "purely destructive" and impersonally directed against property and the "sacrosanct fetish" of the British public, science, will be a suitable demonstration to fill that public with a proper horror of Anarchists—a horror which will take the form of drastic repressive measures agreeable to

the policy of his own swinish Hyperborean government. His secret agent, Mr. Verloc, is to get the deed done. Mr. Verloc does. Hence the story, which is in the sanguinary quality of the action all that even the melodramatist could desire. There is, nevertheless, a vast gulf fixed between Mr. Conrad and the melodramatist, between the human tragedy of "The Secret Agent" and the detective story of commerce.

* * *

March 14, 1908

UPTON SINCLAIR'S "THE METROPOLIS"

A Debauch of Interior Decorations, Orchids, Bathtubs, and Other Wicked Features of Babylonian Luxury

THE METROPOLIS
By Upton Sinclair
New York: Moffatt, Yard & Co.

Mr. Upton Sinclair's new book is not important, it is not literature, it is not "a good story." To say of it that it has a sneer on every page, and on many an incendiary utterance, might be giving the author too much credit. Mr. Sinclair's sneers are not always intentional, probably, and his incendiary utterances are not those of a combatant. The recurring warning of "another civil war" does not mean that the author is ready to take up arms.

"The Metropolis" is a jumble of odds and ends. The yellow "sensations" of two or three years reappear in a barbarous melange. It has all been done, and much better. The literary manner of Mr. Thomas W. Lawson is more effective than Mr. Sinclair's in this book. The vanity, selfishness, and extravagance of the rich have long been favorite themes of popular story tellers. But as a story teller, in "The Metropolis," Mr. Sinclair is vastly inferior to Pierce Egan, Sylvanus Cobb, Jr., and Mrs. E. D. E. N. Southworth.

As an exposure of vice in New York life, the book might be compared with Solon Robinson's once famous "Hot Corn." That belonged to a simpler epoch, when the well-to-do of the much smaller and plainer metropolis were all God-fearing and respectable. To be solvent then was to be honorable. Vice stalked in the poor neighborhoods. The hideous manner of its stalking in "Hot Corn" caused a general shudder.

We do not believe Mr. Sinclair's picture of vice among the almost fabulously rich of this hour will make anybody shudder. It is all so inept, extravagant, and false. What does Mr. Sinclair know about fashionable New York society? He seems to have studied social life in the restaurants of the Tenderloin, manners in the vaudeville theatres, and the ways of clubdom in chop houses. His personages are labeled freaks. The caricaturists and farceurs have pointed the way for him. His book is full of echoes of newspaper yarns. "Society," that many-headed monster, will not glance at it with one of its many pairs of malevolent eyes. With Mrs. Wharton to picture social shortcomings and the modern equivalent for manners,

Mr. Howells to portray minutely the foibles of our typical men and women, and a host of lesser, but still competent writers such, for instance, as Robert Chambers and David Graham Phillips, giving us fresh and entertaining studies of contemporary extravagance and vanity, it is difficult to place Mr. Sinclair at all. As a satirist of society he is hopelessly out of it.

The protagonist in this new and depressing drama of "New York's business and political aristocracy" is Allan Montague, the grave son of a Northern father and a Southern mother, bred in Mississippi, who arrives in New York, wide-eyed and inexperienced, at the age of 30. He has here a brother, who is his antithesis, a light-hearted, unprincipled young man, who has made a great social hit. He lives like a prince and spends money with an extravagance quite beyond the means of a multi-millionaire. He is impossible, but we should not think of criticising the book harshly on that account. It is permissible for a romancer to write romance. Allan is also impossible. A man of 30, admitted to the bar, who could come to New York without precisely the ideas of its wealthy people expressed in Mr. Sinclair's book could never have read the newspapers. Those ideas prevail throughout the country. When Westerners and Southerners come here they learn that they are not true.

The first day Allan is in New York he attends a meeting of the Loyal Legion in a "quiet uptown hotel" with marble pillars and gilded carvings. Interior decorations are Mr. Sinclair's hobby. He indulges in a debauch of bronze doors, marquise furniture, opal glass, polished hardwood floors, vaulted roofs, silver sconces, Flemish tapestries, orchids, jade, and carvings. Like most literary invaders of society, he is strong on bathrooms. One of his multi-millionaire's palaces must have been built in imitation of the New York Athletic Club. If his wicked rich are not clean they are neglectful of their opportunities.

At the Loyal Legion meeting there is a florid description of the Battle of the Wilderness. Then on the way home Allan passes a socialistic street meeting. The keynote has been struck. Then the colors are piled on thickly to describe the kind of life the wicked rich live. The characterizations of the men are utterly commonplace, but the descriptions of the women must have been studied from the wax figures in department store windows. There is scarcely a touch of gentle femininity in it all. The sporty girl, the flirtatious girl, the enticing matrons are all lifeless puppets.

There is a great deal of food. Peaches that cost $10 apiece, grapes grown in paper bags under glass are described by the novelist in a way to make the rural reader sit up, if he had not sat up so many times in response to similar descriptions. The New York correspondents have done this thing to death. But so far as we can remember not one of them ever sat down at a "topsy turvy" lunch in a Long Island roadhouse, with a company of fashionable motorists. Did Upton Sinclair? The menu includes, in this order, baked ice cream, turtle soup, plum pudding, quail in casseroles, cafe parfait, roast beef. Nothing is too grotesque for a socialistic writer in delivering his message to the common people.

In the description of a gay dinner at the hunting lodge—a castle of seventy rooms in a park of 10,000 acres—the only real touch of human nature is Allan Montague's wonder what the servants think about the goings on. Unsophisticated youth always feels that way about the waiters when he is not with a noisy party in a restaurant. If people who have "lodges" on Long Island call "shooting" "hunting," they are not the Anglo-maniacs we have been taught to believe them.

The whole fabric of the book is antique in style, while it is stale in its materials, and lacks the touch of verisimilitude. The financial misdoings, the life insurance exposures, the charges against some well-known men are mixed up in it, to no great effect, and there are amorous imbroglios of small interest, because the personages are so unlifelike. But there is no doubt about the spirit of Mr. Sinclair. He seems inspired by a terrible hatred. There is no love in his socialism. All humanity, except the few who think as he does, are under his ban. His ethics are the ethics of the rat pit.

None of the signs that make many apprehensive persons uneasy appear in "The Metropolis," except the willingness of a few irresponsible creatures to turn discontent to their own pecuniary advantage. Selfishness, extravagance, the lack of brotherly love, the everlasting striving to get ahead, are not confined to the very rich. Some of the wealthiest may set a bad example, but what is the use of free schools, a free government, the means of enlightenment and intellectual progress on every hand, if that comparatively unimportant bad example is to cause an overturning? Moreover, the bad example, as Mr. Sinclair depicts it, only disgusts educated people because of the falsity of the picture, and ought to make the multitude laugh.

* * *

June 12, 1909

PHILOSOPHER'S AUTOBIOGRAPHY

"Ecce Homo," Nietzsche's Last Work, Directed Against Everything Christian, Appears in a Luxurious Edition

ECCE HOMO: Wie Man Wird—Was Man Ist
By Friedrich Nietzsche
8vo. Pp. 154. New York: Brentano's. $6.20.

"Ecce Homo" is Nietzsche's autobiography. It comes to us in this luxurious limited edition, with somewhat eccentric decorations on the title page and elsewhere, in the style of the "new art," as it is understood in Germany; and yet Nietzsche is said to have expressed the wish that it should be published cheaply, for a wide circulation. "Ecce Homo" is the last book he wrote before the darkness came finally and inevitably upon his soul—or, more probably, after the premonitory symptoms of the collapse had manifested themselves. He wrote it in three weeks, in October, 1888, "at a white heat"; in about two months thereafter the collapse came.

Speaking of this autobiography Nietzsche wrote to Brandes thus, as quoted by Mr. Huneker in his brilliant essay on Nietzsche in the recently published volume, "Egoists":

I have now revealed myself with a cynicism that will become historical. The book is called "Ecce Homo" and is against everything Christian. . . . I am, after all, the first psychologist of Christianity and, like the old artillerist that I am, I can bring forward cannon of which no opponent of Christianity has even suspected the existence . . . I lay down my oath that in two years we shall have the whole earth in convulsions. I am a fatality. Guess who it is that comes off worst in "Ecce Homo"? The Germans! I have said awful things to them.

Well, the whole earth has a habit of not falling into convulsions, and Nietzsche's book has not had the effect that in his unbalanced nervous state he expected. It is, as Mr. Huneker says, rather a disappointment. Yet it has much that is brilliant, much that is mordant, and much that throws a still brighter light on places that Nietzsche's audacious philosophy had sought out with its searchlight before.

These are his characteristic headings: "Why I Am So Clever." "Why I Am So Wise," "Why I Write Such Good Books," and under the last named he takes up seriatim his ten published volumes; he goes on with "Why I Am a Fatality," and "Fame and Eternity." Equally characteristic are his prefatory words, written on his forty-fourth birthday:

On this perfect day, when everything is ripening and something besides the grapes are becoming brown, a ray of sunlight fell upon my life; I looked back. I looked outward, I never saw so many and so good things at once. Not in vain have I buried today my forty-fourth year—I could bury it. What was life in it is rescued, is immortal. The first book, "The Transvaluation of All Values," the "Songs of Zarathustra," the "Twilight of the Idols," my attempt to philosophize with the hammer—all gifts of this year, even of its last quarter! Why should I not be thankful to my whole life? And so I tell me the story of my life.

Nobody need, nor probably would, expect an autobiography like any other from such a man. It is rather another contribution toward the elucidation of his own philosophy, through the elucidation of his own fiery and aggressive personality and through energetic criticism of many things, through perversity and paradox. He reaches both high and low. Germans are the victims of much of his savagery. Their cooking is one of the weak points through which he touches them. He also aims at more immaterial German shortcomings. He discusses morals and his own position as an "Immoralist"; Schopenhauer's philosophy, Kant's philosophy, the stunning blows he himself has given to Christianity. He speaks much of music and much of Wagner—without Wagner's music could Nietzsche not have endured his own youth: "If you wish to throw off an unbear-able burden, you need hasheesh. Well, I needed Wagner. Wagner is the antidote against all that is German par excellence." He loves to clear the table, he says; no half-way speaking. He breaks finally into lyric utterance; at least it seems to be so, from the typography. With this he brings the book to its close, if not its climax.

The editor supplies a final word; he is Raoul Richter, who writes of the origin of this book: "No question," he says, "but that the autobiography as a whole and in detail would have read differently if the catastrophe of the intellectual darkening had not occurred at all, or so soon. It would be doing Nietzsche a poor service, and would bring a smile to the lips of every physician, if this suggestion were concealed or veiled." It will be impossible to suggest the limits that separate the passages occasioned by disease from the others without a high degree of philosophic, artistic, medical, and human tact; determined clearly and demonstrated they will never be. But the lucidity and transparency are perfect, Herr Richter thinks, though all may not agree. The style is on the usual, unaltered high plane. Not the "what" but the "how," the tone, the dynamics of the utterances are the matters in which the organic disease is disclosed. "So the reading of 'Ecce Homo' puts tasks before the reader that we should undertake only in hours of intellectual concentration." Then only are we ripe, concludes Herr Richter, for the high and tragic style of this work.

* * *

August 14, 1909

THE BEARER OF EVIL TIDINGS

Ambrose Bierce, in a Volume of Essays Entitled "The Shadow on the Dial," Takes a Gloomy View of Most Everything—Recalls the Fate of Cassandra and Fears His Words Will Pass Unheeded

THE SHADOW ON THE DIAL AND OTHER ESSAYS
By Ambrose Bierce
San Francisco: A. M. Robertson. $2.

By HILDEGARDE HAWTHORNE

There is something of the noisy fierceness, the animosity, the spitfire scratchiness of the cat in a corner confronted by the huge wondering head of an inquiring dog in Mr. Bierce's volume of essays and jeremiads. Woe, woe is the burden thereof, and nothing in all the sad round world gets any praise or hope; nothing, with one exception, which does receive Mr. Bierce's unqualified admiration and unconcealed approbation. This solitary exception we will leave the reader to discover for himself.

There is no subject alien to Mr. Bierce's pen. He is equally willing to throw light on the secret workings of the Divine Mind as upon the character of dogs—and here indeed the cat is all claws and bristling hair. He dubs alike the reformer and the murderer fool and villain, beings to be stamped down into the bloody dust. He has but one regret—that, besides being a

literary light throwing far gleams into a naughty, naughty world, he is not, space and time so far hampering even the godliest, capable of easing the mortal strain by also fulfilling the possibilities open to the statesman, the lawyer, the preacher, yea, to woman herself in this little world he spans with his spread thumb and finger.

"I sometimes wish I were a preacher," he cries. "Preachers do so blindly ignore their shining opportunities. I am indifferently versed in theology . . . but know something of religion." Then turning to the law he remarks: "I have looked into this thing a bit, and it is my judgment that all the methods of our courts, and the traditions of bench and bar exist . . . for the one purpose of enabling lawyers as a class to exact the greatest amount of money from the rest of mankind."

"Civilization does not, I think, make the race any better," says the author, in the essay devoted to that topic. Yet in the first paper, which lends its title to the book, we are told, regarding the anarchist, that he should be extirpated. "I favor the mutilation of anarchists convicted of killing or inciting to kill—mutilation followed by death." This because the anarchist is inimical to civilization, because he stands for reversion, for a time when a man's nose, ears, wife, young, labor, clothes could be taken from him by the stronger hand, as it was in the thirteenth century. "In Europe and America to-day these things cannot be taken away from even the poorest and humblest without some one wanting to know the reason why." Since there was some sort of civilization even in the thirteenth century, Mr. Bierce may possibly intend the race in prehistoric days. Yet he says elsewhere: "Two human beings cannot live in peace together without laws—laws innumerable—if there were in all the world none but they." Surely the beginning at least of civilization.

Occasionally the author hauls off from thumping the universe to deliver a few special blows at his own country. We will quote two or three of these knocks:

"In learning and letters, in art and the science of government, America is but a faint and stammering echo of England. For nearly all that is good in our American civilization we are indebted to England; the errors and mischiefs are of our own creation. . . . The English are undoubtedly our intellectual superiors; and as the virtues are solely the product of education (is not education a part of civilization and were we not just told that it did not tend to improvement?)—a rogue being a dunce considered from another point of view—they are our moral superiors likewise. . . . Is not every American young woman crazy to mate with a male of title?" and so forth.

Mr. Bierce entertains for the word idiot a real passion. Like the small boy on All-Fools' Day, he may be observed dashing from one unconscious back to another, pinning his little scrap of paper, on which the obnoxious title is largely printed, to coattail after coattail. Not that the paper is always misplaced, but the humor of the situation is often increased, to the onlooker, by having the active little boy similarly decorated and equally unconscious with his victims of the telltale addition to his raiment.

Doubtless there is a deal of sense mixed up with the rest of the material in these essays. Mr. Bierce's arraignment of many of the shams and faults of our modern life is apt and just enough, if not very new. But his self-conscious cleverness, degenerating only too often into actual cheapness, his desperate scrambling on the slippery footing of epigram and phrase, tend to confuse the vision of the beholder, who, engrossed in watching the fantastic progress, fails to realize the indicated heights.

When Mr. Bierce says that the Golden Rule is sufficient for all the needs of life he is on safe if not original ground, and though he leaves us to struggle along with whatever makeshifts we can devise until this rule is universally adopted, we are willing to range ourselves with him. But when a moment later he pleads for the eye for an eye law as the only one a sane community should uphold, where are we to consider him as standing? He claims that he can easily and infallibly judge what Jesus would do under any given circumstances, and that no other guidance is required; but furiously desires, on another page, that prison reform and the humane treatment of criminals should cease. Behold him on his tight rope, a vision of wild waving arms and gesticulating leg. Whither is he bound—straight on, straight up, or horribly downward? We watch with mingled interest and terror—yet hoping, if it be downward, that we may be there to see, since a man hurtling through the air is at least a sight.

"I should like it understood that, if not absolutely devoid of preferences and prejudices I at least believe myself to be," so speaks the author. A half page further on he alludes to the great secret societies as lying and as having for their sole object "the mitigation of republican simplicity by means of pageantry and costumes grotesquely resembling those of kings and courtiers."

"All languages are spoken in hell, but chiefly those of Southeastern Europe," says our unprejudiced commentator further on. "I do not say that a man fresh from the fields and factories of Europe—even of Southeastern Europe—may not be a good man; I only say that, as a matter of fact, he commonly is not. In nine instances out of ten he is a brute whom it would be God's mercy to drown on his arrival, for he is constitutionally unhappy."

"Against the life of one innocent person the lives of 10,000 murders count for nothing. Their hanging is a public good without reference to the crimes they disclose," so on one page. On another: "The law of a life for a life does not altogether prevent murder. No law can altogether prevent any form of crime, nor is it desirable that it should . . . constituted as we are we can know good only by contrast with evil. Our sense of sin is what our virtues feed upon; in the thin air of universal morality the altar fires of honor and the beacons of conscience

could not be kept alight. A community without crime would be a community without warm and elevated sentiments—without the sense of justice, without generosity, without courage, without magnanimity—a community of small, smug souls, uninteresting to God and uncoveted of the devil."

This being so, we submit that Mr. Bierce's attitude toward the thief and murderer is blind and illogical. Surely a benefactor to the degree implied above ought to be pensioned rather than executed.

We must cease quoting from this mass of wisdom, though much remains—for instance, the disputed field of heredity versus environment. "The phenomena of heredity have been inattentively noted; its laws are imperfectly understood, even by Herbert Spencer and the prophets," says Mr. Bierce. But luckily "my own small study in this amazing field convinces me that a man is the sum of his ancestors; that his character, moral and intellectual, is determined before his birth." Mr. Bierce being convinced, who, to be sure, shall longer remain in doubt?

But reluctantly—for if Mr. Bierce does not contribute vastly to the knowledge of the world, he assuredly adds delightfully to its amusement—reluctantly, with a few last words from our hero—author we mean—we close.

"Formerly the bearer of evil tidings was only slain; he is now ignored. The gods kept their secrets by telling them to Cassandra, whom no one believed. I do not expect to be heeded . . . but I have looked at the dial of civilization; I tell you, the shadow is going back."

According to one among Mr. Bierce's many dictums, we may then begin to look for better things.

* * *

December 5, 1909

NATIONAL PARKS BY JOHN MUIR

Beauties and Utilities of the Country's Great Preserves Described and Pictured in a Sumptuous Volume

John Muir's "Our National Parks" (Houghton Mifflin Company, $3), appearing in a new and revised edition, contains considerable additional matter designed to perfect the work in respect to its statistics and to bring it up to date. Some new illustrations also have been provided, including a photographic picture showing the author standing by the side of one of the great trees in the forest that bears his name.

These various additions naturally enhance the value of the work for some persons; but there are others who will not attach much importance to them, inasmuch as they will find their chief delight—in the new edition as they did in the old—in the charming chapters in which the author discloses his love of the mountains and forests, and his understanding of the life with which they teem. It is to these chapters, too,

Copyright, Houghton Mifflin Company

"A Cinnamon Bear." From "Our National Parks."

we shall turn when we consider the relation of Mr. Muir's work to the policy of conservation, of which we hear so much in these days, and undertake to appraise the support he gives to that policy.

Mr. Muir is a distinctly infectious person when, in a glow of enthusiasm, he pictures the beauties of the Yosemite, the Yellowstone Park, and the region of the great sequoias, and tells of the joys of living in those earthly paradises. One must be abnormally immune who reads unmoved what Mr. Muir has written with his inspired pen and puts down his book unconvinced that among this country's needs there is no one more imperative than that which calls for a closer relation between the American people and Old Mother Earth, a better love for Nature, and a more prevalent determination to repair the damage that has been done the country through the de-naturing process that has been going on for years.

If Mr. Muir has found health and happiness in one of Nature's wilds, why should not other men take to the woods, camp under the trees, loll in the flower beds, and make playmates of the birds and squirrels! And of course if it be granted that what is good for John Muir must be good for the rest of us, the next proposition necessarily is that we must see to it that the country is well supplied for our health hunts and pleasure hunts; we can't all of us go chasing across the continent when we feel the call of the wild.

It is all well enough to talk about preserving our natural resources, reforesting our denuded plains and mountain

sides, and refilling our empty river basins; but we doubt very much that the masses of our people are vitally concerned in that aspect of conservation, which really seems almost irrelevant to their interests. It is the sentimentalist like Mr. Muir who will rouse the people rather than the materialist.

MUSIC

February 18, 1900

MR. CHADWICK'S "ADONAIS"

A New Elegiac Overture by the Talented American

George W. Chadwick's "Adonais," an elegiac overture, was recently produced by the Boston Symphony Orchestra. W. F. Apthorp wrote of it in The Boston Transcript as follows:

"Mr. Chadwick's new overture, written in memory of his friend Frank Fay Marshall, who died in 1897, shows the composer in a somewhat new light. It is the most modern in spirit of anything I know from his pen. Hitherto Mr. Chadwick has adhered pretty strictly to the classic forms—at least, as strictly as Brahms—and his works have been redolent of the spirit of those forms. His 'Melpomene' overture, for instance, is nothing if not classic. That he has shown perfect freedom in the classic vein, that his inventiveness and expression have not been in the least trammeled by the forms he chose to work in, is only to his credit; it shows him to have been in perfect sympathy with the forms, that his adopting them was a case of natural selection, not a mere copying of classic models. And now, in this 'Adonais,' the form he chooses is an equally natural expression of the more modern spirit in which the work is conceived. He has outgrown the classic idea, his time for being modern has come, and he follows the new instinct with complete willingness and frankness.

"In this matter of form, it is important to distinguish between the mere scheme of a form and its essential character, the spirit in which it is treated. As far as mere formal scheme and plan go, the form of the 'Adonais' is virtually the same as that of his older overtures. There is still a first part, a middle part of free fantasia, and a recapitulation followed by a free code. The fact that he omits repeating his first theme at the beginning of the recapitulation is not, in itself, new; if I remember aright there is the same omission in the 'Melpomene' as there certainly is in Brahms's tragic overture. This omission is not unclassic per se. But, if the scheme is practically the same, the spirit and treatment are different; both are essentially modern and romantic. The very character of the thematic material in the 'Adonais' is modern, in sharp contrast to the classic reserve shown in the 'Melpomene'; the expression is more outspoken, more purely emotional and dramatic. When his second theme comes in—in an entirely new tempo, as it does in the first movement of Tschaikowsky's Pathetic Symphony—there is something more than the classic change of mood; there is what corresponds to an actual change of scene, so to speak (in the dramatic sense), the formal unity is broken, and much more effectively than it would have been had there been no second theme at all, or by any other mere irregularity. Remember, I say only that the formal unity is broken; for there is no lack of inner coherence, the second theme itself is based upon a figure that appeared earlier in the overture, and is no interloper; it is in no sense merely episodic. But here we have essentially modern and romantic musical development, not the old classic structure.

"As for this extremely beautiful and soulful second theme, is it unfortunate or not that its initial phrase is, note for note, the same as that ever-recurring cry of 'Ach! Isolde!' (not in the text, but in the orchestra) that pervades parts of the third act of 'Tristan'? Is it unfortunate or not that the ear is prepared for recognizing this reminiscence by the augmented sixth harmonies in the slow introduction? There can be no charge of plagiarism here; for neither Wagner nor any one else can claim a figure of but three notes as indefeasibly his own, and Wagner has no copyright on the augmented sixth. Both figure and chord (which, by the way, do not go together, but belong to different parts of the overture) have probably been used a thousand times by composers; there is no more plagiarism in using them again than there would be in an author's using the word 'and' or the expression 'sunlit heights.' Still, the coincidence leads one to feel that there is a certain Wagnerish flavor to some passages in the 'Adonais'; one feels that all in it would not have been just so had Wagner never existed.

"To me the 'Adonais' is exceedingly beautiful, noble, profoundly expressive. I am particularly delighted that, at the last hearing, I could not always find my bearings in it. It is only the weak work that is understood at a flash; the strong, profound, and original work takes time to soak in. After a single hearing, I understand this 'Adonais' no more completely than I did Tschaikowsky's 'Pathétique,' the prelude to 'Tristan,' or Beethoven's Eighth Symphony. But I have an inkling that it is splendid music, all the same."

* * *

April 6, 1900

BACH'S B MINOR MASS

Its First Performance in This City by the Oratorio Society Last Night

Bach's B minor mass was performed in its entirety for the first time in this city by the Oratorio Society at Carnegie Hall last night. The society had been preparing carefully for some

time past for this performance, and its intention of giving the work had been fully made known. The result was that an audience such as is seldom seen at the presentation of any oratorio other than the popular "Messiah" was present. The attitude of the assembly spoke volumes for the advance of serious musical taste in this community. The profound music was followed with the closest attention, a very considerable number of the listeners using scores to aid them in absorbing the details of the work. The applause which followed some of the stupendous climaxes of the jubilant portions of the mass such as the "Cum sanctu spirita," was most enthusiastic. What would the modest and self-contained cantor of the Thomas school have said could he have witnessed such a production of his work and such an audience.

It is no light-minded music lover who hears this majestic work carefully. It belongs to the latter years of Bach's life— the years when the introspective nature of his unique genius had reached its complete development, and when he had ceased to vex himself with the practical problems of performance. As Wagner has well noted, he had finally come to despair of adequate productions, and had settled himself to write out of the plenitude of his inspiration. He dared to be himself, perhaps with that prophetic vision of genius which trusts to posterity for the fullness of a justice denied in life. It is true that this mass was neither a spontaneous conception nor aimed at the choirs of Rome's cathedrals. It was written to win the favor of a King, and it was made for use in Protestant churches. But, as Spitta has beautifully argued, it strikes at those deeper roots of Protestantism which broke the very soil of Catholicism itself. It voices a spirit which lay in the heart of Rome's best aspirations—a spirit which found its concrete expression, its outward demonstration, in the revolt of Luther.

Such a mass embodies the significance of a liturgy and the vitality of a faith common to both branches of the Christian Church. It is a colossal culmination of centuries of development of the Italian mass, shaped and colored by a Protestant feeling which was the fundamental motive of all Bach's church music. And, perhaps above all, it is the most complete and moving embodiment of a musical personality whose constant emotion was one of worship and whose ceaseless endeavor was the vivifying of religion by the most splendid architectural enshrinement possible to musical art. To listen to such a work is not amusement, and one cannot help feeling that the applause and glamour of the concert hall are a less suitable tribute to its majesty than the dim, religious light of the church and the eloquent silence of the elect.

The performance of last night was one to be remembered for many striking merits and to be regretted for some defects. The meed of praise must be awarded first of all to Mr. Frank Damrosch for the sincere attempt to give the work an adequate presentation. The chorus had been carefully rehearsed, and most of its contributions to the performance were worthy of the admiration which the audience gave them. A fine body of tone, careful attention to the phrasing, and effective employment of the mass effects of light and shade were the

salient features of the choral work. The soloists were Miss Sara Anderson, soprano; Miss Gertrude May Stein, contralto; Mr. Nicolas Douty, tenor; and Mr. Joseph Baernstein, bass. Both of the ladies seemed to lack full mastery of their difficult music and their singing was deficient in ease, fluency, and certainty. This, of course, detracted much from the effectiveness of their numbers. Mr. Douty sang with poor tone and a weak style. Mr. Baernstein alone displayed a sufficiency of tone, a requisite breadth of delivery, and a firmness of grasp in his music. He was heartily applauded and he deserved to be. The orchestra was ragged in its work and left much to be desired in the matter of intonation. The horn obbligato was well played, but the trumpets were only fairly successful in their formidable task. The solo violin was poor in tone and not at all distinguished in style. On the whole, however, the Oratorio Society deserves gratitude for undertaking its labor of love, and praise for going so far toward impressive achievement.

* * *

December 9, 1900

MR. DOHNANYI'S RECITAL

An Enthusiastic Audience Hears Him at Mendelssohn Hall

Mr. Ernst Dohnanyi, the young pianist who has made such a deep impression by his sound readings of the masterpieces of piano music, gave his third recital yesterday afternoon at Mendelssohn Hall. The audience was a large one, and its enthusiasm was of the kind to please all who have the advancement of public appreciation of music at heart. It is a solid comfort to hear people launch into such eloquence of approbation as followed the young man's performance of works by Beethoven and Brahms. It seems that, in spite of the more or less cogent arguments made by those who believe that Beethoven is out of date, and that Brahms was never in, there are still many who enjoy hearing their music, and would rather listen to it than to much more sentimentally cloying stuff. Mr. Dohnanyi's programme was Spartan in its laconism and its freedom from any appeal to the mere senses. Its egotism may be pardoned on account of the apparent general opinion that every pianist ought to compose. The list was as follows: "Chromatis Fantasy and Fugue," Bach, Beethoven's sonata in G major, opus 31, No. 1, Brahms's variations on a theme by Handel, opus 24, and the pianist's own C sharp minor scherzo, intermezzo in F minor, and cappriccio in C minor. These were supplemented at the end after several recalls by a barcarolle of Rubinstein.

The essential features of Mr. Dohnanyi's have already been pretty thoroughly discussed in this paper, but such excellent piano playing should never be permitted to pass without comment. Crystallized clearness of purpose is apparent in every reading which this young man makes. He has probed his own conception to its minutest corollaries, and has

prepared the means of expression down to the finest item of accent and color. Thus he keeps his hearer interested throughout. And furthermore his conceptions are almost invariably satisfying. With such intellectual writers as Bach, Beethoven, and Brahms he is in perfect sympathy. He understands the loftiness of their simple diction, the sunlit snows of their sky-reaching austerity. He interprets them with a deep insight, with an infinite variety of sidelights, with an appropriate color scheme, and with a perfect dignity and style. His technic is so well developed that he plays with consummate ease, and has sufficient reserve power to enable him to maintain in the most intricate passages perfect independence of finger and the resultant diversity of accent. He played the Bach number yesterday with splendid mastery, and the Beethoven sonata he read with complete penetration of its inner thought and a most exquisite finish in the nuancing. It was a remarkably beautiful piece of piano playing, but there was more to come.

In the Brahms variations the pianist let loose the treasures of his intelligence, his musical feeling, and his technical mastery in a most uncommon performance. No pianist who has played these variations here, not even Mr. Pederewski, has given them with such a whole-souled absorption of their spirit and such a brilliant outpour of technical resources just suited to its exposition. One never thinks of Mr. Pederewski as especially a Brahms player, but Dohnanyi enters into the employment of the new piano language as one to the manner born. His own compositions show the influence of the modern idioms which Brahms did so much to establish. These compositions are agreeable, but not refreshingly original in their thematic matter. They are well made, and they fit the piano. A good pianist can excite the enthusiasm of an audience with them. It should be added that after the tremendous burst of power and dash required by their performance, the pianist caused the wires to sing the Rubinstein barcarolle with luscious tone and a restful finish in the delicate gradations.

* * *

December 12, 1900

MME. SEMBRICH'S RECITAL

A Great Audience Hears a Great Singer at Carnegie Hall

Mme. Marcella Sembrich's second song recital took place at Carnegie Hall last night. Again the sweet little cherub that sits up aloft had turned loose in the course of the day the worst manners of the elements, and so to many to go to the concert was in itself an evidence of esteem for the singer. But to the concert the public did go in such numbers and in such brave array that the scene in the hall was like that in the opera house on a festal night. And it was a festal night too, for not within the memory of living men has such perfect vocal art been heard on the concert platform, except from the same lips as opened their rosy barriers to breathe it forth last night. We

have had song recitals of no small excellence in this town, and we are not likely soon to forget the achievements of Lilli Lehmann, Blanche Marchesl, and others. But none of these have possessed the superb vocal equipment of Mme. Sembrich. Her glorious voice and unsurpassable method put her far ahead of those who have preceded her here in this particular field, and with her fathomless depth of feeling, her skill in detailed dramatization, and her knowledge of all stage effects, she stands forth the master singer of our time. Again she offered a programme, the mere presentation of which was in itself a triumph. Here it is:

PART I.

Aria, "Deh Vieni". .Mozart
"My Mother Bids Me Bind My Hair" Haydn
"Delphine," "Auf Dem Wasser zu Singen" Schubert

PART II.

"Ich hab' ein Kleines Lied erdacht". Bungert
"Standchen" . R. Strauss
"Als die Alte Mutter" . Dvorak
"Des Glockenthuermers Toschterlein,"
 "Niemand hat's geschen" O. Lowe

PART III.

"Che t' ho fatto". Cansona Napolitana
"Kan fra Hallingdalen" .Norwegian
"The Coolin'". Iriah Folk Song
"Gai Colon la gai le Rosier" Canada
"Das Muhlrad," "Spinnerliedchen"Deutsch
"Gdzie to jedziesz". Polnische Duma
"Krakoiwak" .Polnisches Tanzlied
"Daleskaia i Blyskaia" .Kleinrussisch

All these songs, except "The Coolin," were sung with the original text, thus making the recital an exhibition of mastery of languages as well as of singing. It would perhaps be unprofitable to attempt an itemized review of this entertainment. It certainly would be easy to fill a column with such a consideration of the wealth of art revealed in it. Some particular mention may be made, but at the outset it seems best to summarize the qualities of an art so beautiful, so potent, so flawless. What are the secrets of such singing? They are, first of all, obedience to that rule which Wagner laid down as the fundamental factor in a perfect interpretation of his works, namely, a complete dramatic comprehension of the text. Mme. Sembrich studies each text as if she were to recite it, not to sing it. Then she is ready to mold her phrasing, her accentuation, her nuancing of the music to the complete and lifelike embodiment of the sentiment of the song. All the resources of her vocal art, her wonderful mastery of the perfect legato, her exquisite coloring, her delicate enunciation, and her perfect tone emission, are directed to the one end, that of conveying to her hearers the feelings to be found in the song.

It is this penetration of the inward life of each song which gives her such a wide variety of styles, while her facility of delivery enables her to put on her programmes some songs

not to be attempted by the ordinary singer with any hope of success. Thus she was able to bring forward Schubert's "Delphine," which few of last night's audience could have heard before. A strange, wild, rhapsodic poem set to perfectly sympathetic music, music calling for voice and declamation, and ranging as high as C sharp, is this little work, and Mme. Sembrich sang it with fervid eloquence. The enthusiasm of the audience was so great that she followed the Schubert numbers with "Du Vist die Ruh."

Lovely as was her delivery of the Dvorak song, she eclipsed it when she applied the resources of her colorature style to the first of the Löwe songs, which was a triumph of smooth delivery of difficult music. She had to repeat part of this song, and after the second Löwe number she gave as an encore selection Brahms's familiar "Ständchen," which she sang most archly. The group of folk-songs at the end of the programme gave the audience great pleasure. All were delightful, and each was thoroughly characteristic. The singer was at her best in the tenderness of "The Coolin," the gayety of "Gai lon la," and the fascinating piquancy of the "Spinner liedchen." The audience recalled her most enthusiastically after the dashing Russian dance song, and she repeated the number. That did not appease the assembly, however, and she was recalled again and again till she took off her gloves and sat down at the piano. Then to her own accompaniment she sang "Way Down Upon the Suanee Ribber" as it has not been sung since Christine Nilsson used to sing it twenty years ago. But Nilsson never had Sembrich's heart, and the old song last night had something it too often lacks, the note of passionate sincerity. That was the dismissal of the audience, and two remarkable song recitals passed into the annals of music in this town.

* * *

December 20, 1900

MR. KREISLER'S VIOLIN RECITAL

When Moritz Rosenthal, the Roumanian piano whirlwind, made his first appearance before the connoiseurs of Gotham in the Fall of 1888 he was assisted in his concerts by a boy, who played the violin. This boy was an awkward youth, and the long Hessian boots which he wore did not add to the grace of his bearing, for they seemed to make him heavy-footed. But it was conceded that the boy had a talent for playing on the violin. The boy has come back. He is no longer a boy, but a man, a big, broad-shouldered fellow, with pointed moustachios and a pair of intense, flashing dark eyes that tell of a world of passion. He made his reappearance here at the recent concert of the Philharmonic Society, but at that time the interest of those who make public their impressions of musical performances was absorbed by a weird and powerful and disturbing composition by the wild man of Munich, Richard Strauss; and so the violinist, Fritz Kreisler, was passed by with the slightest mention.

Yesterday afternoon, however, Mr. Kreisler gave a recital at Mendelssohn Hall and there was ample opportunity to take the measure of the grown artist. His programme was well suited, to a full revelation of his powers. It comprised a suite by Bach, Vieuxtemps's second concerto, short pieces by Mozart, Nardini, Corelli, and Chaminade (the last arranged by Mr. Kreisler), and the violinist's own transcription of Paganini's "No Piu Mesta," itself a transcription. The fact that this composition in its original form was not hard enough to satisfy this young man might lead to a suspicion that technical agility constituted the extent of his claim to consideration. But this would be a false assumption. It is true that Kreisler is a technical wonder worker. He plays with great dash and assurance and attacks alarming difficulties with a boldness that must astonish more cautious players. He shows uncommon recklessness in rushing up the finger board to the high positions, but his seemingly wild shots at harmonics only rarely miss their mark.

He plays a very fast and clear staccato, and his double stopping is clean and generally accurate. It must be admitted, however, that his intonation is not always impeccable. It has uncomfortable moments. His tone is big, but neither noble nor melting. It is a heroic tone, and its robustness is well paired with the performer's general style of playing. The suave and serene do not appear to lie comfortably within the grasp of this violinist. He is happiest when he is storming the heights, when he can declaim in rhapsodical passages or flash along in chromatic trickeries and hazardous leaps. But behind all his work there is warmth of temperament which prevents his playing from descending to the level of a mere technical display. His warmth is communicative, and he should always be heard with interest, albeit the mature hearer will surely long for more of the repose and finish and authoritative poise of a refined art.

* * *

January 11, 1901

THE MORGAN QUARTET

First Concert of the Season Given at Mendelssohn Hall

The Morgan String Quartet gave the first of two concerts last night at Mendelssohn Hall. The members of this organization are Geraldine Morgan, first violin; Eugene Boegner, second violin; Fritz Schafer, viola; and Paul Morgan, 'cello. Their programme was short and pithy. It consisted of Mozart's quartet in B flat, numbered 458 in the Koechel catalogue, and the first of Beethoven's Rassomouffsky quartets, opus 59, No. 1. Certainly no one could complain that his mental digestion was taxed by such a programme. Its brevity and conciseness made music lovers wish that the example of the Morgan Quartet might be widely imitated.

Quartets with women as their leaders are not unheard of, though it must be admitted that they are not common. The temptation to question the ability of a woman to act as a musical leader need not prevail here, for surely if there is any

department of art in which the delicate taste and sympathetic insight of a woman might be expected to work for good it is that of chamber music. The performance of the Morgan Quartet last night showed that such an expectation would in this case not be wholly disappointed. In the quality of its tone this quartet leaves not a little to be desired, but in substance and balance the tone is good. It should be noted, too, with particularity that the four players are nearly always in tune. Furthermore, they perform their work in a smooth and well-prepared manner, which gives to the hearer most of the superficial beauties of the music.

It is in the higher requirements of quartet playing that this organization seemed to be deficient last night. Its work was honest and unaffected, and in certain passages of the slow movement of the Mozart work really interesting. But on the whole the presentation of the works lacked just that peculiar warmth of expression which transforms a quartet playing from a performance into a communication. The audience was one of meagre size and moderate demonstrativeness.

* * *

February 5, 1901

"TOSCA" AT THE OPERA

The Second Work of Puccini to be Produced This Season Is Well Received

"Tosca," a melodrama in three acts by G. Puccini, was performed at the Metropolitan Opera House last night for the first time in the United States. The audience was a large one, and there was abundant enthusiasm from the devoted band of Italians who always support the work of their countrymen. The enthusiasm which followed the first act, evoked as it was by the composer's building up of a mass effect, was from all over the house. A good deal of it was intended for Signor Mancinelli, who completed his fifty-second year yesterday, and whose desk was decorated with flowers. The applause at the conclusions of the other acts was for the admirable acting of Miss Ternina and Mr. Scotti, who added new laurels to their already large wreaths.

Puccini's "Tosca," which was produced at the Costanzi Theatre, Rome, in January 1900, is his fifth work for the stage. The others are "Le Villi," a one-act opera, produced at the Teatro dal Verme, Milan, in 1884; "Edgar," La Scala, Milan, 1889; "Manon Lescaut," Turin, 1893; and "La Boheme," Turin, 1896. The last two have been heard in this city, "La Boheme" being one of the novelties of the present season at the Metropolitan. Puccini is without doubt the most talented of the younger school of Italian composers, and the production of a new work from his pen is an incident not to be passed over without careful attention. The book of "Tosca" is accredited to Victorien Sardou, Luigi Illica, and G. Giacosa. Sardou's share in it was nothing more than his drama "La Tosca," which the opera book follows as closely

as possible. The lyric arrangement was made by the other two, who are now the Barbier and Carre of the young Italian.

The story is tragic and repulsive. There is little in it to touch the gentler feelings. It does not appeal to the sweeter sentiments of our natures. Those who are familiar with the drama will remember that it was notable chiefly for the opportunities it afforded to Mme. Bernhardt for some graphic acting. Perhaps a similar memory will follow those who witnessed last night's production of the opera. No doubt that which impressed itself most forcibly on the mind was the acting of Miss Ternina and Mr. Scotti. The music certainly occupied a secondary place. This, to be sure, need not be accepted as a demonstration of the weakness of the score, for the music of an opera, if it fully and eloquently interprets the story, may well be absorbed unconsciously. But in that case the critical mind will discern the part which the music plays in composing the entire impression of the performance.

Careful study of the score, attentive preparatory hearings, and finally, the observation of the work brought to the most eloquent theatrical realization last night, give ground for the opinion that the music does not reach the full height of the scene except in a few scattered places.

Angelotti, having escaped from St. Angelo, hides in the church, and makes himself known to Cavaradosse, the painter, who paints there and scandalizes the sacristan by his devotion to a fair idol instead of to the saints. In that first episode the composer seeks to impress upon us the idea of a vast cathedral with its industry of worship going on in the halls or chapels other than that which we see. The bells toll out the hour or the angelus and make themselves ready to be imposing in ensembles. The dialog flows smoothly and mellifluously. It is the familiar dialogue of "La Boheme" that is elegant, facile, tenuous. Soliloquizing on the likeness and unlikeness of his Madonna to his Tosca, Cavaradossi sings his "Recondita armonia," a really seductive piece of cantilena, of the best Italian brand, the genuine Puccini. It awakens every expectation. More dialogue and then the entrance of Tosca. A duet, of course, very sweet, very languishing in the grace and demi-melancholy of its poise, but without the variety of passion that one finds in the words. In Tosca's longest speech in this scene, however, with the words "Non la sospiri" there enters a fine place of music, filled with changeful and subtle expressiveness. It was such writing as this that made Verdi see in Puccini his successor. After that the duet is melodious, but not especially significant, to the close. Angelotti comes from the hiding place in which Cavaradossi has put him and goes forth. Scarpia arrives in search of this escaping prisoner. Tosca, returns in search of her lover, and Scarpia arouses her jealousy of the portrait with the blue eyes. All is well written, smooth and fluent, and in at least one speech of Tosca and in one of Scarpia with true dramatic significance. The finale comes with a soliloquy of Scarpia, to which an imposing background is given by the entrance of priests and choir and the singing of "To Deum," with bells and cannon in celebration of a victory over Napo-

leon. Here there is a strained heaping up of effects, but the result is theatrically pompous and stirring to the easily moved.

The second act tells the story of the torture of Cavaradossi to make him reveal the hiding place of Angelotti, the confession of Tosca to save her lover, and the driving of the hard bargain for her honor by Scarpia whom she slays as in the play, leaving him dead with the lighted candles and the crucifix. All of this is well written but it never once reaches that level where word and action and music stand together. The score is literally a setting of the text to music; the music never seems to burst spontaneously into flame from the inward heat of the poetry. It is made music, extremely well made indeed, but nevertheless made. The power and influence of the act are Sardou's, and the effect upon last night's audience was that of the tremendous earnestness of Ternina and Scotti.

The third act tells the story of the dreadful post-obituary vengeance of Scarpia, the "simulated" execution, in which Cavaradossi is done to death in the presence of the deceived Tosca waiting to see him rise and fly with her. And here, again, the master who moves us is Sardou. Puccini has provided music, good and suitable, but he has not placed himself beside the French dramatist. Comparison is not criticism, but one may be permitted here for a moment to recall the equally unsuccessful attempt of Rossini to put into music the test of William Tell and, on the other hand, the perfect success of Verdi in rising to the full height of the murder of Desdemona. In the latter scene the music of the immortal Italian made the acting of Tamagno seem as great as that of Salvini, but probably the most thoughtful of last night's audience were those who remembered how much more touching was Bernhardt without the music than Ternina, no mean actress with it.

The summary of the whole matter, then, appears to be this: Puccini has written a clever score, one that displays genuine talent and a large command of the materials of opera, especially in the management of thematic ideas. Much of his music has a fascinating quality and his melodies have individuality. One coming into the opera house without knowing who was the composer would have no great difficulty in guessing that the author of "La Boheme" had penned these airs. Grace and sweetness are to be found in abundance and of the usefulness of dissonance and abrupt change of rhythm in depicting a tragic situation this composer is well aware. His orchestration is always solid, picturesque, ingenious. He uses voices with the skill of an Italian. In short, he is a gifted and well-trained composer, who has chosen a most unhappy subject, affording little opportunity for a display of the most winning kind of operatic writing, and who has only in the more sentimental episodes of his story risen to the level of the situation. For this we believe the subject is chiefly to blame. The prevailing moods of the story are not inspiring. Puccini will do better work with a better story.

The performance calls for high praise, but it cannot be given in detail at this time. Miss Ternina's acting was almost great, and her singing was highly impressive. She dressed the part beautifully and was a commanding figure. Mr. Scotti's Scarpia revealed the combined stunning, cruelty and passion of the man fully. His singing was broad and vigorous. Mr. Cremonini was a sympathetic Cavaradossi, and his voice proved to be well suited to the music. The other parts were well done. The chorus was fairly good, and the orchestra played very well indeed.

* * *

February 9, 1901

CONTINUOUS MUSICAL PERFORMANCE

The continuous performance has made its appearance in music. It will not be long now, probably, before the flaming announcement will greet the eye: "After breakfast go to the concert." Just exactly how much delight the new system will afford a waiting populace it is not yet possible to say. Its time is not yet ripe. The initial day of the plan was not one to fill its inventor with rejoicing. The day was yesterday and the place Mendelssohn Hall. A concert was given there in the afternoon and repeated in the evening. There were not many in the house at either performance. But, then, it must be stated that the stars of the concert were the colossal baritone, the Marquis de Souza, and the unique Dutch pianist, Martinus Sieveking. The Marquis sang once more the prologue from "Pagliacci," Wolfram's address from the second act of "Tannhäuser," and some minor numbers. Mr. Sieveking played the "Sonata Appassionata" of Beethoven, and some shorter numbers, including Chopin's C minor nocturne and Liszt's arrangement of the "Erlkönig."

The Marquis has undoubtedly a wonderful baritone voice, which would be a gift of inestimable value to a man of high intelligence and pure artistic instincts. But he contents himself with making ad captandum effects by forced contrasts of powerful tone with a most delicate and admirably delivered mezzo voice. He could do anything with such a voice; he does it; but he has not the slightest idea when to do it nor for what reason he does it. Such singing may answer in countries where only the delivery of tone counts, but it will not do here. Mr. Sieveking's piano playing yesterday more than justified all that has been heretofore said in these columns. His performance of the "Erlkönig" was weird and disheartening. He probably struck more false notes in that one number than all the other soloists this season together have struck. And more than that, his treatment of the rhythms was unpardonably bad. There is no reason for exploiting such piano playing. If the continuous performance in music is to be successful, the "turns" will have to do better.

* * *

PERFORMANCE OF PUCCINI'S "TOSCA" AT THE METROPOLITAN OPERA HOUSE

The production of Puccini's "Tosca"—to which even the management persists in prefixing "La"—was the musical incident of the past week. Perhaps the first duty of to-day is to emphasize the fact that Mr. Grau deserves the greatest possible credit for the presentation of the two works of this interesting Italian composer, and for the admirable manner in which he has put them on the stage. The production of "La Bohème" was excellent, but that of "Tosca" gave the manager a wider opportunity, and he was not in the least niggardly in employing it. The scenery is all new and all generously constructed. The church interior of the first act is one of the handsomest and most effective ever put on the stage in this city. The chamber scene of the second act is naturally less striking, but it deserves praise for its perfect adaptation to the action and for its purely Italian color and style. The platform of the Fortress of St. Angelo, seen in the final act, is an admirably designed and painted exterior, and its effectiveness was spoiled on the first night only by the helpless stupidity of the electrician. The management of lights at the Metropolitan Opera House would be discreditable to a Bowery music hall. There seems to be absolutely no intelligence in this department of the theatre, and it is all the more pitiful that such should be the case when really beautiful and appropriate scenery has been prepared.

It might be worthy of note in passing that at La Scala, in Milan, Toscanini has arranged a plan for lighting by which all the light can be thrown from one side of the stage and yet sufficient brilliancy given to prevent too heavy shadows. When this plan was put into operation at the Christmastide production of "Tristan und Isolde" at La Scala, the German managers all sent representatives to observe its working. It must have been very successful. Siegfried Wagner, who was present at some of the performances, told Toscanini that the production excelled even those of Munich and Berlin. It would be well worthwhile for Mr. Grau to investigate the workings of Toscanini's plan, for if, as now seems possible, he may make a feature of new productions in the future, he cannot do better than to make them as complete in every way as he has made that of "Tosca" scenically.

It is a pity that we cannot have a little improvement in the scenic attire of the Wagnerian dramas, which form such a prominent part of the repertory of the house, but that is past expectation. We shall undoubtedly continue to see the same old woolly toy horses caracole down a sharp-edged cloud in "Die Walküre," the same old sawdust rocks loom up in the last act of the same drama, the same miserable imitation of the burning of Walhalla in the final scene of "Götterdämmerung," and the same old set tree shadowing the couch of the Valkyr. For the Wagner dramas draw good houses in their old clothes; and as long as they do that, they are not likely to get any new ones.

The performance of Puccini's "Tosca" presented in a new light that notable artist, Milka Ternina. If this public is as hungry as it seems to be for interesting artistic personalities, there is one upon which it can feed itself to repletion. When this lady made her first appearance in New York, in the early Spring of 1896, she was warmly praised in this place for the beauty of her voice and the exquisite smoothness and grace of her cantilena. At that time she was an actress of dignity but not of power. Since then she has developed dramatically at some sacrifice of her former perfection of singing. At that time this writer expressed a doubt that her voice would prove large enough for such rôles as Isolde. That doubt has been justified, for in that rôle she is compelled at times to force the voice to attain a sufficient sound. This same difficulty interferes with her work in the rôle of Tosca, but it is not unjust to other admirable artists to say that there is no one now known to this public, except possibly Emma Calvé, who could realize for us the operatic Tosca as Miss Ternina has done, and Mme. Calvé could not sing the music.

In the purely technical matters of makeup and dress, alone Miss Ternina has revealed unsuspected taste and skill. Her gowns in the first two scenes are marvels of characterization in costume. In both she looks the Roman singer, while the second is so cunningly designed as to preserve the character and add to it the dignity of tragedy. Her comedy acting in the first scene is delightful in its sincerity and its certainty of touch, while in the passionate emotions of the second act she rises to heights not excelled by her in any of her other parts. And she individualizes her Tosca. There is not a suggestion in it of her Brünnhilde or her Isolde. It stands on a separate and clearly drawn identity. This is a demonstration of high art. As for the singing, this is good, but it is not unique. Miss Ternina's acting is what makes her Tosca a splendid addition to our operatic acquaintances. The singing would count for more if Puccini had written more music of an effective sort. In the one cantabile of the second act Miss Ternina makes a fascinating point, and on the first night the unreasonable Italian contingent, which still persistently refuses to accept an opera as a drama, would fain have encored it. Miss Ternina, being a true artist, paid no attention to the cheers and shouts of "brava."

Mr. Scotti's Scarpia is a brilliantly vigorous and aggressive impersonation. His voice is admirably suited to the music, and he sings his measures with a full appreciation of the brutality of the nature of the creature he represents. His acting is always good, and he makes the second act impressive. Mr. Cremonini is not an actor, but he is singularly well suited to the rôle of the slight and impulsive Cavaradossi. His voice, too, suits the character of the music excellently, and so without any especial effort on his own part he fills the picture fairly well. He might easily be more touching in the last act, but that would require some subtlety, of which he is quite innocent.

A word of praise is due to the inconspicuous Mr. Bars for his correct make-up and action as Spoletta, the police agent. It would be very easy to spoil the second act by a bad performance of this secondary rôle, and Mr. Bars must be thanked for not doing so. Mr. Gilibert contributes to the representation a capitally acted sketch of the Sacristan. It is a genuinely

artistic bit of character work. To Mr. Mancinelli must be awarded the honors due to a maestro in the conductor's chair. This experienced routinier has never shown to better advantage than he did last Monday night when he carried the noisy finale of the first scene through successfully in spite of the erratic doings of the men with the big bells and the cannon. These at one time threatened disaster, but Mancinelli's generalship was equal to the emergency.

* * *

January 27, 1902

VERDI'S REQUIEM MASS

Finely Rendered at the Opera House by Noted Singers

Patrons of Sunday-night musical affairs were given the greatest treat that they have enjoyed this season at the Metropolitan Opera House last night. The day was the anniversary of Verdi's death, and in commemoration of the great Italian composer his requiem mass was rendered. Walter Damrosch conducted. The entire Opera House orchestra was reinforced by the full chorus, and the soloists were four of Mr. Grau's best singers—Mme. Gadski, Mme. Louise Homer, Mr. Salignac, and Mr. Edouard de Reszke.

The work, which is familiar to patrons of the Metropolitan Opera House, is one which calls for perfect rendition, and one would be hypercritical who would find fault with last night's performance. The soloists, particularly Mme. Gadski and Mr. de Reszke, were in the best of voice and sang with an enthusiasm that the great audience fully shared with them. The magnificent choral numbers were splendidly handled, the chorus performing its duty as though the mass was one which they had in constant rehearsal. Altogether, it was a musical event of which those who participated in it have reason to be proud and those who listened to it to be gratified.

* * *

March 26, 1902

THE KNEISEL QUARTET

Two Novelties at the Fifth Evening Concert in Mendelssohn Hall Last Evening

The fifth evening concert of the Kneisel Quartet of Boston took place last night at Mendelssohn Hall. The programme was as follows:

Quartet in G minor, Opus 10. A. C. Debussy
Quintet in F major, for three violins,
 viola, and 'cello . C. M. Loeffler
Septet in E flat, Opus 20, for violin, viola, horn,
 clarinet, bassoon, 'cello, and double bassBeethoven

The quartet had the assistance of W. Krafft, violin; K. Keller, double bass; A. Hackebarth, horn; N. Lebailly, clarinet; and A. Debuchy, bassoon.

The performance of two novelties in one concert was unusual, even among the achievements of the Kneisel Quartet, whose leader, Franz Kneisel, is of the opinion that it is a duty of his organization to give hearings to new compositions in the field of chamber music. This self-imposed mission is an amiable one, and is not without a spirit of self-sacrifice. It would be easier to select from the well-trodden field and easier to prepare the performance of familiar works. Furthermore, there would be a greater certainty of satisfying the public by keeping to the beaten path, for the public, even the most musical part of it, is not always in an industrious mood, and the hearing of new music is not a task for the indolent mind.

Achille Claude Debussy is certainly quite unknown to this public. He is one of the young school of French composers, is thirty-nine years of age, a graduate of the Conservatoire, and a winner of the Prix de Rome. He has composed an opera, "Pelias et Mélisande," a cantata on Rossetti's "Blessed Damosel," several orchestral works, and many songs. The quartet heard last night has been played in Brussels and in Paris, and in both places called forth lively critical comment. The principal characteristics of the composition are its leanings toward Orientalism in the conception of its melodies and the stringency of its close harmonies.

The first movement is entirely the best of the four in melodic invention and in development. The themes are fecund in possibilities and the working-out is rigorously logical. Hardly a bar of extraneous matter appears, and the composer's grasp of his fundamental material never loses its firmness for a moment. The movement consists simply of proposition and discussion; there is neither recapitulation nor coda, and the conclusion follows abruptly upon the climax of the development. The second movement is the scherzo, and here the composer is again skillful in his handling of form. He uses the scherzo motive and the trio motive as contrasting themes and works out his material much after the manner of the first movement. A strikingly effective use is made of pizzicato writing in this movement, which is second only to the first in merit. The slow movement, which is next, begins and ends tolerably, but its middle episode is weak. The final movement is extremely poor in material and a continued straining after effect in the part writing does not hide the fact. As a whole, the quartet is interesting, but seems to be a labored work, smelling of the midnight oil. The constant combat of opposing rhythms and the struggle of ceaseless dissonances stimulate the intellect of the thoughtful listener, but there is little to appeal to the fancy and still less to move the heart. Yet the composition has a certain individuality, and demonstrates that its writer has a good mastery of the materials of his art. He is more than merely an accomplished workman; yet he does not appear in this music to be gifted with genuine inspiration. He has something to say, and he knows how to say it; but after we hear it, we would the gods had made him poetical.

C. M. Loeffler is not unknown to local music lovers. He shares with Mr. Kneisel the first desk among the first violins of the Boston Symphony Orchestra, and several of his compositions have been heard here. His tone poem, "The Death of Tintagiles," and his work for violin and orchestra, entitled "Nights in the Ukraine," will readily be recalled. Mr. Loeffler is French by training and tendency, and he has shown a strong sympathy with the "decadent" poetry of France. His new quintet is novel in form and in the choice of instruments. It was an unexpected movement to extend a quartet to a quintet by adding a third violin. Usually two violas or two cellos are employed. Mr. Loeffler's quintet is in one movement, marked allegro commodo, though there is an episode marked poco allegretto. The opening allegro is built on two contrasting themes, according to the fashion laid down by the fathers, but the complete sonata form is not used. The episode is Slavonic in character, its melodic basis being the air of a Russian folk-song. After the episode a return is made to the themes of the allegro commodo, and the composition closes with a coda. The plan was evidently designed to give the effect of three movements without break and using the device of community of theme.

Mr. Loeffler's music proved to be attractive and interesting. Graceful, fluent and melodious in theme; clear, well-balanced and solid in part-writing, it worked itself out in a lucid, symmetrical shape, and left the hearer with a refreshed mind and a warmed fancy. We cannot, however, avoid the conclusion that the effect was that of a single movement. There was a want of that sense of completeness which comes from a hearing of successive movements of contrasting character. Mr. Loeffler's middle episode did not satisfy the cultivated craving for excursions into new tonality, new rhythm, and new thought. As a single movement, however, the composition was wholly delightful. The Beethoven septet brought the concert to a charming close. This and the other two numbers were beautifully played.

* * *

April 7, 1902

SOUSA AT THE METROPOLITAN

Herr Crasz, French Horn Player, Under Musical Union's Ban

The usual large and enthusiastic Sunday night audience greeted Sousa and his band last night at the Metropolitan Opera House. The soloists were Blondelle zer Treese, soprano; Ruby Gerard-Braun, violiniste; and Arthur Pryor, the popular trombonist. Every number received at least one encore, while Miss Zer Treese's cavatina from Gounod's "Queen of Sheba" and Arthur Pryor's trombone solo,

"Love's Enchantment," and the final number, variations from Massenet's "Scenes in Naples," received several calls.

The band last night had to get along without the services of one of its most important members, Herr Crasz, a French horn player, who was picked up by Mr. Sousa in New Orleans on his recent Southern tour. Herr Crasz played at all the concerts until early last week, when the band appeared in Brooklyn. Shortly before the concert a question was raised by the Musical Union as to Herr Crasz's eligibility to play, as under their rules nobody can play in a union organization unless he has been in this country for six months. Herr Crasz was placed under the ban, as he has been here only a short time.

Another French horn player, Herr Wagner, was secured for the New York engagements, and Herr Crasz will rejoin the organization when it goes on tour, as the rules of the Musical Union do not hold outside of the city.

* * *

April 20, 1902

A NEW CANTATA

A concert on Friday evening at the Central Presbyterian Church, in West Fifty-seventh Street, was signalized by the first production of a new cantata, "The Celestial Country," by Mr. Charles E. Ives, the organist of the church, the words being Alford's not particularly felicitous English version of Bernard of Cluny's famous hymn. The work is scored for solo, quartet, octet, chorus, organ, and string orchestra and two horns. As heard on this occasion it obviously suffered from the want of the chorus, the octet being the extent of the vocal force available, the choral climaxes thus failing of their intended effect, and the scale being to that degree lost. This misfortune the conductor attempted to obviate by diminishing his pianos almost to inaudibility and thus preserving the dynamical relations, but this expedient could not be altogether successful.

The composition seems worthy of a more complete hearing. It has the elementary merit of being scholarly and well made. But it is also spirited and melodious, and, with a full chorus, should be as effective in the whole as it was on this occasion in some of the details. The most successful numbers, as it was heard, were the quartet, "Seek the Things Before Us," the baritone aria (sung by the contralto), "Naught That Country Needeth," and a pretty intermezzo for strings.

The cantata was preceded by a miscellaneous concert, comprising selections on the organ from Bach, Brahms, and three French composers of the seventeenth century, the "Quis est Homo," and a notably finished performance of three movements of Beethoven's first string quartet by the Kaltenborn Quartet.

* * *

December 28, 1902

AN AUTOBIOGRAPHIC SYMPHONY

Berlioz's "Episode in the Life of an Artist" and His Terrible Plan of Revenge on an Indifferent Lady Love—The Failure of the "Infant Prodigy"

The orchestral works of Berlioz, like those of Liszt, reappear from time to time in the concert programmes as a tribute from orchestral conductors to men who loom large in the history of modern music and who were both consumed with a desperate ambition to play the part of great composers in it. There is talk of a Liszt "revival" or a Berlioz "revival" now and again. Perhaps there is one now in progress without much knowledge of it on the part of the public. Three of Liszt's symphonic poems have been played in New York already this season—his "Préludes," his "Festklänge," and his "Tasso"—and a weak attempt has been made at his concerto in E flat. The first and last named are usually with us every season. Of Berlioz there have been heard the "Benvenuto Cellini" and the "Roman Carnival" overtures, and now, at Mr. Wetzler's concert this week, his "Symphonie Fantastique" is to be played. It is not often put before this public nowadays, though there has been ample time to form a taste for it since it was first made known to New York by the Philharmonic Society in 1866.

Though it is an early work of Berlioz, written in 1830, in his twenty-seventh year, it is thoroughly characteristic of his inspiration, and it is doubly characteristic on account of the somewhat amusing chapter of autobiography that is bound up in it. In 1829 Berlioz was at the height of his wild infatuation for the Irish actress, Miss Harriet Smithson, who, two years before, had revealed Shakespeare and her own beauty at the same time to the young romantic. She came to Paris in 1827 as one of the minor people in Charles Kemble's English company. Suddenly called on to take the part of Ophelia, which she had never played before, she did it with such force and originality as to capture the hearts of the Parisian public, among them that of Berlioz, who thereupon began besieging her with flamboyant ardor of passion that knew no bounds. She paid no attention to him at that time, notwithstanding all his efforts to gain access to her and to impress her and touch her heart with his music—of which she knew and understood absolutely nothing.

In 1829 she had completed a European tour and had returned to London, whence reports of her triumphs were brought to her burning lover. He still had dreams of capturing her through the power of his music. For this purpose he destined a grand composition which he should play in London and in which he would win his triumph by her side. It was his "Episode in the Life of an Artist," the "Fantastic Symphony." But at the end of these two years of waiting and unremitting anguish, when the symphony had already taken shape in his mind, he experienced a very sudden cure. Various unfavorable reports about Miss Smithson reached him, to which by that time he was only too disposed to lend a willing ear, and he dropped the rôle of desperate lover—though he did not accomplish this without a shock and a struggle of the spirit that kept him wandering two days about the suburbs of Paris, sleeping in the fields and given up by his friends for dead. And at about the same time another young woman and a fresh passion entered into Berlioz's heart. The name of this new divinity was Mlle. Camille Moke.

But the Smithson, though expelled from her altar in that temple, was by no means forgotten by Berlioz. How should her wicked indifference to a tremendous passion and a once-anguished soul be punished? How otherwise, indeed, than by that very work intended once for her glorification, now to be turned into an engine for her destruction! That purpose now beset him as fiercely as the passionate obsession had before. The "Symphonie Fantastique" should be his revenge; it should be an allegory directed against her; it should signify his scorn; it should punish her in public. Now for the first time was he able to force himself to its composition, and after three months of flaming energy directed upon it he could announce with savage joy that he had written the last note of it. The hour of his vengeance was at hand.

He was to have the symphony performed at the Théâtre des Nouveautés in May, 1830. There should be printed notes distributed to the audience, so that everybody should understand his cruel allegory. Miss Smithson herself should be enticed to the performance. The whole public should recognize her. It would make him famous and hasten his union with his new love. Unfortunately, this precious scheme fell through. There was a pretense of a rehearsal, then everything was given up, and Berlioz walked the streets in debt for the copying of his score and the preliminary preparations for his concert. In December of the same year he secured at the Conservatoire a performance of three movements of the work. Miss Smithson had in the meantime returned to Paris and had met with reverses of fortune; she was no longer a favorite of the Parisian public. But she cut her quondam admirer dead the first time she saw him, and he determined to go on with the vengeance. Alas, the lady escaped the expiation planned for her. Instead of going to the concert she was appearing that evening at a benefit organized for her, and never even heard of what was impending. The symphony attracted some attention, and passionate strife was even then engendered between the admirers and the detractors of Berlioz. But of the dark and vengeful significance of the "Symphonie Fantastique" the public knew or cared nothing.

It only remains to chronicle the fact that the first complete performance took place in Paris in 1832; that this time Miss Smithson was present in a box; that the public, its curiosity piqued by the reports about Berlioz's relations toward the once popular actress and the allusions in the programme, turned a curious gaze upon her. But the composer in the meantime had been jilted by Mlle. Moke; he had changed his mind again about Miss Smithson and the purposes of the "Symphonie Fantastique." It was now once more a pledge of

his adoration for her; she accepted it as a tribute, though she knew little of what it was all about. In 1833 they were married, and lived unhappily thereafter till her death, twenty-one years later.

The significance of this symphony Berlioz expounded in a note prefixed to the score, detailing the contents of each of the four movements. The young artist whose life it depicts suffers from the effects of a dose of opium; the symphony is his dream. He sees in this state a woman who unites all the charms of his ideal. This being always presents herself to his mind accompanied by a musical theme—the famous "idée fixe" of Berlioz's invention, recurring in all the five movements of the symphony.

The second movement shows a ball scene, where still the cherished image troubles his soul. In the third he is represented of an evening in the country and hears two shepherds playing on their pipes; he experiences mingled sensations of hope and despair. In the fourth he sees horrible visions, dreams that he has slain the beloved one, is dragged to the gallows, and witnesses his own execution, to the music of a march, "now sombre and wild, now brilliant and solemn," at the end of which the first four measures of the "idée fixe" return as a last memory of love before the axe falls. The last movement depicts the "Witches' Sabbath"; in the midst of the hurly-burly the melody of the loved one reappears, but it has lost its original character, and has become a grotesque, trivial dance tune. It heralds her approach to the orgy, in which she joins. Then comes a parody on the plain song church melody of the "Dies Irae," which is mingled with the witches' music for the close.

It is not difficult to perceive the allusions that the composer wished to make to his own experiences here for the punishment of his disdainful love. It is still easier to see it in the programme as Berlioz first devised it, and as it was printed at the first performances. In this the opium dreams of the artist began after the third scene. The march to the scaffold and the witches' Sabbath were the only hallucinations represented; the other scenes were realities. As M. Jullien points out, there is no difference for the listener, but a very considerable one from the point of view of the composer, who had changed his purpose from revenge to the offer of tribute. More unpleasantly is original ferocity of purpose shown in a phrase used by Berlioz in describing the approach of the once-beloved to the "Witches' Sabbath"—"only a courtesan is worthy to figure in such an orgy." This and some other vivid touches in the original explanation were cut out at the performance that proved to be for Miss Smithson's honor; for which, even at this distance of time, we may be truly thankful.

* * *

January 31, 1903

A FINE MATINEE PERFORMANCE OF "LA BOHEME"

Caruso's First Appearance as Rodolfo—"Aida" Repeated in the Evening

Mr. Caruso showed yesterday afternoon for the first time since he has been in this country the supreme beauty of his voice and the perfection of his style when he is at his best. He took the part of Rodolfo in the matinee performance of "La Bohème" at the Opera House—the part which he was prevented from assuming in the first week of the season by the throat trouble that temporarily put him out of commission in Mr. Conried's forces and that left its traces after he had returned to service.

Mr. Caruso plays the part of Puccini's Latin Quarter hero with especial sympathy and presents a figure of unusual attractiveness. Its attractiveness is the more remarkable after the somewhat dull and unimpressive impersonation he gave of the artist Cavaradossi in "Tosca." It has distinction in its kind, bonhomie, humor, pathos. But it was most striking in its musical side. Mr. Caruso's voice has never sounded so deliciously pure, rich, and smooth, so clear and warm in its upper tones, so full and free in its emission without a trace of the "white" and open quality that was objected to at his first appearance.

He sang with great fervor and passion, and poured out his voice with prodigality. Now we know what Mr. Caruso's voice really is. As it was displayed yesterday afternoon, it was such a one as has not been enjoyed here for a long time, and enjoyment of it was raised to a higher power by the skill with which it was put at the service of a keenly felt dramatic conception.

The other elements of the cast—with one woeful exception—were such as to make the performance brilliant and sparkling; a performance much superior to the one previously given in its spirit and spontaneity. The participants in it, with the exception noted, were same as before; there was Mme. Sembrich's delicious impersonation of Mimi, which gains in apt and characteristic expression with every repetition, and offers a pure delight in its interpretation of Puccini's music; Mr. Campanari's Marcello, Mr. Dufriche's Schaunard, and Mr. Journet's Colline. Mr. Rossi took the two parts of Benoit and Alcindoro humorously.

The fly in the ointment was the appearance of Miss Estelle Liebling as Musetta, which in that companionship and to that audience was little less than affront. A voice of gruesome quality and diminutive volume, a characterization that vulgarized the part and crippled the effect of every scene in which she appeared made up the sum of what she contributed. There was renewed admiration for Mr. Vigna's spirited conducting, and for his insight into all the subtler effects of the music, his skill in bringing them out. There was an audience of good size that showed full appreciation of the uncommon excellence of what it was hearing.

A considerably smaller gathering heard an admirable performance of "Aida" in the evening, in which the cast was the same as in the previous representation, except that Mr. Dippel appeared as the Rhadames. He always challenges hearty praise by the whole-hearted devotion and energy with which he throws himself into everything he does, and his Rhadames has a manly attractiveness that all the interpreters of the rôle do not always achieve. He was in excellent voice, and the intelligence of his enunciation, phrasing, and declamatory power were to be appraised as of high value in the effectiveness of his interpretation.

Miss Edyth Walker deepened the impression she made in her first appearance as to the remarkable beauty of her voice, its purity power, smoothness, and delightful equality; and, when she is moved to exert it in that direction, its dramatic expressiveness. Miss Walker's routine somewhat overpowers the exposition of her individuality and dramatic conceptions, which she might do well to cultivate. That she has them is to be seen from her strength and freedom in the prison scene of the last act. There is certain to be much of importance contributed to the season's enjoyment by Miss Walker's appearance in it.

Mme. Gadski was in fine voice, though at the close she was sometimes disposed to sing sharp, and gave the picturesque and passionate representation of Verdi's heroine that her admirers have learned to expect unfailingly of her. Mr. Scotti's splendid Amonasro, Mr. Plancon's Ramfis, and Mr. Mühlmann's king made up the rest of the characters. Miss Schaffer sang the music of the priestess with somewhat more tunefulness than she did the other evening. Mr. Vigna again conducted with superb breadth, freedom, and dramatic power.

* * *

December 7, 1903

A BERLIOZ CONCERT

Celebration of the French Master's Centenary by the New York Symphony Orchestra

The third of the concerts of the New York Symphony Orchestra, under Mr. Walter Damrosch, which was given yesterday afternoon in Carnegie Hall, was devoted to the works of Hector Berlioz, to commemorate the hundredth anniversary of his birth, falling on Dec. 11. The concert was planned upon an unusually elaborate scale, enlisting the assistance of three solo singers and a chorus from the Oratorio Society. The programme was so designed as to give a representation to all the musical forms in which Berlioz worked—opera, symphony, dramatic cantata, mass, and song.

There were a number of selections included in it that were quite unknown to concert-goers in New York, and that were set down upon the programme as being given for the first time in America. The preparation of it all, as Mr. Damrosch

confided to the audience in his preliminary remarks, had been a labor of love. There seemed to be no doubt of this, for as conductor he had plainly entered into the spirit of the music with affection and with the enthusiasm that was bespoken by his comments on the several numbers performed; while the orchestra and singers amply seconded his endeavors and the orchestral playing was both finished and brilliant, and fulfilled all the technical demands made by the music.

It ought not to be difficult from the works of a composer so voluminous and varied as Berlioz to make up a programme of unflagging interest, if there is really so much vitality in them as there is represented to be; but it was made clear before the end was reached yesterday afternoon that Mr. Damrosch had not done it. The pieces that are most familiar, it seemed evident, had become so through the process of survival of the fittest; few of the new ones made much impression or helped dispel the doubts of the doubters. The "Benvenuto Cellini" overture is tolerable in spite of its musical emptiness by reason of its rhythmic energy dress, as is the "Roman Carnival" overture, though that has more to satisfy the longing ear in its substance; and the graceful fairy music and the sonorous setting of the Rakoczy march from "The Damnation of Faust" will long retain their fascination.

But the two airs from "Benvenuto Cellini," which Mrs. Hissem de Moss and Mr. Dan Beddoe sang with every evidence of sincere and careful preparation, are not likely to be heard often for their own sake. The overture to "Beatrice and Benedict" Mr. Damrosch rashly compared to that of Mozart's "Figaro," and characterized as a model of what a comedy overture should be; but the performance was far from justifying this admiration, for it seemed to show it merely as a piece of wearisome reiteration of unimportant subject matter, in which gayety and graciousness of spirit are sought for, but one attained only in the merest outward simulation by the help of skillful orchestral coloring and finesse. It was hard to share Mr. Damrosch's surprise that the piece had never, so far as good memories go, been performed in this country before.

The duet from the same opera, "Vous soupirez, Madame," has some exquisite touches of twilight tenderness, and was heard with real pleasure. There are some characteristic effects of monotony, and a clearly established mood in the song with orchestral accompaniment, "Sur les Lagunes," that Miss Hall sang. The movement entitled "March of the Pilgrims," from the "Harold Symphony," however, is exceedingly wearisome in its endless repetitions of the hymnlike theme, and the Sanctus from the requiem mass, with its Hosanna in a three-part fugue, seemed like a well made piece of choral writing without remarkable distinction of substance or the attainment of real dignity or deeply moving power.

The concert as a whole was one that did honor to the memory it was celebrating, in so far as it gave one entirely adequate exposition of the music that was chosen to represent Berlioz's art. There was lively enthusiasm at the outset, but it waned considerably before the afternoon was ended. The audience was noticeably smaller than those at the previous

concerts. There was much to admire in the singing of Mr. Beddoe, who appeared before a New York audience for the first time, and who showed an agreable tenor voice and a manly and unaffected style. Mrs. Hissem de Moss and Miss Hall sang with much intelligence and fine taste.

Mr. Damrosch's next programme will be devoted to Tschaikowsky. The orchestral numbers will include the Marche Slav, the "Hamlet" fantasie overture, and the "Nutcracker" suite; Miss Aus der Ohe will play the B flat concerto for piano, and Mr. Mannes a couple of short violin pieces.

* * *

December 13, 1903

THE BOSTON ORCHESTRA

Berlioz's Memory Honored with His Harold Symphony—
Mr. Krasselt, the New 'Cellist, Plays

The changes that were made in the programme of the Boston Symphony Orchestra at their Thursday evening concert required also a rearrangement of the orchestral list announced for yesterday afternoon. As revised it contained Beethoven's overture to "Fidélio," Smetana's symphonic poem "Vysehrad," and Berlioz's "Harold" Symphony. Mr. Krasselt, the new first violoncellist of the orchestra, was the soloist, playing Saint-Saëns's concerto in A minor, and Mr. Férir, the new first viola, played the obligato that runs through all the movements of the symphony.

The new violoncellist made a very favorable impression, and it was very clear to him that he had made friends for himself in the New York public. He is a very young man, but he is already an accomplished master of the technique of his instrument, and a player of fine spirit and intelligence. A great one it is not yet possible to call him, and he did not show that he could penetrate deeply into the hearts of his hearers with a tone of the greatest nobility, sensuous beauty, or poignancy of expression. His bowing is fluent, strong, and flexible, and his command of the fingerboard of the instrument extremely facile. All in all it was an admirable performance of the Saint-Saëns concerto, not a great work in itself, but at least one that does not stultify the instrument quite after the fashion of most concertos of its kind.

Smetana's symphonic poem is the first of that series of six that the Bohemian composer wrote to give expression to different aspects of his fatherland, as they presented themselves to an ardently patriotic musician—another one of which series is, by chance, to be given to-night at the Metropolitan Opera House by Mr. Mottl. They are strikingly picturesque and varied in their form and content; and "Vysehrad," giving the composer's idea of a famous actress of glorious and chivalrous memories, has an exterior brilliancy that is most engaging. Profound or deeply felt it cannot he called; but all there is of effect in it was shown forth by Mr. Gericke's men.

The "Harold" Symphony was the Boston conductor's tribute to the hundredth anniversary of Berlioz's birth that is affecting the programmes this month of orchestral organizations the world over. As such it was listened to with all due attention; but that it made a deep impression cannot be said. It is full of orchestral color and subtlety, of elaborate strivings to present a picture of events in tone; but interesting as they are from a technical point of view, they fail because of the absolute dullness of the music as music and the lack of idea, of the means to express the ambitious ideas that the composer set before himself.

Artificiality is the quality that constantly forces itself upon the unprejudiced listener. It has been called "half symphony, half solo, concerto, half opera without words"; and the characterization expresses the uncertainty of its form and purport.

* * *

March 22, 1904

"SYMPHONIA DOMESTICA," WITH COMPOSER LEADING

Dr. Richard Strauss's Latest Work Given for the First Time
HEARD BY A LARGE AUDIENCE
A Difficult Problem in Programme Music at the Composer's Last Concert in Carnegie Hall

More than twenty years ago Richard Strauss's symphony in F, the work of an unknown young German composer, was first brought before the world by a performance in this city. Last night the latest composition of Dr. Richard Strauss, the foremost man of the day in music, his "Symphonia Domestica," was also given its first public performance here. It was in Carnegie Hall, and was the climax and culminating point of Dr. Strauss's visit to this country. The significance of the occasion was recognized by the large audience present, who listened to the new symphonic tone poem with close attention, and manifested their interest in it by many recalls of the composer at its close. Enormous pains had been expended upon it to obtain a proper performance; many rehearsals had been directed by the composer himself, to secure which the piece had been shifted from its place originally announced for it in the series of concerts, and finally the concert itself had been postponed for many days after the time first set for it. Dr. Strauss, whose somewhat cool attitude toward the performance under his baton was noted at the first concert in which he conducted, threw himself into the affair with a great access of energy, and worked indomitably to obtain from an orchestra of by no means remarkable ability justice to one of the most complicated orchestral scores ever produced.

The general outline of the "Symphonia Domestica" has already been described in The Times. It is in three main divisions with an introduction, corresponding, according to the composer's intentions, to the general aspect of a symphony,

though it is perhaps needless to say that in its form it bears little relation to symphonic development as evolved by the classical masters. For the "Symphonia Domestica," although Dr. Strauss has not given any definite indication of it in his score, is programme music in the fullest acceptation of that term. Its form is as completely determined by the ideas and incidents that swayed his imagination as anything he has ever composed; and those who are led by its title to attempt an identification of it with the symphonic form will be hopelessly led astray. No detailed suggestion of what these ideas and incidents are has been published before the performance, since Dr. Strauss has desired that the composition shall stand for itself as music, and shall be listened to as such. But now, on the authority of the composer himself, many of the most intimate details of the "Symphonia Domestica" and the succession of pictures may be disclosed.

To begin with, Dr. Strauss gives as a sub-title to the work "Ein Tag aus meimém Familienleben" ("A Day in My Family Life"), introducing at once the personal element that is generally recognized to enter into "Ein Heldenleben," and making the new symphonic tone poem, as it were, the familiar and humorous everyday counterpart of that stately picture. Its three principal themes represent "Papa, Mama, et Bébé," the father, the mother, and the child. The humorous strain, the spirit of sportiveness run through it, with certain passages of nobler and more serious import, as well as many more that the most anxious desire to follow Dr. Strauss cannot make other than hateful, needless, and distressing ugliness. The humor of it is very elaborately and sometimes very strenuously voiced, and the gentlemen of the orchestra, as well as most of the audience, doubtless found it a most serious matter.

The introduction presents the three themes that are representative of the husband, the wife, and the child. The husband's theme comprises three contrasted sections. These are expounded in the order mentioned, the child theme being represented by the tender and gracious tones of the oboe d'amore, which Dr. Strauss has awakened from its long slumber of a century and a half to take a place in the modern orchestra. A curious detail is disclosed in the score. The only hint that its pages present of any incident depicted in the music is a passage in which the aunts are represented as saying, "Just like the father," "Just like the mother."

The scherzo that follows is a development of these three themes, "like a playing of the father and mother with the child," as Dr. Strauss has described it; the third theme, the child's, is carried out to a special elaboration. A "merry episode" closes this movement, in which—and this is on the authority of the composer—the child is washed and put to bed with a cradle song. The clock strikes 7.

The adagio shows us papa alone. He is in a reverie. He is at work—being a composer, he is composing music, and Dr. Strauss has attempted as an ultra refinement of the programme idea, to show, through music, himself in the act of composing music. There is a love scene. He is troubled with the cares of his family. He dreams. The third part brings us to the next morning. The clock again strikes 7. The baby wakes

and cries. Finally there comes a dispute between papa and mamma over the bringing up of the child; it is represented by a double fugue—in the Straussian definition of that term, one at which Fux and Albrechtsberger would have torn their hair, and which is likely to give pause to theorists of much more modern tendencies.

Its subjects are, first, a version of the child's theme in "diminution," as the musicians call it, and, second, a theme in sharply accentuated, excited sixteenth notes—clearly a feminine argument! It is carried on with great animation, rising finally to a terrifying orchestral clash. There is then reconciliation and peace. A simple song-like passage is developed from the child theme. But then comes again more orchestral chaos. There is an incoherent tossing about of all the themes, apparently in every key, in every interlocking rhythm, and with an effect that can only be described as a bedlam of sound. It is one of the most impossible passages that Richard Strauss has ever penned.

The subject and the treatment of the "Symphonia Domestica" easily lend themselves, nay, invite, to gibes and levity. The invitation will doubtless be utilized to the fullest extent. But Dr. Strauss and his music are deserving of a more serious consideration and a sincere effort to approach them from his point of view. Yet the work is one to cause even his most sincere admirers perplexity. It would be hard to believe that such a subject could incite even so active and fertile an imagination as Dr. Strauss's to the production of music equaling his compositions on heroic or fantastic or tragic subjects that have influenced and moved the world in literature. Nor has it. The "Symphonia Domestica" is, like all his music, deeply interesting, in some respects fascinating. It is full of new effects, and many of his old ones are repeated with a supreme mastery of technical manipulation that seems raised to a higher power than ever. The thematic development is carried to the furthest limit. The combinations of themes—counterpoint, if there were only that regard for euphony which it is the function of counterpoint to protect—are bewildering. The cacophony upon which the harmony sometimes enters is recklessness.

The composer is as unsparing as ever of his listener's ears in this respect. The instrumentation is scarcely more natural than it is in some of his previous works—there is much forcing of instruments into impossible registers and heart-breaking demands upon their technique. There are enormous difficulties, and the ensemble is most exacting. The orchestration of the "Symphonia Domestica," indeed, has much that characterizes that of "Don Quixote," a certain openness or exposed quality, as it were, of a vast piece of chamber music, with much independence of the voices of the different choirs. But the composition as a whole lacks something of the irresistible sweep, the large contour, of his other works, the persuasiveness that goes so far to compel acceptance from the unwilling.

Some of its themes, while they are plastic and yield amazing results under his manipulation, have little potency of their own, little characteristic physiognomy. That of the child is the most distinctive. The cradle song is beautiful; so is much of the adagio; there are extremely interesting points

in the development of the fugue, vigorous and exhilarating stretches in the introduction. But there is much that does not deeply touch the imagination. With all his magic, Dr. Strauss has not succeeded in the "Symphonia Domestica" in reaching the highest point of characterization, as he has in other works. And, after all is said and done, there seems to be little justification in the subject, and the treatment of it for all this expenditure of tremendous orchestral resources and the composer's transcendent technique. The whole thing seems to be incredibly out of proportion. If he had been writing of the Judgment Day he could not have done more.

Dr. Strauss's desire to have this work heard as music and to speak for itself under its title is an inexplicable one. The title alone gives little help, or is worse than useless in stimulating the hearer's imagination. It is either too much or too little. What starting point is there for the listener in the knowledge that a "domestic symphony" is to be set before him? What is a "domestic symphony"? If he listens to a tone poem on "Don Quixote" or "Don Juan," or even on "Till Eulenspiegel" or Zarathustra's sayings, he knows or may know what the subject matter is, or if he hears an overture by Mendelssohn on "Fingal's Cave" or an "Ocean" symphony by Rubinstein he has in the title a stimulus that may make his fancy keep pace with the music. But he does not even know that a "domestic symphony" is a day in the composer's or anybody else's family life.

Is not the hearer constantly impressed, in hearing this one, that something of apparently tremendous import is going on of which rightful knowledge is denied him? Is he not tantalized by sounds that are plainly meant to be to the mind something more than they seem to the ear? It was very difficult to perceive for Dr. Strauss's performance of this enormously complex and detailed piece of programme music without a word of explanation any sufficient cause. Even with a knowledge of all his intentions, the "Symphonia Domestica" does not reach complete success in characterization, notwithstanding all its prodigious cleverness. Without that knowledge the music rarely explains itself or justifies itself as music. The fact that his programme has served his own purpose in inspiring him to its production is not sufficient. Their experience last evening ought to be full of suggestion to all who heard the "Symphonia Domestica" as to the philosophy of programme music.

The performance was, on the whole, an extremely fine one, in many respects brilliant. There were slips at some of the points of cruelest difficulty that probably most were fain to extenuate. But there was subtle nuancing, and adroit exposition of the intricate pattern in the woof and web of the musical fabric, and apparently a proper realization of all the composer's intentions. Dr. Strauss conducted with tremendous energy and alertness. His perfect mastery of the score, his authority in the orchestra, his insistent and unceasing command over every choir, and, as it almost seemed, each player in every choir disclosed his stature as a conductor as it has not been disclosed before.

The concert began with a fiery and highly colored performance of the "Don Juan" tone poem, and closed with a repetition of "Also Sprach Zarathustra," both of which had been played before at these concerts.

* * *

<div align="right">December 9, 1904</div>

THE BOSTON SYMPHONY ORCHESTRA PLAYS

Eugene Ysaye's Reappearance as Soloist
GREAT VIOLINIST'S TRIUMPH
A Remarkable Performance of Concertos by Bach and Bruch— Brahms's Third Symphony Played

Seldom has the audience of the Boston Symphony Orchestra been so stirred as last evening at the second evening concert of the season. The third symphony of Brahms was the first incitement to the unwonted enthusiasm—music of supreme beauty marvelously played, with the fresh and buoyant spirit, the poetry and romantic mood reproduced as by an immediate contact with the composer's purpose.

Flexible tempo, plastic modeling of phrase, perfect translucency in the instrumental voicing marked the performance, and the two middle movements especially were made notable by the limpidity of the wood wind instruments. It was highly appreciated and warmly applauded, and Mr. Gericke was made to feel that he had made an uncommonly deep impression.

But the occasion resolved itself chiefly into a welcome for the great master-violinist, Eugène Ysaye, who appears in New York for the first time after an absence of half a dozen years. He had rearranged the programme as it was originally announced, and played besides Bach's concerto in E major, Bruch's second concerto in D minor, instead of the same composer's fantasie on Scotch airs.

Mr. Ysaye returns in the plenitude of his powers, which are those of a supremely great master, an interpreter in the highest sense, who glorifies and ennobles all he touches, with the communicating flame of his ardent musical temperament. Greater technicians there may be, but none who have spoken with a higher and nobler eloquence, with deeper poetical insight; none who can so pluck the heart out of the mystery of great music and impart that mystery so fully and unreservedly as he. As he plays, all considerations of technique vanish, all the processes by which the deed is done are forgotten.

The personality of the executant is sunk and merged in significance of what he is doing; and it is as if the listener were put into immediate communion with the music for its own sake alone. So it was in his interpretation of Bach's concerto, a work that he played frequently at his former visits to this country.

It is music of imperishable beauty, as fresh and vital to-day as when it was written, and Mr. Ysaye's playing of it presents it with all its throbbing vitality, all its infinite tender-

ness. His reading of the first movement is of magnificent breadth and muscularity, romantic and deeply appreciative of the poetry that finds utterance in it.

In the adagio he voiced its ineffable tenderness with a poignancy that tugged hard at the heart strings of those who heard it—an interpretation of supreme beauty that revealed the very essence of the music. In the last allegro Bach brings us back to earth again as from celestial regions, but it is a quality in Mr. Ysaye's mastery that he can follow the master here without snapping the thread or breaking down the mood that has been previously established.

After this the concerto of Bruch seemed dull and futile. Yet the great artist's touch transfigured this music with a sort of added glory; and it seemed worth while, if only because he had done it. As to how he accomplishes this, much might be said; of his heart-searching tone, rich in indefinable shades of emotional expressiveness and color; of his broad and sensitive bowing, of his subtle plasticity of phrase, his instinctive following of the melodic line, and his infinitude of nuance. But all these things yield to the general impression and the irresistible magnetism that is the great artist's mysterious possession.

After his performance of Bruch's concerto Mr. Ysaye was recalled again and again, and the audience seemed loath to let him go in peace.

The orchestra played Felix Mottl's arrangement of Liszt's piano piece, "The Sermon of Saint Francis of Assizi to the Birds," and Berlioz's "King Lear" overture. Both seemed dwarfed into insignificance and commonplaceness after the splendor of Brahms's symphony and Bach's concerto, though both were superbly played and in a manner to make their instrumental effectiveness count for the utmost.

* * *

January 9, 1905

THE NEW YORK SYMPHONY

New Pieces by Debussy Played—Josef Hofmann's Brilliant Playing

The New York Symphony Orchestra continues to attract large audiences to its Sunday afternoon concerts in Carnegie Hall. Mr. Damrosch usually manages to put some interesting novelty on his programme; yesterday it was the two nocturnes by the French composer Claude Debussy, who is striking out into original paths, where the ordinary music lover sometimes finds it hard to follow him. These nocturnes are in his most daring style, showing the strange tonalities and adventurous harmonies, sometimes harsh, sometimes lusciously beautiful, but almost always seizing and haunting the imagination. The two pieces are of strongly contrasted character. The first, "Nuages," has the vague and cloudy suggestiveness that Mr. Damrosch pointed out in his preliminary words, in which it was not difficult to hear, with him, the warm splash of rain, and to feel the oppressiveness of the

mood. The second, "Fêtes," he called a festival time on Montmartre, with joyful throngs indulging in boisterous mirth. It has unquestionable picturesqueness. Both are full of subtle and transparent orchestral color, and both made an evident impression upon the audience.

Mr. Josef Hofmann has not been heard to better advantage since he appeared this season than in his extraordinarily brilliant, powerful, and incisive performance of Rubinstein's G major concerto. The piece is seldom heard, and is considerably inferior in musical value to the same master's D minor concerto, much beloved of pianists. It has some of Rubinstein's characteristically savory tunes, but they are developed almost solely with a view to producing big and sonorous "pianistic" effects, projected against a singularly ineffective orchestral background. Mr. Hofmann was enthusiastically called back many times, and Mr. Damrosch finally announced that he would play an extra piece at the end of the concert—which he did in the shape of Chopin's A flat ballade.

Beethoven's "Eroica" symphony opened the programme; it was a strong and musical intrepretation, but the orchestra did not entirely succeed in bringing out all his desired nuances; its playing was in many places somewhat ragged.

* * *

March 15, 1905

DVORAK'S 'STABAT MATER' AT ORATORIO CONCERT

Chief Number on the Programme for the End of the Season
STRAUSS' "TAILLEFER" GIVEN
Its First Performance in This Country Shows a Brilliant and Noisy Musical Setting of Uhland's Ballad

The Oratorio Society devoted its last concert, given yesterday evening in Carnegie Hall, to two modern choral works as different in spirit and structure as could be imagined—Dvorak's setting of the "Stabat Mater" and Strauss's of a ballad by Uhland "Taillefer." Dvorak's composition had been performed in New York by the Church Choral Society, but Strauss's ballad was new to this country. It is one of his latest works, bearing the opus number 52, and was first produced in 1903. There was a very good audience, indeed; an audience that recognized by its presence the deserts of the Oratorio Society in mastering modern works of the difficulty present, but one, it may be feared, that found the concert tiresome before the principal number on its programme was half finished.

Dvorak's setting of the "Stabat Mater" has innumerable beauties of all sorts—beauties of structure, of harmonization, much of which is extremely original; of instrumentation. But it suffers from a monotony of effect that becomes almost intolerable before the end is reached. The composer builds up many of his movements out of single brief phrases that are repeated persistently with slight change or development.

With all the beauty and originality of harmony that are frequently shown, there are certain constantly repeated traits, progression, and color effects that begin to fall. The slow tempo prevails in almost all the ten numbers (nine of which were sung, the quartet, "Quis est Homo" being omitted), and the general emotional plane is on a level of plangent, mournful uniformity.

The variety of resource with which this mood is sustained is to be admired, but the resources are all used toward the same end, and the effect is wearisome. Relief comes at the end, in the "Amen," a movement in quick tempo, of muscular strength and energy, with a finely effective passage in seven parts, unaccompanied, on the words "Quando Corpus Morietur."

The music seems like a very personal utterance; the grief, the petitions, the sympathetic tenderness, all give the impression of springing from the composer's own ardent devotion. It is also none the less characteristic that Dvorak has made a number of mistakes in his Latin accent, as when he puts the stress on the second syllable of "ardeat" and of "virginum."

The "Stabat Mater" was the first work that attracted attention to Dvorak outside of Bohemia and Austria, and it is easy to see how its many profoundly beautiful qualities should do so. It is certainly true of Dvorak of his earlier and unspoiled period. It is only to be regretted that it has in so large measure the defects of its qualities.

Strauss's "Taillefer" is brief; in its musical interpretation of Uhland's ballad it goes straight to the point, with much dependence on a brilliant and noisy orchestra for its effect. Its outlines are broad and simple; the themes on which it is based are easily grasped. Their development is chiefly symphonic. The orchestra has much to do in presenting a graphic background, and there is a crashing representation of the battle of Hastings. On the whole a noisy piece, but the freshness and spirit in it have their effect.

The performance was of more than average merit. The Oratorio Society is still sadly lacking in tenors, and the female voices have undue preponderance. There was an unfortunate mistake in the very first entrance of the tenors that made it necessary for Mr. Damrosch to begin the instrumental prelude over again; but both works were well prepared.

It may have been that more spirit and accent in the "Stabat Mater" would have taken away some of its monotony of effect; the "Taillefer" has some places of great difficulty, and that the chorus could hardly hold its own at times against the orchestra was not to be wondered at.

The solo quartet was uncommonly competent. Mme. Lillian Blauvelt, soprano; Mme. Kirkby Lunn, contralto; Mr. Daniel Beddoe, tenor; and Mr. Herbert Witherspoon, bass. Mr. Beddoe was the only stranger; he has a powerful, occasionally rather hard, voice, with a tinge of metallic quality, but his singing is mostly intelligent and, at its best, finely artistic. The others sang for the most part in a way to deserve praise.

* * *

November 11, 1905

PHILHARMONIC OPENS ITS CONCERT SEASON

Willem Mengelberg of Amsterdam the Conductor

A BRILLIANT PERFORMANCE

Schumann's Fourth Symphony and Strauss's "Ein Heldenleben" Played—Miss Otie Chew, Violin, the Soloist

The first concert of the Philharmonic Society, given yesterday afternoon in Carnegie Hall, was no doubt listened to with judgments and emotions as varied as ever are called forth by an orchestral performance. The audience made as brave a showing as the supporters of the stanch old society have ever made; for its present season is about to witness an uninterrupted continuance of that interest that has been bestowed upon its efforts for the last two years. Few of the "guest conductors" that are coming this season are of the eminence and distinction of the previous ones; and it is significant, perhaps, of something more than curiosity on the part of the Philharmonic audiences that maintains their interest.

The conductor of this first concert was Mr. Willem Mengelberg, a young Dutchman, who has won distinction outside of his native Holland through his direction of the Amsterdam Orchestra. His less than thirty-five years mark him as the youngest of all the foreigners that the Philharmonic has imported, but he is not the least of them in his mastery of the orchestra. He is young and "hath put the spirit of youth in everything," as it seemed from yesterday's performance. Seldom has the Philharmonic played with more vivifying spirit and seldom have its players been more thoroughly controled by the purposes of the conductor. His programme, however, was not altogether fortunate—Schumann's D minor symphony, Strauss's portentous tone poem, "Ein Heldenleben," separated by Brahms's violin concerto, of which the tonality and the general color offered little contrast to the symphony, and the manner of its performance served in no wise to distinguish the occasion.

Mr. Mengelberg's methods have nothing of the sensational. His beat is firm and decisive, his indications to his players explicit and commanding, and effectually realize his intentions. There is something alluring in his straightforwardness and the directness of all his methods, and in the transparency of his conceptions. The symphony was played with great freshness of spirit and rhythmic buoyancy and with a skillful adjustment of the tonal values that elucidated all the underlying ideas of the work in the clearest fashion. Schumann's orchestration of it is by no means skillful, and the conductor who commands so ample and rich a body of tone as the Philharmonic offers him can do much to make the work sound more plausibly orchestral and clarify much that may sound thick and uncertain. It was clear that Mr. Mengelberg approached it with sympathy and devotion and with a

communicating energy. There was, perhaps, more energy than poetic spirit, and the treatment of certain phrases may have seemed sentimentalized by the retardation he introduced, as in the suave violin figure in the trio of the scherzo. But there was on the whole a pungency and a tang in the reading that could scarcely fail to win acceptance.

It was in "Ein Heldenleben" that Mr. Mengelberg showed his mastery as a conductor at its highest power. It was a truly astonishing exhibition that he gave. He is one of Dr. Strauss's ardent adherents and most earnest propagandists. "Ein Heldenleben" is dedicated to him, and he knows it, with all its enormous complications and mazes of sound, by heart. He conducts it without the score and with a never-failing certainty and authority. He models all its phrases, its sections, with a wonderful plasticity, with a subtle feeling for their significance and proportions in the whole, keeping that vast maze clear and distinct, warming and coloring each after its fashion, and lifting them to the high power of eloquence. So it was in the sections of sustained melodies interwoven. And even in the notorious "battle" section, where all the bedlam of modern orchestral noise is let loose the thematic structure was never lost sight of. Crashingly discordant unrelentingly ugly it is; but the thread of its continuity was not lost. Mr. Mengelberg has definite and complete ideas of the logical consistency of the work, through all its reckless ramifications; and this he never let escape him.

As to the value of all this there is room for much doubt. "Ein Heldenleben" was twice set before the Philharmonic's audiences while Emil Paur conducted the society some years ago. Since then it has not been heard; but it would not be patiently heard by a large part of the Philharmonic's audiences under any circumstances.

In no other work has Strauss so deliberately affronted the ear with long-continued din and discord, or has so consciously used ugliness in music to represent conceptions of ugliness. In no other has he, or perhaps any other musician, gone further beyond the limits of beauty and euphony, or so tortured the instruments of the orchestra into utterance abnormal to them, or indulged in so much extravagance of every sort. The supporters of Strauss are hopelessly at odds as to the value of "Ein Heldenleben" as representative music. Before its value in this direction must come its value and potency as music in and of itself. In this respect there are passages of superb effectiveness, as the opening section, and that devoted to "the hero's works of peace," in quotations from Strauss's earlier music.

That there are pages of beauty and eloquence here, of wonderful skill in all that relates to thematic treatment and orchestral elaboration can hardly be denied. Nor is it true that their effectiveness is alone the result of contrast with the crass ugliness and tonal fury that alternate with them. That there is commonplace in some of Strauss's music is undeniable, but there is, after all deductions are made, a strangely potent element that will not be thus explained away. It is more overlaid with the impossible and the unbearable in "Ein Heldenleben" than in any of his tone poems; but it is there.

That this remarkable performance was cheerfully listened to could not be said, and there was a procession to the doors begun soon after the piece was under way.

Miss Otie Chew, a young English violinist, well reputed abroad, made her first appearance in this country at this concert. She performed Brahms's violin concerto in a way that it should not be performed before a Philharmonic audience. She seems to be not without musical talent; but it would be a mournful task to enumerate the defects of her playing. It is to be hoped that they were, at least in part, the result of indisposition or of nervousness and that at the concert this evening both she and her hearers will fare better.

* * *

January 9, 1906

PHILADELPHIA ORCHESTRA

First Appearance in New York of Arthur Rubinstein, Pianist

The Philadelphia Orchestra, under the direction of Fritz Scheel, gave a second concert here last evening in Carnegie Hall. It served to introduce to New York a young pianist with the somewhat onerous name of Rubinstein; but it was not a concert of the kind usually arranged for the special benefit of a soloist. It was a dignified programme of music substantially valuable, culminating in Brahms's second symphony. But the pianist was the subject of chief interest.

His coming had been preceded by circumstantial stories of his past and present prowess. He was an infant prodigy, but was preserved from the fate of infant prodigies, and is now a mature artist, though he is still a youth. This younger Rubinstein is undoubtedly a talented youth, but his talent at present seems to reside chiefly in his fingers. He played Saint-Saëns's G minor concerto. This is not, to be sure, a work that is calculated to bring out much of the deeper strain of the artistic nature in emotional power or passion or poetical insight.

But it is one in which a mature artist can exhibit a certain weight and dignity and many of the finer graces of style. Mr. Rubinstein has scarcely arrived at these qualities. He is full of the exuberance and exaggeration of youth, and he is at present concerned chiefly with the exploitation of his dexterity and with impressing not only the ears, but also the eyes, of his hearers with his personality and the brilliancy of the effects he can produce. For this he is well equipped. He has a crisp and brilliant touch, remarkable facility and fleetness of technique—though this is not altogether flawless—and much strength of finger and arm. He knows how to make all these things count for the utmost; and his performance of the concerto was imposing, if there was no thought of any deeper significance that lay behind the notes.

His delivery of the preluding of the opening movement, with its suggestion of Bach, was emphatic without being really impressive; and its rhythmical structure was not fully made clear. There was grace in the scherzo, and the tarentelle

of the last movement, which he took in a great speed was brilliant and also hard. There is little warmth or beauty in Mr. Rubinstein's tone, and little variety in his effects. All is meant for brilliancy and display; and in so far he is highly successful. It would be interesting to know whether he can expect some of the deeper things there are in music of deeper import. Until he can show this he is not likely to impress himself upon this public as a musician of influence.

He was much applauded after the concerto, and played again, a piece of pure display, an arrangement for piano of Liszt's orchestral piece, "The Mephisto Waltz" in the "Episodes from Lenau's Faust."

The orchestra opened the concert with Georg Schumann's overture, "Liebesfrühling," a melodious and spirited work made known here a couple of seasons ago by the Boston Symphony Orchestra, that leans strongly upon "Die Meistersinger," but is pleasing in its delineation of a light-hearted mood. It was admirably performed. Mr. Scheel's reading of Brahms's symphony aimed at variety of nuance and of tempo, but it was gained at the expense of repose and proportion, though there were many interesting details in it. The brass choir, which did well at the first concert of the orchestra here a month ago, did not at all distinguish itself this time, but committed a number of blunders. The programme closed with Max Schillings's symphonic prologue to Sophocles's "Oedipus Rex."

* * *

February 15, 1906

PRESIDENT SAYS NEGRO MAKES AMERICAN MUSIC

May Furnish the Foundation of the True National School

HE GREETS NEGRO STUDENTS

Also Says That the Only Really Good Charity Teaches Persons to Help Themselves

WASHINGTON, Feb. 14—That the music of the negroes will probably be the basis for the development of an American School of Music was the opinion expressed by President Roosevelt to-day. He was speaking to negro students from the Industrial Institute at Manassas, Va., who were introduced to him by Booker T. Washington and the Rev. Edward Everett Hale, Chaplain of the Senate.

The students sang several songs for Mr. Roosevelt and after he had greeted each personally he said:

"The other day a great French literary man who was peculiarly interested in popular songs, in the music developed by the different peoples of the Old World, came here, and he happened to mention incidentally to me that so far as he could see there were but two chances for the development of schools of American music, of American singing, and those would come, one from the colored people and one from the vanishing Indian folk, especially those of the Southwest.

"I want all of you to realize the importance and dignity of your musical work, of the development of music and song among you students. I feel that there is a very strong chance that gradually out of the capacity for melody that your race has we shall develop some school of American music. It is going to come through you originally."

Speaking generally to the students, he said:

"No body of our fellow-citizens can have a greater claim to being received at the White House than a body like this, which stands for the fundamental duty of American citizenship, the duty of self-education.

"There are a great many very excellent charitable people in the country, but some of them tend to forget at times that the only charity that does permanent good is that kind of charity that is not charity at all, that teaches some one how to help himself or herself. The only way in which any section of our citizens, of no matter what color, can be permanently benefited is by teaching them to pull their own weight, to do their own duty, their duty to themselves, their duty to their neighbors, their duty to the State at large.

"I have felt about the schools of which this is a type just, for instance, as I feel about Mr. Washington's school at Tuskegee—that one of the reasons they are so good is that they can serve as an example of which we should try to develop just as many schools of the kind as we can for the white people just as much as for the colored people.

"The white man needs just as much as the colored man to learn that for the average man the education which fits him to do work in life is industrial. Other things shall be added to it, or ought to be added to it, but that must remain as the basis.''

* * *

February 16, 1906

MAHLER'S FIFTH SYMPHONY PLAYED

The Boston Symphony Orchestra's Concert in Carnegie Hall

A NEW AND DIFFICULT WORK

Splendid Performance by Mr. Gericke and the Band— Harold Bauer, Soloist, in Schumann's Concerto

The fourth evening concert of the Boston Symphony Orchestra was given last evening in Carnegie Hall, before one of the finest audiences the orchestra has had. It was made notable by the performance of Gustav Mahler's fifth symphony for the first time in New York. But, notwithstanding the notability of this event, there was still much distinction in the first part of the concert, which consisted of Beethoven's "Egmont Overture," played with nobility of style, but without the dramatic nuances that Wagner advocated. Mr. Harold Bauer played Schumann's pianoforte concerto with exquisite poetical grace and charm, and rhythmic coherency; it was playing that had truly musical qualities, that sought to express only such qualities, without

an effort to turn the first and last movements into brilliant display pieces.

Mahler's symphony imposes by its length and breadth, the vast number and extent of its themes, the skillful handicraft with which they are put together, the bigness of the orchestral apparatus, the extraordinary skill with which it is managed. Yet it is a less unusual apparatus than that required by the less impressive fourth symphony, with its singing voice in the last movement, as it was heard here last season; and a much less elaborate machinery than is required for Mahler's second symphony, which has never been done in this country. This fifth symphony is a work that cannot be dismissed at one hearing as harsh, diffuse, lacking in distinction of theme and definiteness of purpose; although all these things appeared from time to time to be true of it, as it was unfolded before an uncommonly attentive and patient audience last evening.

That it is deeply felt and tremendously sincere music is continually borne in upon the listener; but that it is not the product of a strong and vigorous creative genius, an original force in music, is also evident. It seems that the composer is most strenuously seeking for self-expression; but though he is equipped with all that modern musical skill can give him in methods of treatment and resources of orchestration, his achievement seems continually to pant behind his ambition, rarely overtaking it.

There was discussion and explanation at length in last Sunday's Times of Herr Mahler's work and his attitude toward the "programme" and the explanation of music. This symphony has no suggestion of what it is; and the lack of one is inevitably felt as a bar to its understanding. For Herr Mahler plainly had some definite idea in his mind. We simply do not know what he is driving at; for it seems undeniable that many portions of his five movements are not intelligible simply as music—the treatment and the development seem unable to account for themselves purely as such.

The unusual division of the work was described the other day in The Times. The funeral march with which the symphony opens is highly effective—yet there are certain commonplace passages in it that let down the "high erected thoughts" with jarring suddenness. The episode of wild and passionate outbursts in the midst of this march is seizing. The second movement carries on the feeling of the march, but is less tangible. In the Scherzo Herr Mahler has sought for a contrast with all this. Here is a "Läudler," a country waltz theme of naïve tunefulness; but here, too, is the Mahler of the fourth symphony, who produces naïve tunes only to toss them about and torment them with strange development and strained harmonies that leave little of their pretty and somewhat commonplace lustre.

There is here, and through the work, an ingenious and bold utilization of numerous themes in the crass kind of forced union that does duty in these most modern days as counterpoint—a union that is effected without regard to euphony. The adagietto has more ingratiating traits than any

of the other movements; there is a poetical suggestion in it that the others have not, yet even here there is a certain lack of cogency and point; the movement seems to have little definite issue. The last movement is a "rondo-finale," and still shows the lack of a clearly discernible purpose. It has many interesting moments. There is a fugato of considerable extent; there is a long climax in a sustained melody of a choralelike character that is developed. There is also much that is dry and harsh, as there is in every one of these five movements.

The symphony arrests the attention of the listener for the hour of its duration. Its vague and indeterminate bigness of conception and elaborate dexterity of execution engage the interest of those who wish to follow the technical methods or the composer. But of specific musical inspiration it seems, from the first hearing of the work, that the composer has little. He appears, for instance, to stand considerably below Strauss in originality. He is in many respects dramatically opposed to Strauss; but he seems a lesser talent.

The performance of this symphony was an extraordinary achievement on the part of the orchestra and Mr. Gericke. He had devoted great care to its preparation, and the perfection of its reproduction was the result of much labor. It is said that Herr Mahler had sent Mr. Gericke some revisions of the orchestration. The audience listened to it with close attention to the end, but manifested little enthusiasm over it.

* * *

INDIAN AND NEGRO MUSIC

The President's Suggestion as to Their Value for American Composers

The President's utterance the other day (prompted by the remark of "a great French literary man") as to the value of Indian and negro music for American musical development has led an inquiring correspondent to wonder how that can be. "Utah," in a letter to The Times, indicates his belief that the native Indian music is "a sort of wild barbaric wail"; and wishes to know what this negro music is of which our President thinks so highly. The subject is not a new one, and others before the "great French literary man" have turned their attention to it in the way of actual experiment and of animated discussion.

The power and charm of a native folk-song element in artistic music have been admitted by many. Some of the great masters of Germany, from Haydn to Brahms, have been strongly influenced by it. Haydn filled his music full of reminiscences of the Croatian folk-tunes that were his by inheritance; and how deeply Brahms drank at the spring of German folk-song is known to all lovers of his music. The clearly defined influence that has worked upon Chopin, Liszt, Grieg, Smetana, Dvorak, and the Russian composers is more familiar.

Why, it is asked, should not Americans try to obtain something of the same sort from native sources, and by injecting it into their music, create a similarly potent charm? The two sources that have been considered most promising are the songs of the Indians and those of the negroes. The only other approach to a native folk-song is to be found among the people in Louisiana who were French in their origin. But the United States is a large country, and this corner of it has not been much heard of musically since Louis Moreau Gottschalk emerged from it and brought with him some pretty piano transcriptions of the Louisiana songs.

Much attention has been paid to Indian music by American ethnologists and musical students, who have found in it a potent expression of the Indian life. Dr. Baker, Miss Fletcher, Mr. Fillmore, Arthur Farwell, Harvey Worthington Loomis, and Miss Natalie Curtis are among the most prominent of those who have collected a large mass of material. It differs in character greatly. There are strains of a weird and haunting power; there is much that is little more than a sort of formless chanting. On the whole, it seems of more interest to the ethnologists than of value to the musician.

Surrounding all Indian song and forming its background is the vast Indian mythology, which is of the greatest beauty and poetic suggestiveness. Separated from this, Indian song would be like, let us say, mass without the Catholic religion. No one who merely knows the sounds of Indian music can rightfully say that he understands Indian music. One must have a glimpse of the all-enfolding mythos, of which song is but the breath.

They are in that stage of development where music is never conceived as complete in itself, independent of poetry; it links itself inseparably to the religious ceremonial, the myth, the folk-tale, which is enacted or related to the point where verbal expression fails; and at this point song enters.

These are the words of an upholder of the Indian music as an inevitable component of the future American art. But they are, after all, an amplification of what has just been said, that the Indian music is necessarily of more interest to the ethnologist, the folk-lorist, than of value to the composer. The material is stiff and intractable to the musician. He works in artistic forms, for listeners whose attention is directed not to the "mythos," the religious ceremonial, the folk-tales of a race touching their lives in no single point, of whom they know nothing, but to a purely aesthetic enjoyment. Nor have the musicians been able to do much with the Indian music. Mr. MacDowell's Indian suite is the most important attempt that has yet been made in this direction. But whatever its effect is as music it owes little of it to its Indian components. Mr. Farwell and Mr. Loomis have worked in smaller forms on the piano; both have produced something that may interest intelligent listeners by the ingenuity of the treatment; but in listening to these pieces the interest is more engrossed in observing the skill with which they have attacked a difficult problem, the methods they have employed to overcome a self-imposed handicap, than in the music itself.

The discussion about negro music as a factor in an "American school" is recent. It was precipitated by Dr. Antonin Dvorak's American productions, the "New World" Symphony, the string quartet, and the string quintet that accompanied it. He wrote them on American soil, and, as he himself avowed, with the suggestion of popular music that he heard here, chiefly negro music. Of this music he made no exhaustive study; and indeed the materials available for such a study are not easily available even yet. But it may be observed, for the benefit of "Utah," that the negro music concerning which he inquires is not at all "about the same" as the Indian. It has been strongly influenced by years of contact with the white population of this country. It is the product of conditions that are known more or less well to the dominating race. Its melodic and rhythmic characteristics are equally well known, and strongly appeal to the musical sense as musical in and of themselves—not representative of things unmusical, far off, and unknown. The characteristic negro music was developed under slavery, of course, and it has the qualities of a true folk-song, that are becoming more and more excluded from the possibility of perpetuation by the increasing sophistication of modern life.

Fortunately there have not been lacking enthusiasts in this specialty who have taken down many of these songs in permanent records before their final and inevitable extinction. As to the origin of them, there has been much debate, and it seems certain that some of them have been derived from contact with the whites. It is equally certain that there are African characteristics in them, as of rhythm and of intervals in the scale on which some of them are based. But that they are easily intelligible and highly sympathetic to the white race needs no argument to prove. One indication of it is the craze for "ragtime" that caused a flood of weak and bastard stuff from the watery brains of the Tenderloin school of "composers," now happily subsiding.

As to the value of the negro folk-song as a stimulus for American composers in producing American music, there is still a wide difference of opinion. The debate that arose over it when Dvorak produced his "American" works was in some respects strange. It was held by some that the symphony and the chamber works had no trace of "negro" influence in them; that there was at best no negro "folk-song," and that, even if there were, it should have no place in American music. But Dvorak himself explained that this influence had been decisive upon him in suggesting these works; that though he used no negro tunes, he had deliberately employed some of their essential characteristics of melody and rhythm; and he summoned the American composers to take heed of this potential element in their work. How he himself was influenced and how he would have had Americans influenced, he indicated in an article that he published in Harper's in 1895, laying stress on the quick ear a modern composer should have for the music of the people. He wrote:

When he walks he should listen to every whistling boy, every street singer, or blind organ grinder. I myself am

often so fascinated by these people that I can scarcely tear myself away, for every now and then I catch a strain or hear the fragments of a recurring melodic theme that sounds like the voice of the people. These things are worth preserving, and no one should be above making a lavish use of all such suggestions. It is a sign of barrenness indeed when such characteristic bits of music exist and are not heeded by the learned musicians of the age.

On the other hand, it is to be said that while a characteristic and penetrating charm was given to Dvorak's works (his native as well as his American compositions) by the processes here described, they have had to pay the penalty of provincialism, of a certain primitiveness, of being an expression through a dialect. It is to be said that not many of the American composers have as yet showed much disposition to follow Dvorak's advice and example in their efforts toward the evolution of American music.

In the meantime they are warned, from the other side, to beware. The American composer of true talent is told that he will win renown in other countries not because he writes music of a distinctively American flavor, but because he writes music that will appeal by its beauty and strength and emotional quality to the men and women of any country who are sensitive to musical impressions. When a noble work of musical art by Mozart or Beethoven is played, asks Mr. Philip Hale, is the first remark "Oh, how Austrian"? Is César Franck or Debussy applauded first of all for a French flavor? Those who hold with Mr. Hale declare that the great music of the world has something more than a national flavor.

Whether or not this is true, the danger of producing "the great music of the world" does not seem to be imminent in America just now. The danger of missing greatness by following Dvorak is perhaps not so immediate as to outweigh certain marked, even if temporary, advantages that might be gained in so doing.

RICHARD ALDRICH

* * *

November 4, 1906

DR. SAINT-SAENS'S FIRST APPEARANCE

The Distinguished French Composer Plays in Carnegie Hall

AN ENTHUSIASTIC GREETING

He Contributes Music of Small Importance to the New York Symphony Orchestra's First Concert

The season of orchestral concerts in New York was opened last evening by the first concert in the series of the New York Symphony Orchestra, under Walter Damrosch. It was given in Carnegie Hall, and was made notable by the co-operation of Dr. Camille Saint-Saëns. It was his first appearance in New York, and, as it turned out, his first appearance in America, by the dispensation of fate operating through his case of tonsilitis that compelled him to give up his projected Boston appearance earlier in the week.

He is one of the foremost personages in the world of music at this time—the reasons for his distinction, as set forth in another column of this paper being more or less well known to most who follow music. His coming is thus a notable event in our musical annals, and it was properly marked as such by the spontaneous and enthusiastic welcome given him by a very large audience and by a fanfare from the orchestra as he came upon the platform, an elderly gentleman short of stature but robust in figure, of quick and rather precise movements, gray bearded but darkly thatched except for an oncoming bald spot, whose face, with its striking aquiline nose, has long been familiar from his portraits. The personality of such a man is of itself something to hold the attention of music lovers, especially when he comes to interpret his own music. But it would seem that the presence of Dr. Saint Saens ought to have been made to count for more than it did last evening from a purely musical point of view.

Acquaintance with his music in New York had preceded his coming by many years; it was not increased in any important degree by the performance which he took part in last evening. Dr. Saint Saens presented himself as a piano virtuoso and played three pieces, then adding another that, while they were all practically unknown here, have small claim to be set forth as really representative of his quality as a composer. He is an adept in orchestral conducting, if not a "virtuoso" conductor of the current type; but he was not called upon to conduct his symphonic poem, "Le Rouet d'Omphale," as he and others have done here many times before. That alone represented him as an orchestral composer. With these things Dr. Saint Saens's part in the proceedings was brought to an end and the weightier matter of the concert came on with Beethoven's "Eroica" Symphony. Too much should not be asked of the distinguished Frenchman's seventy-two years; but the occasion seemed to call for something more significant than was offered.

He played his fantasie for piano and orchestra, entitled "Africa"; a waltz-caprice for piano and strings, called by the English name of "Wedding Cake" (composed for the marriage of a pianist friend); and an "Allegro Appassionato" for piano and orchestra, said to have been written for the examination of the pupils of the conservatoire in 1884. "Africa" is purely a virtuoso piece, brilliantly and elegantly made but slender in its substance. It is apparently an experiment in exotic folk-music such as Dr. Saint Saens has made from time to time in the musical dialects of Arabia, or the Spanish and Algerian Moors, of the Canary Islands, of Spain, of Russia, of Denmark, of some of the provinces of his native land, and even or Japan and of ancient Greece.

It is elaborate in its exploitation of themes of curious intervals and syncopated rhythms, some of which are attractive

and might be the ground work of an Oriental fabric. But there is not the least attempt to create any atmosphere with them, to produce music that shall even have picturesque suggestiveness of the sources and surroundings from which it is supposed to be drawn. The listener is dragged breathlessly on through one corruscation to another; everything is treated in the frankest manner for the display of the pianist's agility, and without thought of developing the musical interest. Still more tenuous is the "Wedding Cake" waltz, which is a most unconscionable trifle, spun out to considerably greater length than its musical value would warrant; and the "Allegro Appassionato," a graceful web of passage work adorning a melody more ingratiating than passionate. A pity that Dr. Saint-Saens should come three thousand miles and expend his prodigious talents to acquaint us with these things that are not representative of the real master in him!

His playing is full of charm and of wonderful facility, when his years are considered, and it is necessary to consider them. There are sparkling clearness, grace, and elegance in his rippling passages and runs; he phrases and sings a melody with distinction and point, and all is done with perfect repose, though on a somewhat miniature scape and within restricted limits of dynamic contrast and tonal color. Nothing that he played called for eloquence or for feeling that even scratched the surface: and he gave no sign of either. The orchestral accompaniment in the "Africa" showed the need of more rehearsal and a fuller acquaintance with his intentions as to tempo. He was tumultuously applauded, however, and many times recalled after both his performances, and a huge structure of flowers and flags was handed up to him. He at least can have no doubt as to the consideration in which he is held here.

The concert was begun with a performance of Georg Schumann's brilliant overture, "The Springtime of Love," that was heard here some four seasons ago under Mr. Gericke, and was heard again with pleasure. It is exuberantly spirited and overflowing with melody that the composer is not in the least ashamed of, though even a second hearing suggests that it is a bit superficial, and that he is considerably in the debt of some of his predecessors for his ideas.

He makes the most of them in his development, and especially through the brilliant orchestration, in which he has garbed them, shot through and through with gleaming strands of instrumental color. The piece was admirably played, with unflagging spirit and abundant nuance, and so was the more fragile "Omphale's Spinning Wheel," except for an undue hurrying of the time in the middle section of it, as if Mr. Damrosch thought it rather a dull passage, which it is, and wished to get by it. The programme was closed with Beethoven's "Eroica" symphony.

* * *

"FAUST" FOR FIRST TIME AT THE METROPOLITAN

Miss Farrar and Mr. Ransseliere in the Leading Parts
A BEAUTIFUL MARGUERITE
Her Singing and Mr. Ransseliere's—Mr. Plancon as Mephistopheles and Mr. Stracciari as Valentine

WITH: Mme. Farrar (Marguerite); Mme. Jacoby (Siebel); Mme. Simeoli (Marthe); Mr. Rousseliere (Faust); Mr. Plancon (Mephistopheles); Mr. Stracciari (Valentin); Mr. Begue (Wagner); Mr. S. Bovy (Conductor).

New productions at the Metropolitan Opera House postponed the first production of "Faust" to the sixth week of the season. But the turn of "Faust" is sure to come, and it came last evening. The performance was welcomed by a large audience, and, of course, it brought forward in the parts of the hero and heroine Mr. Rousseliere and Miss Farrar, who are both new to this audience in them. Mr. Stracciari was the Valentine and Mme. Simcoli the Marthe. Mr. Plancon and Mme. Jacoby took the parts they have been associated with for longer and shortage periods at the Metropolitan.

Miss Farrar is a Marguerite of fascinating beauty, a beauty of individual charm and allurement. This charm, however, is scarcely one of guilelessness. In fact, Miss Farrar's Marguerite is rather a sophisticated one. Her singing had much beauty of tone, especially in the lower ranges of her voice; but she is inclined in this music, as in other that she has sung, to force it in the upper tones, and this sometimes lends to sharp intonation. There were likewise passages in which the faults of her vocalization came to the fore. Mr. Rousseliere's Faust will not be recorded among the great impersonations that have been seen and heard at the Opera House. He presents an attractive figure, and acts with force and dramatic power, though not always with distinction. His singing has the same qualities. He loves the robust and explosive phrase, but in music where less power is required there is little suavity or sweetness in his cantilena.

Mr. Stracciari sang with much energy—with too much energy at times, but was a gallant Valentin. Mme. Simeoli sang with tremulous and unpleasing voice. In this performance the perfect art of Mr. Plancon comes especially to the fore. Such singing as he commands, invariably and never failing, it is a blessing to hear, and his Mephistopheles is and remains a classic. Mr. Bovy's conducting was incisive and vigorous, and many of the accompaniments he played with much discretion. The stage setting is new and picturesque, characteristic of the time and place, and the management of the stage effects was artistically controlled.

* * *

January 23, 1907

HOW THE AUDIENCE TOOK IT

Many Disgusted by the Dance and the Kissing of the Dead Head

Ten extra policemen were required last night to handle the crowds who flocked to the Metropolitan Opera House to hear the Oscar Wilde version of the story of Salome and John the Baptist set to music by Richard Strauss.

The dance of Salome before Herod for the head of the prophet, and the report that the opera would contain many other sensational features brought a throng of men and women such as no previous opera has drawn to the Metropolitan.

Herr Conried was ill, but his assistants were on the spot, and they, with the police, tried to control the crowd. At 8:30 o'clock the speculators in front of the building left, and the man in the box office declined to sell even a ticket for standing room.

It was between 9:30 and 10 o'clock when the preliminary concert was over and the curtain went up.

The three balconies over the horseshoe were packed with men and women anxious to hear the music that Strauss had written for the Wilde play. There were many Germans present. Those who were not Germans bought librettos giving the German and English versions of the work. In the orchestra the seats were all filled, and the aisles behind the seats and at the side were packed with standing men and women.

Puccini and Mme. Cavalieri were in a box. In the grand tier the seats began to fill a few minutes before the musical tragedy began. Although it was not a subscription night and the public had its choice of seats, there was a rustle of gowns and a craning of necks in the pit which told of the arrival of this or that social celebrity.

After the curtain went up on "Salome" there was no sensation until the dance began. It was the dance that women turn away from, and many of the women in the Metropolitan Opera House last night turned away from it. Very few men in the audience seemed comfortable. They twisted in their chairs, and before it was over there were numbers of them who decided to go to the corridors and smoke.

But when, following the lines of Wilde's play, Mme. Fremstad began to sing to the head before her, the horror of the thing started a party of men and women from the front row, and from Boxes 27 and 29 in the Golden Horseshoe two parties tumbled precipitately into the corridors and called to a waiting employe of the house to get their carriages.

But in the galleries men and women left their seats to stand so that they might look down upon the prima donna as she kissed the dead lips of the head of John the Baptist. Then they sank back in their chairs and shuddered.

* * *

February 12, 1907

"MME. BUTTERFLY" SUNG IN ITALIAN

Puccini's Latest Opera Given at the Metropolitan for the First Time

A FINE PERFORMANCE

Composer Present and Was Applauded—Caruso, Scotti, and Miss Farrar Sing

WITH: Mme. Farrar (Cio-Cio-San); Mme. Homer (Suzuki); Mme. Mapleson (Kate Pinkerton); M. Caruso (B. F. Pinkerton); M. Scotti (Sharpless); M. Reiss (Goro); M. Muhlmann (Lo Zio Bonzo); M. Rossi (Yakuside); M. Begue (Il Commissario Imperiale); M. Arturo Vigna (Conductor).

Puccini's latest opera, "Madama Butterfly," was produced at the Metropolitan Opera House last evening for the first time under the most brilliant and favorable circumstances. There was an enormous audience, with all the glitter and sumptuousness of the Monday night tradition; there were favorite and much-admired singers in the cast, and the composer, who had himself superintended the production, appeared upon the stage and was acclaimed with every demonstration of enthusiasm and recalled time and again.

The opera was presented with the strongest forces that the company of the Metropolitan Opera House can command. Messrs. Caruso and Scotti, who took the parts of Pinkerton and Sharpless, the American Lieutenant and the American Consul, did so with the perfect familiarity gained by two seasons of repeated performances in London. Madama Butterfly was Miss Geraldine Farrar; Suzuki, Butterfly's serving woman, was Mme. Louise Homer, and Goro, the marriage broker, was Mr. Reiss. Mr. Vigna conducted, but through every measure of the performance, both in the orchestra and in the action upon the stage, was to be perceived the fine Italian hand of Mr. Puccini himself, who had molded it according to his own ideas and had refined and beautified it into one of the most finished performances seen at the Metropolitan for many a long day.

The new opera, which was heard for the first time in the original Italian, was known to many, no doubt, from the numerous performances it had here in November and December, when it was given in English by Col. Savage's company at the Garden Theatre. Those performances gave an excellent showing of the opera; yet it was inevitable that a representation so carefully prepared under the eye of the composer as this one, presented with an orchestra of the size and efficiency of that belonging to the Metropolitan Opera House, and with singers of the sort that are cast for it there, should bring out a certain order of excellence that was not to be expected of the English performances. The use of the original Italian libretto, too, smoothed over many of the bald and crude places that in the prosaic English version struck a disturbing false note. On the other hand, it is unquestionable that something was lost of the delicacy of

the picture in the vastness of the Metropolitan Opera House.

The delicacy, the shifting pictorial beauty, the completely penetrating atmosphere give perhaps greater delight in this opera of Puccini's than in any of his others. In nothing else has he so completely identified the music with the action, the sentiments, the passions, and the surroundings that are shown upon the stage. The story is one of emotion and suffering, the development of a tragical situation through circumstances of fantasy and romance, rather than one of strong dramatic action. It is an old story, and in its present form need only be suggested again—that of the passing fancy of a man for a woman, the devotion of the woman to the man, her abandonment by him for another, his casual return to find his cast-off love still awaiting him and preferring death to deprivation of him.

The man is Lieutenant F. B. Pinkerton of the United States Navy, on his ship, the Abraham Lincoln, in Nagasaki Harbor; the woman the geisha, Cio-Cio-San. His marriage to her is after the Japanese fashion, and, as he understands it, is of no more permanency than the lease he takes of the little Japanese house in which he installs her. But the geisha girl, whose union with him is arranged in the usual manner by a Japanese marriage broker, Goro, is devoted to him beyond the custom of her class; she gives up her ancestral religion and her ties of kinship for him and imagines that her marriage makes her an American wife, with all the rights of one. The tragedy, it will be recalled, is developed through her long wait for him after his departure to America, her passionate refusal of a rich and princely suitor, her ecstatic joy at the return of the ship Lincoln, and her delight in preparing for her lord's coming, only to spend the long night watching for him in vain and to hear of his return in the company of his American wife. The end is marred by the painful introduction of this wife, her awkward and feeble offer to take away Cio-Cio-San's little boy; but there is a final touch of quaint and pitiful tragedy in the way the mother sets the child blindfolded upon the floor with an American flag, to await his father's coming, while she goes behind a screen and stabs herself.

Doubt may be thrown upon the exact conformity of some of these details with the national customs and the national character, which may be no more accurate than the title of "Sir Francis Blummy Pinkerton" for the American Lieutenant. But they may be accepted in the main as plausible, if not just. The picture is full of exquisite and delicate detail, of the spirit and flavor of the Japanese scene and the Japanese personages who people the scene. So skillfully have authors, composer, and stage manager co-operated in producing an effective whole that the attention, and frequently the tense sympathy, of the listeners are engaged, and they are beguiled by the quaint charm, the poetical atmosphere, the warm and genuinely emotional expression of the whole, notwithstanding certain realistic details that now and again seem out of tune with its harmony.

Puccini has wrought his music into the very substance and spirit of the drama. It is his subtlest and most highly finished orchestral score, and denotes an advance on his previous operas in the matter of fine detail as well as powerful effect of orchestration and the manipulation and development of his themes. In specifically musical invention "Madama Butterfly" may stand below "La Boheme" and "Manon Lescaut," but he has attained a finer treatment in it, even though his general method has not changed. His use of local color compels admiration for its skill and sincerity, as well as for its restraint; for an excess would soon weary and offend. The several Japanese tunes he employs are unmistakable in their character, but they bring no ugly and jarring element into the score. It is not easy to avoid the suggestion of the burlesque in the introduction of Oriental measures, but Puccini has, in truth, dignified and at times even ennobled them. So with the strain of "The Star-Spangled Banner," which he brings in from time to time as a suggestion of the Americanism of his Americans, and which is by no means the uncouth intrusion that it might be.

He has heard new harmonies, and has adventured further afield in the use of augmented intervals and chords of the higher dissonances in strange sequences than he has before, even in "Tosca." Nor has he forgotten the flowing and mellifluous melody that speaks eloquently in "La Boheme" and "Tosca," as in the love duet between Butterfly and Pinkerton at the end of the first act. A more robust and dramatically potent passage is the superb duet between Pinkerton and Sharpless at the beginning. Puccini has always shown a remarkable adroitness in his musical representations of a bustling throng expressing diverse sentiments and animated by diverse purposes, and his skill has not failed him in the scene of the bride's relatives coming to the wedding and curiously interested in all they see. It is introduced by a delightfully poetic effect of their distant song as they approach, and by the voice of Butterfly rising above the rest. The marriage ceremony, with its accompaniment of Japanese instruments and Japanese tunes, is one of the points where Mr. Puccini has blended his esoteric effects into a most striking musical picture.

A climax of ravishing poetical beauty is that rendered at the end of the beautiful second act, where Butterfly, delirious with joy at the news of Pinkerton's return, prepares for it by scattering flowers upon the floor and shaking the blossoms from the cherry at the threshold for him to walk upon. The music has the freshness and jubilance of Spring. In poetic atmosphere and the evocation and sustaining of the mood nothing produced in opera for a long time equals the scene where Butterfly and her baby and her maid take their places at the torn holes in the paper window panes to watch for Pinkerton's coming. The scene is broken into by the fall of the curtain upon the watchers, leaving them to their vigil through the night and rising upon them unchanged in their positions when the dawn is supposed to be breaking—an unfortunate interruption of the emotional current made necessary by the length of time supposed to lapse. Music can hasten the nominal passing of the hours on the operatic stage, for which purpose are "intermezzos" devised; but no doubt

Mr. Puccini was disinclined to risk so great a poetic license as would be involved in compressing a whole night into a few moments of music.

The dawn breaks and the orchestra eloquently sets forth the conflicting emotions of this hopeless vigil, and the chorus of the distant sailors in the harbor hints of morn. There is tragic and forthright intensity in the trio between Suzuki, Pinkerton, and Sharpless, and the climax is wrought with unerring dramatic skill, except for the appearance of Pinkerton's American wife, which seems now, as it did at the first, a false note that delays the effect of the tragic culmination.

It is enough to say that Puccini's music by no means loses in its force and appeal through a new hearing under new conditions, but that rather it gains in intensity and value through this presentation. It is indeed a remarkably beautiful presentation.

Upon the representative of Mme. Butterfly depends much. She carries the weight of the whole dramatic fabric after the first act, and in a large part of that Miss Farrar puts a notable impersonation to her credit in it. She is charming in appearance, as scarcely need be said; and her bearing, transformed into the Japanese character, is full of grace and sinuous subtleties, of smiling eagerness, and submission, of tenderness and gentle longing, as well as of tense and self-contained anguish at the end. She has an infinity of plastic poses and postures that she knows how to make count at every point. The steady crescendo of emotional tension she expresses with ample dramatic resources, and her accent of heartbroken despair and of tragic resolution is fully expressive. The music she sings with charm, with intense dramatic fervor. The part of Pinkerton is unsympathetic, necessarily, and Mr. Caruso is not the man to impart distinction to such a one. But his singing of this music is of much beauty. It is as though written for his voice and fits him to perfection, and of such music he is the very man to make the most.

Mme. Louise Homer made the part of Suzuki carry its full weight through her remarkably intelligent and carefully modeled impersonation.

There is more in the part of Sharpless, the American Consul, which Mr. Scotti interprets with an admirable dignity and such chivalrous tenderness as it admits of. It is at least the representation of a gentleman, and Mr. Scotti deserves thanks for finding this in it, and the means of establishing it, as well as for singing the music with such power and finish. Mr. Reiss adds another to his admirable gallery of clever character studies in his impersonation of the obsequious and officious Goro, and Mr. Mühlmann made a picturesque representative of the incensed and obstreperous bonze, though a somewhat more reckless impetuosity would become the character.

Mr. Vigna conducted with zeal; somewhat too much zeal, for the orchestra was lacking in finish and subtlety, and was often somewhat too loud for the evident intentions of the composer. The chorus performed its vivacious bit in the first act fairly well. A picturesque and appropriate stage setting was provided; the scene of the first act shows a garden, with the little Japanese house in the corner of it, fruit trees in rich bloom, the harbor of Nagasaki and a glimpse of the town in the distance. The second act shows the interior of the house characteristically Japanese in structure, with a smiling Spring garden seen through the sliding doors.

* * *

<div align="right">March 20, 1907</div>

"APOSTLES" SUNG

The Oratorio Society Repeats the Famous English Work
THE COMPOSER CONDUCTS
A Large Audience Hears an Excellent Performance of a Most Difficult Composition

The Oratorio Society has been a zealous interpreter of the later works of Sir Edward Elgar, since he arrived at his present position in English art. It was the first to present "The Dream of Gerontius" in the New World, and the first to present "The Apostles." This year it intends to bring out "The Kingdom"; and as "The Kingdom" is the continuation of "The Apostles," Mr. Damrosch has very properly arranged to have the two works heard in immediate succession, as the composer intended, no doubt, to have them. As a preparation for its performance of "The Kingdom" next Tuesday, the society repeated last evening "The Apostles" in Carnegie Hall. It was first given here on Feb. 9, 1904, and was repeated on March 25 of the same year.

The work was given under the direction of the composer himself, who was invited to come from England to conduct the performance of it and of "The Kingdom." He was most warmly and demonstratively greeted, and the long and exceedingly complicated work was listened to with close attention by an audience that was large, considering the inclemency of the weather and the general public disposition toward music in the oratorio form.

At its previous performances here "The Apostles" was found to be a composition of unequal merit, one which notwithstanding certain passages of great power, of tender and poignant expressiveness, of deep characterization, is lacking in broad and continuous development and in high and sustained inspiration. In these respects it seems to stand lower than Sir Edward's "Dream of Gerontius." It is a noteworthy attempt to vivify the oratorio form by the use of all the resources which the development of modern means of expression has put at the commend of the modern musician; and Sir Edward Elgar is a master of them all. His orchestra is raised to the highest point of eloquence by his skill and finesse in orchestration. His treatment of the chorus has not only imposing grandeur in the effects of great masses and the building up of climaxes, but is even more remarkable in his disposition of subtler effects of color and skillful polyphony; and there are more than a few passages in which his setting

off of the solo voices in contrast with the choral masses and in a union with them presents new and beautiful effects.

"The Apostles" is the product unquestionably of a powerful and acute intellect at work with material of which it is a complete master; but it leaves the impression on the whole more of the intellectual process involved than of a potent inspiration seeking its inevitable expression. The text itself is a marvel of ingenuity, mosaicked as it is from sentences culled throughout the whole Old and New Testaments and the Apocrypha and put together to form a continuous whole. It gives many opportunities for the composer's dramatic sense and for his power of characterization, in the various episodes it contains. The mystical atmosphere of the prologue is one in which Elgar's imagination loves to play. The passages representing night in the mountain, the dawn, the call to worship, with its use of the "Shofar" or ram's horn of Jewish ritual (represented in the performance by a stopped trumpet), are full of poetic suggestion and vivid depiction of scene and mood.

The morning psalm is built up to a grand and inspiring climax—one of the truly impressive moments of the composition. There is more than conventional force in the representation of the storm upon the Sea of Galilee and the miracle of Jesus walking upon the waters. The final chorus is full of religious exaltation. The characters of Mary Magdalene and of Judas are strongly outlined in the music.

But there are in the course of the work many long and dull passages and many that are laborious and that show the labor of their intricate involution. The score is compact of "leading motives" or representative themes and is itself in many places almost as much a painfully continued mosaic as the text itself. It is a most elaborate apparatus, and the result often is that the composer seems to be hampered by its complexity and his unceasing submission to his self-imposed conditions rather than helped toward a fuller and freer expression. So it seemed when the work was given here before, and so it seemed last night.

The performance was in most respects an excellent one. Composers are by no means always the best conductors of their own compositions, but Sir Edward Elgar evinced authority and a technique ample to gain what he wanted from chorus and orchestra, both of which had been prepared for him, and well prepared, by Mr. Damrosch, for a task that is in every sense formidable, full of difficulties of every sort. The chorus of the Oratorio Society was reinforced by a special chorus of the Musical Art Society. The solo parts, difficult and exacting almost all, were sung by six singers who were admirably qualified for their work: Mrs. Corinne Rider-Kelsey, Mrs. Von Niessen-Stone, and Messrs. Frank Croxton, Claude Cunningham; Edwin Evans, and George Hamlin. Of these especial credit belongs to Mrs. Rider-Kelsey and Mr. George Hamlin for their exceedingly artistic and beautiful singing, and to Mr. Frank Croxton for his most characteristic interpretation of the part of Judas.

* * *

'TRISTAN UND ISOLDE' AT THE METROPOLITAN

Gustav Mahler Makes His First Appearance as Conductor

MME. FREMSTAD'S ISOLDE

A Remarkable Performance in Which Both Make a Deep Impression—Van Rooy and Knote in Familiar Parts

WITH: Mme. Fremstad (Isolde); Mme. Homer (Brangaene); Mr. Knote (Tristan); Mr. Van Rooy (Kurwenal); Mr. Blass (Konig Marke); Mr. Muhlmann (Melot); Mr. Reiss (Stimme des Seemanns, Ein Hirt); Mr. Bayer (Ein Steuermann); Mr. Gustav Mahler (Conductor).

The German works have had scant showing at the Metropolitan Opera House so far this Winter. Their time has come now, however, with the coming of Gustav Mahler to occupy the chief place in the conductor's chair. He made his first appearance before a New York audience last evening, conducting the first performance given there this season of "Tristan und Isolde." The occasion was doubly notable because it was also the first appearance of Mme. Olive Fremstad in the part of Isolde.

There was enough here to key up the interest of the lovers of Wagner's great tragedy to a high pitch, and there was the promise of a performance remarkable in many respects. The promise was kept, and more than kept. The performance was indeed a remarkable one. It not only disclosed splendid artistic gifts on the part of the two people in whom the public had its greatest curiosity, but there were not a few new features in the performance of the rest of the cast, all of whom were familiar in the parts they were representing, and who were spurred on to achieve unwonted excellence.

The influence of the new conductor was felt and heard in the whole spirit of the performance. He is clearly not one of the modern conductors, upon whom the ban of the Bairenuth of the present day rests, with the result of dragging the tempo and weighting the performance of Wagner's works with lead. His tempos were frequently somewhat more rapid than we have lately been accustomed to; and they were always such as to fill the music with dramatic life. They were elastic and full of subtle variations.

Most striking was the firm hand with which he kept the volume of orchestral sound controlled and subordinated to the voices. These were never overwhelmed; the balance was never lost, and they were allowed to keep their place above the orchestra and to blend with it always in their rightful place. And yet the score was revealed in all its complex beauty, with its strands of interwoven melody always clearly disposed and united with an exquisite sense of proportion and an unerring sense of the larger values. Delicacy and clearness were the characteristics of many passages, yet the climaxes were made superbly effectual. Through it all went the pulse of dramatic passion and the sense of fine musical beauty.

It was certain that Mme. Fremstad would present even in her first performance—for it was the first time she has sung the part of Isolde—an impersonation of originality and power, and, above all, of dramatic sweep. It is an impersonation that discloses at once her dominating dramatic gifts, her accomplished stage-craft, her intelligence in possessing herself of the essential qualities of Wagner's heroine. She is of the race of the great interpreters of Isolde. There are memories that will not down, and which she cannot efface; and she has not yet reached her real stature in the part.

Mme. Fremstad's Isolde is destined to be much greater than it is. She has not yet made herself completely mistress of all this woman is and does. So complex a character is not to be possessed at a single bound by any singing actress, however great her gifts may be. Mme. Fremstad's conception has the prescience, the skill of a great artist; but there are details that she does not now express, and that she will find her way to express before she has grown much older in the part. Her representation is absorbingly interesting upon all its sides.

In its outward appearance it is of fascinating beauty and allurement; of grave dignity, rather of gentleness than of regal imperiousness; in her first state rather of wistful sadness than of the suppressed and raging fury of the woman scorned. The scorn, the irony, the bitterness, the hate that are pent up in her soul, are suggested rather than fully denoted by her. It is a marvelously beautiful impersonation, granted the point of view; but there still is needed more salient and sharply drawn outline. Her representation of the scene after the fatal potion has done its work is full of passionate ardor, and in the second act there is the burning flame of passion; in the third she strikes the note of grave and tragic tenderness reaching at the end the fullness of lofty eloquence.

Mme. Fremstad's voice is of indescribable beauty in this music, in its richness and power, its infinite modulation in all the shades and extremes of dramatic significance. It never sounded finer in quality, and never seemed more perfectly under her control. And her singing was a revelation, in the fact that the music was in very few places higher than she could easily compass with her voice. The voice seems, in truth, to have reached a higher altitude; and to move in it without strain and without effort.

The contributions that Mr. Knote and Mr. Van Rooy made to this performance were extremely fine. Their quality is well known from previous years. The audience was very large. It greeted Mr. Mahler upon his entrance into the orchestra with several rounds of hearty applause, which he acknowledged with bows. After the first act he was called out again and again, and received a token of approval that this audience is slow to bestow upon any newcomer. That he made a deep impression upon his first appearance here was unmistakable. Mme. Fremstad also received unmistakable tokens of the great favor with which her new impersonation was regarded.

* * *

TO AID COPYRIGHT BILLS

Composers Want Protection Against "Machine"-Made Music

Victor Herbert, John Philips Sousa, and several other American composers are planning to go to Washington next week to do all they can toward getting the new Copyright bills of Representative A. J. Barschfeld and Senator A. B. Kittredge through Congress. The bills provide that makers of mechanical musical instruments shall pay royalties to the composers. There is an opposition bill which has been introduced by Congressman Frank D. Currier of New Hampshire, which the composers are fighting.

"For all our music which is used by phonographs, graphophones, mechanical pianos, and hurdy-gurdies we do not get one penny," said Victor Herbert yesterday. "The singer, like Caruso, who sings into an instrument, gets paid roundly for it, but if he sings an air by Puccini, for instance, that composer gets nothing."

* * *

FIRST HEARING HERE OF DEBUSSY'S OPERA

"Pelléas et Mélisande" Sung at the Manhattan Before a Crowded House

MUSIC OF STRANGE QUALITY

Misses Garden, Gerville-Reache, Messrs. Perier, Dufranne, and Arimondi in the Chief Parts

WITH: Miss Mary Garden (Melisande); Mlle. Gerville-Reache (Genevieve); Mlle. Sigrist (Little Yniold); M. Jean Perier (Pelleas); M. Hector Dufranne (Golaud); M. Arimondi (Arkel); M. Crabbe (The Doctor); M. Cleofonte Campanini (Musical Director).

Claude Debussy's opera, "Pelléas et Mélisande," was produced for the first time in America last evening at the Manhattan Opera House. There was a very large audience present—an audience of an altogether unusual intellectual quality and musical discrimination—that listened to the work with intense interest and absorption. There has been a great curiosity on the part of the music-loving public not only in New York but in other musical centres as well to become acquainted with this remarkable product of twentieth century art, and there were persons present who had come from a long distance to witness this performance.

The production was generally acknowledged to be a highly important one, on account of the position that Debussy has taken as the leader and most original exponent of a new departure in music; in the eyes of his admirers it was of an importance comparable to the productions of "Parsifal" and "Salome." It was an act of courage and dar-

ing on Mr. Hammerstein's part to bring out in New York a work of such a character that its appeal to the operatic public on which he relies for his support must necessarily be a matter of uncertainty; and still more, to bring over for the purpose two of the singers from the Opera Comique in Paris who have been identified with it from the beginning, Messrs. Dufranne and Périer, besides two more whom he already had in his company, Miss Mary Garden and Miss Gerville-Réache. To do so was, as a matter of fact, the only way to make possible the production of a work that is absolutely sui generis, that departs widely from the methods and traditions of the lyric drama as hitherto accepted, and whose spirit and essence can be caught and set forth only by artists who have become fully possessed by them.

Mr. Campanini's Feat

An altogether remarkable exception to this statement is the fact that the performance was prepared and carried out under the direction of Mr. Cleofonte Campanini. He had never even heard the work; and Italian though he is by birth, and cosmopolitan by virtue of his profession and experience, he found the innermost secret of this most elusive of all music, and his rendering of the score was a marvel of sympathy of subtle appreciation of the composer's purpose, and mastery of the refinements of his orchestration. All this he secured in the short space of two weeks, and with a very limited number of rehearsals. He had, to be sure, the invaluable counsel and assistance of singers to whom the work and all its secrets are as an open book; but the task was one that only a musician of the highest powers and widest sympathies could have accomplished as Mr. Campanini has accomplished it. Never, indeed, has the commanding genius of this great artist so completely established itself as in this achievement.

Maeterlinck's drama, as Debussy has used it for his musical setting, was described at length in last Sunday's Times. Yet description of the action is far from giving an insight into the meaning of the piece. The music by which Debussy interprets the drama is equally elusive of analysis. It is cast in the same spiritual mold; it is an absolute reflex of the drama, the thing itself transmuted into tones. It seems like the same intellectual and emotional stuff in another form, so subtly and so exactly has he found expression for it in all its qualities.

Maeterlinck's play is far removed from the realities of life, as it is from the conventionalities of the drama. It is a dim and shadowy world in which these characters move, as in a dream. They are drawn by the inevitable power of fate toward catastrophe; and this power is ominously indicated, suggested rather than delineated, by effects that the dramatists use. The personages themselves are compounded of mystery; they reveal themselves by speech and action that seem like the operation of fate working through them without their consciousness or even their volition. What they do, "gentle, hesitating figures that speak in the voices of dreamland," is less action than it is the disclosure of their souls' state. Withal, they exert a strange fascination upon the sympathies of the listener, and the development of their relations and the maturing of their fate limned as they are in suggestion and vague outline, rather than in unmistakable traits, may work upon the sensibilities more deeply than forms and concepts of sharper reality.

Story of Wandering Souls

Yet these characters have strong and clearly discerned lineaments of their own; Golaud, the elder brother, is the dominating figure upon the scene; a figure tormented by the doubts that come to him, a stern man uncertain of his way through the baffling circumstances that beset him, and seeking it with intermittent rude force; desponding, and at the end torturing his dying wife to resolve, for the sake of his own pride, doubts whose resolution can avail nothing. Pelléas and Mélisande are wandering souls, drifting on the current of their own feelings, which bears them steadily toward the inevitable end; Pelléas hesitant impotently, vaguely thinking to free himself by going away, but never going; Mélisande, simple, ingenuous, wistful, passive, and but dimly conscious of the forces that are bearing her, absolutely straightforward in her answers to her lord's feverish questioning as she lies dying. Arkël embodies the gracious and sweet benignity of the wisdom of age, and there is much that is beautiful and touching that comes from his lips.

There has been much said about the symbolism of Maeterlinck's drama. It is not necessary to enter into much perplexity on this account; especially in the form in which Debussy has compressed it, in which certain passages of symbolic import are eliminated. There are some scenes that seem disconnected with the progress of the drama, even accepting the vague and disconnected sequence that forms its substance. These may be felt to be suggestions pointing the way to the end, and contributing by the indirection and indecision, which are of the essence of Maeterlinck's art, to the result he is striving for. The drama explains itself to the sympathetic listener with its indication of character, its representation of mismated souls, its under current of foreboding, its dim and subtle imaginative suggestion.

It is fascinating; and its fascination is now, and is likely long to be, inseparable from the music through which Debussy has heightened and deepened its significance. Debussy's art has heretofore become familiar to the frequenters of orchestral concerts; and it is essentially the same, as he has molded it to dramatic purposes in "Pelléas et Mélisande." Its beauty is almost indefinable; strange and unaccustomed; but it is very real. It may be said to be, for the opera goer accustomed to all the wide gamut of musical expression from Gluck and Mozart to Wagner and even Strauss, almost a complete negative of all that has been hitherto accepted as music. It is a complete stranger to traditional art.

Melody, even as melody has been recognized in the most recent of Debussy's predecessors, is here only dimly hinted at, and such melody as there is is but the slender scaffolding for a rich and ever varying harmonic structure. It is by the shimmering and iridescent play and change of harmonic and

orchestral color that this music has its most potent effect. The orchestra has the entire predominance. Of vocal melody there is nothing. The voices have not even the endless arioso of Wagner's style. Their declamation is little more than sustained speech in musical tones, sometimes falling into a suggestion of Gregorian chant. Around this flows an endless orchestral stream of marvelous and delicate beauty. It is saying too much to say that this music is built up of "leading motives" in the sense that Wagner has made familiar. There are recognizable harmonic groups and melodic outlines, but their definite association with particular ideas, or emotions, or personages, is by no means certain. Yet this orchestral part is poignantly and potently suggestive of the changing moods of the drama. Of musical characterization of the personages there can scarcely be said to be any. There is no place in this music for the sharp outlines, the strong coloring, that such characterization would imply. Suggestion, allusion, shifting colors and interplay of light and shadow are what Debussy has aimed at and what he has achieved.

In a Strange Wonderland

In his harmonic substance, of which his music is so largely composed, Debussy has penetrated into a strange, new wonderland. He owes no allegiance to any harmonic system; tonality, the very foundation of hitherto accepted harmony, is almost non-existent in this music. He has gone to the very extreme of new and unfamiliar combinations, of progressions and juxtapositions, that seem fantastically to mock the rules and the axioms of the musical grammarians. These discords—if a term of the ancients may be used in connection with this new art—have scarcely a name and a designation in those rules. And it has been said of them that they are so far from being justified by the grammarian that they cannot even be convicted by him. Yet they bear their own justification with them to the ear that is attuned to hear their strange eloquence. The beauty of this harmonic flow is inexplicable, but is irresistible.

All this is inseparably connected with the skill in orchestration that the composer has shown. What looks harsh and unbearable on paper, what sounds impossible upon the piano, is transformed into a golden and opalescent beauty by the magic of the instrumental color. Debussy's technical mastery of his medium is of the highest. His orchestra is small; he makes no demand for extra instruments, but from the familiar choirs he extracts timbres of exquisite beauty, lucid, transparent, delicate, incessantly changing. The orchestral part is subdued, rarely rising to a fortissimo; and it is adjusted with an unerring skill to support and envelop the voices upon the stage.

Debussy, even when the opportunity is offered him to suggest exterior impressions with his orchestra, abstains; as when he could suggest the murmur of the sea, or the whispering of the wind through the leaves, or the striking of a beam of moonlight into the dim recesses of the cave, or the flash of Mélisande's ring falling into the fountain. His artistic reserve prompts him to deal more with the psychological than the sensuous.

It is difficult to point out scenes and passages that one of especial beauty in a score so intimately knit, and so consistent in its structure. The first scene of the meeting between Golaud and Mélisande, the scene where Pélleas comes to Mélisande's window in the tower and seeks to touch her hand and her long hair, their scene by the fountain, when the ring is lost, their final scene together when the passion of their love is fully disclosed, and several of the passages that fall to Arkël, linger and haunt the memory.

Weaknesses of the Score

The weakest places of the score are the passages the orchestra plays between the scenes while the curtain is down; and the history of these explains their weakness. They were extended by the composer after he had finished his work, to meet the exigencies of the scene shifters—to last for so and so many minutes each. They are hence an excresence upon the conception of the work as the composer originally conceived it. But from this must be excepted the music that accompanies the change before the last scene of the fourth act, which is of superb eloquence, the orchestra rising to a power steadily denied it theretofore.

Debussy in this music is as original as it is given any creative artist to be in an art that is built upon the achievements of those who have gone before. It is comparable with no other music but his own. It is easy to say that but for Wagner and César Frank the score could not exist as it is, but that is scarcely more than to say that Debussy comes after those two masters in point of time. There are indeed, traces a few of "Tristan," of "Parsifal," but they are not important. It is an artistic phenomenon that, as far as may be, begins with this composer. Whether it will end with him is something for the future to discover.

The interpreters of Debussy's opera gave a performance, which, so far as the principal characters were concerned, was of a rare finish and perfection. Of Mr. Campanini's part in it we have already spoken. The Misses Garden and Gerville-Réache and Messrs. Périer and Dufranne created in Paris the roles of Mélisande, Geneviève, Pélleas, and Golaud, respectively; and they are completely identified with its spirit at every point. Miss Garden made in it a new disclosure of her art and of the power of her dramatic personality. She is the dreamy wistful maiden, wandering, uncertain, unhappy; and her denotement of the veiled and mysterious character is of much beauty and plastic grace. In places, as in the difficult scene with the wounded Golaud, and in the scene in which he does her violence, she rises to a height of tragic power that ought to put her among the greatest of lyric actresses. It was difficult to believe this statuesque mediaeval maiden was of the same stuff as Thais, as Louise. Melisande adds many cubits to Miss Garden's artistic stature.

The Newcomer

The two newcomers are both important additions to singers who have been heard here. Mr. Dufranne has a baritone voice of resonance, of dark and rich color; his enunciation

is of exquisite perfection, his treatment of the phrase most musical, his declamation of true eloquence. He is an actor of strong individuality and varied resources. So is Mr. Périer, the tenor, whose representation of the hero has the suggestion of longing, of hesitancy, of waxing passion. His voice, which has something of the baritone about it, has less of fine quality as it is disclosed in this music, but he has admirable enunciation and admirable skill in the management of it. Mr. Arimondi, naturally enough, could make less of the part of Arkël, to which he is new, nor is his French diction above reproach. But it was a creditable attempt at a difficult part. Miss Sigrist, in the slight part of Yniold, the little boy, met with fair success.

An elaborate series of scenic pictures is an indispensable part of the representation of Debussy's opera, and these had been provided. They are admirable in design, and they give the pictures that are evoked by the text. Their deficiency lies in their color, which has not been applied always with the eye and the feeling for harmony of an artist. Some have richness of effect, as the scene of the window of the castle looking out over the sea, and that of the castle tower. In others a garish note has been allowed to obtrude. The management of the lights, while it was well planned, sometimes resulted in somewhat too great an illumination of what should have been more dim, more mysterious. There are many rapid changes of the scene during the playing of the orchestral interludes, which, it is quite indispensable, should be done promptly, and they were most successful.

The audience, while it was not at first highly demonstrative, was closely attentive, restrained its applause during the changes of scene, and at the ends of the acts let its appreciation find expression. This expression reached its highest pitch after the fourth act, in which theatrical effect is strongest. Here it became positive enthusiasm. All the principals were called out repeatedly, and then Mr. Campanini and Mr. Coini, the stage manager. Finally Mr. Hammerstein came and made a speech. He said:

"If a work of such sublime poetry and musical grandeur meets with your approbation and receives your support, it places New York at the head of cities of musical culture throughout the world. As for myself, I have had but one object in presenting the opera—to endear myself to you and perpetuate myself in your memory."

* * *

December 9, 1908

MAHLER'S SYMPHONY PLAYED

*A Work of Colossal Proportions Given Under
the Composer's Direction*

Gustav Mahler conducted the second of his concerts with the New York Symphony Orchestra last evening in Carnegie Hall, and made his programme consist solely of his own sec-

ond symphony. It is a work of colossal proportions that lasts more than an hour and a half in performance and requires a huge apparatus for its presentation—a greatly enlarged orchestra, including distant horns, trumpets, and other brass instruments; organ, a soprano and a contralto soloist, and a chorus of mixed voices. It is an extreme instance of the growing demands of the modern composer for the most elaborate and sonorous utterance of his ideas.

Music of Mahler's has been heard here; his fourth and fifth symphonies have been played, and both have taxed the receptive power of those who listened to them, even with the greatest seriousness. The same sort of demand is made by this symphony, but in a far higher degree. The work shows striving of the most exalted sort; a struggling ambition to set forth in music vast conceptions of human aspirations, the destiny of the soul, unformulated and unexpressed in words; ideas that, according to the musician, are beyond words, and only to be voiced by the eloquence of his art.

Such things are only for the greatest; and to say that Mr. Mahler's achievement has not soared so high as his ideal is but to repeat the history of human ambition in many guises, a history that has many illustrations in musical art. His enormous symphony is not all that he set out to make it; but it is nevertheless in many respects a remarkable work, one that cannot fail profoundly to impress any one who listens to it with sympathy.

There is in much of this work an intense conviction. There are blood and iron in the music; there are tenderness and poetry of true elevation. With them there are effects that are obviously made with only skill and industry and that do not flame with the fire of inspiration. There are passages that are theatrical with the quality of Meyerbeer; there are trivialities and crass contrasts. But of the deep seriousness of the composer's work there can hardly be a question. The music is a faithful reflex of an artistic personality.

The specifically musical inspiration of the work is of widely differing value. It would be too much to say that it is not sometimes reminiscent. There are broad and sweeping themes in the first movement that are full of character, but with all the breadth of the treatment there is form.

* * *

December 11, 1908

GERMAN OPERA AT METROPOLITAN

An Excellent Performance of the Last of Wagner's "Ring" Dramas

MR. TOSCANINI CONDUCTS

Mme. Fremstad Appears for the First Time as Bruennhilde— Schmedes and Hinckley in Cast

WITH: Olive Fremstad (Bruennhilde); Rita Fornia (Gutrune); Natalie Gorski (Erste Norne); Mary Ranzenberg (Zweite Norne); Felice Kaschowska (Dritte Norne); Lenora Sparkes (Erste Rheintochter); Henrietta Wakefield (Zweite Rheintochter); Louise Homer (Dritte Rheintochter); Erik Schmedes (Siegfried); Allen Hickley (Hagen); Adolf Muehlmann (Gunther); Otto Goritz (Alberich); Arturo Toscanini (Conductor); Anton Schertel (Stage manager).

Wagner's "Götterdämmerung" was produced at the Metropolitan Opera House last evening, and a performance in many respects of remarkable quality was given. Not one of the least remarkable facts about it was that, though the Opera House has distinguished German conductors upon its staff, at least one of them one of the most distinguished, this production was intrusted to the Italian, Mr. Toscanini. Indeed, it had been much heralded in advance as one of his most noteworthy achievements; he has conducted it in Italy, and has made of it one of the cornerstones of his reputation.

He performed the remarkable feat of conducting it entirely from memory; but this is, in truth, only of subsidiary importance, since the audience does not go to the Opera House to see a conductor's feats. The important thing was that he produced a fine performance of the work upon which he was engaged, and that he showed himself to be thoroughly in sympathy with the music, to understand it, and to possess in a pre-eminent degree the power of reproducing it in its larger sweep, its deeper significance, and its finer details.

It cannot be said that he made a new revelation of this score to the lovers of Wagner in New York who have heard interpretations of supreme authority; but he presented a performance of remarkable energy and dramatic power, as well as one of great musical beauty. It was not in every respect ideal, even so far as the conductor's work could make it so.

There were passages in which he was carried away by the sweep of the music, as other conductors have been before him, and urged the orchestra to excessive power, to a degree of tone against which the voices struggled in vain. There were, on the other hand, innumerable passages of the utmost poetic refinement and beauty, in which the balance of the orchestral tone was skillfully calculated, and the beauty of Wagner's tonal coloring and instrumental detail were exquisitely conjured up. Some of his tempi were more rapid than we have been accustomed to. In certain of these instances justification is not lacking.

The spirit of the performance on the stage was of remarkable excellence. Chief among the singers was Mme. Fremstad, who for the first time appeared here as the Brüennhilde in "Götterdämmerung." It was an altogether noteworthy addition to the great performances that she has given here. She conceived the part on strongly dramatic lines and she has the power to give an interpretation embodying a conception of tragic intensity.

It ran through a wide gamut of emotional expressiveness: the womanly tenderness of its first aspects, the shock and horror of the tragic situation with which she is brought face to face, the solemn transfiguration of grief in her final apostrophe to the dead hero, she denoted with a wonderful poignancy, with a fullness of dramatic resource that wholly compassed their significance. Mme. Fremstad sang the music with magnificent richness of voice. There are passages that seem too high for her, but they are not many, and there was a thrilling meaning in every tone she gave forth.

Mr. Schmedes was the Siegfried, a commanding figure, a skillful interpreter of the character, but in voice rarely satisfying, less so than he has been in other performances in which he has appeared here. Mme. Rita Fornia, as Gutrune, also appeared for the first time, singing the music with beauty of tone and intelligence, and making of her performance one of the best that has been seen here of the character for a considerable time.

Mr. Hinckley's Hagen had many excellent qualities, particularly in voice; he sang better than he has in some of his previous appearances. His acting, however, needs more vitality. The Gunther of Mr. Mühlmann is familiar, and Mr. Goritz was the Alberich. The Rhine Daughters were excellently represented by Mmes. Sparks, Wakefield, and Homer, and the Norns by Mmes. Gorski, Ranzenberg, and Raschowska. Especially good was the barbarous chorus of vassals, vehement both in song and action.

The version of "Götterdämmerung" presented last evening differed considerably from what has recently been heard here; for the first time in a number of years the "Norn" scene of the prologue—or a portion of it—was presented; a scene musically beautiful and preparing the hearer by its dim suggestiveness for the ominous unfolding of fate that is to follow, but dramatically of little importance and difficult to present in a convincing picture.

On the other hand, the whole of the scene between Brüennhilde and Waltraute was cut out—a scene not only of moving power in itself, but closely knit into the dramatic texture of the whole. But something must be sacrificed in a drama of the gigantic proportions of "Götterdämmerung" if it is to be brought within the possibility of an evening's representation. There were other lesser restorations and omissions in the rest of the drama.

The audience was large, but not one of the largest. There was much appreciation of the labors of those concerned in the representation and an unusual amount of applause at the end.

* * *

December 27, 1908

MAHLER'S WORK AT THE METROPOLITAN

His Remarkable Presentation of "Tristan und Isolde" Pleases Devotees of Wagner

Mr. Mahler's remarkable performance of "Tristan und Isolde," at his reappearance in the conductor's stand at the Metropolitan Opera House last Wednesday, again delighted the lovers of Wagner's drama. It is full of note-worthy points of excellence that denote the fine feeling and the strongly musical qualities of the conductor, as well as his dominating instinct for the dramatic aspect of the score.

There was a certain disappointment felt last season by some of the Wagnerians—were they not younger ones?—in Mr. Mahler's reading, and there will doubtless be again this season, since his reading has not changed. They complained that it was not "dramatic" enough, that he did not let loose the power of the orchestra in places where the superlative climaxes come. Some of the "thrills," so it was declared, and may be again, were missed. The ebb and flow of the great orchestral tide, it was thought, was too much in miniature.

But Mr. Mahler has a very definite and distinct purpose in presenting the orchestral score in the light he does. It is really for a higher dramatic purpose, not a lesser one. That purpose is that the voices of the singers may come to their fullest rights upon the stage. His orchestral reading is on a fine and delicate scale of dynamic nuance; it is abundantly sonorous when there is need for sonority, but it is always kept beneath and subordinated by the voices. Its details are brought out with an unerring appreciation of their significance, and with a plastic modeling of every phrase and every note; but all within the tonal limits proposed by Mr. Mahler's ideal of the theatric drama.

That ideal is that every word of the singers, every phrase of the text, should be intelligible to the listeners; or that it may be so. Unfortunately, a conductor can only make it possible for a singer to be heard and understood if he or she sings with a diction sufficiently finished to make the words clear. Even under the most favorable auspices they are not likely to carry all parts of the Metropolitan Opera house. But it is the business of the singers to launch their text into the auditorium with perfect enunciation, and it is the business of the conductor, and the works of Wagner, as well as others, to make his effects with the orchestra in such a way that, while they shall count for all they should, they shall make no interference with the main business of the opera, which is the drama. Wagner founded his reform of the lyric drama on the dictum, printed in large type, that "the error in the art genre of opera consists herein: that a means of expression, music, has been made the end, while the end of expression, the drama, has been made the means." It too often seems, as if the conductors of Wagner's works were losing sight of this principle as much as the older composers of the flimsy Italian opera.

As to what Wagner himself thought and said about this matter there is plenty of evidence. Thus Angelo Neumann, in his book, "Personal Recollections of Wagner," an excellent English translation of which is published by Henry Holt & Co. in this city, gives a characteristic anecdote that is highly significant of Wagner's intentions as to the balance between the orchestra and the voice. Neumann was rehearsing the "Nibelung" dramas in Berlin for the performances of the cycle there in 1881. Anton Seidl was the conductor. Says Neumann of Wagner's part in these rehearsals:

"His little admonition to the musicians was, most characteristic, and worthy to be noted by many an orchestra of the present day. 'Gentlemen,' he said. 'I beg of you not to take my fortissimo too seriously! Where you see an "ff" make an "fp" of it, and for "piano" play "pianissimo." Remember how many of you there are down there, against the one poor single human throat up here alone on the stage!'"

Felix Weingartner told a similar anecdote in an article published first in the Allgemeine Musik-Zeitung, and translated in The New Music Review of March, 1905. He says: "The intoxicating, luxurious, saturated tone of Wagner's orchestra, especially in the works next preceding his last, is a continual hindrance to the full comprehension of his art work. All sinking and lowering of the orchestra are in vain. It is necessary to suppress the sound, even change marks of expression, if the performances are not time and again to seem more like a conflict between the instruments and the singers than a unity of expression. 'Cut the trombones out of the second act!' cried Wagner in irritation to Levi, the conductor, when after a considerable interval, he had heard 'Tristan' again at Munich.

"Wonderful, on the other hand, is the transparent clearness of the 'Parsifal' orchestra; still more wonderful is it that none of those who fancy they are following in Wagner's footsteps has understood the hint the master gave in this change, out of the fullness of his experience. In the opera of to-day the cry always is: 'Orchestra, orchestra, orchestra! Singers, look out for yourselves as best you can!' "

Mr. Weingartner's suggestion as to the need of changing the marks of expression is thus shown by Neumann to be not in the least impious toward the master, for he himself counseled the same thing directly to the musicians who were playing his score. But it is all in the direction of reducing the scale of the orchestral dynamics.

Is it possible that some of our Wagner lovers have lost their sense of proportion through the love of certain conductors for sonorous and crashing orchestral tones? In the older days of Seidl there used to be complaint from the boxes that the music of "Tristan und Isolde" was so soft that it was not possible to converse comfortably without arousing anger in the pit. That, after all, implies a certain ideal.

RICHARD ALDRICH

* * *

January 29, 1909

STRAUSS'S "SALOME" AT THE MANHATTAN

Excellent Representation of the Much-Discussed Music Drama

MARY GARDEN AS SALOME

A Remarkable and Original Impersonation—Fine Achievement of Mr. Campanini as Conductor

WITH: Miss Mary Garden (Salome); Mme. Doria (Herodias); M. Dalmores (Herod); M. Dufranne (Jokanaan); M. Valles (Narraboth); Mlle. Severina (Page of Herodias); M. Sellav, M. Venturini, M. Montanari, M. Daddi, M. Collin (Five Jews); M. De Segurola, M. Maifatti (Two Nazarenes); M. Crabbe, M. De Grasia (Two Soldiers); M. Fossetta (A Cappadocian); Mlle. Tancredi (A Slave); M. Cleofonte Campanini (Musical Director).

For the second time in New York, Richard Strauss's musical drama of "Salome," a musical setting of Oscar Wilde's piece, was given last night at the Manhattan Opera House. The audience was enormous, its expectancy highly keyed, and the impression it received from the remarkable work was evidently a deep one. The brief and stormy career of "Salome" at the Metropolitan Opera House just two years ago, its withdrawal after one performance for which the most laborious and elaborate preparations had been made, are still fresh in the public mind. "Salome" is destined for sensation and unrest by its very nature. In Mr. Hammerstein's house the work has not been directly such a celebrated case as it was two years ago, though the operatic lightning has recently played about it briefly and fiercely, and public interest in it has received many fillips.

Strauss's music is of such difficulty and enormous complication as to make the most exacting demands on singers, players, and conductor. Its preparation involves enormous labor and the overcoming of the cruelest sort of difficulties. Under the circumstances that prevail at the Manhattan Opera House these offered the most serious of problems, and that they were solved with a success so remarkable is little short of a triumph for Mr. Campanini, who conducted the performance, and for Miss Garden, Mr. Dalmores, and Mr. Dufranne, who enacted the principal parts, as well as Mr. Coini, the stage manager, and the rest who were concerned in it in more subordinate capacities.

Effect of the Work Profound

The effect of Strauss's work was again profound. Of that its most determined opponent could make no doubt. Its dramatic force is irresistible, its musical expression, often harsh and mordant, bites deep into the consciousness of all who see and hear it. Whether we like it or not, whether we believe in it or not, there is a power in it that has a sway not to be shaken off. There were predictions when this music drama was given here two years ago that it would go down to the speedy oblivion that has practically enwrapped the composer's two previous dramatic productions. But in the year 1908 there were 217 performances of it in Germany alone, a fact which shows that its vitality is still strong.

The audience last evening listened with deep attention, evidently submitting to the spell of the dramatist and the musician, but the applause at the close was by no means voluminous or enthusiastic.

Whether its effect is to call forth wonder, admiration, and delight, or is to cause repugnance and deep dissent from all that is aimed at and achieved by the composer, it is clear that the work is the product of a potent musical force; of a faculty, if not productive of beauty, then certainly wonderfully powerful in execution, of inexorable logic, of marvelous technical skill in the treatment of all the resources that the evolution of musical art and science has accumulated, and fecundity in the invention of new ones. Of "inspiration" in "Salome" it seems more difficult than ever to speak. It is a dominating intellectual power that has created the music, a masterful intelligence that has gathered up and concentrated upon one object all that the material of music can offer to work with.

The subject of "Salome," as Wilde elaborated it in his drama, is abhorrent. The characters, except that of him who represents the Biblical figure of John the Baptist, are ignoble, weak, or perverse. The whole picture is a baleful representation of decadent human character in a period of universal decadence. The time, that of the Roman domination of Syria, is one in which immorality, weak superstition, erotic sensuality, and grisly cruelty were the prevailing forces of a corrupt civilization in which uprises the stern figure of the Baptist with his proclamation of a new light and a new ethical standard. The whole is weighted down with a heavily erotic, unwholesome atmosphere. A strange and intangible feeling of horror pervades it, a sense of indefinable dread. Strauss has most skillfully seconded Wilde in enveloping the scene with this atmosphere.

The play itself is the product of a brilliant, constructive imagination that has projected upon this background strongly outlined and characterized figures of the personages that are dimly suggested in the brief Biblical narrative. Its vivid and swiftly moving action differs materially in motive from that which that narrative suggests. "But when Herod's birthday was kept," says the Evangelist Matthew, "the daughter of Herodias danced before them. Whereupon he promised with an oath to give her whatsoever she should ask. And she, being instructed of her mother, said, Give me here John Baptist's head in a charger. And the King was sorry." Here is no sumptuousness, no background, no viciousness other than Herodias's revenge. This Salome was but an obedient servant of her mother's vengeance. Wilde's Salome is impelled by her own thwarted passions, her perverted desires for the prophet's love, her longing to kiss his mouth. She is "athirst for his beauty, hungry for his body." The drama furthermore focuses for us in a single scene a strongly outlined, highly colored picture of the time and place, the characteristic point of view of the people. It differentiates for us with the broad and yet detailed brushwork of a master of technique Herod the restless, inconsequent neurasthenic; the voluptuous, per-

verse Salome; the hard, implacable Herodias; the stern, impassive, formidable Jokanaan.

A Symphonic Poem

Strauss's music has all the characteristics of his later symphonic poems, and it is a logical development of the method he has pursued in them, "Salome" has, in fact, been characterized as a huge symphonic poem, with obbligato action upon the stage. The music is closely knit with the text in substance and follows in every minute shadow all its changing expression, as the symphonic poems follow the composer's definite programme. It carries to the furthest extreme Strauss's ideas about the delineative power of music. From the purely musical point of view it shows the same falling off from his earlier work in freshness and spontaneity as do the "Symphonia Domestica" and others of his later symphonic poems, Music has come to mean to him principally, not beauty, nor even suggestion through a beautiful medium, but the crassest kind of pictorial draughtsmanship. Everything in this score is calculated to that end. There are passages in which there are soaring, thrilling climaxes, and mellifluous cantabile. But there is much that is petty, dry, tediously ugly. Beauty, indeed, has been far from the sole aim of Strauss's endeavor. He has sought ugliness just as eagerly when it suited his purpose—the exigencies of the stage situation—and it often suited them. Cold audacity in dissonance, effrontery in combining harmonies of incommensurable keys, confront the listener repeatedly. They grate and jar—and they are intended to grate and jar, because the composer's conception of the scene calls for it.

It has often been charged against Strauss that his specifically musical invention is weak; that he has small melodic gift; that his themes are commonplace and musically insignificant. It seems sometimes as if he had deliberately thrown overboard considerations of invention, beauty, and distinction in his preoccupation with musical material that he conceives to be delineative and plastic for manipulation. He also has been accused of gaining easy effects by the trick of reverting suddenly, after his most extravagant outbursts of discord, to simple, smooth melodic passages, usually harmonized in mellifluous thirds and sixths, with the curious chromatic turn that is characteristic of him in such passages.

But the final justification of a musician's themes is the use they lend themselves to, and what he makes of them. And of many of them Strauss has been able to build up a superb fabric—dazzling, thrilling, overpowering, often beautiful. There is often cold perversity in this music, and much that seems purely cerebral in the calculation of its effects, but it is, at all events, wonderfully expressive of what he aimed to express. He extorts from the listener's intelligence what he is unable to gain from his sympathy and musical feeling.

The music rises and falls in interest with the drama. There are dull and tedious spots, spots in which the discord becomes wearisome and in which the music lacks distinction. The points of greatest value are, on the other hand, remarkably pregnant and subtle in effect. The music in which Salome cajoles Narraboth into ordering the prophet brought forth from the cistern has charm. The orchestral passage that shows Salome's eager expectancy as the soldiers go to fetch Jokanaan is a subtle piece of delineation. His appearance is impressive as the gaunt figure of the prophet emerges, accompanied by the measured strains of his motive of proclamation. His first solemn words in rebuke of Herodias are equally impressive. The mounting passion of Salome for him is depicted with subtle resource and continence of expenditure. The music is delicately scored here. Salome's seductive paeans in praise of Jokanaan's body, of his hair, of his mouth, are expressed in terms of ecstatic longing that stand out against the sudden hysterical revulsions of feeling that follow his rebukes. The climax of the situation is reached in her passion for his mouth, her desire to kiss it, from which she will not be turned. Here is the first part of the great climaxes of the drama, and the use of the theme expressive of the culmination of her longing, scarcely more than a fragment in itself, and not without suspicion of the commonplace, evolves all the raging storm of sensual desire that now sways the Princess.

Dance a Tour de Force in Rhythm

The unquiet restlessness of Herod, his indecision, his inconsequence, his terrors and uneasy imaginings, are all set forth in music that is "expressive," delineative, and unbeautiful. Again, it takes a seductive charm as Herod sees Salome and invites her to drink wine with him, eat fruit with him, sit by him, and finally to dance for him. The episode of the Jews quarreling with each other before the Tetrarch about God, His nature, His works, the prophet, Elias, and the Messiah, is one of the capital points of the score. It is the one place in "Salome," where Strauss, the humorist in music, has given his sardonic sense full play. It is a quintet, animated, tumultuous, raucous as music, but voicing the quarrelsome triviality of the dispute. Salome's dance is an amazing tour de force in rhythm and in its note of Oriental color, and then of a more personal tone, voicing the character and passion of Salome, but still singularly untouched, musically, with voluptuousness. After Salome has made her atrocious demand for the fulfillment of the Tetrarch's pledge, his vain implorings that she accept some substitute are expressed in an urgent outpouring of picturesque music, accompanying his enunciation of all he has that may be hers instead—his pearls, topazes, chrysolites, beryls, his greatest emerald, his white peacocks. After the executioner has gone down into the cistern to his work the situation of tense and fearful expectancy is wonderfully set forth in the thin tremolo of the orchestra, through which sounds an uncanny dull tone—that famous stroke upon the pinched string of the double bass—"like the suppressed groaning of a woman."

Salome's long apostrophe to her hideous trophy upon the silver shield is the veritable climax of the work. The music is wrought with a wonderful skill, with a marshaling of the motives that expresses anew all the succession of desires that have stormed through her soul, and finally the exhaus-

tion of the voluptuary who has sated her abnormal passion. It has been remarked, and it is a significant commentary upon the work, that the music rises to the nearest approach to eloquence and sustained beauty at the unloveliest, most abhorrent passage in the drama—the passage in which Salome surrenders herself to her unnatural admixture of passion and revenge of the woman scorned.

The performance, was under the circumstances a wholly remarkable achievement. That it was an entirely complete interpretation of the music-drama would be too much to say. It was a new revelation of the wonderful versatility and commanding power of Mr. Campanini, who can get so close as he does to the true significance of Italian opera of the older and the newer spirit of Debussy's "Pelléas et Mélisande," and now, of this music of Strauss's. He has an orchestra to work with that is not of the highest competence, but he obtained results that were truly astonishing in flexibility, in power, in mastery of the great technical difficulties of the score, and in a close weaving together of its varied and complicated strands. Certain effects were lacking: certain instrumental voices were not heard; certain of Strauss's delineative touches were lost. But the orchestra accomplished wonders on the whole, and its enormous burden was borne with success.

Those who have heard other performances of "Salome"— and notably that given in New York two years ago—missed a certain atmosphere in this representation that ought to be one of the most characteristic features of it. What it is, how and why it was missing would be hard to define. But there should be that uneasy dread to which Herod and some of the other participants give such frequent utterance—"something terrible is going to happen." Jokanaan hears "the beating of the wings of the angel of death." The performance had scarcely this sort of suggestion.

The language used on this occasion was French—the original version in which Wilde wrote the play. It is characteristic of Strauss's indifference to the vocal part of his work that he has made the many changes in the declamation necessitated by the change of language with the utmost unconcern, altering the rhythm and even the outline of many phrases.

New Laurels for Miss Garden

Miss Mary Garden added a new laurel to her trophies as a dramatic artist. Her portrayal of Salome is an astonishing achievement. It is original, and it is a conception consistent in its form and development and wrought with the subtle skill of an accomplished dramatic artist. She is less an imperious and regal figure, more a discontented, almost naive, one at the outset. She emphasizes the curiosity that at first is her impelling motive and that soon grows to a consuming flame of desire. Even that consuming flame has its fitful flickering, and her waxing passion as she besets Jokanaan with her vain importunities is portrayed with an eagerness that is mingled with something like curiosity, with plastic and incessantly changing posturing. When she is at last obsessed by the full power of her passion, she is the eager feline sensualist.

It had been widely announced that Miss Garden would herself dance the "Dance of the Seven Veils," and she did it with a fascinating skill in characterization. It is no conventional stage movement and pose that Miss Garden gives in this. It is truly Oriental, a dramatic dance pantomimic and frankly suggestive of the obvious purpose. In it, and in certain other passages in the drama, Miss Garden goes quite to the limit of the permissible as a result of the successive removals of bodily covering. Her lithe grace and ingenious posturing, the variety of expression which she continued to get into it, made the dance a most effective episode. It gains greatly in this effect and in its realism by being executed by the singer herself instead of by a professional substitute.

Of singing in "Salome" there is little question. There is scarcely more than a suggestion of Wagner's "endless melody." There is very little more than declamation in musical tone. There is left little raison d'etre for either beauty of tone or justness of intonation, and the listener ends by becoming indifferent to them. He becomes indifferent even to the shrill harshness and unsteadiness of Miss Garden's tones in the upper ranges of her voice.

Yet there were places. as in the final climax, where it was evident how greatly a big and noble dramatic voice would have enhanced the musical effect.

On the other hand, Mr. Dalmores keeps the sonority and beauty of his tones all through the formless declamation of his part, and one is tempted to say that he sings the music too well. He presents a fearful and wonderful sight as the nerve-shattered, dream-haunted Tetrarch Herod. But does he show forth all the characteristic traits that are suggested in the text, and still more in the music—the uneasy air, the incessant movement, the extravagant gesture, the unstable purpose, the repeated forgetfulness? Mr. Dalmores's impersonation has many significant traits, but it is at present somewhat lacking in flexibility.

As Jokanaan Mr. Dufranne has all the requisites. Here there is singing to do, and he intones the sonorous phrases of the prophet with noble tone and deep impressiveness. He is the embodiment of grim asceticism and the one noble and commanding personage in the drama. Mme. Doria as Herodias is competent as the representative of the hard and wickedly unnatural Herodias. Praise is also due to Mr. Valles as Narraboth. The quintet of Jews did not make all that there is to be made out of their caricatured disputation, though they carried the brief scene through with effect.

The Scenic Picture

The scenic picture is contained in one single setting, which is elaborate and ornate. It represents the great terrace of Herod's palace, upon which the banqueting hall opens. In the distance is a glimpse of the town between dark cypress trees. The scene is well built, with an effect of solidity. But there might be some question as to the propriety of the architectural style in which it is designed. It is distinctly Assyrian in character, with the bearded, man-faced lions and the stiffly postured men carved in high relief that belong to Assyrian

art. Now Herod's palace was in Syria, not Assyria, and the period of the Roman occupation was later than that of Assyrian art. But more to the point is the fact that the coloring is garish and inharmonious.

There was artistic and properly reticent treatment of the much-debated episode of the severed head brought out on a charger. It was well-nigh hidden in a deep dish and was not obtruded upon the unwilling spectator. During Salome's ecstatic apostrophe to it and her frenetic mowing and embraces the stage was partially darkened. And so the ghastly horror of it was reduced to the lowest terms. It may be said that the illumination at its height was a little too bright for even a semi-tropical moonlight, and also that it was a mistake not to represent the orb in the sky as a part of the picture, since the moon is a subject of so much fantastic and involved imagery from the very beginning of the drama.

"Sublime!" Cries Hammerstein

At the conclusion of the opera Mr. Hammerstein went to Miss Garden's dressing room, extended his hands, and said:

"Sublime! Sublime!"

Miss Garden's eyes filled with tears. She threw her arms around the impresario's neck and kissed him.

The curtain did not go up until 9:25 o'clock, as the line of carriages was so long that it was impossible for them to arrive quickly enough to discharge their occupants in time for the scheduled curtain. Mr. Campanini and the orchestra were ready at 9 o'clock sharp, but Mr. Hammerstein ordered the curtain held until the confusion caused by persons arriving had subsided.

Nearly every one had obtained his tickets beforehand, and the ticket speculators found many unsold on their hands. At 9 o'clock they were offering $10 seats for $5.

* * *

February 20, 1909

"BARTERED BRIDE" AT METROPOLITAN

The Bohemian Composer's Opera Given for the First Time in America

A GAY AND NAIVE COMEDY

National Characteristics Portrayed in the Music—Mme. Destinn Heard in the Chief Role

WITH: Robert Blass (Kruschina); Marie Mattfeld (Kathinka); Emmy Destinn (Marie); Adolf Muhlmann (Micha); Henrietta Wakefield (Agnes); Albert Reiss (Wensel); Carl Jorn (Hans); Adamo Didur (Kezal); Julius Bayer (Springer); Isabelle L'Huillier (Esmeralda); Ludwig Burgstaller (Muff); Gustav Mahler (Conductor).

Smetana's opera, "The Bartered Bride,"—"Prodana Nevesta" is the composer's Bohemian title—was produced last evening at the Metropolitan Opera House for the first time in America. There was a large audience, among which

there were many compatriots of the composer, the conductor, Mr. Mahler, and the chief woman singer, Mme. Destinn.

The opera gave much pleasure, and was received with genuine enthusiasm, not only by the representatives of the Bohemian colony who were present, but also by the great body of the audience, perhaps more sophisticated in the matter of new productions, and not especially prejudiced in favor of peasant operas, of which this, by the way, is the fourth specimen that has been given in this house this season. There was not only enthusiasm but also amusement that rose at times to hilarity, for the comic spirit of the performance and the ingratiating tunefulness of the music were infectious through the whole of the auditorium.

Instrumental music of Smetana has long been familiar to New York concert-goers—music for orchestra and string quartet, chief among it being the overture of this opera—and it has been much admired for its spontaneousness and individuality and as an important contribution to the "national" musical literature. But this was the first opportunity that has been given to New York to become familiar with the Bohemian national opera, to which Smetana and Dvorak both made important contributions, and of which Smetana, through this very opera, is regarded by his countrymen as the founder. "The Bartered Bride" has been long in reaching New York; yet it has for some years had a popularity of its own in Germany and Austria; it has been given also in London and St. Petersburg and other capitals.

"The Bartered Bride" was intended by its composer to be typical of Bohemian life and character; to be a national opera, rooting in native soil, and so it clearly is. It illustrates national types and the Bohemian village life; and, according to the Bohemians, it does so truly. It is based on a simple story, mirthful, bordering on the farcical, of obvious and innocent humor. For an opera it has the drawback of presenting very little action on the stage. You are told by the characters of most of the things that happen, rather than shown by self-explanatory action. The humor is in the idea rather than in the proceedings on the stage, though these are not without their mirthful points, especially as the ensemble, dances, &c., are given in this production. And this is a handicap at an opera house where the language is foreign; where few in the audience take the trouble to acquaint themselves with the libretto and depend for their comprehension of it upon what passes before the eye.

The story, which has been related in The Times, is about the impending marriage of a Bohemian village maiden to a shy, stammering, awkward lout, while she is really in love with another youth, who appears in the guise of a wandering good-for-nothing, though he is in reality the other's half brother. Both are the "sons of Micha," and on this rather obvious quibble the plot hinges. An officious and voluble marriage broker—said to be a characteristic Bohemian type—has much to do with the affair. The title of the opera is derived from a trick of the favored lover, who lets the marriage broker persuade him to sell his claim on his sweetheart to the "son of Micha" and then, when the maiden is properly

indignant at this venal perfidy, announces himself as equally the "son of Micha," and easily wins back her favor, while his half brother is satisfied with the attractions of a pretty dancer in a wandering troupe of mountebanks.

There is much charm in the way this village chronicle is developed in the opera. Smetana's music is extremely melodious and full of life and expressiveness; light, as becomes the subject; simple and transparent, never straying into any abstruseness, and never finding occasion to grapple with problems or to illustrate more than a passing shadow of melancholy.

There is no trace of "music drama" in "The Bartered Bride." It is frankly made after old-fashioned models, with airs and recitatives—these latter substituted by the composer for the spoken dialogue originally employed, after the work began to make its way outside of Bohemia—concerted pieces and instrumental dances. Yet Smetana was an admirer of Wagner, and an ardent follower of Liszt. To their influence may perhaps be traced some clever allusions and reminiscences of melody between different parts of the opera, but these are far from being treated as "leading motives." The work, indeed, often grazes the line that divides opera from operetta, and more than once enters the region of broad farce. The impression of the whole is spirited, naïve, unpretentious.

The composer scarcely reaches anywhere in the opera the mastery and brilliant elan that he discloses in the overture; but there are many pages of delightfully fresh melody and a number of fine concerted pieces. Melody, indeed, flows in a broad, if not a deep, stream through the whole opera. The music naturally abounds in Bohemian color and rhythmic and harmonic turns. Peculiarly characteristic is the frequent interchange of the major and the minor modes in the same melody. There are Bohemian dances, of which the polka is the most familiar representative; there is the "furiant" that has become pretty well known through Dvorak's use of it in his instrumental works.

The prevalent rhythm in much of the music is duple or quadruple, with a syncopated accompaniment. It is, indeed, so prevalent as somewhat to pall. But except for this, Smetana has not unduly forced the note of nationalism, has not obtruded it so as to hamper the enjoyment of the world outside of Bohemia. The music has character and individuality and it fits the scene, the people, and the doings on the stage like a glove.

The orchestration has color and contrast. Listeners to the details of the orchestration will discover a remarkable fondness for the wood wind instruments in it. The clarinet, which is said to be the favorite instrument of the Bohemians, has much to say, and so has the oboe. The composer uses the bassoon amusingly in enforcing some of his comic situations, as other composers have done before and since.

There is excellent musical characterization by the people who carry through this little comedy. Chief among them is the bustling marriage broker, Kezal, really the central figure of the opera, who is sharply defined by many clever touches in the music associated with him. His scenes all through are treated with a real comic effect. So, also, is the music of the stammering son, who stammers most melodiously, always a beat behind in the measure.

There is a charming duet between Marie and Hans in the first act; a trio between Kezal and the father and mother of a humorous accent; an agreeable air for Hans in the second act; Marie's melancholy song in the third act lamenting her lover's perfidy has a pleasing expressiveness. One of the most striking concerted numbers is the sextet in this act. The choruses are all written with much vigor, and in them the Bohemian character is often made prominent.

The performance owed much of its success to the life that was infused into the doings on the stage by excellent stage management, to the splendid vigor and tunefulness with which the choruses were sung, and especially to the way in which the dances and the amusing scene of the circus troupe in the second act were presented. The polka in the first act was danced by a corps of Bohemian dancers in the true Bohemian manner, which is not that of the ballroom. The furiant was done by members of the ballet, but plainly under an equally Bohemian influence.

And in all and through all the master hand of Mr. Mahler was evident, whose performances all have a special quality of their own, in the finish and dramatic potency with which the music is presented, and all the factors of a vivid operatic representation are brought together and co-ordinated. The overture was played between the first and second acts, instead of at its place at the beginning of the opera, in order that late comers might hear it. This was good for the late comers, but not for the proper effect of the piece itself, which deserves a place among the most apt and witty overtures to comic opera as preparing the mood of what is to come.

The opera was admirably cast, Mme. Destinn as Marie and Mr. Jörn as Hans were exceedingly fine in both their singing and their action. Mr. Didur has done nothing better at the Metropolitan than his impersonation of the marriage broker Kezal, a thoroughly studied and consistent piece of comic acting. And Mr. Reiss as Wenzel added another portrait to his small but classical gallery of character studies in which he is unique among operatic actors. He did not succeed in getting out of the character even when he appeared before the curtain with the rest to acknowledge the applause. This was bestowed upon the performance and all concerned in it with unusual gladness and liberality.

* * *

March 16, 1909

RAGTIME MUSIC DEAD IN THIS TOWN

John Philip Sousa Says the People Have Had a Surfeit and Are Sick of It

OLD COMPOSERS IN FAVOR

Hotel and Restaurant Orchestras Have Cut Out Ragtime Altogether—New Composers Also Popular

Ragtime music is dead, according to the managers of the various hotels and restaurants in the city, and there is no longer a demand for the tunes that used to cause jig steps to come to the feet, accompanied by a desire to get up and do a cakewalk. According to the same authorities, ragtime has been shelved to make way for the tuneful airs of the popular musical shows that last but a season and for the music of the old composers. There is also a demand for the scores of Victor Herbert, John Philip Sousa, and other popular music writers.

The death and funeral of ragtime, according to John Philip Sousa, who has the credit of being the originator of that class of music, is due entirely to the poor class of the product turned out in latter years.

"Ragtime had the dyspepsia or the gout long before it died," says Mr. Sousa, who is now touring in the South with his band. "It was overfed by poor nurses. Good ragtime came, and half a million imitators sprang up. Then, as a result, the people were sickened with the stuff. I have not played a single piece of ragtime this season, and it is simply because the people do not want it."

Mr. Sousa's estimate of the popular taste is the result of observation on the tour of his band, and it is borne out by the hotel and restaurant managers of this city, who have entirely cut ragtime from their musical programmes.

"Our orchestras have not played ragtime in a long time," said Manager Barse of the Waldorf-Astoria last night. "We have always made it a rule to furnish the music our patrons wanted, and most of the programmes have been made up 'by request.' The people have simply stopped asking for ragtime tunes. Mr. Boldt, the proprietor, is particularly fond of music, and he always supervises our programmes before they are played, but he has always been perfectly willing to let the people have a proportion of good ragtime when they asked for it."

At the Plaza Hotel Nahan Franko said that his clientele did not care for ragtime, and he is never asked to play it. "The people like high-class music, and are fond of Wagner, Liszt, and Beethoven, among the old composers, and Victor Herbert and John Philip Sousa among the new. They like the catchy airs from the Broadway musical shows while their popularity is at its height, but, take it through and through, the general public is being better educated in music, and the standard works are growing more popular."

Manager Hahn at the St. Regis, Manager Wood at the Gotham, and Mr. Muschenheim of the Hotel Astor, all joined in the same opinion as to the death of ragtime and the desire of the people for high-class music.

"We find that our patrons prefer French and Viennese music," said the manager of Sherry's, "and we have an imported orchestra to meet their desires. Our musicians know absolutely nothing about ragtime and are, of course, never asked to play it."

Cakewalk tunes have been banished from Delmonico's, and in their stead may be heard the prettiest airs of the musical shows and light operas, interspersed with music from grand opera and the older composers.

A trip through Broadway, where the after-theatre parties had assembled for supper, showed the same condition to exist at Rector's, Churchill's, Shanley's, Martin's, the Hotel Knickerbocker, Murray's, the College Inn, the Marlborough, Imperial, and Victoria Hotels, while in the table d'hôte dining rooms ragtime music has been made to take a back seat.

* * *

July 5, 1909

"I DO CARE!" CRIED TANGUAY

Shrieks of Actress When Arrested Scare Rockaway Audience

That ebullient music hall singer, Eva Tanguay, at Morrison's Theatre, Rockaway, last night belied the reputation she has gained by singing "I Don't Care" and "Nothing Bothers Me" to such extent that she will be compelled to give a great proof of her sangfroid before she will again be received with open arms by the cult of the careless.

If you had had illusions about nothing bothering Miss Tanguay they would have been rudely shattered last night if you had heard her shriek "Don't touch me!" "Don't you dare come near me!" "How dare you!" "Go right away from here!" and other sentiments to the same effect. Even these sentences seemed to be too much for Miss Tanguay's nerves, for in the end she compromised on piercing shrieks which startled the Sunday night audience at Morrison's Theatre into hysterics.

Last night's anger was caused by a plain clothes policeman, one James McVey, who had been delegated to arrest Miss Tanguay because it was believed that she was breaking Article 2,152 of the Penal Code, which suggests that artists who appear in Sunday night sacred concerts at the variety theatres shall wear only clothes of the sort which can be worn in the streets.

As a matter of fact Miss Tanguay was fully clothed in tights. Compared with some other exhibitions she was like a Russian Princess going for a sleighride. But it was Sunday.

Policeman McVey waited until Miss Tanguay had retired to her dressing room after her act. Then he approached her with intent of arrest. Her screams, as has been suggested, made the audience believe that bedlam had broken loose. They finally aroused Patrick Morrison, the manager of the theatre.

He succeeded in finding a lawyer in the audience, Moses H. Grossman. Miss Tanguay was packed into the necessary amount of street clothes, after the two had dried her tears, and escorted in a taxicab to the police station.

At the station Lieut. Clare listened to her story with a bored air, and finished by asking her to come around this morning at 9 o'clock to see Magistrate Gilroy. Patrick Morrison deposited bail of $500, and to-day Miss Tanguay, with the aid of Lawyer Grossman, will plead her cause.

* * *

November 5, 1909

THE PHILHARMONIC GIVES FIRST CONCERT

Ancient Society Begins Its 68th Season by Radical Changes in Its Methods

MAHLER NEW CONDUCTOR

Has Secured a Greater Homogeneity and Blending of Different Choirs and Instruments of Each Choir

The New York Philharmonic Society began its sixty-eighth season last evening with a concert in Carnegie Hall. The beginning of its new season is marked by radical changes in the ancient corporation, its methods and organization, if not its policy. Considering what a past the Philharmonic has, what it has accomplished and stood for, what it has been in the musical life of New York, and what a mark it has made in musical history, its new departure is a matter of much significance. The details of it are well enough known to need only mention—the surrender of the old co-operative plan by which the members of the society controlled it and elected its conductor; the assumption of that control by an outside board; the elimination of some of the older and superannuated members; the addition of younger and abler men; the great enlargement of the scope of the season's activity by the giving of extra concerts; the change of conductor, Mr. Safonoff being replaced by Mr. Gustav Mahler, with the almost autocratic powers that are generally considered essential in the organization and drill of a first-class orchestra.

These changes had long been delayed, but the history of the society's recent years showed that something of the sort was necessary, if it was to survive, and hold the interest and attention of its public. Its original plan of organization was fitted for the conditions of musical activity in New York in 1841, and for the pioneering work it had to do then. That plan had long since become obsolete—a hindrance to the higher development of the orchestra. The wisdom of the change in general can hardly admit of a doubt. It was a question of the survival of the Philharmonic Society. Time will show whether the details have been worked out in the best way. As for the change in conductors, that is an incident that has occurred and must occur in the history of every organization of men in this mundane sphere, and the wisdom of the partic-

ular choice that has been made in this instance is another thing that will be determined by time, and by the results achieved. Mr. Mahler, who had already been heard in New York last season, both as a dramatic and a symphonic conductor, is a man of great and established reputation as a musician, as a drill master, and as an organizer. Upon him has fallen the difficult task of reorganizing the personnel of the orchestra, and of unifying it, and getting it into shape.

He has by no means started from a clear field. There are very many familiar faces in the orchestra that have been known to the frequenters of its concerts for years. Most of the changes are among the wind instrument players, and in this department there is a great improvement. Scarcely within the memory of man have the wind choirs played so nearly in tune and with such brilliancy and precision as was the case last evening. There has been a diminution in the number of the stringed instruments, a change in the proportion; the greatest reduction has been in the double basses, and there are now only eight instead of the fourteen that for years stood in a half circle behind the other payers. The result is a loss of the preponderating string tone, the thick and solid quality that was one of the characteristic features of the Philharmonic's playing. The general effect is now more brilliant; and the change will not please some.

The quality of the orchestra is probably not at present so good as it will be when Mr. Mahler has obtained what he wants and has secured a greater homogeneity and blending of the different choirs and the several instruments of each choir. A week or so of rehearsal by a body in large part new and under a new conductor is far from enough to acquire this, and there is, indeed, a good deal still to be desired in this direction. There is also a good deal to be desired in precision and certainly of ensemble; and this, too, is a matter that comes from habit as well as from the authority of the controlling head.

The general impression derived from the concert last evening even before the first number was finished, was that the orchestra was already something very different from what it has been for long years; in many respects better; in some respects perhaps a disappointment to those who have been bred upon the ministrations of the Philharmonic Society. But there is every reason to expect that the orchestra will be, when its transformation is finished, an extremely fine one.

Mr. Mahler's programme at this first concert may in some way be taken as an indication that his sympathies include both the classic and the modern in music. It comprised Beethoven's overture, Op. 124, called "The Consecration of the House," his Eroica symphony, and two symphonic poems, Strauss's "Till Eulenspiegel," and Liszt's "Mazeppa."

The overture has long been considered appropriate to opening functions, to "inaugurations" of all sorts; and to this fact more than to its intrinsic interest it probably owed its place at the beginning of this concert. Mr. Mahler's performance of the ninth symphony season last season gave something of a forecast of his views as to playing Beethoven, and this performance of the Eroica amply confirmed it. He sought for a dramatic expression highly colored, strongly emphasized, very

free in tempo, into which he introduced many modifications; an exceedingly strenuous interpretation, in which there was much to arouse dissent, though there was also much that was extremely fine, poetically expressive, noble, and authoritative.

But on the whole the nobility and dignity, the Olympian poise, that are the fundamental qualities of the work, suffered from this kind of treatment. The breadth and sweep of the line are interrupted by the frequent insistence upon points of emphasis and of color. It is not that this or any work of Beethoven's should be played in a colorless or perfunctory manner, with observation only of the obvious variations of dynamics and expressive nuance.

It is a question of degree and of style. There was a splendid rhythmical quality in Mr. Mahler's reading everywhere that was never lost, and there were many beautiful and expressive details in all four of the movements, especially in the last, the series of variations in which there is much opportunity for plastic modeling, of which he took the fullest advantage. There was perhaps too much insistence on the loudest things, on the strokes of the kettledrums, the blasts of trombones and trumpets.

This was the case with Strauss's "Till Eulenspiegel," which, of course, endures it much better, even if it does not require it. But the performance of this extraordinary work was an extraordinary one. Never has there been a more clear and brilliant setting forth of its complications, and with such fluency and dexterity; it seemed more than ever impossible to believe that such cleverness could really exist.

The wind instruments, beginning with the new first hornist, covered themselves with glory that was shared by the rest of the orchestra. After this Liszt's "Mazeppa" seemed tame and labored; a very hard and rather futile striving after something that Strauss really did.

The audience at this concert was large, but it did not quite fill the hall. It was enthusiastic, and gave Mr. Mahler a very cordial greeting and applause that he waved over to the members of the orchestra.

* * *

November 29, 1909

NEW CONCERTO PERFORMED

Rachmaninoff Plays His Composition with
New York Symphony Orchestra

At the concert given by the New York Symphony Orchestra yesterday afternoon in The New Theatre, Sergei Rachmaninoff, the Russian composer-pianist, played his new pianoforte concerto (No. 3 in D minor) for the first time anywhere. It is seldom that a New York audience has an opportunity to hear the first playing of a work of this sort in the larger forms of musical composition, and yesterday's audience, which was very large, seemed to be extremely appreciative of this chance to hear a composition at first hand.

Mr. Rachmaninoff's new concerto is unusual in many respects. In the first place, the title, "Fantasie," would seem to suit it better than "concerto." The work is rambling in its texture and unstereotyped in its makeup. The first movement, the test of a pianist in the ordinary concerto, is neither long nor brilliant. The first theme is strongly Russian in character and bears a marked resemblance to the idea of this composer's C sharp minor prelude. A singing second theme follows as a matter of course, and the two are worked out and repeated in the ordinary form, with a startling pianissimo finale. A wailing Russian note pervades not only this movement, but the other two as well.

Mr. Rachmaninoff has labeled the second movement, which takes the place of the ordinary "andante," an "intermezzo." It is rambling in character, in several tonalities and several tempos, and leads finally into the finale, which is the longest and the most brilliant movement in the work.

Yesterday, when the composer had finished the finale, he received a well-deserved ovation from the audience, and it is likely that the concerto will be heard soon again, if for nothing else but this last movement, which is quite out of the ordinary in its effectiveness. It commences with a choppy, dashing theme in the minor mode, and the ordinary finale manner. Other ideas follow each other. In the middle there is introduced a long passage in slower tempo with a very lovely melody. A cadenza and a repetition of the original ideas lead to the coda, which commences prestissimo and pianissimo and ends with a repetition of an earlier theme, played broadly by orchestra and piano.

The finale made a deep impression, and the concerto as a whole is interesting. Probably many other pianists could play the work better than the composer himself, and yet his reading of it was in many ways masterly. Mr. Damrosch's interpretation of the accompaniment could hardly have been improved.

The programme included Mozart's C major symphony, Lalo's "Arlequin," a pretty trifle played for the first time by this orchestra, and Chabrier's familiar "Marche Joyeuse."

The stage setting for the orchestra has been changed so that the stage is now entirely boxed in. As a result, much more sound came out into the auditorium. The new experiment with the acoustics seemed to be the most successful yet attempted. The programme will be repeated Tuesday evening at Carnegie Hall.

DANCE

September 16, 1900

THE EXPOSITION THEATRES

*Good Rendering of the Old Showman's Patter Outside
La Roulotte*

VARIOUS NATIONAL DANCES

*Characteristics of the Races to be Studied in the Forms of
This Art They Have Evolved*

Foreign Correspondence New York Times

PARIS, Sept. 7—From the theatrical point of view, the exposition cannot be described as a supreme success. This is disappointing, inasmuch as Paris prides herself so much (and rightly) on her dramatic genius and the all-around excellence of her theatrical entertainments. True, at the exposition proper, in the Champ de Mars, there is an interesting museum of theatrical properties and souvenirs, and there you may trace the developments of scenic art and its countless accessories of stage carpentry and of machining, and of both the external and internal architecture of theatres right back to that epoch-making date when M. de Poquelin founded the Comédie Française, and under the pseudonym of Moliere established French drama on a pedestal of eternal greatness, and obtained if not benefit of clergy, at least some sort of social condonation for the universally despised profession of Mummer.

There are even relics of an earlier period. There are also interesting reconstitutions of famous scenes in well-known operas and plays, to which electric organs play appropriate accompaniments. There is Talma in one of his romantic rôles—that of the Cid if I remember rightly—and Mlle. Mars in her dressing room the furniture of which, in purest Empire style, loaded with gilded bronze, was a present to the great actress from the great Napoleon. Then of engravings dealing with the history of the French drama are very many choice and valuable specimens, precious to the art collector as well as to the playgoer, and countless knick-knacks—all the bric-à-brac of the greenroom—Mlle. Rachel's rougepot and the snuff box and stick of Frederick Lemaitre, the Prince of stage dandies.

Of the modern actor or actress there is no trace. Mme. Sarah Bernhardt has, indeed, a private exhibition of her own in the jewelry section, and her bronze paper weights, chiefly fish of fantastic shape, with big bejeweled eyes, and her bust of Sardou (also her marble group "Le Noyé" at the Palais de la Femme) are a tribute to her modeling skill, but it is as a sculptress and not as an actress that we meet her at the exposition. The living stage is only poorly represented. Mlle. Charlotte Wiehe came for a few days from the Theatre Royal at Copenhagen and added one more name to the list which is growing alarmingly long of new Duses and new Sarahs. She played at the Auteurs Gais in a one-act piece entitled, "The Hand," and gave a clever analytical demonstration of the terror which a respectable young woman would naturally feel at the sight of a big male hand being suddenly pushed through her bed curtains from the inside, to be followed quickly by a ferocious burglar.

Mlle. Wiehe, who was sufficiently pretty to attract a portrait from Jules Cheret, is to be succeeded by Succi, the champion faster, who will certainly not find the Auteurs Gais in a mood for feasting. Like most of the small theatres established in the Rue de Paris, the Auteurs Gais, which was to have made a specialty of recitations and songs by the Montmartre humorists and chansónniers, such as Georges Courteline, Auriol, Allais, and the rest, came to early grief, the public of the exposition being indifferent to the comicalities of the Butte, which, require a special état d'âme in a special atmosphere to be appreciated. Like the Auteurs Gais, the Grand Guignol and the Tableaux Vivants have had to abandon their original programmes. At the last named is a wretched troupe of tiny Spanish boys and girls, who dance and sing to empty benches, while a flat-faced waiter in a voice crapulous with alcohol, urges the unwilling public to come in. Here originally were tableaux vivants illustrative of Armand Silvestre's poems. A cadaverous-looking young man dressed in an 1830 costume and with a vague resemblance to Lamartine rolled out in sepulchral tones a wordy libretto to a series of elaborately dressed groups representing "Paradise Lost" and "The Ages of Man." A young woman with a chronic catarrh occasionally intervened in a higher key. An American bar faced the stage.

Of the Grand Guignol it suffices in all charity to say that the real Grand Guignol at Montmartre, where those clever one-act pieces are played, such as "Le Pendu" and "L'Aiguilleur," carefully denies all kinship with its rival of the Rue de Paris.

A Clever "Parade"

La Roulotte has had something of a success, but this is mainly, if not entirely, due to its admirable "parade," in which the chief role is held by an excellent actor, M. Martel, to whom, indeed, the honor is due of having revived in all its pristine splendor of wit and topical allusion the old "parade" (the showman's patter) of the French traveling booth. M. Martel is a trifle severe on the Government, as becomes a vagrant from Montmartre, but surely no Pitre was ever more delightfully burlesqued or possessed an elocution so unctuously humorous and rich. The little dwarf from the Quat'z' Arts, whom Leandre has immortalized in pastel, alternately dressed as a miniature Aiglon and an English hussar, ably seconds him, as do Mlle. Frédéric (from the Odéon) in multi-colored tinsel, and a wondrous little drummer boy, "Le Petit Tambour d'Arcole," whose rataplan deafens the whole of the Rue de Paris and would suffice, one would think, to at least awaken from the dead the miscalled tableaux vivants of M. Armand Silvestre.

But if you are wise, laugh indeed to your heart's content over the spiritual appeals of M. Martel, and his troupe, and admire the perfection of their art, but stop there. Do not be

enticed inside, for a woeful disappointment awaits you. All the originality and charm of "La Roulotte" is on the outside—or nearly all. A wearisome revue, "A la papa, a la parade" takes up a third of the programme, then come the old songs of France, with costumes of their respective epochs, which have a pleasant savor of reminiscence, and finally an act by the Cantomimes, a troupe of pantomimists and singers, dealing with a comic or tragic incident in the farinated life of Pierrot—a second-rate entertainment at the tail of an incomparable "parade."

The Jardin de la Chanson is an ordinary beuglant, or inferior music hall, where some of the fallen stars of the Scala, the Eldorado, and the Cigale still scintillate dimly. At the Maison du Rire, which is in association with the "Rire," that caricature sheet of malodorous notoriety, an unsuccessful attempt has been made to revive the Chat Noir—the Black Cat of Montmartre, which met the proper fate of all cats some years ago with the late Rodolphe Salis attached to its neck in the guise of a millstone. A collection of the most sensational cartoons of Le Rire does not seem to attract many visitors, who remain equally indifferent to a second edition of the old songs of France, established as an independent set off to the Chat Noir. The old songs of France, like many other old songs, have the demerit of being either exclusively sentimental or interminably long. The price of listening to these old songs is excessive, and their special atmosphere being that of the morgue, you may weep in Maison du Rire, but you will not laugh, unless your sense of the ridiculous is peculiarly subtle.

The stately minuets danced by grand ladies of the Court of Louis XVI in the presence of Marie Antoinette and to the accompaniment of a harp and a spinnet are charming at the Palais de la Femme. The costumes, the dancing and the music leave nothing to be desired. A most delightful half hour may be spent in the society of those exquisitely mannered and graceful ghosts of a brilliant reign which was to end so tragically.

Much of the Dancing Genuine

There is a vast deal of dancing at the exposition, and on the whole it is more interesting and aesthetically effective than the dramatic entertainments. Some of the dancing is pure sham, but a goodly proportion of it is genuine and in a high degree characteristic and picturesque. A wise man has said that the Russians and the English dance with their feet, the French and American women with their legs, the Spaniard with her hips, and the negress from her hips upward. This is a rough classification which states the case fairly enough. Dancing is, of course, a medium of expression and evocation influenced by temperament, education, and nationality, and the exposition gives a valuable opportunity of studying this universal art, for there are no nations which do not dance. Dancing is either monogamous on polygamous. It may be Christian, or Islamic, or Buddhist or frankly pagan. It may even be Catholic or Protestant.

The nations of the South of Europe and of the Orient dance in a very different way from the people of the North.

When the Highland fling was invented the Scotch must have been a sober race; what they may have become since it is not necessary to inquire, but the reel and the fling, together with the kilt, are nearly identical with the dances and the dress of the Albanian mountaineers, to whom whisky is unknown.

Of Protestant dancing, a unique and withal fascinating example is that of Miss Loie Fuller. Miss Sada Yacco a moment before has shown you at the same theatre a Buddhist dance—a languorous evocation of Nirvana. Later on, by the way, this same young Japanese artist of genius, whose success in London and Paris has procured for her the Mikado's consent to act at Tokio—the first Japanese woman to whom this privilege has been granted—will show you how the Buddhist geisha murders her rival in a fit of jealousy and then dies in her lover's arms.

Acting in Japan is still very closely allied to dancing, as is the case all over the East. Sada Yacco's action is a series of rhythmic poses. She adds motion to the poses one sees on Japanese fans or vases, and thus we have a series of tableaus to which the science and the discipline of the dance supply life and color. Her death, with its queer winkings and shudderings and upheavals of breast and stomach, is the danse du ventre de la mort. Some critics have said that Sarah Bernhardt herself never died better, or even as well. This is nonsense. Sarah Bernhardt is an actress purely. She personifies and incarnates a character by a method of auto-suggestion and by a power of projecting her personality outside of herself. This is a gift more than an art. But to transmute it into art requires the closest study of nature in direct action, and Sarah when she kills strikes. Sada Yacco merely poses, and she herself told me that she had never seen anybody die. Her husband had taught her to die, just as he had taught her to dance. And very rhythmic and beautiful is her manner of death.

At the Oriental Theatres

At the Egyptian Theatre the Oriental dance is certainly shown in perfection. The almée Matouka, in her dance with glasses, and the almée Zohra, in her candle dance, express by a marvelous combination of movements, chiefly muscular, without being ambulatory, the whole attitude of the East toward woman both in its strictly Islamic (Arabic) and its wider polygamous (Turkish) phases. The woman dancer of the Orient is submissive to her lover, her lord. She is grateful for his attentions. She is purely receptive, never inceptive, and never for a moment questions her lover's superiority. She has no desire to prove her agility, as in Europe. She regards her lover with the humble worship of a dog for its master. She cowers at his feet, and every nerve in her body quivers with the curious mixture of adoration and passion which in the East is the love of women, passing the Occidental understanding no doubt, but evoked with amazing artistic precision and power of suggestion by these dark-skinned houris.

The male, on the contrary, seeks to prove his superiority in agility and muscular strength. His dance is therefore in many respects an acrobatic performance. It involves rhythmic duels with swords or sticks and a prolonged whirling around of the

entire body, indicating sureness of foot and freedom from vertigo. Apart from these athletic exercises, the man is chiefly an onlooker at the dance performed by the woman, and accompanies her on strange instruments, tomtoms, mandolins, and a kind of zither whose monotonous melodies encourage and excite her. The Egyptian almées at the exposition dance in a regular Arabic opera in three acts, which relates a war between Persians and Arabs, in which the latter are successful.

It is at the Persian Court that Matouka and Zohra produce their most exquisite morceaux. Zohra in particular makes her trinkets dance, sending a shudder of gold from her shoulder to her hips with a magnificent Oriental effect. A remarkable interlude is provided by five negresses, who in a dance nerveuse borrow the most weird contortions and twitches from the phantasmal borderland of hypnotism and hysteria. With their flat-faced, copper-colored features thrown back so that only the neck is visible, they have an atrocious air of being decapitated, of dancing without heads.

On a less gorgeous scale, but very interesting nevertheless, is the dancing in the Turkish Pavilion. Here the almées, wearing red rags, look as if they were robed in streams of blood. A black spanks a big white gourd, which he holds across his knees, and from time to time gives vent to little hysterical screams. There is the Slavonic brigand with a breast covered with cartridges, the fat impassible Turk running his finger down the strings of a zither, and the dark Levantine with the face of a dog—all Turkey in fact.

Perhaps of all the Oriental dances the most rhythmic and pleasing to the eye is the Cingalese Club Dance, which may be seen at an odd little place near the Trocadero called The Mysterious Grotto of Abou-Mama. These Cingalese have the straight noses of Aryans, and are hardly darker than Spaniards. They sit about at the door of their show in the erect and impassible pose of Vishnu, and with their mitre-like head adornments of gold might indeed be taken for Buddhist idols.

Of the Spanish dances at La Feria restaurant there is not much to be said, except that they are quite good if a little second rate, are very popular, but make one regret the marvelous performances of the gypsy Soledad at the last exposition. Spanish dancing with its "Olle! Olle!" and handclapping from the musicians seated around the principal performer, has an Oriental reminiscence, but in its essence it is the opposite of the Oriental idea, being the suggestion of female grace in form, color, and movement. An ogrish gypsy almost black, in a green coat, a little girl covered with roses, who dances a fandango in mimic perfection; a splendid Spanish woman in red skirts, looking like a wild poppy whose every movement is a poem, are the chief impressions left behind by La Feria.

At the Palais de la Danse there is little serious dancing; it is mostly sham, that is to say, the national dances introduced are sophisticated to suit a French palate and to fit into the frame of an ordinary ballet. The only exception is the Russian troupe, who are marvelously agile, and whose movements are full of a wild humor. Humor is the counterpart of misery, and the Slav still dances as a slave. For the rest the entertainment at the Palais de la Danse is typical enough of modern French ballet-dancing, which has but little meaning and just as much suggestion as could appeal to a bourgeois brain principally absorbed with business. It is, however, very fair of its kind, and repays a visit.

R. S.

* * *

January 11, 1901

LOIE FULLER CLOSES

Engagement at Koster & Bial's Brought to an End by Mutual Agreement

Loie Fuller has stopped dancing at Koster & Bial's because her New York audiences have been smaller than she expected. Her last appearance in the Thirty-fourth Street music hall was on Wednesday, when City Marshal Klune took possession of the box office and thereby caused the row that was recounted in yesterday's papers. On the morning following that episode the dancer went to Manager N. Hashim and said that she wished to terminate her engagement. Now she is resting at her hotel, and her many tons of baggage, personal and theatrical, are in process of packing for transportation no one knows whither.

"It was all a mistake," said Mr. Hashim last night. "She had a reputation. She had danced in Paris. Cablegrams said that she was the whole thing. Then she came here for a ten-weeks' engagement at Koster & Bial's under my management. She began to dance on the new year. She danced to fairly good houses for the first two nights, but since then we have not taken in much over $300 at any performance.

"The contract between us was to the effect that she was to get 20 per cent. of the gross receipts and also a stated weekly sum. This held good for a few days. Then she came to me and told me that the reason she was not drawing crowds was that people wanted higher prices. She said that 'of course nobody would come to see Loie Fuller for a dollar.' After some argument I consented to raise the prices of the house. But it was conditionally. I told her that if she was going to run my theatre she could not expect me to give her a regular salary. She agreed to give up the stated sum and to be content with the percentage, if I would raise the prices. But when they were raised no improvement came, and the crowds were as small as ever."

The manager intimated that Miss Fuller had ceased to be an attraction on this side of the water. He added that after all the accounts between them had been balanced up, she still owed him at least $1,000 for what he had paid out in helping her to arrange the stage appurtenances for her act. The cessation of her engagement, he said, was at her initiative, not his. It was a friendly separation, however, and no lawsuit is likely to result.

The dancer, through her lawyer, gave out a statement that agreed substantially in its general points with the story told by Mr. Hashim.

Meanwhile, while the star and the manager were disagreeing, City Marshal Klune kept the box office receipts that he had grabbed on Wednesday night in consequence of a judgment that had been rendered against Alexander Hashim in favor of Jennie Joyce. N. Hashim went to the City Court in the morning and made arrangements for a suit against the Marshal for trespass. The Judge who had issued the papers for the collection of the amount of the judgment corrected the mistake that he had made in naming Albert, instead of Alexander, Hashim as the defendant. Alexander Hashim is in Philadelphia, where the judgment will have to be served on him. N. Hashim says that he will get his cash back to-day.

* * *

September 1, 1901

REVIVAL OF THE BALLET

BONFANTI AND HER TRIUMPHS

VOGUE OF THE BRITISH BLONDES

An Attempt to Revivify the Sensation of the Black Crook Days

There is at hand a renaissance of the ballet in America. We have had signs and signs, but now it seems to have come. Probably the best of these signs was the ballet of "Versailles," given in Koster & Bial's Thirty-fourth Street house several years ago. "Versailles" was doubtless the most complete and artistic ballet seen here since the glory of the "Black Crook" dawned upon a virtuous but discreet public. There is no comparison drawn here, however.

During the past season we have had ballets at the New York Theatre, at the Victoria, and there now begins an inaugural season of ballet which is but the herald of a five years' spectacle of the kind which shall precede the Wagnerian season at the Metropolitan Opera House.

This new ballet is clever in conception, and it only remains to be seen how well the idea of an "Around Town Ballet" has been carried out by Mr. Aarons, whose enterprise it is, and by Signor Albertieri, who has the ballet under hack.

The "Around Town Ballet" marshals nurse maids, letter carriers, policemen, messenger boys, Tenderloin damsels, and Waldorf-Astoria dames, all in Amazonian order, and a shipload of British blondes has arrived to march in the ranks of the Broadway Squad and to appear as some of "The Finest."

But America welcomed the seed British blonde of the universe many years ago, and they must be blondes indeed and British to the backbone and wicked and skittish and all the rest of it to a superlative degree to make the man of Lydia Thompson's day turn a hair.

Never again can come the good old times of 1867—when the original "Black Crook" burst into view. Later the beauties of the blondes were of a more bursting order yet and a dignified journal of that time said deliriously: "The season of golden hair is upon us."

But the blondes were not the ballet. It had arrived before them. Fannie Ellsler had danced here, but her appearance was several times in period of years beyond that time, "whereof the memory of man runneth not to the contrary." The inaugural ballet of our time was that of the "Black Crook," given by "Jarrett and Palmer's Great Parisienne Troupe." Men will speak of the dawn of those beautiful women, and women of genius, with a kind of awe. They revealed to a startled public the true poetry of motion.

"Never has there been anything like it in heaven or on earth," said an old man the other day, who admits having occupied a box during the initial run of the "Black Crook" for thirty nights without interruption. He said, in speaking of it: "And if I had not run short of money I had been there yet."

There were fortunes spent in flowers alone, in those days of the "Black Crook." One florist said not long ago: "Bonfanti made my fortune. You see that house out there?" He referred to a palatial country house owned by him. "Well, Bonfanti's flowers alone nearly did it. Every night, every night. Rich men, and men who could not afford it. If an admirer left town I received a telegram from him: 'Do not forget Bonfanti, Sangalli, Rigi, or whoever the favorite might be—and I didn't forget. There were others than Bonfanti, but they meant less. The "Black Crook" did it. Such days can never come again. I don't know whether the women no longer exist to furnish the powerful provocation or why—but I am sure it will never happen again."

One rich in reminiscence tells of the first night of "The Black Crook": "New York did not know what it was going to see, and consequently it turned out to learn en masse. The curtain rose on a spectacle before undreamed of as a possibility to stage mechanics, and eight premières occupied the first row." This last bit of artistic and managerial superlative was told with an impressiveness that would befit the most tremendous occasion.

"There were twelve première danseuses in all, and every member of the ballet trained in the ballet schools of France or Milan and representing the perfection of the art of dancing.

"There were two bright particular stars among them—they danced together—Bonfanti and Rita Sangalli. There certainly was never anything like it. I am not referring to the anatomical part of it. I don't know that we old fellows thought about that; it was art, magnificent art. It nearly 'knocked' us emotionally. But I doubt if any of us stopped to dissect or to analyze. It was the coloring, the aggregation of beautiful women, the music, the motion, everything. Oh, it was great! Our sons will never see anything like it. Tastes have become too vitiated nowadays for them to appreciate anything so delicately beautiful. We saw then, and for the first time, the ballet in its perfection, and it stunned us. . . . Our boys will never see anything like 'The Black Crook'—thank Heaven, for it made me poor.

"Sangalli and Bonfanti danced together. Sangalli was a full-grown woman, experienced, and had had ten years at La Scala. Her dancing was very fine, nearly perfection. It was precise, technically beautiful, and all that a reasonable mortal would exact, but—she danced with Bonfanti. That settled

Sangalli. I guess she was the best the management had to put up alongside of Bonfanti, but it couldn't last. It was Bonfanti. She was the most adorable creature ever seen in this country. She was little and dark—a flashing, scintillating point of fire. She was a little girl. When she came she seemed to be a bursting bud. Two years later we could see the womanishness that had crept upon her almost under our very eyes. Bonfanti was an inspired fairy. That first night I got behind the scenes as soon as I could shake my sisters—I had 'em there, two of them. They were a bit shocked but they were so delighted with the shock they went three nights running.

"One of them is old and fat, as I am; but the dear woman, woman of the world as she is, still shakes her head and looks solemn when that night is recalled. She says, 'There was never anything like it, was there, Tom?' There never was.

"I went behind, as I say, and all the people were shouting for Bonfanti. Nobody could find her at first, and Wheatly and the others were fuming about when one of them nearly fell over her, tumbled down upon a bit of prostrate scenery, fast asleep. She had left the stage and in one second had forgotten where she was, and had gone dead off. She was just a little girl and tired out. They waked her up and towed her toward the entrance, and she took her encore. Whenever she came off that night she went to sleep. Later in the engagement dissensions arose. Sangalli became soured. It was all Bonfanti with the public. I don't know that she did anything to Sangalli. It was just her youthful splendor. However, Sangalli gave the management the alternative—Bonfanti should go, or Sangalli. Sangalli went—nice dancer, too.

"After that night everybody was scandalized. I had never realized how virtuous people could be till then. When I am in doubt if there are any virtuous people I hark back in mind to the morning after "The Black Crook." It was so scandalous a thing—that modest ballet—that every mother, husband, son and daughter had to go lest one or the other should find himself there unprotected. It was a great old time. I believe that gave the sign for Young America's latch-key. We went night after night, then met to talk it over, then to serenade the girls. The florists kept open all night."

"That's a long time ago?"

"Thirty—thirty-four, five years isn't it? I was only twenty-six! The dress of the ballet in those days was modest in the extreme. None of your wisps about the middle and a 'guess coming' for the rest. Modest and beautiful. Women were chosen for their ability to dance, not for their avoirdupois. They were more fragile, more petite than otherwise. Preachers added to the clamor. It is certain that when they saw the house doing so well because of the gossip the management hired divines to preach against the ballet.

"There was later a ballet of torches, if I remember rightly, and it was popularly called 'the burning shame.' As a matter of fact, upon that occasion Eve's fig-leaf was a waterproof cloak as compared with the costumes of the women who danced 'the burning shame.' But these tactics should not be confounded with the more artistic performance of "The Black Crook.""

"I recall the fact that a member of Palmer's company, Miss Wells who was a rare comedienne, took the part of an old woman in 'The Black Crook,' and used to amuse the audience greatly by pretending that she believed the flowers thrown to the premières were for her. She would advance to the footlights as if overwhelmed, and with a comical manner all her own would pick up the flowers. Afterward she would resign them to the owner. She had but one fault, it seemed to me, as an artist; she often enjoyed her own fun and the absurdity of her situations so much that it became evident to the audience, and then they laughed with her and not at her.

"Troops, groups, and vast agglomerations of girls crowded the Niblonian stage, and if I am not mistaken, there was a male dancer imported, once, who performed the feat of jumping into the air and turning round three times before touching the ground again. I do not mean somersaulting, but keeping his body vertical, twisting around as if upon a pivot run through him perpendicularly, from top to toe. Try it—before breakfast. It used to give me the something-articularis every time I beheld the performance. There were changes of light and many beautiful effects produced by it then, but, of course, these light effects would be quite thrown in the shade in these times, when electricity is used. There is more delicacy and seriality, as it were, in the tone and 'atmosphere,' which electricity enables people of the stage to obtain now. But all such advantages are lost because applied to such poor material.

"I recall another night of glory at the performance of 'The Black Crook.' It seems Bonfanti had danced and danced till she had become too tired to maintain a certain poise longer. She then executed a step which was unfamiliar to her admirers, and the house rose as one person. Bonfanti thought the house was on fire. She could not speak a word of English. She turned and ran like a deer. The manager was jumping up and down, trying to get her back for her encore. Bonfanti was turning round and round like an eel in his hands, talking loudly in Italian. After a few moments he made her understand there was nothing wrong—just an uproar of enthusiasm, and not a fire—and all because Bonfanti had tried to rest her toe.

"Then came the last night, before the troupe left for Chicago. Everybody was tired to death. Nobody got started for home until long after 1 o'clock. When Bonfanti got to her house there was a regular election night crowd about it. Policemen had to help her through to her door. In front of the house stood an immense wagon with choice wines, in which the two or three thousand people were continually invited to drink to Bonfanti's health. Strange men and women went up and down her stairway till daylight, just to say "goodbye, Bonfanti; come back." And flowers, flowers everywhere. The halls were full of policemen to keep order and see that nothing went wrong, and the best that could be got were there to serenade her. It kept up until broad daylight, and Bonfanti departed, half asleep and smiling, with a string of carriages behind her three blocks long.

"The most I recall of her fads was the fad to be 'good.' The women were in raptures about her, and I remember that she used to say in the queerest kind of English: 'I mus' be ver'

good.' And she always was ver' good. She married into one of the proudest and richest families of this town. She was as good as she was brilliant and wonderful, and her big toe was certainly the greatest thing in the world thirty-four years ago."

Marie Bonfanti still voices her fetish in broken English. She lives in New York City, a charming, engaging, black-haired, black-eyed woman, her English only slightly improved. She speaks little of her triumphal days, but what she says shows her to be the same "good" Bonfanti. In a short interview she kept to the subject of the dance and away from the subject of herself.

"Zair eez no more dancing I zink. Eet eez now what eez is called zee spleet, zee keeck, zee, zee stupeed zing. Girl—girl—and some more girl—no dance—dance, and more dance. Zay will do eet again, I zink. Zay always do zee zings again—but zey do not do zem now; zee soul make zee dansaire; zee soul make everyzing. You feel somezing up here"—tapping her breast. "And you grow volante—ah—like zis"—and she took a few steps on the points of her toes as the Bonfanti of old must have done.

"Everybody lost his or her mind when you came here, did they not, Madame?"

"Ze ladies, zay like me," discreetly answered Bonfanti. "Zee best zat happen me sometime was Meester Augustine Daly. He have ze Fifth Avenue long ago. I never dance zat he do not go in front to zee me. A man like Augustine Daly was no man to waste ze time seeing a woman dance. But he always come and pay ze tribute to my art. He write me a leetle note and he zay: 'You dance most beautiful, Bonfanti. And eet will please you zat all zee ladies say: 'Oh! I love her dance. Ze Bonfanti eez—eez—eez—n-i-z-e.' "

After fishing about in her vocabulary for some word that would not seem too fulsome in praise of herself, Bonfanti drawled this word n-i-c-e in the most inimitable way. Then she leaned over and remarked reflectively and seriously:

"Eet must mean, because zee ladies like me zat I am—am—er—g-o-o-t?"

While talking with this charming woman one does not doubt for a moment that she is always "g-o-o-t."

After "The Black Crook" came the deluge—the British Blondes fairly inundated the town.

No manager can show more girl than was then shown to the public. No public will ever again appreciate seeing so much girl at one time as that public did—they absorbed their dose at that time up to the full physiological effect.

The British Blondes, of which Pauline Markham was one of the greatest in several senses, did not represent the ballet; even the element of the ballet introduced in their burlesque was truly a burlesque of the honest, beautiful ballet. A man of literary fame sang sonnets to Pauline Markham's eyebrows and sold his magnificent library for her and did all sorts of absurd things as if she were beautiful, talented, and as overflowing with genius as with avoirdupois.

If the beautiful ballet had given cause for remark, what did Lydia Thompson's Blondes do? The Tribune of July 23, 1872, devoted three-quarters of a column to telling the public

what a shame it would be to notice the show. Three-quarters of a column was hardly space enough in which to explain how indecent a thing we had in our midst. This occurred after a run of burlesque, and in the article was this: "The time has been when there was thought to be sanctity about the beauty of woman—when it was idealized in the imaginations of the young men, known in their hearts and reverenced in their minds—when all manner of sweet and lovely qualities of nature were associated with it, and to feel its influence was to be conscious of a strange, delicious, but chastening joy." It then went on to indicate that Lydia Thompson's beauties had made all this noble condition a thing of the past. That is the way one journal said it felt about it. There were all sorts of funny things said at the expense of the women, and another newspaper spoke of the "whole country bowing down in pious (?) adoration of the fatted calf.' "

"The Black Crook" was written of as the "centinedal drama," and it was written that Mlle. Bonfanti was plunging the moral Chicagoans "into the seventh heaven." But the British Blondes were another story. When matters ran too high or not high enough a delegation of clergymen were invited to go behind the scenes, and see how modest and shy the show was. They accepted the invitation, and needless to say the blonde contingent was on its best behavior and the verdict was eminently satisfactory. This gave the burlesquers a new lease of life.

After this period there seemed to be "nothing doing." Or perhaps so much had been done that whatever was done after that seemed unworthy of notice. But about ten years ago dancing took a new start and women pranced before us doing splits, winks, and acrobatics of various kinds—but principally the dance came to us in skirts. They were skirts that were meant to outdo any nakedness of the past in point of immodesty, because with those skirts came no skill, and they spoke too loudly of that which was hidden. From this moment all the dancers of the stage ran to clothes. The magnificent toe of the première disappeared. The well-timed, hard-worked ballet dancer gave place to arms that waved wildly and none too well, and feet that simply got in the way of those they belonged to, and in the way of those who were looking at the stage.

After a while came Versailles—imported from London, I think—and if it was a wild waving of the hands and none too much technique about it, it was a good effort in a better direction.

Now we are at it again.

Dancing abroad has ever been a serious matter to those who danced. In Italy it has meant first, a certain knowledge before a candidate for membership was able to qualify for admission into the school of dancing. Once admitted, the pupil danced from 9 o'clock in the morning till 5 o'clock in the afternoon every day from three to seven years. When such a one received her diploma, that was all she got. No effort was made to place her or to help her make a living. But since she possessed the cachet of the school, she was recognized as one worthy of attention and managers were pretty sure to engage her.

There are several distinct schools or methods of dancing which are significant of national characteristics. The Italian school teaches the simplest step, but that step is of a kind the most difficult of execution. It requires more attributes than any other of the several methods. All is elegant, detailed, poetic.

The French school of dancing is full of eccentricity: more action, more abandon—more personal, if one may so describe it.

The German school is composite in method. The Germans have adopted that which is most excellent in either school—French and Italian—and made it theirs.

Again, the Russian knows a method peculiar to the country and to the Russian temperament. All that is barbaric enters into the dance. A Russian ballet may employ swords, cutlasses, &c., in forming its figures. The dance itself appears to the Western mind to smack of savagery. The Russian ballet is most eccentric.

America is not without her school. And that school is precisely what might be expected of America when she came to dance. All that is extreme in the dance America has adopted. Dancing America will kick higher, when called upon by the exigencies of the case to kick at all, than any other nation in the world—the height of her women makes that possible. If an American ballet decides to perform pianissimo, as it were, one could hardly perceive her. If the American ballet should find it desirable to be elegant, it would certainly be elegant—after the fashion of certain nouveau riche of whom the Baroness Bellière once wittily said: "She attempts to be the grande dame—but it seems to me she only succeeds in being damn grand."

But this fault of going to extremes is not for lack of training. It is the fault of the American public. The public demands the extreme or thinks it is not getting its money's worth. The manager is accessory after the fact, and gives the public what it wants—that is what the manager says about it. We have excellent ballet masters in America, and should have a magnificent ballet made of American girls.

Albertieri, the ballet master of the Metropolitan Opera House, comes of a family of dancers par excellence. His is an Italian art of a high order. There is so much art about the matter with him that he has refused to coach ballets in the town unless permitted to choose "dancers instead of girls."

Romeo, Albertieri's assistant, and also director of certain ballets lately seen here, did not begin to dance till he was twenty-seven. Before that age he was a chef of magnitude.

Alviene had a lawyer for his father and a dancer for his mother. He is the best master of eccentric dancing in the country.

Narwig represents still another school of ballet dancing. With him it is action, more action, and still more action.

There is every facility in America for building a good ballet. Temperament of the women and a beauty than which none is superior—and it is a beauty that can be depended on to last the season through. We do not need more British blondes or old Italian ladies such as may often be seen at the stage door of the Metropolitan Opera House. We need no more, half-witted wholly self-conscious Frenchwomen to do our dancing We can do it ourselves.

* * *

August 12, 1905

THE DANCE AND THE CHILD

Dancing Now a Recognized Factor in Education—Its Popularity Growing Steadily

There was a time when dancing, far from being considered a necessary part of the training of a boy or girl, was looked upon as positively wicked, and, indeed, there are many persons not entirely lacking in brains who now condemn it as an invention of Satan. Which makes it all the more remarkable that this much-abused pastime is really establishing for itself a fixed place in the curriculum of many a well-regulated school. Hundreds of teachers there are who view dancing not as one of the "fads and frills," but as almost a necessity in the school course.

In Europe this is no new thing, but here it is. On the other side of the Atlantic the educational value of dancing has long been recognized, and children there early become versed in the poetry of motion. America either could not or would not—probably the latter—absorb the idea, and the present year finds the teaching of dancing in schools, though rapidly growing more popular, still unimportant compared to its status in Europe.

Every teacher in and about New York City will recall the National Physical Culture Convention at Columbia last Spring. And nobody who attended any of the sessions can forget the prominent place given to the teachers of dancing and to the children who acted as demonstrators. Not a day passed but there was an exhibition of some variety of dancing. One enthusiast gave a lecture on straight-foot dancing, proving to the satisfaction of many of her hearers and certainly to her own that the natural and beautiful way for the foot to be placed was with the toes straight ahead, instead of turned out. Many different theories as to detail were attacked and defended.

There is much more behind the teaching of dancing than appears to the casual observer. Those who have gone into the subject most deeply find in physical motion a fundamental and necessary stage of development. The primitive, the very first method of expression, they will tell you, is the gesture, the movement of the hand, head, or foot, an undeveloped form of dancing. The art of motion, according to their theory, is just as much an art as is either poetry or music. And it should precede either of these two because it is more natural, primitive, spontaneous.

There must be pioneers in every movement, and in this case it is a woman. Miss Caroline Crawford of Teachers' College, Columbia, is perhaps the most ardent adherent of educational dancing, and it is she who is doing most to

spread abroad among teachers the realization of what she believes to be its importance. Though the external features, the way in which it should and should not be taught, are an open book to her, it is the relation of dancing to the entire growth and development of the individual that is her particular study. If there is needed any proof of the seriousness with which the authorities at Teachers' College regard dancing and bodily rhythm it can be found in the announcements for the coming session.

Under the head of "Physical Education" three of the most important courses deal with dancing. All of them belong to Miss Crawford. One is devoted to "The Dramatic Game," being six lectures with illustrations of games, song, and dance. "Rhythm and Dancing" is the name of another course, and another, "Folk Drama," consists of fifteen lectures, with dramas. This last concerns itself with early forms of dramatization as illustrated by the folk games and dances of Europe. Ring dances, festival dances, and national dances will be viewed from the standpoint of their origin and significance.

It is almost unnecessary to say that the children for whose benefit all this study of the dance is intended are delighted with the innovation. They know nothing about its origin, its significance, or its various psychological features which interest the grown ups; all they know and all they care is that it is exhilarating and altogether delightful to exercise their little bodies rhythmically to the beat of music. Recruits for the dancing class are never lacking and there is no room for many who would be therein.

A bevy of dancing graybeards from Providence, R. I., furnished the great sensation at the Physical Culture Convention. Their act, performed on the floor of the gymnasium of Columbia University, closed the four days' session of the convention. Of its kind the exhibition was about the strangest thing that has happened in New York recently. One of the men was a prosperous banker over seventy years old, with a flowing beard of white; another, nearly as old, was one of the foremost citizens of Providence; two or three had passed the sixty mark. These old men, surrounded by an audience many members of which rested dizzily on parallel bars and flying rings, danced jigs and cut capers which were calculated to make their stern New England ancestors turn in their graves.

This was not long after Dr. Osler made the famous speech in which he declared, or is supposed to have declared, that after sixty a man might as well be chloroformed anyway, as far as his future usefulness was concerned. If the celebrated physician had been present in Columbia gymnasium that night he might have rubbed his eyes and wondered if some modern De Soto had not sought, and this time successfully, the fountain of youth. The old men from Providence formed a class that amused itself by regular dancing, and is probably still doing so, in the Rhode Island capital. They seemed to take it as a matter of course and expressed surprise that any particular notice should be taken of them.

The forms of dancing practiced in society nowadays, the waltz and the two-step, play no part in the most modern and approved scheme of educational dancing, though they may be taught carefully at so-called "finishing" schools. Free, open movements, movements that give every encouragement to ease and grace, are what the teachers aim at. They begin with the simplest, of course, advancing later to more complicated steps and figures. There are certain old, familiar dances which are always taught; how much originality is injected into the course depends quite naturally on the originality of the ideas of the teacher.

Perhaps the dancing courses are nowhere so popular as in New York City. In many of the private and public schools lessons in dancing are among the first given to the very young boys and girls. Long before they are able to learn things that are taught from books the little ones become adepts at dancing; they take to it as a fish takes to water. There seems to be little doubt that eventually the educational uses of the dance will be generally recognized.

* * *

January 5, 1906

BAN ON ISADORA DUNCAN

Berlin Police Forbid Her to Dance in Public—Reason a Mystery

Special Cable to The New York Times

BERLIN, Jan. 4—Astonishment has been caused not only in Berlin but all over Germany by an announcement which appeared in the Tageblatt, to the effect that the police had prohibited the dancing in public of Miss Isadora Duncan, the American performer.

Miss Duncan dances barefooted, but in a country where women, even of the upper classes, sometimes swim in public attired in costumes which would cause their arrest at Atlantic City or Narragansett Pier, it is inconceivable that this circumstance caused the official order.

* * *

March 25, 1906

BRINGING TEMPLE DANCES FROM THE ORIENT TO BROADWAY

Hindu Types and Ceremonies in a New Jersey Girl's Novel Exhibition

Society has discovered something new under the limelight. Out of the jaws of vaudeville a group of New York women who still keep a weary eye out for up-to-date novelties, have snatched a turn which they hope to make more or less of an artistic sensation. A set of Hindu dances performed by a New Jersey girl with a rather convincingly clear notion of what she is doing, constitutes this latest find.

The fascination of the Orient is eternal. Women's clubs that have sipped tea over pretty much everything from Sun Worship

to Mental Science generally fall back on Eastern lore for things to be enthusiastic about. The "Road to Mandalay" is ankle deep with the papers of progressive reading societies.

Though Radha as a goddess is some six thousand years older than any of us, Radha as a dance on a Broadway stage has a fair claim to novelty. Moreover, her high priestess and exponent, Ruth St. Denis, seems interesting enough to win a hearing.

Miss St. Denis is a slender, fair-haired young woman fully six feet tall, who dances in Hindu costume with graceful Hindu posturings amid the braziers, altars, and incense fumes of a Hindu temple. She has extraordinarily long, flexible hands, and a general look of lithe tirelessness. Her chief dance, in which she appears as Radha, is ingenious.

It appears that Radha, one of the wives of Krishna, the popular and much-married favorite of Hindu deities, had a rather graceful way of rewarding the devotion of her faithful priests. On occasions when these temple worshippers had fairly outdone themselves in salaams and ceremonies before her image, this mysterious and spiritual lady used to enter into the idol, step down from the daïs, and edify the elect with a dance that invariably bore some weighty message or advice.

It is therefore as Radha that Miss St. Denis has chosen mainly to present herself. When the curtain rises she is seen in the familiar seated pose of an Indian idol. Around her are censers and screens and the elaborate bric-à-brac of an Oriental shrine. Two or three scantily clad priests and temple attendants, who by the way are real Hindus, perform a series of incense burnings and prostrations. When they have worked themselves up to the proper pitch of ecstasy, the lights soften, Radha enters into her idol, and, stepping out of the cloud of incense to the sound of the Lakmè ballet music, proceeds to deliver her terpsichorean message.

Her text in this case is the renunciation of the senses. Jewels, bells, garlands, and bowls, manipulated in various silent poses, symbolize the five senses. Then comes a suggestion of unrest, of striving to overcome these fleshly attractions, and the end of the dance aims to express the victory that follows release from the bondage of the senses and the peace of attainment and liberation. Finally Radha resumes her position on the daïs, gradually withdraws in spirit from her image, and the curtain falls on the rigid idol alone in the dim twilight of the temple.

Besides this temple dance, Miss St. Denis has invented two others of a more colloquial kind. The first, which she calls the Spirit of Incense, takes place in a humble domestic interior, and might conceivably be executed by the daughter of the house as an amiable diversion during her daily task of

feeding the censers. In a dim-lit space surrounded with dark Indian stuffs, the dancer, wrapped in gray, scarflike garments, seeks by slow, lithe movements of the arms and body and soft shuffling steps, to suggest the melting spirals of green and purple smoke that rise from the braziers. The way she contrives to send long, undulating ripples down her hand and arm as she drops incense into the jars, is certainly striking.

The other dance she calls the Cobra. She appears on the stage in the nondescript brown rags of a typical fakir. On either middle finger she wears a huge emerald, which gives her exceptionally long, pointed hand a sufficiently serpent-like look. In the crouching pose of the snake charmer she makes her arms glide and crawl about her neck and body in endless soft turnings and twistings, pausing to let them seem to drink from a bowl on the floor, and finally lifting her hands high above her head and darting her pointed fingers forward in a quick movement which fairly makes one's scalp lift.

This Cobra dance only needs an old house corner of stained yellow stucco, a dirty awning, the blazing sunlight of an Indian noon, and an earthen jar or two on the ground to be as realistic a dash of Oriental atmosphere as one could ask to see.

The girl who devised these dances has never seen India.

"I got my first idea of the thing from the Streets of Delhi, at Coney Island, two or three years ago," she explains. "But besides endless reading, I have had the help and advice of every Hindu that ever came within my reach. At first they were very cool about it. They said these Oriental scenes had been done in this country in comic opera Midway fashion that disgusted them; but when they found out just what I was really trying to do they gave me all the help I wanted—and that was a good deal.

"It's no easy thing to get information about the inside of a Hindu temple. Few Englishmen ever get in. The immortal Mulvaney, who whiled away a spare evening as the incarnation of Krishna, is the only case of daring that compares with mine," laughed Miss St. Denis, "and you know it was only by all his wits, combined with the luck of a man on a spree, that he got out of it alive."

It is probably quite true, as Miss St. Denis insists, that we have no idea in the Western world of how much dancing really means in the Orient. In India dancing as a phase of expression is infinitely more developed than singing. An Indian nabob, when he wishes to spread himself on an evening's drawing room entertainment, hires a Nautch dancing girl at several thousand rupees, just as a New York matron might engage Melba or Caruso at the cost of a check that would be sure to be quoted in the newspapers next morning.

Dancing girls in the East are often immensely wealthy and enjoy all the prestige of our theatrical stars and opera singers. Dancing is, of course, one of the chief features of Oriental religious ceremonials and the temple dancers are trained from generation to generation with the utmost care and finish.

There are also fundamental differences in the dancing itself. When we think of dancing we usually think of a more or less energetic exhibition of clever gymnastics of move-

ments that are mainly remarkable because they go to extremes. High kicks, complicated steps, and lightning changes are the commonest elements of our stage dancing.

Now your Oriental cares little for this kind of thing. His idea of dancing is a slow, rhythmic succession of graduated movements that never jerk to extremes, that melt into each other by easy transition, and that impress one with an almost listless ease rather than by any suggestion of effort. Every part of the body co-operates with every other part, and one posture dissolves into another almost imperceptibly.

Furthermore, for the Oriental, dancing has real interpretive meanings. An Eastern dance is so expressive to an Eastern audience that it is almost like a song with words. Its symbolism is simple and immediately recognized.

If one understands Miss St. Denis aright, this is the kind of motive that pervades her work.

"Delsarte, the much ridiculed," she stoutly maintains, "is, in spite of all the silliness and stupidity that has been committed in its name, the best foundation of all truly expressive dancing. When I first began to study I went the rounds—Bonfanti for toe dancing, Marwig for Spanish technique, and Bossi for ballet. I never retained anything I learned from any one of them except general points of technique. They all have a method. The moment you commit yourself to any one teacher you are pretty sure to bear his stamp for the rest of your life."

After several years' self-development in dancing along her own Delsartian lines, Miss St. Denis spent two or three years on the stage in straight drama, most of the time with Mr. Belasco.

"I wanted some practical stage experience," she said. "When I began I was a bundle of nerves, impossibly agitated and restless in manner. I remember the first thing Mr. Belasco tried me in was the part of Mme. Dufrene, in 'Zaza.' You remember at the opening of the third act, as she finishes writing a letter, she has to sit alone and perfectly quiet for some two minutes until the maid responds to the bell. Well, to save my life I couldn't do it without fidgeting. Mr. Belasco simply remarked that I should never do in the world in that state, and made me an understudy. Then I set to work in earnest. It took me two years to get the repose I needed. But I finally had the satisfaction of playing Mme. Dufrene to Mr. Belasco's approval, and the change amazed me almost as much as it did him."

Miss St. Denis probably caught her stage manager's instinct from Mr. Belasco. With the help of her mother she arranges all the detail of her performances, working out the lighting and scenic effects. To see her at rehearsal patiently going through her dance for the seventeenth time with an overheated plate of incense in her hand, calling minute directions to three calcium-light men and listening to advice from half a dozen friends in front, is an object lesson in feminine energy.

Her theories about dancing are simple and to the point.

"All the motions one needs to study for dancing," she claims, "can be found in nature. Furthermore, there is a natural climax in all nature movements. The motionless waiting, the

quivering crouch, and the final spring of a cat or tiger make such a climax. Also trees in a storm. At first not a leaf moves. Then come the first rustlings and stirrings and finally furious swayings and lashings when the storm breaks. All these things contain perfect suggestions for human movement.

"Take the invisible motions of the clouds at sunset; one form melts into another, while one is almost unconscious of a change. It is just these imperceptible progressions of movement that I try to catch in suggesting the wreaths of ascending smoke or in the undulating of my arms in the cobra dance.

"Flexibility, combined with great strength, as you find them in the tiger, for example, should be the dancer's ideal. No motion should be sharply abrupt. There must be no angles. A cat lies down in a series of curves. The rhythmic motion of a dance should similarly include only lines that never turn sharp corners."

Twenty-six women united last Thursday afternoon in giving a matinée of Miss St. Denis's dances for the pleasure of their friends at the Hudson Theatre. Among the twenty-six were Mrs. Ben. Ali Haggin, Mrs. Richard Mansfield, Mrs. Howard Mansfield, Mrs. George A. Meyer, Mrs. James M. Townsend, Mrs. Richard Watson Gilder, Mrs. Eliot Norton, Mrs. Paul Leicester Ford, Mrs. Edwin H. Blashfield, and Mrs. Orlando Rouland, whose husband is painting a series of portraits of Miss St. Denis.

* * *

October 18, 1907

IMPORT BRITISH BALLETS

Klaw & Erlanger Will Give Famous London Spectacles Here

Klaw & Erlanger announced yesterday that they have completed negotiations by which the English ballets from the Alhambra and Empire Theatres in London are to be presented in New York and elsewhere in conjunction with the regular bills of their vaudeville circuit. This is to be a permanent institution in advanced vaudeville.

To this end a ballet is now being planned that will be typically American. Based upon the English idea of developing a story in pantomimic style, this ballet will tell the story of America's birth and development. It will consist of present dances representing Columbus's expedition of 1492, the stirring scenes of Continental days from Bunker Hill to Yorktown, the later days of strife from Sumter to Appomattox, and the present-day progress.

American ballets will be staged and directed here. Fifty of the coryphees or principal dancers from the Empire and Alhambra appear here in these dances. Mlle. Kate Laner, known in England as the Maitresse de Ballet of these spectacles, will come to perfect the productions for American pre-

sentation. Lavator Lee, the clown at the London Hippodrome, will also be brought here as a permanent feature at the New York Theatre.

To bring the ballet up to the necessary number, American dancers will be trained. The dances will run for about half an hour and will conclude each evening's advanced vaudeville performance.

These ballets are an important part of the London music hall programme. They are produced each season on the most elaborate scale, with the pick of Europe's dancing talent. From 200 to 300 persons appear in each ballet, and a complete story is told.

At first some of the most important of the Empire and Alhambra ballets will be presented here. Among them will be Les Papilions or the "Dance of the Butterflies;" Monte Cristo, "Around Town," and the press ballet from the Empire. In this last dance the participants represent newspapers of the United Kingdom, and in this country they will typify the best known of the American journals.

From the Alhambra will come the ballet of diamonds.

* * *

June 8, 1908

DANCER WARNED OFF STAGE

Manchester Authorities Disapprove of Maud Allan's Salome Dance

Special Cable to The New York Times
LONDON, June 7—Miss Maud Allan, the barefooted and otherwise scantily clad dancer, in whose favor a very profitable boom has been worked up in London, and whose manager is anxious to give New Yorkers a chance of witnessing her Salome and other dances, has been warned off the stage in Manchester, which is the most important theatrical city in England outside of the capital.

Miss Allan was booked for a series of performances at the Manchester Palace of Varieties, but as a result of a communication from the authorities, her manager decided to cancel her engagement. The Manchester authorities consider Miss Allan's entertainment open to exactly the same objections as those of the living statue variety.

Miss Allan's manager asserts that the fact of her having danced before the King and Queen at the party given by Lord and Lady Dudley the other evening is a sufficient answer to what he calls the Manchester prudes, but he omits to mention that on the occasion in question Miss Allan did not give her Salome dance, which is the only one of her répertoire possessing a very special attraction for her habitual audiences.

* * *

A "SALOME" DANCE BY MISS HOFFMANN

Two Performances in a Brevity of Costume Given at Hammerstein's

BIG AUDIENCES SEE HER

"The Vision of Salome" Produced with Special Scenery in a Subdued Light—Several Curtain Calls

Gertrude Hoffmann gave her first imitation of Maud Allan's dance, "A Vision of Salome," at Hammerstein's Theatre yesterday afternoon and repeated it on the Roof Garden in the evening. Miss Hoffmann amply fulfilled her promise to give a "life-like impersonation" of Miss Allan's dance. The suggestion that there was to be in some particulars a brevity of costume was not forgotten.

The "Vision of Salome" was produced with special scenery, which showed to more advantage in the theatre than on the Roof Garden, and with the original music, played by an augmented orchestra of thirty pieces. Miss Hoffmann appeared before the largest audience that has been seen on Hammerstein's roof this Summer. Her husband, Max Hoffmann, led the orchestra.

The dance was done in a subdued light. Miss Hoffmann wore adornments of jeweled design above the waist and a transparent black skirt, embroidered in gold around the edges. The skirt disclosed with unmistakable exactness the extent of the rest of her costume.

That the performance had artistic and aesthetic merit was not to be denied. The setting, representing the garden of Herod's palace, was appropriate and carefully constructed. The dance was in four parts. The first was a sinuous movement of the Oriental order. In the second movement Salome rushed to the edge of the well, where was the head of John the Baptist on the traditional "charger," seized it, and placed it in the middle of the stage. Then, in wild exultation, she danced in a wide circle around the head, whirling till her slight skirt rose in the air and giving full vent to the emotion of the theme. She then cast herself on the ground and crawled to the head, which she kissed. Rising to her feet, she kissed the head again and pressed it to her bosom. With the next impulse she flung it into the well.

The music well represented the changing emotions of the dance and pantomime. The audience applauded vigorously.

* * *

ISADORA DUNCAN IN GRECIAN DANCES

Reappears After Ten Years' Absence and Delights Audience at the Criterion

MUCH SPIRIT AND POETRY

Miss Duncan Was the Dancing Teacher Who Marched Her Class in Safety from Windsor Hotel Fire

Isadora Duncan, who was last known in New York as the dancing teacher who marched her class in good order from the ballroom of the burning Hotel Windsor, nearly ten years ago, returned to New York last night at the Criterion Theatre as a dancer of classical dances. Since the day of the Windsor fire Miss Duncan has traveled far. She has studied the poses of Grecian dancers on vases and the relics of antiquity, and has reproduced these in a creative harmony of succession, building up from the separate poses a series of dances. With these dances she has been seen in the great European cities.

Last night's audience testified, through applause and cries of "Bravo!" that, so far as it was concerned, Miss Duncan's engagement here shall be as successful as her European appearances.

Miss Duncan chose as the medium of her American début the dances and choruses from Gluck's opera, "Iphigenie en Aulide" (1774), which follows the story of the daughter of Agamemnon and Clytemnestra after the manner of Euripides's play, known in the English translations as "Iphigenia at Aulis." Artemis having been offended, the Greek fleet is detained at Aulis. Calchas, the seer, declares that the goddess can be appeased only through the sacrifice of Iphigenia. At the last moment Artemis relents and substitutes a hind in the sacrifice. Iphigenia is carried by Artemis to Tauris that she may become the priestess of Artemis.

When the curtain went up last night after an augmented orchestra had played some of the Gluck music, the audience saw a stage set only with dull gray draperies. Miss Duncan started with a handicap. The audience saw a woman who at first glance did not appear overly attractive, apparently in bare feet, and clad in a loose gray robe. The dance, one of little skipping steps and supplicating arm postures with a constant play of happy feature and side to side head movement, slowly assumed the familiar poses of the dance known to us through Grecian antiquities. Miss Duncan had interested her audience at once. Still she was not as yet in its mind graceful. The succession of postures was too rugged.

Grace however, was added in the second dance, which represented the maidens of Chalkis playing at ball and knuckle bones by the seashore. The costume was perhaps a little looser and fell more from the shoulders. It still came to the seemingly bare ankles. The dance as the imaginary ball was tossed in the air and caught was graceful, but the gestures of the dancer as she half reclined and tossed and caught the knuckle bones removed entirely the audience's first impression.

Then the costume became shorter. There was a dance of the maidens (represented alone by Miss Duncan) as they saw the Greek fleet in the distance and danced for joy. All five movements of this dance expressed joy but the air gai of the final movement seemed to catch at familiar memories. Its tempo for the first time was quick and whirlingly joyous. The audience thought with a smile of a cake walk, but if cake walk it was it was a sublimated cake walk. Then there was a gay little dance in abbreviated red costume in which seemingly bare limbs flashed out "Choer des Pretesses," followed by a clothed slower atmospheric aftermath.

"Danses ides Scythes" was a rhythm of motion, whose theme was manifestly reaping. After Musette Sicilienne, and Bacchanale, dances of life and movement in which flowers played a part, Miss Duncan, in response to the demands of her audience, danced her interpretations of Schubert's "Musical Moment" and the Strauss waltz, "Blue Danube," as encores. These were the lighter parts of Miss Duncan's store. She even added a Spanish dance.

In Miss Duncan's dancing there is the spirit and poetry of things suggested. There is no hint of the personality of the artiste. Neither is there tone of sensuous, or sensual. The dancer's costumes appear merely a background for her art. The audience never centres its attention upon them to the exclusion of the dance's theme.

Last night the orchestra, by beginning the wrong dance twice, put Miss Duncan from poised flight to immobility, but by a suggestion, as elusive in analysis of means employed by any she conveyed during the evening, she set them right.

The effect of the orchestral feature was heightened at times during the overtures, when the dancer changed her costume, by the addition of the low voice of a woman who was seated with the orchestra. In all, Miss Duncan danced nearly an hour and a quarter, counting the time when the stage was bare and the orchestra was playing.

* * *

August 29, 1908

MISS DUNCAN SCORES IN NEW DANCES

Audience Content Only After Two Encores and a Curtain Speech
HER WORK IS UNUSUAL
Glided About, in Chopin Prelude, with No Suggestion of Dance Steps, Arms Behind Her

Isadora Duncan was decidedly successful last night at the Criterion Theatre in the new programme of dances which she has selected for the remainder of her engagement. There was a large audience present and the dancer received an enthusiastic reception. At the end of the programme the audience did not leave its seats until Miss Duncan had given two extra numbers and made a speech, in which she characterized her

work of the evening as "ambitious," in that she had attempted to portray the ideas of great pieces of music with an art that had been dead for more than two thousand years.

The programme was made up of dances to Beethoven's Seventh Symphony and eight of the shorter pieces of Chopin. An augmented orchestra under the direction of Gustav Saenger provided the music.

The Beethoven number came first on the programme. The orchestra played the first movement before the rise of the curtain and with the second Miss Duncan began her dance. The first part of her dance followed the shadings of the music and might be described as a series of pictures portraying the alternating feelings from woe to gayety, which the dancer interpreted as the composer's meaning. With the rollicking scherzo of the final "presto" movement, however, subtlety was cast aside, and the dance became frankly joyous.

The Chopin numbers, consisting of three mazurkas, three preludes, and two waltzes, were more varied in character. In all of them Miss Duncan held the audience almost breathlessly attentive. For several of them she wove little stories, others were made dramatic.

In the preludes, the orchestra carried the principal part, the music being accompanied on the stage by a series of simple poses. In one of them the dancer remained with her arms locked behind her back, moving slightly about the stage without a suggestion of dance steps. The concluding numbers, two waltzes, were given with more abandon, though Miss Duncan did not fail to introduce the contrast of pensiveness, which is in the Polish composer's music.

After the last number, there were the encores, a speech, and many recalls, in one of which Miss Duncan presented a bouquet to Conductor Saenger, who came in for a share of the applause.

* * *

November 7, 1908

MISS DUNCAN'S DANCING

A Large Audience at Her "Interpretation" of Beethoven's Symphony

Miss Isadora Duncan, who last Summer tried in vain to interest a New York public that was largely absent from the city or indisposed to entertainment within the walls of a theatre in her dancing, succeeded to a remarkable degree in interesting it yesterday afternoon. To the music of the New York Symphony Orchestra, under Mr. Walter Damrosch, she danced upon the stage of the Metropolitan Opera House, and the auditorium was filled to its utmost capacity with interested spectators. Miss Duncan's performance included an "interpretation" of three movements of Beethoven's seventh symphony, and of two preludes, a valse and a mazurka by Chopin. These latter, being composed for the piano, were transcribed for the orchestra.

Wagner's ideal interpretation of Beethoven's symphony as "the apotheosis of the dance" was a temptation to an artist so clever as Miss Duncan. But there will be much question of the necessity or the possibility of a physical "interpretation" of the symphony upon the stage. Nor did Miss Duncan make it appear that the music has spoken insufficiently for itself during the hundred years or so of its existence. If the contention is that, wishing to dance, and, finding no music of the kind she desires, she has taken it provisionally as a medium adapted for her purposes, there would be more to be said. But even then it seems like laying violent hands upon a great masterpiece that had better be left alone. And the same is applicable to the pieces of Chopin.

Miss Duncan's dancing has a singular charm and impressiveness of its own. It is dance and pantomime at once, and shifted freely across the impalpable line that divides the two. She herself is not remarkably gifted with beauty of face or of figure, so she helps herself little by accessories of costume, and not at all by those of scenic surroundings. Her costumes are of the simplest and her background the severest of drab hangings. All her effects are gained by the grace and significance of her bodily movements. What their significance is, as for instance, in the last three movements of Beethoven's symphony which she dances, is not definitely and in detail communicated to the spectators: yet there is felt to be a certain consistency in their delineation and they speak a language of their own and express a mood and a general intention.

There was an evident sympathy with Miss Duncan's doings on the part of the spectators, and she was much applauded. The orchestra, which sounded rough and unfinished, played as musical interludes Lola's rhapsody, "España," and the andante from Tschaikowsky's string quartet, Op. 11.

* * *

March 8, 1909

DANCING AND THE DANCERS

The great ado about a purely supposititious modern revival of the saltatorial art seems to increase rather than diminish. The reappearance on the London stage of Miss Maud Allan has been made the text of positively profound articles on the relation of the dance to art. This young woman, like Miss Isadora Duncan, steps, poses, and gesticulates to musical phrases and movements never designed by their composers to serve as accompaniments to dancing. Beethoven's Seventh Symphony, for instance, is not dance music or music whose emotional content can be well illustrated by attitudes of the feminine figure; nor is Mendelssohn's Spring Song. Not all the art at the command of Miss Allan and Miss Duncan, or all the vehement praise of their admirers, can alter this fact. People who fancy they like a Beethoven symphony illustrated by a dancer are the kind of people who lack the spiritual uplift and the musical sympathy

and culture to comprehend the symphonic form and the genius of Beethoven.

The two prodigiously popular women we have named are graceful and ambitious representatives of an art which has greatly declined since the era of Fanny Elssler, Taglioni and Cerito, and the youth of Mme. Celeste. We have had a few competent pantomimic dancers in later years, especially Mme. Cavalazzi and Mme. Bartoletti. But Terpsichore has had no really great votaries since the old days. Her ablest modern representatives would be just as interesting if they did not take off their shoes and stockings before appearing in public.

Miss Allan, who lectures as well as dances, firmly believes that her mission is to revive a noble Greek art. She says, very prettily, that Greek dancers reflected "the harmonious movements of nature, the laughing dance of fallen rose petals in an eddy of the wind." Perhaps. But Greece has gone, and the Greek spirit and point of view can scarcely be revived in London or New York. Miss Allan and Miss Duncan would be more welcome missionaries if they could reform the dance of society and restore some of its old-time graces. Perhaps they intend to do this, but their efforts, thus far, have been unavailing. The everlasting waltz and the unlovely twostep still prevail in the ballroom. The square dances of old, which graceful dancers could make charming, have entirely disappeared. Each year we are told that the dance of society is to be reformed, and made beautiful again. But yearly it seems to grow more tiresome and formless, while there is more dancing of the hop and jump variety than ever before.

* * *

November 2, 1909

DAZIE IN DANCE PANTOMIME

Presents a Sketch, "L'Amour de l'Artist," Artistically at Hammerstein's

Mlle. Dazie presented her pantomime dancing sketch "L'Amour de l'Artist," at Hammerstein's Victoria Theatre yesterday afternoon.

Three characters appear in the two scenes of the dance—an artist, his sweetheart, and a flower girl, who wins his love. The first scene shows a restaurant and the second the artist's studio. The dance concludes with the death of the flower girl, stabbed by her jealous rival.

The success of the sketch depended upon Mlle. Dazie's dancing and her pantomime. In both she succeeded in giving the spirit of the character—that of the flower girl. Her assistants were thoroughly capable of doing their share of the interpretation.

* * *

November 2, 1909

DENOUNCE CLASSIC DANCE

Ministers Severely Criticise Isadora Duncan—
Society Women Defend

Special to The New York Times

ST. LOUIS, Mo., Nov. 1—The classic dance of Isadora Duncan to the accompaniment of Walter Damrosch's orchestra prompted the Methodist Episcopal ministers of St. Louis and East St. Louis to adopt resolutions denouncing the dance as immodest. The resolutions say in part:

"It is to us a matter of exceeding regret that in the name of Charity and before an audience of character and culture at the Coliseum, the people's building, and excused only by being high art, a performance was given that is a gross violation of the proprieties of life, and we trust it may never be repeated in our fair city."

A score of society women in interviews defended Miss Duncan's dancing as modest, graceful, and beautiful.

* * *

November 10, 1909

ISADORA DUNCAN REAPPEARS

Gives Her Dances Assisted by Damrosch and
Symphony Orchestra

Miss Isadora Duncan, who has evolved a style of choreographic art which corresponds in a measure at least—according to a comparison with the figures on ancient vases—with the dances of the ancient Greeks, made their reappearance in New York last evening at the Metropolitan Opera House assisted by Walter Damrosch and the New York Symphony Orchestra.

The programme stated that Miss Duncan would dance to the ballets and choruses of Glueck's "Iphigenie en Aulide." Most of her dances were accomplished to such aid, but at least one of them, a "Chorus of Priestesses," was taken from "Iphigenie en Tauride," and its original purpose and signification were greatly distorted by the dancer. It is a number which was never designed for dancing, and to any one who has heard it in its proper place in the opera it must seem more or less of a sacrilege to have it put to such purpose.

There can be no possible objection, however, to Miss Duncan's appropriating the ballet numbers from the Gluck operas for her particular purpose. It is a well-known fact that Gluck composed many of his ballets because they were demanded by the audiences of his time rather than by the exigencies of his operas. It is also quite as true that the list of them includes much that is best of the Gluck music.

They are particularly fitted in their nobility and lack of sensuousness to accompany the moods and poses which Miss Duncan portrays in her dances. She is at her best in dances which depict life and gaiety and motion. In this she is always sure of communicating her meaning to an audience. The Bacchanale which ended the formal programme particularly expressed these features. The play of the arms in the moderato and allegro in which the Maidens of Chalkis play at ball and knuckle bones by the seashore was also one of the effective bits.

The dances last night were in nowise different from those in which Miss Duncan has appeared in past seasons in this country and Europe, and her draperies were the same beautiful Greek arrangements. Repetitions of several of the dances were demanded by the large audience, and at the end of the programme Miss Duncan gave several extra numbers, concluding with "The Beautiful Blue Danube" waltz.

* * *

November 17, 1909

NEW DANCES HERE BY RUTH ST. DENIS

In "The Purda," the Spirit of Incense, the Dancer Moves in
Harmony with Smoke

SNAKE CHARMER'S DANCE

Woman Moves with the Sinuousness of the Cobra—Hindu
Attendants in the Nautch Dance

After an absence of two years, spent in England and the Continent, Miss Ruth St. Denis reappeared in her dances yesterday afternoon at the Hudson Theatre. There were a houseful of people to see her, an orchestra under the direction of Walter Meyrowitz to furnish her with music, and a company of Hindoos to assist her by supplying a realistic background for the stories she told in her posturings.

One can say, without being called to task for it, that the dances offered by this American girl are music in color and motion. Her sinuous body, the rippling muscles of her arms and hands, the expression of her face that changed with the tempo of the sound music, are harmonies on one theme, differing only in key. Whether in the gay whirl of the Nautch dance, or in the almost dirgelike movements of the Yogi episode, she was the East.

Miss St. Denis offered five dances, two of them new to New York, and the old ones so elaborated and so perfected as to be almost new themselves. The first was "The Purda," the curtain that separates the women's apartment from the rest of the house. This dance represented the spirit of incense, in which the white-clad dancer moved in harmony with the smoke from several braziers, colored by rays of light. The second was "The Street," that showed a bazaar in a small town, with the sellers and street people about. Here the dancer, dressed in the ragged garments of a snake charmer and wearing great green gems on the first and little fingers of both hands, represented the sinuousness of the cobra, sway-

ing and striking. In this dance the effect of intense sunshine was a strong contrast to the semi-gloom of the first number.

The third feature of the programme showed the interior of a Rajah's palace. The Rajah receives a guest, and for his entertainment provides a Nautch dancer. Miss St. Denis appeared in voluminous iridescent bordered white silk skirts, and with the attendance of four Hindoo musicians. This dance was full of fire and of happiness, executed with much abandon of movement. The fourth dance represented the meditations and final exaltation of a Yogi. The scene was a forest, close set with trees. To the accompaniment of a 'cello, played off stage, the dancer began a series of slow posturings indicating the practices of the Yogis seeking to attain perfection, concluding with a crescendo with the full orchestra.

The last number of the afternoon was called "The Temple," or the dance of the five senses, the first dance Miss St. Denis gave in America. This was in two scenes, the first showing the temple gates guarded by a yellow-clad Yogi. Men and women passed in and out until the bells called to service. The second scene showed the interior of the temple. Behind latticed doors was a statue of Rhada, the wife of Krishna. Priests and acolytes performed their rites at the foot of the pedestal upon which she sat. To the waving of lights and the presentation of offerings Rhada came to life.

In the dance which followed was shown the renunciation of the senses—sight, hearing, smell, taste, and feeling, and at the end Rhada returned to the shrine and the doors closed. In this dance Miss St. Denis wears a close-fitting jacket and trunks, and many jewels. In all of her dances, except "The Street," her feet are bare. She uses very little "make-up" except as to her face, but leaves her skin the very light brown of the Parsees of Benares, rather than the deep tones of the Hindoos of Bombay.

At the conclusion of the performance yesterday afternoon there were a dozen or more curtain calls, to which the dancer responded with a quaint, and, presumably, Eastern salutation.

* * *

December 1, 1909

LOIE FULLER SHOWS HER DANCING GIRLS

Orchidee, Young and Beautiful, Dances to a Prelude of Chopin, in Greek Costume

ONE MUSE IS OF MADNESS

Rita Sacchetto Achieves a Remarkably Novel Effect—Thirty Young Women Appear in Fire Ballet

Miss Loie Fuller, known in Paris as La Loie, returned to dance in New York yesterday at the Metropolitan Opera House after several years' absence. Miss Fuller, it will be remembered, invented the serpentine dance, and devised light effects to simulate fire and other natural phenomena. It was

in dances which employed manifold draperies and numberless colored lights that the dancer was formerly seen here. Since then, however, Isadora Duncan and Maud Allan have revived the Greek dance, at least their own idea of the Greek dance, and Miss Fuller's performance yesterday afternoon included examples of these latter-day conceptions as well as many of her own earlier ideas.

For the first time that she has been seen here she was surrounded by a group of dancers, a complete ballet, in fact. Added to these were several solo dancers, many of whom have achieved Continental fame quite independently of Miss Fuller, but who have joined her company for this American tour. The programme, therefore, presented a varied aspect.

Miss Fuller and her muses were seen at the beginning in an interpretation of the Bach-Gounod "Ave Maria." Following this Orchidee, an American girl, who is young and beautiful, danced to a prelude of Chopin in Greek costume and with bare legs. Orchidee was later seen in a "Diana Dance," which was most effective, and an interpretation of Mozart's "Turkish March."

Mme. Thamara de Swirsky, a Russian dancer with quite another style but the same sort of costume, followed. Mme. de Swirsky makes a more sensuous appeal than most dancers of the classic type. Miss Irene Sanden, a German girl, who is said to find her chief joy in dancing waltzes, followed in a waltz of Rubinstein and Strauss's "Roses from the South."

The second part of the programme was in many ways the best part of the afternoon's entertainment. Miss Rita Sacchetto, who is well known in Europe, danced a dance of madness to Chopin's Tarantelle. The explanation of this dance is that a maiden who has been stung by a deadly spider can save her life only by mad dancing. The tempo increases with such intensity that the dancer breaks down, completely exhausted, only to rise again to intensified emotion.

Miss Sacchetto achieved a remarkably novel effect in this dance and succeeded in working the audience up to a high degree of enthusiasm. Many doubtless wished that they could see her do her Spanish dances.

Miss Gertrude Van Axen, who shared this portion of the programme with Miss Sacchetto, was seen in Greek dances, into the scheme of which she fitted perfectly. Her figure is beautifully modeled and she is marvelously plastic.

The entertainment concluded with the Ballet of Light, in which the older ideas of Miss Fuller were incorporated and manifolded. If you have seen Miss Fuller do her fire dance in which the draperies take on the color and texture of flames, conceive of it done by thirty young women at once and you will have a picture of the Ballet of Light. Other dances of Miss Fuller's were manifolded in this same way, and the programme closed with the appearance of Miss Fuller herself.

A very large audience, which included many notable people, was in attendance, and the entertainment seemed to meet with approval. The Metropolitan Opera House orchestra, under the direction of Max Bendix, furnished the music.

THEATER

December 26, 1900

SARAH BERNHARDT AS THE DANE

"HAMLET" ACTED IN FRENCH AT THE GARDEN THEATRE

The Strange but Fascinating New Prince of Denmark Associated with the Richly Humorous Shakespearean Clown of Constant Coquelin

WITH: Sarah Bernhardt (Hamlet); M. Coquelin (1er Fossoyeur); M. Rebel (Le Roi); M. Deschamps (Polonius); M. Deneubourg (Horatio); M. Desjardin (Laerte); M. Ramy (Osric); M. Dara (Rosenkrantz); M. Laurent (Guildenstern); M. Guiraud (Un Pretre/1er Comedien); M. Krauss (Marcellus); M. Stebler (Bernardo/2eme Comedien); M. Cauroy (Francisco); M. Durce (Le Spectre); M. Chabert (2eme Fossoyeur); M. Fusch (Fortinbras); M. Barry (Voltimand); M. Stephano (Cornelius); M. Francais (Un Marin); M. Deneuville (Un Comedien); Mme. Marcya (La Reine); Mme. Damiroff (Ophelie); Mme. Boulanger (La Reine Comedienne).

"Hamlet," translated into French prose by MM. Eugene Morand and Marcel Schwob, was acted at the Garden Theatre last evening, with Mme. Bernhardt in the title rôle and M. Coquelin as the First Gravedigger. Because of the unfortunate postponement of the performance from Monday night, probably, and the consequent disappointment of many persons who had secured seats for that evening, the house was far from crowded, but the performance, which from beginning to end was strangely interesting, and, in spite of its oddity and the bizarre character of some of the reading and "business," was not without positive value as an interpretation of Shakespeare from an intelligible point of view, was followed with close attention and many signs of admiration.

It never secured any very demonstrative expression of favor, however, and it, is likely that this, in spite of its merit, will be the least popular of all the great actress's impersonations in this country. We English-speaking folks are fond of saying that Shakespeare's genius belongs to all ages and the whole world, but whenever a foreigner tries to act Hamlet we cry out that he cannot act it because he cannot possibly comprehend it.

This new Prince of Denmark, so low of stature, so wonderfully graceful in every motion and gesture, so agile, and so restless most of the time, but so incomparably effective in repose; this Hamlet of the short tunic, the daintily molded limbs, the broad, pale forehead surmounted by yellow hair; the strangely mobile face of a Pre-Raphaelite, or decadent cast—whichever one chooses to call it—this odd, pathetic, eloquent, courtly, gracious, lithe, explosive, grotesque, hysterical Hamlet of splendid contradictions, will please the few, the art-loving, the appreciative, if not the multitude.

This Hamlet is not to be fairly judged by direct comparison with any standard impersonation of the Prince now known or vividly remembered on the English-speaking stage. It is not nearly so "Shakespearean," in its tone, temper, and form, as the portrayals of certain German actors who have appeared on our stage in comparatively recent years, as Ludwig Barnay's, for instance, or Josef Kainz's. On the other hand, it is not as bizarre, as volatile in temperament, as essentially emotional rather than intellectual as the Hamlet of Jean Mounet-Sully, the exuberance of which was somewhat held in check, too, by the traditional requirements of the delivery of alexandrines on the French stage. Bernhardt's Hamlet does not shed tears or walk sideways.

Of the new French version of "Hamlet," it is enough to say now that it is lucid and sensible. There are no striking vagaries in the very creditable and intelligent attempt to render the humor and philosophy, the majestic thought, the horror and passion of the original into modern French prose. The arrangement, in five acts, follows our own arrangement of the Shakespeare play closely enough. The omissions and curtailments are generally copied after the best-known English stage versions. These translators, unlike most of the French writers of their generation, are familiar not only with English literature, but also with the manners and traditions of the English stage.

They were not always able, of course, to transfer famous passages from the one tongue to the other with all their original dignity. Much of the eloquence of the great soliloquies is lacking in the French. The wisdom of Polonius becomes the quintessence of the commonplace in French prose. But this speech Bernhardt now cuts altogether.

For "mobled queen" the translation has "la reine emmouflee," thus accepting the definition of the mysterious word of the quarto as "muffled" instead of "mob led." For "Frailty, thy name is woman," the new Hamlet says "Fragilitè ton nom est femme." "To be or not to be" is rendered "Etre ou ne pas etre." Thus faithfully does all the text follow the original. A few familiar speeches like "Though I'm native here and to the manner born" are missing.

Mme. Bernhardt has greatly shortened the play, however, for her American tour, and she might well shorten it still further by omitting Voltimand and Cornelius.

The dignity, grace, and feeling of Mme. Bernhardt's acting in Hamlet's first scene made one forget the "eternal womanly" in her appearance that costume cannot hide. From the Prince's first reply to Claudius to the emotional outburst after the exit of Horatio and his friends, the commingling of princely grace and dejection in her acting was admirable. No Hamlet has ever made more, and with less fuss, out of Hamlet's acceptance of the message of the soldiers and his college friend.

In the first view of the Ghost, however, and the "Unhand me, gentlemen," the actress sounded the hysterical note. She seemed the very woman there. But in the interview with the Ghost, in which, like all other great actors, she gave the Royal Spectre the centre of the stage and did not put the Prince forward too much; and in the wild succeeding scenes he would be a carper, indeed, who could point out a serious defect in her acting. Personality, of course, cannot be hid-

den. But Sarah Bernhardt surely acts the Prince in these few episodes perfectly.

The bizarre, grotesque, and childish "business" in Act II, can easily be reconciled with the wild and extravagant text if one cares to undertake the job. In fact, both the blue-bottle fly business with Polonius, to illustrate the "buzz, buzz, buzz," and the silly bumping together of the pates of the two courtiers have been done on the English-speaking stage. It seems, after all, that there can be nothing new in "Hamlet."

The "business" with the players here and elsewhere is not particularly interesting. That motley group of montebanks, male and female, are surely not the famed Tragedians of the City. But the "Oh, What a Rogue!" is well rendered. The soliloquy on immortality is beautifully done, too. The scene with Ophelia, though, seems to lose all its complexity of emotion, and to become merely the scolding of a weak and utterly uninteresting woman by a strong one.

The fine speech to Horatio, before the play, goes for nothing, as does also the advice to the players. But the striking pictorial effect and emotional force of the play-scene as Bernhardt does it are not to be gainsaid. The Prince leaves his seat at Ophelia's feet to climb stealthily up the front of the balcony on which the King sits, and this brings him face to face with that culprit as the fright seizes him. However, Mr. Sothern's acting in this episode, not to mention any other recent Hamlet, will be better liked by the multitude.

The "hire and salary" speech, with the King at prayer, is beautifully done, and so is all of the colloquy with the Queen, though the brutal spitting of poor Polonius, in whose carcass the Prince's sword blade is permitted to remain a moment or so after it has done its work, seems a questionable bit of "business." The change from violence to amazement and pity at the second apparition of the dead King is highly effective. In the churchyard, however, the fury of Hamlet seems to a mere Anglo-Saxon to run away with his impersonator, while the droning monotone over the skull of Yorick is, to speak frankly, tiresome. But what Hamlet of glorious memory has not had his tiresome moments?

It was nearly midnight before Coquelin emerged into view in the guise of the loquacious and philosophical Gravedigger, a character always allotted on the English-speaking stage to the "first low comedian." The most famous exponent of the merry rascals and mendacious valets of Molière was, of course, found to be quite at home as one of the best of all the clowns of Shakespeare.

Coquelin had been seen in only one other Shakespearean rôle, and his Petruchio, though a graceful and vivacious humorist, had not been regarded in this country as one of his best portrayals. There could be no two opinions, however, of the rich drollery and naturalness of his acting as the Gravedigger, of the graphic skill displayed in his denotement of the harmless vanity and inherent humor of the fellow.

The Gravedigger wore a faded blue tunic and a leather apron, and his stockings were not mates. Yet there was nothing grotesque or essentially theatric about him. He enjoyed hugely the jests he made with his slow-witted companion, and had plenty of fun in his colloquy with the Prince. It was, in short, a wholly commendable and artistic embodiment of a comparatively unimportant rôle. It will not increase Coquelin's fame, but it will do him no harm.

There is always a hint of humbug when a great actor appears in a small part. We do not generally want to see an Edmund Kean as the Duke of Venice, an Edwin Forrest as Banquo, an Edwin Booth as Horatio, or a Joseph Jefferson as Nick Vedder. But Coquelin is an artist always, and he finds something in this scraggly bearded, sapient wielder of the mattock to make the part worth his while.

What is left of the character of Ophelia is acted rather prettily and feebly by Mlle. Damiroff. Desjardins is a vigorous and effective Laertes. The Queen of Mme. Marcya, the King of Rebel, the Horatio of Deneubourg, and the Ghost of Durec are competent impersonations. Most of the other rôles are, at least, respectably filled.

The scenery from the Théâtre Bernhardt, in Paris, had to be cut down to fit the Garden Theatre stage. In the circumstances it was not as well displayed as the designers had intended. But the coloring is all charming and, while the great hall in the Elsinore Palace is a somewhat grotesque and unearthly specimen of architecture, the two outdoor scenes are fine pictures.

The lights were generally well managed last night. The Ghost was revealed at first behind a transparency, but stood in the open upon "the dreadful summit of the cliff." In the Queen's closet the pictures wore life-sized panel portraits of the two Kings, and within the frame of that of the dead Hamlet the elder his spectre appeared.

* * *

February 5, 1901

ETHEL BARRYMORE

*The Promising Young Actress in a New Farce
at the Garrick Theatre*

WITH: H. Reeves Smith (Robert Carrolton Jinks); George W. Howard (Charles Lamartine); H. B. Taber (Augustus von Vorkenberg); Edwin Stevens (Professor Belliarti); Estelle Mortimer (Mrs. Greenborough); Mrs. Whiffen (Mrs. Jinks); Fanny Addison Pitt (Mrs. Stonington); Sidney Cowell (Miss Merriam); Lillian Thurgate (Miss Pettitoes); Anita Rothe (Fraulein Hochspits); Kate Ten Elyck (Mrs. Maggitt); Beatrice Agnew (Mary); Ethel Barrymore (Aurelia Johnson).

The charm of Ethel Barrymore as yet is only the charm of high-spirited youth and infectious gayety. She is not a histrionic genius, surely, and her good natural gifts have not yet been fully developed by experience and practice. But she has learned something in the few years she has been in the view of the public. She moves about in the scene with barely a hint, now, of the angularities and ineptness of "the awkward age." She has developed into a graceful young woman whose manner also frequently suggests graciousness.

She still makes too much of her charming smile, which someone has told her is irresistible, and she employs it sometimes, as Cora Potter used to employ that lovely smile of hers, when a grave expression of countenance or even a frown would be more appropriate to the sentiment of the situation. This makes the sensitive spectator nervous, as he fears she is losing her grip on her role and is going to have a laughing fit. Charming smiles are mighty good capital for actresses, but they should be used sparingly. Miss Barrymore would do well to note what good use Eleanor Robson makes of her own charming smile.

But Miss Barrymore at the present stage of her career impresses a careful observer as being a young woman who will bear a good deal of watching in the future. She comes of excellent stock, she is handsome, she has "presence," she has a sense of humor, she has a good voice, she already has appreciable force. She may yet do wonders.

She is, to be sure, entirely too young and undeveloped to be put forward as a star, and her manager, Charles Frohman, probably has no idea of starring her at present. But, although the house bill gave the proceeding no countenance, Miss Barrymore was welcomed, with diffusive applause, as a star when she appeared at the Garrick Theatre last night as the heroine of an invertebrate and preposterous three-act farce with an interpolated sentimental interest. There was some justification in the attitude of the audience, which was largely made up of good-looking young persons of both sexes, because Miss Barrymore's pretty, vivacious, and promising acting was far and away the best part of the evening's entertainment.

"Captain Jinks of the Horse Marines," as a play, is as weak stuff as we have been inflicted with lately. While its action is supposed to pass in New York in "the early seventies," the text is full of allusions to Mapleson, in the era of Strakosch and Maretzek; to Puck years before the late Mr. Bunner became a humorist, and to other persons and things unheard of in "the early seventies." But, what is more important, the piece lacks any sort of verity or logic, is deficient in wit and humor, and has to commend it only a sort of frisky juvenility, which will soon weary the wayfaring man if he happens even to be made aware of "Captain Jinks of the Horse Marines."

Indeed, it is all so feeble and paltry that it seems a pity to waste severe criticism on it.

The thing is all rather prettily done, too, and the exaggerated costumes serve their purpose. Miss Barrymore invariably looks lovely in her paniers and chignons, and the comic women look exceedingly funny. The extravagant ballet scene is not out of place in such stuff, but the apparition of a woman dressed as a figurante as to her lower limbs, and wearing the bonnet and veil of a mourning widow seems not even grimly humorous. Clyde Fitch confesses to the authorship of this piece, but he can stand it. Everybody knows now how much better work he can do. The fact must be borne in mind, too, that Miss Barrymore was received last night with all the honors due to a Modjeska or a Cushman.

* * *

THE JEWISH KING LEAR

AMERICAN AUDIENCE ACKNOWLEDGES THE MERIT OF THE PLAY

People Who Frequent Broadway Playhouses Moved by the Adlers—A Benefit Performance

A line of carriages and cabs, extending from the People's Theatre, on the Bowery, to Rivington Street, discharging an unusual number of fashionably-dressed persons, served to excite comment on Monday evening last. The lobby was crowded and the press about the box office was great. While the east side element was not altogether lacking, the audience that came together for the presentation of the Jewish King Lear on that night was conspicuously such a one as might be seen in a Broadway playhouse on any night in the season.

The fact that the presentation of the play was for the benefit of the Seward Park Playground, and that the Outdoor Recreation League managed the sale of tickets, served to differentiate the character of the audience from that which ordinarily assembles in a Bowery theatre. Most of the seats had been sold in advance, and late comers were accommodated with difficulty.

In some respects the audience resembled a big family party. Almost everybody who is interested in philanthropic work was present, and there were to be seen settlement workers, nurses, and a large number of that class that represents the actual practical working side of the east side altruistic movement. Besides these, there were men of wealth and influence from the upper sections of the city, as well as an occasional first-nighter and regular theatre habitué, attracted by curiosity.

It is safe to say that a part of the audience had never heard of the Jewish King Lear or of Jacob Adler until their attention was called to both by the announcements of the benefit. Of those who did know that such a thing as a Yiddish theatre flourished in New York, few had seen any actual performances by the company. The general attitude may best be described as one of good-natured curiosity. More than one person admitted a little shame-facedly, after the play was over, that he had come "just for the fun of the thing."

"I confess I had my doubts," said one man, whose judgment in theatrical matters is above the average. "I had read a great deal about these Yiddish players, but I set down the praise they received to tolerance for things foreign. I was not in a friendly mood when I came in. But my scepticism soon gave way to admiration."

There were many similar expressions from persons who had come to scoff and who remained to be convinced.

Mr. Gordin, the author of the play, has put it forward as representing the realistic school. While no exception can be taken to that as far as the general scene, the presentation of customs, and dress are concerned, it is impossible to look upon the motive and action of the Jewish King Lear as other than that of romantic drama.

The Plot of the Play

The action of the play is laid in Wilna, Western Russia. In the first act the scene is placed in the home of David Maisheles, a wealthy merchant. The festival of Purim is being celebrated, with a supper at which there are present the two sons-in-law of David, with their wives, and his youngest daughter, Teibele, a part played by Mrs. Adler. Jaffe, a teacher, has come to give the young woman a lesson. The comedy element is furnished by Shamai, the faithful servant of David, a role assigned to the actor Perlmuter. The two sons-in-law represent the two sects of the orthodox.

The older of the sons-in-law belongs to the sect "Mithnagdim," a man well versed in Talmudic law, but a calculating egotist.

The other is a "Chasid," hot tempered, but with fine impulses. At the table a quarrel soon ensues between the two couples, but it is checked by the arrival of David. The old man is good humored and pleased to see Jaffe. He asks him to put on his hat and drink "L'Chayeim" to each other's health.

Then the old man proceeds to give rich gifts to his daughters, the elder ones receiving theirs with demonstrations of deep appreciation. To the youngest daughter he gives a brooch valued at 88 rubles. She thanks him, but says she sees no use in such finery. David is angered and throws the gift aside. He announces later that he has decided to go to Jerusalem to spend his last days in the study of the Law and the service of God. His fortune, he says, he will turn over to his children. All thank him but Teibele, who says that he will regret the step. His brutal frankness excites the old man who orders her from the house.

Jaffe thereupon relates the story of King Lear and compares Teibele to Cordelia. He expresses the hope that David will not meet the fate of Shakespeare's unfortunate King. The old man laughs contemptuously at the idea.

The second act opens one year later. David has returned from Palestine, but finds only neglect in the house, which is now in charge of the elder son-in-law and his wife. The mother has been made the drudge of the household. Teibele, the youngest daughter, in this act informs her father that she will go to St. Petersburg to study medicine. He receives the suggestion with indignation. The son-in-law fails to treat him with respect, but he is finally aroused to energy. He orders that he be addressed standing as a mark of respect, and demands that the keys of his safe be returned to him. When that is done he says that, although the Russian laws allow him to reclaim his donated possessions, his conscience will not permit him to retract his words. One of his sons-in-law in a fit of intoxication, causes a disturbance and the old man, overcome with such a scene in a house where once was a sanctuary, falls in a swoon.

In the third act, while Shamai, the faithful servant, is rocking the baby's cradle he falls asleep and dreams of food. Teibele arrives and tells him that she has been graduated from the medical school. Shamai relates to her how sad her father's lot has become, and tells her that the old man is now blind. The mother and the old man arrive from the synagogue and

the old woman goes out to beg food for her husband. In the meantime, Shamai prepares David for the meeting with his daughter. The scene of the meeting presents a pathetic picture. Mrs. Adler's chance for emotional acting came a few moments later, when, indignant at her father's neglect, she denounces the cruelty of his treatment.

Despair of the Jewish Lear

David, believing himself alone, reasons on the evils of the world. The son-in-law, overcome with wine, enters with others as intoxicated as himself. They throw the old man from his chair, and when he asks to be led out of the house he is led to the wall, and a barricade of chairs ranged about him. Teibele and Jaffe enter, and the young student violently assails the drunkards. He and Teibele leave to go to the authorities in David's interest. Finally David, overcome with shame, decides to leave the house. He is bitterly reminded of Jaffe's early allusion to King Lear, and in a scene of absolute despair passes out, crying, "Give alms to the new beggar! Alms to the Jewish King Lear!"

The enthusiasm that followed the fall of the curtain continued until Mr. Adler responded to no less than six curtain calls. Cheers and bravos, starting in the boxes and among the more conservative auditors, were echoed from all parts of the house. Finally Mr. Adler led Jacob Gordin, the author of the play, before the footlights to share in the ovation.

In the last act Teibele and Jaffe are about to be married. The joy of the occasion is marred by the absence of David. Shamai finally leads him in. David does not at first know where he is, but the truth is revealed to him. General forgiveness follows. David declaring that, after all, the greatest thing in the world is love.

* * *

May 22, 1902

MRS. FISKE AS NORA

A Matinee Performance of Ibsen's "A Doll's House" at the Manhattan

In few of Mrs. Fiske's parts are her excellences and her limitations more clearly to be seen than in Ibsen's Nora in "A Doll's House," which was given yesterday afternoon at a special matinee at the Manhattan Theatre. Whereas Mrs. Fiske is, in her own person, the embodiment of nervous energy and intellectual penetration—the highly trained and cultivated intelligence—Ibsen's Nora is, at least as she first appears, the embodiment of everything primitively feminine. The task of bridging the gap between her personality and the part is one that reveals Mrs. Fiske's many and extraordinary abilities and at the same time clearly marks their limitations.

As far as intelligence and serious feeling can go in creating Nora, Mrs. Fiske's intelligence and feeling went. Needless to say, the passages of serious emotion toward the end of

the play that denote the awakened Nora she rendered with a force and conviction of which she alone is master. For the rest she was quite sufficiently light and irresponsible—a creature of the superficial feminine intuitions, arts, and allurements. In the scene, for example, in which Krogstad reminded her that she had forged her father's name, her look of childish innocence and birdlike lightness of heart were consummately rendered—so irresistibly naïve and true as to have a poignantly comic force.

Where Mrs. Fiske fell short was in denoting sheer sensuous womanhood. Nora is the type of the plaything primitive man—and men are so very primitive!—makes of primitive woman. Her whole aim in life, as she herself points out on leaving Thorwald, has been to divert and allure him. If she has an end of her own to gain, she gains it by bribing him, and her bribe is to dance before him in their chamber by moonlight. Physically, and to some extent by temperament, Mrs. Fiske lacks this exuberant instinctive coquetry.

The result was greatly to impair the force of the emotional climax of the play. Nora, it will be remembered, conceives that she has only a few hours to live, and, true to her primitive hunger for joy and her instinct for giving others happiness, she resolves to spend them in mirth. At the end of the act she bursts into a tarantella she has learned in Italy. As Sorma plays the part, and as, indeed, any one should play it, there is an extravagant grace and vitality in this dance, an overflowing of animal gayety that has something wild and terrible about it. In the range of the modern drama there is probably no vivid contrast of emotions that is so powerfully and so legitimately achieved as this last burst of the spirit of the primitive Nora. As for Mrs. Fiske, she took a few mincing steps, a hop or two, and then cast away her tambourine. It can scarcely be said that she danced at all. Ibsen once remarked at a rehearsal in Norway: "It pleases the ladies and gentlemen to play another scene than that which I have written." The saying might well be applied to Mrs. Fiske's rendering of the end of the second act.

Yet, when all possible shortcomings are noted, the fact remains that the performance was one of unusual interest and pleasure. Enough of Nora was there to carry the play—indeed to give it a spirited illustration. The people are very few who would care for an extended diet of Ibsen, but no person of intelligence can fail to be grateful for an opportunity to see for once in a while a work of such great intellectual purport so intelligently represented.

The rest of the cast were scarcely more than adequate. The Thorwald of Max Figman was stiff in some parts and overwrought in others, being at its best in the passage where Thorwald is the better for champagne. The Krogstad of James Young was intelligently conceived, but seemed to be represented from the outside—not from within the skein of the part. The best performance in the support was the Rauk of Claus Bogel, which was simple and impressively pathetic. It should be added, however, that Mr. Bogel's carriage was too vigorous and animated for that of a man whose days were numbered by an incurable disease.

Parts of the play were cut, for what reason it would be hard to say. In the work of Ibsen every syllable is necessary to the whole.

* * *

January 14, 1903

"THE WIZARD OF OZ"

A WARM WELCOME AT THE NORTH POLE OF BROADWAY

Brilliant Scenic Effects and Good Comic Acting by Anna Laughlin, Fred A. Stone, and D. C. Montgomery

With a dash of brilliant discovery "The Wizard of Oz" last night discovered the north pole of the Broadway theatrical world in the Columbus Monument, at Fifty-Ninth Street. In a proximity as close as that of the Majestic Theatre frosts undoubtedly threaten, just as there is said to be a gathering chill in the theatres situated near the south pole in the Flatiron Building. But if anything is proof against the icy blast of popular neglect the spacious and comfortable auditorium of the Majestic ought to be it, and especially when it invites to as brilliant and snappy a show as that with which it has opened.

"The Wizard of Oz" is in its way the Darling of Mr. Belasco's Gods. It opens with a cyclone that sweeps pretty Miss Anna Laughlin and Mr. Stone, her pet cow, through at least twenty-seven heavens and perhaps nine hells of spectacular scenery into the fairy country of the Munchkins, ruled over by the Wizard of Oz. Here they meet many strange creatures, and stranger adventures, which give scope to no end of Belasco gorgeousness of scenic effect, varied by Weberfieldian song and dance.

It is not possible to say that the scenic effects are as beautiful as those indigenous to Forty-second Street, for Mr. Julian Mitchell's reds and pinks exploit their family disagreements in much the same manner as they used to do in the South Temperate Zone; yet one would go a long way before finding as pretty effects of costumes and dance, cyclones and snowstorms as are to be seen at the Majestic.

The scenery was supported with great ability by Messrs. Fred A. Stone and David C. Montgomery. Mr. Stone made his first appearance as a scarecrow on a post, and he acted the part so well that few in the audience suspected that he had the possibilities of life in him until Miss Laughlin, who had just received a fairy wishing ring, wished him alive.

Then, in a series of dances the grotesque mimique of which were admirable in the well-known manner of scarecrows, he ambled through the show, with straw in his toes and making musical nonsense wherever he went. Mr. Montgomery was all compact of large sheets of tin plate, and when the rust had been oiled out of his joints his dancing was as clever and characteristic as that of the scarecrow.

Miss Laughlin was charmingly girlish and graceful, and sang with pretty humor. One of the most amusing members

of the cast was the Cowardly Lion of Mr. Arthur Hill, who was far more lifelike in his appearance and demeanor than the run of comic opera beasties. Miss Grace Kimball was pretty and agile, and Miss Helen Byron made as much out of the part of the Lady Lunatic as seemed possible. The chorus was graceful and spirited and pleasing to look at.

The book and lyrics are by L. Frank Baum, and the music by Paul Tietjens and A. B. Sloane. It cannot be said that the authors have shown any great originality, but they have thrown old and well approved materials into a pleasing shape.

There is a greater display of tights than one has been accustomed to of late, and there is also not a little of the old familiar marching and countermarching. But these things are not to be stigmatized by calling them old-fashioned. They appear in the sculptures of the pyramids and no doubt will last until the crack of doom.

The play was first produced in Chicago at about the same time as "The Sultan of Sulu." The jokes and the accent of the performers have a decided Western flavor, which is well enough, but might not the allusion to the carettes of North State Street, Chicago, be adapted to fit the Fifth Avenue stage?

* * *

February 19, 1903

DAHOMEY ON BROADWAY

WILLIAMS AND WALKER MAKE AN OPENING AT THE NEW YORK THEATRE AND HOLD IT

All Negro Book and Music Played by an All-Negro Cast—The Negroes in the Audience Were In Heaven

A thundercloud has been gathering of late in the faces of the established Broadway managers. Since it was announced that Williams and Walker, with their all-negro musical comedy, "In Dahomey," were booked to appear at the New York Theatre, there have been times when the trouble-breeders have foreboded a race war. But all went merrily last night.

The huge auditorium was packed to the doors with a chuckling, gurgling, and roaring multitude, and the utmost satisfaction seemed to reign behind the footlights. These able vaudevillians have seen much water go under the bridge since they were first hailed as low comedy artists of the first order. That was in the days of Koster & Bial's. Since then they have flourished in the various vaudeville houses, and have filled the Grand Opera House on Eighth Avenue with parti-colored audiences. But until last night Broadway has been a Promised Land long denied.

As usually happens in pieces of the kind, the headliners were the whole show. Williams, in particular, had electric connections with the risibilities of the audience. He is of a serious, depressed turn of countenance—dull, but possessing the deep wisdom of his kind; slow and grotesquely awkward

in his movements. He holds a face for minutes at a time, seemingly, and when he alters it, bringing a laugh by the least movement. His song of the Jonah man convulsed the audience with every repeated stanza, until at last his least movement brought forth a roar.

He has the genius of the comedy in full measure. Walker is an able second, but distinctly a second. The pair are not yet a Weber and Fields, but they are often quite as funny as anything to be found lower down Broadway. Their methods, in fact, reveal a close study of the prime Yiddish comedians. They are a distinct notch above all the rest of those who have elected to trudge along behind in the Weberfieldian path.

The footlights drew a sharp color line, and will doubtless continue to do so. Mr. James Vaughn, the musical director of the show, who led the permanent orchestra of the house, and the boys who peddled water in the aisles were the only persons of color on the floor or in the barnacle-like proscenium boxes.

As the most comfortable chair in the house costs a dollar, such a result is a triumph in tact for all concerned. At intervals one heard a shrill kiyi of applause from above or a mellow bass roar that betokened the seventh heaven of delight. All parties were satisfied.

Behind the footlights was a rhapsody of color. Mr. Williams made up with burnt cork like a minstrel, and one of his fakir friends made down with a red nose of inebriety. A third party made over into a Chinaman. But none of these really added to the variety of color in the cast.

The actors were dark, medium, and light. Some of them were so light that they might have passed for white, except that the flare of a nostril, the weight of an eyelid, or the delicate fulness of a lip betrayed them to minute inspection. One of the chorus girls had blonde hair that was clearly not peroxide. She had a smile like the smile of Sarah the divine.

The play is already familiar in its main outlines to the theatregoing public. The plot combines a search by detectives for a silver box with a cat scratched on the back, and a plan for solving the negro problem by colonizing Africa.

In more senses than one local color abounded. The first act was in a public square, Boston; the second in the South, and the third in the heart of Dahomey. The book is by J. H. Shipp, the lyrics by Paul Laurence Dunbar, and the music by Will Marion Cook. The whole was well up to the not very exalted average in this kind of show.

In one way the book was well above the average, for it was, in its main outlines, an admirably conceived satire on racial foibles that gave scope to no little fun in the picturing of character types.

* * *

February 22, 1903

COLOR LINE FOR A PLAY

Following their action of the opening night on Wednesday, in restricting the location of negroes, Klaw & Erlanger, the

managers of the New York, sent out yesterday the following notice:

The "color line" at the New York Theatre, drawn for Williams & Walker's engagement in "In Dahomey," gives the lower floor, orchestra, and orchestra circle, all boxes except the top tier, two sections of the dress circle and one section of the balcony exclusively to the whites. This leaves one section of the dress circle, two sections in the balcony, and the entire gallery to colored people. No colored person will be admitted to the sections reserved for the whites, and no white person will be admitted to the parts of the house reserved for colored people. In this way all question of race discrimination is avoided.

* * *

May 26, 1903

THE YIDDISH SHYLOCK

JACOB ADLER AND THE AUGUSTIN DALY PRODUCTION

An Interesting Performance at the American Before a Large and Enthusiastic House

Jacob Adler, who has for many years been known as the great Yiddish tragedian of the Bowery, appeared as Shylock last night at the American Theatre, speaking his part in Yiddish, with an English-speaking support, and the magnificent production used four years ago by the late Augustin Daly. The spacious auditorium was so crowded with his friends, and others who were attracted by his fame, that the reference on the programme to the ordinance against standees seemed a hollow mockery. He received an enthusiastic welcome, and was followed breathlessly to the end. If he failed to command a place among the greatest interpreters of the part, this was largely, no doubt, due to the fact that to make Shylock fully sympathetic to a Jewish audience is virtually impossible.

There are, roughly speaking, two views of the character. To those who have studied the esthetic environment of the Elizabethan theatre and the traditional treatment of the Jew on the Shakespearean stage, there is little doubt that Shylock was acted essentially as a comic grotesque—a man hated and baited after the manner of Marlowe's Jew of Malta (who, indeed, seems to have served as a prototype) and in the end brought to a cruel defeat—enlivened by such exultation, even laughter, as was natural to a Jew hating people whose national amusement was bear baiting.

This mediaeval conception of the Jew was Shakespeare's point of departure in creating Shylock; but it was only that. He overlaid the rough ground plan with a character so truly and sympathetically rendered that one sees Shylock, as it were, in the full round of life. To those inclined to sympathize with the downtrodden, it thus became possible to conceive of him in a radically different light—to make of him a sort of hero of his race, a demigod whose very sins were to be pitied, not hated, and whose fate was to be viewed as the trag-

edy of a great race. Such are the revenges brought about by the whirligig of time in this matter of Shakespearean interpretations!

To Adler, as to all other modern actors, the Elizabethan Shylock is of course out of the question; and to him more than to another it is needful to represent the Jew in his most sympathetic and most exalted light. But in order to do this it is necessary to ennoble in the acting such passages as tend to buffoon his character, and, if they cannot be ennobled, to cut them.

Adler failed, in so far as he did fail, because his artistic good sense impelled him to give, on the whole, a simple, unaffected, and naturalistic rendering of the part, to eschew the Hebrew prophet of modern sentimentality, and to stick to the Shylock of Shakespeare—and of the Ghetto. He thus fell, as it were, between two stools.

The audience laughed heartily at national traits and applauded Shylock's outbursts of indignation against the Christians; but it failed to be swayed with full dramatic force for the simple reason that it was both repelled and mystified.

In attitude and demeanor he was the Jewish money lender—dignified, but in a manner that was matter-of-fact and unimaginative. The grim austerity of Irving and the malignancy of Mansfield were alike absent. It was probably because of this lack of spiritual exaltation in the character, rather than because of any studied design, that so many of his lines raised a laugh. The laughs are in the lines right enough, and no doubt were welcomed by Shakespeare's company; but they are well night fatal to any interpretation of the part which can sway the deeper emotions of Mr. Adler's audience.

It was for a similar reason that the lines went for so little in which Shylock is reminded alternately of his own losses and Antonio's disasters. It bears every evidence of being a bravura passage, and it is usually played as such. Mansfield reveled in the quick transitions from the heights of exultation to the abyss of chagrin; and if Irving did not do so, it was seemingly because he lacked the physical and the temperamental force.

Mr. Adler has the requisite abilities, as those who have been familiar with his work at the Windsor and the People's Theatres are abundantly aware; but he failed of full effect in the passage, as it seemed, because he feared to overstep the bounds of what is realistically possible. Whatever dignity he achieved by his sober reading came at the cost of a strong theatric effect.

* * *

September 27, 1903

TOPICS OF THE DRAMA

*The Art of Low Comedy at Weber and Fields's
"Arrah-na-Pogue"—The Old Stage Convention and the New—
A Definition of Melodrama in re Mr. Augustus Thomas and
Mr. William Gillette*

Why is the low comedy of Weber and Fields so much more delicious and satisfying than that of any of their thousand and

one competitors? Who knows? And if any one knows, would he seriously try to tell? Wordsworth has spoken in scorn of the race of scientists who, he avers, are accustomed to botanize on their mothers' graves; and certainly there is a danger of being fatuous in the attempt to probe the low-lying springs of laughter. Yet there are those who maintain that the more intimate one becomes with flowers of memory the more beautiful they are. And is it quite certain that one muddies the wells of mirth by exploiting their depths?

Low Comedians Who Are Comedians

One reason why the arch comedians of broken Yiddish low comedy amuse is that in addition to being low they are comedians. To say this is not quite to beg the question. Many performers on vaudeville and other stages satisfy themselves—and, it must be admitted, their audiences—when they don song-and-dance clothes and spring joke after joke in rapid fire. To cut capers and to spring gags—that is their alpha and their omega. Weber and Fields, and the many artists of the first water in their company, do as much of this as anybody. But in addition they create distinct characters and act out little ten-minute plays—horse plays, be it granted—in which the distinct characters act and react upon each other as subtly and vividly and with as accurate results as the characters in a comedy of Molière.

It is true that Weber is always Weber and Fields always Fields. Or, to put the case more accurately, Weber is always Mike, whether he is Michael Schlaatz, formerly of New York but late of the German Army, and the possessor of an airship, or whether he is Michael Suppegreentz, a retired New York corner grocer, looking for a safe investment; and Fields, by the same token, is always Meyer, whether he is Meyer Ausgaaben, also of the German Army and the airship, or Meyer Schmartzgeeser, ambitious to be a financier but lacking the price. Low comedy has its roots in the recognition of a few fixed types, always has done so, and always will do so.

The Case of Meyer Schmartzgeeser and Michael Suppegreentz

The signal fact is that Meyer and Mike are imagined with true creative insight. Meyer is stupidly clever and unscrupulous, inventing skindicates, banking ventures, and operations on the Stockings Exchange in order to touch the pocket of Mike, and Mike is stupidly honest and slow, with a distrust of Meyer as deep and disquiet and all-pervading as only the distrust of a stupid person can be, and with it all a blind affection for Meyer and a helpless trustfulness before the leg-pulling schemes of his friend, of which also only a booby is capable. These characters are no mere stage presentations of the personalities of the actors. Off the stage, it is said by those who know, Mike Weber is the hard-headed business man, who, under the stress of the new theatrical enterprises of the firm, has seriously thought of quitting the boards altogether; while Meyer Fields is far the less Meyer of the two. And not only are the two characters deeply imagined; they are admirably contrasted for the purpose of comedy. Any passage of horse-play in which they are concerned of necessity involves the struggle of opposing forces, which, learned and analytic critics tell us, is the essence of all drama. They are as fruitful of plots as the scamp slave and the youthful lover of Menander and Terence who in Molière appear as Scapin and Leandre; as the Harlequin and Pierrot of pantomime.

Classical Horse Plays

The nonsense of Meyer and Mike have all but become proverbial. A few years ago there was a passage in which Meyer was running Mike in the usual manner. Mike stood it for a while, but was at last forced to clear out. At the door he stopped, bursting with resentment, and shouted through his teeth: "I laugh at your chokes!" That season, when any one was being horsed, the response was pretty sure to be: "I laugh at your chokes!" Another year there was a passage in which Meyer and Mike had only a nickel between them, which, of course, belonged to Mike. Meyer was thirsty. So he proposed that they go up to the bar together, and when he asked Mike what he would have to drink, Meyer was to say, "I ain'd tdirsty," and Mike was to say to the barkeep, "One beer," and drink it. They rehearsed this three times to make sure that Mike understood. While they were waiting at the bar Meyer said to himself, 'Tdere's someding insite tdells me tdis nickel scheme ain'd a go." When the barkeep came up Meyer said to Mike. "Vell, vat's yours?" Mike answered. "I ain'd tdirsty," but added, with his accustomed stupidity, "I'll take a cigar." And while he lighted it Meyer leaned against the bar with his tongue hanging out. There were Wall Street men that year who were kept out of wild-cat operations by a still small voice that said, "Tdere's someding insite tells me tdis nickel scheme ain'd a go!" "Skindicate" and "Stockings Exchange" have become gems of the common speech.

The sincerity of Weberfieldian comedy is as evident in touches of pathos as in touches of folly. Last year Meyer was choking Mike with violence and two vigorous hands at his throat. Willie Collier came along, and taunted Meyer with not knowing how to choke. In the instant the abused Mike was all loyalty to his friend, and proposed a competition to decide which was the better choker. Bout after bout he yielded up his gorge to the rival chokers with a patience in long-suffering that was almost as touching as it was funny—and it was screamingly funny. This year it is Louis Mann who pulls out the stops of tears. With Meyer and Mike he is conducting a hotel, and is forced by the emptiness of the larder to kill two pet chickens for his guests. His grief at the death of his pets suggests a plot to the hungry Meyer. Mann is egged on to display his bereavement before the diners in the hope of routing them revolted from their meal. The plan succeeds, and the three hungry landlords sit down to devour the birds over whose death they have just been so copiously lamenting. Never on any stage has there been a more convincing portrayal of sentimental mourning than Mr. Mann displayed over the bodies of his two late pets, and Meyer's cry of "Some day we all of us shall be as dead as Fritz and Nina" struck a note of tragedy so true and deep that it could only be drowned in uproarious laughter.

The Art That Pays

Such episodes are no doubt due to the fertile invention of Mr. Edgar Smith, who is past master at this sort of thing; but they can be carried off only by the sincerest sort of acting. The slap-dash methods of the common run of Yiddish comedians, effective as it is with the more unthinking spectator, would be fatal to all effect. At Weber & Fields's the pace is never forced. Every laugh is skillfully constructed and worked out with an elaboration of preparatory detail that the ordinary manager would regard as suicidal. Let the exponents of "ginger" and "snap" stop and reflect. No one proposes that they follow art for art's sake, or would do so even if there were every chance of moving them. The virtue of such methods lies in the fact that they promote enjoyment and laughter. As long as Weber & Fields run the season through on Broadway year after year, there can be no doubt that even in low comedy art pays.

"Arrah-na-Pogue" and the Elder Theatrical Conventions

There are a host of good reasons why any one who cares for the theatre should not miss Mr. Andrew Mack's revival of Boucicault's "Arrah-na-Pogue," the prosperous run of which has been lately extended at the Fourteenth Street Theatre. To begin with the least momentous reason, the play is an admirable example of how far the technique of play writing has progressed in the comparatively brief period since the Boucicault melodrama was a welcome guest in the fashionable theatres up town. For better or for worse, the public now demands of a playwright a far more thorough adherence to the minor details of actuality in the stage presentation of life. The facile apostrophe to the audience is gone; and its slightly more seemly relatives, the aside and the soliloquy, are fast disappearing. The stage manager no longer permits buildings which, by a simple manipulation of lights, may be made to reveal to the audience what is passing inside. That is a truly moving crisis in which one looks through a stone wall up stage to see the McCoul escape to the cliff, while his redcoat pursuers are overrunning the front of the stage! And as regards the essential truth of our stage portraits of character, we are as far removed from the methods of Boucicault's as in these minor matters of technique. The language of the gentlemen and gentlewomen of "Arra-na-Pogue" is a highfalutin far beyond the loftiest efforts of those lady novelists whose tales used to sell in such numbers to aspiring souls in the pantry and the kitchen, even while the speech of the peasants is a model of vernacular point, and humor. It raises a reasonable doubt as to whether the intent of the highfalutin is not consciously comic. Was it Mr. Boucicault's purpose to renew all possible atmosphere of social superiority by making the gentlefolk ridiculous? There must be those who are wise on this point. It is their duty to tell. Certainly the audience, or parts of the audience, laughed at the language of the fine lady most heartily. As for the scene of Shaun's court-martial, it is a flight of imagination beyond the reach of the librettist of musical comedy in these degenerate days. Yet if any one needs to be reminded of how near all this is to our modern stage, he has only to recall the actualities of life as presented in "The Henrietta," and even in "Aristocracy," which is as yet only a dozen years old. Mr. Bronson Howard is far more nearly allied to Boucicault than he is to the best of our modern playwrights, just as the Pinero of "Sweet Lavender" is more nearly allied to Robertson than to the Pinero of "Mrs. Tanqueray."

Boucicault is supreme to-day, as he was twenty years ago, in the power of getting his story and his characters across the footlights. Our modern refinements of technique and of veracity in detail are no doubt the expression of a superior theatric intelligence. They have come for good and have come to stay. But they have rendered it very difficult for our best playwrights to reach those auditors who are not on their own plane of sophistication. Wherever there is a heart and a soul in the audience Boucicault, at his best, strikes at it unerringly; any one, of whatever worldly wisdom, who can witness Mr. Mack's present piece, "The Shaugraun," or "Rip Van Winkle" without an outflowing of sentiment must be suffering from an exceptionally bad dinner or from a constipation of the emotions. The scene in which "The Wearing of the Green" is sung can make a casehardened playgoer cry like a bull pup. And that very scene of the court-martial, in which Shaun beseeches the Sergeant to get him an alibi, and talks to his judges with the same familiar comradery he applies to his clansman among the stage audience, is truer in the matter of essential character, more laughable, more touching, than any scene that comes to mind in the modern drama or melodrama. Shaun's love for Arrah has the quantity, if not the quality, of the most moving passages of longing in the English drama. One is often inclined to be impatient with the manager of to-day when he sticks to the false standards and the outworn conventions of the older stage. And it is true that, considering things as they are, there can be no reasonable doubt that he is on the side of stupidity and conservatism. But an evening at the Fourteenth Street Theatre, though it cannot excuse his error, goes far toward explaining it.

The Shaun of Mr. Mack is a thoroughly able and a thoroughly moving performance. The simplicity of the character—which is so simple that every god in the gallery must feel a mental as well as a physical elevation in contemplating it—Mr. Mack denotes with charming naturalness and humor. Shaun's honesty, his self-sacrifice, his loyalty, and his love, are done with as firm and delicate a touch. The Arrah of Edith Barker and the Col. O'Grady of Thomas J. McGrane are likewise admirable. It is hoped that Mr. Mack's approaching engagement with Mr. Frohman will not prevent him from giving us more Boucicault. Certainly no one who cares for this sort of thing should miss the present opportunity.

Augustus Thomas, William Gillette, and Melodrama When It Is Polite

Prof. Brander Matthews writes that he has a bone to pick because a recent article in these columns, describing Mr. Augustus Thomas and Mr. William Gillette as "men of signal and often proved talent," added that they "may be called not so much dramatists as writers of polite melodrama." Prof.

Matthews says: "There is melodrama in 'Secret Service' and 'Held by the Enemy,' in 'Arizona' and 'In Mizzourah'—but to me it is not melodrama for its own sake, but rather melodrama as a framework of action to present character. Both Gillette and Thomas are true observers of life and character, and their plays have 'atmosphere.' This, it seems to me, differentiates their work from that of the British and French melodramatic writers, who have striven solely for effective plot and situation, each for its own sake." To this the adversary picking the other side of the bone replied that he used the term "melodrama" in its strict sense, to indicate a play of whatever excellence in which the working out of the theme is determined by fortuitous circumstance rather than by the inherent necessities of the characters or the emotions involved. In this sense "Hamlet" is a melodrama as regards its fundamental plot; it is a tragedy only in proportion as the elements of character and emotion, which Shakespeare superadded, overshadow the plot of the old play on which he worked. Prof. Matthews replied that the definition was very like his own, which is to the effect that in a true comedy or tragedy the characters determine the action, and that if the action determines the characters the play is a melodrama or a farce. He adds that in his book, "The Development of the Drama," it is pointed out that even Euripides "dropped into melodrama more than once." To this last remark the only possible objection is that in some cases, as, for example, the "Alcestis," Euripides did not drop but ascended to a point many notches above certain of his pure tragedies. It need scarcely be added that in calling the plays of Mr. Thomas and Mr. Gillette "polite melodrama" the intention was to describe them with accuracy rather than to cast upon them that which has come to be known as asparagus. Prof. Matthews adds: "I relish highly the best qualities of both Thomas and Gillette. 'Sherlock Holmes,' for example, frankly impossible as it was, delighted me. I saw in the play far more gray matter than in—" (the comparison is omitted, but it is very laudatory to Mr. Gillette). "And Thomas's 'Alabama' had charm in a high degree." To all of which, even the suppressed comparison, let us say "Amen," and with a protest against the "Weberfieldian hoop-dee-doo" that Amen is what you say after a long conversation.

JOHN CORBIN

* * *

October 14, 1903

"BABES IN TOYLAND"

NEW EXTRAVAGANZA AT MAJESTIC THEATRE
A GREAT SUCCESS

Victor Herbert's Music is Highly Satisfying and Julian Mitchell's Stage Pictures Are Most Satisfying

It is a common saying that "lightning never strikes in the same place twice." That seems to be one of the differences between lightning and theatrical success. If one may judge from the result at the Majestic Theatre last night, where the new extravaganza, "Babes in Toyland," had its first production before an audience that for two hours and a half took everything that came its way and then greedily cried for more.

"Babes in Toyland" is as full of good things as Jack Horner's Christmas pie was popularly supposed to have been, and the persons engaged in exploiting it are quite as deft in extracting the plums as was that youthful hero, even though they may not accomplish it by the same rule of thumb.

The music of "Babes in Toyland" is by Victor Herbert, and it may be said at once that nothing more satisfying of its kind has been heard here in many a long day. Mr. Herbert seems to have caught the true spirit or this dainty pantomimic play, and in the lyrics and the incidental melodies he has been remarkably successful.

There are half a dozen songs which linger insistently in the memory and are sure to become popular successes, while in such scenes as that in the second act, where the Babes make their way into a gloomy cave, infested by huge spiders and all manner of curious creeping and flying things, there is just the right quality of sombre mystery and suggestiveness.

The book is by Glen MacDonough, and while the dialogue is by no means brilliant at all times, there is a good laugh in it for persons whose digestions are in a reasonable state of health.

The great success of "The Wizard of Oz" at the Majestic has caused a good many persons to wonder how the management could follow it with an attraction that by contrast would not seem "stale, flat, and unprofitable." Well, "Babes in Toyland" is not stale, it is not flat, and it certainly will prove highly profitable.

Prognostication as to futures in dramatic success are often about as trustworthy as those which concern the weather. But eliminating the sort of catastrophes that go to make up the saving clauses in insurance policies, the snows of midwinter and the zephyrs of balmy Springtime are each in their turn likely to find the two Babes still wandering hand in hand through the oft times beautiful, sometimes awful, scenes of their mimic woes and joys.

There is a freshness about this new extravaganza and a wholesome jollity, too, that is most satisfying. It has its moments of horse play, to be sure, and the queer humor of the vaudevilles is apparent at times, but, taken as a whole, it is a remarkably clean and wholesome entertainment. It is the kind of show that every child will want to take his parents to see, and no child need hesitate to do so for an instant.

Of course it's quite reasonable to suppose, on the other hand, that some fathers and mother will see in it just the sort of thing to hold over the heads of the little ones, with a "If you're good you go, and if you're naughty you don't," but then "Babes in Toyland" is worth being good for.

Maybe the story in this sort of an affair doesn't matter very much, but some persons will want to know that there is a wicked old man, one Uncle Barnaby, who wants to get the fortune of his nephew and niece, Alan and Jane, played respectively by William Norris and Mabel Barrison, both of

whom were thoroughly and consistently charming throughout. The wicked old man hires a pair of ruffians to make away with the children. First this pair take them on shipboard; then they scuttle the ship. Result—a stage picture of storm and shipwreck at sea.

Of course, the children escape, and they are next shown in Contrary Mary's garden, where all of the people beloved in the nursery, from Tom, Tom, the Piper's Son, to Little Bo Peep and the rest of them, are introduced. In this scene it develops that Alan is in love with Mary, his rival being the old miserly uncle who is trying to have him and his sister put out of the way. That is enough to indicate the general trend of the story, which is carried successfully through three acts of pictures and music.

One of the quaintest and daintiest songs imaginable is that in which a dozen or so of school girls seated on a wall join in the chorus of "I Can't Do the Sum," sung bewitchingly by Mabel Barrison. They tap their slates with pencils, keeping time to the music and nod their pretty little heads with a suggestiveness of the hard, hard tasks of school days that is simply captivating. The chorus:

Put down six and carry two,
Gee, but this is hard to do.
You might think, and think, and think, Till your brains
 are numb.
I don't care what teacher says, I can't do this sum!

had to be repeated over and over again.

The song "Rock-a-bye Baby," splendidly given by William Norris with an accompaniment of business full of originality, introduces an orchestration that is delightful. Another hit was the "Legend of the Castle," sung by Francis Marie, and "Toyland," sung by Bessie Wynn, has a dreamy refrain, exquisitely pleasing.

A march of toy soldiers, and many new effects in costumes, lighting, and scenic transformation serve to make "Babes in Toyland" an achievement in the line of light and pleasing entertainment.

Among the actors, other than those already mentioned, were Gus Pixley, who made a very comical detective; Amy Ricard, whose one song, "Mary, Mary," revealed vocal accomplishment never suspected by those who saw her last season as the Girl from Butte in "The Stubbornness of Geraldine," and Dore Davidson, who played an old toymaker, seeking arduously to endow his creations with life and soul. The whirlwind dancing specialty which Guyer and Baly have been doing in the vaudevilles was introduced into one scene and aroused much enthusiasm.

No end of credit should go to Julian Mitchell, who staged the piece. In this latest effort he excels himself, and that, in the light of past achievement, is saying a good deal.

* * *

October 11, 1904

MRS. PATRICK CAMPBELL IN SARDOU'S "SORCERESS"

A Gorgeous Spectacle Drama of the Inquisition
NOT 'SARDOU FOR EXPORT ONLY'
An Ably Contrived Vehicle for Mrs. Campbell's Virtuosity Stops Short Only of the Great Dramatic Emotions

WITH: Frederick Perry (Ximenes, Grand Inquisitor); Guy Standing (Don Enriquez de Palacios); George Riddell (Padilla, Governor of Toledo); L. Rogers Lytton (Cardenos); Fuller Mellish (Cleofas, physician); H. Ogden Crane (Oliviera, surgeon); Orme Caldara (Ramiro, Esquire to Palacios); H. L. Forbes (Fray Eugenio Calabazas); R. C. Morse (Fray Teofilo Ibarra); F. M. Wilder (Fray Miquel Molina); E. J. Glendinning (Fray Hernando Albornos); William Balfour (Farez, a Moorish muleteer); Laurence Eddinger (D'Aquilar); John W. Thompson (Gil Andres, executioner); C. H. Ogden (Don Ambrosio); George Lane (Rioubos); Walter Henry (Velasco); W. Raulton (Christobal); Edgar Allan Woolf (A Goatherd); William Marsion (Gines); Henry Forbes (Arias, an officer); Mrs. Patrick Campbell (Zoraya, a Moorish woman); Alice Butler (Afrida, an old peasant); Gertrude Coghlan (Manuela, a young peasant); Margaret Bourne (Fatoum, a converted Moor); Mildred Beverly (Aisha, a servant to Zoraya); Martha Waldron (Joana, daughter to Padilla); Katherine Raynore (Zaquir, a boy); Florence Gelbart (Dona Rufina); Sara Leigh (Dona Syrena); Guilia Strakosch (Dona Sarafina); Edna Larkin (Dona Fabia); Euginia Flagg (A Peasant Woman); Otis Skinner (The Harvester); J. M. Colville (Francois); George Clarke (The Seigneur); Walter Lewis (Tony); Ben T. Ringgold (Thomas); Russell Crauford (Martin); Daniel Pennell (Simon); John Boylan (Gustave); Lizzie Hudson Collier (Toinette); Maud Durbin (Aline); Marion Abbott (Catherine).

A large and fashionable audience gathered last night at the New Amsterdam Theatre to see Mrs. Patrick Campbell create in English the latest of the melo-tragic rôles which the master French playsmith Sardou has written for Sarah the Divine. They had seen her in her repertory of modern intellectual dramas—the pastor's doubting wife in Bjoernsen's "Beyond Human Power," Beate, the martyr of free love, in Sudermann's "Joy of Living," the soul-sick Melisande in Maeterlinck's anaemic dream tragedy, Pinero's Paulo Tanquery and Agnes Ebbsmith. In all these parts they had conceded her mastery over the ultramodern woman of refined gentility, of cerebral passions, and of unstrung nerves.

But Sardou calls for the simpler, more ardent moods of what Sir Walter Scott used to call the big bow-wow style. How would she portray Zoraya, the Saracen of the Middle Ages, whose soul deals in mysterious arts and in whose veins runs the fiery passions nurtured by the African sun?

It was in the more refined and gracious aspects of the part that Mrs. Campbell was most satisfying. She had all the supple and sinewy grace of the Saracen and something, too, of the rich emotional color, inherent, no doubt, in her own half Spanish blood. High-bred and intelligent she seemed in the extreme degree. Her gowns were marvels of splendid good

taste, and she wore them as if they were the glittering armor of a serpent sorceress.

In her subtler moments (there were none of them so very subtle) her art was fluent, diversified, and finely modulated, adroit in attack, and certain in every stroke. Her voice, if nowhere rightly golden, always of silvern purity and delicacy—vibrant at times with incisive and ringing, if somewhat brittle and metallic, passion.

In the first act she appeared, in a costume of black with silver stars, on a moonlit mountain side, gathering bitter herbs and sweet flowers with a silver sickle, that flashed in the light of the crescent moon like its earthly symbol—a double emblem of the faith of Allah. It was here that she met the young Christian Enriquez, and cast upon him, to the undoing of both, the spell of her smile, her eyes, and her caress, and here her art was at its completest, full of half lights and subtle, evanescent shadows. It was all a symphony of moonlight passions, with the Pleiades caught in her flowing Moorish veil.

In the later acts the passions became simpler and more intense, and the art of the actress at once less subtle and less salient. Against all reason and justice one continually imagined how much greater—and more theatrical—Bernhardt must have been in the rôle. Mrs. Campbell cannot raise the golden cry of cosmic sorrow, rage, despair—and faint in coils!

It was not until the end of the fourth act, where the author's craft in developing broadly contrasted emotions to a melodramatic climax came to her aid, that she rose to any great height. Tortured by the diabolic inventions of the Spanish inquisition, she met attack after attack with superb disdain, trenchant scorn, and a large pity for human frailty; and was swayed and broken at last only when she found that her lover's life and honor depended upon her falsely declaring that she was indeed the witch the superstitious Christians imagined her.

She delivered her tirade with an inner reserve of power, an outward passion of hatred that was dampened by no possible comparison, and her final moment of suffering self-sacrifice roused the house to a spontaneous outburst of applause. The big bow-wow is not her metier; but if there is any English-speaking actress who could play this part with more distinction and power, her name does not now come to mind.

But the play! "The Sorceress" has all the spectacular appeal of the pieces which Sardou has of late years written for Sir Henry Irving—"Robespierre" and "Dante." Each of its five scenes is a vast and richly colored composition of romantic life under the Inquisition, with its mingling of the half barbaric splendors of Moor and Christian, of the gorgeous habiliments of the insolent Spanish army and the scarcely less gorgeous vestments of the Spanish Church—all magnificently realized on the stage.

But "The Sorceress" is not, as those pieces were, "Sardou for export only"—a mere jumble of ill-composed scenes and passions, without even the theatric appeal for which their author is famous—and infamous. It cannot, to be sure, be said that it shows the originality and the firmness of the hand that wrote "La Tosca." One somehow feels the duller invention, the colder passions of age. Yet the story is cleverly conceived, and is deployed through five acts (which are rather a prologue and four acts) with all the precision and some of the effective unexpectedness of the traditional "well-made play."

Sardou's astuteness is shown in his use of our modern knowledge of hypnotism to create his main situation. To us, Zoraya is not a sorceress, but a Portia of medicine. She has inherited from her physician father the lore of the Saracen, which was in fact beyond anything then known to the Christendom of 1507, and which we readily believe to have included a use of the marvels only lately made known to us by science. Her persecution—and the theatric surprise of the evening—arise from the fact that she heals in charity the maladies that have defied the Spanish doctors.

In the hour in which she is condemned to be burned as a witch, it is so contrived that she has left Joana, daughter of the Governor of Toledo, in a beneficent hypnotic sleep, from which, if Zoraya dies, no one can awaken her. In the last great moment of the play Zoraya agrees to awaken Joana as the price of her release from the fagots. The girl is brought in on a couch. Zoraya, in the presence of the mob gathered to witness her own death, raises her as if from the dead, and is herself freed.

But, though released by the bargain from the terms of the Inquisition, she falls victim to a new and unexpected danger. The populace, having witnessed the exercise of what is to it the black art, falls upon her to force her to the burning. At bay with her Christian lover on the steps of the cathedral, they both take poison with a kiss, and roll in death to the feet of the infuriated mob.

The love story shows something less of the accustomed tact, at least from the point of view of romantic and dramatic interest. Zoraya's lover, a young Christian guardsman, Enriquez, is betrothed to the daughter of the Governor, even while he is carrying on his hazardous intrigue with Zoraya, and rather basely keeps Zoraya in ignorance of these facts. Such a love motive, if treated sincerely from the point of view of human character and emotion, would no doubt engross the Parisian; but as the spring which moves the rather primitive and conventional figures of Sardou romance it is to be doubted whether they are to be found moving, even on the boulevards. The essence of melodrama is simplicity and universality of appeal—it is nothing if not conventionally moral. It is the story that is to blame for a part of the prevailing lassitude last night.

Granting the materials, however, the action is handled with the accustomed skill. The punishment for intercourse between Christian and Saracen is death; and in combining this motive with the motive of Zoraya's supposed sorcery Sardou has shown the acutest sense of the logic and the effects of the theatre.

The opening scene, in which Zoraya and Enriquez first meet, centres about the cruel punishment of a Christian lover and his Saracen mistress, and the two themes of sorcery and tragic love which it strikes are followed out with increasing

interest until the final curtain. What stagecraft can do to redeem such a theme has been done.

The supporting actors, like the scenic part of the production, were of a very high order. Guy Standing made the transition from modern costume no less successfully than Mrs. Campbell. His figure and plastique were entirely heroic, and he wore his gorgeous renaissance doublets and hose as if to the manner born. The part of the weak-willed, renegade Enriquez rendered any striking effect out of the question; but he left little that was possible.

As an old hag and a young peasant brought in witness of Zoraya's alleged witchcraft, Alice Butler and Gertrude Coghlan had each a moment of intense power that roused the house to an outburst of applause. As the arch inquisitor, the Cardinal Ximenes, Frederick Perry was diabolically sinister in a manner appropriately restrained. The comedy hit of the evening was made by Fuller Mellish, who lent the breadth and unction of the elder school to the part of the physician to the inquisition who was outraged by the triumphant skill of the Saracen practitioners of medicine. A large part of the power of the last act depends upon the effective drilling of the mob. The performance left something to be desired, but was not without striking effect.

It is our modern custom to sneer at Sardou from a somewhat Olympian height, even while applauding to the echo his American imitators. Though the present play and performance are not of the highest quality even in their kind, they are the best of second best; and judging by the reception last night are destined to ample popular recognition.

* * *

November 8, 1904

COMPLICATED "JOHNNY JONES"

George M. Cohan and Ethel Levy, chief entertainers in "Little Johnny Jones," at the Liberty Theatre last evening, have both contracted what may be termed the Dan Daly cult. Both recited rather than sang the songs allotted them in the three-act musical play that now serves as the vehicle for the Four Cohans of vaudeville days.

George Cohan and Ethel Levy both dance well, which counterbalances in great measure either natural deficiencies as vocalists or severe colds. The rest of the company, with the sole exception of Tom Lewis, have little to do except to fill in a lot of pictures, for "Little Johnny Jones" has even less of a dramatic reason for existence than did "The Governor's Son," with which the Cohan family first invaded the legitimate. This Tom Lewis stood out with almost stellar brightness in a bit of character acting as "the unknown," who has a continuous but quiet "jag."

"Little Johnny Jones" has a story based on "Tod" Sloan's experiences as a jockey, coupled with a suspected kidnapping of the girl the jockey loves. It takes a lot of pretty girls dressed in gayly colored costumes, several dances, a number of songs, an Amazonian march that recalled "The Black

Crook" of old Niblo's Garden days, and a constant halo of limelights to straighten out the love affairs of the pair.

* * *

October 31, 1905

SHAW'S PLAY UNFIT; THE CRITICS UNANIMOUS

Police Called to Handle Crush at "Mrs. Warren's Profession"

McADOO SAT IN A BOX

Thinks Shaw Wise in Putting Play in Unpleasant List—Comstock May Get Warrants To-day

Crowds began struggling to get into the Garrick Theatre as early as 6:30 o'clock last evening to see the first performance in this city of George Bernard Shaw's play, "Mrs. Warren's Profession," by the Arnold Daly Company. When the curtain went up there was not a vacant seat in the house, and as many as the management would allow to do so stood back of the rail. Between 2,000 and 3,000 persons had been turned away at the door. Extra police were ordered out to handle the crowd.

It was an audience that had paid for its seats, and many of the typical first-nighters were absent. Knowing that the demand would be great, the speculators got to work early. As much as $30 each was paid for orchestra seats and $5 was the prevailing price for the top gallery. The tickets were eagerly snapped up at these prices.

Dense crowds thronged Thirty-fifth Street between Fifth and Sixth Avenues from 6:30 to 8:30 o'clock, and when those who had tickets began to file in, it was almost impossible for a carriage to force its way to the curb in front of the building. There were as many women as men in the throng. Several policemen were on duty in the lobby and street, but they were powerless to keep the crowds moving.

A slim young man stood in the street and bawled out at intervals: "I have the only unsold ticket for this show in New York, ladies and gentlemen, but I won't have it long."

"How much?" yelled a dozen voices at each announcement.

"Only fifteen dollars?" replied the young man.

He did not seem to have any competitors, and after a time his voice was silenced. He probably got the fifteen. Three policemen in the lobby took turns in declaring to the crowds:

"There ain't no tickets; there ain't no seats on sale; there ain't no admission nor no standin' room on'y."

When the policemen got tired, the man in the box office stopped counting money long enough to emphasize their remarks. He counted money with exasperating coolness, and wrapped up dozens of parcels of it with red strips of paper, on which were printed the inscription, "$100."

McAdoo Saw the Play

One feature of the audience was the presence of a number of young girls. This fact was commented upon by Police

Commissioner McAdoo as he stood watching the theatre squad take care of the crowd that poured out of the house and got into the waiting carriages that stood for a block in each direction in Thirty-fifth Street.

Mr. McAdoo saw the play from start to finish. He occupied one of the upper boxes on the right-hand side of the house. Inspector Brooks was there, too, and so were several of the Headquarters staff. Two of these, at the instance of the Commissioner, went back on the stage after the play was over and Mr. Daly showed them the original prompt book of the play and the cuts he had made in the original business and dialogue.

Anthony Comstock was not in the theatre, but it was said by the management that he had two of his agents there who would make a report to him this morning. It was said that these agents would apply for warrants to-day, and that an effort would be made to have the show stopped to-night. This information came from the management, but how they got it they would not say. It was said for Mr. Daly that he was prepared to meet any of these attacks, and would argue the matter out in court if such a proceeding became necessary.

Many Young Girls There

Police Commissioner McAdoo refused to say anything when he came down stairs after the third act. When the play was over he said:

"I will not say now what I will do, if anything. It appears to me, however, that this is not the usual first night audience at a New York theatre. Most of these people came in their own carriages, and it looks like an opera first night. I don't think that this is a good test of trying it on the dog. The dog in this instance is rather high bred, and the ordinary run of dog may have different ideas." Then looking over the crowd, Mr. McAdoo said:

"Remarkable, isn't it, what a lot of young girls there were in the house tonight? It was also rather interesting for me to find out that there were Raines law hotels in Budapest and several other places on the Continent.

"At least Mr. Shaw is frank when he puts this play in his book among his 'plays unpleasant.' Mr. Daly sent for me to come back on the stage, but I sent word that I couldn't see him this evening."

Mr. Daly's Speech

At the end of the third act, in response to repeated calls, Mr. Daly came before the curtain. He said:

"So much has been said—too much has been said—about 'Mrs. Warren's Profession,' so that I do not intend to go into an ethical discussion as to its fitness or purpose, further than to say that, in my opinion, we should be able to face the problems of life when we attain our majority, and willingly cast off illusions and youthful legends to do our day's work. But I also believe that the person who attempts to disillusionize a child, or to take from them their legends—as of Santa Claus and our revered Washington and his little hatchet—is a brutal and conscienceless destroyer of all that youth owes us. We have many theatres devoted to plays appealing to the romanticist or child.

New York has even provided a hippodrome for such. Surely there should be room in New York for at least one theatre devoted to Truth, however disagreeable Truth may appear.

"If public opinion forces this theatre to close and this play to be withdrawn it will be a sad commentary indeed upon twentieth century so-called civilization and our enlightened new country."

It was said at the box office last night that nearly every seat in the house for the week has been sold. Should the play be stopped the money will be refunded.

The Audience Polled

At the door last night the agents of The New York World gave every one who went in this card:

> In your opinion is "Mrs. Warren's Profession" a play fit to be presented on the American stage?
>
> FIT.
>
> Erase one
>
> UNFIT.
>
> This card will be collected as you leave the theatre.

According to The World's poll, there were 963 persons in the theatre and 576 voted. Of these 304 voted "Fit" and 272 "Unfit."

PLAY STUPID AND VICIOUS
A Performance About as Elevating as a Post-Mortem

WITH: Fred Tyler (Sir George Crofts); George Farren (Mr. Praed); John Findlay (Rev. Samuel Gardner); Arnold Daly (Frank Gardner); Miss Mary Shaw (Mrs. Warren); Miss Chrystal Herne (Miss Vivie Warren).

Arnold Daly has made a serious mistake. "Mrs. Warren's Profession," whatever its merits or demerits as a play for the closet, or as an exposition of the author's views upon a sociological question, has absolutely no place in a theatre before a mixed assemblage such as witnessed it at the Garrick last night. The post-mortem and the clinic undoubtedly have their place as utilities of scientific investigation. But they would lose their value if permitted to become subjects of general and morbid curiosity.

"Mrs. Warren's Profession," as an acted play, bears about the same relation to the drama that the post-mortem bears to the science of which it is a part. Mr. Shaw takes a subject, decayed and reeking, and analyzes it for the edification of those whose unhealthy tastes find satisfaction in morbific suggestion.

As a play to be read by a limited number of persons capable of understanding its significance, of estimating Mr. Shaw and his themes at their full value, and of discounting them through their personal knowledge of him and their general knowledge of the life he seeks to portray, it undoubtedly has

a place. But as a play to be acted before a miscellaneous assemblage, it cannot be accepted.

If there had been any doubt upon that subject it was dispelled after seeing the performance last night. "Mrs. Warren's Profession" is not only of vicious tendency in its exposition, but it is also depressingly stupid. And those who would be likely to condone the first fault will find it extremely difficult to forgive the latter. Lines that impressed themselves upon the mind as one read the play, and whole passages that impressed one in the reading as examples of Mr. Shaw's brilliant capacity for argumentation, when delivered by the actors became simply long, dry, tedious shallows of nugatory talk. The fact that the dialogue had been pruned to some extent was hardly apparent in the actual effect of the representation. The whole thesis involving Mr. Shaw's value as a moralist, of "Mrs. Warren's Profession" as a moral treatise, becomes ridiculous in the consideration of it as acted drama.

As it stood revealed last night, it was neither drama nor moral. It failed to qualify as the one primarily by reason that in its writing no attempt has been made to mould it to any sort of form suggestive of a play to be acted, beyond the fact that it is divided into scenes and its dialogue is framed in the familiar manner of the theatrical manuscript. It failed to qualify as the other by reason of the fact, first, that its lesson, if any, is not conveyed in such a way that it is readily received by an audience; second, by reason of the fact that the audience which had assembled to see it was not prepared to recognize or accept any lesson.

In these matters there is always this element of the audience to be taken into consideration, and here it is that Mr. Shaw in his larger way, and Mr. Daly in his lesser one, have failed to take account of the conditions that exist, that up to the present have always existed, and will probably continue to exist. The persons in the Garrick Theatre last night represented an average theatre assemblage. There was so far as could be determined no preponderance of any one class such as might have been expected under the circumstances.

It was, on the other hand, an audience of average intelligence and of average quality. But when it laughed—and the laughs were few enough—one had the uncomfortable feeling that it was a moment that might better justify tears, and when it applauded one knew that the sentiment would have been more properly met with silence or some show of disapprobation.

While we do not admit that Mr. Shaw's works are as inscrutable or triple-plated with meanings as some of his critics would have us believe, and while there is every reason for attributing much credit to his magnificent powers of mentality, and while we feel that tragic seriousness, not willful flippancy, may be the motive for his work, we must exclude Mrs. Warren from our theatre—reject her, as a moral derelict. She is of no use to us as a lesson or a study.

When she becomes a subject for laughter and amusement, as occurred last night, she is something more than useless—she is vicious. She may serve a purpose when we are free to ponder over her under our own vine and fig tree, without the uncomfortable conviction that others, not, perhaps, so earnest as we, are gaining a certain amount of unholy enjoyment from the utter profundity of the horror.

In the acting of the chief rôle there was exactly the over-emphasis of its more repugnant features that might have been expected. Mary Shaw, an artist of broad experience and undoubted ability, has been successful in the theatre exactly in proportion to her knowledge of theatrical needs. In playing such a rôle as Mrs. Warren she approaches it primarily from the point of view of the actress who knows when and how to get her effects. As a result we find Mrs. Warren depicted from the very outset in the broadest tints.

Miss Shaw lays on her colors too heavily, and the result is that, while giving us a portrait of a person who undoubtedly has existed and unfortunately does exist, she fails to impress us as reproducing the particular type that Mr. Shaw has in mind. Mrs. Warren's exact status would have been at once patent to her daughter and to every one else had she been the sort of person shown to us by Mary Shaw.

Viewed merely as an exhibition of theatrical characterization, however, Miss Shaw's performance justifies a share of appreciative comment. She reflected to an astonishingly offensive, natural degree the abandoned creatures after whom she has evidently modeled her study. It is not the creature of the text, but it is true to the type it seeks to reproduce, so true in fact that it contributes to the generally revolting picture another and a nauseating quality. But, though it was for the most part highly colorful acting, it was acting of a most uneven character. As an artistic achievement it did not approximate her performance in "Ghosts."

Mr. Daly's fault in the exploitation of "Mrs. Warren," however misguided it may have proved itself to be, can in no wise be laid at the door of personal vanity as regards the hope of distinguishing himself in the rôle of Frank Gardner, for it is a part about which he can have had no beforehand delusions. He is perhaps the more to be pitied—that his aim in producing it was so single. There are only two possible exculpating reasons for the acting presentation of the play—a blind, unreasoning desire to revolutionize the moral state-of-being, or else a wholly unnatural and somewhat disgraceful attempt to win much tainted notoriety. Personally we believe Mr. Daly has simply made the error of attaching to this work of Mr. Shaw's an artistically dramatic value which it does not possess.

Of the actors in the cast, Chrystal Herne, though temperamentally opposed to the rôle of Vivie, and generally unable to realize it, had occasional impressive moments, and the others acted as well as could be expected under the circumstances.

* * *

November 7, 1905

A JOYOUS NIGHT WITH "PETER PAN"

Maude Adams Triumphs as "The Boy Who Wouldn't Grow Up"
AN EXQUISITE DREAM PLAY
The Fanciful Barrie, at His Best, Sympathetically Acted—
New York's Second Childhood

WITH: Miss Maude Adams (Peter Pan); Ernest Lawford (Mr. Darling/James Hook); Grace Henderson (Mrs. Darling); Mildred Morris (Wendy Moira Angela Darling); Walter Robinson (John Napoleon Darling); Martha McGraw (Michael Nicolas Darling); Charles H. Weston (Nana); Jane Wren (Tinker Bell); Violet Rand (Tootles); Lula Peck (Nibs); Frances Sedgwick (Slightly); Mabel Kipp (Curly); Katherine Kappell (First Twin); Ella Gilroy (Second Twin); Thomas McGrath (Smee); Wallace Jackson (Starkey); William Henderson (Cookson); Paul Tharp (Cecco); Thomas Valentine (Mullins); Harry Gynette (Jukes); Frederick Raymond (Noodler); Lloyd Carleton (Great Big Little Panther); Margaret Gordon (Tiger Lily); Anna Wheaton (Liza).

Barrie, the fanciful; Barrie, the one-who-will-never-grow-up; Barrie, the talented father of so many sweet and delicate-mind children, has introduced to us another of his fledglings—Peter Pan by name. Peter Pan isn't a play. It is just a gentle jogging of the memory and a reminiscence of your childhood. It is what you remember thinking long ago, or, if you didn't think it, you should have thought it, and weren't a normal child, anyway, so it doesn't matter about you.

Peter comes at such an opportune time, just when there is to be heard in the farthest far distance the jingle of Santa's reindeer bells, and when each of us has a deep-rooted yearning—which none of us would be weak enough to confess—for the power so long gone of feeling the old Christmassy glow and expectation, and the perfectly mad enthusiasm and the pure unadulterated joy of little-boy-and-girldom. To each and every one who has the faintest stirring in his heart of such a yearning let it be said, "You needn't confess it if you're ashamed, but just run over and listen to the message of little Peter Pan, and you can lay the most expensive shaving mug you expect to get at Christmas (or you, Madam, the box of Paris gloves) that you will not be drawn out of yourself into forgetting the latest scandals, and the existence of those strange places of strange amusements called theatres—and you'll lose.

In "The Little White Bird" Peter Pan was a joy to read about. And in the person of Maude Adams, so delicately suited to the child-lore of which the story is a part, Peter Pan is a joy to meet. Winsome, lonely little dreamer of dreams, Peter has lost his shadow. It all happened (don't let there be any dispute, if you please, about the certainty of that. Of course it happened!) because Peter was too fond of gazing in at the children in the nursery, and his shadow got caught in the window sash. Poor little Peter, he wants that shadow, which has been found and kept carefully hidden away in a big drawer by Mrs. Darling, the mother of the three little Darlings, Wendy, John, and Michael, in whose nursery we first meet Peter. So he determines to recover what is his and when the children are asleep he steals in at the window, accompanied by a glancing flame of light and a musical tintinnabulation, ephemeral witnesses that Tinker Bell (of the ilk of the fairies) is his companion, and makes a search for his shadow.

But Wendy wakes, and with the maternal instinct which is sometimes very strong in tiny women of six or so, she offers Peter her sympathy and a kiss. But Peter is ignorant of that most familiar observance of nursery life, and so Wendy withdraws her proffer and gives him a thimble instead. And ever after that to Peter a thimble and a kiss are identical. John and Michael are awakened now, and Peter regales the three with the story (oh, blessed be Barrie) of how children, lost through nursemaidery carelessness, are given sanctuary in the far-off-Never-Never-Never-Land—his home. Their curiosity being aroused, Peter teaches them to fly, and they depart, under the self-assigned guardianship of Wendy, who is already full of the delightful assurance that she shall play mother to the whole party of motherless children in the about-to-be-visited lands.

When they arrive (in the next act) they find the ill-starred charges of careless nursemaids living together most cozily, making their homes in the trunks of trees, and Wendy, true to her instinct, mothers them, one and all. Wendy and John and Michael and the others (all save Peter) fall into the hands of the pirate horde at the head of which is the fearsome James Hook, so-called because of the fashion of his right arm, which ends in a hook instead of a hand, a la Captain Cuttle. (Question: How did the toughty James style himself before his hook came into requisition and christened him, and whence this custom of selecting surnames so late in life?) But to continue. Things look dark for the little hostages, and the audience should properly (if they are any audience at all) prepare to wipe icy beads of terror from their brows. But pshaw! where is our faith? Have you never heard of Peter Pan? Know you not that "Peter the Avenger" is near? Fear not, he will save them. But how?

Like all men of cruel mould, the Terrible Hook has his vulnerable point, his pet bugbear, as it were. This same bugbear (somewhat incongruous this) is in shape of a crocodile, who has feasted off James Hook's hand, when James's hand was where his hook is now. The crocodile, peculiar in tastes—very—and with a mind to finish the meal it had begun, consecrates its life to the mission of pursuing the rest of Hook. But it is unfortunate in its internal organism, for a clock swallowed long ago, and never properly digested, announces its approach in the most baffling way, to the mingled terror and delight of Hook.

Peter is wily. Peter provides himself with a clock and frightens the pirate into hiding. He loosens the bonds of his little friends, saves them from "walking the plank," and sends Hook and his crew splashing over the side. Home now for Wendy, John, and Michael darlings, and happiness for everybody—everybody except little Peter Pan, who is left to gaze in at the window as of old, a pathetically lonely little lad, half child, half fairy.

Maude Adams is Peter—most ingratiatingly simple and sympathetic. True to the fairy idea, true to the child nature, lovely, sweet, and wholesome. She combines all the delicate sprightliness and the gentle, wistful pathos necessary to the rôle, and she is supremely in touch with the spirit of it all.

It was a night of triumph for Maude Adams. But though she is the centre of it all, there are several others in the cast who deserve more space for praise than can be spared just now. Especially Mildred Morris, whose task next to hers was perhaps the most difficult; Ernest Lawford, who in his dual role of Papa and Pirate developed the proper ferocity to suit the case, and his chief bloodthirsty assistant, Thomas McGrath, who was also most excellently ferocious. Violet Rand and Anna Wheaton contributed a share of the generally sympathetic acting, while the dog, the crocodile, and the rest of the live stock were—well, they were very much like life.

All New York may not believe in fairies, but there was no doubt last night, when Tinker Bell was dying, that the audience in the Empire, irrespective of age or condition, had gotten back very near to second childhood.

* * *

December 13, 1905

BERNHARDT IN ONE OF HER GREATEST ROLES

Again Compels Enthusiasm in "La Dame aux Camelias"

FAMILIAR POWERS REVEALED

No Apparent Decrease in Her Capacity for Simulation—A Moving Death Scene

WITH: Mme. Sarah Bernhardt (Marguerite Gauthier); M. Deneubourg (Armand Duval); M. Chameroy (Saint Guadens); M. Krauss (De Varville); M. Piron (Georges Duval); M. Cauroy (La Docteur); M. Guide (Compte de Giray); M. Puylagarde (Gustave); M. Bary (Gaston Rieux); M. Habay (Un Domestique); M. Cartereau (Un Commissionaire); Mlle. Seylor (Nichette); Mme. Boulanger (Nanine); Mlle. Cerda (Olympe); Mme. Irma Perrot (Prudence); Mlle. Alisson (Anais); Mlle. Duc (Un Groom); Mlle. MacLean (Esther); Mlle. Roger (Une Dame).

The role of Marguerite Gauthier was played by Sarah Bernhardt at the Lyric Theatre last night, which is equivalent to the statement that, for the time, the unfortunate Lady of the Camellias became a living, breathing, humanized being, enforcing rapt attention, demanding admiration, compelling sympathy, no matter what one's previous views may have been upon the dubious ethics involved in the familiar Dumas play.

The ordinary superlatives of appreciation fall short when one seeks to describe the actress's achievement in this rôle. More years ago than one likes to remember she made it her own, and exercised the potent spell which was again manifest last night. Time has worked few changes in her methods, has had little effect upon the means she employs to gain her ends.

If there has been any change at all in her playing of the part it is perceptible only in an emphasized repression here and there, a suggestion now and again of an effort to produce her effects with the least possible expenditure of energy of voice and gesture and movement. Her Marguerite Gauthier stands revealed as a portrait, painted for the most part in pastel shades, its subdued tints only now and then relieved by a flare of brilliant coloring.

Of moments of excessive passion the characterization has few, but in the infrequent instances in which suffering and disappointment give the cue for an outburst of emotion, Mme. Bernhardt still succeeds in wringing the heart as few players, we may assume, have ever succeeded in doing. As a matter of fact, not to have seen her as Marguerite Gauthier is not to have seen her at her greatest.

In the varying passages of the five long acts her magnificent accomplishments are in evidence with a steady progression from the lighter phases of a most natural comedy method to the equally natural but more infinitely moving power of heart-rending pathos. As in her performance the night before, the chief occasion for astonishment here is the realization of the fact that to all intents and purposes she is as young to-day as she was forty years ago.

Occasionally, to be sure, her face, revealed in the full glare of light, shows some lines of time underneath its mask of chalk and rouge, but in the Bernhardt's case it is apparently a reversal of the old saying. Here one is justified in believing that the woman is only as old as she feels.

There are actresses on our stage to-day, capable, clever ingenués, who, with all the natural graces in their favor, could not begin to approximate in simulation her reflection of the spirit and abandon of youth. Still, even in the gayest passages of the first two acts one was made to feel the undercurrent of seriousness, the suggested note of impending sadness.

In the presence of such a work of art as Mme. Bernhardt provided last night the ordinary processes of analytical criticism seem hopelessly inadequate. One might indulge in all the verbal extravagances, utilize a board vocabulary, and fall back upon a handy book of synonyms without feeling that justice had been done or the subject exhausted.

To the reviewer, hurried and hastening—for the performance lasted until well on to midnight and linotypes and forms wait for no man—there come memories of scene after scene of the most proficient employment of the means of dramatic expression and execution that can be imagined. Time is lacking for their description even were a description possible. But one may recall, in a word the scene with the elder Duval, which, conceived and executed for a time in a spirit of almost girlish ingenuousness and charm, developed subsequently into an exhibition of hysteria and moving pathos.

Here, as elsewhere, there was never a suggestion of excess, not the slightest semblance of anything that resembled ranting or the tearing of a passion to tatters. And in its very restraint, suggestive of the weakened physical capacity of this creature whose powers were being slowly undermined by disease, there was a tremendously increased impressiveness.

In the fifth act with her slowly sinking vitality, she conveys a touching, childish gleefulness during the exquisite reading of her precious letter—it is a never-to-be- forgotten accomplishment, a perfect fragment of a perfect whole. Her death scene and the scene with Armand and Nanine, just preceding, are so utterly heartbreaking that they leave one with a sensation of comfortless desolation, which is the best possible proof of the wonder of her art.

The Armand Duval of M. Deneubourg is more than ordinarily competent for the most part, though it falls a little short of what one might desire in the occasional dynamic outbursts, such as that with which Armand greets his father after the reading of Marguerite's letter at the close of the third act. In the final scene, however, his exhibition of emotion is so simulative of sincerity that it adds no little to the general impressiveness. The Prudence of Mme. Irma Perrot and the Georges Duval of M. Piron were the other conspicuously competent contributions to the performance.

* * *

January 2, 1906

FAY TEMPLETON AFIELD IN SIGHT OF BROADWAY

George M. Cohan Helps Comedienne Lose Her Way

PUNS AND SENTIMENT

A Combination Which Fails to Show This Artiste at Her Best— Vaudeville Actor's Hit

WITH: Fay Templeton (Mary Jane Jenkins); Lois Ewell (Flora Dora Dean); Julia Ralph (Mrs. David Dean); Marion Singer (Mrs. Purdy); Donald Brian (Tom Bennet); Victor Moore (Kid Burns); Charles Prince (James Blake); James H. Manning (Daniel Cronin); Louis R. Grisel (Andy Gray, the butler); Maurice Elliot (Station Master); Floyd E. Francis (Police Sergeant) Nat Royster (Messenger Boy); Mabel Ellis (Polly Poughkeepsie) Fern Minard (Pauline Peekskill); Desiree Lazard (Tessy Tarrytown); Hazel Cox (Fannie Fordham); Madeline Le Boeuf (Rosie Rye); Marguerite Lane (Minnie Melrose); Nevada Maynard (Teresa Tuckahoe); Margarette Masi (Winnie Wakefield).

Fay Templeton was lost last night, and it happened not forty-five minutes from Broadway. Which fact is very surprising when one remembers that the comedienne, herself no stranger in New York, had on this occasion as her chief pilot into town that astute young man, George M. Cohan, who is generally credited with being particularly well informed regarding the metropolis.

It was simply a case of two very clever people wandering afield. Mr. Cohan, who has a capital idea of the writing and staging of musical comedies, made the error of attempting something which, beginning in that vein, was interesting, and developing into melodrama of a very obvious sort, became most tiresome.

"Forty-five Minutes from Broadway" makes few demands upon Fay Templeton's best talents, and it requires from her an effort at a sort of emotional expression, which, however clever her simulation—and it is clever—proves ineffective, by reason of her peculiar personal equipment and the previous condition of her servitude. Having laughed at Fay Templeton all these years it is asking too much to expect people to cry with her. This Mr. Cohan does. In other words "Forty-five From Broadway" is a case of oil and water. Its ingredients do not mix.

If Miss Templeton were less an artiste it is not impossible that she would have succeeded better. "She hasn't handed me a laugh to-night," remarked the comedienne at one place in the proceedings, and the line about described the efforts of George M. Cohan as far as Miss Templeton is concerned. That is not to say that there was not plenty of laughter in the New Amsterdam Theatre last night. An easily satisfied assemblage went into paroxysms over the most distressing puns, and Miss Templeton's part, when not serious, is mostly puns. When it is not puns—that is to say, when the actress is not talking at all— she is generally skulking in the background, in doorways, or up a flight of stairs, ready to hear the whispered secrets of plotting villains, or emerge triumphantly in time to foil the Irish gentleman-burglar about to rob the hero's safe.

There are four or five capital songs in the first act of the play, sung with spirit, and with business that is novel and effective. That is where the hand of George M. Cohan apparently shows itself at its best. Later a missing will turns up— that long-lost, missing will—which eventually is the means of transforming poor, honest, hard-working Mary Jane Jenkins (Miss Templeton) into a lady of wealth and position. In the meantime the supposed heir to the millions has fallen in love with a chorus girl, is a slave to her hectoring mother, and tries to enjoy himself by showing the good people of New Rochelle what it is to be "a real, live sport." Mary, on her part, has been betrayed by Daniel Cronin, a villainous Irishman, but wins the affection of Kid Burns, ex-race horse tout and personified fable-in-slang.

This Burns is the source of most of the amusement contained in "Forty-five Minutes From Broadway." Played by Victor Moore, who has only recently been transferred from the vaudeville stage where he was deservedly a favorite, he repeats his success here. He has most of the good lines of the play, but it may be said to his credit that many others take on a quality of humor simply because he has a natural and unctuous manner of speaking them. And his occasional lapses into sentiment have a genuine ring.

On the others in the cast the demands are slight, but Lois Ewell pleased by reason of a dainty personality, and Julia Ralph was successful in an unpleasantly aggressive role.

* * *

September 25, 1906

THE RED MILL

MERRILY GOES THE MILL

Sails Swing Round to Gay Music and Laughter at the Knickerbocker

"While the Going is Good." That is the name of a song and they sing it in "The Red Mill," which began to go last night at the Knickerbocker Theatre. It is an apt song. The going in "The Red Mill" is always good—or so nearly so that it is quite superfluous to note exceptions. Mr. Victor Herbert's music, Mr. Henry Blossom's lines, the droll extravagances of Messrs. Montgomery and Stone, and a clever and well-trained company combine with beautiful stage settings to cheer the heart, delight the eye, charm the ear, tickle the fancy, and wreath the face in smiles. At least that was the effect upon the people who filled the house—stalls, galleries, and standing room—last night. One rarely hears at a first performance so much hearty and unmistakably spontaneous handclapping or such satisfactory laughter. And the people were singing and humming the music as they came out.

Particulars are not, perhaps, altogether necessary, but they are plenty, and some may as well be given. Fred Stone and David Montgomery, famous as scarecrows and thugs, represent here two impeounious Americans detained for board bills at the inn of Willem at Katwyk-am-Zoe. The Red Mill stands in the middle of the stage with practicable sails. Willem has a daughter, Tina (Ethol Johnson), an exceedingly well-turned, springy young person. There is the Burgomaster (Edward Begley), foursquare of figure, most mechanically pompous. He also has a daughter, Gretchen (Augusta Greenleaf), and a sister (Aline Crater), the first in love with the wrong man, though engaged to the right one, and both in conspiracy against the rightful guardian. The mill serves as a prison for Gretchen and as a place from the top of which she can sing sentimentally, musically, and effectively, while the practicable sails enable the Americans to rescue her. They swing up by these sails and swing down on the other side, one of them holding on by one hand and grasping Gretchen about the waist with the other arm. It is a thrilling moment.

Thus, indeed, amid thunders of applause, ends the first act. In the second act, quaintly uniformed in blue deft at the Burgomaster's hall, Miss Crater has a song with a chorus of the most picturesque domestics all armed with brooms. You learn that Grechen's wedding is due and the bride is lost. Montgomery and Stone enter disguised as Italian hurdy-gurdy men. They are funnier than ever. The monkey is there also. Next comes the bridegroom, the Governor of Zeeland (Neal McCay), escorted by hussars and gorgeous to behold. Mr. McCay is a noble old fop, and he sings in a noble, foppish fashion a song with this refrain: "Every day is ladies' day with me."

On the top of that comes Bertha—she's a widow, and her "late husband's means justified his end"—and substitutes for

Gretchen with the Governor's full consent. These two sing the best song in the piece perhaps, taking account of words, music, and execution, "Because You're You."

Montgomery and Stone reappear as Sherlock Holmes and Dr. Watson, summoned by the Burgomaster to find his daughter. Montgomery smokes furiously and Stone says "Mar-vel-ous!" And once more they are funny as can be.

* * *

October 31, 1906

'CAESAR AND CLEOPATRA' AN ARTISTIC TRIUMPH

Earlier Scenes Most Effective as First Acted on the Stage

FORBES-ROBERTSON SUPERB

Gertrude Elliott's Cleopatra Reveals Her as a Most Attractive Commedienne—Play Beautifully Mounted

WITH: Charles Bibby (A Persian Guardsman); Charles Vaughn (Belxanor, Captain of Cleopatra's Guard); Frank Bickley (A Nubian sentinel); Vernon Steel (Bel Affris, military novice from the Temple of Ra, in Memphis); Miss Adeline Bourne (Ftatateeta, Cleopatra's nurse); Forbes-Robertson (Julius Caesar, aged 54); Miss Gertrude Elliott (Cleopatra, aged 16); Charles Langley (Pothinus, Ptolemy's guardian); S. T. Pearce (Theodotus, Ptolemy's tutor); Sidney Carlisle (Ptolemy XIV, Cleopatra's brother); Halliwell Hobbes (Achillas, Ptolemy's chief General); Percy Rhodes (Rufio, Caesar's Lieutenant); Ian Robertson (Brittanus, Caesar's secretary, a Briton); Walter Ringham (Lucius Septimius, military tribune in Alexandria); W. Pilling (A Wounded Soldier); Frank Ridley (A Professor of Music); Miss Dorothy Paget (Charmian); Miss Esme Hubbard (Iras); J. Herbert Beaumont (A Major Domo); A. Hylton Allen (Apollodorus, the Sicilian).

It is not often that an actor meets with such an ovation as was Forbes-Robertson's last night at the end of the first act of "Caesar and Cleopatra." It was a triumph for the artist, for Miss Elliott and last, but by no means least, for George Bernard Shaw. And in justice to each of these it must be said that there was every reason why it should have been so. But that burst of enthusiasm was of the exhausting kind. It made what followed seem comparatively tame.

Caesar and Cleopatra is a delightful play to read, and though there were undoubtedly those at the New Amsterdam last night who will not share the sentiment it is a most delightful play to see. Not all of it is as engrossing as the scene of Caesar's meeting with Cleopatra in the first act, in fact there are times when the interest of even the most zealous Shawite must flag, but it mingles throughout such a spirit of pure fun with such amazing touches of true dignity and tenderness that one must be a dullard, indeed, who will not enjoy it. What does it matter if it is or is not history?

Mr. Shaw refers to a lot of authorities to prove his case about Caesar. But some of us at least in the spirit of thanksgiving are quite willing to let the authorities go hang, for whether this Caesar ever divided Gaul into three parts or not

he is—with his keen sense of humor, his gentle philosophy, and his masterful resource—a rare figure in a play.

Mr. Shaw has been fortunate in his interpretations. There is not a mood in the role which Mr. Forbes-Robertson does not compass. He might be more forceful perhaps in an occasional passage, such as that, for instance, in which he exclaims in horror at the revelation of the death of Pothinus, but what the scene loses in dynamics it gains in tremendous, if necessarily enforced, physical repression. Certainly nothing could be finer than the scene in which he turns in denunciation on the boasting Lucius, who has sought to make a virtue of his share in the death of Pompey.

In the hurried notice possible between the close of such a performance and the going to press one can do faint justice to the acting, to its varied phases, and many excellencies. But the briefest record must take account of the actor's success in showing forth the underlying humor of the character as Mr. Shaw has drawn it. It is a vein of conscious, almost melancholy mirth at times, and is conveyed most expressively and most engagingly.

There are moments when this Caesar is like Hamlet—not because the best of the living Hamlets is playing him—but because he is so situated that there is a resemblance in speech and plan. Pothinus is a bit of a Polonius in his way, cut from the same cloth, colored in the same dye, with much the same garrulousness and guile.

There does not appear to be any good reason why the play, in successive representations, should not be subjected to cuts. A whole act was omitted last night without ill-effect. Caesar and Cleopatra cannot be cut down to situations, of course, for Mr. Shaw's method defies the methods of ordinary procedure. But the opening scene of the first act, with its verbose exposition; the scene in Cleopatra's chamber, and the one upon the rooftops might be pruned with distinct advantage to the whole.

In producing the play the hand of sympathetic and intelligent stage direction is discernible. The scene pictures are rich and apparently correct in archaeological detail. The picture disclosing the murdered Ftatatteta—the name is quite as difficult to spell as to pronounce—lying dead before the blood-spattered altar of Ra left the spectators somewhat cold, probably through sheer horror of the gruesome spectacle. But the audience at the New Amsterdam enthused most properly at the picture in the first act when the lifting loom revealed that sleeping Cleopatra resting between the paws of the Sphinx, her head reposing on a mass of poppies. And in that indescribably humorous scene which follows Miss Gertrude Elliott very quickly demonstrated her fitness for the difficult task with which she had been intrusted.

Her Cleopatra is the character Shaw has drawn filled with girlish spirit, lightened on the one side with the playful humor of childish fear, darkened on the other side by the vengeful cruelty of superstition and suddenly acquired power. It will perhaps be argued that in occasional later scenes Miss Elliott lacks the power of dominating majesty. But Mr. Shaw's Cleopatra, with her schoolgirl ideal of love maintained until the last, is at no time regal, and Miss Elliott's playing is in harmony with the text. She reads with beautiful variety, and there is not a single mannerism to mar the flow of eloquence. And she is beautiful with a strange sort of dusky beauty that fulfills the ideal of this youthful Cleopatra.

There are other excellent acting achievements in this performance, which can only be briefly mentioned, notably the grim Ftatateeta of Miss Adeline Bourne, the bluff "Rufio" of Percy Rhodes, and the slow, drawling, typically British "Britannicus" of Ian Robertson.

The story treats of the visit of Julius Caesar to Egypt at the end of the thirty-third dynasty, the Winter of 706–7 in Rome; Christian computation, October, 48 B. C., to March, 47 B. C.

At the time of Caesar's arrival in Egypt two factions were contending for the throne. Ptolemy Dionysus, aged 10, reigned in the palace at Alexandria, supported by Archillas, the General of the Roman army of occupation left by Aulus Gabinius. The supporters of Cleopatra have fled with her to a palace on the borders of Syria.

The opening scene is laid within the walls of a palace on the Syrian border of Egypt. This palace, an old, low Syrian building of whitened mud, Mr. Shaw takes pains to explain, was not so ugly as Buckingham palace. The courtyard is filled with officers and soldiers of the Egyptian army, and the action begins with the arrival of Bel Affris, a military novice from the temple of Ra, in Memphis. He comes to bring to Cleopatra information of the approach of the Roman army under Julius Caesar, who, it is announced, has landed on the shores of Egypt and will make himself master of the country. Great excitement follows this announcement, and Ftatateeta, the nurse and guardian of Cleopatra, finds that in the confusion the young Princess has disappeared.

The scene changes to a sphinx in the desert, disclosing Cleopatra asleep between its paws in a heap of red poppies. Then out of the deep silence of the night comes a man in Roman armor, lost in contemplation. This man is Julius Caesar. Caesar discovers Cleopatra's identity, but she does not recognize him as the conqueror. The scene changes to the throne room of the palace, where Cleopatra, still ignorant of Caesar's identity, is crowned by him Queen of Egypt. As the Roman soldiers troop in tumultuously they dress in military order opposite the throne, lift their swords in salutation, and exclaim "Hail, Caesar!" to Cleopatra's astonishment.

The scene of the second act is the council chamber of the Chancellors of the King's Treasury in Alexandria, some days later. The young King, a mixture in character of boyish impotence and petulance, is on the throne. The King, guided by a Minister, relates the history of his house and the restoration of his father to the throne by Mark Antony. Now his sister, Cleopatra, has cast a spell on Julius Caesar to lead him to uphold her false pretense to the rule of Egypt. Caesar comes and demands the payment of the debt contracted by Ptolemy's father with the Roman Triumvirate. This refused, he desires to settle the question in dispute between Ptolemy and Cleopatra, and, to the surprise of all, produces the young Queen. His proposal that Ptolemy and Cleopatra shall reign jointly is rejected by Achillas and Lucius Septimius, who

command greater Roman and Egyptian military force than Caesar, and the act ends in a battle and the great fire in which the library is destroyed.

In this act Cleopatra mentions to Caesar the beautiful young man with strong, round arms, who came over the desert with many horsemen and slew her sister's husband, and gave her father back his throne. "I was only 12 then," she says, wistfully: "I wish he would come again now that I am Queen. I would make him my husband," and Caesar responds: "It might be managed, perhaps, for it was I who sent the beautiful young man to help your father."

The third act is presented in two scenes, one representing a room in the palace and the other the roof gorgeously decorated. Pothinus, Ptolemy's guardian, proposes to Cleopatra that she betray Caesar. When she refuses he denounces her to Caesar as a traitor. She revengefully orders Ftatateeta, her nurse, to kill Pothinus, and this tragedy brings about an attack on the palace by his followers. The act ends with the killing of the nurse by Rufio, Caesar's lieutenant.

The last scene as the play has been prepared for the stage shows the East Harbor with Caesar's galley ready to sail for Rome. The campaign is over. Ptolemy has been drowned in a battle with the legions of Caesar and Cleopatra is now really Queen. Caesar appoints Rufio Roman Governor, and is about to board his galley to depart when Cleopatra comes in black, mourning for her nurse. Their parting is brief, and as he sails he tells her he will send Mark Antony, "a Roman from head to heel," for whom she has already voiced a decided preference.

* * *

November 14, 1906

MME. NAZIMOVA GREAT IN "HEDDA GABLER"

Playing in English, She Scores a Remarkable Success

A BRILLIANT ACHIEVEMENT

Generally Superior Performance of Ibsen's Morbid Play—Actress's Reply to Demand for Speech

WITH: John Findlay (George Tesman); Dodson Mitchell (Judge Brack); John Blair (Eilert Lovborg); Mrs. Thomas Whiffen (Miss Juliana Tesman); Miss Laura Hope Crews (Mrs. Elvsted); Mrs. Jacques Martin (Bertha); Mme. Alla Nazimova (Hedda Tesman).

The English-speaking stage is richer today by one great artiste, Mme. Alla Nazimova, who, appearing for the first time at the Princess Theatre yesterday afternoon, provided one of the most illuminative and varied performances which our stage has seen in years. Her acting of Hedda Gabler—a rôle rich in possibilities for an actress, but demanding at the same time a most unusual and comprehensive command of the means of expression—places her at one bound in the very first rank of English-speaking actresses.

In the year and a half she has been in this country Mme. Nazimova has done something more than learn to speak the tongue, as the phrase is ordinarily understood. She speaks it to-day better than nine-tenths of the recognized leading actresses in America, in respect to the fact that she gives its letters and sounds their proper values, demonstrating in the pliant mather of her enunciation that the language is lacking in neither richness nor variety. It may seem strange that this lesson had to be learned from a Russian woman; but it is not strange when one remembers that the actress was trained in a school where it is not deemed unimportant to learn how to use the instruments of human speech.

Mme. Nazimova has not been able as yet to rid herself entirely of an accent. Occasionally there is a foreign flavor to her speech, but peculiarly enough, though the Russian tongue is generally considered cold and hard, the slight accent only seems to lend warmth and richness to her English speech.

In her performances with the Orleneff Company Mme. Nazimova gave ample evidence of exceptional ability. But under the previous conditions much had to be taken for granted. In her English performance the actress reveals powers of imagination, gifts of expression, and a capacity for simulation that could hardly have been more than guessed at before. As she has trained her voice so she has trained her face and body, to respond promptly and freely to every changing mood. After this, for great creative acting, all that remains is that the actress shall be possessed of enough intellectuality or imaginative sympathy to take hold of her author's text, grasp its meaning, and body it forth in expressive and appealing histrionic symbols. This capacity, finally, Mme. Nazimova possesses. She is, in short, one of the remarkable actresses of the times.

If there was any one fault in her performance yesterday it was in a tendency toward too great deliberation, especially in the earlier scenes. Mme. Nazimova's poses are beautiful in their plastic freedom; she is grace incarnate in movement and in repose, with a dark, rich, lustrous beauty of feature, heightened by all the possible artifice of judiciously blended color in costume and drapery. But in the beginning one somehow felt that this Hedda, moving slowly and mechanically under the burden of her wearisome domestic monotony, was also somewhat too much inclined to pause in poses for the mere pleasure of the picture.

The fault is a minor one, however, in an acting achievement full of general and detailed excellence. The suggestion of the woman's loathing of her surroundings, of her contempt for Tesman's commonplace ideas of life, the craving for excitement, and her deliberate embarkation on the enterprise which, though it may ruin other lives, will satisfy her desire for mental sway—all the unhealthy, morbid, depraved phases of this utterly worthless and unfruitful being are outlined and underlined with exquisite precision and directness. There could hardly be anything finer in suggestive reading than her repeated answer, "Yes, I hear," to Tesman's frequent interjection of astonishment. And yet the brief phrase seemed never to be spoken above the tone of ordinary con-

versation. Her irony was acid, her scorn keen, subtle, and far-reaching, yet with occasional flashes of humor, more terrible than anger, because of its underlying bitterness. In the scene with Thea, in which she wheedles the young wife into a confession of her relations with Lovborg, there was a superb suggestion of latent power of malignant passion at moments almost beyond control. The realization of the ignominy of Lovberg's end, the gradual dawning upon her consciousness of the power which Brack holds through his knowledge of the ownership of the pistol, the development of her ultimate resolve to cheat him of the fruits of victory; in short, each successive phase of Hedda's ruinous career, was driven home in the firm strokes of informed, authoritative, sympathetic, and analytic art.

The performance on the whole was maintained on a high level of excellence, Mr. John Findlay's Tesman being the least successful of the contributory characters. Tesman is not a buffoon, and even Hedda, who appreciates him least, remarks that he is not ridiculous. Mr. Findlay made him appear so. Mr. John Blair, less mannered and strutting less than has been his wont of late, was an excellent Lovborg, and the scene of his return after the ill-night orgy was played with a fine suggestion of sincerity. As Mrs. Elvsted, Miss Laura Hope Crews was slightly labored and mechanical in the earlier scenes, but played the later passages most admirably. Mr. Dodson Mitchell's Brack was capital, while Mrs. Whiffen as Juliana Tesman was delightfully sweet, gentle, and winning. The small part of the servant was also well handled by Mrs. Jacques Martin.

The stage direction left little or nothing to be desired. Mr. Henry Miller's devotion to this important branch of dramatic art is a matter for general congratulation.

In response to prolonged applause, Mme. Nazimova said, after some hesitancy: "Let me feel, not speak." It would be fortunate if the injunction could be brought home forcibly to the crowd that constantly demands the destruction of illusion by its vulgar insistence for a "speech."

* * *

November 20, 1906

DIVORCE THEME IN "THE NEW YORK IDEA"

Langdon Mitchell's Play Is Hard, Cold, and Brilliant
SATIRE DOES NOT BITE DEEP
The Piece is Splendidly Acted by Mrs. Fiske, John Mason, George Arliss, and Other Clever Players

A hard, cold, sparkling play, brilliant, wonderfully brilliant in dialogue, a play made possible only by an arrangement of characters in situations suggestive of farce rather than comedy, obviously satirized in its intent, but never quite realizing that intent, a play in which matters that ought to be sacred are handled in the way of irrepressible and irresponsible flip-

pancy; in short, a play which should preach a moral but doesn't because its scintillating diamond dust of wit blinds the sight to deeper things—this is Mr. Langdon Mitchell's "The New York Idea," which Mrs. Fiske—herself hard, cold, and brilliant as her play—and a very superior company of actors produced at the Lyric Theatre last night.

"A woman should marry when she has the whim, and leave the rest to the divorce court"—that is the New York idea as one of the characters boils it down. Obviously, of course, he speaks for the smart set, from among whom Mr. Mitchell selects his types. Obviously, too, his play has about as much of sweetness and of light as the midweeklys which rehash, under very thin disguises, the reeking scandals of the day.

It is hardly the kind of play one would like to see often. It is hardly so representative of actual conditions as its titular intention. But it is clever in invention, though the flow of wit is not often relieved by any sort of gripping action.

"The New York Idea" is the drama of a quadrangle. John Karslake and Mrs. Cynthia Karslake, divorced, are the chief figures. Mrs. Cynthia, after a few months of freedom, is about to contract a new alliance with Philip Fillimore, a Supreme Court Judge, also divorced, heavy, middle-aged, looking for the halcyon calm of second choice, of tea, and toast, and tranquillity.

The complications are also to involve Mrs. Vida Fillimore, the Judge's wife, bored, heartless, but ready to marry again if the right man comes along; finally Sir Wilfrid Gates-Darby, an Englishman of some means and no conscience, but an easy prey to women.

Now bring all these people together, at the home of the Judge, as happens in the first act, and observe the amusing result. Mrs. Phillimore sets her cap for Karslake. Cynthia, more interested in horse races than in halcyon calm, and her tranquil prospective bridegroom, promptly jealous. The Englishman attracted by both women, ready to marry either, and already making love to both.

There is a delightful passage here where Sir Wilfrid for the first time meets the two ladies with the misses to their names. He congratulates Karslake on the charm of his wife, only to be met with the statement that the lady is not his wife. He indulges in conventional pleasantries with Mrs. Phillimore regarding her husband, then learns that he is not her husband. The situation perplexes him, as well it may, and his perplexity is shown forth with delightful humor by Mr. George Arliss.

Cynthia, of course, conceals from John the exact state of her feelings, but she manages to arrive at Mrs. Phillimore's house the next morning in time to meet her ex-husband there as well as Sir Wilfrid; both of whom have been more or less upon the point of succumbing to the woman's highly colored story of a Garden of Eden where they were to enter, lock the gate and lose the key under a rose bush. Sir Wilfrid has very frankly avowed that he would first propose marriage to Cynthia, but in the event of her refusal would be glad to console himself with Mrs. Phillimore. That lady accepts the alternative.

The Karslakes meet. The wife asks her husband-that-was to forget and forgive. She is to be married at 6 o'clock: why shall they not be friends? He reminds her that she left him for a trifle. He is proud, obdurate. Very well, she is willing, but, she argues, "if we cannot be decent, let us at least be graceful; if we cannot be moral, let us not be vulgar." The value of her sentiment is shown a few minutes later when she accepts Sir Wilfrid's invitation to go with him to the races, although it necessitates a telegram to the Judge asking that their marriage be postponed until 8 o'clock.

In the next act the Judge, like the lady in the song, is waiting at the church. Cynthia, in fact, has telegraphed "Let the church wait." She arrives on the scene at about 10:30. In the face of family protestations the Judge prepares to carry out his part of the contract. John's departure with Mrs. Phillimore, and Cynthia's belief that they are to be married causes her to weaken. She is about to start for the altar, then reconsiders, calls for a cab, departs post haste for John's home in Madison Avenue, and arrives, as she supposes, too late. A wedding has taken place. John's groom assures her of that fact. But Sir Wilfrid and Mrs. Phillimore are the contracting parties.

For a moment there is a sentimental turn. The woman melts into tears. With John's arrival she is again on the defensive. Then they begin to chat in a reminiscent vein. They recall one day when they were in the park together, riding. A man came along who amused them greatly, he rode so badly, so very, very badly. At the recollection Cynthia is off in a gale of mirth. Then she pauses. Who was the man? "Phillimore."

The rest is easy to guess. Phillimore ridiculous. It is the last straw. So once again it will be Mr. and Mrs. Karslake.

Occasionally Mr. Mitchell strains hard to get his laugh. For instance, in the first act Cynthia remarks to Mrs. Fillmore: "You must feel at home in a house where you made so much trouble—I mean tea." The thing is inconceivable. But there are few faults of this kind. One is hardly able to believe, however, that even New York's most sacred social precincts contain such conversationalists, that such brilliancy of speech is common.

But in other respects Mr. Mitchell, with the conjunction of a number of exceptionally able artists, has succeeded in reflecting something that for once gives a very fair impression of smart life.

Mrs. Fiske, precise, correct, absolute, sure of herself, with a show of abundant spirit where it is needed, and with just a suggestion of underlying sentiment in the final scene of reconciliation; Mr. Arliss, delicately and deliciously humorous; Mr. Mason, sturdy, clean-cut, manly, and with a fine suggestion of underlying good spirits; Miss Lea, Mr. Harbury, Mr. Mack—in fact, a complete cast of wholly competent players, do all that is possible with the work.

* * *

January 29, 1907

ELLEN TERRY WELCOMED IN COMEDY BY SHAW

Appears at the Empire in "Captain Brassbound's Conversion"
OVATION FOR THE ACTRESS
Mr. Shaw's Hits at British Judiciary Finds a Ready and Sympathetic Response Here

WITH: Ellen Terry (Lady Cecily Waynflete); Rudge Harding (Sir Howard Hallam); James Carew (Captain Brassbound); George Ingleton (The Rev. Leslie Rankin); George Elton (Felix Drinkwater); Frederick Lloyd (Redbrook); John Macfarlane (Johnson); Tom Paulton (Marzo); David Powell (Sidi el Assif); George Barran (The Cadi of Kintafi); O. P. Heggie (Oaman); James Ferguson (Hassan); W. T. Lovell (Capt. Hamlin Kearney, U. S. N.); John Hood (American Blue Jacket).

Ellen Terry, making her reappearance at the Empire Theatre last night in Bernard Shaw's "Captain Brassbound's Conversion," met with a reception that can leave no doubt in her mind of the loyalty of her great host of American admirers. It is the customary complaint of players that theirs is an ephemeral art; that nothing that they do lives after them to be appreciated by succeeding generations. But they may at least lay this unction to their souls: no other class of artists enjoys the prompt and personal response vouchsafed to the actor.

For Miss Terry last night's performance was an ovation. She was called before the curtain at least a dozen times during the evening, and the audience, as usual demanding its baker's dozen, did not leave the theatre after the final curtain until she had come out of character long enough to express her thanks, while begging to be excused from any further effort in the line of speechmaking.

Of Miss Terry's performance of Cecily Waynflete, the heroine of Mr. Shaw's satirical comedy, it may be frankly said that it will not be one of the rôles upon which her fame, long since established, will need to rest. There is uncertainty in the actress's delivery, hesitancy in her speech, and a restless uneasiness in much that she does, but withal an amazing quality of gracious charm and appealing humor.

For the first two acts Lady Cecily is rather overshadowed by the other characters, but from the time that she begins to exercise her influence on the persons about her, making conquests not only of Capt. Brassbound but of the meanest member of his rapscallion crew, there is an insistent graciousness of manner and persuasiveness in Miss Terry's acting that cannot be resisted.

It is to be presumed that by now playgoers will already have possessed themselves of some information regarding Mr. Shaw's play. It was originally published in "Plays for Puritans," containing also "The Devil's Disciple" and "Caesar and Cleopatra," with both of which our audiences by now are tolerably familiar. But the present work, obviously a satire on conventional justice, and aimed more especially at the British

judiciary, has qualities which may possibly make it more popular with our audiences than the other plays.

Like everything that has come from Mr. Shaw in the way of material for the theatre, it suffers in places from the author's unwillingness to conform to rules, even where observance of them could not possibly work any ill upon his general plan, and might do good. But it is keenly humorous, has two or three characters that are indescribably funny in action, and will be generally intelligible even to those who still insist upon regarding Shaw as enigmatical and vague.

In smiting the general British legal countenance over the head of the Sir Howard Hallam of his story, Mr. Shaw strikes a note of satire which finds a sympathetic response here. And American audiences, familiar as they must be with every detail of the ordinary methods of defense and prosecution, can hardly fail to see the point of some of the keenest of the jests.

Capt. Brassbound, leader of a band of wastrels, outcasts of humanity from many places, though he would scorn to be called a pirate, is in reality a rather dangerous sort of brigand, who manages to ply his trade under the protection of a friendly sheik and who occasionally arranges, for purposes of revenue, to conduct tourists from the port of Mogador to the interior.

An English Judge, Sir Edward Hallam, comes to Mogador, accompanied by his sister-in-law, Lady Cecily Waynflete, who has no end of curiosity and the courage to satisfy it no matter what the hazard. And in a land where certain death awaits the unprotected infidel, there is plenty of danger to be combatted. Lady Cecily, contrary to advice, insists on visiting the spurs of the Atlas Mountains, a region regarded as especially dangerous for the traveler, and Captain Brassbound, after some hesitation, agrees to act as escort.

Then, when the party is isolated in a castle on the hills, far away from probable rescue, it develops, in the coincidental fashion at which Shaw himself would be the first to smile nowadays, that Brassbound is no other than Judge Hallam's nephew, that he owes his uncle an old grudge, and has purposely brought him here to pay back the score. He has arranged that Hallam shall be taken into captivity by the hostile natives, and is well on his way to a consummation of the plan.

But now the influence of Lady Cecily begins to make itself felt. She is past mistress in the art of flattery, and has a pretty way of shaking hands and making friends with every one she meets. Sheiks, Cadis, knooboys—even Felix Drinkwater, otherwise Brandy-Faced Jack, the roughest and toughest of Brassbound's crew—cannot resist her. And Brassbound is finally induced to forego his plans for vengeance.

But the lady's persuasive powers are subjected to a further test, for when the tables are turned and Brassbound and his gang are to be brought down to the coast in chains at the command of an American Captain who has opportunely arrived in a gunboat, she conducts the prosecution with such amazing tact and skill that the entire party is acquitted.

Here, then, we find the dramatist hanging, so to speak on both horns of a dilemma, or rather such might be considered the case were the dramatist another than G. B. Shaw.

What follows is anti-climax, but it is interesting. The brigand—as a brigand—has practically ceased to exist, he has been converted from his evil ways and from being a very decent sort of an interesting rascal, is now a rather weak and colorless person. Obviously according to all the rules of the trade, the least Lady Cecily can now do is to offer him her heart and hand, with the curtain falling on the promise that they will live happily ever after. But, that is not Mr. Shaw's way of doing things.

At the signal gun for Capt. Brassbound to rejoin his ship he suddenly rouses himself as from a dream, bids the lady farewell, and is presumably allowed to go on freebooting to the end of his days. Lady Cecily in the mean time, much perturbed at the idea that she will have to consent to a marriage, now breathes more freely and voices her relief in the brief but emphatic comment, "What an escape!"

Oddly enough, a situation such as might seem to promise most under ordinary conditions in the case of this play failed to carry much weight. But Mr. Shaw is not ordinary even in that. The scene in which Brassbound discloses his identity to Hallam, denouncing the Judge for crimes perpetrated in the name of justice and for actual dishonesty and brutality, is not dramatic, as it should be, and with Miss Terry, as Cecily Wanyflete, sitting calmly by, working on lint bandages and apparently little concerned in the revelations, it develops one of the tedious passages of the play. The trial scene, however, and the successive appearances of Drinkwater, played with exceptionally admirable humor by George Elton, would go far to atone for a far less interesting play.

As Captain Brassbound, James Carew, picturesque, easy, graceful, and generally intelligent in his reading and his acting, gives a fine suggestion of dogged determination and moody strength, though perhaps slightly lacking in any outward vigor of expression. W. T. Lovell plays the American Captain with agreeable effect and an English accent that is delightfully incongruous, and others are generally competent.

The final scene of renunciation both Miss Terry and Mr. Carew play with a fine suggestion of sincerity, and the note of humorous relief blended into the actress's final line is one of those bits of simulation that remain with one a long time as a reminder of what is really natural acting.

* * *

February 26, 1907

MANSFIELD SEEN IN IBSEN'S PEER GYNT

An Astonishing Exhibition of Illuminative and Varied Acting

PLAY AND SPECTACLE

*Curious Blend of Drama, Pictures, and Music,
Interesting in Many Ways*

WITH: Mr. Richard Mansfield (Peer Gynt); Miss Emma Dunn (Ase, his Mother); Mr. Frank Kingdon (Aslak, the blacksmith); Mr. Cecil Magnus (Mads Moen, the bridegroom); Mr. Marc MacDermott (His Father/Monsieur Ballon/Captain of the Ship); Miss Sydney Cowell (His Mother); Miss Adelaide Nowak (Solveig); Miss Ory Dimond (Helga, her sister); Mr. James L. Carhart (Their Father); Miss Vivian Bernard (Their Mother); Mr. Walter Howe (The Hegstad Farmer), Miss Evelyn Loomis (Ingrid, the bride, his daughter); Mr. Kingdon (Mr. Cotton); Mr. Mendelssohn (Herr Von Eberkopf); Ernest C. Warde (Herr Trumpeterstrale); Miss Irene Frahar (Anitra); SUPERNATURAL BEINGS: Miss Gertrude Gheen (The Green Clad Woman); Henry Wenman (The King of the Dovre Trolls); Mr. Thomas (First Troll Imp); Mr. Prescott (Second Troll Imp); Arthur Row (Third Troll Imp); Mr. McDonald (The Ugly Brat); Arthur Forrest (The Strange Passenger/The Button Moulder).

Mr. Mansfield acted "Peer Gynt" at the New Amsterdam last night with the vigor, variety, and definite authority which have come to be associated with his accomplishments as with that of no other of our American players, and if he did not always succeed in making the poem appear dramatic in the sense in which the word is employed in the theatre, he probably did more than has ever been done with it before, and as much as could be done under any possible conditions.

Providing in himself a thoroughly comprehensive and intellectual embodiment of Ibsen's remarkable "hero" he has apparently spared no pains to put the poem into action in a manner befitting its dignity and importance. It is a curious work, this fantastical "Peer Gynt," generally translatable into the moods of human experience, if one so views it, equally capable of creating a condition of mental obfuscation, if one persists in regarding its obscurities. For it has obscurities despite the labor of much intelligent commentary.

If Mr. Mansfield does not succeed then in making entirely clear during some three hours of performance all that the poet has tried to express, and if there are moments when the human element of intelligent elucidation goes down under the load of extrinsic adornment, including scenery and lights and much music, it is only what might have been expected.

The character, however, despite efforts to make its meaning vague, is one that lends itself reasonably enough to the usual symbols of great acting. In the poem Ibsen has limned Peer Gynt with enough clearness to enable the actor to build upon such inspiration as the printed page affords a creature of flesh and blood who will objectively present a type.

Regard Peer Gynt, if you will, as the symbol of Norway herself, or regard him as a mere abstraction, or accept him as a concrete conveyance of the lesson of self-surrender, and

the fact still remains that Ibsen has put his premise and argument and final deduction into the form of a human being; as such the central figure must be acted. Peer's lusts, his desires, all his wavering impulses and strivings, his compromises, his selfishness and greed—these express themselves readily and intelligibly, and they are so expressed by the player in action.

The supernatural element, if one may call that supernatural which in reality represents psychic and the mental states, permits more license, The Dovre King and the Trolls, the Green Clad Woman and her Brat, even the great Boyg himself "spirit of compromise," with his insistent injunction to "Go Round"—these are at once the easiest and most difficult of theatrical tests. They are easy since they must follow no given law, for who shall say how a troll will act, how the Boyg will deliver his instructions? They are difficult, because to be impressive in their grotesquerie they demand a condition of extreme imaginative elasticity on the part of those who view them.

It speaks much for Mr. Mansfield's dominant personality, for his artistic feeling for effect, and for his capacity in individual simulation and general direction that he is able to hold his audience in an expectant and sympathetic mood through this long and varying spectacle. For when all is said and done, much of "Peer Gynt," as we have it on the stage, is spectacle—not pure and simple, as the saying goes, but decidedly turgid and obscure. So, at least, it must seem to the ninety-nine out of every hundred in the theatregoing crowd who know their plays only as they see them on the boards, whether the playwright be Fitch or Ibsen or Theodore Kremer.

Into the acting, however, Mr. Mansfield throws all the ardor of eager and enthusiastic art. His Peer Gynt is an amazing exposition of variety in virtuosity. A complete catalogue of his accomplishments is impossible, however, in the hurried review of a first night that lasted until well on to 12 o'clock. Disclosed first as the boy Gynt, made drunk in the wine of his own egoistic longings, and carried through space on the whirlwind fancy of his own imagination, he appears a picture of vigorous youth, strong and lithe of limb, with a strange dark face, the sensitiveness of which is emphasized in full rich lips and black slanting brows. Sensuous, dreamy, playful, and boisterous by turns, he is momentarily tender with his mother, then bitterly ironic. The story of the reindeer ride becomes a panoramic revelation in utterance. Similarly the tale of how he imprisoned the devil in a nut is an amazing recital in a mood of audacity.

In the scene where his self-confidence is gradually conquered by fear of the unknown and where the visions of his weaknesses and desires confront him in the shape of the ghastly trolls, he passes from the state of flaunting insolence to frozen fear and despair, culminating in the pitiful appeal, "Mother help me—I die," and leading up to the sharp struggle with the Boyg, represented by flashes of light and a voice in the darkness. The voice was so muffled last night that the words were inaudible, and in consequence the scene took on more mystery than is necessary.

There is momentary premise of happier, cleaner, sweeter things in the meeting with Solveig, interrupted by the appearance of the Green Clad Woman and her Brat, typical of Peer's sin, and the cue for his sudden realization of the instability of hope. This passage, as Mr. Mansfield plays it, is filled with qualities suggestive of a wild, vague, groping after the unattainable and a sense of despair and abasement. Even finer, perhaps, as an acting achievement is the scene immediately following—the farewell to Solveig, leading up to the speech, "Be the way long or short, you must wait." It is given with a wealth of sympathy and tenderness.

If one contrasts this scene, or the remarkable one of Asa's death, describing the wonderful drive to the gates of Paradise—and Mr. Mansfield leaves nothing to be desired in his reading of that scene—with the one in which he next appears as the smooth, smug, venerable merchant drinking his wine under the palms and entertaining his friends with tales of his illicit traffic, some idea of the actor's versatility is gained. The fantastic disappears, modernity is at hand, in the crisp, dry understandable humor of every day. One can hardly recall any scene in comedy more delightful.

There is a sense of uncertainty again in the scene of the shipwreck, and all that immediately precedes it for the whistling of wind, the darkened stage, and the hurried utterances of all the people on the stage, combine to defeat hearing. But the wreck is excellently managed, and is mechanically effective. To the end of the chapter he passes, making the change in appearance to the person of a little, weazened, dried-up hulk of humanity, adrift on the shores of time. The meeting with the button molder, and the return to Solveig, completes the tale. Of the former's part in the drama there is scarcely enough to be clear, and yet more one would hardly demand. The incident of Peer's meeting with Anitra and her robbery of him is entirely omitted and the execution of a graceful dance by Miss Frahar is all that excuses Anitra's presence.

There is only time now for a word in commendation of Miss Nowak's "Solveig," eminently satisfying in its suggestion of gentleness and spirituality, and of Miss Dunn's Asa, which is excellently played. Mr. Wenman conveys the Dovre King in what one may accept as a properly grotesque spirit, and Mr. Forrest is impressive in what remains of the Button Moulder. Peer Gynt's foreign friends on the coast of Morocco are very badly played, but in other respects the cast meets requirements.

* * *

SUPERB STUDY IN MOVING PATHOS

By Miss Barrymore in John Galsworthy's Remarkable Play "The Silver Box"

A CRITICISM OF LIFE

Mr. McRae Divides Attention and Several Others Give Excellent Support

WITH: Eugene Jepson (John Barthwick); Hattie Russell (Mrs. Barthwick); Harry Redding (Jack Barthwick); William Sampson (Roper); Ethel Barrymore (Mrs. Jones); William Evans (Marlow); Anita Rothe (Wheeler); Bruce McRae (Jones); Fanny L. Burt (Mrs. Seddon); James Kearney (Snow); Forrest Robinson (Julius Holden); Mary Nash (An Unknown Lady); Dorothey Scherer, Helen Mooney (Two Little Girls); Soldene Powell (Livens, their father); Louis Eagan (Clerk of the Court); M. B. Pollock (Relieving Officer); Howard Hull (Swearing Clerk); Harry Barker (Constable).

A grim story of life set forth in the simple narrative of reality with as little as possible of the dramatist's underlining for effect—this is John Galsworthy's "The Silver Box," acted at the Empire last night and acted in the principal rôle by Miss Barrymore with such essential realization of its inherent tragedy that the impression will remain long after the play has faded from view.

In respect to old conventions "The Silver Box" is not a well-made play. But it is a deal more interesting than most of those that are well made. That is because Mr. Galsworthy has a story to tell that is worth the telling. That he is, also, a man with a mental bias is apparent. He believes, for example, that since the prevailing social structure is maintained through laws, those laws ought to be operative in the case of rich and poor alike; but he has the propagandist trick of overlooking the existence of virtue on the opposite side of argument. All his prosperous people are quite heartless; all his poor, if not exactly saints, more sinned against than sinning.

When all is said and done, however, he offers a series of well-conceived incidents growing out of a plausible experience, and so presented as to make the most for sympathy. One feels the tang of observant cynicism behind the tale, but in itself it is the outgrowth of the cold, hard, unrelenting fatality of fact. Mrs. Jones, charwoman, honest, long-suffering, decent as circumstances will allow, goes down to misfortune through the force of circumstances beyond her control and outside of her understanding.

A night of dissipation on the part of young Jack Barthwick, son of Mr. John Barthwick, M. P., provides a beginning for the sorry tale. Jack has been visiting a young woman—not of his class—and in a moment of high dudgeon, helped on by too much wine, has carried away her reticule. Unable to find the keyhole of his own domicile, he is aided into the house by Mr. Jones, vagrant, who has a habit of hanging around the neighborhood, as his wife is charwoman in the Barthwick house. The youth tells the man how he has "scored off" his female

acquaintance, which prompts Jones to "score" on his own account after Jack is asleep and he is properly maudlin with liquor. A silver cigarette case first tempts him; then he happens to see a silk purse that has fallen from the reticule unperceived by Jack. Morning brings a visit from Jack's female friend, who encounters the elder Barthwick, and is reimbursed after she has hinted at a newspaper scandal. The son, mystified as to the circumstances surrounding the purse, is further confused when the servant brings news of the missing box. Suspicion points to Mrs. Jones, the charwoman, as she has been the only servant alone in the room. This much is told in three or four short scenes comprising the first act.

The second act shows the bare and squalid lodgings of the Joneses. Mr. Jones, aroused from sleeping, rails against the world in general, and announces his own particular intention of giving up the hunt for work. The story of the purse comes out, and a moment later Mrs. Jones discovers the silver box. She insists on taking it back to the owner, and while the pair quarrel a detective enters, perceives the box, and is convinced of the woman's guilt. Here Jones's latent spark of manhood flares up; he insists that he is the culprit, and springs at the detective's throat as he is about to put handcuffs on the wife. Result, a charge of assault for Jones, in addition to one of robbery for his luckless wife.

A third act reveals the plans of the Barthwicks to keep their own escutcheon clean, and in the fourth, with the scene of a courtroom that object is accomplished. Mrs. Jones is acquitted, but her husband is sentenced to hard labor for a month. The young cub's offense, however, has been entirely hushed up.

There has never been a better opportunity to judge Miss Barrymore's genuine claim as an artist away from the allurement of her charming personality. In the charwoman one still sees traces of youth and good looks which years of brutal living have not effaced, but Mrs. Jones is, on the whole, a poor, broken creature, taking life not exactly in patience, but as a matter "of course," with a whine of self-pity as her only solace. Her hands are grimy, her hair matted, and anaemia is written in the dull, leaden pallor of her cheeks. A blow given by her husband has left a permanent ailment, and to add to the general misery there are children who cannot be fed.

All this in dumb pathos is conveyed by Miss Barrymore, who becomes for the time being the embodiment of this miserable plaything of fate. The woman has little imagination, but is able to see the utter futility of her own protests once suspicion has been aroused. In the trial scene she has the wistful, hunted look of an animal—unreasoning, uncomprehending. And at the end with a mute appeal for aid to inflexible authority she stirs the imagination with as moving a picture of haunting pathos as the theatre ever gives.

Not all of the acting is up to the best standard, but Mr. McRae fairly divides attention with a singularly suggestive portrait of the burly husband. The relatively small part of the Barthwicks' man servant is played by William Evans with naturalism seldom excelled. Miss Nash, Mr. Redding, Mr. Powell, and Mr. Robinson fill in smaller parts with distinction.

FILM

June 3, 1908

PICTURE SHOWS IMMORAL

The Rev. Zed Copp Wants the Moving Picture Houses Investigated

Special to The New York Times
WASHINGTON, June 2—The Rev. Zed Copp, the Washington clergyman who sprang into prominence a few months ago by announcing his discovery that hell was located in the sun, appeared in a new role to-day before the District Commissioners.

He has made the discovery that the nickel theatres within the shadow of the dome of the Capitol are immoral, and that 75 per cent. of the moving pictures shown therein are demoralizing. He was supported by a flying column from the Women's Interdenominational Missionary Union.

"Oh, they are awful," he shuddered, "I should say that 5 per cent. are instructive, 20 per cent. are amusing, and the remainder are bad, oh, awfully bad!"

Clergyman Copp said he blushed terribly upon leaving one show, and acknowledged having visited eight of the twenty-five that have sprung up along Pennsylvania Avenue to tempt the Innocent and unsuspecting Senators on their way to and from the Capitol.

The Commissioners promised to investigate the matter. Only after the pledge was given did Mr. Copp lead his flock forth.

* * *

October 10, 1909

BROWNING NOW GIVEN IN MOVING PICTURES

"Pippa Passes" the Latest Play Without Words to be Seen in the Nickelodeons

THE CLASSICS DRAWN UPON

Even Biblical Stories Portrayed for Critical Audiences— Improvement Due to Board of Censors

"Pippa Passes" is being given in the nickelodeons and Browning is being presented to the average motion picture audience, which has received it with applause and is asking for more. This achievement is the present nearest-Boston

record of the reformed moving picture play producing, but from all accounts there seems to be no reason why one may not expect to see soon the intellectual aristocracy of the nickelodeons demanding Kaut's "Prolegomena to Metaphysic" with the Kritek of Pure Reason for a curtain raiser.

Since popular opinion has been expressing itself through the Board of Censors of the People's Institute, such material as "The Odyssy," the Old Testament, Tolstoy, George Eliot, De Maupessant, and Hugo has been drawn upon to furnish the films, in place of the sensational blood-and-thunder variety which brought down public indignation upon the manufacturers six months ago. Browning, however, seems to be the most rarified dramatic stuff up to date.

As for the "Pippa" without words, the first films show the sunlight waking Pippa for her holiday, with light and shade effects like those obtained by the "Secessionist" photographers. Then Pippa goes on her way, dancing and singing; the quarreling family hears her, and forgets its dissension; the taproom brawlers cease their carouse, and so on, with the pictures alternately showing Pippa on her way, and then the effect of her "passing" on the various groups in the Browning poem. The contrast between the "tired business man" at a roof garden and the sweatshop worker applauding Pippa is certainly striking.

That this demand for the classics is genuine is indicated by the fact that the adventurous producers who inaugurated these expensive departures from cheap melodrama are being overwhelmed by orders from the renting agents. Not only the nickelodeons of New York but those of many less pretentious cities and towns are demanding Browning and the other "high-brow effects." The clergymen who denounced the cheap moving picture plays of the past would be surprised and enlightened to find the Biblical teaching, eliminated from the public schools, being taken up in motion pictures. Impressive nativity plays have been given with excellent scenic effects, while Mounet-Sully played Judas in an Easter play prepared by a French firm. An American firm is now specializing on the Old Testament. "Jeptha's Daughter" and "The Judgment of Solomon" have already been given in excellent form, and have proved very popular. A play of Joseph and his brethren is being prepared.

A series of historical plays have been done, and more will follow. An experimental afternoon was given in a public school in Fifth Street, with a programme of instructional plays for history and English courses. One of the district superintendents gave the accompanying talk to assembled teachers and children. The result was regarded as satisfactory,

and more is planned along this line, though no public announcements have been made.

It would be absurd to pretend that the manufacturers had voluntarily turned from cheap to expensive productions. The change has been brought about indirectly through the establishment of the Board of Censorship at the request of the "show men." They were tired of being arrested for questionable plays, which they had only rented from the manufacturers, and were individually powerless to control. They presented their case to the People's Institute, which evolved the censorship plan. Any manufacturer who refused to submit his films to the board was to be blacklisted.

In the very first month the board destroyed $12,000 worth of films. Then the manufacturers began to fall in line and sent orders to their playwrights forbidding "murders, burglaries," and other questionable themes as subject for plays. The board now censors all the films used in New York and 55 per cent of the output for National use, for the censorship is now maintained at the request of the censored. The European producers proved a trifle obdurate and a lengthy correspondence ensued. Pattie Freres, the famous Paris firm, makers of some splendid and some distinctly sophisticated films, were first indignant, then incredulous, but now have settled things by sending only plays for Puritans to their American agents.

In some ways the manufacturers have gone further than the censors in forbidding their authors to construct plots involving battle, murder, and sudden death. The law of the board is not the decalogue, according to John Collier, the General Secretary, but the rules of good taste. "To eliminate all murders would be to eliminate Shakespeare and nearly all the classic drama, which would be absurd. But we object to laboratory displays of crime. We won't have a burglar demonstrate exactly how one picks a lock or jimmies open a door. You must remember our audience consists largely of impressionable children and young people. It is not a Broadway audience. We have Miss Evangeline Whitney and Gustave Straubenmuller of the Board of Education to guide the decisions on what is harmful for children, but the rules of good taste for humor as well as plot are insisted on."

In Chicago, a Police Lieutenant has charge of the censoring, and certain acts of violence are on a proscribed list. Some films are expurgated by merely cutting out the portion of the picture in which the proscribed act occurs. A duel is censored, for instance, by omitting the precise moment at which one of the men is killed. This, the National Board believes, is a typical example of the workings of hard-and-fast censorship rules.

1910–1919

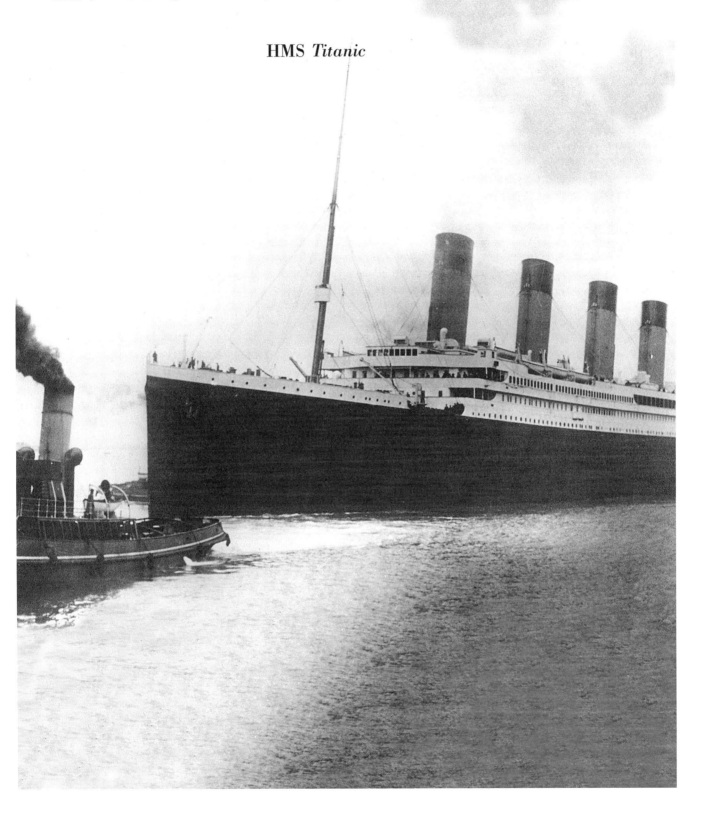

HMS *Titanic*

MAJOR EVENTS OF THE DECADE

Russian artist Wassily Kandinsky begins the first entirely abstract (nonrepresentational) paintings. Over the next three years, he completes the three abstract series *Compositions*, *Improvisations* and *Impressions*.

Launched amidst claims that it was unsinkable, the *Titanic* sinks on its maiden voyage, killing more than 1500 people.

New Mexico and Arizona become states.

In China, the boy emperor Hsuan-t'ung abdicates, ending the long rule of the Manchu emperors. A republic is formed, but unrest continues for many years.

Archduke Ferdinand and his wife are assassinated by a Serb nationalist in Sarajevo, launching World War I in Europe. The major Allied Powers are Britain, France, Russia and Italy. The Central Powers are Germany, Austria-Hungary and Turkey.

The Panama Canal opens, connecting the Atlantic and Pacific oceans.

W.C. Handy publishes "St. Louis Blues," the best-known blues song of the era and influential in defining the blues as a musical genre.

Albert Einstein formulates the general theory of relativity, which revolutionizes the science of physics.

The Easter Rebellion in Ireland protests lack of home rule and is followed by a period of guerrilla-style warfare.

Magaret Sanger opens the first birth control clinic in America.

World War I ends when an armistice is signed on November 11. The following year, the Peace Conference at Versailles produces formal treaties to officially end the war and a resolution to create the League of Nations.

The worldwide influenza pandemic begins. Eventually it will kill 21 million, roughly twice the number of deaths attributed to World War I.

In Germany, Walter Gropius founds the Bauhaus, a school that seeks to unify the arts within the world of architecture in the service of mass production in the modern age.

1910 1911 1912 1913 1914 1915 1916 1917 1918 1919

Mexico's President Porfirio Diaz is overthrown by Francisco Indalecio Madero, which initiates the Mexican Revolution and a long period of political unrest.

Roald Amundsen of Norway becomes the first explorer to reach the South Pole, amidst competition from German, Australian, British and Japanese expeditions.

American composer Irving Berlin writes his first international hit, "Alexander's Ragtime Band." Berlin's continued success helps Tin Pan Alley, the New York base for songwriting, dominate American popular music for over 50 years.

The U.S. Supreme Court upholds recently passed antitrust laws and orders the breakup of the Standard Oil Trust and the American Tobacco Company.

The Triangle Shirtwaist Company fire kills 146 sweatshop workers in New York City. The tragedy leads to more stringent fire safety laws and lends impetus to America's labor movement.

The first female scientist to garner worldwide acclaim, Marie Curie is awarded her second Nobel Prize for her work on radioactive substances.

The Armory Show introduces impressionist and cubist work to America, including Marcel Duchamp's *Nude Descending a Staircase*, which garnered much attention.

The German manufacturing company Neufeldt & Kuhnke develops the armored diving suit with ball-and-socket joints in the arms and legs, facilitating underwater exploration.

Russian composer Igor Stravinsky's ballet *The Rite of Spring* is met with harsh criticism when it premieres in Paris.

A German U-boat sinks the passenger ship *Lusitania*, killing 1198 people.

D.W. Griffith directs *Birth of a Nation*, a feature-length film that represents the culmination of Griffith's innovations in the development of film techniques. The film's racist content is attacked by the liberal and African American press.

Coast-to-coast telephone service begins in the United States.

The U.S. enters World War I.

In the October Revolution, the Bolsheviks led by V.I. Lenin seize control of Russia.

The Pulitzer Prizes, awards for achievement in American journalism and letters, are established.

The Original Dixieland Jazz Band makes the first jazz recording, "Darktown Strutters Ball."

The Fascist movement is founded in Italy by Benito Mussolini.

Mohandas Gandhi (Mahatma) begins a campaign of passive resistance to Britain after that country extends unpopular wartime powers in India.

U.S. Attorney General A. Mitchell Palmer begins the infamous Palmer Raids, a high point in the anti-anarchist, anti-communist Red Scare of the era that entails a severe compromise of civil liberties in the United States and results in the deportation of Emma Goldman, among others.

INTRODUCTION

ART IN THE MIDST OF TURMOIL

By D. J. R. Bruckner

During the decade starting in 1910, the world came unglued. World War I ended the German, Austrian, Ottoman, and Russian empires. The first three were keys to the political coherence of central and eastern Europe and the Middle East, and the fourth stretched from the Baltic to the Pacific—at those latitudes, just short of halfway around the globe—and from the Arctic south to Iran, Turkey, Syria, the Hindu Kush, Mongolia, and China. And in 1911, three years before the war started, the Ch'ing dynasty had collapsed, ending several thousand years of imperial rule in China. Altogether, never had such a large area of the Earth, or so great a portion of its human population, been thrust into political and social disorder in so brief a time.

Americans were as ambivalent about the war after it ended as they had been before the U. S. entered it. From 1914 through 1916, President Woodrow Wilson's stubborn neutrality was very popular, but it was huge private American loans that kept Britain and France on the battlefield against Germany and its allies. When Congress declared war in 1917, popular enthusiasm for the war effort soared as the American Expeditionary Force of 2 million men effectively doubled the Allied forces in the field. But when the war ended in 1918, Americans seemed determined to forget it at once; Wilson won the Nobel Peace Prize, but his own country rejected the League of Nations he had proposed as the keeper of the peace. All people seemed to notice was that France and England had emerged from the conflict almost as bankrupt as the losers and the United States was the world's great economic powerhouse.

At home the war produced some ugly effects. At the time only those Americans whose forbears came from Great Britain outnumbered those whose ancestors came from German-speaking countries. The Alien and Sedition Acts, possibly the harshest instruments of suspicious oppression ever enacted in the U. S., were aimed at that huge latter group and fueled a wave of revulsion against them. Even former President Theodore Roosevelt thundered against what he ominously called "hyphenated Americans." The reaction to the Russian Revolution, itself brought on by the war, was no more benign. In 1919 Attorney General A. Mitchell Palmer ignited a Red Scare that threw suspicion on labor leaders, anarchists, people suspected of socialist sympathies, and foreigners in general. In a one-night sweep of 33 cities, federal authorities arrested 4,000 people on suspicion of subversion. And, in this climate of nervous distrust, a wave of violence broke out against blacks, beginning with a riot by whites in East St. Louis, Illinois, in 1917. By 1919 rioting swept through northern cities, notably New York, Chicago, Omaha, and Washington, and scores of people were killed. In several Southern cities mobs turned out to intimidate returning black veterans of the war.

But amid all this turmoil the one event that may have produced the greatest social changes in the United States was a simple business decision. In 1914 Henry Ford set up the first assembly line for mass production in the world, and he announced that every Ford worker would be paid at least $5 a day. Within a couple of years, Ford was selling millions of Model Ts a year, rather than thousands, and by 1920 he had dropped the price of the car from over $800 to under $300. One impact was immediate: in 1916 Congress passed the first federal appropriations for roads. And that $5 wage symbolized the sudden thrust of the working class into middle-class values and aspirations. Putting a car within the reach of anyone with a job virtually changed the character of ordinary Americans, igniting swift changes in everything from sexual mores to housing to divorce rates. For individual Americans, the Model T was a great deal more revolutionary than politics, domestic or foreign.

Among what Gilbert Seldes called the lively arts, dance was the most somnolent before 1910. Isadora Duncan, Maud Allan, Adeline Genee, and Ruth St. Denis and Ted Shawn had created dedicated audiences, but they were more isolated cults than a public. A few opera companies aped the European tradition by tacking ballet programs onto opera evenings, but the audiences were not there for the dance. The arrival of Anna Pavlova in March 1910 for the first of 15 years of world tours changed everything. That the superbly disciplined prima ballerina of the Russian Imperial Ballet captivated boisterous American audiences still defies explanation. The imperial tradition had already been rendered obsolete by the choreography Mikhail Fokine created for Serge Diaghilev's Ballet Russe, and American audiences had no experience of either. Yet the spark Pavlova struck set ballet in this country on a rocket ride of popularity. Her beauty and grace, and the perfection of her line, stunned diamond-studded crowds in New York, Philadelphia, and Boston and created a buzz out in the streets. And the heroic stature and athleticism of her partner on the first tour, the great dancer Mikhail Mordkin, even silenced much of the prejudice against male dancers.

After that tour Pavlova changed male partners with almost every return trip, so that none ever upstaged her. But a number of them helped develop American ballet. Mordkin established a company and school in New York that trained many people in the cadre from which George Balanchine would draw dancers. Adolf Bolm, another of Pavlova's early partners, returned in 1916 as a member of the Ballet Russe and stayed to the end of his life. He learned choreography the hard way. When Diaghilev was invited to come to America, the war in Europe had already scattered his company, and he had to gather whomever he could to recreate it. In this emergency, Bolm, with little experience as a choreographer, was handed the job of preparing the company, in a few weeks, for the 20 ballets to be presented in New York. The reviews were ecstatic. The Metropolitan Opera then asked him to choreograph *Le Coq d'Or* and *Petrushka.* In 1919 he created *The Birthday of the Infanta* for the Chicago Opera Company, marking the first time a leading Russian ballet star collaborated on a new work with Americans: composer John Alden Carpenter, designer Robert Edmond Jones, and principal dancer Ruth Page. Bolm then became ballet master of Chicago Allied Arts, the most innovative dance organization of the 1920s, before going on to a brilliant choreographing career in San Francisco in the 1930s.

Actually, New Yorkers had caught a sneak peek at a version of the Ballet Russe five years earlier. Sneak peeks—essentially rip-offs—were not uncommon in that era. Taking advantage of the Pavlova explosion in 1910, Gertrude Hoffman, a star in vaudville before she turned producer, put on a Russian ballet program on Broadway in 1911. She reconstructed Fokine choreography, and even some of Leon Bakst's Ballet Russe designs, from memory, and they were a rousing success. Later that year the *Swan Lake* of another imperial Russian dancer, Ekaterina Geltzer, was also a heavy borrower from Diaghilev—without permission.

The first visit of the Diaghilev company in 1916 was arranged by Otto Kahn, an investment banker and member of the board of the Metropolitan Opera who for several decades was the most insightful and generous patron of the arts—dance, theater, opera, literature—in New York City. The Met's management treated Diaghilev like an invader, which so enraged Diaghilev that he vowed never to return to New York. But the Met invited the company back later that year—with Vaslav Nijinsky, not Diaghilev, as its director. In the event, Adolf Bolm carried the load of directing the company; though no one knew Nijinsky was only months away from a psychiatric clinic, it was clear he was no administrator.

The articles in this compilation contain some humor about Ballet Russe. Apparently its success got to *The New York Times* music critic Richard Aldrich, who fired a barrage at ballet for what he argued was violence done to musical scores. Also, certain ballets looked different at home than they did abroad. In 1912 and 1913, the paper ran overheated stories about public tumult in Paris over *The Afternoon of a Faun* and *Rite of Spring.* At *Faun* the audience rioted over what it saw as masturbation on stage by Nijinsky. In the headline of the review of "Faun" in New York the paper called the piece "A Pastoral Work." *The Times* had long cultivated neutral headlines, but this one was breathtaking. And there is, in retrospect, a sad aspect to one ballet, *Til Eulenspiegel,* which Nijinsky choreographed

to the Richard Straus tone poem. It was his only creation as a choreographer, and it turned out to be a very mixed affair that was dropped quickly. Since there are no records from which to reconstruct it, presumably it perished when the last people who saw it died.

The articles in 1919 that assess the aptitude of American women for ballet dancing and survey the growth of dance in America are a fitting close to this period. The assumptions in them about the public's understanding of ballet would have made them impossible to write a decade earlier.

Dance's work was to create an audience. By 1910 the problem of filmmakers was to keep up with an enormous and insatiable audience. When the decade began, most films were seen in nickelodeons, storefront theaters, or other entertainment venues that occasionally showed movies. Virtually all the films were one-reelers of 15 to 18 minutes, and the overwhelming public preference was for genre pictures—westerns, war pictures, Indian films, romances. It should be noted that in this period westerns and Indian films were separate; cowboys against Indians had not yet been invented. The Indian films, mostly acted by groups of American Indians, were idyllic and pastoral.

Almost all the films were produced by businessmen who got into the movie game for the money and had no artistic pretensions. They resisted a star system in the movies, but the public, which had grown accustomed to star worship in opera and on Broadway, broke their resistance shortly after 1910. The film companies began to sell postcards of top actors, and newspapers learned they could lure readers with photographic spreads of them.

This pressure increased greatly when American producers began making feature films, and the theater owners began to realize that the stars sold the films. Europeans had pioneered feature films from the turn of the century and dominated the American market until 1915. In fact, Europeans had dominated the worldwide film market before 1910 for a perverse reason. The Edison Company held patents on parts of all cameras and fought to enforce them. But by 1908 Edison realized its mistake and began a campaign that would make American filmmakers not only kings of the business worldwide but owners of the biggest European production companies. The vehicle was the Motion Picture Patents Company, organized by Edison, which tied together the biggest American producers into a trust. Inevitably this gave rise to competing groups. The news coverage in this collection occasionally refer to mysterious legal battles; the struggle between rebellious independents and the Motion Picture Patents Company lies behind them. For years independents around the country had to keep one eye on the camera's lens and the other on the streets around, since Edison detectives shadowed them looking for chances to sue for patent infringement.

Such an oligarchy was doomed by the size of the industry, by 1915 the fifth largest in America. In the background of reviews and stories, you can see the shadows of corporate struggles developing, as production companies merged, gobbled up smaller rivals, and competed to establish monopoly ownership of theaters. By the end of the decade, the control of movies by large companies was so well advanced that a group of the most popular stars—including Douglas Fairbanks, Charlie Chaplin, and Mary Pickford—sought to protect their artistic freedom by forming their own company, United Artists, which itself became a major studio in the late 1920s.

Feature films inevitably produced star directors like D. W. Griffith. The ambition of Griffith was salutary in an age when the movie companies looked only at what box offices told them the public wanted—by the end of the decade, death-defying stunts in which the greater the violence, the more popular the film. Griffith's films, in which his direction gave depth and subtlety to complex stories, proved at the box office that public taste was discriminating, and popular excitement over his epics silenced many objections to the growing notion that films might become an art. Of course, ambition is what it is, and it is amusing to find Griffith dreaming of films killing off libraries and predicting that shortly no one would ever find it necessary to read history again.

Governments paid their own tributes to movies, especially once World War I began; movies were great instruments of propaganda. After America went to war in 1917, there was a flood of films about the conflict—not newsreels from battlefields, but patriotic sermons. But it was a different kind of combatant who first foresaw the public relations value of movies. Six months before World War I

broke out, Pancho Villa struck a deal with a New York producer to take film crews along on his forays in the Mexican civil war. This was two years before President Wilson sent General John J. Pershing and the cavalry into Mexico in pursuit of Villa. They went all the way to Mexico City and never found him. One wonders why the President did not just ask the filmmaker to locate Villa for him.

Historians of music used to say that for the Metropolitan Opera the decade of the 1910s was the summit against which the rest of its history should be judged. The range of operas presented in those 10 years is enormous, and the roster of leading singers is a kind of pantheon of voice: Lucrezia Bori, Frances Alda, Geraldine Farrar, Rosa Ponselle, Enrico Caruso, Giovanni Martinelli, Antonio Scotti, Leo Slezak. Leafing through programs from those years makes you realize anyone could assemble a personal list and make an argument that it included many of the best singers ever heard.

When the Met was founded, opera was a secondary concern. The opera house at 39th Street and Broadway was built to show off not the stage but the golden horseshoe, the ring of box seats. The building was actually owned by the box holders; the price of a box was that of a share in a corporation that was both an opera company and a real estate trust. As long as the boxholders controlled the management of the opera company, standards were wildly erratic. Oscar Hammerstein's rival Manhattan Opera often seemed on the verge of sinking the Met entirely. Finally a group in the Met's board, led by Otto Kahn, took control of the artistic direction from the old elite. Then they paid Hammerstein $1.2 million to shut down his company and stay out of the way. In 1908 they hired Giulio Gatti-Casazza, the manager of LaScala, as general director of the Met, and he brought Arturo Toscanini and several other leading LaScala conductors with him.

Gatti-Casazza could make Flo Ziegfeld look laid back. He established prizes for new operas by American composers and persuaded many Europeans to offer their new operas to the Met for world premieres. Through the years, he brought 110 new works to the house. As the Met's reputation soared, so did its roster of singers. And Gatti-Casazza was a master manipulator. Toscanini, for instance, thought he would be musical director of the Met. Gatti-Casazza, who knew how to keep his hand on all positions of power, kept Toscanini in the pit, but he also helped him start a new career as an orchestra conductor, a role in which he became a national icon. The excitement of the Met in those years can be felt in many reviews in this collection—the uproarious ovations for Caruso, the unending curtain calls that interrupted performances, audiences that often outnumbered available seats by many hundreds.

If the Met simply bought out the competition, no orchestra in the city could hope to do that—on the whole there were too many of them. An audit of the 1915 season reprinted here is telling. The Philharmonic, the New York Symphony under Walter Damrosch, the Boston Symphony, which had a regular New York season in those days, and several special orchestras, such as the Russian Symphony, gave a total of 125 concerts in a single season. Managements seem to have competed like rival capitalists, and they kept that up for another 15 years before some dropped away.

Competition did not mean varied programming; the fare was virtually all European, as were the conductors and soloists. And managements and audiences alike were mightily resistant to anything new. The fear of Arnold Schonberg that vibrates through a number of stories here is amusing and instructive. It was enterprising of *The Times* to bring in the eloquent and entertaining James Gibbons Huneker to ridicule the whole Schonberg scare in 1913. His many books on music were hugely popular, and he was so well known that he could get away with the tongue-in-cheek attitude he assumed here. Everyone would have laughed aloud at his description of "the Schonberg aura" as one of "original depravity, of subtle ugliness, of basest egotism, of hatred and contempt, of cruelty, and of the mystic grandiose." There are many delicious things tucked away in this essay, including the tease about Schonberg's purple cows, which is enough to leave one wondering whether the composer inspired Gelett Burgess's nonsense verse about the purple cow or whether Huneker was simply pulling the public's leg.

The Times in these years did not cover popular music in the depth it later would and certainly did not assign critics to it. But a few articles on the songs of the day are revealing. The great venue for them was the vaudeville stage, the next, the Broadway musical. But if a composer and a publisher

were to make a living on popular songs they had to depend on sheet music stores where singers at pianos belted out tunes to sell copies of the sheet music. How chancy success was is brought home by stories about the search for a hit when the United States went to war. If John Philip Sousa's contribution in 1918 is any indication, the effort was much harder than we might have imagined.

But trust Irving Berlin—as the country did for many decades—to come up with one that worked, in this case a song for a Broadway show in which a doughboy laments the hard life of a soldier, emphasizing in the refrain how much he hates to get up in the morning, sung, of course, to the tune of the reveille played by the buglers.

On the whole, as these articles make clear, the range of subjects in popular songs was very narrow. American popular music aped the European models remembered by immigrants. That habit would last until the next decade when jazz changed everything—melody, lyrics, rhythm, and above all the emotions that gave rise to music and that music sought to raise.

The biggest event on Broadway in the decade came at the end, and it occurred off stage. Actors Equity Association, organized in 1913 to seek uniform rules and pay for performers, had about 2,700 members by 1919, a small fraction of the total cadre at work in theaters. Negotiations begun in 1917 idled along for two years before Equity leaned on the theater managers. Finally the managers agreed to all items in dispute except pay for extra matinees on holidays and limiting performances to eight a week. Equity had long been wary of suggesting it might become a union, but by August it decided to act like one; on the 6th it called a strike. As it began shutting down those shows in which its numbers were large enough to give it muscle, the stagehands union and the musicians joined in. Suddenly Broadway went dark. The enthusiasm of the actors, including the majority who had never joined Equity, was a complete surprise. Protest parades drew huge crowds eager to see stars close up, and the picket lines became public attractions. The sight of that popular old vaudeville queen Marie Dressler teaming up with the young aristocratic actress Ethel Barrymore to lecture crowds was something to be seen. Obviously newspapers could not resist such a show. Neither could the American Federation of Labor, which committed its support without question. On September 6 the managers caved in, and Equity found itself with 14,000 members. It quickly brought a kind of energy to Broadway that had been missing for years.

The strike was all the more dramatic for coming at the end of 10 years of stupefied satisfaction. Around this time Bernard Shaw was complaining in the British press that London theater was 20 years behind the times, but it was years ahead of New York. And through much of this period, critics were as somnolent as the producers. There were 15 of them writing for the daily newspapers in New York City, and most of them were content to track the rise to stardom of John Barrymore or toss bouquets at the beautiful Laurette Taylor. An early exception, for a time, was James Gibbons Huneker, the music writer. His command of languages, extensive travel, and acute ear made him a fine commentator on theater, and for a couple of years he was the *Evening Sun's* critic. He knew how to expose stupidity and make his readers laugh at it. Forty years later, Brooks Atkinson wrote that Huneker "was the best critic Broadway ever had."

It would be a safe bet that the one person to disagree with that would have been Alexander Woollcott. A man who in later years could comfortably step into the title role in a road company production of a play written to hold him up to derision—*The Man Who Came to Dinner*—had no ego problems. *The Times* hired him as a police beat reporter and, when he returned from army duty in World War I, let him loose on theater. He brought to it a forceful style, volatile impatience with dullness, and the energy to seek out good plays off Broadway if that was the only place they could be found. It was downtown that he found Eugene O'Neill and became his champion. A few years later he became one of the most persistent attackers of O'Neill. By then everyone else was praising O'Neill and that was enough to set off Woollcott.

A few determined playwrights—Elmer Rice outstanding among them—tackled social problems and tried new dramatic techniques. But they were lost in parades of the familiar, led by Shakespeare, Wilde, Pinero, Barrie and Galsworthy. Every year there came the "repertory" runs by E. H. Sothern

and Julia Marlowe, repertory in this case meaning selections they cobbled together from old favorites. The same operettas and musicals were revived in a monotonous cycle. And humorous plays were largely the kind that George M. Cohan was king of—what the newspapers often called "business comedies" (they did not mean pieces poking fun at business, but ones that could be quickly assembled from existing material, the way your order would be filled by Sears Roebuck from stockroom shelves). It was bad enough that the papers treated Galsworthy and Booth Tarkington with deep respect for plays no one would now read or produce. But they were resolutely hostile to Ibsen and Strindberg, who created work that would change theater profoundly. It is demoralizing to see *The Times,* in headlines over reviews, calling Ibsen's *Little Eyolf* "a queer play" and Strindberg's *Countess Julie* "revolting."

Of course, most people going to the theater in those years did not give a thought to any of these plays. To the crowds, the Ziegfeld Follies were the top of the line, and they were, in fact, class acts. A big vaudeville house like the Palace could draw up to 20,000 ticket buyers a week, and the best vaudevillians invented the forms, techniques, and lines that were transformed into the radio comedies of the 1930s and 1940s and the live television comedies of the 1950s. And then there was the Hippodrome. Built by Diamond Jim Brady in 1905, it created shows with casts of hundreds that played to crowds of 5,000 twice a day, and it was regularly on top of current events. World War I was only days old in 1914 when the Hippodrome mounted an extravaganza of mayhem called *Wars of the World* that surveyed the history of major warfare, complete with cavalry assaults and cannon battles. When this theater staged a monster drama concocted by R. H. Burnside or a tremendous musical by Carroll Fleming and Manuel Klein, it was nothing for it to put more than 700 actors on stage, supported by 500 stagehands and theater attendants. It had an immense tank sunk in the stage for water ballets or naval battles, and if the tank was drained and supplied with ramps, armies could drop out of sight into it. In one show that was talked about for a generation, a company of Cossacks mounted on black horses swept across the stage and disappeared without trace. And the Hippodrome had a sense of humor about itself; in 1916 its season-opener was called simply *The Big Show.*

In retrospect, glimmers of hope are to be found in the theater of this decade. One group of young people in Greenwich Village that included O'Neill, Max Eastman, Floyd Dell, and others started the small Provincetown Playhouse on Sullivan Street to produce serious plays, including a few of O'Neill's one-acts. In 1914 the Henry Street Settlement founded the Neighborhood Playhouse on the Lower East Side, dedicated to plays about social issues, and several years later that organization became a source of innovation not only in theater, but in dance. In 1915 a group of amateurs that included John Reed and Edna St. Vincent Millay was brought together by Lawrence Langner, a lawyer and occasional playwright, to start the Washington Square Players. In 1916 it rented a 600-seat theater on 41st Street and began producing works by Ibsen and others whom Broadway ignored.

Art needs a little effort from the reader. In no area of culture has the thinking of ordinary people changed so profoundly since the beginning of the 20th century. In 1910 the editors and readers of *The Times* would have agreed that for art to be a big story there had to be a lot of it, preferably worth a large fortune—like the Altman bequest to the Metropolitan Museum of Art or the gift of the Frick collection, along with the house built for it, to the city. The paper's itemization of the Altman collection would have been caviar to readers' imaginations. Readers would have heeded the declaration that the National Academy of Design, the leading organization of painters, needed more space for its shows; that was a matter of civic pride, and no one would have cared that the academy was a very restrictive outfit. They would have been very attentive to the ideas of Kenyon Cox, the muralist who was the soul of the academy establishment, about how art should develop in the United States, and they would have been chagrined at the judgment of Guston Borglum, the sculptor of Mount Rushmore, that Chicago far outstripped New York in art education.

Looking back from this century, we think the coteries of modernism built up by Alfred Stieglitz at his Gallery 291, the formation of rebellious groups of artists like the Ashcan School and, above all, the Armory Show of 1913—none of which occupied even a whole column of *The Times* in that era—

are infinitely more important than any concerns of the establishment. We are also likely to wonder why the paper gave scant critical attention to the commercial galleries and their role in the culture of art. For instance, little distinction seems to be made between the Duveen brothers gallery on Fifth Avenue, which, with the help of chief evaluator Bernard Berenson, ferreted out old masters for the very rich, and the Anderson Galleries, which allowed groups of artists to stage their own exhibitions and often combined other arts with painting to educate would-be connoisseurs. And why is William Macbeth almost ignored when his gallery, from the 1890s to the 1950s, was the prime booster of American art among commercial galleries, an institution at least as important in that respect as any art school or publication in the country?

In fact, the Armory Show in 1913, which exposed the public for the first time to such European innovators as the Cubists and Futurists, was organized by artists who made their living from Macbeth's honest salesmanship of their work. No art show in New York had ever produced such publicity as this one. Curiosity had been whetted by stories of uproars in Europe caused by the Futurists and Cubists—*The Times* editorially referred to the work of both as mental pathology—and the public flocked to it. Marcel Duchamp's *Nude Descending a Staircase No. 2* was the great succès de scandale. When J. F. Griswold's cartoon for the *Evening Sun,* "The Rude Descending a Staircase (Rush Hour at the Subway)" had the whole city laughing but also understanding exactly what Duchamp intended, no one was more pleased than the painter. After all, who was a sharper satirist than Duchamp? As it turned out, Duchamp himself was the great gift of the Armory Show, for after it he spent most of his life in New York, and through the next four decades virtually every new art form he dreamed up took root in other artists' minds. The changes for which he was responsible—in art, theater, dance, and even music—were very great.

The Armory Show was meant to get attention for a long roster of American artists who exhibited in it by associating them with the European avant-garde, but few of them got much attention from the press. Predictably, Kenyon Cox mounted an assault on the show, particularly denigrating Picasso and the other Cubists, but he also saved a few shots for several Americans, notably Marsden Hartley. Hartley was a fleeting target; he was in his early 30s and still absorbing the influences of one school after another every couple of years until in his later life he developed a remarkable mastery of color and a style that deeply affected a few outstanding painters like Robert Indiana and Jasper Johns. Shortly after the Armory Show, Hartley went to Berlin where he joined the Blaue Reiter organized by Kandinsky. A 1915 story in *The Times* must have puzzled painters in New York who knew him well. The report says his pictures, filled with German military symbols, flags, and insignia, made many Germans wonder whether he was not mocking their vaunted army, then in combat in World War I. Two years later many of those pictures were hung in a New York show, and the newspapers wondered whether Hartley was not glorifying an army that was now the enemy. The local papers were right. Hartley had become enchanted by the pageantry of the German military and, as it turns out, by more than symbols. The key painting among these pieces, *Portrait of a German Officer,* is a startling assemblage of decorations from uniforms. It was Hartley's tribute to Karl von Freyburg, an officer who had become Hartley's lover before he was killed in battle. Von Freyburg's initials are in the painting, along with an elaborately scripted "E," standing for Hartley's given name, Edmund. People in the New York art crowd who knew Hartley could have intuited easily what was going on without knowing who the other man was.

The social establishment in New York thought the American artists in the Armory show were aligned with the forces of anarchy. They had a point. Robert Henri, one of the Ashcanners, ran a school and many of the Armory Show organizers had been his students. Henri and his student John Sloan, a realist painter with a fine satirical eye, were regular cover contributors to *The Masses,* which had drifted from satire to radical socialism. Like Sloan and George Bellows, many of the realists, whether Ashcanners or not, intended their art to stimulate social change through its withering comments on poverty, racism, and injustice. When a textile workers strike began in Paterson, New Jersey, shortly after the Armory Show, organized by the most anarchic of all unions, the Industrial Workers of the World, a pageant was staged in Madison Square Garden to raise money for the workers. It was

scripted and directed by John Reed and the Fifth Avenue heiress and socialite Mabel Dodge. Many of the Armory Show artists contributed posters and other art work; John Sloan painted the 200-foot backdrop for the pageant.

So it was natural for people to imagine a connection tying together all these hotheads seeking change. After all, the Futurists seriously proposed turning Venice into islands of factories and thought that all art not born of machinery was ersatz. In some ways they were more threatening than communists—although soon enough the communists who took control of Russia also thought machinery was the future, in art as well as in social progress. Nor could the establishment take any comfort in the group that arose to do battle with the Futurists, the Dadaists. The richness of the artistic ferment of the time, and the bewildering contradictions of political directions implicated in some of the art movements, are fine theater, really. For instance, Dada is normally associated with Zurich in 1919 when it flourished there with Tristan Tzara and his associates. But the Dadaists said some of their roots were to be found earlier in Alfred Stieglitz's Gallery 291 in New York, specifically to ideas disseminated by a periodical that Stieglitz, Duchamp, and Francis Picabia started there in 1915, called simply *291*.

Which brings us full circle. In the three tiny rooms of Stieglitz's gallery, New York collectors and artists first came in touch with the work of Cézanne, Brancusi, Braque, Picasso, and Picabia. Gallery 291 was a kind of never-ending seminar where some extraordinary minds collided in a friendly setting. One collector who frequented it often, even though he disliked Stieglitz personally, turns up in these clips about the Armory Show. John Quinn is worth remembering, one of those people you meet at almost every turn in the development of modernism. He was a lawyer who knew everybody in the avant-gardes of several countries, especially France and the United States. When he died in 1924, at 54, he owned the greatest collection of modern art in America, more than 2,000 pieces. What is more important, he was one of the great facilitators of modernism in art and literature. He led many American collectors to Matisse and Picasso, and he was one of the first public figures to challenge American publishers to break Washington's ban on James Joyce's books. Had he lived long enough he might have pulled it off; after all, he did use the publicity of the Armory Show to boost his personal campaign to get the government to drop all import duties on foreign art, which it did shortly after the show closed.

In this era, architecture could have used someone like Quinn. In public discussion it seldom rose above the level of real estate, as is quite clear in the article *The Times* ran on plans for the Woolworth Building in 1910. By far the most valuable part of that story is the recollection of the house of the former mayor, Philip Hone, which stood on the site in the 19th century. *The Times* was not especially negligent of architecture. It had not occurred to any newspaper to draw readers' attention to the philosophy of architecture, and most comment on aesthetics was superficial. There were no architecture critics. Things were no different in other cities, not even in Chicago where Louis Sullivan, the great pioneer of steel frame construction, was practicing and writing brilliantly and where his one-time apprentice Frank Lloyd Wright was building his revolutionary Prairie Style houses and pamphleteering his architectural ideas with wit and enthusiasm. It was as though architecture was beyond the aesthetics of the public at the time.

Not even the architects and real estate moguls were on top of their game. It is amusing to find *The Times* giving a platform in 1912 to a developer's unheeded argument that the Equitable Insurance Company should replace its burned-down building with nothing higher than 12 stories. The replacement, filling an entire city block, rose 40 stories, a structure so massive it still intimidates people on the street. It obliterated light in such a large area that it inspired the 1916 New York building code that has given the city its characteristic look ever since—with stepped-back towers and limitations on the numbers of very tall structures in any block. It is even more amusing to find Whitney Warren, the architect of Grand Central Terminal, arguing that railroad terminals would become the great central mechanisms of cities, the engines to keep them moving—that at the very time when the auto assembly line and advances in aircraft design signaled the doom of railroads as the principal carriers of goods and people.

As the 1912 Presidential election approached, Theodore Roosevelt—who had left the White House in 1908 and who had persuaded Republican Party leaders to dump the man he chose to succeed him, William Howard Taft—let the Progressives in the party know that if they bolted the GOP and created a new party he would bolt with them. It was widely assumed that the Progressives' nominee would be Senator Robert M. LaFollette of Wisconsin, their acknowledged leader. And many, including LaFollette, later claimed that Roosevelt had committed himself to LaFollette. But that summer Roosevelt backtracked, took the nomination of the new party himself, and in the campaign siphoned off enough votes from the Republicans to hand the White House to Woodrow Wilson.

LaFollette immediately wrote an autobiography and had it in the bookstores in May 1913, less than three months after Wilson took office. The Book Review ran a long assessment of LaFollette's book, written by a man who had been an insider to at least some of the talks among the Progressives in 1912. The review, like the book, threw serious doubts on the integrity of Roosevelt's negotiations the year before and ended by challenging the former President to write a book of his own about the whole affair.

Here was something new. For a leading politician to take an inside argument to the public in a large book was startling. And for The Book Review to have used it to enter a political fight was a large step. In subsequent decades its editors would carefully avoid letting someone with such intimate knowledge of a battle like this review the book. But the review is a stark declaration that the publication was abandoning its previous model—the literary feuilleton familiar in European papers—and was becoming part of a news operation. Its commitment to public affairs becomes pronounced in the decade after 1910.

It was certainly a convenient time for that shift of direction. The literary lions were dying off—Mark Twain in 1910 and Henry James in 1916—and there was only so much to be said about the muckraking novels of Frank Norris or the somewhat more serious social thinking in those of Theodore Dreiser (although The Book Review deserves some credit for reaching out to H. L. Mencken for its review of *The Financier*). The Book Review also changed its format and became the small magazine it would remain throughout the century. It moved away from anonymous reviews, many written by staff members, that had dominated it since 1896, in favor of bylines, mostly those of people like Mencken, who had no connection with the newspaper. And *The Times* began to sell it in bookstores as a virtually independent publication.

It is striking that the most persistent social issue The Book Review took up during this decade was the deterioration of the social, political, and economic position of blacks in the country and the spread of institutional segregation from the old South to the entire nation. In 1910 a perceptive reviewer of *The Story of the Negro* by Booker T. Washington pointed out that there was a connection between what was happening and the rise of scientific racism as a fashionable theory among intellectuals, and a direct relationship between the way European colonial powers presented "darkest Africa" to the world and the way white Americans looked at black Americans.

But we do not find other book reviewers picking up on this idea. For instance, the reviewer of Teddy Roosevelt's 1910 book *African Game Trails*—a vastly amusing story of his safari into Africa within months of his leaving the White House, in which he made clear that he was larger than all the lions and rhinos he was collecting for the American Museum of Natural History but in which he also starkly outlined the rigid segregation of his group of white hunters from their African carriers and outriders—never reflects on what this segregation means. And one would like to think that if the first Tarzan book by Edgar Rice Burroughs had appeared not in 1914 but 50 years later, a reviewer might have asked why Tarzan had to be white and why, growing up in "darkest Africa," he seemed to have no connections with black Africans.

In a 1915 review of three books about race, the reviewer is palpably uncomfortable with some of the more radical ideas advanced by W. E. B. DuBois, but what was uncommon then is his rude dismissal of the arguments set out in a volume by a Southern segregationist. It was a hard time for people as civil as that reviewer. Just before this, for instance, William Archer, the critic and director who was a champion of Ibsen and the star of many of Shaw's plays, toured the American South and

published in England a book largely justifying segregation, on the grounds of eugenics. In news reports and magazines his ideas resonated throughout this country and did some real damage.

The deep personal anger of people as different as Washington and DuBois is striking. Why at this time? It is not as though these men suddenly discovered the history of American blacks. It is hard to avoid the suspicion that they were fired up by the 1896 Supreme Court decision in *Plessy v. Ferguson,* which was intended only to validate separate-but-equal arrangements in schools but which ramified rapidly throughout society and produced a severe degradation of blacks both North and South. But at least The Book Review kept books on the subject in public discussion.

One misses any real discussion of the vigorous surge of leftist and revolutionary thinking after 1910. But the silence reflects the reluctance of book publishers to take it up more than any bias in *The Times.* Most of the intellectual political fights were given voice in the small magazines published by groups in Greenwich Village and their allies. *The Times* may not have been sympathetic to them anyway (the 1919 review of John Reed's firsthand account of the October 1917 communist coup in Russia, *Ten Days that Shook the World,* gets the tone just right), but if these struggles had found their way into books, the paper likely would not have ignored them.

In a very different area, finding nothing in The Book Review about the political rise of women in this decade is stunning. It is hard now to imagine that, with the ratification of the Constitutional amendment that would give women the vote becoming more certain as the decade advanced, there would not have been a flood of books, and thus reviews, about the event and its consequences. But there was not even a good history of the suffragist movement in this period, or a biography of any of its leaders.

Finally, for all its familiarity, it was a distant time. A glance at the review in 1918 of *The Education of Henry Adams* brings that home with a blush of recognition. That a reviewer could have written only about the charm of this extraordinary confession's reminiscences and completely missed its dark, if not despairing, psychological undertone strikes us now as ludicrous. It is a forceful reminder of the hazards of judging the past by present standards; people really do think differently in different ages.

ART AND ARCHITECTURE

February 3, 1910

THIS NO ART CENTRE, J.W. ALEXANDER SAYS

For We Can't Find a Place to Show the Art That Is Being Developed Here

PLEA FOR AN ART BUILDING

Other Cities Have Them—Dr. Bensel Glad the Skyscrapers Haven't Hurt the Skyline

Graduates and former students of the Schools of Science and Architecture of Columbia University crowded to the limit last night the grand ballroom of the Hotel Astor at their annual dinner. They marched in headed by a drum and fife corps, and the Columbia Glee Club aiding and abetting, the 500 old students, many of them gray headed, romped through all the old college melodies. Edward E. Sage and Jasper T. Goodwin, members of the only American crew that ever defeated the English at Henley—which was in 1878—were among those present.

The dinner was in a way a farewell to two members of the Faculty—C. F. Chandler, Professor of Chemistry for thirty years, Dean of the School of Mines, and J. H. Van Amringe, retiring Dean of the university. Daniel E. Moran was toastmaster.

John W. Alexander, President of the National Academy of Design, in his speech after dinner, noted an increasing tendency toward co-operation in the art world, as in everything else, and expressed the opinion that there is an art wave going over the country, affecting a larger and larger number of people every year. Notwithstanding this increased interest in art, however, Mr. Alexander said that in spite of the growing spirit of co-operation in the allied arts, New York City, the real metropolis of America, had not a single place where there could be placed on exhibition the current products of American art.

At the last exhibition in the National Academy of Design, said Mr. Alexander, some 1,600 paintings had been accepted as worthy of hanging, and yet there was room for only 270. He believed that at the coming Spring exhibition the number of paintings deserving of a place on the line would mount up to 2,000, of which not more than one-sixth could be hung. Yet several other cities in the United States had permanent homes for current productions of the fine arts larger and more fitting than New York could offer. Under such circumstances, New York was not and could not be the art centre of the United States, and the city loses a great deal because of this lack of an adequate and permanent fine arts building.

Mr. Alexander called upon his hearers to do all they could to fill this urgent need. He said the National Academy of Design was ready to erect a building if the city would furnish the land.

Dr. Rossiter W. Raymond made a plea for more scientific thinking. Thomas B. Stearns, a mining engineer in Colorado, spoke of the hills of gold and the valleys of vegetation of that State, and in the end promised:

"If you will come out there we will show you the ferocious suffragette as gentle as a lamb, eating a small bit of political patronage tamely and graciously from the masculine hand."

John A. Bensel, President of the Board of Water Supply and of the American Society of Civil Engineers, expressed the opinion that the fears about the disfiguring of New York's sky line by the rising skyscrapers had died down, and that people had come to see that the new buildings were more beautiful than the old ones they had supplanted. The crying need of the world, he declared, was for Philistines, men who tear down old things and put in their places new and more useful things.

Other speakers were Walter H. McIlory, a civil engineer of New Orleans; William H. McElroy; Dr. Rudolf Tombo, Jr. and President Nicholas Murray Butler of Columbia.

* * *

April 2, 1910

YOUNG ARTISTS' WORK SHOWN

Many of the Exhibits Display a Highly Trained Craftsmanship

The exhibition of Independent Artists which opened last night at 29 West Thirty-fifth Street is an interesting and creditable showing of the work of the younger generation of artists in New York, many of whom have been represented in the exhibitions of this city and Philadelphia, others of whom are new to the gallery-visiting public.

The impression upon entering the galleries is one of vigor and sincerity rather than novelty. A considerable proportion of the exhibits display a highly trained craftsmanship, a mature vision, and a clear knowledge of the resources of their medium. Such painters as John Sloan, Ernest Lawson, Arthur Davies, Robert Henri, Everett Shinn, George Bellows, Leon Dabo, to choose at random, would stamp any exhibition in which they appeared together with authority. Although one-man shows and sporadic examples of the work of the different exhibitors have familiarized us with many of the individualities represented, their appearance together and surrounded with less-known painters of their kind is what gives the present exhibition its distinctive character.

A few years ago we should have been startled by the pyrotechnics of Ben Ali Haggin and the spotted harmonies of Maurice Prendergast. Now they are classic, since this is America and we assimilate quickly. If we are not startled, however, by finding that our young painters are no longer the "enfants terribles" we once believed them, we are none the

less interested in their development. It will strike many a visitor with the force of novelty that so large a proportion of the pictures are purely American in subject. The younger school of painters includes many who have been, and several who still are, workers on the newspapers; and it fairly may be claimed that their quick instinct for the pictorial in the every-day life about them, their downright manner of handling their subjects, and their sturdy acceptance of inevitable limitations are not unrelated to the drill they have had in newspaper work.

Certainly they have managed to fashion a most inspiriting kind of romance out of the fabric of our contemporary local conditions and have got into their work the multitudinous aspect of our metropolis as none of their forerunners succeeded in doing. For this we should be grateful if they had done nothing else to further the so-called "cause" of American art. They have, however, done much more, and while a good deal of the work in the present exhibition is crude, the best of it demonstrates a healthy spirit and honest intention. The individual exhibits will receive later notice.

* * *

May 29, 1910

INTEREST IN MURAL PAINTING IN THIS COUNTRY A NEW SIGN OF PROMISE IN AMERICAN ART

The rapid increase in the United States of enthusiasm for mural paintings is one of the most important of the various signs of promise for American art—signs which are obvious enough to those who look for them in the right places, however persistently they may be denied by pessimists.

It cannot, of course, be assumed that when we have innumerable portraits and mural decorations we shall be an art-loving country, but we shall certainly have a community of thriving artists whose skill will be sharpened by the constant demand upon it, and whose ideas will gain in variety and appropriateness as new occasions for the exercise of their talent arise. Portraits and mural decoration have always been popular forms of art in countries and periods of rich civilization for reasons too clearly apparent to be retold.

Within the last few years we have had some very distinguished decorations for our public buildings, and, what is no less significant, a number of equally interesting decorations for private houses, and while the Boston Public Library and the Library of Congress at Washington are still the buildings to which public attention chiefly is directed when decoration is discussed, there are now many buildings throughout the country, and particularly in the West which contain work of as high a general standard and possibly of more conspicuous technical merit.

Nevertheless the public does not yet fully realize the amount of knowledge that goes to the making of a successful mural decoration. It is still inclined to regard the painting of walls as a form of activity rather less impressive and valuable than the painting of easel pictures. As a matter of fact, the painting of pictures upon walls in a manner truly to add to their beauty is an undertaking so fraught with difficulty that comparatively few of the painters of easel pictures—only those whose work is based upon the fundamental architecture of all good design—are fitted to cope with the problems involved.

There must be not only ordered and dignified composition, but a competent perversion of ordinary facts of appearance in order that the design shall look right under special conditions. As Mr. Kenyon Cox put it in one of his lectures: "You must tell certain lies in order to seem to tell the truth." Take, for example, a lunette of a theatre decoration which may be some forty feet wide and some fifteen feet high, and designed for the space over the proscenium where it will be seen from below by the audience in the body of the theatre. It is easy to understand that a picture painted on a canvas some two feet by three or three feet by four, and intended to be seen at close range, would present an entirely different set of difficulties.

The wall decoration, too, in order to be completely successful, must harmonize with the architectural forms of its framework, which are apt to be much more complicated and exacting than the ordinary rectangular frame of an easel picture. The whole room in which the painting is placed must be regarded as its frame, and if it contradicts the style of the architecture it is out of place and a failure. The arrangement of the linear composition in a wisely conceived decoration for a difficult space—a spandrel or pendentive, for example—is a matter for wonder to the ordinary observer, so slyly and efficiently do the lines draw attention toward and away from the bounding lines which they echo or contradict, and thus carry on the linear scheme of the setting in addition to fulfilling the minor compositional intention.

The color, too, must be adapted to the lighting of the room, and to the tone of the woods and marbles employed in it. And however greatly decorative painters may differ as to the necessity of avoiding cast shadows, probably none will be found to deny that the impression of the wall as a flat surface must not be contradicted to the observer's eye, however the effect of flatness may be gained.

Not to go too far into matters which only the deeply initiated can discuss intelligently, it will suffice to call attention to but one more point—that of invention. It is perfectly possible to make a wall decoration of a highly intellectual character that shall be pure design, into which the element of representation does not enter at all. This may even be considered the most austerely appropriate of all decorations to the austerity of pure architectural forms. But as the case now stands the mural painter either is expected or chooses to write some kind of history or fable in his picture. It is desired to lead the mind of the observer toward memories or thoughts or imaginations that fit his environment, according in some degree with the uses and character of the building, and this results in a necessity for the artist to use his mind in two ways, in a kind of literary way, if you will, by devising some sort of a story or allegory, and in the arduous technical labor that has been but partially

described. The completed work embodies two kinds of idea, a literary idea that might very well be fitted to words and a purely artistic idea that can only be expressed in terms of art.

Consequently the artist who succeeds in making his decoration a good thing from these various points of view is bound to be a fairly accomplished and cultured man, with a well-furnished mind and adequate training. His work as a rule does not get before the public except as the public comes to its permanent abiding place. The exhibition galleries of the more important cities are too restricted in space to permit the mingling of mural decorations with the exhibits of other kinds that are periodically shown, and no special effort seems to have been made to hold exhibitions dedicated to this form of art alone—probably because no body of artists are working at the same moment on decorations which they can count on finishing at one time to meet the practical obligations involved in hiring a large exhibition space for a given period. The annual exhibitions of the architectural societies contain photographs and drawings and small decorative paintings, but these, of course, serve to give only a very imperfect idea of the completed works. Thus the public may well be grateful when, as occasionally happens, a mural decoration is shown in its final or almost final state in a gallery of the Fine Arts Building or elsewhere, prior to sending it out to its ultimate destination. We have seen in this way, among others, the learned compositions of John La Farge, with their wealth of historical associations and their extraordinary grasp of the ideals of races and epochs widely separated in time and tradition from our own; the formal and traditional but sound and increasingly rich and expressive decorations of Kenyon Cox, whose technique developed by unremitting research into the resources of design is broadening in these later years to include a more fervid emotional appeal, a more sumptuous color, a line no less firm and correct but more ingratiating and tender, and the decorations of Edwin E. Blashfield, uniformly refined and spirited, but subject to many variations of subject and ingenuities of pattern, obviously the product of a mind trained to think closely and clearly and to fit any form of expression with nicety to the informing idea.

Mr. Blashfield's paintings for the four pendentives of the Mahoning County Court House, Youngstown, Ohio, exhibited this last week at the Fine Arts Gallery, have furnished, in fact, the suggestion for this tardy word of comment on the expansion and development of an art which, important as it is, pursues its way with so great a reticence.

In these four arrangements of two figures within a high and narrow space there is not, of course, the chance to grapple with elaborate composition, or, to speak more justly, the difficulties of the composition are in the harmonizing and bringing together of the four groups rather than in the treatment of the individual spaces, but the handsome figures freely drawn and modeled, with nobility of contour and type, and the high-keyed color scheme pitched to suit the dim diffused light of a dome of colored glass, speak with authority of the artist's richness of invention and fine definite execution. They show particularly his ability on the technical side to achieve a statu-

esque effect suitable to the dignity of the architectural setting without losing the sense of pulsating flesh and blood beneath the white draperies that cling to the colossal forms; and on the inventive side of his artistic tact in harmonizing types of past and present. The theme is the development of the law from remote antiquity when it was based on tradition to modern times when it is based on equal rights. Without essentially changing the type, the corresponding development from the rugged, primitive force of the first figure representing remote antiquity, through the dominating militant authority of the figure representing classical antiquity, and the withdrawn austere aspect of the mediaeval abbess to the intellectual fire and aggressiveness of the figure representing modern times, the significant ballot box by her side, is subtly yet saliently rendered. We cannot say whether the people of Youngstown will regard this last figure as symbolic of the rights of women or not, but such an interpretation irresistibly suggests itself, and without a trace of incongruity.

* * *

September 18, 1910

WHAT THE PICTURES OF THE "PRE-RAPHAELITE BROTHERHOOD" CONTRIBUTED TO THE WORLD OF ART

Fortunately we have now little to do with the remarkably vexed question of who initiated the Pre-Raphaelite Brotherhood. The account of its beginnings which the late Holman Hunt expanded to many pages in his book "Pre-Raphaelitism and the Pre-Raphaelite Brotherhood" is the official record, and with the death of Hunt the long drawn dispute is ended. Few will be found to go back of an old man's recollection of what he thought and did in his youth.

What is much more interesting to a later generation is to ask of the pictures themselves the quality or qualities contributed by their technique and character to the sum of British art. Their first virtue, direct reference to nature, was that which separated them most conspicuously from the works of Etty, Mulready, and other popular painters of the day. The Pre-Raphaelites were not perhaps fighting so much against the tendencies of these painters, however, as against the tendencies of the art schools from which they had freshly emerged when the brotherhood was formed, and where they had been taught to build their conceptions of art on Raphael, and on various conventions adopted in his name by his followers. In fact, according to Hunt, the very title of the brotherhood came from the schools, their fellow-students responding to the proclamation of Hunt and Millais that Raphael's cartoon of the "Transfiguration" was a signal step in the decadence of Italian art; "Then you are Pre-Raphaelite."

They were not, of course, the only defenders of nature in art. Constable had had his mighty fling with blue skies and green grass, and Ruskin had been pounding away at the queer composite doctrines which included advice to the young artists of England to "go to nature in all singleness of heart and

"Ecce Arcilla Domini" by D. G. Rossetti

Hunt's own account of their methods. Millais chose his background for "Ophelia in the Stream" with great care, and painted it leaf for leaf, twig for twig, through a long Summer and Autumn; Hunt in his "Light of the World" worked in a sentry box with his feet in a sack of straw and a candle to give him his working light, from sundown till morning, during the Autumn, and later for months from his Chelsea window on moonlight nights with some "dried clinging tendrils of ivy" fastened to an old board for his model of the vine on the door. Both were happily inspired to use their color pure and to work on a white ground, and the daintiness of their palette suited their meticulous method.

The results had a surprising charm, due in part to the fact that both painters had enough imagination to fuse their literal transcripts into a more or less coherent impression which was as far as possible from the impression conveyed by the natural scene with its fluent changes of light and color, but which answered the pictorial need of unity.

As all the world knows from the manifold revelations of the circle in which these blithe spirits moved, Rossetti, the third important member of the P-R. B., was at heart antagonistic to nature, although he curbed his inner vision by constant reference to his model even in his late work, done long after the initials "P-R. B." ceased to have any significance.

The habit formed by the brotherhood of painting the backgrounds of figure subjects directly from nature persisted even with him certainly well into the middle years, since at 49 he was painting roses and honeysuckles and sycamore buds from the flowers themselves at the cost of such bother and effort as he greatly disliked to spend.

But the brotherhood's realism or naturalism by itself would have had little effect in turning the course of British taste had it not been for a romantic avoidance of the obvious, which may or may not have had its origin in the exotic temper of Rossetti's mind, but which may still be found in his work after Millais had slipped into a deep rut of commonplace and Hunt had grown archaeological at the expense of mental energy.

It was this quaintness of invention, this power of seeing a mental vision in its minute particulars, that cast over the early paintings of the three Pre-Raphaelites the mystery of originality, always resented by the public at its first appearance in a new form.

Take any three of the pictures, take Rossetti's "Ecce Ancilla Domini," Hunt's "Rienzi Swearing Revenge Over His Brother's Corpse," Millais's "Ophelia in the Stream," and one perceives in them all a certain intensity of expression—in the "Ophelia" the intensity is that of peace after death—an innocence of type, and a simplicity of gesture sufficient to constitute a family likeness. The minute and realistic detail emphasizes by contrast the curious spiritual delicacy and force of the emotion conveyed. The painters seem to have tasted Blake's potion that which made him "drunk with intellectual vision," although so firmly in contact with the pleasant visible world.

It was only during the Pre-Raphaelite period, liberally construed as the period at which Hunt, Millais and Rossetti

walk with her laboriously and trustingly, having no other thought, but how best to penetrate her meaning, rejecting nothing, selecting nothing, scorning nothing."

But these clever boys, hardly out of their teens, sincerely believed that they had discovered nature for themselves, and if their application of their ingenuous young wisdom had been governed by an artist of synthetic vision, how rich might have been the reward. As it was, none of them went so far as Ruskin would have had them go in his rhapsodic blasphemies against that "art" which Mr. Brownell astutely tells us he not only did not understand but did not really like.

In his later years, Hunt recalls that he and Millais held to the belief that selection, not imitation, was the task proper to an artist, and also that they agreed in the idea which, of course, they considered another discovery of their own, "that a man's work must be the reflex of a living image in his own mind and not the icy double of the facts themselves."

At the time, however, nature held them closely enough to the limitation of her external features, if we may judge from

met frequently and discussed each other's work in friendly criticism, that this quality of imagination, or, in Blake's phrase "spiritual sensation," flowered freely in the work of all three. Gradually it died out in Millais as he compromised with popularity. In Hunt it reached its height in his romantic "Lady of Shalott," with its sentiment of fatality and weird. With Rossetti it expressed itself in constantly more sensuous forms, in constantly increasing opulence of physical type, but it continued to dwell in the suggestion of brooding on the unseen which to the sad end he managed to convey.

Perhaps none of the three was so much as Rossetti the gainer by Hunt's theory of devotion to nature. It proved excellent ballast for his fancy, prone to interrogate shadowy places of the soul and to drift among formidable indecisions of action. Perhaps none was so much as Hunt the gainer by Rossetti's "mediaevalism," as the latter's romantic investment of ideas drawn from great literatures was termed by the more prosaic thinker.

Certainly the mingling of influences resulted in a type of art unique in the nineteenth century. As the essence of its charm belonged to youth—such youth as sang in the poetry of Keats—it is not surprising that it died without having communicated its potency to any school of followers. Most of the men and women who later came under the Pre-Raphaelite mantle, although they produced careful and often charming, even exquisite work, missed the spiritual significance of the original band. Imitation and illustration took the place of that subtle fervor inspiring the detailed exactness of the founders of the movement. The figures betray no emotion, the settings are lifeless in all but the best of the modern "Pre-Raphaelite" pictures: their grace and dainty loveliness is the embroidered shroud in which the original impulse is wrapped for burial.

The indirect influence of the brotherhood, however, has been considerable and will be more justly appraised when it can be seen in a longer perspective, and there are three or four painters among those who still work in the Pre-Raphaelite manner who possess a true claim to distinction. Mrs. Stillman, the model for Rossetti's famous "Finmetta," is one, her dainty landscapes and views of English parks, and gardens achieving a genuine if not a large success with their harmonious blending of detail. A more ambitious painter is Anna Lea Merritt, whose recently painted "Lamia," in the collection of Mr. Samuel Bancroft of Wilmington—the most important collection of Pre-Raphaelite material in America—has the true spirit of wonder in the aspect of the long snakelike figure, with its tipped-back head and heavy-lidded eyes, and also the amplitude of Pre-Raphaelite detail in the landscape setting, with its symbolic fritillary and green toad.

In the same collection superb paintings by Rossetti—the "Lady Lilith" of his middle years, the "Found" of his youth, the "bottle picture" which he did under Ford Madox Brown and from which he fled to Hunt for artistic succor, the "Magdalen," the "Ruth Herbert," the "Bella Mano," and others—may be compared and contrasted with equally representative paintings by Burne-Jones, who usually is spoken of as

"The Huguenot" by John Millais

carrying on the Rossetti tradition, but who took from the older painter only one strain of inspiration and so changed it by the influence of his individual temperament that he can only be said historically to belong to the same school.

Much more in Rossetti's characteristic vein is the work of Frederic Sandys, a few years younger than Rossetti and a painter of remarkable and insufficiently acknowledged gifts. He is represented in Mr. Bancroft's collection by a couple of heads, one in particular—that of a girl with rippling coppery hair who holds a purple flower and wears a bit of coral, painted with accuracy of observation and the precise and delicate touch of a miniaturist, the textures and local color on the same plane of interest as the characterization, the work of a "little master" rather than a great one, yet more insistently appealing than much that makes a fuller claim to recognition, and refreshing in the pure perfection of its technique.

There are others, of course, to whom it would be difficult to deny a share in the development of the Pre-Raphaelite movement if the manner and choice of subject alone were considered; but there is little indication that the vitality of Pre-Raphaelitism is not limited to the small original circle whose works are so securely isolated by their individual character as to constitute a class by themselves. Whatever their

fortunes in the market place, they will never lose their peculiar intrinsic value as things precious and apart.

* * *

NEW WOOLWORTH BUILDING ON BROADWAY WILL ECLIPSE SINGER TOWER IN HEIGHT

On the site of Mayor Philip Hone's famous Broadway residence "opposite the Park" is to be erected a towering office building which, in every sense of the word, will be an architectural ornament to the city. This is the Woolworth Building, owned by the Broadway-Park Place Company, F. W. Woolworth, President, for which plans have just been completed by the architect, Cass Gilbert. The structure, which in several respects will be one of the most notable edifices not only in the metropolis, but in the world, will occupy the southwest corner of Broadway and Park Place, having a frontage of 105 feet on Broadway, occupying the entire block front with the exception of the Barclay Street corner, opposite the Astor House, while on Park Place the frontage will be 197 feet.

It is estimated that this newest addition to New York's great skyscrapers will cost close to $5,000,000. The plans filed last week for the foundations alone aggregate $500,000 in cost. From the sidewalk to the top there will be forty-five stories, the total height being 625 feet, exceeding the height of the Singer tower, just five blocks below, by thirteen feet. Only one building in New York will be higher, the Metropolitan, whose tower rises 700 feet and 3 inches above the street level. The only other loftier structure in the world is the Eiffel tower, 985 feet, making the Woolworth Building the third highest edifice in the world and the second highest in America.

These facts, while revealing something of the magnitude of the building, by no means tell the full story of its many interesting features. Indeed, the complete story will probably not be written until after its completion on Jan. 1, 1912. Few structures in the city, whether designed for commercial or other uses, have received such careful attention in working out every detail of both the architectural and structural features as the new Woolworth Building. Fully a dozen sketches have been made by the architect, and Mr. Woolworth has made suggestions and scrutinized every one more critically than is often shown by the prospective builder and occupant of an expensive private house.

An Ornament to the City

"I do not want a mere building," Mr. Woolworth remarked one day. "I want something that will be an ornament to the city."

Upon this plan both owner and architect have labored, and the privileged few who have had an opportunity of seeing the accepted design and studying the plans have no hesitation in saying that this latest skyscraper will not only be an ornament, but will set a high standard for architectural excellence in the future. Without question it will be one of the few structures which will stand out prominently as a distinguishing type of the so-called New World architecture, as exemplified in the possibilities of steel construction for lofty business edifices.

The architect has cast the much-used Renaissance type entirely aside. In general treatment the façade will be gothic in style, and yet, while a semblance of gothic, it will not be wholly gothic in method of construction or exact forms of detail. It will represent the gothic principle in treating the problem of vertical lines as frankly as treated by many cathedral builders. The vertical lines will be relieved at stages by horizontal lines of gothic treatment, and the top of the main structure as well as the belvedere sections of the tower will be richly ornamented in gothic details.

The main building will rise to a height of twenty-six stories. The tower, beginning at that point, will contain nineteen stories. This tower will be the spectacular feature of the building, as its pinnacle, which will be brilliantly illuminated at night, will be discernible at a distance of fifty miles or more from the city, a prominent mark in the landscape. The tower will be eighty-six feet square, larger in dimensions by about twenty feet than the Singer tower. There will be thirteen stories in the main tower section, while the upper section is to be treated in four stages, and will contain six stories.

The same architectural features and system of adornment devoted to the front of the building will be similarly carried out on the rear and sides, Mr. Woolworth having insisted that there are to be no blank walls or weakening of architectural effect in any way. This fact, somewhat unusual in tall commercial structures, while giving a harmonious charm to the structure means an additional cost of several thousand dollars.

Structural Features

It is needless to say that it will be of fire-proof construction in every respect. No wood will be used in the general structural work. The main entrance on Broadway will lead into a well-lighted hall with a broad marble staircase at the end, leading to the second floor, which has been taken as the new quarters of the Irving National Exchange Bank, Lewis E. Pierson, President. At the end of the main hall will be an arcade hallway leading to Park Place, this entrance from the latter street being near the end of the building at that point. For passenger service there will be fourteen high-speed elevators, two bank elevators, and one large freight elevator. The greater part of the ground floor will be utilized for stores and large offices.

One of the many novel features will be a large swimming tank in the basement lined with marble. There will also be shower baths, lockers, and other conveniences. The building will probably contain a well-equipped gymnasium and running track on the roof.

A portion of the upper floor will be used for a restaurant, while the twenty-fifth floor of the main building, just under the tower section, will be fitted up as a lunch club, with facilities for about 200 members. The club will have a large dining room and several private dining rooms, a cheerful lounging room with a magnificent billiard room, on one side

of which will be a loggia, and an observation room in the form of a palm garden on the roof. Besides these airy eating rooms, there will be a restaurant or rathskeller in the basement, the entrance being from the Park Place side. Provision has also been made in the basement for a safe deposit vault to contain about 2,500 boxes. There will be a barber's shop on the ground floor connected with the swimming pool.

From the structural standpoint the foundations for a building of this size deserve more than passing notice. Having a sandy foundation to work upon, borings have been made to a depth of 130 feet to bedrock, and thirty-eight caissons, some over sixteen feet in diameter, will be sunk to bedrock level to obtain a firm setting for the 625-foot structure. Below the sidewalk there will be three stories, the basement and a sub-basement with the boiler rooms below forming the first real floor level. Counting these, the building will actually have forty-eight stories. Next to the new Municipal Building, the Woolworth Building represents the largest caisson job ever undertaken in the city.

The area covered by the building is about 18,500 square feet. It occupies the site of the old structure formerly known as 231 to 237 Broadway and 6, 8, and 10 Park Place. The greater part of the property was purchased by Frank W. Woolworth a little less than a year ago, costing somewhat over $2,000,000, so that the total investment, with the completed building, will be not far from $7,000,000, making the operation one of notable financial magnitude in the city.

Site of Hone Residence

The corner selected by Mr. Woolworth for his mammoth structure is one of the most interesting from a historical point of view in New York. The mere fact that Mayor Philip Hone, who presided over the municipality in 1826, had his residence there is sufficient from his social and political prominence, to add more than usual interest to the site, but besides Mayor Hone many others of note in early New York days have contributed worthy reminiscences to the spot. Philip Hone's house was at 235 Broadway, adjoining the Park Place corner. It was a wide, handsome building in its day, fronting thirty-five feet on Broadway, and was the scene of probably more social events of interest than any other house of its time. Mr. Hone bought the place from Jotham Smith, a famous dry goods merchant, a century ago, whose store was on the site of the present Astor House, in 1821, for $25,000.

Mayor Hone's most valuable contribution to New York, however, is his diary, than which no more entertaining record of early New York has ever been written. To dine at the Hone table was an honor. He was an intimate friend of Daniel Webster, Henry Clay, Washington Irving, Fits-Greene Gedleck, John Jacob Astor, Chancellor Kent, John Howard Payne, James W. Wallack, William H. Seward, Samuel B. Ruggles, James Gore King, Charles King, and every merchant and financier of note, all of whom were frequent visitors to the fine old house at 235 Broadway. No ugly-looking Post Office Building obscured his view then, City Hall Park extending clear to the lower end of Park Row, and directly opposite his

house was the popular Park Theatre, where the worthy Mayor was a confirmed first nighter. He was one of the organizers of the Union Club in 1836. Late in life Mr. Hone met with financial reverses, and President Taylor appointed him naval officer of the city. He died in 1851 in his new home on the southeast corner of Broadway and Great Jones Street.

In 1836 Philip Hone sold his Broadway residence, being virtually driven out by the expansion of business. He tells of the incident in his diary under date of March 8, 1836:

"I have this day sold my house, in which I live, at 235 Broadway, to Elijah Boardman for $60,000, to be converted into shops below and the upper part to form part of the establishment of the American Hotel, kept by Edward Milford," and again he adds: "I am turned out of doors. Almost everybody downtown is in the same predicament, for all the dwelling houses are to be converted into stores. We are tempted with prices so exorbitantly high that none can resist, and the old town burgomasters who have fixed to one spot all their lives will be seen during the next Summer in flocks marching reluctantly north to pitch their tents in places where in their time were orchards, cornfields, or morasses, a pretty smart distance from town."

Gave Way to American Hotel

His house was quickly remodeled for the enlargement of the American Hotel, which had opened several years before on the Barclay Street corner, and under the head, "American Hotel," The Commercial Advertiser of June 30, 1836, tells of the improvements made to this famous hostelry:

"This old and famous establishment has been still further extended by connecting therewith the large and elegant houses recently vacated by Philip Hone, Esq., in Broadway and also the commodious house adjoining the same lot fronting, however, upon Park Place. By these additions the apartments of the American Hotel embrace the whole front sweep of the block between Park Place and Barclay Street to say nothing of the Park Place house on the north corner of that street and Broadway, which has been kept as a branch of the American Hotel for eighteen months past. The first mentioned pile of buildings, including the houses lately belonging to Mr. Hone and John Wilson, though appearing like separate establishments in front, are all connected internally and by the rears of the several houses.

"Mr. Hone's late superb drawing rooms are thrown open as parlors in common for the ladies and gentlemen of the hotel, and Mr. Wilson's late residence has been converted into private or family apartments. The establishment is now of great extensiveness, and is excellently well kept by Mr. Milford, than whom, on the score of address and a desire to please, there is no more deserving or better qualified caterer for the public in this country."

Elijah Boardman, who paid Mr. Hone the big price of $60,000, made no money on his purchase, for in 1839 he was willing to sell at the same figure to Joseph Kernochan, and twelve years later, in 1851, he sold it to Frederick Tracy and James Irwin for $80,000. They remodeled the building, and for

fifteen years or more, under the firm name of Tracy & Irwin, it was one of the best-known dry goods stores in the city.

Famous Dry Goods Centre

The Tracy family was prominent for years in the business and social life of the city. The elder Tracy, Frederick A., was one of the early Wall Street brokers, being in 1817 one of the twenty-eight brokers of the old New York Exchange Board. In 1864 the dry goods merchants sold their store to Abia A. Selover for $150,000, and, according to the records of the property with the Title Guarantee and Trust Company, William Butler Duncan purchased it in 1873 for $325,000. The records indicate a depreciation after this, for in 1888, when it passed to the late Trenor L. Park, the consideration is given as $200,000.

The adjoining property at 233 Broadway once bordered, when the home of Mrs. Charles Startin, the large yard of John C. Vanden Heuvel, the wealthy West Indian merchant, who owned as his country residence the Bloomingdale property, later known as Burnham's, and which is now occupied by the Apthorpe apartment house between Seventy-eighth and Seventy-ninth Streets, Broadway and West End Avenue. In 1870 it is recorded as owned by the Countess Martha Verasis de Castiglione, one of the heirs of Henry H. Porter, and it was purchased at foreclosure in 1878 by Mahlon Sands for $45,700, and from him it passed to George Noakes, the late owner, in 1883, for $73,250.

Benjamin and Halstead E. Haight purchased the corner, 237 Broadway, 25 by 120, from Trinity Church in 1830 for $10,000. The Haights were prominent merchants, and owned a great deal of property in the immediate vicinity. Halstead Haight died in 1831, and the following year the corner was sold to Silas Bronson for $37,000, showing a good profit, and in 1851 the Broadway Bank got the plot for $95,000, and soon after erected the old seven-story building recently torn down. In 1903, when the Mercantile National Bank, the recent seller, absorbed the Broadway Bank, it purchased the plot for about $650,000, and it is said the price paid for this corner in the recent deal was $750,000, quite a handsome advance over the paltry $10,000 paid to Trinity Church eighty years ago.

Cass Gilbert, the architect of the Woolworth Building, has designed, among other notable structures, the New York Custom House, the Minnesota State Capitol, and he is now building the St. Louis Public Library.

* * *

<div align="right">January 14, 1911</div>

SLASHES FAMOUS PICTURE

Discharged Naval Cook Mutilates Master's "Night Watch" at Amsterdam

AMSTERDAM, Jan. 13—Rembrandt's famous picture, "The Night Watch," was badly damaged to-day by a dis-charged naval cook named Sigrist, who entered the Rijks Museum and with a knife deliberately slashed the masterpiece.

The cuts traverse the principal figures of Captain Frans Banning Cocq's company of arquebusiers, but art experts who viewed the work afterward expressed the opinion that the damage was not beyond repair.

Sigrist, who was arrested, declared that his vandalism was an act of vengeance against the State because of his discharge from service in the navy.

"The Night Watch," or "Sortie of the Banning Cocq Company," is Rembrandt's most famous work. It shows Capt. Cocq's company of arquebusiers emerging from their guild-house on the Singel. In the middle of the canvas the Captain marches in front in a dark-brown, almost black costume. At his side is Lieut. Willem van Ruitenberg in a yellow buffalo jerkin. Both figures are in full sunlight, so that the shadow of the Captain's hand is distinctly visible on the Lieutenant's jerkin. On the Captain's right is an arquebusier loading his weapon, and next to him two children. One of them, a girl, has a dead cock hanging from her girdle, perhaps one of the prizes. On a step behind them is Ensign Jan Visser Cornelis-sen. The other side of the picture is pervaded with similar life and spirit to the extreme corner of the canvas, where Jan van Kamboort energetically beats his drum.

The scene is laid in a lofty vaulted hall, lighted only by windows above and to the left. The remarkable chiaroscuro which usually prevails in imperfectly lighted interiors on bright sunny days is reproduced with such poetic fancy that it was long supposed that Rembrandt intended to depict a nocturnal scene. The peculiar light and the spirited action of the picture elevate the group of portraits into a most effective dramatic scene.

"The Night Watch" is the largest of Rembrandt's paintings, measuring more than 11 by 14 feet. It was painted in 1642 for the Kloveniers-Doelen at Amsterdam. Sixteen of the group are portraits of members of the guild, and each of these paid 100 florins for the artist's work. In an oval frame on a column in the background are inscribed the names of members of the guild.

The painting was successfully cleaned by Hopman in 1889, and experts in this city when they heard of the act of vandalism yesterday were hopeful that the painting could be repaired. One means of restoring a painting that has been slashed with a knife is to put a new lining on the back, drawing it together until the edges of the canvas are joined in their original position. This has been successfully done in cases where the edges were cut clean with a sharp knife. If the cuts are ragged and any of the paint is removed by the raveling of the canvas, retouching is necessary. No workmen are more skilled in this delicate operation than those of Amsterdam.

The recurrence of such attacks on priceless paintings in European galleries has often led to a proposal that they all be placed behind glass, but the objection that part of the effect of the painting is thus lost has so far outweighed considerations of safety.

* * *

April 30, 1911

OUR ART HAS A TERRIBLE ATTACK OF UGLINESS

By EDWARD MARSHALL

We have an art, and it is getting better; to send young men and women to the schools of Europe for their education is an asininity, although they may, with value, certainly, go there to study after they have formed their groundwork; in some details our art is the best art in the world to-day, but no nation in the world, if it is to win real victory for beauty, must fight so hard as we must against ugliness.

These and many other things which are of interest and which will be found, in due course, by all those who read this interview in its entirety, were told to me by Kenyon Cox, generally of New York, at present of Chicago, and, really, of the United States—more truly still, a citizen of the whole world of art, an American who has won much distinction and deserved all he has won.

I saw him first at the entrance to Chicago's great art institute, (a wondrous and an admirable institution which every city in the land should copy, if it can, and which New York especially stands much in need of,) and, afterward, across Michigan Avenue, in his room at the Chicago Athletic Club, from which breezes from Lake Michigan, beyond the institute, blow some part of Chicago's smoke away. He is a healthy, though ascetic man, whose nervousness is energetic and not enervated. He talks fluently and logically, and he has real things to say. Perhaps the best thing I can do is, now, to let him say them without further introductions. His big eyes set in a long face with high cheek bones, was very earnest as he made his points.

"Have we an art?" I asked.

"Of course we have."

"What perils mostly threaten it?"

"The errors which handicap and the perils which threaten the young artist in this country," Mr. Cox replied, "are those of the whole world. My point of view may not be God's eternal truth, but I think all art has been suffering from too much naturalism, too much effort to record facts. That is not art, I think. There has been too much personality, too; too much individual whim, due to lack of really complete education, and, in general, to lack of discipline. Briefly, all modern art is too naturalistic, or too purely personal."

"The cause of this has been?"

"That all traditions perished at the beginning of the nineteenth century, and all modern art has been attempts to get something fine and interesting without ascertained facts to use for guides. One man tries this, another that. There has been nothing any one could rest on without becoming merely whimsical and personal."

American Art Superior in Some Ways

"And these conditions are characteristically American?"

"No, these are the difficulties of all modern art. American art is less given than some others are to personal whim and mere naturalism. We are, indeed, paying more attention than any other country to proper consideration of the art of the past, and striving harder to work upward from sound bases.

"But American art is not brand new, nor are the principles on which it has been founded new. We are simply and, I think, quite wonderfully, for we are not by nature real conservatives, developing a more conservative native art than I see current signs of in any other country in the world. We have men who show modern tendencies, but they do not go so far as the extremists of the other countries. They work less eccentrically."

"Therefore, you would advise the young American who wishes to learn art to stay at home, rather than to go abroad?" With thousands of Americans, I fancy, I had supposed that art could only be achieved in European schools.

Kenyon Cox who, if any one should know, should be a real authority, emphatically nodded.

"If what I've said is true, it naturally follows that the best place for young Americans who have artistic tendencies is to give them their development right here in America. They will find more thorough instruction, more sound training, in the United States than they will find in any foreign country. Foreign worship is mere caddism—caddism of the worst kind. It has hampered us, but it is dying out. There is enough of it remaining, though, to make it worth emphatic words of protest."

"When may our real American art be said to have begun?"

"Americans have had an art they did not know about, appreciate, or support much longer than most of them know. We had a real art of our own in the early part of the nineteenth century, and it produced things of value for many years. Stewart, Ingalls, S. F. B. Morse, the inventor of the telegraph and, also, a really good artist, all were splendid men. At that time we had a school of art as well as architecture. But it did not last. We did not live up to our good beginnings.

"In architecture, in painting, and in all those things, as the country began to grow away from the colonial into the frontier stage, art died out. It had reached its lowest ebb at the time of the civil war. The first succeeding forward movement was sporadic, and began soon after the war, with Winslow Homer, George Innes, John Lafarge, Eastman Johnston, and a few others. This was in 1876, or thereabouts."

Foreign Worship Stupid

"When I, myself, began serious work, there was very little of good schooling to be had in the United States. Almost all the men of my generation, many of the foremost men of to-day, were educated in Paris or Munich, because they had no choice. But within a few years they began to come back from foreign schools, and with them as its founders there has grown up an American art which makes the foreign worship I have spoken of a truly stupid thing. Such men as Walter Shirlaw, William M. Chase, Frank Dumdenick, Augustus St. Gaudens, and Will Low returned with the ability and training to lead us, and there were others whom I have not for the

moment thought of. The stream kept on for quite a while. There were Brush and Douglas Volk, and many others—all good men.

"I returned in 1883. The modern American school had already begun with the founding of the Society of American artists in 1881 or 1882. That school, despite the curious national prejudice against native and for foreign art, has gone on, with more men and more work, getting stronger every year, until now it seems absurd to bow down to the foreigners to the exclusion, even, of right admiration for our own. The schools developed opportunity for worthy education here at home. To-day a great many of our best young painters have had practically no foreign education, and for this they deserve congratulation, not neglect. Of many who have studied art abroad it may be said that quite the best they know was learned at home. For the student of to-day there is every argument against European study for his actual education. It may be well to finish with a look around at the great works of the Europeans, but a better actual education can be gained in this country by the American art student than can be found in Europe. And we're even wiping out the old necessity for traveling abroad in order to see what the masters of the past have done. The wealth of private collections in America is extensive, if almost unknown to nearly every one. Even through our public collections, which have, hitherto, been meagre and ill chosen, it is now beginning to be possible to get a better idea of the art of the past than any one would have imagined ten, or even five, years ago.

A Great American School

"Take the Art Institute here in Chicago, for example. It includes a collection of a number of pictures of very great importance. Like most such American collections, it is mainly of the Dutch and Flemish schools, as regards old masters. It has one Rembrandt, which is justly considered one of the great painter's best small portraits—one of the best in the whole world. Yet, even in Chicago may be found Americans familiar with the galleries of Europe who do not know this, although Chicagoans are less acute in foreign worship, probably, than the people of the East. There are a lot of good Dutch pictures by the minor men here, and among the pictures loaned now to the institute are two admirable Van Dykes, owned in Chicago. Taken all in all, it is a fine collection, including, also, splendid examples of the best work of the masters of the modern schools. There is one extremely important Millet, for example, and another admirable example of his early work, besides several pieces of importance from other men of the famous Barbizon school.

"In the Metropolitan Museum in New York we have to-day not only a remarkable collection of Dutch pictures, including Rembrandt, Vermeer, De Hoogh, and some of the best Hals to be seen anywhere, but many other pictures of worldwide importance, among them one of the greatest of Van Dykes. The collection of the works of the early Italian painters in the Metropolitan Museum also is important. The

Veronese 'Venus and Mars Bound by Cupid' is among these, and would be ranked a gem in any European gallery. It is, in my opinion, one of the finest examples in existence of the great Italian's early work. Does all this help to make the silliness of foreign-worship clear?

"It is a pretty good beginning, is it not, toward supplying here the kind of culture which so many think cannot be got except through travel. And there is more in store for us. Mrs. Jack Gardner's collection in Boston will probably become public property ultimately, and when it does, first-class examples of Titian, Raphael, Botticelli, and a number of the others of the great Italians, of whom these are three, will be added to the rich possible material which American students may study here at home, without crossing any ocean.

No Need To Travel Nowadays

"Most of the other great American collections will, also, probably, soon or late, become public property, so that the time has come, I think, when it may be safely said that while it will always be advisable for the American to travel for the purpose of studying certain world-renowned masterpieces, and especially to see the decorative work upon the walls of churches and public buildings, which can never be seen otherwise, yet the time is not far distant when a fairly adequate conception of the world's best art will be attainable without traveling beyond the boundaries of the United States. And our own men are doing worthy work worth study.

"There are a number of American artists now in Europe who are among the best of the contributors to the foreign exhibitions, but the point I wish especially to emphasize is that men living and working at home, here in their own country, are producing now art more original and more American—and more original and more American because more conservative and less affected by the purely modernistic tendencies of foreign schools, than the work, admirable as it may be, of those Americans who, by their continuous residence abroad, are necessarily more affected by the current wholly foreign work with which they are, of course, surrounded.

"And, as I have said, the caddism of foreign worship is dying out. Most American artists are, to-day strongly of the opinion that the future is with us. The standard of our exhibitions, even now, is higher than the standard of any other country. The general average attained among our painters is the greatest of surprises to artists coming here from foreign countries, whether they be foreigners or Americans who have lived long in Europe. Most artists know how good our American painters are; some collectors are gradually learning, but the public does not know at all—that public of America which is so prone to worship foreign things!"

No Support for Native Art

"American art is not yet supported as it should be. It is still true of the American with money, who can purchase pictures, that the aureole of foreign reputation transfigures many rather inferior painters into heaven-kissed geniuses—painters whose

work could easily be bettered by men at home who have not and do not want the halo of foreign reputation. This worship of foreign art is among our worst provincialisms. Americans do not know art themselves, and it is natural, perhaps, that for them the stamp of recognition from nations which have possessed art for centuries should mean something very serious—as, indeed, it really does. Our buyers can hardly be expected, possibly, to trust their own tastes and judgment until some one with the voice of an authority has uttered his approval.

"Especially in New York one of the reasons why the work of our American artists is not supported as it should be is that the city has no proper facilities for its fitting exhibition. The result is that the city where the great bulk of our art work is produced never sees it to the best advantage, and never sees a great deal of it at all. It will not be until New York awakens to the real necessity for providing something nearly as adequate in the way of a building for the exhibition of her current art, as is provided by half a dozen Western cities, that the people of our great metropolis will have any opportunity to know what we are doing in this country. New York, until it wakes up to this need and properly supplies it, cannot obtain the position which she ought to have in the art movement in this country. The city and State of New York have done much for the Metropolitan Museum of Art, but they do nothing toward the exhibition of the products of the living, working, striving, rising artists—the men and women upon whom the future of the country rests, so far as pictures are concerned. While artists hold exhibitions in New York today that really are good, they are invariably held in circumstances so unfavorable that they suffer seriously and can get no justice, and many artists will not show their work in New York at all."

Our Best Mural Work Not Exhibited At All

"One of the most notable lines along which American art has most notably progressed has been the line of mural work, but few Americans have any idea whatever of its merit or its volume. It cannot now be shown at all. If the United States were France and New York City Paris, every one of the really fine mural paintings which have been done and scattered to the buildings for which they were designed would have been shown first in New York City before being sent to places where, upon the walls in permanent position, they can be seen only by the traveler and the local population. As things stand, New York has not seen much of the best work Americans have done. When we have in New York City galleries sufficient for the combined annual exhibition of all the art societies centering in New York, then we shall make a showing which will astonish those who see it, and be one of the really great exhibitions of the world.

"And, unfortunately, most of the American art critics who have any real knowledge of the subject (and they are a very small minority of those who write for us what passes as 'art criticism') are apt to become jaded from constant visiting of exhibitions and to discharge only that part of their proper function which consists in finding fault—to praise only when something absolutely peppery in its novelty tickles their pal-

ates. They leave the sober, worthy accomplishments of our best men to make their way with very little help. One imagines, also, that some of them are frightened by the critical blunders which have marked the nineteenth century, and that, knowing that much of the work now admired was at first thought eccentric, they have come to the conclusion that anything eccentric is likely to be good, and that that which is not is quite certain to be bad."

"Have our women done as well as our men have?"

Good Work by American Women

"There are several American women of very distinct accomplishment in art, and I think it may safely be said that a large majority of those women who have achieved in art in this generation are Americans. Perhaps the one woman who ever made a distinctive art of her own, who counts very seriously among the original painters of her time, is an American—Mary Cassatt. She is a Philadelphian and studied first in Philadelphia. She has now attached herself to a foreign school, but is an American, and is an original personality in that school. I don't know any other woman, in this or any other country, who has shown such a degree of originality and become so important. But without quite attaining that position, there are other American women whose work is fully equal to that of our best men, the most notable instance which now comes to my mind being that of Cecilia Beaux, another Philadelphian. She is the only woman ever made a full Academician of the National Academy of Design. Her portraits are always among the best in any exhibition wherein they may be seen.

"Oh, yes; our women have done well. In painting children and in painting miniatures our women artists easily excel our men."

"How about the work of our illustrators?" I inquired. I had been expecting some exultant comment on this score.

"I imagine that our illustration ranks very high, indeed, and should be prepared to agree with any one who told me that it is the best in the whole world," Mr. Cox replied, "but I cannot make the statement of my own knowledge. It is not and never has been my especial field. I am not qualified to praise or blame with real authority."

Artistic Morals Good These Days

"And the morals of our artists?"

"I believe," said he, "that artists here, as elsewhere, are as decent, as a class, if not more decent, than the general run of people. The moral standard among artists has raised the whole world over."

"Has this been good or bad for art?" I had seen a wild lament not long before in a great London weekly of the passing of the Latin Quarter and the decency of modern artists.

"I, myself, believe in good, ordinary standards of clean living, alike for artists and for other men," said Mr. Cox. "And the majority of artists, as I know them, are rather above the ordinary run in sexual morality, in business probity, and in personal habits. Many of the best of our artists are ideal

types of respectable fatherhood and motherhood, and I am glad that this is so, of course.

"And right here let me say just a word about the model. The professional artists' model, as I know her, is a painstaking, hard-working, highly respectable professional woman. She is neither more nor less than that, and if she were any less she would get very little work in the studios of artists who mean business. What there may be by way of morals or their lack among a certain class of young men in this country I would rather not express an opinion of, but such conditions are not characteristically and exclusively American. And such young men are not the ones who will 'win out.'

"The passing of bohemianism, and it certainly has passed, has been a good thing for art. No man can do his best work unless he keeps himself in pretty good mental, physical, and moral health, and toward that bohemianism did not tend. Of course, the profession of art, like all professions, has its loose fish, but it is not only true that they are now exceptions to the general rule, but it is true that they rarely attain and maintain high positions in their art. A good many men have found that it was very clearly a question of giving up bohemianism or giving up the serious production of art. The choice that they made between the two determined the position which they occupy to-day."

"If you were to offer some condensed advice to young Americans who have to-day ambitions to be artists, what would it be?" I asked.

Advice to the Young Artist

"This," said Mr. Cox, after a little thought. "That in spite of the extraordinary facilities for notoriety to-day, there is no short-cuts in art. Nothing but determined souls, indomitable perseverance, endless painstaking will produce anything worth while. To try get-famous-quick proceedings is quite as dangerous as to try get-rich-quick methods. I tell every student I can reach to learn everything he can in both of the aspects of nature and the history and traditions of art; to try always to do the right thing and the fine thing, and let the question of whether or not it is unusual take care of itself; I tell them that the only individuality worth much to the world is the disciplined individuality which speaks through training and through knowledge got by training."

"How about our national toleration for the ugly? It is everywhere in evidence, and it cannot be denied."

Now Kenyon Cox drew a long breath. It was plain that I had touched him on the raw—had flicked a nerve which tingled often with recurring pain.

"Yes, yes," he said with very actual emphasis. "One of the things I should like to go into is the possible advertising value of beauty. Our advertisements, particularly those which are the net result of millions spent outside the printed pages of the newspapers and magazines, are startling, horrible, sometimes, in their sheer ugliness. And if the advertisers only knew it they would do themselves more benefit and sell more of their goods if they omitted them entirely or erected beautiful and tasteful advertisements than they do or sell and by the display of the truly agonizing signs we often see along the railroad lines and elsewhere now.

"In the street cars of New York city a little while ago, an advertising card was shown. This card was printed simply with black letters on a pure white ground, and asked the folk who saw it which card in the car they thought best. A small reward was offered for the best letter written in reply.

"I don't know how the contest terminated, but if I had cared to enter the competition for the prize I should have answered:

" 'Your card is the best. It has no violent colors, it has no badly drawn pictures, it does not shout—it speaks like a gentleman, and is heard, because it is in good taste. It is conspicuous in a crowd of vulgarities.' "

I now questioned him. "Would such simple refinement sell as many goods to the American public, do you think, as the cards which you consider vulgar do?"

Some "Ads" Repellant

"I am no salesman," Mr. Cox replied, "but I can say this: a certain kind of vulgar 'ad' was, to me, so thoroughly repellant, that for a long time it deterred me from buying products which, when I did try them, I found to be most excellent. How many people there are like me I don't know. If you stand on the street corner long enough, continually shouting a given name, you make sure that for a time that name will not be forgotten. But there is this question: Will it not be cursed by those ears which have been continually tortured with it? The hideous signs which border on our railways have often made me, at least, definitely resolve never, under any circumstances, to buy the articles they advertise."

"Could any signs along the railways and upon the buildings be made beautiful and attractive to the artist's eye?"

"No signs could be. And advertisers will in time learn that they do no good and give them up, confining their advertising to the mediums best fashioned for it—the newspapers and magazines. They will leave nature's beauties once again revealed to the passing traveler, and thus achieve his gratitude and help the nation toward good taste and art development."

"You see a decrease in vulgarity of advertising now?"

"Unfortunately, no. But I think that while vulgarity of advertising is still on the increase, there is also an increasing restiveness beneath the cruelties of its infliction, and I believe the day will come when, if the evil does not cure itself, it will be cured by law, and it will be decided that the torture of the human eye is just as much a nuisance, abatable by law, as it is now agreed the torture of the human ear by untimely and discordant sounds is.

"We have our dreadful ugliness, but they will cure themselves. Our architectural ugliness has, already, started in to do so. Architects and patrons are being educated to far better things than we have known in times gone by. One of the things coming more and more to be recognized among us is that beauty pays as a mere business proposition, and that the best advertisement that a firm or corporation can devise for itself is a building so beautiful that it is an ornament to the

town in which it stands, and thus and therefore is pointed out to the visiting stranger.

Growing Demand for Beauty

"Everywhere throughout this country, whether or not there is toleration of ugliness, there is still a growing demand for beauty. The result to-day is rather patchy and the beautiful things are scattered among ugly ones; but when beautiful things and ugly things thus come in contact the end is absolutely certain. Unless a nation is in a late stage of decay the beautiful things will conquer. In the end we shall regain a uniformity, but it will be a uniformity of beauty, not of ugliness.

"I think New York is rapidly becoming a beautiful city, and this is especially gratifying to an American, because it is along absolutely new lines. Lower New York presents to-day one of the most extraordinary spectacles the world can show. By its mere size the thing becomes distinctly glorious to look upon through play of clouds or rain or sunshine. When I returned from Europe last Fall I came up the bay at four or five P. M. Those stone and brick and mortar masses on the lower island built themselves up before me like an Arabian Night's exaggeration of the old towered hill cities of the Italy I had just come from. There was still daylight enough to let me see quite clearly, but dusk was coming on, and the great spectacle was ineffably tender against the further sky. When, presently, as I still watched, the lights began to flicker here and there among them, as if a flock of fireflies had alighted on their sides and parapets, and their golden points, reflected in the water of the bay and river, flickered, multiplied; their whole effect seemed really more wonderful, more beautiful, than anything I had seen in Europe.

"But this, to some extent, is accidental. It is not the thing you get in the Cathedral or the Campanillo in Florence, or the Piazza San Marco in Venice, where the effect is all intentional—created art; it is more the beauty of a natural scene, of something which has become lovely almost without intention. Some of the buildings which made up the lovely mass are of themselves good, many of them are bad; the effect of the whole was not intended or designed by any one. It is none the less eminently beautiful on that account, but, perhaps, this gives us some less reason for real exultation over it.

"Another thing about New York: Fifth Avenue is rapidly becoming a really beautiful street, and this is much less accidental; it is due more to the work of architects and to the sense of capitalists who are more and more allowing architects to take into consideration in their planning the relations of the new buildings to those buildings which already stand and which will neighbor it.

"But we need more, far more of civic planning, before we get anything near to National beauty in our towns and cities. His work along that line is one of the things for which we shall miss Carrere, who was killed recently by a taxicab. But the real beauty movement is growing stronger every day.

"We shall always go abroad—we must, we can't afford not to; but the time is surely coming when the Europeans must also come to us. They must come to see our real achievements, for some of them are very real. The prosperous and cultivated people of all Europe will, in times to come, and, possibly, not very distant, make the tour of the United States, not alone nor even principally for the natural wonders of our country, but travel here, guide book in hand, to study our buildings and our monuments, our mural decorations, and our galleries of native art, as we now travel in the old world."

* * *

August 20, 1911

FUTURISTS CONDEMN NUDITY IN PAINTING

Men Who Urged Factories Instead of Palaces for Venice Issue Another Manifesto

FORMULATE NEW ART CREED

Portrait Should Not Resemble Its Model; Landscape Should Be Imaginary—Space No Longer Exists

From the office of Poesia, "Moteur du Futurisme," at Milan, has come another of those surprising Futurist manifestoes that, if they are nothing else, are at any rate suggestive and interesting.

This manifesto is rather more definite than its predecessors, in that it formulates a more or less understandable programme and expresses some new theories in reward to pictorial art. It is signed by five artists—Umberto Buccioni, Carlo D. Cara, and Luigi Russolo of Milan; Giacomo Balla of Rome, and Gino Severini of Paris.

The manifesto begins by referring to the first declaration of the Futurists, "hurled at the public" from the stage of the Chiarella Theatre at Turin in March, 1910. It will be remembered that the Futurists, among other things, demanded that Venice be turned into a city of factories and declared that factory chimneys were more beautiful that quattrocento palaces.

"The fight at Turin," says the new manifesto, "has become legendary. We exchanged almost as many blows as ideas in our struggle to rescue from a miserable death the genius of Italian art. It was a fierce and formidable struggle, and during this momentary truce we come forward to explain as untechnically as possible what we meant by futurism in painting, though at our exhibition at Milan we have already given a practical demonstration."

The manifesto proceeds to formulate a new art creed.

"Our growing art," it says, "can no longer be satisfied with form and color; what we wish to produce on canvas will no longer be one fixed instant of universal dynamism; it will simply be the dynamic sensation itself.

"Everything is movement, transformation. A profile is never motionless, but is constantly varying. Objects in movement multiply themselves, become deformed in pursuing each other, like hurried vibrations. For instance, a runaway horse has not four legs, but twenty, and their

movement is triangular. In art all is conventional, nothing is absolute. That which yesterday was a truth to-day is nothing but a lie.

"We declare, for instance, that a portrait must not resemble its model and that a painter must draw from his own inspiration the landscape he wishes to fix on canvas. To paint a human face one must not only reproduce the features, but also the surrounding atmosphere.

"Space no longer exists; in fact, the pavement of a street soaked by rain beneath the dazzle of electric lamps grows immensely hollow down to the centre of the earth.

"Thousands of miles divide us from the sun, but that does not prevent the house before us being incased in the solar disk.

"Who can believe in the opaqueness of bodies since our sensibilities have become sharpened and multiplied through the obscure manifestations of mediumnity?

"Why do we forget in our creations the doubled power of our sight with its scope of vision almost equal in power to that of X rays?

"It will be enough to quote a few of the innumerable examples which prove our statements.

"The sixteen persons around you in a tramcar are by turn and at one and the same time one, ten, four, three, they are motionless yet change places; they come and go, are abruptly devoured by the sun, yet all the time are sitting before us and could serve as symbols of universal vibration. How often, while talking to a friend do we see on his cheek the reflection of the horse passing far off at the top of the street. Our bodies enter the sofa on which we sit and the sofa becomes part of our body. The tramway is engulfed in the houses it passes and the houses rush on the tramway and melt with it. The construction of pictures has hitherto been stupidly conventional. The painters have always depicted the objects and persons as being in front of us. Henceforth the spectator will be in the centre of the picture. In all domains of the human spirit a clearsighted, individual inquiry has swept away the obscurities of dogma. So also the life-giving tide of science must free painting from the bonds of academical tradition. We must be born again. Has not science disowned her past in order better to satisfy the material needs of our day? So must art deny her past in order to satisfy our modern intellectual needs.

"To our renewed consciousness man is no longer the centre of universal life. The suffering of a man is as interesting in our eyes as the pain of an electric lamp which suffers with spasmodic starts and shrieks, with the most heart-rending expressions of color. The harmony of the lines and folds of a contemporary costume exercises on our sensibility the same stirring and symbolic power as nudity did to the ancients.

"To understand the beauties of a futurist picture the soul must be purified and the eye delivered from the veil of atavism and culture; go to nature and not to museums. When this result is obtained it will be perceived that brown has never circulated beneath our epidermis, that yellow shines in our flesh, that red flashes, and that green, blue, and violet dance there with voluptuous and winning graces. How can one still see pink in the human face, when our life doubled by nocturne life has multiplied our colorists' perceptions? The human face flashes of red, yellow, green, blue, and violet. The pallor of a woman gazing at a jeweler's shop window has rainbow hues more intense than the flashes of the jewels which fascinate her like a lark.

"Our ideas on painting can no longer be whispered, but must be sung and must ring on our canvases like triumphant fanfares. Our eyes, accustomed to twilight, will soon be dazzled by the full light of day. Our shadows will be more brilliant than the strongest light of our predecessors, and our pictures beside those in museums will shine as a blinding day compared to a gloomy night. We now conclude that now-a-days there can exist no painting without divisionism. It is not a question of a process which can be learned and applied freely. Divisionism for the modern painter must be inborn complementarism, which we declare to be essential and necessary.

"Our art will probably be accused of decadence or lunacy, but we shall simply answer that, on the contrary, we are primitives with quickened sensibilities, and that our art is spontaneous and powerful."

The futurists proceed to make the following "declaration":

That all forms of imitation must be despised and all forms of originality glorified;

That we must rebel against the tyranny harmony and good taste, which could easily condemn the works of Rembrandt, Goya, and Rodin;

That art critics are useless or harmful;

That all worn-out subjects must be swept away, in order that we may have scope for the expression of our stormy life of steel, pride fever, and swiftness;

That the name of madmen with which they try to hamper innovators, shall henceforth be considered a title of honor;

That inborn complimentarism is an absolute necessity in painting as free verse in poetry and polyphony in music;

That universal dynamism must be rendered in painting as a dynamic sensation;

That above all sincerity and purity are required in the portrayal of nature;

That movement and light destroy the materiality of bodies.

"We fight," say the signers of the manifesto,

Against the bituminous colors with which one struggles to obtain the patin of time on modern pictures;

Against superficial and elementary archaism founded on flat uniform tints and which, imitating the linear manner of the Egyptians, reduces painting to an impotent childish and grotesque synthesis;

Against the false avenirism of secessionists and independents, who have installed new academies as traditional as the former ones;

Against nudity in painting as raucous and tiring as adultery in literature.

"Let us," the Futurists conclude, "explain this last question. There is nothing immoral in our eyes; it is the monotony of nudity that we fight against. It is said subject is nothing, and all depends upon the way of treating it. Granted. We also

admit it. But this truth which was unobjectionable and absolute fifty years ago is no longer so to-day, as to nudity, since painters beset by the longing to reproduce on canvas the bodies of their lady loves have transformed exhibitions into fairs of rotten hams! We require during the next ten years the total suppression of nudity in painting!"

* * *

August 23, 1911

'LA GIOCONDA' IS STOLEN IN PARIS

Masterpiece of Lionardo da Vinci Vanishes from Louvre—Known as Mona Lisa

FRAME FOUND ON STAIRCASE

Picture Not Cut from It, but Carefully Removed—Army of Detectives at Work

ONE OF WORLD'S TREASURES

Some Judges Regard the Painting as the Finest Existing— $5,000,000 Said to Have Been Offered for it

Special Cable to The New York Times

PARIS, Aug. 22—Impossible as it may seem, it is a fact that Lionardo da Vinci's masterpiece, the "Mona Lisa," was stolen yesterday from the Louvre, where it had been exhibited in the famous Salon Carré for the last five years.

The news, which was made public by a short announcement in the Temps at 5 P. M. to-day, has caused such a sensation that Parisians for the time being have forgotten the rumors of war.

A great crowd collected in the neighborhood of the museum, where, however, no information was given to the public. The museum had been closed, said the policemen at the main entrance, because of the bursting of a water pipe.

When The New York Times correspondent arrived there at about 5:30 o'clock many Americans were standing outside the gates, unable to understand why they had been turned out of the Louvre. A party of tourists who had been "doing" the galleries since mid-day, had been requested to depart at 3 o'clock without any plausible explanation.

M. Bénédite, Assistant Curator of the Louvre, received the correspondent in his office immediately after the Chief Inspector of Police and sixty detectives, who had been searching every nook and corner of the many miles of exhibition rooms and corridors, had left the premises without having found the precious picture.

Last Seen on Monday Morning

" 'La Gioconda' is gone. That is all I can say," said M. Bénédite. "So far we have not the slightest clue as to the perpetrator of the crime. The picture was last seen in its usual place yesterday morning at 7 o'clock, when two of the guardians, busy, as usual, in cleaning the rooms, stopped before it and exchanged remarks about the enigmatic smile of 'La Gioconda,' which for centuries has inspired so many eulogies.

"Yesterday being cleaning day, the museum was closed to the public, and no one noticed the absence of the picture. This morning the guardian of the Salon Carré noticed its disappearance, but attributed it to the negligence of the official photographer, who often took it up to his own studio and returned it the next morning before the gates were open to the public. Toward midday, however, the man became uneasy and informed the Superintendent, who rushed to my office and told me nobody knew what had become of the picture.

"Twenty minutes afterward I was in the cabinet of Police Prefect Lépine, who immediately ordered the closing of the museum and dispatched in great haste an army of detectives, who after searching an hour discovered the heavy frame of the picture standing alone on a staircase leading to one of the cloakrooms.

"The frame bore no trace of violence. The thief or thieves evidently took plenty of time for the operation of dismounting the picture, and left the frame behind as too bulky. How he or they came or left the premises is as yet a mystery.

"Why the theft was committed is also a mystery to me, as I consider the picture valueless in the hands of a private individual. The case is now in the hands of the police, under the personal direction of Prefect Lépine and Supt. Amard."

The correspondent also interviewed M. Le Prieur, Art Curator of the Louvre, who said he felt certain that the picture had been stolen with a view to returning a good copy of it later anonymously. He added:

"I have studied the picture for years, mounted and unmounted, knew every minor detail of it, and would recognize a copy, however perfect, after five minutes' observation."

May Be a Case of "Sabotage"

A different view as to the motive of the theft is entertained by Prefect Lépine.

"Whatever the Curator's idea may be," he told The New York Times correspondent, "I have perfect faith in my men and am sure the picture is not now hidden anywhere in the Louvre. The thieves—I am inclined to think there were more than one—got away with it all right. So far nothing is known of their identity and whereabouts. I am certain that the motive was not a political one, but may be it is a case of 'sabotage,' brought about by discontent among the Louvre employes. Possibly, on the other hand, the theft was committed by a maniac. A more serious possibility is that 'La Gioconda' was stolen by some one who plans to make a monetary profit by blackmailing the Government. Anyway, I think we will soon be able to locate the picture."

No information was obtainable at the Ministry of Beaux Arts beyond the fact that the permanent Under Secretary of Fine Arts, M. Dujardin-Beaumetz, who is at present at Carcassonne, has been telegraphed for and will be here tomorrow morning.

There have been no developments tonight except the information that the authorities seem to have ascertained that the theft was committed between 7:30 and 8:30 A. M. yesterday.

In the meanwhile, pending a further police search, the Louvre remains closed to the public.

Feeling here about the affair is intense. An extraordinary number of absurd theories are advanced, while there is general criticism of the Louvre authorities, who have proved unable to guard what is considered the most precious work of art in the world.

It will be remembered that about thirteen months ago a Paris weekly, the Cri de Paris, caused a sensation by its assertion that "La Gioconda" had been secretly exchanged for a fine copy, while the original had crossed the Atlantic to become part of the collection of a famous American amateur. The editor of the Cri de Paris told The New York Times correspondent this afternoon that the story was printed only as part of a campaign against the Louvre authorities to induce them to keep a better watch over the treasures in their care. The campaign was begun after several cases of vandalism in the museum.

PARIS, Aug. 22—The art world has been thrown into consternation by the announcement of the theft of Lionardo da Vinci's "Mona Lisa" from the Louvre.

The first searches for the painting having proved fruitless, the Under Secretary of State for Fine Arts has lodged a charge of theft against a person or persons unknown with the Minister of Justice, who has appointed a Magistrate to open an immediate investigation.

The Under Secretary has also summoned all photographers who have the privileges of the Louvre, and the police are interrogating the curators and their assistants.

There is a scaffold against the façade of the Louvre, placed there in connection with the installation of an elevator. By this scaffold it would be easy to enter and leave the building, and a person acquainted with the interior and provided with keys to the various rooms could easily reach the Salon Carré.

About 800 persons, including copyists, photographers, workmen, cleaners, and officials, had access to the gallery yesterday. All of these persons have been interrogated by the police, but are unable to furnish the slightest clue. The police are hunting for a mysterious German whose continual presence in the Salon Carré recently attracted the attention of its guardians.

The celebrated engraver, Frédéric Laguillermie, who is working on a series of engravings in the Salon Carré, points out that the photographers who are admitted there on Mondays carry large boxes, and that it would be quite feasible for a stranger to enter on the pretext of carrying plates, &c., to the photographers, steal a picture, and put it in the box. Then, when the guardian's attention was relaxed, he could smuggle it out of the building. In the case of "Mona Lisa," however, M. Laguillermie admits that this would be quite a feat, as the picture is painted on a stout wooden panel and is heavily backed, and, therefore, it would require a person of considerable strength to carry it away.

Public opinion is greatly aroused over what is considered the inadequate surveillance of art treasures in the Louvre. Pictures are frequently removed from the walls and taken to the official photographer's studio without the guardians being informed.

Deputy La Roche announced to-night that he would interpellate Minister of Public Instruction Steeg to-morrow on the "Mona Lisa" affair and the measures the Government is taking adequately to preserve national art treasures from thieves, madmen, and vandals.

* * *

October 8, 1911

ECCENTRIC SCHOOL OF PAINTING INCREASES ITS VOGUE IN THE CURRENT ART EXHIBITION—WHAT ITS FOLLOWERS ATTEMPT TO DO

Among all the paintings on exhibition at the Paris Fall Salon none is attracting so much attention as the extraordinary productions of the so-called "Cubist" school. In fact, dispatches from Paris suggest that these works are easily the main feature of the exhibition.

The "Cubists," be it known, are a school of artists who believe that the right way to paint persons and things is to paint them in cubes, squares, and lozenges. They have been before the public now for several years.

PORTRAIT DE FEMME

When they first burst on the astonished gaze of Paris and the rest of the universe they were known as the "Invertebrates." That was in 1905. On recovering from its first fit of amazement at the astonishing productions of the "Invertebrates" the public promptly dubbed them the "Wild Beasts." Now they are "les Cubistes."

Whatever their name, they continue to paint pictures before which descriptive adjectives retreat in disorder. They slap colors, apparently in haphazard fashion, on their canvases, draw back a step, slap on another assortment, and then calmly label the sensational result "A Woman," "A Landscape," "Still Life," or something equally innocent and inadequate. If you seek to find out where they got their ideas you will learn that the "Invertebrates" and "Wild Beasts" and "Cubists" call themselves disciples of Matisse. But there are those who say that Matisse stands aghast before these madnesses.

In spite of the crazy nature of the "Cubist" theories the number of those professing them is fairly respectable. Georges Braque, André Derain, Picasso, Czobel, Othon Friesz, Herbin, Metzinger—these are a few of the names signed to canvases before which Paris has stood and now again stands in blank amazement.

What do they mean? Have those responsible for them taken leave of their senses? Is this art or madness? Who knows?

At all events the devoted group, advancing—or receding—year by year, can at least say that plenty of people waste time and adjectives upon them. If, like Kipling's "Bandar-Log," the foolish monkey-folk of the jungle, their desire is to be "noticed," they have been richly rewarded during their brief existence.

Last year Gelett Burgess, he of "Purple-Cow" fame, also known as an artist of eccentric habit, went to Paris and became inspired with a desire to find out something about this weird school. Perhaps the same twist of mind that caused him to turn out his sinuous and popular "Goops" moved him to undertake this voyage of discovery among hidden Parisian studies. Anyhow, he ventured forth on his quest, found what he sought and described what he found in The Architectural Record.

The lust for discovery first stirred in Gelett Burgess when he entered the Salon des Indépendants and caught his first glimpse of a painting by one of the "Wild Men of Paris"—thus it is that he dubs those we know as "Cubists."

Here is how he describes that first glimpse.

"I had scarcely entered the Salon des Indépendants when I heard shrieks of laughter coming from an adjoining wing. I hurried along from room to room under the huge canvas roof until I came upon a party of well-dressed Parisians in a paroxysm of merriment, gazing through weeping eyes at a picture. Even in my haste I had noticed other spectators lurching hysterically in and out of the galleries; I had caught sight of paintings that made me gasp.

"But here I stopped in amazement. It was a thing to startle even Paris. I realized for the first time that my views on art needed a radical reconstruction. Suddenly I had entered a new world, a universe of ugliness. And ever since, I have

LANDSCAPE by DERAIN

been mentally standing on my head in the endeavor to get a new point of view on beauty so as to understand and appreciate this new movement in art.

"'Une Soirée dans le Désert' was a fearful initiation.

"It was a painting of a nude female, seated on a stretch of sand, devouring her own knee. The gore dripped into a wine glass. A palm tree and two cacti furnished the environment. Two large snakes with target-shaped eyes assisted at the debauch, while two small giraffes hurried away from the scene.

"What did it all mean? The drawing was crude past all belief; the color was as atrocious as the subject. Had a new era of art begun? Was ugliness to supersede beauty, technique to give way to naïveté, and vibrant discordant color, a very patchwork of horrid hues, take the place of subtle, studied nuances of tonality? Was nothing sacred, not even beauty?

"If this example of the new art was shocking there were other paintings at the Salon that were almost as dire.

"If you can imagine what a particularly sanguinary little girl of eight, half-crazed with gin, would do to a white-washed wall if left alone with a box of crayons, then you will come near to fancying what most of this work was like.

"Or you might take a red-hot poker in your left hand, shut your eyes, and etch a landscape upon a door.

"There were no limits to the audacity and ugliness of the canvases. Still-life sketches of round, round apples and yellow, yellow oranges, on square, square tables, seen in impossible perspective; landscapes of squirming trees, with blobs of virgin color gone wrong, fierce greens and coruscating yellows, violent purples, sickening reds, and shuddering blues.

"But the nudes! They looked like flayed Martians, like pathological charts—hideous old women, patched with gruesome hues, lopsided, with arms like the arms of a Swastika, sprawling on vivid backgrounds, or frozen stiffly upright, glaring through misshapen eyes, with noses or fingers missing.

"They defied anatomy, physiology, almost geometry itself!"

GEORGES
BRAQUE

Burgess shares the opinion that, although Matisse is named as the man responsible for all these horrors, he is, in reality, by no means so black as he is painted.

"Poor patient Matisse" he exclaims—and imagines that artist "breaking his way through this jungle of art," to see his followers go whooping off in wild paths of their own.

Matisse may have said, perhaps, conjectures Burgess, that "the equilateral triangle is a symbol and manifestation of the absolute—if one could get that absolute quality into a painting it would be a work of art."

Thereupon one of the maddest of his pupils dashes off and builds a woman entirely out of triangles.

Then, perchance, Matisse talks of the "harmony of volume" and "architectural values."

Result: Another madman "builds an architectural monster which he names Woman, with balanced masses and parts, columnar legs and cornices," and still another— "molds a neolithic man into a solid cube, creates a woman of spheres, stretches a cat out into a cylinder, and paints it red and yellow!"

All that may shock Matisse: nevertheless, he is accused of painting his own wife with a stripe of green down her nose, so he is by no means so quiet and conventional himself, in spite of his sad sighs when confronted with the work of his "disciples."

It was pointed out to Matisse once that he had painted a woman with only three fingers.

"True," he agrees, "but I couldn't put in the others without throwing the whole out of drawing—it would destroy the composition and the unity of my ideal. Perhaps some day I

may be able to get what I want of sentiment, of emotional appeal and, at the same time, draw all five fingers. But the subjective idea is what I am after now; the rest can wait."

And the missing fingers wait!

Burgess's quest of the wild men of Paris took him into remote quarters of Montmartre and Montparnasse, into chaotic studios where worked men "all young, all virile, all enthusiastic, all with abundant personality and all a little mad."

There is Georges Braque, who paints nudes with square feet and right-angled shoulders. Braque is of athletic build, with broad shoulders, of shy demeanor. Before one of his weird productions—a woman with a balloon-shaped stomach—he remarked:

"I couldn't portray a woman in all her natural loveliness. I haven't the skill. No one has. I must, therefore, create a new sort of beauty, the beauty that appears to me in terms of volume, of line, of mass, of weight, and through this beauty interpret my subjective impression.

"Nature is a mere pretext for a decorative composition plus sentiment. It suggests emotion and I translate that emotion into art. I want to expose the absolute, and not merely the factitious woman."

Thence one may go to the studio of Derain to see "a group of squirming bathers, some green, some flaming pink; all, apparently, modeled out of dough."

Here, also, is "the cubical man himself, compressed into geometric proportions, his head between his legs."

Also, a portrait of Derain's cat in the shape of a cylinder, and a lot of weird African carvings.

"A wild place, fit for dreams, but no place for mother!" exclaims Gelett Burgess.

Derain, like Braque, tries to put his ideas into words.

"What, after all, is a pretty woman?" he asks. "A mere subjective impression—what you yourself think of her. That's what I paint, another kind of beauty of my own. There is often more psychic appeal in a so-called ugly woman than in a pretty one; and, in my ideal, I reconstruct her to bring that beauty forth in terms of line or volume.

"A homely woman may please by her grace, by her motion in dancing, for instance. So she may please me by her harmonies of volume. If I paint a girl in the sunlight, it's the sunlight I'm painting, not the real girl; and, even for that I should have the sun itself on my palette. I don't care for an accidental effect of light and shade, a thing of mere charm."

"The Japanese see things that way. They don't paint sunlight, they don't cast shadows that perplex one and falsify the true shape of things. The Egyptian figures have simplicity, dignity, directness, unity; they express emotion almost, as if by a conventional formula, like writing itself.

"So I seek a logical method of rendering my idea. Africans, being primitive, uncomplex, uncultured, can express their thought by a direct appeal to the instinct. Their carvings are informed with emotion. So Nature gives me the material with which to construct a world of my own, governed not by literal limitations, but by instinct and sentiments."

Picasso, wildest of wild men, "comes rolling out of a café, wiping his mouth, clad in a blue American sweater, to be interviewed and photographed."

"Picasso is a devil," asserts Burgess "I use the term in its most complimentary sense, for he's young, fresh, olive-skinned, a Spanish type. I thought of a Yale sophomore who had been out stealing signs and was on the point of expulsion."

Incidentally, Picasso is "the only one of the crowd with a sense of humor."

His studio is an incredible jumble of junk and dust bottles, rags, paints, sketches, clothes, food, ashes, and hair-raising pictures.

"Picasso is colossal in his audacity. Picasso is the doubly distilled ultimate. His canvases fairly reek with the insolence of youth; they outrage nature, tradition, decency. They are abominable.

"You ask him if he uses models and he turns to you a dancing eye.

" 'Where would I get them?' grins Picasso, as he winks at his ultramarine ogresses."

Then there is Czobel, who paints women "aged 89, as a rule," with very purple complexions, mustard-colored spots, yellow throats, orange and blue arms. "Sometimes, not often, they wear bright, green skirts."

Czobel hasn't much to say about his art or his ideals or anything. Not so Othon Friesz. He talks sensibly about the wild things he paints.

He calls the mad riot of himself and his colleagues a "Ueo-classic movement, tending toward the architectural style of Egyptian art."

"Modern French impressionism is decadent," he says. "In its reaction against the frigidity and insipid arrangements of the Renaissance it has itself gone to an extreme as bad, and contends itself with fugitive impressions and premature expressions.

"This newer movement is an attempt to return to simplicity, but not necessarily a return to any primitive art.

"It is the beginning of a new art. There is a growing feeling for decorative values. It seeks to express this with a certain 'style' of line and volume, with pure color rather than by tones subtly graded; by contrasts rather than by modulations; by simple lines and shapes rather than by complex forms."

Just around the corner from Friesz's studio is that of Herbin, a melancholy hermit of a wild man, "who has no friends and wants none."

"I don't distort Nature," he declares, alluding to works on the walls of his lair that seem to refute his statement utterly. "I sacrifice it to a higher form of beauty and of decorative unity."

Metzinger has more to say about his "art" than the lone and mournful Herbin.

"Instead of coping Nature," he says, "we create a 'milieu' of our own, wherein our sentiment can work itself out through a juxtaposition of colors. It is hard to explain it, but it may perhaps be illustrated by analogy with literature and music.

"Edgar Poe did not attempt to reproduce Nature realistically. Some phase of life suggested an emotion, as that of horror in 'The Fall of the House of Usher.' That subjective idea he translated into art. He made a composition of it.

"So music does not attempt to imitate Nature's sounds, but it does interpret and embody emotions awakened by Nature, through a convention of its own in a way to be aesthetically pleasing. In some such way we, taking our hint from Nature construct decoratively pleasing harmonies and symphonies of color expression of our sentiment."

Thus talk the wild men. Their talk sounds like sense. When they solemnly juggle with terms like "beauty" and "Nature" it all sounds very nice.

But when they stop talking and exhibit their canvases! That is quite another matter.

* * *

<div style="text-align:right">January 14, 1912</div>

PLACE HEIGHT LIMIT ON NEW BUILDINGS

Equitable Fire, Says Mr. Parish, Brings to an Issue Future Skyscraper Operations

A CONGESTION MENACE

An Injury to Neighboring Property—Advocates Twelve-Story Structure for Burned Block

Has the time arrived when restrictions should be placed by the city authorities upon the height of buildings? John L. Parish, one of the leading real estate brokers of New York City, in deducing some lessons from the recent Equitable fire and the effect of additional skyscrapers in the congested downtown district, stated positively yesterday that he believed it was now high time for some action to be taken toward regulating the height of future buildings in the city. He called the destruction of the Equitable Building a calamity of further reaching results than was at first apparent, for apart from the loss to the owning company it has brought to an immediate issue the question of the reimprovement of the entire block.

"This question has been a menace to the downtown office-building district for years," said Mr. Parish. "As year after year the height and magnitude of office-building construction has increased the menace of deadly competition among such structures has taken definite form and constantly increasing peril, until now it can no longer be ignored. Until the Woolworth monstrosity was projected and authorized this menace was of such subordinate dimension as to attract the very close attention of those only who were directly concerned.

"It was still a menace that was presumed to be within the control of ordinary economic laws and operations. It was never supposed that owners would give very weighty consideration to the rights and interests of their immediate neigh-

bors; their own business interests were sufficient to absorb all their attention. And when a project for reimprovement was initiated the problem involved was first of all financial and economic. It called for close calculation of cost and probable income return. And this involved calculating various kinds and heights of construction.

"As bases for these calculations there were the rents obtainable in the vicinity. Careful calculators tried to get at these as reflected in the net annual returns from typical buildings. But all calculators were not careful, or found accurate information inaccessible, and so proceeded upon the surface showing reflected by the average square foot rate of rents obtainable. By either process the objective point in the calculation appeared to be the production of as large an area of rentable space as the plot would carry. The more rentable space the higher rental income, and the higher rental income the higher net income from the property, was the process of reasoning uniformly employed.

"This is the economic phase of every new improvement that has ever taken place in the city. It takes no account of the effect upon the property that is not improved, the adjacent and neighboring property of other owners. The process is strictly individualistic and competitive; every man for himself and save himself who can.

"The results of this process of improvement of the greatest city of the Western World through skyscraper construction for a single generation are beginning to be apparent. There is congestion unprecedented within limited areas and stagnation or strangulation elsewhere. Between William Street and the East River and between Church Street and the North River there are hundreds of properties that would bring no more in the open market to-day than they would have brought a hundred years ago. While between these expensive areas there is a narrow strip that has advanced fifty to a hundred fold in market value within the same period.

"The construction of skyscrapers, originally intended to meet the demands of a congested population, has only intensified this congestion and begotten an increased demand for more skyscrapers within a limited district. But every additional skyscraper was an additional competitor for the favors of the renting population, and the production of gigantic skyscrapers has within the last five years been so far in excess of even a supporting demand for rentable space that the competition for tenants has entered a ruinous stage. Every big building is a menace to every other big building.

"The Equitable fire was a windfall to some of them. But the construction of another Equitable of gigantic dimensions, such as was indicated by the plans filed in 1908, would send many of the buildings in the vicinity to the real estate morgue. Besides being an architectural monstrosity, it would tower like a upas tree over all its immediate surroundings, casting a chilling, killing, blight upon them, and sapping their vitality. No building in the vicinity would fail to suffer from it.

"These facts would seem to raise the question to the plane of an issue vital to the orderly and equal development of the city—whether the time has not arrived when a limit should be placed upon the height of buildings to be erected in the future in this city. It is easily demonstrable that this limit should have been fixed by law twenty-five years ago. It would have been better for all owners, even for the owners as well as the projectors and builders of the highest of the high buildings. If it had been, there would by this time have been a more harmonious and symmetrical development of all parts of the city, and the incomes of properties would have been better established and assured."

Instead of erecting a towering structure Mr. Parish asked whether the insurance companies would not profit more now and in the long run by the construction of a building not more than twelve stories in height, but a building of larger spaces, higher ceilings, better design, and with better light and more ample conveniences than any of the purely commercial buildings in its vicinity? Such a building, he added, would be an honor and a perpetual, creditable advertisement for the Equitable Life Assurance Society, and an ornament to the city.

"But even though," he concluded, "as is much to be desired, they should do so, the question still persists whether the condition of affairs in the real estate market does not require the immediate limitation by law of the height of pretty much all construction in this city in the future."

* * *

February 25, 1912

FREAKS OF THE FUTURISTS

Pictures Shown in Paris—As Amazing as the Boast of the Artists

Special Correspondence The New York Times

PARIS, Feb. 16—In Turin in March, 1910, the propaganda of the Futurists was launched. The Futurists, according to an individual and collective declaration, consisted of poets, artists, novelists—in fact, all disciples of the arts of expression—who believed that the most permanent result of art was revolution. This revolution was against everything that was conventional and accepted. Action should take the place of repose; emotion that of suppression; freedom that of restraint; the horrible that of the beautiful.

Thus said their manifesto, which was let loose on 3,000 parti-colored leaflets from the dizzy heights of the gallery in the Teatro Chicarella of Turin, on that March evening. In the following July a second manifesto was issued. This time it took the form of thousands of leaflets showered down on the Piazza di San Marco at Venice from the towers of the famous church which overlooks that historic square.

Later the Futurists started a magazine printed in several languages. In prose and verse the Futurists protested against the accepted order of things. In Italian, French, German, English, and Russian they demolished the famous poets and prose writers of the world, and set up new standards, the elements of which were force, movement, and horror.

Meanwhile the artists among them had been getting ready. At last they have their chance. What Futurism means in art is now exhibited in Paris. The exposition includes the work of the Italian Futurists Boccioni, Carra, Russolo, Balla, and Severini.

As the cable dispatches have informed you, it is a display of terrible and awesome effects, in which the impossible runs riot with the improbable, and action and movement find their ultimatum in a medley of chaotic lines, angles, cubes, shadings, and obliterations behind which some sympathetic souls say they have discovered an idea—yet to be born, yet to be touched with vitality. Others believe that the supposed idea is beyond all vital touch, and exists only on that indefinite hinterland which separates genius from something else.

Be that as it may, the Futurists have published a neat brochure descriptive of their pictures and the spirit that inspired them. It opens with the following astounding remarks:

"We declare without vanity that this premiere exposition of Futurist paintings at Paris is also the most important exhibition of Italian painting ever submitted to the judgment of Europe. In short, we are young and our art is revolutionary."

* * *

June 2, 1912

FAMOUS ARCHITECT DEAD

D. H. Burnham Planned Chicago World's Fair and Manila

Daniel Hudson Burnham, Chief Architect and Director of Works for the Chicago Exposition 1890–93, and Chairman of the National Committee for Beautifying Washington, died yesterday in Heidelberg, Germany. Accompanied by his wife, son, and daughter, he was making an automobile tour of France, Germany, and Italy.

Mr. Burnham was born in Henderson, N. Y., Sept. 4, 1846; removed to Chicago in 1856, where he received his early education, and took up the study of architecture. He received honorary degrees from many large universities. He was senior member of the firm of Burnham & Root, 1872–91, D. H. Burnham & Co. since 1891. He was architect of the Rookery, the Masonic Temple, and other buildings in Chicago and the Wanamaker stores in New York and Philadelphia, besides other notable structures throughout the United States.

He planned the beautification of Manila. In 1894 he was President of the American Institute of Architects.

WASHINGTON, June 1—President Taft paid a high tribute to Mr. Burnham. He said:

"Mr. Burnham was one of the foremost architects of the world, but he had more than mere professional skill. He had breadth of view as to artistic subjects that permitted him to lead in every movement for the education of the public in art or the development of art in every branch of our busy life.

"Without pay, at my instance he visited the Philippine Islands, in order to make plans for the beautification of Manila and for the laying out of a capital in the mountains in the fine climate of Baguio.

"He was at the head of the Fine Arts Commission, and I venture to say that there was no man in the professional life of the United States who has given more of his life to the public without having filled public office than Daniel Burnham. His death is a real loss to the whole community."

* * *

June 23, 1912

WHISTLER COLLECTION AT CAPITAL STIRS MRS. PENNEL

Biographer of the Noted Artist Says the Pictures Are Poorly Lighted and Badly Hung, and That the Public Is Indifferent to the Opportunity to See Part of the Great Gift to the Nation by Charles L. Freer

The opportunity to see in Washington part of the collection promised by Mr. Charles L. Freer to the Nation does not seem to have received the attention or the recognition which the Nation ought to be giving it. Though admission was free to the exhibition, the day I was there not a dozen visitors were in the gallery; a curious commentary on the American love of art. Had a dollar been charged the place would have been jammed.

If we are to have a great National Museum of Art the chances are it will have to depend—as most National collections have depended—on the gifts and contributions of private individuals. The Government is not likely to put its hand in its pocket for the small, or large, fortune that pictures, or any works of art worth having, cost nowadays. But if we must look to gifts we had a great deal better consider their quality, as well as the generosity of the giver, before we accept them with enthusiasm, or, as the years go on, we shall find ourselves, as many European galleries have found themselves, burdened with acres of rubbish.

The National Gallery in London, probably the best and least overburdened in Europe, has to send on tour in the provinces pictures it once received with gratitude, while the Tate Gallery has consigned to almost invisible corners some of the treasures fully believed a few years ago by the donors to be masterpieces.

And, indeed, already some of the gifts which form the nucleus of the National collection at Washington are little more than warnings of what should have been avoided and what must be avoided. Washington has a way of relegating things to the future. It has had about a century to put itself in order, but it still explains away the medley of splendor and decay in its streets by the fine things that are to be done when the plans for beautifying the city are carried out. That is why no official assurance of what our National Gallery is destined to be should shut the Nation's eyes to what in the meanwhile is going on at the National Museum, or the Nation may wake

up suddenly one day to find the same sort of medley on the gallery walls.

Of the several donations to the National Gallery, Mr. Freer's promised gift is by far the largest and the widest in scope. By this time, every one who cares knows that it consists chiefly of work by Oriental artists on the one hand and of three or four American artists on the other. Of both he has now sent a small selection to Washington.

For Americans, there is no question that interest centres about the Whistlers. Whistler is the greatest of all American artists, the one great master the country has as yet produced, and it should be the ambition of every American to see him as well represented in Washington as Velasquez is in Madrid or Rembrandt in Amsterdam.

It is too late in the day to explain just what Whistlers are in Mr. Freer's collection. The collection has been described and many of the pictures and prints were shown in the Boston and Paris Memorial Exhibitions, and in the London Memorial, which was by far the finest and most complete, and the only one arranged by artists intimately associated with Whistler, though in this country artists seem to be the last person referred to for the arrangement of an exhibition, or the management of their own affairs.

Mr. Freer has also lent his Whistlers from time to time to other galleries. It is interesting now to see which have been selected as the most representative for the present purpose, and how they have been hung. Whistler, who was an artist in all things and neglected not the smallest detail connected with his work, attached the utmost importance to selection and hanging.

There are twenty-five examples of his work, and these, together with Oriental paintings, drawings, and pottery, and pictures by Dewing, Tryon, Thayer, and Winslow Homer, are shown in one of the large rooms upstairs at the National Museum. The room is spacious and well-proportioned; and so far untouched by the decorator who has had such full sway in the Library of Congress. The simple grayish white walls make a pleasant background.

But the light is abominable. When I was at the National Museum on a hot June day, the fierce Washington sunshine poured through the flat glass roof, where there was not so much as the pretense of blind or shade to temper it. Whistler's paintings can stand the test, though they were not meant to be exposed to it. Never was an artist more particular about the light in which he wished and insisted that his pictures should be seen. One of his worst "eccentricities," in the opinion of the British public that discovered the "eccentric," in everything he did, was the velarium which he used for his own exhibitions and for those of the British Artists and the International Society while he was their President, and the velarium was designed to prevent just such inartistic crudeness.

He would have shrunk from the glare at the National Museum, and one can only hope that this is not a foretaste of the treatment his work is to receive when, or if, eventually it fills a permanent gallery in Washington.

Nor is the hanging any better. Little, if any, respect for line or balance is displayed, and a group of those small paintings, which are such marvels of delicacy and subtlety, have been strung up and crowded together on the wall as if for an auction sale. As Whistler, in his time, did more to revolutionize the arrangement of picture galleries and to make of it an art than any other man, some little consideration for his methods does not seem too much to have expected from the organizers of the exhibition.

As for the paintings themselves, it is difficult to understand just on what principle they have been chosen by Mr. Freer from his large collection. No doubt it was not easy to choose so few from so many; certainly the result suggests that the choice was left very much to chance. However, it is always a pleasure to see again any work of Whistler's, and, though one cannot help wishing that chance had been more discriminate, still that there should be any chance at all is something to be thankful for.

The two full-length portraits may not rank with his finest—Mr. Freer does not possess any of the finest—but they are full of interest, as all Whistler's portraits are, even the least successful, and they have besides a distinct biographical value.

One is of Leyland, the wealthy ship owner, who played a prominent part in the lives of so many English artists of Whistler's generation, but in none so prominently as in Whistler's, and whose name will be remembered until the last bit of blue and gold has faded from the Peacock Room, which Whistler decorated for him. The portrait is not so familiar to the public as other of the full-lengths. It was discovered to be in existence and shown for the first time in the London Memorial. It is not so fine as the "Carlyle" or the "Sarasate"; we have the record of the trouble it gave to Whistler. But face, figure, and pose are strong in character—it is one of his many arrangements in black—and it marks his breaking away from the more purely decorative treatment in the "Mother," the "Miss Alexander," and the "Carlyle," to those broader atmospheric effects which were his absorbing concern in the later portraits. Unfortunately, like several of the others, it is in a very bad state.

"L'Américaine," as it has been called, an "Arrangement in Black and White," is the portrait of Maud Franklin, Whistler's model for many years, and an important influence in his life. It is still less known than the "Leyland." It was shown at the British Artists' in the eighties, passed somehow into a private German collection, and there remained, unseen, until a few years after Whistler's death. I saw it then in M. Théodore Duret's apartment, in Paris, but the light was not good, and my pleasure now in coming upon it a second time at the National Museum is to find it so much more distinguished than my memory of it. It cannot compare with the "Mother" or the "Miss Alexander" of an earlier period, or with the "Yellow Buskin," painted about the same time. But the black and white scheme is beautifully carried out, the atmospheric envelope well felt, and the modeling and rich coloring of the face most subtly expressed.

The interest of the picture is added to by the fact that it is in the original frame designed and decorated by Whistler. These two may not be the portraits, especially among those now owned in America, which I would want to show first to the student ignorant of Whistler's work as a portrait painter, though I would not think the student had completed his study of Whistler until he had seen them.

Of the latest period of all, there is an example in the "Little Green Cap," one of the small impressions of children of which Whistler made so many toward the end of his life. It has charm, but Whistler gave greater charm to "Lillie in Our Alley," "The Little Lady Sophie of Soho," and the "Roses of Lyme Regis," which I believe are all in America.

The nocturnes are few, but they form a group of unusual interest. Dominating them is the memorable upright "Valparaiso" from the McCullough collection, the result of Whistler's famous, but incomprehensible, visit to South America. It is one of the great paintings of modern times, and has had a more healthy influence on modern art than any other work. It has been often described. Many have tried to put into words the blue and gold loveliness of night as Whistler put it into paint. Almost nothing seems left to be said about it.

But at the National Museum it looked to me as if something had been done to it since I last saw it in London. The detail was so much more distinct, the red and orange of the lights on the ships and in the falling rocket were so much more vivid. This may have been due to the June sunshine turned like a searchlight full upon it. Hanging with it is a nocturne, "Blue and Silver, Battersea Reach," one of the most marvelous of them all, the chimneys and factories on the far shores melting into the shadows and gradually emerging again even as you look, the long line of lights on the far bridge stretched like a string of jewels across the shadowy water—the same subject that Whistler painted again and again, but each time investing it with some newer poetry, finding some new effect, and always rendering it with a subtlety that no other painter of night has ever equaled. Yet Whistler himself said that all he had done in these pictures was to translate the art of the East into the art of the West—to carry on tradition. The "Trafalgar Square, Chelsea," is better known because in the Goupil exhibition of 1892 it was the occasion of one of Sir Frederick Wedmose's many blunders, immortalized by Whistler in his catalogues. The "Symphony in Gray, Early Morning, Thames," is amazing in its truth to any one who knows the river as it flows through London, and it is further notable because it is signed by one of the early realistic Butterflies placed in a long cartouche which also shows the date, '74, below.

In the "Bognor," also signed with an early Butterfly, one seems to see Whistler escaping from the influence of Courbet, while to "Blue and Silver—Trouville," with its beautiful sky, one can turn for the source of the influence which Whistler eventually had upon Courbet. This group alone is worth the visit to Washington for which so little time remains. The exhibition, I understand, is to close by the first of July.

It is when one comes to the next group, to the small paintings of which the "Little Green Cap" forms the centre, that the carelessness of the hanging is most unpardonable.

I remember the care with which Whistler showed these small paintings in his own studio as in any gallery where they were exhibited, the place apart he demanded for each, the ample wall space. I remember especially how eager he was that the little "Phryne the Superb" should be hung with all due respect, when he sent it to the International, in order that the world might see how, on a few inches of canvas, he could give the impression of size that other painters required six feet to render. And now, this beautiful nude, which he watched over with such tenderness, is huddled up with a number of other studies and impressions, with no apparent idea or scheme in the hanging except to crowd together as many frames of much the same dimensions as possible. There is not one among them that did not deserve more intelligent treatment.

Here is one of Whistler's rare landscapes, a space of green hillside with houses perched on top, and here one of the marvelous seas which no modern has so filled with life and movement—and a proof of this can be had in the many feet of empty marine canvases incumbering the walls of some of the adjoining rooms, while there is more knowledge of Nature in the tiny study of "Wortley" than in all the examples of Mr. Tryan put together. Here, too, are his little shops, his notes of the Chelsea he loved, his little figures, the basis of harmonies, his little pastels, one or two beauties, stuck upon pilasters. The "Petite Mephisto" is one of the arrangements in red that prove he never was mannered. In fact, so unlike his other work are several similar pictures that when they were sent to the London Memorial Exhibition the committee was in grave doubt as to whether they should be hung, and that was before a large factory of Whistlers was in full swing, though even then a water-color version of "Valparaiso," later found to be a forgery, crept in. So, too, did a version of "Whistler in His Studio," now one of the glories of the Dublin Gallery of Modern Art, that Whistler in his lifetime declared was a copy. Happily the Chicago Art Institute now possesses the genuine picture.

Some of these small subjects at the National Museum are evidently early works signed by Whistler years afterward, for the "Butterfly" is no less evidently late, proved by comparing it with the Butterflies on the "Bognor" and the "Early Morning, Thames." Whistler was willing at times to put the Butterfly on unsigned paintings and prints. But when he did this it was always with he Butterfly he this it was always with the Butterfly he with the years.

The method of arrangement in a gallery is always important, though Americans do not yet realize it. The present collection is so devoid of any arrangement at all, either artistic or chronological, and other exhibitions superintended by Mr. Freer have been so little better, that the question inevitably suggests itself as to whether he is the man to be intrusted with the final placing of the Whistlers in Washington.

It appears to be believed in this country that the donor of a work of art is the only authority concerning it, the only per-

son to be consulted, the only person to dictate to the Nation as to its hanging or arrangement. Such a system and such patrons would not be tolerated anywhere else. It is but recently that the magnificent Salting collection was left to the British Nation to be hung in the National Gallery. But Mr. Salting was a collector who, though he wished his collection to belong to the nation, recognized that the importance of the pictures and the addition they meant to the history of art as recorded in the gallery were the main consideration, rather than the glory of the donor, and he wisely agreed that the trustees, after his death, should make a selection from his pictures of those which would add to and worthily complete the great national collection.

I have been accused of praising Whistler indiscriminately. I have done nothing of the sort, and I know that he, more than any one, would object to seeing some of his pictures now in American public collections.

Pictures are hung in public galleries presumably for study and comparison and not simply because they happened to belong to some well-meaning collector. The Whistlers now shown by Mr. Freer are all genuine and far more interesting than many at present in other exhibitions in America. The Metropolitan Museum in New York may be taken as the most glaring proof of what I say. Of all the Whistlers on its walls but one deserves to be there, and even that one, the "Irving," is not a first rate example. The two next in size were hawked about Europe, and probably offered to every collector in America, and were refused simply because they are unfinished works that do not represent Whistler adequately, and that should never have been accepted by the Metropolitan Museum. The Cremorne just hung has been refused by galleries in Europe, and even in Australia. In view of what has recently happened in Europe and America, the Directors of galleries should refuse any painting by Whistler which is not of supreme merit, is not signed, and, most important, has not a proper pedigree. It is only the other day that a collector proudly pointed to a couple of genuine signed Harper Penningtons as a great Whistler discovery, and this discovery was indorsed by a French critic and an American painter.

The catalogue of the Whistlers at the National Museum leaves much to be desired. The only authority quoted concerning Whistler is an unsigned article from a publication of 1893–4, which contains some blunders and mistaken criticism.

The one water color by the late Winslow Homer is worth all the other paintings, and Winslow Homer, it may be interesting to note, was, in the opinion of European critics, the most genuine American painter, after Whistler, in the recent Roman Exhibition; the only American of to-day who has really painted his own country in his own way.

* * *

October 20, 1912

100-STORY BUILDING ENTIRELY POSSIBLE

All a Question of Economic Success, Says Cass Gilbert, Who Is Now in London

ELEVATOR SERVICE THE KEY

Designer of Woolworth Building Is Taking a Model of That Structure to Munich Museum

Special Cable to The New York Times

LONDON, Oct. 19—Cass Gilbert, ex-President of the American Institute of Architects, and designer of the Woolworth Building, is in London on his way to Munich, where he will arrange to set up a model of the tallest building in the world in the Deutches Museum there.

This is the result of the visit to America a few months ago of a Munich commission, headed by Dr. Otto von Miller, whose object was to obtain for the museum a model of the best specimen of the American skyscraper. The choice fell on the Woolworth Building, a model of which, twenty feet high, will soon find a permanent resting place there.

On leaving Munich Mr. Gilbert will go to Athens and Rome, where in the latter city he will look over the plans of the new buildings of the American Academy, which are to be erected and in which J. Pierpont Morgan is taking great interest. Mr. Gilbert expects to be away from New York for sixty days. When asked whether he thought that the Woolworth Building would be the last word in the skyscraper building, Mr. Gilbert replied:

"There isn't any last word. The only question is one of economic success. Provided with sufficient base, there is no reason why a hundred-story building should not be erected, as far as safety is concerned; but the question is whether it would be a paying investment. It is a matter of economic limit in which the elevator service plays an important part. In order to provide proper elevator service we estimate that one elevator can serve about 18,000 square feet of floor area. By computing the area of the floor space we arrive at the number of elevators required. This has proved a reasonably good service. Consequently the higher the building the greater the space taken up by the elevators, and hence, from an economic standpoint, the height of buildings must be limited, owing to the excessive amount of rentable space used by these."

When asked concerning the trend of American architecture, Mr. Gilbert said:

"In our public buildings the tendency is to classic buildings in the Renaissance style; in residential buildings toward the English and Gothic, and in commercial buildings a type has grown up which can be scarcely classified in character of style, but is distinctively American and based upon conditions existing to-day, rather than upon a precedent.

"To me the skyscraper is the most modern and most interesting problem there is in America. It is most difficult of solution. The economic conditions, which call for the use of

every bit of available space, and, at the same time provide ample light for rooms, leave little opportunity for the arrangement of masses or for simple wall service.

"Story upon story of practically equal heights necessarily divide the structure, and each story, having the same functions, must be lighted with windows of practically the same area.

"The exterior design under these conditions becomes exceedingly difficult, and therefore interesting.

"The polyacron decoration is to some extent being used in these structures, and the huge masses of buildings, as they occur in groups, are, in themselves, very picturesque."

While here Mr. Gilbert, who is a member of the Royal Institute of British Architects, has been renewing friendship with several prominent British architects, including Sir Aston Webb, who is designing the new front of Buckingham Palace.

"I have always admired the architecture of London very much," said Mr. Gilbert. "There is a charm and dignity about it which gets home all the time. Of the more recent designs I very much admire the work of Sir Aston Webb, Mr. Lutyens, John Burnett, Sir Ernst George, and others whose names escape me at the moment."

* * *

January 2, 1913

MODERN ART EXHIBITION

2,000 Works of American and Foreign Artists to be Shown on Feb. 15

The International Exhibition of Modern Art, organized by the Association of American Painters and Sculptors, will have its official opening on Feb. 15, and will continue day and evening until March 15. It will be held in the Sixty-ninth Regiment Armory, Lexington Avenue between Twenty-fifth and Twenty-sixth Streets.

There will be on view 2,000 works of American and foreign artists, and all the varied phases of what is known as the modern movement in Europe, and, particularly in France, will be shown. The works will begin with those of Ingres and end with those of the Italian Futurists.

Twenty-seven temporary rooms will be arranged on the drill floor of the armory, including three centre halls, for sculpture. The exhibition will be so rich in the works of Cezanne, Gauguin, Van Gogh, Matisse, and Redon that each artist's work will be shown in a room by itself. There will be a large room for drawings off the other exhibition rooms.

Two catalogues are being prepared for the exhibition, the large one having a number of reproductions of the most characteristic European work.

A statement has been issued by Arthur B. Davies, President of the Association of American Painters and Sculptors, announcing the non-partisan attitude of the organization, and saying that in arranging for the exhibition it has "embarked on no propaganda," and does not propose to enter "into a controversy with any institution." Its sole object is to place the paintings and sculpture where the intelligent may see and judge of them for themselves.

* * *

February 9, 1913

THE GREAT RAILWAY TERMINAL OF THE FUTURE

"It Will Be a Way Station," Says Whitney Warren, Chief Architect of the Grand Central

Even while the invitations were being issued for the inspection of the new Grand Central Terminal on the day before the formal opening, Whitney Warren, the chief architect, paused amid the preparations to reflect on what its successor would be like, for he, like all others who have dealt with the problem, knows that however vast and however magnificent, the new terminal is bound to have a successor. And the striking thing in his point of view is that the successor of the new terminal will not be a terminal at all, but a way station!

He consented to talk about it the other day in his office in the Ritz-Carlton Building, one of the most sumptuous and most distinctive offices in New York.

"We are really prepared now," he said, "to study the problem of the railroad station in a great metropolis in its relation to the past, the present, and the future. We know its primitive origin in the stage coach and can watch its development from that. The point of departure of the modern station can be likened to that of a great public place of the city of olden time, from which the stage coaches started on their various journeys. The public place was surrounded by the various conveniences necessary to travelers—shops, hotels, baths, barbers, and the like—the only difference being that the place itself was uncovered and that it is now covered, so as to better protect from the weather the clients of the railroads and their friends. Also many facilities have been added from time to time as the public has become more exacting and fastidious.

"You must have read of the days when the trains had to be towed by horse to City Hall, because the engines were not allowed below Fourteenth Street, and then came the day when steam was abolished entirely, and with that abolishing went the bells and the dirt and the noise of the locomotives which used to make the vicinity of the old Grand Central a perfect hell. But now we have electricity and a station becomes, instead of a detriment, an asset to its environment.

"That is the development to the present. No one can have studied it without knowing that the future development will be just as great and just as marked.

"I for one am of the opinion that the terminal of the future will not be a terminal, but a way station: that the great central station of the future in New York, as in other great cities, will be a union station and a through station. At the time the present Grand Central was contemplated there was a sugges-

tion that while some of the tracks should loop at the Forty-second Street site others should push right on through to join the Pennsylvanian's tracks on Seventh Avenue. But the two roads did not approve the idea.

"Yet in the not so very distant future I think they will come to that—a Union Station, say, of the Erie, the Pennsylvania, and the New York Central. Perhaps they will see that this will make traveling pleasanter and that what makes traveling pleasanter increases business and profits. They will see in it an economy.

"Connecting the present stations by through tracks?"

"I am afraid not. I am afraid that too many underground operations at the Grand Central, too many subways, either built or determined upon, have pre-empted the space that is sufficiently near to the surface. Maybe when the business of 'unionizing' the station facilities of New York's roads comes it will have to be done beyond the Harlem River. They may have to do it some day, in my opinion.

"After all, why shouldn't they? It is really grotesque that there should be a hold-up at Chicago and a big city to cross. There ought to be no interruption at New York. There ought to be a straight road from Trenton to Yonkers or between any two points of importance. There ought to be no terminals at all.

"I think all big cities will have to come to union stations in time, and the great trouble is that the roads have been built and the terminals acquired without foresight of this future necessity. Berlin is the only city I know where the good strategic relation exists, where the engineers have built all along as though they knew the union station would come. The roads are placed so that its position is logically determined in advance."

Mr. Warren, who had been hearing a deal of compliment on the superb ceiling of the new terminal's concourse, was willing to say of it simply:

"It fills the bill. After all, that's what a thing must do architecturally. Somewhere I have called architecture a reasoned art.

"This astronomical ceiling of blue and gold was decided upon to fill the need for a flat surface of some sort. We wanted to get away from the caisson ceiling patterned after the Pantheon at Rome. Such a ceiling would have been constructionally difficult and costly to an extraordinary degree.

"When we decided upon a flat, hung ceiling it became a question of decoration. All decoration means something if it is appropriate. The column grew from the wooden porch before the temple or before the abode of the warrior, where he hung the trophies of chase or battle. The windows of the New York Yacht Club suggest the place for the skipper when on shore."

"And the starry ceiling," his interviewer suggested, "reflects the guidance of travelers of old?"

Mr. Warren assented, and paused to ask if the composition of the decoration had not been successful, approving the break in the monotony of mere stars by the golden figures of the zodiac and the great sweeping arcs of the circles.

"And by that same token," he said, "a great terminal is the outgrowth of the gate to a city, and the architecture of the Grand Central tries to suggest the arch of triumph, such as was built at the gates of the olden cities. This station site was once a city outpost, beyond which the city has spread just as Paris has spread beyond the Porte St. Denis and the Porte St. Martin. So the main façade of the Grand Central was designed to suggest a triumphant portal to New York."

Lecturing the other day before some students in architecture at Harvard, Mr. Warren begged their indulgence for such imperfections as might appear in some of the stations toward the building of which he had contributed his share.

"A station" said Mr. Warren, "should be fool-proof; there should be no possible way of making a mistake, and every step taken in it should be one in advance toward one's destination and none retrograding.

"Once having entered the station the traveler should find himself in a large vestibule and, theoretically, directly in front of the Information Bureau, so that in case he does not know his way about and cannot read the various signs he may address himself and be properly directed without loss of time and encumbering space. Here should also be found the ticket offices, and not far removed, and yet again in a direct line to the train, the baggage checking department. This department is in a state of evolution, as far as new stations are concerned. This evolution was brought about in the following way:

"At the Union Station in St. Louis some changes were being made, and when the station was reopened for business it was found that it was practically impossible for the passenger to go to the baggage room after having purchased a ticket and reclaim his baggage to have it checked.

"An attempt was then made to check by the use of the pneumatic tube. Of course in the beginning many mistakes were made, but finally a system was perfected, and to-day is successfully practiced in the biggest and finest stations that have been constructed. This innovation is a great help, removing as it does the cumbersome and unsightly baggage room from the immediate vicinity of the public part of the station. It is now generally placed either over or under the tracks, space which heretofore was sacrificed as useless.

"The traveler, having purchased his ticket and checked his baggage, should find himself in close proximity either to the waiting room, in case his train is not leaving for some time, or to the outgoing concourse, in case he has only time enough to catch his train. Opening off these two component parts of the station should be found the restaurant, parcel checking counter, newsstands, apothecary shops, telephones, waiting rooms and the many booths which modern stations are being flooded with. In fact, the up-to-date station resembles a bazaar as much as anything, in view of the thousand and one accessories people now find it agreeable and necessary to have at hand when traveling.

"The incoming portion of the station should be so built as to get the traveler out of the way as quickly as possible. This is generally accomplished by not allowing him to enter the station proper at all, but shooting him off by the concourse either to the right or to the left, as the case may be. Here he should find the vehicle or tramway which is to conduct him to his hotel.

"Some modern stations possess their own hotel and many have office buildings, but personally I am of the opinion that this is a bad thing, only serving to congest further an already overtaxed area. However, in this case a separate entrance may be planned."

* * *

50,000 VISIT ART SHOW

Armory Exhibit a Big Success, Press Dinner Guests Are Told

Art and noise met last night when the Press Committee of the International Exhibition of Modern Art entertained at Healy's, Sixty-sixth Street and Columbus Avenue, their "friends and enemies of the press." Though art was present, the affair had little of the Latin quarter air, and Bohemian trimmings were absent. The chief contributor to the noise was D. Putnam Brinley, the artist.

The affair was a beefsteak dinner in the log cabin room. In the intervals of passing about the beef young women, also artists, sang and danced. When they were not dancing Mr. Brinley, who is nearly seven feet tall, danced.

The climax came in a high-kicking contest, which was won by Mr. Brinley. Frederick James Gregg, Chairman of the Press Committee, was Chairman. Mr. Gregg insisted upon reading a short address he had prepared to deliver at the opening of the exhibition, but had no chance to "put it across."

John Quinn, who is a lawyer and not an artist, spoke upon the success of the present show, which, he said, was one of the most important international exhibitions of contemporary art that had been held in any country in the last quarter of a century.

"In the nineteen days that it has been open," he said, "nearly 50,000 persons have visited the exhibition in the Sixty-ninth Regiment Armory. There have been sold over 160 works of art, and the association has entered into a contract with the Chicago Art Institute, by which a major part of the works exhibited here will be exhibited in Chicago.

"Its success in attendance and sales demonstrates that the American people as an art-loving people are second only to France. Even as to the Cubists, our association has shown true courage. I will not here attempt an explanation of the Cubists or of Cubist art. I might, however, compare the Cubists to the members of eugenic societies in England and other countries. The Cubists are trying to improve the breed of painters, as the eugenists are apparently trying to improve the breed of men. Some of the intermediate types may not be perfect or examples of wondrous beauty, but they are alive and vital, and we may say for them that 'they don't know where they're going, but they know they're on the way,' which is not only true of the Cubists, but of all art that is living and vital and progressive."

* * *

CUBISTS EXHIBIT WILDER PRODUCTS

"Solo of a Brown Line" One Specimen of Art Anarchy in the Salon des Indépendants

ANOTHER GEOMETRICAL HASH

Americans' Works Not as Numerous as Last Year, but Some Canvases Are Admired

By Marconi Transatlantic Wireless Telegraph to
The New York Times

PARIS, March 22—The Cubist and Futurist movements have evidently come to Paris to stay for a time. The products of their followers fill fully a dozen of the fifty rooms housing the Salon des Indépendants, which opened this week.

The huge temporary building of wood and canvas, as long as a railway station, which starts on the Quai d'Orsay, was thronged on varnishing day by a dense crowd of visitors, all bent on extracting the maximum of amusement out of the 3,400 pictures and sculptures of all degrees of eccentricity that line the walls.

By the thoughtful arrangement of the hanging committee the exhibits are carefully graded, starting at the entrance with the most academic and increasing in wildness until, after half an hour's walk, the limit of involved incomprehensibility is reached.

Typical examples of this Spring's cubist crop are two paintings by the Bohemian, Francis Kupka, called "Vertical Planes," and "The Solo of a Brown Line." The first consists solely of three blue oblongs on a dark background, while in the second, which is meant to depict the union of music and color, an object resembling a corkscrew passed under a tramcar wheel, meanders across the canvas.

Another picture, which the Futurists assert is a brilliant example of their tendencies, is a wilderness of squares, triangles, circles, dots, and dashes, and is called, "Whatever You Like—the Evacuation of the Universe." For some reason Americans are not in such evidence at this time as last year, although their work exhibited shows a high standard. George Oberteuffer has three admirable canvases: "Nôtre Dame," "A Riverside Scene," and "The Reclining Woman," which are attracting notice among the critics. So are also two scenes, "Dawn" and "Midday," in glaring red and yellow ochre by Stanton MacDonald Wright, one of the most advanced American artists in the colony.

An astonishing "Synchronic in Green," a composition in the strongest possible tints, is shown by Morgan Russell of New York.

Helena Dunlop of Los Angeles has added to her reputation with her "A Garden Table" as well as "A Field" and "A Spanish Door."

In the Applied Arts Section the beautiful embroidery of Mrs. Bertha Holly of New York is among the most striking exhibits.

Other Americans showing at the Societé des Artistes Indépendants are E. F. Folsom, Ida Clark Hunter, Monton Johnson, Mrs. Charlotte Rogers of New York, Allen Tucker of New York, Theodore Butler, and A. Frost.

No American sculptor has sent any work and such sculpture as is exhibited is extremely futurist. Archipento, whose so-called "Venus" occasioned much talk at the Autumn Salon last year, is very prominent here.

Among the few French painters of note who exhibit are Francis Jourdain, Pierre Laprade, Georges Lorin, Rene Just, and Ernest Puech.

The general impression of the public seems to be that the Indépendants' Salon this year is less interesting than that of twelve months ago, now that the first novelty of artistic anarchy has passed.

* * *

May 18, 1913

EXTRAORDINARY EXHIBITION AT THE BROOKLYN MUSEUM OF JAPANESE CEREMONIAL COSTUMES AND ASSOCIATED OBJECTS OF GREAT ARTISTIC INTEREST AND VALUE, THREE HUNDRED YEARS OF ART IN DRESS DISPLAYED

"The imparting of emotions and the bestowal of a pleasurable effect." This is the aim of art as defined by an Oriental critic, and no one at all familiar with the art of Japan fails to recognize the general acceptance of this interpretation by the Japanese race. For the Japanese art enters into life everywhere, flows through it and over it, flooding it with beauty and grace where beauty and grace would seem to a Western mind not only unobtainable but even out of place. A coat of coarse cloth or skin, a child's cheap game, a button, a common soup bowl furnishes sufficient excuse for a decoration that in this country and in most Western countries would be reserved for costly material and luxurious usage. The arrangement of a miniature garden or of a single flower, the placing of a screen, the writing of an inscription gives opportunity to exercise exquisite discrimination and show knowledge of space composition that the most ambitious of decorators might envy. In a word, to the Japanese art is art and does not ask for special privileges as the price of displaying its lovely virtue.

All this is matter of common knowledge. We have been initiated and beguiled by prints and porcelains and stencils and this and that of sprightly dainty conception and deft execution. We have not greatly bothered our heads about degrees and shades of merit, and we have been hospitable to much that the Japanese themselves would have left on the doorstep. But we have had a few collectors with a clear perception of differences and a few connoisseurs incapable of confusing the rarest works of Oriental genius with the clever brevities of the professional cartoonist. From time to time occasions arise for the deeper initiation of the general public as well, and the exhibition at the Brooklyn Museum this week is one.

At this exhibition Japanese costumes and related objects recently acquired by the Museum are to be shown to members of the Japan Society. Most of the things were collected in Japan last year by Mr. Stewart Culin, a member of the society and the Curator of the Japanese Department of the Museum, and they consist chiefly of women's costumes dating back from 150 to 300 years. In addition the many Japanese objects of significance and value previously owned by the Museum will be shown, the rooms have been painted with dull gold walls and blue bands, making a distinguished setting for the objects shown and conveying at once the spirit of the exhibition, an essentially artistic spirit.

The art of the costume in Japan is a quite different matter from the capricious rulings of taste and fashion to which we are indurated. There is a special dress for each of the multitude of officials attached to the Court, the material, color, and ornament each playing its part in indicating the rank of the wearer. The priests, many of them descended from noble families, lavished, according to convincing authorities, astonishing sums on their robes, while the costumes worn to the No dances were almost incredibly rich and gorgeous. Various ceremonials require as many variations of vesture and the present collection consists entirely of ceremonial garments, the frequently depicted costumes of actors and geisha girls having been left quite out of the account.

These wonderful ceremonial costumes represent the highest form of this branch of art in Japan. The color, often strong and glowing, invariably is subdued to a noble gravity, a veiled splendor, like the color of ripe fruits that shows through a subtle bloom of surface texture. There is a case of robes from the Imperial Court. One is black, but the material is woven in an almost indistinguishable pattern that enriches the effect without disturbing its superb dignity. Another is red, honest vermilion burning like flame, but it is flame softly enveloped with films of smoke, a red seen through a dense atmosphere at once modifying and deepening it. Another is blue that would be black if it were not seen in juxtaposition to black. In this case hangs also a print that once belonged to Mr. La Farge, showing courtiers seated in robes like these.

In a neighboring case are the football costumes, still more serious and sober, taupe color and gray, with large patterns in the same color. The game receives in Japan what our young men will recognize as an appropriate reverence, being played only by nobles.

The most imposing of the Court costumes is in a case by itself and consists of three robes, the outer one of white wadded damask with a coat of salmon pink and a strange shade of purple that changes from dark to light as it is seen from different angles. This and the two underrobes are enriched with a woven pattern emblematic of a particular imperial family. The fan carried with this costume is also in the case, and its cords of purple, white, red, yellow, and green signify the five directions of the ancient religious law. A crown also belongs with this costume which closely resembles that of an empress. Cumbersome as are the wadded folds and multiplied robes, the discreet color, not less

Japanese horse armor of man of rank.

refined than sumptuous, and the exquisite patterning answer the requirement of imparting an emotion and bestowing a pleasurable effect.

In the opposite case is an ordinary woman's costume, an inner robe, brilliant in color to the verge of sharpness, with a pattern of pine branch and plum blossom. Nothing so bright would be worn as an outer garment, unless by children, the fine reticence of Japanese taste dictating quietness in external aspect however the inner fires might flare and blaze. Near this is a Japanese cotton, an old "Sarassa" made in imitation of Indian cottons like our calicos. In another case is a striped robe in delicate colors of Satsuma Jofu, a special kind of hemp that is woven into a fabric resembling pineapple cloth.

A curiously shaped garment in dark blue with a band of gray printed in blue, designed to be carried over the head on a frame made of whalebone, is shown, and there is an interesting case of priests' head dresses with a priest's robe in blue and brown and white, a sombre harmony of great beauty. Near at hand is a fisherman's robe of blither aspect, such as he wears when, having made a good catch, he sallies forth to

unlimited sake and the inevitable result. Both fisherman and priest are made decorative figures by their costumes, the vigor and dignity of which are cheerfully and incorruptibly independent of the pursuits of the wearer.

There is, however, a system of very delicate adjustment between the wearer and the costume in Japan. Elderly women have their appropriate dress from the general style of which they do not depart, and the case of sober, rich robes dedicated to these ladies who approach the age of many privileges in a country where years in themselves bring honor bears witness to the admirable taste that governs here as elsewhere the application of art to objects of utility.

The designs on these costumes are of great variety, free from the conventional dullness common to mediocre work—some delicate and graceful, as in the robes decorated with drooping vines and wisteria blossoms, others bold and energetic as in the instance of the war coat embellished by a magnificent four-clawed dragon, or the robe of taupe colored satin with a large design of a tabouret surmounted by a teacup and saucer and a solid colored hexagonal figure in

alternation. In no case, however, do they fail to meet the requirements of decorative art and the refreshment of the powerful and mature designs ill prepares one for enjoying the commonplace patterns that have become the accepted standard of the Western world.

Of course, back of the artistic character of the designs lies a whole world of symbolism, which no more than the Imperial Palace is open to the stranger. Mr. Culin calls attention, however, to the fact that much of this symbolism has been rather solemnly explained in a manner quite at variance with the spirit in which it is conceived. This spirit seems to be that in which games are played and puzzles solved. The symbolic design is a kind of rebus. Thus, if it is desired to find an emblem of official advancement, a deer is chosen. Because the deer is fleet, elegant, a highly organized animal suited for aristocratic office? Not at all. Simply because the word for deer sounds like the word denoting official advancement. Hence, why not? It is very simple to the Japanese mind. The family name of Buddha, again, is Sakya, the word for lion; therefore a lion has become a Buddhistic emblem. Generalization is perilous enough at best, never more so than when we are discussing the still unknown Orient.

Passing from the type of costume described above to the room containing the Ainu costumes, the visitor is at once impressed by the more powerful and abstract nature of the design, the heavier quality of the material, the sombre force of the color, and the simplicity of the color arrangements. The cloth is made of the bark of the elm tree and is coarse but quite closely woven. The prevailing color is a tree brown. The pattern, usually, geometrical, with no obvious source in Nature, is applied in Japanese cloth of a different color. The robes in this exhibition are most of them made of the elm-bark cloth, with the pattern in dark blue. There is one, however, of the Japanese blue cloth with the pattern applied in brown. One stout robe of heavy deerskin has the Ainu design and is the kind of coat worn by Guild Masters in processions. The Japanese coolies also wear Ainu designs on their cotton coats.

It is in this room with its suggestion of savagery and archaism that we get the deepest sense of art as fulfilling the first clause of our quoted definition. Here emotions are imparted that reach the stern sources of the human spirit and fortify it for the struggle that is life. These harsh robes, formed for a harsh race, are eloquent of the joy in beauty which the physically strong may feel. These angular and formal patterns hint at the clash of metal and ornament of strong armor. In contrast with the flowing sweetness of the Japanese designs, they make an especially potent appeal to the imagination.

Turning from the costumes to the other objects in the exhibition the visitor will find ample evidence of pleasure in design. In the case of games is the game of the "Messenger Boy," in which the delaying youth whose reputation is worldwide is depicted at various stages of his progress, stayed by the temptation to join in all the sports known to Japanese boyhood. The drawing is sprightly, full of movement and humor, and is by an artist of sufficient fame to cause his works to be collected.

The battledores made for the game of Battledore and Shuttlecock also are decorated invariably with a scene of festivity associated with the New Year, as this game is played only at that time. One sees elaborately dressed court nobles seated about the New Year's emblem, and here also the drawing is occasionally excellent. The "Dolls' Festival," which occurs in the third month, is illustrated by a beautiful collection of dolls and pigmy household articles in lacquer, arranged, as the custom is, on steps covered with red cloth. There is also a shrine of great interest.

The paintings and color prints in the exhibition seem to have been selected for the most part for illustrative purposes, and occasionally to show strange borrowings, as where there is a picture of the birth of the Buddha amid Japanese surroundings. Another print of extreme rarity depicts a woman at her toilet, her attendants about her, and a merchant just outside her doorway displaying his jewels for her approval. The pictures of low life offered by the prints are to be depended upon for veracious statement, but those in which personages and customs of the Court are portrayed cannot be trusted, as they were chiefly drawn from literature and the stage, the print-makers having no social standing and consequently no first-hand knowledge of such subjects.

In the section of armor are many beautiful pieces of fine workmanship, and there are lacquers and leathers and pieces of metal each of which bears testimony in some degree to the national love of art.

Such an exhibition naturally gives most to those who bring most to it, but even upon the mind innocent of preconceptions, perhaps most of all upon the mind thus innocent, it must make a deep impression and kindle a lively desire to know more of the why and wherefore than can be gained through books. Glimpses of a delight in pleasure and games of skill and chance such as we hardly may conceive, glimpses of a warlike spirit, of a gentleness and a ferocity, of dainty beauty, and dim horror, these, without understanding, we feel in these beautiful rooms, themselves decorated so simply and with such practical tact and appearance of ease and inequitableness. To be interested and observe and learn by actual contact is the best way to get knowledge through art and the least informed student who makes his way through this section of the Brooklyn Museum will find himself started on the right road to this end. The collections and the arrangement are worthy of that exacting pride which declines compromise.

* * *

January 22, 1914

ART NOTES

Exhibitions of Pictorial Photography and Phases of Fashion

At the Ehrich Galleries is an international exhibition of pictorial photography. Nothing so good in its kind has been seen here. There are Baron di Meyer's brilliant portraiture

and that of Gertrude Käsebier, landscapes by T. and H. Hofmeister, Alvin Langdon Coburn's portraits of places and Robert Demachy's genre scenes and still life, big subjects and small subjects, straight photography and prints from manipulated plates but nothing that has not some degree of aesthetic appeal and merit of execution.

It is a number of years since very serious departure was made from the conventional photography of professional studios, yet much is still to be accomplished before the new schools can make photography a wholly satisfactory medium for personal expression. As one looks about an exhibition of such excellent work as that now shown, the first impression is that of a devitalized art, an art from which the movement of life is absent. Nevertheless there are signs that an artist sufficiently aware of this effect and sufficiently on guard to counteract it can produce astonishingly successful results. There is a little portrait study by Arthur D. Chapman of a man at work in front of a curtained window through which the sunlight sifts in broken bars. The plate appears not to have been worked over and the textures of the workman's apron and the accessories of the room are fresh and varied. But the broken glimmer of sunlight against the figure is what makes the thing a picture. It supplies an atmosphere similar to that for which painters strive with rough canvas and broken tones.

Then there is a remarkably clever still life by Katherine Stanbery Burgess, two Chinese porcelain figures on a polished table and seen against a hanging of some brocaded stuff. In front of them is the figure of a little waterfowl of some kind. The figures are reflected in the polished surface of the table, which nevertheless keeps its quiet, general tone in strong contrast with the broken tones of the tapestry background against which the little Orientals are delicately defined. There is a certain quaintness and humor of feeling in the composition perfectly in harmony with the subject and the fine balancing of plain with varied surfaces and the sensitive gradations of value make the unpretentious print a true work of art.

There are few nudes in the exhibition, from which we hopefully infer that the use of the undraped figure as a subject for the photographer is declining in popularity. Robert Demachy has, however, a "Study in Grey," in which the figure is charmingly posed, although the difficulty of getting expressive accents in shadow is seen in the partly withdrawn leg which fades away quite helplessly where a painter would have indicated its form and efficiency as a means of support by a judiciously placed accented line. In the tomb drawing from Westminster Abbey by Frederick H. Evans may be found another instance of the tremendous obstacles offered by photography to a personal interpretation of many a subject. Here, of course, what the artist would feel in this theme of an outstretched warrior stark on his tomb is the horizontal line and the rigidity. But there are details of armor that insist upon intruding, and there is no possibility for that intentional exaggeration of the line of direction, that emphasis upon the expressive character, which is the life of art.

When all defects in accomplishment are noted, however, and every reserve made, the unprejudiced observer must

admit that a great deal of progress has been made toward placing photography among the media properly claimed for art. And it should be kept in mind, as Mr. Anderson has reminded us, that Leonardo da Vinci bitterly complained because the critics of his day called painting "mechanical" because, forsooth, it was "done with the hand."

* * *

January 27, 1914

MUSEUM TAKES ALTMAN ART

Metropolitan Trustees Agree Fully to Terms Set Forth in the Donor's Will

THE CITY MADE GUARDIAN

Mayor Can Take Over $15,000,000 Collection if Museum Breaks Its Agreement

PUBLIC TO SEE IT SOON

Masterpieces Will Be Shown In Temporary Quarters—Full Text of Museum's Agreement

The Trustees of the Metropolitan Museum of Art have accepted the art treasures of the late Benjamin Altman, the largest and most valuable gift of paintings, porcelains, tapestries, rugs, china, enamels, stationery and other objects ever received by that institution, and arrangements are now being made to provide a complete public exhibition of them. All the terms set forth in the will filed for probate on Oct. 14, 1913, have been agreed to in the formal acceptance, following conferences between the Trustees of the Museum and the executors of the estate.

For the temporary exhibition of the great collection alterations have been begun in the main gallery of the Museum to provide space for an adequate display of it pending the completion of the new south wing of the building, where it will be housed permanently.

Desiring to conform to the wishes expressed by Mr. Altman the trustees will so arrange the temporary exhibition as to make it a fac simile of the gallery in the home of the donor. The collections have not been disturbed, but are exactly as they were in the lifetime of Mr. Altman, and when the museum galleries are ready for their reception the art objects will be removed and put in place in the museum in the same relative positions they now occupy in the rooms at 626 Fifth Avenue and 1 West Fiftieth Street. The paintings will be hung in a single line and not one above the other, according to the suggestion of the donor. The cabinet treasures will be displayed as they were arranged by Mr. Altman.

To Retain Altman Curators

Under the contract between the Museum Trustees and the executors, Mr. Altman's request that Theodore Y. Hobby, who had charge of his private collections, and his secretary, Arthur

J. Boston, who assisted him, should continue as caretakers of the exhibit in the Museum, will be met. They are to receive the same salaries they received from Mr. Altman, and for this provision has been made under the will through a fund amounting to $150,000. Some authorities have appraised the collection of which they have charge at $15,000,000.

One clause of the Museum's agreement accepting the Altman bequest provides that in the event of any violation of it the residuary legatee or the city may interpose through the Mayor or some other city official to compel the fulfillment of its terms; or an application may be made to the Supreme Court for an order disposing of the collections under some other trust, which must always be carried out so as to make the collections available to the public at all times.

President Robert W. de Forest of the Metropolitan Museum of Art signed the contract on behalf of the Trustees. The executors of the Altman will who signed it were Michael J. Friedsam, residuary legatee of the Altman estate, and Vice President of the corporation of B. Altman & Co.; Bernard Sachs, George R. Read, and Edwin J. Steiner. The agreement or contract was signed Jan. 5, but was not made public until yesterday.

Mr. Friedsam said of the agreement:

"I am sure the Trustees of the Museum will do everything in their power to carry out the wishes of Mr. Altman. And, speaking for myself and the other executors, I may say that we shall assist them in every way that we possibly can."

President de Forest expressed the satisfaction of the Trustees over the successful conclusion of the negotiations in regard to the collection. The assistance accorded them by the executors, he said, was a source of gratification to him and to his colleagues on the Board of Trustees of the Museum. Here is the full text of the agreement:

The Agreement

This agreement, made the 3d day of January, 1914, by and between the Metropolitan Museum of Art, a corporation duly incorporated under the laws of the State of New York, hereinafter called the Museum, party of the first part, and Michael Friedsam, Bernard Sachs, George R. Read, and Edwin J. Steiner, as executors of the last will and testament of Benjamin Altman, deceased, hereinafter called the executors, parties of the second part, witnesseth:

Whereas, Benjamin Altman, late of the City of New York, by Article XII. of his last will and testament bearing date the second day of May, in the year 1912, which, with a codicil thereto bearing date the 12th day of June, in the year 1913, was duly admitted to probate by the Surrogate of the County of New York having jurisdiction upon the 6th day of November, in the year 1913, did give and bequeath to the Museum his collection of paintings, Chinese porcelains, tapestries, rugs, Limoges enamels, rock crystals, marbles, bronzes, furniture, and objects of art contained in certain catalogues, 1, 2, and 3, with such catalogues, and any other articles or objects of art thereafter to be acquired and added to said catalogues and to such collection, upon certain express conditions set out at length in said Article 12, a copy of which article, so far

as it relates to such subject, is hereto annexed marked Exhibit "A," to which reference is had with the same effect as if each and every of the conditions and provisions contained in said Article XII. had been in this agreement set out at length, and which paintings, Chinese porcelains, tapestries, rugs, Limoges enamels, rock crystals, marbles, bronzes, furniture, and objects of art, constituting the collection so-called by said testator, consist of the objects specified in the schedule or list hereto annexed and marked Exhibit "B"; and

Whereas, The Museum, by resolutions of its Board of Trustees, adopted on or about the 20th day of October in the year 1913, in due form accepted the said bequest upon the conditions in said Article XII. set forth, and proposes by the execution hereof to comply specifically with the provisions of Subdivision 4 of said Article XII., which said subdivision reads as follows:

"4. That the Museum shall execute and deliver to my executors, or such of them as may qualify, as soon as practicable, and at all events within three months after probate of my will, a contract, under its seal, whereby it accepts this legacy subject to the aforesaid conditions, and agrees on its part to permanently comply therewith and to do and continue permanently to do everything on its part to be done to conform thereto.

"This contract shall contain such alternative or other disposition of all my works of art included in this legacy in case of breach by the Museum of any of the provisions of this contract by it to be performed, and the continuance of such breach after notice from my executors or any of them, or my residuary legatee, or any person or official by law charged with the supervision or enforcement of public charitable gifts or bequests, or any person or corporation interested to take advantage of such breach, as shall be prescribed and set forth in said contract by my executors."

Now, therefore, the parties here to hereby agree as follows, namely:

Museum Accepts Conditions

First—The Museum hereby accepts the legacy contained in Article XII. of the last will and testament of Benjamin Altman, deceased, and each and every part of the same as appears by the schedule or list hereto annexed and marked Exhibit "B," subject to all and singular the conditions and provisions in the said Article XII. contained, and hereby agrees to permanently comply therewith and to do and continue permanently to do everything on its part to be done to conform thereto, and to faithfully carry out the same.

Second—The Museum further agrees to provide and permanently maintain in the new south wing of fireproof construction, fronting on Fifth Avenue, in the City of New York, now to be added to its building, funds for the erection of which wing have been authorized by the Board of Estimate of the City of New York, or in such other portion of the building now erected or to be erected, of fireproof construction, as shall be agreed to by the Museum and the executors, one suitable room of sufficient size to contain all the said paintings,

statuary, rock crystals, and Limoges enamels, and one other suitable room to contain the said Chinese porcelains, which rooms shall be adjoining and opening into each other, and neither of which shall be less in floor space than the corresponding room in which such collection has heretofore been kept in the galleries connected with the house at 626 Fifth Avenue and 1 West Fiftieth Street, in the City of New York, occupied by Benjamin Altman during his life, and which rooms, so to be provided, shall be in all respects suitable and sufficient to insure adequate space and light for the display of said collection, the same to be approved by the executors, and expressly arranged for the exhibition of the said collection in a manner perfectly satisfactory to them.

The Museum further agrees to permanently install the said collection in the extreme southerly portion of the second floor of the said south wing of the said Museum, when erected, and to devote thereto the entire space of the second floor of the said extreme southerly portion for the entire breadth of the said wing, being some thirty-five feet in width, more or less, this space to be divided into two rooms, adjoining and opening into each other, and neither of which shall be less in floor space than as in said will and hereinabove provided, and also to devote thereto such further portion of the second floor of the said south wing, immediately adjacent to the above-mentioned rooms, as shall be in all respects suitable and sufficient for the display of said collection. The Museum has exhibited to the executors the plans for the construction of such south wing of the said Museum, which have been approved by the authorities of the City of New York, and, with reference to the question of adequate space and light, has also exhibited to the executors the galleries of the north wing of the building at the extreme northerly end thereof, which are in respects to space and light and also as to general finish substantially the same as the corresponding galleries are to be in such south wing except when changed by way of improvement; and the Museum agrees that such galleries in such south wing when built, shall be expressly arranged for the exhibition of the said collection in a manner in general similar to the galleries in the said north wing as now constructed, with at least as good a finish, wall covering, floor covering, and general arrangement.

Executors Approve Arrangements

The executors hereby approve such location, and declare that the location, space and light so to be provided, and the arrangements contemplated for the exhibition of the said collection, will be when completed satisfactory to them.

The Museum further agrees that in case, with the growth of the Museum or changes in the building, a change of location of rooms shall become necessary, the new location shall always be not less accessible nor less satisfactory for the purpose of the exhibition of the said collection than the rooms hereinbefore designated or to be hereafter agreed on; and the parties hereto further agree that in case the construction of such south wing shall be unduly delayed, or if for any reason beyond the power of the Museum such south wing shall not

be constructed, some other selection of space shall forthwith be made in consultation with the executors which will insure the exhibition of the collection according to the terms and conditions set forth in said Article XII. of the said will.

Third—The parties hereto further agree that if any suitable space shall be vacated in the north wing and at the disposal of the Museum and the Museum shall be able to devote the same to the exhibition of the said collection according to the terms and conditions set forth in said Article XII. of said will, the Museum shall notify the executors, and the parties hereto thereupon may agree upon a location in the north wing in the place of a location in the south wing, in which case all the terms and conditions herein prescribed in respect of the installation of said collection in the south wing shall be applicable to its installation in the north wing.

Fourth—The parties hereto further agree that, so far as respects action by the Museum, the construction of such south wing shall proceed as rapidly as possible, but it is understood that the construction and final completion of the same are dependent in considerable part upon the action of the authorities of the City of New York.

Fifth—The Museum further agrees that on the completion of such south wing the said space, hereby devoted to such collection—or such space, if the same be changed, as shall hereafter be devoted thereto, wherever the same may be, shall be arranged expressly for the exhibition of the said collection in as complete and satisfactory a manner as similar space is arranged for the display of collections in other portions of the building.

The Museum further agrees that upon final installation of the collection it shall be so arranged as to exhibit the same in a proper and suitable manner, and the Museum will consult with the executors, or their survivors, and make due effort to reach a harmonious agreement in reference thereto.

Special Rooms for Collection

The Museum further agrees that the space hereinbefore referred to or such other space as shall be devoted to such collection shall be devoted solely to the collection of the said Benjamin Altman, deceased, and shall contain no works of art or other exhibits except the articles bequeathed by him and formerly in his collection; that the paintings shall be hung in a single line and not one above the other; that notices or signs of proper size shall be placed and maintained in such room or rooms so as to indicate clearly that the collections therein contained were bequeathed to the Museum by the said Benjamin Altman; and that a proper rail shall be provided, some distance from the wall for the protection of the paintings.

Sixth—And whereas it is provided in the said Subdivision 4 of Article XII. of the said will that this contract shall contain such alternative or other disposition of all the works of art included in the legacy contained in said Article XII., in case of breach by the Museum of any of the provisions of this contract by it to be performed, and the continuance of such breach after notice from the executors, or any of them, or the

residuary legatee under the said will, or any person or official charged by law with the supervision or enforcement of public charitable gifts or bequests, or any person or corporation interested to take advantage of such breach, as shall be prescribed and set forth in this contract by the executors; and

Whereas, it is doubtful whether at the present time there is any institution or public or other charity in the City of New York which could advantageously be named in the place of the said Museum to receive and care for the said collection in case of such breach, and whether any definite alternate or other disposition of the same to a named person or corporation could herein advantageously be made;

Provision for Breach of Contract

Now, therefore, the parties hereto further agree that in case of breach by the Museum of any of the provisions of this contract by it to be performed, and the continuance of such breach after notice from the executors, or any of them, or the residuary legatee under said will, or any person or official by law charged with the supervision or enforcement of public charitable gifts or bequests, or any person or corporation interested to take advantage of such breach, the following shall be the alternative or other disposition of said works of art included in said legacy, which, pursuant to said Subdivision 4, was in such case to be prescribed and set forth in this contract by the executors, to wit: In such case it shall be competent for the executors, or their survivor, or successor or any administrator with the said with annexed, or the Museum, or the residuary legatee under the said will, or any person or official by law charged with the supervision or enforcement of public charitable gifts or bequests, or any person or corporation interested to take advantage of such breach, to institute an action or other proper proceeding in the Supreme Court of the State of New York, or in some other court having jurisdiction, joining therein the Museum and such other party or parties as may be deemed requisite, and to present and submit the matter of the disposition of such collection to such court for its adjudication, and thereupon, on due hearing, to obtain from such court an adjudication whether any alternative or other disposition of the said collection is necessary, and, if so, what shall be such alternative or other disposition, which adjudication shall be in satisfaction of and a performance of the said provision in said subdivision 4 of Article XII. of the said will for an alternative or other disposition of the said collection in case of the breach of the terms of this contract; and such corporation, person, or persons as shall in and by such adjudication aforesaid be adjudged to have and receive such collection shall be and are hereby empowered to receive the same, the executors assuming that the court will in and by such adjudication, prescribe such terms and conditions in regard to the maintenance and exhibition of the collection as shall be suitable and proper to fully carry out the conditions and intention of the said will; and if for any reason it shall be adjudged or decreed that the manner above set forth of ascertaining what shall be the alternative or other disposition thereof does not comply with the provisions of the said will and cannot be availed of, then and in that event, in order that no question may remain as to the full compliance with such provisions the City of New York, by whatever corporate title the said municipality may then be known, is hereby named and appointed to receive the same, the executors assuming that the proper authorities of the said city will take all such action in regard to the maintenance and exhibition of the collection as shall be suitable and proper to fully carry out the conditions and intention of said will.

Seventh—And whereas it is further provided in and by the said Article XII. of the said will that, in case the Museum shall avail of the bequest contained in said Article XII. and satisfy the executors as to the arrangements for the ultimate reception and exhibition of the said collection, the executors are authorized to deliver the same to the Museum and to agree to the temporary exhibition thereof until arrangements for the permanent exhibition thereof shall be complete; and

Whereas, the Museum, by the resolution aforesaid of its Board of Trustees and by the terms of this instrument, has availed of the said bequest, and in the manner hereinbefore set forth has satisfied the executors as to the arrangement for the ultimate reception and exhibition of the said collection, which arrangement is hereby accepted by the executors, after a full examination of the location;

Executors Transfer Collection

Now, therefore, the executors hereby transfer the said collection to the Museum, and agree to the temporary exhibition thereof until arrangements for the permanent exhibition thereof can be completed, upon the terms following, viz.:

1. That there shall be devoted to the temporary exhibition of the said collection the galleries known as Nos. 35, 36, 37, 38, and 39, on the second floor of Section C of the present main building of the Museum, which are now occupied by the Crosby Brown collection of musical instruments, and such space shall be apportioned to the said collection as follows unless otherwise agreed between the parties:

Gallery 39.—Dutch paintings and a few sculptures.
Gallery 37.—Italian, Spanish and Flemish paintings, with kindred sculptures and two cases containing gold objects and crystals.
Galleries 35 and 36.—Chinese porcelains and certain rugs.
Gallery 38.—Rugs and furniture.

2. That the light shall be improved by whitening the surfaces above said galleries; that a new floor shall be laid, of cork or similar substance now used in Museum galleries; that certain of the doorways shall be closed and coverings placed on the walls which coverings shall be at least as good as those in the general galleries of the Museum devoted to painting; and that, in consultation with the executors, the Museum will install the said collection to the best of its ability and in as appropriate and effective a manner as possible.

The executors hereby express their satisfaction with the arrangements for such proposed temporary exhibition as

above described, believing that the same will provide as safe, prominent and dignified a space for the exhibition of such collection as is practicable at the present time.

It is further agreed that until the arrangements for the temporary exhibition of said collection can be completed, and until notice of the completion thereof has been given by the Museum to the executors, the said collection shall remain in the galleries connected with the house 626 Fifth Avenue and 1 West Fiftieth Street, in the City of New York, occupied by Benjamin Altman during his life. If, however, the said premises should be sold prior to the completion of the arrangements for the temporary exhibition, or if for any other reason a removal is necessary or proper, the Museum will provide as far as possible some suitable place in its building for the care and preservation thereof until the arrangements for such temporary exhibition shall have been completed.

Eighth—And whereas it is further provided in and by Article XII. of the said will as follows:

"I further give to the said Metropolitan Museum of Art, provided my executors shall arrange with the said Museum of Art to have the same, or some of the same, transferred to the said Museum, my paintings of the 1830 French school; also my collection of Japanese lacquer work and other objects of art contained in my catalogue No. 4, together with the cabinets containing the Japanese lacquers and said catalogue No. 4, which contains a description and history thereof, to be disposed of as may be agreed upon with my executors."

And the executors have arranged with the Museum, within the terms of the said will, to have transferred to the Museum certain of such paintings of the 1830 French school and certain other paintings, together with the collection of Japanese lacquer work and certain other objects of art contained in Catalogue No. 4 as aforesaid, and the cabinets containing the Japanese lacquers and said Catalogue No. 4, according to a schedule or list of the same hereto annexed and marked Exhibit C;

Terms of Temporary Exhibition

Now therefore it is further agreed that in such temporary exhibition of the said collection so to be made shall be included such of the said paintings, lacquer work and other objects of art, contained in the said schedule or list marked Exhibit C, as shall be agreed upon between the executors and the Museum; and it is further agreed that in the permanent installation of the said collection as hereinbefore provided for the said pictures and objects of art mentioned in said schedule or list marked Exhibit C, other than the lacquer work, shall not be exhibited as a part of the said collection or in connection therewith but shall be distributed by the Museum in the appropriate place in its galleries with similar objects, and that the same and all of the same shall be plainly marked and distinguished as being the gift of Benjamin Altman, deceased; and in the said agreement installation the lacquer work mentioned in the said schedule or list

marked Exhibit "C" shall or shall not be exhibited as a part of the said collection or in connection therewith, as shall be agreed upon between the executors or their survivors, and the Museum.

Ninth—The Museum further agrees that, upon the payment to it by the executors of the sum of $150,000, given and bequeathed to it in and by said Article 12 for the purpose of providing, salaries for Theodore Y. Hobby and Arthur J. Boston, if they shall be employed by the Museum, and of providing also for the maintenance and preservation of the works of art in said collection, the Museum will, except as otherwise in this Paragraph 9 hereinafter provided, hold the said sum of $150,000 as a perpetual fund, the income of which only shall be used and applied to the salaries of said Hobby and Boston, and to the care, maintenance, and preservation of the said collection, any surplus of said income, if any, to be applied to the general uses of the Museum in the discretion of its Trustees.

The Museum further agrees that in case of any breach by the Museum of this contract, and the taking effect of the alternative or other disposition of such collection owing to such breach, as hereinbefore provided, the principal of the said fund of $150,000 and any unexpended income shall be paid by the Museum to such corporation, person, or persons as shall be adjudged to have and receive such collection.

Tenth—This agreement shall bind the Museum and its successors and successor, and the executors and the survivor of them and their and his successors, and any administrators or administrator with the said will annexed.

In witness whereof the party hereto of the first part has caused its corporate seal, attested by its Secretary, to be hereunto affixed, and these presents to be signed on its behalf by its President or a Vice President, and the parties of the second part have hereunto set their hands and seals in duplicate, as of the third day of January, one thousand nine hundred and fourteen.

THE METROPOLITAN MUSEUM OF ART.
BY ROBERT W. de FOREST, President.
(Corporate Seal)
Attest:
H. W. KENT, Secretary.
MICHAEL FRIEDSAM (L. S.)
BERNARD SACHS (L. S.)
GEORGE R. READ (L. S.)
EDWIN J. STEINER (L. S.)
Executors of the last will and testament of
Benjamin Altman, deceased.

The Collection's Contents

The agreement between the Trustees of the Metropolitan Museum and the Trustes of the Altman collection contained this official list of the works of art embraced in the collection:

Chinese porcelan, 424 pieces; Chinese snuff bottles, 171 pieces. Paintings, Rembrandt—"The Man with a Steel Gorget," "Portrait of an Old Lady in an Arm Chair," "Portrait of Rembrandt's Son Titus," "An Old Woman Cutting Her

Nails," "Pilate Washing His Hands," "Portrait of Rembrandt," "Portrait of a Man," "The Man with a Magnifying Glass," "The Lady with a Pink," "Portrait of a Young Man," called Thomas Jacobsz Haring; "Portrait of a Young Dutch Woman," "Portrait of Hendrickje Stoffels," "The Toilet of Bathsheba After the Bath."

Paintings, Frans Hals—"Jonker Ramp en zyne Liebste," "A Youth with a Mandolin," and "The Merry Company After a Meal," Bartholommeo Montagna—"Portrait of a Lady of Rank, as St. Barbara," Gerard Dou, "Portrait of the Artist"; Van Delft Vermeer, "Young Girl Asleep"; Nicholas Maes, "Young Girl Peeling an Apple"; Pieter De Hooch, "Interior with a Young Couple"; Meindert Hobbema, "Entrance to a Village"; Anthony Van Dyck, "Portrait of the Marchesa Durazzo" and "Portrait of Lucas Van Uffelen"; Aelbert Cuyp, "Young Herdsmen with Cows"; Gerard Terborch, "A Lady Playing with the Theorbo"; Jacob Ruisdael, "Wheatfields"; Hans Memling—"Thomas Portinari," "Marie, Wife of Thomas Portinari," "The Betrothal of St. Catherine," and "Portrait of an Old Man."

Fra Angelico, "The Crucifixion"; Hans Maler von Ulm, Haler zu Schwaz, "Portrait of Ulrich Fugger"; Diego Valesquez, "Christ and the Pilgrims of Emmaus" and "King Philip IV of Spain"; Bernard Van Orley, "The Virgin with the Child and Angels"; Albrecht Durer, "The Madonna and Child with St. Anne"; Sebastianno Mainardi, "The Virgin and Child with Angels"; Gerard David, "Christ Taking Leave of His Mother"; Hans Holbein, the younger, "Portrait of Margaret Wyatt" and "Portrait of Lady Rich"; Francia, "Portrait of Federigo Gonzaga"; Giorgione, "Portrait of a Man," possibly Ariosto, the court poet; Filippino Lippi, "The Virgin and Child, with St. Joseph and St. John"; Sandro Botticelli, "The Last Communion of St. Jerome"; Andrea Mantegna, "The Holy Family"; Dirk Bouts, "Portrait of a Man"; Da Messina Antonello, "A Portrait of the Artist"; Andrea Verrocchio, "Madonna and Child"; Cosimo Tura, "Sigismund Malatesta"; Titian, "Portrait of Filippo Archinto, Archbishop of Milan."

The list then enumerates rock crystals and gold enamels, marbles and terra-cotta, including, by Jean Autoine Houdon, a marble bust representing Louise Brongniart, a marble statue representing the Bather; by Falconet, a marble group representing Venus Instructing Cupid; by Giovanni da Bologna, Virtue Overcoming Vice, and many other statues by old masters.

Then there are bronzes, limoges enamels, tapestries, rugs, and Italian and Persian art objects, glass, scarabs, furniture, a Greek terra-cotta vase, and Greek glass.

The modern Dutch paintings include "Changing Pasture," "Crepuscule," and "Return to the Fold," by Anthony Mauve.

The Barbizon paintings are "The Ferryman," "Souvenir of Normandy," "Allie des Arbres," by Jean Baptiste Camile Corot; "Landscape," by Theodore Rousseau; "Les bords de l'Oise" and "Landscape with Storks," by Charles François Daubigny; and "A Clearing in the Forest of Fontainebleau," M. V. Diaz. Then there are Japanese lacquers, Chinese jades,

amethyst and other mineral objects, Japanese bronze knife handles, and a Chinese cloisonne.

* * *

January 24, 1915

NEW YORK A SIEVE FOR ART JUNK, SAYS BORGLUM

We Have Lost Our Leadership in Art, According to the Noted Sculptor, and the Time Has Come to Organize to Regain It— Chicago Offers Some Object Lessons to This City

By EDWARD MARSHALL

That New York should be of great importance in the art world, and might be, but is not, is the opinion of Gutzon Borglum, one of the most important of our living sculptors.

He says frankly that it has no artistic character of its own, but he has interesting suggestions to make, which, he thinks, if followed out would make its position not only important, but one approaching supremacy. Chicago, he declares, is doing far more than New York is doing, and he believes the worthy influence of its Art Institute to be far greater than that of New York's Metropolitan Museum.

For the latter institution he has made some novel and interesting plans, having constantly in mind such methods as will bring its educational possibilities into reach of the general public and supplement them with the influence of energetic and concentrated schools, including all the fine arts. In the interview which follows the sculptor strikes from the shoulder.

"New York is a most interesting reflection of Europe and our estimate of European culture, and not much more than that," he declared, as we talked in his big studio, under the benign gaze of his great Lincoln head and within sight of the mystic wonder of his beautiful, if startling "Conception."

"What does this vast town express, artistically?" he went on, and then answered his own question with: "Simply what men of wealth and ability to get, with no knowledge at all, have happened to collect of what time has established as the standards of culture.

"The men who thus have set New York's artistic standards really have not had an opportunity to formulate their own ideals. They are afraid of new things in art. They don't want things made to satisfy new tastes or even made to satisfy their own tastes. They want things made to fit what they have been solemnly informed, sometimes by those who have had a right to an opinion and oftener by those who have had no rights at all to any opinion whatsoever about art, is good taste and ought to be their taste.

"This fact has brought an army of business men to New York who cater to those who have just arrived (financially) and are groping, some of them intelligently and more of them unintelligently. Such men are engaged to fit the possessors of new fortunes with an artistic sense as others are engaged to fit

them with topcoats. The tailor oftener than the picture-dealer turns out a good job.

"It is this which has created in America, and particularly in New York, the turnkey home—the contractor-built, contractor-furnished, contractor-decorated, and contractor-pictured and statued residence. It has made us victims of shop-culture. It is scarcely an exaggeration to say that the newly rich man wires from his just developed bonanza mine to New York City: 'Make me a home, very choice, exceedingly expensive, and have it ready for me when I reach town four days from date upon the Twentieth Century Limited.'

"Arriving, he finds even the flowers in their vases on the tables. Which, by the way, is not so serious a matter, for flowers cannot be so very dreadful, and they will fade. But the vases, and the tables, and the rooms in which the tables stand, and the pictures on the walls! They are the product of the combination of the contractor and the wired order—and the rich American believes them to be very beautiful, whether he likes them or not, because he is assured, when he pays six prices for them, that they are the fanciest and most expensive to be found in this great market.

"Such is New York's true relation to art.

New York the Melting Pot

"I don't think any one especially ought to be blamed, but every one especially ought to be helped. It probably has been a less serious matter for New York's art that the city is the great melting pot for foreigners from the East than it is that it is the great polishing roller and varnishing pot for Americans from the West, the Northwest, and the Southwest—not to forget the Middle West.

"New York has had to dress, to feed, and to teach the newcomers, and they have cared far more about being dressed and fed than they have cared about being taught. It has been a truly awful task which has been thrust upon this poor old town.

"And if she has had trouble with art patrons, she has had trouble, also, with art learners. As she has drawn to herself from all parts of the country those who can afford to purchase art, so, also, has she drawn to herself most of those who, mistakenly or rightly, have determined to create art.

"There are splendid men and women among them, and she is fortunate in that she has so much vigorous and virile territory to make drafts from, for, probably, there are not half a dozen important artists in the city today who did not come here from outside.

"But they are from everywhere, they are not concentrated, when they get here, as artists and those striving to be artists are concentrated in the centres of European art, and it seems almost inevitable that each one coming should, after his arrival, cater to the tastes he left behind him, or, rather, to the tastes which were created in him by the influences—frequently unfortunate—which maintained in the place he left behind him.

"New York is a great lodestone for the man who yearns to give expression to himself through art, but arts and artists do not work together here. New York's whole artistic life is granular and not coherent. And so, while she has been forced into the position of a melting pot for American art, she is not that, at all, for no big heat, no dominant influence is at work here.

"I am a New Yorker and I love New York, but New York's art influence remains to be created. Chicago, San Francisco, even St. Louis, have more. In Chicago big things have been done and are being done; in California there is a real spirit belonging to the place (for there was something there two centuries ago;) even in New Orleans there is an influence coming straight out of the quaint environment.

"But New York either is not old enough to have an individual artistic spirit or she is too transiently peopled; no one group of her population gets old enough in one environment to produce anything truly characteristic.

"Influences are scattered here and weak. We lie between the Old World and the new and are part of neither. In consequence, we have been and are a great sieve, through which the junk of Europe is sifted ere it passes westward. The biggest and most expensive, but not the best, pieces clog our meshes and remain with us, to damn us and our children. Let us hope that they may not damn our children's children!

"And if we are the sieve through which the European junk is sifted, so, also, are we the bathhouse where men coming from the other way pause, bask, clean up, redress, and preen.

Organization Is Needed

"So we get junk from one direction and purchasers who do not know the difference between junk and jewels from the other. That is why we are disorganized and that is why we must organize. We are not, but it should be our destiny to be the great clearing house for the distribution to Americans of decently high and clean artistic taste. We might be if we wished to be. I believe we shall be."

"What have we done in recognition of this destiny? What are we doing?" I inquired.

"Um!" said Mr. Borglum. "Um! Well, there is the Academy. One must speak of it with reverence. It has been here a hundred years. During that time it has accumulated some property and has acted as an incubator for a number of institutions.

"But the city has outgrown the Academy, its abilities and ideals. The Academy has failed to see the magnitude of its own opportunity; it has failed to fulfill its mission. Every big impulse in it has resulted, not in the progression of the Academy, but in an insurgent movement, costing it some of its best blood. Most, or at least many, of the Academy's admirable workers have rebelled, seceded, and stayed out. Every big impulse originating in the Academy has resulted in a new organization which has injured the parent body and which has been handicapped itself by weakness of numbers and the opposition of the stalk from which it sprang.

"This is absolutely as it never should have been. The only excuse for a grouping of artists is increased ability to bring their wares to the attention of the public in a proper way. The first impulse back of an exhibition made in common by a group of men is a division of expense. That obviously is true.

"Therefore, there is no reason why the Architectural League should not be an integral part of the National Academy. Is it reasonable to say that the National Academy should not comprehend all the branches of the fine arts which are comprehended in the Paris Salon?

"As a result of such linking public interest would be increased immensely, attendance would be larger, and educational influence would be magnified by manyfold.

"An exhibition of pictures should be, first of all, an educational influence. Pictures are not painted with an eye primarily to the market, but with the hope that through them may be communicated a valuable something to the world which could not be communicated in any other way.

"This takes us to the very heart of the question. My attitude toward the Academy, and so on, is very impersonal. I have the greatest admiration for the individual members of the Academy as public servants. The Academy holds, and ought to, an important place in any movement which reasonably can hope to have a national influence upon art in America, and before any attempt is made to replace it no effort should be spared which might help it to fill, in the biggest way, that position of leadership which it occupies at present but does not fill.

"But we must have real leadership. With nothing like the money available in New York, Chicago has had the patriotism and courage to build up an institution which outranks anything we have here in New York and anything which exists elsewhere in the country. Her Art Institute fills for Chicago and the Middle West exactly the position which I, as a New Yorker, wish the Academy might fill, not only for New York but for the entire country.

"But no; the exhibitions at the New York Academy hardly can be compared with those at the Chicago Art Institute, and certainly there are several exhibitions west of New York and yet east of Chicago which put New York's to the blush.

Chicago Has Initiative

"Whether Chicago can do a thing or not she tries to do it, if it is worth doing and sometimes she does things, by means of lectures, exhibitions and the widest possible freedom and use of her institution, which New York never even attempts. The art works of the world which she has had the fortune to accumulate are for the benefit of her citizenship, and it reaps that benefit. Chicago is awake to art. Her lecture rooms devoted to subjects related to art in all its branches are perhaps the best attended in America.

"Although her schools have few instructors nation-known upon their lists, still they command an attention elsewhere in the Western world unknown. Three thousand pupils and more are this Winter studying art in the Chicago Institute under conditions free, helpful, agreeable. There is nothing like it in America, and certainly there is nothing in New York which approaches it. In fact I know of nothing like it in England or France.

"The Chicago Art Institute night classes, alone, draw an attendance of 1,500 men and women, who take back from them to their daily labors the drawings, and, what is more important, the cultural development which they gain from studying the masterpieces in the crafts which are accumulated at the institute. I have been out there recently and I found the whole thing stimulating.

"Apparently there is a great difference between the Chicago and the New York impulse. I have not even hinted at much that they are doing in Chicago; I have barely hinted at the things which I have mentioned. Now what are we doing in New York?

"New York City has a school attendance of between 700,000 and 800,000, I think, and Chicago has a school attendance of 370,000 or 400,000. But there is no comparison between her attendance at the art schools and ours. We have not a school, nor a combination of schools which meets the art-educational demand in an admirable way—not one. We have separate schools, but they miss fire. We need a centre such as Chicago has, or better.

"Where separate schools are established, as they have been here, each dealing with its tiny detail of the art impulse, the work is incomplete. The various branches of art instruction should be grouped.

"In schools like the Art Institute, Chicago, the art impulse, stimulation, energy—whatever you may wish to call it—flows from room to room and grows. Why should not modeling stimulate the love and knowledge of the water-color student; and both stimulate the architecture student? They do, if they but have a chance. In Chicago there is such an opportunity; in New York there is not.

Faults of System Here

"And if New York's schools are unattached units, our instruction is disintegrated and, therefore, very largely futile. Our Beaux Arts for architecture is doing splendid work, but narrow, for it ought to be connected with the Metropolitan Museum. At one time it was planned to buy for it the block opposite the Museum, but this was not done. And it would not have been wise, for the museum is the school, and there should not be a road between them. They should be one and indivisible.

"When you go into the Chicago Art Institute you go into a school; when you go into the Metropolitan Museum, New York, you go into society; and if you are not of society you feel out of place there.

"The greatest possible service to the public as a whole could be rendered and the greatest possible compliment could be paid to the men who generously have contributed to New York's wonderful collection if the people had the opportunity and impulse to go and admire it. Intimacy is the greatest thing in the world. New York has a fine collection, but it is not intimate with it; it does not love it; it does not even know it. Nor can it ever know it if things remain as they are now.

"Intimacy? It is an essential of real appreciation, actual love. I put the Newark Lincoln on the ground, so that even little children could go to it, really see it, learn to love it and to be inspired by the great character which it represents. A

pedestal would have done much to rob it of its influence upon the people.

"New York puts all its art upon a pedestal, where few can see it and where most of those who see it get distorted views of it. Chicago puts her art upon the ground, where children may look straight at it and by it be inspired.

"Our art is under glass, under guard, to be seen once a year. It ought to be in our homes. It is in more Chicago homes than New York homes. I was astonished by the robustness of the men and women in the Chicago Art Institute lecture rooms. I found lectures on Mozart and Franz Hals attended, in Chicago, as a moving picture show is here. In New York such lectures would not draw enough listeners to take the chill out of the air.

"The Metropolitan Museum recently has opened a lecture room and made some provisions for students from the public schools studying in some of the lower rooms in a limited way. I would state that my hope then was that the institution should continue its larger life under a new charter, which would make proper provisions for its enlarged usefulness as an educational institution.

"It stands on public ground. My great hope was that it might be rebuilt, reorganized, and recreated into a national institution. New York's opportunities are far greater than Chicago's. This is a national city. Whatever stain is tolerated on this city extends throughout the nation, for this is the nation's port of entry. It is more important that we should be national, with a sense of national responsibility, than it is that Chicago should be anything whatever.

"But here in New York, essentially a world city in population and in potentiality, yet in this (of many things) it is unorganized, inchoate, missing all its opportunities, not helping the United States, but handicapping the whole nation."

"How might we so organize as to change these things for the better?" I inquired.

"First of all," said Mr. Borglum, "there should be a series of conferences, attended not only by artists, but by all men interested in the development of art in this country. The object of their meeting should not be the bandaging and patching of a lame dog, but the creation of a nationally influential institution and the assemblage into it of all the scattered influences that now are wasting their strength, their resources, and their influence.

"Each little group now has its audience. There are thirty of them, with half, at least, which should be combined in the great central body. It would have power and influence appropriate to the greatest city of America.

"That united organization ought not to advocate Greek, French, Japanese, Scandinavian, or German art. It should not attempt to tyrannize over the community by forcing upon it any particular school.

"The great public service such an institution might render would be first of all, unity of interest in all movements for the advancement of beauty—beauty of the painted canvas, of the sculptured marble, of the drama, of literature, of all the crafts which go to make life beautiful.

"The immediate expression of such an institution would be the acquisition of a location and the construction thereon of buildings containing large exhibition rooms, with other facilities for handling exhibitions of any of the five allied arts which are today seeking corner room in the Fifty-seventh Street barracks or lost in one of the armories.

"The building should be the most beautiful in the world, the plan chosen by selection, not by competition, from many offered by the best men in the work. Thus only would we get the best. The sculptors should make their work upon the building their contribution to this period of ours in New York City and America; and so on.

"The building in all its details should be the best of which American art is capable; it should be a part and parcel of the exhibition and the school.

"I know this could be done in that way, and I know we could get the men to give their work to it. And we could get the money for it, too; we could go around with a big hat and get it very quickly if we started with a big enough conception to appeal to really big men.

Will Be a Centre of Impulse

"If we make it generous and sufficiently inclusive, and then do not try to own it after we have got it, but make it truly New York City's, we can get it. And then it will be the centre of New York's stimulated impulse; it will be the centre of the American impulse and will be one of the centres of the world's impulse.

"It should be the home for the Academy of Arts and Letters in America; it should be the great annual exhibition place for all the allied arts, including the liberal arts, painting, sculpture, ornament, architecture, literature, the making of beautiful books. It should include wall decorations, furnishings—everything—and should add an impulse to American life which ever has been lacking. The ancients ornamented all the little implements they used. We don't. Why not? It gave them meaning.

"All such things should be shown. Europe is showing them in all its national exhibitions, but New York might go further, showing wall paper and rugs, beds, needlework, what not—making this the clearing house for the annual passage of all the fine things done in the whole nation. We should consult with and be advised by agents everywhere throughout the country as to where the best is being done and by whom, so that we might get a glimpse of it and profit by it.

"With this accomplished New York would really have its place as the American art centre, not only in regard to impulse but in regard to market. Purchasers would come here and purchases be made here. Societies all over the country have funds to buy with, they would have representatives here on watch. They can't do that now, for everything is scattered and not to be found except by chance or luck.

"It not only would be a big artistic proposition, but it would be a big commercial proposition, and that would make it still further American. There are five or six bankers in this town who would have as much right as anybody on the gov-

erning committee, and the President of the United States should be its honorary President."

* * *

PICABIA AND PICASSO

Picabia is now at the Photo-Secession Gallery, with an exhibition logically following that of Picasso last month. Three pictures with titles have perhaps a direct bearing upon the artist's intention, but are not to be read by one who runs except in their detachment, "Marriage Comique" is one, and another is "Je revois en souvenire ma chère Udnie," both most unpleasant arrangements of strangely sinister abstract forms that convey the sense of evil without direct statement. A much breezier though still abstract composition is that entitled "C'est de moi qu'il s'agit." On the whole it is not an agreeable change from Picasso, whose strangeness is more often than not sheer beauty.

Probably we shall have another chance to appreciate Picasso. "If at first you don't succeed—" In time, no doubt, such is the assiduity of those charged with the education of the public, we shall have all the Picassos, the many gifted personalities working through that one brain and that one pair of hands. Perhaps of them all the most engaging is the Picasso of "Le Lapin Agile," 1905, in which the painter in Pierrot costume sits at table with a man and a woman in the famous Paris café.

Then there is the painter who followed Daumier with strong contrasts of dark and light and rich modeling. And, further back, the painter of the young girl with her head crowned with flowers. It's a long, long road to the comparatively new Picasso with his figures and letters of the alphabet and pieces of newspaper and his cubistic drawing and "absolute painting." He can be poignant, the "Dead Pierrot" showed that, he can draw vice as cruelly as Balzac, those "Apaches" in the etching of 1905 prove it; he is sensitive to personal significance and cognizant of decorative values, both qualities are in the "Seated Pierrot" of 1903; and since most of us grant that the writing of experience is never wholly erased from a still sound mind, no doubt we should assume that the poignancy and cruelty and tenderness are all in the complicated designs with their beautiful flickering lights and darks and their interesting and tremendously difficult perspectives. We of the public live by faith alone, and it is not a faith to come at easily in the case of Picasso, yet his sincerity and his skill are both so apparent, that the absence of a clearly defined artistic meaning in his work is unbelievable.

At the Photo-Secession Galleries in one of the inner rooms are half-a-dozen drawings, and an impression of the "Apaches" illustrating the progress of Picasso, synthetically presented. This inner room is the magnet for students of art.

* * *

EXAMPLES OF WINSLOW HOMER'S WORK IN THE LIGHT OF FULFILLING A NOTABLE IDEAL

When we say that Winslow Homer is an American type of painter, fulfilling a National ideal that has singularly few exemplars in art, we think perhaps most often of his coast and sea pictures, with their rugged naturalism, and their stern portrayal of the struggle between man and the elements. This is the temper we like to think of as expressive of our pioneer strength in establishing a new world on savage ground, this is what we hope still typifies the firm sinew of our National character beneath the fluctuating surface acted upon by invading armies from all parts of the globe. Homer's is the kind of painting that one would have expected to rise from the fires of our necessary holocaust of all inherited aesthetic influences during the first days of our long battle with the wilderness. As a matter of fact, our earliest American painters had very little of this initiative energy in their exceedingly academic paintings. The Nation had not yet had time to grow young and develop its individuality in matters of art. It was a bundle of imitations and traditions in that direction, and Homer's early art, as it is represented in the exhibition at the Metropolitan Museum, has little in it that promises to the casual or even to the curious observer the freedom and breadth, the sense of nature strongly felt and strongly stated, the truly astonishing simplicity of the later work.

His "Sunday Morning in Old Virginia" has, indeed, ample simplicity of spirit in the grave candor of the representation. The negro types in particular are given their true psychological value by the sheer honesty of the artist's objective point of view. But the execution is commonplace, hardly even skillful, yet always firm and lucid. The composition from the first has an element of distinction. It is here that Homer's greater qualities find consistent expression. He could not put five lines together without making them suggest strength and stability and balance. If we look at "The Light on the Sea" or at "The Undertow" or "The Fox Hunt" we see clearly how the strong untrammeled movement of the lines of direction establishes the splendid force of the picture's construction and how independent it is, not only of the subject interest, but of the realism which is supposed to constitute so large a part of Homer's equipment. What could be finer in vigorous arrangement than the "Cannon Rock" with which visitors to the Metropolitan Museum have long been familiar? Others have painted water with quite as successful an interpretation of its physical characteristics, its weight and liquidity and color and movement, but it took a bold architect to place that severe triangle like a wedge between the dark masses of the rocks and under the long strip of dark sky unmodified by clouds. The geometry of the picture is so bald that the slightest feebleness of execution would have been at once revealed, and the painter thus imposed upon himself an exaction, the severity of which only his fellow-technicians properly can appreciate.

In the same way Homer's color, true enough to local conditions and usually pure in quality, is of minor importance compared with the masterly arrangement of his values. These, marshaled with a noble breadth, reveal the susceptibility of the painter to the plastic quality of his material. Nothing that he paints looks empty or flat: yet he indulges in very little of the "round modeling" by which feebler workmen strive to indicate their sense of form. He works legitimately with broad planes of light and dark unbroken by any babble of detail, and his massive rocks tell us of their shape and ponderable substance, without spending description upon the delicate fluctuations of light and color on their surface.

Only in his watercolors does Homer reveal the sensitiveness of his vision to the opulent world of rich and sparkling hues. These show that in spite of his dominant personality he reacted to impressions of a world quite different from that in which he habitually secluded himself. The stark watcher of sullen waters and iron skies becomes in his Southern environment a creature of Southern mood, vivacious, radiant, responsive to the glory of color saturated with hot light.

In spite of his reticence of life, possibly because of it, we hear a great deal more of Homer as a man than as an artist. It is almost as pleasant to get away from the discussion of his solitariness into the stimulating region of his art as it is to get away from Whistler's reputation as a wit into the true intimacy of his works.

In New York his fellow-Centurions keep green the memory of his rare visits to the club as they do the memory of La Farge's lambent talk and Martin's robust humor, and this, of course, is as it should be, the annals of club life sheltering these precious personalities under the warm protection of good comradeship. But the great public who will visit the Museum to see Homer, the man of art, reflected in his many-sided yet singularly coherent accomplishment will see chiefly the vigor of his mind and temperament. He might have been a viking, fond of wars and words, and lashed into form by the constant onslaught of the ocean winds, so far as these sea paintings say to the contrary. He might have been a Venetian tossing his balls of crimson and blue in a lively game of color, making energetic tones and hues do the work of energetic line, so far as these water colors made in Bermuda tell us of his artistic temper.

There is nothing really primitive about him, taking the word in its right significance, nothing of the feeble, ingratiating gesture and painstaking conscience of the newcomer into art. Neither is there any trace of decadence in his method or vision. He represents full manhood, fortifying nature with all the resources of a strong intellect trained to its task. No more health-enhancing influence ever came into our art.

If in the Winslow Homer gallery we get the special savor of the American art spirit, working in solitariness upon native material, in the gallery dedicated to the loan exhibition of European arms and armor we come into contact with a civilization and an art of which we have no relics or memories in this country. For this very reason it is desirable to bring before the public these lively reminders that such a civilization existed and made its impression upon European art.

The armor shown in the present collection is drawn from four centuries, the fourteenth, fifteenth sixteenth, and seventeenth. It has been said that a full suit of fifteenth century plate armor is the most perfect work of craftsmanship that exists. This is easy to believe in the presence of such examples as the suit lent by Mrs. Rutherford Stuyvesant, (No. 5 of the catalogue,) in which not only the general lines but the details are of the utmost grace and of a beautiful simplicity. Passing from this Gothic type to the Maximilian type, we find greater clumsiness, but the three-quarter suit lent by Edward Hubbard Litchfield is extraordinarily fine in workmanship and in the lines of the fluting which is a characteristic of this type. Later came overelaboration and decadence. The materials are poorer, and occasionally machine work seems to have taken the place of the early hand work. Even the poorest bit in the collection, however, would put a modern metal worker to embarrassment were he asked to copy it. The vitality of the forms is given by the creative instinct of the old armorer, who was an artist as well as a craftsman, and who, to the credit of the brave Dark Ages, had as much honor in his own country as his fellow-artists who worked with their more responsive materials. A part of the beauty of a well-made suit of armor lies, indeed, in the sharpness of the fight between the craftsman and the material, and in the fact that the craftsman gains the day through at least a partial submission. There is something of the same dignity in an ancient Egyptian statue carved from basalt, and this wonderfully wrought metal. The introduction to the catalogue emphasizes this point of view in a very informing paragraph:

"For the armorer, at each stage of his work, modeling in hard metal, had to be skilled in subtle processes which taxed to the fullest both his hand and his judgment. If, for example, at any stage he chanced to heat the metal to excess, his labor was in vain: with a few strokes of his hammer he might weaken his work at a critical point and render it valueless; or if he changed the form of an object in its beginning even by a finger's breadth, there would not remain enough material to complete the desired contour. The making of arms was, in former centuries, an art among arts, which everybody, rich and poor, appreciated in quite a technical way, but which to-day, many, even amateurs, do not understand."

* * *

H. C. FRICK BOUGHT FRAGONARD ROOM

Panels from Morgan Collection in Metropolitan Museum for His Fifth Avenue Home

SOLD IN 1898 FOR $350,000

Report That Present Purchaser Paid $1,425,000 Is Denied—His Many Art Treasures

Henry C. Frick, it developed yesterday, was the purchaser, through an agent, of the famous Fragonard Room, part of the collection of J. P. Morgan in the Metropolitan Museum of Art, the sale of which was announced last week. The price reported was $1,425,000, but this was said yesterday to be incorrect. Mr. Morgan bought the fourteen panels from the Agnews in London for $350,000, in 1898.

The panels are not gallery pictures, and will be placed in the drawing room of Mr. Frick's new home at Seventieth Street and Fifth Avenue, instead of in the big art gallery. This room will be remodeled for their reception, and in it the panels will appear much larger than they have in the museum. There they were mounted in the same setting which Mr. Morgan had built for them in his home at Prince's Gate, London, and this room was so small that a considerable margin of the panels had to be turned in to accommodate them to their frames. The concealed parts will now be disclosed. The drawing room is to be designed by the English decorator, Sir Charles Allom.

This is said to be the largest art transaction in which Mr. Frick has had a part, although he has been collecting for years, and now owns, exclusive of the Fragonards, some seventy-five pictures, each a masterpiece of its class. Among his art possessions are Valesquez's "Portrait of Philip IV.," Rembrandt's "Dutch Merchant," Romney's "Lady Warwick," and Franz Hals's portrait of himself.

* * *

EXHIBITION OF CONTEMPORARY ART

Many Wholesomely Objective Paintings in the Exhibition at the Brooklyn Museum: Thomas Eakins and Robert Henri

The exhibition of contemporary American art at the Brooklyn Museum shows as well as any large exhibition and better than most the quality of material used in building these lower stories of our house of art. It is apparent that the building has not got very far from its somewhat fragile foundations; it is equally apparent that the architectural style is not less eclectic than one would expect from the nature of our social fabric, and that no coherency exists, yet it is our house and its excellent points reveal themselves to us even in this fragmentary state of the structure whose finishing is not to be foreseen.

The works assembled disclose many varieties of temperament as well as an appalling absence of temperament in a great number of instances. The lure of paint for men who are not and never could be artists is one of the mysteries of the universe. Possibly the mystery is greater in the case of those who produce art apparently without lending anything of their own to the result. Such a painter is Thomas Eakins one would say from the two examples of his work on view. There is nothing in either to tell you of subtle interior influences that have operated to make him see life personally. His history seems not to go back of the work in hand with its honest craftsmanship. In consequence you are able to enjoy it freely as craftsmanship, without asking of it poetry or drama, imagined beauty or fused experience. You look at it as you look at a good piece of needlework or weaving, with a high degree of respect and no disquieting emotion. The picture of "William Rush Carving Allegorical Figure of Schuylkill River" is thoroughly characteristic. The device hints at an appeal to curiosity. The sculptor is seen only after assiduous peering, far in the background working at his almost indistinguishable statue, enveloped in shadow. In the foreground stands his model, the true theme of the composition, and near her sits her duenna, a naïve commentary on the period. It is not a distinguished design and the color is the brown of ancient leathers. The interest centres in the structure of the gaunt young body with its protuberant shoulder blades, its sinewy upper arm, its thin, flat back. It would be hard to find a truer description of the anatomical facts or one that brought more clearly to mind the severe beauty of the type.

The other painting is a portrait of a man seen full length, standing, his hands in his pockets, his head bent, his expression reflective. The figure is silhouetted against a light background, and is thoughtfully built up so that it shows in the loose and clumsy clothing a truth as convincing as that of the little nude model in the first picture. On account of the low key and a kind of brushwork in vogue day before yesterday, one notes with unworthy surprise the fact that the suggestion of movement has been caught most happily, the attitude seeming a pause and not a fixed position. There is no occasion for surprise, the suggestion of movement dating further back than Douris and his Greek combats, but we get in the habit of thinking that, because the modern painter concentrates his attention upon one thing, he has discovered it.

Robert Henri earlier in his career concentrated his attention for a considerable time upon the problem of black seen against black and similar problems of value. Now he is reacting in favor of brilliant color, occasionally with loss of sensitiveness to delicate relations of tone. His beautiful little nude in the present exhibition reveals the most acute observation of principal facts, which in this case again, as in the Eakins picture, are the lankness of a young figure, its length of line, and its firmness of muscle. Mr. Henri adds what Mr. Eakins intentionally omitted, its brilliancy of flesh tints and its sup-

"Rose to Rose," by Arthur Davies. (On exhibition at the Brooklyn Museum.)

pleness. The head surmounting the bony shoulders is a familiar type, wet red lips and swimming blue eyes and untidy red hair, a very sloppy little head, closer acquaintance with which you can do without, but it belongs to the picture, which is one of the artist's best. Fifty years from now it will perhaps be possible to discern a degree of kinship between Mr. Eakins and Mr. Henri that now seems incredible. Neither is concerned with his own feelings but with the object before him. The result of this objective attitude is art of peculiarly equal quality, free from moods and impulse, wholesome, sound easily understood. Much American art shares this character, but comparatively little is so rich in conscience and respect for the medium.

An early Arthur Davies is in the exhibition and exhibits the contrary tendency. There will be much to say of Mr. Davies and his various manners in the art history of the future. When it comes to discerning the bridge between his paintings of five or six years ago and those of today neither documents nor contemporary criticism will convince all the connoisseurs that there were not two men by the name of Davies, one much younger than the other and subjected to the influence of a certain twentieth century French school. Each Davies, it will be granted, took a deeply personal view of life, brought to us gifts of what had pleased him and stirred his emotions, looked into his soul before he painted, and remem-

bered music in developing his compositions. One of those painters, like Giorgione before him, entered the region of the painted myth with his own ideas to establish. The two young girls, one brushing the other's hair, in the Brooklyn collection, have nothing to do with mythology. The name of the picture is "Rose to Rose," which means something to the artist and to the public is a cryptogram. Yet that public has no difficulty in responding to the imaginative appeal of the lovely work. Anatomical precision is deliberately avoided in favor of poetic generalization; the long, smooth curves of the distant landscape, and the bland, sinuous line of the figures, the rich, warm flesh tones relieved against the light sky, the gold glow holding all the separate colors in a fused tone, combine in that romantic magic which one thinks again and again forever has fled from art, only to come upon it in some modern creation as the Venetians came upon it in the late fifteenth century with surprise as something counter to the spirit of the time.

It is present again and in a full degree in the Ryders. It takes on a cooler and even more mysterious aspect in the work of J. Alden Weir, whose "Still Life" in the exhibition is an extraordinary performance. It has all the cool gray ghosts of passionate feeling to be found in Hawthorne's stories, plus something wiser and deeper than Hawthorne put into his thinking. It is rather easy of analysis, too, but analy-

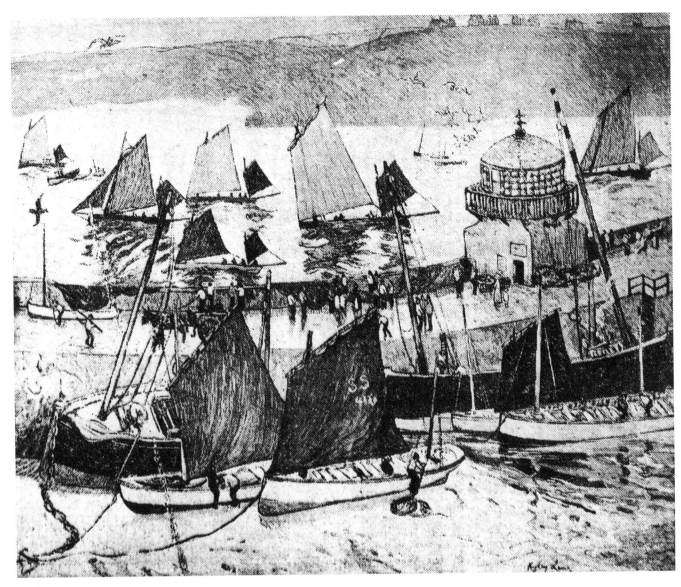

"The Harbor, St. Ives," by Hayley Lever. (In the exhibition at the Brooklyn Gallery.)

sis fails to exhaust its quality. The artist has painted some partridges lying on a metal platter. The color is gray with hints of gold. Others painters of still life would be apt to do one of two things: They either would work in the old way and give each feather its separate fringe, and make silver, brass, and pewter dwell each in its separate star, or they would make a mad dash for synthesis and give you simply a few lines of direction and a color scheme. Mr. Weir combines these methods. He tells you the main facts quite definitely. Your mind has no work at all to do in arriving at the character of the materials and substances portrayed. These feathers are feather soft, the deep, tender breasts are rather harrowing in their lovely softness, yet not a feather is described. The platter provides the contrasting texture, and nothing could be more clearly metal hard, but what kind of metal it is need not interest any one—probably pewter or tin, from its gray color, but that could be arranged according to the color desired for the harmony. Such an artist could be

trusted to paint a portrait of a face in a way to fix forever what one loved best to remember in it after the color of eyes and hair had dimmed in the mind's vision.

In the landscapes also are found indications of tendency. There are the artists who study nature and make their pictures in her likeness with as little departure from the recognizable features as possible. If they arrange these features in a design they veil its structure. Opposed are the artists who say as little as possible of likeness in their portraiture of nature, and strive toward a schematic rendering of observed facts. Thus Mr. Manigault, whose "New England Town" is shown again. Then there are the artists who are heartily in love with nature and next to nature art, and who reconcile the two passions with astonishing felicity. Mr. Lever is one of these, and his fresh version of the harbor at St. Ives, shown for the first time, will delight the observer who sees in it only the gleam of light on silver water and picturesque sails, and that other observer who perceives a quite uncon-

Portrait of Mr. Gaddes of Toledo, by Henrik Lund. (On exhibition at the Bourgeois Gallery.)

ventional arrangement of values attempted and successfully carried through.

The exhibition remains open until May 3, giving an opportunity to study the interesting features, which are numerous, and include a group of miniatures by the newly formed Brooklyn Society of Miniature Painters and a collection of sculptures by R. Tait McKenzie.

* * *

December 19, 1915

AMERICAN ARTIST ASTOUNDS GERMANS

Marsden Hartley's Exhibition in Berlin Surprises, Pains, and Amuses

IS A NEO-IMPRESSIONIST

Also, Apparently, a Cubist—Battle Pictures Show Triangles, Squares, Flags, and Iron Crosses

From a Staff Correspondent

BERLIN, Nov. 5—The "nerviest American" isn't any one of the swarm of alleged war correspondents who have infested war-torn Europe, making life miserable for leading Generals and statesmen, but an American artist, New York born—Marsden Hartley, who with the eccentricity of genius thought that Berlin was a good place in which to give an exhibition of his master works, in optimistic defiance of the bad taste left behind by the submarine controversy and the very sore, ever present feeling about American ammunition. And Mr. Hartley, who admits that he is a modernist and who, according to the unanimous verdict of all the art sharps has outfutured the Futurists, has still another claim on fame by reason of having done the impossible in adding a new thrill or horror to war, according to your proclivities, some critics asserting that he has violated all the ancient and accepted international laws of art as well as the basic principles of humanity, whereas others think that Mr. Hartley, like the offensive submarine, is merely ahead of his time. Whatever the merits of the art controversy, he has put over something new and made the German art critics not only sit up noticeably, but ransack their reservoir of words to describe it.

To add insult to injury, these modernist American canvases, many of them earmarked with war inspiration, are hung within the shadow of the Brandenburger Tor, the triumphal archway of the Hohenzollerns, lining the walls of three rooms in that fashionable exhibition place, the Berlin branch of the Graphic-Verlag, München, on the Pariser Platz, diagonally opposite the Adlon and directly opposite this year's Berlin Salon. For the information or mystification of the visitor (German or neutral,) Mr. Hartley has supplied a pamphlet printed in German setting forth in the form of an "Artist's Prologue" his artistic creed, as follows:

"Pictures that I exhibit are without titles and without description. They describe themselves. They are characterizations of the 'Moment,' everyday pictures, of every day, every hour. I am free from all conventional aesthetics, and leave every artist his. Art is or it is not, just as every artist is or is not. What he desires to represent and express is of no great importance, excepting only if he desires to represent ideas that are not personal with him. The reigning tendency of every modern movement is against individuality. With this strongly marked individuals have nothing to do. They have enough to do to create according to their own conceptions of nature, of life, of aesthetics. Art means a sad and sorry fight against conventional ideas. But somehow she manages to go her way in peace. She waits only for visionary individuals, intellectual, spiritual, but in any case soulfully visionary ones. Appearance is to be imitated, reality never."

Having absorbed the foreword, you enter the first room of the American exhibition and pause before the perhaps most remarkable painting in the collection. Mr. Hartley, with a prophetic intuition of coming events, had immortalized the Kaiser's own Cuirassier Guards going into war on canvas two months before war was declared—a regiment of white-leather breeched cuirassiers, with vicious lances fluttering the black and white Prussian pennant, eagle-crested helms, and all. You know they are going to war because the horses' noses are pointed to the west; only their tails are depicted, but these squarely face the American war corre-

spondents languishing in the Adlon—a bit of satire which the cynical artist conceived two months before these hapless journalists ever thought they would have to pose as war correspondents, most of the time at the rear.

* * *

March 5, 1916

FRENCH ART AND WAR

Important Members of the Cubist and Other Schools Have Apparently Not Renounced Their Principles

By WALTER PACH

In the Magazine Section of The New York Times there appeared recently an interview with a young painter, back from abroad, who declared that the war had swept away Post-Impressionism, Cubism, and the other developments of art which France has produced in the decades, and that the artists not at war, even those who were formerly ultra-modern in their tendencies, have become conservatives.

While exhibitions of work by the artists of the modern schools will in the course of time show how groundless are the hopes of the young "traditionalist" who would have it believed that what he repeatedly calls crazy art is at an end, it may be well to point out at once that his statements, at their most essential point, do not bear the test of facts.

On the same day that these statements appeared, another New York paper published interviews with Marcel Duchamp, Albert Gleizes, Jean Crotti, and Francis Picabia, and their remarks as to their work, far from indicating any turning away from the principles of the Cubistic group—of which they are among the most important members—guaranteed their continuing the advance to new truths, without a hint of going back to the old ideas which it was the mission of their predecessors to express. Of the most important remaining members of the new schools—Matisse, Derain, Duchamp-Villon, Brancusi, Metzinger, Dufy, Rouault, and others—the writer can affirm, from having visited their studios since the war began, that nothing is further from their minds than any renunciation of the principles for which they have been contending for so many years. So what becomes of the assertions of our young traveler, Harry B. Lachman, when he says that the new schools have been swept away?

He is on somewhat safer ground when he speaks of their disappearance, for here he may mean that he saw no more of them in Paris. It will be difficult for him to say the same here, for he will find that the Post-Impressionist and Cubist pictures are not, as he affirms, "in demand only in Germany," but that in this country many collectors and dealers are well pleased to give them room in their galleries.

Mr. Lachman is to some extent correct when he speaks of the sales of Post-Impressionist and Cubist works in Germany. He doubtless knows little, however, of the extent to which

they have been accepted in France—how from President Poincaré and members of his Cabinet through all ranks of French society there are numberless collectors of the modern work in the country which originated it. He does not know—or if he does, he carefully refrains from mentioning it—that French critics admittedly of the highest type, men like Rémy de Gourmont, Elie Faure, and Alexandre Mercereau, have written frequently and vigorously in defense of the Post-Impressionists and Cubists.

A well-known French artist recently said what many of us have thought, that one of the bitterest phases of the calamity which has befallen the world is that it would have been made impossible if peace had been preserved for even a few more decades. The bonds of intellectual indebtedness among the nations were strengthening, slowly but surely, and the day was coming when the new generation, seeing more clearly than the men of today, would have declared that the advantages of mutual influence outweigh a thousand times any satisfaction to be obtained for old wrongs or any material gains accruing from violence.

This idea was the keynote of the propaganda of many societies and publications in France and Germany. The generous enthusiasm of the French for German music, their rapidly growing desire for the visits of German composers and singers, was paralleled by Germany's applause of French art and literature. And this was by far the most marked in the desire of both countries to know what was the newest, most expressive of contemporary thought in the neighboring people. The "revolutionary" Richard Strauss gave the initial performance of one of his works in Paris at the moment when "revolutionary" French painters were holding an exhibition in Berlin.

If artists like Saint-Saëns in France and Gerhart Hauptmann in Germany become narrow chauvinists and try to find a foothold for the crimes of war in the realm of ideas, one may perhaps see some excuse for them in the stress of war-time emotions. There is no such excuse for a man whose country is at peace; and not the least ugly sentences in Mr. Lachman's interview are those in which he repeats the accusations of a very few French opponents of the modern schools, and adds a flourish of his own to the effect that "many a young artistic revolutionist paid for his studio in the Quartier Latin, his absinthe, and his red wine with money that came to him from his nation's hereditary enemy."

And witnessing the heroism of France in her hour of struggle he dares to recall the word frivolous as applied to her before the conflict. His case is too insignificant to demand comment for itself, but in his words about the "amazing phenomenon" of the change "in all phases of French life" he repeats what more capable writers have said. How is it possible that such nonsense has not been shamed out of court long before now? Even the greatest events add no qualities to individuals or nations; they only light up with their fire the things that existed before. From ancient times to the present, France has been giving the world a prodigious, unbroken line of masterpieces—of thought and of art. It is a time for those to

blush who did not see before that in her past achievement the country gave the lie to the accusation of frivolity.

* * *

August 21, 1916

SALES OF ANTIQUES INCREASED BY WAR

Americans Are Gathering Millions Worth of Treasures in Markets of Old World

STRIPPING MANOR HOUSES

Many of the Landed Gentry of Europe Forced to Sell in the Slump That Preceded the War

Special Correspondence of The New York Times
LONDON, Aug. 4—The effect of the war upon the landed gentry of Europe and upon those who have acquired wealth because of the war is peculiarly emphasized in the growing market for antique furniture and art objects within the last few months.

In London, nearly every other day, so says Frank Partridge, who is regarded here and in America as a pre-eminent authority, there occur auction sales that reflect an abnormal demand in America, as well as in the European countries, for antiques.

While, during the first twelve months of the war the market for antique treasures sagged to nearly nothing, it has picked up to such an amazing extent, according to Mr. Partridge, that within the last four months more than $10,000,000 worth of furniture and objects d'art have been bought by eager connoisseurs in Europe and America. Of the aggregate sales of antiques, America has absorbed 60 per cent.; in other words, America has put $6,000,000 in the hands of London's antique dealers since last April. And the demand is growing every week.

Although prices dropped sadly just after the war, until the antique dealers preferred to keep their stocks intact rather than let things go without profit, they have picked up within the last six months, until now they are, in most instances, as high as before the war began. And as the demand keeps on, the prices keep going up.

"Every week, yes, I might say every day, big auction sales of antique furniture and objects d'art are going on in London and high prices are prevailing." said Mr. Partridge.

"When the war came, most Americans who wanted to buy felt they would hold off until the dealers would feel obliged to sell for next to nothing. It was a natural impulse and one shared by many buyers throughout Europe.

"On account of this tendency, at the beginning of the war there were a few bargains to be picked up, of which the Englishmen took advantage. The Englishman has always been a buyer of antiques, and he saw his opportunity when the market was glutted with rich treasures. It must be borne in mind that although America buys 60 per cent. of the antique furniture over here and an equal percentage of other objects of art, still the Englishman himself is always in the market.

"With the war there came an entirely new class of people looking for antiques; they were those who had acquired sudden riches through supplying Great Britain and her allies with things needed in running the war. They are the ones who have been supplying ammunition, clothes, everything, in fact to the belligerents. In Germany as well as in England, France, Holland, and the United States, fortunes have sprung up as a result of the war.

"Now, it's just this class of people who have been the big buyers. Naturally we don't get any of the German demand here, and little, comparatively, goes to France right now, although France is buying, while waiting until the end of the war for its antiques to be shipped on.

"While America waited in the earlier months of the war for prices to drop, it found, because Englishmen and others in Europe were dipping into the market, that it would have to buy, itself, if it hoped to get any of the rich treasures the market afforded. So America has now plunged into the market, and every steamer carries over immense shipments of antiques.

"So far as the likelihood of a slump goes, it may be said it doesn't exist at all. The whole question hangs upon supply and demand. Where does the supply come from? Europe. And from what class? The aristocracy. In the general slump that seized Europe for the ten years before the war, the aristocracy let go of much of its store of antiques. The market became filled with it.

"The war has not hit, thus far, any but the landed gentry of Europe, and it is their stuff that is going into the auction rooms, although it must be said that a large part of what is now being sold on the market reached there in the time just before the war.

"Yes, the war has hit the landed gentry and people with fixed incomes who have no working business. Therefore, the supply must come from this source more and more as the months go on. But right here I want to say that the tenacity of the Englishman in holding to his treasures as long as he can, although at a deprivation, is amazingly manifest. His disposition to wait and not become panicky, keeping what he has until actually forced to part with it, is one vital factor in the spirit of the English in this war. It is that element that will count, as much as anything else, in enabling the Government to push the war through to a conclusive end.

"One auction room in London is now selling $5,000,000 worth of antique furniture a week, of which 60 per cent. is going to America. This house sells half the antique ware in London. Six months ago it hardly had a sale worth the telling, excepting to Englishmen.

"The sales now consummated every week—every day, one might say—in antique furniture that goes to America, embraces Chippendale, Queen Anne and all Gregorian furniture and early English styles. America is getting the pick of the market now and is taking advantage of it."

* * *

February 18, 1917

THE WILLIAM M. CHASE
MEMORIAL EXHIBITION

The exhibition of pictures by the late William M. Chase at the Metropolitan Museum is a gratifyingly prompt acknowledgment of the importance of that painter in the artistic life of the community. Those who have dared comparisons have placed him by the side of Whistler and Sargent, and this only moderately representative collection of his varied and brilliant performance justifies their daring.

That Chase was not quite serious has been the feeling of the general public to whose interest in anecdote and fully explained processes he declined to cater. He seemed to care so much for the way of doing things that an American public found it difficult to believe in his care for the thing done. A dead fish seemed beautiful to him as a slaughtered ox to the Dutchman Rembrandt. He had a way also of not sticking to his specialty. His dead fish became famous and he painted many versions of the subject, but he also painted studio interiors and portraits, and beach scenes and Italian gardens and himself. Nothing paintable was alien to him, and he never forgot that to paint is the first concern of the painter. He gathered all possible information that touched upon the technical side of his work. He knew colors and brushes and vehicles. That his pictures show no great range of exploration in modern fields indicates that he found his way readily to the path he chose to follow, and not that he was ignorant of the existence of other paths.

He practiced and taught lightness of touch. This, perhaps, is the most recognizable of the qualities characterizing his own paintings and reappearing in those of his pupils. It makes for joyous effects and the charm of fugitive suggestions, yet regarding the collection of his pictures as a whole the observer must be impressed by the gravity of the total aspect.

A studio light plays over most of the pictures and we almost have forgotten studio light in the fierce radiance that beats upon modern painting. Few of the pictures in the collection approach so nearly to a high key as the beautiful little "Idle Hours: Shinnecock," painted in 1902. The exhibits are numbered (not arranged) in chronological order, and the change in color is easily traced. The very early things are, of course, steeped in Munich browns. Wilhelm Leibl was the German from whom Chase gained most of his inspiration during the five years spent in Munich, and the catalogue advises comparing the earlier pictures with the admirable little Leibl in Gallery 19 of the Museum. Such a comparison shows at least that Chase kept himself free from crass imitation. There is almost nothing of Leibl's close, patient technique in either the "Court Jester" or "The Apprentice." Painting "alla prima" on the groundwork of a swift, clever sketch is a very different matter from painting alla prima on the groundwork of a drawing reconsidered, rubbed out and remade in part or as a whole, of a first painting treated in the same way until the canvas or panel was saturated with reminiscences of discarded effort.

There is no indication in these early studies by Chase that he pursued the more laborious method. Whistler comes closer to Leibl so far as the method of his preparation for an integral and fresh surface is concerned.

Among the later pictures are several in which the happy faculty of artistic selection is exercised on material already once sifted in accordance with the artist's fastidious taste, with a result rich in personal quality. What could be more charming in its domestic pleasantness than "The Back Yard: Breakfast Out of Doors"? A woman in a hammock, the artist's wife at a table set for the al fresco meal, his baby daughter in a high chair, and a young girl at the right against the background of a Japanese screen, a scene of lovely accessories turned to homely uses in a life not keyed to the commonplace. The case is similar, with a greater intensity of expression, in "The Tenth Street Studio." This is the room where Mr. Chase painted after his return to New York in 1878 after a year spent in Venice; the room also where the Society of American Artists met in its youth and on the walls of which hang trophies of the artist's foreign travel, the great stuffed goose, armor, draperies sketches. Tea is going on, people are looking at pictures, the big spaces of the room are filled with delicate shadows. It is a beautiful picture and painted intimately with full consciousness of all the "points" of these chosen objects. Elsewhere the picture first formed in the artist's mind has dictated the introduction of this or that detail, but here the tribute is clearly to a picture already perfected in the making of the room and asking only for scrupulous record. Everything is recorded with the security that nothing unpaintable has made its way into the charmed environment.

In "Sunlight and Shadow" we have a slightly different note, that of basking ease in surroundings planned for any aesthetic adventure and mellowing through a long succession of such. The scene is laid in the courtyard of an old Dutch inn. A man is seated by the side of a set table—Mr. Chase was fully alive to the piquancy of food and drink in a picturesque frame—a woman is reclining in a hammock and an old woman is standing in the background near a red brick house. Ugliness, if it existed, is "presumed absent." The objects are wrapped in soft airs of that felicity experienced in Europe by artists of Mr. Chase's generation. All the poetry of the place has been absorbed from it, and it is chiefly in his portraits of places that the artist made manifest a poetic side.

In his portraits of people not much is given us to wonder about. Sometimes the note is that of decorative grace, as in the portrait of "The Sisters," two women in white against a background of architecture and landscape, an obvious essay in the English eighteenth century style; or it is that of candid objectivity, as in the portrait of Louis Windmuller; or that of more or less interested interrogation of character, as in the portrait of Clyde Fitch. But the portrait of a person was evidently counted as in the day's work, to be got through with conscience and as much enthusiasm as might be possible, but not an affair to stir aesthetic pulses, unless by chance the sitter were "My little daughter, Helen Velasquez, posing as an

"Mrs. Chase in Spanish Dress" (In the Chase Memorial Exhibition at the Metropolitan Museum)

these best things are still retained in the West and in public galleries may simply be taken as an expression of the Museum's intention to "let nothing great pass unsaluted or unenjoyed." Mr. Chase's accomplishment was great measured by the standards of modern painting. The exhibition lasts until March 18 inclusive.

* * *

March 11, 1917

"TEN AMERICAN PAINTERS" HOLD EXHIBITION

The exhibition of the Ten American Painters is on at the Montross Galleries. They bring their own standards with them, and offer collectively so imposing a presence that it is impossible for even the unsympathetic to approach them flippantly, to take liberties with their established conventions, to look at them otherwise than with respectful admiration for achievement so complete and finished. The exhibition will strike such visitors as may have made the round of many galleries many times with a sense of strange finality, as being, indeed, the last word in this particular chapter of the book of art. No one again will say the thing so well, we may assume, and no one for a long time will seek elegance with such zest, welcome restraint with so much fervor.

Glance at Mr. Benson's "The Open Window." A woman in an Oriental jacket sits knitting in a room so discreetly unfurnished as to somewhat flaunt the discrimination of the decorator. "To go without beautifully, that is wealth," the room says, and the woman says nothing. Not a syllable concerning her relation to the room, human or aesthetic, escapes her. Without her we conceive that it would be more beautiful than with her, which, of course, is the truth concerning many living rooms. The only trouble with this room is that it is not a living room. It has no pulse, the air fails to stir in it, the light that illumines the pinkish drab of the innocent walls has no suggestion of change. It is a room in a trance at best. One recalls Blake's room, drawn by Fred Shields, a room with a blowing curtain by Menzel, and just what is missing becomes clear. It is a matter of getting into a painting that which constitutes the life of your subject. Occasionally rather poor painters do it, and occasionally excellent painters do not. Mr. Benson has made amends and his peace with art by painting a flight of birds so gayly and truly as to suggest that he is becoming ever so little bored by rooms, even those that are beautiful and have the windows open, and feels himself most at home in the free air, with unlimited sky and birds in flight.

Mr. Hassam also paints rooms featuring windows, but his material is more docile under his hands; he treats it in a manner more sympathetic and loose and free; he and his rooms are boon companions on excellent terms with each other, and if he does not take the trouble to read their character to any great depth, he gives you their temper at the moment. "The Fifty-seventh Street Window," from which a lady looks forth with shallow interest on a street view that boasts a waving

Infanta," or "Mrs. Chase in Spanish Dress," when the painting could be done in an air cleared of all but aesthetic values.

The pupils of Mr. Chase speak of his superiority to the old sentimental and romantic mussiness of dress and studio, boast with pardonable pride of his neatness in the performance of his task and contrive to give an impression of a temperament entirely free from the "artistic" taint, a temperament cool and antagonistic to the waste and murk of the old-fashioned studio. To argue from such an attitude the absence of sensitiveness would be the most absurd of mistakes. Nothing in the present exhibition is more apparent than the extreme sensitiveness of the painter to the subject, environment, and mood of his picture. His failures are quite as eloquent as his successes, and by including some of the former the committee responsible for the exhibition enhances the value of the latter. There are forty-six pictures in the gallery. The public naturally gets a less favorable general impression than from the retrospective exhibition held in 1910 at the National Arts Club, with its 142 examples, many of them of the highest importance in the history of the painter's career. But if one of the two exhibitions must be inadequate there is much satisfaction in the fact that the artist could know during his lifetime how his work summed up on public parade, the best things to the fore and bearing witness. The memorial exhibition assembled while many of

"Black and Gold" by T. W. Dewing (In exhibition of ten American painters at the Montross Galleries.)

flag, is far from a great success as a picture, but you have your reward in it. "Fifth Avenue: February, 1917," gives you more. It is not amiss to regard it as history and patriotism if you choose, but the important fact is the beauty of the American flag waving over drenched streets and sloppy blue pedestrians, the stripes and starry field carried through to aesthetic victory. The windows are interesting to Mr. Hassam this year; one might say they had renewed his youthfulness, if that invincible quality ever had shown sign of exhaustion.

J. Alden Weir is another of the Ten whose art is youthfully exultant. He is happier this year in his landscapes than in his figure subjects. "White Oaks" is a cluster of thin tree trunks, and one of stouter girth, with frosted foliage seen against a sky of which the blue is both tender and deep, a lovely picture. "Truants," not yet in the catalogue, shows the painter's tact in treating a theme inviting anecdote without hint of banality. The story is there plainly enough and delightfully told, with a kind of reminiscent whimsy. Two boys have strayed off to a rocky field and have hidden themselves under the shelter of a vast, comforting, conniving rock. There they have built their fire, which sends up a charming thin thread of gray and orange against the green of the hill. It is the hill however, that is the picture.

Edmund C. Tarbell shows a number of portraits. Among them is that of "Mr. A. and Daughters," in which the man's form is remorselessly sacrificed to the saliency of the two children. The background of books, their dull colors brightened by the gleam of gold titles, is well carried out. The portrait of "My Daughter Mary" has a less fortunate background, the pattern of a gold screen becoming insistent and responsible, no doubt, for the extreme definition of the head. A little black and white study for this head is exhibited, and one laments the loss of its sensitiveness in the painting.

A lovely pastel head by T. W. Dewing and a figure subject, a woman seated, constitute the meagre contribution of this important member of the group. The figure is very finely drawn, and the color, indicated by the title, "Black and Gold," has the general tone of ancient vellum. The other contributors are Willard Metcalf, who sends half a dozen landscapes and a drawing in silverpoint; Joseph De Camp, who also has silverpoint drawings, and a couple of sturdy portraits, the better one that of Robert Treat Paine, 2d, in which the repeated accents of blue are very effective in leading up to the blue of the eyes, and Edward Simmons, whose little nude figure is quite the best thing he has yet shown in these galleries, studied, modeled with simplicity, and beautiful in color. William M. Chase is represented by a superb fish picture.

* * *

April 2, 1917

TOPICS OF THE TIMES

Eccentric Art Explained

Painters—it is not quite necessary to call them "artists"—who belong to the schools designated by such names as "cubist" and "futurist," can find themselves and their curious productions explained with what, to those painters and to their admirers, will be decidedly painful plausibility in the leading editorial article in the current issue of The New York Medical Record.

The writer of this article does not make the mistake of which so many of us have been guilty—that of declaring these pictures as meaningless as they are ugly. On the contrary, he asserts that they are full of significance. It is, however, a significance that can be brought out only by an application of the principles and methods of psychoanalysis. That done, all their mysteries are soon dissipated, and the result is a valuable contribution, not to the realm of art, but to that of mental pathology.

What the futurist does is to reveal his own struggles with reality and environment, and the partial adjustment thereto which he has succeeded in establishing through these projections into visibility of his vital energies. The results are not pictures in the ordinary sense of that word, for they fail to meet two decisive tests—they do not convey any meaning at all to "the man in the street," and even the producer, if con-

fronted by a new work in his own manner, produced by a member of his own school, could not tell what its originator intended to convey. He would, indeed, get an impression of some sort, but the sort would be determined by his own psychic condition, not by that of the painter.

Pictures more or less like these are produced in great numbers in insane asylums, especially by sufferers from the form of alienation known as dementia precox, and it is to that class that the writer of The Record's article assigns the painters of these new schools. There is some comfort for them, however, in the fact that in them the process of regression toward infantilism has been arrested, temporarily at least, and perhaps permanently. That occasionally happens in dementia precox, and those thus favored by fortune are not only saved from sequestration, but they may even remain of some real social value.

Of course, the elderly psychologists who reject with such amusing manifestations of indignation or horror the theories of Freud will scorn this interpretation of futurism and the related eccentricities, and that ought to start a really interesting row in medical and art circles.

*　*　*

June 10, 1917

OUR INDUSTRIAL ART NEEDS CO-ORDINATION

In the Summer of 1914, at the little outdoor theatre of the Pré Catalan in Paris, lovers of drama sat under the shadow of the trees and watched the acting of a play by the younger Rostand. It had to do with the mental attitude of the artist, symbolized by a youth, Septentrion, dancing and dancing on the hilltops, deaf to the voice of the messenger who came, as in classic drama, to announce a succession of terrible misfortunes. The death of parents, the loss of homestead, the summons to a friend wounded in battle—nothing of these moved the heart of the dancer, who, in an ecstasy of devotion to his art, flitted in and out among the trees, his face to the skies. The actors did their work charmingly and the little dancer who took the part of Septentrion danced indefatigably. At the end of the July afternoon the audience picked its way across the grass, their minds filled with the beauty and coldness of art.

A twelvemonth later the artists of France were giving their lives and fortunes to their country at war, passionately ready for sacrifice and showing themselves of the type that meets danger with a courageous and practical spirit. "Septentrion" no longer existed. The artists he was supposed to represent were in the trenches, in the hospitals, dead on the battlefields, or exercising their peculiar skill in the camouflage.

The artists of this country have been no less prompt to respond to the call of war. They have organized the American camouflage. They are at work on recruiting posters. Some of them have long been with the ambulances. Others are putting aside their technical training and doing the simplest work that presents itself. There is no doubt of the loyalty of the artists

as a class, and their practical genius already has shown itself in many departments.

There is, however, a task ahead of them that will tax their powers to the utmost and that they alone will be able successfully to carry through. It will call for a steady patriotism and self-sacrifice more difficult to maintain than the spiritual ardor awakened by a national crisis. Already students of the country's industrial position recognize that almost at once we must depend upon our native designers and workmen, and also that our native designers and workmen lack the special training necessary to raising our standards to the European level. We are beginning to be interested in certain home crafts—dyeing, weaving, pottery, &c.—but these are carried on in a fragmentary fashion by individual workers. The most gifted of the artists engaged in them are unable to meet the technical requirements of the manufacturers. There is still that separation, not only physical but mental, between the designer and the maker which works against a product harmonious in all its parts. Clutton Brock in The London Times makes a strong plea for recognition of the true relation between science and art. The beauty of objects of use must, first of all, be a functional beauty produced by science, he says, but when this beauty is recognized by the maker, and consciously emphasized, the man of science becomes an artist expressing his delight in the beauty of objects designed as well as they can be designed and made as well as they can be made, and increasing that beauty by the passion of his expression. "We need to understand that there is the same relation between science and art as between philosophy and poetry; the art of objects of use is science become passionate, and, therefore, become beauty." Our designers must have first the science of the workman or their designs will fail to unite with the material in giving the impression of artistic oneness. "What we need, then," Mr. Brock concludes, "in our art education, and in all our education, is an insistence on the fact that art is not opposed to science, but rather the flower of science."

The training of a corps of designers and industrial artists to a degree of efficiency that will cause their work to blossom thus from a strongly rooted stem, is a matter of immediate concern, for years of vigorous study and discipline are behind their successful competitors in Europe. The first necessity is, of course, collaboration between the artists, the manufacturers, the public, the schools, and the museums. The spirit from which effective collaboration springs already is awakened in these various groups. A few weeks ago about 300 heads of industrial, professional, and educational organizations met in convention to crystallize into action a nationwide campaign "to encourage by product, precept, and practice a higher standard of furnishing American homes." The trade magazine Good Furniture reviews the addresses made in the course of the convention, all of which emphasized the importance of quality in construction and design, of teaching the public to recognize and demand excellence of quality and of training workmen and designers to produce it. As the manufacturers were responsible for organizing the campaign for better furnishing, it is significant that the artistic side of the problem

was so fully recognized and discussed. The schools have taken the first steps toward practical education in art, and the museums are directing their energies toward making it easy for the public to become familiar with their resources. A more definite and thorough co-ordination is needed, however, and some authoritative plan by which the process of making artisans of our artists and artists of our artisans should be freed from unnecessary hindrances and delays.

Other countries, far ahead of our own country in the production of industrial art, have felt the need of an energetic and well-directed campaign. In Great Britain the movement known as the Renaissance of the Decorative Arts had got so far before the breaking out of the war as to receive the official recognition of the British Government and held exhibitions on the Continent under the auspices of the Board of Trade. The latest of these was held at Paris in the Pavillon de Marsan in the Summer of 1914, and made a deep impression by the breadth of the field covered and the knowledge of manual processes possessed by the designers. The efforts made by the London County Council's Central School of Arts and Crafts toward substituting an efficient system of training for the industrial artist to take the place of the old apprenticeship system already have been noticed and applauded in these columns. Nevertheless, the standard of workmanship and design left, in the opinion of native as well as foreign critics, much to be done before an exigent student could take any very deep satisfaction in the position occupied by England's artistic industries.

France also is much concerned for the future of her industries, and is not deterred by war from pushing forward in this direction. A series of conferences has been held this Spring in Paris by the Comité Central Technique des Arts Appliqués, with the purpose of determining the course of action best adapted to stimulate the industries into which art enters, and to improve the teaching of art throughout the country. The general principles forming the basis of the technical conferences at the first normal session organized by the committee are considered and presented with such precision of thought and clarity of expression as to give them value in the discussion of similar problems in other communities. They are stated as follows in the bulletin published in Les Arts Français: "The basis of teaching in any craft or industry is the technique, of which the design and modeling are the chief modes of expression. The technique of a craft or industry comprises complete knowledge of the laws governing the material employed, all the means employed by tools and machinery to fashion this material and create objects serving definite needs.

"The objects are given forms always conditioned by the needs to which these objects must respond, and by the choice and requirements of the material employed in their making. The decoration must intervene only to complete the perfection of the craftsmanship and not to mask deficiency. The decoration comes in to define the significance of the forms and to accentuate the function. When divers materials enter into the making of an object, each should have its reasonable

use, and the decoration appropriate to it. Thus the decoration is never an element foreign to the object to which it is applied, as the phrase 'applied art' might lead one to suppose.

"The artisan is he who creates objects serving definite needs. The 'workman' and the 'artist' become true 'artisans' only when they create objects at once useful, sincere, and beautiful, that is to say, responding to the conditions of destination, material, and expression. The initiative of the artisan is manifested in two ways, industrially and artistically. The industrial sense is developed in the artisan partly through learning the laws of the craft and their intelligent application to definite ends; and partly through the study of economical combinations based upon the rational employment of the material, tools, and machinery.

"The artistic sense is developed in the artisan through the intelligent observation of life. This observation of life is expressed through simultaneous study of design, modeling, and color. The study of these different modes of expression results in the creation of decoration. The destination of the object must determine the choice of the material; the material employed must condition the form and the decoration.

"The manufacturer creates, causes to be created, or selects models; he directs the manufacture and perfects the processes. He establishes the net cost and the sale prices according to the technical and economic laws governing his industry. He must, then, like the artist, have full knowledge of the technique of his craft. All the laws and all the general principles constituting the basis of technical and artistic teaching appropriate for artisans are applicable to the manufacturer.

"There should be both technical and artistic instruction, and both should be at the same time theoretic and practical. Neither the inventive nor the artistic faculty benefits by the examination of ancient works if the technique of the craft and manual facility are not already possessed to a certain degree. If the apprentice or pupil is put too soon and without having been sufficiently informed in the presence of the works of forerunners of all epochs and countries, he risks losing his initiative and his personality, and abandoning himself idly to the copying of the antique or the exotic. When the pupil visits the museums, it is indispensable that he possess already the power and the will to analyze his admiration. Without this he will retain only the external aspect of things, and fall easily into routine. On the other hand, if nourished and ripened by the knowledge of technique, the pupil will be able to discover the utilitarian material qualities of the epoch or the region, the methods imposed by the material, and the processes of execution. He will then combat these with his individual reason, or, if he finds them possible to appropriate, will assimilate them. The artisan should neither disown the traditional past of France nor the universal past, but he should never forget that he belongs to a human period distinct from all preceding periods, and should never fail to remember that the needs of his contemporaries and compatriots are not those of his ancestors or of foreigners."

From this one gathers that in all the useful arts or the industries involving art, the first necessity is that the artist

understand the technical side of the industry. That this is not the case in America has been recognized by many clear thinkers.

It also is apparent that the manufacturer must understand the artistic side of his industry, and this again is the case only in rare instances. It would seem almost that our manufacturers should be sent to art schools and our designers to industrial schools in order to counteract the unfortunate tendency to specialization and consequent separation between the technical and artistic elements in our industries. For about five years the Metropolitan Museum has made definite efforts toward reaching the teachers, especially the teachers of industrial art, and has had a most encouraging response. The course of lectures planned for salespeople, buyers, and designers has not, however, met with as much success. The Natural History Museum's textile expert has lectured on his special subject before an audience of American manufacturers, illustrating his talk with museum examples. These efforts certainly are worth making, but something more radical and far-reaching must be undertaken if we are to maintain a position worthy of our opportunities among the industrial communities of the world.

The outcome of the Convention of Allied Home Furnishing Industries already mentioned is the appointment of a large organizing committee to build a campaign for the production and distribution of better furnishings, and this committee includes representatives of all the important art associations of New York, the Metropolitan Museum, the National Mural Painters' Society, the Architectural League, and others of similar standing. A small committee of nine was also appointed to take the first active steps in organization, and the well-known mural painter, William Laurel Harris, was made Chairman. This is an important move in the direction of effective collaboration between artists and manufacturers, and it will be interesting to follow the development of the plan.

It is enlightening to note from the replies to the questionnaire sent out by the French committee to which we have referred, and reported on by regional committees, that many of the adverse conditions found in our own country have their counterpart in France, and the remedies suggested merit our consideration. The Marseilles committee, for example, proposes to combat the prejudice against the education of an artisan as compared with the "liberal" education lending toward the professions by holding conferences for the benefit of parents in which the dignity of manual labor and its practical advantages are emphasized. The same committee, finding the educational resources of the public institutions inadequate, suggests the organization of studio-schools for the different crafts, to be founded by patrons of these crafts, and in which the pupils must follow to completion a thorough course of instruction.

The committee of Dijon also emphasizes the desirability of doing away with the class prejudice that separates manual, workers from those who purchase their work, and urges the early awakening of the childish mind to the interest and importance of the various crafts. The child should be taught to know the peculiarities of different materials and should be taken at an early age to various manufactories and studies of the region in order to become so familiar with them that choice of a craft in later years would be founded upon actual acquaintance with it.

The Toulouse committee puts aside all prejudice of war and frankly acknowledges the extraordinary merit of the German industrial organization. To compete with it there must be a new thoroughness in teaching design and directing it to utilitarian ends. The instructors should be technicians. There should be special privileges and advantages created for industrial workers. Diplomas should be issued to pupils of proved competency. Their military service should be shortened to permit their serving the State industrially. Taxes and tariffs should be adapted to their requirements. They should, in a word, be the privileged class in the new society. But the committee insists there should be placed in control of all these activities a technical committee of patronage drawn from the various elements of instruction, commerce, and industry, which should watch over the intelligent application of programs and facilitate co-operation.

* * *

March 10, 1918

RYDER EXHIBITION AT METROPOLITAN MUSEUM

To see the Albert P. Ryder exhibition at the Metropolitan Museum is to approach the baffling genius of that master from a quite new angle. Practically all periods and all phases of his work are shown, and their unity makes a deep impression. It is one vision from the beginning to the end, and one technical achievement carried through against innumerable obstacles and with many variations, but without a break in its essential integrity.

These canvases, with their smoldering color and lacquered surfaces, are like a group of early Chinese wares, thick in body, roughly finished, with heavy glazes charged with color that have been lavishly applied, flowing slowly over the underlying material, wrinkling here and there in the sluggish course, and breaking into cracks and fissures. The forms conceived by Ryder also fit into this comparison. They are massive and simple, like the stout, strong specimens of Sung pottery that recently have established their influence over the American collector. Moreover, the potter working with his clay could not be more indifferent than Ryder to the representative side of his design. Trees, cows, human beings are all of one material and one texture. There is no attempt to show that water is liquid and stone hard, that flesh and blood are stirred by the pulses of life; that the birds must be able to fly through the foliage, or the clouds shift to let light and moisture drip through.

This restriction of textures to one rich and precious material is, of course, intentional, as the restrictions of artists

"Joan of Arc," by Albert P. Ryder, on exhibition at the Metropolitan Museum of Art.

invariably are. How perfectly Ryder could have manipulated his pigment to other implications is seen in the little study of a dead bird, where the down of the breast and the smooth sleekness of wings and tail, the ruggedness of the stiff claws and the hardness of beak are indicated with amazing skill and without a trace of meticulous imitation of nature. It is clear that to Ryder's mind, steeped in the love of his medium, this unity of substance is an ideal as it was for the early Egyptian sculptors and the Oriental potters before the brilliancy of their workmanship eclipsed the early splendors of their art.

It is clear, also, that in the development of his idea Ryder's grasp of the possibilities within his self-imposed limitation strengthened. Observe the patterns of his earlier pictures, the charming "Joan of Arc," the subject from mediaeval legend, and note how dim and vague they are in comparison with the positive shapes, the assertive patterns bravely and definitely placed in the given spaces, of such compositions as "The Toilers of the Sea," in which the boat climbs toward the horizon dark against the moonlit ocean, pale against the darkened sky or the "Moonrise" with its sparse shapes and deep color of cloud and sail.

It often has been assumed that Ryder failed in technique precisely because of this technical superiority, this neglect of the cheaper effects possible to an imitative brush, this concentration upon the message of the material which we so readily recognize as the strength and power for beauty in the golden ages of the past. It is a measure of how far we have traveled from any such age of gold that the greatest technician of our time is praised for anything except for his mastery of his medium and tools. Without the help of the fusing fires that burned the potter's glazes into noble profundities of color, he forced the raw pigment to the utmost of its resource and gained something for his art by the hand-to-hand struggle devoid of accident.

Such command of expression of course makes possible an emotional eloquence where emotion exists to be communicated, and Ryder drew upon depths of emotion not to be sounded by the ordinary mariner with his shallow plummet. His rising and falling waves of line, the unexpectedness of the deviations from the regular in his designs, so apparently simple and yet with such interesting complications and inflections, the modulations of his color in which the blue of steel and the yellow of gold lose their metallic associations and swim in molten glory, all unite to express a personality as mystical as Blake's and as certain of realities hidden from the realists. Blake easily might have had Ryder's vision of the "Pegasus," the version owned by Mr. Gellatly, and like Ryder would have made us aware not so much of the likeness between the horse of daily usefulness and the poet's steed as of the mighty lift into space given by the winged beast freeing himself from contact with the earth. In Mrs. Merton's version of the subject we have a more consciously symbolic treatment, the horse coming as a messenger with wise sublimal gaze, appearing to curious and awestruck maidens.

The "Constance," a mother and child in a boat that drifts on a sea lighted by an invisible moon, has the strangely tragic rhythm of Vittoria's song to Italy.

"I enter the black boat
Upon the wide grey sea,
Where all her set suns float,
Thence hear my voice remote:
Italia, Italia shall be free!"

The ease with which literary and dramatic analogies are summoned to accompany the purely aesthetic message of Ryder's art again is misleading. Pictures through which step figures from Wagnerian opera, the adventurous ladies of Shakespearean comedy, the personages of the Bible, the heroines of French romance, what have they to do with pure painting and the art that abjures subject interest? Everything and nothing. They exist as conclusive evidence that a picture may borrow its subject matter from literature and the stage without subordinating its power to move by purely aesthetic means. Ryder, for example, has taken the "Flying Dutchman," and his color design and his linear pattern have awakened the emotions that leap into life at the sound of that

opera's music. It is the stage scene turned into precious substance, made rare and poignant by an artist's treatment of a theme that is rare and poignant in another artist's medium also. You see not the stage-set of the Flying Dutchman but the music as it crashes and hurls itself into the air.

In "The Forest of Arden" it is theatre turned to something finer and more essential than any scene upon which the curtain falls. Here the stage properties are accepted with a greater naïveté. The wearied Celia, the courageous Rosalind, wear doublet and hose straight from the costumers. The broken tree rising stark against the light sky, the unreal glow on the horizon, the clean shapes silhouetted sharply on the background, are almost what meets the eyes of the stage-goer in the nineteenth century interpretation of the Elizabethan stage. The difference again is in the treatment of the substance, but one feels a certain compromise with the mock reality of the stage not felt in any of the opera subjects where music sustains and inspires its companion art.

If we find in Ryder's transmutation of literary and dramatic material a molding of the subject matter to the stringent limitations of pictorial art, we have the clue to his treatment of nature. A horse in the stable or cows in the field are subdued to his technical method in the same degree as Siegfried and the maidens are, removed, that is, to a world in which all actual appearances are given only the significance of their character, that inmost character of which the outer semblance is the shadow or mask. The great white recumbent cow in Mr. Gellatly's "Pastoral" is interpreted as the Chinese potter, to revert to the comparison previously made, would interpret it with passionate truth to all that is monumental and permanent in it.

That is one salient characteristic of Ryder's art. Nothing is taken lightly; even the most graceful of his compositions, drawn from some fairy tale, is given significance and profundity by this solemn craftsmanship. The ugly little peasant girl, Joan of Arc, who sits at the foot of a tree forgetting her sheep, is noble in the largeness of her outline, and exquisite in the color that burns through the Ryder glazings. "Perrette," a long-limbed girl with a tub on her head, a cowherd with her cows about her, is a shifting harmony of aubergine and blue and yellow that engrosses the attention to the exclusion of the subject.

The conclusion to be drawn from the Ryder exhibition is that to which a survey of all stimulating art must lead—that accident played no part in this achievement, that it is the outcome of an intellectual force, fed, but not controlled, by emotion. Ryder and all other artists of genius could say with Blake in one of his simple profundities:

"Thought is life,
And strength, and breath;
But the want
Of thought is death."

* * *

April 27, 1918

ART NOTES

Some Pictures by Leaders of the Cubist School

At the Anderson Galleries is an exhibition of prints, paintings, and sculpture belonging to M. Leonce Alexandre-Rosenberg, an art dealer of Paris, and to James Howard Kehler, whose Japanese color prints include many celebrated subjects and a number of rare impressions.

The most unusual feature of the collection of paintings is a group of Cubist works by such leaders of the school as Picasso, Gris, Rivera, and Herbin. These are characteristically schematized with deformations of the figure where human beings are the subject, and many exercises in the problem of the relation of planes, the artist using mechanical objects instead of organic forms. Contrast of textures with alternating rough and smooth surfaces is a device freely used by the Cubists to stimulate the tactile sense, and appears in many of the paintings on exhibition, which, taken as a whole, fairly represent the experiments of Cubism. The experienced public now recognizes the experimental nature of such work, and the absence from it of that art of expression which in the work of such masters as Cézanne and Van Gogh underlies and fulfills the art of representation.

A few paintings by the Neo-Impressionists also are included in the collection. There is a Maurice Denis, the fight of St. George and the Dragon under the shadow of the red rocks of Brittany, with the deep blue sea in the distance. The color, red passing into yellow, and a very splendid and pure blue, is warm and rich and characteristic of the painter. So also is the apparently capricious derangement of proportions and perspective, making the figure of St. George on his horse abnormally smaller than that of the praying maiden, to say nothing of the extraordinarily large size of the Breton peasants at the left of the foreground. Denis is one of the most ingratiating of the painters who abjure the arrangements of nature in favor of their own. Not one of the Cubist group but seems heavy-handed in comparison with his light and dainty skillfulness. Paul Signac, with a much more conventional method, is still daintier and lighter and more charming. He has much to say of sun-filled air and prismatic color in the sky and water of his harbor picture. The boat with its bending masts, and the lovely towers at the entrance of the harbor of La Rochelle, are rendered by his square brush marks with the most luminous effect. It is a beautiful picture, the result of sane feeling and serious thought.

The exhibition continues until the date of sale, May 3.

* * *

March 23, 1919

EFFORTS TO PREVENT INARTISTIC WAR MEMORIALS

With Skilled Advice Ready at Hand, the Public Will Have No Excuse for Providing Ugly or Unsuitable Tributes to Our Fighters

The Lincoln Memorial, Washington, D.C.

"Every good war memorial must be the individual work of an artist. And we must not try to get our ultimate war memorials just yet; we shan't get them even if we do try!"

These are the first principles for the public to master in the much-talked-of matter of war monuments, says Charles Moore, Chairman of the National Commission of Fine Arts and of the General Committee for War Materials of the American Federation of Arts, to which organizations' questions about setting up memorials to our heroes and our victory are coming from all parts of the country. We are to have thousands of such monuments the country over, Mr. Moore believes. Out of the number he hopes that some will take their place among the great things of lasting beauty in the world. But we must not be in too much of a hurry, he cautions us; and above all things we must not think that a "stock pattern," the repetition of some conventional figure or design, will serve our purposes of commemoration.

"The thing that our memorials should commemorate is the spirit of the nation as a whole," he said, "not the soldiers alone, but the people everywhere, who gave their service and made their sacrifice for the triumph of our cause in the war. It was not a war won only by the fighting men; it was the war of a whole nation, doing battle for its ideal. That is the spirit that must be commemorated by the great war memorials.

"Such a piece of work requires an artist. Only in the work of an individual artist, putting his effort into this one special task, can we hope for any good war memorial. The great working principle of Saint-Gaudens was: It doesn't make so much difference what you do as how you do it. That is true here; it does not so much matter what form the memorial takes as how the work is done.

"Then there is the matter of time. We cannot expect to create adequate war memorials at present because we are still too close to the war. We are still struggling for the ideals for which we have only lately ceased to fight. We have not yet got the peace treaty. We are working for the ideal of a League of Nations. It will take some decades to decide whether the world shall reap the victories won by the armies in the war. We are demanding war monuments, but we have not yet clear and distinct ideas about what they should express. We are still too close to it all.

"Most of the best monuments we have to commemorate the civil war are the work of Saint-Gaudens, who was a boy, an apprentice, when the soldiers were coming home. The Lincoln Memorial is just being completed. We were slow about our civil war memorials, it is true, because we were slow in getting sculptors. We have a body of sculptors now, so the situation in that respect is different. Yet it is my own belief that most of the great monuments of this war will be the work of men who are yet unknown.

"I am looking for good work from the men who have been overseas. In an army of more than 2,000,000 it is not unreasonable to suppose that there was an appreciative number of artists. Some of them we know already—I am expecting great things from Robert Aitken, and I might name others in the same way."

"The Lincoln Memorial is the greatest memorial in this country and one of the greatest in the world. It will be one of the world's beautiful things for thousands of years, as the Parthenon is, and the Pantheon at Rome. It is worthy to stand beside the most beautiful work that man has ever done. Yet it is nearly sixty years since Lincoln died. The United States waited while Lincoln's fame was tested out in the courts of world history. The memorial has employed the best thought of the country. Among artists, McKim, Burnham, Saint-Gaudens, Almsted, Adams, Gilbert, Hastings, Anderson, Pope, Blashfield, and Wier, and among laymen, Presidents Roosevelt and Taft and Secretaries Hay and Root each had his helpful part in the production, which exemplifies the talents of Henry Bacon, architect; Daniel Chester French, sculptor; and Jules Guerin, mural painter.

"Certainly our great memorials do compare well with those of Europe. I might mention others as showing what good work our artists have done. Among such works of art in this country are the Battle Monument at West Point, which The London Architectural Record declares to be 'one of the finest monuments of its kind erected in modern times'; the Shaw Memorial in Boston, beautiful both in conception and treatment, sculptural, architectural, and in its setting; the Washington Arch, which the critic I have just quoted hails for 'the noble proportions of its mass and the extreme beauty of its details'; the Farragut Memorial here, the Washington Monument in Baltimore."

It is likely, Mr. Moore says, that we shall be oppressed with a plague of bad monuments "worse than those Egyptian pests which hardened Pharaoh's heart." The American Federation of Arts is ready to offer all assistance to the public, in making the memorials fitting, worthy, and beautiful.

Courtesy of the National Commission of Fine Arts

Washington Monument, Baltimore, Md. An example of memorial art—One of the Fountains, Piazza of St. The Washington Arch, New York City
Peter's, Rome.

The General Committee of the organization, its regional subcommittee, and its professional advisers are mobilized for the purpose.

"We are not as a nation artistic in the expression of our ideas, but we are artistic in our desire for art," added Mr. Moore. "We want war memorials; we are going to spend a great deal of money on them, we want good ones."

A war memorial may take one of many forms. The Commission of Fine Arts and the American Federation of Arts have issued a bulletin suggesting and commenting upon some of these and enunciating general principles in connection with them:

Flag Staff With Memorial Base. The expense may be little or much, according to the simplicity or elaborateness of the base and the extent of the architectural setting.

Tablets, whether for out-of-doors, or for the walls of church, City Hall, lodge room or other building, offer a wide field for the designer.

Gateways to parks or other public places.

Symbolic Groups, either in connection with architecture or isolated.

Fountain, which may be designed so as to afford places for inscriptions. It may cost $1,000 or tens of thousands.

Bridge, which shall get its chief beauty from its graceful proportions and the worthiness of the material used.

Building, devoted to high purposes, educational or humanitarian, that, whether large or small, costly or inexpensive, would through excellence of design be an

example and inspiration to present and future generations.

Portrait Statues of individuals. A portrait statue which is also a work of art is not an impossibility, but it is such a rarity that committees should exhaust other possibilities before settling on this one.

Medals. To make a good medal is one of the most exacting things an artist can be called upon to do. Properly to execute a medal takes much time and study, even from the most skillful and experienced.

Stained Glass Windows. The subject is one requiring special study and consideration, and should only be taken up with competent advice.

Village Green, which exists in almost every small town or may easily be created.

Bell towers, hand stands, memorial doorways, and memorial rooms are also suggested as possibilities.

"As great examples of some of these forms, I might mention the flagstaffs of the New York Public Library, the Alexander Bridge in Paris, the fountain at St. Peter's in Rome, the Harvard Gates, and the Princeton Gates," said Mr. Moore.

Cass Gilbert has summed up the character of the war memorial:

The most impressive monument is one which appeals to the imagination alone, which rests not upon its material use but upon its idealism. From such a monument flows the impulse for great and heroic action, for devotion to duty and for love of country. The Arch of Triumph in Paris, the Washington Monument and the Lincoln Memorial are examples of such monuments. They are devoid of practical utility, but they minister to a much higher use; they compel contemplation of the great

men and ideals which they commemorate; they elevate the thoughts of all beholders; they arouse and make effective the finest impulses of humanity. They are the visible symbols of the aspirations of the race. The spirit may be the same whether the monument is large or small; a little roadside shrine or cross, a village fountain or a memorial tablet, speaks the same message as the majestic arch or shaft or temple, and both messages will be pure and fine and perhaps equally far-reaching, if the form of that message is appealing and beautiful. Display of wealth, ostentation and over-elaborateness are unbecoming and vulgar. Elegant simplicity, strength with refinement, and a grace of handling that imparts charm are the ends to be sought. These ends require, on the part of everybody connected with the enterprise—committee, adviser, and artist—familiarity with the standards of art, and, above all, good taste. Only by a combination of all these elements can a really satisfactory result be obtained.

"A memorial should be made to last a thousand years," concluded Mr. Moore, and repeated, "let us not be in too much of a hurry! But there is one kind of memorial which may be and will be, set up at once. That is the commemorative tablet to those who have served and to those who have died. That we shall have everywhere."

* * *

November 30, 1919

DANTE GABRIEL ROSSETTI AND WILLIAM BLAKE

The Grolier Club is planning for next month an extensive and exceedingly important exhibition of the works of William Blake, whose fame as an artist has grown steadily and, in late years, rapidly with that wider public to which every artist, however fastidious, longs in his heart to appeal. Blake was not fastidious in his determination to let nothing interfere with the direct path of his artistic message. He was fastidious enough in his predilections to prefer Michelangelo to Rubens and Albert Duerer to Raphael, but his habit was not to whisper his preferences in discreet intimacy. He shouted them to the wide world, and we safely may assume that it would give him joy to know that the wide world begins to listen to that trumpeting voice.

Now that Museum Bulletins are filling pages with accounts of Blake and his art, exhibition galleries are underlining his significance, and private collectors are trying, rather late in the day, to follow the lead of the enlightened connoisseurs who many years ago felt his extraordinary quality; now that, in the common phrase, he is an accepted "master," it is both just and pleasant to recall the ardor of a boy of nineteen, who, browsing about the British Museum, was offered Blake's now famous Manuscript Book by one of the museum attendants for ten shillings. The boy, Dante Gabriel Rossetti, rushed away to his brother, who was the financier of the family, and borrowed the ten shillings and bought the book. He doubtless paid his debt in part, as we find him writing toward the end of his life

that the Manuscript Book belonged to himself and his brother jointly.

The interest in Blake demonstrated thus early in Rossetti's career continued until his latest years. In 1862 and 1863 he was engaged in finishing the Life of Blake begun by his friend Alexander Gilchrist, who had died in 1861 from an attack of scarlet fever. "He did a good deal toward completing certain parts of the biography," William Rossetti writes, "and in especial edited all the poems introduced into the second Section. He again did something for the re-edition dated 1880."

To leave it at this is gravely to underestimate Rossetti's devotion to his voluntary task. At the time when Mrs. Gilchrist took up the new edition of her husband's work Rossetti was deep in the clutches of the disease from which he died, although mentally still capable of original work. His will power was impaired and his general condition that of a man who might well have excused himself from all but the most necessary and inevitable mental effort.

A collection of his letters written to Mrs. Gilchrist (and now belonging to Mr. W. A. White of Brooklyn) shows in how different a temper he accepted the responsibility of revising the biography. In preparing the early edition of the poems he had made certain emendations or variations from the originals of which later he questioned the wisdom, and he thought first of his opportunity in the new edition to adopt another method of treatment. His explanation to Mrs. Gilchrist is that his aim was to make Blake as accessible as he could to readers. "With this view I sometimes filled in imperfect lines, &c., though often the changes I made (as regards chiefly the *Poetical Sketches*) were merely to put into clear arrangement of metre what author or printer had run together as prose." This bold tampering with text was not a Pre-Raphaelite trait and is interesting as emphasizing Rossetti's free mind and fundamental lack of sympathy with the meticulous code of the Brotherhood. "I know you would not quite have coincided in my method of treatment," he wrote to the faithful William concerning the emendations, and certainly such must have been the case, as William Rossetti had precisely the miniature type of scruple from which Dante Gabriel was free.

On the other hand, it is amusing and to a degree enlightening to trace the divergence of Rossetti's mind from Blake's, quite as marked as his divergence from the Pre-Raphaelites. At the moment when Rossetti found the Manuscript Book and read in it that "Ideas cannot be Given but in their Minutely Appropriate Words nor Can a Design be made without its Minutely Appropriate execution," he was under the thrall of Pre-Raphaelitism and felt no doubt that he had found a new and overwhelmingly convincing witness to the wisdom of Pre-Raphaelite methods. But he had known the "Songs of Innocence and Experience" before this and must have felt in the author of "Tiger, Tiger, burning bright" the throb of his own passionate interrogation of the unseen world, the unexplored realms of emotion and imagination. There is something of the mystic in all young thought and feeling.

But while Blake's mysticism was essential to his whole existence, Rossetti could get on without more of such ecstasy than must lie at the root of all creative force. Rossetti, looking upon physical beauty, could not have said with Blake: "I question not my Corporal or Vegetative Eye more than I would question a Window concerning a Sight. I look through it and not with it." Moreover, Rossetti had the straightforward habit of a practical man if not the surface conscience of the Pre-Raphaelites, and if he saw the sun he saw it as the golden disk Blake would not see, and not as Blake did "an Innumerable Company of the Heavenly host crying Holy Holy Holy is the Lord God Almighty." He saw thistles as thistles and sheep as sheep and not as the "old men grey" and wondrous architecture they looked to Blake. In a word, he lacked the power of the true mystic, the power possessed in abundance by Blake, to run the molten substance of an idea or vision into any mold of form that seemed to fit it. His "Corporal or Vegetative Eye" was slower than Blake's astonishing orb to catch obscure resemblances and relationships between apparently unlike things, and he was frankly baffled by the wealth of imaginative allusion in the Prophetic Books which have continued to baffle critics and commentators to the present day. In the letters to Mrs. Gilchrist he shows the complete absence of intellectual pose and the boyish candor that made him always so charming to his friends. Writing of Swinburne's criticism and Blake's two works, the "Jerusalem" and the "Marriage of Heaven and Hell," he says: "S. is, however, a *downright* enthusiast through thick and thin; and thick is the Jerusalem at any rate, whatever the Heaven and Hell may be. My brother, who has as analytical a mind as I know for such purposes (and an absolutely *safe* one) admits the continual and inscrutable incoherence of the Jerusalem. I heard him say so the other day. I myself cannot tackle such a book at all." This recalls his frank admission in one of the few letters to Anne Gilchrist that have appeared in published form—that "as regards such a poem as 'My Spectre' " he did not understand it "a bit better than anybody else."

Further along in Mr. White's set of manuscript letters, however, we find him pricking up his ears over a more possible problem to the solution of which he thinks he has found a clue. Worn and sleepless, a victim to chloral, and almost at the end of his term, he plunges joyously into the labyrinth of Blake's personal grievances and cryptic references thereto.

Blake gave himself the relief and healing of full expression of his resentment of injury in his poetry, and it may be assumed also in his drawings. Feelings that men less endowed would have locked up in a poisonous repression were hurled by Blake into the mass of intellectual and emotional material from which he built his poems and designs, and any key to his personal experiences would be apt to set free some puzzling passage in his work. Rossetti found such a key in the name of a drunken soldier with whom Blake had quarreled and who had had him arrested for treason. The soldier's name was Schofield, and this name is intro-

duced in the "Jerusalem" as that of a particular group who were made to

—revolve most mightily upon
The furnace of Los, before the eastern gate bending
* their fury.*

Rossetti is hot upon the scent and tries to identify the other names in the passage with the soldier's comrades and witnesses, and in his revision he refers to water color versions of a design in the Jerusalem on which names are inscribed. The design shows "Skofield" discomforted and "finally retiring fettered into his native element,"; two of his friends appearing prostrate at the misfortune, according to Rossetti's interpretation, which is not very convincing.

In another passage he thinks he may have found in a reference to a certain "Hand" among "the terrible sons and daughters of Albion" a dart shot at Leigh Hunt, who was editor of "The Examiner," in which Blake was "persecuted" in his own and Rossetti's opinion by adverse critics.

As the correspondence proceeds Rossetti shows increasing zeal in making his additions and changes, in suggesting illustrations and, with characteristic generosity, recommending others who would be qualified to help with the work. Of Frederick Shields he says, "Of course his labor would be purely one of love. He is an ardent worshipper of Blake, and no man could write better about him or with more practical exactness." Mrs. Gilchrist accepted the advice, and many improvements in the new edition are due to Shields. And in regard to a new binding he says: "The binding is an ill concocted thing. There is a very simple fairy design on a large scale (of fairies and flowers) in my MS. which would serve admirably as a design for the binding. This I would get into shape with title as needed, if authorized. Of course for my part I shd make no charge." The charming design was used in the form to which Shields finally adapted it.

The correspondence throughout redounds to Rossetti's credit as a careful and zealous editor and a generous friend. Nor was he blind to the faults of Blake, for whom he had kept his youthful enthusiasm. In one letter he speaks deprecatingly of the lavish praise for Hayley's work expressed in some of Blake's letters to Hayley that had come into his hands; praise that was in strong contrast to the sentiments of Blake's private memoranda. "The thanks I (like yourself) believe to have been especially deserved by poor Hayley, but the admiration expressed for H.'s works must surely be 'turned on.' Alas for dire necessities! Even Blake I suppose could not always be above them." It was characteristic of Rossetti that he should find this form of human weakness particularly abhorrent and also characteristic of him, that he should look indulgently upon its manifestation in a character so generally above pettiness as Blake's.

Rossetti's attitude toward Blake and his work is one that well might be generally adopted. It was the attitude of a strongly intellectual mind. While he found it amusing enough when it came in his way to puzzle out allusions and hunt for

connecting ideas, and interesting to pull into shape chaotic material that should not, he thought, "again be shot upon a shrinking public in this state," while he felt the zest of unearthing hidden secrets he never made the mistake of supposing these to be hidden treasure. Blake's treasure is all open and accessible—his soaring line, his learned architecture, the richness and dignity of his design, his power to clothe abstract ideas and emotions in expressive form. Rossetti was able to meet him where he was greatest both as poet and designer, and put himself clearly on record when he told Mrs. Gilchrist that, although he could not understand the poem "My Spectre," he knew better than some might know that it had "claims as poetry apart from the question of understanding it."

Let us, by all means, play the fascinating game of trying to "understand" Blake, but also let us not forget that in the art that has brought him immortality he speaks a universal language.

* * *

December 7, 1919

H. C. FRICK'S PAINTINGS WHICH CITY IS TO HAVE

Collected With Ardor and Sound Judgment, and Covering Italian, Dutch, Spanish, and English Schools, They Are Remarkable Both for Excellence and Number

The late Henry C. Frick was one of the small group of American collectors of art whose collecting was done with the mingling of personal ardor and sound judgment essential to success in this very difficult pursuit. Later in the field than Mr. Morgan and Mr. Altman, he had somewhat different problems to solve, and he knew how to solve them, taking his own way, and often keeping an important picture in his house for months before deciding to buy it, while in other instances he could make his decision in ten minutes. While he insisted upon making his liking for a work of art the final reason for his purchase of it, he insisted no less upon authenticity and quality, and sought advice where he was sure of its authority. For this reason it is folly to pin the estimated value of his collection down to thirty million, or forty, or fifty. If it were in the market, as now it cannot be, it would bring what the collectors of the world might wish to pay for incomparable examples by the greatest masters.

His interest in art was intensified by his desire to benefit the public through his collection, which he planned for the city and developed with the scrupulous spirit of a loyal trustee. His pictures, to say nothing of other objects of art in his possession, are a series of masterpieces and their number, in view of their excellence, is astonishing. Not all will go to the city, as those remaining at Prides Crossing belong to Miss Frick and are of various schools and periods. The most important things are, however, in the New York gallery.

A few selected almost at random, will indicate the general high level and the wide range. Seven of the more notable and representative are reproduced in the Rotogravure Picture Section of The Times today—a Rembrandt, a Velasquez, a Van Dyck, a Reynolds, a Romney, a Vermeer, and a Bronzino, illustrating the rare quality of the collection which is eventually to become the property of the people of the City of New York.

Italian Paintings

Among the Italian paintings, Titian's great portrait of Pietro Aretino stands pre-eminent, a discerning, uncompromising version of "the founder of modern journalism," as Berenson calls him, whose robust skepticism and "enormous appetite for success" are apparent in the dusky heat of his large face. The vigorous ease of the brushwork, the merging of the contours with the background, the extreme simplification of the masses and, above all, the astute characterization, revealing the sitter's reaction to life, all belong to the high tide of Titian's genius.

Giovanni Bellini's "St. Francis in the Desert" shows Italian art at the moment of freeing itself from the close compression of the Primitives. The landscape in which St. Francis is seen standing before his cell is the most important example of landscape painting in the Italian art of the late fifteenth century, and its perfection of condition makes it, apart from its beauty and from a technical standpoint, one of the finest things in the collection. The Titian was bought before 1905 and the Bellini in 1916, the years between having been marked by one acquisition after another of a distinction so great and a quality so pure as to make the inevitable clamor over the enormous sums of money necessary to secure them an offense against the spirit of the collection. Among the less notable Italians represented is Bronzino, whose beautiful portrait of the young Francesco de Medici places him, for the moment at least, on the plane with the greatest masters of portraiture. There are also two fine decorative compositions by Paolo Veronese and two admirable examples of Guardi's Venetian scenes.

The Dutch Masters

The Dutch group is dominated by Rembrandt's "Portrait of Himself" of the date 1658, the year in which he became bankrupt and in consequence was thrown back upon a simple personal life in place of the social pleasures of his middle years. His pose in an armchair is that of a monarch on his throne, and the gesture and expression imply the haughty reticence of deeply experienced souls. In the catalogue of the Hudson-Fulton exhibition, where the portrait was shown, its effect upon the beholder was expressed in these words: "Seldom has an artist, arrayed in such humble garments, presented more consciously and imposingly his true majesty to the eyes of the world. To the society which will no longer recognize him he presents a countenance of royal disdain and smiling scorn, expressed with a perfection of technique as simple as it is powerful."

This noble painting is one to endow any collection with distinction of the highest order, and the other examples of Rembrandt's work that companion it, although less poi-

gnantly expressive of the genius of the artist, exhibit his vital quality. There is the "Old Woman in an Armchair with a Bible in Her Lap," resembling in type the "Old Woman Paring Her Nails" in the Altman collection, without, however, the majesty of age revealed in the latter. There is the "Polish Cavalier," romantic and brilliant, with a gayety and animation unusual in Rembrandt's work; there is the "Portrait of a Young Painter," and there is the "Dutch Merchant," from the Earl of Faversham's collection.

Vermeer of Delft, the sunlight to Rembrandt's shadow in the picture of Dutch art, is represented by three examples. Where Rembrandt is undefined, mystic, and profound, Vermeer is definite, serene and open. Pale lemon yellow and a cool blue in connection with white and gray are Vermeer's colors, and his simple figures are set in a simple environment and seen in a diffused light. The "Soldier and the Laughing Girl" exhibits these characteristics in a less degree than the more beautiful "Music Lesson" with its compact grouping, its gentle illumination and pure color. The third Vermeer is a recent acquisition.

The Dutch group also includes examples of Frans Hals, Ruysdael, Hobbema, Cuyp and other artists of the famous seventeenth century school.

A Fine Example of Rubens

By the side of Rembrandt's portrait of himself Mr. Frick placed the portrait of the Marquis Ambrose de Spinola by Rubens. This portrait was painted about 1620, some ten years before the death of the Spanish General who put the Netherlands under the Spanish yoke, and four or five years before the capture of Breda, the culmination of his career as a commander. The aspect of this distinguished sitter has been made to accord with what we know of his history. The color is grave, without a touch of the blithe palette used in other paintings of the same period. The serious, worn features betray the strain of the twenty years of effort to defeat the Dutch. They show also something of the personal ambition that kept the Spaniard striving toward the honors attending a grandee against obstacles threatening both his fortunes and his peace of mind. He is painted with his hand on his sword, but not in armor, as in the other two portraits of him by Rubens in European collections.

In William Valentiner's "The Art of the Low Countries," published in 1914, the author laments the paucity of representation given to Rubens in American collections. "While the great private collections of America long since admitted Van Dyck," he says, "they open their doors more hesitatingly to his great master. In the Altman, Frick and Huntington collections in New York Rubens is not represented at all." In acquiring in 1916 this superb example, in which experts have detected no other handiwork than Rubens's own, Mr. Frick removed the ground of Dr. Valentiner's just reproach.

Spanish Masterpieces

The portrait by Velasquez of Philip IV. of Spain, considered by many a connoisseur the most distinguished canvas in Mr. Frick's collection, was painted about twenty years later than the Rubens. It shows the weak King at the age of 39 in the splendid uniform of a Field Marshal, and combines all the qualities of portraiture. The reading of character is clear and dispassionate, the wilful, self-indulgent face representing that Spain in which Olivares could find "no men," only children. There is no attempt to make a hero of a royal patron, but the brush that played over the canvas caressed its surface with every stroke and the color has the tonic quality reserved for Spain. The portrait has a romantic history in addition to its intrinsic beauty. It was discovered at the castle of Schwartzau, near Steinfeld in Austria, after having lain quietly buried among the possessions of the ducal family of Parma for many generations, passing from one member of the family to another until it arrived with Duke Robert at Schwartzau. Its discovery occasioned consternation among certain critics, who always had regarded the very fine copy in the Dulwich Gallery as an original and were loath to yield the point.

Other Spanish pictures that support the Velasquez are El Greco's portrait of Vincentio Anastagi, and three examples of Goya, two portraits, one that of the brilliant Count de Teba, a Grandee of Spain who fought under Napoleon, and whose daughter Eugenie married Napoleon III., the other that of Goya's lively landlady at the Bordeaux. The third Goya is the magnificent "Forge," in which all the energy and saliency of the master of the etchings is displayed. Three men stand at the forge, one with his back turned to the spectator lifting his hammer for the blow at the iron, which the others are holding on the anvil. The fire burns vermilion, and makes a positive note in the quiet color scheme of gray and yellow.

Two Cromwells by Holbein

Two examples of Holbein's art are both portraits of Thomas Cromwell, one painted a few years later than the other. The second portrait was acquired during the war from Sir Hugh Lane, who, in the course of his visit to this country, arranged to have the painting brought over on an American ship in spite of the perils of a wartime crossing. It arrived in New York on the steamship Philadelphia the day after Sir Hugh's departure for England on the ill-fated Lusitania. It is a fine example of Holbein's art, and was rescued by intelligent cleaning from a poor condition, brought about by overpainting and so-called restoration. Included in the extraneous matter removed by the process was a ribboned inscription across the top of the canvas eulogizing the sitter.

Van Dyck

One of the great features of Mr. Frick's collection is Van Dyck's full-length portrait of Paola Adorno, Marchesa di Brignole-Sala. The lady, wife of a Doge of Genoa, is seen standing, her magnificent costume relieved against one of the stately architectural backgrounds beloved by the artist in his Genoese period. Claude Phillips, writing of the picture when it was exhibited at Burlington House, declared the harmony made by the tawny red of the hangings and the white and gold of the dress one of the finest in art. Mr. Wid-

ener has a portrait of the same lady by Van Dyck, but different in pose. In Mr. Widener's picture the Marchesa is seated in a high-backed chair and holds the hand of her son, who stands beside her, his dog at his feet. In this Genoese period Van Dyck was blessed by all the powers that rule a painter's fortunes. His natural love of splendor and patrician types was reinforced by models belonging to one of the most distinguished races in Italy, bold and energetic in bearing, devoid of those languors which later he was to find in the English Court, magnificent in setting and attire. His art was still so young that he undertook its education without the aid of the assistants presently to swarm to his studio. He had come under the influence of the greatest masters of the age and was turning the knowledge he gained from them into his own idiom with emotional enthusiasm.

Another Van Dyck is the portrait of Frans Snyders, formerly owned by the Earl of Carlisle, the sensitive and melancholy features and the brooding eyes brilliantly rendered at a single painting. The portrait of Snyders's wife is also in the collection, and the two mark, according to Dr. Valentiner, "the summit of Van Dyck's achievement in the portrayal of the well-bred bourgeoisie of Holland." Other Van Dycks in the Frick Gallery are the portraits of Marchesa Giovanna Cattaneo and of Canevari, both coming from the Palazzo Cattane.

From these Genoese portraits, painted while the influence of Titian rested upon Van Dyck's design and while he was more deeply concerned with physiognomy than with technical facility, one may turn to the portrait of the Earl and Countess of Derby and their child to see the painter at the crest of his English style. Something of the splendor of Italy persists in this quiet group, but it is harmonized with the profound naturalness of the English type. The deep-breasted, smooth-browed lady, standing with dignity and serenest composure by her husband and child, is the typical mother of English sons as the poets speaking for the people all adore her. Health and self-control and prosperity are in her plan of life. Perhaps no painter of English birth could have seen so truly the elements of her greatness, the classic, opulence of her design.

The British School

The English painters saw her more decoratively and less humanly as the examples of the school in the Frick collection sufficiently prove. The eighteenth century school of painting in England is remarkable for its variations between extraordinary charm and commonplace. With few exceptions the painters usually classified as belonging to this school have balanced works of great merit with others that are uninteresting and uninterested, and to collect a representative group of English paintings of this period fine enough to hold their own with the best of the Dutch, Flemish, Spanish, Italian, and French could not in the most favorable circumstances have been an easy task. In Mr. Frick's collection it has come amazingly close to accomplishment, with one or two examples of a quality to brave any comparisons.

The chief treasure of the group is "The Mall," by Gainsborough, expressing the genius of that master in his loftiest and most gracious mood. The lines of the composition flow in the loveliest of rhythms. The union of the figures and landscape in the beautiful outdoor scene is accomplished with an appearance of naturalness that is the outcome of the most subtle art. There are movement and character and grace in the individual figures, the trees stir in the light breeze and have their own form and structure, the color is high in key, but warm and sensitive.

Painted late in the artist's life, "The Mall" embodies all his passion for the natural world and his delicate perception of its poetry, while the figures placed in the landscape reflect his long dedication to portraiture in the ease with which they are drawn and the justness of their relation to their surroundings.

It is a very great, probably the greatest, Gainsborough, and stands quite alone in aesthetic value, but the group of pictures by Gainsborough's contemporaries and countrymen includes a number of other examples of importance. There are five Romneys, more than any other American collection can boast, among them the handsome group portrait of Lady Warwick and her two children, which is a striking example of Romney's efficiency and tact in the portraiture of children. The Countess sits in a crimson armchair, her right arm about the waist of her daughter. Near them stands the boy with a hoop. The children are on a plane of more rugged and vigorous physical condition than one infers from the delicate aspect of Gainsborough's types, but there is nothing of the peasant in their sturdiness. They are slightly reticent, slightly formal, well-behaved little creatures, suggesting behind their disciplined exterior the potentiality of gay and natural activities.

Lady Hamilton, by Romney

Another very interesting Romney is the "Lady Hamilton as Nature," the earliest portrait of the fascinating Emma, whose influence on the painter's art perhaps has been exaggerated but who fulfilled his fairly conventional ideal of feminine beauty. It was inevitable for him to emphasize charm in his sitters and understate any characteristic that might interfere with the general impression of good looks and a pleasant aspect. Probably we get from his portraits of Emma something more and something less than a psychologically scrupulous painter would give us. As "Nature" she is freer from conscious pose than in any of her other symbolic roles. She looks from the canvas with merry and sweet eyes and her beauty is such that she may easily be pardoned the satisfaction in it that caused her to write from Naples, where she was languishing in the absence of her devoted Greville: "I walk in the Villa Reale every night. I have generally two Princes, two or three nobles, the English Minister and the King with a crowd around me."

The Frick portrait passed presumably from Greville to Sir William Hamilton and was bought at his sale by Lister Parker, then passing for 50 guineas to Mr. Fawkes. The blacksmith's fair daughter is painted with a spaniel in her arms and the dog is one of the best achieved by Romney, whose strength lay elsewhere than in the portrayal of canine

character, his loyal descendant and biographer to the contrary notwithstanding.

The portraits of Lady Milnes and Miss Finch-Hatton are less important but representative and agreeable specimens of Romney's art.

Full length and half-length portraits of graceful English women in Gainsborough hats or Romney ribbons or the generalized costume invented by Sir Joshua, in fact, are present in numbers. Here is the prim little face of Gainsborough's young Mrs. Hatchett, a matron at seventeen, with her hair falling over her lovely shoulders and on her compressed lips the presage of temper. Gainsborough was the right one to paint her. But he could paint a generous face as well, and did so in his portrait of the Honorable Anne Duncombe, childlike with its bulging brow and pouting under lip, stately in poise, and carrying the multitudinous garments hung upon her little figure with the disciplined dignity of her class. "When things are as pretty as that," said Stevenson of a similar type, "criticism is out of season."

Other British Painters

Lawrence with his "Lady Peel," heaps his lesser talent on the altar of shining hair and swimming dark eyes and moist red lips. Sir Joshua's "Lady Skipwith," with her powdered hair and big be-feathered hat surmounting her slim little figure like an enormous blossom on a slim stem, and his "Elizabeth, Lady Taylor," more buxum and livelier, are here in outdoor settings, such outdoors as got within the walls of the Reynolds studio. There is nothing to wonder at in the hypnotic effect upon collectors of the eighteenth century portraits, although no American would go as far as the English collector who is said to have confined his collection entirely to the Lady Hamiltons.

In the "Mortlake Terrace," by Turner, we see one aspect of the environment in which such beauties moved, the spacious brick house with the sun warm on its ruddy side, the great curve of the river bank, and the stately traffic of the river. The time is early Summer morning and the day is fine. It is a most satisfactory Turner, with its normal lighting and its satisfactory composition, the most impressive of the three in the collection.

Constable's "Salisbury Cathedral" was painted in the same year, and was ranked by W. Roberts, the Constable authority, as one of the three finest examples of that master in America, the other two being Mr. Morgan's "Scene on the River Stour," and Mr. McFadden's "The Lock."

The prizes among the French pictures are, characteristically, not pictures but a room, and such a room as only eighteenth century France could evoke at the price of courtiers' heads and the thrones of kings. The fourteen panels painted by Fragonard by order of Louis XV. for the favorite, Madame du Barry, tell the story of lovemaking as the century knew it—too literally, as one of them shows us the flight of Love after all the excitement is over, and the favorite rejected them all because of this cynical true touch.

As paintings the panels are the finest and gayest flowers in that conventional French garden of lilies and roses. They show all modern decoration how to play a scrupulous game. Not a line or tendril or flying ribbon is out of place, not a petal has fallen where it should not, there is no heightening of color beyond the discretion of the whole, there is no false step in the mad dance of the lovers—yet the effect is that of irresponsibility and young abandon. It was not the painter who lost his head in the reign of the Louis. Other French paintings are by Boucher and Pater.

A Fine Whistler

To pass over the Barbizon pictures, which include beautiful examples, it is interesting to find among the modern pictures Whistler's noble "Rosa Corder," his triumphant solution of a problem that assailed him over and over, the problem of painting black against black and keeping the values true. The technical problem here is offered by Miss Corder's black dress seen against a black background, but the freedom and authority of her pose, the beautiful drawing of her figure in its heavy garments, the distinction of her physiognomy also are here for the public.

Mr. Forbes Watson gave the clue to the particular charm of the picture when he wrote of it: "The extraordinary refinement, distinction, subtlety and selection in this portrait are indeed suggestive of great Chinese painting. But the Japanese and Velasquez influences are not imitated, but absorbed. Whistler has made these things his own. Rosa Corder is not seen through Oriental eyes. Although it partakes of the universal quality in art, the painting is essentially personal, and, essentially, be it risked, American."

Another modern American picture of much interest is George Fuller's "Romany Girl," and there is of course the "Washington" recently bought.

Without attempting to anticipate the complete list that soon will be published, this fragmentary sketch will indicate the place the Frick Collection must occupy in the life of the city. It is the first step taken here toward the only reasonable solution of the problem of placing art. In small museums, each with its definite plan, the public can study its art without bewilderment or fatigue, and better than studying what was made for enjoyment, it can gain both repose and stimulus from the presence of art, and build up unconsciously a standard in the unwieldy corporate mind. When Henry Frick the steel magnate is but dimly remembered, Henry Frick the art collector will live in the thought of the people. It is a kind of immortality that always has won respect.

LITERATURE

March 12, 1910

NEGRO PROGRESS AND BACKGROUNDS

The Rise of the Race from Slavery Considered in a New Work by Booker T. Washington

THE STORY OF THE NEGRO: The Rise of the Race from Slavery
By Booker T. Washington
In two volumes. New York: Doubleday, Page & Co.

True to his character of Great Pacificator between the races, white and black, Principal Booker T. Washington of Tuskegee in his latest book strives as he has always done to foster the ambition of his own people without antagonizing their white neighbors. He never forgets his two separate audiences and the fact that what is intended to appeal especially to the negro will be read by the white man and—perhaps—very differently interpreted. It is a high tribute to his shrewdness that he is so generally accepted as the leader of his people. For it is his backing among the whites which gives him that leadership rather than the free suffrages of the negroes themselves.

In the present work, which is in two volumes and really contains little that is new—for the Principal of Tuskegee has long ago exhausted all the phases of his perennial subject which he thinks it wise to touch upon at this stage—the aim is to provide for the American negro, in his own eyes especially, a historic background which will extend beyond the slave ship, and, as Kipling says, lend him "right to pride." The method is to make the most of any signs of civilization among the various black races in Africa, to assemble from various writers on the African at home passages which exhibit him in an encouraging light as to morals, intellect, arts and crafts, or institutions, and thus by suggestion to substitute as the portrait of his ancestors in the American negro's mind the composite picture thus created for the naked savage of Darkest Africa, who now serves that purpose in the world's imagination and, as Dr. Washington confesses, the negro's own.

There is no effort to show that the actual ancestors of the American ex-slave are these exceptionally civilized black men. What Dr. Washington is after is to overcome the notion which the negro has absorbed in the white man's country—that a black skin is the sign of a backward race. He works on the idea so shrewdly, quotes from travelers, missionaries, even modern investigators, so selectively that it is easy to understand how the negro reader might rise from the book with a positive conviction of a real negro civilization, from which his ancestors were snatched into bondage.

Of course there was no such civilization, and equally of course Dr. Washington produces no real evidence of any, but the idea is implanted—and the idea means much. It was only the other day that Edgar Gardner Murphy pointed out that the

insuperable thing which set the American negro apart from all his fellow-citizens of European origin was that Africa stood behind him—Africa as it is. If Africa can be made to seem less African, the gulf seems by so much to be narrowed.

Having thus provided the Afro-American with a distinctly African tradition acceptable to pride and precedent to his expatriation and life in slavery—given him, as it were, an international status not unlike that of the German-American or the Irish-American—Dr. Washington is at some pains to hearten his people further by showing that the white indentured servant of Colonial times was to all intents and purposes, while his indenture lasted, not less a slave than the African bondsman. Thus he seeks to destroy—for he understands (none better) the simplicity of his people—another idea firmly implanted in the ordinary negro's mind—viz., that slavery and a black skin have a necessary connection.

Note is made—with figures to enforce the point—that Rhode Island was the most active of the American colonies in the business of promoting African immigration by means of slave ships, and some account follows of how that traffic was carried on from 1619 till the last cargo—though the slave trade had long been forbidden—was landed at Mobile during the civil war. Then with a light and careful hand the Principal of Tuskegee reviews the history of slavery in America with a special eye to the enumeration of individual slaves and "free persons of color" who showed unusual ability and thrift. The list is both interesting and impressive; so is Dr. Washington's estimate of the property acquired by negroes before abolition. Here you are led to see the survival of the negro's native powers in the white man's country.

Dr. Washington is careful nevertheless to establish the black man's Americanism, insisting that the Southern plantation is a part of his background as truly his own as Africa itself. The text, too, touches discreetly upon Nat Turner and other leaders of servile insurrections, including some of John Brown's black followers, and points out that the negro hymns in slavery days frequently voiced unrebuked an aspiration for freedom which was not (though it took that form) the mere antithesis of the theological thralldom of sin.

As for the progress of the negro since the war between the States in education, in wealth, in morality, Dr. Washington has written so often and at such length that one need not go over the ground with him again here. Once more he marshals encouraging examples and statistics. He devotes some space, however, to showing that the negro's crime record has reached and passed its flood tide, and points out that the longer terms of imprisonment customary in the South serve to magnify the South's apparent proportion—and, therefore, the negro's share—in the statistical showing. Most such statistics deal with the prison population each year. Taking the annual record of commitments to jail instead as a basis, the South's proportion—and the negro's—is perceptibly reduced. It might have been added that fewer criminals, once indicted, escape conviction in the South, where the machinery of legal

evasion is less elaborately developed. On the other hand, too, for many minor offenses against property the negro is rarely haled to court at all. Unless he pilfers from another negro who becomes the complainant, offenses of this sort are very apt to be overlooked until they become flagrant.

Incidentally Dr. Washington has something to say about the "tragedy of color," upon a supposed phase of which a very young playwright has recently built a melodrama which New York has been invited to regard as in some way typifying the real problem.

"Hardships and even injustice," says the Principal of Tuskegee, "when they concern the relations of people who are divided by creed, by class, or by race, are not exceptional. On the contrary, they are common, and every race which has struggled from a lower to a higher civilization has had to face these things. They have been a part of its education. Neither is there, so far as my experience goes, anything particularly tragic connected with the life of the negro except in the situation of those members of my race who, for one reason or another, have yielded to the temptation to make a secret of their lowly birth and appear before the world as something other than they are. I should say it was only when an individual suffers for his own folly rather than the mistakes of others that he is likely to become the hero of a tragedy. This is just as true of races."

* * *

June 12, 1910

"THE WAY OF ALL FLESH"

A Novel by a Man Bernard Shaw Acclaims as Great Beyond England's Deserving

THE WAY OF ALL FLESH
By Samuel Butler
E. P. Dutton & Co.

By H. W. BOYNTON

In the preface to Bernard Shaw's "Major Barbara" occurs the following passage:

It drives one almost to despair of English literature when one sees so extraordinary a study of English life as Butler's "The Way of All Flesh," making so little impression that when, some years later, I produce plays in which Butler's extraordinarily fresh, free and future-piercing suggestions have an obvious share, I am met with nothing but vague cacklings about Ibsen and Nietzsche. . . . Really, the English do not deserve to have great men.

Nobody who is familiar with Shaw, though unfamiliar with Butler, will be likely to take this rebuke too much to heart, to fancy that he may have ignored a veritable masterpiece. Mr. Shaw, with all his acuteness—perhaps because of it—has

never abandoned the cart-tail or the drum. Even his acknowledgments of indebtedness must be made through a megaphone. Samuel Butler, author of "Life and Habit," "Erewhon" and "Erewhon Revisited," was hardly a great man. He is of importance to Shaw in his character of rebel against certain cherished conventions of the British public—more particularly the convention with regard to the natural subservience and inferiority of children to their parents. "The Way of All Flesh" may easily have been the first great cause of "You Never Can Tell" and allied works of the energetic Bernard.

It is, in fact, an unsparing recital, chapter by chapter and verse by verse, of the bitter wrongs visited upon children by their unworthy parents. If only the accursed institution of parenthood could be abolished, if only, say, the race could be propagated by spores—it is easy enough to see what a pleasant time we should all have of it. As it is, the curse is passed along from one generation to another. A man is the brutal and selfish father of an innocent and receptive child. As he grows up, the child resents, and perhaps rebels against, the meaningless tyranny which has dogged him from the cradle. But he no sooner becomes a father himself than the dread inheritance asserts itself in his hitherto blameless veins. From that moment it is all up with him as a decent member of society; he takes his place, ex officio, among the blackguards and dastards of society.

Something very much like this, reduced to bald terms, is the theme of this tale by Mr. Shaw's great man. Indeed, no great reduction is necessary, since the satirist's method is as close upon total baldness as nature inclines to permit. Such veiling as his uncompromising opinions have is due sometimes to an elaborate irony of form, as in the following utterance:

I submit as the result of my own poor observation that a good deal of unkindness and selfishness on the part of parents toward children is not generally followed by ill consequences to the parents themselves. They may cast a gloom over their children's lives for many years without having to suffer anything that will hurt them. I should say, then, that it shows no great moral obliquity on the part of parents if within certain limits they make their children's lives a burden to them.

Truly, a book conceived in this vein of paradox could not well have achieved popularity with an Anglo-American audience. Its character of iconoclastic tract is too evident, moreover, to qualify it as a work of pure art. The writer is not content to embody his theories in a set of human people, and to let their speech and action bring home the moral. He is always passing from the particular to the general, abandoning his exhibit for the sake of a more sweeping demonstration. That is, instead of leaving his sad hereditary procession of outrageous fathers to speak for themselves as unfortunate individuals, he must go on to insist, in good set terms, that all fathers are outrageous. The effect is a little ludicrous.

But the story as a story is far from ineffective. The hero, Ernest Pontifex, is prototype of who can say how many irresponsible and protestant heroes of later fiction. To be sure, he

goes about his business of insurrection in a less direct way than is now the fashion. He is a long time coming to the realization of the paltriness and insincerity of his parents; but he makes a thorough job of it in the end. His father is a clergyman of the Church of England, who has been thrust into orders against his will, and under the mean (but in British fiction invariably successful) threat of disinheritance. His feeble resentment passes into feeble acceptance, and by the dire change of time he becomes himself the domineering father, and forces his own son Ernest into the Church. Ernest does not stay put. He disgraces his cloth and is sent to prison. On dismissal he marries a drunken woman of the street, and sells second-hand clothing. He is saved—and here is the weak and conventionally British element in a story, which does its best to steer clear of anything of the sort—he is saved by the inheritance of a considerable fortune. The possession of money makes a man of him again. Meantime he has become a parent himself, and his solution of the problems of parenthood, his triumphant avoidance of the inheritance which he feels sure would make a brute of him, is to farm out his children to a pair of honest bargees, and have nothing further to do with them. The story, it will be seen, lacks temperance and balance. It is interesting as a document of reaction, and may even be recommended (in small doses) as a wholesome if acrid remedy for complacent parents.

* * *

August 27, 1910

MR. ROOSEVELT'S AFRICA

A Characteristic Account of a year Spent by the "American Hunter-Naturalist" in Pursuit of Big Game

SPORT, PHILOSOPHY, LITERATURE

Observations on Many Matters in an Entertaining Book of Travel

AFRICAN GAME TRAILS: An Account of the African Wanderings of an American Hunter-Naturalist
By Theodore Roosevelt
50 Illustrations. Charles Scribner's Sons. $4.00.

By FRANCIS A. COLLINS

Any one unfamiliar with the personality or writings of Theodore Roosevelt if such a one could be found, might well imagine his new book to be the work of a syndicate of authors or perhaps an entire college faculty. Mr. Roosevelt's bewildering versatility has never found fuller expression than here. He has shown himself a "jack of all trades," and professions as well, and master of many. In its sub-title his book is defined as an "Account of the African Wanderings of an American Hunter-Naturalist." This, however, indicates but a small arc of the circle. The entire population of the jungle— and nothing escapes Mr. Roosevelt's attention—is passed in review, together with the natural history, botany, geology, and physical conditions of the country. His observation of native

conditions, of the "white man's burden," and various problems of administration, of which Mr. Roosevelt speaks with high authority, might well be included in the title.

The object of Mr. Roosevelt's African expedition, it is explained repeatedly, was purely scientific. It was undertaken primarily to collect birds, mammals, reptiles, and plants, and especially big game for the National Museum at Washington and the Natural History Museum of New York. No game of any kind was shot except for scientific purposes or for food. On this subject Mr. Roosevelt pays his compliments to a certain class of critics in a characteristic sentence, "Game butchery," he writes, "is as objectionable as any other form of wanton cruelty or barbarity, but to protest against all hunting of game is a sign of softness of head, and not soundness of heart."

The geography of the trip is comparatively simple. Mr. Roosevelt, his son, Kermit, and three naturalists landed at Mombasa, on the east coast of Africa, and, first by raft and afterward by caravan, proceeded in a general northwesterly direction, crossing the Victoria Nyanza, and finally reaching the upper waters of the Nile. Several side trips, seven in all, were made for hunting purposes. On the day after the party emerged from the jungle at Khartoum, after a year's travel, Mr. Roosevelt dispatched to his publishers the final chapters, appendices, preface, and title of his book.

The railroad out of Mombasa carried the party at once into the jungle. Seated on the cowcatcher—strangely misnamed in the jungle—Mr. Roosevelt enjoyed the "most interesting railroad journey in the world," as they sped through a "naturalist's wonderland," or a "vast zoological garden." One day the engine ran over a hyena, and previously the train had actually killed a lion, and the engineer had brought in the head in triumph. "Mishaps," Mr. Roosevelt observes, "such as could only happen to a railroad in the Pleistocene." During this trip the natives were objects of especial interest, and Mr. Roosevelt closes a long account with the remark that, "To an American, who necessarily must think much of the race problem at home, it is pleasant to be made to realize in vivid fashion the progress the American negro has made by comparing him with the negro who dwells in Africa untouched, or but lightly touched by white influence."

The party found their caravan awaiting them at a little station well inland on the Kapiti Plains. The equipment necessary for traversing the jungle and for preparing the animals suggested a military expedition. More than 200 men must be employed to carry the tents and provisions. Incidentally some four tons of salt had to be carried for preserving the skins.

To guard against the danger of attack by wild animals the camp was organized and patroled as on a military expedition. The picture of this tented town, which was Mr. Roosevelt's home for many months, is vivid:

The tents were pitched in long lines, he writes, in the first of which stood my tent, flanked by those of the other white men and by the dining tent. In the next line were the cook tent, the provision tent, the store tent, the

skinning tent, and the like; and then came the lines of small white tents for the porters. Between each line of tents was a broad street. In front of our tents, in the first line an askri was always pacing to and fro, and when night fell we would kindle a camp fire and sit around it under the stars. . . . Here and there were larger fires around which the gun-bearers drew or groups of askris or saises might gather. . . . After a while the talk and laughter would gradually die away, and as we white men sat around the fire, the silence was unbroken except by the queer cry of a hyena or much more rarely by the sound that always demanded attention, the yawning grunt of a questioning lion.

The party plunged at once into the heart of the jungle. The book offers such a wealth of matter descriptive of the hunting of every conceivable variety of game that it is difficult to make a selection. Mr. Roosevelt's first lion will serve as a typical "kill." The party found themselves one day peering into a patch of tall grass, from which issued ominous sounds of terrifying volume. A moment later, as Mr. Roosevelt elsewhere remarks, they "came out biling":

I sprang to one side, writes Mr. Roosevelt, and for a second or two we waited, uncertain whether we should see the lion charging out ten yards distant or running away. Fortunately it adopted the latter course. Right in front of me, thirty yards off, it appeared from behind the bushes which at first had screened him, the tawny, galloping form of a big maneless lion. Crack, the Winchester spoke. The soft-nosed bullet plunged forward through his flank; the lion swerved so that I missed him with the second shot, but the third bullet went through his spine, and forward into his chest. Down he came, sixty yards off, his hindquarters dragging, his head up, his ears back, his jaws opening, and his lips drawn up into a prodigious snarl as he endeavored to turn to face us. His back was broken, but of this we could not at the moment be sure, and if it had been merely grazed he might have recovered and then, even though dying, his charge might have done mischief. So Kermit, Sir Alfred, and I, almost together, fired into his chest. His head sank and he died.

There are scores of similar adventures with lions, hippopotami, rhinoceroses, hyenas, every variety of game big and little. To the layman in such matters it is sometimes difficult to follow Mr. Roosevelt in his tireless enthusiasm, but the subject changes so quickly that the narrative never drags.

In the course of his travels Mr. Roosevelt visited many missions, which interested him deeply. It may come as a surprise to many to find him an ardent advocate of foreign mission work. . . .

In the records of receptions and entertainments one may read between the lines of the fame which had preceded Mr. Roosevelt to the most remote parts of Africa. One delightful story, which we can imagine Mr. Roosevelt telling with a characteristic smile, is dated from Ndorobo:

When we camped in these high forests the woods after nightfall were vocal with the croaking and wailing of the tree hyraxes. They are squat, wooly, funny things and to my great amusement I found that most of the settlers called them Teddy Bears.

Mr. Roosevelt has high praise for the English rule in Africa:

The Wakamba, he writes, for instance, are as yet not sufficiently advanced to warrant their sharing in the smallest degree in the common Government; the "just consent of the governed" in their case, if taken literally, would mean idleness, famine, and endless internecine warfare. They cannot govern themselves from within, therefore they must be governed from without, and their need is met in highest fashion by firm and just control, of the kind, on the whole, they are now getting.

And, again, the English rule in Africa has been of incalculable benefit to Africans themselves. Mistakes have been made, of course, but they have proceeded at least as often from an unwise effort to accomplish too much in the way of beneficence as from a desire to exploit the natives.

In selecting his library for this long journey Mr. Roosevelt inevitably reveals his most intimate literary convictions. The series of books chosen was called the "Pig Skin Library," from the special binding selected to withstand rough usage on the march. The original list comprised one or more works from a list of some thirty-seven authors, while half as many more were added during the journey. The authors include such widely contrasted names as Shakespeare, Spencer, Marlow, Mahan, Macaulay, Homer, Chanson de Roland, Nibelungenlied, Carlyle, Shelley, Bacon, Lowell, Emerson, Longfellow, Tennyson, Poe, Keats, Milton, Dante, Holmes, Bret Harte, Browning, Crothers, Mark Twain, Bunyon, Euripides, The Federalist, Gregorovius, Scott, Cooper, Froissart, Thackeray, Dickens, and the Bible.

In an appendix Mr. Roosevelt discusses very frankly the claims of a rival, the famous "Five Foot Library," suggested by Dr. Charles W. Eliot. He frankly states that several of the books which Dr. Eliot has placed on a five-foot shelf he, Roosevelt, would not put on a fifty-foot shelf. Thus he declares:

I think it slightly absurd to compare any list of good books with any other list of good books in the sense of saying that one list is better or worse than another. . . .There is no such thing as the hundred best books or the best five-foot library. . . . Let us be modest about dogmatising overmuch.

These pages gain interest of association in being dated from Khartoum.

Mr. Roosevelt's latest book exemplifies the virtues as well as the limitations of its author's literary style, and both his admirers and critics will find in it material for renewed argument. In the well-nigh interminable discussions as to the "Roosevelt style" the best possible authority seems to have been overlooked, namely, Mr. Roosevelt himself. We have his repeated assurance—comforting, to say the least—that he is not a genius, and that his success is due to the possession of familiar traits of character and temperament and of abundant energy. Certainly, no contemporary writer on either side of the Atlantic has coined more words and phrases which pass current among us. It is very high praise of any style, moreover, that it should have been employed with such conspicuous success in setting forth such widely contrasted subject matter. A masterpiece of prose Mr. Roosevelt's latest book is not. In its perusal, however, one enjoys a very pleasant if not brilliant record of travel couched in a style direct and pliable. In a word, "African Game Trails" is a piece of work frequently lightened by touches of genius and always readable.

<p style="text-align:center">* * *</p>

<p style="text-align:right">**March 5, 1911**</p>

JANE ADDAMS: HULL HOUSE

Twenty Years' Social Service in Chicago and the Worker's Equipment for her Task

TWENTY YEARS AT HULL HOUSE: With Autobiographical Notes
By Jane Addams
Illustrated by Norah Hamilton. The Macmillan Co. $2.50.

A settlement is not only a neighborhood house with residents, devoted to philanthropic, civic and social work. It is more than that: it is an idea; it is almost a religion. This settlement idea, which sprang in England from the gentle and fervid spirit of Arnold Toynbee, was transplanted to America twenty years ago by Jane Addams. A record of these twenty years at Hull House in Chicago, and of the previous thirty years of a life preparing unconsciously for its great mission, is more than an autobiography; it is the story of the growth of spiritual democracy in America.

Jane Addams was born in a well-to-do home, devoted to a father whose personality is in her memory inextricably bound up with the influence of Lincoln. She was excellently educated, and impelled from the first by a love of workers, a keen sense of responsibility and a tender mercy. Yet with all these riches of life and spirit she had still to contend with obstacles that, as one reads of them, seem insurmountable. From childhood she suffered from curvature of the spine; she was always delicate; and at about the age of twenty

years she was confined to her bed for months with spinal trouble, which left her in a state of nervous exhaustion. Her "lehrjahre" were long and difficult; she traveled much, thought much, suffered much; and then in her thirtieth year she came out of England, after the turmoil of thought and feeling, with the idea of Hull House clear in her mind, and in her heart the devotion and self-giving of a transfigured spirit. She does not say these things. One feels them through the text. There is in her book an undercurrent of power and experience, even more in what she leaves out than in what she says. No wonder that hers is the philosophy of overcoming much, that she pleads for sheltered youth the right to obstacles, the right to suffer, to conquer and to serve. Mothers who cannot understand the discontent of their cared-for and pampered daughters would do well to read this book, and to allow those whom they have taught to be good, the opportunity and freedom to do good also.

If to Jane Addams the "snare of preparation" seemed unnecessarily long and difficult, it developed in her that marvelous sympathy for the rich as well as for the poor, her unerring and liberal interpretation of all human life. In her earlier books the originality of interpretation and opinion seem always to spring from immediate experience. Here that experience is set forth. Through twenty years of incredible toil and cheerful sympathy and fine sensitiveness she has built up for herself and the Nation Hull House, with its many devoted residents, its clubs, its theatre, its restaurant, its labor museum and its library, its liberal culture and its democratic neighborliness. Hull House has entertained most of the heroes of social service; and from Hull House have sprung many reforms, labor legislation, labor societies. There has been opposition to meet; there have been struggles and disappointments and the spirit of sweet tolerance that overcomes all. Perhaps Jane Addams's greatest work has been that of mediator, of spiritual interpreter for the diverse peoples that make America. She has discovered the emotional and artistic riches of the immigrant, who seemed so poor; she has been as a fire to melt the barriers of iron and gold between generation and generation, between class and class.

This book, with its beautiful pictures and its artistic dress, seems a fitting birthday expression for Hull House, after its twenty years of industry and art, of work and play. The greatest modern books are not in any real sense literature; or, at least, we cannot measure their literary value. Books have not been great in every age, and men have always been greater than books. Though books may be a convenient form, they are not the only form of expression of a great personality. The personality of Jane Addams—faintly reflected in her books—is one of the finest achievements of that idea of democracy, service and freedom for which America means to stand before the world.

<p style="text-align:center">* * *</p>

October 8, 1911

THREE LIVES IN SUPREME TORTURE

Mrs. Wharton's "Ethan Frome" a Cruel, Compelling, Haunting Story of New England

ETHAN FROME
By Edith Wharton
Charles Scribner's Sons. $1.

Mrs. Wharton prefers to present life in its unsmiling aspects, to look at it with the eye of the tragic poet, not with the deep sympathy, smiling tenderness, and affectionate tolerance of the greatest novelists. Thus she never shows life as it is, as the great novelists do, but an aspect or view of life—the reflex of life on the writer if you will—which colors all things with some mastering mood of him or her.

The present grim tale of a bud of romance ice-bound and turned into a frozen horror in the frigid setting of a new England Winter landscape is conceived in the remorseless spirit of the Greek tragic muse. The rigidity of the bleak Puritan outlook on life does duty for the relentless Fates. It is a powerful and skillful performance and seems to recreate a life and an atmosphere essentially the same as that which breathes in the romances of Hawthorne. That atmosphere is, no doubt, the true emanation of the soul of New England—that New England, warped by the dour theology of the cruel and fanatic age that planted it, which was Hawthorne's own, and which now has retired to such frozen fastnesses as the lonely and starved village among the barren hills in which Mrs. Wharton places her story.

The story itself is one which will hardly bear even indication of what it is without an effect of marring it. It deals with a gaunt, tall farmer and his wife and another woman—a young girl, the wife's poor relation, who is, like them, an inmate of the desolate farmhouse perched bleakly in the midst of its barren acres. The man is one of those—found in all starved communities—who have been chained to the soil by the duty of caring for a family of stricken elders—a very incarnation of the tragedy of youth and strength wasted in the service of useless age. The wife is, as a wife, an accident. She is a whining slattern who hugs her imaginary ailments to her flat and barren breast and spends the scant substance wrung from the grudging northern earth upon quacks and patent nostrums. That, also, is a common type in starved and hopeless rural communities.

The girl is a pretty, gentle creature whose worldly efficiency has been tried and found wanting in the hard tasks of the shop girl in some busy little New England mill town, a human reed bruised in the wind. On the face of it it is a very sordid triangle. Actually, Mrs. Wharton has been able to invest the girl with such sweetness, such delicacy, such innocence, such child-likeness, to endow her with such simplicity and such wistfulness; the man himself is so utterly simple, so starved of joy; and both are so helpless in the tolls of bitter circumstance that the effect is anything but sordid.

Moreover, the whole drama is enacted for the reader under the spell of a sure foreknowledge that tragedy is coming swift-footed to end the hardly more than glimpsed hope of happiness for the doomed pair who dwell apart in that house and watch for little comforts like faint candle beams beneath closed doors. A brief interlude of smiles and tears and shy glances and a mad moment of stolen kisses—and then the end. All that is crushed beneath the horror of a stretch of long, ruined years. Retribution sits at the poor man's fireside in the shape of two haggard and witchlike figures—the gaunt wife and the wreck of the girl that was.

It is a cruel story. It is a compelling and haunting story. But it is a story which a bald telling, without the art which has thrown the crude material of the plot into due dramatic perspective and given it poetic atmosphere, could easily make absurd, or even revolting. The mere saying that Mrs. Wharton has brought about the catastrophe by sending two of her principal characters coasting down an icy hill and "smashing them up" for life—but not killing them—against a great tree near the bottom, conveys an impression of clumsiness and brutality which only the actual reading of the story will avail to dispel. Mrs. Wharton has, in fact, chosen to build of small, crude things and a rude and violent event a structure whose purpose is the infinite refinement of torture. All that is human and pitiful and tender in the tale—and there is much—is designed and contrived to sharpen the keen edge of that torture. And the victims lie stretched upon the rack for twenty years.

The author of "The House of Mirth," which lacked much of being either a great novel or a true one, and which lacked also not a little of being a really convincing drama, in spite of the element of truth and the wide popular appeal which has caused it to stand forth in the public mind as Mrs. Wharton's most conspicuous achievement, has accomplished in this story something very much finer and stronger. There is in it much of the keen concentrated effectiveness which the author has more than once obtained in her short stories. If "Ethan Frome" is not a great novel—it is, indeed, hardly long enough to be called a novel at all, though it far oversteps short-story limits—it is, at least, an impressive tragedy.

There are writers who are both great novelists and great dramatists; that is, who reflect life with singular completeness and faithfulness at the same time that they give the overpowering impression of a shaping and designing destiny governing the fortunes of their leading personages and driving to an inevitable conclusion. Such a novelist, for instance, was George Meredith, from whom the modern makers of fiction borrow so much consciously and unconsciously. There are writers, again, who are merely novelists—who send their creatures to school, to life, not without smiles and tears and pangs to see them suffer. Such a novelist was Thackeray. And there are dramatists who do not write for the theatre and so pass as novelists. It seems to this reviewer that Mrs. Wharton belongs properly to the last classification, and that "Ethan Frome" is the proof of it.

* * *

December 3, 1911

PINNOCHIO, THE PUPPET

It is hard to believe that a puppet boy, carved out of a piece of wood, could be quite as naughty as was Pinnochio, or live such a long and varied life. There are 268 pages of it in the book, "Pinnochio, the Story of a Puppet," translated from the Italian of C. Collodi by M. A. Murray, with innumerable pictures, black and white, and a few full-page colored ones by Charles Folkard. (E. P. Dutton & Co., $2.50.) Pinnochio begins to be naughty as soon as he is carved out of wood by Papa Geppetto. He grabs off his wig as soon as his arms are made, delivers a kick on his nose as soon as his leg are in form, and then naughty Pinnochio runs away as fast as his new feet will carry him. There are no end to the things that a naughty puppet can do, and it is not until the very end of the book that Pinnochio turns over a new leaf, takes good care of his poor old father, and to reward him the fairy turns him into a real boy, with chestnut hair and blue eyes. But before that he has told so many lies that his nose has grown yards long, and he has more adventures than any other boy or puppet ever had, but the history of them must be read and the pictures—such very good and exciting ones—studied to know all about it.

* * *

December 17, 1911

MR. CHESTERTON'S PRIEST-DETECTIVE

Father Brown Ferrets Out the Evil-Doer with Mingled Pity and Benevolence

THE INNOCENCE OF FATHER BROWN
By G. K. Chesterton
Illustrations by Will F. Foster. John Lane Company. £1.30.

As a disciple of Poe and a rival of Sir Arthur Conan Doyle, the ingenious Mr. Gilbert Chesterton has made a by no means contemptible showing in the series of tales of the homicidal and criminal which have been collected into the present volume after publication in an American periodical the name of which, Mr. Chesterton professed (in conversation with this reviewer) his inability to recall. Doubtless that was Mr. Chesterton's little joke. And these tales of men slain with so nice a sense of dramatic effect, of crimes invented and circumstanced, with such care against offending an educated and fastidious taste in murder and theft of mysteries so admirably and surprisingly solved—perhaps these, also, were originally designed as Mr. Chesterton's little joke.

Perhaps the idea was to show how thrilling and feverish a detective story could be made if you took pains to arrange that no single step of the process of tracing the crime had any locial connection with the preceding step or the one that followed. If he were quite solemn about it, there is no doubt that a man much less clever than G. K. C. could write a detective story that way and get away with it. But Mr. Chesterton, after all, is a person with a particularly keen sense of the connection between the little things and the big things to which they are the key. And the art of the detective is above all, the art of noting and putting together just such tremendous trifles. Therefore, it is not at all surprising to find that instead of composing subtle ironies, Mr. Chesterton actually writes extremely good detective stories—detective stories the more fascinating because if there is about them a hint of irony, there is also more than a hint of poetry and a shadow—or, if you will, a glow—of the mystic and the supernatural.

It is the symbol of all this that the tracer of crimes and the solver of mysteries is a good little fat priest with blinking eyes, whose business it is to ferret out the evil doer, but by no means to send him to the gallows or the jail. Thus the spirit is not that of the hound upon the blood-trail. Rather it is that mingled pity, benevolence, and nobler rage for right reflected by Robert Louis Stevenson in the quest of the Rajah's diamond, which the Prince of Bohemia caused to be placed in his royal hands by the Rev. Simon Rolls, (who has stolen it,) and thereupon tossed the wicked bauble into the Seine, saying: "Amen, I have slain a cockatrice."

From this comparison with Stevenson it will appear that Mr. Chesterson is something more than a plot concocter, with the knack of getting at the plot backward—like Doyle. Rather he is an artist with something of the art of Poe himself. There are also, of course, the qualities which may be called Chestertonian, the gift of flashing sidelights, a certain trick of seeming to see out of the back of the head.

Sometimes, as in the grisly tale of "The Secret Garden," one of the best—the scene is the house of the Chief of Police of Paris—the author gets effects which are genuinely hair-raising. Again, in such a story as the one entitled "The Flying Stars," he accomplishes a sort of harlequinade of the true detective story, a thing all the easier because the story of harlequin is, in its essence, a tragedy in comic dress. Yet, again, curious hypnotic effects are accomplished by the repetition, after the scene has been carefully set for the purpose, of a phrase in itself perfectly commonplace. An atmosphere of stifling evil and horror, like a nightmare, is created, for instance, by the little priest's solemn insistence that a knife and a piece of paper are "the wrong shape." You feel the thing creeping on and growing blacker and thicker each time those two simple words recur.

The most extraordinary of these effects of suggestion, however, is that which Mr. Chesterton accomplishes in the tale entitled "The Queer Feet." All that he does is to describe the sound of footsteps in a corridor outside a locked door—footsteps now slow, like one who strolls, now a rush of rapid patter—all the steps obviously made in the same pair of shoes. You speculate with the man behind the locked door on what these steps mean—and you feel your fever rising and rising. Doubtless the most characteristic of the tales—the most characteristic, that is, of the Chesterton one knows as paradoxical essayist and revealer of those things which are so obvious that all the world refuses to see

them—is the story named "The Invisible Man." The invisible man, by the way, presently appears to be the postman, who is mentally invisible as a possible murderer because one instinctively relegates him to the status of mere street scenery, like the lamppost and the letter box and the policeman—only more so. It is for this story that the author has borrowed a pleasant beginning from Owen Wister's "Lady Baltimore." In the English story the Woman's Exchange becomes a pastry cook's shop in a London suburb out toward Hampstead Heath. The Girl—though she is the same girl—confesses she used to tend bar for her father, who kept the inn called the Red Fish at Ludbury. Even the wedding cake is there.

Another of the best of the tales—there are a round dozen in all—is alluringly entitled "The Sins of Prince Saradine," and what makes it so is not the story, though that, too, is well enough. It is the stage setting—the marvelous word-painted scenery with which the author has surrounded it. We must be content here with a brief description of what we may call the overture curtain. Two men are sailing down (or up) one of the wonderful little English rivers winding between green banks, with a slow tide that fills them nearly to the grassy brim. They have lain moored under the bank for the night. Now they awake before it is light, or rather before it is daylight, "for a large lemon moon is only just setting in the forest of high grass above their heads, (as they lie in the boat, of course,) and the sky is of a vivid violet-blue, noctural but bright."

"Both men had simultaneously a reminiscence of childhood, of the elfin and adventurous time when tall weeds closed over us like woods. Standing up thus against the large moon, the daisies really seemed to be giant daisies, the dandelions to be giant dandelions. Somehow it reminded them of the dado of a nursery wall paper. The drop of the river bed sufficed to sink them under the roots of all the shrubs and flowers and make them gaze upward at the grass."

Thus are the boatmen wafted into fairyland—and you with them as a preliminary to their adventure. So Mr. Belasco used to transport his audiences to a land of mist and visions preliminary to showing a fierce and bloody legend of old Japan. Here also it is a bloody legend that follows. In the words of Father Brown, wise priest and reader of the mazes that lead backward from the crime to the criminal, it is not always wrong to enter fairyland, but it is always dangerous. That is good theology, no doubt, for the perils of the imagination which serves indifferently pretty children's fancies and the visions of the opium-eater.

* * *

March 3, 1912

ZULEIKA DOBSON AS SEEN BY MAX

Mr. Beerbohm in His First Novel Contributes His Masterpiece to English Literature

ZULEIKA DOBSON
By Max Beerbohm
John Lane Co. $1.20 net.

It may seem strange to some of us to consider Max as a classic, to think of him as sharing the seats on Parnassus with the giants of our literature. Yet this truly great man has shown in his latest book—his first novel—that that whimsicality which made him eminent as essayist, as caricaturist, is sufficiently vital to entitle him to a place among the Immortals. He has, in "Zuleika Dobson," produced his masterpiece, and a masterpiece in English literature. Wheresoever we find Addison; wheresoever we find La Bruyere; wheresoever we find Stevenson, wheresoever we find Steele; wheresoever we find Swift or Rabelais—there Max will be! He has used "Zuleika" as the last rung of the ladder of delightful works that lifts him into the presence of the Gods.

Max has proved his title to fame. And it is pleasing to bear witness that his success has been due, not to mere cleverness, as with some; not to mere brilliancy; not to that originality which is galvanized into life by the shocks it produces in innocent minds, but to that sincerity that springs from sheer independence of character. Beneath the polished cadences of his sentences, that style as ceremonious as a minuet and as exquisite, beneath the humor and the jesting, exists his chief characteristic, a sane sincerity. It is the touchstone to his work.

No other writer could have created Zuleika. She is a fairy spun of Max's finest fancy. Who is She? How describe Her in ought but Max's own characterization? She is the Omnisubjugant. She is a fever, an epidemic. She is the Scourge of Man. There was only one who could withstand Her charms. And he, like Adam, parleyed a while and fell. The world of the music halls, the world of society, bowed before Her. The All Conqueror there, She sought other worlds to conquer, and selected that concise little walled world of Oxford. Dons, Deans, Masters, Scholars—all desert the rhymes of Homer for the rhythms of Zuleika's skirts.

We—poor people!—who manage through gross deception, by hiding our real selves, to win a friend here, an admirer there, cannot realize the loneliness of the heights where dwell the chosen few whom all the world loves. Read of Max's "Zuleika" and you will appreciate their feelings, for Zuleika was one of these. Men were worth nothing to Her because all men loved Her. Only the Duke could withstand Her charm a moment—he "whose feet were so slim and strong, of instep so nobly arched, that only with a pair of glazed ox tongues on a breakfast table were they comparable." He was Her destined mate. She knew that. And soon, too, did he: "Conscious that every maiden whom he met was

eager to be his Duchess, he had assumed always a manner of high austerity with maidens. And even if he had wished to flirt with Zuleika, he would hardly have known how to do so. But he did not wish to flirt with her. That she had bewitched him did but make it the more needful that he should shun all intercourse with her. He must not dilute his soul's essence. He must not surrender to any passion his dandihood. The dandy must be celibate, cloistral; is, indeed, but a monk with a mirror for beads and breviary; an anchorite, mortifying his soul that his body may be perfect. Till he met Zuleika, the Duke had not known the meaning of temptation. He fought now, a Saint Anthony, against the apparition. He would not look at her, and he hated her. He loved her, and could not help seeing her. Inexpellable was her image."

How could he resist temptation? As well ask why the rivers seek the ocean or the moonbeams kiss the sea. How could he fail to love Her whom even the Emperors on the Sheldonian Theatre loved passionately. Listen how they feared her, these Emperors, and thank whatever gods there be that your glance rested not on the Temptress!

"As the landau (with Zuleika) rolled by, sweat started from the brows of the Emperors. They, at least, foresaw the peril that was overhanging Oxford, and they gave such warning as they could. Let that incline us to think more gently of them. In their lives, we know, they were infamous, some of them— 'nihil non commiserunt stupri, saevitiae, impietatis.' But are they too little punished after all? Here in Oxford, exposed eternally to the four winds that lash them and the rains that wear them away, they are expiating, in effigy, the abomination of their pride and cruelty and lust. Who were lechers, they are without bodies; who were tyrants they are crowned never but with crowns of snow; who made themselves even with the gods, they are by American visitors frequently mistaken for the Twelve Apostles. . . . To these Emperors time will give no surcease. Surely it is a sign of some grace to them that they rejoiced not, this bright afternoon, in the evil that was to befall the city of their penance."

The Emperors guessed rightly. Zuleika brought ruin to their city. One day her classrooms are empty, her shrines forsaken. All her scholars, her future D. C. L.'s, her coming D. D.'s and D. F.'s, her Masters—past masters in the art of skimming through examinations—plunge into the foaming Isis. Isis gathers to her bosom those whom Zuleika spurns. Only the Duke—brave fellow!—leaves a token to hint to his Destroyer that perhaps it was not merely for Her that he died. Zuleika is thunderstruck. She staggers to her table, seizes her favorite book, encrusted with amethysts, beryls, chrysoprases and garnets—her beloved Bradshaw—and leaves—for Cambridge!

It is fooling. Only fooling of quality divine. For Max can trifle without being foolish—the mark of the supreme humorist. He is particularly clever in so shifting his humor that the reader produces yet more humor by reading between the lines, so that a veritable conspiracy for the creation of humor exists between author and reader. Every sentence used to describe a personality is a satire on a type. In its main features his humor is almost more American than English, in spite of his Anglicism. For the difference between American and English humor is this: that the former tends to blur the outlines, the latter to sharpen them; and Max produces many of his best results by blurring the image.

Again, his humor is essentially of the earth. That is, it is not elemental; it achieves results not in broad generalizations, but rather through details. That same spot in Max's sense of humor that forbids him seeing the fun in the eternal joke about mother-in-law or about the piece of bad cheese; that prevents his laughing when a man falls down stairs unexpectedly, is the sole fault in the cosmic sweep of his wit. Indeed, Max lacks that broad religious sense on which all jokes ultimately depend, that heat balancing of thought that sees men small as men yet big as Man (that doctrine of the Fall) on which the humor of the man slipping on a banana peel depends. For all jokes, like all good things, have their roots in the Scholastic Philosophy. Yet Max's humor is by no means vegetarian: it is essentially virile and meaty; indeed, almost brutal, seen in certain lights, as all true humor must ultimately be. Yet, withal, it is delicate; brutal in essence, delicate in execution. To stretch words and the idea—call it Rodin in Dresden china.

Of his style a note must be appended ere we stop. Max's style is just sufficiently dyed with his own personality to be slightly eccentric. Indeed, by satirizing his own style, by just tipping the balance ever so slightly, he obtains his most humorous results. Max satirizes himself to satirize his fellows. Yet his prose is, as Edmund Gosse once remarked, the prose least tainted by contemporary literary movements. That is to say, it will always defy the corrosion of time, will never be outdated. It is, to quote another critic, tinged with a richness as deep as Elia's own.

L. H. W.

* * *

June 9, 1912

PROF. DEWEY ON WILLIAM JAMES

Reviews the Great Philosopher's Last Volume on Radical Empiricism and Comments on Pragmatism

ESSAYS IN RADICAL EMPIRICISM
By William James
Longsmans Green & Co.

By PROF. JOHN DEWEY
Columbia University

The history of philosophic thought exhibits few more surprising events than the intellectual achievements of William James in the last decade of his life. Careful readers knew that his monumental "Principles of Psychology" carried, scattered through its pages, the essentials of a philosophic attitude. The essays published in 1897, with the title "The Will to

Believe," elaborated many of these points and gave the name of radical empiricism to the attitude. But, none the less, Mr. James's important work and that to which his reputation attached were in the field of psychology. Indeed, among professional philosophers it was rather the fashion to speak in a tone of amused disparagement of his philosophic attempts. The unusual, the almost unique thing is that after having reached an age when most men simply repeat and expand their own past, Mr. James compelled the whole world to take note that a new way of thinking in philosophy had made its appearance. Of course, much of his influence is due to the remarkable vitality and picturesqueness of his style. But literary style alone does not explain the phenomenon. The times were ready; the general state of the imagination had moved so that it was ready and eager for the very ideas that in the earlier days of James's prophetic vision had meant nothing to it.

The words that happen to close the present volume express the general spirit of Prof. James's thought, and help us understand the rapid extension of his influence: "All philosophies are hypotheses, to which all our faculties, emotional as well as logical, help us, and the truest of which will at the final integration of things be found in the possession of the men whose faculties on the whole had the best divining power." We are far enough away from any "final integration of things." But every generation must make its own relative integration, and the extraordinary rapidity with which Pragmatism, as the name for a method, and Radical Empiricism, as the name for a system, have made their way is sufficient tribute to the genuineness of Mr. James's divination. That philosophies are hypotheses, rather than mathematical demonstrations; that personal factors, emotional and aesthetic, enter into the formation of these systems; that strictness of logical reasoning is ultimately effective only in the degree in which it works out an original non-logical vision or divination; and that the vision of Mr. James is extraordinarily pertinent to the general trend of contemporary thought—these things the progress of events has proved.

The present volume of "Essays in Radical Empiricism" is the third and presumably the last (unfortunately) of the writings published since Mr. James's all too early death. Taken together, they leave his philosophy incomplete, a sketch and a programme, rather than a carefully wrought and inclosed system, like that, for example, of Bergson. While we cannot too much regret that Mr. James is not still with us to give needed developments and explanations, there is still something congenial to Mr. James's personal temperament and to his philosophy in this unfinished state. For there is nothing more characteristic of the substance of his thought than the belief that the world itself has an element of unfinishedness in it, and that one of the standing errors of philosophers has been to attribute to reality a completeness which as matter of fact it does not possess.

In the final essay from which we have already quoted, Mr. James gives so precious an expression of this belief that it may well be quoted at length:

The "through-and-through" universe seems to suffocate me with its infallible impeccable all-pervasiveness. Its necessity, with no possibilities; its relation, with no subjects, makes me feel as if I had entered into a contract with no reserved rights, or rather as if I had to live in a large seaside boarding house with no private bedroom in which I might take refuge from the society of the place. . . . The "through-and-through" philosophy seems too buttoned-up and white-chokered and clean-shaven a thing to speak for the vast, slow-breathing, unconscious Kosmos, with its dread abysses and its unknown tides. The "freedom" we want to see there is not the freedom, with a string tied to its leg and warranted not to fly away, of that philosophy.

The present volume falls in with his "Meaning of Truth" rather than with his "Pragmatism" or his "Pluralistic Universe." It is not a volume of spoken lectures addressed to a more or less popular audience, but a series of written essays addressed for the most part to his professional colleagues. This does not mean that Mr. James has parted with his direct and living style of expression; he could never have surrendered that and remained himself. But it does mean that it occupies itself largely with technical matters and is more argumentative, and less purely expository, in expression. It is concerned not so much with setting forth and making vivid and persuasive a certain attitude and method as with applying that method to the consideration of a number of problems mooted among philosophers. As a consequence, it is quite likely that while pragmatism will be popularly identified with the name of James, in professional philosophic circles the considerations presented in this last volume of posthumous essays will be in the end most influential. At all events, as the editor, Prof. Perry, rightly notes in his preface, Prof. James "came toward the end of his life to regard radical empiricism as more fundamental and more important than pragmatism."

What, then, is this "Radical Empiricism"? Empiricism is an old and well-established doctrine, and it is clear that the key to what is distinctive in the Jamesian type of empiricism is to be found in the adjective "radical." Yet of empiricism in its more generic form he gives his own statement, which must be quoted in order that we may understand its radical quality, for even here Mr. James puts the emphasis in a different place than would be expected by those who have learned to identify empiricism with the sensationalism of Hume and the Mills. In the first place, he dwells upon its hypothetical, non-dogmatic character. It is "contented to regard its most assured conclusions regarding matters of fact as hypotheses liable to modification in the course of future experience." And in the second place, it is a postulate of method of procedure in philosophy. This method may be stated as follows:

Nothing shall be admitted as fact except what can be experienced at some definite time by some experient; and for every feature of fact ever so experienced, a definite place must be found somewhere in the final

system of philosophy. In other words: Everything real must be experienceable somewhere, and every kind of thing experienced must somewhere be real.

Some light is thrown upon part of the significance of this definition by what Mr. James says elsewhere in reply to a critic who asked him if his view precluded the possibility of things beyond experience, acting and being acted upon by experience. "Assuredly not their possibility," replies Prof. James, adding, "yet in my opinion we should be wise not to consider anything or action of that nature, and to restrict our universe of philosophic discourse to what is experienced, or, at least, experiencable."

So far, however, we are well within the limits of an empiricism which was held by many thinkers prior to the writings of James. If we read between the lines, the radical quality of this empiricism is at least suggested in that part of the passage quoted where it is said, "Every kind of thing experienced must somewhere be real." Those who have gone by the name of empiricists have been practically unanimous in denying the reality of universals, indeed, of relations generally. They have spent much time and ingenuity in explaining them away; in showing how they are grafted from without upon particulars which alone are real. In short, they have set out with an idea of what experience must be, and have then translated the facts of experience into accord with their prior assumption. In opposition, James holds that if we go to experience itself "we find the relations between things are just as much matters of direct particular experience, neither more so nor less so, than the things themselves."

The development and application of this proposition are contained particularly in the first five essays of the present volume, all of them, however, enforcing the thesis that various problems which have given philosophers all kind of difficulties are simplified and made solvable if we stick to the empirical relations of different sorts which are found among the various items of our experience. The net outcome is that philosophy must regard reality as an "experience-continuum": the doctrine, more elaborately stated, that "though one part of experience may lean upon another part to make it what it is in any one of several aspects in which it may be considered, experience as a whole is self-sustaining and leans upon nothing else."

The first essay applies the conception of empirical relation to the vexed question of the nature of the physical and psychical, things and consciousness. It propounds the radical, almost revolutionary, doctrine of pure experience which is prior to the distinction of mental and physical and wholly neutral as to the distinction. This room, as directly experienced, for example, is not in itself either physical or mental; it is just what it is as experienced; it is an experience. This experience, however, may enter, in its totality, into two different contexts, or may function in two different ways. When it enters into one context, that which we call the history of the house to which the room belongs, it becomes physical; to be taken in this kind of empirical relationship is, indeed, what

we mean by physical. As entering into the context of personal biography, it becomes mental or psychical. Taken in this relation, it is what is called consciousness, and it is all that consciousness is or means in experience. Thus the splitting up of experience into thing and mental state is not original, but is added to an experience as that enters into relations in different ways. Or, as Mr. James sums up the doctrine: "Consciousness connotes a kind of external relation, and does not denote a special stuff or way of being."

This doctrine is sufficiently thorough-going that it will occupy philosophers a long time while they digest and criticise it. But it has equally revolutionary attachments. Mr. James also holds that concepts, the world thought of, as well as the world perceived, is in its first presentation a matter of pure experience, in itself neither mental nor physical. We do not remember a memory, we do not imagine a fancy, we do not think a thought. We remember, imagine and think realities, bits of pure experience which as directly experienced are perfectly real. Only because of their subsequent history do these realities get split up, some of them forming, say, the world of ideal mathematical relations wholly objective in their ideality, and some the world of our purely mental reveries.

In the fifth essay, called "The Place of Affectional Facts in a World of Pure Experience," Mr. James makes a very interesting application of the doctrine of a pure experience to the matter of values and of appreciation. Emotions and affections are generally regarded as purely mental and subjective. At the same time naively we treat qualities of value as belonging not just to our feelings but to objects. We speak of a precious diamond, a fine day, a beautiful painting, a good man. Those committed to the doctrine of the purely subjective nature of such qualities regard this attribution of value-qualities to objects as a case of transfer or projection, and build up an elaborate machinery for objectifying the subjective. How much simpler and more direct, says in effect Mr. James, to take these qualities of value as realities, just as they are experienced, recognizing that they afterward become subjective or objective according as they act upon their neighbors in experience. The ambiguity of the qualities of appreciation—such qualities as hateful, lovely, good, evil, fine, ugly, precious, trivial—thus becomes a confirmation of the doctrine of pure experience. The doctrine itself saves us from the necessity either of making the values upon which ethics, aesthetics, and logic depend purely subjective and mental, or of calling in some transcendental, unexperienceable principle to give them validity. It would be hard to find a better illustration of the importance which Mr. James attached to the recognition of the complete reality of the empirical relations which the parts of experience bear to one another.

It is impossible to try in passing to give anything more than indications of the meaning of the principle of pure experience. But we cannot close without noting the classification of kinds of relations which is developed in the second and third essays, especially as this affords the systematic basis of the well-known pluralism of Mr. James. The usual procedure of philosophers, facing the problem of relations, has been

either (with the empiricists) to deny their reality altogether, or (with the rationalists) to resolve all things into a single closely knit system of relations, or some kind of all-inclusive absolute. Mr. James suggests the simple but almost revolutionary method of sticking to direct experience and recognizing that various types of relations exist which are incapable of resolution into one another, from the comparative externality and mutual indifference of space, mere coexistence, up to the intimacy and mutual interpenetration of our personal strivings. That the world arrived at by such a method is a much more loosely jointed thing than the world of orthodox realism or idealism, empiricism or rationalism, is indeed true. But what stands in the way of accepting the principle save an à priori prejudice that the whole universe must be made on a single uniform plan? It must also be noted that the same essay contains an application of the Jamesian conception of empirical relations to the explanation of the nature of knowledge—a theory which gives the foundation of his pragmatic theory of truth. It would not do to say that an adequate consideration of this foundation would convert Mr. James's critics, but it is not too much to say that it would put the whole controversy on quite a different basis from that on which it is usually conducted.

The review should not close without a recognition of the care and thoroughness with which the editor of the volume, Prof. Perry of Harvard, has done his work—an acknowledgment all the more due since he has kept this work in the background in the most objective way. It is impossible to estimate as yet what the fate of the Jamesian Radical Empiricism is to be. But this review has wholly failed of its purpose if it has not made clear the reviewer's conviction that Mr. James has opened a new road in philosophic discussion. He has compelled philosophers to rethink their conclusions upon many fundamental matters, because he has led them to a new mode of approach. Mr. James left the new philosophy in too undeveloped a state for it to win disciples wholesale; but the contribution of a new organ of vision and criticism is a more precious contribution than that of a complete system based upon any traditional point of view.

* * *

October 13, 1912

CONAN DOYLE'S STORY

Of Pterodactyls, Iguanodons, Dinosaurs, and Missing Links

THE LOST WORLD
By Sir Arthur Conan Doyle
Illustrated. George H. Doran Company. $1.25.

When Conan Doyle sat down to write "The Lost World" did he say to himself he would prove that Rider Haggard had not exhausted the possibilities of weird and amazing fiction? Or did he stick his tongue in his cheek and set out to write a

Sir Arthur Conan Doyle

caricature of novels of adventure? Or did he just simply take all the strings off that scientific imagination of his and let it riot unrestrained with his central idea? Whatever his purpose, he has produced a highly interesting tale of outlandish adventure of a sort to stir the pulses and arouse the wonder of even the "jaded" novel reader. For he goes back of the hintermost beyond of man's knowledge, and has his little company of twentieth century scientists and adventurers test their courage and their skill against the huge and loathsome beasts of the Jurassic period. They fight for their lives with pterodactyls, see iguanodons at play, and watch the tragedies of life among gigantic dinosaurs. And finally, as the climax of their nightmareish experiences, they come upon a tribe of man-apes, missing links, and for a time it looks as if the twentieth century would go down before the survivals of antiquity.

The author's passion for detail, and his skill in handling it, together with his exact scientific knowledge, make it all seem not only possible but perfectly real. His pterodactyls and his dinosaurs and even his missing links are, indeed, rather more real and convincing than his two scientists, who are portrayed with broad and humorous caricature. The easy, plausible steps by which he leads up to the starting of the expedition and the realistic and amusing account of the public meeting in London at which it has its inception are all skillfully done and serve their purpose perfectly. But one can hardly say the same of the ending of the tale, where, in order to preserve the color of actuality, Sir Arthur has overreached himself and

stumbled into an anti-climax. After the returned party has turned a young pterodactyl loose in a London lecture hall it is something of a jar for the reader to be taken aside and be shown a cigarbox full of diamonds. Such prizes have been the purpose, the excuse, the climax, of tales of adventure time out of mind, and they look commonplace enough at the end of such experiences as this party had gone through and beside such loot as they had brought back.

Whether or not Sir Arthur meant to satirize fiction of adventure in general he surely wrote with the satiric mood strong upon him. The little touch of young ladydom at the beginning and the end is a delicious bit of irony. The feud between Prof. Challenger and Prof. Summerlee, the two scientists of the expedition, is made to yield a constant stream of broad satiric humor. Challenger himself, a burly, black-bearded, violent-tempered, Bashan-bull sort of a man, is a distinctive creation, although he is a caricature rather than a character. But he is always amusing. More interesting, because approaching nearer the true type, is the character of Lord John Roxton, explorer and mighty hunter, who joins the expedition because "this huntin' of beasts that look like a lobster supper dream" promises "a brand-new sensation." It is to be hoped that we have not heard the last of Lord John, that, indeed, he may succeed Sherlock Holmes in Conan Doyle's affections.

* * *

November 10, 1912

DREISER'S NOVEL

The Story of a Financier Who Loved Beauty

THE FINANCIER
By Theodore Dreiser
Harper & Brothers.

Theodore Dreiser's new novel, "The Financier," shows all of the faults and peculiarities of method that gave a rude barbarous sort of distinction to his "Sister Carrie" and "Jennie Gerhardt," those arresting tales of yesteryear. The man does not write as the other novelists of his day and generation write, and, what is more, he does not seem to make any effort to do so, or to have any feeling that such an effort would be worth while. You may read him for page after page, held spellbound by his people and their doings, and yet not find a single pretty turn or phrase, or a single touch of smartness in dialogue, or a single visible endeavor to stiffen a dull scene into drama, or any other such application of artifice or art.

For all the common tricks of writing, in truth, he reveals a degree of disdain amounting almost to denial. He never "teases up" a situation to make it take your breath; he never hurries over something difficult and static in order to get to something easy and dynamic; he never reads you into ambus-cades of plot or sets off stylistic fireworks; he never so much as takes the trouble to hunt for a new adjective when an old one will answer as well. In brief, his manner is uncompromisingly forthright, elemental, grim, gaunt, bare. He rolls over the hills and valleys of his narrative at the same patient, lumbering gait, surmounting obstacles by sheer weight and momentum, refusing all short cuts, however eminently trod, as beneath his contempt, and turning his back resolutely upon all the common lifts by the way.

But do I give the impression that the result is dullness, that all this persistent, undeviating, effort leads to nothing but a confused and meaningless piling up of words? Then I have described it very badly, for the net effect is precisely the opposite. Out of chaos, by that unceasing pounding, order finally emerges. Out of the disdain of drama comes drama stirring and poignant. Out of that weiter of words step human beings, round, ruddy, alive. In other words, Dreiser accomplishes at last, for all his muddling, what men with a hundred times his finesse too often fail to accomplish, and that is, an almost perfect illusion of reality. You may say that he writes with a hand of five thumbs, and that he has no more humor than a hangman, and that he loves assiduity so much that he often forgets inspiration altogether, and you may follow up all of these sayings by ample provings, but in the end you will have to admit that Carrie Meeber is far more real than nine-tenths of the women you actually know, and that old Gerhardt's veritable existence is no more to be doubted than the existence of Pere Goriot.

If "The Financier," on a first reading, leaves a less vivid impression than the two books preceding it than that apparent falling off is probably due to two things, the first being that its principal character is a man and that in consequence he must needs lack some of the fascinating mystery and appeal of Carrie and Jennie; and the second being that the story stops just as it is beginning, (for all its 780 pages!) and so leaves the reader with a sense of incompleteness, of a picture washed in but not wholly painted. Final judgment, indeed, will be impossible until the more important second volume is put beside this first, for it is there that the real drama of Frank Cowperwood's life will be played out. But meanwhile there can be no doubt whatever of the author's firm grip upon the man, nor of his astute understanding of the enormously complex interplay of personalities and events against which the man is projected.

This Cowperwood is meant, I suppose, to be a sort of archetype of the American money king, and despite a good many little deviations he is probably typical enough. The main thing to remember about him is that he is anything but a mere chaser of the dollar, that avarice as a thing in itself is not in him. For the actual dollar, indeed, he has no liking at all, but only the toleration of an artist for his brushes and paint-pots. What he is really after is power, and the way power commonly visualizes itself in this mind is as a means to beauty. He likes all things that caress the eye—a fine rug, an inviting room, a noble picture, a good horse, a pretty woman, particularly a pretty woman. There is in him what

might be called an aloof voluptuousness, a dignified hedonism. He is not so much sensual as sensitive. A perfect eyebrow seems to him to be something worth thinking about, soberly and profoundly. The world, in his sight, is endlessly curious and beautiful.

And with this over-development of the esthetic sense there goes, naturally enough, an under-development of the ethical sense. Cowperwood has little more feeling for right and wrong, save as a setting or a mask for beauty, than a healthy schoolboy. When a chance offers to make a large sum of money by an alliance with political buccaneers, he takes it without the slightest question of its essential virtue. And when, later on, the buccaneers themselves lay open for pillage, he pillages them with a light heart. And as with means, so with ends. When Aileen Butler, the daughter of his partner and mentor, old Edward Malia Butler, the great political contractor—when Aileen comes his way, radiant and tempting, he debauches her without a moment's thought of consequences, and carries on the affair under old Butler's very nose.

The man is not vicious: a better word for him would be innocent. He has no sense of wrong to Aileen, nor of wrong to Butler, nor even of wrong to the wife of his youth. The only idea that takes clear form in his mind is the idea that Aileen is extremely pleasing, and that it would be a ridiculous piece of folly to let her charms go to waste. Even when he is the conquered instead of the conqueror, not much feeling that an act of conquest can have a moral content appears in him. Old Butler, discovering his affair with Aileen, knocks over his financial house of cards and railroads him to prison, but he shows little rancor against Butler, and less against the obliging catchpolls of the law, but only a vague discontent that fate should bring him such hardships and take him away from beauty so long.

This term in prison is a salient event in Cowperwood's life, but it cannot be said that it is a turning point. He comes out into the Philadelphia of the early seventies with all his old determination to best the game. He has been defeated once, true enough, but that defeat has taught him a lot that easy victory might have left unsaid, and he has full confidence that he will win next time. And win he does. Black Friday sees him the most pitilessly ursine of bears, and the next day sees him with a million. He is now on his feet again and able to choose his cards carefully and at leisure. With the utmost calm he divorces his wife, tucks Aileen under his arm, and sets out for Chicago. There, where the players are settling down for the wildest game of money ever played in the world, he will prove that luck in the long run is with the wise. And there, in the second volume of this history, we shall see him at the proving.

An heroic character, and not without his touches of the admirable. Once admit his honest doubts of the workaday moralities of the world, and at once you range him with all the other memorable battlers against fate, from Prometheus to Etienne Lantier. The achievement of Dreiser is found in this very fact: that he has made the man not only comprehensible, but also a bit tragic. One is conscious of a serene dignity in his chicaneries, and even in his debaucheries, and so his struggle for happiness becomes truly moving. I am not alluding here to that cheap sympathy which is so easily evoked by mere rhetoric, but to that higher sympathy which grows out of a thorough understanding of motives and processes of mind. This understanding Dreiser insures. Say what you will against his solemn and onerous piling up of words, his slow plodding through jungles of detail, his insatiable just for facts, you must always admit that he gets his effect in the end. There are no sudden flashes of revelation; the lights are turned on patiently and deliberately, one by one. But when the thing is done at last the figure of the financier leaps out amazingly, perfectly modeled, wholly accounted for.

So with the lesser personages, and particularly with Aileen and her father. Old Butler, indeed, is worthy to stand just below the ancient Gerhardt, by long odds the most real of Dreiser's creatures, not even excepting Carrie Meeber and Hurstwood. You remember Gerhardt, of course, with his bent back, his squirrel's economies, his mediaeval piety and his pathetic wonderment at the deviltries of the world? Well, Butler is a vastly different man, if only because he is richer more intelligent, and more powerful, but still, in the end, he takes on much of that reality and all of that pathos, raging homerically but impotently against an enemy who eludes him and defies him and has broken his heart.

And so, too, with the background of the story. I can imagine nothing more complex than the interplay of finance and politics in war time and during the days following, when the money kings were just finding themselves and graft was just rising to the splendor of an exact science. And yet Dreiser works his way through that maze with sure steps and leaves order and understanding where confusion reigned. Of tales of municipal corruption we have had a plenty; scarcely a serious American novelist of to-day, indeed, has failed to experiment with that endless and recondite drama. But what other has brought its prodigal details into better sequence and adjustment, or made them enter more vitally and convincingly into the characters and adventures of his people. Those people of Dreiser's, indeed, are never the beings in vacuo who populate our common romances. We never see them save in contact, with a vivid and fluent environment, reacting to its constant stimuli, taking color from it, wholly a part of it.

So much for "The Financier." It is the prologue rather than the play. The real tragi-comedy of Cowperwood's struggle for power and beauty will be played out in Chicago, and of its brilliancy and mordacity we have abundant earnest. Dreiser knows Chicago as few other men know it; he has pierced to the very heart of that most bewildering of cities. And, what is more, he has got his secure grip upon Cowperwood.

H. L. MENCKEN

* * *

March 23, 1913

MR. MUIR AND SPRING

Famous Naturalist's Autobiography a Seasonable Book

THE STORY OF MY BOYHOOD AND YOUTH
By John Muir
Houghton Mifflin Company. $2.00.

By JOYCE KILMER

Now that Spring is close at hand, wild Nature seems more than ever desirable to the captive of the city. Life should be spent, it seems, where the gay colors of the young season show not in haberdashers' windows but in meadow and forest; where the odor of April, unmarred by smoke and dust, rises sweet and strong. But even for the desk-fettered there is some balm. A kindly magician has put all outdoors between the green covers of a book. John Muir's "The Story of My Boyhood and Youth" is as invigorating as the wind that blows from the North Sea through his native village on the coast of Scotland.

The title of Mr. Muir's book is a misnomer, for in it he tells of only the first twenty years of his life. Youth is a period from which he has never emerged, as all who know the fresh adventurous spirit of his writings can testify. This is merely the story of his first twenty years of youth.

Mr. Muir has three qualifications for autobiographical writing. The first is the youthfulness already mentioned, which enables him to write of boyhood not as a thing seen but as a thing felt. The second is the trained observation of a scientist, which makes him interpret the events of his early life in Scotland and Wisconsin by the light of later experience. The third is his power over words, his simple, exact, illuminating style.

The story is of such absorbing interest that the details of the narrator's skill are, as they should be, hidden. One instance is enough to show his careful phrasing. He is telling of the discovery of a field-mouse and her young. He has to describe the sound made by the field-mouse. Shall he call it shrill, or piercing? Neither of these words is sufficiently descriptive. It is "a sharp, prickly, stinging cry!" And later, with Greek felicity in combining words, he speaks of "the needle-voiced field mouse":

When I was a boy in Scotland I was fond of everything that was wild, and all my life I have been growing fonder and fonder of wild places and wild creatures.

So, this record of his thoughts and acts, while it tells much of his parents, his schoolmates and his neighbors, tells even more of the dogs, woodpeckers, pigeons, turtles, horses, cows, and other creatures that were his intimate friends.

The Scotland of his boyhood was a stern, bleak place, but it could not crush his gay young spirit. The parental command to play at home in the garden could not keep him, always a lover of nature, from the delights of field and seashore. The seashore, however, was not solely a place of recreation. He describes vividly being taken by a servant, when he was between two and three years old, to a deep pool in the rocks and plunged down, gasping and shrieking, among "crawling crawfish and slippery, wriggling snake-like eels." In a few years he learned to associate the seashore with other things than compulsory bathing, and spent many joyous hours swimming, fishing and exploring. In school the system which produced in most cases splendid results savored not at all of Froebel or Montessori. The master assigned the lessons, explained them, and insisted that they be learned—that was all.

If we failed in any part, however slight, we were whipped; for the grand, simple, all-suffering Scotch discovery had been made that there was a close connection between the skin and the memory and that irritating the skin excited the memory to any required degree.

But the days of a Scotch boy were not exclusively devoted to studying and being beaten. There were trees and garden walls to climb, strenuous, muscle-testing games to be played, larks, crows, gulls, solan-geese and foxes to know. Muir took part in great battles with snowballs, fists, and clods, shot slugs of lead from cannon made of gaspipe and joined his friends in twenty-four-mile races over the hills. No modern diet reformer advocates simpler eating than that of the children of that place and time. Breakfast was a wooden dish of oatmeal porridge, with a little milk or treacle. Dinner consisted of vegetable broth, a little boiled mutton, and barley-meal scones. For "tea" there were half a slice of white, unbuttered bread, barley scone, and "content." This beverage was made by adding a little milk and sugar to warm water. A boiled potato with a piece of the inevitable barley scone made the usual supper.

It was a fortunate chance that turned the thoughts of Muir's father to America, the country of vast spaces and fertile soil, of gold mines and trees that bled sugar. The young naturalist needed to see the wonders of the New World, to know birds and beasts unheard of in Scotland. The Muir family settled in a clearing by the side of a lake in a Wisconsin forest. Even before Muir had entered the new house he found a bluejay's nest and climbed a tree to look at the birds and their gay green eggs. Other discoveries followed, frogs, snakes, and turtles in the creeks, woodpeckers boring round holes in century-old trees, whippoor-wills shouting their strange command, and lightning bugs flashing across the dusky meadows.

Everything about us was so novel and wonderful that we could hardly believe our senses, except when hungry or while father was thrashing us.

Mungo Siddon and the grammar school were a thousand miles away, but tasks more severe than spelling and calculating were at hand. First the land was to be cleared for the plow by the burning of the brush that covered it. Then came plowing, hauling, sowing, and all the arduous labors of creating a farm in the wilderness. Muir rose at four in Summer, ground

scythes, fed the animals, chopped stove wood, and brought in water from the spring until breakfast time. Dinner came after a morning in the hay-field. Supper did not mark the close of the day's work, for there were "chores," to be done, extending the working day to sixteen or seventeen hours. He arose later in Winter, but his time was no less filled with constant, exhausting work. One task that came after the new "Hickory Hill House" was built was the digging of a well ninety feet deep, of which eighty were through fine-grained sandstone. In the morning Muir was lowered in a wooden bucket and left to chip away with mason's chisels all day, being lifted out for dinner. But these exacting duties could not keep this born naturalist from enthusiastic enjoyment of his surroundings. Page after page of this frank record is filled with tales of Buck, the ox who crushed pumpkins with his head and opened the gate into the cornfield; of Jack, the Indian pony, who carried young Muir on many a wild journey bareback through the forest and brought in the cows from the pasture like a shepherd dog; of Nob, the wise, strong workhorse. Here are vivid memories of yellow frogs pursued by green-striped snakes; of sunfishes plowing the gray mud of the lake bottom with their noses to make round bowls for their eggs; of lady-slippers, goldenrod, asters, and daisies coloring the fields and woods. Now he swims among the lily-stems, now he shoots hawks, muskrats, and wild geese. He sees moccasined Indians running over the snow after deer, he visits Mr. McRath and his pet coon. This is an excellent text-book of the flora and fauna of old Wisconsin, for in it are descriptions, graphic and interesting, of all the birds and beasts and trees and flowers within twenty miles of the Muir homestead.

Farming of the most difficult sort and the study of nature were not sufficient occupation for this extraordinarily energetic mind. In spite of the displeasure of his Calvinistic father, who said "the Bible is the only book human beings can possibly require throughout all the journey from earth to heaven," young Muir, who had not been to school since he left Scotland eight years before, devoted his few minutes of leisure to mathematics and grammar and to reading Josephus's "Wars of the Jews," D'Aubigne's "History of the Reformation," Plutarch's "Lives" and the novels of Sir Walter Scott. He grew to appreciate poetry and stole many happy minutes with Milton, Shakespeare, Cowper, and Campbell. In order to indulge his passion for mechanics, he secured permission from his father to rise earlier than the rest of the family, and for a year he left his bed daily at 1 o'clock in the morning and spent the hours before breakfast making water-wheels, latches, thermometers, barometers, and self-setting sawmills. He had never seen the inside of a clock or watch, but he had learned from a book the time-laws of the pendulum. So he completed, in all, three clocks of which the works were entirely of wood. One of these told not only the hour and minute, but the day of the week and the day of the month. "Though made more than fifty years ago," writes Mr. Muir with pardonable pride, "it is still a good time-keeper." Another of his inventions was a thermometer three feet long, so sensitive that the heat radiated from the body of any one approaching within four or five feet of it

caused the hand of the dial to move so fast that the motion was plainly visible.

A neighbor's praise of these remarkable contrivances led Mr. Muir to take them to the State Fair at Madison. With $15 in his pocket and two clocks and the thermometer on his back, he set out from the farm. The ticket agent at the fair grounds looked at his strange burden and at once admitted him, and the professor from the University of Wiscosin, who was in charge of Fine Arts Hall, received him courteously and had his clocks and thermometer given a prominent place among the exhibits. Naturally these things attracted the attention of a curious crowd, and the Scotch plowboy found himself at once a public character. He was given a position in a machine shop in Prairie du Chien, which he left to work his way through the University of Wisconsin. There his career was like that of many another industrious youth from a farm, except that his mechanical genius asserted itself in the invention of a desk which automatically pushed before him and opened the book first to be studied in the morning, closed it after a fixed number of minutes and substituted the next in order. After four years he graduated, leaving, as he says, "the Wisconsin University for the University of the Wilderness."

The succeeding volumes of Mr. Muir's autobiography may be richer in scientific interest, they may deal with famous people and events. To this book, however, belongs a singular charm, the charm of brilliant, adventurous and wholesome boyhood—boyhood spent among the great forests and broad plains of a land that had not yet learned the weary lesson of civilization.

* * *

April 6, 1913

THE ADVENTURE OF LIFE

YOUTH AND LIFE
By Randolph S. Bourne
Houghton Mifflin Company. $1.50 net.

To take up this volume of essays by Mr. Bourne is like turning from the dust and hurly-burly of a high road into the fragrance and living shade of a woodpath. Not that it is removed from life, but it leads away from racket and confusion to what is beautiful, steadfast, and gentle; it gives an opportunity to understand the ways and uses of the high road itself, and provides a short cut to the ideal goal of that road.

A number of these papers have appeared in The Atlantic Monthly, but these have been enlarged, and others have been added, so that the volume is practically new. Even if it were not, those who have become acquainted with Mr. Bourne's work will be glad to have it in a permanent form. Though he is but 23 years old, the exigencies of life have so worked in him that his mind is singularly ripe and balanced, without any loss of that "vision splendid" which belongs to youth. Both his questions and his answers concerning "The Adventure of Life" are interesting and important. He questions the world

and his relations to it with utter sincerity and courage, and such solutions as he brings are modern and radical without being hysterical or crude. He tells us:

> It is the glory of the present age that in it one can be young. Our times give no check to the radical tendencies of youth. On the contrary, they give the directest stimulation. A muddle of a world and a wide outlook combine to inspire us to the bravest of cadicalisms. Great issues have been born in the last century, and are now loose in the world. . . . Our elders are always optimistic in their views of the present, pessimistic in their views of the future; youth is pessimistic toward the present and gloriously hopeful for the future. And it is this hope which is the lever of progress.

Particularly delightful is the essay on "Virtues and the Seasons of Life," with its interpretation of the child's point of view and sensations:

> The natural child seems to be impregnable to any appeals of shame, honor, reverence, honesty, and even ridicule—in other words, to all those methods we have devised for getting a clutch on other people's souls, and influencing and controlling them according to our desires. And this is not because the child is immoral, . . . but because these social values mean as yet nothing to him. He lives in splendid isolation from our conventional standards, . . . unconscious of our interests and motives. . . . Even obedience, which we all like to think of as one of the indispensable accomplishments of the well-trained child, seems to be obtained at the cost of real moral growth. . . . Trust life, and not your own feeble efforts, to create a soul in the child.

There is a good deal of whimsical humor to be found in these papers, as where we are assured that "Your eccentric man par excellence is your perfectly conventional man, who never offends in the slightest way by any original action or thought." A thesis which Mr. Bourne proves in the succeeding paragraph to be the sanest truth. Indeed, as one studies these pages, one is constrained to agree for the thousandth time that nothing is so removed from sober common sense as the conventions and traditions of society. Be thoroughly sensible, simple, and sincere in your attitude, and you will strike the ordinary observer as a being beyond the horizon of the astonishing.

The last article is both touching and full of a deep insight. It in some sort explains the arresting breadth and sympathy of Mr. Bourne's conception of men and things, and contains, besides, a great comfort. For who among us is not handicapped in the battle we have to fight or to endure, and who will not be glad of the measure of peace and courage which is offered in "The Philosophy of Handicap"?

* * *

May 25, 1913

A POLITICAL MYSTERY

Senator La Follette Reveals Much Curious Unwritten History Growing Out of His Dealings with Col. Roosevelt

LA FOLLETTE'S AUTOBIOGRAPHY: A Personal Narrative of Political Experiences
By Robert M. La Follette
Madison. Wis.: The Robert M. La Follette Co. $1.50.

By CHARLES WILLIS THOMPSON

A mist has always hung over the political history of the year preceding Theodore Roosevelt's declaration of his candidacy for President on Feb. 26, 1912. The conferences in Washington among the Progressive leaders, ending in Senator La Follette's appearance as a candidate; the subsequent rumors about Mr. Roosevelt's intentions, growing stronger and stronger, until the demand made for his candidacy by the seven Governors; the contradictory reports about the relations of the Progressives with each other, including the story that Senator La Follette had withdrawn from the race because of a physical breakdown, and all the other confused news reports of that hectic year, were obviously only surface outcroppings of something that was going on very busily and industriously under the surface. The veil has never been lifted. Senator La Follette now lifts it.

The story is not complete, but it is complete so far as he can make it, for he tells everything that he knows about it in the last part of his autobiography. It could be made complete if Mr. Roosevelt would tell his side. For, it is not to be expected that Senator La Follette, chafing under a bitter sense of wrong, would be strictly impartial in his account of it. All that could be expected is that he should tell his side of the case—and that he has done with a savage frankness.

He tells it as a story of betrayal and broken faith. . . . He believes that Mr. Roosevelt, with deep craft, encouraged him to be a candidate in 1911, so that he could "put forth another man and feel out the Taft strength," and then throw him over. This is not Mr. Roosevelt's way. Most readers will be astonished to learn that Senator La Follette actually believes he might have been nominated in 1912 if Col. Roosevelt had not entered the race. . . .

His story goes back to the time of Col. Roosevelt's return from Africa, when no one knew how he was going to line up in the fight between Mr. Taft and the insurgents. La Follette visited him at Oyster Bay on June 27, 1910. . . .

Mr. La Follette explained the grounds of the insurgent opposition to Mr. Taft, showing him how Mr. Taft had fallen into the arms of Senator Aldrich, and "Roosevelt's only comment was that 'sometimes a man makes a very good Lieutenant but a poor Captain.'"

In the beginning of 1911 the Progressive Senators and Representatives held many conferences, Senator La Follette says, and all favored bringing out a candidate against Mr.

Taft. Col. Roosevelt was not a participant in these conferences, but he "caused it to be known" through friends who were, that "while he was at last hostile to President Taft, he was not in favor of opposing his renomination." These friends were Messrs. Gifford Pinchot, E. A. Van Valkenberg, manager of the Philadelphia North American, and Gilson Gardner, a Washington correspondent. They told the Progressives that Col. Roosevelt was confident that President Taft could not be beaten for the nomination, and that even if he could, 1912 was sure to be a Democratic year; "that, therefore, he would prefer to see Taft renominated without opposition and beaten at the polls". . . .

It is here that Senator La Follette begins to interpret Col. Roosevelt's mental processes, and to depict him as craftily resolving to "put forth another man, and feel out the Taft strength." In the Spring of 1911, he says, Mr. Gardner came from Oyster Bay bearing "a most important message." He says that Col. Roosevelt had changed his mind, believed that the Progressives should put forth a candidate, "that I should be that candidate, and that I should get into the fight at once."

It may not be quite within the ordinary province of a book review, but Mr. Gardner tells me that Senator La Follette is mistaken in thus giving the impression that it was Col. Roosevelt who induced him to become a candidate. The Scripps newspapers, by whom Mr. Gardner is employed, wished to support a Progressive candidate. Mr. Gardner inquired of Senator La Follette if he were a candidate, and was assured that he was. Mr. Gardner then went to Col. Roosevelt, he says, to ask him if he would object to Senator La Follette's candidacy, and Col. Roosevelt replied that he had "no objection," but Mr. Gardner could not get him to promise to come out for Senator La Follette. Mr. Gardner carried this information to Senator La Follette, who wanted to be assured that Col. Roosevelt himself would not be a candidate. Mr. Gardner could give no such pledge, and Senator La Follette replied, "Well, if he does, damn him, I'll fight him". . . .

Such is Mr. Gardner's version, as given to me a few days ago. It seems more in harmony with Col. Roosevelt's usual way of doing things, and with his subsequent course, than Senator La Follette's account and Senator La Follette's theory of his mental processes.

On April 30 a final conference of the Progressives was held in Washington, at which Senator La Follette was decided upon as the candidate. . . .

Senator La Follette opened his campaign in July, 1911. A Progressive conference was held in Chicago on Oct. 16, at which he was indorsed, although the indorsment was opposed by Mr. Roosevelt's representative, James R. Garfield. About this time Senator La Follette noticed more and more talk in different localities about Col. Roosevelt as a possible candidate, and he wanted a statement from the latter that he would not be one, but this Messrs. Gardner and Pinchot said he would not give. Mr. Houser, the campaign manager, proposed that a letter be written to Mr. Roosevelt which would compel him to answer definitely, and two or three drafts were made, but it was found that they could not be so worded as to avoid contingently pledging Senator La Follette to support him if he should become a candidate. And Senator La Follette told his associates "that if I were brought face to face with the question for final decision, I was not prepared to say that I would accept him as a Progressive candidate, or could even support him if he were nominated." It is plain, in fact, that he would not have supported him.

Hearing of this, Mr. Pinchot called on Senator La Follette to tell him that "there must be no break with Roosevelt; that should one come, he and the other two [Gardner and Medill McCormick] had decided that they would go with Roosevelt." Senator La Follette gave Mr. Pinchot his reasons for believing that Col. Roosevelt was going to be a candidate, and Mr. Pinchot replied:

But suppose you are right about it, and Roosevelt comes out as a candidate, what can you do? You must know that he has this thing in his own hands and can do whatever he likes.

Senator La Follette retorted by warning Mr. Pinchot that if Col. Roosevelt did run, "he will be confronted with his record, which is not that of a Progressive." Two days later Mr. Roosevelt invited Senator La Follette's manager, Mr. Houser, to meet him, but Senator La Follette would not permit it because, he says, he "was unwilling that there should be any beaten pathway between my headquarters and Mr. Roosevelt's offices," for fear that a relationship between the two men might be predicated upon it. Two of the Progressives, however, visited Col. Roosevelt with Mr. Gardner, and reported to Senator La Follette that Mr. Roosevelt would not make any announcement that he would not be a candidate: "that if it were found in the convention that I could not make it, then he might come in; but that 'under no circumstances ought we to permit the wires to be crossed' or any division or contention come between our friends in the campaign."

Senator La Follette then made a speaking tour with a success which convinced him that his candidacy was prospering; but at that very time, he says, Col. Roosevelt wrote to Gov. Johnson of California saying "in substance" that it was necessary "that I should be set aside," and suggesting that Gov. Johnson "would make an admirable candidate for Vice President." He then recounts the various desertions of leading Progressives from him to Col. Roosevelt, which early in January became quite a stampede. The situation was so mixed, he says, "that doubt and confusion prevailed everywhere, outside of the little circle of which Roosevelt was the centre". . . .

On Jan. 20 Mr. Cummins declared his candidacy, and Senator La Follette bitterly comments, "Nothing weighs lighter than a promise."

Two days earlier there was another Washington conference, at which Mr. Pinchot urged that the two wings combine, but the proposition was not accepted, and Senator La Follette believed that the whole matter was settled. But on Jan. 29 Mr. Pinchot called another conference, at which Sen-

ator La Follette was asked by Mr. Pinchot, his brother, Mr. Gardner, and Medill McCormick to withdraw from the race. He refused to do so.

On Feb. 2 came Senator La Follette's failure with his speech at the Periodical Publishers' banquet in Philadelphia. He was ill, but he says that a week's rest put him in shape again. But in the meantime his illness had been made an excuse for supporting Mr. Roosevelt, and it was reported that he had broken down completely. On Feb. 26 Mr. Roosevelt declared his candidacy.

If Senator La Follette's story does not make out quite such a black record of treachery as he believes it does, it is at least a mighty interesting contribution to history, and it clears up to a great extent the mystery that has hung over that cloudy year. Because of its historical interest we have dwelt on this part of his autobiography to the exclusion of the earlier chapters. The rest of the book is extremely interesting as a record of a long, gallant and single-handed fight. . . . Its account of his solitary battle in Wisconsin and of the formation of the Progressive group in the Senate makes a great story.

* * *

June 5, 1913

AMUNDSEN'S BOOK

An ancient Norseman's saga sung in the language of the twentieth century . . .—such is Roald Amundsen's book, "The South Pole: An Account of the Norwegian Antarctic Expedition in the Fram, 1910–1912."

. . . There are some half-dozen heroes to be found in the pages of this stirring narrative of discovery. But the figure that tops them all is the modest, big-hearted explorer, who shoulders the responsibilities and shares the privations of the expedition, and who generously lets his comrades come in first at the goal of his own ambition. . . .

The story of the discovery of the south pole—just as Amundsen's account of his discovery of the Northwest Passage—is essentially a human story. A record of adventure untouched by the darkening clouds of tragedy. . . . And yet the picture is not without its sombre shadow at times. On one of his preliminary sallies southward to the pole, from the Winter camp at Framheim, Amundsen tells how, on reaching 82 degrees south, the five dogs accompanying him showed signs of succumbing under the strain of their terrible journey:

They were completely worn out, poor beasts. This is the only dark memory of my stay in the South—the overtaxing of these fine animals—I had asked more of them than they were capable of doing. My consolation is that I did not spare myself either. To set this sledge, weighing nearly half a ton, in motion with tired-out dogs was no child's play. And setting it in motion was not always the whole of it; sometimes one had to push it forward until one forced the dogs to move. The whip had long ago lost its terrors. When I tried to use it they only

crowded together, and got their heads as much out of the way as they could; the body did not matter so much. . . .

Without his dogs, as he calculated the chances and perils of the expedition, the south pole would have been unattainable for Amundsen. He contrasts his pack of ninety-seven, the number which he took with him from Christiania, with Scott's equipment of Manchurian ponies, the animals preferred to dogs for exploration in the antarctic by the leader of the British expedition.

Although I had never seen this part of the antarctic regions, [comments Amundsen,] I was not long in forming an opinion diametrically opposed to that of Shackleton and Scott, for the conditions both of going and surface were precisely what one would desire for sledging with Eskimo dogs, to judge from the descriptions of these explorers. If Peary could make a record trip on the arctic ice with dogs, one ought, surely, with equally good tackle, to be able to beat Peary's record on the splendidly even surface of the Barrier. . . .

. . . Certainly events have proved the admirable foresight shown by Amundsen in choosing dogs as his main reliance in carrying the final exploring party from Framheim, the Winter headquarters of the expedition, on their overland journey of 870 miles to the south pole. When this party set out, on Oct. 20, 1911, it consisted of five men, four sledges, provisions for four months, and fifty-two dogs. On Jan. 25, 1912, the five men reached Framheim on the return trip, with two sledges and eleven dogs, "men and animals all hale and hearty." Considering the amazing thing that had been accomplished in this period of three months and five days, it is extraordinary that there were any dogs left at the home-coming. . . .

No one could have reached the south pole in any other way, the reader is apt to assure himself after following Amundsen's account of the great exploit. And it is the details of it all, especially the preliminary details—the homely life of these Norwegian giants during the waiting Winter months at Framheim—that seem to make it so easily and logically possible. Apparently there is never any depression of spirits, any weariness, ennui, among these companions in adventure. The atmosphere of camaraderie is exhilarating. . . .

The hut in which the party lived at Framheim was carried from Norway to its destination on the shore of the Bay of Whales, at the edge of the "Great Ice Barrier." It resembled "an ordinary Norwegian house, with pointed gable, and had two rooms." One of these was the dormitory and living room, nineteen and a half feet long; the other served as kitchen, six and a half feet long, with a loft for the storage of provisions. A coat of tar was given the outside of the hut, the roof of which was covered with tarred paper. . . .

. . . It was a happy party that assembled in the hut the first evening, and drank to the future to the music of the

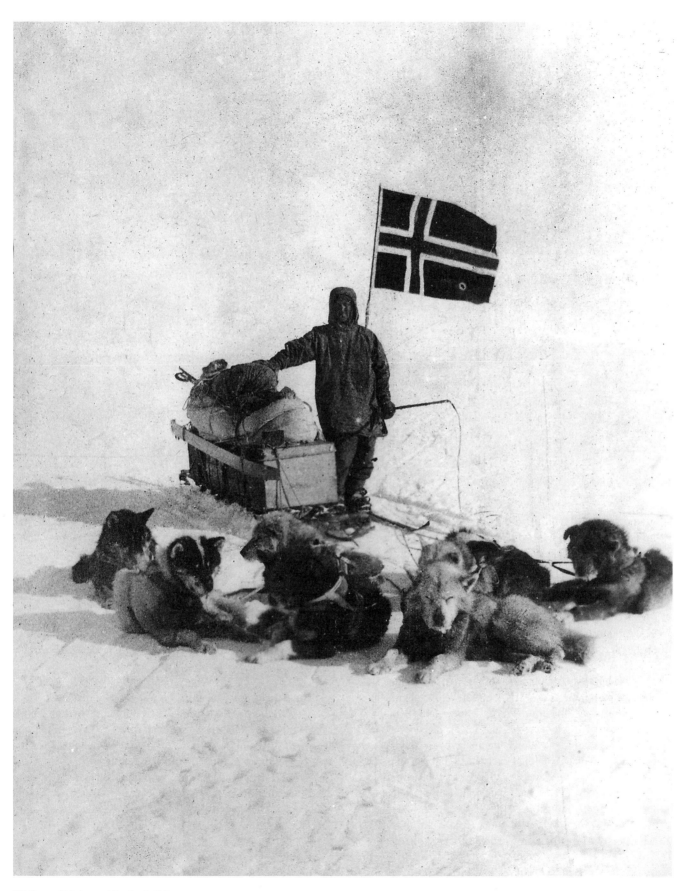

Wisting and his team at the South Pole.

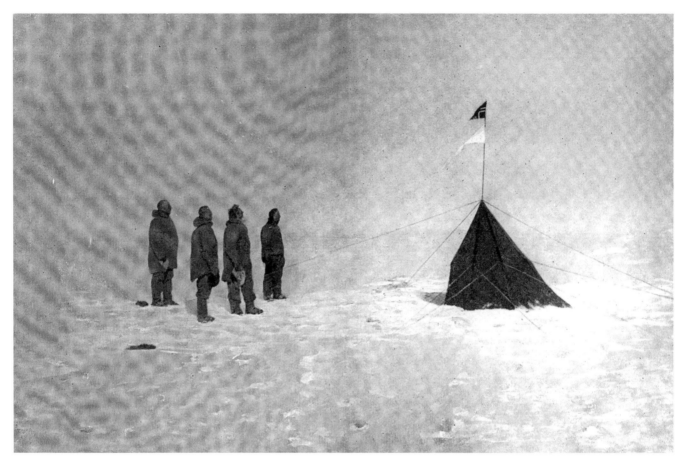

Bidding good-bye to the South Pole.

gramophone. All the full-grown dogs were now brought up here, and were fastened to wire ropes stretched in a square, fifty yards on each side. It may be believed that they gave us some music. Collected as they were, they performed, under the leadership of some great singer or other, daily, and, what was worse, nightly concerts. . . .

. . . Amundsen quotes a day from his diary—March 25— to give a picture of life at Framheim:

Our seal hunters were out this morning and brought back three seals. This makes sixty-two seals altogether since their return on March 11. We have now quite enough fresh meat both for ourselves and for all our dogs. We get to like seal steak more and more every day. We should all be glad to eat it at every meal, but we think it safer to make a little variety. . . . Every Saturday evening a glass of toddy and a cigar. I must frankly confess that I have never lived so well. And the consequence is that we are all in the best of health, and I feel certain that the whole enterprise will be crowned with success.

In this way Amundsen and his party lived for nearly nine months, counting the weeks until the right season would give them the start on their great undertaking. . . . And then, the

long-expected day came, Oct. 19, ushering in the Springtime of the antarctic. The departure of the five adventurers was typically simple.

. . . Our coursers were harnessed in a jiffy, and with a little nod—as much as to say, "See you to-morrow"— we were off. . .

There were five of us—Hanssen, Wisting, Hassel, Bjaaland, and myself. We had four sledges, with thirteen dogs to each. . . .

Once under way, the dogs became the engrossing topic of interest to the travelers. It was a veritable survival of the fittest among these hardy animals, and nearly every night one or more of them—usually those that were not fitted for the task given them—dropped out, or was killed. . . .

Arrived at the first of the great polar plateaus, the party was "weather-bound" for four days. And it was here that the tragic slaughter of twenty-four dogs, decided upon days before, took place:

We had agreed to shrink from nothing in order to reach our goal. Each man was to kill his own dogs to the number that had been fixed.

The pemmican was cooked remarkably quickly that

evening, and I believe I was unusually industrious in stirring it. There went the first shot. I am not a nervous man, but I must admit that I gave a start. Shot now followed upon shot—they had an uncanny sound over the plain. A trusty servant lost his life each time. . . .

And then came the momentous day—Dec. 9, five days before the pole was reached—when the "Furthest South" was passed.

We had a great piece of work before us that day: nothing less than carrying our flag further south than the foot of man had trod. We had our silk flag ready; it was made fast to two ski sticks and laid on Hanssen's sledge. I had given him orders that as soon as we had covered the distance to 88 degrees 23 minutes south, which was Shackleton's furthest south, the flag was to be hoisted on his sledge. It was my turn as forerunner, and I pushed on. . . . I had long ago fallen into a reverie—far removed from the scene in which I was moving; what I thought about I do not remember now, but I was so preoccupied that I had entirely forgotten my surroundings. Then suddenly I was aroused from my dreaming . . . and stood speechless and overcome.

I find it impossible to express the feelings that possessed me at this moment. All the sledges had stopped, and from the foremost of them the Norwegian flag was flying. It shook itself out, waved and flapped so that the silk rustled; it looked wonderfully well in the pure clear air and the shining white surroundings. Eighty-eight degrees 23 minutes was passed; we were further south than any human being had been. No other moment of the whole trip affected me like this. . . . We all shook hands, with mutual congratulations; we had won our way far by holding together, and we would go further yet—to the end.

They waited to pay a tribute of admiration to Sir Ernest Shackleton, whose "name will always be written in the annals of Antarctic exploration in letters of fire," and then they pressed onward exultant as they had never been before. . . .

At length the great day arrived—December 14. . .

At three in the afternoon a simultaneous "Halt!" rang out from the drivers. They had carefully examined their sledge meters, and they all showed the full distance— our pole by reckoning. The goal was reached, the journey ended. I cannot say—though I know it would sound more effective—that the object of my life was attained. That would be romancing rather too barefacedly. I had better be honest and admit straight out that I have never known any man to be placed in such a diametrically opposite position to the goal of his desires as I was at that moment. The regions around the north pole—well, yes, the north pole itself—had attracted me from childhood, and here I was at the south pole. . . .

We reckoned now that we were at the pole. Of course, every one of us knew that we were not standing on the absolute spot; it would be an impossibility with the time and the instruments at our disposal to ascertain that exact spot. But we were so near it that the few miles which possibly separated us from it could not be of the slightest importance. It was our intention to make a circle round this camp, with a radius of twelve and a half miles, and to be satisfied with that. After we had halted we collected and congratulated each other. We had good grounds for mutual respect in what had been achieved, and I think that was just the feeling that was expressed in the firm and powerful grasps of the fist that were exchanged.

After this we proceeded to the greatest and most solemn act of the whole journey—the planting of our flag. Pride and affection shone in the five pairs of eyes that gazed upon the flag as it unfurled itself with a sharp crack, and waved over the pole. I had determined that the act of planting it—the historic event—should be equally divided among us all. It was not for one man to do this; it was for all who had staked their lives in the struggle, and held together through thick and thin. This was the only way in which I could show my gratitude to my comrades in this desolate spot. I could see that they understood and accepted it in the spirit in which it was offered. Five weather-beaten, frost-bitten fists they were that grasped the pole, raised the waving flag in the air, and planted it as the first at the geographical south pole. "Thus we plant thee, beloved flag, at the south pole, and give to the plain on which it lies the name of King Haakon VII.'s Plateau."

* * *

June 14, 1914

OTHER PEOPLE'S MONEY, AND HOW
THE BANKERS USE IT
By Louis D. Brandeis
Frederick A. Stokes Company. $1.

Norman Hapgood has furnished a preface to this book which shows how the savings of the people are invested without regard to the interests of the small borrower; how through a vast system of interested directorates and banking customs the control of the business of America is virtually in the hands of a few men; how business credit as governed by them affects the public at large through railways and all industrial enterprises. So far it forms an interesting commentary on the Federal investigation that is now taking place into the affairs of the New Haven Road, but beyond this the author outlines constructive measures which he believes will remedy the defects in the present system, where the few can manipulate at will the money of the many.

* * *

July 5, 1914

WITH ANTHROPOID APES

TARZAN OF THE APES
By Edgar Rice Burroughs
A. C. McClurg & Co. $1.30 net.

As the result of a mutiny aboardship, an English nobleman and his wife are marooned in a jungle inhabited by anthropoid apes. Here a child is born; a year later the mother dies. A great ape kills the father, but the baby boy is adopted by a female ape whose own child had just been killed by a fall. The subsequent adventures of Tarzan, as the boy is named by the tribe, make a story of many marvels. An ape in his agility and his prowess, heredity asserts itself; the boy tries to clothe himself, and, without ever having heard any save the ape language, without any conception of the sound of English, he teaches himself to read and write from books found in his father's cabin. With adventures and perils the book is replete, nor is a strange love story wanting. It closes with a great renunciation, but with the promise of another Tarzan book, which leads the reader to hope that the renunciation was not final. Crowded with impossibilities as the tale is, Mr. Burroughs has told it so well, and has so succeeded in carrying his readers with him, that there are few who will not look forward eagerly to the promised sequel.

* * *

May 16, 1915

NORTH OF BOSTON

Robert Frost's Poems of New England Farm Life

NORTH OF BOSTON
By Robert Frost
New York: Henry Holt & Co. $1.25.

By JESSIE B. RITTENHOUSE

Mr. Robert Frost has been fortunate in living down the fulsome and ill-considered praise with which he was introduced to the American public. When an American poet comes to us with an English reputation and prints upon his volume the English dictum that "his achievement is much finer, much more near the ground, and much more national than anything that Whitman gave to the world," one is likely to be prejudiced, not to say antagonized, at the outset. Just why a made-in-England reputation is so coveted by the poets of this country is difficult to fathom, particularly as English poets look so anxiously to America for acceptance of their own work. It would seem that we hold the telling verdict when it comes to the practical success of an English poet of today, and without the suffrage of America even men like Alfred Noyes—whose reputation in this country is far greater than in England—would have but a meagre field of operation.

Fortunately for Mr. Frost, his work is able to meet its own test. While it bears no more relation to the work of Whitman than a well-tilled field bears to the earth, this is to the credit of Mr. Frost. He is not a cosmic poet, not a great social seer, he is none of the things that Whitman was, and he refrains from assuming to be something that he is not. Mr. Frost is, indeed, too sincere a poet to look outside of his own experience for inspiration. The field that he has pre-empted is distinctly his own and one hitherto uncultivated in American poetry. It is the life of men and women on stony hill farms "north of Boston," life stripped of externals and lying sheer and bare to this analyst. There have been plenty to interpret rural New England in fiction, and Mr. Frost himself is a story teller plus the poet's spiritual focus upon the one essential motive of the story. He is able, as a writer of the short story (from the demands of the form) cannot do, to epitomize the many details of a narrative into some poignant episode which will illuminate the entire life he has chosen to reveal. For Mr. Frost is a psychologist, he is concerned entirely with the spiritual motives which actuate these folk on barren hill farms where life is largely reduced to its elemental expression. As faithfully as Sarah Orne Jewett, Mary Wilkins or Alice Brown has been able to interpret, through the much more flexible medium of the short story, the lives of these people, Mr. Frost in a few passages makes us free of their world.

It is a bleak world, infinitely sad. The spectre is always there, looking out of the eyes of men and women whom life has defrauded of joy. New England in literature is always stark and grim, but Mr. Frost is not an implacable realist; the grimness is there, but with it the tenderness of one who sees deeply into this phase of life because he has lived it. Mr. Frost was himself a farmer in New Hampshire and tilled his own acres before he converted them into the intangible estate of poetry.

Farm life, remote from centres, is much the same everywhere. The story of "The Hired Man" could be transferred without loss of color to any other section than New England. The pathetic old figure,

With nothing to look backward to with pride.
And nothing to look forward to with hope,
So now and never any different,

is common to every community. What gives the poem its deep appeal is the insight of the woman who touches so tenderly the vagaries of the poor old derelict who has come back to die. Mr. Frost knows women and his truest studies are invariably of them. "Home Burial," perhaps the strongest of his poems, certainly the most dramatic, probes a woman's nature to the quick. One would have difficulty in finding, in such a compass, so powerful an illustration of the spiritual gulf between a man and a woman. The blunted sensibilities of the man who could dig his own child's grave, and the finer sensibilities of the woman upon whose soul every detail is stamped, could scarcely be rendered more effectively. A single passage from Mr. Frost's poem is hardly sufficient to

suggest the play of character, but one may see in the following the truth of his psychology. To the remark,

> And so it's come to this,
> A man can't speak of his own child that's dead,"
> the wife replies,
> "You can't because you don't know how.
> If you had any feelings, you that dug
> With your own hand—how could you?—his little grave;
> I saw you from that very window there.
> Making the gravel leap and leap in air,
> Leap up, like that, like that, and land so lightly
> And roll back down the mound beside the hole.
> I thought, Who is that man? I didn't know you.
> And I crept down the stairs and up the stairs
> To look again, and still your spade kept lifting.
> Then you came in. I heard your rumbling voice
> Out in the kitchen, and I don't know why,
> But I went near to see with my own eyes.
> You could sit there with the stains on your shoes
> Of the fresh earth from your own baby's grave
> And talk about your every-day concerns.
> You had stood the spade up against the wall
> Outside there in the entry, for I saw it.

In the last two lines Mr. Frost has one of his characteristic touches. To the man the spade was a spade, though he had dug his own child's grave with it; to the woman it was a thing of horror, and it was impossible to understand how he could calmly stand it up outside the door as upon any other occasion. It is in these little things that loom so large that one sees the subtlety of Mr. Frost's analysis. Psychology, however, does not make poetry, and one inevitably questions whether the short story would not fit this material quite as well as the form which Mr. Frost has chosen. There is little of poetry in the ordinary acceptance of the term, little of beauty, of magic, but there is the poetry of divination, the vision of souls, the poet's penetration into the one impulse which persists through all the deadening force of circumstance.

While personally a skeptic as to the poetic value of most of the free verse of the moment, it seems to me that Mr. Frost, who is not writing in *vers libre,* has chosen the exact vehicle for his themes. That rhyme would rob them of their atmosphere is evident from the fact that Mr. Frost has one rhymed narrative, "Blueberries," which is insipid as compared to the homely power of the remaining work in the volume. One's expression is temperamental, innate; the form it takes is not the question, but whether the form befit the substance, whether something true and convincing, result from the union of the two. One can scarcely read these stories, characterizations, or whatever one may term them, without feeling that Mr. Frost and his medium are at one, that he has struck bedrock, penetrated to the reality of life in the field he interprets, and chosen the simplest and most human vehicle of expression.

* * *

July 18, 1915

A HUMAN ANTHOLOGY OF SPOON RIVER

An Entertaining Comedie Humaine of Village Life as One Finds It in the United States Furnished in a Volume of Vers Libre by Edgar Lee Masters

THE SPOON RIVER ANTHOLOGY
By Edgar Lee Masters
Macmillan Company. $1.25.

Not the least charm and piquancy of "The Spoon River Anthology" is the frequency with which it compels one to change his mind. One's first reaction to it is distinct from his second, and between this and his final judgment he has many impressions as there may have been readings. This is to say that the book is provocative, that it repels and attracts, and mixes these qualities so cleverly as to keep one in a perpetual state of change.

Doubtless one's first reaction to it is unpleasant. One questions at the outset whether a community ever existed so in need of moral prophylaxsis as Spoon River. Did a community of so limited an area ever produce so many drunkards, thieves, suicides, murderers, adulterers, not to mention the minor sins of selfishness and hypocrisy? "Here," we said, "is a notebook for Zola; here is the coarseness of Rabelais without his power; here are all the graceless thieves of Villon without his grace to make them lovable; here is a man obsessed by sex, who makes it insistent, paramount, and revels in depicting its subtlest nuances." All this, and more, was embraced in our first reaction to "Spoon River"; yet so different is the work in perspective, so much greater is its total effect than that of its individual sketches, that one would be as unjust to himself as to Mr. Masters to permit this impression to stand as his final one.

It is not, however, that one wholly abandons his first judgment, but that he finds himself constantly modifying it as he progresses in the Anthology, by the fact that Mr. Masters has so arranged the sketches as to bring the finer types of his characters toward the end of the book. When one has despaired of humanity as expressed in Spoon River and has made up his mind that Mr. Masters's conception of the Comédie Humaine is warped, he begins to meet the redeeming minority and to see that Mr. Masters is quite as keen in their behalf as he is relentless in exposing the weakness of the derelicts. Since, however, the weakness of humanity, in its manifold phases, is more dramatic, more picturesque, than its strength, one must confess that from the standpoint of portraiture Mr. Masters's best work is done with the former types.

While the village community presents a microcosm of life and an opportunity to study character impossible to the more hidden and complex life of the city, when degeneracy is found it is likely to be overemphasized by the pitiless exposure which it meets. The weakling or the criminal in a village community has no defenses, no subterfuges; every spring of his action is open to him who can analyze it. In the city the weak

and the degenerate tend to segregate; the individual is lost in the class. In the small community the exact opposite obtains; the individual who falls below the community standard or departs from its regularity, stands out with uncompromising distinctness. This is quite as true of the eccentric, the original, or the gifted; their departure from the normal brings them as unsparingly into the light as the defections of the weaker class. The village knows everything, comments upon everything, judges everything; and out of this knowledge Mr. Masters, looking back to his youth in the environs of Spoon River—which is a veritable stream—has reconstructed the life of the neighborhood so as to give us a complete group of portraits of the folk who gave individuality to the community. It is a great creative idea, and if at the outset the weak and criminal aspects of humanity seem to be overemphasized, it is because the village emphasizes them, because they are the first and most obvious facts of the life he has set himself to depict.

In the scheme of Mr. Masters's psychology, however, the novel point is that the subject confesses from the immunity of the grave. The shades of Spoon River rehearse their crimes, sadden us with their little, sordid, futile lives, and now and again hearten us with their dreams and victories. They keep nothing back, not even the aspiration not bold enough to face a philistine world. They reply to each other from the grave, refuting accusations, gibing at hypocrisies, contrasting points of view with delightful humor, satire, and irony.

There is Archibald Higbie, the artist, who could not shake the heavy soil of Spoon River from his feet, and, laboriously working in art schools in Rome, persisted in getting a trace of Abe Lincoln into the face of his Apollo. There is Tennessee Claflin Shope, the laughing-stock of the village, because, in defiance of the Rev. Peet and all authorities of Spoon River, he had presumed to set up his own spiritual standards:

Before Mary Baker G. Eddy even got started
With what she called science,
I had mastered the "Bhagavad Gita"
And cured my soul, before Mary
Began to cure bodies with souls—
Peace to all worlds!

There is Hortense Robbins, at whose doings Spoon River was always agape:

My name used to be in the papers daily
As having dined somewhere,
Or traveled somewhere,
Or rented a house in Paris
Where I entertained the nobility.
I was forever eating or traveling
Or taking the cure at Baden-Baden.
Now I am here to do honor
To Spoon River, here beside the family whence I sprang.
No one cares now where I dined
Or lived, or whom I entertained,
Or how often I took the cure at Baden-Baden.

In the matter of ethics Mr. Masters is quite as keen as in the lighter phases of his work. He never blurs his values, one sees in an instant what made or unmade a character. There has, indeed, been some excellent philosophy garnered on the banks of Spoon River for him who cares to profit by it. The sketches of Henry C. Calhoun, Robert Davidson, and others bear out this assertion.

As to poetry, one comes to a question of disputed boundary. No sooner does one set his careful stakes about the preserve of poetry than some invader strides across and upsets them. Poetry is, indeed, a domain of constantly moving outposts, again and again the stakes are set, again and again the ground is yielded, until he is rash who should predict the final territory.

It seems, however, that one convention remains, one differentiation exists between the arts of prose and poetry—that while both have rhythm, but one has a rhythmic beat, a blending of rhythm and tone, which must be distinct from the rhythm of prose. This beat may not be one of conventional feet, amenable to the laws of scansion, but it is none the less recognizable and definite.

In many of Mr. Masters's sketches the rhythm, if present, is too subtle for gross ears, while the beat has escaped in some overtone. The majority of the sketches could quite as well be set as prose, since the line division is arbitrary and not inherent, but there remains a minority where the rhythm is not only definite, but of distinct beauty, and, coupled with exaltation, the result is a poem about whose credentials there could be no quibbling. One of the finest of these in poetic heightening and ecstasy is that of Caroline Branson singing a canticle of the flesh, or of Thomas Trevelyan "reading in Ovid, the sorrowful story of Itys" and unsealing anew its "little thuribles" of dream and wisdom. Since we have not space for these there is the brief but beautiful summary of the life of Alexander Throckmorton.

In youth my wings were strong and tireless.
But I did not know the mountains.
In age I knew the mountains.
But my weary wings could not follow my vision—Genius
is wisdom and youth.

Or the words of Anne Rutledge, for Spoon River embraces the Lincoln country:

Out of me unworthy and unknown
The vibrations of deathless music:
"With malice toward none, with charity for all."
Out of me the forgiveness of millions toward millions
And the beneficent face of a nation
Shining with justice and truth.
I am Anne Rutledge who sleeps beneath these weeds.
Beloved in life of Abraham Lincoln,
Wedded to him, not through union,
But through separation.
Bloom forever, O Republic,
From the dust of my bosom!

Poetry is more than form, and while many of Mr. Masters's characters deliver themselves in unequivocal prose, prose that would gain in effectiveness by freeing itself from a purely arbitrary connection with verse, there is a group whose expression must be measured by other standards. This expression may be satirical, it may be ironical, it may be tender, but whatever form it takes, it has an art of its own—by what name we call it is of small moment.

* * *

July 18, 1915

'AMERICA'S GREATEST PROBLEM: THE NEGRO'

Three Students of the Subject View the Racial Question from Different Angles and Offer Suggestions for Its Solution

AMERICA'S GREATEST PROBLEM: THE NEGRO
By R. W. Shufeldt, M. D.
Illustrated. Philadelphia: F. A. Davis Company. $2.50.

THE EDUCATION OF THE NEGRO PRIOR TO 1861
By Carter Du Bois Woodson, Ph. D.
New York: G. P. Putnam's Sons. $2.

THE NEGRO
By W. E. Burghardt Du Bois, Ph. D.
Home University Library. New York: Henry Holt & Co. 50 cents.

Of these three books on the negro Dr. Shufeldt's is the least satisfactory, but it shall be discussed first because the others refute some of its sensational statements. It has the merit of sincerity, and it is not without substance; but its violence and prejudice destroy its value. The defect of its judgments is seen in statements such as this: "Men like Booker T. Washington and W. E. B. Du Bois are traitors to their race in this country, and are the worst enemies the negroes in the United States have today."

According to this author the full-blooded negro in this country has never "contributed a single line to literature worth the printing; a single cog in the machine of invention; an idea to any science; or, in short, advanced civilization a single millimeter since the first Congo pair was placed on this soil." A large portion of the book is devoted to trying to prove scientifically that all negroes come of cannibal stock, that they are hopelessly sensual, subject to "sex madness," and incapable of improvement. "It is impossible to improve the morals of a people when they have no morals to improve" is one of his comments. Burke once said that one cannot indict a whole nation, but Dr. Shufeldt would indict a whole race.

The deplorable situation in parts of the South, of course, with the daily terror that it imposes on white women, is discussed at length. The problem is there, and grave enough it is, but it requires a different treatment from that given it by an author who can see nothing but a "seething mass of black bestiality." Dr. Shufeldt asserts that miscegenation is going on in our cities through the lower-class whites, and he jumps at the conclusion that because there is some white blood in 4,000,000 of the 10,000,000 negroes in the United States the whole negro population is going to be absorbed into the white race to our lasting degradation. Our only salvation, he believes, is in "complete and thorough separation" of the two races, and he therefore urges

the enactment of a Federal law to the effect that all negroes and descendants of negroes within the boundaries of the United States of America shall leave this country for all time within ten years after the passage of said law.

Dr. Shufeldt would send them to the Philippines, South America, Mexico, the West Indies, and Haiti, and he says we could well afford to spend $150,000,000 on the work. He thinks such a law would "entail no hardship whatever," but he would hardly take the same view if the people to be expatriated were white. The book is so intemperate and unjust that it defeats its own ends.

Dr. Woodson's "The Education of the Negro Prior to 1861" is a dispassionate monograph, done in the modern scientific spirit, to show the persistent strivings of slaves to learn to read and write. It covers a chapter of American history hitherto almost untouched. Dr. Woodson has gathered his facts from innumerable sources and assembled them in an orderly mosaic. His method involves a good deal of repetition, but it leaves no room to question the soundness of his conclusions.

This book recalls the half-forgotten fact that in the beginning the negro slaves were taught to read and write as freely as they were taught Christianity. That epoch continued until about 1835, and it produced some brainy persons of color, such as Phyllis Wheatley, the poet, and Benjamin Banneker, who, in 1770, made the first clock manufactured in the United States. Another instance is that of James Durham, who spoke French and Spanish fluently, as well as English, and was a distinguished New Orleans physician. The noted Dr. Benjamin Rush of Philadelphia once deigned to converse with him professionally and afterward confessed: "I learned more from him than he could expect from me." Dr. Woodson also tells of a native African who had amazing powers as a mathematician. Many such instances controvert Dr. Shufeldt's sweeping negatives.

About 1835, however, the dark age set in, when it became a crime even for a negro to teach his own children to read and write. The coming of the cotton gin and other modern machinery, coupled with an increasing fear of negro insurrections, caused the slave barons to enact stringent laws forbidding the education of negroes. Dr. Woodson's chapter on "The Reaction" sounds almost incredible, but it is well-authenticated American history.

The policy of keeping the slaves in complete ignorance soon had a deteriorating effect on their minds and characters,

and the more thoughtful whites tried to overcome this by teaching them "religion without letters," but even such enlightenment often brought persecution to the teachers. A chapter entitled "Learning in Spite of Oppositions" tells of secret struggles to overcome these obstacles—with pathetically meagre results.

The thirteen chapters of this book cover all the main phases of ante-bellum attempts at negro education in the North as well as in the South. It is a thorough and intelligent study, with just enough sympathetic spirit to humanize its array of well-ordered facts.

Critics on both sides of the Atlantic have long agreed in praising the high average of the compact little volumes in the Home University Library of Modern Knowledge. The volume on "The Negro," by Dr. Du Bois, editor of The Crisis, measures up to the standard of the series. It is a brief history of the black race in Africa, of its beginnings of culture, and of the slave trade and its disastrous effects. The author holds—with modern science to support him—that there are no definite lines separating the various human races, and that the comparative backwardness of the black race is due mainly to the fact that the interior of Africa contains no natural barriers such as protected early civilization in the Nile Valley and in Europe. Thus the beginnings of culture on the Niger and Congo were repeatedly wiped out by savage invasions and especially by the slave raids of Mohammedan and Christian nations.

That there was such a thing as negro culture in Africa is abundantly attested. At the time when Columbus was discovering America a full-blooded black, Mohammed Askia, was ruling over an empire as large as all Europe. On his pilgrimage to Mecca he was accompanied by "a brilliant group of scholars and holy men with a small escort of 1,500 soldiers and $9,000,000 in gold. He stopped and consulted with scholars and politicians and studied matters of taxation, weights and measures, trade, religious tolerance, and manners. The University of Sankore became a centre of learning in correspondence with Egypt and North Africa, and had a swarm of black Sudanese students. Law, literature, grammar, geography, and surgery were studied."

In a chapter on "African Culture" Dr. Du Bois tells of the achievements of African negroes as workers in iron, bronze, copper, wood, and pottery, recalling that "Schweinfurth, von Luschan, Boaz, and others incline to the belief that the negroes invented the smelting of iron and passed it on to the Egyptians and to modern Europe."

All this was swept away by the slave trade, says the author. He estimates that every slave imported to America cost "five corpses in Africa or on the high seas," and that the American and Arabian raids together meant the death, expatriation, or forcible migration of at least 100,000,000 natives. "And yet people ask today the cause of the stagnation of culture in that land since 1600!"

The last two chapters are devoted to the negro in the United States. The author defends the fifteenth amendment, believing that it alone could have insured his race such measure of freedom as it now has. He holds that in the chaos of reconstruction days "the venality was much greater among whites than negroes," and that "while ignorance was the curse of the negroes, the fault was not theirs, and they took the initiative to correct it." As usual, Dr. Dubois opposes Booker T. Washington's ideas of education, one of the few mistakes that he makes in this book. The whole is written with an intellectual force, a breadth of learning, and a judicial poise that compel respect.

* * *

August 1, 1915

OF HUMAN BONDAGE

OF HUMAN BONDAGE
By W. Somerset Maugham
George H. Doran Company. $1.50 net.

It is not so very many years ago that the three-volume novel was declared to be extinct—a dictum many will remember only because it inspired Rudyard Kipling's famous poem. For like so many forms of art over which funeral orations have been pronounced, the supposedly dead three-volume novel was only in a sort of chrysalis sleep, from which it has been awakened, though in a greatly altered shape. Very different indeed from the "old three-decker" of romance which carried "tired people to the Islands of the Blest" is the long novel of today—as different as is the sailing ship from the passenger steamer. It is not meant to provide pleasant voyaging for the weary; one needs to be quite thoroughly awake to enjoy a trip with the modern writer of three-volume novels—with Mr. Onions or Mr. Beresford or Mr. Maugham. True, "Of Human Bondage" is issued in one volume, but it is quite as long as three ordinary novels; following the method of the older English writers which has recently become so popular with their present-day successors, it relates with strict accuracy and an abundance of detail the story of a man's life from his ninth to his thirtieth year.

Philip Carey's history has a good deal of variety in its scenes and incidents. We meet him first as a very little boy, taken by his nurse to bid good-bye to his widowed and dying mother; then he is a rather forlorn child in a country vicarage, cared for to the best of their rather limited ability by his childless uncle and aunt; from their home he goes to school at "Tercanbury"; follows a year in Germany, then London and the office of a chartered accountant. Quickly coming to the conclusion that the profession of accountant is not the one for him, Philip, who has a few thousand pounds of his own, decides to go to Paris and study art, but after a couple of years he very wisely accepts his master's advice, and, realizing that Foinet is right in telling him that his work shows "intelligence and industry" but no talent, he renounces art and begins to study medicine. Financial troubles force him to drop his hospital work for a time, and he learns by bitter experience what it means to be one of the unemployed. Presently he is only too glad to take the place offered him of floorwalker in a

ready-made clothing shop, but at last the death of his uncle, for which he has long been waiting and hoping, enables him to return to the hospital and finish his course there; when we finally part with him he is a qualified doctor.

The novel is written with a carefulness and conscientiousness which are entirely praiseworthy. The very leisurely method gives opportunity for any quantity of pictures, pictures in which each minute detail is elaborated and finished. Life in the country vicarage, with the selfish, slightly sensual vicar and his humble little wife, so grotesque to look at, so warm and generous of heart; the Paris studio and its habitués, among whom poor, proud Fanny Price toiled and starved and made herself generally disliked, while full of a mistaken self-confidence she labored at the painting for which she had no gift, until the inevitable tragedy came; the hospital, and Philip's acquaintances and experiences therein, and especially interesting to Americans because it describes customs so unlike our own, the shop where Philip "lived in," sharing a room with three other employes. The characters, of course, are many, and nearly as diverse as the scenes in which they play their parts; so many of them are there, indeed, that while almost all of them deserve special comment, it is only possible to say that they are real, and with a few exceptions rather disagreeable people; but there are, of course, two or three who stand out in the foreground.

First and foremost of these is Philip Carey himself, a personality well and consistently developed from the opening page to the last. He has a club foot, and the effect of this deformity upon his actions and his temperament is traced with numerous little deft touches. Sensitive, intelligent, impressionable, passionate, sympathetic, and weak-willed, his inner life is revealed in its every phase. Yet interesting, lovable even as he is, the reader's principal feeling for him is pity. For throughout a very considerable portion of the book, Philip is a slave to his entirely physical passion for a selfish, ignorant, stupid, vulgar woman—a woman he thoroughly despises, while he grovels at her feet. This love causes him intense suffering, and even at the very end he realizes that he will never be "quite, quite free" from his passion for Mildred, "vile woman" as she is, and as he knows her to be. She is one of the book's memorable characters, a creature without, so far as one can discover, a single redeeming trait, so utterly loathsome that while one pities Philip's agony, it is difficult to prevent contempt from mingling with that pity. It is easy to understand why Philip attracted Miss Wilkinson and Norah Nesbit—plucky, large-natured Norah, one of the few people in the book whom one would like to meet in the flesh—and healthy, happy Sally, who resembled "milk and honey," but Mildred's charm is entirely that of the erotic and perverse. She is also exceedingly well drawn.

Philip's path through life is marked by the making and breaking of friendships, the formation and destruction of one illusion after another. Brought up to believe that while salvation outside of one particular creed might be possible, it is decidedly improbable and that all "infidels" are necessarily wicked people, he is astonished to discover that the American

Weeks, "who believed in hardly anything Philip believed . . . led a life of Christian purity." This discovery is the beginning of doubt; from doubt he goes on to atheism, and presently he forms a rule of life "to follow one's instincts with due regard to the policeman around the corner." Put into practice, this rule does not work very well, and it is succeeded by a theory of making a beautiful pattern out of one's life which is scarcely more successful. However, it is quite impossible to deal other than superficially with this very long book within the limits of a review. Each section of Philip's life deserves a column to itself, for each is rich in analysis, in observation, in the thoughtful comments on life and living of an exceptionally intelligent man. The vivisection is at times a little too minute, the small incidents rather over elaborated, and there are certain episodes, like that of the Chinaman and Fraülein Cäcilie, which seem both repulsive and superfluous. Nevertheless, Mr. Maugham has done a big piece of work. His book is one of those novels which deserve and should receive the attention of all those who care for what is worth while in contemporary fiction.

* * *

February 13, 1916

THE THIRTY-NINE STEPS

THE THIRTY-NINE STEPS
By John Buchan
George H. Doran Company. $1.25 net.

Richard Hannay was bored. A mining engineer who had spent most of his thirty-seven years in South Africa, where he had "made his pile," he had returned to England, expecting to enjoy himself. But he had no intimate friends in London, and soon found time hanging so heavily on his hands that he quickly decided to return to South Africa. Then one evening a little man in a terrible state of mind came to him with a most remarkable tale of conspiracy, possible war, and threatened murder, and from that moment Mr. Hannay, who tells his own story, found himself quite as busy as he had any desire to be.

For soon he was in the wildest part of Scotland, fleeing for his life both from the police and from the agents of the mysterious Black Stone. Luck was with him, and, aided by his really remarkable power of impersonation, he managed to get along without any overwhelming difficulty until he met the Bald Archaeologist. After that only an explosion could save him. And then at last he took part in a great council, and had an active share in keeping some extremely important knowledge from the German Secret Service. In short, "The Thirty-nine Steps" is a fairly lively yarn, but one which suffers from a lack of clearness and cohesion in motive—so much so, indeed, that it reads as though the author had written part of it before and part after the outbreak of the present war, changing certain of his plans in the meanwhile because of that occurrence.

* * *

February 11, 1917

WHY MEN FIGHT

WHY MEN FIGHT
By Bertrand Russell
New York: The Century Company. $1.50.

A letter to President Wilson from the Hon. Bertrand Russell which was brought over by secret and more or less mysterious means and published in the newspapers about Christmas time drew public attention to the author of this book and his recent experiences.

Mr. Russell is a grandson of Lord John Russell, once Premier of Great Britain, and is heir to the present Lord Russell. His wife is an American. Until recently he was a lecturer at Trinity College, Cambridge, and is celebrated as a mathematician. He was to have delivered a series of lectures at Harvard this year on ethics and mathematical logic, and it has been rumored that he would be invited to the chair left vacant by the death of Professor Josiah Royce. But, believing that it is the urgent duty of mankind to find some better means than war by which to compose its international difficulties and being convinced that man's spiritual freedom is his most precious possession, he endeavored to lighten the hardships suffered by those in England who have conscientious objections to warfare, and in consequence he was arrested, fined $500, dismissed from his connection with Cambridge, prohibited from lecturing—which he purposed to do, in order to earn his living, in a large part of the United Kingdom—and forbidden to come to America to fulfill his engagement at Harvard.

Mr. Russell is known as one of the most profound philosophical thinkers of the present age. His book on "Why Men Fight" consists of a series of eight essays, or lectures, in which he examines, with keen, incisive thought, judicial temper and broad, tolerant mind the elements in human nature which impel to warfare in order to see what influences it will be necessary for mankind to bring upon its own development if it desires, as the people of most civilized nations say they desire, to prevent the recurrence of such devastating conflicts as the war that is now going on. Only two of the lectures deal directly with war, although in all of them there are many references to it or to conditions that it has brought about or to tendencies it has emphasized.

Mr. Russell believes that "a great many of the impulses which now lead men to go to war are in themselves essential to any vigorous or progressive life," and his effort is to try to find some means of conserving those impulses and directing them into creative rather than destructive ways. He recognizes that the basis of the opposition to pacifism felt by many men is due to the fact that "the very same vital energy which produces all that is best also produces war and the love of war." He refers to William James's statement of this problem nearly twenty years ago and says that he faced the problem adequately, but that his solution was not adequate. Mr. Russell thinks that the problem is one of degrees and that so considered it is capable of partial solutions. Under such subjects as "The State," "War as an Institution," "Property," "Education," "Marriage and the Population Question," "Religion and the Churches" he considers various phases of the problem. From the investigation he derives the hope of seeing such political institutions established in Europe as would make men averse to war. Much of his thinking is of a very radical complexion, although it is individual in its radicalism and is not to be labeled with any existing brand of reform.

* * *

April 7, 1918

HOW WICHITA AND EMPORIA
VIEW THE WAR

A Unique Chronicle of Travel and Romance by William Allen White—Latest Fiction by John Galsworthy, George W. Cable, Edward Lucas White, and Others

THE MARTIAL ADVENTURES OF HENRY AND ME
By William Allen White
New York: The Macmillan Company. $1.50

Henry is the editor and owner of The Wichita Beacon. His friend is the editor of The Emporia Gazette. But you

William Allen White

wouldn't know them by either of these characterizations. You might be led to suspect from them that they were both detachedly critical serious, that worse bugbear still, "literary." That would show that you don't know either Wichita or Emporia. You remember that H. G. Wells, when he came here, started to criticise us before he sailed from England, his criticism being based on the way the questions were put on his passport blank. And don't editors and writers belong to the same breed generally? Well, Henry and his friend do not. They represent Wichita and Emporia. Their trip to the war is begun in somewhat the spirit of any American business man, "fat, bald, and middle-aged," about to start on a Cook's tour in the ancient times when the earth was at peace. That is what gives this book its validity.

Henry and his friend might be any two middle-aged bald men from the "thousand replicas of Wichita and Emporia splattered like guinea freckles all over the American map for 3,000 miles." Henry and his friend are provincial. They admit it and are proud of it. They judge things by the standards of Wichita and Emporia. Henry stands on the deck of the Espagne, bearing Red Cross nurses and doctors to France and looks at the ocean with the critical eye of the Wichita real estate speculator. He decides that it needs considerable draining! Bordeaux, they think, would make a good film if it had Mary Pickford. It is Mark Twain all over again making jokes before a masterpiece. Frankly, the jokes are a trifle old-fashioned. But after all jokes have little or nothing to do with the real purpose of the book. Here are two plain, middle-aged Americans, who have devoted their lives to the local history of Wichita and Emporia, going to war with commissions in their pockets as Colonels to investigate the Red Cross. They are as nonmilitary as missionaries. How is the war going to strike them?

The essence of provincialism on its worst side is narrowness, inflexibility of mind. It is really a colossal provincialism which lies at the back of Germany's imperialism. And you very soon realize, even before they have left the boat, that of this gigantically vicious provincialism Henry and his friend, that is to say Wichita and Emporia, which means America, have not a whiff. There are strange people on the boat. There is a lady, for example, who does not resemble any ladies Henry and his friend have ever met. Her millinery was strange and wonderful, and her eyes, unlike those of Emporia ladies, were "full of sex instead of vision." And to the grotesque and incongruous motley of standards they meet on the boat here is the Emporia editor's reaction:

So there we were. The Col-o-nel and the lady with their idea on the woman question, the Armenians with their bizarre music, the Yankee with his freaky humor, and the sedentary gold dust twins from Kansas, and a great boat load of others like them in their striking differences of ideals and notions, all hurrying across the world to help in the great fight for democracy, which, in its essence, is only the right to live in the world, each man, each cult, each race, each blood and each nation after its own kind. And about all the war involves is the right to live, and to love one's own kind of women, one's own kind of music, one's own kind of humor, one's own kind of philosophy; knowing they are not perfect and understanding their limitations, trusting to time and circumstance to bring out the fast colors of life in the eternal wash.

This is a different kind of provincialism. It is willing to recognize other provincialisms and that one's own is not perfect. It has a real sense of humor and an open mind.

But there is more to it than that. A little incident on the boat gives a glimpse of another facet of the localism of our friends: One night they get distress signals from another boat, and to their astonishment the Espagne speeds away as fast as possible. That was because the distress signals might have been a U-boat lure. It is a favorite trick of the Germans. The incident moves Henry to reflection:

I've been thinking about this U-boat business; how it would be if we had the Germans' job. I have been trying to think if there is any one in Wichita who could go out and run a U-boat the way these Germans run U-boats, and I've been trying to imagine him sitting on the front porch of the Country Club or down at the Elks Club talking about it; telling how he lured the Captain of a ship by his distress signals to come to the rescue of a sinking ship and then destroyed the rescuer, and I've been trying to figure out how the fellows sitting around him would take it. They'd get up and leave. He'd be outcast as unspeakable, and no brag or bluff or blare of victory would gloss over his act. We simply don't think the German way. We have a loyalty to humanity deeper than our patriotism. There are certain things self-respecting men can't do and live in Wichita. But there seem to be no restrictions in Germany.

Now this homely bit of visualization of the Wichita Country Club and the hypothetical bragging of one of Wichita's citizens about sluking a rescuing ship expresses the American spirit in this war as simply and as poignantly as it could be expressed. It is absolutely genuine and sincere. It tells you more about why we are in the war than the perusal of a score of White and Green and Blue papers can tell you, or the international lawyers or the expounders of egotism in German philosophy. It is because Germany has acted in a way that Wichita and Emporia simply couldn't stand. And it makes you feel rather warm and comfortable about Wichita and Emporia.

Henry and his friend go to Paris and stop at the Ritz— which makes every one smile, for they are so obviously from Wichita and Emporia. And then, with their departure for the front their real adventure begins. They see battle. They see the land that has been scarred and churned by shellfire. They sleep in Red Cross hospitals where thousands of men have passed through, many of them on the "long journey." They see death and suffering and heroism. There isn't much joking

in this part of the book. The description is tense and spare and vivid. They tell of Germans shelling hospitals. They learn an inspiring lesson for the race:

> That Courage—that thing which the Germans thought was their special gift from Heaven, bred of military discipline, rising out of German Kultur—we know now is the commonest heritage of men. It is the divine fire burning in the soul of us that proves the case for democracy. For at base and underneath we are all equals. In crises the rich man, the poor man, the thief, the harlot, the preacher, the teacher, the laborer, the ignorant, the wise, all go to death for something that defies death, something immortal in the human spirit. Those truck drivers, those mule whackers, those common soldiers, that doctor, these college men on the ambulance, are brothers tonight in the democracy of courage. Upon that democracy is the hope of the race, for it bespeaks a wider and deeper kinship of men.

Throughout the book runs a thread of fictional narrative about a young American nurse, whom Henry and his friend sportfully name "The Eager Soul," and her two suitors; the "Gilded Youth" and a young doctor. We are told later that the young doctor symbolizes the spirit of America in the war, and the nurse, the idealism of youth. The story leavens the description of trench and hospital. But the significance of the book lies elsewhere—in the viewpoint of Wichita and Emporia. Henry and his friend may be provincial in trivialities; but in the things of the heart and spirit their reach is as wide as the ocean.

* * *

July 21, 1918

EZRA POUND, POET OF THE STATE OF IDAHO

LUSTRA
By Ezra Pound
Alfred A. Knopf. $1.50.

Something over thirty years ago, when Idaho was still a Territory, and the rush to its gold fields was almost as eager and turbulent as it had been to the California of two generations before, when the shake-roofed cabin of the miner and stock raiser had only recently succeeded to the teepee of the Indian, Ezra Pound was born in one of its deep-cut valleys, beneath the fantastic skyline of the Sawtooth Range.

It is a long trail, indeed, from such a far outpost of civilization to post-mediaeval France and Italy, via the sophisticate circles of the art world of modern Paris and London, yet Mr. Pound has taken it as swiftly and surely as "the inland-born sea creature seeks the sea's breast out." Perhaps it is the swing of the pendulum between extremes; perhaps some old atavistic inheritance is at work; perhaps it is only the common revolts of youth working in an uncommon mind. The

riddle remains; a riddle that harks back to the day of the actual, not the nominal, Philistine; out of the strong has come forth sweetness.

For, though conventional sweetness is strenuously, even vehemently, avoided by Mr. Pound, he is a fanatic lover of beauty—

> Thou hooded opal, thou eternal pearl,
> O thou dark secret with a shimmering floor—

and he seeks for it as other men for hid treasure.

He is constantly halted in his search, however, by encountering the reverse of beauty, and pausing to slay it. If it is true that poetry is "a criticism of life," it would seem to follow that poets should be critics of life. But very few of them are. Ezra Pound is among the exceptions. He is homesick after his "own kind"; and "they"—the outside world—whose "virgin stupidity is untemptable," the "generation of the thoroughly smug," the "they" who imagine his verse to be risqué, and like or dislike it for that reason, are the victims of his joyous battle-lust.

Years ago Mr. Pound wrote that "good art begins with an escape from dullness," and dullness is the quality with which he has ever since had least patience—which is to say none at all. He hates the dullness of democracies and the dullness of aristocracies; the dullness of no art at all and the dullness of the dernier cri in art. His apostrophe to the "helpless few in my country . . . lovers of beauty . . . astray, lost in the villages," is no bitterer in its implications than the picture of the beautiful woman:

> Like a skein of loose silk blown against a wall,
> She walks by the railing of a path in Kensington Gardens,
> And she is dying piecemeal of a sort of emotional
> anaemia. . . .
>
> In her is the end of breeding.
> Her boredom is exquisite and excessive.
> She would like some one to speak to her,
> And is almost afraid that I
> Will commit that indiscretion.

And the satire upon

> . . . that school of thought
> Which brought the haircloth chair to such perfection,
> is no more vengeful than that of "L'Art, 1910":
> Green arsenic smeared on an egg-white cloth,
> Crushed strawberries! Come, let us feast our eyes.

In a word, Ezra Pound hates the dullness which is born of provincialism, whether it is a geographical provincialism or a state of mind, and the play of his satire upon it is unceasing. But by no means all of his satiric criticism of life is criticism by cudgel. In "Gentildonna" he breathes, delicately as a reed, one of the little ironies of immortality, and in "The Study in Aesthetics," the stroke by which he evens the beauty of a

woman with that of a fine catch of fish, is gay and good-humored. Neither does Mr. Pound exclude himself from his own satire. Like many another poet he is self-conscious, but, unlike them, he is conscious of his self-consciousness.

Keats sang, "For large white plumes are dancing in mine eye." In Ezra Pound's eye is continually dancing his own soul—"Animula, vagula, blandula." Continually he wonders whither it is bound; not the soul which theology knows, but the soul which is in his poems, restless, windblown, future-haunted. He sends it on a hundred errands. Now he bids it

Go to the adolescent who are smothered in family—
Oh, how hideous it is
To see three generations of one house gathered together!
It is like an old tree with shoots,
And with some branches rotted and falling.

Go out and defy opinion,
Go against this vegetable bondage of the blood,
Be against all sorts of mortmain.

Now he whimsically protests—

You are very idle, my songs.
I fear you will come to a bad end.
You stand about in the streets,
You loiter at the corners and bus stops,
You do next to nothing at all.

You do not even express our inner nobilities,
You will come to a very bad end.

But however lightly Mr. Pound may seem to take himself and his profession as poet—one almost wonders if he has not deliberately set out to be the antithesis of Wordsworth in this respect—the plasticity of his verse-forms and the clearness and precision with which they clothe his thought, reveal a man whose passion stops at nothing less than perfection. He has said in his "Don'ts for Imagists": "Don't imagine that the art of poetry is any simpler than the art of music or that you can please the expert before you have spent at least as much effort on the art of verse as the average piano teacher spends on the art of music." Here speaks the real man—the man who, by dint of serious purpose and hard work, has achieved such a mastery over his art that he can afford to play with it when it pleases him.

The background of Mr. Pound's poetry is curiously blended of scholarship, passionate human interest, and a clear-eyed, frequently satiric, independence. He has a certain disdain for the easy laurel of the popular poet, and the popular mind retorts by dubbing him freakish, exotic, an imitator of long-dead men. It is true that he takes what he deems best in the manner, not the matter, of others; it is one of his maxims, "Be influenced by as many great artists as you can." But what he takes goes through the alembic of his own personality and comes out an individual thing. This is least true, perhaps, of

the Celtic influence. He has been accused of imitating Yeats, but the fact is that he goes beyond Yeats, back to the ninth century, or earlier. Oddly enough, it is in some of the free interpretations of ancient Chinese poetry grouped under the title of "Cathay," which form perhaps the most interesting part of "Lustra," that the resemblance to early Irish poetry is most marked. They voice the simple, wondering delight in "red jade cups, food well set on a blue jeweled table," in "silver harness and reins of gold," in dragon-like horses— horses with head-trappings of yellow metal," which the Celtic bards so constantly sang. But besides that, there is in the poems of "Cathay" a spiritual awareness, a memoried tenderness, quite strange to the early Celt. There is, too, a tremulous sensitiveness to natural beauty:

March has come to the bridgehead,
Peach boughs and apricot boughs hang over a thousand
 gates;
At morning there are flowers to cut the heart,
And evening drives them on the eastward flowing waters.

It is hard to leave "Cathay" without quoting voluminously, but one more excerpt must suffice. An old exile recalls the adventures of his young manhood, his journeys over "roads twisted like sheep's guts," the music of instruments "like the sound of young phoenix broods," and how "the foreman of Kan Chu, drunk, danced because his long sleeves wouldn't keep still with that music playing." In the place there was

Pleasure lasting, with courtesans going and coming
 without hindrance,
With the willow flakes falling like snow,
And the vermilioned girls getting drunk about sunset,
And the water a hundred feet deep reflecting green
 eyebrows—
Eyebrows painted green are a fine sight in young
 moonlight, gracefully painted—
And the girls singing back at each other,
Dancing in transparent brocade,
And the wind lifting up the song, and interrupting it,
Tossing it up under the clouds.
And all this comes to an end,
And is not again to be met with. . . .
And once again, later, we met at the South bridgehead;
And then the crowd broke up; you went north to
 San Palace;
And if you ask how I regret that parting,
It is like the flowers falling at Spring's end, confused,
 whirled in a tangle.
What is the use of talking, and there is no end of talking?
There is no end of things in the heart.

So it ends, like most deeply human poems, on the note of Ecclesiastes.

The "Three Cantos," last in the book, are not easy reading in one sense, though they are clear enough. Their full appre-

ciation calls for an uncommon background of scholarship, though every lover of poetry, albeit unlettered, can get something from them. They are like an old Italian slope, where the very earth speaks of warriors and singers and lovers whose dust it is. They echo, they are haunted.

And the place is full of spirits, not lemures.
Not dark and shadow-wet ghosts, but ancient living,
Wood-white, smooth as the inner-bark, and firm of aspect.

A far cry indeed from the virgin Idaho Valley, under the shadow of the Sawtooth Range, to this soil, deep-mulched in tradition! Ezra Pound has made a dramatic flight, whose significance we as yet scarcely grasp. He is still a young man—his flying days are far from over. One wonders will he ever wing his way, burdened as he is with the spoil of antiquity, back to the wilderness?

* * *

October 6, 1918

MY ANTONIA

MY ANTONIA
By Willa S. Cather
Illustrated. Houghton Mifflin Company. $1.60 net.

Nebraska is the scene of Willa S. Cather's new novel, the central character being a young Bohemian girl, Antonia Shimerda, the daughter of immigrants. Her father and mother came to Nebraska, where they had bought a farm out in the prairie from a fellow-countryman, who cheated them badly. Jim Burden, who tells the story, is an American boy, living with his prosperous grandparents on their big farm, which, as distances go in that country, is not so very far from the Shimerdas' place. Jim's grandparents befriend the Shimerdas, and it is Jim himself who teaches Antonia English. A large part of the book is given over to an account of the work and play of these two during the year when Jim was about 10 and Antonia about 14.

There is a carefully detailed picture of daily existence on a Nebraska farm, and indeed the whole book is a carefully detailed picture rather than a story. Presently Jim's grandparents decide that they are getting too old to run the farm, and move to the little town of Black Hawk. Then we are told all about the long Summer days, the bitter cold of Winter, the games and music at the Harlings', and the arrival of the dance tent which made so pronounced a change in the town. Antonia, who had come to live with the Harlings as their "hired girl," was fascinated by the dancing, and presently quarreled with her employers because of it. But she was a born country-woman, and after a very unfortunate experience she returned to the country and the farm. The book is full of sketches of farm life, of plowing, reaping and thrashing, of the difficulties of feeding cattle in Winter, and all the routine of husbandry. Antonia is a true daughter of the soil, thus described: "She had

only to stand in the orchard, to put her hand on a little crab tree and look up at the apples, to make you feel the goodness of planting and tending and harvesting at last." There are other immigrants in the book besides the Shimerdas, Norwegians, Danes, Russians, &c., and the ways of all of them are more or less fully described. They are all, to some extent, pioneers, the period of the book being that in which the first foreign immigrants came to Nebraska.

* * *

October 27, 1918

THE EDUCATION OF HENRY ADAMS

A Charming Autobiography That Sheds Light on Many Things
Historical and Otherwise in New England D
uring the Last Century

THE EDUCATION OF HENRY ADAMS: An Autobiography
With an introduction by Henry Cabot Lodge
Boston and New York: Houghton Mifflin Company. $5.

For the autobiography of Henry Adams we have waited for twelve years. It is a book of unique richness, of unforgettable comment and challenging thought, a book delightful, whimsical, deep-thinking, suggestive, a book greatly worth the waiting for. It has had a curious history. Written in 1905, "The Education of Henry Adams: A Study of Twentieth Century Multiplicity," was a sequel to "Mont-Saint-Michel and Chartres: A Study of Thirteenth Century Unity," which had been finished and privately printed the year before; 100 copies were privately printed, and sent to persons interested, in 1906; it is now published, by the Massachusetts Historical Society, for the first time. Yet in 1913, when the Institute of Architects published the "Mont-Saint-Michel and Chartres," scholars already knew the "Education" well. Mr. Adams, however, to whose literary career a severe illness had put an end in 1912, had decided to leave his autobiography, as Senator Lodge points out in his preface, "unpublished, avowedly incomplete, trusting that it might quietly fade from memory." It has not faded from memory. But it is unfortunate that the general public in his own country has given so little of its attention to the American historian who was Charles Francis Adams's son. It is to be hoped that the publication of "The Education of Henry Adams" will serve as introduction where that is needed. The book would be worth reading for no other purpose. It is worth reading for many purposes besides.

Says Mr. Adams, delightfully, at the very beginning of his book, of his life's beginning:

A hundred years earlier, such safeguards as his would have secured any young man's success; and although in 1838 their value was not very great, compared with what they would have had in 1738, yet the mere accident of starting a twentieth century career from a

nest of associations so Colonial—so troglodytic—as the First Church, the Boston State House, Beacon Hill, John Hancock and John Adams, Mount Vernon Street, and Quincy, all crowding on ten pounds of unconscious babyhood, was so queer as to offer a subject of curious speculation to the baby long after he had witnessed the solution. What could become of such a child of the seventeenth and eighteenth centuries, when he should wake up to find himself required to play the game of the twentieth? Had he been consulted, would he have cared to play the game at all, holding such cards as he held, and suspecting that the game was to be one of which neither he nor any one else back to the beginning of time knew the rules or the risks or the stakes? He was not consulted, but had he been taken into the confidence of his parents, he would have certainly told them to change nothing as far as concerned him. He would have been astounded by his own luck. Probably no child born in the year held better cards than he. Whether life was an honest game of chance, or whether the cards were marked and forced, he could not refuse to play his excellent hand. He could never make the usual plea of irresponsibility. He accepted the situation as though he had been a party to it and under the same circumstances would do it again, the more readily for knowing the exact values. To his life as a whole he was a consenting, contracting party and partner from the moment he was born to the moment he died. Only with that understanding—as a consciously assenting member in full partnership with the society of his age—has his education an interest to himself or to others.

As it happened, he never got to the point of playing the game at all; he lost himself in the study of it, watching the errors of the players; but this is the only interest in the story which otherwise has no moral and little incident.

So, delightfully begun, the book delightfully continues. Its dry comment on things Bostonian and otherwise, its whimsical humor, its detached way of presenting the subject of the history—who is always referred to in the third person in this autobiography—its charming, tender, vivid portraits—all these are irresistible as matters of readability and as features of the author's literary style. His record of his childhood is unforgettable in its charm and vividness. Of the New England atmosphere in which he was brought up he writes:

Resistance to something was the law of New England nature; the boy looked out on the world with the instinct of resistance; for numberless generations his predecessors had viewed the world chiefly as a thing to be reformed, filled with evil forces to be abolished, and they saw no reason to suppose that they had wholly succeeded in the abolition; the duty was unchanged. That duty implied not only resistance to evil, but hatred of it. Boys naturally look on all force as an enemy, and

generally find it so, but the New Englander, whether boy or man, in his long struggle with a stingy or hostile universe had learned also to love the pleasure of hating; his joys were few.

Outstanding among the portraits of his boyhood are those of his grandfather, "the President," and his grandmother, "the Madame"—the latter "Louis Seize like the furniture" and not a Bostonian; his father, and his father's friend, who was the hero of his boyish worship, Charles Sumner. They are long pen-pictures—too long to quote—but once read they remain in the reader's own "portrait gallery."

School the boy disliked, and he always reckoned his school days as "time thrown away." From school he went, as all the Adamses and the Brookses had gone, to Harvard College, which, "so far as it educated at all, was a mild and liberal school, which sent men into the world with all they needed to make respectable citizens, and something of what they wanted to make useful ones." He continues:

Leaders of men it never tried to make. Its ideals were altogether different. . . . Disappointment apart, Harvard College was probably less hurtful than any other university then in existence. It taught little, and that little ill, but it left the mind open, free from bias, ignorant of facts, but docile.

Henry Adams made friends in Harvard—as everywhere but the most lasting academic impression came to him from James Russell Lowell, who had brought back from Germany the habit of private reading with his students, and who led Adams to go himself to Germany when he left college. As education, Germany was a failure. But the young American learned there that "the Germany he loved was the eighteenth century, which the Germans were ashamed of and were destroying as fast as they could. Of the Germany to come he knew nothing. Military Germany was his abhorrence." He liked "the blundering incapacity of the German for practical affairs"; German "system" was horrible to him.

He was 23 when his father was appointed Minister to Great Britain and took his son with him as private secretary. That was, as every one knows, in 1861, and the years to come were trying and perilous beyond words. "Of the year 1862 Henry Adams could never bear to think without a shudder." The history of these civil war years when English governmental feeling so strongly favored the Confederacy is told in a fashion arresting, personal, unique. There are sentences, paragraphs, whole pages that the reviewer is deeply tempted to quote. Suffice it again to recommend the public to read the book as a whole!

For it is deeply valuable on three counts: valuable as literature for its style, for its interest as a piece of reading; valuable for its records and comments on important events, its portraits of great men known through a long life; valuable as the study of a man's "education" in life, a thoughtful and keen analysis. At the end the author sets forth his theory of

history. And in connection with that it is interesting to quote an article by Henry Osborn Taylor in the current Atlantic:

He taught history at Harvard from 1870 to 1877, at the latter date intimating to me, disappointed of his teaching for my coming senior year, that he had been professor as long as one ought to be. He says in his book that he left with a sense of failure; but it was certainly far from that in the convictions of his students. He was the first teacher of history at Harvard to discard the textbook, and put his students to work for themselves.

"The Education of Henry Adams" is, as was said at this review's beginning, a book uniquely rich. It is a book that every American should read.

* * *

December 15, 1918

TOTEM AND TABOO

TOTEM AND TABOO
By Professor Dr. Sigmund Freud, LL. D.
Authorized English translation with introduction, by A. A. Brill, Ph. D., M. D. New York: Moffat, Yard & Co. $2.

This wonderfully penetrating inquiry into the origins of religious and social restrictions, prohibitions, and observances is another of the fast accumulating pieces of evidence of the profundity and wide application of the psychoanalytic technique. The author traces them back to the unconscious motivations of the outworn religio-social institutions of totemism and to the early prohibitions or taboos of civilized society.

Unless familiar with the enormous summation of impulses which Freud includes under the period of childhood, one is inclined to doubt his assumption that the civilized adult is the sum total of his early impressions. So constantly does the human psyche enlarge and change that one feels there must be some new increment of possibility being constantly generated between environment and individual, even after the years of childhood have passed. It seems arbitrary as well as blighting to limit a human individual to the sum total of his early impressions. However, this point, which is a stumbling block to many of Freud's critics, becomes quite negligible in this particularly small volume, when compared to the amazing number of suggestive and permanently valuable observations crowded into it. The translation is excellent. The carefully collected material is absorbingly interesting, but it would appeal only to mature minds.

The author finds that the history of taboo may be studied in the same way as the compulsive prohibitions of a neurotic patient are investigated. The neurotic restricts his actions by many rules, which show a striking correspondence with the taboos of savage and semi-savage races. These rules in regard to the treatment of enemies, of rulers, and of the dead are vouched for by numerous and suggestive historical instances, and the reader is constantly interested to supply additional examples of customs corresponding with the ones cited, and existing in the present day, either as single exceptions or as quite generally practiced.

We learn that the complicated and contradictory relation of primitive people to their rulers arises in much the same way as the excessive tenderness and anxious worry of compulsive neurotics for certain persons. It is due to an ambivalent attitude in which hostility and tenderness are in constant conflict. The hostility is unconscious, but cannot be kept in a state of repression except through a compulsive force of excessive tenderness. While the taboo ceremonial of Kings is an expression of veneration and of protection, it is also a mark of punishment and revenge. The extensive ceremonial of neurotics in an elaborate and symbolic way quite similarly serves such purposes.

Freud has noted that a favorite prohibition of the neurotic is against pronouncing names of certain persons or things, and that one of the most instructive taboo customs of mourning among primitive races is against pronouncing the *name* of the deceased. In the first case, it is a defense against a hostile wish, and in the second, a protection against what was conceived to be the evil spirit of the corpse, since it is quite probable that primitive races believe that death comes only through being slain, whether by violence or by magic, and that therefore the deceased would carry a spirit of revenge. Likewise neurotics take measures of precaution against their evil death-wishes.

Besides discussing the origin of taboos regarding death, burial ceremonies, beliefs in the "here" and "beyond," evil spirits, demons, ghosts, the author thinks that the understanding of taboos throws light on the nature of conscience, which originally arose as a sense of guilt after the violation of a taboo. The social feature of taboo arises when a violator is not punished spontaneously for a misdemeanor. A collective feeling awakens that all are threatened, and they hasten to inflict the punishment themselves. It is a question of fear of the contagious example. "In order to keep down the temptation, this envied individual must be despoiled of the fruit of his daring. Not infrequently the punishment gives the executors themselves an opportunity to commit the same sacrilegious act by justifying it as an expiation. This is really one of the fundamentals of the human code of punishment which rightly presumes the same forbidden impulses in the criminal and in the members of society who avenge this offense."

In his treatment of animism, magic, and the omnipotence of thought, he concludes that mankind did not create its first world system through a purely speculative thirst for knowledge, but felt also a practical need for mastering the world. Sorcery is essentially the art of influencing spirits by treating them like people under the same circumstance. Magic is something else. It uses special means. It mistakes an ideal connection for a real one. It makes thought omnipotent. To frighten away a ghost with noise and cries is a form of sorcery, to force him to do something by taking his name is to employ magic against him. As animism gradually yields part of this omnipotence of ideas to spirits, it begins to form a religion.

These spirits and demons were nothing but the projection of primitive man's emotional impulses, and the tendency to projection becomes stronger where it offers psychic relief. This occurs when several impulses struggle for omnipotence. The author thinks that what a mourner conceives to be the spirit of the deceased is in the last analysis "the faculty of remembering and representing the object, after he or it was withdrawn from conscious perception."

According to Freud, when we get behind the conception of the animistic soul, of superstition, anxiety, dreams, and demons, we realize that the psychic life and cultural level of savages is more closely related than has hitherto been appreciated, and the relation of the child to the animal has much in common with the relation of primitive man to animals. He shows how the morbid fear of animals which children frequently display is really a fear of the father displaced upon the animal.

If then the totem animal itself is the original father of the tribe, Freud concludes that the two main taboo rules which constitute the nucleus of totemism—not to kill the totem animal and not to cohabit with a woman belonging to the same totem—agree in content with the two crimes of Oedipus, who slew his father and took his mother to wife, and also with the child's two primal wishes, whose insufficient repression or whose re-awakening form the nucleus of perhaps all neuroses. In the remainder of his book, the author emphasizes and elaborates this similarity by ethnological citations.

The ambivalent emotional attitude which still marks the father complex in our children and so often continues into adult life also extended to the father substitute of the totem animal. What the father's presence had formerly prevented they themselves now prohibited in the psychic situation of subsequent obedience which we know so well from psychoanalysis. They undid their deed by declaring that the killing of the father substitute was not allowed and renounced the fruits of their deed by denying themselves the liberated women. Thus they created the two fundamental taboos of totemism out of the sense of guilt of the son . . . Whoever disobeyed became guilty of the only two crimes which troubled primitive society.

Freud proceeds to trace in the further development of religions the two opposing forces of the son's sense of guilt and his defiance, and notes that the endeavor of the son to put himself in the place of the father god appeared with greater and greater distinctness. The conclusions which he draws concerning the meaning of Christianity are original and especially interesting, since they are those of a student who belongs to a line of pure Jewish ancestry, devout and full of erudition. These conclusions merit long stretches of quotation, but only a small fraction can be given:

In the Christian myth, man's original sin is undoubtedly an offense against God the Father, and if Christ redeems mankind from the weight of original sin by sacrificing his own life, he forces us to the conclusion that this sin was murder. According to the law of retaliation, which is deeply rooted in human feeling, a murder can be atoned only by the sacrifice of another life; the self-sacrifice points to a blood-guilt. . . . In the same deed which offers the greatest possible expiation to the father, the son also attains the goal of his wishes against the father. The religion of the son succeeds the religion of the father. He becomes a god himself beside, or rather, in place of the father. As a sign of this substitution the old totem feast is revived again in the form of communion, in which the band of brothers now eats the flesh and blood of the son and no longer that of the father, the sons thereby identifying themselves with him and becoming holy themselves.

The creative sense of guilt has not become extinct with us. We find its social effects in neurotics producing new rules of morality and continued restrictions, in expiation for misdeeds committed, or as precautions against misdeeds to be committed. But when we examine these neurotics . . . we are disappointed. We do not find deeds, but only impulses and feelings which sought evil, but which were restrained from carrying it out. . . . It is characteristic of the neuroses to put a psychic reality above an actual one and to react as seriously to thoughts as the normal person reacts to realities. . . . Primitive man is not inhibited, the thought is directly converted into the deed, which is for him so to speak rather a substitute for the thought, and for that reason I think we may well assume for the case we are discussing though without vouching for the absolute certainty of the decision that, "In the beginning was the deed."

This conclusion, of course, turns the old psychology upside down. But that is what Freud is doing, and in the meantime he is releasing a multitude of incalculably valuable ideas about human personality. Many of his assumptions, as in the last sentence of the quoted matter, are not at all convincing, but all his works, whether one accepts his conclusions or not, are most suggestive, and open many fields of inquiry and speculation. In closing this volume the words "In the beginning was the Word" immediately come to mind, and it becomes quite evident that Freud classes St. John as a neurotic, a believer in magic. The question irresistibly follows as to whether all neurotics are not attempts at improving humankind, whether they are not supermen in the first incomplete and imperfect forms. While not intending to detract in the least from the phenomenal achievements of Freud in the field of psychotherapeutics, we must admit that in the more speculative parts of his work one often misses the assurance that the dynamic force of the psyche urges forward and not always backward.

* * *

March 30, 1919

DEVELOPING THE AMERICAN FROM THE ENGLISH LANGUAGE

THE AMERICAN LANGUAGE: A Preliminary Inquiry into the Development of English in the United States
By H. L. Mencken
New York: Alfred A. Knopf. 1919. $4.

By BRANDER MATTHEWS

Hidden in the second volume of Mark Twain's miscellaneous sketches and essays there is a paper entitled "Concerning the American Language." A footnote informs us that it was part of a chapter crowded out of "A Tramp Abroad." It purports to record a conversation supposed to have taken place between Mark and an Englishman in the same railway compartment. With captivating tactfulness the Englishman complimented Mark on his English, adding that Americans in general did not speak the English language as correctly as Mark did. . . .

And now comes H. L. Mencken, armed at all points, to maintain the same contention. . . . He holds that the tongue which we speak on this side of the Western Ocean is no longer English, but is now American. He quotes George Ade in support of Mark Twain:

> The American must go to England in order to learn for a dead certainty that he does not speak the English language. . . . This pitiful fact comes home to every American when he arrives in London—that there are two languages, the English and the American.

Mr. Mencken does not consider the fact pitiful; he regards it as inevitable and satisfactory. He brings forward testimony to the same effect from the latest edition of the Encyclopaedia Britannica:

> It is not uncommon to meet with [American] newspaper articles of which an untraveled Englishman would hardly be able to understand a sentence.

Before considering the evidence that Mr. Mencken advances in support of his thesis it may be well to say that his book is interesting and useful; it is a book to be taken seriously; it is a book well planned, well proportioned, well documented, and well written. . . .

Mr. Mencken would see nothing objectionable in the placard said to have been displayed in the window of a Swiss shop: "English Spoken and American Understood." He would accept this as a plain statement of an obvious fact. Everybody knows that there are a host of divergences between the English language as it is now spoken in the British Isles and as it is now spoken in the United States, differences of intonation, of pronunciation, of vocabulary, and even of grammar; but nobody has ever marshaled this host as amply, as logically, or as impressively as Mr. Mencken has done. There are half a dozen dictionaries of Americanisms, all of them more or less heterogenous. Any helpful survey of the subject must begin by a classification of these so-called Americanisms to ascertain if they are rightly so called.

First of all there are the words which Americans gave to things unknown to the British—canoe, wigwam and moccasin, chowder and barbecue, caucus and gerrymander, telephone and phonograph. These are all American contributions to the English language; they are words in good standing because they are the only words to describe the things they designate. Then there are the good old words which have dropped out of use in Great Britain and which have survived in the United States: Fall, (Autumn;) wilt, (wither;) deck, (pack of cards.) These have never ceased to be good English, even if the British themselves do not know this. These survivals are so many that they supplied Senator Lodge with abundant material for an illuminating essay on "Shakespeare's Americanisms." Thirdly, there are the slang terms and phrases of indigenous origin and of ephemeral existence, springing up overnight, carried across the continent on the wings of the morning, and fading into contemptuous oblivion the day after tomorrow: Skiddoo, let her go, Gallagher; twenty-three for you. These inept expressions do not rise to the dignity of Americanisms. And finally there are the true Americanisms to be set over against the corresponding Briticisms: Elevator, (lift;) drugstore, (chemist's shop;) spool of thread, (reel of cotton.)

It is upon these that Mr. Mencken focuses our attention. He shows that American speech began to differentiate itself from British speech in the eighteenth century. He quotes from Thomas Jefferson (writing in 1813) an assertion that "the new circumstances under which we are placed call for new words, new phrases, and for the transfer of old words to new objects: an American dialect will therefore be formed." And Mr. Mencken has found, in a dedicatory letter written to Benjamin Franklin, in 1789, a similar assertion by Noah Webster:

> Numerous local causes, such as a new country, new combinations of ideas in arts and sciences, and some intercourse with tribes wholly unknown in Europe, will introduce new words into the American tongue. These causes will produce, in a course of time, a language in North America as different from the future language of England as the modern Dutch, Danish, and Swedish are from the German, and from one another.

This prediction of a hundred and thirty years ago has now been fulfilled, so Mr. Mencken maintains. Mark Twain and George Ade were justified in asserting that there are now two languages, English and American, the latter differentiated by "its impatient disdain of rule and precedent, and hence its large capacity (distinctly greater than that of the English of England) for taking in new words and phrases and for manufacturing new locutions out of its own materials," (Page 19.) The American is restless, impetuous, and swift to take short cuts. He is not, however,

lacking in a capacity for discipline; he has it highly developed; he submits to leadership readily, and even to tyranny. But, by a curious twist, it is not the leadership that is old and decorous that fetches him, but the leadership that is new and extravagant. . . . A new fallacy in politics spreads faster in the United States than anywhere else on earth, and so does a new fashion in hats, or a new revelation of God, or a new means of killing time, or a new metaphor or piece of slang, (Page 22.)

As a result of the widening difference of our American speech from British speech is "not merely a difference in vocabulary," but "above all a difference in pronunciation, in intonation, in conjugation and declension, in metaphor and idiom, in the whole fashion of using words," (Page 34.)

These things may be admitted, all of them, and in fact they must be admitted, but this admission does not carry with it any acknowledgment that there are now two languages or that there ever will be. Mr. Mencken is rejoiced by the vitality, the vigor, the freshness of the American language, and he looks forward to a time when the foremost American authors will cast off all allegiance to the traditions of the language as these came into being in England. Yet he has to regret that he can see no sign of any new departure in the writings of these foremost authors. Walt Whitman and Mark Twain and Mr. Howells are devoid of any colonial subservience to British standards, but what they wrote is still English and English of an indisputable purity. Even Mr. Mencken's own book is written in what he would call English and not in what he would call American.

The fact is that we Americans are all of us the children of Chaucer, the subjects of King Shakespeare, the coheirs of Milton and of Dryden; and we are proud of that ancient and honorable descent. There is really no probability that we shall ever renounce that inestimable heritage, however frankly we may free ourselves from outworn shackles and however bold and willful we may be in verbal innovation. What is probable and increasingly probable, as Mr. Mencken himself is too shrewd not to see clearly, is that the British will prevent the gap between our speech and theirs from becoming wider than it is at present by accepting the best of our linguistic novelties. In a footnote (written in 1894) to the latest edition of the "Biglow Papers" Lowell declared that he could not take up a British journal without finding Americanisms. "The majority of Englishmen continue to make borrowings from the tempting and ever-widening American vocabulary," Mr. Mencken asserts; and "what is more, some of these loan-words take root, and are presently accepted as sound English, even by the most watchful," (Page 134.) And the exacerbated protests of a Frederic Harrison are significant admissions as to the ever-increasing penetration of American words and phrases into current British speech.

Mr. Mencken really gives up his case for the future development of a separate American language when he tells us that "the American dialect of English . . . because it is

already spoken by a far larger and more rapidly multiplying body of people" than the British dialect, will, very likely, "determine the final form of the language," (Page 317.) If the current speech of the United States is not to differ still more widely from that of the British Isles, it must be—and it will be—because the British will accept the best of the American contributions and modifications.

There is a significant remark, credited to Mark Twain and characteristic of his common sense, which I have never been able to find in his writings and which is to the effect that the King's English is the King's English no longer, "since it has gone into the hands of a stock company—and we Americans hold a majority of the stock." That is to say, the English of the future will be colored by the American of the present. In linguistic matters we shall pay little deference to contemporary British conventions, although we shall always be stanchly loyal to the traditions of our forefathers.

It has seemed best in this review to deal with Mr. Mencken's fundamental thesis and to resist the temptation to follow him into the alluring bypaths of linguistic inquiry. Yet there is one excursus I must permit myself. Mr. Mencken asks what effect upon the future of our speech is to be produced by the unassimilated folk of variegated ancestry who have been poured into the melting pot. I wish that he would give me an answer for one linguistic peculiarity which puzzles me. When a Scotsman says, "dinna ye fash yersel'," we see that this is the French "ne vous fachez pas"; and we may explain this as due to the intimate relations of France and Scotland in the days of Mary, Queen of Scots. But when an Irishman says of a portrait that it is "the very spit of him," we recognize the French "c'est son portrait tout craché"; and we wonder how the men of Dublin and the men of Paris happened to hit on the same strange figure of speech. How is it that there are similar parallelisms between American colloquialisms and French? Our "that's the limit" is their "c'est un comble." Ludovic Halévy describes his heroine as "pas coquette pour un liard," and this runs in double harness with "she doesn't flirt for a cent." We call the ballyhoo man outside a show a "barker," and the same functionary in the Parisian fairs of the eighteenth century was known as the "aboyeur." And how is it that a common American affirmative is "sure!" and a corresponding Italian affirmative is "sicurp"?

I find I cannot quit Mr. Mencken without a little faultfinding. He avoids the violent vituperation which used to characterize linguistic debate; but he is not always so courteous as he might be toward the predecessors with whom he does not agree. He mentions the American Academy of Arts and Letters only to sneer at "the gifted philologs of that sanhedrim." He speaks slightingly of the late Thomas Raynesford Lounsbury, who deserved well of all linguistic inquirers: and he adds injury to insult by calling him Thomas S. Lounsbury. And he terms the writer of this review "a pundit." What have I ever done to deserve this stigma?

* * *

April 27, 1919

BOLSHEVISM, IN THEORY AND PRACTICE, AS FRIEND AND OPPONENT SEE IT

BOLSHEVISM, THE ENEMY OF POLITICAL AND INDUSTRIAL DEMOCRACY
By John Spargo
With an appendix and documents. 389 pages. New York: Harper & Brothers.

TEN DAYS THAT SHOOK THE WORLD
By John Reed
371 pages. With illustrations, reproductions, and an appendix. New York: Boni & Liveright.

By CHARLES E. RUSSELL

Two books further apart in method and manner would be hard to find, yet in its own way each of these is a valuable addition to our mounting literature about Bolshevism. Mr. Spargo's great work is an overrunning storehouse of facts for which all students will be grateful. Mr. Reed, besides furnishing his own picturesque versions of historic incidents, casts a great, if unpremeditated, light upon the strange operations of the Bolshevist mind, though the contribution for which the historians most will thank him is the unequaled collection in his book of documents, proclamations, and posters.

Mr. Spargo builds a book of this kind as in the Middle Ages men built churches. He selects his site, puts in the underpinning, sees to the foundations, lays course upon course according to a plan drawn with precision and research. He forgets nothing, he overlooks nothing; every point he causes to count for something toward the designed whole; and when it is done, behold, however it may be examined, order, clarity, coherence, and solidity.

To tell us about Bolshevism he goes back almost a century, explains all the conditions that made a soil for such seed, describes its genesis, follows its growth, considers every influence that fostered it, and when it comes at last full fledged into action his readers see it without mystery or obscurity. Having mastered the story of Bolshevism, philosophical and psychological, he goes sanely to work to illumine for the rest of us that dark and chaotic terrain. You wonder equally at his patience and his insatiable care. He will have authority for every statement; he will take no unsupported testimony. Handling the hottest topic of the day, he never varies from the one attitude of cool and reasoning inquiry. There is no denunciation in his book, and no conclusion that seems tinged with prejudice. To what is urged in behalf of Bolshevism he applies a simple, straightforward test in the manner of a mason measuring stones for an arch. How does the idea square with human experience, needs, and progress? is his question, and he announces the result impartially but unmistakably.

The best way to show his methods is to summarize his seven chapters. "The Historic Background" tells the beginning of the revolutionary movement in Russia and its slow development in the hands of the pioneer leaders and thinkers to the uprising of 1905. "From Revolution to Revolution" carries the story from the birth of the Duma to the beginning of the world war in 1914, and includes a brief but effective sketch of Nicolai Lenine and his novel doctrines. "The War and the People" deals with the changes the war wrought in the revolutionary movement, including its hothouse effects upon Lenin's conception of a proletarian State without any proletarian power. "The Second Revolution" discusses and analyzes the final expulsion of Czarism in March, 1917. "From Bourgeoisie to Bolsheviki" reviews the history of the ill-fated Provisional Government and takes the purely conventional view, common among those that have not been in Russia, that it brought all its troubles upon itself. "The Bolshevik War Against Democracy" relates the revolt by the forces that Lenin had consolidated, the suppression of the people's Constituent Assembly after Lenin and Trotzky had both advocated it and given an implied pledge to abide by its decisions as the expression of the popular will, the restoration under the Lenin Government of all the oppression and all the methods and ways of it that had blackened the record of the Romanoffs. "Bolshevist Theory and Practice," the concluding chapter, is one of the best in the admirable work. The futility of the Bolshevist conception of life and society was never better revealed than in this relentless examination. Some of the comments are beautifully apt. Here is one:

> Notwithstanding the plain lesson of history and experience, the reminder impressed upon every page of humanity's record that between the glow and the glamour of the vision and its actual realization stretches a long, long road, there are many simple-minded souls to whom the vision glimpsed is the goal attained. They do not distinguish between schemes on paper and ideals crystallized into living realities. This type of mind is far more common than is generally recognized.

He ends his lucid summary of these phenomena with this prescription:

> Just as the world of civilized mankind recognized Prussian militarism as its deadly enemy, to be overcome at all costs, so, too, Bolshevism must be overcome. And that can best be done, not by attempting to drown it in blood, but by courageously and consistently setting ourselves to the task of removing the social oppression, the poverty, and the servitude which produce the desperation of soul that drives men to Bolshevism. The remedy to Bolshevism is a sane and far-reaching program of constructive social democracy.

Mr. Spargo is a Marxian Socialist. It seems to him important to show that the teachings of Marx are incompatible with the words and deeds of the men that have wrought the ruin of Russia and the sufferings of millions of its people. Not many of his readers will be impressed with the necessity of this demonstration, but none can deny that he makes his point

clear and interesting, as he makes everything he discusses. It is a book of a thinker for thinkers; serious, adequate, and worthy of the man and the occasion.

All revolutions are good; some revolutions are better than others; the Bolshevist revolution was of the best.

This is Mr. Reed's underlying thesis, and there is no doubt that he writes of it brilliantly and entertainingly. His familiar powers of graphic description and moving narrative are here at their best. In his own way he retells the story of the rise of the Provisional Government, of the gathering strength of the Bolshevist minority, the half-witted revolt of Korniloff, the blood-stained overthrow of the Kerensky administration, the dispersal of the Constituent Assembly, the fighting, the barricades, and the machine guns. It cannot be said that he adds anything to the essentials of the narrative already told by his talented wife or to that in the luminous pages of Miss Bessie Beattie. But he fills in some details, (from his own point of view,) and to those not familiar with the Bolshevist coup d'état his account will be virile and interesting, if not at all times clear.

Many of the incidents he relates afford new and convincing sidelights upon the Bolshevist spirit and methods. In the chapter called "Victory" (being the celebration of the final triumph of the armed Bolshevist minority over the unarmed or badly armed majority) he relates his ride to the front in a motor truck loaded at one and the same time with soldiers and with loose hand grenades and bombs filled with the most powerful of explosives. The bombs and grenades were allowed to roll and bounce around the bottom of the truck while Mr. Reed and his soldiers went on their joy ride, which might have ended any instant in the obliteration of them all.

> Occasionally a patrol tried to stop us. Soldiers ran out into the road before us, shouted "Shtoi!" and threw up their guns.
>
> We paid no attention. "The devil take you!" cried the Red Guards. "We don't stop for anybody! We're Red Guards!" And we thundered imperiously on.

Nothing could have been more typical. In a short time Mr. Reed was taken from the truck, which went on without him. Other soldiers now stood him against a wall and made rapid preparations to shoot him. What for? Apparently on blind impulse and because shooting people was the day's work. He had a pass from the central Bolshevist authority guaranteeing his safety. Of no avail was that; nobody could read it. By the merest chance he escaped the fate that befell thousands of others—befell them in the same way and for the same reason. Long live the revolution!

These flashlights come and go continually across his pages. It is hectic reading, but fascinating—to some minds. What is all the turmoil, shooting, and murder about? We are left at the close wholly uninformed. In this respect Mr. Reed differs in no way from the others of his faith that have essayed the apotheosis of the rifle as the arbiter of social progress. We are left with a clear sense of Mr. Reed's delight in these scenes, but not a

suggestion as to why he should deem them delightful. No doubt the Bolsheviki slew with great energy and success; but what was the slaying for? The nearest approach to an answer to this pertinent question is a paragraph in Mr. Reed's preface:

> Instead of being a destructive force, it seems to me that the Bolsheviki were the only party in Russia with a constructive program and the power to impose it upon the country.

What the world is thirsting to know is the nature of this constructive program thus left within the dark adytum. When less than one-sixth of a country's population undertakes with ruthless slaughter and horrible deeds to impose a program upon the unwilling remainder, persons not entranced with murder have some right to know what all this means. Assuredly their desires in this respect will not be supplied by anything in Mr. Reed's book. He himself propounds the question that is on so many million lips. "What is Bolshevism?" he asks, and the only hint of a response is that this is among the questions "that cannot be answered here." Nothing stranger has been known in human affairs. We have the adherents of a professed idea going forth with weapons to overthrow many Governments in Europe and threatening to overthrow government here, and yet none of them, apparently, able to tell what is the idea they serve or why there should be all this overthrowing. To revolt for the sake of revolting, to fight for the joy of fighting, to slay valiantly, to ride furiously, to shout vehemently, are activities glorious. This we can easily perceive from Mr. Reed's book, as from the others. But as to why we should revolt, fight, slay, ride, and shout we are left darkling.

* * *

June 29, 1919

WINESBURG, OHIO

WINESBURG, OHIO
By Sherwood Anderson
New York: B. W. Huebsch. $1.50.

Conceivably these stories might have been written before the advent of the new psychology, but if so they would not have been understood. The characters are actuated by motives not exterior: their actions give something of the startling effect of a head and shoulders snapping suddenly out of a hidden trapdoor in an empty room. But Mr. Anderson's expositions make these sudden, infinitesimal, half-mad actions as natural to the reader as an excrescence to a physician; both are the result of accumulated secretions. Freud and Jung have taught us how hopes and ideas crammed back into subcellars of consciousness emerge in grotesque masquerade when pressure slackens or becomes too taut; the little tragedies and comedies which take place in Mr. Anderson's town of Winesburg, Ohio, have the support of scientific revelation.

Not that Mr. Anderson's preoccupation has been with science, not even, as in several of the stories, when he deals with characters who live in the borderlands of sanity. His is a purely human curiosity. The passionate school teacher, Kate Swift, in her yearning to have a share in molding the life of a boy she feels to possess genius, says to him:

I would like to make you understand the import of what you think of attempting. You must not become a mere peddler of words. The thing to learn is to know what people are thinking about, not what they say.

This is Mr. Anderson's creed also, and his realization of it in this book gives it an extraordinary quality of vividness, sincerity, tenderness. The inclusion of the last quality may seem surprising in view of what is perhaps the unfortunate introduction to this review; that may have suggested that Mr. Anderson uses the scalpel. Well, he does, but not in the interests of sensation. He loves what he touches; there is the poetry and pathos of the opening story in the book, "Hands," as tragic as the stories dealing with Elizabeth Willard, "Death" and "Mother." The latter tells of a mother who lives in the hope of a destiny for her son removed from drabness. Yet she cannot make the boy see it; it is the tragedy of the inarticulate. The woman's futile struggle to speak reminds one somehow of John Barrymore's dumb gestures when he played Falder in "Justice." Then there are the closing words in "The Philosopher," a characteristic passage, again addressed to young George Willard:

If something happens, perhaps you will be able to write the book that I may never get written. The idea is very simple, so simple that if you are not careful you will forget it. It is this—that every one in the world is Christ and they are all crucified. That's what I want to say. Don't you forget that. Whatever happens, don't you dare let yourself forget.

If this book came out of Russia we should do it lip-service. But even its American origin ought not to dim Mr. Anderson's achievement. It is an easy way of rubber-stamping works of art to compare them to others that have won consideration. Only this prevents us ranking "Winesburg, Ohio," with "Spoon River," or such sketches as Tolstoy's "A Blot of Ink." Besides, Mr. Anderson's voice is his own. He has not been afraid to speak. He has plucked at the heart of the mystery.

* * *

October 5, 1919

VESTED INTERESTS VERSUS HUMANITY

THE VESTED INTERESTS
By Thorstein Veblen
New York: B. W. Huebsch.

Professor Veblen is from Missouri, but he does not wish to be shown. On the contrary, he is the chief of a little group of serious thinkers who are dissatisfied with the world as it is, and seek themselves to show it how much better its affairs might be managed. The text of this book is the one-sided development of the progress from the feudal to the industrial age. The industrial revolution which followed the Napoleonic downfall was not accompanied by a similar development in the law. In that respect we are two centuries behind our own times, and our great need is the disestablishment of industrial vested interests which take the place of the old feudal barons. They protected their vassals, but our modern industrial barons fatten their fortunes by exploiting the workers who earn them, but who do not receive the fruits of their labor. The mediaeval point of view has been carried over into modern times, and needs to be brought up to date.

In Adam Smith's time the unit of labor was the man. In our times the unit is "the plant," the machine which runs the machines, the hands being less important than the tools with which they work. That is as true of distribution as of production, and includes transportation as part of distribution. Master and man have disappeared. Instead there are mechanisms, and mechanical methods of thought. Workmen often do not know their employers even by sight, and human relations no longer survive in industry. Yet the modern point of view is that industrial relations are still those of the man to man contract for work and pay which succeeded feudalism and preceded modern industry. The corporation is the employer, and the owners of the shares are the vested interests entitled to the earnings, with scant regard to the welfare of the workers. Hence the distinction between incomes earned by productive work and unearned incomes arising from ownership of shares in corporate enterprises. No one is more generous than Professor Veblen in recognizing that there has been a great increase—he says "inordinate" increase—in the value of product over the human cost of it. The question is over the distribution of it. Should it go to the workers or to the owners of the shares? And in what proportion of division?

Thus far there is little novel in Professor Veblen's view. But he goes on to contend that the real producer is not the corporation, but the community. No corporation can be a producer in isolation from the entire community. "The total product is the product of the total community's work." More than enough is produced to support both the producers and the wasters. It is the function of investors to "see that no unconsumed residue is left over to cumber the market and produce a glut." The evil of this is that the potential surplus production is neither produced nor consumed, but is restricted in the manner best adapted to increase profits by artificial scarcity, instead of "inordinate" production and distribution. So great is the capacity of machinery that there is only sometimes a necessity to employ all workers or the entire mechanical plant. If that were done customarily production would be so great as to be destructive of profits through the fall of prices. This restriction of output is the community's loss, and the Professor loosely calculates that "the habitual net production is fairly to be rated at some-

thing like one-fourth of the industrial community's productive capacity." That is our existing labor and plant should quadruple, or at least could quadruple, our output of goods in normal times, except for that regard for vested interests which result from the survival of the mediaeval frame of mind, which it is the Professor's object to modernize. By a different route the professor arrives at Karl Marx's indictment of capitalism—that its object is the production of profits rather than goods.

But the indictment of capitalism on that ground must also include labor. Labor is thoroughly up to date, and regards the object of industry as the production of wages rather than of goods. If labor were to work as the professor thinks that capital should work, he easily could double his calculation of potential surplus, which it would be more accurate to consider an assumption of what good things might be distributed regardless of either cost or price. That is a reduction to absurdity. The community could not consume or even waste goods in such quantity. It is easier to assume, in the professor's manner, that capital earns its profits and that capitalists are not "kept classes" who practice sabotage, in the manner of the classes which the professor would prefer to see "kept." The difference in the cases is that labor always gets its wages while capital often works for less than nothing, even sometimes losing its advances in hope of profit. It is easy to see between the lines of the professor's indictment of capital what capital does for the community. It stands ready to serve even while idle, and readiness to serve in emergency is worth money. It supplies the plant which is so "inordinately" productive, and which labor seeks to reduce in efficiency, sharing what the professor imputes to capital for a fault. Capital willingly works piecework, which labor regards as slavery. Capital works with its brain as well as with dollars, and labor regards muscle as worth more than both together. Imagine muscle alone either conceiving or wishing to produce what capital enables it to produce, with less rather than more effort. There are errors in the professor's account of the legal support of capital, but they are venial compared with the principles which he advances. The time has come to denounce the false humanity which is proclaimed as progress, and alleged justice to labor, which more truly is destructive privilege for labor. If capitalism is not defended by its friends as valiantly as it is attacked, the community is in danger of losing by default the "inordinate" production of consumable goods which the world needs more than it needs to turn labor into a "kept" class.

The professor carries his argument into the relations of nations as well as of workers and employers. In its origin and its prosecution it has been an industrial war, growing out of that same spirit of pushing to excess the principle of vested interest and right to seek profit in any manner. The result of the war is a peace which asserts the right of vested interests of the world to restrain the insufferably extortionate vested interests of nations individually. "Demagogues" are as much agitated over the threat to national sovereignty as the vested interests are over the invasion of the sacred rights of property. The purpose of the League of Nations is to preserve the influences which caused the war, and only "insufferable superfluity of naughtiness is to be disallowed." The experience of the war has shown that no nation can stand alone among nations any more than single plants or industries can stand alone in any community, and that tariffs hereafter will be aids to keeping prices up by keeping supply down, by hindering competition and checking production, thus crippling industry for the sake of business. The professor is as much in favor of disallowing the vested interests of nations as of capital, and contemplates that "reconstruction will be likely materially to revise outstanding credit obligations, including corporation securities, or perhaps even bluntly to disallow claims of this character to free income on the part of beneficiaries who can show no claim on grounds of current tangible performance." This would be a mere disallowance of ownership, not a destruction of useful goods. It would merely relieve the industries of fixed charges, and promote production. In short, the destruction of vested interests is the one great boon which the world has yet to hope for. Those who like that idea will like the book. It is well written from that point of view, which is held by so many that it is time to make a stand against the defiance of experience.

MUSIC

January 7, 1910

BERLIOZ SYMPHONY AT PHILHARMONIC

Mr. Mahler Conducts a Fine Performance of It at the Fourth Concert

A WORK THAT FASCINATES

Interesting in Every Way Except Musically—Mr. Busoni Plays Beethoven's E Flat Concerto

The fourth concert of the regular series of the Philharmonic Society was given last evening, (to be repeated in due course this afternoon.) Berlioz's "Symphonie Fantastique" was the principal orchestral number on the programme, the only other one being the prelude to Wagner's "Meistersinger." Mr. Ferruccio Busoni, pianist, was the soloist; he played Beethoven's E flat major concerto, instead of Liszt's arrangement with orchestral accompaniment of Schubert's "Wanderer" fantasie, that had been announced.

Berlioz's symphony has had several performances in New York in the last few years, two of them being due to the fact that both Mr. Colonne and Mr. Weingartner have made the work one of their battle horses, and when they came to New York as "guest" conductors in the interregnum before the engagement of Mr. Safonoff, each, not unnaturally, wished to

produce it, as something of which they stood as exponents of special authority. But years before that the symphony had been made familiar to the subscribers of the Philharmonic, which had been doing pioneering work for Berlioz from its early days.

It is still an astonishing work, considering the date of its composition and the youthfulness of its composer when he created it. It embodies in perhaps the highest degree Beriloz's originality of mind and his strivings to embody in musical art his conception of the delineative function of music, and concentrate many of the strangely fascinating qualities of the man that still exercise their potency and keep the musical historians, essayists, and critics writing about him and the ideas that he set in motion.

It fascinates through the dramatic and poetical intentions that underly it; the seething imagination that endeavors to find expression in it; the autobiographical significance he gave it, which is hinted at in the annotation of the programme; the extravagance of the whole conception, which is an epitome of the nature of the composer—its extravagance in tenderness and romantic impulsiveness as well as in its sardonic and baleful conclusion.

It fascinates equally by many of its technical features; the interesting rise of the "fixed idea" throughout its movements, and its development; by the originality and power of its instrumentation, though this no longer seems of such richness and beauty as it once did. It fascinates in almost every way—except, alas, that of specifically musical invention, musical beauty, musical characterization and musically compelling power.

Here was Berlioz's weakness, and the Symphonie Fantastique is a conspicuous example of that colossal ambition that panted so urgently after musical inspiration all his life, and that so seldom caught up with it. He is most successful when he has need to be least musical, where the subject is grotesque, diabolical, as in the "March to the Scaffold" and the "Dream on the Night of the Witches' Sabbath," or where there is something of purely decorative significance to be set forth, as in the ball scene.

The movements that would naturally call for the most eloquent, the deepest musical expression, are the weakest. The first, called "Dreams, Passions," is vague and disjointed, a helpless inconsequence of insignificant ideas. The "Scene in the Fields" has poetical passages, but they are fleeting, and as music it is pale and unsubstantial.

The performance under Mr. Mahler's direction was a wonderfully graphic, vivid, and powerful reading of the score, and let no detail in it escape its due presentation, in its proper proportion and significance. The reading was free, full of expressive nuance, intensely colored and brilliantly rhythmed. He put at least a plausible poetical accent into the first movement, and especially into the "Scene in the Fields" in which there was an especially imaginative quality, the effect of a free improvisation.

The effect of the "March to the Scaffold" was most incisive and picturesque, and in the final phantasmagoria there was nothing lost of all Berlioz's sinister imagination. The orchestra was enlarged to meet Berlioz's demands for sonority, in which it may be hoped there was complete success.

The last two movements of the symphony aroused the audience to stormy applause, and Mr. Mahler made his men rise to take for themselves their share of it—well deserved, for the performance was most brilliant.

Mr. Busoni returns to America after several years of absence, and this was his first appearance. His art has undergone little change since he last played here, apparently.

He is a pianist of consummate powers, of a very finished style, of the most perfect and polished technique. His performance of Beethoven's concerto had dignity of style and continence of expression. It was a remarkably clear exposition of the contents of the work, as regards phrasing, accentuation, and the adjustment of its proportions. It was deeply interesting, but it was interesting in an analytical way rather than compellingly emotional, and it did not, on the whole, greatly warm the heart. The rhythmical incisiveness and glitter of the last movement under his hands stirred the audience deeply. He was again and again recalled, and finally sat down to play again, not in accordance with the well-justified rules of the society for such cases made and provided. His piece was Chopin's A flat Polonaise, of which he gave an impressive performance.

The playing of the prelude of "Die Meistersinger," was broad and dramatically pulsing; yet it seemed that Mr. Mahler used his augmented forces a little too eagerly in the production of a merely loud sound without consideration of its stridency. There was much fine detail in the exposition of the complicated contrapuntal passages, and the performance was not finished and ornate in detail as it was splendid and sonorous in its larger proportions.

* * *

January 28, 1910

RACHMANINOFF AS CONDUCTOR

Russian Composer Directs First Performance Here of His "Isle of Death"

The ministrations of the Russian Symphony Orchestra continue to be features of certain Thursday nights of the musical season. Last evening the third concert of that organization in Carnegie Hall brought forth an audience of a larger size than usual, which might have been explained by the fact that Sergei Rachmaninoff, the Russian composer, who several times this season has appeared as a pianist, playing his own works, last night appeared for the first time in New York as a conductor, directing the first New York performance of his symphonic poem, "The Isle of Death."

This new composition was inspired by Arnold Boecklin's more or less celebrated picture of the same name, which hangs in the Leipsic Museum. Arnold Boecklin did for cer-

tain German galleries what Gustave Moreau has done for certain Parisian galleries, that is, filled them with distorted visions of a more than imaginative eye. However, this particular picture, which occasionally looms familiar in engraved copies from 'stationers' windows, depicts only an island with towering cliffs, fringed with majestic cypress trees. Near the shore is a boat bearing a bier, by which stands a white-robed figure.

Rachmaninoff's description in tones of this picture is more or less new. It was played for the first time in Moscow about a year ago, and has since been heard in Berlin and other Continental cities. It was played in Chicago in November, and the Boston Symphony Orchestra, under the direction of the composer, gave it a performance two months ago.

Russian music in general, and Rachmaninoff's music in particular, is weighted down with a melancholy, which seems to be racial in its insistence. It is but natural under the circumstances that this composer should turn with a sort of gruesome delight to so congenial a subject for his inspiration. His music in this instance is written more or less in the form of a funeral march, with a deep and insistent rhythm and figurations in the strings which seem to be intended to represent waves washing against the sides of the boat with its sad burden. However, beyond the aforesaid rhythm and a certain melancholic mood, unrelieved in its monotony, the content of the "tone poem" is not important.

The melodic outline is scarcely apparent, and there are neither strange harmonic combinations nor instrumental effects of sufficient interest to divert the ear. It was possibly the composer's intention to show that death is as empty as life. Under the inspiration of the composer's baton the band developed qualities of sonority and precision which it has hitherto given little evidence of possessing.

The programme ended with a performance of Rachmaninoff's second piano forte concerto, which he played himself. This is a work which is not worth such frequent performances as it has received this season, and not in any way comparable to Rachmaninoff's third concerto. The orchestra, under the direction of Mr. Altschuler, played Arensky's variations for strings on a theme by Tschaikowsky and Tschaikowsky's "Romeo and Juliet" fantasie.

* * *

February 23, 1910

"PIQUE DAME" FOR THE FIRST TIME

Tschaikowsky's Russian Opera Finely Given at the Metropolitan Opera House
SLEZAK AS THE HERO
His Excellent Singing and Acting—An Opera with Good Music and Unsympathetic Characters

WITH: Leo Slezak (Hermann); Adamo Didur (Count Tomsky); John Forsell (Prince Jeletzky); Wilhelm Otto (Czekalinsky); Adolf Muhlmann (Tsurin); Glenn Hall (Tschaplitzky); Anton Ludwig (Narumoff); Anna Meltschik (The Countess); Emmy Destinn (Lisa); Florence Wickham (Pauline); Marie Mattfeld (The Governess); Lenora Sparkes (Mascha).
Characters of the interlude: Alma Gluck (Chloe), Pauline (Daphis), Tomsky (Plutus).
Gustav Mahler (Conductor).

For the first time in America Tschaikowsky was given a hearing as a dramatic composer, with a stage performance of one of his eight operas, yesterday afternoon, when his "Pique Dame" was presented at the Metropolitan Opera House. The performance was under the direction of Gustav Mahler, who then appeared there as conductor for the first time this season. The Russian composer himself set much store by his dramatic works; and there are those among his admirers who consider him as a dramatic composer most completely in his element. This theory will hardly commend itself to those to whom Tschaikowsky's quality as a musical dramatist was first revealed yesterday, and who have become intimately familiar with the power of his symphonies and other great orchestral compositions.

But "Pique Dame," in the excellent performance it received, presented itself as an opera above the level of many modern lyric dramas. It is a work of imagination, if not always of the most vigorous invention, supported by a skill in instrumentation, in graphic representation and plastic development of musical material and with many pages of passionate and meloncholy expression, such as we have long known in Tschaikowsky's music for the concert hall. The composer's individuality and originality are constantly revealed in it. It is undoubtedly a part of the genuine Tschaikowsky that is embodied in this opera. He wrote it with intense conviction; veritably wreaked himself upon its chief scenes, and himself fell under the spell of his own conjuring.

It has qualities, however, that are unlikely to gain it immediate popular favor. The subject is dark, the outcome dismally tragic. There are certain enlivening episodes of a pleasing and picturesque character; but the general course of the action, the motives that lie at the bottom of it, the milieu in which it is disclosed, make little appeal. Nor are the chief personages of the drama, especially the hero himself, such as to claim much sympathy in their struggle with the fate that overtakes them. Yet, given these antecedents, these personalities and these somewhat melodramatic series of events, the librettist—who

was Tschaikowsky's talented brother, Modest—has composed from the tale of Pushkin, which furnished him his material, a strong and dramatically effective opera book, far removed from the commonplace, at its climaxes are truly thrilling, evoking an uncanny suggestion of the supernatural and unearthly that has for the moment something of real conviction; and to this the musician has made a contribution of compelling power.

Hermann, the young Russian Lieutenant, is wrapped in a true Byronic gloom, from which he never emerges. From the beginning of the opera to the end he is a subject for an alienist. His passion for cards and his hope of a fortune to be gained thereby rule him alternately with his love for Lisa, already betrothed to Prince Jeletzky; but they dominate and overcome this love. His obsession becomes complete when, having broken her engagement for love of him, Lisa learns from him the truth of her suspicions that, though he did not kill her grandmother, the wicked old Countess, he frightened her to death in trying to extract from her her secret of the three winning cards. She implores him to fly with her, but he babbles of his three cards and repulses her; and as she throws herself into the Neva, his attention is scarcely diverted from the three-spot, the seven, and the ace. In this brief scene Lisa emerges from a vague indistinctness that has only been now and again lightened, and is vividly outlined as a grief-stricken character.

The old Countess, the "Queen of Spades," is a unique operatic personage, with traits skillfully suggested both in the music and in the situations in which she appears. She dodders upon the stage, scolds her grandchild, reviles the manners of the present day, sings of her youthful conquests in Paris, croons an air from Grétry's opera "Richard, Coeur de Lion," falls asleep, only to be awakened by the intruder demanding her secret at the point of a pistol, and expires speechless. Twice she reappears to him as a spirit, once when he is alone in his garrison quarters, and reveals to him the three cards; again at the gaming table, amid the noisy crowd of gamblers, visible to Hermann alone, grinning at him in mockery when his winning ace changes before his eyes to a queen of spades as he would turn it, and he loses all he has staked. In these three scenes the composer has given characteristic musical embodiment in different guises to their gruesome spirit, with orchestral means of no elaborate or extravagant sort, but employed with the sure hand of a master, and amazingly effective.

Tschaikowsky's operatic style is like that of many another composer who has gone beyond the set form of the older operas, and has not accepted that of the "music drama." He writes arias, duets, choruses, ballets, but they are used with dramatic appropriateness and with a skillful fusion that puts no bar to the dramatic progress of the work. There is much melodious arioso, and to the orchestra is given more than the function of mere accompaniment. Its part has often an independent significance and a symphonic development. There are a few leading motives that Tschaikowsky has used with something beyond the hesitating half-heartedness of many modern operatic composers. One that relates to the old

Countess and her three cards is heard often, and with significant force. Tschaikowsky's orchestra is not the brilliant and imposing orchestra of the symphonies, with crashing sonorities often let loose. It is for the most part singularly restrained. It has many touches of delicate color, and has, at least as Mr. Mahler interprets it, a certain open and transparent quality. The skin of the Russian is not sufficiently scratched in "Pique Dame" quite to show the Tartar, so far as the music is concerned, however characteristic of Russian life and Russian character its story and development may be.

The opera does not find its level until after the first scenes, which are in the nature of somewhat conventional preluding, and statements by some of the subordinate characters as to the posture of circumstances—the play of the children in the park, the meeting of the young Russian noblemen. Hermann sings in ecstasy of the woman of his hopeless love, but the music is not ecstatic. A short quintet of the assembled friends is written by a master of part writing, and is uncommonly effective, and Tomsky's ballad-like description of the old Countess's lurid past in Paris, with the refrain of the "three cards" of which so much is to be heard later, has spirit. There is more "conversation music" in the next scene between young ladies in Lisa's house, with a very pretty Russian song by one of them, and the scolding of the governess at their "unladylike" behavior; the chief value of which is that Lisa may then be left alone to sing of the unhappiness brought to her heart by the image of Hermann imprinted there. Now first comes the true Tschaikowskian melancholy and passion into the score, and they wax to an impassioned climax in a duet when Hermann himself appears to press his love upon her and finally to persuade her to break her engagement and promise herself to him.

In the second act there is a masked ball; festal music, a little play of shepherds and shepherdesses, with chords, a duet, and a minuet. In this music Tschaikowsky pays tribute to Mozart, known to readers of his biography to be his chief admiration among composers. Several of these pieces most skillfully reproduce the Mozartean spirit and form. In the midst of these gayeties there is an impassioned interlude between Hermann and Lisa, in which she appoints a meeting with him that evening in the old Countess's chamber. Here Mr. Mahler has made certain rearrangements in the order of the music, as between this duet and the proceedings of the masked ball, with the intention, doubtless, of enhancing the dramatic effect—a step that does little violence to the composer's work.

The scene of the lovers' meeting in the Countess's dimly lighted chamber, unexpectedly interrupted by her return and retirement to sleep, is the scene of Hermann's attempt to wrest from her her secret, and her death. It is rapid in its movement, grim in its depiction of the intruder's frenzied purpose, and its tragic failure. However melodramatic in its conception, it is given a finer quality by Tschaikowsky's restraint and precise touch in the use of his musical material.

Of similar power is the next act, when the Countess's ghost appears to Hermann in the barracks as a storm rages

outside; and here, too, the music gives conviction to the scene. The climax of the human tragedy of the piece, of the pathos of the woman's broken heart, and the man's insensate folly, comes now in the scene where Lisa waits for Hermann on the quay, thinking herself deceived and betrayed by him till her heart is lightened by his coming, only to be cast down again by his indifferent avowal that he caused the Countess's death and his feverish eagerness to get to the card table with his secret of success. The music of the duet has again the passion and the power of Tschaikowsky's more characteristic strains.

A brilliant and varied scene is set forth now at the gambling house, in which, if the picture is not original, its colors, its lights and shadows, are heightened by the strongly picturesque music, especially a stunning chorus. Many things happen; but the significant one is Hermann's appearance, ghastly pale and distraught, and the bewitching of his last card, the rising of the Countess's ghost among the gamblers to leer at him in mockery as he stabs himself.

The new opera is given a handsome and appropriate setting and is enacted with power and appreciation of its less obvious qualities by those chiefly concerned in it. The performance, under Mr. Mahler's direction, especially that of the orchestral score, has remarkable finish, delicacy, and finesse and a strong vitality.

A large part of the success the opera had yesterday—and there was evidence that it had pleased a large proportion of the audience—was due to the superb performance of Mr. Slezak as Hermann. He made a real personality out of that strange figure, and did what could be done to win it sympathy. It was acting of a high order that composed the part so artistically, that developed its significant features and found convincing dramatic expression for them. Equally fine was his singing of the music, which had a splendid vigor and deep feeling. In fact, Mr. Slezak has done few things that redound more to his credit than his performance of this difficult and ungrateful task.

Mme. Destinn was Lisa, a part that only at times gives her her fullest scope. Such a passage as that at the Neva quay she filled with a searching, tragic power. Her singing throughout and especially in the duet in this scene was superb.

Mme. Meitschik gave an admirable character study of the old Countess; and of the men, Mr. Didur ought to be praised for his gay and characteristically debonair impersonation of Tomsky, though all in this group of officers were capable. There was magnificent singing by the chorus, especially in the gambling scene of the last act. What a pity that so efficient an arm of the service is to be disbanded!

* * *

March 13, 1910

TWENTY-FIVE YEARS OF CHAMBER MUSIC

No musical organization in America holds a higher place in the development of music in this country or in the affec-tions of music lovers than the Kneisel Quartet, which celebrated during the past week its twenty-fifth anniversary, a long period of activity for any society which has devoted itself only to the exposition of the best in chamber music. Before Col. Higginson brought Franz Kneisel to this country, in 1885, to act as concertmeister of the Boston Symphony Orchestra and to found the quartet which bears his name and with which he has always been associated as director and first violinist, there had been no very serious attempts to establish a chamber music organization in this country. There was the Mendelssohn Quintet, but this organization included a clarinet and gave concerts of a mixed nature, nearly always with a singer.

Franz Kneisel is a Roumanian by birth and a graduate of the Vienna Conservatory of Music. He made his first appearance in public Dec. 31, 1882, when, at the age of 17, he played Joachim's violin concerto with the Vienna Philharmonic Society. Soon afterward he was offered the position of solo violin in the orchestra of the Imperial Court Theatre. Later he became the concertmeister of the famous Blise Orchestra in Berlin, which had been held before by Ysaye, Halir, and Thomson.

The original Kneisel Quartet consisted of Franz Kneisel, first violin; Emanned Fiedler, second violin; Fritz Giese, 'cello, and Louis Svecenski, viola. Beside Mr. Kneisel, Mr. Svecenski, the violist, has remained faithful to the quartet through its twenty-five years' existence. The second violin and the 'cellist, however, have changed several times. Giese died and was succeeded by Anton Hekking, who in turn was followed by Hans Schroeder, and, only two years ago, by Willem Willeke. After Emanuel Fiedler, Otto Roth became second violinist. He was succeeded by Karl Ondricek, who, in turn, was followed by Julius Theodorowicz. Julius Roentgen at present is second violinist of the organization.

Mr. Svecenski, like Mr. Kneisel, is a graduate of the Vienna Conservatory, and came to Boston in 1885. He was one of the first violins of the Boston Symphony Orchestra for some time, and later took the leadership of the violas of that organization.

Julius Roentgen, the second violinist, was born in 1881, and comes from Amsterdam, his father being a well-known pianist. His grandfather was concertmeister of the Gewandhaus in Leipsic. Mr. Roentgen studied under Joachim, and gave up the position of concertmeister with the Düsseldorf Symphony Orchestra in order to join the quartet.

Willem Willeke, the 'cellist of the quartet, was born in The Hague in 1878. He studied in the Haager Royal Conservatory in The Hague. In 1896 he was engaged as solo 'cellist at Riga. At the age of 18 he was engaged by the Düsseldorf Conservatory as a teacher of 'cello and chamber music.

The history of the quartet means, in a large measure, the history of chamber music in this country. Doubtless other organizations had made known the Beethoven quartets to small audiences in drawing rooms, and concert organizations had occasionally played these specimens of chamber music in miscellaneous programmes.

Still there had been no organized and determined attempt before the Kneisels came into the field to play the best classic and modern chamber music in a regular series of concerts.

At first, as is natural, the Kneisel concerts were given in Boston. Tours of the surrounding country quickly followed. The first New York concert was given in Steinway Hall some twenty-one years ago. Eighteen years ago the Kneisels started to give a regular series here, but it proved unprofitable, and after a time this attempt was abandoned and the organization returned to Boston, which seemed to be more in the mood for receiving the best in chamber music.

Mr. Kneisel tells a story of how at that time he dined one night before one of his concerts with a well-known New Yorker. After dinner his host shook hands with him.

"Aren't you going to the concert?" asked Mr. Kneisel in surprise.

"No; I can't listen to chamber music unless I'm lying on a sofa and have a cigar," was the reply.

"Some years later," Mr. Kneisel says, "he came to all of our concerts, in spite of the fact that neither sofas nor cigars were provided."

After a lapse of time the quartet naturally was brought back to New York. From that time to this its rise in public estimation has been gradual but continuous. There were always the few who appreciated the quartet, and of late years there have been the many, until now the headquarters of the organization can be said to be in this city, where a great number of concerts—at, least for a chamber music organization—are given each year.

Besides providing a suitable diet of classics for the public consumption this organization has given many works their first American performances. Among others may be mentioned in this connection quartets by Franck, Debussy, Ravel, Fauré, Duvernois, d'Indy, Brahms, Tschaikowsky, d'Albert, Dohnanyi, Borodine, and Dvorak.

Mr. Kneisel tells an interesting story of his first meeting with Dvorak.

"We were giving a concert at Chickering Hall," he said, "and had included in the programme Dvorak's quartet in E major, a work which is very seldom played and has never been as popular as his other works. The composer was living in New York at the time, and he came to hear the quartet, although we did not know he was in the hall. After the concert was over he came back to see me, all alone. There was no introduction. He kissed my hand and I kissed his, and after that we were friends.

"Later he gave us two of his manuscript works to play. On Jan. 12, 1894, we played for the first time anywhere the so-called American quartet and the quintet. In order to devote the entire programme to Dvorak, we also played his sextet.

"Dvorak gave me the manuscript parts of the two new works, and I still have them. The scores of the quintet and the quartet were sent at once to Europe for publication. As it would have taken a long time for the proofs to be sent back to America for correction, Brahms was asked to make the cor-

rections. He did so. Dvorak, after hearing the works in rehearsal, also made corrections in our manuscripts. So now, as we always play directly from our manuscript parts, our performances of these works, especially the quartet, differ from the scores as published."

* * *

June 26, 1910

DEBUSSY DISCUSSES MUSIC AND HIS WORK

Cannot Explain How He Composes and Does Not Understand Those Who Are Methodical

HAS TWO OPERAS IN HAND

They Are Founded on Poe's "Fall of the House of Usher" and "The Pit and the Pendulum"

Special Correspondence The New York Times

PARIS, June 17—"I don't know how I compose; really, I don't," said M. Claude Debussy, shrugging his shoulders and reaching out for another cigarette.

The large French window was open, and from the old-fashioned garden was wafted the perfume of leaves freshened by a light shower. Not a noise came through the window, not a suspicion of city life, although the house is but a stone's throw from the Avenue du Bois de Boulogne, where, at that very moment, hundreds of automobiles were madly racing up and down.

"M. Debussy lives at the other end of the square," the concierge had said, and it was indeed a quiet and secluded spot. A delightful house with an atmosphere of peace and work about it, full of wonderful pieces of antique pottery and Oriental curios. The lightly carved walls are painted white in almost Colonial simplicity. The heavy buff carpet on the floor shows off to perfection the handsome Oriental rugs spread on it. In his study M. Debussy has few pictures, but many books. In one corner is his piano, which at the time of my visit he had just left to sit down at his desk. Such meticulous order as his desk showed! The blue blotter almost entirely free from ink stains, a score book lying neatly on it; a couple of writing pads placed geometrically, an inkwell or two, and a rather large jar of handsome green pottery for cigarettes. If at first the jar seemed too large for the purpose, a few minutes conversation with M. Debussy made one come to the conclusion that it could not be large enough—so fast did he smoke.

"No," he continued, taking up the strain of his first sentence. "I do not know now I compose. At the piano? No, I can't say I do. I don't know how to explain it exactly. It always seems to me that we musicians are only instruments, very complicated ones it is true, but instruments which merely reproduce the harmonies which spring up within us. I don't think any composer knows how he does it. If he says he does, it seems to me he must be deluding himself. I know I could never describe the process.

"Of course, in the first place, I must have a subject. Then I concentrate on that subject, as it were—no, not musically, in an ordinary way, just as anybody would think of a subject. Then gradually after these thoughts have simmered for a certain length of time music begins to centre around them, and I feel that I must give expression to the harmonies which haunt me. And then I work unceasingly.

Ideas Fail for Weeks

"There are days and weeks and often months that no ideas come to me. No matter how much I try I cannot produce work that I am satisfied with. They say some composers can write, regularly, so much music a day—I admit I cannot comprehend it. Of course, I can work out the instrumentation of a piece of music at almost any time, but as for getting the the the theme itself—that I cannot do.

"I have tried it. I have forced myself to work when I felt least like it, and I have done things which did not seem so bad at the time. I would let those compositions lie for a couple of days. Then I would find they were only fit for the waste basket."

M. Debussy had finished another cigarette and was beginning a third. An extremely sensitive man he seems to be, and entirely unaffected. Very reticent toward strangers, among friends he is a delightful talker. His rough blue suit, immaculate as his desk and well cut, seemed to typify the man, a man to whom frills and fancies are abhorrent, and yet who, at the same time, in no way neglects his personal appearance. Around M. Debussy, as in his studio, there was no air of "artistic temperament." Probably M. Debussy, like most men who amount to anything, has so much artistic temperament that it takes the form of work, not of disorder and outlandish clothes.

"Don't expect me to talk of myself," he went on. "Please don't ask me to. No, I was in no wise an infant prodigy. I think that some musicians, in talking of their youth, are inclined to embroider their memories, and they will tell you they did this and they did that at the tender age of 10 or 11. No, I confess, I did not write an opera at the age of 3½, nor did I conduct an orchestra at 7."

M. Debussy's eyes sparkled mischievously. Strange that the touch of humor did not show itself before, for M. Debussy has a sense of humor. It brightens his discourse wonderfully.

"No, you see, I was quite an ordinary child in every way, very disobedient and very confident that my ideas were the right ones.

Dissatisfied at Conservatoire

"Well, like many other young men, I was sent to the Conservatoire. From the very beginning I was dissatisfied. I was taught that this chord must be like this and another like that—this is a case of perfect harmony, I was told, and this is not. Then, as now, I believed there was no such thing as a perfect chord. For a long time I did not want to study what I considered foolishness. Then I realized that I must at least pretend to study in order to get through the Conservatoire. So I studied, but all the time I worked out my own little schemes, and when-ever we were taught anything I made a note in my mind as to whether I considered it right or wrong. Don't imagine for a moment that I told any one of this. I kept it all to myself. Until I could give a proof of my ideas I did not care to talk of them.

"Well, finally, as I left the Conservatoire I won the Prix de Rome." [The greatest honor that can come to a young musical student.] "So I went to Rome. In the beginning I was bored to death, then gradually I began to work, and finally got along quite well. Then I returned to France and didn't know exactly what to do with myself, until I came across "Pelléas et Mélisande." Since then you know what I have done.

"At present I am working on two operas centering around Poe's stories, "The Fall of the House of Usher" and "The Pit and the Pendulum." When shall I finish them? I don't know, I am sure. I've been working on them a long time already, and I'm afraid it will take some time yet. As I said before, I can't force myself. It's just like producing vegetables or anything else. If you put a lot of chemicals and goodness knows what in the earth you may be able to raise salad in Winter, but it is not the real, true salad and doesn't taste like it. And in the same way music born under such conditions is not true music—it is a hot-house product.

"No, I have never been in America. In fact I never go any place where my work is being performed. I never go to hear my own work. I can't."

M. Debussy almost trembled with emotion. One felt the musician's soul striving for expression and unable to find it.

Opera and Drama Contrasted

"It is too terrible for me," he added. "The interpretation is always so different from what I mean it to be; not in the singers, but in the general interpretation. An opera is not like a drama. In a drama the words go directly to the spectator's brain or to his heart, as the case may be. At any rate he understands them. But in music it is so different.

"In the first place, how many persons really understand music? Of course, most people are fond of some form of it. I mean they like to hear it, but how many think in music? How many associate music with ideas? While the dramatist's words may not always reach the spectator's heart they at least reach his brain, and thus the dramatist stands a much greater chance of being understood than the musician, who has to work with what is an unknown quantity to most of the audience.

"In the second place, the dramatist makes his words felt directly. He does not have to have a third person interpret them. A composer's works have to pass through a conductor. If the conductor is at all good, even though he may try to render the composer's idea, he will put in his own soul, and the moment the conductor puts in his soul the composer is already in the background. So it pains me to hear my own work." And it seemed to pain him merely to think of it.

"Music is so much a part of myself that I do not recognize it when it is handled by others. To give you an example: The other night a few friends spent the evening with us and one of the ladies favored us with a song, 'One of your own compositions,' she said. I am glad she said it; otherwise I

should scarcely have known it. Her conception was entirely different from mine."

M. Debussy paused for an instant, and one felt how he suffered at the recollection of certain performances of his works.

"No," he continued: "I cannot bear to have my work interpreted just the contrary of the way I want it. Ah, indeed, it is hard to be a musician. You are quite right; my compositions are part of myself, almost like my own children. I hate to see them grow up, for then they have to leave me. They must in time, of course, and one knows it all the while, so one tries to have them behave as well as possible after they have left the home—but one never knows what their fate will be, and that always causes suffering.

Success Has Its Pain

"Success or failure is about the same thing. Of course, you like to have your work admired—and then, on the other hand, do you? I don't know how to express what I feel, but to me music is almost like a human being. Now, you know, if you love a person very much and you can be alone with that person, you do not ask for anything more. And the more the loved person or art is admired, the more it is taken away from you. And you only have to share with many what you previously had entirely to yourself. So that celebrity means nothing to me. I do not care for it."

There was no affectation about M. Debussy. It was entirely natural, this shrinking away from the public gaze. In fact when M. Debussy talks one feels it is because his ideas demand expression, and not because he wants to talk. One seems to see his brain work and force his mouth to speak. He would rather say nothing at all.

"Yes, I was always fond of music," he replied, in answer to a question. "What kind of music? All kinds. Here you hit upon what I think is the greatest mistake of the present day, the desire to classify all music. How can you do that? You speak of German music, Italian music, impressionistic music, and various other kinds. What is the difference? I mean, if you are speaking of a work of art, you cannot say definitely that it belongs to any great group. It is a work of art, and that is enough.

"There is no vital difference between French music and German music, for instance. There is a difference between the temperaments of the various composers, that is all. Of course, as a rule, we French people have a love of clearness of expression and of harmony, (which we are losing, by the way) which the Germans do not have to such a great extent. Italian music may have more melody, you say. Yes—in a way. I really don't know. What do I think of it? That all depends upon the humor I am in. I may go to hear a Verdi opera when in a pleasant state of mind and I find it admirable; I go another day less well disposed and I find it abominable.

Beauty Means Very Much

"Italian music commonplace? I don't know. You say it is like a woman who is beautiful, but has no intelligence. But beauty is a great deal—a very great deal, indeed, and not

everybody can have that. See how people are carried away by Italian music. It touches a chord in their hearts. Beauty in a woman—and in music—is a great deal, a very great deal."

Again M. Debussy paused and took another cigarette. He was evidently thinking over what he had said. Suddenly he leaned back in his chair and made some rings of smoke. Then he leaned forward again.

"Don't talk to me about elevating public taste," he exclaimed "That is the greatest bluff one can din into your ears. How would you do it? By what means? Just think for a moment what the public is composed of. How many persons in an audience understand music? How many devote themselves to music during the day? An infinitesimal number. The rest, where do they come from? From offices, stores, business houses of some kind. Or they come from insipid afternoon teas and gossip. And then they go to hear an opera.

"Most of them are tired after the day's work or idleness. And such people you expect to take an interest in anything new or serious? You demand the impossible. No; the only thing a composer can do for the public—and for a limited part of the public at that—is to lift it, for one moment, out of its daily thoughts. Music may, for one short moment, make the auditor forget his financial operations or his social rebuffs. And with that we have to be content.

"Under such conditions, what difference does it make whether you have German, Italian, or French opera? There is no immovable truth in art; you cannot say that this is so or so. And what difference do the means make, as long as the end is accomplished? If Italian opera is more effective than German, what does it matter? All art is untruth. You may have been told that art is eternal because it is true, but there you are mistaken. Art is the most beautiful of all lies, but it is a lie.

Art a Beautiful Lie

"There is nothing sad in that. It is quite obvious. Art is beautiful, divine, but is it not true. What is truth? It is the exact rendering of things as they are. When do you find that in art? You may sometimes find what one man says he considers the truth, but even then, does he really believe so, at the bottom of his heart? Does any man really 'paint the truth as he sees it?' He often pretends he does. But does he? Take the example of Wagner—a man whose music seems to express the most wonderful, magnanimous soul and who in real life was extremely petty and whimsical.

"No, there will always be an enormous breach between the soul of the man as he is and the soul he puts into his work. A man portrays himself in his work, it is true, but only part of himself. In real life, I cannot live up to the ideals I have in music. I feel the difference there is in me, between Debussy, the composer, and Debussy, the man. And so, you see, from its very foundations, art is untrue. Everything about it is an illusion, a transposition of facts. It neither represents the man who produced it, nor life as it is. Art is a most wonderfully beautiful lie, but it is a lie."

The interviewer looked at M. Debussy and had great difficulty in not shouting, "But M. Debussy, you are the absolute

contradiction of what you have been saying!" For as M. Debussy said that the artist and his work were entirely separated, he spoke with such warmth, he was so carried away, that one felt how the work of the French composer is exactly a reproduction of his soul—a sensitive, delicate soul, yet determined and firm. And at that moment, Debussy the man and Debussy the composer, were but one being.

* * *

September 18, 1910

HOW POPULAR SONG FACTORIES MANUFACTURE A HIT

The music of the multitude has always been a powerful factor in the social development of nations, but only with the past half century has the supplying of it become an important industry.

Nowadays, the consumption of songs by the masses in America is as constant as their consumption of shoes, and the demand is similarly met by factory output.

Songs may be properly classed with the staples, and are manufactured, advertised, and distributed in much the same manner as ordinary commodities.

The minstrels and ballad writers of old probably brought more talent to bear upon their work and took greater pains with it than do their latter-day successors. The former followed their vocation for the love of the thing, and looked for no greater compensation than the means of keeping body and soul together.

The song writer of the Middle Ages, and even much later periods, seldom enjoyed more than an uncertain supply of food and clothing as a result of his efforts. The singer of the same times was glad to receive a night's lodging and a meal in payment for an evening's entertainment. The best of them never earned in a month one-half as much as the dirtiest Italian with the most asthmatic organ contrives to pick up in a week. We are careless of our money, and indiscriminate in our taste. The village boor of Queen Anne's England was more critical and exacting.

There was a great difference in the character of the old-time ballad and that of the present day. Before the age of machinery the lives of the masses were quite as prosaic as they are now, perhaps, but they were less hard and sordid. The softer sentiments found ample room for play in the hearts of the common people. For diversion their minds turned to stories of action and adventure, and so they demanded in their ballads a virility of theme and setting which is almost totally absent from the present-day productions. The ballads of our ancestors fostered family pride and patriotism; they influenced great movements and made history.

To-day our lower orders live in a sordid atmosphere of matter-of-fact and arduous efforts to meet the butcher's weekly bill. There is little room for sentiment in the lives of the mechanic and the working girl. But they feel the want of it and seek it in dime novels and popular songs.

In fact, they need this natural mental pabulum so badly that the dose cannot be too sickly or maudlin for their taste. The songs which catch their fancy most readily are stories of love, with a strain of sadness in them and a plaintive touch in the melody. With these vie in popularity the comic songs that meet their hearts' demand for laughter, and the songs which depict the everyday incidents of their lives in such a manner as to show the underlying human interest.

And the people pay well for their musical diversion. The favorite song writers of the present generation enjoy incomes equal to those of bank Presidents. Several of them net $10,000 a year and more, but it is a precarious income.

The composition of popular songs, whether it be the words or the music, seems to be largely a matter of knack. The ability is often suddenly exhibited and as often suddenly passes away. In many cases the first production has been a success. In not a few the writer or composer has never been able to do anything good afterward.

Sometimes after three or four successes he loses the knack and, perhaps, never again excites popular approval. Or there may be intervals of long, lean years between the seasons of terrapin and champagne which mark the hits. The song writer generally lives up to his income when it is high and, as a consequence, experiences painful periods of reluctant economy.

The production of popular songs has grown to enormous proportions in the past twenty years. The aggregate sales may exceed 30,000,000 copies during a season in which several successes are launched.

The avenues for distribution are numerous. Aside from the ordinary stationery and book stores, large quantities are sold by the department houses, and the publishers receive extensive orders by mail.

In New York there are a number of places devoted exclusively to the sale of popular songs and music. The ten-cent music stores on Broadway that keep a singer pounding out the latest hits on a piano from noon till far into the night sells thousands of copies daily. It was to answer the demands of such places that the scenic cover, with its added appeal to sentiment, came into vogue.

The idea of picturing the song story was carried a step further when the scheme of employing a set of lantern slides as an auxiliary was devised. The sale of slides is no small part of a popular music publisher's business.

The business of popular song publishers is decidedly speculative. From $500 to $10,000 apiece is paid for songs, but neither publisher, writer, nor audience can tell with any degree of certainty whether or not a new production will be a success.

The sale of a song for which no one at the outset entertains great expectations may run into a million copies in the year.

"In the Good Old Summertime" lay for months in a safe before it was launched, and the manner in which it took was a surprise to every one concerned.

On the other hand, a song which gives every promise of success may hang fire hopelessly and never receive recognition, or in the midst of apparent failure it may suddenly

Victor Herbert

spring into unexpected popularity owing to some helping event, or the original rendering of some singer.

"Break the News to Mother" was written in 1897, and created little attention before the outbreak of the Spanish-American war.

"I Have Rings on My Fingers" was published more than eight years ago in England, but never created any particular enthusiasm. A popular vaudeville singer introduced it to American audiences last Winter. It immediately "caught," and for several months was the best seller in the cheap music stores.

A considerable number of our street songs come from the other side, but we send over many more successes than we receive. The English people have developed a strong liking for American popular songs. The productions of our composers usually have choruses that are easily picked up and go with a swing. These are essential characteristics with an English music hall audience, which is always ready to "join in, all together!"

A popular music publisher's place is a veritable factory. There are rooms where composers are submitting their productions to the critical judgment of the manager; other rooms where vaudeville singers are trying new songs. Half a dozen pianos may be accompanying as many voices at the same time, and occasionally a banjo or mandolin joins in the musical medley. There is the stock room, where hundreds of thousands of printed copies are piled up on partitioned shelves. There is the slide department, with its stacks of boxes, and the business office, where the ultimate product, still in the form of notes, is handled.

Few songs reach the publisher in a finished condition. The original lyric is usually altered more or less and sometimes the original song is not recognizable in its ultimate form. "Two Lovely Black Eyes" was first submitted as a sentiment ditty, but immediately struck the publisher as affording greater scope for humorous treatment.

It seldom happens that the music as presented by the composer is altogether acceptable. Sometimes he has nothing more than a rather crude melody to offer, which his inability to write music has prevented him from committing to paper. It may be "good stuff," as far as it goes, and in that case it is taken down as the composer hums or whistles it and sent back to the department where the music is doctored and the scores arranged. Here it is worked into shape by technical musicians with the aid of the originator, to whom fresh inspiration is apt to come in the course of development.

Writers and composers with established reputations object to liberties being taken with their productions and will hardly ever brook the least suggestion of change. The man who has made a recent hit is a difficult person to deal with. He is filled with the idea that the whole country has its ear cocked to hear from him again. He must have things precisely his way. He is stiff in his terms, demands a certain kind of picture cover and a certain singer to introduce his song. The publisher dare not deny him, but he knows that he is taking a big chance of the next attempt proving a failure. As often as not, it does and the third falls flatter still. Then the man of one hit joins the ranks of the humble pie eaters and is glad to get a production printed on any terms. He goes on writing things that won't go off, hoping some day to make another hit, and now and again he does.

It is a remarkable fact that a large number of men seem to have just one good melody, or one good lyric, in them, and no more. Another peculiar thing about popular songs is that, while there is a distinctly effeminate quality in the majority of them, it is very seldom indeed that either words or music emanate from a woman. Furthermore, the masculine point of view predominates in the sentimental as well as the comic songs, but nevertheless women are by far the largest purchasers of them.

In fact, a song that should fail to appeal to the female element of the middle and lower classes could not possibly be a success. The mystery of that appeal no mere man can fathom. Look around you in a music hall when a supposedly funny song story is being rendered, dealing with the betrayal of a wife's trust. The most appreciative members of the audience are women. They, again, are the most commiserate when the singer, in plaintive numbers, unfolds a similar tale, sentimentally treated.

In America the popular song is of comparatively recent introduction. Its prototype was a composition with monoto-

nous refrain and elaborate setting, which could only be rendered by a trained voice after laborious practice. It was seldom heard outside of drawing rooms, where it was sung with due ceremony and technical precision by prim young maidens in fresh white gowns and dapper swains in swallowtails. The only part of it that ever impressed the unfamiliar ear was the insistent refrain, which always ran something after this fashion: "Evangeline, where wendest thou? Where wendest thou, Evangeline-where wendest thou-where wendest thou-wendest thou-wendest thou-thou-t-h-o-u!!"

The song always left you in doubt and wonderment. You never learned where fair Evangeline wended, nor why she wended; nor indeed any single fact of interest or consequence regarding her.

That sort of song could never have become popular. You couldn't expect the messenger boy and the shopgirl to take a very keen interest in Evangeline's wendings when they led to nowhere. The masses need something more direct—something with a more human appeal. One of the chief secrets of popular song writing is to tell a simple story and to tell it completely.

At that time no attempt was made to cater to the musical tastes of the people. It was not supposed that they had any. Almost the only approach to popular ballads were a few well-worn war songs and plantation ditties. But two or three American song writers were trying to get a hearing with the kind of appeal to the people which in England, where the music halls afforded a ready avenue for reaching the masses, had been successfully made for many years.

American publishers were not at all receptive to the new idea. There was a handsome profit in editions of five or ten thousand at $2 a copy, and they little suspected the bonanza to be found in catering to the multitude. When the author of "After the Ball" offered the production to publishers twenty-seven years ago he could not find one willing to take it in the original form. They recognized unusual merit in the song, but wanted to transform the lyric to the thee-and-thou type, and to elaborate the music. Charles K. Harris, who was the author of both, refused to make any change in the song and ultimately published it himself. It was an immediate and tremendous success, and became the foundation of one of the largest popular music publishing houses in the country, which has a little red imp chasing a football for its trademark.

To one who has never tried it would seem to be an easy matter to write a popular song and no great achievement to set it to taking music. The greatest hits do not display any considerable degree of literary or musical ability. The words are generally inane and the construction not infrequently ungrammatical. The music is often such a simple tune as a child might conceive. But many talented writers and composers have failed utterly in the attempt to produce one or the other of the component parts of a popular song. Others—Some of whose photographs are shown here—have caught the secret.

Popular songs may be roughly divided into sentimental and comic—there are subdivisions in which fall novelty songs, waltz songs, character songs, and so on. Whether a song be sentimental or comic, it should tell a simple story, or deal with a simple incident of every-day life that will go home to the average American, who, according to the census, is John Smith, the mechanic, earning $18 a week. The melody should be equally simple, something that can be caught and retained by the average ear—say Mrs. John Smith's on the third or fourth repetition. Any attempt at elaboration in words or music is bound to be ruinous.

The title should tell the story to three words—"After the Ball," "Alone in the City," "Love by Telephone." The slimmer the peg on which the two verses of the lyric are hung the better.

Love is, of course, the basic motive in 99 per cent of sentimental songs. Some of the most successful of these have been suggested by a trivial incident or haphazard phrase, and the story conceived on the instant. The best results are produced under these conditions and when the writer works off this lyric while the inspiration is strong upon him. Spontaneity, even though accompanied by crudity, is the life of a popular song. Studied effort kills it. It is not to be supposed, however, that a writer ever dashes off a complete set of verses. He may come very near to it in the first hour of effort and spend three weeks groping for a single word.

A successful song writer has the faculty of seeing the element of human interest in the life about him. He never has to hunt for themes. He finds them on every hand. The author of "If I Should Meet You"—and, by the way, a quarter of a century ago it would have been "If I Should Meet Thee"—was closing his window against a sudden storm when he noticed a young woman hurrying across Broadway with bent head at the moment that a man came out of a hotel and started to cross the street in the opposite direction. They ran into each other, looked up, and started back in evident amazed recognition. The song writer imagined a chance meeting of erstwhile lovers after years of separation. He fancied the gush of sudden emotion and the quickening of long dormant sentiment. There was the theme of a song story ready made to his hand.

Two little children, a girl and a boy, were building sand piles. The girl had raised one to a height of which she was delightedly proud when her companion in a spirit of mischievousness kicked it down and ran off a little way to laughingly watch the effect of his devilment. But when he saw his little playmate sobbing in distress he came back and kissed the smiles into her face again.

The whole incident occupied less than five minutes, and before he left the bench from which he witnessed it a song writer had outlined "Kiss and Let's Make Up."

A chance expression has more than once furnished the theme for a hit. Two men—a writer of lyrics and a composer of song music—met casually in a barber's shop one midsummer morning. "My wife's gone to the country," remarked one. "Hooray! Hooray!" exclaimed the other. In a flash the possibilities struck both of them. They went off and constructed the song.

That afternoon it was tried over at a publisher's. The same evening of the same day it was sung in several Broadway cafés and caught the audiences at once. The publisher printed an edition in hot haste. Carts carrying pianos were sent out on the streets with singers announcing to the sympathetic multitude the interesting and suggestive fact that their wives had gone to the country. In less than ten days all New York was whistling the tune, and it had reached San Francisco in a month, which is half the time a success usually takes to travel across the continent.

This was an instance of popularity born in the street. The vaudeville stage is the most common medium of introduction to the public. As with a leading part in a play, a great deal depends upon the interpretation, and a song that falls flat under the treatment of one singer may be a pronounced success in the hands of another.

* * *

January 21, 1911

DIE MEISTERSINGER AT METROPOLITAN

Wagner's Comedy Revived and Preparations Made to Bring Out Others of His Works Here

ONLY THEATRE TO DO THIS

Even at Beyreuth Later Productions of the Composer Are Not Heard—Opera Well Sung Last Evening

WITH: Emmy Destinn (Eva); Florence Wickham (Magdalene); Carl Jorn (Walther von Stolzing); Walter Soomer (Hans Sachs); Otto Goritz (Beckmesser); Herbert Witherspoon (Veit Pogner); William Hinsliaw (Kothner); Glenn Hall (Vogelgesang); Julius Baver (Zorn); Pietro Audisio (Moser); Walter Koch (Eisslinger); Gaston Martin (Nachtigall); Louis Wespi (Ortel); Marcel Reiner (Foltz); Frederick Gunther (Schwartz); Albert Reiss (David); Antonio Pini-Corsi (Eln Nachtwachter); Arturo Toscanini (Conductor).

Wagner's comedy of mediaeval Nuremberg, "Die Meistersinger," received its first performance of the season last evening at the Metropolitan Opera House. In a few weeks "Das Rheingold" and "Die Götterdammerung" are to be brought forward, and then every one of the important works of Wagner will be in this season's répertoire at this theatre. Only "Die Feen," "Rienzi," and "Der Fliegendé Holländer" will remain unsung.

There is not another theatre in the world of which this can be said, for no other theatre except Baireuth has "Parsifal" in its répertoire, and at that festival house the répertoire for any one season never includes all of the later works of the composer.

Arturo Toscanini conducted "Die Meistersinger" for the first time here last season and brought out the poetic details of the score in a manner which made the performance one of the most notable of the year. Last night again the colors of the orchestral score were painted vividly by his very certain hand. Such a ceaseless flow of melody occurs in very few scores, and under the direction of Mr. Toscanini Wagner's music glows with life. There is some difference of opinion about the German comedic element which abounds in this book. There are some who feel that Mr. Toscanini does not bring this out to the extent that a German might. However, his poetic reading of the music is compensation enough in any case.

The cast last evening differed in many particulars from that of last season, but all the singers had been heard here before at various times in their respective rôles.

Miss Destinn returned to the part of Eva and she sang the music with a beauty of tone and a freedom of utterance which aided materially in the spirit of the performance. Miss Wickham sang Magdalene well and gave to the part a humorous characterization.

Carl Jörn, who had been the King's son in Humperdinck's new lyric drama the evening before, was the Walther on this occasion. This tenor has seldom sung here with better effect. Occasionally his throat method of producing his tones was noticeable, but usually he was more than excellent, both vocally and dramatically.

To Walter Soomer fell the part of Hans Sachs. Sometimes too Baireuthian in his methods, he sang much of the music extremely well.

William Hinshaw was a newcomer in the cast. He sang the Handelian measures of Kothner in the first act without by any means exhausting their possibilities. Mr. Witherspoon was the Pogner.

It is unnecessary to refer at length to the familiar characterizations of Beckmesser and David by Mr. Goritz and Mr. Reiss. The former, however, is a masterpiece of humorous action and voice coloring which never falters for an effect, and Mr. Reiss's David is both sympathetic and accurate.

The stage management last evening was excellent in detail. The chorus sang splendidly, especially in the difficult finale of the second act. The audience was very enthusiastic and there were many curtain calls, several of which were shared by Mr. Toscanini.

* * *

November 25, 1911

DOUBLE OPERA BILL; CARUSO AS CANIO

Large Audience Hears "Cavalleria Rusticana" and "Il Pagliacci"

MME. DESTINN AS SANTUZZA

Caruso's Singing Rouses the Audience to Enthusiasm—The Donkey Furnishes Amusement for a Moment

CAVALLERIA RUSTICANA
WITH: Emmy Destinn (Santuzza); Jeanne Maubourg (Lola); Riccardo Martin (Turiddu); Dinh Gilla (Alfio); Marie Mattfeld (Lucia).

PAGLIACCI
WITH: Bella Alten (Nedda); Enrico Caruso (Canio); Antonio Scotti (Tonio); Angelo Bada (Beppe); Dinh Gilly (Silvio); Giuseppe Sturani (Conductor).

The "double bill" of "Cavalleria Rusticana" and "Pagliacci," with Mr. Caruso in the latter and Mme. Destinn in the former, attracted an enormous audience at the Metropolitan Opera House last evening, as this familiar combination of two dramas of sultry Italian passion may be relied upon to do. Both performances presented features that have long been well known to operagoers, and are evidently highly approved by them. And it is no wonder that Mme. Destinn's Santuzza should be so, so filled is the impersonation with deadly intensity, so beautifully sung. There is little that is new to be said now of Mr. Martin's Turiddu or Mr. Gilly's Alfio or Miss Mattfeld's Lucia. Mme. Maubourg gave interesting evidence in her singing of the music allotted to Lola of an improvement in her style and vocal method. It was charmingly shown in the little song that she has to sing as she first enters upon the stage.

The gayety of the proceedings in the first scene of "Pagliacci" when the strolling company of players arrives was enhanced by the independence of the donkey that draws the cart. He decided to rest upon the ground; and it engrossed the attention of the comedians for some moments to free him from his trappings and set him upon his feet again. Gayety is short lived in "Pagliacci," however, and matters soon became very serious, indeed, with the complications in which the passions of the human actors were involved. Mr. Caruso found them never more so, and they roused him to some of his most boisterous and vehement singing. He has rarely been more prodigal of his voice or more reckless in his outpourings or in his accentuation of all the sobbing passion that he feels as Canio, reaching its climax in the song at the close of the first act. There was no continence or circumspection here, and he roused the audience to riotous demonstrations of enthusiasm. Mr. Scotti sang the part of Tonio in his accustomed manner; Miss Alten was the Nedda and Mr. Gilly the Silvio. Mr. Sturani's conducting had energy and a certain authority, at least, if not finish.

* * *

February 23, 1912

THE "RING" CYCLE ENDED

A Superb Performance of "Götterdämmerung" at the Opera

The cycle of Wagner's trilogy, "The Ring of the Nibelung," was brought to a close yesterday afternoon with a performance of "Götterdämmerung" that will stand in the annals of the Metropolitan Opera House marked with a distinction such as few performances of this work have ever merited. The whole cycle has been presented to the Wagner-loving public in a manner that is deserving of the highest credit. It was unfortunate that it could not have been compressed within the space of a week that it might have had more the effect of one whole that Wagner intended for it; but as the exigencies of the regular repertory made this impossible, its audiences have been fain to be content with a representation on so uniformly high a plane as to have added a new distinction to the institution that has provided them.

The audience that listened to "Götterdämmerung" was a very large one. It was profoundly impressed and deeply moved by the performance. It was an audience of music-lovers who came to hear the music drama, and not because they had subscribed for a season of opera and took what was given them. It knew, and it appreciated what was offered to it, and it displayed a kind and a degree of enthusiasm that is not often liberated at the Metropolitan. The high merits of the performance, its uniform excellence in ensemble, its absence of weak points, its dramatic power, its essentially musical beauty that were due in so large a measure to Mr. Hertz's conducting, and especially the excellence of the orchestra's playing, all contributed to the effect produced by the performance.

But much of the applause was especially meant as a recognition of Mme. Fremstad's marvelous representation of Brünnhilde—an achievement that over-topped anything she has yet done, and that raised her still higher, if that were possible, in the admiration of those who love Wagner's lyric drama. At every successive appearance of Mme. Fremstad in the Wagnerian parts that she has of recent years made her own, she has risen to a loftier stature as an artist. It has seemed that the very summit had been reached in her latest impersonations of Isolde; but as Brünnhilde she disclosed a still nobler art, a still greater dramatic power. Mme. Fremstad's resources for the embodiment of all the sweep and storm of emotions that beset Brünnhilde's soul, and of the majestic repose and dignity of her final proclamation over the dead hero's body were inexhaustible. In voice she has never been finer; and yet attention was not centred upon the voice, for all its beauty, its dramatic color, its poignant declamation and phrasing seemed indissolubly mingled with her action, gesture, pose and facial play as essentially a part of one and the same expression.

Of the others, all now known to this public in the performances of "Götterdämmerung," words of high praise are also to be spoken; of Mr. Burrian's Siegfried, of Mr. Weil's striking

and finely conceived Gunther—an impersonation that really shows what this figure stands for in the drama; of Mr. Griswold's exceedingly powerful and vividly represented Hagen; of Mr. Goritz, long admired; of Mme. Fornia's Gutrune, intelligent and sympathetic in its portrayal, and especially of Mme. Homer's Waltraute. Mme. Homer's voice has never been richer or finer in dramatic quality, and her representation of the scene with Brünnhilde in the first act was very impressive. As one of the Rhine Maidens with Mmes. Sparkes and Alten, she contributed much to the beauty of their song in the last act.

* * *

March 7, 1912

"DIE MEISTERSINGER" GIVEN

An Admirable Performance of Wagner's Comedy Under Mr. Toscanini

WITH: Emmy Destinn (Eva); Florence Wickham (Magdalene); Carl Joern (Walther con Stolzing); Hermann Weil (Hans Sachs); Otto Goritz (Beckmesser); Putnam Griswold (Veit Pogner); William Hinshaw (Kothner); Lambert Murphy (Vogelgesang); Julius Bayer (Zorn); Pietro Audisio (Moser); Charles Hargreaves (Eisslinger); Gaston Martin (Nachtigall); Paolo Ananian (Ortel); Carl Hager (Foltz); Bernhard Heidenreich (Schwartz); Albert Reiss (David); Antonio Pini-Corsi (Ein Nachtwaechter); Arturo Toscanini (Conductor).

"Die Meistersinger," as it is performed at the Metropolitan Opera House, has in recent years been one of the most notable productions to be heard there—one that is in many respects almost an ideal fulfilment of Wagner's intentions as embodied in this music drama. It was given there last evening for the first time this season—a late addition to the repertory as it has been for the last two years. Two seasons ago its direction was entrusted to Mr. Toscanini, and he again has it. There is room for some discussion as to his reading of the work in certain particulars, as there has been in the past. But it can hardly be denied that this reading is one of the richest, fullest, most entrancing musical beauty. It has exquisite finish and a perfect balance and adjustment of the orchestral components that give it a ceaseless, golden euphony, and that bring always uppermost the melody that sings and swells through the score. The melodic line is beautifully preserved. Some of Mr. Toscanini's tempos seem somewhat fast, and his treatment of some of the scenes of comedy is a little unyielding. His attention is directed, perhaps, more to the purely musical side of the work than to the dramatic. But this is of surpassing beauty, and many of the scenes have scarcely been done better, as that of the riot at the end of the second act.

There were some new appearances in the cast, of which most were familiar from performances in previous seasons. Mr. Hermann Weil took the part of Hans Sachs for the first time here. It was an intelligent impersonation, and many of

its details were excellent in conception and in their relation to the whole. But Mr. Weil did not lay much emphasis on the side of kindly humor and geniality, the "Gemuthlichkeit," that is so essential an element in the character. His action was lacking in unction and mellowness; nor were these qualities prominent in his singing. Mr. Putnam Griswold's Pogner was a new and delightful disclosure of his powers in both singing and impersonation; admirable in feeling and sung with a noble and beautiful voice. Of the other mastersingers Mr. William Hinshaw's Kothner deserves praise for its excellent qualities; it will deserve more when he has gained greater flexibility and fluency in the part.

Mme. Destinn as Eva, Mr. Jörn as Walther, Miss Wickham as Magdalene, Mr. Goritz as Beckmesser, and Mr. Reiss as David, are well remembered and most of them much admired representatives of these characters, and they do much to give the performance the distinction which it has.

The audience that heard "Die Meistersinger" was large and gave indications of unusual enjoyment and appreciation of it.

* * *

April 8, 1912

NIKISCH IN ON EVE OF LONG CONCERT TOUR

Famous Conductor, Still Young Looking, Back After Nineteen Years' Absence

SHUDDERS OVER SCHONBERG

His Music Nothing but Dissonance—Enthusiastic Over Strauss Opera—Won't Play Novelties Here

Arthur Nikisch, the conductor of the famous Gewandhaus concerts in Leipsic and of the Philharmonic Orchestra in Berlin, arrived in New York yesterday on the Caronia to conduct a series of concerts in this country with the London Symphony Society, with which he has frequently been the guest conductor. Mr. Nikisch has not been in this country since 1893, when he was conductor of the Boston Symphony Orchestra, a post which he had held from 1889 until 1893.

In spite of his long term of service he retains a most youthful appearance. His masses of hair and beard and his short stature (yesterday clad in a comfortable lounging suit) complete a picture which is well known to countless American music lovers.

"The crossing was a good one," said Mr. Nikisch yesterday at the Hotel Astor, where he is stopping, "But I caught a very bad cold which has left me feeling not at all well. I hope to be better by to-morrow night, when I conduct my first concert in Carnegie Hall, for after that I start on a strenuous tour, which I have only equalled once before in my career, when, with the Berlin Philharmonic Orchestra, we gave forty-three concerts in forty-five days in such diverse countries as Spain, Austria, Italy and Belgium."

No Novelties for America

"You are not including any novelties in your American programme?"

"No, the compositions are all tried and true. There are few novelties that are worthy of performance at present."

"What is your opinion of the value of the new German music? How do you like Schönberg, for instance?"

"Schönberg!" Mr. Nikisch threw his hands high in the air. "If that is music then I do not know music. I cannot think of Schönberg as anything but a bluff. He is trying to see how far he can go. A child could compose music as good. There is no sequence, no tone, nothing but dissonance. None of the parts have any relation to the others. There are no bars. It is as if he wrote a flute part on the top of the staff—just notes, that's all; under that the oboe part entirely different, with no relation to the other, and so on. If that is composition I know nothing about music."

"Does he go further than Reger?"

"I should think so. Reger is a great musician. He is a marvelous contrapuntalist. To be sure, he lacks invention and his music is lacking in passion or fire."

Orchestral Music's Future

"What will be the future of modern orchestral music? Do you think it will be Schönbergian?"

"If it is and I had to conduct music of that character I should change my occupation. Still, Schönberg undoubtedly has many imitators in Germany. Strauss is writing nothing but operas now. Since the 'Sinfonia Domestica' he has written nothing for the orchestra alone. You haven't heard his 'Rosenkavalier' over here and it is most marvelous music. What poetry, what beauty, what passion there is in that music, and so different from his other scores.

"I also admire the modern French school, particularly Debussy, who has his genre and has made much of it. He in his way is a great revolutionist, but he has succeeded in writing beautiful music, even if it is different."

* * *

November 26, 1912

SING 'GIRL OF GOLDEN WEST'

Puccini's Opera with Miss Destinn and Caruso Again Stirs Audience

WITH: Emmy Destinn (Minnie); Enrico Caruso (Dick Johnson); Pasquale Amato (Jack Rance); Albert Reiss (Nick); Adamo Didur (Ashby); Dinh Gilly (Sonora); Angelo Bada (Trin); Giulio Rossi (Sid); Vincenzo Reschiglian (Bello); Pietro Audisio (Harry); Lambert Murphy (Joe); Antonio Pini-Corsi (Happy); Bernard Begue (Larkens); Paolo Ananian (Billy); Marie Mattfeld (Wowkie); Andrea de Segurola (Jake Wallace); Paolo Ananian (Jose Castro); Lamberto Belleri (The Post Rider); Giorgio Polacco (Conductor).

"The Girl of the Golden West" still remains Puccini's latest opera, and, from all accounts, it is likely to have this distinction for some time, for this Italian composer turns out surprisingly little work. Last night the opera was performed at the Metropolitan Opera House for the first time this season. "The Girl" belongs peculiarly to this theatre, as Puccini introduced her to the public there, and, as a matter of fact, this is practically the only city where the opera has had success.

The performance of the opera no doubt contributed strongly to this condition of affairs in the beginning, and Mr. Gatti-Casazza may better congratulate himself on the singers which he was enabled to produce it with than with having produced the opera itself. In the beginning it was recognized that the east could scarcely be bettered, and last night's cast was identical in all essential particulars with that which originally appeared.

As for the staging of the piece, that was originally in the hands of David Belasco, and most of his directions have been followed since with a keen regard for keeping the performance on as high a level as possible. There have been a few cuts made in the first act, and these have all been for the best.

Miss Destinn sang the part of Minnie last night as she always has here with great dramatic effect and with such quality and quantity of tone as few sopranos could muster. Mr. Caruso's assumption of the part of Dick Johnson has always been one of his most successful attempts at characterization. Mr. Amato's Jack Rance completes the trio which gives this opera its importance. Mr. Gilly's Sonora is worthy of a word of praise. The Algerian baritone brings much sympathy to the part.

The novel feature of last night's performance was the conductor, Mr. Polacco, as Mr. Toscanini has hitherto conducted the work in New York. But if Mr. Polacco as a conductor of this opera was new to this audience, the opera is certainly not new to Mr. Polacco. It was in fact Mr. Savage's production of the work in English which brought him to this country last season. He has also conducted many performances of "The Girl" in Italy.

It may be said that he brought great vigor and force to the work, almost too much at times, when it seemed that he drowned out the voices unnecessarily. He also carved out the finer portions of the score with great delicacy. In fact, his reading was extremely interesting. It differed very little in general effect from that of Mr. Toscanini, and it must be remembered that both conductors were taught their tempi by the composer.

The audience was enthusiastic, and after the melodramatic second act there were a great many curtain calls. Miss Destinn and Mr. Amato received flowers, and Mr. Amato handed one of his roses to Mr. Caruso—an act which resulted in one of those comedy scenes which the tenor loves to play before the curtain.

* * *

March 3, 1913

THE NEW YORK SYMPHONY

A New Work by Jean Sibelius Played for the First Time

Mr. Damrosch prefaced his performance of Jean Sibelius's new symphony at the New York Symphony Society's concert yesterday afternoon with a brief statement in the nature of a warning. He was performing the symphony for the first time in America, he said, as a duty, because it was the last word in symphonic composition of a man who had previously made a recognized place. And if any did not like it, or liked it only in parts, they were to remember this fact.

The symphony, when it was heard, seemed to justify Mr. Damrosch's statement, and the opinion he added that it was the work of a man "tired of the musical effects of the past, or of what have hitherto been considered such"; also that it embodied the most extraordinary ideas of symphonic development that ever he had seen.

The symphony certainly signifies a sudden departure of its composer from all his previous musical ideals, as they have been made known in the works hitherto performed in New York. It is a few weeks since the Boston Symphony Orchestra played his first symphony here—strong, sinewy, gloomy music, showing a strong, imaginative flow, a rich, even if a harsh, expressiveness; and certainly no doubt in his own mind as to what he meant.

This new symphony seems hemmed in with doubts of the composer's own raising, uncertainties, half-hearted attempts, beginnings without issue. His themes are generally long and diffuse, though they sometimes have character. One of them strangely resembles the pastoral theme in Berlioz's "Fantastic Symphony." But they are developed with singularly little feeling for a definite result, often gropingly, tentatively; they are dropped and something else is taken up; they vanish mysteriously and leave no results. There is little constructive feeling in any of the movements—they simply expire, like a candle blown out, or, as Mr. Maxson says in his programme note, like a soap bubble, pricked. There are few attempts to build up instrumental effects. The instrumentation is very light and transparent. The themes are often presented in imitation by one and another choir, with so light a harmonic background as to give the effect of barrenness. Biting dissonances in the leading of these open voices the composer is unconcerned about. There are other "modern" effects of "whole-tone scale." The substance of these four movements is rhapsodical. The second movement begins somewhat more coherently with the feeling of a scherzo; in a rhythmically striking theme for the oboe, but the mists soon gather around it. In the third there is a strong and eloquent passage of a more determinate character, but it, too, "dies and makes no sign." The work leaves an impression on a first hearing of something vague, shadowy, elusive, not to say inconsequential. Whether it is truly the realization of a more definite purpose than was to be heard in it yesterday perhaps greater familiarity with it would disclose.

Mr. Arthur Hartmann, a violinist who has been heard in New York, but not recently, played Mozart's concerto for violin in E flat with taste and skill, but in a style rather limited and subdued beyond what the character of the work required. He played with correct intonation and with a tone somewhat small, but not unpleasing in quality. The programme began with the ballet music, "Les Petits Riens," by Mozart, which Mr. Damrosch was the first to play in New York a few years ago.

* * *

April 14, 1913

TOSCANINI CONDUCTS SYMPHONY CONCERT

In Wagner's "Faust Overture," Strauss's "Till Eulenspiegel," and the Ninth Symphony

A SUPERB PERFORMANCE

Great Qualities of the Conductor Disclosed—Orchestra, Chorus, and Quartet Meet High Expectations

The last of the season's Sunday night concerts at the Metropolitan Opera House took on a character that this popular series has but once before assumed—the character of a symphony concert of the highest type, conducted by Mr. Toscanini, who then made his first appearance in America as a symphonic conductor. When Felix Mottl first came as a conductor to the Metropolitan ten years ago, he conducted one symphony concert of this kind; but Mr. Conried saw, or thought he saw, signs that this was not the sort of thing his Sunday night audiences wanted, and the concerts promptly resumed the ephemeral and popular character they have retained ever since.

Last night, however, it was clear that this was the sort of thing this particular Sunday night audience wanted. The announcement that Mr. Toscanini would conduct Beethoven's Ninth Symphony, Wagner's "Faust" Overture, and Strauss's "Till Eulenspiegel" had aroused the greatest interest among the educated and discriminating members of the New York musical public for whom the ordinary Sunday night concert scarcely exists, and the house was filled to its utmost capacity in every part. It was an audience in which, besides habituées, there were many prominent musicians, and many fastidious lovers of symphonic music. Mr. Toscanini has made so profound an impression as a dramatic conductor that there was the keenest interest to observe what he would accomplish in another field—a field in which his remarkable powers must necessarily achieve remarkable results.

The orchestra was the orchestra of the Opera House, somewhat augmented; the chorus that of the Opera, and the solo quartet comprised members of the company—Miss Frieda Hempel, soprano; Mme. Louise Homer, contralto, and

Messrs. Carl Jörn, tenor, and Putnam Griswold, bass. The orchestra in the years that it has been under the control of Mr. Toscanini has gained greatly in suppleness and plasticity as well as in precision and perfection of ensemble; and in last evening's concert it accomplished some remarkable things. Its quality of tone is not of the highest beauty or richness; but in all the music played last evening it was a most responsive instrument under Mr. Toscanini's hands.

He revealed in the fullest measure the qualities of the great symphonic conductor. He showed that he had a profound understanding of the widely differing character of the three compositions that made up the programme, and that he brought his ideas to the fullest realization seemed evident. The "Faust Overture" has seldom been made more impressive in its gloom and pessimistic spirit. The "Till Eulenspiegel" has seldom been played with a more dazzling brilliancy, verve, and bravura, with a more perfect ensemble, or a more complete mastery of all its bristling difficulties, especially those of its rhythms, that make its ensemble difficult.

Interesting as these were and satisfying—perhaps, even to those zealous enthusiasts who did not know "Till Eulenspiegel," or the movements of the symphony, well enough to refrain from applauding till their end—attention was naturally centred chiefly upon Mr. Toscanini's performance of Beethoven's Ninth Symphony, which he, as well as most others of his guild, evidently looks upon as the supreme task of a symphonic conductor.

In this Mr. Toscanini met in an unusual degree Wagner's criterion of the "melos," of keeping unbroken the essentially melodic line that underlies it. The orchestra sang throughout; and in all the nuances of his performance the melodic line was not interrupted; nor, in all the plastic shaping of phrase was the symmetry of the larger proportions or the organic unity of the whole lost sight of. It was rhythmically of extraordinary vitality. It was a conservative reading without exaggerations or excesses. There were subtle and significant modifications of tempo, but never of a disturbing sort. It was devoted to the exposition of Beethoven and not of Mr. Toscanini, and it rose to heights of eloquence without the intrusion of the conductor's personality. Some may have preferred the adagio a little slower, and Mr. Toscanini would have done well to have joined this movement to the final one without making the break that he did.

The effect of the last movement was supremely stirring, and it marked in many ways the summit of Mr. Toscanini's achievement. It is not often that the movement is presented with so few evidences of labor and effort on the part of the singers. The chorus sang with thrilling vigor and apparent spontaneity, and attacked the cruel high passages with spirit and elasticity. So, too, the solo quartet mastered the difficulties that confronted it with the appearance of ease that made for the finer elaboration of the musical effects. Mr. Griswold declaimed the bass recitative with dramatic power and cogency, and Miss Kempel's command of the high tones of her part enabled her to move at ease among them. And

Mme. Homer and Mr. Jörn were their fitting companions in the quartet.

It was recognized as a remarkable performance, and a profoundly impressive one. And one of its obvious results was to prompt the wish that a way might be found for Mr. Toscanini to conduct more symphonic concerts for the New York public.

* * *

November 21, 1913

THE PHILHARMONIC PLAYS

A New Suite by Max Reger—Kramer, Concert Master, Soloist

A new composition by Max Reger, his "Ballet Suite," Op. 130, was played for the first time in New York at last evening's concert of the Philharmonic Society, and was found interesting and attractive in a measure beyond many of the prolific German composer's works that have been heard here. It is one of his latest—though in the case of one who so frequently bestows new ones on the world it would be dangerous to say that it was his very latest. It had a special interest for the audience of the Philharmonic Society from the fact that it is dedicated to Mr. Stransky, who brought it with him on his return this Autumn to New York.

Reger has dropped or concealed much of his contrapuntal severity in the six movements of this suite. which moves in the imaginary world of a pantomime, and is concerned with the conventional characters of the ballet, Columbine, Harlequin, Pierrot, and Pierrette, with a Valse d'Amour, and gives in addition an Entrée and a Finale. There is play of fancy in the six movements, and though the composer uses only a moderate orchestral apparatus he uses it with much skill in gaining varied and delicate orchestral tints. There is something alluring in the amorous languor of the "Columbine" and in the unstable kaleidoscopic harmony of the "Harlequin" with its abrupt and unexpected ending. A 'cello solo is the principal feature of the "Pierrot," but there are many interesting fragmentary suggestions in the orchestral treatment that are left undeveloped. The "Valse d'Amour" perforce invites comparison with certain noted specimens of this genre. It is not without distinction in its insinuating melody, and was immediately called for a second time.

The suite is one of the more interesting of Reger's orchestral works, though far from one of his most pretentious. He has made a small amount of musical idea go a good way in it, but there is enough more than skill and craftsmanship in it to give it value among the meagre orchestral productions of recent years.

The orchestra played the "Ballet Suite" unusually well, with fine finish, and a full exposition of the rich and delicate orchestra color. Mr. Stransky conducted it with obvious zeal and enthusiasm. There was much brilliancy and dash, too, in its performance of the overture to Mozart's "Mar-

riage of Figaro." The last number was Tschaikowsky's Fourth Symphony, with which Mr. Stransky is in fullest sympathy.

The new concertmaster of the orchestra, Mr. Leopold Kramer, made his first appearance here as a solo player in Max Bruch's second violin concerto. It was a praiseworthy performance; not that of a great virtuoso, but intelligent and in many ways musical. Mr. Kramer's tone is not all that it might be in beauty, warmth, or power; nor has his playing all the finish and precision expected from one who devotes himself wholly to the playing of concertos, which it could hardly be expected to have. But he won the approval of the audience, as was made evident.

* * *

December 8, 1913

PHILHARMONIC CONCERT

Two Compositions by Americans Well Received by Audience

The Philharmonic Society gave a conspicuous position on its programme yesterday afternoon at Carnegie Hall to two compositions by American composers on American subjects. They were Henry F. Gilbert's "Comedy Overture on Negro Themes" and William Henry Humiston's "Southern Fantasy." Besides this the orchestral programme included Haydn's symphony in G major (the "Surprise Symphony,") Beethoven's Leonore Overture, No. 3, and Tschaikowsky's Theme and Variations from Suite No. 3, Op. 55. Alice Nielsen, soprano, was the soloist. She sang an aria from Mozart's "Nozze di Figaro" and the Gavotte from Massenet's "Manon."

Both the American compositions have had previous hearings, Mr. Gilbert's overture having been performed in 1911 by the Boston Symphony Orchestra and a few weeks ago at the opening concert of the Century Opera House Sunday evening series. In them that division of the music world which argues that American national music should be founded on the melodies of the negroes had its say yesterday.

Both compositions were interesting and justified their being placed on this programme. Mr. Gilbert's overture has a frank and graceful quality that interests at once; its development is well knit and easily followed, and the whole composition carries without effort. Its melodious character, the varied yet always sane harmonization, and the clear and graceful orchestration make it a grateful number. It was well received yesterday, and when Mr. Stransky brought the composer to the platform he was heartily applauded. Mr. Humiston's "Southern Fantasy" does not make use of such plainly marked negro melodies, and the composition is less joyous in its nature, but it had many of the characteristics of the other work. It was also well received.

The rest of the programme was not as "heavy" as Mr. Stransky sometimes makes his programmes. The symphony received a careful and sympathetic treatment, which did not overlook any of its gracious character, and the Beethoven overture was revealed in its best light. Miss Nielsen's voice did not seem to be in the most dependable condition.

* * *

January 27, 1914

SCHONBERG'S QUARTET

Flonzaley Players Give First Hearing of a Revolutionary German's Work

The Flonzaley Quartet made their second concert of this season notable by the production for the first time publicly in New York of Arnold Schönberg's string quartet in D minor, Op. 7. This performance, which took place last evening in Aeolian Hall, may properly be considered notable, whatever may be thought of the merits of the composition itself. It is a work of enormous length and difficulty; its preparation has occupied the players for a long time. They put into it not only their great accomplishments and highly finished skill, but also much anxious thought and intellectual study. They gave it also a genuine devotion and enthusiasm. They clearly believe in it themselves, and they played it with the earnest purpose of making their listeners believe in it.

To prepare their listeners for a better comprehension of it, they had offered a preliminary hearing to such of their subscribers as cared to take advantage of it some four weeks ago, at the Court Theatre, where Mr. Kurt Schindler also delivered an explanatory and analytical address. This address has since been printed as a pamphlet, with an enunciation in musical notation of the principal themes of the quartet.

Music becomes a pretty serious problem when a string quartet needs such preparation. But Arnold Schönberg and his music have already occupied so much attention and created so much controversy abroad, that it was high time some of it should be heard in New York. Hitherto, only a couple of quite innnocent songs of his have been heard here, about which no controversy at all was possible. His five small pieces for orchestra, which gave rise to "sensational outbreaks of temper," as Mr. Schindler calls them, among the public and critics of London, caused similar eruptions not long ago in Chicago—and Anglo-Saxon musical audiences are not much given to making such demonstrations about music they do not care for.

It is perhaps not necessary to say more than who Schönberg is and what he is doing. Mr. James Huneker just a year ago devoted a page article in The Sunday Times to the man and his work. He is 39 years old, a Viennese by birth, and has already equalled Beethoven in one respect, in that he is now writing in his "third style." It is this "third style" that is causing so much trouble in the musical world. Schönberg worked in poverty, piling up "silent scores," bewildering scores, till now he has gained the ear and the attention of the musical

world, and is the subject of violent controversy, discussed as a chief revolutionist, the most forward of the innovators.

The string quartet heard last evening belongs only to his "second style," and is not really matter to cause serious disturbance or riot. Its unrelieved length is one of its greatest difficulties. Though it is presented in one movement, there are evident divisions corresponding to the four movements of the "antiquated" sonata form and marked by their changes in spirit and mood. Nor is the music so fearsome in dissonance and harshness of harmony as some had been led to believe. The themes are not in themselves beautiful, but for the most part dreary and inexpressive, and there is little light and warmth in their development. This is elaborate and abstruse. The composer has carried to an extreme point their transformation, juxtaposition, inversion, and development in independent and polyphonic part-writing. Schonberg's "logic" is one of the qualities on which his admirers put the greatest stress; and this purely intellectual quality dominates the entire work. He seems to be little concerned with beauty for its own sake, or with emotional expressiveness. Nor with all this logic does there seem to be continuity of thought or a determinate and precise issue, but rather one ingenious experiment after another.

Occasionally one of them succeeds in ways that lift the listener for a brief moment out of these abstruse combinations; there are such moments in what correspond to the adagio; and at the end there is a coda in which, for the first time the impression of beauty is sustained. But of the prescience of a master, of the vision of a seer into unknown realms of beauty, this quartet shows little or nothing.

Will our grandchildren see it and smile indulgently at bewildered listeners of 1914? The question is not really important; bewildered listeners of 1914 can only listen for themselves. The audience was large, profoundly attentive, and evidently desirous to appropriate all the players could give them. At the end there was long, continued applause. The performance at least deserved it; it denoted a wonderful mastery of a most difficult score, perfect in intonation in the exact exposition of complicated rhythms and in the balancing of themes.

At the beginning and end of the concert there was easy enjoyment of Mozart's adagio and fugue in C minor and Beethoven's quartet in G, Op. 18. No. 2.

* * *

March 20, 1914

THE BOSTON ORCHESTRA

Mr. Paderewski as Soloist Plays His Own Concerto

The Boston Symphony Orchestra, now on its fifth visit to New York, the last one of the season, devoted its concert last evening to works of three living composers, all of whom were present in the hall. George W. Chadwick's symphony in F, No. 3; Rubin Goldmark's tone poem "Samson," and Ignace Paderewski's concerto in A minor for pianoforte and orchestra were the works presented, and Mr. Paderewski played the pianoforte part in his concerto.

The two American compositions did honor to American art, and the audience was enthusiastic in its applause of both of them. Mr. Chadwick's symphony is twenty years old and more. It won a prize offered by the National Conservatory of New York in 1894, but it has had a more fortunate career than many prize compositions, which are often not heard of a second time. It is dedicated to Theodore Thomas, and he played it not once but several times and the Boston Orchestra has played it before. It has been said of this symphony that it was composed at a time when the writing of melody was not considered necessarily the proof of a sterile mind, nor the resolution of discords an indication of imbecility.

Mr. Chadwick's symphony is not deficient in frank melody, often of a distinguished sort and his harmonic treatment is rich and expressive, even though it has few of the significant features that are considered "modern" to-day. The music is strong, vigorous, manly, without affectation, both in the themes and in the development through which they are put, and this development is not only lucid and logical, but it is also finely and artistically conceived, musically beautiful. Mr. Chadwick's use of the orchestra is skillful, giving color and euphony. The symphony dates from the time when Dr. Dvorak was urging "Americanism" upon American composers, and whether or not that was the influence there are a few suggestions of a turn of melody that might be considered to be derived from the folk song of the negroes. At all events this symphony may be considered and prized as truly American music.

Mr. Goldmark, in his symphonic poem, "Samson," on the other hand, has deliberately chosen an esoteric subject, and has devoted his resources to representing the emotional and dramatic aspects of the Old Testament narrative, and, at the end, to some suggestion of the demolition of the Temple. But this delineation is hardly more than suggested, and Mr. Goldmark has done wisely in keeping to the field that music more rightfully claims as its own. The piece is in one movement, but there are four divisions, intended to portray Samson, Delilah, the betrayal, and the end in the Temple. The general impression is of somewhat too great length, and an insufficient differentiation and contrast of the musical substance.

There is, in fact, something of monotony. Yet there is much that is noble, dignified, impassioned, and exalted in Mr. Goldmark's music; finely expressive themes, stirring development of them, and an especially fine skill in the orchestral treatment, which is warmly, at times gorgeously, colored. There is little or no attempt to produce an Oriental atmosphere; but the mood of passion, of despair, of tragedy, is little lightened and ends by becoming oppressive. It was the first performance in New York of Mr. Goldmark's composition, which is still in manuscript; an admirable performance, as was that of Mr. Chadwick's symphony.

Mr. Paderewski's concerto, after a long rest, had been heard in New York a few weeks ago from Miss Katherine

Goodson. The composer played it with inimitable brilliancy, power, and bravura with elegiac tenderness and poetry in the passages of cantilena.

The music has vitality, though the composer did not forget when he wrote it that one of the purposes of a concerto is display. In the last movement, indeed, he gave this a preponderating role. Yet even in the most dazzling pages of this music there is something more than mere glitter; there is a substance beneath it, and this Mr. Paderewski raised to its highest power.

* * *

November 17, 1914

THRONG WELCOMES OPENING OF OPERA

*Verdi's "Un Ballo in Maschera" Splendidly Sung
at the Metropolitan*

CARUSO IN FINE VOICE

*Mme. Destinn, Miss Hempel, Mme. Matzenauer, and Amato in the
Cast—More Than 4,000 Present*

WITH: Enrico Caruso (Riccardo); Pasquale Amato (Renato); Emmy Destinn (Amelia); Margarete Matzenauer (Ulrica); Frieda Hempel (Oscar); Vincenzo Reschiglian (Silvano); Andrea de Segurola (Samuele); Leon Rothier (Tomaso); Angelo Bada (Un Giudice); Pietro Audisio (Un Servo); Arturo Toscanini (Conductor).

The Metropolitan Opera House opened its doors upon a new season last evening with all the pomp and circumstance, the glittering brilliancy, the enthusiasm, and the air of anticipation that properly belong to the great social function. The house was filled to its entire capacity with an enormous audience that must have strained the Fire Department's rules to their limit, as it always is and should be on so momentous an occasion. There was much applause and enthusiasm, for some of the greatest and most popular singers of the company appeared, and Mr. Toscanini returned to conduct the performance. What the particular opera is that is chosen by the manager for the opening night is not a question of the greatest importance nor the one uppermost, probably, in the minds of most. Last night it was Verdi's "Un Ballo in Maschera."

A sumptuous performance of this opera was prepared as one of the half-way novelties of last season and was given five times. The opera was not a familiar one, for it has had only a somewhat fitful career on the operatic stage in New York in recent years. Its principal attractiveness now is found in the fact that it provides more or less effective and "grateful" parts for four or five of the leading members of the company. The opera itself seems today old fashioned. It is of Verdi's "middle period," but it has little of the vitality that belongs to "La Traviata" and "Il Trovatore" of about the same period. It is an opera for singers accomplished in the art of song. Available operas of this sort are gradually becoming fewer and fewer,

and the fact is enough to account for Mr. Gatti Casazza's restoration of it to the list last year and again this.

Some of the most glaring absurdities that used to disturb those who looked on opera as a kind of drama have fortunately been eliminated from the production of "Un Ballo in Maschera," now to be heard at the Metropolitan. The action is no longer supposed to take place in Colonial Boston; there is no Governor of Boston, no throng of Puritan courtiers, nobody disguised as a Neapolitan fisherman. Both Boston and Naples having been eliminated, the proceedings go on in some undesignated country. Opera goers fifty years ago cared little about these things, but they would annoy the eye, jar upon the intelligence, or else arouse the derision of their successors in the stalls and boxes of today.

There are pleasing numbers that as "numbers" may still give pleasure when sung with the art and skill that were devoted to them last evening. There are numerous airs and concerted pieces, with which the principal characters are copiously supplied, spirited choruses. Many of these were properly enjoyed last evening and were enthusiastically applauded. The singers came to their tasks fresh in voice and the performance was in every respect one that did credit to the Metropolitan Opera House and reached in every respect its exalted standard. The influence of Mr. Toscanini was everywhere apparent in the finish and mellifluous smoothness with which it was carried off, the vigor and dramatic accent that marked every scene.

Mr. Caruso has not in recent years been in more admirable voice. He has much to sing in this opera, and he sang everything in his most perfect style, with all his beauty of tone, without exaggeration or forcing of the note of passion.

Miss Hempel was charming as Oscar, the page, and her singing of the few songs that fall to her lot augured well for future enjoyment of more important things to come. It was a pleasure to hear Mme. Destinn's beautiful voice again, and Mr. Amato and Mme. Matzenauer made their excellent contributions to an ensemble that was of the most excellent.

Chorus and orchestra showed in everything the highest pitch of finish and perfection. It was a performance that did everything that could be done for "Un Ballo in Maschera"; and the opera season was launched with every prospect of an artistic success in no way inferior to what has been reached there in recent seasons.

* * *

November 30, 1914

HEAR ONLY "BLUE DANUBE"

Attempts to Play Other Tunes Put Down at Composers' Feast

The members of the American Society of Composers, Authors, and Publishers, which was organized to facilitate the fight which is being made to tax hotels, cabaret shows,

and moving picture theatres where popular music is played, held their first annual dinner at Lüchow's, in East Fourteenth Street, last night. At the feast the members talked over the big royalties they expect to receive. Victor Herbert presided, and many prominent composers and publishers were present.

The music was furnished by an orchestra of three pieces—a flute, violin, and harp—which makes daily trips between South Ferry and Staten Island on a municipal ferryboat. The programme for the evening was the "Blue Danube." Once the leader, in a moment of forgetfulness, began "Finiculi, Finicula," but there was a loud shout of protest.

"Well, what shall I play next?" he asked.

"The Blue Danube," said Mr. Herbert; "that other one is too recent."

The leader waved his bow and the strains of "The Blue Danube" were heard again. Mr. Herbert resumed his seat and the next course was served.

The floor manager made this explanation to the reporters: "There were so many requests to have certain compositions played, and so many requests that certain artists should be retained that to prevent ill-feeling we decided on a neutral tune and an orchestra that could give offense to no one.

"Later as a variation," he said, "Charles K. Harris will be asked to sing 'After the Ball,' which sold 8,000,000 copies, although it is the worst song ever written. We want to tell our grandchildren that we heard him, and we hope he will do it."

There was a lot of serious talk about the work of the society after the coffee was served. At this point the orchestra was led from the room amid the cheers of the diners.

"We now have eighty-five hotels on our list," President Maxwell of the society said, "and the others will soon fall into line. We have a schedule of license taxes of $15, $10, and $5 a month for different classes of places, and the average for the places which now pay the license is $8.23 a month. There are 105,000 moving picture theatres in the country. Now, I think I am conservative in saying that within a few years we will have 100,000 places in the country paying license fees, and that will amount to $823,000 a month, or $9,876,000 a year. If half of that is taken up in expenses, we will have $4,928,000 to divide among our members pro rata, in accordance to the popularity of their works."

* * *

February 18, 1915

BRAVOS FOR CARUSO AT OPERA FAREWELL

Vast Audience at Metropolitan Compels Tenor to Break Rule and Make a Speech

REMAINS AFTER 'PAGLIACCI'

Raises Great Din, and Singer Appears in Street Clothes, Waving a Scarf—A Thousand Turned Away

Caruso made his farewell to New York opera-goers last night with none of the features that have attached themselves to the event in late years missing. There was a huge audience for the performance of "L'Oracolo" and "Pagliacci," with enormous prices paid for tickets and easily 1,000 persons turned away. There were noisy demonstrations of approval through the performance, and at the very end the audience remained and demanded a speech, which it got, the brand new season's rule to the contrary notwithstanding.

After the "Ridi, Pagliacci," at the close of the first act there was tumultuous applause, and the tenor was obliged to respond to ten curtain calls. They said behind the scenes that tears were in his eyes as he did so.

When the final curtain descended the applause broke out in renewed volume. There were many recalls, which Caruso shared with the others, and finally he appeared alone. The audience was shouting and he came before the curtain four times and bowed his thanks. Then the asbestos curtain descended and the stage lights went out.

But that did not send the opera-goers home. Hundreds stayed in their seats and many who had gone to the coat rooms returned with their wraps to applaud. Many people in the boxes remained and there were several hundred in the parquet. They applauded for more than five minutes without anything happening. Then a woman in evening dress among those who crowded down front began rapping with clenched fist on the inside of the partition wall of the orchestra pit. Others followed suit, and men put their walking sticks into play for the same purpose. This din had the required effect. In a moment the footlights were turned on and the asbestos curtain raised again.

Caruso appeared on the stage in his street clothes, waving gayly a white handkerchief, a scarf about his neck, perhaps to conceal the fact that he had not had time to get his collar on. There were renewed bursts of applause and finally signals for quiet and shouts of "Speech!" Those who knew of the rule which forbids speeches from the stage posted at the beginning of the season on account of just such events in this last year, wondered what would happen.

In a moment they knew. The tenor broke the rule so badly that it will never be the same again.

"It is against the rule to make a speech," began Caruso when it was evident that nothing but the sound of his voice would send the audience home. "The direction has forbidden the artists—"

"Nothing is forbidden to you here," came the voice of a man from somewhere upstairs—perilously near the Directors' box, by the way—"make a speech!"

"I am very much touched," began the budding orator again. "There is nothing for me to say, I cannot find words."

"Come back to us!" interrupted a woman who spoke from one of the boxes.

More applause.

"You can be sure I will always remember this night. Thank you," said Caruso and the speech was over. Then the audience consented to go home.

* * *

March 28, 1915

THE SEASON'S ORCHESTRAL MUSIC—SOME REFLECTIONS ON MANY CONCERTS—NEW WORKS AND OLD ONES

The three chief series of orchestral concerts given in New York during the season have now all been closed, the Philharmonic Society's popular concert of last evening being the last. The Philharmonic Society, the New York Symphony Society, and the Boston Symphony Orchestra between them have given 85 concerts in 23 weeks—statisticians would say, an average of 3.7 a week. There will have been, by the time the opera season is ended, 23 more given on Sunday nights at the Metropolitan Opera House. The Young People's Symphony concerts are 6 in number, the People's Symphony Concerts 3, the Russian Symphony Orchestra's regular subscription concerts 3, besides several more on Sunday nights of a popular character.

The Philadelphia Orchestra came over once to supply any possible deficiencies the New York public may have felt in the way of orchestral music. There have been various others, including some of a popular kind on Sundays. Altogether, the number of orchestral concerts heard during the season will have been well over 125, good, bad, and indifferent.

The number seems to some greater than the actual needs of the musical population call for. Yet there must be something more than a vain optimism that prompts the managers of these various enterprises to add continually to the number of such concerts beyond actual requirements. No doubt the demand increases, in a way, proportionately to the increase of the city's population; but the managers seem always eager to keep ahead of the demand with their supply. How far ahead is probably to be read in the profit and loss accounts in their ledgers, which are not always set forth for the public to inspect. Of course, it is well known that the two principal local orchestras, the Philharmonic Society and the New York Symphony Orchestra, do business at a large annual loss. Each has to make arrangements for covering a financial deficit every year. They do this, as everybody knows, on the ground that the giving of orchestral concerts is not a business like another, but a provision of artistic nutriment that is not to be put on a business basis; or that it is an educational provision,

such as are the great universities, which are run at a cost far beyond any sum that their tuition fees bring them in and are heavily endowed for that very purpose; or they could be compared to the great museums and public libraries, which are for the public good and in this country acquire most of their resources from private munificence.

Supporters of the great orchestras, therefore, would say that the fact that most of them have reported deficits by no means indicates a bad adjustment of supply to demand. They would ask what, precisely, is the right adjustment? They would point to the fact, that some of the more obviously popular series are profitable, and would say that the best must be artificially promoted, or it would have no chance. How Major Higginson enters on his books the balance brought by the crowded audiences that hear his Boston Symphony Orchestra in Carnegie Hall is not revealed. On the face of it these particular ten concerts presumably show a profit; but, of course, it must be properly apportioned among the annual expenses of the organization which, while they do not all directly bear upon its New York appearances, are necessary to them. The New York receipts are only a way of reducing a deficit that is practically an indispensable condition of the orchestra's existence.

Much might be said and discussion might be continued indefinitely upon the question of how much orchestral music a city like New York "needs," how much it can assimilate, whether it is oversupplied, whether less would be more fully appreciated. The results, if any were arrived at, would not be conclusive, nor would they be final in the case of a community such as this, that has such great increases in its population annually, and that presumably is advancing in the love and appreciation of music, growing by what it feeds on.

The time is not a propitious one for the production of new works of consequence, and there have not been many such heard here this season. Few of those that have been played here have gained enthusiastic acceptance. The Philharmonic Society has presented for the first time in New York Henry Hadley's tone poem, "Lucifer"; Arthur Hinton's suite, "Endymion"; Erich Korngold's "Sinfonietta," Op. 5; J. Guy Ropartz's Fourth Symphony; Sigismond Stojowski's Suite, Op. 9; Henry Burck's "Meditation" for strings; and Nicola Laucella's "Prelude and Temple Dance."

The New York Symphony Society's new performances were Percy Grainger's British Folk Dances, Josef Suk's "Scherzo Fantastique," Maurice Ravel's symphonic fragment from the ballet, "Daphnis et Chloe"; Roger-Ducasse's "Le Joli Jeu de Furet," Albert Roussel's "Le Festin d'Araignée," Florent Schmitt's waltzes, "Reflets d'Allemagne," and, at a special concert, not in its regular series, these American works: Frederick S. Converse's "Ormazd," David Stanley Smith's overture, "Prince Hal," and two movements from a symphony by Frederick A. Stock.

The record of the Boston Symphony Orchestra's New York concerts shows only these absolutely new compositions: E. Reznicek's "symphonic biograpy," "Schlehmihl," and Vincent d'Indy's fantasy for oboe and orchestra, though

Mr. Converse's "Ormazd" was presented to the general public for the first time and Ropartz's symphony followed the Philharmonic Society's first performance of it by only eight days.

It might be recalled to the Boston Symphony's New York auditors who complain of Dr. Muck's tendency to lay emphasis upon modern works that out of thirty-five compositions played in the ten concerts seventeen are what may be called "classic" in a sense that may be accepted today and that will reckon Brahms, Schumann, Mendelssohn, and Weber as among the classics. There was protest earlier in the season that he was "relegating the classics to the discard." He is seen thus to have preserved an almost exact balance between works of the classical spirit and those of a different kind. Bach's Shepherds' Music from the "Christmas Oratorio" and his concerto for two violins, Beethoven's third and eighth symphonies and his overtures to "Coriolanus," "Egmont," and "Leonora," (No. 3); Mozart's symphony in C and overture to "The Magic Flute," Haydn's "Surprise" symphony, Schubert's symphony in C, Weber's overture to "Euryanthe," Mendelssohn's violin concerto, Schumann's overture to "Genovena," and Brahms's first and second symphonies and variations on a theme by Haydn comprise these works.

Mr. Stransky has followed out the moral obligations placed upon the Philharmonic Society in accepting Joseph Pulitzer's bequest of $750,000. This bequest was to "perfect the present orchestra and place it on a more independent basis and to increase the number of concerts to be given in the City of New York, which additional concerts I hope will not have too severely classical programs and be open to the public at reasonable rates, and to recognizing my favorite composers, Beethoven, Wagner, and Liszt." Mr. Stransky has not made his programs "too severely classical," and he has "recognized" Beethoven, Wagner, and Liszt. Beethoven's third, fifth, and seventh symphonies, the overtures "Coriolanus," "The Dedication of the House," "Leonore," (No. 3); the violin concerto, the triple concerto for violin, violoncello, and piano, and numerous vocal pieces; several "Wagner concerts," at which and on other occasions were given the available preludes to the music-dramas, various excerpts from those dramas, the "Faust" overture and "Siegfried Idyll," as well as vocal selections; and Liszt's "Dante" symphony, two symphonic poems—"Les Preludes" and "Tasso"—the E flat concerto for piano and orchestra, and orchestral arrangements of two of the Hungarian Rhapsodies—these have constituted the recognition hoped for by the testator and imposed as a moral, if not a legal, obligation on the society.

Fortunately Mr. Stransky has not interpreted his duties as to Liszt too strictly and has given only seven performances of his works in New York, (eleven if repetitions at the second of a pair of concerts be counted.) If he reads the likings of the real musical public aright there is not likely to be that glorious "Liszt revival" which some of the faithful and vociferous little band of admirers have been hoping for—a revival that is always coming, but never arrives. An endowed series of prescribed Liszt performances would bring dismay to many stout-hearted concert-goers in New York, and it might be found that it is possible to pay too dearly even for $750,000. Some will recall the quaint fact that Karl Graun's once-favorite oratorio, "Der Tod Jesu," is still given perforce once a year in Berlin because somebody left a bequest strictly for that purpose, long ago, when the work was still alive. It is dead and decently buried in the musical histories now, but has to undergo an annual exhumation because some almost forgotten testator left "direction" instead of Mr. Pulitzer's more prudent "hopes."

Mr. Stransky has shown a strong fondness for Tschaikowsky as represented by three symphonies, the "Romeo and Juliet" overture, the "Italian Capriccio," the "Nutcracker Suite," and some other works: for Strauss, Dvorak, Grieg, Rimsky-Korsakoff; not much for Brahms, whose fourth symphony and "Tragic" overture are the only orchestral works represented on the programs, except orchestral transcriptions of two Hungarian dances.

Mr. Damrosch, with the New York Symphony Society, showed more sympathy with Brahms, whose second and fourth symphonies, "Academic" overture, D minor piano concerto, and violin concerto were played at his concerts. Beethoven's symphonies had an unusually small representation on them—the third and the instrumental movements of the ninth alone appearing, besides which the "King Stephen" overture, the E flat concerto, and some songs were heard. Only Tschaikowsky's fourth symphony and third suite, one of Strauss's symphonic poems, none of Dvorak's symphonies, but the orchestral suite, Op. 39, and the notturno for strings; of Liszt only an orchestral transcription of his "St. Francis Preaching to the Birds," besides the "Hungarian Fantasy," and the "Mephisto Waltz" were heard. Mr. Damrosch lent a willing ear to the modern French sirens—Debussy's "Iberia" and "Nocturne," No. 2; the new pieces of Ravel, Roger-Ducasse, Roussel, and Schmitt testify to it, and of more conservative French music Saint-Saëns's C minor symphony, Berlioz's "Fantastic" Symphony, and "Roman Carnival" overture, and a transcription of César Franck's "Prelude, Choral, and Fugue" show attention to this section of the orchestral repertory.

RICHARD ALDRICH

* * *

November 18, 1915

'BORIS GODOUNOFF' SUPERBLY PRODUCED

Moussorgsky's Opera of Russian Life Is Sung at the Metropolitan

MR. DIDUR AGAIN AS BORIS

The Cast, with the Exception of Max Bloch, the Same as Last Season—Giorgio Polacco Conducts

BORIS GODOUNOFF, Modest Petrovitch Moussorgsky's opera. At the Metropolitan Opera House.
WITH: Adamo Didur (Boris); Raymonde Delaunois (Theodore); Lenora Sparkes (Xenia); Maria Duchene (The Nurse); Angelo Bada (Schouisky); Vincenzo Reschiglian (Tchelkaloff); Leon Rothier (Brother Pimenn); Paul Althouse (Dimitri); Margarete Ober (Marina); Andrea de Segurola (Varlaam); Pietro Audisio (Missail); Marie Mattfeld (The Innkeeper); Max Bloch (The Simpleton); Giulio Rossi (A Police Official); Carl Schlegel (Tcerniakowsky); Giorgio Polacco (Conductor).

Moussorgsky's opera, "Boris Godounoff," which has been one of the most interesting and impressive of the new productions of the last two seasons at the Metropolitan Opera House, is retained in the repertory for the current season, and took its place as the opera given there at the second performance last evening. The audience was not large, nor was the enthusiasm so great as it has been on some of the occasions when the work was given before. It remains to be seen whether the enthusiasm over this opera will retain its potency.

"Boris Godounoff" is a wide departure from the familiar forms of operatic art, old and new, and depends for its effect upon the vivid representation it gives of a people and a life strange to most of its listeners at the Metropolitan, the power with which the elements of folksong are used in the massive choruses, and the tragic climax to which it is conducted at the end. It is episodic, and some of its episodes, as that of the love making in the garden scene of the second act, have little to do directly with the development of the opera; but all of them, however loosely they are put together, have in themselves something fascinating and original. The music is directly sprung from the Russian soil, rooted deep in the native folksong. It is not strange that the work should have had its powerful appeal especially in the superb production that is given of it at the Metropolitan Opera House.

The production given last evening is very nearly the same as that which was heard last season, with the exception of Max Bloch, who took Mr. Reiss's place as the Simpleton, and Mr. Polacco took Mr. Toscanini's place. The exception was naturally important. Mr. Polacco conducted "Boris" at one of the last performances of it here last season, and he has frequently conducted it in performances it has had in Europe; he is therefore wholly familiar with it, and his familiarity was evident in the manner of his conducting it and the results he achieved.

Some of Mr. Polacco's tempos seemed not quite fortunate, and need have surprised nobody that there were places where some of the electric and sweeping power of Mr. Toscanini

was absent; but the solidity and the dramatic force of his reading were in evidence, and he made most of the picturesque scenes move with their accustomed effect.

Mr. Didur's intensely tragic impersonation of Boris, sometimes somewhat overdrawn, is remembered as the most imposing single figure in the opera. The cast as a whole is singularly efficient. The chorus last evening was in fine form, and so was the orchestra.

* * *

November 21, 1915

BAUER AND CASALS PLAY

Give a Recital of Sonatas for Pianoforte and Violoncello

Two artists with an unusual disposition toward the playing of ensemble music, Messrs. Harold Bauer, pianist, and Pablo Casals, 'cellist, greatly interested the musical public last season with their recitals of sonatas for pianoforte and violoncello, of which they gave no fewer than five. They gave another yesterday afternoon, which may well be expected to be the first of a series, for Aeolian Hall was completely filled, and as much room as could be spared on the stage was given over to people who could not be accommodated in the audience room.

The two players hold the finest and most musical point of view toward their art; and their ideas as to interpretation and style are so singularly at one that the value of their appearance in co-operation is truly doubled. This cannot always, nor indeed often, be said of the co-operation of two great artists accustomed generally to appear as soloists. The virtuoso type of artist does not take kindly to ensemble playing, in which mutual sacrifices of self are essential to the finest results. Sacrifice of self is the last thing that appeals to the true virtuoso. But neither Mr. Bauer nor Mr. Casals is of the virtuoso type.

The two artists played four sonatas for pianoforte and violoncello, somewhat too many at a sitting; and as the repertory of such works is limited, it behooves them for this reason, if for no other, to practice economy. They began with Brahms's sonata in F, less often played than its fellow in E minor, though it is one of the most genially and poetically conceived works of his ripest period, in which the two instruments move on an equality and are both treated with a keen insight into their own distinctive natures. The violoncello is made especially to give forth a noble and passionate utterance in a style truly idiomatic to it. Nor are the two later sonatas of Beethoven often played, Op. 102, Nos. 1 and 2. They are works of especial charm to those who penetrate beneath their surface, but they have not the well-organized solidity of the sonata form. They are full of a wayward fancy, tenderness, passion. There is a fugue in the second sonata at the end, treated with the freedom that Beethoven used toward this mode of expression in his later works, and the adagio is beautiful in its serenity and grace.

The last sonata is by Emmanuel Moór, a Hungarian musician whose residence in New York is not wholly forgotten, and whose name from time to time appears on concert programs affixed to music of every sort, which he produces somewhat too copiously for the best results. The most interesting portion of this sonata is the scherzo, strongly Hungarian in its character and captivating in its rhythm and melodic figuration; there is an energetic Hungarian strain also in the final allegro.

The playing of the two artists in these works was of exquisite sympathy and mutual understanding, finished, and perfectly balanced.

*　*　*

January 2, 1916

THE STORY OF IRVING BERLIN

A good many years ago, several more than make up a quarter of a century, a rabbi and cantor named Baline left his native Russia and came to breathe the freer air of America. With him came his family, a wife and several boys and girls, and they settled in that melting pot of Manhattan—the lower east side.

One of the boys was a little tike of 8 years, with very black hair and very black eyes. He grew up as do most of the children of that crowded neighborhood, which is to say in the street, and as he grew to be a sizable boy, he devoted his time to making money the easiest way he could. From his father he learned about music, not from a technical standpoint, although the elder Baline, being a cantor, understood music thoroughly, but how to sing, and before his father's death a few years after their arrival in their adopted country the boy sang in the choir of the synagogue where the cantor presided.

So it came about that with his aptitude for music and his money-making instinct the lad gravitated to one of the cheap cafés of the Bowery. The resort was not of the saw-dust-on-the-floor variety, but of that higher grade, equipped with a piano whose metallic notes accompanying the raucous voices of entertainers make concentrated thought on the bitterness of the beer a sheer impossibility. Here the boy Baline spent most of his spare time, singing popular songs and diving for nickels tossed from the tables—"busting" they called it at Nigger Mike's in Chinatown.

Often when the shutters had been put up, and only the barkeepers polishing their glasses for the next day were left in the café, the youthful Baline remained behind to pick out bits of melody with one finger on the piano. They were not the tunes he sang to the patrons—songs picked up in the theatres of the neighborhood or from the hurdy-gurdies—but scraps of melody that filtered from nowhere into his head. Another favorite pastime was fitting new words to the songs of the street and singing the parodies to the patrons. Sometimes he would equip his own tunes with words, till the habitués of Nigger Mike's looked upon the lad as an unusual boy, a sort of prodigy in a sphere where phrases that parse are unheard and a rhyme seems a miracle.

It is a far cry from Nigger Mike's to the fashionable Globe Theatre, and yet the span of one life at least joins the two. Almost any night in the promenade in the rear of the orchestra stalls may be seen a slender young man listening to the syncopations of "Stop! Look! Listen!" and observing intently the audience. He wears his clothes, 1916 model, with an undeniable air that distinguishes him from the scores of young men along Broadway who appear to have just stepped out of the clothing ads.

The young man, who has very black hair and very black eyes, watches the performance so frequently and so intently because he composed the music and wrote the lyrics. He is, in fact, the Baline boy of the Mott Street restaurant grown to manhood and known to the ragtime whistlers of many nations as Irving Berlin, composer of "Alexander's Ragtime Band," "When I Lost You," "When I Bid the World Goodbye," and scores of other shoulder shakers.

This narrative of the early career of the now successful and rich young composer is in no way an exposé, for success has not spoiled him. He changed his name because Baline was forever being misspelled, and his borrowed name, even in the ante-Zeppelin days when he took it, was fairly well known and easy to catch over the phone. It was George M. Cohan, toasting young Mr. Berlin at a Friars' dinner given in his honor some years ago, who described neatly in typical Cohanese his simplicity.

"The thing I like about Irvie," said Mr. Cohan from the north corner of his mouth, he facing west as he spoke, "is that although he has moved uptown and made lots of money it hasn't turned his head. He hasn't forgotten his friends, he doesn't wear funny clothes, and you will find his watch and his handkerchief in his pockets, where they belong."

And shortly afterward, Mr. Berlin arising to speak, sang a song composed especially for the occasion.

The progress from Nigger Mike's to the Globe was one of gradual evolution. From the downtown restaurant he moved to one in Twenty-third Street. He was trying hard to write original songs, now, and finally one was accepted for publication. That was called "Marie from Sunny Italy," and it was published eight years ago. Since then he has written several hundred songs and the music for two popular revues, "Watch Your Step" and the current Globe offering. A number of the songs have each earned him more money in royalties than the President of the United States receives as salary in a year.

To date Mr. Berlin's "Alexander's Ragtime Band" has been his biggest seller. Nearly two million copies of the catchy song, on which a few years ago the sun never set, have been sold. Some of his later songs may eventually eclipse this record, but with the benefit of age it still leads.

One of the curious things about Mr. Berlin and his work is that he does not understand music technically. He can only play the piano in one key, F sharp, and then his right hand is never sure what his left hand is doing. When he composes he sits at the piano picking out the melodies that have crystallized in his mind, working them over, twisting the rhythms about till they satisfy their creator. His piano is specially con-

structed with a device by which Mr. Berlin can stick to his sharps and still play in any key. When he gives the word his secretary, Clifford Hess, transcribes the tune. This is his method of composition for single songs, but for the more complicated measures of musical comedy ensembles and finales he molds them in his head and then hums them to his secretary. They are then turned over to men who do the orchestration, for Mr. Berlin does not think in terms of the various instruments.

"I do not know what the different kinds of instruments are," he said the other day, "but I do have ideas about certain effects I wish to achieve in my music. When I have visualized just what it is I want I tell whoever is orchestrating the score and he knows just what instruments to use to gain the desired effect.

Mr. Berlin does not believe in inspiration. He recognizes that one may be gifted to do certain things, but it is his experience that his most successful compositions are the result of work.

"I do most of my work under pressure," he said. "When I have a song to write I go home at night, and after dinner about 8 I begin work. Sometimes I keep at it till 4 or 5 in the morning. I do most of my writing at night, and although I have lived in the same apartment four years there has never been a complaint from any of my neighbors. Probably that is because I keep the muffler on.

"Mr. Dillingham commissioned me to write the music for 'Stop! Look! Listen!' some months ago, but the business of writing the music was put off till three weeks before the time scheduled for the production. I hadn't seen the book till then, and as a delay meant that Mr. Dillingham would have to pay Gaby Dealys a huge salary with no return until the show was ready, there was nothing to do but get to work. So I wrote the songs in the remaining time. Each day I would attend rehearsals and at night write another song and bring it down the next day."

Mr. Berlin was asked whether he liked better composing the scores of musical plays or writing popular songs.

"Popular songs," he answered, "for in fifteen minutes I can write a song that may bring twenty-five or thirty thousand dollars in royalties. 'When I Bid the World Goodbye' was written like that, although it was in reality the result of several years' thought. This is the story of how I happened to write that song: Some years ago Wilson Mizner and I were discussing verse. We often get together and talk about unusual poems we have seen, not the poems of the big poets, but stray selections we have run across. Mizner told me that night of one he had read of a pauper who, when he died, left a will in which he bequeathed the sunshine, flowers, and other beautiful things of the world to various classes. 'There's a great idea for a song in that,' I told him, 'and I would give a lot for the rights to it.' But he didn't remember where he had read it and although he tried to locate it he couldn't find it.

"Then last year at the Selwyn party Bob Davis, editor of Munsey's, and I were talking about the same subject and I told him of the pauper and his strange will. 'You don't have to look any further for that,' he said. 'I published it myself and will send you a copy of the magazine it was in.' It was not a poem, but an article that told the story of Charles Lounsbury, a Chicago lawyer who died penniless and left such a will. So I dedicated my ballad to Charles Lounsbury, because I had borrowed his idea and put it in bad verse calculated to catch the royalties."

This estimate of his own lyrics created mild surprise in his listener, who asked whether he had ever studied versification.

"I never have," was the reply, "because if I don't know them I do not have to observe any rules and can do as I like, which is much better for me than if I allowed myself to be governed by the rules of versification. In following my own method I can make my jingles fit my music or vice versa with no qualms as to their correctness. Usually I compose my tunes and then fit words to them, though sometimes the other way about."

A year or two ago there was a report cabled from abroad that Mr. Berlin had been invited by Giacomo Puccini to collaborate with him in writing an opera in which syncopation would figure largely. The syncopation master never heard of the offer beyond what he read, although he admitted the report might have arisen from some stray remark of the composer of "Butterfly," as when Leoncavallo once said to Ray Goetz that with the melody of Mr. Berlin's "Dixie" as a theme he might compose an opera. But Mr. Berlin believes syncopation has great possibilities, and that it will be a still more important feature of the music of the future than of contemporary music.

"Syncopation is ordinarily thought of as being comic, but it is not necessarily so. The serious and sentimental can be expressed in terms of syncopation as well as the humorous. In the finale to the first act of 'Watch Your Step' I proved that. In that the figure of Verdi appeared and called upon a group of moderns to quit making rags of his masterpieces. The thought was not a great one, but there was an element of seriousness, of pathos, almost, in the ghost of the composer appearing and feeling sad at the treatment his works were receiving. Syncopation, too, will bear repetition of thought better than other forms. You can repeat 'I love you' a number of times in syncopated measure very effectively, whereas if you used the ordinary forms it would sound simple.

"And so if I were assigned the task of writing an American opera I should not follow the style of the masters, whose melodies can never be surpassed. Instead I would write a syncopated opera, which, if it failed, would at least possess the merit of novelty. That is what I really want to do eventually—write a syncopated operetta."

*　*　*

October 18, 1916

CONCERT OF INDIAN MUSIC

Charles Wakefield Cadman and Princess Tsianina Make a Demonstration

A concert to explain and illustrate Indian music in its native state and as utilized by American composers, particularly by Charles Wakefield Cadman, was given by Mr. Cadman last evening in Aeolian Hall. Mr. Cadman is known as the composer of several "best sellers" in songs, and his audience was consequently large. Among it were Indians and students of Indian music. He had the assistance of Princess Tsianina, of the Creek Indian tribe, who sang and of Messrs. Artady Bourstin, violin, and Paulo Gruppe, cello.

Mr. Cadman spoke first of the Indian music as a natural expression of the sentiments and feelings of the Indian singers, and maintained that in listening to it, music lovers ordinarily spoken of as civilized should put out of their minds the crudities of the performance and the instruments used in it and think of its emotional expressiveness. To illustrate this point, which he did not elaborate, he had the Princess sing first, "The Old Man's Love Song," an Omaha melody, without harmony, as the Indians sing it, and then as harmonized by Arthur Farwell, also the Omaha tribal prayer, a Gregorian chant, and what was called an ancient Egyptian chant. He spoke of the involved rhythms of the Indian; and this was illustrated with the drum—though the rhythms illustrated seemed not at all involved to those who have listened to the rhythms of other primitive peoples. A number of "harmonized and idealized Indian tunes" were sung then and later by Princess Tsianina, mostly in Mr. Cadman's settings. She sang pleasantly in an agreeable voice of no great cultivation, sometimes with the aid of pantomime and gesture, and presented a strikingly handsome appearance, in a costume that hinted both of the Indian and of modern civilization.

Then Messrs. Bourstin, Gruppe and Cadman played Mr. Cadman's trio for pianoforte and strings in D. Op. 56, a feeble composition, showing a complete misapprehension of the spirit and style of chamber music, and a slender musical inspiration, which was naturally somewhat influenced by Mr. Cadman's obsession with the Indian motives, rhythms and intervals. Several Indian instruments of percussion were shown, and Mr. Cadman demonstrated the Omaha flageolet, playing some melodies and "love calls" upon it.

Much might be, has been, and will be said as to the quality and value of Indian music in artistic use. What Mr. Cadman showed last evening, like what has been shown before, seemed limited in scope, monotonous in intervals and rhythms: intractable material yielding small results except in the rarest instances. Indian music was again demonstrated to be something more interesting to talk about than to listen to.

* * *

December 3, 1916

DAY OF NOTABLE MUSIC

The Boston Symphony Orchestra, Spalding, Bauer, and Thibaud Heard

The music in New York yesterday was given in three notable instrumental performances besides a repetition at the opera of Bizet's "Pecheurs de Perles." The Boston Symphony Orchestra gave its matinée concert. Albert Spalding his third and last violin recital, and Harold Bauer and Jacques Thibaud united in an ensemble performance.

Dr. Muck's program for the Boston Orchestra included Brahms's first symphony, Smetana's symphonic poem. "Wallenstein's Camp," Debussy's prelude to "The Afternoon of a Faun," and Chabrier's rhapsody, "Espana." The orchestra and the conductor were in their finest vein, and they have rarely given a finer performance. The symphony was superbly played, the austere grandeur of the first movement, the impressive introduction to the finale, the deeply romantic beauty of the slow movement, were profoundly felt and reproduced with a magnificence of tone that left none of the subtleties of the score out of account, and with a balance of the tonal values that kept the flow of the "melos" continually in the listeners' ears.

Dr. Muck had a deep sympathy with Brahms's thought and an equally deep understanding of his orchestral speech that is so fine and so characteristic when it is understood and truly interpreted. He has an equal insight into Debussy's thought that moves on another plane; and the performance of the prelude—which still seems the finest of the composer's orchestral pieces, written with a greater spontaneity than many of his later works, and when he had no anxiety about a Debussy formula to be maintained—was of exquisite charm, and had the freedom of an improvisation. Smetana's piece was not known to most of the audience. It lacks distinction and definiteness. Its effect is noisy; except the andante episode with the plucked strings, an interesting and suggestive passage. Smetana was at his best when he let the national spirit of Bohemian music inspire him. This work is far from showing the free inventiveness and originality of the Bohemian tone-poems, or of "The Bartered Bride." And as for Chabrier's Spanish rhapsody, it may be accused of a touch of vulgarity; but it has that which makes the listener catch his breath and beguiles him with its brilliant coloring.

Messrs. Bauer and Thibaud played three compositions for pianoforte and violin—Schumann's Sonata in D minor, Brahms's in A, and Schubert's Fantasia in C. They are both accomplished ensemble players and are not strangers to each other in this branch of the art. Mr. Thibaud had apparently recovered from the indisposition that affected him to some extent at his recital a short time ago, and his playing had great refinement, poetic feeling, and intensity of expresion, as well as beauty of tone and technical finish. Mr. Bauer's playing of the pianoforte part was of the same quality and the two artists saw eye to eye in their view of the music under their consid-

eration. The audience gained great delight from their performance and recalled the twain many times, especially after Schumann's sonata.

Mr. Spalding played music of Tartini and Bach, Spohr's Concerto in A minor, ("Gesangsscena.") his own Suite in C, and compositions of Franck, Arthur Whiting, Walter Henry Rothwell, and Wieniawski. André Benoist assisted at the piano. As at his previous appearances, Mr. Spalding did some fine playing, which represented a serious aim and success in achieving it.

* * *

May 10, 1917

'THE MOCK DOCTOR' GAY GOUNOD OPERA

Society of American Singers Gives Sixty-Year-Old Work Based on Moliere's Comedy

ITS MELODY IS FACILE

A Spirited Performance In English, in Which Kathleen Howard, Chalmers, and Hamlin Excel

THE MOCK DOCTOR, comic opera in three acts, founded on Moliere's "Le Medecin Malgre Lui." Composed by Charles Gounod. English version by Alice Mattullath. At the Lyceum. WITH: Percy Hemus (Géronte); Idelle Patterson (Lucinda); Rafael Diaz (Leander); Thomas Chalmers (Sganarelle); Lila Robeson (Martine); Kathleen Howard (Jacqueline); George Hamlin (Lucas); Carl Formes (Valero); Paul Eisler (Conductor).

The new project of the Society of American Singers was continued at the Lyceum Theatre last evening, with the first change of its bill, a performance of Gounod's opera "The Mock Doctor," in the original, "Le Médecin Malgré Lui." This is, in length at least, more ambitious than the previous undertakings of the society, as the opera is one that fills a whole evening. It was no less successful, however, than the previous productions, and its success confirmed the judgment that selected this almost forgotten and unknown opera of Gounod's as a part of the repertory of the short season now begun. The audience was large and liberal in its applause, and the applause was deserved by the excellence of the performance as well as by the beauty and piquancy of Gounod's music and the gayety of the opera.

It is, of course, a setting of Molière's well-known comedy, and the libretto, by Barbier and Carré, librettists of the "Faust" which was composed at the same time, closely follows the original. The central figure is the immortal Sganarelle, a personage who appears in other of Molière's plays, and who is the instrument of Molière's satire against the medical profession of his time. He was fond of satirizing it, and did so in several of his plays, among them "L'Amour Médecin," of which Wolf Ferrari's operatic setting was produced at the Metropolitan a few seasons ago.

Sganarelle in "The Mock Doctor" is a wood chopper, who ill-treats his wife; Géronte is a landed proprietor whose daughter Lucinda, to avoid a distasteful marriage, is feigning dumbness, and a doctor is sought for her. Martine, Sganarelle's wife, looking for trouble on his behalf, tells them that he is a learned doctor with an eccentric disinclination to practice except under the compulsion of a beating. He is found, beaten, and forced to attend Lucinda—which he does with an amusing parody on the medical pedantry of Molière's time. Then comes Leander, Lucinda's lover, and arranges to elope with his sweetheart while Sganarelle engages the father with solemn professional jargon and prescribes a dance and a song. The couple return married, and the indignant father is about to hand Sganarelle over to judicial punishment when Leander announces that he has inherited a large property and is, hence, a perfectly eligible son-in-law.

Gounod's music to this is wholly in the spirit of the French opéra comique of sixty years ago, when it was composed. It has lightness, facile melody, piquant rhythm, and harmony; and, through it all, distinction. Such music shows a side of Gounod's art unfamiliar to those who know it only in "Faust" and "Romeo et Juliette" and "Mors et Vita." The best of it is found in the second act, when Molière's jest reaches its point and the mock doctor is engaged in exploiting his own audacity and the credulity of the old man and his servants, if not of the daughter. Here the music has true expressive power and comic suggestion. The ensembles are of masterly skill, especially the sextet in which the daughter joins with her gibberish, and later the quintet of the others—music in which the varying sentiments of the different personages are separately expressed and combined in a brilliantly homogeneous musical picture. The serenade with which the lover opens the act is likewise charmingly written—apparently this is one of the passages in imitation of Lully's style, of which Gounod speaks in his Mémoires. The lover also has, by the doctor's prescription, a song to Lucinda in this act that is very pretty. The "Glou-glou" song with which Sganarelle apostrophizes his bottle in the first act hardly seems as admirable now as it did when the opera was first produced.

The performance maintains the high level that has been set by this excellent company of artists. Thomas Chalmers, as Sganarelle, sings well and makes the comic and the burlesque spirit of the character amusing. Mrs. Kathleen Howard likewise gives an excellent account of her music, and in appearance quite explains the mock doctor's infatuation with her. One of the most excellent pieces of character acting in the performance is that of George Hamlin as Lucas, and Géronte, the father, was suitably impersonated by Percy Hemus, as was Lucinda, the daughter, by Miss Idelle Patterson. Most of these sang their English text in intelligible fashion, and almost without exception are to be praised for the excellent delivery of the spoken lines, whose verse-structure they do not allow to interfere with the sense. Paul Eisler was the conductor and obtained a spirited and finished performance.

* * *

May 12, 1917

GEORGE M. COHAN'S PATRIOTIC SONG

Since the entrance of the United States into the war George M. Cohan has received several hundred letters from persons in all parts of the country asking him to write a patriotic song suitable to the day. He has acceded, and the song, both the words and music of which he has written, will be sung for the first time by Nora Bayes this afternoon, at the Thirty-ninth Street Theatre. In his early musical plays are two songs about the flag: "Any Place the Old Flag Flies" and "You're a Grand Old Rag."

* · * · *

June 3, 1917

AMERICAN SONG MAKERS SEEK WAR TUNES OF THE "TIPPERARY" KIND

The American "Tipperary" has not been written, so far as can be ascertained by an uncensored inquiry along Tin Pan Alley. Publishers and composers admit it. Makers of popular songs are an honest lot at heart. They are like the rest of us in that they want attention drawn to their own modest efforts. At first blush an investigator into the present condition of the patriotic song market will gather the impression that, if the truth were told, each writer of patriotic songs is absolutely certain he has written the patriotic song to which our marching armies will react throughout the war.

But this is only a little human weakness on view. The composer doesn't really think his song is the one for which the country is waiting. He says he does when informed that the writer of such a song is wanted for purposes of the interview, and he sings it while you wait with vigor and yours-sincerely gestures; but if he is asked a moment later for his honest opinion he will confide, a little weariedly, that no one has yet turned the trick.

Ever since the earth's first war, the militant representatives of combating powers have had their battle songs and their camp ditties. Up to date, leaving out several hundred other titles of contemporaneous vaudeville interest, we have "What Kind of An American Are You?" "Yankee Doodle," "The Man Behind the Hammer and the Plow," "If We Had a Million More Like Teddy," "Yankee Doodle," "Let's All Be Americans Now," and again "Yankee Doodle." General Grant is said to have known only two tunes, one of which was "Yankee Doodle" and the other wasn't.

Several hours spent in the song studios of Forty-fifth, Forty-sixth, and Forty-seventh Streets listening to the loudly accompanied efforts of the tune poets have led to the conclusion that, although a great deal of strength is going into the making of patriotic harmonies night and day in these thoroughfares with the result that hundreds of jingling and inspiriting tunes are making themselves felt at theatres and recruiting stations throughout the country, there has yet to be let loose the kind of a song that set the British soldiers marching in 1914 and has kept them at the proper pitch for doing the day's work.

It's a trick, the song writers say. A song may have nobility, exaltation, and spiritual valor and not cause a single foot to move in the direction of the enemy. Sentiment is not the thing, apparently. What could be further from the great war than the "Tipperary" song? Yet it captured the whole British Army just because it had a lilt and hit the public at the psychological moment. So it was with our own men in the war that made "There'll be a Hot Time in the Old Town" famous. That early and vigorous example of ragtime was a real marching song, and the subject matter counted not at all.

Publishers and composers will relate with vehemence how such and such a song is "stopping the show" wherever sung, one reason being that "it has a wallop in every line." A favorite way of demonstrating that there is a great deal of restraint in such a statement is for the publisher to call for the composer of the song and for a piano player and then lead the way into a soundproof and airproof room where the product is sung straight at the heart and patriotic impulses of the visitor.

The big song is not going to be a patriotic song, however. So the energy exerted by writers who rhyme rally with dally, and o'er the sea with liberty, and fray with day, and so on, will probably find that the melody hit of the war will be written by some hitherto unknown person who will chance to send forth a swinging song in which, doubtless, there will be no reference to war. Harry von Tilzer, who has written hits almost without interruption for thirty years, and whose "The Man Behind the Hammer and the Plow" is, perhaps, at least as popular as anything that has as yet come out, says the American soldiers' marching song will most likely be a freak little thing with a girl in it.

"I wrote a song this morning," continued Mr. von Tilzer, "called 'When the Boys Come Marching By.' I may be wrong, but I rather think there is a chance that it will strike twelve. Suppose the silly little thing called 'Row, Row, Row' were to come out now and make the hit that it did make a few years ago?—it would, in all probability, be the marching song for the American Army. I wrote it and can, therefore, call it a silly little thing; nothing to it except a catchy air. 'Bedelia' is the kind of thing I mean. Jean Schwartz wrote it more than a dozen years ago. Let such another hit be made now, and, regardless of the words, it will be the American 'Tipperary.'

" 'Tipperary,' written at any other time, would have been a total flivver. But there is no doubt about it that the British Tommy goes into battle to it with a lot more dash than he would to 'God Save the King.' When this country's hit is made, it will be through some actor on the stage."

A regiment in California has adopted "What Kind of An American Are You?" written by Albert von Tilzer, as its official song, and another melody which helps recruiting Sergeants in their work is Irving Berlin's "It's Your Country and My Country." Cliff Hess, writer of hits on his own account and "arranger" of Berlin's successes, (Berlin gets the thing and plays it on the piano with two fingers, and then Hess writes it out,) is another capable workman who believes

none of the composers has hit the American mark in the present war.

"They are all trying too hard," said Mr. Hess. "The result is that the songs are all too mushy and patriotic. Now, I believe I have a little thing that will do the trick. Of course, you can't tell. But my idea is that the people are tired hearing about what they must do in this war. I mean to take the other angle, and my song will be called 'There's Nothing Too Good for the Soldier.' Get what I mean? 'Don't get in a whirl, if he steals your girl, there's nothing too good for the soldier.' "

A day in Tin Pan Alley should be followed by a month in Northern France, where the attack is suspended now and then.

* * *

November 16, 1917

JASCHA HEIFETZ, SOLOIST

He Plays Bruch in D Minor with the Symphony Society

At the concert of the New York Symphony Society yesterday afternoon Jascha Heifetz, the young Russian violinist, who was found so admirable an artist at his opening recital three weeks ago, made his first appearance here with an orchestra. He played Bruch's concerto in D minor, not a work of the first order, and not one making the highest demands upon an artist's emotional or intellectual equipment. But the music was put on a higher level by Mr. Heifetz's noble and dignified performance of it.

There was all the beauty, the richness, the seizing quality of tone that he displayed at his recital; there was the fine finish, the unerring certainty in intonation, the security and firmness of rhythm, the beauty and elegance of phrasing through breadth and elasticity of bowing. All these qualities appeared in a performance of the concerto marked by singular poise, simplicity, and concentration. Only a master plays with such style and such effect. The desire still remains to hear Mr. Heifetz in concerted music of the first rank. There was much applause for his playing.

The orchestra repeated its effective performance of Théodore Dubois's "French" symphony, and closed with George Schumann's "Variations and double fugue on a merry theme": pleasing music of its kind with a high Teutonic flavor.

* * *

December 2, 1917

ENGLISH AND SCOTTISH FOLK SONGS IN AMERICA—CECIL SHARP PUBLISHES HIS FINDS IN THE SOUTH

By RICHARD ALDRICH

One of the recent and interesting discoveries made by the seekers after folk songs in this country is the fact that in a large district in the United States there is a rich field for the collection of English and Scottish songs and ballads surviving in the minds and hearts of the people. This is the Southern Appalachian Mountain region, in the western parts of Virginia, North Carolina, South Carolina and Georgia, and the eastern parts of Kentucky and Tennessee. In recent years certain portions of this region have been the scene of investigation by numerous students—most of them, unfortunately, interested in and familiar with only the verbal part of songs and ballads, and unskilled in the difficult art of noting down the music which, in the minds of the singers, is inseparable from the words of what they sing. There has been one admirably made collection in which the music has been given equal prominence with the words—that by Miss Loraine Wyman and Howard Brockway, and called by them "Lonesome Tunes." These were collected in the mountainous region of Kentucky. Mr. Brockway has harmonized the tunes, and provided them with artistic and characteristic pianoforte accompaniments, so that a number of singers have been glad to include selections from the volume in their concert programs.

Attention was called last season to the fact that these ballad collectors have recently had the invaluable reinforcement of Cecil J. Sharp, the chief authority on English folk song. Two Summers he has now spent in the mountainous regions of the South; he has made discoveries and amassed collections that will necessitate some important and thoroughgoing revisions of previously accepted ideas about English and Scottish and American folk song, and the living survival of that folk song.

The first fruits of Mr. Sharp's investigations are contained in a volume just published by G. P. Putnam's Sons, entitled "English Folk Songs from the Southern Appalachians," by Olive Dane Campbell and Cecil J. Sharp. It represents the result of Mr. Sharp's first season's work in the mountain region, with the help of Mr. Campbell, when he collected and noted down some 450 songs and ballads. This year he worked again in a different part of the same field—mostly in Kentucky—and gathered no fewer than 600 more. So in two years he has found in this country more than 1,000 English or Scottish popular songs and ballads, preserved purely by traditions in the mouths of genuine folk singers, many, if not most, of whom cannot read or write.

It must be remembered that these results were gained in America, where it was thought hopeless a few years ago by the chief authorities on the subject of folk song and ballad to look for anything of the kind, since folk singing of traditional song, it was supposed, had completely died out here. Instead of this being the case, folk singing of this sort flourishes here in the Appalachian region, it is quite within bounds to say, more vigorously than anywhere else in the world. Songs and ballads survive here that are completely extinct in England, and that the surviving folk singers there know naught of.

Mr. Sharp's book is the most valuable contribution that has ever been made to this special phase of folk song. It is the product not only of great learning and a minute familiarity with the subject of English and Scottish songs and ballads, but also of great skill in the difficult art of noting down the

exact musical shape of the tunes, often strange and irregular in rhythm, rarely in the major and minor modes known to artistic musicians, but cast often in one or another of the ancient modes, and in "gapped" scales, that is, pentatonic, omitting two notes, or hexatonic, omitting one.

In this book Mr. Sharp gives 122 songs and ballads, showing in the words and music of many of them from one to eleven variants.

The tunes are given as sung, without harmonization. The name of each singer is inscribed on the song he contributed and the place where the song was sung. There is a full series of notes to each song, identifying its connection with previously known versions and with references showing where such versions may be found. The ballads number fifty-five. Thirty-seven of these are related to ballads given in Professor Child's "English and Scottish Popular Ballads," the great thesaurus and final authority in this branch of literature. The remainder, as Mr. Sharp says, were either deliberately excluded by Child or were unknown to him. There are fifty-five songs and twelve "nursery songs."

Mr. Sharp traveled through one of the most secluded and inaccessible regions in the United States, mostly on foot, with interludes by wagon. There are few roads, most of them mountain trails, and no railroads. The inhabitants, until very recently, and for a hundred years or more, have been completely cut off from the rest of the world. To this fact is, of course, owing the preservation of the custom of ballad singing, and of the tradition of the words and the music.

Mr. Sharp is full of admiration for the people, their independence, their hospitality, their dignity and good breeding, and he maintains that though only a few can read and write, they have the essentials of a high culture. This is due, he says, to the fact that, having a large amount of leisure, "they have one and all entered at birth into the full enjoyment of their racial heritage"—their language, wisdom, manners, and the many graces of life that are theirs. They remind him somewhat of the English peasant, but they are freer in manner, more alert, less inarticulate, and have no trace of the obsequiousness of manner that now characterizes the English villager.

His enthusiasm for his folk singers carries him far. He writes:

"The wonderful charm, fascinating and well-nigh magical, which the folk singer produces upon those who are fortunate enough to hear him, is to be attributed very largely to his method of singing; and this, it should be understood, is quite as traditional as the song itself. The genuine folk singer is never conscious of his audience—indeed, as often as not, he has none—and he never, therefore, strives after effect, nor endeavors in this or in any other way to attract the attention, much less the admiration of his hearers. So far as I have been able to comprehend his mental attitude, I gather that, in singing a ballad, for instance, he is merely relating a story in a peculiarly effective way which he has learned from his elders, his conscious attention being wholly concentrated upon what he is singing and not upon the effect which he himself is producing."

But the American singers are sometimes able, as the English singers rarely are, to separate mentally the tune from the text, and even in some cases to discuss the musical points of the tune with considerable intelligence.

Mr. Sharp found that in the mountains everybody sings. In collecting folk songs in England attention had to be centred on the aged; nobody there under 70 possesses now the folk song tradition. The young have lost it, or are ashamed of it. In the South he found himself for the first time in his life in a community where singing was as common and almost as universal a practice as speaking; as he calls it, "an ideal state of things." There was no difficulty in persuading the people he visited to sing for him—especially after they had found out that their visitor had not come to "improve" them. "Very often," he says, "we would call upon some of our friends early in the morning and remain till dusk, sharing the midday meal with the family, and I would go away in the evening with the feeling that I had never before been in a more musical atmosphere nor benefited more greatly by the exchange of musical confidences."

There are recorded in Mr. Sharp's book not only variants of songs as sung by different singers, but also often the changes made by the same singer in successive repetitions of the tune—changes that are of interest and significance and that show remarkable inventiveness on the part of the singer.

The tunes mostly have the simplicity and searching quality that belong to the genuine folk song. They also show the various modal influences to which folk singers untouched by modern musical developments, are always subject. The modes are much more ancient than the modern scale, and have persistently kept their place in folk songs. The modes most often appearing in these songs are the Dorian, the Mixolydian, the Aeolian: that is, the succession of intervals obtained by playing the white keys of the piano beginning, respectively, on D, G, and A.

What is equally noticeable is the great number of tunes in "gapped" scales, pentatonic, or hexatonic, that is, with two notes or one note omitted. The most familiar pentatonic scale is that which omits the fourth and seventh, as in the oldest Scottish and Irish tunes. The modal peculiarities are retained. The pentatonic scale is unquestionably of the greatest antiquity, and the hexatonic and heptatonic were, in Mr. Sharp's theory, gradually formed by the speculative and hesitating introduction occasionally of the missing tones.

Mr. Sharp's deductions from the use of "gapped" scales in the mountain tunes are interesting. The songs seem to show that the people came from the north of England or the Lowlands of Scotland, rather than the Highlands. For these tunes have more affinity with English than with Gaelic. But his alternative theory is suggestive. It is that the folk singers of the eighteenth century all over England may still have been using the "gapped" scale—this being an earlier and more primitive one than that now generally used—and may not have advanced to the seven-note scale till the next century. The ancestors of the mountaineers brought over the "gapped" scale, which alone they know, and continued to use it here,

while their collateral descendants in England moved on to the more advanced scale form.

Among the ballads represented by various forms in this book are some of the most famous and widely spread, as well as others that have not hitherto been known by the modern collectors in actual circulation among folk singers. Thus of "The False Knight Upon the Road," with which Mr. Sharp begins his collection, Child says, "This singular ballad is known only through Motherwell," i. e., the collection made by him in 1825. Yet two versions were obtained by Mr. Sharp, one in Tennessee, the other in North Carolina. "Lady Isabel and the Elf Knight," of which Mr. Sharp gives five variants, from five different States, Child says has probably obtained the widest circulation of all ballads all over Europe. "Earl Brand" is one of the most ancient. "The Two Sisters" Child mentions as one of the very few old ballads not extinct as tradition in the British Isles.

The "Lord Randal" of the English and Scottish singers is disguised as "Jimmy Randolph" and "Jimmy Randal," and he leaves horses, "buggies," and mules to his partner and brothers, which he probably never did in England. As to "The Two Brothers," which was found in North Carolina and Virginia, Child remarks that it was found in Scotland in the first third of the nineteenth century and not heard of there again, but that in recent years "the ballad was obtained from the singing of poor children in American cities."

Of "Lord Thomas and Fair Ellinor" Mr. Sharp gives no fewer than eleven different versions. "Barbara Allen," which appears here in ten variants, is the same "little Scotch song of Barbary Allen" that Pepys records he heard sung in 1666 "in perfect pleasure," and of which Goldsmith in 1765 wrote: "The music of the finest singer is dissonance to what I felt when our old dairymaid sung me into tears with 'The Cruelty of Barbara Allen.' " And there are interesting things about a great number of these ballads and songs.

* * *

'MAROUF,' OPERA OF THE ORIENT SUNG

American Premiere of Rabaud's Fairy Comedy of "Arabian Nights" at Metropolitan

NOVEL ORCHESTRA EFFECTS

De Luca Scores as Cobbler of Cairo and Mme. Aida is Pleasing Princess in a Splendid Performance

MAROUF, or, THE COBBLER OF CAIRO, opera in four acts, the book from the 959th of the 1,001 "Arabian Nights." Libretto in French by Lucien Nepogy, music by Henri Rabaud. Produced for the first time in this country at the Metropolitan Opera House.
WITH: Giuseppe de Luca (Marouf); Frances Aida (The Princess); Leon Rothier (The Sultan); Kathleen Howard (Fatimah); Andres de Segurola (The Vizier); Thomas Chalmers (Ali); Robert Leonard (A Pastry Cook); Angelo Bada (A Fellah); Albert Reiss (Chief Sailor); Angelo Bada, Pompillo Malatesta (Two Merchants); Giullo Rossi (The Cadi); Max Bloch, Angelo Bada (Two Muezzins); Pietro Audisio (A Donkey Driver).
Oriental Divertissement by Rosina Galli, Premiere Danseuse; Giuseppe Bonfiglio and Corps de Ballet.

The Metropolitan Opera House last evening made the first of the new productions that have been announced for this season. "Marouf," an opera in four acts by Henri Rabaud, one of the few French operas of the most recent years. It was given for the first time in America. Owing to circumstances that will be evident to everybody, little had been heard of the new opera in this country. There was, however, a large audience at the first performance that showed the curiosity of a "first night" gathering, an audience that showed increasing interest as the performance went on.

"Marouf" was first produced at the Opéra Comique, Paris, in May, 1914. It was enthusiastically greeted by French critics, both "moderns" and conservatives, and thereafter had a great success in Paris and in some other cities even after the onset of war. Its composer, Henri Rabaud, is a conductor at the Opéra Comique; he had previously held the same position at the Grand Opéra for some time, and since he took the Roman Prize at the Conservatoire in 1894 has been a fertile composer.

The story of "Marouf," as has been made known already, is taken from "The Arabian Nights Tales"—"The Thousand Nights and a Night," as they prefer to call them now. Marouf is the henpecked cobbler who seeks an escape from his trials by shipping as a sailor, is wrecked and rescued and found by a rich merchant friend, who undertakes to give him what is known as "the time of his life" by introducing him to the Sultan as the richest man in the world with a wonderful caravan coming. The Sultan offers him his daughter in marriage and entertains him lavishly. Marouf finally confesses to the Princess that it is all a hoax, and the two flee from the wrath to come in disguise. They reach the desert and find one of those iron rings in the ground that are so common in "The Arabian Nights," and appear so seldom anywhere else; which, on being rubbed, calls forth a genie, who supplies incalculable

treasure as genie are expected to do. It is just in time, for the Sultan is in pursuit. He arrives, and simultaneously appears a great caravan, provided by the genie for Marouf. The cobbler triumphs and all are made happy, except the suspicious Vizier, who is thrashed.

An Engaging Fairy Tale

It is an innocent and engaging fairy tale, well adapted for operatic treatment in a lighter vein, a tale without horrors, without gloom, without problems, and offering many opportunities to the musician for variety, illuminating description, characterization, and local color. The local color is, of course, Oriental. The Oriental in music is always a temptation, but it may be a dangerous one. The Oriental idiom is easily at the disposal of any well-informed musician. But nothing so easily becomes monotonous to the Occidental ear as the Oriental formulas. Mr. Rabaud has drawn deeply from the Oriental spring and has saturated his music with its waters.

The composer's method is, naturally, that of the modern musical dramatist. The orchestra is the unceasing commentator and expounder of the dramatic situation and action. There are recurring themes developed orchestrally. The voices sing in declamatory style without often finding an opportunity to broaden or intensify in a more purely lyric manner a particular episode. There are, of course, some such passages. Those that are cast in the Oriental formula are apt to lose for Western ears something of their potency of emotional expression. There are passages for chorus, the most noteworthy being that which accompanies the gathering of townspeople at Khaitan, the capital where Marouf has been rescued from the sea; and especially at the very end, where there is a sonorous chorus in a fugato style, in praise of Allah, effective in its substance and rhythm—one of the best things in the opera, but coming unfortunately late in the proceedings to count for its true value with an audience already starting for home.

Elaborate Ballet Music

In the second act the music is lifted for considerable lengths of time from what cannot be called other than the monotony prevailing in the first, for in it there is little that forms a musical centre of interest. It is a distribution unfortunate for the appeal of a new and unfamiliar opera. Here there is a greater variety of expression and of rhythm. There is elaborate ballet music, in which Mr. Rabaud has said his Oriental say without circumspection. There is love music that Marouf sings to the Princess, characteristic in its flow, but hardly highly distinguished and not heavily fraught with passion—perhaps, under the circumstances of the meeting, not intended to be. And there is an air sung by the Princess of a similar sort.

Where Mr. Rabaud shines most brilliantly in this opera is in his treatment of the orchestra. There is much finely chiseled, detailed filigree work here, much subtle and delicate instrumental color, with some that is applied more broadly. There is the effect often of novelty. He deals often in complicated and mixed rhythms.

The performance was an excellent one of a work offering many difficulties in detail and in ensemble. It was under the direction of Pierre Monteux, the new French conductor of the Opera House, who showed his admirable musicianship and his firm command of the situation in the good results he obtained. The orchestral part, a delicate and closely woven tissue with a constant shifting of instrumental color and rhythms, was played with finish and nice balance: and the choruses, also difficult, were sonorous and effective.

De Luca the Adventurous Cobbler

Marouf is represented by Mr. De Luca—for it is a baritone's opera—who has done nothing better than this insouciant and humorous impersonation of the adventurous cobbler. The music is singularly well suited to his voice and he sings it in excellent style, in that baritone that so often and so curiously verges on the tenor quality. Mme. Aida is most prepossessing in her quality of Oriental Princess, both in appearance and in action, and her singing of the music had more excellencies than some of her offerings this season, so far. Mr. Rothier, Mr. Chalmers, and Mme. Howard made valuable contributions to the representation. Excellence of French diction is not a notable quality of the performance as a whole; for which reason Mr. Rothier's came into a special prominence.

* * *

February 8, 1918

GORGEOUS REVIVAL OF 'LE PROPHETE'

Caruso Sings Superbly Fanatical Leader of Holy War in Meyerbeer's Old Opera

MME. MATZENAUER, FIDES

Coronation March of 400 in Muenster Cathedral Earns 14 Curtain Calls—Bodanzky Conducts

LE PROPHETE, opera in four acts; original text in French by Eugene Scribe; music by Glacomo Meyerbeer. At the Metropolitan Opera House.
WITH: Enrico Caruso (Jean of Leyden); Margarete Matzenauer (Fides, his mother); Claudia Muzio (Bertha, his bride); Max Bloch, Carl Schlegel, Jose Mardones (Jonas, Mathisen, Zacharia, Anabaptists); Adamo Didur (Count Oberthal); Louis D'Angelo (An Anabaptist); Basil Ruysdael (A Captain); Pietro Audisio (An Officer); Vincenzo Reschiglian (A Peasant); Minnie Egener, Cecil Arden, Marie Tiffany, Veni Warwick (Four Choir Boys).
Incidental dances by Rosina Galli, Giuseppe Bonfiglio, and Corps de Ballet.
Artur Bodanzky (Conductor).

Signor Caruso, for fifteen years the Metropolitan's unchallenged star in Italian opera, whether tragedy or comedy, and of late in French rôles as well, made his first essay last evening as hero in Meyerbeer's "Le Prophete," which had not been seen and heard on Broadway in all the period since Caruso came to New York. The famous tenor will celebrate his forty-fifth

birthday on Feb. 25 next, according to a semiofficial note, and his assumption of more than one new rôle this season had already proved of great interest to his American admirers.

As Jean of Leyden he sang superbly last night, with an earnestness and dignity, a beauty of voice and restraint of action, that made up any lack of inches for the towering figure of the fanatical leader in a historic episode of Holy War. In the assisting cast, Matzenauer, as the Prophet's mother, sang well, though too heavily at times; Muzio was the younger heroine, Didur the rascally Count Oberthal, and Mardones, Schlegel, and Bloch the sonorous Anabaptist trio.

Mr. Bodanzky conducted the music, in which he was said to have made judicious cuts. The long opera ended well before midnight, no mean achievement in view of the many scenes newly designed by Urban, and made more difficult of presentation by an entire new system of lights, as well as by the assembling, under Ordynski's guidance, of more than 400 persons on the stage.

A Splendid Spectacle

Mr. Gatti-Casázza's production, rivaling any the Golden Horseshoe has seen under his direction or that of his predecessors, found a popular climax in the skating ballet that ended in a kaleidoscopic maze of apparently real skaters and dancers under a whirlwind of paper snow, and was followed by many curtain calls for Galli and Bonfiglio. The tent scene, with Urban's finest draperies and banners, and a famous trio wherein the Anabaptists strike a light from a flint to recognize their enemy, the Count, afforded a transition to the solemn scene before battle, where Caruso sang the "Roi des Cieux" to a heroic chorus and great applause.

Meyerbeer's first two acts of the original Paris five had been shortened by combining the opening pair as scenes of a single act. These were pictures of humble life of Westphalia, contrasting with the gorgeousness later on. Mme Matzenauer's "Ah, Mon Fils," to her son in Jean's inn, won much applause, half a dozen stars, indeed, shared the recalls after each of the early scenes. The solid, built-in pillars of the Cathedral of Munster, its several floors and balconies for congregation, choirs and trumpeters, made an impressive finish to Act 3, while Caruso sang his best in the Prophet's proclamation of himself as heaven-sent—an idea used by Meyerbeer a year before Wagner's "Lohengrin," and a generation before "Parsifal."

There were fourteen curtain calls after the Coronation March of the 400 in Munster Cathedral, and Caruso brought out with the singers Chorus Master Setti and Stage Director Ordynski, as they well deserved. Conductor Bodansky had his share of the enthusiasm each time he entered the orchestra pit. The fourth and last act, much shortened in the episode of the prisoners cavern, added another brilliant view of the banquet hall, where Caruso as king of the revels, a king of misrule at last, sang his final aria before the explosion that brought the opera to a close at 11:40 o'clock.

The tenor's drinking song earned ten more curtain calls at the close.

Produced at Niblo's Garden

"Thirty-five years have gone by since 'Le Prophete' was brought forth at the Théatre National, in Paris, and a little less since it was made known to American audiences, in its Italian garb, by Max Maretzek, under whose management and leadership it was presented—as were almost all the great works of that age, soon after their production abroad—at Niblo's Garden, in this city." So wrote a critic in The New York Times of another Metropolitan revival, already another thirty-five years ago now, in the first season of New York's present opera house.

"In Paris, Roger was the tenor, and Mmes. Castellan and Viardot (Pauline Garcia) the prima donnas. In New York, Mmes. Bertucca-Maretzek and Steffanone were the songstresses, and Signor Salvi was the tenor." The critic added that "Il Profeta," though frequently performed in the early days, had "not been heard in New York since 1868," when Mme. Lagrange was the only artist of eminence in the cast, and that in 1884, "to the younger spectators assembled in the Metropolitan," then recently opened, the opera was "no doubt somewhat of a novelty."

Comparing "Il Profeta" with its popular mate, "Gil Ugonotti," the critic of that period missed the "sharply contrasted expression of religious feeling, the no less distinct delineations of character, and the vivid and sonorous musical effect." Nor did it contain "any single number worth of mention with the duet and benediction of the sword," in Meyerbeer's better known work. On the other hand, "Il Profeta" came nearer, he said, to "the modern ideal of opera." The conventional forms of the older Italian composers were more sedulously avoided than in "Gil Ugonotti," although the "accompaniments" were yet often at variance with appropriate dramatic effect.

The plot of "Le Prophete" is familiar even today, and in the main is based on fact. It embodies the historical story of Jean of Leyden, who, in 1538, became the leader of the Anabaptists of Munster, who proclaimed him their King and Prophet. This leader was finally put to death by the victorious Bishop of Munster, who with his adherents, after having been driven from the town, presently returned, laid siege to the place, and captured it. Meyerbeer's librettist, "the Scribe of a hundred opera texts," of course, did not scruple to add to the facts of history such details as the supposed persecution of Jean's mother and his affianced bride by Count Oberthal, with other incidents calculated "to give artistic verisimilitude to an otherwise bald and unconvincing narrative," as we believe W. S. Gilbert once said of his own works; or rather, in this case, to give vivacity and variety to the action of historical events portrayed as dramatic spectacle.

First Produced in Paris in 1849

"Le Prophete" was first produced in Paris on April 16, 1849, and is said to have reached America by way of the French Opera House at New Orleans on April 2, 1850. The first performance in New York, if the date is exact, was Nov. 20, 1854. At the Metropolitan it had a single Italian performance in this theatre's first year, 1883–1884; it made

its greatest run in the German seasons thereafter, having some twenty-three hearings up to 1891, and after that a bare seven in French under the several managements of Abbey, Schoeffel, and Grau. The opera was last given on one occasion in Grau's final season, 1902–1905, with Albert Alvarez and Schumann-Heink. Its last local revival, by George Lucas, Mmes. d'Alvarez and Walter-Villa, was in 1909, at Hammerstein's Manhattan, in English.

Those who sang "Il Profeta," March 21, 1884, were Stagno, Scalchi, and Valleria, with Guadagnini as the Count, and Mirabella, Contini, and Stagi as the Anabaptists—recorded as the "positive, comparative, and superlative of bad." Mme. Cavalazzi, now a veteran, was the dancer, and twice in the ballet a skater fell. Signor Vianesi conducted. Leopold Damrosch led the first German version "Der Prophet," Dec. 17, 1884, with Schott, Marianne Brandt, and Schroeder-Hanfstaengl. Blum as Count, Kamlitz, Miller, and Koegel as Anabaptists. Wilhelm Hock, the stage manager, left his job because the stockholders would not let him turn out the theatre's lights in the then "new" Wagnerian way. Herr Silva sang the Prophet Nov. 27, 1885, with Brandt, Kraus, Alexi Remlitz, Kaufman, Lehmler, and Walter Damrosch, new as conductor.

The late Albert Niemann was hailed as the greatest of Prophets when he sang Nov. 17, 1886, in the third German season and for years after that. With Brandt in the cast, there were also Lilli Lehmann as Berta, Dr. Bosch as Count, the famous Max Alvary as the First Anabaptist, with von Milde and Sieglitz: Mme. Cavalazzi danced, Walter Damrosch conducted, and Van Hell was stage manager.

When Jean de Reszke appeared as Jean of Leyden, Jan. 1. 1882, a performance but once repeated, the opera was given in French. Lehmann was again the Berta, and Giulia Ravogli sang Fides, with the late Edouard de Reszko as Count Oberthal, and Martapoura among the Anabaptists.

Mr. Gatti's production last evening was the thirty-second performance of "Le Prophete" in the Metropolitan's thirty-five years, according to the records of the house.

* * *

March 24, 1918

'SHANEWIS,' INDIAN OPERA, CAPTIVATES

Charles W. Cadman's Little Work of Folk Songs Is Tuneful and Picturesque

'THE DANCE IN PLACE CONGO'

Henry F. Gilbert's Ballet the Most Artistic Piece of Negro Ragtime Rhapsody Broadway Has Shown

SHANEWIS, or "The Robin Woman," an American opera in two parts; book in English by Nelle Richmond Eberhart, music by Charles Wakefield Cadman. At the Metropolitan Opera House. WITH: Sophie Braslau (Shanewis); Kathleen Howard (Mrs. Everton); Marie Sundelius (Amy Everton); Paul Althouse (Lionel); Thomas Chalmers (Philip); Roberto Moranzoni (Conductor).

THE DANCE IN PLACE CONGO, ballet pantomime after a story of old New Orleans, by George W. Cable; book of action and music by Henry F. Gilbert. WITH: Rosina Galli (Aurore); Guiseppe Bonfiglio (Remon); Ottokar Bartik (Numa); Pierre Monteux (Conductor).

Something like a new Declaration of Independence, as far as concerns American opera or American music of the theatre, native scenic art, home-bred music and singers, was signed, sealed, and delivered with the production at the Metropolitan Opera House yesterday afternoon of two little works, both tuneful and captivating, beyond question of authentic originality and native worth—Charles W. Cadman's "Shanewis," and Henry F. Gilbert's "The Dance in Place Congo." The brief hour of lyric opera, not only native, but naïve, was picturesquely paired with the twenty-minute dance, to which Broadway's finest audience found itself keeping time with its toes.

Together, these works formed parts of a triple bill, all American in scene, as the matinée ended with Franco Leoni's vivid slice of life from San Francisco's Chinatown in "L'Oracolo," repeated for this occasion.

The two novelties set a new world record for stage performance sincerely and genuinely based on the folk songs of the American Indian and American negro, songs and snatches that thousands of Americans know by heart as they do their mother tongue. Mr. Gilbert made most of the familiar Southern tunes in an artistic score of ragtime rhapsody. Mr. Cadman's quest for songs of remoter lilt and cadence lent color to a simple story of the West today, yet carried a thought of the cool morning of life on this continent in aboriginal ages long ago.

Earned 21 Curtain Calls

Walt Whitman would have "heard America singing" in such a day's music, and when Sophie Braslau darted on the stage, it was good to hear a New York crowd applaud an American star at sight, then applaud her songs, her love duet with Althouse. The two acts of Cadman's opera earned twenty-one curtain calls from the house, all the singers appearing, joined at the third call by Mr. Bamboschek, the pianist in the stage "concert," and at the seventh by Mr. Cadman.

The Pittsburgh composer received repeated ovations, alone and in company with Miss Braslau. By odd coincidence, Tsianina Redfeather, the Indian original of Shanewis, walked down an aisle during intermission and was promptly mistaken for the star. After the second act, Conductor Moranzoni was brought out, and twice Mrs. Eberhart, the librettist, while Messrs. Ordynski and Setti, who rehearsed the stage crowd and chorus, remained invisible.

The Cambridge sage, Mr. Gilbert, nonconformist no less in his music than in his modest bearing, came out after the "Dance in Place Congo" for seven curtain calls with Galli, Bartik, and Bonfiglio. The house clapped its hands to see the cotton plantation, it clapped the superb "Bamboula" dance boldly orchestrated in brass and xylophone.

Here and there, whether in fancy or in fact, the hearer caught the French words of "Un, Deux, Trois, Caroline," and

"Quand Patat' Est Cuit, Na Va Manger," to melodies of American childhood that brought to many faces honest tears as well as smiles.

Mr. Gilbert's dance was the most artistic piece of ragtime theatrical Broadway has shown, while Mr. Cadman's charming lighter lyrics, set off with celesta bells and all the modern apparatus, also made a popular success. The musicians heard their own music from Boxes 44 and 46, where Mr. Gilbert's mother, wife, and two little daughters from Boston sat with Mr. Cadman's two aunts from Cantor, Ohio, and four cousins from Pittsburgh. "Otherwise," as Cadman said, "there was no clacque."

Mr. Cadman's Music a Surprise

What yesterday's audience first heard was Mr. Cadman's overture in sharp contrast with much that was to follow; a tragic overture to a merry scene, as surely as his opera's later intermezzo was light and gay by way of prelude to a swift, sombre culmination. The double contrast was intentional, it was clever, and it worked like yeast in the dough. Under the sparkling froth of a society in which moved and sang an Indian girl of today, there could be felt the dark current of past dealings with the Red Man. In mastery of orchestration, though often sophisticated as to the actual native melodies used, Mr. Cadman's music was a surprise to many who knew him only as a composer of graceful songs. His opera proved a succession of songs, a constant delight in this respect, less successful in its treatment of dialogue, which was brief, and less sustained in its climax, which CRIED for more poetic text.

What the audience saw as the curtains parted on the California bungalow scene was a really livable American interior of recognizable redwood; a double-decker living room, with balconies giving on upper rooms, and with open latticed sides showing the Pacific Ocean, for once calm as its name, in the wake of a full moon. James Fox's pictures might have been the view from mountain villas above Santa Barbara. The chorus was conceivably a company of guests, and its remarks were cheerful if not always intelligible. Miss Howard as a hostess in white carrying obviously this season's ostrich fan from a famous Pasadena farm, Miss Sundelius as a sweet girl graduate just from Vassar and the East, fitted in the picture. Mr. Althouse and the men seemed a bit formal for bungalow life in dress suits.

Miss Braslau a Beautiful Indian

With its year of preparation and weeks of daily rehearsal, the opera found a heroine at a few hours notice in Sophie Braslau, whose Shanewis will outshine all her previous rôles. In white-fringed caribou hide, dark braids and simple headband, Miss Braslau was a beautiful as well as a good Indian and one very much alive, her stealthy moccasin-tread and unstudied poses suiting action to word from the first real Indian songs to the last defiance of civilization. Her voice dominated and gave dignity to the final scene. Mr. Cadman had told the origin of some of his songs from melodies of the Cheyennes, the Omahas, the Osages, as recorded by Miss Curtis and Miss Fletcher, Mr. La Flesche and Mr. Burton, but in performance the songs told their own story.

The big Indian scene on an Oklahoma reservation, designed by Norman Bel Geddes with a feeling of limitless open-air, of vastness and mystery, of mirage that is part of the true Western landscape, had all the realistic details of tents or tepees with open smoke flaps, of lemonade and peanut stands gay with American bunting, of a ramshackle prairie wagon, and a presumably popular make of motor car with about as much "spring" in it as the present month of March in New York. Cecil Arden, Marie Tiffany, Phyllis White, and Veni Warwick crossed the stage once singing as four high school girls. Angelo Bada, Pietro Audisio, Max Bloch, and Mario Laurenti had a moment before the footlights in a powwow of Indian dance.

A more concise telling of incidents has not been heard or seen in grand opera, so unassuming is Cadman's method and so direct his conclusion. Thomas Chalmers lent his good baritone to the presentation to Shanewis of a bow and poisoned dart that had protected an Indian maid of the tribe from a white betrayer. He also shot the same arrow, which killed a rather double-dealing hero hesitating between the opera's two young heroines. Here the story was just opera, the eternal triangle. In its more general outlines it was derived from the history of a young Indian woman, Tsianina Redfeather, descendant of Tecumseh and well known as a singer on Mr. Cadman's lecture tours. She was in native costume in the audience yesterday.

Kept Dancing Feet Busy

Midway in the matinee bill Mr. Gilbert's "The Dance in Place Congo" shared interest out of all proportion to its little length, less than twenty minutes, but enough to keep dancing feet busy all that time and as many times more as the season allows. A scene, not of the old New Orleans waterfront square of famous slave revels, but out across the river or bayou, with the city's spires in the sunlit distance, and black folk coming from the "quarters" under the shady cottonwood trees, was the work of Livingston Platt, as were the costumes, a banzai sunburst of bandannas. Ottokar Bartix, who worked out Mr. Gilbert's bit of love story in low life, had been to New Orleans for local color, and what was better, he had introduced traditional figures, at least one Uncle Tom, and a half-dozen Simon Legrees. The ballet "chorus" distinguished itself once when it not only danced but sang.

Mr. Gilbert's music, expanded forty bars in one instance to let in the booming bell of slavery's work-days with its whiplash obbligato, is for all its realism as genial a piece of symphonic writing as has come to local hearing in some time. Like Mr. Cadman, he also has told the sources of his tunes, and some he did not need to tell. The "Bamboula," borrowed by Gottschalk many years before Coleridge-Taylor, is universally known in the West Indies and the South, while Louisiana long ago furnished its mate in "Michie Bainjo," and the love song, "Ma Mourri," as well as the only air actually sung near the end yesterday, the "One, Two, Three, Caroline" of a good old darky breakdown.

Something of George W. Cable's story to which Mr. Gilbert set music and action may have evaded the grasp of trained dancers in conventional ballet, but the dances, not the darky love affair, were the main thing, and they set the stage awhirl. Mr. Bartik made a point of the villain's consultation of the fortune teller. Mr. Bonfiglio gave sufficient evidence of a passion for the quadroon girl. Miss Galli, who within a fortnight had become a stage-centre star in Russian "Coq d'Or," achieved an astonishing transformation to the kinky-haired, black-faced vixen of the "Place Congo." Her climax of the dance, a trance-like orgy ending with much writhing and mopping of a carpet spread on Massa's cold, cold ground, was a tarantella of terpsichorean virtuosity, the last word in dancing on the Metropolitan stage or anywhere else since Pavlowa's Manhattan "Carmen."

* * *

November 21, 1918

SERGE PROKOFIEFF A VIRILE PIANIST

Young Russian Composer Makes New Music and an Instant Success at Debut

HIS FINGERS LIKE STEEL

He Has Speed and Surety, but a Narrow Gamut of Dynamics. All "Crash" or Whisperings.

New ears for new music! The new ears were necessary to appreciate the new music made by Serge Prokofieff in this first pianoforte recital at Aeolian Hall yesterday afternoon. He is younger looking than his years, which are patriarchal, almost twenty-seven. He is blond, slender, modest as a musician, and his impassibility contrasted with the volcanic eruptions he produced on the keyboard. We have already one musical anarch here, Leo Ornstein, yet that youth's "Wild Man's Dance" is a mere exercise in euphony, a piece positively Mozartian, in comparison with the astounding disharmonies gentle Serge extorted from his suffering pianoforte; the young man's style is orchestral, and the instruments of percussion rule in his Scythian drama.

He is an individual virtuoso with a technique all his own. He can create big sonorities, sometimes mellow to richness, more often brittle and raucous. His fingers are steel, his wrists steel, his biceps and triceps steel, his scapula steel. He is a tonal steel trust. He has speed, surely, but a narrow gamut of dynamics, all crash or whisperings; no tonal gradations, with a special aptitude in the performance of double notes, octaves and chords taken at a dizzy tempo, again orchestral, all this. It is for Prokofieff the mere breaking of a butterfly on a wheel to play other men's music. But the gracious butterfly of Scriabine was metamorphosed into a gigantic prehistoric pterodactyl with horrid snout and crocodile wings which ominously whirred as they flew over the pianist. Ah! a Jabberwock, it was, not a butterfly!

He played in addition to his own music three preludes of Rachmaninoff—who was in the audience—and two études of Scriabine, one in C sharp minor, the other in D sharp minor, (Dis Moll) and introduced here by Josef Hofmann, who plays it in the grand manner without shattering its syntax or our ear-drums. It is really, this study, in echo of Chopin's D minor prelude and not so poetic. One of the Rachmaninoff preludes in G minor is also a Hofmann favorite. Prokofieff did not play it like Hofmann. He is not that sort of a virtuoso. His treatment of trifles is brutal. But unquestionably a virile pianist.

As a composer he is cerebral. His music is volitional and essentially cold, as are all cerebral composers. At first you are stunned by the overwhelming quality of his music; presently a pattern is noted. The lyric themes are generally insipid. The etude-form, and there is a well-defined one, predominates. Immense technical difficulties deafen one to the intrinsic poverty of ideas in his music. The four etudes have in a nutshell his style; the sonata, a second one, contains no sustained musical development, the first allegro being a mosaic, violent in transitions, in moods rather monotonous; but in the scherzo he swept everything before him with its tremendous rhythmic urge. Again, the etude scheme. His sonata form is rather negligible, the very formal virtue which Scriabine possesses. Scriabine evidently has been an inspiration to this gifted young man. The finale of the work evoked visions of a charge of Mammoths on some vast immemorial Asiatic plateau. Rebikoff seems a miniaturist after this.

Prokofieff uses, like Arnold Schoenberg, the entire modern harmonies. The House of Bondage of normal key relationships is discarded. He is a psychologist of the uglier emotions—hatred, contempt, rage—above all rage—disgust, despair, mockery, and defiance legitimately serve as models for moods. Occasionally there are moments of tenderness, exquisite jewels that briefly sparkle and then melt into seething undertow. The danger in all this highly spiced music is manifest; it soon exhausts our faculty of attention; Pelion must be piled on Ossa, else the lights burn dimmer. His scale scheme is omnitonic—or is it emphelic? But now and then we get a glimpse of a recondite region, of a No Man's Land wherein wander enigmatic and fascinating figures, an unearthly landscape, an atmosphere, murky and heinous, but painted in the bold, feverish strokes of a canvas by Boris Anisfeld. We confess that we anticipate novel things in the Prokofieff concerto for pianoforte, which he has played for Harold Bauer; also something new in his symphony, which we are to hear next month at a concert of the Russian Symphony Orchestra. The gavotte he gave yesterday is one of the movements, certainly it is symphonic in tone. His "Suggestion Diabolique," which, barring several encores, closed the afternoon, derives from Liszt—the B minor dance in Lenau's "Faust."

A parterre of pianists greeted the newcomer with dynamic applause. Of his constant success there can be no doubt. Whether he will last—Ah! New music for new ears. Serge Prokofieff is very startling.

* * *

NEW SOUSA MARCH SONG PUBLISHED FOR FIRST TIME

Below is published for the first time anywhere the refrain of a new march song by John Philip Sousa, the celebrated march king, composer of "The Washington Post," "The Liberty Bell," "King Cotton," "El Capitan," "The Stars and Stripes Forever," and a score of other marches which have made his name a household word all over the world. Soon after the United States entered the war against Germany Sousa volunteered his services and those of his band. They were attached to the Great Lakes Training Station, and Sousa received the rank of Lieutenant. During the war he wrote several patriotic pieces, which he has now capped with the march published here, composed in honor of our returning heroes.

The words of the march song are by Helen Sousa Abert, daughter of the composer, and the song is published by Harold Flammer, Inc., of New York. Here are the words:

> *The boys will greet their mothers,*
> *Sisters, cousins, and others*
> *With a very Frenchy "Parlez-vous Français";*
> *And those who have been smitten*
> *With the language of Great Britain*
> *Will be full of "Bli-me, swank and Oh, I say!"*
> *But when those fighting Yankees greet the girls that*
> * they adore,*
> *Their sweethearts of this land of liberty,*
> *They'll forget the French and English and they'll yell out*
> * with a roar:*
> *"Say, girlie, but you sure look good to me."*

REFRAIN

> *When the boys come sailing home,*
> *When the boys come sailing home,*
> *The girls will hug them, kiss them, and caress them,*
> *When the boys come sailing home.*

> *A luscious ven'son pasty,*
> *To a Briton's very tasty,*
> *And a haunch of mutton he calls proper food.*
> *And when it comes to eating,*
> *France will take a lot of beating,*
> *For each spoonful must have sauce to make it good.*
> *But when our soldier boys were out on guard or in*
> * a trench,*
> *Their thoughts were centred on a juicy steak;*
> *They said: "Keep the concoctions of the English and*
> * the French;*
> *Give me the pies that mother used to make."*

REFRAIN

> *When the boys come sailing home, &c.*

* * *

RACHMANINOFF RAISES THE ROOF

By JAMES GIBBONS HUNEKER

No, he did not play It at Carnegie Hall yesterday afternoon. That is, Serge Rachmaninoff, the doubly distinguished composer and pianist, did not play his celebrated Prelude in C sharp minor, though the Rachmaninoff "fans"—and there were thousands of them in the audience—clamored for the favorite piece of Flatbush "flappers." They surged toward Serge in serried masses. They clustered about the stage. They raised aloft their arms as they supplicated the Russian to give them his recollection of the Henselt concerto. But to no avail. He played five encore numbers, one of them being the Prelude in G minor, first made known here by Josef Hofmann, who does not play it so rapidly, thereby getting a more sonorous tone. It is dangerous, however, to criticise the interpretation of a composer. He ought to know what he wishes. So please do not accept our opinion as official. He also played his own "Humoreske," which we didn't know till a friend prompted us. It is truly humorous, with more than a moiety of the deviltry that lurks in the dark forest called the Russian soul. The other three encores were salon music, clever, not very original, though effective. But the chief thing is the fact that Rachmaninoff did not play It. All Flapperdom sorrowed last night, for there are amiable fanatics who follow this pianist from place to place hoping to hear him in this particular Prelude; like the Englishman who attended every performance of the lady lion tamer hoping to see her swallowed by one of her pets.

Otherwise the program was far from exciting—old-fashioned, it could have been called. Mozart's familiar variations in D, and the D major Sonata of Beethoven, opus 10, No. 3, began the afternoon. The oldsters were reminded of van Bülow. The same cold white light of analysis, the incisive touch, the strongly marked rhythms, the intellectual grasp of the musical ideas, and the sense of the relative importance in phrase-groupings proclaimed that Rachmaninoff is a cerebral, not an emotional, artist. Not Woodrow Wilson himself could have held the academic balance so dispassionately. Even the staccato Princeton touch was not absent. Nevertheless, there were some disquieting details in the reading to conservative Beethoven students. The principal one hinged on the question of tempo. The first movement is a Presto. It was taken at a prestissimo, plus a prestissimo. Not a blurred outline was there, yet the speed detracted from the essential weightiness of Beethoven's proclamation. The Largo was better, the Menuetto most ingratiating, the Rondo full of the quizzical huntsman interest in its challenging theme. Both the Mozart and the Beethoven were as clear as a dry-point etching. (But we wished that he would have discarded the double-bars).

We have said that Rachmaninoff is not emotional, but that must be taken in a limited sense. Josef Hofmann is not emotional, as was his master, Anton Rubinstein, yet there is a color, a glow, not in Rachmaninoff, whose touch is like a

boulder of granite in chord playing, whose piano voice in cantilena is not velvety. The C sharp minor nocturne (Opus 27, No. 1) by Chopin was thoroughly satisfactory because of its superlatively fine adjustment of tonal dynamics with the tragic mood-picture. It reached the head, not the heart. The A flat Valse Opus 42 was brilliant, while the best of the group was the Polonaise in C minor, Opus 40, seldom heard—Paderewski loved it—and when heard seldom played in the profoundly significant manner that the virtuoso delivered his moving measures yesterday. It is a pendant to the popular Polonaise Militaire, and might be the obverse of the heroic medal; after the bugle blasts, the proud panoply of war, follows fast the awful penalty. "Home they brought her warrior dead!" is the motto of this processional elegiac polonaise, its melancholy muted, its resignation worn like crêpe in every bar. Rachmaninoff played the work nobly.

His own compositions were enjoyable, and the C sharp minor rhapsody of Liszt dazzling. He gave a polka that made one long to be up and dancing. Rubinstein in "Le Bal" has a fetching polka, and the form is almost of the ragtime persuasion. After the Chopin polonaise we were most impressed by the encore, which appropriately trod on the heels of the Beethoven sonata. It, too, was from a Beethoven sonata in A flat; Opus 31, No. 3, the scherzo-like allegretto, which von Bülow played so overwhelmingly. Rachmaninoff took it quicker than the nimble little Hans and with the same clarity and electric precision. The Russian is a master etcher on the keyboard.

* * *

December 29, 1918

"OBERON" REVIVED AT METROPOLITAN

By JAMES GIBBONS HUNEKER

"Oberon," opera in three acts by Carl Maria von Weber, was sung yesterday afternoon at the Metropolitan Opera House for the first time in this city in nearly a half century. The Lord High Keeper of New York's musical archives, H. E. Krehbiel, has found no record of a performance since 1870, so the present revival of Manager Gatti-Casazza is a genuine novelty to the present generation of operagoers and music lovers—not always to be confounded—and a very fascinating novelty it proved to be both as music and as spectacle. Strictly speaking, Weber was as great an innovator as his follower Wagner, not alone historically but actually. More original and prolific in musical invention, he has been a veritable Forty Thieves cave for the plunder of later composers. All have helped themselves from his liberal hoard, but few have acknowledged their indebtedness; and he remains the chief source of the modern-music drama of which Richard Wagner is the supreme development.

It may be set down to the credit of the composer of "Tristan" that he gratefully applauded the genius of Weber and almost joyfully conceded to that master his enormous debt. After a single hearing of "Oberon" the "Wagnerisms"

of the score furnish food for much moralizing; and one inference is inevitable—that music is like a living torch whose sacred fire is passed from hand to hand through the ages. There is no such thing as absolutely original music.

The Singers in "Oberon"

We append the cast of this performance, sung in English, as a matter of record.

WITH: Paul Althouse (Oberon); Rosa Ponselle (Rezia); Alice Gentle (Fatima); Albert Reiss (Sherasmin); Marie Sundelius (Mermaid); Raymonde Delaunois (Puck); Giovanni Martinelli (Huon); Louis D'Angelo (Harun-al Raschid); Mario Laurenti (Babekan); Paolo Ananian (Abdallah); Leon Rothier (Charlemagne); Carl Schlegel (Almanson); Giuseppe Del Grande (Mesour);
Artur Bodanzky (Conductor).

The opera was sung for the first time at Covent Garden, London, April 12, 1826. The composer was also the conductor. In his introductory remarks to the revised edition of the work Arthur Bodanzky tells us, in the Schirmer pianoforte edition, of the cuts and changes made necessary by the clumsy construction of the drama and its numerous scenic changes. There were twenty-one stage tableaux which he has reduced to seven. No need here to print the list of his extensive alterations. They were imperative as otherwise they impeded the action of a not swift moving play. Mr. Bodanzky has also suppressed several characters, transposed scenes, changed certain speaking parts into lyric ones, and has generally speeded up the movement of the piece, which is static, not dynamic in character. He also interpolated fifteen musical recitatives. But what he does not mention in his beneficent editing is the happy idea of orchestrating a piano piece of Weber's and using it as an introduction to Act II. This composition is well known to piano pedagogues as a Momento Cappricioso, a study in B flat major—which antedated Schumann's famous Toccata, and in double notes as well as velocity. Orchestrated by Bodanzky it has all the fairy murmuring, shimmering, and scherzo-like quality of Mendelssohn. It is delightful music and appropriate. Before the composer of the miraculous overture to "Midsummer's Night Dream," Weber had discovered the fairy realm of music, with its imps and nymphs, its sprites, hobgoblins, snouted crawling monsters, its fays and fire-flies, and the mystic rustlings of Summer woodlands at midnight wherein birds and fabulous animals converse as humans and lovers stray in the magical moonlight, "horns of elfland faintly blowing."

Weber was not the first poet to speak in terms of music, but he was the first of a long line to invest with the glamour of romance the music of opera. In the phrase of the psychiatrist he was a "visual" and an "auditive"; he saw his situations and landscapes and characters before he heard them, painted them in tone. He was a master of that elusive quality we call atmosphere.

He was also the first in German music to develop the exotic. He loved the fantastic in literature as his preference for Tieck amply proves. He found in Cervantes his "Preciosa," Spanish and gypsy motives. He made tentative sketches for

"The Three Pintos"; "Turandot"—since set by Ferruccio Busoni—after Gozzi-Schiller, he employs a Chinese theme. In "Oberon" we hear Turkish and Arabic music. Withal, in "Der Freischutz" he has written the most distinctively national music in literature "Euryanthe" is not a close second, though, steeped as it is in romanticism.

Overture Is High Water Mark

Some one has said that the overture to "Oberon" is the whole opera. There is a certain element of truth in the witticism. In its introduction we encounter the magic horn motive—Oh! Siegfried, before you a bold knight wound his horn in the service of distressed damsels—the fairy motive, the Charlemagne motive, a march at the close; and in the Allegro con fuoco there is a travel motive, later heard in the quartet. "On board," and motives of devotion, jubilation—Huon's thoughts of the beloved in his aria, "From boyhood trained in battlefield," and Rezias rejoicing in the "Ocean" aria. But older critics have warned us that this wonderful overture should not be considered as a mere mosaic of tunes, apart altogether from its formal perfection. It inducts us into the spirit and color of the play, into a fairy-land of wicked princes and potentates where wrong is righted and the brave win the fair; where "shining cupolas, fantastic minarets, palm-woods, lovely women, Saracens, Franks, combats and Oriental intrigue make a dazzling Fata Morgana." It must be admitted that the overture is the high water mark of the opera with "Ocean! thou mighty monster," that perennial stalking-horse of ambitious prima donnas as the next in degree.

Innovator as he was, Weber adhered to the classical treatment of the vocal parts. His voices are handled as instruments and as an integral part of the instrumental phrase and are often cruelly driven. Like Beethoven in "Fidelio," the vocal treatment is symphonic, and not the free flowing meles of the Wagner music-drama. The quartet already mentioned is an admirable example of the old-fashioned system, which is as rigid as the new way is elastic. The consequence is that to sing Weber well makes demands on the singer that are terribly trying. As for the great "Ocean" aria that is only the dramatic sopranos who possess the "grand manner," rather deprecated nowadays because it is so rare, the case of the fox and the sour grapes. Huon's part is exacting. The choruses are conventional, the characterization excellent, especially of Puck. King Oberon is a desultory person, Fatima a lay figure, and the Sultan and Charlemagne nullities. Accustomed as we have been to modern exoticism from "Aida" to "Marouf," the incidental music of "Oberon" seems tame and timid, yet, considering its age, how ingenious and individual! And with what stirring effect is the "quotation" of Siegfried's Sword motive—proof before all letters—in "Ocean! thou mighty monster." Like Molière, (and Shakespeare, too,) Wagner knew where to find what he wanted. Siegfried's sword was forged in Weber's smithy.

Libretto Based on a Fairy Poem

There is some confusion about the libretto of "Oberon." It was written by a clever London man of letters—of French extraction—J. R. Planché, based on a fairy poem by Wieland of Weimar, an elderly contemporary of Goethe, and a translator of Shakespeare admired by the poet of "Faust," who before that had nourished himself on the chaste Dodd's "Beauties of Shakespeare." Wieland, who was with Ephraim Lessing, the big man of the older group, naturally wrote his "Oberon" under the influence of Shakespeare. It was translated by Sotheby, but is hardly a masterpiece. Before Weber set the Planché version the epic was a favorite on the German stage in the guise of a fairy spectacle. In clarity the English book is superior to the books of "Magic Flute" and "Euryanthe," but that is not saying much. Grown-up people may seek the moral, the little folks will enjoy the fable. Logic is not a predominant characteristic. The music is melodious, the tunes come in squadrons, there is charm, and there are the inevitable "longuers"—what opera is without its quarter hours of ennui?—and the antique machinery too often creaks.

Mr. Bodanzky might have profitably made more excisions—that boresome duo which begins Act III., and a chorus or two—without impeaching the integrity of the music. As for his own personal part in the performance there can be no words but those of warmest praise. He is that rare avis, a musicianly conductor with temperament. He is a great conductor whether in Weber or Wagner, and his interpretation of the famous overture was poetic and electric. The orchestra played to a man with fire and finesse. It always does under his inspiring baton. With his Weber-like profile, alert eyes and infallible hearing, he dominated the stage from first to final curtain. For his devotion to the memory of Weber, he, like Signor Gatti-Casazza, deserves the gratitude of the musical community. Whether or not "Oberon" proves a magnet is a question for future discussion. Critics are seldom prophets honored by their own pronouncements. But we may say without peradventure of doubt that there is more music in "Oberon" than in an entire fleet of modern operas. Weber was a composer and a dramatist.

A Sumptuous Production

The production was sumptuous, it even outdid that of "Marouf" in its lavish Orientalism. Whether the decorations are in the key of Weber we leave to the purists. Certainly the "Ocean" aria has never been sung to such atmospheric surroundings, thereby greatly gaining in suggestiveness. The forbidding, desolate rock-riven coast is slowly transformed by the rays of the rising sun on the sea, and as the music pulsates with splendor you exclaim: "O Weber! mighty ocean of music, thou hast forestalled the sun-smitten awakening of Brunnhilde on the fire-begirt heights as Siegfried discovers sex in his universe." The ecstatic tremolo is not missing. Joseph Urban designed and painted the various pictures, and also designed the costumes, executed by Mme. Musaeus. The seascapes are in the ultramarine blues of Maxfield Parrish. The fairy episodes and interiors are gorgeous. The ballets were composed by Rosina Galli, and the chorus trained by Giulio Setti, and when we add that Richard Ordynzki managed the stage, and that the entire production was under the

supervisory eye of Director Siedle, no more need be said in praise of the successful solving of many difficult scenic problems. In strict fact the entire Metropolitan Opera House technical staff covered itself with glory.

There is an old saying in the theatre that the better the last rehearsal the worse the first performance, and vice versa. At the full-dress rehearsal last Thursday morning neither the singing by the principals nor the general performance was too smooth, whereas yesterday the reverse ruled. The enthusiasm of Mr. Bodanzky was contagious. Mr. Martinelli sang the difficult measures, both martial and amorous, allotted him with energy and art. He was a gallant appearing Knight. Mr. Althouse had an ungrateful role, and made the most of it. Miss Marie Sundelius sang her mermaid's song as she sings everything, artistically. Miss Raymonde Delaunois was a shapely, sprightly Puck and agreeable to gaze upon. Miss Alice Gentle deserves praise for her Fatima. Mr. Reiss as a squire was amusing. The English diction of the foreign-born in the cast was understandable though unmistakably streaked with strange accents.

Remains Miss Rosa Ponselle, upon whose broad shoulders rested the hapless heroine Rezia. To say that she has grown in artistic stature would only be the truth. Singing Verdi, especially with Italian blood in her veins, is not the same as delivering the majestic and tragic music of Weber. Miss Ponselle is too young, has had too little experience to sound the heights and depths of the mighty "Ocean" aria—itself at times too grandiloquent, not to say stilted: but with her dramatic temperament, musical intelligence, above all with her beautiful, natural voice and its remarkable range, from a rich, velvety contralto to a vibrating, silvery soprano—well, for a newcomer on the operatic boards a few months ago, and with her artistic training and antecedents, we confess our hearty admiration for her work and high hopes for her brilliant future. Her scale is seamless, so equal are her tones from top to bottom. Her personality is pleasing, her acting immature.

She has a buxom, well-proportioned figure, and in Turkish trousers she was fascinating; her wig was a palpable one. In excellent voice, she sang not only the big aria with better effect than at the rehearsal—rhythmically she has gained while the plaintive cantilena in the last act caught the fancy of the audience and the applause was spontaneous. In one costume, and she wore several gorgeously barbaric, she resembled Henri Regnault's Salome. Her features seemed more Moorish than Italian. That she won her hearers there can be no possibility of a doubt; to alter slightly a colloquialism, she "has arrived with both lungs." The attitude of the audience throughout was interesting. The scenery was applauded. Martinelli, Reiss, Althouse, and Gentle were called out, and, of course, Ponselle, Bodanzky, and Stage Manager Ordynzki and Chorus Master Settl. A success, old daddy Weber, anyhow at his New York revival. If he could have witnessed this extraordinary stage production joy might have killed him on the spot. "Oberon" is a charming novelty.

* * *

OTHER "OBERONS" RARE HERE

One of those things that "every one knows," and therefore no one does know, is the reason for a haunting familiarity of Weber's "Oberon" airs to musical folk in America. When, where, or by whom this newly revived masterpiece was first produced in New York is a matter yet disputed. A local guide of the popular sort speaks with a master's voice, however, when it gives as a tentative date March 29, 1870, ignoring a possible earlier history. The New York Times for March 30 of that year said, indeed, that Weber's last opera "was given at the Academy of Music last evening," that it was "the first hearing of the work in this city," and was "enjoyed by a very numerous and unusually brilliant audience." Then why was the music not unfamiliar?

"With the most melodic portions of the production there was no lack of acquaintance, be it said, previous to this occasion," the record continued. "Whether the enterprise and industry of the present company displayed in interpreting the work will be rewarded by a notable extension of that acquaintance is at least doubtful. 'Oberon' is inferior in character to 'Der Freischütz' and less well endowed with those elements of popularity which the most elaborate instrumentation will not replace."

The Times' critic of that day found the story "as difficult to relate as it is to understand from its stage rehearsal." As for fathoming the power of such a plot upon the creative mind, he recalled Mozart's "Magic Flute" as such another tale "to set speculation at naught as to its evil influence upon genius." If Weber's music was not executed in its entirety, so little was omitted as to show to the full the many beauties it possessed. The "magnificent" overture, in which "every imaginative effort of the composition is summarized, and each linked to the other until perfect symmetry of form is secured," had been played here by orchestras "richer in strings."

From this and other sources it appears that the soprano rôle in "Oberon" was sung here, and later in Chicago, by Euphrosyne Parepa, wife of Carl Rosa and daughter of Elizabeth Seguin. The creator of the part in London in 1826 was Miss Paton, who, as Mrs. Woods, came to New York in 1833, while Braham, the English original of Huon, also toured America in 1840.

Parepa-Rosa as Heroine

"The character of Reiza is without doubt one of Mme. Parepa-Rosa's best," the writer of 1870 went on to say. "It exacts little histrionic ability of its personator, and demands the strength and evenness of tone which so few singers have, and which this lady, whose triumphs in oratorio are still fresh in our memory, is conspicuous for the gift of." A suspension of phrase that, if not of judgment.

The principle interest of the entertainment centred in her share of it from the outset of the first act—the vision scene—reminding one of the picture in 'Faust.' The aria, 'Ocean, Thou Mighty Monster,' the most weighty part of her task, and

one sufficient to exhaust the resources of voice and declamation of most artists in the first bars, was recited by Mme. Rosa with especial dignity and effect, and made a deep impression.

"The Fatima of Mrs. Seguin was, in its way, a contribution almost as deserving of unqualified commendation. The ariettas, 'A Lonely Arab Maid,' and 'Oh! Araby, Dear Araby,' the latter noticeable for the descriptive accompaniment, were sung with case and correctness, justifying the applause that followed, while her aid, as contralto in the concerted passages with Mme. Rosa, was as carefully and efficiently accorded as ever.

"A more virile Sir Huon might have been gotten, we opine, than Mr. Castle, whose execution of 'Oh! 'Tis a Glorious Night' was not marked by the vigor needed. Sherasmin was embodied by Mr. A. Laurence, and Hassan by Mr. Hall. Mr. De Solla was Oberon. Puck was satisfactorily represented by Miss Geraldine Warden, a newcomer.

"The chorus was strong and well disciplined, and its members executed with a due regard for the composer's intentions the delicate fairy songs, colored, the admirer of 'Oberon' need hardly be told in relation to this most prominent feature of the score, by orchestration of the most delicate and suggestive kind.

"The work was listened to yesterday with a sustained attention bestowed upon no other production given this season," concluded the report. "It will, of course, bear several repetitions, of the earliest of which it will be more profitable to write than it is for the first of so lengthened and elaborate a composition. But four nights of English opera, however, occur hereafter."

Composer Studied English

While there is little record of "Oberon," save on the concert stage in America, until the opera's current performances at the Metropolitan, its history in England is written large—by the late Dr. Philip Spitta of Berlin, apparently—in Grove's classic dictionary of musicians.

Prize operas are proverbially tailor-made, music cut to order, yet three generations have found inspiration in "Oberon," which the composer of "Freischütz" and "Euryanthe" produced under pressure and which he twelve times conducted in London, with original English text, in 1826. Charles Kemble, brother of John Philip and of Sarah Siddons, was the actor-manager at Covent Garden whose $5,000 fee secured the work, a sum not incomparable to the Metropolitan's late $10,000 to American composers. Weber was so much in earnest, says the British Grove, that at the age of 37, and with one foot in the grave, he "began to learn English systematically," and soon was able to carry on his own correspondence in English. When in London "he astonished everybody by the ease with which he spoke."

The language of Shakespeare suggests a likeness of the character Oberon in the Bard of Avon's plays, but the source of Weber's and Planche's joint production is Wieland's poem translated by Sotheby—and, as a laconic American comment

had it, "German by Hell." It appears that Weber, intending to remodel the opera for Continental Europe, had each number, as fast as he composed it, retranslated by Theodor Hell of Dresden, instructing him to make the words correspond as closely as possible to the melody. Hell's workmanship was not of the best, and Weber was much too occupied to correct all his blunders.

Grove recalls one glaring instance in Reiza's grand scena, "Ocean, Thou Mighty Monster." A beam from the setting sun parts the storm clouds, as the heroine exclaims, "And now the sun bursts forth," which Hell translated "geht auf." Thus the astonished spectator beheld the sun set in the same quarters from which it had just "risen." The passage is always so sung in Germany, and the absurdity, if noticed, is laid at the English librettist.

Weber got his translator to make a reduction in the number of personages introduced. In the quartet, "Over the Dark Blue Water," Planche gave the bass to a sea captain, and in the duet, "On the Banks of Sweet Garonne," associated a Greek fellow-slave with Fatima, in both cases because the original Sherasmin was a poor singer. The song, "Yes, Even Love to Fame Must Yield," composed in London for Braham, is omitted in the German, while another addition, "Ruler in This Awful Hour," is retained. The composer saw that the prayer materially strengthened the part of Huon.

Music Inspired Mendelssohn

Sir George Grove declared the music to "Oberon" delightfully fresh and original. The keynote of the whole, he wrote, is its picture of the mysteries of Elfland, the life of the spirits of air, earth, and water. What Weber did in this direction was absolutely new. His melody, the chords of his harmony, the figures employed, the effects of color so totally unexpected—all combine to waft us with mysterious power into an unknown land.

Of a charm almost unparalleled is the introduction to the first act, with the elves flitting hither and thither, softly singing as they keep watch over Oberon's slumbers. The second act is rich in delicious pictures of nature, tender and dreamy, savage and sublime. Puck's invocation of the tempest, Reiza's grand scene of the calming of the waves beneath the setting sun, and the finale, with the mermaids' bewitching song, and the elves dancing in the moonlight on the strand—these are musical treasures which have not yet been exhausted.

Mendelssohn, Gade, Bennett drew the inspiration for their romantic scenes of a similar kind from "Oberon." Even Schumann trod in his footsteps in "Paradise and the Peri" and "Manfred." Of German opera composers, the British enthusiast concludes: "I say nothing; their imitation of him is patent." And it need hardly be added that audiences today will hear "Oberon" largely in the light of its better known follower, Mendelssohn's "Midsummer Night's Dream."

The first performance of "Oberon" took place on April 12, 1826, at Covent Garden Theatre, conducted by Weber himself. The audience gave it an enthusiastic reception, and paid lavish tribute to the popular master.

During his sojourn in London Weber was the guest of Sir George Smart, in whose house he finally closed his eyes on June 4, 1826. "Oberon" was the swan song of the master, who died in his fortieth year.

* * *

January 21, 1919

ARTHUR RUBINSTEIN

A pianist of charm and technical finesse is Arthur Rubinstein, who gave his first pianoforte recital at Carnegie Hall yesterday afternoon. The newcomer has played here before, ten or twelve years ago, it is said. We heard him in London several seasons ago and perhaps at Steinway Hall in that city, a hall better suited to his rather light tone and casual style than the greater spaces of Carnegie. Rubinstein is a miniaturist; he is more affiliated in style to Emil Sauer—who played so sweetly—or even to the magical Do Pachmann, than to the first and only Anton of his name, or to Josef Hofmann and Ethel Leginska. But, while his scale of dynamics is not wide within its compass he admirably succeeds. He is a trifle old-fashioned in style; the Viennese school, with its light action keyboard, the lack of depth in his chord playing, the too rapid scales, also superficial in tone, above all, his pedalling after, instead of before, his attack. The triceps play a minor rôle. Finger velocity, and a staccato, brilliant, incisive with a splendid left hand, are undeniable qualities coupled with a sweet ringing touch and musical temperament; traits sufficient to equip a half dozen pianists. Strangely enough his tone was occasionally hard and his phrasing not ductile, but slightly angular. After all, a debut with its concomitant nervousness.

* * *

January 21, 1919

"LE COQ D'OR" REVIVED

By JAMES GIBBONS HUNEKER

There was a double bill at the Metropolitan Opera House last night: "Le Coq d'Or" (deferred several weeks) and "Cavalleria Rusticana"—we print them in the order of their relative artistic importance, although this order was reversed in the performance. Here is the cast of Rimsky-Korsakoff's opera-pantomime, which was sung in French and mimed in the universal language of gestures, attitudes, and dancing:

WITH: Mabel Garrison, Rosina Galli (The Princess); Adamo Didur, Adolph Bolm (The King); Sophie Braslau, Queenie Smith (Amelfa); Ralph Diaz, Giuseppe Bonfiglio (The Astrologer); Pietro Audisio, Armando Agnini (The Prince); Louis D'Angelo, Ottokar Bartik (The General); Vincenzo Reschiglian, Vincenzo Ioucelli (A Knight); Marie Sundelius (The Golden Cock); Pierre Monteux (Conductor); Adolph Bolm (Production Director).

The anniversary of the production in New York of this unique work occurs early next Spring. To our way of thinking

it was an artistic event of the first magnitude, and it is a pity that "The Golden Cock" is not long enough to be presented alone, as its proximity is dangerous to compositions of lesser calibre. Last season it was harnessed to a harmless operetta, last night to a running mate equally ill-chosen. Why can't the orchestra play as a prelude one of the Russian's suites, "Scheherazade," for example? Mr. Monteux has proved himself particularly happy in the interpretation of Rimsky-Korsakoff. The obviously passionate music of Mascagni does not go well with the Russian's fantasy. You can't hitch a brassband wagon to this blazing star of the north.

"The Golden Cock" is delightful. Enjoy it as a fairy tale, forget its hints of political satire, and you will enjoy it at its best. No doubt the key to Plato's "Republic," More's "Utopia," Rabelais, or Swift's "Gulliver" is easy to find, but sensible readers prefer these books purely as literature. Why dig deep into "The Isle of Penguins" or "The Revolt of the Angels" for occult meanings? The subtle ironic prose of Anatole France should suffice. As well consider "Alice in Wonderland" as a veiled attack on modern civilization, (which, by the way, it is.) It may not be difficult to discover in the Rimsky-Korsakoff opera political innuendo, and as appropriate now as during the second decade of the nineteenth century when the Decembrist outbreak occurred in Russia. During old King Dodon, the protagonist of the pantomime, might be any ruler any where on the globe, who, when his country is threatened by an aggressive enemy, adopts a policy of "dolce far mente." The libretto is rich in tempting satire on the fatuity of unpreparedness and the supine pose of the pacifist. However, the story may be comprehended by children quite as well as by politicians and other equinoctial persons. And, again, it may be viewed as a parody on grand opera, Wagner and "Salome" in particular.

We have been told the history of "The Golden Cock"; of its failure as opera, and its subsequent recrudescence as pantomime with singing. Composed in 1907, shortly before the composer's death, the opera was forbidden at Petrograd because of the implied satire lurking in Pushkin's fairy-tale, turned into a libretto by Bielsky. Whether or not this book is a political allegory need not concern us; suffice to say that the difficulties of the roles made the opera well-nigh impossible. Michael Fokine, the brains of the original Russian Ballet, conceived the happy idea of transforming the work into a composite of pantomime, dancing and singing. As in the Greek play he placed the chorus on either side of the stage, on terraced seats from which the principals and chorus sang, while below the actors mimed and danced. Surrounded by bizarre scenery and floated on an orchestral stream of pertinent and lovely music, "The Golden Cock" created at London in 1914 a marked impression. At Paris the protests of the Rimsky-Korsakoff family prevented more than a few performances, but as there was no copyright law in England to protect their interests the composition was heard and admired at Drury Lane Theatre.

The score is not unlike in oriental coloring the Suite "Scheherazade," and that is high praise. Moods, shifting, picturesque, fluid and passionate, and daring rhythms; the music is saturated with extravagant humor. The vocal parts are grateful

despite their difficulty. The leading motive assigned to that bird of ill-omen, the Golden Cock, was evidently suggested by the call of the Valkyries. The music accompanying the giants, dwarfs, and queer animals is characteristically ludicrous. All the primary rainbow gamut with their complementary tones are in the joyous symphonic mimicry by the Russian Berlioz. The three scenes and the costumes were designed by Willy Pogany, and the scenery painted by P. Dodd Ackermann. Striking, barbarically beautiful, the second scene is positively blood-curdling. Mr. Setti's chorus, garbed like the solo singers in maroon-tinted mediaeval drapery, was all that it should have been. So well drilled was the ensemble that if you looked only at the mimes you seemed to hear them singing. Rosina Galli and Adolph Bolm, respectively, mimed the Queen and King, though their voices issued from the throats of Mabel Garrison and Adamo Didur. Marie Barrientos originated the role of the Queen last year. Miss Garrison replaced her several times.

She sang the elaborate vocal part, with its roulades, cadenzas, top notes, (E in alassimo is one) and melting Russian folksong, most spontaneously. She literally caroled with her beautiful crystalline organ.

Mr. Didur delivered the music of the King with unctuous humor, mock pathos, and expressiveness. Louis d'Angelo was the General—last season it was Basil Ruysdael—admirably mimed by Ottokar Bartik. Marie Surdelius sang the trying music of the Golden Cock with rare skill. The rooster itself is a splendid stage property, a master work of Technical Director Siedle. Rafaelo Diaz as the vocal end of the Astrologer deserves praise. He poured out with prodigality his voice; a high C he compassed with ease. The other end of the sketch on the stage below was Giuseppe Bonfiglio. Cunning little Queenie Smith was the Amelfa, her vocal counterpart Sophie Braslau of the luscious contralto. If there is such a thing as spiritual dislocation, then it was embodied in the extraordinary pantomime of Adolph Bolm, with its delicious burlesque, its broad humor, and ironic underlining. Like a toy awakened from its wooden slumber, this king of shreds and patches touches your funny bone, yet enlists your sympathy. He was a glorious and pathetic fool and true to royal type.

As for Rosina Galli, she was a vision of fantastic loveliness; she evoked Sheba's queen, who was called Belkis, and, according to legend, stirred the neurasthenic Solomon into pessimistic admiration; she also teases the timid hermit St. Antony in Flaubert's magnificent prose-epic. Galli's dancing was dazzling, though not in the key of conventional ballet pirouettes. She was eloquent, disdainful, provocative, enchanting, she sang with her toes and with as much virtuosity as her lyric alter ego, Miss Garrison.

There is mock wailing by a cynical chorus after the King's death, and the scene fades into the vast inane. But the Astrologer, old Father-I-Told-You-So, is the fatal chorus before the curtain who blandly assures the audience that the Queen and himself are the only living persons in the play; the others a delirious dream, pale spectres, nothing more. But in action these same spectres were far from pallid. Both in London and

Paris as well as in New York, "Le Coq d'Or," was conducted by Pierre Monteux, and to him is due praise for his important share in the production. It is a redoubtable task to synchronize the singing, miming, and dancing with the orchestra.

Thanks to the unerring baton of Monteux hardly a slip was noticeable in the complex mechanism of the score. A brilliant audience in happ moode enjoyed the Russian piece, also enjoyed "Cavalleria Rusticana" with such interpreters as Crimi, Montesanto, Claudia Muzio, and Flora Perini. Roberto Moranzoni conducted. Recalls were numerous.

* * *

January 31, 1919

GOLDMARK'S "REQUIEM"

Philharmonic Plays Work Based on Lincoln's Gettysburg Speech

Lincoln's Gettysburg speech was printed in last night's Philharmonic program books at Carnegie Hall, its text—of which some words were quoted over phrases of the music—having furnished the theme of Rubin Goldmark's manuscript "Requiem," for which the composer was called on the stage after a stirring performance. The new work was "not intended to be programmatic, except in so far as Lincoln's immortal address called for the certain moods in the composer." Its five unbroken episodes began with trumpet calls of war, then grief for those fallen in battle, an elegy, a martial dirge, and a glowing conclusion.

Themes representing Latin sentences of the "Requiem" and Lincoln's "Government by the people" were developed with a ring of sincerity in the instrumental voices of that fiery finale. There was a wreath for Mr. Goldmark from the New York Bohemians. Harold Bauer in Tschaikovsky's concerto closed the concert, which Mr. Stransky had begun with Bach, nine short pieces, set for orchestra. The entire program will be repeated this afternoon.

The Symphony Society played in the same hall yesterday afternoon, and will again on Saturday night, a program with Toscha Seidel as star in Mendelssohn's violin concerto, in which the most strenuous of the young Russians showed unexpected grace and gentleness of style. Mr. Damrosch also gave a recent "Symphonic Suite" by the Italian de Sabata, and an entire second part of selections from Wagner's "Master Singers," "Parsifal" and "Tristan."

* * *

February 3, 1919

CASELLA'S WAR "FILMS" HEARD

Alfredo Casella's "Films," which bore the sub-title "War Pictures" to mark their source in the recent worldwide reproduction of photographic scenes of war, made a profound impression at first hearing by yesterday's audience of the Symphony Society in Aeolian Hall. The young Italian composer's

work, which Mr. Damrosch prefaced with a brief explanation, achieved distinction in the use of discord, notably in the exquisite anguish of the muted "Alsace: The Wooden Cross," relieved by a single broken quotation from the "Marseillaise."

Casella's "Cossack Ride" was added to the four little pieces announced, which included also a novel and realistic treatment of such episodes and scenes as the German cavalry passing through Belgium, the ruins of Rheims Cathedral, representing France, and a warship on the Adriatic, for the composer's own Italy. There was characterization in the music of remarkable power and more extraordinary brevity. The work should be heard again.

Raoul Vidas repeated his recent performance of Mozart's violin concerto in E flat, and Mr. Damrosch conducted Schumann's fourth symphony and Wagner's finale from "The Rhine Gold."

* * *

February 7, 1919

"TRAVIATA" AND "PETRUSHKA"

By JAMES GIBBONS HUNEKER

A double bill at the Metropolitan Opera House last night brought a repetition of "La Traviata," with Hempel, Egener, Mattfeld, Hackett, De Luca, Rossi, Hada, Reschiglian, and d'Angelo; Roberto Moranzoni, conductor, and a ballet pantomime, "Petrushka," scenario by Alexander Benois, music by Igor Stravinsky, staged by Alexander Bolm, and conducted by Pierre Monteux. Here is the cast in the pantomime:

WITH: Rosina Galli (The Ballerina); Adolf Bolm (Petrushka); Giuseppe Bonfiglio (The Moor); Ottokar Bartik (The Old Magician); Armando Agnini (The Merchant); Regina Smith, Florence Rudolf (Street Dancers); Lillian Ogden, Bessie Roggie (Gypsies).

The scenery and costumes were designed by John Wegner, a Russian, and the scenery painted by James Fox.

Mr. Bolm has told us that "Petrushka" has not been given in Russia. Diaghileff, who produced it here a few years during his season of the Ballet Russe, had planned to go to Petrograd, but the war intervened. The tragi-comic story has been called the Russian "Pagliacci." It shows the rivalry of the puppets, Petrushka and the Moor, for the love of the little Ballerina. But the Old Magician who controls the puppets, punishes the hero for his quarrel with the Moor and locks him up in the dark. He later meets the Moor and is slain. Then to calm the crowd the Magician proves Petrushka to be only a rag doll. The moral might be: What fools these puppets be to pattern after mankind.

Stravinsky's music is delicious, absurd, grotesque, with streaks of genius mixed with the mud-gutter vulgarity of the gamin who twiddles his dirty fingers at his nose-tip. Suitable music with dislocated rhythms and the noises of crockery broken in a drunken rage, and picked up, carried away by dissipated pouter pigeons, xylophones, pianoforte arpeggios and harp glissandi. The performance was capital, just missing the native wood-note wild of the original Russian ballet. As the curtain went up after 11 o'clock, details of the solo pantomimists and dancers must be deferred. The audience greatly enjoyed the new piece, which was given a fitting production, as may be well imagined.

But the evening for the musical will be a memorable one. "La Traviata," that hackneyed apotheosis of a sentimental lady—the French slang is now "Ma vague"—Violetta Dumas fils, took on new life because of the beautiful singing and acting of Frieda Hempel. She has seldom sung with such fervor and delicacy, acted so unaffectedly and with such pathos, or looked so charming. What a singer, what an artiste, what a charming personality! Her "Addio" in the last scene was exquisite, and the scene with that old humbug father—we suspect he was fond of his son's mistress—was, thanks to the co-operation of De Lucca—whose "Di Provenza" was particularly good—went very well. Pity it is that Miss Hempel nears the end of her present season at the Metropolitan. Her art is rare nowadays.

Young Carlo Hackett confirmed the favorable criticisms of his first appearance last week as Almaviva in the "Barber." Alfredo is a severer test, but he stood it. He has a lyric tenor, musical as to quality, which he uses intelligently. He has youthful mannerisms; he spins his tone down to a pianissimo but too slowly, thereby stopping the flow of the music. He has some fire, though the texture of his voice is not warm. Owing to natural nervousness he sang flat in the first act duo a half dozen bars before and after his "Miseria." His enunciation is clear, his pronunciation good. He has style, too, and no little authority for such a novice. Perhaps he exaggerates his portamente, not an unusual trait in a singer with an abundance of voice.

His acting, not skillful in the early scenes, became freer, in gesture more varied, as he forgot himself in the role. He overemphasized the woe of the farewell to Mlle. Tubercules, indulging in the "voix larmoyante" and not disdaining the always conveniently thrilling glottis-stroke. A well-set-up young man is Mr. Hackett and of gallant bearing. He needs routine, of course—so do some of his older and more experienced contemporaries—and it may be recorded that he made a gratifying impression. The audience was very enthusiastic and at the end he was, with La Diva, heartily applauded. If only a Hackett cult is not started to spoil a promising singer. However, the abiding impression with us is the lovely singing and impersonation of Miss Hempel.

* * *

DANCE

PAVLOWA TO HELP REVIVE THE BALLET

Russian Dancer from St. Petersburg Represents the Traditions of the Classic School

DANCE INSTITUTION THERE

Two Nights a Week Are Given Over Exclusively to the Ballet in the Imperial Opera House

New York has seen Spanish dancers, beginning with Carmencita; Egyptian dancers, Salome dancers. Greek dancers, with flowing draperies and bare limbs, have been much the mode of late, thanks to Isadora Duncan and Maud Allen. Adeline Genée has recently brought about a revival of the classic toe dance, and now a little Russian woman, Anna Pavlowa, has come to show us how well the traditions of this school are preserved at the Imperial Opera in St. Petersburg. Mlle. Pavlowa will make her first New York appearance to-night at the Metropolitan Opera House in a revival of Delibès's ballet "Coppelia."

Mlle. Pavlowa in appearance is typically Russian, with very dark hair and eyes, and the fascinating smile which a dancer in the ballet must have. Yesterday she talked for a few moments to a reporter for The Times about herself.

"I was born in St. Petersburg. I studied dancing in St. Petersburg, and I have danced at the Opera in St. Petersburg. That is my career," she said. "And so far I have danced scarcely anywhere else. You see, in St. Petersburg we still have the ballet in its glory. The ballet is as important at the Imperial Opera as the production of opera itself. Two nights a week the ballet is given, and the other nights opera. These ballets are long. They last from 8 o'clock until 12. Not a word is sung—it is all pantomime and dancing—and there is a great a subscription for these nights as there is for the opera.

"Of course certain operas demand incidental dances, and then the corps de ballet appears in them, but never is it the case, as in Paris, that a short ballet is given before or after the opera. The two are kept distinct. One evening is for dancing and another for singing. It is perhaps better so. I, myself, have danced in two operas—'Carmen' and an opera of Glinka's.

"But naturally it is in the ballet as an institution, not as an incidental divertissement, that I am chiefly interested. The foremost Russian composers have devoted their talents to writing works for our dancers. Of course, we often dance Tschaikowsky's 'Belle au Bois Dormant' and 'Casse-Noisette.' Glazounow has writen some of our most delightful ballets. Then there is an arrangement of Chopin compositions to which we dance.

"Here I shall appear in 'Coppelia,' which we often give in St. Petersburg, and in some special divertissements. No other complete ballet seems to be ready for presentation. Of course, I love 'Coppelia' and the other ballets of Delibes."

Mme. Pavlowa was asked for her opinion of Miss Duncan and the so-called Greek dancers.

"I have seen Miss Duncan," she said, "and I admire her dancing. What difference does it make what sort of dancing one does? To suitably portray different sorts of characters in pantomime ballets one has to do Egyptian dancing, Turkish dancing, Greek dancing, tragic or comic dancing. One has to be an adept in the art, to know it from its foundations, and all about it.

"And there is the technique, too, the technique of the toe dancer. It is very difficult. You watch the dancer poised on her toe and it seems simple. It is simple, but only for one who has worked very hard. It is just as necessary for me to practice every day as it is for the concert pianist. The day after I landed I went to work at the opera house with Mr. Mordkine, who has come over to dance with me. You see on board the ship I was not well. I was very ill, in fact, and anyway how can one practice dancing on a ship? So for many days my feet could not practice. I tell you that I was very, very quick in getting to work after I had landed. You see, in all my career there has never been the lapse of two days without practice, and I was afraid, but it is all right—I haven't forgotten." The dancer smiled again. "Two hours every day is necessary—two hours of very hard work.

"Last Spring I danced in Paris at the Châtelet. Then I went to London for two weeks to dance at a private soirée, which the King attended. I have never danced publicly in London, but I go there directly. I finish here to fill an engagement at the Palace Theatre with Mr. Mordkine again. After London I go to Paris to dance at the Opera for the first time. We are to give two Russian ballets there in the Summer. And then I go back to St. Petersburg.

"Shall I come back next year? I don't know. That must depend on whether New York likes me and wants me to come back. I am fascinated with the city. All of it is so tall! But will it be fascinated with me?"

* * *

ANNA PAVLOWA A WONDERFUL DANCER

Little Russian, Lithe, Exquisitely Formed, Captures Metropolitan Audience in First Waltz

HER DEBUT IN "COPPELIA"

Her Technique of a Sort to Dazzle the Eye, and She Has Grace and Humor—Mordkine Assists

More than two-thirds of the boxes at the Metropolitan Opera House were still filled with their occupants at half after 12 last night. It was not a performance of "Götterdämmerung" without cuts that kept a fashionable Monday night audience in

its seats, but the American debut of Anna Pavlowa, the Russian dancer from the Imperial Opera in St. Petersburg. Mme. Pavlowa appeared in a revival of "Coppelia," which was given at the Metropolitan for the first time since the season of 1904–5. As this was preceded by a performance of "Werther," the ballet did not commence until after 11, and it was nearly 1 before it was finished.

However, Mme. Pavlowa easily held most of her audience. It is safe to say that such dancing has not been seen on the local stage during the present generation. If Pavlowa were a regular member of the Metropolitan Opera Company it would also be safe to prophecy a revival of favor for the classic ballet.

The little dancer is lithe and exquisitely formed. When she first appeared just after the curtain rose there was a dead silence. She received no welcome. She wore the conventional ballet dress and her dark hair was bound back with a blue band.

After the first waltz, which immediately follows her entrance, the audience burst into vociferous applause, which was thereafter repeated at every possible opportunity. Pavlowa received an ovation of the sort which is seldom given to anybody at this theatre.

And her dancing deserved it. To begin with, her technique is of a sort to dazzle the eye. The most difficult tricks of the art of the dancer she executed with supreme ease. She even went further. There were gasps of astonishment and bursts of applause after several of her remarkable feats, all of which were accomplished with the greatest ease and lightness.

Grace, a certain sensuous charm, and a decided sense of humor are other qualities which she possesses. In fact, it would be difficult to conceive a dancer who so nearly realizes the ideal of this sort of dancing.

In the first act she was assisted at times by Michael Mordkine, who also comes from St. Petersburg, and who is only second to Pavlowa as a remarkable dancer. Their pas de deux near the end of the act was perhaps the best-liked bit of the evening. It was in the second act in her impersonation of the doll that Pavlowa disclosed her charming sense of humor.

At this time it is impossible to write any more about this dancer, but there is no doubt that she will prove a great attraction while she remains in New York.

The performance of "Werther," which preceded the ballet, was the first that has been given this season at the Metropolitan. This lyric drama of Massenet's has been heard previously this year at The New Theatre, however. The cast last night included Miss Farrar and Messrs. Clement and Gilly.

* * *

March 2, 1910

RUSSIAN DANCERS IN AMAZING FEATS

Anna Pavlowa and Michael Mordkine the Feature at Metropolitan Fund Benefit

WHIRL TO WILD MUSIC

Divertissement Ends with Girl, Supported by Man, Flying Through Air, Circling His Body Round and Round

The second appearance at the Metropolitan Opera House of the two Russian dancers, Anna Pavlowa and Michael Mordkine, was undoubtedly the feature of the performance which was given there last night for the benefit of the pension and endowment fund of that institution. The auditorium was packed for the occasion, and the total receipts were somewhere in the neighborhood of $15,000.

Very late in the evening before these two dancers had appeared in Delibes's ballet "Coppelia." Last night they appeared alone without the assistance of the somewhat ragged corps de ballet of the Metropolitan Opera House in two divertissements, which were so entirely different from anything they had done in "Coppelia" that any one who had seen their previous performance would have had difficulty in recognizing them.

Such dancing has not been seen in New York in recent years, and last night's audience manifested its feeling as heartily as had that of Monday evening.

Early in the evening the curtains parted on a woodland scene which left a large open space on the stage. The orchestra played an adagio of Bleicham's. First Mordkine darted on to the scene dressed as a savage. Pavlowa followed him. The two danced together and then alone. Mordkine whirled for long seconds on one foot, with the other foot pointed at right angles from his body. He did another dance, in which he shot arrows from a huge bow behind his shoulder. The celerity, the grace, the rhythm of his terpsichorean feats were indescribable in their effect.

Pavlowa twirled on her toes. With her left toe pointed out behind her, maintaining her body poised to form a straight line with it, she lept backward step by step on her right foot. She swooped into the air like a bird and floated down. She never dropped. At times she seemed to defy the laws of gravitation. The divertissement ended with Pavlowa, supported by Mordkin, flying through the air, circling his body around and around. The curtain fell. The applause was deafening. Again and again the two were called before the footlights.

Later in the evening the two danced again to music from a ballet of Glazounow's. This special divertissement was called "Autumn." The music was gay and furious in its rhythm. The two in Greek draperies dashed about the stage, veiled in a background of floating gauze. The music became wilder and wilder, and wilder and wilder grew the pace of the two. The Bachanalian finale, in which Pavlowa was finally swept to the earth held the audience in tense silence for a moment

after it was over, and then the applause broke out again. The curtain calls after this dance was innumerable.

The performance last night, like the one of the evening before, was very long. It commenced with the first act of "Pagliacci," in which Mme. Destinn and Messrs. Caruso, Amato, Bada, and Gilly appeared. Mr. Tango conducted. The fourth act of "Trovatore" was sung by Mesdames Gadski and Homer and Messrs. Martin, Gilly, and Audisio. In the second act of "Tosca" Miss Farrar and Messrs. Jadlowker, Scotti, Bada, and Bégué appeared. The third act of "La Gioconda" was sung by Mesdames Noria and Meltschik and Messrs. Caruso, Amato, and de Segurola. Mr. Toscanini conducted, and the corps de ballet danced the "Dance of the Hours."

* * *

March 5, 1910

PAVLOWA AT NEW THEATRE

Brilliant Russian Dancers Appear in "Coppelia"— House Sold Out

The Russian dancers, Anna Pavlowa and Michael Mordkin, appeared for the first time at The New Theatre last evening, and, as a consequence, that place of amusement was sold out for the first time in its existence, at least on an opera night. The first act of "Coppelia" was danced after a performance of "Madama Butterfly," and the entire audience remained until the curtain fell a little before midnight.

It seems unfortunate that while two such brilliant dancers are in New York "Coppelia" cannot be given in its entirety. The ballet was written in three scenes, the last of which gives the dancers their greatest opportunities. Of late years this last scene has been cut even at the Opera in Paris. The reason is obvious. No audience will sit through a long ballet unless a dancer of more than ordinary gifts is appearing in it. Two such dancers are now in New York.

Monday night's experience, when the final curtain fell after 12:30, showed the management that even two scenes of the ballet could not be given with an opera of ordinary length, and so last night still another scene was cut. But why not give the entire ballet with a one-act opera?

The audience last night was just as enthusiastic as previous ones who have seen these dancers have been. It is unfortunate that they have very little support either from the corps de ballet or the conductor. However, their own performances are brilliant enough to stand alone.

"Madama Butterfly" was sung last night by Miss Farrar, Miss Fornia, and Messrs. Martin and Scotti.

* * *

March 6, 1910

A GREAT DANCER DISCUSSES HER LIFE AND ART

Anna Pavlowa Tells of Russian Ballet and Wonders if the Laws of Her Country Are Potent Here

"I was born in St, Petersburg—on a rainy day," said Mlle. Anna Pavlowa, in relating the story of her life and her art to a representative of The Sunday Times. "You know, it almost always rains in St. Petersburg. There is a certain gloom and sadness in the atmosphere of the Russian capital, and I have breathed the air of St. Petersburg so long that I have become infected with sadness. I love the note of sadness in everything, in art, in the drama, in nature. Ah, in nature above all! I love the dreamy Russian forests and the dream-inspiring English parks!"

Anna Pavlowa, the Russian dancer who has created such a genuine sensation in New York, a slim, dark-eyed, dark-haired young woman, was seated in a rocking chair in her room at the Knickerbocker Hotel, eating candy, resting after her matinée performance, and talking as rapidly as she can dance.

"I feel much better now than on the day of my arrival in New York," she remarked.

"Do you think that your success in New York has something to do with the improvement in your health?"

"Oh, no, this success cannot affect me," she smiled. "We have been spoiled by success everywhere, in Russia, in Germany, in France, and in England. But I feel happy, nevertheless, that our art is appreciated in this country. You see, in Europe we make a specialty of the ballet, while here I understand it is merely incidental. In Russia particularly the ballet is a branch of art to which much attention is paid. There are theatrical schools there which are supported by the government, and dancing is one of the favorite amusements of the Czar!"

"Have you ever seen the Czar?"

"Have I ever seen the Czar?" repeated Mlle. Pavlowa, her dark eyes half smiling, half surprised. "Why, he stroked my hair when I was a pupil—he praised me. He used to come to our school and talk to us and tell jokes and eat dinner with us—the same things we used to eat."

"Did the Czar tell clever jokes?"

"I can't remember any of them now," replied the little dancer, "but I remember the performances the children gave in his honor. The ballet in Russia is a Court luxury. The masses cannot pay for it there, and the imperial deficit on the ballet and the opera amounts to almost four million roubles. In Russia we have numerous new ballets every year—about twenty different ballets. We have an enormous repertoire as compared with the ballet in France or Germany.

"Do you think that there is to be a general revival in this form of art?"

"Yes, I believe we are on the eve of a decided revival. Until recently the ballet made no progress. In fact it lagged

One of her postures.

A moment of repose.

behind every other form of art. While the drama and the opera kept developing new forms, the ballet created nothing. It remained on one plane. And dancing ought to make a wider appeal than the drama or the opera. In the drama, as well as the opera, there must be national characteristics, distinctions and peculiarities, while dancing is more readily understood by all."

"May I know what led you to take up dancing as your life work?"

"As a child of ten I saw for the first time in my life a ballet at the imperial dancing school of St. Petersburg, and since then dancing became the dream of my life. I pleaded with my parents that they send me to the school, and at the age of eleven I was already a pupil there. I have now been ten years on the stage, and I am still seeking new forms; I am working now harder than ever before. I am studying every day. I believe that the greater the artist the more he must study, it matters not whether he or she is a painter, a writer, a musician, or a dancer. In Russia my day is crowded with work, I rise early, at nine or ten o'clock in the morning. I go out for a little walk and then go to the theatre to rehearse. Sometimes I am so busy rehearsing that I take breakfast along with me. I eat it quickly in the theatre, and I rehearse until four o'clock in the afternoon. Then I go home. I glance over the newspa-

pers and read a few pages of my favorite poet or my favorite novelist."

"Who is your favorite poet?"

"Nadson."

"And your favorite novelist?"

"Turgenev, of course."

"And of the contemporary writers?"

"Of the contemporary writers I like Andreyev. But I prefer to see his dramas on the stage. When I read them in book form they make a terrible impression upon. On the stage it is different. The characters become human and I can understand them better. I had this experience with Andreyev's "Anathema." By the way, have you heard that the Holy Synod has forbidden the production of "Anathema" in Russia? It is strange, isn't it? The censor has approved it, the play has been given hundreds of times all over Russia, and suddenly the synod has stopped it. Does this mean that this play must not be produced here either?" she asked naïvely.

"Do you think that the Russian laws prevail in this country, too?"

"Don't they?"

"You were telling me how you pass the day in Russia. I interrupted you."

"From five till six in the afternoon I receive. There are many artists, painters, sculptors, among my friends. But I devote only one hour to them. In the evening I sometimes have additional rehearsals. When I do not perform and have no rehearsals in the evening, I go to the theatre. I prefer the drama—the heart-stirring drama. Occasionally I go to a good concert. When some celebrated artist visits St. Petersburg, such as Nikisch, for instance, I always go to hear him, and that is a real holiday for me. I love music and I enjoy animals. I have a fine English bulldog at home. Well, what else can I say? That is all, that is my life."

"Are you interested in any of the sports?"

"I need no sports of any kind. Occasionally I go horseback riding, but that isn't very good for me. I must keep my body in a certain position for a long time when I am on horseback, and this interferes with my art. You see, I do not need any of the sports because my art combines them all. Some people use the bicycle, others play baseball or football, some people run, others take long walks, but I do not need any of these things to develop my muscles. My work, my art is developing every muscle of my body better than any of these exercises. There is but one thing I love passionately, outside of my art, and that is nature. The cold, dreamy forests appeal to me, to my imagination. Tropical plants do not interest me so much. You cannot dream under palm trees. I like the melancholy note in nature, there seems to be so much poetry in it, and I forget myself, and I dream. Poetry, dreams—after all these are the only things worth while in life."

"Is it true that Stanislavsky, the head of the Artistic Theatre of Moscow, has made arrangements with Miss Duncan to have her instruct the new school of plastic art, which he has established?" I asked.

"Stanislavsky is a great artist, and his theatre has done wonders. But Stanislavsky is not content with what he has already accomplished, and he is searching after new forms. He thinks highly of Miss Duncan's work; he respects her and is enthusiastic over her, and he wants her assistance in his experiments and efforts to perfect dramatic art. I believe that he is working in the right direction. The plastic element has been neglected in dramatic productions. I believe in progress, in going forward, forward, I believe that the ballet, for instance, should not adhere to the classical pieces only. I like to see the ballet reformed just as opera has been reformed by Wagner, who introduced live drama, live art into music."

Mlle. Pavlowa helped herself to some more candy and rapidly changed the conversation, and began to speak of New York.

"I haven't seen anything here as yet. I haven't had time. You know, life here seems to be rushing at a maddening pace. It is like a crazy wheel, revolving with lightning-like rapidity. I am afraid that it would be hard for me to keep pace with it. By the way, a young woman asked me about marriage. She wanted to know whether it was true that I haven't married because I have not had the time for it. In America that must seem strange, for here I understand— one, two, three," she snapped her fingers, "and you are married. There is no time to waste. And then—one, two, three— and you're divorced. In Russia such an event in a person's life is considered slowly and carefully; the couple must know each other for a long time; they must first find out whether their characters are suited for each other; they reflect; they deliberate; they go through the poetic period of wooing; and then they marry. In Russia such a step is indeed an event, and it really takes up much time. Besides, I believe that artists who are really devoted to their art should not think of marriage."

Mlle. Pavlowa's phenomenal success in Russia as well as abroad is due chiefly to the intellectuality which marks her art. It is this feature that distinguished her from the famous Parisian ballet dancers and put her into a class all by herself. Even among the Russian dancers she stands out prominently because she is not merely a wonderful dancer, but she is also a great pantomimist, expressing various shades of feeling and emotions in a remarkable manner.

Mlle. Pavlowa is assisted in her work here by Mr. Mikhail Mikhailovich Mordkine, the leading ballet dancer of Moscow. Mr. Mordkine is a graduate of the Moscow Imperial Theatrical School. He distinguished himself while he was still a pupil, and the management frequently selected him at that time to appear in Moscow in the same ballets in which he is appearing now.

"They used to pay me a rouble for each performance— that is, 50 cents—and I used to do the same work that I am doing now," he laughed.

In speaking of their great success in New York, Mr. Mordkine said:

Mlle. Anna Pavlowa

"We have grown accustomed to success. But what interests me most is the manner in which the audiences in the different countries express their approval. Last night, at the Metropolitan, the audience applauded in the middle of a dance. We had to tax all our efforts to hear the music so as not to miss the rhythm. A dancer, to be a real artist, must be a good musician. He must also be strong. But it is our good fortune that our work is such that we have no need for any additional exercise."

He went through a series of movements to illustrate how every muscle of the body is developed by dancing.

"We have here breathing exercises, all sorts of gymnastic work, mimicry, and besides we know how to walk. There is an art in walking properly, and it takes some time to learn it. Most people do not know how to walk."

Mr. Mordkine recalled some of the compliments that had been showered upon Mlle. Pavlowa and himself by the celebrities and crowned heads of Europe in recognition of their wonderful work.

It was about eight o'clock in the evening and Mlle. Pavlowa quickly prepared to go to hear Glazunow's new concerto as played by Mischa Elman and Altschuler's Russian Symphony Society.

*　　*　　*

March 18, 1910

PAVLOWA IN NEW DANCES

Her Poetic Conception of the Swan a High Achievement

Mlle. Pavlowa and Mr. Mordkin introduced two new dances to this public at The New Theatre yesterday afternoon. Both of the new dances were better suited to the smaller stage of that theatre than "Coppelia." In the first Pavlowa danced alone to Saint-Saëns's "Le Cygne," played on the solo violin with a harp accompaniment. This dancer's poetic conception of the swan was an achievement of the highest order of imagination. It is the most exquisite speciment of her art which she has yet given to this public.

Immediately after, to the accompaniment of Chopin's C shap major waltz, played on the pianoforte, Mordkin and Pavlowa danced a pas de deux in early nineteenth century costumes. This was as beautiful in its way as the other dance. The two will be repeated to-night at The New Theatre.

The dances were preceded yesterday by a performance of "Werther," in which Mme. Noria and Messrs. Clement and Dutilloy appeared. Mr. Tango conducted.

In the evening "Pique Dame" was given at the Metropolitan Opera House. Mmes. Destinn, Meitschik, Wickham, and Gluck, and Messrs. Slezak, Didur, and Forsell were in the cast. Mr. Mahler conducted.

* * *

October 16, 1910

RUSSIAN DANCERS AGAIN TRIUMPH HERE

Pavlowa and Mordkin Exhibit Their Poetic Art in Adolphe Adam's Ballet, "Giselle"

TRADITION OF THE WILIS

Pavlowa in Wild Dance Under the Forest Trees—Bewitching as Captive Princess in "The Legend of Azylade"

To say that history repeated itself yesterday afternoon at the Metropolitan Opera House when Pavlowa and Mordkin reappeared with their own company, to give for the first time here a programme all by themselves, would be to express the case very mildly indeed. It might almost be said that history was made on this occasion. It is doubtful if such dancing has ever been seen on the Metropolitan stage save when these two Russians were here last season, and it is certain that there never has been more enthusiasm let loose in the theatre on a Saturday afternoon than there was yesterday.

The programme included two complete ballets and several divertissements, and from 2:30 to 5:30, with intermissions now and then, Pavlowa and Mordkin gave exhibitions of their highly finished and poetic art.

The afternoon began with a performance of Adolphe Adam's ballet "Giselle," which has never been given before on this stage and probably not often in New York, although it was seen here in 1842, one year after the original Paris production, which occurred at the Opéra, with Carlotta Grisi as the unhappy heroine.

The subject for the ballet was taken from Heinrich Heine's book about Germany. "There exists a tradition of nocturnal dancers known in the Slavic countries as the Wilis. The Wilis are betrothed girls who have died before their marriage. These poor creatures cannot remain tranquil in their tombs. In their hearts which have stopped beating, in their dead feet exists a love for dancing which they have not been able to satisfy during their lives. At midnight they rise and gather in troops, and unfortunate is the young man who encounters them. He is forced to dance with them until he falls dead.

"Garbed in their bridal robes, with crowns of orange blossoms on their heads and brilliant rings on their fingers, the Wilis dance in the moonlight like elves, their faces, although white as snow, are beautifully young. They smile with a joy so perfidious, they call you with so much seduction, their manner gives so many soft promises, that these dead bacchantes are irresistible."

Theophile Gautier is said to have run across this passage one day and to have exclaimed involuntarily: "What a subject for a ballet!" Whereupon he sat down and wrote across the top of a blank sheet of paper: "Les Wilis, un ballet." However, he probably would have forgotten all about it if he had not encountered a composer at the Opéra that same evening. The result was that he and Saint-Georges collaborated on the book and Adam wrote the music. Coralli, the ballet master of the Opéra at that period, had enough to do with the book so that his name appears on the title page with the others.

This passage, from Heine, afterward attracted the eyes of other composers and librettists. The English composer, Loder, used the idea for his most successful opera, "The Night Dancers," produced shortly after "Giselle," and Puccini wrote his first opera, "Le Villi" on the same theme.

Carlotta Grisi danced the ballet and "Giselle" became the rage. Flowers, hats, gloves, dogs, and horses were named after her. The ballet was done almost immediately in England and America. But, strangely enough, it disappeared from the répertoire of the Opéra until it was revived in 1863 with Mlle. Mourawieff, herself a Russian from Moscow. She was described by one critic of the day as having plenty of technique but "not an atom of poetry."

In Russia "Giselle" has always been popular and Mrs. Newmarch says that it was Tschaikowsky's ideal ballet when he composed his "Lac de Cygnes." In Paris the past season has seen a revival of it, again by Russians.

The music is gently fragrant, a little faded here and there, but a pretty score, and one of Adam's best. Cuts were made freely. In fact, almost one-half of the music had been taken out, and this was probably for the best, as far as present-day audiences are concerned. There was one interpolation. In the first act a waltz from Glazunow's "Raymonda" was

introduced which was very much as if some conductor had performed "Also Sprach Zarathustra" somewhere in "Fra Diavolo."

Mlle. Pavlowa yesterday revivified this honeyfied and sentimental score of Adam's full of the sad, gray splendor of the time of Louis Philippe. Grisi is said to have been gently melancholy in it, but Pavlowa was probably more than that. Her poetic conception of the betrothed girl's madness when she finds that her lover has deceived her, and her death, came very close to being tragic. It is almost impossible to describe the poetry of her dancing in the second act, where as one of the Wilis she engages in the wildest sort of measures under the forest trees.

Mr. Mordkin had no dancing to do in this ballet, but in appearance and action he was superb. For some reason the programme referred to the Wilis as "fairies," which can scarcely be regarded as an accurate translation.

The second part of the programme consisted of divertissements beginning with a very pretty performance of Liszt's second rhapsodie by Mme. Pajitzkaia, and the corps de ballet. After this Pavlowa and Mordkin danced the adagio of Blechman and the Tschaikowsky Variation, in which they were often seen last year. After the bow and arrow dance, with which this divertissement concludes, it seemed as if Mr. Mordkin would never be able to leave the stage, the applause was so deafening and so long continued.

Some Russian dances followed to music from Glinka's "A Life for the Czar," and not by Tschaikowsky, as the programme stated, and this section of the programme was completed with the "Bacchanale" from Glazunow's ballet, "The Seasons," in which Pavlowa and Mordkin swept the audience almost literally out of their chairs. This dance to many reaches the heights of choreographic art.

The ballet which concluded the programme was called "The Legend of Azylade," and was doubtless suggested by a performance of Rimsky-Korsakoff's symphony "Sheherezade" as a ballet at the Paris Opéra last Summer. However, Mordkin had arranged for this occasion an entirely different story and the music was taken from many sources although some of the themes from Rimsky-Korsakoff's symphony were retained. Among the dances introduced was one from Bourgault-Ducondray's opera "Tamara," distinctly Persian in character, and quite extraordinarily sensuous in its rhythm and tonal monotony. Several other composers, including Chaminade and Glazunow, were called upon to contribute.

Pavlowa as the captive princess was as bewitching as possible, and Mordkin was so beautifully kinglike that many in the audience were heard to condemn the escape of the captive princess at the close as an unhappy ending.

The small group of dancers which accompanies Pavlowa and Mordkin on this tour are most of them Russians and seemed to indicate that in Russia as well as America Pavlowa and Mordkin are unsurpassed. The corps de ballet appeared to special advantage in "The Legend of Azylade."

To Mr. Mordkin the highest praise is due for his work as a ballet master, for it was he who arranged the steps of all the

dances and the programme of the afternoon which contained just the correct amount of diversity.

Theodore Stier, the conductor of the Bechstein Hall concerts in London, made his first American appearance and gave an especially poetic performance of "Giselle," and put the requisite amount of sensuousness in the music for the Arabian ballet. The orchestra's performance of the music to which Mr. Mordkin dances the bow and arrow dance would suggest that more rehearsals might do it benefit if it were not remembered that the Metropolitan Opera House orchestra last season never succeeded in playing it even respectably.

The scenery for "Giselle" was painted by James Fox of the Metropolitan Opera House, and was very pretty and appropriate. That for the Arabian ballet was furnished by Paquereau of Paris.

* * *

December 13, 1910

ANCIENT EGYPTIAN RITES SEEN IN DANCE

Ruth St. Denis in Series of Graceful Posturings, with Lavish Costume and Scenery

RUSSIAN ORCHESTRA PLAYS

Combined Musical and Terpsichorean Effort Provides Novel and Interesting Afternoon

The efforts of Ruth St. Denis and the imperial Russian Court Orchestra, alternately appearing, served to provide an entertainment of a novel and interesting sort at the New Amsterdam Theatre yesterday afternoon.

Miss St. Denis has been at great pains to create a new series of dances to replace her former Hindu repertoire, and in respect to color, rhythm, strangeness of locale, and pictorial effect the present ones are admirable in fact. The ritual and superstitions of ancient Egypt furnish the themes.

Yesterday the waits between scenes were somewhat too prolonged, but in future these will be amended, no doubt. And certainly, even under the conditions, the successive beauty of the pictures and the dances was sufficient to encourage patience.

Four series of dances, involving twice as many scenes, are included in Miss St. Denis's present programme, which opens with the "Devotion to the Nile," Miss St. Denis, a picture of the ancient Egyptian as she appears to modern imagination, made an undulating entrance along the banks of the stream, represented in broad washes of green, shimmering under the sunlight and fringed on either side by hedges and bullrushes.

The remarkable part of the dance . . . is its conveyance of a sense of liquid movement. Miss St. Denis's command of the muscles of the hands and wrists and forearm is especially wonderful, and she makes these members eloquent aids in her effects. An especially beautiful moment shows her kneeling by the riverside, her face upraised, while her body from

the waist downward is bent almost to the ground. Arms and upraised palms slowly suggest the rising of the waters.

Impressive again is her next dance, scheduled as "The Feast of Eternity," in which, at the very height of the festivities, the Osirian mummy is introduced, "to remind," as the programme explains, "that life is only transitory." In this connection, by the way, it may be mentioned that a fuller significance of the intentions should be included in these programmes, with a more detailed synopsis of the dances.

Two scenes are comprised in the next number, "The Mystery of Isis," in which the lavishness of the garment, a massive effect in embroidered gold stuffs, is in itself remarkable. But the height of the pictorial effect is attained in the final dances, representing the Festival of Ra, with an opening scene showing a vast expanse surrounded on all sides by rocky cliffs, from among which a group of women garbed in neutral tints, with draperies flowing in the breeze, go through a series of remarkably graceful evolutions prior to the entrance of the principal dancer, who, amid changing lights and colors, and with singularly suggestive gesture and movement, voices the life of man and the passing of the soul. The blend of emotions here compasses moods of extreme gayety and seriousness, the terpsichorean gamut being broadly varied in consequence and demanding a considerable degree of variety of expression. Needless to say Miss St. Denis attacks her difficult self-imposed task with great skill. The general result is most beautiful.

The charm of the Russians' playing has lately been described in these columns, and it will be a pity if music lovers do not take advantage of the present opportunity to hear them. Yesterday afternoon they were applauded to the echo after every number. "The Russian Cradle Song" (Gratchaninoff) and "The Russian Butterfly Valse" (Andreeff) were especially well liked. Mr. Andreeff conducted.

The music for Miss St. Denis's dances is provided by Walter Myrowitz, and serves its purpose nicely.

*　*　*

February 16, 1911

MISS DUNCAN DANCES TO WAGNER MUSIC

Her Impressions of the Paris Version of Bacchanale from "Tannhauser" Are Very Pretty

ALSO DANCES "LIEBESTOD"

Big Audience Greets American Barefoot Dancer's Reappearance with Damrosch and Symphony Orchestra

Miss Isadora Duncan, the American girl who is directly responsible for a train of barefoot dancers who have spread themselves, like a craze, over two continents in the last five years, has returned to America, and yesterday she gave a new exhibition of her dancing, with the assistance of Walter Damrosch and the Symphony Society, at Carnegie Hall. Before the doors opened there were no seats to be had, and the long line of carriages which drew nigh the portals as the hour set for the dancing to begin approached indicated that Miss Duncan not only was the first of the barefoot dancers, but also the last. She not only has established her vogue, but she has also maintained it.

It has long been the custom for Miss Duncan to do her dances to music which originally belong either to the opera house or the concert room. In years gone by she has lifted her feet to Chopin measures; to dances from the Gluck operas; and even to Beethoven's Seventh Symphony. This last was considered by many as a desecrating escapade, but many others paid money to see her do it, and Miss Duncan achieved some of her greatest popular success with the symphony which Wagner called the "apotheosis of the dance." Doubtless many people thereby became acquainted with a work of Beethoven which they never would have heard otherwise.

Yesterday Miss Duncan forsook the masters who have given her most of her material for dancing until now. She had arranged, in fact, an entirely new programme, through which to display her art. It was made up of excerpts from the Wagner music, dramas and Bach's Suite in D.

If Bach did not intend that his music should be danced to at least several of the numbers in this suite bear the names of dances, so Miss Duncan cannot be taken too much to task for using them for her purposes.

The stage setting was what it usually is at a Duncan seance. Green curtains depended from the heights of the stage and fell in folds at the back and sides leaving a semi-circular floor in the centre on which dim rose-colored lights flitted here, contrasting with shadows there. When Mr. Damrosch came to the conductor's desk and raised his baton, all the lights in the auditorium were extinguished. The orchestra played the prelude to the suite and then Miss Duncan appeared.

She wore, as she always does, some drapery of diaphanous material. She stood for a moment in the shadow at the back of the stage while the orchestra began the "Air," the celebrated slow movement in the suite, which violinists play on the G string. Miss Duncan waved her arms and posed during this movement but did not do much of what is conventionally called dancing.

In the two gavottes and the Gigue which followed, however, the dancer was seen at her best. She flitted about the stage in her early Greek way and gave vivid imitations of what one may see on the spherical bodies of Greek vases. The Boursée from the Suite the orchestra played alone and the first part of the programme closed with the Polacca from the first Brandenburg Concerto, also undanced.

There was a brief intermission before the Wagner excerpts were played. Then the house was darkened and the "Lohengrin" Prelude was performed. After this Miss Duncan gave her interpretation of the Flower Maidens' music from "Parsifal."

This time she appeared in white gauze, beautifully draped. Her hair was caught up with flowers of pinkish hue. She evidently danced with an imaginary "Guileless Fool" standing in the centre of the stage. To him she appealed with all her

gestures and all her postures. It was an interesting attempt to give the spirit of the scene in the Klingsor's garden. What it meant to those who have never heard Wagner's music drama this writer cannot profess to know.

The next number announced on the programme was the Prelude and "Liebestod" from "Tristan und Isolde." Instead, however, of rapping for attention from his orchestra, Mr. Damrosch asked the audience for attention, turned about, and made a little speech.

The purport of his remarks was to the effect that it had originally been intended that Miss Duncan dance only music which had been arranged by Wagner in his music dramas for that purpose.

"It had been my intention," said Mr. Damrosch, "simply to play this music from 'Tristan.' Yesterday, however, Miss Duncan modestly asked me if I would go through the 'Liebestod' with her. She has, as is well known, a desire to unite dancing to music in a perfect whole, as an art which existed in the time of the early Greeks. Whatever she does now, of course, must be largely experimental. However, the results which she has already achieved with the 'Liebestod' are so interesting that I think it only fair to set them before the public. As there are probably a great many people here to whom the idea of giving pantomimic expression to the 'Liebestod' would be horrifying, I am putting it last on the programme, so that those who do not wish to see it may leave."

There was applause and then Miss Duncan gave her impressions of the Paris version of the Bacchanale from "Tannhauser," which were very pretty but hardly as bacchanalian as might have been expected. After the orchestra had played the prelude to "Die Meistersinger" she danced the Dance of the Apprentices from that music drama. It may be stated that Miss Duncan did her best dancing of the afternoon to this number and it was repeated.

As for the "Liebestod," the anticipation of it evidently was not too horrible for any one to bear. People did not leave their seats, except possibly the usual few who are obliged to catch trains. Miss Duncan's conception of the music did not seem to suggest a pantomimic Isolde, nor was it exactly dancing. In other words, she puzzled those who knew the music drama, and did not interest those who did not. Therefore one may ask, Why?

* * *

MISS DUNCAN DANCES AGAIN

Vividly Portrays a Fury and a Happy Spirit to Music by Gluck

It was to the operas of Gluck that Miss Isadora Duncan went for her first inspiration when she began her revivals of the Greek dance, and yesterday afternoon in Carnegie Hall she returned to Gluck. Her previous attempt to dance to the music from the lyric dramas of Richard Wagner had not resulted in complete success, but her spectators yesterday were pleased to see that Miss Duncan was herself again.

The first half of the programme consisted of copious excerpts from "Orfeo," played in chronological order, and embracing the chief incidents of the book, with the exception of the scene in which Eurydice persuades Orpheus to turn and gaze upon her face. The Symphony Society of New York, Walter Damrosch conducting, played the music; a small chorus, seated among the orchestra, sang several of the choruses, and Mme. Florence Mulford sang several of Orpheus's airs.

In the first act, in a long robe of flowing gray, Miss Duncan represented one of the companions of Orpheus. Her poses and movements were intended to suggest the deepest grief. It was in the first scene of the second act, that of the scene in Hades, which was given in its entirety, that Miss Duncan, portraying one of the Furies, first aroused the enthusiasm of the audience. She indicated the gradual wavering of the Furies from the tremendous "No" in the beginning to the end when the Furies allow Orpheus to pass on to the Elysian Fields. The Dance of the Furies, with which this scene concludes, was a remarkable exhibition of dancing, one typical of high imagination.

It had originally been intended that several of the choruses and Orpheus's air from the scene of the Elysian Fields should be included in the programme scheme, but evidently it was found necessary to omit these. Only the ballet airs were presented from this scene, including the famous air with flute obligato, which was exquisitely played by Mr. Barrère.

Miss Duncan, as a happy spirit, was as much at home as she had been previously as a Fury. From here on a long excision was made in the score until the finale was reached; even the famous chaconne was omitted. In the final scene, in which the chorus again appeared, Miss Duncan indicated the triumph of Love.

The excerpts were beautifully played by Mr. Damrosch and his orchestra. It is worthy of note that the seldom heard overture, a usually omitted ballet air, and the finale, which is replaced at the Metropolitan Opera House by a finale from another opera of Gluck, were restored. As has been suggested, much else was omitted.

After an intermission Miss Duncan danced to some music by Schubert, and the orchestra played Dvorak's "In the Spinning Room."

* * *

PAVLOWA DANCES FAREWELL

Appears in New Divertissement, "Chopin," and Triumphs in Spanish Dance

Anna Pavlowa danced her farewell for the season at the Metropolitan Opera House yesterday afternoon, and perhaps her farewell to that house, because just what is to be done

with the various sets of Russian dancers who loom on next season's horizon is not yet decided. In any case, Pavlowa had arranged a decidedly novel programme for the occasion.

The first of the novelties was a divertissement called "Chopin," in which that composer was discovered seated at the piano as the curtain rose, playing one of his preludes. This finally merged into a nocturne, played by the orchestra and danced by four of the dancers, who represented, according to the programme, "the surging thoughts that sweep through Chopin's mighty mind." The music changed again to the C-sharp minor waltz, and Pavlowa appeared. The "Minute" waltz was danced by two other dancers, and another nocturne ended the little play.

Later Pavlowa was seen in her Swan dance; but after that she cast aside ballet slippers and appeared as a character dancer. With Mr. Morosoff she danced a Russian dance, in which, it will be remembered, she appeared with Mordkin once or twice last season.

It was during her next appearance, however, that she achieved the triumph of the afternoon, in a Spanish dance to the music of Rubinstein's "Toreador et Andoulaise," which she danced with Mr. Morosoff. In a brilliant costume of green, silver, and white, Pavlowa danced with a passion and a fire which aroused the house to a storm of applause. She and her partner were recalled and recalled, until finally she gave the conductor the sign to repeat the dance.

At the end of the programme she took her part in the octet mazurka from Glinka's "Life of the Czar," which has often been danced here by the Russians this season, with Mlle. Pajitskaia as the leader. She was deluged with bouquets and applause, and the curtain rose again and again, to disclose her bowing her thanks.

The programme contained several other interesting features. All the dances, it may be said, had been arranged especially for the occasion by Pavlowa. One of them was the Snowflake ballet from Tschaikowsky's "The Nut Cracker," in which a large corps of dancers appeared, assisted by an invisible chorus. The scenery for the third act of "Königskinder" made a very pretty background as the dancers twirled in the falling snow.

The Misses Schmolz, Kuhn, Plaskowietzkaia and Bewickowa and Mr. West appeared in a Dance of Pierrot and Pierrettes; the Misses Schmolz and Kuhn danced an Italian tarentelle, and the Misses Schmolz, Kuhn, and Plaskowietzkaia and the Messrs. West, Trojanowski, and Barboe danced a very brilliant "Dance Bohemienne."

Miss Lydia Lipkowska had been announced to sing twice on the programme, but illness prevented, and in her place Mme. La Salle-Rabinoff appeared, singing the first time the mad scene from "Lucia," and later "Caro Nome" from "Rigoletto." The orchestra, under the direction of Theodore Stier, played two movements from Tschaikowsky's fifth symphony and Beethoven's overture to "King Stephen."

It may be stated that the advent of a new lot of Russian dancers in New York next season may result in the temporary absence of Pavlowa and Mordkin. A large company of dancers, headed by Nijinsky, Karsavina, Gheltzer, and eight other women, will appear at the Metropolitan and on tour. Two of the ballets to be danced are "Sheherazade," fashioned from Rimsky-Korsakoff's symphony by that name, to which his widow has violently protested, and a new work by Tcherepine, entitled "Le Beau Narcisse."

Pavlowa and Mordkin will have a company entirely separate from this one, and will confine most of their attention to the larger cities of the country.

* * *

June 15, 1911

RUSSIAN BALLETS AT WINTER GARDEN

Gertrude Hoffmann Shows Novelty in 'Cleopatre,' 'Les Sylphides' and 'Sheherazade'

A MAD WHIRL OF COLOR

Mlle. Lopoukowa Applauded In Solo Dance as Leader of Greek Bacchanale—Acted with Realism

Gertrude Hoffmann began her "Saison des Ballets Russes" at the Winter Garden last night, and New York was introduced to another novelty to be added to the list the season has afforded. Just how much New York will like this new entertainment remains for further nights to decide. Last night's audience liked much of it a great deal.

It, the entertainment, comes in three parts, three ballets of differing types. The first, "Cleopatre," is a short love drama, with a tragic ending; the second, "Les Sylphides," is a series of dances to Chopin's music, and the third, "Sheherazade," is another love drama, with another tragedy to end it. Scenery, costumes, light effects, and the ensemble of the company are of high merit in all of them.

The scene of "Cleopatra" is at a shrine on an oasis in the desert. The stage represents a high columned hall of Egyptian type, with a view of the Nile between the pillars at the back. Here an archer and girl meet, love, and are joined by a priest. Then Cleopatra, the queen, arrives, attended by slaves of half a dozen different nations. For some reason, presumably symbolic, she arrives in a mummy case, and has to be relieved of numerous bindings of colored scarfs. She falls in love with the archer, wins him from the girl, and permits him to drink poisoned wine at the end.

Whirling draperies of Greek dancers, the brilliant colored costumes of Hebrews and Egyptians, fill the stage during this ballet, with the music by S. Taneieff, Rimsky Korsakow and A. Glazounow. There are solo dances, and ensemble numbers and marches, all of them well done, if not excellently performed. Opportunity to see dancers of this sort has been so slight that it is impossible to judge the merits of the players in this ballet.

Gertrude Hoffmann appeared as the amorous Queen, but did not dance. Marie Baldina had the rôle of the archer's

sweetheart, Theodore Kosloff played the archer, and Lydia Lopoukowa and Alexis Kosloff had the rôles of slaves. Toward the end of the ballet Mlle. Lopoukowa had a brief solo dance as leader of Greek Bacchanale, and to her went much of the applause at the end of the first number.

"Les Sylphides" comes back to the more conventional ballet, with the filmy, wide skirts, and the toe dancing. In this the music was Chopin's, and the dancers were Lydia Lopoukowa, Alexander Volnine, Mlle. Cochin, Marie Baldina, and Mlle. Gluck, with a corps de ballet of twenty-two. With a background of a forest, a nocturne was first danced by the principals and the coryphees, and then followed a waltz, a mazurka, another waltz, another mazurka, winding up with a waltz brilliant.

And for this the audience applauded again and again, calling back all of the principals, demanding to see the coryphees again, and finally insisting on the director, Theodore Kosloff, and one of the managers, Morris Gest, being brought before the curtain. Even then the appluse continued, and large floral pieces continued to go over the footlights, until Mlle. Lopoukowa took a call alone. Then the enthusiasm increased. What ever the public is going to do about the ballets, this particular principal will hold the place she acquired last night for a long time. It will be remembered, in this connection, that she was one of the Russian dancers who appeared in "The Echo" this season and whose début was marred by a slippery stage.

"Sheherazade," the final ballet, is called on the programme a "choreographic drama." Its story is the introduction to the Arabian Nights Entertainments, and its scene is the harem of the King of India and China. The costuming, the setting, and the arrangement of the music suggest ancient Persia. The King and his brother start on a journey, leaving their wives in the keeping of the chief of the harem. No sooner have the monarchs departed than the women wheedle the keys from the keeper and let in the men slaves from another part of the palace. A noisy revelry takes place, during which the King and his brother return. Soldiers are called in and all are killed except the King's favorite. She begs for mercy, and, when her husband orders her execution, she kills herself with a knife she has taken from one of the soldiers.

The effect in this ballet of Oriental languor, followed by the cumulation of passion that has vent in wild dancing, is extremely well managed. The stage is crowded with men and women in kaleidoscopic costumes, and the finale before the entrance of the King and the soldiers is a mad whirl of color that brought a burst of applause last night. In this piece Miss Hoffmann has the rôle of the favorite wife, and wears a costume of less meagre dimensions than the Cleopatra dress. Mlle. Lopoukowa, Mlle. Baldina, and Mlle. Cochin appeared as odalisques, and the principal male rôles were taken by Alexis Bulgakow, Nicolas Solanikow, Theodore Kosloff, and Alexis Kosloff. The music is by Rimsky Korsakow.

The orchestra, much enlarged, was directed by Max Hoffmann, who succeeded in obtaining excellent results.

Much money and good taste have been bestowed upon the preparation of these ballets, but whether the taste that

selected the Cleopatra and the Arabian Nights number was as good is a matter about which individuals will probably differ. Their stories are erotic and the scenes are played with much realism—as far as dancing and pantomime can be realistic. The audience liked "Les Sylphides" probably as much for its delicacy as for its good performance.

* * *

December 20, 1911

FANTASTIC BALLET OF RUSSIAN DANCERS

Tschaikowsky's "Le Lac des Cygnes" at the Metropolitan Is a Tale from Chivalric Age

MISS GELTZER A SUCCESS

Dances Brilliantly and Her Technique Is of High Order—Some Charming Music and a Beautiful Production

Tschaikowsky's four-act ballet, "Le Lac des Cygnes," received what was probably its first production in New York yesterday afternoon at the Metropolitan Opera House. The occasion also marked the return of the Russian ballet and the first American appearance of Katrina Geltzer, the first dancer of the Moscow Imperial Opera, who created the sort of an impression which is only conjured up by great dancers.

"Le Lac des Cygnes" is an early work of the Russian composer, written in 1876, when he was in a period of great mental and physical unrest. Its opus number is 20 and it is preceded in his list of works by nothing more important than the first and second symphonies, the first string quartet, and the orchestral fantasie, "The Tempest."

Tschaikowsky, like other Russians, was a devotee of dancing, and Begichev, then stage director of the Opera at Moscow, proposed to him that he write a ballet. The composer agreed, but stipulated for a fantastic subject from the chivalric age. His favorite ballet at that period was "Giselle," for which Théophile Gautier wrote the book and Adolphe Adam the music. Begichev himself sketched out the plot for "Le Lac des Cygnes."

We are introduced in the first act to Siegfried, a Prince of the fifteenth century. He has just come of age, and the opening scene is a celebration of this event. As the festivities draw to a conclusion a flock of swans wings its way across the sky, and Siegfried and his friends depart to shoot them.

When they near the swans, however, they perceive beautiful young maidens, who tell how they are in the power of a sorcerer and may only achieve their human forms at night. Siegfried falls in love with the most beautiful of these swan maidens, and she tells him that she may escape the enchantment if she finds a man who will be true to his love for her. He promises to return to claim her.

The sorcerer, however, summons a spirit to impersonate Siegfried's swan love, Odetta, and Siegfried, deceived, proves false to his promise, and Odetta returns to the sor-

cerer's power. In despair, on learning the truth, he attacks the demon, who hurls him into the lake. He has now proved his love, and Odetta regains her original form, but now that Siegfried is dead, she, too, seeks death in the lake.

This romantic tale did not suffice for the purposes of the Moscow ballet master, and he asked Tschaikowsky to write a suite of national dances for the third act. They have nothing whatever to do with the story, but they serve their purpose as pretty character episodes.

The music is not by any means Tschaikowsky at his best. Both "La Belle au Bois Dormant" and "Casse-Noisette" are much better ballets. Some of the music of the first and second acts is very banal, and there is a good deal of padding, mainly in the shape of long sequences, but every now and then, of course, there is very charming music. The waltzes are especially pretty and the dramatic music is usually good enough for its purpose. A good deal of it was cut yesterday.

It is a curious fact that the principal theme of the ballet, which recurs again and again, is practically the same as the "Mystery of the Name" theme from "Lohengrin," the note to which Lohengrin sings, "Nie sollst du mich befragen." Now, Tschaikowsky visited Bayreuth in 1876, the year he wrote the ballet. Of course, "Lohengrin" was not sung at Bayreuth before 1894, however.

In the ballet of "The Sleeping Beauty" there is another curious Wagner reminiscence. The theme representing the sleeping Princess has a close analogy with that depicting the sleep of Brunnhilde. That, however, might have been conscious humor on Tschaikowsky's part.

Katrina Geltzer made a great success yesterday afternoon. In the second act of the ballet, in which she made her first appearance, she seemed nervous, but in the third act she danced so brilliantly that she soon had the house in an uproar.

She is not very tall and rather lithe, although the lower parts of her legs have an unfortunate muscular development. Her face is piquant and always expressive and her body has been trained to suggest every emotion. Her technique is of a very high order. Her pirouette, for instance, is nothing short of astounding. She has a fine sense of humor, which is displayed on occasion, and also imagination, poetry, and intelligence. She seems to be more physical in her appeal than Pavlowa, and less delicate, not so mysteriously beautiful.

The comparison of the two inevitably brings to mind Taglioni and Fanny Elssler, and Miss Geltzer is more like the descriptions of the little Austrian.

Mr. Mordkin looked very wonderful and added greatly to the effect of the ballet, although he had very little dancing to do. The others were in the picture and assisted when necessary. Some of the dancing of the corps de ballet as swans was picturesque especially at the close, where the waving fingers of the girls were weird in their effect.

The scenery, painted by James Fox of the Metropolitan Opera House in emulation of the Russian impressionistic style, was very nice, indeed. Why are not more productions made along these simple lines? The costumes, especially those of the third act, were beautiful. The lighting was good, and so was the stage management, but the swans flying across the background were not very successful. It would, perhaps, be better to resort to a cinematograph for this effect. The orchestra, it must be confessed, played very badly.

After the ballet there were a series of divertissements. Alexander Volonine had a chance to show his facility in a classic dance, which he had previously exhibited at the Winter Garden when he appeared with Miss Gertrude Hoffman's troupe. Bronislawa Pajitskaia, who in private life is Mrs. Mikail Mordkin, was seen in a visualized conception of "Anitra's Dance," from the "Peer Gynt" suite.

But almost the clou of the afternoon was the wonderful dancing of Katrina Geltzer and Mikail Mordkin in a number simply called "Etude." This dance, which included a little touch of bacchanale, was irresistible, and is likely to be given countless repetitions during Miss Geltzer's brief stay in New York.

* * *

January 16, 1912

BALLET STRIKES IN PARIS OPERA

Part of Audience Protests When Dancers Refuse to Appear in "La Roussalka"

THEIR DEMANDS IGNORED

Maeterlinck's "Monna Vanna" May Be Halted, as Orchestra and Stage Hands Are Supporting Ballet

Special Cable to The New York Times

PARIS, Jan. 15—A strike of the ballet dancers at the Paris Opera this evening prevented the performance of "La Roussalka" while Maeterlinck's "Monna Vanna" was being performed. A deputation of the dancers requested an interview with the manager and directors, who, however, refused to see them, whereupon the ballet corps refused to appear.

Not only do they demand an extra $100 yearly, but they object to the engagement of two new dancers.

When the stage manager appeared before the curtain and announced the impossibility of performing "La Roussalka," a section of the audience raised loud protests, but the majority accepted the situation good humoredly.

The ballet's salaries now range from $540 to $600 yearly.

It is believed the opera management is confronted with the most serious strike in recent years, as the orchestra, chorus, and stage hands are said to be supporting the ballet, rendering all performances impossible.

* * *

June 8, 1912

PARISIANS HISS NEW BALLET

Russian Dancer's Latest Offering, "The Consecration of Spring,"
a Failure

HAS TO TURN UP LIGHTS

Manager of Theatre Takes This Means to Stop Hostile
Demonstrations as Dance Goes On

By Marconi Transatlantic Wireless Telegraph to
The New York Times

PARIS, June 7—"Bluffing the idle rich of Paris through appeals to their snobbery is a delightfully simple matter," says Alfred Capus in Le Figaro this week. "The only condition precedent thereto is that they be gorged with publicity."

"Having entertained the public with brilliant dances," he adds, "the Russian ballet and Nijinsky now think that the time is ripe to sacrifice fashionable snobs on art's altar. The process works out as follows:

"Take the best society possible, composed of rich, simple-minded, idle people. Then submit them to an intense regime of publicity. By booklets, newspaper articles, lectures, personal visits and all other appeals to their snobbery, persuade them that hitherto they have seen only vulgar spectacles, and are at last to know what is art and beauty.

"Impress them with cabalistic formulae. They have not the slightest notion of music, literature, painting, and dancing; still, they have heretofore seen under these names only a rude imitation of the real thing. Finally, assure them that they are about to see real dancing and hear real music.

"It will then be necessary to double the prices at the theatre, so great will be the rush of shallow worshippers at this false shrine.

"This," observes M. Capus, "is what the Russian dancers have been doing to Paris. The other night, however, the plan miscarried. The piece was 'The Consecration of Spring,' and the stage represented humanity. On the right are strong young persons picking flowers, while a woman, 300 years old, dances frenziedly. On the left an old man studies the stars, while here and there sacrifices are made to the God of Light.

"The public could not swallow this. They promptly hissed the piece. A few days ago they might have applauded it. The Russians, who are not entirely acquainted with the manners and customs of the countries they visit, did not know that the French people protested readily enough when the last degree of stupidity was reached."

In conclusion, M. Capus warns Parisian snobs not to make fools of themselves by going into ecstasies over the Polish actors who opened a season at the Gymnase this week.

Since M. Capus's article there have been disorderly scenes at the Champs Elysee Théâtre, where the Russian ballet is appearing.

"The Consecration of Spring" was received with a storm of hissing. The manager, M. Astruc, however, has devised a novel method for silencing a demonstration. When hisses are mingled with counter-cheers, as they were the other night, M. Astruc orders the lights turned up. Instantly the booing and hissing stop. Well-known people who are hostile to the ballet do not desire to appear in an undignified role.

Igor Stravinsky, who wrote the music of "The Consecration of Spring," says that the demonstrations are a bitter blow to the amour propre of the Russian ballet dancers, who are sensitive to such displays of feeling and fear they may be unable to continue the performances of the piece.

"And that is all we get," added M. Stravinsky, "after a hundred rehearsals and one year's hard work."

The composer, however, is not altogether pessimistic, for, he adds: "No doubt it will be understood one day that I sprang a surprise on Paris, and Paris was disconcerted. But it will soon forget its bad temper."

Nijinsky himself is responsible for the stage setting of the piece, which theatregoers here aver is badly done. He is a wonderful dancer, Parisians admit, but they add that he knows little about stage setting.

* * *

June 15, 1912

DARING BALLET STIRS THE PARIS CRITICS

Production by Russian Dancers Condemned, but Public Rushes
to See It

RODIN IS ITS DEFENDER

Famous Sculptor Brings Storm on His Own Head by Praise of
the Art of Nijinski

By Marconi Transatlantic Wireless Telegraph to
The New York Times

PARIS, June 1—Very strong protests are uttered on all sides against Gabriel Astruc's production at the Châtelet Theatre on Wednesday of "L'Après-Midi d'un Faune" by the Russian ballet.

The new ballet, which is founded on Debussy's symphonic piece, depicts the gambols of a faun with nymphs in a forest. The interpretation of the central figure by M. Nijinski was considered by the audience to surpass all limits of convention, and, in spite of the fact that Nijinski had always been a very great favorite with the Paris theatre-going public, he was roundly hissed at the end of the piece.

Its reception of the ballet by the press was very hostile, and the more serious papers, such as le Figaro and le Gaulois, omit criticisms, printing in their place strongly worded editorial articles condemning the performance.

Gaston Calmette, le Figaro's editor, has a signed article headed, "A Mistake," in which he says that he is obliged to suppress a notice of the ballet, and that any one who can call such an exhibition scientific, artistic, or poetic is misguided. Such realism, he declares, will never be accepted by the real public.

Le Gaulois heads its editorial "A Mistake Which Must Not Be Repeated," and says it hastens to approve of the protests which were made at the Châtelet on the evening before. Le Gaulois refuses to print any account of the exquisite music "until the public has received the apology due to it."

Other less severe journals call attention to the marvelously supple power of Nijinski's interpretation of this character, and the word "humanital" has been coined to express the impression he produced.

The uproar has raised once more the whole question of the limits to be set to artistic production by convention, and a lively controversy is now proceeding, stimulated by an article which appeared the morning after the new ballet in le Matín signed by Rodin, the sculptor. As already briefly reported in The New York Times, Rodin writes in terms of growing enthusiasm of Nijinski.

* * *

January 6, 1914

NOT THE DANCE, BUT THE DANCERS

In all the heated and protracted argument concerning the tango and other lately devised dances, it is to be noted that condemnation comes chiefly from persons whose habits of thought and standards of conduct impel them to denounce dancing as a pastime whenever opportunity offers, and that, in the sane judgment of unprejudiced observers, the new dances are objectionable or not according to the way they are danced. The tango can be a graceful and beautiful dance, it can be, and is, made ugly and vulgar by dancers who lack a sense of decency. Precisely the same things could be said, and were said, in former years of the polka and the waltz. An applicable moral, neatly expressed in verse, lingers in the memory:

Said the Rev. Jabez McCotton,
"The waltz of the devil's begotten!"
But Jim made reply,
"Never mind the old guy,
To the pure almost everything's rotten."

The psychological reason for the recent revival of dancing has not been discovered. Perhaps the popularity of the Russian ballet dancers and the new development of theatrical dancing generally have influenced it somewhat. Perhaps social man had grown over-tired of the strain of cares and responsibilities and felt the need of more relaxation than can be obtained by sitting silently to look and listen while other people do things. Anyhow, within two years people whose "dancing days were over" have found new dancing days and nights, while youth is dancing more furiously than ever before. That the craze has its comical side is indisputable, that much of the dancing one sees is pretty poor dancing nobody will deny, but that the contemporary dance is essentially immoral is not true. Every dancer is not a satyr or a hilding. In fact, in the present state of society the supply of such is lim-

ited. The tango is as innocent as any dance when the dancer is innocent. When it is immoral it ought to be discountenanced for its immorality, not just because it is the tango.

* * *

February 21, 1915

ISADORA DUNCAN FAREWELL

On next Thursday afternoon and Tuesday evening, March 2, Isadora Duncan will give her farewell performances at the Metropolitan Opera House before her departure for Greece with her school. For her final two performances Miss Duncan will again have the assistance of her school, of Augustin Duncan, and an orchestra conducted by Edward Falck. On these occasions Miss Duncan will present a number of waltzes of Brahms for the first time, and three dances of Beethoven. The "Marche Militaire" and "Moments Musicales" of Schubert, and twelve Schubert waltzes will also be given.

* * *

September 26, 1915

DIAGHILEW

By WILLIAM J. GUARD

This account of the westerly advance of the Russian ballet was sent from Paris to the Metropolitan Opera House by William J. Guard. The ballet, Nijinsky and all, will follow the opera season next Spring, but it will first be seen in mid-Winter at the Century.

For six years America has been hearing about The Ballets Russes. Of course there are Russian ballets and Russian ballets. But there is only one Diaghilew Russian Ballet and that is THE Russian Ballet, which, when it invaded Paris in the Spring of 1909, created a sensation in the French capital, the memory of which even the war has not obliterated—that sensation which New York and other large cities in America have been longing to experience, but which so far has been denied to them owing to the multitudinous difficulties involved in bringing this wonderful and really unique organization across the Atlantic.

Attempts have been made from time to time to present imitation Russian ballets or fragments of Russian ballets in America of late years with more or less success, considering the material obtainable. The real Russian ballet, however, Les Ballets Russes, which Paris and London lost their heads over, is possible only when it has at its head Serge Diaghilew. That is why it is equally well known as the Diaghilew Ballet throughout Europe.

And then who is this man Diaghilew? In a word, he is the organizing, vitalizing spirit of this extraordinary combination of artists—the co-ordinating brain of this body of dancers, composers, painters, and poets, all of whose services he has combined to produce the astonishing and fascinating stage

pictures which, with their riot of color, movement, and music, have furnished a new form of entertainment to the seekers after novelty in sensation.

Though just rounding 40, Diaghilew's has been a life full of activity, an activity devoted chiefly to artistic pursuits. An attaché of the Russian Court, some years ago as a rich amateur it was his habit to surround himself with and encourage the efforts of younger and less fortunate men of talent in music, painting and literature. He showed a fine appreciation of real worth in the matter of art. His generosity was unstinted. If he saw a young man that he thought had something in him, Diaghilew's purse was at his disposal. No one knows how many young painters sold their first picture or got their first commissions through him. More than one young composer has had his maiden sonata heard in public, thanks to his good offices. The ambitious young Russian poet also has found an editor by grace of a letter of introduction from Serge Diaghilew.

It was way back in 1908 that Diaghilew conceived the idea of opening the eyes of the skeptical Occident to what might be called the Renaissance of artistic Russia, something up to then almost totally unknown beyond the frontiers of the Czar's domain. Without any flourishing of trumpets, Diaghilew appeared in that year in Paris with several dozen cases full of pictures by his young friends of the modern school of Russian painting. He secured a modest salon without any fuss or feathers and personally superintended the hanging of these canvases. When he had everything to his liking, he invited artistic Paris to come and see the exposition. The next day the Russian pictures were the talk of the town. The jaded palate of Paris experienced a new thrill. "Les Russes" at once became the vogue, and that picture show was the advance guard of the famous Russian ballet invasion.

Diaghilew, to whom his grateful artistic associates were only too glad to ascribe the credit of the exposition's success, became a sort of hero of the hour. It did not spoil him, however. In fact, it was the limelight that sought him, not he the limelight. His enthusiasm was further stimulated by what he had accomplished on behalf of the art life of his country, and he at once saw the possibility of even more effectively making known to the Western world the artistic soul of Russia. The next year he organized a great series of Russian historical musical concerts at the Paris Grand Opera and presented for the first time with a company of Russian lyric artists Moussorgsky's opera, "Boris Godunof" with the original scenery painted in Russia, which has since become the valued possession of the Metropolitan Opera Company of New York.

The success of the concerts and of "Boris" was really immense. It was a revelation of the possibilities of Russian art heretofore undreamed of by Westerners. The season following, Diaghilew broadened his program, bringing more Russian operas and introducing for the first time in Paris the wonderful ballet which he had himself organized in every detail and which included the very best available exponents of the poetry of motion on the Russian stage, the most star-tling effects of latter day Russian scene painting and ballet music composed not only by the Russian composers already known outside of Russia, but by several younger men who might be called Diaghilew's discoveries.

The successes of the previous year were reaffirmed with a crescendo. The Russian ballet became an annual necessity in Paris's Springtime. Doubtless thousands of pleasure seekers came to Paris especially to see it. They never went away disappointed.

* * *

January 9, 1916

A TALK WITH SERGE DE DIAGHILEFF, BALLET WIZARD

He Brings to Our Shores a Strong Prejudice Against Being Told What to Do or When to Do It, and Against Having His Picture Taken

By WILLIAM J. GUARD

In view of the fact that Serge de Diaghileff's Ballet Russe, the members of which left Europe for this country on the steamship Lafayette, is to make its first appearance here within a few days, the following interview with M. Diaghileff, secured recently in Europe, is of timely interest.

Is Diaghileff himself going to America?"

This was the first question that Leon Bakst, the eminent artist who is the creator of the modern Russian school of scene painting and costume designing, put to me. I had called upon him to urge him to visit the United States, where two exhibitions already have made him known and admired, on the occasion of the first presentation in this country of Serge de Diaghileff's Ballet Russe, which for several seasons past have been the artistic sensation of Paris and London.

"Certainly, Diaghileff is coming," I replied.

"Then all will be well," was Mr. Bakst's assurance. "It doesn't matter who the principal stars are if Diaghileff is with the troupe."

Five years ago I saw Mr. Diaghileff first during one of his Ballet Russe seasons in Paris—saw him but a few minutes, perhaps, but long enough to feel that his was an unusual personality. Then it was that I learned the important rôle this young man of thirty-five years had played in the new art movement—the artistic renaissance, it has been truly termed—in the land of the Muscovite, the borderland of Oriental and Occidental civilization.

A native of Novgorod, Russian of Russians, Slav of Slavs, child of a noble family, educated in the Moscow University, honored with the position of Counselor at Court, friend of the Empress, to all these advantages Mr. Diaghileff brought a nature of singular charm, a rare artistic sensibility, a Sherlock Holmes-like "flair" for talent in others, a genius for organization in unexpected conjunction with an artist's

temperament, and, above all, a personality so potent that once within the zone of its influence you must surrender to it—or be torpedoed!

"We owe everything to Diaghileff," said Mr. Bakst reminiscently. "We had ballets in Russia at our great theatres in Petrograd and Moscow before Diaghileff's day, but they were just ballets, good, bad, and indifferent. No such ballet as his existed until he saw the possibilities of choreographic art combined with the other arts. It was, in fact, a new correlation of arts that he conceived, and in the realization he awoke modern Russian art to a full consciousness of itself."

Two occasions this Summer gave me opportunities of studying Serge de Diaghileff at close range. The first was in Milan, where he came to discuss some modifications of the original contract for the season in America. The modifications seemed very simple, very reasonable from the practical American point of view. Probably an American ballet impresario and the representative of ordinary American theatrical enterprise would have settled the whole business in half an hour in the morning, and by noon both parties would be off to their destinations on the same train.

How long do you suppose it took to satisfy Mr. Diaghileff?

Exactly seven hours—not including an hour and a half at déjeuner!

I had nothing to do with the affair. I was present only by courtesy. But I count those seven hours of discussion (not omitting the déjeuner) as an episode in life well worth the time it consumed. The amusing feature about it all was that both sides of the argument were right and that everybody in the end got just exactly what he wanted; but, while on one side "business" was the keynote, on the other—need I say Mr. Diaghileff's?—"art" furnished the tonality.

What wonder, then, when he was told in the plain language of American "business" that he must do thus and so, have his troupe on hand at such an hour on such a date, and see that his scenery is at the theatre on such a moment on such a morning, he almost turned pale with amazement.

"Why!" he exclaimed, jumping up from his table—and this not once, but half a dozen times—in fine artistic fury, the one white lock in his thick dark hair dancing menacingly on his broad high forehead—"why, if I have to be bothered about all these details imposed upon me in a country I never saw and of which I know nothing, I'll tear up the contract! I won't go! I simply won't go! If you want my Ballet Russe, if you want it as I have given it in Paris and London, then you must make it possible for me to present it in the only way in which I would think for a moment of presenting it—as perfectly as possible. This is not a 'show' that I am going to take to America. It is an art exposition. But if you don't facilitate my coming, if you are going to hamper me in this absurd way, then in Europe I stay and America will have to get along without my Ballet Russe!"

That is one view of the man.

Two weeks later on my way from Paris to Milan I stopped at Lausanne to pass an hour between trains with Mr. Diaghileff. The cab driver knew his address, Villa Belle Rive. Down the hill we drove toward Ouchy. Presently we reached a sort of country lane. Entering it, we continued for a few hundred yards, when we found a charming but simple dwelling house, hidden away in what seemed a little park. It was Mr. Diaghileff's temporary domicile and workshop, loaned by a rich Swiss banker. He heard my voice and was soon on hand to greet me.

It was quite a different Diaghileff from the artist in fine fury whom I had seen in Milan. Here was Diaghileff the cordial Russian host.

"Spend an hour between trains!" he exclaimed in amazement. "Mon cher ami, you mustn't leave until tomorrow; in fact, you shan't leave. I want you to see what we have to show you. I'm sure you'll find it rather interesting."

Others who knew him had said he is irresistible. I found him so, and speedily changed my plans. So first of all he showed me all over his temporary house and the grounds around it—an ideal spot of several acres, abounding in dates and oleanders, pines and maples, lilacs and roses.

Following a little by-path through the miniature woodland, we emerged on a little garden surrounding a smaller villa. "Here," said he, "is where most of the members of my colony live," and then, leading me within, we visited half a dozen rooms, in each of which I found a young woman or man busy with pen, pencil, or brush. All were Russians, and few of them even spoke French, so that our conversation, even with Mr. Diaghileff as interpreter, was rather restricted. One of the women—a striking Slav type—I learned was the granddaughter of the Russian novelist Pushkin, Natalie Gontcharova, who is designing the scenery and costumes for a newly composed Ballet Russe; while a tall young painter I found to be another of Mr. Diaghileff's "discoveries," Michel Larionow, who also is at work on the decorations for another choreographic composition.

"And now to the school," said Mr. Diaghileff.

"School? What school?" I asked.

"The ballet school," he returned. "The entire troupe are here in Switzerland, and they are kept constantly at work. We have three lessons every day under the direction of Cecchetti, an Italian who has lived and taught in Russia for nearly forty years, and who taught Nijinski and Karsavina and Pavlowa and Mordkin and all the rest."

The school we found in a hall specially engaged by Mr. Diaghileff. The girls' class was just finishing as we arrived, but the merry-eyed, agile little old gentleman who was presiding put them through a few more turns to let Mr. Diaghileff see how they were doing. Then each young woman approached the director and modestly and gracefully extended her hand, which he took with a paternal air, at the same time speaking a brief word of criticism or commendation, which was received with a blush or a smile.

Then came a private lesson for a young man dancer whom Mr. Diaghileff recently "discovered" in Russia, and to whom he pins his faith—a young fellow of medium height, all grace and muscle, with the head and eyes of a poet rather than a

Serge de Diaghileff, from a painting by Bakst.

dancer—like Mr. Diaghileff, a Slav of Slavs, his father from the heart of old Russia and his mother from the Caucasus.

"That young man is a star already," was Mr. Diaghileff's comment to me as we rose to go. "I have entire faith in my judgment in such matters. I'm keeping him for America to 'find.' "

At déjeuner I had to undergo a rigid cross-examination. I should have been an American encyclopedia, edition of 1915, to have been able to answer all the questions my inquisitive host put to me. Heaven forgive me for all the honest misinformation that I gave him. However, I think I succeeded in convincing him that it would be worth his while to cross the Atlantic.

"Of course, the newspapers will want your picture," I remarked en passant.

"My picture in the newspapers!"—and he dropped his knife and fork. "My picture in the newspapers!"

"Certainly, if you interest them," I replied, "and perhaps they will want to interview you."

"Mon cher ami, that cannot be! It never happens. Let the papers print pictures of the ballet and the dancers! All well and good! But why drag me into it? It is never done, you know."

"Then you had better not come to America if you regard this inevitable experience with such horror," I told him laughingly. "If the Czar should visit us we'd do just the same thing with him. If he didn't like it—well, I think we'd make him like it and perhaps you won't find it so painful, after all."

Mr. Diaghileff looked thoughtful for a moment or two, then picked up his knife and fork and after half a dozen mouthfuls and a sip of choice old sherry, remarked, resignedly:

"Perhaps! Perhaps!"

With afternoon tea time arrived on a bicycle from Merges a young man about 30 years of age, keen of eye, prominent of feature, nervous in movement, quick in observation, rapid in speech. The newcomer was introduced to me as Igor Stravinsky, the composer of the music of "L'Oiseau de Feu" ("The Fire Bird"), "Petrouchka," and "Sacre du Printemps." Later came along Ernest Ansermet, the French-Swiss chef d'orchestre, whom Mr. Diaghileff is bringing to America as musical conductor. Two hours passed before we knew it, during which Mr. Stravinsky did most of the talking, which ranged all the way from the new ballets which are either in embryo or in development, Russian art in general and music and literature in particular. Stravinsky, I said, did most of the talking (and a brilliant talker he is, so that none objected) but every one else had his share, while the "Maitre," as they all called Mr. Diaghileff, with timely question or objection or counter-argument, played with the mentalities of his friends and co-laborers as an organist with the stops of his instrument.

The discussion was resumed at the dinner table, and was only terminated when Mr. Diaghileff insisted upon taking the party a thirty-mile motor ride to the interior of the country. There we found a lonely lake, surrounded by hills. Not a sign of life anywhere except far off in the distance on the shore a glow of a single window in a farmhouse. We sat on a big log

watching the dark water below for nearly half an hour, during which my host hardly opened his mouth.

"Time to return," he said at last, as the full August moon peeped from behind a cloud. We remounted the motor car, and this time headed for Lake Leman. It was midnight when we parted at my hotel and I wished him "au revoir" in New York.

An uncommon afternoon and evening, I assure you. Certainly some reader will envy me my experience, and would have been willing—as I was—to catch just such a cold in the head, as I did, sitting on that old log and gazing silently on that dark, deep, lonely lake, side by side with the Slavic Sorcerer whose name is Serge de Diaghileff.

* * *

January 18, 1916

DE DIAGHILEFF'S BALLET IMPRESSIVE

Russian Dancers' Performance at Century the Most Elaborate Ever Seen Here

ITS PRODUCT IS ARTISTIC

Effects Obtained by Bewildering Color Combinations in Costuming and by Music—The Artists

The Serge de Diaghileff Ballet Russe gave its first performance in America last night at the Century Theatre. For months the newspapers and magazines have been printing the bright-hued colors of its costume plates, or black and white reproductions of its artists and scenes. For months they have been devoting their reading columns to exposition, illustration and argument concerning various phases of its being, until finally there seemed nothing left for pictures or printed words in their task of explaining the fame the organization had won. Now it is here itself to tell its own story, the first chapter of which was set forth last night.

The bill consisted of "L'Oiseau de Feu," by Fokine, with music by Igor Stravinsky; "La Princesse Enchantee," music by Tschaikowsky; "Soleil de Nuit," by Massine, music by Rimsky-Korsakow, and "Scheherazade," by Bakst and Fokine, music by Rimsky-Korsakow.

What was shown on the stage of the Century Theatre last night constitutes the most elaborate and impressive offering that has yet been made in this country in the name of the ballet as an art form. The ballet has not fared well in America. A little less than a century ago, when the Bowery Theatre, the centre of fashionable theatregoing, was opened, our forefathers are said to have seen the ballet skirt for the first time, with the result that when the dancer appeared on the stage the ladies in boxes arose and left the theatre. Thus the ballet skirt was officially snubbed at the beginning of its American career.

It is different now. Anyway, the Diaghileff Russian Ballet is a thing different from what has gone before and apparently the public nowadays is not indifferent to it. There was an

audience last night which filled every available seat. It watched and listened eagerly, discussed volubly, and seemed much impressed.

Makes Good Its Title

Let it be said at once that the Diaghileff Ballet made good its title to being an organization with an impressive individuality. Even the hitherto skeptical in the audience must feel that in what it does there is always a sensitive and broadminded artistic intelligence at work. Its effects are obtained now by the dancing, now by the imaginative effects in the scenery and stage business, now by flashing or bewildering color combinations in the costuming, now by the music. The interrelation of all these is active, and its product is an artistic whole, quite different from anything our public has previously known.

To this extent the first appearance was eminently successful, and according as to whether this has the power to interest and satisfy the public, the ballet will be a success here. It seems quite likely that it will.

On the other hand, this a ballet whose dancers do not measure up individually to the success that has been made in other departments. It is a familiar story that Nijinsky and Karsavina, who were the principal dancers of the company in Europe, are not here with it. What their absence means to the company is not matter for speculation to us in America, who must take it as we find it.

The Principal Dancers

In last night's program Xenia Maclezowa, Lubow Tchernichewa, Flore Ravalles, Adolf Bohm, and Leonide Massine appeared as the principal dancers. Mlle. Maclezowa had the greatest burden to bear, for she had the leading female parts in "L'Oiseau de Feu" and "La Princesse Enchantee." She is not an impressive dancer, for though she possesses certain technical skill, she lacks finish and surety in it, and the spark of vivid personality needed to supply the final touch to a dancer's art. Neither does Mr. Massine impress himself particularly in his work.

Adolf Bohm worked under the disadvantage of illness, which perhaps militated against his appearing in his best form. Among the five principal dancers only Lubow Tchernichewa seemed to measure up to what we have been led to expect, although her rôle was not of the importance to make this observation in the abstract wholly just to the others. It nevertheless remains the fact that the dancing done by the principals has been surpassed by others, and not only by the one other who would be thought of among the women, but by several.

As a matter of fact, however, this does not have the importance it might seem to among those who have not seen the performances. There is so much to occupy the attention and stimulate the imagination that an audience of the right sort will not feel a lack of great personalities among the dancers.

So far nothing has been said about the music. The orchestra was organized several months ago by Nahan Franko, and

rehearsed under him for some time before the ballet's conductor, Ernest Ansermet, arrived to take charge of it. The result of this care, apparently characteristic of the company's methods, is that such difficult music as Stravinsky has written for his "L'Oiseau de Feu," was presented practically without a blemish. Mr. Ansermet is a skillful conductor and obtains distinctive results.

This "L'Oiseau de Feu" of Stravinsky's was perhaps the most important number on the program, viewed from all aspects, especially since the music of Rimsky-Korsakoff's symphonic suite "Scheherezade," the other long piece, has been so often heard in the concert rooms and in two different ballet productions.

"L'Oiseau de Feu" is the first piece of Stravinsky's which was done by the Diaghileff Ballet, which gave it in June, 1910, and its success led him to link his musical fortunes with this organization. The work is in the "advanced" style which the composer's later works have carried a step further, and it is one of those compositions identified with the organization which have made its name a factor to be reckoned with when musical history is written.

What must undoubtedly have struck those in the audience last night who have heard Stravinsky's "advanced" work in the concert room, or have heard some of the other new Diaghileff ballet music performed in concert form, is the fact that its presentation with the accompanying explanatory action on the stage is a revelation. What was so puzzling before and so bewildering as to cause almost the impression of absurdity, becomes plain immediately.

Instead of a "wild futurist," Stravinsky becomes a very talented young man with decided gift for vivid orchestral coloring and much skill in writing descriptive music. There are still things which the conservative will not accept, but they are toned down, either because their purpose is understandable, or because, with the action going on, one only half hears the music. Musical psychologists should get much entertainment out of deciding which.

Effective Stage Settings

The stage settings of Bakst, Golovine, and Larionow that were shown last night need not be enlarged upon, for their effectiveness is an old story. Suffice it to say that when seen on the stage they perform their function of arresting the attention, or being delicately suggestive of the atmosphere of the particular ballet, or startling you, and always succeed in appealing to the fancy or the imagination. The gorgeous crimson landscape from no existing land that Bakst has devised for an ordinary pas de deux, "La Princess Enchantee," lifts it out of the ordinary immediately and almost suggests that the title means something which it does not.

Another point that must be noticed is the general direction of choreography. We have been accustomed in a ballet to seeing the principals dance, while the coryphees stood about in lifeless groups and watched. Last night there was a constant meaning to the subordinate groups, which always had something worked out for them which was significant, even if it

was only, as one group did in "L'Oiseau de Feu," to sit huddled on the steps outside the gate and sway in rhythmical motion. On paper that does not sound impressive, but as a matter of fact in practice it lent a subtle touch in characterizing the weird doings of The Immortal and his bizarre retinue.

There were some minor defects in the staging. Such a thing as letting the young hero climb over a "stone" wall which sagged and wobbled painfully, or throwing open the mysterious gates to the Immortal One's palace and letting it be seen they were very obviously held together by thin laths and faith, were among such defects. Also the miming was sometimes very obvious and "theatrical," when from such an organization one would expect a departure from the time-worn into more subtle dramatic means.

Yet, casting whatever can be said against it into one side of the balance, the other will rise swiftly, for the Diaghileff ballet is the most impressive new stage enterprise with an artistic meaning that has been seen here for a long time.

* * *

January 19, 1916

RUSSIAN BALLET IN A PASTORAL WORK

"L'Apres-Midi d'un Faune," a Vaguely Fascinating Episode, Given at the Century

CHARMING STAGE PICTURE

"Prince Igor" Dances Splendidly Express Barbaric Effect— Performances of Principals Spirited

The Diaghileff Russian Ballet gave its second performance in this country at the Century Theatre last night. The new works offered were "L'après-midi d'un faune," a "choreographic picture" based on the Prelude of that name the composer Debussy wrote, and the Polovtsian dances which form an important part of Act II of Borodine's opera "Prince Igor." There were repetitions of "L'Oiseau de Feu" and "Scheherazade" of the opening night's bill.

"L'après-midi d'un faune" is a vaguely-fascinating pastoral episode with an ending which would not have been thought of except in the spirit of those who will not be satisfied unless they are improving upon accepted notions. The accepted notion of a pastoral is that it shall be, above all things, expressive of simplicity and innocence. Nijinsky, who devised this episode, introduced the complexity of passion and found, or seemed to find, that Debussy's music painted lust.

If you accept the basis, "L'après-midi d'un faune" is a pretty enough ballet. Bakst has designed a charming stage picture in which the faun and seven nymphs disport themselves. Disport is perhaps rather the conventional than the apposite phrase in this case, for the figures move deliberately and always in the poses of an antique Greek vase. The face turned profile and the peculiar angle of arms and legs were very characteristic and effective.

The dances from "Prince Igor" were splendidly suggestive as to the scenery and costuming of Roehrich, which caught and expressed a fine barbaric effect. As was the case with the production of the same ballet for the first time a few weeks ago at the Metropolitan Opera House there were ascending columns of smoke from some of the tents. These, remaining fixed and immovable throughout the action, as no real smoke ever did, suggested the query as to whether a scenic setting is devised especially to be aimed at a momentary picture when the curtain first goes up.

The dances of Mlles. Tchernikowa and Pflanz and of M. Bolm, as well as those of the various groups into which the subordinate members of the ballet were divided, were spirited and pictorial. It was not overpowering, however, perhaps because advance laudation had built up an imaginary picture impossible to be lived up to. In fact, the recent production at the Metropolitan, though inferior as to setting and costuming, had more real thrill in its savagery than this one, especially to the extent it was provided there by individual dancers and their contrast with the group work.

The repetitions of "L'Oiseau de Feu" and "Scheherezade" had all the effect they made known on the opening night. The dramatic splendor of the latter did not perhaps receive its full share of attention in this place yesterday. In some ways it is the best thing the organization does, and the manner in which Bakst and Fokine have adapted the action to the music is worthy of special notice. The orchestra repeated its fine work last night.

* * *

January 23, 1916

MUSIC OF THE RUSSIAN BALLET

Violence Done to Certain Masterpieces Never Intended to be Danced To

The needs of the new art of the Russian Ballet, which has been so zealously exploited in Paris, London, and now in New York, seem to take it far beyond the music that has hitherto been specially provided for the purposes it pursues. The eagerness of its promoters in laying hold of everything and anything that they think can be applied and exploited is something that will arouse questioning and even resentment in the souls of some music lovers. The Russian Ballet did not begin all this. It is now some seven or eight years since Miss Isadora Duncan undertook to "interpret" music written for purely musical purposes by her methods of "dancing" it. She had pieces of Chopin, written for the piano, transcribed for orchestra; and then, coming out upon the stage, undertook to illumine and add to its significance by an art of her own entirely foreign to anything poor Chopin had ever thought or dreamed of for it or imagined as necessary for its interpretation. Still more venturesome was Miss Duncan's undertaking to "interpret" Beethoven's Seventh Symphony by turning it into music for

her dancing, miming, and posturing. Wagner did, to be sure, write an essay declaring the Seventh Symphony to be the "apotheosis of the dance"; but he did it on his own responsibility, and it was with him a purely figurative and subjective discussion. He nowhere showed that he ever dreamed of any solitary lady in tights and cheesecloth draperies taking him up so literally and expounding his vision of Beethoven's meaning by her bodily contortions.

Now comes the Russian Ballet and undertakes with much richer and more attractive resources to do what Miss Duncan did. It does not undertake to persuade us, as she did, that by laying violent hands—and feet—on certain masterpieces it is contributing a needed "interpretation" hitherto lacking. It does not seek to conceal the fact that it is appropriating its own wherever it can find it; that its own proper material is insufficient and that it is piecing out the existing store of ballet music by turning to the purposes of the dance, or pantomime, music that composers never meant to be dance music.

The Russian Ballet is most fortunate in its possession of certain pieces of ballet music. Igor Stravinsky's "Oiseau de Feu" and "Petrouchka," which are in its New York repertory; his "Sacre de Printemps," Maurice Ravel's "Daphnis et Chloe," certain original ballets by Rimsky-Korsakoff and Tschaikowsky, other compositions by Russians, especially, not all to be done in New York, are invaluable and in different degrees fascinating contributions to this new adaptation of the art of ballet as the Russians practice it. But they are not enough; or in the opinion of the managers of the company, they do not offer enough variety. Consequently the list must be enlarged by laying violent hands on other music and forcing it into subservience to their purposes.

The most notable sufferers so far have been Schumann, in his "Carnaval." Debussy in his "L'Après-Midi d'un Faune," and Rimsky-Korsakoff in his "Scheherazade." As Debussy is still living and must have by the copyright laws some control over his music and what shall be done with it and to it, he has presumably allowed the use that is made of his delicately and subtly conceived orchestral piece. Schumann, like Walther von der Vogelweide, "a good master—but long since dead"—has no control over his "Carnaval." He wrote it for the pianoforte. It is as much of a pianoforte piece, as little of an orchestral piece, as can well be imagined. It is a very epitome of Schumann's pianoforte style. Messrs. Rimsky-Korsakoff, Glazunoff, Liadow, and Tcherepnine are set down as the transcribers for orchestra.

They should all have been in better business. The first named, at least, was one of the greatest of modern masters of the orchestra, but the transcription is not an effective orchestral piece; it misrepresents Schumann's thought and is only a makeshift for the purpose to which it has been turned. We need not dwell on the further and greater misrepresentation of Schumann that is embodied in putting the poetical and romantic pigment of his imagination upon the stage at all. The characters include Pierrot, Harlequin, Columbine, Pantalon, types of carnival figures, to whom he added Florestan and Eusebius, representing the two sides, passionate and dreamy, of his own

artistic nature; "Chiarina," the Italianized form of the name of Clara Wieck, who became his wife; Estrella, representing Ernestine von Fricken, an earlier flame; Chopin, Paganini. The great majority of the successive musical numbers are most ingeniously formed on three or four notes, "musical letters," that contain mystical allusions to that earlier flame and to himself. To attempt to fix Schumann's abstraction of himself and still more his two lady-loves, even under the disguises he has given them, and the other characters he imagined in this succession of pieces does violence to his imagination. It is an injury to those who know and love the music, who are familiar with Schumann's poetical fantasy, who have communed with him through the "Davidsbündler."

So, too, they who have glimpsed with Debussy the delicious figure of his faun and his bewildered reveries, through music that so subtly conjures up the mood of Wallarmé's afternoon, will not thank the Russians for the opportunity that occurred neither to Wallarmé nor to Debussy of seeing a nymph drop her nether garment. Nor is the suggestion of lust at home in the charm of Debussy's music.

Rimsky-Korsakoff apparently had nothing to do with the utilization of his symphonic tone poem, "Scheherazade," as a ballet. He died eight years ago before the vogue of the present company was established, outside of Russia at least. His widow is said to have protested strongly, but vainly, against the use that has been made of her husband's work. It is difficult to conceive of a composer approving of the violence that has been done to a composition so singularly successful in its own way. If Rimsky-Korsakoff took any pride or interest in the programmatic delineation he achieved in "Scheherazade" he can hardly have been pleased at its use to tell a story of something entirely different, in which the suggestion that he put into the music is wholly lost. His symphonic poem describes: I.—The sea and Sindbad's ship; II.—The story of the Kalandar Princes; III.—The young Prince and the young Princess; IV.—The Festival at Bagdad, the sea, the shipwreck. There is a characteristic recurring theme representing Scheherazade, who relates these four wonderful stories. The sea is depicted, and they who are deeply moved by musical depiction find it one of the most suggestive representations of the vast swell of the ocean in all music. The resemblance of two themes in the third represents the likeness of the Prince and Princess. The sea and Scheherazade again appear in the last picture.

But what becomes of all this carefully wrought musical picturing in the ballet? The music is there; its substance, its character, its quality are not changed. But lo, everything else is changed! Its "meaning" has been completely overturned without a word. We are now invited to see in it, or at least through it, the depiction of King Shahriar's discovery of the faithlessness of his favorite, surprising her and the other women of his harem in the arms of their lovers—all cut down except the princess, who snatches the executioner's sword and slays herself.

There are also the pianoforte pieces of Chopin that have been transformed into orchestral ballet music, not for the first time, by this organization. The music is originally idealized

dance music, and perhaps some sort of a case can be made out for using it as actual dance music, though at an inevitable loss in committing Chopin's pianistic style to the orchestra.

Doubtless many will listen with sympathy if they are told that the Russian Ballet thus utilizes masterpieces for strange purposes because it has not enough material of its own. But at the same time many will fervently hope for the production of more masterpieces of Stravinsky's own kind, or of a different kind, intended specifically for the Russian Ballet. There is an abundant opening here.

RICHARD ALDRICH

* * *

January 25, 1916

POLICE ARE TO EDIT THE RUSSIAN BALLET

After Complaints a Letter Summons Manager to Magistrate McAdoo's Office

The Russian ballet by the Serge de Diaghileff dancers under the auspices of the Metropolitan Opera Company at the Century has run afoul of the Police Department. John Brown, General Manager of the Metropolitan, yesterday received a letter from Third Deputy Commissioner Lawrence Dunham, asking him to meet representatives of the department at the office of Chief Magistrate McAdoo this morning to confer with the Magistrate and representatives of the department about making certain changes in some of the ballets.

The action of Deputy Commissioner Dunham followed a visit of department representatives to the Century for the matinée performance Saturday. These witnesses were sent to watch the dancing after many letters of complaint had been received at headquarters.

The program at the matinée included two of the ballets calculated to arouse the most discussion—"Scheherezade" and "L'apres-midi d'un faune." The former pictures in pantomime an episode in a harem, when the Sultan, returning, finds the women of the harem have been holding revel with the slaves. Their punishment is death at the hands of the Sultan's guard. The latter is a pastoral study, in which a faun frightens away seven Greek maidens who are disporting themselves near his cave, and carries away a garment one of the maidens had removed.

The letter sent to Mr. Brown follows:

Serious complaints have been received by this department as to certain alleged objectionable features of the Russian ballets being performed at the Century. In order to get at the facts the Saturday matinee was attended by witnesses in whose judgment the department has confidence, and their statements are on hand.

In order to avoid recourse to the law and assuming that after the objections have been pointed out to you you will correct the same, and after consulting Chief

City Magistrate McAdoo, I am writing this requesting your presence at Judge McAdoo's office 300 Mulberry Street, at 11 o'clock tomorrow (Tuesday) morning, where you will be joined by representatives of this department. It is important that you be present at the time and place mentioned.

It was reported yesterday that the Catholic Theatre Movement, a society formed several years ago to censor theatrical entertainments by issuing a white list of approved ones to its members, had circulated a private bulletin against the Russian ballet.

* * *

January 25, 1916

'PETROUCHKA' GIVEN BY RUSSIAN BALLET

Igor Stravinsky's Extraordinary Work Is Found Amusing and Exhilarating

A SPLENDID PERFORMANCE

Miss Lopokowa and Messrs. Massine and Bolm in the Chief Characters

A change was made in the program of the Russian ballet at the Century Theatre last night, and instead of two new ballets but one was given. This was Igor Stravinsky's "Petrouchka." It was preceded by "Les Sylphides," to Chopin's music, and followed by "Carnaval," to Schumann's. "Petrouchka," which was given for the first time here, is called "burlesque scenes in four tableaux," and is altogether one of the most extraordinary products of the contemporary Russian school, both in its pictorial effects—the phantasmagoria of color, of Russian carnival characters, costumes, and boisterous action—and in its music, equally a phantasmagoria of incomparable verve and brilliancy, fitting and illustrating in every detail for the ear what is presented to the eye. Both are of an indescribable fascination.

The Russian carnival scene is the setting for a drama of love, intrigue, jealousy, and murder, enacted by three puppets inhabiting a booth that is part of the carnival outfit; one is a pink-cheeked waxen doll, a ballerina; one a blackamoor; one the simple Petrouchka. The carnival scene is suddenly blotted out in darkness, and the puppets appear in their grotesque mummery, going through what has been called a travesty of human passion, charged with irony, expressed in terms of puppet gestures. The carnival scene then reappears; the outcome of the tragedy seems at first to call for the intervention of the police, but the police retire in indifference when it is discovered that death has been dealt only to a puppet.

The details of the music by which all this is expressed and illustrated are of infinite ingenuity and skill, and are richly amusing. The grotesque note is never lost, but the manner of its expression is ever changing. The music is charged to overflowing with illustrative and picturesque details. Stravinsky

has learned some of them, doubtless, from Strauss; perhaps he has drawn largely from "Till Eutenspiegel" and other sources of supply, but he has contributed much of his own. His resources in laying on of orchestral color and descriptive effect are extravagantly employed. He has not scorned the use of melody, but melody is a secondary matter with him—it is well enough for his representation of the two hand-organs that come upon the scene, and there is perhaps ironical significance in its dismissal when they disappear.

The performance of this extraordinary score will test any orchestra in the severest way; the test was remarkably well met last evening, so far as the general effect gave evidence. It needs a close observer to be certain of all the details. A solo pianoforte that is used as one of the orchestral instruments demands little less than a virtuoso to play some of the passages given it. The carnival scene upon the stage was brilliantly and amusingly represented; the costumes were in part rich, in part drawn from all the ragbags of Russia. The scenery is in the style now familiar as that of contemporary Russia—some of it gorgeous.

The three chief characters in the tragedy were admirably and most characteristically represented. The ballerina was Miss Lydia Lopokova; Petrouchka, Mr. Leonide Massine; the blackamoor, Mr. Adolf Bolm.

The piece, with all its exaggerated grotesquerie and burlesque features in the music—music that would be wholly unintelligible, useless, and tedious apart from each single detail of the accompanying action—evidently made a deep impression upon the public—an impression of amusement and exhilaration. "Petrouchka" seemed, indeed, a work of art singularly successfully in achieving the precise purpose that its authors had in view.

* * *

January 26, 1916

RUSSIAN BALLET MODIFIED

*"America is Saved," Mr. de Diaghileff Says
After the Change is Made*

A somewhat denatured version of the ballet "L'apres-midi d'un faune" was given by the Serge de Diaghileff Ballet Russe at the Century last night, as a result of the action of the Police Department, taken after letters complaining of the moral tone of two of the ballets had been received, and after the Catholic Theatre Movement had issued a bulletin condemning them.

In the two performances of the ballet given last week, the faun, after he had frightened away the Grecian maidens who came to bathe near his cave, picked up a filmy garment one had cast off, and, placing it upon the rock whereon he had been reclining, lay down upon it. Last night the faun placed the drapery gently on the rock and sat gazing at its silken folds. Then the curtain fell.

When the audience had ceased applauding, after the ushers had carried out huge armfuls of flowers sent to Leonide Massine with requests that they be delivered after his appearance as the faun, Mr. de Diaghileff came smiling from his seat in the orchestra circle down the aisle to where Mr. Gatti-Casazza, John Brown, and other heads of the Metropolitan were standing, and said in French, "America is saved!"

Mr. de Diaghileff had modified the ballet under protest. At the conference between representatives of the Police Department and heads of the Metropolitan Opera Company, under whose auspices the ballet season is being given, held yesterday morning before Chief Magistrate McAdoo, he pointed out that "L'apres-midi d'un faune" and "Scheherazade," the other censored ballet, had been performed numerous times in all of the principal cities of Europe and no objections had ever been made against them. He said the Emperor of Germany, Queen Alexandra of England, and the Belgian Queen had witnessed performances of the former. Two command performances had been given for Queen Alexandra, he said.

"The reception the American public has given the dancers," Mr. de Diaghileff said in French last night, "indicates that their taste is no different from that of European nations, and at the same time makes ridiculous the attitude of the police."

"Scheherazade" will be danced tonight. Mr. de Diaghileff said he did not see how he could change it much since an affair in a harem could not well be made into a pink tea.

* * *

April 4, 1916

RUSSIAN DANCERS GIVE NEW BALLET

*Diaghileff Troupe Returns in "Le Spectre de la Rose," a
Charming Fantasy*

BASED ON GAUTIER POEM

*Miss Lopokova and Alex Gavriloff Appear in Romantic Work at
Metropolitan Opera House*

The Russian Ballet comes to take the place of the Metropolitan Opera Company at the Metropolitan Opera House and to finish out the season with performances of ballet to last for four weeks longer. The first performance was given last evening. The audience was a good one in point of numbers and followed the performance with interest and sympathy, if not with evidences of an overwhelming enthusiasm.

New York became familiar with the Russian Ballet in the two weeks when it appeared last January at the Century Theatre. The company is the same. There was talk of the distinguished Najinsky, who was detained by the fortunes of war and did not come to this country with the others, rejoining it for the season at the Metropolitan; but he has not done so yet. Mme. Karsovina is another distinguished principal who was missed at the performances in January, but of her coming there was no possibility.

Several new pieces will be presented during the month to increase the repertory that was made known here in the previous engagement. The first of these was given last evening, "Le Spectre de la Rose," a romantic tableau based on a poem by Theophile Gautier. There are still not enough ballets originally composed as ballets to suit the purposes of this company, and it is necessary to collect for it music written with other ends in view. "Le Spectre de la Rose" is danced to the music of Weber's "Invitation to the Dance." Weber's music is sufficiently "dansante" to make its use in a ballet performance not inappropriate, though he did not mean it to be danced. But though he himself provided no "program" for it, the music suggests a different sort of scene from that embodied in Gautier's verse as it was mimed last evening—a scene whose romance belongs in the more conventional surroundings of the ballroom.

"Le Spectre de la Rose" represents the dream of a young girl who falls asleep after her return from a ball with a rose in her hand. As she dreams the rose comes to life, a symbol of her romance, and dances with her. She wakes and finds only a few rose petals at her feet, where her dream lover had been kneeling. Miss Lopokova and Mr. Alexander Gavriloff took part in this very brief but charming fantasy. Weber's music was played in the orchestration of Hector Berlioz.

The other ballets in the evening's performance were "Les Sylphides," the music for which is an arrangement for orchestra of several pieces of Chopin, Igor Stravinsky's "Petrouchka," for which the music was originally composed, and the Polovtsian dances from Borodin's "Prince Igor." Stravinsky's grotesque pantomime and Borodin's barbaric dances were the most notable performances of the evening.

"Petrouchka" is one of the most characteristic productions of the young Russian composer, and its extraordinary features, musical as well as pantomimic, may well have left many of the audience, unaccustomed to these latest developments of musical art, with a feeling of bewilderment. The difficulties that the orchestral score present were admirably mastered. Those of Berlioz's arrangement of the "Invitation to the Dance" are very considerably less, but there might have been more precision and brilliancy in the playing.

* * *

April 8, 1916

NIJINSKI AT ODDS WITH BALLET RUSSE

Famous Dancer Says That His Financial and Artistic Terms Have Not Been Met

WOULD REHEARSE DANCERS

His Objection to Diaghileff's Way of Performing His Ballet "Faun" Leads to Its Withdrawal

Warslav Nijinski, the world's most famous male dancer, who landed here a few days ago, and whose appearance with the Diaghileff Ballet Russe at the Metropolitan Opera House was accepted as a foregone conclusion, may not, after all, be seen with that organization. Mr. Nijinski admitted this fact last night to reporters who had been led by the events of the day at the Opera House and the mystery the ballet officials threw over them to suspect that trouble was brewing again within the ranks of the organization.

The first result of the differences between the dancer and the ballet became public property when posters were put up last night for this afternoon's performance, omitting "The Afternoon of a Faun," to the presentation of which Nijinski had strongly objected. The dancer did not know it had been withdrawn when the reporters saw him last night.

Mr. Nijinski was found with Mme. Nijinski in the restaurant of the Claridge, where he lives, and told the inquirers that he had no contract with the ballet and had found no one who would assume the responsibility of meeting the financial and artistic terms which he proposed for his engagement.

The dancer talked in French and Russian, and his wife, who is constantly with him and keeps in close touch with his affairs, occasionally added remarks in English. The gist of what they said was this:

"I was released from detention in Austria through the intervention of Ambassador Penfield at the instance of Otto H. Kahn. At that time I had no contract with the Diaghileff Ballet, and I was surprised when I arrived here to learn from friends that I had been advertised to appear with it over the United States.

"When I arrived here I naturally expected that I was to dance with the ballet since I had been a member of the organization and had been connected with its activities. When I spoke to Mr. Kahn he referred me to Mr. Diaghileff on arranging the details of my appearance. I found Mr. Diaghileff unwilling to take a definite agreement, and I was referred to John Brown.

"The only progress our negotiations made was to a point entirely inadequate for an artist of my standing. The ballet was unwilling to make what I considered satisfactory financial terms, and was equally unwilling to make artistic concessions, which I insisted upon just as strongly as the financial side.

"These artistic demands concerned details of stage production which concerned my work as a principal dancer.

"One of the principal of these was that the ballet, 'The Afternoon of a Faun,' should not be given as the organization is now presenting it. That ballet is entirely my own creation, and it is not being done as I arranged it. I have nothing to say against the work of Mr. Massine, but the choreographic details of the various rôles are not being performed as I devised them. I therefore insisted strongly to the organization that it was not fair to me to use my name as its author, and continue to perform the work in a way that did not meet my ideas.

"I also wanted to rehearse the company in others of the ballets in which I appeared to bring them to the shape in which they were originally created by Fokine, with whom I was in the closest association when he was working them out. The only person now connected with the organization who

knows these things and how they can be put into effect is Adolf Bolm, the choreographic director.

"These things are what I mean when I speak of the artistic conditions I have made. But I cannot see any agreement to meet them, any more than I can see a willingness to meet my financial terms. What they have offered is less than is proper for an artist of my standing.

"I am only too ready to appear as soon as it can be arranged. I have kept myself in practice, even doing daily exercises on the ship coming over, because I assumed there would be no difficulty about my appearing. During my negotiations they have told me that if I did not dance it would damage me with the American public, who would think I had no wish to dance.

"That is not true. I am an artist and only too anxious to get before the public, especially because I have not danced in so long a time. I have not appeared with the Diaghileff Ballet in four years. Mr. Diaghileff and I had a break at that time over some financial matters which have never been satisfied as far as my side goes.

"If matters are arranged on a basis compatible with my professional standing, the American public will see me dance and will see me doing my best."

It had been whispered about the Opera House during the afternoon that Nijinsiki had issued a flat ultimatum to Mr. Diaghileff to the effect that if "The Afternoon of a Faun" were done at today's matinée he would not dance with the company. The eleventh hour withdrawal last night was regarded as a concession to the dancer.

The difficulties with the star are reflected in the fact that the ballet has not published its répertoire for the coming week except the bill for the Monday night performance, which does not include ballets in which Nijinski is necessary. It is always customary for organizations of this type to publish the répertoire for one week not later than the middle of the previous one, so that the public will have ample opportunity to learn when the works it is interested in will be performed.

The bill for last night's performance at the Metropolitan Opera House included no ballets which have not been given already this week. The list comprised "L'Olseau de Feu," "Carneval" and "Scheherazade."

* * *

April 13, 1916

NIJINSKI PUTS LIFE IN BALLET RUSSE

He Shows Grace and Finish at His Debut in "
Le Spectre de la Rose"

LETTER DISTURBS DANCER

Mlle. Revalles Hysterical Over a Missive Containing Powder,
Which Rose Into Her Face

Warslav Nijinski made his first appearance in this country yesterday afternoon at the matinée performance of the Diaghileff Ballet Russe at the Metropolitan Opera House. He danced in "Le Spectre de la Rose," a pas de deux in which the other rôle brings forward Mlle. Lopokova, and in "Petrouchka," Stravinsky's ballet, which enlists the services of most of the company, with Mlle. Lopokova and Messrs. Bolm and Cechetti in the other principal characters. The remainder of the bill comprised the Polovtsian dances from "Prince Igor," and the ballet, "Scheherazade."

Mr. Nijinski's debut was a success, though he scarcely provided the sensational features that this public had been led to expect of him. This was to some extent due to the rôles in which he appeared, which are limited in their possibilities in one sense because they are "character rôles." The guise in which he presented himself yesterday was rather that of a highly accomplished dancer whose work put new life into those appearing with him, than as one especially remarkable in himself. The public will probably have to wait for his appearance in ballets of the purely classic style to get more knowledge of the technical wonders that have been so liberally promised and that were indeed foreshadowed yesterday.

To a certain extent his rôle in "Le Spectre de la Rose" is in the classical style, but story and atmospheric demands restrict the dancer in several directions. There is no denying that new meaning was read into the little ballet by the version of yesterday, and that the grace and the finish of Nijinski's dancing and his intelligence as a stage director were largely responsible for this.

There was a discordant note in a super-refinement of gesture and posture that amounted to effeminacy. The costume of the dancer, fashioned about the shoulders exactly like a woman's decollete, with shoulder-and-arm straps even, helped to emphasize this, as did certain technical details of the dancing, such as dancing on the toes, which is not ordinarily indulged in by male dancers. The obvious reflection in justification of Mr. Nijinski's characterization is that the ghost of a rose is not exactly a masculine commodity. Precisely! Then why devise a ballet in which a man dances that character? As well put a lyric soprano to singing Rhadames in "Aida"!

As Petrouchka, the dancer gave a splendid performance of this fantastic rôle. Both in the purely external characteristics of the puppet-lover and in suggesting an actual pathos in his imaginary life-drama, he made his effects with mastery. The tales of his re-rehearsing the ballets in which he appears were borne out in the performance of this work, as well as in the case of "Le Spectre de la Rose." By little touches of stage management the story was made easier to follow. Among those that come to mind quickly were those concerned in the first dance of the three puppets, where the showman's manipulation of them was more clearly suggested, and in the entrance of the bear. The prominence the music gives the latter incident was formerly somewhat obscured by the crowding of the stage. Yesterday the bear was visible to the audience as soon as he appeared, and the sudden ponderous voice of the orchestra music was thus immediately explained. These are only two points of many.

The matinee was disturbed yesterday by a change in the order of the ballets. This was announced from the stage by an explanation that Mme. Revalles had received a letter on entering the theatre which had so disturbed her that she would not be able to go on immediately in "Scheherazade," which was scheduled first. The "Prince Igor" dances were put in its place.

It was later explained behind the stage that Mme. Revalles's letter had contained some powder which rose up into her face when she opened the letter. The dancer became hysterical, it was said, thinking someone was trying to poison or blind her. Later she calmed down and took her place on the stage.

The letter, whose text was ill-written and incoherent for the most part, was mailed Tuesday morning from Seabright, N. J., according to the cancellation, and its envelope was stamped with the name of the Peninsula House. It was signed "A. A. de von Zeil," and its writer asserted, among other things, that he was a Russian Prince born in this country and a cousin to the Kaiser. The ballet authorities said they would hand the letter over to the police.

In the evening bill, "Thamar," a drama arranged by Leon Bakst, with music by Balakireff, was given for the first time here. Flore Revalles was the Princess of the Caucasus who lures lovers to their destruction, and Adolf Bolm had the part of her victim. The ballet is a short but very effective one, in which there is some fine dancing by Mr. Bolm and the corps de ballet, dancing of a wild and savage sort that had a thrill to it. Mlle. Revalles was excellent. The orchestra was not at its best. The stage setting and costuming for "Thamar" has not been bettered for its pictorial effect and striking colors by anything of Bakst's that has yet been shown by the company.

* * *

October 17, 1916

BALLET RUSSE GIVES 'SADKO' ITS PREMIERE

Dance "At the Bottom of the Sea" in a Fantastic Work by Adolf Bohm

COLOR AND MUSIC CHARM

Performance at Manhattan Includes "Les Sylphides" and "Le Spectre"—Pierre Monteux Conducts

The Diaghileff Ballet Russe opened its engagement at the Manhattan Opera House last night, and once again the features of that organization's work which were made known last season were put before the public for its enjoyment. In honor of the occasion the Opera House had been attractively redecorated, and with green carpets stretched from the doorways to the curb, long lines of carriages in front, and Oscar Hammerstein himself gracing the corner of a box, the place seemed once again to assume the air of the times when it was writing daily chapters of American operatic history.

The occasion had all those pleasant earmarks of a "smart" opening night. The Diaghileff organization is now an old story here, and the performance last night revealed nothing new in general principles. There were some new details, such as a premiere of a ballet and the début of a conductor, but the principal thing remained that the public was reminded of the combination of dancing, color, and music under the head of a stage performance which constitutes the uniqueness and the appeal of the organization.

The company is practically the same as that seen here in last season's engagement of the ballet. Nijinsky, having injured his ankle last week, did not appear, and nothing was said to indicate when he would appear.

Mmes. Lopokova, Pflanz, Revalles, Sokolova, and Wasilewska are still the principal female dancers, and among the men the leaders are Messrs. Bolm, Gavrilow, Kremneff, Pianowski, and Sverew.

There is a new conductor, Pierre Monteux, an important French orchestral leader, and he is an element of strength in the conductor's stand.

The program last night comprised "Les Sylphides," to music from Chopin, "Sadko," to music by Rimsky-Korsakoff; "Le Spectre de la Rose," which is performed to Weber's "Invitation to the Dance," and "Scheherazade," to Rimsky-Korsakoff's suite of that title. As an entr'acte a Prelude and March from Rimsky-Korsakoff's "Le Coq d'Or" were played for the first time in this country.

Much of the interest of the evening centred in the première of "Sadko," a fantastic ballet by Adolf Bohm, in which that dancer had the title rôle. The scene is laid on the bottom of the sea and embodies a Russian fairy tale which tells the story of how Sadko, a poor wandering singer from earthly regions, wins the daughter of the Czar of the Seas and holds the Czar and his submarine Court under thrall by the power of his music.

It is a very interesting work, similar in general mood to "The Fire Bird," and takes its place beside "The Fire Bird" and "Petrouchka" on the fantastic and bizarre side of the organization's work. When the curtain first goes up a very striking picture is presented, and not once through the course of the ballet does Mr. Bolm let us forget that we are watching queer, unnamable creatures who inhabit the depths of the ocean. The effect is carried out by many details in posturing and dancing, one of the most obvious being the continual swaying of hands and arms that inevitably suggests the balanced movement of fins or the quiet flex and relax of gills.

Mr. Bolm danced the rôle of Sadko, Mlle. Doris was the daughter of the sea-god, and Mr. Jazwinsky was the Czar of the Seas. The audience apparently liked the ballet very much and the author was recalled many times.

The other works provided familiar matter. It seemed as though Lydia Lopokova had gained in charm and surety during her Summer's work with the ballet in Spain, and in "The Spectre of the Rose" she was very charming. Mr. Gavrilow ably seconded her efforts in the rôle which Nijinsky made

famous and which, one is bound to say, even when he dances it, seems a wholly artificial proposition.

In "Les Sylphides," provided with a new scenic investiture, many of the company had their opportunity to show what they could do in the strict classic ballet style and in this type, which seems the least significant in results for this particular organization, provided a charming contrast for the more individual things to come.

"Scheherazade," one of the first of the organization's works, and still one of the most popular, closed the program and allowed Mme. Revalles again to display her sinuous grace and Mr. Bolm his technical prowess, which had been restrained by the character of his rôle in "Sadko."

A record of the première would not be complete without a word in appreciation of the orchestra. Again the Diaghileff Ballet has shown its careful attention to the musical side of its work and has gathered a body of orchestral players which is something more than merely competent. No doubt the hall had something to do with this, for somehow the Manhattan Opera House seems the best setting in which the ballet has yet been displayed. Its acoustic properties are especially good.

* * *

October 24, 1916

PORTRAY IN BALLET STRAUSS'S GAY TALE

Till Eulenspiegel Interpreted by Nijinsky at Manhattan Opera House

"PAPILLONS" DANCED ALSO

Audience Enjoys Two Novelties Produced for the First Time by the Russian Performers

When Richard Strauss was asked on the occasion of its first performance to supply a "program" of events which his orchestral rondo "Till Eulenspiegel's Merry Pranks" was supposed to picture in music he declined, saying he left it to his hearers to solve the problem, which was in accordance with his usual practice. There have since been many attempts, semi-official and otherwise, to supply what Strauss had withheld, as every faithful reader of symphony orchestra program books knows. Last night Waslav Nijinsky tried his hand at it.

The occasion was the first presentation on any stage of the ballet he has devised to Strauss's music, and it marked in addition his first appearance this season with the Diaghileff Ballet Russe at the Manhattan Opera House, an injury to his ankle having prevented his dancing with the company during its opening week. As still further providing an element of novelty for the evening, there was the first performance in America of "Papillons," a ballet arranged to Schumann's piano pieces of that name.

Mr. Nijinsky has the advantage of previous commentators on Strauss, since, while they had only cold type on the printed page to work with he could express himself in living embodiments of the creatures of his imagination. His independence of words was fortunate in at least one instance, for, although he described his production on the program as a "ballet comi-dramatic," which is not English, his audience had no doubt what he meant by the time the curtain was well up.

The epithet expressed fully the spirit in which the new ballet was done. Therefore, even those in the audience who had never heard of Strauss found something to enjoy. "Till Eulenspiegel" is full of the prankish humor that distinguished the old folk tales from which the legend was taken. In everything that was done on the stage there was the evident purpose of being odd, freakish, and whimsical.

The main incidents of the accepted "program" of Strauss's music are carried out. There is the upsetting of wares in the market place, the masquerade as a priest, the love episode, and the wooer's flouting, the confusing of the philosophers; finally, his death on the scaffold, and the proclamation in the epilogue that he will live forever in the minds of the people.

Probably many of those in the audience last night did not worry themselves too much over the musical aspects of the ballet. But what they saw must have satisfied them. The new ballet is highly effective as a spectacle. The stage setting and costumes, designed by Robert Edmond Jones, an American artist, were singularly striking and impressive. Lighting effects played a more important part in this work, both secondarily and as an end in themselves, than they do in almost any of the ballets the organization gives.

Without attempting to go into details of the scenic costume, and lighting effects of the ballet, it is enough to say that they form one of the most impressive exhibitions of the kind to be seen anywhere on our stage today. As for the chorus movements, Mr. Nijinsky has furnished abundant proof of his genius as a stage director. There is almost none of what the average audience would call "dancing." It would be out of place as Nijinsky has conceived the ballet. Instead, the members of the company have been drilled in strange posturings and queer little movements that constantly pique the interest and remind you that you are in the midst of a mediaeval fantasy.

Some slight defects might be noticed. One is that when the hero is before the gibbet, figures between him and the audience are allowed to obstruct a view of his characteristic miming at that point, and another that there is a long and awkward wait while he hangs on the gibbet, due probably to the necessity of substituting a dummy. And should not he show himself at the very outset of the piece, when the orchestra very conspicuously sounds the "Till" theme at the opening?

Nijinsky's own miming is delightful in its expression of the roguish and irrepressible character he portrays. The other characters, while they fit admirably into the ensemble, are not very important individually, with the exception, perhaps, of Mme. Revalles in a ludicrous but still not unbecoming burlesque of the costume of the great lady of the period.

Dr. Anselm Goetzl conducted the orchestra with spirit in a performance of the score that was entirely adequate to the occasion, even though it might not be considered refined or full enough for the concert stage.

It seems altogether likely that "Till Eulenspiegel" will be accepted as one of the most ambitious and satisfying productions of the ballet.

"Les Papillons" is a short ballet which tells the story of a Pierrot who sets a candle to attract butterflies, captures one of the throng that responds to the lure, and then finds his butterflies have in reality been young girls attending a fancy dress ball, the one of his choice scorning him as she goes off home on the arm of her sweetheart. Mlles. Lopokova and Sokolova and Mr. Bolm had the principal rôles.

The ballet was attractive in an unexciting way as a setting for dancing in the classical style. The orchestral arrangement of Schumann's music was not nearly as effective as has been provided in "Carnaval," but partial explanation for this may lie in the fact that it is not as strongly characteristic in itself.

The other ballets of the evening were "Le Spectre de la Rose" and "Scheherazade," Mr. Nijinsky dancing again in the latter.

* * *

January 21, 1917

OVATION FOR PAVLOVA AT FAREWELL

Anna Pavlowa, the Russian dancer, finished her twenty weeks' engagement at the Hippodrome last night. Her final appearance was made the occasion of a demonstration and she received a great number of floral pieces and much applause. One bouquet contained a blossom from each member of her chorus. The flowers were passed down the aisles and, before the curtain fell, the stage was a rose garden.

Miss Pavlowa will not be seen here again for several years. Next month she goes to Havana for the balance of the Winter, and will leave there to tour South America.

* * *

April 29, 1917

SHARP WORDS FOR OPERA

Isadora Duncan Doesn't Like its Policy—Takes a Fling at Sunday

Isadora Duncan, in a curtain speech at the Metropolitan Opera House yesterday criticised the boxholders of the Opera, with the exception of Mrs. Harry Payne Whitney and Otto H. Kahn, in pleading for the establishment of a free theatre. She declared America had as many great artists as any other country, but they didn't get a chance to show their ability.

"This is not a democratic theatre," she said. "I would like to see a theatre where there were no first tier boxes, second tier boxes, and galleries. I have told Mr. Otto Kahn that the people on the east side would enjoy the nine symphonies of Beethoven if they did not have to sit on the ceiling to hear them. Art cannot flourish without the aid of the Government. In France the Government gives me a theatre to perform in

because it thinks I am doing an educational work. Here I have to pay $1,000 for this house and $1,500 for the orchestra. Forgive me for mentioning these dreadful things, but I would not make a speech at all if it were not for my school. I have been trying for twelve years to get someone to support my school here. I have devoted all that I have made to this cause. I have no capital. I don't believe that people should have capital. Their worth should be in themselves."

Then she pointed dramatically to the boxes. "Not one of the boxholders," she continued, "retained the boxes for these performances. I beg your pardon. Mrs. Harry Payne Whitney did. That was very sweet of her; and Mr. Otto Kahn."

Here Miss Duncan launched into an attack on Billy Sunday. "Certain persons in your city," she said, "have raised $100,000 in order to bring a speaker to this city to tell us strange things. I am the daughter of Aeschylus, Sophocles, Euripides, Tyndall, Huxley, Herbert Spencer, and Walt Whitman; and this speaker tells me that they are all in Hell. Well, I wish he would go to that Hell so that he may speak with authority."

Miss Duncan closed her season with yesterday's performance.

* * *

August 21, 1917

ADOLF BOLM GIVES HIS EXOTIC DANCES

Russia, India, Java, and Japan Represented in "Ballet Intime" at the Booth

WEIRD "DANCE OF DEATH"

Roshanara and Ratan Devi in East India Nautch, and Itow in His Own "Wine Dance"

Adolf Bolm, who was the "brains" of the Russian Ballet in its American seasons, as Michael Fokine was in Europe, presented at the Booth Theatre last evening his latest assembling of exotic dances, called "Ballet Intime," drawn from original sources as various as Russia, India, Java, and Japan. Among his associate artists, Roshanara led with a "Hindu Fantasy" in dark silhouette, danced to the air of the "Hindoo Song" that Alma Gluck sings, played on this occasion by Jerome Goldberg as a violin solo with orchestra. There were also Roshanara's "Snake Dance," "Ceylon Harvest," and an East Indian Nautch, with Ratan Devi, the British India singer, who on a platform before the footlights gave some of her own familiar and authentic folksongs and classics of the East.

Michio Itow of the Imperial Theatre, Tokio, staged his own "Wine Dance," suggesting the methods of modern Japanese art, and the "Fox Dance," in mask and eerie fantasy, recalling the courtly "Noh" dances of old Japan. The principal new production, recently rehearsed here before a tour of the Summer colonies from Washington to Newport and Bar Harbor, was Mr. Bolm's adaptation of Saint-Saëns's "Dance

of Death" in the manner of the choreodramas of the Diaghileff troupe, with Rita Zalmani for a tiptoe partner, and Marshall Hall as the grinning Death, who tunes the fiddle and takes toll of the dancers at last, an idea congenial to that of the composer of the "Macabre."

Eva Gauthier sang "The Star-Spangled Banner" in the intermission. Marcel Henrotte played Schumann's "Carnaval" for piano during briefer pauses, and in conclusion there were Bolm's "Assyrian" and "Prince Igor" dances from the Russian tour.

Some of those besides the stars in a long program were Mary Eaton, Mary Palay, Tulle Lihndahl, Janka Mieczkowska, Nina Artska, Louise Sterling, Bertha Selsky, Elizabeth Gardner, Edwin Strawbri, and Alexander Umansky.

Opera and theatre goers in about equal measure made up an appreciative audience, that applauded the presentation of a laurel wreath to Mr. Bolm, who hopes later to produce here an American dance after the "Red Mask" of Edgar Allan Poe.

* * *

November 16, 1917

TORTOLA VALENCIA DANCES

An International Program at Century—Young Duncan Dancers

Tortola Valencia, of whose Maja Dance one catches a fleeting glimpse in "Miss 1917," gave a program of eight numbers yesterday afternoon at The Century. Besides La Maja, only one of the dances was Spanish, a tragic gypsy dance. Two of the remaining numbers were Arabian and two Indian; one, a funeral march, was classical, and one, the Dance of the Gnome in "Peer Gynt," was Norwegian.

Senorita Valencia is happiest in work that calls for bodily vigor and saliently characteristic expression. In the Hindu Snake Dance the movements of her arms and hands were extraordinarily suggestive of serpentine writhings, and the Dance of the Gnome was a striking achievement of squatting, bounding, grotesque. In the other numbers her most notable effects were the deliberate grace of the Maja Dance and the sombre, hag-like passion of the Gypsy Dance. A large audience was liberal in applause.

The Century Theatre Orchestra accompanied the dances, and in the intervals there was music by the Blue and White Marimba Band.

Isadora Duncan's young dancers, without their chief, who is leaving for a tour of her old home, California, arranged by Coburn & Neagle, began a series of independent matinees at the Liberty Theatre yesterday, assisted by the Little Symphony, under George Barrere, and by John Cowper Powis in an opening address. There were dances from the "Iphigenia" and "Orpheus" of Gluck, and some closing waltzes of Schubert, which earned his "Musical Moment" and "Marche Militaire" four encores, as well as many flowers for the young women, known only by their

first names, Anna, Therese, Irma, Liese, Marguerite, and Erica. The dancers showed individual charm and talent, deserving not only their present exhibition, but also the chance to make a reputation under their own proper names.

* * *

February 26, 1918

DANCERS IN AIRY ATTIRE

Helen Moller's Young Temple Girls Both Applauded and Hissed

Helen Moller, with fifty lithe young girls and little children, the most recent exponents of barefoot dancing, lightly clad, and collectively announced as pupils of Miss Moller's "temple" of that advanced form of art, appeared distinctly "ex cathedra" in more theatrical surroundings, far from their templed shades, on the Metropolitan's sun-kissed and blazing stage yesterday afternoon. A large audience applauded many times, and at other moments hissed, as audiences here do rarely, to express varying views of the public exhibition of so much "nature" in visible forms. The idea was not new, however, and from the point of view of row AA it could be denied that the dancers appeared more than casually or instantaneously nude.

Of Miss Moller's solo pieces, the Saint-Saëns "Danse Macabe" and Sibelius "Valse Triste" were done in the one instance, the "Death Dance," with a wisp of black veil and scarlet scarf falling away like the famous cloak of Lady Godiva, obviously without tights, while the "Sad Waltz," under a vanishing mist of white gauze, sought the shadows of the stage, only to reappear under a shaft of red light that bathed the dancer in fire like a salamander. Free verse has its "buttons," but the modern free dancing bars so much as the twinkling of a hook and eye.

The children, some under 6, and all under 16, appeared in similar airy fashion in Schubert's C major symphony, which Miss Moller presented as a Spring's awakening of "the living green sprigs" revealing themselves as maidens. She herself was Spring, soon crowned as Summer, and finally as Autumn, surrounded by a bevy of nymphs tossing green and purple garlands in a wild bacchanale. After Chopin's lullaby, a march and Israel Joseph's lullaby, a charming "Praeludium" by Jarnefeldt earned an encore for the tiniest babes, to whom Miss Moller, as a faun, played the pipes of Pan.

A Tschaikowsky "Overture 1812" by the leader alone, with its contrasting Russian and French battle airs, was dramatically unequal to Isadore Duncan's recent acting of the "Marseillaise" here, but on recall the entire ensemble gave Sousa's "Stars and Stripes Forever," all the little hands upholding a vast, imponderable American flag of filmy silk, almost spanning the stage, while Miss Moller danced below its waving canopy. Another and last encore brought the house up singing, while the fifty dancers accompanied with their evolutions "The Star-Spangled Banner."

The Orchestral Society, led by Max Jacobs, furnished the music, including an overture from Gluck's "Iphigenia in Aulis," and before the second half of the program Sibelius's "Finlandia," which was well played. The dancers were announced to reappear March 19 at the Metropolitan, as well as in a series of mornings, starting next Saturday at the Theatre du Vieux Colombier.

Miss Moller, an American from Bird Island, Minn., who since her music study in New York has established her dancers in a former temple of a Portuguese congregation in upper Madison Avenue, issued this statement last night in reply to some criticisms of her matinee:

"According to pure Greek art as shown by its statuary, mostly of the dance, there is nothing 'nude' in the nude, but, on the contrary, it expresses the most beautiful conceptions in nature. In my art I try not to be of the modern-day conformists with their many artificialities, but rather to interpret the aesthetic and classic ideals through spontaneous rhythmic expression, and to costume myself accordingly.

"In my 'Valse Triste' I wore chiffon 'drapes,' similarly as I did in all my other numbers. While it is possible that the light effects in that number may have seemed to some to show me undraped, nevertheless if that was the effect I hope—from the fact that this 'Valse' was the most encored of my program—that it emphasized among a large majority of the audience that our art-loving and theatregoing public have advanced beyond Puritanical and false standards and are quick to appreciate the pure, the beautiful and the chaste, for to the pure all things are pure."

* * *

Photos by Moffet

Oukrainsky (above) as the "God Dragon" in the ballet of the opera "Sampson and Delilah." Mlle. Anna Ludmilla (below) in a costume of feathers worn in the "Sampson and Delilah" ballet.

February 2, 1919

AMERICAN GIRLS AS MEMBERS OF OPERA BALLET

They Are Far Superior to Europeans, Says Russian Dancing Expert

American girls compose the Pavley and Oukrainsky ballet with the Chicago Grand Opera, which will open a five-week season at the Lexington Theatre tomorrow. Even Mlle. Anna Ludmilla, who is one of the six premier danseurs, is of American birth and so are the two score in the regular ballet. Many of them received their training in the Pavley and Oukrainsky studios.

"Contrary to the generally accepted belief," says Mr. Pavley, "European girls do not make the best ballet girls. I have found by practical experience that American girls are far superior.

"In the first place they are more intelligent. They learn more quickly. They are better nourished, and that means they are in better physical condition. Physique means a tremendous lot in ballet work. Then, too, American girls are as a rule prettier.

"The reason that foreigners have held the first place in ballets and as premier danseurs in past years is that they have received the proper training. That is the only drawback with Americans in a great many cases. They want to accomplish everything in one minute."

The accompanying photographs show Serge Oukrainsky and Mlle. Ludmilla in ballet poses during the performance of "Samson and Delilah."

* * *

June 22, 1919

INVITING YOUR SOUL IN THE DANCE

There is no real reason to believe that every woman who is making a practice of dancing is doing so from soul-uplifting motives, but some of them are, while others confess finding more of vital good in dancing than they had ever hoped to find there. They are, in some cases, too, developing a unique profession for themselves.

Some years ago the Castles brought into prominence the practice of ballroom dancing. Then everybody did it with such enthusiasm that it was sure to wane sooner or later, but through the intervening years, even while the war was on and dancing for mere frivolity was more or less taboo, the girls who were teaching kept up for themselves a fair trade among those who just liked to dance.

Then came the steady stream of interest in the direction of aesthetic dancing, in which field much that is interesting is being developed. And, now that the war is at an end, there is a noticeable increase of popularity in both of these avenues of approach to a comparatively new and untried profession for women.

So many more men are around now that the girls who are teaching new steps have a chance to get in their innings. They can teach the men and the women. There is a growing custom of hiring experts to dance with when one would have a really perfect dancing afternoon or evening. And, more and more, girls are making it a paying business. They charge for their services by the hour just as they would in any other business.

Of course, there are the ballet dancers and the dancers in the chorus. It is no new thing, the way in which they earn their living, though of late there does seem to be an extraordinary call for the sort of thing they do. The Russian Ballet had much to do with this state of affairs. It raised a new standard for the originators of the ballet; it put a new fire into those who were dancing in this manner; it planted new ideals in the audiences patronizing the performances. Then, along with the improvement of the scenery and costumes inspired by Bakst, there came a vast improvement in the dancing inspired by Nijinsky and his contemporaries. Today there are all sorts of opportunities for those who like to see dancing. Everywhere, in odd little theatres, in private halls, in big places of amusement, there are cropping up some really unusual dances beautiful to see and marvelous in the expression of the art which they represent.

And, as this art develops, girls of greater power and ability are taking it up as a profession. No wonder the performances are more attractive than they were. More brains and personality and studied charm are being sunk into them. It is on the aesthetic side, however, that dancing as a serious attempt has taken its greatest strides. It is perfectly astonishing to learn how many women are devoting their attentions to this end of the game and to discover how really seriously they are regarding their own efforts. They claim that they are working toward a future where dancing will be much more a natural part of regular human activities than it shows the least sign of being today. They promise wonderful things for the development of the human being under the regular stimulus of its practice. They do not regard ballroom steps as expressing their notions. They see them only as a low form of the art, though they admit that the popularity of this form of dancing is only the effort of those enthusiasts to find their own expression. They believe that, before long, the time will arrive when every one does his portion of expressive dancing during the day and that they will be following no set rules for steps laid down by some arbitrary authority. They pine to lead the world away from this sheep-like following of a given pattern and more surely in the paths of developing, by this means, their own particular self-expression.

This, then, is the theory of the aesthetic dancer as explained by Miss Grace Cowie, who lately danced in "Shakuntala":

The aesthetic dancer, much more than any other sort of dancer, has a chance to express the thing that is herself. In fact, that is the theory of the whole thing as it is taught to the students and diligently practiced by those who have become proficient in the art. The whole point of the training is to make the student realize that the motions which she goes through with are not so much her own doing as the accomplishment of some artistic expression for which she is the human instrument. She is aware of the fact that her subconscious self is the part of her that is telling the story, whatever it may be, through the medium of the dance. Therefore sets of studied steps and poses have nothing whatever to do with her stunt. She listens to the music, puts herself into a subjective and relaxed state, and the expression of the soul of the music seeps through her, as it were!

It may sound, just from this casual statement of the purpose of aesthetic dancing, as though there were no especial technic required in order to convey the message. However, quite the contrary is true. Before one can hope to give forth beauty one must thoroughly realize what is beauty in this particular direction, and in order to understand in the least what the theory and purpose of aesthetic dancing contain, one must be put through a long course of training in learning how to handle one's body and muscles so that every motion, whether interpretative or not, shall be one of pure harmony. After that point has been reached and after one has gained the aptitude of responsiveness by means of steps and poses, then and then only can one hope to be a truly

aesthetic dancer. The whole idea is to get as far away from self as possible.

As to the opportunities offered in esthetic dancing as a means of earning one's living, it actually has shown some possibilities in that direction and the enthusiasts who are interested in its things in the future. How far their hopes will be realized is, of course, a matter of conjecture. They insist that, in the not far distant future, dancing will be a natural part of any school curriculum, and that the requirements will not only cover but, more likely, confine themselves to the esthetic or rhythmic school. Already in many private schools the course is in full action and teachers who specialize in the subject are being employed. In a few colleges the study of this art has been introduced.

Then there are the indoor and outdoor pageants which are becoming more and more a part of our community life. They always include dancing, if they are not wholly made up from dances of various sorts. Special teachers familiar with the study needed for the direction of these spectacular events.

At settlement houses and as a part of most of the club work for girls, as well as boys, esthetic dancing is becoming quite generally popular. The children love it always. It gives them an outlet for their purely animal spirits as well as an expression for whatever rhythmic art they possess.

* * *

December 31, 1919

FOKINE AND FOKINA DANCE

Russians Appear in His Creations Before Throng at Metropolitan

Morris Gest, who brought over the first Russian dancers in "Scheherazade," before the coming of the famous stars and finally of the ensemble of the Petrograd troupe, gave New York last night a single view of that ballet's reputed originator, Michael Fokine, in an entire program of his creations, danced where Pavlowa and Mordkin, Nijinsky, and others had danced them, at the Metropolitan Opera House. No dancer ever drew a greater audience there in this decade, for the name of Fokine, like that of the painter Bakst, had been known wherever the Russians appeared in this country, and the present Metropolitan public showed an amazing eagerness "to recapture the first rapture" of those sensational debuts of ten years ago.

Mr. Fokine was assisted by his beautiful wife in the familiar "Spectre of the Rose," and Mme. Vera Fokina gave a solo, "The Dying Swan," both challenging comparisons with former interpreters trained to the hour; it was a breathless task to essay these same evolutions after a season or more off the stage, and neither the woman's tiptoe technique nor the man's athletic leaps were of the virtuosity remembered by Americans who saw them in Paris. In character rôles, however, they were most remarkable. Nothing in the Russian repertory has had more native charm than their final group of Slavic folksongs, in one of which Mme. Fokina carried a property baby across the stage, pausing in the limelight as at war's alarm, then silently crooning in the shadows, while Mr. Fokine as the peasant father sat and slumbered.

It was of interest that their own boy, a sturdy lad of 13 years, in Russian sailor suit, looked on from a box last night and during the intermissions played like a happy child along the corridors of the parterre. Of the other dances, Mme. Fokina's "Salome" and Mr. Fokine's "Bacchus" were less effective than their pair of Spanish pieces later, which were encored. An orchestra made up largely of Philharmonic players served admirably under the direction of Josiah Zuro, both in accompanying the stars and in a half dozen intermezzi, and there were obbligato parts for violin and cello, played by Sacha Fiedelman and Gaston Dubois, in several numbers.

THEATER

April 19, 1910

NAZIMOVA'S THEATRE OPENED BY HERSELF

Actress's Remarkable Performance of Rita Allmers in Ibsen's "Little Eyolf"

QUEER PLAY, BUT WELL GIVEN

Excellent Acting by Miss Conquest and Brandon Tynan—New Playhouse Cozy and Intimate

Mme. Nazimova's reappearance last night in a new theatre which bears her name, though accomplished in a play of Ibsen's which never can be popular in the playhouse, and always leaves the reader in some doubt, nevertheless was artistically accomplished. Again, as in her several appearances in Ibsen rôles, Mme. Nazimova gave this one a distinct quality, making it interesting and differentiating it from every other one in which she has appeared. What is more important, perhaps, is that she bodies forth for all who see it the essential characteristics of the figure of Rita Allmers, in the Norwegian's somewhat baffling play of "Little Eyolf."

The character of Rita in its main essentials is clear enough, however vague the outlines and intentions of some of the other figures. She is undoubtedly a subject for the alienist, and like others of the Ibsen fold—an abnormal creature. But for something like her counterpart it would hardly be necessary to go as far as Norway. She is an animal, it is true, but not a healthy animal, as some of the commentators still insist; rather a being who, for one reason or another, has lost her mental poise, and a victim of neuresthenia in its most violently aggressive form. It is needless to dwell upon one, at

least, of the causes which contribute to this condition of affairs. Ibsen himself displays it frankly enough for those who need to understand. Physicians will probably be able to recognize the symptoms.

And it is not surprising if the rôle appeals to any actress with a leaning toward the picturesque. The abnormal, especially as it is manifested here, provides at least means to color and variety in interpretation. And yet Mme. Nazimova, for all her plastic grace, her ease of movement, and resourceful expressiveness, never seems merely a pictured fable of the stage. For the time she appears the Rita Allmers of the text, a creature of fire and longing, a being of elemental passion, who yearns for the impassioned poetry of love rather than its prose.

For her there can be no middle course; it is all or nothing. Her love for Alfred Allmers is everything to her: she demands complete surrender on his part. She has had bitter disappointments. First Asta, the supposed sister, has stood in the way of complete possession; then his work has taken part of what she demands; at last, Little Eyolf, his child and hers, yet never wholly either his or hers, has forced his way between them.

Of course, the idea that a mother should so regard her offspring is at once evidence of some queer mental quirk, though to the symbolists all these things are clear enough. Asta, for instance, is Allmer's higher nature, Eyolf his remorse; also "the compensation granted with the law of change." But, happily, Mme. Nazimova is not too much employed with symbols, so we get the play more as a human document than a befuddling assemblage of weird impressions. At that, there are things in it no audience will understand any more than they can be understood when the play is read.

The Rat-Wife, for instance, in the simplest and most general interpretation—as a symbol of approaching death—still seems a very queer exposition of that idea. Nor is she impressive, for all her strangeness, as she must be acted, and was acted last night, with the familiar mechanics of voice and movement of the first old woman of the theatre. She might have been one of the witches in "Macbeth" quite as well, or any one of a host of figures that have trooped along from time to time to do theatrical service as representatives of the supernatural.

Primarily the performance of "Little Eyolf" will be interesting on account of Mme. Nazimova's really wonderful histrionic capabilities. Secondarily because, intelligible or not, it brings one of the most peculiar of Ibsen's plays to the stage in a way to lend dignity even to its most baffling phases. No one laughed last night as they laughed when "Little Eyolf" was last presented here, simply because it was all done beautifully, sympathetically, and in perfect taste. The staging of the play has been very admirably managed, and the three pictures are very fine, especially the last, a cliff in Allmer's Park, with the glowing evening light slowly fading into twilight and pale green reflections illuminating the darkness of the sky. Here the lighting for the most part is perfectly attuned to the requirements of the text.

Of Mme. Nazimova's acting a hasty résumé, besides generalizing upon its admirable conveyance of the character, must note several moments of exceptional impressiveness—the sense of disillusionment and yet the note of longing and of hope in the scene in which Rita speaks of the "champagne you tasted not," that wine which to her was all of life, the life which was still strong and vibrant in her, though the man's pulse beats were now so much slower than her own.

Lying prone on a couch, with her figure quivering, her nostrils dilating, her fingers twitching and nervous twinges playing about her mouth, it was a picture of desire not soon to be forgotten, an amazing exposition of a mood shortly to give way to another of forced calmness and restraint or to pass into one of quick, querulous resentment, expressed in a word, the quiver of a lip, or the flash of an eye.

This is one of the remarkable things about Mme. Nazimova. She is always acting, yet not seeming to act, and with all of her body, her face, her hands, her eyes, her lips. Every least little part of her organism seems to yield itself to the needs of the histrionic exposition. She is, in short, a great actress, one who, though there are still moments when her English is indistinct, need not make her words fully understood to be intelligible enough. People who have not read "Little Eyolf," like people who have read it, will still be in the dark about much of its meaning. But there is complete illumination of the central rôle as Mme. Nazimova acts it.

It is one of the most unsatisfactory parts of theatrical reporting that effects often elude description. How, for instance, shall one convey an impression of the heart-cry in such readings as her "I don't care for resurrection," or "I don't want to be sensible"? How reproduce the sense of horror conveyed in her description of the wide-open eyes of little Eyolf lying still at the bottom of the pool, or of the terror in the one word "evil," as she repeats it after Allmers in this strange scene. As one reads there seems a monstrous sort of side to Rita Allmers, but there is tenderness and cause for pity, too, and these qualities are beautifully conveyed in the actress's impersonation.

The difficulties are great for the actor who must play Alfred Allmers, for this curious weakling dreamer is a man of many more words than moods, and played at best he is likely to sound preachily monotonous. Mr. Brandon Tynan does not quite succeed in ridding him of this fault, but there is satisfaction at least in the fact that the speeches are beautifully read, that the passages are differentiated as much as seems possible, that Allmers seems as nearly human as possible with the material the actor has to work upon.

Of the others, Miss Ida Conquest, acting Asta Allmers, gave on the whole the best acting performance of any she has ever given in New York, bringing both understanding and sympathy to the rôle, and maintaining it in exactly the right mood to best suit the play as a whole. Mr. Haines, talking deep in the throat, as is his habit, made Borgheim rather unnecessarily debonair, and Master George Tobin was sufficiently childish as Little Eyolf. Miss Berkeley's "Rat Wife" was an intelligible theatrical symbol of something harsh and strange, but did nothing to

illumine that queer creation of the author. However, the actress need not despair. Probably it can't be done.

The new theatre is of the cozy type, very small, but comfortable, and an excellent sort of house for intimate drama and comedy. The decorations are in good taste and not extravagant.

* * *

June 21, 1910

"FOLLIES OF 1910" ON NEW YORK ROOF

A Big Beauty Show, with No End of Specialties and Comic Interpolations

THE FOLLIES OF 1910, a musical revue, in two acts and thirteen scenes. Words by Harry B. Smith, music by Gus Edwards and many others. Jardin de Paris.
WITH: Harry Watson (Stage Manager Mitchell); George Bickel (Musical Director Levi); Joroge Van Norden (Stage Doorkeeper); Fanny Brice (Miss Pansy Perkins); Rosie Greene (Mazie Muggs); Hazel Robinson (Geraldine Grouch); Vonnie Howe (Sadie Spooner); Elsie Hamilton (Flossie Frost); Aline Boley (Flossie's Mother); Grace Tyson (Iona Carr); John Reinhardt (Towne Duer); Clifford Saam (A. Walter); Maurice Hegeman (Andy C.); Arthur McWaters (Jim Hill); Jacques Kruger (John D.); Alice Hegeman (Hetty G.); Charles Scribner (J. Pierrepont); Edward Devlin (The Office Boy/"the Common People"); Lillian Lorraine (Mlle. Cavalieri); Bert Williams (A Caretaker).

They caught folly on the fly at the New York Theatre last night, incidentally creating a little folly of their own, as is generally the way in the annual Ziegfeld Revue, which for want of a better definition might be called a "fly" show at that. And, having appropriated one of the baseball reporters' terms, it is just as well to go a little further with his lingo and remark that not in a long time, if ever, has there been as much playing in the outfields as in this particular entertainment.

Often as not the actors and the chorus, instead of being on the stage, where by rights they are supposed to be, were suddenly discovered out near the bleachers. And from time to time they made their entrances to the stage by way of the auditorium, which they reached through special staircases and traps cut through the floor. After which it may easily be inferred that there was a deal of craning and twisting of necks on the New York roof last night.

However, not all of it was due to the unexpected ways the people had of coming on and going off. There was one time at least where chins were very near the perpendicular simply because what was to be seen was up in the air and not to be seen any other way. This, a swing song, and a very lovely feature though not so absolutely new as some of the other items on the big show menu, showed Miss Lillian Lorraine as chief beauty, assisted by the Misses Howe, Christy, Maxwell, Cobway, Morris, St. Clair, Mackey, and Hoyt, and doing pretty well on the beauty score themselves.

The swings with their human freight flew to and fro over the auditorium and the heads of star-gazers, while the girls by a series of cords manipulated a chime of melodious silver bells.

In the apple blossom grove, a very dainty symphony in pinks and delicate greens, with gowns and hats exquisitely blended and becomingly displayed, Miss Lorraine was again the featured beauty, but it may be said to her credit that she seems not to have placed entire reliance upon her looks. Her voice is very agreeable and shows signs of cultivation.

One doesn't look for grand opera material in a show of this kind, which is fortunate, for one wouldn't find it. But another pleasant voice is possessed by Miss Eleanor St. Clair, who uses it to good advantage as an accompaniment to a moving picture effect illustrating the recent flirtation of the comet and the earth.

Fannie Brice, not especially prepossessing elsewhere, scored a hit with "Lovey Joe," for which her eccentric facial expression and queer vocal interpolations were largely responsible. Bobby North, too, was among the singers who gave satisfaction, his new medley being well up to his best vaudeville standard.

There is no more clever low comedian on our stage to-day than Bert Williams, and few, indeed, who deserve to be considered in his class. Last night he was warmly welcomed, and deservedly so, though he has occasionally had better songs. In fact, without Williams to sing them, there would be little to any of these particular numbers, with the possible exception of "Constantly," in which he scored his best success.

With Bickel and Watson introducing various amusing stunts, Billy Reeves staggering about and doing impossible falls, one of which landed him in a pool of water after half a dozen Ziegfeld mermaids had used it as a diving tank, and various other people making quick changes from one costume and make-up to another, there is plenty in the way of beauty, variety, and comic effort to keep things moving between songs, dances, and specialties. Grace Waters, a clever woman with an unfortunate manner of babying her lines, however, contributed one or two funny songs, and Julian Mitchell emerging from the "obscurity" of stage management in a scene in a pantomimic specialty, "The Vampire," to which Miss Louisa Alexander contributes her temperament and beauty. Rosie Green also dances neatly.

The late "Café de l'Opera" is amusingly satirized, and of course Col. Roosevelt's return plays a part in the more or less satirical feature of the entertainment, and "Chantecler" does not escape.

All in all, "The Follies of 1910" is a long show and a good one, with plenty of variety. It may lack the one or two big conspicuous sensational features that are generally relied on to attract attention, but this is made up for by the diversity of the specialties.

* * *

November 28, 1911

RIOT IN THEATRE OVER AN IRISH PLAY

Vegetables and Asafoetida Balls Hurled at Actors in "The Playboy" at the Maxine Elliott

WOMEN JOINED IN PROTEST

Some of Them Put Out with the Men—Police Kept Busy Till Play Ends—Seven Distrubers Fined

That Irish play by J. M. Synge, "The Playboy of the Western World," became a fair, a Donnybrook Fair, at its first performance in the Maxine Elliott Theatre last night. It has had more or less of a lively time in the other cities where The Irish Players have presented it, but the disturbances elsewhere were as prayer meetings in comparison with the reception it got here.

The curtain rose, and that was the signal for a stir that swept through the theatre like the rustle of leaves that foretells a storm. The shabby actors in the humble dress of the Irish peasant appeared and began their lines.

Christopher Mahon, (Fred O'Donovan), the leading character, was on the stage with Margaret Flaherty (Eithne MaGee). They went on with their lines, he trying to persuade her to his will and she resisting. He insults her and she runs for a flatiron to assault him, and he, hoping to restrain her by fear, cries out:

"I killed my father a week and a half ago for the likes of that."

Instantly voices began to call from all over the theatre: "Shame! Shame!"

A potato swept through the air from the gallery and smashed against the wings. Then came a shower of vegetables that rattled against the scenery and made the actors duck their heads and fly behind the stage setting for shelter.

A potato struck Miss MaGee, and she, Irish like, drew herself up and glared defiance. Men were rising in the gallery and balcony and crying out to stop the performance. In the orchestra several men stood up and shook their fists.

"Go on with the play," came an order from the stage manager, and the players took their places and began again to speak their lines.

The tumult broke out more violently than before, and more vegetables came sailing through the air and rolled about the stage. Then began the fall of soft cubes that broke as they hit the stage. At first these filled the men and women in the audience and on the stage with fear, for only the disturbers knew what they were.

Soon all knew. They were capsules filled with asafoetida, and their odor was suffocating and most revolting.

One of the theatre employees had run to the street to ask for police protection at the outset of the disturbance, but the response was so slow that the ushers and the doortenders raced up the stairs and threw themselves into a knot of men who were standing and yelling "Shame!"

Many Disturbers Thrown Out

The employes grabbed these men and began hustling them toward the doors. Every one they got there was thrown out and followed until he became a rolling ball that thumped and thumped down the stairs. On the lower floor a big man caught them and threw them out without bothering to open the swinging doors first. They crashed through with enough momentum to carry them out in the middle of the street.

It was said later that when the police were appealed to for help they were loath to interfere. Those that were thrown out were kept out, but for some minutes no policeman came into the theatre. Then word of the trouble got to the West Thirtieth Street Police Station, and twenty men in uniform and all of the detectives on hand were sent on a run through the street.

Broadway had thrown a big part of its crowd into Thirty-ninth Street in front of the theatre, and the sidewalks and roadway were jammed with men and women. The police went through this crowd without ceremony and began clearing it. Inspector Leahy arrived hotfoot and ordered out part of the reserves from the station and all of the plain clothes men he could reach.

Men still were rolling down the stairs and yelling out that they were being outraged and would have the law on somebody. Up the steps ran half a dozen policemen. If they hesitated at the outset to take a hand in the row, they seemed to be anxious to make up for it now. No questions were asked, but they reached for every man who was on his feet and dragged him to the stairs, where willing hands helped him to the street.

One of these men was Shean O'Callaghan, a big harness maker, who yelled out in fury as he was being thrown out.

Potato Shower Continued

Even while the police were at work missles kept striking the stage, and the actors, with one eye on them, were going on with their parts. A potato struck Miss MaGee and rolled to the wings. Lady Gregory, who has followed the play about on its troublesome course, picked it up and said she would keep it as a token of her visit to this country.

During the rattle and bang in the house there could be still heard cries of protest, "Shame! shame!" and one man shouted out an oath and yelled that it was a disgrace to put such a foul thing upon the stage.

Just then a policeman reached for him and dragged him to the door. He said he wanted the policeman's number, declaring, "I will have you broken." The policeman stood him up in a well-lighted corner and waited until the man found a pencil and took a note of his number. Then he threw the man out with a violence that threatened him with permanent injury. But once outside he scampered away.

Three women in evening dress came rustling out to the doors. With them was a man who wanted to know:

"What authority have you to put me out?"

The policeman just pushed him out and the women followed him.

Then came C. J. O'Lee, Mrs. Shelle O'Lee, Miss Coil O'Lee, Miss Mora O'Connor, and Patrick Cavanagh, all of

them members of the Philo Celtic Club. They were very much excited and kept exclaiming that it was an outrage that such a play could be staged in this city and those who protested should be treated so brutally. They were shown out.

First Act Repeated

Still the play went on, and when the first act was finished an announcement was made that it would be repeated, so that all present could see it. This is the first time such a thing has happened in the history of the stage in this country. The scenes were shifted again and the stage setting at the beginning rearranged. And then the players came on and began again at the beginning.

And still the missiles flew. By this time the police were so thick that there was no longer danger of more than sporadic cases of violence. But through the first act again and through all of the other acts there were still cries of protest and still vegetables fell upon the stage. One man threw an old Waterbury watch that struck one of the actors and then fell jingling to the stage.

During the trouble Lady Gregory talked to the reporters. She said:

"I wish the men who threw the things on the stage had taken better aim, for I can't believe that they intended to hit anybody. Miss MaGee would have been injured if her thick hair had not protected her. She was struck on the head, but fortunately she escaped without hurt.

"The play was first produced in January, 1907, in Dublin, but we had no trouble like this. The police put a stop to it. The second time it was put on in Dublin the disturbers were put out right at the beginning. We had some trouble in Boston and in Providence, but nothing like this."

George C. Tyler, manager of the show, said: "We will keep the play on and play it through if it takes us all night."

When the actors had ended the performance, for which most of the audience remained, though little could be heard, the police had made ten prisoners. They were Barney Kelly of 2,165 Fifth Avenue; Frank O'Coffey of 5,918 Fourth Avenue, Brooklyn; Shean O'Callaghan of 227 East Thirty-ninth Street, a harnessmaker; N. Mathias Harford, clerk, of 664 Third Avenue; Matthew Gambler, liquor dealer, of 165 East Sixty-sixth Street; John F. Neary, instructor, of 487 Kosciusko Street, Brooklyn; John P. Barren, mason, of 142 West 101st Street; John Joseph Cassidy, bartender, of 63 East 122d Street; Dennis Croly, carpenter, of 133 East Ninetieth Street; Patrick O'Connor, electrician, of 305 East Thirty-fifth Street. Miss Rosina Emmett of 62 Washington Square South went to the police station as a witness against O'Callaghan.

Last Act in Night Court

From the police station the scene shifted to the Night Court. It was already crowded when the two patrol wagons rolled up to the door with the ten prisoners in charge of Capt. McElroy of the West Thirtieth Street Station, and the hundred who had followed from the theatre found it almost impossible to get a position where they could hear the proceedings.

Apparently the trouble had not been unexpected, for Attorneys Dennis A. Spellisy of 257 Broadway and John T. Martin of 154 Nassau Street were ready to appear for the defendants.

When Magistrate Corrigan called the cases Mr. Spellisy entered the plea that the prisoners in hissing and jeering and hooting had only attempted to voice their disapproval of the play.

"That's all right," replied the Magistrate; "they can express their disapproval if they like, but they must keep within decent bounds, and they have no right to act like rowdies."

Mr. Spellisy, who is an Irishman, broke in to make a comment on the play.

"I was in the theatre myself," he said, "and the sketch was the nastiest, vilest, most scurrilous and obscene thing I have ever seen. I don't blame them for hooting and hissing it."

"But kept within the legal limits," returned the Magistrate.

The case of Shean O'Callaghan of 227 East Thirty-ninth Street, who was charged with throwing eggs at the actors from a vantage point in the balcony, aroused the most interest and he was fined $10. One of the witnesses against him was Miss Emmet, a niece of Robert Emmet. She said she saw O'Callaghan throw four eggs.

Six others who it was alleged by the policemen, hooted and jeered and stood upon the seats in their efforts to show their resentment at the staging of the play were also fined in amounts from $2 to $5. The other three were let go.

The Messrs. Shubert issued this statement:

"We did not receive any advance protest of any kind from the Irish societies, and we had no intimation that it would be distasteful to the Irish people. If we had received any such warning we would have taken up the question, and would doubtless have arranged matters so as not to have booked this special piece. We do not see anything objectionable in the work ourselves, and we have the highest respect for the producing management, but we would not voluntarily or intentionally offend the Irish societies or the Irish public of this city."

"The Playboy of the Western World" is objected to by the Irish people because it shows an Irish girl loving a man who murdered his father and willing to marry him as her ideal hero. Seamas MacManus, the Irish author and lecturer, said to a Times reporter on Sunday in reference to this play:

"In the 'Playboy' is shown a simple Irish maiden of the remote coast speaking in language that I feel confident very few girls of the street in New York or Chicago would bring themselves to use in ordinary conversation. Yet this play pictures these modest Irish maidens as tumbling over one another to win a blackguard, whose fascination is that he murdered his father.

"And, apart from the gross immodesty and repulsive vulgarity which the Irish colleen stands for in this play, I know of no other viler libel that could be put upon her than, as in the play, to show her throwing herself at the head of a scoundrel—throwing herself at him because he was now her ideal hero."

* * *

October 15, 1912

VERY SMART ARE ANATOL'S AFFAIRS

And Very Charmingly Done Are These Schnitzler Episodes at the Little Theatre

THE "AFFAIRS" OF ANATOL, a sequence of five episodes, by Arthur Schnitzler, paraphrased in English by Granville Barker. The Little Theatre.
WITH: John Barrymore (Anatol); Oswald Yorke (Max); Marguerite Clark (Hilda); Gail Kane (Blanche); Doris Keane (Mina); Katherine Emmet (Gabrielle); Isabelle Lee (Lona); Alfred de Ball (Walter); Albert Easdale (Frans).

A very smart entertainment is "The Affairs of Anatol" at the Little Theatre.

Which is as it should be, of course, since the title itself involves a suggestion of something at once particular and polite. Note at the outset that these affairs are not of the common order—business, finance, politics. Not by any means. They are the affairs of the heart, or what passes for it in the peculiarly sensitive organism of this highly bred, idle, rich young man. For to have had such affairs amid such surroundings Anatol must have been one of the "aristocracy of wealth," if not of brains. A bit of a blackguard, too, this same Anatol—the sort of chap who will kiss and tell and run away.

All of which is far from making Anatol dull. They eliminate two of the affairs at the theatre, and it is just as well. Indeed, five of them seem more than enough on the stage, though, happily, as they are presented the last is the liveliest, and sends one from the theatre in a pleasant state of mind. Therein one sees "the biter bit," so to speak, which is an added satisfaction to the moralist. And one may smile at the sight of Anatol—after a succession of affairs in which one lady has usually been sent on her way to make room for the next—himself caught on the hook. This time it is matrimony from which wiggle as he will he cannot escape.

It would be difficult indeed to imagine any much better fun than the exhibition of Anatol on this wedding morn of his struggling to keep back the secret of his impending marriage from the blondined person who has accompanied him home the night before from the opera ball. Even in the face of this disregard of the proprieties, Anatol can justify himself or thinks he can. For he is a sentimental egoist with all the rest.

"It was my opera ball," he says, "given on purpose to say 'good-bye to poor bachelor me.' " And he had just come from father-in-law's, where they all drank his health, and would insist on kissing him, and made stupid jokes about the impending nuptials. After all, one might find some reason in this for sympathy with Anatol.

But for those who have neither seen nor read the plays—dialogues rather—one must mention that the lady who accompanied him home was a long-lost (or purposely mislaid) love, one Lona—these people never have last names—and that when Anatol is fuming, wanting to dress for his wedding, in great danger of not reaching the church in time, she is insisting on a nice little breakfast at home and a morning of billing and cooing. Max, his friend—you will know him through other plays—has come in, too, and is pressed to join the party. But he is to be a bridegroom, and is also anxious to be off. Meanwhile Anatol hasn't the courage to tell Lona that he is about to be married. When he does so there is some smashing of furniture, tearing of hair, and hysterics. Also, Max's bouquet for the bridesmaid is sacrificed when Lona finds she can't get her hands on the orange blossoms carried by the faithless Anatol.

It is the resourceful Max who ultimately prevents the bereaved one from hurrying to the church, forbidding the bans, and creating a scene.

"It's not so much you he's treating badly," he argues. "Suppose he leaves her some day. Wait and see."

Max, you see, knows Anatol. So, evidently, does Lona. And she is willing to trust to time.

Mr. Barrymore plays here with charming variety and plenty of the right sort of humor. Indeed, he does that throughout. The role of Anatol lies comfortably within the lines of his personality and his art. The Lona is Isabelle Lee, and she looks it and plays it for all it is worth.

To describe "The Wedding Morning" before the others in the bill is, in a sense, to put the cart before the horse. But the sketches are really independent of one another, though Anatol and Max figure in most of them. In the first, "Ask No Questions" comes a delightful touch of cynicism. Anatol loves little Hilda, and he is sure she loves him.

But is she ever faithful?

He doubts it. So does Max.

Now, Anatol, it appears, has developed some powers of hypnotism. And it is Max who suggests that he put Hilda to sleep, then ask her the question, which she needs must answer. Anatol jumps at the idea and Hilda, when she comes, is nothing loath to having him try his skill on her. When she sleeps Anatol cannot bring himself to the point of making doubt a certainty. Finally, after listening to Max's gibes, he sends him out of the room.

"If I'm to know the worst I'll hear it privately," he says. "Being hurt is only half as bad as being pitied for it. You'll know just the same, because if she's—if she has been—then we've seen the last of her."

But after Max has retired he cannot ask the final question. He awakens Hilda, whereupon Max, re-entering, assumes that his friend has been reassured. But Max can still be cynical.

"Perhaps," he concludes, "you've made a scientific discovery. That women tell lies just as well when they're asleep."

To Mr. Barrymore's good acting in this and the intelligent co-operation of Mr. Oswald Yorke, little Miss Marguerite Clarke, as Hilda, adds a piquant charm and not a little delicate art in the moments immediately following the girl's awakening.

"An Episode" with its story of the egoist's undoing by the girl from the circus who doesn't remember him, though he is sure that his few minutes alone with her provided the

romance of her life contains much that is amusing, though it is not quite so well done on the whole as the others. Also, it is apparent here that an attempt has been made to fit the role to the actress, since the actress does not fit the role.

But Miss Doris Keane provides a very amusing figure as the more or less vulgar and hungry music hall lady who comes to tell Anatol that all is over between them at the very moment he is hesitating about making the same declaration. Best of all, perhaps, in its setting and in the charming sentimentality which it conveys is "A Christmas Present," with an adorable view of a florist's shop, the one note of color in a dark street, into which the rain is pouring, as the hero and his old flame—now a married woman—meet to renew memories and awaken some regrets. And of them all is it possibly the most satisfying in the acting. Certainly Mr. Barrymore here sounds a very sincere note, and Miss Katherine Emmett is exquisitely natural and appealing as Gabrielle. There are just the right touches of ice in her tones, and there is exactly the right softening at the close. But of Gabrielle, one somehow wonders, would she have been happy "if she hadn't been such a coward!" One is rather inclined to doubt it.

Within the limits of his personality, Mr. Yorke provides a good supporting figure as Max. But it seems possible that another type would have helped to give greater contrast to the action. The successive episodes are all very much in one key and this, too, in spite of the variety of the pictures and the introduction of a new woman character into each. But good taste marks the presentation of Anatol from start to finish, and the settings are charmingly appropriate and beautiful.

* * *

December 21, 1912

'PEG O' MY HEART' CHARMS AT CORT

Propitious Opening of a New Theatre with Fascinating Playing by Laurette Taylor

AN ADORABLE IRISH LASS

'Love Me, Love My Dog,' Her Motto, and Everybody Will Surely Accept the Condition

PEG O' MY HEART, a comedy in three acts, by J. Hartley Manners. Cort Theatre.
WITH: Miss Emilie Melville (Mrs. Chichester); Peter Bassett (Footman); Miss Christene Norman (Ethel); Hassard Short (Alario); Reginald Mason (Christian Brent); Miss Laurette Taylor (Peg); Clarence Handyside (Montgomery Hawkes); Miss Ruth Gartland (Maid); H. Reeves-Smith (Jerry).

Her father was a believer in original sin; wherefore he punished himself whenever she misbehaved.

It's "Peg O' My Heart" we're speakin' of. And do you ask who's heart is it you're referrin' to? Why, her father's heart, to be sure, though before long it'll be the truth you're tellin' when you refer to her as "Peg O' Everybody's Heart."

For a fascinating, red-headed little Irish hoyden is this Peg, as she comes through in a role that is filled to the edges with quick Irish wit and cunning and devilment and tenderness, that has you laughing most of the time, but is not without the moments that bring moisture to your eyes. And all there is in it and more Miss Laurette Taylor gets out of it—puts into it, say, rather, for after last night's performance at the Cort it will be impossible to imagine "Peg" without Miss Taylor, or, for a long time to come, Miss Taylor without "Peg."

A comedy actress of very remarkable flavor and variety—she proves that most positively in this play, which without her would be like "Hamlet" with the Dane left out, and equally tragic, we have a mind. As it is, the burden is still great. For, fascinating as Miss Taylor makes the role, there is something too much of it, the kind of something that makes for tedious repetitions. It would be difficult, however, to think of another actress who could do so much for it, who could provide such a succession of fresh, exhilarating, spontaneous laughs as punctuated the play last night.

Coming back to that theory of her father—Peg thought it an excellent way to bring up children. And from the children's point of view it is. But remember, all of them aren't Irish with the wit that's a saving grace. However, Peg is Peg, and that is all there is to it. Wherefore, when she arrives in the richly appointed living room of Regal Villa—there's an aristocratic locale for you—your heart goes out to her in her dowdy steamer frock and shady hat with its disreputable red flowers and you're willing to take her, "Michael or no Michael," as the case may be. Which is more than her recently rich, just now impoverished, aristocratic relatives are ready to agree to. For Michael is a dog—plain mutt, if you must have it, and though there is room in the house for the haughty Ethel Chichester's toy pup, Michael is not welcome. And Peg objects strongly to "class distinction in dogs."

But the aristocrats hold the whip handle. For, you see, Peg doesn't know that she is an heiress, and that she is being taken in solely because the £1,000 a year she is to pay for being taught manners is all that will keep the haughty family roof over the haughty family heads. Wherefore Peg, too, has a dog's life of it, until she meets Jerry, who is a real man, and who, moreover, discovers himself as executor, guardian, lover, and various other things before the final curtain falls.

"Say, what do you do in your spare time," asks Peg, not inaptly, after she has discovered Jerry's various occupations, and, also, the heartrending truth that he has a handle to his name. But what's a title when two hearts beat as one? And after all wasn't it Peg's father who always told her "There's nothing half so sweet in life as love's young dream," which, as you may have guessed, isn't original with Peg, nor her father, nor Hartley Manners, who wrote the play, and who very properly puts it in quotes on the programme.

How Peg prevents her haughty cousin Ethel from making a fool of herself one dark and stormy night—it really does storm a lot in this otherwise sunshiny little play—and how she at last softens the icy heart of that young lady need not be told in detail. For it is Peg herself and her immediate con-

cerns that hold the eye and the ear throughout the progress of the rather kindergarteny stage story. But it is worth mentioning that Peg's naughtiness—if such it may be termed—is due, according to her, to a little devil in her innards.

"He's tuggin' at me now—he hates knowledge," she says, when her aunt tries to keep the girl's mind on the lesson books. And that, by the way, isn't easy with a girl who frankly admits that she "can't see the sense of learning the height of a lot of mountains she is never going to climb," and who, when she has to draw the map of Europe, represents England, Germany, and France with dots, and writes Ireland all over the rest of the sheet. From which it may be inferred that Peg is an original little heathen, and one who is certain to be adored.

Mr. Manners calls his play a comedy of youth. That it certainly is. And it undoubtedly provides Miss Taylor with a rôle in which to shine. The others do not matter, with the exception of Mr. H. Reeves-Smith, who does mostly nothing, but does it splendidly. In fact, when Miss Taylor is off the stage the curtain might as well be down. Which is one reason, perhaps, why she is never off long.

The opening of the new theatre was certainly propitious. It is a comfortable, handsome house, in which the Petit Trianon idea is carried out even to the charming costumes of the pretty ushers, any one of whom might fit nicely into a picture of the garden at Versailles.

* * *

February 11, 1913

'ROMANCE' A PLAY OF TENDER MOODS

Brings Back Memories of Long Ago in Love Story of Old New York

MUCH CHARM IN WRITING

Doris Keane Scores in an Excellent Characterization and A. E. Anson Provides an Interesting Figure

ROMANCE. Play by Edward Sheldon. Maxine Elliott's Theatre. WITH: William Courtenay (Bishop Armstrong/Thomas Armstrong); William Raymond (Harry); Louise Seymour (Suzette); A. E. Anson (Cornelius Van Tuyl); Gladys Wynne (Susan Van Tuyl); Grace Henderson (Miss Armstrong); Mrs. Charles de Kay (Mrs. Rutherford); Edith Hinkle (Mrs. Frothingham); Claiborne Foster (Miss Frothingham); Dora Manor (Mrs. Gray); Mary Forbes (Miss Snyder); Paul Gordan (Mr. Fred Livingstone); George Le Soir (Mr. Harry Putnam); Gilda Varesi (Signora Vanucci); Paul Gordon (M. Baptiste); Herman Nagel (Louis); Yorke Erskine (Francois); Alexander Herbert (Eugene); Hermann Gerold (Adolph); M. Morton (Servant); Harry Georgnette (Butler); Doris Keane (Mme. Margarita Cavallini).

A play of moods, gentle, sentimental, and tender, occasionally florid, and not infrequently dramatic, such is "Romance," acted last night at the Maxine Elliott Theatre.

It blends the love story of to-day with the romance of yesterday, and for the most part does it charmingly. Where it is least convincing the fault is due to an inconsistency in character, which, though not necessarily impossible, here seems somewhat overwrought. It is in the character of the young clergyman, suddenly converted from a gentle and reasonable human being to a wild-eyed fanatic, that Mr. Sheldon's error seems the gravest. And it was upon the actions of this character that the play vacillated most uneasily as it was acted last night.

But on the whole Mr. Sheldon has written with unusual grace. He has made his blend of the new and the old with considerable feeling, and has ornamented the structure with delightful touches in character and incident and sentiment.

Throughout "Romance" one gets the mellow memories of far-off things. And in the figure of its heroine there is the interest that comes from contemplation of that very contradictory thing—the artistic temperament. Margerita Cavallina, with her curious mixture of good and bad, her cruelty and tenderness, her little passions, and her one great love, provides a splendid study.

Mr. Sheldon has been peculiarly happy in the prologue and epilogue to the main story of the play. At the outset a youth in love with an actress comes to his uncle, the Bishop, with the announcement of his coming marriage. And the old man does not respond as sympathetically as he had hoped. Wherefore the youth declares that age cannot understand such sentiment as his, and is about to depart. The old man goes to his desk and takes out a little handkerchief and a faded bunch of white violets. Then, as the room grows shadowy in the twilight, he begins the recital of his own love story.

When the curtain again rises it is this romance that is being unfolded in the Fifth Avenue mansion of forty years ago, when the old Brevoort House was a centre for the fashionable life of the time, and when the young bloods unhitched the horses from the carriage and dragged the reigning opera singer home. It is Margerita Cavalinna who is the adored of these young bloods, as she is the toast of their elders and the particular friend of Cornelius Van Tuyl, now entertaining her in his home and inviting some criticism from his more punctilious guests. And it is here, in a delightful little scene, that Thomas Armstrong, the youthful rector of St. Giles, first encounters the singer, and is in turn humiliated and fascinated by her before he is aware who she really is. By the time her identity has been made clear to him the charm has worked its spell.

Then comes her confession of early faults with complete disillusionment postponed until both the singer and Van Tuyl have perjured themselves for the sake of the young man's peace of mind. Before the truth comes home to the young clergyman there have been a number of delightfully varied passages, one particularly human and delightful one being an exchange of courtesies between the singer and an Italian organ grinder, the bond of sympathy vested in the fact that they are "both musicians" and that each is the owner of a monkey.

When the young clergyman carries his doubts of the truth of the singer's statement beyond her to the man whom she has declared to be nothing in her life, he rather forfeits sympathy, though, as it happens, his suspicions are justified. But

the passion is overpowering, and the subsequent act presents him in a mad and whirling state forcing his way to her presence, out-storming John Storm, and ultimately losing all sense of everything except the one desire to possess her.

In a passage in which the contrite woman begs him to leave her in her newfound sense of innocence and real love, Mr. Sheldon has written simply and impressively. The scene, eventuating in the lover's withdrawal and farewell, has also the ring of real pathos. And there is a poignant touch in the final moment of the epilogue, when the old man, hearing the news of the day read from an evening paper, is startled with the statement of Cavalinna's death in far-off Italy.

Miss Doris Keane's performance of the opera singer is richly characterized, touched with lightness and humor and realistically reflective of natural traits. It is easy to see how the part might be translated into an entirely different mood. But in the lines of her conception of it Miss Keane is always interesting, frequently brilliant and generally successful. Her dialect is capital. She is especially happy in conveying the suggestion of that impulsiveness commonly attributed, and not infrequently characteristic of those whose lives are lived largely in the imagination.

In the earlier scenes Mr. William Courtenay played well, and the transition from age to youth was excellently done. But he allowed emotion or first-night nervousness to carry him too far in the bigger scenes, where his vocalization was notably deficient.

The rôle of the other man was beautifully played by Mr. A. E. Anson, whose rich and varied reading alone was a rare contribution. Gilda Varesi, appearing on short notice, did much with a comparatively small part and provided an unusually fine characterization. And Paul Gordon did two contrasted parts excellently. Gladys Wynne and Louise Seymour did other rôles charmingly, and a word is due Grace Henderson.

* * *

April 29, 1913

A REVOLTING PLAY

―――――――――

"Countess Julia" Serves for Ill-Advised Debut of Miss Marcia Walthier

―――――――――

COUNTESS JULIA, a play in one act, by August Strindberg. Translated by Edith and Warner Oland. Forty-eighth Street Theatre.

August Strindberg's revolting play, "Countess Julia," was acted at the Forty-eighth Street Theatre yesterday afternoon, and will be repeated to-day and Friday. For those who are interested in seeing how queer a thing may be which is still

hailed as a "masterpiece" by some people, this exhibition provides an unusual opportunity. For "Countess Julia," despite its undeniable strength in some respects, is undoubtedly a queer thing.

That it contains the results of morbid brooding upon a question of class distinction, together with some competent deductions in regard to certain phases of human nature, cannot reasonably be denied. But that it is the product of a diseased imagination, and that, as such, it reflects a disordered mental state, is equally true. One may get certain truths from it. But at what a cost! And, when all is said and done, what is its philosophy worth? It needs no ghost come from the grave or Strindberg brought from the madhouse to tell us that vicious tendencies may be resident in high places and that what is bred in the bone may come out in the flesh. Still, it may be admitted that "Countess Julia" is strong. As much may be said of over-ripe oysters.

The matinees have been arranged primarily for the purpose of introducing Miss Marcia Walthier, at one time a concert pianist. When an accident to her hands unfitted her for a continuance of such effort a number of wealthy men, believing she had great dramatic talent, are said to have sent her abroad to study dramatic art. If this is true it would appear that some injustice was done Miss Walthier in encouraging her to pursue an art for which she seems peculiarly unsuited. She is not without magnetism, and in occasional quiet passages yesterday afternoon her playing justified and held respectful attention. But she seems wholly without the power to express great passion, her speech is not infrequently marked by affectation, her gesture is awkward and restricted, and her general organism is of a kind which in reading rôles nothing short of transcendant genius would make effective in the theatre. And "Countess Julia" provides opportunities at least for tremendously impressive and varied acting. The rôle would be beyond the powers of most of the players on our stage. And obviously a novice, even after a course of lessons in Paris, must court disaster in attempting it.

In the rôle of the valet Mr. Frank Reicher played with a sure touch and succeeded admirably in contrasting the real cynicism and mock romanticism of the despicable creature. And a competent and interesting performance of the kitchen maid was provided by Miss Adelaide Wilson. The incidental dances were not impressive and merely served to prolong the general agony.

There will be two more matinees in which persons may have an opportunity to know "what happened to Julia." In the meantime, at the same theatre, they may see at night "What Happened to Mary." But let it be understood, the two cases are not analogous in any sense.

* * *

March 17, 1914

ELTINGE SUCCEEDS IN 'CRINOLINE GIRL'

His Female Impersonations in Otto Hauerbach's New Play Are Warmly Applauded

RAPID AND FUNNY FARCE

Herbert Corthell Ably Assists Star in Keeping the Fun Going at the Knickerbocker Theatre

THE CRINOLINE GIRL, with Julian Eltinge, a comedy with songs, by Otto Hauerbach: lyrics by Julian Eltinge, music by Percy Wenrich. At the Knickerbocker Theatre.
WITH: Helen Luttrell (Dorothy Ainsley); Herbert McKenzie (Lord Robert Bromleigh); Joseph S. Marba (Smith); Augusta Scott (Marie); Charles P. Morrison (Richard Ainsley); Herbert Corthell (Jerry Ainsley); Maidel Turner (Alice Hale); Julian Eltinge (Tom Hale); James C. Spottswood (Charles Griffith); Walter Horton (John Lawton); Edna Whistler (Rosalind Bromleigh); Edwin Cushman (William).

Julian Eltinge, one of the most popular and successful "road" stars on the stage to-day, made another try for a New York indorsement last night in "The Crinoline Girl," a farce with songs, at the Knickerbocker Theatre. If Mr. Eltinge does not get his wish, expressed in a curtain talk following the second act, to stay in New York this time longer than usual, he might just as well consider himself doomed to the provinces and the resulting dollars forever, for his new entertainment is far and away the best he has been seen in here. Mr. Eltinge's peculiar talents and his ability to wear women's clothes without being offensive in his female impersonations get every opportunity to show to great advantage, and he makes the most of them in this farce by Otto Hauerbach.

Mr. Hauerbach is best known as a writer of musical comedies, and "The Crinoline Girl" is, in construction, story, and stage setting, a typical musical comedy. However, the piece is presented as a farce, and the only music is furnished by Mr. Eltinge himself, who sings a number of pleasing songs composed by Percy Wenrich.

What "The Crinoline Girl" lacks in that mysterious something known as "class" it makes up for in speed, and during the entire three acts there is not a dull moment on the stage. There are plenty of laughs that come naturally out of well-built situations and the melodramatic twist to the story, while very reminiscent and not exceedingly puzzling, is nevertheless interesting.

There is, unfortunately, some exceedingly bad acting by one or two members of a not too well selected cast, but Mr. Eltinge and Herbert Corthell keep the fun going all of the time so that the work of Herbert McKenzie, as a titled crook, while not forgotten and forgiven, is at least swallowed up in the general enjoyment of the farce.

The story of "The Crinoline Girl" is not really as complicated as it sounds. Dorothy Ainsley, sweetly played by Helen Luttrell, is madly in love with Tom Hale, Mr. Eltinge's rôle. Tom is a brother of Alice Hale, who is engaged to marry Jerry Ainsley, the nephew of Dorothy's father, who objects to the girl simply because her brother has a bad reputation as a spendthrift and reckless young man. During the unfolding of the love story of the two young couples Lord Robert Bromleigh, the Raffles of the play, is busily engaged in stealing all the jewelry of the guests at the Hotel de Beau Rivagne in Lausanne, Switzerland, where the action of the farce takes place. The titled crook is ably assisted by the Ainsley family butler and also by a Scotland Yard detective who fails to detect. There is another accomplice, a girl in a crinoline, and Tom Hale and a newspaper friend succeed in drugging her, taking away her dress, and with this costume for Tom to wear the rest is easy.

Incidentally, by recovering the jewelry and catching the real thieves, Tom earns $10,000 or so, which happens to be enough to convince his prospective father-in-law that the young man can actually earn a living. After that all objection to Tom ceases and, quite naturally, the play comes to an end.

When Mr. Eltinge stepped on the stage on his first entrance he received a remarkable demonstration, the applause lasting for several minutes. At the finish of the second act Mr. Eltinge, as said before, obliged with a speech in which he said that he hoped that the reception tendered him was really an indication that this time he would remain here for an extended visit.

* * *

August 20, 1914

'ON TRIAL' PROVES MOST INTERESTING

All That is Melodramatic in the Criminal Courts is in This New Play

BY ELMER L. REIZENSTEIN

His First Work Has the Manner and Fascination of a Good Detective Story

ON TRIAL, a play in a prologue, three acts, and an epilogue, by Elmer L. Reizenstein. At the Candler Theatre.
WITH: Frederick Perry (The Defendant); Constance Wolf (His Daughter); Mary Ryan (His Wife); Thomas Findlay (Her Father); Frederick Truesdale (The Dead Man); Helene Lackays (His Widow); Hans Robert (His Secretary); J. Wallace Clinton (A News Agent); Lawrence Eddinger (A Hotel Proprietor); George Barr (A Physician); Florence Walcott (A Maid); John Adams (A Waiter); Frank Young (The Judge); William Walcott (The District Attorney); Gardner Crane (The Defendant' Counsel); John Keindon (The Clerk); J. M. Brooks (The Court Stenographer); Charles Walt, James Herbert (The Court Attendants); Howard Wall (Jury Foreman); R. A. Thayer, Edmund Purdy, Arthur Tobell, Samuel Reichner, Anson Adams, Robert Dudley, Harry Friend, Nat Levitt, J. H. Mathews, Joseph McKenna, and George Spivins (The Jury).

Those who like to settle into a comfortable chair and stay there for hours in the company of a good detective story, those who read with peculiar fascination a chronicle of

cross-examination and those who will often struggle fiercely at the door of a courtroom for a chance to hear a session of a big criminal trial will find something to interest them mightily in the new play which has come to the Candler Theatre. It is "On Trial," by Elmer L. Reizenstein, a melodrama of the criminal courts. In fashioning his play, it was this new playwright's idea to put upon the stage the record in the prosecution and defense of a man charged with murder in the first degree and to hold the interest of his audience by letting them pick up the truth, bit by bit, in the order of its unfolding as witness follows witness on the stand. Mr. Reizenstein has done his work well.

It is no new thing to see a courtroom reared, in however wabbly a fashion, on the other side of the footlights. It has been done again and again either with fell melodramatic intent as in "The Cowboy and the Lady" and "The Last Resort" or playfully as Gilbert did it in "Trial by Jury," and as Barrie did it in the wonderful prosecution of Leonora. But it is a new thing to have an entire play written out of the record of a murder trial, from the swearing of the last juror to that moment when the foreman rises in his seat to answer the question: "Guilty or not guilty?"

And because he has done this, the author of "On Trial" has been able to rely on that fascination which lies in the unfolding process of the ingenious detective story. He has been able to rely on the fact that in the theatre it is often quite as interesting to find out what has happened as to find out what is going to happen. And as the reader of the story, so the playgoer at the Candler Theatre sees the truth of the matter in the dim distance, and watched with all the relish in the world as it is slowly brought to light.

Mr. Reizenstein has done this in a stage courtroom which is remarkably life-like, and at point after point the play is the better and the more vivid because a keen observation has brought in some of the little things which make a courtroom interesting to those who go to one to hear the stories told there. It is not true that the entire picture of a big criminal trial is here. Probably that could be done only with great difficulty and at heavy cost. Nor is it true that Mr. Reizenstein has followed in all fidelity the various customs of criminal procedure in this jurisdiction to which certain details of his play commit him. But it is true, and for his purposes highly important, that he has reproduced with singular success the very manner of our courtrooms. The jury is almost startlingly perfect, and as for the Judge as played by Frank Young, he can be seen any day of the week in the big, ugly building that stands at Franklin and Centre Streets.

Robert Strickland faces trial on the charge that he has murdered his friend Gerald Trask. There are witnesses enough to prove beyond doubt that he did the killing and he himself a broken man, will say nothing in his own defense and begs only that he be sentenced and put out of the world's way and his own. But the lawyer who has been assigned to his defense and who has been unable to wring so much as a word from his unhappy client, is struck with certain inconsistencies in the prosecution's theory that the killing was done in the course of a robbery. To get at the truth, to find out what had gone before the shooting in the library of the Trask apartment, to search out and bring before the jury the motives that had moved all the actors in the tragedy—this is his task and to perform it he must rely on what he can draw from the witnesses as one after another they are called to the stand.

It is his task and it is Mr. Reizenstein's. And to do his part, the playwright has relied on a device which is most difficult to handle and which is highly successful here because it is used so thoroughly. As the witness on the stand begins to tell her story, the stage darkens and the story told is acted out before the eyes of the audience.

In three sessions of the trial and at three important moments in the unfolding of the story, the court room fades away and the audience, like the jury, is carried back to see the things as they happened.

For a playwright to allow one scene to be followed by another that precedes it by however little in point of time is usually the one for vast excitement among the discriminating and endless paragraphs must have been written concerning the wisdom of such tampering with the strict chronology of a play.

But Mr. Reizenstein has done this with such hardihood, and the recessions in his play are so continuous and so thorough, that he wins by the very daring of his plan. It is not orthodox, but it works.

It is with capital ingenuity that the key to the case is withheld until the very end, when the jury is in the midst of its deliberations and when the jurors, in sifting the evidence, come upon a small, unconsidered trifle in the evidence on which, as it happens, the question of the guilt or innocence of Strickland depends entirely. Outside is the swift-carried news through the courtroom that the jury is coming in. Has there been a verdict? Have they agreed? And on what? It is the putting on the stage of one of the tensest moments an observer can find in a day's search of a city. But the jury here has come out to ask for testimony on this one point, and on this point the case turns and the play comes to an end.

All this is very well told and most competently acted. Mr. Reizenstein may be thankful that his play has been put into the hands of an exceptionally good company. "On Trial" is melodrama ingeniously written and ably acted. The chief regret is for the tendency to undue uproar which is present in all the scenes where the testimony of the witnesses is being embodied. The high moments of even a frankly melodramatic murder play can be presented in subdued fashion, and two of the scenes in "On Trial" would be more effective if they ended with Mary Ryan expressing her emotions at something less than the top of her voice. And those same two scenes would be still more effective if something were done to make the lying of the wife and the villainy of Trask a little less needlessly and excessively transparent. These are objections to points that can be easily remedied.

All the people who have been called together to present "On Trial" do their part so well that it is not easy to talk except at length of individual performances. A note may be made, however, of the excellence of the work done by Mr.

Young as the Judge, Mr. Crane as the defendant's counsel, Mr. Wall as the foreman of the jury, Constance Wolf as Strickland's little daughter, and Mr. Robert as the murdered man's secretary.

* * *

October 13, 1914

SHAW'S 'PYGMALION' HAS COME TO TOWN

With Mrs. Campbell Delightful as a Galatea from Tottenham Court Road

A MILDLY ROMANTIC G. B. S.

His Latest Play Tells a Love Story with Brusque Diffidence and a Wealth of Humor

PYGMALION, a romance in five acts, by G. Bernard Shaw. At the Park Theatre.
WITH: Philip Merivale (Henry Higgins); Dallas Cairns (Col. Pickering); Algernon Greig (Freddy Eynsford-Hill); Edmund Gurney (Alfred Doolittle); Herbert Ranson (A Bystander); E. J. Ballintine (Another One); Mrs. Patrick Campbell (Eliza Doolittle); Mrs. Edmund Gurney (Mrs. Eynsford-Hill); Olive Wilmont Davies (Miss Eynsford-Hill); Moire Creegan (Mrs. Higgins); Nellie Mortyoe (Mrs. Pearce); Maude Phillips (Parlormaid).

"Pygmalion," the latest play from the pen of George Bernard Shaw, was shown to Broadway for the first time last evening at the Park Theatre. All that was essential in cast and production for its hearty success in London is most happily reproduced in its preparation for the enjoyment of New York. In chief, it presents Mrs. Patrick Campbell, who is delightful in the delightful rôle of Eliza Doolittle, and, in the part of Prof. Higgins, Philip Merivale rather more than reconciles one to the fact that Sir Herbert Tree did not elect to come over with the rest of the company. And the play itself is as simply entertaining a piece as the author has ever deigned to write.

For the new Shaw play is a romance or as near an approach to one as the Irish dramatist is likely to proffer in the course of a decade. The surprising word "romance" appears not only on the programme, but in arresting, incandescent letters in front of the big Columbus Circle playhouse, which was thrown open last night for the first time as a New York home for the Liebler productions. And the word is legitimately used, for "Pygmalion" does set out to amuse with a variation on the eternal theme of the way of a man with a maid. It is highly characteristic that the variation should involve the way of an irritable, self-absorbed professor with a flower-girl fresh from Tottenham Court Road.

The flower girl is the latter-day Galatea, and the Pygmalion of Mr. Shaw's nimble fancy is no statuary of ancient Cyprus, but a specialist in the science of phonetics, who vows he can take a girl of the slums and merely by due attention to her vowels and consonants make a perfectly good duchess out of her in six months. Not as a man thinks, but as he pronounces, so is he. To prove his contention and to win a wager

with a sceptical colleague, Prof. Henry Higgins takes as his subject an 'orrid-spoken flower girl in the name of Eliza Doolittle.

What happens afterward must be fairly familiar to many theatregoers, for Mr. Shaw created a gratifying amount of discussion nearly a year ago by first producing his play in German. It was seen here in German last Spring at the Irving Place Theatre, and it was hugely successful in its Spring and Summer season at His Majesty's in London. By the time the training is done and the wager won the abstracted, phonetical Pygmalion finds he has wrought a creature from whom he cannot part without unbearable discomfort to himself and who seems inclined to exact from him something of the treatment due a duchess even of his own creation.

Now this is a romance, but the man who has devoted so much of his incomparable brilliance to writing "plays for Puritans" goes about telling his love story with a shy brusqueness. You can amuse yourself by detecting a certain fierce fastidiousness in this relation of the romance of the once hawful Eliza and her growling professor. There is love in "Pygmalion" but no loving.

The nearest that the distinctly Shavian professor will come to making advances to his Galatea is his gruff admission amid snorts to the effect that she is "a liar" and "a hopeless idiot," that it has been nice to have her about, and that her regard for his comfort has been comfortable. But he violently refuses to admit that her services to him even begin to match all he has done for her. He simply insists that she stay about. It is apparent that she intends to. As she flounces out for the last time he calmly bids her bring him home some gloves from the shop. Mr. Shaw left his German audience to speculate as to whether she would or not, but the play as prepared for London's consumption—and ours—ends with Eliza poking her head in the door to inquire:

"What size glove?"

In the development of Eliza from the really ghastly mouthings of her first appearance to the smooth patter of her later speech there is a world of fun. This comes in greatest abundance when her course of instructions is half covered and the professor recklessly decides to exhibit her at a small reception. The sound of her speech—when she is careful—is beyond criticism, but the professor has neglected all attention to its content and the result is some fearful reminiscences of gin-drinking aunts in Whitechapel gravely related in flawlessly Vere de Vere tones. This is hugely amusing and was received last night with a delight quite independent of the utterance of the word to which London takes such vigorous exception and to which Mr. Shaw's more tart English critics were wont to ascribe the unquestioned success of "Pygmalion" at His Majesty's.

Nor is the fun all on account of Eliza, for Eliza's father, Mister Halfred Doolittle, is a rare character, a golden dustman. He is an unctuous representative of the "hundeservin' poor," far more in need of assistance, as he plaintively explains, than any deserving widow who gets aid from six charity societies on the strength of one dead husband. He feels that "hall 'is

loife" he has been a victim of middle-class morality, which he resentfully defines as an excuse to keep him from getting what's coming to him. But Mr. Doolittle himself, through an unwelcome inheritance, becomes a silk-hatted member of the middle class before the play is done, and his consequent exchange of his 'appiness for respectability is tragic.

The rôle of the unhappy Mr. Doolittle is played with great gusto by Edmund Gurney. Mrs. Campbell is Eliza, and her performance is a pleasure to watch from first to last. She is a marvel of slovenly inarticulateness at the start and most amusing in the scenes of Galatea's first cautious entrance into society. Of course she is complete mistress of such emotionalism as the play requires. More difficult is the work called for in the nice shading of the gradations of Eliza's development. She does it admirably and with the deftest touch suggests the lingering impression that the old Eliza is not so very far below the surface after all—and that that does not matter.

Mr. Merivale, who played a minor part in the London production, steps into Sir Herbert Tree's rôle of the modern Pygmalion. He did the stepping rather shakily last evening, for he was obviously suffering from acute nervousness, but despite the weight of his anxiety he gave a performance that was not only highly intelligent but alight with humor and charm. His playing is one of the welcome features of a production that is itself most welcome to New York.

* * *

December 9, 1914

'WATCH YOUR STEP' IS HILARIOUS FUN

Irving Berlin's Revue at the New Amsterdam Is Festivity Syncopated

TINNEY AND THE CASTLES

They Are Only Three of the Lights of a Lavish and Lively Entertainment

WATCH YOUR STEP. A musical show in three acts. Music and lyrics by Irving Berlin. Plot by H. B. Smith. At the New Amsterdam Theatre.
WITH: Sam Burbank (Willie Steele); William J. Halligan (Silas Flint); Justine Johnstone (Estelle); Harry Kelly (Ebenezer Hardacre); Al. Holbrook (Howe Strange); Elizabeth Murray (Birdie O'Brien); Sallie Fisher (Ernesta Hardacre); Vernon Castle (Joseph Lilyburn); Charles King (Algy Cuffs); Dama Sykes (Iona Ford); Elizabeth Brice (Stella Spark); Mrs. Vernon Castle (Mrs. Vernon Castle); Harriet Leidy (Anne Marshall); Harry Ellis (The Ghost of Verdi); Frank Tinney (A Carriage Caller at the Opera/A Pullman Porter/A Coat Room Boy); Irving J. Carpenter (Denny); Gus Minton (Josiah Jay); Dorothy Morocco (Samantha Jay); C. L. Kelley (The Man in Box 51).

Charles Dillingham has done it again. Not content to stage "Chin Chin" and call it a season's work, he went down from the Globe to the New Amsterdam Theatre last evening and there presented as gay, extravagant, and festive an offering as

this city could possibly hope to see. For no particular reason this new piece is called "Watch Your Step." It is one which the London dailies would describe in accents of horror as a "big, noisy, typically American entertainment," and which the London public would witness clamorously and with every evidence of high approval. As large a portion of the New York public as could be packed into the New Amsterdam last evening seemed uncommonly pleased, and with reason. "Watch Your Step" is no end of fun.

So many things have been called musical comedies that "Watch Your Step" might as well be called one. The programme sees fit to describe it as "a syncopated musical show." It is really vaudeville done handsomely. It is a large and expensive variety show, with Mr. Dillingham doing the booking in a prodigal mood and Irving Berlin called upon to do his best for all the acts. Mr. Berlin did his best and the result is highly entertaining. Also Mr. Dillingham did his best. Most of the chiefs of the assembled company could command the choicest position on a vaudeville bill and many of them have.

More than to any one else, "Watch Your Step" belongs to Irving Berlin. He is the young master of syncopation, the gifted and industrious writer of words and music for songs that have made him rich and envied. This is the first time that the author of "Alexander's Ragtime Band" and the like has turned his attention to providing the music for an entire evening's entertainment. For it, he has written a score of his mad melodies, nearly all of them of the tickling sort, born to be caught up and whistled at every street corner, and warranted to set any roomful a-dancing.

Berlin has always enjoyed capturing a strain of fine, operatic music and twisting it to suit his own ragtime measures, and so in this, his first musical comedy, it is altogether fitting and proper that he should escort the rest of the entertainers to the Metropolitan, where the ghost of Verdi might chant a protest against an irreverent chorus of syncopated classics, and where, as part of the fun, a mock Caruso can be seen singing against the unmannerly patter chorus in the boxes.

"Watch Your Step" affords this song writer a rare opportunity. He has availed himself of it. In this new attack Berlin has found New York defenseless and captured it.

Of the entertainers, the happiest is surely Frank Tinney, one of the funniest men treading the boards today. He has come back from Europe with all his tricks and his manners unimpaired. Most of his jokes are new and all of them are funny. He was never more hugely amusing than he is in "Watch Your Step."

Then there are the Castles, appearing largely as themselves in that cheerfully personal way that is part of the vaudeville touch. Mr. Castle, on his return to musical comedy, has a name of some sort attached to the character that he is supposed to play, but Tinney will keep calling him "Vern," and he himself sings a self-introductory song about one who "knows how it feels to use automobiles, for he's a dancing teacher now."

Mr. Castle is so variously competent that besides taking a stage fall that would make even Maude Eburne pale, he plays

the traps and generally adds to the impression that "Watch Your Step" is not only as rapid, but just about as noisy as the Twentieth Century Limited. He dances several numbers with Mrs. Castle whose work is a delight.

These three entertain in their own fashion, and probably with many inventions of their own. The programme has it that the plot (if any) is by Harry B. Smith. He was in good form when he did his part, and he was careful not to get in anybody's way. For besides the Castles and the dark Mr. Tinney, the stage is crowded with such folk as Elizabeth Murray, who sings some darkey songs with great gusto; Harry Kelly, who is funny and whose dog is one of the best entertainers in these parts; Sallie Fisher, and the most engaging Charles King and Elizabeth Brice.

And then there is the chorus, spirited, multitudinous, and possessed of good looks in abundance. They sing and dance as if they knew in their hearts that all was quite well with "Watch Your Step."

* * *

April 4, 1916

'JUSTICE' DONE HERE WITH SUPERB CAST

Moving and Deeply Impressive Performance of Galsworthy's Drama of the Criminal Law

JOHN BARRYMORE'S HOUR

Youngest of a Famous Stage Clan Comes Into His Inheritance in This New Play at the Candler

JUSTICE—John Galsworthy's drama. At the Candler.
WITH: Henry Stephenson (James How); Charles Francis (Walter How); O. P. Heggie (Robert Cokeson); John Barrymore (William Falder); Cecil Clovelly (Sweedle); F. Cecil Butler (Wister); Watson White (Cowley); Wallis Clark (Mr. Justice Floyd); Thomas Louden (Harold Cleaver); Lester Lonergan (Hector Frome); Rupert Harvey (Captain Danson, V. C.); Walter Geer (The Rev. Hugh Miller); John S. O'Brien (Edward Clements); Ashton Tonge (Wooder); Charles Dodsworth (Moaney); Walter McEwin (Clipton); Warren F. Hill (O'Cleary); Cathleen Nesbitt (Ruth Honeywill).

"Justice," a play in four acts by the English dramatist, John Galsworthy, was presented to New York for the first time last night, and the members of the audience that packed the Candler to the doors for the première will remember it all the days of their lives. They saw there a powerful realistic drama of the criminal law, profoundly moving in its direct appeal to the sympathies; beautiful both in its fidelity to life and in its utter simplicity, instinct with that social pity which is a distinguishing mark of the big plays of our time, and so thoroughly dramatic that its great moments held them spellbound, fascinated.

They saw a large, shrewdly chosen company give, even in the briefest and most inconsiderable of the rôles, a performance that was as close to perfection as you would be likely to find in a long, long succession of first nights. In particular, they saw John Barrymore play as he had never played before, and so, by his work as the wretched prisoner in "Justice," step forward into a new position on the American stage. The first New York performance of this celebrated Galsworthy drama was in every way satisfying and memorable. It was a great occasion.

"Justice" is a tragedy. It is not for those who feel defrauded if two hours of idle merriment do not accompany every theatre coupon, for those who, as they say, "gotta have a good laff when they go to a show." It is decidedly not for those who when they go to the play leave their minds at home under the paper of fishhooks in the ginger jar on the dining room mantelpiece. But for those who would relish a superb performance of one of the notable plays of our day—why, it awaits them at the Candler.

In his dramatic study of the workings of the prison system in England, Mr. Galsworthy has written a play that takes its color from the prison gray—a sunless play warmed only by an immense, ever-present compassion. In any fair report on "Justice," you must repeat that same penetrating comment the young girl made on "Hamlet." Said she, putting her unerring finger on the salient characteristic: "It is a sad play."

Acted at various times in England and in Germany, and here widely circulated both as a magazine feature and in a book that has run through many editions, this latter-day tragedy—its story, significance, manner, and intent—is by now quite familiar in this country. Briefly it recites the story of a weak young clerk who, frantic in his desire to put the girl he loves beyond reach of a drunken and hideously brutal husband, steals for her, is caught, convicted, imprisoned, and at last turned loose on a well-meaning but incompetent world—a creature without hope. When in the end he kills himself, if his despairing and fatal leap is to be read as suicide, it is in no heroic climax of high resolve nor because, with 11 o'clock, it is time for the play to end, but simply and inevitably because all the hope has been crushed out of his life.

"The law is what it is—a majestic edifice sheltering all of us, each stone of which rests on another."

Thus the complacent judge when he sentences young Falder to three years at penal servitude.

"Justice is a machine that, when some one has once given it the starting push, rolls on of itself."

So speaks the lawyer for the defense. And it is, as a machine, an institution grown mechanical, that in this play you see this man-made justice in deadly and ponderous operation. And this pitiable little clerk, deciding wrong one Spring morning in the space that a breath is held—you see him caught up irresistibly, sucked in among the slow-moving, impersonal wheels and there just ground to pieces. Justice for him is as inescapable, as inexorable as the Fates in the drama of long ago.

Mr. Galsworthy takes a crime that would call for punishment in any society that even pretends to think of punishment as a deterrent, has it committed against employers more than commonly decent and tolerant, leaves the verdict to an

upright, unimpeachable court, puts the prisoner into the bands of a kindly jailer, sees to it that all concerned should be as well intentioned and friendly as could be expected, and so, by the development of his story, leaves you to feel overwhelmingly that there is something wrong with the system—something disheartening in the very fact that it is a system, a machine for handling human beings. Keep it pliable, keep it human—that is the message of this work. Mr. Galsworthy says his say wisely, justly, reticently. His play is too little categorical to be an indictment, too little forensic to be a plea, too much a work of fine art to be either. It is just a reminder. "Justice" is a reminder and you will never forget it.

The place of "Justice" in the drama of our time is already fixed and familiar. It remains to be said after its first performance here that when embodied on the stage it is piteous and finely dramatic. Its first act caught and gripped even last night's audience, which, betrayed by too many false alarms as to the hour of the curtain's rise, arrived late, heavy-footed and croupy. Its courtroom scene is almost oppressive in the perfection of its reproduction from life. Its terrific climax, where, in the tiny, dimlit cell, the prisoner, driven to frenzy by solitude and the hypnotizing sound of the other men beating on the walls, goes mad before your very eyes—this is a scene that burns itself into the memory, a thing of horror almost without parallel in the theatre of this generation.

Of where the sympathy lies, for all Mr. Galsworthy's fine disdain of adventitious aids to melodrama, there is never a moment's doubt. At the time of the summing up last night it was the inferior performance that made off with the lion's share of the applause because the speaker spoke for the defense. When the young Church of England chaplain grew a little smug, you felt an impulse stirring through the audience to mount the stage and lock that chaplain "in solitary." When, toward the end, the junior partner met the pariah and just shook hands with him unaffectedly, there came whoops of applause like those inspired by the heroics of an older dispensation.

That the play stirs so deeply is due, in large measure to the complete adequacy of its performance. B. Iden Payne, in charge as director, must have used great skill and discretion; his company was the best obtainable material. There is room here to mention only O. P. Heggie, endeared to us all as Androcles, and very fine indeed now as old Cokeson; Henry Stephenson as the senior partner, Cathleen Nesbitt as the woman, Cecil Clovelly, Thomas Louden, Walter Geer, John S. O'Brien, and Charles Dodsworth.

And John Barrymore. Mr. Barrymore, associated mostly with farce, mild comedy, and melodrama, comes into his own in "Justice." It is an extraordinary performance in every detail of appearance and manner, in every note of deep feeling. He is a being transformed beyond all semblance of his debonair self, and from his speech you would think he had never dwelt a day beyond sound of Bow Bells. He looks and sounds the undernourished underclerk of Mr. Galsworthy's story, and in the big scene within the solitary cell he displays extraordinary power. Of all this more

another day, but you do not know this actor if you have not seen him in "Justice." You are missing a superb performance of one of the foremost of modern dramas if you miss the new play at the Candler. Don't miss it.

* * *

June 23, 1916

'THE PASSING SHOW' IS A LIVELY ONE

Expensive and Gayly Bedecked Jumble of Seasoned Vaudeville Talent

STIRRING CAVALRY CHARGE

Ed Wynn, Swor and Mack, and Many Nimble Dancers in the Summer Revels at the Winter Garden

THE PASSING SHOW OF 1916. A musical revue in a prologue and seventeen scenes. Book and lyrics by Harold Atteridge. Music by Sigmund Romberg and Otto Motzan. At the Winter Garden.
The Players: Fred Walton, Ruth Randall, Stella Hoban, Frances Demarest, Ed Wynn, Herman Timberg, Jack Boyle, James Hussey, Florence Moore, George Baldwin, William H. Philbrick, Thamara Swirskaia, William Dunn, Dolly Hackett.

"The Passing Show of 1916," the Winter Garden's yearly Summer time production, arrived with a bang last evening. An amiable audience assembled at that home of frivolity found it a large and expensive jumble of tried and true vaudeville talent, lavish scenery, skillful dancers of every description, and decorative maidens innumerable. It is neither so good-looking as the rival Follies nor so amusing as Mr. Cohan's already hardy annual at the Astor, but 'twill serve. It will serve quite well as a lively light-headed entertainment, designed, like the costumes considerably allotted to so many of the scenes, for warm weather.

"The Passing Show" is a typical Winter Garden production, only more so. It is a little bit of everything. The program humorously ascribes the book to this man, the music to several others, but that is just from force of habit. As a matter of fact, few traces of any book survived the dress rehearsals and most of the music has been picked up around town. The program might read this way:

Book (reduced to a folder) by Harold Atteridge. Music by Ethelbert Nevin, Victor Herbert, the composers of "Katinka," and others. Humor by Ed Wynn and Swor and Mack, especially by Swor and Mack. Talent supplied (after a struggle) by the United Booking Office.

There is really no use trying to give a coherent account of last evening's proceedings at the Winter Garden, but here are a few of the ingredients which linger in the memory:

1. A burst of preparedness propaganda, beginning with a "What's the Matter With You" song splendidly roared by George Baldwin and ending with a stirring cavalry charge that shows a troop riding at full speed directly toward the

audience. This is the old trick of the treadmill, as used in "The County Fair" and "Ben Hur" in years gone by, but here somewhat altered and magnified many times. The effect of the mounted men coming on at a furious drive in a cloud of borde and dust provides a genuine thrill, and the applause last evening was deafeningly vehement.

2. A disrespectful but amusing political revue. You hear Colonel Roosevelt cheering for the President. "What's the matter with Wilson? He's all write." If he (the Colonel) had been in Washington the war would have been over by this time. "Yes," says Mr. Wilson acidly, "over here." And so on.

3. Ed Wynn.—Mr. Wynn, late of the Follies, is much the same. "The Passing Show" leans on him rather heavily and some of his humor takes a good deal of time in passing a given point, but his pseudo-impromptu prattle is always entertaining, and any revue is the better for his hanging around. He received a cordial greeting last evening when he was first discovered sitting in a box and shouting out, "This show's terrible." Much of the applause that followed this remark was no doubt a personal tribute. His garage scene is amusing.

4. Swor and Mack. These are two blackface comedians of the Conroy and Lemaire, McIntyre and Heath school. Their banter, which they import bodily from the two-a-day, is immensely entertaining.

5. Hussey and Boyle. Two more recruits from vaudeville singing the songs and cracking the jokes which have pleased Palace audiences this season but which were received with disconcerting coldness last evening. Hussey, if Hussey is the tall and grief-stricken member of the team, is one of the cleverest, and will doubtless fare better on other evenings.

6. Six Violin girls. These are a half dozen Hazel Dawns who just can't keep still while they fiddle. They play for their own dancing and carry their violins with them wherever they go. They bob up with them in Capulet's garden and they smite these blooming instruments in ancient Greece.

7. Dancing. There is a lot of it. There is a pretentious and often effective ballet with a "Sheherazade" idea worked out against a Greek background. Here dances one Thamara Swirskaia, an extraordinary vision. The finale is capital. There is much boneless dancing of the Harry Pilcer variety, especially well done by James Clemons and Herman Timberg. There is buck-and-wing dancing by the Ford sisters, who, as you might have suspected, are obliged to sing a song called "Your Auto Ought to Get Girls," the season's worst lyric.

8. Smutty jokes. There are none.

9. Shakespeare travesties. Few and not worse than usual.

10. Girls galore and all of them pretty. They are decked out in saucy costumes and, when they can be persuaded to stay on the stage at all, which is oftener than in seasons past, they trot to and fro before a rapid succession of settings, many of them exceedingly handsome.

Here, then, are at least ten items from the Winter Garden Inventory, and if they do not persuade you that you should buy several rows of seats immediately you are quite incorrigible.

* * *

March 13, 1917

A BITTER COMEDY ON OUR EXPATRIATES

"Our Betters" Exposes a Striving, Rancid American Colony in London

By W. SOMERSET MAUGHAM

Rose Coghlan Shines in a Clever and Interesting Play, Well Presented at the Hudson

OUR BETTERS—A comedy in three acts, by W. Somerset Maugham. At the Hudson.
WITH: Chrystal Herne (Lady Grayston); Rose Coghlan (Duchesse of Surennes); Leonore Harris (Principessa Della Cercola); Diantha Pattison (Elizabeth Saunders); John Flood (Arthur Fenwick); Fritz Williams (Thornton Clay); Joseph McManus (Fleming Harvey); Ronald Squire (Antony Paxton); Cecil Fletcher (Lord Bleane); Arthur Chesney (Ernest); Robert Brinton (Pole).

In the bitter and exceedingly interesting comedy which was proffered to New York last evening at the Hudson Theatre, a brilliant English writer presents a scorching satire on the American colony in London. It is called "Our Betters," and is the work of W. Somerset Maugham, author of such clever plays as "The Land of Promise" and "Caroline" and of one great novel named "Of Human Bondage." For his new play he has taken as his subject a group of our expatriates as they appear to an exceptionally clear and serene English vision.

Many an American playwright has had his fling at the rootless American climbers, who buy their way into English society and rot there, but none has succeeded in presenting them in quite so penetrating and unpleasant a light. No "man from home" has ever exposed them so completely and so contemptuously. "Our Betters" is simply withering. It is now given at the Hudson by a clever company that has, for the most part, been wisely chosen. There are several rather luminous members of the American stage in its large cast and the one that shines brightest of all is that seasoned expert, that veteran actress, Rose Coghlan.

Miss Coghlan plays one of the Americans abroad, and as this scandalous comedy unfolds you soon gather that one and all are in no sense innocents abroad. First and foremost is Lady Grayston (née Saunders, New York), who has entered successfully into the grand game of London intrigue, with its close admixture of society, politics, and finance. She has learned early in the game that the English cannot possibly feel cordial to the richly dowered American girls who marry their available men, and that in order to hold her place she must spend money like water. She trades on her suspicion

that no Englishman, however haughty, can resist getting something for nothing. But her own 8,000 pounds a year are scarcely enough for her ambitious purposes so, on the side, she becomes the mistress of Arthur Fenwick, a vulgar, sensual American, who is in business in London on a large scale.

Then there is the Duchesse of Surennes (née Hodgson, Chicago), an amorous old woman who romances a rather restless young English lover. Nor must we forget the expatriated Thornton Clay, who speaks disdainfully of "Americans in America" as one might speak of "Russia in Asia." He thanks his stars his tailor has disguised him thoroughly and that his taste for tea is so strong he might have been born for it. For these rank idlers the great war is a sort of vague background that throws their futility and worthlessness into sharp relief. It would have pointed the satire nicely and pleased some of us immensely had this precious group indulged now and then in some withering long-distance criticism of President Wilson.

All that is rancid in this life is fairly visible under the smart veneer, but not to Lady Grayston's sister, who comes over to get another title for the Saunders family. She has accepted an honest and engaging young nobleman when she runs across one of Lady Grayston's bland indiscretions.

When she discovers further that all the foul epithets hurled at that unabashed but rather irritated lady at the climax of the second act are not only deserved, but quite exact descriptions of her, she is so utterly sickened that she leaves Lord Breane and England and takes the next American boat and the next American man she sees. She is revolted at the morale of a house party which Elinor Glin might have imposed and has in more book than one. It would take several old but unprintable terms to describe some of the people in "Our Betters," and a few of these are used with startling effect in the text of the play.

Rose Coghlan is superb as the old Duchess, playing her faded witcheries with the greatest relish and aging visibly before the audience's very eyes when she discovers that her hostess and dearest friend has in a reckless and mischievous moment gone off into the garden with the Duchess's bought-and-paid-for swain. There is brilliance in Chrystal Herne's performance as Lady Grayston, a rôle whose hard glitter might have tempted Emily Stevens. Miss Herne is often admirable, but she overstresses her every point, and, possibly through the nervousness of a first night, did a good deal of shouting last evening, which suggested at times that she must be under the impression she was still playing Cassandra in the vast stadium of City College. A remarkably telling performance is given by Leonore Harris as a sad-voiced American Princess, who had given her love to her Prince when he had not wanted anything except her five millions.

Fritz Williams is capital as the complete expatriate, and John Flood, when he can go through his part without lapse of memory and infectious nervous prostration, will be excellent as the gross American business man who, the lobby gossips have it, is a quite recognizable character drawn from life. Cecil Fletcher is clever and pleasing. So, despite a curiously strangled utterance and a bad habit of making faces into space, is Diantha Pattison. Indeed, in the large and competent cast John D. Williams has selected for "Our Betters" the only choices difficult to account for are Joseph McManus as the "man from home"; Ronald Squire, an excellent actor, but scarcely the lapdog boy of twenty-five the text demands; and Arthur Chesney as a dancing teacher to the idle rich. The idle rich are always targets for the satirist, but when you have the rich doing their idling in a country that does not belong to them and does not want them you have found a chance for a dramatist like Somerset Maugham to write an excoriating comedy. "Our Betters" is just that.

* * *

April 8, 1917

SECOND THOUGHTS ON FIRST NIGHTS

"Out There"

"Out There" is the latest and best of the war plays, a simple, uncomplicated, unperplexed study of patriotism that is quite glorified by the eloquent and infinitely touching performance of Laurette Taylor as the little Cockney girl whose tremendous passion for service wins her at last the honor of the red cross. This is the sixth play by J. Hartley Manners in which she has appeared in New York—the latest product of a delightful partnership of the theatre that seems destined to find a place in its history as honorable as that won by the partnership of Gilbert and Sullivan or Barrie and Maude Adams.

Laurette Taylor as the Little Cockney Jeanne d'Arc in "Out There," the graphic and mighty appealing war play now on view at the Globe.

It is incomparably finer and more appealing than most of the war plays that have been launched at the unprepared and defenseless theatregoer since first the great assault was made. It is different from all of them. We have had every kind of war play, from those which merely post-dated such old favorites as "Shenandoah" and "Held by the Enemy" to those which depressed and bored the audience by expositions of war's waste, war's horror, and war's futility. We have had everything dramatized, from the biggest Kaiser to the littlest war baby. There have been those which merely used Belgium or France as a sort of repainted backdrop for some ancient farce or romance. There have been those which merely mobilized the little tin soldiers from the dust and rust of the property room. There have been those which appeared to have been evolved after reading one book and having one talk with some one who had met someone who had done his bit at the front.

But "Out There" is made from fresh materials, gathered on the spot. Its extraordinary second act, one of the longest, most unusual, and most telling acts our theatre has known in many a day, is simply a visit to a hospital somewhere in France, the account of a visit such as an alert, observant, sympathetic correspondent might send back home to his newspaper in New York. In this account is many a swift, graphic sketch, many a character study of humor, diffident kindliness, stoicism, unconscious heroism, odds and ends of the great struggle which the historians will not have time to tell, which could find no place in the blazing oratory of the war, but which touch you deeply and splendidly illuminate the picture. "Out There," then, is just a good journalist's "human interest" story of the war. Written and staged by a gifted playwright in four hurried weeks, it is journalistic playwriting, with some of the defects and many of the virtues you might expect to find in a work of its kind.

It is a play of the moment and for the moment. It has been brought forward in New York at a time so psychologically right as to be the envy of every counting house on the Rialto. Its every line has a hundred heartwarming associations for every one of us. It strikes a hundred chords strung tight by the great events to which we march. It is difficult to imagine what our reaction to its appeal would have been had it been brought to us instead of "Peg o' My Heart" four years ago. Perhaps it cannot long survive after the soldiers have been mustered out. But in its day and hour it is the seventh wonder of the season.

Here, then, is a series of sketches of the war, simple, authentic sketches used as a significant background for the swift unfolding of a character. It studies war neither as horrors nor as heroics, neither as an anachronism nor as an economic fact. It presents war as discipline. It preaches the ancient gospel of service. It watches the growth of the soul of Annie 'Udd of Camden Taan in the times that try men's souls.

You first meet little Cockney Annie in her dismal, hopeless home in Camden Town—'Aunted Annie who has talked her bloke into going off to the wars and who burns to get "out there" herself and do her bit for England. Her strange, wide-eyed fervor gives her slacker brother and sister the fair pip and stealthily, for fear of their gibes and jeers, she sews away on a home-made nurse's uniform, a white robe on

which a raffish red cross sits askew. It is such a costume as she wears in her brave dreams at night, when, for a few hours, she is a real nurse tending the sick and wounded at the front. She is sick with envy of the fine ladies whom she suspects of going "out there" just for the excitement and t' get their fices in the illustrated pipers. All she asks, as a starter, is a chance to run errands, make beds, scrub floors—anything to get "out there," and she is all-of-a-tremble with eagerness when her moment comes to plead her cause before a big doctor who has been assigned to a British hospital in France. Could she go with him? She must go with him. You see her shining eyes and tremulous lips as she tries valiantly to choke back her emotion long enough to tell that startled gentleman a few choice stories just to show him how well she could entertain the boys at the front. Of course he takes her. And really it seems no extravagance. When you hear her plead her cause, you don't see how he could very well help taking her.

Then comes the hospital itself—the row of beds with the wounded men from every corner of the unparalleled empire. You see her bustling about among them—'appy Annie now. You see her scrubbing diligently when the nurse is watching but devoting herself to their amusement when the chance is offered. She is the apple of their eyes, and even the gloomy Irishman lights up at the sight of her, though he groans aloud when she sings and though, when she confides to him that she fair wished herself "out there," he loudly and rudely hopes to God that she will wish herself back again. Her services are innumerable. She may be merely getting a fair copy of the magic word "holocaust" so that the New Zealander can spell it right in writing home. She may be merely applauding the Scotchman when he essays a Lauder song or rescuing his "preecious bonnet" when the others hide it from him. You watch her forage for cigarettes and cigars for her charges and hear her fascinate them with some fearful ballad of the music halls. Now she is saluting the big Canadian with some such greeting as "Cheer-O Kennida," and trying most artfully to get for herself his bit of shrapnel to make a breast pin to go with her cap from Flenders and her belt made of a rescued flag from Wipers. Now she is chatting with the lonesome Cockney about prize-fighting and particularly about the fearful 'ook and the wicked left which had made her brother famous in Camden Taan.

She is the joy of the ward and when she is told again and again that she must not bother the men, must not smuggle contraband luxuries to them, and above all must not lift and comfort them when they are in pain, she simply does not understand. The impulse to take care of them is stronger far than her faint notion of discipline, but little Annie has the makings of a good soldier in her and in her great hour her new sense of duty resists all the impulses of her heart.

That great hour comes when two wounded men are brought in fresh from the field—two grievously wounded men, quiet, for the moment, under the first opiates. Only Annie is left in the ward with them, and as she crawls along the floor with her brush and pail, there comes suddenly the sound of one of them calling out in delirium, a high-pitched, anguished voice that

says again and again in more and more ominous tones: "One two, three, four—charge; one, two, three, four—charge; one, two, three, four—charge." She is in a torture of anxiety to do something, and knowing she may not even put a soothing hand on the troubled head, she stands in suffering indecision for a while and then, with an inspiration, creeps toward the cot, bends over it in an agony of solicitude and softly croons the strains of "Rockaby-biby." Gradually it takes effect. Gradually the delirium subsides and only the music of the lullaby can be heard in the silent ward. Then comes the scaring moment when, out of that silence, the other man lurches forward with a dreadful shriek and Annie, as she throws obedience to the winds and forces him back on his pillow, sees that it is her own man, her own feller she had been walking out with and whom she herself had beguiled into the army. The doctor, hurrying forward then, knows that the time has come either to throw Annie out of the hospital or recognize her as a nurse. So, at the last, she is sitting there with her funny, treasured red cross cap on her head, holding her own boy's hand close to her beating heart. It is the post of posts in all the world for her, but when the delirium calls her once more, it is after only a moment's inner struggle that she leaves that post and goes to tend the stranger. Then is she Nurse Annie indeed, a little wide-eyed, happy-go-lucky Cockney drudge who has learned the lesson of service.

This is the climax of the second act, an extraordinarily long act which, for the most part, is so cheerfully devoid of all that the wiseacres of the theatre call "action" that it probably gave Mr. Manners some qualms of uneasiness and doubtless led him to call his piece not a play but "a dramatic composition," a curious kind of evasion which usually is the preamble to something pretty painful in the way of entertainment. This act, this celebrated act, is as disrespectfully unlike a portion of a "well-made play" as you could well imagine and it is a most fascinating thing to see and hear. It is too bad that "Out There" could not end there. It is too bad there has to be a third act at all.

But probably it is necessary. It is no doubt a sound tradition which says a play must last till 11 o'clock, or nearly that. And those who have watched Annie from her first, almost hopeless, aspirations for war service are doubtless entitled to see her at last in her red cross uniform. But the act devised for this laudable purpose is disappointing. It is disappointing even now that it has improved immeasurably over the chaos of the first night, when the desperate speed of the preparations, brought it to New York in no condition to be seen at all.

In this third act you see the Hudd family renovated by the war. Chunky 'Erb is in khaki and straining at the leash to get "out there." 'Aughty Lizzie is making munitions and will entertain no proposals of marriage until she has pulled the Government through. Even Ma 'Udd is door-tender at a hospital and has given up gin for the duration of the war, with no more than a sigh and a bit of a prayer that the war won't last long. And Annie—Annie is a speaker at recruiting meetings, and so successful, they say, that her hypnotized listeners enlist without even knowing a war is on, going to sleep civilians and waking

up in khaki. Thus loudly does this act roar and thunder in the index and it is small wonder that the speech we then hear her make in Trafalgar Square seems a bit short-weight after such an introduction. When "Trilby" was staged it was not only not feasible to engage, but it was impossible to find anywhere in the world, a singer who could bear out satisfactorily the reputation of her magic voice, and when George M. Cohan wrote a play about Billy Sunday he was far, far too clever to try to write one of his speeches. Mr. Manners has written a speech for Annie to deliver, but it is a lame speech, absurdly confined to generalities, strangely centred on the question of preparedness, and monstrously worded to apply to America. It is helped out by cheers from the listening crowd and by the fine stimulation of "Rule Britannia" and "The Marseillaise," but it is a disappointment to all who have felt the thrill of what has gone before.

This play—this little gospel of service—is intrusted to an uncommonly competent cast. In the carefully chosen company at the Globe no one is inadequate, and among those who help Laurette Taylor, Lynn Fontanne and Leonard Mudie play with really brilliant skill and finesse. But the play belongs to Miss Taylor and it strengthens the hold she has upon the affection and admiration of New York. You could ask nothing better than the girlishness, the jaunty humor, and the fine fervor—the uplifting fervor of this performance. You can imagine nothing more inspiring in the theatre just now than the sight of her standing with her hands clasped, her cheeks flushed, and her eyes as big as saucers, while she whispers again and again, "We're goin' t' win, ain't we, doctor? We gotta win! Bli' me!"

ALEXANDER WOOLLCOTT

* * *

April 19, 1917

AN ACTING EDITION OF 'PETER IBBETSON'

Ingenious Play Catches Something of Its Fine Fragrance and Elation

WITH THE BARRYMORES

The Brothers Lead an Admirable Performance of This Piece Made from du Maurier's Dream Story

PETER IBBETSON—A dramatization by John N. Raphael of George du Maurier's novel, in four acts. At the Republic.
WITH: John Barrymore (Peter Ibbetson); Lionel Barrymore (Colonel Ibbetson); Wallis Clarke (Major Duquesnois); Montague Weston (Mr. Lintot); Leo Stark (Raphael Merrydew); Eric Hudson (Crockett); Alexander Loftus (The Bishop); Cecil Covelly (Charlie Plunket); Benjamin Kauser (Achille Grigoux); Lowden Adams (The Prison Chaplain); Constance Collier (Mary, Duchess of Towers); Laura Hope Crews (Mrs. Deane); Alice Wilson (Mrs. Glyn); Catherine Charlton (Madge Plunket); Barbara Allen (Lady Diana Vivash); Martha Noel (Victorine); Nina Varesa (A Sister of Charity); IN THE DREAM: R. Bogislav (Mme. Seraskier); Vernon Kelso (M. Pasquier de la Mariere); Viva Burkitt (Mme. Pasquier de la Mariere); Joseph Eagles (Gogo); Madge Evans (Mimsey Seraskier).

Du Maurier's "Trilby" had scarce run its eventful course in Harper's Magazine and its memorable popularity was at high tide when a makeshift play was fashioned from its pages and exhibited with great success and profit on the boards of this country and England. But his earlier, rarer, and finer novel did not reach the stage until a quarter century after it was written, and, except for a single performance for a war benefit in London, was never presented to an audience until last evening. Then, at the Republic Theatre, the play of "Peter Ibbetson" was given here, an interesting and ingenious play that catches something of the fine fragrance, something of the strange elation of one of the happiest stories ever told.

It is appreciatively mounted and it is admirably played. There is Laura Hope Crews as Mrs. Deane, there is Constance Collier as that wondrous woman—Mary, Duchess of Towers. There is Lionel Barrymore as the loathsome Colonel Ibbetson, Lionel Barrymore, whom our stage has not seen in nearly a dozen years, returning to give a graphic and telling performance and share the honors with his brother John, who leads the company with his resourceful, finely imaginative playing as Peter Ibbetson. The reappearance of these two gave a special quality to the evening, and at its great moments the Barrymore-Drew box wept as one tear duct.

It is a difficult task for this reviewer of dramatic entertainment to give a reliable account of last evening's proceedings at the Republic Theatre. It is a difficult thing for one who has read "Peter Ibbetson" again and again, who loves it dearly and who knows it from cover to cover, to tell how much of background and flavor he is supplying to the play out of his own memories of the book.

It is a peculiarly difficult thing for any one to write quite fairly of a play brought to the public so long before its due time that all the elaborate lights and most of the elaborate scenery fail to behave. The tasteful and appropriate investiture provided by Gertrude Newell and Caroline Dudley misbehaved so outrageously last evening that the spell of several scenes was rudely dissipated and the performance was made to straggle along until nearly midnight, but the conditions which told so heavily against the piece last evening may be but nightmare memories to the actors tonight.

With all these apologies and explanations, it should then be said that one who is inordinately fond of "Peter Ibbetson" enjoyed the play greatly, feeling that it reproduced its story ingeniously and well, caught admirably a good deal of its precious flavor and blundered only twice—in each of the scenes that close the last two acts, when far too little was left to the imagination and when at least one painful touch was added that seemed false to Du Maurier, false to "Peter Ibbetson."

"Peter Ibbetson" is the story of the man and woman who dreamed true. Have you even experienced a recurrent dream? Was it one that took you back as a fascinated spectator to the wonder days of your childhood? Suppose that you learned the trick of thus revisiting that scene any night that it pleased you. Suppose, Sir, that there you met and spoke with a beautiful woman whom you had seen wistfully and but for a moment once before in your waking life. Suppose that later in everyday life you were to cross her path again and learn by chance that at the same day and hour she too had been dreaming, and that in her twin dream she had met and spoken with you.

Then would you have the conditions of Peter's great adventure, the strange capacity these two had for dreaming deliberately and spending their dreaming hours together—Peter Ibbetson and Mary the Duchess of Towers, Mary, who had been the little short-haired Mimsey Seraskier of his childhood. How this spirit romance flourished unseen to the world which separated them as widely as the Poles, how, even after Peter was sent to prison for life, he lived for forty years in blessed union with the gracious lady of his dream, this is Du Maurier's famous story, which, after many years, has reached the stage in a play by the late John N. Raphael.

The difficulties of staging such a story thicken, of course, when the effort must be made to show the limitless resources of these two spirits who could travel together to any spot on the world, who could fit out their dream house with all the finest furniture they had ever seen, hang its walls with the great pictures of the world, and hear at will the finest music the memories of either of them could recall. It is with a glimpse of the opera house—in Milan, perhaps—that the curtain falls on the third act, a rather dinky opera house with a disappointing substitute for Patti's voice. Then, too, the play must needs escort Peter to the world beyond, when the Duchess of Towers has died and he follows to find her waiting for him, an attempt to go on and on after Du Maurier had, with the artist's discretion, laid down his pen.

John Barrymore, though he lacks the gigantic stature which Du Maurier chanced to bestow on Peter Ibbetson, does bring riches of skill, eloquence, and imagination to a part as different from any we have seen him play as was his wretched Falder in "Justice." There is tenderness, romantic charm and wistfulness here—and then a fine, black rage for the murder of Colonel Ibbetson. Particularly in the first act last night (when none of the scenery fell on him) there was a notable spirituality in his sensitive performance that gave the play its tone.

Lionel Barrymore's arresting and ingenious playing as Colonel Ibbetson is an admirable thing. It is a delicate and charming performance which Miss Collier gives as the Duchess of Towers, though she comes no closer to resembling the Mary of Du Maurier's drawings than does Barrymore to the Ibbetson. Miss Crews is agreeable and sufficient in a minor rôle, and a capital bit is done by Wallis Clarke as the poor old Major, who is the only survivor poor Peter finds when he makes his disconsolate, solitary pilgrimage to his beloved Passy before he learns to dream true.

* * *

December 26, 1917

'WHY MARRY?' A HIT AT ASTOR THEATRE

Aspects of Modern Matrimony Discussed in a Diverting Stage Story

NAT GOODWIN ON DIVORCE

Excellent Cast, with Ernest Lawford, Edmund Breese, Beatrice Beckley, Estelle Winwood

WHY MARRY? A comedy in three acts, by Jesse Lynch Williams. At the Astor Theatre.
WITH: Lotus Robb (Jean); Harold West (Rex); Beatrice Beckley (Lucy); Nat C. Goodwin (Uncle Everett); Edmund Breese (John); Ernest Lawford (Cousin Theodore); Estella Winwood (Helen); Shelley Hull (Ernest); Richard Pitman (The Butler); Walter Goodson (The Footman).

The holy estate was again up for inspection last night at the Astor. Jesse Lynch Williams would, it is to be presumed, acknowledge the debt to Bernard Shaw which is owed by so many writers of modern social comedy. This granted it must also be acknowledged that his play is written from a thoroughly original point of view, is as keenly satirical as Shaw at his best and, last but not least, as amusing. From start to finish it held its audience in rapt attention, made it bubble with deeply felt comedy and not infrequently shout with delighted laughter. In Chicago the play ran ten weeks, which, as Nat Goodwin intimated in a curtain speech, is, in Chicago, a long time. It gives every promise of the best of fortune here.

It is against the financial basis of modern marriage that Mr. Williams makes his main drive. The world knows well enough by now that where wife, and even children, were once an economic asset, they have become a heavy liability. On people who live by the professions the fact bears with crushing weight. The young hero of the play is a brilliant scientist whose work is of the utmost service to humanity; and the girl he loves is his most efficient assistant in the laboratory. But their joint income does not suffice for married life according to the standards of the middle-class folk among whom they were born. What shall they do?

The girl has the faculty of seeing things clearly, if rather hectically, and of expressing herself with starting vigor. Children being financially impossible, and the society aspect of matrimony negligible to her, she declares for living and working with her man in a free relation. Among her near relatives are a lawyer, a minister, a judge, and a successful business man; and in the upheaval which her announcement causes the kinks in the holy estate as at present practiced are very thoroughly explored. Many wise things are said with startling freshness, many gibes made at all of us with irresistibly comic effect. Short of Shaw, no one has ventilated such a subject with such telling satire and explosive humor. And there are certain respects in which, as it seemed, the play surpasses even Shaw.

For this comedy is not merely a discussion. It tells a story which, granted the exacerbated attitude of its heroine, is plausible enough and which is worked out in terms of normal human nature too often incomprehensible to G. B. S. One is quite convinced that these are real young people, that their love is sincere and beautiful, and that their hearts are as warm as their ideals are high. The play is not only an admirable comedy but a good stage story.

There is, perhaps, a tendency at times to hammer away at current standards in conduct and to underline ideas. The head of the heroine's family, the business man and "old-fashioned husband," played by Edmund Breese, seems rather a bête noir to the author. He is made such a cad as to be quite out of any picture of normal moderns. But he at least does this service, that he makes comprehensible the revolt of his dependent sister, the heroine.

His wife, played by Beatrice Beckley, is the "old-fashioned woman" and seems likewise somewhat stereotyped. But she is in the main true enough, and the part is played with such charm and deep sincerity that Miss Beckley scores a real triumph.

The part of the Judge, on the other hand, is a comedy creation of the first order, full of character and humor, and, as played by Nat Goodwin, is the king post of the performance.

This Judge has lived with his wife for twenty-five years and they have reared a family, but she is now in Reno, and, as it seems, he is reconciled, even enthusiastic. In the earlier parts of the play his strictures on the marital relation are a source of incessant laughter; and it was only in part due to the fact that they emanated from an actor whose authority on the subject is recognized. The amusement was not lessened when this Judge turned out to be really monogamous, and delighted at the return of his wife. The performance was sometimes unduly emphatic, tending toward the manner of farce; but it was always irresistibly comic.

Ernest Lawford was the clergyman and, though the part is not a showy one, he again evinced his quality as an artist by making it very sincere and appealing. Shelley Hull was the hero, and though a recent addition to the company made an impression at once strong and fine. Estelle Winwood played the heroine with great charm and intensity of feeling, sounding all its varied notes inerrantly. As the heroine of a subsidiary love story, Lotus Robb was very pretty and did her few scenes with admirable effect.

The company was, in short, one of the most distinguished of the season, and in the main worthy of a play which is perhaps the most intelligent and searching satire on social institutions ever written by an American.

* * *

February 1, 1918

'OH LADY! LADY!!' IS AFTER 'OH, BOY!'

A Good Story, Clever Lines, Tasteful Music, and Girls Long on Grace and Refinement

OH, LADY! LADY!! A musical comedy in two acts. Book and lyrics by Guy Bolton and P. G. Wodehouse; music by Jerome Kern. At the Princess Theatre.
WITH: Constance Binney (Parker); Vivienne Segal (Mollie Farrington); Margaret Dale (Mrs. Farrington); Carl Randall (Willoughby Finch); Harry C. Browne (Hale Underwood); Edward Abeles (Spike Hudgins); Florence Shirley (Fanny Welch); Carroll McComas (May Barber); Reginald Mason (Cyril Twombley); Harry Fisher (William Watt).

Once more Comstock, Elliott, and Geat have shown their allegiance to the policy of supplying popular entertainment which is mitigated by all available talent and good taste. "Oh, Lady! Lady!!" is the much punctuated title of a musical play which is obviously designed as a pursuing sequent to the only less punctuated "Oh, Boy!" The dress rehearsal last night at the Princess went off with every indication of success.

If the offering lacks highly sensational features, it has the rarer virtue of being thoroughly well rounded and virtually flawless. The book, by Bolton and Wodehouse, has a measurably novel plot that actually sustains interest for itself alone. The lines are bright and the lyrics well written. The music, by Jerome Kern, is in his familiar vein of easy gayety tinged at times with reverie and sentiment. The long cast includes many actors of genuine attainment in their quality, and the ensemble evinces a notable instinct for casting, down to the chorus which, though by no means epoch-making in the matter of good looks, touches the high-water mark of seemliness and refinement. To a generation long sated with tricks of novelty, even artistic excellence and unerring good taste may well prove a more drawing card.

The story concerns a young bridegroom, who is confronted at his wedding rehearsal by an abandoned fiancée. His valet, who is a graduate of prison reform at Sing Sing, is also about to be married; and his lady, like himself a master of the arts mercurial, steals a pearl necklace from among the wedding presents. The story begins in the bride's home on Long Island and progresses on the roof of a studio building in Waverly Mews, among the happy villagers of Greenwich.

Carl Randall is the young bridegroom and, though not long in the histrionic line, makes full amends by the really marvelous grade of his dancing and the lightness of his upsprings. Vivienne Segal is his bride, and wonderfully pleasing she is, not only in face and figure, but in song and dance.

Edward Abeles and Florence Shirley are the Sing Sing specialists, and Carroll McComas the abandoned fiancée from Gilead, Ohio, now a metropolitan dressmaker. Margaret Dale is the bride's mother. Reginald Mason the detective and Harry Fisher an elevator man. It cannot be said that any of these artists adds to his laurels, but each one of them adds in full measure to the effect of the play in hand, and that is, at present, the important point.

The scenes are handsome, the studio roof being notably atmospheric, and the gowns are in admirable taste, with no touch of the sensational or bizarre.

* * *

August 20, 1918

'YIP! YIP! YAPHANK!' MAKES ROUSING HIT

Sergt. Irving Berlin's Musical Comedy at Century Has Points on the Service Shows

ITS MUSIC BEST FEATURE

All of the Numbers Are Patriotic and Its Chorus "Maidens" Are One Long Laugh

The induction of Irving Berlin into the National Army naturally marked the beginning of a new era in musical military affairs, and some of the results of the amalgamation were revealed at the Century Theatre last night in the shape of a rousing show given by and for the men from Camp Upton. Previous service shows have demonstrated that this type of entertainment requires no handicap from the musical comedy of Broadway, and the Uptonites, with the professional hand of Berlin at the helm, have turned out an entertainment which is in all respects the equal of the service shows which have gone before, and in several particulars their superior. "Yip! Yip! Yaphank!" is the name of it, and the audience of theatrical notables who made up the first night audience received it with the acclaim which only Broadway knows how to lavish.

Merely to say that these shows are as good as the average Broadway piece is grossly to undervalue them. "Yip! Yip! Yaphank!" for example, is vastly better: It has, of course, one immeasurable advantage over the commercial musical show, for the fact that it is being played by men in service can never for a moment be lost sight of. This fact is of greatest value, of course, when the "female" chorus is on the stage, and then, assuredly, no one can forget that these chorus maidens are soldiers. The chorus of "Yip! Yip! Yaphank!" is guaranteed to be one long laugh, whether one regards the third from the left, the fourth from the right, or the ensemble in general. Whoever picked its members was nothing less than inspired.

But the piece does not depend solely upon such obvious points for its merit. It is at its best when the music is playing, for Berlin is first of all a song writer, and a librettist second. Army life and its adjuncts are the theme throughout, and the author has found plenty about which to lyricize. The most appreciated number was an old one, Berlin's classic bugler lyric, but half a dozen others ran a close race for second place. Most of them will probably soon be more than familiar, for they are certain to find their way into vaudeville or musical comedy when "Yip! Yip! Yaphank" is permitted to pass.

The author appeared twice during the evening, once to sing the bugler number and again as a member of the despised kitchen police. The military police were there as well, and so were the cooks, the doctors, and the various other addenda of a training camp. There were also the girls from the "Follies," who are not generally regarded as a necessary camp adjunct. They brought with them the "Follies" principals, the best of whom were Ann Pennington and Eddie Cantor, impersonated by Privates Kendall and Cutner, respectively.

The nature of the specialties indicated the presence of more than one regular performer in the company. There was, for example, a juggler, a workmanlike imitation of Joe Jackson, and a troupe of acrobats, to say nothing of some clever dancing and some varying singing. Benny Leonard, prizefighter, gave an exhibition of his skill somewhere around the hour of 11, after which a patriotic number, although they were all patriotic, brought the show to a close.

Major Gen. J. Franklin Bell made an address from his box following the performance, and vain efforts were made to coax a speech from Sergeant Berlin. "Yip! Yip! Yaphank!" will be played at the Century for the rest of the week, with matinées tomorrow and Saturday, and the proceeds will be used for the erection of a community house at Camp Upton.

* * *

January 19, 1919

THE MYTH OF "REPERTORY"

By JOHN CORBIN

The present dramatic season, as yet scarcely half over, has witnessed the inception and the abandonment of two organizations that proclaimed themselves repertory companies—one managed by Iden Payne, the other by Norman Trevor and Cyril Harcourt. Last year saw the end of the Washington Square Players, and the year before the end of Grace George's "repertory" productions at the Playhouse. Scarcely a season has been without a similar phenomenon back to the New Theatre, which failed gigantically. And still the call is heard for "repertory." In reviewing William Winter's "Life of David Belasco," J. Ranken Towse, dramatic critic of the Evening Post, holds it against Mr. Belasco that, though "the best qualified man in his profession" and phenomenally successful financially, "he has not, as the old-time managers did, founded a permanent repertory company."

The question seems apropros whether Mr. Belasco would be as successful, or, indeed, would be regarded as so well qualified in his profession, if he had founded one of these companies. When the two late repertory ventures were announced at the beginning of the present season that genial and shrewd observer of things theatrical, George S. Kaufman, remarked that the prospect was very hopeful. "There are only two things that can kill a repertory company," he said. "One is a failure, and the other is a success." The simple fact seems to be that "repertory" is a myth, a will-o'-the-wisp, and that the pursuit of it, if it is sincere and resolute, is the most fatal

undertaking possible in a profession which is, above all others, strewn with the corpses of the fallen.

The sincerity of this season's ventures is at best questionable. They were certainly not resolute. To those who are wise in the mental processes of Broadway, the significance of such schemes is obvious. A manager has a play, perhaps several plays, which he knows to be ill-adapted to the general public, but which he hopes will attract a special public for a few weeks. He has also a theatre for which a profitable tenant is not forthcoming. So he puts the dubious play into the doubtful theatre and announces a repertory venture—relying on the vogue among our intelligentsia of an utterly vague and indeterminate phrase to attract the attention of the special public he is after.

If the play fails there is an end of everything—as happened with Iden Payne at the Belmont. If by any chance it succeeds the end of the "repertory" idea is equally indicated; for the part of managerial wisdom is to continue the production as long as it pays a profit and then send it out for a tour on the road, after which there will be further profits in moving picture and stock rights.

In the venture of Messrs. Trevor & Harcourt at the Comedy there seems to have been an unusual element of sincerity—and the result was unusually misfortunate. Their opening production, "An Ideal Husband," by Oscar Wilde, succeeded beyond expectation; but they held loyally to their plan of producing other plays and so ended its run, sending it on the road. They themselves, of course, had to remain behind, and other members of the cast refused to leave New York. So they had to improvise a substitute cast—with the result that the production died the death in Chicago. Their loyalty to the "repertory" idea had slaughtered a valuable property. Then their second production failed, and the Comedy Theatre ceased to be the home of "repertory." This, or something very like it, is the story of most ventures of the kind, including Grace George's two memorable seasons at The Playhouse.

It is high time that the simple truth be told about this myth of repertory and this will-o'-the-wisp of the stock company. What is a repertory? When we speak of a singer's repertory we know what we mean. It is "a store or collection, a treasury, a magazine," of songs which he has mastered and which constitutes his professional stock as a singer. What a repertory theatre is Henry James knew very well when, in "The Tragic Muse," he spoke of "a great academic, artistic" institution, "rich in its repertory, rich in the high quality and the wide array of its servants."

The Theatre Français is a repertory theatre, and by means of a large and versatile company residing permanently in Paris, it revives from time to time the great Greek and French classics, together with the more memorable French plays of recent times. There are repertory theatres in the capitals of Germany and Austria and Hungary which keep alive and vivid in the national consciousness not only the Greek and German classics, but classics of Italy, Spain, France, and England. This is the sense in which the founders of The New Theatre used the word—and it is a

sense in which there has never been a repertory theatre in any English-speaking country.

It is possible, of course, for a theatre to have a repertory which is less extensive. Granted a large and versatile resident company, a certain number of plays can be kept in hand and revived from time to time. Until toward the close of the last century the versatile resident company was the characteristic type of theatrical venture in England and America. In point of fact, the majority of their productions were new plays of a quality necessarily inferior. They revived some few classics, and even modern successes of note, but only at irregular intervals and generally as a stop-gap when the supply of novelties temporarily failed. Primarily they were not repertory companies. They were merely what they were called, stock companies.

Why did the stock company fail and die out? Simply and solely because the railway succeeded. From the beginning of time theatric art had been local, each company being limited to a single city. Toward the end of the last century the civilized world had become a network of steel rails, along which a production which was successful in any city could speed to all others, reaping a profit in each "stand" on the route. Intense competition ensued, as a result of which money was lavishly spent on scenery and costumes; the salaries of actors doubled and redoubled. Today, even if a manager were willing to forego a great fortune to become director of a stock company, he could not do so and live. As for the true repertory theatre, it has never been possible, even on the Continent, except with a liberal subvention.

This effect of the railway was felt less severely in Europe than in America. Distances were shorter and capitals, each with its established art theatre, were much more numerous; so that people of the provincial cities continued to seek their dramatic education and their theatric diversion in the metropolis. It long remained the custom among playwrights to sell the rights in each new piece only for a local production.

Great actors are no longer content with a merely local public and with local pay. Coquelin and Bernhardt left the Français to become world-famous. Guitry and others followed. In Vienna, Sonnenthal and Kainz retained their connection with the Hofburg Theatre until their death; but they demanded (especially Kainz) frequent leave to make tours, and they exacted salaries far beyond their actual commercial value to the management of the Hofburg. In Berlin and the minor German capitals the actors who remain in the royal companies are turgid and old-fashioned to a degree—actors for whom no other public is possible. The playwrights followed the actors, especially in France. Thus Rostand, though he owed his start to the Français, gave "Cyrano," "L'Aiglon," and "Chantecler" to Coquelin, Bernhardt, and Guitry, respectively, who produced them on the boulevards.

The attempt of the founders of the New Theatre to establish a repertory company was misinformed and misguided, precisely as was the attempt of the framers of our National Constitution to adapt essential principles of English Parliamentary government. In both cases obsolete or obsolescent institutions

Granville Barker, English theatrical manager, who is a believer in the repertory system.

failed to meet the real needs of a world that had passed beyond them. In New York when a manager revives a play the public looks askance at it—as at an attempt to galvanize a dead one and palm it off as a novelty. The New Theatre ventured on the experiment only once, and then with a modern play. It never had a repertory of any kind. And it never had a real stock company. The leading Shakespearean actors of the country were engaged for it, but they required salaries far beyond their local earning power, and proved otherwise impracticable. After they left plays with great parts—"Hamlet," "Othello," "Lear," "Macbeth," and, in fact, all the greatest classics—became impossible. Even in minor classics leading parts were largely played by guests imported into the company—Grace George, Annie Russell, Bertha Kalich, and others. The difficulty as to new plays was similar. Leading playwrights, accustomed to the rewards of a road tour, refused to give the theatre their pieces. In addition, many needless mistakes were made, as for example in the size of the theatre and the scale of expense it involved. The total loss on the institution was upward of three millions. Even this did not discourage the founders, who were to the last eager to fulfill their promise to the city. They actu-

ally secured a new plot of land in the Times Square section, and employed an architect to design an ideal house. But in the end the practical difficulties of the problem wore them out. The repertory art theatre, it would seem, is a last year's nest.

The practical difficulties of the undertaking were further illustrated in the subsequent venture of Granville Barker, who shared, and doubtless still shares, in the "repertory" delusion. He brought five plays. The opening production, "Androcles and the Lion," was a success of the first order. But, like Messrs. Trevor and Harcourt, he remained loyal to his ideal, with this difference that he attempted to run the second production. "A Midsummer Night's Dream," concurrently at the same theatre, in the Continental manner, the two alternating from day to day. Now, nothing is more sensitive than the life of a "run." All managers declare, and have abundant proof of the fact, that to interrupt a run, even to change it to another theatre, is generally most harmful. The effect of producing another play at the same house is to cut in half the number of those who are seeing and talking about the first, and to give the impression that it was not really a success. In the case of "Androcles," this impression was strengthened by the fact that the new piece failed. When "The Doctor's Dilemma" was added to the "repertory," and likewise failed, disaster overtook the enterprise, which closed with a loss of many thousands of dollars.

There can be little doubt that if "Androcles" had been produced at a smaller theatre, such as the Maxine Elliott, which was then available, it would have had a long and very prosperous run, followed by an equally prosperous road tour. The other plays could have been produced elsewhere, and when they failed could have been withdrawn at once with a minimum of loss and without harm to "Androcles". The one success would have amply paid for the two failures, and, perhaps, have provided for further productions, possibly successful ones. In a word, the only practical form of production today is the production for an uninterrupted run.

The fascination which the repertory theatre, even the old stock company, exerts upon the minds of theatrical idealists is easy to understand. A "great academic, artistic" institution, which would imbue each succeeding generation with the best spirit of national drama and the drama of the world, would be of inestimable value in the life of the city and of the nation. As a training school for actors it would be beyond price.

Meanwhile, in the absence of an endowment of millions, the best point of attack on the problem is obviously that which involves the least risk of money and which is most nearly in harmony with the present methods of the theatre, the present psychology of the playgoing public. Shortly after the demise of The New Theatre a Society was organized to support good productions of any kind by taking tickets for them, with the intention of making an occasional production of its own. The war reduced the membership of The Drama Society and further embarrassed it by virtually putting an end to the production on Broadway of really artistic plays. But before going into abeyance it produced "The Tempest" with considerable success, both artistic and popular, and with a

financial loss which, in comparison with the losses of other like ventures, was negligible. Whereas Augustin Daly's production of "The Tempest" ran for only thirteen performances, that of The Drama Society ran for thirty-five performances and was witnessed by over 45,000 people, largely school children who paid from 10 to 50 cents.

More strongly than ever I am convinced that the most hopeful method is to form a society and produce plays singly in any available theatre for as long a run as possible. If the organization meets with popular encouragement and artistic success there will be plenty of time to buy or build a theatre and to think of establishing a repertory. If not, the loss both of effort and of money will be reduced to a minimum.

* * *

September 22, 1919

A DELIGHTFUL TARKINGTON COMEDY

CLARENCE, a new play in four acts by Booth Tarkington.
At the Hudson Theatre.
WITH: Susanne Westford (Mrs. Martyn); John Flood (Mr. Wheeler); Mary Boland (Mrs. Wheeler); Glenn Hunter (Bobby Wheeler); Helen Hayes (Cora Wheeler); Elsie Mackay (Violet Flaney); Alfred Lunt (Clarence); Roa Martin (Della); Barlowe Horland (Dinwiddle); Willard Barton (Hubert Stern).

By ALEXANDER WOOLLCOTT

Write it on the walls of the city, let the town crier proclaim it in the commons, shout it from the housetops that "Clarence," the new and capitally acted play which so vastly amused its first New York audience at the Hudson Theatre Saturday night, is a thoroughly delightful American comedy, which the world and his wife and their children will enjoy.

It is as American as "Huckleberry Finn" or pumpkin pie. It is as delightful as any native comedy which has tried to lure the laughter of this community in the last ten seasons. And yet it is by Booth Tarkington.

We have said—all of us—that Booth Tarkington could not write a good play. He can. He has done so. It is called "Clarence." We have said—all of us—that he had no idea how to write dialogue which would sound human when spoken across the footlights. To an extraordinary degree, "Clarence" abounds in just such dialogue. We have all noted how, in a sort of stagefright, he became stale and mechanical when turning his pen to such indifferent stuff as "Mister Antonio" and "Up From Nowhere." Yet "Clarence" is as fresh and unspoiled and deftly artful as a Barrie comedy. We have all given a verdict, on the strength of a crushing accumulation of circumstantial evidence which had been augmented this very season, that the author of "The Gentleman from Indiana" and "Seventeen" could never, never, never write as well for the theatre as he did for the library. But in humor, in characterization, in wise and amused observation of American life "Clarence" is certainly on a par with "Ramsey Milholland" and "The Magnificent Ambersons." Mr. Tarkington as a playwright has been a

long time on the way, but he is here at last. And no one was ever more welcome.

"Clarence" might have been called "Civilian Clothes." This time it is not the potentially bitter comedy of the disillusionment born when the hero doffs his Sam Browne belt, his shining spurs and Croix de Guerre. Rather it is the rich humor found in the effect produced on a gabby American family when they condescendingly take in a dilapidated soldier to be a handy man around the house and when they pour their individual troubles into his ear, in the easy habit formed of talking, friendly fashion, to any one in uniform. Finally Clarence extracts his back pay from a retentive government, casts off the ill-fitting, ill-matched, shoddy O. D. and emerges, stately and distinguished, in civilian clothes.

"Who are you?" cries his exasperated host at last, when both his wife, his daughter and the latter's governess have all grown addled over Clarence.

"I supposed you knew," replied Clarence, withdrawing hurt and dignified, to repair a leak in the basement heater.

"I supposed you knew all the time that I was the foremost coleopterist in this country."

Which provides as a third-act curtain line loud calls for "Who's Who" and Webster's Dictionary. Clarence, who was shot in the liver at target practice in Texas, had really been engaged because, while applying for a job, he had overheard too much of the chatterbox family's affairs to be left around loose, although the old man had been further moved to engage him because Clarence was able to drive the army mules without swearing. Unfortunately, that was all a misunderstanding. Clarence had merely claimed that, when transferred from the band to the mules, he was not obliged to learn to swear at them. Another complication had arisen when the languishing Della, a housemaid, learning that he was engaged in a laboratory before the war, hastily spread the report that he used to work in the men's washroom in a big hotel.

There are two true Tarkington adolescents in "Clarence." These are Bobby, who has been expelled from three of the most exclusive prep schools in the East and who has just taken to spats, and Cora, who is in the throes of her first two or three romances. Imagine a rather shallow Jane Baxter grown to 16 and you have some notion of Cora. Imagine her consumed, temporarily, by a, great passion for a grass widower of her acquaintance. Imagine her forbidden to see him and weeping hysterically and a thought histrionically in consequence. Imagine her staging a real scene of Didoesque despair, with the whole family quite interested in the heroine, even if the governess does interrupt occasionally to correct her grammar. And then in comes father, raging. Does he say: "My daughter, what grief has come to you?" He does not. He gives her one withering look and snorts:

"Go upstairs and wash your face." The memory of Cora's baffled gaze, the memory of her dead, tragic accent as she repeats, incredulous, the words; "Wash my face!" will linger with us till May comes again.

Very likely these little samples of "Clarence" suggest only faintly how entertaining it is from first to last. Nor is it easy, in the allotted space, to do justice to a cast which so nearly approaches perfection that it seems invidious to list one before another. Probably Glenn Hunter and the beguiling Helen Hayes as the youngsters would be the most difficult to replace. They could scarcely be improved upon. Little Miss Hayes, who won all hearts in this neighborhood last Spring as the gentle, wide-eyed might-have-been daughter in "Dear Brutus," reveals her versatility by her shining success in this totally different rôle. She in a seventeen-year-old Marie Tempest with the world at her feet.

Alfred Lunt, for all his somewhat heavy strokes in the first act, is exceedingly good as Clarence, John Flood does a fine bit of work as Father, and Elsie Mackay, whom Cyril Maude imported some seasons ago, has grown in skill without losing a whit of her English prettiness. As for Mary Boland, she never did better work than she does right now as the slightly imbecile stepmother—unless, perhaps, it was when she went overseas last year and worked like a horse giving farces and melodramas for homesick Yanks in the great, cheerless base hospitals of the A. E. F.

* * *

November 19, 1919

ANOTHER MUSICAL SHOW

IRENE, a musical comedy in two acts and seven scenes. Book by James Montgomery, lyrics by Joseph McCarthy, music by Harry Tierney. At the Vanderbilt Theatre.
WITH: Walter Regan (Renald Marshall); Hobart Cavanaugh (Robert Harrison); Arthur Burckly (J. D. Bowden); John B. Litel (Lawrence Radley); Walter Croft (Clarkson); Edith Day (Irene O'Dare); Eva Puck (Helen Cheston); Gladys Miller (Jane Gillmour); Florence Mills (Mrs. Marshall); Bernice McCabe (Eleanor Worth); Dorothy Walters (Mrs. O'Dare); Lillian Lee (Mrs. Cheston); Bobbie Watson (Madame Lucy).

By ALEXANDER WOOLLCOTT

Broadway's desperate plight, with only seventeen or eighteen musical comedies on view, was magnificently relieved last evening when a new one called "Irene" was rushed into the breach at the Vanderbilt Theatre. This proved to be a brisk and pleasing piece, as moral as "Daddy Long Legs" and yet apparently full of things calculated to entrance the exhausted commercial gentleman. It has no prohibition joke, no Ford joke. It has no shimmy in word or deed. But it has a lot of catchy music. Also it has Edith Day and a comic fellow named Bobbie Watson. Also it has a plot. You never can tell what you are going to find in a musical comedy these days.

Not so very long ago, it was the way of these things to consist entirely of girls and music and jokes and dances and scenery. There was no plot and it was the fashion to call attention to the fact. "Of course," you would say "there isn't any plot to the darned thing, but it's amusing." You never said: "Of course there isn't any plot to the darned thing, so its very amusing." And the producers, stung to the quick, have taken to putting all sorts of things into their musical shows—plots and Julia Deane and everything.

The way now is to take a comedy that for some reason has not gone well, or that has not even been tried, diminish and elaborate the costumes, add twelve songs, stir passionately, and serve.

So it happened that a comedy called "Irene O'Dare," and written some seasons ago by James Montgomery, author of "Ready Money," was tried out on the road by a theatrical firm of bygone days known as Cohan & Harris, found wanting, shelved, and then taken down at last, renamed "Irene," and hurried into New York to fill one of the vacant theatres.

"Irene" not only has a plot. It also has a sociological import. It is concerned with the adventures of three poor little shop girls who are taken up by a modiste, dressed perfectly elegantly, and introduced to society, where they are actually taken for ladies. How shocking to think that the foundations of our society are as shaky as that: It fairly gives one the vapors just to contemplate the idea .

Of course the producers of this particular transformation had to go and spoil the moral by having Irene look eleven times as pretty in her plain little suit as she does when she emerges as a butterfly. She is brought out dressed like a showgirl on parade and the audience is expected to leap rap-turously and say: "Why, she looks just like a lady!" when, as a matter of fact, she does not. It is all very confusing.

Irene is pleasantly embodied by Edith Day, who is pretty to behold, who sings passably, and who dances rather better than that. Indeed, everybody in the company dances a little bit better than they do anything else. Of course, as an actress Miss Day is handicapped by the fact that she is supposed to come wandering forlornly on in a drab little dress and talk just a touch of a brogue.

Whereupon every one thinks of "Peg o' My Heart" and Laurette Taylor. This makes them reminiscent, and that is enough to cramp any actress's style.

But if there is one thing the American theatre can be counted on to play to the Queen's taste, it is a male dress-maker. The male dressmakers in our shows are always good and the one in "Irene" is a perfect scream. His name is Dob-bie Watson.

Dorothy Walters as Mrs. O'Hare and Walter Regan as a gentleman also acquit themselves creditably. They add good touches to a musical show that extracted from last night's audience the kind of audible approval which cannot be hired for the occasion.

FILM

MOTION PICTURES ARE MADE TO TALK

Edison Invents a Machine that Combines the Kinetoscope and Phonograph

RECORDS TAKEN TOGETHER

When the Pictured Man Acts the Voice in the Box Speaks, and Illusion Is Perfect

Thomas A. Edison gave to an audience of not more than a dozen men last night the first exhibition of his talking pictures, the product of the new Edison kinetophone, which combines in one machine the wizardry of the phonograph with that of the kinetoscope. The brief glimpse offered in the laboratory in West Orange was enough to show that Mr. Edison has achieved what he and a host of other inventors have long striven for—the perfect synchronization of sound and action for the moving picture screen.

Into the scene thrown upon the screen last night a man walked, and as his lips moved the sound of his voice issued from the concealed phonograph, effecting an illusion that was perfect. This was all that Mr. Edison would show, but he has more in preparation, and his plans for the future of his kinetoscope are boundless.

"We'll be ready for the moving-picture shows in a couple of months," he said, "but I am not satisfied with that. I want to give grand opera, I want to have people in far stranded towns able to hear and see John Drew. And," he added in a burst of confidence, "I want to have 'Teddy' addressing a meeting."

But these things are not yet. A year or more Mr. Edison allows for their achievement. Already he has an ambitious drama reproduced on a long film, but there are flaws in one or two places, and he is unwilling to show the play. The kine-tophone as it now stands is the product of two years' labor, which Mr. Edison has shared with his assistant, Mr. Hyams.

One Operator Does It All

It is one machine, part phonopragh, part kinetoscope, and it requires but one operator. From the projecting machine behind the audience, wires run along the ceiling to the screen behind which stands the phonograph. The two parts are operated by the turning of the handle beside the kinetoscope portion.

In the newly perfected process the records and pictures are taken at the same time, a sufficiently sensitive record having been devised to catch and retain the slightest sound accompanying the portrayed action. Here has been the stumbling block in the effort to accomplish this result. Hitherto the pictures and records had to be taken separately, in the face of the difficulty of receiving in the horn the voices of the actors, and at the same time, having them move freely and, as far as possible, dramatically around in an unobstructed range of the camera. The special recorder used for the kinetophone permits of the speaker being twenty feet away.

A little platform with a lecturer's table and back screen was the picture last night. On the screen was flashed a fairly impressive man in a frock coat, who explained the points of the kinetoscope. There was no flaw in the illusion. He seemed to be talking. The sound of the working of the con-

cealed phonograph could not be detected four feet away. To demonstrate its possibilities the gentleman on the screen bounded an iron ball on the floor. There was an accompanying noise. He carelessly dropped a plate with a resounding smash. He pounded with a mallet, and finally tooted an automobile horn with uncanny effect.

There is another feature of the combination which the inventor has been working as a side issue. He hopes soon to have the pictures reproduce the natural color of the originals.

In honor of his audience made up largely of newspaper men, the first picture shown last night, of the old and silent type, was entitled "The Big Scoop, a drama of a metropolitan newspaper." It was all about a young and handsome reporter, who had been discharged, regaining his prestige by overhearing some prominent bank officials discussing highly important matters in a restaurant. The bank was going to close its doors in the morning, and his paper made an unpleasant point of it all over the front page. No one enjoyed it half so much as Mr. Edison himself. He fairly beamed as the handsome young reporter went home and told his wife about it.

The inventor takes immense satisfaction in watching moving pictures, and never seems to tire of them.

* * *

May 26, 1911

PICTURES IN MADISON SQUARE GARDEN

Several Thousand in Audience at Opening of New Venture

Madison Square Garden was opened as a motion picture house yesterday afternoon with an audience of several thousand at the first performance. The entertainment consisted of a series of high-class pictures, and musical selections by the Musical Vassar Girls' band.

For this new venture, which the management hopes will be profitable enough to save the Garden from being sold, about two-thirds of the arena is used. The stage and screen on which the pictures are shown have been set up about ten feet from the side exit gates and facing Madison Avenue. It is intended to keep the house open with pictures for four months, with a brief intermission, and to have the shows run continuously from 1 to 11 o'clock. The entertainment is being conducted by the Madison Square Garden Company.

* * *

July 30, 1911

EXPORTING AN IMAGINARY AMERICA TO MAKE MONEY

Moving Picture Lovers in Foreign Cities Prefer Indian and Cowboy Films to All Others

There is one American article of export out of which fortunes are being coined in every corner of the world, and which, under its rightful name, does not appear upon a single steamer's manifest. This is the picturesque—what is bizarre, exciting, and unusual in American life, chiefly scenes of cowboys and Indians. This picturesque, a real, definite commodity of genuine commercial importance, goes with many another moving picture film across the seas, and Britisher, Frenchman, German, Spaniard, Italian, South American, Australian, and South African clap their hands with joy, or otherwise show their approval, when the exploits of their "Yankee" brothers are flashed upon the screen.

Exporting the picturesque has thus become a money maker. The average American film on other subjects is not apt to "take" with the foreigner. He likes, beyond all, dash and action. The cowboy and Indian, especially when they have a strong, simple story behind them that he can readily catch, appeal to the most uninformed peasant and the most stolid mechanic. The story must be simple, for his delight is not at its keenest unless he fully understands what the strange figures are doing. Then they are very much to his taste.

It does not seem as if too many of these Indian and cowboy films could be fed to the moving picture goers of the rest of the world. From Liverpool to Moscow and from Stockholm to Melbourne the patrons eagerly watch the unfolding of every one of the highly colored dramas of the prairies and the mountains. It does not matter if the story is only slightly different from what they have seen before. This is the America that they have long imagined and heard about.

The crouchers on the benches of many a darkened room in far away foreign cities are quite aware that there are big cities in America teeming with gold for the workers, wonder places when one gets to them. These are not, just the same, the real America of their dreams. Outside of them, just beyond the sky-scrapers, they know there is a great, open wild-land, filled with almost savage beings. Nothing like these real Americans exist anywhere else in the world. They do the maddest, most exciting things. And though the foreigner of the moving picture show does not say this in so many words, these scenes fully realize the ideal long tucked away in his head of what the Americans must be.

Of course, this exporting of the picturesque and making it into a big, profitable trade has not come about by chance. The film-makers of America, like those of any other country, and like other purveyors of amusement the world over, have made it a point to study audiences everywhere. They have sent out experts to visit the nickelodeons of the various nations, with instructions to penetrate into even the smallest cities and find

out what people want. When it is remembered that a year ago it was figured out that fifteen million dollars was invested in moving picture studios for the making of films all over the world, more than a million dollars in America alone, and that these figures have since materially increased, it will be seen that meeting the tastes of audiences is a matter of much importance. Motion pictures, the "canned drama," has one distinct advantage over the regular drama—it is quite easily possible to see what class of films "go" the best, and then stick to that.

The experts discovered one very interesting thing. What people liked to see on the screen—it did not matter what country they belonged to—was something that agreed with their preconceived notions.

The more a series of pictures differed with what they believed the less popular it proved. That, then, was simple.

Europe, Asia, Africa, and all the Australias believed in the existence of the cowboy of romance, of the "Deadwood Dick," the "Alkali Ike," "Deerfoot," and "Uncas," the "big, heap chief," the prairie wagon, the beautiful young white girl carried off by a masterful, lank savage, the squaw, the papoose, the Indian village, and, perhaps, the detachment of United States troops arriving just in time. Nothing easier. They should have them.

As a matter of fact, these exciting Western plains films do exceedingly well in this country, perhaps because of the many foreigners that crowd the moving picture theatres. They are profitable investments before they ever become articles of export. The export trade in them is a fresh profit, and one that is steadily growing larger. Some audiences will take an interest in Niagara Falls and New York's and Chicago's giant buildings. But the field of these is uncertain. Every time, though, the foreigner will sit with open-mouthed joy at the "round-up," the adventures of the fearless scout, the battle of the redskins. It is wonderful how such a film never fails.

If anything, the nations abroad have taken to the moving picture even more than this country. In England alone, according to the latest reliable statistics, there are more than two thousand theatres showing moving pictures. New ones are being opened constantly, but they only seem to be meeting a very evident public demand. A curious feature is that all over Great Britain the American films, particularly those of this Western life, are the most popular of all. The stolid British workman likes them, and his pennies go in an unceasing stream to the purveyors who realize what he wants to see. The only real rivals to the American films in England are some produced by energetic and enterprising Italian manufacturers.

For the American firms engaged in this exporting of the American picturesque the situation is ideal, for London is rapidly becoming the great selling centre for films for all sections of Europe, and even Australia and New Zealand. The great demand all over England for the cowboy and Indian films has spurred on the agents for "houses" in other countries to compete for the pick of these. Thus there is an active market for every new subject of this order, and fresh stories

of the life of the plains cannot come across the ocean fast enough.

In Germany the importation of these melodramatic American films is constantly increasing. Each programme now has at least one American story. If it shows some sort of a battle it meets with great favor. Here the Indian and the cowboy unfailingly score.

Spain and Italy, even Russia, the big cities of South America and far-off Oceanica tell precisely the same story. Russia, curiously enough, is getting to be a stronghold of moving pictures, and the most insignificant towns and villages, even in remote districts, are being well provided with these amusements. There are reported to be 1,200 electric theatres alone in the Russian Empire. On Sundays and holidays the crowds, as a Moscow visitor recently wrote home to this country, "are so great that additional police officers are often required to keep the immense number of people moving and to prevent possible accidents."

An American film that met with immense success, showing Napoleon at St. Helena, was made, as a matter of actual record, on the shore of Coney Island. And thus, there need be no surprise that practically every one of these thrilling Indian and cowboy scenes are "put together" in the suburbs of New York City, actually photographed in fields and woods that are not further, at the most, than half an hour from Broadway. If the trusting foreigner in far away Russia or the villager of Spain or Cathay should ever know this, it might disgust him. In all likelihood, though, he would never believe it. The pictures as they are unreeled before him look too good and real.

Once upon a time, it is related, a film manufacturer wanted to reproduce with great accuracy and completeness the scenic story of Custer's last fight. Disregarding expense and plunging enthusiastically into details—he brought a band of Sioux Indians on from the West. Three of them were actually chiefs who had taken part in the tragedy. The films that resulted were naturally magnificent and made a large sum of money for their owner.

Such trouble and expense as this is seldom worth while, however. That film manufacturer was an exception, and this is why the story of his production has been told. In practically every case it is possible, no matter how elaborate the drama, to "stage it" with ordinary scenery of the New York suburb brand, carefully selected, of course, and with regular actors of the "company."

Thus each time that in Naples, the Tyrol, Vladivostok, and Johannesburg the worthy day worker settles down in his seat and witnesses the most exciting of double-distilled romances of the plains he is really seeing a "canned drama" made up on the outskirts of New York, with its Indians and cowboys simply actors. In reality this is a great advantage. Actual red men and true heroes of the plains could never act half so well for the purposes of the camera. There have been player dukes on the stage that seemed more true to life than the genuine article. In the moving picture drama trained actors are even more an essential than on the regular stage. Real Indians might whoop and dash through a show at a Broadway theatre with

great effectiveness; they would fail on a film where professional actors would make themselves vivid red men.

This picturesque that makes such a valuable commodity when it is exported has to be prepared with the greatest care. Just the proper sort of country has to be chosen, in the first place, for a background. As exploits of the sort that are popular must cover a wide territory, and as frantic long rides and thrilling stern chases must be included great attention must be paid to the landscape. Then, before even the camera is brought out, the manager must drill his corps of men and women in the part they are to play. Over and over again must they act the scenes that are to be photographed, but not until each actor and each horse is "letter perfect." A film play like this depends for its success upon its absolute naturalness. It must seem to have really happened and anything that is "stagy" in the least will spoil it utterly.

With a good manager, these Western dramas are very easily run off, however, and an astonishing degree of perfection attained. For several years, now, the moving-picture studios have had excellent companies of actors. The "trick" is a little different from that of the regular stage, but is quickly learned by the ordinarily clever of the "profession." Constant practice makes them perfect. The cowboy and the redskin, the kidnapped maiden and the settler's wife in the prairie wagon, after they have rampaged through a dozen of these melodramatic stories, become far better from foreign consumption than their originals would be.

Nor is this new and profitable article of export difficult to get in its raw state—that is, the material of the story or the scenario. The form and general idea are so well laid out that a novice can make the necessary variations. There are not even "properties" to be bought for every moving-picture studio has long since had all the equipments and accoutrements of the plains and of Indian braves. The moving-picture plant can today almost as easily fill an order for another of these dramas as the corner grocer can for a peck of potatoes. And great is the manufacturer's profit thereby.

* * *

January 7, 1914

VILLA TO WAR FOR "MOVIES"

*Becomes Partner of H. A. Aitken, Who Sends
Camera Squad to Front*

Pancho Villa, General in command of the Constitutionalist Army in Northern Mexico, will in future carry on his warfare against President Huerta as a full partner in a moving-picture venture with Harry E. Aitken of 180 West Fifty-seventh Street, this city.

The business of Gen. Villa will be to provide moving picture thrillers in any way that is consistent with his plan to depose and drive Huerta out of Mexico, and the business of Mr. Aitken, the other partner, will be to distribute the resulting films throughout the peaceable sections of Mexico and the United States and Canada.

To make sure that the business venture will be a success Mr. Aitken dispatched to Gen. Villa's camp last Saturday a squad of four moving picture men with apparatus designed especially to take pictures on battlefields.

Another squad of four men with machines of the latest design is being assembled in San Antonio, Texas, and they will go to the front tomorrow. It is the hope of Mr. Aitken to have moving pictures from the field of Villa's operations here by Saturday and to show them to moving picture audiences, following them up with a fresh supply every week until Huerta falls.

To supply the moving picture operations the whole field of talent in this country was combed over and men were chosen who for the most part have been under fire before. The leader of the moving picture battery at the front is an Italian who has bullets in his body received in the Balkan war while operating a moving picture machine for a European company. Mr. Aitken is President of the Mutual Film Corporation. Asked about his partnership with General Villa, in his apartment in West Fifty-seventh Street at 1 o'clock this morning, Mr. Aitken exclaimed:

"How on earth did The Times hear about that? We have our own publicity force, and we have not yet taken it into our confidence in the matter. I did not want the story to get out yet.

"But it is true. I am a partner of Gen. Villa. It's a new proposition, and it has been worrying me a lot all day. How would you feel to be a partner of a man engaged in killing people, and do you suspect that the fact that moving picture machines are in range to immortalize an act of daring or of cruel brutality will have any effect on the warfare itself? I have been thinking of a lot things since I made this contract.

"It was only completed Saturday, and I received the message from my agents on the ground only this morning. It is quite a responsibility, and I see it in a different light now than I did before.

"How did I do it? Well we decided to go in to cover this war for the movies quite a few weeks ago. I sent an agent to Villa's camp. He lived with Villa in his headquarters for some weeks making negotiations.

"Meanwhile there was the question of the cameras. We wanted a camera that would stand up and take pictures of a battlefield and yet operate in such a way that the man with it could keep under cover while the machine was exposed.

"Such a camera was designed, and ten of them were ordered. We next had to consider the question of men. We wanted daring men, of course, and also men who would know how to take care of themselves in military operations. We didn't want greenhorns in army matters, who would welch out at the first experience under fire.

"We have ten men in our squad at the front, two of them operating cameras to take pictures where the movies cameras will not be practicable. We are holding another man here ready to go at a moment's notice to any point where there may be a chance to catch some good manoeuvre.

"I expect myself to go to the border in a week or two to look things over and see that our men are fixed up all right. The final negotiations were carried out in Juarez Saturday, when Gen. Villa was visiting there.

"The first squad of men that went forward left our offices at San Antonio, Dallas, and El Paso. What worries me most is the chance that Gen. Villa may want to send films to some part of his army—a privilege he has—and that he may wish to show on the films some horror that will strike terror into the hearts of his men. It isn't pleasant to contemplate the possibilities of such a situation."

The moving picture operators, it was explained, were all provided with letters from the proper authorities in Washington, so that their status as American citizens and non-combatants will be maintained. One part of the contract is that Gen. Villa must not allow any other moving picture men except those of the company in which he is interested on the field during his battles.

* * *

May 10, 1914

GEN. VILLA IN THE MOVIES

His Battles with Mexican Federals Clearly Shown at Lyric Theatre

Moving pictures of the operations of Gen. Villa against the Mexican Federals in and around Torreon were shown for the first time yesterday at the Lyric Theatre and will continue to be the attraction at that house.

The films, which were taken by the Mutual Film Company, through an arrangement made with Gen. Villa, show much of the actual fighting in Mexico. There are many scenes in which Gen. Villa is seen directing the movement of his troops and artillery and cavalry battles are shown with remarkable clearness.

Other views show the burning of the bodies of dead soldiers on the battlefield and the work of Villa in reconstructing railroads in order to push his troops on against the Federals. Many of the pictures were taken in the thick of the fighting.

The pictures, which were taken by H. M. Dean during the four months leading up to the taking of Torreon, are the first ever shown here of actual warfare.

Following the battle pictures there is shown a movie drama which is said to tell the melodramatic story of Villa's life. Villa himself poses in these films, aided by a motion-picture stock company.

* * *

September 6, 1914

FAKE WAR PICTURES STIR THE EAST SIDE

Foreign Colonies of the Bronx Also See Movies Purporting to Show Battles
REISSUES OF OLD FILMS
Cost of Chemicals and Other Studio Supplies Rises—Employes Go to the Front

A glance at the posters displayed in Fourteenth Street and on the east side in front of the motion-picture playhouses convinces one that war is the one current attraction which needs no arranged publicity.

Lawrence Marston, principal director of a motion-picture company, recently noted posters on the following bellicose productions: "War is Hell," showing "burning war balloons and the last desperate stand of a fallen aviator"; "With Serb and Austrian": "The Battle of Waterloo"; "The Battling British"; "The Tyranny of the Mad Czar"; "The War of Wars, or, the France-German Invasion of 1914—the kickiest two-hour show ever—an eternal masterpiece of tremendous magnitude"; "The Last Volunteer," "so real you can see the damage of the bullets"; "Faithful Unto Death," advertised to contain scenes showing "actual engagements, bursting bombs, blown-up bridges, severed telegraph wires, and sparing none of the horrors of war."

In a short walk in the same district on the east side Mr. Marston jotted down the following film titles from the lithographs outside the playhouses; "Ambushed," "A Horn Warrior," "Napoleon, the Warfare of One Man Against the Whole of Europe, Comparable with the Present Situation of the German Emperor" and "European Armies in Action," one section of which was advertised to show "an entire army crossing a chasm thirty feet wide," while yet another strip of the same 4,000 feet of film featured the making of a cannon, "an awe-inspiring, death-dealing monster."

"Up in the Bronx, in the foreign colonies," continued Mr. Marston, "I was startled by posters advertising an English film company's thriller, 'The Terror of the Air,' depicting the dangers which London fears from German Zeppelins; by an Italian film, 'The Next in Command'; a German release, 'Kaiser Wilhelm II.'; 'Northern Lights,' a film in which a coward was billed to duly redeem himself on the battlefield; 'The Envoy Extraordinary: or The World's War'; 'The Three Allies,' 'Germania,' 'England's Menace,' 'The Warfare in the Skies,' 'Under Fire in Mexico,' 'The Battle of Shiloh,' 'Dan,' an American civil war drama; 'The Dishonored Medal, Featuring the Death-dealing European Conflict at Close Range'; 'The War of the Powers,' 'the Man-o-War's Man,' 'Private Denis Hogan,' 'The Birth of the Star-Spangled Banner,' 'Across the Border,' a Mexican war feature, which was followed on the programme by 'The Battle of Torreon' and 'The Life of Villa.'

Photo Dramas in Yorkville

"In the Yorkville section I had my choice of the following, 'The Old Army Coat'; 'Buffalo Bill's Indian Wars'; 'The Foreign Spies,' 'All Love Excelling,' showing the 'undying devotion of a woman which carries her through the Crimean war'; 'The Boer War'; 'Shannon of the Sixth'; 'Wolfe, or The Conquest of Quebec'; 'Francis Marion, The Swamp Fox,' a tale of Revolutionary days, a picture version of the battle of Fontenoy entitled 'A Celebrated Case,' and 'Captain Alvares,' a drama of the Mexican revolution. Even the peace propagandists were represented with films entitled, 'Lay Down Your Arms,' and 'The Curse of War.'

The slide and poster companies aim to outdo one another. Long range actions are not in favor with the artists and the favorite themes seem to be close views of Uhlan charges and executions of prisoners, tied to the canon's mouth.

"Unless the local authorities take some steps to curtail the activities of some exhibitors, I am afraid we will have riots on the east side before the war is over. Already in San Francisco, exhibitors have been warned by the police against showing pictures dealing with the present war. A riot at one of the photoplay houses between excitable French and German reservists resulted in the arrest of the theatre proprietor who displayed a film showing re-enacted scenes from the Franco-Prussian conflict in 1870.

"The 'weeklies' which furnish moving picture theatres with a topical or current event programme are foaming over in their war furor. 'War extras,' compiled from sections of film released many moons ago, are being advertised as having been 'just received from the front.' 'Educationals,' showing last year's manoeuvres and exhibition drills of the German Army, the 1910 cavalry practice of the Uhlans, the barrack reviews of Russian Cossacks filmed in 1911, and the target tourneys of French riflemen billed as 'smashing events from the theatre of war.'

"Scenes showing the torpedo and battle formation practice of English torpedo boats taken two and three years ago are advertised as stirring events now taking place off the Kiel Canal, where the German fleet is in hiding, while even scenes showing the coaling of American battleships have been dragged out of the storehouse and rushed up to the firing line.

"Practically every motion-picture company in the business is searching its fireproof vaults for anything which contains more than a Corporal's guard of actor-soldiers. I wish to say for the benefit of the public that not a single foot of film showing scenes from the present war has been received from Europe since the beginning of hostilities. All views purporting to have been received from the front are merely reissues of old films.

Rise in Price of Supplies

"The war really has affected the American end of the film industry. Soft core carbons have gone up from $20 to $40 a thousand, while metol, used in the development of film, has jumped in price from $3 a pound to $10. Hydrochinon, which was selling at a dollar a pound a month ago, is now quoted at $5. Both of these chemicals can be produced in this country, however, so unless the market has been cornered, manufacturers should feel no immediate concern. American condensing lenses do not come up to the requirements of motion picture projection, and as no more German and French lenses can be obtained until the cessation of hostilities the supply in America is now at a premium.

"Gun cotton, which serves as one of the bases from which raw film stock is made, is now at low prices, however, and as most of the film is manufactured in the United States, there need be no legitimate rise in the price of film stock in this country. The best photographic gelatine, which also is used in the manufacture of raw film, comes from Germany and film manufacturers must expect a rise in the price of this product. Printing colors from Germany and France also have markedly advanced in price of late.

Large numbers of the foreign-born employes of American studios have come back to Europe since the beginning of hostilities, among the most prominent being Claude Patin, general secretary of the Eclair plant, Lieut. Gustave Ehrhart of the Essanay Company, Guy Standing of the Famous Players, Arthur Roussel and L. P. Bonvillain, the two Vice Presidents of the Pathé Freres American branch in Jersey City; together with the son of Chief Director Mones and various office clerks, cameramen, actors, directors, and other employes in the mechanical departments of the Franco-American film companies.

"Corporal of Dragoons Escoffier, a number of the Pathé Stock Company, who was one of the first to leave for the front, has been decorated for 'gallantry in action,' according to a cable report received by the remaining American officials of the plant. Henry Machen, photographic expert of the Universal's Bayonne laboratories, left on La Lorraine on Aug. 5 and A. R. Ferrand, recently American manager of the Eclipse-Urban Film Company, who is a Corporal in the French reserves, left on the same vessel.

"The closing of the French and German plants and the limitation of the output of the Italian concerns enables American manufacturers to make a strong bid for the South American film market, which hitherto has bought largely on the Continent. In the neutral countries and even in England the market, which formerly has been supplied by the French and German manufactures, will turn toward America for photoplays. American films predominate in Russia, and American manufacturers will soon be able to supply that market by the Pacific route.

"Only in Germany, France, and Belgium have imports and exports practically ceased. The suspension of the importation of French and German films to this country of course leaves the American market wholly to American manufacturers—and that circumstance spells profit and prosperity for American film men."

* * *

March 28, 1915

FIVE DOLLAR MOVIES PROPHESIED

D. W. Griffith Says They Are Sure to Come with the Remarkable Advance in Film Productions

By RICHARD BARRY

David Griffith is today the biggest figure in the moving-picture world. As the creator who is stalking ahead of the procession and lifting it literally by its own boot straps, he is now a marked man throughout filmdom. He has done more subtle things, more delicate things, and more gigantic things on the screen than any other man.

However, it was not in his capacity as a showman only that I approached Mr. Griffith. While he is a producer without a rival and a generalissimo of mimic forces whose work has never been equaled, it was as a thinker pondering the new problems of filmland, a triumphant Columbus of the screen, that he talked with me for The Sunday Times recently.

"It is foolish to think that the moving picture has reached its climax of development," said he. "We have the moving-picture theatre as well built and as well run as any other theatre; we have the moving-picture show that brings $2 a seat; we have the foremost actors and the foremost writers of the world working for us. So people are prone to think we have gone the limit and there is nothing more to be done. But I tell you that moving pictures are still only in their swaddling clothes."

"Would you mind predicting something about the maturity of this promising infant?" I suggested.

He smiled that courteous, humorous, knowing smile of the Southerner, (his father was a Kentucky Colonel, brevetted Brigadier General of Volunteers by the Confederate States of America.) He said that he had been obliged to predict so much for motion pictures while talking of their possibilities to capitalists that he would welcome the chance to go into the prophecy business, where it costs nothing to make good.

"But," he added seriously, "I am not a dreamer in the sense that I see fantastic things unlikely of realization. I haven't dreamed an impossible thing in seven years—since I started in pictures. That is the beauty of this work. It makes dreams come true.

"My first prediction is that a moving picture will be made within three or four years for which the entrance money will be $5 and $6 a seat. It is easy to predict that."

"But will the public pay $5 a seat merely to see a picture?"

"They are already doing it—to ticket speculators. When I first proposed asking $2 a seat for my new film not a single man in the theatrical business could be found to say I was making a sound business move. Regular theatres on all sides were cutting prices, not advancing them, and 50 cents a seat had always heretofore been considered a record price for the best films.

"The public is quick to see values. If they are willing to pay 5 cents to see a picture that costs $500 to produce and 50 cents

Photo by Bangs

D. W. Griffith

to see a picture that costs $50,000 to produce, they are willing to pay $2 to see one that costs half a million to produce.

"And when we can put on a picture that will cost $2,000,000 to produce the public will be willing to pay $5 a seat for it."

"Two million dollars!" I exclaimed. "Where are you going to get the money and how are you going to spend it?"

"If you had asked me a year ago where we could get the money I would have believed it would be impossible," replied Mr. Griffith, "for up to that time an investment of $50,000 was considered utterly daring for a picture; but the days of little things in the pictures are gone by forever. When I started in the business only seven years ago a producer who spent $500 on a picture was considered very extravagant. Not today. We spend that much on a single scene that runs less than a minute, and then often throw it away because it doesn't fit, or is not just right.

"The experimental work on a big picture costs thousands of dollars. The trying out of new effects to see if they will reproduce is a costly process, and when one has the inventive faculty and is anxious to produce new things he is likely to bankrupt his promoters."

The mellow smile came back to the Griffith countenance. "However," he added, "that is the only known way to get the big, new effects."

"What will happen to the regular theatre when its prices are being cut while yours are advancing?"

"The regular theatre," he continued, "will, of course, always exist, but not, I believe, as now. The pictures will utterly eliminate from the regular theatre all the spectacular features of production. Plays will never again appeal to the public for their scenery, or their numbers of actors and supernumeraries. Pictures have replaced all that.

"The only plays that the public will care to see in the regular theatre will be the intimate, quiet plays that can be staged in one or two settings within four walls, and in which the setting is unimportant, while the drama will be largely subjective. Objective drama, the so-called melodrama, will be entirely absorbed in the pictures.

"The audiences for these old-fashioned theatres will be drawn from old-fashioned people who remember the days of old and how plays were produced by Belasco and Frohman when 'I was a boy.' The new generation will be wedded to the movies. You won't be able to satisfy them with anything else."

"What of the written and spoken word that is so vital to true drama? Do you intend to kill that, too?"

"On the contrary, we intend to vitalize it. The bane of the drama is verbosity, but we can't produce any picture without some words. In one of my pictures we throw on the screen over 7,000 words, in which there are at least four pages from Woodrow Wilson's history of the United States. That is more words than are used in the average short story.

"We are coming to pay more and more attention to the words we use on the screen. The art of writing for the pictures is developing almost as rapidly as the art of acting for them. And the great rewards to be gained there by a writer will be a powerful incentive for him to learn to tell his story more crisply, more tellingly, more alluringly, than he ever could, even in the best spoken drama."

"But this will mean a great revolution in our methods of thought?"

"Of course," answered the multiparous Griffith, "the human race will think more rapidly, more intelligently, more comprehensively than it ever did. It will see everything—positively everything.

"That, I believe, is the chief reason that the American public is so hungry for motion pictures and so loyal to a good one when it comes along. They have the good old American faculty of wanting to be 'shown' things. We don't 'talk' about things happening, or describe how a thing looks; we actually show it—vividly, completely, convincingly. It is the ever-present, realistic, actual now that 'gets' the great American public, and nothing ever devised by the mind of man can show it like moving pictures."

At this point the director, who counts that day lost whose low descending sun finds no new idea hatched, produced an illumination for the future right out of his egg, (we were at breakfast.)

"The time will come, and in less than ten years," he went on, "when the children in the public schools will be taught practically everything by moving pictures. Certainly they will never be obliged to read history again.

"Imagine a public library of the near future, for instance. There will be long rows of boxes or pillars, properly classified and indexed, of course. At each box a push button and before each box a seat. Suppose you wish to 'read up' on a certain episode in Napoleon's life. Instead of consulting all the authorities, wading laboriously through a host of books, and ending bewildered, without a clear idea of exactly what did happen and confused at every point by conflicting opinions about what did happen, you will merely seat yourself at a properly adjusted window, in a scientifically prepared room, press the button, and actually see what happened.

"There will be no opinions expressed. You will merely be present at the making of history. All the work of writing, revising, collating, and reproducing will have been carefully attended to by a corps of recognized experts, and you will have received a vivid and complete expression.

"Everything except the three R's, the arts, and possibly the mental sciences can be taught in this way—physiology, chemistry, biology, botany, physics, and history in all its branches."

Seven years ago this man who talks thus glibly of "revolutions" was an actor out of work, and a director without a prospect. He was walking along Broadway as are thousands of others today.

While now his annual salary is reputed to be $100,000, Griffith at that time was so hard up that he clutched desperately at the chance to earn fifteen a week as extra man in "pictures." His play, "A Fool and a Girl," had been produced out of town by James K. Hackett and had run one consecutive week. He had been an actor in California and once had received as much as $27 a week.

Yet he was just turned thirty, in perfect health, with an excellent education. He walked to the office of a little motion-picture concern, the Kalem Company, and asked its manager, Frank Marion, for a job as extra man. Usually in those days actors changed their names before dropping so low; not Griffith.

He also kept his nerve. Griffith said to Marion: "I believe motion pictures might be dignified and put on a par with the spoken drama. In my opinion you've got to change your whole style of acting. At present it's only horseplay and not true to life. Moreover, you don't use the right kind of stories and your photography is rotten."

"I'm afraid I can't use you," said Marion, "you seem to be a bit visionary."

The next place Griffith applied was at the office of the Biograph Company, up in the Bronx. He kept his opinions to himself and he got a job at $15 a week. What happened after that is a vital part of the history of moving pictures.

To say that Griffith almost single-handed revolutionized the moving-picture business is only to repeat what many of its students and historians have said before. He introduced naturalistic acting and he began, in a small way, the develop-

ment of handling crowds that has led to the half-million-dollar picture with 18,000 people and 1,500 horses.

As soon as he had induced the Biograph people to let him direct a picture in his own way his advancement was rapid. Within four years his annual salary with the Biograph was said to be $50,000. The Mutual bought him away only at the published price of $100,000 a year and a percentage of the profits.

Many of the big stars of the pictures, from Mary Pickford to Blanche Sweet, were "discovered" by Griffith, and a large number of the best directors have learned their trade under him.

For seven years he has been leading the motion-picture procession. If he makes one-quarter the "discoveries," "improvements," and "revolutions" in the business in the next seven years that he has in the past seven, then the prophecies of today may be less absurd than was his comment to the manager who first refused him because he was "visionary."

* * *

October 21, 1915

BERNHARDT IN PHOTO PLAY

Her Lameness Hidden in "Jeanne Dore," Shown Privately

The first acting done by Sarah Bernhardt since the loss of one of her legs by amputation last Summer was shown in motion pictures exhibited privately yesterday afternoon at the offices of the Universal Film Company in the Mecca Building. The film was a screen arrangement of Tristan Bernard's drama, "Jeanne Dore," and was taken in France.

It was in this play that Mme. Bernhardt was appearing in her theatre in Paris when the trouble with her leg forced her to leave the stage. Mme. Bernhardt's role is that of a middle-aged woman, and while she appears a trifle older in the pictures, perhaps, than on her last visit here, otherwise she looks the same wonderful artiste of other years. Her great visual charm and her marvelous facial expression are still potent.

The film itself was so arranged before it was sent to this country that all evidences of the actress' lameness because of her artificial leg have been deleted. So the film, as it reached America, never shows the actress walking. In every scene in which she appears she is shown either seated or standing, and whenever she starts to walk the scene is immediately changed through the devices of the switchback, the cut-in, or the printed legend. Thus, if Madame rises from a chair and starts to walk across the room to a window, she is seen to rise, the picture is snuffed out for an instant, and when it again covers the screen the actress is shown at her destination.

The effect is no more confusing than in the average picture, which often baffles and irritates all but the incorrigible movie fan. The picture is so focused that the feet of the actress do not show, or if they do only for short intervals, so

there is nothing in the many scenes of the protodrama, which is melodramatic in the extreme, that would apprise the uninformed of her misfortune.

According to the motion picture people Mme. Bernhardt will never be able to act again on the legitimate stage. The directors who took the film so informed the company controlling the American rights. But William F. Connor, Mme. Bernhardt's American representative, denies this, and insists that she will make her American tour this Winter as planned. "Jeanne Dore" has been announced as one of the new offerings of her répertoire when she arrives. The picture shown yesterday, after further excisions and rearrangement, will be exhibited publicly within the month.

* * *

November 1, 1915

GERALDINE FARRAR SEEN BUT NOT HEARD

Singer Comes to the Strand in Bold and Vivid Screen Version of "Carmen"

PROMISING MOVIES DEBUT

Theda Bara Is Presented as a Rival Carmen In a Scenario That Follows the Opera

Geraldine Farrar, favorite prima donna of the greatest opera house in the world, came to New York yesterday. She came not in the flesh but in the shadow, not on the operatic stage nor on the concert platform but on the screen. The place was the Strand Theatre, the occasion the first New York presentation of "Carmen," an ingeniously prepared, picturesque, amorous and exceedingly physical photoplay based on the novel by Prosper Merimée. In this picture, a handsome and creditable product of the Lasky studios now released like any other in the Paramount program, Miss Farrar, plays, of course, the leading role, and by this means makes her first New York appearance in the movies.

It is a curious commentary on the crazy economy of the theatre that a supreme dramatic soprano should give any of her precious time to a form of entertainment—to an art, if you will—wherein the chief characteristic is a complete and abysmal silence. But, though the call of the movies is audible enough, there is small reason for fear that, after Miss Farrar's success, there will be a great rush of prima donnas to California, for precious few of them could so meet the exactions of the camera.

As for Miss Farrar, let it be said that among movie actresses she is one of the best. The Strand may be besieged all this week simply because her name has long been one to conjure with, but it seems altogether probable that when, if ever, she appears in another picture, the movie patrons will crowd to see it because they cherish her as one of their own. There is every indication that new millions will soon be calling her "Our Geraldine."

This new movie star "registers," as the film folk have it. There is no doubt at all about that. She does more than make faces at the camera; she knows that in acting for motion pictures, she must do more than go through the motions. And she does. Her familiar vigor and dash are helpful, and she can make good use of the flashing Farrar smile. But quite aside from these, she brings to the richly colorful performance a degree of vitality that animates all the picture and offers a good illustration of the difference between posing and acting for the camera.

Her playing is able. Also it is bold, bald, and in dubious taste. Many portions of the film are successive pictorial studies of physical passion, and it is small wonder that in some quarters the much belabored censors winced.

Merimée's story of the gypsy has been skillfully and imaginatively adapted in the Lasky studios, and the product is pictorially handsome. Many stretches of the film are impressionistic and reveal the strides the movie directors are taking in their business. The unfolding of the film at the Strand is accompanied by a clever arrangement of music from the opera. Most of this adds considerably to the entertainment, but it is rather too bad to have the "Habanera" sung poorly offstage as it was yesterday afternoon.

The Fox film studios boldly challenged comparison with the Farrar picture by bringing a screen "Carmen" of their own to town on the very same day and displaying it to the patrons of the Academy of Music and the Riverside Theatre. This "Carmen" has in the leading role Theda Bara, a movie star who is widely known as "the vampire woman" of the screen and who is immensely popular in the theatres where her pictures are shown.

This second "Carmen" is an example of excellent motion picture photography, but its scenario, which follows the opera libretto rather than the Merimée story, is loose and vague, and Miss Bara seems very mechanically seductive when compared, as she must be, with Geraldine Farrar. The Fox "Carmen" has none of the elements which make the Lasky "Carmen" remarkable, and none, it should be added, of the elements which make the latter picture objectionable.

* * *

November 15, 1915

USE A SUBMARINE IN NEW MOVIE PLAY

Undersea Boat's Working Shown in a Comedy Film at the Knickerbocker

ANOTHER CHAPLIN SEEN

Strand Theatre Produces Robert Hitchen's "Bella Donna," with Pauline Frederick as the Star

One of the chief rights of the movies to attention is their timeliness. The movie camera is here today and there tomorrow, snapping whatever is of interest. Unlike the legitimate stage, the screen does not have to wait for a dramatist to become inspired before it may present the topic of the hour; instead, the scenario writer jiggles his bag of tricks and spills his situations over the object of interest.

The submarine has occupied the first page for many months, so in "A Submarine Pirate," one of the new Triangle films shown for the first time yesterday in the Knickerbocker Theatre, an undersea craft comprises most of the plot. The submarine was borrowed from the United States Navy, and it is said that when the original time allotted for its use was up an application for two weeks' more time was asked and granted. And now, the press agent goes on to state, the Navy Department is so pleased with the film it is going to use it to encourage recruiting.

The film does give a good idea of the workings of a submersible craft. The submarine is shown above water, submerging, and firing a torpedo. The interior is pictured when the boat is up and as she goes down, and the use of the periscope is also illustrated. All of this is part of a comedy picture in which a battleship and a big passenger liner are concerned. Syd Chaplin, a relative of Charles of the old clothes and moth-eaten mustache, is the principal comedian. He affects his kinsman's mannerisms, even to the mustache, but he is not so good a comedian. Charles can kick twice as often and as hard as Syd, which means that he elicits twice as many laughs.

"Jordan Is a Hard Road," another Triangle film, is taken from one of Sir Gilbert Parker's stories. It is a Bret Harte sort of a story of the Golden West of broad hats, cattle rustlers, and restless revolvers. In it Frank Campeau, who as a bandit reforms, and Dorothy Gish as the daughter he gives up as a baby and reclaims in after years, do effective acting.

Robert Tichens's book, "Bella Donna," a dramatization of which was acted here several years ago by Alla Nazimova, has been made into a picture by the Famous Players Company for the Paramount program. It was shown in the Strand Theatre yesterday. Pauline Frederick was the villainess of the title who tried to kill her husband with poison put in his coffee because of her infatuation for Baroudi. Her radiant beauty made her an attractive Bella Donna. Then there was Julian l'Estrange, disguised by a fez and wicked mustache as Baroudi.

The picture was taken in Florida, and with the semi-tropical background afforded the Egyptian atmosphere is well simulated. But the scenes with the pyramids painted out of drawing on a backdrop might well be deleted. "Bella Donna" is primarily a character study of an adventuress. The essence of the movies is action, not character, so while the picture is a fair example of its type, it does not convey an adequate idea of Mr. Hichens's work.

* * *

December 13, 1915

FANNIE WARD AS A MOVIE TRAGEDIENNE

She Appears in "The Cheat," an Ultra Melodramatic Picture, at the Strand

LOU-TELLEGEN ON SCREEN

In "The Unknown," a Romance of Algeria, at Broadway, He Splendidly Portrays Soldier of Fortune

Recently from the Lasky Studios in California, Jesse L. Lasky, head of the film producing company of that name, wrote his New York offices that in his opinion a picture entitled "The Cheat," for which Fannie Ward acted the principal role, was the finest picture the company had ever produced, and that when it was exhibited he believed Miss Ward would be hailed as a great tragedienne of the screen. The picture was released yesterday through the Paramount program in the Strand, and simultaneously in the Broadway Theatre another Lasky-Paramount picture entitled "The Unknown," with Mr. Lou-Tellegen as the star, was shown.

If Mr. Lasky has not seen "The Unknown," he should have the studio folks unreel it for him at once, and see whether he still feels the same about "The Cheat." Perhaps Mr. Lasky knows his public, and what it wants, and then again he may not. If he does, and from a commercial standpoint "The Cheat" is a better picture than "The Unknown," the movie public should be spanked and kept from indulging in their favorite pastime until they have reformed.

For from every point of view "The Unknown" is infinitely superior to "The Cheat." It is all of the things a movie should be—things a movie will have to be to compete with the spoken drama, after the first novelty, which has not yet lost its spell, has worn off.

It tells a tale of romance in Algeria, a romance unreeled amid exotic scenes so that the imagination is stirred and the clang of the Broadway cars sound far away while the film flickers. Its episodes are the red-blooded episodes of the great out-of-doors, and in their swift succession there is cumulative dramatic force. But the movies are essentially narrative rather than dramatic; more dramatic force can be crowded into a single spoken line than in six reels of pictures; so if they would beat the spoken drama, they must do it at their own game, not the drama's.

This "The Unknown" does. The picturesque Mr. Lou-Tellegen is shown as a ne'er-do-well who has joined the foreign legion in Algiers. Early in his career as a member of that body he wins the hatred of the Captain, who has him lashed and later court-martialed for mutiny. It is the Captain himself, however, who finally allows him to escape with the girl of his dreams after he has discovered the young man's identity.

The Oriental background is very well simulated. Many of the scenes pass in the desert, and in their grouping and light values are artistic in an unusual degree. The young soldier of fortune is taken with the troop to hunt a band of robber Bedouins in the desert, and the pictures of the cavalcades of horsemen scouting, pursuing, fighting, and fleeing are highly pictorial. Mr. Lou-Tellegen is a splendid mime, and the beauty of his Grecian head and features and the grace of his physique in motion add greatly to the merit of the picture.

"The Cheat," on the other hand, belongs to the "modern society" category. It tells the story of a butterfly wife who hypothecates charity funds in her keeping to gamble in stocks, and when she loses, accepts money from a rich Japanese with the promise that she will pay the price. Offer to repay Jap and be released; refusal; tussle; burning brand on her shoulder; bang, bang; enter husband; ditto police; "I shot him;" trial; husband convicted; wife bares branded shoulder; everybody happy but the Jap.

Mr. Lasky's enthusiasm is not wholly without reason, for the picture is much above the average of its kind. But is there any more excuse for this sensational trash than for the old-fashioned melodrama in which half the characters were killed off at the end of the play? Miss Ward might learn something to help her fulfill her destiny as a great tragedienne of the screen by observing the man who acted the Japanese villain in her picture.

The new pictures and their stars shown in the other movie houses yesterday were Henry Woodruff in "The Beckoning Flame" and Nora Talmadge and Robert Harron in "The Missing Link" at the Knickerbocker; Ralph Kellard and Dorothy Green in "Her Mother's Secret" at the Academy of Music and Riverside; Virginia Pearson in "Thou Art the Man" at the Vitagraph, and Triangle films at the Eighty-first Street.

* * *

January 2, 1916

AT LEAST $500,000,000 INVESTED IN "MOVIES"

They Now Rank Fifth in List of Country's Big Businesses— Moving Picture Shows Attract 10,000,000 Paying Spectators Every Week

A new "big business" has appeared in America, and today it ranks fifth in importance among the industries of this country. First comes agriculture, second transportation, third oil, fourth steel, and then motion pictures.

From small beginnings the motion-picture industry has reached a stage of development where it is conservatively estimated that $500,000,000 is invested. That is only the investment, however. The amount of money spent annually in the motion-picture industry is far in excess of that sum.

Government experts, will tell you that some 10,000,000 persons in the United States pay admission to picture houses each week. This means that one out of every ten men, women, and children in this country visits a photoplay theatre

weekly. It means that more than half a billion admissions are paid annually to the box offices of motion-picture theatres.

It is difficult to think in small figures of this industry. For instance, more than 75,000 miles of film are manufactured and exhibited annually in the United States. Like a mushroom the industry has grown. It has made millionaires whose fortunes have sprung like weeds in fertile soil.

Less than ten years ago the motion-picture industry was small. In that short span it has developed from the one-reel, slapstick comedy or cheap drama to the present artistic feature production, in which stars of international repute appear. Ten years ago if a motion-picture producer spent more than $100 for 1,000 feet of film, which required fifteen minutes to be shown on a screen, he blamed himself for being extravagant. Five years ago the average sum spent in producing 1,000 feet of film was $1,000. Today there are productions, such as "The Birth of a Nation," which cost $250,000.

Just now, in the Island of Jamaica, British West Indies, William Fox is spending $1,000,000 on a production which, when complete, will be shown in such theatres as have been or are now playing "The Birth of a Nation." Incident to the taking of this feature a Moorish city has been constructed on the coast of Jamaica—a city which is the replica of a turreted, castled stronghold built by the Moors many hundreds of years ago. There has also been constructed on the coast of Jamaica a gigantic submerged photographic tank, in which a battery of cameras "shoot" the aquatic scenes which form a part of the million-dollar production. An ancient fortress, in addition to the Moorish, city is being built, only to be destroyed by high explosives.

There is scarcely, a community of more than 1,000 inhabitants in the United States which has not a motion-picture house. The industry has brought the photoplay to the very doors of those who for years have been deprived of such amusement.

The motion-picture theatregoing public has the Federal Government to thank for the fact that there is no trust in the moving-picture business. The exhibitor buys his pictures on the open market. Competition in the production and sale of motion pictures is keen.

The restraining hand of an alert Government has been responsible for this, and with this result, the character of motion pictures has steadily improved in tone. Keen competition among the producers has brought out the best that is in them.

This happy state of affairs has not always existed, however, in the moving-picture business. In the latter part of 1908, when the money-making possibilities in the motion-picture film industry began to become quite evident, ten manufacturers of American-made films combined under a trade agreement and created one of the tightest trusts that had ever appeared among American industries. These ten manufacturers had, or believed they had, about all the patents covering the making and projecting of motion pictures. Exhibitors throughout the country soon found that in order

to get film they must sign an agreement with the trust, pledging themselves to buy from it alone and to rent no other film. As the trust controlled approximately 95 per cent. of American-made film, and a large percentage of foreign-made film, it had the situation well in hand. The exhibitor was at its mercy. It was a case of buy from the trust or close his door.

At that time one dealer in motion-picture films refused to accede to the demands of the Film Trust. The fight that ensued resembled that of a bulldog yapping at the heels of an elephant. But in the end the bulldog won.

One day William Fox, President of the Greater New York Film Rental Company, went to Washington and laid a few facts before George W. Wickersham, then Attorney General. Shortly thereafter the Sherman anti-trust law was taken from its shelf, dusted off, and applied to the elephant. The Government's dissolution suit against the Film Trust was slow, as such dissolution suits must necessarily be. Many million words of testimony were taken. But the courts decided that the Government was quite right—that the Film Trust had no place in the business world of these United States. This United States Court decision was handed down on Oct. 1, 1915. Long before that, however, the Moving Picture Trust had clearly seen the handwriting on the wall, and it dissolved itself, thereby opening the field again to competition.

The ramifications of the film industry are almost limitless. Just how many hundreds of thousands of persons are engaged in it is difficult to ascertain. Many other industries have been made richer through the development of the motion-picture business. Iron and steel are used in the manufacture of projecting machines, electric light frames, and what not. The textile industry has been made richer by the money spent in costumes for motion-picture plays, and so it goes throughout the list.

A new type of actor has been developed by the movies—an actor who by voice-less expression alone must convey meaning as clearly as his brother of the legitimate stage conveys it through gesture accompanied by the spoken word. A bitter fight is now on between the actors of the legitimate stage and the actors of the screen, but it is not unusual that a star is found playing on the legitimate stage in one theatre, while down the street he or she may be seen in another production at a photoplay house on the screen.

While many thespians have entered the picture drama successfully, although untrained in picture acting, the majority of successful movie stars are men and women who have risen from obscurity to prominence in picture land.

The motion-picture industry has also developed a new type of artist, separate and quite distinct from the movie stars. This artist is the director. Five years ago the motion-picture director who received a salary of $50 weekly considered himself fortunate. Today there are directors whose annual income is equal to that of the President of the United States. David W. Griffith, Herbert Brenon, and several others are numbered among those whose work yields a revenue greater than that which the Government pays its Chief

Executive. In fact, there are few large motion-picture producing companies which have not a corps of directors whose salaries range upward from $25,000 and who are under contract for several years. These contracts, ranging from one to five years, show the faith the film manufacturers have in the future of the motion-picture industry. Among the successful directors, whose salaries range upward from $25,000 are Reginald Barker, Tom Ince, Mack Sennett, Allen Duan, Raoul Walsh, J. Gordon Edwards, Cecil De Mille, James Kirkwood, and Ralph Ince.

Still another product of the motion picture industry is the camera man. Five years ago the services of an expert motion picture camera man could be obtained for $25 or $35 a week. Today there are many camera men receiving salaries of from $150 to $250 a week. The development of the camera art has kept pace with the general development of the motion-picture industry.

Just now the moving-picture industry of the United States is beginning to look beyond the horizon for further fields to conquer. Several enterprising production concerns have invaded Canada. Others are preparing to open the South American field, and are arranging with European agents for the distribution of films in those countries which are now at war.

* * *

January 24, 1916

THEDA BARA FILMS TEST PLOT WRITERS

The Task of Making Them Vampirish Enough Calls Forth All Their Ingenuity

WELL CAST IN 'THE SERPENT'

Actress Impersonates an Adventuress, but Keeps Spectators' Sympathy—Other New Films

The ingenuity of the men who write scenarios for Theda Bara must be hard pressed at times, because Miss Bara, according to her press agent, is a perfect specimen of the "vampire" type, and the story must be bounded on four sides by a certain kind of atmosphere. Since Miss Bara is so well fitted by looks to act this sort of creature before the camera, it would be squandering her resources to cast her in a Mary Pickford sort of role.

Whoever wrote the scenario of "The Serpent," the new William Fox picture revealed simultaneously in the Academy of Music and the Riverside yesterday for the first time, should therefore be praised in the introduction for having furnished this actress, who is no novice in the films, with a stirring story. After that the producer should receive a kind word for the little touches that go to make "The Serpent" above the average of its kind.

One of these touches comes to mind immediately, because it is in the last reel. The scene is a Russian peasant's cottage and the father of the girl portrayed by Miss Bara attempted to draw on his boot. When it won't go on he looks within and discovers a mouse. Business of close-up of the boot showing the mouse. The cat by the hearth sniffs, and when the mouse is turned out of his home, pussy is seen chasing him to a corner, and—exit mouse. Which is only one of a number of realistic touches that add interest to the picture.

The problem of having Miss Bara play the part of a vampire and still retain the sympathy of the audience is solved by making her evil deeds the figments of a dream. Vania Lazar, the serf's daughter, whom Miss Bara impersonates, dreams that the Grand Duke has ruined her life, and that in vengeance she sets out upon a career of wickedness that covers several continents.

First she goes to London and wrecks a perfectly good home by causing one brother to break a wine bottle over another's head for love of her. Then she becomes a famous actress and the Grand Duke, not recognizing her, pays court to her. From him she learns that his son is convalescing in a Paris hospital from wounds suffered in battle, and she hastens there and becomes a nurse that she may be near him and drag him into her web. Her revenge is complete when she brings father and son together and causes the son to utter this subtitle: "My Wife."

That is her dream. What really happens is that Vania falls out of bed and goes downstairs to finally gain her father's consent to wed Andrey Sobi, her real sweetheart. Thus is art and virtue served and the sympathies of the audience preserved with no sacrifice of thrills.

The interpolation of scenes illustrating episodes not directly concerned with the plot is a favorite practice of directors. Thus Vania, sitting beside the wounded son, says: "Tell me the story of the battle of Ancourt," and presto, a succession of unusually thrilling battle scenes is unreeled. They are so realistic that until the hero himself is identified leading charges one begins to believe they are scenes from the real war, and not a mimic one staged in New Jersey.

Miss Bara's following is easily accounted for by this picture. She is a clever actress with a high sense of screen values. Hers is a marvelously mobile and expressive face that can express deeper scorn by a curl of the lip or greater sorrow through an expression of her eyes than the average screen player can denote with exaggerated heavings and writhings.

The handsome opera house in Lexington Avenue at Fifty-first Street that Oscar Hammerstein did not raise to be a movie theatre became that yesterday. Hereafter it will be known as the Strand. That it does not hope to rob the Broadway institution of its following is evident from the fact that it does not receive its features till that house is through with them. Yesterday's feature was "The Cheat," seen several weeks ago at the Strand. A large orchestra has been installed and a musical program will be given in connection with pictures of all kinds.

These pictures were shown at other theatres yesterday: "Acquitted," featuring Wilfred Lucas, and "Perils in the Park," at the Knickerbocker; "The Call of the Cumberlands," with Dustin Farnum at the Strand; "The Ragamuffin," with

Blanche Sweet in the title rôle, at the Broadway; "The Salamander," taken from Owen Johnson's book, with Ruth Findlay in the principal role, at the Hamilton and Regent; "The Wood Nymph," with Marie Doro, and "A Movie Star," at the Eighty-first Street, and "The Birth of a Nation" in Proctor's Twenty-third and 125th Street houses.

* * *

FOX'S GRAPHIC TALE SHOWN ON THE FILM

*Stirring Scenes in "The Trail of the Lonesome Pine"
Thrill Spectators*

MISS WALKER THE HEROINE

*Wins Applause in Part She Created on the Legitimate Stage—
Other New Movie Productions*

John Fox's novel, "The Trail of the Lonesome Pine," has been translated into movie form. Several years ago the dramatic story of life among the moonshiners of the mountains of Virginia was adapted for the stage by Eugene Walter, and after that a song for the hurdy-gurdies was written with the book's title as an inspiration. And now in the newer medium the story is being repeated.

The movie version, which was exhibited for the first time yesterday at the Strand, is more successful than was the play originally acted several years ago at the New Amsterdam with Charlotte Walker in the principal rôle. The bold, melodramatic events of the story, that on the vocal stage were a bit trying on the nerves are just the stuff movies are made of. Then Mr. Fox's tale is one of action, much of it in the great outdoors, and action is the essence of the cinema.

There are some thrilling and tense moments in the picture, which is from the Lasky studios. The escape of Hale, the revenue officer, through the clever conceit of setting the straw of the barn afire with coals from his pipe and burning the cord that binds his hands behind him, draws an audible shudder from the audience by its realism. Follow in rapid succession the flight of Hale on horseback, the assault upon him from ambush, the capture of young Tolliver by the revenue men, and their visit to the Tolliver cabin with the youth as a hostage. These are only a few of the stirring scenes that fill the latter half of the film.

Eventually, perhaps, more movie makers will realize that the outdoors is their stage, the groves, the hills, the fields their mise en scènes. There ought to be a law setting a maximum on the number of feet of "studio stuff" a producer might use in any one film.

Charlotte Walker, who played the rôle of June, the mountaineer's daughter, who fell in love with the revenue officer, when the play was produced at the New Amsterdam, acted the part before the camera. Miss Walker does not suggest the young girl of Mr. Fox's book, but she played the part with

discretion, and in most of the scenes presented an attractive picture. Theodore Roberts, in the rôle of the elder Tolliver, gave another of the fine character studies with which he is enriching moving-picture productions.

A few years ago a bedimpled, flaxen-haired little girl appeared in the title rôle of Edward Peple's war play, "The Littlest Rebel," on Broadway. Her name was Mary Miles Minter. It still is, for that matter, but Miss Mary is no longer a little girl. She is a grown-up movie actress who has her name on the lithographs.

One of Miss Minter's pictures was shown yesterday at the New York Theatre. It was called "Dimples," the title referring, obviously, to the erstwhile littlest rebel. Miss Minter's rôle was that of a poor little rich girl whose miserly father finally died and allowed her to go South to live with a less miserly but scarcely more pleasant aunt. It is not necessary to go into the details of the plot. There were two sudden deaths, the visit of a thief, the hiding of the miser's treasure in Dimples's doll, and the impending engagement of the young miss to a scion of one of the First Families as you enter Savannah before the end of the second reel was reached. Miss Minter shook her flaxen curls, that seem to have a permanent wave, through the five reels, and as she is always frolicsome and presents a picture of girlish beauty, her followers probably do not demand that the scenarios furnished her shall possess literary merit.

Other new features shown yesterday were "The Fool's Revenge," with William H. Tooker and Maude Gilbert, at the Academy of Music; "A Parisian Romance," with Dorothy Green, at Proctor's Twenty-third Street Theatre; "Nearly a King," featuring John Barrymore, at the Broadway, and "Daphne and the Pirate," with Lillian Gish, at the Knickerbocker. Today Bessie Barriscale in "Honor's Altar" will be shown at the Eighty-first Street Theatre.

* * *

MARY PICKFORD IN BOY'S MASQUERADE

Movie Favorite a Kidnapped Foundling in "Poor Little Peppina"

AMUSING, BUT IMPROBABLE

*Long Arm of Coincidence is Wrenched Badly,
but the Spectators Like it*

A new Mary Pickford picture was shown for the first time yesterday in the Broadway Theatre, and there were times in the afternoon and again at night when a queue of loyal subjects of this movie favorite stood outside in the falling snow waiting for a chance to sit at her shadow feet. The picture, called "Poor Little Peppina," was the first seven-reel film for which the star ever acted and the first Pickford film to be released since "Madame Butterfly" was shown at the Strand about two months ago.

There is nothing mysterious about the hold this little actress has on her public. In all of her moods there is a fascination that does not elude the camera. She is always dainty, spontaneously playful when the scenario demands it with never a suggestion of the hoyden, becomingly demure, and prettily sentimental. So when Mary smiles her audience smiles with her; when she makes love, hand clasps out front are tightened; and when she hangs her pretty head with its curls, handkerchiefs absorb briny moisture from the sea of upturned faces. Hers is a peculiarly sensitive face that registers distinctly the varying emotions, and then she possesses in marked degree that indispensable screen qualification—eternal youth.

In her latest piece Miss Pickford is the little daughter of wealthy parents kidnapped in babyhood and put by her abductor in the home of a poor Italian family to be reared. The story begins in Italy and shifts to New York, with enough twists of the long and exceedingly elastic arm of coincidence to incapacitate that overworked member for all time. The story is melodrama of the most improbable sort, but no one expects the events of screenland to be ordered by mortal rules.

Some of the most stirring scenes of the picture are in the first part, in which the kidnapping of the child by a member of the Mafia is shown. The father has incurred the hatred of the man by aiding in his capture when he stabs one of his enemies on the father's estate. The murderer is sent to prison, but escapes, and for revenge steals the little girl and carries her away. An accomplice tells the distracted father and mother the next day that he saw a man and child drown in the bay, and so she is mourned as dead.

This much of the film is in the nature of a prologue, for during it Miss Pickford does not appear. And then she flashes forth as Peppina, the kidnapped child grown to a girl in her middle teens, and the audience is happy. Miss Pickford has chameleon eyes that photograph dark or light, and as she wears a dark wig she makes a likely daughter of Italy. She is not unhappy with her foster parents, although the cruel padrone beats her, till they betroth her to him. The day of the betrothal comes and in the midst of the festivities she runs away and hides.

Then with the aid of Beppo, the youth with whom she has grown up, Peppina assumes the masquerade of a boy and starts for America with some money a woman, no less than a Duchess, has given her. The Duchess also has given her a card bearing the name of her brother in New York, but Peppina loses it, only to discover her loss hours afterward.

The long arm of coincidence becomes active on shipboard when Peppina, who has gone aboard as a stowaway, is discovered by the Duchess's brother in his stateroom appeasing a hunger of several days' accumulation. Then when Peppina lands in New York through the connivance of a stoker coincidence leads her to the saloon of her abductor. There she stays, her identity undiscovered, till she wearies of the man's cruelty and runs away and becomes a messenger boy.

Again the long arm reaches out and leads the heroine with a message to the shop where a little while before she had

innocently given a counterfeit bill in payment for a hat. With so much assistance from coincidence the denouement is naturally swift and complete. The kidnapper and coiner is dragged before the District Attorney, who happens to be the Duchess's brother. The discovery is made that Peppina is the child the man stole years before and father and mother come from their estate up the Hudson to have their lost one restored to them. It seems hardly necessary to add that Peppina marries the District Attorney.

Miss Pickford in boy's clothes with short hair is altogether adorable, but she is that in her peasant clothes and later in the frock of a young woman of fashion, so one may overlook the improbabilities of Kate Jordan's story. Anyway, a loyal movie enthusiast dismisses his reason with his dime when he enters a cinema. The picture was taken with careful attention to detail, many of the rôles being played by Italian actors who lend the proper atmosphere. Eugene O'Brien acted the part of the District Attorney. Mr. O'Brien should not think for a minute that he can wear a white vest with a dinner coat with impunity just because he is in the movies.

A picture called "Pawn of Fate," with George Beban as the star, was shown last night in the Forty-eighth Street Theatre. The new program at the Knickerbocker had for its feature an Ince picture, entitled, "Bullets and Brown Eyes," with Bessie Barriscale in the principal rôle. Blanche Sweet in "The Blacklist" at the Strand, William Farnum in "Fighting Blood" at the Academy of Music, Billie Burke in "Peggy" at the Eighty-first Street Theatre, and S. J. Ryan in "The Fourth Estate" at Proctor's Twenty-third Street were other features exhibited yesterday. Marcus Loew has opened the roof of the New York Theatre to take care of the overflow from the auditorium downstairs.

* * *

May 22, 1916

GERMANY'S SIDE SHOWN ON FILM

First Motion Pictures of the Campaigns in Serbia and Gallipoli Peninsula

GEORGE BEBAN IN 'PASQUALE'

*Charles Chaplin in Last Picture to be Released by Essanay—
"Sweet Kitty Bellairs"*

Another set of films of the great war has reached New York. The pictures, which are being shown at the Irving Place Theatre, tell the side of the story acted by Germany and her allies and, like all of the other animated records of the struggle that have been seen here, are exceedingly impressive.

The most interesting feature of this new group is the view of the campaigns in Serbia and the Gallipoli Peninsula they give. Movies of the war in most of the other participating countries have been previously shown here, but unless the

information at hand is at fault these are the first pictures of the Turkish defence. There are views of various troop movements in this drab stretch of sand, and one thrilling picture of a large body of Turks pouring up a hillside with knapsack on back like a swarm of bees on a honeycomb.

One reel is given over to scenes of the Bulgarian drive through Serbia, and some of these pictures of picturesque bodies of troops marching through the mountain country are pictorially fine.

The name of George Beban to one who knows his vaudeville and movies immediately conjures up visions of spaghetti and strings of garlic. One would as soon expect to see Frank Tinney without burnt cork on his face or Joe Weber without padding as to see Mr. Beban in any but an Italian role. So in "Pasquale," a new picture shown yesterday at the Broadway, this actor of types appears as a swarthy son of Italy running a little grocery store in America.

Charles Chaplin is to be seen this week at the Rialto in the last picture to be released by Essanay, his former producer. The comedian is up to his familiar tricks in the picture, and scarcely a foot of film passes that his foot doesn't. It all depends on the point of view whether this picture, called "Police," is funny. If one likes Chaplin, it is; if one doesn't, it closes the bill and one may leave.

At the Strand yesterday the feature was "Sweet Kitty Bellairs," with Mae Murray as the star. William Farnum was seen at the Academy of Music in "The Battle of Hearts." "A Child of the Streets," with Mae Marsh, will be shown at the Eighty-first Street today, and at the Seventy-seventh Street Theatre the offering will be "The Come-Back," with Harold Lockwood and May Allison as stars.

* * *

June 3, 1916

INCE PHOTO PAGEANT SHOWN

"Civilization" is a Spectacle of the Physical Horrors of War

"Civilization," Thomas H. Ince's effort to rival D. W. Griffith with a photo spectacle of the scale and scope of "The Birth of a Nation," was displayed in New York for the first time last evening at the Criterion Theatre. It is an excellently elaborate photo pageant on the physical horrors of war, a big motion picture marked by lavishness in production and beauty in photography.

"Civilization" attempts to serve the pacifists as "The Battle Cry of Peace" tried to serve the cause of preparedness. Its argument is elementary, a leaf out of the pacifists' primer, a projection on the screen of something of that state of mind that was most in evidence in this neighborhood at the time the Ford expedition set forth from these shores. Its program describes it as a direct appeal to the "mothers of men."

The hero of "Civilization" is the submarine commander who, secretly wearing the purple cross of the Mothers of Men Society, refuses to torpedo a defenseless passenger vessel. In the mutiny that follows the submarine is sunk. He is drowned, and his spirit goes to an inferno inspired by Doré. There the Christ comes to him, receives him as a redeemed soul, returns among men in the discarded body of the dead man, and there takes the warlike King on such a review of war's horrors as to make him cry for peace. The King then heeds the pleas of the Mothers of Men, and the last picture shows the soldiers returning jubilant to their peasant homes.

In the earlier part of this photoplay there are many stirring battle scenes, and the whole episode of the submarine and the sinking of another Lusitania is extraordinarily graphic—so graphic, indeed, that at this point in the unfolding of the spectacle last evening Billie Burke fainted.

"Civilization" was displayed last evening with a full orchestra in full blast, with off-stage singing, both solo and choral, and with a preliminary corporeal pantomime of the sort employed in "Ramona," and always of doubtful value in the screen world. A large audience, full of notables, saw and applauded the picture at its first showing, and at the end called for Mr. Ince, who was led on by Al Woods, his associate in the New York display of the film. Mr. Ince spoke his acknowledgments with a modesty and brevity in striking contrast with the fulsome Ince-adulation which makes the program such painful reading. He has projected a philosophy of war on a par with "War Brides," an entertainment on an artistic level with "Ben Hur," a dramatic photo spectacle that falls somewhat short of "The Birth of a Nation."

* * *

June 7, 1916

AMERICA IS INVADED AGAIN IN THE FILMS

"The Fall of a Nation" Another Sensational Photoplay Plea for Preparedness

DEVISED BY THOMAS DIXON

Lively, Interesting, and Sometimes Preposterous Picture with Herbert's Music at the Liberty

When the new insistence on a greater consideration of our national defenses first became a topic of daily conversation the Vitagraph Company prepared a preparedness photoplay called "The Battle Cry of Peace" as the movies' contribution to the propaganda. Now comes Thomas Dixon, author of "The Clansman," with an equally lurid and sensational but far better managed photoplay, which follows much the same scheme and, like its predecessor, dwells on the horrors of America invaded, to the utter confusion of the pacifists. This is called "The Fall of a Nation," and it was shown in New York for the first time last evening at the Liberty Theatre.

For this motion picture Victor Herbert prepared a special musical accompaniment, and both he and Mr. Dixon were in

evidence at the Liberty last evening. The other members of the large audience found unfolded there an unbridled photo play of the battle, murder, and sudden death species, much of it graphic and exciting, some of it quite absurd, and all of it undeniably entertaining.

The idea behind "The Fall of a Nation" is such a good one it is small wonder that more than one big movie and many magazine writers have made use of it since the war began. Its development this time is marked by a few points that offend against good taste and several points that outrage the intelligence, but many stretches of the film are finely spectacular and it is full of battlefields and such pictures of avenging cavalry sweeping along moonlit country roads as the movies always do particularly well. "The Fall of a Nation" is full of thrills.

Viewed as propaganda, it is a pity it is so reckless. Both "The Battle Cry of Peace" and the Dixon photoplay allow a huge invading force to reach these shores with America apparently caught unawares. There is something said about the Panama Canal being blown up, and you see a sinister fellow cutting a telephone wire in what seems to be the suburbs, but there is no real explanation of how a European fleet reaches Long Island and lands its forces there before our own authorities wake to the unpleasant fact that anything is the matter. Offended by this leap so plainly made for melodrama's sake, those disposed to resist the preparedness argument will rebel at this point and laugh all the rest of the film to scorn.

You are given to understand that all this invasion is prepared from within by some disloyalists. There is a head villain called Waldron (a multi-millionaire) and his confidential adviser whom Mr. Dixon elects to call Villard. Congress is warned (and this is the heart of the matter) that all this strange effort to make America defenseless is directed by some unseen, guiding hand. With one of those swift leaps the movies can make, you see pacifists arguing that America hasn't an enemy in the world, and the next moment see a loft in the slums occupied by secret bombmakers working for the enemy.

The enemy is a debt-ridden participant of the present war, a country of incredible efficiency whose commanding officers are given to mustaches strangely like the Kaiser's. You have one guess as to what country Mr. Dixon had in mind. You have also one guess as to whom Mr. Dixon was thinking of when he introduced one Barker, a meretricious peace-at-any-price Chautauqua lecturer. His make-up would give you a hint, and the audience fairly yells with delight when he is later seen peeling potatoes for the invaders. There are many touches in the captions about "the blood-red soil of crowns" and "the poison of Kings."

Once having shown America under the heel of the conqueror, Mr. Dixon achieves her rescue by a master stroke. His Klu-Klux-Klan memories come to his aid. A Loyal Legion of American women is formed, seemingly to spread the Emperor's gospel, but really to vanquish the invaders. On the night of nights their leader receives one of those movie telegrams to the effect that all of her plans have worked out and that 200,000 imperial soldiers have succumbed to the blandishments of presumably as many women, and thus lured from

their posts of duty, have made easy the work of the American men. "Amazons in breeches" astonish the Philadelphia garrison and certain "hell-cats" unman the hostile fleet with another tea party in historic Boston Harbor.

The battle scenes on Long Island are admirably worked out, but Mr. Dixon is shrewd enough to sprinkle the picture with children. A tiny Italian boy is seen after the battle is over groping among the dead for his father, a tiny American girl is seen hiding under the table where some invading officers have just been dining riotously.

Mr. Herbert's score is effective. It helps a lot. It is easy enough to find miscellaneous musical motifs to accompany a photoplay, but here we have a score adjusted also to its rhythms. Of course there are dissonantal crashes for the battle scenes. In one scene of lamentation, the figure on the screen moves to the measures of a strain that is a blending of "Lead Kindly Light" with taps. And in the prologue the origins of this country are traced, in scenes which show it as a place of refuge and new life for the variously oppressed of Europe, to a musical accompaniment wherein is woven from time to time the airs of our national anthems.

This music adorns a photoplay that lasts all evening, an example of good motion picture photography without any evidences of the advance for which one must watch with interest in the handling of this new art form. And, like all big spectacular pictures, it must face the eternal question, "Is it as good as 'The Birth of a Nation'?" It has not yet been possible to answer this in the affirmative.

* * *

September 6, 1916

'INTOLERANCE' IMPRESSIVE

D. W. Griffith's New Picture is a Stupendous Spectacle

Ever since the remarkable film, "The Birth of a Nation," was unreeled before an amazed public more than a year ago, the question of whether it was an accident or whether D. W. Griffith, the man who directed its taking, was really a new master of the cinema has interested those who study the personalities that manipulate the puppets of stage and studio. The answer came last night when Mr. Griffith's second big picture, "Intolerance," was exhibited in the Liberty Theatre before an audience that might have gathered to witness the premiere of some favorite dramatist's latest work, so dotted was it with prominent folk of the theatre.

The verdict "Intolerance" renders in the controversy concerning its maker is that he is a real wizard of lens and screen. For in spite of its utter incoherence, the questionable taste of some of its scenes and the cheap banalities into which it sometimes lapses, "Intolerance" is an interesting and unusual picture. The stupendousness of its panoramas, the grouping and handling of its great masses of players, make it an impressive spectacle.

An excerpt from the highly literary program will give some idea of Mr. Griffith's latest offering.

"The purpose of the production," so runs the foreword, "is to trace a universal theme through various periods of the race's history. Ancient, sacred, mediaeval, and modern times are considered. Events are not set forth in their historical sequence, or according to the accepted forms of dramatic construction, but as they might flash across a mind seeking to parallel the life of the different ages.

"There are four separate stories, each with its own set of characters. Following the introduction of each period there are subsequent interruptions as the different stories develop along similar lines, switching from one to the other as the mind might while contemplating such a theme."

What Mr. Griffith has attempted to do in his eight or nine reels of film is to show that intolerance has always been a vice of man. To prove his point he has unfolded a tale of Babylon when Belshazzar was King, has prepared a series of a few rich tableaux of the persecution of the Nazarene, has pictured with a wealth of atmosphere the massacre of St. Bartholomew, and paralleling these has spun a lurid, modern melodrama in the prevailing mode of the screen.

Shorn of the impressive bibliography recorded on the program and of the somewhat hazy symbolism that flickers between the episodes, "Intolerance" is a regulation photodrama, superior to the average feature picture because of the skill with which it is handled, and an amazingly accurate and thrilling picture of Assyrian civilization.

The French scenes and those of the life of Christ constitute only a smart part of the film. They were apparently included to develop the idea of the presence of intolerance through the ages. In spite of their general excellence and the faithfulness with which they have been reproduced, they do nothing but add to the general confusion and might well be eliminated. This is especially true of those scenes in which the Christ is impersonated, always a questionable proceeding if the feelings of many are to be respected.

It is the Babylonian portion of the film that will commend it to the great public. These pictures of the walls of Babylon, broad enough for chariots to pass at ease, of the great gates thronged with picturesque caravans, of the palace of Belshazzar with its myriad slaves and dancing girls, and of the siege and fall of the city are indeed masterpieces of the cine.

They are so splendid that it seems a pity the story was not deleted.

* * *

February 25, 1917

NOTES ON THE SCREEN

A motion picture stands or falls by the measure of its interior scenes. Any director can photograph nature and have it look real and often artistic, but not every one can give the semblance of life to an interior scene. Too often they are palpably things of paint and canvas, tasteless and tawdry, and with no illusion of solidity or reality.

One of the reasons "Joan the Woman," which has attracted large audiences to the Forty-fourth Street Theatre, for many weeks, is one of the finest screen spectacles ever produced is that its interior scenes are as fine as those reflecting great stretches of out-of-doors peopled with the hosts of the Maid of Orleans in shining array. The average spectator departs with the scene of the cavalcade breaking camp to go to the rescue of Orleans, the charge upon the outposts or the burning of Joan most deeply impressed on his memory, but these are no more notable than the coronation scene, in which a sense of real regal splendor has been caught by the camera.

Of itself this scene possesses little that is dramatic. It is true that when Charles was made King of France at Rheims the zenith of the Maid's career had been reached. Her downfall was measured from that very day. What the coronation does supply to the spectator of the Joan picture, however, is a certain positiveness of reality in the panorama unreeled before his eyes. In this bit of staging and directing Cecil B. DeMille struck a new note in picture making.

History has not recorded many of the details of Charles's coronation, and it devolved upon Mr. De Mille, Geraldine Farrar, who contributed richly to the artistic side of the production, and Wilfred Buckland, art director of the Lasky studio, to fill in the details.

On the screen the great interior looks for all the world as if it had been photographed within a cathedral. So it was, but it was an open-air cathedral, three sides of which extended about thirty feet in the air. These side-walls rested on a stage. Two thousand persons participated in the coronation, which required two full days to "take," despite the fact that it remains on the screen only three minutes. There are 110 trumpeters, 235 pages, 46 acolytes, 550 men of arms in full armor, and 52 ecclesiastics on the dais, with the Bishop and hundreds of spectators in the great hall.

During the making of the scene Mr. DeMille made use of a simple scheme of signals. Back of the camera stand he placed a brass band of twenty pieces which rendered the compositions of John Philip Sousa as King Charles, Joan and the procession marched with stately tread. At a change of tune several hundred players, previously advised, would start a demonstration, followed by other groups until the entire throng had joined the cheering.

One of the interesting objects on exhibition in the lobby of the theatre is the ermine robe worn by Raymond Hatton as Charles in the coronation scene. It is seen in the picture not longer than thirty seconds, yet it is said to have cost $800.

The profligate movies!

* * *

February 26, 1917

NEW COLOR MOVIES SHOWN

Wonderful Results Obtained in Pictures at the Strand

The movies have merely scratched the surface. The enthusiasts have proclaimed all along that as they developed they would gain in effectiveness, and pointed to the possibilities of color reproduction as one of the directions in which they would develop. How infinite these possibilities are became evident at the Strand yesterday, when color movies made by a new process were shown for the first time.

The subjects were many and varied, and included land and seascapes, animal pictures, and portraits of people. The irridescence of the surface of a soapbubble in the sunlight, the glow of a woman's cheek, the brilliance of the setting sun have all been caught and reflected with amazing veracity. One especially alluring picture of a herd of cattle rounding the crest of a hill gave the feeling of a Bonheur painting come to life. The color gives a third dimension to the pictures, so that in many instances the perspective is quite remarkable. The films were made by the Prizma process.

A commendable screen version of Oliver Goldsmith's "The Vicar of Wakefield" was exhibited yesterday at the Rialto. This film had the honor of being the first one to win the stamp of approval of the recently formed Photoplay League. The movies love misery if it can be shut off in time for a happy ending, so this classic in which the woes of the Primrose family are recited conforms to the photoplay norm.

A careful selection of backgrounds has helped give an old English flavor to the picture. More than to any other one factor, however, it owes its success to the acting of Frederick Warde in the title rôle. That veteran of many rôles and years not only looks the part, but acts it with great skill and understanding.

Rex Beach's Alaskan story, "The Barrier," has been made into a strong photoplay, which was exhibited for the first time yesterday at the Broadway. The film's makers have succeeded in conveying to it something of the virility of this author's stories. The players were chosen with a sense of types. An adaptation of Winston Churchill's novel, "The Crisis," was put on exhibition at the Park.

* * *

March 12, 1917

SARAH BERNHARDT IN REAL WAR FILM

"Mothers of France" from Scenario of Jean Richepin Moves Rialto Audience

TRIUMPH FOR THE ACTRESS

Camera Shows Her in Hospitals, Camps, and the Very Trenches with the Poilus

"Mothers of France," a cinematic epic of the great war, is the photodrama for which Sarah Bernhardt acted before she sailed from France to come to America last Fall. Jean Richepin, dramatist and Academician, wrote the scenario, and the French Government offered every facility for enacting its scenes before a truly martial background. It was exhibited here for the first time yesterday at the Rialto.

"Mothers of France" atones for most of the sins of the movies; to see it is recompense for having sat through a series of atrocious and banal war films purporting to point a moral. It is propaganda subtle and powerful that must move even the most calloused and neutral observer. Only the pro-Teuton could see it and not be touched by its sincerity and its art— the art that is inherent in truth.

It is a brief for the women of France who are doing their bit behind the fighting lines, told in terms of the most vivid realism. The story unfolded is of the sacrifices of a small group of neighbors in a village of France. It is a tale whose various details have been duplicated in every corner of that fair land since the war began.

A woman, whose son has been wounded, leaves the base hospital at Rheims, where she is serving as a nurse, to search for him. She finds him in the first aid station to which he has been carried, and shortly after her arrival he dies in her arms. The death of her husband, a Major, in battle, is her next bereavement, but still she is brave, hiding her feelings in public and doing her part in the great work of healing torn bodies and lives. "We have not the right to curse," she tells her stricken neighbor whose son has been blinded in battle. "Those for whom we weep are dead in order that our mother shall possess all things. France never dies."

A nation at war provided the mise en scène for this universal drama of France, and that nation's greatest actress gave her services that the world might weep with the mothers of France and rejoice at their courage of the spirit, a courage that passes all understanding. Mme. Bernhardt acted the rôle of the central figure of the story, a choice that was ideal both because of her art and because more than any other living person she typifies to America the joy, the warmth, the strength, the capacity to drink to the full of life that is France.

The power of the movies to obliterate space removes the handicap of her inability to walk freely; she is always revealed standing or sitting, and one is conscious only of the wonderful expressiveness of her countenance and gestures. In one scene in particular, in which she stands before the por-

trait of her dead husband, the poignancy of the grief expressed seems to lose nothing through its inarticulateness.

The skill of the players, all of whom, even to the children, possess the Gallic felicity of gesture, combines with the unmistakable veracity of the scenes to make this a film unique in its power to stir the emotions. Mme. Bernhardt, in the rôle of the mother, is pictured in the hospitals, the commissary camps, and even in the very trenches with the poilus. Once she is shown waiting in the corner of a transverse to allow a squad of soldiers to run by, each carrying an aerial torpedo.

Again she stands before the statue of Joan of Arc in front of the war-scarred Cathedral of Rheims, its shattered windows and bag-protected buttresses plainly visible. Real chateaux, real peasant women toiling in the fields, and real munitions smoke give a flavor that no amount of paint and plaster villages and trenches filled with tin soldiers hired at a dollar a day could ever hope to approximate.

The artistic value of the film itself has been enhanced by the manner of exhibition. The singing of the "Marseillaise" precedes the showing, and throughout its course appropriate music, with the French national anthem as the recurrent theme, is played. Then by the process of double projection glimpses of Geraldine Farrar's portrayal of Joan of Arc are thrown on the screen synchronously with the other picture.

A picturization of "A Tale of Two Cities" was the new offering at the Academy of Music. "Sapho," with Pauline Frederick in the title rôle, was shown at the Strand.

* * *

October 15, 1917

THEDA BARA AS CLEOPATRA

With Much Rolling of Eyes She Portrays "the Siren of All Ages"

Cleopatra of Egypt was among the earliest of the vampires of history, if not the earliest, and it was therefore but a matter of time until the siren Theda Bara should duly attend to the transfer of that temptress to the movie screen. The result is "Cleopatra," an uncommonly fine picture which was unreeled for the first time at the Lyric Theatre last night before an audience which included the dazzling Miss Bara herself. The star, by dint of much rolling of eyes and many other manoeuvres, contributes a thoroughly successful portrait of "the serpent of the Nile, the siren of the ages, and the eternal feminine," in the words of the screen, and thus does the ill-starred Queen of Egypt become the well-starred queen of movies.

The story of Cleopatra's many loves needs but the slightest elaboration to make it the finest sort of film fare, and movie fans are certain to flock to it. From a scenic standpoint, also, it is quite a triumph for the director. The Sphinx, the pyramids and a goodly section of Rome are duly duplicated, and the larger scenes are handled in a way that suggests D. W. Griffith. The naval battle at Actium is made most impressive, and the handling of the chariots also furnishes many a thrilling moment.

Miss Bara, to quote the program, "wears fifty distinctively different costumes," many of which are so thoroughly in attune with the period that they are likely to cause not a little comment. In addition to the star, the film enlists the services of Fritz Leiber as Caesar, Thurston Hall as Antony, and Henri de Vries, the Dutch actor, as Octavius. The picture was photographed in California during last Summer.

At the Strand Theatre Billie Burke was seen for the first time yesterday afternoon in "Arms and the Girl," and "The Co-respondent," with Elaine Hammerstein in the leading rôle, began an engagement at the Broadway. Charles Ray, in "The Son of His Father," is the new attraction at the Rialto, and Alice Brady, in "A Maid of Belgium," opened at the Park on Saturday.

* * *

April 5, 1918

WAR VIVIDLY SEEN IN GRIFFITH FILM

"Hearts of the World" Also Tells a Story That Quickly Stirs the Emotions

IT BEGINS BEFORE CONFLICT

Germans Advance with Fury Upon a French Village Harboring a Romance of Boy and Girl

Invited spectators who filled the Forty-fourth Street Theatre last night were stirred as few audiences at war plays and photoplays have been by the private showing of D. W. Griffith's "Hearts of the World," which will have its first public presentation at the theatre tonight. Mr. Griffith's film seeks to make the war a big reality, to bring as much of it as possible within the four walls of a comfortable Broadway theatre; and, if the demonstrations by which those who saw the picture manifested their succession of emotions can be accepted as faithful indications, the motion picture succeeds in its ambitious aim.

But the picture is not just a series of photographs of fighting. Mr. Griffith does not plunge his spectators straight into action that would be only confusing and spectacular. His story begins some years before the war, the scene in a quiet French village where the homely people have no thought of war and death and disaster. There is a young girl living with her old grandparents. And there is a young man living with his parents and three little brothers. Monsieur Cuckoo, The Little Disturber, The Village Carpenter, A Deaf and Blind Musician, and many others are village characters with their happiness and little difficulties that do not matter.

The Girl and the Boy love each other. The Little Disturber, delightful little devil of a flirt, loves the Boy, but he loves the other Girl and angrily spurns her. The Disturber at last turns to Monsieur Cuckoo, who has been pursuing her from the first. The Littlest Brother of the Boy, as fascinating a little fellow as has been seen on any stage, idolizes his big brother

and gives the spectators much amusement with his merry exhibitions of affection. The scenes of this French village suggest all that had been known by travel and books of provincial France before the war. Many times those in the theatre broke into applause just at some particularly beautiful landscape of rural vista.

Into such an atmosphere and environment the war bursts. First a German spy inspecting possible fortifications appears with sinister suggestion. Then, just before the set wedding day of the Boy and the Girl, the town crier startles the village with the mobilization order. The whole peaceful arrangement of life is violently shattered. The men rush off to war and the women stay behind to worry and wonder.

With the beginning of the war, the film introduces the first of the scenes of actual fighting made by Mr. Griffith at the front with the co-operation of the British and French Governments. These scenes are skillfully worked into others specially made for the play, so that, were it not for the appearance of characters peculiar to the plot of the play, one would scarcely know where the actual ends and the made-to-order begins. Sometimes one does not know whether what he is seeing is a real war or screen make-believe. The pictures of hand to hand fighting in the trenches, the bursting of shells from big guns, the demolition of buildings, the scouting trips and raids into enemy trenches are impressively realistic.

Continuing the story, the Germans advance against the village; many of the inhabitants flee in confusion, while shells do their destruction around them; others remain behind and seek shelter in cellars and crypts and vaults. Certain characters in the play are killed; others survive to face the fearful future. After furious fighting the Germans take possession of the town and Prussian brutality reveals itself in a number of vivid scenes.

The horrors of German occupation are shown, chiefly as they affect the persons in the play, the Girl and the Disturber, who become companions in misery. There is a great deal of detail, both of actual fighting and of play plot, and finally the Boy, whom the girl had left for dead on a battlefield, enters the village disguised in the uniform of a Prussian officer and finds his sweetheart, who escapes with him from the clutches of a Prussian officer to a garret room, where a struggle that has all of the thrill of melodrama takes place. But this little clash of individuals is not long continued. Soon the French troops retake the town and more of the action of real war is seen.

The conclusion shows the characters of the play, lovers reunited, on a furlough, and as they are dining, American troops pass outside. The Stars and Stripes enter, and at the very end ultimate victory for the Allies is symbolically forecast.

All of the actors in the play were frequently applauded. Lillian Gish, as the Girl, moved the people in her biggest moments, and Dorothy Gish, as the Little Disturber, with her bewitching ways, was applauded many times after stepping beyond the range of the camera just as if she had been on the stage in person, retreating into the wings after an effective scene. Ben Alexander as the Littlest Brother was a child wonderful, and Robert Harron as the Boy, Robert Anderson as

Monsieur Cuckoo, George Fawcett as the Village Carpenter, and Eugene Pouyet as a Poilu were especially good.

Descriptive music, in which the leading characters had motifs that accompanied their appearances, added greatly to the performance.

After "The End" had been flashed upon the screen the spectators stood and shouted for Mr. Griffith until he appeared on the stage. He said that he had no speech to make, but only wanted to thank those present. When he attempted to ask the spectators to pray for and support the men fighting in the war, which, he said, the flickering shadows on the screen represented in a small way, his voice broke and he never finished his sentence.

Historic meetings of the British Parliament and French Chamber of Deputies, as well as the leading figures in France and England were shown and received ovations. A representation of the Kaiser was eagerly hissed.

The scenario of the play was written by M. Maston de Tolignac and translated by Captain Victor Marier. The film is presented under the management of William Elliott, F. Ray Comstock, and Morris Gest.

Many officers of the allied armies and navies, public officials, and friends of the producers were present by invitation.

* * *

July 15, 1918

BURNING FILM STUDIO MADE PART OF PLAY

Fire in Lasky Plant Used in De Mille's
"We Can't Have Everything"

VIEWS OF MITCHEL FUNERAL

Enid Bennett in a New "Vamp" Story—Another Kentucky
Melodrama

The most pretentious of the feature photoplays presented at the leading moving picture theatres this week is Cecil B. De Mille's "We Can't Have Everything," and in many ways the production is above the average, but its merit lies more in separate scenes and individual accomplishments by director, actors, and camera than in the play as a whole. The scene of a burning moving picture studio, for example—which is said to have been made possible by the opportune fire at the Lasky studio in California—is remarkable, both for its pictures of the actual fire and for the staged confusion of the studio people, and there are many entertaining scenes concerned with the making of a movie. Kathlyn Williams, Elliott Dexter, Wanda Hawley, Sylvia Breamer, Thurston Hall, Raymond Hatton, Tully Marshall, and Theodore Roberts have the principal parts, and there is little, if anything, to complain of in their acting. Also the capable hand and eye of Mr. De Mille are evident through the picture.

But as a whole the photoplay falls down. There is a great deal in it, and yet it is about nothing much at all, that is,

nothing much that seems real and convincing. It may be that Rupert Hughes's novel, upon which the play is based, said something with a meaning, but if so the camera failed to catch it, recording simply a rather inconsistent and impossible story.

This story is about Charity Coe Cheever and Peter Cheever, her husband; Jim Dyckman, who loved Charity, and Zada L'Etolle, who loved Peter; Kedzie Thropp, a moving picture actress, who wanted everything and pretty nearly got it, and the Marquis of Strathdene, who represented the highest rung in Kedzie's ladder. When the action began Peter was having an affair with Zada, a vampire of a woman, and Jim was telling Charity that she ought to have married him. Charity told Jim to find himself another wife and he stumbled into a company of moving picture people, with whom he met Kedzie. She heard he had $6,000,000 and went after him. The relations of Peter and Zada reached a crisis which resulted in the divorce of Peter and Charity, so that Peter was left free to marry Zada. Charity was also free, but found that Jim had married the moving picture actress. Some months later Kedzie thought she had everything she wanted and was bored to death, but just then the Marquis turned up and she discovered that she wanted him. A badly bungled situation involving Jim and Charity gave Kedzie her chance to divorce Jim and marry the Marquis, and Jim and Charity, after they had gone to the war as soldier and Red Cross nurse, finally married—and the play was over.

The Rivoli Animated Pictorial seemed much more worth while in the watching than the feature film. It included excellent scenes of Major Mitchel's funeral, the Handley-Page biplane, and the third chapter of the Allied War Review, showing the building of a pontoon bridge in Italy, the cannonading of the enemy lines by the English, and the United States marines reviewed by General Pershing just before starting for the front. The War Review is also on the program of the Strand, and scenes of the late Mayor's funeral are shown there and at the Rialto.

In honor of the day Desere La Salle, at the Rivoli, sang "The Fall of the Bastile," and other numbers on the program were an unusual picture of the roping of a Canadian lynx, the overture from "La Forza del Destino," played by the orchestra, and "In an Old-Fashioned Town" and "Darling Nellie Grey," sung by Martha Atwood.

The best exclusive feature at the Strand this week is an installment of the Outing-Chester travel pictures, entitled "The Unblazed Trail." It shows feats of mountain climbing and views amid snow-capped peaks and glaciers that hold one by their imposing beauty.

The photoplay at the Strand is "Sandy," with Jack Pickford in the leading rôle. After one has grown weary watching Mr. Pickford's rather blank face and monotonous expressions, the play develops a certain melodramatic interest that might stir a degree of response if it came before the seat got so uncomfortably hard. The story is about a Scotch-Irish boy who came to America as a stowaway, fell in love with a little girl on the way over, whom he met years later when he had established himself in a Kentucky town, and whom he married after several scenes in which a horse race, an attempted murder, two near-lynchings, and a convenient death occurred.

One's mind goes back to before the war when "Paris the Beautiful," released by Beacon Films, Inc., is shown on the screen of the Rialto. Entrancing views of Paris with no atmosphere of war around it stir happy memories in those who have known the city and a fervent prayer that it may be saved in those who want to know it.

"The Vamp," at the Rialto, is a pleasant light comedy for some fifteen minutes or so in which Enid Bennett, at her entertaining best, appears as Nancy, an ingenuous wardroom girl at a musical comedy theatre where she hears sophisticated chorus girls tell how the female of the species may make the male buy her dinners and diamond bracelets by "vamping" him. Nancy loves a young minister who lives at her boarding house, and feels sure that he loves her. But he does not propose. So Nancy, taking a tip from the chorus girls, "vamps" him—and the wedding is a quick result. All of this is the pleasant part of the play, but, instead of continuing in this happy vein, the story becomes an incongruous hodge-podge of melodrama, farce and factitious patriotic appeal. The minister and his wife go to a mining town; a repulsive citizen in the pay of Germany is attempting to foment labor troubles; Nancy tries her "vamping" tactics on him and he confesses his crime; and, although Secret Service men appear who know all about the German agent, and would have arrested him without Nancy's aid, she is credited with having accomplished something for her country. Maybe the rest of the people in the play wanted to be kind to her.

The Rialto Animated Magazine is interesting, and the musical program is up to the theatre's high standard.

* * *

October 21, 1918

CHAPLIN AS SOLDIER DROPS OLD DISGUISE

Camouflaged Star in "Shoulder Arms" at Strand Has His Fun in Capturing the Kaiser

SAILORS IN FILM AT FULTON

Wild West Plays Include Lewis's "Wolfville" at Rivoli—Cavalieri and Others in Current Bills

"The fool's funny," was the chuckling observation of one of those who saw Charlie Chaplin's new film, "Shoulder Arms," at the Strand yesterday—and, apparently, that's the way everybody felt. There have been learned discussions as to whether Chaplin's comedy is low or high, artistic or crude, but no one can deny that when he impersonates a screen fool he is funny. Most of those who go to find fault with him remain to laugh. They may still find fault, but they will keep on laughing.

In "Shoulder Arms" Chaplin is as funny as ever. He is even more enjoyable than one is likely to anticipate because he abandons some of the tricks of former comedies and introduces new properties into his horseplay. His limber little stick, for instance, which had begun to lose its comic character through overuse, does not appear. Instead Chaplin, camouflaged as a tree trunk, plays destructively with one of the tree's branches. The baggy, black trousers are also gone, giving place to a uniform and such equipment as a soldier never dreamed of. The comedian begins as a rooky, the most awkward member of the awkward squad, and ends by capturing the Kaiser, the Crown Prince and von Hindenburg. Between the beginning and the end there are many laughs.

There is a Burlingham Travel Scenic on the Strand bill which shows many interesting views of wounded British soldiers arriving in Switzerland, where the people bedecked them with flowers, and there are views of a French tuberculosis hospital in the mountains.

"Shootin' Mad," with Gilbert Anderson, also at the Strand, is a Wild West photoplay without much merit, either as comedy or melodrama.

Another Wild West production was new yesterday at the Rialto. It is "The Pretender," with William Desmond, and in it there are at least comedy bits that deserve the laughter they get. The Rialto also shows "The Triumph of Transportation," which sketches the evolution of transportation from the stage of the naked negro carrying loads swung on a pole to the triumphant time of the modern motor truck. The film shows something of the construction of trucks, and their use at the front and in rural communities.

Speaking again of the Woolly West kind of film, the best of the week is at the Rivoli. It is an Alfred Henry Lewis story, "Rose of Wolfville," turned into an amusing photoplay.

"A Woman of Impulse," with Lina Cavalieri in the leading rôle, is the Rivoli's featured offering, and although Mme. Cavalieri is undoubtedly capable of good screen acting, and the director of the production, Edward Jose, succeeded in creating a number of scenes dramatically and scenically effective, the play whole bores one, largely because it starts out in the mood of grand operatic tragedy and then works clumsily into that of modern fictitious trash with a "happy," but weak and wan, ending.

" 'Midst Peaceful Scenes," the pictorial at the Rivoli, is one of Van Scoy's, released by the Post Film Company. This will recommend it to many.

"The Making of a Sailor," an official naval film illustrating the process of sailor-making from the time a youth gazes at a recruiting poster until he becomes a full-fledged seaman, was shown last night at the Fulton Theatre to invited spectators, consisting mostly of the families of men in the service. It was enthusiastically received.

* * *

October 28, 1918

EVE'S DAUGHTERS SEEN IN 'WOMAN'

Maurice Tourneur's Film Play Eloquent of Emancipation for Those Serving in War

'NURSE CAVELL' AT STRAND

Julia Arthur's Beauty Enhances an Appealing Story of "The Woman the Germans Shot"

The ability of Maurice Tourneur to create pictures, not just single scenes without meaning or connection, but eloquent, beautiful pictures in motion that make a poetic story come true for the time being, has never revealed itself more fully than in "Woman," the principal offering at the Rivoli this week. The magical Mr. Tourneur has taken a series of episodes from history and tradition and brought them to life on a screen.

The work is supposed to have some central idea, something to do with the place of woman in the history of mankind, which, it would seem, was one of "soul-warping slavery" until the war came as a great emancipator and released women for "glorious living and doing." This somewhat romantic conception may seem poetry to some, and silly twaddle to others, and "Woman" has little value as evidence for or against the basic truth of the idea.

In seeking to set forth his idea, however, Mr. Tourneur selected a number of episodes—those of Adam and Eve, Messalina and Claudius, Heloise and Abelard, Cyrene and The Fisherman, a Girl and an Officer in the civil war—and it was in telling the stories of these that he found full expression for his genius and created a succession of ballads in pictures, each of which was a thing of beauty by itself with the convincing power of a good story exceptionally well told. The applause of the spectators after each indicated that they had been caught by Mr. Tourneur's magic and held by his subtle spell.

One might write much in detail about the film, mostly to exclaim in delight about this or that particular touch or masterful stroke, and just a little to point out inharmonious notes—as when Adam was represented strikingly as a primitive man and Eve as an obviously modern young lady minus her clothes, but amply protected by tresses over which the hair-dresser and wig-maker must have spent considerable time. Good words might also be said for the persons in the cast, each of whom played his or her part well. It should be noted that Paul Clerget, as Claudius, was impressive in moments of artistic pantomime, but was so seldom in the forefront of the action that one could determine nothing about his rank as a screen actor.

Something must be added about the excellent presentation of the picture. John Wenger prepared a stage setting of unusual charm, even as compared with his other works, and the orchestral prelude and accompaniment, arranged and in part composed by Hugo Riesenfeld, assisted by Edward Falck, contributed much to the effectiveness of "Woman" and decidedly enhanced its beauty.

Julia Arthur made her "debut," so the program said, on the screen at the Strand yesterday as Edith Cavell in "The Woman the Germans Shot," and displayed, of course, a beauty that is not forgotten on the American stage today. In her portrayal of one of the fine characters of this war, there was amid the personal tragedy a note of triumph for the present battles of Europe and those who win them. The film tells a story of the English nurse that goes back to her young girlhood and prepares one for the nobility with which she went to her tragic end. It will undoubtedly have a strong popular appeal.

For the first time in its history the Strand is running a film for its second week, Charlie Chaplin's "Shoulder Arms," which also will be at the Broadway beginning today.

The featured offering at the Rialto yesterday was "When Do We Eat?" with Enid Bennett.

* * *

November 11, 1918

'LITTLE WOMEN' SHOWN ON SCREEN

The Strand Presents Brady's Motion-Picture Version of Louisa M. Alcott's Book

BERT HALL AT THE RIVOLI

Aviator Appears Personally in "Romance of the Air"—"Woman's Experience" at the Rialto

William A. Brady as producer, Harley Knowles as director, and all others concerned, have done a good piece of work in the so-called "picturizing" of "Little Women," which was shown yesterday at the Strand Theatre. Of course Louisa M. Alcott's famous story cannot be told on the screen completely, and no doubt many of those who love it will consider any attempt to turn it into a "movie" as a sort of sacrilege; but leaving these considerations aside, and judging Mr. Brady's production on its merits as a photoplay, one must say that it is good. And there will be a large number of admirers of the original "Little Women" who, instead of offense, will find delight in the animated illustrations of the story.

Owing to the co-operation of the Alcott Memorial Committee in permitting scenes of the photoplay to be made in and about the author's home in Concord, Mass., and owing also to a careful attention to costuming and other details on the part of Mr. Knowles and others, "Little Women" on the screen really has what can best be described by that much-abused word, atmosphere—the atmosphere of a New England home in the sixties. Many of its scenes are charming glimpses of the period.

The acting, on the whole, is satisfactory. At times there is about it too much conscious posing and a lack of character delineation, but these faults become less conspicuous as the story proceeds and heightened interest supplies deficiencies. Another criticism that must be made is that the action is too

frequently interrupted by sub-titles. And while minor shortcomings are being indicated, it should be mentioned that in reproducing a telegram supposed to have been sent in 1863, the director permitted the name of Newcomb Carlton, President of the Western Union, to show at the top of the blank. Mr. Carlton was born in 1869. Yesterday's spectators at the Strand seemed to respond with mirth and quick sympathy as gay scenes and grave were flashed before them.

Another item on the Strand bill is "Scrambles in the High Alps," a Burlingham travel-scenic, showing unusual views of mountain climbing in the Alps.

Mary Boland's Film Debut

"A Woman's Experience" at the Rialto is that type of photographed stage play which, in the opinion of some, can never put the screen in high place as a vehicle for drama, but of its kind it is one of the best productions seen on Broadway recently. By the technique of Perry N. Vekroff, the director, and a number of the actors the situations are vividly developed to something approaching dramatic climaxes. Mary Boland, the featured player, who makes her debut on the screen, is often effective, though she sometimes falls short of the mark or overreaches it. Corine Uzzell, whose exceptional pantomimic ability was strikingly demonstrated in the part of the mulatto in "A Woman of Impulse," again plays with distinction. There are two scenes between her and Sam Hardy, who is also adequate, in which the action is made dramatic and clear without the aid of a single subtitle.

The photoplay, which is based more or less faithfully upon Paul M. Potter's "Agnes," has nothing in itself to commend it. It pretends to be a story of high life, with a moral, but the pretense is not sustained.

"Sumatra," a Post travel picture of the Malay Archipelago, offers education by way of entertainment.

Bert Hall Sees His Picture

"A Romance of the Air," the feature of the Rivoli, is a melodrama of the war in which Lieutenant Bert Hall of the Lafayette Escadrille and Edith Day play the principal parts. It is highly melodramatic, but includes a number of excellent scenes of airplane activity, and the story holds interest. Lieutenant Hall adds to the interest by a personal appearance at each showing of the film.

* * *

February 3, 1919

THE SCREEN

Speaking generally, John Barrymore is an actor of double talent. Formerly he was known on the stage for unusual ability in comedy, and latterly in "Justice" and "Redemption," for example, he has achieved distinction in tragic rôles. Any one who has seen him in both characters must recognize that his serious work is infinitely the greater art, and surely no one would have him turn back to the lighter rôles of his past. Yet,

because he was so delightful in those still remembered comedies, one cannot be blamed for feeling a slight regret that it is practically impossible to have both Barrymores on the stage—that is, if one restricts his attention to the stage. If one will look elsewhere, however—namely, on the screen—the regret will vanish, because Barrymore, the comedian, remains on the screen, while Barrymore, the tragedian, continues on the stage. There are two Barrymores growing where but one grew before.

The word "growing" is not misapplied, for John Barrymore seems an even better comedian on the screen than he did on the stage. In addition to being an actor who can speak his lines, he has a remarkable talent for pantomime which finds full opportunity within the limits of photoplay technique, and he becomes more exact and expressive in each succeeding vehicle. His latest is "Here Comes the Bride," at the Strand this week, and to see him in the rôle of the bridegroom is to enjoy one of the most laughable farce characters known on the Broadway screens. Most people will probably remember the original of this piece of foolishness, and, taken by itself the play is so extravagant that one may be disinclined to follow it into its numerous far-fetched situations, but, with Barrymore in the leading rôle, supported by Faire Binney, Alfred Hickman, Frank Losee, and others, it is something to smile and laugh at from beginning to end. And John S. Robertson, the Director, should be included when credit is being distributed.

The Strand program this week has other numbers of merit, too. There is a color picture entitled "Catalonian Pyrences" that is made up of beautiful views, and the "Educational" is interesting, with Raymond L. Ditmar's "Porcupines," and another of the "Analysis of Motion" pictures, showing boxing.

Cecil B. DeMille's "Don't Change Your Husband," at the Rialto this week, has the finished workmanship recognizable in the DeMille productions, and Elliott Dexter, Gloria Swanson, Lew Cody, Theodore Roberts, and Sylvia Ashton, in the principal characters, keep up to their high standard. But if dissatisfied wives were guided by the argument of "Don't Change Your Husband," the divorce courts would be more crowded than they are now. Its emphasis is all in favor of changes, provided its formula is followed.

When the story begins Leila is married to James Porter, a Glue King. James has lost his waist line, he chews up one end of a cigar while the other is burning, he knocks ashes on the rugs, he eats onions, and, all in all, offends Leila's delicate tastes in about everything he does. So she changes, and takes for husband Schuyler van Sutphen, an immaculate young philanderer, who wears his evening clothes well and dances divinely. Schuyler, however, continues to philander, and Leila has to smell whiskey on his breath instead of the onion odor of her first mate. She is heartily sick of her change when James reappears.

Left alone with his shortcomings he had taken pains to correct them. He had sworn off on the onions, he smoked carefully clipped cigars in a clean holder, he had shaved off his moustache, he had put himself under the tyranny of an athletic instructor, in fact, he had thoroughly and completely reformed. And he still loves Leila, so she gets him back, fashioned to her taste.

So, clearly, the moral of "Don't Change Your Husband" is "Change your husband—and then change back."

The Rialto magazine includes some magnificent views of Mount Edith Cavell, in Canada, released by the Ford Motor Company, and a number of other excellent chapters.

* * *

February 17, 1919

THE SCREEN

When Dr. Leonard S. Sugden was here about two years ago with his first series of Alaskan pictures the people of New York, as he put it, "made him mad." It was not that they did not like his pictures. They did—emphatically. But they liked best of all the pictures which he had made at the risk of his life, and they wanted more of that kind. They wanted to sit in their comfortable theatre chairs and be thrilled, and they seemed to think that Dr. Sugden was inconsiderate because he had not flirted with death often enough to satisfy them. This was what so aroused Dr. Sugden, and to work off his anger he went back to Alaska to get enough photographic thrills to satisfy the people or die in the attempt. He did not die—and he brought back the thrills. The first of them was exhibited yesterday afternoon at the Rialto, under the title of "Lure of Alaska."

The picture shows Dr. Sugden shooting the White Horse Rapids of the Yukon River, first in a small boat and then on a raft, which carried also his motion-picture camera. Seldom have nature pictures been such a combination of thrills and wild beauty. They are a notable accomplishment of the camera—and Dr. Sugden's nerve. It should be added that the camera was a Prizma machine, which recorded the colors of rushing water, foam, rocks, sky and men vividly, greatly enhancing the pictures. Dr. Sugden made a personal appearance with the film, explaining how and why it was made.

The photoplay at the Rialto is a screen version of Charles Klein's "The Lion and the Mouse," with Alice Joyce in the leading rôle. As may be remembered, the central figure in the play is Shirley Rossmore, "the mouse." Her father is a Federal Judge who, with more honesty than business intelligence, invests all of his hard-earned savings in a company and then forgets all about them. At least, he fails to keep track of the company and does not know when it is absorbed by a larger corporation. The larger corporation is involved in litigation before him and he decides in its favor. That is what John Burkett Ryder, "the lion" has been waiting for. He wants to "get" the Judge, and has him accused of deciding the case in his own favor. No one believes that the Judge has been stupid enough not to recognize the foster parent of his own company.

But the Judge had written Ryder two letters which would show that he was innocent, provided Ryder did not deny he had ever received them and charge that the Judge had written

them after committing his alleged crime. Shirley and her family become obsessed with the idea that these letters would be acceptable as evidence, so she sets to work to obtain them from Ryder. She spends most of the play trying to get them, and when she finally gets them she does not use them. She is able to frighten Ryder into letting up on her father instead. And she marries Ryder's son, too.

Miss Joyce, as the "mouse," was as human and effective as her rôle permits, and Tom Terriss, the director of the production, obtained a number of striking photographic effects.

Another well-known work, "Mrs. Wiggs of the Cabbage Patch," with Marguerite Clark, is at the Strand this week. Much of the atmosphere of comedy and sentiment that made the original so popular has been brought over to the screen. Especially appealing in their rôles are Miss Clark as Lovey Mary, Vivia Ogden as Miss Hazy, Gareth Hughes as Billy Wiggs, Mary Carr as Mrs. Wiggs, and Maud Hosford as Mrs. Morgan.

Also at the Strand is an amusing James Montgomery Flagg comedy entitled "Beresford and the Baboons," a burlesque of the Tarzan stories. Beresford, son of the Earl of Swank, is shipwrecked on a lonely isle and brought up by a family of baboons, who teach him "mining engineering, stud poker, and hemstitching." He also learns to wear a wrist watch, and his principal friend is "a black and white taxi-crab." He enjoys life until rescued by a lady who had known from the first that he was her soul mate. Olin Howard plays the part of Beresford merrily.

The Strand program is enriched by another picture of "Analysis of Motion Series," showing juggling, and by color views of "Picturesque Japan."

Henry B. Walthall has come back to the screen and those who recall his past performances and see him in "The False Faces," a German spy play, at the Rivoli, will be glad. Mr. Walthall is certainly one of the most talented of screen actors. Whether or not the spectators like his play this time will depend upon their taste. It makes most other melodramas turn pale with envy. Whereas other melodramas make some effort to create the temporary illusion of possibility and consistency, "The False Faces" soars through its own high course of fights and feats and thrills, regardless of all laws, human and divine. Thomas H. Ince, who produced the photoplay, and Irvin V. Willatt, who directed it, seem to have set out to make No Man's Land look tame compared to the New York battlefront, and they have done so.

"Here and There," a Prizma color picture of birds and flowers, is an attractive addition to the program.

* * *

February 24, 1919

THE SCREEN

Those who have enjoyed Captain Bairnsfather's famous characters on the stage will inevitably make comparisons when they see the screen version of "The Better 'Ole" at the Strand this week, and the picture will suffer thereby, for, without doubt, there will be many to whom Old Bill and Bert and Alf on the screen will lack the life of "the three musketeers" as impersonated by Mr. Coburn and his companions. But, despite the popularity of the play at the Cort, there are many who have not met Old Bill personally and these will find him, in much of his real character, at the Strand. And even some of those who have heard Old Bill's "Ullo" will be able to hear it in fancy when they see him in silent pictures, for Charles Rock, the English actor who took the part, gave a faithful performance before the camera. The same may be said of Arthur Cleave and High E. Wright, as Bert and Alf.

"The Better 'Ole" on the screen, although weaker in characterization and atmosphere than the stage production is still "The Better 'Ole." It has the unmistakable stamp of Captain Bairnsfather's human humor and it gives what will be to many an illuminating and thoroughly enjoyable picture of life in the British trenches, as represented in his cartoons. This much must be said and not withdrawn, but it should be added that the screen version of "The Better 'Ole" would have been even closer to its original if, going around or over the play, it had gone straight back to the original drawings for its inspiration. Although the photoplay, if it may be called such, includes many scenes not on the stage, it is essentially the stage work adapted to the screen, and, it would seem, the English producers missed a great opportunity in this taking of their material at second hand. Also the introduction of a "love element" in the person of Old Bill's niece and a Soldier Poet remains foreign to the production throughout and does not help it.

The Strand program is built largely around its feature. "Airs of Old England," played by the orchestra, and "An Episode in the Trenches," with Malcolm McEachern, provide an appropriate setting for the picture.

The Rialto program this week is predominately comedy, and good comedy—"The Girl Dodger," with Charles Ray, and "A Night in the Show," with Charles Chaplin, the latter being the first of a series of Chaplin revivals announced by Mr. Riesenfeld.

Charles Ray's play is a nonessential piece of nonsense, but it gives Ray abundant opportunities for some of his best comic pantomime, and this makes it worth while. Whether in serious or comedy parts, Ray is a screen actor of the first rank, not just an actor posing for a series of photographs, but an actor who knows how to make the photographs live. Watch his hands, watch his feet. They talk. It would be easy to produce a photoplay with him in the leading rôle, for which subtitles would be superfluous. He brings screen setting to such a high point, sometimes, that one enthusiastic for the development of the art feels an impulse to cry out " 'Ray, 'Ray, 'Ray!" In "The Girl Dodger" he has adequate support from Doris Lee and Hal Cooley, in prominent parts, and Jerome Storm, the director.

Charles Chaplin, farce pantomimist without equal, is as funny as ever in "A Night in the Show," and it seems a safe prediction that Mr Riesenfeld's faith in it will be justified. It goes back to the custard-pie days and the simple comedy of

smash-and-smear-up everything and everybody, but Chaplin is in it with his inimitable pantomime and this gives it a quality not possessed by other farces of its age.

Dr. Leonard S. Sugden's second Alaskan picture is also at the Rialto this week. The doctor, in his lecture accompanying the exhibition, somewhat boastfully states its charms, but there will be few who will feel that he overstates them. In Prizma colors he has pictured ice fields, glaciers, and the "birth of bergs," which is their breaking off from mountains of ice. The splendor of the scenes needs the color camera. It cannot be described, except possibly by a poet. But the pictures are there for any one to see.

* * *

March 24, 1919

THE SCREEN

D. W. Griffith never produces what, judged against the field of photoplays, could be called a poor work. His power of making pictures is too great and by now too instinctively self-assertive to permit his falling below the average of others. But he is sometimes disappointing, because the public has come to expect so much of him and he cannot always live up to expectations. In one or two of his recent pictures, especially in "A Romance of Happy Valley," he was disappointing, at least to some. It is a pleasure, therefore, to record that his latest work, "The Girl Who Stayed at Home," at the Strand this week, satisfies every expectation. Judged by the Griffith standard, it is good. In some ways it even adds to its producer's long list of achievements.

For one thing, Mr. Griffith does in it what he usually requires a longer photoplay for. He weaves several stories together in the same plot and preserves unity, at the same time using one story to heighten the suspense of another or ease its tension, and finally bringing all of his narrative threads to an even end. Mr. Griffith has been noted for his ability to handle plots of varied and extensive range, but he has never done it so well before in a photoplay designed for routine exhibition. "The Girl Who Stayed at Home" is not what is called in the trade a "super-production," it is a regular Artcraft release; yet it has all of the scope and wealth of treatment that might be put into a "super" film.

Another characteristic that "The Girl Who Stayed at Home" shares with the greater Griffith productions is its blending of melodrama, delineation of character and humor. The melodrama seems an integral part of the play's action; the characters, although a bit heroically drawn, impress themselves upon the mind as individuals, and the humor, instead of being forcibly inserted as undisguised "comedy relief," comes spontaneously as the three-fold story progresses.

And, of course, Mr. Griffith's subtlety and strength in making pictures, scenes of pure beauty and scenes of dramatic meaning, has not failed him. He is not only an artist in pictorial composition, but, by technical skill, often along

original lines, he produces effects that others in time learn to imitate. No pictures seem to have the perspective of his. Some of them are practically stereoscopic. Also, in some way which has not yet become general, he dramatically emphasizes the central figures of a scene by throwing all its other objects so out of focus that they remain to provide suitable background and environment for the action without competing with it for the interest of the spectators. This is an artistic development of the close-up. In certain scenes it has all of the psychological effect of the close-up and something else. It makes the action more eloquent by keeping it in its environment, it preserves the continuity of the story, and it adds smoothness and beauty to the picture as a whole. And when Griffith does make a close-up, it is a soft, delicately shaded portrait.

These remarks, while general, are pertinent here because they appertain particularly to "The Girl Who Stayed at Home."

After this, however, a question must come. Why does Mr. Griffith, who can make such eloquent, intelligible pictures, go to such pains to spell everything out? Why, for example, when he has a wounded German soldier utter a cry which every one knows instantly is an appeal for water does he insert a subtitle reading "Wasser, wasser," and then inform the spectators that the words mean "Water, water"? Certainly his text is often unnecessary and frequently mars the artistry of his pictures.

The cast of "The Girl Who Stayed at Home" is excellent without exception. Lillian Gish is missed, but Clarine Seymour, who takes the part she probably would have had, is never deficient, and Robert Harron, Richard Barthelmess, George Fawcett, Tully Marshall, Adolphe Lestina, Carol Dempster, Syn De Conde, Kate Bruce, and all of the others do everything that could be required of them. The plot is built around the war and deals with the experiences of various persons who come into contact with the fighting in one way or another.

In "The Poppy Girl's Husband" at the Rivoli William S. Hart has what many will doubtless consider one of his best vehicles for a long time. The part played by Hart not only suits his style of acting, but has the virtue of being different from the usual Hart rôles. And, while the story is dramatic, it also touches a truer human note than that of the average photoplay. Hart is seen as a burglar, first in prison and later out in the world, finding it "out of joint" and trying to "set it right."

One of the altogether charming numbers on the Rivoli program is a "silhouette dance," arranged by Adolf Bolm in a setting by John Wenger, with music composed by Victor Herbert.

* * *

March 30, 1919

"THE TURN IN THE ROAD"

King W. Vidor, who is said to be not quite 25 years old, has written and directed the production of a photoplay enti-

tled "The Turn in the Road," which was shown at the Eighty-first Street Theatre on Monday, Tuesday, and Wednesday of last week.

In what it attempts and in what it actually accomplishes it is worthy of note.

The most serious fault to be found in the photoplay is emphasized by its most prominent virtue. Mr. Vidor shows that he has a grasp upon the fundamentals of pictorial composition and the technique of making pictures dramatic and meaningful. Yet he does not depend upon pictures to tell his story. He relies upon uninspired subtitles at points where the full force of moving pictures is essential for strength. Because he sometimes uses pictures so effectively one is disappointed when he leans on the broken crutch of words.

An illustration may serve to suggest Mr. Vidor's power with pictures. One of the characters in the story is a little boy who is the personification of confident love. Another is a man chiefly distinguished by his money and his meanness. They are in their separate homes when a furious storm breaks. The child is shown in his bed, half sitting, looking out of a window on the storm. He is interested, and, apparently, it does not occur to him to be afraid. Each flash of lightning illuminates his radiant, innocent face. The man is shown sitting in his luxurious library. At each flash of lightning and instinctively imagined crash of thunder, he winces, shies, as it were, in fear of forces which his money and power cannot overcome. This is a simple contrast. But it is effective.

Other excellent pictures reveal more about all of the characters in the photoplay and advance plot between interruptions of text.

The delineation of the characters does not depend entirely upon the composition and arrangement of the pictures, however. All of the players put meaning into their parts. Little Ben Alexander, who was the fascinating Littlest Brother in "Hearts of the World," is one of the few real child stars of the screen. He is a skilful actor and a charming child at the same time—a rare combination. George Nichols is the wealthy tyrant, and he imparts reality to the character. Helen Jerome Eddy is attractive and convincing as the heroine, and Lloyd Hughes, who, according to report, makes his screen début in the photoplay, gives a consistently excellent performance. Pauline Curley and Winter Hall complete the main cast in acting as well as in name.

Discussion of the theme of "The Turn in the Road" would be lengthy and involved. The production is frankly a preachment, but, lest the wary be frightened away by this, let it be added that the plot has dramatic appeal that, so far as most people are concerned, is not likely to be destroyed by the sermonizing.

Apparently, Mr. Vidor was anxious to make "The Turn in the Road" proclaim his belief that God is Love and Light and his production brings something of this message, but it cannot be denied that it also has something of the shortcomings common to most photoplays with a purpose. How much of the message is brought, how much of it is lost and the effect upon the story of its moral burden, will depend, in the case of each spectator, upon individual reactions.

* * *

April 28, 1919

PICTURE MAKERS TO CENSOR FILMS

Six Per Cent. of Local Producers and Distributers So Agree at Claridge Meeting

OPPOSE A NATIONAL CENSOR

Brady Announces Decision to Ask Federal Amendment if Needed—Cites Free Press Laws

Members of the National Association of the Motion Picture Industry, said to constitute 95 per cent of the producers and distributors in the country, have agreed to submit their films to a censorship of their own association and to refuse to sell pictures to exhibitors who show films of which the association has disapproved. In so doing, they plan to oppose any official censorship by the Government. This is the substance of a statement made yesterday by William A. Brady, President of the National Association.

Mr. Brady said that the members of the association had met at the Hotel Claridge and adopted resolutions embodying their principles and purposes. These resolutions, in detail, provided that members should accept "any and all rulings" made by the proposed National Association censorship; that the first reel of every picture produced by them should bear a mark or stamp, as authorized by such censor, and that they would agree to any eliminations in pictures or changes in titles or subtitles that should be ordered. They condemned the exhibition of "all pictures which are obscene, immoral, salacious, or tend to corrupt or debase morals."

"The National Association of the Motion Picture Industry," added the resolutions adopted at the Claridge meeting, "reaffirms its unalterable opposition to any form of legalized censorship of motion pictures prior to their exhibition. We shall endeavor to cause to be adopted an amendment to the Constitution of the United States prohibiting the enforcement of any law abridging the freedom of expression through the medium of the motion picture, to the same effect as is provided in Article I. of the ten original amendments to the Constitution of the United States that were declared in force Dec. 15, 1791, prohibiting the enactment of any law abridging the freedom of speech or of the press."

It was further resolved that the National Association urge the passage of a law by the next Congress amending that section of the Penal Law of the United States which now prohibits the transmission by mail or otherwise of indecent pictures or literature, so as clearly to include the prohibition of a like transmission of obscene or indecent motion pictures.

Those present at the meeting which adopted there resolutions were William A. Brady, Arthur S. Friend, John C. Flinn,

Walter L. Greene, J. Robert Rubin, Percy L. Waters, Herman Robbins, Ronald Reader, N. J. Baumer, J. Stuart Blackton, Charles C. Pettijohn, E. J. Ludvigh, A. Alperstein, Arthur Ryan, Louis J. Selznick, Joseph M. Schenck, Jesse L. Lasky, Adolph Zukor, Walter W. Irwin, Richard A. Rowland, P. A. Powers, D. MacDonald, Gabriel L. Hess, Paul H. Cromelin, William Wright, J. E. Brulatour, E. W. Hammons, Emil L. Shauer, John R. Pembleton, Al Kaufman, Lewis Innerarity, and Frederick H. Elliott.

* * *

June 2, 1919

THE SCREEN

In an introductory subtitle, D. W. Griffith says that everything in his "True Heart Susie," at the Strand this week, has happened in real life. He might have said that the photoplay holds a mirror up to life, for in it is reflected what has happened, not once, but thousands and thousands of times, is still happening and will happen always.

By itself, however, this is not praise of "True Heart Susie," for a photoplay may be a "true story" and still be valueless. Many "true stories" are uninteresting, and many times literally real life as pictured on the screen does not seem real, and, of course, it is the seeming, rather than the being, that is important. It must be asked, therefore, whether the photoplay which has taken its story from life has selected something in life that is worth setting apart by itself, and, having selected something worth while, whether it has made its subject seem real on the screen.

Were the originals of its characters human beings deserving life in moving pictures, and do they live as pictured? These are the questions to be asked and, for "True Heart Susie," they are answered in the affirmative. This is the important fact about the photoplay. Once more, D. W. Griffith, ably assisted by Lillian Gish, Robert Harron, and Clarine Seymour, G. W. Gitzer as photographer, and others, has brought meaningful humanity to the screen, more nearly pure, less mixed with artificiality, than it has ever been in a motion picture play, except in other works of Mr. Griffith, with the best of which, considering its pretensions, it holds its own.

The story is simple. Susie is a country girl and William is a country boy. The girl loves the boy and will sacrifice anything to give him happiness and an opportunity to realize his ambitions. She makes sacrifices unknown to him and he rises, while she remains just a plain country girl. She puts him beyond her reach, and within the reach of another who is chiefly interested in making a "desirable" marriage. He marries the other, never dreaming of the final sacrifice that Susie makes. The ending is "happy," but this is unimportant. It might just as well have been "unhappy." The importance of the photoplay is in the humanness of its characters.

Susie is not perfect. A little worldly wisdom, without sophistication, would have saved her much suffering. The boy is not heartless. It was natural that he should love the physically attractive Betty rather than the plain Susie. And Betty, although selfish and calculating, does not deliberately rob Susie, and throughout her life is never more than "a little unfaithful."

These human beings, with their virtues and shortcomings, making their mistakes and going wrong blindly, are the essence of "True Heart Susie," and the environment in which they move, the rural scenes and characters of the background, have been represented with such care and faithfulness that the photoplay as a whole is a unit, harmonious throughout.

Lillian Gish as Susie has created another character of exceptional quality; Robert Harron as William is, it sometimes seems, better than he has ever been before, and Clarine Seymour fulfills every bright promise she made in "The Girl Who Stayed at Home."

"Where the Screen Tree Grows," an Outing Chester picture, is also on the Strand program. And, of course, the Topical Review.

* * *

August 19, 1919

THE SCREEN

"Deliverance," a screen life of Helen Keller, written by Francis Trevelyan Miller and directed by George Foster Platt, was presented last night at the Lyric Theatre.

There is more in a "life" of Helen Keller than is dreamed of in any other life. It is a succession of wonders, of strange, mysterious, awe-inspiring things at which ordinary human beings can only marvel—and, perhaps, be stirred to greater endeavor in their own lives. It is such a life that the screen attempts to depict and its success is remarkable. With a cast of unusual excellence, with exceptionally good photography by Arthur Todd and Lawrence Fowler, and with one of the most wonderful stories in the world, "Deliverance" is one of the triumphs of the motion picture.

The story is divided into three acts, or chapters. The first is about the child Helen, deaf, dumb, and blind, a little wild animal raging in a strange world until her famous teacher, Anne Sullivan, comes to bring knowledge and understanding slowly into her life. This is, perhaps, the most appealing and at the same time the most amazing part of the story, for it shows in eloquent moving pictures how the process of instruction was begun and how it progressed. At first there is the tedious spelling of "water" by Miss Sullivan's pressing her fingers in the palm of Helen's hand, and then other words follow until deliverance has really begun—Helen can communicate with her fellow creatures.

The second wonder follows after a long struggle in which the child's passionate eagerness to learn is seen in everything she does—Helen learns to talk. The effect of the picture on the spectators may be indicated by the fact that when she was represented as saying "I am not dumb now," the house broke into spontaneous applause. A number of times while the pic-

ture was being shown there were such outbursts, showing that the story, as a narrative, was holding and stirring those watching the screen.

In the first part the rôle of Helen is played by Edna Ross, a child of truly unusual talent, and others in the cast, including Tula Bell as little Nadja, Edythe Lyle as Miss Sullivan, Betty Schade as Mrs. Keller, Jenny Lind as Pickaninny Martha Washington, and Sarah Lind as an Old Mammy, make their characters live.

In the second part Ann Mason appears as Helen Keller, the young woman, and she matches the performance of little Edna Ross. This part shows the continued growth of Miss Keller's mind and the development of her accomplishments. In the third, and last part, Miss Keller herself appears, and with her Miss Sullivan, now Mrs. Macy; Mrs. Kate Adams Keller, her mother; Phillips Brooks Keller, her brother; Polly Thompson, her secretary; Ardita Mellinina, as Nadja, and Parke Jones as Nadja's son. Helen Keller's life today is pictured. She is seen at her work, at her dreams, at her play, and her message of courage and faith is emphasized by quotations from her writings and symbolical scenes. The story ends with the woman seeking to bring deliverance to a blind world, and in the possibilities of which she has unshakable faith.

All through the photoplay there is symbolism, and some of it is impressive and peculiar to the power of motion pictures. And, let it be repeated, the story, as a story, grips and holds the interest as few photo stories do. In places it is overburdened with moralizing, and its optimism is sometimes spread too thickly, but throughout its main course it is compelling.

Dr. Anselm Goetzl has arranged an excellent musical accompaniment for the picture and conducts the orchestra.

Miss Keller originally intended to appear last night in person, but when she learned that the actors were striking against the Shuberts, who own the Lyric, she declined to come to the theatre.

"The Mother and the Law," which is the somewhat amplified modern version of D. W. Griffith's "Intolerance," was presented at the George M. Cohan Theatre last night as the fourth offering of the Griffith repertory season.

In this picture, as those who saw "Intolerance" will recall, Mr. Griffith turns his camera on social conditions. He uses the method of the story, and his story has the elements of popular appeal, but it is not told for the sake of its telling; its purpose is to present a cross-section of life at different levels and to show how the life on any level is related as cause or effect to that on another. In order to deal with individuals, it was necessary, of course, for Mr. Griffith to isolate human beings and their experiences, and he was not able to cover the whole social field, but he took cases sufficiently typical to be true, and based his story on the fundamental truth that human selfishness, blindness, and intolerance are the prime cause of human misery.

The principal figures of the story are in one of two groups, that of the smug social uplifters whose "charity" is financed by an "industrial overlord," and that of the mill workers who are the victims of the vicious charity and the overlord's oppression. As the success of the uplifters increases, as measured by

dance halls closed and babies "rescued" from "unfit" mothers, the suffering and degradation of the people on the lower and ever-lowering level increases correspondingly. And playing their destructive part are intolerant laws, political corruption, and man's inhumanity to man as revealed in many ways.

In driving home his facts Mr. Griffith used dramatic strategy and screen technique. By cutting in and back, as may be done only on the screen, he brought contrasting scenes together to emphasize the tragedy and bitter irony of their relation, and never before has the close-up been more effectively used to focus attention on little things big with meaning. "The Mother and the Law" is distinctly a motion picture.

Chief among those in the cast, not only by her name, but by her performance, is Mae Marsh. As the little girl who becomes the woman and the mother, she is the centre, and the most appealing victim, of the story. Miss Marsh is reported to be enjoying now a happy home and family of her own, and for this all are glad, but, at the same time, one cannot be blamed for hoping that she will find a way to come back to the screen. Miriam Cooper is in the cast, and gives a noteworthy performance, as does Robert Harron also. Walter Long, Vera Lewis and others make their roles realistic.

The nature of "The Mother and the Law" has been only suggested, and what has been said is perhaps unfair to the story, from the point of view of those who want a story first of all. The film is not simply a preachment. It is dramatic, at times theatrical, in its narrative, and may be criticised, in fact, for being too melodramatic in its last reel. For the sake of those to whom the characters are just screen folk it has "a happy ending," but it is a tragedy nevertheless, and its real ending is on the fact that the conditions pictured still continue—and the unhappiness of this cannot be put out of the mind by the purely accidental good fortune of the hero and heroine.

* * *

August 26, 1919

THE SCREEN

Houdini, the latest addition to the film stars, was shown for the first time last night in "The Grim Game" at the Broadway Theatre. The familiar feats, with which he has entertained audiences for so many years, were more baffling than ever, and airplanes, high-powered motor cars, and heights of treetops were brought into service to give the audience the best possible thrill in stock.

For the first time, too, Houdini combines love with his daredevil accomplishments, and throughout the picture his attractive young sweetheart is carried from the secret recesses of a wild hunting lodge, guarded by desperate-looking characters, to perilous heights in the clouds just out of reach of her courageous hero. All this, because he has been unjustly accused of the murder of her guardian. When the plot begins to unravel Houdini is incarcerated for the murder and his means of evading the plotters includes his escape after he has been heavily bound in irons; a wild ride

under a speedy truck; once caught, releasing himself from a straitjacket hanging by his feet at the top of a six-story building; another escape after he has been tied securely to the treetops, and finally a thrilling fight in the clouds in which he endeavors to rescue his faithful sweetheart from the villain who has carried her off in another airplane. The fight ends in a collision and one of the machines falls to earth but all are saved.

Houdini appeared in person after the picture was shown and declared that he would give any one $1,000 who could prove that the collision was not an authentic one. He explained that a real accident had occurred, but that they were saved only because the machines were 4,000 feet in the air and were able to right themselves before they reached the ground. It looked real enough, and as thrills were furnished in rapid succession, there is little possibility that it will not be accepted as a very good entertainment for the devotees of motion pictures and the followers of Houdini.

* * *

September 1, 1919

THE SCREEN

The task of outfitting the popular screen ingénues with a succession of rôles in which they can exhibit all their talents is unquestionably a difficult one, and, accordingly, it is perhaps inevitable that arbitrary methods should occasionally be brought into play. Certainly something of the strain is felt in "The Hoodlum," in which Mary Pickford appears as the particular luminary of the new program at the Strand.

"The Hoodlum" is a picturization of a story by Julia M. Lippman entitled "Burkeses' Amy," and is the tale of a snobbish young granddaughter of the rich who is compelled by circumstances—the circumstances being that there had to be a picture—to acclimate herself to slum life. Here, it will be seen, is full opportunity for contrasting work on the part of the star, and it is perhaps superfluous to add that full advantage is taken of the fact.

Miss Pickford's conversion from Fifth Avenue snob to hoodlum is not only insufficiently motivated in the story, but vastly overdone in the filming. If one is willing, however, to let logic go by the board of censors, then there are many amusing bits in the picture, and entertainment a-plenty.

Something of this same compulsion to give the star her due is evidenced in "The Right to Happiness," which began a run at the Park Theatre on Saturday night. "The Right to Happiness" has been put through the S. L. Rothapfel process, and emerges with a scenic and musical prelude which is entirely too elaborate for the picture.

There is, for example, the Russian Cathedral Quartet, first introduced to lower Broadway in "Redemption," and there is the Russian Balalaika Orchestra in a box, in addition to a symphony organization in the pit. Assurance is given, also, that the Russian border posts which flank the two sides of the stage are thoroughly authentic.

The entire nature of the introduction, in fact, leads one to hope that that which follows may be a film of some significance and of real ideas. What it actually is, however, is a conventional and oppressively banal Russian-American story, prepared solely from the motion-picture angle. It is the work, as to authorship and direction, of Allen J. Holubar, and it has the merit of giving Dorothy Phillips the opportunity to give two interesting performances in the rôles of twin sisters—one raised in Russia, the other in America.

Billie Burke is at the Rialto this week in "The Misleading Widow," which was known as "Billeted" when Margaret Anglin acted it in New York a season and a half ago. It is an amusing little story of an aspect of war life, and, while it may appear strange that Miss Burke should fall heiress to a rôle originated by Miss Anglin, the fact remains that she is quite at her best in it.

* * *

October 13, 1919

THE SCREEN

Will Rogers's personality penetrates through lenses and film to the screen. Rogers in motion pictures is not Rogers himself, with his chewing gum, rope, and conversation, but there is a thoroughly delightful person in a photoplay called "Almost a Husband," at the Strand this week, who will be recognized as the former star of the Midnight Frolic. For one thing, Rogers is genuine in everything he does, and genuineness counts for as much on the screen as on the stage, and, furthermore, he is by no means an insignificant actor. Cast in a part that fits him, he puts meaning into his playing, so that it is playing, and not just posing. His part in "Almost a Husband" fits him. He is the school teacher, lawyer, author, and emergency husband of Opie Read's "Old Ebenezer," from which the photoplay was derived, and the character takes on life through his impersonation. To Director Clarence G. Badger should be given credit for not forcing Rogers out of his natural rôle. He would not, for instance, seem right in protracted love scenes, and, although he becomes quite, rather than almost, a husband, there is no billing and cooing until the final fade-out, and this is beautifully brief.

Some may know, and others may not, that the story is about a New England school teacher imported into a village on the Mississippi River. He is instinctively a philanthropist, and, after saving a poor family from disaster, rescues the leading banker's daughter from an undesired suitor. At a party he goes through a mock wedding ceremony with her, and then discovers that it was valid. He gallantly offers to free the girl, but when he learns that she is safe from the villain as long as she is married to him, he as gallantly volunteers to remain her husband. The rest of the story is concerned with the unsuccessful efforts of the villain and his accomplices to get him unmarried.

The chief interest of the photoplay is in the characterization by Rogers and the performance of Peggy Wood and Herbert Standing, who play the banker and his daughter.

For once, spectators also enjoy some of the sub-titles flashed on the screen, which are surely from Rogers himself.

The Rivoli is all comedy this week and starts, after the overture, with another Briggs comedy, "Saturday," fully as amusing and as true to the boyhood of a generation ago as "Company."

Then comes a screen version of George Broadhurst's farce. "Why Smith Left Home," in which love triumphs over family interference, a train wreck, a fire, an earthquake, and the blunders of friends. Bryant Washburn has the leading rôle, and Lois Wilson is the girl. Mame Kelso, Winter Hall, Walter Hiers, Margaret Loomis, and Carrie Clark Ward are the others in the cast. Donald Crisp directed the production. Altogether, they succeeded in making the picture diverting. It would be more diverting, however, if there were not so much of it.

"Why Divorce?" another comedy, with Mr. and Mrs. Carter De Haven in practically the only parts, is intermittently funny.

Augustus Thomas's old melodrama, "In Mizzoura," has been made into a photoplay by Beulah Marie Dix as scenario writer and Hugh Ford as director. Robert Warwick has the leading rôle, and he is supported by a well-chosen cast including Robert Cain, Noah Beery, Eileen Percy, Monte Blue, and Milla Davenport. It is at the Rialto this week.

The plot revolves about familiar types, the simple (though in the present case not simple minded) strong man, the misled beautiful girl, and the villainous "slick city feller." It has what the trade calls "heart stuff," and ends in a succession of fights, which give it plenty of "punch." Despite its too familiar face, however, the photoplay will be found enjoyable by many, because the things done so often are well done, and Warwick is not the usual hero who invariably makes every one hope that the villain will win. He seems sincere and unconscious of the camera.

"Amid Peaceful Scenes," a charming Post Nature Picture, set off by well selected quotations from poems by Rupert Brooke, Joyce Kilmer, and others, and accompanied by an ensemble from the New School of Opera, adds greatly to the entertainment value of the Rialto program.

* * *

November 24, 1919

THE SCREEN

Cecil B. De Mille's "Male and Female" came to the Rivoli yesterday.

When it was announced that Mr. De Mille would produce a screen version of "The Admirable Crichton," but that the title would be changed to the phrase from Genesis, i., 27, it was explained that the original title would cause confusion in the minds of exhibitors and the movie-going public. Many people,

it was said, did not know how to pronounce "Crichton" and some were under the impression that he was a naval officer of high rank. These explanations, however, do not justify the dropping of the name of Barrie's play. It is justified by the simple fact that "Male and Female" is not "The Admirable Crichton" at all. It is not Barrie. It is not English. It's a typically American movie romance.

This should be borne in mind by those who know and love—and all who know must love—The Admirable Crichton. Mr. De Mille has a right to borrow Barrie's story, alter and arrange it to suit his purpose, completely change its emphasis and character, and issue the product of his motion-picture mill under the title of "Male and Female." This is his right and no one should deny it. In this connection it is important only that every one realize at the outset what Mr. De Mille has done, so that no one will waste time and perhaps spoil the picture for himself by expecting to find Barrie in it.

"Male and Female" should be considered simply as a motion picture. As such it has noteworthy merit. It is not, as its title, certain scenes and lettered labels seek to make it, a philosophic presentation of elemental human realities. It is a movie romance, and those who "go to the theatre to be entertained" need not be afraid of it. Of course, if any one is profoundly impressed by the solemn assurance that the best looking, most competent man and the prettiest girl of a party shipwrecked on an island will, in two years, gravitate toward each other, regardless of the fact that in England one was a butler and the other a "lady," for that one "Male and Female" is apocalyptic. But the same person should ponder deeply over the revelation that two and two make four.

The press notice sent out about the production states that "the shipwreck scene in which a real ship meets a real wreck; the Babylonian episode, where Crichton's dream that he was King in Babylon and Lady Mary a Christian slave is visualized. . . . and the bathroom scene are three features that stand out." This is true, and serves to indicate the nature of "Male and Female." Lavishly staged, skillfully directed, adequately acted, with a good story well told, it is a remarkable movie.

First credit for its excellence should go to Mr. De Mille, for without his ability behind the camera much of the material used might have been wasted. Those in the cast, however, deserve recognition for more than satisfactory work, especially Theodore Roberts, as Lord Loam; Gloria Swanson, as Lady Mary; Thomas Meighan, as Crichton; Lila Lee, as Tweeny; Raymond Hatton, as the Honorable Ernest Wooley, and Robert Cain, as Lord Brockelhurst.

Doing what many others have done before him, but better than most of them, Allan Dwan produces a screen melodrama for which Richard Harding Davis's "Soldiers of Fortune" provides the story. It is at the Capitol this week.

Most persons familiar with Mr. Davis's romantic's story and Mr. Dwan's work will know what to expect, and they will not be disappointed. They may even be pleasantly surprised for Mr. Dwan has never done better than in "Soldiers of Fortune" and in some particulars he has never done so well. Many directors could take lessons from him in pictorial composi-

tion, for with the same magnificent country, numbers of men and stage sets at their disposal, they do not make pictures that the eye must admire. There are broad views and long vistas in "Soldiers of Fortune" that almost make any one, and do make some, exclaim out loud, and when it comes to presenting "action," the battle of armies or the love-making of one and one, Mr. Dwan is also competent. If "Soldiers of Fortune" were not so well done, it would be uninteresting, because in one version or another its story has often been told on the screen and it is not a story of any great enduring quality, but it is exceptionally well done—and, therefore, enjoyable.

Among those who help to make it enjoyable are Pauline Starke as the heroine, Norman Kerry as the adventurous engineer who operates a mine and interferes with a revolution in a South American republic, Wallace Beery as the revolutionist, Herald Lindsay as the wife of the republic's President, Anna Q. Nillson as a most particular person even in movie-ized South America, Philo McCullough as an upright soldier of fortune, and Fred Kohler as the hero's dependable friend.

The acting of Anita Stewart, Conway Tearie, and Hattie Delaro does most to make the screen version of Pinero's "The Mind-the-Paint Girl," at the Strand this week, interesting. The photoplay has another claim to distinction in the fact that it does not tumble absurdly into a conventional "happy ending." The ending may not be tragic, but it is far from gay. Its virtue is that it is consistent. The picture was directed by Wilfrid North.

*　*　*

December 1, 1919

THE SCREEN

Apparently Mary Pickford is facing the realization that she cannot go on forever as the sweet, cute, and kittenish little darling of the screen, for her latest motion picture, "Heart o' the Hills," which is at the Strand this week, shows her in more serious moods and with more mature manners than her previous productions. She is still, at times, the hop-skip-and-jumping young thing she used to be all of the time, but in a number of scenes she makes real emotional efforts, and throughout the photoplay attempts to portray a character of interest to others besides children and adults feeling childish. And it will be good news to the many Pickford fans, as well as to those who believe she "could do something else if she would only try," that she is adequate in every scene. She attempts nothing very exacting, but she does enough to give promise of more, and her progress from juvenility to complete maturity will undoubtedly be watched with universal interest.

"Heart o' the Hills" is an adaptation of the novel by John Fox, Jr., and is faithfully John-Foxy, employing all of the intriguing ingredients of romance, sentimentality, adventure, and atmosphere so successfully compounded into stories of the Kentucky and North Carolina mountains. Despite its unreality of plot and action, however, it approaches the genu-

ine in its characters, the most important of which are delightfully impersonated by Miss Pickford as an untamed mountain girl, Harold Goodwin as her boy companion, Claire McDowell as one of the pathetic clods in every mountain cabin, Fred W. Huntley as the ancient but still active head of his clan, and Sam De Grasse as the scheming traitor to his people.

The picture was directed by Sidney A. Franklin, who brought some of the mountain scenery effectively into it, but not as much as could have been used to advantage. He left little to be desired, however, in costuming and interior settings.

The Strand Topical Review is unusually rich this week, because it contains, in addition to its news pictures, one of Max Fleisher's "Out of the Inkwell" drawings and Pathécolor views of provincial France. Mr. Fleisher's work, by its wit of conception and skill of execution, makes the general run of animated cartoons seem dull and crude, and the colors in the Pathe scenics are pleasing to the eye and remarkably true to actuality.

The comedy at the Strand is a Harold Lloyd piece of foolishness entitled "Captain Kidd's Kids."

"Eyes of Youth" is the kind of play that is dear to the hearts of many actresses and a large number of the public. It offers such a variety and intensity of histrionic moments to its actress and is so steeped in "heart interest" and "sob stuff," sweetened by assurance of a happy ending, that it is simply irresistible. It was on a Broadway stage for numerous weeks, and now it has come to the screen. It is at the Rivoli, and Clara Kimball Young, an infrequent visitor this year, is in the leading rôle.

Miss Young has been missed, and if her next picture is as far away from the present as her last she will be missed the more because of her performance in "Eyes of Youth." When she undertook her latest work she promised to do something better than she had done for a long time, and she has fulfilled her promise. Although one may be unmoved by the story, he is bound to feel the force of her performance in the multiple rôle of the girl who images her future along three of the four roads open to her and finally takes, with happy confidence, the one she doesn't investigate. At least, she knows that it cannot be as bad as the other three.

Miss Young does not give much of opportunity to her supporting company, or its members do not take advantage of their chances, despite the fact that many of them are well known. They are Gareth Hughes, Pauline Starke, Sam Sothern, Milton Sills, Ralph Lewis, Edmund Lowe, William Courtleigh, and Vincent Serrano.

Pictorial effects and characterizations by Lon Chaney, Priscilla Dean, and William Stowell give most of whatever entertainment value there is to "Paid in Advance," at the Capitol this week. The picture comes to life in the scenes in which they appear. William Burress also should not be overlooked. The titular star of the production is Dorothy Phillips, who, although equal to some of her scenes, for the most part is too camera-conscious to be convincing. The picture was directed by Allen Holubar and was derived from a story by James Oliver Curwood. It deals with the miraculous escape of a pure young girl from barbaric men of the American Northwest and Alaska.

On the Capitol program are "Such is Life in Greenwich Village," one of Hy Mayer's Travel-Laughs, and "Speed," a comedy, with Al St. John, Roscoe Arbuckle's former associate.

* * *

December 8, 1919

THE SCREEN

Many who saw Eric Stroheim as a Prussian villain in "The Heart of Humanity" and other war films may have wondered, because he seemed so completely designed for his part and nothing else, what he would do when the public no longer demanded a Hun to hiss. If they will go to the Capitol Theatre this week and see "Blind Husbands" they will know that whenever Mr. Stroheim desires to give up acting, or is not required, in pictures, he can devote all of his time to directing—and if the promise that is borne of his first performance as a director is fulfilled, the screen will be greatly enriched.

"Blind Husbands," as it stands, is superior to most of the year's productions, and, more importantly, its outstanding pictorial quality indicates that Mr. Stroheim, unlike many directors, grasps the fact that the screen is the place for moving pictures and that whatever is to be done on it with artistic finish, must be done pictorially. So many directors use moving pictures chiefly to ornament and enliven their stories. They do not depend upon them in crises. Whenever dramatic moments come, or when plot is to be unfolded or carried forward, they turn to familiar, but ineffectual, words. But Mr. Stroheim, although he has not done all that he might in the elimination of text, has evidently relied principally upon pictures and in a number of his dominating scenes there are no words at all, only eloquent pictures, more eloquent than words could ever be.

The climax of the play comes when two men, an Austrian Lieutenant, a "love-pirate" and "lounge-lizard," and an American surgeon, a man of worth-while ability, climb one of the peaks of the Dolomites together. The Austrian has boasted to women of the mountains he has climbed and he has influenced the surgeon's neglected wife, but when he stands before the steep side of a real mountain he is adequate only as to his faultless Alpine costume. He does not choose to climb, but he must. The other man has forced him to it. As he goes up he weakens, while the other increases in strength, and when the two stand alone on the pinnacle one is the master and the other a contemptible thing. The story gives dramatic suspense to this scene, but the suspense is heightened, the scene is developed to its full power, by pictures, for which no words are needed and few are used. And so in smaller scenes, in their intelligibility of action and genuineness of setting, Mr. Stroheim has worked and succeeded with the camera.

He needed, of course, competent actors, and found them in himself as the Austrian Lieutenant, in Sam de Grasse as the surgeon, and in Francelia Billington as the woman. H. Gibson-Gowland, as an Alpine guide, and others in supplemental rôles met all requirements for background and atmosphere.

By its pictorial quality, therefore, "Blind Husbands," not especially original in plot, and weakened somewhat by its resort to the well-worn theatrical trick of withholding important information from the spectators, is interesting throughout and at times supremely compelling. Some of its scenes are continentally frank, but they are not offensive, nor more suggestive than is necessary to present the triangle of the self-absorbed husband, the neglected wife, and the human bird of prey.

It ought to be added that Mr. Stroheim originally named his production "The Pinnacle," and, according to report, seriously objected when the cheapening title, "Blind Husbands," was plastered on it by the proprietary company.

"Tom's Little Star," one of the Stage Women's War Relief films, in which a number of theatrical celebrities are displayed, is also at the Capitol.

Charlie Chaplin is screamingly funny in his latest picture, "A Day's Pleasure," at the Strand, when he tries in vain to solve the mysteries of a collapsible deck chair. He is also funny in many little bits of pantomime and burlesque, in which he is inimitable. But most of the time he depends for comedy upon seasickness, a Ford car, and biff-bang slapstick, with which he is little, if any, funnier than many other screen comedians.

The pleasing personality of Will Rogers, enhanced by quite a little acting talent, brightens "Jubilo," the longer photoplay at the Strand.

The Prizma Pictures Corporation has departed from its usual path in the general direction taken by the Post Pictures Corporation by producing "Memories," a sort of screen version of Whittler's poem, "In School Days." It has gone even further than other makers of scenic pictures in the way of employing narrative, and its experiment is interesting, and should lead to a big, new field. In the present instance, however, the use of colors is not entirely satisfactory, and undoubtedly "Memories" would have been better if it had not departed from "In School Days" so far, even to the extent of changing one of Whittler's lines and dulling the point of his poem thereby.

"More Deadly Than the Male," with Ethel Clayton, is the photoplay at the Rivoli.

* * *

December 29, 1919

THE SCREEN

D. W. Griffith has said that it is his ambition to put humanity on the screen, and his last several pictures, though colored vividly with melodrama, have shown characters seeking to live as real people with more than a little success. If, in some instances, through emphasis of this or that trait, they have become stock types, rather than true human beings, for the most part they have had genuine kinship with humanity, and some of them have been genuinely life-like. In his latest production, "The Greatest Question," which is at the Strand this

week, Mr. Griffith is still striving for verisimilitude, in his characters at least, and again he has been successful to a degree, with the aid of Lillian Gish, George Fawcett, Eugene Besserer, Robert Hurron, George Nichols, Josephine Crowell and Tom Wilson in the principal parts. Despite the exaggeration and artificiality apparent in each characterization, one recognizes something familiar in every one of them.

They are not all lovely, by any means. Mr. Griffith has been compared to Dickens, and he is like Dickens at least in the firmness, almost fierceness, with which he presents the ugly and repellent as well as the attractive. And, if he is seeking to make a picture a cross-section of life, must he not include brutality, viciousness, selfishness and the like, as well as gentleness, virtue and love? The question, of course, is in what measure and manner the frightful and repulsive shall be shown, and on the subject opinions will differ according to individual ideas of art or thickness of skin.

Photographically, Mr. Griffith's latest work is excellent. Some of his night scenes, especially, are about the best of their kind ever seen on the screen. Considerable credit for this should go to G. W. Bitzer, the Griffith cameraman.

The failure of the film is in the answer it offers to "the greatest question," that of human survival after death. Mr. Griffith apparently has been dipping into psychical research, but only dipping timidly. He does not face the question squarely and answer it clearly one way or the other. The subject of survival comes into his story only twice briefly and each time in such a way as to leave the question answered. Once a youth appears to his mother at the moment of his death far away, and subsequently the dead boy stands before her and his father when she appeals to him for a sign of his continued existence. The woman and her husband are convinced, but the first case might be explained as telepathy or coincidence and the second appearance may have been a hallucination. Neither is real evidence of survival. The photoplay should have testified boldly to the fact of survival, denied it unqualifiedly, or admitted its uncertainty. As it stands, it ought to satisfy both those who want to believe in survival, and those who don't, but it contributes nothing to the solution of "the greatest question."

The story of the photoplay is relatively unimportant, as Mr. Griffith, no doubt, meant it to be. It is concerned principally with an orphaned girl thrown upon a poor farmer's family from whose kindly shelter she is drawn into the power of a man and a woman as utterly abhorrent as may be imagined. After a melodramatic sequence of events, at the climax of which the good farmer finds faith in God and oil in the ground apparently in the relation of cause to effect, everything is as should be in the best regulated story.

Attractive on the Strand bill, and with a Griffith film, is a color series entitled, "Children of the Netherlands.

It took Douglas Fairbanks, his director, scenarist, or somebody on his staff to discover the really comic possibilities of a flood. His latest picture. "When the Clouds Roll By," at the Rivoli this week, is brought to a rushing conclusion by the breaking of a big dam, and in the final scenes Daniel Boone Brown, hero, and Lucette Bancroft, heroine, are floating on the roof of an uprooted house. A minister is all that is necessary, and soon he comes by clinging to the tower of his church. The wedding immediately takes place, while many witnesses shout their approval from perches near by.

The whole picture is full of Fairbanks's fun, and will greatly please the legion with whom the acrobatic actor is a favorite, although the symbolic scenes, which seek to show what is going on in the mind of the hero, probably seem somewhat crude and out of harmony with the rest of the story. Kathleen Clifford is the acceptable heroine and Victor Fleming directed the production.

That the Rivoli is enriched by "Memory Lane," a Paramount-Post scene, was testified to by the applause of the spectators yesterday afternoon.

Charles Ray, by common agreement, one of the best screen players in America, is at the Rialto this week in "Red Hot Dollars," a photoplay of seedy rural and industrial setting in which there is much of action and interest and something of tedium. Ray, of course, is always delightful, and his leading woman, Gladys George, is attractive. Charles Mailes gives a fine performance as an old Scotchman, and William Conklin is satisfactory as a steel manufacturer. Jerome Storm was the director.

The hero works in a steel mill, falls in love with the Scotchman's daughter, saves the life of his employer, is adopted by him, and then finds himself in trouble when he learns that his foster father and hoped-for father-in-law hate each other. They are reconciled, of course, and all is well.

"Chilkat Cubs," a Bruce scenic, shows the amusing antics of two little bears and some of the magnificent scenes of Alaska.

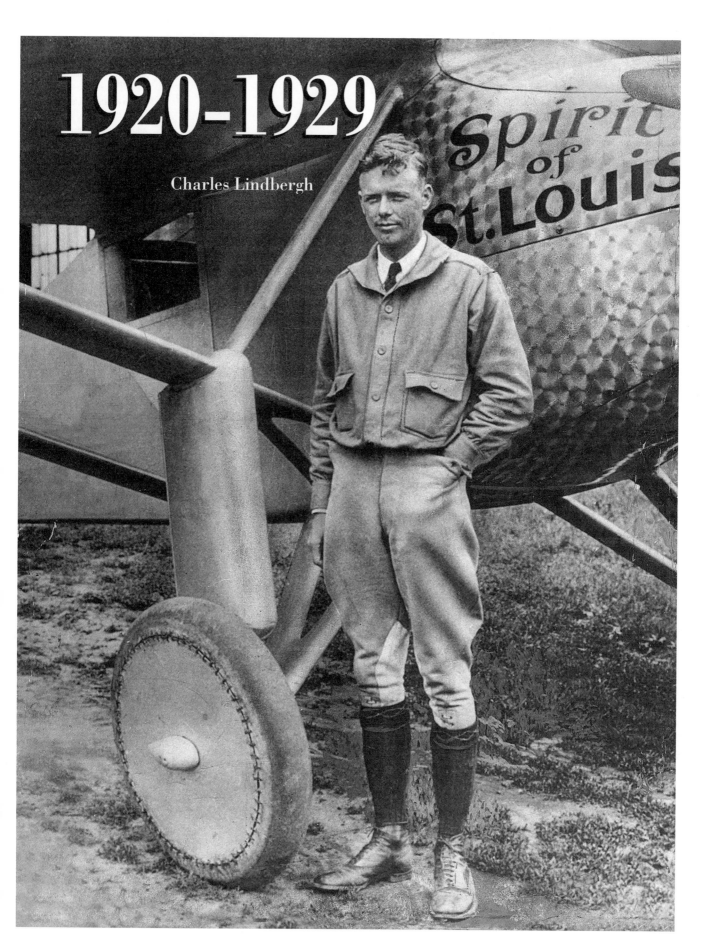

1920-1929

Charles Lindbergh

MAJOR EVENTS OF THE DECADE

The 18th Amendment to the Constitution starts Prohibition in the U.S.

The 19th Amendment gives women in the U.S. the right to vote.

American novelist F. Scott Fitzgerald publishes his first novel, *This Side of Paradise*, establishing him as a representative of the Jazz Age.

KDKA in Pittsburgh, Pennsylvania, becomes the first commercial radio station.

The first blues recording is made by an African American artist, "Crazy Blues" by Mamie Smith.

Tutankhamen's tomb is discovered in Egypt.

An ill-organized but effective march on Rome brings Benito Mussolini and his Fascists to power in Italy. Mussolini is made prime minister.

Russian-born American engineer Vladimir Zworykin patents the iconoscope electronic television camera tube. The following year, he patents an improved receiver (the picture tube), making possible the modern, electronic scanning television system.

In Paris, Irish writer James Joyce publishes the novel *Ulysses*, the most prominent example of the stream-of-consciousness technique.

T.S. Eliot publishes "The Wasteland."

Wyoming elects Nellie Taloe Ross as the first female state governor in the U.S.

Two year's after the death of Vladimir Lenin, Joseph Stalin assumes singular control of the Soviet Union.

Alexander Fleming discovers penicillin.

Chiang Kai-shek is elected president of China.

Arturo Toscanini becomes conductor of the New York Philharmonic Symphony Orchestra.

Walt Disney introduces Mickey Mouse to the world in the animated short *Steamboat Willie*.

| 1920 | 1921 | 1922 | 1923 | 1924 | 1925 | 1926 | 1927 | 1928 | 1929 |

Tennessee forbids the teaching of Darwin's theory of evolution, leading to the Scopes Trial.

Alban Berg's opera *Wozzeck* premieres, representing the twentieth century's first atonal masterpiece.

The New Yorker is founded by Harold Ross.

Russian filmmaker Sergei Eisenstein directs *Battleship Potemkin*. Its worldwide distribution reveals to filmmakers around the world the montage editing practices innovated by Russian directors up to this point.

The Grand Ole Opry, the longest-running country music radio program, is launched.

The Wall Street stock market crash on October 29, 1929, ushers in the Great Depression, affecting not only the U.S. but the entire world.

American Martha Graham founds her own dance troupe, which will be a seminal force in modern dance.

The Museum of Modern Art opens in New York City.

Ireland becomes a free state within the British Empire. Northern Ireland is created, but the Irish Republican Army (IRA) continues opposition.

The first all-black Broadway musical, *Shuffle Along*, opens to critical acclaim, which helps launch the Harlem Renaissance.

Charles Lindbergh flies the first nonstop flight across the Atlantic, going from New York to Paris in 33 ½ hours.

The Jazz Singer, the first film to use synch-sound dialogue, opens in New York City. Its box office success signals the end of silent films.

Turkey is declared a republic, signaling the end of the Ottoman Empire. Modern Turkey had been established from the dismembered Ottoman Empire in 1920, and the last Sultan deposed in 1922.

George Gershwin composes "Rhapsody in Blue."

Fiddlin' John Carson makes the first country music recordings.

INTRODUCTION

A TIME FOR CHANGE

By D. J. R. Bruckner

All school children know how the Roaring Twenties ended: In 1929 the astronomer Edwin Hubble, working at the Mt. Wilson telescope in California, announced that all galaxies are receding from us at accelerating speeds; humanity began to understand how enormous the universe is, and scientists had the key to figuring out how it started. It was only several years earlier that his observations from the giant telescope had confirmed a growing hypothesis among astronomers that many cloudy-looking objects in the sky, revealed by much smaller telescopes for a century, were in fact galaxies like the Milky Way, which was once thought to be the whole universe. It had only been two years since Lindbergh had shrunk the Earth to a size that made it seem manageable, and now it was a mere speck.

And, of course, just about the time Hubble published his great discovery, the stock market—which had been hugely inflated by overspeculation growing out of the manipulations of holding companies, stock pools, and ever-increasing margin trading—collapsed. Some eye-openers!

The pair of Constitutional amendments that opened the decade look sedate in comparison: In 1920 one of them gave women the right to vote and the other outlawed the sale of alcoholic beverages nationally. That the two were ratified at the same time was no accident. Suffragists, who had been campaigning long before the temperance movement began, eventually came to feel that the culture of alcohol had more than a casual connection to the subjugation of women, and the two movements became allies. Their successes were very different. Suggesting today that the country return to an exclusively male electorate would be a bad joke. So would suggesting that it return to prohibition. It is doubtful that any other piece of legislation turned so many citizens into criminals. In the dozen years before prohibition was triumphantly repealed, federal agents obtained convictions of more than 300,000 people for bootlegging—a percentage of the total number of traffickers so small that jailing them had no noticeable effect. And the crime syndicates spawned by prohibition remained tenaciously powerful into the next century.

As articles from *The Times* in this volume indicate, the wealth of the era, while it lasted, was a powerful impetus to some forms of culture, especially movies, music, theater, and dance. It allowed one new cultural form to advance from birth to maturity in a few years: Commercial radio broadcasting began hesitantly in 1920; in 1924 it had a measurable effect on the national election and the next year turned the Scopes Monkey Trial into a coast-to-coast sensation. In 1927 two national networks were organized, and by 1929 radio was the largest single source of music, entertainment, and news in the country.

Nothing symbolized the sense of change speeding out of control more than Lindbergh's transatlantic flight in 1927. The first California-to-New-York nonstop flight had occurred only four years earlier, and as various distance records for overwater flights fell in the mid-1920s, international excitement was immense. For Americans, Admiral Richard Byrd became a national hero when he flew over the North Pole in 1926 and then over the South Pole in 1928, when he also established the Little America permanent exploration base in Antarctica. Less noticed but more important was the Post Office's development of airmail during this decade, which stimulated the building of the nation's first network of airports. In 1927 the first scheduled commercial flights were started. In 1928 Pan American Airways and Trans World Airways were founded, followed by Delta Airlines in 1929.

In the 1920 Presidential campaign, Warren G. Harding's highly effective slogan was "a return to normalcy." What happened hardly strikes us now as normal, but, as F. Scott Fitzgerald so memorably dramatized in his novels, gut reactions to change that rise to the level of chaos can be shocking. Thus we find in 1921 Calvin Coolidge, then Vice President of the United States, writing magazine articles

attacking the leading American universities as centers of sedition. That year two immigrant anarchists, Nicola Sacco and Bartolomeo Vanzetti, were sentenced to death for murder on evidence profoundly troubling to leading jurists—a case that would darken public discussion of politics right through the decade, even after the two were electrocuted in 1927. Politics itself grew dark. The corruption of the Harding administration was indeed normal, but the election early in the decade of Ku Klux Klan members as governors in Oregon and Oklahoma and a virtual sweep of the government in Indiana by the Klan in 1924 were ominous. But perhaps nothing was so emblematic of the mean mood of the country as what was called "reform" of immigration, accomplished by Congress and three different Presidents through legislation and visa regulations enacted in 1921, 1924, and 1929. Before 1921, immigrants were received from anywhere without restriction. By 1929, the laws rigidly limited numbers of immigrants and restricted them almost entirely to people from northern Europe. In effect the country was telling the world "keep your tired, your poor, your huddled masses unless they are white Protestants." By 1930 immigration fell to the lowest level recorded since 1830. Obviously such a headlong retreat into isolation could have disastrous consequences, and in the case of one law from those years the disaster was immediate. Congress developed a severe antipathy to imports and in 1929 instituted the highest tariffs in history, despite serious warnings from trading partners, most notably Canada, that reprisals would be inevitable. The Smoot-Hawley tariff laws came into effect just in time for the market crash, after which American exports plummeted, exactly when they were most needed. Congress indeed froze out the world, but it had not considered that that meant freezing America in.

Broadway in the 1920s looked like a different place than it had been for decades. Eugene O'Neill made much of the difference. In the half dozen years before 1920, he had written at least fourteen one-acts and a couple of full-length plays and had seen only a few of the short ones produced briefly on neighborhood stages. He used to joke ruefully that he had a trunkful of plays ready. He did nothing to muzzle his contempt for Broadway, and he assumed that his attitude meant he would always be exiled. That is one reason why he adopted a strategy of publication from the outset. Thus you find in The Book Review in 1921 a laudatory assessment of a three-volume set of his plays, published when practically none of them had been performed. The strategy worked. Readers he won over included international figures in literature and psychiatry who spread the word among the European literati. When he was given the Nobel Prize for literature in 1936, his greatest plays were not yet written, and they would not be seen until several years after his death in 1953.

The Theater Guild had mounted a small production of *Beyond the Horizon* in late 1919, and an actor who saw it persuaded the producer of Elmer Rice's play *For the Defense* to offer *Horizon* as a matinee. That led to a regular Broadway production of it in 1920; it won a Pulitzer Prize, only the second ever awarded for a play. (O'Neill would win two more in the next seven years.) *The Emperor Jones* went to Broadway the same year, followed in 1921 by *Anna Christie*. Pauline Lord, who took the title role, until then had been cast only in roles that would not distract people's attention from her looks. She got raves for her Anna. She was only one of many known actors who found new depths in O'Neill plays in the 1920s. *The Hairy Ape* came to Broadway in 1922; *All God's Chillun Got Wings* (Paul Robeson's debut) and *Desire Under the Elms* in 1924; *The Great God Brown* in 1926; and *Marco Millions* and *Strange Interlude* in 1928.

Between 1920 and 1923 O'Neill completed seven full-length plays—and to him length sometimes meant five hours; sell-out audiences would arrive early to sit through two hours before a dinner break, after which they would return for the rest of the evening. He participated in almost all productions of his work, and he drew strength from the huge controversies the plays aroused—over his dramatic use of the ideas of Freud and Nietzsche, the unbuttoned language of his dialogue, the suspicion that he was inculcating socialism and anarchy in his audience, and especially his outright assaults on racism.

In 1924 the district attorney brought obscenity charges against O'Neill for *Desire Under the Elms,* but a jury disagreed. The publicity vastly magnified the draw of the show. But the d. a. learned nothing. You will find in this collection a short negative review from 1926 of a small play called *Sex,* ostensibly by one Jane Mast, but actually by its star, Mae West. The district attorney branded it lewd,

and police padlocked the theater and sent West to the workhouse for ten days. After that she was a star no matter what she did.

In play after play, O'Neill invented new dramatic forms and revived some not used since Elizabethan times. Above all, in ways that even daring novelists were wary of, he threw a pitiless light on how religion and society's rules produced individual suffering. He gave heart to playwrights like Elmer Rice—who was daring and innovative but had been treated by critics as an eccentric outcast—and to the generation of playwrights who in the 1930s and 1940s made theater a cockpit in fights over politics, public morality, and social standards. Finally, O'Neill's performance at the box office made Broadway producers a little more daring than they ever had been.

The producers also had a new competitor who helped enforce that openness. After the Washington Square Players went bankrupt in 1917, the amateurs who founded it regrouped in 1919 as the Theater Guild. Their premise was that if they could not find serious theater on Broadway, they would produce it themselves. They rented the 600-seat Garrick Theater from the ever-resourceful banker Otto Kahn (who told them that in months when they made the rent they would pay it and when they did not they would not) and, as the 1919–20 season was about to begin, they made a deal with the Irish playwright St. John Ervine to produce his *John Ferguson*. Ervine had a following, and the Theater Guild had a neophyte's luck. Since it was one of the few producers in town that already observed the work rules of Actors Equity, it was not closed by that season's actors' strike, so its run of *John Ferguson* sold out.

The Guild jumped from success to success for ten years. It took on difficult projects like Leonid Andreyev's *He Who Gets Slapped* and made them pay the rent. It charmed Bernard Shaw into giving it the world premiere of *Heartbreak House*. It was the producer of O'Neill's *Strange Interlude* and of *Porgy* by the Heywards. After its first few years it was in the catbird seat; it had built an audience that bought tickets because the Guild was producing a play, regardless of what the buzz was on the street or what the critics said. By 1929 the Guild had four productions running simultaneously on Broadway and seven companies on tour.

Seriousness was popping up all over Broadway, including in John Barrymore's appropriation of Shakespeare, in which he turned out to be impressive in some of the great roles no one had thought he could handle. Constantin Stanislavsky brought his version of *The Cherry Orchard* over from Moscow in 1923 and taught his "method" to enough New Yorkers to establish a tradition. A bitterly realistic antiwar play, *What Price Glory* by Maxwell Anderson and Laurence Stallings, was a hit. And, if you want a smile with your seriousness, read Stark Young's review of Max Reinhart's extravaganza *The Miracle*; he transformed a theater into a medieval cathedral at huge cost, and in one scene had 700 supernumeraries bowed in prayer. But for a glimpse of how much the new spirit had opened Broadway to real life have a look at one of Brooks Atkinson's earliest reviews for *The Times*, of Sophie Treadwell's 1928 realist drama called *Machinal*. It is impossible to summarize, and besides, you will get the pleasure of learning that Clark Gable might right then have become Rhett Butler, long before Margaret Mitchell even began writing *Gone With the Wind*.

Even musicals and comedies got serious in their own ways. Most of them had plots and clear story lines, and the books began to live up to the composers: Berlin, Kern, Hammerstein, Rogers and Hart, and the Gershwin brothers. By the time Ziegfeld produced *Showboat* in 1927, the Broadway musical could challenge some operas. With the arrival in comedy of writers like George S. Kaufman and S. N. Behrman, the clichés that had been the mainstay of comic theater were hooted away. It was inspired of the producer to match Kaufman and Berlin with the Marx Brothers for *The Cocoanuts*—although one has to admit that no contribution by anyone else could top the Marxes' performance in 1928 in *Animal Crackers*. And suddenly comedy took aim at targets it would never have sighted before. Kaufman and Edna Ferber took on the Barrymores in *The Royal Family* (for which Ethel Barrymore despised them till her death), and in *The Front Page* Ben Hecht and Charles Macarthur even shot down the institution theater was most dependent on: the press. Almost all of this was simply imposed on the top of the old Broadway—the same kind of fare that had survived from the late 1800s.

No one seems to have given much thought to what the movies would do to Broadway once they had sound—the exodus of writers, actors, choreographers, and directors; the complete loss of old standbys, such as murder mysteries, to a more effective medium; the loss of the right to dramatize novels, since no Broadway producer could compete with a big studio. The 1929–30 season, which began two months before the stock market crash, saw 297 plays open on Broadway, the greatest number ever. The crash alerted even some of the laziest producers that Broadway would not match that number again the next year. It never came anywhere close, ever again.

What is one to make of all the talk of jazz overrunning classical music in the 1920s? Not much. As a letter to *The Times* in 1927 included in this volume points out, many people talking about jazz, including the popular band leader Paul Whiteman, didn't understand it. Almost all the "jazz" heard by readers of *The Times* in this era was played by white men. One has to remember that black and white musicians did not appear together on stage in the 1920s and there was only one club in Manhattan outside Harlem where black musicians regularly played jazz. What is more important for readers of the music articles in this collection to keep in mind is that none of the critics knew anything about jazz. What we have here for the most part is really a record of amusing, and revealing, misunderstandings. What was really going on in most use of jazz by white musicians was pretty much what Hollister Noble, in a 1926 article, says about white use of the blues: it was "sophisticated decadence" of the genre. The only work by a classical composer reviewed in these articles that at least tried to get jazz right is Ernst Krenek's opera *Jonny spielt au* (Jonny gets it going)—but the role of Jonny was taken, as was customary, by a white man in blackface.

Two great forces were at work in the 1920s to make the real masters of jazz and of blues the creators of modern American popular music for the rest of the century: records and radio. By 1925 W. C. Handy had sold five million blues records, and the jazz bands were not far behind him. Bix Beiderbecke, one of the first white men to become a jazz master, first heard this music in Iowa on radio and then began to develop his own style by listening to records. Radio stations grew by the hundreds per year in this decade, and they needed thousands of hours of sound every year to stay in business; most supplied that need with music, recorded and live. The audience for this music, which had previously been heard only in black neighborhoods and clubs in New Orleans and Chicago, expanded to include the whole country within a few years. And by the end of the decade, Duke Ellington began to show bands how jazz could be transformed into swing—enormously sophisticated and in no way decadent. That was when American music became a world phenomenon. Even critics and musicians whose pronouncements about jazz were foolish were right about one thing: they could sense that something profound was happening around them. As for jazz itself, its immediate acceptance in Europe and Latin America when it was heard live or on records is better testimony than anything written; it was its own authentic language, and its originality was immediately recognized around the world.

Another constant in these articles is mention of machine sounds in music. That this development was commonly called American is odd; it started in Europe. But the European composers called it an American sound, an expression of the energy and tumult of American cities. The Italian Futurists in one of their manifestos called for "a music of noise" shortly after World War I, and in a short time several European composers were obliging. Americans like Edgard Varese and George Antheil, who hauled machines, especially fire sirens, onto the stages of concert halls, were followers, but European critics called them the originals. George Gershwin's arch reference to all this—those taxi horns in "An American in Paris"—is characteristically mild, but pointed.

World War I made the United States a natural venue for almost any kind of new music. During the first fifteen years of the twentieth century, a season's programs in any major American orchestra might be as much as two-thirds German music. That ratio was cut in half in the war years. Conductors ransacked other traditions for replacements. Impresarios searched frantically for American pieces that soloists might use in concerts. Hatred of the enemy was a bonanza for American composers. If the operas of Deems Taylor did not survive the man, much of the work of Charles Yves and John Alden Carpenter, first heard in Carnegie Hall and on ballet programs at this time, is still part of the standard repertory.

By the late 1920s there were more than a dozen new organizations promoting American music. The prototype was established by Varese, a young Frenchman who came to New York in 1915 and settled in. He was an inveterate networker, with tremendous energy and a genius for publicity. Public outrage put some of his concerts on the front pages rather than among music reviews, and his International Composers Guild introduced to American audiences an enormous range of innovative composition. Others copied his methods, but few had his gift of persuasion. To make the unfamiliar less threatening, he talked leading classical conductors into taking the podium for the ICG concerts, including Serge Koussevitzky, Leopold Stokowski, Artur Rodzinski, Willem Mengelberg, Otto Klemperer, and Fritz Reiner. Product endorsement of that caliber is rare in any age.

One remarkable aspect of the new organizations is that while they provided prominent stages for American composers, none had a provincial outlook; they acted like global entrepreneurs and simply assumed they could shape the musical tastes of audiences worldwide.

In 1921 the American Conservatory was established at Fontainebleu. It would take generations of aspiring composers and other musicians to France to study with Nadia Boulanger, who infused them with a confident cosmopolitanism, and a number of them returned as very serious apostles of American music. Among the first was a most enthusiastic theorist, Aaron Copland. After he returned, his articles filled magazines and journals for the rest of the decade, and he became the focus of a large group of young American composers intent on revolutionizing music. In fact, within a few years this group was seen as a new establishment. Henry Cowell in San Francisco then started an alternative, the New Music Society, and in 1927 began publishing a quarterly devoted to scores of new compositions. He argued that the scores, which could travel around the world when the composers could not, were the most effective shock troops in the American invasion of world culture. He was also a surprisingly effective promoter of new music through recordings and radio. The assumption had been that popular audiences would resist the unfamiliar. But broadcasts of the recordings created vast new audiences.

So much emphasis on new music and new sounds inevitably led to weird technologies, a few of which appear in the stories in this volume—like the German jazz piano designed to break the hands and mind of anyone trying to make it speak. My favorite is the theremin, versions of which resurface all the time; this device lets you produce sound by just waving your arms in front of it. Then there was the clarilux, which fired up inspirational light as a kind of visual dance to the music. When you read what its inventor said about how dazzling it might make people's living rooms, you realize he had an early vision of the disco.

In the 1920s all this change must have been much less urgent to audiences, who felt it as an occasional tremor. The merger of the Philharmonic and the New York Symphony was probably more radical to individual concertgoers, and it came just in time, for the Depression would have sunk both if they remained in competition. And of course Carnegie Hall was to be demolished because the land under it was developers' gold. This rumor resurfaced regularly as a kind of popular entertainment for more than forty years.

A pause to let gritty reality fill in the background. In 1920 there were seventeen daily newspapers in New York City. It was obvious that not all could survive, and some winnowing began in this decade. Determined to make *The Times* the leader in circulation among morning papers, publisher Adolph S. Ochs was more insistent than ever that the paper should be the most comprehensive in every department, and he increased the already large percentage of profits plowed back into the paper's operations.

In The Book Review the number of outside bylines increased dramatically as more-authoritative writers were enlisted as reviewers; the publication hired under contract people at the center of literary life in France and Germany to write about literary events and new books; and it began occasionally to review books not yet available in English and ones that were banned in the United States.

In one case, one has to wonder whether it was not competing with the news departments of its own paper. When Lenin died in 1924, The Book Review quickly ran a front-page piece about half a dozen books published in Moscow within weeks of his death. The review is at least as much news story as lit-

erary analysis, for the books, coordinated by the Communist Party, laid out the key elements of the party line regarding the founder of the Soviet Union and certain elements of his programs.

James Joyce's *Ulysses* presented a different challenge. From the time fragments of it began appearing in small journals in Europe, and, for a time, in Margaret Anderson's avant-garde journal, the *Yellow Book,* in New York, the American government judged it obscene and banned it. When Shakespeare & Co. published it in Paris in 1922, no American publisher would risk buying the rights. Customs agents kept an eye out at ports for any copies travelers might try to smuggle in. Joyce was a totem for prophets of the modern, however, and book banning was a social evil to *The Times.* So *Ulysses* was definitely worthy of a long review. Joseph Collins, a doctor associated with the Neurological Institute in New York who knew a great deal about Freud and psychiatric practice and who had read the novel twice and discussed it with Joyce, turned in a shrewd piece of work. Without giving away the story he let his readers know what frame of mind they would have to assume to comprehend the book, which, he made clear without ever saying it, was a masterpiece of a wholly new order.

If that review was kindling for high-class dinner table talk, imagine the effect of the 1921 appraisal of three books on relativity, including one by Einstein. For a reader without any physics but with patience, this article is comprehensible and, for its time, pretty much state of the art. It is a serious scientific assessment obviously meant to put some steel in the spine of the ordinary citizen who might have been hesitant about voicing an opinion on the work of the most celebrated scientist in the world.

With Oswald Spengler's *Decline of the West,* the problem was that its title was in everyone's mouth, with any meaning anyone wanted to lay on it, but nobody outside a few historians would ever read the book. So the reviewer confined himself to explaining the origin of the book, accounting for its unusual influence long before it was published and telling the reader what Spengler thought his thesis implied.

It is as though, in the reviews of the Lenin canonization and of Joyce, Einstein, and Spengler, the newspaper was sending a message, especially to people not yet its regular readers: if you buy this paper you can sound smarter.

But there are comforting reminders that no one becomes sophisticated all at once. Very few newspapers took notice of Margaret Mead's *Coming of Age in Samoa.* The Book Review, when it did review it, gave readers no clue that anthropology is not simply reporting or travel writing and that a reader of the book might completely miss the underlying assumptions—which is precisely what happened to generations of lay readers. And the tone of the review of *The Rise of American Civilization* by the two Beards is very much that of Henry Luce decreeing that the twentieth was the American century. It is one thing to approach with unbridled enthusiasm Frederick Jackson Turner's identification of the frontier as the defining American vision or Carl Sandburg's novelistic biography of Lincoln, perhaps still the most readable American biography; but it is quite another to look at the Beards with no skepticism.

What does one miss? The Harlem Renaissance for one. You can read through not only The Book Review but also other sections of the paper covering culture in the 1920s and pick up at best only a hint that something so unusual was happening. The growth of the American avant-garde in France was also overlooked. Not only was an enormous amount of experimental writing going on there, but dozens of little publishing houses were putting it out in editions of such small numbers they were practically fugitive from day one. The culture of coteries was still below the journalistic horizon, and no newspaper was on top of this phenomenon, not even the *Chicago Tribune,* which employed many experimental writers and publishers as copyeditors of its Paris edition in the 1920s. Thus Gertrude Stein did not appear here until the 1930s. Even less easy to explain, neither did T. S. Eliot. Finally, one misses any discussion of literary criticism itself; it was still pretty much left to the tonier magazines, and even there it did not amount to much. Compared with the feisty public discussion of literary values promoted by people like Bronson Alcott and Margaret Fuller in the first half of the nineteenth century, literary criticism in the early twentieth century looks embarrassingly soft. It would take the ideological battles of the 1930s and 1940s to bring its level up to that of a century before.

The history of dance in the 1920s was written mostly by its audience. Dance companies, theaters, and the press all seem to have been unprepared for the crowds dance drew. It began to take over Broadway stages on afternoons when there were no matinees. And everyone in entertainment wanted a piece of it. When the women of the dance line at the Roxy could form a ballet company, you know there was a craze. And at least one Broadway gypsy, calling herself Tamaris, was a ballet star for a time. Top stars could draw stadium crowds of 10,000 or 15,000, and one program comparing two seminal American dance styles drew an audience of 50,000.

Dance companies seemed eager to break out of tradition. In 1920 an Adolph Bolm company packed Carnegie Hall when it reduced its musical accompaniment to a single player piano. Another company sold out that hall dancing to one of George Antheil's compositions that used the sound of industrial machines, huge fans, and fire sirens. A ballet based on *Krazy Kat,* the hottest dancer in the comic strips, was staged at the Met. Throughout the decade there were ballets with no music at all, living testament to the later lofty pronouncement by Martha Graham that dance is not about something; it is an absolute. The point was made in a pleasant joke in 1927 when Bolm, Ruth Page, and their Chicago company brought to New York a ballet that had minimal music and dancers all outfitted as musical instruments.

Ballet invaded Broadway musicals. The European dance star Harald Kreutzberg stunned Broadway audiences in a couple of Max Reinhart's theater spectaculars. Producers of musicals began advertising choreography by ballet dancers as a box office draw, and it worked.

The dance audience produced changes in the newspapers as well. They had relied on staff writers from theater and music to cover dance. In 1924, Olin Downes, *The Times* music critic, could still confidently sum up Pavlova. But shortly afterwards the paper hired John Martin, whose knowledge of dance was nearly as solid as his opinions, and he became a shaping force in ballet. Three of his survey articles on dance in 1929 are still models followed by dance journalists. He also had a gambler's instinct—as when he mentioned that the luxurious anarchy of the art suggested the need for a New York ballet company that could bring the city to the forefront of dance worldwide and mentioned George Balanchine as a possible director. He was only five years ahead of events.

The excerpts from the dance coverage in this volume form a historical diorama. In the early 1920s Pavlova and the Folkines were the crowd pleasers while the innovators like Bolm and the Swedish Ballet created all the stir. In 1922, Isadora Duncan, nearing the end of her life, returned from Russia to affectionate acclaim, but when she died her intensely romantic style died too. Of the American companies, Denishawn was triumphant, but there is a sense here that it was in its autumn.

By the end of the decade, the public discussion of the relationships between dance and music and dance and theater was enormously sophisticated, and Doris Humphrey, Martha Graham, and Agnes DeMille were the attention grabbers. Humphrey has never been given the full credit she deserves for making the whole world the mise-en-scéne of dance, but her effect can be felt in these reviews. The growth of Martha Graham is more fascinating. From being a singular figure in the Denishawn company, she moved on to become a revolutionary dancer caught up in an intellectual quest for a method to define and transmit the enormous range of possibility she envisioned for ballet.

DeMille is the shooting star. From one season to the next, in little more than a year, she made a deep initial impression with a dancing style all her own and then returned with a program of dances on popular American historical themes performed to music by popular American composers—including one that brought down the house, a number showing the apotheosis of a Broadway chorus girl by jazz. This tells a lot about why DeMille remains a loved memory on Broadway. In the history of dance she is not Olympian, but in the history of the American audience for dance she is a great figure.

Mention the 1920s in any conversation about film and everyone thinks "sound." Getting movies to talk had been the ambition of inventors for more than thirty years before *The Jazz Singer* was released, and their hopes were justified; sound did change everything. Hollywood had long known that the entire approach to acting would have to change. There was no theory about how to entice sound effects, including music, into a conversation with cinematography (which is paradoxical since off-camera string groups had been used for years to create moods in the actors in silent movies).

Nonetheless it is easy to sympathize with the curmudgeonly objection of King Vidor in a story reprinted here that the arrival of sound was untimely, coming just when the story-telling power of the silent films was reaching perfection. The emotional power of the best silent films remains startling. Ernst Lubitsch is persuasive here when he says that by 1923 there was no longer a need for titles in these films; they told a story in great depth all on their own. It is doubtful that Cecil B. DeMille was ever as effective in sound as he had been in the silents. It is hard to imagine that *The Four Horsemen of the Apocalypse* or *The Battleship Potemkin* would not be destroyed by sound. Could sound improve the powerful realism of *Nanook of the North*?

Comedy is an even better test. The masterpieces of Charlie Chaplin, Harold Lloyd, and Buster Keaton all date from before sound, and much of their comic power depends on the viewer's imaginative ear. And would the subversive humor that makes the Valentino films so fresh even now be possible if the characters spoke? Not likely. Parody also worked better silent than it ever has in sound. The most famous case involves the 1925 realistic shocker about World War I, *The Big Parade,* directed by Vidor. It took a competitor less than four months to get *Behind the Front* with Wallace Beery into the theaters, and it remains a perfect model of demolition.

In any case, from the point of view of some moviemakers, sound was not the only big technical innovation of the 1920s. In this period, animation developed almost all the tools it would ever need to produce feature films made entirely of graphics. If any static medium at the time was an equal competitor with films for public attention surely it was the comics, and by the late 1920s the filmmakers could kidnap the comic strips any time they wanted. And if you read the story about the animation invented to film Arthur Conan Doyle's story *The Lost World,* you will see where George Lucas and computer animation came from.

For the public, the experience of movies in the 1920s became what it would remain for fifty years. For the movie palaces of the era, a philosophy of architecture was developed on the proposition that the illusory experience of the film should begin at the sidewalk. This aspect of the business pretty much reflected the business reality behind it. The studios wanted the movie houses to project power. How the rat race of the decade before assembled itself into this human pyramid ruled by a handful of giant companies is very well described in an article in this collection by Robert L. Duffus, who reviewed books for *The Times* for more than fifty years. He plowed through the mountain of documentation in the government's antitrust case against the studios in 1925 and reduced it to a comprehensible account of the industry. Whole libraries have been written about it, but Duffus's trusty little guide will save you a lot of time.

That cannot be said for film criticism on the whole in the 1920s. Writers covered the movies rather than analyzing them, and they often took their cues from the audiences. Perhaps it was just as well that the critics waited for a generation to develop their own art. A piece in this collection about Fritz Lang's *Metropolis* by H. G. Wells suggests that humanity had to live much longer with films before it started to pontificate about them.

The studios hired their own pontificator to protect them from criticism of their moral standards and to claim the high ground for films. In 1922 their trade association hired as its executive Will Hays, who had been chairman of the Republican Party and Postmaster General. Hays immediately declared that movies might become the stabilizers of the common culture, and the Hays office became the preproduction censorship machine that for forty years dictated what might be shown or said on screen. That there was almost no protest against this preposterous self-deception at the very outset is astonishing. People in the industry thought it was dangerous to criticize the Hays office. So it is refreshing to find Eric Von Stroheim, then riding high as a director, derisively calling movies mental chewing gum, and Lillian Gish writing in *The Times* that not only was moral uplift not the business of movies, using movies for such a purpose might be downright dangerous.

A vignette: On March 14, 1926, at a meeting of the Society of Indepedent Artists, a debate was staged between Rockwell Kent, arguing that museums should validate American painters by showcasing their work, and Walter Pach, a painter and lecturer at the Metropolitan Museum, holding that museums should highlight only the best, whatever its origins. When Alfred Stieglitz and the sculptor

Gaston LaChaise rose to attack Pach, it fell to John Sloan, then president of the Independents, to rule them out of order.

What a cast and what a scene! This must have been the only time on record when anyone silenced Stieglitz. For 20 years he was so well known for his nonstop theorizing about art at Gallery 291 that Henry McBride, the critic for the *New York Sun,* said it was never clear whether the art or Stieglitz was the exhibition. John Sloan, a taciturn Ashcan satirist, was once asked if he had visited 291. Once, he said; Stieglitz had talked off most of one ear, and while the ear had repaired itself since, Sloan had never gone back. In 1912, while Pach was an art student in Paris, he scouted out the European artists who made the Armory Show of 1913 a revolutionary event. And LaChaise had been a partner in an artist-run gallery that promoted American art. So, everyone involved here except Kent shared an understanding of art and society, and all of them would have thought this debate pointless. But in the 1920s arguments about art tended to be not about ideas but about money and position.

Money was secondary. Among commercial galleries, Macbeth, Knoedler, Montross, and several others were energetic promoters of new American art, and even the publicity-rich inauguration of galleries in Grand Central Station by 100 artists and 100 business leaders, while it exposed the commercialism of the age, could hardly do much more for the artists. Articles in *The Times* on gallery seasons, in fact, indicate robust sales and wide interest. What the artists longed for was something like the vast democratic public of ballet. If they had found it, of course, they would have discovered it was addicted to comic strips and advertising—just as the pop art pioneers found forty years later.

New York painters and sculptors were not ready to make that leap in the 1920s. Even caustic realists like Robert Henri and Sloan were captives of nineteenth-century theory and of the city. Some regionalist artists were already making connections with American history and manners that would prove mainstream in the development of art from the 1960s on. It was in the 1920s that Thomas Hart Benton painted the series of vast canvases *The American Historical Epic,* which give a rich alternative reading to the nation's story. And it is not impertinent that at this time Grant Wood found the perfectly ambiguous expression of the American public's view of itself in *American Gothic,* the most popular American painting in the world. Wood, of course, took his inspiration from photographs. And Benton had apprenticed for five years in the most democratic art of all; he was a scene painter for the movies.

East Coast critics treated regionalists like village idiots, and their attitude told on New York artists. It also shaped the philosophical outlook of many art schools springing up in the 1920s, and certainly of the fine arts departments in vogue in the leading private universities. As for the museums, they were caught up in one of those moral uplift cycles that afflict the nation in times of wealth; the articles here reveal them on a mission to improve the taste of the population in furniture, clothing, decoration, home design, and consumer products. The mission extended to architecture as well, if only to the extent of embedding stone carving into the walls of skyscrapers to divert and instruct people at street level. Now all that strikes one as a little fey, but it was part of an international movement culminating in 1925 in Art Deco, which took its name from the Exposition Internationale des Arts Décoratifs et Industriels Modernes in Paris.

Strictly speaking, Art Deco had no more to do with architecture than did the gothic stonework John Mead Howells used to disguise the steel skeleton of his Chicago Tribune Tower. This design won a competition sponsored by that paper and juried by architects, beating out visionary submissions by several of the great innovators in what would come to be known as the International Style.

But at least in the 1920s, the *Tribune* and other newspapers were beginning a public discussion of what architecture ought to be. As one article in *The Times* magazine included in this volume makes clear, some architects thought of it primarily as a projection of power—whether in Mussolini's plan to build an 1,100-foot tower in Rome or in the dreams of some American designers of building an entire city of nothing more than skyscrapers. But other articles here document the paper's effort to let readers know that some European architects, such as Le Corbusier and Eliel Saarinen, were trying to turn architecture into an expression of modern life.

It is interesting to find that Le Corbusier and Walter Gropius, the founder of the Bauhaus in Germany, both thought Ford's River Rouge plant near Detroit was an archetypal expression of modern life—the first fully integrated manufacturing facility ever designed. Its enormous structures sweep across hundreds of acres, each building devoted to one section of a car, all connected by fantastic ribs of conveyors. Steel, rubber, sand, and fabric went into one end of this complex and shiny cars came out the other. In the 1920s Ford hired Charles Sheeler, a painter who had also become a photographer, to make a record of the Rouge, and Sheeler fell in love with the industrial landscape of the country. His pictures, which evoke Renaissance paintings and mimic medieval religious art, circulated worldwide and became almost cult artifacts. Occasionally a gentle satirist like Charles DeMuth might try to send them up, but these were murmurs against a torrent.

Among the great enthusiasts for a culture of machinery and industry were, oddly, the Russian Constructivists, led by Vladimir Tatlin. Tatlin's work was championed here and in Europe by Katherine Dreier's Societe Anonyme, but contemporary critics hardly noticed that the Constructivists and the leading American industrialist were joined at the hip. The Constructivists had been fanatical supporters of the Russian Revolution and were dedicated enthusiasts for the Communist regime. They supplied the vision for Russia's determination to best the West, and when at last the Soviet government had the power to begin building places like Stalingrad and Magnitogorsk, basically vast machines with humans huddled around, what it constructed were colossal magnifications of the idea of Ford's River Rouge plant.

In the 1920s, however, Russia and the Rouge plant must have seemed equally distant from a New York newspaper, and Art Deco was right next door. Any New Yorker who wants to see it need only look up; the 180-foot spire of the Chrysler Building is a steel sculpture that spectacularly expresses the style in an assemblage of automobile parts. Since, as well, it is a finger thrust by Walter Chrysler into the eye of his rival Ford, it is also a pleasant joke about the ambitions of industrial monarchs.

ART AND ARCHITECTURE

January 18, 1920

MELCHER'S PAINTINGS ON VIEW THROUGH JANUARY

Northern talents subjected to the influence of the South respond with a peculiar graciousness. Since Gari Melchers has taken to painting the pleasant landscape of Virginia, green-walled by the hills of Maryland, a new charm has come into his work without reducing its strength in any way. Nothing can reduce its strength, that quality having been gained by thorough training and a liking for the third dimension which will not down however decorative a composition is made. The "Old Hunter" is very decorative with the man's enpurpled visage surrounded by the useful patterning of evergreen branches, his gun thrusting its firm diagonal across the design. It is a fresh, spontaneous picture that gives the kind of pleasure one associates with the consciousness of youth, a consciousness that does not come, to be sure, until youth is on the wane. Possibly Mr. Melchers will paint it again and put an impudent bit of background behind the man's head in its place, but the perfect version hardly can be so good as this sparkling study with its bit of a defect.

Another study made con amore and alla prima, and so on, is the long, narrow panel immortalizing "Uncle Jim." Mr. Melchers never has done anything in which the character of the subject was more delightfully interpreted. There is "Uncle Jim," and that is all there is to be said about it. Those who know the type of negro will realize its every merit as characterization, and as handling of paint it is light as a feather and sound as the soundest fruit on the tree.

Then there is "St. George's Church," with the man on horseback in the foreground, and a bush in full flower and a happy dog and warm color on the church wall, and Spring in the air and in the heart of the painter, a beautiful picture, bringing with it the sense of holiday, and again the sense of youth—as it passes.

That is what one finds in all the Virginia subjects, a certain boyishness of mood, with the vigor of a manly talent. It is a glorious combination.

Older canvases are the portrait of the artist's mother, painted in 1908, and another link in the long chain of evidence that artists are human and like to do their best by their mothers; the "Girl in Hat," with the familiar, large patterned Dutch cape of the early pictures, and also their solid modeling, and a "Mother and Child" lent by Mrs. J. M. Longyear, in which a yellow plate is used, not quite happily, to impersonate a halo behind the young mother's yellow head, and the child is humanly angelic.

In manner between the close firmness of the earlier things and the careless freedom of the latest is "The Arbor," an idyll of outdoor comfort, with a pretty play of light and shadow over the scene. It is an exhibition that shows the independence of Mr. Melchers's art. He has formed no school and followed none, although he was formed in the mold of well-established tradition. He has not worried about the mold, but has been himself consistently through a period of much straying about among the delights of stimulating influences "from away," as the Long Islanders put it. The exhibition lasts until Jan. 31.

At the Macbeth Galleries the entertainment is more varied, the annual exhibition of "Thirty Paintings by Thirty Artists" occurring this month. The arithmetical precision of the title quite fails to indicate the nature of the exhibition. The effort to get representative work from artists who have interesting things to say in their special language has been well rewarded. There is hardly a canvas that does not tell even a slightly experienced visitor just who painted it, yet there is hardly one in which the strong stamp of style has become mechanical.

Take the "Interior" by Childe Hassam. Other painters have done rooms with old-fashioned furniture and new-fashioned windows letting all the sunlight in with a reckless modern disregard of fading carpets and hangings. Other painters have shown nice women busy—no doubt—with their household accounts; the day of being busy with love letters is over in art, except when Lester Hornby shows a little Paris bread girl reading one as she treads surefootedly the treacherous streets of her town. But no one possibly could mistake this Hassam for a Dewing or a Tarbell. It would be much easier to mistake a Vermeer for a De Hooch. Apart from the technical differences in the handling of the pigment, which, of course, settle the question beyond the dispute of the most expert, there is this little matter of outdoors. In Mr. Hassam's pictures it always exists, you cannot make your walls thick enough to shut it out, you cannot ignore it. The happiness of being in one of his rooms is the constant feeling that you can get out of it, that the free world of sky and weather is waiting for you just beyond, however you may seem incarcerated.

And this outdoorness is made also to play its part in the beauty of the indoors. It is made very clear to you not only that you are indoors because you want to be, but why you want to be there and not outside. The freshness and sweetness of outdoors is invited within, with the suggestion that all roughness be left outside. It would be balm to any hurt to rest in a Hassam room. The radiance of this especial room, the delicately broken symmetry of its furnishings, the faint embroidery of flower color and fruit color among the prevailing blues, and the sun peering in at the windows, rushing in at the door!

The girl's head by J. Alden Weir has, naturally, a conspicuous place on the walls, and here again is the sure knowledge that among the tens of thousands of girls' heads that have issued from American studios this one could have been painted only by Weir. The combination of sensitiveness, the indefinable mark of delicate breeding, and the simplicity of perfect candor is there as a matter of course, but it is not this alone that makes it indisputably Weir. On the technical side it is like some of his work and wholly unlike other; in color it is like him, but others have used a not dissimilar palette; the

design is a little more complicated than we usually find in these portrait heads, the peacock feathers and band of carved weed giving it an ornamental value with which he usually dispensed; but across the two galleries the grave young face is seen eloquent of an art that reveals the shy soul of a people, the American people as known by the generation to which Weir belonged.

It would be difficult to find a more complete contrast than Frieseke's picture affords. Here also is a young woman with delicate color about her. The painter's characteristic flesh tones are hers, pearly and exquisite and ever so little worn; the blues and pinks are those of tissues, not of flowers, the eyes are steady but not sweet; the painting is beautiful, but in comparison with Weir's it savors of recipe. The cooking school product is ever so much more certain than the cake that was made with a pinch of this and a dab of that, but when the pincher and the dabber was a genius something happened that does not happen to order and that made an incomparable article of diet.

Charles Melville Dewey sends to the exhibition a landscape entitled "Evening Light," in which the poetry of his vision frees itself completely from the fetters of realism without ceasing scrupulously to interpret the real world. This power of finding poetry in the real is curiously misunderstood by a literal generation—or perhaps the trouble is that the generation is not literal enough. It stops at the fact that the real can be and often is ugly, broken, accidental, petty, indeterminate. With further research it would find that the real can be and often is, harmonious, sensitive, rhythmic and beautiful. It is the same trouble that confronts us when human nature is under discussion. A man who says unpleasant things is accepted as a truthful man, even when he is abominably lying, and a kind and richly courteous mind is branded as insincere.

As material for art, ugliness and beauty matter very little. Art can use all material to advantage. But the beauty of a landscape has a quieting and strengthening effect upon the human mind that an artist of intellect and feeling must deeply desire to produce with his picture. He cannot do it by merely copying the more obvious features of his subject. He must create it anew with all the forces determining its life again at work. Mr. Dewey's landscape would be prose, not poetry, if the light of the sky were not stronger in even its mild evening radiance than any reflected light any where; or if the color of the picture were not integral, with no possibility of changing it in any one spot without injuring the general effect, or if the foreground trees were not in front of the hills and the heavens back of them and over them, if the tree trunks were not fully rooted in the earth and their branches springing from them with organic growth, if their foliage had not depth and the hill ponderable substance under its amethyst veil. Poetry never is gained by denying truth, and only a profound thinker can make poetry at all, though all the crowd may turn to silly rhyming.

As an individual example of the artist's work "Evening Light" is completely representative of its best qualities, and

the pattern woven by the tree branches is almost exasperating in the subtlety of its apparent simpleness.

Mr. Dewing's "Lady in Pink" also is a particularly fine example of that artist's style, a style that has nothing to say to the present mode, but that is formed from a persistent concentration upon one form of personal expression, and is certain to have much to say to the future of a kind of art that will not appear again until the world's kaleidoscope has been shaken for several aeons and the old combinations again are imminent.

Mr. Metcalfe's landscape is another example of his skill in suggesting the movement of foliage. The air enveloping the objects in his scene does not move quite so surely, but his picture is very charming, with successful accents of color in the small, delightfully characterized figures moving across the middle distance.

Louis Loeb's work seldom comes into the exhibition rooms, and the example in this exhibition is one that shows him in his most ingratiating mood, an idyllic landscape with a green sky, and trees moved strongly but not tempestuously by the wind, and under them a poetic little figure, generalized yet keeping a clear individuality, a very successful composition of the "Landscape with Figure" class. There is a landscape by Daniel Garber, with flat-faced sallow buildings in the foreground, a snowy hillside in the background, infinitely depressed and weeping trees denuded of their leaves, and far down in the foreground a couple of little figures with wholesome sharp notes of blue and red in their costume, snapping the picture into life and holding out the hope of ultimate recovery from its languor of feeling.

Taking the exhibition as a whole—there are landscapes by C. H. Davis and Emil Carlsen and Ranger and a harbor scene by Lever and figure subjects by Richard Miller and Robert Henri and Ivan Olinsky—the general impression it makes is one of health and cheer, and this is the note of most of our American work at the present moment as the exhibitions held all over the country amply prove.

* * *

February 13, 1920

PHOTOGRAPHS BY ALFRED STEIGLITZ

At the Anderson Galleries is an exhibition of photographs, old and new, by Alfred Steiglitz of 291 fame. He is trying in his recent photography some psychological revelations. He takes a portrait of a man as he looks to the casual visitor exchanging with him remarks about the weather. Then he takes a portrait of the same man with his polite mask removed. It is not exactly a case of Dr. Jekyll and Mr. Hyde, it is simply a case of the "My John" and "Your John" and "John's John" immortalized by Dr. Oliver Wendell Holmes, whose greatness as a writer came from his ability as a physician. The John revealed by Mr. Steiglitz is not, of course, the ultimate John, for there is no such animal, but it is a John with a good deal of the primitive getting the upper hand. If

you are at all afraid of yourself keep away from Mr. Steiglitz the photographer.

Other photographs show a pair of hands, the same pair throughout, clasped in prayer as Duerer once drew a pair of hands; fluttering, youthful and gay; gripping and powerful in the stress of an overpowering emotion, mature and muscular hands; hard at work peeling vegetables, knotted, twisted, old, laborious hands. The different expressions of these hands are incredible, but Mr. Steiglitz has worked with direct methods; there is no retouching.

The face belonging to the hands also is given a series of interpretations. There are many other interesting items in the exhibition, which is one that goes much further toward proving the artistic value of photography than any of the purring processes used to get rid of its essential character.

* * *

March 24, 1920

LEADING FIGURES IN MODERN IRISH ART

The first American exhibition of contemporary Irish art opens tomorrow at the Helen Hackett Gallery. On the eve of this interesting event it is our privilege to offer the following article by George Russell, best known in America as "AE," who writes about "Some Irish Artists."

By AE

DUBLIN—The Irish genius has found its fullest expression in drama, story telling and poetry. The names of Yeats, Synge, Shaw, Moore, Stephens, Dunsany, Colum, Hyde, Lady Gregory are as well known in America and Great Britain, and many of these through translations in Europe, as in their own country. Some indeed are better known outside than inside Ireland, for it is a poor country suffering from a long neglect of education.

I believe that if any of these I have mentioned had to rely on royalties from the sales of their books in Ireland, even the most famous would hardly have the comfort of an agricultural laborer. They are more fortunate than the artists, because what they do can be multiplied. Artists are engaged making the unique, for in the reproduction of pictures they lose almost everything which makes them sought for by lovers of art. Irish artists who, unlike Sir William Orpen or Sir John Lavery, chose to live in Ireland had a precarious existence.

Yet in spite of natural poverty there has been in my lifetime an Irish art of real worth and distinctive character. Three men but lately dead—Nathaniel Hone, John Butler Yeats and Vincent Duffy—have all painted beautiful and memorable pictures. Hone, who died at an advanced age, was at his death the last survivor of the Barbizon school. He was in youth a comrade of Millais, Corot, Rousseau, and his art at its best might be set beside that of almost any landscape painter, though it was too austere, too elemental, for it ever to become popular.

John Yeats, the father of the poet, began as a pre-Raphaelite and ended as an Impressionist. In all phases there was talent, but I like him best in romantic pictures like "King Goll," which showed how much he possessed that poetic imagination which found full expression in the poetry of his famous son.

The talent of Duffy was slow in maturing and only in old age did he show what poetry was in him. In our National Gallery in Dublin there is a lovely twilight over a heath, a picture steeped in poetry, which shows his art almost at its best. I remember with real grief that this beautiful picture was painted on a canvas from which the artist had scraped a still lovelier painting which was unsold because he could not afford to buy a new canvas. I found him scraping out one masterpiece so that he might be able to paint another.

This fragment of Irish art history might suggest what courage devotion to art required. Yet there are some artists of great talent living in Ireland. Jack B. Yeats, brother of the poet; John Keating, Sarah Purser, Harry Clarke, Patrick Tuohy, Paul Henry, Humbert Craig and Leo Whelan are most prominent. I write in Dublin not knowing what artists are represented in this exhibition other than myself, so I cannot refer to particular pictures.

Jack Yeats has the most original talent of any. It is impossible to mistake his pictures for another's. They are charged with character and a wild poetry. His pilots, farmers, actors, horsemen, tramps and landscapes have a quality of rugged intensity I cannot find in any of his contemporaries. John Keating is hardly less individual in his painting of West of Ireland folk. Like Jack Yeats, he is in love with that Western world and its people who are still, to use Synge's phrase, "fiery and magnificent and tender." The quality of his imagination suggests he is the ideal illustrator of Synge's passionate and picturesque people.

Harry Clarke has another kind of intensity. Sometimes there is so sinister a beauty in his work that one might use in reference to it De Quincey's words: "Holy was the grave to him, saintly its darkness, pure its corruption." One could imagine that he read only tales like Poe's or monstrosities like Bram Stoker's "Dracula," so horror-laden are these water-colors and black and white drawings. He is better known for his stained glass, which for beauty of coloring and design is not surpassed by the work of any modern.

Paul Henry and Humbert Craig concentrate almost altogether on landscape. Henry has a rare gift for decorative landscape, for selecting and simplifying until his bogs, mountains, lakes and trees become symbolic rather than realistic representation of nature. Every now and then these decorative landscapes of his have a dream-like beauty. Humbert Craig is more realistic. He is so much in love with his nature that he is out in all weathers, surprising lovely things in nature at her coldest and loneliest; and as I look at them I realize how much we miss of the beautiful world, we who shiver if the day is cold and forget that it is in frost and storm that nature gives her sweetest kisses to her lovers.

Sarah Purser, Patrick Tuohy and Leo Whelan are admirable picture painters. Miss Purser is one of the personalities of

Dublin. Marie Bashkirtseff refers to her in her "Diary," and though she was known so far back in time as that, she is younger than anybody. Tuohy is temperamental. If he gets a sitter who interests him, as James Joyce's father did, he surprises us with his intensity. When deeply interested, he is a most conscientious painter. Leo Whelan is one of our best portrait painters, but he is still better, I think, in the painting of interiors, which he executes with a Dutch-like fidelity.

We have, as every country has, young moderns like Miss Stella Steyn and Miss Jellet in revolt against academic art and tradition. I can see their talent though they speak an artistic language not known when I was a boy and which I do not now perfectly comprehend.

Some of my own pictures are in this exhibition. They are the artistic recreations of a writer who slipped into painting when he was 40, because when he closed his eyes he saw pictures. He could never have dared to exhibit his work but that collectors like Sir Hugh Lane and John Quinn found something personal in it. They are all painted either from memory or imagination, without the use of models, more to please himself than to please others, and he asks pardon for the companionship of his fantasies with the work of artists who have studied their craft and have technical accomplishment as well as character and imagination.

* * *

April 18, 1920

GOOD TASTE HAS A SLUMP

Decline, Probably Temporary, in American Conceptions of Decorative Art and Architecture

By HELEN BULLITT LOWRY

The war owes America another indemnity that wasn't mentioned at Versailles, for the great American taste is taking a slump down hill—yes, in spite of Browning Societies, still conscientiously studying "his Italian period"; in spite of the "Better tastes" pages in our women's magazines, even in spite of missionarying "interior decorators" who are traveling all the way to Tulsa to convert the new American millionaire.

In the war aftermath, the Poor, contrary to all Biblical precedent, have ceased to be with us, at least in their accustomed places. Instead the Poor are striking and buying, and, what between the two favorite outdoor and indoor national sports, the long slow, upward progress of American taste is suffering a sharp decline. So declares Richard F. Bach, associate in Industrial Art of the Metropolitan Museum of Art. And so, in a bit less impassioned language, says Henry W. Kent, Secretary of the Museum.

As these Museum authorities tell the tale, it belongs to economic history rather than to the history of art as she is taught in the finishing school, with Italian Renaissances and things. In their story the blame rests more on industrial conditions

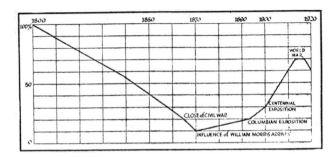

FLUCTUATIONS IN GOOD TASTE IN THE UNITED STATES SINCE THE YEAR 1800.
Chart Showing How Appreciation of Decorative Arts and Architecture Declined After the Period of Handcrafts, and then Began to Improve About 1870. Another Decline Is Now in Progress but an Upward Turn Is Predicted. (On the Chart the Handcraft Period Is Made to Represent 100 Per Cent of Good Taste for the Purpose of Comparisons With Subsequent Decades.

caused by the influx of new buyers than on the inexperienced buyers themselves.

Before the war, they say, manufacturers from Grand Rapids and other places had been competing hotly with each other to keep pace with the improving popular taste. In 1915 they simply stopped competing. It was the customer's turn to do that. Pantingly, laboriously, American taste had reached a point where the cabinet mantel had ceased to be the standard for industrial art and where antlered stags no longer functioned on the front lawn. The able assistance of bargain-counter Summer tours through Europe for thrifty school teachers and the "Colonial furniture" fad had accomplished that much, along with some other influences.

War, Then Slump in Taste

The living room was actually elbowing the parlor out of the suburban home, and the tiled bathroom had become a standardized token of applied art that the tiredest of business men could compass. Demand for "good things" had got greater than the supply, salesman knew less than the customer and therefore the manufacturer was having to meet the new conditions with striding improvements in design. The six years from 1914 to 1920 might have witnessed the final obsequies of the mirrored folding bed and of the red-shaded parlor lamp. But along came the war!

Labor was called off for war contracts. Building—and architecture with it—ceased. Shops ran at part-time. The manufacturer couldn't turn out as much of the old stuff on the old machinery as he could sell. Why should he install new, expensive machinery to carry out new designs as art propaganda, when art would be just painting the financial lily? Only in women's wear did it pay to develop new ideas—and in this one field was there improvement, while the pots and the pans and the wicker chairs and the parlor clocks ticked on in the same elevation.

So, for three years, American industrial art, and national taste with it, which must see before it can desire, stood still. On a chart which Mr. Bach draws to illustrate his point, a

plateau occurs during wartime in the ascending course of American taste. For fifteen years there had been a sharp advance. Since the World's Fair in 1893 the improvement had been perceptible.

But the plateau "wasn't the half of it." Peace came—and with it a dizzy drop on the Museum's chart. Even if it wasn't "technical," peace was with us, with its strikes, its Tulsa millionaires and its moneyed engineers, outlaws and otherwise. Hundreds of thousands of new buyers were hurled into the purchasing field over night. Less and less was supply able to keep pace with demand.

The Present Decline

Then supply just had to be turned on more quickly. Those subtle grays and blues require more time, finer workmen, surer dyes? Oh, that's easy! Use red instead. That Louis Seize chair demands a skilled craftsman and our craftsmen are on a strike? Well, what's the matter with giving it a Louis Quinze leg where plaster will do the trick?

Appropriate needlework lacking for the seat? All right, try a piece of Empire damask. The high salaried person that delivers our milk won't know the difference, and the professor that used to buy our chairs is having to spend it all for milk these days. What difference today if the result is gaudy? Tomorrow we may have to use art again, pay designers, and buy new machinery. So cash in while the cashing's good!

That is how the Museum expert analyzes the devastating movement in our midst, which is filling the stores again with gilded lamps and parlor sets, and infesting even erstwhile "arty" Greenwich Village show windows with gilded rolling pins. The Museum expert is sad that this backset has come into the life of American industrial art, for it is to promoting a national industrial art that this Museum has been consecrated ever since Mr. Kent became its Secretary eleven years ago. But there is not discouragement. Better days are coming—and that as soon as two sure events shall have occurred.

Some day, perhaps in a year, perhaps in three years, supply will have caught up with demand. So goes the prediction. The manufacturers know that day is coming, and so they are buying designs for furniture and for household textiles, and laying them away to keep the designer in the field. Meanwhile—and this is the other event—the new buying public will be learning the gentle art of buying, for "taste is discrimination many times exercised." That also is on the schedule, as Mr. Bach routes the turning point of that drooping line.

"Art follows trade, not trade art," he explains. "That's history. The wild buyer of today is the connoisseur of tomorrow."

At which he outlines the American system of getting "cultured" till it might be the history of England in the days when Dane made invasion on Anglo-Saxon. As they were the same general race, it didn't take so many years for the invader to get converted and civilized—when along would come a new invasion, which would conquer the last lot. And the work of converting and civilizing would begin all over again. Yet each time the process of absorption was a success. That is, as much culture was absorbed as was already current—whether the stage happened to be old England or modern America. Just at present we are trying to absorb an extra large invasion.

In listening to Mr. Bach one infers that we were all of us barbarians a couple of generations ago—nor was this art barbarianism a local peculiarity. It stretched across the world. Wherever machinery had come barbarianism came also. Its devastating influence lapped on the American shores. It swept inland. It changed the homespun rug into a Brussels carpet. Massive Georgian lintels became jigsaw puzzles. Cabinetmakers were transformed into lathe turners. To this day you can see what it did to France, whenever Bernhardt makes a farewell tour, carrying her nineteenth century parlors with her. The hand crafts had passed away.

Meanwhile, in America as the thirties became the forties things went from bad to worse. Men grew so busy working out the technical problems of machinery that design was forgot. Art was boxed up in a gorgeous gilt frame, hung on the wall by a triangular cord till a more convenient season, and horsehair sofas and human hair jewels, whatnots and nineteenth century mansions flourished in the land. Then with the sixties came a war and its aftermath—even as yours and mine (they really were having wars in those days, though such quaint old affairs that we'd hardly recognize them). Psychologically at least, industrial art got into the same hectic state that it is today. The same sharp descent in taste occurred that is taking place today, and for the same causes. But they already were going down hill, so it didn't matter very much after all. We were going up. In the late nineteenth century, realization had come to a prosperous land that it was "missing a trick," and that thenceforth design must rule machinery, not machinery design. Therefore there is the more sadness today upon our local Acropolis because of this "complex" of good intentions. But also there is less desperation.

"At least there are enough people in the land who know that there is such a thing as taste for them to tell the others about it in time," Mr. Kent argues. "Sixty years ago not even the cultivated people were conscious of any standard except the money value. After the civil war the idea of design as a commercial asset was extinct. Today even the newest millionaire soon learns that there is such a thing as art, because somebody is trying to sell him something in its name.

"He learns the catchword of interior decorator, because one of them is quickly trying to charge him up for services under that head. What matter in the long run that the one whom he first hits on knows nothing, and as promptly surrounds a sturdy old man with a boudoir style? He has learned, probably at great expense, that there is something besides furniture in a room, and something besides stone in a house. The minute he realizes that art has a commercial value he is self-consciously aiming at that goal, even if he hasn't its range.

"The decorator's game, it would seem, is to inspire that millionaire with new desires that she may gratify them at great expense to the party of the second part. So the Museum's game is to inspire not only the newly hatched millionaire, but also the moneyed day laborer with this new and unexplored desire for taste—because that millionaire and that

laborer are both going to demand what they want, as is invariably noticed by the very general public.

"It will take time for him to desire the beautiful for its own sake, instead of as a symbol of prosperity," expatiates Mr. Bach on this same theme. "And 'propagandists' must be content for No. 2 to arrive first, he lays down the law firmly. That's biological, and the sooner you submit to biological laws the better. Doubtless Mr. Cheops himself got more fun out of the 'mine' on his nice new pyramid than aesthetic thrill, as he watched it pierce the blue Egyptian sky.

"Watch the psychology of it working out in each fresh, uncured millionaire. On the desk of another rich man whom once he envied there was a humidor made from an old Venetian box. Perhaps the box was a treasure—perhaps not—anyway, our hero wants it because it spells wealth to him.

"He goes to an antique shop, which he is informed is the 'most expensive.' One thousand dollars. But why? Oh, because it is an antique art treasure. He did not have to make a mental step to understand why the diamond on his finger cost money yesterday, but today this is all different. Therefore a new element enters his life. He buys this new thing labeled art, although it is not yet beautiful to him. Secretly he thinks it's hideous—and maybe it is, and maybe it is worth $10 instead of the thousand. But the first makings of a collector, eventually of a connoisseur, have been accomplished.

"The next time he will do better—and the next time better still. I happen to know of one of them who insisted on the crack in an Italian Renaissance chair getting copied, too. That crack pinched him. His second imitation antique was sans crack. The same psychology holds good of the woman who is sitting today at her Sixth Avenue window, with her elbows resting on a pillow adorned with giant poppies. Today her poppies are redder and cruder than ever before, because it is a brand-new pillow, and the gaudier the colors the easier a job it was to turn out for the harassed manufacturer. But some day that woman is going to stray into a Fifth Avenue shop. Accidentally she will discover that a less obvious design costs more. She wants it, and the beginning of her evolution has come."

Trust the American people to be ever looking for better things, he goes on thoughtfully.

"It is that one quality that I am betting on, rather than on the results of the art uplifters. We art uplifters have our place on helping the manufacturers supply the wants, after those wants are aroused. Just at present we've just got more new spenders about than the old spenders can absorb. And so the new taste is in suspension. Give it time."

And not so much time either may be needed, according to a designer in an established decorating house.

"Take Mrs. Blank"—he calls the name of a nation-famous oil magnate. "Three years ago she came in, while the fortune was very new. How timid she was! We could sell her anything, and by the dozen. Oh, yes, I'm afraid we did, too, for she was very fearful that we would discover that her money was new. By another year her manner had changed. She was letting her taste express itself. She was choosing the gaudiest rugs and tapestries in the house—everything silk, all the furniture French Regency, and preferably more so. In short, she had been to enough hotels for her to be convinced that she knew what was what.

"But, by another year, Mrs. Blank had 'got in.' Anyway, she had got in far enough to see domestic interiors, and she didn't want hers to resemble a hotel any more. She had learned, too, that we had ideas to sell, as well as rugs, and she wanted to get her money's worth. Three years had been enough for her evolution into a sane and clever buyer. Of course they all don't learn as quickly or as well as Mrs. Blank. Some of them may never learn. But, as a business man, I calculate that three to ten years is enough to absorb them into the general population. After that they are well-dressed and well-housed."

Strangely enough women's clothes have not followed the same downward plunge that is shown in the chart of taste in decoration and architecture. Economic reasons are the cause. With 1915 such an impetus came to the dress goods manufacturers and to the costumers of this country as was never known by land or sea. With Paris out of the running, with American women demanding new silks and skirts and hats, something simply had to be done. As a consequence the textile houses that have specialized in dress fabrics have made a spectacular record in design. So have our costume designers correspondingly improved. In short, there is enough good stuff in the markets for the spender of new wealth to be pretty apt to stumble on it.

"She's more apt to be wearing the wrong dress for that occasion," explains a fashionable costumer, "than to be buying a dress that is fundamentally of poor design. She may wear her ermine coat in the morning and her evening dress in the afternoon and her tennis costume motoring, but she has all the dresses."

* * *

<div align="right">June 27, 1920</div>

HISPANIC SOCIETY'S NEW MURALS BY SOROLLA

About ten years ago an exhibition of paintings by the Spanish artist, Joaquin Sorolla y Bastida, was held in the museum of the Hispanic Society of America. The exhibition was open for slightly more than a month, and over one hundred and fifty thousand people visited it—visited and loved it. Never was art more lovable by grace of its buoyancy, its power to make youth and health and happiness seem the commonplace of experience. The subjects were various, children romping in the water and on the beaches, oxen beaching the fishing boats, fishnets drying in the sun, market places, orange trees, fountains, palaces, gardens, hay makers, farmhouses, mediaeval towers, streets, people; but over them all was thrown a transforming fabric of joyous color and light.

No doubt toward the end of the exhibition many came to see the pictures for no other reason than that so many others had come; no doubt it became the fashion exuberantly to

"Sorolla," bust by Mariano Benlliure, Hispanic Museum.

admire what so exuberantly had been admired; but with all allowance made for the herding instinct in the public, that golden Spanish wine—so unmistakably "bottled in Spain"—needed no bush. The best proof is that those who saw remembered, that upon the strength of his one exhibition here the gallery visitors of New York have impressed upon their minds a clear image of the art of Sorolla, of what he told concerning the visible world and of what he left untold, and especially of the passion he had for sunshine and the activities of young athletic creatures.

It now is learned that at the time of this triumphant exhibition the Hispanic Society, with happiest forethought, commissioned the artist to paint a series of mural pictures for the museum, to run as a frieze along the walls of a room that formerly was the reading room of the society and that has been remodeled with especial reference to these decorations. They will be ten or eleven in number, covering a space 13 feet in height by 205 feet in length. They will be ready to put in place by November or December of this year when Sorolla will come over from Spain to be present at the installation, and they will be exhibited publicly at the end of December or during the early part of January.

It has been an ambitious undertaking even for a talent so adequately prepared as Sorella's, whose work, Mauclair has said truly, conceals by its brilliancy the lifelong preparation that has gone to its sound construction.

The subjects of the paintings are to represent characteristic phases of the Spain of today, taking the whole peninsula, province by province, with the widely different types and costumes, the differing landscape, and the more important monuments. In general plan the compositions will show a group of life-size figures in the foreground and beyond will be the long vistas of natural scenery accentuated with the architecture of the region.

This plan carries the artist through an extraordinary variety of themes. The violent contrasts in climate, vegetation, and ethnic character found in the numerous provinces of the profoundly interesting little peninsula call for scrupulous interrogation on the part of an artist attempting a trustworthy record as a foundation for his aesthetic achievement.

Sorolla's sincerity may be counted upon to have sustained him during this protracted demand upon his powers. The superficial charm of his work is so great that naturally it is the impression of his rapid technique, his blonde color, his cheerful subject matter, that lives most prominently in the minds of those who visited the American exhibition; but beneath his joyous and almost incredibly swift execution could be discerned the spiritual gravity of the Spaniard. Even in his least ambitious studies he conveyed the deeper impression of having told the essential truth about the Seville of palaces and mosques, the little Jávea of jeweled rocks, Segovia the morose and Valencia of sun-drenched beaches.

Nor will any one who saw his picture of "The People of Léon" be in doubt as to his ability to tell the exact truth about the human types he has been asked to portray. That sumptuous canvas with its full chorus of varied colors is dedicated to the people of Northwest Spain and the ethnographical fidelity of the portraiture affirms itself.

It was not in formal portraiture that Sorolla showed himself strongest, yet even here he frequently dug deep into character before flinging his robust brush strokes upon his canvas. Now that all America knows the famous Señor D. Vicente Blasco Ibañez by his translated works, it is evident that Sorolla's portrait described the man himself for us with a lively and appropriate idiom, brusque, powerful and direct.

Thus, across the ten years' space separating our impressions of Sorolla from the announcement of this new opportunity to enjoy his work, the genius of the painter appears more substantial and serious than it seemed to most of us when it blazed out in its positively theatrical naturalness. The very proof of its value lay in this accentuation of its quality.

The sagacity of selecting a genius so normal and vigorous for a monument of this permanent character will be appreciated more fully today than it could have been before the disintegrations of the war had awakened our appreciation of integrity and normally directed energy. M. Mauclair long ago defined the effect produced upon him by Sorolla's art. "The painter," he says, "seems to live in a state of permanent and radiant exteriorization. It is enough for him that he suggest joy, that all his work be a hymn to strength, suppleness, animal grace, in the work or play of his bargemen, grape gatherers, urchins. All are sharing the gratuitous feast of water and light; their faces are laughing, their muscles are tense. Not a careworn face, not an enfeebled body, not a spiritual shadow in these beings vibrating among poetic surroundings, beautiful with a pagan beauty, of a naturalness magnified by the intoxication of living, an intoxication free from voluptuousness, of a joyous chastity seeking with physical sports to refine and strengthen and exalt these bodies impregnated with the salt of the wholesome sea and whipped by the winds of open spaces. An hour passed in spelling out one by one the strophes of this vast chant to health, and one emerges calmed and with a vision of light upon the retina and within the mind. Is this not a way of putting psychology into painting? After so much of melancholy beauty in modern art, I avow my taste becomes ardent for this muse happily dispensing its lightness of heart."

How much more welcome today is such an art! The Hispanic Society did even better than it knew when it secured Sorolla's decorations for its museum.

For those who are not familiar with his history a brief outline of it may be of interest. The son of humble parents, he was born at Valencia, Spain, on Feb. 27, 1863. Not much of a student in the ordinary school courses, he early showed his talent for drawing and at fifteen was permitted to give himself up to the study of art. He won a scholarship that sent him to Rome, where academic methods were dominant, and upon a visit to Paris he saw the works of Bastien Lepage and those of the German Menzel, receiving from these very moderate revolutionaries a new impulse toward naturalism. Possibly any modern work of fresh inspiration would have done as much for him, for he was ready for the liberating touch. He

turned in his original work toward the simple natural style of Bastien Lepage while still occupied with copying the old masters, and gradually worked his way through one influence and another to his own jocund and richly personal manner. Arrived at the fullness of his powers, he led the reaction in Spain against the influence of foreign schools, especially those of France, and the movement toward establishing in Spain a native school of realists, concerned with rendering "in a natural, unidealized and unacademic form, the manifold customs and emotions of her laborer, artisan and peasant people." He was a robust and inspiriting leader, and with his passion for industry and his vitalizing energy easily maintained his first place among them. "New Spain" hardly could have a more favorable representative at the court of the arts. Several of his earlier paintings in striking contrast with those of his later period were sombre and depressing in both subject and treatment, and two of these are owned in America.

One of these is called "Another Marguerite" and has found its way to St. Louis. It represents a girl of the lower classes who has been guilty of infanticide and is being taken as a prisoner to the place of her punishment. The scene is the interior of a third-class railway carriage, in which the prisoner sits with two members of the Civil Guard. There is no melodrama in the portrayal of the girl's misery, but an uncompromising realism that insists upon the harsh character of the episode and the prisoner's unhappy condition.

The other picture is called "A Sad Inheritance" and was lent to the Sorolla exhibition by its owner, John E. Berwind. It has for its theme the ministrations of a dark-robed priest to a group of crippled boys from a house of refuge for such helpless children. The sad, misshapen figures are drawn with the same authority as that shown in the splendid children of the later Valencia beach scenes, the composition is impressive and the coloring appropriately sombre. It is interesting to see with what success a painter whose whole temperament draws him in an opposite direction can paint a gloomy subject and subordinate to it both his technique and the natural temper of his mind which we are able to trace in the majority of his works.

The Metropolitan Museum in 1900 acquired three excellent examples of the representative canvases, the "Swimmers," "The Bath, Javea," and "Beaching the Boat: Valencia," as well as the handsome portrait of the artist's wife in a black dress with a rose at her belt.

In the group of painters and sculptors who belong to the young, manly and hopeful Spain is the sculptor Mariano Benlliure y Gil, also a Valencian, less than a year older than Sorolla. Like Sorolla he early showed his genius for art, and at the age of 12 carved in wood a lifesize "Descent from the Cross." At 17 he went to Rome, where he was awarded a medal, and much later—from 1904 to 1907—he was Director of the Spanish Academy in Rome.

This sculptor has modeled a portrait bust of Sorolla, now in private possession in this country, which undoubtedly will be shown, however, at the time of the exhibition of the mural paintings in the Hispanic Museum. Benlliure's style is well adapted to emphasize the simplicity and force of Sorolla's physiognomy and to suggest through the forms of the individual features the unity of purpose and intensity of life bringing them into harmony with the whole character of the artist. His mind is fixed not upon the superficial characteristics of his sitter, but upon those fundamental traits that can be expressed only in the relation of the large planes of the head. The bust of Sorolla follows portrait statues of Velasquez (in front of the Prado at Madrid) and Goya.

* * *

August 8, 1920

ALL THE ARTS

The Detroit Orchestral Association publishes a magazine called All the Arts, the current issue of which forms a valuable work of reference, as it contains a series of articles on the principal museums of the country, with brief synopses of their organization and aims. An editorial note states that the material gathered so far overran the limits assigned to it that the next issue also will be devoted to this subject.

The museums covered in the present issue are the Detroit Museum, the Metropolitan Museum (New York), the Minneapolis Institute of Arts, the Toledo Museum, the Brooklyn Museum, the Cleveland Museum, the Corcoran Gallery of Art (Washington), the Hackley Art Gallery (Muskegon), the John Herron Art Institute (Indianapolis), and the Milwaukee Art Institute. The question of support naturally is of first importance with all these institutions and it is interesting to compare the different methods.

The writer of the article on the John Herron Art Institute speaks of this problem of support as "the old man of the sea who rides on so many shoulders," and continues with the statement that although in some instances an art museum receives full municipal support in this country, in most cases "a combination of the city's money, bequests, private gifts and a varying roll of members with annual dues furnish to a degree what is needed. Such is the support of the John Herron Art Institute. The time will come, however, when everywhere an appreciation of the arts will be deemed as important as the need of books, the town will be looked to for the fulfillment of a real and truly felt public need, and the art museum will justly be regarded and used as a community centre of the highest type."

The writer of the article on the Brooklyn Museum takes a philosophic view of the combination of public and private support, and with an extraordinary and rather refreshing frankness owns that it works out well in practice. "The generosity of private citizens," he says, "is much encouraged by the generous contributions for equipment and running expenses which are made by the city. On the other hand, these contributions from the city are naturally justified and promoted by the knowledge that the exhibits are all purchased by private subscriptions."

The Toledo Museum has no municipal support and the site for the splendid building erected in 1912 was presented by

the museum's President, Edward Drummond Libbey, who also agreed to give a large portion of the money necessary for the erection of the building if the remainder could be raised by popular subscription. This was accomplished with contributions ranging from 10 cents to $10,000. Mr. Libbey later contributed to an endowment fund of $400,000 provided one-half that amount could be raised by popular subscription, and this was done in spite of the calls made upon the citizens of Toledo by the war.

* * *

January 2, 1921

WORLD OF ART:
AMERICAN INDUSTRIAL APPLICATIONS

The Metropolitan Museum of Art is holding its fifth exhibition of American industrial art. It is showing, that is, current work by manufacturers and designers who have found their inspiration in original objects in the Museum collections. "It is an exhibition," Mr. Bach says, "of today's workmanship, taken right out of stock; pieces to be found on a score of salesroom floors in New York and other cities; goods sold across the counter at our department stores have been brought together in a gathering of hundreds of designs in several dozen different kinds of objects, and in all of them the collections of the Metropolitan have been of direct use. There are laces and rugs, fashion designs and advertisements for perfume, lamps and marquisettes, chairs and batiks, mirrors and clocks and so on." The things shown are only a few selected from many, and are intended especially to "direct attention to the great value of collections of art in the improvement of American design."

Certainly it is a collection that demonstrates good taste in the choice of models. We see silver that owes its simplicity and its vitality of surface to the Paul Revere pieces; furniture that belongs to the Colonial family or the reigns of the Louises; textiles that correspond in feature to Portuguese and Spanish originals; lacquers with sparkling little designs borrowed from Persia, and in general the finer periods and examples have been chosen for the compliment of imitation. Passing through the galleries an impression is gained that the modern designer, even where he has not made a direct copy, has felt the chains of the copyist as the ancient designer, who also copied, did not. There is not as much as one would like to see of bold playing with a suggested theme; but that, of course, presupposes an ease in the presence of art which we have not yet attained. Most of us in the presence of "real art" are anxious and subdued, and if we use it we do so timorously and with consciousness that we are taking a liberty. Later exhibitions undoubtedly will show increasingly the spirit of the Elizabethan dramatist who made what he took more robust and alive with a contemporaneous accent. It may be also that the vagueness of a visitor's memory of sources contributes to a falsity of impression. It would be an admirable idea if some of the originals could be placed in the galleries with the

objects they have inspired. The visitor then could see what happened when the mind of the designer began to work upon his material, and could instruct himself in the differences for better or worse between the original and the modern version. In such ways standards are built up, and great would be the joy if something American and modern, something all our own and for that reason legitimately dear to us, should prove of finer grain, of stronger fibre, of more engrossing beauty, than the Florentine or Egyptian or Versailles model.

But it is profitable to consider what the exhibition does show of progress and interest. It shows, for one thing, a definite realization of the value of color. In the printed and woven fabrics especially, color is used as an element in the design and not as an applied detail. In one or two instances this thoroughly intelligent conception of color betrays a design by revealing its poverty, but the cases are far more numerous in which the color emphasizes the structural force of a pattern and thus enriches it organically.

In the section of iron work is found a strain of originality that comes perhaps from the discipline of working a resisting metal. And in this section are items indicating the desire of the maker to meet the familiar needs of contemporary life without introducing the note of archaism.

The furniture reaches, perhaps, the highest level of plain competency, and this only can be ascribed to the influence of study of antique models over a longer time than has been given to other forms of "period" art. A writer in the current number of Good Furniture Magazine points out that the remarkable improvement which has taken place in American furniture during the last ten or fifteen years is at least partly due to the fact that "the very process of attempting to render, over and over, certain forms of historical furniture, has compelled closer and closer study of antique models, by the furniture industry as well as by the public." He points out also that the secret of knowing how to add the maximum value to a minimum of materials and labor lies with the designer, with his genius for thinking out his problem in terms of proportion, shaping, color.

The costume designs are not the most impressive section of the exhibition, but they show to a greater degree than most of the designs a fresh feeling in handling the suggestions provided by the originals. One clever designer has drawn a group of people in various modern-looking and far from eccentric costumes, and in the background of the little composition has sketched the paintings from which the inspiration came. Here the visitor does find himself in a position to note the degree of adaptation, and to form an opinion of the character of the new design in comparison with the character of the model. The crisp lines of the modern costumes and their appropriateness and elegance promise well for the growth of a genuine style out of the influence of a far-distant past.

And whatever use is made of the Museum sources, whether the "golden age" of this or that art is asked to assume responsibility for a brazen modernism or is given the high function of creating a young school and continuing

a great tradition, the hospitality of the Museum to manufacturers and designers is of the utmost value. Nowhere else could these find their chance to link themselves to the great traditions or to study design in its final form of an accomplished object.

Mr. Bach's comment in the current number of the Museum Bulletin is illuminating, both in its optimism and its restraint.

"These pieces," he says, "brought together from factories and shops, with the earnest co-operation of some threescore firms and individuals in fields ranging from millinery to rugs, from jewelry to furniture, are a direct reflection of trade conditions, recording as truly as the money market itself the ebb and flow of prosperity, the ascendency of the new rich, ill-begotten fads created out of hand by scheming producers, unemployment, strikes and the devious ways of modern selling. For these all and for many more this exhibition is a sort of sounding board without which the complex of our industrial production would be a jangle of discordant notes instead of a hum of progress. Each piece in the exhibition bears further the marks of special conditions of production characteristic of its own trade field or even of a specific phase which could describe that trade field only at a certain period of a given year, so rapidly have things been moving in the business world. But the aggregate is a hopeful token, for it is seen each time we bring this exhibition together that the standard of design is higher, that the perfect triad of material, execution and design is assuming more stately proportions in the minds of those who make and those who sell objects of industrial arts; that the seed has penetrated further into fertile but hitherto fallow fields where a rich growth has begun. Throughout, the Museum is the humble agent of great things; it has become the quietly effective teacher of great numbers for whom none of our educational institutions has thus far held a light; by aiding the producers in mills and foundries it has hastened the day of better taste among us."

One of the indications offered by the exhibition in proof of a growing sense of organic beauty among those who are making our styles is the tendency to go back to the strong and unpolished periods of art for inspiration. Some one has said that when a tradition attains perfection we must break with it to prevent its spirit from wasting as it travels constantly further from its source. We must go back as near as we may to that source, and strengthen the growth of the tree by chipping away the branch that is weary of flowering. Even where the objects in the present exhibition show feebleness it is something that they are not based upon decadent forms of art; that many of them are obviously the outcome of study of periods preceding the late years of the last quarter of the eighteenth century, with their fragile elegances, their elaborations so easily crushed by the rude democracy of a new day.

* * *

January 17, 1921

TACTILISM GREETED BY DADAIST HOOTS

Futurists Present the Newest Art Form Which Their Enemies Declare 'Just Rot'

POEMS TOLD BY TOUCH

Thus Little Squares of Cloth Convey a Story of French Gayety When Touched in Order

By Wireless to The New York Times

PARIS, Jan. 16—The Dadaists and Futurists who have been brothers and enemies ever since the inception of the former, have come to open war. What it is all about only they themselves know, for no outsider, even if he does pretend to understand the futurism of Signor Marinetti, can ever understand Dadaism. Even the Dadaists don't. They, however, have taken the offensive in the war and, apparently jealous of their place as the very newest of all new movements, they have banded together to declare as utter foolishness "tactilism," the latest form of art discovered by the Futurist leader, Marinetti.

Tactilism, in the opinion of the Dadaists, is "just rot," and in true Futurists' fashion, for they are descendants in the direct line, they scoff at all allegiance to their former leaders and poured scorn on Signor Marinetti when he tried to expound his great discovery before them.

Tactilism, it should be mentioned, is all of touch which, according to the futurist leader, has been sadly neglected by mankind. As much aesthetic and imaginative pleasure, he declares can be had from touch as from sight, smell or hearing. But touching real things is not art. There is, of course, a pleasure in holding a cold stone to the forehead and breast, a pleasure in feeling the waves curl and beat on the body or in a hot bath. But tactilism has not really anything to do with these matters. At least they are only the beginning. Marinetti arranges objects which touched successively tell a whole story just as a poem or a sonata unfolds itself.

Thus he had square inches of different kinds of clothes to represent the lightness and gayety of the French people which is conveyed to senses and brain by touch. When one comes to a strip of silver paper one knows one is crossing the Seine, while a score of other places and impressions of the capital, including the bustle of traffic, are supposed to be conveyed by brushing the fingers over clothes of different texture—at least to those whose nervous systems are properly organized.

To all this "rubbish" the dadaists who make music with combs in schoolboy fashion and pretend at least to gaze enraptured at smudges of color quite unlike anything except an accident, objected violently during Marinetti's speech. Both sides, however, are quite content so to fight, for in that way they make all the more noise in the world.

* * *

September 27, 1921

SAYS AMERICAN ART MUST FOLLOW PARIS

Cecilia Beaux Tells World Congress United States Has No Distinct School

FOREIGN ARTISTS DISAGREE

They See the Beginning of a National School—Painters of 24 Lands to Promote Peace

PARIS, Sept. 26 (Associated Press)—America has no national art and for many years must come to France for inspiration, Cecilia Beaux, a New York artist, told the delegates to the International Art Congress, which opened here today.

Miss Beaux explained that the country was too young to have its own school of art, although the art conscience of the nation had awakened to a greater extent than that of any other country of the world.

"American artists owe a great deal to France and always feel that they have in her an almost infallible source of art knowledge," said Miss Beaux. "America is constantly striving for its own national art and in time it will come, but for many years we shall have to find our chief inspiration in Holland and Italy, and especially in France."

The assertions of Miss Beaux caused much comment among the delegates from twenty-four countries, and in informal discussions after the first session some of the delegates said specimens of American art they had seen indicated a national school already had been established in its preliminary stages.

The United States is also represented by Miss Edith Abbott of the Metropolitan Museum in New York, and John Cotton Dana of Newark, N. J., is expected. Robert W. de Forest of New York, Chairman of the American section, was not present at the first session.

The delegates were unanimous in agreeing that art should try to promote international amity and to prevent war. This could be done best, they said, by the widest dissemination of art knowledge, which would have a pacifying effect on the world.

All the delegates said in their speeches that Paris remained the undisputed art capital of the world, despite the war and the efforts of other cities to assume that title.

The congress will remain in session until Oct. 5. One of its chief purposes is to reassert the pre-eminence of the old-established principles of art as opposed to new movements.

* * *

October 12, 1921

NEGRO ARTS EXHIBIT

To the Editor of The New York Times:

Last evening I went to see the Negro Arts Exhibit, which has been at the New York Public Library, 103 West 135th Street, since Aug. 1. I wonder how many of the art loving public of this city have gone to see it. I wonder how many know how well worth seeing it is. The guardians of the place should have put me out, for I was so interested that I forgot the flight of time, but my pleasure was undisturbed by any reminder of the lateness of the hour. I expected to see something more colorful and bizarre, but found the pictures full of spirit combined with a fine restraint. The exhibit is beautifully arranged, the pictures, the books, the needlework and the basketwork arranged with an artistic love that one felt like an atmosphere. One hopes that hereafter these exhibits will be a regular, permanent feature of the city's artistic life. The negro's contribution to American art is interesting, valuable and full of promise.

LAVINIA LEITCH

* * *

February 7, 1922

ART CLUB TO HEAR PROTEST ON NUDE

George W. Bellows's Painting Immoral, Some Members Complain

TOO DECOLLETE, THEY SAY

Artist's "Old Lady in Black" Took First Prize in Annual Exhibit of 1921

The Arts Committee of the National Arts Club, 15 Gramercy Place, will act at a meeting tomorrow afternoon on protests against the hanging of George W. Bellows's painting, "Nude Girl With a Shawl," in the annual prize exhibition of paintings and sculptures at the club. Some members have complained that the work is immoral, and one formal protest in writing was made to the Board of Governors.

Mr. Bellows's work, together with eighty-one other paintings and five works of sculptors, has been adorning the gallery of the club since Jan. 1. The exhibition was to have been for January only, but was extended two weeks because of delay in preparing a February exhibit.

The painting represents a young woman seated. A black silk gown covers the lower part of the body, but above the waist she is nude except for an airy white shawl that gently caresses her shoulders and arms. The face is attractive. Her straight black hair is parted in the middle and done up into a puritanical topknot. An artist who sympathizes with Mr. Bellows's work said yesterday that there would have been no objection had Mr. Bellows painted an entire nude; that the trouble seemed to be that he had painted a decolleté gown and cut it too low.

Opinions differ among members of the Arts Committee. One said he considered Mr. Bellows was looking for publicity, that the painting was a "stunt," and that the objectors were playing into his hands. Another praised the work, and referred to Bellows's "Old Lady in Black," which took first prize at the annual exhibition of 1921.

"Mr. Bellows is a member of the jury," said John Clyde Oswald, Secretary of the club, and Secretary of the Arts Committee, "and it is the custom to accept exhibits from a member of the jury without any question. Now that a protest has been raised, it has been referred to the Arts Committee, which by our general rule is supreme in all matters of art."

F. Luis Mora is Chairman and George Glenn Newell Vice Chairman of the committee. The other members, besides Mr. Bellows, are Chester Beach, George Elmer Browne, Charles K. Carpenter, Oscar Fehrer, Ben Foster, Edmund Greacen, George Harris Jr., Robert Henri, Harold Howland, Ernest L. Ipsen, Francis C. Jones, Katharine Lord, Hobart Nichols, Henry R. Rittenberg, Douglas Volk, Dan Everett Wald, Edward J. Wheeler and Mrs. Tunis G. Bergen.

* * *

February 12, 1922

FINDS INDECENCY FLAUNTING AS ART

Vice Suppression Society Executive Says Displays in Windows Are Worst in Years

OVERBOLD PHOTOGRAPHS

"Moral Backwash" Since Dry Wave Has Made It Difficult to Fight Evil, Says Summer

The so-called "moral backwash," resulting from the reform wave which carried prohibition through and had strength enough left in New York State to impose a censorship on the motion pictures, is interfering with the work of the Society for the Suppression of Vice, according to John A. Sumner, the executive of the society.

Although Frederick A. Whitin, director of the anti-vice crusades of the Committee of Fourteen, holds that it is impracticable to initiate reform measures of any kind while the present tide of reaction was on, Mr. Sumner insists that it is time for greater activity than ever.

"Temporarily, the producers of indecent photographs which masquerade as art have obtained the upper hand, but we will have it out with them later," said Mr. Sumner yesterday.

"There have been one or two decisions against us which we would have won a year or two ago before the present lax sentiment became so pronounced. We prosecuted the seller of the worst pictures which have been exhibited in show windows for years, if any have ever equaled them before. Two years ago conviction would have been a certainty. But the spirit which seems to prevail at the present time won a victory. The defendant was freed and the picture was decreed to be an artistic pose."

This defeat of the Society for the Suppression of Vice occurred in December. The picture in question had been cautiously displayed once or twice before that time, but since the acquittal it has been plastered in show windows by the hundreds, temporarily eclipsing news, athletic and film star pictures.

The controversy which once was aroused over the innocent "September Morn," whose display was fought by the late Anthony Comstock, appears to date back to Puritan times, in comparison with the picture which in December was held in court to be chaste and artistic. It is a photograph of a woman dressed only in a fishnet of two-inch mesh. The society labored to convince the Court that a photograph was worse than a painting, and that the output of the camera might be immoral, even though similar products of the brush of artists might be accepted as classics. But the Court would not allow that what was excusable on canvas was culpable in a photograph. Since this picture was vindicated, scores of similar pictures have appeared, making window decorations until recently unknown.

"But we will keep right on prosecuting," said Mr. Sumner. "Before long somebody will try to exhibit something still worse, just to see how far he can go. We will go after him and convict him. One week we lost a clear case against a man who has perpetrated a moral outrage, and the next week we convicted a man who, though guilty, may not be quite so bad as the man acquitted."

The Society for the Suppression of Vice temporarily has dropped its fight against bold photographs to carry on a crusade against "double entendres" and rough jokes, which, it is said, are printed in some tiny periodicals.

"We have started three such prosecutions within a week," Mr. Sumner said. "We have had numerous complaints against such magazines, if they may be called that—many complaints from New York City and many from places as far away as Watertown. Some of these publications exist for no purpose but to print smut, and they constitute a new development. The conviction of one or two publishers of such things will put a stop to it.

"Indecent fiction is occasionally printed in some of the magazines whose titles or cover pages suggest that they are very shocking, but most of them are careful to keep on the safe side. We convicted the proprietor of one of them last year, and they have been cautious since then."

* * *

December 3, 1922

J. M. HOWELLS WINS CHICAGO TRIBUNE PRIZE

New York Architect Submits Best Design for the New $7,000,000 Building

Special to The New York Times

CHICAGO, Dec. 2—John Mead Howells of New York City, son of William Dean Howells, novelist, has won the first prize in The Chicago Tribune's $100,000 competition, and thus becomes architect of The Tribune's new building to be erected at 431–439 North Michigan Boulevard at a cost of $7,000,000.

Mr. Howell's immediate honorarium is $50,000. Associated with him in preparation of the design was Raymond M. Hood of New York City.

Eliel Saarinen of Helsingfors, Finland, wins the second prize of $20,000. He was the winner of the second prize in the competition for the peace palace at The Hague. His associates in the preparation of The Tribune design were Dwight G. Wallace and Bertell Grenman of Chicago.

William Holabird and Martin Roche of Chicago win the third prize of $10,000.

The new structure will be named The Tribune Tower. Mr. Howells's design will be executed in stone of a light color. It is a gothic expression of the structural fundamental of the American skyscraper theme. That fundamental is a steel cage.

The fact that there is no impediment to a view of each of the four sides of the building and the further fact that its site is nearly square (100 by 185 feet) have given Mr. Howells an opportunity to plan an effect at once towering and militant. He asserted that the conditions he had to deal with provided the greatest opportunity that has been presented to an American architect for the working out on American soil of effects which up to the present have been best realized in the Woolworth and Bush Terminal Buildings in New York City. Those effects, centring around the commanding theme of a Gothic tower springing from the ground to a height of 410 feet have, however, never been carried to the point expressed by Mr. Howells's Tribune design.

Designs were submitted by architects from every civilized country, all of them beautiful to a marked degree. It is felt that this competition has served to spur architects and designers to greater efforts, and that this will be reflected in Chicago and other cities. It also is considered certain that all of the designs submitted will eventually be sold to builders in Chicago or elsewhere.

* * *

February 3, 1923

WHAT NEXT IN ART AND ARCHITECTURE?

By WILFORD S. CONROW

A wise man once remarked that the doing of something is never so difficult as knowing what to do.

For the sake, then, of both a point of contact and a point of departure, let us consider art and architecture as they are now known and practiced to be problems yet but partly solved. Let us put away any lingering complacency and fancy ourselves animated by keen expectation. Let curiosity urge us on, as James Harvey Robinson has suggested, to wondering and looking, and, perhaps, seeing what we had never perceived before.

We find ourselves living in a time of pulsing energy and accomplishment. There is prosperity enough and to spare, to permit many possessing artistic abilities to receive careful training in the arts, and to give employment to the most

highly endowed of those so trained in their specific fields of art work. Nevertheless, we can be proud without qualification of but too little of all that is being done in the laying out of parks and grounds and in the design, construction, decorations and furnishings of our buildings, either public or privately owned. Why is it so difficult to find today a completely satisfying ensemble, consistent throughout, right for its purpose and beautiful in its environment? The fact that such results have been achieved in certain notable epochs of the past should be but a challenge to spur us on to emulate and surpass them. The writer believes that a generation succeeding our own may accomplish this; but let us bear in mind that the doing of a thing is easier than knowing what to do. Therefore the gaining and disseminating of more complete knowledge than is now common would seem to be our next logical step.

What next to know then? Let us examine our way of doing things in the field of art and architecture. Can we lay a finger on some conical points there? Perhaps it may be the fact that there is today little or no co-operation or inter-relationship between the professions that erect our buildings and furnish and decorate them. But why should there be inter-relationship? Do not they who accomplish great things work intuitively or knowingly in accord with natural law? We should not forget first, that the distinguishing feature of man's mind is his vision of unity (Latze); and second, that his mind is made not only for action but for relations, we being equipped by nature to live in a concrete world of never-ending relations, in a world, in short, in which all things are knit up indissolubly together (H. C. King). The degree of relationship introduces us to proportion, which the reader is asked to remember because it is the key to much that follows. In none of our present-day building and decoration do we carry relationship as far as the more highly trained human mind craves. As a consequence our contemporaneous art accomplishment is inferior to what it may be.

Again it is a matter of common knowledge that a completely uniform and unchanged condition has a tendency to make us lose interest and certainly fails to arouse complete satisfaction. A demonstration that is undeviatingly logical becomes increasingly difficult for us to follow, and we are grateful to the wise man who relieves the strain of concentrated attention from time to time by a play of wit and humor. Yet for several centuries our architects and builders have designed and erected buildings mechanically exact and undeviating in line.

If, therefore, we can introduce into the field of all the arts two things—some factor common to all, and which will serve to interrelate all the elements that comprise a given project; and can incorporate throughout in the construction or execution variations from mechanical exactitude, we shall be satisfying a now too little considered natural demand, and shall have made a logical step toward our goal of greater beauty and perfection.

Happily the present seems a time peculiarly ripe for such an advance, because taste and discrimination have already

become refined to the point of revolt against factory-made furnishings of many types and periods scattered about in the same room, and there is a wide demand for the interior decorator who at least gives possible consistency in period furniture and textiles, and brings in the greater charm of the hand-made. This is good as far as it goes, but it is not enough. The time will soon come when we shall be ready for the general acceptance and application of two immensely useful principles which have been rediscovered, and this should be a matter of national pride, by Americans. These two discoveries are of world-wide importance.

The first is the rediscovery of the principles of Egyptian and Greek design by the late Jay Hambidge, called by him "Dynamic Symmetry," which makes it possible to have interrelated proportion of area in the design of grounds, buildings, interior decorations and furnishings.

The late William H. Goodyear was the father of the second discovery, which the late M. August Choisy of the Institute de France recognized as destined to cause a veritable revolution in architecture. Professor Goodyear has found and proved the existence of intentional irregularities or "refinements" purposefully built into more important buildings from remote antiquity to the Renaissance. Such "refinements" add to a building logically designed and well built qualities which we feel to be mellow, gracious, charming, lovable, whereas we might turn away from the same building lacking the "refinements" with comparative indifference. Refinements in architecture are analogous to wit and humor in a strong, purposeful man. Him we find companionable and likable, and we are glad to co-operate with him in a common task. Lacking these saving graces, his concentrated, undeviating purposefulness could too easily become at last almost unbearable.

Thanks to Hambidge and Goodyear, whose discoveries are so happily complementary, we are aroused to expectant belief that our landscape architects, our architects and builders, our sculptors, interior decorators, mural painters, furniture-makers, craftsmen of all kinds and artists may indeed achieve a perfection of completely interrelated beauty that shall equal, and even may surpass, anything that the world has known. To accomplish this it is necessary that there be throughout complete and understanding co-operation, inspired by intense enthusiasm among all, employed and working under the direction of the master mind, in carrying out some given project to completion. This presupposes a wider spread training in the use of the really simple principles of dynamic symmetry and an intimate acquaintance with the refinements found in important buildings of the past, of which Professor Goodyear accumulated an amazing number of facts in his research expeditions sent out under the auspices of the Brooklyn Museum. It is a matter of general interest that Mr. Hambidge had put in press a new book written from the point of view and for the working designer, artist and architect; and it is to be hoped that Professor Goodyear's manuscripts for his long-awaited books on refinements in cathedral architecture planned to follow his

"Greek Refinements" will be published and so complete his monumental researches.

Among architects, artists and craftsmen in general there has been wide misunderstanding of the essential simplicity of "dynamic symmetry" as a principle. It should not be forgotten that the facts were first arrived at by analysis and that in this, arithmetic, with the long series of decimated numbers which has appalled many students, was a necessary and useful aid. Facts that had been lost to human knowledge since perhaps the end of the first century A. D. were so established. Those who have made practical use of dynamic symmetry so far have been largely those endowed with a certain persistence and concentration which enabled them to translate these analyses into the simple synthesis of the working artist. The only instruments that the Egyptian and Greek designers really needed were a straight edge, a right angle and a pair of compasses or their equivalents, and we can do it all with just these if we will. The demonstration for the art worker of the simplicity of the use of dynamic symmetry is in part the purpose of Mr. Hambidge's forthcoming book.

The Greek principles of dynamic symmetry are found in the thirteenth book of Euclid, and so have never been lost to mathematicians although the fact that these theorems and demonstrations had a practical connection with design had been forgotten for many centuries. The Greeks used by preference certain highly interesting rectangles originally derived from the square and its diagonals which they subdivided into areas proportionately related to the parent area by simple logically drawn lines starting with the diagonals of the whole rectangle and the perpendiculars to them from each of the four corners, which perpendiculars they extended to their point of contact with the opposite sides of the rectangle. From each of these points another line parallel to the side was drawn across to its diagonal and continued across to the opposite side—and so on as described completely by Mr. Hambidge in his publications and in his courses for students of design.

Thus are obtained, logically and naturally, the most significant foci and areas that can be derived from the original rectangle, and the artist is provided with a widely varied choice of points and spaces to which individual judgment and taste is free to attach limit or place the silhouette of a design and of its decorative subdivisions. The result of this when carried out with fine feeling was and is a subtle but recognizable consistency due to truly logical interrelationship in the design and appearance of certainty of rightness and of strength again due to proper co-ordination and relationship. Dynamic symmetry puts, as it were, a vital skeleton into a design and can carry its proportioning properties to the most minute details to which the designer may care to carry them. And the general principles and methods of procedure of dynamic symmetry, be it understood, apply to any rectangle, and their use need not be restricted to that narrower category of especially significant and geometrically interesting rectangles that are found in both Egyptian and

Greek art during the centuries of their most notable greatness. We have in dynamic symmetry, therefore, something capable of introducing a proportional relationship into the design of a project, no matter how vast or how minute it may be. This is truly solid ground under our feet and a basis for a practical look forward toward the future expectancy, which becomes radiant with the unexpected promise of a rebirth in the arts endowed with strength and qualities of beauty that the world has not known for centuries. It should not be asking too much of the reader to imagine himself living in a not distant time when the principles of Hambidge and Goodyear shall be common knowledge and when it shall be possible to have a great body of highly trained men and women working together under a single head on a given commission and with the privilege of carrying the complimentary principles of dynamic symmetry and refinements to their logical conclusion, a serious attempt to create a completely interrelated whole mellowed by intentional deviations from the mechanical. So difficult would such a project be from the proceedure to which we are accustomed that it would really be an epoch-making venture in the field of all arts. The planning of a universal exposition would be a tempting illustration, but for simplicity let us choose a more modest American country place.

It is understood that all minor details are to some extent determined by and partake somewhat of the nature or character of the parent rectangular area. Common sense and local conditions would determine what this parent area should be. The time may come when travel by airplane shall be so common that we shall wish to take into consideration the design of a large terrain as seen from above. In that case the rectangle formed by tangents to the outermost boundaries of the country place, or the rectangle inscribed within it, might be chosen as the parent area. Under more ordinary conditions the architect may decide to use the rectangle enclosing that portion of the grounds on which are to be placed the house, outhouses and the formal garden, or such part of these as can be considered as expedient for the purpose. The character of the terrain itself will suggest much. Having considered all factors and having chosen the parent rectangle, dynamic symmetry can assist the landscape architect, co-operating with the architect, in determining the exact placing and dimensions of buildings, gardens, roads, paths and woods. The architect proceeds by working proportionately from the parent area, to determine the areas of the house in plan and elevation and of all their constituent parts without and within. The areas which he subsequently turns over to the sculptors and mural painters are consequently logically related to the house itself. They, using the same principles of dynamic symmetry, design their decorations and carry them on to completion. The interior decorators choose craftsmen who design and make textiles, wall papers, floor coverings based on that derivative from the parent area which is the area of wall, floor or ceiling of the room for which their products are to be placed, consistency with the purpose of the room and with the style chosen by

the architect always being maintained. Furniture-makers, potters, metal workers follow suit. Contemporary landscape and still-life artists and portrait painters may receive commissions for paintings that shall fill designated areas, each in accord both with the character of the artists' intended composition and with the symmetry of the wall area of the room itself that every picture will appear to and really belong in its environment when hung.

So far so good, but to make this house and its furnishings inexhaustably lovable, the architect, builder and craftsmen, should employ the Goodyear refinements. Harsh straight lines will be avoided. In the house itself in plan and elevation, even in the roof line, intentional deviations from the rectilinear will be introduced, line quality can be added to woodwork, moldings, furniture, picture frames by hand-tooling. Constant and subtle variations should meet the eye if we wish to live in surroundings that will be unfailingly interesting and delightful.

A country place so planned and carried out would provide perennial satisfaction to the mind and the eye. The first complete and master achievement of such a program may acquire wide fame as an epoch-making milestone in the history of modern architecture and art.

* * *

March 18, 1923

BUY YOUR MASTERPIECES BETWEEN TRAINS

The busy man—or busier woman—may now buy a masterpiece between trains. If the business world has no time to go to art galleries, then art galleries must go to the business world. At all events, the pioneer in this democratic venture has just swung out a shingle in the Grand Central Station at Vanderbilt Avenue and Forty-second Street. Paintings by our best-known artists hang but a few steps from the electric locomotives that start our cross-country fliers on their way. The man from San Francisco or San Antonio may step from gallery to parlor car or vice versa without losing more than a fraction of his valuable time.

The new black arrow which has been added to that labyrinthian maze of granite corridors leading to sundry levels blazes a direct trail to the new national art gallery on the sixth floor of the Grand Central Station building. This trail is a short and easy one, ending in a suite of pleasant rooms hung with pleasant pictures—an oasis in the centre of this city of 6,000,000. The commuter, as well as the lonely traveler from afar, may find it a profitable resting place. The gallery will be opened to the public on Wednesday, March 21.

For some time there has been agitation over what would be the most practical way of giving the public a chance to see good pictures hidden away for long periods of time in artists' studios. It was suggested to a group of business men by a group of artists that there should be some way for at least a

portion of these works to be made of service. Pictures must be seen to be admired and must be admired to be sold. They are practically nonexistent when out of sight. As one of the organizers of the Painters and Sculptors Gallery Association put it, practically pictures hidden away are dead capital. Every picture that is sold makes the painter of it better known and gives him a better opportunity for further recognition and sales. And at the same time the public has a chance to see pictures they might not see in any other way and a chance to buy good paintings at a reasonable figure.

A committee of approximately one hundred painters and sculptors, headed by John Singer Sargent and Daniel Chester French, and another committee of one hundred prominent business men throughout the United States are behind the organization, which has worked the initial plan out to completion. For the last six months the work of reconstructing the dome floor of the Grand Central Station to suit the needs of an art gallery has been going on. Five of the rooms have been completed and many of the pictures hung. The remaining fifteen rooms will be completed by Sept. 1.

Pushing through a heavy curtain into the first room of the new gallery, the visitor is greeted by the sound of falling water. A small fountain splashes in a red-tiled basin. Three maidens in a Blashfield mural, their pale fingers straying among paler lilies, guard this spacious anteroom. Four tapestries hang against the walls. Glimpses of smaller rooms beyond and a narrow apartment with a gilded niche at one end, a window at the other. To the right of the entrance down a short corridor is the salesroom, hung in gray-brown velvet. And off that room, in a good-sized apartment, convenient racks hold the pictures which are for sale. Those already hung are also for sale, and will be replaced at intervals by the paintings from the salesroom. In this way the public will have a chance to see at one time or another hung on the walls of the new gallery all the pictures sent to the committee.

Colorful canvases of life among the Pueblo Indians of far-off New Mexico give vivid emphasis to the two-toned hand-plastered walls. A red-haired girl, a purple book, grapes piled high in one bowl and nasturtiums in another, attract the layman fond of bright tints; while a pleasant woodland scene, with a log thrown across a lazy stream, attracts the pastorally minded. Many of the canvases are small and would lend themselves to the needs of apartment dwellers who long for at least one small painting to enliven their walls. Prices are as democratic as the venture. A hundred dollars buys a picture. And there are others for $10,000.

Among the pictures now in place is the painting presented to the gallery by John S. Sargent. The background of this work suggests the Maine woods to the layman, and the man in white duck on his camp stool is an arresting figure against the dark pines and scraggling tree stumps. Charles Hawthorne, Edwin Blashfield, Ezra Winter, Ralph Clarkson, Cecilia Beaux, Ernest L. Blumenschein and Robert Chanler are a few of the long list of prominent painters whose pictures are to hang in the new gallery. A collection of interesting sculpture has been

"The Artist Sketching," by John Singer Sargent.

sent in by well-known sculptors, among them Robert Aitken, Daniel Chester French, Lorado Taft, Frederick MacMonnies, Janet Scudder, Mrs. Harry Payne Whitney, Gutzon Borgium and Herbert Adams.

Not only will the new gallery provide a centrally located selling place for works of art, but it will be the headquarters for collections of pictures which will be sent out to all parts of the United States and exhibited. The founders claim that the work of the gallery will in no material way interfere with that of regular picture dealers. It will instead be a means of reaching a large number of people who would not be apt to purchase pictures in expensive galleries, and who later may be led to do so. The committee has already planned to send exhibitions to Western cities.

Whether or not works of art should be placed in public buildings, railway and subway stations, and other places where city crowds gather, has been a question causing curious vituperative reactions from various groups of people. Many of more democratic views feel that this placing of paintings and sculpture in places easily accessible to the general public will create a broader national interest in art, and will result in the personal acquisition of a larger number of good pictures. The plan as so far worked out has succeeded in bringing together not only a considerable group of our best painters and sculptors, but a large number of men and women earnestly interested in art and its future development. Members of the laymen's committee each give $600 a year for three years. This fund has been found sufficient for merchandising the pictures, for rental and other expenses. Artist members give one picture a year for three years. This entitles them to life membership in the organization, and they may send as many paintings as they wish, to be sold by the gallery. A very nominal percentage will be charged for pictures sold. The intention of those behind the project is to clear nothing beyond expenses.

One of the important features of this new enterprise is the opportunity for younger men whose work has not yet become

widely known to exhibit their paintings and sculpture in a good gallery with little or no expense to them. And with the plans for exhibitions in various large cities throughout the country, the possibilities for selling these pictures are greatly increased. For the man of established reputation the added publicity will not mean so much. But the interest which artists of national and international prominence in the art world are taking in the project will be of immense value to the whole art fraternity. It is in a way what the Equity Players are doing for their profession—helping to market the talent of younger players who without this assistance would have a hard time in reaching successful and prominent places in the theatrical world.

In older countries the value of art treasures as a practical business investment has long been recognized. Even in our young and less sophisticated land, paintings of American artists have sold for very considerable sums of money. This is another point brought out by the men who are behind the present venture, and who are looking on the enterprise as a new venture in the art world capable of wide development. It is probable that the permanent gallery in the Grand Central Station is the forerunner of other permanent galleries throughout the country, although the committee has not considered this phase of the question further than to plan on taking exhibitions to various large cities.

Artists say that the difficulty and expense of packing, shipping and insuring their pictures have handicapped exhibitions of their works, which would not only be of interest and value to the entire country, but would also be profitable to themselves. The wider field which the committee is opening up by assuming all responsibility for the showing of objects of art marks a new era in the development of this side of America's activity.

Nearly forty New Yorkers have given their support to the Association of Painters, Sculptors and Laymen, among them being Irving Bush, Mrs. Joseph H. Choate, Robert de Forest, Miss Helen Frick, Walter F. Gifford, Mrs. E. H. Harriman, Mrs. Otto Kahn, Mr. E. R. Stettinius, H. B. Thayer, Paul Warburg and Mrs. W. K. Vanderbilt. Other members are Charles L. Hutchinson, Potter Palmer, R. T. Crane Jr., R. P. Lamont and a score of others, all of Chicago; General Butler Ames, Mrs. Oakes Ames, Dr. Richard C. Cabot and Arthur R. Sharp of Boston; Samuel Rae, Mrs. Edward T. Stotesbury, W. M. Elkins of Philadelphia; William K. Bixby, Wallace D. Simmons of St. Louis; James Parmelee, Charles C. Glover of Washington; John Hill Morgan of Brooklyn; Howard Heinz of Pittsburgh; Mrs. William Sloane of Norfolk, Va.; and Miss Lucy M. Taggart of Indianapolis. Many other names well-known throughout America appear upon the lists of the two committees.

Delano & Aldrich are the architects of the new gallery, which, according to Joseph Pennell, "has the finest lighting system he has ever seen." The rooms so far finished are pleasant, intimate and un-gallery-like. There are no bleak distances or gloomy vistas often sadly unescapable in larger picture galleries. The two-toned walls have warmth and glow, not found in the usual rough gray plaster finish. With air-cooled ventilation and outside windows, the gallery is able to take care of large crowds without subject visitors to be of the heavy, dead air found in so many art galleries. In fact, the plan has been worked out with a view to giving the public all possible comfort in their first national art gallery.

* * *

April 22, 1923

CENTURY OF PHOTOGRAPHIC PROGRESS

After millions of scattered snapshots, the whole art and science and business of photography has been gathering its forces for a gigantic "time-exposure" a week long in Grand Central Palace. The occasion is the First International Photographic Arts and Crafts Exposition, which opened yesterday.

The entire development of photography is included within the past century. Indeed, the written account of Daguerre's most important discoveries was not turned over to the French Government till 1839. But it happens that in this very year of 1923 France is planning to celebrate the centenary of discoveries made by another man whose name is scarcely known here—Joseph Nicephore Niépce.

Niépce deserves a place in the sun, for he was one of the great pioneers in the development of the sun-picture process. But curiously enough, the predecessor of Daguerre left the key to a method that had to wait till the end of the century before it came into general use. He was the real Columbus of the photo-engraving. His experiments were largely made on metal. He had obtained interesting results as early as 1816. By 1823 he had advanced perhaps to his highest essential achievement. But Daguerre only heard of him in 1826. They corresponded and agreed to pool results. Thereafter it was Daguerre who took the final steps to effective use of sun-portraiture.

Like Darwin and Wallace

England contributed important features through Sir John Herschel and William Henry Fox-Talbot who showed primitive photographic prints within a few weeks after the great news from France. Fox-Talbot's relation to Daguerre is not unlike that of Alfred Russel Wallace to Darwin, in the development of the theory of evolution.

The first instantaneous photograph is said to have been taken of New York harbor in 1854.

Due attention will be paid to history in the approaching exposition. But the applications of photography to the uses of today are so various that a large part of the space will be needed to give the spectator a lens-eye view of the present. Here are a few points that suggest the wide range of the camera's use:

Astronomy's amazing progress would be inconceivable without the lens as a means of recording as well as exploring. It is said that more photographs of the heavens are taken at

Harvard than anywhere else on earth. It is a pretty clever star that gets away from that sky-detective bureau.

Chester F. Stiles, of the Goerz Company, one of the organizers of the present show, happened to be at Harvard when the report came from Germany of the discovery of Eros. The Cambridge astronomers looked over their records and proved that they actually had the photographic basis for more accurate and complete data about that "unknown" luminary than they could obtain from the discoverer. They simply hadn't got around to checking up accounts.

During the war the Department of Justice in Washington took 36,000,000 photostats.

Bacteriology owes much to the lens. Photomicrography is just beginning to be applied extensively to analysis of metals.

Views of the stomach's interior may be obtained by swallowing a miniature camera, with a tiny electric light.

There is no end to the improvement in detail throughout the whole process of picture-making—in the camera's construction, the lens, paper, methods of development. Consider the matter of speed. Niépce's process took ten hours, Daguerre's forty-five minutes; it is now possible to secure a negative with an exposure of $\frac{1}{2,000}$ of a second.

There is one phase of possible development that seems to be as slow as a siege. That is color. A few good things are shown on glass, but no practical method has been successfully worked out for recording actual colors as the eye sees them in a final print.

Color Comes Slowly

The moving picture demand for color is helping to get action. Here the problem ends with the negative film. One method is to run parallel strips, each bearing a different color. These are expected to blend on the screen, but sometimes they fail to synchronize. A recent variation places one color on each side of the same film.

The spirit of the old-time photographer is shown by the reaction Sir Arthur Conan Doyle has produced with his spirit photographs. The exposition authorities are very certain that the great body of interests they represent would refuse overwhelmingly to accept any supernatural explanation. They seem to feel that the honor of their craft is somehow involved.

S. H. Horgan, who made the first half-tone plate, declares that if Sir Arthur will come to the Orange Camera Club, he may have his portrait taken with any ghost he pleases.

Spirit Pictures Not New

"There isn't one of these ghost effects that photographers have not known how to make almost from the beginning," declared Mr. Horgan. "In 1875 a man named Mumler did a land office business in Boston taking spirit portraits at $10 each. They ran him out of town and he came to New York and founded an electrotype company."

Many so-called ghost pictures have a wholly natural explanation. For example, during the war photographic supplies ran short. Manufacturers got all the old negatives they could collect, cleaned and resensitized them. But old negatives have a way of clinging to the glass, in spite of every means taken to insure their removal. So every now and then a dim trace of an old portrait would appear beside the new image. People whose friends had been killed might sometimes find in these shadows the likeness of their desire.

Some of the methods of producing "spirit photographs" are described in "Photographic Amusements," by Walter E. Woodbury (American Photographic Publishing Company, Boston). This book was written years ago and is now in its ninth edition.

"With a weak-minded sitter, over whom the operator had complete control, the matter would be in no wise a difficult one. It would then only be necessary for the spirit, suitably attired for the occasion, to appear for a few seconds behind the sitter during the exposure and be taken slightly out of focus, so as not to appear too corporeal.

"If, however, the sitter be of another kind, anxious to discover how it was done and on the alert for any deceptive practices, the method described would be rather a risky one, as he might turn around suddenly at an inconvenient moment and detect the modus operandi. In such a case it becomes necessary to find some other method where it would not be requisite for the 'spirit' to make its appearance during the presence of the sitter.

"The ghostly image can be prepared upon the plate, either before or after the exposure of the sitter. The method is this: In a darkened room the draped figure to represent the spirit is posed in a spirit-like attitude (whatever that may be) in front of a dark background with a suitable magnesium or other artificial light thrown upon the figure, which is then focused in the 'fuzzy-type' style; or, better still, a fine piece of muslin gauze is placed close to the lens, which gives a hazy, indistinct appearance to the image. The exposure is made and the latent image remains upon the sensitive plate, which is again used to photograph the sitter. Upon developing we get the two images, the 'spirit' mixed up with the figure. The spirit should be as indistinct as possible, as it will then be less easy for the subject to dispute the statement that it is the spirit-form of his dead and gone relative. Some amount of discretion in this part of the performance must be used, we fancy, otherwise the same disaster might happen as did to a spiritualist some little time ago. An elderly gentleman had come for a séance, and, after some mysterious manoeuvres, the gentleman was informed that the spirit of his mother was there. 'Indeed,' replied the old gentleman, somewhat astonished. 'What does she say?' 'She says she will see you soon,' informed the medium. 'You are getting old now and must soon join her.' 'Quite right,' replied the old gentleman, 'I am going around to her house to tea tonight.' Total collapse of spiritualist.

"Fluorescent substance, such as bisulphate of quinine, can also be employed. This compound, although almost invisible to the eye, photographs nearly black. If a white piece of paper be painted with the substance, except on certain parts, the latter only will appear white in the picture."

This book reproduced as illustration a portrait by a so-called "spirit photographer." W. M. Murray, a member of the Society of Amateur Photographers of New York, called attention to the similarity between the "spirit image" and a portrait painting by Sichel, the artist.

The Australian Photographic Journal once printed the following method of making so-called spirit photographs.

"Take a negative of any supposed spirit that is to be represented, put it in the printing frame with the film side out, lay on the glass side a piece of platinotype paper with the sensitive side up, clamp in place the back of the printing frame and expose to the sun for half a minute. Now place in the printing frame the negative of another person to whom the spirit is to appear and over it put the previously exposed sheet film side down; expose to the sun for two minutes until the image is faintly seen, then develop in the usual way and the blurred spirit photograph will appear faintly to one side or directly behind the distinct image. Sheets of paper with different ghost exposures can be prepared beforehand."

* * *

May 20, 1923

THE WORLD OF ART

Some of the Paintings to Be Seen in Washington

M. Jusserand said the other day that he had seen one-quarter of the population of Washington added in the twenty years since he came to America. Probably the growth of the city in paintings of assured merit in public and private collections has been still more rapid. The opening of the Freer Art Gallery naturally will give impetus to collecting and installing at the national capital, and that—together with the fixing of Whistler's place in the national consciousness—will be its first best gift to America.

But the Freer Gallery is not, of course, the only step that has been taken either toward collecting works of art or fixing Whistler's place. Wisdom and taste have been shown spottily perhaps, but unmistakably, in the acquisition of pictures by the Smithsonian Institution, by the Corcoran Gallery of Art and by Duncan Phillips in his Gallery of Modern Paintings. Taking them altogether you could not possibly afford to miss Washington in any truly devout pilgrimage.

The quartering of the art field in Washington is decidedly intelligent in its original idea, although even more decidedly evaded and broken into by benefactors and others. In the Smithsonian Institution you are supposed to look chiefly for old masters, but the Evans collection of modern pictures is so extensive that the old masters are crowded to the rear. At the Corcoran Gallery most of the recent accessions are both modern and American and include beautiful examples. The Library of Congress takes care of the prints, most of them, but prints are practically everywhere. There is nothing to

lament in this and nothing to lament in anything, for that matter, save the visibility of the city's sculpture and certain rank insults to the city's plan which belong to another chapter, or series of chapters.

For the present the limited space of a couple of newspaper pages may be counted upon to overflow with even the little that can be said concerning a few Duvenecks and Sargents, Homers, Ryders and others in Washington and not in the Freer Art Gallery.

It is said that Mr. Sargent liked his forgotten "Oyster Gatherers" when he ran across it at the Corcoran Gallery. It is proof of strength when a painter can look back some forty years and see that he was good. And Sargent was amazingly good in "The Oyster Gatherers," painted when he was 22 years old. That, to be sure, was a ripe age for a man who began work when he was 4, but at least he was not yet the magician of the Boston decorations or the London portraits. A group of girls and women with their oyster baskets moving across the silver sands, their figures casting shadows where it happens to be dry and reflections where the moisture is concentrated in shallow pools. The tall foreground girl is handsome and vivid, with red gold hair and bright notes of color in her clothing, definitely affirmed as to form and feature. A towheaded boy at the right rolls up an abbreviated trouser leg. Other figures troop down. It is all realism tempered by joy in objective beauty and natural grace. Straying figures in the background write with the foreground figures in an undulant garland of line and color. A curious hint, difficult to trace, of "L'Embarquement pour Cythère" in a fresher and more youthful mood, other echoes of Watteau, and of Claude also, in the pale shimmering light and the elegance of the forms. There are more experienced pictures in the collection. Few are lovelier. Its qualities are youth, health and genius.

Much later in the day Sargent painted another picture now in the same gallery, a recent accession and not yet catalogued. This is the portrait inscribed "To My Friend, Dan Nolan." It is contemporaneous with the portraits of Mr. Rockefeller and Mr. Wilson, a performance superior certainly to the latter, which might be expected as the artist was painting his pleasant friend, an employe of the Copley Gallery, Boston. In the nature of a sketch it still is an unmistakable oil painting, which is just what Nolan wanted. Sargent had offered to do a drawing of him, but he was disappointed and said he would rather have a painting. So he had it, and his widow has the proceeds of its sale and the Corcoran Gallery has the vigorous easy study of the spirited head, candid and good natured, with a touch of defiance in the square mouth, mark of a race that defies all things. The story is current in Washington that a rich man, attempting to get through the eye of Sargent's needle, inquired his whereabouts of Nolan, saying that he was going to try to get him to paint his portrait. "Well," said Nolan, "he's down in Florida now, painting John D. Rockefeller. He's going to stop off at Washington on his way back to paint President Wilson. Then he's coming to Boston to paint me."

"The Oyster Gatherers," by John S. Sargent. In the Corcoran Gallery of Art.

Another recent accession by the Corcoran is a landscape by Kenyon Cox. Cox was pioneer in America in painting the nude, a thoroughgoing student of the anatomy of the human figure and of the principles of mural painting. No one more conscientiously built the scaffold of design upon which mural decoration depends for its permanence of interest. But very few of his figure subjects and decorations are so intimately appealing as this heavily modeled landscape with its kinship to La Farge in the rich naturalism of the forms that nevertheless fall into decorative relation. The palette is brown, red and green. Unimaginative color, unimaginative vision, stability, sincerity, straightforwardness and impregnable dignity. It was in line, apparently, with the present policy of the Corcoran Gallery to acquire something by a well-known painter at once characteristic of his quality and refreshing in its unfamiliarity. The notion of getting something because it is almost exactly like something else only recently has become unpopular with public and private collectors.

The Corcoran also has the "Self Portrait," by Abbott Thayer, more in the nature of a revelation of human character than anything in the Thayer group at the Freer Art Gallery. An emphatic note, convinced and convincing. It is interesting to compare it with the portrait of Anne Palmer Fell, now on loan in an adjoining room. The latter is the early Thayer, filled with a tender distinction. The flesh is softly modeled and glows with the agreeable warmth of the friendly pigment known as "light red." In the "Self Portrait" manner and technique have changed completely. The madders in the flesh tones lend a hint of macabre to the color. The head is modeled as though with clay flattened with a modeler's knife.

In Washington are three examples of Frank Duveneck's painting that show him more diversely than he is seen in any city other than Cincinnati. Not very "important" examples from the point of view of those who estimate values by the accidents of size and period, &c., but extremely important from the point of view of the artist and student of art. No one could say much against the size of the "Water Carriers" at the National Gallery except, perhaps, that it is too big. It is not one of the finest Duvenecks, but it shows the kind of thing he did in paint when the subject was the kind of thing he did better on a copper plate (or probably a zinc plate).

The sturdy, careful painting of the masonry expresses, however, more clearly than most paintings of Venice are asked to express it, the massiveness of the city that melts so distractingly and misleadingly in air and light. Duveneck in all his Venetian work, etchings or paintings, gives us a Venice that is tangible and vigorous in architecture, cheerful, easy-going, happy on its human side, eloquent of a place built for a long

"Portrait of Daniel J. Nolan," by John Singer Sargent. Recently acquired by the Corcoran Gallery of Art.

life and traditional importance. The backgrounds are full of the strong vitality of the past, the foregrounds of the glib picturesqueness of the present.

Elsewhere in the same gallery is the head Duveneck painted from Walter Shirlaw. It is worth while to note first the extraordinary likeness, just to rub it in that a great portrait painter is apt to get an admirable likeness, and that to crawl out of this responsibility on the ground of giving instead a work of art is not now and never has been cricket. No one who ever made a drawing under Walter Shirlaw's whimsical eye will fail to find likeness in this brusque painting.

Just as painting it is in the vein of the splendid head at the Brooklyn Museum, flat and sallow and swept into being with careless authority. Painted over a dark ground, it is cracking, or rather crackling, but in spite of this preserves its effect of unity.

The third Duveneck is a little head, acquired a short time ago by the Corcoran Gallery—a head in which Duveneck speaks with an altogether different accent, but one quite as unmistakably his own. A brown head of a young girl, a child, in a brown hat tied under the chin and over rumpled brown hair; the beautiful brown little face also a bit rumpled, very plastic, the eyes a trifle screwed up as though the sun were shining in them from without and a delicious spirit of mirth were shining through them from within. On the hat is a bunch

of flowers, and for this the artist has used the end of his brush handle, scribbling it in. The bow at the throat is scribbled in by the same means.

The Phillips Memorial Art Gallery, to use its formal title, probably still needs to be explained to the general public, although the plans have been made and discussed for several years.

The general plan is related to that of the Freer Art Gallery in two particulars, differing from it in all other respects. The idea underlying the grouping of different schools and nationalities is the essential homogeneity of all great art; the exhibition idea involves keeping to a restricted and intimate gallery space, the items not on exhibition being disposed conveniently for reference at the request of students. The collections are to be kept flexible, with additions and subtractions at will. Modern painting is especially emphasized, although a fine El Greco is one of the first things to the eye in the temporary quarters on Twenty-first Street.

The paintings now on view in the temporary gallery and elsewhere in the house in Twenty-first Street range through many degrees and phases of stimulating beauty. Even more acutely than in Mr. Freer's collection the impression is given of one man's choice, since in the case of Mr. Phillips the choice depends more securely upon a personal response to esthetic claim. The breadth of the inclusions makes an exacting demand. To browse in the fields of modern art and choose what seems to one contemporary taste most to be coveted, without falling back upon the extraneous "educational" interest, or the interest of expert approval, or any interest except the esthetic appeal of the pictures themselves, is to set one's self an appallingly difficult task, one that can be carried through only with the help of profound conviction.

It is therefore the happiest discovery that the collection, the part of it displayed, is composed almost entirely of works that Berenson would call life enhancing, that give no suggestion of declining to prettiness or stereotyped substitutes for personally interrogated form. Personal predilections are boldly followed. The predilection for the work of Arthur Davies is followed, to the strengthening not only of the collection but of the public estimate of this so various talent. Upon one wall is found the early "Rose to Rose." Probably early. The date, forgotten, is not essential, since the point is that the picture belongs to a mood now gone and probably never to be recaptured. A Venetian mood, ripe to the danger point, opulent in form, luscious in color, the fruit of delight in material charms. A girl with hair of "Titian red," the true Titian, is combing the hair of another girl. The lovely young faces are rounded and rich with health and warm in color. It is quite a glorious episode in the artist's already ample performance, and, recalled in connection with the exquisite painting "At Her Toilet" in the Bliss collection, awakens a possibly unkind regret that Mr. Davies failed to stick to this particular last. He still was at it when he painted the "Children in the Wood," a deep background of green foliage, the foreground festooned with lively figures, natural

figures just enough diverted from normal to be individual without insistence.

There are other things, nice but not compelling, and then we come to the "Tissue Parnassian," a new decorative note in American painting, stemming apparently from the painters of Japan, the eighteenth-century painters now represented in one room of the Freer Gallery. The relation is chiefly in the reduction to one plane, the sacrifice of many beauties to one, the denial of rhetoric, the economy of statement and the substitution of suggestion for statement—an array of relations. Yet the differences are as many. The trees in this milky fabric of sparse stitches are in the modern manner of Cézanne, beautifully adapted to a Davies arrangement. Yet not so Cézannesque as altogether to avoid a hint of Gainsborough's scribbled outline about his color patches, so generalized and elegant. Then the figures in themselves are rather Greek than Japanese, and the one figure leading with immense stride from right to left across the composition is neither Greek nor Japanese, but pure Davies, leaping out of the real into the ideal with unhuman energy. Such a handsome painting and so expressive of the link between poetic feeling and visible beauty that you only can understand your failure completely to enter into the vision by reference to another and simpler vision on the adjoining wall, the "Winter" by Twachtman.

Twachtman also felt the influence of Oriental spacing, of Oriental reticence, but his art, like that of Whistler, was chiefly a matter of supreme instinct, the discriminations of a mind incorrigibly artistic, that among all the confusions and possibilities of the given scene, flies to its own as a bird to her young. Nothing planned and directed can take the place of this instinct, rising out of the subconscious, of course, where all memories are held. In Twachtman's picture it leads to a potent stillness. The stillness of a Winter scene, alive but sleeping; pale, but warm in pallor; quiet yet stirring pulses, expectant placidity. The absence of pose, even of attitude, in the gentle presentation of the beautiful theme supports better than any external imitation could the Oriental point of view. "The world thinks," said Li Ling-mien, "that placidity must necessarily be associated with a cross-legged position but placidity is in the heart and not on the outside."

In the Phillips collection color and romance abound. Two Ryders, among the Americans, strike the keynote. One is a sea picture falling a trifle short, pleasantly short, of stylization, and thereby achieving a greater style. The pattern of cloud and wave and boat is clearly felt, but less than usually emphasized. The other is a figure subject, "Desdemona," in which, as in most painting of as pure an emotion, classic and romantic meet. The figure of Desdemona hints at the proportions of the Elgin marbles, but in the suffusion of color and muffling glazes we meet the mystery which it was the aim of the Greek to do away with.

Inness, however, is here in the strength of an early landscape, 1869, brilliant, natural, with a good bony understructure. A building on a cliff, hills and tree and curving water, a

cloth spread with picnic intention on the grass, gay animated figures; a thoroughly pleasant example. Luks is here, also in formidable dignity. "The Dominican" holding its own and more than holding its own with Greco. There are splendid Lawsons and the Roman water color by Maurice Prendergast. Weir is exceptional in a picture of monumental boulders seen at close range, the gray stone dappled with patches of cold green foliage, warming and lightening toward the crest. Rockwell Kent's burial scene communicates a sense of reality the more potent for its absence of obvious emotion. Whistler's "Lilian Woakes" is one of the perfect things that find their way to every one.

There are many other Americans, and to weave along among them is finally to come full upon modernism in Preston Dickinson's "Along the River." The sharp young enunciation in this painting curiously separates it from everything else. Nothing else speaks in just that way, yet the things said are not so different. Breughel said his trees like that, almost exactly like that, with small, stark black branches. Greco said color like that, coldly penetrating with sabre thrusts of light. And the Chinese were that way in their drawing, caligraphic. Everything looks very simple and real, very careful and true, and with no pretense of anything only an extreme effort toward accuracy. That is the note of modernity. Tell truth and shame all the devils of the sentimental past.

* * *

January 20, 1924

BLACK BRICK BUILDING FOR NEW YORK CITY

Daring Departure From the Conventional in American Radiator Company's New Structure

A daring departure from the conventional in office building construction marks the new home of the American Radiator Company at 40 West Fortieth Street.

Unlike any office building in the country, the new structure is faced entirely with black brick with golden colored stone trimming, worked together to give a rich black and gold decorative effect.

The building has already provoked wide discussion in professional circles because of its unique design. It contains 77,000 square feet of floor space, 22,000 of which will be occupied by the American Radiator Company's executive offices and New York sales branch, including extensive show rooms on the ground floor. An interesting feature is that over 90 per cent of the floor space is within 25 feet of windows.

Raymond M. Hood, architect, associated with John M. Howells, who took the first prize for The Chicago Tribune building in the international competition held last year, designed the building. Of its features, Mr. Hood says:

"The radical departure from standard practice arose from a feeling that so many office buildings are monotonous if not ugly.

"Monotony and ugliness in office building seem to come from the fact that the windows are actually black holes, and the regular spacing of these black holes makes a building look like waffles or doormats hung up to dry.

"The solution to this problem lay in finding a color of wall that would tie together the black holes and make them less apparent. Rather timidly, black was suggested, but with fears of producing a gloomy result.

"But as the building progressed we found it struck a very cheerful note. The idea of gold trimming came next and caught the fancy of us all. Precedent, at least in Europe, pointed to other periods of architecture where black had been used effectively, particularly, for example, in the Grarde Place of the Hotel de Ville, Brussels. In Pompeii, also, and in France at the time of the Empire, whole rooms were done in black with only a slight relief of color.

"We felt that the old problem in office building design demanded a new solution and that just as other architects have broken away from conventional treatment in certain directions and raised the standard to higher levels, we might contribute a new plan of coloring which would make for progress."

The building was erected by Hegeman-Harris Company, Inc., builders, and occupies a plot 77 feet front by 100 feet deep. It is estimated that the building, including land, when fully completed, will cost in the neighborhood of $2,000,000.

Cross & Brown, 18 East Forty-first Street, have been appointed renting and management agents of the structure, which will be ready for occupancy about May 1.

* * *

January 27, 1924

THE WORLD OF ART

Modern Art of One Kind and Another

The public is like the Frenchman who was glad he disliked spinach, because if he liked it he'd eat it, and he hated it. The public delights in hating modern art, otherwise it would have to look at it. To make the public look at it is the aim of all its friends.

No better means to this end has been devised than the portfolio "Living Art," issued by the Dial Publishing Company. This folio consists of twenty facsimile reproductions after paintings, drawings and engravings, and ten photographs after sculpture by contemporary artists, the originals selected by the editor, Schofield Thayer.

Mr. Thayer explains in his preface that although the idea was to bring together examples of the best and most characteristic work of the leading artists of our time, many had to be left out—a necessity hardly calling for statement—not only on account of the unwieldy proportions the folio promptly would assume with any additions to its already liberal contents, but partly because it is an absurdity to consider the finest possible reproduction of an oil painting a "facsimile." In spite of the latter difficulty Bonnard and Matisse were considered so supremely and fundamentally important that their work, albeit in oil, was included in the representation. Moreover, it is a party of associated temperaments and Monet, Zuloaga, Sickert and Sargent received no invitation, no doubt were hurt, but it couldn't be helped. Moreover again, the word "living" in the title must be taken in a spiritual sense in order to account for the presence of the German sculptor Wilhelm Lehmbruck who has been dead four years. As the title is "Living Art," not "Living Artists," this part of the explanation is superfluous, but the whole matter of adjusting words to art, living or dead, is too difficult for quibbling.

The first plate in color is "La Rochelle," by Paul Signac. The "proud city of the waters" loses none of its pride under the touch of this Neo-Impressionist. The roundness of towers, the movement of cloud and water, flattened reflections, all clearly understood and conveyed in light patchings of rose and blue, with modifying notes of yellow; the construction as delicate as the color and as clear; no confusion of form, no fusion of colors; an exquisite picture to have by you—a French port seen from a window; enchanting. With the best will in the world to indulge a personal prejudice against color reproduction, it is impossible to find the sweet thing injured by the printer's translation. In the absence of the original, at least, it seems to have Signac's true quality, even to the sensitive gradation of his blues that pass imperceptibly into green.

With the second plate Bonnard and the problem of reproducing oil painting. A pleasant Bonnard, a farmyard or something with cattle and goats and chickens and children, treated with originality and probably very nice in color, but the color of the reproduction does fail in luminosity, and that is just where you cannot make yourself believe that Bonnard would have failed. The Matisse gives you the same sense of disappointment, but it should be kept in mind that Mr. Thayer told us so, that he practically said, "They'll be failures, of course, but we had to have them." That is just the case, but a much better Matisse than the well-known "La Danse aux Capucines" could have been found for the purpose, one with his arabesques in black, to keep the color more within the frame.

Next come half a dozen paintings in water color and tempera, "Les Collines," by André Derain, very synthetic, but without much fullness of expression, a good thing to choose, since it would be difficult to go wrong with it; a street subject by Vlaminck, the originality of which lies chiefly in the manner of laying on the sepia washes, heightened with vermillion, but another perfect choice for purposes of reproduction, impeccable as this, and a handsome open composition with lots of air and space, the abruptly foreshortened street curving nobly; a tempera painting of horses by Picasso, beautiful

horses stepping into the waters of a blue bay or out from them on to a brown shore, nude riders, simplification carried as far as a vibrating outline permits, the kind of thing that might have been done by a Greek provided he was also Picasso; "Lower Manhattan," by Marin, master of water color, but not in this case of design, the variations of scale expressing, no doubt, the artist's sense of the inchoate aspect of lower Manhattan, but expressing also an incoherence of esthetic plan. Again, however, the selection must be praised for its appropriateness to the reproductive processes used by these masters of printing, whoever they may have been, who convince the eye beyond the power of the best of phonographs to convince the ear.

Demuth's "After Sir Christopher Wren" in tempera and practically printer proof, with its neat boundaries and limited palette of sober browns and grays, touched here and there with sedate reds and a good common blue. An aviator who saw it some years ago said the air was painted as it felt when you were flying. An almost wholly uninteresting embroidery by Duncan Grant, agreeably vivacious in its changes of direction, otherwise an empty caprice, but certainly as good here as it can have been in the original. Finally, a water color by Marc Chagall, the Russian pupil of Bakst and follower of Picasso, more openly dependent upon human associations and memories than any one else in the group, a brilliant designer, vital, intense, visibly seeking to make the spirit penetrate the mask. In its contrasts and bold silhouette this plate is the most convincing of them all, not a translator, but a transcription.

Passing to the drawings, the case naturally is much simplified. Nothing to interfere with the autographic effect. A pen-and-ink drawing of a Spring morning (why, with such efforts and such successes, should a proofreader have balked at the spelling of so simple a word as "morn"), the artist André Dunoyer de Segonzac, the picture, little slim trees shaken with merriment like giggling girls, swift clouds, a clear stream, all loveliness and nothing to startle an Academician; a woodcut by Edward Munch, "The Last Hour," concentrated sorrow with more than a hint of horror, pure Munch; Boardman Robinson's "The Hands of Moses," less compressed, less moving, easier to refer to literary sources, the year, 1918, explaining much; a woman's head in red crayon by Gaston Lachaise, monumental in the style of his sculpture; a pen-and-ink drawing by Pascin, thin line suggesting fat forms, infinite bulk in a little room; a pencil drawing by Wyndham Lewis, firm, delicate-mannered; a girl's head by Marie Laurencin disguising a sharply defined idea in a gray mist, a note of sharp rose color, another of blue, hints of feathers and flowers and ribbons and lace, the Nattier tradition expressed in a personal idiom, the unfamiliar argot of the modern studio, leaving off at the moment of beginning, carefully emphasizing a trifle, leaving vague the matters of importance, content to be peculiar so long as there is no slovenliness.

Then three versions of Picasso illustrating his versatility of mind, "Le Ménage des Pauvres," well known but always arresting; a pen-and-brush drawing of two women, one

From "Living Art." The Dial Publishing Company.

"After Sir Christopher Wren," by Charles Demuth.

draped, the other nude, but made apparently as a first study for a draped figure, all the modeling done with a scurry of line and a bit of tone rubbed into the drawing where the third dimension was wanted, the kind of thing for a student to memorize in order to free himself from the bondage of "good drawing," on the whole, the most valuable plate in the collection; last, a pencil drawing so complete of line that the complicated beauty of the composition is too easily ignored, a line soft, warm, flawless, beside which ink has no standing or rank.

The photographs of sculpture one would think more manageable, but in reality they are less successful—are, that is, altogether too much "in reality." The realism of a photograph is an afflicting property and the proof of it is here. The heavy black backgrounds of Maillol's two figures seem to creep into the shadows, laying upon them a deathly weight of impenetrable substance; Lehmbruck's "Kneeling Girl" is better, with its lighter background, but there is little enough vitality; the bronze figures by Ernesto do Fiorj and Alexander Archipenko suffer hardly at all, nor does Brancusi's marble or Frank Dobson's woody carving in ash; but the "St. Francis" of Alfeo Faggi keeps little more than its dignity of mass, and the tactile quality in Lachaise's mountainous woman is lessened.

What especially strikes one in the whole collection is that it is a lot of highly intellectual art. Brains have been consciously used to mix the colors, or, more accurately, to put them on unmixed; brains have been on the job whether to make a piece

of architecture architecturally, to build up a structure of rhythms that sway and bend without anywhere jeopardizing the integrity of the building; to build with color, to model plastically with more of the third dimension than we have had since the fifth century, or to emphasize in any other way the fact that art was made for the artist, not the artist for art.

There long has been a funny notion that art was greater than any of the men making it—based, no doubt, on the axiom that the whole is greater than any of its parts, an axiom that has no application whatever to the case between art and artist. Art is precisely what the artist makes it, and the more abstract the terms he uses the freer his personality seems to get in self-assertion. Few have been more personal than these modernists, with their ideas about pure painting and pure music, &c. That is one of the things to be got from the portfolio, and as soon as people realize it they will begin to feel more interest in modern art. You've got to be human, Mr. Luks says, "who wants an abstract woman to cook his breakfast for him!" and, the implication: who wants an abstract painter to paint his pictures for him! But in this portfolio there are no abstract painters. Or sculptors. None exist. The most any of them have done is to clear away certain concrete obstructions to make more room for their emphatically, sometimes excessively, human personalities.

The paintings, marbles and bronzes in the current exhibition at the Kraushaar Galleries belong for the most part to drama. They illustrate, that is, the comedy of contemporary life without reference to history or the classics or schools of art. Humanity has interested the artists on its pathetic, its amusing, its lively or its solemn side. Knowledge of tools and mediums has been used for the expression of contemporary types and episodes interesting to us because we recognize them. They are what we see all about us and they are not on parade, they happen and they are beautiful because fine minds have seen their beauty and detached it for us so that with any kind of mind we can see it. That is what Mr. Luks told us the other evening, that it takes a fine mind to see beauty. To see it for the first time, that is. After it has been often enough pointed out it seems to become more obvious.

The beauty of the two little street waifs dancing, "The Spielers," painted by Mr. Luks sixteen or seventeen years ago, is clear enough now to every one; even that of "The Wrestlers" is perceptible to our cultivated minds, so delicately averse from rude sports. Nothing in this exhibition will bother a public already introduced to the conscious naïveté of the later schools. And much, nearly everything, will give pleasure.

The "Erie Canal," by Davies, gives a pleasure puzzling to many of us. How, we ask of it, can you look at the same time so old-fashioned and so modern? Durand or Doughty might have chosen such a subject and looked at it with just such loving observation of natural detail. Trees with weeping foliage, a cloud-filled sky, rolling fields dotted with other trees small in the distance, quiet water, little bridges, small boats, people on the banks and in the boats, a wide-spreading landscape punctiliously portrayed. What it has that others lack is

accentuated elegance. The twinkling brightness of the little blond tree lifting its head toward the drooping boughs of its neighbors, the sparkle of the little white bridges neatly balanced at the opposite ends of the composition, the sharp heat of the autumnal foliage splashed in ruddy drops across the low mounds, a girl's figure in the nearest foreground, flowing hair and outspread arms, these are the jeweled ornaments of the design, and the rest is done by the Davies brush that glides and dips over the surface of a panel or canvas with the smooth certain motion of a bird. Skillful planning by the artist's rare intelligence and the skillful use of his incomparable brush, that is all that separates him from a reverent Durand or Doughty.

Another panel that in proportions and size might almost be a pendant to the Davies is Gifford Beal's "Moonlight," more poetic in atmosphere, softer, richer, with subtleties of color in the flowers growing over the house, in the moon's broad path over the water, in the flounced and hooped skirts of the strolling ladies yet stouter in fibre and more generous in arabesque, a more muscular, less nervous design. It is in this way something that would be serene and satisfying to live with.

Guy Pène du Bois provides a surprise. After showing us one of his silhouettes, sharp as vinegar and definitely ironic, he faces us about to a recently finished portrait of a woman in

"A Portrait," by Guy Pene du Bois. In exhibition at the Kraushaar Galleries.

an armchair (replacing that of George Moore which retains its place in the catalogue), the freshest thing he has done, the richest in color, no superficialities, an air of distinction in the model supported by a very distinguished and individual technique. In saying that the chairs in the composition are masterpieces of skillful painting there is no intention of minifying the treatment of the figure. But it is more unusual thus to simplify accessories until they assume a monumental effect and yet manage not to thrust simplification into your face.

Jerome Myers is another who steps out of his beaten track with great advantage. It is in truth great advantage to a serious artist who has developed a style and a beautiful technique upon one class of subject to shift his baggage to another spot and use his powers to place before us something that we can see with that fillip of the unexpected which goes so far toward making a holiday in a workingman's experience.

This "French Music Hall" provides also the fillip of a subject in itself entertaining, and Mr. Myers has made full use of its resources. His characterization in the figures of the audience is excellent, his stage is piquant. A welcome contribution.

Maurice Prendergast in "Crepuscule" plays with his public his usual baffling little game of pretending to repeat himself and never doing it. That psychically sensitive public continually is hypnotized into thinking that because the little figures continue satisfactorily to exist without features and to picnic joyously upon a sunny shore there is nothing new to be got out of the Prendergast designs. Let them invent a little game for themselves and practice tracing the composition in pure line. Hardly a painter can be found to give more variety of linear pattern. And humor abounds in this lovely unsentimental twilight scene. It is perhaps the best thing the painter has done in pure esthetic expression, with no end of humanity thrown in. You must have the humanity, Mr. Luks says.

You have it rather conspicuously in "McSorley's Bar," by John Sloan, that well-behaved bar to which no ladies were admitted and from which all drunkards were ejected, which offered chiefly ale, and absorbed a little art from its nearness to Cooper Union; there it is as Sloan saw it in the very old days, prosaically literal in the handling of the human material but delightful in color. In his preface to the catalogue Mr. Du Bois says that Mr. Glackens is one of the finest of our draftsmen. The "Peruvian Girl," hauteur in pose and slanting gaze, lends color to the emphatic statement, a concealed draftsmanship with adroit lapses, but surely there with a model so securely built and with such potentiality of movement.

Two fine landscapes by Ernest Lawson, failing only in that deep desire for movement which is all over the world today, was whispered a century ago by Goethe, was shouted a few decades ago by the Secessionists, was sung by the Futurists, is the root of Pirandello's philosophy, is all over the place everywhere—and always has been Samuel Halpert's almost famous "Interior of Toledo Cathedral," Eugene Speicher's splendid "Torso" thick and strong and heroically human. Marbles and bronzes by Gaston Lachaise, the most dauntless a partly draped figure of Pentelican marble, modeled to a form of slenderness and grace rarely encountered in the art-

ist's various expressions of womanhood although freely given to peacock, hound and seal. As though surprised herself at her gracile proportions this captivating creature turns her face toward you with upraised eyebrows, with a smile of gentle mockery on her lips, with an alert poise of the beautiful small head, truly a living art.

The exhibition will last to the middle of February. It brings together strong and varied talents that help each other. Modern art, certainly, but not quite in the state of flux to which the extreme modernists aspire.

A small book just issued by the New Gallery contains reproductions of more than fifty of the paintings sold by the gallery in the first half year of its existence. These have a good deal to say of this state of flux in which becoming is the important matter, arrival the death. From Gregoriev's stripped anatomies to the swathed inhumanities of Modigliani, to the dancing arabesques of Matisse, to the flashing cross lights of Kostini, there is no rest and no haste. Planning, moving, escaping, they move as exiles from an ancient country. To the looker-on they seem to have no home in nature, seem to exist outside of nature criticizing with unfriendly intention her old-fashioned ways.

It is like the little old man and women of the barometer, when one comes out the other goes in. Just now love of nature in the old-fashioned sense has gone in. What has gone in, however, is only the mawkish or theatrical form of the sentiment, the love of nature's often stupid little face. Not that of the forces of life that make us kin of the flower and mountain and beast and bird. St. Francis, favorite of the ancient arts, is still with us in a new incarnation. Our "Little Brothers" are united to us not by visible ties but by those invisible. Our modern art at its highest point, whatever the society to which it belongs, whatever nationality it has back of it, is concerned to make the invisible visible, to distinguish within our corruptible the incorruptible.

There has been a real advance in America away from the literal and meticulous to the true and synthetic. Not, of course, an advance by small and steady steps. A trifle wildly, with long pauses and strange leaps as a butterfly hunter crosses a Summer field. It goes far enough to show us that our idea of truth in art has begun to change. That we are less worried about cheating others than about cheating ourselves. That last must be avoided at any cost.

One way of avoiding it is to resist the potent lure of symbol. The use of symbol is a primitive device still dear to the primitive mind, but almost powerless to move the composite sophistication of America. The American, facing the increased vogue of machinery in the arts, conscious of our growing dependence upon the machine, frankly accepts the machine as an interesting subject for art. The European tries to find a symbol for the machine and our dependence upon it. At least some Americans do the one and some Europeans the other.

Alexander Archipenko, now exhibiting at the Kingore Gallery under the auspices of the Société Anonyme, has originated what he calls "sculpture-painting" and a method of relief modeling in which he employs a combination of vari-

ous metals, and feels that he thus expresses the spirit of today, the multitudinous presence of mechanical devices in the environment of the people, their reliance upon the machine and their demand for quantity production.

Archipenko is a Russian, has lived most of his life in Paris until the past two years, which have been spent in Berlin, where Klinger also once strove to express the spirit of his time through the combination of many and diverse materials. With Archipenko, as with Klinger, however, no symbolic expression makes so deep an impression upon the mind as the simplicity of certain works in which pure form utters its eloquent message. A "Torse," by Archipenko, slim-waisted and turning at the waist, the plane of the chest high and firm, the line of the shoulder as sensitive as a flower petal, stirs the pulse of an American lover of art where the remotest suspicion of the symbolic would repel him. That is the way we are. Or were.

* * *

February 3, 1924

SAYS MUSEUMS CAN AID EDUCATION

Schools Neglect Their Opportunities in This Country, Says Mr. Bach of the Metropolitan

WHAT IT HAS TO OFFER

It is One of Sixty Devoted to Art In United States—There Are 540 More for Other Purposes

The educational facilities offered by the museums of the United States are called to the attention of teachers and students by Richard F. Bach of the Metropolitan Museum of Art in an article on "The Museum and the Teacher" of which a rescript from School and Society was issued recently. Mr. Bach shows how museums may be used by schools.

"We have some 600 museums of which almost 60 are devoted to art," says Mr. Bach. "Not a baker's dozen of these art museums are used by teachers. It is an open question whether as many teachers of art could be found that could present a workable thesis as to how an art museum could be used to full advantage by a school.

"The conception is new, it is agreed. Yet it is hardly a new idea to use original sources in education. The soundest interpretation of rock formation is found in rock itself; it tells its story in a way that the eye can convey to the mind without the agency of words. So the mineralogist goes forth with his hammer to get at facts. Any kind of stupid still life work, any amount of vapid lecturing on 'art appreciation,' any quantity of clever effects of light on glazes and fabrics in the studio, but never a glance at the real things of art that museum galleries show.

A Question of Co-ordination

"Yes, there are requirements of curriculum, there are schedules, there is the so-many-hours-per-week-per-term limitation—necessary evils but not insurmountable obstacles. It is a

question of co-ordination. There is a machinery of school management and there is another machinery of museum management; they can be harnessed together, driven by the same dynamo of energy and enterprise that we call co-operation.

"Singleness of purpose is needed, but a union of effort to attain it. How much shall each do? It is difficult to say until current experiments have had longer trial. New York, Cleveland, Chicago, Toledo, Indianapolis, some eight or nine other cities, too, have turned to with a will and in these cities a new creed in art teaching is being formulated.

"An inspection of educational facilities at our leading museums will show how such a laboratory can grow, extending its assistance along a score of channels, the majority of which can be of value to teachers in any or all fields. At the Metropolitan Museum will be found, as apart from the collections themselves, with their departmental chiefs or curators, the following facilities mainly organized as educational work: Staff of instructors, interpreters of the collections; lending collections of lantern slides, photographs, maps, charts, casts, reproductions, post cards, textiles and laces; lectures, Saturdays, Sundays, and special series; publications, bulletins, leaflets, historical catalogues; Bureau of Information regarding the museum, its work and collections; story hours for children; photographs, complete file of all museum objects, prints of which are for sale; special permit and privilege cards for designers, students and copyists; opportunity to purchase casts of certain objects; special room for close study of objects removed from the galleries for that purpose; easels and stools and locker room for drawing materials; class rooms with lanterns available for teachers and school groups; service department for manufacturers and designers and a staff member to visit factories and workshops; study hours for salespeople and 'buyers'; publicity service to newspapers and trade journals; special exhibitions by schools, manufacturers and designers of their own work; special exhibitors of museum material of value to manufacturers and designers; lectures for teacher groups, for high school students, co-ordinated with regular classes in history, civics, English, &c.; field work by staff of instructors in elementary and high schools, vocational and training schools, factories and workshops.

Other Types of Work

"This does not complete the list, for there are other types of work that have no relation to the topic in hand. Yet how many of these lines of effort can be made profitable to teachers and schools? Practically all. But the mountain cannot come to Mahomet.

"But museums are young in America—the Metropolitan Museum is but 50 years old—and collecting must precede exploiting. The inexperience of art museums in educational matters is a fair match for the narrow-gauge slowness of the schools in grasping their opportunity. It cannot be a matter of choice between inexperience and inertia.

"Schools, and so teachers, have never faced, except in nature itself, such an opportunity of free access to first-hand

courses of guaranteed authenticity and quality. A museum is worth having only if it works, if it is useful. Its content and character are distinctly that of object lesson material, that of a demonstration laboratory.

"A good laboratory, to a great extent, must develop a functional mechanism of its own. It will devise methods of making its contents available to classes, to specialists, such as designers and manufacturers, for all of whom a certain freedom and ease of access can be promised.

"It will interpret its material to interested groups, offering, for instance, story hours for children, lectures and exhibitions for adults, special collections of value to the trades, special facilities for teachers, lending collections of lantern slides, photographs or the objects themselves. These things form part of the ideal of museum usefulness, and they are but a few of the possibilities of even small museums.

"In such lines of effort the schools and teachers can find a splendid aid. The museum is not a direct educational agency. Even if it runs a school of its own, it must be primarily an art school for specialists. The art museum, in fact any museum, is an allied educational institution."

* * *

October 12, 1924

THE WORLD OF ART

The Beginning of the Exhibition Season

Shorter and shorter grows the exhibition season and, naturally, more and more numerous grow the exhibitions. As the weather becomes impossible we notice the sudden increase in them. In the Fall and Spring, when New York blooms like a garden and to be in the streets is exhilarating, very little goes on behind the handsomely draped windows of the art galleries. All perfectly natural on the part of the galleries, of course, but not the least little bit the art of exhibition, subtlest and most puzzling of all the arts. Space and time are of the essence of the contract and every season the contract is naïvely broken with no demur on the part of any one.

It may be delusion, but one does seem to begin to hear a low muttering, precursor of the battering down of gates of tradition. Probably it is delusion, since October strides in with the usual paucity of important events in the exhibition world. At least that would be the judgment of one trained to estimate events in accordance with a social and commercial standard of importance. A plain person concerned only with the simplicities of art, itself so plain and aristocratic in its simplicities, might get a good deal of pleasure out of the scanty offerings of the Autumn. Some of the pleasure certainly consists in the ability to get your breath between times, to get your breath and mull over your impressions for a moment or two, and then go back to your favorites and either correct or fortify your impressions by a second seeing.

"Dance of Spring," by Joseph Stella. At the Dudensing Galleries.

This particularly with reference to the Ferargil Galleries, newly established in the new "Quarter"—not Latin. The early exhibition gains here by its setting. Genuine art in the setting, and again not Latin, excellent American. Actually linen hangings for the exhibition rooms, no velvet or plush or imitations of these—just admirable linen, the best background conceivable for pictures worthy of any background at all. How dignified for example, the portrait of a woman by Duveneck, a red-faced woman with heavily veined hands and hair brushed back severely; everything—composition, type, workmanship—so eloquent of the even greater and rarer Leibl that one almost wonders. Black against black superbly discriminated, and the ruddy note of the face. And, almost as a part of the distinction, the austere linen background!

For Hunt Diederich's sculpture this is just as truly the right thing as for Duveneck's painting. The lively arabesque and strong silhouette of the Diederich designs are at their best. Hounds in leash and prancing horses get the full benefit of their tense outline. A painting done several years ago by Karl Anderson is in the exhibition and profits rather especially by the flax-colored wall, something dry in the color and the flatness of its application making it integrally a part of such a wall. In these galleries the mural simplicity is explained as a kind of esthetic morality: "No picture ought to look better in a gallery than it will in the house of the buyer." But how are

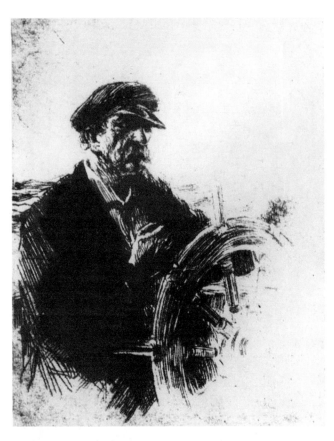

"The Skipper." Etching by Dwight C. Sturges. Winner of one of the four Logan Medals at 1923 exhibition of the Chicago Society of Etchers. In exhibition at the Salons of America at the Anderson Galleries.

you going to help it if the buyer insists upon velvet and damask in his house?

Further up and eastward we came to the Anderson Galleries and the Ambitious Salons of America. The Frenchness of the title works injustice to the association. Napkin in America no longer is serviette. Why assume a salon if you have it not? Setting aside the title, however, there is in the exhibition of water colors, prints, and drawings an agreeably modest note, and especially an agreeable sense of freedom on the part of the exhibitors to go their ways without troubling about possible criticism. Isabel Whitney, for example, with her bouquets, loosely bunched leaves and blossoms and the pitcher or vase holding them merely a pencil sketch offsetting the sparkling color of the bouquet itself. A mingling of the elements not to be tolerated by an academic mind classifying pencil as pencil and color as color, to be kept one on either side of the meeting house and never allowed in the same pew.

A still better example Adelaide Lawsen with her green "Landscape," a sketch with significance of design. No stiff-minded person would exhibit a water-color drawing in which colors and lines impinge so recklessly upon each other, a green bank passing like a ghost straight through the little bark that is pulled up against its grassy flank; a man in another boat dabbling his hands in the water but no clear boundary that says to hand or boat or water: Thou shalt not pass. No clear boundaries anywhere, yet no confusion, for the

whole idea of the drawing is a strong composition of directions—a shallow curve, a swift diagonal, quick horizontals, everything held together and up by this stout scaffolding. No danger to any detail with so competent a sub-structure. The visitor looking for pictures would see at once that this one wasn't carried very far. A student looking for comparisons and guidance would see that the building was completely finished, nothing but hardware and trim to be added.

This self-confidence and lack of self-consciousness are marks of progress in the art of exhibition. At least the exhibitors have both courage and conviction. Not quite in the same way. Edwin Booth Grossmann omits the unessential in his water color drawing of a hillside. He shows unmistakably, though far from obviously, that he omits what he closely has considered and excluded, not that at which he simply has not yet arrived. His drawing seems to be all films and washes of color gliding toward and away from one another, but you are conscious also of directions, of a path that leads in and up to the burst of sunrays in the sky, of another path that leads straight out of the picture. The two give at once a sense of intimacy and freedom. Ours not to reason why.

Mr. Grossmann's other exhibit is a drawing in monochrome of three girls, bathers, grouped monumentally with a suggestion of Renoir in their rounded splendor of contour, but with also a crispness in the boundaries of shadow that is not at all Renoir. Less of pulp in the roundness. Color in the exhibition runs all the way from Paul Rohland's beautiful block prints, as strong and dim as an antique rug, to the sharp, frank oppositions of Edward Beck Ulreich's "Sun Dance," in which the dancers move with the muscular adequacy too often left out in portrayals of this most athletic of the arts. At each extreme the color has appropriateness, the dim strength of Mr. Rohland's palette to the saturated surfaces of Spanish hill towns. Mr. Ulreich's tingling contrasts to the sudden changes of direction in the movement and gesture of his dancers. Mr. Ganso in a study of a fat and coarse woman in her dressing room plays cleverly with his reds, and here again the color, both crude and rich, supports the subject in the total impression.

Among the etchers Frederick Polley has an eye for likeness, and calling Pittsburg "the Volcano" makes it that, spitting flame and steam from a hundred openings in its blackened shell, a road climbing to its summit. Brockville, Ind., is Toledo for him, and he shows the Toledo character of its topography. Not a conceit or a pun but the humor of comparison and simile. Louis Lezoweck has a quite different way of treating Chicago. Buildings, bridges, elevated roads, stockyards are all there, truthfully telling the story of the city, but not all shown from start to finish, shown rather in significant samples, broken parts in an unbroken unit. Broken not blurred. Every edge a cutting edge, every arch with a spring that should satisfy an engineer. And with the cold, impersonal rendering an immense variety of forms and shapes gained chiefly by the differences in scale of a myriad rectangular openings. A fine example of the clarity of vision and statement characteristic of certain modern art-

ists—a large enough group of sufficiently varied talents to make this common gift of clarity seem representative of the spirit of the time.

Yakima Canutt, the cowboy rider, is the subject of a spirited plate by Henry Ziegler. A little polo group, "England vs. America," makes a sharper impression because of the cleaner wiping. Ink outline and wandering fragments of tone have a charming effect in Mr. Speck's drawing of a man sketching in a studio. This apparently irresponsible drift of tone, resembling nothing so much as the wrack of cigarette smoke, is the other side of the modern shield, the nebulous, suggestive side, admitting no finality of statement, no clarity that seems to put an end to anything. Yet on this side also modern art is intensely sure of itself and as far as possible from irresponsibility. The man sketching among the drifts of tone is completely realized if not completely stated. There is no more of emptiness in the one method than of surplusage in the other. These occasional indications of how modern art is working out the principles upon which art of many centuries has been founded are what make such a quiet little exhibition as this of the salons truly interesting. Of course, there are also many examples of how the principles are not being worked out, but that is always the case.

The word has come of the definite opening of the new wing of the Metropolitan Museum on Nov. 10, and there will be so much to say about the individual exhibits at that time that one grabs at the opportunity for a general word in advance. Mr. Halsey has made the Museum Bulletin his organ for dispensing extremely valuable information concerning the early American work that will be shown. He points out that from the very beginning, when the American people were recovering from the financial disasters of war, the individuality of American homes was composed of mingled Eastern and Western influences. Our ships went to the Orient and brought back pottery and textiles, and from other ports the fashions of the Old World were brought to the New. At the time of Washington's inauguration the American eagle, bird of freedom, flapped into the decorative and industrial arts as the accepted emblem of nationalism and Washington. Some of our most skillful cabinetmakers worked it into the decoration of furniture in place of the conventional urn and flower. It was capitalised and used everywhere, Albany, Boston, New York, Philadelphia, Baltimore, on the best pieces, showing the finest craftsmanship. This spread eagle is what we are to look for in the exhibition. Inlaid in mirror frames, breakfast tables, tambour and slant-top desks, corner cabinets, tip-tables, Pembroke tables, rectangular and semicircular card tables, tall clocks, knife boxes. It will be a merry game of hunt the eagle.

In the textiles we shall see foreigners catering to the American trade. Toiles de Jouy, with designs symbolizing American heroes and their victory. The manufacturers seem occasionally to have been put to it for their models, and it was good luck for them that Valentine Green scraped a mezzotint from the portrait of Washington done from memory by John Trumbull. What with Trumbull's memory and

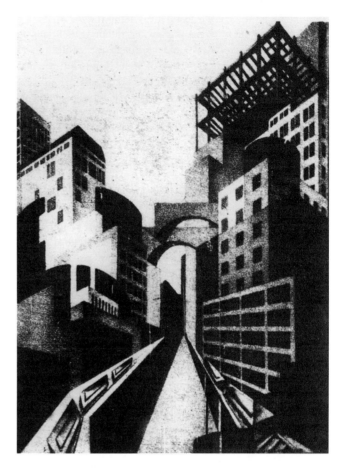

"Chicago," by Louis Lozowick. In Salons of America exhibition.

Green's translation and the manufacturer's translation of the translation, it is a queer enough Washington that appears among goddesses and Cupids and various objects of allegory. Franklin himself helped out now and then, and Mr. Halsey quotes his letter to Robert R. Livingston describing a design he has invented for a medal, representing the United States as an infant Hercules in his cradle efficiently strangling a couple of serpents, the British armies at Saratoga and Yorktown, Minerva as France standing by, spear in hand, &c.—rather a ghastly design, which must have caused great satisfaction to the clever old philosopher. Astonishing that it should so successfully work into the pattern of the toile.

In the ceramic field rich harvest is promised. Franklin and Washington were idealized in both England and France, and their potters sent wares in plenty decorated with flattering emblems and portraits. How valuable the trade of the new nation! How valuable it continues. The pages of The Bulletin articles are crammed to overflowing with the human interest investing industrial art at all stages of civilization. They should be, doubtless will be, gathered into pamphlet form for the use of visitors to the exhibition when it opens.

Whatever the visitor learns of history, however, will be of less importance than what he may, if he chooses, learn of quality. The several thousands of us who have picked up antiques, who have congratulated ourselves on our "collec-

tor's luck," who have gazed lovingly upon the piecrust edge of our tip-table and the sheaf of wheat rather crudely cut on our Heppelwhite backs, should approach the exhibition in dead earnest, not for a smattering of styles, but to let sink into the soul that indescribable difference between first and second best which sets them worlds apart. The crude wheat garlands and the thin piecrust with its acid little edge will never look the same to us again, and if we bemoan a lost illusion it is in the spirit of the time to prefer truth to falsehood. The really great value of this most interesting collection of early American furnishings lies in the dissatisfaction it should engender; the wholesome and recreative dissatisfaction with scamped labor and shoddy material and vulgar taste. In The Bulletin article we are told that the American Heppelwhite and Sheraton will be seen to bear comparison with the best English furniture of the period, and how good the best English was may be seen this moment, without waiting for the opening of the exhibition, by looking at the superb tripod table of about 1700, now in the Recent Accessions Room. It is, of course, excellent that we should praise famous men and our fathers that were before us, and the best way to praise them is to preserve and display their creditable works. But we can do more for them than this—we can emulate them. We can furnish our houses, or those slices of home that we get in apartment houses, with objects that are sound in craftsmanship, suited to their purpose and free from vulgarity. And we can learn to do this through studying the collections in the new wing of the Metropolitan Museum.

An article by Phyllis Ackerman in the September number of the International Studio gives an interesting account of the cottage industries movement in England and its effect upon cottage furnishings in that country. "The English people," she says, "for four centuries had an undeniable genius for domestic architecture which determined every detail of the house and its furnishings, even down to such minor factors as coal shovels and nail heads. It is this return to the fundamental native instinct for domestic designs that vitalizes the most productive movement in the decorative arts in England today."

The work is done not in city factories but in workshops in scattered towns, and includes almost everything needed in a modest home, silver, glass, napery, rugs and carpets, pillows, &c., and all with the "quality of genuineness which is the peculiar esthetic attribute both of the antique English furniture and of this new." The description of the character of the pieces makes quite clear the significance and the debatable phrase "quality of genuineness."

"The furniture is plain and straight, but it has none of the clumsy, rigidity and really absurd massiveness of the old craftsman or mission furniture," Mrs. Ackerman specifies. "Most of it is in unfinished oak which will mellow with time and use, but there are richer woods, too, such as a fine buried walnut. The construction is very strong and firm, but no heavier than is absolutely necessary for long durability under hard, practical use. Though always plain, the designs are never barren.

The cottage cabinetmakers have avoided the customary pitfalls of the modern self-conscious hand craftsman and have, therefore, produced pieces that have permanent distinction. The ornamentation that the cottage designers use to lift this work above the merely negative is thoroughly good because it is not in any specious sense applied, but derives almost wholly from the perfection of the workmanship. The turn of a bedpost and the cut of its finial are all that is necessary to give a bed character and emphasis. The beveling of the drawer panels of a buffet where they fit into the frame refines the proportions, makes clear both the construction of the piece and the character of the wood, and also introduces the necessary variety. Similarly, the curve of a stretcher where it meets an upright can reveal craftsmanship, reinforce the effect of the structure and introduce a graceful line. In short, the designs are conceived in structural terms."

It is just this appreciation of the relation between structure and the finished beauty of the work that is and always has been necessary for a great style in furniture. In the eighteenth century the English had it and so did we have it. We are working toward it again as the English are, although along a different path. With public support we can reach the not impossible goal, and public support will be strengthened, we hardly can doubt, by the approaching exhibition at the Museum.

At the Dudensing Galleries may be seen the latest work of Joseph Stella. So much solemn nonsense is written and spoken about the newer schools of art and about the older schools of art that when one is confronted with a work of such great beauty and unclassifiable character it is tempting not to write about it at all. No doubt the artist would be well pleased thus to escape what is so likely to prove distasteful praise. It is, however, not alone the artist or the writer who is concerned with a work of art. Sooner or later it becomes the affair of the public, and the sooner Mr. Stella's "Dance of Spring" becomes a public affair the better. As befits the title, it is a composition of remarkable liveliness, one in which the whole creation moves to a dancing measure. It is thus composed in the mind of the artist without visible reference to the usually casual arrangements of nature left to herself. Each object in the composition, on the other hand, is scrupulously true to the original, the result of the closest study of the original and most careful analysis of its typical and peculiar features. From the oddly shaped blossom poised like a ballet girl on its stem in the centre to the rumpled feathers on the little birds, everything is precise in portraiture. Not a shadow of doubt that a botanist familiar with the woods and fields could name each leaf and blossom from this account. In the background is the first thought from which the composition sprang. Pattern of frost on a window. Vast implacable cliffs and caverns of snowy ice. Across the canvas bands of sunlight, the yellow an almost miraculous value, so unlike what usually is born of paint.

This, the spectator probably will say to himself, is modernism. It may be in the sense of cutting loose from any inherited recipes; but it is not more like other paintings of the

present time than like the works of the past. It is a very intellectual, wholly original working out of an idea with an execution that so much subdues the labor of creation as to make it seem spontaneous and effortless. One beauty of it lies in the fact that it does not reveal itself at once, that clear and decisive as it is, it holds back much of its interest so that you can come back to it again and again and find fresh enjoyment.

If modern art is remarkable for its clear-cut definition and concentration upon significant features, it also in many of its finer examples is remarkable for its complication. Not in the building up of a single tone by many contributions of color; not in the careful development of the material substance by many over-paintings or glazings, but in the use of intricate rhythms of line and elaborate and rich arrangements of color. Joseph Stella represents modern art on this side and, so far as he stands in his brilliant individuality for any group, it is the group opposed to sensual expression, the group that, on the contrary, expresses the spiritual enjoyment of life and nature.

The layman trying to work through the picture to the artist's method—with the layman's insatiable curiosity as to how the wheels go round—will stand before the "Dance of Spring" and in his rather untrustworthy mind's eye see the artist going out into nature as he might go into the April meadows, picking for himself a kind of bouquet of all that communicates to him the joy of the season, the tall stems and long grasses, lily pads, chirping birds, sunbeams, in dark, cool places lingering fragments of snow and ice, &c.; bring these back home with him and spreading them out on a table as a woman might the flowers she had picked to decorate her rooms, selecting what he wanted for this side of his canvas and what for that, putting his whole mind to the arranging until not only the items of his bouquet but their rhythmic relation to one another reproduce for him the mood of the lovely moment.

* * *

December 28, 1924

ARCHITECTS DREAM OF A PINNACLE CITY

Advocates of the Tower Idea Would Make Each Building a Single Stupendous Column

By ORRICK JOHNS

Figures grow less and less impressive as one deals with great altitudes mechanically achieved by men. Seeing is believing, and while few of us probably will ever forget our first trip in the little cylinder that hoists one to the cupola of the Woolworth Building, or our first gasp at the structure's sheer lines mounting to the sky, the information that it stands 792 feet in its sockets means comparatively little. It sounds, if anything, inadequate.

To scale the clouds, by one means or another, has become a commonplace of the age, along with girdling the globe by invisible voice channels. On paper, a few thousand feet more or less of airplane flight or a dozen or so of added stories in a building are hardly a matter for long reflection by ordinary folk. Doubtless the 29,000 feet of Mount Everest itself do not create a definite picture in the mind of one man or woman out of a thousand.

So it fails to arouse the expected shudder when one learns that Signor Mussolini hopes to erect in Rome a building 1,100 feet high, or something like once and a half the height of the Woolworth Building, and 100 feet higher than the Eiffel Tower, which is the tallest man-made structure in existence—true, an exhibition piece, carrying no burden but its own weight.

The Mussolini Symbol

The Mussolini building has been designed by a distinguished architect of the Italian race, but one who has imbibed the spirit of the New World—for Marlo Palenti is described as a citizen of the Argentine Republic, and the designer of buildings on the modern scale in Buenos Aires. The Roman structure is to be the central tower type, eighty-eight stories over all, and spread upon its broad base of a third that height over a frontage that would equal three New York Blocks, or not much less than a fifth of a mile. In this lavish use of space, as well as in its design, it differs from anything that is ever likely to be built in New York. The building is to be called the "Mole Lictoria," or tower of the lictors, thus being in name as well as in magnificence a symbol of the Fascist regime and the dictatorial power of Benito Mussolini.

There is a vast fascination in the idea of superlative bigness, so the building, without doubt, if completed will become the object of world-wide curiosity. It has a special interest for Americans, since we have hitherto been builders of the highest habitable structures, and if nothing is done to prevent it the Palenti achievement will transfer the honors from our shores to the Old World.

It is true that leading American architects, especially those in New York, have interested themselves of late years less in sheer height than in problems of a more subtle and esthetic character. Cass Gilbert's fine achievement with the Woolworth nickels and dimes has stood undisputed for a decade. There have been other worlds to conquer besides blue sky. The desire for more style in architecture and a finer organization of lines and masses has diverted some of the busiest of our designers. The zoning laws and the growing congestion of traffic, due in great measure to our huge buildings, have been powerful influences in transferring attention from mere competition in tall buildings to problems less sensational but of as great importance.

Moreover, it is possible for an absolute dictator to do things with a large and imposing gesture that can hardly be imitated by the ablest and most talented craftsman of a republic. The marvels of New York architecture have been accomplished in the face of overwhelming obstacles, economic and public. Architecture must pay as well as please and conform to the best interests of the community. It has

been a long battle of vision, enthusiasm and confidence against the lethargic forces of the every-day world.

Being interested in the question whether American architects were altogether prepared to abandon leadership in high building, the writer discovered that many of the craft at the present moment are engaged upon plans that exceed Mussolini's by a goodly margin. These men are very much interested in height. They are not the most numerous, but they constitute one of the important schools of thought among men engaged in problems of engineering and designing connected with the future of architecture in this country.

Another group, of which one has heard much recently, is composed of advocates of the pyramidal form of construction, the step-back type of building, both as the most logical development under the zoning laws and as the most promising from which to evolve a typical and enduring style of modern urban architecture. But the members of the "aerial school" declare in favor of sheer, tower-like construction, rising from the ground on a uniform width. These men eschew the spreading base, the step-back, terraces, escarpments and all other characteristics of the graduated construction. This ideal means actually a pillar in a plot of ground, just as you would raise a flag pole in a square of turf in your garden.

It may be said that this difference of opinion has existed for hundreds of years, but it has never before concerned itself with the complex difficulties and ramifications of steel construction.

To secure the necessary floor area and "cubic building space" to compare favorably with what has been called the "beehive," or graduated building, these towers would tend to be exceedingly high, considerably higher than Mussolini's temple of Fascismo and on an incredibly small base in comparison. Raymond G. Hood, the designer of the new American Radiator Building on Fortieth Street, as well as the winner of The Chicago Tribune building competition of two years ago, is engaged on sketches for a New York structure that will rise to a height of fourteen hundred feet on a base one hundred and twenty-five square! Set your fountain pen on end and you will get a picture of something like the same proportions.

Problem of the Engineer

To the untechnical mind the first thought suggested by Mr. Hood's building would be terrifying instability, but engineers are perfectly calm about it. The only thing necessary is to base the building deeply enough. These steel and concrete bases play a large part in modern building. They may go to a great depth in cases where a hard enough substance cannot be found closer to the surface. New York's rocky foundation eliminates a great amount of difficulty in this respect, but in Chicago and other cities the modern builder must pierce considerably over a hundred feet through the soft upper stratum until he is able to get a sound standing on the underground shell of the planet.

Before the period of perfected steel construction heavy buildings used to be floated in Chicago, exactly as a houseboat

is floated on a scow. Louis Sullivan's famous Auditorium building, a landmark, by the way, in early tall architecture, was floated in such a manner.

The ultimate development of this tower idea, if adopted at all widely, would be a city of needles extending to great height and surrounded each by its plot of ground perhaps three times as large as the base of the building. If the reader will imagine a grove denuded of its lateral branches and cleared of undergrowth he will obtain an impression of this city—a city of continuous parks and sharp pinnacles.

Instead of the immemorial column being a part of the temple or building, the building itself is transformed into a single stupendous column, carrying its own decoration, and supporting an interior. If these were indefinitely multiplied, one might imagine one's self in a roofless colonnade of gigantic proportions.

Advocates of this metropolitan scene declare that it will provide more light throughout the city and within the buildings, that it is inspiring to the modern mind and more strikingly suggests the spirit of the age of steel, and that it is economically sounder than the pyramidal construction, since tenancy of such buildings would be more desirable and demand therefore more constant.

As to the question of height in itself, the Mussolini undertaking does not arouse any amazement in the minds of American builders. It is physically possible to set a number of Mole Lictorias one on top of another. All that is required is a broad enough base. It is legally possible to rise many times eleven hundred feet in altitude even in the heart of Manhattan. This is in theory, of course, our perfectly practical theory. The zoning laws provide that a certain portion of the ground space can be carried as high as the builders choose. Again, from the engineering standpoint, structures of steel may be erected many thousands of feet high, provided the load is scientifically spread. What is called the "crushing point" of steel, to give an idea of the potentialities involved, is reached only at the base of a solid column of that material 20,000 feet high.

So it is not wholly impossible that architectural structures may some day only stop short of the point where breathing, day in and day out, would become inconveniently difficult. The power exists in the materials now available, and in past periods the endurance of materials has been the only limitation on height. But materials and material conditions are two different things, and the discrepancy between steel and masonry too enormous for direct comparison, so it is probable that for some decades at least the wizards of building will stay within reason.

When the Skyscraper Began

It is a far cry from these extraordinary reaches to the days only forty years ago when builders began to realize that in order to erect high structures something must be done to make the upper stories much more independent of the lower. The Auditorium in Chicago, already mentioned, was one of the first to exemplify skeleton construction, of what has been

picturesquely called "the umbrella frame with a picture hung around it."

Sullivan was one of the leaders who awoke the architects of his day to the use of iron work both as a carriage and a frame for masonry. Masonry alone had long proved discouraging. It had reached its apogee in the Old World, where, by means of costly, ponderous and laborious devices, builders had arrived at a height of approximately 500 feet—in such structures as St. Peter's at Rome, the Cologne Cathedral and the Pyramids—buildings that were either solid in construction or carried no interior weight.

For modern uses the Ames Building in Boston, 120 feet high, was about the limit obtainable, and its walls at the base were some five or six feet thick. Window openings of any size were a precarious risk, as the full strength of the stone walls was needed for the load.

Whatever method of building may be adopted by the majority of architects here, the isolated tower-unit style is certain to be seen among us. As Mr. Hood enumerates the advantages of this construction, "it takes you away from all the natural pests and annoyances of the earth. You avoid dirt and dust and insects as you go higher. Intense heat cannot follow you into the air. The temperature drops about one degree in every hundred feet of altitude. You not only enjoy cooler air but cleaner air and more sunlight. Noise is greatly diminished, workers are more contented and efficiency is increased.

"And imagine the improvement in the appearance of your city. Great open spaces may abound. Every building will have its broad stretches of ground, if the owner chooses, without economic loss. For this type of design, owing to the height and consequent multiplication of floor area, is as profitable as any that is now prevalent."

* * *

April 26, 1925

DIANA LOOKS AT A CHANGED WORLD

She, Like Bacchante and the Greek Slave, Has Outlived Her Sins

By GEORGE MacADAM

Diana has but a few more weeks atop the tower of Madison Square Garden. If that gilded goddess is like mere mortal; if impending removal from the place where she has dwelt for so many years brings reminiscent thought, the burden of it is, "How times have changed."

No, if memory is stirring within that beautiful bronze head, it is not whispering of the northward migration of the city's night life—a life that used to swirl and eddy about Madison Square, then about Herald Square, that now has its vortex at Times Square. Nor is it whispering of the passing of the Fifth Avenue Hotel, the Hoffman House, Delmonico's and a score of other places of genial dalliance that used to be within the sunrise shadow of Diana's lofty

tower. Nor is she even thinking of the skyscrapers—mercenary upstarts that they are!—that have eclipsed her old-time aerial pre-eminence.

Womanlike, she is thinking of the gossips, thinking of what people said about her when she first moved into the neighborhood, comparing her ostracism of that day with her present popularity. This bronze lady has never worn clothes. When she was discovered unblushingly showing her beauty, many there were who denounced her, protested that she should not be allowed to tarry in that or any other neighborhood. Today, when she is about to lose her old abiding place, she is offered a dozen or more homes. The only question now raised is: Where can she show her beauty to the best advantage?

Diana Not Alone

Thirty years ago, a brazen-faced hussy; today an impeccable goddess! Yes, indeed, Diana, times have changed.

But you were not alone in your nakedness, not even in those days. Don't you remember, Diana, those four nymphs in the barroom of the Hoffman House? There was a huge gilt picture frame that bore a label: "Nymphs and Satyr—Painted by W. A. Bouguereau." Within that frame was a bit of forest, the warm light of a Summer sun flecking the foliage, four nymphs trying to drag a satyr into a rivulet.

Describing this picture, a contemporary critic wrote: "Four beauteous young girls—not so correctly to be called nude as undressed—but gay, graceful blonde, white and pearly—are drawing the satyr, like a harnessed team of mischief.

These are not the nymphs who make the life of the woods and streams, tanned by sunshine, strengthened by exercise; they are pretty female sprites who have only just divested themselves of the cambric and lace which habitually fetter their bodies."

Bouguereau's four nymphs were one of the sights of Main Street, Manhattan Island, back in the '80s and '90s. No male visitor from any other of the nation's many Main Streets felt that he had really seen New York until he had gazed upon the "gay, graceful, blonde, white and pearly" beauty of those nymphs. They never excited any righteous wrath in the public's bosom, however, for during their stay in New York they were never seen outside of a barroom.

The Hoffman House is gone. What is the resting place of its once famous picture available records sayeth not. But if it were exhumed, again placed on exhibition, it is a safe wager that its pristine allurement would pale beside any up-to-date hosiery "ad."

But, Diana, you hadn't dwelt long atop the tower of Madison Square Garden when you had a sister in sartorial sin—Bacchante, who scorned petticoats with your own Olympian scorn and who was berated as a shameless hussy, even as you had been.

MacMonnies's blythe pagan was offered to the Boston Public Library. In October, 1896, the Boston Art Commission blackballed it, voting that "the Secretary be instructed to inform the Trustees of the Public Library that, while recog-

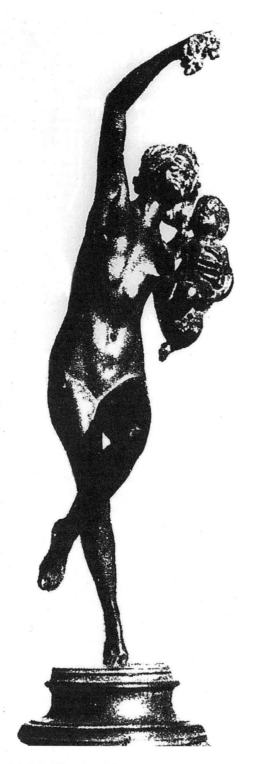

The Much-Rebuked "Bacchante," by Frederick MacMonnies.

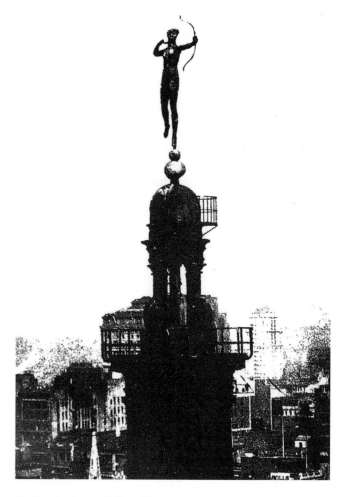

The Sharply Censored "Diana," by Augustus Saint Gaudens.

nizing the remarkable technical merits of Mr. MacMonnies's statue of a Bacchante as a work of art, this commission does not regard it as suitable to the Public Library Building."

About a year later the "Bacchante" found a home in the Metropolitan Museum of Art in this city.

Then the storm! Shocked decorum protested loudly, fiercely. That naked young wanton, dancing from the sheer joy of animal existence, was an outrage upon decency. Public exhibition could not, must not be tolerated.

A month after the "Bacchante" had been placed upon her pedestal of green Connemara marble in the Metropolitan Museum it was reported that:

"General Louis P. Di Cesnola, the director of the museum, still receives protests against its acceptance. Letters have been received from the Rev. W. F. Crafts, Superintendent of the Reform Bureau at Washington, D. C., and Aaron M. Powell, President of the American Purity Alliance. The last protest to come in is from Mrs. Harriet S. Pritchard, State Superintendent of the Woman's Christian Temperance Union in New York, for purity in literature and art. In speaking of the statue yesterday, General Di Cesnola said: After its exhibition at the Salon the French Government offered Mr. MacMonnies 150,000 francs for it in order to secure it for the Luxembourg Gallery. Now these people want to protest against our accepting it. But the "Bacchante" is here now and here to stay."

A Contemporary View

To quote a contemporaray editorial:

"As might have been expected, as soon as that eminent and experienced judge of statuary, General Di Cesnola, had an

opportunity to examine with care the MacMonnies "Bacchante" he discovered in it an artistic merit that had escaped the notice of all other observers. He saw, just above one of the bronze lady's knees, a slight depression and, setting his powerful mind at work, the General decided that this could be nothing else than the result of an intention on the sculptor's part to reproduce the mark left by a garter recently removed. This theory was revealed to a convenient reporter and appeared yesterday in the columns of an esteemed contemporary. General Di Cesnola has done much for art in the past but his previous services, compared with this one, sink into insignificance.

"Hereafter everybody who sees the Bacchante will look for the sign of the garter and, finding it, will appreciate thoroughly the high intentions of its maker and attain to an understanding of esthetic realism almost as perfect as that of our great instructor. A few, moved by jealous hatred, may hint that Bacchantes didn't wear stockings and therefore were not likely to feel the need of a device for controlling an article of dress that was not invented for a good many centuries after the worship of Bacchus had ceased to be a religion. Such criticism as that is too trivial for consideration, and, of course, the General will not be disturbed by it. We humbly venture to suggest that microscopic examination of the mark he has found will disclose not only that the "Bacchante's" garter was made of silk and rubber combined, but that it bore a motto well known, to students of heraldry—a motto that deserved especial study by the people of Boston."

Yes, Diana, the "Bacchante" can tell the same story that you tell. Thirty years ago, looked upon as a hoyden; today, basking in the sun of universal admiration.

Critics regard the "Bacchante" as one of the half-dozen best studies of the nude in the United States. There is a replica of her in Paris, another in Brooklyn, and a third—of all places in the world—in Boston, the city that distinguished itself by once turning her out of doors.

Another lady severely scolded for her nudity was the "Greek Slave" of Hiram Powers. She was brought to this country years and years ago, when marble ladies without drapery were regarded as "foreign indelicacies." What a tongue-lashing the poor "Slave" got! It far outdid the castigation given "Diana" and the "Bacchante."

Powers began his artistic career in Cincinnati and Washington, where he executed a number of portrait busts, acquiring quite a reputation. In 1837 he took up his residence in Florence. It was there that he executed his first ideal piece, "Eve." This was followed by the "Greek Slave," which was finished in 1843, at once attracting world-wide notice and placing its author in the front rank of contemporary sculptors.

Powers discussed these two statues with an American friend. One feels that despite the sculptor's sojourn in Italy he had not entirely succeeded in shaking off the then prevailing standards of Main Street, Cincinnati.

Explaining the Nude

"It is a difficult thing," said Powers, "to find a subject of modern times whose history and peculiarities will justify entire nudity, but where the subject and its history make this necessary, it may be looked upon with less reserve than it could be if the exposure were intentional on the part of the artist. In the case of my 'Eve' clothing would be preposterous, for she was conscious she was naked only after she had fallen. History and nature both require entire nudity. The 'Slave' is compelled to stand naked to be judged of in the market—this is an historical fact. Few such subjects, however, can be found."

Said the sculptor's friend, in a letter to Cincinnati:

"Unlike other female statues I have seen, they ['Eve' and the 'Slave'] combine all that is beautiful in the ideal that glows in the fancy and all that is cheerful and homelike in the fair beings who cluster around our own firesides and live in our hearts. They are perfectly nude figures, and yet so pure in every line and movement and expression that one feels as if standing in the garden where Eve stood among the flowers, with angels and with God, 'and was naked and was not ashamed.' An impure thought cannot rise in the bosom of the gazer unless he be one who is unfit for the society of a pure woman.

"Some familiarity with foreign manners has made me prize more than ever the brightest gem which adorns the American woman—that primitive virtue which recoils from the very shade of impurity. And so far from feeling any apprehension that the exhibition of these statues in America would have any tendency to introduce among our women foreign indelicacy, I am persuaded they would be warmly greeted by all the enlightened and by all the pure of both sexes, and leave every spectator with more exalted conceptions of the beauty and dignity of virtue."

The "Greek Slave" was sold to Prince Demidoff for $4,000, and at the death of that nobleman it was bought by A. T. Stewart for $11,000. The New York Merchant allowed the statue to be put on exhibition in this country.

It was "warmly greeted." It stirred the country as no other art matter—unless it were the first Cubist and Futurist Exhibition—has ever stirred it. The marble lady's decency was attacked and defended; she was cartooned and lampooned; she was even debated in the pulpit.

From the fervid defense made by the Rev. Dr. Dewey of New York:

"The 'Greek Slave' is clothed all over with sentiment, protected by it from every profane eye. Brocade, cloth of gold, could not be a more complete protection than the vesture of holiness in which she stands.

"For what does she stand there?

"To be sold—to be sold to a Turkish harem.

"A perilous position to be chosen by an artist of high and virtuous intent. A perilous point for the artist, being a good man, to encompass."

The "Greek Slave" retired to the seclusion of a private gallery. Years later she passed from mortal gaze into the obscurity of a storage warehouse.

She made her second public appearance in 1913. She was put on exhibition in the Anderson Galleries before being auc-

tioned off. And there she stood, just as she stood in the day of the Rev. Dr. Dewey—"to be sold—to be sold to a Turkish harem"—and not a soul realized the perilous position chosen by the artist.

It was in this same year that Anthony Comstock, walking through West Forty-sixth Street, was suddenly brought to a stop. In the shop window of an art dealer he had spied a picture of a young maid standing knee-deep in the water of a lake.

Mr. Comstock entered the shop, beckoned a salesman. The newspapers, in front-page stories, reported the following conversation:

"Take her out at once."

The salesman looked in surprise.

"The picture of the girl without any clothes on," Mr. Comstock said.

"But that is the famous 'September Morning,' " the salesman explained.

"There's too little morning and too much maid," Mr. Comstock said severely. "Take it out."

The picture, the original of which had been awarded the gold medal—the highest possible award—at the Paris Salon the year previous, was removed from the window.

When the proprietor of the shop returned he ordered the picture back in the window.

"I will keep it on display," said he, "if I have to spend the value of my entire stock in contesting the point with Mr. Comstock."

But he didn't have to spend a cent: the public laughed Mr. Comstock into inactivity.

Yes, times have indeed changed since "Diana," the "Bacchante" and the "Greek Slave" gave the American people the moral shivers.

* * *

April 26, 1925

ABOUT BOOKS, MORE OR LESS: THE AMERICAN IDIOM

By SIMEON STRUNSKY

What, figuratively speaking, is the life expectancy of an artist in America? Theodore Dreiser in a recent number of The Nation examines the problem. His answer is what one would expect from the conscientious and thoughtful Mr. Dreiser. The artist has a pretty hard time in America, but, after all, it is the only country the American artist has. If it is any additional comfort to the American genius contending against an unfavorable environment, he is invited to remember that genius has nowhere and at no time had a particularly easy time of it. Very much to the point is Mr. Dreiser's appeal to the artist's professional pride. This unkindly environment is in itself a challenge to the artist. It is one of the difficulties which it is his business to overcome. The artist must always shift for himself as best he may. "He is not here or anywhere long before he realizes that this is true, and in consequence seeks to make the most of an untoward scene while he does what he can."

The alternative to doing what you can in your own country is, of course, to migrate to some more favorable clime and do nothing at all. There have been exceptions—Henry James, Sargent, Whistler. But in the first place exceptions are exceptions, and in the second place it is still to be proved that a Whistler or a James would have been frustrated in his own country. Van Wyck Brooks in "The Pilgrimage of Henry James" (Dutton) is the latest to recall the doubts that beset the most famous of American exiles. "A man," said James, "always pays in one way or another for expatriation, for detachment from his plain primary heritage." "Saturation is almost more important than talent." Of Mrs. Wharton he wrote: "She must be tethered in native pastures, even if it reduces her to a back yard in New York." But the problem of the expatriate artist hardly needs discussion at this late day. There can be no case for the uprooted in an age which affirms the truth that art must well up from the soil and the artist must draw life through his roots. This will be admitted by the Americans on the Boulevard St. Michel. They will insist, nevertheless: "Does or does not Mr. Dreiser admit that an artist's chances are smaller if he is born in America than almost anywhere else? It is a matter of comparison and degree."

On this point, I am afraid, Mr. Dreiser does not make out a very good case. He does confess to a depressing list of bunkers and hazards on the great fairway of American art. There is our huge and regrettable national wealth, which demands of the artist a greater resolution to starve than is required of him in poorer countries. And there are of course, the familiar deterrents: The "100 per cent. American home," mother, father, wife, husband; the K. K. K., watchful of Catholics; the Catholics, watchful of clean books; the Rotarians, Kiwanisians, Baptists, Methodists; in other words, the entire demonology of the American "creed," which consists in regulating the life of the other fellow.

It is not a convincing argument. Most of the obstacles here enumerated did not exist twenty years ago, when Mr. Dreiser himself had such a hard time making his way. They flourish today, but "only think of the army of young realists now marching on New York, the scores of playwrights and critics who vie with one another to keep the stage and the book untrammeled." The contemporary untrammeling and vieing are not to be denied. Why, then, pick on the poor K. K. K. and Kiwanis? Why not rather cite the mobilized realists in support of Mr. Dreiser's main contention, that the artist will in the end triumph over the most obstinate of environments? Why not rather stress the point that the more K. K. K.ing we have the more untrammeling and vieing we shall have? Why not assert for art the proud claim that, like faith, it thrives on persecution, and the blood of the martyrs is the seed of the Church?

Ku Klux, Knights of Columbus, Rotary, Kiwanis, the Methodists and the Eighteenth Amendment do enter intimately into the question of America and the artist. They affect the problem of what I have called, loosely, the American idiom. They are an essential part of the problem. It is rather absurd to take fifty million members of the K. K. K.,

K. of C., employers' organizations and religious denominations and damn them wholesale and out of hand as so many hosts of darkness arrayed against the free artistic spirit. You cannot take half a nation and dismiss it as constituting so many "difficulties and obstacles." By the time you get through enumerating them all you may find that the difficulties and the obstacles make up 95 per cent. of the nation. If the Rotarians, the Ku Klux and the Methodists are a real factor in American life, then they can be no more disregarded by the artist than he can disregard the Mississippi River, the Rocky Mountains, the United States Constitution, the public school, the Ford car and other essentials of the national life. The Methodist and the Anti-Saloon League are, in this sense, as much a part of the "soil" from which the artist must draw his sap as are the mountains and prairies and the New England temperament. I should go further. If the American artist is truly an artist I should expect his sensitive soul to mirror Kiwanis and the Southern Baptists along with the prairie, the New England village and the sun going down behind the Sierras. If genius in these United States is out to sound an authentic note, how can it conceivably make a noise except in the American idiom?

The national idiom must inevitably be shaped by the national realities. The American idiom in literature cannot be the Dostoievsky idiom or the neo-Zola idiom or even the Anatole France idiom, for America is not Russia or Gaul. Mr. Dreiser admits it. It is not a Kiwanensian or a Rotarian speaking, but Mr. Dreiser who declares that a "thoroughly prosperous country such as America is and is presumed to be" cannot be as stimulating to the highest form of art, namely tragedy, as a country "in which misery reigns."

It is Mr. Dreiser, and not the National Chamber of Commerce, who asserts that "the contrasts between poverty and wealth here have never been as sharp or as desolating as they have been in the Orient, Russia and elsewhere; the opportunities for advancement not so vigorously throttled, and hence unrest and morbidity not so widespread, and hence not so interesting." To be sure, there is enough raw material for tragedy to be found in the most prosperous of countries. Enough unhappy men and women may be found in the Packard and Pierce-Arrow classes to keep an American genius happy. But the American artist—and this is my thought and not Mr. Dreiser's—must be content to look for his tragedy in America, where it can be legitimately found, and not import his tragedy from Russia or Sweden. If he insists in doing so he must not wail because America refuses to recognize herself in the imported package.

It is a point rather well illustrated, I think, in Eugene O'Neill's "Desire Under the Elms." To the extent that O'Neill's concern lies with human greed, with human lust and passion, New England of half a century ago is just as fair game for him as Paris of today would be or Ur of the Chaldees of 4,200 years ago. But when O'Neill injects into his play the land-hunger motive he is obviously importing from Europe. In that old, overworked and overparceled Continent the peasant's savage passion for a foothold on the soil, which is so recurrent a motive in the literature of Europe, is an understandable thing. It is not an understandable thing in the New England farmer of fifty years ago, with a million square miles of the agricultural West to be had for the asking. So fierce is the European peasant's attachment to the land and so bitter is his need of it that if you give him a rock he will turn it into a field by carrying the soil to it in basketfuls on his back. But New England's abandoned farms are here to testify that earth exercises no such clutch on the Yankee heart, and the Puritan Transmississippi is here to testify that the Yankee found property and contentment elsewhere. When, therefore, O'Neill makes the desire for acreage the mainspring of incest and murder in New England he is, frankly, imitative. He is not speaking in the American idiom.

In the same manner Mr. Dreiser himself wanders from his idiom when he indulges in the mild sneer against the "100 per cent." American home, 100 per cent. American husband and wife. Here we have a strong intimation that in the matter of sex morality the only difference between America and the older lands is the well-known Anglo-Saxon hypocrisy. And yet other differences in appreciable degree there must be. They are suggested by the very nature of the embittered artist's indictment against America. If it is true that America's chief idol is Mammon, then it is a reasonable deduction that less attention is paid here than elsewhere to the worship of Astarte and Cytherea. To the extent that the manhood of a nation expends part of its energies on the golf links, the tennis courts, the baseball lots and the propulsion of fifteen million automobiles, it must be true that American manhood has a good deal less time for the practice of amour than the much more sedentary populations of the Continent. Take the severest count in the indictment. Take the popular explanation of Ku Kluxism, Rotarianism, Anti-Saloon and censorities as only the outburst of repressed sex instincts. Yet the fact of repression is admitted, and the American realist cannot have it both ways. He cannot insist that American men and women stifle their emotions and at the same time insist on representing the facts of American life as though repression did not prevail.

It may seem a reckless thing to say, but, after all, the Fourth of July orators are, in substance, right. America is different. The discontented American artist will have to recognize and accommodate himself to that fact just as his fellow-dissenters in politics and sociology are now doing. For instance, under the impress of the late La Follette experiment there has been an inclination in Progressive quarters to re-examine the question of the British Labor Party as a model for this country. Astonishing discoveries have been made. It has been discovered that the field of opportunity is much more open in this country than in England; that American workmen earn more than English workmen and drive more automobiles; that America is far less caste-ridden than England and, therefore, less subject to social revolution; that America has a great many more farmers than England has; and so on. Not such very astonishing discoveries? Well, perhaps not. These are truths accessible in all the textbooks and

almanacs. Yet they are now announced with something of the air of stout Cortez wild-eyed on a peak in Darien. Serious thinkers are discovering the Fourth of July orators.

Some such rediscovery of America awaits the American artist. Does it mean that he will thereby find himself excluded from outlooks and interpretations that are vouchsafed to his European colleague? Very likely. As long as America remains prosperous and democratic he may be prevented from writing a great American tragedy, as Mr. Dreiser suggests. As long as Americans prefer golf to cafés and Buicks to boudoirs the American artist may be lamed in his efforts to probe sex with D'Annunzio and Strindberg. But perhaps he may find compensations. Perhaps he may be qualified to explore channels of life that are closed to D'Annunzio and Strindberg. That is certainly a state of things not to be regretted from the humanistic point of view. The best kind of a world, every one admits, is one in which every nation is free to bring the contribution of its own genius, its own idiom, to the common world stock. After all, Americans do not sit about and mourn because they can grow only corn, wheat and cotton and must leave silk growing to the Chinese and coffee to the Brazilians. The economists think that this is the best method for supplying everybody with more hogs, wheat, silk and coffee than if we went in for silks and coffee, the Chinese for hogs and the Brazilians for wheat. The American artist can do his best for world art by not going in for raising Strindberg in Kansas and D'Annunzio in Indianapolis—under glass.

* * *

May 17, 1925

FINNISH ARCHITECT PRESCRIBES FOR US

Eliel Saarinen's Designs for Chicago and Detroit Skyscrapers in Harmonious Groups

By ORRICK JOHNS

It is not often that one meets a contemporary practitioner in any art who holds steadily to the historical view of his work, even at the cost of some pride in achievement. The historical view has a tendency to dwarf the contemporary in eternal values, but the contemporary submerges the historical in importance. Generally the artist is so absorbed in the act of producing, in answering a timely need or expressing the mood of the moment, that he loses the sense of being a detail in a long perspective.

To him as a rule his effort seems to have little or no relation to what has passed. Be it a building, a painting or a book, it is a queer animal, born for the first time into the world and standing alone. The convenient name we give to it is "modern," but it is a name without a distinction.

Eliel Saarinen of Finland is an architect who holds to the historical view of his art. While he is deeply stirred by the importance of American architecture, has contributed to its

development very effectively, and expects to be engaged here for some years on the actual construction of buildings, he does not grant that he and his American confrères produced a "style." As yet he does not know what we are producing. In 200 years perhaps we shall be able to see what characteristics were unique in our age, and it will be found that these characteristics are also universal. It will then be time to talk of "Twentieth Century American," in the same way that we talk of Renaissance, Egyptian or Queen Anne.

In his native Finland, as a practicing architect, Mr. Saarinen met with no conditions such as ours, high buildings, heaped-up cities, congested areas, incredible traffic tangles. From his forest studio, however, he kept an eye on developments in other parts of the world. Besides designing banks, country houses and office buildings in Finland, and such great civic structures as the Main Station to Helsingfors, Saarinen contributed residences to Germany and Esthonia, and won a prize for an Austrian capital building. His only experience up to three or four years ago in the design of high buildings had been the erection of towers for European City Halls and other structures of that type.

But Saarinen is a town planner, and this phase of his work led him to familiarize himself thoroughly with the problems of our cities. His next step was to participate in The Chicago Tribune Building competition. Though he was practically unknown to the judges his work secured immediate admiration. It was a severely plain tower, sculpturally projected, and giving the maximum illusion of height. The jury awarded it second prize.

The designer had never seen America, but he now came over to study the country more closely. Before he had been here six months, he was absorbed in a complete plan to reconstruct imaginatively a portion of the Chicago lake front. This work was done on his own initiative, almost in secret and without hope of its ever being put into execution. When finished, it was found to be an exhaustive solution of the difficulties involved, carried out to the last degree of detail in street planning, traffic regulation and even railroad design.

In his Chicago scheme Saarinen consciously attempted to use the high building, not as an isolated conception, but as an accented note in a broad composition. The design calls for a towering structure at the end of Grant Boulevard, a long and imposing thoroughfare. This sculptural or monumental use of tall buildings has been neglected by our architects—from necessity, of course, the inability to command more land than that which the building rested upon. Its magnificent possibilities are felt in such undertakings as the Nebraska State Capitol, by the late Bertram Goodhue, or the dominating structures around New York's City Hall Park

About a year ago Saarinen began teaching at Ann Arbor, and since then has worked out a plan for the beautification of Detroit's river-front, one aspect of which is illustrated on this page. This plan has been accepted by the City Council of Detroit and will be carried out if the necessary expense can be met.

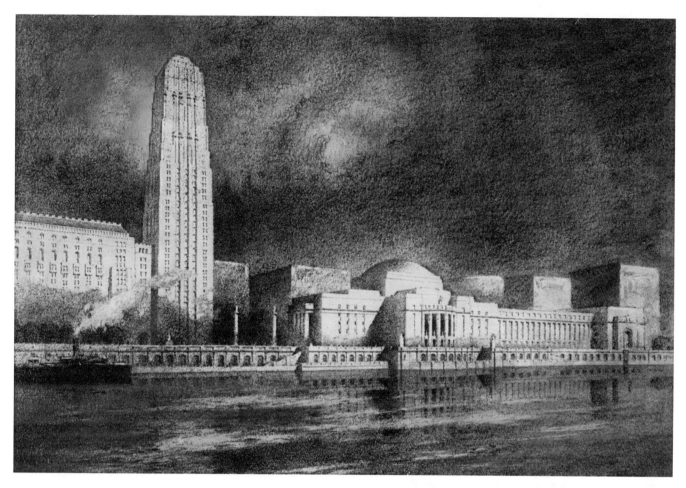

Saarinen's plan for the beautifying of Detroit's riverfront.

A Town-Planning Architect

The American activities of Eliel Saarinen are typical of the man's imaginative scope, for he not only sees our age in historical perspective, but be believes in regarding large units of area as a single problem. He is a town planner first of all, and he foresees that the great architect of our period will be a town planner. He will be a man who can re-create in his own brain the whole picture of the life of a community, and provide for its best growth and expression down to the smallest detail.

To quote Dr. Raymond Unwin, Chief Architect of the British Ministry of Health, whose ideas on some points are endorsed by Saarinen, what the architect needs is "that range of knowledge which will enable his imagination to picture the city as it might be, to see all the parts and functions in their true relation, see the life going forward in his imagined city, study that picture and adapt it to meet the realized needs." In short, he must be a Balzac with a T-square.

"Your cities of today," said Mr. Saarinen, on a recent visit to New York, "are an agglomeration of buildings each of which expresses one man's idea of how a certain problem should be solved. Many of these individual solutions are splendidly executed. Many of them show sincere effort to solve the problem in the best way, and express the character of the time architecturally. But in the great periods of architecture you do not find this emphasis upon individual buildings. A whole city had 'style'; the buildings of a whole period were marked by it. Architecture is not the expression of a person or of a year, but of a civilization.

"Take one of your individual buildings, the Shelton Hotel. That is a fine solution of a certain problem, but it is the solution of one architect, Arthur L. Harmon. It is too individual for us to say that it has 'style,' though it deserves great admiration. But if a structure like the Shelton Hotel were an accent in a group of buildings, in a composition that brought out the fine points of each individual building, the group itself and each member of it would approach more nearly the conception which we call style.

"This is the reason large problems like the Chicago lake front and the Detroit riverfront have attracted me. It was an effort on my own account to find out how the skyscraper and other forms of building common to your civilization could be used together to the best advantage of all. For the buildings of a city must go together. Each must meet the needs of its own use perfectly and yet stand in the proper relation to all the others. The group is the unit that has immortalized architecture for us. Sometimes the effect of harmony is achieved by contrast, as in

the Piazza San Marco, one of the most beautiful spots in the world. There the greatest variety exists, a tower, monuments, houses, church. It is like the orchestra, consisting of tones and instruments sharply differing from one another, but blending together through the genius of the composer.

"Again you may achieve harmony in the group by similarity, in long rows of buildings charming in themselves and varying in detail, but giving the general effect of repetition. An example is the Rue de Rivoli in Paris."

The writer asked Mr. Saarinen what he thought of the analogous "similarity" being evolved in New York by the multiplication of setback buildings.

"It is very good," he said. "It might be called the pine forest motif, many buildings close together with tapering tops. Later you will come to great freedom in it, some high, some low, some treated one way, some another, and possibly planned in larger groups. In that way you will develop harmony through variety.

The Fourth Dimension

"Which reminds me that we need a new word for city planning. A city plan, strictly speaking, is in two dimensions. Architecture is three-dimensional. Perhaps city building is a better term. We must keep in mind the mass and silhouette as a whole, as well as the plan. It all grows out of the plan, of course, but it is the mass that people see. One instance will illustrate the importance of each part to the whole. I have been living in the little town of Ann Arbor. It was very nice when I went there, very pleasing to the eye. But since then a single building has been erected that has spoiled the appearance of the whole town.

"I have said that architecture is three-dimensional, but I like to think of it as four-dimensional. The fourth dimension is the distance from which a building can be seen in its surroundings, the sum of all its aspects, so to speak. Today we plan too much on paper, far away from the site we have to build on and without intimate knowledge of it. This means that we neglect the fourth dimension.

"We are accustomed to say that practical considerations stand in the way of beauty. But, of course, on the other hand, the practical is what we must work from, and beauty really begins with it, ultimately grows out of it. In dealing with modern tangles like the traffic, for example, the architect must be practical above all things. He is the artist as well as engineer; but for the time being he must solve the traffic problem so it will work and forget the beauty. If only the practical element results the work will be forgotten. If beauty has been achieved it will endure

"The crowded condition of our cities has made the architect think more than ever of the practical side of his calling: this only means that we had forgotten some fundamental elements of architecture. The architect is deeply concerned in traffic. It seems a new thing. But it is not. The first building, and every one erected since, had a traffic problem. People, materials, services, had to reach it, go into it and come out of it."

Mr. Saarinen's Tribune Building design was much discussed, at the time it was made public, for its bareness and paucity of ornament. The writer asked what he thought of ornamentation on modern buildings.

"If I were making that design now," replied the architect, "I should make it even plainer. The trouble with all of our ornament is that it must be borrowed and does not fit. Ornament is like clothing. A prominent banker of today does not put on garments from the fifteenth or the eleventh century. To my mind there is something just as incongruous if he does his work by the light of a Gothic window or enters his office through a Roman doorway.

"Ornament should be authentic. It should be the work of contemporary artists directly on the building. It should grow out of the same times and customs as the architecture. We cannot do a Gothic building properly today, because the sculpture is not sculpted. It is drawn on paper and a contractor executes it.

"For these reasons I think it is best to do without ornamentation, until the appropriate ornament is spontaneously produced. Solve the problem in an honest, simple way, let the sculpturesque quality come if it will, and we will have characteristic ornament in time."

* * *

January 10, 1926

DECORATIVE ART REACHES NEW FIELDS

American Artists Are Turning Their Talents Toward Articles Used in Daily Life of the People

Art, applied to the everyday uses of life—in the office, the shop, the home—has come within the last few years to occupy so important and so self-conscious a place that the moment seems to have arrived to restore art so applied to its traditional place in the public esteem, lately monopolized by the art called "fine" or pure and resting in our time the principal emphasis on painting and sculpture.

Our public and private galleries are still full of pictures and statues and our artists continue to increase the number of paintings and to multiply the pieces of sculpture in marble and bronze. More and more people, no doubt, go to look at these works of art in the galleries and museums. But even the galleries and museums are taking more and more account of the work of artists who aspire to make, or are content to make, useful things which one does not have to go to museums and galleries to see. A while ago these artists were distinguished as craftsmen—which is a fine old word—and their field of endeavor was labeled "arts and crafts."

But since an artist is, or ought to be, a craftsman as well; since the importance of the work the craftsmen are doing has prodigiously increased; since artists who used not to call themselves craftsmen have taken up that work; since whole regiments and battalions of younger artists are being trained up

especially for that work—the distinction is insisted on with less vigor. The tendency grows to treat what the artist does as craftsman or in alliance with craftsmen as serious art. That is clearly the way in which it will have to be treated in future.

Obviously the field is a wide one, and equally obviously, it is a field where, before the age of machinery, the artist and the craftsman worked together for centuries. Just of late there happens to have been more activity in and more talk about a field of craftsmanship which had for more than half a century quite escaped from the artist's influence, though it had not so long ago counted among those who thought it worthy of their attention a great artist like Robert Adam. It is clear that the cabinetmaker's craft is again recognized as an art, even if it is not agreed that modern cabinetmakers have yet created a new art worthy to succeed that of the eighteenth century masters of the craft in England—Chippendale, Heppelwhite and Sheraton.

Everybody knows that the public is buying all it can get of the good work of these masters and their imitators and adapters—including especially the American adapters of their styles. Evidence abounds that a large number of reproductions and adaptations of the fine eighteenth century models of chairs, desks, tables, sideboards, chests of drawers and so forth are being made here and now and absorbed into the furnishings of our homes. What is significant is that they are being so absorbed because they are recognized as having a virtue of proportion and a quality of good taste which stamp them as "art." One of our best authorities on old American furniture goes so far as to say that cabinetmakers are to be found in this country today not a bit inferior to the cabinetmakers who worked here in the late Colonial and early Republican days—and these, he insists were as good as all but the very best in their contemporary England, who were the best in the world. If this is so, with all the demand for good furniture that has arisen and all the activity going on toward supplying the demand, it seems to be demonstrated that the province of modern art to which furniture belongs is an important province and quite worth the attention of serious artists—quite worth the attention of critical persons who can inform the public of what is doing and give them some of what is being worthily done.

Scope of the New Field

Thus furniture, it plainly appears, is included in the scope of the new art criticism. So is the interior architecture of the room in which the furniture is placed, whether it is an office to work in, a shop to sell things in or part of a home to live in and play host in. So are all sorts of accessories that go with furniture proper—meaning the cabinetmaker's contributions to the ensemble. These are hangings and curtains and upholstery and wall paper—or at any rate the patterns of the fabrics that are used for these purposes and the colors and combinations of colors that make them fit to live with.

An Entering Wedge

Included also are iron and bronze work for screens and grills and doors and stair rails and the supports of lights, as well as the sort of metalwork that goes out of doors on balconies and terraces and serves as the embellishment of gardens. Even the stonework and brickwork of garden walls invites the application of very real art, and fires the imagination of artists worthy of the name. And, of course, there are fountains in infinite variety. Nor are the magnificent opportunities offered by mantels to be overlooked, since, in spite of steam heat, they have come back to the home along with the fireplaces—another opportunity for brass and iron work in the way of fire dogs, fenders and fire screens.

Here is an entering wedge for almost any sort of artist to apply himself to the useful and make it beautiful. If he is a sculptor he can carve doors and mantels, and even chairs and chests. He can do it in wood for any of these items of the interior. Or he can work in stone or iron or bronze or even plaster for any one of a dozen contributions to the effect of the grander sort of house—of which a great many are still being built in the country, even if most of those intended for private use are being pulled down in town.

If he is a painter—even a portrait painter—he can take a leaf out of the book of John Sargent and paint murals. They need not be big murals such as those which adorn the Boston Public Library. They can be quite modest murals in a quite small house—like a flight of storks that somebody has done for a sedate family dwelling, with the symbolical birds flying upstairs to my lady's chamber.

The potter and the silversmith were included among the artists of the elder days. The world once more has room for artists in this line. Especially since the finest old pieces are being lest to the home and coldly bestowed in museum cases, where such warmly human things as tankards and teapots seem to the layman cruelly wasted.

Akin to the potter, with the numberless vessels he can make and the inspiration—or despair—he can gather from the work of all the past masters in ceramics from China and Japan to Bennington, Vt., with all the colors and glazes they have to show, is the tilemaker. He also was once an artist—not a maker of plain blue and white glazes for sanitary purposes. He is becoming an artist again, and he is having a chance to use his artistic sense to his own advantage and that of the public.

When it comes to fabrics the artist has another vast world ready to his hand. There are not only all sorts of hangings and coverings and floor cloths with infinite possibilities in the way of artistic decoration by printing or weaving or otherwise; there are dress stuffs of every hue and material, both simple and elaborate. Also there is the voracious demand of fashion for new materials and new designs to keep up with the awakened artistic sense of the acknowledged leaders in the process of remaking the United States of America into an artistic country. The women started it. The women are keeping it up. They have long since rescued the American male, in the cities at least, from the shamefaced attitude toward the sense of beauty—except in the female face—which our national form of Victorianism had made second nature with him. Even in Texas and in Kansas a man need not blush because he knows

good furniture from bad and in the East he is not disgraced if he takes an esthetic interest in what his wife wears.

Whether the rage for new materials and designs is or is not fanned to fiercer flame by the people who have to make a living but of selling new things every season is a question which need not be too deeply probed here. The rage exists, and in order to find the new designs the treasury of old and lovely things is being constantly levied upon and the artist called upon to adapt the old idea to the new purpose. A discovery like that of beautiful and precious objects in an Egyptian tomb, or an expedition to midocean wonder spots like the recent one of William Beebe's Arcturus, may equally supply the hint. It is a curious item that a concern in this city has commissioned one of Beebe's artists to turn her drawings of strange Sargassan bugs into a suitable motif for a fabric. It was required that the effects should not be insectile and crawly, even though the originals of the patterns applied as "art" had in nature been bugs—and probably had crawled.

Artist As An Ally

What has been run over thus lightly and informally—so as not to make this article a catalogue—is only a small part of the field of art practically applied to the needs and amenities of everyday life. In proportion as the culture of the people ripens under the hot house processes now at work among us the substitution proceeds of specially made things for quantity production things in the American home. As that substitution goes on the field of the artist is automatically enlarged.

That does not mean that everything in the ordinary home will presently be the work of a great artist. It does not mean that many homes will be furnished with "originals" but it does mean that the originals of the things found in the home will be more and more the sort of thing that the artist takes joy in doing. In short, the artist will be the ally of the manufacturer as he used to be the ally of the craftsman—who used often to run a pretty big shop for his time. And because quantity production in the large sense is the negation of art the manufacturer will have to adapt himself—as he has already adapted himself in the matter of so-called exclusive patterns and designs of fabrics and gowns—to the fundamental psychology which governs the demand for good things. That psychology insists that everybody shall not have a good thing exactly like everybody else though all are equally good.

* * *

March 7, 1926

DR. BODE SURVEYS THE ART MIGRATION

By LINCOLN EYRE

BERLIN—"Enthusiasm, patriotism and wealth are the three factors whereby the United States of America will eventually become the greatest repository of art in the world." This admission, cheerful as it is to American art lovers and collectors, had a mournful inflection as it came from the lips of Dr. Wilhelm von Bode, one of the world's recognized authorities.

"That is," he went on, "in so far as the art works can be removed from their century-old homes and transplanted to the soil of the New World. Nothing can alter or avert this eventually, for no power on earth can turn back the pages of history to the first of August, 1914, on which day forces were set in motion that were to result in a complete reversal of all hitherto existing political, geographical, social and economic values. No one could have foreseen at the time that the world's accumulated art treasures would also be affected by these sweeping changes."

Dr. von Bode, who on Dec. 10 last entered the ranks of the octogenarians, confesses that it is heartbreaking for men who, like himself, have spent their lives in building up their collections from small beginings to impressive monuments, to sit passively by and see these collections depleted. While this is not true of collections in the Berlin museums of which Dr. von Bode was the General Director for a long span of years, it is true of the museums of the Continent in general, as well as of the magnificent private collections in England.

The Migratory Movement Began

"The art production of the world had long ago been distributed among the civilized nations of the earth in a fairly even proportion, and art dealers with potential patrons ready to pay any price for a coveted masterpiece were in despair at the thought that these treasures were fixtures for all time," said Dr. von Bode. And then, without any warning, the face of the earth began to tremble and the migratory movement began! Not only have the defeated nations been obliged to pay tribute in the shape of art works, but even the victor countries are faced by the economic imperative of parting with their priceless art treasures.

"Any one who a decade ago had even hinted at the possibility of Gainsborough's 'Blue Boy' making its way across the Atlantic to become the central gem in the Huntington collection, would have been thought mad. He might as well have suggested the uprooting of England's century-old oaks, or the removal of the Rock of Gibraltar. And yet the impossible has happened, and not only the famous 'Blue Boy,' but many another of the world's masterpieces has traveled the same route.

"Starving Vienna, no longer able to afford the luxury of her famous Gobelins, has been obliged to barter them for bread for her children. Russia's aristocracy, now scattered throughout Europe, is living from the sale of art works and jewels that it was able to smuggle out of that Bolshevik-ridden country. May not these art works themselves be likened to emigrés, torn from their native soil and scattered to the four winds of heaven? They are now at the mercy of the highest bidder, and this bidder is America, the land whose treasury vaults contain half the gold of the world.

"This is the greatest transplantation of art works the world has known since the Roman plundering of Grecian art and the rape of the churches and museums of Europe whereby Napoleon enriched the Louvre. I can even foresee the time when art students from Europe will turn their faces

westward to glean inspiration from master works, wrought while the world was young and 'men worked for the joy of the working.' Fortunate America—unhappy Europe!"

Dr. von Bode, while disclaiming any intention of making a defense of monarchy, spoke with much feeling when he said: "One of the blessings the world was to receive from the war was democracy. Monarchy, so we had dinned in our ears, was a pernicious and baleful form of government. I shall not go into this as a political issue, but as a servant of art I must remain true to my convictions that Europe owes her art impulses and art production primarily to her monarchical institutions. Without her art-loving rulers and their generous subsidies, struggling genius would never have flowered and reached its highest expression. One has only to think of the collections in the Louvre, the Hermitage in Petrograd, the art galleries of Italy and the museums of Berlin, Dresden and Munich to realize that the harvest sown by the rulers of Europe is now being reaped by the bourgeoisie of the world."

In explaining why Germany, despite her bankrupt condition, has succeeded in conserving her art works to a great extent, Dr. von Bode said: "The German Ministry of the Interior took the initiative—unfortunately too late to safeguard many valuable private collections, notably private scientific libraries—by appointing a commission of art experts to make a list of works, the sale of which would mean an irreparable loss to the nation. This list comprises 900 works—paintings, sculpture, valuable specimens of the arts and crafts as well as objects of purely national and historical significance.

"The tag 'Verboten' was also attached to collections privately owned or such as had been bequeathed by their owners to the State. In this category are to be found the priceless collection of Böcklin canvases in the Schach Gallerie in Munich; the private library of the former Kaiser's most intimate friend, Prince Egon von Fuerstenberg, who has in his castle at Donaueschingen an unparalleled collection of medieval manuscripts and first editions; and the Gobelins from the Royal Palace in Berlin, together with other treasures belonging to the private possessions of the Hohenzollern family."

Dr. von Bode here made a digression and gave a vivid account of the rescue of the "Palace Watteaus" from the frenzied mob of soldiers and sailors that plundered the palace on the memorable night of Nov. 9, 1918.

"My first thought," he said, "upon hearing that the revolutionists under the leadership of Karl Liebknecht had broken into the palace, was for the Watteaus. With a squad of trusty assistants, I hurried across the square, to find a scene of indescribable chaos. While Liebknecht was haranguing the mob from the historic balcony where had stood, at one time or another, practically all the rulers of Europe as the guests of the German Emperor, the mob surged through the rooms plundering at will.

"The garderobe of the Kaiser and Kaiserin had been stripped of all articles of value; writing desk, chest and commodes had been pried open; glass doors of vitrines had been smashed; while bronzes, rugs and brocaded hangings were lying about in confusion ready to be carried off with

the loot. As I took a hurried glance about the rooms, I saw that two valuable paintings by Lucas Kranach the elder were missing, and my heart sank at the probable fate of the Watteaus. But, strangely enough, these had been overlooked in the first onslaught, and we were successful in getting them out of the building without attracting the action of the mob, which probably took us for fellow-looters. We smuggled them over to the Kaiser Friedrich Museum, where they are being held in safe-keeping pending the time when the Prussian State shall have made a final decision as to the Kaiser's personal property."

He Praises America

Coming back to the question of the future of art in the United States, Dr. von Bode does not agree with certain of his colleagues who maintain that art enthusiasm in our country is based less upon scientific knowledge than upon the collector's passion and the ability to gratify this desire. He pointed out the manifold phases of art development in America and the systematic effort to arouse an intelligent appreciation for art among the wider circles of the public. The Metropolitan Museum of Art now ranks among the foremost art institutions of the world, while those of Chicago, Boston, Philadelphia and Detroit have become educative factors of tremendous importance.

He referred appreciatively to the research work of American scholars in Athens, Rome, Egypt and Mesopotamia, which, thanks to the generosity of wealthy Americans, can be carried on under the most auspicious conditions. He singled out for special mention Allan Marquand of the Princeton Facult, "author of the most exhaustive work on the Della Robbia family"; cited Perkins's work on Italian sculpture, and called attention to the catalogues deluxe, to which J. Pierpont Morgan gave the initial impulse and which are now followed by the Fogg Museum and other leading art institutions. He pronounced the ethnographical collection in the Field Musuem in Chicago second only to the one in Berlin, the latter, he said, forfeiting its impressiveness by the congested condition of the rooms.

* * *

March 15, 1926

PAINTERS DEBATE ART POLICIES HERE

Rockwell Kent Attacks Stand of Museum on Native Work, Saying Europe's Is Favored

WANTS AMERICANS AIDED

Walter Pach of the Metropolitan Defends Purchasing Plan— Holds Our Students Need the Best

Starting as a friendly debate—in which the attitude of American museums and collectors toward American art was attacked by Rockwell Kent, painter, and defended by Walter Pach, also a painter and lecturer on art at the Metropolitan

Museum, a meeting under the auspices of the Society of Independent Artists last evening at the Waldorf-Astoria ended in a group discussion that brought forth personal criticism.

John Sloan, President of the society, presided and allowed remarks from the floor when the debaters had concluded. When Alfred Stieglitz, noted as a photographer, and Gaston LaChaise, sculptor, took the floor to attack Mr. Pach's work rather than his viewpoint on museums, Mr. Sloan interrupted and asked them to confine themselves to the subject. The audience apparently was with Mr. Sloan in both instances, judging by the applause.

Mr. Pach's Argument

Mr. Pach based his arguments on the viewpoint that American art should be judged by its quality rather than by the nationality of the artist, and that American museums should be and have proved to be the study places of people interested in art and so should contain only the best in art in order that Americans might develop a sense of the best rather than a sense merely of the American. He traced the history of American art, denying statements made in a letter by Mr. Kent to the effect that American genius was being destroyed because American buyers cared nothing for works that were not old and foreign.

"American artists do not want to be given philanthropy," said Mr. Pach. "They want their paintings to be judged for quality, and the place of the museum is to be the hanging place of the best. When it steps out of that role it diminishes its capacity for good."

He said other nations collected the great works of earlier days and the United States was showing no disregard for its own work because it bought the great works of other nations, also. He cited France as having realized that Italy's background was better than her own and having gone to Italy to study her works, thus to build the foundation of her own art.

"The United States must face the issue, too," he said, "and the museum is the means of facing it."

Wants Our Art Developed

Mr. Kent argued that America should develop her own art and that her collectors should aid the artists by purchasing their works.

"When the excavators dig in the ruins of this nation," he said, "they will find a lot of old art and statuary and Grecian mummies. They will not know what our art has been. After all, the rich people are the only ones who build substantial homes and fill galleries, but what are they putting into their homes? Second-rate European stuff, while hundreds of American artists go along with no encouragement.

"Europeans came to this country and this nation has been built up. There was nothing in Europe like conditions here. We were individual, but we have built up no individual art and the world looks to us asking when it will come."

He pictured American collectors as in the hands of dealers they recommended the purchase of European works because they could buy such works for $5,000 and sell them for $100,000 but would have to be satisfied with 20 per cent. of the price of an American painting.

"American artists will produce as much as Americans want," he said, "but our Morgans and the rest show them no encouragement. The American millionaire merely wants to fill his home with old art and furniture."

He suggested as the answer, the expenditure of the Munsey millions as a support for American art.

Attacks Artist's Writings

Mr. Pach was attacked for certain of his writings, Mr. Steiglitz charging that he had always favored French works rather than the American, and that he stood before a meeting under the auspices of the Independent Artists although he was not himself an independent. Mr. Steiglitz also said that Mr. Pach compared American millionaires with wealthy persons of the past who supported art, but that he erred, for the American millionaire today did not support art of his own day, whereas the earlier-day collector did.

Mr. Pach replied that the old collectors gathered old works for the knowledge they could obtain from them, and that the American collector today did the same thing. The debate was held in connection with the annual exhibition of the Independent Artists. About 300 persons attended.

* * *

March 21, 1926

EXHIBITION SEASON IN ART CIRCLES

Lack of Popular Patronage of Art—Paintings, Wood Carvings and American Glass—Observations in Many Galleries

The pros and cons of the value and place of the museum were discussed at the "Independent Exhibition", last Sunday night by Rockwell Kent and Walter Pach. Mr. Kent felt that because the museum was spending its money on old instead of on new art, both contemporary art and the contemporary artist suffered. Mr. Pach replied that the museum was not a philanthropic institution; that its province is not to support artists because they are poor. And blame was laid at the door of the American public, which, he contends, deserts its artists.

In one of those extraordinary volumes of statistics it has been computed that we spend thirty cents per capita on mirrors and twenty cents on all works of art. If people could learn to derive as much satisfaction from being patrons of art as from looking at themselves in a glass, what a boon it would be to artists! One art dealer observes that people wander into his gallery, enjoy the works on the walls, and go out again with words of enthusiastic praise. Praise alone cannot support the artists. Yet, of course, the public cannot be scolded into buying.

In purchasing contemporary works of art one must rely solely on one's own judgment. Not even the price gives a hint as to the value. This makes the quest of worth-while new

things doubly fascinating. As it happens, this week is full of opportunity. There are many group exhibitions by contemporary Americans. The list is as follows:

The Neumann Print Room—Ernest Fiene, Walt Kuhn, Charles Sheeler, Max Weber, &c. The Academy—The International, with the American section chosen from the members of the Grand Central Galleries, at the Grand Central Galleries. The Independents at the Waldorf-Astoria. The New Society of American Artists at Knoedler's, including, among others, Hayley Lever, Eugene Ullman, Jerome Meyers, Emile Waters and John Noble. The Whitney Studio Club at the Anderson Gallery. A small group at Babcock— Jessica McMann, L. Summer, Helen Stockman and William Fisher, Women Painters and Sculptors. The Macy Gallery. Pen and Brush.

Three Exhibitors

On looking at the work of Charles Bateman, one thinks: "Another of these sad painters"—only to find, on further investigation, that although the artist may be sad, he is not dreary, and that there is lurking mischief somewhere that almost denies the melancholy.

On the "Conjurer's Table" lie the poor things of the craft. The trick in this particular episode is not to be found on the table, but in the funny details of the room: the arabesque of a wooden grille and the neat plaits of a curtain. A "Blue Lamp," spreads inadequate light, but light sufficient to expose the fat stomach of the lamp base. "White Silos," with an air of apology for living, climb up the side of a red barn.

Regardless of where he may be sitting, the artist records all that he wants to see, even those objects that may be beyond the physical vision. The only duty of an arbitrary perspective is to nourish the design.

Charles Bateman's wife, Myra Musselman-Carr, is exhibiting sculpture. She has the very interesting modern tendency of making sculpture compact through the energy of the subject. As the "Mother and Child" hug each other or as the "Lady with Folded Arms" hugs herself they perform the double duty of pleasing themselves and strengthening the form.

In speaking of Mario Toppi, the word "little" naturally applies itself. He does "little" well-constructed water-colors on religious themes. Certainly he is sincere. His only reason for being an Italian peasant of the fifteenth century is that he cannot be otherwise. Charles Bateman—Myra Musselman-Carr— Mario Toppi—The Weyhe Gallery—Closes March 27.

Wood Panels

Elmer L. MacRae's wood panels are happy in color and appropriately designed, with a drawing that fits the craft. He has used Dutch sailing ships and frigates, scooping the wood for the white sails. He has enriched the pattern with Currier and Ives, whales and the ripples in the water. Flowers and swans also have served. The "Swans" are particularly successful. They are swimming toward the spectator with real movement and buoyancy. Elmer L. MacRae—The Montross Gallery—Closes March 27.

Glass

The phrase "art and industry" abounds. The Ferargil Galleries are exhibiting modern American glass through the courtesy of the Steuben division of the Corning Glass Works, where industry rather than art has been emphasized. This is not meant as an adverse criticism. These glassmakers are frankly experimenting, Some of the experiments have been thoroughly successful and beautiful; others have not. In the search for new methods there is no knowing what may be discovered.

Horatio Walker's new group of water-colors, at the same gallery, carries on the work he has been doing. As always, the pig is chosen as a favorite sitter. From this distance it can be a delightful animal.—Exhibition closes March 27.

Cats

Cats, as they are, without any changing or manipulating, are a great subject for an artist. They have grace and movement. They are so impersonal that one cannot sentimentalize them and in any way hold to the truth. It is a subject that protects the artist. P. G. Mories's quick eye catches the cat in charming attitudes.—P. G. Mories—The Rehn Galleries— Closes March 27.

Space and Pattern

In his etchings William George Reindel fills space with line and makes value through line rather than through mass. A field of corn that just pushes its head above the lower edge of the plate is turned to a well-considered pattern. A bird-house that lifts almost to the upper edge is so placed as to fill the space. In this fashion all sorts of objects have been used as pattern. Not the least amusing are a horse and wagon moving along the Rotterdam Canal. There is also a pattern of crows in flight. William George Reindel—The Miller Gallery—Closes March 27.

Shipping

Frank Vining Smith confesses being fascinated by the sails and riggings of old ships. He has used them half realistically, half as decoration. "The Roaring Forties" is most noteworthy because it is most different from the usual run of sailing pictures. The deck is seen, as the title indicates, in a heavy storm. The decorative quality is to be found in the twist of the ship and in a close view of some of the puzzling ropes. Even though these painters of ships may not be great artists, one always feels certain they are great sailors, who know all there is to know about the sea. Frank Vining Smith—The Schwartz Gallery—Closes March 27.

A Successful Autumn

Autumn is a snare for the painter who is satisfied to copy rather than to translate the scene in his effort to give a sense of the reality. John Newton Howitt has been able to adhere closely to the visual scene and still paint an Autumn that does not degenerate into a cheap red and yellow. "The Golden Carpet" he calls it. One stands under yellow trees that are

saturated with sun. The exhibition on the whole is very pleasant. John Newton Howitt—The Ainslee Galleries—Closes March 30.

Auguste Lepere

In the rich, full, crowded etchings of Lepère there is a cultivated balance of strength and delicacy. A bold tree lurches exuberantly across the composition, the outline trembling with delicate staccato touches that become the foliage. For a cathedral, Lepère used quite an opposite treatment, curbing his enthusiasm. The hard clarity of stone is expressed through an almost rigid perpendicular, that does not lose the sense of the direction no matter how filled the space may be with softening edges of Gothic sculpture. "Carrières d'Amérique, près Paris" is contemporary in its form, giving a sense of space and freedom.

Wood engraving, as Lepère used it, seems rather an old-fashioned and stuffy medium. Today, with a far simpler technique, we are achieving something that is nearer to the wood and unquestionably more alive in color. Auguste Lepère—The Keppel Gallery—Closes March 27.

Charles Bargue

The paintings of Charles Bargue have so little of the quality that, rightly or wrongly, we look for in a painting (regardless of its date), that it is difficult to be properly appreciative. Certainly one could all but pull a loose tile from an Eastern wall; yet that kind of meticulous copying makes small appeal nowadays.

With the drawings it is quite otherwise. They have so compelling a charm that no one cares whether they happen to fit any of the various standards. A man practices on the flute. His hands are beautifully drawn. There is enchantment in the shadows that lurk in the silk ribbon tying his peruke. In the trunk of a tree one discerns terrifying animals. There are children tumbling over one another in play; ladies coquettishly showing their clothes.

Bargue was a pupil of Gérome and, like his master, went to the East to paint. He had a short life and, it is said, an unhappy one. He died in 1883. This is the most comprehensive collection ever presented of his known works, the principal paintings being a loan from museums and private collections in this country. Charles Bargue—The Fearon Galleries—Closes March 31.

An Impressionist's New York

Marjorie Phillips's "New York" might have been painted by a Frenchwoman. Then, too, she can compose figures in a landscape or in an interior and keep a certain moving unity. Curiously enough, although her treatment of American buildings is less rigid than the hard stuff of which those buildings are actually made, her drawing of people and animals is stiff and quaint. Children and horses may have wooden joints. Yet the line of the composition as a whole moves spaciously and with fluid ease. Marjorie Phillips—Durand-Ruel Galleries—Closes March 31.

Breakfast Set

The chief feature of the Keramic Society's exhibition is its table arrangements. Various breakfast and lunch tables have been set. In each case linen, glass and china have been planned to fit. There is no remarkable designing. The color is cheerful, and, most important of all, the effect is appetizing—if a bit "arty." The society apparently contents itself with painting and decorating glass and china, and has not probed the technical difficulties of glassblowing or pottery. Keramic Society—The Natural History Museum—Closes March 27.

A Various Group

The Macy Gallery has succeeded in putting together as heterogeneous a show as it has ever been the privilege of the present writer to see. The clubs have been called upon—both Salmagundi and Whitney—with artists known and unknown, conservative and radical, filling the space between these two poles.

The "sold" mark is another innovation. Instead of the little red star, as tiny as a French decoration, a huge insignia splashes, proclaiming the picture's success. This is a good show. In spite of the fact that Gertrude Heilprin Smoleff's "Spring Flowers" are of an ordinary garden variety, there is something intense and passionate about them. Arnold Blanche has put his energy into making "Tiger Lilies" crisp and neat, though they are thereby no less alive. Margaret Chaplin's "Bouquet" is a straightforward statement about flowers that have derived nourishment from a fertile earth they still remember.

Rudolph Watterau is a new name. His barns have been painted at their reddest, when the sun is low and projects horizontally, like a spotlight. Henry Mattson has a way of dotting his landscape with isolated boxes—little houses that seem as lonely as human beings. Frank Swift Chase has contributed a conventional group. Harry Leith-Ross has saved his with uncommon color. Both Lucille Blanche and Harry Gottlieb have achieved distinction in their respective landscapes through a sensitive consideration of the relation of values. Contemporary American Artists—The Macy Gallery—Closes April 15.

Another American Group

Helen Park Stockman's has the strongest talent shown in the group now exhibiting at the Babcock Gallery. The "Tight-Rope Walker" goes far toward filling the two possibilities of a painting: interest in the subject matter and a design that through the emotional quality of its line and light interprets the subject. She has a various ability. The "Pink House," with shadows moving across its surface, is as gentle in its design as the circus picture is dramatic. In "Dawn in the Ambrose Channel," L. Summer has made a pattern of the buoys and has achieved a sense of silence through the simplicity of the form that suggests the time of day. Jessica McMann, preoccupied with horses, gives them the dignity they deserve. An American Group—Babcock Gallery—Closes March 27.

The New Society

The New Society of American Painters is showing little new work. The freshest episode not on exhibition is the Spring coat of paint on the President's yacht by Haley Lever, Emile Waters's "Snowbound Village" lies behind a grille of trees that helps imprison it. Jerome Meyers's "Park Concert" has been heard before. John Noble's "Brittany Coast" is not only the most familiar picture in the show but also the most stirring. The New Society of American Painters—The Knoedler Gallery—Closes March 27.

Famous Authors

William H. Cotton calls a group of caricatures "intimate portraits by famous authors." They are funny in their literary quality rather than, in an intrinsic sense, humorous drawings. Sherwood Anderson sleeps uncomfortably on a volume of Freud. Willa Cather is horrified to find herself a best-seller and is stalking away with a map of Arizona under her arm. We see the agony of Theodore Dreiser. D. H. Lawrence directs an orchestra of cupids. The Theatre Guild is lean and hungry for a new play, and poor Barrie tries to escape his Peter Pan shadow. William H. Cotton—The Ehrich Galleries—Closes March 31.

* * *

May 16, 1926

ADVERTISING SHOW IS ARTISTIC TRIUMPH

Fifth Annual Exhibition at Art Centre Displays Increasing Ability of Artists, Working in Harmony with the Demands of Business, to Produce Pictures of Intrinsic Beauty and Merit

The fifth annual exhibition of advertising art opened last week at the Art Centre with a collection of designs showing more clearly than any earlier exhibition the increasing appreciation of the need of art in industry. The appreciation is by no means on the side of industry alone. A large part of the indifference to art formerly shown by the business world was due to the intolerance of artists in meeting any requirements save those they set themselves in carrying out their work. Their repugnance toward "dictation" from an outside world caused that world to remain very definitely outside. On the other hand, the resentment of the business world toward a group of human beings who felt their superiority to the great forces controlling demand and supply raised an absurd wall between business and its brilliant ally in the field of art. These misunderstandings obviously are disappearing with some rapidity.

Artists of Standing

The present exhibition shows this. Among the artists represented are a number whose work in the field of advertising gives them a standing that might well be envied by their companions who confine themselves to the so-called fine arts.

They have taken the material offered them, worked within the prescribed rules and restrictions, obeyed every order, met all exactions and, with their knowledge and feeling for an esthetic result still in control, have produced designs of genuine beauty. Within their stiff limits these artists work with a free hand, demonstrating easily that they have learned a lesson which in a more practical age came by nature; the lesson that art is no respecter of subjects but can make with an egg and a skillet and a can of cooking oil a picture fundamentally as beautiful as an arrangement of saints and angels on the wings of an altarpiece.

The best designs are carried out with much diversity of style, and this is the most encouraging note in the exhibition. Take a few almost at random. H. J. Finley places mail carriers of all races and costumes, each in a diamond-shaped space, all in exactly the same pose, gaining an effect of geometry without relinquishing individuality of type and detail. George Pickens makes a landscape of mountains, trees, sky, the different features of the scene running into a silky pattern typical of modern design in just that fabric. Everett Henry places an automobile in front of a building the structure of which is indicated with the reticence of a modern method, architectural dignity gained with a few graduated darks uninterrupted by ornament or detail. Merritt Holden sticks some carnations in a vase and proceeds to extemporize on the theme of the carnation petal. One sees it reappear, masked as a sort of generalized floating hint of pattern on the vase, and in the background it becomes more mysterious and ghostlike, all trace of actuality gone, yet carrying off the stage to the sound of very sweet music the spirit of carnation petal. Possibly the artist meant nothing of the kind, but he cannot now escape the fact that he has done it and so beautifully that one is bound to applaud. With a keen, quick magic René Clarke goes on with his egg tricks, asking nothing except the few simple properties of the advertisement.

Old Map with Variations

Edward A. Wilson uses the old map motif with refreshing, independence. A sweep of shore, cherubs blowing winds across the bay roads, junctions, directions, places written down with the old handsome chirography of Ortelius and Blaeu, a spouting dolphin, a cartouche. But these are combined with the gay mockery of the new for the old, avoiding any suspicion of crass imitation. The young mermaids supporting the cartouche lift astonished eyebrows at the world confronting them. The dolphin spouts with ironic intention, and the cartographic value of the drawing is unimpaired by its whisper of quaintness.

Dozens of other examples, babies kicking rosily on a pillow, cups of tea and glasses or grape juice, shingled houses, long Elizas of the present mode, ballrooms and dinner tables, masked balls, motor cars, with almost as much variety in treatment as in subject, and a more than reasonable majority with some note of quality beyond the mere utterance of a slogan.

If one looks back to the advertising pages of thirty or forty years ago or to those of ten years ago, the advance in

the art of advertisement seems almost a miracle, in spite of the fact that it has not yet caught up with its own new ideal. The advance in the art of the poster has been much slower, and the reason is not apparent, for the start was fair enough. Edward Penfield, whose memorial exhibition recently held at the Art Centre fairly represented the range of his work, is called the pioneer in the field of American posters. Naturally his work possessed unusual individuality, the standardized "poster style" not yet having an international influence. Curiously, however, he went for his inspiration straight to a source toward which many hundreds of young artists and decorators are turning today: to the Egyptian exhibits at the Metropolitan Museum. Here flat masses, bold outlines, contrasted colors, gave him the key to a style which he made individual by his original and personal composition and an indefinable character of existing because of the artist's pleasure in his subject and independently of any commercial or otherwise external demand upon his talent. In his book "Poster Design," Charles Matlack Price gives a clear account of Penfield's technical qualities in his work at the end of the past century when he was almost alone in recognizing commercial art as worthy of an artist's best endeavor. "One finds," Mr. Price says, "strong composition, equally strong color, applied in great flat masses, bold delineation of outline, and lettering at once an integral part of the whole, and unquestionably adequate and co-important in mass and relative scale. There are no confusing elements of composition—no puzzling distances or distracting backgrounds. All the action is at the front of the stage, and any accessories that appear are so skillfully subordinated as to detract in no measure from the simplicity of the motive and directness of story as expressed by the main figures. Masses of small letters have been sublimely ignored, and every one of these posters breathes of a largeness and freedom peculiarly adapting them for purposes of outdoor advertising. They are all so eminently self-sufficient—with a poise of their own and a gracious self-assurance like well-bred people, never obtrusive, but ever prepared to take their part in whatever surroundings their fortunes may place them. One has hung these posters in every kind of room and habitation—but they never seem out of place or tiresome."

Element of Fancy

The final sentence or two in this criticism will wear the unfashionable cloak of fancy to the critical expertise of the present moment, but without them the passage would almost wholly miss the point. It is the personal and delicately fanciful element in Penfield's work that sets it apart from its kind and missing that one would miss the quality in it that triumphantly eludes standardization—the crime of crimes in all forms of art.

While a poster design to be successful in its own field must have a salient aspect, draw prompt attention and carry its message clearly and intelligibly at a considerable distance, these are merely the essential physical characteristics determining its special fitness for a special purpose. To be a

work of art much more is necessary. It is only since poster artists in this country have begun to realize that while they must work within the limitations of their field, working within these limitations, they can use all there is in them of esthetic sensibility and knowledge of the finer issues of art, that we have developed a small but very significant school of designers for posters and placards made to announce and advertise events and wares in a fashion to stimulate the interest of the public.

Naturally enough the merely efficient designer standardizes his method, uses a certain restricted color combination of aggressive character and achieves boldness and legibility if nothing else. If he is sensitive to the nice relations between a design and its subject, he goes further and adapts his manner in each instance to the spirit of his subject as well as to its external aspect.

Thus in the poster recently made for the American Wing at the Metropolitan Museum of Art by T. M. Cleland we move backward to a Colonial street with trees in Autumn leaf lightly fanning the warm brick faces of Colonial buildings. The prevailing curiosity of each good American of that day concerning his neighbor's affairs is delicately intimated by the expressions on the faces of the men and women leaning out of windows or passing in the street with elaborate bowings, or pausing in groups to talk, one dragging at a child who in turn drags at a toy.

Autumn Street Scene

The street is filled with activity and leisure. The weather is important. It may be an Autumn day such as that recorded in a newspaper of the late eighteenth century, when Philadelphia "by one of the best thermometers in the city" recorded 89 ½ degrees at 4 P. M., with a constant breeze from the southwest that made the air agreeable. Unquestionably it is warm. An old negro is driving a landau with its cover pushed back for Summer weather. A child leans against a tree, hat in hand, watching an artist sketching out of doors. A dog droops by his side. A cart with a barrel of water or something plods by. A boy rolling a hoop has upset the equilibrium of an old gentleman, who shakes his stick at him. High beaver hats, poke bonnets, shawls, fichus, small waists, curls, parasols, cobblestones. Sentiment, humor, manners, charm. A beautiful poster in which the artist seems literally to have entered into his subject and produced it enriched by its own appropriate mood, saying not a word of our own time, yet inevitably showing this warm and pleasant Colonial street cheered by agreeable southwest breezes and mildly astir with social life, as it looks to us across two centuries. It conveys the precise temper of mind in which we make our way to the American Wing in order both to cherish and assuage our nostalgia.

A poster artist who combines with quite extraordinary tact a genuine esthetic emotion and clear control of typical poster quality is Lucien Bernhard, whose exhibition at the Art Centre made a favorable impression upon the most exacting critics of this special form of art. Mr. Bernhard also exhibits in the current exhibition of advertising art a little placard touch-

ing the boundaries of the Currier & Ives or Godey's Lady's field—two discreet and graceful young women discussing lengths of cotton cloth over a counter. The spacing and line quality in the design are noteworthy. It did not of course require the artist's experience as a designer and decorator of interiors to do this kind of pretty card successfully, but the qualities that served the larger experiment are quite visible in the smaller and lift it easily to its plane of significance as art.

Lettering and Design

Another characteristic of Mr. Bernhard's work shown in his general exhibition is noteworthy. He is one of the comparatively few who thoroughly grasp the importance of making the lettering an essential part of the design, so that the whole gives the impression of a unit. In each of his posters the lettering harmonizes with the subject and helps to express its spirit. In a very beautiful example designed for a dealer in silks, for example, the dealer's name, simply and boldly spread across the top of the panel, flows with a silken suavity. It is impossible to convey in words the effect of this supple lettering taking its turns and folds with the same swift smoothness as that of the variously patterned lengths of fabric pouring across the space below.

Another poster advertises an automobile tire. The essential characteristic of the tire is thickness, and this characteristic is repeated in the lettering, in which the third dimension is emphasized by shadow, so that it seems to stand out from the flat background as positively as the realistically drawn tire.

Realism plays a considerable part in most of these posters, the precise rendering of the significant characteristics of an object satisfying not only the requirement of advertising value but the legitimate liking of the average observer for the authentic stamp of likeness. A sensitive appreciation of the beauty of material objects carries this realism even further, making it a kind of sublimated portraiture, more real than the reality. Thus in the poster showing an electric light bulb the transparency and exquisitely delicate reflections in the bulb are written unforgettably upon the mind.

It is a very fine art to extract from commonplace familiar objects in the service of a commercial intention their most significant qualities and present these with the clarity and vigor of the true poster and with the insight of a true artist. The result is far more beautiful than any effect gained by slurring or weakening reality in favor of a fashionable simplicity. To simplify is one thing, to synthesize another. There can be no primitive simplicity in any art growing from modern life. Modern life has banished this form of primitive. But there can be no strength in obvious complication, therefore the stronger minds of the age have created a sophisticated synthesis in which complication is resolved and reduced to singleness of effect. The loutish simplicity of the inexperienced mind works a powerful charm over the modern intelligence, wearied of conflicting demands upon it; but the superior force of art that has met and conquered the innumerable influences of contemporary life must ultimately be recognized.

William Zorach is extending his range of decorative sculpture. The unveiling of the mechanical clock, symbolizing the creation of beauty through silk, which he designed for the entrance of the Schwarzenbach Building in this city, marks the development of a new spirit in the business and industrial world of New York. We have had decorative sculpture, of course, on the outside and on the inside of our handsome buildings, but up to the present time there has been little, if any, of that fortunate cooperation between the owner of the building and the artist resulting in a personal expression.

Swiss Wooden Clock

The clock was designed in the spirit of the Swiss wood carvers, who for centuries have delighted in galvanizing into an apparent life the creations of their clever tools. Two figures surmount the clock case—one Zoroaster, the master spirit and the doer of all things, the other a young girl, the Queen of Silk, who emerges from the broken shell of a cocoon as the hour strikes 12. It was necessary that a sculptor of substantial and unconventional gifts should carry out such a theme, if it were to be made impressive for the sophisticated minds of our generation. Mr. Zorach has such gifts, and his weighty modeling is appropriate to the size and position of this unique timepiece, which first was carved in wood and then cast in bronze.

Even more important, however, are the entrance doors of the same building, designed by Mr. Zorach and executed in forged and hammered bronze by Peer Smed. The motifs are the silk moth, the cocoon and the mulberry leaf. They are woven into a massive pattern lightened by open spaces and frequent piercings of the larger masses.

* * *

July 25, 1926

PAGEANT OF ART AT SESQUICENTENNIAL

It Marches From the '70s to the Present, Linking Artists Famous in the Past With Those Who Are Making History Today—Summer Exhibitions Are Now on View in New York

Sesquicentennial means one-half more than centennial. This presumably superfluous bit of information is offered after consultation with large numbers of educated and literate people who needed it, although within easy reach of their dictionaries. The passion for looking things up is almost as much out of date as the costume of 1876.

With the definition in mind it becomes obviously appropriate that the exposition at Philadelphia should deal especially with the one-half more of years that have elapsed since the Centennial of 1876. The immensity of the task hardly can be realized by the public, and many of those engaged in it had at the outset no conception of its magnitude. The delay in completing the buildings and installations has been sufficiently irritating, but face to face with the operations involved

the competence and speed with which they are being carried through become another bit of testimony to the efficiency of the half century represented.

A Half Century of Art

The Fine Arts Building at the time of writing is completed, although only part of the exhibits is in place. These have been assembled with the proper Sesqui idea of illustrating the developments in art during the past half century. There was not enough time, perhaps not enough money, to plan and carry out a logical sequence by which the visitor could make the journey with constantly increasing rapidity from the '70s to the present year, but a number of the earlier artists are represented and take their places among their successors.

At the great Centennial of fifty years ago art was treated rather casually, but it was a period of stirring beginnings and strong personalities. William M. Hunt was in Boston doing some of the best work of his life and reflecting that in another country he might have been a painter. John La Farge was decorating Trinity Church in Boston and preparing for the decoration of St. Thomas's in New York. Whistler in England was "the American artist" at work upon the "Rosa Corder," and with the famous "Mother," the "Thomas Carlyle," the "Miss Alexander" already to his credit, as well as the "Princess of the Land of Porcelain" and other of his "Japanese" pictures. In 1876 the Peacock Room was begun. Winslow Homer was painting his charming genre subjects, "The Visit of the Mistress" and "The Song of the Lark," having given up his illustrative work for Harper's Weekly. Frank Duveneck was among the new men who exhibited at the National Academy in the historic exhibition of 1877 that resulted in the formation of the Society of American Artists. The sensation of the Academy exhibition was Duveneck's "Turkish Page," which seems today so conservative and quiet. One of the contemporary criticisms praising it referred to the artless centennial in the following comment: "Ten years with such a start as this and we shall send to the next exposition something better than sewing machines and patent cow milkers. We shall send pictures and statues that will not be shamed by being set alongside the work of France and England."

George Fuller gave up his farming in 1876 and started upon his more remunerative period as an artist. He and Ryder and Chase and J. Alden Weir all belonged to the Society of American Artists and the last three are represented in the Sesquicentennial collections.

Chase was one of the most versatile of the group and exercised perhaps the widest influence of any. It is a pity they could not have got for the present exposition some of the beautiful early works that revived the memory of his talented youth at the Panama-Pacific. Here three examples show something of his variety, a still life of fish, a group portrait with three figures and "The Fishmonger's Shop." Ryder is seen in one example, "Macbeth and the Witches." There are several Weirs, a sensitive portrait of a woman, a little town, a

Alcove of the Pennsylvania State Building at the Sesquicentennial Exposition in Philadelphia. The frieze shows the signing of the Declaration of Independence.

landscape, all touched with the magic of the artist's pure invigorating style.

So small a representation gives, of course, no basis of comparison between the older and the newer schools, yet seeing these men in the large community of their successors it is possible to infer in them a quality hardly to be found in the latter. Even in Chase, whose vision was accepted as the most objective of his time, one discerns a tendency to wrap the significance of a subject, when this has been determined, carefully in veils; never to report quite bluntly the facts of a case, always to communicate something of the incommunicable in one's expression or a chosen theme. They were continually conscious of the limitations of the visible, and when they least attempted to transcend these limitations they nevertheless implied them.

Linking Past and Present

As one moves toward the immediate present, there are many contacts with later men, for whom also the invisible world exists. With some of them, as with Childe Hassam and Arthur Daviés, it is a world evoked by culture, by close acquaintance with the imaginations of the long past and sensitiveness to the more poetic aspects of the present.

Here, for example is Hassam's picture of a little nude among dark rocks, painted in 1912. It is just that, with no obvious literary allusion, nothing of cross illustration in a pseudo-classic idiom, yet what associations with the world of

Theocritus it carries, how much is in it of the spirit of the country-loving Syracusan!

'Tis Thyrsis sings, of Etna and a rare sweet voice hath he.
Where were ye, Nymphs when Daphnis pined? Ye nymphs,
oh where were ye?

One nymph, at least, was waiting for the brown rock in green shade and the twentieth century.

This interest of association with ideas born of culture is by no means confined to the older painters. It crops up in fertile oases all through the exhibition, which, on the whole, suggests a literal attitude of mind. But whatever attitude of mind is suggested the contemporaneous note has its thrilling command for any truly interested observer. "Why should not one feel," asked Mr. Brownell in one of his early chapters of criticism, "the same quick interest, the same instinctive pride in his time as in his country? Is not sympathy with what is modern, instant, actual, and apposite a fair parallel of patriotism?" Passing through the galleries from the first room, with its memorial groups of Bellows and Metcalf, to the collection of modernists, the consciousness of the world in which we are living today is clearly with us.

The general tendency in collecting the exhibits has been to concentrate upon prize-winners, and this, of course, prevents the pungent flavor of personal choice in the character of the collections. It is fair enough, however, to assume that if there can be an occasion for the discarding of personal choice, it is the occasion of an avowedly historic exposition. All such expositions adopt an impersonal pose, and in spite of it are conquered by the intensity of personality required to produce a work of art. The galleries at the Sesquicentennial are filled with pictures in which personality mocks at prizes even while it takes them.

Names of the artists, taken at random, will indicate to any regular gallery visitor the very wide sweep that has been described. Here are some of them: Fromkes, Raditz, Troccoli, Pearson, Blumenschein, Borie, McCarter, Kroll, Lathrop, Johansen, Ezra Winter, Dunton, Ross Brought and Ross Moffett, Oberteuffer, John Carlson and Emil Carlsen, MacEwen and Ipsen and Bellows, Cimiotti, Garber, Lie, Redfield, Folinsbee, Wetherill, Seyffert, Vonnoh, Griffin, Lawson, Luks, Ritman, Frieseke and Miller, Ufer, Sloan, Davey, Higgins, Bernstein, Molarsky, Spencer, Woodbury, Guy Wiggins, Bohm, E. D. Roth, Hawthorne, Cowles, Hudson, Wenger, DuBois, Breckenridge, Rolshoven, Giles, Schofield, Farndon, Harding, Anderson, Grabach, Nordell, Bredin, Sandzen, McLane, Henri—a hundred others.

With such diversity of type and method and subject and outlook it would seem impossible to gain a general impression. Yet one visitor at least put such an impression into words, without any of the argot of criticism. He liked the pictures, he sweepingly told his companion, because they all looked natural. Doubtless, without knowing it, he liked them more for the beauty of the hanging, a strenuous task and a fine achievement.

"Foxgloves," by C. W. Hawthorne. In the Summer Exhibition at the Knoedler Galleries.

The water colors and etchings were not yet hung, nor the work of the group of which Demuth, Preston Dickinson, Nordfeldt, Biddle, Dasburg, Rosen are conspicuous members. These and others of the "advanced" schools are in the exhibition, however, and there will be opportunity enough for any student to follow with reasonable steadiness the larger movement of tendencies in art in this country. Any attempt to get back of this larger movement to the darting, irregular course of talents less belabored by publicity must in any case be undertaken in privacy.

The main thing is to note that in spite of having to do in a couple of months what should have occupied as many years, those responsible for the collections in the Fine Arts Building have got together an impressive series of works both in the field of painting and that of sculpture.

In addition to the American exhibits, a considerable group of Russians occupy one gallery and include two or three large canvases by Burliuk in only one of which he achieves consistent abstraction, and the less expert, more deeply moving "Destruction of the Ghetto" by Abraham Manievich. Another gallery is given to fifty works by the Yugoslav sculptor, Ivan Metrovitch. These include two carved wooden panels, "Christ and the Merchants" and "Madonna and the Angels," outstanding works of their kind, and also three important marble groups, the property

of the Yugoslav Government. Many of the works have never been exhibited in the United States and several have never been placed in exhibitions of any kind. None of the sculpture is done in temporary materials, but includes work in marble, bronze and wood. A small collection of prints and seventy oil paintings are also included in the Yugoslav group. Painters among the exhibitors are Ljube Babic, Vladimar Becic, N. Bijelic and Peter Dobronic. A collection which had been arranged for the Panama-Pacific International Exposition in 1915 was unavailable because of the war, which makes this exhibit the first comprehensive showing of Yugoslav art in the United States.

The modern German exhibits were still in their cases. The room to be devoted to Rodin's work was not yet arranged, a few Japanese paintings were temporarily hung, the French gallery was still to be completed, the Persian gallery was felicitous at every point, but especially in its ancient tiles. All this, however, must wait for the Fall harvest properly to be seen, and any comment must be taken as merely a friendly assurance of value to be received.

With that understood, it is pleasure enough to visit the Sesquicentennial without either trying to measure its importance against that of other exhibitions or taking too seriously the merits of individual exhibits. To wander into the grounds at the stage when all sorts of labor is making a good deal of noise, when boards take the place of neatly graveled paths, when feeble little plants put forth a rosy hopeful bloom, when the famous Persian building cranes its domed head to peer over yards of scaffolding, this is to be free to use your imagination and see the whole more clearly than you will ever see it again.

Effect One of Unity

Without the distraction of flying about on the clever little railroad from one building to another, it is possible to observe how, gradually emerging from chaos, a fine standard of taste is being established. The architecture of the buildings already discloses an ideal in which refinement and novelty are happily united. The silhouette of the Pennsylvania building is extraordinarily beautiful and the delicate flush of color on its walls sufficiently signifies the restraint in which the scheme of a "Rainbow City" is to be held. The quietness and dignity of the old American town is curiously echoed in the ambitious modern structure.

The grounds as well as the galleries promise to look "natural." The more or less sensational effects of colossal statuary and elaborate artificial lighting are balanced by the spacing and proportion which have been given extraordinary consideration with admirable result. Gardens and courts, so far as these have been arranged and developed, emphasize the underlying good taste upon which the whole exposition has been formed.

The various notes sent out from the exposition in the interest of publicity include an explanation of the idea of the sculptural ensemble as "that of the nation progressive under the spirit engendered in 1776," and the preliminary glimpse of the exposition as it is now, open, but still in the making, surprisingly suggests just that. Later, perhaps the progressiveness may obliterate more of the spirit of '76; but at the present illuminating moment one sees how stalwartly our initial distinction of plainness has withstood progress. To be plain, even in the degree at present apparent in the Sesquicentennial Exposition, when the occasion is that of celebrating fifty years of physical prosperity, amazing invention and discovery, incredible acceleration of speed in getting from any place to any other place in the world, unquestionably is to have kept the essential virtue of our beginnings.

Turning again to the Summer attractions of New York, the eighteenth annual Summer exhibition at the Knoedler Galleries as usual offers a small collection of especially interesting items. A Winslow Homer, "Fisher Folks, Tynemouth," has the charm and graciousness and style which some of his critics deny to any of his work. Painted walls of rose and gray, a graceful woman holding a basket in the doorway, women knitting on either side; children on the steps, rose and blue and violet and gray in the color schemes, beautiful films of color caressing sound young forms. If anything, too much of charm and graciousness and style to suit the taste of the moment which is more in sympathy with the direct realism of sea pictures.

A Blakelock, finer than most, of medium size, blue in tone, an exciting sky burning with a cold light, tight-curled foliage, a central pool, the pigment ribbed and knotted. Two Sargents, a wood scene and a flower study, hollyhocks growing outdoors. "Sunrise in the Orchard," by George Inness, a red sun coming up from behind spectral trees, the smoke of a brushwood fire, a dim figure.

From these names, widely known and abundantly honored, one may turn with a secret delight to the comparatively unappreciated art of Theodore Robinson in one of its most ingratiating examples. A lady reads a letter among the delicate greens of early Summer. A cat lies near her on the grass. Both figures melt into the landscape without losing the crispness of their characterization. The color is enchanting—strong and pure and pale. A gentle master who distorts nothing, flatters nothing, sees everything with a pleasant intimacy and clarity.

Close at hand is James M. Hart at his best. Just why he is not sharing the vogue of haircloth and Parian marble vases is difficult to say. Samuel Isham found him with the rest of the Hudson River School even at its best, lacking the "indefinable gift of style, inseparable from great painting," and one of the Pre-Raphaelite critics of the New Path wrote of one of his paintings exhibited in 1863 that there was nothing in it "surprising or unaccountable," except the fogginess of the distant trees and the bright sunshine in the centre of the picture, these resulting from the "Rules of Art" followed by the painter. Supplementing this last criticism, the New Path critic added a bit of explanation worth quoting today when so few critics venture to point the way their artists should go. "In all the scenes of nature," he constructively advises, "great or small, brilliant or gloomy, there are

always spots of color, and bright lights or mysterious darks in places where we never should have looked for them; things that we cannot account for and do not understand. So if a picture be not in some respects surprising to us, asserting positively some things which we had never thought of and which we find it hard to believe, it can hardly be true to nature and will certainly not be in any sense great." In the same article Winslow Homer's picture is described as "signed all over with truth."

Various Excellent Examples

There are excellent examples of Gari Melchers, Irving R. Wiles, W. Granville Smith, Louis Dessar and Charles P. Gruppe, each unmistakable in style, and a charming little girl done in pastel by Mary Cassatt has the artist's invariable distinction and a delicacy of workmanship that was not invariable with her. A thinly painted red-haired girl by Robert Reid is a characteristically plaintive version of young beauty. A cathedral by Van Veen fills a large canvas with its intricate façade. Charles Hawthorne forbears to hint at oilskins in his picture of a young woman holding a parasol and looking down at a bed of foxgloves drenched with sunlight, a beautiful picture with flexible contours. Louis Betts is romantic and surprising in his painting of a partly nude figure. The black hair and red drapery and the effect of storm in the background add to the picturesqueness of the work, but its originality and force depend upon the combination of beautiful draftsmanship with extreme freedom of rendering.

* * *

November 28, 1926

FRENCH MODERNIST URGES NEW ART IN ARCHITECTURE

Le Corbusier, a widely known French architect, in building houses in Paris and other French cities is putting into practice his personal theories. He believes that this age calls for a new architecture; that most "styles" are bad, false, imitative and no longer useful, and he says "style" is distinct from styles, and, to him, means unity.

In a home the beauty should be in its proportions, not in its decorations, he theorizes. It should also be nearly empty. A minimum of furniture is his aim and that built in wherever possible, like bunks on shipboard, shelves, closets and lockers. Every house, even the simplest workingman's home, should have all modern conveniences—sanitation, terraces, garage, roof garden, or sufficient ground for a garden around it. Believing all this is possible by building along the line of his ideas for reducing cost, he has drawn plans for a "villa apartment" house of two-story homes with "hanging gardens"—that is, individual gardens on every floor and a communal roof garden, swimming pool, outdoor gymnasium and autodrome on the roof.

His book on architecture has caused much controversy on the Continent.

Our modern achievement, even in America, he thinks, has been all in the direction of engineering, which has progressed while architecture has stood still. Where it has advanced, it has applied the lessons to be learned from the engineers, Le Corbusier believes.

Industrial Architecture

The best architecture to be seen today is not in homes, museums or other public buildings, but in office buildings, warehouses, grain elevators, he asserts. These answer the purpose they are built for—have unity, simplicity and usually are constructed with primary geometric forms. He admires American office buildings and factories when no architectural decoration has been added.

Le Corbusier furthermore believes that the greatest beauty has been achieved in this age by industrial products. The automobile, the airplane, the transatlantic liner are beautiful; the average house is not. He feels that this is due largely to standardization.

In building an airplane, an automobile or a boat there is a constant attempt to solve a problem, to make them answer the purpose for which they are made. This, judging from the results, is not always the case in building houses; else they would not be so inconvenient, unhealthy and ugly as they usually are. The automobile and the airplane are beautiful although there is little attempt to make them decorative. We have achieved these results with automobile and airplane through standardization and selection. They are now built on inevitable lines. Why not apply these same principles to houses? Thus argues Le Corbusier.

Le Corbusier believes that all houses will eventually be factory made of standardized parts. He has constructed several houses in this way and one entire industrial village is under construction at Bordeaux. He asserts his theories apply not to cheap dwellings—although construction will be very much cheaper even when more elaborate than at present. His houses have all modern conveniences—a basic requirement.

He believes that the Parthenon is the supreme achievement in sculpture for all time and says this is also a result of standardization and selection. The Greeks had been building temples for a hundred years, always along the same lines. The supreme genius of Phidias selected from the other models and produced something we have never equaled. He thinks our nearest approach to it has been in industry and engineering.

We can also learn from the Romans and the Egyptians, Le Corbusier continues, because they used primary geometric forms, but not from Gothic. "A cathedral is not really beautiful. It may be dramatic and interesting, but it is essentially a drama rather than a plastic work of art—a conflict against gravity. We are compelled to invest it with all sorts of subjective emotions to be able to believe it is beautiful."

An Ideal of Harmony

Le Corbusier is not merely utilitarian, however. Over and above his ideas of simplicity and utility, of the essential adapta-

tion of a building to its function, there is an ideal of harmony which is achieved in this way and which is, he says, the essence of architecture and is all too rarely achieved. Architecture, he says, is a pure creation of the spirit. That is why it should not copy nature or anything else; why "styles" and "periods" are bad.

Architecture should be based, he believes, on geometry, especially on primary geometric forms—cubes, triangles, cones, cylinders. It should have the respect for line, mass and space which we have to a great extent lost. Blank spaces, if harmoniously proportioned, are not ugly, but most of our attempts at decorating them are ugly. Blank surfaces, consequently, form a feature in his architecture.

* * *

January 16, 1927

OUR TOWERS TAKE ON DECORATION

Color and Ornamentation Come to the High Walls of Skyscrapers

By H. L. BROCK

Because New York's new architecture deals with masses on a great scale, what no eye can miss about it—and what has been profusely written about and lavishly pictured—is the mass effect. We are enormously conscious of our new Babylonian towers. The tall buildings, which are a necessity on Manhattan Island and an obsession everywhere else, do, in fact, present to the architect his major problem as one of mass set aspiringly on end. In the solution of that problem lies, it is commonly assumed, the architecture of the future which is hopefully expected to redeem America's artistic reputation—take away from us the reproach of incorrigible imitativeness.

But the architect in New York has another problem. His buildings rise so steeply from the street that the ordinary passer-by may easily—and often does—miss all their effect of mass and height. So that to make a building seem different—to attract attention—more can sometimes be accomplished by novelty of decoration in the first thirty feet of elevation above the sidewalk level. Until very recently this was mainly done with effects of columns or pilasters. But the practical combinations of these effects are limited. And the newer buildings are so tall that pilasters—let alone columns—in order to match the rest, have to reach up so high that their function is obscured and their quality is lost to the eye of the pedestrian. Even the bus-top rider hardly gets the perspective.

Doorway Ornamentation

Take those new apartment hotels in Fifth Avenue just above Washington Square for instance, and observe, by cruelly craning your neck, what has happened to their excessively high pilasters, with the great piles of brick wall rising blankly above them.

Clearly, something else had to be done about it—and of late the ingenuity of architects has been exercised upon doorway and window ornamentation—especially doorway ornamentations that lie flat along the wall, or nearly so. The cutting off of stoops and protections that came with the forced widening of the streets started experiments in this direction, just as the law requiring the set-back for the light's sake was the beginning of the Babylonian tower development. Necessity has not ceased to be the mother of invention because man has so effectually harnessed the elements and past inventions have created new conditions.

Decoration on the flat naturally brought the use of color expressed in terra cotta and tiles and encouraged the revival of iron grillwork and carving in low relief. If you look at the new French Building in Fifth Avenue at Forty-fifth Street you will see—at a considerable price in neck twisting—that color has been lavishly used in connection with the set-backs. It has been used instead of the romanesque arches which have been the favorite decorative device there aloft since the Shelton Hotel displayed the motive so successfully. Red and green tiles brighten each terrace, black sets off the colors, and the tower has a pattern of still brighter colors accented with gold high up on its somewhat grotesquely flattened shaft.

An interesting example of the use of color within more convenient eye-range is the doorway of the new apartment hotel at 28 East Sixty-third Street, where rose-colored terra cotta on a ground of buff terra cotta has been used to frame the doorway, while set in the rose color above the doorway is a mosaic in brilliant colored glass—the last a very unusual, if not unique, exterior decoration in New York. The effect is surprising at first, but the architects have used considerable ingenuity and notable discretion in suiting the ornamentation to the general architectural scheme of the front. This is of brick laid in patterns, with a simulation of panels, leading up to set-backs so broken up that the first terrace in the middle of the front appears as a recess in the façade. In this case there has been a conscious and confessed attempt to avoid the pretense that the brick covering of the steel frame is a real wall—but the effect is solid enough.

Henry S. Churchill and Herbert Lippmann are the architects. The mosaic is the design of Bertram Hartman, but was actually made in Germany. Mr. Hartman, who is a Kansan by birth, is, by the way, an artist of some versatility. He is also an illustrator and a designer of batiks.

The iron grill of the door, framed in green, inside the rose terra cotta, is the work of Edgar Brandt's concern. The design follows the light and graceful type of the much-talked-of ironwork in the building at Madison Avenue and Thirty-fourth Street, which the Paris craftsman decorated for the silk house of Cheney Brothers. The exterior of that building is another example of the sort of thing we are discussing. The decorative effort is concentrated on the handsome grillwork of the doorway and on the ironwork framing of the lofty glass front of the shop.

A little further downtown—at Fourth Avenue and Thirty-second Street—is the Schwartzenbach Building, with

The entrance doorway of the Apartment Hotel at 28 East Sixty-third Street.

flowers in a design resembling a tree of life. Naturally they are more curious and amusing than important. Perhaps the main trouble with this whole scheme of decoration is the fact that it escapes attention so completely.

An example of something different which narrowly avoids the same fate is furnished by the carved stone frames of the large windows of the big Babylonian-towered office building at Fortieth Street and Madison Avenue. These windows are two stories high and run around the building on both streets. The carvings, which have been done by hand in the stone after it was set in place, are disposed in small quatrefoil niches running up each side of each window and across the top—something like a dozen of them to a window. In each quatrefoil is a little figure, usually less than half length. One might walk by the place a dozen times and never see the figures at all. But once attention is attracted one is apt to linger for a review of the whole gallery.

For among those scores of carvings—done roughly and very simply—are dozens and dozens of different figures. One window is devoted to war—from Mars to the doughboy. Another is a galaxy of seafaring persons from Triton to the skipper with his spyglass. Another illustrates hunting and fishing—from the boy with the slingshot to the fly fisherman with his reel. Another presents those who play at games—with racquets, baseball bats and all that sort of thing; another those who ride the horse, from the plumed lady of romance to the cowboy with his lariat. Elsewhere the arts and crafts are celebrated. Here is the man with the hammer and chisel—and there is the young thing in the latest flapper hat busy with her pencil. Obviously she is a designer of costumes. Next to her the fool in motley with his bells looks out mockingly. In another place is the college girl with mortarboard, elf-lock bob and large-rimmed spectacles. In yet another place a fellow is suffering acutely from the toothache.

Humor in Carvings

Not all of the carvings are as good as others. But some of them have the sort of humor that belonged to those old medieval stone-carving fellows who were not afraid to be funny, even in cathedrals. As a decoration, as far off as across the street, the effect is a narrow ornamented stone band running around just at the turn of the window recess.

The rest is a matter for careful and deliberate examination. It would be hard to say that the window decorations had any necessary connection with the general architecture of the building. But more than one artist of some celebrity in this town has been seen lingering about the place, peering upward and smiling to himself. The architects in this instance were Rouse and Goldstone, and the carvings, done from thumbnail sketches in wax, were actually executed by George Huber and James P. Whittlesey. People in the building across the street watched them as they chipped away the stone. The responsible director was Arthur Seale, Inc.

Lower down Madison Avenue—in the block above the Morgan houses—is an apartment hotel just being completed

inconsiderable general architectural pretensions, though it was designed by McKim, Mead & White. The embellishment here has been done so modestly that the passerby is more than likely to miss it entirely unless he has been told what to look for. The building has two rather small, plain doorways in the plain, stone-faced wall of the front. Between and above these doorways is a bronze clock decorated with silkworms and mulberry leaves—for this also is a place where silks are dealt in—while on either side of the clock are butterflies carved in the flat stone of the wall. Clock and butterflies are the work of William Zorach, the sculptor and woodcarver. Zorach is also responsible for the bronze grills of the two doors. These latter are arrangements of mulberry leaves and

which not only has an entrance which catches the eye but an extraordinary frontal effect above that entrance, over which brood a set of strange carved stone birds. In this case the motive used is the Romanesque arch. Against the dark brick walls, slender pilasters leap up ten stories to the arches just below the set-back—in a part of the façade, past a recess which creates a loggia just beneath the arches. Above are more arches with pilasters not so tall, and more strange stone birds. Altogether the architect, Andrew J. Thomas, seems here to have contrived a particularly good "perpendicular" effect. The ten-story rise of the slender pilasters does not destroy its own attempted illusion as the tall, flat pilasters do in the big Fifth Avenue apartment hotels mentioned earlier in this discussion. They are not intended to carry the eye up from the street level far enough to excuse the enormous height of wall on top of them and then stop. They leave the street level effect to be taken care of by the entrance design with its columns of modest height. What they take care of is the job of holding together the main façade; they carry it up airily to the break of the terraces receding toward the roof, which has a peak several stories higher up.

Graceful Iron Work

No such modern problem is offered by the simple and dignified front of a gray stone-faced house at 5 East Seventy-ninth Street just off Fifth Avenue. It is a dwelling house with no excessive height to conceal or accentuate. And the architect, Van Buren Magonigle, has chosen a sufficiently conventional French Renaissance style. The notable feature here is the graceful iron work—the doors and the handsome window grills and balconies done by Samuel Yellin.

A little further uptown, at Park Avenue and Eighty-first Street, is an apartment house with ironwork doors by Edgar Brandt. For the man in the street—unless he is particularly interested in that sort of thing—the ironwork ornamentation if it is confined, as it often is, to the doors, is too inconspicuous. He is more easily caught by bold effects in color, such as are obtained by the combination of rose terra cotta and glass mosaic already described in connection with the Sixty-third Street building. Brandt's doors are here, too, but they are only a part of a composite and arresting scheme.

After all, the most lavish use of color, so far, is high up on the French building. A really good look at those gay hanging gardens of black, red and green, piled up like colored blocks on top of the main building, is only got at considerable risk of being run over, unless the observer takes up a point of vantage down one of the adjacent crosstown streets west or east. Along the avenue the view is lamentably cut off by other tall buildings. Coming from the south even the very gay crown of the very high tower—the flamboyant design here is enriched with gold—is not visible till you are almost at the foot of it.

It is one of the most amazing effects that the new architecture has produced. With the sun shining on it, the building is like a bright painted pasteboard toy meant for a most prodi-

gious giant. New York is a prodigious giant—and one so far from grown-up that she breaks up her toys almost as fast as she gets them. Yet the architects keep on building as if the particular toys which are houses were going to last. They keep on expending upon them such ingenious effects as have just been described—and lavishing infinite pains, regardless of the fact that the average citizen hardly takes the trouble to look at them.

* * *

February 13, 1927

AMERICAN PRINTS ARE SENT TO FLORENCE

GRAPHIC ARTS

Exhibition Assembled by American Federation of Arts

By ELISABETH L. CARY

This week a significant group of American etchings, lithographs, wood block prints and other forms of graphic art is to be shipped to Italy by the American Federation of Arts for inclusion in the International Exposition held at Florence in April. The group is significant both for the quality of the work sent out and for its inclusiveness. It ranges from conservative to modernist and brings together many men of many minds who are seen in America in widely separated galleries and generally in the deadly "one man" exhibition which reduces all but the strongest artists to their minimum of effectiveness.

These prints have been chosen from work by members of the Brooklyn, Chicago and California societies, and by independent artists as well, the jury of selection consisting of John Taylor Arms, Ernest David Roth and Thornton Oakley. Twenty nations are to be represented in the exposition and the gallery set aside for the Americans will have a typically American aspect, the wall-covering, the few pieces of furniture and decorative pottery coming from this country.

Most of the work is by living men and women, with a few well-directed exceptions. Ernest Haskell, Joseph Pennell, Henry Wolf and Helen Hyde. The rest of the exhibition is given to artists more or less known to those interested in the graphic arts, technically expert and quite strong enough in their several fields to fear no comparison with their European companions.

In looking over the catalogue it is obvious that many of the subjects will carry an associative interest, bringing the still unfamiliar American scene to the Italian public. The modern American artist, in contrast to those of the preceding generation, is quite inclined to cultivate his own dooryard, and that without restricting his outlook, since his dooryard embraces an area of many thousand square miles and provides various types of picturesque material, from the Spanish Mission to the adobe hut or the Colonial house, from the Grand Canyon to the Maine coast, from the American Indian to the Vermont farmer.

A Visitor's First View

Looking at the prints, most of which have been exhibited here, from the imagined point of view of another nation, it seems also to be obvious that, precisely because of their scrupulous integrity, they hardly can convey the impression the actual scene would make at first view upon a visitor from Florence. Such a visitor could not possibly get an impression corresponding to the objective rendering of an artist familiar not only with the scene before him but with the type to which it belongs. Certain features would detach themselves and unite with memories of other scenes and everything would be slightly out of its normal relation to its surroundings. Doubtless to the fresh vision of a foreigner nothing would seem more recognizably New York than John Marin's "Woolworth Building."

Certain natural affiliations also suggest themselves. One may judge from the graphic work of Italy's own artists that Joseph Pennell's Williamsburg Bridge and Vesey Street caissons must call clearly to the Italian public with its sense of drama in commonplace. And one counts instinctively upon Philip Little's emphasis, upon the animation of William Meyerowitz, upon Nordfeldt's clarity of statement and the stylistic excitement of Birger Sandzen, upon Woodbury's knowledge of sea rhythms and upon Childe Hassam's purity of method to make their special definite appeal. But it is quite on the cards that this unknown public will reverse all our predictions and will most appreciate what appears least to belong to their experience and taste. Whatever their response may be, the list shows that we have sent them a collection of sincere and competent work, the kind of work in which we who have nothing to do with producing it take a deep and impertinent pride.

Polychrome Sculpture

After France we think of Italy as the nation that most has influenced American art. Her Primitives are still in the minds of our decorators, and the sculptors who derive from the American Academy at Rome have attacked old problems in a way to revive their interest for modern communities. In the coming exhibition of the Architectural League, which, most unfortunately, is to be open for only two weeks, John Gregory and Paul Jennewein will show their polychrome sculpture for the Philadelphia Museum of Art. They have collaborated with Leon V. Solon in reproducing the color effects of Greek architecture as it was about 300 A. D., and during the exhibition Mr. Solon and others will discuss color in architecture, ancient and modern.

In the work of the sculptors who have studied in Rome the roundness of the Roman ideal of form is usually present, and this third-dimensional quality is present also in the mural painting of Thomas Benton which will be on view at the New Gallery during the period of the Architectural League Exhibition. The great difference between the two types of roundness lies in the interior framework. Where Mr. Jennewein, for example, makes much of an interior plane determined by the muscle and bone of a figure, and accents his smooth modeling with the sharp angle of a shoulder blade or some other witty interruption to bland statement, Mr. Benton's modeling flows on fold upon fold, as a piece of drapery billowing in a purposeful wind. In the single figures these waves of voluminous form that tell you so little of the human mechanism through which human energy is made efficient are somewhat trying. They tell you too little of their significance in design to convert you from your traditional belief in the divinity of anatomical facts.

Where the composition is fully carried cut, however, as in the series of panels proposed for the New York Public Library, you discover in the closely woven complication of the whole design the energy that seemed to be missing in the single figures. Many a mural painting in which the separate figures wear the appearance of having been modeled from the useful anatomical dummies of the class rooms, stripped to their subcutaneous layer of muscle and sinew, shows actual languor in the interplay of the elements of the design. The anatomy of Mr. Benton's figures is reduced to its simplest terms. The important thing is the anatomy of the design itself and its contribution to an organic structure. It is not, of course, primarily important that he select types from the life of the present day to convey his artistic idea. He thinks, rightly enough, that a longshoreman, farmer or fisherman is quite as worthy of a place in the art of a period as traditional and academic substitutes representing abstract ideas of labor; but it is equally true that the concrete or abstract conception hardly matters so long as the artistic idea is rendered with justice and power. What is far more important is that these figures from the life of today are used in a manner that conforms to the new modes of living and building.

In the preface to the catalogue of Mr. Benton's exhibition Lewis Mumford calls attention to the third-dimensional character of the murals as fitting them to take the place commonly occupied by conventional sculpture relief. "These panels," he says, "are a summons to the architect; they call for an architecture of clean surfaces, large unbroken volumes, and a massive serenity; within buildings so conceived Mr. Benton's designs offer the life, the movement, the variation in detail, the points of special interest that are necessary in great buildings to complete the structure itself. Here is a painter who meets the sculptor half way, a painter with as keen a sense of mass and abstract design as the most able of our architects, ready to come to terms with the actual problem of design for a particular wall and enclosure, and ready to aid the architect in sloughing off the ridiculous stage in ornament to which the designer is committed for lack of time and ability, under modern conditions of work, to handle more than the bare program of the building."

This ability and willingness to cooperate with the architect who has had thrust upon him new problems of design for modern building is the first in order of Mr. Benton's merits as a mural decorator. The newer architecture is still empty of appropriate ornament. Mr. Mumford looks forward to the development of new modes of such ornament and surface

"Developing Stage," African panel in a series called "Picturesque Modes of Transportation." In Architectural League exhibition.

relief fitted to our own day, and he ends on a loyal note: "The modern artist will not forever be kept apart from the score of crafts and technologies that are now united in a modern building; for in a deep sense he is the light and the life, and without him no work may be called finished and no building fit for permanent human habitation."

* * *

February 13, 1927

DARKEST AFRICA SENDS US ART

Stimulating Work of the Negro Craftsmen Has Been Hitherto Neglected

By SHELDON CHENEY

A recent purchase in Europe has been the means of bringing to America a collection of primitive African sculpture that promises greatly to stimulate interest in this little explored field. The collection, made by Raoul Blondiau in Brussels and embracing between four and five hundred examples of Belgian Congo art, is now on view at the New Art Circle, under the auspices of the Theatre Arts, Inc.

It is necessary to explain, perhaps, that Belgian Congo art has nothing to do with the Belgians in the Congo, but only with the products of the negroes of that region in the centuries before they came into close contact with the whites. That the black peoples of "savage" Africa produced sculpture and craftswork that may ultimately place examples of their workmanship among the most prized creative treasures of the world's art museums and collectors, is no secret to those who have been initiated into a knowledge of their accomplishment in wood, ivory and metal. Unfortunately, the standard histories of art are silent on the subject.

The founding of special museums of negro art in several European art centres and the opening of African wings in some of the less conservative museums elsewhere have

added official recognition after a decade or more of personal discovery and appreciation. Perhaps it is of unusual significance, then, that a carefully chosen and representative collection should be in New York for exhibition at this time (and the collection is to remain here permanently). For however rich the other treasures out of the past that our collectors and institutions have acquired, African art has remained neglected and practically unknown except to that small group that has rallied around the "modernist" painters and sculptors.

Discovered by "Wild Men"

The first acquaintance of most of us with the fact that a considerable body of negro sculpture exists came about fifteen years ago when the "Fauves" in Paris, the reddest of the red wings in the modern movement, set up the black African artist as a sort of idol. Those "wild men" of French painting (they are now, under the same leader, Matisse, accepted as the solid citizens of contemporary French art) discovered in the negro fetiches and masks just the qualities of direct expressiveness, of naïveté, of non-realistic formalization which they were advocating as the keys to the saving of European art. Since then there has been more discriminating study and appreciation of the negro's work. Just as the aims of the modern painters have become clarified and their acceptance made less dependent upon "anything new," so the best African pieces have been sifted from much that was merely primitive and novel. Even so, it must be said at once, darkness still envelops most of the facts usually recorded about the origins of an art; the names of the individual artists, not one of which is known; the dates, which are approximate only by centuries—probably from the sixteenth to the nineteenth—and the racial backgrounds.

The old dynasties of Central Africa have decayed; the tribes have been re-grouped time after time; there is hopeless confusion in the mass of memories, legends and myths. There are, of course, no written records, either of history or of the arts. Most of what the ethnologists have learned is based on what a few tribes could report, and most efforts to classify the art manifestations have been on the basis of earmarks of form or on obvious utilitarian purpose.

But certainly the lack of some of our Western civilization's most impressive aids to cultural development, such as writing and printing, did not deter the black peoples from creating objects that compel appreciation for their sheer beauty as sculpture and as craftswork. Judged merely as works of esthetic expression, the figures in wood, the ivory jewelry, the sculptured cups and stools and chairs have that authentic formal quality that demands the tribute of universal understanding and enjoyment.

One can imagine a musician of our day looking with something akin to wonder and envy at the extraordinary grace of a negro stringed instrument and the bit of sculpture ornamenting it. One can imagine milady of Park Avenue puzzled to find that the cosmetic boxes of the ladies of mid-Africa should have a decorative richness more genuine,

This very ancient ceremonial mask shows ornamentation in paint, metal and cowries.

if less conventional, than her own and that the half-clothed negresses' comb should be exquisitely carved out of wood and ivory.

The virtues of negro art are neither in a skillful imitation of nature nor in prettification, in sentimental idealization of natural objects. They lie rather in the skill, the appropriateness of the craftsmanship and in direct emotional expressiveness, in a stern formalization of nature that lifts the individual pieces out of the realm of mere likeness and into a realm of creative and imaginative expression. It is here that the parallel to modernist art comes in. Modernism is a revolt against realism, against photographic aims; a return to creative design as against imitation or romanticizing within the limits of natural objects as ordinarily seen.

There is also the fact that negro art was a part of life as lived by the people who made and enjoyed these works. The revolt against eighteenth and nineteenth century European traditions in painting and sculpture was founded on the recognition that art had been divorced from life; was academicized, a thing set apart from ordinary living. Art had gone into studios and museums, and had gone stale—if, indeed, it was not dead. In the search for a way back to a living art it seemed significant that these black people should instinctively have enriched the cups they used, the combs they put in their hair, the tom-toms they beat on, the sceptres and canes their chiefs and medicine men carried.

A Kasai chief's stool, which combines appreciable esthetic effort and simple utility.

That European artists imitated too directly certain negro works—inappropriately, in another place, another climate, another civilization—is neither here nor there in the debate on the merits of the works themselves. A chase of African modes is of no more significance today than is the pursuit of Greek classicism or medieval naïveté or South Sea primitivism in a machine age. But return to the fundamental principles underlying negro art and early Greek art and Gothic art will give, is already giving, the artists and craftsmen of today a new starting point, after centuries lost in sterility and confusion. Stepping out of the limits of naturalistic imitation, they are, briefly, coming to value creativeness above portrayal; emotional expressiveness and the search for that elusive something called form above exactness of representation.

The conditioning factor of 99 per cent. of the negro work was use. There was practically no art merely of illustration. Latterly, under the force and example of white exploitation, the negroes have manufactured innumerable pieces for sale, without relation to their own deeper life, except as copies of older works may carry a surface reflection of something originally added out of love and instinct. But in a collection like that of M. Blondiau there is nothing approaching a painting in our sense, or a statue. The many statuettes are fetishes for the medicine man's use, or for prayer or ceremonial, or are for use after death. Almost without exception there is a ritual or a utilitarian reason for everything. Living relationship and background characterize each product. Although it is the absolute esthetic value that moves us today—perhaps one, two or three centuries after the article was made—each work of art was linked with its owner's life, with his racial customs, with his background of work, pleasure, superstition, culture.

The very old ceremonial mask is an example of sculptured wood with ornamentation in paint and applied metal and cowries. Designed for ritual dancing, it is an excellent example of the painstaking work lavished on all articles intended for use in connection with tribal festivals. It stands midway between the more elaborate masks designed primarily to inspire fear in the beholder (as in the war masks and those designed for secret societies) and those that are simple wooden faces, highly formalized but sculptured with extraordinary directness and subtlety. In other words, this mask stands between the group most interesting to the ethnologists and the group interesting for art values alone.

There are many legendary stories concerning the origin of the mask. One has it that Kashashi, Queen to the ninety-third King of the Bakubas, and apparently a forerunner of contemporary women, wanted to get away by herself for a time. But when she left the village her little boy followed, and nothing she could devise prevented him from clinging to her, so that she had to return and abandon her plans. After reflecting through the night, she engraved and painted a horrible face on a calabash. When the little boy again followed her, she turned aside for a moment, placed the calabash over her face, then turned and ran toward the affrighted child. The latter, believing a terrible phantom was after him, fled to the village, and the mother was free.

Bolongongo's Annoyance

Her kingly husband, Shamba Bolongongo, evidently with an inkling of the possible ultimate significance in this trivial happening, expressed, according to the chronicles, a considerable annoyance over the invention of the mask, saying very wisely: "What shall we come to if our sons learn to be frightened of women?" He thereupon forbade women the use of masks and formed a secret society among the men in which masks were used for initiation.

Another legend has it that this same King first had masks made as a protection for his policemen: if they all wore masks identically alike the wrongdoers whom they arrested and punished could not recognize them and take revenge on any individual. There are other and perhaps more tenable theories. Some attribute the mask to an attempt to become temporarily the incarnation of a spirit; others make it an outgrowth or elaboration of the decorative combs used in ceremonial dancing. Whatever the origin, the mask ultimately became one of the most important of the media in which the negro sculptor immortalized his creative talent.

If the objects used in ritual demanded loving craftsmanship, no less did articles made for personal adornment for everyday use. Two types of sculptured pendant in ivory are especially common in the Congo. One is a miniature mask, the face pared down to hardly more than mouth, nose and

eyes, with a banded forehead above. The other is a sort of primitive negro Venus in two-thirds length, ordinarily with the hands clasping the breasts. A part of the charm of these jewels is doubtless in the finish they have taken on with age and in the flowing modeling that also has doubtless been helped by time.

In the combs and hairpins of the Blondiau collection, however, one probably has authentic examples of applied art very much as it came from the hands of the unknown craftsmen. In some cases—in the wooden combs particularly—there is miniature sculpture combined with general decoration; but some of the finest pieces in ivory are more restrained and show an exquisite sense of formal ornamentation.

Equally painstaking craftsmanship is revealed in the hunting whistles, horns, mandolins (almost invariably of an exceptional grace in outline and proportion), tobacco pipes, drinking cups, snuff-takers, cosmetic boxes, drums, anklets and bracelets, and even such kitchen utensils as grinding pots and spoons. Most of the craftswork and sculpture are in various woods; but ivory is not uncommon, and the collars and other personal jewelry may be in brass or copper.

Statuettes may be inset with bits of ivory, hammered copper or cowry shells. Use is made also of those novelties bartered from the European explorers and settlers: beads, nails, bits of mirror. Looking, however, at the series of forty wooden drinking cups in the collection, one feels that the "straight" carving, without admixture of ornamental bits from other materials, is most successful. These cups, indeed, might alone be used to prove the instinctive feeling of the African artist for the right line, the harmonious volume, the appropriate decorative mode.

The making of vases in America has improved immensely during the last twenty years under the stimulus of small hand-work potteries, interested in simple proportioning and restrained decoration rather than in elaborate design and intricate ornamentation. But there is hardly an approved vase form in the whole range of modern European and American practice, restored to us largely from the Greeks, that is not duplicated in the vessels, and particularly in the cups, of a representative African art collection. Nearly a third of those gathered by M. Blondiau are sculptured cups in the general form of a human head (or two heads in the examples designed for the use of twins): the others range from squat bowl-like forms, through the several stein shapes, to the slender tall vases and amphoras. In the head cups the texture interest is largely gained from the beautifully carved and smoothed wood surface, while the others are usually covered with patterns in very simple designs, but with a total impression of richness.

A collection such as this at the New Art Circle might well invite an inquiry into the wholesomeness of the division of all esthetic territory into "fine" arts and applied arts; into a questioning of what really is "primitive" in art—these things having certainly a primitive vitality and directness, but being in no sense lacking in delicacy of workmanship; or into inquiries about modern expressionism as a return to ancient principles, and the lack of a real religion of modernism as a reason for the lack of any but a weakly imitative art life.

General ignorance in America concerning negro art may be taken pretty much for granted, there having been practically no opportunity to see examples, and a literature of the subject being all but lacking. Even the fugitive printed material is hidden away under cryptic titles like "Les Baholoholo" and "The Great Zimbabwe" and "Aniota Kifwebe." Perhaps the exhibition of the Blondiau collection will start a wave of public appreciation of African art and a consequent demand for the opportunity to see it in accessible collections and to be able to read about it in accessible books.

* * *

September 25, 1927

FINE ART TURNED PRACTICAL, AND A LESSON FOR CRITICS

ART IN ADVERTISING

Thomas M. Cleland's Work on Exhibition—Metropolitan Museum as an Educator

By ELISABETH L. CARY

A small exhibition of the work of Thomas M. Cleland is now open in the exhibition rooms of the Pynson Printers. It offers a variety of pages from a book on his work which is to be published next Spring, and covers with representative examples his book illustration, advertising design, title-pages, &c. Although Mr. Cleland is a master of fine and formal ornament, echoing without imitating classic examples, he is best in his advertising cards. In these his invention plays at ease, usually in the borrowed costume of another period as if the ball were one for masques, but with his own gesture and pose. So slight a thing as a design for a box to contain milk chocolates is a beautiful little curtain raiser to eighteenth century romance. A milkmaid and a gallant at a stile, a rustic cottage, an interested cow, turtle doves, a basket of overturned fruits, a vine growing over a lattice—all the immemorial symbols of country joy, with laughing allusion to the ingredient of the chocolates. A cover advertising a product without emphasizing the advertisement. A particularly happy use of map design describes the course of the Sleepy Hollow Country Club, the lengths between the holes scrupulously recorded and all the hazards, trees and bushes noted and worked into a handsome pattern. Not too many liberties taken. A twentieth century country club respected as the Theatrum of Great Britain was not required to be, three centuries earlier.

Following Favorite Characters

In the more elaborate designs the inventive spirit of the artist creates a great variety of subsidiary detail inviting the interest of the observer and beckoning it from one point to another until the whole design becomes a definite possession of the

mind and unforgettable. In the group of individual items forming the present exhibition it is possible to follow favorite characters in their wanderings through an unrelated series of drawings. This tall, charming lady in a Watteau gown with a parasol which she may hold herself or which a black page may hold for her; this effeminate youth doffing his three-cornered hat and sweeping an elegant gesture as he bows; this comfortable plebeian dog slinking into or out of the composition; these piles of books tumbling over the edge of an austere colophon; these books everywhere, drawn like truth from the bottom of a well, scattered along the counter of an ancient print shop, handled by ladies and by youths and by old men, everywhere exercising their magic in a reading world—to find all these things so often and playing such changing roles is to have this various work tied together for us with a bright harmonizing ribbon. Humor is everywhere, subtle and ingenious; gaining its effects through values of association and the immense seriousness with which absurdities are taken for granted. This page in Chinese red, ornament like carved lacquer, at the top two windows through which are seen China-men of sinister suggestiveness, below Chinese warriors on guard, in the centre the treasure—a huge bird-cage with a pretty, nude girl on a swinging perch, intent upon a book; in place of the cups for seed and water at the sides of the cage small protuberant bookshelves loaded with little volumes. Then this drawing for a firm manufacturing inks, the legend "Paper in Search of an Ink," the design a labyrinth, amazing in delicate draughtsmanship, through which lovely shadowy shapes weave urgently toward the central inky goal. The humor eluding analysis sends life through the designs.

Tact of Arrangement

There are other pieces, clear geometric shapes, drawings of instruments and globes, in which tact of arrangement is the conspicuous feature. In nearly all the work shown, something larger than mere tact of arrangement is found. An architectural interest in building up shapes, solids and open spaces, and even a specific interest in architecture is represented in the settings of the little dramas which Mr. Cleland stages as though to theatre born. The architecture of a street scene in which the action takes place on three levels, for example. A thick wall divides the composition into two irregular sections and a flight of steps connects these. The beautiful shapes into which the space is cut constitute the true importance of the design, while the liveliest interest for the most of those who look at it lies in what is going on everywhere, above and beyond the wall where a small crowd is attending a Punch and Judy show, where soldiers with bayonets are pacing, where women are leaning from a balcony; below and in front of the wall where a bill-poster on a ladder is pasting up a notice of a variety entertainment, where this performance is watched by those who stroll by, where children are listening to a story told by a man seated on a post, and on the stairway where a youth among those passing up and down leans to take a letter from the lady in the Watteau gown who hangs on the arm of an elderly man. An easy drama to understand and

one from which it is possible to gain not only diversion but a sense of character. The abundance of incident is carried through without emergence into spot light or interruption to the unified effect of the architectural design.

If we have reached a point where advertising design calls forth talent of this order or, to use a more logical sequence, where talent of this order concerns itself with advertising design, we are on our way to becoming that thing which does not exist, an artistic nation. Especially it gives reason for confidence in that visionary future that Mr. Cleland's activities are as eclectic as this exhibition proves them to be that he can do a Grolier Club page with the same sensitive adjustment of style to the matter in hand as when he is doing a cover for a list of wines or helping by his work to sell feminine luxuries of the toilet table. An astronomer could not be other than satisfied with his illustrations of the early uses of geometry in studying the stars. His precise portraits of the astrolobe used for measuring the angles of the stars and the ancient Hindu bronze sphere of the heavens with the stars inlaid in silver are for antiquarians and specialists as definite in detail as these critics would demand, yet escaping by some magic of his art the dryness and rigidity of the ordinary charts of science. An appreciation of the essential of a subject guides him in all his adventures, as it always and everywhere has guided the essentially artistic mind.

A Metropolitan Lesson

The Metropolitan Museum rightly emphasizes its educational function. Its efforts toward reaching that public which vies with the celebrated Rosa Dartle in wanting to know have been recognized in recent years at something approaching their true worth. But there are more ways of educating a public than those adopted by the trained and systematized educator, whether professionally casual or professionally regular. It is hardly conceivable that Mr. Ivins, Curator of Prints, thinks of himself as an educator of any kind, but in the latest Bulletin he has an article on "Titian's Pharaoh in the Red Sea" which contains the gist of all that profitably may be taught on the plaintive subject of art criticism; and after telling us in unmistakable words, he shows us in a couple of illustrations what he has been telling us.

The peg upon which he hangs his argument is the recent acquisition by his museum of parts of the great woodcut of Pharaoh's Crossing of the Red Sea by Titian and Domenico dalle Greche. These with other parts already in the museum make it possible to assemble a complete set of good impressions which when put together will make a picture eighty-six inches by forty-nine inches in size. This great size has been against the preservation of the print, which is "one of the most powerful and artistically important prints ever made in Italy."

Germans and Venetians

Titian, alone of the major artists of the first half of the sixteenth century, was interested in designing woodcuts, and this

"Storm," an Etching by Roland Clark. Courtesy of Harlow Galleries.

woodcut in its splendid freedom and energy leads to a discussion of the difference between the Germans and the Venetians in their fundamental conception of a woodcut. In Germany there grew up a "fairly definite tradition of good woodcut manners" and the sixteenth century artists in that country drew for the woodcutters under the constraint of that tradition. The Venetians of the same century, on the other hand, seem to have had no generally accepted code for drawing on wood, and the Pharaoh in the Red Sea has no woodcut manners at all. To the Germans it would be "not a 'woodcut' at all, but a mere imitation in wood of a great free drawing in which no thought has been given by the designer to the little housekeeping niceties and meticulousnesses in which the German prints, even by the greatest masters, abound." Conceived first of all as a design and carried out quite simply as a drawing, "it has nothing whatever that is artificial in its linear handling, no conventional second-hand recipes for rendering, none of the tightness or pettiness of the Northern work. Its web and woof are so bold and strong that they have no need for mere embroidery to lend them interest. And just because of this, and in spite of the fact that it is one of the greatest masterpieces in its medium, it has rarely or never received the

homage and praise that, because of their mere adherence to the canons of artificiality, have so lavishly been bestowed upon infinitely less genial things."

From this starting point Mr. Ivins leads the way toward the release of criticism from the "hobbles and restrictions that go with any canon of execution," to the end that the importance of a print be recognized as existing in its design and not in its obedience to any technical code. "In the graphic arts, at least," he says, "such an understanding is the first and most important requisite to a free-moving mind and appreciation, because it means manumission from the slavery of technical prejudice. Once that has been gained, it becomes possible to address one's thought to the major problems of draughtsmanship, composition and expression—that is to say, to the real things in picture-making as distinct from tidy hatching and sweet impression."

Accompanying this article are two illustrations, one a detail from Titian's "Pharaoh," the other a detail from Dürer's "The Knight and Man-at-Arms," reproduced in their actual sizes. "Through the one blow the salt winds of heaven and inspiration; the other, however lovely, knows not even a draught, for it is but decorative stitching on a heavy curtain."

Such a fragmentary account of a well-ordered and logical piece of writing robs its significant message of much of its force, and is intended only to direct attention to the original article. This article might well be printed separately and distributed wherever the graphic arts are discussed, especially where they are studied for the purpose of forming connoisseurs and establishing the taste of collectors. Education in its larger sense hardly could be better served.

"Storm," the dry-point of black ducks reproduced [here], is from the recent work of Roland Clark at the Harlow Galleries. The artist has described the place and theme of this particular print with the intimate enthusiastic knowledge of the sportsman doubled by that of the etcher. It has for its settings, he says, the backwaters of the Cooper River, in South Carolina, famous from time immemorial as a paradise for many varieties of water-fowl.

"Old rice-fields, long since abandoned to time and the river's ravages, still yield each year a 'volunteer' crop, sparse, to be sure, yet sufficient to lure a host of migrating ducks.

"Calm weather induces in the duck family at large a strange lethargy. Hundreds—thousands—of ducks may be close at hand in the stilly marsh, yet to the gunner crouching in his blind not a feather be visible above the horizon line. But let it blow, and quickly the marsh is teeming with life. It is for rough weather, darkening skies and slashing wind that the duck-shooter prays when he takes to the blind.

"Black ducks to the sportsman seem to embody the very spirit of the storm. No duck so restless, so endlessly on wing; none, moreover, that decoys more readily than the wily black duck when every condition of the elements is at its very worst."

* * *

March 4, 1928

OUR LAND GROWS KEENLY AWARE OF ART

Prosperity and Popular Education Speed the Awakening and Create Wide Demand for Beauty

Earlier articles in this stocktaking of American culture have examined the fields of literature, the drama and music. A critical discussion of the country's recent contributions to architecture by Harvey Wiley Corbett will conclude the series. It will appear March 18.

By FORBES WATSON

Probably the artist of every period has striven to achieve an individualized statement. But in no other epoch was he so immune from traditional compulsions as he is today, or so driven by outside forces toward a recognizably personal mode of expression. Art consciousness is more awake than ever before in America and is affecting the newspapers, commerce, advertising, decoration and education. The artist is surrounded on every side by the workings of a vast demo-

"The Thinker," by Thomas Eakins, a contemporary of Ryder. Courtesy of the Metropolitan Museum of Art.

cratic system of education which, now that it has finally "got art" is making idealistic efforts to democratize esthetic appreciation.

Facing the unprecedented situation in America, the untrammeled optimist sees ahead of him an on-rushing awakening to art, affording astonishing opportunities not yet within the reach of the creative artist, while the pessimist examines with a magnifying glass what he considers to be the destructive influences of those irresponsible enthusiasts who

fail to apply the tests of quality or truth to questions involving art or artists.

To estimate what America has done in the field of art during the twentieth century is exceedingly difficult because not only are the conditions in the United States complicated in this regard—they are unparalleled. What our artists have done in this period cannot be approached sympathetically, I believe, without taking account of the growth in the same epoch of the three giants of America democratic education, publicity and economic supremacy.

Nations which enjoyed the state of being economically supreme before our turn came have handed down historical data upon which we can base calculations of the effect of great prosperity upon esthetic production. But publicity and democratic education, as developed in this era of rapid communication of ideas, have a possible influence upon the relation of the artist and his client (the public) that is incalculable. To begin with the question of education, first, in its relation to the difficult problem of teaching the appreciation of art, and, second in its relation to the training of the artist in his craft.

America's belief in redemption by education has resulted, during the last thirty years, in an extension to its institutions of learning that is fabulous. Into this optimistic system of education the shy and not always fully clad lady holding a palette and symbolizing "Art" was practically the last person to enter. As short a time ago as twenty-five years the college museum, when it existed at all, played an apologetic and insignificant part in university life. In 1900 the original Fogg Museum at Harvard was known to most students primarily as a lecture hall devoted to all sorts of subjects besides art, although years before it was built Charles Eliot Norton had dropped into the more refined life of Cambridge the seed of a Ruskinized aesthetique.

From that seed grew courses in the fine arts which attracted enthusiastic followers, until today at Harvard the Department of Fine Arts, with its new museum building opened last June, with its benefactors and growing collections, with its library, study rooms and learned staff, is prepared to send out into the world a stream of embryonic experts, museum specialists and esthetic historians. The same period has seen the Department of Fine Arts at Princeton grow from comparative insignificance to an importance matching Harvard's. And whereas at Yale, in 1900, many students came and went without knowing that Yale possessed the famous Jarves collection, Yale now plans to make its Department of Fine Arts as imposing a monument to culture as are the corresponding departments at Harvard and Princeton.

A similar, if unequal, development has taken place in many other colleges, including the University of Pennsylvania, Vassar, Bryn Mawr, Wellesley, New York University, Columbia and the University of Chicago. (I am not referring to schools of architecture, which have grown out of a more practical need, nor to professional art schools where painters and sculptors go to learn their craft.)

College departments of fine arts undoubtedly do attract more than their rightful share of overprecious students. They

are inclined, perhaps, to stress disproportionately history, archaeology, expertizing and "learnedness," as contrasted with the capacity to apprehend the vital quality of art. On the other hand, with the change of spirit that has come over them in recent years, it is quite possible that they may turn out to be the white hopes of American civilization, for they do respect intellectual and esthetic values.

They are certainly sending out into the American communities in addition to specialists, a body of students who, as future manufacturers, lawyers, business men or newspaper men, will not be satisfied with bland ignorance of art. This may result in progressively changing for the better the community's attitude toward the artist and his attitude toward the community. Though democratic in their accessibility, the university fine arts courses are not so democratic in their teaching as are a whole group of institutions outside.

While the universities of the more developed type have been lifting the appreciation of art from a secondary to a primary position in the college curriculum, the preparatory schools have lagged behind in this respect. In planning this article I sent a questionnaire to 425 leading college preparatory schools, with the object of finding out how much attention they give to the teaching of art and the appreciation of art. The College Entrance Board examinations do not concern themselves with music, art or the history of art, and the colleges which accept certificates from certain schools allow no credits for the subject of art. Consequently it is not surprising to learn that, generally speaking, the preparatory schools either give no courses in art or give a few voluntary courses attended by a small proportion of the students.

In the progressive schools for younger pupils on the other hand the teaching of art receives far more consideration than it did even a decade ago. And in the museums the educational departments have been so greatly enlarged that it has not yet been found possible to engage for all of them a staff adequately prepared to carry out their aims. The vigorously managed modern museum supports a dual staff. There are the experts, the curators and the other scholars who are responsible for the collections. Our museums have increased so rapidly during the first quarter of the twentieth century that even by absorbing a majority of the most promising graduates of the various university departments of fine arts they are not always able to keep their staffs as well manned with museum specialists as they would like.

Meanwhile, in addition to their curators, they are called upon by both practical and educational demands to maintain a kind of secondary staff, the members of which are devoted to popularizing art. They institute lecture courses and interest the schools, women's clubs, manufacturing organizations and other groups in the use and possibilities of the museum. They might be said to run a kind of educational department store of art appreciation in which they offer to every taxpayer the little or the much that he requires for his esthetic needs. The museum Educational Department is an invention of the twentieth century, and in many of its activities it is closely related to press publicity and propaganda.

The American museum of today is not content to sit quietly by and make the best possible collections in the best possible way. From various quarters, to which it must look for its financial support, the demand is made upon it that it shall not wait for the people to come to art. On the contrary, it is expected to make active efforts to attract the people and, whenever possible, to take art to the people. Booklets and story hours for the children, instruction in home decoration, talks on dress designing, lectures, popular and learned, eager attempts to make art and trade companionate; photographs, handbooks, bulletins, guides, study rooms, libraries, university extension courses, gallery talks—these are but a few of the activities which the modern director of a great American museum is supposed to inaugurate to bring the museum into the daily life of the people. From this it will be seen that the great museum of today in America is an infinitely more complex and active organization than the casual observer knows.

Supplementing the unequally organized activities of the big and the little museums and the official art associations along the lines of education, a swarm of hopeful beings pass over the country sharing their crumbs of information with millions of uplifters. So universal has the American's desire become to know something of art that in small communities, not yet possessing their own experts and not yet having the means to invite experts from other communities, it is not unheard of for a member of the local culture club to read the encyclopedia, borrow a box of slides and give a talk on any subject from Chinese bronzes to Byzantine mosaics.

All of these activities, tapering down from the serious work of the more advanced universities and the richer museums to talks by unequipped idealists, have resulted in an enormous increase in the number of citizens who have some appreciation of the meaning of art. At one extreme of the line our friend the pessimist will have observed that history and archaeology are easier to teach than sensitiveness to quality, while at the other extreme he may have noted that the simpler aspects of art have been lost sight of in a deluge of sentimental uplift.

Despite these observations the pessimist will be unable to deny the fact that America's democratic system of education, when it finally came upon art, went at the business in a whole-hearted manner, and that it has on the credit side of its books much more than on the debit. There is no question but that the appreciation of art has made tremendous strides in the United States in the last thirty years.

Accompanying the growth in the teaching of appreciation, there has come a hardly less remarkable growth in the number of art schools and art students. The Chicago Art Institute boasts proudly of having the largest art school in the world, and the standards in such schools may fairly be said to be thoroughly democratic. But the artist who does not eventually take an anonymous position in the army of commercial draftsmen and who finally comes to be recognized as a distinctive figure does not pursue a democratic course of education throughout. For him art is neither a storehouse of learning nor a storehouse of objects of the past. It is a living force, a personal expression, one individual's communication to another individual.

For reasons not easy to explain, our democratic system of education, though it reaches into the art schools in an unconscious effort to democratize the creation of art as well as the appreciation of art, has never succeeded in getting on very good terms with the artist as an individual. There may be a fundamental reason for this inasmuch as the artist wishing to express his own ego also wishes to protect that very valuable asset. So intent upon the protection of his own personality is he that he is sometimes tempted to be somewhat aggressive in ignoring the possible benefits that he might derive from the educational institutions that have grown up around him.

It is part of a superstition that pervades the ordinary group of practicing art students to despise critics, lecturers and every educational factotum. He considers these judges of his labors to be rank outsiders, and often in his early absorption with the problems of his craft, as a craft, he forms a fixed and unfortunate habit of looking down upon the very purpose of the educational activities related to the appreciation of art.

Early in the American artist's life there comes the ambition to go to Europe. If this ambition is fulfilled the chances are that he will at least go through a period, including his stay in Europe and the years immediately following it, of patronizing the standards of appreciation in America and the art of America. Returning to America he is likely to discover that a large proportion of the audience within which he might hope to find his own special public is more impressed by the lecturer's word than by the word of the artist.

He finds also that only a few, comparatively, of the many people that read and listen to words of wisdom about art are aware of the channels of thought that affect the practicing artist of today. His years in Europe during a susceptible period of his life have taught him that the attitude of the European toward American art is, to put it mildly, patronizing. Consequently when he returns to America to attempt to make a position for himself among his fellow-countrymen he is likely to feel a little out of it and a little over-impressed by conditions in Europe.

It has been said of the modern French that they are more interested in movements in art than they are in art itself. True or not about the French it is certainly true that our democratic system of education at the point where it touches contemporary art is deeply interested in movements and in famous names. The conditions which the young American artist starting out on his own finds before him are roughly as follows.

He finds a great body of rich collectors interested exclusively in old masters, and an increasingly large number of collectors who are interested in the work of the famous masters of modern art. He finds an enormously increased general interest in art, and a wonderfully generous group of capitalists who are willing to help any organized educational effort for the improvement of art. But he does not find many Americans so susceptible to the specific quality of a particular picture that they wish to buy that picture if it is by an unknown artist. Consequently, name seems to be of the first importance and since

people are so interested in movements, when they are at all interested in contemporary art, the temptation to be in a movement is great.

At this point the young artist, standing apart from and untouched by our vast democratic educational system, becomes aware of the power of that third American giant, publicity. Newspaper publicity and art discovered each other within the present generation. They have been having a heavy affair ever since, an irregular affair in which neither has behaved perfectly. This affair between art and publicity may not have changed the course of art. It has had a profound effect upon its material conditions and, I suspect, has actually affected the quality of its production.

Publicity cannot make art, but it does influence the point of view of everybody, including the artist. It is a powerful ally, both helpful and dangerous to art, because in its present stage of development it is deeply interested, if not always responsible. Never before did the artist have such a baffling and tempting giant to deal with.

Himself the product of a highly individualized course of education, what has the American artist accomplished in a time of great financial prosperity and surrounded by a democratized appreciation which has taught so many people to measure each contemporary artist's production by standards evolved from an overpowering past? As George Bellows once put this phase of present conditions, the American educator has forgotten that in the life of such an artist as Velasquez there was a time when friends meeting him slapped him on the back and said: "How goes it, Diego, old boy?" In other words, every old master was once a human being, and some contemporary human beings will eventually rank as old masters.

In the period immediately preceding ours such figures as Ryder, Eakins and Whistler loomed as distinctively American artists, seeing the world in their own separate ways, and Twachtman had utilized the theories of Monet to convey his personal outlook on purely native material. Whistler and Twachtman died in 1903, while Eakins and Ryder lived nearly fifteen years longer. Meanwhile William Chase had become the most popular teacher in America. It was when Robert Henri broke away from the Chase school that the first large group of American students was inspired to go outside of the studio and look at life.

While Henri was the first teacher to bring to many an uncouth and longing young American the knowledge of Manet, Degas and other Frenchmen who looked at the life about them, he was also the first American teacher to give to American students in any large numbers the faith that there is inspiration in native material. He led his students away from studio settings and stuffs, such as Chase had found admirable in the work of Alfred Stevens, and inspired them to look at New York streets and New York life. He inspired them to stand on their own feet as Americans and not lean feebly on Paris.

Since Henri and his group organized the first independent exhibition some twenty years ago and since he led the younger men away from the recognized artistic subject to a less circumscribed outlook, modern art in its narrow sense has swept over America. It was too exciting, fifteen years ago, not to imitate, or at least not to try out the eager theories that echoed in the studios and that later, after the echoes were heard in the outside world, found their way into print. The smoke of the battle has passed, the independent artists are on the top of the wave, and the discovery has been made that modernistic theories will not of themselves create personality and, vitality; that indeed there are no manneristic clichés that will make a man's art modern.

The almost schoolgirlish excitement over such high-sounding phrases as "significant form" has given way to the effort on the part of the contemporary American artist to evolve a vehicle of expression out of his own visual ideas. The result has been that we now can see in the galleries where young Americans display their art an astonishing freedom in the selection of material and an equal freedom in the manner of portraying it.

We are in the very act of making, on a larger scale than ever before, free personal contributions to the sum of the world's art of today. Without indulging in the pernicious practice of ranking one name above or below another. I will conclude by saying that the contribution to art of the American artist is becoming more and more liberated and inspiring. It seems to me that the work of such artists as Eugene Speicher, Edward Hopper and Charles Demuth, to mention a few of the many who might be mentioned, justifies the conclusion that the contribution to art of the American artist is becoming more liberated and at the same time more definite in statement.

* * *

March 18, 1928

AMERICA'S GREAT GIFT TO ARCHITECTURE

Her Skyscraper Towers Are the First New Structural Form Since the Ancient Romans Invented the Arch

By HARVEY WILRY CORBETT

America, culturally, is in transition. We have attained enough leisure to review ourselves critically, but we have not yet acquired enough tradition to create fluently and richly. It is, therefore, an age of stock-taking. We want to know where we stand before we attempt to scale the peaks.

Others have been asked by The New York Times to take the reviewing stand in behalf of our native literature and painting, our music and sculpture—men who are capable judges and impartial critics. It is my pleasurable lot to discuss the one art in which, at present, America is accorded first place by the rest of the civilized world, and in which she is suspected of having created radically new forms.

The task, therefore, calls for more than the usual caution.

Not long ago I came across the following paragraph in an article by Kineton Parkes in The Architect's Journal of London. It was called "The Art of the Skyscraper."

"Reality has again resulted in romance. In the ever-recurring cycle of the arts there is change and decay, evolution, revolution and devolution. Architecture, since the eighteenth century, has been struggling with a problem which New York has at length solved. It has revolved around old styles and evolved itself into something new and strange. The world has been waiting for the American Architect. He has arrived with a pyramid. The pyramid is not that of Egypt, a vast uninhabited verticism, but a populated beehive harboring thousands of workers; an upright city within a city reared above the outgrown horizontalism of the past and passing present. It has but one possible antithesis, the underground dwelling and workshop foretold by knowledge novelists. These are far away on the horizon of time; the New York skyscraper is here with the world today."

This charming rhapsody, even if rather obscure in expression, is plain enough in intent. It has a pleasant ring to American ears, coming as it does from one of our English cousins, who are customarily less enthusiastic over manifestations of transatlantic enterprise. I, myself, in the endeavor to awaken my countrymen to the beauty of modern American architecture, have more than once erred on the side of enthusiasm. Although I have usually adopted what I hope was a less apostolic manner than Mr. Parkes's, I have none the less asserted most vigorously that America was on the crest of the architectural wave.

Indeed, until a couple of years ago, it had seemed to me that the most extraordinary phenomenon of modern times was being calmly taken for granted. Now the worm has turned, and the press rings daily with a great deal of indiscriminate praise of American architectural prowess, so that I sometimes fear we may break our arms from an excess of backpatting.

Confronted with the task of evaluating American architecture soberly and systematically, I am of a mind to ask three questions: Have we created any new forms in architecture? If so, how do they differ structurally from what has gone before? If some new principle has been evolved, to what can we attribute its advent?

If we can answer these questions satisfactorily, we shall have gone a long way toward formulating a sound estimate of the place of architecture in American cultural achievement.

But first we must survey briefly the basic principles that have governed building construction in the past. I say basic principles because such a change in the evolution from Doric to Ionic in Greek architecture is a matter of style, not structural principle. Similarly, when Romanesque spread north in Italy, it changed in style, not in structure.

For more than three thousand years Egypt built with only one fundamental structural principle, namely, the "post and lintel." The clear span under the roof was limited by the length of a stone lintel supported on columns. Only the expert archaeologist can date Egyptian structures and indicate the dynasty under which any given building was erected. The average tourist could never tell whether the tomb of King Tut-ankh-Amen came before or after the Temple of Thebes.

Greece added no new principle to the basic Egyptian design. She achieved, however, a perfection of detail and refinement of proportion which the world has never equaled. It remained for the Romans to devise the second new structural element—the masonry arch and dome—and use it on a grand scale. It was not until the masonry arch came into being that architecture was enabled to produce enclosed spaces of really impressive vastness.

From then on Italy produced nothing new. All the periods of Romanesque and neo-classical were simply variations on two given themes.

Gothic in the minds of most, is utterly different from Roman. Certainly the effect upon the eye of the Rouen Cathedral, with its springing lines and its multitudinous detail is as different from the domed mass of St. Peter's as night is from day. Yet Gothic actually involves no fundamentally new principle. Gothic vaulting is simply an adaptation of the masonry arch principle as varied by Brunelleschi in the Duomo. Then, as the desire arose to make churches ever larger and taller, buttresses were devised to carry the vault thrust to the ground, but in the end they were simply a rearrangement of the same underlying principle that carried the thrust of the masonry arch.

Thus two thousand years rolled by with no actual change in basic design. Then came steel.

Meanwhile, the New World had added nothing to the sum of the world's architectural progress in the seventeenth or eighteenth century. There were beautiful buildings in Colonial days, but they were derived from old-country models. Jefferson had a fine feeling for the classical, and there were many capable adapters of other forms in the early nineteenth century. In mid-century Richardson introduced the Romanesque, which soon became absurd in the hands of less skillful imitators, and Hunt dealt exquisitely in Italian Renaissance and early French. At the time of the World's Fair there was a recrudescence of the classical under McKim, Mead & White, which swept the country like a forest fire.

From the '70s to the end of the century and beyond young scions of cultured families were returning from several pleasant years at the Beaux Arts in Paris and were setting up shop to practice the then "gentle" art of architecture. (How far from gentle it is today!) They had been apt pupils and it was not long before the world's best imitations of Greek temples, French chateaus, English manor houses, Romanesque churches and Gothic spires were being done in the United States. For skill in the refinements of design they had no equal. They were past masters of detail. It was natural enough for them to become expert, for practice makes perfect, and nowhere in the world could they have found so much to practice on. Money was being coined by the fistful and the population was increasing apace. The more demand for building there is the more quickly architecture changes and evolves. To this day I believe we have no equals in the mastery of "styles."

But to return to the '80s. In the course of that traditional decade a new phenomenon had begun to appear—the sky-

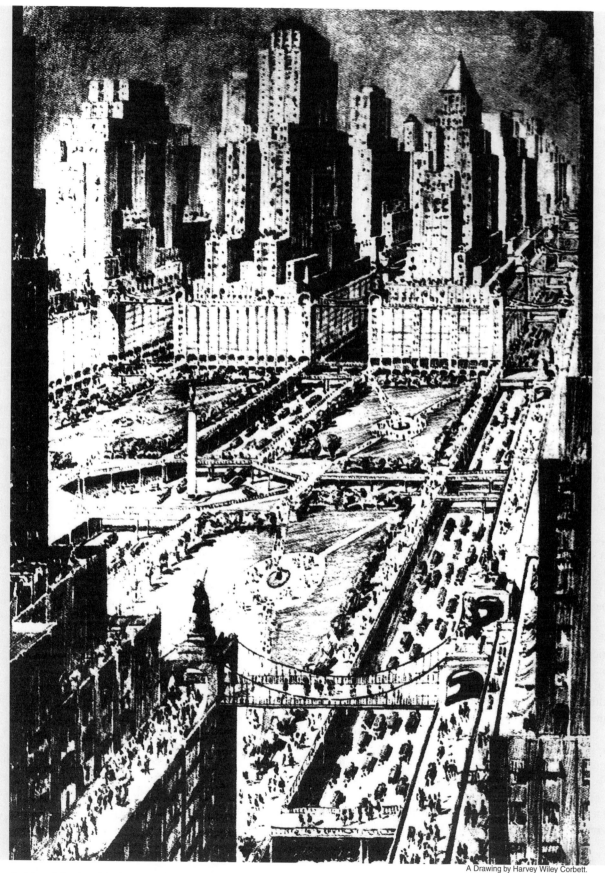

A Drawing by Harvey Wiley Corbett.

A vision of the city of the future. Residences will be above business offices and there will be different street levels for pedestrians and motor cars, with overhead promenades for the residents who live above the din of traffic.

scraper. In 1880 a Minneapolis architect, Leroy S. Buffington, conceived the idea of building a huge edifice in which the veneer of masonry would be carried on shelves jutting out from a braced steel frame at each floor, thus eliminating heavy masonry at the base to carry the load. By 1883 he had completed a design for a twenty-eight-story building embodying the principle. But delays occurred and the papers were not filed at the Patent Office until 1887. On May 22, 1888, letters of patent were granted to him on a steel frame building for the United States, England, France and Germany.

It may not seem to be an enormous step from steel as a strengthener of stone to steel as a carrier of the masonry load at each floor. But the fact remains that that step is the most momentous single discovery in the history of architecture since the days of Rome. In a single bound architecture was freed from the shackles of stone-weight and made flexible beyond belief.

Meanwhile, Chicago architects had been flirting with the use of iron as reinforcement, and the Home Insurance Building, finished in 1885 by W. L. B. Jenney, contained square cast-iron columns built in the walls. Buffington had already used this device in the Boston Block in Minneapolis in 1883. The Monadnock Building in Chicago, completed in 1889, was probably the first to earn the sobriquet "skyscraper," although it was of solid masonry construction throughout its sixteen stories, and did not embody either the reinforcement or the skeleton principle. The walls, in fact, had to be made nine feet thick at the base to carry the weight of the superstructure.

Buffington could find no backers for his twenty-eight-story building, and in the meantime steel had begun to be used in various building enterprises. It is doubtful, however, if the principle which the Minneapolis architect patented was ever fully used until 1893 or 1894. Buffington fought his claim in the courts for years, but could never get a hearing on the priority of his patent, which has now expired. In fact, as late as 1903, when the old Gorham Building at Fifth Avenue and Thirty-fifth Street was erected with a steel frame, the masonry on the piers had to be self-supporting because "building regulations required it."

Chicago was the real cradle of the skyscraper in actual practice. New York soon took the lead, however, for the simple reason that there was greater need there for the concentration of population which the skyscraper afforded.

Although the steel-skeleton principle thus suddenly became an actuality, it was a long time before any one realized how momentous it was. Architecture had suddenly been given a new dimension—the possibility of almost unlimited verticality. The verticality of Gothic was apparent, not actual, for, as we have seen, it was an adaptation of horizontal principles.

But the architects still continued to treat the skyscraper as horizontal. Twenty-story buildings, with ponderous base walls, rows of nonfunctioning columns, heavy projecting cornices and walls crusted with Renaissance detail, began to go up. They looked exactly like what they were—travesties of Old World styles. The first really distinguished skyscraper, in which the inherent vertical quality of steel construction was strictly observed, was the Woolworth Building. And even there Gothic was borrowed for the motif.

It can be said with accuracy that architects have only begun within a dozen years or so to recognize that steel construction involves entirely new architectural principles and to treat it accordingly.

The extent to which steel has liberated architecture from the burdens of past building methods may be observed in its current use in literally every type of structure. It is now the accepted method of construction even in small horizontal types of building, for the simple reason that it saves space and makes for economy and speed. Walls can be made thinner without sacrificing strength; construction goes forward five times as rapidly at half the expense.

It would appear, then, that America actually has created a new architectural principle. To my mind it is just as great a departure from the masonry arch as the masonry arch was from the post and lintel. True, it requires a new building material, but does that in any way discredit it as architecture? There are some purists who will always insist that steel construction makes a bastard architecture, that it is simply giving crutches to stone and brick. Steel is a crutch, indeed, when it lends itself to the reinforcement of bad derivative styles, with which it was not originally associated, and which it permits us to distort and deform. A thirty-eight-story Spanish hacienda is an abomination, and when I see one masquerading under the name of "apartment hotel" I groan and wish that steel and stone had never been wedded. But when such a splendid example of the new architecture as the Telephone Building is brought into being, with its frank, clear-cut structural qualities, its fine proportions and its total lack of borrowed detail, I rejoice and call the new building material thrice blessed.

Thus far I believe we have shown that the skyscraper is a new structural form—the first one since Rome—and why it may be considered new. Our third and final question is: To what can we attribute the advent of this new principle?

Reduced to their simplest terms, buildings have never been anything more than enclosed spaces designed for human needs. From the tombs of Egypt which sheltered the dead to the towers of New York which house the living, the problem has always been the same—enclosed spaces for human accommodation. With the ancients life in the world to come was the vital issue. Our present problem is not how to die magnificently but how to live more happily and efficiently.

Since man in nearly all walks of life spends all of his sleeping and the greater part of his waking hours indoors, buildings mean more in comfort, convenience and well-being than any other material entity. If they serve his purpose, life is good; if they fail to serve, life is harsh. But buildings change as human relationships change. And in the past 100 years human relationships have modified more rapidly than ever before.

Let us take note of a few of these altered relationships.

1. In former times men lived and worked in the same building or the same locality. Today places of business and residence are widely separated.

2. In the past, municipal or governmental agencies were the only builders of large structures. Today private enterprise builds on a greater scale than any Government ever needed to or could build.

3. Formerly the majority of the population worked on the land. The necessity of producing food for themselves and others held them slaves to the soil. Machinery has changed all that and released them to engage in manufacturing in cities, which calls for an enormous increase in the production of buildings, both industrial and commercial.

4. Buildings used to be erected to last indefinitely. Europe still clings to the notion that old buildings can be used for new purposes. But in America, and notably in New York, any structure, no matter how great its historic or esthetic value, is scrapped as soon as it ceases to fulfill its purpose.

5. In the past the bulk of commerce was carried on between more or less immediate neighbors. Today all business is national, most of it international. This means great central headquarters.

Now what is the effect upon building of these radical changes in social and commercial life? Simply this: Domestic and business architecture has evolved to bring business men as close together as possible. For commercial efficiency is in direct proportion to the proximity of its individual personalities. In other words, the more business people you can put on a given area of land, consistent always with health, comfort and facility of movement, the more business can be done. In the final analysis, all important deals are closed by personal contact, in spite of telephone, telegraph and other means of communication.

So America, unhampered by tradition, unencumbered with antiquated structures which have to be used whether suitable or not, unembarrassed by the necessity of doing what grandfather did, has forged ahead and built to meet the new business requirements. When special demands develop rapidly, then rapid building meets the demand.

Steel has made this building speed possible. In a steel-frame building construction can go forward on all floors at the same time. Fifty stories are built more rapidly than five in the old days.

Indeed, the skyscraper is something at which the world may well marvel. The groups of tall buildings in New York— finance in Wall Street, law near City Hall, building interests in the Forties, theatres along Broadway, automobiles about Columbus Circle, are something new under the sun.

In the beginning it was a blind sort of growth, one that sprang from necessity. The architect and builder did not suddenly create the skyscraper. It was not as simple as that. They built it to satisfy a demand that had been growing as steadily as American business.

As soon as capital realized the possibilities in tall structures the demand for them increased, giving an impetus to the American building industry that effected radical changes in it. With practically unlimited opportunity for experiment, backed by great wealth that wanted new forms, architects were free to think in terms of larger and less limited possibil-

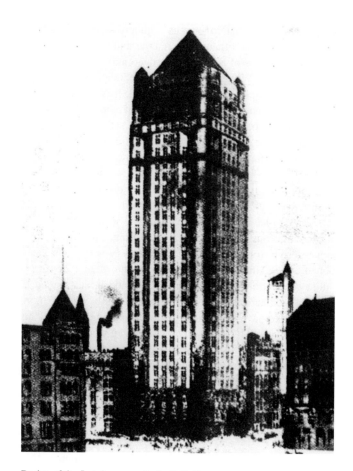

Design of the first skyscraper, by L. S. Buffington.

ities than any of their predecessors. They were separated from the builder and craftsman and turned to design; but at the same time they were more closely allied with the practical engineer than ever before, for in evolving new forms they had to heed stability, economy and utility.

There has been very little waste. Certainly, men adapted— and, I am sorry to say, still adapt—old forms to new buildings for which they are quite unsuited; these, however, are the copyists, the hacks, the parasites lacking in originality that cling to every art and make its new shoots here and there grotesque. With the material in his hands the architect at once began to mold it into forms of great beauty. New York calling for towers in a day challenged the human imagination and the requirements of the city gave men practical limits within which to keep their thought. Conceiving structures in hitherto undreamed proportions, they built in a new medium, steel, and they had unprecedented success. Whereas they had hitherto designed in old forms, many of which were unsuited to their needs, the architects, under the stimulus of commercial necessity, began to design in terms of the building itself. They began to regard each building as a machine with a special use and peculiar possibilities. They began to understand that every building must be developed as a distinct problem in beauty and utility. This new machine design has grown from and been shaped by the needs and aspirations of man in the machine age as surely as Gothic cathedrals from those of another period.

In decoration heterogeneous adjuncts were replaced by more harmonious ornaments. As the building grew to be designed in terms of a machine its decorations were designed in terms of it. Witness the New York Telephone Building. Absolutely simple in outline and detail, it is an outstanding example of the new architecture. Also, of course, it admirably represents the possibilities in the use of setbacks as required by zoning. The example set by the American Radiator Building with its painted crown has been followed by others and in New York we may yet have a skyline as colorful as that of Autumn hills. In many cases the bronze decorations serve to house powerful lamps that illuminate the towers at night.

America has come to life artistically in her architecture. To be vigorous, sound, healthy, enduring, any form of art must derive from essential needs to satisfy which it is fashioned. The American business man knows that he wants more concentration and specialization, and he has begun to understand that it is more satisfactory and only slightly more expensive to have beautiful cities instead of ugly ones. Thus willingly backed by the power of American wealth American architecture has a future more hopeful than that of any other period. We may conceivably perfect in a few years an architecture that will not only be our own but will also be beautiful—and in a grand manner.

* * *

March 25, 1928

A NEGRO ARTIST PLUMBS THE NEGRO SOUL

By EDWARD ALDEN JEWELL

Strange paintings, the work of a young American negro artist, Archibald J. Motley Jr., were shown recently in New York and they have set the art-critical world to wondering and talking. Vivid pictures they are and weirdly unique their subjects. Here are steaming jungles that drip and sigh and ooze, dank in the impenetrable gloom of palm and woven tropical verdure, or ablaze with light where the sun breaks fiercely in. Here are moons that rise, yellow and round, quizzical and portentous, aureoled with a pallor or sorcery; crescent moons with secrets cryptically packed in the shining simitar, and moons that wane and die with a shudder of spent prophecy.

There are mummified heads of enemies rudely cased in clay, embellished with gaudy colors. There are devil-devils watching in the solemn night or poised to swoop on hapless human prey. There are thunders and lightnings with revelation imprisoned in their heart of death. There are charms, simple or unsearchable, to lure a smile or to ravage with the hate of vampires.

Glistening dusky bodies, stamping or gliding, shouting or silent, are silhouetted against hot ritual fires. Myriad age-old racial memories drift up from Africa and glowing islands of the sea to color more recent ghostly memories of plantation days when black was black and slaves were slaves; and these memories sift, finally, through negro life in Northern cities of the present, leaving everywhere their imprint and merging with a rich blur of tribal echoes. Such are the themes and the material that enter into this artist's work.

Mr. Motley appears to be forging a substantial link in the chain of negro culture in this country. The exhibition alluded to was significant both because of the quality of the paintings themselves and because it represented, so one understands, the first one-man show by a negro artist to be held in New York. This painter, fighting against perhaps more than the usual odds in his determination to liberate the creative urge within him, has already contributed eloquently to the artistic accomplishments of his race, and—since he is now only 37 years old—his future may be felt to hold promise of still richer achievement.

In his paintings of the Voodoo mysteries, the interpretations of modern American negroes at play, in the weird allegorical canvases and in the portraits, Motley directly or by subtle indirection lays bare a generous cross-section of what psychologists call the subconscious—his own and that of his race. The ancient traits and impulses and superstitions of his ancestors in Africa, Haiti, or wherever they found their habitation, trace here a milestone on the unending march; but the phantasmagoria is fascinatingly spiced with modern molds into which so much of the old race-life has been poured. The same fundamental rhythms are found, whether the setting be a jungle presided over by witchcraft or a cabaret rocking to the syncopation of jazz.

"Dancing," Havelock Ellis has observed, "is the primitive expression alike of religion and of love; of religion from the earliest human times we know of and of love from a period long anterior to the coming of man. The art of dancing, moreover, is intimately entwined with all human tradition of war, of labor, of pleasure, of education, while some of the wisest philosophers and the most ancient civilizations have regarded the dance as the pattern in accordance with which the moral life of men must be woven. To realize, therefore, what dancing means for mankind—the poignancy and the many-sidedness of its appeal—we must survey the whole sweep of human life, both at its highest and at its deepest moments."

It will hardly be necessary to say that young Mr. Motley has not surveyed "the whole sweep of human life." He has taken only a segment of it, phases of which he has knowledge and whose expression flows in his veins; but in this restricted sphere he has caught the spirit of life at moments both high and deep; and it is doubtless the underlying seriousness in his work that forces the spectator to pause and try to understand what he has done, what it is his steady aim to accomplish.

From a tender age, Motley says, he felt himself attracted to art. Almost from the first likewise, he was absorbed in contemplation of the contrast often so suggestive and so luminous between ancient expressions of his race and expressions such as manifest themselves today. The river of emotional and intellectual reaction to life he sees as a "deep river," flowing out of the mists of the past, through the present and off into the vanishings and veiled potentialities of the future.

Born in New Orleans in 1891, with a background of slavery still fresh enough to leave its impression upon his mind,

"Waganda Charm-Makers," by Archibald J. Motley Jr.

Motley was taken, two years later, to St. Louis. Thus his childhood was not spent in the South, where racial fires may be said to burn most powerfully. To have lived there long enough to absorb into his being the vivid atmosphere of post-slavery plantation life might have proved of inestimable value. On the other hand, as so much of his work now shows, Motley possessed a genius for picking up scattered threads; for visioning and reporting upon the varied existence of black people plunged in the great American crucible of change. It was perhaps as well for the subsequent versatility of his canvas that stakes were pulled up when he was still very young.

The family did not remain long in St. Louis. Thence a move was made to Buffalo, and the final stopping place was Chicago, where Motley has lived for about thirty-four years. In Chicago there was plenty to see. For the inquiring mind of a boy there was plenty to ponder over. On leaving the high school Motley took up art work seriously. Dr. Gunsaulas, President of the Armour Institute in Chicago, urged him to become an architect and offered a course gratis. But Motley knew that he wanted to be instead a painter, and he stuck to his ambition. Dr. Gunsaulas, who believed in the boy, offered to pay for his first term at the Art Institute. Again Motley's independence asserted itself. He preferred to make his own way, and secured a "tuition job" at the institute, paying for his lessons by work on the side. He was then about 21 years old.

Mr. Motley, looking back over the early stages of his progress, says the man from whom he learned the most about painting was Karl Buehr. Albert Krehbiel impressed upon him the importance of composition, while John Norton instilled into him a knowledge of the technique of drawing. Mr. Norton's method Motley found particularly to his liking. Instead of working directly from nature, meticulously copying the model, he would draw a few simple lines, as a child does to designate a human figure. Posture would dictate the position of these lines. Afterward the figure would be modeled in and built up after nature upon this primitive scaffolding. To this day Motley works in that manner.

The years of study at the Art Institute produced a great increase in technical proficiency; also they had developed the young negro's sense of self-sufficiency; but he left the institute at 25 full of doubts regarding the future and without much confidence in himself. Extreme sensitiveness, no doubt, accentuated by the fact that his skin was not so white as that of the other young artists with whom he had studied, kept him for a long time from sending pictures to the Art Institute exhibitions. He was afraid they would be rejected. It was not until 1921 that this fear was overcome.

But not for a moment did Motley abandon his aim. He was tremendously eager both to express himself as an individual and to further the cause of negro culture in this country. Since obviously it would be out of the question to earn a living with his art work, he plunged with hopeful enthusiasm into labor that was sure to be remunerative. It might not leave much spare time for art, but to be self-supporting was recognized as his first duty.

The jobs to which he turned his hand were varied, and some of them called for much physical strength. One of the less muscular occupations was acting as waiter on the dining car of which his father was chef. As Motley waited on the table aboard lurching and speeding trains the passengers he served did not know he was furtively studying them. All this was grist for the art mill. Motley says he has had so many jobs that he cannot recall them all. For a while he worked with his brother as a steamfitter in the Chicago stock yards. There he learned the plumber's trade and went on dreaming of becoming a painter in earnest.

On the side, and at night, he tried to do a little sketching and painting. This instinctive determination of his cost Motley his job at the stock yards. It seems that he always carried a sketchbook with him in a pocket of his overalls. One day when he had a few idle moments he went into the boiler room and began making a pencil sketch of one of the workmen. The boss caught him thus engaged and asked what he was doing. Motley told the truth and was fired. The stock yards, said the boss, was no place for an artist. This appeared at first a rather dire calamity, but soon he was reinstated—not in the steam-fitting department but as a coal beaver. It was hard work. Work, however, was what the young man wanted. He mentions with pride that never after he was 15 did his parents have to buy him a suit of clothes or a pair of shoes.

A few years ago his tide began to turn. Having managed to paint a few pictures, Motley exhibited with other artists at the Municipal Pier in Chicago. There, as it chanced, Count Chabrier saw them and became interested. He corresponded with Motley and in 1925 wrote an article about him and his work in the Revue du Vrai et du Beau, published in Paris. Life became more interesting. More of Motley's work appeared in exhibitions in this country. His remarkable portrait, "A Mulattress," won the Frank G. Logan Medal and prize at an exhibition held in the Chicago Art Institute. And now he has come to New York.

Mr. Motley says he has always found his chief inspiration in the nineteenth century French artist, Bouguereau, whose work is "full of feeling." Technique is not everything—although, incidentally, Mr. Motley has worked out a very creditable technique of his own. "The real artist puts on canvas what he feels," the artist said not long ago. "The present school of painting is too much interested in the technical side; too much interested in portraying exterior personalities and not enough interested in translating inner emotion." Any one who has seen Mr. Motley's pictures knows what he means by this. There is, in nearly all the pictures he showed here in New York, a kind of inner fire—whether native to the artist or to the subject may not always be clear. Perhaps there is something reciprocal about it.

Because Mr. Motley is a colored man his road has been harder than if he had been born white. Color can still make a difference, even in the realm of the arts. "I have found that, try as I will, I cannot escape the nemesis of my color," says Mr. Motley—though without any inflection of bitterness. He relates an instance. At one time he and another Art Institute student applied for a commercial art job. The other student, although inferior as an artist (he had stood, it seems, at the bottom of his class), got the job. When asked why this choice had been made the proprietor of the concern admitted that it was because they could not take on a negro. Motley has frequently bumped against this barrier.

But he remains philosophical. "I am not complaining. I am satisfied to go quietly along, doing what I can, painting the things that suggest themselves to me. In fact," he says, "I believe, deep in my heart, that the dark tinge of my akin is the thing that has been my making. For, you see, I have had to work 100 per cent harder to realize my ambition."

This ambition of his has been defined by a friendly critic: "It is to arouse in his own people a love of art; and he feels that his goal can be reached most effectively if his people see themselves as the centre of some artistic expression." Mr. Motley appreciates keenly the difference between education and culture; knows that a man may be highly educated without possessing culture in the true sense. He also believes that it is through culture alone that the colored road can work out its destiny.

For his work, as has been said, Motley chooses themes that run like strong, bright threads through the whole history of the negro. He looks back upon savagery and finds the same expression, if in other guise, that reasserts itself today. This,

of course, is tree of any race; for race rhythms do not die so long as the race endures.

"There is something deeper than the sensuousness of beauty that makes for the possibilities of the negro in the realm of the arts," observes Benjamin Brawley in "The Negro Literature and Art"; and that "is the soul of the race. The wall of the old melodies and the plaintive quality that is ever present in the negro's voice are but the reflections of a background of tragedy. No race can rise to the greatest heights of art until it has yearned and suffered. There is something very elemental about the heart of the race; something that finds its origin in the African forest; in the sighing of the night wind; in the falling of the stars. There is something grim and stern about it all, too; something that speaks of the lash; of the child torn from its mother's bosom; of the dead body riddled with bullets and swinging all night from a limb by the roadside."

Yet Motley has caught as well the gayety, the child-like abandon of his people. He paints them at play, when the somberer side of existence is put by and laughter rules. Sometimes the scenes are lurid, and always they are imbued with the negro's natural love of bright colors. Frequently they are decorative rather than realistically compelling. But in all his work Motley shows an alert mind that draws its material from a sound esthetic fount. And, as was suggested in the beginning, in the Voodoo pictures he displays an imagination deeply stirred by conflicts that have torn the primitive soul of the black man. His fires are so hot that one hesitates, almost, while the initial impact remains sovereign, to touch the canvas on which they are depicted. Yet here there is not a trace of so-called realism. The wraiths that ascend in smoke are terrible. In "Spell of the Voodoo" we see the startled whites of eyes, and above, in the mysterious void of sky, are stars that gleam with the same whiteness—but so passionlessly as to stand tokens of what in life is mocking and unplumbed.

* * *

May 20, 1928

THE END OF THE SEASON

OFF WITH THE SMOCK!

Art Schools, After a Profitable Year, Begin To Ease Their Pace— A Brief Survey

New York's many art schools—far too numerous to be included, all of them, in a brief survey—are winding up their work for the season; some have already called it a year and packed the empty, echoing classrooms in camphor balls for the Summer (unless there be Summer courses in prospect); a few are now in the final, exciting throes, with exhibitions outspread for all who will to witness. Among those in the last-named stage is the Grand Central School of Art—which, adapting a slogan of the Grand Central Art Galleries, would probably be safe in boasting that it is the only art school located in a railroad terminal.

Perhaps what fires the imagination of the outsider is in part the novel environment; the proximity of arriving and departing trains—though high up on the perch at the top of the building this youngest of New York's important schools of the arts is as far removed from the details of coming and going in a great metropolis as could be asked. Down on lower levels travelers bound for all regions of the earth save Europe scurry about with time-tables and porters; commuters pour in at the appointed morning hours and pour out again as punctually, snatching an evening paper as they run; but in a region seven stories nearer the sky—consequently more on a line with the fabled Mount of the Muses—art students transact, with perfect detachment, a business of their own. Here the only significant departures concern embarkation upon a career, and the only significant arrivals—well, these too must be thought of in the same poetic strain.

Judged according to the merits of this latest exhibition of students' work, filling one of the large galleries on the floor below, the year's effort has been well spent. For this is indeed a creditable showing; one that embodies (in a phrase polished almost by overusage to the vanishing point) "both achievement and promise." Water colors, oils, black and whites, these cover the exhibition walls; and besides there are smart little examples of interior decoration, painstakingly complete and, in at least one or two instances, fresher and more suggestive of comfort than are those sumptuous imported French ensembles with which we have become so familiar.

In this gallery we see displayed the Grade A whipping cream of a year's "achievement and promise." By traversing long, secret corridors and climbing mysterious stairs (this journey is safely taken only with an experienced guide) we reach the workshop itself—7,000 square feet in size, if you care for statistics, and as romantic a place as you ever explored, even under the mansards of Paris. Students are still on hand: energetic smocked young men and women who, pursuing their tasks, combine in demeanor the keenness and nonchalance of young medical internes or newly graduated mechanical engineers.

Yes, it is all very romantic, this life on top of a railroad station. But of course romance lives only for the outsider who has made his way up there with a guide. Young art students who are really earnest never think for an instant about "atmosphere"—or do they, now and then, even they, in secret? Hard work is the order of the day. And surely it is worth while to work hard when as a result you can make so fine an annual gesture downstairs in the gallery.

"The interesting feature about this art school," says its President, Edmund Greacen, "is that it was organized and is being run by artists. The Faculty is composed of artists"— George Pearse Ennis, Sigurd Skou, Howard L. Hildebrandt, Mr. Greacen, Wayman Adams, Arshele Gorky, Henry B. Snell and others—"who are active today in the various branches of their profession. The present exhibition represents the end of our fourth season and we have this year an enrolment of 1,200 students, coming" (as is especially appropriate, considering the location) "from all parts of the world.

Our idea it is that a thorough technical training may be secured without prejudicing the mind of the student in favor of any particular creed of art, leaving him free to express his own individuality without undue influence brought to bear on the part of the instructor. We have," says Mr. Greacen, "no cut-and-dried system of art education, but aim to get results by development of each individual."

Not, of course, that this aim is unique. There is no patent on it, nor is it copyrighted; were such the case, then most of the other art schools would be liable to all sorts of harrowing experiences in the courts. "Let the individual express himself" is the prevalent modern password. Perhaps the only institution visited by the writer, on a brief tour of inspection, that does not quite subscribe to this enticing Open Sesame is the eldest of them all, the Art School of the National Academy of Design, which brought to a close a few weeks ago its one hundred and first year.

This is how Mr. Blashfield has phrased it: "The Academy believes firmly in the development of the individuality, but denies that such development is helped by the ignoring of the universal heritage of the graphic manifestations of man's temperament and impressions. It therefore approves careful consideration of the art of the past and its correlation with the art of the present," and condemns "only ignorance, insincerity and the contempt which is born of them."

In this school, which is next door neighbor to the rising Cathedral of St. John the Divine, training of students is strictly academic. No "false gods" of modernism, however great may be their vogue elsewhere, are allowed to enter. This year's graduating class was assured that going back to the Primitives does not spell progress. Going back to the technically expert masters of a later period, however, one perceives, is of the utmost importance; going back to ancient Greek sculpture, too, of course. Primitives and "false gods" of today who revere the Primitives constitute navigation perils and must be designated as such on the charts. After a student leaves the Academy School he may follow what course he likes, but so long as he is there he must pay close heed to "fundamentals" and to sound academic technique. The students produce, on this basis and within these limitations, work of high excellence. Naturally, it is what they do after they go out into the world that determines their status as creative artists.

This school, supported entirely by the Academy, is at present seeking more funds in an effort to enlarge its equipment and to maintain the "free" plan on which it operates. No tuition is charged, the students, most of them self-supporting, paying merely a nominal matriculation fee of $10 a year.

The Art Students' League, quartered in the Fine Arts Building in Fifty-seventh Street, is, on the other hand, "a cooperative society run by students for students." Tuition is arranged according to courses, and thanks to an extensive membership list the organization finds itself in a very prosperous state. The Art Students' League represents a reaction from the Academy, though it calls itself conservative, too. A line in the catalogue reads: "New ideas, which find difficulty of expression in other types of organizations, are here given an opportunity to develop. To offer freedom to pursue a well-rounded course of study is its only object." Each instructor, one learns, is allowed complete freedom as regards his methods of teaching, while "each student has equal freedom in his choice of classes and as to the length of time he wishes to study."

Like the Academy and unlike the Grand Central Art School, the league restricts itself to the fine arts (including graphics), and does not directly prepare students for the various branches of commercial art. The Faculty numbers many well-known artists, including Robert Henri, Rockwell Kent, Walt Kuhn, Richard F. Lahey, Kenneth Hays Miller, Boardman Robinson, John Sloan. Gifford Beal is President of the Board of Control.

In some respects the most completely equipped of the local art schools is the School of Fine and Applied Arts in Pratt Institute, Brooklyn, founded and endowed in 1887 by Charles Pratt, a manufacturer, who was deeply interested in education. Here one finds the atmosphere of a university, not at all the atmosphere of Bohemia. There are both specialized and general courses, and certain university features are obligatory, such as physical training.

The classrooms are splendidly arranged and a carefully worked out laboratory system makes it possible for student sculptors and architects to become thoroughly grounded in a knowledge of the materials they use. This school has a total enrollment of about 1,500. Its forty-first annual exhibition will be held on Thursday, Friday and Saturday, May 31, June 1 and 2.

Another old and very well known institution is the New York School of Applied Design for Women, whose annual exhibition, opened last week, gives a comprehensive picture of what has been done this year. The school, founded in 1892 by Mrs. Dunlap Hopkins, has educated more than 23,000 students; and it further asserts that by adjusting art instincts to a remunerative end, as well as by giving these instincts an opportunity to develop, the school has "laid the cornerstone of industrial art for women." The "practical" side is constantly stressed, and W. G. Bowdoin, Chairman of the Extension Committee, observes that thousands of women graduates have been fitted "for positions in textile, poster, wall-paper, fashion designing, architecture, interior decoration and other branches of manufacture involving the use of ornamental design."

Emphasis on this phase of art instruction is also placed by the School of Design and Liberal Arts, which occupies the top floor of an old house, with delightfully creaking stairs, in West Fifty-ninth Street, facing Central Park. This small school, numbering between fifty and seventy-five students, is likewise holding an exhibition. That its aims are similar to those of the School of Applied Design appears in the following statement made by the director, Irene Weir: "This school is a highly specialized workshop. It trains students to become designers and artists for the many fields of art and industry in which skilled workers are required." There are classes in

drawing, painting, interior decoration and fashion illustration. "Spontaneity" is the slogan.

E. A. J.

* * *

May 27, 1928

GROPIUS PRAISES EFFICIENCY HERE

*Says We Can Build as Cheaply as Germany, Where Labor Costs
One-fourth Ours*

STUDIED TIME SAVING WAYS

*Founder of Bauhaus Sails to Start Manufacturing Berlin Houses
on New Production Plan*

Professor Walter Gropius, founder of the Bauhaus, at Dessau, Germany, a school for architecture and allied arts, whose members are said to be largely responsible for the "modern movement" in German art, sailed back to Germany yesterday on the Albert Ballin. He spent seven weeks in this country to study American methods of mass production, particularly in relation to time-saving efficiency.

"You can build a house as cheaply here as one can in Germany," he said, "even though your workmen are paid about four times as much; simply because your technical methods enable them to make much more efficient use of their time."

Professor Gropius was particularly interested in the technique of the American building industry because on his return to Germany he is going to Berlin to start building houses on a principle he has been advocating for fifteen years. In conjunction with Adolph Sommerfeld, one of the largest building contractors of Berlin, he is starting mass production of dwelling houses on the principle of a child's building blocks.

Unit parts of the houses will be produced on a large scale at the factory, and out of these dwellings can be assembled in an almost infinite variety of forms to suit the individual taste and purse of the buyer. With a saving of 15 per cent in construction costs at the outset he hopes, by increasing efficiency, to eventually save 30 to 40 per cent.

Professor Gropius said his plan has the backing of Dr. Otto Braun, Prime Minister of Prussia, expected by many to become the next Chancellor of Germany, who hopes it will help to relieve the present German housing shortage. There is said to be a shortage of 1,300,000 dwellings in Germany.

He said he found many men here interested in fitting modern art to industry as it is done at the Bauhaus at Dessau, but unable to carry on research due to lack of funds. He urged that private, independent endowments be set up here for the purpose.

"That would be better than a Government bureau," he said. "I talked to many of the men at the Bureau of Standards at Washington and they are doing wonderful work. But they all complained that when they reach any conclusions as to the greater availability of any particular material over another they can't express themselves because the Government refuses to intervene in business.

"I did not come here to study American architecture. There is no true American architecture yet. The set-back law for skyscrapers in New York has made a beginning, however, and with the tremendous tempo of American life I am sure you will soon arrive at it. The most modern pieces of architecture I saw here are the River Rouge plant of Ford and the grain elevators of Chicago. And it is noteworthy that the beauty of these is born out of the starkest utility and with no conscious attempt at decoration."

* * *

June 17, 1928

MODERN FRENCH MASTERS

BOURGEOIS'S CATALOGUE

*Outstanding Canvases by Rousseau, Van Gogh, Cézanne,
Vlaminck Discussed*

By ELISABETH L. CARY

Indispensable as histories of art undoubtedly are to the student attempting an orderly arrangement of his mind, too much dependence upon them is likely to bring about a spinsterish concern for tidiness at the expense of better things. The kind of history that comes nearest to satisfying a mind less eager for boundaries than for extensions must include a series of catalogues of personal collections, especially of collections formed upon a more liberal plan than that suggested by the golden inscription of the National Gallery in London, to which M. Alexandre refers in his preface to the catalogue of the Kelekian collection, and which decides autocratically for ancient as against modern art.

The most valuable of all, regarded simply as histories, are the annotated catalogues of that art which is thrown across the ever existent gulf between the past and the future, the gulf which we, in our puzzled nomenclature, call the present, although before we speak the word it becomes the past.

The catalogue of the Adolph Lewisohn collection of modern French paintings and sculptures, edited by Stephen Bourgeois and published by E. Weyhe, is an example of this useful type. Mr. Bourgeois's preface takes reading. His introductory essay on "French Painting During the Nineteenth Century" traces back to the Catacombs and forward to that Custom House officer, Henri Rousseau, about whom so much has been written and so little is known, and who, Mr. Bourgeois believes, took the first decisive step "leading to the solution of all the problems which had agitated the artists of the nineteenth century." Doubtless, as this critic says, the fact that Rousseau had no schooling to get rid of made originality easy, and his extraordinary impressionable temperament made the strange aspects of exotic growth in southern forests, seen during his Mexican experiences, an indestructible part of his mental equipment. It is open to doubt, however, that the path he blazed

will be followed by any save those who, like himself, are born with the rare power of what Blake called "organic perception." Blake himself found no difficult problem in the difference between optical and mental seeing; "as a man is so a man sees," he explained to a dull patron; "the tree which moves some to tears of joy is in the eyes of others only a green thing which stands in the way." The parallel between Blake and Rousseau stops there, but they continue alike in the extent to which each is isolated among his fellows.

The two examples of Rousseau's art in the Lewisohn collection are of the finest. Both jungle scenes, through which animals peer, alert, watchful and fierce. Both characterized by sharpness of silhouette and clarity of light. Again one of Blake's illuminating explanations serves. "A spirit and a vision," he says, "are not a cloudy vapor or a nothing; they are organized and minutely articulated beyond all that the mortal and perishing nature can produce."

Seeing spirits and visions thus definitely is supposed to be an indication of abnormality, and in the literal sense certainly it is. Genius and madness alike are off the norm, and if the great genius of Blake had its tincture of madness, we hardly can doubt that only a thin partition divides Rousseau's gift from the heightened sensibility of an over-excited mind. At any rate, he believed in ghosts and saw them everywhere, those who knew him tell us. One of these tortured him for more than a year. He was also tortured as well as exalted by his habit of falling in love. He had the great generosity of the truly simple mind. He attributed to these whom he loved in succession potent and kind influences. He had also the straightforward vindictiveness of the truly simple mind, uncomplicated by passion for his art. "When he received an order for a portrait or a landscape," says Mr. Bourgeois, "the question of payment dictated the result. If the patron paid well, Rousseau painted a good picture; if the patron was stingy, the quality of the work was in accordance."

As one surveys the record of this catalogue the collection seems to revolve about this simple, childish, gifted man, with his pinch of madness, "more modern than any of the artists of the present time," the "first interpreter of a new idea." It would be an uncomfortable thought to entertain if the new idea presented itself as limited to this first interpretation. But as we look back through the orderly sequence of the art brought together by Mr. Lewisohn in a manner to indicate milestones and stages along the path pursued by the modern art of France, we see gathering about the little douanier other interpreters of ideas, not quite so new, yet each marking a definite turn in the path.

These others also are a little mad, or more than a little, and greatly gifted, and possessed of simplicity; but their simplicity, unlike his, represents the fusion into a strong unity of many constituent elements. Turning to Van Gogh, intensity of seeing is the visible sign of intensity of feeling. He wrote to his brother that what he wished to achieve was that one should say in the presence of his work: "That man feels deeply, and he feels delicately," in spite, he added, of his so-called coarseness, perhaps even on account of it.

Jan Gordon has understood Van Gogh as one must think he himself realized his own being. Although Mr. Bourgeois believes that his restless nature did not reach the clear, objective outlook necessary to complete control over the phenomena of nature and the fusing of these phenomena in sharply defined forms, Van Gogh himself felt that he was so devoured by curiosity for the possible and actual that he had neither the wish nor the courage to seek an ideal which could arise out of his abstract studies. He nevertheless felt that nature contained more than mere actuality and continually sought to fuse nature's phenomena in an expression of vital significance. A letter written from the Asylum for Nervous Diseases describing a landscape seen from that place is quoted by Mr. Gordon in his "Modern French Painters." It reveals not only Van Gogh's close and penetrating observation but his power to evoke by means of line and color in significant relation a poignant life drama independent of subject. The final passage of the letter reads: "You can well imagine that this combination of red ochre, of green bedimmed with gray, and of black lines defining the forms, may help to call forth the feeling of fright which often seizes many of my fellow-sufferers. I have described this in order to show you that one can give the impression of fear without going direct to the historical Gethsemane." These are the words of a painter pure and simple, though not of a simple man.

Mr. Lewisohn's "L'Arlésienne" represents Van Gogh in his calmest, most objective mood, trying to give space values and arabesque as a Japanese master might give them, and reading character with Oriental precision. It is a great picture on the side of its qualities as art, but to get the whole man, isolated by the depth of his emotions, we must go also to one of his landscapes impregnated with feeling.

Turning from Van Gogh, so great, so tortured, tossing into the fire of his art all of himself that counted, his brain, his heart, his noble conscience, we reach Cézanne. Another madman, busy with the cosmos, caring nothing for human emotion so long as he could build worlds and set them moving in orbits, drawing each other toward and away. This exalted and supersensitive mind worked upon a plane far above any upon which could be lived the everyday life of a man. The happy carpenter who makes a stout box with true corners and a neatly placed lock may rejoice in his handiwork and think like a philosopher in his off hours. Not so a poor, manacled human being engaged with equivalents for cosmic forces. His off hours know him as a weaving of stretched nerves, cringing, trembling, angry, petty. Meier-Graefe has put into words the essential of Cézanne's creed: "Do not that which your finite members are capable of, but that which in moments of the greatest tension you dimly guess at as a transient possibility, and let your fingers look to it how they can manage to get along." To pursue this phantom, clear to the inner vision and continually escaping the actual grasp, was the fate of Cézanne. A fate that changed the art of two continents.

Two pictures of the three representing Cézanne in this catalogue form an eloquent contrast. One is the early portrait of a middle-aged man. Thick pigment, broad masses, a trow-

eling of the surface with large strokes of the palette knife. A brilliant sentence in the accompanying commentary places with precision one element in the artist's complex mental equipment: "He realized," Mr. Bourgeois says, "the necessity of identifying himself with his subject from the inside and following out its plastic logic. He followed this point of view throughout his life, to its latest consequences." Thus we come upon it again in what is said to be a late portrait of his wife, flowing and calm and devoid of emphasis, working out the subject from within and thus demonstrating by the very unlikeness of the one picture to the other the integrity of his method.

Associated with Van Gogh and Cézanne by intensity of vision is Vlaminck, but the intensity of this artist differs fundamentally from theirs. It is an intensity of theatre which may be dismissed on the fall of the curtain. Mr. Bourgeois speaks of a playfulness in his work and ascribes it to the fact that he never intended his painting to become a means of livelihood. It may also have something to do with the Flemish strain in his blood. Whatever the cause, it is there and communicates a sense of holiday. Matisse and Gauguin from their opposite poles also find their contacts in this group and contribute, the one a livelier enjoyment than Vlaminck offers, the other a conscious, decorative solemnity developed through running away from contemporary life and literature to primitive civilizations. The young Fauve, André Derain, who followed Cézanne with so much intelligence and broke away from him with a still greater intelligence, is growing old with dignity. His "Portrait of an Englishwoman," representing him in the catalogue, is all compact of this normal dignity. Picasso, passing from influence to influence, is seen in three distinct phases. Toulouse Lautrec, with whom he had perhaps more in common than with any other of his guides, is adequately suggested by his ironic rendering of a scene from the opera "Messalina," as played by a provincial troupe.

The earlier masters leading toward the twentieth century include Delacroix, now inevitably a "forerunner" by consent of the newer schools; Degas, not always so acceptable as ancestor; Corot, Courbet, Daumier and Forain, Carrière—in this galére!—Millet, Manet, Monet, Monticelli, Pissarro, Redon and Renoir, Seurat and Sisley and the feminine, fantastic Marie de Laurencin, to whom a new justice is done. There are three sculptors, Rodin, Bourdelle, Maillol. In the arrangement of the catalogue, although a consecutive march conducts the older names toward those of today, a liberal interpretation of the relation between them is accepted, an interpretation built upon a personal view of psychological resemblances, and, in consequence, one that interests and challenges or convinces according to the personal view of the reader. It is more than a contribution to the history of French art in the nineteenth century or in one notable collection, it is a valuable document to file concerning the contemporary mind at work upon collecting and explaining art.

* * *

September 9, 1928

NEGRO ARTISTS ARE DEVELOPING TRUE RACIAL ART

By WORTH TUTTLE

Back in 1921 the first exhibit of the work of American negro artist was held at the 135th Street branch of the Public Library. Last January their first annual show was held under the auspices of the Harmon Foundation and the Committee on Church and Race Relations at International House. In the early Spring of this year Archibald J. Motley, a man of 38 who worked as a laborer until his recognition as a painter came, held the first negro one-man show of any importance in New York. The career of this remarkable painter was sketched in an article appearing in The Times Magazine for March 25. In his first exhibit was all that one missed in the two general ones— the first displaying the work, some good, some very bad, of thirty-eight negro artists; the second, of a somewhat higher and more even level, the work of eighty-seven.

After the first show I wrote in the now deceased Freeman: "As individuals they [the contributors] have not yet become sufficiently introspective or sufficiently brave to reap in art the harvest which their race has sown in suffering. . . . Yet in the field of painting and sculpture the American negro has a freedom for self-expression that has been denied him in literature. For such expression three sources of inspiration and material are open to him. There is the history of the race, there are the contemporary types of Afro-Americans, and there is also, as Benjamin Brawley points out in "The Negro in Literature and Art,' the racial temperament."

All of this Mr. Motley has both realized and executed, going back for his material to the jungle and to the plantation, to the negro belts of modern cities, and weaving into all that rich racial fabric an emotion which no white man can experience, knowing within himself what modern psychologists have stated about the inferiority complex: ". . . the dark tinge of my skin is the thing that has been my making. For . . . I have had to work 100 per cent. harder to realize my ambition."

While in the two general exhibits there was no one to equal Mr. Motley in imagination and in emotion, it was gratifyingly clear that in the seven years elapsing between the two events some progress had been made in a utilization of the material found in contemporary Afro-American types and in an improved technique. In the first show, for instance, Tanner's "Washing the Disciples' Feet" and Meta Warick Fuller's symbolic figure of a young girl, called, I believe, "Africa's Awakening," were needed to hold the thing together—though they were well aided by the work of Laura Wheeler Waring and William H. Scott and even by those photographic studies of Southern negro types so skillfully done by Professor Battey of Tuskeegee Institute.

The exhibit at International House, with all its shortcomings, did stand on the feet of the coming young painters and sculptors in the race; in the Brittany seascapes of Palmer C. Hayden, a youth rescued from a Village attic last year by the first Harmon Award and now at work in Europe; in the

Portrait by Archibald J. Motley Jr. In the Chester Dale Collection.

matured ability of Laura Wheeler Waring, a young teacher of normal school art recently returned from three-years' work at the Julien Academy; in the sculpture of Sargent Johnsen, a picture framer of Berkeley, Cal., and in the composition work of Marvin Gray Johnson, a student who has established a prize-winning record at the National Academy of Design. There were, too, Aaron Douglas's illustrations for "God's Trombones," mural studies for public buildings in Chicago and Milwaukee by William H. Scott, others by Hale Woodruff, and one powerful bit of sculpture, the head of a negro, by Augusta Savage, a young woman from Florida who, surrounded by a dependent family, is working toward recognition in a room on 137th Street.

Miss Savage, finding that all of her work, in its first form, tends to be too negroid, is fighting down this very racial expression in which Mr. Motley has so effectively immersed himself. For this reason it will be particularly interesting to watch her work—if circumstances are not too much against her. Her "Green Apples," a study in bronze of a small colored boy with colic, has just been catalogued by Gorham. But she is at work now on very Anglo-Saxon illustrations for a life of Whitman.

In that initial exhibit the few landscapes shown were suggestive in that there were scores of North Carolina pine woods done by a North Carolina negro. But they were crude compared to "A Home in Bretagne" and "St. Servan," by Palmer Hayden, in this second show. To judge from the work of his that has been shown, his bent toward the objective will not permit him to develop as a "racial artist." Mrs. Waring, on the other hand, with a matured technique in portraiture and with a beautiful unconsciousness in her personality of anything so limiting as race, makes an intellectual gesture toward a racial consciousness, even a racial pride, in her portraits. They run the gamut of color tones, from the dark brown of her "Anna Washington Derry," the vigorous but sentimental study of a middle-aged woman that won the first prize of $450, to the quite Nordic skin of "A Portrait of a Child." Her "Young Girl," a head done in rich mulatto tones, was by far the best painting in the room in design and descriptive effect. In sculpture the two most arresting items were the black porcelain, "Sammy," and "Lust of a Child," by Sargent Johnson. These two, together with his work in relief—"Elizabeth Cee" and "The Parade"—made up a charming group.

Who but a young Southern negro, painting in the North, would remember and execute, with a feeling that a white artist could easily miss, a baptismal scene in a river: dark faces above varicolored garments, a grouping in ceremonial order? That much at least, was in the only traditional American negro description shown at International House. Inadequately done as it was, it made one wish for others of its kind—for a tobacco barn at the drying season; for Negro Day at a Southern State Fair; for what I later found at the students' exhibit at the library; a burial under pine trees; for such a cross-section of Southern life as is so truthfully portrayed in "Porgy." These are the hinterlands of inspiration to which the "race man" alone can penetrate, far away from such show places of negro life as Harlem, to which the inquiring white artist can go.

And who but the American negro artist will experience a direct quickening of the imagination in that recently discovered theatre of the pre-dynastic empires of Africa from which, it is hinted, Egyptian culture might have sprung? "African art," says the Theatre Arts Magazine, "presents to the negro in the New World a challenge to recapture this heritage of creative originality and to carry it to distinctive new achievement in the plastic arts." The very fact of its recent discovery and the widespread interest it has aroused in this country and in Europe, influencing such contemporary moderns as Matisse and Picasso, is an urge in itself, capable of producing a deep excitement and response in the American negro whose knowledge of his past has hitherto gone back from a plantation cabin to a jungle hut. In order to foster this interest in the racial past the entire third floor of the 135th Street Library has been set aside as a permanent museum of "historical records and literature by and about the negro and to African and American negro art." Primitive African art—masks, fetishes, musical instruments, jewelry, decorated arms and pottery—which formed the Blondiau-Theatre Arts collection, is on view there.

While one does not want to limit the negro artist to the confines of race, one does wish to see him overcome his sensitiveness about revealing this inner life of his people. Writ-

ing in The Nation some time ago, Langston Hughes, the negro poet, said: "I am ashamed for the colored artist who runs from the painting of negro faces to the painting of sunsets after the manner of the academicians because he fears the strange unwhiteness of his own features. . . . The duty of the younger negro artist, if he accepts any duties at all from outsiders, is to change through the force of his art that old whispering, 'I want to be white,' hidden in the aspirations of his people to 'Why should I want to be white? I am a negro—and beautiful.' "

That attitude, even as a conscious pose, seems to me desirable, not only for the fresh material it provides, but also for the emotional release it has given such an artist as Mr. Motley. Certainly one cannot see his work and agree with George S. Schuyler Jr. that there is no racial art; that an alien absorbed by any nationality displays the characteristics of that nationality and not those of his race when he points only to individuals—Claude McKay as English, Pushkin as Russian, Antar as Arabian, Dumas as French, in proof of his statement—seemingly forgetting that one individual isolated in a country in which he grows up as a native is quite different from millions of them growing up in a nation in which they are oppressed.

Not one of the long list cited by Mr. Schuyler in his article of a few years ago had felt the sting of racial discrimination as a negro artist in America has almost surely felt it at one time or another. And it is just this plowing his way through and above oppression that will make the work of the young negro artist exciting in painting and in sculpture, as it has already made it in the poetry of Weldon Johnson and Countée Cullen, in the prose of Jean Toomer and Eric Walrond.

And bearing in mind the difficulty of skilled expression in the plastic arts as compared with that same expression in literature, one need not be disappointed in watching the development of the "new negro" in the second annual exhibit which will be held at International House from Jan. 3 to 15, and in the continuous exhibits, by one man or by a selected group, that are always open at the 135th Street Library.

* * *

June 9, 1929

ART GLIDES SMOOTHLY INTO ANOTHER SUMMER SEASON

WORK OF TEN NATIONS

The International Summer Exhibition in Brooklyn Includes Artists Seldom Seen

By ELISABETH LUTHER CARY

International exhibitions of art usually provoke comparisons, odious or otherwise, and the Summer exhibition at the Brooklyn Museum is no exception. It is devoted in the main to artists who are seen but infrequently, and in the role they play in these galleries we see them as races more clearly than as individuals. In spite of the colossal movement toward breaking down racial and national boundaries through modern inventions almost without number, it is comparatively easy to place most sections of the work without reference to the catalogue. Art seems still to be in the position of the telltale ear in Mr. Berenson's philosophy of attribution: it is that feature of a country least likely to change suddenly in appearance. It can be counted on as a durable clue to nationality. Even when it bounds into modernism in the appropriate garments for that athletic sport, the difference between the modernists of different countries is promptly betrayed. In each case, the more a national art changes, the more it is the same, as the saying still is.

For countries represented in the present collection, we have France, Germany, Hungary, Italy, Japan, China, Palestine, Russia, Mexico, the United States. France and Germany are almost negligible so far as clues and comparisons go. France is present only in the work of the blind Lemordant, which, nevertheless, hardly could have come from another nation, so fully does it embody the cheerful courage of France under any blows of fate. Germany sends a group of water-colors and drawings that speak somewhat confusedly, somewhat elaborately, of the peaceful preoccupations of the Germany we have forgotten. These are countered by the specific, clear, posterish work of Roland Rolando, given to Germany in the catalogue and showing bird and animal drawings from the New York Zoological Garden, at once lively and weighty, with sly readings of character as shown in the less obvious modelings of physiognomy.

Berta de Hellebranth and Elena de Hellebranth have more than fifty exhibits to their united credit, and it must be confessed that this large consignment flatly contradicts our too inclusive initial statement. Such familiarity with Hungarian art as one gets in outside exhibitions adds not a hint, not a breath, of recognition to our contact with these pictures. This, in spite of an "expressionism" that might have been developed in Berlin, could not be said of the baker's dozen works by Lajos Tihanyi. Rugged and ribbed and twisted, kaleidoscopic, violent, they make an attack upon the sensibilities, direct and compelling, such as we believe to be the authentic Hungarian method in all the arts. The portrait of the "Family" shows also the ability to dig out fundamental qualities of temperament which again is characteristic of all the best Hungarian art that has reached foreign exhibitions.

Frank Horowitz brings Russia as close to Hungary as she was before the readjustments of boundaries, but one is conscious in his work of a slower movement of mind, and his art is much more literal than that of Tihanyi. His portrait of Epolitoff Ivanoff, the Russian composer, is a vigorous interpretation of a vigorous personality, the effect is that of sails moving before a brisk wind, of pennants flying, of life at full, in spite of the marks of age on the striking features. Portraiture emphasized and made salient, without the excess of grimace.

Mexico in Angel Zarraga lives in a trance, the intensities revealed by Orozco and even those calmer fervors embodied in the frescoes of Rivera having no place in this Nirvana. The

decorations from Aztec sources and from European, the Indian types and others to be found in complex Mexico, the emotionless figures in the "Triptych of Peace," whose gestures symbolize brotherly love devoid of warmth as perhaps brotherly love in a universe broken into diverse races must continue to be, the serene Annunciations emptied of wonder, all speak of a sleeping spirit. When we turn to a portrait of an American whom we know, the valiant sculptor, Malvina Hoffman, we can see that this reading is not so far amiss. The likeness is admirable. The clear-cut features, young after twenty years of recognition and awards, make their distinction felt; the green workman's blouse reinforces by its simplicity the impression they make of single-minded effort; but the chief element in the face, an eagerness fused with force, is left out of the picture. It may be this way, also, with the composite portrait of Mexico.

Italy, too, is shown in her lighter and more practical moments. In sculpture by Fausta Vittoria Mengarini of a period removed in temper of mind much further than in time from the contemporary work of Young Italy as it was seen here two or three years ago; and in silhouettes by Ugo Mochi, gay, elegant and unbelievably expert. The complicated designs in black alone are finer than the elaborate effects in color. There are Chinese paintings by Kwei Teng—"in the Old Manner"—yet with surplusage eloquent of the number of things unloaded by the Western world upon Chinese reticence. There are Japanese water colors by Koowhoo Iahl, who accepts complexity in the Western scene, but as yet hardly knows what to do with it. Later his inheritance of facility to clearing a path will see him through.

More interesting than any of these are the paintings and drawings of Israel Paldi and of Rubin, the two artists who have made Palestine a land of promise in art. Such groups as Rubin's "Jerusalem Family" and "Holiday in Jerusalem" are like towers or temples in a smiling land. The "Holiday in Jerusalem" is the most architectural in its arrangement. The massed figures of men in the centre flanked by the smaller masses of women and houses lend to the composition an aspect of fortification, a town fortified against assault from without.

Other of his canvases offer a gentler vision of a country dotted with flora and fauna of an appealing character. Rubin leads upon the stage a flower-carrier, mounted on a donkey, holding his great bouquet shielded with paper. The donkey turns his head, curving his neck toward a bit of green leaf escaping within reach of his nibbling lips. The audience smiles. Rubin makes a goat pathetic, camels absurd, fruits and flowers and rounded hills enchanting. His interiors open upon a stretch of water view. The contrast between that pleasantness and the tawdry laces and embroideries of the window draperies is amusing. In a word he dignifies simplicity and turns the lack of it into fussiness. His brushwork turns fussy the moment it touches the elaborate, but it can flow unbroken and pure over serene surfaces.

Israel Paldi's way with Palestine is different. He is all for motion and strict statement; if a mouth stretches large with but a modicum of efficient teeth the Arab boatman must sacrifice enough of his picturesqueness to make place for that repellent feature. Men with grotesque faces cross the Jaffa ferry with him; the women at the well are not as painters of sentiment would see them: some of them are old and ugly and bent, others are straight and fine in carriage. But these details detract nothing from the lure of place as he draws it across our vision. The boat paddled through a rough sea by men straining against violent forces of nature looks anything but comfortable, yet any one with the spirit of adventure strong within him must long to board that tossing boat and feel the splash of those insistent waves. The fine little drawings in pen and ink exercise the same spell. We see Tell-Aviv Street with a donkey of comedy straddling down its length and we are in that street at once, looking with neighborly eyes at those flat-faced houses and shouting encouragement to the pack-beast.

Among the small group of Americans Malvina Hoffman has the most imposing exhibit with a number of the large sculptures seen in New York this season and also with portrait busts which make a deeper impression in their more effective arrangement. The bronze portrait of Anna Pavlowa is one of the most satisfying in this kind. It can have been no easy task to capture the austerity of that beautiful head and infuse its almost forbidding reserve with the energy of genius, keeping it very quiet, very plain, as Pavlowa was when at rest.

The other Americans are Harriet Blackstone, too deeply imbued with a personal idea of mysticism to appeal to a crude onlooker, Bessie Lasky, Kenneth Frazier with both landscapes and portraits—once a familiar figure in American art exhibitions, Arthur R. C. Goodwin, for whom the New York scene becomes foreign and picturesque, and Isabel Whitney with the beautiful material of Columbia Heights in Brooklyn yielding a considerable degree of its fascination under her brush. This American group will receive later notice.

* * *

September 6, 1929

MODERN ART MUSEUM TO OPEN HERE NOV. 1

Mrs. J. D. Rockefeller Jr. One of Distinguished Group Backing the New Institution

GREAT COLLECTION IS AIM

Gallery Would Complement the Metropolitan as Luxembourg Does the Louvre

A permanent museum of modern art is to be founded in New York, including among its organizers Mrs. John D. Rockefeller Jr., who will act as treasurer, and A. Conger Goodyear, lumber merchant and banker, who will be the chairman, it was announced yesterday.

The plans, formulated at a luncheon in the Hotel Madison, call for the establishment of a gallery to display the works of modern and contemporary painters and sculptors to whom such an institution as the Metropolitan Museum of Art denies a place because its policy demands that the lapse of time eliminate the possibility of error over the value of a work of art.

The sponsors of the new museum intend that it shall complement the Metropolitan in much the same relationship that the Luxembourg bears to the Louvre.

"It is not unreasonable to suppose," a prospectus of the museum says, "that within ten years New York, with its vast wealth, its already magnificent private collections and its enthusiastic but not organized interest in modern art, could achieve perhaps the greatest modern museum in the world."

The museum, which is expected ultimately to have a building of its own, will find temporary quarters on the twelfth floor of the Heckscher Building on Fifth Avenue. Exhibition space there will make it possible to show about 100 canvases at a time and there is room on the same floor for expansion.

French Works To Be Shown

Paintings and drawings by Cezanne, Van Gogh, Gauguin, Renoir and Seurat, French forefathers of the modern art of today, will comprise the first exhibition of the museum, which will function at the beginning as a gallery for temporary loan exhibitions, each to remain for one month. This first showing will open about Nov. 1.

A group of American painters, masters of the last fifty years, Ryder, Winslow, Homer, Eakins and others, will be shown later. Exhibitions of the works of distinguished living American, French, German and Mexican artists will follow.

The director of the museum will be Alfred H. Barr, who has done extensive work at Princeton, Harvard and the Fogg Museum in Cambridge. In addition to Mrs. Rockefeller and Mr. Goodyear, the organizers include Professor Paul J. Sachs, who has been associated in the direction of the Fogg Museum; Frank Crowninshield, Miss Lizzie Bliss, Mrs. W. Murray Crane and Mrs. Cornelius J. Sullivan.

While for the first year or two the new museum will be largely a loan affair, it is hoped gradually to acquire works of art and also to arrange semi-permanent exhibitions. The museum hopes first to establish "a very fine collection of the immediate ancestors, American and European of the modern movement—artists whose paintings are still too controversial for universal acceptance." This collection would be formed by gifts, bequests, purchase and perhaps by semi-permanent loans. Permanent collections of the most important living artists, it is also hoped, may be formed.

"Experience has shown," observes the prospectus, "that the best way of giving to modern art a fair presentation is to establish a gallery devoted frankly to the works of artists who most truly reflect the taste, feeling and tendencies of the day. The Louvre, the National Gallery of England and the Kaiser Freidrich Museum, to mention only three national museums, follow a policy similar to that of our Metropolitan. But they

are comparatively free of criticism because there are in Paris, London and Berlin—in addition to and distinct from these great historical collections—museums devoted entirely to the exhibition of modern art. There can be no rivalry between these institutions because they supplement each other and are at times in close cooperation.

The Museum of Modern Art would in no way conflict with the Metropolitan, says the prospectus. The policy of the Metropolitan, often criticized as ultra-conservative, is thus defended by the sponsors of the new museum:

"Its policy is reasonable and probably wise. The Metropolitan, as a great museum, may justly take the stand that it wishes to acquire only those works of art which seem certainly and permanently valuable. It can well afford to wait until the present shall become the past; until time, that nearly infallible critic, shall have eliminated the probability of error.

"But the public interested in modern art does not wish to wait. Nor can it depend upon the occasional generosity of collectors and dealers to give it more than a haphazard impression of what has developed in the last half-century."

* * *

September 15, 1929

ARTS AND CRAFTS FLOURISH IN OUR MACHINE WORLD

Demand for Hand-Made Fabrics, Toys and Gay Pottery Has Stimulated Anew Peasant Workers in Many Lands

By MAURINE ROBB

Some think of the world today as machine mad, its driving force a mechanical god. Yet never before was there such a craze for the products of handicrafts. Few people find life complete without the conveniences made possible by modern machinery. Yet the standardization that has resulted from mechanical inventions has created the demand for the individual beauty that the painstaking fingers of man alone can produce. Nor is this love of the art of handicraft confined to women; many discriminating business men are now equipping their offices throughout with hand-made furniture.

A revival of handicrafts the world over has followed this demand for hand-made goods. Practically every country contributes one or more articles, until it can truthfully be said that the world today knows more handicrafts than before the beginning of the machine industrial revolution.

How does it happen that this revival of handicrafts is taking place now, rather than earlier or later? As usual, it is the World War that is at the bottom of it. After its confusion and the resultant changes in the boundaries of Europe; after the revolutionary movements which overthrew monarchies and caused financial upheavals that wiped out fortunes, it became necessary for many to labor who had never labored before. A revival of the nation's handicrafts followed.

In Russia, noblewomen remembered the days of their well-trained youth when embroidery frames and hand looms were in every gentlewoman's boudoir. Refugees in strange countries, peasant and aristocrat alike, learned that by their needles they might earn bread. Hence the supply of so-called peasant frocks and blouses finally organized and sold in New York in both the exclusive and other less conspicuous shops.

Necessity has driven the people of a number of countries back to the pursuit of their native crafts. Hungary, Austria, Germany and the Balkan States have embroidered busily for several years and have not only added pennies to their incomes, but have developed a keener national pride and have become better known to the world.

Perhaps the nation that has made the most of its handicrafts, however, is Czechoslovakia. The bright, crudely designed pottery of that energetic country has become almost too well known since merchants in New York have started turning it out from factories manned by Czech laborers. Yet the encouragement of the Czech handicraft pottery, painted wooden figures and toys has been the means of helping many an impoverished family to eke out a decent living. Realizing this, the Red Cross provided funds for Czech children in their schools to be taught how to make toys and small wooden figures. In one of the mountainous districts, the children have been able to provide themselves with excellent schools largely through the money they have earned by pursuing their native handicrafts. The parents are chiefly weavers and glass makers, and in these occupations the children assist. But through the Young People's Red Cross Society the children have learned also how to make ornamental glass beads and small wooden figures with a popular appeal. It is hoped to enlarge the scope of this work and teach the children to make embroidered bags, and laces and ornamental lamp shades for which there is constant demand.

Thus quietly flourish in the homes of Czechoslovakia crafts that have remained unspoiled by mass production in these fields. Last year an association was formed to keep alive the peasant customs and folklore of the country. This organization, known as the Detva, succeeds another formed thirty years ago that practically died out owing to the cheap imitations of the handcrafts which machinery made possible. Believing that to foster native crafts is to encourage a national spirit, the association maintains a permanent exhibition of Slovak arts and crafts in Prague. Here the work of the thousands who belong to the association is displayed for sale. The voluminous homespun skirted peasant costumes, topped by gayly embroidered bodices with fantastically shaped sleeves and odd little bonnets, are a joy to foreigners. Collectors feel themselves fortunate if they chance on a genuine "antique" costume and are able to persuade its owner to sell it.

Just as the Czechoslovak pottery became overpopularized when desire for large profits superseded the love of the craft, so, too, it happened for a time with the handicraft of Brittany. Tradition, however, and a deep-lying love of the old arts of the province in the final analysis kept alive and unspoiled the

quaint Quimper ware with its stiff little yellow, blue and brown figures. The design, which, through imitations, is well known today, was created in 1872, just after the Franco-Prussian War. Although the making of Quimper by the Bretons is still a handicraft, it is done in large plants. The peasant artists are untrained, in so far as schooling is concerned, but the free-hand designs which they copy day after day and year after year from the old plates and platters used as patterns have become almost family heritages. Grandchildren, seated beside their grandparents, learn the same designs, and rarely does a son or a daughter enroll in a factory where his or her ancestors have not labored. Since there is no attempt at exactness of design in the drawing, much of it is from memory. Pieces vary according to the skill of the artist.

Although in Czechoslovakia the painting of furniture is one of the handicrafts, it is not so important as in Bavaria. It was about the seventeenth century that the peasants of Bavaria first began to paint crude, brightly colored designs on the headboards and footboards of their beds and on their chests and cupboards. Birds, fruit and flowers were the favorite designs. Each succeeding generation of peasants kept on with this painting of furniture. Occasionally artists wandering through Bavaria would purchase a chest or a cupboard and take it back to their homes in the cities. About thirty years ago one of these artists, a Bavarian, whose love of Alpine climbing led him into remote villages, began idly to copy the painted furniture he found in the huts where he stayed for the night. He left unchanged the traditional characteristics of the designs, although his execution of the motifs was, of course, more finished. When he exhibited these pieces after his return to his home, they attracted attention and a few wished to purchase pieces like them. Since 1910 this artist, Alfred Link, has devoted himself to this reproducing of peasant art. Last year he had an exhibition at the Leipzig Fair. He now employs a number of young artists in his workshop to design and paint furniture after the fashion of rural Bavarians in the seventeenth century.

Some painting of furniture was and still is done in the Scandinavian countries, which are, however, more especially noted for their hand-carved woods. In rural Norway are to be found barn doors so beautifully hand-carved as to be suitable for decorating the finest of city homes. In their carvings the Norwegians cut out their national symbol—a viking ship. Today one buys in the silver shops of Oslo dainty viking ships in hand-carved silver, whose only duty is to carry tiny cargoes of salt on the dinner table.

But this carving of woods and silver in Norway and the other Scandinavian countries has until recently been falling more and more into disuse. Now the governments of both Norway and Iceland have started movements for teaching the young people in the schools that ancient art of carving which was part of the equipment of every one in viking days. The folk festivals attended by the peasants in all the brightness of their national homespun and embroidered costumes have done much to review all the native handicrafts. The government encourages these festivals, pays for instruction in the schools,

and through public exhibitions helps draw the attention of the public to the revival of the nation's handicrafts.

Other countries are taking similar action, realizing that some of the finest elements of national life are bound up in a country's native crafts. The Government of Bombay, for example, appointed the assistant curator in one of the museums to investigate and prepare a report on the making of carpets, prints, silks, carvings and lacquer work. On the strength of his report the government proposes to take steps to revive these handicrafts and to encourage the natives to pursue them extensively.

Dr. Barbeau of the National Museum of Canada has helped foster the handicrafts of French Canada and its folk music. John Murray Gibbon, poet, novelist and official of the Canadian Pacific Railway, and Dr. Barbeau deserve much credit for the revival of the French-Canadian handicrafts and their being brought before the rest of the world. For the past year or two Mr. Gibbon, with Dr. Barbeau's help, has arranged folk festivals at the Chateau Frontenac, a number of skilled weavers and spinners being brought down from their homes in distant parts of rural Quebec with their looms and spinning wheels. Under the curious gaze of fascinated tourists they pursue their customary task.

The same revival is true of the making of lace in many countries where it is the leading handicraft. In Bohemia not only do women and girls make lace but the men, during the Winter, make yard after yard of the more common narrow strips for which steady demand has been created in America. It was in the sixteenth century that lace making first came to Bohemia. Many of the laces show Slavic designs; some show Czech and Polish influences. After the mechanical inventions which provoked the industrial revolution not so many Bohemians plied the trade of lace making, but the craft persisted in the homes of mountaineers. In 1906 there was an exhibition of some of the work done in the Adler Mountains. Since then, steps have been taken to revive the trade.

* * *

September 22, 1929

MUSEUM OF MODERN ART FOR NEW YORK

At Last the Significant Work of Contemporary Artists, Either Radical or Conservative, Is to Be Assembled and Eventually Housed in a Gallery That May Become America's Luxembourg

By EDWIN ALDEN JEWELL

Modern art rides now on the crest of the wave, and at last it is to have a museum in New York. Announcement of the plan to establish such a museum constitutes perhaps the most significant piece of art news in this community in a decade. Of course, all will depend upon how the project carries through; upon the wisdom of its gradually formulated policy; last—but far from least—upon the quality of support it receives from the public. At any rate, the initial move has been made.

New York is to have a Museum of Modern Art (the term applied in its most catholic sense, to embrace all that is best in the art of today, whether ticketed "radical" or "conservative"); a museum devoted, at the start, to systematically arranged loan exhibitions, but dedicated to an ideal of acquisition, by gift and purchase, so that eventually it may house, in a building of its own, a splendid permanent collection.

Yet when one says permanent one means fluid, too, for in the anticipated cooperation of the Metropolitan Museum, whose attitude at present seems friendly, a scheme of "graduation" similar to that embodied in the relationship of the Luxembourg and the Louvre, is adumbrated. The idea of a Luxembourg for New York has been in the air of late, and one or two attempts have been made to realize it. This is the first plan that promises to reach fruition.

Philosophers argue convincingly enough that "art is absolutely necessary to all civilized life," while, to put it the other way about, "a man or woman entirely insensitive to all the arts can hardly be deemed civilized." And, emboldened by this speculation, one may go so far as to suspect that even modern art is absolutely necessary to civilized life. The artistic taste of the once so-called "masses" may not run very high, and it may be difficult to refute the assertion that you are more likely to encounter the "masses" in moving-picture palaces than in galleries. Nevertheless, popular appreciation of art increases as people in increasing number explode for themselves, or see exploded, the shibboleth that art is something to be found only at rarefied altitudes where none save rarefied souls is able to breathe. As for modern art, it is discharging its apologists and propagandists right and left. Charles Demuth was prompted by the gods when he said:

"Paintings must be looked at and looked at and looked at. . . . No writing, no talking, no singing, no dancing will explain them. They are the final, the nth whoopee of sight. A watermelon, a kiss, may be fair, but after all have other uses. 'Look at that!' is all that can be said before a great painting at least by those who really see it. . . . Only prayer, and looking and looking and looking at a painting—and prayer—can help."

Modern art—as witness this freshest proof, the proposed museum, where one may look and pray in perfect security—modern art rides on the crest. Yet how precarious the climb has been, and what battles have had to be waged, and what dark hours lived through?

It is only fitting to pause a moment, remembering what Cézanne, for instance, was up against—disowned by even his best friend, Zola, who yet found it possible to accept Manet. One day the French novelist told Vollard:

"My house, you understand, is the rendezvous of artists. You know how fair-minded they are, yet how severe with each other. I could not leave my best friend, the companion of my youth, to their tender mercies. Cézanne's pictures are under triple lock and key in a cupboard, safe from mischievous eyes. Do not ask me to get them out; it pains me so to think of what my friend might have been if he had only tried to direct his imagination and work out his form."

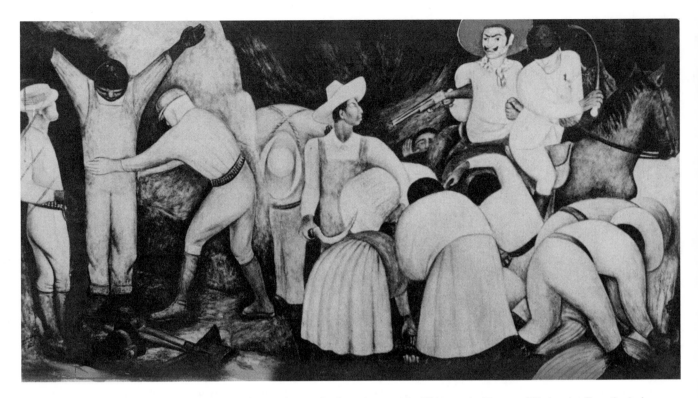

"Social Chaos," by Diego Rivera, the gifted Mexican whose works are to be shown in a special exhibition at the Museum of Modern Art. From the Andrews Collection.

Another day Renoir met Cézanne in the street, carrying a canvas so big that as he walked it dragged along on the ground. "There's not a cent left in the house," he confessed. "I'm going to try to sell this." It was the famous "The Bathers" (of the Caillebotte Collection, transferred some months ago from the Luxembourg to the Louvre). A few days later: "My dear Renoir, I'm so happy! I've had great success with my picture. It has been taken by some one who really likes it!" But the "buyer," it transpired, was "a poor devil of a musician who had all he could do to earn four or five francs a day." This poor friend of Cézanne's had so sincerely admired the picture that Cézanne—though no one with money recognised his genius and although there was "not a cent in the house"—made him a present of "The Bathers." In 1929 the tale would probably have a different ending.

And we may well pause, with modern art in its heyday, to remember the "howls of derision and execration" that filled the air when Manet exhibited his pictures, so that the police had to be called "to guard his canvases from the knives of fanatics." Those were among the darkest, if also the most exciting, of modern art's dark hours. For Napoleon's official David was in the saddle; and when Manet's "Olympia," now in the Louvre, was shown in the Salon des Refusés, the police had again to be called in, and the picture was roped off. Thus the mob was kept at arm's length; yet even so, it is related, the rope was not far enough from the wall to prevent the "Olympia" being spit upon.

Today there are no ropes, no mobs, no howls of outraged propriety. Modern art, if not always understood, is generally respected. The worst of the carnage seems to be a thing of the past. Over the battlefield smoke clears. True, the conflict is not altogether won yet, particularly as regards struggling and hopeful contemporary painters. Witness the following, which proves that not even in America's Middle West, where, oddly enough, modern art has enjoyed the most success, are conditions all that they might be.

In Chicago (the Birch-Bartlett Collection notwithstanding), earnest young radicals have, it is said, to exhibit where best they can. According to a recent report, "the motion-picture theatres and automobile salons are eagerly offering space to the radicals and are finding it a good publicity policy. One of our painters has no illusions about such invitations. Dropping into the salesroom where his paintings were hung as bait he found a ladder resting on one of his canvases. He remonstrated with the proprietor and was told they didn't want the ladder to mar the walls."

Yet the tide has definitely turned. Nothing, alas, can efface the fact that Manet's "Olympia" had literally to be forced into the Louvre by Georges Clemenceau, Manet's life-long friend. Nor can we blind ourselves to the existing poverty of modern art's representation in the Metropolitan. But if the great museums of the world are in general "so afraid of the twentieth century that they are trying to pretend in order to protect their own timidities, that it has not yet begun," as Forbes Watson declares, outside them the art that has been produced in our own time has come more and more to be accepted as "a barometer of the social outlook." And modern art, pending complete "official" recognition, establishes itself on an inde-

pendent popular basis. Here we swing back to our own new museum, and may briefly consider its aims and problems, in the light of similar aims and problems that have been worked out elsewhere.

The founders of the Museum of Modern Art in New York have not as yet enunciated a policy in detail. Their immediate purpose is the establishment on Fifth Avenue of a gallery in which exhibitions, lasting one month each, may be held; and the fundamental purpose, as already stated, is the creation of a nucleus from which a great collection may grow. Experience will dictate the best course to take as the new organization proceeds. But we have the director's word for it that choice of material will not confine itself to extremes. This, then, is not to be a temple devoted exclusively to "radical" modernism, but one that sympathetically welcomes high achievement in whatever form, so long as it genuinely reflects the mood of the time. Here the best products of art of the last fifty years will find a place.

Naturally, as the permanent collection begins to get under way, care will have to be taken at every step, lest the new museum—modern though it be in scope—find itself cluttered with worthless specimens of purely ephemeral art. Of course speculation in an enterprise of this sort is legitimate, for one knows not yet what degree of permanent value will attach to any of our modern art.

We build with strength the deep tower wall
That shall be shattered thus and thus.
And fair and great are court and hall,
But how fair—this is not for us,
Who know the lack that lurks in all.

Still, it is to be hoped that the policy will be such that the new museum may find itself enabled gracefully to refuse the proffered gift when of dubious value; that selection may always be made on the understanding that pictures, failing in the course of years to "survive," may be disposed of as seems best. Vigilant editing and unsentimental elimination, it is recognized, must keep the upper hand. In this way many of the blunders of other institutions will be avoided.

One point ought to be made perfectly clear: In spite of the fact that it has been organized by a group of wealthy persons, the Museum of Modern Art is dedicated to the people. The educational aspect, says Alfred H. Barr Jr., the director, stands uppermost in the minds of the sponsors. Only if it be supported loyally and enthusiastically by the public can the new museum be said to fulfill its mission. There is no commercial note in the chord as sounded by the prospectus. No fee of admission will be charged. None of the art shown will be for sale. Catalogues, for those who desire them, will be sold at cost; and it is proposed to prepare for all the exhibitions catalogues that shall be of permanent value—like the catalogues issued by the Metropolitan for the Bellows memorial show.

In the popular mind modern art, exploited and adulated by little cliques, has stood more or less for something esoteric, for something highbrow, if you will—largely, no doubt, because it

is not always easy at a glance to determine what the artist was about. But this unfortunate state of affairs is being remedied. Jan Gordon not long ago observed. "A sundering division has fallen between Art and art. Art: the aloof, the abstruse; art: the homely, the lovable." It seems rather an anomaly that the expression of one's own age should have to be considered "aloof and abstruse"; but the Museum of Modern Art, once the people recognize it as belonging to them, ought to go far toward making contemporary messages "homely and lovable."

To accomplish this the museum will not have exactly to pioneer, though every new enterprise is in a sense unique. Most of us are familiar with the operation of the Luxembourg, that renovator of the great old Louvre. We are less familiar with the progress made by modern art elsewhere abroad. Mr. Barr, preparing for his new responsibility, journeyed through Europe noting at first hand what has been accomplished. He tells us:

"In Berlin the historical museums are supplemented by the National-Galerie in the Kronprinzen Palast, a post-war development. Here Picasso, Derain and Matisse rub shoulders with Klee, Nolde, Dix, Feininger and the best of the modern Germans. In Munich the Neue Staatsgalerie (in operation for some time), with its five Cézannes and six Van Goghs, competes with the series of old masters in the Alte Pinakoteck. In Amsterdam the Stedelijk Museum bears a similar relation to the Rijks Museum. Reorganization within the last couple of years had made it possible to accept the most advanced pictures.

"Even in London, a city which Americans tend to consider rather conservative in art, there has been the most remarkable activity. To the Tate Gallery have been added, largely through the gifts of Samuel Courtauld, magnificent rooms of French paintings—Seurat, Cézanne, Gauguin, Van Gogh, Matisse, Bonnard, Braque, Rouault, Utrillo, Dufresne. Very recently Sir Joseph Duveen has given money for a new gallery of modern sculpture, for which works by Maillol, Epstein, Méstrovic and Modigliani have already been acquired."

The Tate is also strong in its representation of modern English painters—just as it is hoped that the Museum of Modern Art here may eventually be strong in its representation of work done by Americans ranging all the way from painters like Ryder and Homer and Eakins to painters like Marin and Arthur Dove.

New York has surprisingly lagged behind even such American cities as Chicago, Detroit, Cleveland, Providence, Worcester, Los Angeles and a score of other centres, which, Mr. Barr points out, "provide students, amateurs and the interested public with more adequate permanent exhibits of modern art than do the institutions of our vast and conspicuously modern New York." The brave effort on the part of Mr. and Mrs. William Preston Harrison to bring modern art to Southern California is beginning to tell in Los Angeles, despite all the discouragement thrust in its path by trustees of the Los Angeles Museum, where to the modern groups wall space has been grudgingly given. The Harrison collections, both of France and of American art, are "a gift to the people" as well as a rebuke to old-fogyism.

Our Museum of Modern Art will be able to profit by all sorts of mistakes in other quarters as well as by the example of experiments that have proved brilliantly successful. The "purgatory" system in the Luxembourg, for example, has just resulted in considerable embarrassment, due to a failure to look ahead and prepare for the exodus to "paradise." Jacques Mauny thus describes it:

"Last December the Direction of Fine Arts announced that the Luxembourg would be closed for one week during the transfer to the Louvre of the painters born before 1848; but week after week went by and the reopening was still postponed. Something was evidently wrong. However obstinate the professors of the Ecole des Beaux Arts, the institute and the academicians in general might be, they realized that it was impossible to hang in the Louvre their immense salon pictures—so boring or so comical—bought by the State. Besides, there was absolutely nothing decent to put in the place of the Caillebotte collection, the chief point of interest of the gallery. The mediocrity of the Museum of Living Artists was becoming too scandalously evident. In order to hide this situation the young and intelligent assistant curator, M. Robert Rey, was dispatched in haste to borrow pictures from the best collections in town, and with this emergency loan the museum was able to reopen on Feb. 25."

No situation as distressing as this is likely to confront the director and the committee of the Museum of Modern Art for a long time to come; nor is it likely that it will ever occur. But far-sightedness is the better part of enthusiasm. That much

said, there is little left to do but applaud an effort that promises to mean so much to this city.

Many will doubtless regret the committee's decision that the first of the forthcoming loan exhibitions shall be French rather than American. True, much of the argument in favor of this plan seems to be sound. Cézanne, Van Gogh, Gauguin, Renoir and Seurat are to form the initial group, and these painters (though others might be added to the list) are genuine prophets of modern art, regardless of nationality. On the other hand, it would have been a gratifying gesture if American ancestral painters (Ryder, Homer and Eakins are to be the second attraction) might have inaugurated New York's first home of modern art. It was argued informally the other day that the public has a much wider opportunity to look at American pictures than it has to look at French pictures, since the local galleries are full of the former; but surely we have had, and doubtless shall continue to have, a not too meagre chance to study the work of the greatest modern Frenchmen, besides which the showing of American art in a museum is an honor that does not attach, in the same measure, to its showing in a dealer's gallery.

However, this is no time to cavil over trifles. What should most largely concern us is the fact that modern art has come so handsomely into its own in New York. Modern art rides the crest. The adventure grows more absorbingly interesting day by day; and "whoever participates in the adventure of men has his portion of immortality."

As Elie Faure proclaims: "A great mystery is being wrought. No one knows whither it is leading us."

LITERATURE

October 17, 1920

AS MRS. WHARTON SEES US

THE AGE OF INNOCENCE
By Edith Wharton
New York: D. Appleton & Co. 1920. $2.

A Review by WILLIAM LYON PHELPS

In this present year of emancipation it is pleasant to record that in the front rank of American living novelists we find four women, who shall be named in alphabetical order . . . Dorothy Canfield, Zona Gale, Anne Sedgwick, Edith Wharton. From the first we have thus far had no new novel in 1920; but the year must be counted as a notable one in the history of American prose fiction when it has seen the appearance of three works of the distinction of "Miss Lulu Bett," "The Third Window" and "The Age of Innocence."

Mrs. Wharton's admirable career is a progression from the external to the internal; she began as a decorator and is now an analyst. She has always been an expert in gardens and in furniture. . . . I do not remember when I have read a work of fiction that gives the reader so vivid an idea of the furnishing

and illuminating of rooms in fashionable houses as one will find in "The Age of Innocence." . . .

Those who are interested in good dinners—and who is not?—will find much to admire in these brilliant pages. . . . The formal and elaborate dinner parties in New York in the seventies are described here with a gusto that the steady undercurrent of irony quite fails to conceal. . . .

It was "The House of Mirth" (1905), that gave Mrs. Wharton an international reputation; if one wishes to see how far her art has advanced since that popular book, one has merely to compare it with "The Age of Innocence." By the side of the absolute mastery of plot, character and style displayed in her latest novel, "The House of Mirth" seems almost crude. That austere masterpiece, "Ethan Frome," stands in a room all by itself; it is an illustration, however, of the fact that our novelist, who knows Paris and Continental urban scenes so well, was equally at home in a barren American village. . . .

The two previous novels in her career which most clearly foreshadow the power and technique displayed in "The Age of Innocence" are "Madame de Treymes" (1907) and "The Reef" (1912). I think, with the exception of the novel now before us, "The Reef" is her finest full-length story. In one of the many intimate letters written to her by Henry James, and

now published in the already famous two volumes, we find the following admirable remarks on "The Reef" and if one will read them immediately after finishing "The Age of Innocence," one will see how perfectly they apply to Mrs. Wharton's style at its best:

In the key of this, with all your reality, you have yet kept the whole thing, and, to deepen the harmony and accentuate the literary pitch, have never surpassed yourself for certain exquisite *moments,* certain images, analogies, metaphors, certain silver correspondences in your *façon de dire,* examples of which I could pluck out and numerically almost confound you with, were I not stammering in this in so handicapped a way. . . . For, dearest Edith, you are stronger and firmer and finer than all of them put together: you go further and you say *mieuk,* and your only drawback is not having the homeliness and the inevitability and the happy limitation and the affluent poverty of a Country of your Own (*comme moi, par exemple!*)

The style of "The Age of Innocence" is filled with the "silver correspondences" spoken of by Henry James: and the book would be a solid satisfaction, as it is an exquisite delight, had the writer only possessed the homeliness, the rugged simplicity that is lost under the enamel of finished sophistication. . . .

Yet I am in no mood to complain. Edith Wharton is a writer who brings glory on the name America, and this is her best book. After reading so many slipshod diaries called "novels," what a pleasure it is to turn the pages of this consumate work of art. . . .

Here is a novel whose basis is a story. It begins on a night at the opera. The characters are introduced naturally—every action and every conversation advance the plot. The style is a thing of beauty from first page to last. One dwells with pleasure on the "exquisite moments" of passion and tragedy, and on the "silver correspondences" that rise from the style like the moon on a cloudless night.

New York society and customs in the seventies are described with an accuracy that is almost uncanny; to read these pages is to live again. The absolute imprisonment in which her characters stagnate, their artificial and false standards, the desperate monotony of trivial routine, the slow petrification of generous ardours, the paralysis of emotion, the accumulation of ice around the heart, the total loss of life in upholstered existence—are depicted with a high excellence that never falters. And in the last few pages the younger generation comes in like fresh air. Mrs. Wharton is all for the new and against the old; here, at all events, her sympathies are warm. . . .

The two young women of the story are contrasted in a manner that is of the essence of drama without being in the least artificial. The radiantly beautiful young wife might have had her way without a shadow on it, were it not for the appearance of the Countess Olenska, who is, what the other women are not, a personality. Newland Archer, between these two women, and loved by both, is not at all to be envied. The love scenes between him and Ellen are wonderful in their terrible, inarticulate passion; it is curious how much more real they are than the unrestrained detailed descriptions thought by so many writers to be "realism." Here is where Mrs. Wharton resembles Joseph Conrad and Henry James, for the love scenes in this book are fully worthy of those two men of genius. So little is said, so little is done, yet one feels the infinite passion in the finite hearts that burn. I wonder what old Browning would have thought of this frustration: for the story is not altogether unlike "The Statue and the Bust."

I do not believe I shall ever forget three scenes between Archer and Ellen—the "outing" at Boston, the night carriage drive from the ferry in New York, and the interview in the corner of the Museum of Art, with its setting of relics. These are scenes of passion that Conrad, or Henry James, yes, that Turgenev might have written.

I wonder if the horrible moment when Newland Archer, looking at his incomparably lovely and devoted young wife, suddenly has the diabolical wish that she were dead, is a reminiscence of Mrs. Wharton's early studies of Sudermann. In a powerful story by that writer, "The Wish," not only is that momentary impulse the root of the tragedy, but it is analyzed with such skill that no one is likely to forget it. It comes into this novel like a sudden chill—and is inexpressibly tragic. You remember what the doctor said in Sudermann's tale?

The harmony of Mrs. Wharton's management of English sentences is so seldom marred that I wish she would change this phrase, the only discord I found in the book (page 141): "varied by an occasional dance at the primitive inn when a man-of-war came in."

And is not Guy de Maupassant out of place in the early seventies? Archer is unpacking some new books (page 137); "a new volume of Herbert Spencer, another collection of Guy de Maupassant's incomparable tales, and a novel called 'Middlemarch,' as to which there had lately been interesting things said in the reviews." I suppose Mrs. Wharton knows her Maupassant thoroughly; but unless I am quite at fault, it was not in the early seventies, but in the early eighties, that his tales began to appear.

But these are flecks. The appearance of such a book as "The Age of Innocence" by an American is a matter for public rejoicing. It is one of the best novels of the twentieth century and looks like a permanent addition to literature.

* * *

November 7, 1920

FRONTIERS IN AMERICAN HISTORY

THE FRONTIER IN AMERICAN HISTORY
By Fredertok Jackson Turner
Henry Holt. $2.50.

American democracy and Americanism itself were made in the West, according to Professor Turner in "The Frontier in American History." The West—that is, the frontier—was a shifting thing. The frontier was once at Albany; the West once meant, to the Bostonian, the scattered villages in Western Massachusetts. The general conception of the West came to mean a long slit of territory running down from Western Pennsylvania, through Virginia and the Carolinas; then Kentucky and Tennessee, then the old Northwest and the prairie, then the Rockies, at last the Pacific Coast.

Professor Turner shows that this ever-changing, ever-shifting frontier had ever the same ideals, which always fought with Eastern ideals. The East of course, enlarged in size as the West did, so far as ideals did, so that now Illinois has an understanding of what New York is thinking, which is as yet, perhaps, denied to the people of Oregon. But Professor Turner shows that in every contest between Eastern and Western ideals the ultimate advantage has remained with the West, because it was the frontier always which was creating the new race of Americans, whether that frontier was at Chens Falls or Schenectady or Kentucky or Kansas.

The frontier began not far from Richmond and Massachusetts Bay, and ended when, after California had been settled, the frontiersman turned eastward again to fill up the intervening spaces. The battle really ended in the Rockies, after they had been passed in the race for the coast. It was in 1890 that the Superintendent of the Census announced in his report that there was no longer a frontier, and that in future reports it would not be treated separately. A few years later the discovery of gold in Alaska built up frontier conditions again for a moment. But by this time the frontier had made, had created, the type of man who is the American race, not a transatlantic European, but something entirely different from all other races. It is with the victory of Andrew Jackson that Professor Turner places the first definite conquest of the ideals of frontier democracy, to which the East has ever since slowly yielded.

As Professor Turner paints it, the fight for the frontier has been the distinctive feature of American history. Tocqueville talked about the wonderful race of the Europeans for the Rocky Mountains, but the race began on the few rocks back of that bay in Massachusetts. Even that was not the first frontier, although it was the rockiest. The gallant fellows at Jamestown started shoving the frontier back thirteen years before it had occurred to the Yankee in Holland to make himself a Yankee in Massachusetts Bay.

The frontier shifts. Massachusetts undertook to define it by law, and even went so far in her inoculous attempt as to post sixty soldiers at each frontier village, so as to make the frontier visible and lawful. Is that humorous? It is, when we consider that General Braddock tried to find the same frontier at Pittsburgh and died while his reeling columns went surging back to Virginia. It is, when you consider that Daniel Boone, impervious to the wars between England and the Colonies, went on imperturbably weaving the web that should endure after the statesmen who thought of America in tidewater terms should be dead. It is, when one thinks of James Robertson hiking across the mountains year after year to tell the folks back home how the Tennessee settlers were making out.

It is, when one thinks of the "Old West," settled in what is now the East, but to the back of it: the long slit that started in Pennsylvania and ran down till it bumped into Georgia, all Western, mostly German and Scotch-Irish, and the maker of the true West, which was to make the great big dent in American history, the dent first made by Harry of the West and then by Old Hickory. Afterward the prairie was settled and then the great Northwest—"the Old Northwest" as Professor Turner calls it. Then, of course, we come to the conquest of the Rockies, which Tocqueville foresaw, and the overrunning of the Pacific Slope; and, strange to say, the intervening desert was not captured till long after the Western Sea had been annexed, to the fear and wonder of Japan and the wonder of China.

Arizona, New Mexico, Colorado, Utah, the Panhandle, even Nebraska itself, were still in the desert: the black rocks, the ginmills, and the murder dens still portrayed Montana to the East, and the sheep herder still fought homicidally with the cattleman in Wyoming and Northern Utah when the blanket bill was passed to wipe out the West, Senator Quay standing sponsor for it. He and men like him guaranteed the future and laughed at the past, even as Harriet Martineau had laughed at it in 1834, when she came here as an English visitor and said:

> I regard the American people as a great embryo poet, now moody, now wild, but bringing out results of absolute good sense; restless and wayward in action, but with deep peace at his heart exulting that he has caught the true aspect of things past and the depth of futurity which lies before him, wherein to create something so magnificent as the world has scarcely begun to dream of. There is the strongest hope of a nation that is capable of being possessed with an idea.

When Harriet Martineau wrote, the frontier scratched the Mississippi. It was true when the strange prairie wagons struck their way to the Great Divide and beyond. The men and women who died in the Mountain Meadow Massacre partook of that dream, and so did the Destroying Angels who slew them. Colonel Colton's friends who found Death Valley and died there, leaving him a survivor, were a part of the Homeric epic which began when Massachusetts Bay ordered sixty men each to its western towns and said, "Thus far west shalt thou go, and no further." Virginia did the same thing at the same time. New York fixed its lowlands, but the frontiersman was laughing at the order long before General Schuyler had fixed

his abode in the north and the Indians were coming to the post around Albany, and even Schenectady, with their furs.

"The Pioneers!" When Cooper wrote that title as a sort of climax to his Leather Stocking stories, Natty Bumppo brought his furs into Albany from Glens Falls. To the men of that kind it seemed the limit. Nearly a hundred years later the sale of scalps dropped off or was forbidden, and even up to our own day, or the day of men now living, Indians have brought furs and skins to the outposts of their reservations. The massacre of Fort Phil Kearny, the Custer Massacre, occurred long after Cooper was dead. The three-hundred-year war between the white man and the red ended in 1890 at Wounded Knee, when Miles wiped out the last vestige of the fighting Indian except Sitting Bull, who died strangely and violently in his tent.

But the conquest of the West was not alone a conquest of men, but a victory over land. Roosevelt, who brought irrigation into the conquest of States and Territories, was as much a warrior for the West as Miles and Crook, the last soldiers who brought to an end the thirty-decade war begun by Miles Standish and John Smith.

Was there any one characteristic that distinguished this shifting movement of the frontier from the western side of Massachusetts and Connecticut to the Golden Gate and Honolulu? Yes, it was a made-up democracy in pioneer democracy, nothing like any democracy ever invented in the Old World, even in Switzerland. There was an old aristocracy at tidewater. The further you got away from tidewater the nearer you got to this new, strange democracy that in a way made itself, the yeomanry of England that accommodated itself to new conditions and brought out in some queer fashion something which the English yeomanry had never thought of. Why not, when that whole strip from Western Pennsylvania down to Georgia was made up of Germans and Scotch-Irish, with no streak of the English yeoman in them? It was queer to see how they blended and how, when they streaked across the mountains under the lead of some Boone or Robertson they made themselves into a strange democracy that was not German or Irish or English, something entirely new. From them came the motley crew that streamed across the mountains to destroy the might of England and bring the Revolutionary War to an end at King's Mountain.

It was not until Jackson's time that the new and Western democracy came to their own. He was their spokesman, their speaker, their embodiment. With him they came into the Government of the United States, from which power they have never departed. Aside from Lincoln there has never been a complete embodiment of them such as Jackson was, but the subsequent Presidents have meant them and been them, and none has dared to disavow them or depart for a moment from the principles of pioneer Western democracy which the frontier brought forth. Perhaps they cannot make those principles deal effectively with the economic issues that have come forth in the last few years, but who is to say that they cannot? They have won out so far.

* * *

December 26, 1920

THE AFFAIR AT STYLES

THE MYSTERIOUS AFFAIR AT STYLES
By Agatha Christie
New York: John Lane Company. $2.

Though this may be the first published book of Miss Agatha Christie, she betrays the cunning of an old hand. She first presents the mysterious affair of Styles as it became known to the world in July of a certain year of the war, and then proceeds to make it more and more mysterious by leading us gently to all sorts of wrong theories about the criminal. Mrs. Inglethorpe, rich, elderly lady, is found early one morning writhing in pain from the effects, as is determined later, of poison. She dies with the name of her husband on her lips. This husband (her second) had been her secretary, and was twenty years younger than she. His intrusion had been highly resented by John and Lawrence Cavendish, sons of Mrs. Inglethorpe's first husband by a former marriage, by John's wife, half Russian by birth, by Miss Evie Howard, faithful companion and general factotum of Mrs. Inglethorpe, by Cynthia Murdoch, a young protégé of the old lady, and in general by all and every one composing the household at Styles Court in the English County of Essex. All these people were impecunious and some of them deeply in debt, so that all were deeply interested in the disposal of Mrs. Inglethorpe's estate. But the facts that there was "the most awful row" between Mr. and Mrs. Inglethorpe on the day preceding the crime, that on the same day Mr. Inglethorpe was declared by the village chemist to have bought a bottle of strychnine on the pretext of having to kill a dog, that the story was about that he had been conducting an intrigue with a certain farmer's young and pretty wife, that he was absent from the house the night of the crime, that the remains of a burned will were found in the old lady's room, and that Mr. Inglethorpe, though denying all guilt, was quite unable to prove an alibi at the time that he was said to have visited the chemist's shop—all these things made the case very black for the young husband.

Mr. Inglethorpe would certainly have been arrested there and then had it not been for a certain delightful little old man, a refugee from Belgium and formerly a famous detective, who took a hand in the case. He prevented the arrest by producing an unimpeachable alibi for him, and secured that of John Cavendish. But if you think that that ends the story you are mistaken. You must wait for the last-but-one chapter in the book for the last link in the chain of evidence that enabled M. Poirot to unravel the whole complicated plot and lay the guilt where it really belonged. And you may safely make a wager with yourself that until you have heard M. Poirot's final word on the mysterious affair at Styles, you will be kept guessing at its solution and will certainly never lay down this most entertaining book.

* * *

April 17, 1921

THE SKYSCRAPER BUILT BY EINSTEIN

TIME, SPACE AND GRAVITATION
By A. S. Eddington
Cambridge: At the University Press. 1921.

RELATIVITY
By Albert Einstein
New York: Henry Holt & Co. 1920.

THE FOUNDATIONS OF EINSTEIN'S THEORY OF RELATIVITY
By Erwin Freundlich
Cambridge: At the University Press. 1920.

A Review by BENJAMIN HARROW
Author of "From Newton to Einstein"

More than a year has passed since British astronomers startled the war-weary world with their experimental confirmation of Einstein's theory of gravitation. We have since had time to dissociate ourselves from the Einstein mob of hysterical shouters, to digest books and pamphlets on the theory of relativity which, in number, must rival those of the stars, and to reflect upon the mental food so absorbed. Despite the endless confusion of thought and obscurity of expression in which the popular and scientific essays on the relativity theory abound, a careful sifting of the literature brings to light three outstanding features in the Einstein theories. . . .

In the first place, science has become more unified than hitherto. Detached theories and discoveries, in themselves beacons of enormous luminous power in the onward march of science, have been coordinated and shown to belong to one family. . . .

Secondly, Einstein has succeeded in bridging the gap between the experimental philosopher on the one hand and the speculative philosopher on the other. Time and space and matter . . . take on a form which, in some respects, is not altogether strange to the thinkers of any age. Using mathematical tools and applying scientific knowledge, Einstein has built a skyscraper which reaches the very heavens themselves.

Thirdly . . . Einstein has succeeded far better than any one before him in dissociating the observer from the thing observed. . . . It is this dissociation of the observer and the observed that has given rise to a conception of the world strangely unfamiliar to us.

These, to my mind, are the outstanding achievements of Einstein's theory. It is a vast improvement over any in the past, but it is no more than an improvement; the last word is yet to come. As Professor Eddington in his admirable exposition says, we are in grips with the form, but still not with the content.

Einstein's theories lead to conclusions which can be tested experimentally. Two of these, the distortion of oval orbits of planets around the sun and the deflection of a ray of light in a gravitational field, have been confirmed. . . .

Einstein . . . built a theory based on two postulates, neither of which has been severely challenged by physicists: that we cannot detect absolute but can detect relative motion; and that the velocity of light is the same for all observers, irrespective of the velocity of the source of light—an inference that certainly is not in conflict with the Michelson experiment. With these two postulates as a basis, Einstein arrived at precisely the same contraction formula as that of Lorentz; with the advantage over Lorentz, however, of not having had to make use of questionable means to arrive at the end, for no hypothesis as to the structure of matter is involved.

Without diving into the sea of mathematics with which Einstein's exposition is necessarily encumbered, the consequences of the logical application of the two postulates may be stated as follows:

1. Two observers in relative motion will not agree in their measurements of the time interval necessary for a given event to take place. (The idea of "simultaneity" which underlies all measurements of time interval, becomes meaningless.)

2. The measurement of time is no vaguer than that of length.

3. Neither is the mass of a body a fixed quantity, for it varies with the velocity of the body.

4. Matter and energy are merely different names for the same fundamental entity.

. . . So long as the velocity of an object, say the earth, is small as compared to the velocity of light, length, time and mass will seem to change little, if at all; when, however, the velocity of the object becomes appreciable as compared to that of light—as in the velocity of electrons shot out from radium—this no longer holds true.

"Time and space by themselves are mere shadows," cries Minkowski; and to him we owe the development of the time-space conception, wherein time merely figures as a fourth co-ordinate, the other three being the usual three-space, or three-dimensional co-ordinates. Minkowski showed how, by the application of a four-dimensional analysis, we get equations which are more universally applicable than those of the three-dimensional type. This four-dimensional structure is of such a nature that an indefinite number of three dimensional structures can be drawn through it—in much the way that any number of planes can be drawn through a cube—only a certain one of which may give us a picture of the world as we on this planet see it. Einstein quickly grasped the value of Minkowski's space-time analysis.

So far Einstein, like his predecessors, had confined himself to motions of bodies which are in uniform translational motion to one another. But if the theory is to be universally applicable it must include not one, or even several, but all types of motion. Why should not all systems in relative motion to one another be equivalent? Hence the need for a more general theory of relativity which is to include the special theory to which we have thus far confined ourselves.

How Einstein approached this new phase of the subject, and how it inevitably led him to include the concept of gravitation, may be made clear by selecting his own classical example, given in "The Theory of Relativity." . . . He pictures a man enclosed in a box which is situated somewhere in

space. The man finds that objects in the box fall to the ground with constant acceleration. He may draw the inference that the box is within the sphere of influence of a heavenly body, and that the fall of the object is due to gravitational phenomena. He may, however, with equal justice, regard the box as moving upward with constant acceleration: for were that the case, the objects would fall in precisely the same way. The analogy of the person falling backward as the train pulls out of the station may here be applied; if we do we shall blame "inertia" for the occurrence.

Einstein's illuminating illustration is followed by far-reaching consequences; for we are forced to the conclusion that gravitation and inertia are not two distinct, but rather interchangeable, conceptions (principle of equivalence); and both depend upon the same factor, mass. It further points to the introduction into our system of what has been called "that most universal property of all matter, gravitation"—one wholly neglected in the earlier or special theory of relativity.

The general theory of relativity must include gravitational phenomena. Hence the setting up "of a differential equation which comprises the motion of a body under the influence of both inertia and gravity, and which symbolically expresses the relativity of motions. . . . The differential law must always preserve the same form, irrespective of the system of co-ordinates to which it is referred, so that no system of co-ordinates enjoys a preference over any other." (Freundlich's "The Theory of Relativity.")

The intricate mathematical details involve a knowledge of the theory of invariants and the calculus of differentials—subjects which the present writer has far from mastered. Only Einstein's select group of twelve persons . . . are quite at home with matters of this kind. But in a general way—at the risk of confusing the issue a little more—it may be stated that it became necessary for Einstein to develop differential equations for each of ten coefficients that appear in a general equation which we shall call A. By developing these differential equations, Einstein was led to certain definite values which when inserted in A converted the latter into a form which could be tested experimentally. Not the least interesting result was Einstein's proof that where, as with the motion of the planets, the velocities are small as compared to the velocity of light, his intricate differential equations emerge in the simple and majestic form of Newton's law. But Einstein further showed that his own law was the more embracive of the two, for it accounted for the discrepancy in the motion of Mercury's perihelion and foretold the extent of deflection of a ray of light passing near the sun.

It may be remarked in conclusion that Einstein's equations inevitably lead to the conception of a non-Euclidean space, and they also point to a universe finite and yet boundless—somewhat after the manner of a spheroid.

"If one, two, three and four dimensions, why not five, six, seven . . . n dimensions?" asks my literary friend. Such a reflection in itself would suggest that Newtons and Einsteins yet to be born will perfect an even grander and truer picture of the universe than that given us by Einstein. And then again

the history of evolution—the history of the world—teaches us that we may go from good to better, but never to best, for the latter is the goal we approach . . . and yet never reach.

* * *

June 19, 1921

EUGENE O'NEILL, DRAMATIST

PLAYS BY EUGENE O'NEILL
Vol. I., Beyond the Horizon.
Vol. II., The Emperor Jones. Diff'rent. The Straw.
Vol. III., The Moon of the Caribbees.
New York: Boni & Liveright.

A Review by WILLIAM LYON PHELPS

In less than two years Eugene O'Neill has won a position in the drama, where he has even more fame than popularity. He by no means lacks the latter, as the fact that "The Emperor Jones" has run for over 200 nights sufficiently demonstrates; "Beyond the Horizon" was a sensational stage success, "Diff'rent" has been acted this year, and "Gold" was produced for the first time last week. He won the Pulitzer Prize by "Beyond the Horizon," with the ratification of public applause; but he has something more and something finer than popularity; he has the foundations of a reputation; he has

Eugene O'Neill

the beginnings of fame. Now, as Harry Vardon remarked, "It is easier to make a reputation than to keep it." Yet it really looks as if in Eugene O'Neill we have caught that rarest of all birds, an American dramatist. Why does this seem true of him when in so many other cases our hopes have turned to dust? Why? Because he is "diff'rent."

Eugene O'Neill knows how to write dialogue, how to create characters, how to contrive situations; he knows the theatre and he knows the public. Many other successful American playwrights have had these advantages, and yet while reclining in their motor cars they must have been sometimes disturbed by the thought that they are persons of no importance. Mr. O'Neill is "diff'rent." It is not that he prefers tragedy to comedy, for that is merely a question of taste. He sees life unsteadily and sees it black; but his vision is penetrating even in the darkness, and there is in his work the unmistakable tone of authority.

Eugene O'Neill is not only no caterer, he is no follower; he is a leader. He does not permit the public to decide for him how or what he shall write; that question he settles himself. He is young and willing to learn; but he is not looking to his inferiors for guidance. Those who spend their lives amusing children must, in the last analysis, be led by children; those whose highest ambition is to "get a laugh" must accommodate their talents to that end; but those who have something to say, who are more interested in what the public needs than in what the public wants, will make their own decisions, and in the field of art will be creative.

New York has more theatres than any other city in the world; and yet America has never produced a dramatist who is equal to any one of four British dramatists living and active today. This is not altogether the fault of the public—for there is a public in New York ready and eager to spend applause and cash on first-rate plays. The success of the Theatre Guild has astonished many different kinds of people, but its success ought not to be astonishing, for the organization has the conditions that make for success. In two years it has risen from nothing to the leadership of the metropolitan theatres; this sharp ascent may be accounted for by the selection of good plays, by admirable and self-effacing team acting, by adequate scenery and stage setting, by intelligent direction, and by a spirit of co-operation. One feels sure now that if it is "a Theatre Guild Production" it is worth seeing. Yet all its successes have been made by European plays—"John Ferguson" and "Jane Clegg," "Heartbreak House" (where the acting was better than the play), "Mr. Pim Passes By" and "Liliom." There have been many other excellent dramas produced in New York during the present season, so that Alexander Woollcott had no difficulty in making out a list of ten best plays, which indeed he might have extended to fifteen. Such a list is a matter of personal taste; my own would certainly have included George M. Cohan's "The Tavern," which is the most original and perhaps the best American play of the year. If we included revivals, Shakespearean performances, and so on, it would not be difficult to make a list of twenty-five theatrical offerings during the present season, every one worth

the time and attention of intelligent spectators. When we remember that New York has been since 1914 the musical capital of the world, we are safe in ascribing to this city the intellectual and artistic leadership of America.

Now in Eugene O'Neill we have a real dramatist, who may in time—if he develops properly—become a figure of international significance. He was born in New York City, Oct. 16, 1888, was a student for one year at Princeton, and one year at Harvard, has had varied experiences as a business man on land and sea, has been an actor in vaudeville and a newspaper reporter. He has never been far from salt water; in addition to two years at sea, he has lived in New York, New London, and Provincetown; most of his plays smell of the ocean.

In "Beyond the Horizon" we have a genuine family drama, where the two brothers are as different as brothers usually are, and where their difference leads in this case inevitably to tragedy. This play should particularly arouse the ire of Storm Jameson, because it contains not one single character who has any mark of greatness; they are all just ordinary folk, in an ordinary environment, who suffer horribly. But they are true to life; the action and the dialogue are natural; and there is a rude strength in the piece which indicates stores of health and vigor in the author. Many of our clever playwrights seem to lack energy; here is a writer charged with vitality.

In "The Emperor Jones" we have one of the best first acts in contemporary drama. Could the play have maintained the level of that first scene it would have been a masterpiece. But it is always easier to write a first act than a last one—in this case repetition becomes less impressive to the audience than to the protagonist. Of course, the very construction and idea of the play demanded the accumulation of terrifying experiences, with the repetition-motif given by the drum; but it is a fact that instead of the audience becoming more and more excited they actually witness the growing terror of the actor with less and less emotion.

The tragedy "Diff'rent" will seem to many exaggerated in the conclusion. The conclusion is perhaps just what it would be with such a woman; but I doubt, given such a sea Captain and remembering that after all these years he has remained sound in body and mind, and has steadily laid away money, that he would have hanged himself. Either he would have married some one else long ago, or have gone to pieces long ago, or remained a man of iron after his final disillusion. To me this is the least convincing of Mr. O'Neill's work.

In "The Straw" we have a sanitarium play, by no means a new thing on the stage, though commoner in Europe than in America. Whether the audiences will stand this tuberculosis tragedy remains to be seen. I am sure they would if the Theatre Guild had the playing of it; it will take intelligent and sincere acting to make this play really effective. Here the best act is the last one; the ending is ingenious.

The volume called "The Moon of the Caribbees" contains seven plays of the sea, where a sailor's life is represented as sordid misery—just as bad as farm life in "Beyond the Horizon." Mr. O'Neill's characters never have any fun, and there

is just enough light to make the darkness visible. This book ought to be recommended to boys who are tempted to run away to sea; it might cure them. We have seven short plays where tragedy and horror, death and madness, are piled on thick. There are some hours of dissipation, but none of happiness; there is some laughter, but no mirth; there is much suffering, but no dignity; life is absolutely without zest. An overworked school mistress in a village school has more romance and adventure than all these sailormen who circumnavigate the globe.

<div align="center">* * *</div>

May 28, 1922

JAMES JOYCE'S AMAZING CHRONICLE

ULYSSES
By James Joyce
Paris, France: Shakespeare & Co. 1922. Price 200 francs.

A Review by Dr. JOSEPH COLLINS

. . . "Ulysses" is the most important contribution that has been made to fictional literature in the twentieth century. It will immortalize its author with the same certainty that Gargantua and Pantagruel immortalized Rabelais, and "The Brothers Karamazof" Dostoyevsky. It is likely that there is no one writing English today that could parallel Mr. Joyce's feat, and it is also likely that few would care to do it were they capable. That statement requires that it be said at once that Mr. Joyce has seen fit to use words and phrases that the entire world has covenanted and people in general, cultured and uncultured, civilized and savage, believer and heathen, have agreed shall not be used, and which are base, vulgar, vicious and depraved. . . .

An endurance test should always be preceded by training. It requires real endurance to finish "Ulysses." The best training for it is careful perusal or reperusal of "The Portrait of the Artist as a Young Man," the volume published six or seven years ago, which revealed Mr. Joyce's capacity to externalize his consciousness, to set it down in words. . . .

He was sent to Clongowes Woods, a renowned Jesuit college near Dublin, and remained there until it seemed to his teachers and his parents that he should decide whether or not he had a vocation. . . . After some religious experiences he lost his faith, then his patriotism, and held up those with whom he formerly worshipped to ridicule, and his country and her aspirations to contumely. . . . After graduation he decided to study medicine. . . . Eventually he became convinced that medicine was not his vocation . . . and he decided to take up singing as a profession, having a phenomenally beautiful tenor voice.

. . . Matrimony, parentage, ill health and a number of other factors put an end to his musical ambitions and for several years previous to the outbreak of the war he gained his daily bread by teaching the Austrians of Trieste English and Italian. . . . The war drove him to the haven of the expatriate,

Switzerland, and for four years he taught German, Italian, French, English. . . . Since the armistice he has lived in Paris, finishing "Ulysses," his magnum opus, which he says and believes represents everything that he has to say and which ill advisedly he attempted to submit to the world through the columns of The Little Review. It is now published "privately for subscribers only."

As a boy Mr. Joyce's favorite hero was Odysseus. He . . . envied him the companionship of Penelope, all his latent vengeance was vicariously satisfied by reading of the way in which he revenged himself on Palamedes, while the craftiness and resourcefulness of the final artificer of the siege of Troy made him permanently big with admiration and affection. But it was the ten years of his hero's life after he had eaten of the lotus plant that wholly seduced Mr. Joyce, child and man, and appeased his emotional soul. As years went by . . . he decided to write a new Odyssey, to whose surge and thunder the whole world would listen. In early life Mr. Joyce had definitely identified himself as Dedalus, the Athenian architect, sculptor and magician. . . . It is as Stephen Dedalus that Mr. Joyce carries on in "Ulysses." Indeed, that book is the record of his thoughts, antics, vagaries, and more particularly his actions, and of Leopold Bloom, a Hungarian Jew, who has lost his name and religion, a sensuous rags and tatters Hamlet, and who took to wife one Marion Tweedy, the daughter of a non-commissioned officer. . . .

Mr. Joyce is an alert, keen-witted, brilliant man who has made it a lifelong habit to jot down every thought that he has had, whether he is depressed or exalted, despairing or hopeful, hungry or satiated, and likewise to put down what he has seen or heard others do or say. It is not unlikely that every thought that Mr. Joyce has had, every experience he has ever encountered, every person he has ever met, one might almost say everything he has ever read in sacred or profane literature, is to be encountered in the obscurities and in the franknesses of "Ulysses." If personality is the sum total of all one's experiences, all one's thoughts and emotions, inhibitions and liberations, acquisitions and inheritances, then it may truthfully be said "Ulysses" comes nearer to being the perfect revelation of a personality than any book in existence. . . .

He is the only individual that the writer has encountered outside of a madhouse who has let flow from his pen random and purposeful thoughts just as they are produced. He does not seek to give them orderliness, sequence or interdependence. His literary output would seem to substantiate some of Freud's contentions. . . . Mr. Joyce transfers the product of his unconscious mind to paper without submitting it to the conscious mind, or, if he submits it, it is to receive approval and encouragement, perhaps even praise. He holds with Freud that the unconscious mind represents the real man, the man of nature, and the conscious mind the artificed man, the man of convention, of expediency. . . . For him the movements which work revolutions in the world are born out of the dreams and visions in a peasant's heart on the hillside. . . . When a master technician of words and phrases sets himself the task of revealing the product of the unconscious mind of a

moral monster, a pervert and an invert, an apostate to his race and his religion, the simulacrum of a man who has neither cultural background nor personal self-respect, who can neither be taught by experience nor lessoned by example, as Mr. Joyce has done in drawing the picture of Leopold Bloom, and giving a faithful reproduction of his thoughts, purposeful, vagrant and obsessive, he undoubtedly knew full well what he was undertaking, and how unacceptable the vile contents of that unconscious mind would be to ninety-nine men out of a hundred, and how incensed they would be at having the disgusting product thrown in their faces. . . .

It is particularly in one of the strangest chapters of all literature, without title, that Mr. Joyce succeeds in displaying the high-water mark of his art. Dedalus and Bloom have passed in review on a mystic stage, all their intimates and enemies, all their detractors and sycophants, the scum of Dublin and the spawn of the devil. Mr. Joyce resurrects Saint Walpurga, galvanizes her into life after twelve centuries of death intimacy with Beelzebub, . . . and proceeds to depict a festival, with the devil as host. The guests in the flesh and of the spirit have still many of their distinctive corporeal possessions, but the reactions of life no longer exist. The chapter is replete with wit, humor, philosophy, learning, knowledge of human frailties and human indulgences, especially with the brakes of morality off. . . . It reeks of lust and of filth, but Mr. Joyce says that life does, and the morality that he depicts is the one he knows. In this chapter is compressed all of the author's experiences, all his determinations and unyieldingness, most of the incidents that have given a persecutory twist to his mind, made him an exile from his native land and deprived him of the courage to return to it. He does not hesitate to bring in the ghost of his mother whom he had been accused of killing because he would not kneel down and pray for her when she was dying and to question her of the verity of the accusation. But he does not repent even when she returns from the spirit world. In fact, the capacity for repentance is left out of Mr. Joyce's make-up. It is just as impossible to convince Mr. Joyce that he is wrong about anything on which he has made up his mind as it is to convince a paranoiac of the unreality of his false beliefs, or a jealous woman of the groundlessness of her suspicions. It may be said that this chapter does not represent life, but I venture to say that it represents life with photographic accuracy as Mr. Joyce has seen it and lived it. . . .

Mr. Joyce had the good fortune to be born with a quality which the world calls genius. Nature exacts a penalty, a galling income tax from geniuses, and as a rule she co-endows them with unamenability to law and order. . . . Mr. Joyce has no reverence for organized religion, for conventional morality, for literary style or form. He has no conception of the word obedience, and he bends the knee neither to God nor man. It is very interesting, and most important to have the revelations of such a personality, to have them first-hand and not dressed up. Heretofore our only avenues of information of such personalities led through the asylums for the insane, for it was there that such revelations as those of Mr. Joyce

were made without reserve. Lest any one should construe this statement to be a subterfuge on my part to impugn the sanity of Mr. Joyce, let me say at once that he is one of the sanest geniuses that I have ever known.

He had the profound misfortune to lose his faith and he cannot rid himself of the obsession that the Jesuits did it for him, and he is trying to get square with them by saying disagreeable things about them and holding their teachings up to scorn and obloquy. He was so unfortunate as to be born without a sense of duty, of service, of conformity to the State, to the community, to society, and he is convinced that he ought to tell about it, just as some who have experienced a surgical operation feel that they must relate minutely all the details of it, particularly at dinner parties and to casual acquaintances.

Finally, I venture a prophecy: Not ten men or women out of a hundred can read "Ulysses" through, and of the ten who succeed in doing so, five of them will do it as a tour de force. I am probably the only person, aside from the author, that has ever read it twice from beginning to end. I have learned more psychology and psychiatry from it than I did in ten years at the Neurological Institute. There are other angles at which "Ulysses" can be viewed profitably, but they are not many.

Stephen Dedalus in his Parisian tranquility . . . will pretend indifference to the publication of a laudatory study of "Ulysses" a hundred years hence, but he is as sure to get it as Dostoyevsky, and surer than Mallarme.

* * *

September 24, 1922

THE MAN FROM MAIN STREET

BABBITT
A novel by Sinclair Lewis
New York: Harcourt, Brace & Co. $2.

A Review by MAY SINCLAIR

In "Main Street" Mr. Sinclair Lewis wrote the history of a highly complex organism, . . . a town that was Everytown and yet itself, given in all its raw, reeking individuality. . . . But in the nature of the case the interest is scattered, and the book lacks a certain concentration and unity. . . .

In his last novel, "Babbitt," Mr. Sinclair Lewis triumphs precisely where in "Main Street" he failed. By fixing attention firmly on one superb central figure he has achieved an admirable effect of unity and concentration. Not once in all his 401 close-packed pages does your gaze wander, or desire to wander, from the personality of George F. Babbitt (of the Babbitt-Thompson Realty Company). You are rapt, fascinated, from the moment when you find him waking in the sleeping porch of his house at Floral Heights to that final moment of sorrowful insight when he sees himself as he is. You have the complete, brilliant portrait of a man. . . . Mr. Sinclair Lewis has done his work with a remorseless and unfaltering skill. Yet in himself Babbitt is colorless. . . . The main effort of his life is to give value and distinction to this nonentity which is him-

self, to fill up the empty framework of his ego with flattering illusions. . . . Babbitt's conflict is not with the community, but with his ego and with his wife and children, so far as they are hindrances to the cheerful, important expansion of his ego. . . .

There are wonderful scenes: Babbitt in his bath; Babbitt in his office, dictating letters to his typist—"What I can't understand is, why can't Stan Graff or Chet Laycock write a letter like that? With punch! With a kick!" Babbitt drawing up an "ad."— "Course I believe in using poetry and humor and all that junk when it turns the trick, but with a high-class restricted development like the Glen we better stick to the more dignified approach, see how I mean?" Babbitt making his immortal speech before the Zenith Real Estate Board. . . .

Like the heroine of "Main Street," Babbitt conceives himself to have "Vision" and "Ideals." He has the preposterous dream of "the fairy child, a dream more romantic than scarlet pagodas by a silver sea." But his "Vision" lands him in certain commercial transactions of doubtful integrity; his "Dream" drives him to philandering with the barber's manicure girl and to the society of Mrs. Judique and "the Bunch." Not for one moment will he admit that he has fallen from the standards of high morality. . . .

Babbitt sees himself as a strong character, full of "Inspiration and Pep," of "Zip and Bang"; but in reality he has no will power. He is at the mercy of his habits and desires. He perpetually tries to bring his gross, sensual self into conformity with his moral ideals, and perpetually he slips back. Always he is just going to "quit his darn smoking," and never does. He tears himself from Mrs. Judique and "the Bunch," only to sneak back to them again. Finally he breaks down under the illness of his wife, whom he has tired of and neglected and deceived.

Instantly all the indignations which had been dominating him and the spiritual dramas through which he had struggled became pallid and absurd before the ancient and overwhelming realities, the standard and traditional realities, of sickness and menacing death, the long night and the thousand steadfast implications of married life. He crept back to her. As she drowsed away in the tropic languor of morphia, he sat on the edge of her bed, holding her hand; for the first times in many weeks her hand abode trustfully in his.

And suddenly self-revelation comes. In the beginning of the book we find him boasting: "When I was a young man I made up my mind what I wanted to do and stuck to it through thick and thin, and that's why I'm where I am today, and—" At the end he confesses to his son Ted (who has had the courage to go his own way and marry imprudently): "Now, for Heaven's sake don't repeat this to your mother, or she'd remove what little hair I've got left, but, practically, I've never done a single thing I've wanted to in my whole life! I don't know's I've accomplished anything except just get along. I figure out I've made about a quarter of an inch of a possible hundred rods. . . ."

It is a very remarkable achievement to have made such a thing as Babbitt so lovable and so alive that you watch him with a continuous thrill of pleasurable excitement. Mr. Sinclair Lewis's method of presenting him is masterly, and in the highest sense creative because it is synthetic. He does not dissect and analyze his subject, but exhibits him all of a piece in a whole skin, yet under such powerful X-rays that the organism is transparent: you see all its articulated internal machinery at work. Never for a moment do you detect the clever hand of the surgeon with his scalpel. Not once does so much as the shadow of Mr. Sinclair Lewis come between you and Babbitt. In his hands Babbitt becomes stupendous and significant.

The minor characters have not perhaps the solidity and richness of the persons of "Main Street," because in "Main Street" the protagonist is the community, and all the cast are principals, significant members of the group. Here the minor characters are important only in their relation to the central figure, but (with the exception of one fantastic caricature, the poet, Chum Frink) each one of them is drawn with the same devout reverence for reality; each is alive and whole in its own skin. . . . If reality is the supreme test, Mr. Sinclair Lewis's novel is a great work of art.

And it is an advance on its predecessor in style, construction and technique. One might say it would have as many readers but that "popularity" is a mysterious and unpredictable quality. For though nobody will recognize himself in George F. Babbitt, everybody will recognize somebody else. Here, as in "Main Street," Mr. Sinclair Lewis has hidden the profound and deterrent irony of his intention under the straightforward innocence and simplicity of his tale.

* * *

May 2, 1923

DOOM OF WESTERN CIVILIZATION

Oswald Spengler's Famous Treatise Appears in an English Version

THE DECLINE OF THE WEST: Form and Actuality
By Oswald Spengler
Authorized Translation with Notes by Charles Francis Atkinson. 413 pp. New York: Alfred A. Knopf. $6.

By WILLIAM MacDONALD

Let it be said at once, by way of warning to those whom the title of this extraordinary work may attract or repel, that the book has nothing to do directly with the World War or with the immediate political future of what is commonly called Western Europe. The title, the author tells us, was decided upon in 1912 and the work itself was ready for publication when the war began. The only immediate connection between either the title or the contents of the book is the author's conviction that Germany was the place of all others in which the ideas of the book should be made known and his prevision of the war as one of the elements, or better, perhaps, one of the striking illustrations, of the theory which he propounds. . . .

By the West Spengler means the culture of Western Europe and America, "the only culture of our time and on our planet which is actually in the phase of fulfillment." The decline of the West may be described as the progressive completion of that fulfillment, a completion which touches already upon its end and across whose path is written destiny. . . .

What Spengler offers us, in other words, is a new and provocative philosophy of history as important for the scientist, the statesman, the moralist or the man in the street as it is for the historian, for destiny holds us all. . . . We divide history into "periods" duly labeled ancient, medieval or modern, notwithstanding that those absurd distinctions represent no development that the world itself has known. "We know quite well that the slowness with which a high cloud or a railway train in the distance seems to move is only apparent, yet we believe that the tempo of all early Indian, Babylonian or Egyptian history was really slower than that of our own recent past." . . .

All the interpretations of history which do not recognize in cultures the essential characteristics of living organisms, to be studied structurally with a view to obtaining thereby a "morphology of world history," are, in Spengler's theory, both mistaken and mischievous. There are, indeed, many cultures, and world history is a picture of their "endless formations and transformations," but while each culture has "its own new possibilities of self-expression which arise, ripen, decay and never return," there is "no aging mankind." . . .

The first task of the world historian, therefore, is to determine what each of the great cultures that the world has known—classical, Egyptian, &c.—really is, to discover what is typical in it and what is necessary. With this accomplished, it becomes possible to discern, by analogy, comparison and a spiritual interpretation which in Spengler's pages seems often to approach the mystical. . . . Spengler makes it clear in this connection that the decline of the West is in reality the problem of civilization. Civilization is "the inevitable destiny of culture," and the various civilizations that history has known are "the most external and artificial states of which a species of developed humanity is capable." . . . Humanity has its Spring, Summer, Autumn and Winter, its infancy, youth, maturity, and old age. Civilization is mankind become old, and its destiny is to linger for a brief time and then cease to be. We have become civilized, and for that reason we must die. . . .

For the classical world the transition from culture to civilization was accomplished in the fourth century, for the Western world in the nineteenth. The "great intellectual decisions" that follow those dates are made, not in what might previously be regarded as the whole world "where not a hamlet is too small to be unimportant," but in three or four world cities "which have absorbed into themselves the whole content of history." . . .

It is in the city accordingly, especially the great city, that we find the characteristics of that developed civilization which is carrying the Western world to its end. As in Rome, so in the modern city, the hallmark is money. . . . The predominance of the city destroys all sense of the intrinsic values of things since all values are reckoned in terms of money: it creates a literature, drama and music which are unintelligible to villagers or country folk and develops an "uncomprehending hostility" to all the traditions that represent culture and a "keen and cold intelligence that confounds the wisdom of the peasant." . . .

As the hallmark of city civilization is money, so the typical symbol of the "passing away" is imperialism. Imperialism is civilization unadulterated. Where the cultured man directs his energies inward civilized man directs his energies outward. . . .

What, some one will ask, is to be hoped for the future in the face of this inexorable destiny that has humanity in its grasp? According to Spengler, nothing. "We have no right to hope in the face of facts." . . .

From whatever angle the question is viewed the outcome is the same. Every philosophy, for example, is merely the expression of its own time, since there are no eternal truths, but what passes for philosophy today is only a futile threshing of old straw. . . .

As with philosophy, so with art. Civilization ends great art, first by producing a classicism imbued with sentimental regard for an ornamentation long archaic and soulless, and second by gendering a romanticism which sentimentally imitates not life but an older imitation. . . .

The outlook for Western science is no brighter.

The few sciences that have kept the old fineness, depth and energy of conclusion and deduction and have not been tainted with journalism—and few, indeed, they are, for theoretical physics, mathematics, Catholic dogma and perhaps jurisprudence exhaust the list—address themselves to a very narrow and chosen band of experts. . . .

Lastly, in the field of ethics or morale mankind of the West is "under the influence of an immense optical illusion. Every one demands something of the rest. . . . Socialism, which to many has seemed to offer the prospect of a happy ending, "owes its popularity only to the fact that it is completely misunderstood even by its exponents, who present it as a sum of rights instead of as one of duties." The man of culture possesses an instinctive and conscious morale, but when life becomes fatigued, when in a great city one feels the need of "a theory in which suitably to present life to himself," morale becomes a problem, and problems are functions of logic. Culture, in short, has soul, while civilization has only activities and actualities.

Such in barest outline is the Spengler philosophy of history. . . . Analogy has never failed to prove itself a dangerous method when applied to history, and one who aspires to interpret the past runs always the risk of finding what he wishes to find and of discerning tendencies where on other grounds he hopes they may appear. . . . There is an uncomfortable impression that the theory proves too much, that the analogies between historical periods or phases of life are sometimes farfetched and that the spiritual relationships which are brilliantly clear to Spengler may be less clear to other scholars equally well informed.

Whatever the personal reaction, however, the theory and its outlook are alike appalling. The larger part of what has

passed for progress in the historical epochs of which we know most turns out to be under Spengler's withering scrutiny only progress toward decay. The destiny of civilization is destruction, and there is no power in mankind to stay the event. We are the victims of inexorable fate and one thing shall happen alike to us all.

* * *

August 17, 1924

CHALLENGE AND INDICTMENT IN E. M. FORSTER'S NOVEL

Fresh Evidence That "East Is East and West Is West" in "A Passage to India"

A PASSAGE TO INDIA
By E. M. Forster
322 pp. New York Harcourt, Brace & Co.

A Review by HERBERT S. GORMAN

. . . E. M. Forster is indubitably one of the finest novelists living in England today, and "A Passage to India" is one of the saddest, keenest, most beautifully written ironic novels of the time. . . .

"A Passage to India" is both a challenge and an indictment. It is also a revelation. But so intricately is this matter treated that the average reader is quite unaware of a smoldering subterranean passion in the depths of this carefully conceived study of two humanities—indeed, two worlds—in hopeless clash. A panorama of objective incidents and gestures is unfolded . . ., and somehow the reader experiences an intense concern and despair before a situation that is both inevitable and impossible. Certain obvious words suggest themselves as descriptive of this book and among them are "subtle" and "acute." But they are not exact enough to describe that peculiar cool, clarified exposition that seems to miss nothing and that is so impregnated with unexplainable implications. Almost imperceptibly Mr. Forster develops a character until the reader has acquired the most meticulous comprehension of the deepest channels of being.

Such a proceeding was of the utmost difficulty . . . for many of the characters who fit into the delicate structure of that book are Indians. . . . Mr. Forster . . . knows the Indian mind and the clear shafts of his sentences pierce into it with a disturbing frequency until the reader is apt to wonder whether or not the Indian is as complicated a being as he seems to be. Yet in a last analysis he is. India remains India and no number of British civilians or army corps can hope to divert that huge, semi-supine dreaming giant from immemorial methods of existence. . . . Yet if the idea be given that "A Passage to India" is the usual type of Indian novel in which patriotic impulses heroically manifest themselves, a genuine wrong is done the author. Mr. Forster is quite aware that right and wrong may not be so easily separated; that, in fact, both sides may be right and wrong at the same time. His objective

E. M. Forster

is to show modern life in India, in Chandrapore, and to do this he draws with a superb finality, a group of Indians and British civil officers and women. The utmost care is shown in interlocking the various urges in this book. The result is a bewilderingly vivid presentation of life.

A mere résumé of the novel gives no adequate idea of it, for the prime importance of Mr. Forster's work lies not so much in situation as in the development of a dozen apparently trivial incidents leading up to it. Odd words, single sentences, flashes of characterization, the general atmosphere which is so precisely built up—these are the touches that set Mr. Forster apart as a novelist. It conveys no more than his modus operandi to state that the book circles about a young Indian, Dr. Aziz, who is unjustly accused of attempted assault by a hysterical English girl and who therefore serves as a binge from which both humanities— British and Indian—break. Certain things become apparent as the book progresses and not the least of them is the stupidity of the British. There is no other word for it. This system of the conqueror which prevents an Indian from being a member of a white man's club, which assumes a cocksure knowledge of the Indian mind when that knowledge is based on a dull misconception, which eternally

suspects and belittles—this is the aspect of life in India which Mr. Forster brings out most clearly. Before noting the specific characters, a single episode may be noted as a fair exemplification of this. Dr. Aziz, calling on Fielding, the Englishman who stands by the Indians and commits the last sin by not blindfolding his judgment and sticking with the Britishers, gives the white man his collar button in a burst of generosity when that individual has broken his own. Later we find the City Magistrate, Heaslop, remarking: "Aziz was exquisitely dressed, from tie pin to spats, but he had forgotten his back collar stud, and there you have the Indian all over: inattention to detail, the fundamental slackness that reveals the race." . . .

It is in his characterizations that Mr. Forster reaches his finest triumphs. Ronny Heaslop, the typical, good-hearted Britisher in India, "slogging away at his job," as he would call it, . . . is particularly fine. The reader will experience the wildest rage at Ronny's shortcomings, at the obtuse attitude he persists in as far as the native is concerned, but the man's existence is understandable. His success in India depends on his obtuseness. He cannot venture an equality that would undo decades of laborious empire-building. Even worse than he is the doctor, Major Callender, a typical fire-eater who considers Indians "niggers" and believes in the efficacy of guns when problems are to be solved. The one Englishman who ventures to understand the native is Fielding, the educator, and he is nearly broken when he persists in siding with Aziz in that native's trouble. No finer scene has been drawn in a novel in a long time than the one in the club after Miss Quested has forced the arrest of Aziz and lies in a hysterical condition in her room. The white-faced, low-voiced Englishmen insisting on fairness as they approach the problem, muttering those phrases that have carried them through a thousand deaths, "An English girl from England," and "the women and children," become suddenly telescoped under the faint irony of Mr. Forster's prose. . . . Fielding is the one man who takes this attitude and he is thrown from the club. He is a disgrace to English honor. There is an immense satire all through this scene and yet it is the sort of satire that the gods might adopt toward a curious race of pigmies. . . .

The Indian portraits are superb even to the slightly stilted English they speak and which carries an atmosphere of its own. Dr. Aziz, of course, is more fully drawn than the others, for he serves as that aspect of India which Mr. Forster is anxious to bring to the fore—the educated Indian who under-stands British civilization, but who can never be really identified with it. Aziz and Fielding, the reader will feel, are the two aspects of India and Great Britain that might eventually meet on a common footing, and yet as the book ends and they part there is no real hope held out for any such entente. "Why can't we be friends now?" asks Fielding. "It's what I want. It's what you want." And the book ends:

> But the horses didn't want it—they swerved apart: the earth didn't want it, sending up rocks through which riders must pass single file: the temples, the tank, the jail, the palace, the birds, the carrion, the Guest House, that came into view as they issued from the gap and saw Mau beneath: they didn't want it; they said in their hundred voices, "No, not yet," and the sky said. "No, not there."

Dr. Aziz is an intricate portrait and through him the reader comes, perhaps, closer to India than in any other personage unless it be the Hindu, Dr. Godbole. Aziz is quick-tempered, suspicious, ardent, full of sudden impulses, automatically courteous, the clever, unstable, educated Indian. Godbole is nearer what we mean when we say the mystery of India. He is sparingly drawn and yet he stands out through his very silences. The final chapters of the book, filled with the picturesque Hindu temple ceremonies, serve almost as much as a background for him as for Aziz. The other natives . . . all serve as differing types of that great body that is known as India. They disagree among themselves, but they are one in their subtle antagonism toward the British.

Indeed, one thing that "A Passage to India" seems to assert is the hopelessness of any clear understanding and agreement between India and her conquerors. Two peoples who will never mix are here, and when this is so there must always be two groups. . . . The few points in this book which have been noted are but a tithe of the riches that may be found there. The crystal-clear portraiture, the delicate conveying of nuances of thought and life, and the astonishing command of his medium show that Mr. Forster is now at the height of his powers. It is not alone because the canvas is larger and the implications greater than in "Howard's End" and "A Room With a View" that this is so. The real reason is implicit in the author's unmistakable growth, the deepening of his powers and the assurance of his technique.

* * *

November 9, 1924

LENIN CANONIZED IN PRINT

The Flood of Books About Him Endowed by the Soviet State

Em. Yaroslavsky. ZHIZY I RABOTA LENINA. Gosudarstvennoye Izdatelstvo. Moskva. 1924. (Life and Work of Lenin, By Em. Yaroslavsky. Government printing. Moscow. 1924.)

Em. Yaroslavsky, VOZHD RABOCHIKH I KRESTIAN. Gosudarstvennoye Izdatelstvo. Moskva. 1924. (A Leader of Peasants and Workers, By Em. Yaroslavsky. Government printing. Moscow. 1924.)

I. Stalin, O LENINR E LENINISSE. Gosudarstvennoye Izdatelstvo. Moskva. 1924. (About Lenin and Leninism, By I. Stalin. Government printing. Moscow. 1924.)

G. Zinoviev, NA SMERT LENINA. Gosudarstvennoye Izdatelstvo. Leningrad. 1924. (On the Death of Lenin, By G. Zinoviev. Government printing. Leningrad. 1924.)

L. B. Kamenev, LENINSKY SBORNIK. Tom I. Moskva-Leningrad. 1924. (Lenin Collection, Edited by L. B. Kamenev. Vol. 1. Moscow-Leningrad. 1924.)

N. Krupskaya, O VLADIMIRE ILYICHE. Gozudorstvennoye Izdatelstvo. Leningrad. 1924. (About Vladimir Ilyich, By N. Krupskaya. Government printing. Leningrad. 1924.)

A Review by ELIAS TOBENKIN

The spirit of Lenin is brooding over Russia. As the seventh year of Bolshevism becomes history this Lenin worship seems to be the distinctive aspect of the Soviet empire; neither new leaders nor new ideas to modify the existing Communist regime have risen. Lenin, dead, is still the guide of the Soviet State and "Leninism" more than ever is its gospel.

In order that the name of Lenin, and more especially his ideas, his message, "Leninism" in a word, might be carried "to fathers and to grandfathers," so that they in turn might retell these things "to their children and grandchildren," the Bolshevist authorities set aside a fund equivalent to $1,000,000 with which to spread the works of Lenin and popular books about him. The first batch of Lenin biographers issued under this grant has just come from the printing presses of Moscow and Leningrad. A new, hitherto unknown Lenin emerges from them.

These biographies of Lenin are written by his intimates and former associates. His wife, Mme. Krupskaya, in a small volume intended for wide distribution among the masses and entitled simply "About Vladimir Ilyich" dispels the myth of Lenin the mathematical machine experimenting with people as a scientist might experiment with chemicals. Nor was he "a dry ascetic." Lenin loved life in all its phases, Mme. Krupskaya asserts, and drank it in eagerly. Yaroslavsky, Stalin, Zinovieff, Preobrajensky contribute books in this series of Lenin biographies. Trotsky is at work on what perhaps will be the most extensive and significant of all these biographies. . . .

Lenin's two sisters and his only living brother, Dimitry, have been drained of memories and information concerning the childhood of their famous brother. Lenin's former schoolmates and playfellows contribute their reminiscences of "Volodya," the name by which he was known to them in childhood. . . . The peasants in the Siberian village with whom Lenin found living quarters when he married the woman who followed him into exile, his present widow, Mme. Krupskaya, have been questioned for every possible memory. Nor have Lenin's court and prison records in the city now called by his name—Leningrad—been overlooked. And it is interesting information these prison records furnish.

All the Lenin biographers, dwelling on his great role as a teacher of internationalism, paint him as a Russian of the Russians. Lenin's internationalism was a matter of intellect; his soul was Russian. While his mind was that of a philosopher, his heart was that of a peasant. This, much more than the efforts of his friends, is responsible for Lenin's great popularity in Russia during the years of the revolution and for the phenomenal devotion to his memory which has been sweeping over Russia since his death.

. . . . Lenin's biographers stress the fact that his father, in spite of a lifetime in Government service, did not acquire an estate or land in any form, a thing almost unheard of among the universally prevailing corruption and graft that marked the officialdom of the Czars.

Lenin's mother comes into the story as a lady of sorrows. Lenin was inordinately fond of her; she died abroad in 1913, having followed her son in his exile. . . .

Lenin did his most effective work from abroad. He started a revolutionary paper called Iskra (The Spark), which was regularly smuggled into Russia. Early in his career abroad he had become a convert to the Bolshevist psychology and to Bolshevism as a revolutionary weapon. In 1903 he was one of the organizers of the Bolshevist wing of the Russian underground Socialist movement.

The political philosophy of Lenin—Bolshevism—is stressed by every one of his biographers. Em. Yaroslavsky, in his volume of 300 finely printed pages, entitled, "Life and Work of V. I. Lenin," devotes several chapters to an exposition of this philosophy. In a small booklet intended for the peasantry and called reverently "About Him," E. Preobrajensky states the Lenin philosophy in a few paragraphs. It may be summed up in a sentence: To Lenin, to the Bolshevist view generally, the peasant, the tiller of the soil in the country, and the worker, the manual laborer and factory hand in the city, are the cream of the earth.

. . . He could lose himself in a peasant crowd, no one would suspect him of being a political leader. . . .

Into the dullest nooks and remotest regions of the Soviet Empire, M. Yaroslavsky reports, the name of Lenin has penetrated. Peasants hang lithographs of him beside the prints of saints in their huts. Whence comes this love, this devotion? the writer asks, and then proceeds to answer his own questions.

What makes Lenin so universally revered in Russia [M. Yaroslavsky says] is the fact that he had been able to combine within his person the qualities of a great leader with the simplicity of a common man. Lenin was kin in spirit and in soul to the most backward workingman, to the "darkest" peasant. . . . Unusually simple he was in his manners, in his ways. When Lenin spoke about the needs of the people the illiterate peasant felt as if the speaker were taking the thoughts out of his, the peasant's, own mind, was taking the words from the tip of his own tongue

The Russian revolutionary movement had had its professionally "great men," its "famous men," who, although loyal to the cause of the people, were not free from certain vanities, men who combined with their great sincerity also a measure of posing. Lenin was not among these. His own dignity was the last thing of which he was conscious. The last thing he wished was to leave the ranks and step to the front. He who almost overnight became the most-talked of man in the world, according to his biographers, did not seek the spotlight. As illustrating this simplicity of Lenin, M. Stalin in his book entitled "About Lenin and Leninism" tells the following story:

I met Lenin for the first time in December, 1905 and he disappointed me in two ways. Several revolutionists in their writing had spoken of Lenin as a "mountain eagle" and I expected to come face to face with a man of gigantic dimensions. Instead I beheld a very ordinary-looking man, below medium height. His conduct was even more ordinary than his physical appearance. . . .

Both Mme. Krupskaya, Lenin's widow, and Gregory Zinovieff, who had lived with the Lenins for years, in Switzerland and in Galicia, devote much space in their biographies to the human side of Lenin. While his revolutionary disciples stressed his enormous capacity for work, for self-sacrifice, his widow and his nearest personal friend, Zinovieff, tell of his human frailties and playfulness, of his tastes and distastes. . . .

The best picture of Lenin, however, is to be found in his own letters. The first volume has just appeared under the editorship of L. B. Kamenev and is entitled "Leninsky Sbornik." The letters contained in this collection are chiefly those written to Maxim Gorky.

* * *

April 19, 1925

SCOTT FITZGERALD LOOKS INTO MIDDLE AGE

THE GREAT GATSBY
By F. Scott Fitzgerald
New York: Charles Scribner's Sons. $2.

Of the many new writers that sprang into notice with the advent of the post-war period, Scott Fitzgerald has remained the steadiest performer and the most entertaining. Short stories, novels and a play have followed with consistent regularity since he became the philosopher of the flapper with "This Side of Paradise." With shrewd observation and humor he reflected the Jazz Age. Now he has said farewell to his flappers—perhaps because they have grown up—and is writing of the older sisters that have married. But marriage has not changed their world, only the locale of their parties. To use a phrase of Burton Rascoe's—his hurt romantics are still seeking that other side of paradise. And it might almost be said that "The Great Gatsby" is the last stage of illusion in this absurd chase. For middle age is certainly creeping up on Mr. Fitzgerald's flappers.

In all great arid spots nature provides an oasis. So when the Atlantic seaboard was hermetically sealed by law, nature provided an outlet, or inlet rather, in Long Island. A place of innate natural charm, it became lush and luxurious under the stress of this excessive attention, a seat of festive activities. It expresses one phase of the great grotesque spectacle of our American scene. It is humor, irony, ribaldry, pathos and loveliness. Out of this grotesque fusion of incongruities has slowly become conscious a new humor—a strictly American product. It is not sensibility, as witness the writings of Don Marquis, Robert Benchley and Ring Lardner. It is the spirit of "Processional" and Donald Douglas's "The Grand Inquisitor"; a conflict of spirituality caught fast in the web of our commercial life. Both boisterous and tragic, it animates this new novel by Mr. Fitzgerald with whimsical magic and simple pathos that is realized with economy and restraint.

The story of Jay Gatsby of West Egg is told by Nick Carraway, who is one of the legion from the Middle West who have moved on to New York to win from its restless indifference—well, the aspiration that arises in the Middle West—and finds in Long Island a fascinating but dangerous playground. In the method of telling, "The Great Gatsby" is reminiscent of Henry James's "Turn of the Screw." You will recall that the evil of that mysterious tale which so endangered the two children was never exactly stated beyond a suggested generalization. Gatsby's fortune, business, even his connection with underworld figures, remain vague generalizations. He is wealthy, powerful, a man who knows how to get things done. He has no friends, only business associates, and the throngs who come to his Saturday night parties. Of his uncompromising love—his love for Daisy Buchanan—his effort to recapture the past romance—we are explicitly informed. This patient romantic hopefulness against existing conditions, symbolizes Gatsby.

F. Scott Fitzgerald. Author of "The Great Gatsby." New York: Charles Scribner's Sons.

And like the "Turn of the Screw," "The Great Gatsby" is more a long short story than a novel.

Nick Carraway had known Tom Buchanan at New Haven. Daisy, his wife, was a distant cousin. When he came East Nick was asked to call at their place at East Egg. The post-war reactions were at their height—every one was restless—every one was looking for a substitute for the excitement of the war years. Buchanan had acquired another woman. Daisy was bored, broken in spirit and neglected. Gatsby, his parties and his mysterious wealth were the gossip of the hour. At the Buchanans Nick met Jordan Baker; through them both Daisy again meets Gatsby, to whom she had been engaged before she married Buchanan. The inevitable consequence that follows, in which violence takes its toll, is almost incidental, for in the overtones—and this is a book of potent overtones—the decay of souls is more tragic. With sensitive insight and keen psychological observation, Fitzgerald discloses in these people a meanness of spirit, carelessness and absence of loyalties. He cannot hate them, for they are dumb in their insensate selfishness, and only to be

pitied. The philosopher of the flapper has escaped the mordant, but he has turned grave. A curious book, a mystical, glamourous story of today. It takes a deeper cut at life than hitherto has been essayed by Mr. Fitzgerald. He writes well—he always has—for he writes naturally, and his sense of form is becoming perfected.

EDWIN CLARK

* * *

July 5, 1925

PROUST THE "MOST COMPLEX PROBLEM OF THE DECADE"

Two New Books Translated in His Fifteen-Volume Novel

THE GUERMANTES WAY
By Marcel Proust
Two volumes. Translated by C. K. Scott Moncrieff. 1925. New York: Thomas Seltzer. $6

By ROSE LEE

Only imagination and belief can differentiate from the rest certain objects, certain people, and can create an atmosphere.—PROUST.

A French critic, Jacques Boulanger, has described Marcel Proust as a man shut up in his ego as in a railway carriage, indefatigably looking out of his window at the landscapes passing by. This description of "Remembrance of Things Past" as a series of psychological travel-pictures should be qualified by the fact that the train of M. Proust's ego moves backward, in pursuit of vanished scenes and sensations. . . .

Previous to the appearance of "Swann's Way" in 1913, he was known vaguely as a litterateur—the author of some slight sketches, some literary parodies in the styles of famous masters, and for fifteen years the translator of John Ruskin's writings. . . . To most of his world, however, Marcel Proust appeared chiefly as a frail and fashionable dilettante—so sensitive that, lying in bed on the fifth floor of his house, he could feel a draught created by the opening of a door on the ground floor.

He was a full-fledged adult, stocked with the memories of many years, before he perceived what he calls "that invisible vocation, of which these volumes are the history." With the zeal almost of a visionary he set out upon his tremendous pilgrimage, to retrace his life in literature. Before his death in 1922—at the age of 51—he had, with incredible pains, completed fifteen volumes of "Remembrance of Things Past." This novel, based for the most part on personal observation and experience, is the longest ever written within the memory of man; even so, it is incomplete, the later volumes being unrevised and faulty.

Six volumes have already appeared in English translation, the first four published under the titles "Swann's Way" and "Within a Budding Grove," and the latest being "The Guer-

mantes Way." They are all in the same key, quiet, rational and very leisurely, so that it is possible to open any volume at any page and continue from that point with a good deal of understanding. But to grasp the full intention of any chapter, it is necessary to have read all the preceding ones.

Through the deliberate recurrence of certain themes, persons, places, names and sensations, the successive volumes of Proust are subtly intertwined. The title of "The Guermantes Way," for instance, refers back to the very first book, to Proust's childhood at Combray, when with his parents he walked on sunny afternoons along the hawthorn-hung paths of the Méséglise way or followed the Guermantes way beside the banks of the Vivonne. The loveliness of those walks filled his mind with images and indelible fantasies, which conditioned many of the tastes and reactions of his later life. . . .

These perpetual returns to his own past impressions and childhood influences are certainly employed, to some extent, for literary effects; but they are actuated by motives of human sincerity as well. Among other things, they emphasize the particular bias of the author, they define the limits of that instrument of literary reproduction known as Marcel Proust. This is confirmed by the fact that Proust, in describing his own tendencies, is scientific, detached and singularly modest.

. . . His persistently personal approach is never dictated by narrow egotism or pride of conquest, but by a desire to depict, as honestly as possible, human life as it has passed through the secret passages of one man's personality.

. . . Persons and scenes unfold as in life, continually modified by the discovery of new facts or traits of behavior hitherto unseen. Sometimes the key to an important character is withheld and for hundreds of pages he will wander in an atmosphere of mystery and suspense, to be finally illumined in a perverse blaze of light. . . .

In spite of his independent manner Proust has managed to inspire his novel with the prudent technical virtues of suspense and unity. These signs of formal interest are what make "Remembrance of Things Past" a novel, rather than mere rambling reminiscence; but even in its technical aspects it seeks to follow the lines of life. . . .

The accounts of Proust's literary parentage are almost as various as those given of Chaucer's or Boccaccio's. As far as we can discover, no two critics are entirely agreed upon the question of his antecedents, so that he would indeed be wise to recognize his own father. Instead of adding to this genealogical dilemma it seems sensible to waive the matter of Proust's literary origins and discuss his work in terms of his own intentions.

Concerning these, Edith Wharton (writing in the Yale Review for January, 1925) has found Proust's central theme to be "the hopeless incurable passion of a sensitive man for a stupid, uncomprehending woman." This does not seem entirely just to an author who is known, among other things, as an authority on sexual inversion. . . .

It is true that Proust has frequently described the unequal passion of a sensitive man for a less ardent, uncomprehending woman—in the incidents of Swann and Odette, Robert and Rachel-when-from-the-Lord, and his own successive

loves for Gilberte, Albertine, and the distant Duchess. Certainly these men suffer honestly and fiercely, while the fixation lasts; but suffering, according to Proust, is the necessary accompaniment of all love, even the love for one's grandmother. If sexual love, and especially one-sided love, is a topic to which Proust devotes many pages of anecdote and reflection, it is because he considers this to be the most common and the most powerful instance of man's creative imagination. It is the supreme delusion of the mind. . . .

A similar readiness to form a priori images which result in disillusionment is illustrated in Proust's idealization of the Guermantes family, hereditary lords of Combray. For years, whenever he thought of the Duc and Duchesse de Guermantes, he pictured them to himself with synesthetic exuberance. . . .

So, in Volume I of "The Guermantes Way," we find the adolescent Proust cultivating a very idealistic passion for that worldly Duchess, whose salon is the apex of aristocratic society, whose costumes are the last word in elegance. He walks out every morning in the hope of meeting her and receiving a brusque, irritated bow; and he sees nothing comic in his antics. She satisfies his historical and aesthetic sense, for he is in love with the Duchess as the symbol of her race. . . .

Proust's first great entry into the fashionable world occurs at that dinner party of the Duchesse de Guermantes, which consumes nearly 200 pages of "The Guermantes Way," volume II. Of this he produced a very exact, if protracted, piece of satiric reporting. Naturally, he is unhappy to find his aristocrats so much like common people; on leaving the party he at first consoles himself by supposing that he has never been there at all, that it was only a dream. Presently he resigns himself to the truth in more realistic fashion, realizing that in certain essential ways the Faubourg Saint-Germain is still different from any other world and that its residents are peculiarly interesting specimens for study. Living personalities have emerged from the mists of the Guermantes name, revealed by the facts of their own behavior. They do not always appear to advantage, especially when faced with a delicate situation: the Duc's boorish encounter with the doctor, for example, at the moment when Proust's grandmother is ill; or the embarrassment of the Duchesse in that superb incident which closes "The Guermantes Way," when Swann tells her that he cannot come to Italy because he happens to be dying. And the Duchesse,

> placed for the first time in her life between two duties as incompatible as stepping into her carriage to go out to dinner and showing sympathy for a man who was about to die . . . could find nothing in the code of conventions that indicated the right line to follow.

When "The Guermantes Way" appeared in France, Ezra Pound said that the perfect criticism of it should be written in one paragraph, seven pages long and punctuated only by semicolons. That was hyperbole—Proust's sentences seldom run over a page and a half apiece—but it had the germs of accuracy. Those spiral sentences of Proust's, fastidious and tortured, have their physical counterpart in an incident of a

revolving door in which Proust once found himself imprisoned. Just so (though on occasion he is capable of aphoristic brevity) he will involve himself in a sentence so full of similes and modifying clauses that one begins to wonder whether he can ever extricate himself. Certainly he was straining for sincerity rather than for effect. His elaborate style—a balance of broad vision and minute observation—reflects the man, delicate, abstruse, as fearful of overstating a mood as of allowing a shade of thought to escape him. To read him thoroughly constitutes a mental discipline, more humane, surely, but equal in rigor to Euclid. That is why, in spite of the piquant nature of much of his material, Proust will never be a widely popular writer.

<p style="text-align:center">* * *</p>

<p style="text-align:right">February 7, 1926</p>

SYMBOLISM RUNS RIOT IN LAWRENCE'S NEW NOVEL

His Tale of Modern Mexico Is Cloudy, but Fired With Imaginative Power

THE PLUMED SERPENT (QUETZALCOATL)
By D. H. Lawrence
445 pp. New York: Alfred A. Knopf.

By PERCY A. HUTCHISON

That Mr. D. H. Lawrence had in preparation a new novel the scene of which would be laid in Mexico was rumored some time ago. And now the novel, on full wing as it were, has burst into view. An amazing flight. . . .

"The Plumed Serpent," as a narrative of modern Mexico, begins as any novel might do. It opens with a bull fight attended by certain Americans, one of them a Kate Forrester, a widow in middle life who is so revolted by the scene that she soon escapes from the arena. But this introductory chapter has for its purpose, as the reader presently discovers, merely the setting of the emotional and intellectual tempo; it is, with some slight stretching of the word, purely symbolical. Kate, who is the central figure of the book, revolts at the sight of the disemboweled horses and the bull streaming blood, not because she is civilized, but because she is over-civilized. Kate, who is of Irish birth, and who had lived in England and in the United States, symbolizes the outworn and outgrown culture of Europe, and the dead standardization of this country. Mexico, we are paraphrasing Lawrence, or, at least, two of his characters to whom we shall presently turn—Mexico, by trying to superimpose on the ruins of Aztec civilization a dilution of European civilization, has only made herself emotionally weak, sinister, vindictive. Kate is not sinister or vindictive; but her emotions are attenuated. Mexico—we now come to what must be termed the philosophic motif of the story—must be saved. Kate must be saved. And both are saved through the same process, by the same agency.

From the jacket design for "The Plumed Serpent."

Mention was made in the paragraph preceding of two other characters in the book. One of these is Don Ramón, of mixed Spanish and Indian blood. The other is Cipriano, who is pure indian. This trio, Kate, Don Ramón and Cipriano, are the three personages about whom everything revolves; all other characters, and all else in the narrative, are merely accessory. Don Ramón and Cipriano are bent on redeeming Mexico—redeeming Mexico from herself. And this is to be accomplished by restoring the old Aztec religion, the hierarchy of Aztec gods, with the man-god Quetzalcoatl (the Plumed Serpent) at their head. Don Ramón impersonates or, at least, is the symbol for Quetzalcoatl; Cipriano is to be assumed as filling the rôle of Huitzilpochtli, the fire god. By indirection Huitzilpochtli was also the Aztec god of war; hence, in this program of Lawrence's for the rebirth of Mexico, Don Ramón is the head of the restoration movement and Cipriano the one actively to put it into execution. They are represented as banishing Christianity in Mexico, and if the scene savors of impiety in which the holy images are borne from the cathedral and burned—a chapter to which is given the title "Auto da Fé"—it will be remembered that this action is but symbolic also.

It may puzzle the reader to understand why Lawrence adopts the thesis that Mexico, which has already been posited in the chapter of the bull fight as sinister and cruel, is to be saved by such an atavistic move as the adoption of Aztec religion when it would be difficult to find among savage religions one more cruel and sinister. Yet here is the kernel of the author's philosophy. The religion that had for its head Quetzalcoatl was primitive, undiverted male in essence. Its cruelty was male cruelty; if it reveled in blood that was a sign of its manhood. If priests and practitioners were actuated by blood lust that was indicative of the will to purify, to keep clean. Hence, also, the important function of fire, the positing of a fire god. Fire, flame, cleanses. The cruelty of the bull ring which revolted Kate was a sniveling, weak and cowardly sort of cruelty, it symbolized degenerated Mexico. And the reader who grasps this distinction will be prepared for Lawrence's purification of the land by the return to Quetzalcoatl; he will be prepared for Kate's marriage to Cipriano (Huitzilpochtli). There is regeneration, reincarnation, through a mystic intermingling with that which is primitive male essence. . . .

In "The Plumed Serpent" there will be found much of poetry, passage after passage of flashing color and the austere passion of the books of the Hebrew Prophets. And Lawrence also, in his effort to convey what he obviously considers the spiritual meaning of his allegory—for must this novel not in the end be termed allegory?—resorts again and again to what he designates as hymns. These hymns have a passionate lyricism which will lead many to consider them of true excellence; some may even go so far as to embrace the opinion that the book might have consisted solely of these poems, with the prose narrative omitted altogether. But perhaps this is captious. . . .

A passage which will give some indication of Lawrence's sweep of imaginative conception, as well as of his dazzling command of language, may also stand as the key to the book. . . . It is Kate, who is in company with Cipriano, who speaks.

The mystery of the primal world! She could feel it now in all its shadowy, furious magnificence. She knew now what was the black, glinting look in Cipriano's eyes. She could understand marrying him now. In the shadowy world where men were visionless, and winds of fury rose up from the earth, Cipriano was still a power. Once you entered his mystery the scale of all things changed, and he became a living male power, undefined, and unconfined. The smallness, the limitations ceased to exist. In his black, glint-eyes the power was limitless, and it was as if, from him, from his body of blood, could rise up that pillar of cloud which swayed and swung, like a rearing serpent or a rising tree, till it swept the zenith, and all the earth below was dark and prone, and consummated.

It would be possible to read "The Plumed Serpent" as romance; but it would be possible to read it as romance only to those who could blind themselves to its real sincerity of thought, who could remain unmoved by the author's gropings. . . . But it is not a little mind which is twisting and turning, without sense of direction, in these two books. Both are the fumblings of a powerful and brilliant, yet sadly befuddled, intellect.

Yet it would be grossly unfair to state this as the final word on "The Plumed Serpent"; for so left, the criticism would be too closely confined to Mr. Lawrence. Spiritually, if not intellectually, the world is groping now as it never groped before. D. H. Lawrence seems to us, and we imagine he so seems to others, to be striving for something really important, he knows not what. . . . But the thinking of "The Plumed Serpent," if at times flamingly set forth, is confused and contradictory. The reader will find himself repeating Orphelia's lament on Hamlet.

O, what a noble mind is here o'er-thrown!

And if Lawrence's is not, literally, as we do not wish to imply that it is, a mind o'erthrown, it is, we are convinced, essentially a noble mind. And so, too, there are other noble minds today showing the same confusion; and literature is finding itself more and more on the horns of a dilemma. Literature must either be photographic, perhaps whimsically, as in T. H. Powy's recent "Mockery Gap," and devoid of any large idea, or it must strive for something and fail, as in the last analysis "The Plumed Serpent" fails, although, perhaps, like the fall of Mephistopheles from heaven, it is a glorious failure.

* * *

February 14, 1926

WHEN LINCOLN RODE THE CIRCUIT

Carl Sandburg's Vigorous Biography of the Prairie Years

ABRAHAM LINCOLN: The Prairie Years
By Carl Sandburg
2 Vols. 480, 482 pp. New York: Harcourt, Brace & Co. $10.

A new experience awaits the reader of Carl Sandburg's book on Lincoln. There has never been biography quite like this before. But if Mr. Sandburg breaks new ground, it is not in the sense that Gamaliel Bradford and Lytton Strachey did. There is no question here of a new school of biographical writing. The thing Mr. Sandburg has done cannot well be repeated; his achievement is an intensely individual one, suffused by the qualities which are peculiarly his own as a poet. As those who have read him know, they are not the qualities of conventional poetry, nor is this new book of his a merely emotional rendering of the Lincoln story. It is as full of facts as Jack Horner's pie was full of plums. In the work of reporting, of assembling the vast stores of Lincoln material, Mr. Sandburg has been untiring. No less unsparing have been his researches beyond the immediate circumstances of Lincoln's

life; like any good biographer, he has gone thoroughly into the economic and social background of the period he covers.

But when one has said that Mr. Sandburg has been scholarly, that he has seen to his foundations, one has not indicated the grounds for believing that he has written a book which will become a permanent part of American literature. An extraordinary vitality pervades this story of Lincoln's life up to the time of his leaving Springfield for the White House. Part of that vitality comes from the poet's transforming touch, that power of suggestion which lies at the heart of poetry. Part of it comes from the quality of historic imagination, which is closely allied to poetry, for the surging, restless march of the westward movement streams through this book like the recurrent theme of a symphony. Part of it comes from a vivid sense of character, the play of which is not restricted to the central figure. And there are other elements which have gone into the fibre of "Abraham Lincoln: The Prairie Years." Carl Sandburg grew up in that section of the country where the greater part of Lincoln's life was spent. He had in mind for more than thirty years the writing of such a book. It was not the President he would write about, but "the country lawyer and prairie politician."

> The folk-lore Lincoln [he says in his preface], the maker of stories, the stalking and elusive Lincoln, is a challenge for any artist. He has enough outline and lights and shadows and changing hats to call out portraits of him in his Illinois backgrounds and settings—even had he never been elected President.

Viewed simply as a contribution to Lincoln literature, as an additional source of our factual knowledge concerning Lincoln, the book does not have the importance which it assumes as a piece of creative writing. Mr. Sandburg undertakes to settle no disputed questions, but has apparently been content to build carefully upon what has already been established and accepted. That is not to say that his book contains no new material. There are many new anecdotes and hitherto unpublished letters. . . .

The outstanding feature of recent research into Lincoln's ancestry has been the growing certainty that he was not derived from "poor white" stock, even on the paternal side, and that his grandfather on the distaff side was a wealthy Virginia planter, with all that that implies in the way of breeding and education. Mr. Sandburg accepts these conclusions, but they do not impress him. That is to say, he does not seek to find in them, as others have, an explanation of the man Lincoln became. Thus he finds no place for the statement frequently attributed to Lincoln that "his power of analysis, his logic, his mental activity, his ambition," were his inheritance from that grandfather whose illegitimate child was Nancy Hanks, Lincoln's mother. Carl Sandburg prefers to see Lincoln as the product largely of those wilderness and prairie years. He emphasizes the loneliness in which the boy lived, "the wilderness loneliness," "not like that of people in cities who can look from a window on streets where faces pass and repass."

He lived with trees, with the bush wet with shining raindrops, with the burning bush of Autumn, with the lone wild duck riding a north wind and crying down on a line north to south, the faces of open sky and weather, the axe which is an individual one-man instrument, these he had for companions, books, friends, talkers, chums of his endless changing soliloquies. . . .

He found his life thrown in ways where there was a certain chance for a certain growth. And so he grew. Silence found him; he met silence. In the making of him as he was the element of silence was immense.

But if silence had a part in his making, so, too, did the early contact into which he came with the moving currents of American life. That is a fact worth remembering about Lincoln. While he was still a small boy, living on the Knob Creek farm in Kentucky, the Louisville and Nashville pike ran past the Lincoln cabin. Settlers in covered wagons, Congressmen, members of the Legislature on their way to Lexington, traveling preachers—all these passed and many stopped at the Lincoln door. And a few years later, when the boy was 16 years old and the family had moved on to Indiana, he ran a ferryboat across the Ohio River. It was a great highway of traffic and a fine vantage point for a boy with eager eyes and ears. There "he saw and talked with settlers, land buyers and sellers, traders, hunters, peddlers, preachers, gamblers, politicians, teachers and men shut-mouthed about their business." One remembers, too, the voyage three years later, down the Mississippi, and the new horizon unfolding at New Orleans. . . .

When Lincoln, at 22, left his father and stepmother and went to New Salem to clerk in Denton Offut's store, he knew his way about among men. Even if the passion for self-advancement had not burned in him he would have won a distinctive place in the community, but he was a man marked off from the beginning. In the portrait of "the country lawyer and prairie politician" that he became, Carl Sandburg does not hesitate to leave in the crude, harsh lines. Only in the earlier portions of the book, dealing with Lincoln's boyhood, does Mr. Sandburg's emotional reaction to his theme sometimes lead him astray, and there, if it does occasionally bring to the saturation point the explanation of Lincoln in the terms of his environment, the general effect is nevertheless of the highest potency in evoking the background out of which he came. In his treatment of the Lincoln of mature years, the poetic infusion is mostly absent. One meets with Lincoln the shrewd handler of men, the endless teller of stories, coarse often as not, the frankly office-seeking Lincoln, who never hesitated to write letters urging the consideration of his claims. But there is marvelously little that can be said honestly today in disparagement of Lincoln. As in the case of Washington, the essential purity of the man's character suffers no cloud to rest upon it.

Carl Sandburg has written a book that merits the reading and meditation of every American. In the first place, for the extraordinary living warmth of the Lincoln he has drawn; and for such things as the beautiful, tender handling of the story

of Nancy Hanks and of Lincoln's unhappy love affair with Ann Rutledge.

Of that tragedy in Lincoln's life Mr. Sandburg has written with a splendid union of feeling and restraint. There is piercing sharpness in this brief paragraph in which he sets down the tragedy:

> Ann Rutledge lay fever-burned. Days passed; help arrived and was helpless. Moans came from her for the one man of her thoughts. They sent for him. He rode out from New Salem to the Sand Ridge farm. They let him in; they left the two together and alone a last hour in the log house, with slants of light on her face from an open clapboard door. It was two days later that death came.

Too little has been said here of the wider aspects of Carl Sandburg's book. Suffice it now to say that nobody can go through these two volumes without a more vivid sense of what the pioneer breed was really like, and a clearer perception of the forces that year after year were splitting the country until the ultimate gulf of disunion opened under it.

* * *

May 23, 1926

"ARCTURUS", WHITHER AWAY?

Mr. Beebe Reports His Latest Adventure in Science

THE ARCTURUS ADVENTURE
By William Beebe
With 77 illustrations from colored plates, photographs and maps.
439 pp. New York: G. P. Putnam's Sons.

By R. L. DUFFUS

Like the legendary comedian who succeeded in being funny without being vulgar, William Beebe is popular without being unscientific. This stamp was upon "Jungle Days," which earned him his first wide reputation, it was upon "Galapagos," and it is upon this latest volume, which, if you take the trouble to read the subtitle, is really "An Account of the New York Zoological Society's First Oceanographic Expedition." There are others besides Mr. Beebe who have made science palatable—Mr. Slosson, for example, and Vernon Kellogg. But Mr. Beebe has done a little more than that—or a little less, as the harder boiled among the scientists might say. He has made science poetic and glamourous. He has made it an adventure. And he has thoughtfully omitted the higher mathematics, the smells of laboratories, the mountains of dry detail or should one say, in this case, of wet detail?

To what extent the voyage of the Arcturus, as set forth in these pages, is typical of modern scientific research the layman can but guess. There is a kind of research which consists in breeding countless generations of fruit flies, or of inoculating hundreds of guinea pigs, or of squinting through a microscope until one staggers out half-blind into the sunlight, or of spending months in dizzy astronomical calculations. This sort of science is about as comprehensible to the man in the street as is the philosophy of a flagellant monk. But the man in the street can understand William Beebe, because Mr. Beebe is a wanderer and an adventurer, and we are all homesick for wanderings and adventures.

This should not be taken to mean that Mr. Beebe's narrative is all pie and no crust. His success, as well as his soundness, is due to an artful mingling of various elements. He writes with the skill of an after-dinner speaker—which, by the way, he is. He gives his audience as much science as it will take without wriggling; but when it begins to fumble with its knives and forks he brings it up standing with high—or, as in his utterly fascinating account of his experiences with the diving helmet—low adventure. Few of us have the slightest interest in the proceedings of the Xesurus laticlavius; and if any one but Mr. Beebe tried to tell us about this fish, it would go hard with him. In Mr. Beebe, however, we are willing to endure some discussion of basal and caudal plates and anterior hooks, because we know that he will not inflict unnecessary suffering.

He cannot be dull, even when he tries. He is too human and sees too much humanness in nature. The attempts of an albatross to get about on land remind him of "the peripatetic progress of Charlie Chaplin." The movements and facial aspects of groupers and wrasse, thirty feet below the surface of Chatham Bay, "brought often to mind a gait, a glance or a trick of the hand" of some friend of the human species. His mind is always jumping out of its strictly scientific groove, as in this description of under-water life:

> The great backbone of the population, the host of "common peepul," was what I called Percolators—although some of them were aristocrats and many did not percolate. As a whole, however, they lived their lives in and out of the coral and rocks, never becoming surface lovers, nor settling down in any special crevice. . . . Like New Yorkers at lunch hour, they were victims of idle curiosity, and I shall never see a throng watching with breathless interest the working excavators or the rhythmical riveters on some new building without remembering the crowd of small Percolators who always rushed toward me when I first submerged, swimming rapidly with a my word! see-what's-here expression.

Perhaps the most romantic aspect of the voyage of the Arcturus, as it was planned, was the search for the Sargasso Sea. Since Columbus's time the existence of this great mass of floating seaweed has been a legend among mariners. One might not look in vain there, if story tellers were to be believed, for Spanish galleons, with skeleton crews, rotting timbers and holds full of pieces-of-eight. Mr. Beebe does not seem to have shared this interesting illusion. His hopes were modest. All that he asked was an acre or two of matted weed such as he had often seen from steamers while on his way to and from British Guiana. Underneath such patches of weed

were sure to be found rich and novel forms of sea life. But the expedition not only did not find any galleons but did not come on any patches of weeds much larger than a man's head. This was the Autumn of the Sargasso and its life was at a low ebb. But, as Mr. Beebe observes, a failure in science is almost as good as a success:

> We had set out to find vast fields of weed teeming with living creatures, and we found only small mats and plaques almost destitute of life. A negative result such as this would be accounted a failure in business or hopeless in religion. To science it was of concrete value, and added a wholly new interest to the entire problem.

Yet some of the specimens brought up had stories to tell which were more wonderful than any legend of the Spanish Main. At "30 North and 60 West" the nets yielded hundreds of Leptocephali. The life history of this creature has been worked out, though not by a member of the Arcturus expedition. In infancy it lives in the Sargasso as a transparent larva with "mother-of-pearl eyes." Its parents are eels—European in some instances, American in others. As it approaches maturity it swims slowly toward the parental coasts and rivers, of which it can have but an ancestral memory—the European eels toward Europe, the American eels toward America. Perhaps a dozen years later the female returns to the Sargasso to lay her eggs. Mysteries like this pop up at every turn. Almost any haul at the nets might bring up new ones or contribute something toward solving old ones.

From the Sargasso—or rather from the spot where the Sargasso ought to have been—the Arcturus steamed to Panama and passed into the Pacific. Here were adventures enough to suit the most exacting. The first was a great tide rip, caused by the meeting of two currents and swarming with sea life. Later the expedition was present at "the birth of a volcano" on Albemarle Island in the Galapagos. Mr. Beebe and John Tee-Van landed during the first spasms of this eruption and came near being suffocated by the out-pouring gases. Nine weeks later, on their return from a trip to Panama for water, they witnessed the majestic spectacle of a great stream of lava pouring into the sea.

"It was," says Mr. Beebe, "a battle, a cosmic conflict among fire, water, earth and air, such as only astronomers might dream of or a maker of worlds achieve."

But the most thrilling part of the narrative has to do with the author's experiences under water. The apparatus consisted of a copper helmet with weights and attachments. Putting on a bathing suit and adjusting this over his head, the diver sank to the bottom in twenty or thirty feet of water and inspected the underwater life at leisure. This underwater life included sharks, which Mr. Beebe, with a courage no battle-field could surpass, trusted would not attack him. As it turned out, they did not—not even the "tiger sharks." Had this detail of natural history been of a different nature there would presumably have been no "Arcturus Adventure"—at least from the pen of Mr. Beebe. Sharks are really "indolent, awkward,

From a Photograph by the Wide World Studio.

William Beebe

chinless cowards," but some one had to offer himself as a possible tidbit before this could be stated with certainty.

One day Mr. Beebe was about to enter an underwater grotto when part of the grotto began to move, and resolved itself into an octopus. The next moment a nine-foot shark drifted around the corner. And then even Mr. Beebe was moved to go away. He returned, however, many times, seeing the submerged world with an artist's eyes as well as a scientist's:

> In the middle distance I saw the palace of the Dalai Lama at Llhasa, with its majestic, down-dropping lines; beyond it the corals had wrought a fairy replica of the temple of the Tirthankers at Benares. Then a cloud of pagodas filled the end of the sandy vista, silhouetted against the blue at which I can never cease marveling whenever I think of this water world—a pale cerulean, oxidized now and then with the glimmering through of some still more distant monument. Invariably the architecture of the East was brought to mind, not the semi-plagiarized structures of most of our Western efforts, but light, uplifted pagoda roofs, curving domes and stalagmite minarets, together with scroll work which is lacelike but never gingerbready.

For adventure of the more conventional sort—though exciting enough for all that—the reader may turn to the chapters on Cocos Island, where pirates as well as more honest mariners used to stop for water and cocoanuts, and where, as on all islands worth bothering with, there is buried treasure.

Another kind of island—perhaps of more concern to scientists—was "Seventy-four: An Island of Water." "Seventy-four" was simply the "station" of that number, in the open sea, south of Cocos. Here, assuming an earthquake or eruption to thrust forth a new wart on the earth's surface, it was an interesting speculation to ascertain what inhabitants it might come to have. This Mr. Beebe tried to do by keeping tab of the flowing life of air and water which passed by. In ten days he counted more than four hundred individuals of thirty-four species, including four species of plants, all of which could have landed and thrived upon the theoretical island.

The purely scientific results of this expedition will be recorded in other—and for the layman duller—books and monographs. There will be other expeditions, for the Arcturus no more exhausted its field of labors than its captain could have emptied the ocean by dipping up a pailful of water. The service Mr. Beebe does is in making the scientist a human and engaging figure. We see him in this case as a man hopelessly afflicted with the wanderlust; he reveals a sense of humor which makes him love to record the "oldest able seaman's" remark about the scientists, "I never seen such funny folks"; he has imagination, and he has courage. These are qualities which even those who live in modern apartments in cities can understand.

It is hard to do justice in a short space to a book so varied and so enormously entertaining. And it is impossible to indicate the beauty of many of the drawings and colored plates. Isabel Cooper's colored plates are gorgeous, and there are some delicate things by Don Dickerman, Dwight Franklin and Helen Tee-Van. For, strangely enough, there is often loveliness of color in fish which live in the Stygian blackness of the great depths.

* * *

December 13, 1926

LAWRENCE ISSUES HIS ARABIAN BOOK

Abridged Edition of the Long-Awaited Volume Is in Hands of a Few Friends

FIRST MANUSCRIPT STOLEN

Author Rewrote 400,000 Words, but Limited Circulation to Eight Copies at First

Special Cable to The New York Times

LONDON, Dec. 12—The book relating the extraordinary adventures of an extraordinary man, Colonel Thomas E. Lawrence of Arabia, has at last been published. While awaited eagerly by two continents for six years, the book is now in the hands of only a few friends of Colonel Lawrence, who subscribed thirty guineas (about $156) per copy for it. No review copies have been sent to the newspapers, but the book is described in The London Times by D. G. Hogarth, the author of "The Penetration of Arabia."

Hogarth is a close friend of Colonel Lawrence's. He states that Lawrence agreed, just before his departure the other day for a long period of foreign service, to the publication of an abridged edition of his book, which he has named "Seven Pillars of Wisdom."

Colonel Lawrence first wrote the book in Emir Feisal's temporary home in Paris after both had withdrawn embittered from the Paris Peace Conference, because of its failure to modify the French plan for a mandate over Syria. After finishing the book, in which he tells the story of how he caused and led the Arab revolt against the Turks upon the promise of the Arab autonomy which the French refused to allow the Arabs to wholly realize, he returned to England. Leaving his satchel containing his manuscript notes and many illustrations unguarded for a moment at Reading Railway Station, it was stolen and was never recovered. For a time it was thought that the manuscript had been stolen for some definite purpose at the behest of persons interested, but it is now assumed that it was taken by a sneak thief.

Colonel Lawrence then rewrote his narrative in 400,000 words and had eight copies printed, of which four or possibly five remain. Twice he was induced to publish the book for wider circulation, but he backed out each time.

Finally, he consented to publish the present edition on the persuasion of the late Gertrude Bell of Arabian fame. Colonel Lawrence wished but few eyes to read his book, for a reason, so Hogarth says, apparent to those who obtained copies of the limited edition.

The book is said to be a marvel of typography and illustration. Under a subtitle, "An Arabian Epic," The London Times says of Lawrence's adventures:

"Of all the campaigns of war, none has been stranger or more picturesque than the struggle between a small group of Riffian leaders, with their fickle and uncertain tribal levies, and the armies of the Turk."

The most spectacular feat of Colonel Lawrence described in his book is his ride through enemy territory to stir up the tribesmen in Wadi-Sirhan and the capture of Akaba, which set the Arabs free of Turkish rule.

Another exciting incident is when Colonel Lawrence was almost killed when leading a camel charge against the Turks. He was saved from death by the body of his fallen camel. He also describes his adventures in wrecking railway trains, which earned for him the title among the Arabs of "Wrecker of Engines."

* * *

April 3, 1927

SACCO AND VANZETTI

THE CASE OF SACCO AND VANZETTI: A Critical Analysis for
Lawyers and Laymen
By Felix Frankfurter
118 pp. Boston: Little, Brown & Co. $1.

In the now almost seven years that the case of Sacco and
Vanzetti has been before the courts of Massachusetts and
taking a prominent place in the newspapers of the whole
country it has aroused an interest so great and so widely
spread that it has become of international consequence. Its
echoes have come back from several European countries,
while in the United States it has enlisted the active interest
of many prominent people. The author of this little book,
who is a member of the Faculty of the Law School of Har-
vard University, has considered it of such importance as to
warrant the prolonged study of its record necessary for the
critical analysis he presents.

He has gone through the record of the successive court
proceedings, covering thousands of pages of printed matter,
and on it has based this judicial résumé. Although there has
been wide and general interest in the case, the public has
heretofore had only newspaper narratives of events as they
ran from day to day upon which to formulate opinion. But
Professor Frankfurter presents in brief compass a résumé of
the affair from the hold-up and murder of the paymaster and
his guard and the theft of the money he carried in South
Braintree, Mass., April 15, 1920, to the present time. In a lit-
tle more than a hundred pages he makes a survey of the case
that is wonderfully compact, but complete enough to bring
together all the essential developments and present them in a
lucid, readable narrative. His temper is judicial throughout,
both in the relation of facts and in the occasional discussion
of some outstanding feature.

He presents both pros and cons of evidence and situations
and then tells the reader to judge for himself. But when he
comes down to recent developments he does make his pre-
sentation a plea for the granting of a new trial to the accused
men, on the ground that not to consider in this way the new
evidence available would be unjust and contrary to the spirit
and principles of Anglo-American law. An appendix contains
a tabular study made by counsel for Sacco and Vanzetti of the
two hypothetical explanations of the crime, and another
quotes an editorial from a Boston paper on the subject of the
application for a new trial.

* * *

April 24, 1927

A NEW EPIC OF AMERICA'S MAKING

Professor and Mrs. Beard Interpret Our National Development

THE RISE OF AMERICAN CIVILIZATION
By Charles A. Beard and Mary R. Beard
2 vols. 1,624 pp. New York: The Macmillan Company. $12.50.

By EVANS CLARK

Most history is either a catalogue or a story book—an
annotated list of important happenings or a narrative of the
deeds of the military or political great. But the history of
American civilization which Professor Beard and his wife
have written can only be described as an epic. . . . Almost
every page smacks of the pungent irony, the sardonic
humor, the hawk-like discernment that are characteristic of
Charles A. Beard.

The book is epochal as well as epic. For the first time
modern American scholars have taken a full-length panorama
of American life. To Professor and Mrs. Beard "history" can-
not be cribbed, cabined or confined. They do not pick out one
segment of life and examine it without relation to the rest. To
them military history without its political parallel, or either
one without the economic background, would be a story
without a plot, and to ignore the art, the science and the liter-
ature that grows out of the crude soil of human existence
would be to tramp the fields without ever noticing the flowers
that enrich them. The field of vision in this book includes the
whole circle of American life. . . .

Professor Beard sees in the swirls and eddies of
expanding American life surface indications of deeper
currents which have their source in the desire of men for
material gain. When Dr. Beard's book on the Constitution
was first published it met with a storm of indignant protest
from those who believed the Fathers of our country were
actuated by different motives from those which dominate
the modern statesman; he had analyzed the actions of the
delegates to the convention that framed the Constitution in
terms of the economic and social interests they reflected—
as any good journalist would report a political gathering
today. In the magnum opus which is his latest book he
applies the same general procedure to the entire sweep of
American history. . . .

But in this book he has brought the economic influences
still recognized as the dynamic power in human affairs into a
more balanced relation with the rest of life.

In the second volume of the present work the authors point
out that the present age has produced:

> no romantic history, explaining the wonder-working
> providence of God in the United States after the
> fashion of Bancroft, no large philosophic view of
> America in a world setting after the style of Hegel, no
> interpretation of American intellect in terms of material
> circumstance according to the formula of Buckle.

The illustrations on this page are from decorations by Wilfred Jones for "The Rise of American Civilization."

But it may now be added that the present age has produced at least one notable attempt to tear aside the veil of myth and prejudice which has hung about the people of the United States and to reveal them as they are: neither supermen nor morons, but ordinary human beings, creatures of impulses, high or low according to the observer's predilections, creatures very much intent on the business in hand and through it working out a collective destiny that for swift drama and stirring incident, has never had an equal. . . .

Dr. and Mrs. Beard have done to history what a great artist does to a landscape. He brings out certain salient features that a camera could never disclose.

As they consider, one by one, the critical periods of American history the broad outlines assume a very different pattern from that which has been built up by historians of the conventional school.

The settlement of the Colonies was not so much a noble adventure in religious freedom and high pioneering as it was the inevitable expansion of a nation "engrossed in applying ever increasing energies to business enterprise"—one more outlet "for the employment of capital and administrative genius." England had a "large and growing estate of merchants, a body of yeomen ready for adventure and a supply of free agricultural laborers." The combination precipitated colonies.

But the same social forces that sent the colonists across the seas conspired to turn them into revolutionists. The war for independence was a clash between the interests of the British merchant classes and the commercial ambitions of a new country which, in spite of the scant two centuries of life, had already threatened the trade of its ancient progenitor.

. . . The American Revolution was an internal revolution as well. "It was in truth an economic, social and intellectual transformation of prime significance—the first of those modern world-shaking reconstructions in which mankind has

sought to cut and fashion the tough and stubborn web of fact to fit the pattern of its dreams." At a stroke the vast domains of the English crown became vested in the Legislatures of the several States. There came a "smashing confiscation of estates," the abolition of the system of entails and primogeniture and so on—"shifts and cracks in the social structure" which became fissures later on.

The Constitution is brought down from the mists of sappy sentimentalism into the more robust atmosphere of human actuality. . . It was in fact a "treaty of peace between the commercial and planting States" that set up a stable central government to protect the growing commercial interest of the North and at the same time leave undisturbed the slave-labor system of the South.

It was neither conceived in unanimity nor born without a struggle. The convention that drafted it, like most important conventions before and since, was composed of a "wrangling body of thoughtful, experienced and capable men, but harassed men, torn by interests, prejudices and passions, drifting one day in one direction and the next in another, deciding long-debated issues, opening them again, altering their previous views and adopting novel solutions."

The constitution they drew up was "a bundle of compromises," a "mosaic of second choices accepted in the interest of union and the substantial benefits to flow from union." And it was put over on the States only with the greatest difficulty—owing largely to the opposition of the farming interests. "No more than one-fourth of the adult white males in the country voted one way or the other in the elections at which delegates to the State ratifying conventions were chosen"—the framers did not dare to put it to a vote of the Legislatures of the States.

Again, the war of 1812 appears in the pages of Dr. and Mrs. Beard's analysis not as "springing inevitably" from the depredations of England on American trade and her impressment of American seamen. It was the result of a sort of agri-

cultural imperialism produced by the surge of population beating on the westward frontier. "Besides getting rid of the Indian barrier to the advance of the agricultural frontier, besides gathering in the rich fur trade enjoyed by the British, the American war party also hoped to acquire the farming lands of Canada." It was under the same influence of agricultural imperialists—"who read between the lines the promise of a free hand in the South west"—that the Monroe Doctrine, a generation later, was announced.

What is still supposed in the North to have been a righteous war to free the slaves is drawn in very different perspective by Dr. and Mrs. Beard. They call it the second American revolution. The slave question was merely incidental to a titanic struggle for domination in the councils of the nation between the rising capitalism of the North and waning power of the planters of the South. . . .

For the Beards American history has revolved around the varying fortunes of these three great economic groups, "the capitalistic Northeast, the planting South and the farming regions beyond the seaboard—with the mechanics of the towns coming into play whenever the aristocracy of wealth and talents was to be pommeled." As the reader surveys the whole panorama of American development laid out in the pages of these volumes he sees the full turn of the cycle from the Northern domination of the Hamilton Federalists when the Republic was young, through the rise and rule of the planting-farming combination that culminated in the crass democracy of Andrew Jackson and burst asunder with the Civil War, back to domination by the Northeast again in the gilded age of "acquisition and enjoyment" during which big business came to flower and the Republican descendants of Hamilton presided over the nation's political destinies for an unbroken period of twenty years.

The issues in which this struggle has been embodied have run like a golden thread through all three transformations—the tariff, immigration, the currency, States' rights. The agricultural interest favored free trade, restricted immigration, decentralized currency, State sovereignty. The capitalist interest called for protection, free flow of immigrants, a strong banking system and more power for the Federal Government. As each group came to control so were the policies of the nation directed to its interest.

But since the turn of the century the web of American politics has been cut across by forces not accounted for by this simple pattern. . . .

First the redoubts of government were stormed by those who would hedge about the acquisitive freedom of Government officials. Civil service reform came to blast the sacred doctrine of "to the victors belong the spoils." The direct primary and the abolition of party conventions followed. Next,

the august Senate was compelled to take its mandate from the people themselves, and women were allowed to vote. . . .

The "Communist march," which the Hon. Joseph H. Choate feared and denounced before the Supreme Court in 1895, "had eventuated in a vivid realism." And yet "the solid structure of manufacturing enterprise remained intact throughout the land." And, as the new century advanced, "intransigeant hostility to great organizations of capital seemed to be on the wane. At any rate, the threat of horrible dissolution almost vanished as their securities flowed out into the hands of small investors, profit-sharing employes, saving banks and endowed institutions," while "Socialist proposals to transform the new leviathans into national property produced practically no response."

Then with the post-war years came the machine to buttress the existing economic system with the golden props of a prosperity more widely diffused than ever before. In spite of a "standardization of American society" that had "daily increased in precision and completeness" under "the remorseless hammering of the machine" it would appear that

America of the machine age offered material subsistence for a life of the mind more varied and more lucrative, both relatively and absolutely than any nation that had flourished since the beginnings of civilization in the Nile Valley.

Interspersed among the authors explanations of the significant American developments are chapters which attempt to assay the more subjective elements of life, literature, drama, art, science, education and the views of men. . . .

In what direction the cosmic flow of circumstance is leading, the Beards do not attempt to indicate. Writing of the most immediate past that blends with the present they remark that

If the generality of opinion, as distinguished from that of poignant specialists was taken into account, there was no doubt about the nature of the future of America. The most common note of assurance was belief in unlimited progress . . . moving from one technological triumph to another, overcoming the exhaustion of crude resources and energies, effecting an ever wider distribution of the blessings of civilization—health, security, material goods, knowledge, leisure and aesthetic appreciation.

"If so," they conclude, "it is the dawn, not the dusk, of the gods."

* * *

May 8, 1927

MAN'S RELATION TO HIS WORLD IN THOMAS MANN'S NOVEL

"The Magic Mountain" Is a Record of Profound Mental and Spiritual Experience

THE MAGIC MOUNTAIN
By Thomas Mann
2 volumes. Translated from the German by H. T. Lowe-Porter. 900 pp. New York: Alfred A. Knopf. $6.

By JOHN W. CRAWFORD

Artifices without end have appeared in fiction to crystallize out of complexities those stark clear values which have seemed to express man's dramatic relation to his world. It has remained for Thomas Mann to discover and to exploit the strangest device of all: a tuberculosis sanitarium. The character of Hans Castorp, one of the patients in the Berghof, in the Swiss Alps, provides the novelist with an additional degree of detachment, a further invitation to those more abstract concerns which have so little to do with the preoccupations of life in the flatlands. Hans Castorp passes the long, indistinguishable time intervals by taking stock of himself, his derivations, his significance in the world, and the meaning of the world to him. Castorp, further, comes in contact with other patients, representing every aspect of philosophy, whether reasoned and codified in thought or unthinkingly applied in living. Imperceptibly, yet overwhelmingly at the end, it becomes apparent that, through the supine, passive personality of Hans Castorp, situated in his removed, changeless sanitarium, Thomas Mann has wrought a synthesis out of the whole diversity of modern being.

As the novel opens, Hans Castorp is already on his way to the cure. He is "an unassuming young man," whose sole distinguishing characteristic is his faithfulness to a certain cigar. He is of an old burgher family of Hamburg, settled, sober people who have been the backbone of that tight oligarchy of trade for generations. Hans Castorp has just finished his engineering studies and has a position waiting for him with a firm of shipbuilders, conducted by traditional friends of his family's. He is going to spend three weeks in the company of his unhappy cousin, young Joachim Ziemssen. From the moment Joachim conducts his cousin from the narrow gauge railway compartment, it is apparent that a distinct mode of being exists upon that remote, bewitched mountain. "We up here," Joachim observes, "measure time on the grand scale, and consider three weeks nothing to speak of, a mere week-end."

Thomas Mann transforms Hans Castorp from a civilian with a part to play in the active business of Hamburg to a reflective, experimentative onlooker, by such gradual stages that the transitions are entirely organic. At one point, Castorp is nothing more than the visitor, making only those provisional adjustments to a new environment which spring from a natural wish to benefit by a vacation. Visibly he is inveigled and at length entirely absorbed by the conditions of these exotic surroundings. He develops a cold and a high fever. An examination and the revelations of the X-ray betray the little moist spot in his lungs which is destined to keep him at the Berghof for seven years instead of the original three weeks.

The sensible, physical universe of the Berghof is delimited by the Hofrat Behrens, the surgeon and head physician of the establishment; by the psychoanalyst, Dr. Krokowski; by five hearty meals each day; by the people at Castorp's table; by the strict regimen of rest, alcohol rubs, taking of temperature and so on, and by the imminence of death.

Hans Castorp soon has qualified these general conditions with the particular elements which appeal to him, and which serve to betray and accentuate his essential personality. Both his father and mother are dead, and his grandfather died when he was still a child. He himself is frail. He has not been a patient long before he discovers in himself an infinite, almost morbidly sensitive, tenderness toward suffering and dying. He sets himself the duty of visiting those who are about to end the fight for health, and be carried out, silently, and in the absence of the inmates, and put on bobsleds to be transported down the snow-covered mountainside to the railway.

Thomas Mann is infinitely, scrupulously fair. He is at pains to present Castorp in a dry light, free of prejudice. In addition, he gives unlimited license to all the speculators and theorists assembled at the Berghof, who inevitably cross the path of Castorp, and find his deference and his youth and his teachableness irresistible. The result is that Castorp listens to the Italian libertarian, son and grandson of classic humanitarians, and finds Ludovico Settembrini stimulating, provoking, sometimes aggravating. He also draws out the subtle Jesuit, Naphta. Hans is, too, the devoted friend and ally of the extraordinary Dutch Colonial, Pieter Peeperkorn.

It is impossible to read far into Thomas Mann without realizing that he is a tacit but inexorable advocate of the aristocratic principle. The democracy of Settembrini is allowed fullest expression, but there is always Naphta to riddle it, and to make the gallant Italian slightly ridiculous. In addition, there is the fascinating Russian woman, Clavdia Chauchat, bespeaking the life of the senses, and controverting with the spell of her greenish eyes and her red hair the austere humanity of Settembrini and its effect upon the impressionable Castorp. Further, there is Peeperkorn, reminding the Berghof inmates that sheer physical personality, deriving out of uncharted primitive forces, dominant in its own right, is an unanswerable challenge to reason and dialectic.

So soon as these tentative conclusions are reached, however, and the innate significance of the novel has appeared to have been deposited, crystalline-clear, once for all, the neatly arranged categories disappear at a breath, and it is all to do over again. Mynheer Peeperkorn, although he has won Clavdia Chauchat away from Hans Castorp, and commanded the respectful admiration of Castorp himself, and although he rules the oddly assorted little company, is yet diminished by the very power which has given him ascen-

dency. He is aging, and that is the final answer, perhaps, to the form of the aristocratic principle which he represents.

The end of Peeperkorn is only one among many moments that would have tempted a lesser writer to rodomontade. Thomas Mann takes it all in his stride. He has established, early in the narration, an acceptance of this "eternal day that is ever the same" at the Berghof. Peeperkorn's view of things is given in a number of passages. Perhaps this instance might serve as illustration:

> Life, young man, Peeperkorn observes to Hans, is a female. . . . She mocks us. She challenges us to expend our manhood to its uttermost span, to stand or fall before her. To stand or fall. To fall, young man—do you know what that means? The defeat of the feelings, their overthrow when confronted by life—that is impotence. For it there is no mercy, it is pitilessly, mockingly condemned.

Even the brief quotation conveys a sense of the tempestuous ardor of this ageing monarch of a man, a magnificent conception.

Subsequently Castorp involves his friend Settembrini in a quarrel with Naphta. The Jesuit has been scoffing at freedom and the French Revolution, with an acid, malicious wit. Indeed, the dialectics between Naphta and Settembrini are among the most brilliant passages in the book, although it must be admitted that they also at times descend to long-winded argument and become slightly tedious. The Italian rebukes Naphta for misleading Castorp and filling him full of persuasive paradoxes. The upshot of it is a duel, in the early morning, with pistols. Settembrini has so often offered his determined opposition to suffering, to violence, and to death, has so often been the tolerant yet austere proponent of life and freedom and equality that his part in the duel is somewhat paradoxical in itself. As it happens, he fires into the air, and leaves the maddened Naphta no alternative but to blow his brains out.

After seven years of Castorp's false security, war breaks out in 1914. Thomas Mann wisely abandons his character after a brief glimpse of him in the midst of fighting on the flatlands. The enchantment of the magic mountain has at last been lifted, but it is death, after all, which is to take off the victory.

The reader looks in vain through "The Magic Mountain" for the docketed views and pat opinions of Thomas Mann. That in itself, considering the subject and the nature of the book, is a signal and grateful achievement. What he finds, instead, is the extraordinary spiritual, mental and physical adventures of Hans Castorp.

The recognition of Hans Castorp, on his isolated peak of arrested temporal experience, set free as he never could have been in the flatlands to explore and participate in many different ways of life and thought for himself, come perilously, breath-takingly near to charting a discovery of the modern world. It is a fine, noble, inspiriting "Yes," which Thomas Mann returns to life. Yet "The Magic Mountain" falls just short of being that work upon which the thoughtful wanderer among contemporary perplexities may build a serene, untroubled, understanding acceptance of life. But it goes far on the way. In this, the translation of H. T. Lowe-Porter is an adequate, but not invariably a satisfying, assistance; it is workmanlike, but a translation.

<p style="text-align:center">* * *</p>

September 25, 1927

HERMANN HESSE, GERMAN OF THE GERMANS

GESAMMELTE WERKE IN EINZELAUSGABEN (Collected Works, Published Separately)
Hermann Hesse. Berlin: S. Fischer. Der Steppenwolf (The Prairie Wolf)
By Hermann Hesse. Berlin: S. Fischer.

BERLIN—To the many beautiful editions of the collected writings of present-day authors which we owe to the publishing house of S. Fischer, there now is added the work of one of our most deeply read German men of letters, Hermann Hesse. True, he has not uttered or written a single patriotic phrase in all his life, and during the World War, when he lived in Switzerland, there rose from his bleeding heart bitter criticism of conditions in his home, causing some parties simply to declare him a traitor and as such to hold him up to shame.

And yet no other of our authors reveals as typically as Hermann Hesse the character of the Allemannic Germans (not the North Germans), with all its peculiarly surly, abrupt, self-contradictory outward appearance, a glaring contrast to a prodigiously sensitive, delicate soul full of longing for beauty and perfection. None except, perhaps, the more robustly moulded Emil Strauss. Both are sons of the Lake of Constance, that lovely, fertile region whose people are experts in the enjoyment of good wines and where drinking is a fine art and almost a sacred rite because it transports these melancholy men into a happy state of slight intoxication in which beautiful illusion enables them to forget their deep-brooding nature. There are many Swiss and Swabian elements in their make-up, which gives them constant trouble because their sharp corners and edges bring difficulties into one's relationship with them. They lack entirely the "joviality" of the Rhino-lander, who is mobile and inclined toward jesting, more like his French neighbor.

One must know all this in order to understand properly the books of Hermann Hesse. For he is one of those authors who never present objectively viewed pictures of the world, but whose books always are more or less masked confessions and revelations of their own divided, tormented souls.

Even in his story of boyhood, "Unterm Rad" (Under the Wheel), Hesse laid bare the tortures of his misunderstood youth, thereby winning vigorous applause. A general cry of indignation arose at the time against the crime committed against child minds by ossified scholastic discipline. It would

be unjust, however, to class Hesse among the authors who preach social reform. He is purely poetic always, in all his writings. Few men, indeed, are poets to such a degree. The great success of his "Peter Camenzind" was due to this. The public felt that this portrayal entered deeply into the character of the South German; thousands of young men felt that a great part of their hidden selves had been brought to the light of day. Even this youthful work ends in a sad, melancholy resignation that casts a shadow over practically all of Hesse's books. The poet is happy only when he turns away from men and toward nature. It comes to life for him in a thousand most delicate shades; it reveals itself to him with such deep spirituality and gives him such sweet consolation as he seeks in vain among men. He accuses them bitterly, and sometimes unjustly, of this. For why are his fellow-men to blame if Hermann Hesse's senses are more keenly and delicately receptive to the barely noticeable movements of nature than to those of human beings?

This is why his most lifelike descriptions are of characters which still are very close to nature: children and young girls of the people, vagabonds like the harmless good old tramp Knulp, and artists demoniacally bound to nature. The most powerful of these is the painter Klingsor in one of his most colorful short stories, "Klingsor's Letzte Sommer" (Klingsor's Last Summer). Klingsor is Hermann Hesse, like Peter Camenzind and the painter in that moving tragedy of family life, "Rossholde." The marriage problem, the hopeless and sterile welded union of two people of fundamentally opposed characters has rarely been handled with more delicate and yet merciless truthfulness. Even the death of the child both of them love most tenderly can not bring them together again. This because the dividing force is not misunderstanding, unfaithfulness or superficial difficulties, but the flowing apart of the primitive currents of their natures in different directions. The illness and death of the beautiful little boy, Pierre, is one of the finest passages of our enduring literary heritage.

Curious revelations, verging on the mystical and inexplicable, of the developing soul of the growing boy, its friendships, its erotic emotions, and of the powerful influence of a superior character on a gentler and more receptive nature—these form the content of the novel "Demian," the story of Emil Sinclair's youth. For some reason, unknown to me, Hesse did not publish this book under his own name. Thereupon much guessing went on in literary circles as to who might be the author of this remarkable masterpiece. And then Hesse was unable to maintain his anonymity for any length of time. There were not many writers to whom could be attributed this clear-flowing, flexible, soul-stirring style, free of any intentional mannerism or superfluous ornamentation.

In his most recent writings Hesse has discarded entirely the cloak of the novel with which he had heretofore disguised his confessions to some extent, and has given himself in all his contradictory character, in all his wealth and poverty. For as one grows older one feels, more than in one's youth, that even the most stubborn hermit and enemy of the age is deeply bound to it, and is the child of its thousandfold deficiencies, sublimity, pain and happiness.

Thus "Der Kurgast" (The Watering-Place Hotel Guest) and "Der Steppenwolf" (The Prairie Wolf), came into being; here let me remark that in the writing of both of these, but especially of "Der Steppenwolf," Hesse most certainly was thinking of himself only, and not at all of others.

His longer works are interspersed with some excellent collections of short stories, and there are two little books in which Hermann Hesse speaks to us purely as a lover of nature, revealing the childlike soul he usually keeps covered with the shield of bitter misanthropy. His view of the landscape is so much that of the artist that one can easily presuppose talent for graphic art in him; and his "Wanderungen durch das Tessin" (Roaming through the Ticino), where he lived for years, and his "Gedichte des Malers" (Poems of the Painter) are illustrated with colored paintings and drawings by his own hand. Very simple, primitive motifs, trees, stones, outlines of landscapes, little chapels and the like, with only light touches of color, set down with such powerful purity of perception that we comprehend and are moved by the childlike nature of this dual personality. In the final analysis, and in spite of everything, it is blessed, indissolubly wedded to all the purity, strength, growth, blooming, star-like brightness in the world.

And now the author follows this harmoniously perfect book with the atrociously horrible "Steppenwolf." "Harry Hallers Aufzeichnungen" (Notes of Harry Haller) is the subtitle. In his introduction the supposed editor says:

Haller is one of those men who have happened to come between two gees, who have fallen out of all security and innocence, whose fate it is to experience all the questionable elements of human life with extreme intensity.

A man who finds satisfaction and supreme enjoyment only in the highest forms of art, in Novalis and Goethe, in music only in Mozart; who, longing for peace, views the neat and dainty house of his landlady with reverent emotion. And in this man there lives a fierce, shy, surly beast of the wilderness which, sneeringly, destroys and calumniates everything admired by the man beside him, and which the author calls the "prairie wolf." The two—the pure soul of the man and the damned spirit of the beast (actually his unhappy temperament)—are in a constant dispute that is brought into the realm of magic spells and is carried out cleverly and with profundity until the man comes to the final conclusion that no death can liberate him, and that hatred and fury against his present life, with all its grotesque manifestations, will only increase his despair. So that nothing remains for him but to endure the whole thing obediently, just as he must dispose of his manifold souls and even of the prairie wolf.

This is no book for merry youth or to bring cheer in hours of despondency. But it is a most valuable contribution for the serious psychologist, for the seeker of knowledge of the

abyss of the human soul. At the same time it is infinitely rich in colorful fancy and poetic variegation.

GABRIELE REUTER

* * *

March 4, 1928

TWO WHO REPRESENT ASIA'S REVOLT IN THE WESTERN MIND

Gandhi's "Young India"—Sun Yat-sen's "Three Principles"

YOUNG INDIA
By Mahatma Gandhi
984 pp. New York: The Viking Press. $5.

THE THREE PRINCIPLES OF THE PEOPLE
By Dr. Sun Yat-sen
514 pp. Published by the China Committee, Institute of Pacific Relations, Shanghai. $4.

By CHARLES JOHNSTON

Gandhi and Sun Yat-sen represent to the Western mind the revolt of Asia. They burn with revolutionary fire. They are gifted with an abundant flow of impassioned speech. They have made themselves conspicuous by vigorous political action. These two apostles of the militant Orient were born about sixty years ago, the Chinese leader being the older of the two. They were, by character and impulse, adventurers, seeing many lands and many cities, traveling with enthusiasm, and forming plans for the regeneration of their nations. But beneath these similarities there are sharp contrasts between them, and therefore equally sharp contrasts in the results they have produced. Let us take a closer view of them, beginning with Gandhi.

Gandhi has been described by ardent admirers as the son of a Prime Minister, and therefore endowed with hereditary statecraft. His father and grandfather had in fact held office in the little native State of Porbunder, with an area of 638 square miles and a population of 85,000. This small principality is on the coast between Bombay and the mouths of the Indus. It is true that even in a little State, one might learn something of statecraft, but, as we shall see, statecraft is one of the things about which Gandhi has learned nothing.

"Young India" is interesting and valuable because it shows his intellectual and moral growth. It is made up of Gandhi editorials in a little weekly of that name, which has a circulation of about 20,000 among his English-reading admirers. Besides a riper view of life, Gandhi has developed a sense of humor, which he is quite able to turn against himself, so that, with a sufficient dose of Oriental patience, one can read his thousand iterative pages with both entertainment and instruction. His sense of humor shows best in one of his editorials: "Am tired of Mahatma." We have respected his wish in omitting that magnificent title, though his publisher still uses it.

Gandhi, in these meandering essays, unfolds three constructive ideas and two valuable criticisms. His three ideas are, Hindu-Muslim unity, the relief of the "untouchable classes," and the spinning wheel; and he holds that the third is the most vital, for reasons we shall presently consider. The problem of Hindu-Muslim unity somewhat ironically illustrates the danger of "interfering with the balance of nature," in complex political fields. The Muslims, the Mussulmans of India, are a minority, but a rather overbearing minority, cherishing traditions of conquest and dominion, even though the vast majority of them are converted Hindus who went over to Islam to escape Brahman priestly tyranny, and had absolutely no part either in the conquest of India or the dominion of the Moguls. To protect them and guard their susceptibilities, the Government of British India devised what is called communal representation—that is, a system under which the Muslims and others, were represented as communities. The result of this really well-meaning effort was to increase and inflame the class consciousness of both Mussulmans and Hindus. They did not fly at each other's throats. What they did was this; The Muslims somewhat obtrusively slaughtered cows, which for the Hindus symbolize the Holy Spirit, distilling the milk of divine kindness on human souls. The outraged Hindus retaliated by marching with bands and blaring conches past Muslim mosques during the hour of prayer. This is the rift that Gandhi has set himself to close and his plans are sensible and practical. He is equally definite and concrete regarding the "untouchables": he seeks to gain for them admission to the public schools and Hindu temples, and free access to public wells, and to do this without having recourse to any violence whatever. Again, one can have nothing but commendation both for the aim and for the sane methods he advocates. But it is when, to use his own fine phrase, he "harps upon the spinning wheel" that Gandhi becomes truly eloquent and persuasive. The impelling motives of his crusade are moral, esthetic and economic. He says, with deep truth, that excited passions and inflammable nerves are lulled to a fine philosophic calm by plying the sweetly murmuring wheel; and it seems that he even succeeded in persuading his fellow politicians to impose upon themselves a spinning-wheel ordinance, so that only industrious spinners could be elected to the National Congress. We are absolutely in favor of introducing this reform to Occidental lands if possible in conjunction with his system of a day of silence once a week. The esthetic beauties of spinning came as an afterthought, a reward. The first impulse was and is economic.

There are his three practical plans. His two criticisms are not less important. He is absolutely opposed to the practical operation of Bolshevism; and he has set his face like flint against political assassination. To sum up: Next year will come the critical revision of the Government of India. It is clear that Gandhi's plans will not greatly help in that difficult task; but it is also certain that he is doing much to create an atmosphere of moral and mental calm, in which a sound solution may be reached. He seems to favor Dominion status within the British Empire for India.

It is curious that, while Gandhi has the air of a visionary, he is really more practical than Sun Yat-sen, who has all the

appearance of a political philosopher. Gandhi sees the small, definite thing to be done first. Sun Yat-sen reasons learnedly about large conclusions, and seems unable to take the first step. There is a close likeness between the lives of the two Oriental leaders. Sun Yat-sen went as a boy to Honolulu and was graduated from the American high school. He then studied in the British College at Hong Kong, and for a short time practiced medicine. An abortive revolution led to exile, and he visited America and Europe, narrowly escaping an adventure in the best style of our mystery writers, when minions of the Chinese Government captured him, intending to smuggle him back to China for summary punishment. A faithful English friend rescued him. In due time he returned to China, and became the founder as his biographer says, "of the Revolution of the Republic of China." There is a good deal of irony in that sentence, much more than the writer of it realized. What he really helped to establish in China was chaos.

Looked at objectively, what happened in China in 1911 can hardly be called a revolution. It was really the collapse of a corpse. The last effective plans for the betterment of China were worked out, some time before the close of last century, by the youthful Manchu Emperor, Hwang-su and his gifted Minister, Kang Yu-wei. Their idea was to copy Japan's extraordinary success in borrowing from the West, and to use Japanese skill in rebuilding the much larger realm of China. But there was a lion, or, rather, a lioness, in the path, the intensely nationalistic Dowager Empress, Hse Tsi-an, "the only man in China," as she was called, a ferocious lady, so endowed with personal magnetism that she could charm birds from the trees. Kang Yu-wai got wind of her prejudice against him and escaped to Tien-tain by a neck, with a heavy price on his head. Nationalism had won, and, inspired by the grim lady and Prince Tuan, a kindred spirit, the Fists of Righteousness brought about the Boxer uprising in the Summer of 1900. The expedition of the Western powers broke the back of the Manchus, and their elimination was only a question of time. The ferocious old lady died. The youthful Emperor did not survive. It was openly said that the partisans of the Dowager could not risk his survival, so they helped him to a happy decease. A child Emperor was left to represent the discredited Manchus, and this is what Dr. Sun pushed over in a brief campaign of three months. It was like upsetting a scarecrow.

Dr. Sun became President of a non-existent Chinese Republic, but was soon pushed aside by the more vigorous Yuan Shih-kai. The confusion and muddle of Chinese events in the last few years needs no commentary.

In March, 1925, Sun Yat-sen died in Peking. In the period immediately before his death he delivered before an audience of Chinese intellectuals in Canton the lectures which make up the book under review. His three principles are nationalism, democracy, livelihood, and he develops his ideas on each of them with considerable skill, covering an immense area in which he sometimes loses his way, but in the end enunciating general ideas of real validity. But that is not where the shoe pinches. We have already suggested that Gandhi's distinction is his ability to see the small practical thing to be done first.

Dr. Sun never does: he soars and soars through the empyrean, weaving great circles, but getting nowhere. He philosophizes about statecraft, but he is the antithesis of a practical statesman. He is on far firmer ground when he deals with economic problems, as in his analysis of the blundering prophecies of Karl Marx. But, after all, what is Karl Marx to China? So it comes that all Dr. Sun's plans have failed. He laid down ideal designs for a Chinese Republic. But China is not a republic and is not likely to become one. He sought to break the hold of the Western powers on Chinese industry and finance, but failed completely. He staked his hopes on an alliance with Soviet Russia. The Chinese have recently severed that alliance by measures that would have delighted the Dowager.

* * *

October 14, 1928

MR. HUXLEY'S NEW NOVEL IS SAVAGE SATIRE

POINT COUNTER POINT
By Aldous Huxley
432 pp. New York: Doubleday, Doran & Co.

It seemed once, most of all perhaps in his first novel, "Chrome Yellow," that Aldous Huxley had in him, not only brilliant gifts of satire, wit, fantasy and style, but the makings of an important creative novelist. With the passing of time and the writing of other novels, however, he seems less likely to have them. He remains where he began: a satirist, a sophisticate, a worker in the "novel of ideas." His people are created statically, they almost never develop, they almost never influence one another, they almost never work together in the interests of a central theme or story. They speculate about life, rail against it, wound and weary one another. That is their function as people. And they call forth in the reader a moral protest against their kind, a moral abhorrence, or dismay, or indignation. That is their function as satire.

In "Point Counter Point" Mr. Huxley is more scathing and savage than ever before in his picture of contemporary intellectuals. In "Antic Hay" the underlying tone was futility, in "Those Barren Leaves" it was boredom. But the underlying tone of "Point Counter Point" is disgust. We go into a world of writers, editors, artists, scientists, musicians, wastrels, dilettantes, society women; and to put it tersely, one is worse than another. These people stoop to trickery, bait the helpless, wound the decent, trifle with young men sincerely in love, drive a woman to suicide, murder a man. Those who are not ridiculous or silly are for the most part vicious or cruel. Only three or four of these people can be deemed humanly worthy.

The aim of this book is not idle amusement for the sophisticated, but a grasping of the intellectual Zeitgeist and a biting criticism of it. Even as a novel of ideas the book attempts to reveal the character of those who express the ideas. We have a hint of this intention in the notebook of one of Huxley's characters.

The great defect of the novel of ideas is that it's a made-up affair. Necessarily; for people who can reel off neatly formulated notions aren't quite real; they're slightly monstrous. Living with monsters becomes rather tiresome in the long run.

Is this an apologia, or just another "idea"? At any rate, in "Point Counter Point" the people are slightly monstrous. But the fault lies in this particular book rather than in the limitations of the novel of ideas. Huxley himself proves this. In "Antic Hay" the people are not monsters, but valid satiric representations; satire does not run away with itself, but has pertinence and point. This book is ruined by overstatement.

That there is powerful writing to the book cannot be denied. Certain parts of it have great force. But it is force exerted without restraint or cumulative meaning, good only in terms of itself. There is a brilliant malice in some of the portraiture, an almost diabolic ability to reveal man in ridiculous and mean and embarrassing situations. But one misses the supremely judicious, controlled, comic, pathetic implications of "Antic Hay"; one misses what seemed so promising, and proved so beautiful in the earlier Huxley; things like the fantasy of the dwarf in "Chrome Yellow" and the tale of the half-witted girl in "Those Barren Leaves." Here one must be content with an astringent, brittle wit, a maturity of observation, a powerful outburst of disgust. These may well be extraordinary gifts, but they are not new ones. And as they have served their usefulness to better advantage before, one may be justifiably guarded in praising them. The needless length of this book, too, is at least possible evidence of its disorder. If "Point Counter Point" is the most powerful and vitriolic indictment of the intellectual world we have had in years, it is also the most exaggerated and unrelieved.

LOUIS KRONENBERGER

* * *

October 21, 1928

MRS. WOOLF EXPLORES THE "TIME" ELEMENT IN HUMAN RELATIONSHIPS

ORLANDO
By Virginia Woolf
333 pp. New York: Harcourt, Brace & Co. $3. (The first edition, limited to 861 copies, price $15, is published by Crosby Gaige of New York.)

Those who open "Orlando" expecting another novel in the vein of "Mrs. Dalloway" and "To the Lighthouse" will discover, to their joy or sorrow, that once more Mrs. Woolf has broken with tradition and convention and has set out to explore still another fourth dimension of writing. Not that she has abandoned the "stream of consciousness" method which she used with such conspicuous success in her previous novels, but with it she has combined what, for lack of a better term, we might describe as an application to writing of the Einstein theory of relativity. In this new work she is largely preoccupied with the "time" element in character and human relationships, and with a statement of the exact complexion of that intangible moment, a combination of past and future of objective reality and subjective consciousness, which we refer to as the present.

An hour [she explained], once it lodges in the queer element of the human spirit, may be stretched to fifty or one hundred times its clock length; on the other hand, an hour may be accurately represented on the timepiece of the mind by one second. . . . The most successful practitioners of the art of life, often unknown people by the way, somehow contrive to synchronize the sixty or seventy different times which beat simultaneously in every normal human system so that when eleven strikes, all the rest chime in unison, and the present is neither a violent disruption nor completely forgotten in the past. Of them we can justly say that they live precisely the sixty-eight or seventy-two years allotted them on the tombstone. Of the rest, some we know to be dead, though they walk among us; others are hundreds of years old, though they call themselves 36.

Mrs. Woolf's hero-heroine is hundreds of years old. At the beginning of the book Orlando is a boy of 16, melancholy, indolent, loving solitude and given to writing poetry; the age is the Elizabethan; the book ends on the 11th of October, 1928, and Orlando is a thoroughly modern matron of 36, who has published a successful book of poems and has evolved a hard-earned philosophy of life. Thus, to express her very modern fourth-dimensional concepts, Mrs. Woolf has fallen back upon one of the most ancient of literary forms, the allegory. In doing so she has left the book perhaps more confused than was strictly necessary.

At the first reading it is somewhat difficult to grasp the structure of the novel. During the Elizabethan period Orlando is a young nobleman, a favorite of Queen Bess, discovering for himself the world he lives in; first gloomy and in love with death; then amorous and florid, roistering in taverns; then a sprightly and dashing young courtier, engaged three times and finally jilted by a beautiful Muscovite Princess. Disillusioned, he returns to his estate in the country and devotes his energies entirely to writing.

By this time the Elizabethan background has gently faded away and it is the eighteenth century. Before he was 25 he had written some forty-seven plays, histories, romances and poems. By the age of 30 he had become disillusioned with literature: "not only had he had every experience that life has to offer, but had seen the worthlessness of them all. Love and ambition, women and poets were all equally vain." Consequently he gave himself over to the enjoyment of nature and to deep reflection about the ultimate realities of life, finally deciding to carry on the noble tradition of the members of his family who had generation after generation added to and improved the castle which he had inherited. His philosophic calm was eventually shattered by an importu-

nate Archduchess, who pursued him so insistently that, to escape her, he was driven to serve King and country and to accept the Ambassadorship to Turkey, a position which he filled with distinction.

At this point Orlando unexpectedly changes sex, and throughout the rest of the novel is a woman. There is a revolution in Turkey; she escapes and for some time wanders about Central Europe with a band of gypsies; eventually her British love of nature asserts itself and she hastens back to the hills and hedges she is so fond of. Later she comes to London in search of "Love and Life," she experiments with the various diversions the city has to offer, but finds them empty. Fashionable society is exciting for the moment, yet "nothing remained the next day;" she becomes intimate with Pope, Addison and Swift, but finds them dull fellows compared with their books. Then the eighteenth century fades from the screen and Orlando finds herself in the age of Victoria.

The rest of the novel may be divided into two parts; the first deals somewhat whimsically with Orlando's attempts to adjust herself to the conventions of nineteenth century England. The second, and by far the most stimulating section of the book, describes Orlando at the present moment, and traces with breath-taking delicacy the influence of her past upon her present. It is in these last thirty-odd pages that the book springs startlingly to life. Up to this point it had seemed a pleasant narrative made notable by a number of passages of great beauty and by occasional bits of vivid description, but marred by a rather self-conscious facetiousness on the part of the author, an addiction to parenthetical whimsicalities that are not particularly effective.

In the closing pages of the novel Mrs. Woolf welds into a compact whole what had seemed to be a series of loosely connected episodes. In them she seems to reach down through the whole superstructure of life and to lay bare a new, or at least a hitherto unperceived, arrangement of those ephemeral flashes of memory of perception that go to make up consciousness. Throughout the ages people have remarked that time, under certain circumstances, seems much longer than under certain other circumstances. Mrs. Woolf presents concrete proof that this is not merely an impression, but a fact, by showing of what time, not as a mechanical but as a human element, consists. She has carried the "stream of consciousness" technique a step further; she has not been satisfied to present a succession of thoughts and sensations passing through the mind; she shows what is behind those thoughts and sensations, whence they spring, and how great their relative value.

In attempting to describe such subtle and illusive qualities—or should they be called quantities?—Mrs. Woolf has faced squarely one of the most puzzling technical and esthetic problems that confront contemporary novelists. The mere fact that she has stated the problem as succinctly as she does in the course of this book is immensely stimulating, whether or not one feels that she has achieved a final solution of it. It is something of a question whether the tendency of contemporary novelists to become more and more introspective can profitably be carried much further. If it is to continue, however, Mrs. Woolf has pointed out the direction in which it must develop.

CLEVELAND B. CHASE

* * *

November 4, 1928

THE ADOLESCENT

COMING OF AGE IN SAMOA
By Margaret Mead
Assistant Curator of Ethnology, American Museum of Natural History
Foreword by Franz Boas, Professor of Anthropology, Columbia University.
Illustrated. 297 pp. New York: William Morrow & Co. $3.

The "difficulties of adolescence" are spoken of generally not only by the lay public but by educators and philosophers, as if their existence must be accepted axiomatically in human life. Indeed, Dr. Franz Boas not only reminds us that "when we speak of the difficulties of childhood and of adolescence, we are thinking of them as unavoidable periods of adjustment through which every one has to pass," but adds, "the whole psycho-analytic approach is largely based on this assumption." Alone, probably, among students of allied subjects, the anthropologist has doubted the correctness of so general an assumption: Are the difficulties of the transition from childhood to adult life due to adolescence itself, and therefore universal and unavoidable, asks the anthropologist, or are they the result of the impact between developing youth and a civilization which at once restrains and complicates?

Anthropology has been asking this question for a long time. Now in an extraordinary fashion, an anthropologist has answered it.

With the National Research Council's fellowship in Biological Science, Miss Mead went to Samoa to study the development of youth under what may paradoxically be called a highly developed primitive life. It was a life highly developed because it presented a distinct pattern of civilization which for long ages "other members of the human race had found satisfactory and gracious"; it was primitive because it not only lacked the appurtenances of modern progress, but subsisted with very simple standards and needs; in every way it presented a vast contrast to all of Western civilization. In this pattern of life Miss Mead fitted herself, studying the language, living as the people lived, making them her friends; she was with them for nine months. She did not on the one hand make a superficial survey of a large district, nor on the other choose only a few "cases" to investigate: she made an absolutely complete study of all the girls in three native villages, and of the life of the people generally from birth to old age. Her findings confirm the suspicion of the scientist that in the "coming of age" of human life, "much of what we ascribe to human nature is no more than a reaction to the restraints put upon us by our civilization," and offer invaluable material against which to study better the conditions and problems of our own youth.

As Miss Mead's careful scientific work deserves the most earnest tribute, so her method of presenting its results calls for the highest praise. Her book, broad in its canvas and keen in its detail, is sympathetic throughout, warmly human yet never sentimental, frank with the clean, clear frankness of the scientist, unbiased in its judgment, richly readable in its style. It is a remarkable contribution to our knowledge of humanity.

*　　*　　*

June 2, 1929

WAR'S HORROR AS A GERMAN PRIVATE SAW IT

"All Quiet on the Western Front" Is An Extraordinarily Vivid Document

ALL QUIET ON THE WESTERN FRONT
Translated from the German of Erich Maria Remarque by A. W. Wheen.
291 pp. Boston: Little, Brown & Co. $2.50.

By LOUIS KRONENBERGER

It would seem that now, ten years after the war, we are ready to write about it with the dispassion, the collectedness, the impartial understanding that will put meaning into what we say. Until this year, except for "The Enormous Room" and one or two other books, we have had little of lasting value; now, within one year, Europe has given us four vital and informative commentaries on the war. One of these, "Siberian Garrison," will appear in English next Fall. The three others have become available to Americans in quick succession. Interestingly enough, each has a different point of attack: in "The Case of Sergeant Grischa" it is philosophical, in "Journey's End" it is psychological, now in "All Quiet on the Western Front" it is physical, so that the three, taken together, offer a comprehensive outlook upon the war.

In this book it is the war as, in all its physical horror, it passed before the eyes of a twenty-year-old German private, an intelligent but not unusual boy who, with no preparation, with no fixed principles, was sent away to fight. We are told in a foreword that it is not to be a confession, or an accusation, or an adventure he chronicles, but the tale of a "generation of men who, even though they may have escaped its shells, were destroyed by the war." They were destroyed because they were cut off from life before they had found a fixed scheme for living:

All the older men are linked up with their previous life. They have wives, children, occupations and interests, they have a background which is so strong that the war cannot obliterate it. We young men of twenty, however, have only our parents and some, perhaps, a girl . . . some enthusiasms, a few hobbies and our school. Beyond this our life did not extend. And of this nothing remains.

From the jacket design for "All Quiet on the Western Front."

This sense, less of being uprooted than of never possessing roots, is the governing motif of the book, the tragedy that Paul Räumer and all his fellows instantly recognized and that has proved itself in the ten years since the war. Here are boys bewildered not only by war, but also by lacking standards to which they can revert in a psychological escape from war. Here are those whom Gertrude Stein indicated as a "lost generation." Only it is a little ironical that these very Germans have adjusted themselves better than any other race.

One may see how badly the war upset these lives and yet realize that theirs was not the supreme torture. For this soldiery of whom Remarque, through Paul Bäumer, writes took the war more unflinchingly, more directly, in a certain sense more phlegmatically, than many other participants. Certainly they saw it in all its physical horror, and in "All Quiet" we have a picture of that physical horror unsurpassed for vividness, for reality, for convincingness, which lives and spreads and grows until every atom of us is at the Front, seeing, mingling, suffering. For us readers, indeed, the picture finally acquires a kind of fascination; it so rivets our senses that it no longer terrorizes our imaginations. Under such a spell we can take in everything and need run away, psychologically, from nothing.

It almost certainly had no such fascination for these soldiers: yet "All Quiet" remains, essentially, a document of men who—however else their lives were disrupted—could endure war simply as war. It is for that reason representative of the largest number of men who fought, an Everyman's pil-

grimage through four years of fighting. For the same reason, it is about youngsters who were half-puzzled over what it all meant: who were not driven to mental torture because they could not endure what they knew or check their imaginations at what they saw. They sit around, half shrewd, half naïve, and speculate now and again. "Every full grown emperor requires at least one war, otherwise he wouldn't become famous," says one with a school boy cynicism. "It's a kind of fever," says another. But there is no sense of terrible knowledge, of moral responsibility. That is why, as pure revelation, "All Quiet on the Western Front," though magnificent within its own limits, is yet definitely limited.

In "Journey's End" sensitive men, by drinking, by quoting from "Alice in Wonderland," by using any makeshift to hand, seek to forget, to evade the mental wrack every moment of their fighting lives. The result is inwardly more terrifying to us than the physical terrors of "All Quiet." In "The Case of Sergeant Grischa" men are burdened with moral responsibility, with the responsibilities of both their positions and their knowledge, a whole philosophy of war is shattered by one man's fate, value is pitted against value. We are both morally outraged and morally fortified. But "All Quiet" is a story of privates with nothing on their consciences, with only a job to do, who are killed or maimed not quite as puppets and not quite as responsible men. We get truth that is memorable, but not always inner truth. It is only at the greatest moments of the book that this profounder revelation comes, as when Paul kills his first enemy in a shell-hole face to face, and acquires a momentary feeling of responsibility which we no more than he can ever forget.

There is one further quality about "All Quiet" in addition to its magnificent physical picture of war and its burden of a lost generation, and that is its humanity. It is an objective book, an ironic book, but it is never callous, never hard-boiled, never unfeeling. There is almost no stock pathos, but there is a warmth, a youthful sadness, a release of natural emotions unburdened by that sentimental restraint common to the men in "Journey's End." And there is a moment like that when Paul, about to give away the potato cakes he is too overwrought to eat, thinks of his mother, desperately ill, making them over a hot stove, which brings us nearer to the central suffering of life than to mere homely pathos.

We must end by examining the purely literary side of the book a little more closely. It is told as a kind of journal which Paul Räumer writes down in the present tense until, at the end of the book, we are informed of his death. Thus in form, as in content, it is documentary. It seems always genuine. But it is never raw fact: a sensitive memory and a sure feeling for effect have brought art to bear upon it, so that its totality is greater than any mere sum of transcribed wartime experiences could make it. The characters are not merely varied but are significantly varied, ranging from the semi-literary narrator to the practical Kat, the simple Tjaden, the odious Himmelstoss. So, too, with graduations of intensity the scenes shift from the front to behind the lines. The

explicitness of the detail, slightly overemphasized though it is—the hunger, the rats, the filth, the awful suffering and mutilation, the bodily fear of men new to the front—stamps this life with a veracity borne out by every movement, every action, every thought and feeling of those who share it. In Germany it must have recreated the war for a multitude of men, but it has an extraordinarily vividness for men who never saw the trenches. It is not a great book: it has not the depth, the spiritual insight, the magnitude of interests which make up a great book. But as a picture, a document, an autobiography of a bewildered young mind, its reality cannot be questioned.

* * *

August 18, 1929

A NEW NOVEL BY JEAN COCTEAU

PARIS—On the first page of "Les Enfants Terribles" (Bernard Grasset), the new novel by Jean Cocteau, one finds a list of his work. He has divided it, not into poems, essays, criticism, drama and drawings, but into poetry—poetic novels, poetic criticism, poetic drama, poetic drawings. Such a voluntary repetition of the word "poetry" proves that Cocteau knows himself well, for he is above all a poet. To do him complete justice it is necessary to add, in capital letters, that he is a poet in his conversation. There are few contemporary pleasures more vivid and perfect than listening to Jean Cocteau in conversation. He knows how to make things graphic, and how to mimic; he is at once diverting and profound, tragic and gay, serious and comic. His conversation partakes of the quality of Shakespearean comedy, of the songs of Heine and of the designs of William Blake. The sparkle of Cocteau as a conversationist helps to explain the great influence that he has had on French art.

It is a fact that in music as in painting, in literature as in the moving picture theatre, the French artists who have tried to renovate the forms of art have often been discovered and always championed by Cocteau. Among the musicians whom he has launched are Milhaud, Honegger, Poulenc, Germaine Tailleferre, Auric; among the novelties, Raymond Radiguet, who died at such a young age a few years ago. If Cocteau has been misguided at times it has usually been through an excess of generosity that has every so often led him to mistake a slight and charming work for a masterpiece. But "it is a sure sign of mediocrity to praise ungraciously."

It is a trait to be remarked upon that this writer who so rightly passes for one of the most "modern" of his generation, this Cocteau who has no desire to grow old and who, in fact, ages very little, should at the same time have such a love for the great classics and also a wish to be inspired by them. He does not seek, as do so many others, for the extraordinary and the unintelligible; it often happens that he is misunderstood, but he doesn't wish this to be so and he is troubled by it. He has not the prejudice, so dangerous, which consists in fearing the patronage of a wide public—as if art were not

meant to touch the greatest possible number of men—as if Homer, Shakespeare, Dante, had been poets of the ivory tower!

"Les Enfants Terribles," which has just been published, should be placed in the category of "poetic novels." The children, Elisabeth and Paul, live alone together, adore each other, and often hurt each others feelings; they are "terrible," but not at all vulgar. They even have an astonishing quality of poetry about them. In what does their charm consist? Somewhat in their imagination which, no sooner than they are in their neighboring beds, transports them to a dream world, somewhat in the attractive atmosphere of their room which is "furnished by dream." Elisabeth and Paul draw two other persons, Gerard and Agatha, who, themselves rolled in their coverlets, come to live in the dream room. A young American Jew has been enamored of Elisabeth and leaves her his fortune when he dies. The four dreamers move to more luxurious quarters, but their one common desire is to recapture the happily disordered atmosphere of their dream room, its air of "city under the snow." Agatha falls in love with Paul and tells Elisabeth about it; but the latter doesn't want to change the hard, brilliant beauty of their life together, and when Paul, very sick, is about to die, she kills herself with a pistol. The thread is broken. The dream room is snatched away.

An analysis can hardly reveal the beauty of a book that derives its value from the tone, the style and the ordering of a poem. But nothing I know of is more successful, from the point of view of pure technique, than the snowball battle between students that opens this book, and the remembrance of that scene that runs through the narrative. The children of Cocteau are real children. Justice is thereby rendered to a writer who has known how to keep his own spirit young and charming.

ANDRE MAUROIS

* * *

September 29, 1929

LOVE AND WAR IN THE PAGES OF MR. HEMINGWAY

In "A Farewell to Arms" He Has Written a Beautiful and Moving Tale of the Italian Front

A FAREWELL TO ARMS
By Ernest Hemingway
335 pp. New York: Charies Scribner's Sons. $2.50.

By PERCY HUTCHISON

As in "The Sun Also Rises," Ernest Hemingway lays the scene of his new novel in Europe. But, unlike the earlier novel, he is not concerned with the aftermath of the war, but with certain years and phases of the war itself. Consequently, "A Farewell to Arms," if it is to be given classification, belongs to the rapidly crowding shelf of war novels. . . .

Suffice it to say, however, that Mr. Hemingway has concerned himself with a phase of the war not yet much used, the collapse of the Italian front in 1917, and that, in consequence, so far as his novel is to be regarded solely as a war book, it has the freshness of depiction in a new field.

Dramatic as are the pages dealing with the Caporetto débâcle, the war, however, is but a background for the real story. . . . The love of Lieutenant Henry for the nurse Catherine Barkley, a love so great that Henry eventually deserts, as he puts it, "declares separate peace," could only have come in the war and out of the war. The story of this attachment is poetic, idyllic, tragic. The part which will sit least comfortably with the reader is Henry's desertion. For however humorous may be the Lieutenant's gloss, and how much he may have been justified in his own eyes by the shooting by the "battle police" of officers who failed to hold their troops in line (assuming that this was done), nevertheless, so great a fetish is heroism, that, however often it may not be practiced in fact, one cringes slightly at an author's flouting it in fiction in which he had already focused the attention on a lyric relationship.

And yet perhaps with the mention of this as a debatable point one has gone to the very core of what may be termed the Hemingway school. For this school admits the validity of no fetish, in life or in art. It prides itself on its cold reportorial aloofness. And men did desert during the war. Moreover, Lieutenant Henry was in the ambulance service, not a line officer. It is all one, therefore, with fiction's employment of Caesarian operations and the mention of obscure anatomical parts. It is the new art.

There is in "A Farewell to Arms" no change from the narrative method of "The Sun Also Rises" and "Men Without Women." Ernest Hemingway did not invent the method, which is chiefly to be characterized by the staccato nature of sentences (an effort at reproducing universal conversational habit), and its rigid exclusion of all but the most necessary description. Yet if Hemingway was not the inventor of the method, tentative gropings toward such a manner having been made by many of his immediate predecessors, the author of "A Farewell to Arms" has, in his several books, made it so strikingly his own that it may bear his name, and is likely to henceforward. . . .

The chief result is a sort of enamel lustre imparted to the story as a whole, not precisely an iridescence, but a white light, rather, that pales and flashes, but never warms. And because it never warms, or never seems to warm, the really human in Hemingway (and there is a great deal in Hemingway that is human) fails of its due. It is not impossible that Ernest Hemingway has developed his style to the extreme to which he carries it because in it he finds a sort of protective covering for a nature more sensitive than he would have one know. . . . Mr. Hemingway's manner does not seem to be quite an enduring thing, any more than was Victorian heaviness enduring. But the Hemingway manner is arresting purely as craftsmanship. And if its extreme naturalism borders dangerously on unnaturalism, for the reason that the effect of the printed pages must be, perforce, different from

Photo by Helen Breaker, Paris

Ernest Hemingway

the effect of speech, then it behooves other craftsmen to find the proper modification. Yet it expresses the spirit of the moment admirably. In fact, seldom has a literary style so precisely jumped with the time.

The Caporetto retreat, which forms the background for an entire portion of the book, and furnishes the action, is a masterly piece of descriptive narration. Not static description (which Hemingway abhors), and not merely action, but a subtle weaving of description and narration, this has all the movement of the retreat, its confusion, its horrors, and also makes the reader see the retreat. It is the longest thing of its kind that Hemingway has done, although there is something resembling its craft in the bullfight pages of "The Sun Also Rises." The effect of the whole, the cumulative effect of the whole, with the devastating effect of the débâcle on the minds and the morale of those engulfed by it, cannot be rendered by quotation. It is therefore only in the hope of suggesting something of the book's effectiveness here that quotation is attempted. This is but a fragment, of course:

As we moved out through the town it was empty in the rain and the dark except for the columns of troops and guns that were going down the main street. There were

many trucks, too, and some carts going on the other streets and converging on the main road. The troops, the motor trucks, the horse-drawn carts and the guns were in one wide slow-moving column. The truck ahead stopped. The whole column was stopped. It started again and we went a little farther, then stopped.

They come to a river. There is still a bridge across, and over the bridge all move. And at the other end are the "battle police" with their orders to shoot officers who had abandoned their troops.

At the far end of the bridge there were officers and caribiniere. I saw them silhouetted against the sky-line. The officers were scrutinizing every one in the column. They took some one out just as we came opposite. I saw the man. He was a Lieutenant Colonel. I saw the stars in the box on his sleeve as they flashed a light on him. His hair was gray.

The man, who had commanded troops in the advance of the Summer, and, when the Austrians, aided by German divisions, broke through, had been borne along in the rout, is questioned.

"If you are going to shoot me." the Lieutenant Colonel said, "please shoot me at once. The questioning is stupid."

He made the sign of the cross. The officers spoke together. One wrote something on a pad of paper.

"Abandoned his troops. Ordered to be shot," he said.

There will be debate as to whether "A Farewell to Arms" is a finer piece of work than "The Sun Also Rises." And there will be cogent arguments advanced on either side. On the surface, the newer story is more effective than the earlier novel. There is more drama, the movement is more nearly continuous and better sustained. And the story of the love between the English nurse and the American ambulance officer, as hapless as that of Romeo and Juliet, is a high achievement in what might be termed the new romanticism. And yet for the present reviewer "The Sun Also Rises" touches a note which Hemingway caught once, and, in the very nature of the thing, cannot touch again. In the attachment of Lady Brett for her physically incapacitated lover there is a profound and genuine affection which has something of inspiration. And the pathos of Lady Brett, that she can maintain this only by derelictions, evidences psychology so subtle that it has hitherto evaded the literary worker, and been not always discernible to the scientifically schooled. Others could have done the Caporetto retreat, though perhaps not so dramatically; and others would have imagined the lyric love of "A Farewell to Arms," although perhaps not carrying it through so poetically. "The Sun Also Rises," as it seems to this writer, at least, is more nearly unique as a document and as a novel. Yet he would not wish

to lose, therefore, "The Farewell to Arms." It is a moving and beautiful book.

* * *

October 27, 1929

A NOVEL OF PROVINCIAL AMERICAN LIFE

LOOK HOMEWARD, ANGEL
By Thomas Wolfe
626 pp. New York: Charles Scribner's Sons. $2.50.

Here is a novel of the sort one is too seldom privileged to welcome. It is a book of great drive and vigor, of profound originality, of rich and variant color. Its material is the material of every-day life, its scene is a small provincial Southern city, its characters are the ordinary persons who come and go in our daily lives. Yet the color of the book is not borrowed; it is native and essential. Mr. Wolfe has a very great gift—the ability to find in simple events and in humble, unpromising lives the whole meaning and poetry of human existence. He reveals to us facets of observation and depths of reality hitherto unsuspected, but he does so without outraging our notions of truth and order. His revelations do not startle. We come upon them, instead, with an almost electric sense of recognition.

The plot, if the book can be said to have a plot at all, is at once too simple and too elaborate to relate in synopsis. "Look Homeward, Angel" is a chronicle of a large family, the Gants of Altamont, over a period of twenty years. In particular, it is the chronicle of Eugene Gant, the youngest son, who entered the world in 1900. W. O. Gant was a stonecutter, a strong, turbulent, sentimental fellow, given to explosions of violent and lavish drunkenness, and to alternating fits of whining hypochondria. Eliza Gant, his second wife and the mother of his family, was an executive woman with a passion for pinching pennies and investing shrewdly in real estate. The Gants grew in age and prosperity with the growth of the sprawling mountain town of Altamont.

By 1900 the Gants were firmly and prosperously established in Altamont—although, under the shadow of the father's whining dread of the tax collector, they continued to live as if poverty and destitution lay just around the corner. They kept a cheap, garish boarding house called Dixieland, living their daily lives on the fringe of a world of paying guests whose necessities had to be considered first. Eugene Gant grew from childhood into an awkward and rather withdrawn adolescence, hedged about by the turbulent lives of his family and singularly lonely in the midst of them. Indeed, each of the Gants was lonely in a separate fashion. Mr. Wolfe, in searching among them for the key to their hidden lives, comes upon no unifying fact save that of isolation.

Through the book like the theme of a symphony runs the note of loneliness and of a groping, defeated search for an answer to the riddle of eternal solitude.

Thomas Wolfe

Naked and alone we come into exile. In her dark womb we did not know our mother's face; from the prison of her flesh have we come into the unspeakable and incommunicable prison of this earth. Which of us has known his brother? Which of us has looked into his father's heart? Which of us has not remained forever prison-pent? Which of us is not forever a stranger and alone?

Eugene grew into life hating its loneliness and desolation, its lack of meaning, its weariness and stupidity, the ugliness and cruelty of its lusts. For the rawness and evil of life was early apparent to him—hanging about the depressing miscellaneous denizens of Dixieland, delivering his papers in Nigger-town, growing up in the streets and alleys of Altamont. He found a poignant beauty in it, too—the simple beauty of things seen in youth, the more elusive beauty to be found in books, and later, after his years at college and the death of his brother Ben, the terrible beauty flowering from pain and ugliness. But always there remained in him that loneliness, and an obscure and passionate hunger which seemed to him a part of the giant rhythm of the earth.

"Look Homeward, Angel" is as interesting and powerful a book as has ever been made out of the drab circumstances of provincial American life. It is at once enormously sensuous, full of the joy and gusto of life, and shrinkingly sensitive, torn with revulsion and disgust. Mr. Wolfe's style is sprawling, fecund, subtly rhythmic and amazingly vital. He twists language masterfully to his own uses, heeding neither the decency of a word nor its licensed existence, so long as he secures his sought for and instantaneous effect. Assuredly, this is a book to be savored slowly and reread, and the final decision upon it, in all probability, rests with another generation than ours.

MARGARET WALLACE

MUSIC

January 11, 1920

A TEMPOGRAPHIC RECORD

The orchestra of the Rialto Theatre recently played under the direction of an animated cartoon representing Hugo Riesenfeld with variations—and exaggerations. The performance was decidedly a hit—but something that everyone regarded as comedy. It caused laughter as it was intended to and that was all. William H. Humiston, assistant conductor of the Philharmonic Society, however, believes that a new alliance between music and motion pictures may be formed through the application with serious purpose of the idea employed frivolously at the Rialto. Discussing the subject he says:

"The showing on the screen of an orchestral conductor in action in the person of Hugo Riesenfeld at the Rialto Theatre, with the orchestra following the screen conductor as though he were a living conductor, brings up the question as to how useful such screen pictures could be made. In the case mentioned the screen conductor was photographed from life, but the films were redrawn into cartoons and the emphasis was placed on the comedy. The experiment has been tried, however, of photographing a conductor in addition. The rather inexcusable error was made at first of operating the camera by hand, when the whole value of the reproduction lay in its exactness. The taking film must be run at an exactly uniform rate of speed; and the resulting positive must be run at exactly the same rate. Exactly in this case must be taken in its mathematical sense.

"This would reproduce the tempo of a composition—the tempo of every single bar—and this means every slightest variation in tempo indulged in by that conductor. One famous composer once said that no two measures should ever be taken in exactly the same tempo. This is somewhat exaggerated, though from the standpoint of mathematical exactness it is doubtful if they ever are. But tempo is the one duality in interpretation that cannot be indicated with precision by the composer. Instrumentation, dynamics (loudness and softness) are in the score; the former exactly; the latter nearly so, or enough for practical purposes. But tempo can only be indicated broadly—even metronome marks only indicate the beginning of a tempo; variation—accelerations and retardations and these infinitely finer nuances of tempo that are only prompted by feeling cannot be so indicated.

"There is an item that even the movie machine cannot take into consideration—that is, the size of the sound producing media. This not only means the orchestra, but the auditorium.

A small orchestra in a small hall needs a somewhat quicker tempo to produce the same effect that the larger orchestra in a large hall takes. But it certainly would be interesting to measure the exact details of interpretation—in matters of tempo—of a performance by Nikisch, for example, and if we could have had Wagner's "Ring" as conducted by Hans Richter in '78 what an authority it would be! But the film must be made from a conductor beating time for an actual playing orchestra. There would undoubtedly be a loss of concentration on the conductor's part, if nothing else, if taken from one merely reading the score."

* * *

January 29, 1920

NEW OPERAS AT THE LEXINGTON

MADAME CHRYSANTHEME, lyric comedy in prologue, four acts and epilogue, book in French by Georges Hartmann and Andre Alexandre, from Pierre Loti's story of Japan; music by Andre Messager. At the Lexington Theatre.
WITH: Charles Fontaine (Pierre, Ensign); Hector Dufranne (Yves, Sailor); Edmund Warnery (Mr. Kangourou); Tamaki Miura (Madame Chrysantheme); Anna Corenti (Madame Prune); Dorothy Follis (Oyouki); Jose Mojica (The Lookout); Louis Hasselmans (Conductor).

L'HEURE ESPAGNOLE, a "musical comedy" in one act, libretto in French, by Franc Nohain, music by Maurice Ravel. At the Lexington Theatre.
WITH: Desire Defrere (Torquemada); Yvonne Gall (Concepcion); Alfred Maguenat (Ramiro); Edouard Cotreul (Don Inigo Gomez); Edmond Warnery (Gonzalve); Louis Hasselmans (Conductor).

I PAGLIACCI, drama in two acts, in Italian: words and music by Rugiero Leoncavallo. At the Lexington Theatre.
WITH: Forest Lamont (Canio); Maria Santillan (Nedda); Titta Ruffo (Tonio); Lodovico Oliviero (Beppo); Desire Defrere (Silvio); Gino Marinuzzi (Conductor).

By RICHARD ALDRICH

Yesterday was a day of new things at the Lexington Theatre. The Chicago Opera Company has brought East a whole bagful of novelties, and the first of these were disclosed yesterday at the matinée and evening performances, respectively. In the afternoon, before a small audience. André Messager's opera of "Madame Chrysanthème" was performed, and in the evening Maurice Ravel's "L'Heure

Espagnole" (with Leoncavallo's "Pagliacci.") Both were heard for the first time in New York.

"Madame Chrysanthème" is the work of a musician better known by name to this country than by his works. He came a year ago to the United States as conductor of the orchestra of the Conservatoire in Paris; twenty years before he had been here to conduct his opera of "Véronique" in a Broadway theatre. He has been conductor at the Opéra Comique in Paris, one of the Directors of the Grand Opéras in Paris, and also one of the conductors there, and succeeded to the honorable post of conductor of the Conservatoire Orchestra.

Mr. Messager has not only been greatly admired as a conductor but has been for forty years one of the most fertile composers of operas, opéra comiques, and ballets, most of even his more serious operas being of a rather light and diverting character, among which "Madame Chrysanthème" is to be counted. The best known of them are "Véronique" and "La Basoche." The lists of his works give near a score of operas and half as many ballets.

"Madame Chrysanthème" is founded on the story of that name by Pierre Loti, the libretto having been arranged by Messrs. Hartmann and Alexander. It is said that at the request of the Chicago Opera Association Mr. Messager has made several changes in his opera to "bring it up to date." This opens a new perspective, new vistas of possibilities in the contemporaneousness of opera, of which much might be said, did time and space permit.

But whether "Madame Chrysanthème" is "up to date" or not, as it stands, it must be confessed that there is in it that which leaves a bad taste in the mouth. The librettists have indeed sensed the need for operatic purposes of more sentiment and less of the frankly cynical, and at bottom rather brutal basis of Loti's adventure. They have screwed up the situations into a little greater sentimental tension, as he fits an operatic libretto. The opera might be considered a "Madama Butterfly," with the omission of much of the poetry and pathos and tragic intensity. In "Madame Chrysanthème" the officers of a French warship arriving at Nagasaki make arrangements for the purchase of temporary wives properly authenticated by legal documents, after what we are assured is the Japanese custom. Pierre is provided with one who pleases him by the marriage broker, Mr. Kangourou, and goes to live with her in the house of Mme. Prune—a boarding house, of course. In the opera he is made to have a somewhat warmer interest in his bride than he has in the story, where he loses no opportunity to express his boredom. Pierre has a chum, a married man, Yves—strangely enough, a common sailor—who declines to join in the custom of the Japanese country; but he seems fond of Chrysanthème—fond enough to stir in Pierre a little languid jealousy, for which there is no reason. Finally the ship is ordered off, the officers say good-bye. Madame Chrysanthème shows some mournful regret and intrusts Yves with a letter to give to Pierre after the ship is at sea, telling him that she really loved him. There is no tragic grief, no deception of a trusting young girl, no touching anticipation of regaining the absent husband when

the robins nest again. It is a rather squalid end of a rather squalid little episode.

Messager's music for this is gracious, suave, well written, finely orchestrated—and yet is rather devoid of savor, originality, or power. It may be listened to with a certain amount of pleasure, but without causing the pulse to accelerate or the emotions to be touched in any particular. Music of Messager's is known that has charm, a stimulating feeling for beauty. This is the music of a gentleman and a scholar who had all the resources of the genre at his finger's ends, but simply, just at that moment, had to write without the inner prompting. He has not attempted to introduce the Oriental note, unless perhaps in one or two passages that will hardly attract attention, as the little nuptial march in the first act; and in this he was no doubt wise. There are pleasing and in their way effective solos for the principals, naturally; there are a few choruses; there are some orchestral interludes. None of them finds much lodgement in the listening ear.

"Madame Chrysanthème" was no doubt taken up as a "vehicle" for the art of Mme. Tamaki Miura, the Japanese soprano of the company. Most operas nowadays in the last analysis are put on as "vehicles." It is a very suitable one for her. She is captivating as the Japanese wife, with the grace and quickness, the sinuous movements, the picturesque attitudes that her Occidental companions in Japanese impersonation try in vain to imitate. She has a sufficient command of a voice not of the greatest beauty, and sang with intelligence and expression. Mr. Fontaine as Pierre showed an agreeable tenor voice, a little uneven in quality, and sometimes a little disposed to flat, but with plenty of power, and his impersonation was vigorous and manly. Mr. Dufranne was most sympathetic as Yves, giving distinction by his singing, his fine diction, his skillful acting, to a part of no great prominence. Other parts were acceptably undertaken, and Louis Hasselmans conducted with a sufficiency of routine skill.

The scenic pictures of the performance had unusual interest. They were partly contained in, partly overflowed from, a large frame, surrounded by decorative hangings. The garden and the square in Nagasaki were effectively depicted, and the bridge of the ship, on which the prologue and epilogue are represented, was more accurately represented at the end than at the beginning. There is a Japanese spectacle and ballet in the third act that were carried out with some elaboration.

"L'Heure Espagnole"

In the evening there was a large audience again to witness the presentation of a "double bill," which had features of exceptional interest. It comprised the one-act comic opera, "L'Heure Espagnole," by Maurice Ravel, and Leoncavallo's "Pagliacci," in which Mr. Tito Ruffo appeared as Tonio, it being the first time he has been heard in New York since he was heard in "Hamlet," given by the Chicago-Philadelphia company seven years ago.

"L'Heure Espagnole" is a mirthful and in some ways exceedingly witty production that, up to the present time,

constitutes the entire dramatic baggage of one who has made for himself a leading place among modern French musicians. Ravel is known here chiefly through the music for the ballet "Daphnis et Chloe," his string quartet, some piano pieces and songs; not a long list, but one that has impressed on all who know it his originality in the manipulation of the modern musical material, his capacity for finely wrought detail, his refined feeling for timbres and tonal colors, and the picturesque suggestion in music.

The book of "L'Heure Espagnole" is by Franc Nohain and is what the French term "dangerous." It tells of the devices resorted to by Concepcion, the wife of a Spanish clockmaker, Torquemada, to dispose of two lovers, Gonzaive and Don Inigo, who visit her in her husband's absence, and who hide in two grandfather's clocks standing in the shop. These devices involve the moving of first one clock and then the other to her chamber upstairs, and their return to the shop several times, at first empty and then occupied by one or the other of the lovers, who have sought concealment in them, by the lusty and accommodating muleteer, Ramiro, waiting in the shop to have his watch mended. One lover is a poet, more concerned with his verses than with his amours; the other a banker; and they both succeed finally in highly displeasing the lady. She leaves them immured in their respective clocks in the shop, while she invites Ramiro to a tête-à-tête; and they return as the husband enters, who promptly sells the two clocks to their occupants. In a final quintet they address the public on the moral of the occasion.

Ravel's score is a tour de force of musical characterization, of amusing employment of musical and unmusical clockworks and cuckoos in the orchestral fabric, of parody on Spanish dance rhythms, and of ingenious and elaborate orchestral effects of a subtle and suggestive sort. He writes naturally in the most modern French idiom, and sets forth little of what the operatic audience will appreciate as melody, a good deal of mordant and acidulous discord.

It is a finely wrought score of subtle ingenuity, with innumerable acutely calculated instrumental effects, often difficult. Such a score needs to bring it all to realization a more skillful and highly trained orchestra than the one that played it last evening, and greater adeptness in the players of certain instruments, on whom exacting demands are made. Perhaps it needs also a firmer and more influential hand in the conductor's chair.

The performance, however, was in many respects adequate. The singers entered with spirit into the comedy. Edmond Cotreul as Don Inigo was new; he showed more address as an actor than beauty of voice. Messrs. Defrère, Maguenat and Warnery were competent, and Miss Yvonne Gall presented a face and figure sufficient to account for the masculine interest shown in her. The final quintet, one of the most musically humorous and effective fragments of the work, was sung with capital spirit and suggestiveness.

In "Pagliacci" Mr. Tito Ruffo dislocated the usual order of things somewhat by making the baritone part of Tonio the centre of attraction, instead of Canio. The enthusiasm, laid in trains throughout the house, smoldering impatiently during Ravel's comedy, was ready to take fire on the mere appearance of Mr. Ruffo before the curtain in the prologue; and did so. So great was the excitement after it that he finally repeated the last part.

Mr. Ruffo's voice, which seems finer than it did on his former appearance in New York, is one of immense power and sonority. It is still young, fresh, and vibrant. It is a voice of rather metallic quality; a voice of bronze till it is forced to its extreme power in the upper tones, when it is as a brazen clarion. And it is needless to say that, things being as they are, Mr. Ruffo neglects few opportunities to emit these powerful tones. They are the sensational feature of his singing, the one that arouses excitement.

Mr. Ruffo's portrayal of the clown is an exceedingly clownish one and has features of this sort that are not familiar here and will hardly commend themselves. It is a violent clownishness; and it may be said that in many places it approaches nearer to a representation of congenital idiocy than has been seen in "Pagliacci" here for some time. But it profoundly impressed certain sections of the audience which were insistent in their applause.

Maria Santillan, the Nedda, who made her first appearance here, displayed a voice of not very agreeable quality and a style not highly finished. Mr. Forrest Lamont was the Canio, and made his own addition to the stentorian features of the occasion.

* * *

February 1, 1920

CLEOPATRA'S NIGHT—Opera in two acts: book in English by Alice Leal Pollock, from Gautier's story; music by Henry Hadley. At the Metropolitan Opera House.
WITH: Frances Alda (Cleopatra); Orville Harrold (Meiamoun); Jeanne Gordon (Mardion); Marle Tiffany (Iras Millo Picco (The Eunuch); Louis d'Angelo (A Roman Office); Vincenzo Reachiglian (The Voice of Mark Antony); Gennero Papi (Conductor).

By RICHARD ALDRICH

The Metropolitan Opera Company, faithful to its purpose of encouraging American operatic composers, encourages this year Henry Hadley by producing his short two-act opera of "Cleopatra's Night." This was performed at the matinee yesterday afternoon for the first time. There was a very large audience, whose presence was assured by the fact that the second part of the bill consisted of "Paglacci," with the participation in it of Mr. Caruso. Thus a double service was done; a large audience was provided for Mr. Hadley and his opera, while the audience enjoyed the new work and then a well tried one.

"Cleopatra's Night" is the tenth American opera given at the Metropolitan Opera House under the present management; and it may be said at once that it is the best of the ten; the most competent, the most skillfully made and the most "viable." Most of these presentations have been made with a lavish outlay for scenery, without stint in the mounting and stage pictur-

ing; they have been carefully prepared with all the pains that are expended upon new productions at this house; in some cases prominent and distinguished members of the company have been cast in them; and, in any event, the performances have been made with a high degree of competence.

That is the case with "Cleopatra's Night." A stage setting of imposing splendor has been provided for it. Mme. Alda, Mr. Harrold and two of the more promising lesser lights of the company, Miss Gordon and Miss Tiffany, have been entrusted with the chief parts. Mr. Papi prepared the ensemble with evident care, with Mr. Setil's assistance in the chorus and Miss Galli's in the dances. The performance was excellent.

Mr. Hadley is known as one of the most proficient and fertile of American composers, and a conductor of experience and skill. Four symphonies, four operas (besides this one), several overtures and other symphonic works as well as many smaller ones, have been composed by him. His orchestral works are familiar, several of them, to New York concert-goers.

The libretto was made by Alice Leal Pollock from the story by Théophile Gauthier. "Une Nuit de Cléopâtre" is one of the minor works of the French romantic, noted for the fiery part he played in the battle of romanticism in 1830 and later, for the historic red waistcoat with which he signalized his appearance at the first performance of Hugo's "Hernani," for books that include "Mlle. de Maupin," "Capitaine Fracasse," "Emaux et Camées," for years of critical activity, dramatic and musical, though his musical knowledge has been more than questioned; "le bon Théo," "Une Nuit de Cléopâtae" is written with the gorgeous descriptive power, the high light of imagination, the faculty of vividly reproducing sensuous impressions in words that made him one of the most notable figures in the literature of his time.

The story appealed to Mr. Hadley in his student days, and when he went to Egypt and saw that portion of the Orient he determined to write an opera with the romance and mystery of Egypt for its background. Gauthier's story was done into English by that other remarkable artist in prose, Lafcadio Hearn, and from it Mr. Hadley's book was made by Mrs. Pollock. She has provided a "practicable" libretto that serves its purpose, but one that it is hard to consort with the names of either Théophile Gauthier or Lafcadio Hearn, so far short of its sources does it fall in literary style and in imagination and poignancy of expression.

Its outlines are slender but vivid. Meiamoun is a chaste lion hunter of the desert, one of many men who fell in love with Egypt's Queen. He shot an arrow entwined with a message telling of his love, which lighted at the Queen's feet as she is preparing for the bath. The young Egyptian follows his message, swimming up through the pool, braving death. His ardor melts her and she yields to it so far as to offer him a single night of royal splendor and love's transports if he will die at sunrise. Seating themselves in the royal barge, they are rowed away to the palace.

There, on the terrace, a banquet is prepared. Cleopatra puts Meiamoun beside her on her throne. When the feast is over and the night is waning, she urges him to accompany her to a hidden temple where they can be alone. He sorrowfully points to the east, where the day is dawning. In a fury of impotence she declares she will shut out the day; for a whole month of darkness shall reign. "The night is still yours—yours but to desire." Proudly refusing, Meiamoun answers, "Naught have you left me to desire." The poison-bearer enters, holds out his fatal goblet to Meiamoun, who takes it, and as he seems to hesitate at Cleopatra's imploring, Antony's horn is heard approaching in the distance. Meiamoun drinks the poison and falls dead. To the messenger from Antony, Cleopatra turns and says imperiously. "Tell him I await him eagerly!" She clasps Meiamoun's body as Antony approaches, then resolutely goes to meet him as the curtain falls.

Mr. Hadley writes as one expertly familiar with the orchestra, and possessing a true feeling for dramatic movement and expression and contrast, and for the emotional current impelled and directed by the dramatic movement. He employs the modern idiom, or idioms. It would be too much to say that this music shows strong originality or powerful individuality. There is much that is effective, much that is well conceived, appropriate to the action and the situation, expressive of emotions of the drama. It is made with ability and competency. But of burning passion, rapturous intoxication, luxurious sensuousness, there is not so much as will possess the listener's senses and transport him in imagination to the Nile banks. There is something of exotic color, but in his use of Orientalism is his music Mr. Hadley has been shrewdly sparing. In the dances of the Greek maidens and the strange desert girls there are fancy and movement. The voices of the two lovers intone sensuous music, insinuating, seductive, passionate, even if it does not always rise to the highest transport nor kindle responsive flame.

Mr. Hadley is not oblivious to the voices that have been raised before him in the musical world in recent years. The voice of Strauss is not to be mistaken; the Strauss of various periods of his career; there are themes and a treatment of them that recall an expert model. The language of the modern Frenchmen and of some of the less modern is not unknown to Mr. Hadley, though he speaks it in more robust tones than some of them. It would not be in the order of nature if the voice of Warner were not heard beneath and through some of this score. A composer stands on the shoulders of his immediate predecessors, and it is not strange to find Mr. Hadley planted there.

Mr. Hadley has a leaning in this music at times for the astringent dissonances, the augmented intervals, and other earmarks of the "modern idiom." These he uses, interspersed with broad and flowing melody of a different cast altogether; for Mr. Hadley has by no means done away with "melody" in an older definition than now sometimes is held. Thus, when the Queen has read the papyrus borne to her by the arrow, she has a long and expressive cantilena to sing, a song quite of another style from what has gone before; and there is something more of the same sort when the lovers speak. Such is the originality and inventiveness of the librettist that the literal burden of both is "I love you."

There are a few themes that are associated with certain elements of the drama. The composer has pointed out the short phrase for clarinet combining "two curious scales" that is easily distinguished very early in the drama and is suggestive of the strange love of the lion tamer. Another may be identified with the Queen. Very likely there are more, but the score is not filled full of "leading motives," and those mentioned are not used as material, out of which to weave the orchestral fabric.

In his writing for the orchestra Mr. Hadley has shown his fine skill and his command of the modern resources, as well as discrimination, a dramatic sense, and appreciation of the fitness of dramatic music. He has not overwhelmed the singers, and he has made it possible for them to sing and be heard and, what is more and much rarer, be understood. His score has variety, depth, color, and significant detail of instrumental effect, and is a pleasure to hear.

The introductory orchestral measures, played after the curtain has gone up on an empty stage, suggests in cursive touches the mood of what is impending. There is an extended intermezzo between the two acts, in which the Oriental atmosphere envelops the languorous passion of the lovers. The dances, first of the Greek and then of the desert maidens, with the bacchanalian close, has Greek serenity and orgiastic fury.

It hardly seemed as if Mme. Alda had been most judiciously cast as Cleopatra. Beautiful as she is, her type, her face, and figure are not such as are most easily associated with the royal Egyptian. She gave, however, a skillful impersonation of the part, and she sang the music brilliantly and with power, except when it lay in the lower ranges of her voice, which are weak and insufficiently under her control.

Mr. Harrold's Meiamoun was in many ways superb. He, too, has not exactly the physical qualifications that seem to be called for, but his singing and his action were both passionate, robust, tender. His voice has rarely sounded more vibrant. But the most miraculous quality of it all was his diction. Here at last was at least one singer in "opera in English" who could be understood and followed. For this the composer's judgment is in part responsible, but Mr. Harrold's beautiful enunciation did for his lines what the composer alone could not do in anything like such measure for the others.

Miss Jeanne Gordon sang well as the Queen's handmaiden, Mardion, enamored of the lion tamer and ready to die when he secures the Queen's favor. But her acting was fussily amateurish. Miss Marie Tiffany had less to do as Iras.

There are two fine scenes in the opera, the first representing Cleopatra's bath, a stately structure with great lotus-capped Egyptian pillars; the second, the terraces of her palace, an expanse of massive wall painted with hieroglyphics, pierced by a great portal from which broad steps descend and through which glows the deep blue of the Egyptian night. Both these scenes are finely designed to represent architectural massiveness and solidity, and are admirable and harmonious in color.

There was cordial applause at the end of each act; how much of it was a matinee audience's friendly manifestation and how much came from a general liking of the opera will be later determined. At the end of the second act, besides the principal singers, Mrs. Pollock, Mr. Hadley and Mr. Papi appeared, and finally Mr. Hadley alone. He made a little speech in which he recalled that Balzac, when he spoke of himself or his work, used to take off his hat. He, Hadley, would take off his hat to Mr. Gatti Casazza for all he had done to make the performance possible, and he expressed warm thanks to all who had taken part in it and in its preparation.

At the popular Saturday evening performance Puccini's trylich, "Il Tabarro," "Suor Angelica" and "Gianni Schicchi," were performed with the singers that have been heretofore heard in them.

* * *

February 24, 1920

THE BIRTHDAY OF THE INFANTA

THE BIRTHDAY OF THE INFANTA, ballet pantomime in two scenes, arranged by the composer from the original story by Oscar Wilde: music by John Alden Carpenter. At the Lexington Theatre.
WITH: Ruth Page (The Infanta); Adolph Bolm (Pedro, the Grotesque); Magit Leerass (Principal Gypsy); Caird Leslie (Juggler); Alexander Oumansky (Tight Rope Walker); Paul Oscardier (Matador).
Gardeners, playmate girls and boys, gypsy dancers, Foreign Ambassadors, Ministers, cook, palace servants, grooms, and guards.
Louis Hasselmans (Conductor).

By RICHARD ALDRICH

For the first time in New York John Alden Carpenter's ballet pantomime, "The Birthday of the Infanta," was presented yesterday afternoon by the Chicago Opera Company at the Lexington Theatre. It was followed by Maurice Ravel's one-act musical comedy, already seen at this theatre, "L'Heure Espagnole." This was a special holiday matinée, given for the benefit of the Society for the Prevention and Relief of Tuberculosis. There was a large and brilliant audience present, and at the largely increased prices, this meant a large profit for the beneficiary.

Mr. Carpenter needs no introduction to New York, where his music in a number of forms has long been known and admired. He has not before undertaken anything of a dramatic character; but his imagination, his fine taste and skill in writing for the orchestra have been so fully demonstrated that something uncommonly beguiling was to be expected from his treatment of this subject.

That subject, which has also been made into a play, is an almost ideal one for such a pantomimic work as this, and for the spirit in which Mr. Carpenter has treated it. It is taken from Oscar Wilde's tale of the same title and has been skillfully arranged by the composer himself, the dances and

scenes being the devising of Adolph Bolm, who also has a principal part in the performance.

The garden of the palace, an interior court, is first shown; gardeners prepare its decorations for the Infanta, who has a birthday, but is not expecting a celebration. She comes forth alone in a delightful expansive scarlet and gold gown such as Velasquez represented, also such a headdress—the costume that is soon more copiously exemplified by other ladies of the court. The Infanta suddenly finds herself surrounded by groups of children and their elders, who come to pay her homage. A procession comes with servants bearing gifts; there is a birthday cake with twelve candles.

The spectacle in honor of the occasion begins when the ladies have taken their places on the terrace. There are gypsy dancers, jugglers, tightrope walkers, a miniature bullfight with a make-believe bull and beautiful banderilleros, matador and picador. Finally comes Pedro, the grotesque, deformed and misshapen. He begins a wild dance; few are interested but the princess, who throws him her scarf. It means more to him than she intended; he takes it as a sign of her love. The spectacle ends; the guests enter the palace, but Pedro is held back by the guards. The curtain falls.

It rises upon a vestibule in the palace just inside the door from which Pedro was barred. He stealthily enters; he sees himself in two tall mirrors, and discovers his ugliness. He begins to dance desperately, in a frenzy till he falls dead of a broken heart. The guests, and finally the princess, come in. She looks at him lying there, requests him to dance again for her; then she discovers that he is dead. She draws away from the body. The curtain falls.

Mr. Carpenter has written music filled with fancy, with fantastic imagination, now grotesque, humorous, now picturesque and brilliant; music of subtly suggested realisms, glittering and shimmering with shifting orchestral colors. He has found exactly the right expression for the story. His instrumentation is light, exposed; often expressive in its timbres, ingenious and skillful in the manipulation of all the modern resources. There is naturally a Spanish note in certain passages, as in the dances; a note suggested rather than too obviously emphasized.

The score is fascinating. It would perhaps be saying too much to say that it is highly original. Mr. Carpenter has copied nobody; but he has heard Stravinsky, especially in his "Oiseau de Feu," and has profited by it. And he has written with brilliant and refined skill, as a master.

The performance was carried through with inimitable grace and expressiveness. Ruth Page as the Infanta was a seductive figure. Adolph Bolm, perhaps more wild than ugly in his appearance, danced with the intensity of expression the occasion demanded, with tragic fury at the end. The several participants in the spectacle gave it variety and picturesqueness and a ceaseless animation.

The mounting was quite worthy of the piece; the costumes richly picturesque, the stage picture appropriate. Mr. Louis Hasselmans conducted the performance with much zeal and effectiveness. There was hearty applause, and after the final curtain, besides the principals, appeared Mr. Carpenter, Mr. Robert Edmond Jones, designer of the scenery and costumes, and Mr. Hasselmans. There was regret that there will be no further repetition of the work in the Chicago Company's season, now coming to a close.

* * *

January 12, 1921

MR. TOSCANINI'S ORCHESTRAL CONCERT

The second subscription concert of Mr. Toscanini's orchestra from La Scala in Milan was given last evening in the Metropolitan Opera House and, as at the first one, the house was filled full and there was demonstration of enthusiastic applause, and even bravos for Brahms, or for Mr. Toscanini's playing of Brahms.

The program began with his second symphony; the one whose selection would seem naturally to commend itself to an Italian conductor. It was a curiously and at times strangely alluring Italianate performance of the work. The orchestra returned to its Opera House tone, in quality and body, after having been heard to its better advantage in Carnegie Hall; and this is one of the facts that must be reckoned with in considering the performance.

Besides a somewhat deliberate opening tempo, there were to be noted all through the symphony that translucent clarity in the exposition of all the voices, that perfect finish of the ensemble and in the turning and the moulding of each phrase, that flexibility of tempo that were to be noted in the previous concerts. Whatever the reading of the symphony may have been, it was quite evident that it was an exact reproduction of Mr. Toscanini's idea of it; that it was played just as he wanted it. Certain portions seemed unsubstantial, lacking in weight, as in the adagio. The feeling of the whole was essentially lyric, and of course, in a way, that is the true character of the symphony. There were certain phrases that you will perhaps never hear played with such a golden concentration of musical beauty. There were others that needed a more rugged statement. On the whole, for all its beauties, the reading of the symphony seemed rather small, short-breathed and over-detailed. But it called forth bravos from M. Toscanini's trusty supporters, and applause from the more soberly musical.

There followed a "Notturno" and a "Rondo Fantastic" by Riccardo Pick-Mangiagalli, composer of "Il Carillon Magico," the ballet now current at the Metropolitan Opera House. The "Notturno" is devised almost in the manner of chamber music, with a constant recurrence of solo passages for many of the orchestra instruments, with delicate color contrasts. The "Rondo" is a much more elaborate piece, of a strongly marked rococo effect for a highly trained virtuoso orchestra such as this.

Albert Roussel's tone poem "Le Festin de l'Ariagnée," heard here some six or seven years ago, played by the New York Symphony Orchestra, is arranged from a pantomime ballet. As a suite, without the picturesque illustration of the

action on the stage, it seems long and not always musically self-sufficing.

Mr. Toscanini repeated what Mr. Mengelberg had played in the afternoon, Strauss's tone poem, "Don Juan." There were here, again, great finish and clarity in the orchestral playing, rhythmic tension, concentrated and burning passion; and something lacking in the mere weight and power of the thing. It had beauty and power, however, which were recognized. Mr. Toscanini ended his program with the overture to Verdi's opera of "I Vepri Siciliani," lest we forget what and whence this orchestra is.

* * *

November 1, 1921

DR. RICHARD STRAUSS CONDUCTS

Carnegie Hall was filled to at least its legal capacity last evening to welcome the return to American concert halls of Dr. Richard Strauss, the celebrated German composer. He had appeared in Carnegie Hall in the Spring of 1904, and returns now, as he came then, chiefly as an exponent of his own works, as an orchestral conductor. He was greeted at his first appearance on the stage with a roar of applause that persisted till he had bowed many times. He is the same tall, slender, upstanding figure that he was seventeen years ago; impassive, immovable in countenance—yet evidently a little moved from his impassivity by the enthusiasm of his greeting—and somewhat grayer at the temples and balder further back.

The program of his first concert comprised three of his symphonic poems—"Don Juan" (which took the place of "Also Sprach Zarathustra," first announced), "Till Eulenspiegel" and the "Symphonia Domestica," which he had brought over with him to New York in 1904 and played for the first time in Carnegie Hall. The orchestra that he conducted was the Philadelphia Orchestra.

The performance throughout was an extremely fine one, the instrument upon which he played is one of the best orchestras in the country, and Dr. Strauss again showed himself, as he had before, to be a conductor of supreme authority, skill and finesse, moulding it to an expression of his wishes with an extraordinary richness and clearness of detail, subtly graded nuance and dynamic variety and suppleness of tempo.

It could hardly be expected of course, that there should be any great new revelations in the three pieces he conducted. The first two, at least, have become some of the most familiar and popular pieces of the modern orchestral repertory, The "Symphonia Domestica," for reasons that have often been discussed, has never taken root in the affections of music lovers and is not likely to, even if all performances of it were so remarkably finished as that of last night. A great elaboration and clarification of detail was one of the outstanding features of the performance; details that have often been buried in the complication of the score were made to gleam through it, and the welter of certain fortissimo passages was suddenly clarified.

Partly, perhaps, as a result of this elaboration of detail, it seemed as if the "Don Juan" had not all the glowing impetuosity and thrilling power that it has sometimes gained from other conductors. On the other hand. "Till Eulenspiegel" lost none of its incomparable verve, and gained an emphasis in certain points of expressive potency that the composer brought out. And it may be said that the much greater complications of the "Symphonia Domestica" were made clearer than perhaps they ever have been before to this public—and that at the same time the essential commonplaceness of the themes, the futility of ingenuity with which they are developed, combined, superposed, intertwined, the pretentious poverty of the whole vast fabric were also and by the same token laid bare.

Dr. Strauss's manner of conducting is that of a master; quiet, self-contained, and apparently almost casual and desultory, till the listener notes how minutely and definitely the significance of each phrase has been calculated; and how broadly and powerfully the whole musical structure is developed. Dr. Strauss makes all his effects through the ear and none through the eye of his listener.

The applause was great after each number; and after the second one there were extensive tributes of flowers laid upon the stage and a wreath tied up with little flags of black, white and yellow.

* * *

December 2, 1921

SCHOENBERG'S SEXTET WINS

Musical Cubist's "Radiant Night," by Boston Symphony, Applauded

That a musical cubist should be jeered and applauded in the same week in New York is the paradox of Schoenberg. Two days ago the Philadelphians had brought his "Five Orchestra Pieces" to be taken less seriously here than in their home town. Last night the Boston Symphony men came to Carnegie Hall, bearing the composer's more youthful "Radiant Night" sextet, Op. 4, which Mengelberg and the National players had given last year, and which had been first heard as chamber music. Whatever the value in its various magnitudes of string constellations, the work was beautifully played last evening, and it was enthusiastically received. Conductor Monteux was recalled and, with his orchestra, applauded.

Sibelius's second symphony also was received with great favor, while Weingartner's orchestral dance to Weber's "Invitation" was much liked, as always it is. After Schoenberg, the concert closed with the benediction of Beethoven's third "Leonore."

* * *

January 6, 1922

"LE ROI D'YS" AT THE METROPOLITAN

LE ROI D'YS, opera in three acts and five scenes; book in French by Edouard Blau; music by Edouard Lalo; At the Metropolitan, Opera House.
WITH: Beniamino Gigli (Mylio); Giuseppe Danise (Karnac); Leon Rothier (The King); Paolo Ananian (Saint Corentin); Millo Picco (Jahel); Rosa Ponselle (Margared); Frances Alda (Rozenn); Albert Wolff (Conductor).

By RICHARD ALDRICH

Another of the new ventures of the management of the Metropolitan Opera Company was launched last evening when for the first time in New York, and for the first time in America outside of the half-mythical French opera of New Orleans, Edouard Lalo's opera of "Le Roi d'Ys" was given. The opera was heard in a production in many ways fine, and engrossed the attention of a large audience that found abundant reason for cordial applause, though that applause apparently seldom rose to the pitch of an overwhelming enthusiasm.

The production of "Le Roi d'Ys" at this time suggests no reckless or improvident haste on the part of the management. It has taken the opera some thirty-three years to reach the stage of the Metropolitan, during which time it has been well seasoned by uninterrupted prosperity at the Opera Comique in Paris and in other institutions abroad. But it had been announced for production here from time to time without tangible result in the jaunty manner of the operatic impresarios of other days. It may be said that the freshness and bloom of youth is no longer upon its countenance.

The French music of thirty-four years ago was a very different thing from what it is today. The Wagnerian influence was then strong upon French composers, perhaps at its height. Lalo was thought in those days to have a strong leaning toward Wagner. He was spoken of quite as a matter of course by some of his conservative compatriots as "at the head of our most ardent, most advanced and most uncompromising Wagnerites." It was said that in "Le Roi d'Ys" he had made a practical application of the extravagant principles that he maintained in theory.

The charge of "Wagnerism" was habitually brought against any who departed from the traditional methods of the French opera, and especially against any who had a predilection for the orchestra and who wrote for it with any skill and success. Now, Lalo had been known before "Le Roi d'Ys" was heard of as a symphonist, and by some it was considered not only to disqualify him for operatic composition but also, when his opera was produced to be a certain evidence of his "Wagnerism."

In a way, no doubt, Lalo had submitted to this influence; but it seems strange today that "Le Roi d'Ys" was ever thought to be "Wagnerian" in its musical substance. It seems peculiarly and characteristically French. In so far as it denotes the abandonment of the old-fashioned recitatives and arias and set divisions of "numbers" in favor of the freer and more logical treatment of the lyric drama, it no doubt shows that Lalo, in common with most others of his day and generation, had been tarred with the Wagnerian stick.

There are now and then odd little reminiscences that will strike the observant listener more with amusement than with any sense of Lalo's plagiarism—a measure or two that seem to start off into the "Tannhäuser" overture; another measure of two that can hardly be restrained from launching into Weber's "Invitation to the Dance." But they are wholly inconsequential—as inconsequential as most of the bags of the reminiscence hunter usually are.

There is much in "Le Roi d'Ys" that is vigorous and alive today. The libretto is effective in a somewhat conventionally operatic way, though there are spots in it of dramatic nullity where the composer can hardly do more than mark time and fill in. The action of the opera is presented in broad and simple lines, without complications and without subsidiary intrigue. It turns upon the jealousy and lust for revenge of a woman infatuated with love, namely Margared, daughter of the King of Ys, for Mylio, a warrior of her father's court, though she is to be betrothed to Prince Karnac.

But Mylio, who has taken ship for foreign parts and is thought to have perished, has given his heart to Margared's sister, Rozenn. As the betrothal is about to take place Mylio returns, and Margared publicly refuses to wed Karnac, who thereupon, justly enraged, throws down his gauntlet at the King's feet.

In the war that follows Mylio gains the victory, and the defeated Karnac meets Margared after the battle at the chapel of St. Corentin and conspires with him for revenge. She takes her revenge by giving him the key to the sluices which protect the town of Ys from the inroads of the sea. He opens them and the tide rushes in. As the town and its people are on the point of being submerged Margared is stricken with remorse and throws herself into the sea. St. Corentin, the patron saint of Ys whom Margared and Karnac had affronted in their conspiracy on the rocky coast before his shrine, accepts the sacrifice of her life; the sea rolls back and the town is saved.

This is a retelling of a Breton legend which is said to appear in various forms in the folklore of other branches of the Celtic people, the Irish and the Cornish, but which has been considerably modified and simplified with the chartered libertinage of operatic librettists, for use as an operatic libretto by Edouard Blau. There are pages by which more than by Lalo's music, something of "Lohengrin" is involuntarily suggested to the listener. He is reminded of Telramund by the gloomy and defeated Karnac; of Ortrud by the passionate and vengeful Margared. There is even a herald. The nocturnal plottings after the battle and the appearance of the pair together as the wedding procession has entered the chapel can hardly fail to recall the similar scenes in Wagner's opera, in mood and suggestion, even though the resemblance is hardly more than superficial.

Music by Lalo is well known in the New York concert halls. The overture to this opera—played in the performance not at its place in the beginning but in two intermissions

between the first and second acts in order not to "waste" it on mere early comers—has long been a familiar number on orchestral programs, considered a strong representative of the French music of its period. His "Symphonic Espagnole" is an indispensable part of the repertory of the violin virtuoso, and his violin concerto, in the more usual form, has been often played. Other of his orchestral works are not unknown.

In this opera, as in those pieces, Lalo's music is of strong fibre, vigorous and picturesque rather than subtle. One of its admirable qualities comes from the composer's gift of significant characterization in the music he allots to and throws about his characters. He can write pregnant and warmly felt melody. Thirty-three years ago such melody was not so much in disfavor as it is now, and it probably never occurred to Lalo to hide or disfigure his melodic gifts. The overture, of the type made familiar by Weber, giving a résumé of some of the important material used in the opera, reveals much of this melodic quality.

It was natural that in treating a Breton legend, Lalo should turn to the Breton folksong; and he has made admirable use of a few Breton melodies. The most striking and most beautiful of them is in the nuptial chorus with which the third act opens, and the answering strophes sung by Mylio; a characteristic and full-flavored tune of its type, of which the composer has made delightful use. Likewise of the folk tune character are the strophes that Rozenn sings in the same answering form.

There is another Breton folk tune in the chorus with which the opera opens that has a charming effect.

There are beauties in certain pages of the passionate duet between Margared and Rozenn in the first act, though in others notably in the second act, the passion seems hardly to have translated itself into the music; nor is there the highest exaltation in the scene in which Mylio returns and finds Rozenn, nor in the dramatic scene in which Margared disowns her promise to Karnac and he throws down his gauntlet. There is more in the long and passionate aria with which Margared in the hall of the palace opens the second act. The scene of Margared's meeting with Karnac at night after the battle has an orchestral color suited to the scene and the situation, but the music is not of itself essentially eloquent.

The last act is the weakest, both musically and dramatically. The edge has been taken off redemption through the sacrifice of a woman by both Weber and Wagner. And when Lalo endeavors to depict the scene of horror, the flooding ocean, the terrified crowds, the plunge of the guilty woman, he has few resources left.

In his use of the orchestra Lalo shows richness and color and a general effect of robustness and perhaps an ever-fondness for fanfares of trumpets and other brass instruments which lose some of their effect by their frequency. The choruses are among the finest, most powerful and most skilfully written constituents of the opera. Besides those already mentioned, there are others of splendid vigor.

In fact, the impression produced by the opera if not one of the highest inspiration, is of unfailing skill and success in the disposition and treatment of all the material. The composer writes with understanding and effect for the voices. His treatment of the orchestra is that of one who thoroughly knows its senorities, its colors and contrasts and the orchestra has been given its significant and well calculated functions in the whole.

It may be said that everything in the opera is effective; that it "sounds"; that it is the work of one thoroughly at home in his profession; that it is "well made." It is a work that can interest and even engross the musical understanding as well as the dramatic sense, and the mounting is such as must please the eye.

The performance had many excellent features. Mme. Alda as Rozenn presented a figure not unsympathetic, though hers is not the character in the opera that will evoke the deepest interest in the audience, even through her wholly justified claims to sympathy. Perhaps if Mme. Alda sang with more beauty of tone and mastery of style she would secure more sympathy for the gentle sisterliness of the heroine.

Miss Ponselle presented the turbulent Margared as a dominating personality, full of passion of the robustest sort, and singing with an equivalent turbulence and passion and with no little violence done to vocal beauty. There was great musical value in Mr. Gigli's singing; more restraint and less persistence, in the use of the fullest voice than he has sometimes shown; and in certain passages, as in his air at the opening of the third act, "Vainement, ô bien-aimée," with beautiful refinement of art. But Mr. Gigli will have to "find himself" a trifle more in the part of Mylio if he is to give a convincing picture of that heroic person. He must make him more interesting, more human, more moved by the passions and impulses of a man and a lover. As he presents him Mylio is a rather aloof personage.

There was savagery enough in Mr. Danise's picturesque and vigorous Karnac, the music of which he sang very well. Mr. Rothier added one more to his gallery of kingly portraits with much intelligence and skill.

The scenic pictures of the new opera are made with artistic justice and effectiveness. The terrace of the palace in the first act, the hall in that palace, the wide plain under a murky sky and the chapel of St. Corentin somewhat curiously placed, the castle court—an especially fine effect of architectural solidity and of color—and finally the hilltop above the city where the people have take refuge from the flood, all are well represented, and in accordance with the excellent traditions of the house.

Mr. Wolff conducted the performance with the energy that he has so often shown before, and with similar results in obtaining rapid movement and dramatic vigor. The performance of the overture in its distorted position was exceedingly good, and especially notable for its finish. The audience enjoyed it and gave the tribute of hearty applause. So it did to the principal singers, who were frequently recalled. The chorus had the chance of its life and sang with splendid vigor and fine quality of tone.

* * *

February 12, 1922

WANTS LEGISLATION TO STOP JAZZ AS AN INTOXICANT

KANSAS CITY, Mo., Feb. 11—Jazz music has much the same effect on young people as liquor, and should be legislated against, I. I. Cammack, Superintendent of Schools here, asserted in a speech before 1,000 public school teachers today.

"The nation has been fighting booze a long time," Mr. Cammack said. "I am just wondering whether the jazz isn't going to have to be legislated against as well. It seems to me that when it gets into the blood of some of our young folks, and I might add older folks, too, it serves them just about as good as a stiff drink of booze would do.

"I think the time has come when teachers should assume a militant attitude toward all forms of this debasing and degrading music."

* * *

April 7, 1922

MUSICIAN IS DRIVEN TO SUICIDE BY JAZZ; WOULDN'T PLAY IT, COULDN'T GET EMPLOYMENT

His fellow-lodgers at 124 East Thirty-first Street said yesterday that jazz was responsible for the death of Melville M. Wilson, 72, a musician, who committed suicide Wednesday night. Wilson shot himself with a pistol. Finding that he had not inflicted a mortal wound, he laid the weapon down and inhaled gas through a tube fastened to a jet in his room.

A note, evidently printed with the utmost care, lay beside the chair in which he was found. It read:

"When I am dead notify Harnleys, Akron, Ohio. Melville M. Wilson. I want no funeral service. The Church will please keep its hands off."

Wilson for twenty-five or thirty years had been a 'cello player in various restaurant orchestras in New York. He had taken pride in his work. He lived alone and music was his chief delight. In the mornings before he went to his daily task in a cabaret, the deep wailing tones of his instrument were often heard from his little room on the third floor back.

Then came jazz. The old man revolted. He wouldn't insult his 'cello, he said, nor the old melodies he had played so long and loved so well. Therefore he lost the job he had with a cabaret in Upper Broadway. At first this did not worry him. There would be other places, he thought, where jazz was not the rage and he would find them.

But it was difficult. Jazz was everywhere and no one seemed to have any use for Wilson and his 'cello. He finally found a place in the Bronx, but left it immediately, because, he said, the piano player, who headed the orchestra, succumbed to the lure of jazz.

This was a month ago, and since that time Wilson had been without a job. He was heard Wednesday softly playing old tunes and it was thought he had found work. It was only his farewell, however, spoken through the 'cello.

Frank Orbis, who occupies a room adjoining that of Wilson, smelled gas just before noon yesterday, Patrolman Joseph O'Brien was notified and they found Wilson's body.

* * *

May 14, 1922

'THE DEMON,' OPERA OF RUSSIA, SUNG

Anton Rubinstein's Fantastic Work Produced Here for the First Time

APPLAUD SOLDIERS' CHORUS

Composer's Music Enthralls and His Caucasian Dance Recalls the Most Exotic of Ballets

THE DEMON, fantastic opera in three acts, comprising six scenes, with prologue and epilogue. Book in Russian by Wiskovatov, from the poem of Mikhail Yurevitch Lermontov. Music by Anton Grigorievich Rubinstein. At the New Amsterdam Theatre.
WITH: Nicholas Karlash (Prince Gudal); Nina Koshetz (Tamara, his daughter); Vladimir Svetloff (Prince Sinodal); Gregory Ardatoff (Old Servant); Efim Vitis (Messenger); Barbara Loseiva (The Old Nurse); Jacob Lukin (Demon, the evil spirit); Emma Mirovich (Angel); Michael Fevelsky (Conductor).

Musically, a crescendo of interest marked the Russian Opera Company's first week of native works in their own language, at least half of them unknown, which reached a climax yesterday afternoon when one of two packed houses for the day heard Anton Rubinstein's opera "The Demon." It was sung for possibly the first time here, certainly the first of anything like equal adequacy. Local records and guides to operatic Broadway supplied no previous such occurrence.

Rubinstein in 1872, as a visitor to America, had opened a cycle of fifty years' growing acquaintance with Russia's music, as already mentioned in The Times. He was also then the first of all the great European virtuosi and composers to appear here, followed a generation later by Tschaikovsky, by the French Saint-Saëns and the German Strauss. Remarkable, indeed, would be the absence, if true, of any of his twenty stage works from our theatres during a half century.

A "sacred opera," however, "The Tower of Babel," was given as an oratorio in 1881 by Leopold Damrosch, and actual scenes from it subsequently, at the composer's suggestion. Walter Damrosch gave the first scene with the Symphony and Oratorio Societies Jan. 18 and 19, 1889. Reinhold Herman and the Liederkranz added the third on Jan. 27 of that year, while both the third and fourth scenes were staged at the Cincinnati Festival May 25, 1894, by Theodore Thomas.

In "The Demon" yesterday the name rôle was sung by Jacob Lukin, who had previously appeared only as the villain—a famous Chaliapin rôle—in Rimsky-Korsakoff's "The Czar's Bride." Nina Koshetz, again a guest, not only sang but

danced as the heroine, Tamara. Vladimir Svetloff, following only a minor tenor rôle in Moussorgsky's "Boris," acted the young hero, Prince Sinodal, killed in the first act.

Familiarity has bred respect, rather than the contrary, for still others of the troupe. There were Nicholas Karlash as Prince Gudal, the girl's father; Gregory Ardatoff, stentorian bass, as their old servant, and Barbara Losieva as the old nurse. It was a pleasure to see Efim Vitis, an active chorus man all week, in a modestly named but well-sung part as messenger. Especially it was a pleasure to see Emma Mirovich, sister of the Russian pianist, as the Miltonic good angel of supernatural scenes.

"The Demon" has its demoniac choral prologue, like Boito's "Mefistofele," and its finish like Gounod's "Faust" in angelic tableau. Rubinstein's music throughout enthralls the musicianly hearer, his Caucasian dance of the bride awaiting her slain lover recalling some of the most exotic of the Russian ballets, while yesterday's audience gave its biggest ovation to his Cossack soldiers' chorus, of churchly harmony and basso profundity, sung at a shrine under the night stars of the Caucasus mountains.

The mountain princess's hall was staged in Asiatic simplicity as an open court amid the same snow-capped vista, its stone walls hung with Oriental rugs and shawls. Old-fashioned as is the opera, produced in 1875 at Petrograd and in 1881 as "Il Demonio" at Covent Garden, London, the Russians attempted no illusion of "fade out" views of the amorous Devil himself; he popped in, pursued by red light, lurking ever in the wings of the stage as the devil is supposed to do, despite all the press agents of Hollywood these days.

Lermontov's poetic devil is the poet-librettist himself thinking aloud, suffering from boredom, seeking happiness in a woman's love. Seeing Tamara, a beautiful Caucasian, betrothed to Sinodal, he has the soldier shot by Tartars in the mountain pass to her home. Tamara gets her to a nunnery. The Devil follows, though the Angel would bar the door. When the girl would wed the Devil to reform him, she dies at celestial voices' call.

The poet (1814–41), was a Petrograd cadet and officer of the Guards. To his own and the nation's anger at the loss of Pushkin in 1837, says the Britannica, the young soldier gave vent in a passionate poem addressed to the Czar, "and the very voice which proclaimed that, if Russia took no vengeance on the assassin of her poet, no second poet would be given her, was itself an intimation that a poet had come already."

The Czar of those days seems to have found more impertinence than inspiration in the address, for Lermontov was forthwith sent off to the Caucasus in charge of dragoons. He had been there with his grandmother as a boy of 10, and he found himself at home by yet deeper sympathies than those of childish recollection. The stern and rocky virtues of the mountaineers against whom he had to fight, no less than the scenery of the rocks and mountains themselves, proved akin to his heart; the Emperor had exiled him to his "native land."

* * *

'JAZZ A LA CARTE' HILARIOUS

Musical Art Institute Students Give Burlesque of Their Work

Well known musicians laughed with the students of the Institute of Musical Art at their 1922 show, performed last evening in the crowded hall at Claremont Avenue and 122d Street, where it will be repeated tonight. "Jazz à la Carte" was the new burlesque, enlisting graduates, seniors and "subs." Its music was jointly by Richard C. Rodgers, not unknown to Broadway, and Gerald Warburg, who has written musical pieces for the Junior League. The lines for the lyrics were by Frank Hunter and the satirical plot by Miss Dorothy Crowthers. As stage manager, Herbert L. Fields, son of Lew Fields, also led the dances, while the musical director was William Kroll, winner of this year's $1,000 Loeb prize.

The young players "jazzed" their serious year's work and, amid shrieks of amusement, the classics of great composers. Among those taking part were Cyril Towbin, Robert La Follette, Lillian Gustafson, Nora Fauchild, Janet Beck, Charles McBride, Louis Sugarman, Hyman Wittstein, Jacqueline de Moor, Frank Barber, Omino Bottega, Bernard Ocko, Anna Blumenfeld, Claire Stetson, William Nachman, Jeannette Hall, George Morgan, Hazel Sampson, Robert Norton, David Buttoff, Gladys Briski, Theresa Fayer, Theola Allshesky, Rose Eisen, Lillian Fuchs and Helen Weidinger.

Antonio Scotti, tumultuously greeted, arrived in time for a "Tosca" burlesque in which Mr. Hunter, as Jeritza, introduced his most blood-curdling ballad of "Mary, Queen of Scots." A bobbed-hair ballet made a hit, and so did Mr. Ocko's singing of "What Ragtime Did to Business," Miss Fauchild's of "Waiting," Miss Gustafson's of "Every Time I Think of You" and Miss Stetson's of "My Prince of Wales."

There were impersonations of eight Farrar opera roles, skits on "The Sheik," "White Shadows," "He Who Gets Vamped," "Liliom" and the best liked chorus, "Every Girlie Wants to Be a Sally," not by Broadway's old girls repainted, but by actors, from precocious children to promising future professionals, who put the glow of youth and the training of artists into the show.

* * *

BAN ON JAZZ SACRILEGE

Syncopation of Chopin's "Funeral March" Arouses French Society

By Wireless to The New York Times

PARIS, Nov. 3—The raid of jazz plagiarists on the music of the masters to meet the demands of the dancing craze of Paris has aroused to action the Société des Auteurs et Com-

positeurs. This organization has declared itself the guardian of the rights of authors and composers who have been dead for more than fifty years. In order to protect the works of these artists from the onslaughts of the music pirates they plan a direct appeal to the dance hall musicians of the city. These musicians will be circularized and personally solicited to join in the general refusal to play plagiarized music. If necessary, the organization will resort to the courts.

Chopin's "Funeral March" syncopated to fox-trot time, is the atrocity that has aroused the society to action. Previously Saint-Saën's "Dance Macabre" had achieved a paradoxical popularity by a "blues" twist.

* * *

November 7, 1922

NO OPERA BY RADIO DURING THIS SEASON

Metropolitan Directors Find No Genuine Popular Demand and See No Benefit

RIVALS RACE FOR PRIVILEGE

Two Radio Companies Eager for it—A. T. & T. Official Denies His Company is Applicant

There will be no radio broadcasting of the performances of the Metropolitan Opera Company during the present season, it was announced yesterday by the Metropolitan management. Many proposals have been made by radio companies, but the Directors and officials of the company have not yet been persuaded that there is a genuine popular demand for radio opera or that the reaction would be favorable to performances within the opera house.

"The idea has been taken up time and again," said a representative of the management, "but we can't see where it would be beneficial to opera. There is no chance of anything of the kind at present."

The Radio Corporation of America, the Westinghouse Company and the American Telephone and Telegraph Company were reported yesterday to be in a race to see which could be first in giving opera to the audience of 2,000,000 persons throughout the country who have access to radio receiving devices.

The telephone company was reported to have engaged an armory for operatic purposes and to have decided to wage war against the Westinghouse Company, but both these reports were denied yesterday by Vice President Walter S. Gifford of the telephone company, who said:

"We have made no preparations for giving opera and we are in no conflict with any other radio company. We are developing radio along different lines. We are prepared to sell radio service to any one who has a message to deliver and who wants to hire high-power radio apparatus to deliver it. The other companies are broadcasting for the purpose of increasing interest in radio and in selling radio equipment.

"So far our effort to sell radio service has not been much of a success, but we do not feel that the experiment has continued long enough to show definitely that there is no demand for this kind of thing. Direct advertising by radio is forbidden by the Government, and of course radio would be killed completely if advertisers were allowed to broadcast the news of bargains and the merits of their articles. About the only possible kind of advertising is the so-called 'courtesy business.' A big department store gives a musical entertainment or a newspaper broadcasts, play by play, an account of the football game, and the only benefit they receive is goodwill derived from the announcement the entertainment or report was furnished by them.

"Within limits there may be a field for certain kind of propaganda by radio. The apple men, for instance, might be able to find something interesting to radio to the country during apple week. Cuba, or any other country or resort, seeking to create public interest, might broadcast information about themselves. It would have to be interesting. Nobody wants to listen to anything dull. One of the purposes of our experiment is to find out just what the people like and what will bring them to listening instruments, instead of driving them away from it. A company which is building homes recently used our broadcasting station to tell about Nathaniel Hawthorne. The only advertising was in the fact that they had used the name of Hawthorne for their property. The company informed us that they had sold a house the following day to a radio listener, and some of the listeners wrote in that they had been much interested in the Hawthorne number.

"Aside from the business use of radio, we make an effort to produce the best entertainment possible, and any rumors of conflict between us and other companies may be due to the fact that the program managers of two companies may sometimes try to engage the same attractions for broadcasting."

* * *

November 12, 1922

GRAND OPERA HEARD BY 600,000 ON RADIO

"Aida," Sung by Metropolitan Soloists and Chorus With Orchestra, Is Broadcast

15,000 IN BIG ARMORY

Sounds Reproduced Satisfactorily to an Immense Audience in Radius of 1,000 Miles

Grand opera on the most elaborate scale ever attempted by radio was sent broadcast last night when artists, orchestra and chorus of the Metropolitan Opera Company gave the opera "Aida," in oratorio form, in Kingsbridge Armory, the largest armory in the world, where more than 15,000 persons went to enjoy the performance.

"Aida" was given by the Metropolitan singers and musicians in connection with the Armistice Day Musical Festival

in the Bronx. More than 600,000 receiving sets within an area of 1,000 miles were notified in advance that they could "listen in" on the opera if they tuned their receivers on the 450-meter wave length of Station WEAF of the American Telephone and Telegraph Company.

Persons who heard the oratorio as it was broadcast in the Times Square district agreed that the voices and instruments of the Metropolitan were reproduced with great beauty and clearness. No effort was spared by the broadcasters to ensure reproduction of the opera by wireless without distortion.

Engineers of the American Telephone and Telegraph Company spent a week in the armory making their tests. They were handicapped by their inability to hold a rehearsal, but as an alternative they sang themselves in different parts of the huge armory, assured themselves that the average human voice could be reproduced with fidelity and then experimented with a half dozen canaries to make sure that the amplifiers would catch even the elusive bird-like notes of the Metropolitan singers and orchestra.

When the oratorio was begun last night at 8 o'clock the huge armory was filled with crippled veterans, a thousand of whom were invited to attend the performance by Maurice Frank, concert manager, who arranged for the musical festival as the wind-up of the celebration of Armistice Day in the Bronx, and in addition there were hundreds of other veterans, all in uniform, with a special section in the audience set aside for gold star mothers.

The Armistice Day Musical Festival, according to an announcement by Mr. Frank, was arranged as the beginning of a movement to build an academy of opera in the Bronx, where high opera and high-class music of all kinds might be furnished at moderate prices, probably from $1 to $2 a seat, to persons who otherwise would find no chance to go to an opera.

Mr. Frank said he had received wide endorsement of the project, and he pointed out that the bringing of people outside Manhattan into contact with good music would create a greater demand for the best music.

Verdi's opera in oratorio from was given by the full orchestra and chorus of the Metropolitan Opera Company and by the following singers: Mme. Anne Roselle, soprano of the Metropolitan; Mme. Carmella Ponselle, mezzo-soprano; Leon Rothier, French basso of the Metropolitan; Demitri Dobkin, Russian tenor; Giordano Paltrinieri, tenor of the Metropolitan; Paolo Ananian, basso of the Metropolitan; Alfredo Gandolfi, baritone. The orchestra was conducted by Guiseppe Bamboshek, conducter of the Metropolitan, and the chorus was under direction of Giulio Setti, conductor at the Metropolitan.

The American Telegraph and Telephone Company arranged amplifiers on and near the stage in the armory to reproduce the solos and ensemble, and used high-quality wires, such as are employed for transcontinental telephoning, to carry the sounds from the armory to its amplifying station at 24 Walker Street, where other powerful amplifiers were employed before the music was relayed to the broadcasting station of the Western Electric Company atop 463 West Street, to be turned loose into the air.

* * *

January 18, 1923

DARIUS MILHAUD AND HIS MUSIC

By RICHARD ALDRICH

There was a new and strange interest injected into the concert of the City Symphony Orchestra's series given yesterday afternoon in the Town Hall by the participation in it of Darius Milhaud, the French composer, and the performance of some of his works and works of other modern French musicians.

Mr. Milhaud has recently arrived in this country, where he is to spread the gospel of the latest French ideas in musical art. He is a member of the "Group of Six" in Paris, now reduced to five by the secession of one. He appeared yesterday as composer, conductor and pianist. The program included his "Ballade" for piano and orchestra, in which he played the piano part, and his "Serenade," which he conducted. There was other modern French music on the program; Erik Satie's "Two Gymnopédies," piano pieces orchestrated by an admiring Debussy; Arthur Honegger's "Pastorale d'Eté" and the second of Debussy's three "Nocturnes" for orchestra called "Fètes." The program began with Rimsky Korsakoff's "Scheherazade," played in a singularly laborious and unspontaneous manner. It took the place of Berlioz's "Fantastic Symphony," which could not be rehearsed owing to Mr. Foch's illness.

Mr. Milhaud's "Ballade" was the most difficult and problematical of all the modern French music presented; or, say, the worst. The piece seems to be permeated by a Spanish dance rhythm; but there is no "program"; "no connection with words, pictures or colors," as the composer expressed it in the notes which he contributed about his own and other French music. Some of the unregenerate would have added "or music." There are themes, as Mr. Milhaud points out, and even elaborate development of them. But the themes reach the extreme of insignificance and commonplaceness; and their development is equally unimportant. They are presented through a thick haze of discordant harmony, in which the orchestra is playing in several keys at once. As a guarantee of good faith, there is at the very end a perfectly good diatonic scale, up and down.

Mr. Milhaud played the piano part, which as he pointed out in his note, is not a solo but a voice in the orchestra, zealously; but the piece could not be given any importance whatever by any amount of zeal. His other composition is a "Serenade" in three movements; and, as in his account of the "Ballade" he did not hesitate to bring in the name of Bach, so in writing of this one he suggests Mozart as his model in form. It is considerably more like music than the other.

The first and the last movement begins with real tunes of a lively character; there is a suggestion of a fugato in the first— a very short one—and both are carried on into the same

unnecessary ugliness of the discordant harmony resulting from playing in several keys at once. A milder species of this ugliness ends the slow middle movement which begins with a likeness of the theme for English horn in the "Scene in the Fields" of Berlioz's "Fantastic Symphony," announced for this concert and not played.

Erik Satie's "Two Gymnopédies (a word whose meaning is not revealed) are unpretentious and straightforward, hardly seeming to contribute much to that marvelous record of "the whole evolution of modern music" which Mr. Milhaud finds in this composer's work. Nor does Arthur Honegger, in his "Pastorale d'Eté," show any of the horrific adventure that was heard in his "Horatius Triumphans," recently played by the Boston Orchestra here. It is simple, if not limpid, as Mr. Milhaud calls it and goes some way to justify its title.

Among these pieces Debussy's impressionistic and pungently colored "Fêtes" seemed like the work of a towering genius.

Mr. Milhaud, whose appearance as conductor and pianist was unpretentious and unassuming, was hospitably welcomed and his music was politely applauded. There was applause for the other pieces; also a tendency to leave the hall before the end was reached. It did not seem certain that the number of convinced admirers was large, or that their enthusiasm was contagious; or even that the addition made to the knowledge of a new movement was highly significant.

* * *

January 28, 1923

GUEST CONDUCTORS AND STAY-AT-HOMES

By RICHARD ALDRICH

This is a season of "guest" conductors in New York. The term is transferred from the German, but makes fairly good English, and is at least intelligible. A favorite German quotation that German writers seldom fail to use in speaking of such circumstances is taken from "Die Walküre," Act I., in Sieglinde's narration of an incident in her home life: "Gäste kamen und Gäste gingen." The United States seems to be an attractive place for musical guests to come to; one they leave with reluctance.

The orchestral conductors who have come or are coming soon in this capacity have been more numerous recently than at any time since those three seasons of 1903–4, 1904–5, and 1905–6, when the Philharmonic Society was without a regular conductor and filled in the interim by inviting "guest" conductors to direct its concerts—most of them from Europe In the first season, that of 1903–4, the guests were Edouard Colonne, Gustav Kogel, Henry J. Wood (now, as the English would always add, Sir Henry J. Wood), Victor Herbert, Felix Weingartner, Wassily Safonoff and Richard Strauss. The next season, Kogel, Colonne, Safonoff and Weingartner returned and Karl Panzner was added. And in the third guest season came Safonoff and Herbert again, and Willem Mengelberg, Max Fiedler, Ernst Kunwald and Fritz Steinbach. The list is a

distinguished one and the view of the successive celebrities was exciting; more exciting, probably, than healthful for the organization or its audiences.

The present season is less exciting but there will be a number of guests, some of whom have already come. Mr. Albert Coates has conducted and will conduct the New York Symphony Orchestra; and later Bruno Walter, a noted German conductor, will do the same. Mr. Mengelberg is coming again to the Philharmonic, as he has before; and before he arrives there will be just time enough for another Dutch conductor, Willem van Hoogstraaten, to try his hand on the orchestra in one concert. Mr. Enesco began in this city his work with the Philadelphia Orchestra in Mr. Stokowski's absence in Europe, and Darius Milhaud was entrusted with the conducting of his own and other French pieces with the City Symphony. Mr. Stokowski is fulfilling the functions of a guest in Paris and Rome; and Mr. Damrosch has taken a busman's holiday by conducting the Minneapolis Orchestra.

What is gained by the advent of a guest conductor for the New York orchestras; and what, if anything, is lost? Guests are invited usually because they have distinction, a repute for unusual skill and power; or because they are desired to conduct their own compositions, as Richard Strauss and Vincent d'Indy last season. Both of these men, especially the first, are experienced conductors. There is usually a risk in entrusting the conducting of a new composition to a composer who is not a conductor. He may know what he wants; but he often has not the technical skill and authority to obtain it.

But what of the conductors who came to conduct purely as conductors and without any ulterior view upon their own effects in their own works; and what of the orchestras they conduct? There is much interest in the contemplation of the appearance, the personality, the visible methods of a new conductor. There are instant partnerships formed, for and against. Without touching too rashly upon delicate questions, it may be said that female music-lovers are the ones who are the mainstays and bulwarks of the cults for conductors. Some ladies feel so strongly upon the subject that they cannot resist the urge instantly to form, organize and finance a new orchestra for a conductor who has especially roused their admiration or who has persuaded them that he is the one who knows the most secrets of orchestral conducting.

How far a personal equation enters into this elemental impulse it would be difficult to say; it would be even dangerous to attempt to say. But, from time to time in the last twenty-five or thirty years it has been manifested, sometimes with results and sometimes without, but generally costing somebody a good deal of money that might have been spent to better advantage. It is an impulse that never seems to lose its force, any more than the attraction of gravitation. Hence it is still at work.

A conductor gains his highest and best results, supposing that he is in all respects worthy of the trust and confidence reposed in him, by long-continued work with an orchestra. He not only drills it in the more obvious technical sense, he molds it to his heart's desire by continual insistence upon bal-

ancing and adjusting the several choirs; upon producing the quality of tone he requires; upon modeling the kind of phrasing, the proportion and volume of dynamics, the rhythm, the accent, and, in a word, all the more or less intangible things denoted by the word style.

These are not to be achieved in a day or a year, and the finest orchestras and the finest orchestral performances are those that have been evolved by long-sustained labor over a long period of time. What Theodore Thomas did with his orchestra in New York and then in Chicago; what Wilhelm Gericke did with the Boston Orchestra and then what Dr. Muck carried on with the same; what Frederick Stock has done with the Chicago Orchestra and Leopold Stokowski with the Philadelphia Orchestra are some of the things that stand out in the minds of most music lovers.

Richard Strauss is said to have told an interviewer not long ago that there were no good or bad orchestras, there were only good or bad conductors. He had just had several months' experience with the Philadelphia Orchestra, which had been put into his hands as a well-nigh perfect instrument to play on. That experience might reasonably have made him express himself a little differently. He might have remembered his different experience in New York some nineteen years ago, when a very different kind of instrument was put into his hands—an orchestra that he labored over in very many expansive rehearsals and that then broke down in his performance of his "Don Quixote." He might not be so sure that there were only good and bad conductors in a case like that.

The thoroughly organized, long perfected and drilled orchestras of this country are, to be sure, something that "guest conductors" can play interestingly upon. Their members are expert readers; they are expert in catching the meaning and understanding the signs of a new conductor, made familiar at rehearsals; in following and assimilating his wishes. The London players are especially proud of their prowess in this direction. They claim to be the best readers in the world. But their knack in this direction is a substitute for rehearsals. The English orchestral conductors have to be very economical in their rehearsals. But nothing is more certain than that fine performance is dependent upon sufficient and persistent rehearsal.

The most experienced listeners to orchestral performances generally come to the conclusion that, while the powerful personality of an efficient guest conductor can gain from time to time fine and engrossing results with an expertly trained and finished body of orchestral players, it is in the long run the stay-at-home conductor and his results that are the best for human nature's daily food. It is he who makes the orchestra what it is and prepares it for the achievement of "tours de force." He may lose glamour by constant appearance. The outline of his back and the movement of the left arm may not have the thrill of novelty to the more susceptible among his listeners but provided he is the man he ought to be, he is the one to keep the home fires burning. It is not easy to imagine anything more demoralizing than such a constant succession of guest conductors, one for each pair of concerts, as the Phil-

harmonic Society indulged in for three seasons—demoralizing to the organization and in a way to the listeners. But we manage it in a more moderate and sensible way now. All guest conductors now do not think it indispensable that they should conduct Beethoven's Fifth Symphony and Tchaikovsky's Sixth as they did in the hurly-burly of 1903 to 1906 giving the management much trouble to direct their attention to other things. There is still a good deal of insistence on Brahms's Fourth and Liszt's "Preludes," but on the whole things are much better.

But the chief danger of the guest conductor is that he will monopolize attention—he and his methods and mannerisms (if he has any) and his "readings"; that he will divert the mind of the audience from where it belongs, upon the music. The temptation is strong. His stay is generally short and time to show what he can do is fleeting. His pay is generally large and he feels in duty bound to earn it, by doing something, and generally as much as possible, that the plodding stay-at-home never thought of. All this is likely to work against the true interests of musical art.

Nevertheless, because the guest conductor is interesting, exciting and stirring, he is an institution not likely to be put away.

* * *

March 2, 1923

MONA LISA, opera in two acts, with prologue and epilogue. Book in German by Beatrice Dovsky. Music by Max Schillings. At the Metropolitan Opera House.
Characters in Prologue and Epilogue:
Michael Bohnen (debut) (A tourist); Barbara Kemp (debut) (His young wife); Curt Taucher (A young monk).
Characters in the Other Scenes:
Michael Bohnen (Francesco); Barbara Kemp (Mona Flordalisa); Curt Taucher (Giovanni); William Gustafson (Sandro); Carl Schlegel (Pietro); George Meader (Arrigo); Max Bloch (Aleasio); Louis d'Angelo (Masolino); Frances Peralta (Ginevra); Ellen Dalossy (Dianora); Marion Telva (Piccarda).
Artur Bodanzky (Conductor).

"Mona Lisa," by Max Schillings, was given for the first time in America last evening at the Metropolitan Opera House. It is the second of the two new operas that were announced to be given there this season, and its appearance is made according to the schedule. The production was arranged to occur upon the arrival of two new German members of the company, Mme. Barbara Kemp and Mr. Michael Bohnen, who assume the two leading parts in it, having won fame thereby in Germany. It is an opera that concerns them chiefly, in which the other characters are hardly more than subsidiary. They have a heavy burden to carry in it.

Both the two principals showed themselves last evening to be artists of high rank. Their performance in the opera was in nearly every respect superb, and made a deeper impression on the audience than has been made for a considerable time at the Metropolitan Opera House. After the first act, which closes

with a powerful scene, though somewhat long-drawn-out, there was great applause, and Mme. Kemp and Mr. Bohnen were repeatedly and enthusiastically called out. Whatever may be thought of the opera itself, it was clear that they had made a success.

Max Schillings ranks in Germany among the most prominent composers; he is now 55 years old. Not much of his music has ever been heard in New York. The preludes to his earlier operas "Ingwelde" and "Der Pfeifertag," and a symphonic prologue, "Oedipus the King," has been played in years past by the Philharmonic Society. David Bispham used to recite his "melodrama"—verses spoken to musical accompaniment—"Das Hexenlied." Perhaps a few more of his pieces may have been done by other musical agencies. But is must be said that none of them have left any enduring mark.

"Mona Lisa" is not a new work. It was first produced in 1915, and has made no little success in Germany. Of course the heroine is none other than the original of the famous portrait by Leonardo da Vinci, that, as "la Gioconda," has for many years hung in the Louvre in Paris and was mysteriously stolen and restored to that gallery not long ago—the portrait whose waffling smile has intrigued generations of its admirers.

Beatrice Dowsky, the author of the libretto, has imagined a grewsome tale about this lady and her life and experiences in Florence. She is presented in the opera as nearly like the famous portrait in appearance and expression as theatrical skill in make-up and in facial expression could mold her; and no small part of Mme. Barbara Kemp's success has been in achieving this remarkable resemblance.

Mona, or Madonna Lisa, was historically the wife of Francesco del Giocondo of Florence. Any Italian lady of the fifteenth century, for the purposes of an operatic librettist, was unhappily married to a monster of cruelty and had a lover; and this is the starting point of the opera. The lover was Giovanni Salviato, delegated by the Pope to buy a pearl from Giocondo's collection. The jewels are taken from a large cabinet set in the wall, and are shown to and discussed by the assembled company. Mona Lisa recognizes in the papal agent the lover from whom she was parted by her marriage, and the jealous husband is immediately filled with suspicion. Giovanni departs with the others but steals back for a secret interview. But the husband returns unexpectedly and the lover is unable to make his escape in time. Francesco discovers him in the cabinet and immediately pushes to and locks the door. Mocking his tortured wife in a long scene with derisive love-making and a refinement of ironical cruelty in his references to the imprisoned lover whom she knows to be dying, Francesco finally throws the key of the cabinet out of the window to drop into the Arno beneath, and embraces her, fallen senseless, as the curtain drops.

Thus she spends the night; and in the dawn is still lying there, at the beginning of the second act. She is roused by others and her young step-daughter brings her the key of the cabinet which has fallen, not into the Arno, but into her boat. Mona Lisa starts to open the door of the cabinet, well knowing her lover must be dead, when Francesco enters. She very

calmly hands him the key, to his amazement and rage; and by her calmness, as she asks him for some other pearls, makes him think that his vengeance has miscarried. He opens the cabinet to get her the pearls, and as he enters it she crashes the door upon him, shutting him in as her lover had been shut in. A few frenzied words from her and the end comes.

This is the action of the tragedy; but it is represented as being the story told by a young priest of the present day who is showing a couple of tourists, a man and his young wife, over the palace of Giocondo in Florence. As he began his narration, the stage had been darkened, the scene changed and the action unfolded. At the close the stage is again darkened, the scene changed back again, and the tourists are shown taking their leave in modern Florence. Quite unnecessarily the young woman drops a bouquet for the priest as she goes off; and quite as unnecessarily he apostrophizes her passionately as he gathers it up, as "Eve, Magdalen, Bathsheba, temptress." This may have some occult connection with the story he has been recounting, some symbolical significance in connection with it. But it is perfectly inconsequential as far as the story goes and quite superfluous for the audience.

This whole contrivance of making the opera the realization of the story told in the prologue is analogous with the contrivance of the dream in "Die Tote Stadt," that other new German opera that has recently been visible at the Metropolitan. It seems, in fact, needless, and does something at the close to damage the dramatic illusion of what has gone before. Why not have presented it as a mediaeval tragedy standing on its own legs? It is a vivid piece of operatic melodrama, drawn in strong and somewhat garish lines; a libretto of unusual strength and effectiveness, one that in and of itself can hold the listener's attention tense. It supplies not only quick and vigorous dramatic situations but as well a clear and vivid unfolding of emotion and passion, and characters drawn with broad, if rather obvious, strokes.

Mr. Schillings was well served by this literary basis for an opera. It offers great opportunities for a realization of the romantic atmosphere of the Renaissance in Italy; for dramatic music accompanying the stirring incidents, to illustrate character and to interpret the phases of passion and emotion that are disclosed upon the stage.

But the composer seems hardly to have done it full justice in his music. It is difficult to give it any higher place than skillful "Kapellmeistermusik," as the Germans call it; the music of a professional who has learned his business thoroughly. It has in several places dramatic quality and truly expressive power. But it bears traces more of careful calculation and the use of well approved means than a genuine and individual inspiration. This, indeed, seems frequently to lag. The music is lacking in potency, in real expressiveness. There is much in it that is simply dull; and the second act is musically naught.

The composer has follower a post-Wagnerian style in his declamation for the singers; and the general impression of the music, its harmonic sense, is such as to be attributable to the influence of Wagner, with the modification of Strauss. It is at

least without the intention of the newer, bold, bad harmonies of this latter day. Though the orchestral part is frequently thematic, it shows not much strong invention, or much spontaneity in this direction. Much seems the product of thought, of labor. At the decisive moments of the drama it has little to say. At the start, of the second act, for instance, when Mona Lisa disposes of her husband, the orchestra's brief emphasis is made by some emphatic turn upon the xylophone, and this is far from impressive. Its contribution in the emotional passages is not distinguished.

The orchestration is that of a competent practitioner. It, too, is generally lacking in real distinction or force; though it is not infrequently loud, which is a different matter. The singers are confined to an incessant arioso of not much real significance musically; and in the "strong" scenes they are made to be more rhetorical and explosive than expressive.

The chief interest in the production was the notable interpretation of Mme. Barbara Kemp as Mona Lisa, and, in almost the same measure, of Michael Bohnen as Giocondo, the husband. Both artists are ranked among the finer of the contemporary exponents of the lyric drama in Germany; both showed unusual power in this opera. Both have the skill of dramatic singing, the potent expression of passion and emotion, and both showed remarkable endurance in exceedingly exacting parts.

The remarkable resemblance with which Mme. Kemp is made to represent the lady of Da Vinci's portrait is the most obvious feature of the portrayal; and not only physically, but spiritually. She denotes the character thus represented with repose of manner and with an intensity and poignancy that are equally notable. Her plasticity of pose, her gesture, her subtlety of facial expression that is a summons to pity, all are focussed skillfully upon the portrayal. She showed qualities, in fact, that make her a lyric actress of unusual power and resource. She is a singer of parts, with a voice perhaps not of the most beautiful quality, but possessing emotional and dramatic expression and capable of power. But it will need a further experience in works of a more specifically musical quality to determine what the true value of the voice is.

Mr. Bohnen made a characteristic figure as the Italian nobleman, likewise modeled apparently after some of the Renaissance portraits. He has skill as an actor; alert, active, picturesque—sometimes perhaps a bit too consciously so— he is fully expert in denoting the malevolent nature of the injured husband, ragingly possessed of the desire to injure. He disclosed a voice of uncommonly fine quality, somewhat metallic at times—the metal is bronze—but often of rich color and expressiveness, as well as sonority. His singing is better than that of some Germans lately heard here. He has a power of dramatic declamation, a fitness of the words to the action, that stood him in good stead throughout.

Mr. Taucher was acceptable as Giovanni, the lover, but hardly distinguished, though he did some good singing of a passionate sort. Mr. Meader had an agreeable song to sing in the first act, which he did well, and added the one small touch of humor to an otherwise unrelieved tragedy.

The setting of the drama is confined to the hall of the palace, sumptuously designed and carried out, with a picturesque view of Florence and the surrounding hills through the broad windows. The prologue and epilogue take place in a gallery of a cloister, also effective in its architectural features.

The performance had clearly been prepared with much care and was conducted by Mr. Bodanzky with unflagging zeal and devotion, with great elaboration of the orchestral part, and with as much of the illusion of musical impressiveness and power as could well be given it.

* * *

March 5, 1923

PLAY "FUTURIST" MUSIC AMID MUCH UPROAR

Conflicting Views of International Composers' Concert Expressed in Cheers and Hisses

Modern tone-painters and poets of the International Composers' Guild had some equivalent of an unvarnished hanging day for new music, on which the ink was scarce dry, at their season's third and last concert in the crowded Klaw Theatre last evening. Strong feeling increasingly marked the "futurist" music's progress, a feeling that sent some chattering to the doors, just as it prompted others to stay longer for fair play, or even to sign subscriptions for a third year.

Conflicting views reached a climax when the last piece, a crash of nine brass and fourteen tympani players, by the Guild's founder, Edgar Varese, was encored amid confusion, laughter and hissing.

"Please," shouted Carlos Salzedo, leaping to the stage, "it is a serious work—if you do not like it, go away."

The speaker himself had his innings earlier, when his "sonata," of every strange device known to harpstrings, was played by Marie Miller and accompanied by Salzedo at the piano, to a less divided "ovation."

New songs sung by Lucy Gates included, among three by Lord Berners, a "Du bist wie eine Blume" wherein the titled composer referred to a reputed note of Heine that he had written the poem after seeing "a beautiful white pig." Carl Ruggles's "Toys," a lyric at least comical to the layman, was encored. A string quartet by Bela Bartok, which led the formal program, proved disappointing in view of the Hungarian composer's European reputation. Leo Ornstein, whose piano sonata in more classical manner was well liked, gave with rare humor as his encore a simple theme and variations by Haydn.

* * *

February 1, 1924

'SACRE DU PRINTEMPS' PLAYED

By OLIN DOWNES

To Pierre Monteux and the Boston Symphony Orchestra fell the task, superbly executed, of introducing to the public of this city Igor Strawinsky's "Sacre du Printemps," as the work is most commonly known, last night in Carnegie Hall. This work, which created a riot when it was first performed by Mr. Monteux and the Russian Ballet in Paris in 1913, has been more discussed than any other composition of Strawinsky.

The audience, knowing this and fearing more through the many articles of a descriptive kind which had appeared in the daily press, came prepared for the worst, to listen to the new music. After the first part of the score had come to an end there were a few hisses—whether in indignation or to suppress premature applause was not easy to tell. After the second part had ended it was apparent that a majority had enjoyed themselves. The applause of this majority was long and loud, and to all appearances most sincere. It repeatedly acclaimed Mr. Monteux and the gentlemen of the orchestra.

Misleading things are always said about a work with such a sensational history. Two false impressions had been spread abroad, concerning this music, first, that it was unequaled in ugliness and fearfulness generally, and, secondly, that it was completely unprecedented among Strawinsky's compositions. Both these reports, as Mark Twain would have said, seem greatly exaggerated. The music, filled as it is with a primitive and at times vertiginous energy, has pages of a rare and highly individual beauty. The score is obviously a logical evolution of the style of Strawinsky, following naturally indications contained in "The Fire-Bird" and "Petrouchka." There are a number of passages in "Sacre du Printemps" which could come straight from both these earlier works. In fact, it contains in one place a quotation. almost exact, of the music of the magician Katschei from the "Fire-Bird."

The expression, however, is greatly intensified. It is done principally by means of the force and individuality of the counterpoint, and also by rhythms that have at times a well-nigh hysterical shock and fury. There is the effect of complete abandon of mood and manner in this music. We believe that it is thought and written with the most exact precision, with enormous power and with an uncanny knowledge—prescience—of the capacities of a greatly extended orchestra.

And it is music, not mere sound to accentuate or accompany something done in the theatre. This should be emphasized, as Strawinsky has emphasized it in various statements. "Sacre du Printemps" is not an accompaniment for a ballet. It is the other way round. The ballet was the accompaniment or the representation, after the conception, of the music. Its scenario will serve as a description of the general tenor of the score, which, however, might be fully as well comprehended if it simply bore its general title, "Sacre du Printemps"—

"The Rite of Spring," or, in a more exact translation of the Russian title, "Spring Consecration."

The scene on the stage, when the work is thus performed, is first of dance of youths and maidens in the Springtime, a ceremony of incantation in primitive fashion, with vigorous stamping of the ground. There follow the mock abduction of a maiden; "Spring Rounds"; "Games of Rival Towns"; an old man, a celebrant, who prostrates himself and kisses the earth. In the second part, after an orchestral introduction called "The Pagan Night" there are preparations for the ancient pagan sacrifice of a human victim to Spring; the choice of the victim; her glorification; the "Evocation of Ancestors," the sacrificial act of the victim, who must dance herself to death.

Long before the scenario of the ballet existed, as Strawinsky told Michel Georges-Michel, he had conceived the "embryo-theme" of the score. "As this theme," said the composer, "with that which followed, was conceived in a strong, brutal manner, I took as pretext for developments, for the evocation of this music, the Russian prehistoric epoch, since I am a Russian. But note well that this idea came from the music; the music did not come from the idea. My work is architectonic, not anecdotical; objective, not descriptive construction."

That is the story, and we believe the sincere story, of the musical evolution of this extremely interesting and exciting creation. As far as appraising its ultimate value is concerned, that is a responsibility fortunately visited neither upon audiences nor reviewers of the present. Their responsibility is to react honestly to what they hear, and, in the case of the newspaper man, to record it. The inspiration of this music seems to us profound and genuine. And Russian, which is another sign of its authenticity, since, when a composer speaks most truly, he is most likely to express not only himself but his native land. The Russianism in the music is not superficial. It does not depend upon the use of a Russian folk-song here and there, or some familiar idiom of popular Russian music. It is much more fundamental than that.

What stands out technically and emotionally in this work, and gives it a place significant, as it seems today, in the history of the modern development of an art, is its unprecedented energy, definiteness and power. No orchestra that we have heard throws off such heat, such sonorities, such galvanizing, rhythmical force as this orchestra of Strawinsky.

The remainder of the program consisted of the Mozart "Jupiter" symphony given a performance different in kind but not in standard by Mr. Monteux and his now highly perfected orchestra, and the Sibelius violin concerto, which Mr. Burgin, concert master, was courageous enough to play and interpret with splendid sincerity, expression and fire. His appearance was not the least significant element of a program laden with riches.

* * *

February 13, 1924

A CONCERT OF JAZZ

By OLIN DOWNES

A concert of popular American music was given yesterday afternoon in Aeolian Hall by Paul Whiteman and his orchestra of the Palais Royal. The stage setting was unconventional as the program. Pianos in various stages of deshabille stood about, amid a litter of every imaginable contraption of wind and percussion instruments. Two Chinese mandarins, surmounting pillars, looked down upon a scene that would have curdled the blood of a Stokowski or a Mengelberg. The golden sheen of brass instruments of lesser and greater dimensions was caught up by a gleaming gong and carried out by bright patches of an Oriental back-drop. There were also lying or hanging about frying pans, large tin utensils and a speaking trumpet, later stuck into the end of a trombone—and what a silky, silky tone came from that accommodating instrument! This singular assemblage of things was more than once, in some strange way, to combine to evoke uncommon and fascinating sonorities.

There were verbal as well as programmatic explanations. The concert was referred to as "educational," to show the development of this type of music. Thus the "Livery Stable Blues" was introduced apologetically as an example of the depraved past from which modern jazz has risen. The apology is herewith indignantly rejected, for this is a gorgeous piece of impudence, much better in its unbuttoned jocosity and Rabelasian laughter than other and more polite compositions that came later.

The pianist gathered about him some five fellow-performers. The man with the clarinet wore a battered top hat that had ostensibly seen better days. Sometimes he wore it, and sometimes played into it. The man with the trombone played it as is, but also, on occasion, picked up a bath tub or something of the kind from the floor and blew into that. The instruments made odd, unseemly, bushman sounds. The instrumentalists rocked about. Jests permissible in musical terms but otherwise not printable were passed between these friends of music. The laughter of the music and its interpreters was tornadic. It was—should we blush to say it?—a phase of America. It reminded the writer of some one's remark that an Englishman entered a place as if he were its master, whereas an American entered as if he didn't care who in blazes the master might be. Something like that was in this music.

There were later remarkably beautiful examples of scoring for a few instruments; scoring of singular economy, balance, color and effectiveness; music at times vulgar, cheap, in poor taste, elsewhere of irresistible swing and insouciance and recklessness and life; music played as only such players as these may play it. They have a technic of their own. They play with an abandon equalled only by that race of born musicians—the American negro, who has surely contributed fundamentally to this art which can neither be frowned nor sneered away. They did not play like an army going through ordered maneuvers, but like the melomaniacs they are, bitten by rhythms that would have twiddled the toes of St. Anthony. They beat time with their feet—lese majeste in a symphony orchestra. They fidgeted uncomfortably when for a moment they had to stop playing. And there were the incredible gyrations of that virtuoso and imp of the perverse, Ross Gorman. And then there was Mr. Whiteman. He does not conduct. He trembles, wabbles, quivers—a piece of jazz jelly, conducting the orchestra with the back of the trouser of the right leg, and the face of a mandarin the while.

There was an ovation for Victor Herbert, that master of instrumentation, when his four "Serenades" composed for this occasion were played, and Mr. Herbert acknowledged the applause from the gallery. Then stepped upon the stage, sheepishly, a lank and dark young man—George Gershwin. He was to play the piano part in the first public performance of his "Rhapsody in Blue" for piano and orchestra. This composition shows extraordinary talent, just as it also shows a young composer with aims that go far beyond those of his ilk, struggling with a form of which he is far from being master. It is important to bear both these facts in mind in estimating the composition. Often Mr. Gershwin's purpose is defeated by technical immaturity, but in spite of that technical immaturity, a lack of knowledge of how to write effectively for piano alone or in combination with orchestra, an unconscious attempt to rhapsodize in the manner of Franz Liszt, a naiveté which at times stresses something unimportant while something of value and effectiveness goes by so quickly that it is lost—in spite of all this he has expressed himself in a significant, and on the whole, highly original manner.

His first theme alone, with its caprice, humor and exotic outline, would show a talent to be reckoned with. It starts with an outrageous cadenza of the clarinet. It has subsidiary phrases, logically growing out of it, and integral to the thought. The original phrase and subsidiaries are often ingeniously metamorphosed by devices of rhythm and instrumentation. There is an Oriental twist to the whole business that is not hackneyed or superficial. And—what is important—this is no mere dance-tune set for piano and other instruments. It is an idea, or several ideas correlated and combined, in varying and well contrasted rhythms that immediately intrigue the hearer. This, in essence, is fresh and new, and full of future promise.

The second theme, with a lovely sentimental line, is more after the manner of some of Mr. Gershwin's colleagues. Tuttis are too long, cadenzas are too long, the peroration at the end loses a large measure of wildness and magnificence it could easily have if it were more broadly prepared, and, for all that, the audience was stirred, and many a hardened concertgoer excited with the sensation of a new talent finding its voice, and likely to say something personally and racially important to the world. A talent and an idiom, also rich in possibilities for that generally exhausted and outworn form of the classic piano concerto.

Mr. Gershwin's rhapsody also stands out as counter-acting, quite unconsciously, a weakness of the program, that is, a tendency to sameness of rhythm and sentiment in the music.

When a program consists almost entirely of modern dance music, that is naturally a danger, since American dances of today do not boast great variety of step or character; but it should be possible for Mr. Whiteman to remedy this in a second program, which he will give later in the season. There was tumultuous applause for Mr. Gershwin's composition. There was realization of the irresistible vitality and genuineness of much of the music heard on this occasion, as opposed to the pitiful sterility of the average production of the "serious" American composer. The audience packed a house that could have been sold out twice over.

* * *

June 8, 1924

NEW GERMAN PIANO NOW JAZZES UP JAZZ

Quarter-Tone Instrument Makes Mixed Noises Like Ukelele, Banjo and Chinese Piano

BERLIN, June 7 (Associated Press)—New fine points for jazz music will be made possible by the invention by Grotian Steinweg of Brunswick, Germany, of a quarter-tone piano which produces sounds described as a cross between the gliding airs of a ukelele and a banjo and the exotic intervals of a Chinese string piano.

Two pianos, one tuned to standard pitch and the other a quarter tone higher, are connected with a keyboard on which red and brown keys are inserted between the ordinary black and white keys. The playing of this new composite instrument has a fascinating effect, according to persons who have heard concerts given by the inventor. Alois Haba, composer of quarter-tone music, who has been at work on scores of this kind for some time, sees a far-reaching future in quarter-tone music, and regards Herr Steinweg's invention as epochmaking.

At the musical festival in Frankfort-on-Main in June, which will be attended by Germany's best-known musicians, as well as by musicians from various other countries of Europe, the quarter-tone keyboard will have a place on the program. If it finds favor, it is expected it will draw in its wake a revolution in pianomaking.

Not only will the ear have to become accustomed to differentiating between intervals of only a quarter of a tone, but the whole technique of piano playing will be changed.

Women with small hands will be eliminated as pianists, since the new octave will require a greater hand span. The entire mechanism of playing will also become greatly complicated, since there will be one-third more keys.

Musical critics who have heard Herr Steinweg's instrument have reserved judgment on it. They appeared to fear being classed as old timers if they do not fall in with the modern tendency toward the unusual, yet at the same time they admit their ears are not yet educated up to the new invention.

* * *

November 9, 1924

MAGIC OF OPERA'S GOLDEN HORSESHOE

Judge Gary Buys a Box in the Charmed Circle Where Few Sit Privileged

By JAMES C. YOUNG

When Elbert H. Gary paid some $150,000 the other day to the Frick estate for a box in the golden horseshoe his purchase stirred new interest in that magical half circle. No other single spot in New York may compare with this gathering place of the socially great. Every night of the season it holds the fascinated glance of thousands, a rival in color and splendor of the spectacle upon the stage.

The Metropolitan Opera House is New York itself in many ways, and to some at least the golden horseshoe is the opera's reason for being. No other institution typifies the city so well nor in so many changing moods. Especially is it social New York in a brilliant phase. From the day that the city's brave and fair first adorned that bending row of boxes the right of entry has been a privilege belonging to the few. As the mythical Four Hundred constitute the inner shrine of society so the thirty-five parterre boxes in the Metropolitan are the goal of the socially ambitions. The privilege of being a boxholder involves more than money or achievement. Newcomers must receive the seal of acceptance from their neighbors along the tier. It is a court without appeal.

Origin of the Horseshoe

The Metropolitan Opera House really was built to create a golden horseshoe. Any student of times and manners and growing wealth may draw his own conclusions. From the middle of the last century opera had been presented in the old Academy of Music in Irving Place. And it was first-class opera, too, with many celebrities in leading roles. Architecturally, no better theatre ever has been erected in New York.

But the Academy of Music had one outstanding deficiency. There were but nine boxes in the parterre circle. And smart New York could not possibly crowd into those nine boxes. In the seventies, despite hard times, New York society expanded broadly. There was an increasing demand for places at the opera, which had to be met with the so-called artists' boxes, full as comfortable and convenient, but not among the envied nine.

Demand arose for a new opera house. Finally it culminated in the purchase of the Metropolitan site, then away uptown, and plans were drawn for an opera house worthy of a world city. No structure of anything like the same size had been built in America for such a purpose. It was to include every appointment that could be devised for an opera house. Particularly there were to be enough boxes for everybody; in fact, seventy were provided in a double row, one above the other.

New York discussed its new opera house with eager interest. It was a sight of the time to go there on a Sunday afternoon and estimate the progress. By degrees the massive walls

arose, the roof was put on, and interior work begun, while the city held its breath over this great enterprise. Finally it was completed at a cost of $1,500,000

Memorable Opening Night

Then came the night of Oct. 22, 1883, when "Faust" was presented for the first time, with Mme. Christine Nilsson in the role of Marguerite. We may be certain that not one of the boxes was unoccupied. Each of the six chairs in every box must have been used, and doubtless a few more were added. For one thing, the boxholders intended to get their money's worth. Considerable grumbling had resulted when these fortunate ones were asked to pay $1,200 box rent for the first season, with a promise of $600 more if a deficit developed. So the opening night was an occasion not to be missed.

A great crush developed at the three entrances and when the conductor raised his baton at 8:23 P. M. the house was only partly filled. Boxholders struggled in the crowd surging up the grand staircase to reach the coveted horseshoe. Many were delayed until long after the curtain arose, and many more entered late of their own accord.

The dedication of a new opera house is a matter attended by numerous superstitions and natural fears. The opening of the Metropolitan was a great adventure. That same night the Academy of Music also was opened for its usual season, with Colonel James H. Mapleson, an Englishman, in charge. Colonel Mapleson had wrought wonders at the Academy, and offered to the opera going public one of its greatest favorites of all times—Adelina Patti. By way of counterstroke the Metropolitan presented Mme. Nilsson, who had been before the New York public for years and enjoyed a place in its favor equaling, and perhaps surpassing, that held by Patti. The opening of the two operas was a matching of prima donnas in a duel of song.

What a fine sight it must have been to look down from one of those red and gold boxes in the parterre circle upon the crowded auditorium below, and directly upon the great stage. Above, the glided roof gave back the soft light of massive chandeliers, with a Greek bole prominently mingled here and there in the Renaissance architecture. Surely it was a night of nights when the beautiful Nilsson raised her voice in the plaintive role of Marguerite. Henry E. Abbey, impresario of the house, and also from England had done his work well. The performance moved smoothly, the singers were in excellent voice, the audience was responsive.

Nilsson swept along in her winning way, and soon the Metropolitan resounded to the applause that has rung there continuously with every new opera season. The house was a success. Abbey was lionized. But there were complaints about the boxes. Some of those in the upper circle thought themselves singled, although boxes had been drawn by lot and none could be said to have enjoyed favor. Still the second row was held less desirable than the first. And thereby began a rift that was to have later developments.

The Metropolitan was opened sumptuously and its company performed splendidly. But after the first flare of public interest the increasing number of empty seats gave the directors reasons for thought. Abbey had a guarantee of protection against loss up to $60,000. Beyond that figure the risk was his. Colonel Mapleson did not surrender as many had expected. Instead, he presented some amazingly fine opera in the Academy. Patti sang her sweetest. The public veered from one house to the other and not infrequently Mapleson had the best of it.

Heavy Loss for Manager

Before the end of the season Abbey saw a stupendous loss hanging over him. It has been estimated that the deficit ran up to $800,000! Other observers place it at $300,000, a great sum indeed for those times. Whatever the exact figures, Abbey was ruined for the moment and the future of opera in the Metropolitan looked dark indeed. But it had been established by men who were not likely to turn back at the first defeat. These men included James A. Roosevelt, first President of the board, George Henry Warren, Luther Kountze, George Griswold Haven, William K. Vanderbilt, William H. Tillinghust, Adrian Iselin, Robert Goebel, Joseph W. Drexel, Edward Cooper, Henry G. Marquand, George N. Curtis and Levi P. Morton.

In the Summer of 1884 it was a question whether the Metropolitan would be reopened in the Fall. Negotiations abroad had failed to produce an impresario with the means to venture where Abbey lost so much. So the opportunity arose for German opera. At first the idea was rejected forthwith. New York had been accustomed to Italian and French music, especially Italian. It was not likely that the Metropolitan could succeed with German when Mapleson was offering the accustomed bills. But supporters appeared for the German idea and argued that the cheaper seats could be filled with German immigrants then coming to this country. And German opera would be a novelty, marking the Metropolitan with the distinction of something different. Finally, and particularly, it would be cheaper.

Damrosch Backed German Opera

Dr. Leopold Damrosch was the man responsible for introducing the German idea to the directors. Although a physician by vocation he was a musician by choice and he convinced the metropolitan directors that he could win where Abbey had failed. Forthwith there were many orders and great preparations and the Metropolitan went into its second season as a German opera house.

The expected patronage in the cheaper seats developed. But the boxholders complained German opera was not the sort of thing they had associated with the Metropolitan; it was gloomy and tragic and depressing, no matter what might be said of its art. Thus the rift was widened between the boxholders viewpoint and the obvious necessities of the directors. The latter replied that German opera was in a fair way to pay and must receive a trial. So Damrosch went ahead.

The wisdom of this decision was soon proved. The next season of 1885–86 saw the end of Colonel Mapleson at the

Academy and the firm establishment of the Metropolitan. But the boxholders still found fault with the German bills. Now, it was argued, Italian opera could be restored, since competition had been removed. But the Germans enjoyed the prestige of success. The house was going well financially and artistically so much was to be hoped.

From 1887 to 1890 the Germans continued to hold sway and developed their Wagnerian performances to a point which compared well with European productions. Nevertheless the boxholders' opposition endured. There came a day when the Golden Horseshoe was almost deserted. Obviously something had to be done. Abbey returned for the season of 1891–92 with Maurice Grau as a partner. French and Italian opera again held the boards.

Before the new policy dictated by the boxholders could have a full trial an event took place that changed the whole course of the Metropolitan's history and gravely affected the boxholders. This was the fire of Aug. 27, 1892. A match carelessly thrown aside by a scenery painter destroyed the stage and ruined the auditorium. Although such a thing seems inconceivable now, there was no insurance and the owners suffered heavily. Again there was fear that the house might be abandoned. Many of the boxholders, who also were the proprietors, had no heart to re-erect the house. A number of them dropped out of the negotiations. Finally, the building and ground were sold at foreclosure and bought in by some of the more determined spirits.

The New Golden Horseshoe

It reappeared in many ways unchanged from the first interior. But there was one significant difference. The second row of the horseshoe was eliminated. The new Golden Horseshoe had but thirty-five boxes, and each of these belonged to one of the supporters. Thus a box represents a thirty-fifth share in the Metropolitan property, now popularly valued at $7,000,000.

Any one who doubts the city's love for opera should walk around the Metropolitan on a rainy Winter night when the wind is blowing away umbrellas and cutting to the bones of pedestrians. Here is a silent cue, winding about the opera house from the southern side of the Broadway entrance, down the side street and sometimes into Seventh Avenue. No matter how cold the rain and strong the wind, the cue is always there, just before 8 o'clock, patient in its resignation until the standing room seats go on sale at $1 each.

At last comes the word, the cue moves on its weary feet— with three hours of standing ahead—through the broad entrance and finally into the warm house, for a golden evening of music—and a glance at that other golden attraction—the magical horseshoe.

* * *

AN OPERATIC SPECTACLE

SONG OF THE FLAME. A romantic opera, in a prologue, two acts and an epilogue. Book and lyrics by Otto Harbach and Oscar Hammerstein 2d, music by Herbert Stothart and George Gershwin, settings by Josef Urban, costumes by Mark Mooring, book staged by Frank Reicher, dance arranged by Jack Haskell, produced by Arthur Hammerstein. At the Forty-fourth Street Theatre.
WITH: Greek Evans (Konstantin); Tessa Kosta (Aniuta); Dorothy Mackaye (Grusha); Hugh Cameron (Nicholas); Bernard Gorcey (Boris); Phoebe Brune (Tartar); Ula Sharon (Nadya); Guy Robertson (Volodya); Leonard St. Leo (A Dancer); Blanche Collins (Olga); Paul Wilson (Alexis).
Russian Art Choir.

Although "Song of the Flame," mounted last evening at the Forty-fourth Street Theatre, is labeled "a romantic opera," it is frequently quite as much a romantic spectacle, and is perhaps most distinguished for the gay-colored, variegated settings of Josef Urban and the frequent ensemble groups that constantly sweep the stage with the beauty of bizarre costumes and hangings. In spite of the generous quantity of music composed by Mr. Stothart and Mr. Gershwin, some of it pretentious in form and technique, and the generous quantity of singing voices to keep the theatre alive with its rhythms, nothing in the entire production is so striking as the samovar room scene of the final act. On the dance floor of a Parisian cabaret whirls an entrancing ballet, symbolic of Russia's long Winter of adversity and the first flush of vernal peace. As soon as the gleaming white costumes of that number have vanished, two segments of the rear settings part, discovering a Russian choir in the rich trappings of the peasantry. And with perfect attack and enunciation they sing folk-tunes of their vast and youthful land. Rarely does "Song of the Flame" blend the elements of music and scenery so effectively.

To compose a "romantic opera" upon the Russian Revolution of 1917, to fashion a romantic theme upon a frightful social gestation, is perhaps not the quintessence of literary propriety. But the authors of "Song of the Flame" have used the revolution chiefly as a device for crowding the stage with a huge chorus, dressing them in primitive colors and evoking the voice, not of individuals, but of a nation. In the prologue particularly they have made full use of their opportunity. When the curtain first rises, it discloses a scene of hands, all pointed menacingly in one direction—a thrilling symbol of revolution. None of that thrill is lost in the succeeding musical numbers, "Far Away," with theme based on the peasants' lament of a late Spring, and "The Song of the Flame," in which the composers have captivated the mass emotions of the rabble stirred to the pitch of violence.

And although all of the music is not so distinguished as these two opening numbers, and some of it merely fulfills the conventions of musical comedy, the composers frequently express the fullness and superstitious wealth of their

subject matter—"The Cossack's Love Song," for instance, is a rich number—and even the inconspicuous "Woman's Work Is Never Done" blends male and female voices in an imaginative design. Occasionally the elemental rhythms of jazz break out in the easier flow of musical accompaniment. And throughout, the orchestration enhances the beauties of the themes.

In a romantic opera, of course, you expect to find two lovers kept apart by inexorable circumstances—until the final curtain. In "Song of the Flame" that tradition has been preserved. For the rising of the rebellious forces in Russia, which involved arson, rapine and assassination, also divides the communistic Aniuta from her fair, capitalistic Prince Charming, Volodya. And more than that, it gives point to pastoral scenes in Southern Russia, a wanton ball in a palace ("You pack of drunken libertines!" hisses the upstanding hero), the invasion of the peasant mob, who are singing "Song of the Flame" while they brandish their weapons, and finally scenes in a Russian cabaret in Paris where the one-time nobles eke out their frugal existence as common waiters. Many of the incidental humors and embellishments seem ponderous rather than exhilarating and might be omitted to good advantage.

As Aniuta, the Flame Girl whose very nostrils breathe red fire, Miss Kosta has the leading role. Her voice is supple and clear, although none too strong, and she sings her numbers easily. As the merry maid of the pastoral scenes she occasionally overacts with an eagerness that is too expressive. As the masculine revolutionary, and incidental villain, Mr. Evans brings a fine baritone voice to the production. Mr. Robertson, who is romantic lover and tenor at one and the same time, sings his numbers quite as well. As the comedian, Mr. Gorcey of diminutive stature and lisping speech, is agreeable without being funny. Miss Mackaye makes a pleasant flirtatious lass, although her singing voice does not carry above the orchestra.

Inasmuch as "Song of the Flame" exploits group emotions rather than individual, the chief emphasis has been laid upon the chorus. And the Russian Art Choir of fifty-three voices and the American ballet of an equal number of ladies and gentlemen respond well to their opportunities. They cross the stage in varied processions and form ingenious patterns upon successive entrances. The size of the production makes the opera generally heavy. With so much and such splendid equipment "Song of the Flame" might well lend itself to more varied, lighter treatment.

* * *

January 31, 1925

MUSICAL CENTRE IS LIKELY TO SHIFT

Approaching Sale of Carnegie Hall Will Compel Building in Another District

PHILHARMONIC AND OPERA

Directors Will Work in Harmony With a Possibility of Sharing Use of New Structure

With the definite announcement that contracts are being drawn for the sale of Carnegie Hall, discussion was stimulated yesterday in musical circles as to where concerts are to be housed when the building is no longer available.

With both Carnegie Hall and Aeolian Hall sold and certain to be altered to new uses within a few years, and with gossip about a new building for the Metropolitan Opera Company revived, musical interests saw yesterday the possibility of an entirely new centre being created for their activities.

The general opinion was that the new owner of Carnegie Hall would develop the site he has acquired in such a way as to preclude the thought of a permanent home there for large musical enterprises. It was pointed out, however, that Robert E. Simon's statement of his purpose had left the possibility open of so altering the present structure that it might be made to pay as a whole for some years to come without abandoning the auditorium. The prospect of raising the fee for use of the hall was considered.

An Entirely New Problem

It was pointed out that an entirely new problem exists in establishing a new music centre for New York. Structures like Carnegie Hall and the Metropolitan Opera House were built in times when their sites and construction were comparatively cheap.

It is said that Carnegie Hall has never failed to pay a return on the basis of the original investment, in spite of the fact that during the last few years approximately $100,000 was spent in making it conform to new building lines. Last year $15,000 was distributed as a bonus among employees and this was regarded as a sort of profit-sharing gift on the part of Mrs. Carnegie.

But with the new real estate values that have grown around these structures, the hall cannot pay a return on a basis of comparison with other uses to which the site could be put. The opera house, with its larger receipts, can still hold its own, but from an economic standpoint it is a structure entirely inadequate to the great value of the block square site it occupies.

It is believed, therefore, that when a new concert hall is erected music will have to seek a new geographical centre as the theatres have done.

Those who have actively discussed the project of a new concert hall want to keep it below Fifty-ninth Street and not too far west, but there are those who believe they will not be able to realize their inclination in full, but may have to follow the latest trend of the theatres, which long since stepped over

the old boundary of Broadway and has even found its way westward beyond Eighth Avenue.

The Orchestral Societies

The Philharmonic Society is vitally interested in what can be done to replace Carnegie Hall, if it is to be replaced, for that has been the historic home of its activities. The New York Symphony Society, of which Henry Harkness Flagler is the leading guarantor, is only slightly less interested, for it gives some concerts in Carnegie Hall and its official home, Aeolian Hall, is probably on an even more insecure footing than the Fifty-seventh Street auditorium. It has been said by officials of the Philharmonic that there was room in any building plans it might undertake for participation by Mr. Flagler and the New York Symphony.

An interesting sidelight in the discussion yesterday was supplied by those who pointed out that in his total holdings Mr. Simon has a plot approximating in size that of the Metropolitan Opera Company. These persons also emphasized that the Philharmonic Society and the Metropolitan Opera Company had a close connection in that the Chairman of the Philharmonic's Board, Mr. Mackay, is very active in the opera direction and that the Chairman of the Metropolitan Opera Company Board, Otto H. Kahn, is a prominent figure among the directors of the Philharmonic. There are other identifications of personnel, Frederic A. Juilliard, for instance, being President of the Philharmonic Society and a director of the Metropolitan Opera Company.

Boards to Work in Harmony

In view of these facts it was taken as a foregone conclusion that the interests of the orchestra and of the opera would be equally well looked after in the event of changes and in looking for new sites and planning building operations, and that such activities would be planned and carried out in cooperation, each board knowing what the other was doing.

Those who reasoned along these lines saw at least the possibility presented of a combined building operation involving the opera and the orchestra, though the same auditorium could not be used for both, or of the opera making provision for the orchestra in its present home while it moved to a new one.

About a year ago Otto H. Kahn declared in a public address that a new home was needed for the opera which would provide, especially, much larger accommodation for the cheaper seats. He added that he did not think the new structure would be built during the time of the present board.

* * *

April 26, 1925

CRITICAL ESTIMATES CHECKED UP ANEW

By OLIN DOWNES

The scrapbook of a musical season makes useful and entertaining reading, even if the reader is responsible for most of the clippings therein. It may be remarked here that there are writers who profess never to read an article, once written. Why return to the scene of the crime? This writer enjoys reading and re-reading his paragraphs, rolling the ones that please him on his tongue. But it is not only writer's vanity that is gratified by such mulling over of the hastily compiled notes of the season's musical activities; there is a glimpse of the season as a whole and cross-strips of music itself placed in advantageous perspective. The Winter now past is particularly interesting to think about. Articles in these pages have concerned themselves with special phases of it—with the imposing list of "guest" conductors, the Metropolitan Opera season, and so forth. A limited number of statistics have been hurled, and those with a passion for ascertaining how many times "Aida" or "L'Oracolo" have been performed in the season have, we hope, been gratified and not misled by errors, which sometimes have a frightful way of creeping past two and three pairs of eyes on to a printed page. Aside from the statistics, what are the reactions of the season from the standpoint of the individual adventuring among masterpieces?

A great deal of new music was heard. The hearing of new music is as a rule a pleasant occupation, a relaxation, a stimulation to bored ears and tired nerves. First of all, you never know what is going to happen. A concert, of ultramodern music will be a concert of more or less wild and footless experiments. But any one of its compositions may disclose something distinctive, something really new, at least something that invites an expository article. And then, even when nothing of permanent worth is heard, there is the feel of the day in the music. It is a reflex of what and how modern composers are thinking, what they are dreaming and groping for. This feel of things contemporary is very useful, indeed indispensable, for appreciation of the few figures who will emerge from the confusion with compositions of real importance. Not only the greater but the lesser, in fact, the smallest as well as the greatest men of a period must be known. It is the little fellows who toil and spin or "strut their uneasy hour" who are background and index to the accomplishments of the great genius. For a Stravinsky a host of unsuccessful experimenters, for a Debussy or Ravel a hundred Saties. The concerts of the modern music societies in New York are among the most useful of the season's activities. They have also introduced and hastened the recognition of important music.

Among modern works eminently worth a hearing were the "Sette Canzoni" of Malipiero and the "Pierrot Lunaire" of Arnold Schonberg. This latter work was heard for the second time in New York, but was unexplored territory for a majority in the audience. Music by Schonberg of more recent origin did not make a favorable impression at a first hearing. Compositions by Paul Hindemith had a facility and brilliancy which may lead to something more original later on. New music by Stravinsky was heard under the baton of the composer. Most of it proved to be poor, although the piano concerto was in its way a highly exciting composition, an indication, perhaps, of a Stravinsky who may still have something important to say. We were not mightily impressed by Germaine Taillefere's piano concerto, nor are we converted to the effusions of Edgar

Varese. It must be acknowledged that little of the new music heard during the Winter remains with us after a few intervening weeks—very little indeed, that seems truly provocative or that leaves this reviewer with a feeling of uneasiness lest he might have intolerantly condemned a masterpiece.

What he has gained from the season is a series of new impressions and reevaluations of compositions called familiar. Very possibly this is an indication of advancing years and the stagnation of ideas supposed to result from their passing. If so, well and good. If this is conservatism let our friends of the Left make the most of it.

We remember a talk with Dean Pound of the Harvard Law School about the making of laws. It was said to the Dean that law in America, both in the making and the enforcement, was incredibly behind the times. The Dean mildly replied that all good law was behind the times, that very few laws proved advantageous or readily enforceable unless they were at least a quarter century behind the ideas of the more forward-looking citizens of the community!

He proceeded to explain himself. A law, to be a good law, must represent the settled convictions of the community. It went without saying that individuals were done marked injustice, at times, by legislation that was unprogressive and inadequate to their needs. But the greatest good to the greatest majority was accomplished by the law which represented the crystallization of the thoughts and wishes of the population.

Is not the same thing true of music?

Let us by all means hie ourselves to the concerts of ultra-modern music and rejoice in such discoveries and sensations as they provide. Let us each take our pot-shot at the new works. It is a free country, and, although it is not the case, one man's opinion is supposed to be as good as another's. In the course of time the composers of merit will be winnowed out from the chaff of the day and their compositions be given the exhaustive study they deserve. In the meantime the reviews of the new music will be the most impulsive, momentary and unreliable in their character that are written. It should be so. There should be the give and take of contemporaneous feeling about new music. New works should be heard to the accompaniment of shot and shell from as many stations of support and attack as possible. A just valuation of the music is the nearer for that, and the compositions with the stuff in them will inevitably ride out the storm. But the opinions of the more permanent character, and also the point of view from which new music can be most profitably examined, are provided by the study of music of previous periods.

There are two pleasures that an individual who likes music and is curious about it should have. One is the feeling of ground solidifying under his feet, and the other is fresh horizons constantly opening before him. To read an old book when a new one is published is more than the gesture of a reactionary. Provided the new book is read afterward, it can be an excellent background from which to approach the task of criticism.

One reason why there is little perspective in musical criticism and why that work is pursued in such an extremely hit-or-miss, slap-dash way is the fact that our knowledge of music preceding the dawn of the nineteenth century is so very fragmentary. It becomes more fragmentary, less complete and reliable, with every fifty years that we go backward. The average music lover dates the history of music from the time of J. S. Bach, of whom there is still an enormous amount of information to be revealed. The music primers tell us in the main of Bach, Handel, Gluck, Haydn, Mozart, Beethoven and then onward with much more particularity. But this is not telling the half or quarter of music history, and even the composers who receive particular attention are not provided with adequate background.

When one recalls that it has taken a Landowska in the last season to give contemporaneous audiences a true conception of what the performance of a Mozart piano concerto should mean, we have an indication of how utterly ignorant we are of even so recently and comparatively well published a phase of the musical art as this one. Our knowledge of the art, and even of familiar masterpieces, is ridiculously superficial and limited. There is surely no other art in existence, and certainly no science, treated in so amateurish a manner. That is one reason why, after hearing new compositions, this reviewer returns with ever-increasing pleasure to music of earlier periods and composers, and makes a host of discoveries which to him, at least, are instructive. Of these experiences a later article may speak in detail.

Serafin to Conduct "Parsifal"

One of the most interesting events of the present tour of the Metropolitan Opera Company is the designation of Tullio Serafin, the Italian, and a Wagner enthusiast, to conduct the performance of "Parsifal" in Cleveland next Saturday.

Before leaving New York Mr. Serafin said: "I look forward with a great deal of pleasure to conducting 'Parsifal' in Cleveland. I am an enthusiastic lover of Wagner. What musical conductor could be otherwise? I have conducted 'Parsifal' a number of times in Italy and elsewhere, including South America and Paris, as well as the other operas of Wagner. Here in the United States I am known only as a conductor of Italian opera. Of course I love the works of my compatriots, but as a musician I always have been an eclectic. Every real lover of music should be an eclectic. I detest narrow-mindedness, and know two kinds of music—good music and bad music. I have no sympathy with any exaggerated nationalistic propaganda in any art. Art should be world-wide in its appeal; what is beautiful in Italy should be equally beautiful in China or Peru, Vienna or New York.

"Especially is this true of music. We want good music, no matter where it comes from or who composes it. It is not the source but the quality which gives a work of art it's value."

* * *

May 3, 1925

STRAVINSKY AS A "SUPERMAN OF JAZZ" IS LOCAL COMMENTATOR'S VIEW

Writing of "Stravinsky as a Symptom" in The American Mercury, Daniel Gregory Mason speaks first of "jazz." It is not necessary to share his extremely unfavorable view of this popular musical product to enjoy the skill and energy of its employment as a lance with which to pierce the armor of the most famous and fêted of ultramodern composers. "Jazz is the doggerel of music. It is the sing-song that the schoolboy repeats mechanically before he becomes sensitive to refined cadence. It is not, accurately speaking, rhythm at all, but only metre, a monotonous repetition of short stereotyped figures. For precisely this reason is it popular with listless, inattentive, easily distracted people, incapable of the effort required to grasp the more complex symmetries of real music. If I am so dull that I cannot recognize a rhythm unless it kicks me in the solar plexus at every other beat, my favorite music will be jazz, just as my favorite poem will be 'The Boy Stood on the Burning Deck' or its equivalent. . . . I have also the hostility of the dull to all distinction, the desire to pull everything above me down to my own dead level of mediocrity that seems to be a part of my American gregariousness; I can complete my esthetics by 'jazzing up' whatever genuine music may happen to come my way. With Paul Whiteman, in his much discussed jazz concert last year in Carnegie Hall, I can render Chopin indistinguishable from Gershwin, I can reduce Beethoven to terms of Irving Berlin, and, like some perverse tonal Burbank, I can transform MacDowell's 'Wild Rose' into a red cabbage.

"Now if we were to take this formula of jazz—short rhythmic or metrical figures, formally inane but physically pungent, mechanically repeated—and put at its disposal all the resources of modern musical technic, particularly in the matter of complex harmony and tone-color, what should we get? We should get, I think, the so-called ultra-modernist composers, headed by Stravinsky.

The reason we do not usually recognize this curious esthetic kinship, this atavism by which the traits of savage ancestors reappear in neurotic descendants, is that the modernist composers have drawn the red herring of harmony and tone-color across their trail. A page of Stravinsky is so much more sophisticated in technic than a page of Mr. Gershwin that he does not realize that esthetically they are tweedledum and tweedledee. But harmony and tone-color are matters of superfices, not of substance. Take a banal bit of melody, and reduplicate it as many levels as you please, as in the favorite 'parallel dominant ninth' chords of Debussy or the more ferocious dissonant combinations of Stravinsky, and though you lavish upon it all the exotic colors of your jazz band or Stravinskian orchestral palette, it can never become anything but the banal melody it was at first. Harmony and color are only costume; the persons of music are the rhythmed melodies; and dress them as you will, they remain fatally themselves, like the tramp in the story who awoke in the king's palace.

"Well, the Stravinskian melodies are just the jazz tunes over again, more strangely and handsomely dressed. They are the tramp in the king's crown and robes. No doubt the crown is dazzling bright, the robes of iridescent silks and luxurious brocades: Stravinsky is a master of the orchestra. But he is no master of rhythm—rather the slave of metrical formulae. Modern music avoids long living curves of rhythm, and becomes ever more choppy and more mechanical. In Casella and Malipiero, in Ornstein and Prokofieff, in the French Group of Six, even in Debussy and Ravel, we note the same reliance on brief bits and snippets of tune, on stereotyped clichés, and on the ostinato, that degenerate modern grandchild of the savage tom-tom. It is a decrepit, senescent, decadent art that we see about us, slowly dying of hardening of the arteries.

"As we look about a concert hall at the faces of the audience, so little concentrated, so easily distracted, so incapable, apparently, of sequacious thought or feeling can we wonder at the popularity of the most banal and obvious sing-song 'hits' of the day?

"We cannot stand Meyerbeer any longer, though his contemporaries preferred him to Wagner; nor Spohr, though he was ranked above Beethoven in their lifetimes; nor Mendelssohn, so much the popular hero when Schumann was still ignored. In the same way we may suspect that our descendants will find the monotony of Stravinsky's primitive rhythms intolerable. Indeed, some of his contemporaries are beginning to find them so already. Boredom for the popular idol is the beginning of the end. And so Stravinsky may turn out, after all, to have been the superman not of music but only of jazz."

* * *

July 5, 1925

RAVINIA OPERA SEASON OPENED WITH "L'AMORE DEI TRE RE," JUNE 27

By OLIN DOWNES

CHICAGO, June 30—The fourteenth season of Summer opera and concerts in Ravinia Park opened with Montemezzi's "L'Amore dei tre Re" on June 27, as previously stated in The Times. In a season that lasts until Labor Day some thirty operas will be given. They will be given with casts consisting of important singers from the Metropolitan and Chicago Opera companies, in a theatre exceptionally adapted for its purposes, with a chorus selected from those of the opera companies just mentioned, an orchestra of sixty players from the Chicago Symphony, and scenic settings especially contrived for these occasions. They are given under circumstances that have no parallel in America and that oblige me to go back to certain performances heard in European cities in the Summer time to recall performances of a similar nature.

The acoustics of the Ravinia opera house are justly famous. This is a theatre one story high, open at the sides, set in a beautiful spot among the trees. The seats, which sell from $1 to $2.50, in addition to the entrance fee to the park, number 1,500. Outside these seats, and beyond the shelter of

the roof, are about 800 other seats, free to those who pay their dollar admission to the park. Still further outside is free standing room for hundreds more. On the most popular nights not only all of the seats are taken but hundreds stand in circles far outside, to the number of between four and five thousand. The theatre has an uncommonly resonant pine roof; the sound of voices and orchestra carries clear and far. On the opening night this season, which was cold, 1,500 were seated under the roof, these seats having been sold out for the entire first week of performances; 800 were in the free seats, and over 200 stood, a total of 2,500. Montemezzi's opera was given with two artists whose interpretations were of the highest excellence—Lucrezia Bori and Virgilio Lazzari—and two others less distinguished from the critical standpoint, but notable nevertheless—Messrs. Martinelli and Danise. The distinction was one of individual capacities. All the artists ranked high and would be welcomed in internationally known theatres. And certainly from vocal or orchestral standpoints the presentation was far superior to those which most European opera houses offer their patrons, particularly in the Summer time. The Ravinia repertory lacks principally the Wagner operas and such works as "Otello" or "Pelléas et Mélisande"—operas that require special scenic and orchestral resources and perhaps special audiences—to equal in extent and variety that of the most pretentious organizations. There are limitations, of course, to the theatre, such as its comparatively small stage and orchestra pit, &c., but a repertory that ranges from Montemezzi to Flotow's "Martha," given the second night of the season, and including most of the standard works of the French and Italian schools, is one that commands attention and respect. The casts speak for themselves. Following the opening performance of "L'Amore dei tre Re" came that of "Martha," with Tito Schipa and Lazzari for the men, and Florence Macbeth and Ina Bourskaya for the women. The singing of Mr. Schipa was a joy equally to the ear and understanding—or perhaps "sense of style" would be a better term applied to the interpretation of Flotow's music. The audience vainly tried to break the rule against encores. Lazzari showed a capacity for comedy little beneath his qualities as a tragedian displayed the previous evening. A vocal specialist might have taken exception to Miss Macbeth's methods here and there, but she too showed taste, flexibility, considerable tonal charm and the appropriate sentimentality required by the music. Bourskaya was reasonably in the picture. The question of certain of Mr. Hasselmans's tempi and occasional heavy-handedness with the orchestra could be made matter for discussion here or at the Metropolitan or anywhere else. The point is the prevailing standards of the casts and interpretations. Other operas and casts announced for the first week are "Aïda," with Rosa Raisa, Martinelli, Bourskaya, Danise, Rothier; "The Barber of Seville," with Elvira de Hidalgo, Mario Chamlee, Messrs. Rimini, Lazzari, Trevisan; "Faust," with Marie Sundelius, Martinelli, Rothier, Defrère; "Madame Butterfly," with Raisa, Chamlee, de Basiola, formerly with the San Carlo and next year with the Metropolitan, and Bour-

skaya, Poltrinieri, Ananian, &c.; Massenet's "Manon," with Bori, Schipa, Rothier, Defrère.

All this does not surprise music lovers of the Middle West or professional observers or visitors from other parts. But it would surprise many who seldom or never come even halfway West and believe that there are only two operatic institutions of any mark in this country—those which function in New York and Chicago in the Winter time. The Ravinia opera is not, obviously, an individual company. It is an organization made up of artists from other famous bodies, wisely selected and assembled for their work but it is an institution that stands on its feet and is attaining more impressive proportions every year.

The beginnings of this operatic activity were modest and of a relatively superficial nature. Fourteen years ago they gave songs, vaudeville performances, fragments of ballets, with some instrumental music thrown in. But the public interest was engaged and the institution grew. Under the watchful and generous support of Louis Eckstein it has become today one to be reckoned with. Ravinia has within recent time added to its resources studios in which scenery and properties are made especially for this stage. Nor are the efforts to increase the scope of the undertaking confined only to matters musical. This season there has been waged a spectacularly successful campaign against mosquitos, which have been on some days in past seasons an inconvenience that seriously interfered with enjoyment of the music. Ravinia Park, about the theatre, has been absolutely freed of these pests, a proceeding which necessitated the treatment of every stream and damp place for forty acres around, and then a further campaign over a radius of a mile and a half out from this centre. This was not a minor matter. A harrowing tale could be told here of mosquitos on a famous prima donna's back, but discretion forbids. In every respect this institution grows in its completeness and service to the public; and the public responds. In Chicago they think nothing of distances. A mere twenty-one-mile elevated ride to your theatre and a return late at night by the same route on the "opera specials" that the elevated company provides are nothing but a small evening jaunt. This, perhaps, is not unnatural in a city of such enormous lines and areas laid out along the lake front and through the suburbs with a spaciousness that has often been heard of but that without being seen is not to be realized. The attraction is, of course, exceptional, but would surfeited Easterners go so far, even in the Summer, for their opera? Perhaps they would. The distance to the Stadium concerts in New York, however, is a step compared with the journey to Ravinia and back again; while as for Boston—the Boston Opera House, some three miles from the centre of the city, is still regarded as inconveniently remote and on one side of principal communications! Not only the public but the critics too go out to Ravinia.

Finally, there are the physical ease and pleasure in listening as one of an attentive and comfortable audience to music performed in the open air. No longer shall conscience smite us, or the feeling of black guilt pervade us, at the drowsiness that insidiously creeps upon the professional listener at the

end of a heavy day in a New York concert hall. It is surely in large part a matter of ventilation. A few whiffs of good fresh air would do more for the critical consciousness than any Straussian fortissimo. Not in many places is there such listening to music as here in Ravinia, or such genuine informality, earnestness and pleasure in it. And this in the land popularly supposed to be the kingdom of Mr. Babbitt, his cronies, his progeny, his civilization. America has moved musically since the '80s and '90s, and Ravinia tells a different story.

* * *

January 2, 1926

PAUL WHITEMAN'S NOVELTIES

The program given by Paul Whiteman and his great concert orchestra last night in Carnegie Hall had as its major items Deems Taylor's instrumental suite "Circus Day" and George Gershwin's "jazz opera," known as "135th Street," the text by B. G. de Sylva. Both of these works were scored by Ferdie Grofe, who knows at least as much about "jazz" orchestration as any man living, and whose remarkable instrumental combinations were one of the particular triumphs of this concert.

Mr. Taylor's "Circus Day" is amusing and very well composed. It is humorously descriptive music. There are various kinds of descriptive music, some good and some poor. "Circus Day" has wit and invention. "This is not one of the colossal, three-ringed aggregations that travel in special trains," says Mr. Taylor of his fantasy. His circus is a one-ring affair. The admission is a quarter, "but it is worth it"! The small town boy follows the band and enters the big tent. There he sees the bareback riders, the jugglers and clowns; the trained animals, including lions and tigers, seals, monkeys and elephants dancing a waltz; trapeze performers and the maiden who takes the "slide to death," assisted in the one and only manner she should be by the orchestra—namely, the snare drum and the whack of the big drum when she lands. The loping of the horses about the ring and the motions of the jugglers are suggestively conveyed, and in a manner more than the merely ingenious, Mr. Grofe helps Mr. Taylor to make the lions and other animals audible, and this, too, is amusing and indicative of what Mr. Whiteman's instruments and players can do. Mr. Taylor very sensibly had Mr. Grofe instrumentate for him, but Mr. Grofe had material to instrumentate, material clearly conceived and clean-cut in its structure. The result was a composition that accomplished what it set out to do very well.

Mr. Grofe was not less sympathetic and skillful in serving the needs of Mr. Gershwin than he was of Mr. Taylor. The Gershwin score was sketched seven or eight years ago for the musical comedy stage. In performance it takes twenty-five minutes. The scene is a cellar and bar in Harlem in momentary danger of a closing by the police; the characters are negroes, the subject a simple and tragic episode consequent upon "a woman's intuition gone wrong," as a solo singer, al la "Pagliacci," explains.

In the score itself there is excellent material. The writer was fortunate in hearing it rehearsed by orchestra without singers or action. There are not only some good melodies, but certain genuinely dramatic passages, some use of dissonance that is striking and germane to the stage situation, and finally a considerable degree of flexibility and the rudiments of dramatic commentary. More than once Mr. Gershwin breaks up his duple rhythms and employs scraps and fragments in a manner that is free, emotional, theatrical.

Now this may astonish some who listened last night and who felt, perhaps with the writer, that "135th Street" did not on the whole come off. Nor was the music over-effective. But these facts are not inconsistent. What was shown last night was the enormous distance that lies in writing for orchestra and for the set songs and choruses of musical comedy, on the one side, and the writing of significant recitative and an effective libretto on the other. All that is best in a piece which has a subject and an idiom rich in possibilities is in the orchestral score, aside from everything else in the production.

The libretto, if such it can be called, is very poor for its purposes. It is after all only the sketch of a vaudeville act and not the nub of a realistic music drama. There is no centralizing or emphasis of motive. The climax—the shooting of the lover by his girl, gone mad with jealousy—comes without any preparation and is over before the audience has even begun to expect that it will happen. Nor did the comedians come up to the hopes of those who found possibilities in Mr. Gershwin's music. They performed as those doing a vaudeville turn, and not with unconventional or emotional intensity—but then, that would have been hard with the de Sylva lines.

There was also the great disadvantage of a concert platform for what should have been seen on a stage. A few chairs and table, with an apology for a bar, gave no suggestion of the scene described in the libretto. Furthermore, the orchestra was too near the singers; even Mr. Whiteman's control could not keep the instrumental tone as far down as needed for the best good of the vocal parts. As a result even the set melodies failed to reach the audience as they should over the footlights. For all that, there is in this work a potentiality for more than operetta, which is its main importance to Mr. Gershwin. With a properly fashioned libretto he might go far. The cast was that of the first performance last Tuesday night: Joe, Charles Hart; Vi, Blossom Seeley; Tom, Jack MacGowan; Mike, Austin Young; Sam, Benny Fields; Cokey Lou, Francis Howard, and Mr. Whiteman conducting.

* * *

January 13, 1926

NEGRO MUSIC AT COLUMBIA

Paul Robeson and Lawrence Brown Delight Audience of 1,200

Paul Robeson and Lawrence Brown gave a program of negro music before 1,200 members of the Institute of Arts

and Sciences in the McMillin Academic Theatre at Columbia University last night.

"Water Boy," "Li'l David," "Pretty Li'l Gal" and "Didn't It Rain?" were included in a group of folk songs. Among the spirituals sung were "Swing Low, Sweet Chariot," "Bye and Bye," "Stand Still, Jordan" and "I'm Goin' to Tell God All My Troubles." The audience, which taxed the auditorium to capacity, applauded insistently after the program ended. The singers sang "Joshua Fit the Battle of Jericho" as a concluding encore.

* * *

September 26, 1926

SAD, RAUCOUS BLUES CHARM WORLD ANEW

Their Music, as Old as the Hills, Is Working a Weeping, Sweeping Jazz Revolution

By HOLLISTER NOBLE

Blues, raucous blues! Blatant, tender, sardonic, sentimental, poignant or pathetic, this musical medium of modern life has attained the proportions of a phenomenon worth attention. Battles over jazz continue to rage. Ernest Newman, noted English music critic, pronounces jazz "dead from the neck up." Enthusiasts point to its vitality from the waist down. German bands are beseeching Government legislation to bar American jazz bands, which are over-running the Fatherland. Native musicians here lay their troubles to a queer ingredient of popular music called the "blues."

Blues in the original form are vanishing, but their influence has wrought a revolution in jazz and the moans of sad horns and the wails of demoniac saxophones have caught the country's ear until the intelligentsia debate their worth; sponsors of the blues produce erudite anthologies, and sober psychologists ponder the social significance. While they do so, the blues sweep and weep over the world. Zulus in Africa are reported to have retreated before the menacing strains of "The Memphis Itch." A war tribe in the Congo was delighted with the "Rockpile Blues." Park Avenue débutantes, the rural élite of Jackson's Corners, Harlem "creepers," and Birmingham belles languish to the melancholy moans of this blue-tinted jazz.

Whence come these sad strains, and why? The growth and appeal of the blues, with their influence discernible in all jazz today, seems too universal to be dismissed as a temporary triumph of cheap music. By all the signs of the times the blues have brought about the true sophistication of jazz. Jazz, until a few years ago, was blatant, direct, often blind in its outbursts of barbaric rhythms. Today, thanks to the blues, orchestration, scoring and musical content have greatly improved. The blues seem to be a form of healthy repentance, perhaps leading jazz, despite Mr. Newman's forebodings, to higher and better things.

The blues attained early popularity, for in them the public found its beloved broken-hearted clown. Wailing minor thirds and shrieking glissandos, with ghastly grins hinting at secret sorrows and employing glycerine tears, guarantee pleasantly to twang the heartstrings of night club patrons and Main Street Lotharios.

Just as negro spirituals were products of higher forms of human sufferings, so the blues first expressed the tragedies, often trivial, of illiterate negroes, bar-room pianists, stevedores, street-walkers, porters and barber-shop habitués. Convicts, construction gangs, track-walkers and river men contributed their individual blues to the great mass of social songs. The negro blues were poignant and usually built on genuine sorrows. Self-pity was a popular ingredient, as expressed in

Po' boy 'long way from home
Got no where to lay my weary head

or "Got de blues but too down mean to cry."

Other laments were mere desperate. There were dire threats of "Gwine take morphine an' die" and "Gwine lay my head on de railroad track."

The iniquitous boll weevil of Southern cotton fields inspired many mournful blues and this term was often applied to hard-boiled railroad conductors who watched the "rods" and side-door Pullmans for non-paying passengers. A black cat's bone, so valuable in love, was celebrated in many a negro song. The blues were seldom symbols of pure despair. In them there was often a bit of philosophy; were always touches of personality, melancholy exuberance, sly humor—occasionally a touch of beauty near to tears. For the blues, which often captured some spark of the spirituals, first sprang from friendless wanderers, jailed transgressors, lonely souls and forsaken lovers. There were pleas for "Jes' one more chance"; for more pay, more food—and, always, less work. "Learn me to let all women alone" was the fervent plea of one early blues.

Handy Daddy of the Blues

In the jargon of the blues, W. C. Handy, colored musician, born in Alabama, is their own true "Daddy." Since the publication of his "Memphis Blues" and "St. Louis Blues" his authority has been unquestioned. He has recorded scores of blues tunes. Genuine "blues" tunes have been notoriously hard to capture. They changed with localities and shifted with the seasons. Mr. Handy in collaboration with Abbe Niles has recently issued an anthology. The blues were born of work songs, slow drags, pats, stomps, love plaints and all the great mass of social songs evolved by the negro in the varied phases of his life in turpentine camps, on the levees, or in the stokeholds of "river fliers." Some negroes recall blues in existence forty years ago. But 1910 marks the first general acceptance of the term. At that date, like a prophetic rash on the gay face of popular music, there wailed forth a series of "Weary" blues and "Worried" blues and "Blue Monday"

blues, all cast in a direct simple mold admirable for projecting one's troubles in a loud lament.

Suddenly a nostalgia for travel seized upon the blues writers. Every vine-covered cottage below the Mason-Dixon Line became the goal for innumerable songsters. Foreign visitors must have thought the second great exodus was under way. Every one born north of the Ohio seemed to long for Dixie, batter cakes, gin rickeys and mammy. The blues of Texas song writers sobbed for Michigan; Michigan minstrels cried for Alabam'; rock-ribbed New Englanders longed for "deah of Georgiah."

The blues underwent a series of amusing developments. George Gershwin's "I've Got the You Don't Know the Half of It, Dearie, Blues," loosed the tongues of a thousand babbling title writers. Music counters were flooded with lengthy labels such as "Gee, But-I-Wish-I-Had-Known-You-the-Winter-Before-Last-Blues," or "Now-I-Come-to-Think-of-What-You-Told-Me-Not-to-Think-of-Blues."

There was the "Dontcha Remember" epoch; the "Gee, I Want to Be There" era; the "Take Me Back to Alabamy" age and the hot-blooded tunes from the East (Side), which have frightened all genuine sheiks into permanent retirement. More recently we have had the anatomical blues dealing with Red Hot Mamas, Ice Cold Sweeties, Hot Lips, Flat Feet, Blue-Gummed Blues, Broken Rib Blues and Luke-Warm Luke. Jazz and her raucous handmaidens have laid rude hands on every country for material. As a blues character "Mama" seems to have had the hardest time of all. There are blues entitled "Blue Mama's Suicide Wail," "Mama's Prison Yard Blues" and "Mamma's Deathbed Shout."

It is interesting to note the metamorphosis of the blues. Poignant with grief against a background of blasted hopes, they first appeared; but when the real blues and the sad secular songs of the blacks fell into the hands of white arrangers and composers, much of their sincerity and depth of grief vanished. The blues of Tin Pan Alley that moan today through the Main Streets of 10,000 towns have effloresced into far subtler forms and strike far different notes than the poignant strains of the old negro blues. But though the old blues lost much of their emotional power, the white man's prosperity, allied with the rush and turmoil of a new age, has transformed the blues into a valuable leaven of jazz which may yet lift the latter form to a position of dignity.

With white people the grief of the blues has degenerated into sentimentalizing. In a certain sense the blues mark the sophisticated decadence of jazz. The unbuttoned gayety and blare of "Alexander's Ragtime Band" and "The Dark Town Strutters Ball" have become tinged with the pale cast of afterthought. Memory, reflection, vague regrets and other features of the "I-Wish-I-Were, I-Want-to-Be, O, Don't-You-Remember" school are all characteristic of the blues. Once jazz was its own blind, blatant self; but now out of its whirring wheels come, thanks to the blues, wild glissandos, minor thirds, malicious discords, Neapolitan sixths and the moans of saxophones that mirror the mixed emotions of the modern age.

Musical Mirror of the Masses

For the blues provide a long-sought musical medium wherein to mirror the fleeting melancholies and light sorrows of today's masses. The blues reflect admirably the social psychosis of the present age. They sing the sadness of satiety, their hoarse joy is torn with discontent. They shout skepticism, nostalgia, humor, exuberance and all the tinselled brilliance of a Coney Island crowd. They are the blues of after-dinner contentment of blasé youngsters, of well-fed loungers, of temporary solitude, flickering flirtations and the amorous aspirations of drug store dandies.

Jerome Kern's "Left All Alone Again Blues" is filled with the doubtful sorrows of a forsaken spouse. Only Clara Smith, billed as the world's greatest moaner, or one of her talented sisters, could have imparted conviction to this song. The wife's heartfelt sentiments sound a bit specious. Behind their smokescreen sighs, all the forsaken lovers of the modern blues seem to be thumbing the leaves of the telephone directory. Years of solitude faced the dark singer of the old-time blues. But today's solitude is a few hours of mild melancholy, a sigh over last night's party, skepticism over tomorrow's blind date, nostalgia over today's duties.

A wife yearns for her husband, who has gone to town for eight hours. A hundred thousand belles of Main Street, surfeited with the dapper youth of the town, sit in dimly lighted ice cream parlors and long for the strong sweep of desert love. Partings, daily adventures, light sorrows, infidelities of friendship and affection, lugubrious humor—all are merged on a vague, misty, emotional plane marking the aura of the blues.

Humor marks the musical notation of many of these songs. "Tempo in weary" directs one composer over the opening bars. "Tempo di sadness, tempo disappointo, tempo di low down," sigh other directions. Sophisticated, subtle, endless in their efflorescence of conflicting moods and moments, the modern blues mock the stars and wail for the moon, ringing the changes of variable temperaments whirled along a jazz-strewn highway vibrating with the rush and roar of contemporary life. There is often an amusing conflict of qualities, true and false, in the blues. They toast tawdry beauty that is close to crocodile tears. There is a catch in the grief-stricken cry that often turn into a hiccough. For the white man blues are a luxury; their sorrows are shallow and their griefs groundless. Their loudest laments are often filled with unconscious irony.

It is these new complexities of the blues that promise to deliver jazz from the monotonous shackles of foxtrot rhythms. George Gershwin's "Rhapsody in Blue" has become the historical example to which jazz and blues reformers point with pride.

To date the blues as developed in commercial music centres have retained a semblance of genuine grief and emotion. The sentiment of the words is excessively naïve and pretentiously sincere. But the music belies the sentiment. Listen to the sardonic groans, the ironic moans, the cries and haunting minors of a good "blues" specimen. Doubt and pessimism,

long since present in the music of the blues, are already creeping into the words. The lonely damsel, according to the latest blues, may be longing for "you-hoo"; but that absurd tell-tale shriek on the saxophone makes you suspect that she already has half a dozen good telephone numbers revolving in her pretty little head. No matter how yearningly the dephlogisticated tenor with belladonna in his eyes wails to the top box, he has no intention of returning to his vine-covered cottage in Alabama.

In John Alden Carpenter's ballet, "Skyscrapers," given at the Metropolitan Opera House last season, there was a brief but striking illustration of this growth. A group of sorrowing blacks begin with a simple, primitive dirge, which develops into a slow, rhythmic lament. The lament rises to the poignant heights of the spirituals; then subtleties of rhythm and accent creep in; the tempi accelerate; the whole movement is suddenly captured by irresistible rhythms and bursts into the utter abandon of jazz, shot through with the minor moans of a mild "blues." In their present form many blues are mild musical hangovers, following the first exuberant outbursts of ragtime and jazz.

Staid inhabitants of intellectual towers and dwellers in the more rarefied realms of musical esthetics may shudder at the boisterous bellows and discordant groans. But to the victims in the din and dust of the marketplace, here is a flexible medium of expression through which, in the popular manner of the masses, may be expressed in infinite variety the tremendous spectacle of a sprawling continent. This lusty concoction of contemporary music, a blend of ragtime, jazz and the blues, reflects with blaring color and barbaric fidelity the gay, absurd and giddy world of Broadway belles, flivver courtships, straphangers, success slogans, tabloids, chewing-gum customers, Hollywood philosophies, Main Street solitudes and all the more trivial trials and tribulations to which America's amazing population is heir.

* * *

October 10, 1926

OPERA OF THE SOUTH

Previous to the opening of "Deep River" at the Imperial Theatre, the names of Arthur Hopkins as producer and Laurence Stallings as playwright seemed to indicate a dramatic production, awaiting the learned judgment of the newspaper mandarins of theatrical events. By the second act, however, Frank Harling as the composer had taken charge of "Deep River" so completely that the rubric "native opera" seemed reasonably appropriate. Being divided in art, as they are in politics, some of the newspapers dispatched their musical emissaries to enjoy in person and to bewail in print, whilst others abandoned themselves to their theatrical writers. Disappointed in the score, the musical reporters trod softly over the drama; the theatrical reporters, in turn, with the attenuated scores of a thousand musical comedies starving their ears, kept honors even by writing gingerly of the music.

Apparently those who are sufficiently ignorant of both music and drama will find "Deep River" entirely to their liking.

Whatever the truth may be about "Deep River," Mr. Hopkins may be sincerely commended for his enterprise in choosing a native theme for embellished treatment in the theatre. For the one perennial topic of both music and opera is American indifference to American themes. As the producer of "What Price Glory," "First Flight," "In a Garden" and now of "Deep River," Mr. Hopkins relieves himself of all such chauvinistic disdain; and the ill-fated "Buccaneer" of last season had an American flavor, although it never actually walked into these cosmic United States. "Deep River" arranges several vignettes of creole and quadroon life in New Orleans about 1835 with a wisp of story supplying continuity. In an extensive program note Mr. Hopkins discusses the social amenities of the creole "half-world of society," the voodoo worship, the origins of the cabalistic chants represented in the second act and the hostilities between the creoles and Kentuckians. For "Deep River," with its chronicle of fatal duels between Kentuckians and creoles over a quadroon maiden, touches all these historical points.

The second act is devoted entirely to a voodoo meeting with a mixed chorus in the background and the voodoo queen and the quadroon suppliant in the foreground chanting weird incantations. Mr. Hopkins explains that the musical themes and idioms employed in this act are taken from notes made by Lafcadio Hearn and newspaper accounts. Under the circumstances it may be of interest to reproduce verbatim one of Hearn's paragraphs in The New Orleans Item, June 7, 1879:

It may not be generally known to New Orleans readers that at certain secret voodoo meetings still held in this city some weird ditties are sung which musical professors would give worlds to hear. After repeated and vain endeavors to obtain an entrance to one of these strange seances—a privilege which neither love nor money seems able to buy—the writer of these lines finally succeeded in obtaining a private interview with one of the sable priestesses of this black Eleusis, and in persuading her to chant the voodoo incantation under promise of a little pecuniary reward. The chant was well worth its price, being one of the weirdest and strangest performances ever heard by the writer, who had made some study of savage music before. The words, written down phonetically, belong to some *baragouin* known only to the voodoo priesthood, containing vocal sounds not to be found in civilized tongues. The singer professed herself ignorant of their meaning. As arranged according to musical writers, the song appeared to have been composed in short lines like Runic verses; but a musical friend, who accompanied us, confessed himself unable to reproduce the music to which they were sung—a great part of it being characterized by quarters delicate training of the ear to memorize and note down. . . . There are little tones in the commonest roustabout song

which are not to be found in civilized music and which few white throats could reproduce; and yet it is of these fractions of tones that the true negro melodies owe their peculiar wild and melancholy sweetness.

All this may indicate the difficulties as well as the ambitiousness of Mr. Hopkins's project in "Deep River." Considered as drama, however, the production lacks substance and movement; and even the long second act, which is all expressed as music, is so wanting in form and progression that Mr. Harling's score does not save it from tedium. As director, Mr. Hopkins has matched the lassitude of the creole gentlemen with a sluggish performance. Like the Philistines they are, the dramatic reporters suspect this loose, slack motion of being merely good opera. For in music they know only what they like—and very little of that.

* * *

January 2, 1927

OPERAS PLEASANT AND UNPLEASANT

Plots Which Are and Are Not Sanctioned by Public Sentiment— The Metropolitan and 'Musica Prohibita'

By OLIN DOWNES

Alban Berg's "Wozzek," mentioned in these columns a week ago, has frightened the correspondent of an English newspaper, who writes home hinting of things "pathological" which "produced a terribly depressing effect upon the audience"—"an unhappy conception made more repulsive by its introspective treatment," and so forth. This is the year 1927. It may be asked, in the name of all that is absurd, atrocious and inartistic in opera, why this straining at the gnat of "Wozzek" after the camels that opera audiences have swallowed whole during the three centuries of the popularization of the art-form? Are not the plots of most of the operas of the current repertory based upon matters that would be considered "terribly depressing," if not, indeed, "repulsive," if any one took them seriously? Is the subject of Berg's opera any worse, is it as bad, from the standpoints of ethics or decency, as many which make the common fare of the audiences at the Metropolitan?

The hero of Berg's opera is a miserable soldier, put upon by circumstances, cursed with a sensibility greater than his intelligence or his will power, who murders a faithless mistress, and then, in the grip of a hallucination, drowns himself. There are conversations which could be called "morbid," there is the touch of the pathological, and a deep note of pity and tragedy. We speak of the drama. The music has not been heard here, and probably will not be. The drama need not be upheld as a model of beauty or a conception calculated to uplift humanity, but the work has interesting characteristics as an art form, and has been hotly discussed in connection

with the influence of Schönberg and his followers upon the opera.

A few days ago the Metropolitan revived Verdi's "Forza del Destino." In the first act the father of the heroine, Leonora, is shot—accidentally—by her lover. Leonora's brother makes two attempts to kill her lover, before the final catastrophe, when Leonora's lover mortally wounds her brother, and the brother, before expiring, stabs the sister, and the lover is left to reflect upon the power of destiny as the others die. Or there is an alternative ending, sometimes employed, in which the one remaining principal character, after viewing the bodies of his beloved and her brother, his erstwhile bosom friend, goes insane and leaps off a precipice. Some would call this plot depressing, though most of us laugh at it. Verdi, however, took the subject very seriously, and the drama from which he obtained his libretto was typical of many that were performed and applauded in a former day in Europe.

Verdi's most popular operas, if we except the nobler "Aida," have to do with lust, murder, seduction and their concomitants. The story of "Rigoletto" is not a savory one, even omitting the final tragedy in which the hired assassin, whom the Jester has engaged to destroy his daughter's betrayer, stabs the daughter, while the father recoils from the final jest of fate. The incredible and tortuous plot of "Il Trovatore" revolves around such delicate matters as baby-frying, self-poisoning and fratricide. The passion, the lack of humor, the excessive violence of feeling which were characteristic of the younger Verdi created some bad music and much very good music in these scores.

Morality, as a rule, has not fared well in opera. "Wozzek" is far from the first operatic character to have had relations unsanctioned by law with a fellow-being. Mozart's "Nozze di Figaro," so far as a number of its literal episodes are concerned, verges perilously near bedroom farce of the polite eighteenth century, and Beethoven lamented that such divinely inspired genius should be associated with such subjects as this one and others that Mozart chose for his plots. Beethoven, writing one of the few operas which hymn the fidelity and self-sacrifice of a wife, was not very successful in music-drama. Rossini was at his immortal best in the same subject of immorality, lack of faith, honor or decency among aristocrats which intrigued Mozart. This subject is a vast one. The loudest propagandists for Wagner have not successfully condoned, for those who stick on such points, the relations of Siegmund and Sieglinde.

These and other things are accepted and placed before people old and young at Saturday matinees and similar occasions, and few dream of taking them seriously or in a spirit of offense. The reason, in the operas that have been mentioned, is no doubt the palliating effect of beautiful music and the actual remoteness of the things depicted on the stage from anything that resembles life at hand. Wagner's lovers are half gods, their acts are allegorical, even if their music is not so. Verdi's melodies stand on their feet, and a suicide or two in the earlier works is usually the very

occasion for an aria or quartet. The same thing is true of the tragic operas of Donizetti or his contemporaries. Mozart and Rossini, in their works that have been mentioned, write operas of manners, and it has long been realized that manners and morals of aristocracy in the eighteenth century were no worse if as bad as manners and morals in a democracy today: The "immoralities" of "Figaro" and "Barber of Seville" in any event are enclosed in the protecting shell of the classic style.

Good manners! Eighteenth and even early nineteenth century stages had them. But what of the later operas and the later days? Take Wolf-Ferrari's "Jewels of the Madonna," a prime Metropolitan attraction, accepted and applauded in modern lyric theatres the world over. The music is superficial and cheap. The drama emanates in its matter from the stews of Naples. It includes a scene of seduction which may fairly be called "pathological," and an act that to the ordinary mind would appear perverse and sacrilegious. But you can escape with a murder or brigandage to your credit if you know how to manage the matter. Which opera is calculated to have the most demoralizing effect, the "Salomé" of Richard Strauss, which the Metropolitan does not dare to perform today, although every European lyric theatre of reputation and the necessary resources has accepted it, or the most popular of all the Puccini operas, "Tosca," wherein our own Jeritza and Scotti continue to delight their local audiences? In the Strauss opera there is the morbid episode of Salomé receiving, caressing and kissing the head of the murdered prophet. In "Tosca" the audience is treated to the spectacle of the Sadistic desires of Scarpia, who, lust-maddened, pursues his victim about the room, and who tortures her lover—whose groans are audible and who has often been seen emerging from the torture chamber with the effect of blood on his face—until he has exacted possession of Tosca as the price of her freedom and the life of Cavaradossi. The second act culminates in the murder of Scarpia, the third act provides an execution in the sight of the audience, and a suicide. This cheerful and ennobling spectacle is decked out by masterly theatrical device and by every appeal to what is neurotic and unhealthy in the human character. The episodes are intensified by means of sensual and melodramatic music. This is horrible, repulsive and distinctly pathological—witness Scarpia's explanation of his sexual ideals. Not a word has been raised against the performance of the opera and it is one of the stand-bys of every repertory, be the producing company great or small.

There is no need to multiply these instances of operatic atrocities and public inconsistencies, and the manner in which opera esthetically and "morally" bad can be made secure in the repertory if the public is not alarmed about it, or informed of its own hypocrisy, or the way in which a hue and cry can be raised over almost any subject if it is sufficiently sensationalized and Billy-Sundayed, and every super-righteous individual in the community impelled to rush to throw the first stone. This is true of everything in human affairs, and indicated with special clearness in that domain of entertainment in which sensationalism and superficiality play all too large a part—that of the opera.

* * *

January 9, 1927

'THE CLOISTER' AT PARIS OPERA COMIQUE

Jazz is still exciting the curiosity and interest of musicians in Paris. André Coeuroy and André Schneffner discuss its origins in Le Guide du Concert. Toward 1842–44 the first colored minstrel troupes attracted attention to their banjo and tambourine entertainments. From the restaurants and dance halls, jazz rapidly passed to the concert platform and the theatre.

"For the second time in the history of the United States the negro, at first merely an accompanist to the dances of the whites, became master of the ceremonies and himself stood in the spotlight. The negro took back the popular songs which his own folklore tunes had suggested to the white composers, and gave them the real negro interpretation. What Stephen Foster and Charles Harris (whose successes at the 1893 Chicago World's Fair contributed to the wide diffusion of ragtime) had done, was done again by Irving Berlin, the son of a Russian rabbi immigrant. To Berlin we owe the Alexander Ragtime Band, and much ragtime music, which he was not able to harmonize or instrument himself. This music of a negroid character awaited only the authentic touch of negro jazz to spread itself all over the world.

"This explains how Darius Milhaud, visiting the United States in 1922, found in the negro theatres of New York a jazz ensemble more specific than elsewhere, from which he drew ideas for the composition of his 'Creation du Monde.' Left to himself, the negro works on the American music which was originally inspired by his race, as he worked on the music of the Protestant chorals, or on the vestiges of his African souvenirs. The negro contents himself with kneading the elements that he seizes from other sources, careless of their origin, religious or profane, sentimental or burlesque, and they become negro and an ethnological product."

* * *

January 9, 1927

AMONG THE HILLS OUR FOLK SONGS THRIVE

By R. W. GORDON

Good roads have come to the mountain district of North Carolina and concrete highways lined with automobiles. Civilization has been brought almost to the very door of even the most inaccessible mountain valleys. Good schools with city-trained teachers have penetrated where formerly the only visitors from the outside world were traveling preachers and a rare surveyor or two. The old roughhewn log cabin with its mud chimney and its outside "root cellar" has, in many

instances, been rebuilt and covered with a modern finish. Parcel post and the R. F. D. flivver have made idle the spinning wheel and the loom, and replaced many a home-made fiddle, banjo and dulcimer.

Wide Circulation

These changes have, in a curious way, affected the songs. A large number of mountain families have moved cityward. Children who, twenty years ago, would have been content to live and die without having gone more than five miles from home are now in city public schools. Brother works in a garage, while sister clerks in a store or has a position in a restaurant. A request for "ballets and dance songs" made at any of the schools in one of the smaller cities will bring forth surprising results.

Everywhere I was told of the effect of the great war in bringing back to the mountain recesses a knowledge of the outside world, in arousing a desire to go out, to earn what seemed to be huge wages, to see the world. And with the emigrants the old songs are coming out of the mountains and beginning to take root in the cities—whether to live or die no one knows.

The last American frontier is disappearing, but it is still possible to find mountain folk and mountain songs in their original and proper setting. The search for the latter requires patience and tact. These songs have never been easy to find, and each day makes the task more difficult. As long ago as 1906 a well-trained American scholar, himself a resident of the mountain district, wrote an article on "Folklore of the North Carolina Mountains," in which he said: "I believe that remnants of the old English and Scotch ballads still linger in some isolated coves, but as yet I have not discovered any of them." The collector who would be successful must live with the people. Even after he has come to know them and to be accepted by them, he must exercise great ingenuity in tracking down the songs and in teasing them out of their hiding places. It is not easy, but it is worth while.

The mountain folk are a wonderful people. They are of pure American stock—as pure as it is possible to find—hardy, grim-visaged, but kindly. The family names are almost entirely of English or Scottish derivation. Their blood has never been mixed with that of the foreign immigrant. Their world is their own, and all outsiders who come to visit it are classed without distinction as "furriners."

Without formal education, the mountaineer is shrewd in the ways of human nature, honest and fearless. He looks you squarely in the eye. He wants quite frankly to know your name, your business, where you come from and where you are going, and he prefers to ask for such information directly rather than in any roundabout fashion. Your answers to his questions he is likely to accept at face value unless he has very good reasons for doubting your truthfulness. But he has an almost uncanny knack of detecting an evasion of any sort.

Genuine Hospitality

Once you have been accepted, there is no halfway hospitality. I have yet to enter a single mountain cabin where I was not urged to stay overnight, even though it was but a few minutes' ride in my car to a settlement and a hotel. "We're poor folk, but you're right welcome to what we have," is the almost invariable preface to any invitation to break bread.

If you wish to get along with the mountaineer, learn his code. He is intolerant, tremendously so, of any violation of it, however well meaning. Men still take precedence by feudal custom, and usually the first table is set for them alone. The man of the house is the "lord of the manor." Address your remarks to him, not to his wife or daughter. Do not brag about your travels or of the cities you have seen; you will only lose your reputation for veracity and consequently his respect. Moreover, what you say is likely to be interpreted as a sort of veiled criticism of mountain institutions and customs. Avoid all debate concerning religion. Above all, remember that however proud you may be of your American ancestry, you are here classed as a "furriner," and that it is your duty to accept and obey the laws and customs of the country the hospitality of which you are enjoying.

My own stay with the mountain folk taught me many things, whenever I was wise enough to be a good listener. It reminded me forcibly again of what I already knew—of how little education makes the man; it restored mightily my faith in American traditions and American character, and it taught me to love these people. Frankly, I would rather have the confidence and esteem of these hardy pioneers than of any group I know.

The first song published below is one of the older ballads, brought over many years ago from England or Scotland, but still a living song. In the process of more than a century of oral tradition it has changed somewhat, but the story is still clearly told. "Gypsy Davie" has become "Black Jack Davy," and the introduction of a derby in the fifth stanza would be somewhat unintelligible to an Elizabethan, but he would at once recognize the tune. It should be sung in a high-pitched voice with a decided trace of nasal accent:

Black Jack Davy

Black Jack Davy come a-ridin' by
He sung so loud and lovely;
His voice was ringin' in the tops of the trees
Till it charmed the heart of the lady,—
Charmed the heart of the lady.

"Come go with me, my pretty fine miss.
Come on with me, my honey;
Come go with me, my pretty fine miss.
You never shall want for money,—
You never shall want for money."

She put on her high-heeled slippers
All made of Spanish leather,
And he put on his old cork boots
And they both rode off together,—
They both rode off together.

Her husband come home late that night
Inquirin' for his lady;
It was reported by a pretty fair miss,
"She's gone with the Black Jack Davy,—
Gone with the Black Jack Davy."

"Go saddle my blondel horse
And hand me down my derby!
I'll ride to the East and I'll ride to the West
Till I overtake my lady,—
Overtake my lady!"

He rode till he came to the bank of the sea,
The sea was deep and muddy;
The tears came a-rollin down his cheeks,
And there he spied his honey,—
There he spied his honey.

"Will you forsake your house and home?
Will you forsake your baby?
Will you forsake your husband, too
And go with the Black Jack Davy?
Go with the Black Jack Davy?"

"Yes, I'll forsake my house and home;
I'll forsake my baby;
I'll forsake my husband, too,
And go with the Black Jack Davy!
Go with the Black Jack Davy!"

"Last night you slept on a feather bed
Between your husband and baby
Tonight you're sleepin' on the cold, cold ground
And a-sleepin' with the Black Jack Davy,
Sleepin' with the Black Jack Davy!"

Songs of this type are, in the main, the possession of the women folk; the men seldom sing them. As the woman does the household tasks, or while she rocks to sleep a fretful child, she will sing. But not when there is a visitor. Tactful persistence will be required to overcome her timidity and her fear that you want only to make fun of her voice and her old songs. Once you can convince her that you are really interested and that you already know something about them, she will surprise you by the number she has stored away in her memory. Usually she will sing without accompaniment, though she may on occasion bring out a guitar or a home-made dulcimer.

Irresistible Temptation

The man of the house you are more apt to find in the proper mood for singing in the evening. Get some instrument in his hands, either a fiddle or a banjo. Ask him to test for you a home-made banjo that you have just bought and brought along for that very purpose. His own is likely to be wanting in one or more strings. Once he used it a great deal—when he was courting—but those days are past. Perhaps he has joined the church and has an uneasy feeling that worldly music is somehow sin-

ful. Still, once he has the banjo in hand, he is yours. It will be only a matter of time before he will play and sing. But first you must listen to his excuses, all of them ready to the occasion. If he was mountain-born he can play; that is axiomatic. Hum a few bars of one of the old dance tunes, pat with your foot on the floor—he can no longer resist the temptation. Carefully and critically he tunes the instrument, testing each string again and again; then with an apologetic smile he begins.

There is no need to send out any invitation to the immediate district. Long ago, even before you arrived, word of your coming has been spread. "A furriner on his way up to Shelton's." Your recording phonograph and banjo have proclaimed you as ostensibly a "musicioner." You may rest assured that many of the neighbors are gathered quietly not far from the cabin. Some of the younger men perhaps have fiddle cases under their arms. Hardly have the first notes of the banjo sounded before they will begin to appear.

If you can guide them, tactfully and without seeming to do so, you may gather rich material before the evening is over. At first it will be a bit hard to induce any one to play or sing for the phonograph, but once they have heard the living voice come back nothing can stop them. Take everything that is offered, for it is very easy to hurt feelings or to arouse jealousy.

One of the younger fiddlers and your host with the banjo have begun to play "Old Joe Clark." Already two of the younger couples are dancing. The fiddler swings and sways as he plays. Every one is tapping time. Your host begins singing the time-honored words, his voice rising clear and sharp above the music. As he comes to the chorus all join in:

I don't like Old Joe Clark,
Don't think I ever shall!
I don't like Old Joe Clark,
Always liked his gal!

Rock, rock, rock, Old Joe Clark!
Good-bye, Billy Brown!
Rock, rock, rock, Old Joe Clark!
Bound to leave this town!

Old Joe Clark's a fine old man,
I'll tell you the reason why.
Run all round the garden spot
An' knocked down all my rye.

This is too much for the fiddler, and he joins in with a contribution:

I went down to Knoxville town,
Hadn't been there before;
Great big nigger knocked me down—
Ain't a-goin' there no more!

I'se a-goin' along the other day
An' I looked up in the sky,

Seen an eagle buildin' a nest
An' I yeared the young 'uns cry.

Fry my meat in a fryin' pan,
Boil my beef in a pot,
Shear my sheep with the old case knife,
An' sell all the wool I got.

Whenever one pauses another is ready to contribute. An old mountaineer in the corner has two stanzas to add:

Once I had a muley cow,
Muley when she's born;
Took a buzzard a thousand years
To fly from horn to horn.

Once I had an old gray mare
In the fields a-pickin' grass,
Thought I heard the buzzard say,
"Tomorrow'll be your last!"

When the dancing is over—and that may not be until late—it will be time to ask for some of the local "song ballets." More modern than the older ballads such as "Black Jack Davy," these may at first seem to be far removed from folk song. Originally, of course, they were the work of humble authors, but the use of dialogue, the frequent repetitions and the rapid action are genuine folk traits. And as they have passed on from mouth to mouth many of them have adopted more and more the folk style. They are true folk songs, of American make.

The text that follows is typical. It tells a true story, an actual happening of many years ago. The girl's name was Naomi Wise, and the song tells the story of her tragedy with just as much fidelity as the average newspaper account of today. The first stanza and the last three show the conventions of the broadside rather than of the older ballad.

This text is from the "Asheville Collection," a series of recordings made possible by the generous cooperation of the Asheville Chamber of Commerce. While Asheville is in every respect a modern and progressive city, her heart is still in the mountains. It is significant and fitting that she should take the lead in active cooperation with an effort to save and preserve her heritage of American song.

Little Oma Wise

I will read you the history
Of little Oma Wise,
How she was deluded
By John Lewis's lies.

He told her to meet him
At the hilly three springs,
He'd bring her some money,
Some other fine things.

She fool like and met him
At the hilly three springs,
But he brought her no money,
No other fine things.

"O Lewis, dear Lewis,
Pray tell me your mind!
Is your mind for to marry me
Or leave me here behind!"

"Get up behind me
And I'll tell you my mind;
We'll go and get married
Down by the riverside."

She mounted behind him
And away they did go,
Yes, down the lonesome valley
Where the deep waters flow.

"Get down from behind me
And I'll tell you my mind;
My mind is to drownd you
And leave you here behind."

"O Lewis, dear Lewis,
Pray spare me my life!
I'll neither go a-begging
Nor neither be your wife!"

"No pity, no pity,
I'll spare you no life!
You'll neither go a-begging
Nor neither be my wife!"

Then he hugged her and he kissed her
And he looked all around;
He cast her in deep water
Where he knew that she would drownd.

He mounted his pony
And away he did go,
Yes, down the lonesome valley
Where the deep waters flow.

Her brothers was a-fishing
On down the riverside;
They saw little Oma's body
Come floating down the tide

Her mamma came screaming
And the words she did say;
"John Lewis killed little Oma
And has run away."

They searched for John Lewis
All over the town,
But his body was missing
And could not be found.

They caught that John Lewis;
They put him in jail;
They white-robed little Oma,
And laid her in her grave.

"Young people, young people,
Take warning in time!
Don't never treat your sweetheart
Like I treated mine!

"Now all royal young soldiers
Who fight for their lives,
If you got a pretty little sweetheart
Don't never take her life!

"I'll eat when I'm hungry
And I'll drink when I'm dry,
And think of little Oma,
Hang down my head and cry!

* * *

January 30, 1927

PRO-MUSICA SOCIETY

By OLIN DOWNES

The "international referendum concert," given by the Pro-Musica Society yesterday afternoon in Town Hall, offered a program that consisted wholly of works new in America or played for the first time anywhere. To this latter class belonged the "Symphony for Orchestra and Pianos," by Charles Ives; to the former Debussy's incidental music written for an Odéon performance of Shakespeare's "King Lear" in 1904, and Darius Milhaud's "chamber opera," "Les Malheurs d'Orphée." This work was conducted by Mr. Milhaud in person. The other conductor was Eugene Goossens.

At the risk of appearing provincial, chauvinistic, this writer records that his preference among the new works of the afternoon was for the music of Mr. St. Ives. This music is not nearly as compact, as finished in workmanship, as smart in tone, as that of Mr. Milhaud, but it rings truer, it seems to have something more genuine behind it. There are ineptitudes, incongruities. The thing is an extraordinary hodge-podge, but something that lives and that vibrates with conviction is there. It is not possible to laugh this piece out of countenance.

Mr. St. Ives began his symphony in 1910 and completed it about ten years ago. The symphony has four movements, a prelude, a fugue, a third movement in a comedy vein and a finale, according to the program notes of Henry Bellaman, "of transcendental spiritual content." The prelude and the lively movement were the ones heard yesterday. The esthetic program of the "symphony" is less explicable than the music—"the searching question of What? and Why? which the spirit asks of life." The prelude, apparently, is supposed to propound these questions and the latter three movements to supply diverse answers. Be all this as it may, the principal characteristic of the prelude is a New England hymn sung in full harmony by mixed voices, with orchestral commentary of a nature rather groping and incongruous with the choral material.

There is the thought of a New England Sabbath—Mr. Ives is a New Englander—when the soul turns in upon itself and questions the infinite. Then, the fugue being omitted, comes the "lively movement," a kind of insane scherzo, in which Mr. Ives thinks of "comedy," but "comedy in the sense that Hawthorne's Celestial Railroad is comedy. Indeed, this work of Hawthorne's may be considered as a sort of incidental program in which an easy, exciting and worldly progress through life is contrasted with the trials of the Pilgrims in their journey through the swamp."

Pilgrim hymns are heard, but are "crowded out" by noisy and restless music.

"The dream, or fantasy, ends with an interruption of reality—the Fourth of July in Concord—brass bands, drums corps, &c. Here are old popular tunes, war songs, and the like." There is a big orchestra in this movement, and a dozen irregular and conflicting rhythms. The program speaks of the blend of cross rhythms, of long and short rhythmic curves, rhythmic clashes, "rhythmic planes"—a basic rhythm marked by gongs and deeper metallic figures; above that drums of various kinds; above these wood and brass used "rather as percussion," and the solo piano in the rôle of leader. There is much more explanation of Mr. Ives's music in the program, but the music is more illuminating.

There is something in this music; real vitality, real naivete and a superb self-respect. The lachrymose hymn, reappearing in the fast movement, is jostled out of existence for periods, only to bob up here and there, as homely and persistent as Ned McCobb's daughter. And then Mr. Ives looses his rhythms. There is no apology about this, but a "gumption," as the New Englander would say, not derived from some "Sacre du printemps," or from anything but the conviction of a composer who has not the slightest idea of self-ridicule and who dares to jump with feet and hands and a reckless somersault or two on his way to his destination.

And the picture of the Concord Fourth of July is really amusing, really evocative of the spirit of that time and day. Those were not safe and sane Fourths; they were Fourths that some survived, when patriotism was more than jingoism, and a stirring thought; when the nation was in its childhood and firecrackers took off the ear or put out an eye.

The scrabble of war songs and brass band tunes that all the villages knew, the noise of the circus, the blare of the band, are in this eccentric symphony, with its holier-than-thou hymn tunes, its commotion, its rowdiness, blaze and blare. There is "kick" in the piece, regardless of the composer's philosophic or moral purpose, his scheme of rhythms, and all

the rest. It is genuine, if it is not a masterpiece, and that is the important thing.

The Debussy music is not important, save for its signature. It is fair theatre music, capable of establishing a tonal background for the episodes in which it is employed. There are two numbers, a Fanfare and "Le Sommeil de Lear," and the title of the pieces is sufficient index to their nature. It is well that it should have been heard.

Mr. Milhaud, following the custom of the younger generation of composers of the day, seeks, in his chamber opera, to condense action and expression as much as possible, to write for quality rather than quantity of tone when he scores for his orchestra or singers, and, composing dramatically, to eschew leitmotifs or anything that savors of the symphonic manner. His Orpheus is not the god of classic myth, but a humble apothecary who lives in a town in the south of France. His Eurydice is a wandering gypsy. The pair leave their companions and their accustomed environment. They find a retreat where the animals who love Orpheus surround them. Eurydice dies of a mysterious malady. Orpheus returns to his apothecary's, shop, but he is blamed by the Bohemians for the death of Eurydice and at last killed. In death he refinds his Eurydice.

It is a typically modern Gallic treatment of the old myth. The same thing may be said of Mr. Milhaud's music. It does not permit itself to become emotional; it parodies more often than it sympathizes with the characters. The scoring is ingenious, for only thirteen instruments are employed, and usually for solo purposes. There are choruses of three and four voices. The music is simple, clear in its lines; the text of Armand Lunel is set with the punctilious regard for the stress and accent of words which usually characterizes French composers. When all this is said what is there to add? The writing is simple, but ugly. It is highly sophisticated. This sophistication does not mean that the composer has gone through and rejected what other composers or what he himself said in other pages. On the contrary, the derivation of many measures is clear. The period of those derivations, which is about ten years ago, is not survived. The music comes partly from Satie and in very considerable degree from the rhythms and the pulsatile instruments of Stravinsky. Like the later Stravinsky, it seems already dated. Within its frame of deliberated, calculated style it is a good piece of workmanship, but more than that is required to create music, and its tricks, its timbres and special dissonances have long since lost power to astonish or arrest the attention for any length of time. The vocal writing is fluent, and regardful of text, but the style is too tabloid for a big musical or dramatic moment to accumulate.

Nevertheless, the Pro-Music Society is to be thanked for bringing this and the other music of the afternoon to a hearing, permitting the public to listen to it and form an opinion of its own. The performances were of a high order. The pianists, all of them admirably competent, in the playing of the "symphony" were Robert E. Schmitz, Marion Cassell and Elmer Schoettle. The singers were Miner Hager, the Eurydice; Eric Morgan, the Orpheus; Greta Torpadie, Rosalie Miller, Radiana Pazmor, John Paris, Irving Jackson, Dudley Marwick. Miss

Hager sang with exceptionally fine musicianship and understanding of the task in hand. Mr. Morgan was not so successful. The concerted numbers were well prepared; Mr. Milhaud conducted with the authority and clearness of intention expected of him. Nor should the prowess of Mr. Goossens go without praise. He accomplished the dangerous task of the conductor of Mr. Ives's music with reworkable authority and control.

* * *

February 18, 1927

'KING'S HENCHMAN' HAILED AS BEST AMERICAN OPERA

Deems Taylor's Work, Sung in English, Is Wildly Acclaimed at the Metropolitan

MILLAYS BOOK IS POETIC

Composer's Expressive Music Has Beauty and Deep Emotional Appeal

MELODIES OF OLD ENGLAND

Lawrence Tibbett, Florence Easton and Edward Johnson Excel— An Artistic Production

By OLIN DOWNES

The most important production of the Metropolitan Opera Company's present season took place last night with the premier of "The King's Henchman," a grand opera in three acts by Deems Taylor and Edna St. Vincent Millay.

The production attracted one of the most brilliant audiences that has gathered for years in this famous lyric theatre. It was greeted with extraordinary enthusiasm. At the end of the first act it was plain that the opera stirred the audience, that the applause, the shouts, the calls and recalls for composer and librettist, who returned ten times to the stage, were inspired by deeper feelings than the politeness and superficial excitement of a première of an amiable chauvinism.

There was an unwonted thrill in the air. It evidently meant that everyone rejoiced in the merited success of two young American artists who had given of their best under circumstances of especial difficulty, and established a new precedent in the field of native opera.

"The King's Henchman" has its qualities and its defects, variously to be estimated, and better to be estimated in a conclusive tone after more than one performance. But it has undeniably theatrical effect, conciseness, movement, youthful spirit and sincerity; its text is poetic and well adapted to the needs of the singers; its music has the impact, the expressiveness and color appropriate to music-drama. From the perspective of other American operas heard or read in score and by the evidence last night of eye and ear, it is clear that Mr. Taylor and Miss Millay have produced the most effectively and artistically wrought American opera that has reached the stage.

Historical Personages

For her plot Miss Millay went to sources which are partly of history and partly of legend. Her principal characters are historical personages, though shrouded in mists and ambiguities of old tales. The Anglo-Saxon Chronicle tells of Eadgar of Wessex, King of England in the early part of the tenth century; of Aethelwold, dispatched to Devon to bring Eadgar a bride; also of the Archbishop Dastan, an unimportant element of Miss Millay's plot, and of Eadgar's resentment when Aethelwold took the proposed Queen to himself. When his trick was discovered Aethelwold was dispatched to fight the Danes and was killed.

Thus the chronicle and the material Miss Millay found ready to her hand. She has of course, treated it in her own way for poetic and dramatic ends, has invoked an old legend of All Hallows Eve to heighten the force and inevitability of her tragedy, and has provided a denouement of her individual making. In the opera Eadgar deceives his King and foster brother, to whom he has sworn allegiance only to be ended by death. He sees Aelfrida to love her. He instructs Maccus, the minstrel, to go back to the King and inform him that the maiden Aelfrida is not fair. Aethelwold then lives for a while in troubled and perilous happiness with Aelfrida as his bride, until the King, missing the companionship of his henchman, comes on a visit to the home of Aelfrida's father, the Thane of Devon. The truth is discovered. Aethelwold confesses his deceit; his King is aghast at his faithlessness and his trust; Aelfrida, who proves a shallow and ambitious jade, resentful of the rank she missed, turns upon him, and Aethelwold, in despair, destroys himself.

These are the main elements of the plot as disclosed in the three acts of Miss Millay's libretto. The libretto has been compared to Wagner's "Tristan and Isolde" for there is a King who sends his vassal to woo; there is a love spell, in the incantation uttered by Aelfrida in the wood—an incantation that destins her to wed Aethelwold; there is a faithful retainer in the person of the minstrel Maccus, follower of Aethelwold; and the sentiments of the King in the last act are those of Mark in the second act of "Tristan." There are these analogies between the two operas, but there are also many divergences of characters and events. It would not be easy to make a drama of love and death that had not some resemblance to Wagner's theme. The question of importance is how sincerely, authentically, and effectively for operatic purposes has Miss Millay compiled her plot and text.

Brilliant Orchestral Prelude

As Mr. Taylor has put it very truly, the audience at a production of grand opera does not see the notes and words that composer and librettist put on paper, but the figures that confront it and the music that sounds over the footlights. The audience last night heard a brief and brilliant orchestral prelude, which announced the knightly music of the King, and heard the voice of the minstrel Maccus, before the curtain rose on the scene of Eadgar's Court at Winchester, with revelry in progress. There Maccus twanged his harp, and sang of a gallant fight and death for a lady. There was a toss-pot jest and various vocal conversation, not heard very clearly through the swelling stream of Mr. Taylor's orchestration, which gave teeming life to the episode and carried everything before it.

Gradually individuals and salient musical characterization emerged from the hurly-burly. The young King—he was nevertheless a widower—disclosed his loneliness. Aethelwold, aglow with the glory of the skies and stars outside, was framed in the doorway. Reluctant at first, and no fancier of women, he at last acceded to the King's request that he go and fetch Aelfrida of Devon as Eadgar's bride. And the two swore blood-brother with cup and sword.

Life, that is stronger than I, is not so strong
As thou and I!
Death, that is stronger than I, is not so strong
As thou and I!
Unquelled, Thou and I,
Till Life and Death be friends!

This to the accompaniment of the musical motive of brotherhood and trust; then the singing by Maccus and the chorus of a rousing folk-song of Cornwall to the text of Miss Millay, "Ceasar, great wert thou, and Julius was thy name!"—music that returned with superb effect as prelude to its tragedy of the last scenes—and the departure of Aethelwold on his errand.

Incantation in Devon Forest

The second act disclosed the forest in Devon, on the night of All Hallow Mass.; Aethelwold and Maccus lost among the trees; Maccus full of forebodings, Aethelwold weary and caring only for sleep. The disappearance of Maccus, Aethelwold's sleep. The coming of Aelfrida, alarmed at the loneliness of the wood, yet determined to try the old incantation, whereby she may escape, the bumpkin her father wishes her to wed. The incantation, spoken in fearful tones, while strange sounds come a-calling through the forest and the orchestra, too, weaves a spell. Aelfrida perceiving Aethelwold, and the charm upon them. Aethelwold, only now aware of whom he loved, striving to remember his vow, and escape with Maccus, but helpless when Aelfrida called him; Maccus sent back to Eadgar with his false errand.

The events of the last act moved quickly, but not the less impressively for the audience: Ase, the serving woman of Aelfrida, at her spinning; Aelfrida distraught and discontent, quarrelsome with Aethelwold, both resolving to fly the place which oppressed them, and go to Flanders. The complacencies of Ordgar, Aelfrida's father, anxious for Aethelwold's good word at Eadgar's court. The sight, in the distance, of approaching men; the appearance of Maccus, with news that the King of England is at hand. The clang and tread of the song of Cornwall and the catastrophe that it brings always nearer; the entrance of the King and his retainers. Eadgar had told Aelfrida to go and hide herself from the King's eye, pour

dust on her hair, stain her face, appear, if she must appear, old and ugly.

But now, in the face of the King's entreaties to see her, Aelfrida appeared; not old not ugly, radiant before the King. Eadgar reproached his henchman, and Aethelwold spoke: "Eadgar, Eadgar, what we have to say must quickly be said . . . Here we stand at last, we three. But the wind is too strong. We cannot hear each other shout. . . . Do ye get what I say, Eadgar, Aelfrida? No? So. Shake your hands and laugh. Let it be so." Aethelwold fell, Aelfrida wept. The King said to her: "Thou has not tears enough in thy narrow heart to weep him worthily." The chanting of the chorus, theme of allegiance and fidelity, heard as a requiem, as the curtain fell.

Combines Beauty and Emotion

By and large, poetic and glamourous material for the theatre. It might be asked whether it is the best kind of material for effective opera or for the special gifts of Mr. Taylor, but that is a matter to be seen. There is beauty and emotion in it all and there is little or nothing unsusceptible to musical treatment, either by the symphonic orchestra of Mr. Taylor or by the admirable cast of Metropolitan singers. If the first act had more of dramatic incident it would be less like a single scene and have more of the strong and salient contrasts of mood which should inhere in a complete section of an opera. But certainly there is no dead wood in it. The second is dangerous because of its long-sustained emotional periods and its comparative lack of movement.

Doubtless this is intentional; it is also a severe test of a composer. Mr. Taylor has made much of its atmosphere of nature and mystery, and has provided contrasts and climaxes in his music. The third act seems on first view the best contrasted and the most effective in its proportions and the opportunities it gives the composer. One would say that Mr. Taylor also felt that way, for he has departed happily from the conventional and somewhat pale third act of which even noted composers have been guilty, and has written here with exemplary vigor and expressiveness.

Proves His Melodic Gift

Mr. Taylor's score proves his melodic gift, his spirit and sense of drama. He had special problems with a libretto which is more literary than dramatic, in spite of its imaginative and emotional character. His text is for the greater part free in rhythm, irregular in its periods, and not always cast in shapes most amenable to melodic setting. Nevertheless Mr. Taylor, in his first essay in the form of grand opera, has succeeded in an astonishing degree in giving this text musical form and organic musical rhythms; in utilizing his orchestral very ably in the Wagnerian manner, and yet in keeping one eye on the tastes and instincts of an opera audience. He develops, combines, transforms his motives in his orchestra; he also writes broad and curving phrases for the singers, phrases reinforced by the surge and impact of the instruments. (And high notes for tenors—vide Mr. Johnson departing on his horse at the end of the first act.) It need not be

claimed, in all this, that he has yet developed the individuality and the incisiveness of musical speech which opera demands for its utmost effect, or that he has always succeeded in hitting his dramatic target. The remarkable thing is Mr. Taylor's degree of success, the communicative and sensuous quality of his music, and, above all, the direct and unaffected manner of his composing.

He has composed with complete frankness and without aping any style. He falls naturally into Wagnerian uses and sometimes idioms, as in the love music of the second act, but his essential methods are far from Wagnerian. They emphasize the stage; they put the singers either in the first place or at least on an equality with the instruments. The symphonic style gives place at appropriate moments to the broadly melodic. The solo of the King relating his longing to Aethelwold is almost Italian in this respect and is one of the most grateful pages of the opening act. This act moves with exhilarating energy and gusto. The folk-song of Cornwall brings a conclusion which Mr. Taylor, with his long knowledge of choral writing, is particularly fitted to furnish.

The orchestral introduction of the second act is an excellent change of atmosphere and the scene of the incantation is admirably contrived in the mixing of the tone qualities of voices behind the scenes, interwoven as they are with the harmonies of the orchestra, and the voice of Aelfrida against this background uttering her incantation. The love duet has abundance of orchestral color and appropriate lyricism, though it is not very original music. On the other hand it is not unduly prolonged, and the act has a climax in the surrender to his temptation of Aethelwold. This is perhaps the weakest of the three acts.

The final act indicates what Mr. Taylor might do with a book that furnished him more incident. It is the strongest and most substantial of the three. The prelude in folk vein is appropriate. The duet of the lovers now wedded, is rather obvious, but good theatre. The approach of the King and his men, the Cornwall song echoing from singers and orchestra, and the bustle and commotion on the stage are the music of a composer who relishes action and event. The close is dignified and pathetic, and Mr. Tibbett's enunciation of some of the best of Miss Millay's lines materially heightened its effect.

Most of Cast Americans

Much has been said of libretto and music, and more will be related after future performances. At this time the exceptional virtues of the interpretation by a cast consisting principally of American singers, with Mr. Johnson, a Canadian, as the hero, can only be mentioned in outline. Above all the other interpreters stands Mr. Serafin. Neither Mr. Taylor nor any other composer could hope for a more masterly and inspired conductor. He secured the very last ounce of tone and response from his forces. The orchestral performance of last night, alone and in itself, would be a lasting monument in this city to Mr. Serafin's fame. Mr. Johnson's singing and diction were admirable.

Miss Easton, like Mr. Johnson, Mr. Tibbett, Mr. Gustafson, was admirable in her diction and in the customary intelligence of her impersonation. Hers is not a very sympathetic part, either as drawn by librettist or composer. Mr. Meader's Archbishop was worthy of his best achievements. The father of Aelfrida should be suppressed, for he is an unutterable ass, even worse than the heavy father in "La Traviata," and not half as melodic. He is not needed in the opera, but was impersonated as well as could be hoped, and with a properly protruding stomach. The various minor parts could be praised in detail. But it was to Mr. Tibbett that the audience finally turned for his creation of the role of the King.

His singing and enunciation were a high water mark in these respects.

There were praiseworthy scenic settings by Joseph Urban, the best of these being the setting of the first act, but all conveying the period and character of the drama.

At the end of the performance there was a full twenty minutes of applauding. Mr. Taylor and Miss Millay were acclaimed; then Mr. Tibbett; finally Miss Easton and Mr. Johnson. Mr. Serafin, the stage director, and others implicated had been earlier recognized. There was a pause and a silence when Miss Millay said, "I thank you. I love you all," with pardonable impulse and sincerity. Mr. Taylor hesitated, then blurted out. "That's just what I was going to say."

* * *

February 27, 1927

CRITICS AND COMPOSERS

The Unrivaled Frankness of the Reviewer—Attitude of American Press Toward Native Talent

By OLIN DOWNES

A good example of the extraordinary ideas some people harbor about music critics is furnished by the detective who approaches a reviewer the morning after a concert and asks, "Tell me, what did you really think of X's performance last night? Of course, I've read what you said in the paper, but what did you *really* think?" If a music reviewer were as careful in concealing what he really thinks as such a question implies, he would have more friends among those whose doings he chronicles. It is because the reviewer says what he thinks that so many of the musicians to whom his opinions are in any degree unfavorable meet him with a smile and a compliment to his face and behind his back tell what *they* really think—a telling by no means consistent with the flattery designed for the critic's consumption. Perhaps it is not unnatural that these people, and others who have witnessed the chicanery and disingenuousness which permeate so many artistic circles, should credit the critic with the insincerity that they believe to be prevalent.

As a matter of fact, the critic is one of the few men in all the world who can free his mind without fear or favor. Certainly this cannot be done by professional musicians. There are too many things to consider, such as relations with colleagues, with individuals and organizations who furnish engagements, with parents and friends of pupils. Obviously, frankness cannot be indulged in by these individuals save under exceptional circumstances. It is of course out of the question in practical affairs, and even in personal relations.

But the critic? He is commissioned to retail the truth, and nothing but the truth, to the best of his knowledge and belief, and his usefulness is proportionate to his sincerity and intelligence. He is the man whose professional activities are unhampered by any of the practical considerations of policy which greet and condition the efforts of artists, however great they may be. It is the privilege of this individual to listen to music, often with intense curiosity and enthusiasm, then enter his office, unroll a desk, put himself and his impressions on paper as clearly and conscientiously as he is able, and go to bed regardless. As artistic criticism is conducted on many American newspapers, it is the freest, the most honest and the most disinterested profession that society affords today. It bestows complete security from contaminating compromises or contacts; it enables the fortunate man to pick his mental companions, to consort with chosen masterpieces, and live in a world where ideas are paramount and indeed of decisive import. And where are there adventures comparable to adventures among masterpieces?

These reflections congeal in connection with the buzz of comment and query which followed upon the Metropolitan production of Mr. Taylor's new opera. Was it "really good"! Had it proved worth while? There is no need for a newspaper writer to say anything in reply to such a question. The only need is for the reader to turn back the files of the newspaper and read his report. There they will find the critic's reactions to the new work, written when and as they possessed him. Incidentally, public as well as critical verdicts have confirmed the gist of the reports that appeared the day after the first performance. Mr. Taylor's opera was unquestionably a success, and the best—as a matter of fact, the first—American opera to prove effective and eloquent in the theatre. In that opera an American composer for the first time grasped the realities of his task, faced them, mastered them as they had not been mastered by any previous aspirant, and wrote music with a zest and technical brilliancy that leaped across the footlights. These facts constituted solid and ample ground for critical enthusiasm. The commentator would have been unobservant and ungenerous who failed to record and to dwell upon them with gratification, arising not only from the individual accomplishment, but from what it betokened for the future of American opera. There were also grounds for critical reservations as to the quality of Mr. Taylor's score, and these also were expressed with befitting frankness. It goes without saying that better and greater operas than "The King's Henchman" will be composed by Americans. One of them is probably on its way from the pen of Mr. Taylor. Whether or not that proves to be the case, he has established a starting point for the creation of native opera in the native tongue. He has been well content

to learn the rules of operatic composition, before treating them in a new way, or completely breaking with them. Lacking this attitude in the past on the part of our American composers, attempts at American opera had consisted principally in lost motion.

The pleasure of the public which listened to "The King's Henchman" was, of course, not due to any particular reflections or perspectives on these subjects. It was simply entertained and pleased by the work, and there was gratification in the success of a young American librettist and composer. The attitude of the reviewers should have gone far to disprove the assumption in some quarters that they are uninterested and cold to the cause of national music. American critics are naturally as desirous as any one else of discovering a genius of the soil, but they have steadfastly and rightly refused to support incompetence. They will continue to do so, and feel the greater pleasure when a work appears which nearly parallels the requirements.

It is partly due to this attitude, as well as to native talent, that technical standards of musical composition have risen as they have in America in the last twenty-five years. None of the young men have reached a higher technical standard, it is true, than that of a George Whitefield Chadwick or, of the next generation, a John Alden Carpenter, but technic among our composers is considerably more widespread than it was a quarter century ago, and there is a more general acquaintance with artistic principles and standards. This is shown in many orchestral compositions which preceded Mr. Taylor's opera, but his work is the first that we know which indicates, in addition to its musical technic, a grasp of the conditions and requirements of the theatre. What Mr. Taylor has yet to achieve is individuality of idiom, and this need is apparent in most of our composers.

One looks in vain, in spite of their modern tone, for a young American who will equal the poetry of a MacDowell, the wit, spirit and personality of Chadwick in his best pages, or the truly racy and romantic expression of Henry F. Gilbert in his most representative compositions. But mean while a foundation is being laid, not only by a very few isolated composers of originality and power, but by the brilliant and conscientious efforts of younger men, among whom Mr. Taylor is now so conspicuous a figure. What should the attitude of criticism be toward these rising creative talents? Should it be tolerant, indulgent of shortcomings, encouraging with the hope of greater things to come, or rigid and unsparing in the estimates of new music, whatever its source? The answer, we believe, has two clauses. There should be the utmost possible encouragement of those who have the urge to create, but the reception of the music should never be one of lowered standards. The favoritism and chauvinism which distinguish too much of European criticism should never be practiced here, and probably never will, which will be to the ultimate profit of our composers.

* * *

February 27, 1927

A GROTESQUE PREMIERE

LEIPSIC, Feb. 12—A sensational opera première took place here last night—that of Ernst Krenek's "Jonny spielt auf." The composer has carried so-called modernism to daring lengths in this work and has left scarcely a single previous conception of opera intact. He has sought to break new highways into the forest primeval of the "new" and "atonal" music, with the result of effects that his most daring contemporary competitors apparently never thought of. The title, which might possibly be rendered in English as "Johnny leads the band" or "Johnny strikes up," is decidedly novel to opera; the hero is a negro jazz band leader, and other leading characters include a grand opera diva, a gifted composer and one of those vain and conceited solo violinists who are the bane of hard-working music critics the world over. The opera "seeks to interpret the rhythm and atmosphere of modern life in this age of technical science." The speedy motor car, the loud speaker, the long-distance telephone and the de luxe express trains are all represented, not only as plot essentials, but also as interpretative factors of contemporaneous existence.

As an art form Krenek's new work lies between opera in its accepted sense and the colorful and spectacular modern revue, or perhaps the motion picture. The young negro Johnny has conquered Europe with the rhythmic fascinations of his jazz band. He has not been on this side of the Atlantic long when he discovers that interracial love and courtship are not disdained by a percentage of the white folks of Europe. Johnny decides to court the beautiful opera singer, and tries the harder upon learning that he has two rivals, the composer and the violin virtuoso. The last act takes place in a large Continental railroad station, where the careless fiddler, failing for a single tragic moment to observe that all-important maxim of modern life, "Watch your step!" is run over by the express train in which the composer and singer are eloping to America, the land of unlimited possibilities and skyscrapers. Suddenly the illuminated station clock becomes transformed into a huge globe, on which we perceive Johnny perched as the real victor in the drama just presented, a drama the moral of which Johnny subtly indicates by inviting all humanity to join in a strenuous outpouring of jazz, with "Johnny leading the band."

A Leipsic critic states that never before has an opera been written which interprets so intensively what the world now experiences in everyday life! Until now only the revues and motion pictures have attempted in any degree to dramatize this sort of thing, and only Krenek himself succeeded previously in conveying something of the meaning of this in a well-rounded and sincerely conceived effort, an early work, "The Jump Over the Shadow." Without regard to ethics or conventions he presents to us in his latest "opera" five characters, one more depraved than the other: First, a composer, who fairly nauseates because of his unbridled weaknesses; then, a typical opera prima donna, loaded with all the superficiality and light-headedness of her kind; next, a chamber-

maid, dancing through life with impulses unrestrained, and the spotlight-seeking violinist, who is unable to produce a single true or convincing tone. And, finally, the black jazz band conductor, the hero of the opera, Johnny. Unable to distinguish between good and bad, Johnny greedily tastes and feels of everything that comes his way; an unscrupulously bold, unprincipled and untutored young barbarian, withal a mixture of conscious animal magnetism and likable good nature. Regardless of how little these characters intrigue us from a strictly human standpoint, they hold the attention of the audience and entertain by reason of the ridiculous capers they cut, and because of the intentional exaggeration of their behavior.

The occasion only becomes painful when a serious note is attempted. Two scenes conceived in this respect just don't seem to belong; one concerns a dialogue of the composer with a glacier, another shows the composer waiting vainly at home for the return of his sweetheart. Krenek is musically at his best only when he seeks and very successfully combines the rhythms of our latest dance music with his modern and "atonal" technic. Jazz music, scored in this manner, is the "making" of two scenes, one showing a hotel lobby and another the terrace of a mountain inn. In the first the strains of Johnny's orchestra suddenly come floating across the lobby at a moment dramatically significant, and the same thing is true of the mountain inn scene, when the jazz music issues from the horn of a loudspeaker. In the last scene the music loses some of its vigor, as if the composer were unable to keep up the tempo he established in his libretto. It was just in this scene that his most convincing effort was expected by the connoisseurs.

The treatment of the orchestra in "Jonny spielt auf" is also significant. The opinion here is that Krenek's opera will at once find a place in the repertory of the more enterprising opera houses. The sensational success of the work in staid old Leipsic (Neues Theater) is due in a large degree to the staging of Walter Brügmann, who apparently well understood how to make the most in a scenic way of the amazing eccentricities suggested in the text and music. Considerable credit is also due to the musical preparation and direction of Gustav Brecher. The singers who interpreted the leading roles kept eager pace with Brügmann and Brecher, as did the supporting stage ensemble, with the result that Leipsic experienced an opera première that will, without doubt, be recalled as an exceptional event for some time to come.

Leningrad and Moscow have been hearing new works by Russian composers. These include several new orchestral works by Gödicke, a symphonic poem by Schillinger and a symphonic prologue by Krjukov. Gödicke belongs to the older generation of Russian composers, while Schillinger and Krjukov are counted among the moderns. Young Dimitri Sostakovics, whose first symphony was played last season, came forward with a piano suite. Chamber music compositions by S. Evfcev, B. Desevor, A. Gladkoski and R. Roslavec were performed, in addition to choruses, by M. Judin, M. Milman and others. A. B. Zataevic, the collector of 1,000 folksongs of the Kazaki people, has found 300 more new Kazaki songs, besides eighteen instrumental pieces from Central Russian Asia. His colleague, B. Uspenslik, has collected 150 Turkoman folksongs.

* * *

<div align="right">

February 27, 1927

</div>

HONEGGER'S LATEST WORK

The Creator and the Executor of Commissions—A Tempest in the Paris Teapot

By HENRY PRUNIERES

Arthur Honegger is today the most conspicuous of the young French musicians. He is even popular, and his "Roi David" has been sung before enormous crowds, which did not weary of acclaiming him. To my mind, it is not Honegger's best music which triumphs. He has approximately the same opinion of art that the ancient masters held; he considers himself an artisan who has not the right to refuse any commissions. He executes them conscientiously, and faithfully delivers them on the day specified. It is in this manner that he once composed the music to "Dit des Jeux du Monde"; then that of "Roi David" (in two months); that of "Judith," and finally "L'Impératrice aux Rochers."

In my opinion, there is a great difference in quality between the works that he undertakes voluntarily and those that he writes on commission; and I greatly prefer the composer of "Horace Victorieux" to the composer of "Roi David." But whatever he does, so great is his astonishing mastery, his prodigious technical skill and, above all, such is the power of his musical temperament, that he never writes anything that is indifferent. I know no other musician in Europe, except Richard Strauss, from whom music springs with the same force.

That great artist, Ida Rubinstein, undertook to produce at the Opéra a drama in verse by Saint-Georges de Bouhélier, entitled "L'Impératrice aux Rochers." I suppose what attracted her in that "mystery" was not the poem in itself (on which I need not here pass an opinion), but the magnificent decorative possibilities that it offered. The legend, inspired by the history of Sainte Geneviève of Brabant, would lend itself to an extraordinary luxury of mise en scène. So Ida Rubinstein ordered from the great Russian painter, Benois, decorations and costumes, and from Honegger the incidental scenic music.

Honegger conceived his task in a purely decorative manner. He illustrated and illuminated the subject, but he had no intention of writing music of the Middle Ages. He did not change his style; only a few more or less Gregorian themes supervene at the apparition of the Virgin and the Angels. The score is very important; unfortunately, the recital of the drama interrupts and cuts it in a harmful manner. You hear a prelude, and fifteen minutes later an interlude. The musical

impression is thus continually interrupted. It is to be hoped that Arthur Honegger will turn his score into a concert suite; but that will be difficult, as the music closely follows the text. "La Chasse de l'Empereur," with its massive chords blown by the horns and trumpets in fourths, the call of the brasses and the sorrowful theme which precedes "La Salle du Conseil"; the magnificent and original march, with its great chords and its long resonances diminishing to pianissimo; the sound of the stopped trumpets which accompany the entrance of the Pope; the adorable prelude which depicts the obstinate fall of snow on Rome, with its tender motif; the enchanting description of the "Jardins du Palais"; the poetical "Concert champêtre"; the powerful "Orgie du Palais"; the miracle on the rock amid the angels' songs; and then the sumptuous finale, where the orchestral voices unite with bells ringing to celebrate the miracle—all this is Honegger at his best: solid music, well constructed, marvelously instrumentated, full of color and poetry. Here again is displayed that gift of Honegger's for obtaining great effects with relatively simple means. But the crowning moment of the score is the scene of the storm, a great symphonic episode, which will certainly be heard in the concert hall.

Honegger has avoided a too direct description. It is as much a spiritual storm as a material one; the atmosphere is charged with electricity, thunderings and whistlings in the orchestra, in the midst of which broad melodies unroll themselves, interlacing in ingenious counterpoint.

Honegger is a true polyphonist; he conceives music in the form of super-imposed themes. In that storm the contrapuntal and polyrhythmic combinations are of extraordinary skill; nevertheless, the music remains perfectly clear from beginning to end. It is superbly effective.

This music of Honegger's won the success that it merited. One must be grateful to Mme. Ida Rubinstein, who revealed herself as the protagonist of the "Martyrdom of Saint Sebastien," by Debussy, to have been the means of bringing Honegger's creation to life.

* * *

March 6, 1927

SUMMING UP MUSIC'S CASE AGAINST JAZZ

British Critic Calls It a Bundle of Tricks Which Restricts The Serious Composer's Power of Imagination

By ERNEST NEWMAN

LONDON—Little did I think what a hornet's nest I was disturbing when, in the innocence of my heart, I wrote an article in a London paper a few months ago on the subject of jazz. The article was reprinted more or less fully in a number of American papers, and from all quarters of the United States the storm broke on my poor head. Arizona became agitated. Nebraska was nettled. Missouri went mad, even the gentle, forbearing gunman of Chicago slid a quick hand to the hip. What I had done to annoy all these good people I am sure I do not know; and what puzzled me most was that even the sweet reasonableness of my request to the jazzhounds to keep their dirty paws off their betters was taken by some writers as an excuse for letting their angry passions arise. Now that I have been asked by The New York Times to do an article on the case against jazz I approach the subject again in fear and trembling.

Jazz Has Two Aspects

Before I deal with the case against jazz, however, let me say a word in favor of it. One or two of my critics asked me triumphantly, with an air of an American dragon that had got St. George down and was biting him hard in a tender spot, to explain why, if jazz is a dead thing from the neck up that I said it was, I took so much trouble trying to kill it. But there is a slight confusion of thought here. Jazz has two aspects—the musical and the terpsichorean. I was considering it only in the former aspect. I meant simply that musical people had mostly ceased to take it seriously as music.

Whatever may be the case in America, I beg to assure the American public that in England the thing, regarded as music, is dead. We all found it amusing for a little while at first; it was like a new cocktail. But when the novelty of it had worn off, musical people became sick and tired of it. I doubt whether a single musician of any standing could now be found in my country to say a good word for it. As music the thing has simply become an infernal nuisance and an unmitigated bore. It is solely its popularity for dancing purposes that keeps it in the public eye and ear: it is still unequaled as a medium by which fair women may perspire in the arms of brave men.

My "case against jazz," then, is purely and simply a musical case. It is as a musician that I object, for one thing, to the ordinary jazzing of the classics. Not that I would ever object to a clever musical parodist exercising his humor at the expense of any master. But to do this acceptably he has to be a master himself: there is nothing more delicious than first-rate parody, but it takes a first-rate mind to do it. The jazzsmiths, however, speaking generally, are not clever enough to make their manipulations of the classics tolerable. They are not artists in the sense that the great literary parodists have been; they are merely hearty grinning chawbacons.

It is one thing to have a good picture turned into a thing of harmless fun by some one who is himself a quick-witted artist; it is quite another thing to have it scrawled over by a moron. The average jazzsmith, in his would-be humorous treatment of a classic, is merely a street urchin who thinks he has been smart when he has sidled up to a poster when no one was looking and added a mustache to the upper lip of the beautiful lady who figures in it. My gentle exhortation to the jazzers to keep their dirty paws off their betters has been grievously misunderstood; to get the true sense of it, it should be read with the accents on "dirty," "paws" and "betters."

So little, indeed, do I object in toto to the musical laying-on of hands that I find myself in the curious position

of having to disagree with some of my critics who generously went out of their way, for a moment, to agree with me. Roger Kahn, for example, who saddened a whole bright Autumn day for me by saying that he had read my article "with great indignation," also "expressed himself," to an interviewer, "as opposed to the jazzing of classical music." I myself would not go as far as that. If any jazzist will write me a musical commentary on something of Chopin's or Grieg's that is as witty as, say, J. C. Squire's parodies of Byron and Wordsworth, or Mr. Sidgwick's of W. B. Yeats's "Innisfree," or Brahms's treatment at certain points of a theme by Paganini, no one will be more pleased with his effort than I. All I object to is the practice of a very difficult and subtle art by thick-fingered bunglers.

Paul Whiteman thought he had convicted me of inconsistency when he said that "Strauss took other men's themes and developed them characteristically; Newman hails him. We borrow themes and develop them in our style, and Mr. Newman objects." Quite so; the difference is simply that Strauss is Strauss and "we" are "we." "There is no protest," said another jazz apologist, "when Dvorak puts a negro melody into a symphony." Precisely; for Dvorak is Dvorak. The negro melody is bettered by Dvorak's treatment of it; but the cantabile melody of Chopin's "Fantasic Impromptu" is decidedly worsened by Harry Carroll's treatment of it in "I'm Always Chasing Rainbows." He has simply made the poor tune commit so to speak, hari-kari on Chopin's door-step. Let the jazzsmith, if he can, give a new turn to the smile of Mona Lisa; but for Heaven's sake don't let him set the lady's charming mouth moving mechanically to the slow conquest of a piece of chewing gum.

Have the jazzsmiths, indeed, any composers in the full sense of the term, and will jazz ever evolve a composer of that kind? We all bear willing testimony to the great skill in the new orchestration that men like Ferdie Grofe exhibit. The probability is very remote, however, that the jazz orchestra will have any influence on the ordinary orchestra; the colors of the former are at once too pronounced and too limited for that, I imagine. It is dangerous to prophesy, of course, but, I doubt whether the saxophone can ever be made to play more than a subordinate part in a concert orchestra; it is an admirable medium for the saying of certain rather obvious things in music, but a very tongue-tied instrument for saying most of the things that a genuine composer wants to say. It is admirable in his own way, and the brilliant jazz scorers are to be complimented on finding out that way and exploiting it to the full; but it is still not the way of the concert orchestra, and I doubt whether the characteristic jazz scoring has much future outside jazz.

But will jazz work out its salvation on its own orchestra? Shall we find it, that is to say, developing an art of its own that will be able to bear comparison with what we generally mean when we speak of "music"? I take leave to doubt this also for the following reasons:

There is not, and never can be, a specifically jazz technique of music, apart from orchestration. We might as well suppose there can be such a thing as Mohammedan mathematics or Buddhist biology, or Peruvian psychology, as suppose that there can be, in the last resort, such a thing as jazz music as distinct from ordinary music.

The Idea in Music

There is only one way of writing music on the large scale; you must have ideas, and you must know how to develop them logically. Now, in both these respects the jazz composer is seriously hampered. If he writes too obviously in what we call the jazz style he will not get very far, for the ideas and the devices are too stereotyped. If, on the other hand, he moves very far away from these devices he will not be recognizable as a jazz composer. Jazz is not a "form" like, let us say, the waltz or the fugue, that leaves the composer's imagination free within the form; it is a bundle of tricks—of syncopation and so on. Tie a composer down to these standardized tricks and he cannot say much in them that has not been said already; let him depart from the tricks, and his music will no longer be jazz. It is an instrument on which little men can play a few pleasant little tunes; but if a composer of any power were to try to play his tunes on it, it would soon break in his hands.

I am confirmed in this opinion by the more ambitious efforts that have been made in America to expand jazz. Deprive Mr. Gershwin's "Rhapsody in Blue" of its jazz orchestration, study it in the black and white of the piano score, and you will be surprised how little jazz there is in it. Mr. Gershwin, it seems to me, in the attempt to sit on two stools at once has fallen between them. His work is not a chemical combination of jazz and "straight" music but a mechanical mixture of the two. He reminds me of the gentleman in "Pickwick Papers" who, having to write an essay on Chinese metaphysics, read up first "China" and then "metaphysics" in the encyclopedia and "combined the information." That essay was never given to an expectant world, but did we possess it we should find, I fancy, that the trouble with it was that the information did not really combine. So with Mr. Gershwin's "Rhapsody in Blue," we say of one passage, "This is China," of another. "This is metaphysics," but hardly anywhere do we find ourselves saying, "This is Chinese metaphysics."

The Gershwin Effort

The reasons are obvious. So long as Mr. Gershwin is exploiting the usual jazz tricks, he gets hardly any further than the average of his fellow-criminals; and when he launches out into "straight" piano concerto music we begin to ask ourselves what all this has to do with jazz. The work was, in fact, though Mr. Gershwin may not have known it at the time, a commendable effort to shake himself jazz-free. Mr. Gershwin is a gifted young man with an enviable facility in producing catchy, piquant, pungent tunes. But when, musically speaking, he wanted to become a man and put away childish things, all we got was a series of reminiscences of the "straight" music he had played on his piano and heard in the concert room—Liszt, Chopin, Debussy, César Franck and others. It was a creditable first attempt to do something big-

ger than jazz, but it ceased to be jazz as soon as it tried to be big; I would guarantee that if I placed the majority of the pages of this score before any musician, hiding from him the name of the composer and the title of the work, it would never occur to him that it was anything else but an attempt at a piano concerto of the ordinary kind. And I gather that Mr. Gershwin is now of my opinion on the main point involved.

"As for jazz itself," he recently said to an interviewer, "certain types of it are in bad taste, but I do think it has certain elements that can be developed. I don't know whether it will be jazz when it is finished."

Precisely; that is what I have been contending all along. The further jazz is "developed," and the more musical talent there is in the composer who "develops" it, the less like jazz will it be. But I should not call such a process "development"; I should call it the abandonment of all that makes jazz jazz.

There remains the point of the supposed rhythmical novelty and the possible rhythmical developments of jazz. That jazz makes a strong feature of certain rhythmical formula that are only sparingly used in "straight" music (for, of course, there is nothing absolutely new in them), is not denied. But in the first place these rhythms are so stereotyped that the constant use of them makes one jazz work and one jazz composer sound monotonously like another; and in the second place nothing is easier than to make new rhythms—in the abstract.

Give me a paper knife and a tea tray, and I will undertake to beat out a very large number of abstract combinations of ones and twos and threes and fours and so on. But realizing these abstract combinations in music is a very different matter. Frequently, in the history of music, composers have been fascinated by the theoretical possibilities of a new development, but have been unable to utilize them freely in their work. Modern harmony is a case in point. Theoretical harmony has outgrown practical harmony. It is easy to manufacture all sorts of new harmonies, but not so easy, as some of our modern composers have unwittingly demonstrated, to make acceptable music with them. They have not yet discovered the new melody to go with these new harmonies; they either fob us off with a melody that can hardly be called a melody at all, or, when they try hard to be melodic, merely fall into the old clichés.

Live music is all of a piece: melody, harmony and counterpoint all work as equals to the same end. Give one of the team its head too much and it upsets the coach. In the early nineteenth century the Italian opera composers tried to "develop" melody; but they could only achieve melodic luxuriance by impoverishing their harmony. Today the situation has been reversed: harmony and counterpoint have rushed ahead too fast for melody to keep up with them. We shall know the next great man in music, indeed, by his capacity to run the new melody, harmony and counterpoint as beautifully in harness together as the older masters did theirs.

But he will only do this by curbing, to some extent, the ambitious pretensions of each of them. And so it is with the jazz rhythms. Regarded in the abstract, some of them are new in the sense that they arrange the time-units in unaccustomed ways. But the jazz writers who are now trying to use these rhythms are not their masters but their slaves; they can exploit them musically only by embedding them in the most woeful melodic common-places and harmonic clichés. We are left once more with a bag of tricks. So I am not impressed by this vague talk about "developing the rhythmical possibilities of jazz."

Jazz has no "rhythmical possibilities" whatever that are not open to "straight" music; the difficulty in both cases is to turn a theoretical possibility into a practical realization. Here again the "Rhapsody in Blue" enforces my point for me: when Mr. Gershwin forgot his jazz associations and settled down to the business of writing a piano concerto he found that in order to make his music flow easily over big spaces he had to stop playing the usual little jazz tricks with his rhythm.

* * *

March 20, 1927

INSISTS JAZZ IS NO PRODUCT OF THE MACHINE AGE, BUT NEGROIC

To the Editor of The New York Times:

Mr. Whiteman believes jazz to be the folk music of the machine age. It is nothing of the sort. It is the folk music of the negro dressed up in a modern dress. All the silken finery of clever orchestration and the white paint and powder merely conceal the black body beneath. Jazz is a new art merely in the sense of its clever dressmaking.

The "rhythm of machinery" has nothing to do with it. It is the rhythm of the banjo or tom-tom. Long before 1915 some of us heard these same rhythms and idioms plucked on a banjo or pounded out on an old piano in the levee dives of the Western and Southern rivers.

Mr. Whiteman thinks it will be the foundation upon which American music of the future will be built. If this is so, the American people will owe a great debt to the negro.

HINTON JONES
New York, March 15, 1927

* * *

November 6, 1927

FIRST NOVELTY OF THE SEASON

VIOLANTA—Opera in one act. Book in German by Hans Mueller. Music by Erich Wolfang Korngold. First time in America at the Metropolitan Opera House.
WITH: Clarence Whitehill (Simone Trovai); Maria Jeritza (Violanta [his wife]); Walther Kirchoff (Alfonso of Naples); Angelo Bada (Giovanni Bracca); Mildred Parisette (debut) (Bice); Henriette Wakefield (Barbara); Max Altglass (Matteo); Giordano Paltrinieri (First Soldier); James Wolfe (Second Soldier); Charlotte Ryan (First Maid); Mary Bonetti (Second Maid); Artur Bodanzky (Conductor).

HANSEL UND GRETEL—Fairy opera in three scenes. Book in German by Adelheld Wette. Music by Engelbert Humperdinck. Revival with new scenic production at the Metropolitan Opera House.
WITH: Edith Fleischer (Hansel); Queena Mario (Gretel); Dorothee Manski (debut) (The Witch); Henriette Wakefield (Gertrude); Merle Alcock (The Sandman); Mildred Parisette (The Dewman); Gustav Schuetzendorf (Peter); Artur Bodanzky (Conductor).

By OLIN DOWNES

A novelty and a revival made the bill of the first matinee of the season yesterday afternoon in the Metropolitan Opera House. The novelty was the one-act "Violanta," music by Erich Korngold, libretto by Hans Mueller, then performed for the first time in America; the revival was that of Humperdinck's "Hansel and Gretel," which has not been in the Metropolitan repertory for a decade.

The novelty first claims our attention. "Violanta" is the early work of an "infant prodigy" among composers. The history of Erich Korngold, who is no longer an infant prodigy, does not require recounting here, save to remark that "Violanta" was composed when the composer was 16 and that no one, apparently, had the discretion to keep him from publishing it. The libretto is crudely sensational, strained, exaggerated, in a manner savoring somewhat of Italian melodrama and somewhat of the one-act librettos of Richard Strauss, which enjoyed even a greater vogue than they do now when Erich Korngold, son of the critic Korngold of Vienna and loudly acclaimed as a "wunderkind" among modern composers, was growing up.

The music is remarkable for its technical precocity, and its lack of originality. Infant prodigies, like mushrooms, are best allowed to mature in the dark. There is nothing of individuality or dramatic conviction or revelation in the score, which is an anomaly of a dozen different musical styles, principally those of Strauss and Puccini, and full of tunes which other composers coming before Korngold had been so inconsiderate as to write down. The best feature of this score, as of so many opera scores, is the orchestration, which is brilliant in the turgid Straussian manner.

The story is brief and torrid. On a feast-day in Venice of the fifteenth century Captain Trovai, the despondent and aged husband of Violanta, misses his wife. A painter, one Bracca, a fop of the town, who is of no particular use in the drama or opera, save perhaps as a light foil to the sable events about to unfold, begs Trovai to go with him and join the festivities. Suddenly Violanta, bearing herself tragically, appears. She tells her husband that she has met and has made an assignation for that very night at her house with one Alfonso, described in the libretto as the "natural son of the King of Naples," a veritable Casanova, who had two years ago ruined Violanta's sister, causing her to drown herself in a canal. Now Violanta plots revenge. When Alfonso enters her house and has discarded his armor she will signal her husband. He will enter and kill the seducer.

Trovai being adverse to this, Violanta works upon his feelings and his jealous fears until he consents. But when Alfonso confronts her Violanta's courage fails. She is impressed by Alfonso's explanation of his stormy life and the temptations, the unhappiness, that dogged him. At last she reveals the truth—the frantic passion she has long felt for Alfonso, and which she has endeavored in vain to still, in plotting his murder. But it is too late. The voice of Trovai, who has been kept waiting some time, is heard. He enters; Alfonso reaches for his sword, but not in time. Violanta casts herself between the two men, receives the husband's knife in her heart, and dies, redeemed, as the gay revelers—oh, cruel and subtle irony of fate!—push in, and confetti are thrown about, as in the opening of the opera, and their choes a dismal verse that is intended as a gay festival song of 15th century Venice, the verse to the effect that this is the day when the very dead rise from their graves and dance "breast to breast."

This balderdash is one more vehicle for the histrionic desires of Mme. Jeritza. She was, of course, a Venetian blond, magnificent and sumptuously attired. Her first scene with Trovai had line and tragic dignity. Her sudden outburst of hatred for Alfonso, her winning the wretched Trovai to her ways, were plausible. But after this Mme. Jeritza's impersonation steadily declined in distinction and merit. She indulged in innumerable contortions and calisthenics, wholly uncharacteristic of a Venetian great lady of the fifteen century, being indeed, often ungrateful, exaggerated and ineffective.

Much more artistic was Mr. Whitehill in the rôle of Trovai. Mr. Bada took a petty part in appropriate fashion. Mildred Parisette made a creditable début in a still smaller rôle. Mr. Kirchoff astonished all. His costume was presumably that ordained for a "natural son of the King of Naples"; it somehow suggested a rather overripe English statesman of the pre-Nelson period, who sported a good leg, and wisely confined himself to speeches, rather than deeds, in his love-making. In this aspect, indeed, Mr. Kirchoff was not less than Chesterfieldian. He seemed to hesitate to close in with his enamorata. He sang with a gallant chestiness and an Italian flow of love. His "apologia pro vita sua" was the high point of his discourse, and it commanded a wave of applause. There was a good ensemble, a rich stage setting.

A pleasure it is to turn from this opera of bombast, superficiality and bad taste to the delightful work of Humperdinck, and a performance which was a triumph of individual and coordinated achievement on the stage. The Metropolitan has

had excellent and popular impersonators of children in "Hansel und Gretel" before this, but it is doubtful if they attained the level reached yesterday by Miss Fleischer and Miss Mario. Especially Miss Mario, whose Gretel was a personification of the German peasant child of the poem and of the child that Humperdinck glorifies in his score. In action and song this was a simple, characteristic and supremely finished impersonation by a young woman whose intelligence and artistic adaptability have long since been proved, but who had not before, in the writer's experience, accomplished what she did yesterday afternoon. The fresh voice, the admirable acting of Miss Fleischer worthily completed the effect of the two child figures.

Mr. Schützendorf's Father must take a place among his most genial and original impersonations. The make-up, the fresh and amusing stage business, are worthy of the highest praise. The audience laughed at and with his toss-pot hilarity and listened like children themselves to his admirable delivery of the couplets about the Witch. Dorothee Manski made her début as that ill-omened personage and was fully on the level of the rest of the cast—an expression that would make your teeth rattle, an apparition that would gnaw the very meat from children's bones. Miss Wakefield's Mother was wholly competent, touching as well as amusing in its picture of anxiety and need. Miss Parisette was heard to better advantage as the Dewman than in the opera of Korngold. Miss Alcock's Sandman was in the picture.

This opera is given an imaginative and poetical setting by Mr. Urban—a setting which is in the folk-vein of the tale. Mr. Bodanzky read the score with humor and fancy, though we would have preferred in general broader tempi and a treatment more warmly lyrical in certain episodes. But all in all, a highly commendable production of an opera that remains adorable in this sophisticated year of 1927; a true product of German folk-feeling and folk-lore, for "Hansel and Gretel" comes from the same forest as that of Weber's "Freischütz." Humperdinck's orchestra, it is true, is over weighted for the musical material and the charming and fanciful character of the subject. But this is a matter for esthetic and, in the light of the true inspiration and poetry of the work, rather academic discussion. Suppose Humperdinck was overly fascinated by the splendors of Wagner's instrumentation, and was at the same time too small a genius to wield that mighty magic with the utmost ease and pliability.

It does not matter very much. A few bushels of notes ("doublings") taken out of the "Hansel and Gretel" score would clarify its sonorities, but the sheer loveliness of the melodic ideas and the splendid contrapuntal workmanship, which never disperses the poetical color of the piece, make it a work of genius without which the world would be much the poorer.

This folk-opera was unworthily coupled yesterday with a tawdry and cheap piece designed for a prima donna's holiday. By so much was it the more welcome when it came, and the more beneficent its ministrations.

* * *

December 2, 1927

STRAUSS OPERA HAS AMERICAN PREMIERE

"Feuersnoth," in One Act, Is Sung by the Philadelphia Civic Company

LAID IN TWELFTH CENTURY

"Die Maeinkonigen," a Pretty Pastoral Work by Gluck, Also Given Before Brilliant Audience

By OLIN DOWNES
Special to The New York Times

PHILADELPHIA, Pa., Dec. 1—In these days of impoverished modern repertory it remained for the Philadelphia Civic Opera Company to give the first American performance of Richard Strauss's "Feursnot," opera in one act, after the text of Ernst von Wolzogen, tonight in the Metropolitan Opera House.

The performance of Strauss's work attended by a large and brilliant audience which included many people from New York, was preceded by a curtain raiser in the form of a short pastoral opera, "Die Maeinkonigen," attributed to Gluck, and known to have been composed to celebrate a birthday of Marie Antoinette. This pretty little piece was performed on a small raised stage with an orchestra of twenty-five. There was an unexpected intermission when all lights in the theatre went out—an effect not planned by the management. Otherwise there were no material mishaps.

The work of Strauss called, of course, for much more extensive apparatus. This was a very ambitious undertaking for an opera company, supported by public funds, which endeavors to achieve effects of rounded ensemble rather than to present leading singers of the day in principal parts. At the beginning the performance was very shaky, but the interpretation gained in security and spirit as it proceeded, and the opera, in spite of immaturities and imperfections, justified the effort spent in its production.

Preceded "Salome" by Four Years

"Feursnot" followed Strauss's first operatic failure, "Guntram," by six years and by four years his "Salome." In the actual chronology of his works it comes between certain of the great symphonic poems. The fact is of particular reason because of its immediate predecessor, the symphonic poem "Heldenleben." In that instrumental work Strauss stands revealed as the "Helden"—the hero, and there is a discordant passage labeled "The Hero's Enemies." These are the critics who would not accept Strauss, and a sour lot they are represented to be by the malicious tongues of his orchestra. In "Feursnot" Strauss's rejoinders to his critics are continued. Here he is again the persecuted great man, pictured as the musical successor of Wagner, with quotations by the orchestra from other operas by Wagner and by Strauss.

All this is an old story in Europe, where this choice bit of Straussian autobiography saw the light in 1901. The origin of

its story is found in a book of "Niederlandische Sangen" published in Germany in 1843. The tale of a pleasingly quaint, coarse and medieval nature, was called "The Unextinguished Fire at Andenaerde." The period of the opera is placed as the twelfth century. The place is Munich, the occasion St. John's Eve. Children go through the streets from house to house, collecting faggots for the bonfires of the evening. They come to the house of Kunrad, student, dreamer, stargazer, regarded by certain narrow and suspicious townsfolk as an evil magician, therefore shunned and feared by them.

Kunrad is confronted with the beauty of Diemut, daughter of Burgomaster Sentilinger. He bids the children destroy the house of books and make of it a blazing fire. He approaches Diemut and shames her by embracing her before the townspeople in the market place. The maiden, secretly enamoured of the reputed magician, is shamed and plots her revenge.

She invites Kunrad to enter a basket suspended by a rope from her window. Pulling him up half-way, she leaves him exposed to the mockery of the townsfolk. The "magician," enraged, denounces the mocking girl and prays that the people shall be deprived of fire. The town is suddenly in darkness and cold, and now the magician—Strauss in obvious and thinnest disguise—addresses the people. He is not a magician, but the pupil of another great and wise man, whose name was Richard. At mention of this potent name the Valhalla motive from Wagner's "Ring" echoes in the orchestra. Master Richard, continues the magician, had bidden his disciple go back to the people who had driven him away—as the Münchener's drove out Wagner and gave him to Baireuth—and enlighten them. But ignorance and darkness have again conquered the truth, and there is only one possible remedy. It is for the hitherto scornful and unresponsible Diemut to scorn or accept her suitor, if the people are to be saved. And now the towns-people cry out their need of fire.

Pray for Obstinate Maiden to Relent

They pray the obstinate maiden to relent. Here, at the climax of the opera, occurs the orchestral excerpt which made its way on American programs long before tonight's performance—the so-called "love scene." On the stage the moon emerges from the clouds; Kunrad is seen on Diemut's balcony. He vanishes within. Gradually the orchestral tone swells and glows; a light comes from Diemut's window. At the swirling climax the fires flare out; there are heard the joyous salutations of the people; youths and maidens sing together, to text a little plainer than English translations permit. In other words, genius has won its way; art, in the person of Richard Strauss, has triumphed, and the public is saved.

The virtues and defects of this curious work make a singular melange, but one that partly survives the test of the theatre, because of the presence of considerable folk music in the score, a frequently superb employment of orchestra and chorus, too, and the virile, if often vulgar force and eroticism of Strauss's writing. But what a mixture. There is an opening in folk vein, distantly suggestive of "Till Eulenspiegel." Several authentic folk songs are employed. The next significant

passage is Kunrad's ecstatic apostrophe to nature, youth and love, as the evening fires blaze out in the darkening sky.

In this part of the opera occurs one of many incongruities and anachronisms, namely, the Viennese waltzes to which the populace dances and sings. These waltzes are cheap and ridiculously out of style. Among the most effective pages are those given the chorus when it cries out in terror at the sudden darkness and begs powers, that it cannot understand, for deliverance from terror and evil. This is Strauss of an operatic period far more advanced than "Feursnot," and behold, as the magician concludes his hectoring address to the public the motive of Agamemnon, of the "Elektra" score, rising from the depths of orchestra, shaking its fist at posterity. The final tableau, where Strauss's orchestra tells the tale, unaided save at the very last by chorus and soloists, is of questionable originality and taste, but of immense and unquestionable effect in the theatre. In "Feursnot" Strauss is young, fiery, conceited, and as completely lacking in a sense of humor as his hero.

Alexander Smallens Conductor

The performance cannot be discussed in detail here. The conductor was Alexander Smallens, musical director of the Philadelphia Civic Opera Company. The artistic director is W. Attmore Robinson. There was a band of seventy-two players from the Philadelphia Orchestra. The principal soloists were Helen Stanley for the role of Diemut and Marcel Salzinger for that of Kunrad. Sigurd Nilssen was the Sentlinger and George Rasely took the comic part of the Bailiff.

These soloists were intelligent and for the greater part of the time effective in their parts. The stage management of the earlier scenes was poor. The chorus was ill at ease for some time in action and song. There was poor intonation, but later compensatory achievement.

Mr. Smallens conducted with unfailing conviction and by sheer enthusiasm carried his forces over rough pages. With this kind of a conductor and an experienced orchestra, plus Strauss's scoring, it was inevitable that the best pages should be those in which the instruments took command of the situation. The lighting was totally inadequate to the demands of the opera. Nevertheless, this departure of a young opera company was applauded and enjoyed by the audience and is to be recorded a courageous, if not wholly adequate, presentation of a work that has waited long for an American hearing.

* * *

March 4, 1928

OPERA IN GERMANY

Novelties and Revivals—Handel's 'Ezio' in Berlin—Munich Sees 'Skyscrapers'

BERLIN—Let us start with the "Reich" this time, as Berlin has had no first performances to offer. There were two small events in Weimar, unimportant in every way (nobody

nowadays writes "great operas," the composers as well as the public have lost their patience and endurance): A chamber opera, "Don Juan's Sohn," by Herman Wunsch, and "Ol-Ol," by Alexander Tcherepnin, representing scenes of university life in Russia. The libretto of the first composition is simple, though it has an effective dénouement. It tells of the love affairs of the son of the famous libertine. Each time, by an unlucky chance, the object of his affections happens to be one of his sisters. A productive father. He dies from gazing at a woman's picture painted in poisoned colors, while his father disguised as a monk looks on. The music is superficial and lacking in emotional quality.

Tcherepnin proceeds with greater verve. The plot deals with pre-revolutionary Moskva, with post-revolutionary morals.

Ol-Ol loves the student Nicholas, whom she cannot marry for lack of money. Her mother forces her to marry the officer Grigori. They live in an atmosphere of quarrels, reconciliations, drinking bouts, general misery—in short, a sentimentally bohemian milleu. Thanks to Russian literature, the German public is ethnographically familiar with the situation, if not morally sympathetic. Tcherepnin's score is rich in choral effects, dramatic interludes and lyric climaxes. His music is simple, unpretentious, but always forceful and never abstract. Despite all this, however, it is unlikely that the composition will have a long life.

Another opera by a famous Spanish violinist has just been produced in Karlsruhe, "Nero and Akte," by Juan Manen. The violinist Manen is more deserving of fame than the composer Manen. The libretto relates a story of the burning of Rome and the persecution of the Christians. It is a most old-fashioned opera, with very little appeal for the modern public. The music is conventional, with a few effective passages. Manen's interest in the German stage is most pathetic, but, we are afraid, hopeless.

"Skyscrapers" a Success

Munich displayed a most progressive spirit by producing John Alden Carpenter's ballet "Skyscrapers." The American public being familiar with the composition, all I want to say is that the stage settings by Heinrich Kroeller and Leo Pasetti were perfect and the young Paul Schmitz conducted excellently. Carpenter himself appeared before the footlights. The joke is that "jazz" entered the national theatre of the Bavarian metropolis (in a mild form to be sure) where Krenek's "Jonny" was rejected with such vigorous indignation. The critics were most favorable. The contrast between the world of activity, with its symbol the sky-scraper, and the world of amusement could have been emphasized to better advantage. Carpenter's music is a little too playful.

The Städtische Opera of Berlin had two offerings. Much has been said about the "Handelrenaissance" and the attempts to revive the Handel opera. This movement originated in the university city of Göttingen, and not a musician but a scientist, Otto Hagen, deserves the credit. One of these Göttingen revivals, Handel's "Ezio," has been transplanted to Berlin. Was it Handel's "Ezio"? Almost nothing remained of Handel's original opera. To treat originals as one pleases is one of the principles of the "style opera." Drastic cuts have been applied to the libretto, scenes and airs have been eliminated, shortened and transferred, some have been borrowed from other operas, until there remain a series of aria torsos, sung in costume by opera and concert singers, with a "rotating chorus." This opera "renaissance" is very much distorted. We have no more male sopranos; the monumental art of song which held audiences spell-bound for five or six hours is also gone. We do not listen to this opera with the right ears, we do not see it with the right eyes. Since we have no more male sopranos, we emasculate Handel's masterpiece. This unfortunate production certainly was a strong blow to the "Handel renaissance."

Lack of Vital Works

Bruno Walter surprised us with a revival of Hugo Wolf's "Corregidor." It looked like a celebration on the twenty-fifth anniversary of the unfortunate composer's death. However, this revival was only a qualified success. Its dramatic effect is not strong enough, although the scene of the jealous miller is impressive. The opera is little more than a string of lyric pearls. The performance had a refinement akin to chamber music. Musicians were delighted with it, including the work of the soloists, Karl Erb, Maria Rajdl and Wilhelm Guttman and others.

Klemperer's State Opera brought out Gounod's farce, "Le Medecin maigré lui," in a very enjoyable performance, with the excellent Karl Hammes in the chief rôle and Fritz Zweig conducting. The composition dates back to the time of "Faust." We are worried about the future of this institution. The State Opera Unter den Linden will open in a few weeks with "The Magie Flute." No doubt, Klemperer will have many rooms to rent if he becomes the only landlord on the "Platz der Republik." His rather limited repertory contains some entirely insignificant works.

The situation of the German opera stage is most baffling. The Handel and Verdi renaissance, as well as the unearthing of the fine and noble but still-born "Corregidor" is only a proof that vital new compositions are lacking, not only in Germany but all over the world. Hindemith's "Cardillac" was the latest effort to overcome this situation. The very active and vivacious Hindemith did not write this work for academic reasons, or as an experiment, but with the purpose of supplying the German opera stage with a trump. Success favored Krenek's "Jonny." In 1926 "Cardillac" was played on more than a dozen German stages, today it is forgotten. It will be interesting to analyze the composition, trying to find the causes of its failure.

Hindemith's "Cardillac"

What are the shortcomings of "Cardillac"? It is hard to criticize an opera which met at its debut only misinterpretations and malicious comments. One would much rather refrain from repeating all the objections so often raised against the libretto: "There is no deep psychology in Ferdi-

nand Lion's adaptation of Hoffmann's goldsmith, who murdered all his customers . . . The rôle of the lady and the knight should be restricted to the first act . . . the scene of the dumb king . . . the excessively skeletonized language . . . and so on. As a matter of fact, the language of the book is not what the composer intended, real opera German, plastic and poetic. Besides, the libretto does not need many words. Its entire structure is so clear and transparent that the most naïve listener can understand it even without the words. The only better libretto of recent times is the "Golem" by the same Ferdinand Lion, with music by Eugen d'Albert.

The criticism Hindemith's music had to face was even more severe. "Incongruity of the libretto and the music . . . a naturalistic interpretation . . . musically stylistic . . . the differentiation between actors and singers . . . the singers give conventional interpretations only . . . there are fuga and fugati, airs with concentrated instrumental effects, choral variations and passacaglia akin to 'jazz.' All this on the stage, while the orchestra follows a different track; everything in the atonal vein, just modern music." What everlasting truths! They found fault with the knight and the lady, subordinate figures both of them, whose sole function was to make Cardillac's part clearer. Without the sonorities of the Wagnerian music drama there is great suspense in this scene; one feels the approach of some mysterious danger. Is there no congruity between the libretto and the music? Is it not the absolute right of the composer to transform the phrases as he pleases and to limit musical effects? It is apparently presumed that the rules governing the relation of dramatic singing to the orchestra were established forever in the second half of the nineteenth century. Every unprejudiced listener must admit the lyric beauty of the daughter's air in the second act, and also the dramatic power of her duet with the officer. The rounding off of this act by the opening and closing monologues of Cardillac, the musical momentum in the chorus scene of the last act, which begins like a passacaglia, all this serves to prove the creative power of the composer. True the transitions are somehow artificial, but the dramatic never becomes "veristic" and the style is far from oratorical. The music of this work is overflowing with sentiment and poetry, which floats above it like the fragrance of a flower.

Fusion of Text and Music Needed

Hindemith's musical declamation raised objections from some of the most experienced critics. This is the point where the conciseness of the composition becomes a danger. The writer considered Hindemith's use of such a method utterly out of place and a mere substitution. This applies also to Stravinsky and to modern music in general. In the case of this composition, however, conciseness and pedantry become an advantage: Is this opera not in keeping with the spirit of Hoffmann's "Gespanster"? To a certain extent at least, though it lacks the warmth and color of Hoffmann. This brings us to the composer's reluctance to use natural harmonies, the only exception being the E major chord of the finale. But why did the composer refrain from utilizing the entire span of the scale? Verdi once wrote a letter to Enrico Bossi, in which the veteran master refers to the way moderns indulge in dissonances, "You say that dissonance has its legitimate place in music: You are perfectly right, though I for one prefer consonance, and I think I make no mistake."

Modern opera will only succeed when text and music meet again—when the librettist will write for the composer and the composer for the librettist: when tone language will be of such general appeal that it will have the public, the great public, on its side. No opera can be written without considering the public taste.

ALFRED EINSTEIN

* * *

May 13, 1928

ORCHESTRA FUTURE

New Philharmonic Spreads Its Feast—Some Further Critical Surveys

By OLIN DOWNES

The consequences predicted in these columns a year ago, in the event of a combination of the New York Symphony and New York Philharmonic Orchestras, are materializing quick and fast. Orchestral concerts may or may not pay, but apparently there are always people willing to back the expenses of costly series of symphonic performances, as there are always in the offing aspiring conductors willing to give these generous individuals a run for their money.

Hard upon the announcement of the merger of the two big orchestras, and previous to the detailed statement of the Philharmonic-Symphony's schedule for next season, the aspiring Beethoven Symphony Orchestra announced last Monday a series of thirty-six symphony concerts next season in place of its former series of seven, with at least one guest conductor, Arthur Honegger, of international reputation as a composer; while at the same time we hear murmurs and portents from the quarter of the Friends of Music, who, it seems, also contemplate an extension of their schedules as they have been in recent seasons, with Mr. Bodanzky as helmsman of an imposing series of concerts offering choral as well as orchestral attractions. No! The merger of New York's two leading symphony societies will not put an end to orchestral competition in this city; will not relieve rival orchestral concerts of numbers of "dead-head" patrons; will not, as was fervently hoped, quench the rivalries of virtuoso conductors. New York will continue to be the happy hunting ground of these persons, who will always be able to find gentlemen, and ladies too—God bless 'em—willing to further their ambitions.

Nor do we believe that the end—with Mr. Georges Zaslawsky looming to the southward and Mr. Bodanzky threatening in the east—is yet. We are certain that other mushroom orchestral growths will rise in the night ere the dawn of the season of 1928–29. They will perish, most of

them, but others will rise in their places to compete for the approval of a city which is almost the largest and probably the richest in the world, with a potential public to be lured to the feet of the most successful "guest" leader. And where is the conductor, celebrated or unsung, who does not cherish the fond belief that he is at least the equal if not the superior of his most distinguished colleague of the baton? We could mention others than Messrs. Toscanini, Mengelberg, Damrosch, Beecham, Bodanzky, Zaslawsky; others also than the alert gentlemen who come here with the visiting orchestras, who sniff the powder in the air and plot conquest from afar. They may be happy and successful in other places; they may have symphony orchestras of their own and a local public at their feet. It is not enough. The battle cry is "New York," as in Europe it is "Paris" or "Berlin." Nothing but a triumph in these spoiled and petted cities, ovations from their audiences, praise by their press, will satisfy the longings of the orchestral leader. So far as numbers of concerts are concerned, the result of the Philharmonic-Symphony merger will merely be more orchestral concerts than ever in New York City. As to their quality—that's another matter. But, be sure, there will be no decline in the numbers of conductors intent on carrying Manhattan by storm; the air will be hideous with the alarums and excursions which precede the assault.

But the Philharmonic-Symphony has planned well and bids fair to occupy a position of unprecedented security. The schedule for next season is skillfully devised to satisfy the needs and minister to the satisfaction of the subscribers to the concerts of both the former orchestras. It is true that the present Philharmonic subscribers who do not wish to double their subscriptions will be asked to content themselves with twelve pairs of Thursday evening and Friday afternoon concerts, in place of the previous twenty, and with thirteen Saturday evening and Sunday afternoon concerts in Carnegie Hall, in place of the previous twenty-four. The seven Metropolitan Opera House concerts will be open equally to all subscribers. So will the six concerts given annually in Brooklyn. In other words, precisely the same number of concerts, share and share alike, will be open to the former New York Symphony and former Philharmonic subscribers. No priority claims are given the advantage in this arrangement.

There will be a rise in the price of seats, but it will not be a large one. The added expenses of the lengthened season of the new orchestra, the increase of its permanent membership to 110 and the increase of wage scales will be offset in considerable measure by increased patronage and by "generous guarantees of patrons of both organizations," which "have further aided in minimizing the increase." Subscribers to the former twenty pairs of concerts, under the new arrangements and prices, may find themselves satisfied with the twelve pairs of the Thursday and Friday concerts and such concerts of the series open to all subscribers as they wish. It is good to reflect that in spite of additional expenses and increase in the cost of most of the tickets, the prices of seats for the "educational concerts" remain as they were; and not only this—there will be provided through the whole seven months' season certain

seats ranging in price from 25 cents to $1.25, "the number of these seats, exclusive of children's and young people's concerts, being officially totaled as 119,811." This meets the needs of Mr. Damrosch's former audiences, who enjoyed similar privileges at Mecca Temple, as well as the Philharmonic patrons of the most modest means, and puts a large number of seats at the disposal of this very important element of the orchestral public.

It is finally of interest to consider the implications of the announcement that whereas this season the Philharmonic-Symphony Orchestra must spend a month out of town on tour, "owing to previous commitments," the tours "will be greatly curtailed in the season of 1929–30." This is in line with the whole wonderful progress of orchestral music in this country in the last twenty-five years, whereby, as more orchestras come into existence, and local orchestral publics grow, and expenses of transportation and of salaries mount, the great orchestras find it more and more expedient, and profitable, to meet the needs and foster the musical development of the publics of their immediate neighborhood. This part of the announcement is also token of the clear intention of the Philharmonic-Symphony to do all that it can to give permanence and stability to its activities, and dominate, as nearly as possible, the orchestral situation in New York City.

* * *

June 7, 1928

'EGYPTIAN HELEN' WINS A TRIUMPH

Strauss's New Opera, With Elisabeth Rethberg as the Heroine, Sung in Dresden

BEAUTIFUL STAGE PICTURES

Production Like Enchanted Land of Sight and Sound—Curt Taucher Excels as Hero

By H. C. COLLES
Special Cable to The New York Times

DRESDEN, June 6—Once again Richard Strauss and Hugo von Hofmannsthal have gone to Dresden for the production of their joint work, and after a first-night hearing of "Egyptian Helen" in the Saxon State Opera House one comes away feeling assured they could not have done better.

With the cast in which Elisabeth Rethberg makes a beautiful and queenly figure as Helen of Troy and Curt Taucher a manly and convincing one as Menelaus; with Aithra, the Egyptian sorceress whose well-intentioned assistance by means of magic potions causes most of the complications in the roles of hero and heroine, well sung by Maria Rajdl, and all other many minor parts of the opera cast to scale; and, most important of all, with the complicated musical ensemble perfectly directed by Fritz Busch, the opera has been assured a first presentation on the highest level.

Moreover, the stage design here is equal to the musical performance in every particular. The stage pictures and costumes designed by Leonhard Fanto, with subtly changing effects of light, which in modern opera houses are almost as significant as what is called light and shade in musical interpretation, were made to weave their spells through the eye as music did through the ear. Certainly if the aim of the opera is to make one live in an enchanted land of sight and sound for a couple of hours, Hofmannsthal and Strauss, with all the resources of the Dresden Theatre supporting them, have attained it completely.

Classicists will not quarrel over the truthfulness or otherwise of this imaginative Helen as they did twenty years ago over "Electra." Moralists will not look askance as they did some time before when Salome first danced her way out of the seven veils. If it is asked and, of course, it must be asked of every German work sooner or later, what is the underlying philosophy of this drama—even that question may be allowed to wait for its answer till the first impressions have worn off. If musicians ask, does Egyptian Helen reveal a new Strauss? Has he become more "polytonal" or "atonal," or does he exploit any of the many devices which have engaged composers since the days when Strauss was considered the "new man"—they may give no for an answer at once.

The music of "Egyptian Helen" shows us substantially the same Strauss, wielding his weapon of a prodigious orchestra more boldly than ever, but also relying more simply than once he did on the expressive vocal line, on the power of the human voice to tell a tale of human emotion.

A Great Vocal Part

Every one will admit Helen has a great vocal part and that Elisabeth Rethberg's singing of it as worthy of the great opportunity the composer offered her. Here it must suffice to describe a few of the details which contribute to the impression that there has certainly been brought forward a work which every opera house having adequate means to present it must give to its patrons as soon as possible.

Wry, twisting arpeggio and clamorous outburst of orchestration precede the parting of curtain, on which appears the palace of the sorceress, supported on golden pillars. Deep blue curtains fill the spaces between pillars—curtains which at one moment have the solidity of walls, at another seem to dissolve, so that the night storm and the actions of Aithra's spirits are visible. Poseidon, god of sea dolphins and shells, decorates her golden pillars with color. Her familiar spirit is the "all-knowing shellfish," who, placed on a tripod in the centre of the stage, shows her visions of what is transpiring.

The shellfish describes Helen and Menelaus on board the ship and reveals the fact that Troy has fallen and the hero has regained possession of his ravished wife. More than that, it tells his resolve to kill her and of how only the storm shattering his vessel impels him to leave his design unfulfilled and save for the moment the woman he meant to destroy. The storm will throw the ill-fated pair at the feet of the sorceress. Its turbulence gradually subsides and lastly, in a moment of complete silence, Helen and Menelaus, half dazed by the violence they have encountered, make their entrance into a now empty palace.

Music Becomes Lyrical

From this point the music becomes lyrical. Some of its melodies sound familiar. Is Strauss deliberately quoting from some of his earlier works or is he unable to rid himself of memories of Wagner's loves? If the latter he must be forgiven, for in this medley of love scenes and potions of forgetfulness and remembrance some reminiscence seems inevitable. Aithra is a beneficent sorceress. She rouses her slaves further to confuse the bewildered mind of Menelaus so that he pursues phantoms of Helen and Paris, imagining he has wreaked vengeance on them, only to return and find Helen enshrined on the magical couch and to become once more enchanted by her beauty.

In the final trio of this act the three sing in exalted tones of forgetfulness of the past, of reconciliation, of peace. Only distant laughter of elves disturbs the scene. In the second act Helen and Menelaus have been wafted by Aithra's power to a palm grove at the foot of the Atlas Mountains. Helen's love song while Menelaus still sleeps is one of the most beautiful things in the opera. But its serene mood is soon broken by Aithra's coming with chiefs of the desert, who lay offerings at the feet of Helen and arouse the jealous forebodings of Menelaus.

In all there is so rich an opportunity for stage effect that the main psychological idea tends to get lost. The action is further complicated by the reappearance of Aithra and her attendants, by an unseen fight, by Aithra's declaration of love for Helen even over the dead body of her son and all this taking place while Helen is mixing the draught which will bring back remembrance to Menelaus. The frivolous-minded may be inclined to suggest that the drinks are too many and too freely mixed in this opera, but such frivolity is destructive to romance and after all their revolts against it, the author and composer of "Egyptian Helen" have come back to romance as the main motive power of their drama.

We must accept it on their terms and perceive Helen restoring her long lost Menelaus to love and confidence by insisting on remembrance and not on forgetfulness as the right attitude for lovers.

And we have little difficulty in accepting the terms when Helen conjures Menelaus to receive this potion with the same music as that of their first scene together when Menelaus responds and their duet is succeeded by another voluptuous trio to which the voice of Aithra is joined and finally when their love is sealed by the appearance of their child, Hermione, who, with all the simplicity of theatrical childhood, asks: "Father, where is my beautiful mother?"

Thus composer and author work together to a conventional happy ending. The opera was received enthusiastically by a crowded theatre containing music critics from all parts of Europe. At the end of the first act Strauss was called to the stage and bowed acknowledgment with the principal singers.

After the second act still more vigorous applause brought Strauss, von Hofmannsthal and Conductor Busch to the stage. Recalls were very numerous and cheers particularly hearty for Mme. Rethberg whose performance created an overwhelming impression.

* * *

November 7, 1928

AMERICAN PREMIERE OF 'EGYPTIAN HELEN'

Mme. Jeritza Sings the Title Role of Richard Strauss's Opera at the Metropolitan

SPECTACULAR PRODUCTION

New Work Sparse in Emotional Emphasis—Its Libretto Lacks Directness and Consistency

DIE AEGYPTISCHE HELENA, music drama in two acts, first performance in the United States. Book in German by Hugo von Hofmannsthal. Music by Richard Strauss. At the Metropolitan Opera House.
WITH: Maria Jeritza (Helena); Rudolf Laubenthal (Menelas); Helen Eisler (Hermione); Editha Fleischer (Aithra); Clarence Whitehill (Altair); Jane Carroll (Debut) (Da-Ud); Philino Falco (Aithra's First Maid); Ina Bourskaya (Aithra's Second Maid); Louise Lerch (First Elf); Charlotte Ryan (Second Elf); Ina Bourskaya (Third Elf); Dorothea Flexer (Fourth Elf); Marion Telva (The Omniscient Shell); Artur Bodanzky (Conductor).

By OLIN DOWNES

Richard Strauss's last opera, "Die Aegyptische Helena," the libretto by Hugo von Hoffmannsthal, was given its American premiere by the Metropolitan Opera Company last night. The opera was first performed June 6 last in Dresden, with Elizabeth Rethberg in the title part. The second performance was given in Vienna June 11, when Mme. Jeritza was the Helen. It is claimed, and there are quoted cablegrams to support the contention, that Strauss wrote the opera for Mme. Jeritza. New York saw last night not only the Vienna impersonation of Helen, but, according to report, the Vienna stage version of the opera. If this is so, it must be remarked that it was the Dresden version—according to eyewitnesses—and not that of Vienna, which followed precisely the stage prescriptions of Strauss's libretto, as the Metropolitan does not do. What it does do is to present to the eye some scenes and, costumes of a semi-classic, semi-fantastic gorgeousness; a libretto which is somewhat rambling and dramatically futile, and a score that runs for one act with plausible routine, and a second act that is sheer emptiness, the whole being signed by a composer of international reputation.

Setting of Palace and Desert

The Metropolitan production, which, thanks to cuts which mutilate text, but which are on the whole well advised, lasts only a little longer than two hours. That is long enough for a Metropolitan audience on election night to gaze upon Mme. Jeritza, in a setting of palace and desert, and to carry away with it any and all of the felicities of Strauss's score. He is not wholly to be blamed if he found himself helpless before the redundancies and futilities of the text of Hoffmannsthal.

This text, as we know, tells a tale of which the background is the Egyptian variant—or variants—of the age-old legend of Helen of Troy. This version is as old, at least, as the Greek poet, Stesichorus; it was known to Herodotus, to Horace, to a dozen other minor authors of antiquity, and to Euripides, who cast it in its most significant and memorable form in his "Helena." This is the strange and fascinating conception of two Helens: the one a phantom sent by vengeful gods to deceive the Greeks and ruin Troy, the other the real Helen, driven by celestial agencies to the sheltering land of Egypt, where she lived, securely guarded, for many years, until Menelaos, returning from the sack of Troy, discovered her and took her back to the Spartan throne.

Opens in Palace of Sorceress

These tales represent von Hoffmannsthal's point of departure, but he goes far in story and in spirit from either Greek or Egyptian sources. His first act opens in the palace of Aithra, who is here a sorceress, and daughter of an Egyptian King. The enchantress is apprised by the Omniscient Sea-shell, which glowing with color tells her of Menelaos's attempt to kill Helen, on the ship that is taking them from Troy. Aithra commands a storm and a shipwreck. Helen and Menelaos appear. Menelaos is resolved on revenge. He raises the knife. The wondrous woman bares her breast, and defeats him with a smile.

Helen is inflexible and confident in her purpose to win again her husband's love. She is assisted by Aithra, who provides a drug which causes the woman for whom guilt does not exist to sleep and to waken like a young and innocent bride. Aithra then bewilders Menelaos with the illusion, produced by her elves, that he is again before Troy, that he hears the name of Paris, whom he must slay. He seizes his knife and returns, as he believes, with its blade dripping blood. The audience sees that the blade is clean. Aithra gives Menelaos also the draught and shows him, in an inner chamber, Helen, asleep—ageless, incomparably beautiful, eternally young. She awakens. Menelaos, intoxicated, cannot believe his happiness. Helen asks Aithra to transport them to a place where no one has heard of Paris or Troy. This place is a palm grove at the foot of Atlas.

But Helen cannot wholly deceive Menelaos; he is restless and discontented; she disdains the companionship which conceals the truth. In the desert, King Altair approaches, overcome by Helen's beauty, contemptuous of the puzzled and glowering Menelaos, determined to possess the Spartan Queen. In turn, Altair's son, Da-ud, who reminds Menelaos of Paris, is enamoured, and is warned by Helen, who is unmoved, of the danger attending his desires. There is a hunt off-stage, and the murder of Da-ud by the jealous Menelaos is described. Altair, desperate with passion, calls his slaves to

kill Menelaos. At this moment Aithra, bearing his sword, appears, and with her the rescuing Poseidon and his train.

And now is the moment of perilous trial to which Helen fearlessly, yes, gaily, addresses herself. She insists, against Aithra's warnings, upon another magical potion, the potion of remembrance. If she is to win back her husband's love it must be with his full knowledge of the past. The goblet is drained. Once more Menelaos raises his sword, but now be perceives Helen as a woman, a hundred times more wondrous and irresistible than she who left Sparta for Troy. They embrace. Hermione, whom Poseidon has produced from nowhere, wishes to know her "fairest" mother. There is reconciliation. As Mme. Jeritza pats the neck of a large horse, the curtain falls.

Similarity in Acts

Not only does this libretto lack directness, consistency and force of development: it also falls between the stools of that which is classic and a modern and feeble neuroticism. Finally, there is the fatal weakness of the resemblance of the dramatic outlines of the two acts. Act II, whatever its philosophic motivation, is for all practical intents and purposes, like Act I. In both acts Menelaos is intent on revenge, then disarmed by Helen's beauty, then joyously reconciled to her. It is philosophically significant that in Act I the killing of Paris is unreal, and that in Act II Da-ud, symbolic counterpart of Paris, is actually murdered. It is clear that the love apparently realized in falsehood and compromise in Act I is made true and enduring by the revelation of actual truth in Act II. But this does not make drama or opera, which especially concerns itself, through music, with sensuous or emotional reactions. In fact, it would not be easy on any grounds to be convinced by Hofmannsthal. This is poor stuff at the best. There is nothing convincing in the operatic Menelaos, who has neither dignity nor distinction of any kind, and whose weak uncertainties and introspectiveness come to nothing. With all the high-falutin', he remains a card-board figure who gives not the slightest justification for Helen's passionate attachment. And Helen, also after high-falutin', is seen as the wife of a man high in Spartan society, only too glad, after having tasted of "life," to get back to her husband's house and board.

Then there is the business of the everlasting potions, draughts of sleep, draughts of forgetfulness, draughts of remembrance. The impression is of something nebulous, artificial, without real basis for being. One thinks of this libretto neither as drama nor opera, but as a kind of musical extravaganza. As composed the only signs of the creative are found in the early scenes, while the latter ones are as empty, futile, still-born as it is possible for the music of an experienced composer to be.

In the performance, particularly of the second act, there were cuts. A page, and a particularly difficult one, of the aria of Helen was cut out. The love song of Da-ud to Helen, a pretty if innocuous passage, was cut. The part of Altair was shortened, and well shortened, since there is nothing in it. The musical pleasures of the evening came exclusively in the earlier scenes, with the opening air of Aithra; the realistic orchestral depiction of wave and storm; the long and melodious duet of Helen and Menelaos, and the effective scenic music that accompanies Aithra's revelation to Menelaos of the beauty of the sleeping Helen. There is Wagnerian ranting in places, where the singers must shout at top voice, over a noisy orchestra. There are various recollections of "Salome," a phrase that corresponds to one of the more obvious fragments of "Electra," and other reminiscences that blend easily with the rest of the music and do not disturb. The orchestration is, of course, expert, and more economical than that of Strauss's earlier operas.

* * *

January 20, 1929

'JONNY SPIELT AUF' OPERA OF THIS AGE

Production in Which Negro Jazz Band Leader Is Hero Has Its American Premiere

BURLESQUE ON THE DECADE

A Breathless Phantasmagoria, With Ultra-Modern Harmonies and Cleverly Parodied Jazz

BOHNEN IN HERO'S ROLE

Drama Capitally Interpreted by Baritone; Also by Miss Easton and Others

JONNY SPIELT AUF, a "jazz opera" in two "parts" and twelve scenes. German book and music by Ernst Krenek. Produced for the first time in America at the Metropolitan Opera House.
WITH: Walther Kirchhoff (Max); Florence Easton (Anita); Michael Bohnen (Jonny); Frederick Schoor (Daniello); Edith Fleischer (Yvonne); Arnold Gabor (Anita's Impresario); George Meader (Hotel Manager); Max Bloch (Railway Guard); Marek Windheim (First Policeman); George Cehanovsky (Second Policeman); William Gustafson (Third Policeman).
Incidental dance by Corps de Ballet in Part II, Scene 8, arranged by August Berger.
Artur Bodanzky (Conductor); Wilhelm von Wymetal (Stage Director); Giulio Setti (Chorus Master); Joseph Urban (New scenic production).

By OLIN DOWNES

Ernst Krenek's "Jonny Spielt Auf," opera of the present age, or parody, in terms of jazz, automobiles, loud-speakers, steam engines, and what not of the world we live in, had its first American performance last night by the Metropolitan Opera Company. This opera has been the sensation of the last two years in Germany, where its premiere was given at the Leipzig Opera House, Feb. 11, 1918. From Germany it spread, with various fortunes, to Russia, to Balkan countries, to Belgium, and last Summer to Paris, where it had a cold reception. But there was no coldness in the reception of the opera last night. The audience, one of the most brilliant of the season, broke into prolonged applause as the curtain fell on the first part; at the end there was one of the most enthusiastic demonstrations of the season.

Whether this enthusiasm was occasioned by the finer points of Krenek's extremely modern, dissonant, but often witty and brilliantly composed score, or whether the audience was simply amused by certain passages of jazz, the antics of Mr. Bohnen in the name part, and the unconventional stage settings, is another matter. Last night "Jonny Spielt Auf" had an unconditional success. The fact of its hero being a negro jazz player, amorous and successful with white women, apparently aroused none of the resentment that was anticipated on some sides.

The reason for this acceptance of Krenek's plot was doubtless because of the manner in which the race element, or issue, was treated. Jonny's advances to Anita were almost eliminated, and Anita was represented as indignant instead of acquiescent, as originally, to his addresses. The stage business of Mr. Bohnen, in black face and white gloves, and Miss Fleischer, the Yvonne of the cast, might have been that of two comedians in any theatre or cabaret. In other words, the particular issue on the Metropolitan stage was tactfully avoided.

To these statements it should be added that the opera as originally planned and presented on the Leipzig stage contained no such reflections upon America as Mr. Urban's misrepresentative might seen to imply. Krenek satirizes Europe and European tastes and customs in a world demoralized and vitiated by sensuality, vulgarity, and materialism and jazz. There are quotations in the score of "Way Down Upon the Swanee River," and there are parodies of "Blues," tangos and other dance steps and rhythms which, as all the world knows, originated here. But there were no American flags, Statues of Liberty and other superfluous and Cohanesque ornaments on Mr. Krenek's stage in Leipzig. There was, instead, a fantastical tableau of Jonny atop an immense globe, which filled almost the whole proscenium. On this whirling globe, so high up that all necks were craned to see him, was Jonny, fiddling rapturously, grandiloquently, and back of him were drunken planets, reeling in the sky, and far beneath him was a mad Bacchanale of men and women in every variety of modern and disheveled dress, cavorting to his fiddle. And finally the whirling globe became stationary and turned into a record disk, with inscription in the form of a circle. 'Jonny Spielt Auf'; Ernst Krenek of 43."

The English translation of the title of this opera lacks the snap and the suggestion of the German. "Jonny strikes up the band" is clumsy. Jonny, the jazz band leader, tunes up, "steps out," "strikes up" for the silly gyrations of existences that mean nothing in an environment of ornate hotels, with managers, bell boys and chauffeurs; glaring city streets; automobiles in which robbery and mayhem are committed; police stations, Summer resorts, railway terminals, with official barkers, porters and policemen; incoming and outgoing trains that move by the clock, and radio apparatus. Everything flies by, or should fly, like scenes in a cinema drama. There is no time for love-making—the taxi waits to transport the prima donna to the train. There is hardly time for murder. It is a breathless phantasmagoria, accompanied by music quite lacking in juice, but often witty, with ultramodern harmonies

"Jonny" (Michael Bohnen, Baritone) in the finale of Krenek's new work, produced last night at the Metropolitan.

that on occasion grate and bite and much cleverly and laughably parodied jazz. Eleven scenes and an apotheosis, and all over inside of two hours and forty minutes! Back of 1914 this could not have existed. It is post-war stuff, probably of only temporary interest, but very interesting in its topical and temperamental characteristics—a symptom and a bitter burlesque of this particular time, even, let us say, decade.

There are just two scenes and one motive, dramatic and musical, in the opera that counteract the realism of the rest of it. They are the scenes before the glacier, which represent, let us say, nature, aloof, inhuman, unsympathetic to our fevers. The mountain has a serene and atmospheric motive. The characters? Max, the weak, indecisive, oversensitive composer, for whom there is no room in this age, is seen on the rising of the curtain saluting the frozen silence, the glittering form, which appeal to him as an artist since they seem to symbolize formal principles of art embodied in nature! Aside from this friendly glacier, to which Max flies a second time to escape from reality, all is frailty, illusion and dross. Krenek seems to us to observe this thing with a certain savage wit, with his tongue in his cheek; also with a very brilliant technic—witness his orchestra and such a "scream" of a passage as the polytonal end of the first part—and a lightness of touch which at once proclaims a Czech and not a German in his style.

Max, on the glacier, is easily impressed by the chorus of Anita, the silly and soft-hearted prima donna. They become lovers. Gone to Paris, to sing in Max's opera, Anita is beheld

by Jonny, besought by him, but won temporarily by Daniello, the vain and sentimental virtuoso. Jonny, forsaking Yvonne, the chambermaid, steals the precious fiddle, with which, as he tells Yvonne, he will fiddle as David before Saul.

The jealous Daniello sees that Max learns of Anita's infidelity. Max begs of his glacier surcease of life, only to be called back to it by the spirit of the glacier, and by Anita's voice, singing his music over the radio! The loud-speaker switches off to the music of Jonny's jazz band, whereupon Daniello, also present, recognizes the sound of his fiddle. Jonny, with the fiddle, is pursued by the police. Max, about to depart with Anita for America, is arrested as the thief. This occurs, in the libretto, at 11:40, by the great station clock. As the D train comes in at 11:53, Daniello falls beneath the wheels and is killed. Max is whisked in the automobile to the police station. Jonny knocks the chauffeur senseless and grabs the violin. There is, or should be, a clap of thunder, and everything disappears. Max is back at the station with a few seconds to spare before 11:58. As the train begins to move Jonny is supposed to leap, landing on the station clock, which, as we have said, becomes the world, with the denouement already noted.

This is the action upon which, with the proper stage setting, the opera depends very largely for its effect. The drama was capitally interpreted by Mr. Bohnen, by Miss Easton, Mr. Kirchhoff and by other admirable participants. Mr. Bohnen is a comedian, when so he chooses to be, of an uncommonly high order. Apparently he modeled his impersonation after the style of Al Jolson, who was present in the audience. He was light as a cat on his feet and no one will forget his strut, impudence and swagger; the black "mug" and the shining saxophone; the leap to the top of the piano, the brazen proclamation of Jonny's creed, to a chorale-like parody of "Old Folks at Home." As if in a church the jazz-artist delivered his sermon, the admiring Anita, powdering her nose the while, at his feet.

Miss Easton was equally finished, as to diction and characterization. The prima-donna airs, the light-headedness, the surrender to Daniello, the embarrassment and evasion a few hours later at the meeting with Max—that was all of a piece. There have been dozens of prima donnas just like that! But not very many so finished in diction and song and general interpretation.

We also enjoyed Mr. Kirchhoff's excellent representation of his part, in spite of his vocal limitations. But Mr. Schorr, the Daniello, was too old in appearance and not sufficiently silky, conceited and curled. Otherwise, of course, a most accomplished artist. Miss Fleischer capered amusingly, somewhat in a soubrette manner and somewhat, too, as a comedy person in a German singspiel—with which style, curiously enough, Krenek's score has passing analogies. And how many laughable and ingenious details there are in this score, from the very beginning, when low-registered wind instruments, from the key, hoot discordantly a languorous "blue" motive, only to splash, as one who should turn a double somersault and land in a featherbed, into the dulcet key of D-flat major.

But we digress. Mention must be made in addition to the stellar roles thus far discussed, of the marvelous hotel manager of Mr. Meader, who touches very little, in the dramatic sense, that he fails to adorn. And Mr. Gabor's manager of the opera singer, and the fun that every one made, so expertly, in ensemble passages, with which Krenek has liberally and amusingly bestrewn his score. This score is distinctive and amusing as long, at least, as it jazzes and parodies. The music in emotional situations, if there can be said to be any, is sterile and dour and gloomy, much like the despondent photograph that we have seen of this serious young misanthrope and farceur, Mr. Krenek.

One suspects that Mr. Bodanzky, looming over the orchestra, with his sharp profile, like some large and intent cormorant, was also amused by this piece. He conducted with zest and a short rythm, which made themselves felt at once in the orchestra. He probably likes the saturnine jests of our strange young composer of the atonal species. It was excellent conducting.

Musically, then, the opera was admirably interpreted—better interpreted, by singers and orchestra than at Leipzig, the home of the original production. But the Metropolitan stage settings for this opera are not up to requirements. If we had seen this Metropolitan production, especially of the final scene (which approximates an American music hall extravaganza of the vintage of the '90s in Berlin, we would have smiled at a Berliner's naive idea of modern life in an American metropolis. We would have expected as much from those who are said still to believe that Indians are encountered in Broadway.

We discovered last night, to our amazement, that Leipzig, with a stage much smaller than the Metropolitan, with much less resources than that theatre and with stage mechanisms that are forty years old and more, gives a spectacle so much more brilliant, modern and imaginative that there is hardly a comparison. If it is desired to see a presentation of a modern opera, reflective of modern life and the age of movement and speed and contemporaneous appliances, go to little Leipzig; watch the spectacle contrived by Walter Brügmann. Here in New York, in the centre of the swiftness and modernism which are inside our houses and outside our doors, we fall short beside it.

Was any note taken at the Metropolitan of the original Leipzig production? If so, was there really the conviction that the local stage representation equaled or surpassed the original?

Mechanically this production is slow-moving. Mr. Urban wavers between familiar mannerisms and a kind of expression as ineffective as it is out of place. The scene of the street lamp and the policemen is an example. In Leipzig there is seen a real street-corner and Jonny speaking under a lampost—not a decorative design which immediately halts the tempo and dislocates the plan of the opera.

But above all, through the whole second part of the opera at Leipzig, the action on the stage became always swifter and more kaleidoscopic to the the moment of the grand formation

of which there is only the insufficient suggestion at the Metropolitan. Admitted the great difficulty of staging this opera, with all our means and reputed ingenuity, is Leipzig to surpass us? The opera lost much by this fact alone. We say nothing of the ineptitudes of such transformations as are made. The fact is that speed and spectacle, movement and action are such integral elements of this opera that it cannot be judged for what it is without them. This is the more the pity because there were such unusual virtues in other details of the performance.

Of the future of the opera it is equally difficult to judge under such circumstances. There is much merit in the score. There is originality, whether it is pleasant or not, in the idea and in the treatment of the stage as originally conceived. There are certain "influences"—Moussorgsky for one, and what are probably intentional parodies of Puccini and other composers. But the score has physiognomy and it is no tyro at work. This, at least, is thus far the most interesting of the season's novelties.

* * *

January 20, 1929

AL JOLSON GREETS "JONNY"

*Stays Trip to Coast to See Opera—
Gives Bohnen Some Make-Up Hints*

Among the prominent people of the Broadway stage who witnessed the premiere of "Jonny Spielt Auf" was Al Jolson, the blackface comedian, who delayed his departure for California to see the German jazz opera with its negro protagonist. After the final curtain he went back stage to congratulate Michael Bohnen, incidentally giving the opera star some suggestions regarding the make-up of the role of Jonny. After a hasty farewell and a final round of handshakes with the other members of the company Mr. Jolson hurried to the station to catch his train for the West.

The Metropolitan's preparations for "Jonny Spielt Auf," especially in the last fortnight of stage rehearsals, are officially admitted to have been the most intricate and costly among all productions of General Manager Gatti-Casazza's twenty-one seasons in America. An estimate of $80,000 to $100,000 expense on Krenek's work was not denied by Mr. Gatti's executive assistant, Edward Ziegler.

Veterans of the opera house staff told yesterday how they handled the job of staging twelve swift scenes on a grand opera in the manner of a modern extravaganza. Twenty "extra" men were assigned, or a crew of forty in all, under Master Mechanic Fred Hosli.

Building the opera's amazing collection of unusual and modern stage "properties" was the task of Philip Crispano and another group of experts backstage.

The saxophones and other American jazz instruments required by Krenek's score considerably increased the Metropolitan's regular orchestra personnel. One entire jazz band

is required in addition for the broadcasting of the Swiss hotel dance music from behind the opera's finest glacier view.

* * *

March 22, 1929

'FRA GHERARDO' HAS AMERICAN PREMIERE

Pizzetti's Opera, Last Novelty of Season, Brilliantly Given at Metropolitan

IT AWAKENS ENTHUSIASM

Contains Some Beautiful Music, Strong Drama and Impressive Scenic Effects

By OLIN DOWNES

The fourth and last of the novelties of the present Metropolitan season was presented for the first time in America last night in the Metropolitan Opera House: "Fra Gherardo," opera in three acts, the libretto and music by Ildebrando Pizzetti.

The production was a very capable one. The opera is exceptionally difficult to perform for many reasons, associated particularly with the number of small parts which must be interpreted effectively yet remain integral factors of an effective ensemble; and also by reason of Pizzetti's technical methods. He has pondered earnestly the problems of modern music drama. He offers us an individual solution of them which demands much of all the participants in the orchestra and on the stage. The performance last night was testimony to the thoroughness and industry with which Mr. Serafin and all who labored with him had prepared the production.

The audience's reception of the work was enthusiastic, and the superb choral ensemble of the last act, for example, fully justified this enthusiasm. Nevertheless, it remains to be seen whether the public will take to "Fra Gherardo." There was plenty of polite applause last night, and some applause that was more than polite. There was the requisite number of recalls after each act, when the conductor and leading singers were brought before the curtain. But this always happens at a Metropolitan premiere. Future performances will determine the fate of this opera, which contains some strong drama and impressive scenic effect and some beautiful music. It is the important novelty, taken all in all, that the Metropolitan has produced this season. And yet it fails, or appeared to fail last night, to completely "arrive" as a music-drama. And for this there are reasons.

Chorus Takes a Prominent Part

The theories of Pizzetti as librettist and composer of opera were described in The Times of last Sunday, and they are not to be recapitulated in detail here. He requires a text stripped to its essentials of poetic and dramatic meaning, without a single word that is unfitted for musical expression. He will not write melodic passages of any length for his voices. Such

operatic writing he considers undramatic. When he writes for voices he does so in the style of melodically heightened recitative. He calls on the chorus to take a prominent part, both as protagonist and commentator, in the exposition of the drama. In this he is near Moussorgsky, as he is obviously influenced by Debussy in writing for the solo voices.

His orchestra is less powerful than Wagner's, for example, since he aims to put the statue of the opera not in the orchestra, as Wagner did, but on the stage, where he considers that it belongs. But the Pizzetti orchestra, as the performance last night showed, carries much of the burden of the music-drama, and supplies in some measure the melodic line and the musical movement that the solo voices do not provide. Of the elements of Pizzetti's musical style it may be said that he constantly aims at economy of means, simplicity of expression; that he is strongly influenced by plain chant, which fashions many of the leading motives in the "Fra Gherardo" score; and that harmonically, as well as stylisticaly, he is affected principally by Debussy and Moussorgsky, but also by other composers, not excluding his countryman and colleague, Italo Montemezzi, composer of the "Love of Three Kings." Could Pizzetti achieve Montemezzi's brevity and concentration of mood, it would be fortunate for him, but in this he fails, and even when he wants it, he has not Montemezzi's melodic gift.

What Pizzetti has is great seriousness and purity of purpose, expert workmanship, marked refinement, if also eclecticism of style, and a true humanity and dramatic intention which carry him far.

Laid in the Thirteenth Century

The scene of the opera is Parma (Pizzetti's birthplace) in the thirteenth century. The plot was suggested in part by chronicles of the Congregation of Apostles, which treat among other things of the appearance of the Flagellants, and include mention of a young Parman, member of the Order of the Lower Friars, who donned the sandals and white tunic of the Apostles and pursued the career of a buffoon and mendicant, once thrown into prison, but admitted as jester to the fat feasts of the clergy of the period. But Pizzetti's Fra Gherardo is entirely another character. He is a medieval zealot and penitent, a man of powerful passions and revolutionary temper, torn between the worlds of the flesh and the spirit, and at last a martyr to the truth and the cause that he espoused.

The first act shows him giving his all to the poor, cozened by beggars, insulted and set upon by a young noble. The girl Mariola rushes to his aid. Gherardo fears her beauty, and repulses her when she asks him to shelter her from an evil aunt, who wishes to sell her to the highest bidder. Gherardo, exhorting Mariola to a holy life, tells her the story of Christ and Mary Magdalen. The girl, with the hot heart of her youth and her ancestry, cries out, "It isn't a sin, then, to love." Gherardo attempts to cast her forth, but when two drunken soldiers appear he defends the girl, and her beauty proves too much for his vows.

The curtain falls at this expedient moment, and a tempestuous orchestral interlude connects the first scene with the second, when the rising curtain shows Gherardo, repentant of his passion, Mariola, overwhelmed by the change in her lover of a few hours before, and the parting of their ways disappears. A procession of Flagellants approaches. Gherardo, on his knees to seek pardon of heaven, joins them, and takes up their cross.

Becomes Holy Man of Fame

In the second act, which is supposed to take place nine years later, Gherardo is a holy man of fame. But deception and insincerity dog his steps. He rebukes Fra Simone for claiming that Gherardo can work miracles, and accepting as advance payment the jewels of a mother whose child is sick. Simone swears vengeance, and the mother, when Gherardo tells her the truth, curses him for his pains. And now old Frate Guido beguiles the people, urging them to yield to the tyranny and extortion of Church and State. Gherardo refutes him and announces that he will lead the throng in revolt. The people go to arm themselves, singing a battle hymn.

Suddenly Mariola totters before Gherardo, having born him a child, which died, but without cursing its father, as the desperate woman whom Gherardo had angered had sworn he would do. Mariola, too, pardons him for whom she has suffered so much. Gherardo now wishes to take up life with her, but Mariola reminds him of his vow to the people. At this moment agents of the Inquisition appear; Gherardo is seized on Simone's information. Mariola calls the populace to arms.

Gherardo Led to Scaffold

Third act. Gherardo, in prison, is told that Mariola is also in danger. To save her he must recant and acknowledge the sovereignty of the Church. Outside a mob gathers, persuaded by an "agent provocateur" that Gherardo and Mariola have betrayed them. Mariola offers her life as surety for Gherardo's honor. A child is killed by one of the soldiers guarding the Bishop's palace. The mother threatens Mariola. Gherardo is led forth. The crowd is appalled when he nods his head in acknowledgment of the Bishop's proclamation of his surrender. But only for a moment. A storm gathers, the lightning flashes. Suddenly Gherardo raises his head and thunders "No!" He is immediately seized for the scaffold. Mariola, overjoyed rushes forward as the woman whose child was killed stabs her. The preparations for the execution are completed. In Pizzetti's libretto the flames of the stake cast a glare upon a scene of a cowed multitude, murmuring pater nosters, an unmoved and impassive clergy and the death that is to unite the man and woman they have killed. The Metropolitan production eliminates the fire, and provides headsmen in its place, who seize Gherardo as the curtain falls.

There is the possibility of good drama here, and sometimes, in parts of the first act, and certain moments of the second and the final scene of the third, Pizzetti supplies it. He defeats his own purpose when he attempts to link his first scene to his second with the orchestral intermezzo designed to depict the passion and remorse of the lovers. He is also guilty

of dramatic oversight in the long scene between Gherardo and Mariola in the second act, a scene which has neither movement nor musical development of a convincing kind, and which moreover is in kind a repetition of the gloomy dialogue of the first act.

The first scene of the third act was given interest by its interpretation, but musically it says little. It is the tumult and movement of the final scene which supplies the climax and most of the excitement and theatrical effect of the opera, and here the writing for the chorus supplements very effectively the situation on the stage.

Some Charming Passages

It is the music for the chorus which has the most importance. Solo passages that immediately impress the listener are rare, though they are beautifully set off with orchestral color. This, however, does not recompense for lack of melodic line, and also the lack, with all Pizzetti's refinement, skill and taste as a composer, of true originality. Now and again comes a charming passage such as the intentional archaism of Gherardo's relating of the tale of Mary Magdalen. These pass. There are even unfortunate concessions, here and there, to familiar effects of conventional Italian opera, as witness some of the fortissimo ascensions of Mariola, or the occasional splurge of orchestra and chorus in the good, old-fashioned manner. These incongruities are comparatively few. In general one reverts to the choral writing as the main strength of the opera.

This writing is out of the lap of Moussorgsky, but it is very well done; superbly "spaced" and arranged for the voices; often intricate, contrapuntal, in its rhythms as well as its voice parts. The orchestration is very beautiful. Often the composer establishes a poetic and pervasive "atmosphere." There is everything in this score except musical line and originality; and there is excess of theory which at times interferes sadly with practice.

Its Ensemble Effect Admirable

The performance in its ensemble effect was admirable, and this is an exceptional compliment to the Metropolitan Opera Company, since Pizzetti's recitative and his choral passages too are written with extraordinary care for the tempo and rhythm of speech, and no consideration at all for the convenience and ease of the interpreters. Chorus and soloists accomplished admirable things in this respect. Mr. Johnson sang with his customary fine intelligence, but his stage appearance was far from the character of Pizzetti's libretto. Fra Gherardo, of the later acts certainly, was an older and more powerful man. Miss Mueller sang with exceptional dramatic effect Mr. Bada's Simone and Mme. Claussen's Mother, Mr. Pinza's Podesta, Mr. d'Angelo's "Squint-eye" and "Red-haired Man" were only a few of many brilliant accomplishments in minor parts. And last, but not least—in fact foremost—the masterly direction of Mr. Serafin.

* * *

GERSHWIN PERFORMS OWN MUSIC AT STADIUM

He Has Clean Beat in First Experience at Leading Orchestra— Record Audience Applauds

The presence of George Gershwin as composer, pianist and conductor last night at the Lewisohn Stadium concert was responsible for an audience of more than 12,000, which included many who had to stand, and which was undoubtedly one of the largest audience of the present Stadium season.

Mr. Gershwin played the piano part in his "Rhapsody in Blue," while Mr. van Hoogstraten conducted the orchestra. Later the composer appeared, for the first time in his life, as conductor of a symphony orchestra. Never, he said, had he conducted before an orchestra or even a jazz band and after the experience he was hardly able to contain his enthusiasm.

Probably Mr. Gershwin would not profess, under the circumstances, to be a virtuoso conductor, but he showed a clear and admirable sense of rhythm, he realized that he had musicians under him, he watched his score closely, and giving these musicians the clean beat and the occasional cue did all that was necessary to give his music a representative hearing.

No doubt the two works heard yesterday rank as Mr. Gershwin's best contributions up to the present time to the symphonic repertory—if the "Rhapsody in Blue," not composed originally with such an end in view can be said to belong in that category. At any rate, "An American in Paris," with its imitations of the taxi horns and the maxixe, while it would probably gain by cutting, carries out the popular and unconventional note struck more modestly and less maturely in the "Rhapsody in Blue." Both compositions were cordially received.

The other orchestral works interpreted by Mr. van Hoogstraten, were Weber's "Freischutz" overture, three of the Brahms "Hungarian Dances," of which the third made such an effect that the applause was continued until it had to be repeated, and the noble Cesar Franck symphony.

* * *

MUSIC PUBLISHERS FAIL; BLAME SINGING FILMS

Waterson, Berlin, Snyder & Co. Also Cites Rise of Radio in Bankruptcy Petition

A petition in bankruptcy was filed in the Federal court yesterday by counsel for Waterson, Berlin, Snyder & Co., music publishers of 1,587 Broadway. The petition, signed by

Henry Waterson, president of the company, says that the company "owes debts which it is unable to pay in full," and that it is willing to surrender all its property for the benefit of its creditors, except such as is exempt by law.

The petition also says that the company is unable to file schedules owing to its inability to determine the correct amount of its indebtedness.

The difficulties of the company, it was reported, were largely due to the "rise of the radio with the development of talking and singing pictures and the use of theme songs."

In April, 1924, the company sued in the Federal Court to restrain Gene Buck, as president of the American Society of Composers, Authors and Publishers, from printing, selling, broadcasting or otherwise using the song "Maybe," a musical composition belonging to the plaintiff. An order was also sought to compel the defendant to account for all licenses issued permitting the broadcasting of plaintiff's songs.

The plaintiff alleged then that during 1922 and later the establishment of large broadcasting stations and the practice of using songs and musical compositions for broadcasting purposes had greatly increased the value of the plaintiff's copyrights.

* * *

AL JOLSON TO LEAVE LEGITIMATE STAGE

Plans to Devote His Time to the Talking Pictures and Tours in Concert

Al Jolson, singer of mammy songs, yesterday announced his retirement from the legitimate stage. Hereafter he plans to devote his time to the talking pictures and to limited engagements on the concert stage under the guidance of William Morris.

Mr. Jolson recently completed "Mammy," his latest talking film for Warner Brothers, and has still another to do in April before his contract with that company is terminated. In May he will begin a series of three films for United Artists.

His concert tour will start on Jan. 15 in El Paso, Texas, and he will appear on several other Texas stages. The singing comedian plans to make these appearances a yearly affair and to go around the world on such a tour.

Mr. Jolson has been virtually in retirement so far as Broadway is concerned for the past four years, his last stage vehicle here having been "Big Boy" in 1925. In March, 1926, he went into "Artists and Models" for a brief engagement late in the run of that show. Last Summer, when his wife, Ruby Keeler, was appearing in "Show Girl" he attended several performances of the Ziegfeld musical comedy and, from his place in the audience, sang one of the song numbers of the show.

DANCE

DANCES 'MOONLIGHT SONATA'

Vera Fokina, Partnerless, Gives Full Metropolitan Program

Vora Fokina, the dancer, her husband and partner being ill, gave an entire evening of dances alone on the Metropolitan stage last evening, seven numbers, with Volpe's orchestra, as well as one, Beethoven's "Moonlight Sonata," to piano solo. This was an "interpretation" in terms of dance, arranged by Mr. Fokine, as he did all the Diaghileff répertory, and accompanying—like an obbligato seen and not heard—the actual performance of a pianist in the orchestra pit, Izia Seligman.

A debt, frankly acknowledged by Russia's dancers to an American, Miss Duncan, is most clear in this use or misuse by dancers of music's greatest classics. The musical question need not here be discussed; from the performer's as from the public's viewpoint the illustration of varying mood and tempo may carry its visual message to even the tone-deaf beholder.

Mme. Fokina, who displayed virtuosity, not to say sheer endurance, in so lengthy a bill, gave to Beethoven a picture of striking simplicity; disclosed on a dark pyramid of lofty steps, she descended—adagio sostenuto—to the stage, in wistful quest of the limelight moonshine; the allegretto proceeded by gentle leaps and bounds, still bathed in light, and the presto agitato in posings of cowering fear and whirls of paused flight. The dancer was applauded. She was compelled to encore Saint Säens's "Dying Swan," and she added Polish, gypsy and Russian peasant pieces.

* * *

THE SAKHAROFFS DANCE

Appear at Their Best in Valse Rouge of Chopin at Metropolitan

Not unnaturally, confessed inspiration of Italian art—the art of Giotto, Botticelli, Fra Angelico—gives more dependable first aid to Alexander Sakharoff, the costumer, than to Clothilde and Alexander Sakharoff, dancers. The color effects, at least, in the very large number of costumes worn during the two hours' exhibition of the two at the Metropoli-

tan Opera House last night were remarkably successful, though there was a touch of decadence about the designs for the male performers.

As for the Sakharoffs' dancing, it is an art not infrequently divorced from both grace and inspiration and wedded to affectation. Both the woman and the man, when they dance to the simpler and more obvious rhythms, do it prettily. Even the man's Spanish dancing is prettily done, the bull-ring being set up in a chiffon shop with a pick chiffon toreador. And when he does what he calls a golliwog cakewalk to music by Debussy he does that prettily also—only Bessie McCoy Davis does it very much better.

Clothilde Sakharoff has the advantage of considerable beauty, and most of her numerous costumes confessed that beauty satisfactorily enough. She did a May Day dance in a particularly charming frock—with piquant omissions—and a "choreographic fantasy on a Spanish dance"—to quote the program—in which the absence of Spanish fire was hardly atoned for by the absence of petticoats, shoes and stockings. The best thing she offered was an eccentric dance to Max Reger's Humoresque, and the best dancing item on the program was the Valse Rouge of Chopin, done smoothly, gracefully and nimbly by the Sakharoffs together. After the real dancing of the Russians at the Russian Isba at the Belmont Theatre, it is useless to pretend that what the Sakharoffs give us is not, as art, more pretentious than important.

The music was the best part of the program and the rendering of Rimsky-Korsakoff's Capricio Espagnol the best single item of the work of the members of the New Symphony Orchestra, conducted by Anselm Goetzl.

* * *

March 18, 1920

BOLM'S BALLET APPEARS

Picturesque Dances Handicapped by Accompaniment of Playerpiano

A picturesque series of dances by Adolphe Bolm's Ballet at Carnegie Hall last night gained in curious interest and lost in all other respects of musical accompaniment by the employment in place of an orchestra as first aid to the dancers of a mechanical piano. The records reproduced were those of performers as celebrated as Paderewski and Percy Grainger, but there was no mistaking the mechanicality, and except where the time was of the marked sort that lends itself to mechanic reproduction the swing and rhythm of the dances suffered.

Bolm, himself, managed the task of marrying the poetry of motion to a machine better than the rest. He is an artist of quite exceptional merit in the first place and in the second among his selections was a Greek warrior dance to Rachmaninoff music with a bold rhythm, which survived mechanization.

The best part of the dance entertainment, however, was that "assisted," as the program put it, by the Little Symphony Orchestra, an Assyrian dance and a Spanish dance by Bolm, a delightfully costumed pavanne by Margit Leerass and Caird Leslie; a waltz by Ruth Page (who did the infanta in the recent ballet at the Lexington), and a hopak dance by Miss Leerass, Alexander Oumansky and others. It should be added that a pantomime to Franz Liszt's Bal Masque was charming in spite of the handicap of the mechanical piano accompaniment.

In short, the performance was at once a tribute to Mr. Bolm's artistry as a stager of pantomimic dances, and evidenced that the player piano is not a complete substitute for an orchestra.

* * *

April 7, 1920

DUNCAN DANCERS CHARM

Win Popular Success in All-Schubert Program at Metropolitan

Evidently there is a public prejudice in favor of dancing to dance music. The unmistakable popular success of the all-Schubert program of the Isadora Duncan dancers at the Metropolitan Opera House last night proves it—and points the finger of odious comparison at other Tuesday night special programs of other dancers in face of the same big houseful. For the audiences at all the performances were curiously the same.

To be sure the Isadora Duncan dancers have the advantage of a rare combination of youth and grace and training. They are young women lovely to look at in motion or poised for motion. But what counts for as much or more is the fact that their moving is done to music written for the rhythm of motion—specifically the motion of young human bodies. Whatever one's private taste in music may be and whatever one's personal opinion of dancing as an art allied to music there is no denying that Schubert's music is dance music.

The combination of that music with the Isadora Duncan dancers produces a lovely, gracious and harmonious whole—a something so provocative of pleasure in people not insensible to simple beauty that it must not be too severely criticised by those who elevate art—their own particular art—to a position above mere beauty and somewhere between science and religion.

Anna, Lisa, Erica, Irma, Margot, Therese—or all but one of them, for one was missing—moved charmingly through tragic and solemn measures, gaily and lightly through waltzes and leaping and tripping harmonies and triumphantly through the Marche Militaire. The applause they won was well earned, and the symphony orchestra under Edward Falck's baton played as music should be played for such dancers. If that be treason make the most of it.

* * *

October 19, 1920

PAVLOWA DANCES FOR THE NAVY CLUB

*Admiral Wilson and Other Officers of Atlantic Fleet Greet
Russian Star's Return*

GIVES 'LA PERI,' A NOVELTY

*Appears with 36 Dancers in "Amarilla," and Again as
Saint-Saens's "The Swan" at Manhattan*

Before a brilliant audience, including Admiral Henry L. Wilson, commander of the Atlantic fleet, and other officers attending in honor of the Navy Club's benefit, which opened her engagement Anna Pavlowa returned last night for a single week in New York at the Manhattan Opera House. Ten years ago she first appeared as a Metropolitan guest here. She had more recently danced here during two seasons at the Hippodrome and had in 1915 been seen with the Boston Opera forces both in the title role of Auber's "Dumb Girl of Portici," called also "Masaniello," and in incidental dances to other operas, notably in Bizet's "Carmen."

Mme. Pavlowa's program last evening, in a house aglow with the colors of navy and signal flags, recalled vividly some of her earlier triumphs in America. Glazounow's "Overture Solennelle," by the orchestra under Theodore Stier, introduced the Russian star and some three dozen dancers in "Amarilla," to music of Glazounow and Drigo. "La Peri," a dance-poem by Paul Dukas, was a novelty once played in concert by the Boston Symphony and now for the first time given with action, as originally in Paris in 1912. Finally, among seven lesser divertissements at the close, Pavlowa again gave Saint-Saens's "The Swan," in which she still stands alone, and with several men of the troupe a "Syrian Dance" by the same composer.

"La Peri," unlike some music "appropriated" by Russian interpreters in the past, is by Dukas's own designation "a ballet." It was composed in 1910 for one Mlle. Trouhanova, who with M. Quinaut, produced it in the French capital in April two years later. The stage of the Châtelet Theatre at the premiere "showed gold mountains, crimson valleys, and trees bearing silver fruit."

The story tells how a Peri in her jeweled robe was reclining in the hall of Ormuzd, when Iskender went about Iran seeking the flower of immortality. From the Peri the invincible ruler seized a lotus bloom, which blazed as the sun. But as he hesitated between the beauty of the flower and the Peri, she danced a dance of the spirits, always approaching him until her face touched his face, until at the end he gave back the flower without regret.

The music is scored for full modern orchestra by the man whose "Sorcerer's Apprentice" is familiar to local concert audiences, and whose "Ariane et Barbe-Bleue" was performed as opera at the Metropolitan. Mme. Pavlowa was assisted in the only rôle besides the Peri, that of Iskender, by M. Stowitts, new to her company here. He also designed the scene and costumes, while the action was that devised by the Petrograd veteran, Ivan Clustine.

In faunlike tights, turquoise and silver, and in attitudes recalling a Debussyan "Faun," Pavlowa beguiled the Ponce de Leon of Persian legend amid heavenly purple mountains, up which she glided in a shimmer of harmony at last. Perfumed music, poetic symbolism of action made you forget the dancer is a gymnast. In "Amarilla," too, it could be said that Pavlowa remains the greatest dancing actress in the world. The pace is slower, yet how quickly she brought the sense of drama to the fore, gripping attention wherever she stood among her coryphées! Her famous dash like a retreating arrow across the stage drew instant applause as in the old days.

Julia Arthur, the actress, now Mrs. Cheney, spoke from the stage in the first intermission on behalf of the Navy Club's work, incidentally telling a story of "Cassidy's Wake" that brought down the house. Mrs. Cheney was a box guest of Mr. and Mrs. Herbert Satterlee, and among others in the audience were Mr. and Mrs. William Jay Schleffelin, Mr. and Mrs. A. Barton Hepburn, Mrs. Otto H. Kahn, Mr. and Mrs. Alexander Smith Cochran, Mrs. Daniel Guggenheim, Mrs. John Ross Delafield and Mr. and Mrs. Jules S. Bache. Of musicians there were Major Ernest Schelling and Dr. and Mrs. Walter Damrosch. Fortune Gallo, who directs the dancer's tour, was able to report that 750 automobiles marked the return of society to the Manhattan.

* * *

January 9, 1921

GIVE JAPANESE 'NOH' DANCE

Michio Itow in Novelty "Tamura" at Neighborhood Playhouse

Twelve performers of the Neighborhood Playhouse assisted Michio Itow and Irene Lewisohn in presenting to a capacity house of some four hundred at the little theatre in East Grand Street last night what was possibly the best approximation to the Japanese "Noh" dance yet seen in New York. There is no "dancing" in the "Noh" dance. Posturing there was on this occasion, of classic and conventionalized sort; costuming also, in gorgeous robes and masks of authentic art.

Musical accompaniment of antique drums, a flute and a masked "chorus" of chanting narrators completed the ensemble. The musicians were August Galton, Harry Bradley and Sara Powell, and the masked singers Ian Maclaren, Alice Lewisohn, John Roche, Mollie Carroll, Constance Gideon, Zoe Bolt, John Ferris, James Phillips and Laura Elliott. The masks by "old masters" were loaned from the collection of Howard Mansfield.

"Tamura," translated by Ernest Fenellosa and Ezra Pound from a Buddhist priest's poem, preserved 500 years in the East, was the work selected, a half-hour fragment, whereas these heroic legends often take a day in the telling. It portrayed the return of the spirit of a General who won provinces

for his Emperor and crowned his works of peace by building a temple to the Goddess of Mercy.

Mr. Itow as Tamura first appeared in the form of a lad sweeping the temple paths, visited by a priest acted by Miss Lewisohn. The boy vanished. The old man, sensing some ghostly vision, passed a night's vigil, here a brief interlude, in prayer to Kwannon, till there appeared as reward the true form of Tamura, acting again his glorious deeds of vanquishing evil, all chanted by the chorus just as voices accompany the action of "Coq d'Or" on Broadway.

The Japanese novelty preceded Rossini's "La Boutique Fantastique," produced at the Neighborhood House recently and in London by Diagileff last year. There will be a repetition of "Tamura" this evening, the only one as yet announced, though it had been Itow's former intention to give a season of the "Noh" dance uptown.

* * *

March 13, 1921

ANNA PAVLOWA BACK IN 'MEXICAN DANCES'

Russian Artists and Associates Win Ovation With Novel Revels at the Manhattan

Welcomed once more as the world's greatest dancing actress, and beyond a peradventure New York's favorite of them all, Anna Pavlowa swept the boards of the Manhattan last night for twelve nights and matinees of farewells after her greatest American tour. Society was in the boxes, and the Camp Fire Girls carried flowers to the stage, their own young society benefiting handsomely by the premiere. For the first night audience, above and below stairs, it was Pavlowa forever, but a new Pavlowa for all that.

The Russian artist brought a novelty of Spanish-American origin, as strange to her admirers here as when once in "Carmen" some years ago, on the same stage, she first put on high heels and ran away with the honors of the diminished vocal stars. For her present return she had reserved from last Fall a long promised production of "Mexican Dances," designed for Pavlowa by native musicians in Mexico City two seasons back and carried afterward to sensational success in Madrid, Paris and London.

"Mexican Dances," three lyric trifles, all lively and gay, tuneful with folk song or popular airs, florally colorful as a flame on a black-framed stage, will be repeated, according to the ten days' advance programs, only tomorrow night and at next Wednesday's midweek matinee. They should be seen oftener, judging by last night's reception of them, and especially of the famous triple dance on the rim of the men's hats. The three pairs of dancers held the house applauding, while Pavlowa in pigtails, pink shawl, red and gold hoops and low green satin slippers, with her more chile con carne companions, went the paces of the revel.

Musically credited to Castro Padilla and two fellow-artists of that country, the dance themes were as modest as they were fresh to Northern ears. The "China Poblana," heard first, was from a song of a Chinese girl of Pueblo, brought as a slave from the Orient, who became by good works a patron saint of local legend. Named in the bills "Danza Texana," its tune bore a not unneighborly resemblance to the old-time "The Arkansas Traveler." A second dance, "Jarabe Tapatia," was a roystering marketwomen's frolic from the gardens of Guadalajara, while the third and last was a presto fortissimo to a lively folk melody called "Diana Mexicana."

Mme. Pavlowa preceded the novelty with her dramatic dance of the gypsy sweetheart in "Amarilla" and the impressionist "Autumn Leaves," with Vollnine as Chopin and Stowitts as the young whirlwind. There were continued ovations for all the dancers, who returned in finer form than in some years. Even the "broiler ballet" had bettered its team work so that seemingly tiny girls shared many curtain calls, while the big uproar of the night came with a series of after-pieces in which Mr. Vestoff cast his shoe off in Boecherini's "Scene Dansante," finishing his pirouette on bare toes when his stockings went by the board also.

* * *

May 1, 1921

GUINEA PIG AMONG PLAYHOUSES

If you'll permit yourself to be the guinea pig that the experiments get tried out on, you can have the best attention gratis—be the experiment a new method of extracting appendixes or a new way of producing ballets. There exists an expensive nose-and-throat specialist who will take out anybody's tonsils (here is a tip to the general public) if the patient will only allow him to do it experimentally with X-rays. The little Neighborhood Playhouse down in Grand Street gets the services of alarmingly eminent professional designers, composers and musicians toward the production of its ballets by the simple expedient of allowing those artists to try out upon it new and untamed ideas.

Such an artist as Robert Edmund Jones takes a fling at staking a ballet sans fee, just before he stages "The Jest" for the Barrymores. Not to fly quite so high, Ernest de Weerth, who has designed the costumes for the Royal Fandango Ballet, which opens on this coming Friday, has sandwiched in his labor of experiment between the movie costumes of Mary Garden and the medieval dressing of Joan of Arc for Margaret Anglin. The guinea pig of the stage gets the benefit of this artistic attention. And, strangely enough, all the injections and serums and operations have made this ballet school of the east side wax more healthy each year—until even the Russian Imperial Ballet is recalled to the senses as the pantomime proceeds.

The most apparent result of successive experiments is that no two ballets suggest each other. The very personnel of the wardrobe room changes. It is not one scientist of the arts per-

forming successive experiments, but successive scientists, each trying out his pet fancy. There is no other such naive gayety getting staged in New York.

For here is dancing for dancing's sake. Here is color for the sake of color. The Neighborhood Playhouse Ballet started out being a "cause." Its purpose was to "uplift" the neighborhood and to broaden the lives of the neighbors. They started out with the pageant germ. But now the Ballet has been elevated—or call it degenerated, if you're that kind of a person. At present this joyous young thing is not trying to elevate anything on earth. It is not even trying to make money. It has the financial backing of Miss Irene Lewisohn, which removes from it the cares of "making things pay."

A series of these ballets has been held— "La Boite aux Jou-Joux," or "Toy Box," "La Boutique Fantasque," or Magic Shop—and now a new one opens which is a Spanish seventeenth century fantasy. Book and music were written by Gustavo Morales, a young Spaniard living in New York. It is of Velasquez period in a Moorish setting—with farthingales and pomp and frivolities; with red rope wigs and fans, with the haughty stride of the proud Castilian and the voluptuous languor of the Andalusian; with the firy briskness of the Aragonese—whose dancing, by the way, is the sort that is popularly known as Spanish. Thus does "The Royal Fandango" unroll its color and gayety masking the undercurrent of Spanish melancholy—but pointing no moral even though it might adorn the tale.

The dancers of the ballet are not professional dancers. In professional circles they are generally known as "Miss Lewisohn's little girls." Originally they were in fact little girls of that crowded exotic neighborhood, for the most part Russian Jewish, coralled in the name of "Causes" for those erstwhile pageants. For twelve years and more these particular girls have danced—until now they are slim young "flappers," bobbed-haired and lithe—every fibre and muscle trained to vibrate to the call of the music.

They are no longer a neighborhood group. Most of the first families of Grand Street have moved to the Bronx or to Harlem or Brooklyn. But every Monday night they come back for the "senior dancing class." And, when a new production is pending, they come back every night in the week to dance and to sew in the workshop—helping create their own costumes to the tune of designs, which were painted "just for fun" or to show the world what some artist really can do.

But, of course, the personnel of the ballet is being constantly recruited with children picked up on Grand Street itself—as they dance self-made dances to the music of a hand organ. According to Esther Peck, the dancing instructor of the children, who has produced several of the ballets, these 7-year-old tads take as seriously and discuss, as technically as could Delores her peacock tail, the wisps of chiffon in which they tread their measures.

For each dancer is a prima donna in her mirror. Each dancer learns the dances of all the others, lest her "chance" come on short notice. There is temperament au Ballet Russe on Grand Street. Passionate despair swept the ballet school when Elsa Duncan of the Isadora clan cut her curls and appeared in bobs. Moreover, in the performance of "La Boutique Fantasque" last month the two "Poodles" of the toy shop one night refused to dance. Positively nothing could be done about their temperament—until some one discovered that the Poodles in real life had been left out of an ice cream and cake party. Quick! Gatti-Casazza couldn't better have risen to the occasion. They were promised an ice cream supper in their very own honor. And the Poodles went on that night.

Curiously enough, very few of these dancers have thus far gone into professional dancing. Indeed, most of the older girls are prosaic grade school teachers by day, with nothing to tell of their double life but the swaying of a graceful young form at the blackboard.

Yet there is a very distinct interest in the professional dancing world in this amateur child of love, born, as it were, out of art's commercial wedlock. One night a flurry occurred behind the scenes. Some one had whispered that the house was half full of the Russian ballet out front inspecting them. And it was.

All of the costumes for the ballet are made in the workshop of the Playhouse. Here, too, there is free labor, because of that same laboratory quality of the Playhouse. Painters and artists who do not know stage technique come to sew and to cut and to paint on the costumes and scenery until sometimes the workroom finds suddenly that it has been entertaining a celebrity unawares.

Again is there a reservoir of gratis labor in the representatives of "Little Theatres" from Oskosh, Wis., and Gopher Prairie. The country has gone Little Theatre mad until some towns have two of them playing rivals. Any train may bring a "student" from one of them into New York to study the Neighborhood Playhouse and to get "inspiration"—that intangible something that New York is supposed to yield up by the yard to our visiting serious thinkers. And very useful the workshop finds them, when it comes to working magic upon oilcloth to create Never-Never Land.

"Give me six yards of oilcloth, three yards of buckram, and a pot of gilt paint, and I'll costume you any production," says Helen Rosenthal, manager of the workroom. The secret of the costuming is to create illusion through ingenuity. Twenty cents a yard cotton flannel, painted with Renaissance motifs, is, from the audience's viewpoint, Venetian brocade. Gorgeous embroidery on the sleeve of Castillian nobles may be simulated by handfuls of knitting wool dyed the proper colors. Glass bracelets form jade earrings.

Boots fit for a mazurka consist of black oilcloth placed so and so about the ankles and legs and, wrinkled just enough, where illusion joins oilcloth to high black shoe. Oilcloth is the backbone of practically every dignified costume—while the same oilcloth, dyed frivolous colors and shredded to ribbons, can seem as airy as fluffs of maline. The farthingales of the Velasquez ladies are constructed of wire and buckram. And still there persists the tale in ballet school circles of the night when just the wire hoops had been fitted over their little

pink knickers—when suddenly they realized the Ziegfeld ideal of a Velasquez chorus.

They really are just gay young girls enjoying the new national fad of self-expression through dancing—only they happen to be doing it better than the others. It is a dance-wise world that the Neighborhood Playhouse Ballet is the guinea pig of.

H. B. I.

* * *

October 8, 1922

MISS DUNCAN DANCES; 3,000 CHEER SPEECH

Dancer Would Make Symphonies 'More Real Than Broadway' as She Gives the 'Pathetique'

Russia has been kind to Isadora Duncan, according to the view of 3,000 admirers who filled Carnegie Hall yesterday for the artist's return after five years for an American tour. So slender she looked that it seemed the Isadora of former days who leaped and bounded through the five-step dance and military march of Tchaikovsky's "Pathetic" symphony. Later, in his "Slavic March," she walked with lowbent form and bound hands, till the old Prince Luff's thrilling Russian anthem rang out in the music, and the dancer rose with free arms in one of those moments of power, such as when she last danced at the Metropolitan to wartime "Marseillaise."

Miss Duncan's great audience, after nearly three hours in stifling heat, still waited to call her back for a speech, which she began by referring to her latest invitation to Russia. She also pointed out the young poet, Serge Yussenin, now her husband, who was quickly recognized on the box tier or outside during promenades, dressed in topboots, long blouse and some yards of flowing scarf at the neck.

"Why must I go to Moscow," the dancer exclaimed, "after illusions that don't exist, when we in America also need the dance for our children. I know the American nervous child, for I was one myself. Soon I hope to show you here fifty Russian children dancing to Beethoven's Ninth Symphony. I can bring that to life in New York—make it more real than Broadway. Why does not America give me a school? That, you understand, is why I accepted the invitation to Moscow."

There was lively applause as she quoted Whitman's "I give you invitations," and continued. "The great symbol of America is Walt Whitman. America has all that Russia has not, Russia has things that America has not; why will America not reach out a hand to Russia as I have given my hand?" Answers came from the crowd in the form of cheers, apparently for Russia more than for the poet Yussenin.

Nahan Franko led an orchestra of seventy in the symphony, as well as in earlier pieces that Tchaikovsky in 1891 conducted here at the dedication of Carnegie Hall. Mr. Franko shared with Miss Duncan the first ovation of the mat-

inee, and earned a laugh as well when he once was drawn within the closing curtains. Miss Duncan dances thrice this week before touring the West.

* * *

October 11, 1922

RUTH ST. DENIS IN DANCES OF FAR EAST

After Five Years' Absence She Appears at Selwyn Theatre Assisted by Ted Shawn

Ruth St. Denis returned, after five years' absence, in a crowded matinee at the Selwyn yesterday, with "visualizations" of music by known composers, ensembles from Spanish art and old Mexican legend, and a superposed climax of Crete and the coasts of Asia, not forgetting a certain Hindu Nautch dance of her former débuts. She was among the first, and has been among the more deftly resourceful, of those who early followed Isadora Duncan, also currently reappearing in her own land. Always in Miss St. Denis's work there was direct, definite fancy and gesture, note for note, none of your picking daisies off bare boards or drinking from fountains of canvas drops.

She gave atmospheric illusion in lighting effects, the glint and caress of rare fabrics, realistic study in movement and background, for example, a flight of seagulls viewed at Brighton Beach for Schumann's "Soaring," or a day spent at Harmon-on-Hudson for a "Garden Dance." St. Denis in her Spanish episode wore a shawl, the gift of Galli-Curci. Two new waltzes were composed by Mischa Levitzki and Mana Zucca, while more serious numbers ranged from a part of Beethoven's sonata, "Pathetique" in classic poses to Chopin's "Revolutionary" etude, waltzes of Brahms and Moszowski and the "Liebestraum" of Liszt.

Miss St. Denis was assisted by Ted Shawn and the Denishawn Dancers, notably Martha Graham and the little Lenore Scheffer, as well as Betty May, May Lynn, Julia Bennett, Louise Brooks, Pearl Wheeler, Charles Weldman and Paul Mathis. Hugo von Hofmansthal once wrote of the "hieratic art" of her strange Asiatic pieces, and in these Miss St. Denis was most applauded by the matinee house. Mr. Shawn also was striking as the Aztec, Xochatl, and in Chopin's "A l'Apache."

* * *

November 15, 1922

MISS DUNCAN'S FAREWELL

Dancer Ends First of Two Programs Here With a Speech

Isadora Duncan appeared with the Russian Symphony Orchestra under Modest Altschuler last evening at Carnegie

Hall, and will reappear tonight, the performances being announced as Miss Duncan's "farewell to America." She danced with more abandon than she recently had done here to the music of Tchaikovsky's symphony "Pathetique," an "Idyll" from the second symphony of Scriabin, the scherzo from that composer's first symphony, and Tchaikovsky's "Slavic March."

Miss Duncan made a speech—upon urgent request. It was not a political speech. She held Mr. Altschuler firmly by the hand and praised his orchestra. Still holding him by the hand, she talked of her little red dress. It was the one (she said) to which Boston had objected. She had danced all her war dances in it since it had been given to her by an old lady in Vienna. She was 18 then. It had never been washed.

People had said to her that she ought not to make speeches, but she wanted to make this little one. She did not preach Bolshevism, but only love—the love of mother for child, of lover for wife, and her own for the top gallery (looking ecstatically) which never stirred. There were also allusions to Russia which were wildly cheered.

* * *

October 10, 1923

PAVLOWA GIVES NOVELTIES

Three Dances From Japan and India Please Manhattan Audience

Mme. Pavlowa's promised "Japanese Dance," which the artist produced at her London benefit for the Tokio earthquake sufferers, together with the "Hindu Wedding" and "Krishna and Rhada" of the Nearer East, had their first local view and hearing by a large audience at the Manhattan last evening. The Japanese airs arranged by native musicians, Koshiro Matsumoto and Miss Fumi, proved a far cry from the old familiar Gilbertian paces of the town of Titipu, though Pavlowa had no part in them until she fluttered on the stage to the later Nautch dances with a new male dancer from Hindustan.

Theodore Stier conducted an orchestra of forty "Westerners," as the phrase is, in this representation of the art of the Antipodes. The two British India bits that completed the novel "Oriental Impressions" were arrangements by Miss Comolata Banerji of cleverly devised drones and drumbeats of striking effect, though drawn from quite customary Western orchestration. To one critic's view, the last Kiplingesque "Krishna and Rhada" produced a genuinely imaginative atmosphere. A dramatic revival which began last evening was Pavlowa's tragic gypsy dancer in "Amarilla." She ended with her famous "Dragon Fly" and golden "Gavotte."

Pavlowa in her new productions, like Chaplin directing his ideal picture, has achieved a work of creative imagination, with the visual truth possible only to a great executant artist. Herself long unseen, she peopled and painted a vast stage with forms and fabrics of exotic movement, pulsing rhythm and orchidaceous coloring.

Foreign and fine-spun music, in the pauses with curtain closed, hardly captured sophisticated hearers, but on each succeeding disclosure the draperies drew aside amid exclamations of delight. Geisha danced here as at the ruined Imperial Theatre of Tokio, followed by priestesses such as travelers see at the temples in Japan's ancient capitals of Nara and Kyoto.

Dervish-like bell skirts, tinted flesh and clanging metal in the Hindu dances were a climax made dazzling by Pavlowa herself in petunia silks and spotlight, as, with bowed head and waving arms, she conjured up an incarnate level of Asia. Next Monday she gives her other Hindu ballet, designed after Buddhist frescoes of Ajanta.

* * *

October 16, 1923

PAVLOWA IN "AJANTA"

Trimphs as Stage Manager and Dancer in Her New Drama

Mme. Pavlowa produced at the Manhattan last evening, as she had previously only in London, her new dance drama, "Ajanta," the most ambitious of those drawn from her recent world tour. The novelty will be repeated twice, tomorrow and Saturday, among her remaining performances. It both impressed and delighted last night's large audience.

Glittering phantasmagoria of tinted forms, amid which Pavlowa darted like an ambodied flame, made a climax of "Ajanta" comparable to the best stagecraft of exotic ballet by Russian masters of the art. It was the woman's triumph as stage manager no less than as dancer, in music as in costume original and daring.

Through outer and inner veils of India's historic rock-carved temples, the rising scenes gave dissolving view of worshippers prone before dim altars. Later, in reverse cycle, the temple walls closed on the vision of a princely Buddha, recoiling from earthly orgy to higher contemplation. Few ballets have so suggested the Emersonian epigram, "Ralph, this is Poetry"—"Margaret, it is religion."

Pavlowa shared her curtain calls with two remarkable native Hindu dancers, a man and woman unnamed, the latter seen for the first time. In the shorter after-pieces, Pavlowa added a new solo, "Wistaria," on a scene bathed in blue light, from her artistic impressions of Japan.

* * *

November 26, 1923

SWEDISH BALLET, COLORFUL MELANGE

Lithe Young Dancers in Grotesque and Mirth-Provoking Episodes at the Century

GIFTED IN PANTOMIME

"Modernist" Stage Pictures and Cubist Character Roles Applauded at Private View—Fantastic Music

From a skating start to a folksong finale, the début of the Swedish Ballet yesterday afternoon on the broad stage of the Century Theatre was an event out of the ordinary in New York's most international season. A single week's stay for the present was preceded by a semi-private and wholly professional view, in the European manner of "repetition generale" before some 3,000 invited musicians, artists, writers and men of the theatre in this metropolis. The house overflowed, between four program numbers, to the Vanderbilt Gallery above stairs for tea and talk. There was cordiality in the company's welcome, an attentive hearing for its music, only momentarily Swedish in origin, first and last, while the more varied "modernist" stage pictures and cubist character rôles by dancers won individual applause.

Sweden could have sent, in fact, all but the music of this colorful melange. The land of the Swedish Nightingale, remembered in the Faustspielhaus lower down Broadway, and of the "Swedish Wedding March," played on forgotten square pianos by grandmothers of the theatregoers of today, has lived too long like America itself on borrowed music. Of literary influences it offered an abundance, influenced in turn though the Northern nation has been by Spencer, Zola, Ibsen and Brandes, but producing in its own right an Ellen Key and Selma Lagerlof, a Strindberg and Per Hallstrom. A city that honors the naturalized John Ericsson's statue in Battery Park was able to receive the latest guests as far other than strangers.

Direct from the Theatre des Champs Elysees, Paris, where Americans have witnessed some of the 850 performances of these dancers abroad, Director Rolf de Mare brought the lithe young dancers, headed by statuesque Jean Borlin, and their musical ensemble under Vladimir Golschmann, a Paci in puppetland, who stood silhouetted against the dark orchestra pit. In the episodes following, three-fourths of the material was French. The Paris Six have smiled upon Les Ballets Suedois. Honegger, of the "Horace Victorious" vividly heard last year, composed the round upon round of the "Skating Rink," to Fernand Leger's designs; a designedly mechanical "monotony of life," with Kaj Smith and Miss Ebon Strandin leading the circling pairs, and Borlin as a cubist madman carrying off the lady while the human cogs resume their mechanical round.

An "Eiffel Tower Wedding's" merry grotesques and monsters might have been the actual gargoyles of Notre Dame, reproduced by Jean, grandson of Victor Hugo. His staring masks worn by all the figures were remarkable as face-cards in a poker deck, their speaking lines voiced from mimio phonographs alongside. A scene of distorted aerial perspective was by Irene Lagut. The music in snatches from all the famed "six" was, like the maskers, weirdly disjointed, nimble and mirth-provoking. It could be surmised here, as was said of "Steeplejack" by a Philadelphia reviewer, that "Paris is the suppressed desires of Sweden."

Most weight was attached to the symbolic piece, "Man and His Desire," after a plastic poem by Paul Claudel, author of "The Tidings Brought to Mary," which was acted here last year. Darius Milhaud composed the curious musical context during a journey to Brazil, while the designs on four raised platforms of the Century's stage were by Mme. Andree Parr. The Man was Borlin, an alert figure of varnished flesh-tint, posing as a Greek Discobolus or whirling in a spotlight. Woman was Miss Strandin, feminine in charm and releasing her single veil to wind and blind Man in a final tableau. Above and below circled slowly two Moons and their Shadows contrariwise, the upper reflected as in a dark pool, and timed to the action like the moon's phases shown in some old Nuremberg mechanical clock.

A Paris Autumn Salon's pictures come to life do not make a northern "Spring's Awakening." It was in "The Foolish Virgins" that the Swedish Ballet brought its day to a close with a wedding procession of light-hearted, vivacious, authentic native character, something less of a long-shot across the Baltic, where choreographic Russia repays now a debt for Swedish culture borrowed long ago. Here was racy flavor of the soil, an approach to the Northland's own "Midsummer Revel," which also is among the half dozen native ballets held in reserve for the company's return from Philadelphia and Boston. Einar Nerman designed the "Vlerges Folles" in colors bright red and green as painted wood-carvings, and quaint as the music by Kurt Atterberg, based on Swedish folktunes.

Static art of picture-book tableau-vivants is Swedish dancing in the forms and disguises here displayed. Without attempting the free technique of Genee or the dramatic genius of Pavlowa, the former Stockholm Royal Opera dancers presented true gifts of pantomimic comedy, while two of their number, as the diving-bell-headed temptresses in "Man and His Desire," moved with miraculous security in their narrow grooves aloft upon well-trained toptoes. There may hereafter be more of Sweden's ancient Sagas, on which Wagner drew, but yesterday's Franco-Swedish caviar had indubitably new flavor.

Among those at the private premiere were Morris Gest, Edward Ziegler, Fortune Gallo, Lee Shubert, Joseph Weber, Ben Roeder, Brock Pemberton and Theodore Bauer, of present or former operatic and theatre folk; former Ambassador Gerard, Norman Bel Geddes, Jesse Lynch Williams, A. E. Thomas, Erik Huneker, Ottokar Bartik, Jules Judels and others representative of arts and letters, drama and ballet.

* * *

February 27, 1924

AMERICAN BALLET MAKES ITS DEBUT

Crowded House at Metropolitan Greets Native Dancers Trained by Fokine

THEY PERFORM IN "ELVES"

Enthusiastic Welcome Accorded to Former Czar's Dance Creator and His Wife

His former compatriots filled most of the crowded Metropolitan last evening at Michel Fokine's first public appearance after some three years spent in developing an American ballet. Society, too, was in the boxes for once on opera's off night. It was apparently a spontaneous popular greeting to the one-time Czar's dance creator "the brains of the Russian ballet," and his beautiful wife, infrequently seen since they first came to America in 1919. There was interest for Russians in an orchestra of their own nationals, led by Alexander Aslanoff, formerly of the Imperial Theatre, Petrograd, while for Americans, at any rate, curiosity ran high as to a new and native ballet.

They made their debut—sixty young American dancers—at the evening's start, in a fantastic piece called "Elves," in costumes still more fantastic on the line of futuristic art, though danced to such classic music as had been arranged from Mendelssohn's violin concerto and his "Midsummer Night's Dream."

In a list of printed names were mentioned Beatrice Belrava, Inga Bredahl, Helen Denison, Desha Podgorska, Lora Vinci, Doris Niles, Barbara Clough, Madeleine Parker, Jeanette Wilde, Janet Justice, Tania Smirnova, Terry Bauer, Nelly Savage, Dorsha Denmead, Alice Wynne and Constance Keller, Vitale Antonoff, Raymond Guerrard and Jack Scott.

Some of those who appeared later were Frances Mahan, Renee Wilde and Katia Repelska, as Greek maidens; Polly Klots, Dorothy Harris, Hebe Halpin, Vera Boudin, among the "waves," and Sigmond Grenewitch among the "warriors," with others as "morning brides," in Fokine's "Medusa," announced as a world-premiere. In important minor roles were Scott as Poseidon and Nelly Savage as Pallas Athene.

The "Medusa" was danced to music from Tschaikovsky's symphony "Pathetique," just as the first Russian ballet ever seen here, that of "Scheherazade," given in 1910 by Morris Gest at the Winter Garden, and later by Diaghileff, was done as a "tragedy of the harem," also arranged by Fokine, and not as the wreck of Sinbad's ship originally depicted by Rimsky-Korsakoff.

A new Rimsky-Korsakoff dance last night was "Ole, Toro," to that composer's popular "Caprice, Espagnole," with the Fokines as a gypsy and a toreador and Jack Scott as "the rival," El Jesloso, unknown to "Carmen," which is chiefly recalled. Charmian Edlin assisted the pair in "Le Rêve de la Marquise" and Mme. Fokine revived Saint-Saens's "The Swan," prime favorite of Pavlowa.

A percentage of the receipts will be given to the Russian Relief Fund through the Monday Opera Supper Club. Among the members of the Supper Club who took boxes and seats were Mrs. Richard Mortimer, Mrs. Henry P. Loomis, Miss Lucile Thornton, Mrs. John Aspegren, Mrs. Ethan Allen, Mrs. Arthur Ryle, Mrs. H. Edward Manville, Miss Elizabeth Achelis, Mrs. E. Roland Harriman, Mrs. W. S. Moore, Mrs. Hoffman Miller, Mrs. Monroe Robinson, Mrs. W. D. Orvis, Mrs. Langdon K. Thorne and Mrs. Alfred Loomis.

* * *

April 5, 1924

DENISHAWN DANCERS IN DIVERSE PROGRAM

Gypsy Number Is Spirited and Effective—Ensembles Are All Admirable

By OLIN DOWNES

Ruth St. Denis, Ted Shawn and the Denishawn Dancers, who appeared yesterday afternoon at the Manhattan Opera House, have succeeded again in presenting the public with a series of admirable pantomimes and dances, seldom by solo performers, almost always by an ensemble which introduces the solo element only when it is an integral part of the stage picture.

The "Cuadro Flamenco," for example, is a gypsy dance scene, in a tavern where loafers, musicians and flower girls congregate. The performances are reproductions or elaborations of dances seen by Mr. Shawn in Spain, and the music has been arranged by Louis Horst from popular dances of that country. A little episode, enacted with much spirit by every one on the stage, portrays the appearance in the company of Lalanda, the matador, who courts La Macarena. He recounts his triumphs in the bull-ring, he offers gorgeous shawls to the object of his pleadings. At last he wins her heart, and the betrothal is celebrated gypsy fashion. There are a number of dances, solo and concerted, all in character with the scene, none superfluous to it, and the grace and piquancy of these dances rang true; it was believable—whether or not it is so!—that such things do occur in cafés in Spain.

The final spectacle, "Ishtar of the Seven Veils," is more ambitious and less convincing. There are Babylonian images and designs. There is much to-do between the guards and Ishtar, as she makes her famous descent to hell to resuscitate her beloved, as recounted in Babylonian legend. The result of all this, however, was mildly disappointing to the audience. It took pleasure in some excellent solo and ensemble dancing, but there was little that was truly illusive in the atmospheric sense of that word.

But these are not the only interesting items of the present repertory of the Denishawn dancers. One that many remembered after all else had faded in the mind, was the "Tragica," "an experiment in the dance as an independent art (that is, without music)", by Doris Humphrey and the ensemble, "Feather of the Dawn," with Cadman's music; the charming waltz—by Miss Humphrey and a quintet; the "Danse Americaine"—why the French title is a mystery—and the spectacle so appropriate to Miss St. Denis's art—that of the "Legend of the Peacock," were items which gave admirable diversity to the entertainment.

This program will be repeated next Wednesday evening.

* * *

May 4, 1924

ELIZABETHAN REVELS AGAIN

Bryn Mawr Students Will Revive the Morris Dances of Old England at May Day Festival on Campus Lawn

By JOSEPH COPELAND

Marshaled by the town crier and village watchman and accompanied by Tom the Piper with his tabor and penny whistle, "whifflers," "hobby-horses" and "fools" will caper, and Morris men, milkmaids, chimney sweeps and villagers will dance before Queen Elizabeth and her court at the May Day fête to be given by the students of Bryn Mawr College on May 9 and 10.

Of all the characters who will thus reconstruct before the eyes of a modern audience an authentic picture of May revels on the grass in the days of Elizabeth, none will be watched with more interest than the Morris men. Theirs is an art that has been preserved in its traditional beauty and grace of movement from pre-Christian times to the present day by the village folk of England.

Morris dancing, which had its origin as part of the celebration of some long-forgotten pagan religious festival—possibly the advent of Spring—survived the attacks made upon it by the early Christian missionaries in Europe. In the seventeenth century it was banned, along with maypoles and other "stynkyng idols, when Cromwell and the Puritans ruled, but it sprang up with renewed vigor when the pleasure-loving Stuarts regained the throne.

From that time to the middle of the Victorian era it flourished, and then all but died out, crushed, not by active opposition, but by the passive, remorseless weight of a growing industrialism—for the Morris is essentially a dance for country folk by country folk. It had its birth in woods and meadows, and needs clear skies, not smoky ones, in order to survive.

It did not quite die out. Here and there in obscure villages of Oxfordshire and Gloucestershire men were living at the beginning of the present century who had danced the Morris in their youth and had not forgotten steps and tunes. It was these men whom Cecil Sharp searched out when he started, in 1898, on his celebrated quest to revive Morris dancing in England.

It was a long, hard task, but he kept at it, getting a step here and a fragment of a tune there, and finally reconstructing the whole dance bit by bit. The old men, once found, helped him, singing or playing the tunes they knew and dancing the steps over and over.

The result of Mr. Sharp's work has been the collection of two hundred or more old Morris dances and a genuine revival of the art in many English villages, as well as widespread interest in America, where there are branches of the English Folk Dancing Society in New York and Boston.

The Morris dancing at Bryn Mawr will be on an elaborate scale, three "sides" or teams of six dancers each having been chosen to dance before the Queen. Charles Rabold of New York, who is Cecil Sharp's representative in America, is directing the work. Three of the dances, Leap Frog, Flowers of Edinburgh and Lads a' Bunchum, have never been attempted by women before, the Morris, always a man's dance, requiring strength as well as skill and agility to do the various steps, hops, jumps and arm movements of which it is made up.

In addition to dancing by "sides" in the original Morris manner, there will be solo dances, or jigs, by "William Kempe, the Nine Dales Wonder," and his partner. In the year 1600 Kempe danced the Morris from London to Norwich in nine days, and later he wrote a pamphlet about it. He was one of the most popular actors of his day, playing with Shakespeare at the Globe and Blackfriars, and taking, among others, the parts of Touchstone, Justice Shallow and Dogberry.

Miss Mildred Buchanan of Philadelphia, a senior, the champion all-around athlete of the college, has been cast for the part of Kempe, the part calling for great skill and endurance as well as artistic interpretation. Her partner will be Miss Nora Trevelyan, assistant gymnasium director, a noted English hockey and lacrosse player. Both will be in the elaborate dress affected by the Morris men, and Miss Buchanan will carry—and use—the pipe and tabor of Elizabethan days, which was afterward supplanted by the fiddle and the concertina.

New York Girls in Dance

Ten of the eighteen Morris dancers are from New York and vicinity. They are Helen Hough, 152 East Thirty-fifth Street; Frances Jay, 49 East Sixty-fourth Street; Virginia Cooke, 64 East Eighty-sixth Street; Betty Jeffries, Scarsdale, N. Y.; Suzanne and Germaine Leewitz, 885 West End Avenue, both of whom are members of the champion varsity basketball team; Ellen Scott, Greenwich, Conn.; Marion Leary, 741 Fifth Avenue; Helen Phelps Stokes, 109 East Twenty-first Street, and Alice Matthew, Bronxville.

The Morris dance has been associated with May Day and May Day games from time immemorial. The dancers were usually accompanied on their rounds by mummers made up

Bryn Mawr students rehearse Morris dance.

peeled willow wands—which the dancers clash together in certain movements of the dance. However, the handkerchief is as much a feature of the Morris as the sticks, for in all dances where sticks are not used each dancer carries two white handkerchiefs, one in each hand, which he twirls and snaps and flutters as the dance progresses. The reason for the handkerchiefs is not known, although Mr. Sharp advances the theory that they may have supplanted the swords or sticks at some remote time.

The most distinctive feature of the costume of the Morris men are the pads of little tinkling bells tied on both legs from ankle to knee. There have been variations in costume among the dancers from the dress of Tudor times—in which the Bryn Mawr dancers will appear—to the attire of the modern dancers of England, which resembles cricket flannels set off with gay ribbons and rosettes, and sometimes garlands of flowers on the hat; but the bells have remained the same from early times to the present.

The significance of the bells is also lost in the mists of antiquity, but when there are no facts to go by, one guess is as good as another and so I put forward the claim that the only reason for the bells is to make a noise. I have no doubt that the first Morris men, stepping forward and back before a smoking altar to bring luck to the house and fertility to fields and herds, put bands of tinkling shells on their shins for no other purpose than to make a joyful sound.

To try to tell in a short newspaper article the manner in which the Morris is danced assumes the magnitude of the task of the young man who tried to explain the shape of a pretzel over the telephone. Mr. Sharp wrote a book about the Morris in which he went to some trouble to tell the uninitiated reader just how to dance it—and followed that book up with a half-dozen more.

In order to master the Morris step, says Mr. Sharp, "let the learner stand at attention and begin to mark time at an elastic trot; right—left—right—left, treading on the ball of the foot only and springing from one foot to the other as in the military 'double.' Instead, however, of bending each knee by turns and picking up the feet alternately, he must keep the knees straight and bring each foot forward alternately in a sharp swing, almost a jerk, of some fifteen to eighteen inches. This constitutes the Morris step in its elementary form."

Having mastered the elementary step the learner may practice it as a forward trot instead of a mark-time and having mastered this he may go forward to the next lesson, where a hop is interposed between the steps, and from that to the caper and the cross-back step and the jump. By that time he is ready to be told that while the legs are stepping and hopping and capering, the hands and arms are executing movements in time with the music, too.

He will learn the "down-and-up" of the arms, the "swing," the "straight-up," the "circle," the "twist" and the "wave." And after all that he will learn to make complicated patterns with the other members of his "side." It is rather different from modern dancing. A little wiggling won't get you by. But

to represent Maid Marian, Robin Hood, Friar Tuck, or a fool court jester, a hobby-horse and other figures. In the Bryn Mawr May Day the traditional figures of Maid Marian as Queen of the May and Robin Hood as King have been retained, but instead of accompanying the dancers they find more exalted places in a play of "Robin Hood," which includes all the other characters of that pleasant story. The hobby-horse, the fool and other figures remain on the green, however with the Morris men.

Other interesting figures on the green will be the characters in "The Revesby Sword Play and Dance," in which the "Sleights," a sword-dance closely akin to the Morris, will be introduced. These figures include such fantastic persons as "Pickle Herring," "Blue Breeches," "Pepper Breeches," "Ginger Breeches," and "Mrs. Allspice." The play is from Lincolnshire and was given by the "Plow Boys and Morris Dancers" of Revesby about the end of the eighteenth century.

It is believed the Morris in its original state may have been a sword dance, this fact accounting for the sticks—sometimes

performed by well-trained men or women, the Morris is a dance of marvelous beauty. I talked to Charles Rabold about it as he rehearsed a "side" at Bryn Mawr the other day.

The Morris was always a spectacular, never a social dance, and as such was always performed by teams of trained men. It was seen on May Day as long as May games were popular, but in later years has been given on special occasions only, usually several times a year.

* * *

ANNA PAVLOWA IN "DON QUIXOTE"

Anna Pavlowa and her company were warmly welcomed at the opening performance of her final American tour last night in the Manhattan Opera House. This performance introduced a ballet new to the American public, but not new in Mme. Pavlowa's repertory, "Don Quixote." "Don Quixote" is staged by Laurent Novikoff, with scenery and costumes by Korovine, and music by Ludwig Minkus. The ballet is in two acts and a prelude. It is a free play for ballet purposes, with colorful scenery, upon some of the motives of Cervantes's tale of the Knight of the Sorrowful Countenance.

The prologue, like that of Strauss's symphonic poem, shows the knight reading crazily his romances of chivalry. There is then seen a market place at Barcelona where Mme. Pavlowa, as the daughter of an innkeeper, with Novikoff and Volinine as rival admirers, excites the chivalrous adoration of the Don. Through his unselfishness she marries one of his rivals, and there is terpsichorean celebration. Later the sorrowful Don dreams of the garden of Dulcinea del Toboso, and Mme. Pavlowa as Dulcinea embodies his ideal. The dreamer kneels and is crowned, in an allegorical spectacle, as her knight. It need not be pretended that this ballet achieves the psychological delineation that Richard Strauss attempted in his symphonic poem, inspired by the same theme, or that it represents a philosophic study of the symbolic meaning of the story. Nor is "Don Quixote" an ideal theme for a ballet, charming though it may be, of the brilliant but necessarily conventionized character of the spectacle offered by Mme. Pavlowa.

But this need not and did not trouble the audience. It saw its idol, surrounded by several soloists of high rank, in a new series of choreographic interpretations. It had repeated occasion to applaud Mme. Pavlowa for the dancing, which is both a finished represenation of the classic school and, when favorable opportunity presents itself, a portrayal of character. There was a brilliant ensemble and a picturesque stage. In the principal ballet, nearly two hours in length, and in the celebrated dance of "The Swan," which came later, Mme. Pavlowa demonstrated triumphantly her gifts as not only one of the greatest executants of the period, but an artist who by physical means reveals poetic beauty.

The divertissements had the variety and individuality that give these features of Mme. Pavlowa's program a special charm. A mazurka was danced by the ensemble. Miss Rogers and Mr. Winter were soloists in a Chinese dance. Mr. Volinine, who seems to grow and not lessen as a virtuoso with the passing years, appeared as Pierrot. Hilda Butsova and Oliveroff danced the familiar and lovely "Voices of Spring." A "Greek Dance," by Mlles. Stuart, Bartlett, Rogers, Nichols, Crofton, Elkington and Mather, was accompanied by music of Brahms, who more than once expressed in his compositions the Greek spirit. The finale was a Syrian dance, with Mme. Pavlowa and Novikoff as leaders, and Messrs. Domoslawski, Nicholoff and Winter to complete the group.

A large and very enthusiastic audience attended this opening, and Mme. Pavlowa, making her first appearance of the evening in the midst of an ensemble of more than eighty performers, was quickly distinguished and danced her first five minutes to unceasing applause.

* * *

PAVLOWA'S LEAVE-TAKING OF AMERICA— HER CONTRIBUTION TO NATIVE MUSIC

By OLIN DOWNES

Musicians as well as all lovers of the dance, oldest of the arts, owe a greater debt to Anna Pavlowa than they may realize. The impetus she has given to creative artistic impulse in many fields in America cannot now be fully estimated, but it is evident on every hand and aside from the mere fact that her performances have familiarized us with some interesting scores, is of very great importance to our composers.

Our composers are unhappily divided in large measure into two principal classes—the well-educated respectables and dilettantes, who pattern their thinking and their creative procedure after more or less fashionable and distinguished European modes, and the mass of musical hacks and routiniers, some of whom are gifted and turn out good things in spite of materialistic environment, most of whom are interested only in the practical considerations and the money-making possibilities of their profession. And it is from these that we expect interesting music. Before interesting American music appears there must be an internal revolution in the breast of the composer, a vast liberation from provincialism and self-consciousness, and a vivid perception of beauty that pervades life and informs joyous, living art.

And of more than one art. The art of which Pavlowa in her own genre is an incomparable exponent is that of sculpture and painting, of drama and music and dance in one. It is poetry, too, unless there is academic insistence on the part of the critic that poetry is an art of words. But most of all does this art glimpse the secrets of music, envisaged in forms of live movement, color and rhythm. It suggests in her bends, what music alone of the arts possesses—complete freedom from things of the earth and the material boundaries of existence, its revelations, made by physical means, are of the incorporeal and the realm that lies beyond good and evil. At

the same time its motives come from life and nature, from other arts and the most varied fields of human experience. Greatest of all—we quote from a lovely and informative volume, "The Dance," by the Kinneys—"greatest of all, perhaps, in its contribution to her particular art is a species of vision into the heart of things, a sensitiveness to what may be called the characteristic state of mind both of animate beings and inanimate things, and receptivity to those impressions which interpreted into expression enable Pavlowa to endow flowers and birds and insects with lively and interesting sentiments."

There are certain musicians to whom a fiddle is a fiddle, and a chord a chord, and nothing more, who will reply, "What of it, What of it." Merely that these small things are more important to a musician's development than all the scale practice and harmony grammars that ever existed. The fact has not been advertised by our bookworms, but nevertheless it is true. The routine of music, indispensable as it is for practical artistic purposes, is not the music. Music remains the magical reflex of nature and the expression of human feeling. "Music," said Busons "was born free; and to win freedom is its destiny. But freedom is something that mankind have never wholly comprehended, never realized to the full. They can neither recognize nor acknowledge it. They disavow the mission of this child, they hang weights upon it. This buoyant creature must walk decently, like anybody else. It may scarcely be allowed to leap—when it were, its joy to follow the line of the rainbow, and to break sunbeams with the clouds." We are reminded of these things—more than that, an inward shout of joy at their truthfulness is awakened in the beholder—by the art of Anna Pavlowa.

The dancing of Mme. Pavlowa and the movement of which she, more than any other single individual has been the protagonist, has become so much a part of artistic life and has acquired so many disciples in the last fifteen years that we have forgotten the first thrill of her achievement. At its base her technic and style are those of the classic school. She was the greatest of the pupils of Marius Petifa. Nevertheless, had she been only a classicist, a grande dame of the days when the old ballet was in flower, it would have gone hard with her in the period immediately to come. For she has seen and survived—while constantly increasing her popularity with the publics of Europe and America—two revolutions in the development of the dance which have taken place in as many turbulent decades.

The first revolution was that led by Fokine and Diaghileff—a direct antithesis of everything that Pavlowa as a young girl had been taught. That revolution was gloriously consummated by the appearance of Diaghileff's troupe for the first ever memorable Saison Russe at the Chatelet Theatre in Paris in 1909, and by the wonders wrought by Fokine and his fellow-artists, among them Pavlowa and Nijinsky. It was signalized by the first performances of such choreographic masterpiece as "Scheherazade," "Carnival," "Thamar," and this form of ballet found in Pavlowa one of its most brilliant exemplars.

These ballets, that fairly set the artistic world afire, were followed, some half dozen years later, by a second revolution, more gradual and less violent than the first, and a revolution that led, with accompanying influences, to a most lamentable decadence. There were indications of it in Nijinsky's pantomime representation of Debussy's "L'Après-midi d'un Faune" and in his version of "Till Eulenspiegel" of 1916. This revolution, or retrogression, led logically to the almost danceless ballet visible in Paris last Summer, in such spectacles as the pantomime that accompanied in a futile and ineffective manner Stravinsky's "Sacre du printemps" and in other fruitless experiments.

Nothing is finer testimony to the independence and the classic yet synthetic character of Pavlowa's art than the fact that she saw and studied all these evolutions, took from each the things she deemed valuable for her own purposes and escaped completely their decadent tendencies. As a public dancer she has conserved the highest esthetic standards and the distinctive qualities of a beauty peculiarly personal and spiritual in its essence. Classicism, romanticism, studied grace, exotic fantasy, all these are in her gamut. She has embodied as no one else cultures of many ages and of strange lands, so that even a nervous public, greedy of sensationalism and all that Pavlowa is not, has understood. She has brought closer together the art spirit not only of Russia and Europe, but of the Old and New Worlds. She will be greatly missed when she has departed, but her accomplishment is present and will remain and bear results in many forms. In the history of art her position will be unique and as immortal as that of an interpreter who cannot leave a written record behind can be, as one of those who devoted all her life to things that uplift the spirit and make humanity creative and free.

* * *

October 26, 1924

THE BALLET—A PROTEST AGAINST ITS USURPATIONS

*The following letter has been received by the Music Department of The Times. It takes issue with the article on the art of Anna Pavlowa which appeared in these columns last Sunday, and is published as the forceful expression of views entertained by many lovers of music—*OLIN DOWNES.

To the Editor of The New York Times:

As a music lover who has read the article by Olin Downes in this Sunday's Times on "Pavlowa's Leave-Taking of America," I wholly dissent; and I especially dissent from the implication of the subtitle, "Her Contribution to Native Music." I dissent from the general proposition upon which it seems to be based, that music is not in itself a complete thing, an art capable of standing by itself, but needs the ballet dancer to complete it and interpret it. "There are certain musicians to whom a fiddle is a fiddle and a chord a chord, and nothing more," says Mr. Downes; he might have added,

"and music is music, and nothing more." Of this last they will not and need not be ashamed. He appears to go on, in his article, to establish the point that only by the aid of the ballet dancer can interesting American music be created; that her doings will bring about a "vast liberation from provincialism and self-consciousness" and produce "a vivid perception of beauty that pervades life and informs joyous, living art."

Nobody will doubt the beneficent effects of such a liberation and of such a perception if and when they are effected; but many, I think, will doubt that they are to be brought about by the dancers whose pretensions have in recent years been so hugely increased. I have nothing against the ballet dancers. Their art is a very pretty one when it is prettily exercised and forms a pleasant diversion for those who like that sort of thing. But when they come to usurping a place in the art of music, and shoving and hustling that art about as they have been doing, somebody ought to protest.

Somebody ought to protest against the idea that the ballet dancers can in some way interpret or illumine or give some real significance to music that it did not have before; to music that the innocent composer thought was expressing all he had in him to say or to express and who never dreamed of the need of being "mimed." To my mind, this dancing that has, in Mr. Downes's words, "become so much a part of artistic life" and has "acquired so many disciples" in the last fifteen years, is a damnable perversion of the art of great masters and should not be allowed to obtrude itself upon that art. When Isadora Duncan "danced" Beethoven's Seventh symphony, she calmly announced that she was "interpreting" it, as if Beethoven had not himself done all the interpretation that was necessary or possible in giving his score to the world to play as he wrote it. There was a miserable performance by a band of scratch players and a woman writhing on the stage, and the symphony was "interpreted" as no mere musicians had ever done. She was led to it, no doubt, by Wagner's foolish remarks about the Seventh symphony being the "apotheosis of the dance," which he probably would hastily have withdrawn if he could have foreseen the results. Beethoven never gave any hint that he considered his symphony anything of the kind, and nobody could by any possibility have gained anything but a wrong, distorted, cheapened, vulgarized idea of Beethoven's work and what he intended by it from witnessing this performance.

Mme. Pavlowa is, no doubt, a more agreeable spectacle in her particular writhings than Miss Duncan was in hers; but when she lays violent hands on great music to be a "vehicle for her art"—otherwise to help her in her trade—she is doing essentially the same thing and no less despoiling the art of music. Let us consider what Mr. Downes calls the "choreographic masterpiece" of "Scheherazade," for instance. Poor old Rimsky-Korsakoff—"ein guter Meister, doch lang schon todt," (as Beckmesser says of another one), and unable to help himself by injunction or otherwise—thought he was writing in his orchestral composition an imaginative piece of program music, not following an anecdote closely but giving hints and suggestions and stimulating the imagination by his

rich thematic invention and glowing orchestration—about what? Why, in the first movement about the sea, which is suggested in the broad sweep of the melodic line, going, perhaps, as far as program music can well go in such an undertaking; and about Sindbad the Sailor; and then about the Kalandar Princes and other things in "The Thousand Nights and a Night" which are particularly indicated in the score. But now comes Mme. Pavlowa in the ballet—if it is the same one that I saw some years ago— and does Rimsky-Korsakoff the favor of "interpreting" his music by some scene in a harem and the incursion of a lot of eunuchs, followed by a general slaughter—if I remember correctly, which, perhaps, after the lapse of years I don't. But at any rate it is something entirely different from what Rimsky-Korsakoff was driving at. The poor composer is nothing so long as the popular and brilliant dancer can make use of him in her own way.

Or take Schumann's "Carnival." Some excuse has been made for "dancing" or "miming" this, on the ground that it suggests a ball and is, in part, composed of music more or less "dansante." But to my mind, "dancing" it only implies a subtler form of the disintegration of taste and right understanding that is implied in all this making of masterpieces into ballet dances. Schumann's imagination, fancy, passion, tenderness, gayety, humor, are all contained completely in the music and are embodied in it conclusively for those who have ears to hear and imagination and intelligence to understand. To "dance" it puts it on the same plane as those picture newspapers for people too indolent or too ignorant to read.

Pavlowa may be, and very probably is, all that Mr. Downes paints her in her own art; though I must confess that there are in any art very few practitioners, living or dead, who can or could have lived up to some of the praise he bestows upon this estimable artist. I acknowledge my inability to understand or appreciate that art or any such standard, or to realize that she has made any such revelation of a new heaven and a new earth as he describes. But when she or any of her tribe come shouldering their way into the art of music with the pretension of widening its boundaries or increasing its potentialities or giving it "freedom," or teaching it anything whatever; or when her devotees undertake to show that "scale practice" and "harmony grammars" are small and useless things compared with the muscular exercises, leaps and contortions, however graceful, that utilize the results obtained through the mastery of musical material to which scales and harmonic knowledge are indispensable; or characterize the followers of music who refuse to be seduced by the contortionists as mere "bookworms"—then I, with other worms (bookworms, no doubt) turn, and wish to scratch, so far as worms can scratch.

There is a story of an unusually wise analytical lecturer on music whose earnest pupil asked: "What did Beethoven mean by the first theme of the 'Eroica' symphony?" and who gave the only answer that then seemed to him possible by saying: "Why, he meant this," and going to the piano and playing the theme. It is all in the modern tendency not to understand this—the sufficiency of music in its self-expression. If Mme. Pavlowa had been there she could no doubt have extempo-

rized a much more agile, graceful and generally interesting exposition of Beethoven's "meaning" than that dull book-worm had evolved with the preliminary training of his "harmony grammars."

Admirable, graceful, agreeable and thoroughly developed in muscle as Mme. Pavlowa is, she is a humble and not quite necessary appendage to the art of music, which is not beholden to her for any instruction, illumination or liberation whatever.

SYLVANUS URBAN
New York, Oct. 19, 1924

* * *

March 18, 1925

PICTURESQUE DANCES BY RUTH ST. DENIS

With Ted Shawn and the Denishawns She Appears in Scenes From Many Lands

Solo dances and scenes from many lands, enacted in pantomime, made the greater part of the program given by Ruth St. Denis, Ted Shawn and the Denishawn Dancers last night in Carnegie Hall. Louis Horst was pianist and conductor of a small orchestra. The dance program was in the main familiar to the many admirers Miss St. Denis and her organization have in this city.

In the first group solo performances by Miss St. Denis and Mr. Shawn and ensemble pieces for a small number of dancers aroused the interest of the audience. Anne Douglas and Georgia Grahama gave a charming performance of their dance, "à la Loie," meaning, of course, a dance in filmy draperies which seemed like masses of many colored flame, as they were subjected to singularly beautiful and imaginative lighting after the manner of Loie Fuller. Then there was the performance of Doris Humphrey, a comely young woman with a large round hoop.

The dance pantomime, "Cuadro Flamenco," is a picturesque scene between a bull fighter, various women dancers who perform in the Spanish styles and a crowd of onlookers whose lively movements, groupings, exclamations, &c., gave the scene much of its atmosphere and character. The dance "Tragica," an experiment in rhythmical pantomime without the aid of music, has a certain rhythmic effect, but is too long and vague in its meaning. Other moments of more than ordinary significance were the dances of Miss St. Denis and Mr. Shawn from the Island of Bali; the "Five American Sketches," created by Mr. Shawn, and "The Vision of the Aissoua"—scenes in a mosque and a café of Algeria, in which the far-famed Ouled Nail girls dance, and there is much local color.

The ensemble performances of the evening were well composed and carried through, and the solo performances of Miss St. Denis and Mr. Shawn gratified the audience.

* * *

April 3, 1925

THE AMERICAN WORKS

The Neighborhood Playhouse has added to its repertory two new works by Americans: "A Legend of the Dance," described as a "medieval interlude," by Agnes Morgan, with music by Lily Hyland, and "Sooner and Later," a "dance satire," by Irene Lewisohn, with music by Emerson Whithorne.

"Sooner and Later" is a satirical conception of three stages of human development, past, present and future. First is a scene of primitive life. At dawn there are calls from the watchers on the hills. The tribe assembles. There is a rite to the sun, and an invocation for fertility. The people depart at the bidding of their Headsman to daily tasks. Returning at sundown, they spread before him offerings of their toil. The day's work is over. There is "relaxation" in the form of wild shouts and savage dances, which mount to frenzied excitement as the curtain falls.

The modern equivalent of all this is the city on a murky day, a fantastical, "expressionistic" scene of house-tops, steel structures, machinery and puppets whose faces are masks. Their toil consists in soulless rhythmical gyrations to music of intentional monotony and discordance. These puppets cease work at the sound of a whistle, and spend their hours of "relaxation" at a "revue." This revue is a parody of Ziegfeld show girls, "folk-dancers," Spanish dancers and jazz dancers, who perform with a vim and exaggeration worthy of the show and the tune which they satirize. (The show is "Shuffle Along" and the tune is "Harry.") The lookers-on at the revue are themselves seized by the rhythmic vertigo. Exhausted, they nevertheless "jazz"-step their way homeward.

The last scene of the ballet shows an imaginary community of the future. In these figures of shadow and transparency there is nothing real. Humanity has lost its primal passions. Feeding, as also Mood, are measured by scientific apparatus. "Relaxation" is provided by the performance of a "Synthetic Mood or Instrumental, Vocal and Color Prelude," followed by a tabloid "Radio Drama," in which a lurid sex drama, with three murders off-stage, implied by incoherent cries of unvisible interpreters, mildly amuses the sophisticated audience. Three pistol shots, languid laughter and applause, and curtain! Thomas Wilfred's "Clavilux," or color-organ, bathes and adds to the fantastical "futuristic" quality of the scene.

This ballet, performed brilliantly, with imagination and no small degree of technical virtuosity on the part of the interpreters, would have significant individuality if only for its nervous, ironic, contemporaneous spirit. It is satire born of today, whether present, past or future make the subject of the moment. The settings and costumes of Donald Oenslager and, in the first part, of Polaire Weissmann, and the stage management of Grace Duncan Cooper are admirably in accordance with and illuminative of the spirit of the piece. The stage, on the whole, conveys very well, with surprising resource and dexterity, the ideas of the authors. Whether Mr. Whithorne's music would stand by itself, divorced from the

spectacle, is a question which need not detain us. He has written music intimately correlated, and descriptive of the pantomime, and his scoring is original and suggestive. The tonal description of the puppets at their ridiculous tasks is an extremely ingenious idea. It has real modernity of idiom and meaning. It could not have been written in another period, or by one unaware of modern cities, noises and atmospheric vibrations—"vibrations" is the word! Mr. Whithorne has written here music of a modern day, music of mechanisms scientific and human, and their "vibrations." He has evoked the sensation of that which is high-pitched and automatic. The music, with its complicated, conflicting and steadily recurrent rhythms, the settings and costumes, worthy of a Tatlin or Picabia, contribute alike to this unique effect—one of the best moments of a hard and witty satire.

Elsewhere the music is of varying degrees of effectiveness. The score of the first scene provides a good imitation of primitive cries and also imitations—probably unconscious but nevertheless inescapable—of Stravinsky. It is not easy to be primitive in music today, as if there had been no such thing as "Sacré du printemps." It is enough that the effect required by the scene is carried out, while the barbaric traditional chants, flung out by the dancers with admirable lack of vocal polish or precaution, have the roughness and wildness required by Miss Lewisohn's scenario.

There are amusing musical quotations in the second act—a take-off of a popular dance tune; the hymn "Onward Christian Soldiers!" chanted raucously and out of pitch by a Salvation Army band supposedly in the streets below, and that heel-tingling tune "Harry" as accompaniment for the amazing, soul-stirring jazz dancing of the four young women who appear with Albert Carroll. Their names should be immortalized, but since the cast of "Sooner and Later" is a very large one and highly efficient individually as well as en masse, few soloists will be mentioned here. The Follies girls descend steps to a chromatic glide out of Stravinsky via Rimsky-Korsakoff. The amusing take-off of a "shimmy" by Marc Loebel and Lily Lubell must be mentioned; and the megaphone puppet of William Beyer; and the taxi puppet of Harold Minger; and the puppet factory workers; and the puppet tailor of George Heller; and the Spanish dancers, Blanche Talmud and Allan Glen—&c., &c! There were numerous capital features of the show by no means confined to the second part. In the first part the men dancers, in particular, performed with a sweep and gusto highly appropriate, and one of the best passages of the music is the combination of the motives of the men and women when action mingles the group on the stage.

The music of the last part of this ballet is at first hearing remarkable principally for its scoring. It is again artificial in intent, but in a manner different from that of the preceding scene, of which the sounds were more stark and powerful. In the final episode Mr. Whithorne has accomplished a curious empty tinkling for the figures, hollow of human feeling. Throughout, he has written fluently in the ultra-modern manner and with a keen sense of stage effect. All in all, a production that reflects much credit upon the creators and

interpreters of the piece, and emphasizes the truly remarkable achievements of the Neighborhood Playhouse in its cultivation of the dance and the art of the modern ballet.

An excellent foil to the modernism of "Sooner and Later" is supplied by the smaller and less pretentious work which precedes it, "The Legend of the Dance," in which a noble host and hostess entertain guests with jesting and tumbling and, finally, with the performance by a company of strolling players of the naïve "Legend of the Dance." This portrays the ascent of the dancer, Musa, to Heaven, and the entertainment on a feast day in Heaven of the Nine Muses, specifically invited up for the occasion from their abode in a nether region. Anne Schmidt's Musa was only one of her accomplishments of the evening. King David was Albert Carroll, and Mr. Loebel recited the legend. For this spectacle Miss Hyland has provided pleasant music in the style of dances, folk music and church chants of the "moyen-age." The performances of a small picked orchestra of excellent musicians make distinctive features of both the production.

[This article, on account of conflicting musical dates, has been written from the dress rehearsal.]

* * *

November 15, 1925

RUSSIAN BALLET HAS RISEN IN REVOLT

Goleyzovsky and Erdman Chiefly Responsible for Upheaval That Followed the Search for New Forms of Expression

By ZAKHARY L. McLOVE

The time has not yet arrived to judge of the influence the revolution has had upon the development of dramatic art in Russia. But one thing is certain: never before has the Russian theatre shown such feverish activity, such boldness in the search for new forms as in this epoch of storm.

With the exception of a very few new plays, the revolution has not yet worked out a distinctly original répertoire. It has undoubtedly succeeded, however, in fixing the revolutionary stamp, upon stage settings, even in the production of old plays.

The struggle for a new manner of staging plays and spectacles has been confined chiefly to drama and comedy; but last season it extended as well to opera, more particularly to the ballet. The ballet reveals almost the aspects of revolt; and it may truthfully be said that the Russian ballet is now passing through a crisis.

Introduced in Russia some 200 years ago, the ballet has always been fostered by the State. It has gradually developed to the highest expression of classical dancing art, unsurpassed in the world. The Russian ballet is well known through its chief exponents: Dagilev, Fokin, Pavlova and others; but it is principally identified as a theatre of Eastern colors, in which the actor himself has become a mere decorative arabesque.

The decorations of such famous masters as Bakst, Benof and others have made the Russian ballet performances resem-

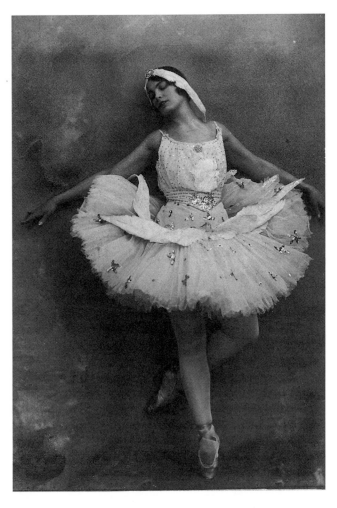

Miss E. Adrianovitch, ballerina of classical ballet.

ble living tapestries. No scope for the creative art of the actors has yet been provided.

During the old regime ballet performances drew smart gatherings of the aristocracy, the nobility, the wealthy classes. Now the audience has changed. Soft collars, Tolstoyan shirts, sporting caps and high boots have replaced the more formal attire. The scene no longer glitters with the diamond necklaces and diadems of beautifully dressed women; the smart military uniforms of an Imperial army. But though the audience has changed, the old ballet pantomimes have remained, and are regularly staged in the national State theatres in Leningrad and Moscow.

Zest for Ballet

In the theatrical life of Moscow the ballet is still an outstanding feature. Not only has the ballet itself not been destroyed by the great upheaval but it has become of greater importance than ever in Russian life.

Never before in Russia were there so many private and State ballet studios, choreographic institutes, classes of rhythm and plastic art and dancing techniques as there are now. Every one, it would seem, is learning the art of ballet dancing, from the office girl working in a Soviet institution to

the young daughter of once well-to-do people who finds it difficult to obtain regular education or employment. Every one of these students hopes to become a famous ballerina, surpassing such prima donnas as Geltzer and Kriger, or at least hopes to attain the technique of Kandaurova, Abramova, Bank and others of the Moscow Grand Theatre.

At all hours of the day one may meet, in Moscow, young girls carrying little cases stocked with dancing shoes and other paraphernalia, hastening to their studios. Masculine relatives and friends have also, indirectly, become interested in the ballet. This, to a certain extent, is responsible for the prosperity of ballet theatres, while all other theatres, according to official figures recently published, are run at a heavy loss.

The National Grand Opera concluded the last season with a loss of nearly $500,000, which had to be made good by the State. At the beginning of this year the large State subsidy which this theatre has hitherto enjoyed was cut to a minimum. This prevented putting on new ballet productions.

But if part of the Moscow population and the administration of the National Theatre are satisfied with the staging of old hackneyed ballets of the last century, such as "The Sleeping Beauty," "Don Quixote," "Le Corsaire," &c., a revolt against the classical ballet has occurred in the ranks of the ballet actors themselves. Moscow is divided into two camps: one group insists on retaining the old forms of dancing, the other clamors for a "revolution" in the ballet. In other words, one group supports the classical, while the other advocates the so-called "constructive" ballet, which during the early period of the revolution gained a place for itself. To the first belong those who value art in itself, independent of modern labels; to the second, those who, first of all, are looking for new forms in art and who are ready to bow to any one who declares himself a leader in revolutionary art.

As in many other domains of Russian life, the ballet cast of the Moscow National Theatre found prophets in their midst. Cassian Goleyzovsky, an inmate of the Leningrad State Ballet School, and Boris Erdman, a young artist, who sprang simultaneously into prominence during the first years of the great upheaval, are chiefly responsible for the revolt of the ballet.

Goleyzovsky broke away from the Moscow National Theatre after a year or two as premier dancer of the classical ballet and set up his own private school. Boris Erdman, now only 28 years old, started his career as an actor of the Moscow Kamerny Theatre, which in its productions has reached the highest forms of "constructivism" and "urbanism" on the stage. Moved by the inclination of his talent, Erdman soon dropped his theatrical career and took to designing scenery and costumes. In 1918 he began to produce plays and in the following years painted decorations for no less than ten new productions, in all of which he followed the ideas of constructivity.

Erdman while manager of the Moscow State Circus designed costumes for the dance. He reached the conclusion that to hide the mechanism of the body does great injustice to the dancer. Hence, he argues, ballet dancers should not be

encumbered with clothes. In his opinion dancers whose every muscle is employed in the dance should appear virtually nude. His costumes have proved such a success that Erdman today is looked on as foremost theatrical designer in Russia.

Goleyzovsky was the first to enlist his support. From among the young students of the numerous private ballet schools, including his own school, Goleyzovsky organized a group of enthusiasts which, following the style of the Moscow Kamerny (Chamber) Ballet, began to give private performances. The outstanding feature of these performances was the absence of classical dancing. Goleyzovsky says that the classical ballet has long since passed into recollection and is no longer an actively creative force. The classical ballet, he believes, has degenerated into an eclectic dancing art that flourishes on every stage. Deprived of creative power, it hides its weakness beneath a sharpness of exterior design. In the classical ballet, cheap motion and sumptuous decorations have replaced genuine dancing because of an inability to interpret the music. The efforts of his school of modern choreography are directed toward a return to pure dancing art and the creation of forms adequate for it. He considers it necessary to clear away foreign influences, which, he says, have enveloped its pure forms. Choreography, Goleysovsky asserts, is an art in itself, subject only to its own constructive laws. The sole material with which choreography works is motion of the human body, taken not in its submissive aspect for the expression of this or that thought and frame of mind, but for itself.

The aim of dancing lies in the rhythmical shaping of the motion. The dance is being built not out of separate movements chained together by the community of ideas expressed by it, but by the fluidity of the unfolding motion. Dancing art is closely allied with music, and the human body is the foremost element in the building up of the dance, as is the sound in music.

Such is the new gospel preached by Goleyzovsky, and such are the principles of his constructive ballet. For his work he selects musical pieces with complicated rhythmical designs, such as works by Scriabin, Debussy and Prokoffyev. In the motion of the dancer he tries to materialize all the rhythmical construction of the musical composition employed.

This complexity of rhythmical construction compelled him to search for movements of the body other than merely those already known to the classical and contemporary ballet. He has become an exponent of acrobatic forms of art. Some of Goleyzovsky's performances have frightened people by their audacity. In order to bring the motion of the human body to absolute perfection, Goleyzovsky, like Erdman, whose cooperation has been enlisted, puts upon the performers as little clothing as possible.

Two Camps Were Formed

He gained notoriety and material success. The bourgeoisie created by a new economic policy, striving to forget the famine, cold and other privations of the first years of the revolution, flocked to his performances. Exorbitant prices were paid for tickets.

The activities of the Goleyzovsky group increasingly attracted the attention of Moscow's artistic circles until, as has been observed, two camps were formed. Those, however, who guided the destinies of the Soviet theatrical policy sided with the classical ballet, and a ban was declared against Goleyzovsky. The Moscow Soviet issued orders forbidding performances of his Kamerny ballet, which was said to have a demoralizing effect upon the younger generation.

Goleyzovsky for a time passed into oblivion. But signs of revolt soon appeared among ballerinas and dancers of the Moscow Academical Grand Theatre. A group of seventy dancers, dissatisfied with the submissive rôles assigned to them in ballets devised to bring into the limelight only a few fortunate prima donna dancers, demanded the staging of such ballets as should give them a greater chance.

At first the administration of the Grand Theatre attempted to quell this movement by threatening to dismiss the ringleaders. Then an experiment was resolved upon. Goleyzovsky was asked to provide a libretto and to produce a new ballet. This was a bombshell in the Moscow theatrical world. Devotees of classical ballet were panic-stricken, and soon Goleyzovsky demonstrated that their fears were well founded. His experiment proved so successful that it startled all Moscow. Box-office receipts bounded upward and crowded houses applauded Goleyzovsky's performances.

The first of his ballets produced on a big stage was the "Legend of Joseph the Beautiful." The enticing of Joseph by Taich, wife of the Egyptian Potiphar, provided good material for putting into practice all the Goleyzovsky principles of dancing. Exquisite costumes designed by Boris Erdman furthered its artistic success.

The stage, contrary to ballet laws that demand clear floor space for dancing, was filled with stairs and platforms, on which the entire ballet was performed. There was not much dancing, in the traditional sense, but there was plenty of beautiful posing, magnificent grouping and choice "plastics." To this the gorgeous, if scant, costumes of Erdman lent color. The performers' bodies, too, were colored from head to foot. There were orange Jews, red Egyptians, brown Ethiopians. Joseph was a lemon-yellow youth with feminine features; Taich, Potiphar's wife, was white as milk. Taich was danced by Miss L. Bank, a beautiful and talented young actress of the Grand Theatre. She appeared upon the stage with only narrow silver strips over bust and hips. Her bobbed black hair was parted in the middle by a string of diamonds. The face was immovable, sardonic. She resembled one of those enticing feminine images the Italian Renaissance masters liked to paint. Everything, even the music, specially written by the Russian composer Vassilenko, was in direct opposition to all the classical ballet ideas.

With the performance of "Joseph the Beautiful," despite its success as a theatrical show, Goleyzovsky laid himself open to criticism. His productions lacked dynamic force. The basis of classical dancing is dynamic movement, while the basis of the new Goleyzovsky productions is plastic, posing and statics. Goleyzovsky throws overboard the entire ballet

technique accumulated during the past century. His ballets, while full of pretentious, convulsive and emotional posing, are not conspicuous for technical difficulties.

Opposing himself to the old ballet and its refined dancing technique, Goleyzovsky opens a wide road for the amateur. In order to dance in his productions it is not at all necessary to be a first-class ballet dancer. Nearly every character could be performed by any student with a year's training as equipment.

In this sense "Joseph the Beautiful" is a test show. Its success was largely due to the success of the designer, Erdman, who approached his subject from a theatrical point of view. He did not attempt, like many other designers of theatrical productions, to nail the artist once and for good to a certain spot on the stage. His first principle was the attaining of color and motion. The monotone of white and black decorations served as a background for the play of costume colors.

Despite the fact that the classical ballet has still a great many followers in Russia the two new prophets, Goleyzovsky and Erdman, have gained such hold upon the administration of the Grand Theatre that a contract has been concluded with them for regular productions of new ballets. Rehearsals are in progress for the staging of a ballet called "Lola," depicting Spanish gypsy life, for which special music is being written. It will be staged on a still bigger scale than was "Joseph the Beautiful," and will require a cast of over 350. Erdman has designed the costumes.

Ballets are less subject to adverse criticism in the Soviet press than are other theatrical productions. There are, however, Communist journalists who attack the ballet on the ground that it belongs to the kind of art which in the old days was most cherished by the aristocracy and the nobility. The revolution proved a severe test for the dancers and revealed the extent of their devotion to art.

During the years of cold and famine performances were staged at the Grand Theatre with the thermometer registering at 6 degrees below zero. The dancers' bare shoulders steamed. Their breaths floated like clouds. The audience, composed of Red soldiers and workmen dressed in sheepskin coats and felt boots, stamped their feet in the orchestra stalls to keep warm.

The training of ballet classes continued under most difficult conditions. The pupils suffered from insufficient food, were ill clad, and worked in unheated rooms. There is, perhaps, no more touching story than that told of the aged ballet dancer, W. A. Tchudinov, who recently celebrated his fortieth anniversary as artist at the Moscow Grand Theatre. He lived twenty miles from Moscow and had to journey in for his performances. For a number of years he played the title rôle in the "Don Quixote" ballet. It once happened that, owing to the illness of another artist, the opera arranged for a certain date had to be abandoned at the last moment, and the administration decided to put on "Don Quixote."

An Heroic Walk to Moscow

Tchudinov was informed that he would have to appear that evening. When he received the news he found that the single irregular daily train to Moscow had already gone. The old artist knew that without his participation the performance could not take place, and despite the fact a heavy snowstorm was raging he decided to walk to Moscow. He reached town just in time for the performance, but was so exhausted that the administration contemplated calling the performance off. Tchudinov insisted it should go on. He danced his part, and next day was removed to a hospital for treatment.

During the first three years after the revolution, artists of the Grand Theatre received reduced salaries in steadily depreciating Soviet paper money. They tried to make a living by playing outside the theatre—at clubs and factories. Money did not count much in those days, as the value was next to nothing, and actors were glad to receive flour, sugar, butter, meat, cheese and sweets as remuneration. Sometimes they were able to get a pair of boots or several yards of cloth for a dress or suit. At one concert organized by metal workers, Geltzer, Russia's most famous ballerina, received as her fee five casseroles, a saw and an axe.

* * *

March 23, 1926

DANCERS GET JAIL SENTENCES

Two men and three girls were sentenced to thirty days' each in the Workhouse when they were convicted yesterday by Justices Murphy, Herrman and McInerney in Special Sessions for an objectionable dance on the night of Feb. 16 in a hall in East Fifty-eighth Street, near Third Avenue. It was the severest punishment ever imposed for the offense. The persons convicted were Alice Leon 145 West Forty-fifth Street; Annette Harrison and Hazel Cyrus, 224 West Fifty-fourth Street, as the dancers, and Arthur Katz, a post office clerk, 158 Ridge Street, and Jack Zucker 512 Cleveland Street, Brooklyn, the men who were in charge of the affair.

* * *

July 4, 1926

NEWEST BALLETS SCORN THE MERELY HUMAN FORM

Bauhaus Movement in Germany Gets Exotic and Colorful Effects With Mechanical and Triadic Figures

By HERMAN G. SCHEFFAUER

BERLIN—New Yorkers have recently been given an opportunity to sample, in "Skyscrapers," a distinctly "modern" ballet; so that perhaps a sort of preliminary groundwork may be said to have been laid, making easier an understanding of some of the really extraordinary things now being attempted in Germany by creators of ballets in the "new" manner. Not, however, that "Skyscrapers," in the light of what is here being done, could be called very extreme. "Mild" may best describe the John Alden Carpenter product

when it is compared with recent activities of the new Bauhaus at Dessau.

The State of Saxony, while yet a kingdom, established and supported an art and architectural school at Weimar called "das Staatliche Bauhaus," or State House of Architecture. After the war that institution, divested of its royal and conservative character, became the stronghold of a group of revolutionary young architects, artists and craftsmen under the guidance of Walter Gropius, who married the widow of Gustav Mahler, noted Austrian musician and composer. Lyonel Feininger, a native American and an exponent of the higher "Expressionist" school, is also a member of this group.

Old Laws Upset

Art and "intellectualized modernity," certain guild principles, a rigid discipline in the teaching of rudiments, an earnest attempt to ennoble factory-made products—these are the chief shibboleths of this destructive and constructive group. But the tenets, principles and products of the Bauhaus aroused such fierce opposition that the State of Saxony refused to give it further financial support. This produced a great uproar throughout intellectual Germany in 1924, and battle lines of artists and legislators were marshaled for and against the Bauhaus. The State and the conservatives won, the old Bauhaus was placed under a new director and Walter Gropius forthwith founded a new Bauhaus at Dessau.

This group of "practical theorists" has been busy upsetting and rearranging all the laws and principles of art, architecture, music, and the like. It has tried to recast the inherited and the traditional into forms considered consonant with the modern age. The whole movement may at times seem like caprice, diabolical spite, impotence, or even sheer lunacy. But they are not to be disposed of so easily. The most obvious and ready formula to fling at this colony of teachers and students is "Cubism!" or "Expressionism!"—any one, in fact, of the stock terms for the new art movement. Their case, however, merits a little study.

The Bauhaus movement is based upon careful, exact, almost mathematical deductions; upon formulas, schematic diagrams and plans, backed up by a fixed faith in the holiness of new theories. As for the theories, these are not only given visible and tangible form, but are also put into action. Abstractions are shown as realities; translated into deeds.

This applies to most of the departments of the Bauhaus, from pottery to weaving and furniture making. It applies to the peculiar Bauhaus stage that, under the direction of Oskar Schlemmer, has acquired a life of its own. Most especially does it apply to the Bauhaus's Triadic and mechanical ballets.

Let us proceed, in dealing with this somewhat abstruse subject, from elementals or first principles. Let us deal with rudiments and win, if we can, a glimpse of the roots from which these strange flowers of a new art receive nourishment.

Light, form, color, line, space, surface, solids—these play their parts. They are analyzed and then built into a new whole. The results are so new, and, indeed, so astonishing,

Above and to right—Dancers in the Triadic Ballet.

that they might be the creations of moon men or of Martians. Schlemmer, for example, takes the human body, neutral and unadorned, and regards it in relation to its environment. This environment is abstract space, cubical "room" (whether it be enclosed by the six sides of a room or not). Spatial forms are transferred to the human body. The head, the trunk, the arms and legs are enclosed in cubic forms—and lo! the human being becomes a kind of architecture in motion.

In another instance the laws of function that govern the human body in relation to space are considered. Here again the corporeal forms are conventionalized. This time the head assumes an egglike shape; the trunk a vaselike. Arms and legs take on the appearance of tapering clubs. The joints become spheres—ball-and-socket joints. The human figure is turned into a jointed doll; a kind of artist's lay figure.

Or suppose we take the laws of movement applying to the human body in relation to space. Here we have rotation, progression, intersection of space. We have the circling movement, the spiral, the movement in a plane. When these several movements are "developed," in a geometrical sense, the result is a kind of toplike figure, cones and flattened globes representing the outer "enclosing" lines of these movements. In other words, these give us the human body seen and conceived as a purely technical organism; a machine, if you will.

Finally, there is the metaphysical or spiritual expression of the body: the starlike form of the hand with extended fingers;

Masks used in the Triadic Ballet.

the double-loop curve of the folded arms; the cross made by the line of the spine intersecting that of the shoulder blades. Then there is the double or threefold aspect of the head—the front face and the two profiles. Then there are the various articulations. The result is highly interesting, if a bit baffling; a "dematerialization" of the corporeal into the symbolical.

These innovations in the realm of the play and of the dance have led to the mechanical ballet, which may be either serious or grotesque. There seems to be here a wish to augment the effect of costume and the capacity of the dancer. Some German experimenters believe, with Gordon Craig, that the "living actor must quit the stage and that his place must be taken by an inanimate figure—the so-called super-marionette." They even closely approach the standards set up by Briussoff, the Russian expert, who demanded that "the actor be replaced by dolls with springs, each doll to carry a gramophone in its interior."

Where the Automaton Scores

Now, a mere human dancer is confined to short steps, a yard or so either way; to low leaps, at most a yard or more above the ground. He is able to free himself from the law of gravity only for a second. When he goes beyond this, assisted by trapezes and tight-ropes, he becomes an acrobat. It is here that the automaton and the marionette come triumphantly into their own. The artificial figure, when equipped with all the subtleties of modern techniques, permits of every possible movement; every possible position at any moment. Then, too, the playwright is enabled to use figures of many sizes—dwarfs and giants. It cannot be denied that the "wonder-sense" and "play-sense" are given almost unlimited expression through these new media or these new forms of old media.

But there is another type of ballet. Contrary to the movement that embues the marionette with human or superhuman

capacities, we have that which reduces (in some cases elevates) the unadorned or abstract or neutral human being to the rank of a puppet. Emotional qualities or characteristics may even be increased, by means of the mask. For the masking of the face and of the entire body achieving the whimsical, the terrible, the gracious, the captivating, the droll, the tragic—may give figurative expression to the living man within the living symbol.

This so-called Triadic Ballet has broken ground in a new world. Fabulous figures carried out in marvelous new materials, such as metals, paper, wood and glass, widen the range of our present symbols, providing a new gallery of forms, a new alphabet for denoting such recondite shades of thought and feeling as visit the modern mind.

This ballet was first suggested in 1912 by a pair of dancers, Albert Burger and Elsa Hötzel. The first attempt at presentation took place in 1915. The first formal performance of the whole ballet occurred in 1922 in Stuttgart—then again in 1923. It consisted of three parts and was danced by three dancers. Some seventeen costumed figures were employed, augmenting, exaggerating or conventionalizing the human and the "geometrical."

The dance proceeded from the comic to the serious. The first part was gay and burlesque in spirit, upon a stage and against a background of pure lemon yellow. The second part was stately and serene, upon a rose-colored stage. The third part was mystic and fantastic, with the stage draped entirely in black. The costumes were in part of stiff or padded fabrics, embracing every tone and color; in part of cardboard, wood or other materials. Even metals were called upon.

The Two Ballet Forms

The two ballet forms are radically unlike. As we have seen, the mechanical ballet is composed of inanimate puppets

and figures, many showing extremely grotesque or cubistic shapes. These puppets are worked in the manner of ordinary marionettes.

In the mechanical ballet we have the actual material expression and operation of such tricks and comic turns as we find in the grotesque "drawn" or designed film. In the marionette plays carried out by these figures no attempt is made to ape the marionette. These, instead, are unabashed, naked sticks, blocks and rods of wood, fantastically relating themselves to human shapes and movements. The possibilities in the realm of the eccentric are, of course, great.

The moving shadow of the human being as projected by the film has already become a universal factor in theatrical mimicry, made possible by photography. There can be no doubt that the triadic and the mechanical ballets open up new and fruitful perspectives. The rude, conventionalized marionette of the mechanical ballet and the strange new forms and figures of the triadic ballet, with its living dancers, have evolved their own laws and will produce their own art, naïve or complicated.

Supreme over all the mummery of mechanical puppets, we may venture to believe, still stands the human figure; the living, breathing, acting, suffering and enjoying human creature-image of ourselves, set in the world we may love or may hate, but with which we must reckon. This is the world we know. The drama of tradition is not yet so dead that it must abjectly surrender the boards to the inanimate. It is highly probable that the vital will always triumph over the mechanical, and especially, perhaps, in the ballet.

* * *

March 28, 1927

LEAGUE OF COMPOSERS

By OLIN DOWNES

Outstanding features of the performances of new ballets and orchestral music by the League of Composers last night in the Jolson Theatre were Alexander Tansman's ballet, "The Tragedy of the 'Cello," and the ballet with music of Henry Eichheim, "The Rivals," after a Chinese story and Chinese themes. These works were mounted and performed by the Adolph Bolm Ballet, which made its New York début on this occasion, with Mr. Bolm and Miss Ruth Page as leading dancers. The orchestra was directed by Tullio Serafin, who presided with the permission of the Metropolitan Opera Company. In addition to the works which have been mentioned there were performances of movements from a "Sinfoniatta" of Mario Labroca; of a ballet, "Visual Mysticism," danced by Mr. Bolm and Miss Page, and "Voyage to the East," after the poem of Amy Lowell, set by Richard Hammond for soprano voice and chamber orchestra. The soprano was Miss Greta Torpadie.

The Tansman ballet was memorable for the beautiful and distinctive settings of Nicolas Remisoff and Mr. Bolm's well-devised choreography. The music has no originality,

but is useful in furnishing rhythms for the dancers. The score is one more testimonial to the devastating influence of the genius of Igor Stravinsky in Europe of today. How many have succeeded in writing as if he had not composed? The ballet is danced by figures ingeniously costumed to suggest instruments—the violin (Adolph Bolm), the 'cello (Mark Turbyfill), the flute (Harriet Lundgren), the trombone (Paul du Pont), the kettledrum (Roger Dodge), the piano (Marcia Preble), the diapason (Irving Chandler). This ballet is intended as ironical parody on themes of love, death, marriage. The irony, like the music and the mise-en-scène, savors strongly of "Petrouchka." The violin and 'cello, rivals for the affection of the flute, fight a duel. The 'cello is killed. He is buried with mock seriousness and ceremony. The diapason unites the violin and flute in matrimony, and the marriage is celebrated in the old home of the 'cello. There is a setting of extraordinary decorative beauty. The costumes are equally effective, certain designs of the scenery being carried out in the costumes of the figures on the stage. The duel was fought with becoming extravagance, grotesqueness, punctilio. There was an excellent ensemble, nor was Mr. Bolm the only dancer who merited the enthusiastic applause.

Mr. Eichheim's music is of the kind that furnishes authentic background and atmosphere for the stage picture. The background is of an unusually genuine and picturesque kind. There are moments when a melodic figure, rising to the surface of the percussive orchestra, gives a poetic or emotional accent to otherwise unemotional and exotic tonal designs. Pulsatile instruments, employed cunningly by the composer, reproduce effects which Mr. Eichheim has heard personally in China. The score, while it is necessarily episodic, and sometimes enslaved by the needs of the dancers, in essence rings true. It is not the score of a stay-at-home showing his friends how confoundedly Oriental he can be; neither is it merely topographical or realistic in quality. Chinese ceremonial music written by an Emperor about 700 A. D. for a slain soldier is employed in the prelude to the ballet and recurs in the scene before the shrine. The orchestra employs percussion instruments secured by Mr. Eichheim in China and rarely heard elsewhere.

The ballet is performed as if it were given in a Chinese theatre. Property men move pieces of scenery about in the sight of the audience. The dances are suggestive of Chinese art and the figures seen on Chinese ware. These motives are freely developed by the dancers, clad in authentic costumes. It is an excellent stage picture, with admirable virtuosity on the part of Mr. Bolm and Miss Page, and a score with an idiom and accent of its own. But the effect of the symphonic poem played two seasons ago in New York by the Boston Symphony Orchestra is better and naturally more organic than the music heard as accompaniment to pantomime last night. At the end of this performance Mr. Eichheim, in response to long and hearty applause, appeared on the stage.

The other performances of the evening do not call for extended comment. The music of Labroca is inocuous and

took up valuable time which might have been better employed—the performances began much later than they should. Mr. Hammond's setting of Amy Lowell's verse is mellifluous and somewhat invertebrate, or was this impression caused partly by the curiously lukewarm performance of Miss Torpadie? This customarily intelligent and excellent interpreter of modern art was obviously not in the vein, or confident of herself. More than mysticism was visible in the evolutions of Miss Page and Mr. Bolm to the music of Scriabin, yet not enough to give a very distinctive impression. But in the ballets by Tansman and Eichheim Mr. Bolm and his associates showed their admirable and enterprising art, and their cultivation of a form bequeathed to this country by the original Ballet Russe, which merits wiser and more intensive cultivation than it has received hereabouts.

Mr. Serafin conducted with devotion to his task. The proceeds of the evening are given to the National Music League.

* * *

August 18, 1927

HUGE THRONG SEES FOKINE AT STADIUM

Dancer, Mme. Fokina and Corps of Seventy Are Cordially Applauded in Ballets

"MEDUSA" IS CHIEF NUMBER

Pantomime to Mozart Music Also Given—Arnold Volpe Returns to Lead the Philharmonic

Michel Fokine and Vera Fokine with their company of seventy dancers appeared last night at the City College Stadium in a series of ballets before a throng that taxed the capacity of the field and amphitheatre. Not since the first performance this season of Beethoven's Ninth Symphony has there been such evidence of popular interest in a Stadium program. Arnold Volpe, one of the first conductors at the outdoor concerts uptown, returned to lead the Philharmonic Orchestra in musical accompaniment for the ballets, which will be repeated tonight and tomorrow night.

Mr. Fokine and his wife are illustrious figures in the history and development of the modern ballet, the artistic culmination of which was revealed a decade or more ago in the performances of the Diaghileff organization. That they still exert a powerful appeal on the public was evidenced by the cordial applause which greeted them last night. It would be both inappropriate and unfair to judge the performance given last night from the standards which obtain in the case of an indoor production under the most favorable conditions. There were crudities in the lighting, doubtless inevitable under the circumstances, and the tread of elfin feet sometimes reverberated with disconcerting effect on the boards of the wooden platform of the temporary structure. Moreover, the art of the principal dancers in its more intimate aspects was often lost in the vast spaces of the arena. But these are matters which

naturally could not be avoided, and the audience was obviously inclined to make all necessary allowances.

The program opened with a "Dance of the Elves," set to music of Mendelssohn, including the overture to "A Midsummer Night's Dream" and the andante and allegro from the violin concerto, Op. 64. The dancers made an effective picture against the moonlit background of sea and sky. This was followed by "The Dying Swan," a solo dance by Mme. Fokina, which will also be remembered as one of Pavlowa's famous performances. The major piece was the elaborate ballet "Medusa," with music from Tchaikovsky's "Pathetique" Symphony, produced a few seasons ago at the Metropolitan Opera House. This was in many respects the most successful performance of the evening, with Mme. Fokina as Medusa and Mr. Fokine as the warrior, Perseus, who vanquishes the serpent-haired monster.

Some delightful music of Mozart accompanied the charming pantomime "Le Rêve de la Marquise," in which the two principal dancers also appeared. Mme. Fokina made a lovely picture as the eighteenth-century marquise, and the small page of Louis Winter, whose difficult task of holding the lady's train in the intricate evolutions of her dance was accomplished with the utmost virtuosity, completely captivated the audience.

Oriental dances with music from the "Caucasian Sketches" of Ippolitoff-Ivanoff, a solo dance, "Panaderos," by Mr. Fokine set to Glazounoff's music, and a group of dances with music of Liadoff completed the long program.

* * *

October 10, 1927

TAMIRIS IN "DANCE MOODS"

Gives a Program of the Pantomimic and Interpretative

Tamiris, a young American dancer who appeared a season or two ago in the Music Box Revue and who is known also in Paris and South America, made her recital début in this city last night at the Little Theatre in a program of "dance moods," assisted by Louis Horst, pianist. Although her program was confined to the pantomimic and interpretative style of dancing in vogue at the present time, it was varied and interesting, covering a wide range of mood and emotional contrast. The young artist is endowed with many natural gifts, a slender elegance of form, personality of real charm and innate refinement.

In many of her dances, notably in "A Portrait of a Lady" and "The Queen Walks in the Garden," she presented a lovely picture. Moreover, she has a genuine sense of rhythm. Unlike many of her colleagues whose posturings show, to the average layman, at least, too little relation to the musical accompaniment, she delicately synchronized gesture and movement to the melodic phrase. Of true virtuosity in technique as exemplified in the art of great dancers she is deficient. With a greater command of technical resource, she ought to go far in her profession.

The dances were accompanied to music of Debussy, Florent Schmitt, Scriabin, Cyril Scott, John Powell, Louis Gruenberg and George Gershwin. The last named composer was represented with excerpts from his "Rhapsody in Blue."

* * *

December 11, 1927

THE DANCE: A RUSSIAN STAR

Mlle. Geva of the Chauve Souris Brings New Expressions of the Art to New York Audiences

With only the kindest of feelings for Maestro Balieff, one cannot help rejoicing that Tamara Geva has elected to remain behind when he resumes his peregrinations after the tour of America. If identification is necessary, Mlle. Geva is the dancer of the Chauve-Souris who has dropped several syllables from her name and put them into her dancing. Inevitably she has caused discussion and dissension among dancers. Some dismiss her as too grotesque for consideration; others hail her as an extraordinary and revolutionary genius. The truth seems to lie, as usual, in neither of these extremes, but to incline somewhat more to the latter than to the former.

Geva is not a pleasant dancer. There is in her work something of the hardness and the profanity of the drawings of George Grosz, under a coating of superficiality that smacks sometimes of the smart aleck, and underneath it all a firm foundation of classical ballet technique. Only a dancer with a marked individuality and a real style could mold these contradictions into consistent form. As it is, even Geva gives one the feeling that he is eating rusty nails along with his ice cream. It is not an altogether healthy manifestation, perhaps, but fortunately it is too difficult of conception to be imitated to any great extent by the merely facile.

If dancers are perplexed and upset by her, audiences are puzzled and unresponsive. The same state of affairs existed when the first exhibition of cubist paintings was held in our midst, except that then we laughed. Now we have learned not to laugh; at least, not always. It has not been more than three or four years since an entire audience burst into roars of mirth at a group of solos for clarinet by Stravinsky. However, dance audiences must sooner or later come to realize that what Geva is giving us now is only by way of preparation for what the Diagileff ballet will almost certainly startle us with in the Spring.

The Art of the Dancer

Her first appearance in the present Chauve-Souris serves a mere warning of what is to come later in the evening. It is called "Romanesque" and is danced to music of Glazounoff. We see a supple, responsive body, inclined a little dangerously toward adiposity, but exquisitely poised. We see movement expert and animated, beautiful but puzzling, for there

are such liberties taken with strict classicism and they are taken with such studied deliberation that rebellion is evident and not merely eccentricity. Before the evening is over one begins to wonder if perhaps she is not herself of the belief that in this number she is tediously orthodox.

Her second number, the "Grotesque Espagnol," carries her rebellion to its height artistically, though she rebels even more violently in her last number. With a consummate energy that makes even her moments of motionlessness dynamic, she dashes through a mad fantasie on Spanish themes, garbed in a costume at once hideous, unbecoming, fascinating and exactly right. The actual choreography defies description; its like has never been seen on land or sea, but the fire is grotesquely that of Spain. Conceived though it is in the spirit of a cartoon, its comment transcends its mood and lifts it into a significant art form. There is, for example, something more than buffoonery in the moment when she halts the swing of the hips and the undulations of the torso, and rising to more than her full height, solemnly crosses herself (in the Russian fashion, by the way) with an impious religiosity, only to resume immediately her blatant seductiveness.

Her third and final appearance is in a number called "Sarcasm," which passes out of the bounds of reason and becomes pure nonsense. In a setting of modernistic absurdity and a costume of the same tone, she has a gorgeous time thumbing her nose at the world. Her sense of the comedy value of line simply for itself is phenomenal and her instinct for timing is faultless. She knows exactly when to introduce the eccentric line into the picture in order to give it the final fillip. Here is no psychological subtlety; in fact, it has its silly moments. There is nothing, for example, of the inner feeling for the humorous line such as Ronny Johanssen possesses, nothing of the warmth and humanity of Miss Johanssen's comedy. But it is wild and weird and novel, and even though it seems to be nothing more than a clever dancer having a bit of fun out of her mat exercises, its comment is biting and its finish exquisite.

The Musical Background

As for the music which is employed as a background, it is difficult to speak, for a strange and unusual thing takes place when Geva is dancing. One does not hear the music any more than if it were not there. It undoubtedly is there, because it is listed on the program and memory recalls some activity in the orchestra. But when the dancer assumes her position of dominance on the stage she restores the dance to mastery over the music—a thing which happens so rarely as to demand special mention.

Of Mlle. Geva's background we have heard nothing heretofore. She dropped among us a few weeks ago as simply a bright star of the Balieff troupe. However, her career has not been without distinction in Europe. Educated in the ballet school of the Marinsky Theatre in Petrograd, she later danced leading parts there and also with Diagileff's ballet.

Her technical proficiency, acquired by the long and careful training for which the Russian ballet schools are famous, and

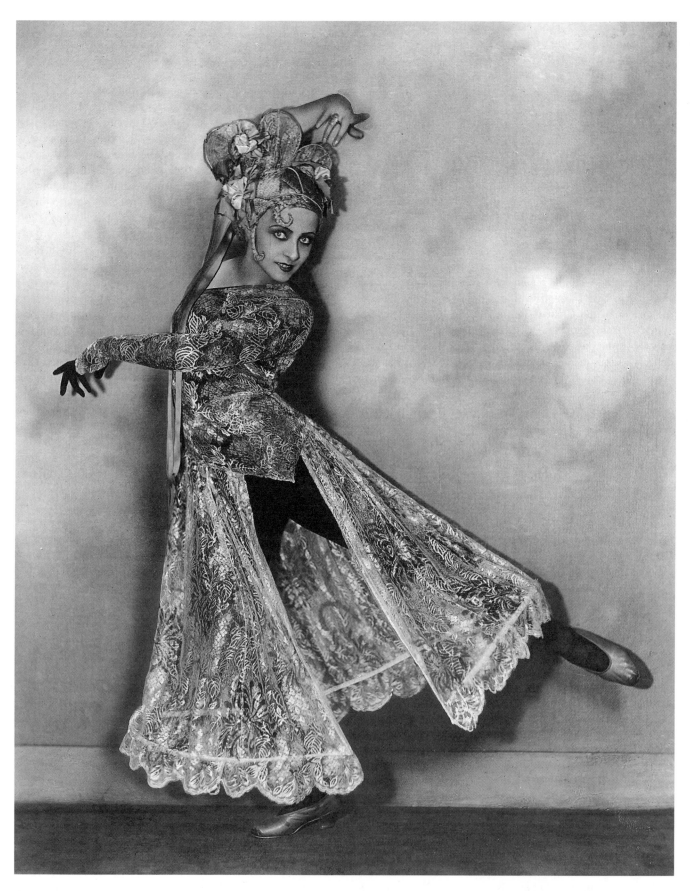

Tamara Geva, the enigmatic dancer of the Chauve Souris.

her wide experience make it evident, even if the eye of the beholder is not especially keen to see such things, that her present departure from tradition is built upon a thorough mastery of that tradition and not upon an ignorance of it. It is a matter of no doubt whatever that she would be a delight to watch in "Les Sylphides" or the "Lac de Cygnes." That she has gone ahead and done something different means simply that she has increased her range and not that she has made the best of a bad bargain.

It would be a matter of deep interest to see Mlle. Geva in a program of her own in freer surroundings than those of the necessarily frivolous Chauve-Souris. Delightful as Balieff's entertainment is, it is not the ideal environment for a dancer of her extraordinary ability.

J. M.

* * *

TWO DANCE RECITALS

One by Mme. Robenne; Other by Mr. Cartier and Agnes De Mille

Two dance recitals were given last night—one at the Forty-eighth Street Theatre, by Mme. Anna Robenne, and the other at the Republic Theatre, by Jacques Cartier and Agnes DeMille. As both programs began after 9 o'clock and were heavy with incidental piano numbers, almost the only thing that a reviewer for a morning paper can review is the audience and the intermissions. One hesitates to say after seeing Mme. Robenne in two numbers that she is certainly not in the first rank of dancers, yet that is the impression carried away after watching a number consisting of bar exercises not well executed and of a dance depicting a wilting rose to the tune of Liszt's "Liebestraum." Of Anatole Viltzak it is impossible to speak with any authority at all until he has made a second appearance.

It is a very much pleasanter task to pass snap judgment favorably, as in the case of Agnes George DeMille, who made her professional début on this occasion. If all her work is up to the standard of her "Degas Study No. 2," she is an artist of unusual qualities. She showed in ebullient humor that intensified the underlying tragedy of the ballet dancer's technical slavery, an exquisite appreciation of Degas's angle on the subject, and the ability to make the number a technical tour de force in itself in the midst of a long program. This program will be repeated on Sunday afternoon, Feb. 5, and thus an occasion will be offered to really observe Miss DeMille's work. Cartier's dancing is more or less familiar hereabouts, and last night's program revealed the same dramatic intensity, sometimes to the detriment of his rhythm, and the same fine masculinity that characterizes his work generally.

* * *

TAMIRIS, DANCER, SCORES

Shows a Breadth of Technique in Second Recital Here

Tamiris, in her second recital at the Little Theatre last night, established herself unmistakably in the forefront of the younger generation of dancers. She has obviously not yet reached the peak of her potentialities, but she has everything with which to build a strong and responsive body, an evenly flowing movement that is as rare as it is delightful to watch, and a breadth of technique which reveals years of hard work in various branches of her art. She chooses to paint with broad sweeps rather than delicate lines, but she sacrifices nothing of nuance in so doing.

In the composition of her dances lies her greatest weakness, particularly in the athletic numbers, the "Bull Ring," the "Circus Sketches," the "Harmony in Athletics" and the "Prize Fight Studies." Here her analysis of movement is clever and even beautiful, but it is without sufficient thematic continuity to make for artistic form.

Quite in contrast to this, however, are the numbers in which the dancer departs from realism, such as the "Portrait of a Lady" and "Hypocrisy." The "Perpetual Movement" and the two negro spirituals are also arresting and well executed plastic concepts. Extremely modern and under the German influence, she yet retains a warmth of style.

Louis Horst played first-rate accompaniments, and among his solo numbers brought to light the old "Maple Leaf Rag," which still retains much of its original vitality.

* * *

THE DANCE: TAMIRIS' ART

Dancer's Movements Have an Efficient Beauty and She Is Skilled in Interpretation

Tamaris has swept across the dancing horizon twice in this her first season as a recitalist, and has left such a widely divided opinion in her wake that it is not without interest to re-examine the evidence and ascertain if possible why the caterwauling on the left and the hallelujahs on the right are so loudly sounded. With a personality as dynamic and positive as hers there is no middle ground, and this is a state of affairs altogether to her advantage in its effect not only upon the box office but also upon her creative faculties. It gives her something to push against, so to speak.

The man who "knows what he likes" will not like Tamiris. That much seems certain. She is individual and cannot be fitted into any preconceived formulae. But whether you like her or not depends upon what you like, and whether she is a good dancer or not depends upon what she does. With likes and dis-

likes put out of the way, the loudest of the cat-callers will have to admit her many and unusual virtues, just as the most ardent of the hallelujah chorus will be faced with certain vices that cannot be cheered out of existence. That the virtues outweigh the vices ten to one would seem to indicate that the paean singers have the best of the argument by a wide margin.

For one thing, Tamaris does her audiences the honor of coming before them prepared. She is a débutante only in the sense that the concert field is new to her. She is no dabbler, no glib exhibitionist. Behind this season of début lie years of work not only in the studio but before audiences. Those who remember such things will recall her presence in the Music Box Revue of some seasons back and in other theatrical productions; and she is reported to be an adept in the Russian technique. Even without these sketchy evidences of a concrete past, however, her poise, her muscular strength, her balance and control bear undeniable witness to a magnificently trained body. One objectionable fault nevertheless stands out conspicuously in a badly "broken" back which results in the habitual turning of the lower vertebrae out instead of under.

Her movement in itself is a delight to behold. It is definite, flowing and simple, with a quality of richness about it that in a musician would be called beautiful tone. It has no prettiness, no flourishes, no "gracefulness," but rather the efficient beauty of a well-designed machine in which every movement is made because it is essential to the functioning of the whole. It is this quality in Tamaris that makes enemies for her—and friends, as well. She uses straight lines and angularity perhaps more frequently than not, but by a warmth of style escapes the pitfalls of hardness and stridency. Only in the repeated use of the hands as unarticulated members is there a hint of monotony.

Strangely enough it is monotony that is most frequently urged against her, whereas as a matter of fact there are not half a dozen dancers in recent memory who approach the scope of what might be called her vocabulary of movement. The criticism probably arises from the same source that causes an unfamiliar spoken language to sound all of a sameness. It was a standard plea against modern music back in the days when Debussy was a radical; Matisse and Picasso and the rest endured it when it was hurled at modern painting; this very season Geva dropped her "Sarcasm" dance from the Chauve-Souris because its vocabulary was unintelligible.

In transmuting her thought—or "mood," as she chooses to call it—into movement Tamiris is notably successful. Her inner conviction is strong enough to project a clean-cut emotional concept without any resort to overemphasis. Undoubtedly her entire approach to dancing aids her in this, for there is no effort to extract from the music some meaning which may or may not have been put there by the composer. Her meaning is her own and the music is rightly enough a secondary consideration.

The composition of many of the dances is faulty. In the athletic numbers in which actual athletic movements are analyzed there is not the cohesion of an artist's finished canvas but rather the scrappiness of his sketches. We go too defi-

nitely from football into swimming, from bareback riding into tight-rope walking; and the result is the overspecificness of a certain type of program music in which we are asked to listen to the twittering of the birds and the babbling of the brook. Those same beautifully visioned movements welded together into a closer unity might make little masterpieces instead of merely clever fragments.

But of all the mistakes which Tamiris has made or is likely to make in future the printed manifesto she has issued stands out most strikingly. It would not require an expert marksman to shoot cannon balls through the holes in its logic, and its dogmatism is calculated to prejudice even the most open-minded. Whatever opinions Tamiris may hold on the arts or other topics she is capable of expressing with power and conviction through her dancing. As a dancer she will undoubtedly one day mingle with the company of the chosen few, but as a doctrinaire, no.

* * *

February 13, 1928

GRAHAM DANCE RECITAL

Artist More Eloquent When She Is Lyrical Than When Dramatic

Martha Graham last night made her first appearance of the season, and incidentally gave the first dance recital in Eva Le Gallienne's newly instituted series of Sunday evening concerts at the Civic Repertory Theatre in West Fourteenth Street. The program, said to be in the nature of a farewell to Miss Graham's familiar style of dancing before she goes over whole-heartedly to the new German technique, was, generally speaking, a résumé of her work for the last several seasons. It ranged from the earlier numbers, which show a strong influence of the Denishawn tradition, such as the Tanagra, the Chinese and the East Indian dances, to the modernistic "Revolt," seen for the first time in her last program.

Miss Graham's flair for line and visual composition is extraordinarily marked, and her aptitude for handling draperies beautifully is uncanny. She is far more eloquent, however, when she is lyrical than when she is dramatic, for her mask is less plastic than her body and is singularly limiting to her emotional expression. The numbers which are free from pantomimic implications are best suited to her talents.

Though her dramatic intention is clear and true, her means of projecting it are slight. The effect is a forcing, which in the Spanish number and the "Lucrezia" becomes neurotic, and in the "Revolt" muscularly strained. When her primary concern is decorative she achieves the happiest results. The musical settings covered a wide scope, from Handel to Honegger.

Miss Graham was accompanied by Louis Horst at the piano and also by George Possell, flutist, of the New York Symphony Orchestra, both of whom contributed solos as well.

* * *

April 16, 1928

DANCE NOVELTY GIVEN BY DORIS HUMPHREY

Artist, With Aid of Company, Reveals Ensemble Type That Has Swept Over Europe

Doris Humphrey, assisted by Charles Weidman and nineteen dancers of the Denishawn School, gave a dance program at the John Golden Theatre last night which to all intents and purposes opened a new chapter in American dancing, in that it revealed for the first time in this country the type of ensemble dance which has swept over Europe in the last few years—which is not to infer that Miss Humphrey has been directly influenced by the European methods, for there is ample evidence that she has not. But the general tendency toward mass movement has here found its expression at the hands of an authoritative and creatively minded artist. The evening took on, therefore, the qualities of a major event centring in the two ensembles, the one entitled "Color Harmony" and the other danced to the first movement of the Grieg piano concerto.

For the theme of "Color Harmony" Miss Humphrey has taken the Young-Helmholtz theory of light which divides color into three primaries, red, green and violet. To this she has attached a profound philosophical parallelism, and through the abstract movements of the seventeen dancers she has built a ballet rich in content, dramatic in effect, steeped in visual beauty, and as nearly perfectly performed as even she herself could desire. The movement once conceived, a musical setting to fit it was provided by Clifford Vaughn and was played under his baton last night.

Of the Grieg Concerto, there is much the same story to tell. Vivid and forceful and full of color, its only weakness lay in the fact that the music demanded more repeats than were necessary to satisfy the eye. A third number of scarcely less interest was the arrangement of the Bach "Air for the G String" for five dancers, which opened the program. In mass composition as well as in individual movement it was a beautiful and finished piece of work.

Naturally, in competition with these larger conceptions, with their sometimes almost breath-taking qualities, the solo offerings seemed somewhat pale. Miss Humphrey's "Pavane of the Sleeping Beauty" and "Papillon" were, however, distinctly successful. Mr. Weidman's comedy numbers, especially the "Minstrels," in which he made one of a trio, were admirably calculated to balance the program. The "Waltz" seemed a trifle pretty, and the "Fairy Garden" was costumed in a manner to pique the curiosity rather than to clarify its intention. It was unfortunately impossible to remain for the last few numbers of the program, which included "The Banshee," danced by Miss Humphrey to the music of Henry Cowell played by the composer.

At the Princess Theatre, Michio Ito presented his pupil, Ninta Sandré in a début recital. Miss Sandré is strongly marked with the Ito style, and offered a program which consisted largely of numbers which have been done before by Ito himself and others of his pupils. As assisting artists, Louis Bourlier Rigo sang several groups of songs and Leon Barzin Jr., played three groups of violin solos.

* * *

April 23, 1928

FINAL GRAHAM RECITAL

Dancer's Program Last Night Proves Most Interesting of All

In her final program of the season at the Little Theatre last night, Martha Graham proved once again that she is a dancer extraordinary. The program, the most interesting she has given, revealed a new vigor and animation with a correspondingly increased effectiveness in the projection of the inner mood. In place of the introspective quality that has in times past approached moroseness, there was visible last night a full-bodied and almost maliciously gay vitality.

Miss Graham is one of the few dancers who can achieve an exquisite lyricism without danger of mere prettiness. On the other hand, in her newer dances she has deliberately sought out ugliness and clothed it with deep and satisfying beauty. Under the surface of all her work lies a glint of biting humor. Of the ten dances presented last night, six were new, and a new spirit seemed to animate the more familiar four, especially the "Deux Valses Sentimentale." "Complaint," to music by Koechlin, revealed an especially beautiful concept of archaic movement. The "Immigrant" group was more successful in its first movement, entitled "Steerage," than in its second, called "Strike," which seemed self-conscious in its revolt against orthodox form and consequently did not quite come off.

The Ornstein group, "Poems of 1917," are likely to provide much subject for discussion. Highly provocative in conception, they produce a striking dramatic effect, whether they are to be classified as dancing or not. In feeling they suggest modern reproductions of ancient wood sculptures, and are deeply moving by their very sparseness.

The "Tragedy" and "Comedy" group is extraordinarily well built and requires a virtuosity of execution which Miss Graham met with ease. "Resonances" was the least successful of the new numbers, being somewhat obvious in its first movement and none too well designed in its second. The costumes were more than adequate, especially that worn in "Steerage."

Louis Horst at the piano and Quinto Maganini with a flute made excellent musical contributions to a program which was of unusual quality.

* * *

April 28, 1928

STRAVINSKY BALLET IN WORLD PREMIERE

"Apollo Musagetes" Opens the Elizabeth Sprague Coolidge Festival in Washington

SCENARIO IS BY COMPOSER

Birth of Apollo Celebrated in Work—Music Is Simple, but Is Expertly Written

By OLIN DOWNES
Special to The New York Times

WASHINGTON, April 27—The annual festival of chamber music which is now given in the Music Room of the Library of Congress under the auspices of the Elizabeth Sprague Coolidge Foundation opened this evening with an event which had been the subject of unusual anticipation—the world première of Igor Stravinsky's ballet, "Apollo Musagetes." The production of this ballet in a concert room suddenly turned theatre marked an entirely new departure in the policies of a festival which has hitherto devoted itself exclusively to chamber music.

Such a departure, however, is in line with many recent modern developments which have given us in Germany, for example, the chamber opera, as well as the miniature ballet. Apparently, such a departure was foreseen when Mrs. E. S. Coolidge, with extraordinary diplomacy and persuasiveness, obtained for the festivals made possible by her generosity the concert hall that is situated in the very midst of the Library of Congress.

This is not only a concert hall of simplicity, comfort and acoustical condition not rivaled by any other in this country, but it becomes, when desired, a theatre with perfect lines of light, a small stage and a sunken orchestra, after the fundamental constructive principles of the Festspielhaus in Baireuth. Therefore, the conditions necessary for the artistic production of a small ballet were complete.

Score Finished Jan. 20

The composer of the first ballet to be given in the Music Room of the Library of Congress especially commissioned for the purpose by Mrs. Coolidge was Igor Stravinsky. He completed his score on the 20th of last January. Thus, "Apollo Musagetes" is the last work to have the light since "Oedipus Rex."

The composer is author of the scenario as well as the music of a classic ballet, which, as presented tonight, employs four characters, Apollo and the three Muses, Calliope, Polymnia and Terpsichore; an orchestra of twenty-five strings and a stage set devised by Nicolas Remisoff. The event celebrated is the birth of Apollo. Originally Leto, mother of Apollo and a necessary agent, even in classic myth, for this ceremony, was to be seen on the stage. Tonight this episode was replaced by an opening ceremony which emphasized the classic and decorative aspects of Stravinsky's latest creation.

The ballet begins when a thurifer appears and places a tripod in the centre of the stage before the curtain. The sacred flames ascend. Three Muses appear. When the curtain parts Apollo is discovered on an elevation before fantastic, Greco-Roman designs of Nicolas Remisoff.

The god, whose musical motive has already been heard, is accompanied on his appearance by a florid cadenza for the solo violin. He now confers upon each one of the nymphs an instrument appropriate to her offices—to Polymnia a harp, to Terpsichore a veil, to Calliope tablets for the inditing of poetry. The three Muses—the six others are ignored by Stravinsky—acknowledge with gestures of the conventional ballet, their presents, and make pantomimic employment of them.

Then they dance with Apollo. Finally, to a musical apotheosis of his theme, Apollo ascends, presumably in the direction of Olympus.

Music Simple, but Expert

The ballet and the score concur with Stravinsky's many recent experiments in the domain of the "Neoclassic." The music, simple but very expertly written, is in the set forms which the ballet of the later eighteenth and early nineteenth century required. The movements have the captions of the traditional ballet—"Apollon"—Apollon et les Muses"—"Variation d'Apollon" (the rising curtain and violin cadenza), "Pas d'Action" for the ensemble of Apollo and the Muses; then further "Variations," of the dance, not of music, Calliope, Polymnia, Terpsichore, in turn; a "Pas de deux" for Apollo and Terpischore; a coda for Apollo and the muses and an "apotheose."

The character of the music calls to mind old composers, from Handel to Bellini, but the horns and hoofs of Igor, the devil in the shape of gratuitous dissonance and a style which is sometimes farcial, protrude in otherwise simple measures.

The harking back to old forms, the merging of old styles, has become itself an old, conventional and rather tiresome procedure of Stravinsky and certain of his contemporaries. There are moments in this score, such as the final apotheosis, when the composer expresses himself with true and classic nobility. There are others when he appears intentionally to caricature his theme. As a consummate achievement in economy of material, in remarkable technical expertness and intuition for effects gained by the simplest means, the piece is worth the hearing. As music that is either sincere or inspired it is of very questionable quality—this in spite of writing which is often lyrical and of an appropriately light touch.

It does not stir or excite. It is not supposed to do so. We are assisting as the French say, at a modern variation of an old form not designed to express feeling, but to amuse and entertain in an artistic manner. And needless to say, Stravinsky knows his business. He indulges in burlesque when he makes a pompous and ridiculous bass of a lyrical theme which one can accept as a take-off of Bellini. His radical point of departure from the old ballet is his employment of irregular rhythms and meters. These offered the dancers problems which were solved

in remarkable style by Adolph Bolm and his associates, who created the choreography.

Amusing Touch Injected

Measures of two and three and nine and seven beats often follow each other, yet there is preserved a longer rhythmic line which includes all these irregularities in its arch, and combines and logically synthesizes them. And that was a task for the dancers. A sly and amusing touch comes with the composing of the "Variation de Calliope"—the muse of poetry. She composes, apparently, in Alexandrines and Stravinsky, quoting in his score a line from Boileau, carefully observes the caesura which broke the phrases of the Alexandrine verse.

We can enjoy this score for its technical mastery and its style—a style too eclectic and too anacronistic in various places to give the listener any confidence in the composer or the authenticity of his inspiration; but nevertheless a style of a sort which is arresting, and which was admirably matched tonight by the dancers and by Remisoff's stage. Those who collaborated with Mr. Bolm were Ruth Page, as Terpsichore; Berenice Holmes, Polymnia, and Elise Reinman, Calliope.

The reception of the ballet, which was well danced, was cool. Much greater enthusiasm was shown later in the evening.

By so much it added to the distinctions of the evening. The works that followed, all in the form of ballets, offered very charming spectacles and much delightful music. There were the choreography of Mr. Bolm and Miss Page for Maurice Ravel's "Pavane Pour un Enfant Défunte"; the "Arlecchinsts," devised for music taken from De Mondonville's "Carnaval du Parnasse," by Mr. Bolm, Mark Turbyfill and Berenice Holmes; and the spectacle, "Alt-Wien," accompanied by Beethoven's "Eli Wiener Tanze" performed by the dancers just mentioned, with the addition of Paul Tchernikoff.

Beethoven composed his dances for a band of musicians who played at the local gasthaus in Modling in 1819. These dances were published by Reimann in 1907. For years their authorship was unknown. But the letters "D" and "B" on a first violin part are ascertained to refer to Beethoven, who threw off, no doubt in considerable haste, a set of small pieces, during the very troubled period of his life when he was completing the "Credo" of the "Missa Solemnis." The dances are insignificant, though they have a certain freshness. What is more remarkable is the audible influence not only of Mozart but Rossini. Vienna at the time was Rossini-mad. Beethoven consciously or unconsciously acknowledged him in the set of short pieces that he wrote, probably, at the importunity of a band of village players.

But the music of Mondonville is of the most delightful taste, sentiment and texture. He was a great man in his day, a protegé of Mme. de Pompadour, to whom he dedicated his "Carnaval de Parnasse," produced in 1749. Later, in the War of the Bouffons, he was to represent French musicians and French dramatic taste as set against the "opera buffo" of the Italians. His opera, "Titon et l'Aurore" was a reply to the sensational success of Pergolesi's "Serva Padrona." The score of

the "Carnaval de Parnasse" lies in the Music Division of the Library of Congress. It is covered with a gallant dedication in the flowery French of the period to the Pompadour.

The work thus dedicated was an opera ballet in three acts. Extracts from it played by members of the Philadelphia orchestra, conducted, as were all of the performances of the evening, by Hans Kindler, made one of the most admirable features of the evening.

Performance of Ravel Liked

Musically speaking, this is the summing up of an evening which was devoted not only to music but to the choreographic interpretation of it. The excellence of Mr. Bolm's representation of the Stravinsky ballet has been described. It has been carefully prepared in collaboration with the composer. The interpretations of other music might be seriously questioned. The audience was evidently delighted with the performance of Ravel's "Pavane," but it is a question whether this music with Ravel's own exquisite instrumentation would not have said as much, or even more, by itself without Mr. Bolm's interesting but somewhat gratuituous stage interpretation.

Was the Harlequinade that accompanied the charming music of Mondonville the truly characteristic presentation of its spirit? The dance was amusing enough, but for us the music of the old ballet has a finer quality and a more Gallic essence. The choreographic illustration of the simple dances of Beethoven was better calculated in its subject matter to parallel the music.

If a moral can be drawn from all this it is that the modern ballet in the form perfected by Stravinsky and his collaborators is an art form of rich and exceptional possibilities, while it is a risky procedure to impose choreographic interpretation upon well-known musical compositions, especially as each listener is likely to have his own conception of a familiar composition which may easily be deranged or disturbed.

The future concerts of this festival, following the interesting experiments that have been conducted this evening, will be devoted as heretofore to chamber music.

* * *

April 30, 1928

STRAUSS DANCERS GIVE NON-MUSICAL PROGRAM

Recital, First of Its Kind in America, Deals With Story of Creation

Sara Mildred Strauss and the Strauss Dancers introduced for the first time in America last night, in their recital at the Guild Theatre, the novel and experimental theory of dancing an entire program without music. Miss Strauss is to be commended for her courage, for she has opened up a field which undoubtedly is capable of interesting and important developments in modern dancing. The success of last night's program, judged solely on its own merits, is, however, open to question.

Music has not been eschewed as completely as might seem to be the case. There was no audible accompaniment to any of the dancing, except in one number, where a syncopated drumming with the feet marked the rhythm; nevertheless, all of the second half of the program and many parts of the first half were built on musical rhythms of varying regularity. At other times a pantomimic basis of action transformed the performance into muted drama rather than dancing.

Purely creative dancing, conceived as such and expressed in its own form, found no place whatsoever in Miss Strauss's scheme of things, and herein lay her greatest weakness. The dancers were sadly deficient in beauty of bodily movement, and an awkward costume did them no service in this direction. As a group, however, they worked well together, sensing nicely each other's presence and moving into a number of decorative patterns and pictorially effective masses.

The program, which built on one theme throughout its length, dealt with the story of creation from a theoretical state of formlessness to an imagined future. A theme of such heroic proportions approaches near enough to complete abstraction to make it suitable for her purposes, but Miss Strauss has erred in the direction of a too great literalness. The result was a certain inadequacy which can only be corrected through much more experimental work before audiences as sympathetic as the one which applauded the performance last night.

* * *

May 6, 1928

THE DANCE: FOUR BALLETS—MUSIC AFIELD IN A SEASON

Stravinsky's Novel "Apollo Musagetes" Created by Adolph Bolm

For the first time in history a major ballet work had its world première in America when Stravinsky's "Apollo Musagetes" was produced on April 7 at the Elizabeth Sprague Coolidge festival of Chamber Music held in the Library of Congress in Washington. Mrs. Coolidge, significantly enough, devoted the first evening of her annual festival entirely to the dance; and of the program of four small ballets created and directed by Adolph Bolm the Stravinsky work was naturally the centre of interest.

Not by any means an epic achievement in the light of what has been done in times past in the field of the ballet, the occasion was sufficiently vital to inspire Mr. Bolm to some clever and delightful choreography. For those who went with the expectation of being carried away by the splendors of another "Oiseau de Feu" or "Sacre du Printemps" or a "Petrouchka," the result must inevitably have been disappointing. Such an expectation, however, would seem to have had scant justification, for the "Apollo Musagetes" was commissioned by the Library of Congress for presentation on the tiny stage of the chamber music auditorium, which is in no wise equipped for theatrical production and where only four or five dancers at

the most can move simultaneously, and even then with no room to spare. It was the problem of the composer, therefore, to devise a work of smallest dimensions, a sort of "chamber ballet," much more nearly akin in proportions to the "Histoire du Soldat" than to his more pretentious work.

The "Apollo Musagetes" directs itself to the intellect. It is dry and unemotional in quality, but—at least in the hands of Mr. Bolm—it is far from dull. Those who claim to understand Stravinsky aver that it is music conceived in all soberness, but Mr. Bohm has treated it with no solemnity. Under his direction it comes forth as a gentle and subtle burlesque, witty and sparkling to the observing eye. It is doubtful if he or any other choreographer has ever been faced with a ballet score of equal length and offering any more difficulties.

As has been frequently stated, the composer in the present work turned to the melodious Bellini as his model, even renouncing his former aversion to strings and employing them exclusively because of their greater sweetness. Superficially, here was ballet music of the most conventional sort; but to the ear of the choreographer this pseudo-lyricism proved to be little more than a candy coating for the most vicious contrary rhythms and the most persistent irregularities of time, which bore no more relation to the conventional ballet than to Bellini, under whose style they were so neatly tucked away. Yet the spirit of the music was undoubtedly of the early nineteenth century, and just as certainly the ballet of the early nineteenth century was strictly conventional.

The ingenious fashion in which Mr. Bolm reconciled these two seemingly irreconcilable conditions furnished the chief delight of the performance. The obsolete elegances of the ballet of Taglioni's day struggling against the underlying obstinacies of modernistic rhythms, mirrored the quality of the music exactly—this music which actually is claimed to be serious in intent!

Mr. Bolm's sense of style, however, made stern demands on his dancers, though they met them more than creditably. With their faces wreathed in properly lyric smiles, they could be seen counting diligently as they executed enchainments originally devised for eight-bar phrases in two-four time, to measures that varied from three to nine beats and phrases that ended whenever the composer chose. Almost equal demands were made on the audience, for without at least a smattering of feeling for the style of the period the performance would have lost all point. It is doubtful, therefore, if any very great popular success could be hoped for the work.

The setting and costumes by Nicolas Remisoff were conceived in exactly the same spirit as the choreography, and were of genuine service in fixing the mood of the production. The scene of the action is not specified on the program, but the first glimpse of the setting makes it evident that it never took place anywhere but in the mind of the early nineteenth century as it looked out upon classical culture.

Before the curtains a priest bears a huge glowing urn to the front of the platform. Three maidens in ballet skirts perform a brief symbolic worship before it and withdraw. Thus is Apollo born, in a manner somewhat less literal than the original sce-

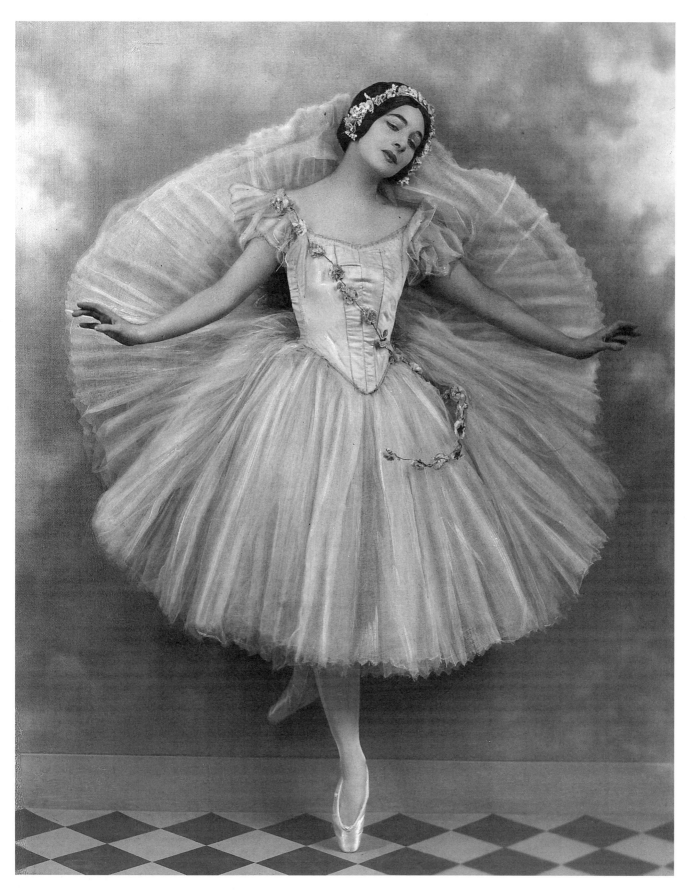

Ruth Page, who appeared at Washington's world premiere.

nario demanded. The curtains then open, and before us is a scene which suggests nothing so much as an "elegant engraving" after Veronese. On our left is a huge pile of rocks and on our right a group of Corinthian columns in ruins. Between the two stands Apollo, clad in gold sandals, pink tights and a gold tunic decorated with red festoons. Upon his long golden curls he wears a helmet from whose crest burst many fulsome plumes. In his hand is his lyre. It is in his character of Musagetes, or leader of the muses, that we see him.

To Apollo come Calliope, Polymnia and Terpsichore, wearing the ballet costume of Taglioni, with a border of gold about their skirts, and fillets in their hair to show that they are Greek. To each of them he gives a particular mission. Calliope is presented with a tablet and pencil and is made the patroness of epic poetry; Polymnia receives the mystic veil and is charged with the care of sacred hymns: Terpsichore is given the Apollonian lyre itself and is made priestess of choral song and dance. This great business performed, the Leader of the Muses climbs up the slope of the rocks and is transfigured by a strong light. His three followers do obeisance to him and the curtains close.

There is scant substance here from which to evolve a second "Oiseau de Feu" or "Petrouchka"; nevertheless, within its own limitations and as realized by Mr. Bolm and his associates, it is a pungent morsel.

Three other ballets filled out the evening's program. The second, which came as a much-needed contrast to the emotional aridness of Stravinsky, was a rather sentimental visualization of Ravel's "Pavane pour une Infante Defunte." Set and costumed in Velasquez style, it created an authentic mood, though it was scarcely equal to the rich loveliness of the music. Mr. Remisoff's setting produced an almost incredible illusion of spaciousness on the diminutive stage.

The third number, called "Arlecchinata," and set to the music of an eighteenth century ballet by Jean Joseph Cassanea de Mondonville, proved to be sprightly and thoroughly ingratiating. It was actually but a trifle, the style of its performance and the excellently grotesque masks, however, making it a little gem of its kind.

The final number bore the title of "Alt-Wien," and was set to "Elf Wiener Tänze," by Beethoven. There seemed no particular reason for tying these little dances together by a story, as Mr. Bolm elected to do, but, granting him this right, the "Fasching Episode," as it was subtitled, was not disagreeable entertainment. In that it provided Mr. Bolm with an opportunity for some excellent miming, it was welcome.

Ruth Page, Berenice Holmes, Elise Reiman, Mark Turbyfill and Paul Tchernikoff were the other dancers participating.

It is a matter of rejoicing that thanks to the generosity of Mrs. Coolidge, it has been proved possible to produce intelligent, adult ballet performances in America.

J. M.

* * *

August 26, 1928

THE DANCE: FINE PROGRAMS AT THE STADIUM

The Esthetic Principles of Two Great Revolutionists in Art Are Revealed

The five programs of dancing which have formed so admirable a feature of the closing weeks of the Stadium concerts have been the source of more than one revelation. As an index to the "dance-mindedness" of the public they are of course invaluable. Upward of 50,000 people signified through them their desire to "assist" at dance performances, signified it, indeed, by arriving as much as an hour and a half and two hours ahead of time in order to obtain suitable points of vantage.

But entirely apart from the consideration of popular interest, these performances must have revealed certain other less superficially discernible facts; for here, as under no other conditions of which one can conceive at the moment, has it been possible to see dancing in the large. The wide area of the Stadium, the distance between the stage and the vast majority of the audience, the rather impromptu lighting facilities, the very largeness of the out-of-doors at night, unite to render ineffectual all subtlety, all niceties of technique, all intimacy of personal contact.

Even so glamorous a personality as that of Anna Duncan is dimmed almost to the vanishing point. All that remains is the dance itself in its broad outline; and in this bald view of the subject there is an unimaginable laying bare of actualities.

In these performances, by Anna Duncan and her associates on the one hand and by Ruth St. Denis and hers on the other, we have seen the esthetic principles of our two great dance revolutionists—the one by proxy, it is true, but the other in the flesh-stripped of detail and standing out for what they are in essence. In this glimpse there must have come, to some at least, the conviction for the first time as a personal discovery that it is beauty alone which goes on forever; its manner of expression is in a constant state of flux. The esthetic standard of one age differs radically from that of another, and the effort to perpetuate a method beyond its period is futile.

A New Style of Dancing

In the "romantic revolution," of which Isadora Duncan and Ruth St. Denis were the leaders, a style of dancing was born which has come to be known as "esthetic," and accurately so. The style of dancing against which it was a protest was undoubtedly soulless and dead; under the leadership of its two prophets it was given a quality of "feeling" where before had been nothing but skill. The esthetic dance was indisputably a contribution not only to the dance but also to life itself.

But the principle that underlies it belongs to a period that no longer exists; it has become weak and artificial in contrast

to what has grown up in our hearts and minds since the war stirred us out of our complacency. We have developed a deeper concept of art; we have begun to see the difference, in fact, between art and estheticism. The esthete demands the constant sensation of pleasure from contact with beauty; ugliness is negation to him and he avoids it. The artist, on the other hand, is not concerned with sensations of pleasure; he is rather seeking truth. When ugliness presents itself, it is his will to stare it out of countenance, to see through and beyond it into the ultimate truth which it hides. He is not willing to add to the deception by further hiding ugliness behind a manufactured prettiness.

And so the method which so magnificently served its purpose twenty years ago has begun to stale. Progress demands that it be superceded by something with greater force and fresher vitality. To cling to it is as idle as clinging to an outmoded style of dress. It will decline in spite of you. If it has had any merit in the first place, it will not die; but after that stage in which it is merely ludicrous and out of date, it will begin to assume the mellowness of "period" and eventually take its place in the field of "classical" tradition. The stultifying viewpoint is in maintenance of any method or theory as the ultimate. There can never be an ultimate.

Of the Duncan tradition there is little one can hope to say. That flame of genius, its creator, is no more, and no prophet has arisen in her train to carry on for her. Her most gifted students must create for themselves in their own world if they are to exist as artists.

Miss St. Denis's Achievement

Of Miss St. Denis, however, there is much to be said. She has had the rare experience of seeing herself become a classic, and she is only now at the height of her powers. The radical method of her youth fits her now like a garment, too small for her; she bursts through it at every seam. Her strength, her vision, her depth of understanding—the abundance of her art seems to be spilling over the edges of a vessel too shallow to contain it. How one would rejoice to see her bid a happy adieu to the old estheticism; to watch her lay away in camphor balls all the veils and scarfs and garlands, and pack in chests the lyres and spears and torches along with the pleasant tunes of Liszt and Chopin and Moskowski, which has for so long been the trimmings of Denishawn dancing.

In their admirable open-mindedness to what is new and progressive, she and Mr. Shawn have reconciled elements in the dance which have been frequently deemed irreconcilable. But perhaps one of the demands of progress which a friendly public has made them overlook is the willingness to drop out the elements that are no longer vital and alive.

It would be a contribution of inestimable value to the dance if Miss St. Denis would create and perform something ugly—searingly, searching ugly. There is so much in contemporary life that begs for the hand of an artist to mold it into form whereby it can be made visible for what it is. If by her very presence she can make so insignificant a thing as

the "Josephine and Hippolyte" take on conviction and actuality, what could she not do with a subject worthy of her mettle? Her beauty of line, her instinctive sense of style, her incomparable hands which seem like thinking organisms in themselves, are only externals to the glowing idealism and the inner spirit which mark her as the outstanding figure of her art today. Yet in much of her work, the very medium by which she has attained to her heights now cramps and confines her.

An exception must of course be made for her Oriental dances. The "White Jade" and "Kuan Yin," for example, are exquisite beyond description. Perhaps the repression of the style itself reveals her artistic vision in greater depth. One need only compare her "Japanese Flower Arrangement" on the recent Stadium program with the coy and meaningless "Liebeswalzer" performed by one of the Denishawn dancers to marvel that the two types of dancing could emanate from the same organization. As a matter of fact, they do not, for Miss St. Denis is not a product of any organization; she is the solitary expression of a personal vision, as all the authentic artists of the world have ever been and must ever continue to be.

Perhaps for the production of such a subtle creation as "The Lamp," the Stadium is not an ideal place, but for the revelation of fundamentals, it has innumerable advantages over the concert hall. Here, at least, there can be no complaint of not being "able to see the forest, for the trees"; here it is all forest and no trees!

J. M.

* * *

September 9, 1928

THE DANCE:
A BREAK FROM MUSICAL RHYTHM

Miss Humphrey's "Water Study" Presents a Variation From Traditional Patterns

The subject of dancing without music is once again brought into the limelight by the excellent program presented by Doris Humphrey and Charles Weidman and their company of dancers and Hans Wiener before the American Society of Teachers of Dancers during their convention at the Waldorf-Astoria a week ago. In arranging such an evening as this the program Chairman, Rosetta O'Neill, showed clearly the high ideals that she and the progressive element among her colleagues hold of the proper scope and function of a convention of dancing teachers.

Assuming an interest among them beyond that of the general public in matters pertaining to their own art, she arranged for them to see a program which was calculated both to provide the thoughtful and advanced with something to ponder over and to upset the complacency of those less given to thinking. That both ends were accomplished was evidenced

by the fact that while most of the company sat in rapt attention others were moved to stuff their handkerchiefs into their mouths to suppress their mirth. It is the normal and healthy manner in which modernism seems to be greeted in any art.

Certainly it would be difficult to conceive of two more antithetical approaches to the unaccompanied dance than those of Miss Humphrey and Mr. Wiener on this occasion. Mr. Wiener's, though more modernistic, was, paradoxically enough, less radical a departure than Miss Humphrey's. As for movement as such, the reverse is the case, for where Miss Humphrey is still working away from old standards Mr. Wiener has completely taken on new ones. The conventional line and attitude are as rare in his compositions as are the conventional melodic line and harmonic structure in modern music. He works in angles and grotesque designs to a great extent. Miss Humphrey and her dancers still move in the more accepted modes of free plastique, in no sense cramped or confined by their orthodoxy, but none the less orthodox.

A Progressive Effort

In the matter of composition, however, Miss Humphrey has put her foot on an untrodden path. Perhaps there is copious testimony somewhere that such things have been done before; there generally is when an innovator appears in the field. In all probability the ubiquitous Greeks can be brought forth as evidence that Miss Humphrey is only a copyist. But until such data are actually presented it seems quite reasonable to believe that her "Water Study" is as fine a piece of progressivism as the dance has seen in many a long season.

Mr. Wiener presented two numbers unaccompanied, the first a "Dance of Evil" and the second a jester's dance. In both cases one could scarcely refrain from composing his own musical setting as the dancer moved. Musical rhythm and musical phrasing were clearly in evidence, and the projection of the ideas in the dancer's mind suggested the mood and character of the unheard melody, as well as of its macabre harmonic background.

In the case of the jester any journeyman musician could have turned out an accompaniment while you waited. To perform the same service for the "Dance of Evil" would have been less simple, for its phrasing was irregular and its mental character less lyrical. Both were impeccably performed and will unquestionably grow in interest upon second seeing. But as for any radicalism in their lack of accompaniment there is little to be said.

Music and the Dance

The common tendency of the new German school to substitute the rhythmic beating of the tom-tom or cymbals for the fuller musical background is begging the question. The dance that adapts itself to an aural pattern, whatever instruments may create such a pattern, is not the purely visual art that the dance is capable of becoming.

A favorite device of the clever tap dancer is to stop the orchestra while he performs his most intricate rhythms, making his own accompaniment by the sound of his feet. Yet

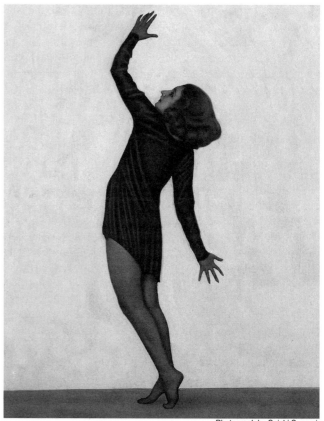

Photograph by Soichi Sunami.

Doris Humphrey in Grieg's Concerto in A Minor.

there is surely no suggestion here of dancing without music; the visual element is no more prominent and no more significant than it was with the orchestra in full blast, nor the aural element more subdued except in volume. The dance is conceived along exactly the same lines in both cases.

So with the artistic dancer, the accompaniment of percussion instruments alone may serve to concentrate the attention more fully on the movement or it may eliminate some extraneous emotional qualities, but it does not alter the pattern of the dance or its general type. Even omitting the percussion accompaniment gains nothing if the blood pulse or the breathing forms the rhythmic measure.

Miss Humphrey in her "Water Study" has completely eschewed musical patterns. Except for a persistent backward and forward movement as of waves, there is nothing at all resembling periodic accent, and this is too slow in tempo to create a feeling of beat. Performed by an ensemble, it is descriptive of the movement of water—not a strikingly original conception, as Miss Humphrey would probably be the first to admit. It starts from a position of complete rest, proceeds through various patterns to a beautiful climax of waves breaking high in air and receding, and ends again in a position of rest.

It must be granted at once that the imitation of nature rhythms is not by any means the ultimate of freedom for the dance as an independent art. We have long since wearied of "descriptive" pieces, of music that recreates the tinkling brook

and the chortling bird, of poetry that relies on onomatopoeia and alliteration. But the "Water Study" gives us no rippling arms or twinkling toes; it pictures no sunbeams or twilight or storm winds. It gives us water subjectively, so to speak, in what Miss Humphrey aptly terms its "structural movement."

Of this composition she has said: "I feel that it is only a transitional study to a more abstract form that ought to come next." Nevertheless, the mere fact of having escaped from the musical concept of dance form is a great step. Here is a composition that moves forward by the force of its own strength, entirely within the boundaries of its own medium. Its phrasing is movement phrasing, its climax is a movement climax, its contrast and balance are matters of movement. The ensemble has been extraordinarily handled as a mass; there is no moment when it breaks up into individuals. Movements flow through the mass rather than from individual to individual.

It is, of course, wholly devoid of emotional content both in itself and in its performance, yet because its form has significance it produces an emotional reaction in the onlooker. Just as one can never have the same feeling for flame after seeing Robert Laurent's sculpture of it, so water must take on a new significance from this moving sculpture of it essence.

For some years the non-musician dance seems to have intrigued Miss Humphrey's interest. In her earlier days at Denishawn she danced the "Tragica" without music, though it was musically conceived; in her concert last season she presented her "Color Harmony," which was created without music and had a musical setting added after it was completed; now comes the "Water Study," entirely divorced from music but relying upon other rhythms. The next step she herself foresees as the "more abstract form" of the independent dance.

The American Society of Teachers of Dancing and Miss O'Neill are to be warmly applauded for sponsoring the first performance—even en famille—of so thoroughly creditable a piece of creative work.

J. M.

* * *

December 28, 1928

IRMA DUNCAN GIVES FINE DANCE RECITAL

Festival Begun Here by Her and Russian Children a Tribute to Isadora

A tribute to the memory of Isadora Duncan is the festival begun at the Manhattan Opera House last night by Irma Duncan and eleven youthful dancers from her Moscow school. Those to whom Isadora is merely a name can find here a convincing explanation of the superlatives which have been universally heaped upon her, for there is recaptured here more of the spell of Isadora herself than in any previous appearance of her disciples, not even excepting the six "Isadorables."

The eleven Russian children are disarmingly beautiful and spirited. Their youth and simplicity escape all the pitfalls of anemia and preciousness which their elders have not always succeeded in avoiding, and their complete sincerity contains no hint of solemnity. Even the little group of Schubert waltzes, in themselves inconsequential except for the fact that they were created by Isadora, are lifted beyond banality by the freshness of these young artists' performance.

Tchaikovsky's "Pathétique" symphony constitutes the main feature of the first program. The emotional character of the opening movement, played by the orchestra in a darkened house, creates a warm and sympathetic atmosphere, and on the crest of this emotional wave Irma Duncan makes her first appearance and, with four of her company, dances the second movement of the symphony. It is in the third movement, however, where an ensemble of six is employed with striking beauty, that the program reaches its highest level.

In beauty of movement, in musical phrasing, and in the utilization of dance form, it can be said to represent the Duncan tradition at its finest. The final movement Miss Duncan achieved less happily. Departing entirely from dance form, she is restricted to the trying ordeal of pure emotional expression, and is not altogether successful. Her sorrow is at moments too explicit to be sorrow in essence, and at most other times is too general to have the force of specific experience.

The final group of the program, entitled "Impressions of Revolutionary Russia," employs the full ensemble, and is not so much dance accompanied by music as it is songs depicted in action. The second one, in particular, a funeral song for prisoners in Siberia, bears little or no relation to the dance and loses correspondingly in effectiveness. The workman's song, which concludes the program, is a fine piece of pure theatre, using song and dance in admirable proportion to create a definite emotional result. It would be carping to complain of the untrained voices of the young dancers, or even of their occasional deviation from pitch and tempo, for theirs is a spontaneous and to all intents an artless performance.

The festival is to run for twelve performances, during which four different programs will be presented. If the remaining three live up to the standard set by the first, the whole will constitute a worthy memorial, indeed, to the great dancer it celebrates.

* * *

January 6, 1929

THE DANCE: CONCERNING THE DUNCAN SCHOOL

Performances at Manhattan Opera House Present Some of Its Essentials

By JOHN MARTIN

The Isadora Duncan dance festival, which comes to a close with two performances today at the Manhattan Opera

House, has served to bring to light as complete a view of the essentials of Duncanism as has been shown in America since Isadora herself was dancing among us. It has probably intensified everybody's convictions, whatever they may have been previously.

Those who have maintained that Isadora was a singular and exceptional genius, whose contribution to her art died with her, have possibly found in the comparative shortcomings of Irma Duncan ample reinforcement for their belief. On the other hand, those who see in the iconoclasm of Isadora a sort of Magna Carta of the dance have no doubt discovered strong reason for their thesis in the unusual performance of the youthful dancers from the Moscow school, whose work during these ten days has been unquestionably delightful.

It is doubtful if anybody who has attended any of the sessions of the festival has done so without taking with him some credo relative to the Duncan school. But whatever one's preconceived notions may have been, surely there must be a united opinion that the season as a whole was eminently worth giving and thoroughly entertaining.

The Veil of Melancholy

It must be admitted at the outset that Irma Duncan is not an impressive figure as a dancer. Her devotion to her preceptress has led her into imitation of externals to such an extent that one feels little of the creativeness of an inspired artist in her. It is as if she were swathed in a thick veil of melancholy, not tragic, but rather with a sentimental assumption of tragedy. This attenuation of vicarious emotion is too thin to move audiences to any great depth of response. It serves at best only to remind us of the power of Isadora's own emotional projection, of which it is so faint an echo.

The suffering which is actually experienced in performance is not within the bounds of the artist's legitimate material; it must be passed through the refining fire of technique before it is molded into form and hence into esthetic validity. That Isadora violated this canon consistently is simply another argument on the side of those who maintain that she was a great, individual genius to whom rules do not apply. But nobody else has been able to follow her emotional anarchy along these lines to the same end. To all intents and purposes, her tragic dancing is interred with her ashes. She left no method of reproducing it, except by imitation, because she had no method of producing it, except by living it.

It is a major misfortune that Isadora scorned technique to the extent that she did. In her passion for freedom she overlooked the vital fact that there is no freedom without law. A dance without a technique is limited and cramped beyond measure; its range of movement is confined to the narrowest boundaries, and it deprives itself of the most elementary principles of significant form. When it overcomes these obstacles and actually achieves the status of art, it is because of an instinctive and unconscious utilization of these very laws which have been cast aside as stultifying.

The Finer Duncan Qualities

There are certain qualities which the best of the Duncan school possess that would constitute an extraordinary addition to the equipment of all dancers if only they could be acquired by a simple, technical method. Their lightness, their speed, their lyric line, would enhance the art of any school.

Whatever reservations one may make as to Irma Duncan's gifts as a dancer, there is only the highest praise for her accomplishments as a teacher as exemplified by the eleven young Muscovites at the Manhattan. They dash through their dances with no trace whatsoever of esthetic importance, no consciousness of beauty spelled with a capital B. And because they are so free from the artifice of an assumed freedom, they accomplish both esthetic importance and beauty spelled sometimes with a very large B, indeed.

As for the gayer aspects of the Duncan type of dancing, one has a growing suspicion that it is admirably adapted to children, but should be forbidden to all those over 20. Even Isadora in her later years was a grotesque figure in her lyrical dances; her body was heavy and her mind introverted. The adoration of beauty as expressed in the physical being can scarcely find a grosser betrayal of itself than in this type of unself-critical performance.

The besetting danger of the whole method—if it can be called a method—is sentimentality. Until this blinding mist is cleared away from the eyes of its devotees it will never be possible to estimate what its positive attributes may be.

We are in the midst of a great wave of Duncanism at the present moment in America, dictated presumably by the desire to memorialize Isadora. Anna Duncan dances next week at Carnegie Hall and Maria Theresa next month, with three of the Elizabeth Duncan school midway between the two dates. Steps are being taken to establish an Isadora Duncan school in America, with Augustin Duncan as chairman of the organizing committee. Perhaps out of all these efforts there will arise something of vitality and importance, in which the method will find its justification as a universal thing. At any rate, if these other performances present any such qualities of charm and loveliness as the festival at the Manhattan Opera House has presented, they will be more than welcome on their own merits.

* * *

January 21, 1929

KREUTZBERG SUPERB IN DANCE RECITAL

Brilliant Audience Welcomes Him—Miss Graham's Unique Performance

An audience of unexceptional brilliance assembled at the Hudson Theatre last night to offer felicitations to Harald Kreutzberg and Yvonne Georgi on the occasion of the initial dance recital of their American season. If the brilliance on the other side of the footlights was not unexceptional, it was at

any rate of a high order, and more than enough to justify the "bravos" and "encores" that seem to have become common practice at dance recitals this season.

Kreutzberg has been seen in New York before, not only in the productions of Max Reinhardt, but also as a recitalist in company with Tilly Losch. Some of the same dances presented on his previous appearance were repeated last night and can, indeed, bear frequent further repetition. For there can be no question that Kreutzberg is a superb dancer. If he is a disciple of the modern German school, he is also an adept at ballet technique and a pantomimist of genuine gifts.

He is the rare type of dancer that can almost make one accept the theory that there are really no varying schools of dance at all, but only, as some one has said, good dancing and bad dancing. It is difficult to conceive of Kreutzberg as ever doing any of the latter kind. His program last night certainly revealed no hints of it. If some of his compositions were less interesting than others, his astonishing vitality and distinctly ingratiating personality succeeded in covering the fact more than adequately.

The range of his program is also a cause for some little amazement. From the height of technical brilliance in the Russian dance, he descends to a rhythmically pantomimic study almost devoid of dancing in its more limited definition, entitled "Three Mad Figures," morbid and hideous, but compelling through the adroitness of its design and the intensity of its performance. There are lyrical moments of exquisite beauty and a hilarious group of low comedy burlesques, which closes the evening. Perhaps the finest of his solo numbers was "The Angel of Last Judgment."

Miss Georgi proved something of a disappointment. She has an extraordinary physical technique, but her breathing is labored and her movement heavy. The contrast of such a partner as Kreutzberg lays a considerable burden on any dancer. She was not without her conquests, however. The "Dance of the Devil" was well designed and danced with spirit, the "Till Eulenspiegel," if too long, was nevertheless cleverly realized, and the Russian dance brought out pleasing aspects of her ability. Her ballet parody was ineffective, as she is not a ballet dancer.

If there had been no other dance on the entire program, however, the "Persian Song" would have justified the voyage of the two dancers across the ocean, for both in composition and performance it is a triumph of simple, lyrical loveliness.

Louis Horst, who played for Martha Graham in the afternoon, rendered similarly admirable service.

Martha Graham's Recital

In her first appearance of the season, at the Booth Theatre yesterday afternoon, Martha Graham gave a program of dances which could not conceivably have been given by any other American dancer. Bitter, intellectual, cold, if you will, her art is arresting, even aggressive, with a hard beauty as of sculptured steel. It is difficult to imagine any one's being indifferent to Miss Graham, but, whether she inspires enthusiasm or intense dislike, the evidences of greatness are inescapable. Her purposes are generally translated into action with a minimum of loss. When she misses, however, she misses completely; with her sparseness, her precision, she could do no less.

In her first dance yesterday, Miss Graham dedicated her program formally to Nietzsche, the selfsame Nietzsche to whom Isadora Duncan also dedicated herself! With characteristic contrariness, this dance, entitled " 'Dance—strong, free, joyous action' Nietzsche," was performed with a minimum of action; the feet never moved from their original stance, the design was constricted, and joy was nowhere in evidence. It was nevertheless strong and full of character. Here, as generally throughout the program, there was to be found an Oriental tendency toward staccato attack and slow recovery which was somewhat overworked. It may be totally absent when next Miss Graham dances, for she is a veritable chameleon in changing her style and method. Nowhere was this more clearly indicated than in those dances which have been included on previous programs.

With the exception of the "Fragilité," they had been greatly metamorphosed. The "Strike," last year a loose and chaotic bit, was now closely knit and gripping; the "Tragedy and Comedy" were heightened and deepened and their indefinable suggestion of the archaic Greek theatre strengthened; even the Ravel waltzes had a new edge to their lyricism. The Ornstein "Poems of 1917" alone have not been improved with age and re-creation, either in design, performance or costume.

Of the new numbers, "Insincerities," to music of Prokofieff, and "Two Variations from Sonatina," by Gretchaninoff were outstanding. The former is impudent and malignant in its comment on the four commonplace human qualities of petulance, remorse, politeness and vivacity. The variations, subtitled "Country Lane" and "City Street," respectively, reveal the dancer's command of plastic design. The charming, lyrical movement of the first part becomes strongly inhibited in the second, at the same time retaining the thematic characteristics. From the standpoint of movement alone, this was the high spot of the afternoon.

In the "Cants Magics" Miss Graham missed her form; it will probably reappear in some future program with its full meaning. The other new composition, "Three Florentine Verses," seems destined for that limbo into which its creator so willingly casts her works that fail to come up to standard.

A crowded house, containing almost every local dancer of prominence, was obviously delighted with the program. Louis Horst, as usual, assisted with first-rate accompaniments on the piano.

* * *

February 17, 1929

THE DANCE: IN PROSPECT

Events of the Spring Season—The Need of An American Ballet

By JOHN MARTIN

With the approach of Spring, the subject of ensemble dancing again forces itself to the front in the attention of dancers. After a Winter of planning and rehearsing, of acquiring something of the feeling for concerted work, many groups begin to develop sufficient confidence about this time of year to face the ordeal of a public presentation, or at least to desire to do so.

Individuals who belong to no group, who have no followers and owe no allegiance, and who therefore might be expected to be excluded from participation in the annual resurgence of ensemble activities, have nevertheless learned to rely confidently on invitations from those who need their services. This year certainly there will be no lack of such invitations, and the dancers who will take no part in any of the ensembles that are destined to be on view between now and Summer will be conspicuous by their scarceness. In fact, from the looks of things at the present writing, it will require something in the nature of a miracle to provide a sufficient number of dancers of requisite artistic calibre to people the casts of the productions that are already planned.

Several Events Forecast

Foremost among the underlined productions, both in point of magnitude and of interest, is the Neighborhood Playhouse season to be held at the Manhattan Opera House toward the end of April. The Misses Lewisohn, after their adventure last year with "orchestral dramas," can be looked to with confidence to bring forth something courageous and provocative that will cause such argument and even more theorizing among its audiences.

Just what the nature of this year's production will be remains to be seen. Reports of almost every conceivable type have been bandied about, naming players, designers, composers, the personnel of the individual casts, and even the very manner and style of the direction. With rehearsals not yet begun, these reports are, to say the least, unreliable, and there has not yet been any official announcement. Two things seem reasonably certain, however, in this connection; one is that the production will not again be identified as "orchestral drama" because of the wide divergence between the public's interpretation of the phrase and the producers' intention; and the other is that the roster will read even more like a directory of who's who in the dance than was true last year.

The Possibility of a Ballet

In addition to this highly interesting event there are others in the offing which bid fair to complicate the theatregoing life of the dance devotee considerably. There is even a strong and enthusiastic movement on foot to establish an American ballet in New York, though the chances of its accomplishment this season are a bit more than doubtful. The point has been reached, however, when names such as Balanchin and Nemchinova and Massine are actually mentioned. There may arise some question as to the American character of an aggregation thus headed, but the idea is not a nationalistic one, and the term "American" is used to signify the locale of the activity rather than the citizenship of its members.

And while on the subject of Massine and ensembles, it is again inevitable to express a hope for the eventual realization of an American ballet of a very special kind at the Roxy. To be sure, a corps that dances four times a day seven days a week has certain insuperable limitations which neither taste nor skill can be expected to contend with; nevertheless, with this reservation, there are possibilities there that have not as yet been dreamed. At least, they have been undreamt of until within the last few weeks and the result of this recent dreaming promises to be an important step toward the realization of those possibilities. A series of ballets is now definitely planned for the Spring, to be staged under the direction of Massine and to be of quite a different calibre from those hitherto presented in motion picture theatres.

Ballet Series Projected

With the usual mystery that surrounds premature announcements of this sort, it is impossible to predict just what the details of this difference will be, but if the taste of Massine and his experience in reaching audiences is given anything like full sway, it is safe to count on an interesting and successful experiment. Patricia Bowman is assuredly as gifted a ballerina as could be found in a month of Sundays; and the ballet corps itself is adequate if not brilliant.

The Roxyettes, it must be confessed, cause one a moment or two of skepticism; but even they, if kept from intruding their tiresome line routine into the midst of the ballet's best dances, might not be too much of an impediment. Therefore, think what one may of the movies, of jazz and of "presentations," it is to the Roxy that all eyes must turn for the nearest and most hopeful solution of the question of a permanent popular American ballet.

From an entirely different viewpoint, a type of ensemble which has grown out of the ideals of Ruth St. Denis and Ted Shawn has found extraordinarily happy expression under the leadership of Doris Humphrey. In working together year after year, as Miss Humphrey and her dancers do, with common artistic purposes, a unity is possible of achievement which is quite out of the question with ensembles engaged for special productions and disbanded afterward.

An important feature of the Spring season, therefore, will be the program, to be presented for two performances, on March 31 and April 7, by Miss Humphrey in collaboration with Charles Weidman and their concert group.

With something of the same general ideals, Martha Graham will shortly introduce an ensemble for the first time; the New World Dancers start a similar type of career this evening; Senia Gluck and Felicia Sorel promise an assisting

company in their forthcoming series of concerts; Gavrilov, of course, has his "Ballet Moderne," and there are any number of other groups with performances pending whose plans are as yet too embryonic to bear revealing.

* * *

AGNES DE MILLE GIVES FINE DANCE PROGRAM

Assisted by Charles Weidman—Three Other Dance Performances

The most stimulating of the four events which yesterday held the attention of dance lovers proved to be the appearance of Agnes de Mille, who was assisted by Charles Weidman, at the Martin Beck Theatre, in one of the best programs of the season. It was what Miss de Mille herself would in all likelihood pronounce a "swell show," and a brilliant and discriminating audience testified unmistakably to its approval of the work of both dancers.

If the favorite pattern of Miss de Mille's dances is beginning to be a little familiar, she has grown amazingly both in technical facility and in stature as an artist since her first concert appearances last season. Perhaps the most finished piece of work she has yet done is the "Civil War" number on last night's program, in which she conveys a genuine poignancy through the medium of a music hall turn supposedly staged at Niblo's Garden in 1863. In form and performance it was an utterly charming creation.

Other new dances included "May Day," danced with Mr. Weidman; "Café Dancer" (Ouled Nail), "Harvest Reel," an extraordinarily well-danced composition, whose purpose was unhappily blurred by a mistaken curtain cue, and "Try-out," the graphic portrait of a Broadway chorus girl showing what she can do with jazz on her toes. Repetitions from last year were the two Degas studies and the rip-roaring "Forty-nine."

Mr. Weidman also contributed what is possibly the best dance of his répertoire, though it was not new on this occasion. This is a study of music of Scriabin which in its few brief measures is an eloquent and beautiful example of plastic design, revealing incidentally the dancer's superb technique. Mr. Weidman's other numbers included "Three Preludes" to music by Gershwin, a dance from the "Russian Suite" of Cyril Scott, "Japanese Actor," his well-known Borodin "Scherzo," and the excellent "Singalese Drum Dance."

Louis Horst presided over the music.

* * *

THE DANCE: ONE ARTIST

Martha Graham's Unique Gift and Steady Development

By JOHN MARTIN

Each successive appearance of Martha Graham makes more emphatic the conclusion that she is a unique figure in the American dance. It is easy to understand how one might dislike her work intensely; it is considerably easier to understand how one might like it with equal intensity and be stimulated and disturbed by it. The only unimaginable reaction would be indifference.

Those who stay away from her concerts offer certain valid reasons for so doing, and some who go because they are interested in spite of themselves share the view. It is held against her, for example, that she is "arty" and precious and solemn; that she belongs to what one of her colleagues delights to call "the morbid moderns"; that she has turned her back on the dance and her face toward the theatre; that her compositions are all in one key and her programs monotonous. To which accusations there is no reply except, "What of it?"

It would be a hopeless task to undertake the refutation of such criticisms, for they are too largely true to admit of being argued out of the way. But such a merely partial catalogue tells only a small fraction of the tale. Through the haze of these items of debit glows the light of one of the few extraordinary talents of the day; and sometimes the very haze itself provides points of shadow that serve to heighten the design.

A Disquieting Art

Audiences who come to be amused and entertained will go away disappointed, for Miss Graham's programs are alive with passion and protest and are couched in a vein to frighten away somnolescence. If the passion of her dances is not of the turbulent and unbridled order, it nevertheless burns with the slow and deadly fire of the intellect. She does the unforgivable thing for a dancer to do—she makes you think; yet it is thinking of a peculiar character, for it is less of the brain than of some organ absent from anatomical charts, that reacts to esthetic stimuli. She leaves you upheaved and disquieted and furnishes afterthoughts not calculated to soothe such a condition.

Frequently the vividness and intensity of her purpose are so potent that on the rise of the curtain they strike like a blow, and in that moment one must decide whether he is for or against her. He either recoils and steels himself against further attacks or accepts her challenge and prepares to indulge in a friendly sparring match. If one tries to sit limp and inactive, the consequences are obvious.

Miss Graham deals more and more in essences. She boils down her moods and her movements until they are devoid of all extraneous substances and are concentrated to the highest degree. She gives less and less of the full dimensions of her meanings; she indicates, she suggests, she leads you on with

her. And because she is so sparing it is not difficult to follow along; there are no sidetracks and byways.

A Developing Technique

If her economy goes much further, however, it is in danger of becoming penurious. Even now there are moments when the flagon appears rather dry and the cupboard rather bare. But one is never justified in prophesying about Miss Graham. Unlike her own dance compositions, she does not develop in a direct line. She is a constant surprise. Even when she repeats dances on consecutive programs they are filled with new colors and sometimes with new designs; they have been pruned and trimmed or even reoriented. One of her strongest attributes is her capacity for self-criticism and her willingness to revise and discard. This makes for confusion when one attempts to prognosticate.

And another item which tends to provide the unexpected in Miss Graham's dancing is her susceptibility to personal moods which cause her to dance now tremendously and again without spirit. Her most recent concert, to be explicit, opened in a wave of disappointment. The "Dance" to music of Honegger, which on its first performance was vigorous and arresting, seemed pale and ineffectual; and it was not until the fifth number on the program that the vibrant strength of the dancer at her fittest asserted itself. Here, with that mordant little masterpiece, "Four Insincerities," the familiar provocativeness began to operate and the afternoon swept on to a stirring finish.

In her newer creations Miss Graham exhibits an unusual originality in her thematic material. If there have been those who have maintained that she had limited herself to the angularity of pseudo-modernism, they are answered fully and finally in two new dances entitled "Resurrection" and "Adolescence." In movement the former is the more striking and the more original; but in the latter there creeps into the dancer's repertoire a new emotional color, a wistfulness that is touching without being sentimental and theatrical without losing anything of visual significance. One cannot but wonder if perhaps this is the presage of another direction for Miss Graham's adventurous talent. It is, at any rate, one in which she might find much unfamiliar material with which to brighten and warm her art.

And she is not one to shrink from adventure. It is rarely that audiences are given the opportunity to watch such vigorous experimentation as she provides, backed by a technical proficiency and an artistic equipment which give her the right to try out new ideas. The interesting question which arises out of this constant variation in style and content is whether she is passing through a period of unsettlement and will eventually find the ground upon which she wishes to stand or whether she has already found herself and that self is one which must be incessantly in a state of change in order to create with vitality. In either case, here is a dancer for the connoisseur, and her every development in whatever direction is significant.

* * *

April 7, 1929

DORIS HUMPHREY GIVES AN EFFECTIVE DANCE

"Life of the Bee" Surpasses All Her Previous Excellent Efforts

In her dance recital at the Guild Theatre last night, Doris Humphrey presented for the first time a composition for ensemble entitled "Life of the Bee," which for sheer effectiveness surpasses all her previous excellent efforts in this medium. Based on Maeterlinck's famous work, it is a ballet with a definite program, thus departing from the general style of Miss Humphrey's other ensembles. It has no great composer's music to lean upon for its dramatic or emotional appeal, for it is performed with no accompaniment except the rhythmic droning of an unseen chorus. Nevertheless, it is intensely dramatic and impregnated with a sinister terror that is, in the literal sense of the word, thrilling. Here are all the evidences of a major contribution to the meager répertoire of the modern dance. The performance it received at the hands of Miss Humphrey, Cleo Atheneos and the ensemble is expert in the extreme and makes for one of the season's most memorable experiences in the dance field.

The program last night contained several other items of interest, chief among them being the first performance of the third movement of the Grieg Concerto in A minor. Last year Miss Humphrey presented the first movement, and in the intervening months she has polished it and allowed it to become richer and mellower. It is scarcely fair to her new movement to compare it with this older and more matured one, which has also a wider musical background to build against. It is, nevertheless, well designed in the main and beautifully danced. If it has barren spots, they no doubt will be filled in before it is next performed.

Charles Weidman, as his best contribution to the program, offered a distinctly enlivening group of three numbers dealing racily with contemporaneous subjects, such as prizefights, jazz and moving picture cowboys. The first and last of the group were excellently danced, or rather mimed, by Messrs. Glenn, Lasky and Le Sieur, and Mr. Weidman himself danced Gershwin's "Preludes" in a manner to provoke not only laughter but genuine admiration. His other new dances, dealing with Savonarola and St. Francis in literary and pantomimic style, are not of any especial interest, nor is Miss Humphrey's new solo without music, called "Speed," though its stern demands on technique are easily met.

Wholly delightful, however, is the new "Air" by Purcell, danced by both Miss Humphrey and Mr. Weidman. It is original in form and content and reveals the dancers in a style completely different from anything they have done before.

The remainder of the program consisted of "Air for the G String" and "Gigue" of Bach, danced by the ensemble; Mr. Weidman's beautiful Scriabin "Study," danced somewhat less well than on its last viewing, and the "Water Study," for ensemble without music.

A second program will be given at the same theatre next Sunday.

At the Martin Beck Theatre, Felicia Sorel and M. Senia Gluck gave the third and last of their programs of "exotic dances," repeating the performance given by them two weeks ago.

* * *

April 7, 1929

THE DANCE: ACHIEVEMENT

The Unique Success of Doris Humphrey In Ensemble Building

By JOHN MARTIN

With the first performance of her new ballet, "Life of the Bee," at the Guild Theatre last Sunday, Doris Humphrey has again furnished occasion for something more than passing comment. Few dancers have a gift for composition which ranks with hers; and, certainly, more than any other American dancer who employs the modern idiom, she is able to see movement in its harmonic and contrapuntal aspects. Perhaps her most outstanding talent, however, lies in her ability to externalize her vision by means of the most difficult of dance mediums, the ensemble, with a minimum loss in the process.

To have an idea and to externalize it are problems that involve very different considerations. The first is chiefly concerned with talent and native equipment, which one either has or has not and there is an end of it; but the second has far less to do with endowments over which one has no control than with laborious processes of workmanship, of experimentation, of routine, which try the vision to the utmost. If it can merely survive the ordeal which lies between conception and birth it has proved its right to live and to be treated with a certain degree of respect. If, as has happened consistently with Miss Humphrey's compositions, it has survived with distinction, a minor miracle has been achieved and the matter is well worth looking into.

A Satisfying Ensemble

In the first place, Miss Humphrey has built up an ensemble which is unquestionably the peer of any similar organization which has been seen in America. The Diaghileff ballet itself presented no more exquisitely plastic an instrument for a choreographer to play upon. It responds to her direction with equal completeness whether the demand upon muscular control seems almost inordinate, as in certain moments of the "Life of the Bee," or whether the necessity is for such subtle mental feats as memorizing the space and its rhythmic counterpart for the "Water Study."

It is a tribute of the highest sort to Miss Humphrey that these fourteen dancers have worked together with her now for approximately a year and a half. There is certainly no hope of emolument to hold them, for their appearances are never more than four or five in a season, and then there is not enough

profit accruing to warrant paying anything like a living wage to such a large number of people. They must provide themselves with livelihoods outside. This, parenthetically, is a sad commentary on the economic situation which faces the dancer—a situation which seems to have no remedy.

On the other hand, no member of an ensemble such as this can have much expectation of fame or personal recognition; for, by the very nature of the work they have thrown themselves into so whole-heartedly, they must merge themselves as individuals into the group. Yet by the sheer vitality of her accomplishment Miss Humphrey manages to hold them together and to increase their range from composition to composition as her own increases.

Difficult to Classify

It is perhaps not strictly in accordance with the facts to refer to Miss Humphrey as a creator in the modern idiom; for the word modern changes its connotations so rapidly that the modern of today is an old reactionary in the eyes of the modern of tomorrow. At the present moment, modernism generally has reference to the method of using the body as an abstract instrument to express visual forms apart from emotional or actual experience. From this point of view Miss Humphrey is to be classified as a romanticist. She employs the body not in an abstract manner, but rather in an impersonal manner; she is not concerned with form for the sake of form, nor on the other hand is she ever guilty in the least degree of "self-expression." She strikes a mean between two schools.

The out-and-out romanticist dances a personal mood, projects a personal emotion basing the validity of the dance upon its close relation to the life experience of the dancer. At the other extreme, the modernist assembles unemotional elements of design, and, by skillful arrangement, by contrast and accumulation, produces an emotional reaction in the onlooker by means purely esthetic.

Her Emotional Quality

Miss Humphrey's dances are peopled with human beings, never with elements of design. They have emotional warmth, whether they are presenting waves of the sea, or bees, or nameless figures moving in response to musical phrases. They do not, however, express a personal emotion; they give you nothing of their private lives and beliefs. The emotional content is generic: it is of any man or any woman; and it has no tendency to evoke a response growing out of sympathetic experience. It is, in other words, realism separated from actuality. Because of this very quality, which can scale tremendous heights of heroic and noble feeling, the greatest danger which besets Miss Humphrey is that of indefinite beauty, or to put it more crudely, prettiness. That she escapes it by a wider margin in every composition indicates how surely she is building. When she has entirely eliminated the suspicion of softness in her strong and grotesque movements, she will have downed her last enemy.

It is extraordinary to consider the variation in approach to the subject which has characterized her four major ballets to

date. "Color Harmony" was more or less symphonic in form, though it grew out of visual form and not out of music; the first movement of the Grieg Concerto was an inspired instance of music visualization, in which the music hovered over the dancers as the gods hovered over the actors in the tragedies of the ancient Greeks; the "Water Study" threw aside musical rhythm and phrasing and arranged nature movements into art form; now comes "Life of the Bee," which is built along theatrical lines, with its two central figures almost "characters."

In this newest work Miss Humphrey may have been moved by philosophical or entomological impulses, but she has actually created a piece of dramaturgy. Its mode of expression is dancing rather than words or pantomime, and it sums up into one of the most tense and beautiful dramatic ballets of our day. Never was music missed less. The humming of an off-stage chorus in varying rhythmic phrases, punctuated at rare intervals by a point of open vocal tone, provides a sinister aural background for a sinister picture. A fight to the death between the two principal figures, with the chorus massed on the floor at the side and back in frenetic expectation, contains as much excitement as almost any three melodramas one can mention.

Because she adapts her method to her subject and lets the performance actually grow out of the idea, Miss Humphrey's répertoire is never likely to become stale.

* * *

April 15, 1929

RECITAL A TRIUMPH FOR MARTHA GRAHAM

Closes Season With Debut of Her Dance Group—Tamaris Reappears

Martha Graham closed her season's activities with the triumphant début of her dance group in a recital at the Booth Theatre last night. Miss Graham's gifts as an individual dancer are a matter of record, but this performance added evidence of an astonishing talent for group composition. Couched exclusively in a modernistic idiom, her work in this medium is at once strikingly original and glowing with vitality. There is no taint of decadence about it, no touch of morbidity. As yet she has not discovered in her group dances the shades and variations that color her solos; the black is all black and the white all white. Also, possibly on account of her sharply characterized personal style, the group has not yet found its individuality apart from her. Frequently the effect was of twelve less expert Martha Grahams. To make objection to these details, however, is to quibble over creative work of distinctly masterful proportions.

Of the four compositions for group, two stand out in exquisite perfection. One, called "Heretic," is danced to an old Breton song of some twelve measures length, repeated

eight or ten times. The spirit of the theme, the character of its primitive musical treatment and the presence of stark, elemental tragedy are presented with an economy of means that fully justifies all Miss Graham's experimentation in the use of mere essences of movement. In "Moment Rustica" she has achieved the antipode of mood, again in a folk style, and again with the least possible movement. A gay, rollicking peasant dance is actually created with only one of the eight dancers participating actually dancing to any great extent.

Because she paints so skillfully with movement, she creates dancing where literally there is none, and arrives at a conclusive answer to the criticism that modernistic dancing is static and introverted and cannot be lyrical.

The other two ensemble numbers, "Vision of the Apocalypse" and "Sketches from the People," contain extraordinary moments, but are uneven, and in the case of the first, a bit choppy.

Four dances by the trio of dancers who have appeared previously with Miss Graham, were uniformly excellent, with the charm of pure lyricism about them. Of Miss Graham's individual dances, "Adolescence" again proved to be a poignant and understanding piece of work, and, like her other numbers, beautifully danced.

The program was undoubtedly the crowning achievement of Miss Graham's career thus far.

Recital by Tamiris

At the Cort Theatre yesterday afternoon, Tamiris gave a second recital, which contained all the new dances first presented on her program last Sunday. In addition, some of her most popular numbers from last year's concerts were included. Among these were "Portrait of a Lady," by many considered to be her best composition; "Harmony in Athletics," "Circus Sketches" and "Peasant Rhythms."

Louis Horst provided piano accompaniments for both Tamiris and Miss Graham.

* * *

April 22, 1929

FOUR RECITALS GIVEN BY DANCERS

Von Grona and His Group Present a "Spectacle" at Hampden's Theatre

BECQUE MAKES HIS DEBUT

Ventures into Musicless Dancing—Ingeborg Torrup Seen— Farewell by Irma Duncan

Two performances by ensembles, both captained by men and leaning heavily on German modernism, divided what meagre audience there was for dance recitals last night. Von Grona and his group presented "a dance spectacle" at Hampden's Theatre for the benefit of the Alabama flood sufferers, and Don Oscar Becque made his début at the Booth in a pro-

gram of "dances without accompaniment," in which he was assisted by a group of four.

In the afternoon there were recitals also by Ingeborg Torrup and Irma Duncan.

Mr. Von Grona's dancing proved to be more spectacular than substantial. He has acquired for himself and passed on to his group of twelve girls a remarkable suppleness of body; they all appear to be capable of executing extremely difficult feats of balance and strength. But the actual vocabulary of significant movement which is at their disposal is distressingly limited. Back bends are employed ad infinitum, and while they are extraordinarily well done, they mean very little, indeed.

Thus Mr. Von Grona's compositions suffer not only from sameness but also from superficiality. The redeeming feature of the program is a sense of the theatrical which provides at least the quality that provokes applause. Mr. Von Grona is a pupil of the Jutta Klamt school in Berlin, but he is fundamentally romantic in his viewpoint rather than modern. The "Anitra's Dance," "Religioso" and "Spirit of Labor" were among the offerings presented some months ago at the Roxy, and most, if not all, of the solo numbers have been on previous Von Grona programs. Musical interludes and accompaniments were supplied by the LaSalle Quartet, Thorpe McCluskey and Mary Lindsay-Oliver, who played two of her own compositions for piano.

Don Oscar Becque's Venture

Don Oscar Becque ventured into the uncharted fields of experimental dancing without music, and, it must be admitted, did little to add to the store of knowledge and achievement in that line. His physical technique is not in any sense fluent and his sense of composition is frankly chaotic. "This program," reads a foot note, "is the result of four years of experimenting with the dance as an independent art form. It is by no means a final statement, but merely points the way to further development in this direction." From the evidence submitted, it would seem wisest for Mr. Becque to consider it "a final statement" and set to work at something else, for he has failed to discover the essential element of the dance as an independent art form, and that is form.

A great deal of labor has unmistakably gone into the making of the program, and the four young women, at least two of whom have danced much better under other auspices, worked diligently and sincerely. The material which was given them to work with, however, was trivial and pretentious. The future of the modern dance assuredly does not lie this way.

Miss Torrup Wins Her Audience

Ingeborg Torrup, who has made herself better known hereabouts as leading woman for Walter Hampden than as a dancer, gave her first dance recital since early last season at Hampden's Theatre yesterday afternoon before an audience which made up in genuine appreciation what it lacked in size. Miss Torrup is a young woman of unusual personal beauty; whether she is moving in rapid figures or merely posing in decorative attitudes, she is always an eye-filling picture. Her movement is flowing and beautiful and her execution clean-cut and decisive. Over-relaxed hands contributed the only blemish on a thoroughly fine technique.

Certainly there is nothing vague in Miss Torrup's ideas or her externalization of them. She bases her compositions exclusively—with one apparent exception—on the fabric of the music which she is interpreting, but her sense of phrasing takes her dancing somewhat out of the usual interpretative classification because of its variety and freedom. If the music chosen for this program seemed a trifle well-worn it is possibly because Miss Torrup's energies have been expended more in the creation of dramatic rôles than in the creation of new dances.

In one instance, however, the note of modernism crept in, and "Dynamics," to music by Herwarth Walden, a dance built on mechanistic designs, revealed in slight measure what lies within the range of the dancer in this direction. It was vigorous and effective, apart from its relation to the music, and constituted the one exception referred to above in which the music appeared to follow the dance rather than the dance the music.

Irma Duncan's Farewell

At the Manhattan Opera House Irma Duncan and the Isadora Duncan Dancers from Moscow gave the fifth and last performance of their farewell engagement yesterday afternoon. They are scheduled to sail shortly for Moscow, with the prospect of a return to this country next Fall problematical. The program consisted largely of compositions of Chopin, with Beethoven, Brahms, Schubert and Mozart also represented. The concluding portion was devoted to the "Impressions of Revolutionary Russia," which have proved the main attraction of the company's répertoire in all their engagements.

* * *

April 28, 1929

THE DANCE: AN ERA ENDS

Increased Opposition to the Romantic Domination

By JOHN MARTIN

Whatever one's personal views on the subject may be, the present season has disclosed that we have definitely arrived at the end of an era in dancing, and the voice of the romanticist will very shortly be no more heard in the land to the exclusion of all other voices.

Styles of dancing arise and disappear with amazing rapidity in the swift tempo of present-day life; but whatever natural speed might be expected has been intensified during the last two or three seasons by the sudden outburst of activity in the field of concert dancing, until it would require another Polonius to classify the various types and schools

that have sprung up. That most of them are by nature ephemeral goes without saying. During the years of comparative neglect, many dancers have been cherishing theories in the privacy of their own studios and longing for an opportunity to give them tangible form and expression. When at last they have felt the great chance at hand, many of them have come boldly forth on the crest of the wave of public interest, only to find themselves sinking quickly and without hope of rescue below the surface, never to come up again. Among the survivors, however, there is such an astonishing lack of unanimity that it is difficult to draw any sharp lines of classification which would group any two dancers in the same school.

The Issues Confused

It is a far simpler matter to see what styles are outmoded and on the verge of disappearance than it is to collect the significant strands and to weave from them a piece of whole cloth for future use. The issues are not clearly defined; there is a revolution of some sort going on, but it is a guerrilla war, and nobody is quite sure what he is fighting for or against.

The dance trails considerably behind the other arts in reflecting the "advanced" theories of the times. Music has long since had its periods of impressionism, expressionism, neo-classicism and one thing and another, and now the term "neoromanticism" is beginning to be heard. But the dance, which on some persistent but insupportable basis is said to derive its sustenance and vitality from music, has by no means kept pace with it. Until the day before yesterday, so to speak, modern dancing meant "interpretative" dancing, "music visualization," and the outgrowths of those influences commonly accredited to Isadora Duncan and frequently termed the "romantic revolution."

The corresponding period in musical history can scarcely be called contemporary; in fact, it is not exactly a secret that we have just celebrated the centenary of Schubert. To interpret or visualize the music of the present day would unavoidably lead dancers far afield from the style of the romantic revolutionists, and the absence from their programs of the names of Stravinsky and Bartok and Honegger and Hindemith is sufficient testimony to the fact that such theories of the dance have little relation to the thinking of today and consequently seem fated to be imminently eclipsed. Within the short space of a season, or at the most two seasons, such theories have become as undisguisedly dated as grandmother's horsehair sofa; and sometimes, it must be admitted, they have the same charm about them that also hovers about grandmother's sofa, but charm and modernity are not necessarily synonymous terms.

Revolts and Movements

By all the rules of the game, we should be on the eve of an era of "neo-classicism." The revolt against the romantic school has made a fetish of "modernism" without in any way defining it. The answer to prettiness has been ugliness, but ugliness without significance is no less sentimental than prettiness. The answer to physical softness has been an amazing development of bodily power, but power without direction is as inconsequential as weakness. The answer to musical domination has been complete rejection of music, but the mere absence of music is only a negation and consequently without substance. Thus modernism as such has succeeded only in substituting one type of superficial performances for another, and the latter state is considerably worse than the former, for it is amorphous and disintegrated.

When the loose ends finally are gathered together, we shall probably discover that the essential difference between the old and the new is one of viewpoint rather than of specific details. The new dance must be a made thing, not a felt one; a work of art, not a segment of life.

Romanticist and Modernist

Where the dancer of the romantic school reacts to certain emotional stimuli and expects to get his effect from an audience by a sympathetic reaction, the modern dancer creates these emotional stimuli in terms of concrete form which he presents directly to his audience. He is himself the esthetic agent instead of being a semi-passive intermediary between the agent and the audience. It matters little or not at all, therefore, whether he employs music and soft lines or moves in silence to angular designs. He is free to adapt his method to his subject, to eliminate everything superfluous, to heighten and point reality, to create instead of to interpret.

Certainly such a viewpoint as this is very near to classicism. If it seems cold and unimpassioned to some it is interesting to consider that the music of Bach has been known to draw down upon itself the same criticism. Thinking has long been anathematized by the so-called creative artist as being positively lethal to inspiration, and possibly this is true, but the translation of inspiration into form is another matter, and one in which occasional cerebration might not prove too deadly. We have unmistakably come to the end of the period where feeling alone is sufficient, and, if all goes well, perhaps dancing will begin to make an appeal to the intelligence instead of merely to the emotions.

* * *

August 11, 1929

THE DANCE: ITS NEW APPROACH TO MUSIC

The Denishawn Program at the Stadium Revives the Subject of the Relationship Existing Between the Two Arts

By JOHN MARTIN

The presentation of several new compositions by the Denishawn Dancers in their three-day season at the Stadium last week brings up once more the ever-agitated subject of the dancer's approach to music. More battles have been fought, more esthetic wounds inflicted and more artistic partnerships

wrecked on this moot point than on any other in the wide range on the dancer's composite art. It is one of those controversial matters that bids fair to exist as long as there are dancers to argue about it. In fact, the recognition of the right to differ about it has become so general that one includes in every estimate, however casual, of a dancer's work some statement of his musical approach, just as one includes a consideration of the technical school to which he belongs.

It is interesting to note, with regard to the répertoire of the Denishawn Dancers that the question of "music visualization," which many years ago was one of violent dispute, with Miss St. Denis and Mr. Shawn among the aggressors, is once again lively, with Miss St. Denis and Mr. Shawn this time on the defensive, so to speak. History has repeated itself, and the radical theory of yesterday has become the conservative opinion of today. Interpretative dancing is nowadays popular art, and a new radicalism has arisen to threaten it—whether in the name of neo-classicism, neo-romanticism or what-not does not matter.

Design for Eye and Ear

Within certain limits, there is no doubt that music visualization is a valid choreographic form. With music of the pre-romantic period, for example, there is a keen delight supplied to the receptive eye in following visual patterns and at the same time hearing musical patterns that seem to parallel them. Here is pure design, unrelated to matters of the life about us—abstract and to a certain extent intellectual. Its only emotional force comes through the esthetic reaction to design, for it does not touch the inner realm of human experience.

To be sure, dancing of this character is of the utmost difficulty. It requires expert training of the ear as well as of the eye; and, besides a sympathetic style, it demands a physical technique adapted to the exactness and formalism of the musical technique. It can have no emotional program, and its participants, if there are more than one, must be de-personalized figures, related to each other structurally but not psychologically. Here, if ever, the classical ballet is indicated.

It was not, however, in the era of the classical ballet that interpretative dancing arose. Indeed, in the classical period the music which accompanied dancing was of scant importance, and generally of scant value as music. So little was it accounted that even Mozart passed completely unnoticed as the composer of a ballet which won its success solely on its choreographic merits without so much as a mention for the composer of the score. Music was supplied largely, one gathers, by hacks who were commissioned to provide accompaniments for ballets after they were completed by the choreographer. The only requirement was that their accents came in the right places and the tempo and general style followed the dancers' action.

Isadora Duncan's Contribution

It was only in the early years of the present century that music began to take a dominant place in the councils of dancers. Isadora Duncan revealed the esthetic value to accrue from allowing fine romantic music to play unbridled over the receptive emotions of a highly keyed artist. Through the stimulation of her own deeply passionate nature by this means she was enabled to hit upon many moments of profound tragic revelation and, because she had no technical barriers to impede her, to project them vividly for others. It was largely a "hit or miss" method, incapable of supporting a technique by which it could be crystallized or handed on to others. But it brought a new musical approach before the vision of the dancer. To be sure, its bequest of good musical backgrounds instead of bad ones constitutes a blessing of great magnitude, no matter what evils and abuses have grown up around it.

Now, however, we are in another epoch, and the romantic, personally experienced, emotionalized art of Isadora's early days is in disfavor. It has entered that period of middle age when it appears dull and lifeless; because of its nearness it is scorned and scoffed at perhaps beyond its deserts. The time has not yet arrived when its niche in history appears richly and amply filled. It is, in short, in the state of temporary obscuration from which it is no kindness to try to extricate it.

Work of the Denishawns

The program at the Stadium last week told the story rather eloquently in the juxtaposition of two musical interpretations of different periods and styles. (The third of the new "visualizations," that of Deems Taylor's "Jurgen," came, unfortunately, at the end of a long program and for that reason cannot here be discussed). In the Mendelssohn "Fingal's Cave" overture, the characteristic method of the interpreter of music, with a deep bow to the ballet d'action, prevailed. The waving of scarves, the decorative prettiness of sea nymphs, the romantic artificiality of a fishermaid and her lover, did no violence to the music. If one could accept the tradition, the work was, if not completely up to standard, at least no worse than commonplace.

In the Honegger "Pacific 231," however, there was a different story to tell. The music is a penetrating portrait of the locomotive; it is more—it is the portrait of a specific locomotive with a heavy, lumbering, friendly if a bit terrifying, identity of its own. Granting that the composer has done his work well, the logical visualization of his music would seem inevitably to be a locomotive. Obviously, this could not be expected to take place through any known process of transmutation on the concert stage. For a group of dancers to imitate the appearance and movement of a locomotive would be puerile.

What, then, are we to deduce? If by following the musical expression of a composer, supplying choreographic image for musical image meticulously from beginning to end, we arrive at a result that is demonstrably different from his own, something seems to be lacking somewhere. With modern music and modern choreography, and more than either of these, with the modern point of view, it is no longer possible to translate the symbols of musical expression into the symbols of choreographic expression without tracing them back to their origin, their relation to life. Once found, it is this rela-

tion to life that must be externalized to parallel in any way the concept of the composer. Merely imitating his outward means is not enough.

The Methods in Contrast

This is not in any way an indictment of Denishawn; indeed, the inspiration and the infinite capacity for taking pains that characterize all the work of Miss St. Denis and Mr. Shawn, the contribution which they have made and are still making to American dancing is too great to be belittled. Music visualization, however, is not Denishawn, nor is Denishawn music visualization. In this same program at the Stadium there were evidenced at least three other approaches to music. In the new "Death of a God" a dramatic scenario was overlaid on Debussy's "L'lle Joyeuse," as in the "Feather of the Dawn" a somewhat similar libretto was fitted with music by Charles Wakefield Cadman. Both of these were echoes of the old method of the ballet d'action in its relation to its music with modern improvements.

In Miss St. Denis's "Kwannon" and "Bas-relief" beautiful dance designs were supplied with musical accompaniment of suitable figuration. In Mr. Shawn's "Spear Dance" and Miss St. Denis's "Nautch Dance," and more especially in Mr. Shawn's new "Ramadan Dance," there was an effort to draw the inspiration of the dance from a common source, as the rituals of natives produce both sound and movement in a unified impulse. In fact, every theory that is consonant with their ideals of progress is welcomed into the catholic répertoire of Miss St. Denis and Mr. Shawn. To be sure, their leanings are strongly toward the right wing of conservatism; the radical departures of today which will be the accepted standards of tomorrow have not appealed to them.

The New Radicalism

The musical approach of the members of this left wing is provocative of the same sort of attack that was made upon the interpretative theory of twenty years ago. In its most extreme

aspects it advocates and practices with no small degree of success the dance without musical accompaniment of any sort. That this is not a desirable end in itself, all but its most fiery champions will admit; but that it is a brave and strong liberator of the dance from its enslavement to music must be equally evident.

When, through experimentation in dance forms without the emotional support of musical masterpieces and without the structural guidance of masters whose craftsmanship is sure and finished, the dancer learns the fundamentals of his own craft, then he can be free to associate his compositions with those of musicians on an equal basis. It is, perhaps, one of the most conspicuous bequests of the modern dance that it will leave behind it the ability to use music instead of being used by it.

In Argentina is the outstanding illustration of how this is to be achieved. Her musicianship is of such a calibre that she can cope with musical problems as they arise. Perhaps she is visualizing the actual musical themes; perhaps she is expressing the composer's underlying intention; perhaps she is simply choosing a background for her own compositions—it makes little difference. The music is not her master, but her servant.

The dancers without accompaniment, those who use only percussions, the advocates of Laban's theory of mechanical music, are all headed in the same direction. And if these appear to be too wholly from the German field, it would not be out of place to mention the Diaghileff Ballet, which in its recent endeavors has traveled a long way from that memorable production of "Sacre du Printemps," in which Nijinsky attempted to have every individual note of the music expressed by some characteristic movement on the stage. In fact, if the trends of the times seem unrelated and diverse, there is at least one point at which they converge and that is in their efforts to reorient their approach to music, and music visualization finds itself ever nearer to being left high and dry on the rocks as the tide flows out from under it.

THEATER

February 4, 1920

EUGENE O'NEILL'S TRAGEDY

BEYOND THE HORIZON, a tragedy in three acts and six scenes, by Eugene O'Neil.
At the Morosco Theatre.
WITH: Richard Bennett (Robert Mayo); Edward Arnold (Andrew Mayo); Helen MacKellar (Ruth Atkins); Max Mitzel (Captain Dick Scott); Mary Jeffery (Mrs. Kate Mayo); Erville Alderson (James Mayo); Louise Closser Hale (Mrs. Atkins); Elfin Finn (Mary); George Hadden (Ben); George Riddell (Mr. Fawcett).

By ALEXANDER WOOLLCOTT

The fare available for the New York theatregoer is immeasurably richer and more substantial because of a new play which was unfolded yesterday afternoon in the Morosco

Theatre—an absorbing, significant, and memorable tragedy, so full of meat that it makes most of the remaining fare seem like the merest meringue. It is called "Beyond the Horizon," and is the work of Eugene O'Neill, son of that same James O'Neill who toured the country for so many years in the heroics of "The Count of Monte Cristo."

The son's advent as a dramatist has been marked by several preliminaries in the form of one-act plays, done by the Washington Square Players and by the Provincetown folk at their little theatre in Macdougal Street, but "Beyond the Horizon" is the first of his long plays to reach the stage, and even this one comes not for a continuous engagement, but for a series of special matinees. It is presented at the Morosco by John D. Williams with a cast chosen from his own "For the Defense" company, eked out by borrowing

from the "Storm" cast at Mr. Broadhurst's theatre. This amalgam, while rather conspicuously imperfect in one rôle, is for the most part admirably suited to the work in hand, player after player rising gratefully and spontaneously to the opportunities afforded by a playwright of real power and imagination.

The only reason for not calling "Beyond the Horizon" a great play is the natural gingerliness with which a reviewer uses that word—particularly in the flush of the first hour after the fall of the final curtain. Certainly, despite a certain clumsiness and confusion involved in its too luxurious multiplicity of scenes, the play has greatness in it and marks O'Neill as one of our foremost playwrights, as one of the most spacious men to be both gifted and tempted to write for the theatre in America. It is a play of larger aspect and greater force than was "John Ferguson," a play as vital and as undiluted a product of our own soil as any that has come this way, since the unforgotten premiére of "The Great Divide." In its strength, its fidelity, its color, its irony, and its pitilessness, it recalls nothing quite so much as one of the Wessex tales of Thomas Hardy. As to whether it will be, or could be, popular—well, that lies not within the province of this reviewer (nor the wisdom of anybody) to say.

"Beyond the Horizon" rehearses the tragedy of a man whose body and mind need the open road and the far spaces, but who, by force of wanton circumstance and the bondage of a romance that soon burns itself out, is imprisoned within the hill-walled boundaries of a few unyielding acres, chained to a task for which he is not fitted, withheld from a task for which he was born. He fails, and his failure distils a poison for all about him. He sinks, amid wretched and disheartening poverty, into consumption, and the life in him wanes before your eyes, through scene after scene written with splendid art and a cunning knowledge of that plague, with its alternating psychology of hope and depression. At the end, he crawls out of the farmhouse to die in the open road, his last glance straining at the horizon beyond which he had never ventured, his last words pronouncing a message of warning from one who had not lived in harmony with what he was.

The accompanying and minor tragedy is that of the brother, a sturdy, generous, earth-bound fellow, born to till those very acres, and sure to go wrong if he ever left the clean earth and the work amid things of his own creation. So in the Hardyesque irony of the O'Neill mood, it is this brother whom Fate and his own character drive out into the lonely open. The measured tread of Fate can be heard among the overtones of this remarkable tragedy.

O'Neill is not only inexorable in the working out of his play to its saddening conclusion, but a bit intractable in the matter of its structure, a bit unyielding both to the habits of the average audience and the physical limitations of the average playhouse. The breaking of his final act into two scenes, mark of a chronic looseness of construction, is distinctly dissipative in its effect and his scenario calls for two pretentious exteriors which the very palpable draperies (painted in the curiously inappropriate style of a German post card) do not provide very persuasively.

If the play itself has a certain awkwardness and if its mere mounting is sometimes clumsy, the cast, at least is uncommonly fine. As the home-bound wanderer, Richard Bennett plays with fine eloquence, imagination, and finesse—a performance people will remember as they remember his John Shand in "What Every Woman Knows." Save for an occasional Farnumesque posture, trailed from the "Storm," Edward Arnold plays the brother with tremendous force and conviction. Then Helen McKellar proves herself a first-rate actress as the woman, while Louise Closser Hale darts (like a trout for a fly) at the best part that has come her way since Prossy bridled in "Candida." Then Erville Anderson, as the old father—well, there are riches in this performance as there are in this play which make the reviewer "yearn for the open spaces" of the Sunday newspaper.

* * *

March 8, 1920

BARRYMORE AS GLOSTER

THE TRAGEDY OF RICHARD III., by Shakespeare. At the Plymouth Theatre.
WITH: Arthur Row (King Henry VI); Rosalind Ivan (Queen Margaret); Burford Hampden (Edward, Prince of Wales); Marshall Vincent (Duke of York); Mrs. Thomas Wise (Duchess of York); Reginald Denny (Edward); E. J. Ballantine (George); John Barrymore (Richard III); Mary Hughes (Edward); Helen Chandler (Richard); Helen Chandler, Lois Bartlett (Children of Clarence); Walter Ringham (Earl of Warwick); Leslie Palmer (Duke of Buckingham); Robert Whitehouse (Duke of Norfolk/Earl of Westmoreland); George De Winter (Earl of Derby); Lewis Sealy (Lord Hastings); Montague Rutherford (Cardinal Bourchier/Sir Richard Ratcliff); Stanley Warmington (Lord Clifford/Sir William Catesby); William J. Keighley (Lord Rivers/Sir William Brakenbury); Denis Auburn (Lord Grey); John M. Troughton (Sir James Tyrell); Malcolm Barrett (Sir James Blount); Isadore Marcil (The Lord Mayor of London); Tracy Barrow (First Murderer); Cecil Clovelly (Second Murderer); Raymond Bloomer (Richmond); Evelyn Walsh Hall (Queen Elizabeth); Helen Robbins (Lady Anne).

By ALEXANDER WOOLLCOTT

On Saturday night at the Plymouth, before an alert, critical, honest, expectant audience, that stood at the end to cheer incontinently while the curtain rose and fell, John Barrymore appeared as Richard the Third. It was his first performance in a Shakespearean rôle and marked a measurable advance in the gradual process of bringing his technical fluency abreast with his winged imagination and his real genius for the theatre. Surely it was the highest point yet reached in that rapid, unexpected ascent which began four years ago with the production of Galsworthy's "Justice," and which has been unparalleled in the theatre of our time.

Fortified by backgrounds and trappings of great beauty, aided (if you care to use the word) by a company that is somewhat short of so-so, Mr. Barrymore held his first audi-

ence riveted until a few minutes before 1—an extraordinary feat in itself. There must needs be a deal of pruning, for, of course, the production will have to be lopped off here and there to make it fit the habit of our less leisurely audiences. The vexing questions of what to cut and what to spare will have to be determined, not by the intrinsic worth of the various materials, but by their effectiveness, when refracted through the wildly assorted media that chance to be assembled in Mr. Barrymore's support—if you care to use the word.

The text is one especially prepared and selected by an unnamed hand—a choice of sixteen abreviated scenes from the third part of "Henry the Sixth," and from "The Tragedy of Richard the Third." The adaptor followed the latter day fashion of nobly flouting the once favored concoction by Colley Cibber yet accepted readily enough the Cibber theory that something rather radical was needed to build a suitable piece about the bent figure of Shakespeare's Gloster. Not that he utterly spurned old Cibber's handiwork, for one of Cibber's lines was evidently too great a temptation and was accordingly retrieved from the scrapheap of a version that served, in its time, for more than a century of limping Richards.

Beginning, as the Plymouth version does, with the stirring, groping boyhood of Richard, when the lad, embittered by his wanton deformity, stands hesitant at the crossroads where part the paths to good and evil—this grouping of the material permits that visible growth and change to a poisonous, dank, sinrotted soul, spinning his plans from the throne of England, like some black and incredibly malignant spider. It is the progressive change which Mansfield so reveled in and which makes a living thing of Barrymore's Richard.

If Richard is worth playing at all, he is worth playing for all the greatness there is in him. After all, he has a titanic quality, a suggestion of a Lucifer defying creation, a Heaven-challenging giant standing outside and above the pygmy mortals with whose destinies he toys so lightly. He is more than inhuman: there must be a touch of the superhuman, and it is a Richard of such stature that Barrymore, in his new-found and still developing power, creates for us. Such a Richard can give a special accent and meaning to the diablerie and inner amusement of the midway scene, to the "Now is the Winter of our discontent" speech and to all its sardonic sequence, as far as the climax of that extraordinary wooing of the Lady Anne, even as far as the acceptance of the crown. When the dissolution comes, it takes the form of no ordinary man's repentance and misgivings, but rather it is the tottering of a mind that has overreached itself. Long before the tent scene, which is none too impressively managed at the Plymouth, before even the cursing of Richard by his mother, the king is streaked with madness—a mental disintegration that is revealed at first as by flashes of fitful and distant lightning.

All in all, a magnificent achievement. It ranks with Ada Rehan's Katherine and Forbes Robertson's Hamlet in this playgoer's Shakespearean experience. He would be tempted to call it great acting were it not for the obviously contradictory fact that John Barrymore is alive, very much alive and disgracefully young, and were it not also for the danger that twelve older and better playgoers would then rise and say in freezing tones: "Ho, ho, I guess you never saw So-and-So play Richard in Upper Tooting in 1869." But there, a fig for them. It is a great performance.

Of the investiture one may speak as heartily. Some of the scenes are of incomparable loveliness. All of them are rich and right—the work of an unerring artist of the theatre, Robert Edmund Jones. We are all always absurdly haunted by the fear that Mr. Jones is about to overstep himself, to import, for instance, a fantastic quality and an enervating prettiness into a Plantagenet play. But Mr. Jones's precision as an artist is as sure as his imagination is boundless. He is always right.

In the work of both Mr. Barrymore and Mr. Jones, it is difficult and quite unnecessary to say where they left off and where Arthur Hopkins began. Mr. Hopkins will probably have to shoulder alone the burden of responsibility for a rag-tag-and-bobtail company, of which half the players are intolerable and the other half are—well, tolerable. The most creditable work is done by E. J. Ballantine as Clarence, with further assistance that is passable by Mrs. Thomas Wise as the Duchess of York, Burford Hampden as the son of Henry, Mary Hughes as the princeling slaughtered in the Tower, Leslie Palmer as Buckingham, Stanley Warmington doubling as Clifford and Catesby, Evelyn Walsh Hall as Elizabeth, Cecil Closelly as the second murderer, and William J. Keighley as Brakenbury. The company is scarcely comparable with the one supporting Sothern and Marlowe. Perhaps we haven't enough players for two Shakespearean companies.

No account of the première of "Richard III" would be complete that did not speak of the electric atmosphere with which the house was charged—the sense of a great occasion. The combination of Arthur Hopkins, John Barrymore, and the Plymouth Theatre, with such precedents as "Redemption" and "The Jest" put into the mind of the playgoers, has recaptured for the New York stage a certain festive glamour that has been missing since Augustin Daly died. The feeling found expression when, just before the curtain rose on the third act, the other members of the famous clan, their work around town cleaned up, entered the royal box. There was thunderous applause, a great craning of necks, nudging of ribs and beaming of faces. Not far from the stage sat the blessed Tom Wise, there, no doubt, to applaud Mrs. Wise and to remember, possibly a time when he and the star of the evening appeared together in a piece called "Uncle Sam"—an obscenely worthless enterprise in which, as we recall, Mr. Barrymore sat in an arbor and embroidered. That was something less than nine years ago, and it may have run through Mr. Wise's head that a good deal had befallen his erstwhile partner in that time. Speaking of growth and change.

* * *

November 7, 1920

THE NEW O'NEILL PLAY

By ALEXANDER WOOLLCOTT

The Provincetown Players began their new season in Macdougal Street last week with the impetus of a new play by the as yet unbridled Eugene O'Neill, an extraordinarily striking and dramatic study of panic fear which is called "The Emperor Jones." It reinforces the impression that for strength and originality he has no rival among the American writers for the stage. Though this new play of his is so clumsily produced that its presentation consists largely of long, unventilated intermissions interspersed with fragmentary scenes, it weaves a most potent spell, thanks partly to the force and cunning of its author, thanks partly to the admirable playing of Charles S. Gilpin in a title rôle so predominant that the play is little more than a dramatic monologue. His is an uncommonly powerful and imaginative performance, in several respects unsurpassed this season in New York. Mr. Gilpin is a negro.

The Emperor Jones is a burly darky from the States who has broken jail there and escaped as a stowaway to what the program describes as "a West Indian island not yet self-determined by white marines." There, thanks a good deal to the American business philosophy he had picked up as a half-preoccupied porter listening wide-eyed in the smoking rooms of the Pullman cars back home, he is sufficiently bold, ingenious and unscrupulous to make himself ruler within two years. He has moved unharmed among his sullen subjects by virtue of a legend of his invention that only a silver bullet could harm him—this part of the play, at least, is *not* Mr. O'Neill's invention—but now, when he has squeezed from his domain just about all the wealth it will yield, he suspects it would be well for him to take flight. As the play begins, the measured sound of a beating tom-tom in the hills gives warning that the natives are in conclave there, using all manner of incantations to work up their courage to the point of rebellion.

The hour of Emperor Jones has come, and nightfall finds him already at the edge of the distant forest, through whose trackless waste he knows a way to safety and freedom. He has food hidden there and, anyway, his revolver carries five bullets for his enemies and one of silver for himself in case he is ever really cornered.

It is a bold, self-reliant adventurer who strikes out into the jungle at sunset. It is a confused, broken, naked, half-crazed creature who, at dawn, stumbles blindly back to his starting place, only to find the natives calmly waiting there to shoot him down with bullets they have been piously molding according to his own prescription.

The forest has broken him. Full of strange sounds and shadows, it conjures up visions of his own and his ancestral past. These haunt him, and at each crisis of fear he fires wildly into the darkness and goes crashing on through the underbrush, losing his way, wasting all his defense, signaling his path, and waking a thousand sinister echoes to work still more upon his terrible fear.

It begins with the rattle of invisible dice in the darkness, and then, as in a little clearing, he suddenly sees the squatting darky he had slain back home in a gamblers' quarrel. He plunges on, but only to find himself once more strangely caught in the old chain gang, while the guard cracks that same whip whose stinging lash had goaded him to another murder. Then, as his fear quickens, the forest fills with old-fashioned people who stare at him and bid for him. They seem to be standing him on some sort of block. They examine his teeth, test his strength, flex his biceps. The scene yields only to the galley of a slave ship, and his own cries of terror take up the rhythmic lamentation of his people. Finally, it is a race memory of old Congo fears which drives him shrieking back through the forest to the very clearing whence he had started and where now his death so complacently awaits him.

From first to last, through all the agonizing circle of his flight, he is followed by the dull beat, beat, beat of the tom-tom, ever nearer, ever faster, till it seems to be playing an ominous accompaniment to his mounting panic. The heightening effect of this device is much as you might imagine.

The Provincetown Players have squanderously invested in cushions for their celebrated seats and a concrete dome to catch and dissolve their lights, so that even on their little stage they can now get such illusions of distance and the wide outdoors as few of their uptown rivals can achieve. But of immeasurably greater importance in their present enterprise, they have acquired an actor, one who has it in him to invoke the pity and the terror and the indescribable foreboding which are part of the secret of "The Emperor Jones."

* * *

November 11, 1920

THE NEW SHAW PLAY

HEARTBREAK HOUSE, a comedy in three acts by George Bernard Shaw. At the Garrick Theatre.
WITH: Elizabeth Risdon (Ellie Dunn); Helen Westley (Nurse Guinness); Albert Perry (Captain Shotover); Lucille Watson (Lady Utterword); Effie Shannon (Heslone Hushabye); Erskine Sanford (Mazzini Dunn); Fred Eric (Hector Hushabye); Dudley Digges (Boss Mangan); Ralph Roeder (Randall Utterword); Henry Travers (The Burglar).

By ALEXANDER WOOLLCOTT

With the first production on any stage of the new Shaw play called "Heartbreak House," the Theatre Guild recorded last evening its most ambitious effort and, all things considered, its most creditable achievement. At the Garrick this brilliant comedy is superbly mounted and, with one fairly insignificant exception, wisely and richly cast. An admirable play has been added to the season's rather scanty list and overnight that list has quite doubled in cerebral values.

"Heartbreak House," despite the doldrums of tedium into which its second act flounders toward the end, is quite the larkiest and most amusing one that Shaw has written in many a year, and in its graver moments the more familiar mood of

Shavian exasperation gives way to accents akin to Cassandra's. Of course that second act seems the more wearing because of our habit and disposition to a lunch-counter tempo, even in the theatre, but inasmuch as the Theatre Guild is not permitted to tamper with the sacred text, it is too bad that its company should feel so oppressed by it.

A good many of last evening's blurred impressions can be traced to players so uneasily conscious of the play's unwonted length that they rattled nervously through their pieces. It will all go better when the conclusion is forced upon them that a mumbled scene may save time, but is the last device in the world to ward off boredom.

Heartbreak House is Shaw's Bunyanesque name for cultured, leisured England (or Europe, for that matter) before the war—as distinguished from that part of leisure England called Horseback Hall, wherein the stables are the real centre of the household, and wherein, if any visitor wants to play the piano, he must upset the whole room, there are so many things piled on it.

The play is his picture of the idly charming but viciously inert and detached people who dwell in Heartbreak House, using their hard-earned (by some one else) leisure to no purpose. They are loitering at the halfway station on the road to sophistication. They have been stripped of their illusions and pretense, but instead of using this freedom to some end they sit around naked and doing nothing, except, perhaps, catching moral colds.

The moral of the piece is spoken by Captain Shotover. It is always possible to find the clear, honest eyes of Bernard Shaw peering out from behind the thin disguise of one of his characters, and it is tempting in this comedy to identify him at times with this disconcerting and slightly mad old mariner whom the natives suspect of an ability to explode dynamite by looking at it. Captain Shotover is sick of a languid reliance on an overruling Providence. One of the casual ways of Providence with drunken skippers is to run them on the rocks. Not that anything happens, he hastily explains. Nothing but the smash of the drunken skipper's ship on the rocks, the splintering of her rotten timbers, the tearing of her rusty plates, the drowning of the crew like rats in a trap.

"And this ship that we are all in?" asks the heroic Hector. "This soul's prison we call England?"

"The Captain is in his bunk," retorts Captain Shotover, "drinking bottled ditch-water, and the crew is gambling in the forecastle. She will strike and sink and split. Do you think the laws of God will be suspended in favor of England because you were born in it?"

No wonder the agitated Hector asks what he should do about it.

"Learn your business as an Englishman," replies the Captain, tartly.

"And what may my business as an Englishman be, pray?"

"Navigation—Learn it and live, or leave it and be damned."

But just then the war visits Heartbreak House in the guise of an air raid that sounds from a distance like Beethoven. It enraptures some, alarms others, exhilarates everybody, kills a burglar and a business man who had hidden too near the Captain's store of dynamite, destroys the rectory and passes on, leaving Heartbreak House not greatly changed, and with no firmer foundations than it had had before.

First honors in the cast must go to Henry Travers as the very Shavian burglar who serves so admirably the indisposition of Heartbreak House toward community service; to Effie Shannon as Mrs. Hushabye; to Elizabeth Risdon as Ellie Dunn; to Dudley Digges (who also directed the production) as Boss Mangan, and to Erskine Sanford as the gentle Mazzini Dunn.

Albert Perry as Captain Shotover, one of the most delightful characters Shaw ever invented, and Fred Eric as Hector Hushabye seem to have the right quality and understanding, but last night they forfeited a good deal of what is in their scenes by missing their right rhythm with almost painful regularity. Here was a defect you felt would pass.

It seems probable, too, that Lucile Watson will be very useful around the premises as soon as she has been persuaded to speak distinctly enough for you to catch at least the drift of her remarks. After all, Shaw never yet wrote a scene that could be expounded in dumb-show. About Ralph Roeder in the rôle of Randall, however, it seems unlikely that anything can be done.

The air raid which jounces "Heartbreak House" out of its purely conversational vein is capitally managed at the Garrick and both the settings, by Lee Simonson, are rich and beautiful. Indeed, they are almost too handsome. Somehow, a lovely investiture of a Shaw play seems a little incongruous—like perfuming the board room in a bank. The austerity of his text seems to chafe against the Simonson opulence as Shaw himself might rebel disgustedly at any *etalage de luxe*.

* * *

December 22, 1920

THE NEW ZIEGFELDISM

SALLY, a musical comedy in three acts. Book by Guy Bolton, lyrics by Clifford Grey, music by Jerome Kern and Victor Herbert. At the New Amsterdam Theatre.
WITH: Alfred P. James ("Pops"); Mary Hay (Rosalind Rafferty); Jacques Rebiroff (Sascha); Walter Catlett (Otis Hooper); Dolores (Mrs. Ten Broek); Marilynn Miller (Sally); Leon Errol ("Connie"); Phil Ryley (Colonel Travers); Irving Fisher (Blair Farquar); Stanley Ridges (Jimmie Hooper); Alta King ("Babe"); Betty Williams (Fluff); Barbara Dean (Tot); Vivian Vernon (Kitty); Gladys Montgomery (Pickles); Mary McDonald (Bobby); Frank Kingdon (Richard Farquar); Wade Boothe (Billy Porter); Jack Barker (Harry Burton); Earl Barroy (Ivan).

By ALEXANDER WOOLLCOTT

By processes of their own, which are made up partly of secret service and partly of premonition, the connoisseurs of musical comedy seemed to know in advance that "Sally," the new Ziegfeld production, would be worth going a long way to see. At least five or six times as many of them as could be housed at the New Amsterdam made a valiant effort to get into that theatre last evening for the New York premiere, and

only those who were left outside were in any way disappointed. It is an amusing and tuneful diversion, this "Sally." It unleashes Leon Errol in his most comical mood, and the spirited and beguiling Marilynn Miller is like a jewel in its lovely setting. But above all it bears witness to the fact that the annual production of the "Follies" does not exhaust the energy and talent of a producer who knows a little more than any of his competitors the secret of bringing beauty to his stage.

It can be imagined that with his own namesake launched on its tour of the richer cities Mr. Ziegfeld, on turning his attention to this provision of an occasion for Miss Miller, he sent for the tireless Guy Bolton and that fount of melody, Jerome Kern, and bade them put together a pretty little piece after the pattern and in the modest manner of "Irene." Then, from sheer force of habit, he began to enroll comedians and dancers as for some pretentious revue, told Professor Urban to spare no pains and so gather about him such a splendor of curtains and settings and costumes as few theatres in the world dare dream of. The result is the gay frolic which was romped last evening on the New Amsterdam's stage.

Also, to judge from the result, he must have told his song writers and comedians that a little vulgarity would not be amiss, for "Sally" is one of these pieces wherein, amid all the profusion of beauty and incongruous daintiness, you keep coming on an occasional jest that belongs in a lower grade of burlesque show.

Mr. Errol is at his best. It was, if memory serves, the hero of "The Egoist" of whom the neighbors said: "He has a leg." So has Leon Errol. It is the right one and all last evening it kept refusing to support him in the manner to which he had been accustomed. Naturally it hampers him in his earnest effort to dance a Russian ballet all by himself. The pitchings and tossings of this zany, the antics of him are beyond description, but they are of no common order. They have style and charm and whimsicality.

So has Marilynn Miller, whose sprightly dancing and tonic freshness have enchanted us all before this, but who seemed to feel that her elevation to stardom called for a greater show of effort. Whereupon, for this occasion, she appears to have gone searching about and returned with a voice. She is singing now as never before.

Then there is the stately Dolores and the captivating Mary Hay (who is a treat to the eye in her Russian costume) and one Walter Catlett, very fresh from his London triumphs. He is like a curious blend of Ed Wynn and Eddie Cantor. To say that he reminds you of each and creates a nostalgia for both would be an unfair thrust and yet the truth lies somewhere within it.

But strangely enough, it is of none of these, not of Urban nor Jerome Kern, not of Leon Errol, not even of Marilynn Miller that you think first as you rush for the subway at ten minutes to midnight. You think of Mr. Ziegfeld. He is that kind of producer. There are not many of them in the world.

* * *

May 23, 1921

'SHUFFLE ALONG' PREMIERE

Negro Production Opens at Sixty-Third Street Music Hall

The principal asset of "Shuffle Along," which arrived at the Sixty-third Street Music Hall last night with the distinction of being written, composed and played entirely by negroes, is a swinging and infectious score by one Eubie Blake. Quite a bit of the melody popularly supposed to be inherent in the negro—even though this supposition be included in the American credo—is to be found in the melodies of "Shuffle Along," and for the remainder of their tunefulness they owe allegiance to the Broadway song hits of yesterday. For the score of "Shuffle Along" is frankly Remickniscent.

The new entertainment is the work of F. E. Miller and Aubrey Lyles as to libretto and Noble Sissle and Eubie Blake as to book. It has here and there a broad comedy scene that is effective, but little or none of it is conspicuously native and all of it is extremely crude—in writing, playing and direction. Unfortunately, also, the limited stage facilities at the renascent Sixty-third Street playhouse enhance the crudities of production until the general effect is about that of a fair-to-middling amateur entertainment.

There is a story dealing with a small town mayoralty election, and its ramifications admit of moderate opportunities. The authors have the leading rôles, but except in a burlesque boxing bout (participated in by the Messrs. Miller and Lyles), they revealed no marked comic talents. There is a good male quartet, and now and then some entertaining dancing.

Last night's première was an invitation performance—the public opening will take place tonight.

* * *

September 23, 1921

THE MUSIC BOX BEGINS TO PLAY

IRVING BERLIN'S MUSIC BOX REVUE, in two acts, by Frances Nordstrom, William Collier, Thomas J. Gray, George V. Hobart and others; music and lyrics by Irving Berlin. At the Music Box. Principals—William Collier, Sam Bernard, Florence Moore, Irving Berlin, Wilda Bennett, Joseph Santley, Ivy Sawyer, Paul Frawley, Richard W. Keene, Emma Haig, Hugh Cameron, Mlle. Marguerite, Frank Gill, Chester Hall, Rene Riano, Rose Rolando, Maurice Quinlivan.

By ALEXANDER WOOLLCOTT

The Music Box was opened last evening before a palpitant audience and proved to be a treasure chest out of which the conjurers pulled all manner of gay tunes and brilliant trappings and funny clowns and nimble dancers. Its bewildering contents confirmed the dark suspicion that Sam H. Harris and Irving Berlin have gone quite mad. Manager and composer, they have built them a playhouse in West Forty-fifth Street

that is a thing of beauty in itself, and then crowded its stage with such a sumptuous and bespangled revue as cannot possibly earn them anything more substantial than the heart-warming satisfaction of having produced it at all.

The Music Box began to play last night and a houseful of wide-eyed, open-mouthed onlookers gave every evidence wondering if it would ever begin to pay. By the time the final curtain fell on the edge of midnight, every one was cheering loudly, and the waggish William Collier was renaming the show "The Harris and Berlin Worries of 1922."

The new revue is ablaze with color—color wrought by Hassard Short into a kaleidoscope of chic and fantastic and bizarre designs with lovely curtains of black lace, with costumes of radiant pearls picked out against velvet blackness, with a hundred and one odd and conceitful costumes worked into gay designs.

Then it is packed with comedians—really funny people like Willie Collier and Florence Moore, who will grow funnier as they throw away the comedy that has been laboriously compiled for them and take (like ducks to water) to the pleasant task of rewriting Mr. Berlin's little revue to suit themselves. Among the comedians, there should be honorable mention for Joseph Santley who is amusing as well as nimble and who seems quite cheerful even when the whole show rests on his shoulders. And of course there's Sam Bernard, who falls down a good deal and works pretty hard.

And there's a tune. Of course Mr. Berlin has tossed off quite a lot of jungly stuff to weave in here and there as an accompaniment to the music. But he has written only one real song. It is called "Say It With Music" and by February you will have heard it so often that you will gladly shoot at sunrise any one who so much as hums it in your hearing.

> Say it with music, say it with music.
> Somehow I'd rather be kissed
> To a tune by Chopin or Lizst.

So runs the foolish refrain of the air which will pursue you relentlessly through the months to come.

Last night's audience was eloquently urged to be on hand at 8 o'clock sharp, so the overture began promptly at 8:25. Even so, it was almost 12 o'clock when the final curtain fell, which means that at least three-quarters of an hour will have to be deleted—according to the increasingly prevalent custom of preparing a revue for presentation just after instead of just before its premiere. That ugly and fearfully stupid ballet which begins the second act can be spared without a pang; also the several dances that were evidently intended to be comic. Also Miss Moore's long and humorless monologue which must have had a similar intention. But why go into details that are no doubt scrapped already?

They certainly cannot spare the two skits borrowed from the old Lambs' Gambols, nor the lovely pageant of the fans, nor Miss Moore's burlesque of the bedroom plays, nor the Three Brox Sisters, nor any of the ingenious ensembles which Hassard Short has devised, nor—but there's plenty of

good stuff for one revue at the Music Box. Why, there's enough for two! And there's this odd thing about the theatre itself: It is not only costly but beautiful.

<p style="text-align:center">* * *</p>

<p style="text-align:right">**November 3, 1921**</p>

THE NEW O'NEILL PLAY

ANNA CHRISTIE, a play in four acts by Eugene G. O'Neill. At the Vanderbilt Theatre.
WITH: James C. Mack (Johnny the Priest); G. O. Taylor (First Longshoreman); William Augustin (A Postman); George Marion (Chris. Christopherson); Eugenie Blair (Marthy Owen); Pauline Lord (Anna Christopherson); Frank Shannon (Mat Burke); Ole Anderson (Johnson); Messrs. Reilly, Hansen and Kennedy (Three Sailors).

By ALEXANDER WOOLLCOTT

The Vanderbilt Theatre, best known to those threading the maze of Broadway as the house where the jaunty "Irene" held forth for two long seasons, was given over last evening to entertainment of a startlingly different sort—a heavily freighted, seagoing play by the man who wrote "The Emperor Jones" and "Beyond the Horizon." This was the piece called "Anna Christie," fostered and produced by Arthur Hopkins in his continuing direction of the career of that most gifted and interesting actress Pauline Lord. She gives a telling performance in a rich and salty play that grips the attention with the rise of the first curtain and holds it fiercely to the end.

This is the play which in an earlier form was once called "Chris," and under that title was tentatively produced at Atlantic City a good two years ago. It might be misleading, however, to suggest that the play which came to town last evening was the result of nothing more than the ordinary retouching to which the new pieces tested on the Jersey shore are so often subjected before they are deemed safe for exhibition in New York. What we have at the Vanderbilt is the play Eugene O'Neill wrote after he had torn "Chris" to pieces and thrown most of them away.

More specifically what we have at the Vanderbilt is a play about a boastful, sentimental, rambunctious Irish stoker who tumbles headlong in love with the daughter of a Swedish bargee and then finds, from her own heroic confession, that she has come east from no pastoral girlhood but direct from a raided brothel in St. Paul. An old story, as you see, but it is the essence of O'Neill's new play and remains its chief source of interest, for all the literary scenic effects with which it is offset, for all the great bales of atmosphere and the salt of the seaspray with which it is set off.

Somewhere along the ambushed highway that leads from Atlantic City to New York, this play was known for a time as "The Old Davil," which is the big Swede's name for the sea he has always feared and cursed. It was to hide her from the sea and its sorrows that he had packed his motherless daughter off to Minnesota years before: it was the sea which, when

she came in time to know it, swept her mind clean and put the spirit in her that made her stand up and tell the agonizing truth to that roaring Irishman of hers. But in this play the part enacted by the sea seems a little forced, a thing of painted canvas, a factor less present and less potent than O'Neill may be guessed to have meant it to be.

"Anna Christie" might be described as a work which towers above most of the plays in town, but which falls short of the stature and the perfection reached by Eugene O'Neill in some of his earlier work. The earlier work had established him as the nearest thing to a genius America has yet produced in the way of a playwright, and, though this "Anna Christie" of his has less directness and more dross and more moments of weak violence than any of its forerunners, it is, nevertheless, a play written with that abundant imagination, that fresh and venturesome mind and that sure instinct for the theatre which set this young author apart—apart from a lot of funny little holiday workers in cardboard and tinsel.

Mr. Hopkins has done well by "Anna Christie." The choice of the difficult Pauline Lord for the central rôle was an inspiration and those genuine and multitudinous cheers which followed the third act last night were for her. The choice of Frank Shannon for the love-smitten stoker was also happy—a shot in the dark, probably. George Marion as old Chris is life-like enough, in all conscience, but a bit too tedious and diffuse in performance. Let there now be a final cheer for Eugenie Blair as a sodden old waterfront courtesan who slouches through the first act and out of the play to its great impoverishment. And let nothing that has been set down here be misread as a suggestion that "Anna Christie" is a play that the adult playgoer can afford to miss. By way of reassuring the timorous, it might even be explained that somehow O'Neill has managed a jovial ending. That, however, is part of the dross aforesaid.

* * *

January 10, 1922

ANDREYEV IN THIRTY-FIFTH STREET

HE WHO GETS SLAPPED, a play in four acts by Leonid Andreyev. At the Garrick Theatre.
WITH: Philip Leigh (Trilly); Edgar Stehli (Polly); Ernest Cossart (Briquet); Frank Reicher (Mancini); Helen Westley (Zinida); Martha Bryan Allen (Angelica); Helen Sheridan (Estelle); Edwin R. Wolfe (Francois/Conductor); Richard Bennett (He); Henry Travers (Jackson); Margalo Gilmore (Consuelo); John Rutherford (Alfred Bezano); Louis Calvert (Baron Regnard); John Blair (A Gentleman); Kathryn Wilson (Wardrobe Lady); Charles Cheltenham (Usher); Philip Loeb (Pierre); Renee Wilde (A Sword Dancer); Oliver Grymes (Ballet Master); Dante Voltaire (Thomas); Joan Clement (A Snake Charmer); Richard Coolidge (A Contortionist); Kenneth Lawton (A Riding Master); Francis G. Sadtler (A Juggler).

By ALEXANDER WOOLLCOTT

The Theatre Guild emerged, flushed and triumphant, last night from the most daring of all its encounters with plays—its gallant adventure in staging "He Who Gets Slapped," by Leonid Andreyev. They have taken this baffling, tantalizingly elliptical tragedy out of the Russian and brought it to life on their stage in Thirty-fifth Street, where you may find it now, alive in its every moment and abrim with color and beauty.

To the mind of the average, plainspoken American playgoer much of it lies just out of reach, like a line of verse half remembered, like a piece of half familiar music coming a little muffled through a wall. But it has things in it that belong to the theatre of all the world, and the Guild engaged imagination and a sense of beauty to work on its unfolding. To all those who greatly enjoyed "Liliom" it may be recommended—recommended with a feeling that they may not find it satisfying, but that they can scarcely afford to go without seeing it.

The scene of this play is the greenroom, or whatever they call it, of a French circus—a circus in such a city, say, as Lyons, or, better still, Marseilles. In the midway off the ring its tale is told—with its clowns and bareback riders and animal tamers as the puppets dancing to the tugs of a most brooding Fate.

Into this fantastic, bespangled world out of the other world which they know of only vaguely as "out there" comes, mysteriously, humbly, appealingly, a nameless gentleman who is known ever after to them and to you as He. Out there a false wife and a false friend have hurt him past all endurance and, a little mad, perhaps, he throws away a great name and seeks refuge in the circus, seeks and finds sanctuary behind the white face and grinning mask of the clown—the clown who gets slapped. How he finds there, too, the loveliness of little Consuelo, the equestrienne, and how, too, he finds, through her, that, after all, there is no real refuge on this earth—all this is set forth in the fitful and sometimes perverse antics of Andreyev's genius.

It is set forth for New York in what seems to an unequipped judge to be an inelastic but endurable translation. It has been most beautifully mounted by the Guild's gifted young scene designer from Harvard, Lee Simonson. His lively sense of the dramatic and the pictorial have been matched, for once, by a kindred spirit in the direction of the play, for Robert Milton has done an uncommonly good job in the articulation of this intractable play. He has had a wisely chosen cast to work with.

To list all those who help would be to give many names already familiar to those who ponder much over theatre programs—names such as those of Frank Reicher, Helen Westley, Louis Calvert and John Blair. There might be a special word for Edwin R. Wolfe and there must be one for one English actor who always plays a minor rôle in Thirty-fifth Street and always plays it flawlessly. That is Henry Travers. Which leaves the remaining space for some inadequate comment on the work of Richard Bennett and Margalo Gillmore.

Mr. Bennett plays the rôle of He—plays it with his customary artfulness and understanding and perhaps with a little more than that, a little more summoned to meet a great

opportunity. It is an admirable and a strengthening performance. But those of us who suspect that there is more mockery and more of heartache in this fey fellow than Mr. Bennett finds there would rather suspend judgment until we could see it played by some one else—by John Barrymore, for instance, or, better still, by Ben Ami. A year ago Arthur Hopkins announced that he was going to present Ben Ami in this play. It might have been written for him.

Of Miss Gillmore as Consuelo it is difficult to speak with a decent moderation. It is one of those perfect performances of which incorrigible young playwrights dream in their hall bedrooms, which is why they so often weep at rehearsals. On other nights, in other plays, we have all seen this young actress fumble and falter and blurr a scene entrusted to her. As Consuelo, no one could ask that a tone, a look, a gesture be altered. Or so it was last evening. It was an unbroken enchantment and it had the sparkle of morning sunlight on a fountain. It was a true occasion for the ink-stained wretches who can write verse.

* * *

February 22, 1922

'FOR GOODNESS SAKE' BRISK

Good Comedians Make New Musical Comedy Entertaining

FOR GOODNESS SAKE, a musical comedy in two acts. Book by Fred Jackson, music by William Daly and Paul Lannin, lyrics by Arthur Jackson. At the Lyric Theatre.
WITH: Fred Astaire (Teddy Lawrence); Adele Astaire (Suzanne Hayden); Marjorie Gateson (Vivian Reynolds); Harry R. Allen (Joseph); Charles Judels (Count Spinagio); John E. Hazzard (Perry Reynolds); Helen Ford (Marjorie Leeds); Vinton Freedley (Jefferson Dangerfield).

An agreeable if not brilliant musical comedy is "For Goodness Sake," fashioned by various hands accustomed to the trade and briskly produced last night in the Lyric Theatre. It derives most of its entertaining power from the talent of its personnel and particularly from the ingratiating brother and sister, Fred and Adele Astaire. In various productions in the past they have proven their skill at dancing; now they are beginning to develop into delightful comedians—particularly the feminine member of the team.

There was a hint of this in "The Love Letter," in which they flittingly appeared earlier in the season, and their most successful number from that production—or one so close to it that you can hardly tell them apart—is to be found again in "For Goodness Sake." It is a burlesque that is well worth repeating and it did all but halt the entertainment last evening.

Aside from the Astaires, "For Goodness Sake" boasts another good comedian in Charles Judels, making a great deal out of none too robust material; a cute young person named Helen Ford; Jack Hazzard, none too generously provided for, and the personable if oversure Marjorie Gateson.

Fred Jackson, who furnished the libretto, has provided one or two hilarious scenes, but the thread of the thing is so terribly thin that the opportunities for comedy are not many.

There are some singable melodies by William Daly and Paul Lannin; a good-looking production, and the customary comely girls.

* * *

March 10, 1922

EUGENE O'NEILL AT FULL TILT

THE HAIRY APE, a play in eight scenes, by Eugene G. O'Neill. At the Provincetown Theatre.
WITH: Louis Wolheim (Robert Smith); Henry O'Neill (Paddy); Harold West (Long); Mary Blair (Mildred Douglas); Eleanor Hutchison (Her Aunt); Jack Gude (Second Engineer); Harry Gottlieb (A Guard); Harold McGee (A Secretary).

By ALEXANDER WOOLLCOTT

The little theatre of the Provincetownsmen in Macdougal Street was packed to the doors with astonishment last evening as scene after scene unfolded in the new play by Eugene O'Neill. This was "The Hairy Ape," a bitter, brutal, wildly fantastic play of nightmare hue and nightmare distortion. It is a monstrously uneven piece, now flamingly eloquent, now choked and thwarted and inarticulate. Like most of his writing for the theatre, it is the worse here and there for the lack of a fierce, unintimidated blue pencil. But it has a little greatness in it, and it seems rather absurd to fret overmuch about the undisciplined imagination of a young playwright towering so conspicuously above the milling, mumbling crowd of playwrights who have no imagination at all.

"The Hairy Ape" has been superbly produced. There is a rumor abroad that Arthur Hopkins, with a proprietary interest in the piece, has been lurking around its rehearsals and the program confesses that Robert Edmond Jones went down to Macdougal Street and took a hand with Cleon Throckmorton in designing the eight pictures which the play calls for. That preposterous little theatre has one of the most cramped stages New York has ever known, and yet on it the artists have created the illusion of vast spaces and endless perspectives. They drive one to the conclusion that when a stage seems pinched and little, it is the mind of the producer that is pinched and little. This time O'Neill, unbridled, set them a merry pace in the eccentric gait of his imaginings. They kept up with him.

O'Neill begins his fable by posing before you the greatest visible contrast in social and physical circumstance. He leads you up the gangplank of a luxurious liner bound for Europe. He plunges you first into the stokers' pit, thrusting you down among the men as they stumble in from the furnaces, hot, sweaty, choked with coal dust, brutish. Squirm as you may, he holds you while you listen to the rumble of their discontent, and while you listen, also, to speech more squalid than even an American audience heard before in an American theatre. It is true talk, all of it, and only those who have been so softly bred that they have never really heard the vulgate spo-

ken in all its richness would venture to suggest that he has exaggerated it by so much as a syllable in order to agitate the refined. On the contrary.

Then, in a twinkling, he drags you (as the ghosts dragged Scrooge) up out of all this murk and thudding of engines and brawling of speech, to a cool, sweet, sunlit stretch of the hurricane deck, where, at lazy ease, lies the daughter of the President of the line's board of directors, a nonchalant dilettante who has found settlement work frightfully interesting and is simply crazy to go down among the stokers and see how the other half lives aboard ship.

Then follows the confrontation—the fool fop of a girl and the huge animal of a stoker who had taken a sort of dizzy romantic pride in himself and his work as something that was real in an unreal world, as something that actually counted, as something that was and had force. Her horrified recoil from him as from some loathsome, hairy ape is the first notice served on him by the world that he doesn't belong. The remaining five scenes are the successive blows by which this is driven in on him, each scene, as written, as acted and as intensified by the artists, taking on more and more of the nightmare quality with which O'Neill seemed possessed to endow his fable.

The scene on Fifth Avenue when the hairy ape comes face to face with a little parade of wooden-faced churchgoers who walk like automata and prattle of giving a "Hundred Per Cent. American Bazaar" as a contribution to the solution of discontent among the lower classes; the scene on Blackwell's Island with the endless rows of cells and the argot of the prisoners floating out of darkness; the care with which each scene ends in a retributive and terrifying closing in upon the bewildered fellow—all these preparations induce you at last to accept as natural and inevitable and right that the hairy ape should, by the final curtain, be found dead inside the cage of the gorilla in the Bronx Zoo.

Except for the rôle of the girl, which is pretty badly played by Mary Blair, the cast captured for "The Hairy Ape" is an exceptionally good one. Louis Wolheim, though now and then rather painfully off the beat in his co-operation with the others, gives a capital impersonation of the stoker, and lesser parts are well managed by Harry O'Neill as an Irish fireman dreaming of the old days of sailing vessels, and Harold West as a cockney agitator who is fearfully annoyed because of the hairy ape's concentrating his anger against this one little plutocrat instead of maintaining an abstract animosity against plutocrats in general.

In Macdougal Street now and doubtless headed for Broadway, we have a turbulent and tremendous play, so full of blemishes that the merest fledgling among the critics could point out a dozen, yet so vital and interesting and teeming with life that those playgoers who let it escape them will be missing one of the real events of the year.

*　*　*

October 31, 1922

THE SIX ORPHANS

SIX CHARACTERS IN SEARCH OF AN AUTHOR, a play in three acts from the Italian of Luigi Pirandello, translation by Edward Storer. At the Princess Theatre.
WITH: Moffat Johnston (The Father); Margaret Wycherly (The Mother); Florence Eldridge (The Stepdaughter); Dwight Frye (The Son); Ashley Buck (The Boy); Constance Lusby (The Little Girl); Ida Fitzhugh (Mme. Pace); Ernest Cossart (The Manager); Fred House (The Leading Man); Eleanor Woodruff (The Leading Lady); Elliott Cabot (The Juvenile); Kathaleen Graham (The Ingenue); Maud Sinclair (The Character Woman); Jack Amory (The Third Actor); William T. Hays (The Fourth Actor); Leona Keefer (The Third Actress); Blanche Gervais (The Fourth Actress); Catherine Atkinson (The Fifth Actress); Russell Morrison (The Stage Manager); John Saunders (The Property Man).

Philosophical fooling and shrewd criticism on the art of the theatre mingle in the Italian play which Brock Pemberton is presenting in translation at the Princess. Imagine a playwright whose creative mind is haunted by six characters, the persons of a harrowing family drama, all urging insistently that they be given full and subtly shaded representation in the theatre. That is the normal condition of authentic creation; but as art consists in rigid elimination as well as in delicate emphasis, many of the aspirations of the six for self-expression have to be denied. Imagine next that the subject of their suffering is not sympathetic to the public, and that the only true and significant outcome is undramatic—not moving and inspiring, but static. That very often happens when a dramatist takes his real inspiration from life as it is actually lived, and in the supreme court of the manager's office he is nonsuited. There is no play.

But there are characters more live and vital than most of those that see the footlights. Imagine, finally, that these characters, still longing to live out their lives on the scene, go out in search of a more obliging author—and find a stage manager who has a company but no new play, only the stock stuff of a world somewhat deficient in new inspiration. Recognizing raw materials of interest and power, the enterprising business man undertakes to supply the place of author. It seems to him a positive windfall to be relieved of that insistent and obnoxious incident of production. He will allow the six characters to live out their own lives while a secretary takes down the dialogue and his company stands by preparing to assume the parts. Magnificent!

Those who look upon ordinary rehearsals as a madhouse will receive illumination. Instead of a single author, long subdued in misery, the manager has his six orphans to contend with. The actors of his company, accustomed to have parts ruthlessly adapted to their personalities, are confronted each with a fury of unreason, demanding the absolute. For these characters, though the shadows of a dream, are "real" in the sense of being raw vitality unshaped to the necessities of art and the practical ends of the theatre. In the turmoil that ensues there is much satire on the foibles of player folk and

managers and no little philosophy of dramatic art and dramatic criticism.

Margaret Wycherly is Mother in the roving dramatis personae and lends to the character genuine imagination and emotional power. Moffat Johnston is the garrulous father, eagerly philosophic and disquisitional. Florence Eldridge is the stepdaughter, overflowing with eager youth and charm. Throughout, the production is able and highly competent. The audience last night, largely composed of folk of the theatre, rose to the novelty and humor of the idea and lingered long in applause after the brief three acts were over.

What the public will say to this rather slender and technical satire remains to be seen, but already it may be said that the season is indebted to Mr. Pemberton for one more exploration of strange fields and pastures new.

* * *

November 17, 1922

A NEW HAMLET

SHAKESPEARE'S HAMLET. At the Sam H. Harris Theatre. WITH: John Clark (Francisco); Lark Taylor (Bernardo/First Player); Frederick Lewis (Horatio); E. J. Ballantine (Marcellus); Reginald Pole (Ghost of Hamlet's Father/A Priest); John Barrymore (Hamlet); Tyrone Power (Claudius); Blanche Yurka (Gertrude); John S. O'Brien (Polonius); Rosalind Fuller (Ophelia); Paul Huber (Rosencranz); Lawrence Cecil (Guildenstern); Burnel Lundee (Player King); Norman Hearn (Second Player); Richard Skinner (Player Queen); Vadini Uraneff (Lucianus); Stephanie D'Este (A Gentlewoman); Frank Boyd (King's Messenger); Whitford Kane (First Grave Digger); Cecil Clovelly (Second Grave Digger); Edgar Stehli (Oaric); Lowden Adams (Fortinbras).

By JOHN CORBIN

The atmosphere of historic happening surrounded John Barrymore's appearance last night as the Prince of Denmark; it was unmistakable as it was indefinable. It sprang from the quality and intensity of the applause, from the hushed murmurs that swept the audience at the most unexpected moments, from the silent crowds that all evening long swarmed about the theatre entrance. It was nowhere—and everywhere. In all likelihood we have a new and a lasting Hamlet.

It was an achievement against obstacles. The setting provided by Robert Edmund Jones, though beautiful as his setting for Lionel Barrymore's "Macbeth," was trivial and grotesque, encroached upon the playing space and introduced incongruities of locale quite unnecessary. Scenically, there was really no atmosphere. Many fine dramatic values went by the board and the incomparably stirring and dramatic narrative limped. But the all important spark of genius was there.

Mr. Barrymore disclosed a new personality and a fitting one. The luminous, decadent profile of his recent Italian and Russian impersonations had vanished, and with it the exotic beauty that etched itself so unforgettably upon the memory, bringing a thrill of admiration that was half pain. This youth

was wan and haggard, but right manly and forthright—dark and true and tender as befits the North. The slender figure, with its clean limbs, broad shoulders and massive head "made statues all over the stage," as was once said of Edwin Booth.

Vocally, the performance was keyed low. Deep tones prevailed, tones of a brooding, half-conscious melancholy. The "reading" of the lines was flawless—an art that is said to have been lost. The manner, for the most part, was that of conversation, almost colloquial, but the beauty of rhythm was never lost, the varied, flexible, harmonies of Shakespeare's crowning period in metric mastery. Very rarely did speech quicken or the voice rise to the pitch of drama, but when this happened the effect was electric, thrilling.

It is the bad custom to look for "originality" in every successive Hamlet. In a brief and felicitous curtain speech Mr. Barrymore remarked that everyone knows just how the part should be acted and he expressed pleasure that, as it seemed, he agreed with them all. The originality of his conception is that of all great Hamlets. Abandoning fine-spun theories and tortured "interpretations" he played the part for its prima facie dramatic values—sympathetically and intelligently always, but always simply. When thus rendered, no doubt has ever arisen as to the character, which is as popularly intelligible in the theatre as it has proved mysterious on the critical dissecting table.

Here is a youth of the finest intelligence, the tenderest susceptibility, with a natural vein of gayety and shrewd native wit, who is caught in the tolls of moral horror and barbaric crime. Even as his will struggles impotently to master his external environment, perform the duty enjoined on him by supernatural authority, so his spirit struggles against the overbrooding cloud of melancholy.

If the performance had any major fault it was monotony, and the effect was abetted by the incubus of the scenic investiture. There was simply no room to play in. It may be noted as characteristic that the Ghost was not visible; the majesty of buried Denmark spoke off-stage while a vague light wavered fitfully in the centre of the backdrop. In one way or another the play within the play, the scene of the King at prayer and that of Ophelia's burial, all more or less failed to register dramatically.

The production came precious near to qualifying as a platform recitation. But even at that Mr. Barrymore might have vitalized more fully many moments. With repetition he will doubtless do so. The important point is that he revealed last night all the requisite potentialities of personality, of intelligence and of histrionic art.

The supporting company was adequate, but nothing more. The outstanding figures were the King of Tyrone Power and the Queen of Blanche Yurka. Neither Polonius nor the Grave Diggers registered the comedy values of their parts, a fact which contributed largely to the effect of monotony. But, strange to relate, the speaking of lines was uniformly good.

* * *

RUSSIAN HIGH COMEDY

THE CHERRY ORCHARD, a comedy in four acts by Anton Tchekov, translated from the Russian by Jenny Covan. At Jolson's 59th Street Theatre.
WITH: Olga Knipper-Tchekhova (Liuboff Andreievna Ranevskaya); Alla Tarasova (Anya); Vera Pashennaya (Varya); Constantin Stanislavsky (Leonid Andreievitch Gaieff); Leonid M. Leonidoff (Yermolai Alexelevitch Lopakhin); Nikolai Podgorny (Peter Sergelevitch Trofimoff); Vladimir Gribunin (Boris Borisovitch Semyonoff-Pishtchik); Maria Uspenskaya (Charlotta Ivanavna); Ivan Moskvin (Semyon Pantelevitch Yepikhodoff); Varvara Bulgakova (Dunyasha); Vassily Luzhsky (Firco); Nikolai Alexandroff (Yasha); Alexei Bondirieff (A Tramp); Ivan Lazarieff (A Station Master); Lyoff Bulgakoff (Post Office Clerk).

By JOHN CORBIN

The Moscow players proceeded last night from the lower depths of Gorky to the high comedy of Tchekhoff, revealing new artistic resources. Stanislavsky, Olga Knipper-Techekhova, Moskvin, Leonidoff and half a dozen others entered with consumate ease into a rich variety of new characterizations. The stage management was less signal in its effects, but no less perfect. Yet for some reason "The Cherry Orchard" failed to stir the audience, even the Russian portion of it, as did "The Lower Depths" and even "Tsar Fyodor."

This is a play of comedy values both high and light. The milieu is that of the ancient landed aristocracy, beautifully symbolized by an orchard of cherry trees in full bloom which surrounds the crumbling manor house. Quite obviously, these amiable folk have fallen away from the pristine vigor of their race.

The middle-aged brother and sister who live together are unconscious, irreclaimable spendthrifts, both of their shrinking purses and of their waning lives. With a little effort, one is made to feel, even with a modicum of mental concentration, calamity could be averted. But that is utterly beyond their vacuous and futile amiability; so their estate is sold over their heads and the leagues of gay cherry trees are felled to make way for suburban villas.

Beneath the graceful, easy-going surface of the play one feels rather than perceives a criticism on the Russia of two decades ago. Here is a woman of truly Slavic instability, passing with a single gesture from heartbreak to the gayety of a moment, from acutely maternal grief for an only child long dead to weak doting on a Parisian lover who is faithless to her and yet has power to hold her and batten on her bounty. Here is a man whose sentiment for the home of his ancestors breaks forth in fluent declaiming, quasi-poetic and quasi-philosophic, yet who cannot lift a finger to avert financial disaster.

In the entire cast only one person has normal human sense. Lopakhin is the son of a serf who has prospered in freedom. He is loyal enough to the old masters, dogging their footsteps with good advice. But in the end it is he who buys the estate and fells the cherry trees for the villas of an industrial population. It is as if Tchekhoff saw in the new middle class the hope of a disenchanted yet sounder and more progressive Russia. The war has halted that movement, but indications are not lacking that it is already resuming.

With such a theme developed by the subtly masterful art of Tchekhoff there is scope for comedy acting of the highest quality. It is more than likely that the company seized every opportunity and improved upon it. But to any one who does not understand Russian, judgment in such a matter is quite impossible. Where effects are to be achieved only by the subtlest intonation, the most delicate phrasing, it fares ill with those whose entire vocabulary is da, da.

As an example of the art of the most distinguished company that has visited our shores in modern memory, this production of "The Cherry Orchard" is abundantly worth seeing. The play in itself is of interest as the masterpiece of the man who, with Gorky, has touched the pinnacle of modern Russian comedy. But if some Moscovite should rise up and tell us that in any season our own stage produces casts as perfect and ensembles as finely studied in detail, it would be quite possible to believe him.

* * *

'ADDING MACHINE' REPLACES POOR ZERO

Elmer L. Rice's Play a Simple Annal of the Glorious Sensing of Life

A BOOKKEEPER'S TRAGEDY

Scenes of Novelty and Power in the Theatre Guild's Production at Garrick Theatre

THE ADDING MACHINE, a play in seven scenes, by Elmer L. Rice. At the Garrick Theatre.
WITH: Dudley Diggs (Mr. Zero); Helen Westley (Mrs. Zero); Margaret Wycherly (Daisy Diana Dorothea Devore); Irving Dillon (The Boss); Harry McKenna (Mr. One); Marcia Harris (Mrs. One); Paul Hayes (Mr. Two); Therese Stewart (Mrs. Two); Gerald Lundegard (Mr. Three/Young Man); Georgiana Wilson (Mrs. Three); George Stehlt (Mr. Four); Edyth Burnett (Mrs. Four); William M. Griffith (Mr. Five/Joe); Ruby Craven (Mrs. Five); Daniel Hamilton (Mr. Six/A Head); Louise Sydmeth (Mrs. Six); Irving Dillon, Lewis Barrington (Policemen); Elsie Bartlett (Judy O'Grady); Edward G. Robinson (Shrdlu); Louis Calvert (Lieutenant Charles).

New York last night was treated to the best and fairest example of the newer expressionism in the theatre that it has yet experienced. The verdict, of course, depends upon the personal reaction on the sensibilities of the observer.

He will see and hear, this observer, in "The Adding Machine," a Theatre Guild production at the Garrick—what starts out to be the short and simple annal of one of the great and glorious unsung of life, not too far above the submerged tenth, of a person, at times symbolical and at other times intensely personal, known simply as Mr. Zero.

For twenty-five years, day in and day out, excepting only national holidays and a week in the Summer, this Zero has added figures. Figures to right of him, figures to left of him, volleyed and thundered from 9 to 5, six days a week, half Saturdays in July and August.

He married, this Zero, what must have been a sweet, moist-eyed, trusting bit of a girl, with infinite faith and pride in his tale of what lay just beyond this necessary beginning as a bookkeeper. But the days became weeks, the weeks became years, and the years decades—and still Zero is no further than his task of adding figures, and the little slip of a bride has become an ill-tempered, nagging, slovenly woman, bitter in her disillusionments and sharp with her tongue at him who is the cause of them.

Comes then, in the language of a great art, the twenty-fifth anniversary of Zero's career with the firm, of Zero still adding figures as he did a quarter of a century before. And at the close of the day's work his employer appears, notifies him that adding machines are to be installed, machines so simple that they can be operated by high school girls, and informs him gently but firmly that his services are no longer required.

For one mad moment all the figures he has ever added whirl madly in the Zero brain—and when he is again aware of the world he has stabbed his employer through the heart with a bill-file.

At his trial he becomes partly articulate—he tries to convey something of what the years of drudgery, endless, aimless drudgery, have done to him. He is sentenced to death and executed.

So far the larger part of his audiences will go hand in hand with Mr. Rice, Mr. Moeller and Mr. Simonson, author, director and designer of last night's offering, and pronounce their work excellent. Mr. Rice, they will say, has written true dialogue, and Mr. Moeller has labored well to bring out the monotony and dullness and stupidity that are the life of the Zero's of the world, and Mr. Simonson, be his methods ever so unorthodox, has created what not even the most orthodox of all can fail to understand.

The part of the fable just outlined runs through two of the play's three acts and four of its seven scenes. One of these early scenes, in particular, displayed a novelty and power that will long keep it in the memory of the beholder. It is simple enough—Zero and a female Zero are reading and checking figures to each other, in a dreary and monotonous sing-song, and as they work they think aloud and show their inmost, sacred selves, but theatrical as the device sounds in cold print, it was weirdly effective and gripping on the stage.

At the beginning of the play's third act and fifth scene at least some part of the audiences will not feel able to carry through. For one thing, this fifth scene, whatever its author's intent may have been, is coldly and gratuitously vulgar.

Some day a doctor's thesis will probably be written on that inward motive that drives the young expressionists to scenes in graveyards. (The father of them all, of course, had such a scene in "Fruehling's Erwachen.") Despite the lack, at present, of an explanation, the fact of the inevitability of such scenes will have to be accepted. Mr. Rice's graveyard last night served as the locale for a scene almost literally from Mr. Schnitzler's "Reigen"—with, it seemed, no reason for the enactment of the scene save that the author willed it so. Certainly there was nothing in the behavior or thoughts of any of the characters that brought it on.

Past the inevitable expressionistic graveyard, the action moves to a pleasant spot in the Elysian Fields. Here Zero is given ample opportunity to catch up with some of the repressions and suppressed desires of his former life, but he turns his back on them at the last moment for fear of being considered not thoroughly respectable. What this scene, and the next and last, are meant to convey is vague, perhaps purposely. Certainly they were not offered as things of beauty by themselves.

At this writing, with the final curtain not yet decently cold upon an expressionist heaven dominated by a gigantic adding machine, the last act remains curious, vague blur, not, however, without excellent moments of satirical observation. It is, nevertheless, by far the weakest part of the play.

Expressionism, of course, is the modern definition for the method of production that covers all conceivable dramatic sins, and no one has a right to say to his brother what is and is not expressionism. To Messrs. Rice, Moeller and Simonson, obviously, it is the form of dramatic expression best conveying the illusion of reality in the presence of the obviously unreal.

The acting was excellent throughout. Helen Westley, without whom a Theatre Guild production is inconceivable, portrayed grandly the monster of a wife created by Zero and later destined to help push him to his earthly destruction. Dudley Digges as Zero lived the dumb, groping, plodding nature of the fellow. Margaret Wycherly played a female Zero with great restraint. Louis Calvert did nicely with an unobtrusive bit in the last scene.

Mr. Simonson's scenery is even more expressionistic than Mr. Rice's third act. In a courtroom scene, while Zero is tried, there is some excellent work by him. He shows us the Zero conception of justice, cold, inanimate, relentless, and the contrast between reality and unreality is heightened by the crooked bars and railings and walls. Mr. Simonson's, too, one suspects, is the effect of the whirling figures and the dashes of red that appear to Zero as his employer hands him his discharge for his faithful quarter century of labor.

Mr. Rice, it should be noted, is the author of "On Trial," an equally revolutionary play, so far as technique is concerned, of a few seasons ago.

* * *

October 30, 1923

"LA DONNA DEL MARE"

LA DONNA DEL MARE, a play by Henrik Ibsen in four acts. At the Metropolitan Opera House.
WITH: Eleonora Duse (Ellida Wangel); Memo Benassi (A Stranger); Alfredo Robert (Dr. Wangel); Enif Robert (Bolette); Ione Morino (Hilde); Gino Fantoni (Lyngstrand); Ciro Galvani (Arnholm); Leo Orlandini (Balleested).

Perhaps because one had been forewarned by reports from London, the art of Eleonora Duse seemed strangely little affected by the lapse of two decades since her last appearance here. The statement is no mere echo of the loyal welcome extended by an audience that filled the vast Metropolitan Opera House—bursting the walls, the roof and the fire laws—and lingered full twenty minutes after "La Donna del Mare" was ended, clamoring to see her again and once again. Most of these enthusiasts heard very little and saw less. The press seats were fortunately well forward, within normal range of the stage.

It is true that Signora Duse's hair has the flashing gray of broken iron at the temples, and is quite white above the forehead. It is true that there are wide, faint circles beneath her eyes and that her marvelous hands, so eloquent in gesture, have more than their pristine slenderness. But the total impression is not so much of age as of the agelessness of an immortal spirit. Her cheeks have no more than their former spare softness, and her slow smile breaks out as of old in spiritual tenderness and sweetness. If she had not in her youth renounced the normal instruments of her art, the humble devices of make-up, the impression would have been that of an artistic vigor and of a beauty of face and form quite unexampled in one of her years.

And then there was the voice. If it has lost quality and power, few could have felt the fact because of the unique and penetrating joy it brought. It is the voice of a silver twilight, peopling an atmosphere Corot might have imagined with multitudinous accents of the human spirit. It is crepuscular in its plaintive repinings, as for a day that is dead—as also in its accents of a soul that struggles forward toward a glory of light beyond the far horizon. Many were present last night who welcomed Duse thirty years ago, when she ran the whole gamut from stark tragedy to comedy airily light. In that generation no voice has been heard even faintly resembling hers—nor is such a voice ever likely to be heard again.

The choice of Ibsen's "Lady From the Sea" for Duse's opening bill must be justified on other grounds than those of dramatic literature. Written in 1888, between "Rosmersholm" and "Hedda Gabler," it lacks the sombre atmospheric splendors of the one and the trenchantly dramatic characterization of the other. Anti-Ibsenites of yore denounced it as a mere study in incipient mental derangement. William Archer himself used it as an example of a theme and scenario hopelessly undramatic. Today interest in morbid psychology is more acute. It is possible that the younger generation will welcome

the play as a remarkably convincing study of the sea-freedom complex. But even they can scarcely find it dramatically luminous.

As a medium for the art of Duse, nevertheless, "The Lady from the Sea" is amazingly, as it is unexpectedly, appropriate. Whatever of movement and development it contains transpires wholly in the realm of the spirit. Imprisoned within the narrow compass of Wangel's household, Ellida lives hectically, brain-sickly, remembering her stormy girlhood romance of the ocean. Every garment has a deep sea note—rich greens and blues of the bounding main, the foam white and the dead grey of the tempest.

When The Stranger returns to claim her she denies him, shrinks from him, lives in a gruesome awe of him. The way in which this Ellida hovers behind Wangel, fluttering those fragile hands about his broad shoulders as if to snatch from him a sturdier resistance, yet peering beyond toward the peril that fascinates, is finely psychologic, superlatively eloquent. When the final test comes and Wangel tells her that she is free to follow her impulse or not as she chooses, all the effulgent silver of Duse's voice quivers with the joy of release and of the return to healthfulness. The "lady from the sea" is on the glad earth again.

The production, which Ibsen intended to be uncommonly picturesque, is bare to the point of crudeness. The supporting company is rather heavily Italianate and middle aged. Only the part of The Stranger stands out, Memo Benassi investing it with a thoroughly adequate spirit of youthful vigor and romance.

* * *

January 10, 1924

COMEDIENNES STAR IN CHARLOT'S REVUE

ANDRE CHARLOT'S REVUE OF 1924, a revue in two acts and twenty-two scenes. At the Times Square Theatre.
PRINCIPALS—Beatrice Lillie, Gertrude Lawrence, Jack Buchanan, Fred Leslie, Marjorie Brooks, Robert Hobbs, Herbert Mundin, Dorothy Dolman, Ronald Ward, Douglas Furber, Jill Williams and Peggy Willoughby.

With three of the most popular London revue comedians as its stars, an English troupe came bravely to Forty-Second Street last night and presented Andre Charlot's "Revue of 1924" at the Times Square. Mr. Charlot, so far as America has been permitted to learn, is the foremost of the English revue producers—London's Mr. Ziegfeld, in other words. The entertainment that he brought to New York last night is frequently brilliant in idea, less rich than American revue, and yet sufficiently attractive to the eye, and particularly fortunate in having Beatrice Lillie and Gertrude Lawrence in its cast.

For Miss Lillie and Miss Lawrence are the mainstays of this English revue—comediennes in two distinct and separate fields, and each excellent. Something of their fame had

already been brought to this shore by returning travelers, but no amount of advance description can take the edge off the enjoyment that is to be had from seeing and hearing Miss Lillie sing "March With Me," for example, or Miss Lawrence in the rendition of "I Don't Know."

There is no one in New York quite comparable to Beatrice Lillie. In appearance she is an exaggerated Lynn Fontanne, and it is in burlesque that she shines. The opening of the second act found her as a fifty-year-old soubrette, still bent upon singing the giddy ballades of her youth. And in "March With Me," a bit of patriotism near the finish, she rose to superb heights.

As for Miss Lawrence, she is invaluable in Mr. Charlot's comedy skits, and she can do wonders with a fair-to-middling song. The third of the leading players, Jack Buchanan, is a lengthy gentleman with an amiable stage presence and first-rate dancing ability, but hardly remarkable otherwise.

Mr. Charlot has probably had the advantage of being able to select his numbers from the numerous revues that he has produced in London, and thus the piece assays high. It is a far more literate entertainment than any American revue—perhaps (terrible thought) it is a bit too literate for the general public.

A skit entitled "Inaudibility" turned out to be much funnier than any description of it would indicate, and there are three or four others equally entertaining. There are also, of course, a few dull ones. But, at least, it is English almost through and through—now and then some one woos a laugh by mentioning "Town Topics" or something else of the sort, but there is precious little concession to Times Square.

The music is swinging and the production moves rapidly, with nary an encore. The chorus, like the principals, is all English, and a little below the Ziegfeld-Music Box standard in appearance.

* * *

January 16, 1924

'THE MIRACLE,' FINE SPECTACLE, SHOWN

Reinhardt's Religious Pantomime Acted in Cathedral Setting at the Century

BEAUTIFUL AS A PAGEANT

700 in Processions of Nuns and Throngs of Worshipers That Vibrate With Life and Color

By JOHN CORBIN

THE MIRACLE, a spectacular pantomime with music, in nine scenes, created and staged by Max Reinhardt. Book by Karl Vollmoeller; score by Engelbert Humperdinck; revised by Friedrich Schirmer. Scenery and costumes designed by Norman-Bel Geddes; produced by Morris Gest. At the Century Theatre.
WITH: Lady Diana Manners (Madonna); Charles Peyton (Sexton); David Hennessey (Assistant Sexton); Elsie Lorenz (Old Sacristan); Mrs. John Major (Old nun attendant); Claudia Carlstadt Wheeler (Mother of the nun); Laura Alberta (Grandmother of the nun); Rosamond Pinchot (The Nun); Mariska Aldrich (The Abbess); Louis Sturez (A Peasant); Lionel Braham (The Burgomaster/The Robber Count/Executioner); Orville Caldwell (The Knight); Rudolph Schildkraut (A Blind Peasant); Schuyler Ladd (His Son); Werner Krauss (A Crippled Piper); Luis Rainer (The Archbishop); Luis Rainer (The Shadow of Death); Schuyler Ladd (The Prince); Rudolph Schildkraut (The Emperor).

Max Reinhardt's long delayed and much anticipated production of his famous religious pantomime was achieved last night, and with all good auguries. The cathedral into which the Century Theatre has been transformed by Norman-Bel Geddes is indescribably rich in color, unimaginably atmospheric in its lofty aerial spaces. The company of principals which Morris Gest has provided is of artists tried and true—in which category is now included Miss Rosamond Pinchot. But the feature of the performance which most impressed last night's audience was that which has been least heralded. It was the noble band of seven hundred supernumeraries.

The truth seems to be that pantomime, even at its best, affords no great scope to histrionic ability of the first order. There were times when the dumb show seemed, in Hamlet's phrase, inexplicable. Even the program synopsis afforded no convincing explanation of the motives and meaning of The Piper, who figured as the active agent in the plot. Werner Krauss is an actor of prime reputation in Central Europe and he brought to bear a pantomimic talent of salient force and subtle intention. But the peculiar combination of beneficent purpose and maleficent effect which he is supposed to symbolize remained enigmatical. Rudolf Schildkraut, Lionel Braham, Schuyler Ladd and others performed simpler tasks more comprehensibly, but none of them won new laurels. Only the Madonna of Lady Diana Manners and Miss Pinchot's Nun made an impression that was indubitable and strong.

Crowd Scored at Every Turn

The crowd scored at every turn—which is right enough in cathedral pantomime. The uniformed processions of nuns and the motley throngs of worshippers vibrated with life and color. Into an atmosphere of stately reverence and hushed religious awe they brought the surging vitality of mediaeval piety, the passion of religious conviction. They burst in at all the entrances of the auditorium, surged down the widened aisles and stormed the chancel on the stage.

The effect here was powerfully and beautifully augmented by Humperdinck's music, by voices from aloft in the cathedral clerestory, and by the far-away chiming of remarkably sweet-toned bells. Incense from swung censers lent perfume, while the smoke intensified the impression of atmospheric richness and depth. But in it all and through it all was the masterly magic of Reinhardt's manipulation of crowds.

It differed from that of Stanislavsky and his Moscow players in that it lacked the wider range of expression made possible by the elucidation of the spoken word; but by the use of dramatic attitude and significant gesture, the tossing of arms and the shuffle of multitudinous feet, universally varied murmurs and sudden concerted shouts, it produced an effect that was at times overwhelming, stupendous.

The Nun's Wanderings

A similar masterhood was evident in the scenes of the Nun's wanderings in the outer world. Whether it was in fact the outer world, or only a cloistered dream of the libido, rioting ashamed in revels of the flesh, was not quite clear. The cathedral piers on the stage remained, as also the auditorium clerestory. But one followed the Nun through a dance of elves in a wood, interrupted by an incursion of huntsmen; through a Prince's nuptial feast and mock bridal procession; through revels in an imperial palace and the phantasm of an insane Emperor; through a proletarian revolution and the bloody orgies of a reign of terror. Everywhere the scene was multitudinously animated, vitalized, by the sweep of Reinhardt's imagination and his marvelous sense of detail.

As for Miss Pinchot, the outstanding impression of her performance was the half animal grace and the physical vitality which first attracted Reinhardt's attention. That is the primary and indispensable qualification for this marathon of parts. But the overtones were adequately varied, clear and strong. So far as pantomime goes, there was every evidence of a sound histrionic instinct, readily amenable to training. Her single vocal essay, a passionate utterance of the Lord's Prayer wrenched out of her in the depths of her misery, was both richly emotional and intelligently phrased.

Both the part and the performance of the Madonna were in striking contrast. For minutes together Lady Diana Manners stood in her stiff garments of brocade quite motionless against the cathedral pier, an embodiment of quiet, womanly grace. In the Madonna's living moments she walked with unconscious dignity and queenly repose among the assembled nuns. Yet the effect was vibrant, as if this creature of divine womanhood were indeed moving in an aura of the spirit.

The audience followed the performance with every evidence of intelligent interest and rapt attention. Probably because of the religious nature of scene and story, there was no great outburst of applause. Enthusiasm took the form of a series of calls at the close for those chiefly responsible for the production. Mr. Gest made a brief speech, referring to the public-spirited citizen or citizens who have encouraged him in this gigantic and thoroughly worthy artistic venture.

SCENIC MIRACLE WROUGHT
Solid Gothic Cathedral Built Inside Big Century Theatre

To provide setting for "The Miracle" a preliminary miracle was wrought in the Century Theatre. Inside the red and gold auditorium of the big playhouse on Central Park West has been set up the solid similitude of a Gothic Cathedral, its soaring columns and groined arches filling the stage and masking the interior of the house as far back as the balcony. The proscenium arch became the choir with the high altar set in the midst and surrounded by twenty 50-foot ton-weight columns in two semi-circular ranks, with their arches rising twenty feet higher and the dim religious light of eleven 40-foot-high stained glass windows splashing upon the scene their pools of deep blue and ruby red shot with green and yellow from the bright garments of the painted saints.

Between the columns are high grilled gates and beyond and around them all about the stage nine groups of lesser 50-foot columns with more stained glass windows forming the chapels of the ambulatory. Where the gilt pillars used to frame the stage on one side was built a solid tower rising to the roof and on the other a pulpit. Where, right and left, the ornate familiar boxes used to be, stand Gothic doors and a great rose window of stained glass. Cloisters sweep backward on either side, framing the house, and more stained glass windows look down from the balconies. Where the gilt dome used to be is a Gothic roof with swinging lanterns of stained glass.

Lined With a Cathedral

Thus the theatre has been literally lined with a cathedral, not a mere contrivance of canvas and paint, but a solid structure of wood and iron and concrete and seeming stone. Where the stage floor was is the pavement of the chancel, reaching far forward into the auditorium, with broad steps where the first rows of orchestra seats used to be. The balcony rail is massed with banners and the sometime carpeted aisles wear the aspect of cold flagstones.

To work this transformation took the labor of 300 people for five months. Three and one-half months were spent building it piece-meal in three studios in various parts of the city. Six weeks have been required to set it up and all that time the theatre has been closed and full of scaffolds and the hammering of carpenters and builders. To build merely the high altar, thirty feet in height, cost the labor of twenty carpenters for a month and something like a million feet of lumber was consumed in the columns and doors and panels and arches. The mullions of the choir windows and the two great rose windows are made of laminated wood that used to give

lightness to the wings and fuselages of war-time airplanes. The painted windows required 10,000 square feet of canvas and the cyclorama which closes the stage at the back and sides uses up 14,000 feet of black felt.

For the transformations which must take place in the dark and must suddenly give to the cathedral the similitude of a forest there are provided two 75-foot shafts, driven by electric motors of fifty horse-power. These motors are harnessed with 26,000 feet of steel cable to the movable scenery, which weighs 24,000 pounds. They send this weight aloft at the rate of a foot a second.

Seven hundred people all told are employed in the production, including fifty stage hands and forty electricians. In order to drill this multitude in the thousand separate tasks which go to make up the massed effect, Max Reinhardt worked with twenty-two assistant stage managers rehearsing the company for seven weeks. For two weeks he has been rehearsing them in the theatre, directing his battalions from a scaffold like a ship's bridge, set in the midst of the auditorium.

Director Controls All Elements

Beside him stood aids with megaphones. Posted about the house, on the stage, at all the entrances, in the galleries, underneath the stage, were other aids, each in charge of his separate cohort. From his high post the director controlled and co-ordinated all the elements which entered into the composition of his spectacle. The movable scenery, the light from a hundred points in the house, the organ in one gallery, the choir in the cloisters, the orchestra in another gallery, the bells, the great drums, the wind and thunder machines beneath the stage, the multitude of actors making entrances and exits all over the house, the principals on the stage—all had to be reached. His orders were passed by megaphone or telephone or signal to his subordinates, and thus gradually all this seeming chaos of men, women, material and machines were wrought into shape.

Nothing like it has ever been done in a New York theatre and probably nothing quite like it anywhere else in the world, though Reinhardt himself has produced "The Miracle" before. It has been done in Berlin and London in great arenas like Madison Square Garden. This time, a cathedral has literally been built for it and that cathedral, though it is inside a theatre, towers a hundred and ten feet from floor to roof-tree, a structure of seeming stone and solid wood and stained glass.

No exact figures of the cost can be given. Even Morris Gest, who has been the master builder, is unable to tell. His estimate runs around $600,000. Under Mr. Gest the organizer of "The Miracle" at the Century has been Max Rein-

hardt of Berlin and Salzburg. The architect of the cathedral is Norman-Bel Geddes, one of the youngest American stage designers.

* * *

January 20, 1924

NEW PLAY IN THE PROVINCES

George Kelly, author of "The Torchbearers," seems to have turned out a promising play in "The Show-Off," produced last Monday night in Atlantic City. A correspondent for the Philadelphia Evening Ledger describes it as follows:

"This play is a straightforward and diligently honest domestic comedy which is often closer to tears than it is to laughs.

"Its chief character, the self-opinionated and spread-eagle young Show-Off himself, talks glibly of places and people in various parts of the city and the automobile accident following which he is arrested for reckless driving and which causes most of the complications of whatever plot there is, takes place at Broad and Erie avenues.

"There is virtually no sentimentalizing nor rose-colored exaggeration about 'The Show-Off.' In that respect it is far truer to the life it sets out to present than was even 'The First Year.' Instead there is a fundamental quality to 'The Show-Off,' a crude but powerful kind of honesty that sets it quite apart from most plays of similar setting and characters.

The leading character, the Show-Off, is a $32-a-week clerk, working for the Pennsylvania Railroad at Fifteenth and Arch Streets, who delights in claiming to be what he is not. He marries into the simple, unpretentious family of a workman and brings trouble to it.

"That, after all, is the gist of 'The Show-Off'; plot in the ordinary sense of the word it has not. At the final curtain one does not feel that the story is any further finished than it was after the second act. It is simply the straightforward and unusually truthful presentation of people and incidents we all know.

"The fact that there is no formal plot, strangely enough, does not prevent it from having more real suspense to the minute than some plays have to three acts. The death of the old father, the arrest of the Show-Off on a charge of reckless motor driving and his hearing, with its resultant fine; the faintly suggested tragedy of the older sister, who possesses the financial means the Show-Off's wife lacks, but desires affection—all these stand out as possessive of vital dramatic qualities."

* * *

"I'LL SAY SHE IS" OPENS

The Four Marx Brothers Provide Some Hilarious Clowning

I'LL SAY SHE IS. A "musical comedy revue" in two acts and twenty-four scenes. Book and lyrics by Will B. Johnstone. Music by Tom Johnstone. At the Casino Theatre.
PRINCIPALS—The Four Marx Brothers, Lotta Miles, Martha Pryor, Cecile d'Andrea and Harry Walters, Florence Hedges, Marcella Hardie, Frank J. Corbett, Edgar Gardiner, Edward Metcalfe, Phillip Darby, Hazel Gaudreau, Ledru Stiffler, Melvin sisters and Bower sisters.

Just about the two funniest clowns around the village at present are a pair of the Four Marx Brothers, whose antics provide the main excuse for "I'll Say She Is." Large parts of last night's audience at the Casino seemed to be previously acquainted with the Brothers Marx through their activities in the varieties, for an occasional revival of a bit of their vaudeville specialty was greeted with unusual fervor. But those who went to the Casino quite innocent of what it was all about joined equally in the boisterous laughter. Such shouts of merriment have not been heard in the Casino these many years.

The two comedians are Julius H. Marx and Arthur Marx. The former is entrusted with the witticisms, whereas the latter runs silent through the proceedings, with a baffling grin replacing the spoken word. These two take part in some four or five goodly numbers in the course of "I'll Say She Is," and even the interludes of sentimental ballads are worth sitting through for the sake of their next appearances. They are gorgeous clowns and uproariously funny.

A third of the Marxes—Leonard, it was—revealed a splendid skill as a trick pianist at a fairly late hour of the evening, after which the silent Arthur performed in equally trick fashion upon the harp. This was in the course of a hilarious Napoleonic scene—there was, to be sure, no reason why it should have been Napoleonic, but it sufficed to keep the Marxes busy. A previous number turned out to be Walt Kuhn's "Lilies of the Field," although Mr. Kuhn was not credited on the program.

The Marxes and their revue have been on tour for a season or so and New York is certain to be no less pleased with them than was the road. Aside from the brothers the company includes a beauteous young person named Lotta Miles—or, at least, so named on the program—who sings well enough and wears gorgeous clothes to advantage. However, the proceedings are traditionally musical comedy-like when the Marxes are not on the stage.

"I'll Say She Is" is made up of two of the Four Marx Brothers, with a few minutes of a third dragged in for good measure.

* * *

IN THE PROVINCES

Arthur Hammerstein's musical play "Rose-Marie" opened in Atlantic City on Monday night. The reviewer of The Daily Press declared that " 'Rose-Marie' is the pioneer in catching the theme of the wild Northwest, on which geographical location it seizes for its picturesque and effective settings. It is a combination of Robert W. Service and Rex Beach set to music."

Otto Harbach and Oscar Hammerstein 2d are the authors of the book and lyrics and Rudolf Friml and Herbert Stothart wrote the score. Thus The Atlantic City Daily Press account of the story:

"'Rose-Marie' concerns a delightful love tale interwoven with the dramatic entanglement of a pantomimic 'killin'.' Up in the frozen wilds of the Saskatchewan country, where, as the novelists put it, 'a man's a man and hate is strong,' Rose-Marie is idolized by Jim Kenyon, dashing gun toter and friend of everyone, including Sergeant Malone of the sartorially resplendent Northwest Mounted. Rose-Marie makes no secret of her love for Jim, much to the dislike of her brother, Emile La Flamme, French Canuck by ancestry, as given to bitter hatred by nature. Emile is strong for Rose-Marie to marry Edward Hawley, wealthy and chesty and somewhat Ritzy. Hawley has an affair with Wanda, bronzed and bare-limbed aborigine, and considerable of a vamp, despite that Black Eagle (Heap Big Chief) is her sweetie.

"In a splendidly executed bit of pantomime Black Eagle is stabbed to death. The killing is blamed on Kenyon, and things look bad. Hawley helps to make matters worse, and Kenyon is hunted by the Northwest Mounted. (They never come back without their man.) While they are hunting Kenyon, Hawley gets in his villainous work with the aid of a soft-voiced female confederate, Ethel Brander, who gains the confidence of Rose-Marie and fills her innocent head with lies about her beloved.

"Naturally, her love turns to hate, and everything is arranged for her to marry Hawley until Wanda's jealous nature leads to a dénouement of Hawley, with whom the Indian maid is violently in love. Crash! goes the hope chest and the trousseau, and the Lohengrin strains are postponed.

"His spirit crushed and his faith in women shattered by Rose-Marie's apparent unbelief, Kenyon is discovered in a Hindu 'dope joint,' and saved just in time to prevent him becoming a victim of hasheesh."

George S. Kaufman and Edna Ferber's "Old Man Minick" was tried out by Winthrop Ames in Stamford on Monday night. The play is based on a short story by Miss Ferber. The Stamford Advocate has the following description of the piece:

"The story is that of an old man left a widower, and in his loneliness coming to live with his son and daughter-in-law in their five-room flat in Chicago. His advent has an upsetting effect upon the household arrangements. The old man, loquacious and inquisitive, though always good-natured, spoils a meeting of a woman's society of which his daughter is Presi-

dent, discloses a carefully guarded business secret, nearly separates a loving couple, and finally steals away to join his cronies in a home for the aged. His son and his son's wife, whose patience he has sorely tried, are not wanting in affection for the old man, who finally discovers that he is in the way.'

"There are three acts in the play. The first has to do with his arrival in Chicago, and his insistence upon staying alone in the flat that night while the young people are off to a party. The second act is taken up chiefly with a meeting of the women's society, which is intensely amusing, though it ends in confusion and hysterics. The third act is the morning after, and its close marks the surreptitious departure of the old man."

There follows The Asbury Park Evening Press account of "Be Yourself," the new Kaufman-Connelly musical play. On the other hand, there are those who were able to confine themselves to prose after seeing the out-of-town opening of the piece.

*"Just take a little harmless plot
Of lovers and a family feud,
Pour in some rain, and then a shot—
(Yes, this is 'Be Yourself' reviewed).*

*"And these warm up with catchy, tuneful songs
That soon will travel thru the land,
Well rendered by the cast, all this belongs
And more, for with a lavish hand*

*"Dash in a lot of wholesome comedy
And spice it with Jack Donahue,
For flavor add a girl or two or three
Oh, pretty?—well, it's all the point of view.*

*"Upon the top, and cov'ring all around,
The cream of all the show, the royalty of dance,
But little Queenie Smith, for not uncrowned
Is she—nor came her rule by any chance.*

*"And when this fare, well-done, is shown
To epicures of Broadway's wit,
They'll all agree it's great, that just alone
Cute Queenie Smith could make the show a hit.*

*"She dashed about, she never stopped to rest;
When Donahue and she just moved their feet,
We swayed with them, we roared at every jest,
So did the crowd that nearly filled each seat.*

*"The first act's pace was strong and fast,
The second act, compared, was much too slow.
But all in all this play may well be classed
A hit to which theatrical New York will flow.
With its good cast, this 'Be Yourself' will last
Much longer far than any recent music show."*

* * *

September 6, 1924

TRIUMPH AT THE PLYMOUTH

WHAT PRICE GLORY, a play in three acts, by Maxwell Anderson and Laurence Stallings. Settings designed by Woodman Thompson; staged and produced by Arthur Hopkins. At the Plymouth Theatre.
WITH: Brian Dunlevy (Corporal Gowdy); Fuller Mellish Jr. (Corporal Kiper); George Tobias (Corporal Lipinsky); William Boyd (First Sergeant Quirt); Louis Wolheim (Captain Flagg); Leyla Georgie (Charmaine de la Cognac); Sidney Elliott (Private Lewisohn); Faye Roope (Lieutenant Aldrich); Clyde North (Lieutenant Moore); Charles Costigan (Lieutenant Schmidt); Henry G. Shelvey (Gunnery Sergeant Sockkel); Jack MacGraw (Private Mulcahy); James A. Devine (Sergeant Ferguson); John J. Cavanaugh (A Brigade Runner); Luis Alberni (M. Pete de la Cognac); Arthur Campbell (Another Brigade Runner); Roy LaRue (Brig. Gen. Cokeley); Keane Waters (A Colonel/Spike); William B. Smith (A Captain); Fred Brophy (A Lieutenant); Thomas Buckley (Another Lieutenant); John C. Davis (A Chaplain); Alfred Renaud (Town Mayor); Thomas Sullivan (Pharmacist's Mate); J. Merrill Holmes (Lieutenant Cunningham); Robert Warner (Lieutenant Lundstrom).

By STARK YOUNG

Just a year ago Maxwell Anderson saw his "White Desert" win praise and pass too quickly off the stage through untoward circumstance. Last night at the Plymouth Theatre he and Laurence Stallings could feel nothing but satisfaction over their new play. "What Price Glory?" is something you can put your teeth into.

On the whole what is usually called the plot is hardly the main interest in this war play. The story, so far as it appears, is of the captain and the sergeant, old enemies with old scores to settle. The captain goes away on leave, the sergeant takes his sweetheart. When the captain returns he finds the girl's father demanding that the man who has deflowered her should wed her and pay him 500 francs. Chance turns the tide on the sergeant, and the captain is prevented from marrying off the pair only by the call to the front. In the dugout of the next act the sergeant gets a start on the captain by acquiring a wound in the leg that might send him back to the town where the girl is. Alsation officers are captured, however, and the captain wins the staff's offer of a month off for his reward. The two arrived within a few minutes of each other in the girl's barroom and carry the struggle through till the call comes to go back to the front, revoking the month's leave.

The fundamental quality of "What Price Glory?" is irony. Irony about life and about the war, but irony so incontrovertible in its aspect of truth and so blazing with vitality as to cram itself down the most spreadeagle of throats. The chaos, the irrelevance, the crass and foolish and disjointed relation of these men's lives and affairs to the war shows everywhere, and the relation of the war to their real interests and affairs. This is a war play without puerilities and retorts at God and society, and not febrile and pitying, but virile, fertile, poetic and Rabelaisian all at once, and seen with the imagination of the flesh and mind together.

The irony of "What Price Glory?" culminates in the creation of Captain Flagg, the best drawn portrait in the realistic method that I have seen in years. In him the irony becomes superb. He is the true labor of war, the rough surface of the deep and bitter in human nature; he is intelligent, tender, brutal and right. He deserves much and wins little either from the world without or from within himself. He is a bum and a contemptuous hero. And he was played last night by Louis Wolheim with a security and a variety that I have never seen this actor achieve before, as well as with intelligence and a kind of husky wit.

The acting in the performance as a whole was above the average. In some places it needed more projection; it remained too much behind the footlights and too little toward the audience; it was too merely natural and not enough theatre. But in the main it went well. William Boyd as the sergeant rival to the captain played better and better as the acts went on. The scene where the captain and the sergeant stood at the bar and drank and quarreled over the girl was one of the best moments of this season; the stage managing also at this point, with the clearing away of the other persons to the far side of the stage and the pointing up of these two tragic, bitter and fantastic figures set there against each other, was perfect. Woodman Thompson's settings were fair but without a creative and dramatic relation to the play.

"What Price Glory?" is not one of those examples of the art of the theatre that discover a story, a pattern of action, that is in itself the very essence and expression of the play. It has not invented images of action or event that embody unescapably the dramatic idea, as the sleep-walking scene in "Macbeth," to take a lofty instance, does, or the great fables that survive the ages of men. It moves in the reverse direction—toward, that is, the creation and employment of character and dialogue for the dramatic purpose. And yet the proportions of story and war and talk and personality are perhaps part of the total idea behind the play. And the story has the advantage of being made cumulative, so that its heaviest weight and greatest tension fall where they should fall, in the final scene.

"What Price Glory?" lags somewhat in spots, no doubt; in the first and second acts it might well be shortened a little. But though it may have lagged, I for my part felt nothing of it, because of the sting and freshness of the writing, because of the speeches, the words and meanings and rhythms, like the beating of the pulse in your ears.

* * *

October 14, 1924

MOLNAR AND THEATRE GUILD AGAIN

THE GUARDSMAN, a comedy in three acts, by Franz Molnar. Directed by Philip Moeller; settings by Jo Mielziner; produced by the Theatre Guild. At the Garrick Theatre.
WITH: Alfred Lunt (The Actor); Lynn Fontanne (The Actress, his wife); Dudley Digges (The Critic); Helen Westley ("Mama"); Edith Meiser (Liesl); Philip Loeb (Creditor); Kathryn Wilson (An Usher).

The Theatre Guild began its season last night with a comedy of marriage and love among the artists. Molnar, who in the past has provided "Liliom" for the Guild and "The Devil" for George Arliss, not to speak of "The Swan" and other pieces that we have seen in New York, leaves us now with an amusing evening's entertainment to remember. "The Guardsman" is not important comedy or distinguished writing in any sense, and the performance at the Garrick is not distinguished. But the play is entertaining most of the time and often witty and full of clever contrivance.

Eleven years ago, in 1913 to be exact, this comedy, under the title of "Where Ignorance is Bliss," and adapted by Philip Littell, was given at the Lyceum Theatre and failed. To judge by the response of its new audience last night it may meet now with better success. Only in the second act, where the progress of the situation seemed to need marking into surer emphasis, did the interest drag.

An actor and his actress wife, after six months of marriage, have already come to troubled ways. He is jealous and suspicious; she has begun to play Chopin again, music whose melancholy and autumnal temper suits her mood and torments her husband, who dreads the end of everything between them after half a year, while May is still at hand and the leaves are not yet turned.

He has invented a test of his wife's fidelity. He walks beneath her window dressed as a guardsman and comes to visit her. In the second act there is a scene in the anteroom of her box at the opera in which she protests that she loves her husband, though she is not in love with him, and in the same breath leads on the passionate Prince. In the last act the actor returns unexpectedly from a supposed journey, and seems to find his wife on the point of a rendezvous. Behind the screen of his costume trunk he puts on the guardsman's uniform and confronts her. She has seen through the disguise from the start, by his kiss, by his liking his cigarettes, and, said more sweetly, by his ardent eyes. They malign one another's acting, they weep, and make it all up.

In the current of this story there are moments full of Molnar's particular brand of facile subtlety, never very profound anywhere, not in "Liliom," not in "The Swan" and not here in this comedy of the artist's temperament and domesticity, but cosmopolitan, easy-going and diverting. Into the performance of it last night a diverting and jolly quality permeated always. The slight depth of the dramatist's theme and treatment kept everything more or less at a certain level. The cosmopolitan and the distinguished, however, as well as the comic, might have been furthered by more elegance in the playing, more style and manner, more elaborate observation of the cynical and bland subtleties of the author's mood.

Lynn Fontanne portrayed the actress often delightfully, with now and again a kind of prima donna charm and no little technical fluency; she could heighten to advantage her whole performance and give it more brilliance and point. Alfred Lunt's actor was less convincing. His natural turn for cues and transitions often helped him out, but he fell a long way

short of both Lynn Fontanne and Dudley Digges, who played the bachelor friend in a manner that was exactly right in every sense. Helen Westley abandoned herself vocally and visibly to a sharp and amusing sketch of Mama, the actress's more or less chaperon.

* * *

LOVE IN THE VALLEY

THEY KNEW WHAT THEY WANTED, a comedy in three acts, by Sidney Howard. Settings and costumes by Carolyn Hancock; directed by Philip Moeller; produced by the Theatre Guild. At the Garrick Theatre.
WITH: Glenn Anders (Joe); Charles Kennedy (Father McKee); Allen Atwell (Ah Gee); Bennett Richard (Tony); Robert Cook (The R. F. D.); Pauline Lord (Amy); Hardwick Nevin (Angelo); Jacob Zollinger (Giorgio); Charles Tazewell (The Doctor); Frances Hyde (First Italian Mother); Catherine Scherman (Her Daughter); Peggy Conway (Second Italian Mother); Thomas Scherman (Her Son).

It is no reflection on the play to say that Pauline Lord walked away with "They Knew What They Wanted" last night at the Garrick, and created something in the theater that ought to run to the season's end.

Sidney Howard, who has already shared this autumn with Edward Sheldon the honors of "Bewitched," writes now a romantic comedy. It is a gentle piece, successful in working its intentions, and very much what the author meant it to be. In a California valley, with the bare hills and the bright sun outside, Tony plans his wedding. He has seen a girl in Frisco, in a spaghetti palace; he has never dared visit her, but has written and proposed marriage. In a moment of fear lest she might not fancy so old a man as he is, he has substituted Joe's photograph for his own and sent that to her. He is a prosperous bootlegger; and too much of his own wine has made him unsteady on his feet when he starts to the train to meet the bride. Since nobody is at the train for her, she comes with the postman; Tony is brought in presently with his legs smashed from an automobile accident. Three months later, when Tony is mending and there is happiness all round, the doctor tells Joe that Amy is going to have a child. The two have not been alone together since that first night. Amy tells Tony everything, he keeps her by him, Joe goes away; every one has what he wants.

The weaker spot in the writing of the play is toward the last. The scene needs to be less soft and expected. Tony needs some more happily discovered things to say when he hears the facts about his wife and when he makes the transition from rage and murder to the final forgiveness. For the rest of the comedy the bare telling cannot convey the kindly, glowing atmosphere and the sense of the children of songs and the vine and the sun that Mr. Howard achieves in the characters. The best writing in the play is in Joe's lines, with their sudden honesties and spurts of feeling; and the part of Amy as it is written is convincing and often touching. The

night of the festa, with its singing and dancing and colored lanterns and sick man's whimsies, has plenty of color and warm, light romance.

"They Knew What They Wanted," however, would rest as a picturesque little play, made up pleasantly out of Western material and smoothly spun to its happy ending, if it were not for the playing that the Theatre Guild has found for it. Glenn Anders steps well out ahead of his past achievements. He understands exactly that kind of shiftless integrity in such a character as this Joe that he plays, a fellow who migrates along from place to place, sometimes talking for the I. W. W., sometimes in jail, sometimes in the orchards and vegetable farms, but honest throughout, and loose and kind, even tender when life comes near to him. Mr. Anders brings to the part his singular gift for a casual naturalness in his readings and inflections and for a varied tempo in his cues. Richard Bennett gave a performance of Tony that was too long dragged out at times, too obviously professional at times, and never imaginative, but a good, popular performance nevertheless, and well able to hold the part and the scenes together.

Pauline Lord gave one of those instances of her work at its best that glorifies and makes pitiful the whole art of acting. Her playing last night had that shy pathos and intensity that we saw in her "Launzi" last year. She is an actress that, when she finds a part within her range, had in that part a range and perfection at the top of all the realism in our theatre. Last night she never missed a shading or a point; she had always a wonderful, frail power in the scene, and throughout her entire performance a kind of beautiful, poignant accuracy. And last but not least, her playing with the rest of the company was admirable and to be recommended all over town.

* * *

ADELE ASTAIRE FASCINATES

In Tuneful "Lady, Be Good" She Vividly Recalls Beatrice Lillie

LADY, BE GOOD! A musical comedy in two acts and six scenes. Book by Guy Bolton and Fred Thompson, music by George Gershwin, lyrics by Ira Gershwin. Settings by Norman-Bel Geddes; staged by Felix Edwardes. At the Liberty Theatre.
WITH: Fred Astaire (Dick Trevor); Adele Astaire (Susie Trevor); Alan Edwards (Jack Robinson); Jayne Auburn (Josephine Vanderwater); Patricia Clarke (Daisy Parke); Gerald Oliver Smith (Bertie Bassett); Walter Catlett (J. Watterson Watkins); Kathlene Martyn (Shirley Vernon); Cliff Edwards (Jeff); Bryan Lycan (Manuel Estrada); Edward Jephson (Flunkey); Victor Arden (Victor Arden); Phil Ohman (Phil Ohman); James Bradbury (Rufus Parke).

There is good news to spread among the mourners for Miss Beatrice Lillie's recent untimely departure from these

parts. She returned last night, with an added freshness and a previously unrevealed dancing talent, in the piece called "Lady, Be Good" that came to the Liberty Theatre. But this time she calls herself Adele Astaire.

It should be explained, probably hastily, that it is a known fact that the Misses Lillie and Astaire are two different persons and that Miss Astaire is not exactly a newcomer. But Miss Astaire, in the opinion of at least one deponent, is as hilarious a comedienne as the gorgeous Miss Lillie. As recently as November, 1922, Miss Astaire was seen in the unlamented "Bunch and Judy," to set sail soon thereafter for London. And ever since then the penny posts have been full of the details of her two-year triumph abroad in, of all things, "Goodness Knows," with the title changed to "Stop Flirting" for no known reason.

But it is a different Adele Astaire whom last night's audience was privileged to see. When she left she was a graceful dancer—and she has returned, not only with all her glorious grace, but as a first-rate comedienne in her own right. Miss Astaire, in the new piece, is as charming and entertaing a musical comedy actress as the town has seen on display in many a moon.

Fred Astaire, too, gives a good account of himself in "Lady, Be Good," participates enthusiastically and successfully in most of Miss Astaire's dance offerings, and is allowed to win the hand in marriage of Miss Kathlene Martyn for the final curtain. A second hero, destined, the librettist intimates, to be Miss Astaire's lifelong mate, is Alan Edwards, recently of "Poppy," who again proves that he is one of the musical comedy stage's very best in one of its very worst assignments.

Walter Catlett, the leading comedian, manages to be consistently amusing almost all of the time, and Gerald Oliver Smith is allowed to deliver several attractive nifties in a pleasant manner. And there is further in the cast Cliff Edwards, who plays a ukulele.

George Gershwin's score is excellent. It contains, as might have been expected, many happy hints for wise orchestra leaders of the dancing Winter that lies ahead and a number of tunes that the unmusical and serious-minded will find it hard to get rid of. The lyrics, by Ira Gershwin, are capable throughout and at moments excellent.

"Lady, Be Good" has exceptionally handsome settings by Norman Bel-Geddes. And there is an energetic chorus that dances excitedly and rhythmically under the direction of Sammy Lee.

The book of the piece contains just enough story to call Miss Astaire on stage at frequent intervals, which thus makes it an excellent book. But it could have had a little more humor.

* * *

December 3, 1924

'THE STUDENT PRINCE' BRINGS OUT CHEERS

Prodigious Operetta, Made From 'Old Heidelberg," Is Magnificently Sung at Jolson's

THE STUDENT PRINCE (In Heidelberg), an operetta in a prologue and four acts. Book and lyrics by Dorothy Donnelly, music by Sigmund Romberg. Settings by Watson Barratt; staged by J. C. Huffman; produced by the Shuberts. At Jolson's Fifty-ninth Street Theatre.
WITH: Frank Kneeland (First Lackey); William Nettum (Second Lackey); Lawrence Wells (Third Lackey); Harry Anderson (Fourth Lackey); Fuller Mellish (Von Mark); Greek Evans (Dr. Engel); Howard Marsh (Prince Karl Franz); W. H. White (Ruder); Violet Carlson (Gretchen); Adolph Link (Toni); Raymond Marlowe (Detlef); Frederic Wolfe (Lucas); Paul Kleeman (Von Asterberg); Fred Wilson (Nicolas); Ilse Marvenga (Kathie); George Hassell (Lutz); Charles Williams (Hubert); Florence Morrison (Grand Duchess Anastasia); Roberta Beatty (Princess Margaret); John Coast (Captain Tarnitz); Dagmar Oakland (Countess Leyden); Robert Calley (Baron Arnheim); Martha Mason (Premier Dancer); Lucius Metz (Rudolph Winter).

"The Student Prince" is a prodigious operetta. The play that was "Old Heidelberg" has been produced again in musical form, and on a scale that never would have been possible in the old days. The production that came to Jolson's last night is richly scored and magnificently sung, and merited even the cheers that were sent across the footlights by a friendly audience.

It is a romantic operetta of the old school, this musical version of the play that Richard Mansfield made famous, and it is almost a perfect example of its kind. The authors and the producers have never for an instant been turned aside from the business in hand. They have told a simple romantic story with all of the aid that music and singing could bring to it, and they have outfitted it with a magnificent production. Not even the comparative absence of the comic element is of importance in "The Student Prince"; the piece concentrates so successfully upon its prime ingredients that nothing more is needed.

The simple story of the Prince of Karlsburg and his love for a Heidelberg barmaid lends itself perfectly to this style of production—it requires a minimum of dialogue and so clears the decks rapidly for the business of an operetta, which is music. The score of this piece is by far the best that Sigmund Romberg has done. The clicking heels of the students and the high patent leather boots of the court are not alone on the stage of Jolson's; they are woven deep into Romberg's music.

The high point of the evening is a gorgeous court scene in the third act (strangely enough, here is a musical play in a prologue and four acts). Here was a familiar enough operetta scene, but the costumer and the producer have taken even more than the customary advantage of it. Here, too, was the point where the cheers burst forth for the splendid voice of

Howard Marsh. Mr. Marsh and a blonde young person named Ilse Marvenga are entrusted with most of the singing, with Greek Evans a prominent third. All three are excellent—Miss Marvenga is not without obstacles to overcome, but grows steadily better as the evening progresses.

George Hassell, technically at the head of the company, is somewhat swamped by the largely musical nature of the proceedings. Now and then, however, he stirs a smile—and when he does so it is tribute to his own powers, not the librettist's. The latter, incidentally, was Dorothy Donnelly, and she has done a first-rate job for the purpose in hand. Another who should be mentioned is the veteran Adolph Link, who played a single scene with mellow effectiveness.

The entire production is on the scale that Jolson's Theatre demands—when the Heidelberg students take possession of the stage, in the first act, they are some forty or fifty strong. And when, all together, they sing one of those rousing drinking songs you are well aware that something is taking place. Especially from the third row on the aisle.

* * *

May 18, 1925

THEATRE GUILD JUNIORS IN 'GARRICK GAIETIES'

Splendid Imitation of Pauline Lord by Peggy Conway in a Revue of Genial Satire

The Junior Group of the Theatre Guild last night entertained at the Garrick in a revue felicitously called "Garrick Gaieties." Before the evening was over nearly everything and every one connected with the Guild had been thoroughly and genially satirized.

The new entertainment—which was announced for last night only but which will be repeated if a public demand is evident—keeps its eyes fixed, though with obvious difficulty, upon such distant and distinct centres as Grand Street and the Winter Garden. What there is in the Grand Street manner is very, very good, and what there is in the Winter Garden tradition is only fair.

By far the most amazing achievement of the evening was an imitation of Pauline Lord by Peggy Conway, in a screamingly funny burlesque of "They Knew What They Wanted." If there is anything characteristic of Miss Lord's acting that Miss Conway has not taken over—voice, posture, attitude—it was not apparent last night.

Excellent performances, in song and dance, were given by Betty Starbuck, June Cochrane, Elizabeth Holman, Sterling Holloway, Romney Brent and Edward Hogan, who romped over the stage with veteran precision but with juvenile enthusiasm. Edith Meiser and Philip Loeb, as might have been expected, did capitally those pieces of legitimate acting put in their way. Hildegarde Halliday offered an imitation of Ruth Draper that was almost as uncannily faithful as was Miss

Conway's of Miss Lord. Rose Rolanda, as usual, danced gracefully and originally.

All of the sketches were funny, though some, like the burlesque of "Fata Morgana," were too Broadwayish to suit the general intelligently amateur tone of the proceedings. A sketch by Arthur Sullivan and Morrie Ryskind called "Mr. and Mrs.," in which President Coolidge returns to the White House after calling on Herb Hoover, to have it pointed out to him that it's past 10, and that Lincoln wouldn't have gallivanted around in such a fashion, had the most genuinely comic idea of them all.

The lyrics, by Lorenz Hart, were mature and intelligently contrived. Richard Rodgers's music was tuneful and well adapted to the needs of the entertainment.

* * *

June 3, 1925

THE RETURN OF JOE WEBER

By STARK YOUNG

Two or three weeks ago Weber and Fields were at the Palace Theatre and people, I was told, were saying here and there that they were no longer funny. I went to see them, fresh from Felix Isman's book of their history; and since they are to come again tomorrow I am writing these lines about them, taken with their magic and astounded at Weber's quality.

I went to the Palace a little late and before long I heard in the wings that familiar voice from many seasons gone— "don't poosh me, Myer"—and saw the old business come to life again. The two figures, one thinner and taller than the other; the two voices; the two ways of listening, one scheming, contriving to outwit, to win, to invent, to lead; the other trusting, waiting ever open-hearted, looking out of gentle, straight eyes, forever abused, exploited, and in the end running after his abuser, trotting along as if it must be true that to the sweet all things are sweet.

The two are before a saloon where there is beer. The bully throws his arms around the little round man.

"Ven I'm away from you, I cannot keep mein mind from off you. Ven I'm mit you, I cannot keep mein hands off you. Oh, how I luff you, Mike!"

Presently, as everybody knew, we should have the fact that the tall man has a quarter, the little man only a thirst. They must not look poor, Myer explains, with these unicorns on. They must walk in, and when he is asked what he will have Mike is to say, stretching himself carelessly, "I don't care for it." Then Myer will have a beer, and nobody know about the poverty. And then it is to go all wrong and Mike will have said, when asked what he would have, "I don't care if I do." After that will come harmony and compromise, and then the statue number, the two whitened up to marble and spilling the game, while the swell young lady looks on. Afterward there will be more of the old gags, more of the classic Weber and Fields repertory bits.

I sat there wishing they would revive that famous game of pool where Mike names his ball Rudolph, that once rocked their doting audiences. I could, how happily, have seen the letter being written to Mike's girl or the scene on the Riviera where Mike is persuaded to open a bank and have his money taken from him by his wily friends! But, no matter. It all seemed to me divine nonsense, full of history, too, and reminding us of how long ago these two geniuses added to the old slapstick and rough-house clowning an element of farce and comedy, to the Fool's and Harlequin's antics something more than the Fool's and Harlequin's philosophy. These jokes, these puns and these skits may be out of date a little nowadays. Their humor may be a little outmoded. Or they may have grown less diverting because of our knowing them by heart, like the man who thought poorly of Shakespeare because he had heard so many of the lines already. But this sort of genius must turn not so much on the jokes as on the artists behind them. No matter about these skits and jokes, take them as you will, the fact stands out that the genius of Weber and Fields comes all over again as a surprise. Nobody could doubt these two. Except for Charlie Chaplin there is nobody like them in our theatre.

Taken Singly

Of the two men Fields seems to be more active, more inventive, more thinking and alert. But he is also more explicable. You watch him and you can see what he is doing. You see how this is managed, and how the devil of satire is at work and the bells of an ancient slapstick comedy are made to ring their tumbling chimes. Watching him you can easily believe, as Mr. Isman insists, that if affairs had been in his hands alone instead of half under Weber's also, he could have nursed the Weber and Fields establishment and their special sort of entertainment through the hard transition into the new productions, the Follies and Revues that were coming in to crowd out of the world the old Music Hall. Fields looks perennially resourceful, managing, clever, and ahead of the game. You lay your laurels at his feet and turn to Weber.

Weber is less active as you see him there on the stage than Fields. That is one of the proofs of his great gift. He is less active, he works less. But he does not have to do so much as his partner. What a talent he has you see at once. He stands still, he waits for life to hit him, he had boundless goodness and folly. I was astonished, looking at him, to see what a mask he has. It is a face full of pathos, an eager, insuppressible capacity for getting into things, having them overwhelm him and remaining as he was, innocent, ready for more, sweet, willing, absurdly gentle, silly and lovable. This figure, we perceive, will go through life like that, he will be always listening to some one's schemes and tricks, he will be always blinking his honest eyes and looking at life, never any wiser, never any bitterer, never less eager, never less dear. He might be the thing, whatever it is, that Charlie Chaplin's pathetic rhythm and humor are talking about. At the same moment he topples us over with a picture of our foolish desires and crazy

enterprises and rattling brains and warms us at our own hearts. He is like a funny little chubby song about humanity that nobody could take seriously, but everybody loves. We lay nothing at his feet, but carry him away with us.

But, like a critic, I shall sit again this week and marvel at the natural gift, the gentle appeal, and the mask.

* * *

December 9, 1925

FOUR NUTS IN "THE COCOANUTS"

THE COCOANUTS, a musical comedy in two acts and eight scenes. Book by George S. Kaufman, music and lyrics by Irving Berlin. Settings by Woodman Thompson; costumes by Charles Le Maire; staged by Oscar Eagle and Sammy Lee; produced by Sam H. Harris. At the Lyric Theatre.
WITH: Zeppo Marx (Jamison); Georgie Hale (Eddie); Margaret Dumont (Mrs. Potter); Henry Whittemore (Harvey Yates); Janet Velie (Penelope Martyn); Mabel Withee (Polly Potter); Jack Barker (Robert Adams); Groucho Marx (Henry W. Schlemmer); Chico Marx (Wilie the Wop); Harpo Marx (Silent Sam); Basil Ruysdael (Hennessy); Frances Williams (Frances Williams).

Perhaps for the first time in their rough-and-tumble lives, the four Marx brothers kept respectable company last evening at the Lyric Theatre, where George S. Kaufman's new musical comedy, "The Cocoanuts," was put on. In a broad and spacious Florida hotel, decorated with the most exquisite taste, and in an airy patio, these low comedians associated on equal terms with people of refinement. For the new comedy is splendidly decked out with costumes of such brilliance that the eye fairly waters; with melodies by Irving Berlin; with Antonio and Nina de Marco for dancers; with Jack Barker and Mabel Withee for singers; with clog-steppers, in sum, with the sublime beauty of a musical comedy set in Florida. Amid this opulent array the Marx brothers go through their antics as before.

In the first act they seem rather thin against the splendor of the general comedy scheme, and only occasionally do they enact the rapid, organized buffoonery that was so painfully funny in these parts last season. In the second act, however, they rise to the surface. Groucho Marx keeps up a steady rattle of patter; Harpo goes through his lazy chicaneries and Chico performs once again at the piano.

At the same time that Florida is developing its land, to the annoyance of the rest of the civilized world, it is apparently developing a restful, colorful type of architecture and decoration. The first scene of "The Cocoanuts" represents the lobby of the hotel where all these revelries occur, on generous, restful lines. And for the first moments of the comedy, ladies and gentlemen of the chorus dance and sing here. Then the earnest, thin, not unkindly face of Groucho Marx, bearing the inevitable cigar, appears tentatively on the stairs, and the fun begins. Through the rest of the comedy the Marx brothers retain their familiar rôles—Groucho in the shabby cutaway, with the inadequate spectacles; Chico with the loud clothes

and immigrant's accent; Harpo with the flaring wig, and the vulgar leers and grimaces far more effective than words; and Zeppo representing by contrast the decent young man.

And, as formerly, the voluble Groucho keeps up a heavy musketry of puns and gibes, twisting everything into the vulgar, unimaginative jargon of the shopkeeper. To him the eyes of his love "shine like the pants of a blue serge suit." When he steps down to the local jail to bail out a $2,000 prisoner, he finds a sale in progress and captures his prey for $1,900. And to him "jail is no place for a young man. There is no advancement." There are puns on a "poultry" $1,000, and a request to the lovers that they transfer their caresses to the "mushroom." Nothing is more amusing than the rapidity with which Groucho reduces everything to the stale bromides of the serious-minded merchant; and the speed with which he twists a burlesque probe for a missing shirt into a tailoring shop where he is measuring the victim for a suit of clothes and trying to sell him a pair of socks. All this with the seriousness of the instinctive man of business, bent upon doing his job well, and with such baffling twists in allusion that the audience is frequently three jumps behind him.

For the organized low comedy in which these brothers specialize, the current skit affords only one or two numbers, fewer than in their last appearance. Harpo shaking down his victims for watches and purses, stealing the detective's shirt from his chest and a guest's vest and coat from his back, or taking dictation on the cash register and calmly tearing the guest's mail into pieces and ripping up the telegrams as fast as they come—all these broad antics are particularly funny. In the first act the comedy is slow in starting, and is less loud and less funny than an expectant audience had hoped it to be. Throughout the second act the comedians are frequently on the stage and in good form. And yet the blatancy and fury of which they are capable do not reach the familiar extremes.

But "The Cocoanuts" surrounds them with better entertainment. Mr. Berlin's music is always pleasing. The number entitled "A Little Bungalow," sung by Miss Withee and Mr. Barker, is especially melodious. The chorus number entitled "Five o'Clock Tea," runs swiftly with a charming theme. Most of the dance numbers, moreover, have an imaginative and elusive grace that are uncommon to the run of musical comedy. And Frances Williams sings the blues and shivers through a Charleston number.

According to the fashion of musical comedy, "The Cocoanuts" occasionally merges into ensemble numbers. At the close of the first act Groucho Marx, on the auctioneer's stand, conducts with all the enthusiasm of the development man and the sly candor of the comedian a sale of Florida real estate lots, some of them in the most exclusive residential district where no one lives at all. The second act resolves a probe into an old-time burlesque minstrel show with incidental clowneries and concludes with a garden fête with the skipjack comedians in ill-becoming Spanish vestments, with Chico "shooting" the piano keys and Harpo fooling languorously with the harp. One must not forget the brilliance of the patter

and joking; it is never commonplace. Nor, as a matter of form, must one neglect to mention the existence of a plot.

* * *

JUNO AND THE PAYCOCK, a play in three acts, by Sean O'Casey. Directed by Augustin Duncan; produced by H. W. Romberg (in association with John Jay Scholl). At the Mayfair Theatre (44th Street east of Broadway).
WITH: Augustin Duncan ("Captain" Jack Boyle); Louise Randolph (Juno Boyle); Barry Macollum (Johnny Boyle); Isabel Stuart Hill (Mary Boyle); Claude Cooper ("Joxer" Daly); Eleanor Daniels (Mrs. Maisie Madigan); Ralph Cullinan ("Needle" Nugent); Kate McComb (Mrs. Tancred); Mildred McCoy (A Neighbor); Lewis Martin (Jerry Devine); Charles Webster (Charlie Bentham); J. Augustus Keogh (An Irregular Mobilizer); Wallace House (An Irregular); G. O. Taylor (A Sewing-machine Man/A Furniture-removal Man); Emmet O'Reilly (A Coal-block Vendor/His Helper).

Comedy of Irish character and tragedy of Irish political life in fairly equal parts compose the substance of Sean O'Casey's "Juno and the Paycock," put on last evening at the Mayfair Theatre. Surely both those elements convey the full quality of the Dublin life four years ago represented by Mr. O'Casey's drama. To join them as bluntly as Mr. O'Casey has done, however, and to require at the same time an even performance, is to throw rather too much responsibility upon the director. In the current version the tragic moments come off vigorously, expressing genuine pathos seasoned with pure theatre; but although the two principal comic rôles are enacted pungently by Augustin Duncan and Claude Cooper, the comedy scenes in general need considerable molding and polishing. Accordingly, one of the most understanding plays of the season, full of folk-life and written with a sense of the theatre, becomes uneven and scattered in the playing.

Most of the theatrical news from Ireland of late has brought frequent report of Mr. O'Casey's remarkable success at the Abbey Theatre, and on the simultaneous rejuvenation of that familiar institution. No doubt, the essential, conclusive proof of the strength of his talent was the reception of his current piece there, "The Plough and the Stars." On the first night the actors were mobbed; only the intervention of the "polis" (whose characters are sadly blackened in "Juno") made the continuance of the performance possible. Perhaps that new tragedy comes even closer home to Dubliners today than "Juno and the Paycock." But after two acts of volatile character comedy, the final scenes of "Juno" are grim enough, pointed enough as well, with their quick revenge for the treacherous murder of a comrade. With pistols drawn, two "irregulars" hustle off Johnny Boyle, already half dead in the service of his country, and word soon comes of his murder in a dark corner of the city.

Thus Mr. O'Casey twists the dagger he has already plunged deep into the life of the Boyle family. For just previously the legacy they had been anticipating rather jauntily had been denied them, and Mary's gentlemanly lover had left her

with child. "Ah, what can God do agen the stupidity o' men!" exclaims Juno in despair. In the accumulation of tragedy, as well in his treatment of an incident, Mr. O'Casey cannot let well enough alone. However skillfully he may have designed this play, he has overwritten nearly every point.

In spite of the fact that the second act in particular expands the comedy of character far beyond its dramatic value, these folk scenes reveal Mr. O'Casey at his best. Not only does he understand the child-like people of whom he is writing here, and sympathize with their points of view, but he also conveys his knowledge through brilliant colloquial dialogue. Part of the flavor of these character scenes is diffused in the current performance by an enervating pace in the acting, and by different conceptions in the creation of the parts. But the scenes portraying the bragging, shiftless "Captain" Jack Boyle and his "artful dodger" satellite abound in gracious, objective humor. For although this lazy head of the family speaks bold and brave words when only the cautious "Joker" is present to echo approval, he quavers before the sharp tongue of his wife.

Upon Juno, wife of the gay, cavalier "Captain," falls all the responsibility of the household. While he drinks with his comrade in the corner "snug," and feels sharp pains in his legs whenever a job looms menacingly on the horizon, she keeps the family in operation, cajoles the green-grocer, cares for her shattered son, protects her daughter when every one else turns against her, and pushes her husband into the moleskin trousers for service on the new job. According to the device of Mr. O'Casey's drama, the gods intervene just in time. Just as the "Captain" seems fated to descend into honest toil, Charlie Bentham appears with news of a legacy. The new turn in the Boyle fortunes gives rise to the jollification of the second act amid all the new furniture, the "jars" full of merriment, the singing of ballads, and "Joxer's" short-memoried attempts at tuneful "renditions."

And the "Captain's" solemn flights at conversation, his manly talk of the decline in Consols, the meddling of the Church in affairs of the nation, and his invariable conclusion: "I tell yer, the whole world's in a turrible state o'chassis!" After the sudden tragedy in the final act, after Juno has gone off to see her murdered son and Mary has deserted the barren household, the play ends on this same note of folk-comedy with the "Captain" and Joxer back from the barroom, their skins full and their lips heavy with philosophy.

Like the direction, the acting is uneven. Mr. Duncan and Mr. Cooper do well with their two rôles, and make for amusing contrast. As Juno, Miss Randolph likewise creates a character in the round without laying on thick the tragedy in the end. Mr. Macollum stresses too violently his voice and his gestures as Johnny Boyle. Miss Hill is difficult to understand in the part of Mary. As a voluble neighbor Miss Daniels is merry and pleasing. Mr. Cullinan's brief appearance as a thrifty tailor reveals a certain strength of character. As Mrs. Tancred Miss McComb is thoroughly competent. But like the play itself, the serviceability of several of the character portraits is endangered by the slow pace of the performance.

Instead of being caught up in the illusion, one has time to see the reverse side of the acting.

* * *

March 21, 1926

'THE PLOUGH AND THE STARS'

DUBLIN—By comparison with what it was a decade ago, playwrighting has become almost a lost art in Ireland. First productions at the Abbey Theatre have become the exception rather than the rule and new plays are rarities. For this and other reasons, therefore, when it was announced that a play from the pen of Sean O'Casey would have its première on a Monday evening early in February there was a run on the box office and every seat in the house for that night, as well as for several following, was sold out almost before the ink on the advertisement was dry on the press.

The sensation caused by the same author's "The Shadow of a Gunman," eclipsed as it was by that which obtained when his "Juno and the Paycock" was staged, together with the extraordinary reception given to the latter play in London, aroused considerable speculation as to what Sean O'Casey's next play would be like. It had been known for a long time that he was at work on a new play and rumor was very busy with regard to it.

When the curtain went up on Monday night on "The Plough and the Stars," the Abbey Theatre was packed to the point of discomfort. Every seat was occupied and the aisles had their full quota of standees. The atmosphere was tense, and, in part, this was due to a report which had persisted for several days to the effect that the new play would evoke scenes of protest if not of violence. Dame Rumor was, however, not an honest woman of her word and nothing happened to mar the first performance of another remarkable O'Casey work. On the second night organized interruption was attempted by—as usual—a small group of overzealous women who claimed to be offended by the appearance of the Irish tricolor in a public house scene. The audience, however, did not rise to music and the interruptions soon subsided.

The first night audience waxed enthusiast as scene after scene took place, and the fall of the curtain on each of the first three acts was the signal for outbursts of very emphatic approval. Feelings finally ran riot with the ending of the fourth and last act, and the ovation given to players and author surpassed anything of its kind that had ever previously taken place in the Abbey. Sean O'Casey has registered another high mark in the annals of Irish drama. In "The Plough and the Stars" he has gone back to 1915–16 for his story and his play obtains its name from the device on the flag of the Irish Citizen Army organized by the late James Connolly, the labor leader, who was executed for his part in the rising of Easter week, 1916.

Jack Clitheroe, a bricklayer, has resigned from the Citizens' Army, ostensibly to please his young wife, Nora,

but it is suggested that the real cause of his withdrawal was disappointment at not having been made an officer. It is an evening in November, 1915, and a monster labor meeting is to take place that night in Dublin for the purpose of rallying the patriotic spirit of labor to militant activity. Everybody in the tenement house in which the Clitheroes dwell is going to the meeting with the exception of the Clitheroes themselves and Bessie Burgess, another tenant, who has a son at the front in the Dublin Fusiliers and who has no sympathy with Sinn Fein or its aims. To Jack Clitheroe suddenly comes a dispatch from General Connolly. It is addressed to Commandant Clitheroe and it informs him that he is to command a force which will later in the night make a practice attack on Dublin Castle. Clitheroe questions the validity of the order as addressed to him, only to be informed that he was appointed to the rank two weeks previously and that a letter to that effect had been given to his wife for delivery to him. It transpires that Nora had burnt the letter and had concealed from her husband the fact of its receipt in the hope of keeping him out of the movement. Husband and wife have their first serious quarrel and the latter departs to assume his command.

Crushed and disappointed, Nora is left alone and a little girl in an advanced state of consumption comes in to keep her company, as a detachment of Dublin Fusiliers, en route to France, headed by a band playing "It's a Long Way to Tipperary," marches past on the street below. As the music dies away the consumptive turns to Nora and asks, "Is there nobody alive with a titther of sense," and the curtain falls on a magnificent and promising first act.

The author, however, reverts to the formless development which characterizes his previous plays and the acts that follow are a series of scenes reflecting the lives of the slum dwellers as they are severally and individually affected by the progress of events leading up to Easter Week, 1916. In the depicting of these scenes the author again reveals his extraordinary knowledge of the people among whom he lived until more or less recently, as well as his remarkable faculty for reproducing incidents which, obviously, he must have witnessed. One sees these tenement dwellers, their jealousies, their quarrels and enmities, their brawls, their weaknesses and their strong qualities. Everything is shown faithfully and pitilessly, and back of it all one feels rather than sees the slow but sure development and growth of the movement which culminated in the outbreak that took Dublin by surprise on Easter Monday, 1916.

This movement is the background on which O'Casey has hung his play, and bit by bit the people of this little corner of Dublin slums are caught up by its tentacles until they are finally united in the common lot which is inevitably born of calamity or unusual crisis. Quarrels are forgotten, enmities are put aside as all combine, first, to share in the looting which grows out of the disorder prevailing in the city when established authority is challenged and put to rout, and, later, when Nora, prematurely confined as a result of her husband's participation in the rebellion and his refusal to yield to her pleadings, needs medical assistance and nursing. The death

of the consumptive girl, occurring at the same time, also brings out the best that is in these slum dwellers.

The first three acts of the play are brimful of rapid changes from the humorous to the tragic, but the last act is the very quintessence of tragedy. The play ends with two Tommies calmly drinking tea at one side of the room, while on the other lies the dead body of the hated loyalist, Bessie Burgess, who had forgotten her contempt for Nora in order to nurse her in her illness and who, in attempting to draw her away from a window to which she had gone in her delirium, had been shot. Jack Clitheroe is dead, killed in the attack on O'Connell Street. His child is born dead and Nora is found, after the death of Bessie, cowering in a corner of the room and she is led away a hopeless lunatic. All the men found in the building, even though they are noncombatants, are rounded up and led away to internment. All is misery and tragedy and out of it comes clarion-like, the author's message of protest against a violence which is the child of patriotism as far as the men taking part are concerned but which, in the final analysis, is the scourge and torture of women. The little consumptive girl sums it all up at the end of the first act when she asks, "Is there nobody alive with a titther of sense?"

And yet one feels that in a month it will be all forgotten. New people will occupy the Clitheroe rooms and a new tenant will take Bessie Burgess's floor. In time they will become part of the tenement house life. New quarrels and enmities will develop, and brawls will have their natural place in the routine of slum life. The Communist, who talks incessantly of the rights of the proletariat, will continue to preach. Fluther Good will go on in his peculiar philosophic way, championing God and the Catholic Church by day against the Communist and consorting nightly with prostitutes. Peter Flynn will boil with rage over the wrongs of Ireland and be ever ready to shoulder a gun as long as there is no prospect of his being called upon to do so, while Mrs. Gogan will, by the death of her child, add the details of that event and of the funeral at night under military escort to her already voluminous store of morbid and gloomy chatter. It will all go on again until the Black and Tan tyranny unites them once more in common trouble. Tragedy and death will once more visit the tenement house and the Minnie Powells will give up their lives for the "Shadows of Gunmen."

"The Plough and the Stars" is strong stuff, and the author has not hesitated to make his characters use the language of their environment. Nothing is left to the imagination. One may not agree with all his theories, but many of them contain an element of truth. When Nora, after her wild rush through the streets of Dublin and among the barricades of Easter Monday, declares that it is not courage or patriotism that is behind the stand being made against machine guns and artillery but fear, the fear of showing fear, one feels that it is in part a terrible truth which at least applies to many of the rank and file of those who fought in the 1916 uprising. The author makes it clear that this theory did not hold good in the case of men like Jack Clitheroe, who was not only willing to but did

actually throw wife, child and home aside for the privilege of leading men into battle against overwhelming odds and who gave his life for the cause he championed. Fear or the fear of showing fear does not prompt men to do these things.

"The Plough and the Stars" is not an artistic improvement on "Juno and the Paycock," as far as technique and construction are concerned. It lacks even the thin thread of plot that holds the latter play together, but nevertheless its rivets attention from beginning to end. It is not a political play, and the politics of its period do not obtrude themselves into the action except in so far as they influence the lives of those concerned. Controversy does not appear and no speeches, political or otherwise, are made. At one period one hears the voice of a labor leader haranguing the crowd, but the sentiments expressed do not grate on anybody's susceptibilities. Again, as in his previous plays, the author blends tragedy and comedy almost in the same breath, but in the last act he abandons that method and paints stark tragic realism. The death scene of Bessie Burgess, in which she blasphemes, curses and prays indiscriminately, is terribly effective, and, while it might, in the hands of an indifferent actress, be made ridiculous, the Abbey artist, Maurean Delaney, made it sink deep and terrible into the minds of the spectators. The presence of a coffin on the stage during the greater part of the final act had no part in the creating of the tragic atmosphere. It belonged. To many its presence was not noticeable, although it occupied a prominent place on the stage. The atmosphere was there, and it was the work of the author, superbly aided by the Abbey players. It was felt at once, and it deepened as the act progressed, even though nobody could faintly guess what was going to happen.

The plays of Sean O'Casey must be taken on their own merit. Three times he has now presented—and presented with telling effect—a more or less disconnected series of pictures. It is useless to take him to task for violating all the canons of dramatic law. He has succeeded by his sincerity and by the faithfulness of his characters of life. Sean O'Casey attempting to write according to the rules would be unconvincing and his efforts would be hopeless failures. He stands alone among dramatists because he is himself alone.

J. J. HAYES

* * *

April 27, 1926

"SEX" A CRUDE DRAMA

One Torrid Love Scene In New Play at Daly's 63d Street Theatre

SEX, a play in three acts, by Jane Mast. Staged by Edward Elsner; produced by C. William Morganstern. At Daly's Sixty-third Street Theatre.
WITH: Mae West (Margie LaMont); Barry O'Neill (Lieutenant Gregg); Warren Sterling (Rocky Waldron); Ann Reader (Agnes Scott); Edda Von Buelow (Clara Smith); Lyons Wickland (Jimmy Stanton); Pacie Ripple (Robert Stanton); Gordon Burby (Dawson); D. J. Hamilton (Jones); Al Re Alia (Curley); Constance Morganstern (Marie); Frank Howard (Jenkins); George Rogers (Captain Carter); Gordon Earle (Waiter); Mary Morrisey (Red); Conde Brewer (Condez); Michael Markham (Spanish Dancer); The Syncopators (The Fleet Band).

A crude, inept play, cheaply produced and poorly acted—that, in substance, is "Sex," which came last night to Daly's Sixty-third Street Theatre as a late Spring entrant in the Broadway field. For at least one act it lived up to the promise of its name and was spicy enough to evoke "ohs," "ahs" and partially restrained titters from its audience and to send several couples out into the night, but after that act—the first—it seemed to reconsider, and except for a torrid love scene toward the end it contented itself with just being pretty feeble and disjointed.

"Sex," lobby gossip had it, is the work of its leading woman, Mae West, who has written under the pseudonym of Jane Mast. Miss West, it was further rumored, is a singer out of the two-a-day. She acted a part she had especially written for herself. The cast assisting her was composed for the most part of unknowns, and there was no one of sufficient promise to warrant being lifted from that category.

The scenes of "Sex" are laid in Montreal, Trinidad and Westchester County. The authorities of all of those places have ample cause for protest.

* * *

September 17, 1926

BEHIND THE BRIGHT LIGHTS

BROADWAY, a "new play" in three acts, by Philip Dunning and George Abbott. Settings by Arthur P. Segal; staged by the authors; dances staged by John Boyle; produced by Jed Harris. At the Broadhurst Theatre.
WITH: Paul Porcasi (Nick Verdis); Lee Tracy (Roy Lane); Clare Woodbury (Lil Rice); Ann Preston (Katie); Joseph Spurin-Calleia (Joe); Mildred Wall (Mazie Smith); Edith Van Cleve (Ruby); Martha Madison (Pearl); Molly Ricardel (Grace); Constance Brown (Ann); Sylvia Field ("Billie" Moore); Robert Gleckler (Steve Crandall); Henry Sherwood (Dolph); William Foran ("Porky" Thompson); John Wray ("Scar" Edwards); Thomas Jackson (Dan McCorn); Frank Verigun (Benny); Millard Mitchell (Larry); Roy R. Lloyd (Mike).

By J. BROOKS ATKINSON

In the uncertain shadows just behind the white lights, life moves with amazing speed, according to "Broadway," put on

at the Broadhurst last evening. With an excellent cast, imaginatively directed, the co-authors of this exciting melodrama have caught the incongruities, the contrasts, the jealousies, ambitions and duplicities and have tossed them all together in blaring, ironic confusion. Their skill in keeping several themes singing all during the drama, the light as well as the malignant, suggests the composer; and their eye for the picturesque—well, perhaps this is the painter. Early in the first act an uptown gangster is fatally shot in the back. In the last act that victim's sweetheart murders the cowardly murderer. With free development such an incident in itself might do well enough for merchantable drama; all of us have paid for that much alone. But the authors of "Broadway" set it against a garish, strident background of cabaret singers, "hoofers," midnight parties, visiting gunmen from Chicago on a drunken spree, with a jazz band outside beating the appropriate tempo. The result is an exhilarating, madly colored melodrama, a kaleidoscope, spattered with the brightest pigments of local color.

Observing those unities of time celebrated by the students of drama, the authors tell their story simply in the private party room of the Paradise Night Club, New York City. When the curtain goes up the cabaret girls and the show "hoofer" are at rehearsal, all in bad temper and quarrelsome, all full of advice. Throughout the rest of "Broadway" this company of midnight entertainers make their entrances and exits, rushing to their dress-rooms, pulling hair and "wise-cracking" each other in the idioms of this pungent vicinity. One of the girls in the company, "Billie" Moore, serves the dramatic function of bringing the two threads of the story together. Roy Lane, the one male entertainer in the cabaret, has picked her, not only as his partner in the big "act" he is working up, but as his sweetheart, subject to the rules and regulations laid down by the marriage bureau. But Steve Crandall, known chiefly as a "big butter-and-egg man" from Florida, apparently has more success with her than the "hoofer." His presents are more lavish; his manners are far more elegant. However, the brightest members of the audience recognize him as a gunman, bootlegger and general tough long before he pulls a "rod" on his uptown competitor and shoots him through the back.

From this moment on the two stories travel in opposite directions. For a time Steve bulldozes the police, and, just as he is on the point of escaping to Canada, perhaps with the cabaret queen by his side, he is killed in revenge for his cowardly first-act murder. On the other hand, the "hoofer" makes rapid progress in his professional and personal career. While Steve lies dead in an adjoining office with the door securely locked, Roy Lane is flirting an offer from a vaudeville manager for his "act" with "Billie" Moore. The Broadway tempo never falters.

Effective though such contrast may be, hard and fleeting in its emotional appeal, the authors have not always managed it perfectly. Particularly in the first act, before the relationships have been firmly established, the transition from one theme to the other occasions a perceptible break in the continuity of the story. And no doubt many of the superfluous incidents and dialogue might be omitted to the advantage of the tale. By defining the important characters completely and

by rushing the drama constantly, especially through the back-stage scenes, the authors, who are also the directors, give their play the illusion of motion even when it is not progressing at all. And the climax to the second act, a perfectly directed incident, has the effect of fusing the various elements of the play definitely. From that time on "Broadway" is firmly packed melodrama.

Although all the parts are played capitally, two of them emerge as excellent pieces of characterization. Mr. Tracy, seen last season in "The Book of Charm," and "Glory Hallelujah," squeezes his part dry. This "hoofer" becomes heroic as well as fatuous, tender and callous at the same time. And Mr. Glecker, seen in "A Man's Man" last year, makes Steve Crandall a sinister character not without a certain charm. As the cabaret girl in dispute between these two men, Miss Field also plays in more than one key. For if "Billie" Moore seems at first to be merely a sweet, young thing, Miss Field gives her uncommon spirit in the end. Conceived in terms of the theatre, written with a true sense of stage projection, "Broadway" makes every part thoroughly actable. None of the players fumbles his chance.

* * *

November 9, 1926

BOOTLEGGING BEDLAM

OH, KAY! a musical comedy in two acts and five scenes; book by Guy Bolton and P. G. Wodehouse, music by George Gershwin, lyrics by Ira Gershwin; book staged by John Harwood; dances and ensembles staged by Sammy Lee; settings by John Wenger, produced by Alex A. Aarons and Vinton Freedley. At the Imperial Theatre.
WITH: Betty Compton (Molly Morse); Janette Gilmore (Peggy); Gerald Oliver Smith (The Duke); Harland Dixon (Larry Potter); Marion Fairbanks (Phil Ruxton); Madeleine Fairbanks (Dolly Ruxton); Victor Moore ("Shorty" McGee); Sacha Beaumont (Constance Appleton); Oscar Shaw (Jimmy Winter); Gertrude Lawrence (Kay); Harry T. Shannon (Revenue Officer Jansen); Constance Carpenter (Mae); Paulette Winston (Daisy); Frank Gardiner (Judge Appleton).

By J. BROOKS ATKINSON

Musical comedy seldom proves more intensely delightful than "Oh, Kay!" the new piece at the Imperial, with a serviceable book by Guy Bolton and P. G. Wodehouse, specialists in collaboration, and a rich score by George Gershwin. Usually it is sufficient to credit as sponsors only the authors and the composer. But the distinction of "Oh, Kay!" is its excellent blending of all the creative arts of musical entertainment—the arts of staging no less than those of composing and designing. For half the enjoyment of the new musical play comes from the dancing, the comic pantomime and the drilling of a large company. Mr. Lee and Mr. Harwood have matched the authors at every turning with inventive and imaginative directing.

After two appearances in America as co-star in the English Charlot Revues, Gertrude Lawrence now appears as a principal in this new comedy. And the plot being what it is,

she comes as the sister of a titled English bootlegger whose yacht hovers off our arid shores amid the excursions and alarums of Federal inspectors. ("The difference between a bootlegger and a Federal inspector," says the incriminating Victor Moore, "is that one of them wears a badge.") Most of us have heard Miss Lawrence singing various musical-hall tunes in good voice and excellent taste, with a wanton twinkle of comedy in her eyes.

In her present rôle she gives expression to that mimic quality more than ever with a versatility barely indicated in the Charlot Revues in which Beatrice Lillie cut such uproarious capers. Miss Lillie, by the way, was among those present last evening. So obliging is the book of "Oh, Kay!" that Miss Lawrence may play not only the love-sick English lady but also the Cockney serving-maid who performs tricks on a long roll of French bread and affects a domestic slouch in her walk. As a low comedian she does not paint the Lillie, but she keeps the enjoyment varied and broad.

Most of this entertainment has to do with a cargo of forbidden liquor and as scurvy a lot of bad puns as ever scuttled a rum-runner. The supercilious duke, with the dapper Gerald Smith "up" on that part, and "Shorty" McGee, buffooned by Victor Moore, have concealed a shipment in the capacious cellar of Jimmy Winter, represented engagingly by Oscar Shaw. As it happens now and then on the musical stage, Jimmy Winter is facing the matrimonial firing-squad with a vixen fiancée whom he does not relish. And all this time a strange English lady seems vastly preferable. Well, things go from bad to worse until the wedding begins solemnly on the efflorescent terrace at Jimmy's luxurious Long Island villa. In the nick of time Federal inspectors, genuine as well as bogus, intervene on the side of law and love.

As the extemporaneous butler, battler or bottler (to speak from the book) Mr. Moore totters languidly through a long roulade of indiscriminate comedy, unseemly impertinence and a constant rattle of amusing "gags." Nothing since the Marx Brothers has been more hilarious than the offhand luncheon served clumsily by Miss Lawrence and Mr. Moore—a clatter of crockery on the stage and ominous sounds from the kitchen nearby. Through all this mixed comedy the diminutive Fairbanks twins wander charmingly, adding roses and honeysuckle to the construction of a "gag" or representing the bridegroom's happy youth.

"Oh, Kay!" bears out the implication of its title most conspicuously in the dancing and in the ordering of the chorus. Leading the footwork light brigade Mr. Dixon becomes wooden or supple according to need in a gauche potpourri of eccentric steps. And for the encore of "Clap Yo' Hands," the most pungent musical number, the chorus performs a cross between anatomical exercise and folk-dance, rapid and energetic.

Mr. Gershwin's score is woven closely into the fun of the comedy. Sometimes it is purely rhythmic, as in "Clap Yo' Hands" and "Fidgety Feet" sometimes it is capricious as in "Do-Do-Do." Mr. Gershwin also composes in the familiar

romantic vein of "Someone to Watch Over Me." In this plaintive number Miss Lawrence embellishes the song with expressive turns on the stage; she employs none of the artful rhetoric of musical comedy singing. For "Oh, Kay!" is the work of no individual. It is a group production to which every one has brought some appropriate decoration. When dramatic organizations pool their talents in this fashion we prattle with smug satisfaction about the universal development of the stage. Revue and musical comedy producers excel in such organized handicraft as a matter of course.

* * *

November 4, 1927

MARK TWAIN TO MUSIC

A CONNECTICUT YANKEE, a musical adaptation of Mark Twain's book in a prologue, two acts and an epilogue. Book by Herbert Fields, music by Richard Rodgers and lyrics by Lorenz Hart. Staged by Alexander Leftwich; dances arranged by Busby Berkeley; scenery and costumes by John T. Hawkins Jr.; produced by Lew Fields and Lyle D. Andrews. At the Vanderbilt Theatre.
WITH: Gordon Burby (Albert Kay/Sir Kay the Seneschal); Jack Thompson (Gerald Lake/Sir Galahad); William Norris (Marvin/ Merlin); William Gaxton (Martin/The Yankee); Paul Everton (Arthur Pendragos/King Arthur of Britain); Nana Bryant (Fay Morgan/Queen Morgan le Fay); Constance Carpenter (Alice Carter/Demoiselle Alisande la Carteloise); William Roselle (Lawrence Lake/Sir Launcelot); Dorothy Roy (Maid Angela); June Cochrane (Mistress Evelyn la Belle-Ans); Celeste Dueth (Queen Guinevere); G. Douglas Evans (Sir Bors); John Morton (Sir Sagramor); Chester Bree (Sir Tristan).

By J. BROOKS ATKINSON

After paying their respects to Mark Twain in their title the artisans of "A Connecticut Yankee," played at the Vanderbilt last evening, make their own tuneful and amusing way through two acts of merry satire. Set to as fresh and lilting songs as we may hope to find, with well-turned lyrics and an intelligent book, "A Connecticut Yankee" makes for novel amusement in the best of taste. Before the final curtain drops the trick of putting brisk American slogans into the language of King Arthur does become rather transparent and labored. But perhaps no one would complain of that if the first half of the piece had not been such capital entertainment.

In this up-to-the-minute Mark Twain burlesque, a brash young American makes his way into Camelot from his bachelor supper at Hartford, Conn. Impertinent and cock-sure, he cuts his smart American capers before the august company of the round-table in clanking suits of armor.

"How long can you keep fresh in that can?" he asks one helmeted walrus flippantly. By the time of the second act he has organized Camelot according to good industrial practice. "I would fain walk a furlong for a Camel," reads one sandwich board. Another, in Old English script, announces "Ye Hiberian Rose of Abie." Between Lucy Stoners, telephone brats, radio, calls for "room service" by Queen Morgan Le

Fay and weather forecasting by Merlin the sorcerer, Camelot clatters as nervously as New York.

Americanization of Camelot is certainly the logical conclusion to any book with Mark Twain's yarn as its model. But the uses of musical comedy are much better served in the first act before efficiency sets in. For the soft-colored costumes of the gracious ladies of the court, the brilliant scenery and the comedy bits are freshest then; and Mr. Rodgers, as composer, plays his best music in these early scenes. Sung charmingly by Constance Carpenter and William Gaxton, "My Heart Stood Still" is one of the loveliest musical compositions of the season.

With "Peggy-Ann" behind him as an earnest of his calibre, Mr. Rodgers has now graduated from the class of beginners. In his unhackneyed score for the current piece he composes with genuine feeling and versatility. There are many fine passages in his score, all the way from the sincerity of hymn motives through the warmth of romance to the crash of jazz. Once he comes perilously close to oratorio. In the lyrics Mr. Hart continues to write original, intelligent, witty rhyme-schemes. Mr. Berkeley has drilled the chorus without stressing the trite dance patterns. From the sensuous point of view "A Connecticut Yankee" is thus refreshingly beautiful. One surmises that only Mark Twain could have kept the book constantly original. As a musical play "A Connecticut Yankee" does not carry its novel idea to fruition.

Impersonating the brassy American, Mr. Gaxton manages, like a good yankee, to maintain the illusion of constant invention even when he is doing the first trick twice. He is winning and active. Miss Carpenter sings and acts with youthful, comely grace. Miss Bryant, Miss Cochrane, Mr. Norris, Mr. Burby and Mr. Roselle perform acceptably the fragile ladies and the humorless jousters of King Arthur's pious court.

* * *

December 28, 1927

SHOW BOAT, "an all American musical comedy" in two acts, adapted from Edna Ferber's novel of the same name. Book and lyrics by Oscar Hammerstein 2d, with music by Jerome Kern. Settings by Josef Urban; dances arranged by Sammy Lee; dialogue directed by Zeke Colvan; costumes designed by John Harkrider; produced by Florenz Ziegfeld. At the Ziegfeld Theatre. WITH: Allan Campbell (Windy); Aunt Jemima (Queenie); Charles Ellis (Steve); Bert Chapman (Pete); Edna May Oliver (Parthy Ann Hawks); Charles Winninger (Cap'n Andy); Eva Puck (Ellie); Sammy White (Frank); Francis X. Mahoney (Rubber Face); Helen Morgan (Julie); Howard Marsh (Gaylord Ravenal); Thomas Gunn (Vallon); Norma Terris (Magnolia); Jules Blodsoe (Joe); Jack Wynn (Dealer/Jeb); Phil Sheridan (Gambler); Jack Daley (Backwoodsman/Max); Dorothy Denese (La Belle Fatima); Bert Chapman (Old Sport); Annie Hart (Landlady); Estelle Floyd (Ethel); Annette Harding (Sister); Mildred Schewenke (Mother Superior); Eleanor Shaw (Kim as a child); Norma Terris (Kim as young woman); Robert Farley (Jake); Ted Daniels (Man with Guitar); J. Lewis Johnson (Charlie); Tana Kamp (Lottie); Dagmar Oakland (Dolly); Laura Clairon (Old Lady on Levee).

The worlds of Broadway and Park Avenue and their respective wives put on their best bibs and tuckers last night and converged at Mr. Ziegfeld's handsome new playhouse on Sixth Avenue. There they milled about elegantly in the lobby, were pictured by flashlight photographers and finally got to their seats and to the business in hand. That was the inspection of the newest offering from the workshops of the maestro, the much-heralded musical adaptation of Edna Ferber's novel, "Show Boat."

From such remote centres of theatrical omniscience as Pittsburgh, Washington and Philadelphia had come the advance word that it was better than good—some reports even extravagantly had it that here was Mr. Ziegfeld's superlative achievement. It would be difficult to quarrel with such tidings, for last night's performance came perilously near to realizing the most fulsome of them.

All right, there you have it: "Show Boat" is, with a few reservations in favor of some of the earlier "Follies" and possibly "Sally," just about the best musical piece ever to arrive under Mr. Ziegfeld's silken gonfalon. It has, barring perhaps a slight lack of one kind of comedy, and an over-abundance of another, and a little slowness in getting under way—this last due to the fact that it is crammed with plot which simply must be explained—about every ingredient that the perfect song-and-dance concoction should have.

In its adherence to its story it is positively slavish. The adaptation of the novel has been intelligently made, and such liberties as the demands of musical comedy necessitate do not twist the tale nor distort its values. For this, and for the far better than the average lyrics with which it is endowed, credit Oscar Hammerstein 2d, who is rapidly monopolizing the function of author for the town's musical entertainments.

Then, too, "Show Boat" has an exceptionally tuneful score—the most lilting and satisfactory that the wily Jerome Kern has contrived in several seasons. Potential song hits were as common last night as top hats. Such musical recordings of amorous reaction as "You Are in Love," "I Can't Help Lovin' That Man," "Why Do I Love You?" are sufficient for any show—to say nothing of "Old Man River," which Jules Bledsoe and a negro chorus make remarkably effective.

If these three contributions—book, lyrics and score—call for a string of laudatory adjectives, the production compels that they be repeated again—and with a short tiger. The colorful scenes on and around the showboat, plying its course along the Mississippi, that comprise the first act lend themselves well to a variety of effects and have been achieved with Mr. Ziegfeld's unimpeachable skill and taste.

In the second act the nine interludes carry the spectator from the gaudy Midway Plaisance of the World's Fair to the sombre quiet of St. Agatha's Convent and then back to the new and modernized floating theatre, 1927 variety. The settings are all atmospherically perfect; the costumes are in the style of each of the periods and there is a finish and polish about the completed entity that caused even a first performance to move with unusual smoothness.

To recount in any detail the plot of a musical comedy usually is a silly and banal business; to tell Miss Ferber's large and clamorous public what happens to Magnolia and Gaylord Ravenal is unnecessary. But to tell them of the manner in which these characters and the many others of the best seller have been brought to life is something else again.

As Magnolia, Norma Terris appeared to be a revelation, even to the first nighters who had watched her work in previous dance-and-tune saturnalias. Her realization of Captain Andy's daughter seemed complete, even when she got around to imitating Ted Lewis and Ethel Barrymore in the final, or 11:45 P. M., scene. Howard Marsh, one of the more facial tenors, made a handsome and satisfactory Ravenal. Helen Morgan, who is among the town's most adept song saleswomen, was Julie, and purveyed two numbers in her distinctive style. As the dour and formidable New England mother, Parthy Ann Hawks, Edna May Oliver played with requisite austerity, although she did forget herself long enough to engage in a dance.

But the outstanding hit of the evening seemed to be reserved for Charles Winninger, who cut capers to his heart's content as Captain Andy.

He is in top form, and when Mr. Winninger is in top form he is an extremely waggish fellow. And in a moment during the "Show Boat's" performance when through the defection of an affrighted villain he is compelled to seize the stage and act out the remainder of the play himself, he is extraordinarily persuasive and convincing. Then there are the reliable Puck and White, presenting the low comedy specialties, and others too numerous to mention.

"Show Boat," as it should not be too difficult for the reader to ascertain by now, is an excellent musical comedy; one that comes perilously close to being the best the town has seen in several seasons. It must have afforded its producer, who has poured dollars into it by the thousands, a certain ironic satisfaction to hear the play's Chicago cabaret manager say with an air of finality, "No, I can't afford to take chances with amateurs with a $2,000 production on my hands." Mr. Ziegfeld can't afford to, either.

* * *

December 29, 1927

MUMMERS ALL

THE ROYAL FAMILY, a comedy in three acts, by George S. Kaufman and Edna Ferber. Staged by David Burton; settings by James Reynolds; produced by Jed Harris. At the Selwyn Theatre. WITH: Josephine Williams (Della); Royal C. Stout (Jo); Wally Stuart (Hall Boy); Murray Alper (McDermott); Orlando Daly (Herbert Dean); Catharine Calhoun-Doucet (Kitty Lemoyne); Sylva Field (Gwen); Roger Pryor (Perry Stewart); Haidee Wright (Fanny Cavendish); Jefferson De Angelis (Oscar Wolfe); Ann Andrews (Julie Cavendish); Otto Kruger (Anthony Cavendish); Lester Nielsen (Another Hall Boy); Frank Vollmer (Chauffeur); Joseph King (Gilbert Marshall); Hubert Courtney (Gunga); Phyllis Rose (Miss Peake).

All through "The Royal Family," shown at the Selwyn last evening, George S. Kaufman and Edna Ferber were watchful and absorbingly with the madness of show folk and the fatal glamour of the footlights. In the play these mummers are the Cavendishes, actors of three generations with a fourth two months matured; and Julie, the most reliable of them, keeps family order, writes checks hysterically and buffets the comic blasts of temperament that assault Cavendish domestic bliss.

Although the authors earnestly and officially disclaim specific models for their character portraits, the lobby scandal-mongers will chatter excitedly of the Barrymores. Certainly the three Barrymores could give it a ripping performance, a range of emotion and a final lustre that it lacks. But fascinating as such piquant speculations may be to the infected layman, "The Royal Family" of the play is obviously no one in particular, but any family in whose blood the deadly germ has lived. They are actors. To them everything outside the theatre is dull and of no importance. Writing wit as well as humor the playwrights fill a long evening with the rigmarole of their dizzy off-stage existence. "The Royal Family" makes for steady entertainment.

One of the outsiders who has the misfortune to love a Cavendish (which is like loving a demented tiger) explains his idea of the show business: "You get your name up in electric lights, the fuse blows out and where are you?" Well, he marries a Cavendish, fathers a baby and gives every promise of having already completed his mission in life. For in the fury of welcoming the dynamic Tony Cavendish back from Europe and getting Gwen Cavendish a part in a Theatre Guild play, a mere husband has no rights and no value. No one notices his unobtrusive exit. What is the public but a coughing nuisance?

For three busy acts, mad with telephone bells, buzzers, frantic servants and C. O. D. packages, the Cavendishes swear they will leave the stage for good and then succumb to the subtle overtures of their crafty manager. Down the flight of steps from the bedrooms they come, spouting chance lines of famous scenes and flinging out gestures. Upstairs the dynamic Tony chases his fencing master from room to room and slays him with a thrust and peroration. He is the best, or the worst, of them according to your susceptibilities. He is heralded by an incoherent telegram reporting foul play in Hollywood. "I gather he's killed some one," says Julie. "Anyone we know?" inquires his grandmother sweetly.

Presently he is home with a bang and a processional of bags, suitcases, golf clubs and hat boxes and a story that cannot wait. All the Cavendishes hang on his words. "Come upstairs, every one, while I take a bath, and I'll tell you all about it," he bellows. Agile, intense, swift, unreasonable, youthfully ingratiating he is the most alluring figure in the play, a "fat part," which Otto Kruger acts for every grimace of humor. In staging it the directors have made rare sport of Tony's wild, impulsive exits and entrances.

Otherwise, "The Royal Family" proves the futility of expecting show folk to behave like "pee-pul." Gwen, repre-

senting the third generation, does marry and give birth to a baby. But she returns diplomatically. Julie, who bears the brunt of family disorder, nearly marries an emerald king from South America, but when she hears him speaking intelligently about intelligent subjects, and speaking with superiority about a non-descript band of troupers, she, too, succumbs to the prospect of a new play. Only ill health has kept her feeble mother from barnstorming up and down the Middle West these past few years; and only the prospect of a new Cavendish, hot for the stage at the age of two months, reconciles her to retirement.

Mr. Kaufman and Miss Ferber have written a more resilient play than the performance expresses; it implies more variety and depth of emotion than the even, sometimes flat, tone of the acting discloses. Mr. Kruger fits his part most completely. Sylvia Field makes an appealing Gwen Cavendish. Haidee Wright describes the humor of the venerable Fanny Cavendish charmingly, although she does not always give her lines the stinging point they need. As Julie Cavendish, Ann Andrews plays intelligently in a part that does not suit her completely. Jefferson De Angelis makes everything of the patient, long-suffering and sentimentally loyal manager. Orlando Daly catches the vanity and the pathos of the Cavendish who is ironically described as a "Lambs' Club actor."

The direction packs "The Royal Family" full of visual motion and general vivacity, and keeps the comedy steadily interesting.

* * *

January 22, 1928

THE PLAY

It was to Washington that Harry Delf went to open "Six Feet Under." Mr. Daly in The Washington Post gave this account of the proceedings:

"The underlying theme in 'Six Feet Under' is one that forthwith has an appeal, having to do with a man who wants to take unto himself all the troubles of the universe; burdens borne by his own immediate relatives. His father is jobless until this fellow gets him a job; his mother toothless, until he buys her bridgework; his sister, an old-maid-to-be until he forces a suitor into an engagement, gets the young man a job and later keeps him out of jail for stealing money; his Aunt Emma, about to undergo an operation, for which he pays; his little brother a truant from school, a crap shooter, a general all-around bad boy, his uncles and his cousins and his aunts his own worst enemies. The only bright spot in this man's life is his wife, sadly neglected because of his family.

"There, the warp and woof of the story. The central character a floor-walker in a shoe store, Mr. Delf has provided himself with a character out-of-the-ordinary; for, with all due respect to other playwrights, none has before this exposed the homelife of a floor-walker. Probably because no one ever thought floor-walkers have homes. The idea, at least, is original and Mr. Delf's handling of the comedy, up to a point, is deft and marvelous. Yet, before and after his second act starts

and ends he loses the thread of it all—and therein is the play's weakness, a poor beginning and end.

"The play opens after the family has come home from a funeral. A little of condolence is enough, but it runs through the best part of an act. Then, after the funeral is finally disposed of, young Elmer Nebblepredder—the floor-walker—works himself into a nervous frenzy, is carted to bed, and made ready for death. With reference to the Grim Reaper all through the first and last acts, the comedy curls up and dies. It seems to be an axiom, outside the theatre, at least, that death is no joke, and life a fairly sweet bon-mot.

"Harry Delf, the author, an erstwhile vaudevillian, and a good one, carries the comedy to a point of excruciation; a fine, masterful bit of work."

They seem to have looked with favor, too, on the play called "La Gringo," which opened last night in Atlantic City. Thus, for example, The Atlantic City Daily Press:

" 'La Gringo' is the story of a warm-blooded Mexican miss plucked from her colorful homeland by a villainous sea captain and transplanted into the cold and clammy atmosphere of New England at the peak of the Victorian era.

"Naturally she does not thrive. The women who should be her friends do all they can to make life miserable for her, and when it develops that her huge fortune is but a handful of coins the sea captain first turns her out and then seeks to lure her as his companion on another cruise.

"The story is not a happy one and the end is particularly lugubrious, but it is gripping, exciting at times and at times provoking laughter.

"Last night's Apollo audience applauded 'La Gringo' generously and kept the curtain rising again for several minutes at the end."

* * *

March 27, 1928

EVA LE GALLIENNE AS HEDDA

HEDDA GABLER, a play in four acts, by Henrik Ibsen, translated by Julie Le Gallienne and Paul Leyssac. Settings and costumes by Aline Bernstein; produced by the Civic Repertory Theatre. At the Civic Repertory Theatre.
WITH: Alma Kruger (Miss Juliana Tesman); Leona Roberts (Berta); Paul Leyssac (George Tesman); Eva Le Gallienne (Hedda Tesman); Josephine Hutchinson (Mrs. Elvstead); Sayre Crawley (Judge Brack); Donald Cameron (Eilert Loyborg).

By J. BROOKS ATKINSON

Close on the heels of the Ibsen centenary Eva Le Gallienne has added the matchless "Hedda Gabler" to her repertory with a performance acted at the Fourteenth Street Theatre last evening. Although Ibsen becomes her well in "The Master Builder" and "John Gabriel Borkman," both of which plays she acted before establishing the Civic Repertory, she does not distinguish herself equally as Hedda. Sometimes her portrayal of this vexed, bored, malignant viper with a weakness for pistols is perfunctory rather than artful. Excepting an

amazingly perfect George Tesman, acted by Paul Leyssac, the group performance of the Civic Repertory company tends too much toward the languor of Miss Le Gallienne's personal performance.

In some respects Ibsen's Hedda is rightly a languid person; there is, perhaps, an academic authority in Miss Le Gallienne's interpretation. For Hedda is a petty daughter of gentility; she is sullen and censorious of other people, but she lacks the courage of self-criticism. Whatever stirs her into activity is negative and unworthy—envy, jealousy, selfishness, perverse vanity. Whatever she accomplishes is likewise negative, such as the wanton destruction of Lövborg's manuscript and a diabolical part in his horrible suicide. With a little more spontaneous spirit she might have turned all her negations into achievements for herself through the others she longed to control.

Being a concept of Ibsen's fiery imagination, however, Hedda radiates force even in the negative impulses that stream from her idleness and her laconical lips. In her performance of three years ago Emily Stevens caught the pulse of Ibsen well-nigh perfectly when she rattled the chains of Hedda's voluntary imprisonment. Miss Le Gallienne's portrayal appears more submissive.

Not that she misses the sinister quality in this modern Fury. Miss Le Gallienne never plays unintelligently; subtleties of gesture and vocal inflections that are grudgingly courteous convey Hedda's negative character. Furthermore, Miss Le Gallienne logically makes a great deal of the pantomime at the close of Act III, when Hedda burns the manuscript—not impulsively, not daringly, but with a sort of timidity that rises finally to a snarling, tearing passion. To a more vibrant Hedda this scene would have been less deliberated; Miss Le Gallienne quite properly makes it count for much in her performance.

The program quotes, to Miss Le Gallienne's personal advantage, Ibsen's own description of the General's daughter: "Hedda is about 29. She is a woman of breeding and distinction. Her complexion is pale and opaque—her eyes, steel gray, express a cold, unruffled repose. Her hair is an agreeable medium brown, not particularly abundant. She is dressed tastefully in a somewhat loose-fitting morning gown." Bringing the part as well as the play up to date, Miss Le Gallienne dresses Hedda in the current mode—even to a jaunty mourning frock. Driven to desperation by the futility of life, she consumes several cartons of cigarettes.

As George Tesman, the weak-kneed pedant, Mr. Leyssac leaves no corner of his part unilluminated. A boor with the best intentions in the world, but a coward damned with a stuffy mind, Mr. Leyssac keeps his imperfections consistently interesting; and that, incidentally, is interpretative acting at its best. Alma Kruger articulates Juliana Tesman quite as lucidly in her brief expository scenes. Donald Cameron makes Eilert Lövborg a positive personality. Josephine Hutchinson expresses the forebodings and the mental tragedy of Mrs. Elvstead without her very tangible maturity.

To accent the various episodes properly the performance needs a great deal more animation in vocal quantities and in pace. One suspects that the draperies that serve for scene designs may have resulted in damaging the acoustics of the stage. At least in the early scenes last evening the speaking was less authoritative than Ibsen's forceful drama.

"Hedda Gabler" appears here in a "revised translation by Julie Le Gallienne and Paul Leyssac," which does not seem radically different from Archer's standard text.

* * *

August 15, 1928

IN NEWSPAPER ENGLISH

THE FRONT PAGE, a play in three acts, by Ben Hecht and Charles MacArthur. Staged by George S. Kaufman; settings by Raymond Sovey; produced by Jed Harris. At the Times Square Theatre.
WITH: Vincent York (Wilson); Allen Jenkins (Endicott); Willard Robertson (Murphy); William Foran (McCue); Tammany Young (Schwartz); Joseph Spurin-Calleia (Kruger); Walter Baldwin (Bensinger); Violet Barney (Mrs. Schlosser); Jay Wilson (Woodenshoes Eichorn); Eduardo Ciannelli (Diamond Louis); Lee Tracy (Hildy Johnson); Carrie Weller (Jennie); Dorothy Stickney (Molly Malloy); Claude Cooper (Sheriff Hartman); Frances Fuller (Peggy Grant); Jessie Crommette (Mrs. Grant); George Barbier (The Mayor); Frank Conlan (Mr. Pincus); George Leach (Earl Williams); Osgood Perkins (Walter Burns); Matthew Crowley (Carl); Gene West (Frank).

By superimposing a breathless melodrama upon a good newspaper play the authors and directors of "The Front Page," shown at the Times Square last night, have packed an evening with loud, rapid, coarse and unfailing entertainment. Set in the press room of the Criminal Courts Building in Chicago, it stirs up reporters, criminals, politicians, wives and sweethearts into a steaming broth of excitement and comedy; and last evening an audience, obviously prepared to be delighted, hung on every line and episode until the end. Ben Hecht, novelist and dramatist and Chicago arbiter of taste, and Charles Mac Arthur, co-author of "Lulu Belle," have told a racy story with all the tang of front-page journalism, and George S. Kaufman has poured it on the stage resourcefully. Acted in the vernacular and in a lurid key by Lee Tracy, Willard Robertson, Osgood Perkins, Claude Cooper, Dorothy Stickney, George Barbier and many others—all welded into a seamless performance—"The Front Page" begins a new season noisily.

In the escape of a prisoner just on the eve of a political execution, and in the draggle-tailed characters involved, the authors have such a picturesque yarn to spin that their insistence upon thrusting bespattered conversation down the throats of the audience is as superfluous as it is unpleasant. No one who has ground his heels in the grime of a police headquarters press room will complain that this argot misrepresents the gentlemen of the press. And the Chicago scribes of "The Front Page," waiting impatiently for the hanging of Earl Williams while experimental sandbags are thumping on the gallows outside, are no cleaner of mouth than of linen.

Wrangling at poker, leering over the political expediency of the execution, abusing the Sheriff and the Mayor insolently, they utter some of the baldest profanity and most slattern jesting that has ever been heard on the public stage. Graphic as it may be in tone and authenticity, it diverts attention from a vastly entertaining play.

The plot of "The Front Page" concerns Earl Williams's escape from jail on the eve of his hanging. For nearly an act he appears to be gone. In the fury of the excitement, when the press room is empty of all save Hildy Johnson of The Herald-Examiner, Williams feebly climbs in at the window and surrenders. But Hildy Johnson thinks fast. Instead of delivering Williams over to the police, who are searching for him far uptown, Johnson slams him into a roll-top desk and preserves him as a physical scoop for his newspaper. But even Walter Burns, the esoteric managing editor, cannot complete the kidnapping. Presently the police ferret out the mystery and only an eleventh-hour reprieve saves the neck of Earl Williams and saves Johnson and Burns from jail sentences.

After producing "Broadway" and "Spread Eagle," Jed Harris could not let such a plot cross the stage unembellished. And no stripped summary of "The Front Page" can convey the rowdy comedy of the pressroom, the whirr of the excitement, of nerves on edge, the apprehensive stupidity of the sheriff, the flatulence of the Mayor, the impatience of Johnson's fiancée who is ready to be married, the bewilderment of her mother caught up defenseless in the hurly-burly of a big newspaper yarn, the attempted bribery of the Governor's messenger and the ridiculousness of the inconsequential items telephoned to the desk while the man-hunt still prowls on. It is all here, down to the popular scrub woman and the policeman dispatched for sandwiches. Author and directors have accounted for every moment, tossed their story rapidly back and forth, and pulled down their curtains on the tensest episodes of all.

Such plays have little leisure for character development. Yet "The Front Page" denies the audience none of Hildy Johnson as he abandons newspaper work forever, blackens the character of his chief decisively, and finally juggles his impending marriage and a newspaper sensation through the rest of the play. Lee Tracy, one-time hoofer in "Broadway," acts the part vividly and impulsively. Willard Robertson, as the jaded sleuth for the Journal, plays admirably; and Osgood Perkins does as well by the managing editor. As Molly Malloy, a sinning sister of Clark Street, Dorothy Stickney gives one of her best performances. All the parts have been admirably cast. Equipped with a good script and directed with a sense of time and color, "The Front Page" keeps melodrama still the most able variety of current stage entertainment.

* * *

September 16, 1928

AGAINST THE CITY CLATTER

By J. BROOKS ATKINSON

In case Arthur Hopkins should be interested, be it known that in "Machinal" he has produced a play impossible to tuck away comfortably in the familiar circumlocutions of the reviewing craft. Usually we regard plays in terms of resemblances; and in point of fact "Machinal" resembles more than one bespattered murder tale. The woman who marries helplessly for protection, takes a lover and kills her husband is no fresh conception on the stage or in life. In "An American Tragedy" we have already peeped in at the gruesome horror of the prison death quarters. Furthermore, the episodic treatment of the story, the skeletonized settings, the descriptions of the dull routine of office life through the medium of adding machines, filing cabinets and typewriters and dogmatic tatters of office conversation, recall "The Adding Machine," "From Morn to Midnight" and the whole mad tumble of expressionistic drama. Yet, from all these factual resemblances, "Machinal" emerges as a triumph of individual distinction, gleaming with intangible beauty. Sophie Treadwell's abstract treatment of the story, Zita Johann's pellucid acting in the leading rôle, Mr. Hopkins's immensely skillful production, have wrought an illuminating, measured drama such as we are not likely to see again.

Long experience has taught us to prepare ourselves for flaming passion and crowded excitement in murder plays. The emotional ordeal of the nameless Young Woman in "Machinal" would be well suited to such torrid treatment. Hating her office duties she marries her employer, whom she cannot endure, goes slumming timidly in the speakeasies in quest of enjoyment, succumbs to the gentle advances of an adventurer, kills her husband, stands trial in a court room scene, listens to the sonorous consolations of a priest in the death cell and stumbles, frightened and ghastly, to the electric chair. The news columns have chronicled that tawdry yarn before.

They have never disclosed it, as "Machinal" does, in terms of an impersonal exposition of character in conflict with environment. In the ten scenes of this play all the emotions well up, but crisp and austere—like intellectual images of what we are usually asked to feel. Flinging overboard the usual sentimentalities, neither excusing nor forgiving, Miss Treadwell dogs the Young Woman's disasters through their successive steps to the chamber of death, linking the end with the beginning, keeping her play restrained and tidy. "Somebody, somebody!" the helpless creature screams in her dying agony. That was a trait of her character in the beginning. When her typewriter broke down in the first scene she groped around blindly for "somebody" in much the same fashion. Trying to explain why she has murdered her husband with a stone-filled bottle she sobs, "I killed him to be free." Those were the words spoken by her lover in an earlier scene when he explained how he had come to murder two Mexican greasers with the same weapon. So "Machinal" is less murder play

than steel-edged study of character, directed and played in perfect harmony with its theme.

As a character this disconsolate Young Woman lays no strain upon the imagination. All she has asked of life in her feeble way are rest and peace, clean air, quiet, freedom from the endless pressure of bodies, pity and understanding; she wants to be let alone. Elementary things to desire, they are rights to which every one should be entitled. Yet nowhere in this shrill and clattering metropolis to which the French title refers is there space for rest—nowhere except for a few sweet and tender moments stolen for her lover. At the office the monotonous, empty prattle of the switchboard operator, the leering "Hot Dog!" of the filing clerk, and the mechanical gibberish tossed between the adding machine and the type-writer press against her like brick and mortar walls. For all his decent consideration her husband never touches her save with fat, moist hands; his pious stencil phrases, his hideous self-assurance, his maddening chuckles dispose of her like the contracts he locks in his safe. At her trial for murder the fulsome rhetoric of her attorney and the vulgarity of his praises of her character roar like words in a distant world. "Why didn't you get a divorce?" the judge asks when she confesses to the crime. "I couldn't hurt him that way," she remarks in words naïve but true to her character; and the court room rattles with frigid laughter. Even in the death cell when she desperately seeks enlightenment about life, the priest replies impersonally in the cadenced ritual of his prayerbook; and as she drags her wretched body toward the chair the holy words and holy names boom over her head like mockeries. "Somebody, somebody!" she screams at the end. Only a pulsating flood of terrifying crimson light, like a still flame, makes reply.

Not that the city is wholly to blame. To test that point completely "Machinal" has made the Young Woman too col-orless, too lacking in personal idealism. But author and pro-ducer have had the rare wisdom to depict her adversaries, not as malicious people, but as well-meaning inhabitants of this aging planet. The switchboard operator may be common in speech and thought, but Millicent Green keeps the part alive with spirited good nature. Nor is the husband a swine. "He's a vice president; he must be decent," her mother fairly observes. In portraying the part George Stillwell does not dwell so much on his mediocrity as to lose his instinctive kindliness. To the lover the Young Woman is one of many amorous experiences; but he does not take without giving. Smiling, glowing with healthy youth, Clark Gable expresses admirably the attractive qualities in this glamorous vagabond. "Quien sabe?" is sufficient to his philosophy.

For people whose desires are so easily satisfied the Young Woman is no match at all. Caught on the edge of the maelstrom, she is torn along with the current, weak and bruised, too unresourceful to save herself. Inevitably the weakling submits; yet submission seals her doom. In a sense, even the murder she commits happens as much to her as to her husband. Zita Johann, who is now making her first conspicuous New York appearance, transforms the part into

a major event of the current theatrical season and imbues it with haunting loveliness and a luminous truth of character. It is a difficult part, setting the tone for the entire performance and disclosing the meaning of the drama. There is nothing stale or faltering in her acting. On the contrary, there are moments of mute rather than spoken eloquence in the shy happiness of the one love scene and the crippled pity of the scene in the death cell.

Whatever doubts there may have been about this truncated technique of story-telling Mr. Hopkins has quite dispelled by the discerning beauty of his production. The ten scenes record this Young Woman's tragic tale like a well-composed frieze that repeats the same motive in variant forms. Robert Edmond Jones's suggestive backgrounds may seem cryptic by compari-son with the customary representational frame settings; but they are vividly alive and splendidly lighted. Matching the style of Miss Treadwell's drama, they have lopped off every superfluous detail; they are electric and vital. And in staging the play generally Mr. Hopkins has surpassed himself. Nothing sours the harmony of the illusion he has drawn from his mate-rials; even the off-stage sounds, which usually rasp against the ear, float gently in and out of the action like the airplane that zooms across the last scene but one.

During the past few seasons most of us have been so bruited about by the thumping drama that we are ill-prepared for such a moderate-tempered play. "Machinal" speaks to the mind. For competitive producing, without the bland assur-ance of a subscription audience, it is a perilous venture. Mr. Hopkins has been in peril before.

* * *

October 24, 1928

ANIMAL CRACKERS, a musical comedy in two acts and six scenes. Book by George S. Kaufman and Morrie Ryskind, lyrics and music by Bert Kalmar and Harry Ruby. Staged by Oscar Eagle; settings by Raymond Sovey; dances by Russell Market; produced by Sam H. Harris. At the Forty-fourth Street Theatre. WITH: Robert Greig (Hives); Margaret Dumont (Mrs. Rittenhouse); Arthur Lipson (M. Doucet); Alice Wood (Arabella Rittenhouse); Margaret Irving (Mrs. Whitehead); Bobby Perkins (Grace Carpenter); Bert Mathews (Wally Winston); Milton Watson (John Parker); Louis Sorin (Roscoe W. Chandler); Bernice Ackerman (Mary Stewart); Zeppo Marx (Jamison); Groucho Marx (Captain Spalding); Chico Marx (Emanuel Ravelli); Harpo Marx (The Professor).

Here come the Marx brothers again with their uproarious, slapstick comedy in a new fury of puns and gibes by George S. Kaufman and Morrie Ryskind, entitled "Animal Crackers" and displayed at the Forty-fourth Street Theatre last evening. And here come their merry audiences who chuckle and roar at Groucho's sad, glib, shrapnel waggery, at Harpo's mum-mery, which is as broad as it is long, and at Chico's barefaced jocosity. For if anything is more remarkable than the outra-geous buffoonery of this team of cut-ups, it is their fabulous popularity.

Speculators swore they could get as much as $100 for two tickets to the opening performance. And most of those who had squeezed into the bulging theatre last evening were obviously in the flattering mood of expecting the Marx brothers to redeem in one evening all the dullness of the current theatrical season. That would be a large order. However, those who remembered that the Marx brothers are not supermen but merely the maddest troupe of comedians of the day, limited in their vein, and compelled to appear in a routine musical comedy—those who were sane were not disappointed.

Their previous appearances have worn some of the freshness off their fun. Especially in the first act, when the musical comedy fiddle-paddle is cluttering the stage, their vandalism leaves a good deal to be desired. Once or twice it is merely nasty. But the second act settles down hilariously to their robust Harlequin du Barry number and one astonishing nonsense sequence that somehow progresses from talk of a robbery to the erection and furnishing of a house. Even Groucho, the intellectual of the troupe, looks bewildered and apprehensive when he realizes where this convincingly rhymeless conversation has led.

To set off their particular brand of humor the authors have turned them loose in a fashionable Long Island house party where Groucho can hurdle over his puns, Harpo can break all the rules of good society and Chico scuttle the estate. The event of the evening is the robbery of a valuable picture.

But the Marx cable accepts all this hodge-podge as so much dead weight, valuable theatrically only for its contrast. The Marx boys do the rest. Delivering his mad-cap chronicle of an African exploration, Groucho touches on nearly every topic of the day and makes some of the most insane verbal transitions heard since his last appearance. "I used to know a fellar by the name of Emanuel Ravelli who looked like you," he says to Chico. "I am Ravelli," says Chico. "No wonder you look like him," Groucho runs on. "I still insist there's a resemblance." Those who heard him last evening turn the title of a popular song into "You Took a Bandage Off Me"; advise a South American traveler "You go Uruguay and I'll go mine"; dictate a formal note to his attorney in full, "Dear Madame: Regards—that's all"; and reply to a woman who charged him with bigamy, "Of course, it's big of me"—those who heard an evening of such things were shamelessly satisfied.

They are nihilists—these Marx boys. And the virtue of their vulgar mountebankery is its bewildering, passing, stinging thrusts at everything in general, including themselves. Burlesquing their own comedy, the show occasionally resolves itself into a vicious circle that is less amusing than it deserves to be. But their stock in trade has other ruffian advantages. They make a good deal of their ludicrous costumes—Groucho in the sun helmet of an African explorer and the morning coat of a floor walker; Harpo in evening dress that slides off and leaves him hideous in trunks and a tall hat; Chico in the ungainly attire of an immigrant.

And they have managed to refurbish some of the ridiculous routines that made their first show a memorable event.

There is another rude card game full of chicanery, and a loud, thumping robbery scene in which they steal a portrait in the darkness during a thunderstorm. But their funniest scene is the du Barry costume assignation just before the close of the performance—the true offspring of their immortal Josephine and Napoleon number. Those who remember Groucho as the Little Corporal will know how comic he can be as the King.

Perhaps it is sentiment, or perhaps it is a fact that neither "The Cocoanuts" nor "Animal Crackers" packs the fun as freshly and rowdily as the original "I'll Say She Is." Or perhaps we are too well acquainted with the Marxian style and range of humor. For all its topical foolery about the avid "Wally Winston" of the "Evening Traffic," "Animal Crackers" is uncommonly perfunctory in its construction as a musical entertainment.

With the music and lyrics, Bert Kalmar and Harry Ruby have done a workmanlike if not a distinguished job. "The Long Island Low-Down" and "Cool Off" are agreeably written and sung. Although the dance designs are seldom original, some of them display the costumes well, and two or three of them are danced with spirit. The task of fitting the Marx boys into such a carnival is thankless at best. Whatever the plot or the background may be these scurrilous mimes remain very much themselves.

* * *

November 27, 1928

HOLIDAY, a comedy in three acts, by Philip Barry. Staged by Arthur Hopkins; settings by Robert Edmond Jones; produced by Mr. Hopkins. At the Plymouth Theatre.
WITH: Hope Williams (Linda Seton); Ben Smith (Johnny Case); Dorothy Tree (Julia Seton); Monroe Owsley (Ned Seton); Barbara White (Susan Potter); Donald Ogden Stewart (Nick Potter); Walter Walker (Edward Seton); Rosalie Norman (Laura Cram); Thaddeus Clancy (Seton Cram); Cameron Clemens (Henry); J. Ascher Smith (Charles); Beatrice Ames (Delia).

With his marvelous gift for spinning, spiraling humors, Philip Barry keeps life gay through most of his new spindrift comedy, "Holiday," put on at the Plymouth last evening. For one act, in fact, he gives full rein to his scattered, mocking, fluffy fooling and to his characters who will not let the fun go out of their lives. Nothing could be grander amusement than that opening act. For no logical reason Mr. Barry also has a thesis on his hands—one so much of the Edith Wharton manner that it tags far behind his mischievous fun. Only the buoyancy of his point of view, the spurts of rippling dialogue and the shining verve of the acting bring "Holiday" safely through the solemnity of that fable.

What he is arguing is the emptiness of the rich, the solidly affluent life. All that stands between Johnny Case and the wealthy Julia Seton is his determination to keep free from the entangling alliances of social position. Having made his one killing in the stock market, he now insists upon retiring early in life when he can enjoy it, rather than late, when the spirit has run out. But to her strait-laced breeding,

such a vagary damns him as an idler. There shall be no pariahs in her domestic life. And that, if you are interested, is the reason they break the engagement, and the reason her rebellious, smitten sister, now released from decent loyalty to a member of her own family, pulls on her cap and runs cheerfully after him.

Since, according to a crusted tradition, a playwright must have a story, let this one pass for what it is worth. For Mr. Barry it is hardly more than an excuse to push his favorite characters onto the stage and to uncork his matchless effervescence. What dialogue! It springs directly from the usual sources of polite banter; it does not eschew the lowly pun. Only a little rougher and disorderly, and it might be the Marx boys up to their old tricks. But Mr. Barry turns it neatly, flips it daintily into the pattern of his story, and for long periods lets it bounce back and forth between two characters like a tennis volley. Occasionally it seems a trifle self-conscious, as when the kin-spirits in worldly irreverence, led by Donald Ogden Stewart in person, sit down gravely while he discloses the secret of his fantastic success. Usually it dances gayly without rhyme or reason and leaves only the impression of lightness when it has stopped. For if Mr. Barry does not scrupulously keep it in character, at least he keeps character in it.

For his chief character, the rebellious Linda Seton, such dialogue is a defense against the melancholy of her thoughts. It is no secret that Mr. Barry has drawn the part to suit Hope Williams, the ironically merry friend of the family in "Paris Bound" last year; and it will soon be no secret that Miss Williams is one of the most clear-headed comediennes we have. When Linda Seton finds the irresponsible Johnny one of kin in temperament and sits down to match nonsense with him, Miss Williams plays quietly with a sort of comic incandescence that is one of the superlative delights of this season. Through all the turns of the play she remains very much herself—boyishly awkward, but quick and sparkling. Whatever she may do with other characters, the style of the Linda Seton is definitely hers.

Having Arthur Hopkins as a producer for this play as well as "In a Garden" and "Paris Bound," Mr. Barry is in good hands. Casting and direction, as well as Robert Edmond Jones's settings, make the most of his comedy. All the acting gleams with light. Dorothy Tree as the reluctant Julia Seton lets the hardness of character break through the charm with great skill. Ben Smith as the blundering Johnny puts ruggedness as well as freshness into his part. In the minor part of despairing brother Monroe Owsley gives a splendid, true performance. Reclaimed from letters and shoved unceremoniously behind the footlights, Donald Ogden Stewart picks up the mood expertly. As the humorless father, Walter Walker manages to keep a stock part humanly believable.

Mr. Barry is effortless with dialogue and characters. But pressing a story around them still keeps him uneasy. "Holiday" does not flow as graciously as "Paris Bound" and does not curl around ideas so amiably. But it has savor, fresh color

and sunny merriment. Even when it is unhappily dramatic it is still a holiday in playmaking.

* * *

January 11, 1929

STREET SCENE, a play in three acts, by Elmer Rice. Staged by the author; settings by Jo Mielziner; produced by William A. Brady, Ltd. At The Playhouse.
WITH: Leo Bulgakov (Abraham Kaplan); Eleanor Wesselhoeft (Greta Fiorentino); Beulah Bondi (Emma Jones); Hilda Bruce (Olga Olsen); Russell Griffin (Willie Maurrant); Mary Servoss (Anna Maurrant); Conway Washburne (Daniel Buchanan); Robert Kelly (Frank Maurrant); T. H. Manning (George Jones); Joseph Baird (Steve Sankey); Jane Corcoran (Agnes Cushing); John M. Qualen (Carl Olsen); Anna Kostant (Shirley Kaplan); George Humbert (Filippo Fiorentino); Emily Hamill (Alice Simpson); Frederica Going (Laura Hildebrand); Eileen Smith (Mary Hildebrand); Alexander Lewis (Charlie Hildebrand); Erin O'Brien-Moore (Rose Moran); Glenn Coulter (Harry Easter); Millicent Green (Mae Jones); Joseph Lee (Dick McGann); Matthew McHugh (Vincent Jones); John Crump (Dr. John Wilson); Edward Downes (Officer Harry Murphy); Ralph Willard (A Milkman); Herbert Lindholm (A Letter-Carrier); Samuel S. Bonnell (An Iceman); Mary Emerson (A Music Student); Ellsworth Jones (Marshall James Henry); Jean Sidney (Fred Cullen); Joe Cogert (An Old-Clothes Man); Samuel S. Bonnell (An Interne); Anthony Pawley (An Ambulance Driver).

Still unwilling to write a conventional play according to the safe, stereotyped forms, Elmer Rice contents himself with writing an honest one in "Street Scene," put on truthfully at the Playhouse last evening. If you disengage its story from its lithographic New York environment you must classify it as the drama of a crime of passion. When Frank Maurrant, a burly stagehand, finds his wife behind drawn blinds with Steve Sankey, a collector for the milkman, he kills both of them. Mr. Rice prepares for this violent scene in the first act, stages it in the second and discloses the consequences and some of its human significance in the last. Slight as this story is, unoriginal as it is, "Street Scene" has little more to say. Yet it manages to be generally interesting, frequently amusing and extraordinarily authentic until the final curtain.

For Mr. Rice has visualized it in terms of an average New York tenement house on the grimier edge of the middle class. And if the crime of passion stirs any emotions within you it is because Mr. Rice has succeeded in relating it to life and enlisting your sympathies for the tatterdemalions who troop along his average street, hang out of the windows on a hot Summer evening, gossip, quarrel, romance and make the best of their stuffy lot. Mr. Rice does not sentimentalize about them. He does not blame them for their prejudices and blunders and short tempers. Indeed, "Street Scene" constantly lacks a point of view. Mr. Rice has squandered all his talent on making each episode and character ring true.

He has observed and transcribed his material perfectly. Never did the phantasmagoria of street episodes seem so lacking in sketchy types and so packed with fully delineated character. No one with his eyes open on the streets of New York

could miss the policemen, letter carriers, babies, janitors, doctors, the Jews, Swedes, Italians and Irish who pass up and down the dingy street, in and out of the seedy tenement door, or loiter on the steps to bear tales of wayward neighbors and muse over the imponderables of life. These obvious traits of our slummy life Mr. Rice has worked into his humane portrait—even to the exercising of the dog and the airing of night clothing in the faint sunlight of the listless city morning.

What distinguishes "Street Scene" from a host of synthetic forerunners is Mr. Rice's remarkable sense of character. Here are not merely the automatons of the giddy city streets, but the people—the intellectual Jew who runs on endlessly about the capitalistic classes, the Italian musician who dreams of the flowery land from which he came, the office girl who wants to move out to Queens, the pleasant woman who is quietly sacrificing her life to a sick mother, the ruffian taxicab driver, the flirt, the school teacher, all brought into focus with telling strokes of character-portrayal.

Most of them are not smashing at the barriers that cramp their lives. Most of them are merely living. And Mr. Rice's flowing, somewhat sprawling drama, catches the primitive facts of child-birth on the third story, the chicken for soup, the petting after dark, the common hatred of the intellectual Jew—race prejudices, class morality, jolly, broad humor, sympathies,

jealousies. Again, he expresses no point of view about such matters. For those who are interested, it is sufficient that he has completed his portrait with remarkable artistic integrity.

As his own director he has cast the parts quite as accurately. Leo Bulgakov's radical Jew, George Humbert's light-hearted Italian musician, Millicent Green's impudent chippie, Mary Servoss's tired Irish mother are excellent pieces of characterization. Some of the acting, like Beulah Bondi's malicious gossip and Erin O'Brien-Moore's office girl, have time and space enough for complete fulfillment. Excepting for a certain lack of restraint, Horace Braham's restless and sensitive young Jew is fine and true. Only the length of the cast prevents naming the boys, girls and the other neighbors who act creditably.

Whether or not an artist should have a more sentient point of view about his material is a question for the higher criticism rather than a newspaper review. Certainly "Street Scene" is not all of one piece. Furthermore, Mr. Rice's concluding philosophy, which intelligently discusses the significance of this neighborhood incident, is nearly lost in the jumble of a street panorama. If you accept on its own terms this new play by the alert author of "Adding Machine" you will find it as vital, as fascinating, as comic, as the streets along which New York people live.

FILM

SURVIVORS OF A VANISHING RACE IN THE MOVIE WORLD

"Lecturers" on the Lower East Side—Five of 'Em —Still Explain Eloquently What Is Happening on the Screen, and Regard Their Work as Art

"I—ah—love you. You must marreh me to day," Edwin declared from his perch on the left-hand side of the screen at the Odeon Theater, somewhere on the lower east side. (Natives will send you to the "middle from Clinton Street" when you ask for explicit directions.)

The single violin played soft, suave music, as swift from the lips of Helen, at the right-hand side of the screen, came the reply in throaty accents.

"No—ah—cannot. No, it can nevah be. I am brown and you are—white! I am a Hawaiian, even though I am a Princess. Your folks will nevah consent to a marriage between us-ah!"

Between Edwin and Helen, Evelyn Nesbit on the screen crushed her face into the pillow on the couch while the scion of the noblest family of the Empire City supported his face on drawn-up knees and mournfully surveyed his spats between the chinks of his fingers.

"For East is East and West is West.
And never the twain shall meet—"

But under the magically eloquent tones of the lecturer, East and West do meet while bearded Jews and matronly, bewigged Jewesses, with seltzer wagon drivers, red-haired, plump lassies and infants in arms heave contented sighs.

Edwin and Helen (O'Neill) were pioneers in that branch of industry—or shall I say art—which numbered in its day thousands of followers. That was a day when no motion picture was complete without its running fire of explanation from the side lines, but the work of the "lecturer" is fast becoming nowadays a lost art. But five of the craft—or shall I say cult—remain, and all are to be found on the lower east side. Recently all five went out on strike with the ushers, managers (who are also ticket takers), candy boys and motion-picture operators. Now, victorious, their Bryan-edged tongues are more dramatic and eloquent than ever.

To do justice to these graphic expositions, I am compelled to go back to the old days when the dollar bought a dollar's worth, and a professor's salary was a thing to respect. Marcus Loew at that time organized, through some of his executives, a staff of motion-picture elucidators, or Ciceros, to cover the country. Perhaps that was because the motion picture was not the finished product it is now. It was going through its teething age. The salary offered surely was no inducement to him who honestly believed that to be a lecturer was the fulfillment of an artistic calling, and Loew, tiring soon of the innovation, or not finding it profitable (so the story goes), discontinued it. The Bronx, Harlem, and Brooklyn, including Flatbush, as well as the "provinces," turned back to voiceless movies.

But the east side kept the voices.

Why? Because, in the words of the lecturers themselves, to be a lecturer you have got to have feeling; to listen to one you have got to have feeling, and this the people of the east side have, whatever they may lack in worldly goods. Besides, it is only the truly critical who understand pure art, and east side audiences are critical to the last extreme.

O'Neill, who was one of the Loew pioneers, from the beginning looked upon lecturing as a matter of artistic import. To interpret the minutest blink of an eyelash, whether of villain or hero, was to him a matter of no slight consequence. Mrs. O'Neill entered "the profession" three years later.

"He made me realize," she said, "that if you want to be an artistic lecturer you got to pay attention to details. For instance, you take scenes where the heroine sings a song. Do you think I talk then? No, I sing. And I sing the kind of song the picture calls for. My husband and I pick out the right kind."

There must be something more, however, to satisfy the audience peculiar to the Ghetto. There are a few materialists in those wooden backed chairs. All are not idealists. But they are all stanch defenders of the theatric illusion. They are the ones who stamp their feet and whistle derisively when a picture is mysteriously decapitated in the flashing. Sometimes flecks which resemble a steady downpour of rain scurry across the screen when no rain is intended, and then an ominous hissing fills the room. They are the ones who in Summer devour many ice cream cones and in Winter many soapy chocolates and fragrant sticks of chewing gum, peanuts and grapes, spiritually oblivious of time and the trials of "Red" plots, treaty debates and society scandals. They are here to learn the "Yankee" language.

It was Harry Levine, one of the lecturers, who pointed out to me their usefulness as Americanizers. After a brief probationary period at the Educational Alliance on East Broadway, the Mecca of fine arts on the east side, he had gone on the "road" with a repertoire company, playing Romeo, and Duncan in "Macbeth." Later he became a railway starter, but the lure of the stage won him back and here he is, a lecturer!

According to Levine, night schools might do well to take a tip from movie lecturers on how to teach English painlessly.

"A fellow comes in here to see a show," Levine explained. "He's just learning to read English. In the old days, when his pay was small and his day was long, he didn't have the time. Now he has the time and the money, and he tries to make it his business to pick up the language in every way he can. That's where we lecturers come in. The fellow isn't as quick as he'd like to be. Here and there he can pick out a letter, maybe a whole word, but not a whole sentence. We read it for him, and, what's more, we explain it to him. That kind of a fellow comes again and again, and he learns, believe me!"

It is Levine's theory that these men and women learn more readily and quickly because they are at ease in the moving-picture theatre. There is no teacher at the front demanding to know what they have learned in the last thirty minutes. And as for the eating, Lavine believes it takes away the pain of concentration. In schools, I remember, masticating any-thing from a pencil eraser to an honest-to-goodness salmon sandwich eased the pain of concentration. If only for the sake of childhood memories I incline to subscribe to the movie-lecturer theory of lingual education.

The old men and women who are parents and grandparents to ever-increasing numbers form the nucleus of the lecturers' pupils. Here they learn English words that they dare not ask of the younger generation for fear of being laughed at. They are usually very simple words, but difficult for the timid tongue. This wrinkled group forms the neighbor-questioning brigade in those motion-picture houses where lecturers are not; and many a time its members withdraw into a sallow, toothless shell, hurt because the neighbor has suddenly developed an attack of deafness. To this group the lecturer is a boon, a ray of sunshine. Now and then the voice coming through the megaphone drops a Yiddish phrase, and then there are wide manifestations of delight.

Where do the artistic perceptions of the audiences come in? Ask Louis Gerdel or Ben L. Moore, the other members of "the profession." Moore told me that his audience was harder to please than a Metropolitan Opera House crowd. His audience at that particular moment was composed of about 200-heat-smothered men, women, and children in various states of exhaustion, all watching the screen with bright-eyed interest. The man who peddled pretzels, tired of dodging the police-man, sat in a corner of the fourth row, his blue shirt loosed at his bosom. Next to him, breathing heavily, sat fat Mrs. Rosen-kranz, clad in a voluminous ruffled gingham skirt and wide kimona, blue with purple flowers. At the end of another row a little girl wearing a pair of new pink striped socks hissed impatiently for the soda boy in the sloppy, white coat to hurry to her side. Her thirst was imperative. Perhaps it was not so much her thirst as her little brother directing vicious jabs at the uncovered part of her legs. Moore tried to prove his contention with a reminiscence much chopped with hoarse chuckles.

One man tried to break into the lecturing business who had not talent, personality or wits. He was told frankly that he couldn't "go over," but, no, he had to try. Here is Moore's version:

"Well, the audience let him know all right, all right. First there was a low whistle and then some boys began to cough all at once. It wasn't long before it looked like everybody in the house had consumption or something—such a sneezing and groaning. Still that fella wouldn't take the hint. Some guys are born thick, ya know! The audience, they didn't want to hurt his feelings, so they just tapped their feet kind of soft and regular, but that fella, he went on, and the feet got louder and louder. And finally the manager, he got busy, but not before the people began to clap their hands in time with their feet. It was the hook for that fella. He wasn't the right artistic temperament for this job."

In the old days there were Jewish lecturers who told the story of the picture in graphic language interspersed with Yiddish, something on this order:

"From behind, the man—he steps up to the lady and grabs her pocketbook.

" 'Ganef! Robber! Help! Ganef!' she screams."

When I broached lecturing to Gerdel, one of those who told the tales partly in Yiddish, he grew dreamy and his thin, wiry figure relaxed as much as the box office of his little movie theatre would permit.

"Those were the good old days," he said, "ubber now, the people won't even listen to you for a half minute. Everybody wants English now. Maybe when the greenhorns come to this country again I'll go back to that way of lecturing. Is it true not a single one can come from Europe for five, six, seven years?"

Gerdel sighed.

"My English ain't good enough."

He sighed again as he pushed two admission coupons through the niche in the window. Once an artist, always an artist!

* * *

January 22, 1921

THE SCREEN

Charlie Chaplin is himself again—at his best, in some ways better than his previous best, and also, it is to be regretted, at his worst, only not with so much of his worst as has spoiled some of his earlier pictures. His return to the screen after more than a year's absence is in "The Kid," which was shown last night at Carnegie Hall as the feature of an entertainment for the benefit of the Children's Fund of the National Board of Review of Motion Pictures. In the near future the picture will come to the Strand Theatre for its regular Broadway run.

"The Kid" is not only the longest comedy in which Chaplin has appeared since becoming the best-known figure of the film world, but it is real comedy. That is, it has something of a plot, its people are characters, and the fun of it is balanced with sadness. And Chaplin is more of a comedian than a clown. It is the comedy that has been foreshadowed by the former shorter Chaplin works.

Also, although the screen's unequaled comedian is in no danger of losing his laurels to any one, haste must be made to mention a new individual in his company, as much of an individual as Chaplin himself, and a source of immense delight. This person is a wonderful youngster by the name of Jack Coogan, surely not more than 6 or 7 years old, and as finished, even if unconscious, an actor as the whole screen aggregation of players is likely to show. He is The Kid, and he will be remembered in the same image with Chaplin. They have many scenes together, and every one of them belongs to both of them. Come on, Jack Coogan, there must be more of you.

The blemish on "The Kid" is the same that has marred many of Chaplin's other pictures—vulgarity, or coarseness. There is only a little of it in the present work, just two scenes that will be found particularly offensive by some. They are funny. That cannot be denied. One laughs at them, but many try not to, and are provoked with themselves and Chaplin for their laughing. This is not good. The laugh that offends good taste doesn't win. And these scenes would never be missed from "The Kid." It has plenty of unadulterated fun to go far and long without them. Why can't Chaplin leave out such stuff? Why don't the exhibitors delete it?

There is less pure horse-play in "The Kid" than in the other Chaplins. The comedian depends chiefly upon his inimitable pantomime, and it scores every time. He also gets many laughs from the ludicrous situations which he concocts. There's nothing clumsy about the picture's continuity. Its "comedy relief" actually comes as a well-timed relief.

The story is simply about a curious derelict who has an abandoned baby thrust upon him. His life with the child fills most of the six reels, and comes to happy issue after a dream of heaven, which for burlesque stands alone.

The competent cast also includes Edna Purviance and Tom Wilson, Chaplin's reliable leading woman and favorite policeman.

Also on the program was the German picture "Passion," with Pola Negri, which rang as true as ever, especially for those who delight in the purity of its acting.

Between the pictures Michio Itow danced, and was well received.

* * *

March 20, 1921

A CUBISTIC SHOCKER

Few motion pictures have excited more interest, advance and accompanying, than the latest German production to reach this country, the cubistic photoplay, "The Cabinet of Dr. Caligari," which the Goldwyn Company has bought and will show at the Capitol Theatre week after next. The picture was first reviewed for American readers in an article in The Freeman by Herman George Scheffauer, which was reprinted in part in these columns on Nov. 28 last. Mr. Scheffauer, who saw the photoplay in Berlin, noted its "bizarre expressionistic form" and described its action as taking place in a "cubistic world of intense relief and depth." He considered it important, however, not so much because of its cubism as because in it space had been "given a voice," had "become a presence."

The picture was also seen in Berlin by Arthur Ziehm, a dealer in foreign films, who has written the following account of it:

"From the viewpoint of effect on their audience, the authors of 'The Cabinet of Dr. Caligari' had the advantage of treating the subject of madness. Granting their mad premise, the story works itself out logically and remorselessly to the final sane ending. While original both in inspiration and interpretation. 'The Cabinet of Dr. Caligari' strikes a pitch akin to that heard in the stories of Hoffmann, Poe, Fitx James O'Brien and Ambrose Bierce. It should be said that while the interpretation has added immeasurably to the photoplay, yet the profounder reason for the thrill which it awakens lies in the actual story of Dr. Caligari.

"That story is told through the lips of a madman, and it is in catching his twisted conceptions that the scenic artists have done notable things. The sets are a little mad. Everything is awry, somewhere; and, because it is almost impossible just to lay your fingers on the place, the sets add to the atmosphere of mystery and terror which permeates the picture. Recently I saw Mr. Jones's 'Macbeth'; the difference between his work in that play and the work done in Caligari is simply that Mr. Jones failed this time—and the artists in the photoplay succeeded. The sets in the picture do not blacken your eye with their aggression or box your ears with their abruptness. They are subtly woven into the tale of Dr. Caligari."

"Since the picture is to be shown in New York, it would not be right to give away the secret behind it, thus robbing it, for those who read this article, of its element of surprise. However, a few general outlines can be given. The picture opens in a garden, with two men talking. One of them remarks that he feels the presence in the air of evil things from the past. A woman, pale, and dressed completely in white, passes; the other man tells the first speaker that the woman is his fiancée, and assures him that, whatever his experiences in the past, they cannot equal those endured by himself and his sweetheart. The scene fades out in old-time movie fashion and fades into the story which is being told in the garden.

"This story within the story is laid in a little provincial town with a half-medieval aspect. Everything has an air of old worldliness, from the student who throws away his book when he hears of the fair to the fair itself and the old men and young men and old women and young women who throng it. Furthermore, everything has an air of exaggeration which makes the characters seem unreal as human beings, but extraordinarily real as embodying qualities of goodness and evil, peace and terror.

"Dr. Caligari, who embodies sheer wickedness, is a masterly conception, and the work of Mr. Krauss in this role will, undoubtedly, arouse as much comment and enthusiasm in America as it did in Europe. The doctor is an elderly man who wears a cape and a battered top hat, while behind his eyeglasses are strange, roving eyes. In the conception of the man who is telling the tale he does evil for the sheer delight that it affords him. This monster reaches the town when the fair is being held and solicits from the town clerk permission to exhibit a somnambulist on the ground. The permission is granted, but not without rudeness on the part of the clerk. That night the unfortunate man is murdered in his bed.

"This is the beginning of a mysterious sequence of crimes. The hero—the story-teller—tells of how he visited the doctor's booth with a friend when the doctor, opening a huge, standing cabinet, revealed an immensely tall and skinny man, fast asleep. This creature is completely under the domination of the doctor. He sleeps until awakened by Caligari, and when awake obeys his master implicitly.

"The showman invites the audience to have their fortunes told by the awakened sleeper and the creature predicts to the friend of the story-teller that he will not live beyond tomorrow's dawn. Next day he is found murdered in his bed. In all the murders a strange, dagger-like weapon is used, so that there is no doubt that they are all the work of one man. Eventually the sweetheart of the hero is threatened with the hatred of the old wretch and from this point onward the story moves to an unguessed-at climax.

"It is obvious that a synopsis of such a story cannot convey the flavor of the actual vehicle. 'The Cabinet of Dr. Caligari' represents to me something very real and terrible. Do you remember the fear that you felt when you were a guest in 'The House of Usher'? The story of Caligari is entirely dissimilar, yet awakens the same kind of fear—that fear of things having no reason and loving evil instinctively."

"The Cabinet of Dr. Caligari" was written by Carl Mayer and Hans Janowitz; it was directed by Robert Wien, and its scenic designers were H. Worm, Walter Reiman and Walter Rork, according to the announcement from the Capitol. Mr. Scheffauer, in his article in The Freeman, credited it chiefly to "Walter Reiman, Walther Röhrig and Hermann Warm."

* * *

March 27, 1921

AN EPIC OF THE MOVIES

By JOHN CORBIN

Once more the dramatist who so proudly scorns the movies (until be discovers that his own plays may be filmed) stands to learn a lesson from the humbler art. "The Four Horsemen of the Apocalypse" is epic drama: it ranges the world, sums up an era into the space of two hours or so, as no modern play has ever done. In the theatre, since the day of the great Elizabethans, drama has steadily shrunk in its proportions. From the multifarious "scenes" of Shakespeare the illusion of which was created by no painted mimicry, flat and dead, but by the vigor of dramatic action and the magic of the spoken word—we have reduced the localities depleted to four, or preferably three, "sets." If a play can be squeezed into a single set, so much the better from the point of view of the thrifty producer. The dramatist, perforce, neglecting large actions, the dynamic forces of ultimate evil and good, has declined upon a sort of cherry-stone carving of character, the exploration of whimsical nooks and subliminal crannies of the soul. And so the artistic drama has slunk from the broad way of popular favor into deserted playhouses and village byways. Meantime the humble popular art has reached outward toward the infinite and upward to the pinnacle of great deeds.

Is it true that we are forgetting the war—have already forgotten it? Producers of plays and publishers of books unite in declaring that the war is "dead." Of course they know. While the war was "alive" they put forth a multitude of crude letters home from the doughboy, of hasty sketches penned by press correspondents: our theatres teemed with crude melodramas of heroic private and sacrificial trained nurses at the front—as seen from the vantage ground of Broadway. It was a

worm's-eye view of the war. A world tense with suspense, hungry for some hint as to the lives of loved ones at the front, lapped it all up; but on the coming of peace that sort of thing was obviously destined to be deader than yesterday's paper. It was not the war but what publisher and producer called the war that lay down and gave up the ghost.

"The Four Horsemen of the Apocalypse" is quite a different matter. It is chary in its use of newspaper gleanings from the front. The humors of the trench and the tedium of the dugout, the shock of battle and the thrill of victory—all that is the mere mechanism of war, void of deep and permanent interest. Biasco Ibáñez had the clairvoyance to see that the real war was fought in the souls of the contending nations. So "The Four Horsemen" endures, heroic in its outlines, with a message that is still capable of attracting the multitude and holding it breathless.

Curiously enough, that quality in the moving picture which has hitherto stood to the legitimate dramatist as a reproach and an inspiration is notably absent from this production. In "The Four Horsemen" there is no material for a closely knit story developing through situations that, so to speak, live themselves on the stage. At best, the development is psychologic, hardly lending itself to picture and requiring endless explanatory texts. Since the truth must be told, the first half of the performance, which begins in Argentina and brings the characters to France and to the verge of the war, is not very deeply interesting, in spite of the excellence of the acting and the amazing prodigality of the production.

One witnesses ranch life in Argentina, the old Centaur Madariaga's longing for a grandson, the birth of Julio and his debauchment in Paris dance halls at the hands of his doting grandfather. There is a fine contrast of myriad cattle grazing on the vast, open range with the close brilliancy, the heated orgies of the tango cabaret. But was it needful to spend half the evening telling us that before the war life was frivolous and inconsequent, reckless, gay? One has only to look about him here and now, in this world that was never to be the same again—today, tomorrow and for indefinite years to come.

The one certain truth of human life is that it is essentially tragic. Individually, we "owe God a death," nor is there any example of a nation, of a civilization, that has endured. But it is not in human nature to realize this from day to day; the moments of tragic feeling are rare as they are exalted. Much time would have been saved in the filming of "The Four Horsemen" if the producers had realized that the true background for a picture of the war is not that vanished yesterday of 1911, but this so called year of grace.

One had almost forgotten the war, like a dream that comes nightly, shaking the sleeper to the centre of his being, but can be remembered only dimly, if at all, by the light of day. There was the calling of young men to arms and their marching away, amid the tears and the fears and the glorious pride of those who loved them. There was the death-haunted slime of No Man's Land and the verminous jollities of the trenches. A pet monkey who went still-hunting in his master's hair was one of the joys of the evening. A spacious castle was occu-

pied by the swarming, insolent Huns; a peaceful village was laid in ruins by German shellfire. But in the final effect all this was incidental. What gripped the audience, as if with a new revelation, was the casting off of frivolity at the summons of war, the instinctive response to the call of duty and service, the still joy of souls that found themselves amid the ruin of all they had once held dear. Julio, petted and spoiled from childhood, hero of dance halls and facile amours, appeared at the end only as something vaguely heroic beneath the flower-strewn sod in a wilderness of white crosses. His mistress faded into remembrance, chastened and happy as never before—the nurse of her divorced husband, whose eyes were gone.

Amid all this the will of the Prussian rose once again, a spectre that refuses to be laid. Is it possible that there are those among us who have forgotten the sufferings, the sacrifices, of France, and her heroic service to our civilization—who, shrinking once more from the tragic realities of life, plead for a mercy that distempers justice? Is it possible that there are those who once more think that this nation, any nation, can live to itself alone; who refuse to make the least abatement of selfish will and pride in order that we may labor in peace, as in war, with those who stand for our common ideals, for the civilization of freedom and peace? In retrospect, far more than when the war was on, "The Four Horsemen" is allied propaganda.

Much has been said of the excellence of the acting, of the exquisite definition of the photography, its subtly blending lights and shadows, its atmospheric depth and suggestions of aerial space; of the fact that the production cost upward of a million dollars, setting a new mark in lavishness. All this is relatively immaterial—or, let us say, too flatly material. The astounding fact is that, in the field of the war play, the humble movies have achieved an effect of grandeur, of exaltation of the spirit, beyond anything as yet achieved by the drama.

This may be due in part to the fact that "The Four Horsemen" has drawn its inspiration from a novel, the work of a vigorous and untrammeled spirit. Yet such a result could not have been attained if the technical resources of the picture stage had not also been vigorous and untrammeled. To find a play that is equally broad in scope and epochal in its implications one must go back to the Elizabethans—for example, to Shakespeare's "Antony and Cleopatra." There one sees the world of Roman liberty going down, as if for the third time, in a sea of luxury and sensuality; and out of the shimmering chaos one sees the rise of Octavius Caesar, hard and cold as he is young—the beginning of the Roman Empire. Critics of the theatre without exception have characterized the Elizabethan stage as bare and crude. Coleridge described it as "a naked room hung with a blanket." Professor Ashley Thorndyke, whose monograph is the fullest and most authoritative record of it yet made, describes it as a mere transition stage, leading to the modern stage of elaborate scenery; he dismisses its artistic capabilities as negligible. Yet the demonstrable fact is that, in respect to its flexibility and scope, it is unmatched in the history of the theatre—

unapproached until the advent of the moving picture. In both cases—the old play and the modern movie—freedom has been achieved by the elimination of dead material—set scenery. The difference lies in the fact that, where the moving picture relies wholly upon photography, a humble art at best, the great Elizabethans employed the live presence of actors and the livelier power of the spoken word.

When the New Theatre planned its production of "Antony and Cleopatra" alternative schemes were considered. One was to present all but two scenes by means of beautifully simple backdrops, each screened by another drop—a colonnade, an open archway, a line of cypress trees. Only the galley scene and the scene in Cleopatra's tomb needed to be "solid." These could be set on the two halves of the revolving stage. To make any desired change it would thus be necessary only to press buttons, handle levers. The performance could proceed uninterrupted, presenting a virtually complete text. The other plan, which was adopted, was to build all scenes solidly. The text had to be severely cut to make time for scene shifting; and, even at that, the first performance lasted until 1 o'clock, so that for subsequent performances still further cuts were necessary. The action, which should have ranged the ancient world—Rome, Alexandria. Athens, Sicily, the Syrian plain, the Egyptian desert—presenting a skillfully woven fabric of color and character, of drama, comic episode and tragedy, and which should end with Augustus Caesar's triumphant cry, "And then to Rome!" was reduced to the bare and sordid romance of two carnal lovers past middle age, which limped along from snippet to snippet of text while stage hands wrestled with the cluttering materials of the stage carpenter. All the resources of the New Theatre could not achieve the effects that were so easily possible on the Elizabethan stage—succeeded only in devitalizing everything.

Fortunately that sort of production has ceased. Perhaps we are to thank the movies for the demoding of the trumpery effects of scene painter and electrician. Yet we are not wholly fortunate in the thing that has taken their place. In Arthur Hopkins's recent production of "Macbeth" the stage was set with neutral hangings—so far, so good! If that were all, the luminous lines of the play might have created their own illusion, as Shakespeare intended. But Mr. Robert Edmund Jones is a symbolist, a futurist or what not. He symbolized the witches' grisly incantations with a comical fall of cheesecloth, which quite hid their forms, and he covered their faces with masks that muffled the matchless lines they speak. Macbeth's castle he represented by an indescribable array of pointed arches, some eight feet high, which rose from nothing and supported nothing. It was as if a naughty girl had cut huge notches into a dining-room screen. Such was the feudal home, bird-haunted in the Summer evening, which the poet thus describes:

This castle bath a pleasant seat; the air
Nimbly and sweetly recommends itself
Unto our gentle senses. This guest of Summer,

The temple-haunting martlet, does approve,
By his loved masonry, that the heaven's breath
Smells wooingly here; no jutty, friese,
Buttress, nor coign of vantage, but this bird
Hath made his pendent bed and procreant cradle.
Where they most breed and haunt, I have observ'd,
The air is delicate.

And note the dramatic effect! The audience knows that the ancient castle, bird-haunted in the Summer air, is about to witness the death of a serene old man, a beneficent king and the guest of his murderer.

Would any movie director in Los Angeles be guilty of the artistic blundering of these prime exponents of dramatic art on Broadway? If so, like Othello, their occupation would be gone. For in one other respect the moving picture resembles the Elizabethan drama; their publics absolutely refused to be bored.

* * *

March 7, 1922

NATION'S STABILIZER HAYS CALLS MOVIES

Ex-Postmaster General Assumes Direction of Motion Picture Industry

SAYS POWERS ARE INFINITE

Declares That England, Through Pictures, Sold the War to Her Colonies

Pensive in mood, and "out of politics and public life forever," Will H. Hays started work here yesterday as the "Landis of the movies." His first day's work was an inspection of his new offices at 522 Fifth Avenue, the reception of scores of visitors in and out of the moving picture industry, and the smelling of stacks of flowers sent by admirers.

His first few weeks will be spent in studying the moving picture industry "from top to bottom," and then he will start work at whatever he thinks is necessary to carry the movies to their destined function as the "stabilizer" of American life.

"You know I was down in the basement of Cyrus H. Curtis's new yacht the other day—finest yacht afloat," said Mr. Hays, "and I saw a big bulb apparatus there that keeps the craft from tilting too far—what do you call it?—a gyroscope?—yes, that's it, a gyroscope, a stabilizer.

"The motion picture is already the principal amusement of a great majority of the people; it is the sole amusement of millions; it may well become the national stabilizer. In this country we speak fifty languages, but the picture of Mother is the same to all—the picture is the quick road to the brain through the eye. The picture is the great influence. England sold the war to her colonies with the picture.

"You take a little baby three days old, and he squalls and yells and gets all red, and you shake a rattle in front of his nose and he shuts up. What he wanted was amusement, and

you give it to him with the rattle. Now, unless you give the American people amusement—they'll get—no, no, not just exactly that, but you know what I mean.

"The potentialities of the moving picture for moral influence and education are limitless, therefore its integrity should be protected as we protect the integrity of our churches, and its quality developed as we develop the quality of our schools. I think the day will come and, mind you, in our day—I'm 42—when the movies will be as common in the schools as McGuffey's Reader.

"If I didn't believe in this future of the moving picture I wouldn't have taken up this work, but I did believe in it and I have left politics and public life forever. I am very happy to be in a cause where we are all on he same side of the table, where there is no harmony and everything isn't strife. I approach this task with much concern but with that confidence which springs from an earnest purpose and from the conviction that we will have the generous help of every one in accomplishing what must be recognized as an effort for the good of all."

The new association is to be called the Motion Picture Producers and Distributors of America, Inc., and the articles of incorporation probably will be filed at Albany this week.

This new association eventually will take the place of the old National Association of the Moving Picture Industry. The Film Theft Committee, one of the most important in the old organization, will be transferred to the new association. According to previous reports, film thefts total more than $1,000,000 a year, so that the work of the committee in attempting to lower this loss was considered extremely important to the industry.

* * *

April 3, 1922

PAY DAY, by and with Charles Chaplin; "Trumps, Ace High"; "The Ballad of Fisher's Boarding House"; "Mark Twain"; "The Cape of Good Hope"; "Felix Makes Good"; "Odds and Ends"; "Dear Old Southland," sung by George Reardon. At the Strand

A new Chaplin comedy, of course, is an event in the motion picture world, and all that the reviewer has to do is announce it. The rest may as well be silent so far as he is concerned, because nothing can be said about Chaplin that has not been said a dozen times already, and most people are not interested in what is said about him, anyhow. They just go to see him and laugh—and some of them understand.

It may not be entirely futile to report, however, that this new Chaplin comedy is one of his best. It is not to be ranked with "The Kid," which was a longer and more penetratingly serious venture, and it has not the significance, perhaps, of "Shoulder Arms," but it has enough pure fun, and sufficient satire, too, for any one. With or without reference to anything else, it is something to relish for its own sake.

Underlying the picture's surface buffoonery is that refreshing treatment of the commonplace by which Chaplin

has so often exposed the irony of life. He shows the gods grinning at human earnestness, yet he does not join them in mocking it. He is a part of humanity, he has the feelings and the aspirations of ordinary men, he is sympathetically one of the crowd. But he sees the fatuity of it all, too, and so is one above the crowd.

For example: He is a poor workman employed in the construction of a building, and he is hopelessly married. But he sees the foreman's daughter and loves her. His love is a poem. It exalts him. She sits with her father's lunch on a platform of the scaffolding outside the unfinished building and he rides the work elevator up to adore her. Every time she notices him he shrinks from her inquiring look and signals the engineman to lower the elevator. But he comes back to worship again, and again gives the signal to descend when she looks at him. She is spreading her father's lunch and puts a round box near the elevator shaft. He comes up once more, the embodiment of true, though timid, love. He embraces her with his earnest eyes. And then he smells the limburger cheese in the box under his nose. For the last time and hurriedly he gives the signal for the elevator to descend. His love is genuine, and in expressing it there is no trace of mockery. But the cheese is strong. And the gods grin.

This is only one little incident in the picture. There are many others. For story the comedy simply takes snatches from the day of a laborer, beginning when he comes late to work and ending when his wife drives him out the next morning to go to work again, although he has just come in from a night in the back room and in the open. Such a life!

As the Chaplin comedy is short—it lasts only twenty-three minutes—Joseph Plunkett, managing director of the Strand, has filled up his program with other short subjects, and on the whole he has made an exceptionally interesting selection. There is "Trumps, Ace High," a Post Nature picture, giving another chapter of the life of that enlivening little terrier Trumps, with the rich scenic background of its predecessors, and there is also a travel-tempting Prizma color picture of Capetown and its surrounding country. "The Ballad of Fisher's Boarding House" consists of faithful and vivid illustrations of the poem, with, however, an energetically sentimental ending which surely Kipling never dreamed of. "Mark Twain," from Kineto's Great American Authors Series, shows places associated with the life of its hero and briefly picturizes his story "The Jumping Frog." A slow-motion picture of ski jumping is included in the "Odds and Ends," and "They Say," while making no particular point in itself, suggests new possibilities for caricature on the screen by the use of distorting mirrors.

* * *

April 30, 1922

THE RATINGS EXPLAINED

The motion picture trade world is something of a mystery, and in its isolated manifestations often irritating, too, to those

followers of the screen who have no connection with the film business, but are interested in the production of imaginative and sincere screen works. Facts which help to illuminate this obscure world, and also illuminating explanations of them, are of value, therefore, to the outsider, for, whatever his attitude toward them may be, it is first of all necessary for him to orientate himself with respect to them, and this he cannot do without a comprehensive understanding of things as they are. It was for its serviceability as a torch in the trade world, then, that a partial summary of The Motion Picture News's table of exhibitors' ratings was printed in these columns last week, and for the same reason this space is devoted today to a letter from J. S. Dickerson, director of The News's Exhibitors' Service Bureau, which the publication of the summary, with accompanying comments, has provoked. Mr. Dickerson's letter is interesting not only because of its amplification of what was printed here last Sunday, but also, independently, because of its exposition of conditions faced by commercial producers, distributers and exhibitors.

Mr. Dickerson remarks that the table of ratings, as it stands, "undoubtedly has some inconsistencies and, also, to the layman, some apparent paradoxes," and particularizing, he mentions "Over the Hill," "The Old Nest" and "The Kid" as pictures "rated just over 80," which, "it would seem, . . . should be listed among the topnotchers." He then continues as follows:

"It was of course necessary to 'start somewhere' in compiling the first table. The place we selected brought the above named features in when they had played all the large or even medium-sized cities, and in consequence reports received were only from the theatres in small towns. Now the small town exhibitor is an exceedingly conservative individual. He plays to a limited clientele and when he rates a picture 'good' it means much more in proportion than a similar report from a house in a city.

"Then there is another reason why we might expect a conservative report from the small towns on 'Over the Hill' and 'The Old Nest.' The small town exhibitor isn't able to do much with a feature which doesn't have a popular star. Norma Talmadge or any other headliner will make more money for the 'tank' town man than the best all-star production ever made, everything else being even. To prove this contention we have only to inspect the facts concerning 'The Miracle Man.' This wonderful picture actually lost money for hundreds of small town exhibitors. It of course did more business than the average picture, but it cost too much and had no star (at that time), which meant anything to the small town fan.

"In regard to 'The Kid.' Now, it is an accepted fact that Chaplin draws his patrons from two great classes: one typified by the banker and the other by the 'gutter.' Further, women as a rule are not especially partial to this player. (If you don't believe this do a little investigating of your own, even here in New York). Now, in small towns there is no great range in caste, and 85 per cent, of the patrons of the picture theatre are women and children. Then there is another thing applicable to all theatres where this picture played. 'The Kid' wasn't a typi-

cal Chaplin picture. It lacked the custard pie stuff that a great many people expect in a Chaplin comedy.

"I suppose you and a great many of your readers, wonder why "Why Girls Leave Home" gets a rating of 80. Now as a matter of fact for the dyed-in-the-wool fan this is one of the best pictures of the year. It has won runs in houses that felt that they were called upon to apologize for the title and assure their patrons that the picture was worth-while in spite of its 10-20-30 name.

"You mention 'Deception' in a manner that makes me think that you believe it deserves a better rating. The small town reason applies to this picture also. Then, too, it is a costume bill and it is a tough job to put over this class of production in anything but the big first-run houses. Then, too, the fact that the picture was German-made didn't help matters any. In a number of small cities there was considerable anti-German demonstration during its run and in some instances the feature was pulled off for this reason.

"Dropping down the column in your list of notations to 'The Four Horsemen of the Apocalypse,' which, to my mind, is the greatest picture ever made. I presume that most people would figure that a better than 70 rating ought to be forthcoming. As a matter of fact this picture should not be listed at all, since it has only been played as a road show at advanced prices, at least $1.50 a top in most instances. If 'The Four Horsemen' had gone out on the regular releasing plan and been sold to the public at the same prices as other pictures, it would undoubtedly lead the list. But a dollar is a lot of money to pay for a picture—especially out in the sticks, where the average admission price is 20 cents.

"You comment on 'The Cabinet of Dr. Caligari' rating. This picture is in a class by itself.' 'Caligari' was a flop because very few exhibitors would book it. Those who did were the ones who saw its possibilities as a freak and exploited it accordingly. As entertainment with the fan, 'Caligari' just wasn't.

"Following your reference to 'Caligari' your observations concerning Mary's 'Through the Back Door,' Miss Pickford has a clientele all her own who insist on her doing certain well-defined rôles and a certain equally as well-defined type of story. 'Through the Back Door' wasn't a Pickford vehicle. After the first few reels she got lost in a complicated made-to-order plot. Pickford fans want Mary in every scene, doing the things that Mary has always done. This accounts for a 70 entertainment rating on this picture against its 77 as a box office attraction.

"The disparity of box office and entertainment ratings on 'The Inside of the Cup' I can't explain, except that the picture, as I remember it, I should call the kind of a production that would please small-town audiences, but with no star to coax the said small towners away from their firesides to see it. The exhibitors reporting on it were all little fellows for the reason that the production is a year old and had played the larger towns before our tables were started.

"There are some apparent inconsistencies in the table which you did not mention. The table shows some pictures

which, in the trade, we term program productions with ratings within ten or fifteen points of acknowledged big pictures. The reason for this is explained by the fact that the program picture is played very largely in the theatres catering to a certain class of patrons—those who want surface melodrama—obvious plots, and orthodox romances. These theatres book the kind of pictures they know their patrons desire and then report accordingly, which is as it should be.

"All of this, of course, the exhibitor knows before he inspects the chart, so he is not misled when he sees a picture that he could book for $10 with a rating nearly as good as one which will cost him $100."

In conclusion, Mr. Dickerson promises that the table of ratings, which will be published monthly in The News, will be improved in the future by inclusion of "reports on all classes of theatres instead of just the small ones, as is the case of certain pictures listed" in the first table upon which his letter is based.

* * *

June 7, 1922

MOVIE "VAMP" EXTINCT

Public Wants "Little Eva" Type Now, Theatre Owners Hear

CHICAGO, June 6—The movie "vamp," with her white face, her penciled eyebrows, green eyes and her jade earrings, is gone and will flaunt her fascinations on the silver screen no longer, motion-picture theatre owners were told at a meeting today.

What the public wants now, according to speakers, are good little girls, heroines of the little Eva type, with golden hair, blue eyes, sincerity and innocence.

"The modern picture heroine," said William J. Sweeney, "must be young and inexperienced in appearance, guileless and appealing in her actions. The public has wearied of the vampire type."

The public itself, he asserted, was voicing a demand for cleaner films and the producers were filling it.

* * *

June 12, 1922

NANOOK OF THE NORTH, produced by Robert J. Flaherty, F. R. G. S., for Revillon Freres; "My Country," one of Robert C. Bruce's "Wilderness Tales," held for a second week. At the Capitol.

If a man goes among a strange people whose life is reduced to an elemental struggle for existence, if he has the disposition to photograph these people sympathetically, and the discernment to select his particular subjects so that their life in its relation to their opposed environment is illumined, the motion picture which he brings back may be called "non-dramatic" only by the acceptance of the trade's arbitrary use of the term. Such a picture has the true dramatic essentials—and such a picture is Robert J. Flaherty's "Nanook of the North," which is at the Capitol this week.

Beside this film the usual photoplay, the so-called "dramatic" work of the screen, becomes as thin and blank as the celluloid on which it is printed. And the photoplay cannot avoid the comparison that exposes its lack of substance. It is just as literal as the "travel" picture. Its settings, whether the backgrounds of nature or the constructions of a studio, merely duplicate the settings of ordinary human experience—or try to. And its people try to persuade spectators that they are just ordinary people, ordinary, that is, for the environment in which they happen to be placed. So the whole purpose of the photoplay, as a rule, is to reproduce life literally. And this is the purpose of the travel film. But the average photoplay does not reproduce life. Through the obvious artificialities of its treatment, through the unconcealed mechanics of its operation, through its reflection of a distorted or incomplete conception of life, rather than of life itself, it usually fails to be true to any aspect of human existence. It is not realistic in any sense. It remains fiction, something fabricated. It never achieves the illusion of reality.

But "Nanook of the North," also seeking to give an impression of reality, is real on the screen. Its people, as they appear to the spectator, are not acting, but living. The struggles they have are real struggles. There is no make-believe about the conflict between them and the ice and snow and wind and water that surround them. When Nanook, the master hunter and a real Eskimo, matches himself against the walrus, there is no pretense about the contest. Nanook's life depends upon his killing the walrus, and it is by no means certain that he will kill him. Some day he may not. And then Nanook will die. So the spectator watches Nanook as a man engaged in a real life-and-death struggle. And how much more thrilling the sight is than that of a "battle" between two well-paid actors firing blank cartridges at each other!

And people want character in their hero, courage and strength, quick and sure resourcefulness and, for them, a friendly disposition. They have all these things in Nanook when he faces a Northern blizzard, when he harpoons a giant seal, when he builds an igloo, when he stands on a peak of ice directing the movements of his followers. He is emphatically a leader, a man who does things, a man who wins but who, at any moment, may lose. He is a genuine hero then, one who is watched with alert interest and suspense and far-reaching imagination. What "dramatic" photoplay can show such a one!

Nor is he alone. His family, his wife, his children, his dogs, and the paraphernalia of his life are around him. So he is not isolated. The picture of his life is filled out, humanized, touched with the humor and other high points of a recognizably human existence. Thus there is body, as well as dramatic vitality, to Nanook's story. And it is therefore far more interesting, far more compelling purely as entertainment, than any except the rare exceptions among photoplays. No matter how intelligent a spectator may be, no matter how stubbornly he may refuse to make concessions to the screen

because its pictures are "only the movies," he can enjoy "Nanook of the North."

And this is because of the intelligence and skill and patience with which Mr. Flaherty has made his motion picture. It took more than just a man with a camera to make "Nanook of the North." Mr. Flaherty had to wait for his light, he had to select his shots, he had to compose his scenes, he had to direct his people, in order that Nanook's story might develop its full force of realism and drama on the screen. So it is due to Mr. Flaherty that Nanook, who lives his life by Hudson Bay, also lives it at the Capitol.

Also at the Capitol, held over for a second week and well deserving the distinction, is the third of Robert C. Bruce's "Wilderness Tales," entitled "My Country." Mr. Bruce's country is the Far Northwest, and as he revels in it many will envy him his possession of it.

* * *

September 3, 1922

MOVIES THAT THE PEOPLE WANT

By BENJAMIN DE CASSERES

Who sets the national and local tastes in motion pictures—the producers or the public?

Are the producers giving the people exactly what they want, or are the producers compelling the people to take what they give them?

The answer would seem to be obvious—you cannot force anything on twenty million people every day in the year that they do not want. It is an economic law that demand is anterior to supply. The producers have nothing at stake but their pocketbooks. There isn't the slightest reason why they should have anything else at stake. They cannot raise the artistic tastes of the people (to use the current jargon of uplifters) if the people have no artistic tastes to raise.

If the moving-picture audiences of this country demanded the work of Shakespeare, Ibsen, Maeterlinck, Anatole France, Thomas Hardy or Gerhart Hauptmann on the screen the producers would give it to them. There are dozens of producers and scenario writers waiting for the people to say so. But they simply do not want the big stuff. It is humorous and hypocritical to ask the great picture companies of this country to go bankrupt out of courtesy to their highbrow critics.

How long would a newspaper, a magazine, a theatrical producer or a sporting organization—not to speak of a department store—last if it insisted on giving to the public the thing that the public has no use for?

Every newspaper writer knows that the news of the day must be told in the simplest, most concrete form. No public is ever literary, artistic or intelligent. The moving picture makes its appeal to the average newspaper reader and those below that average. It depends for its life in a great many sections of this country on those who cannot even read the newspapers printed in their own language.

"What's the matter with the movies?" should then be changed to the question. "What's the matter with the public?" Motion pictures, like everything else in the business world, never rise above the source of their revenues.

"Give us better movies!" has been the howl of the critics of the American motion picture.

"Give us a better public and we will give you better pictures!" might well be the answer of the great picture producers.

"We stand ready," said Mr. Robert Kane, general production manager of the Famous Players, "to give the public of America the great stories, poems and epics of all times and in all language when they want them. We take gambling risks that no other legitimate business in the world takes. But art and reality are one thing, public taste is another."

I have lately examined thousands of exhibitors reports from the small towns throughout the country. Their reports are psychological mirrors of the ideals and mental needs of the people. If there are any independent producers thinking of producing "Don Quixote, " Ibsen's Brand," Anatole France's "The Revolt of the Angels," Cabell's "Jurgen," or Thomas Hardy's "The Return of the Native"—producing them, I mean, as they were conceived and written, not as they might be fixed up for public consumption—I advise them to first of all spend a month in a study of these exhibitors' reports. The public are, unconsciously, in league with the censors to keep everything down to the level below which to fall is sheer idiocy. If the censors are allowed to ride the backs of our moving-picture concerns much longer, it will result in pictures for half-wits.

As a matter of fact, if the army tests are any guide, the country is made up mostly of juvenile minds and half-wits. And it is to this public, aided and abetted by the political job-holders called motion-picture censors, that the great picture industry must cater in order to live.

An exhibitor in Sheboygan, Wis., reports that one of the finest pictures ever made—a picture founded on the "Peter Ibbetsen" of George du Maurier—went flat in his town because it was a costume play. The "élite" supported it the first night. After that the general opinion was that it was a "sleepy" picture—i.e., it has some beautiful dream scenes in it. Peter Ibbetsen was played by Wally Reid, but the fans of Sheboygan want Wally cast in a "happy" rôle. They mean by this that they want to see Wally munching caramels with a flapper sweetheart in a ballroom corner or spinning with her in a Ford to lift the mortgage off her furniture.

The inhabitants of Omaha walked out on a picture because some of the guests on a ranch wore evening clothes. To see a man in a picture walk into a Fifth Avenue mansion dressed in cowboy attire and throw a Wall Street broker in a boiled evening shirt through a window arouses the Nebraskan to a frenzy of applause. But evening dress at a ranch party—à bas the effete East!

Arlington is a small town situated in the State of Washington. A big super-special hit the town—a drama of a blind man. But what do you think drew the Arlingtonians into the theatre? A scene showing a crocodile pit. This scene, when it got noised abroad from pump to pump, sold more tickets than

anything else in the show, according to the exhibitor. There will be standing room only in Arlington when the great aquarium drama hits that town.

Mary Miles Minter hit Augusta, Me., some time ago in "The Heart Specialist." The show nearly went under because the female patrons hotly protested against Mary wearing French heel evening slippers while living in a harem. Augusta should read Pierre Loti. That expert on female raiment tells us that not only do the ladies of the harems now wear French heel shoes, but they bob their hair. But Maine was always strong on the Orient preserving the ancient traditions.

Gloria Swanson in one of her pictures is compelled by her director to swim the Rio Grande. When she emerged on the other side of the river she still preserved her marcel wave. The women of Portland, Ore., would not stand for this. They told the cowering exhibitor in his lobby cubbyhole that it simply could not be done. But I know it can be done—for I saw her do it. As a matter of fact, I saw Ruth somebody swim from the Battery to Norton Point some years ago, and when she emerged her bangs were dry. But how long can the "movies" withstand such Sainte-Beuvery?

Columbia City, Ind., wants Bill Hart to be more tender with children. The fans in Columbia City will not have anything to do with the logic of Bill's parts. They are trying to can Bill because he looks like himself. Smile, Bill—damn you, smile!

Bridgeport, Conn., sends in the news that the picture public there is going for "society and high life." A suppressed New York complex.

San Bernardino, Cal., wires in that they do not want any more pictures for "the grand opera class."

In Hanover, N. H., an exhibitor had his people walk out on him because the picture he showed was "for intellectuals or those with a good education." This picture, by the way, was not "Dr Caligari," but just "Peter Ibbetsen." When culture hits Hanover, we may expect the return of the dodo.

Columbus, Ga., asks for pictures based on stories like "Pigs Is Pigs," where "one can see guinea pigs or rats." That is what they call "the educational motion picture" in the South.

Texas is losing its imagination. An exhibitor writes that his audience could not imagine "a woman cowing a multitude of bad men and then killing the villain."

Waco, Texas, is also moving up a point. They don't want any more "improbable" plots down there. But what is a probable plot and what an improbable one?

In Denver, Col., the motion picture is up against the caste system. Some of the working people out there said that a certain picture was "an insult to their set" because it showed an "intermingling of the classes." I am writing these lines on the one hundred and forty-sixth anniversary of the Declaration of Independence—q. v.

When "Boomerang Bill" hit Freeland, Pa., the consensus of opinion was that a cop never urged anybody to go straight. "If anything, they gave a fellow a push downward." Now, this is sound motion-picture criticism—although I once knew a New York copper who used to take the boys home from "Jack's" every Sunday morning. But evidently they don't make 'em that way in Freeland.

"Give up the society stuff!" howls Greeley, Col.

Lincoln, Ill., wires that the denizens of that town would "go through fire to see Rudolph Valentino."

Dallas, Texas, doesn't want to see any pictures with a "note of sadness in them." I never knew things were as bad as that in Dallas.

Mount Vernon, Ill., just swarms with hunchbacks. It seems everybody out there has a friend or a relative who is a hunchback. Therefore, they ask, please make no pictures that have a hunchback in them. "The Hunchback of Notre Dame" is on the Index out there.

Gilmer, Texas, wants "society pictures, where people wear flashy costumes." Naughty, naughty Gilmer! We've got your speed!

Salt Lake City, Utah, is getting sick of "murder and sudden death." It is swinging toward the Gilmer idea—"society pictures with flashy costumes."

Ardmore, Okla., wants pictures "with lots of clothes—not Western." See what comes of sudden oil wealth!

What is the future of the movies?

Ask the people of the small towns of America.

* * *

September 10, 1922

REVOLUTIONARY TALKING MOVIE

Widespread Changes That Are Predicted If New Invention Is a Success—Elimination of Numerous Stars

Film stars of today will be eliminated by scores, while elocution teachers and throat specialists will become millionaires, if the speaking film of Dr. Lee de Forest, inventor of the audion tube, becomes a great popular success. The whole moving picture world will be revolutionized, according to directors and actors, if the "phonofilm" is a popular hit, but they do not believe it will jump into popular favor.

At Will Hays's office it was said that students of the film generally felt confident that "speakies" would never supersede the movies. Tony Sarg said that thousands went to the movies because they were restful and would stay away from speaking films because they would put too much strain on the attention and would, therefore, be tiring. Robert Ellis thought that the silent film would always hold its place and that the speaking film might be an utter failure, because the illusion created for the eye would interfere with the illusion created for the ear, confusing and bothering the audience.

Both Sarg and Ellis believed that the invention, if a perfect success, would create a new type of drama, distinct from the movies and from the legitimate stage. If it should, contrary to expectations, eclipse the silent film in popularity, they and others agreed that the whole film universe would be turned

upside down. The beautiful dolls of the movies, those who have become queens of the silent drama by shear beauty without intellect or culture, would fade from the picture by dozens, it was predicted.

The legitimate stage would be raided and swept bare by the demand for actors and actresses with trained voices. Voiceless movie stars would besiege the doors of Broadway producers for chances to get experience in the spoken drama.

Breakers Ahead for Some Stars

Chaplin, Fairbanks, Hart and many others, formerly speaking actors, could probably pick up the vocal technique with ease. The Barrymores, Nazimova, Pauline Frederick, Elsie Ferguson and other stars of both arts would probably reach the heights of "phonofilm" stardom. As for film stars inexperienced or little experienced in the theatre, it would be a serious question whether they could master the speaking technique and hold their places. Jackie Coogan would have time to make the transition. Many of the big film directors have had no stage experience. They would find themselves working with new tools. Many might fail to make the adjustment and give place to stage managers with Broadway experience.

The total box-office receipts from the motion pictures last year were $880,000,000. The number of persons gaining a livelihood from the motion pictures is estimated by the staff of Will Hays at 500,000. The capital expenditure involved in making over the whole industry from silent to speaking films might run into hundreds of millions. Millions might have to be spent on remodeling houses for acoustic effects. Studio equipment would be radically altered.

Some of the new forms which might be put on the vocal screen, it was pointed out, might be the following:

Grand opera, with scenic effects surpassing those possible at the Metropolitan.

Shakespeare, preserving the dialogue, but developing the scenes which the playwright left to the imagination.

The drama of today literally reproduced both in word and action for motion picture houses, badly affecting the road and stock companies.

News films, giving new life to big events, by reproducing the shouts of crowds, the roar of flames, applause, booes, hisses and all the sounds that accompany action.

The words of the great, with the embellishments of personal delivery; so that in the future, such events, if they ever occur again, as the Farewell Address of Washington, Lincoln's Gettysburg address, the Webster-Hayne and Lincoln-Douglas debates, will be preserved for history.

The whole tendency, it is believed, would be to intellectualize "the dumb drama, raising it probably above the spoken stage."

"The invention, if it is what is claimed, is one of the most marvelous in history, putting the inventor on the level of Marconi, Edison and Bell," said Robert Ellis, "and coming from a man of such previous achievements as Dr. de Forest, it is to be taken seriously.

Champion of Silent Film

"But even if it perfects the talking film to the highest point attainable, I doubt if the public will prefer it to the silent film. The film began silent and I believe it will remain so. This is the way it appears to me, and I have spoken to many others in this business who think the same. On the other hand, we may be entirely wrong. It would be foolish not to be open-minded in the face of an invention that may completely revolutionize the film.

"Previous efforts to produce speaking film drama have been unsatisfactory, possibly because they were not technically perfect. The illusion of the film and the phonograph seemed to clash. But if there is absolute perfection in the blending of the two, as is claimed for the de Forest invention, it may be different.

"Even if the talking film is a great success, I believe it is more likely to occupy a new field of its own than to displace the picture of the present type. The speaking film, in my opinion, would have far less action than the ordinary picture, but far more action and scenic effect than the legitimate drama.

"It might bring Shakespeare a popularity never before achieved. Shakespeare has never been successfully adapted to the motion pictures, although his technique closely resembles the motion picture technique of today. Shakespeare is full of rapid changes, changes of scene and 'cut-backs.' But the value of his plays lies chiefly in the dramatic dialogue and poetry which are not reproducible on the silent film. It might be, however, that his plays are perfectly adapted for the speaking film. If so, the smallest village could have Shakespeare by the greatest living actors and in the finest settings.

"The problem of producing Shakespeare in the speaking film would be difficult. To develop the action and scenic possibilities while preserving the dialogue would mean that it would take six or seven hours to put on 'Hamlet,' for instance. Experience has demonstrated that two hours is as long as the motion-picture audience wants a film to be. The conflict between scenery and dialogue in presenting Shakespeare on the ordinary stage would be greatly accentuated. If you cut lines, you find that those particular lines were the favorites of all the pedants and amateur actors in the country. You are overwhelmed with reproaches. Actors and managers are taunted into abandoning Shakespeare by the outcry of critics, professors and others who have learning to display. But the speaking-film director would have to make up his mind that he could not please everybody and proceed to do the best he could.

"A modern producer would probably hire four or five thousand people for the mob at Mark Antony's oration over Caesar, as against thirty or forty on the stage at present.

"The experiment of reproducing Broadway drama on the film just as it occurred on the stage has been attempted, but has failed. In fact, it proves one of the greatest bores ever known. But it may be very different with the conversation accompanying the action.

"If it is a success, the overturn of things in the studios will be unimaginable. Some of the prettiest film stars cannot

speak well and would be done for. From time to time film stars lacking stage experience have attempted to go on the speaking stage, but have nearly always been failures. Such legitimate actors have had varying success when they attempted to return to the stage after being for years with the movies. Some have had difficulties with their voices and have failed. Others have been better than before.

"The legitimate actor is often improved by a certain amount of film experience. He usually returns to the stage much improved in his pantomime and in his bearing when he is not speaking lines. Seeing himself in the film gives him a chance to study his faults and correct them.

"Should the speaking film eclipse the silent form, there would be fewer meteoric careers. The training of the voice is probably the hardest part of the apprenticeship on the legitimate stage. Few actors develop magnificent voices without many years of experience. By the time their voice is at its highest perfection they have probably lost the youthfulness which is now the supreme quality in film stars. It is safe to predict that no actress will become a great star in the speaking film in a few weeks or months, and that no actor will rise almost overnight to the heights of stardom.

"Radical changes would have to be made in the technique, both of acting and taking the pictures. It would be difficult, probably, to adjust the voice effect to changes in the apparent nearness of the pictures. Suppose the natural voice were reproduced so as to be heard perfectly all over the house while the actors were apparently at some distance. Then suppose a close-up is introduced. The size of the actor on the film is multiplied. If the voice is multiplied in proportion, the audience would be deafened by the bellow. If the voice remained the same, the effect might be ridiculous as a sound of the same size issued first from a pigmy and then from a giant.

"Another difficulty would be the lip movement. If actors speak out loud when near the lens they are apt to look like town criers. The contortions of the lips in loud speaking in front of the camera are not pretty. Mr. Griffiths has his actors whisper or move their lips without speaking at all. In other studios the actors usually speak in low voices. Some stars are overwhelming personalities who must give all that is in them, and they speak with the intensity of stage-acting. Alla Nazimova and Pauline Fredericks are of this type, and the effect would undoubtedly be highly artistic on the speaking film, although it is doubtful how far personality is transferable through artificial means.

Innumerable Changes

"Titles and sub-titles would probably have to be swept away and innumerable changes made in the mechanics of the film. One of the difficulties would be in estimating how long the audience would laugh at something funny. After a joke or episode at which a laugh is expected, the action is held in suspension on the films at present for a few seconds or a minute, according to the expected reaction. The reaction would have to be gauged with even greater nicety for speaking films. If the audience were not allowed a sufficient laughing interval,

the film dialogue would be resumed before the noise had subsided. The audience would have to practice self-discipline in such cases. Undoubtedly a thousand technical adjustments would have to be made."

Shakespearean plays that are never seen on the legitimate stage, because the action is too slow for modern tests might be "knockouts" on the speaking film, it was pointed out. The pageantry and the wandering, irregular action might be the qualities which made them successful for the talking films. The siege of Troy, the battle of Ajax and Hector, the oratory of the great war councils, Paris and Helen, Ulysses, Agamemnon and Achilles, would probably make a mighty speaking film of "Troilus and Cressidas."

Great Birnam Wood could rise and march with powerful effect to high Dunsinane Hill. The storm in "Lear" could be rendered marvelously. From the prologue of "Henry V." would be cut Shakespeare's apology for the inadequacy of his stage.

Every township of 100 inhabitants could see Forbes-Robertson in "Hamlet" and Sothern and Marlowe in their repertory. If new Garricks, Booths, Irvings and Mansfields arise, their art will not be utterly lost to the next generation.

Whether the art of the drama, silent or spoken, can be preserved indefinitely, however, is another question. Many films deteriorate in a few years. Scientists in the industry are working on the problem of making films that will last for centuries, but at present it is doubted whether any negative so far produced will be good fifty years from now. Whether there is any method of renewing a negative which has begun to deteriorate, or of transferring it in a fresher state to another negative, is also doubtful.

The de Forest speaking film is now in Germany with the American inventor, but will have its first public demonstration in this country in the latter part of the present month. It differs from other attempts at producing "speakies" in that the voice is "photographed" on the edge of the film beside the picture, and the recorded sound-waves later translated into electrical waves and converted again into sound by the microphone and then magnified by the audion as in wireless.

* * *

October 1, 1922

NOW THE CLOSE-UP

The close-up, especially the close-up not expressly called for in the continuity of a photoplay, is judged guilty until proved innocent by the Editorial Committee of the Film Guild, which is producing a series of pictures with Glenn Hunter as their star, the first of which, you may remember, was "The Cradle Buster."

"The close-up mania," says Frank Tuttle, the Guild's director, "is like the drug habit. It grows upon the afflicted company at a constantly accelerating pace until the entire studio is mortally ill of it. And the whole fatal process grows out of two things—the fact that the cutter gets too close to his

story in the process of assemblage and the fact that certain prominent members of some casts regard close-ups as personal advertisements to which they are ethically entitled instead of as integral parts of a dramatic plot.

"The Film Guild has at the outset established a policy evolved from experience in other people's studios. Every close-up is written into the original scenario, at which time the total is reduced to the lowest practicable minimum. The director, the scenario writer, the camera man and the star, who represents both himself and the other actors, are asked to approve the practicability of this script. After it is endorsed the picture must be filmed accordingly, without change, unless the script itself is changed in another conference.

"Therefore, if a close-up must be added, it is because somebody has made a mistake. The director or the star is responsible for not 'getting across' a scene which, according to all authorities, could have been played in long shot. Perhaps the lighting was wrong and the camera man is to blame. At any rate, the responsibility is placed and the guilty party thereupon credited with one error. The close-up committee is called in by the cutter when he reaches such a snag; they view the picture, place the guilt for the mistake and authorize the insertion of the extra close-up. Should this necessitate a new close-up, the required background is made in miniature and double-exposed in behind the head.

"This method prevents the cutter from becoming so fed up with the story, after a month's work, that he imagines that nobody can understand it but himself—that the audience must be told in words of one syllable: namely, in close-ups. It prevents the camera man from persuading that cutter to insert a beautiful portrait shot just because it is beautiful, or the actors from obeying a very natural impulse to use all possible pull to see that their own close-ups are used. Even the director must forego exhibiting gags which redound to his credit but which are entirely superfluous. At the time the company is voting on the original scenario it is always very calm and philosophic and sensible; but when the picture is being assembled for final release, it is all very different—and that is just when our committee system works to perfection.

"As a matter of fact, close-ups should rarely be used showing a character finishing a speech after a title. It bores the audience to tears. What they want to see is the other fellow's reaction. Close-ups of inanimate objects should never be used unless the importance of those objects is registered by a building-up process—somebody starts at the page of a book, for example, and then brightens up with a new interest. There are dozens of other mistakes made in the use of close-ups, because they are taken into account only after the picture is made and not deliberately planned beforehand."

The underlying idea of all the productions of the Film Guild, according to Mr. Tuttle, is "to emphasize story, acting and lighting rather than elaborate realistic sets and mechanical effects."

In addition to Mr. Tuttle, those interested in the Guild are Glenn Hunter, the star; Dwight Wiman, Treasurer; Osgood Perkins and Townsend Martin, actors and authors, and James Ashmore Creelman, scenario writer.

* * *

October 30, 1922

A PACKED HOUSE FOR A POOR HOUSE

OLIVER TWIST, with Jackie Coogan, Lon Chaney, Gladys Brockwell, George Siegmann, Edouard Trebaol, Lewis Sergeant and others, directed by Frank Lloyd, adapted by Mr. Lloyd and Harry Weil from Charles Dickens's novel; "The Fable of the Enchanted Fiddle," the Fokine Ballet. At the Strand.

All things considered, they've done a good job, an excellent job, with Dickens in the picturized "Oliver Twist," which is at the Strand this week, and destined to keep the house full, if the crowds that packed the place yesterday mean anything. But whether it is Mr. Dickens or little Jackie Coogan that is drawing them is, of course, a question.

It is probably, or suitably, both, for both are gratifyingly present in the photoplay. The picture is not unadulterated and unabridged Dickens, but there are many genuine fragments of Dickens in it and not much foreign matter. And Jackie Coogan's Oliver Twist is true, somewhat less pathetic, perhaps, than the original Oliver, but appealing, nevertheless, a characterization you cannot resist and have no desire to. There's Fagin, too, vividly present in the person of Lon Chaney, and Nancy Sykes as you have known her, in the person of Gladys Brockwell. George Siegmann's Bill Sykes seems also to have stepped from the book, Edouard Trebaol brings the Artful Dodger and Lewis Sargent shows you the repulsive Noah Claypool dearly. Most of the others are there, too, especially Mr. Bumble, Mr. Brownlow, Charley Bates, Monks and Charlotte, some more, some less, the fulfilment of their originals, but none of them entirely out of character.

Meeting them on the screen, of course, is not the same as meeting them in the book. It is simply impossible to do in moving pictures what Dickens did in words. There are things that can be done in pictures which he didn't do, but what he did cannot be done, or, at any rate, has not been done, in pictures. Not only have the pictures failed at complete characterization, but they have been unable to contain all the story. In order to keep the photoplay down to normal length, and also to accommodate it to the age of Jackie Coogan, the adapters have brought incidents closer together than they should be, eliminated many things, and made a number of noticeable, though not destructive, changes in the story. As a result, the photoplay often seems hurried and sketchy, especially if the book is fresh in your mind, and you may miss several people you would wish to see. But you will undoubtedly feel grateful for the genuine fragments of Dickens you do find, and, if the story sometimes runs awry in a subtitle, you will enjoy the many times it runs true in its scenes. Also Frank Lloyd, the director, should be enthusiastically commended for not spoiling the part of Oliver Twist with funny business—there

is only a little of it, and the temptation to use Jackie for laughs must have been great—and the pictures, on the whole, have been feelingly directed.

* * *

April 1, 1923

CAN A VILLAIN BECOME A STAR?

A Motion Picture "Bad Man" Has His Followers, but Producers Hesitate at Giving Him Stellar Role

By ONE WHO FAILED

Some years back in my recollection, an aspiring playwright wrote a play around Benedict Arnold, and we had the good fortune to find a man to produce it. When the reviews came in on Tuesday morning a stormy scene took place in the manager's office. The manager, admitting his ignorance, asked why somebody had not volunteered the information that Arnold was a traitor. All the critics had given the manager credit for courage in making the presentation, but none of them held out any high hopes of great financial returns. In the end, of course, New York turned its thumbs down on Benedict Arnold, in spite of the heroic qualities the dramatist made him possess, and they did not overbalance his black deed.

I wonder, as Mrs. Asquith says so frequently, if a fundamental law governs virtue and villainy on the stage and with the motion pictures? Is it possible for a producer to capitalize the art and talent of a man who has lent his genius to portraying unrighteous characters, or a woman whose claim to theatrical fame rests upon her ability to portray "vamp" parts?

On the stage I admit that this question is not as poignant as it is with the moving-picture productions. There are just as many great actresses associated with Camille, Carmen, Cleopatra and Sapho as with Juliet, Ophelia, Portia and Polyanna. Mrs. Leslie Carter was just as successful in "The Heart of Maryland" as she was in "Zaza." One doesn't criticize John Barrymore as Hamlet because he once played Richard III.; George Arliss's Disraeli, because he played the Rajah of Rukh in "The Green Goddess"; and it was regarded as being very white of William Faversham to play Iago instead of Othello in his own starring company.

But drama isn't hampered and confined by fetters of censorship. Still it is a question whether censorship has anything to do with the remarkable fact that so far villainy seems to be less profitable on the screen than on the stage.

It is true that Theda Bara reigned supreme in her specialty for a time, and that this specialty became so popular that it contributed a new name to our American lexicon. But the same fate that overtook Theda Bara engulfed Louise Glaum, Helen Gardiner, Alice Hollister, Rubye de Reamer and all of the other "violently loving" ladies. At one time no self-respecting motion-picture company which expected to make money could do without its regular stock vamp, but now the most ravishing of them are forced to get along the best they can in the cloak of virtue. And it has been rather hard sledding for them at that. The great Nazimova in "Salome" for the screen made out a case which would have carried any judge or jury in the land for the celebrated biblical vamp, and it was only when she returned to the stage that she had the hardihood to present a character which she knew very well would not carry over to the screen—"Dagmar."

The ladies of the screen are so careful of their screen reputations that Priscilla Dean absolutely refused to do Cassie Cook of the Yellow Sea in "Drifting" until the rôle, which had been universally praised when Alice Brady starred in the play several years ago at the 48th Street Theater, had been so transformed as to leave no tincture of censure. So successful were the Universal Company script writers in the renaming of the resulting photoplay that it is considered it does not represent the original Owen Davis play at all, and I suppose the managers do not relish the idea of a $500,000 investment starting off with the certain criticism which would result on the part of every critic who had seen the original play.

But now comes one who may overturn the whole theory and be the exception which proves the rule. When "Passion" was shown in this country a lady of the name of Pola Negri, in an unmistakably vamp rôle, became so popular that she immediately achieved stardom. With the Pola Negri pictures it seemed the policy of wisdom to bring the lady to this country. There is no doubt that the lady is a star, there is no doubt that she won her stardom through vamping. If she continues in this tempo, will she go the way of other vamps, or will the Famous Players-Lasky give her virtuous parts to play? Considerable of this lady's fate hinges on "Bella Donna."

But let us consider the situation of the men. Chivalry compels us to denominate them the real villains, anyway. The case of Lon Chaney is extremely pertinent. For years the remarkable character actor was grooming himself for great things. He had natural talent, strong imitative proclivities and patience. After eight years of obscurity, as far as electric lights were concerned, Chaney began to be a "box-office" attraction. In the production of "Outside the Law" he was almost as strong a drawing card as Priscilla Dean. Various companies began to bid for his services. The first picture in which he had the leading rôle was called "The Trap." It was cleverly designed to try out Chaney's public. In the picture he played a man of two personalities—one good and one evil, for picture purposes of course, the good conquering in the end. It was so cleverly devised that neither the company who issued the picture nor the critics who commended it could answer the question, Can a villain be a star? Another picture is on the table with Chaney as its star which may be more definite in its answer. This picture is called "The Shock," and in it Chaney plays an underworld character whose mind and body are both rectified by the purging fire of the San Francisco earthquake. The National Board of Review gave the picture extremely high rating, and it may be that in "The Shock" will be found the answer. It may be that a villain can become a star.

Another case in point is Wallace Beery. Through successive rôles like Buck Roper in "Wild Honey," Dan Lowrie in "The Flame of Life," Count Donelli in "White Tiger," and in "Bavu," in which he is treading on the steps of a stellar throne, Wallace Beery, he who at one time made millions laugh as Sweedie, is today in the highest demand of any of the numerous bad men of the movies. Beery has not always confined his talents to villainy, either. As King Richard in "Robin Hood" he scored a great triumph. And now several companies are trembling on the brink of starring Beery. Will they be able to get away with it? One look at Beery's face must convince one that to successfully star him he must be cast in heavy rôles.

Another meteoric star of darkness was Stuart Holmes. He ascended an orbit almost parallel to that one great vamp, and his descent, if a little longer delayed, was just as precipitous. It was occasioned through the attempt to star him. It has with one exception proved fatal. That exception is Von Stroheim—practically the only man the public will pay money to hate.

Then there is Norman Kerry, probably as bad a villain as ever was shown on a screen. However, it is believed that because of his personal appearance many a maid in a ten-cent seat has forgiven him for his cunning and wickedness. He has been such a successful villain that Universal starred him in "The Merry Go Round," a picture which will be released next September. Kerry is now playing Phoebus, the juvenile leading part in "The Hunchback of Notre Dame," in which Lon Chaney has the rôle of Quasimodo. But the point is whether the patrons will go and see Kerry as a star as they did when he played the supporting rôle of "heavy."

* * *

December 10, 1923

A COMEDY OF WHIMS

OUR HOSPITALITY, with Buster Keaton, Natalie Talmadge, Ralph E. Bushman, Kitty Bradbury, Joseph Roberts, Leonard Clapham Craig Ward, Edward Coxen. Jean Dumas, Monte Collins and James Duffy; "Among the Missing," one-reel drama; "Gallery of Living Portraits," with Theodore Roberts. At the Rialto.

That stoic comedian, Buster Keaton, has chosen to burlesque the feud drama in his latest effort, "Our Hospitality," which is the feature this week at the Rialto. This picture is one of whims, and in many sequences whimsical. It starts rather slowly, but gathers speed with a vengeance toward the last reel. Mr. Keaton has evolved, and evidently kept secret, many new comical ideas, which will undoubtedly cause the Rialto to echo and re-echo with roars of laughter while this film is filling the screen.

In a perfectly serious way, in fact a reflection of his expressionless physiognomy, Keaton's comicality begins by introducing two hating families, the Canfields and the McKays. There is a splendid bit of satire in this, especially for those producers who have feud films on their hands. A score of years elapse, and Keaton appears as a McKay, journeying South in 1830 to take possession of family property. An old-fashioned locomotive, to which are attached stage coaches with steel wheels to run on rails, carries this McKay on his travels. Illustrating the speed made by this primitive mode of conveyance, McKay's dog keeps up with the train, running under the cars and at times going much faster than they do. There is an intensely laughable sequence when the switchman lets go the switch too soon, with the result that the engine and one car goes along on one track and the other so-called cars on the other. Owing to the incline the coaches without the locomotive reach the town before the engine, which bumps into the coaches a few minutes later. Momentum had won in a race against steam.

The title, "Our Hospitality," is gained from the fact that the Canfields' daughter, who traveled with McKay, unfortunately invites him to the Canfield home. It is the law of the feud that you don't have to shoot one of your rivals when he is being entertained in your home. Hence McKay stays as long as he can eventually, escaping in a woman's skirt and through other amusing contrivances. Keaton, or McKay, falls into the rapids and is suspended over a waterfall on a log, to which he is unfortunately attached. In this sequence there is as much to laugh at as in any comedy.

This funny film moves along quietly at the outset, but in the end it gets there, and to our mind it is a mixture that is extremely pleasing, as there is no out-and-out slapstick effect. Natalie Talmadge is quite good in her part, and the rest of the cast are excellent support for the man who never seems to change his expression, let alone crack a smile.

* * *

December 16, 1923

LUBITSCH ON DIRECTING

Ernst Lubitsch, the man who made Pola Negri famous, who directed "Passion." "Deception" and latterly "Rosita" with Mary Pickford, has been squandering a few days in New York searching for a story. He wants something dramatic, virile, containing picturesque atmosphere without being a costume film. He pricks up his ears at the suspicion of a good yarn, and wherever he wanders, at luncheons, at dinners, in the homes of friends, in the subway crush-hour, he is looking for something or somebody to bring the idea of a story to him, so that he can say he wants such and such a play or some particular book.

Lubitsch is a small man physically slightly given to promising plumpness. His dark eyes are keen and smiling. He is very earnest, but like the angels treads lightly when it comes to criticism. He prognosticated titleless pictures in the future, which may mean from two to twenty years, qualifying this utterance with the conclusion that these pictures without words will be utterly different from any being made now. Paintings of great masters, he argues, speak for themselves, and therefore a motion picture should tell its story. He raised his eyebrows when we suggested that pictures without titles

would be like a wordless stage production. He also ignored the brief, yet interesting, title of an oil painting in his conjectures.

Modest and Quiet

This great director's English is restricted and hesitating, and he is modest and quiet. One of the most interesting statements he made concerned the players when shooting a scene. He said he aimed to obtain action that spoke, and found that too many rehearsals of a scene often tired the players, who toward the end went through the performance correctly, but without the spark with which their portrayal was endowed at the outset.

In beginning the interview Mr. Lubitsch said:

"It is my idea to work with the scenario writer from the very beginning and as I do so I build up in my mind exactly how I am going to direct the picture. When the scenario is finished—I know just what I want. It is important that a scenario should be a good manuscript, as it is the essential in the directing of the picture. You have to know before you start shooting what to do in every scene. Some scenes are taken according to necessity and not according to their continuity. You may begin work on the last scene and then skip to the middle of the production. Therefore, how can one start at the end without having mapped out carefully beforehand every detail of direction of the production?

"Then, I try to exclude titles wherever possible. I want all action, where it is feasible; to explain itself without titles to interrupt the suspense which is so often killed by the insertion of words. For a modern realistic drama, we must have spoken titles; but even these should be made to read just as one speaks in real life, and not according to the stiff conversation of books. The ideal manuscript is one without titles, but it is not for today or tomorrow, but in a couple of years or infinitely longer. This has nothing to do with pictures as they are produced nowadays. In our titles we borrow from the stage or the novel. Later we will have discovered the motion picture style.

An Intimate Drama

"It is very interesting to have every scene speak for itself and what I talk about in this regard may not happen for fifty years. In a painting you understand what it means without titles. All the great masters explain themselves. In my last picture I experienced a great change in my career, as it is the first time I have made an important modern drama. I have gotten away from spectacles, as there are only five characters in this film, which is called 'The Marriage Circle.' It is a very intimate drama. Even the script of this story was different, and I never got so close to real life as I have in this picture. It is a narrative of a serious marriage problem—light, if you like, but very real, and not overdone. Some people are given to being too heavy on the screen. We want realism, and the players should act as they would in the same circumstances in real life. You don't act heavily in real life. I have attempted to exclude this in my last picture.

"My chief worry now is looking for a story. It is always a worry, and far harder to decide on a story than to direct. The

American pictures are fine—there are no pictures that speak as well as the American productions. It is difficult to say which is the best picture I have seen here. How can one say whether Molière or Shakespeare is the cleverer, or compare Bernard Shaw and Gerhart Hauptmann? I think that 'A Woman of Paris' is a marvelous production. I like it because I feel that an intelligent man speaks to me, and nobody's intelligence is insulted in that picture, the treatment and atmosphere in it being wonderful.

"I had a wonderful actress in Mary Pickford and the same adjective applies to Holbrook Blinn. In my latest effort, the five players are Marie Provost, Florence Vidor, Monte Blue, Adolpho Menjou and Creighton Hale. None of them are overdressed. I wanted to have them attired just as they ought to be for such a story. So there are no million dollar jewels and no gorgeous clothes. There is no sweet, nice acting, which is unreal. We want to touch the emotions of the people who see this picture. The players have on as little make-up as possible—only that which is necessary for the lights.

The Spark in Acting

"Yes—yes—I do believe that some time in the future stories will be written direct for the screen. I prefer a manuscript written for the screen by somebody familiar with the dramatic construction of a picture.

"As far as I can, I try to keep the action going without tiring the players. I think over my medium shot when I am making my long shot, and I am ready for what I want when it comes to a close-up. I don't want to get the actors fatigued, and only when it appears absolutely necessary do I insist upon going over the scene three or four times. You lose the feeling when you do. A player may have just the expression you want, but on the fourth or fifth attempt he is too sure of himself."

* * *

December 30, 1923

THRILLS IN FILMS

By LOUIS MAYER

The thrill is probably the one element of the silent drama that has persistently weathered the changes of the screen. When motion pictures passed the novelty stage where a policeman chasing a tramp made a successful film, a thrill injected in a plot was the screen's first step of improvement. Since then tragic, historical, mystery and sympathetic drama, and farce, dramatic and light comedy have had their periodical fling as they moved around on the cycle of time, but the thrill picture has traveled its money-making path uninterrupted.

The exact worth of a thrill in a picture defies prediction. Not until the film is released and the public has placed its price upon the thrill does the producer know the value of his climax. But it is safe to say that the box office magnetism of a real thrill begins at a figure that marks up a profit on the picture. This, of course, is based on the premise that the rest of the production is of good quality.

As a rule, a director approaches the staging of a thrill with about the same joyous feeling that one has on visiting a dentist's chair. It will be a splendid achievement when the job is done, but meanwhile much mental suffering must be gone through.

George Ade says that, while the high-brows may sniff at good old heart-touching hokum on the screen, the American public could not keep house without it. The same thing applies to the thrill as one of the ingredients of dramatic construction. It is the life-blood and motive power of some of our greatest productions.

What would D. W. Griffith's "The Birth of a Nation" have been without the spectacular, wild-riding gathering of the clans? Many who have not seen the picture for years can still describe that epoch-making sequence in detail.

Sea Storm Thrills

One of the most adventurous thrill-filming expeditions on record was the one launched recently by Reginald Barker in favor of "Cape Cod Folks," a screen adaptation of the old New England stage classic. To be sure of screening the utmost in realism in the sword-fishing and sea storm scenes, a company was sent from Los Angeles to the Atlantic to work off the coast of Massachusetts and also at the historic Grand Banks off Newfoundland.

By sheer courage they stuck to their mission although their search for excitement brought them into the face of storms with waves running eighty feet high and made them challengers of swordfish that weighed six hundred pounds and carried swords measuring over six feet in length. Risks without number were encountered, but they passed them off without a thought. They had gone 4,000 miles to photograph the terrific storms and savage denizens of the Atlantic, and they didn't even consider personal risk among the obstacles.

In another Barker picture, called "The Eternal Struggle," the turbulent Seymour Canyon Rapids near North Vancouver was conquered by players in a canoe for a thrilling climax after the old settlers and even the Indians had refused to take a chance with the dangerous stream. Seven weeks were spent in securing enough good footage to run ten minutes on the screen. Suspended from a cable in a steel cage, directly over a waterfall, the photographer ground his camera, day after day, within a few feet of sure death.

Every business has its exalted code of loyalty, but I doubt if any industry harbors a more courageous sense of duty than that reflected in players, directors and their cameramen when it comes to filming thrills for pictures.

Standing directly in the path of a limited train one night recently Maria Prevost and Robert Ellis enacted a very dramatic scene while the engine and its tail of brilliantly lighted cars thundered down toward them and switched off on the next track just in time to avoid a tragedy. Within a few feet of the stars, and sharing in the same danger, were the director, John M. Stahl, and his battery of cameramen and assistants. If the switch hadn't worked—! But it did, and a unique and effective thrill was registered for the theatregoer.

Death Valley

Many colorful tales are told of the incidental thrills that cropped up during Cecil B. De Mille's filming of the chariot race sequence in "The Ten Commandments." Crediting only the minor risks involved, it is safe to say that the seasoned cavalryman engaged to drive the careening war chariots in this splendid production are worthy of medal distinction for their work. The results they secured will go down in cinema history for their startling realism.

Death Valley, that arid, merciless oven that strikes terror to the hearts of even the old desert prospectors, was invaded by Von Stroheim's company in the making of "Greed," and for weeks was compelled to submit to use as a background for scenes. Death Valley's favorite allies, heat, snakes and scorpions, fought the director constantly, but he had scenes to get there and he got them, regardless of the risk and inconveniences.

In the making of the bull-fighting scenes in "Blood and Sand," Fred Niblo and Rudolph Valentino took so many chances with their lives that danger became almost a daily diet. In order to get scenes that would carry through the spirit of their arena episodes, they had to get right down in the ring with an enraged bull that would have made a worthy antagonist for a tiger.

Tom Mix has earned fame and popularity through the thrilling exploits in his pictures, and the thrills are actual thrills, not camera tricks. Hoot Gibson, Eddie Polo, Charles Hutchinson and a number of other stars of like valor have built up reputations that reach around the world on their daring and courageous feats before the camera.

Sometimes the breathless suspense of a thrill is only half told on the screen. The rest of the danger is distributed among the director, cameraman and others of the production staff. To name all of the directors and stars who have hovered on the brink of death in a sincere effort to put realism into their pictures would practically amount to calling the roster of the entire studio world. Some make a regular thing of capitalising unusual hazards and risks for screen thrills, but nearly all the stars and directors have stared death in the face at some time or other in search of a thrill.

* * *

March 16, 1924

STORY OF A GREAT FILM

At a luncheon celebrating the year's run of "The Covered Wagon," Jesse Lasky, head of the production units of the Famous Players-Lasky Corporation, in an earnest and modest speech gave an interesting account of the making of this film, revealing, without the slightest egotism, the fact that he was the guiding genius and that James Cruze performed an even more remarkable effort than was generally known.

It was a talk which would have thrilled anybody, even if he were not interested in motion pictures. Most of the guests present had viewed the picture again the previous evening,

which made Mr. Lasky's words all the more stirring as the scenes of "The Covered Wagon" were fresh in their minds.

Mr. Lasky told of leaving New York with a copy of Emerson Hough's great story of the indomitable pioneers, and of reading it on the train bound for Hollywood. When he was passing a certain stretch of the Arizona desert he visualised trains of wagons and hundreds of players and horses, and was thrilled at the idea of making the production. The train could not carry him fast enough to his destination, so eager was he to have work started on the film, which he anticipated at that early date would stir the whole country.

Viewing the story from the idea of an ordinary picture, the New York producing department had asked $100,000 for producing "The Covered Wagon," and it had already designated the director and a woman player who was to appear in it. Mr. Lasky conjectured that neither the director chosen for the job nor the actress was fitted to the production as he wished to have it made. His first task on reaching the Coast was to sidetrack these two people, not because they were incapable, but on account of the fact that they did not fit in with his scheme of things for the production. A man who could make a splendid society drama would not necessarily be able to direct this great Western story and give it all the atmosphere necessary to make it a remarkable picture. Neither would a girl who could play certain roles in an inimitable way be interested in such a part as played so efficiently by Lois Wilson.

Mr. Lasky's first step was to telegraph asking for $800,000 for the cost of the production, to which Mr. Zukor immediately acquiesced, having implied confidence in his partner's judgment. Following that, Mr. Lasky talked matters over with the director and with the actress, and soon they saw eye-to-eye with him and generously resigned from the production.

Cruze Reads the Story

Then Mr. Lasky called for James Cruze and gave him the story, telling him to read it that night and to talk it over with him the next morning. Mr. Lasky knew Mr. Cruze intimately and was therefore aware of his qualifications—the chief of which was that he, the director, would be inspired by the Emerson Hough narrative and then through associations and antecedents he would be doubly interested in every little detail of the story. As a matter of fact, Mr. Lasky told his hearers that Mr. Cruze has Indian blood running through his veins, something of which this director is justly proud, and that he is instinctively enthralled with yarns, of the pioneers and redskins.

After reading "The Covered Wagon" Cruze hastened to Lasky, and it needed no words to note the enthusiasm of the director. He pictured to Lasky what a wonderful scene it would make to have thirty prairie schooners slowly moving over the desert, a hundred Indians, various other scenes including the fight with the redskins, the disheartened men and women and the theme of the whole story. Cruze was jubilant at having $150,000 to spend on the production, and he conjured up enthusiastically what could be done with it.

Warren Kerrigan and Lois Wilson in "The Covered Wagon."

Then Lasky told Cruze that he was to have not only $150,000 but $800,000, and that instead of thirty wagons there were to be 300 covered wagons and also 300 redskins. Whereupon Cruze could not get at starting the production fast enough, and while waiting for the casting of the picture he mapped out details, and the story to him grew bigger and bigger. Then came the going out on location, the making of some of the scenes, and in course of time the cutting and titling of the film, and Lasky and other persons were eager to see it in finished form.

The First View

Mr. Lasky said that when he first saw the picture he thought it was wonderful, but he found the ending premature. The last scenes, except for a few hundred feet, were when the wagon processions split, one going to Oregon and the other to California. With impressive modesty, Mr. Lasky then told how he realised that this was not an adequate finish for the picture and that it needed quite a good deal to make it entirely satisfactory. By that time the different players who had been acting in "The Covered Wagon" were at work in other productions, some with rival concerns. There was no time to lose, and, after scurrying around, the people were rounded up, and it was agreed that some players with different companies would be permitted to have the week-end to go through the different scenes wanted for a dramatic ending to "The Covered Wagon."

So one Saturday, after things had been prepared in every way possible, the actors and actresses were hastened in racing cars to a scene about 200 miles from Hollywood, and on that Sunday Cruze "shot" about 200 scenes, including some of the most interesting ones in the second part of the production. This, said Mr. Lasky, was a remarkable piece of work, considering the tensity under which the actors and the director had to work.

And After a Year

"The Covered Wagon" after a year does not seem to have slipped behind the times. It is just as remarkable a picture as it was the first day it was presented. Ernest Torrence did some wonderful acting in "Tol'able David," but his supreme effort is undoubtedly in "The Covered Wagon," where every movement of his large mouth provokes interest and a great deal of laughter. There are no better scenes in any picture than those in which Tully Marshall and Ernest Torrence portray the two old scouts who are very fond of their liquor and show their great trust in each other's shooting aim by having beer mugs shot at after the manner of William Tell and the apple.

* * *

April 21, 1924

FUN BY THE MILE

"GIRL SHY," with Harold Lloyd, Jobyna Ralston, Carltón Griffin, Richard Daniels and others, from a story by Sam Taylor, Tim Whelan and Ted Wilde, directed by Fred Newmeyer and Sam Taylor; special tenth anniversary program of the Strand includes "Our Birthday Review," and sequences from some of the first films shown in this theatre; "Odds and Ends," a novelty. At the Strand.

Those who went to the Strand yesterday to see Harold Lloyd in "Girl Shy" apparently forgot about the Easter showers in their merriment over this picture, which is filled with farcical sequences. Mr. Lloyd is a genius in obtaining and making the most of new ideas to bring happiness to audiences, and while we do not think that this particular effort is quite as subtle in its fun as "Why Worry?" there is no denying that row upon row of faces in the packed theatre enjoyed it to their hearts' content.

Mr. Lloyd plays the rôle of Harold Meadows, a tailor's apprentice and would-be author, who in nervous moments stammers and stutters, especially in the presence of girls. In one sequence he is seen on a train, seated next to a charming girl, who wishes to hide a Pekingese from the conductor. In sheer desperation Meadows pulls out the contents of a bag, which he imagines belongs to the girl and stuffs the dog therein. The conductor, business-like and austere, approaches the seat where Meadows and the girl are seated, just at the instant she is proffering some puppy biscuits for the Pekingese. Meadows has no time to think so he snatches one of the biscuits and begins to nibble on it as if he usually took that sort of food from the girl. No audience could have laughed

more heartily at Meadows's grimace as he succeeds in biting a corner off the biscuit.

Arriving at their destination, the girl promises to meet him in his publisher's office on a certain afternoon. When he goes there he is at first stricken with the belief that his literary effort has found favor, but a word from the head of the concern annihilates this idea, and he returns to work in his tailor's shop. He is busy when a letter from the publisher arrives, and, presuming it contains a rejection slip, he tears it up, only to discover that he has destroyed a check for $3,000. Simultaneously he learns that the pretty girl is about to be married that afternoon, and there ensues a succession of rides in stolen cars, on horseback and on a wagon, which are filled with hilariously funny situations.

When he goes to the telephone to call up the girl's home, he stutters so badly that the operator concludes that the wire is out of order, and forthwith disconnects. However, through perseverance the hero eventually reaches the home of the bride-to-be, just at the instant the minister is about to declare the couple man and wife.

One extremely good stretch is where Meadows is seen fishing, with his puppy-biscuit box beside him to remind him of the girl who has stolen his heart. She drives up in an automobile, which breaks down, and in seeing the reflection of her pretty face in the water the tailor's apprentice believes that it is merely the result of his daydream before he discovers that the heroine is near him.

There is much to provoke laughter in this picture, especially the grimaces of the indefatigable Mr. Lloyd when he is in embarrassing situations, as he is most of the time. Jobyna Ralston is clever in her supporting rôle.

Moe Mark, General Manager of the Strand, and Joseph Plunkett, Managing Director, received a number of telegrams congratulating them on the tenth anniversary of the theatre. A special program was published and scenes of the first films shown in the theatre were screened, among them being William Farnum in the famous fight of Rex Beach's "The Spoilers," and scenes with Charlie Chaplin in prehistoric garb, and Mary Pickford in "The Eagle's Nest."

* * *

April 27, 1924

SPONTANEITY IN ACTING

Raoul Walsh, who directed "The Thief of Bagdad," the other day sent us a plea to dig screen acting out of the rut of standardization. He advocates permitting the players to give their conception and expression of the characters, after the parts have been outlined to them.

"With the exception of half a dozen screen players, motion picture acting has made very little progress in the last few years," says Mr. Walsh. "One might almost declare it to be at a standstill. It makes one think that the players are cast in two molds—male and female. Ninety per cent of them play the rôles in identically the same manner.

"The question is whether this is directly the fault of the players. Are our actors and actresses not capable of better things? Personally I think they are. The trouble is in the current practice of curbing the players too much—making them suppress their own feelings and emotions in regard to characterizations so that they may give the director's idea of the rôles.

"As an example let me cite an instance. In directing a picture recently I had a well-known film actor—a man who originally made his reputation because of his able acting. From the very first scene that we filmed I noticed that this actor not only waited for me to give him every minute detail as to how he ought to play the scene, but he seemed to have lost all his former spontaneity, and was stiff and helpless. He asked me now long he should hold such an expression and whether he ought to turn his head more away from the camera and all that sort of thing. After a few scenes, which it was not difficult to see were anything but good, I called him to one side.

"I told him that I knew of his ability as an actor or I would not have engaged him. I informed him that he knew more about playing the part than I did. He knew the story. 'Why,' I asked him, 'do you wait for me to instruct you?' He was surprised. He then told me that hitherto he had put all the spontaneity he could into a part, but that in recent productions under certain directors he found it easier to get along by accepting instruction rather than fighting for his idea of the characterization. I then told him to play the scenes as he felt they ought to be played. 'If I have any suggestions or criticisms I will let you know,' I said. He resumed the rôle and pitched into it with zest and enthusiasm.

"I should like to know how the silent drama is to develop great talent if the practice of curbing the player is adhered to. Granted the director must play an important part, he must supervise the players and see that they are getting the right stuff into the scene. There should, however, be a happy medium, as overdirection causes players to be self-conscious, mechanical and as colorless as dolls or marionettes on a string.

"It is my experience that if a scene is thoroughly explained to the player, and he or she has carefully read the story and knows the character, the player will portray the rôle more naturally and give a far more effective performance if given some personal freedom in the playing of the scenes.

"Intellectual power is at the bottom of all fine work for the camera. There may be temporarily successful work performed without the correct thought back of the action, but it stands to reason that acting without the necessary mental quality behind it is only a flash in the pan. The player who has not an intelligent idea of what he or she is doing and the reason for it will never give much of a performance."

* * *

May 26, 1924

A LIVELY COMEDY

SHERLOCK JR., with Buster Keaton, Katheryn McGuire, Ward Crane, Joseph Keaton, Horace Morgan, Jane Connelly, Erwin Connelly, Ford West, George Davis, John Patrick and Ruth Holley, written by Jean Havez, Joseph Mitchell and Clyde Bruckmann, directed by Mr. Keaton; overture, "La Tosca"; Riesenfeld "Classical Jazz," "Covered Wagon Days." At the Rialto.

As one watches "Sherlock Jr." being unfurled on the Rialto screen, one might observe with a sigh after 500 feet have passed that it is about time the comical Buster Keaton skipped into action. Just about then you realize that something has happened—one of the best screen tricks ever incorporated in a comedy—and laughter starts, and for the balance of the picture you smile, snigger, chuckle, grin and guffaw.

As the embryo sleuth whose actual occupation is that of a projection machine operator in a nondescript motion picture theatre, Mr. Keaton finds the tables turned on him when the pawn ticket for a stolen watch is discovered in his own pocket. He returns to work, dejected at the thought of losing his girl, and falls asleep in the operator's booth as a picture is being screened. What one sees is his dream, which in a measure is something like the dream sequence in "Hollywood."

One views Mr. Keaton seeing his girl on the screen with the villain, he who had really stolen the watch. You see Keaton join the characters in the picture he is projecting, and then he is kicked out of the picture by the villain. He is about to sit on a doorstep when the scene changes and he discovers that he is at the foot of a garden wall. The scene switches again and he narrowly escapes being run down by a train. He does get out of its way, and is then seen peering over a high cliff, which soon changes into the sight of Buster on a rock in midocean. He is pondering in thought, listening to the wild waves, when in comes a scene of Broadway or some traffic-congested thoroughfare. For the most part of this production our hero is endeavoring to get out of the picture he is projecting, or at least out of the swiftly changing sequences into which he has penetrated in his desire to throttle the villain, played by the sinister appearing Ward Crane.

After viewing the antics of the hero on the screen of his own theatre, the director, none other than Buster himself, has seen to it that the whole affair is brought closer, so that one witnesses the full size result. Of course the first part of this long sequence is boisterously funny, and nary the flicker of expression crosses the Keaton countenance, except through the eyes. His face might be made of stone for all the resiliency there is in it.

There is an extremely good comedy which will give you plenty of amusement so long as you permit Mr. Keaton to glide into his work with his usual deliberation.

* * *

July 13, 1924

A COLORED PICTURE AND
A GERMAN NIGHTMARE

The first motion picture to be made almost entirely in colors, which has lost little of its drama in the process, is "The Wanderer of the Wasteland." It is undeniably a praiseworthy effort, but at the same time it has the weakness of being indistinct in many of the scenes, and here and there the acting of the players has received less attention than the colors put before the camera. The director evidently desired to point with pride to a red or a blue—perhaps a temptation in such an effort. Still, in criticizing this picture as a whole it must also be said that there is very little in the way of "color fringing," quite a common thing even in short features produced in more or less natural colors.

Irvin Willat, the director of this production, demonstrates his ability to the extent that we look forward to seeing his next effort in black and white—and black and white is not actually what is seen in the finished print, which it must be remembered is always effectively tinted with blue for night, amber for certain scenes and pink for others. There is no doubt in our mind but colors detract even in such an effort as "The Wanderer of the Wasteland," and we also believe that the usual style of presentation of a film is less wearing on the eyes.

In quite a number or scenes in this Technicolor effort there is an obvious attempt to call attention to the color effects, and, as we pointed out in our criticism, a character whose eye was injured, instead of covering the optic with the ordinary black patch, affected one of a peacock-blue tint. The coloring appeals to anybody, just as water-color paintings do. They are beautiful, but seldom sharp, and when it comes to the delineation of a narrative, sharpness is essential, as, no matter what scenic effects there may be, unless the situations are compelling and the consequent story is interesting, the production inevitably fails.

You may have beautiful sunsets of faded pink and orange, seas of an ultramarine hue and roses that are a natural red, but if the physiognomies of the players are indistinct the artistic affect swamps the action.

Red Blood

There are several strong sequences in this photodrama, one of them being that in which a bandit is thrown into an ore-crusher, and the stream of water emerging from it through a sepia rock is a bloody red. Where blood in the ordinary feature has always been a black smudge, in this film it is a real red, seen frequently in the scenes of fights on the arms and faces of the combatants. A thrilling stretch is that in which Jack Holt, as the hero, on the verge of madness through lack of food, sees a rattlesnake. The reptile is shown so distinctly that one can see—in this tinted sequence—the rattles at the end of its tail. A shudder went through the audience when we were in the theatre the instant the snake struck at its victim, who, of course, was not seen in this particular scene, as the loathsome object is obviously angered.

Most of the real drama of this colored picture is in the sepia-tinted scenes. There is the old maniac who has dragged his faithful and patient wife from civilization to live alone in a desert shack. He decides that every man she talks to is enamored of her. Finally the wretch hurls rocks in his crafty effort to dislodge a great overhanging boulder, in which he eventually succeeds. So the poor woman is crushed to death in her mean abode. We venture that it is hardly natural for a woman to live with any man when he has reached the stage this one had. To show his insanity, Mr. Willat has caused this madman to look at a dog immediately after his disembarkation from the river steamboat. Suddenly he kicks the animal, who flees in fright and pain. His action was passed over in an unusual way by the throng, and evidently the canine had no owner present.

A Nightmare

We remarked in our review of "Between Worlds" that it brought to mind Kipling's "La Nuit Blanche," which, as may he remembered, deals with the ravings of a man suffering from delirium tremens. The first lines run:

In the full fresh fragrant morning
I observed a camel crawl,
Laws of gravitation scorning,
On the ceiling and the wall.

Then there is mention of a "blood-red mouse" and other objects the victim sees. "Between Worlds" is a weird film, which may or may not have been the inspiration for Douglas Fairbanks's charming photoplay "The Thief of Bagdad." Although there are scenes of a magic carpet, the making of an army of lilliputians and other touches of Bagdad, it is never accomplished with the same delicacy and beauty that one beholds in the Fairbanks picture.

It is difficult to fathom what Fritz Lang, the director of this film, is really driving at. This incoherent condition of the picture may have been accentuated by necessary cuts made in the production for presentation in America. Here and there one sees some spectacular scenes which, with all their huge settings, are much behind the times.

Edgar Selwyn's play "The Arab," filmed in Northern Africa, is to be the screen offering at the Capitol this week. This production was directed by Rex Ingram, who has selected wonderful sites for some of his scenes, judging from the still photographs we have looked over. Ramon Novarro enacts the Arab, and Alice Terry has the role of the missionary's daughter.

Another film production which is likely to create a stir among movie enthusiasts is Sinclair Lewis's "Babbitt," which has been translated to the screen by Warner Brothers with Willard Louis, Carmel Myers, Mary Alden and Raymond McKee. This picture was directed by Harry Beaumont.

In "For Sale," the film presentation at the Mark Strand this week, is a cosmopolitan group of players. The story is a drama of modern society and was written by Earl Hudson.

Claire Windsor, who was the heroine in "A Son of the Sahara," has the leading feminine part. Adolphe Menjou, who was last seen in "Broadway After Dark" and before that in Chaplin's "A Woman of Paris" and Lubitsch's "The Marriage Circle," has a role which is said to suit him. The hero is portrayed by Robert Ellis, and Mary Carr, who gained screen fame as the mother in "Over the Hill," has a part different from any in which she has been seen. Tully Marshall, as the father, unwittingly commits a crime and as a result his daughter practically auctions herself off in marriage. Vera Reynolds is seen as a saucy flapper in search of a sweetheart. Certain sequences in this picture illustrate reproductions of the well-known cabarets of Paris—Le Ciel and L'Enfer. The French idea of placing Heaven and Hell next door to each other is symbolic of the theme of the picture, which revolves around the unhappiness of a wealthy girl who possesses everything but love. The cabaret of Heaven is shown with a studded blue sky, angels and cherubs gliding through space. The cabaret of Hell represents the head of Satan with his huge open jaws serving as the entrance. George Archambaud directed this production.

<p style="text-align:center">* * *</p>

<p style="text-align:right">August 17, 1924</p>

LOVE IN THE MOVIE

Although the film version of "Monsieur Beaucaire" is entitled to full marks for the splendor of the settings and the extraordinary beauty of the costumes, the narrative itself is set forth without much subtlety, leaving little to the imagination. The producers have commenced this picture with a gorgeous sight of Louis XV and his court, which is very effective, but it should have been the last chapter of the film instead of the first. The situations in this introduction rob the story of suspense, as they practically reveal the idea which Booth Tarkington in his charmingly written book kept delicately veiled until the climax. The scenario writer has one way of telling a story and Mr. Tarkington has another, and we must say that we like the author's way better. One is artistic and the other is decidedly not. There is no doubt that what is already a remarkably interesting motion picture could have been vastly improved by adhering to the author's ideas in telling the tale.

Mr. Tarkington opens up with the Duke of Winterset in Beaucaire's apartment, where both have been indulging in a card game. Young Beaucaire is an inveterate gambler, and Winterset, the caddish nobleman, was willing to risk his luck with the man he supposed to be the French Ambassador's barber, who had, perhaps, as he vaguely understood it, made money through his luck with the pasteboards. Winterset is caught cheating which stops the game at a moment when £700 is due Beaucaire. The Frenchman suggests that he will cancel the debt on condition that Winterset introduce him to Lady Mary Carlisle, the Beauty of Bath. Winterset alternately purple and white with anger is not particularly

Rudolph Valentino and Oswald Yorke in "Monsieur Beaucaire."

wishful of the tale of his cheating being disclosed, even by a man he supposes to be a barber in the entourage of Mirepoix. He pretends that such a demand by the Frenchman is tantamount to blackmail, and is about to assault Beaucaire when François and the other servants are called by their little master, to the surprise and dismay of the welching Duke.

No Mystery

The identity of the young Frenchman is not disclosed until the end. True, one suspects that he is not a barber, but his true status is not revealed until he is seen at the great reception. The picture producers, or Forrest Halsey, the scenario writer, have strangely permitted the audience to know all about Beaucaire only keeping it dark from most of the characters in the story.

The sub-titles in this production would have been much more fascinating if the film editors had used more of Tarkington's words and, incidentally, spelling. Here and there in the photoplay there is a good title, but not nearly as

many as there might have been, and there are some that are quite awkward.

It was hardly necessary for such a production to have a lengthy kissing scene, when the love scene could have been pictured so perfectly if the scenario writer had clung to Mr. Tarkington's delicate narration of the beginning of the love affair, wherein the trembling gloved hand of Lady Mary is merely touched by the noble Beaucaire. Apparently it was not thought that Valentino would be appreciated in any such dainty love scene, so the picture director Sidney Olcott, who is nevertheless to be congratulated on many sequences in this production, decided to have Valentino take Lady Mary in his arms and press a regular movie kiss to her lips. It is not a kiss such as one would imagine the French noble imprinting on the lips of a dainty girl but a sort of Apache kiss—one of savage affection, which is almost a brutal way to treat the lady described by Beaucaire himself as the "fairest of all the English fair." The director, Mr. Olcott, and Valentino have combined in giving this scene all the delicacy and subtlety one might see in one in which Ben Turpin manifests pseudo affection for a bathing beauty. Mr. Tarkington's description of the scene is worth while quoting in part:

The two hands were shaking like twin leaves in the breeze. Hers was not drawn away. After a pause, either knew how long, he felt the warm fingers turn and clasp themselves tumultuously about his own. At last she looked up bravely and met his eyes. "My beautiful" he whispered it was all he could say. "My beautiful!" But she clutched his arm, startled.

The Queen's Fan

Then followed the attack of the cowardly Duke's cohorts on Beaucaire. Tarkington told his whole story in 25,000 words, while the screen men have been wont to enlarge it fivefold. They wanted lavish scenes, and they have wrought them magnificently, but without a single contrasting note. However, in the Court episode, lovely beyond comparison with any other such effort, there is a touch which is not in the story, but which is peculiarly interesting. It is where the artist, Fragonard, as a youth, presents to the Queen a fan he has painted. Soon afterward Princess Henrietta, unknown to the Queen, accidentally breaks the fan, and the Duc de Chartres, or Beaucaire, shoulders the blame. This is an incident that gives the viewer something on which to ponder.

In various parts of the book reference is made by the gallant and chivalrous Beaucaire to red roses, those he sent to the Duke of Winterset after he had run Captain Rohrer through the left shoulder, and those he made mention of to the adorable Lady Mary Carlisle. From the glimpses one has of the blossoms in this picture they are white roses, and the rose used by the figurantes in the prologue is pink. A trivial point, it would

be, were it not for the fact that if there is a combination of words remembered by readers of Mr. Tarkington's book, it is "red, red roses."

Valentino's Beaucaire

Valentino, with his undeniably good looks, does not stand out as the mental picture we formed of the artistic Beaucaire when going through the book. One forgets the man in the picture when re-reading the book, as one's conception of the delicate little swordsman is thus revived and Valentino is lost. The picture is but a shadow, while the type is still there and the words sink into one's mind far more deeply than do even the entrancing scenes, because the producer in the film has felt it necessary to exaggerate, more in some instances than in others, everything that confronted the eye of the camera. Valentino appears to believe than the French aristocracy uttered their words from the right-hand corners of their mouths and he affects this notion, which is disconcerting to those watching him.

This popular screen player suffices to a certain extent in this production without attaining great heights. As a certain type of screen actor Valentino excels, but he cannot be credited with much more than an attractive physiognomy and the ability to appear an impetuous and ardent lover with an omnipresent underlying consciousness of his own popularity. Such a performance as he renders in "Monsieur Beaucaire" cannot of course stand comparison with John Barrymore's artistic work in "Beau Brummell." Mr. Barrymore comes of a family of actors. He was a celebrated actor when Valentino was engaged in utterly different work. It would be difficult to imagine Valentino playing Hamlet on the stage, but it would not be difficult to conceive Mr. Barrymore giving a far more striking performance of Beaucaire than Valentino's. To keep to the book, Valentino ought to have worn a mustache in the scene in which he confronts the Duke of Winterset with cheating, but the screen favorite refrained from such an adornment. Reverting to "Beau Brummell," it will be remembered that Mr. Barrymore did his best work in this film when he showed the gradual withering of the former dandy with matted gray hair, seared countenance and greasy, threadbare apparel. Would Valentino, we wonder, have cared to obliterate his own looks with such a make-up for the sake of an artistic success?

There is too much of Valentino in Beaucaire and not enough of the aristocratic Frenchman. However, it does not alter the fact that with all the digression from the narrative this is a beautiful and a most interesting production. It is unfortunate that the producers decided to make it a glorious box-office movie instead of an artistic motion picture which in the end might have appealed to audiences just as much as and perhaps more than does this pictorial effort.

* * *

December 5, 1924

FRANK NORRIS'S "McTEAGUE"

GREED, with Gibson Gowland, Jean Hersholt, Chester Conklin, Sylvia Ashton, ZaSu Pitts, Austin Jewell, Oscar and Otto Gottel, Jan Standing, Max Tyron, Frank Hayes, Fanny Midgley, Dale Fuller, Cesare Gravina, Hughie Mack, Tiny Jones, J. Aldrich Libbey, Rita Revela, Lon Poff, William Barlow, Edward Gaffney, S. S. Simonx and others; adapted from Frank Norris's "McTeague," directed by Erich von Strohelm. At the Cosmopolitan.

The sour creme de la sour creme de la bourgoisie, and what might be its utterly ultra habits, were set forth last night before an expectant gathering in the Cosmopolitan Theatre in the fleeting shadows of the picturized version of Frank Norris's "McTeague," which emphasized its film title of "Greed." The spectators laughed, and laughed heartily, at the audacity of the director, Erich von Strohelm, the producer of "Foolish Wives," and the director who was responsible for part of "Merry Go Round." Last January this picture was thought by its director to be perfect in forty-two reels, which took nine hours to view. He capitulated to its being cut down to about 30,000 feet, and is said to have declared that any audience would be content to sit through six hours of this picture. However, it was cut to less than half that length.

It is undeniably a dramatic story, filled with the spirit of its film title, without a hero or a heroine. The three principals, however, deliver splendid performances in their respective rôles. Gibson Gowland is unusually fine as McTeague; but from beginning to end this affair is sordid, and deals only with the excrescences of life such as would flabbergast even those dwelling in lodging houses on the waterfront.

Mr. von Strohelm has not missed a vulgar point, but on the other hand his direction of the effort is cunningly dramatic. There is McTeague, who graduates from a worker in the Big Dipper Gold Mine to being a dentist without a diploma. He hails his new work with silent satisfaction, and when Trina Sieppe, Marcus Schouler's sweetheart, comes to his "painless parlors," he examines her teeth, informing her in due time that she must have three of them extracted and a bridge. The cost immediately enters her mind, but finally there is acquiescence, and she succumbs to the ether. McTeague gazes upon her quiescent countenance, and then, after fighting against his desire, he kisses her.

Sometime afterward he tells Marcus that he is in love with Trina, and the latter surrenders his sweetheart, who on the morning she went to McTeague's parlors had bought a chance in a lottery, the high prize of which was $5,000.

Soon after this one hears that Trina has won the $5,000, and Marcus's countenance is black and ominous. Then follows an obnoxious wedding scene with grotesque comedy. Hans Sleppe, the bride's father, insisting on drilling the figurantes, even to chalking marks on spots for them to stand on. Mr. von Strohelm outdoes himself in the wedding breakfast sequence, as the participants at the meal all attack the edibles in a most ravenous manner, the male element being protected from their ignorance of etiquette by napkins tucked around their necks.

In the struggle for existence Mrs. McTeague clings to her $5,000 even after McTeague is forbidden to practice dentistry and is forced to seek his livelihood as best he can. She gradually becomes a miser, counting her gold on her bed and concealing it in her trunk as fast as she can when she hears her husband's heavy tread. Then she grows eager for every penny she can extort from him, going through his pockets when she knows by his breathing that he is asleep.

It all ends as might be anticipated—in the murder of the woman by McTeague, who escapes to Death Valley with the sack of golden coins, which his wife had polished with such meticulous care night after night.

Marcus, who, in spite of protestations of friendship had never forgiven McTeague for depriving him of the $5,000, is one of the first to read of the reward offered for the murderer. It is not long before he and a posse are plunging forth into the sun-scorched desert in search of their quarry. The Death Valley scenes are stark reflections of what happen in such circumstances and true to Frank Norris's story. Mr. Gowland gives a realistic portrayal of a man struggling along on the hot sands with the blazing sun overhead. He has the gold. He has killed his wife. And Marcus is after him! The climax is not only mindful of Frank Norris's story but also of Jack London's "Love of Life." Mr. von Strohelm has introduced situations which make the fight for existence still stronger in its appeal than one would have imagined. Fancy two-men struggling in the desert suddenly seeing the only possible chance of life—water—being carried away by a frightened mule!

Irving Thalberg and Harry Rapf, two expert producers, clipped this production as much as they dared and still have a dramatic story. They are to be congratulated on their efforts, and the only pity is that they did not use the scissors more generously in the beginning.

Mr. Gowland slides into the character and stays with it, and in spite of McTeague's aggressiveness and obvious hot temper, he and his wife are the only characters with whom one really would care to shake hands. Mr. Gowland is clever in his exhibition of temper and wonderfully effective in the desert scenes with his sweaty arms and bleary eyes.

Marcus Schouler is impersonated by Jean Hersholt, an efficient screen actor, but in this film he is occasionally overdressed for such a part. His rôle also calls for demonstrations which are not always pleasant. ZaSu Pitts portrays the rôle of Trina, into which she throws herself with vehemence. She is natural as the woman counting her golden hoard, and makes the character live when she robs her husband of trifling amounts. The other members of the cast are capable.

* * *

December 29, 1924

A DELIGHTFUL PICTURE

PETER PAN, with Betty Bronson, Ernest Torrence, Cyril Chadwick, Virginia Brown Faire, Anna May Wong, Esther Ralston, George Ali, Mary Brian, Philippe de Lacey and Jack Murphy; adapted from Sir James Barrie's fantasy, directed by Herbert Brenon; special prologue; "The Storm," an "Out-of-the-Inkwell" cartoon. At the Rivoli and Rialto.

By MORDAUNT HALL

That wonderful ecstatic laughter, tinkling and beautiful, just the laughter that Barrie loves to hear, greeted Herbert Brenon's picturized version of "Peter Pan" yesterday afternoon in the Rivoli. Again and again the silence of the audience was snapped by the ringing laugh of a single boy which was quickly followed by an outburst from dozens of others, some of whom shook in their seats in sheer joy at what they saw upon the screen. It was laughter that reminded one of the days of long ago when one believed in a sort of Never Never Land, when the smiling sun on an early morning made one dance with joy over the dew-covered grass, when the fragrant Spring flowers sent a thrill through one's youthful soul, when one gazed at a real fish in a shallow rippling stream and expected to hook it with a bent pin, when one thought that after all it might be possible to fly.

These jubilant outbursts from youthful throats even brought to mind some beautiful anthem one had heard the choir singing in a lofty cathedral. It was laughter that brought a tear of exuberant gladness to our eyes—laughter that makes grown-ups delighted to be alive.

To our right was a mother reading the titles to her tiny son, who was so excited that he only rested against the edge of his seat for fear that the two women in front of him might lean their heads so that he might miss a fragment of the entertainment. He was enraptured, and evidently his mother ceased for a while to explain the captions, as she, too, was engrossed in the story. There were numerous Mr. and Mrs. Darlings in the theatre and often the alto laughter of the young was almost drowned by the merriment of rugged baritones mingled with the bell-toned sopranos. Anybody who had a boy or a girl, or both, was doubly entertained by this charming fantasy, especially when Peter Pan teaches Wendy, Michael and John Darling to fly. The joy of the boys and girls was boundless when John and Michael failed to soar through the air and plunged on their beds. Later the little ones were filled with awe when Michael, after concentrating with a frown on good thoughts, suddenly flew clean across the room and alighted on the mantelpiece.

The young onlookers were dumb with amazement when Peter and the Darling children flew around and around the bedroom, and then out of the window on their way to the Never Never Land.

To many of the boys and girls, Nana was a real dog, awkward but sympathetic and rather clever. They enjoyed seeing Nana give Michael his medicine and they were aghast when Mr. Darling in the most cowardly way poured his nasty medicine into the faithful Nana's bowl. And great was the chagrin in many youthful souls when Nana was taken outside in the cold.

Obviously inspired by his discussions with Sir James Barrie, Mr. Brenon has fashioned a brilliant and entrancing production of this fantasy, one which is a great credit to the Famous Players-Lasky Corporation and also to the whole motion picture industry. It is not a movie, but a pictorial masterpiece which we venture to say will meet the approval of the author. While he has introduced some ideas which were not possible on the stage, Mr. Brenon has not strayed from the theme of the whimsical story. In the Never Never Land mermaids are seen by the sun-lit sea and when the redoubtable Captain Hook has captured the children, these mermaids swim forth to find the crocodile that causes the pirate to quake with terror. The scene of the mermaids is effective and beautiful.

Betty Bronson is a graceful, vivacious and alert Peter Pan. She is youth and joy, and one appreciates that she revels in the rôle. Her large eyes are wide with wonder when she first greets Wendy and she is lithe, erect and straight of limb when she fearlessly fights the horrible Captain Hook on his pirate craft. In most of the scenes her hair seems to have a natural boyish curl, but in one close-up, which might be eliminated, one was strongly reminded of a marcel wave. She is a Peter Pan to delight the children and entertain the adults.

Captain Hook is impersonated by Ernest Torrence, who is as effective as he can be as a gruff pirate whose voice is not heard. However, to make up for the loss of Hook's deep, challenging tones, the pirate has a real ship floating on glistening waters. The fight between the children and the pirates, a source of delight to the small boys, takes place aboard the ship that flies the skull and crossbones. In the film Captain Hook throws the alarm clock to the crocodile, so that he will ever be warned of its approach by the tick-tocking. The brave Peter of the picture relieves the crocodile of the clock so that it can steal upon the unsuspecting Hook and "get the rest of him."

One sees Tinker Bell as a light and also as a tiny, tiny fairy, which is cleverly pictured through double exposure. Cyril Chadwick plays the part of Mr. Darling and, except that he is too quick in his movements in his moments of irritation, he is quite good.

There are some lines we would like to have seen in the captions, but most of the important phrases have been used. In some of the text the title writer has employed some combinations of words that are hardly Barriesque.

Esther Ralston is comely as Mrs. Darling, whose mouth is "full of thimbles." Mary Brian makes a charming Wendy, and Philippe de Lacey and Jack Murphy are effective in their respective rôles of Michael and John.

George Ali figures under the covering of Nana, and he makes the "dog" give an admirable performance. The appealing look that comes to Nana's eyes, the "nurse's" devotion and bewilderment are quite fascinating.

Dr. Hugo Riesenfeld has prefaced this production with a colorful prologue. The same picture is also on view at the Rialto.

* * *

February 15, 1925

HOW MINIATURE REPLICAS OF MONSTERS WERE FILMED

By MORDAUNT HALL

"The Lost World," the film at the Astor Theatre in which reproductions of antediluvian monsters are seen, is an effort likely to provoke a great deal of discussion, as the movements of the dummies appear to be wonderfully natural in many respects, especially when the allosaurus engages the brontosaurus in battle. There seems to be fire in the eyes of the two "monsters" as their jaws open and they come to grips.

Mathematical precision, a deep study of animal life and infinite patience were necessary in making the scenes in which these reproductions are used. One of the visitors to the studio in which this picture was made says that the first thing that met his eyes was a perfect reproduction of a forest, about 200 by 300 feet, with a plateau which looks hundreds of feet high in the picture, which actually was constructed in true proportions to the tiny trees. Therefore it was perhaps three feet high. A tree that looks on the screen to be about 60 or 70 feet high in this beautifully reproduced miniature set was only 18 inches above the flooring.

"This forest looked very real, if small, and the perspective was remarkable when one gazed at it through half-open eyes," said this visitor. "It was designed with much thoroughness and appreciation for the veriest detail, everything being constructed in perfect proportion.

"Monsters" Eighteen Inches

"The monsters were about eighteen inches long, in some cases a trifle smaller and in others somewhat larger. The producing of this film required a most careful study of the habits of animals, how they walked, whether they swung from side to side and the consequent movements of other portions of their anatomy. Everything was a matter of mathematical precision, and the most painstaking work with seven cameras, each one on a trolley, which when moved into position was locked in place. Every little change in movement had to be made for one aperture of the cameras, which is about one-sixteenth of a second. And by the aid of special backgrounds the 'animals' were made to look as if they leapt at each other.

"Although it requires far more attention and study, it is much on the same idea as that of making cartoons—with a separate drawing of the slightest movement for each click of the camera. The seven cameras, worked by one electric button, took one frame together, giving a view from different angles. The movements were most gradual, with the result that when seen on the screen the animals appear to be quite lifelike. Some animals leap, others crawl and still others fly. This had to be carefully considered in the producing of this picture. Then in the movements of the supposed monsters a ponderous effect had to be given by having the suggestion of a wabble.

"Each movement of trifling consequence had to be pictured separately to make the whole effect appear to be real. One has to bear in mind that an animal will move its leg, its eyes, its head, its neck and sides and its tail. Consequently the amount of clever study and minute attention to detail can be grasped when one considers that sixteen frames in a picture pass in a single second on the screen. Then there are different movements according to what the animals are doing, whether they are supposed to be eating or drinking, walking or fighting.

"It must not be presumed that these are mechanical toys, for those movements would never seem natural. To get some of the effects there was not only double and triple exposures for many feet of film, but also quadruple and even up to septuple exposures. Keen attention had to be given and careful notes taken of every click of the camera and what had been snapped on that particular stretch of negative. Then the producers had to bear in mind the position of the miniature cliff when they came to picturing human beings in some long shots where they were supposed to be walking on the plateau.

False Backgrounds

"Each animal was moved into position by hand, and in those scenes where the animals are shown springing at each other they were affixed to special and cleverly constructed backgrounds.

"To accomplish the result a huge staff was engaged, and with all the cameras and all the men at work the result of their week's effort in negative, all of which was probably not used, was at times less than 250 feet, which would pass on the screen in about four minutes."

About seven years ago Watterson R. Rothacker bought the screen rights to Sir Arthur Conan Doyle's fantastic story. Not until a few years afterward, however, was any attempt made to do any real work on the picture. More than two years ago some of the perfect reproductions of the monsters in miniature had been made and they were photographed. At a dinner of the Magicians in New York, at which Sir Arthur was present, a certain footage of this film was shown and the pictorial results then aroused no little curiosity. Willie H. O'Brien had for several years made a deep study of prehistoric monsters. His experiments and work were financed by Mr. Rothacker, who was extremely enthusiastic about making the picture.

On June 3, 1922, Sir Arthur mystified the Society of American Magicians by showing portions of the screen version of his book. Soon afterward there was printed the declaration from Herbert M. Dawley to the effect that devices that had made possible the filming of "The Lost World" had been "pirated" from him. Then Sir Arthur wrote a letter to Harry Houdini in which he explained that the exhibition of the pictures (which he had described as "psychic" and "preternatural," but not "occult" or "supernatural") had been put on to provide a little mystification to "those who have so often and so successfully mystified others." He added that the dinosaurs and other monsters had been constructed by pure cinema and were to be used for "The Lost World" picture, dealing with prehistoric life upon a South American plateau.

"I could not resist the temptation to surprise your associates and guests," wrote Sir Arthur. "I am sure they will forgive me if for a few short hours I had them guessing."

It was Herbert M. Dawley's contention that he had invented the realistic movements of the animals, the undulations of their bodies and the apparent conformity of all parts to their successive changes of attitude. He declared that he held the basic patents and that the Doyle pictures had been worked out with the unlawful assistance of a man who had obtained the secret while working in his studios.

A report of a talk by Mr. Dawley read: "These pictures of antediluvian giants are produced by filming small models on a miniature stage. A twig in the foreground makes a great tree in the picture. A blade of grass near the camera lens shows on the film like some vegetable monolith of the proportions of Washington Monument. With the sense of proportion of the spectator imposed upon by such devices, the small models suggest the greatest of created things." The details were worked out by Mr. Dawley. Professor Henry Fairfield Osborn, Director of the American Museum of Natural History, allowed him to make careful drawings and studies of skeletons and reproductions on exhibition there, and other paleontologists checked the work as the films were prepared.

Sues for $100,000

Mr. Dawley said at the time: "The models are not caused to act and then photographed continuously, as in an ordinary motion picture. They are set up in the initial attitude, and then one photograph is taken. Then they are moved slightly toward a different attitude. Then a second photograph is taken. Each change of attitude is checked up by paleontological data and measurements, in order to make it as correct as possible."

Mr. Dawley said that he was going to sue Mr. Rothaker for $100,000 for the alleged infringement of his patent rights and for an injunction to prevent Rothaker from either producing or disposing of "The Lost World," for which he claimed the rights. He also threatened to sue Sir Arthur for $10,000. Then Miss Catherine Curtis claimed to have purchased from Mr. Rothaker the rights to make and produce the story in question. She told of having paid Mr. Rothaker $35,000 and added that she contemplated spending $100,000 on the picture. All this was brought out through the exhibition of these pictures at the Magicians' dinner.

It is a great pity that the producers saw fit to include in this picture an exaggerated love story which at times is positively ridiculous. To have been content to fashion the story according to the detail furnished by Sir Arthur would have been far more interesting, as the constant close-ups of the heroine are wearying.

* * *

August 17, 1925

CHARLIE CHAPLIN'S NEW COMEDY

THE GOLD RUSH, with Charlie Chaplin, Mack Swain, Tom Murray, Georgia Hale, Malcolm Waite and Henry Bergman, written and directed by Charlie Chaplin: special prologue with singing arranged by Joseph Plunkett. At the Mark Strand.

By MORDAUNT HALL

The great host of spectators that attended the midnight presentation on Saturday at the Mark Strand of Charlie Chaplin's delightful comedy, "The Gold Rush," was convincing proof that a large contingent of New Yorkers is never too tired or too hot to laugh. Quite a number of persons in the interesting gathering had deserted the cool of the country and not a few of them had already been to one show that night.

Just before the curtain went up on the prologue there was a wave of applause and people stood up to behold the little film fun-maker struggling along the aisle, greeting old friends and being introduced to scores of people. He was a little nervous and appeared to be much relieved when he reached his seat in the body of the theatre. No sooner were the lights switched on after the finish of the picture—at twenty minutes past 2 o'clock yesterday morning—than the enthusiastic assembly appealed vociferously for a speech from the author-actor, and Mr. Chaplin, escorted by two friends, went to the stage and thanked the audience, ending his brief talk by saying that he was very emotional.

It was a proud night for Chaplin, as while he sat looking at the picture and listening to Carl Edouarde's orchestra he was not insensible to the chuckles and shrieks of laughter provoked by his own antics on the screen. The joy of the spectators testified to the worth of the picture, on which he had worked for more than eighteen months.

There is more than mere laughter in "The Gold Rush." Back of it, masked by ludicrous situations, is something of the comedian's early life—the hungry days in London, the times when he was depressed by disappointments, the hopes, his loneliness and the adulation be felt for successful actors. It is told with a background of the Klondike, and one can only appreciate the true meaning of some of the incidents by translating them mentally from the various plights in which the pathetic little Lone Prospector continually finds himself. It is as much a dramatic story as a comedy.

Throughout this effort there runs a love story, and one is often moved to mirth with a lump in one's throat. Chaplin takes strange situations and stirs up tears and smiles. He accomplishes this with art and simplicity, and in his more boisterous moments he engineers incidents that at this presentation provoked shrieks of laughter. You may analyze some of them and think them absurd. They are, but it does not alter the fact that you find yourself stirred by the story, gripped by its swing and filled with compassion for the pathetic little hero. You forget the ridiculous garb of the Lone Prospector and he grows upon you as something real.

Chaplin obtains the maximum effect out of every scene, and a fine example of this is where he stands with his back to

the audience. He is watching the throng in a Klondike dancing hall, garbed in his ridiculous loose trousers, his little derby, his big shoes and his cane. He is lonely, and with a hunch of the shoulders and a gesture of his left hand he tells more than many a player can do with his eyes and mouth. He is just thinking of the girl Georgia, the dancing hall queen, who is not even conscious of the presence of the little man who adores her.

Later Georgia and some other girls visit the funny little tramp in his comfortless shack. She learns that this strange little person loves her when she finds a torn photograph of herself and a faded rose under the pillow of his bunk. Georgia and her friends, in a mocking way, chat with the Lone Prospector, but to his great joy they agree to be his guests at supper on New Year's Eve in the shack. He is in such an ecstasy of delight when they leave that he leaps about the tiny place, hurling pillows into the air and literally making the feathers fly. He sobers down when Georgia returns for her gloves, but is oblivious to his ridiculous appearance. His life is one of ups and downs, but he goes forth with a will to earn what he can to make his New Year's Eve party a success.

This Lone Prospector shovels snow, which sequence is reminiscent of the breaking of the windows in "The Kid." Finally the night of nights comes, and the Lone Prospector lays the table for the supper. On Georgia's plate he places a heart-shaped souvenir on which is inscribed, "I love you." A newspaper fancifully torn to make a pattern serves as the tablecloth. There are snappers, presents, but above all, a roast chicken. The tender little tramp looks at the clock as he sits waiting at the head of the table, and finally he falls asleep. There follows a dream sequence of rare charm. The girls have arrived and the host is bubbling with high spirits as he observes Georgia's pleasure over the gifts. He has thought up something to amuse his guests and at the psychological moment he tells the girls that he will demonstrate the "Oceana Roll." The ragged tramp, who incidentally at this juncture has only one shoe, his right foot being wrapped in burlap, digs two forks into two bread rolls and then proceeds to give an amazing conception of a dance, using the rolls as feet, the solemnity of his countenance suiting the dancing action; it reminds one of a caricature with a huge head and a tiny body. Eventually the little prospector awakens from his wonderful dream to realize that Georgia and her friends have disappointed him.

In a preceding chapter our friend is quartered with Big Jim McKay. They are both so hungry that the little man suggests making a meal out of one of his shoes. It may sound utterly absurd, but Chaplin extracts unexpected comedy out of this idea. He boils the shoe, and serves it as carefully as if it were a wonderful chicken. He puts the shoe on a plate and gives Big Jim the sole with the protruding nails, taking the upper for himself. Big Jim gazes upon the portion put before him and decides that he would sooner have the upper. Thereupon Charlie treats the laces as if they were spaghetti, and when he comes to eating the sole, he goes about it as if the dish were a duck or a chicken. He eats the "meat" from the nails, and the audience roared with laughter when Chaplin finds a bent nail and offers it as a wishbone to Big Jim.

Then there is the part where Big Jim becomes half mad with hunger, and in his delirious moments his little companion fades out into a huge turkey. Big Jim is about to slay what he takes to be a tempting bird, when the image fades into Charlie. It happens again, and the supposed bird runs out into the snow, and just as the big man is about to shoot, the bird dissolves into his little friend.

In a subsequent struggle with the starved Jim, the little prospector suddenly finds that his companion has fled and that he is hanging on to the hind leg of a bear. Quick as a wink Charlie seeks the gun he had hidden in the snow and forthwith takes aim, fires. Then, instead of going out to see if the bear is dead, he gleefully lays the table.

Mr. Chaplin's acting in this film is more sympathetic than in any of his other productions. Some persons may think that he looks older in this picture, but this idea is caused by the fact that as a hungry prospector Chaplin puts black under his eyes to make them appear hollow. He does not lose a single opportunity to impress a situation upon the audience. It may only be the raising of an eyebrow, the touching of his little derby, or the longing look at the girl. The scenic effects are splendidly portrayed.

Under his astute and imaginative direction Georgia Hale gives a most natural performance as Georgia. Mack Swain is remarkable as Big Jim McKay and Malcolm Waite is convincing as the sneering villain.

Here is a comedy with streaks of poetry, pathos, tenderness, linked with brusqueness and boisterousness. It is the outstanding gem of all Chaplin's pictures, as it has more thought and originality than even such masterpieces of mirth as "The Kid" and "Shoulder Arms."

* * *

August 23, 1925

PATHOS, POETRY AND FARCE LINKED IN CHAPLIN'S OFFERING, "THE GOLD RUSH"

By MORDAUNT HALL

To want to go to any show four times, especially a screen entertainment, is at least something in its favor; but to be able to enjoy that picture as much, if not more, the fourth time speaks still louder in the film's praise. Of course, we refer to Charlie Chaplin's comedy "The Gold Rush," and those who have seen it four times include George Fitzmaurice, Florence Vidor, Samuel Goldwyn and several other disinterested motion picture celebrities. They have found that there in something to study, something to learn in just looking at "The Gold Rush," and in doing so they are agreeably entertained. Some of them say they like this "dramatic comedy" better on each occasion they view it.

It has much more true pathos than any other production Chaplin has made. It grips one, it brings a tear and when one laughs at certain incidents it is with a feeling that this odd

little tramp is real. The background may be that of Alaska, but when Chaplin wrote and directed this film he was thinking of the pitiless days in Lambeth, London, where he tried and tried, eventually succeeding in playing an absurd rôle in "A Night in an English Music Hall," a sketch said by many to be clever in spots but rather awful as a whole. He wanted then to be a serious actor and thought that he had a chance when he figured as a page boy in a Sherlock Holmes play. Soon afterward, however, he found himself again without work, and it was his brother Sydney who got him placed with the Karno Comedies. Those were the days when he did not always have as much to eat as he wanted, when his clothes were shoddy and patched, when he thought that the true cachet of an actor was to have an overcoat with an astrachan collar. In his still younger days at school he was mentally tortured by the punishments inflicted upon him for not obeying all the rules of the institution. He remembers this—not always with bitterness—and therefore as one gazes upon this, his latest film production, with the knowledge that it is going to be a property that will make him several millions, one can't help thinking of the days that are and the days that have been in this screen comedian's career. He was, as he told me, pirouetted into sudden success. He is the man who is looked up to in the producing of screen material perhaps more than all others in Hollywood. He is known as a comady artist, but since the presentation of "A Woman in Paris," he has shown that he does not have to take his hat off to any other director. In fact quite a number of them are constantly borrowing from his ideas.

The Best Chapter

There are so many fascinating touches in "The Gold Rush" that one hesitates to say which is the outstanding chapter in this charming subject. Personally it is our humble opinion that the scene in which he dreams that Georgia and the other girls have not disappointed him and have come to his New Year's Eve dinner is the finest achievement in this film. It is done so well and with such intense imagination. He is fully aware of his comic appearance, going around as he does in this chapter with a big shoe on one foot and the other wrapped in burlap. Yet he hopes for the love of Georgia, the dance hall queen, a girl who thinks he is a funny little man and then forgets all about him.

He is a pathetic sight in his comedy clothes, but forgets all that in the promise given to him by Georgia that she will come to his party. In this dream one sees his gratification at the pleasure shown by Georgia over his presents. To one of the girls he gives a toothbrush and to another some other cheap but useful little gift. Georgia's place at his right is marked with a heart on which is inscribed "I Love You." For the occasion he has thought up something to amuse the girls, something which will at any rate show to them that he may be poor and homely but that he has a certain originality. His way of entertaining them is to demonstrate what he calls the "Oceana Roll," which he performs with two forks stuck into two bread rolls, which when actuated by his nimble fingers

look like Chaplin's big feet. As he does this dance with the rolls it reminds one of those caricatures with a huge head and a very tiny body, as Chaplin accompanies every rhythmic movement of the forks and the rolls with the facial expression of a serious dancer.

His introduction in this comedy is effectively staged, as after seeing the thin black line of gold hunters in the Klondike snows one perceives the Lone Prospector wandering along a narrow, snow-covered cliff, slipping here and there, and just saving himself from falling by a quick movement of his apparently awkward feet. A bear comes slouching behind him, unknown to the Lone Prospector, and that animal, instead of being perceived by Charlie, suddenly turns into a crevice in the cliff and disappears; and the Lone Prospector never knew that he had been in danger! He continues more or less merrily on his way, sliding down the snowbanks, ever making use of his slender cane and constantly making sure that his hat is on his head.

After seeing this picture more than once one is struck by the magnificent and restrained bit of acting Chaplin does with his back to the audience. He makes you feel a tremendous sympathy for the Lone Prospector. He is permitting his hungry eyes to wander from face to face in the gambling and dancing establishment, standing on the fringe of the throng, his tiny derby on his curly head. As we said, you only see his back; but you can imagine all that is happening on his countenance, although it comes only through a slight shrug of his shoulders and a disappointed gesture of his hand. There is a sigh of self-pity, an echo perhaps of London loneliness!

You are joyful yourself when Georgia consents in one chapter to come with her friends to the little Prospector's party. He has chatted with the girls, who are really mocking him and his appearance. The second they have left and he knows that Georgia is to be his guest on the last day of the year, he leaps about the place in uncontrollable ecstasy. He rips open pillows and tosses them in the air so that the feathers fly all over the shack. Then Georgia peeps in through the door; she has forgotten her gloves, and the look she gives the Lone Prospector betrays the idea that she thinks that he has taken leave of what little senses he had. He sobers up, wondering about that look, obviously sorry that he was so abandoned in his jubilation.

His Rival

Georgia is supposed to be in love with Jack Cameron, the big, handsome fellow who has plenty of cash, with whom she has had a spat. She sends Jack a note saying that she is sorry for what happened and that she loves him. No name except Georgia's is set forth on the piece of paper, and the ungracious Jack shows it to his companions at the table. Suddenly this villain sees the Lone Prospector hobbling into the place, and he tells a waiter to give the note to the Lone Prospector. At the moment it is handed to Charlie, Big Jim McKay, who had shared the cabin with our pathetic hero, suddenly spies his little friend and lunges after him, believing that Charlie can guide him to his "mountain of gold." He alludes to

Charlie as "The Cabin," and shouts it through the dance hall. But as soon as Charlie reads the glorious bille-doux he becomes possessed of marvelous agility and superhuman strength. He struggles free from the giant McKay and darts hither and thither among the crowd shouting "Georgia— Have you seen Georgia?" He leaps from one side of the barroom to the other, as if the devil were after him, and McKay tries to get him in his clutches, not to harm him but to get information. Then like a flashing streak he springs up on a table to the balcony, where Charlie espies Georgia alone. He has her note, never knowing that it had really been written to the detestable Jack Cameron.

The Hilarious Scene

The portion of this film which elicits shrieks of laughter is where the cabin, following a storm, is balanced on the edge of a cliff. You observe Charlie going out to investigate why the cabin wabbles, and all the time you know that if he steps out of the door there is a fall of hundreds of feet. He throws open the door and as it swings out he just saves himself. Big Jim walks forward to investigate, with the result that the shack goes a bit further over. Then there comes the struggle to get out of the place, which, of course, happens finally in the nick of time.

In the end Charlie is shown as a multi-millionaire, who, after having suffered from the cold, wears two fur coats, but true to Charlie's vagaries in a way picks up a half-smoked cigar which Big Jim tosses away and presents him with a fresh smoke. I don't mean to say that Chaplin is in the habit of picking up cigar ends, but in illustrating this point to me in Hollywood he said that ever to this day he economizes on the crêpe hair he uses for his mustache and also on make-up. The crêpe hair costs about a nickel a yard, and yet Charlie dislikes to use up too much of it.

When we were leaving the Mark Strand the other night we encountered a congenial soul who enjoyed this picture just as much as we did. He was Robert E. Sherwood, editor of Life, Mr. Sherwood said that he had only one fault to find with the picture, and that was that it seemed like three reels instead of nine.

If you find that you expected something more brusque, something more hilarious than this picture, go to it a second time, and perhaps you will come away looking forward to seeing it again. We count looking at this production one of the compensations for having to view so many unworthy photoplays.

* * *

September 21, 1925

HAROLD LLOYD AS FOOTBALL PLAYER

THE FRESHMAN, with Harold Lloyd, Jebyna Ralston, Brooks Benedict, James Anderson, Hazel Keener, Joe Harrington and Pat Harmon, written by Sam Taylor, John Grey, Ted Wilde and Tim Whelan, directed by Sam Taylor and Fred Newmeyer; Colony Melody Masters; "Campus Capers," a special prologue to the feature. At the Colony.

By MORDAUNT HALL

If laughter really is a panacea for some ills, one might hazard that a host of healthy persons were sent away from the Colony yesterday after regaling themselves in wild and rollicking explosions of mirth over Harold Lloyd's comic antics in his latest hilarious effusion, "The Freshman." Judging from what happened in the packed theatre in the afternoon, when old folks down to youngsters volleyed their hearty approval of the bespectacled comedian, the only possible hindrance to the physical well-being of the throngs was an attack of aching sides.

In this new production Mr. Lloyd burlesques a young college student with athletic aspirations. While it is a decidedly boisterous affair, it is evident that Mr. Lloyd knows his public. He gives them something easy to laugh at, a film in which the authors could not be accused of dodging slapstick or of flirting with subtlety. It is a story which deserved more gentle handling, but there's no gainsaying that the buffoonery gained its end in its popular appeal. Occasionally this jazz jester rubs in the fun by repeating his action, and he also anticipates laughter.

Harold Lamb (Mr. Lloyd) first is introduced as a deserving youth who idolizes the past year's most popular student at Tate College. Harold's father is a rampant radio enthusiast, and in one sequence is deluded into the belief that he has reached some far-distant country, only to discovery that what he hears are the odd yells of his college-mad son, who is practicing as a cheer-leader in a room above.

We see Harold prancing around a ballroom in a basted dinner jacket, the tailor not having had time to finish the job. Subsequently the sleeves part company with the jacket and the trousers streak open at the sides. He is a gullible young man and heeds the flattery of the College Cad, with the result that his first appearance in the institution of learning is made unexpectedly on a stage, which incidentally was intended to be ready for the head of the Faculty. A kitten disturbs him in his speech and crawls up his sweater, finally squeezing itself out of the collar of that garment, while the mother-cat, quite concerned about its offspring, takes her stand at Harold's feet.

The most amusing chapter in this stretch of fun is where Harold succumbs to the notion that he is a possible candidate for the football team. He permits himself to be tackled and bowled about by the husky students, and is eventually permitted to sit on the players' bench at the most important contest of the season. Tate's team fares badly, one after another being put hors de combat. The coach observes the ridiculous Harold

aching for his chance, but has no faith in the young man who wears his spectacles under his rubber nose protector. Harold's insistence, however, gives him his chances and all sorts of laughable gags follow, one of them being introduced when Harold is warned by the umpire that he must release the ball when the official whistles. Later one perceives Harold clutching the ball, dashing toward the opponent's goal. Suddenly there is a factory whistle. He is five yards from his destination when he halts and throws down the ball.

A number of the subtitles in this picture are quite witty. The football field is alluded to as a place where "men are men and necks are nothing." The coach is described as being so tough that he shaves with a blow torch. The college President is said to be so aloof that he won't marry for fear of hearing his wife call him by his first name.

This is a regular Harold Lloyd strip of fun, which is made all the more hilarious by introducing something like suspense in the sequences on the football field. It is not quite so good as "Why Worry," and not really as sharp in its humor as "Safety Last."

* * *

September 27, 1925

A POET DISSECTS OUR MOVIES

Well-Known English Writer, After Visiting Hollywood, Makes an Unsparing Report of What He Found—He Says That "Hick" Public Dictates, but Also Blames Writers and Producers

By ROBERT NICHOLS

The visitor to Hollywood, conducting a friendly and informal inquiry into the present state of the "Pictures" and in search particularly of an answer to the question, "Why don't we get better pictures?" will be immediately confronted by two obstacles: first, the seeming mass and variety of sometimes conflicting answers offered him, and second, the undoubted fact (witnessed by the tone in which those answers are given and specifically emphasized by some of the most distinguished of those who give them) that the "movies" are an emotional institution.

And the longer he remains in Hollywood the better will he appreciate these conditions as he comes to understand how young the pictures are, how rapid has been their growth, how gigantic is the organization and how inevitably, despite the distance from the audience implied in a mechanical process, the Pictures, the biggest "show business" on earth, share the characteristics of the "show business" anywhere.

A big producer said to me: "Really to succeed with a picture we have to please 9,000,000 people. And the number is increasing—from which you will see the job is not easy and very big risks are entailed. Any one of your big English business houses would think twice before gambling £50,000 on one throw—for, mind you, if our picture 'flops' we don't get much back."

Business a Gamble

No wonder the atmosphere of the business is emotional! Though a certain degree of stabilization has been secured, especially during the last two years (the slump of three years ago was a salutary lesson), and big producers no longer put all their eggs in one basket, yet the business remains, like every other entertainment business, a gamble. But the gambling factor alone does not account for the emotional tone that pervades Hollywood.

That tone is common to all businesses which depend on arousing emotion in the public. Hollywood, catering for a public 80 per cent. American (and the American audience seems to change its taste at present more quickly than any I know), is consequently emotional.

This emotionalism is increased by the fact that the personal stakes are very large; by the often meteoric rise from the ranks not only of actors but of studio managers, directors, press agents and, in fact, everybody around the studios; by the uncertainty of tenure, and by the omnipresent atmosphere of "press stunts," "publicity," bubble reputations and general ballyhoo and flubdubbery.

There is only one philosopher in Hollywood: the lightsman—he who, astraddle the scaffolding in the studio roof, distributes the glare of "arc" or "spot" upon the just and the unjust, secure in the knowledge that light is at least one abiding element in the motion picture, whatever darkness and confusion may remain elsewhere. Chewing gum between rotary mandibles, eyes ironically puckered beneath visor, this god warbles the only certain truth at present discoverable in the movies:

I don't know, she don't know,
We don't know
What it's all about!

The movie, like love, is "too young to know what conscience" or anything else, including itself, is. In such an atmosphere the inquirer can but plot the chart of his bewilderment and attempt briefly to indicate certain of the apparent main features of the terrain.

Anxious, to begin with, for an answer to the question, "Why don't we get better pictures?" he will not have to walk very far before he discovers a Personage-of-Obvious-Intelligence, who will reply: "Ask in the office. They are so dumb in there that they think Darwin is the author of 'Tarzan.' " Upon further inquiry it will usually be discovered that this Personage once had a job but couldn't hold it.

Yes, dumbness is there. I was once asked to remove the word "interminable" from a sketched scenario on the ground that Mr. Blank (supreme head of one of the largest organizations) "won't know what it means and will get 'kinda all wrought up' if he has to stretch for the dictionary." Command of the language, other than profane, and acquaintance with facts of supposed common knowledge are not strong points with producers. Why should they be? "We're no dumber than the public we serve," observed one

Photo by International Newsreel.

HOLLYWOOD—MOVIE CAPITAL OF THE WORLD. The city as it is seen from an airplane.

specimen with the utmost good temper; "get clever and you'll lose money."

"Hick" Territory

In the United States there are immense rural areas, sparsely populated, dotted here and there with small towns, which are known in movie language as "hick territory," or, more briefly, "the hicks." One of the oddest historical curiosities of the modern world and of democracy is that the opinion and culture of these "hicks" should largely determine what happens in New York, London and Paris. Yet so it is.

Lloyd George has confessed that his conduct of affairs during the war was more than once influenced by possible reactions on opinion in the Middle Western farmer and small townsmen (superlatively "hick territory"), against the ordinances of which not the united heads of departmental Washington can prevail. "Hick" sentiment (making for isolation in all things) was no small element in the defeat of Mr. Wilson. Opinion "out in the hicks" today is probably the greatest individual factor against political participation by the United States in world affairs.

The inhabitants of the gigantic "hick" areas are the nearest approach to peasantry that the United States possesses, and they share many of the peculiarities characteristic of the peasant everywhere. Tough-minded Mencken flatly names them the "yokelry," and certainly J. B. S. Haldane would claim them as affording support to his theory that "human progress in historical time has been the progress of cities dragging a reluctant countryside in their wake."

For the yokelry, all screen characters are either heroes, comics or "heavies." All women are of two categories, moral or immoral—the term "moral," of course, being used with reference to sexual matters.

There are many elements of belief indissolubly bound up in the "hick" idea which are not easy to explain—such as that all great cities are exclusively sinks of depravity; that moneyed men spend their entire leisure in cabarets; that most for-

eigners are corrupt and their representatives Macchiavellian; that all French women, save those that are Marquises, are harlots, and that all Englishmen, save those that are monocled milords, are bullying drunkards.

The opinions, prejudices and peculiarities of the "hicks" are of great importance to the movie industry, because, while the sale of a great film in the great cities of the United States and anywhere in Europe may yield a return to the investor of the money spent upon that film, the profit is made in the "hicks." This is perhaps the sovereign problem of the betterment of the movies. The "hicks" decide. Only too many of the very finest films that have "gone over great" in the big cities have completely "flopped" in the "hicks."

Masterpieces, "straight" or doctored, are not for them at present. They know what they want and they see that they get it.

Nobody who has not had experience by direct contact, or through reports of film salesmen, can possibly realize the depth of sheer stupidity, bathos, want of moral courage and general lack of the veriest rudiments of culture prevalent in those territories.

The fact is that there is such a total lack in Hollywood of scenario writers with anything to say worth saying, and there is much blindness among producers as to what is between the lines of a good novel, that both are under the illusion that tuxedos and rags and violent or frivolous surface action constitute interest. Yet interest is something inward. Such, however, is the want of imaginative insight in Hollywood (its supreme sin) that it appears completely unaware of the elementary truth that many of the world's finest dramas, stories and novels dispense with rags, tuxedos and violence altogether.

Must Have Happy Ending

If Hollywood does obtain a glimpse of this truth, the reply is always: "The fans wouldn't stand for it." In point of fact the fans, so far as I know, have never been afforded a chance to "stand for it," because there exists no scenario writer and no producer with the imagination and courage to attempt to reveal the inwardness of contemporary life.

Bound up with this is Hollywood's crassness about what constitutes "a happy ending." In Anglo-Saxon countries the happy ending is obligatory. "You gotta leave 'em happy," said a scenario writer. "The boy's gotta get the girl and the dough. Lots o' dough. Leave 'em all dolled up, driving off in a big car."

Here we have one, and perhaps the chief, reason why so many American films seem and are, in Lord Lee's term, "trash." They envisage life in possessive rather than creative terms, and they steadily eschew "the tragic sense of life," the presence of which is a sign of health. They are the product of a mind so simple that it imagines that happiness can be bought and is not a creation of the struggling soul or the by-product of the soul's struggle to come to terms with its environment.

There are two further factors of immense importance that, in my opinion, make against "better pictures"—the produc-

tion of pictures for sale by "block" and ownership of chains of theatres by producers. In my opinion, the business can remain healthy as long as the exhibitors can pick his pictures as he likes.

The other factor is the ownership of theatres by big producers and distributers. This means, if the present process of building or buying up whole chains of theatres (not only in the United States but abroad) continues an eventual trustification. I am opposed to trustification, because I do not believe that the persons who at present display most signs of being able to effect it have sufficient imagination and innate interest in what is creative to prevent the industry's settling down into the arid production of stereotyped films, with occasional special productions centring rather about, "stars" than about stories.

The independent producer and distributer are now, and should remain, the pacemakers of the industry; for this medium is something far wider and profounder than anything any producer at present dreams of.

The Scenario Writer

Yet another factor that militates against better movies is the poor quality of Hollywood scenario writers. Most scenario writers are hacks of the most pedestrian order. The ability to write, in the sense in which we speak of ability in discussing eminent novelists, is not necessary to the scenario writer. But the integrity of the artist and some measure of intelligence are. I did not expect a Conrad, a Bennett, a Galsworthy, a Virginia Wolfe or a Romer Wilson among scenario writers; but one might expect at best a Shelia Kaye-Smith or an Archibald Marshall.

Such do not exist. Here and there one finds a man with faint remains of an artistic conscience; but for the most part scenario writers do not know the meaning of an artistic conscience.

The fact is that only the "hardboiled" can "stick it." There have been scenario writers with something of the artist in them; but the atmosphere of Hollywood and the ignorance, cowardice and crookedness of producers have been too much for them.

Perhaps it was best so. Hollywood is quite impervious to argument. Men of brains, spirit and integrity rapidly find that the ability to play the faux bonhomme, to intrigue and to truckle is worth all the originality which Hollywood continually protests it desires, and which it not only will not, but can not, for the most part, recognize when encountered.

Directors are better. There are even one or two who will make two or three worthless pictures in order to be able to "fight through" one "better" picture. The producers insist that "the public is not up to this sort of thing." Producers forget that, whether the public taste can be elevated or not, it can certainly be degraded. I am of the opinion that it has been deliberately degraded during the past two years, especially by certain types of cheap "sex" pictures, of which those produced by an English woman novelist are typical.

But the public kicks at last, and there are signs of a reaction. English critics and the English public will best aid by

supporting pictures by such genuine artists (albeit these men's hands are largely tied) as Chaplin, Stroheim, Seastrom, Brabin, Fairbanks, Lubitsch and Monta Bell.

Finally, as a factor against "better pictures" there is Hollywood itself. Hollywood is a suburb of Los Angeles, which has only been in existence as a city of any importance about forty years. Hollywood, hotbed of press agents and "boosters," well aware that most of them are paid out of her own pocket, guilelessly takes their utterances at face value; attributes to herself and her tastes, crazes, fashions, frenzies, disappointments, illusions, disillusions, fretfulness, tantrums, movements and obiter dicta an importance which would cease to be laughable and become exasperating were these manifestations not obviously the product of a temperament almost entirely superficial and a mind patently not only devoid of standards but ignorant of the existence of any such standards in the world (and more particularly the artistic world) at large.

Hollywood, again, is remarkably gullible, a peculiarity it shares with Los Angeles, a city that has become, like all "booming" cities, a Mecca for every sort of "faker," "near-artist," spellbinder, downright charlatan and self-advertising nobody. In the absence of any canon of calibre, the bubble reputation flourishes and achieves proportions that must be seen to be believed.

None the less, some few figures rise superior to Hollywood, to its atmosphere, its adoration of the printed word—no matter what word, printed by whom or for whom—its gullibility, its saturation in the demimonde of culture, its underworld of scallywags, "fakers" and undesirables. In these figures lies the hope of the screen. But they can only continue their work if they receive the discriminating applause of genuine critics interested in the medium as a medium, and the support of the general public, which at present receives but little guidance.

Since over 80 per cent, of the world's "movies" are produced and consumed in the United States it is pertinent to inquire whether there exists in the United States any movement toward better pictures. The stock comment on this subject is: "Those who go to the movies don't criticize, and those who criticize don't go."

There is a great deal of truth in this aphorism. A sort of vicious circle prevails. So many bad films were made that those who might have provided a nucleus of criticism and support have been "sicked off" the cinema and now when an artistically valuable picture is made—as happens now and again—the picture does not receive support.

Progress Has Been Made

Nevertheless, during the past two or three years some progress has been made, progress chiefly attributable to women's clubs and to an organization—the Motion Picture Producers and Distributers of America, Inc., headed by Will Hays. Persons who have not been in the United States can hardly understand the influence exerted by women's clubs. On the movies, with the exception of certain extravagances in the way of censorship, their influence has, as a whole, been

good. Perhaps the best work that the Federation of Women's Clubs does is the publication, by local federations, of lists of films recommended. No mention is made of those not approved. Contrary to expectations of many, these clubs have shown an increasing catholicity of taste and in many cases a genuine appreciation of artistic value.

The Federation has more than once prevented exploitation of unsavory personalities and notorious episodes and the "news value" connected with them on the screen. When any member-company feels in doubt about a book or play, its representative immediately informs the central office. Should the judgment of the company to the effect that to make a picture of the subject matter is inadvisable be confirmed, a notice is sent to all the other member-companies giving the name of the objectionable book or play. Thereafter such companies screen it at their peril.

This plan has resulted during the past year in the keeping from the screen of over 100 plays and books, including some of the best sellers and stage successes.

* * *

October 26, 1925

MR. KEATON'S COW

GO WEST, with Buster Keaton, Howard Truesdale, Kathleen Myers and Brown Eyes, a cow, directed and written by Mr. Keaton; overture, "Tannhauser"; "Heart of the Sky Mountains," a Prizma subject; divertissements, including Julia Glass, pianist; Doris Niles, in a Japanese dance; "In Other Lands," Holland, a scenic organ recital. At the Capitol.

Although Buster Keaton's new film, "Go West," is somewhat lackadaisical in the introductory sequences, when the fun does start popping it is rich and uproarious, with countless novel comedy twists. Mr. Keaton's partner in this pictorial effort happens to be a rather well-fed cow, known as Brown Eyes, who (seeing that the animal has a name) forms a strange attachment for the Drifter, the most tender tenderfoot who has ever been seen on a ranch, impersonated, of course, by the comedian, who makes a mint of money out of his melancholy mien.

After obeying Horace Greeley's advice, the Drifter, having been concealed in a freight car on his journey West, rolls himself out of the comfortless coach inside a barrel. It does not take long in a photoplay for a character to find a ranch, and soon the Drifter has a job, but what he does not know about milking cows would startle a denizen of the east side of New York. He appropriates another man's chaps and belt and, except for the hat, looks as if he might pass muster so long as nobody scrutinized him. His tiny pearl-handled revolver might be apt to bring a frown from any Montana cow puncher and his stature might be alluded to as sawed-off and hammered down. Nevertheless, the Drifter manages to get his daily bread so long as he reaches the table before the others.

The high light of this comic tale occurs when the Drifter, to save Brown Eyes from going to a big city, opens up the cattle cars. Then, to his dismay, not only Brown Eyes but hundreds of other cows and steers follow in his wake. Soon the animals reach a small town and are seen in barber shops, in the Turkish bath, in a grocery store, a costly china shop and many other places, not excepting the police station. The Drifter wants to get the cows together and being quite resourceful he endeavors to find something red in one of the stores. All he can discover is an old Mephisto costume, with horns and tall, and in this he strives to collect the cattle, which is not such an easy task. He is, however, aided by the devoted Brown Eyes and soon is patted on the back by the man who, an hour or so before, would have preferred to wring the life out of the Drifter.

The chapters in which the herds of cattle are beheld roaming through the town created no end of mirth in the Capitol last evening, as did also the Drifter's hapless ideas of milking a cow.

Brown Eyes appears to sympathize with the Drifter and she often turns her head to see where her small, expressionless master is going. Mr. Keaton refuses even to smile at the behest of a cowboy who is sticking a pistol into his chest. By his pantomime at that moment one gathers that his face just won't look cheerful.

* * *

November 20, 1925

THE BIG PARADE with John Gilbert, Renee Adoree, Hobart Bonworth, Claire McDowell, Claire Adams, Robert Ober, Tom O'Brien, Karl Dane and Rosita Maretini, adapted from a story by Laurence Stallings, directed by King Vidor: special music score. At the Astor Theatre.

An eloquent pictorial epic of the World War was presented last night at the Astor Theatre before a sophisticated gathering that was intermittently stirred to laughter and tears. This powerful photodrama is entitled "The Big Parade," having been converted to the screen from a story by Laurence Stallings, co-author of "What Price Glory," and directed by King Vidor. It is a subject so compelling and realistic that one feels impelled to approach a review of it with all the respect it deserves, for as a motion picture it is something beyond the fondest dreams of most people. The thunderous belching of guns follows on the heels of a delightful romance between a Yankee doughboy and a fascinating French farm girl. There are humor, sadness and love, and the suspense is maintained so well that blasé men last night actually were hoping that a German machine gun would not "get" one of the three buddies in this story.

At the outset there is as much fun as there is in a book of Bairnsfather drawings, and yet there is no borrowing from that artist. It is the natural comedy that came to the American troops in France, men who landed in a foreign country without the slightest idea of the lingo. The incidents have been painted skilfully, from the blowing of the whistles as the signal that America had entered the war to the skirmishing

attack in a forest. And even in a large shell hole the three pals find something to joke about.

There are incidents in this film which obviously came from experience, as they are totally different from the usual jumble of war scenes in films. It is because of the realism that the details ring true and it grips the spectator. At this presentation there were men who were not easily moved, men who had seen many pictures and were familiar with all the tricks in making them. Yet these men in the lobby during the intermission spoke with loud enthusiasm about this, a production of one of their rivals.

Just as the scenes are as perfect as human imagination and intelligence could produce them, so the acting is flawless throughout. Nothing could be more true to life than the actions and the expressions of the three buddies in khaki. They are just ordinary United States citizens, one the son of a millionaire, another a rivetter and the third a bartender. John Gilbert enacts the part of the hero, Jim Apperson, the scion of a wealthy family. Tom O'Brien figures as Bull, the jovial Irishman who served drinks across a bar, and Karl Dane is seen as Slim, the fearless rivetter. Renee Adoree impersonates Melisande, the bewitching French girl, who falls in love with Jim, her affection, being surely and certainly reciprocated by that young gentleman, in spite of the fact that he had left a sweetheart in America.

Possibly the scenes where Jim enjoys his flirtation are more delightful than any other part of the story, because it seems so natural for the couple to be fond of each other. They sit together, Jim, proud of his dexterity with his chewing gum, while Melisande, being ignorant of this jaw-exercising concoction, in endeavoring to imitate Jim swallows her piece of gum. When Jim wants to tell Melisande of the trouble that affects his capacious heart, he has to resort to a dictionary, and often he inserts English words to emphasize his utterances, as the foreign tongue strikes him as being so inadequate.

Bull and Slim decide that Melisande is too serious minded, too much infatuated with Jim, so they dodge the idea of romance and become extraordinarily practical. While Jim is upstairs with the French family, pretending to listen to the letters that have come from poilus at the front, Slim and Bull are enjoying themselves in the wine cellar, expressing surprise that any man who has such a wonderful cellar should be content to spend any time elsewhere.

Then comes the time when the call of battle tears Jim away from Melisande. There is a big parade—a parade of lorries filled with American doughboys bound for the fighting lines. Melisande clings to the vehicle carrying her Jim, until she falls in the street, pressing a shoe, he has given to her, to her bosom.

Mr. Vidor is painstaking in putting forth the best work possible, with all the artistry of which the camera is capable, and it is a touch worthy of any artist where Melisande is seen crouched on the straight French road.

Guns, guns and guns roar during most of the second part of this picture, and yet these chapters are flavored with touches that create laughter, coupled as they are with clever captions. For instance: Word is sent to the three buddies while they are in a great shell-hole that one of them must go out and silence that "toy gun." Who will go is the question. This is smartly settled by Slim, the champion tobacco chewer and spitter of his contingent. He draws a circle on the wall of the hole and says that the one who spits nearest the centre will have the chance to go and put an end to the men with the "toy gun." Slim wins easily, as he knew he would, and he drags himself over the top and along the undulating ground, torn with high explosives.

The very lights rend the heavens and he has to duck to save himself from being spotted. Eventually he is seen with gun-butt uplifted and later he crawls out from the mess with two German helmets. The machine guns are popping at him, making noise like a giant tearing calico, and he is wounded. Jim and Bull have to stay where they are, as it is declared that orders are orders. Eventually the two pals go after their friend, and they find he has been "done in."

Jim sees red as he plunges toward the enemy lines, and there follows a striking human incident. He would kill one of the enemy, who is half gone. He is rough with him, but the German asks for a cigarette. Jim has one, only one, in his tin hat. He gives it to the German, who before he has a chance to take a puff breathes his last. Jim looks at the man, and, with that indifference that is bred by war, he takes the cigarette from the man's lips and smokes it himself.

There is the big parade of hospital ambulances, the long stretches of cots in a church, the unending line of lorries, and all that breathes of the war as it was. The battle scenes excel anything that has been pictured on the screen, and Mr. Vidor and his assistants have ever seen fit to have the atmospheric effects as true as possible.

This is a pictorial effort of which the screen can well boast. It carries one from America to France, then back to America and finally to France again. And one feels as if a lot had happened in a single evening.

* * *

December 13, 1925

DRAMA OF MOVIE INDUSTRY IS UNFOLDED

It Is Depicted in 20,000 Pages of Testimony Taken at Washington—Monopoly Output and Distribution of American Pictures Is Charged

By R. L. DUFFUS

The motion picture has recorded the march of armies, sieges, revolutions and Babylonian high jinks. It has retold history with a sumptuousness compared with which the actual historical events and the actual actors in them were poor and shabby things. The real Henry VIII, Charlemagne or Nero would feel like a country cousin if he could wander into the palace the motion pictures provide for the modern

actor who personifies him. Nothing in the Bagdad of the Arabian Nights was as magnificent as Douglas Fairbanks's setting for "The Thief," and nothing that actually occurred in the Westward movement half as stirring as some passages in "The Covered Wagon."

But there is one subject for a motion picture which surpasses in interest, at least to the modern world most of the comedies and tragedies of history, yet to which even a Griffith or a De Mille would find it hard to do justice.

This subject, if done in proper style, would require hundreds of stars, from twenty million to fifty million supers, and a set which would cost between one billion and two billion dollars. It would be the sudden and grandiose rise of the motion picture itself—the blossoming of a new industry and a new art of prodigious importance in an amazingly short time. The motor car alone can compete with the motion picture as a creator of change. It has transformed, and continues transforming, the dress, the manners, the thoughts and the emotions of millions of people.

This will do, perhaps, for the prologue, to be spoken in front of the curtain by a solemn gentleman in evening dress.

The Court Room Scene

Next, after the names and portraits the producer, the director, the camera men, the leading lady, the leading man, the author of the scenario and the film editor who reduced the total length from 1,187,541 feet 8 inches to 4,102 feet three inches should appear a scene in the chambers of the Federal Trade Commission at Washington. This scene should show some, but not all, of the hearings held within the past four years, during which a multitude of witnesses, in 20,000 pages of testimony, tried to prove that Adolph Zukor and his Famous Players-Lasky Corporation were, or were not, attempting to monopolize the fourth largest industry in the country.

The movies have moved up into the front industrial row with steel, railroads and motor cars. If there is a motion picture trust, the character who personifies it should be as fat, have as tall a hat and wear as many dollar marks on his clothes as any of the characters personifying any of the other trusts. It might be a good idea to cut in a scene showing the movie trust, if any, being welcomed by the other trusts.

Then the action would begin. It might show, very briefly, Daguerre painting pictures with sunlight, the marvel of the 1840s, Muybridge taking a series of snapshots of running horses on the old Stanford ranch in California in 1872, Edison tinkering with the first real movies in 1887, Eastman making the first practicable cinematographic film in 1889.

A Bored and Sober America

Another series of flashes might reveal Laura Jeans Libbey, Old Sleuth, Buffalo Bill and other famous scenario authors who were unfortunate enough to live before the motion picture was invented; actors of the old tradition playing "Uncle Tom's Cabin," " 'Way Down East" and "Ten Nights in a Barroom" in town halls and opera houses of the late Victorian period, and sixty or seventy million

THE FILMING OF AN ADVENTURE—A scene from "The Red Lily."

people—or as large a sample thereof as could be gotten on the lot—sitting on front porches or around stoves, yawning, chewing tobacco and telling the same old stories to while away the tedium of Summer or Winter nights. A bored and sober nation, which may have thought noble thoughts but often wished it was time to go to bed. Circus posters—but only one circus a year. Ho-hum!

Rescuing America

Mr. Zukor and his former partner, Marcus Loew, were two men who did much to rescue America from this unhappy plight. Zukor, a native of Hungary, came to this country thirty-five years ago at the age of 16. His first job was in a fur shop, where he earned the munificent salary of $2 a week. He and Loew met and in 1898 were in the fur business together. About 1903 they bought a penny-in-the-slot establishment on Fourteenth Street, and this seems to have been their first venture in the show business. It succeeded, as most of their enterprises have done since that time.

The penny-in-the-slot business led naturally to the motion picture business, and about 1908 Zukor and Loew took over the old Grand Street Theatre, installed a projection machine at one end and a white curtain at the other, and established one of the first full-fledged nickelodeons. These were profitable, but neither the admission price nor the kind of pictures shown satisfied Zukor and Loew.

A nickelodeon was a place to which people resorted when they could not think of anywhere else to go. The pictures were poor, both technically and artistically—if the word "art"

Keystone View Photo

THE MAKING OF THE MOVIES—A Mob Scene in which thousands of "supers" were used.

could be even remotely associated with them. Slapstick comedy and crude "Westerns" were the stock in trade. For many of the patrons the main advantages of the nickelodeons were that they had roofs and were warm in Winter.

Until about 1912 nearly all the motion pictures produced were in the form of one-reel films, each of which ran about twelve minutes. As these were usually changed daily, an enormous number were demanded. In 1912 the distributing field was dominated by the General Film Company, which distributed all the films for ten producing companies. Some of the names of these companies are still familiar—Pathé, Vitagraph, Biograph, Selig, Lubin, Edison, Kalem, Milies, Kleine and Imp. In 1912, 4,852 films were unloaded upon the American public, and of these the General Film Company handled 2,507.

At first the practice had been to sell films outright and the purchasers could get back some of their money after using them themselves by passing them on to other exhibitors. The exhibitor bought by the foot, regardless of the nature of the picture, much as though he were buying cloth or lumber. Usually he bought complete programs, which he was obliged to take as they were sent to him. He was so tied up by contracts that about his only recourse, if he did not like the pictures he was getting, was to go out of business. Under these conditions the motion picture developed slowly.

Pictures, were made in slap-dash manner, with little attention to what are now considered the fine points of setting, costuming and directing. As late as 1915 Mary Pickford contracted to do ten pictures in a year, which at that time, according to the defendants' brief in the present case, was "regarded as a small annual output for a star." The general run of motion picture actors and directors were expected to turn out a complete new picture every few days.

In 1912 the so-called feature film appeared in the form of "Queen Elizabeth," with Sarah Bernhardt in the title rôle, which Mr. Zukor purchased from a French producer.

"Queen Elizabeth" was an experiment to test Mr. Zukor's plan for "the production of motion pictures, each of which would present a continuous story running for an hour or longer, and in each of which stars from the spoken drama would be featured." The result was encouraging enough to lead to the organization of the Famous Players Film Company, in June, 1912, with Daniel Frohman as Vice President and director. Then came "The Prisoner of Zenda," with James K. Hackett in the leading rôle; "Tess of the D'Urbervilles," with Mrs. Fiske; "Cinderella," with Mary Pickford, and "The American Citizen," with John Barrymore. The flood of feature pictures, which were to climb in elaboration and expense until they fairly out-did anything ever seen in real life, ancient or modern, then began.

What Pictures Cost

In 1912 the average picture was slapped together for about $8,000; an average picture today costs at least $200,000. Star pictures, as is well known, cost much more. Eight hundred thousand dollars was spent on "The Covered Wagon," $1,600,000 on "The Ten Commandments," $2,000,000 on "The Thief of Bagdad." Expenses have increased all along the line. In 1914, it was testified, the average price paid for a scenario by the Zukor company was $1,500. A decade later this had risen to $18,000 or $20,000, and when a book or play was much in demand larger sums were being paid.

Incidentally, novels or short stories furnish about half the material for motion pictures, plays about one-fourth and scenarios concocted especially for the film about one-fourth. Consequently, the best way to become a motion dramatist is to become a novelist or short story writer.

When Zukor had completed his first feature film he found that the General Film Company, which then dominated the field (it was dissolved two years later by Federal suit) would not circulate them, and he was compelled, according to testimony put in at the Trade Commission

hearings, to distribute them himself. Out of this necessity came the ownership of "key theatres" by the producers, "block booking" and other conditions and practices which were complained of at Washington.

The same necessity led other producers to go into the business of distribution. It also led to what the Federal Trade Commission has referred to as "integration"—that is, the union of small companies to make big ones and the growth of big ones at the expense of little ones.

The result was three large producing and distributing, companies which, among them, probably control two-thirds of the 250 high-grade feature films—the only ones that can lay claim, even approximately, to being "art"—produced in an average year. One is Mr. Zukor's own company, the Famous Players-Lasky. A second is the Metro-Goldwyn-Meyer, with Zukor's former partner, Loew, at its head. A third is the Associated First National. Famous Players makes and releases about 80 pictures a year, Metro-Goldwyn releases 50, and the First National makes about 20 and buys about 30 from so-called "independent" producers.

All these companies own theatres—"key theatres" which are to the motion picture business what the bell-wether is to a flock of sheep. Zukor has an interest in 180 theatres. If the petition laid before the Trade Commission is acted upon he will be asked to give them up and confine himself to producing. If Zukor is forced to do this other companies, whether belonging to the "Big Three" or not, will have to follow suit. Hundreds of millions of dollars will change hands and the entire motion picture industry will be, it is said, disorganized.

The Small Producer's Position

In this contention lies the whole story of the recent development of the film industry. There is no place in it for the small producer unless he can make a bargain with one of the large distributors. The making of films—and in some cases, even more so, the selling of them—is enormously expensive. Mr. Zukor's company spends as much as 20 or 25 per cent. of the gross rentals on selling costs alone. It costs some companies 70 per cent, of the gross rentals to market their films.

The larger the company, it is asserted, the lower the selling cost which has to be charged to each film. The lower the selling cost the more can be spent on the artistic side of production—on sets, costumes, salaries of actors and directors, retakes, &c. Actors, directors and scenario writers in a large company can specialize, and it is held that specialization in the film business is as productive of efficiency as the same practice in an automobile factory.

Theatre ownership and "block booking" go with size. A producing company cannot afford to invest hundreds of thousands of dollars in a picture unless it is fully sure to get its money back. So it sells its pictures in programs instead of individually—in fact, the exhibitors have been found to prefer this method, since it saves them trouble. The theatres are necessary, it is asserted, in order to be sure of the "key" hearing—or rather the "key" viewing.

Past of the Nation's Life

But to tell the story of motion pictures from the producer's and distributor's side is to tell only part of the story. From the flickering films of the Wild Western dramas of 1908 to such motion picture masterpieces as "The Covered Wagon," and "The Big Parade," is a remarkable change, not only in motion pictures but in audiences. From fat John Bunny's horse play to Charlie Chaplin's plaintive humor in "The Gold Rush" is a long jump in popular taste. The movies have come more and more to depict a representative cross section of American life. Not that they are necessarily true to life—far from it. But they do reflect what, on the whole the American public, of all ages and all classes, wants in the form of dramatic amusement. They are truly national and inherently democratic.

This is the real drama of the film. The motion picture theatres of America can seat 8,000,000 people at once and from 20,000,000 to 50,000,000 persons—the latter figures are confessedly mere approximations—attend once a week. There has never been anything like this before in the history of the human race. No product of human industry and imagination has had the currency of the motion picture. No one has over before been known to so many people, in so intimate a way, as Mr. and Mrs. Douglas Fairbanks, Charlie Chaplin and perhaps half a dozen others. There has never been any means of scattering so many ideas and suggestions in so short a time before so many individuals.

Millions Reached

Country girls try to look like movie queens—and sometimes succeed. Mertons of the Movies may not become stars, but their lives are affected by what goes on upon the screen. New fashions flash across the continent in the twinkling of an eye. Millions are exposed to dramatic conceptions when only thousands were exposed before. Millions are compelled to form at least the rudiments of an artistic judgment. The motion picture is the school, the diversion, perhaps even the church of the future.

A glance into the not remote future may reveal a whole nation looking at a single picture. Listening to a singing voice—from the Pacific to the Atlantic, from El Paso to Eastport Maine, all one ampitheatre, all on Big Parade. Edison's toy has become a new social agency. In time it may create a new art and culture.

Whether Mr. Zukor is on the side of the angels in this development a matter which the layman, fortunately, need not decide. His rise from the fur factory to the head of Famous Players does, however, typify in many ways the material progress of the industry. And those familiar with present conditions predict that the motion picture organizations will grow bigger before they grow smaller.

If the result is a "trust" it will become home to the man in the street as the steel trust or sugar trust never did. With them only his necessities were involved; now it is his amusement that is at stake.

* * *

February 10, 1926

SLAM-BANG COMEDY

BEHIND THE FRONT, with Wallace Beery, Raymond Hatton, Mary Brian, Tom Kennedy, Hayden Stevenson, Chester Cooklin, Richard Arien and Melbourn McDonald, directed by Edward Sutherland; overture, "Il Guarany": Eddie Elkins and his "melody mixers"; "Railing," a "Ko-ko" song; "The Bughouse Cabaret." At the Rivoli.

By MORDAUNT HALL

There are long intervals between really good humorous points in "Behind the Front," the current offering at the Rivoli, which strikes one as a burlesque of "The Big Parade." Most of the fun in this new presentation is wrought with a mailed fist, which is something to the film's disadvantage, as it might easily have been another "Better 'Ole" or something of that sort. Strange as it may seem, the wit in "The Big Parade" is far more keen than any of the comic stunts in "Behind the Front."

That illustrous expert in screen villainy, Wallace Beery, turns his attention to making people laugh in this picture, and he does it with success. There's no telling what might have happened to Mr. Beery's future if the story had been worthy of a Bairnsfather, for there is no doubt Mr. Beery would have held up his end. He is assisted most ably by Raymond Hatton and Tom Kennedy. Mr. Kennedy plays the part of the bull-dog sergeant, while Mr. Berry and Mr. Hatton figure as two army buddies, Riff Swanson, a detective in peace time, and Shorty McGee, a pickpocket. It happens just before Riff and Shorty are recruited that Shorty lifted Riff's watch. Riff gave chase to the artful thief, but circumstances proved too much for the pursuer. During the unfurling of the picture Riff occasionally looks into Shorty's sad eye and mumbles: "Where did I see that face before?"

Through a misunderstanding the two buddies are locked up only for having prodded a martinet General with a bayonet. They pass a good deal of their time in the temporary prison by trying to open one box of army biscuits. They do everything to open the tin without making so much as a dent in it. They even hammer it with their tin hats with the result that their metal headgear looks like a battered derby. No wonder they give up trying to get a biscuit out of the box! Then along comes the sergeant. The two explain that they have been trying to open a biscuit box. The sergeant looks at them dubiously and then takes the box. He uses a little strength and breaks the receptacle in half, which feat causes comment from Riff.

Shorty receives news that he is rejected by the War Department just as he takes his place in the mud of the front-line trenches! Subsequently the two get out into the enemy lines and through an explosion they are saved from the Germans. The two buddies put on Teutonic officers' uniforms, and in No Man's Land they find themselves in a nasty position. While pondering over this matter of life and death Riff meets his New York butcher, one of the enemy, who, after being paid $8 Riff owed him, is instantly blown up.

One has an opportunity of studying Mr. Beery's features in a tank which crawls along over ammunition dumps and rocks. He is also seen hoping for a letter and when he gets one it is from the butcher whom he encounters afterward in No Man's Land.

The pretty face of the story is Mary Brian. It was she who prevailed upon Riff and Shorty to join up. To each recruit she gives a pocketbook in which there is a photograph of herself on which is inscribed "To my hero." She is the sister of the Captain, so our lumbering friends confidentially inform the Captain, during one of his severe moments, that he is going to be their brother-in-law.

The captions of this energetic comedy were written by Ralph Spence, and some of them are very good. Shorty one day goes up to the big sergeant and says: "You big stiff, you hit me." The sergeant leaves with Shorty sticking half way through a wooden wall. Riff looks at his pal and then says: "You showed him up!"

John Murray Anderson, who has been tremendously busy since the new policy at the Rivoli, contributes "The Bughouse Cabaret," an amusing stage offering in which there is the spice of originality and the salt of color. There is a chandelier of geese, an electric blue policeman who plays on a washing board, a male witch who officiates at the piano, a sailor who drinks out of a goldfish bowl, a toe dancer who parodies her art, alarm clocks and what not. It is a number well worth seeing.

* * *

February 22, 1926

A NEW SWEDISH ACTRESS

IBANEZ'S TORRENT, with Ricardo Cortez, Greta Garbo, Gertrude Olmsted, Edward Connelly, Lucien Littlefield, Martha Mattox, Lucy Beaumont, Tully Marshall, Mack Swain, Arthur Edmund Carewe, Lillian Leighton and Mario Carillo, adapted from "The Torrent," by Blasco Ibanez, directed by Monta Bell; overture, excerpts from "Natoma"; Cella Turrill, mezzo-soprano; "Deep River," an A. B. Carrick film; "Dixie Jubilee Singers; Yasha Bunchuk, cellist; "Spanish Rhythans," with Doris Niles and the ballet corps. At the Capitol.

By MORDAUNT HALL

That prolific Spanish writer, Blasco Ibáñez, whose "Mare Nostrum" was presented last week in pictorial form, also is the author of a production at the Capitol this week. This new offering is heralded as "Ibáñez's Torrent," the name of the novelist having been appended to the actual title to distinguish it from a previous photoplay that bore the name of "The Torrent." In this current effort Greta Garbo, a Swedish actress, who is fairly well known in Germany, makes her screen bow to American audiences. As a result of her ability, her undeniable prepossessing appearance and her expensive taste in fur coats, she steals most of the thunder in this vehicle, which was directed by Monta Bell, who honored the shadow field with his clever comedy, "The King on Main Street."

Judging by Rex Ingram's picturization of "Mare Nostrum" and Mr. Bell's handling of "Ibáñez's Torrent," it is not always

an easy matter to instil strong and true drama into the film conceptions of this Spaniard's works. Some of the characters in Mr. Bell's production are not as clearly defined as one would imagine possible, which is due to Mr. Bell's tendency in this instance to jump too quickly from one scene to another, instead of lengthening his sequences as King Vidor did in "The Big Parade."

There is one character in particular in this last photoplay that might have been made far more interesting than he is, for he happens to be a barber named Cupido (Lucien Littlefield), for whom singing has an irresistible charm. He does not talk to his clients, but sings to them, and no matter how important is the chin to which he is devoting his razor, Cupido is impelled to leave his work half finished when the bell-like tones of the heroine's voice fall upon his susceptible ears. His customer can rage all he wants, but Cupido goes on coolly telling Leonora (Miss Garbo) that she must sing from the diaphragm and not from the tonsils.

There is, as one might expect, a flood in this production. It is singularly well done, but part of the action that goes on in Leonora's abode in the small Spanish town causes one to think that the breaking of the dam and the deluge of water have been grossly exaggerated by the camera. At any rate all is soon serene.

Here we have a pretty Spanish girl who is in love with Don Rafael Brull (Ricardo Cortez). His mother is opposed to her son marrying Leonora, and the severe Dona Brull decides to foreclose on the house in which Leonora and her parents reside. Dona Brull permits Leonora's mother to remain in the house to do scrubwork. The pretty Leonora, who has a will of her own, decides to go to Paris. She becomes famous as an operatic star named La Brunna, and her admirers are many. Even the King of Spain is supposed to come to her dressing room. She arrays herself for suppers in ermine and moleskin, and on other occasions in plain ermine streaked with sealskin. One night at a cabaret a performer sings a song about home. Lenora rewards him generously and promptly hies herself back to Spain, where she knows that she still is in love with Don Rafael.

Quite a number of years pass in this story, but Leonora appears unscathed by time. Don Rafael, however, who marries and has two children, shows the results of hard work, and his appearance cools Leonora's spasmodic love for him. He has spectacles with thick lenses and a far-away look in his eyes.

Quite a number or the subtitles are a trifle too verbose, especially one concerned with the torrent, which is alluded to as "a torrent as furious and relentless as the passion in the hearts of the lovers."

Mr. Cortez acquits himself acceptably, but his appearance as a man who has aged moved the audience to mirth yesterday afternoon. Even Miss Garbo smiles with a degree of gratitude at her escape when she observes the changed physiognomy peering in through the door.

Miss Garbo is dark, with good eyes and fine features. In some scenes she is too much the actress and not enough the character, which may be pardoned on the ground that she is

impersonating an opera singer, a girl with a tendency toward artificial gestures so long as she believes they are appealing. Mack Swain, who was seen as the big prospector in "The Gold Rush," officiates in the rôle of a father who is devoted to the hog business. Tully Marshall is splendid in a minor rôle, and Mr. Littlefield could have done more with his barber's part, but as it was he gives a thoroughly capable portrayal.

Mr. Bell's imagination comes to the fore now and again, and one charming spot is where the pigeons fly away from a tower when the bells are tolling. He seems to have had too much action to work upon to make this a clear-cut, sound drama.

* * *

April 16, 1926

FILM STARS FOOTPRINTED

Mary Pickford and Others Make Marks for Pavement of a Theatre

HOLLYWOOD, April 15 (AP)—The footprints of film stars, done in concrete and signed by the makers, will become flagstones in the forecourt of Sid Grauman's new picture theatre to be opened here in May.

Mary Pickford, Douglas Fairbanks and Norma and Constance Talmadge stepped today into forms filled with soft concrete to "make their marks." Grauman plans to add footprints of others.

* * *

July 26, 1926

THE SHEIK HIMSELF

THE SON OF THE SHEIK, with Rudolph Valentino, Vilma Banky, George Fawcett, Montague Love, Karl Dane, William Donovan, Bull Montana, Bynunsky Hyman, Erwin Connelly, Charles Requa, directed by George Fitzmaurice. At the Mark Strand.

That crowd milling around the Strand Theatre yesterday wasn't watching a fight or even a fire, but merely trying to see the sheik of California before he vanished through a side entrance under a police guard. The sands of the desert weren't any hotter than the crowd which stood in the sun and stretched around the corners nearly to Eighth Avenue, waiting to see if "The Son of the Sheik" were as good as his old man in running away with maidens who wandered carelessly into the desert, but they stuck to it and crowded the Strand to its storm doors.

Valentino was there in person to see, as he said, if the sheik's offspring were as popular as his father, and that was responsible for the police lines. And, be it said, to those who like that sort of romantic picture, the latest Valentino effort is full of desert rough stuff and bully fights. It is patterned rather closely on "The Sheik," for when one has as excellent

a recipe as that for a box office attraction what use is there in violating the tradition?

Instead of an English girl, whom his father picked off a horse and made rather rude and hasty love to, the sheik's son falls in love with a traveling dancer, the daughter of a French rascal who leads a troupe of mountebanks and thieves. He makes love to her in the same unrestrained way that made his father such an excellent desert hero, but is captured by the girl's father and tortured. He is led to believe that she tricked him, and so takes a rather primitive and sheikish revenge, and the picture fades out as she is retreating toward a couch, with Valentino advancing in a way which leaves no doubt as to his intentions, which, to say the least, were not honorable.

He learns eventually that she really loved him, and so goes to bring her back to his desert kingdom, where he is heir apparent to the throne, and the tribes of his romantic parent. But before that is accomplished there is some wild riding and fighting which leaves no doubt in the minds of any one that if Valentino really tackled that Chicago editor who said such unkind things about him there would be little doubt about the outcome. This sheik has an arm which would do credit to a pugilist and a most careless way of hurling himself off balconies and on and off horses. One leap from a balcony to a swinging chandelier is as good as anything Douglas Fairbanks ever did, and it is nothing for the young sheik to stand off twenty or thirty bandits with knives and a yearning for his blood.

In its setting of desert sands, those picturesque mounds and valleys formed by the wind, this latest offering of Valentino makes a very good romantic picture. It is a Western thriller in an Arabian atmosphere, except for the exotic Eastern love affair, which no noble hero of the wide, open spaces of the West would ever be let in for in moving pictures, no matter how much he really felt like it. Not even Tom Mix's horse would be caught in a situation like that. There are some humorous episodes, in which the actor who played that delightful idiot, Slim, in "The Big Parade," is the centre. Karl Dane as Slim makes as funny an Arab as he did a member of the A. E. F.

* * *

September 5, 1926

"POTEMKIN"

"Potemkin," the Russian picture which has evoked the highest praise from Douglas Fairbanks and others, was exhibited to an invited gathering last Tuesday in Wurlitzer Hall. It is a subject revealing no little knowledge of dramatic values, and one wherein not a second is lost in unfurling the grim details of a mutiny aboard the Russian cruiser Prince Potemkin in 1905, soon after the Russo-Japanese War. S. M. Eisenstein, the young director of this remarkable picture, obviously has listened to advice from naval experts, for, with considerable skill, he holds the interest from the hoisting of an anchor to the slow turning of the great guns. The photo-

graphic angles are in themselves impressive, and imaginative touches crop up here and there as the story rumbles along. The players are grouped and their efforts never seem to be those of actors. They impress one as being real officers and seamen aboard the Potemkin. The heroes are the seamen and the officers are the villains. Cossacks also figure as fiends.

The straw that broke the camel's back is a rotten piece of meat on which the maggots are swarming. This point is emphasized, as is also the ruthlessness of the Cossacks in a land episode, wherein a baby in its perambulator is depicted rolling down the stone steps after the mother has been killed.

This is a theme that has never been tackled in this country, and therefore to say that it is the greatest film production ever made is hardly a fact. It is an idea near to the mind of the Bolshevik, and while it has been denied that it is subtle Soviet propaganda, because it does not deal with the Russian revolution nor present-day conditions in Russia, it nevertheless whispers clearly that murderous cruelty and rotten food led to the establishment of the present régime.

A number of American distributers and producers have viewed "Potemkin"; but none of them is enthusiastic about its commercial success in this country.

* * *

September 26, 1926

ART, AS APPLIED TO FILMS, DISCUSSED BY MISS GISH

By LILLIAN GISH

Perhaps the chief handicap under which motion pictures presently labor is the over enthusiasm of their more conspicuous champions. The latter are determined that the motion pictures shall fall into the category of the fine arts, and the motion pictures, grateful as they should be for the compliment, suffer from the burden of importance thus placed upon them and the heroic and understandable effort completely to justify themselves in their champions' eyes. The word art, it seems to me, is the most carelessly handled word in our language. Interest and beauty in themselves no longer suffice to satisfy persons; austere labels must be pasted upon them. We are not content to accept things, however estimable they may be in their several and diversified ways, for what they actually are; we must constantly invest them with a spurious dignity and elect them to a metaphorical Legion of Esthetic Honor.

What if motion pictures are or are not art? It is as easy to prove that they are art as it is to disprove. But such devices, I believe, are futile, save by way of gratifying a more or less human disposition to have others regard one's own particular work in the world as something of perhaps greater importance than it really is, and that we in ourselves know it is. What is art? Art is simply beauty reflected through a beautiful fancy. There are moments in moving pictures—moments only, it may be—when the moving pictures thus fall within the definition. There are hours—many hours, one fears—when, by the

same definition, they fall far outside the pale, just as drama and painting and sculpture and music at times similarly do. If the moving pictures are not art because of a thousand cheap moving pictures, then painting is not art because of a thousand Greenwich Village daubs, and music is not art because of a thousand "Yes, We Have No Bananas."

Power of Silence

Drama is art, they tell us, and motion pictures are not. It appears that the latter cannot be regarded as art because they lack the human voice that is drama's instrument. Furthermore, are not some of the finest and greatest moments in drama the silent moments, the moments when not a word is spoken and when the ache or joy, the pain or the ecstasy of human beings is expressed by the features and movements of the characters alone? Again, what if drama were converted into moving pictures with absolute and undeviating faithfulness to the text? This is surely possible, even if it is not a common occurrence. What we get, or may get, is drama read to an audience by silent actors as, in the library, it is read to an individual by the silent actors who walk the stage of human imagination. Again, if motion pictures lack the third dimension, so does painting. If they haven't intellectual content, neither has much of what is agreed to be the world's best drama. If they can be enjoyed by children, so can "Huckleberry Finn" and "The Mikado."

As I have said, although such arguments may be superficially diverting to persons who look on art as a debating platform rather than as a source of beautifully experienced emotion, they are a mere waste of time. Call the moving pictures what you will, they sometimes induce such emotions, and, by their own confessions, in the hearts and minds of cultured men and women. Not too often, I know; but a thing is to be judged fairly not by considering it in its lowest manifestations but in its highest. The Alps are not all Matterhorns.

A Few Pointed Comments

Although the first short commercial moving picture, "The Kiss," was produced in 1896, the first real motion picture, as we know motion pictures today, "The Great Train Robbery," was produced only twenty-three years ago. In these twenty-three relatively short years, the motion picture has advanced a hundred times more greatly than architecture advanced in its first countless aboriginal centuries. If it does not deserve yet to be called an art, may it not conceivably be an art in time? Doesn't such a picture as "The Last Laugh" begin to show the way? Hasn't it sound beauty, sound form, a powerful and intelligent emotional content? Isn't it acted as well as the best drama played during the same year that it was shown? Isn't it as intelligently moving? Aren't its roots as deep in human life?

The aim of the moving picture isn't to uplift the mind any more than the aim of drama is. Like the drama, it isn't designed to teach, but only to make men and women reflect upon what they already know, and in their reflection differentiate between nobility of thought and emotion and meanness of thought and emotion. This aim, the best of motion pictures, as the best of

drama, set themselves to realize. The battle ahead of the pictures is not an easy one, but I feel that they have the courage and resource within them to hazard it. There will be many casualties; there will be many defeats; but I believe they will triumph some day. And they will triumph not because some one has called them an art or not an art, but very simply because, at bottom, they have the same materials to work with that drama has. Let us remember that even now experiments in talking pictures are progressing. And let us remember, too, that if the motion picture is silent, and hence, according to some, not to be considered as an art, so also are Michael Angelo's "Moses," Tintoretto's "Miracle of the Slave," the Beauvais Cathedral, "L'Enfant Prodigue," Joseph Conrad's "Heart of Darkness" and a sunset over London Bridge.

* * *

April 17, 1927

MR. WELLS REVIEWS A CURRENT FILM

He Takes Issue With This German Conception of What The City of One Hundred Years Hence Will Be Like

By H. G. WELLS

Under the general title, "The Way the World Is Going," Mr. Wells is contributing to The New York Times a series of fortnightly articles in which he deals with important events and tendencies of the year. The following article, in which the author gives his views on a German motion-picture attempt to construct the city of the next century, is the eighth of the series.

I have recently seen the silliest film. I do not believe it would be possible to make one sillier, and as this film sets out to display the way the world is going, I think "The Way the World Is Going" may well concern itself with this film. It is called "Metropolis." It comes from the great Ufa studios in Germany, and the public is given to understand that it has been produced at enormous cost. It gives in one eddying concentration almost every possible foolishness, cliché, platitude and muddlement about mechanical progress and progress in general, served up with a sauce of sentimentality that is all its own.

It is a German film, and there have been some amazingly good German films before they began to cultivate bad work under cover of a protective quota. And this film has been adapted to Anglo-Saxon taste, and quite possibly it has suffered in the process, but even when every allowance has been made for that, there remains enough to convince an intelligent observer that most of its silliness must be fundamental. Possibly I dislike this soupy whirlpool none the less because I find decaying fragments of my own juvenile work of thirty years ago, "The Sleeper Awakes," floating about in it.

Originality Is Lacking

Capek's Robots have been lifted without apology, and that soulless mechanical monster of Mary Shelley's, who has

Laborers of the future, as pictured in the film "Metropolis."

fathered so many German inventions, breeds once more in this confusion. Originality there is none, independent thought none; where nobody has imagined for them the authors have simply fallen back on contemporary things. The airplanes that wander about above a great city show no advance on contemporary types, though all that stuff could have been livened up immensely with a few helicopters and vertical and unexpected movements. The motor cars are 1926 models or earlier. I do not think there is a single new idea, a single instant of artistic creation, or even of intelligent anticipation, from first to last in the whole pretentious stew. I may have missed some point of novelty, but I doubt it, and this, though it must bore the intelligent man in the audience, makes the film all the more convenient as a gauge of the circles of ideas and mentality from which it has proceeded.

The word "Metropolis," says the advertisement in English, "in itself is symbolical of greatness"—which only shows us how wise it is to consult a dictionary before making assertions about the meaning of words. Probably it was the adapter that made that shot. The German "Neubabelsburg" was better, and could have been rendered "New Babel." It is a city, we are told, of about 100 years hence. It is represented as being enormously high, and all the air and happiness are above, and the workers live, as the servile toilers in blue uniforms in "The Sleeper Awakes" lived, down, down, down below.

Now, far away in dear old 1897, it may have been excusable to symbolize social relations in this way, but that was thirty years ago, and a lot of thinking and some experience intervene. That vertical city of the future we know now is, to put it mildly, highly improbable. Even in New York and Chicago, where pressure upon central sites is exceptionally great, it is only the central office and entertainment region that soars and excavates. And the same centripetal pressure that leads to the utmost exploitation of site values at the centre leads also to the driving out of industrialism and labor from the population centre to cheaper areas and of residential life to more open and airy surroundings. That was all discussed and written about before 1900. Somewhere about 1930 the geniuses of the Ufa

studios will come up to a book of anticipations which was written as recently as a quarter of a century ago. The British census returns of 1901 proved that city populations were becoming centrifugal, and that every increase in horizontal traffic facilities produced a further distribution. This vertical social stratification is stale old stuff. So far from being a hundred years hence, "Metropolis," in its forms and shapes, is already as a possibility a third of a century out of date.

But in its form is the least part of its staleness. This great city is supposed to be evoked by a single dominating personality. The English version calls him John Masterman, so that there may be no mistake about his quality. Very unwisely he has called his son Eric instead of sticking to good, hard John and so relaxed the strain. He works with an inventor, one Rotwang, and they make machines. There are a certain number of other rich people, and the sons of the rich are seen disporting themselves with underclad ladies in a sort of joy conservatory rather like the Winter garden of an enterprising 1890 hotel during an orgy. The rest of the population is in a state of abject slavery, working in "shifts" of ten hours in some mysteriously divided twenty-four hours and with no money to spend or property or freedom. The machines make wealth. How is not stated. We are shown rows of motor cars all exactly alike, but the workers cannot own these, and no "sons of the rich" would. Even the middle classes nowadays want a car with personality. Probably Masterman makes these cars in endless series to amuse himself. One is asked to believe that these machines are engaged quite furiously in the mass production of nothing that is ever used and that Masterman grows richer and richer in the process.

This is the essential nonsense of it all. Unless the mass of the population has spending power there is no possibility of wealth in a mechanical civilization. A vast, penniless, slave population may be necessary for wealth where there are no mass production machines, but it is preposterous with mass production machines. You find such a real proletariat in China still—it existed in the great cities of the ancient world—but you do not find it in America, which has gone furthest in the

The robot of the film "Metropolis."

direction of mechanical industry, and there is no grain of reason for supposing it will exist in the future. Masterman's watchword is efficiency, and you are given to understand it is a very dreadful word, and the contrivers of this idiotic spectacle are so hopelessly ignorant of all the work that has been done upon industrial efficiency that they represent him as working his machine minders to the point of exhaustion so that they faint and machines explode and people are scalded to death. You get machine minders in torment turning levers in response to signals. Work that could be done far more effectively by automata. Much stress is laid on the fact that the workers are spiritless, hopeless drudges, working reluctantly and mechanically. But mechanical civilization has no use for mere drudges. The more efficient the machinery the less need there is for the quasi-mechanical minder. It is the inefficient factory that needs slaves, the ill-organized mine that kills men. The hopeless drudge stage of human labor lies behind us. With a sort of malignant stupidity this film contradicts these facts.

Man and His Machines

The current tendency of economic life is to oust the mere drudge altogether, to replace much highly skilled manual work by exquisite machinery in skilled hands, and to increase the relative proportion of semi-skilled, moderately versatile and fairly comfortable workers. It may, indeed, create temporary masses of unemployed, and in "The Sleeper Awakes" there was a mass of unemployed people under hatches. That was written in 1897, when the possibility of restraining the growth of large masses of population had scarcely dawned on the world. It was reasonable then to anticipate an embarrassing underworld of under-productive people. We did not know what to do with the abyss. But there is no excuse for that today. And what this film anticipates is not unemployment, but drudge employment, which is precisely what is passing away. Its fabricators have not even realized that the machine ousts the drudge.

"Efficiency" means large-scale production, machinery as fully developed as possible and high wages. The British Government delegation sent to study the success in America has reported unanimously to that effect. Increasingly the efficient industrialism of America has so little need of drudges that it has set up the severest barriers against the flooding of the United States by drudge immigration. Ufa knows nothing of such facts.

A young woman appears from nowhere in particular to help these drudges. She impinges upon Masterman's son, Eric, and they go to the "catacombs," which, in spite of the Masterman's steam mains, cables and drainage, have somehow contrived to get over from Rome, skeletons and all, and burrow under this city of "Metropolis." She conducts a sort of Christian worship in these unaccountable caverns and the drudges love and trust her. With a nice sense of fitness she lights herself about the catacombs with a torch instead of electric lamps that are now so common. That reversion to torches is quite typical of the spirit of this show. Torches are Christian, we are asked to suppose; torches are human. Torches have hearts, but electric hand lamps are wicked, mechanical, heartless things. The bad, bad inventor uses quite a big one.

Builder of the Tower of Babel

Mary's services are unsectarian, rather like afternoon Sunday school, and in her special catacomb she has not so much an altar as a kind of umbrella stand full of crosses. The leading idea of her religion seems to be a disapproval of machines and efficiency. She enforces the great moral lesson that the bolder and stouter human effort becomes the more spiteful Heaven grows by reciting the story of Babel. The story of Babel, as we know, is a lesson against "pride." It teaches the human soul to grieve. It inculcates the duty of incompetence. The Tower of Babel was built, it seems, by bald-headed men. I said there was no original touch in the film, but this last seems to be a real question—you see the bald-headed men building Babel.

A machine of tomorrow, as depicted in "Metropolis."

Myriads of them! Why they are bald headed is inexplicable. It is not even meant to be funny and it isn't funny; it is just another touch of silliness. The workers in "Metropolis" are not to rebel or do anything for themselves, she teaches, because they may rely on the vindictiveness of Heaven.

But Rotwang, the inventor, is making a Robot, apparently without any license from Capek, the original patentee. It is to look and work like a human being, but it is to have no "soul." It is to be a substitute for drudge labor. Masterman very properly suggests that it should never have a soul, and for the life of me I cannot see why it should. The whole aim of mechanical civilization is to eliminate the drudge and the drudge soul. But this is evidently regarded as very dreadful and impressive by the producers, who are all on the side of soul and love and such like. I am surprised they were not pinched for souls in the alarm clocks and runabouts. Masterman, still unwilling to leave bad alone, persuades Rotwang to make this Robot in the likeness of Mary, so that it may raise an insurrection among the workers to destroy the machines by which they live and so learn that it is necessary to work. Rather intricate that, but Masterman, you understand, is a rare devil of a man. Full of pride and efficiency and modernity and all those horrid things.

Then comes the crowning imbecility of the film—the conversion of the Robot into the likeness of Mary. Rotwang, you much understand, occupies a small old house embedded in a modern city richly adorned with pentagrams and other reminders of antiquated German romances, out of which its owner has been taken. A faint smell of Mephistopheles is perceptible for a time. So even at Ufa, Germany can still be dear, old, magic-loving Germany. Perhaps the Germans will never get right away from the brocken. Walpurgis Night is the name day of the German poetic imagination, and the national fantasy capers securely forever with a broomstick between its legs. By some no doubt abominable means Rotwang has squeezed a vast and well-equipped modern laboratory into this little house. It is ever so much bigger than the house, but no doubt he has fallen back on Einstein and other modern bewilderment. Mary has to be trapped, put into a machine like a translucent cocktail shaker and undergo all sorts of pyrotechnic treatment in order that her likeness may be transferred to the Robot. The possibility of Rotwang just simply making a Robot like her evidently has never entered the gifted producer's head.

The Robot is developed in wavering haloes. The premises seem to be struck by lightning repeatedly, the contents of a

number of flasks and carboys are violently agitated, there are minor explosions and discharges. Rotwang conducts the operations with a manifest lack of assurance, and finally to his evident relief the likeness is taken and things calm down. The false Mary then winks darkly at the audience and sails off to raise the workers. And so forth and so on. There is some rather good swishing about in the water after the best film traditions, some violent and unconvincing machine breaking and rioting and wreckage, and then rather confusedly one gathers that Masterman has learned his lesson and that the workers and employers are now to be reconciled, and by "love."

Never for a moment does one believe any of this foolish story; never for a moment is there anything, amusing or convincing in its dreary series of strained events. It is immensely and strangely dull. It is not even to be laughed at. There is not one good-looking nor sympathetic nor funny personality in the cast; there is, indeed, no scope at all for looking well or acting like a rational creature amid these mindless, imitative absurdities. The film's air of having something grave and wonderful, to transparent pretence. It has nothing to do with any social or moral issue before the world, or with any that can even conceivably arise. It is bunkum and poor and thin even as bunkum. I am astonished at the toleration shown it by "a number of film critics on both sides of the Atlantic," and it cost, says The London Times, 6,000,000 marks. How they spent all that upon it I cannot imagine. Most of the effects could have been got with models at no great expense.

The pity of it is that this unimaginative, incoherent, sentimentalizing and make-believe film wastes some very fine possibilities. My belief in German enterprise has had a shock. I am dismayed by the intelligent laziness it betrays. I thought Germany, even at its worst, could toil. I thought they had resolved to be industriously modern. It is profoundly interesting to speculate on the present trend of mechanical invention and of the real reactions of invention upon labor conditions. Instead of plagiarizing from a book thirty years old and resuscitating the banal moralizing of the early Victorian period it would have been almost as easy, no more costly and far more interesting to have taken some pains to gather opinions of a few bright young research students and ambitious modernizing architects and engineers about the trend of modern invention and develop these artistically. Any technical school would have been delighted to supply sketches and suggestions for the aviation and transport of 2027 A. D. There are now masses of literature upon the organization of labor for efficiency that could have been boiled down at very small cost. The question of development of industrial control, the relation of industrial to political direction, the way all that is going, is of the liveliest current interest. Apparently the Ufa people did not know of these things and did not want to know about them; they were too dense to see how these things could be brought into touch with the life of today and made interesting to the man in the street. After the worst traditions of the cinema world, monstrously self-satisfied and self-sufficient, convinced of the power of loud advertisement to put things over with the public, and with no fear of search-

ing criticism in their minds, no consciousness of the thought and knowledge beyond their ken, they set to work in their huge studio to produce furlong after furlong of this ignorant old-fashioned balderdash and ruin the market for any better film along these lines.

Six million marks! The waste of it! The theatre when I visited it was crowded. All but the highest-priced seats were full, and gaps in places filled up reluctantly but completely before the great film was begun. I suppose every one had come to see what the city of a hundred years hence would be like. I suppose there are multitudes of people to be "drawn" by promising to show them what the city of a hundred years hence will be like. It was, I thought, an unresponsive audience and I heard no comments. I could not tell from their bearing whether they believed that "Metropolis" was really a possible forecast or not. I do not know whether they thought the film was hopelessly silly or the future of mankind hopelessly silly, but it must have been one thing or the other.

* * *

May 22, 1927

PEACE-TIME "BIG PARADE"

King Vidor Discusses Motion Pictures—His New Film Is Built Like a Play

King Vidor was talking the other day about motion pictures in general and in particular about "The Crowd," the film upon which he has been engaged since last June. The conversation, which took place in the Loew Building, was a bit disjointed, as conversations are apt to be when two or three persons, each following his own train of thought, are putting questions to another. First, he was asked how he came to do "The Crowd."

"We were finishing 'The Big Parade' " he replied, "and John Gilbert said to me, 'What on earth are you going to do next?' And I said, 'I think I'll do a 'Big Parade of Peace.' And that's exactly what I am planning to do.

"It's the story of one of the crowd. The protagonist does nothing unusual, nothing that every one can't understand. Birth, youth, school, love, business struggles, married life, always against the background of the crowd—that is the motif."

Mention was made of foreign symbolic pictures. Vidor said:

"Pictures must meet a general test. So far as I know, they are the only things that fall within that category. A picture must appeal to the majority of its audience. Even a newspaper has different sections—a sports section, an editorial section, a dramatic section, &c. The newspaper's public can choose, in a way, that section or sections of the newspaper that appeal to it. The picture is just the picture.

His New York Scenes

"I was thinking the other day what it would mean if there should be by necessity only one variety of automobile. Just

what would be the model, and the price that would appeal best to the most persons? I know that analogies aren't so popular, but that speculation, which of course I didn't attempt to carry to a solution, interested me.

"It would be easy to make a motion picture for a selected audience. I could make one in a month. It would be a deal of fun, too. However, we are making motion pictures for every one, and that is work.

"For instance, I began work on 'The Crowd' last June, and I began photography early in December. And here we are in New York—for five weeks, probably, to do the necessary work here.

"We are building this picture as they build plays. This isn't any film that is ordered and turned out and delivered. It's growing and changing in details.

"We had another woman in the story at first, but I have eliminated her. Now, we have only the simple story of the average citizen, and his wife and family and the drama in his life—most of it unknown to him, but I believe dramatic and gripping.

"Persons who want symbolism can find it in this picture; and persons who want human drama can find plenty of that, too. Our symbolism has nothing objectional in it. It merely is fantastic. There is no offensive impressionism, but the impressionism is there. Each set carries out the mood of each scene, particularly designed for the emotion that we are trying to bring out.

"When I said that I was making this picture as a play is made, I meant it. Two months ago we worked it in a theatre—just the scenes that we made at the studio—to get the audience reaction. We undoubtedly will do the same thing here after we have gotten our scenes in New York. I will do it again after the picture is finished.

"These scenes in New York do not mean that New York is to be New York in the picture. It means that we must catch the spirit of a great city—an exaggerated crowd. New York in the picture stands for a great city anywhere. As New York is the biggest city it best suits our purpose to form the background for the average man—a member of the crowd—and the drama of his life."

Several questions had brought out these answers from the brown-haired, brown-eyed, quiet-voiced director. Now he was asked about happy endings. A Frenchman asked him if the American public didn't prefer happy endings. Vidor said:

"There is no doubt that happy endings are more popular. The audience wishes to be lifted up rather than depressed. People want to look up. They seek an ideal happiness on the screen that perhaps they do not find in their own lives. But we have our share of unhappy endings. I think, generally, we work out our pictures to their logical conclusion."

The question of the necessity of motion pictures being made for the majority of persons was revived. And, in the course of his answer, Vidor said:

"Have you ever been in one of those theatres where they show advertisement slides? Haven't you made up your mind that you won't look at them? And yet, haven't you looked at them anyway? That's because in a motion picture theatre

there's only one sense working—the visual sense. You've got to use it. You're forced to."

During the talk Vidor spoke of his troubles in getting sequences in Buffalo and at Niagara Falls. The first day a mist was blowing one way, so that it was necessary to focus the cameras in a particular direction. The next day it blew another way, so that not only the cameras had to be aimed the other way, but the script also had to be changed to meet the changed conditions. And then, after all, it rained, and only half of the necessary footage was made. The cameramen are still up there, and when Vidor gets word that the weather is favorable he will take Eleanor Boardman (Mrs. Vidor in private life), who has the feminine lead, and James Murray (who is a native of the Bronx, and was chosen particularly for this part by Vidor from among extra players), who has the masculine lead, back to Buffalo again.

"The Crowd" is entirely Vidor's idea, and he has worked out the story himself.

"I think we will have a pretty good picture when we are through," he said.

* * *

June 26, 1927

CHOOSING NEWS EVENTS FOR MOVING PICTURES

Lindbergh Assignment One of the Most Difficult Ever Given to Camera Men—Planes Used for Quick Results

Behind the scenes of such events as the Lindbergh New York-to-Paris flight there is always that ubiquitous group of men whose work is known only to their own fraternity. They are the newsreel cameramen who send the news of important events to the screen and in whose lives catastrophes and history-making events are merely so many feet of film.

Emanuel Cohen, for many years newsreel editor for Pathé, who has been charged with the responsibility of organizing Paramount News, believes the Lindbergh "story" was not only one of the most difficult assignments ever given to cameramen but by far the most costly. In an interview he described what was happening behind the scenes from the time the youthful hero hopped off at Roosevelt Field until his return to New York and the methods used by the various newsreel producers in getting their pictures on the theatre screens throughout the world.

"Speed counts in the newsreel field," said Mr. Cohen. "That is why the newsreel companies are the largest users of airplanes today. Planes are made use of not only in covering the assignment but in getting the negative to the laboratories and then in the subsequent race for distribution points, from which the film is sent to some thousands of theatres in which newsreels appear as a regular part of the entertainment."

In detailing the mechanics of covering the Lindbergh story Mr. Cohen said:

"Lindbergh's historic flight and the record-breaking ovations tendered him in the capitals of Europe and in Washington and New York were covered from the time of the departure from Roosevelt Field.

"Prior to Colonel Lindbergh's hop-off for Paris newsreel cameramen made Roosevelt Field their headquarters. The test flights undertaken by the young aviator were covered for future use. His chances of making a successful flight were considered slight by men supposed to be aviation experts, but the cameras nevertheless kept strict track of his movements.

"When word was flashed to Paris that Lindbergh had started, foreign representatives of newsreel organizations immediately arranged to 'shoot' him on his arrival at Le Bourget. S. R. Sozio, our European representative, took several cameramen from the Paramount News Paris bureau to the French flying field. There he learned that should 'Lindy' arrive in darkness the ordinary landing lights used at the airdrome would not give sufficient light for photographic purposes. He hurriedly ordered three huge motion picture studio lights to be sent to Le Bourget by truck, and when Lindbergh finally let the Spirit of St. Louis alight on French soil Sozio and his cameramen got a remarkable picture. Afterward, in talking to Lindbergh, Sozio learned that the 'movie' lights had proved very helpful to the intrepid flier in making his night-time landing at Le Bourget.

Permission to Travel on Memphis

"The tumultuous welcome by the French capital was covered by the cameramen. When he left for Brussels he was followed by cameramen in the air in a fast plane. Later these cameramen flew across the Channel with Lindbergh and landed with him at Croyden Airdrome, the London airport. Riotous scenes of welcome followed and were recorded.

"Meanwhile, arrangements were being made by the United States Government for Lindbergh's homecoming on an American warship. We immediately obtained permission to have one of our cameramen accompany the air hero on board the Memphis. Sozio was in London when word was received in the New York offices of Paramount News that one of its men could take passage on the Memphis, and this information was immediately cabled to Sozio with instructions to report to the Naval Attaché at the Paris Embassy. Time was short, however, and Sozio soon learned that he would be unable to see the Naval Attaché at Paris and get to Cherbourg in time to board the Memphis. It appeared for a time as if some other cameraman from the Paris office would have to go. Sozio, however, had no intention of losing out on any such honor as that accorded him and tried to rent an airplane in London to fly him to Cherbourg. He was not successful. Therefore, he proceeded by train to New Haven, England.

"The steamer from New Haven goes to Havre and it brought Sozio much nearer to Cherbourg, but he was unable to catch a train to connect with the Memphis. Undaunted, he telephoned to Paris to have his camera taken to Cherbourg and then hired a high-powered automobile. Before leaving he telegraphed the commander of the Memphis, asking him to hold the cruiser until his arrival. Then followed a wild ride of several hours across the French countryside. The car stopped only long enough to gas up and was again on its way and they arrived in time for Sozio to board the Memphis.

150 Cameramen at Work

"When the Memphis was a few hundred miles off the American coast the Navy Department sent a destroyer to sea to take off mail and the film made by Sozio and other cameramen. The Memphis then proceeded to Hampton Roads and Washington, where the cameramen continued to grind out film.

"Lindbergh's arrival at Washington was covered by nearly 150 cameramen, who picked up the story and had him almost continually under fire. When he flew from Washington to New York he was followed by cameramen in fast army airplanes. Other cameramen were waiting at Mitchel Field, Long Island, when the daring youth arrived there to change over to an amphibian airplane and fly to the official landing place in New York harbor. Once in New York he was continually in range of cameras on every public appearance.

"The actual making of pictures was less than half of the battle. Rivalry between the newsreel companies was never keener than in their efforts to get their films back from Paris following Lindbergh's arrival there. As it happened most of them took advantage of airplanes to get the negatives to Cherbourg, where they were dropped aboard the Majestic. While that ship was rushing westward rival companies were making plans to get the films off the ship even before it touched quarantine. The use of seaplanes, speedboats and even battle cruisers was contemplated, but in the final count, the films were taken off at quarantine and rushed to the various laboratories. They were on the screens of Broadway theatres eight days following the completion of the flight. On the same day they were carried to Chicago by plane."

There will soon be six competitive newsreel organizations in this country, whose cameramen in all parts of the world will be on the alert and ready for emergency assignments, but the emergency news event, Mr. Cohen said, is not always assigned. Sometimes the news is so "hot" that the assignment editor does not learn about it until the film is dropped from a plane.

Sometimes the greatest and most important events are covered by freelance cameramen. This happened during the Japanese earthquake. A Paramount sales representative in Kobe learned that the only films of the earthquake were made by a Japanese cameraman. He quickly negotiated the purchase of the films to find that the last ship had sailed for America. He sent the films by seaplane to the ship at sea and later arrangements were made by cable to have the films taken off at quarantine off Victoria. From there they were sent by plane to Montana, transferred to another plane and then relayed from Chicago to New York.

The pictures of the eruption of Mauna Loa, the Hawaiian volcano, are a striking example of what newsreel organizations accomplish. When the volcano first began to rumble the newsreel editors arrived in time to fly around the volcano

when in a state of eruption. As the great flaming river of lava three miles wide and 100 feet high rolled over the mountain side, inhabitants fled before it and whole towns were wiped out, but the cameramen continued to crank. Some of them are said to have barely escaped with their lives, but they got "their story."

An outstanding newsreel feat was that accomplished in bringing pictures of Commander Byrd's flight to the North Pole to the screen. These were made from scenes taken by Commander Byrd's own camera and picked up by staff cameramen at Spitzbergen. All speed records are said to have been broken in getting these films to New York.

A more peaceful assignment is, for instance, the Kentucky Derby at Churchill Downs, the annual American race classic. One of the finest pieces of newsreel distribution ever accomplished was that of disseminating prints of the 1927 event. Fifteen minutes after the thoroughbreds had flashed past the post the newsreel men were scrambling for planes to take them to their nearest offices. James E. Darst, a newsreel editor, did not go to the Derby. Instead he sat in a film laboratory in Chicago waiting to put into motion the process of developing the first negative to arrive by air from Louisville.

*　*　*

July 31, 1927

THE WAR-IN-THE-AIR

The Government Cooperated to Make "Wings" Thrilling and True

By JOHN MONK SAUNDERS
Author of "Wings"

The history of "Wings" begins in the library of Jesse L. Lasky's Fifth Avenue apartment in New York City on a cold, gray afternoon in late February.

For an hour Mr. Lasky had listened patiently to the new story as the author recounted it. The plot, he conceded at the conclusion of the tale, held no serious faults for the screen. The author, secure on that point, began warmly to urge its advantages. The war-in-the-air, he said, had never been picturized. With the increased penetration of the motion picture camera into every realm of life, here was yet a virgin province—the kingdom of the sky. Here was the battlefield of the war fliers; here aerial combats took place and planes fell in flames and balloons were shot down. Here was action that could not be put upon the stage or imprisoned within the covers of a book. Here was a subject whose proper medium of presentation was—the screen.

But, objected Mr. Lasky, the cost of these film spectacles of war and destruction was appalling! How could it be done on a moderate scale and at reasonable expense?

It couldn't, admitted the author. If it were attempted at all, it must be done on a grand scale. The very magnitude of the subject demanded heroic treatment.

A multitude of objections crowded into the mind of the producer. How were you to photograph the war-in-the-air? Where were you to put your cameras and the camera men? Where, for instance, were you to get fleets of battle-planes and balloons and pilots?

From the War Department. But how? How could you expect the Government to furnish men and equipment for the making of a motion picture?

There were conditions, the author pointed out, under which the War Department granted the use of troops in the making of war pictures. If the story of "Wings" could meet those conditions and the cooperation of the War Department were obtained, would Mr. Lasky agree to produce the picture? In such an event, Mr. Lasky said, he would bring the full resources of the Paramount-Famous-Lasky Corporation to bear upon the men and material provided.

That night the author left for Washington, D. C. Two weeks later Mr. Lasky was advised by Dwight F. Davis, Secretary of War, that the War Department would extend cooperation subject to certain conditions and suggesting that on account of the presence of the air forces and other arms of the service in the vicinity of San Antonio, Texas, the military features of the picture could be filmed there.

Influence at Work

Since this is a truthful account, it might be well to say here that this decision on the part of the Secretary of War was not induced by the author's powers of persuasion, but by the simple merits of the project itself, the friendly intercession of Mr. Will Hays, the sympathetic attitude of Major General C. McK. Saltzman, the Chief Signal Officer of the army; the kindly interest of Major General John L. Hines, Chief of Staff, and of Major General Mason M. Patrick, Chief of Air Corps.

With the help of the War Department assured, Mr. Lasky brought the forces of the Paramount West Coast studios into play upon the production. Lucien Hubbard, the ablest producer in the field, was placed in charge of the unit. The direction of the piece was given into the hands of William Wellman, a young and skilful director. The finest technical men in the industry were assigned to his staff.

Six months later all the elements of the great undertaking were in flow toward San Antonio. Fliers from Selfridge Field, Michigan; from Crissy Field, California; from Langley Field, Virginia, and outlying stations began to arrive at Kelly Field, Texas. Balloon officers, crews and equipment came from Scott Field, Illinois. Artillery, tanks, trucks, troops, wire and high explosives from Fort Sam Houston were in motion toward the "Wings" location at Camp Stanley.

When the giant forces of modern warfare were unloosed across the war area prepared on the army reservation there were twenty-one camera men set up at different angles to catch every aspect of the terrifying pageant. They were atop hundred-foot towers, they were masked along the side-lines, they were buried in the ground. At the height of the St. Mihiel drive there was, spread out before the eyes some

$16,000,000 in Government equipment in airplanes, in tanks, in guns, in ordnance. To this spectacle, which can never be repeated because of its hazards, more than 600,000 feet of negative were exposed.

A year and a half after the genesis of the piece in the Lasky library the filming of the "Wings" was completed. The result is a slender strip of negative 12,000 feet in length. It can be seen in two hours and a half. But that film will, in the next five years, penetrate the furthest corners of the world; its subtitles will be translated into forty-eight languages; it will be viewed by countless numbers of people. If time and thought and preparation count for anything, "Wings" is a production worthy of the fallen heroes to whose memory it is dedicated.

* * *

October 7, 1927

AL JOLSON AND THE VITAPHONE

THE JAZZ SINGER, with Al Jolson, May McAvoy, Warner Orland, Eugenie Besserer, Cantor Josef Rosenblatt, Otto Lederer, Bobbie Gordon, Richard Tucker, Natt Carr, William Demarest, Anders Randolf and Will Walling; based on the play by Samson Raphaelson; directed by Alan Crosland; Vitaphone interpolations of Mr. Jolson's songs and orchestral accompaniment by Vitaphone. At Warners' Theatre.

By MORDAUNT HALL

In a story that is very much like that of his own life, Al Jolson at Warners' Theatre last night made his screen debut in the picturization of Samson Raphaelson's play "The Jazz Singer," and through the interpolation of the Vitaphone the audience had the rare opportunity of hearing Mr. Jolson sing several of his own songs and also render most effectively the Jewish hymn "Kol Nidre."

Mr. Jolson's persuasive vocal efforts were received with rousing applause. In fact, not since the first presentation of Vitaphone features, more than a year ago at the same playhouse, has anything like the ovation been heard in a motion-picture theatre. And when the film came to an end Mr. Jolson himself expressed his sincere appreciation of the Vitaphoned film, declaring that he was so happy that he could not stop the tears.

The Vitaphoned songs and some dialogue have been introduced most adroitly. This in itself is an ambitious move, for in the expression of song the Vitaphone vitalizes the production enormously. The dialogue is not so effective, for it does not always catch the nuances of speech or inflections of the voice so that one is not aware of the mechanical features.

The Warner Brothers astutely realized that a film conception of "The Jazz Singer" was one of the few subjects that would lend itself to the use of the Vitaphone. It was also a happy idea to persuade Mr. Jolson to play the leading role, for few men could have approached the task of singing and acting so well as he does in this photoplay. His "voice with a

tear" compelled silence, and possibly all that disappointed the people in the packed theatre was the fact that they could not call upon him or his image at least for an encore. They had to content themselves with clapping and whistling after Mr. Jolson's shadow finished a realistic song. It was also the voice of Jolson, with its dramatic sweep, its pathos and soft slurring tones.

One of the most interesting sequences of the picture itself is where Mr. Jolson as Jack Robin (formerly Jakie Rabbinowitz) is perceived talking to Mary Dale (May McAvoy) as he smears his face with black. It is done gradually, and yet the dexterity with which Mr. Jolson outlines his mouth is readily appreciated. You see Jack Robin, the young man who at last has his big opportunity, with a couple of smudges of black on his features, and then his cheeks, his nose, his forehead and the back of his neck are blackened. It is also an engaging scene where Jack's mother comes to the Winter Garden and sees him for the first time as a black-face entertainer.

There is naturally a good deal of sentiment attached to the narrative, which is one wherein Cantor Rabinowitz is eager that his son Jakie shall become a cantor to keep up the traditions of the family. The old man's anger is aroused when one night he hears that Jakie has been singing jazz song's in a saloon. The boy's heart and soul are with the modern music. He runs away from home and tours the country until through a friend he is engaged by a New York producer to sing in the Winter Garden. His début is to be made on the Day of Atonement, and, incidentally, when his father is dying. Toward the end, however, the old cantor on his deathbed hears his son canting the "Kol Nidre."

Some time afterward Jack Robin is perceived and heard singing "Mammy," while his old mother occupies a seat in the front row. Here Mr. Jolson puts all the force of his personality into the song as he walks out beyond the footlights and some times with clasped hands, he sings as if to his own mother.

The success of this production is due to a large degree to Mr. Jolson's Vitaphoned renditions. There are quite a few moments when the picture drags, because Alan Crosland, the director, has given too much footage to discussion and to the attempts of the theatrical manager (in character) to prevail upon Jack Robin not to permit sentiment to sway him (Jack) when his great opportunity is at hand. There are also times when one would expect the Vitaphoned portion to be either more subdued or stopped as the camera swings to other scenes. The voice is usually just the same whether the image of the singer is close to the camera or quite far away.

Warner Oland does capable work as Cantor Rabinowitz. May McAvoy is attractive, but has little to do as Mary Dale. In most of her scenes Eugenie Besserer acts with sympathetic restraint.

Cantor Josef Rosenblatt contributes an excellent Vitaphoned concert number in the course of the narrative.

* * *

January 9, 1928

CHAPLIN OF HOLLYWOOD

THE CIRCUS, with Charlie Chaplin, Allan Garcia, Merna Kennedy, Harry Crocker, Stanley Stanford, John Rand, George Davis, Henry Bergman, Steve Murphy and others, written and directed by Mr. Chaplin; special prologue by Joseph Plunkett. At the Mark Strand.

By MORDAUNT HALL

Charles Spencer Chaplin's latest cure for melancholy now is to be seen at the Mark Strand. This film was offered for the first time last Friday at a midnight showing before a gathering that evinced no little enthusiasm in spite of the hour and the fact that many persons had either come from witnessing plays or acting in them. Mr. Chaplin did not choose on this occasion to leave his California retreat for the launching of this comedy, which is entitled "The Circus." He sent a telegram which was read to the audience. In it the Grimaldi of modern days declared his new production to be the outstanding achievement of his fun-making career.

"The Circus" is likely to please intensely those who found something slightly wanting in "The Gold Rush," but at the same time it will prove a little disappointing to those who revelled in the poetry, the pathos and fine humor of his previous adventure. Chaplin's pictures bring to mind the Scotsman who said that all whisky was good but that some brands were better than others. Chaplin never fails to tickle one's fancy. He lifts the masks from the dejected or the cynical and discovers faces wreathed in merriment.

This current offering is the box-office side of the life of Chaplin of Hollywood. It is a wild series of incidents that are more like his earlier films than either "The Gold Rush" or "The Kid." Call it slapstick if you will, but this exponent is able to set forth old ideas with a toothsome sauce. Chaplin can throw a blueberry pie so that in the action there is a degree of suspense. When in "The Circus" he looks hungry it is so infectious that he makes you want a piece of his roll. When he is sad he makes you forget that this is only a farce, and you are sad with him. When he is in danger, you hope for his rescue. He makes you forget his queer mustache, his absurd clothes and his waggle, by his clever pantomime. A movement here gives you a paragraph, and another action, flashed without the need of a title, informs you of a portent or a hope. It is done so glibly that there is never the slightest doubt as to the meaning Chaplin wishes to convey.

There are passages in "The Circus" that are undoubtedly too long and others that are too extravagant for even this blend of humor. But Chaplin's unfailing imagination helps even when the sequence is obviously slipping from grace. Nevertheless, it is surprising that a clown of such brilliance should permit one episode to fade out leaving you hungry for more and then give you an overdose.

Once, at least, in "The Circus" Chaplin finds himself endeavoring to better his previous idea, and through trying to avoid repeating what he did in "The Gold Rush," the result is tame by comparison.

Excellent, indeed, is the first flash of "The Circus." A star comes to the screen; soon this turns out to be a paper hoop, which, when it is ripped apart, affords a jagged frame through which you see the sawdust ring in full action and a mixed group in the seats.

It is quite a little while before the Tramp (Chaplin) puts in his appearance, but as soon as the swinging cane, the old bowler and the spavined feet were seen at the opening show the spectators were thrown into a high state of glee. A pickpocket slips a stuffed wallet into the Tramp's capacious pocket, and the Tramp, a minute or so later, is perceived watching frankfurters and rolls. Little does he know of the wealth in his trousers. It is here that Chaplin makes people who were thinking about their appearances forget themselves in sheer joy. The Tramp sees an infant looking over his father's shoulder and holding a roll. The Tramp proceeds to make the baby smile and soon the child extends the roll and the Tramp takes a bite. Then he reaches for the mustard and plasters the youngster's roll with it and while the audience is thrown into a state of ecstasy, Chaplin bites off the mustard end.

Nobody will forget in a hurry that portion where the Tramp is told by the Circus Manager to give a pill to a horse. He puts the tube in the horse's mouth and is about ready to blow, when the horse blows first, with consequences that are at least momentarily disturbing even to the Tramp.

The adventuresome Tramp, who is funny when he does not intend to be and, to the Circus Manager, quite pathetic when he tries to be comic, finally discovers that he has precipitated himself into a lion's cage. The Tramp at first looks satisfied, then he sees the lion and his one thought is to be quiet. While he is tiptoeing toward the door the bolt slips down, and the Tramp is cornered. The lion flicks its tail and moves its jaws, while the Tramp stands against the side of the cage unwilling to make a movement that might possibly disturb the sleeping animal. An impertinent little fox terrier turns up to add to the Tramp's anxiety, and although the prisoner shakes his finger and makes silent threats, the dog continues barking. The lion is perceived slipping his tongue over his jowls, causing one to think that he is both thirsty and hungry, though still dozing. Merna, the attractive heroine, appears, and just when it is thought that the Tramp is going to be released, she faints. The Tramp tosses the lion's drinking water through the bars over the girl, and then the lion, with a good long yawn, showing a fine supply of teeth, slowly turns over and wriggles around on his back. Somehow or other the lion is not in a fighting mood, and therefore when he looks at Chaplin he decides to continue his siesta, which inspires courage in the Tramp's breast. Merna recovers and she opens the door, and, to her surprise, the Tramp, instead of darting out of the cage, stays inside assuming the pose of a conqueror. But that is only for a second or so, for the lion again makes a movement and no human being has ever left a cage with greater celerity than this Tramp does.

There are some splendid bits where Chaplin is learning from the circus clowns how to be funny. Here this born come-

dian portrays his genius. The episode wherein the Tramp accidentally releases all the magician's little animals and shows up the conjurer's bag of tricks is excruciatingly funny. Then there is the chapter of accidents with the Tramp, after having a wire attached to him, is hoisted to the dizzy heights of the maintop to do a rope-walking act. He knows he is equipped with the safety appliance and therefore is reckless to a high degree. Finally the rope breaks and the Tramp, not knowing of the accident, goes on just the same, and then his task is made all the more hazardous by his being attacked by three monkeys.

At the end there is a plea for sympathy. The Tramp, after having given up the girl to the tight-rope walker, is left alone while the circus train steams off. You and the rest of the world may smile compassionately upon the pathetic figure of the Tramp who, while the orchestra plays "Blue Skies," waddles off until he is a speck on the horizon.

<div align="center">* * *</div>

<div align="right">May 27, 1928</div>

HALF AN HOUR WITH VON STROHEIM

Erich Von Stroheim, the stormy petrel of Hollywood, producer of such vibrant subjects as "Foolish Wives," "Greed," "The Merry Widow" and, relatively recently, "The Wedding March" (to be presented in a month or so), was seen last week at the Plaza Hotel on his first visit to this city in years. He is as interesting as his films, a man who is never at a loss for an idea and one who reveals the results of his service in the Austrian Army in his discussion of picture-making. He is a bundle of electrified energy, one of the few men who speaks with real frankness about his dealings in Hollywood.

There is no need to sit and spar for an idea when interviewing von Stroheim. He knows what he wants to say and he never gets tired of talking; his descriptions are vivid and clear. He has originality in the mere handling of the tongue of his adopted country. Nothing trite comes from his lips as he darts back and forth in a room.

He's Off

He burst into his sitting room and in less than a minute he had commenced giving a conception of himself.

"Somewhere in my subconscious mind I have a sort of photographic plate," said he. "I did not know this until I had worked on pictorial productions, but since then I have discovered that I see everything in the form of a scene for a picture. Something strikes me as a scene for a film and I will never forget it. When the time comes, although it may be years later, I will reproduce that scene just as I saw it."

Mr. von Stroheim was not boastful but merely enthusiastically informative. He was ready to answer any questions, to reply to any adverse criticism and to give his reasons for filming so much footage for some of his productions. To illustrate his picture ideas he centred his attention on the mantelpiece in his room.

"You see that mantelpiece," ejaculated von Stroheim. "You know that it must be a hotel mantlepiece, for on one corner are six nickel cups while on the other, side are a telephone message and my hat and cane. I would never think of putting my hat on the mantelpiece at home. It is a mantelpiece that gives signs of life in the room, for you can almost tell that the occupant has been away some little time and has recently returned in a hurry."

Mr. von Stroheim then took away the nickel cups, the hat and telephone message and cane and declared:

"There you have a set, one that might be constructed for any picture. I will always remember that mantelpiece as it is with the cups, the hat and cane, the telephone message. This is a nice room, and yet on looking around you realize, aside from the mantelpiece, that it is a hotel room. Look at that picture. It is not straight. Servants in a home would always see that pictures are hung straight. It is important to do so in a motion picture, for to have a picture in a reproduction of a wealthy man's home hanging crooked is absurd."

A Realist

Mr. von Stroheim said that he was a realist, with ideas like Emile Zola's. He hazarded that while detail might not make a story it improved the scene for a wandering eye and that when the detail is wrong it irritates many persons who view the picture. He believed that these people talked more about what they found missing than what they liked.

As he spoke Mr. von Stroheim was impelled every now and again to couple up something with a miltary viewpoint. He said, for instance, that he knew how many buttons a policeman had on his coat, which was due to the years he spent in Franz Josef's army (from 1902 to 1909). He told how he and his young brother used to try to trap each other concerning the meaning of the different military insignia.

"There were 106 infantry regiments in Austria with special markings and stripes. Yet I knew them all."

Mr. von Stroheim was dressed in a gray suit, brown shoes, black socks, big circles of white on a blue necktie. He had a wrist watch with a gold band on his right wrist and a gold bracelet on the other. Around the room were telegrams, sheets of typewritten manuscript, a brief-case that looked like business. It probably contained some of the secrets of his contract to direct Gloria Swanson in a story of East Africa. It is called "The Swamp" and was written by von Stroheim. He is enthusiastic about it and insists that he will produce the picture in the allotted time. In his manuscript Kitty Kelly, the part to be played by Gloria Swanson, is described as follows:

"A beautiful young creature of Irish extraction, gorgeous and graceful as a peacock, but cold, calm, calculating and mercenary. Most of the time she has all the grace, charm, haughtiness and deportment of a born aristocrat, but on provocation she flies into the most unreasonable rage."

This director is forceful in everything he does, and sometimes his verbal description of characters and actors is reminiscent of some of the details of his picture "Greed."

Mental Chewing Gum

Most film writers, directors and others, including the players, are especially tactful concerning their utterances. They are invariably only too eager to praise the powers that be no matter what they may really think of them. Von Stroheim has no axe to grind. He tells what he thinks and rather revels in the fact that no matter what others may say about him they have to admit that his pictures have been far above the average of other good producers.

"Pictures are mental chewing gum for the public that pays for them," said von Stroheim. "The shadows on the screen do the thinking for these spectators. We are not making films for highbrows, although there are some highbrows who go to see pictures. The people for whom the pictures are made like happy endings, because their own lives are so often drab. I myself like a happy ending when it is logical, and I don't like an unhappy ending if it is illogical."

In denouncing some of the Hollywood executives, von Stroheim permitted his voice to rise.

"I remember once when I was working for Universal, making a scene for 'Foolish Wives,' one with a view of a troop of Monegasque mounted men. I had cowboys in the saddles, and cowboys believe in freedom, so they had all unbuttoned their collars, their swords were slung anywhere behind them, tobacco labels hung from their pockets, their shirts were vari-colored and some of the riders had been lying in the sand. They looked pathetic. They fell in on the set and I realized that many of them needed a haircut, particularly as they were supposed to be soldiers. You know you don't see long-haired soldiers anywhere.

"Sir Gilbert Parker was on the set, escorted there by one of the executives. They did me the honor of watching my work, and as I was looking at this and that I heard the executive tell Sir Gilbert that I was a German who took up too much time with insignificant detail.

"At that moment I was concerned with the empty saddle-bags of my heterogeneous troops. All their saddle-bags were as flat as pancakes. I sent around assistant directors and had them stuffed with paper, saw-dust and rags, anything I could find.

Clothes and the Part

"The film executive then said that he had been watching me for an hour and that I had not taken a single foot of film. I told him that I wanted to get things correct. Then this man said that I could have photographed my long shot and attended to the details afterward. Now, I ask you, what good would that have done? I had to bring my camera closer immediately afterward and it would have been ridiculous to have a scene with so many mistakes. There were 500 people on the set, but if it was not produced properly the people would have had to return for an extra day."

To illustrate a point regarding realism, Mr. von Stroheim asserted that his Monegasque soldiers would have looked all the better and felt more like the real thing if they had all had had clean white shirts under the blue tunics, instead of any old shirt. He averred that no actress could play a spiritual rôle after coming from a gay party.

"We are dealing with the cruelest medium, the camera," said the director. "Everything should be perfect to make a good picture. If a man is to be dressed as a tramp, he can't feel like a tramp if he has fine linen underclothes under his tattered garments. Likewise, a Grand Duke or a New York society man must be dressed for the part in every detail Clothes help tremendously in the carriage of an actor."

Mr. von Stroheim said that "The Wedding March" was in fifty reels when he had finished the picture and that he could have cut it down to twelve or fourteen.

"I could have done it, but they couldn't," said von Stroheim. "I say that I could have done it, not boastfully but because I knew every foot of the film, long as it was."

"The Man You Love to Hate"

Mr. von Stroheim said that he had to pay the piper for big electric signs and exploitation. He said that as a matter of fact he did not use up more negative than several other directors.

"When I was filming 'Foolish Wives,' " he shouted, "they had one of the largest electric light sings on Broadway telling of the progress of the picture. Think of it! Persons in New York read that Universal had spent up to a certain hour $975,500.75 on this picture. The figures changed from day to day, and next day they would be up $100,000. That was the sort of publicity that did not help me.

"People came to think of von Stroheim not as a great director but as an expensive director, and Universal liked it.

"Then, again, I was thrown upon the screen and on bill posters with the slogan, 'The Man You Love to Hate.' It riled Americans to think of what I did in pictures. They wanted to kill my like in the war. Yet, do you know, I refused one director to do what he wanted me to do. One idea this director had was that I, as a German officer, should use a whip on women working in the fields. I told him that it was senseless to have an officer on such a job, as it would be entrusted to an inferior type of Sergeant Major, and he would not whip women. I only played those unpleasant rôles because I thought that I could at least make them more real, while there was no telling what would happen if some other person acted them."

*　*　*

July 8, 1928

KING VIDOR SPEAKS OF SOUND

Shaking his head in a somewhat bewildered fashion about things in general, King Vidor, the director, returned from Europe last week. He came back a little earlier than he had intended because he wished to "get back to the battlefield" and felt that New York—and America—is it.

The note of sorrow which he sounded was due to the talking pictures. He does not say he likes them, he does not say he dislikes them; he is, in fact, ready to be shown. But he

thinks it most unfortunate they should flourish now, just as the silent pictures were beginning to come into their own.

"I came back, and the first thing that was said was, 'What do you think of them?' I remarked that the matter seemed somewhat distant, but my friends sent me out to buy a number of trade papers. I looked them over, and see that even in the last six weeks everyone has switched over to talking films.

"When I went away I was just beginning to put my finger on that something which makes up the screen; and in Europe many persons also said they felt it. The screen appeared after a long and bitter struggle to be coming into its own. People were getting enthusiastic about it as a medium, and it seemed to be on a sound foundation.

Sound as Accompaniment

"Now everyone is thinking of the new development, and rushing to get in on it. I have asked why they want to start something else when they have just learned straight pictures, but it does no good. Talking pictures are of a different school—one dealing with voice delivery—and we will have to begin all over again to learn it."

Mr. Vidor said that he liked the use of sound as an accompaniment. In "The Big Parade," he recalled, at the last moment a weakness had developed in connection with the picture of a machine gun, and as there was no time to take the scene over again, he had used orchestral music to give the effect of the gun in action. But that was just in "covering up a weakness." So far there has been no speech in any picture he has directed.

His ideas about screen subject matter are not unlike those of Wordsworth on poetry. That is, Mr. Vidor believes that the characters should be simple ones—those who fight and make love truthfully, not hiding their feelings behind the veneer of civilisation. He is against symbolism in the moving pictures, prefering rather a bold frankness.

The director is a fairly tall, compact man, with a mass of brown hair and clear blue eyes. He speaks slowly and clearly, apparently turning over his thoughts in his mind before telling them. He likes ease now and then, he says, and doesn't believe in running around just for the sake of hurrying.

Mr. Vidor and Tennis

While he speaks authoritatively and cheerfully about his own profession it is not until the subject of tennis is reached that he becomes voluble. Almost the only foreign acquisition he brought back was a machine invented by Rene Lacoste and designed to be the automaton of the practice court.

"As a matter of fact, for a number of years I have been trying to think of a scheme whereby a machine could be used to toss tennis balls to a player wanting them for practice work," he said. "You know, there are some strokes in which you are weak and it's difficult to find anyone wanting especially to just knock balls toward your weakness. As I drove along in the car I would try to figure out some plan. Just when I thought I had it, I happened to see a machine along the same lines in a window in Paris. It's now on its way to Hollywood."

Mr. Vidor relaxed with a smile of triumph.

He will be in New York for a week or so, he said, touring the theatres and conferring about his next picture. He has an idea for one, he stated, but there is nothing definite about it and for the time being he wishes to set off on no false starts.

* * *

July 8, 1928

TALKING FILMS TRY MOVIE MEN'S SOULS

Profits, Players and Peace of the Industry Face Trouble in New Situation

JOHNSON MACHINE WORKING

Senator Operates Steam Roller While Suffering Attack of Hooveritis

By CHAPIN HALL
Editorial Correspondence of The New York Times

LOS ANGELES, July 3—Los Angeles is very proud of her biggest, chubbiest baby, the movies. At the same time no good Los Angelan is willing to admit that the movies constitute the whole family. Interesting—yes; full of cute tricks—of course. But the twins citrus and walnut have been earning their living for a good many years and contribute $150,000,000 or so to the family exchequer every annual payday. The younger juveniles, Firestone, Goodyear, Goodrich et al., with their great production plants, are not to be sneezed at. Another branch of the industrial family already boasts fifteen sturdy branches in the form of aeronautical manufactories with a $4,000,000 payroll. Southern California seems destined to be one of the principal aircraft production centres in the country, and even now planes of all types, ranging from huge tri-motored, ten-passenger ships and dual-motored bombers for military and naval service to small, fast sport planes, are coming from the big and constantly enlarging factories for use, not only in the States, but to find a ready market in Europe, Asia and South America.

It is the movies, however, just now that are all in a lather over the "talking-film" situation. In a recent trip through the manufacturing areas in Hollywood and elsewhere I found many corrugated brows. The manufacturers don't know just how far to go. They realize that the next year or two will see rapid development in the "talkies," and naturally they hesitate to install expensive equipment which may have to be scrapped before the newness has worn off. On the other hand, the public is clamoring for the latest toy, and theatres featuring sound devices are "packing 'em in" at the expense of less progressive houses.

Others Are Worried, Too

The ultimate result may be to revive interest in the legitimate theatre. Words, per se, are bound to be more interesting before they are strained through a loud-speaker, and until

there is a marked advance in present technique picture dialogue is at the expense of action, for the "talky" must be far more concentrated.

The corrugations in the brows of scenario writers come from the fact that a new type of story must be devised—something that will bridge the gap between action and talk. The present sound films are interesting because of their novelty, but as pictures they are flops, and the abrupt change of tempo when the words stop and the action resumes is a terrific strain on the credulity of the customers.

Most of all, the performers' brows are lined with worry make-up, because they see their fat contracts slipping away into the hands of actors who can make language behave. The zero hour of the "beautiful but dumb" is about to strike. Hollywood is filled with pretty little girls who have learned to do exactly what the director tells them to do at the precise moment they are required to do it, and a lot of them never have found out what it is all about beyond that. Now they are to get parts which must be learned letter perfect and then they are to be shoved into mid-stream where the voice of the director must never penetrate and where, if they rock the boat, overboard they go. And that is where most of them are going.

The beginning of a new era is recognized by all hands, but no one yet knows just what it portends. In the meantime the whole industry is nervous and inclined to jump whenever any one says "boo."

* * *

July 29, 1928

LASKY'S VIEW ON SOUND

LOS ANGELES, July 25—Among the many champions of the sound and talking picture is Jesse L. Lasky, production chief of Famous Players-Lasky, whose first pictorial effort, "The Squaw Man," was produced in and around a barn then situated in what is now the centre of the business section of Hollywood. Mr. Lasky is not blind to the adolescent nature of the film with dialogue, but in the course of an interview in his studio office here he voiced the emphatic opinion that the audible picture is not an ephemeral novelty but something that eventually will turn out to be amazingly fascinating entertainment. He said that the public must have patience and tolerance with the initial talking subjects, for producers would have to learn from mistakes and actors would, in the beginning, be just as self-conscious before a microphone as most of them were in their début before a camera.

Like the Automobile

"The talking and sound picture is a big subject," asserted Mr. Lasky, "and it is my firm conviction that it is here to stay. The first motion pictures I ever saw were short films and relatively few persons then dreamed that this entertainment medium would be developed into motion pictures such as we have today. The development of the production synchronized with sound will be equally significant. You will remember that in the early stages of the pictorial subjects eminent oculists proclaimed that the flicker in these pioneering films would ruin the eyesight of the nation. Soon, however, the flicker was eliminated and nobody has complained about that fault since.

"The same progress undoubtedly will be attained in the voices from the screen, for the recording of sound will be perfected in course of time so that it is as natural as photography of material subjects. The talking picture at present might be likened to the automobile in the old days, when the vast majority of people scoffed at the notion that this means of conveyance would take the place of the horse. Think of the progress of science and you will realize that mechanical obstacles in an invention are invariably overcome.

"To my mind the most important feature of the audible film is the use to which the sound is put. There will naturally be numerous imperfect productions made in the haste and rush to meet the popular demand. This early stage is in fact the most dangerous phase of the sound picture and audiences must and critics will have to be patient and tolerant in order to permit this new medium of entertainment to improve. And there is not the slightest doubt in my mind but that it will improve. At the same time I don't think that the silent picture will disappear from the screen, although I do think that almost every film can be helped by sound effects used with discrimination.

The Actors' Voices

"The greatest charm of the motion picture is the rapidity with which it moves, and sound must not retard this technique, which brings a certain fascination to the screen. The sound film will give us an opportunity to picturize stories that were not suited to the silent effort. It will be an entertainment medium that will borrow both from the stage and the silent screen and in my opinion it will after a time be far ahead of any other popular form of entertainment.

"A good deal has been said and written about the voices of screen players but this is really not a great problem. The main point is that the players with voices suited to their personalities will have to learn to be easy and natural in the speaking of their lines. They will need to study stage technique. So far as the directors are concerned, they will have to adapt themselves to this combination of stage and silent screen, and so will the writers. Incidentally the titling of motion pictures has made remarkable strides. Think of what it was in the beginning when, following a scene of a man falling downstairs, there was a caption setting forth, 'The Man Falls Downstairs.' Nowadays the experts in title writing permit the action of the screen to speak for itself and they also refrain from describing a character.

Some Uses of Sound

"Sound and talking pictures will be limited to those theatres especially equipped for the reproduction of this new device, and there will be just about one thousand of these the-

atres in the country by next January. In the houses there will also be shown short sound subjects ahead of the main feature and following it.

"As one ponders on the possibilities of the sound productions, one must also remember that this medium will lend an opportunity to stage artists and those of the opera to give their presence and their voices to posterity. Years ago we made a picture with Caruso. How wonderful it would have been had we had the speaking picture in his day, for, aside from hearing him talk, we would also be able to hear his inspiring singing. What a difference, too, the sound picture would have made in Geraldine Farrar's picture of 'Carmen.'

"An interesting commentary on the silent screen is that in the old days many stage actors went to work before the camera, and it was because they were in the habit of speaking their lines as they acted that the majority of them were failures. Now things have changed. At the present moment we are making a screen version with sound of the play 'Interference,' and two of the principals are Clive Brook and Evelyn Brent, both of whom have had stage experience. They are in the happy position of being able to meet the demands of this new invention, for, while there will be sound, as I said, in most productions, there will be long stretches that will be silent except for incidental noises. These talking pictures also will have far fewer scenes than the silent subjects.

"The sound production has already reached the stage in which but a fair example proves a far better drawing card than a real good silent film. As I sit here now there seems to be no end to the study of sound. I am talking, and while there are undoubtedly a number of other sounds in this office you can hear only the sound of my voice. Hence the producer will have to concentrate on the sound or sounds needed to attract the attention of the spectator. It will assuredly enhance such things as the sight of a ship in a storm, for we can now give the thunder and roar just as we reproduced the whirring of a motor in 'Wings.' "

MORDAUNT HALL

* * *

August 5, 1928

GOLDWYN URGES CAUTION

BEVERLY HILLS, Aug. 1—Samuel Goldwyn, whose name not only adorns the pictures he makes as an independent producer with United Artists, but also those of a rival concern, Metro-Goldwyn-Mayer, said today that producers are making a grave error in their wild excitement over sound pictures. He went so far as to say that he believed that the industry is suffering from hysteria and that if producers were not careful it would go on the rocks. He explained that while the public was attracted in great hosts to the sound film, because of the novelty of the idea, the audible picture might easily discourage attendance at motion picture houses because a poor talking film, after the novelty has worn off, will be infinitely more irritating than a poor silent picture.

He said that it was a pity that so many picture makers were like sheep in imitating the successes of others. "The triumph of 'The Covered Wagon' inspired producers to issue a number of carbon copies of this feature; the same thing applied to 'The Big Parade' and latterly to 'Underworld',", he said. Mr. Goldwyn also pointed out that his production of "Stella Dallas" caused the market to be flooded with mother stories.

"The present state of excitement over the sound picture is virtually due to the financial success of 'The Jazz Singer'," said Mr. Goldwyn, "which it should be remembered featured that inimitable artist, Al Jolson. What would this picture have been without Mr. Jolson? Certainly, it might have made money but it would never have been the outstanding hit it was all over the country without that stellar performer.

"I am by no means opposed to the sound film, but I do think that the hysteria that reigns here at present may mean that so many inadequate talking subjects will be issued that people will eventually long for the peace and quiet to which they have been accustomed with the silent features. They can make all the sound films they want, but I wonder how many pictures will be made with the new medium that will be as beautiful as Chaplin's 'Gold Rush.'

"It is also a question as to where producers will get their stories or whether they will be able to find sufficiently good ones to stand up under the test of sound. Picture producers will soon be making something like 500 sound subjects and while some of them will be stories that already have been filmed, it remains to be seen what they will do for other stories.

"Audible pictures made with competent actors, players who know something about the drama, may be highly successful, but it should be realized that the conditions under which these productions are made are far more trying than those encountered on the stage. Another point is that although great actors may be able to give excellent performances, there will be others in the cast who may detract from the picture as a whole.

"The producers had in their hands a medium that was international, one in which screen performers while silent were able to talk to any country in the world. It is to be hoped that this combination of shadow and sound will not destroy all interest in the silent picture, for after all is said and done there is something gentle and poetic in the idea of being able to tell a story by animated shadows that flit across a screen.

"Of course I fully appreciate that there will be some audible pictures, those in which cinematic values will be adroitly combined with sound. But how many of these will there be? Think of the ridicule with which the badly made talking film will meet. Many of them will be shadow conceptions of Bowery melodramas with rasping utterances. They will be interesting only because man has given a voice to a shadow.

"If the producers took their time in bringing out talking pictures the results might not only be better, but there would not be that danger of killing interest in pictorial features. A great deal of experimenting is needed. For improvements will be made from week to week. A talking picture that is consid-

ered good may be virtually behind the times soon after its release, and when its makers are still working along the same lines another producer may have found a way to picture a sound subject that puts the other man's films in the background. In course of time we may have prismatic pictures with the fourth dimension as well as sound, and it is fairly safe to predict that in the making of such a film great care and study will be exercised."

MORDAUNT HALL

* * *

August 5, 1928

HAL ROACH ON COMEDY

The two-reel comedy, far from being a rickety and unimportant relic of "custard pie" days, now is likely to take a bigger place in the sun than ever before, according to Hal Roach, producer of comedies for Metro-Goldwyn-Mayer, who arrived in New York recently to confer with Eastern executives.

Mr. Roach, who has a football build, a cheery, smiling face and is known on the Coast as an excellent polo player, has done a considerable amount of globe trotting since last December. At that time he and his wife set out from San Francisco for the Philippines and Japan. They visited China, the Malay Peninsula and India, and then went on to Italy, France, New York City and the Coast. Now, after starting his studio off on its production schedule of forty comedies for 1928–29, he finds himself back in the East.

In discussing what he believes to be a new rise in the popularity of the two-reel comedy, Mr. Roach laid stress on quality and originality.

"The short film," he said, "requires just as careful planning, in its way, as the long subject. Experience has shown us that it is fatal to try to turn out half a dozen comedies on one clothes-horse. The average person might be surprised to learn that the well-planned two-reel comedy takes more time, in proportion to its length, than the eight-reel feature."

Sound is welcomed by Mr. Roach as a highly interesting innovation and one having a special bearing on comedy production.

"There may be some speculation as to the ultimate place of sound effects and dialogue for full-length pictures," he said, "but I don't see any question about the value of sound in the one or two reel film. There you have a fine opportunity to try all kinds of novelties without getting the public tired. It's easy to imagine the variety of humorous and farcical effects possible for a sound comedy. And a good dialogue comedy might be compared to a vaudeville skit, with the extra action that the screen can give. The public has already shown unqualified approval of the short sound pictures, the Movietone news reel and the like."

It is Mr. Roach's opinion that sound will exert an important influence in cutting down metropolitan stage presentations in film houses. He looks for a rebound from what he calls the present "overbalancing" to an accepted all-picture program with sound providing the novelty sought for by city showmen who went in heavily for miniature musical comedies to supplement their cinema programs.

"I feel sure," said Mr. Roach, "that the public, as well as the theatre manager, is getting a little jaded with these topheavy stage programs. It doesn't reflect much credit on the strength of a feature picture to devote loss time to its showing than to a supplementary bill of ballet work and assorted stage bits. Motion pictures, as I see them, represent a definite and popular form of entertainment that can stand on its own feet. Why not have the surrounding program made up of short films instead of repetitious presentation acts?"

The comedy producer speculated on the possibility of establishing a Broadway house where nothing but short subjects would be shown.

"I have often wondered," he remarked, "what would be the result of an experiment in which a big theatre could be turned over to the exclusive showing of short feature material. What would be the public reaction? Would there be enough patronage to insure a fair profit? I believe so. Any one can see how comprehensive the field is by just glancing at the current schedules of the leading producers. More comedies were turned out last year than ever before. Besides the news reel, which is a 'must' everywhere. Forty per cent. more two-reel films are shown in first-run houses than was the case three years ago. The UFA 'Oddities' have proved popular and then there are the Technicolor specials, nature studies, the Music Master series, lessons in bridge—in fact, a variety that seems to increase all the time.

"What reception would be given to a program made up, for example, of short features totaling eight or ten reels altogether; perhaps two-reel comedies, a news reel and a number of one-reel novelties? I'd certainly like to see."

One of the things which was most impressed upon him during his recent foreign trip, the comedy producer said, was the necessity of careful discrimination in sending two-reel pictures to the Orient. The Chinaman, for instance, utterly fails to appreciate many stock American jokes. The iceman and the bill collector are thoroughly meaningless figures to him, and comedies centring their appeal about such characters are likely to fail dismally in their purpose. Sub-titles must be discounted as a means of conveying humor, since in translation they often lose all their wit, especially if a slang expression is involved. Thus it takes a discerning person and one acquainted with the Oriental temperament to pass judgment on what will and what won't cause a laugh.

* * *

August 19, 1928

NOW THE MOVIES GO BACK TO THEIR SCHOOL DAYS

As the "Talking" Film Is Developed Our Idols in the Silent Drama of the Screen Must Study Voice Culture and Learn a More Difficult Technique

By JAMES O. SPEARING

The movies are in their infancy again. It hardly seems fair. Peter Pan may be satisfied if he never grows up, but if he started to grow, then, just as he was reaching maturity, suddenly found himself thrown back into boyhood, the chances are that he would feel aggrieved.

After years of floundering and feeling their way, motion pictures began to take definite shape. Starting as animated photographs of running crowds and jumping clowns, they became, at least in the popular sense, an art form. A technique was developed. Such devices as the close-up, the angle shot, the vignette, the dissolve and the insert were employed to point up scenes, to make them meaningful. Directors, scenarists and actors were beginning to learn the silent language of kinetic photography. Now they have to start all over again and learn how to talk.

The development of screen acting was an essential part of the evolution. The first screen actors were stage players out of work. As a rule, they merely posed their parts, or raced through them, speaking lines that were later inserted as subtitles. Their style was that of the stage, and their pictures followed the stage in method and construction. They were literally canned drama.

Came the dawn. Real screen acting appeared on the horizon. Mary Pickford, William S. Hart, Charlie Chaplin, Douglas Fairbanks and others showed how it should be done. It was pantomime, silent expressiveness. It was not stereotyped. Miss Pickford had one style, Mr. Hart another, Mr. Chaplin another and Mr. Fairbanks something else again. But it all belonged in the realm of saying things with faces, feet, arms, hands and legs.

As movies became more and more popular, audiences wanted more and more of the same thing and something else. Norma Talmadge, Clara Kimball Young and others came on the scene, and people began to talk about sex appeal. It was not altogether that, of course. It was personal magnetism, plus appearance, plus pantomimic expressiveness. The actors of the new era were good looking, they could wear clothes well, they had an air about them that suggested distinction without aloofness, something superhuman yet conceivably attainable by ordinary mortals. They became idols in whose images their worshipers were made.

As time went on, screen acting became more and more clearly defined. Among the favorites today are Colleen Moore, Clara Bow, Norma Shearer, Norma Talmadge, Vilma Banky, Gloria Swanson and Lillian Gish. On the roster of most popular men are Tom Mix, Ronald Colman, John Barrymore, John Gilbert, Richard Barthelmess, Lon Chaney,

Wallace Beery, Emil Jannings, Harold Lloyd and the imperishable Charlie Chaplin.

These are only samples. The point is that, in widely varying styles, they are all personable screen players. They are not all beautiful. Emil Jannings, Lon Chaney and Wallace Beery, for instance, often attain the ultimate of ugliness, but their assumed hideosity does not repel. It attracts by the strength of the emotional magnet of which it is a part. The success of these men lies largely in the fact that they make people laugh and cry by the impersonation of characters touched with that nature that makes the whole world kin.

Colleen Moore, Norma Shearer, Gloria Swanson, Ronald Colman, John Gilbert, Richard Barthelmess and the others of their group are the true idols, however. They represent the movie fan's ideal of human attractiveness. They have personality plus pleasing appearance. And they are actors. The things they do mean something. They reveal thoughts and emotions by physical actions and attitudes. By photographable actions and attitudes, too. That touches the core of it all. No matter what a man or a woman looks like, no matter what he or she does, the photographic result is all that counts.

There are many beautiful women in Hollywood who have been denied stardom because they do not photograph well. Capable actors have been stopped in the studios because the camera cannot catch the shadings of their facial expressions. Any one who has served time on studio sets knows that some players who seem vivid as they go through their parts become flat shadows or grimacing grotesques in their pictures on the screen. Others who do not seem to be acting at all, whose changes of expression are apparently slight, reveal a comprehensive variety of sharp and shaded moods when their developed scenes are shown.

The reason for this is that photography, in fact as well as etymologically, is light-writing. The texture of one's skin, the degree to which it catches and reflects light rays, determines the quality of one's screen appearance. Also, an actor whose face is slightly disfigured or disproportioned, so slightly that no abnormality is noticed in real life, becomes a marked man in a large, high-lighted close-up.

The close-up, so essential to the star as well as to the cinematographic treatment of a story, is the ultimate test of screen ability. Many a leading woman of the stage, who is observed and approved from out front in a theatre, has failed on the screen because her face will not stand the close-up. It is merciless on blemishes, wrinkles and irregularities, despite all that make-up can do.

There is the motion picture, then. Or, rather, there it was. For, just as it was becoming settled in style, just as it seemed about to grow up with its own people, its own technique, sound, the element characteristically lacking, has been added to it.

The absence of the human voice and other sounds has played a vital part in the development of screen acting and technique. Many of the devices now used in the treatment of a motion-picture story, the developed pantomime of the players themselves, came into being because of this missing element

Mary Pickford has given up juvenile roles.

Photograph Copyright by Vitagraph Company.

John Bunny, one of the first screen comedians.

of sound. They were evolved to make up for the deficiency. Now that the deficiency has been supplied, it is no wonder that the structure seems about to tumble down.

The whole motion-picture world is rocked. Hollywood is panicky. Nobody seems to know what is going to happen, and everybody, it seems, is more or less perturbed. Directors, scenarists and title writers are trying to adjust themselves to new conditions; for, although relatively few vocalized pictures have been made so far, the producing companies are announcing plans for their production on a large scale. Whether they expect to go through with these plans, or whether they are merely preparing to protect themselves in the event that talking pictures do become a vogue, is a question; but there is no doubt that the threat of vocalized films is hanging over Hollywood like one of Southern California's famous high fogs.

Any one considering the situation should make a distinction between the talking picture and the film supplemented by musical and imitative sounds. When orchestral accompaniments and the noises of such things as steam engines, horses' hoofs, gun-fire and the like were synchronized with pictures, nobody became alarmed. They were an addition, that's all. But when screen actors began to speak lines, the silent drama was attacked. Voices invaded its peculiar domain. Players who had always been dumb—on the screen, at any rate—suddenly feared the command to speak or forever after hold their peace in oblivion.

According to reports from Hollywood, voice culture is becoming the most popular exercise in town. It is said that vocal instructors have sprung up like flowers in the sun shine, or weeds in the rain, as the case may be. Doubtless there are competent teachers among them. Certainly charlatans will reap a harvest, at least for a time. That's the way things go in Hollywood.

All of which is eloquent of the fact that many movie stars are vocally unfit. A few who have had stage experience, and still fewer blessed with natural tone and timbre of voice, are ready to step before the sound-recording machine without fear of unfavorable results But the majority are not so lucky. They are indigenous to Screenland. They have grown up in the studios. Their voices have never been trained, and many of them, exceptionally endowed with personality and appearance, are markedly deficient in voice. It is as if the old law of compensation had been at work again.

It did not take talking pictures to make this evident. A few years ago the motion-picture producers hit on the idea of sending their stars around the country to make personal appearances. They thought it would advertise them. But so many lost prestige as soon as they opened their mouths on the stage that the practice was quickly abandoned. The fans were shocked to hear their glorified favorites speaking in squeaky little voices, provincial accents and rough, uneven tones. The superhuman became all too human for them.

It is the custom of the Writers' Club in Hollywood to stage plays during the Winter season. Motion-picture actors take the parts, and many a player classed as second-rate on the screen has eclipsed a famous star at these performances by the display of vocal superiority. Because of this, some of the sadder, wiser stars now refuse to participate in the club productions.

There are also quite a number of European actors in Hollywood. Most of them speak with a Swedish or German accent. They will have their troubles, too. A Pola Negri or an Emil Jannings might be limited to rôles in which accent was a part of the characterization.

What vocalized films will do to the stars, therefore, has become an agitating question. And what new type of screen actor they will develop is another question dancing on its heels.

In seeking an answer to the latter question, one's thoughts turn first to the stage. Those who have been made most fearful

Gloria Swanson climbed rapidly to stardom.

The lively Colleen Moore.

or hopeful by the introduction of talking pictures see, as in a nightmare or a beautiful dream, all the stage stars of Broadway flocking to the studios. It is extremely doubtful, however, whether any such migration will take place. It is true that motion-picture producers are summoning many stage players to take screen tests, and signing up those who seem at all possible.

It has also been reported that several Broadway producers are planning to make audible film reproductions of their New York plays. But, unless the cinema is to disappear as a distinct medium of entertainment and become merely canned drama again, actors cannot step from the stage to the screen and begin where the silent mimes leave off, for, if the screen player lacks vocality, the stage actor more often than not lacks photographability.

It is a standing irony, as indicated before, that the years which go to make a star valuable on the stage may conceivably militate against that artist on the screen.

Depth of soul and breadth of professional technique which win audiences across the footlights are often attained at a price which repels audiences of the screen. A stage actor flowers usually through experience. It is experience gained from long years in "stock" or on the racking one-night stands or the like. It is experience that often takes toll of the face, showing unmistakably in eyes, in cheeks, in chins. The stage is far enough removed to help conceal such tell-tale signs from those "out front." Distance, supplemented by wigs and grease paint, often effects a wondrous and merciful camouflage.

But facial defects cannot escape the microscopic eye of the lens. The worse they are, the worse they are made to appear under the brutal magnifying of the projecting machine. A Barrymore who combines both seasoned powers and sightliness is as rare as—well, as a Barrymore. Paradoxically, therefore, the more a stage actor has to offer the screen artistically, often the more this seems automatically to disqualify him.

Perhaps there is no more touching sight in Hollywood than the established stage favorite, accustomed to years of professional adulation, who for the first time beholds what he looks like on the screen.

Motion-picture photography will remain light writing. The close-up will still be used. Assuredly, the technique of photoplay construction will be affected by the introduction of sound, but it will still depend largely upon facial fluidity for the portrayal of a character's emotions. Kinetic photography is too well established as a medium of entertainment to vanish at the sound of a voice.

Stage actors have tried the screen before. Many of them have joined the gold rush to Hollywood only to come back to their own world of the stage. Their physical attractions failed at the barrier of the lens. They were not skilled in the pantomime and timing essential to screen performance. Some of them proved to be photographable, but they were the exception, not at all the rule.

These exceptional ones are in the most advantageous position today. They had to check their stage voices at the studio doors when they went in, but now they are called upon to speak their lines trippingly on the tongue. And they can do it, while they also act to the satisfaction of the camera.

It would seem therefore, that, if talking pictures become general, a new school of screen acting must be developed. It will be a harder school than the present, much more exacting. The handsome dancing man and the pretty sales girl, with physical charm and natural gifts for mimicry, will not be able to qualify on these endowments alone. Each must have a serviceable larynx as well.

But the larynx alone will not qualify any one. This point has recently been emphasized by Monta Bell, Production Executive at the re-opened Long Island City studio of the

Paramount-Famous Lasky Corporation, where talking pictures are to be made.

"Stage actors who were denied film careers a few years ago because screen tests proved them undesirable," says Mr. Bell, "should not expect to triumph on the strength of their voices now."

Robert Harris, Movietone executive at the Metro-Goldwyn-Mayer studios, adds:

"There will not be a deluge of stage actors on the screen. Those who do come to the screen will be, for the most part, persons who have had previous experience acting before the camera, although, of course, there are exceptions to every rule.

"We don't feel that our sound pictures will attempt to imitate stage productions. The picture will always be the thing."

Meanwhile, there seems to be no cause for alarm among the screen stars already established in popularity. Even those whose voices lack quality can hold on.

In the first place, as Harry M. Warner, of Warner Brothers, has pointed out, it will take manufacturing organizations at least three years to equip the motion picture theatres of the country with voice-projecting machines. These machines are still in an experimental stage. Improvements are being made in them all the time and no manufacturing company wants to rush into mass production with a machine that may become obsolete overnight.

Also, there is the salvation of vocal doubling. This is something to whisper about. Producers do not want it shouted through megaphones, any more than they hire press agents to advertise the fact, that all the thrilling stunts in the movies are not performed by the heroes and heroines to whom they are attributed. But vocal doubling is possible. A screen actor can go through his scenes, speaking his lines as of old, with no sound recording instrument on hand to betray his vocal shortcomings. Then, by careful timing, some other actor, more euphoniously articulate, can give synchronized voice to his words. It has even been suggested that radio announcers may thus find an extra occupation doubling for raw-voiced screen players.

This resort to double shooting is difficult and adds to the expense of production, but even such an enthusiast for vocalized pictures as P. A. Powers does not believe that the present-day stars of the screen will be discarded because their voices do not register well.

"A popular star represents a big investment," says Mr. Powers, "and has proved screen value. The producers could not afford to scrap such material. By training the voices of those capable of development, and by using doubles for the voices of others, they will keep on the screen the stars the public has come to love."

Reassuring words also come from other producers. Irving D. Rossheim, President of the First National Pictures, says, "The stars of today will lose no importance in tomorrow's

Norma Shearer, who has played in a variety of roles.

talking pictures. Already we have tested the voices of our stars and have found that, with a little training here and there and proper rehearsal before recording, their voices will have the necessary charm and timbre to speak lines effectively."

"To declare that the popular screen stars of today are going into oblivion on account of talking pictures is pure rot," asserts Mr. Warner. "Don't you think the public would rebel if we dropped the people it has grown fond of on the screen?"

"An actress whose charm has won her a following in millions of hearts," adds Mr. Bell, "will not be rejected because her voice is off key."

All of which means that the motion picture producers are not going to throw their expensive stars away. By resort to voice training, vocal doubling, and every other possible expedient they will seek to protect their investments.

This does not mean that, in time, a new school of screen acting will not be developed. Undoubtedly, it will—on the assumption that talking pictures become the permanent and general thing many anticipate. Pretty girls now in the studios looking forward to movie stardom with justifiable confidence in their personality and appearance will fall because of vocal deficiencies. The next generation of movie stars will be different. But, so far as the established stars of today are concerned, the situation seems to be summed up in an old cartoon of the late nineties, which showed a terrified horse running from an automobile, with a farmer, straining at the lines, shouting:

"Whoa! Doggone you! The goldern thing ain't goin' to exterminate you yet!"

* * *

October 7, 1928

RUSSIANS ON SOUND FILMS

What three leading film directors of Russia think of the truly successful linking up of the spoken word with the screen is outlined by S. M. Eisenstein, G. Alexandrof and V. Pudovkin in a joint statement printed in a recent issue of the Vossische Zeitung of Berlin. It reads as follows:

"The old dreams of the talking film are becoming realties. Americans have opened the road to the technique of the talking film and have arrived at the first stages of its realization. Germany is working hard along the same lines. The world is saying that the great mute has found his voice!

"We who are working in Russia know that, considering our technical possibilities, a really satisfactory realization will not be reached very soon. At the same time we find it timely to point out a number of doubts in principle and of a theoretical kind, especially as so far as we know the new improvement is to be used in the wrong way.

"And a false conception of the possibilities of the new technical invention may not only hamper the development of artistic films but may threaten much that has been accomplished thus far in the matter of form.

"The contemporary film, that works through visual forms, has a powerful effect upon human beings and rightly occupies a front sent among the arts. It is well known that the basic—and only—means of action that has raised the film to such a power is the montage (setting). That the montage is the most effective tool has become an indisputable principle upon which the film is being developed on a world-wide scale. The success of the Soviet film on the screens of the world is mainly due to a number of accomplishments in the way of montage which it was the first to develop.

Sound Two-Edged Device

"1. Therefore, it seems that the only important things for the future development of the film are those that strengthen and broaden the effect of the montage upon the spectator. If we look at every new invention from this viewpoint it is easy to see the trivial significance of the color as well as of the stereoscopic film in comparison with the enormous significance of sound.

"2. Sound is a two-edged invention. Probably its exploitation will follow the line of least resistance, i. e., that of satisfying mere curiosity. Here comes, first of all, the commercial exploitation of staple goods, and so we have the talking film. There are such films in which the sounds are produced in a natural way, the sound exactly coincides with the movements in the film and creates a certain 'illusion' of talking persons, falling objects, &c. In the first method of sensational surprise this will not hurt the development of the film art. But it will be awful when the second stage of development will have been attained, when the first surprises of the new possibilities will have become faded and in their place will have arrived an epoch of automatic exploitation of 'highly cultural dramas' and 'photographic performances of

a theatrical nature.' In this way the use of sound would destroy the montage.

"Because when we simply attach the sounds to the parts of the montage, we increase their momentum of inertia as such, as well as their independent importance. And just because of that, the montage, which does not function through individual parts, but through the combination of parts, is injured.

The Blind Alleys

"3. The only use of sound along the line of counterpoint in relation to the visual parts of the montage opens new possibilities for the development and perfection of the montage.

"The first experiments with sound are bound to go in the direction of its sharp division from the visual forms. Only such an invasion will produce the eventual coordination of feeling necessary to create in the future the new orchestral counterpoint of the visual and acoustic forms.

"4. The new technical invention is no mere incidental impulse in the history of the film, but an organic means of escape for the cultural cinematographic advance guard from a number of blind alleys which at first seemed absolutely barred.

"The first blind alley is the film title, with all the helpless attempts to make it a real constituent part of the composition of the montage. These include the breaking up of the title into separate parts and the changing of the size of the letters.

"The second blind alley is formed by the 'explanatory' parts; for example, general plans which only hamper the composition of the montage and slow down the tempo.

"And every day the defining of the theme of the subject becomes more difficult. Attempts to solve the problem by means of tricks with the visual montage alone either lead to nothing at all or they mislead the director into the realm of artificial stunts calculated to make us fear reactionary decadence.

"Sound, as a new element of the montage, as an element naturally coupled with the visual form, certainly will bring new means of enormous power for the solution of the complicated problems which today still seem insoluble to us because of our incomplete methods based upon visual forms alone.

"5. The method of counterpoint in the creation of a sound film not only will do no damage to the internationalism of the film, but it will elevate its importance to an unprecedented power and cultural height.

"With this method the film will not be restricted to the national market, as is the case with the art of the stage or 'filmed' theatrical pieces, but it will have a greater possibility than ever before to carry its idea around the whole globe and to make good commercially on a world-wide scale."

* * *

May 19, 1929

MARX BROTHERS IN FILMS

Harpo Marx is the one player in talking pictures who is said to be fearless before the microphone, because, as has been his habit during his past twelve years on the stage, he

always remains silent. Harpo is the red-wigged unit of the four Marx brothers who made their stage play, "The Cocoanuts," into a moving picture at Paramount's Long Island studio. The film will have its première at the Rialto Theatre on Thursday evening.

Harpo is amused by the fact that his first real part on the screen has come after it has become audible. He relates the story of his previous screen experience when he appeared, for a fleeting moment, in "Too Many Kisses" with Richard Dix.

"I'd been coming over here to work and telling all my friends that I was in the movies," Harpo said. "I was quite excited the night the picture opened. I took everybody I knew down to see me on the screen.

"But it seems the cutters had been at work on the film, and they hadn't figured my acting amounted to much. We sat there waiting for me to come on and dominate the screen, and nothing much happened at all for a couple of reels. Then a short flash of me, looking through a door.

" 'There he—,' my mother started to say. Then I flashed off. '—goes,' she finished the sentence. And that was all they saw of me. I had leaned over to pick up my hat just at that moment, so I never did see myself. I hope I am better off in 'The Cocoanuts.' "

The Spirit Of The Play

Paramount has tried to catch the spirit and speed of the original "Cocoanuts" in the camera. Groucho will pull his rapid-fire line of imbecilities and young Zeppo will be the foil. The cascade of stolen silverware will pour out of Harpo's sleeve, and Chico will let his fingers stagger wildly over the piano keys.

Groucho lived up to his name as the studio schedule forced him to get out of bed after a hard night's work and appear made-up and ready on the set at 9 o'clock in the morning. Harpo is a little fearful that his beloved pickpocket business will be mistaken for trick photography. When he shakes hands with a man on the stage and comes away with his wrist watch, the audience can see that a real manipulation has been performed. Before the camera he will try his best; and the script actually calls for him to steal the shirt off a man's back.

Groucho's mustache came about by chance, he tells you. He used to wear a real mustache; at least real hair pasted on. Then the thing caught fire when he was lighting a cigar, so he evolved the present painted one.

Harpo's grotesque make-up developed by the same chance. He started not as a comic but as the straight of the troupe. They were doing one night stands. By chance they were held over to give a second performance in the same town, and the management demanded a new act.

"In our property trunk I found that old red wig," said Harpo. "So we went out with a slapstick and put on a Patsy Brannigan. It went over so well that we never went back to the old act. The change took place in the town of Commerce, Texas, and I've been a comic ever since. The idea of my never saying anything on the stage was just a chance, too. I was put in a pantomime part once, and it seemed so effective that I just kept on."

Their Early Days

In those early days the Marx brothers were in a musical act billed as the Six Mascots, the others of the sextet being their mother and their aunt.

That mother continued to be their guiding silent partner. She came to the studio to approve or criticize her son's work before the camera. She is the sister of Al Shean of Mr. Gallagher and Mr. Shean fame. She is the daughter of a traveling German magician, and her mother was an accomplished harpist, who handed down her old instrument through the family for Harpo to practice on as a child. Mrs. Marx herself was a professional actress and producer of vaudeville acts.

Those early days before they became the Six Mascots or the Four Nightingales or any of their other vaudeville appellations were grand days of juvenile floundering.

Groucho grew up on the stage, going on first of all as a boy-wonder piano player. Harpo was a bellhop in the Seville Hotel and a cash boy in Siegel & Cooper's department store. He always got fired, however, because whenever there was any music within earshot, he dropped everything and went to it. Chico played the piano, sang, danced, wrestled and entertained generally at the less fashionable little neighborhood theatres. Zeppo was drafted after the war to keep up the Four Marx Brothers tradition when an older brother, Gummo, left to go into cloaks and suits.

It was the mother who assembled this scattered brood, wrote and staged their first act and sent them out on the smallest-time vaudeville circuit for a total of $50 a week.

Their Real Names

One interesting turn of the circle occurs in the making of "The Cocoanuts" as a picture. Just as Groucho Marx was getting his start as a boy here in the old drama of "The Man of Her Choice," another leading man was laying the foundations of a career in, "From Rags to Riches." His name was Joe Santley. And Santley co-directed with Robert Florey on "The Cocoanuts."

Just to keep the numerology straight on the Four Marx Brothers, it might be added that Chico's original name is Leonard; Harpo is Arthur; Groucho is Julius and Zeppo is Herbert. But they call each other by their stage names, and so does everybody else.

* * *

VAMPIRES AND COFFINS

NOSFERATU THE VAMPIRE, with Max Schreck, Alexander Granach, Gustav Wangenheim, Ruth Landshoff and others, directed by F. W. Murnau; Chaplin's old comedy, "The Fireman"; "The Lure of the Labrador"; "Ballet Mechanique." At the Film Guild Cinema.

By MORDAUNT HALL

Because of its age and also the extravagant ideas, "Nosferatu the Vampire," a film supposed to have been inspired by the blood-curdling "Dracula," is not especially stirring. It is the sort of thing one could watch at midnight without its having much effect upon one's slumbering hours. In fact yesterday at the Film Guild Cinema, where this production is now on view, there was at least one man who dozed audibly and another who was either terrified or was enjoying a forty or more winks. But who knows if one or both of these Greenwich Village inhabitants were dreaming of those portions of the picture upon which they had permitted their lazy eyes to fall? There were, however, no signs of these persons having uneasy minds.

This would-be spine-chiller neglects little in its desire to make somebody or other look around for werewolfs, ghosts or vampires. It was directed by F. W. Murnau for a German concern called the Prana Film Productions. The backgrounds are often quite effective, but most of it seems like cardboard puppets doing all they can to be horrible on papier-maché settings.

The chief figure in this orgy of gooseflesh is Count Nosferatu, who is a vampire, according to this story. Prior to disturbing a peaceful village, he contents himself by sleeping in a coffin, using the broken lid as a coverlet. He goes on a voyage, and in picturing this particular chapter Mr. Murnau has made full use of coffins and rats. Shadows are employed to add to the horror of the chief figure, who has extra joints stuck on to the ends of his fingers.

It is a production that is rather more of a soporific than a thriller. Max Schreck's movements as Nosferatu are too deliberate to be life-like. This uncanny person is supposed to have his hands crossed because of his weakness for resting in a coffin. He shuns daylight and creeps about after dark.

Gustav Wangenheim does quite well as the good young man, Waldemar Hutter, who has all sorts of more or less terrifying experiences to get money for himself and his beloved wife.

On the same program is Varick Frissell's "Lure of the Labrador," which is said to have been taken with a small motion picture camera. The result as shown on the screen is interesting, but never quite as absorbing as Mr. Frissell's film, "The Great Arctic Seal Hunt."

* * *

A CHAT WITH CHAPLIN

Comedian Discusses His New Film; Pantomimes Role in Shirtsleeves

HOLLYWOOD, July 10—Charlie Chaplin, who is by no means the easiest man to find in Hollywood, the other day sat at a table in his studio bungalow munching an apple and drinking coffee. He had just changed from his famous big shoes, tiny hat and baggy trousers to his everyday clothes, but as the sun was hot he was in his shirtsleeves. The prince of screen jesters was within a stone's throw of a reproduction of a section of the Thames embankment, erected for scenes in his forthcoming comedy, "City Lights."

He was pensive at first. He may have been thinking of sound versus silence or of new ideas for his current production. Soon, however, as he talked about incidents in his new picture, he became enthusiastic. He is virtually the last of the believers in the silent screen. The only concessions he will make to sound in his "City Lights" will be to have an incidental song, the patter of dancing feet, now and again the tones of a trombone or a cornet that are seen in the picture and the inevitable synchronized music score. He is, however, strongly averse to sound effects, as they are known. He won't have in his film any applause or even the sound of a closing door.

Some of the Scenes

Chaplin doesn't believe that one should really hear anything if one can't hear the characters talk. He portrayed the results by shutting a door and moving his lips without making a sound. From what he said, he was even more strongly opposed to giving shadows a voice than when this present correspondent saw him last year. His friends say that he is worried as to whether his mute work will be successful, but he has no reason for anxiety. For when he expatiated upon the action of his "City Lights" it was quite evident that it was going to be just as delightful a picture as any of his others. Some of the ideas may not be quite new, but they are gilded with Chaplin's whimsy and charming pathos.

He chuckled as he outlined some of the laughable scenes and appeared quite touched over what happened to the little tramp, played by himself. It was the first time Chaplin had told the story of a picture in the making to a reporter and he enjoyed it so that he pantomimed much of the action. It was like watching Chaplin on the stage, minus his disguise. It was a performance that one would willingly have paid well to see. Two friends, who had been seated with him, silently crept away to let the master talk, not that they did not wish to listen, but that they knew that two's company and four's none.

An Attempted Suicide

His denunciation of the talking picture was less interesting than his keen delivery and acting of the three principal characters in his picture. He demonstrated what the tramp did,

what the Jekyll and Hyde inebriate did, and then what the blind heroine did. Chiefly, of course, he emphasized the actions of the tramp who encounters the intoxicated broker on the Thames embankment.

"The drunk, you see," said Chaplin, "is going to commit suicide. He has a noose around his neck and at the other end of the rope is a big stone."

The comedian imitated the way the inebriate fiddled with the rope and then told of the tramp's not being aware of what he was preparing to do. Finally the intoxicated man is ready and then the tramp grasps what is about to happen. He tries to dissuade the other from ending his life.

"He slaps his little chest," said Chaplin, "and admonishes the drunk to be a man and throw out his chest. The actions of the drunk are muddled. He, however, finally slips off the noose and listens to the tramp. Then the drunk decides that no matter what the tramp says, life isn't worth living, and in putting the noose over his own head he also gets it around the tramp's. Then when the intoxicated one stoops to pick up the stone, his own neck is freed from the rope, and when he throws the stone into the river in goes the little fellow."

A Blind Heroine

Chaplin then told of the inebriate's efforts to rescue the tramp and of the scenes in the former's mansion. This bibulous character is, however, a peculiar specimen, for he only remembers his little friend when he is in his cups.

Chaplin then devoted a good deal of time to the sightless girl and the sympathetic tramp, who is at first unaware that the girl is blind. If this is pictured as Chaplin related it, and, of course, it will be, it should make a beautifully poetic sequence. One could shed a tear or two while listening to Chaplin tell the simple little story and one could easily chuckle when he, laughing himself, illustrated the adventures of his three principal characters.

It is a story that rather whets the interest in the picture, for the idea of having seen Chaplin himself acting it in his bungalow, as he did that day, causes one to be all the keener to see the production when it comes to the screen. But when that will be nobody knows, for Chaplin works when he will, or when the spirit moves him. He knows that when the film is finished at least half a dozen men would be ready to give him three or four million dollars for the world's rights, that is, if Chaplin considered disposing of them.

Sound and Just Noise

He said that the success of the hitherto silent screen offerings was due, not to their art, but to the personalities in the productions. Beauty, he said, was frequently killed by the sound of the beauty's voice. Yet, he believed, the actress might have been exceptionally competent in expressing herself in pantomime.

When referring to a dialogue picture he put his fingers in his ears, saying a friend of his had done so in a theatre where a talking film was on view. Chaplin averred that the effect of hearing the voices after gazing at the scenes with stuffed ears, was frightful. He does not believe that the producers know what to do with sound; that is to say, they are not sure where the motion picture finishes and the voices, or the stage technique, begins. He declared that when he sat before a talking shadow he could never make himself believe that the shadow was speaking. It was to him artificial—the voice coming from somewhere, but, no matter how well it was synchronized, not from the image on the screen.

A Dance in "City Lights"

Chaplin, whether he is anxious or not about upholding the silent picture, is well aware that Douglas Fairbanks's production, "The Iron Mask," which has precious little talk in it, was one of Fairbanks's most successful offerings from a financial viewpoint.

In referring to sound effects, Chaplin admitted that he would do a dance in "City Lights," and that the sound of his feet would be heard. He might show a cornetist and a trombone player, and he thought that they should be heard as well as seen. A girl singing a song, he granted, would not hurt his silent production, but he considered that the producers at the present time do not know where to end their penchant for sound. There has been so much sobbing on the screen that people do not want to hear it. It is noise and never stirring!

Chaplin's strongest friends, Douglas Fairbanks and Samuel Goldwyn, who have temporarily deserted the silent picture, do not believe that it has gone for good, even though they anticipate vast improvements in the audible productions.

Harry Myers in Cast

How far Chaplin has gone in his new comedy it is impossible to say, for with his pictures there is always a great deal made that he eventually discovers he does not want. Harry Myers was recently engaged for the part of the drunk, because a predecessor, who had started to work in the film, refused to dive into the "Thames."

Mr. Myers won his greatest distinction by his splendid acting in the Fox picturization of the "Yankee at the Court of King Arthur."

"And who is the girl?" Chaplin was asked.

"Oh," said Chaplin, "she isn't known."

He walked our through the studio grounds to the front gate, where men were busy shifting the façade of the structure to widen the street. None of the workmen appeared to recognize in the clean-shaven, dapper figure the sympathetic little comedian they had so often paid to see on the screen.

MORDAUNT HALL

* * *

September 8, 1929

VOICE, COLOR AND FUN

'Broadway Gold Diggers' a Lively Prismatic Feature

By MORDAUNT HALL

Lively and occasionally broad comedy streaks through Messrs. Warner Brothers' second natural-color talking and singing production, "The Gold Diggers of Broadway," which fact is an emphatic relief after those pictures concerned with a successful singer who wades through a swamp of sentimentality. Not only is this latest offering produced with the late Avery Hopwood's sense of humor, but it also possesses the unusual attraction of lovely pastel shades. And while there is the inevitable stage plot, it is handled with infinitely more intelligence than other similar tales.

The mere fact that it possesses effective clowning as well as appealing prismatic effects makes it an especially satisfactory entertainment. The acting of Albert Gran and Winnie Lightner is easily the outstanding feature of the show. Mr. Gran, who tips the scale at something like 250 pounds, succeeds in giving a true impression of fear of Mabel's (Miss Lightner) boisterous conduct.

There is one episode where Mabel, after pecking Mr. Blake (Mr. Gran) on his chubby cheek and talking to him about "Little Red Riding Hood," leaps on the table and warbles a song called "Keeping the Wolf From the Door," after which she hurls herself into Mr. Blake's arms.

One can sympathize with Mr. Blake when, after he has endured much in the course of the hectic night in a cabaret and is hopeful of a few moments' quiet, Mabel insists on another dance. She declines to listen to her escort's excuses and soon he finds himself performing the more or less light fantastic on the waxed floor.

When these passages were screened on the first night and again last Monday the spectators rocked with laughter. Mabel's effervescence and Mr. Gran's alarm are sure incentives to mirth. The fact that this picture is endowed with natural colors makes the shadows seem all the more real.

In dealing with the Technicolor process the director and others have showered some sequences of this film with lavish settings and costumes. The rainbow hues of the girls' attire are contrasted in some of the stage scenes with those of the ordinary black-and-white dress suits of masculine performers.

It is a picture that affords food for thought, inasmuch as when the wide screen comes into vogue in the cinemas it will give a stereoscopic illusion to ordinary photography, but this impression of depth will be still greater in the prismatic scenes.

The vocal delivery of this film on the opening night was capital, which is possibly due in part to the further experience of operators in the theatre. So for the first time on the screen this "Gold Diggers of Broadway" gave voice, color and a highly amusing yarn. Some of the jokes may not be new, and Miss Lightner undoubtedly distorts her features more than is

necessary, but that does not alter the fact that it is a production with quite a number of convulsing sequences.

Lilyan Tashman, who played Eleanor in the play "The Gold Diggers," in the film portrays that languid creature to a nicety. She endeavors to awe the other fair "forty-niners" with "Oh, mon dieu!" "Epatante," "blagué," "très fatigué" and a few other touches of French embroidery. It is this Eleanor who admits to having a heart of marble, but whose friends cruelly accuse her of having an ossified brain.

Nancy Welford, the Jerry Lamar of this film, does quite well in the part played on the stage by Ina Claire, but she is at her best when she sings. There is a pleasing sureness about her manner of speaking and singing. Conway Teaxle gives an easy performance as Stephen Lee, the uncle. He speaks his lines naturally, without a trace of the discomfort occasioned by the glare and heat of the increased lighting necessary for the Technicolor process, or any apparent self-consciousness concerning the microphone.

Ann Pennington dances two or three times and on one occasion she is perceived tripping through a barrage of multi-colored toy balloons, a scene which is an appealing combination of rhythmic action and pastel shades.

* * *

September 22, 1929

MAMOULIAN'S CAMERA

Rouben Mamoulian, stage director for the Theatre Guild, has finished his first talking picture, "Applause," an adaptation of the story by Beth Brown. Mr. Mamoulian says he tried to incorporate several factors in his picture that will make of it a photoplay that is more than a photograph of a stage play. He has had the courage to forage in what is for him an entirely new medium, and the result will be seen when the picture is shown at the Criterion Theatre on Oct. 1.

"This picture that you will see," Mr. Mamoulian says, "is an example of the use of the perambulating camera along with the ordinary use of the microphone, an instrument that is not yet a selective earpiece."

He forgets, modesty forcing it no doubt, his sense of artistry, his stage experience, his feeling for design and his knowledge of dramatic values.

"When I started my first sequence," he continues, "with Helen Morgan in the leading rôle, the scene that was photographed with a mobile camera ran for 500 feet and then the studio executives thought that I was engulfed in a morass of revolutionary ideas.

"The camera men and technicians didn't quite like the idea either, I suppose. I lifted the sound-proofed camera off its feet and set it in motion on pneumatic tires. Scenes moved out of one room and into others without halt. I tried to introduce what I call counterpoint of action and dialogue. The camera flew, jerked, floated and rolled, discarding its stubborn tripod-legs for a set of wired wheels that raced over the studio floors.

Uninterrupted Scenes

"The camera here becomes descriptive in a new sort of way. Where a break in the ordinary film to allow for a close-up has been the modus operandi, I now guide my lens along a straight and continuous line, without breaks in continuity, without needless explanatory speeches and also sans the printed subtitle.

"Thus the film begins to grow. It has three breaks in it. The first is to denote a passage of twelve years in the growth of a child. We show the youngster, the daughter of a burlesque queen, immediately after birth, lying in its crib backstage kicking its feet at the painted faces of performers leaning over the edge of the bassinet. To denote the passage of time, there is a fade-out to blackness and then in again on another pair of feet, this time they are kicking, but in a dance. It is the same child twelve years later beginning to ape its mother.

"The child's mother approaches her and puts her arms on her shoulders. Some one speaks and offers the suggestion that the baby shouldn't be learning these stage tricks and that she would be better off in a convent, away from the grease paint and the stage. The mother's hands are seen in a close-up on the child's shoulders. The mother says 'No,' but as she says it there is a slow transformation. The soft, manicured hands of the burlesque queen, covered with cheap jewelry, are gradually changed into the bony, severe hands of a nun, and the jewelry has now become a rosary, and the obvious prattle of actors melts into the chanting of the evening prayer.

"The avoidance of the obvious and an interchange of sequences that lends to the speed of the picture without letting up on the interest. This is what I offer in this film. From the point in the convent garden the camera rises and focuses on a cross, high above the convent walls. This cross grows more and more diffused and is gradually changed into the shadow of the mother whose silhouette on the stage curtain—before which she dances with hands outstretched—takes the form of a huge cross.

"As in music, I have tried to attain counterpoint in the film. Not alone in action on the screen, but in sound. For example, when the mother bends over the child singing it to sleep with a lullaby fashioned from a vulgar and blatant burlesque tune, the camera leaves her for a moment and goes to the head of the child, who reaches under her pillow for her rosary and whispers her prayers. Here is a counterpoint of sound: the whispered prayer in opposition to the lullaby. Two unconnected sounds heard at the same time, that form a melodious whole.

"I have also tried to keep design in mind. There is always one force in motion played against another, and the camera rises and falls to catch the decorative element whether still or in motion.

"The camera then becomes an invisible spectator. An invisible and very inquisitive and intelligent one, with a magnificent sense of selection. This invisible person has the ability to glide over to any spot and pick out the more important details without the sacrifice of loss of time or interest. Obviously, this is a decided advantage over a similar performance on the stage.

"By carefully timing the sequences and exercising stop-watch precision in rehearsing the cast, I believe I have a completed film that needs but a minimum of cutting. By cutting-in separate close-ups or irrelevant shots that may possibly have some connection with the story the fluidity of the finished work would be destroyed."

Color does not interest this director yet, because he believes the effects are too glaring and unreal. He says that with such a magnificent scale of values in grays and blacks now possible in photography, he sees no reason for employing color until it has been greatly improved.

Some day he hopes to make a really intellectual film—a story that is beyond that of everyday studio productions and with a psychological rather than a sexual theme.

"This idea that a film may be too far above the heads of the great Western audience or the great Eastern audience is bunk," he said. "There is no such thing. If a film, or any work for that matter, combines a simple genius in depicting the story with a true understanding of what is being done, it will be a success, not alone for a 'certain level' in audiences or in big cities but for every one.

"Of course there are films that could be made but shown only for selective audiences. Shaw, for example, would not be easy for every one to digest. But certainly the time is coming, if by slow stages, when the appeal to the intelligence from the screen will be greater than its pictorial and purely entertaining values."

He feels that there is nothing that he has learned while making the motion picture "Applause" that he could benefit by in his work on the stage. He has tried motion-picture ideas on the stage before with varied success. For instance, the use of the close-up on the screen he attempted in one of his stage productions by employing spotlights and dimming the lights on the other characters. In his production of "Sister Beatrice," which he staged for the Eastman Rochester Theatre, he introduced the four walls idea to the stage. By turning the setting around on the platform and each time removing a different wall, replacing the one that had previously been absent, he said he achieved a movement—a sort of third dimension.